This Book was presented

by

Patricia Mutton

1994

THE ENCYCLOPEDIA OF
AUSTRALIAN
ART

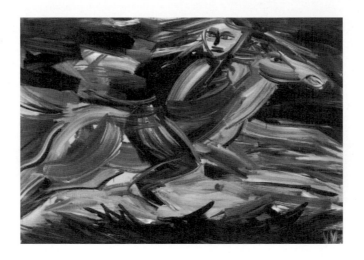

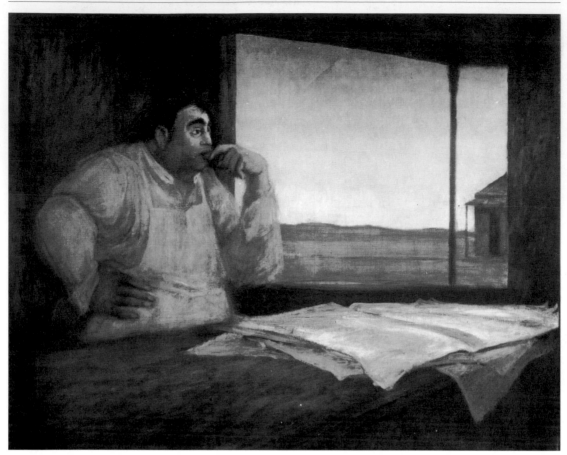

Previous page: Vicki Vavaressos, Spurring the Horse to a Gallop, She Leapt Over the Parapet, Down to the Sea Below, *1990, acrylic on hardboard, 138×183 cm. Courtesy, Watters Gallery, Sydney.*

Above: Russell Drysdale Joe the Greek, *oil on canvas. Private collection.*

THE ENCYCLOPEDIA OF
AUSTRALIAN ART

ALAN McCULLOCH

REVISED AND UPDATED BY

SUSAN McCULLOCH

ALLEN & UNWIN

First edition 1964; reprinted with corrections 1967
Second edition 1984
This edition 1994

Allen & Unwin Pty Ltd
9 Atchison Street, St Leonards,
NSW, 2065.

National Library of Australia
Cataloguing-in-publication
McCulloch, Susan
The Encyclopedia of Australian Art

ISBN 1 86373 315 9

1. Art, Australian – Dictionaries. 2. Artists –
Austalia-Biography – Dictionaries. I. McCulloch,
Alan 1907–1992. II. Title

709. 9403

Designed by Barbara Beckett
Production Susan McCulloch
Typesetting and Separation in Hong Kong by
Graphicraft Typesetters
Printed in Hong Kong by South China Printing
Company

Note: Every effort has been made to obtain copy-
right permission for reproduction of illustrations in
this book. The author invites any copyright holders
who have not been contacted to write care of the
publishers.

This project has been assisted by the
Commonwealth Government through the 'Earnback'
scheme of the Australia Council, its arts funding
and advisory body.

CONTRIBUTORS
Robyn Clarke (updating of Crafts in Australia).
Professor Jenny Zimmer (updating of Collections,
Funding, Magazines section plus 10 essays and two
collaborative essays)

RESEARCH ASSISTANTS
1984 EDITION
Charles Nodrum

1994 EDITION
Andrew Campbell (part-time) October
1991–January 1992
David Thompson (part-time) February 1992–March
1992
Janine Bove April 1992–August 1993

CONTENTS

PREFACE

This is the third edition of the *Encyclopedia of Australian Art*. Its first publication was in 1964 and was written solely by my father, Alan McCulloch, after almost twenty years of collecting material and five years of intensive work researching and writing.

Information in the first edition was largely historical and included relatively small percentage of living artists. For contemporary Australian art while undergoing one of its most vital periods, was still suffering the 'cultural cringe' of the time and was the pursuit of and interest to a relatively small number of the populace. Indicative of this was that the *Encyclopedia of Australian Art* was first published in England — the publishers selling copies to their Australian branch, then little more than a sales office. Indigenous Australian publishing, like most of the other art forms was very much in its nascent stage.

By the second edition in 1984 rapid growth had occurred and about double the number of living artists (around 400) were included. But this was nothing compared to the rate of growth of the arts during the 1980s. In this edition there are about 1800 living artists, some of the many thousands of art practitioners and those employed in arts-related activities.

Artists have been chosen for inclusion if their work is represented by purchase in a national, state or regional gallery or they have won a major prize. This has enabled us to decide from the thousands and thousands engaged in gainful artistic activity who should be included. There will inevitably be omissions, not deliberate but by virtue of the sheer amount of work involved in this project.

We made every effort to contact the copyright owners of works of art. Where contact has not been made we invite owners of the copyright to contact us through our publishers.

Because of the enormous volume of material some selection of information needed to be made. All studies, qualifications, awards and appointments have been included or highlighted to indicate those most significant. In general, numbers of solo exhibitions, the cities and names of the gallery have been included. Group exhibitions have been selectively listed, with a concentration on the most major touring and/or public gallery shows. Where an artist has appeared in a major public or touring exhibition it is recommended that the catalogues of those exhibitions be obtained for further information. Listings of artists' bibliographies were limited to monographs on the artist's work or books in which they are mentioned and issues of art specialist magazines. The many reviews, interviews and feature articles in the daily press were not able to be included. Where possible representation in all public collections and major corporate collections have been specified.

SUSAN MCCULLOCH
APRIL, 1994

A PERSONAL NOTE

'Ars Longa Vita Brevis' may well be the most famous art-related maxim in written history. Attributed usually to Hippocrates it has been quoted by many philosophers and writers including Seneca, Chaucer and Goethe.

Thus at the dawn of written history, art is placed in its time slot; but the maxim does not tell us what art is. As with electricity we know what art does but we don't know what it is. Those who have tried to solve this problem have all concluded that the word 'art' cannot be defined. Support for this conclusion came from Murray in answer to a question about his Oxford Dictionary; 'the word 'art' gave me more trouble than any other word in the English language'. However if history has failed precisely to define the word it has enriched the language with a steady stream of colorful aphorisms, epigrams and adages about the mystery without which 'art is not art at all'. One of the best of these comes from Goethe: 'a work of art is like a monarch, you stand in front of it and wait for it to speak to you'. One of the most beautiful comes from the Jesuit Jacques Maritain: 'the artist is confronted with a sea, vast and lonely without a mast or fertile isle and the mirror that he holds up to it is no bigger than his own hand'. Oscar Wilde believed that art was the one and only morality and paid a hefty price for practising what he preached. And Emile Zola came close to a profound truth when he wrote that 'art is life seen through a temperament'.

Down the centuries within the borders of our Western records there has been a constance change of focus in the visual arts from country to country and city to city. Those centres have shifted from Athens to Rome, Italy to Germany, Germany to Flanders, and Amsterdam, Paris, London, back to Paris and then to New York. Now where? In our confused times the centre has been split. And who knows where or when or how the parts might re-unite? Or what might grow from the grafting of a new tree.

ALAN McCULLOCH
DECEMBER, 1992

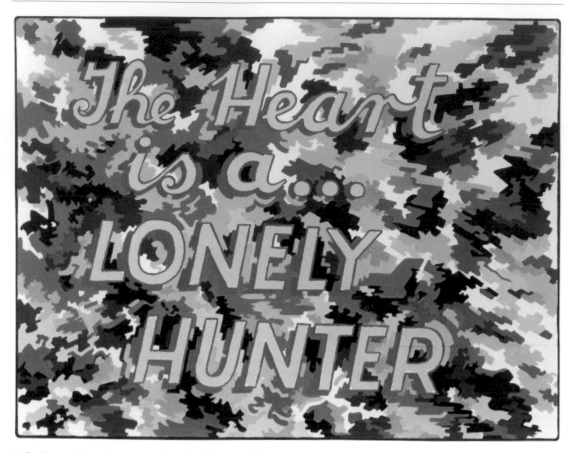

Mike Brown, The Heart is a Lonely Hunter, *1992,*
acrylic on plywood, 91×122 cm. Courtesy, Charles Nodrum,
Melbourne.

INTRODUCTION

Curiosity about living things is vital to the artistic psyche, and just as the first known artworks by prehistoric man in Europe are drawings of animals on cave walls, so the first-known examples of indigenous Australian art are Aboriginal engravings on rocks, and the first-known European representation of a recognisably Australian subject, a drawing of a Kangaroo with young in her pouch. It appeared on the title page of *Speculum Orbis Terrae*, a Latin geography by Cornelis de Jode, published in Antwerp, 1593, and reproduced in Rienits' *Early Artists of Australia* (1963). Of equal interest, historically, are the engravings in Francis Pelsart's *Journal* (Amsterdam, 1648), illustrating the story of the wreck of the Batavia on Houtman's Abrolhos, W.A., 4 June 1629, and the hanging of the mutineers. William Moore (*SAA*, 1934) mentions also Francois Valentyn's *Oud en Nieuw Oost Indien* (Amsterdam, 1726), and a drawing illustrating Willem de Vlamingh's exploration of the Swan River. William Dampier's artist made on-the-spot drawings of birds and fish on the west coast of the continent in 1688, but it was not until 1770 that aspects of the east coast and its inhabitants were pictorially recorded by Sydney Parkinson, Captain Cook's artist in the Endeavour. Unfortunately none of Cook's artists survived the voyage and it was left to later artists of the First Fleet, such as John Hunter, William Bradley and George Raper, to make more accurate pictorial records. The 50 years following Cook's voyages saw the opening up of most of the Pacific area, the recording of its unrivalled ethnological and biological treasures being entirely on the perceptive skills and training of the maritime artists. Whether commissioned for exploration or scientific observation of the planets, all expeditions included artists. William Hodges, William Westall and Ferdinand Bauer were among those serving on British ships; Piron, Nicholas Petit and Charles Lesueur among those on French ships. Bernard Smith gives an excellent account of the various voyages in his *European Vision and the South Pacific* (1960), and in 1981 a set of 17 superb facsimile plates of drawings by the French maritime artists was published by the Bank National de Paris to celebrate the centenary of its operations in Australia.

Chief patron of the first British topographical, zoo-logical and botanical artists was Sir Joseph Banks, and it was due largely to his enthusiasm that officers of the military garrison in Sydney, such as John White, George Tobin and James Wallis, developed their skills as artists. Other artists, such as John William Lewin and George William Evans, arrived as free settlers, and among the best were the convict artists Thomas Watling, John Eyre and Joseph Lycett. Later convict artists included also the architect Francis Greenway. Encouraged by Lachlan Macquarie, governor of the colony, 1810–22, Greenway built the gracious, colonial houses that established him as a forerunner in the history of Australian domestic architecture.

This general pattern of artistic activity in New South Wales was repeated in Van Diemen's Land where, in addition to the paintings of William Buelow Gould, Thomas Wainewright and Thomas Bock, were the Anglicised landscapes of John Glover, an artist of established reputation in London. Hobart Town thus became a small but vital centre of colonial culture, especially after the arrival of Governor Sir John Franklin and his wife, who jointly encouraged artistic activities of all kinds, including the building of cultural institutions. John Glover, who had private means, went on to become known as the patriarch of Patterdale, the farming property he created, and as an institutional figure in his own right.

Less fortunate than Glover was Conrad Martens, a painter whose watercolours of Sydney Harbour, in particular, had much of the radiance of the work of J.M.W. Turner, the painter he most admired. Unable to make a living from his painting, Martens was obliged in 1863 to accept a post as parliamentary librarian, a position which he retained until his death. Similarly, the Tasmanian-born painter, W.G. Piguenit, worked for most of his life in the Civil Service before being able to devote himself full-time to his art. The first half of the nineteenth century was a hard time for artists working in the Australian colonies. The only artist who appears to have made a reasonable living from his art was the field artist, William Strutt, whose experience as an illustrator made him eminently suited to depicting such events as the Separation of Victoria from New South Wales, given by Royal Assent, 5 August, 1850, Black Thursday (symbol of

the disastrous bushfires that swept Victoria in early Feb. 1851), and the opening of the Princes Bridge, Melbourne, 15 Nov. 1851.

The year 1851 was momentous, for in that year, following the discoveries in New South Wales some twelve months previously, gold was discovered in Victoria. The discovery was to change the pattern of Australian society virtually overnight. The richest strikes were at Ballarat, Bendigo and Mt. Alexander, which were soon crowded with hordes of gold-seekers from all parts of the world. In 1850 the population of Victoria was approximately 75,000; by 1854 it had reached 283,942; by the end of the decade, 540,322. The huge peripatetic population included Samuel Thomas Gill, pictorial chronicler of urban life in South Australia prior to becoming celebrated as the artist of the Victorian goldfields. Gill became the victim of the life he so brilliantly depicted, unlike George Rowe, who spent several years completing the series of panoramic drawings for which he had been officially commissioned, before returning to England and the presentation of a gold medal at the Kensington Exhibition in 1862. More lasting in their influence on Australian art were the paintings of the Austrian, Eugene von Guerard, the Russian, Nicholas Chevalier, and the Swiss, Louis Buvelot. Buvelot's landscapes, in particular, had much of the romantic feeling of Barbizon School painting. In the words of the critic, James Smith, 'what Millet and Corot have done for France, M. Buvelot is doing for Victoria.' All these painters had to struggle for recognition, especially in the rip-roaring days of the gold city of Melbourne. But the struggle was much harder for sculptors. Nevertheless the first flowering of this esoteric art (as it was considered then) took place in the goldrush period.

Thomas Woolner produced a notable group of fine bas-relief works, and like the stone-carvers J.S. Mackennal, James Scurry and Francois Fallet, and Von Guerard's friend, Emil Herman Todt, pioneered the art of sculpture in Victoria. Charles Summers produced the great monumental work of the period, the immense bronze memorial to the explorers Burke and Wills, and with the formation in 1898 of the Yarra Sculptors Society by C.D. Richardson, W.C. Scurry, Margaret Baskerville and others, sculpture became well entrenched in the developing culture. Meanwhile the edifices built to enshrine and commemorate the aesthetic achievements of the new country had rapidly taken shape.

Civic pride, fostered by Separation and greatly stimulated by the prosperity of the goldrushes, led to the building in Melbourne in 1861 of the National Gallery of Victoria, the first great Australian public building planned solely for the housing and study of the visual arts. Other state gallery buildings followed. The Tasmanian Museum and Art Gallery was completed in Hobart in 1863, followed by the Art Gallery of New South Wales, Sydney, 1874; the Art Gallery of South Australia, Adelaide, 1879; the Art Gallery of Western Australia, Perth, 1895; and the Queensland Art Gallery, Brisbane, also 1895. Most of these were multi-purpose institutions, housing state libraries and natural history museums.

As well as art galleries; many of the buildings resembled the converted royal places of Europe and many titles were erroneously prefixed with the word 'National', a legacy from the early interstate jealousies. Meanwhile, in London, the Great Exhibition of 1851 had created a precedent for the international exhibitions which sprang up in sequence in Paris, Brussels, New York, Munich, Vienna, Philadelphia and other world centres. While these concerned mainly trade, they gave great stimulus also to the visual arts. Australian's first Exhibition Building was built in Melbourne in 1854, followed by the Garden Palace, Sydney, 1879, and the new Exhibition Building, Melbourne, 1880. The 1879–80 buildings were built specially for the first Australian International Exhibitions of 1879–81.

In *The People of Australasia* (introductory chapter to the *Picturesque Atlas of Australasia*), Frank J. Donohue attributes 'the origins proper' of public collecting in Australia to the International Exhibitions of 1879–80. Meanwhile the situation of professional artists remained precarious and the enthusiasm of the emerging generation of young painters such as Roberts, McCubbin and Streeton was sustained mainly by youthful optimism. Older artists, such as the sculptor J.S. Mackennal and the painter Van den Houten, welcomed assistance from the Art Unions which flourished in Victoria in 1872. Not that the situation in Victoria was worse than in other states; the collapse of the land boom and subsequent disastrous closure of the banks in 1893 effected the whole country. Best off were the artists who obtained work as engravers or illustrators for the illustrated journals and newspapers. Like William Strutt, some of the artists had been trained as field artists. But they were in a minority and in 1878 Julian Ashton was brought from London specially to work as an illustrator for the Illustrated Australian News. His brother George joined him a year later.

George Ashton became Melbourne correspondent for the Sydney Bulletin and Julian moved to Sydney to work on the *Picturesque Atlas of Australasia* for an annual salary of £800, a substantial amount at that time. Published in series (1883–86), the Atlas gave employment to a large number of artists and engravers.

During the last quarter of the nineteenth century, no single artist influenced the course of Australian art more than Tom Roberts. Inspired during travels in Europe, by the new movements in France, specifically plein air impressionism, he returned to Melbourne in 1885, to establish, in company with two old friends, Frederick McCubbin and Louis Abrahams, the first of the artists' camps at Box Hill. Basic to the principles he taught was the depiction of nature painted spontaneously in the open air. In 1888 the group, which now included Arthur Streeton and Charles Conder, moved its headquarters to Eaglemont, near Heidelberg, the climax to the activities being the 9 × 5 Impression Exhibition held in Buxton's Gallery, Melbourne,

1889. The exhibition caused a sensation but its final outcome was to bring before the public the true beauty of the natural Australian landscape. For the first time in Australian landscape painting the eucalypt triumphed over the oak, and the brilliant sun of Australia Felix (title of a painting by Streeton) replaced Europe's softer lights. On large canvases and tiny cigar-box lids the young painters of the Heidelberg School celebrated their discovery of the colours of their country – blue and gold. But to fully understand the importance of this movement, it is necessary to glance at the art societies and institutions which now represented the visual arts at official level. These rallying points for artists and dilettanti began with the South Australian Society of Arts in 1856, followed by the Victorian Academy of Arts, 1870; the Art Society of New South Wales, 1880; the Tasmanian Art Society, 1884; the Queensland Art Society, 1887; and the West Australian Art Society, 1896. Idealistic in the early days of their existence, these institutions later became centres of political conflict, the main issues breaking out between professional and amateur artists. In Melbourne, the young Heidelberg School artists were leaders among the groups in revolt, and their influence soon extended to New South Wales and other States. They fought and won the battles of the societies but in so doing made many enemies, among them some members of the administrative boards of State Galleries. Understandably, institutions governed mainly by laymen in a colonial Victorian society were extremely conservative in their views and therefore unsympathetic towards art of an adventurous or revolutionary nature. This attitude proved to be inimical to the interests of the institutions themselves as well as to the artists. Painters such as J.P. Russell, Rupert Bunny and E. Phillips Fox, for example, left for Europe soon after their student studies, to become permanent expatriates. Other students who left to develop their talents in Europe found no inducements to return and, in Melbourne, the Trustees of the National Gallery of Victoria, became so concerned that they seriously considered inserting a clause in the Travelling Scholarship constitution compelling winners to return to Australia within a prescribed period.

Meanwhile the tide of art affairs had moved from painting to illustration. A great period of book and magazine illustration had set in, and in Australia, as elsewhere, it attracted much talent that might have otherwise been devoted to painting. The period is summed up in Joseph Pennell's book Pen Drawing and Pen Draughtsmen (London, 1889). In Australia, the names of Phil May, Livingstone Hopkins, Alf Vincent, B.E. Minns, D.H. Souter, the Lindsay brothers, the Dyson brothers, Percy Leason, David Low and many others, became famous through their work for the Bulletin. Black-and-white art held its high place as a creative art for more than four decades, and its principal luminaries, among them Norman and Lionel Lindsay, Will Dyson and Percy Leason.

The twentieth century began with the decline of Heidelberg School painting, and after World War 1 artistic emphasis was on ornamentation in pottery and furniture design. Painting of the day was marked by lyricism, romantic feeling and the application of manual dexterity. The mannerist painter, G.W. Lambert, who had drawn for the Bulletin and made his reputation as a war artist was the great name of the period. His Bronzino-inspired, bravura style was complemented by skilful portraits by John Longstaff and W.B. McInnes, and dexterous landscapes in watercolours by Hans Heysen, Harold B. Herbert and their many followers. Offsetting this concentration on skill were the romantic watercolours of J J Hilder, R.W. Sturgess and William Blamire Young, who had responded to the influence of the Beggerstaff brothers, London, and their rediscovery of the poster. A counter to this style was the tonal painting of Max Meldrum, 'the stormy petrel' of Victorian painting for more than two decades. Meldrumism had a large following but, since it was based on personality and scientific observation, it had little effect outside its own circle of adherents.

If this period erred on the side of conservatism and upheld the traditions of the Royal Academy, London, as the epitome of all that was best in art, its influence was already on the wane. As early as 1915 the stirrings of modernism had been felt in Sydney when Nora Simpson, who had been studying in London, brought back reproductions of work by modern French painters, to circulate them among students in the classes conducted in Sydney by Dattilo Rubbo. One of the students, Grace Cossington Smith, painted a picture entitled The Sock Knitter, probably the first complete, modernist canvas painted in Australia. The new movement developed gradually in the work of de Maistre and Wakelin, but it was not until 1931 that Dorrit Black started her Modern Art Centre to give the movement an impetus carried further by the work of Grace Crowley, Rah Fizelle and other enthusiasts. The movement was slower to develop in Melbourne, but when it did (beginning with the activities surrounding the Bell-Shore School, supported by William Frater and Isobel Tweddle, the critics Basil Burdett and Adrian Lawlor and the bookseller, Gino Nibbi) it led to many direct and bitter confrontations. Meanwhile from the 1930s gradually increasing numbers of artists migrating from Europe were helping to improve and broaden aesthetic standards and tastes in most Australian capital cities. To Sydney in 1939 came the Hungarian, Desiderius Orban, to establish his famous school and give new meaning to the medium of pastel and publish a book on modern art, and in many other ways make his name known throughout Australia as artist and educator. Orban lived to the great age of 102 years and was still working in the year of his death. Imre Szigetti, illustrator and draughtsman, also arrived in Sydney in 1939 while in Melbourne in 1940 the ship the Dunera brought the former Bauhaus colourist, Ludwig Hirschfield-Mack, the historian, philologist and anthropologist, Leonhard Adam, and a group of young industrial designers including Erwin Fabian, Fritz Schonbach

and Klaus Freideberger. Leonhard Adam was to collect the neglected Aboriginal art of Arnhemland and Groote Eylandt and establish the Museum of Primitive Art at the University of Melbourne.

In 1938 the Contemporary Art Society of Australia Inc (CAS)was formed in direct opposition to the Australian Royal Academy project headed by the attorney General, the Hon. R.G. Menzies. In the late 1930's the Colonel de Basil Russian Ballets (inherited from Paris and the great Diagilieff ballets of 1909) had given colourful support to the modern movement through the decor designs of the Russians Bakst and Benoir and the French moderns such as Picasso. In much the same way as they effected France the Ballets Russe turned half the theatre going population of Australia into balletomanes and completely changed local concepts of theatre and design. The war between the academics and moderns gained further momentum by the arrival in Australian capital cities in 1939 of the *Exhibition of French and British Contemporary Art* organised by Basil Burdett and backed by Keith (later Sir Keith) Murdoch for the Melbourne *Herald*. This exhibition was to have profound effects on many young Australian artists including Tucker, Boyd and Rees and was the most significant exhibition for fifty years. War broke out before the exhibition arrived in Australia adding a grim note to a period already packed with drama. Directly or indirectly the war cost Australia the lives of Peter Purves-Smith, Wilfred McCulloch, Laurie Veale and seriously disrupted the careers of many others; but in another way it proved to be a catalyst that introduced German Expresssionism and its proponents – Beckman, Grosz, Nolde and Marc to Melbourne.

In Sydney the editor of the magazine *Art and Australia* Sydney Ure Smith published a series of books on modern Australian art including Bernard Smith's *Place, Taste and Tradition* (the second only book on Australian art history, the first being William Moore's *Story of Australian Art*, 1930).

In 1944 newspaper headlines broke the story that legal action had been taken to restrain the judges of the 1943 Archibald Prize from handing over the money to the winner, William Dobell. The plaintiffs claimed that the painting was not a portrait but a caricature. The case caused a sensation that lasted for years and split the arts community irreversibly. Throughout Australia it placed Dobell at the titular head of the modern movement, just as Manet had been placed in France for his *Dejeuner Sur l'Herbe* in 1863 and awakened the visual arts as never before.

A new spirit of expressionism and focus on Australian subjects prevailed in post-war Australian painting and led to important representations of Australian art, first at the Whitechapel Gallery in 1961 then, in full scale, at the Tate Gallery a year or so later. In Sydney in 1951 the former Victorian, Russell Drysdale, had been commissioned by the Sydney Morning Herald to record in a series of drawings, the drought-stricken areas of north-west New South Wales, thus laying a cornerstone for the movement later to be dubbed 'Antipodean'.

Australian history provided another corner-stone for the movement in the work of Sidney Nolan. Inspired by the Russian migrant, Danila Vassilieff, Nolan applied a spontaneous, child-like vision to transforming the bushranger, Ned Kelly, into a folk hero. Many artists had depicted Kelly but none previously had thought to canonise him in this way. The idea ultimately brought Nolan a celebrity that extended beyond the confines of his own country.

In Melbourne Albert Tucker, Arthur Boyd, John Perceval, Noel Counihan, Josl Bergner, John Brack, Charles Blackman, Clifton Pugh, Fred Williams were showing for the first time – often at John Reed's Museum of Modern Art and Design.

Vassilieff in Melbourne and Sali Herman in Sydney found their subjects among the old buildings and streets of the poorer parts of their respective cities, while the fugitive but fascinating abstracts of Ian Fairweather, Godfrey Miller and John Passmore came to the fore to inspire a whole generation of students. Justin O'Brien, Michael Kmit and Eric Smith looked to the religious icon for inspiration, as shown in the work that gained them early success in the Blake Prize for Religious Art. Preceded by the Dunlop Prize in Melbourne, the Blake Prize was the forerunner of a period of great art prizes, a pattern which had swept the art of the USA in the 1930s. National prizes, such as the Alcorso-Sekers, Brittanica Australia, Flotto Lauro, Comalco, Georges, Rubinstein, Transfield, Travelodge, Wills, Australian Women's Weekly, all developed a unique annual glamour, creating interstate forums at which artists, gallery directors, critics and sponsors met in a spirit of mutual optimism.

Australian sculpture also entered a new phase, the main sponsorship coming not from state galleries or even from city-based art prizes, but from the regional gallery at Mildura, Victoria, with the establishment in 1961 of the Mildura Sculpture Prize. This heavily publicised event also drew attention to the Victoria's other fifteen regional galleries, which had started in goldrush times with the building of the Ballarat Fine Art Gallery. By 1980, collectively they owned the largest holdings of Australian art in the country and the regional gallery movement had spread to New South Wales and other states.

In 1953, a series of superb touring international exhibitions began with *French Painting Today*, organised, like most of the others of this period, by Hal Missingham, Director of the AGNSW. Even more colourful were the three first biennial Adelaide Festival of the Arts which began in 1960. The Festivals drew their audiences from all parts of Australia and, in the sense that they were international rather than local, summarised the spirit of creativity of the times.

In 1966, a new influence was brought to bear on Australian painting with the exhibition, *Two Decades of American Painting*. Its immediate follow-up was *The Field*, an exhibition mainly of hard-edge and geometric-abstract paintings by young Australian painters, organised for the purpose of giving the new National Gallery of Victoria a fresh, youthful appearance at its

opening on 20 August 1968. The state galleries had been modernised and extended in Adelaide and Sydney in 1962 and 1972 respectively, but the new multi-million dollar state gallery in Melbourne was the first of its kind, and the first building completed within the vast Victorian Arts Centre complex. The new Art Gallery of Western Australia was completed in October 1979, followed by the new Queensland Art Gallery, opened in June 1982, and the first Australian National Gallery (since 1992, the NGA) which opened in Canberra in October of the same year. All these buildings animated the general art scene and led to important 'changes in the status of artists.

Federal government funding for the arts had been slow in developing, but in 1967 the Prime Minister, the Rt. Hon. Harold Holt, announced the formation of an Australia Council for the Arts and an initiating committee was appointed during the following year. In 1973, Whitlam's Labor Government established the Australia Council. Substantially funded, the Australia Council radically changed the state of the arts in Australia.

Another strong contributory cause for change in the visual arts of the 1960s was the growing interest in fine arts in universities. The first Chair of Fine Arts had been formed at the University of Melbourne in 1946 and by 1970, its graduate students had begun to make their presence felt in many ways, particularly in the areas of teaching, curatorial administration and critical writing. The Power Institute came into being at the University of Sydney in 1967 and, by 1980 departments of fine arts existed in most Australian universities. Arts departments of various TAFE colleges and several colleges devoted to the teaching of the arts provided an increasing number of readily available tertiary practical arts courses.

During the 1970s and 80s the extraordinary global changes had particular consequences for the visual arts of Australia. Protected once by a far-flung geographical location that permitted such influences as reached the continent slowly to develop local characteristics, Australian became exposed in the late 1960's – through direct assault by television and attendant media – to instant world communication. Not recognised at first, this proved in many ways inimical to the culture's pioneering energy and freshness. Thrown into the scrum of open competition, Australian art became a tiny component in a huge game played in foreign terrain.

During the 1980s the struggle for Australia to take its part in this vast art scene continued and saw a huge explosion of visual arts activity both in Australia and overseas. Most promising in Australian terms was the revival of a new Aboriginal art. Mourned once as a culture irredeemably lost the introduction of new materials enabled the talent for visual expression inherent in so many Aboriginal people wishing to keep their culture alive, flowered – the results making Aboriginal art a strong, vibrant and significant force on the world art scene. The 1980s saw too the worldwide phenomenon of art as a corporate commodity – ranging from the enormous sums paid for individual paintings, to the art collections established by many major companies, to the multi-million dollar 'blockbuster' exhibitions. There were several recognisably 1980s 'styles' in vogue for several years during the 1980s by Australian artists – such phases have included the Pop-related paintings reflecting the influence of Andy Warhol; the new expressionism of the Melbourne-based ROAR group of painters; non-objective installations and performances; heavily theorized post-modernist paintings; neo-romantic 'appropriation' with its incorporation of the images of previous centuries. Threaded through these styles largely practised by the youngest and emerging artists have remained the staples of abstract expressionism, geometric abstraction and figuration of the more established painters.

During the 1980s art impinged on the public consciousness more than ever before. Controversies about purchases such as the NGA's 'Blue Poles' and the NGV's 'Weeping Woman' contributed to debates as had the controversy over Ron Robertson-Swann's 'Vault' sculpture in Melbourne's City Square and events such as the Sydney Biennale, Perspecta and the various arts festivals of Adelaide, Melbourne and Sydney. The 1980s saw also a huge increase in art documentation with a number of art magazines ranging from those favouring theoretical and in many cases, obscure writings to those aimed at a more general readership being established. Attendances at galleries increased vastly as did the number of art students graduating from tertiary art schools.

If as is often said, art cannot be defined, it is nevertheless true to say that it is the creative impulse common to all people but implanted in some to an obsessive degree. As such in the 1990s the visual arts in Australia, despite the recessive times of the 1980s has become a major industry employing thousands of practitioners, administrators, and commentators and making a vital and vibrant contribution to Australia's ever-diversifying cultural identity.

ALAN AND SUSAN McCULLOCH

ABBREVIATIONS & CONTRACTIONS

General

APPTS:	Appointment/s
b.	born
BIB:	Bibliography
c.	circa
d.	died
dip.	diploma
Dip. Art	Diploma in Art
Dip Ed.	Diploma in Education
n.d.	no date
NFI	No further information
<q.v.>, <qq.v>	which see
REP:	collections represented in
Uni.	University

Galleries

ACCA	Australian Centre for Contemporary Art, Melbourne
AGNSW	Art Gallery of New South Wales
AGSA	Art Gallery of South Australia
AGWA	Art Gallery of Western Australia
AWM	Australian War Memorial
EAF	Experimental Art Foundation, SA
Heide	Museum of Modern Art at Heide, Melbourne
IMA	Institute of Modern Art, Brisbane
MAGNT	Museums and Art Galleries of the Northern Territory
MCA	Museum of Contemporary Art, Sydney
MOCA	Museum of Contemporary Art, Brisbane
MOMA	Museum of Modern Art, New York
NGA	National Gallery of Australia
NGV	National Gallery of Victoria
QAG	Queensland Art Gallery
QVMAG	Queen Victoria Art Gallery and Museum
TMAG	Tasmanian Museum and Art Gallery

Organisations

ABC	Australian Broadcasting Commission
ACAF	Australian Contemporary Art Fair
AEA	Art Exhibitions Australia
AGDC	Australian Gallery Directors' Council
AICA	Association Internationale des Critiques d'Art
ARA	Associate of the Royal Academy, London
ARCA	Associate of the College of Art
ARE	Associate of the Royal Society of Painter–Etchers and Engravers
ASEA	Australian Society for Education Through Art

AWI	Australian Watercolour Institute
BBC	British Broadcasting Commission
CAAB	Commonwealth Art Advisory Board
CAE	College/Council of Advanced Education
CAS	Contemporary Art Society
CSIRO	Commonwealth Scientific and Industrial Research Organisation
ESU	English Speaking Union
IAE	Institute of Advanced Education
MOMAD	Museum of Modern Art and Design, Australia
MUP	Melbourne University Press
NSWSA	New South Wales Society of Artists
OUP	Oxford University Press
QAS	Queensland Art Society
RA	Royal Academy, London
R.Ag. Soc,NSW	Royal Agricultural Society of New South Wales
RAMC	Royal Army Medical Corps
RAS	Royal Art Soceity, Sydney
RE	Royal Soceity of Painter–Etchers and Engravers
RGANSW	Regional Galleries Association of New South Wales
RGAV	Regional Galleries Association of Victoria
RHSV	Royal Historical Society of Victoria
RNAg.Q.	Royal National Agricultural Association of Queensland
RP	Royal Society of Portrait Painters
RQAS	Royal Queensland Art Society
RSA	Royal Society of Arts
RSASA	Royal South Australian Society of Arts
RWS	Royal Society of Painters in Watercolours
SORA	Society of Realist Artists
VAA	Victorian Academy of Arts
VAB	Visual Arts Board of the Australia Council
VACB	Visual Arts/Crafts Board of the Australia Council
VAS	Victorian Artists' Society
WEA	Workers' Education Association

Publications

A.A	*Art in Australia* (Sydney: art quarterly 1916–42
A&	*Art and Australia* (Sydney): art quarterly successor to *A.A* 1963–
AAR	*Australian Art Review*, Leon Paroissien ed. Warner & Associates, Sydney 1975 & 1978.
AGA	*Artists and Galleries of Australia* Max

	Germaine, most recent edition Craftsman House, 1990.
ADB	*Australian Dictionary of Biography* vols 1–9, Melbourne University Press
AI	*Art International*
AL	*Artlink*
AM	*Art Monthly*
A&T	*Art and Text*
Badham, *SAA*	*A Study of Australian Art*, Herbert Badham, Currawong Publishing, Sydney, 1949.
Benezit, *Dictionaire*	*Dictionnaire critique et documentaire des Peintres, Sculpreurs, Dessinateurs et Gravers*, Paris, 3rd ed. 1976.
Benko, *ASA*,	*Art and Artists of South Australia*, Nancy Benko, Lidums, South Australia, 1969.
Bonython,	
MAP '70	*Modern Australian Painting 1960–70*
MAP '75	*Modern Australian Painting 1970–75*
MAPS '60	*Modern Australian Painting & Sculpture 1950–60* all Kym Bonython, Rigby, Adelaide 1970, 76, 60
Caruana, *AP*	*Aboriginal Painting*, Wally Caruana, Thames & Hudson, 1992.
Chanin, *CAP*	*Contemporary Australian Painting* ed. Eileen Chanin, Craftsman House, 1990.
DAWA	*Dictionary of Australian Women Artists*, Max Germaine, Craftsman House, 1990
Germaine, *AGA*	*Artists & Galleries of Australia*, Max Germaine, Craftsman House, Sydney, 2nd ed. 1984, 3rd ed. 1990
Gleeson, *AP*	*Australian Painting: Colonial Impressionist, Contemporary*, James Gleeson, Lansdowne Press, 1971.
Gunnis, *DBS*	*Dictionary of British Sculptors 1660–1851*, Rupert Gunnis, Oldhams Press, London, 1953, (reprinted Murray, London, 1968).
Horton *AP*	*Australian Painters of the 70s* Mervyn Horton, Ure Smith, Sydney 1975.
Horton, *PDA*	*Present Day Art in Australia*, Mervyn Horton, Ure Smith, Sydney 1970.
Kerr, *DAA*	*Dictionary of Australian Artists, Painters, Sketchers, Photographers and Engravers to 1870*, Joan Kerr OUP, 1992
Kirby, *Sightlines*	*Sightlines; Women's Art in the 1970s*, Sandy Kirby, Craftsman House, Sydney, 1992.
Kroeger, *AA*	*Australian Artists* John Kroeger, Rennicks & Co. Pty Ltd, South Australia 1969.
McCulloch *AAGR*	*Artists of the Australian Goldrush*, Alan McCulloch, Landsdowne, Melbourne, 1977
McCulloch *GAAP*	*The Golden Age of Australian Painting*
	Impressionism and the Heidelberg School, Alan McCulloch, Landsdowne, Melbourne, 1969.
McIntyre, *ACD*,	*Australian Contemporary Drawing*, Arthur McIntyre, Craftsman House, 1992
McIntyre, *CC*	*Contemporary Australian College and its origins*, Arthur McIntyre, Craftsman House, 1990
McKenzie, *DIA*	*Drawing in Australia*, Janet McKenzie, Macmillan, Melbourne, 1984.
Mahood	*The Loaded Line: Australian Political Caricature, 1788–1901*, Marguerite Mahood, 1973.
Moore, *SAA*	*The Story of Australian Art*, William Moore, Angus & Robertson, Sydney, 1935.
New Art 1–7	*New Art* series edited Nevill Drury, Craftsman House, Sydney, 1986–92.
Rienits	*Early Artists of Australia*, Rex and Thea Rienits, Angus & Robertson, Sydney, 1963.
Scarlett, *AS*	*Australian Sculptors*, Ken Scarlett, Nelson, Melbourne, 1980.
Smith, *AP*	*Australian Painting 1788–1990* Bernard Smith & Terry Smith, 3rd edition, OUP, 1990.
Smith *EVSP*	*European Vision and the South Pacific 1768–1850*, Bernard Smith, Clarendon Press, Oxford, 1960.
Smith *PTT*	*Place Taste and Tradition*, Bernard Smith, Ure Smith, Sydney, 1945, new edition, OUP, Melbourne 1979.
Sturgeon, *DAS*	*Development of Australian Sculpture 1788–1975*, Graeme Sturgeon, Thames & Hudson, London, 1978.

Schools and universities

ANU	Australian National University, Canberra
CIT	Caulfield Institute of Technology
ESTC	East Sydney Technical College
NAS	National Art School, Sydney
NGV	School National Gallery of Victoria School
PIT	Preston Institute of Technology, Melbourne
RCA	Royal College of Art, London
RMIT	Royal Melbourne Institute of Technology
SASA	South Australian School of Art
SCA	Sydney College of the Arts
SCAE	Sydney College of Advanced Education
VCA	Victorian College of the Arts
WAIT	Western Australian Institute of Technology

ACKNOWLEDGEMENTS

Many people at a personal and professional level have helped prepare the three editions of this book. Of much help to and warmly appreciated by Alan in the first two editions from 1960 to 1980 were Judy Bligh, Judy Graham, Sally Daly, Wynne Higgins and Gwendolyn Thorne, editor Bridget Everett and publisher's representative Liz Douglas. Special thanks go to gallery director Charles Nodrum who was research assistant for the second edition.

For this edition part-time research assistants were Andrew Campbell, David Thomas and Janine Bove. My thanks especially to Janine Bove whose unfailingly generous spirit, dedication, and love of art led her into spending hours of unpaid time far beyond her official capacity.

My thanks to editors Veronica James and Margie Hartley and especially Katie Purvis and John Bangsund whose meticulous eye for detail was warmly appreciated. Barbara Beckett whose design of the book is so elegant, was a delight to work with and gave, as always, enormous personal and professional support as did Jenny Zimmer, whose eight comprehensive essays on various aspects of Australian art added considerably to the book's breadth. Robyn Clarke efficiently condensed the huge amount of information on Australian craft to update this section.

All private and the overwhelming majority of public gallery directors and many curators, willingly provided essential information. Special thanks to Jane Clark from the NGV, Wally Caruana from the NGA, Ann and Stuart Purves from the Australian Galleries; Bill Nuttall and Fulvia Mantelli from Niagara Galleries; Eileen Chanin from Macquarie Galleries; consultant Jonah Jones; Stephanie Schrapel from the CAS, SA; and to gallery owners Anna Schwartz, Charles Nodrum, Gabrielle Pizzi, Roslyn Oxley and their assistants.

Hendrik Kolenberg and Barry Pearce from the AGNSW read the manuscript – having their experienced eyes reviewing the entries was of great reassurance as were the comments by Julianna Kolenberg.

Many public galleries waived, or charged minimal fees for reproductions to ensure a wide spread of visual material. For this my grateful thanks go to the NGA, AGNSW, AGSA, NGV, QAG, Parliament House, MCA, Sydney, Mitchell Library and Bendigo, Castlemaine, Mornington, New England and Warrnambool regional galleries and especially to the TMAG and MAGNT. The auction houses Christie's, Joel's and Sotheby's also generously supplied transparencies as did a number of private dealers and galleries. My thanks to them and especially to Martin Browne of Martin Browne Fine Art, Chris Deutscher of Deutscher Fine Art, Bryan Collie of Melbourne Fine Art, Jonah Jones of the Moet & Chandon Art Foundation and Denis Savill of Savill Galleries. I would also like to thank the many artists too numerous to mention who allowed their works to be reproduced.

Like most books of historical and biographical content this work owes much to other published material. For the first and second editions of particular importance as source material were William Moore's *Story of Australian Art* and Bernard Smith's *Place, Taste and Tradition*. Bernard Smith's *Australian Painting* with the third edition updated 1970–90 by Terry Smith, Wally Caruana's *Aboriginal Art* and Joan Kerr's *The Dictionary of Australian Artists, Painters, Sketchers, Photographers and Engravers to 1870* were basic and important reference books for this edition. Max Germaine's *Artists and Galleries of Australia and New Zealand* provided clues as to the 1980s activities of some hard-to-trace artists. In the area of women's art Janine Burke's *Australian Women Artists* remains a standard text with Juliet Peer's and Victoria Hammond's *Completing the Picture* catalogue and Victoria Hammond's essay in *A Century of Australian Women Artists 1840s–1940s* shedding much new light on this important aspect of Australian art. I found of interest *Contemporary Australian Painting* ed. Eileen Chanin and the series *New Art 1–6*, all published by Craftsman House. The magazines A&A, *Art Monthly* and *Artlink* remain all-important references as does the *Australian Dictionary of Biography*. All are strongly recommended as further reading.

My warmest and grateful thanks go to the publishers Allen & Unwin – to so many in the Sydney office and the entire Melbourne office whose cheerful comments helped greatly more often than they probably realised. I would expecially like to thank Wendy Canning for her production expertise and the principals of the firm with whom I dealt – Rhonda Black (until mid 1993) Paul Donovan, Patrick Gallagher and Monica Joyce. Without their whole-hearted support and enthusiasm – not to mention huge investment – this book would have been considerably more difficult in the making and would not exist in its present form.

My admiration, at its limits I had thought, grew steadily for my father Alan McCulloch while working on his book. As the late professor Joseph Burke said in a review it is a 'monumental work' and a great personal achievement. I miss enormously his breadth of knowledge, wisdom and infectious laughter. And finally my all-embracing thanks to our family who have lived both with this book and its creators since its birth – my late mother Ellen, whose many wonderful qualities I will always love and admire; my daughter Emily, and to David Faggetter who became my husband during the writing of this edition. Their love and warm support were and are invaluable companions.

SUSAN McCULLOCH
SHOREHAM, APRIL, 1994.

A ARONS TO AUSTRALIANA FUND

AARONS, Anita
(b. 1912, Sydney) Sculptor, jewellery designer, teacher, administrator.
STUDIES: Dip. sculpture, ESTC, 1934–39. She was a member of many sculptors' and art associations in Melbourne and Sydney 1951–1960 and as a sculptor her best-known Australian work is the Children's Play Sculpture, Phillip Park, Sydney. She lived in Canada 1964–84 where she became well-known as a jewellery designer, sculptor, arts organiser and gallery director. She returned to Australia in 1985 to become based in Qld where she became involved in the Noosa Regional Gallery and continued writing and exhibiting.
AWARDS: Society of Good Designers' Award, NSW 1954; Canadian Conference of the Arts Diplome d'honneur, 1983.
APPTS: Teaching, part-time, ESTC, Sydney, 1954; Kindergarten Training College, Melbourne, 1955; lecturer in sculpture, CIT, 1956–63; delegate representing Australian crafts, First World Crafts Conference, New York, 1964; guest lecturer Columbia Uni. (Summer School), 1964; teaching, Central Tech. Art Coll., Toronto, 1964–66; art editor, *Architecture Canada*, 1966–69; exhibitions curator, Art Gallery of Ontario, 1969–73; director Art Gallery at Harbourfront, Ontario, 1976–84; honorary consultant and life member Noosa Regional Gallery 1985– .
BIB: Lenton Parr, *Sculpture*, Arts in Australia series, Longman, Melbourne, 1961; Scarlett, *AS*; Sturgeon, *DAS*. Germaine, *AGA*.

ABBOT, Inez M.
(Active c. 1900) Painter. This otherwise unrecorded Australian painter apparently spent most of her working life in France. A painting by her was bought for the Jeu de Paume, Paris.
BIB: Moore, *SAA*.

ABBOT, Mary
Painter and teacher; assistant to Henry Gibbons at the Sydney Art School after the death of Julian Ashton, 1942.
AWARDS: Bathurst watercolour prize, 1961.

ABBOTT, Angela
(b. 1940, Victoria) Painter.
STUDIES: NGV School, 1960–61; VAS, 1969–73. She held solo exhibitions at private galleries in Melbourne and at the Victorian Artists Society 1974–1992 and was an invitation member of *Twenty Melbourne Painters Society* 1990.
AWARDS: AME Bale Travelling Scholarship, 1983.
APPTS: Adult extension courses; workshops; retirement planning and art society courses; VAS 1992– .
REP: Private collections.

ABBOTT, Harold Frederick
(b. 14/6/1906, Strathfield, NSW; d. 8/6/1986) Painter, stage designer, teacher.
STUDIES: NAS with Julian Ashton and Henry Gibbons, 1924–31; Royal College of Art, London, 1931–33; Royal Academy 1944–46. He designed for theatre including the Independent Theatre, Sydney, 1935–53 and Sydney University Dramatic Society until the 1950s. His paintings were of the modernist style in the 1930s and 1940s and he explored abstract and semi-abstract painting from the 1970s. He held eight solo exhibitions 1934–84 including three at Macquarie (1936, 38, 41). The New England Regional Art Museum organised a major touring retrospective of his work in 1987–88.
AWARDS: NSW Society of Artists Travelling Scholarship, 1931; Sulman prize, 1940; VACB grant, 1975–76.
APPTS: Official war artist 1943–45; teacher, NAS, 1948–70; Head of the NAS and State Supervisor of Art 1964–70.
REP: NGA; AGNSW; AWM; S. H. Ervin; regional galleries Newcastle, Armidale, Campbelltown; several tertiary institutions including ESTC, Armidale CAE; Manly Art Gallery; City Art.
BIB: Badham, *SAA*. A number of AWM publications 1942, 44, 45, 49, 50. *Howard Hinton: A Patron of Art: Memorial Volume* 1951; C. Dixon and D. Dysart, *Counter Claims Representing Australian Art 1938–41*, 1986; Germaine, *AGA*.

ABDULLA, Ian
(b. 1947, Swan Reach, SA) Painter.
STUDIES: Screen printing, Jerry Mason Senior Course,

1988. A leading urban Aboriginal artist, his story-telling paintings are notable for their clear, bright colours and 'naive' quality. They were seen in three solo exhibitions 1990–93 (one at Tandanya, SA; two at Gallery Gabrielle Pizzi, Melbourne) and he participated in a number of group exhibitions 1989–93 including *Balance, 1990*, QAG, 1990; *A Koori/Nunga Perspective*, Tandanya, Adelaide 1991; *Crossroads: Toward a New Reality – Aboriginal Art from Australia*, National Museum of Modern Art, Kyoto and National Museum of Modern Art, Tokyo, Japan, 1991.

REP: NGA; AGSA; AGWA; QAG; SA Museum; Australian Museum, Sydney; MCA, Sydney; Artbank.

BIB: Catalogue entries exhibitions as above. R. Crumlin, *Aboriginal Art and Spirituality*, Collins Dove, Melbourne 1990. Caruana, AA.

A'BECKETT, Edward

(b. 1844, England; arr. Melbourne 1851; d. 1932, Melbourne) Painter.

STUDIES: Royal College of Art, London. Known mainly for portraits, he was a nephew of the first Chief Justice of Vic., Sir William a'Beckett, and of the London *Punch* artist, G. A. a'Beckett. As a boy a'Beckett had the distinction of being number one on the roll of Melbourne C. of E. Grammar School; he subsequently painted portraits of two headmasters.

See also BOYD FAMILY

ABOLINS, Uldis

(b. 1923, Latvia; arr. Australia 1951) Painter, stage designer.

STUDIES: Riga, Latvia, 1936–44 (architecture); Hanover, Germany. Between 1954–75 he held about 12 exhibitions in NSW.

AWARDS: One prize in Adelaide, nine in NSW competitions, 1958–67, all for watercolours.

REP: AGNSW; Newcastle regional gallery.

BIB: Smith, AP

NFI

ABORIGINAL AND TORRES STRAIT ISLANDER ART

Australian Aboriginal engravings on stone dated back by anthropologists and archeologists 30,000 years or more have been located in various parts of the continent; and the cave walls of Arnhem Land, NW Australia and northern Qld – hidden usually in remote areas – are rich in ancient (15,000 years or more) x-ray representations of birds, animals, spirit people and mythological creatures and non-figurative designs, as well as paintings and engravings of more recent origin.

In Arnhem Land and islands to the north, bark paintings attain their zenith. Further south in the desert regions of central Australia, the principal means of perpetuating the tribal culture was through engravings on stone, notably the sacred tchuringas of the central and western deserts.

Other methods of visual story-telling or spiritual representations occurred on decorated grave posts (Melville and Bathurst Islands); elaborately carved tree-trunks (Binnaway, NSW); decorated skulls (some parts of Arnhem Land); painted wood-carvings of heads and figures (northern coastal regions); body painting; paintings on ceremonial objects and ground designs.

THE RENASCENCE OF ABORIGINAL ART

Starting in the 1970s and breaking through to wide acceptance during the 1980s, Aboriginal art has emerged as a significant contemporary art form and means of carrying on a traditional culture.

In the last edition of this book (1984, and written in 1982) a part of this section was headed *Decline and Its Aftermath* and in part said: 'The decline and ultimate destruction of a culture when overtaken by the superior forces of other culture is a tragic thing to witness. . . . In this respect the story of Australian Aboriginal culture is little different from the story of the demise of other primitive cultures.' That those sentiments, widespread at the time, have since been abundantly disproved is a tribute to the strength of the Aboriginal people and a commendation to the advisers who were prescient enough to assist them in their wishes.

Since, Aboriginal art has come to be regarded with international respect as a major force in contemporary Australian art.

TYPES OF ART AND ITS DEVELOPMENT

BARK PAINTINGS

An account of early bark painting or engraving methods in SE Australia is given in 1878 in R. Brough Smyth's *Aborigines of Victoria*: 'The inner side of the bark was first blackened over a slow fire and the design was then incised on the blackened area with the thumbnail.' However, by this time the extinction of the people of the southern parts of Australia was so complete that few examples of the art were even at that time preserved and Smyth's description is unlikely to have applied to indigenous practices. The art of bark painting as now known reached its zenith among the people of Arnhem Land, notably around Kakadu, who were claimed by Baldwin Spencer (q.v.) to have been 'the most artistic of all the Aboriginal tribes contacted by him', and the tribes of Yirrkala, Millingimbi, Groote Eylandt and other islands of the north. Styles and techniques vary according to materials available. Pigments are usually ground from earth (ochres) with greens occasionally being used by mixing black and yellow ochres. Traditionally blue was never used although when Ricketts dyes and washing bleach were introduced they were used in some rock art.

Raw material of the colours is first ground between stones then applied to the smooth, inner side of the bark with a chewed stick or other improvised brush. Delicate passages of cross-hatchings are done with finer brushes made from a small number of hairs. The bark is flattened by drying over a slow fire or by exposure to the sun with the edges of the bark weighted down with stones, wood or sand. The practice of tying two sticks at either end of the bark sheets is a recent European-introduced innovation.

The purpose of the paintings is often educational

and used for teaching the children of the tribe iden-
tification of animals, fish, birds, etc.; or they may be
purely a pleasurable practising of skill.

Bark paintings continue to be produced today in
Arnhem Land without loss of integrity or compro-
mising the cultural beliefs that sustain it. This indeed
is part of the great achievement of modern and con-
temporary bark painters. Since the advent of outside
interest the sheer number of bark paintings has in-
creased vastly.

CAVE PAINTINGS

Paintings, incisions and relief engravings, mainly on
cave walls and rock overhangs, denote tribal sacred
places, and symbolise the spirit world from which the
tribal totems and legends received authority; these
works were maintained and perpetuated secretly by
the old men of the tribes. Among the most celebrated
of the cave paintings are the x-ray cave paintings of
Arnhem Land, depicting mainly animals, and the
Mimi 'spirit people', believed to control both good
and evil forces of the Aboriginal dreamtime and spirit
world. Main centres of the cave paintings include
Nourlangi Rock in the Darwin area, where hundreds
of figures have been described as 'the most extensive
area of mural art in the world', and the Wandjina
cave paintings in the Kimberley region of WA; other
examples are found in the Carnarvon Ranges, Qld;
Hawkesbury River basin, NSW; Flinders Ranges, SA;
and at Glen Isla rock shelter, Victoria Range, VIC.
Early engravings on rocks are also found in Tasmania
and recent discoveries have extended the representa-
tion to many other parts of mainland Australia. Seeing
the art *in situ* is becoming increasingly rare for Europeans
as many of the sites are of sacred significance and
hence 'off limits'.

EXPEDITIONS AND FIELD COLLECTIONS

Although Aboriginal art must have excited the inter-
est of many of the early students of science and biol-
ogy, and attracted the attention of others if only out
of curiosity, for the first hundred years after the
European discovery of Australia, European artists dis-
missed it as a mere barbarous manifestation having
no value whatsoever as art. The first collections were
probably made for scientific purposes, although there
is evidence to show that biologists of the calibre of
Baldwin Spencer, who was also an artist, keenly appre-
ciated the aesthetic aspects. Much wider recognition
of Aboriginal art as an art form of high aesthetic con-
tent began to manifest itself after modern European
artists had begun to find inspiration for their own
work in the art of indigenous peoples. In Australia
field collections were made by missionaries and by
the representatives of museums from the 1880s onwards.
A chronological list of the various expeditions for all
these purposes should include: 1887, Captain Carring-
ton's expedition to the Fields Island and Alligator
River areas; 1894, Horn Scientific Expedition, Central
Australia; 1896, Baldwin Spencer and F. J. Gillen,
Central Australia; 1901, Baldwin Spencer, North
Central Australia; 1912, Baldwin Spencer and P. Cahill,

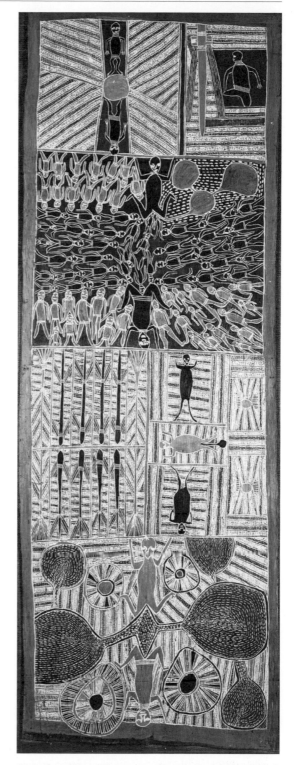

Mawalan, Djang Kawu creation story, *Arnhem Land,
NT, 1959, ochre on bark. Collection,* AGNSW.

Northern Territory; 1921–22, N. B. Tindale, Arnhem
Land and other areas; 1926, Prof. W. L. Warner,
Millingimbi area; 1936–39, Rev. W. Chaseling, Arnhem

Land; 1938–45, Dr H. Petrie, Frobius F. Gray and F. Rose (for Frobius Inst., Frankfurt, and for Melbourne Uni.), various northern areas; 1944–47, C. H. and R. M. Berndt, various northern areas; 1948, Australian–American Scientific Expedition led by C. P. Mountford, Oenpelli; 1954, C. P. Mountford, various areas; 1954, National Geographic Expedition, Arnhem Land; 1958, Dr S. Scougall (for the AGNSW), Arnhem Land; 1958–60, Karel Kupka (for the Museum für Volkskunde, Basle, and the Museum of African and Oceanic Art in Paris), various areas. (Note: The above represents most of the main expeditions and does not include the many smaller private expeditions mainly undertaken after 1950.)

ARUNTA WATERCOLOURS
In 1932 two Melbourne painters, John Gardner and Rex Battarbee (qq.v.), travelled by caravan to Alice Springs and set up camp at nearby Hermannsburg Mission. Their watercolours soon began to attract members of the depressed Arunta tribe of Aborigines, then undergoing great difficulties of integration with the white population. One member of the tribe, Albert Namatjira (q.v.), took special interest and renewed his acquaintance with Battarbee during another visit two years later. On a third visit, in 1936, Battarbee gave Namatjira materials and lessons in painting watercolours. Namatjira learned fast, and aided by natural skill and a good eye, became very proficient at depicting the surrounding desert landscape, its trees, rocks and subtle changes of light. Battarbee made his work known to Melbourne dealers who promoted it with such warmth that Namatjira's name became known throughout Australia. In accord with tribal custom, Namatjira shared both the fruits of his success as well as his knowledge with the members of his tribe. Many others of its members began painting watercolours, all showing natural aptitude for mastering the necessary skills.

Since Albert Namatjira's death in 1959 his works have come to be highly sought after and reach high prices when sold in art auctions and through private dealers. The Arunta watercolours, although their status has declined somewhat through repetition and productivity, are still produced and have become popular with tourists.

1970s–90s
The emergence of Aboriginal art as an important facet of contemporary Australian art and the means by which Aboriginal visual culture was kept alive in the mid-20th century started around 1971 at Papunya, Central Desert. A local art teacher, Geoff Bardon, instigated a painting programme first with children then enthusiastically taken up by the elders who were able to portray, firstly by means of a large mural on the school wall, ancestral knowledge to the children. The designs were at first strongly geometric but became increasingly complex as ancestral references increased and technical ability evolved. The access to Western materials of acrylic paint, fine brushes and boards and canvas enabled the elders to represent stories in a way

unlike any previous methods. The paintings therefore evolved into an entirely new art form and using traditional pictorial language – but one which was able to pass ancestral stories from the elders to younger tribe members.

Not all these works are sacred, to be passed on within the tribe. They include many representations of journeys, landforms, events or animals that can be seen by a wider audience.

PAPUNYA TULA
The Papunya Tula Artists Company was established in 1972 and with the help of some white advisers (including Robert Edwards, then curator at the South Australian Museum, later to become the first director of the Aboriginal Artists Board) began to market the works. Early Papunya artists many of whom became famous in the 1980s included Johnny Warrangula Tjupurrala, Turkey Tolsen Tjupurrula, Tim Leura Tjapaltjarri, Clifford Possum Tjapaltjarri, Mick Namarari Tjapaltjarri.

During the 1970s and early 1980s the output became prolific and the style ever more complex. A description of Papunya paintings is given by Terry Smith in *Australian Painting 1788–1990* (Bernard Smith with Terry Smith, OUP, 1991): 'it works simultaneously on four levels each with two aspects to it: as depiction through inherited forms and techniques of stories from the Dreaming, both as general mythology and as a moment or moral in the particular artist's Dreaming; as a cartography of a place owned by the dreamer-painter, including journeys across it, both by the sacred originators and the artist as a hunter or wanderer; as a witness that the duty of representing and singing the Dreaming has been done, thus constituting a restatement of title or deed to the land indicated; and finally as an individual interpretation of these duties and practices, varying somewhat and thus keeping alive, the obligations and the pleasures of paint.'

This expresses the complexity and levels of meaning of the paintings which from the early 1980s started to be taken seriously by curators in major galleries responsible for selecting works for significant group exhibitions and contemporary collections.

Since then a number of other centres have evolved, ranging north, south and west of Alice Springs in a radius of about 400km, throughout the Kimberley area of north-west Western Australia and throughout Arnhem Land.

(Much of the following information has been taken from *Aboriginal Art* by Wally Caruana, curator of Aboriginal Art NGA, published by Thames and Hudson in the *World of Art* series, 1993. It is strongly recommended for more detailed information on the subject.)

CENTRAL DESERT AND SURROUNDING AREAS
As well as Papunya, major Aboriginal art centres are located at:
Yuendumu, 350km north-west of Alice Springs. This grew in prominence in the mid-1980s and is notable

for its strong representation of women artists (at least half the practising artists are women). Artists from Yuendumu include Paddy Jupurrurla Nelson, Paddy Japaljirri Sinms, Larry Jungarrayi Spencer, Peter Blacksmith Japananga, Jimmy Jampijinpa Robertson, Liddy Napanangka Walker, Topsy Nananagnka, Judy Nampijinpa Granites, Dolly Nampijinpa Daniels, Jeannie Nungarryi Egan, Peggy Napurrurla Poulson, Maggie Napurrurla Poulson.

Utopia, north-east of Alice Springs. Utopia, a cattle station of that name from the 1920s, reverted to Aboriginal ownership in 1979 and became the centre of batik and screen printing. The *Women's Batik Group* was formed in 1978 and manages the marketing and sale of fabrics produced in the area. Silk is the preferred fabric and the designs are mainly based on women's ceremonies. Batik artists include Edie Kemarre, Sandra Holmes Petyarre. In the 1980s acrylic paint began to be used, the resulting paintings similar in style to those of Papunya. Emily Kame Kngwarreye (q.v.) started painting in her mid-70s (in the late 1980s) and has become a highly respected and famous artist. Other well-known Utopia artists include Ada Bird Petyarre and Lilly Sandover Kngwarreye.

Balgo, north-west of Alice Springs on the edge of the Kimberley. The art history of Balgo is similar to that of the central desert areas. Some carvings were made in the 1950s from soapstone, but these were discontinued in the early 1980s and painting has become the main art form. The paintings from Balgo are distinguishable for their use of iconographic forms and deeply hued palettes. Artists from this area include Peter Sunfly (Sandfly) Tjampitjin, Wimminji Tjapangarti, Donkeyman Lee Tjupurrula and Susie Bootja Bootja Napangarti.

THE KIMBERLEY RANGES

Situated in Western Australia at the farthest northwest of the continent, the Kimberley were the site in the 1880s of some of the worst and longest-lasting atrocities ever visited on the Aboriginal people by white settlers. Poisoning, enslavement, massacres, rapes, ethnocide were frequent occurrences. The effects of such recent history and the continuing struggle for land rights has had a strong impact on the Aboriginal peoples of the area, yet their belief in the Dreaming as the source of life remains. The art that is produced has these two streams interwoven.

Rock art is an important part of the art in the central and north-west Kimberley. The most famous examples are the *Wandjina* – spirit ancestors believed to have come from the sky, shaped the land and left images of themselves in ochre and white clay (up to 6 metres long) and in a variety of forms, including the Rainbow Serpent. *Wandjina* images appear on bark and canvas as well as on cave walls. Artists painting *Wandjina* on canvas in the early 1970s included Charlie Numbulmoore, Cocky Wutjungu, Wattie Karuwara, and Manila Kutwit; those of the 80s and 90s included Lily Karedada, Ignatia Jangarra (Dangawala) and Jack Wheera.

Another art form from this area is the highly prized decorated pearl shell, which increased in number following the establishment of the white pearling industry in the early 1900s.

A number of Kimberley artists use only ochre as their medium although watercolours and some acrylics are used.

Southern Kimberley. This includes the areas around Fitzroy Crossing down to Balgo Hills. The paintings of this area tend to be more naturalistic portrayals of the landscape interwoven with spiritual ancestral journeys. Such are the works of Halls Creek artist Rhundta Lightning, Jarinyanu David Downs (who is both a religious leader of his Aboriginal group and a Christian) and Peter Skipper; and those of Jimmy Pike, an artist of the Great Sandy Desert.

Eastern Kimberley. The other significant art centre in the Kimberley is that situated at Warmun/Turkey Creek, whose artists include Rover Thomas, Jack Britten, Queenie McKenzie and Hector Jandany – whose ochre paintings are characterised by blocks of colour outlined with heavy dots.

NORTHERN QUEENSLAND

Including the Cape York Peninsula, Mornington Island and Torres Strait Islands, this is a huge area and includes a number of diverse traditions. The rock art galleries at Cape York Peninsula have been dated to over 15,000 years; other art forms from the eastern seaboard include painted clubs, throwing sticks, paddles, shields and weavings. Sculpture and ceramics relating to traditional stories and events are the main art forms produced in the Cape York area since the 1950s. Mornington Island art is largely focused on bark paintings of naturalistic portrayal of subject. One of its most well-known artists was Dick Roughsey (q.v.). Torres Strait Islanders produce ritual accoutrements such as masks, head-dresses, drums and weavings.

URBAN ABORIGINAL ARTISTS

William Barak (q.v.), who lived on the site of Melbourne in the 1860s and was resettled along with others of his and other groups at Coranderrk settlement, at Healesville, Vic., and Tommy McCrae from the upper Murray, Vic., could be said to be Australia's first urban Aboriginal artists. They both produced figurative works which were encouraged and bought by European settlers. It was not until the 1970s however with the rise of the land rights movement that urban Aboriginal artists came into their own. By the 1980s such artists as Ian Abdulla, Gordon Bennett, Karen Casey, Robert Campbell Jnr, Brenda Croft, Fiona Foley, Lin Onus, Sally Morgan, Arone Meeks, Trevor Nickolls, Jeffrey Samuels and Judy Watson have all become leading contemporary artists whose work represents their Aboriginality in a western art context.

PRINCIPAL PUBLIC COLLECTIONS

Most state galleries and a number of museums have collections of early Aboriginal art. With the explosion of contemporary Aboriginal art in the 1980s all state galleries and the NGA have collected in this area.

Exhibitions based on these collections, supplemented by borrowed works, are frequently mounted.

ADELAIDE:
South Australian Museum: extensive collections including specimens collected at Groote Eylandt by N. B. Tindale in 1921–22, and many from the Australian–American Expedition in 1948. The museum contains also examples of Maung tribe works collected by Miss M. Mathews in the Arnhem Land area opposite Goulburn Island.

CANBERRA:
The NGA collection aims to document the continuing artistic traditions of Aboriginal Australia. The collection is mainly of contemporary work and includes bark paintings and sculptures from Arnhem Land, recent paintings from the eastern Kimberley, desert paintings, urban art and an extensive collection of prints and posters. Australian Inst. of Anatomy: extensive collections including many specimens from the Australian–American Expedition, 1948.

MELBOURNE:
Museum of Victoria: important collections including about 210 specimens collected by Baldwin Spencer, mainly from 1912 onwards. Much of this work came from the Kakadu tribe near Oenpelli, and from other tribes some of which have since become extinct. Included in these collections are films and recordings of Aboriginal music also made by Spencer.

PERTH:
Uni. of WA: includes works collected by C. H. and R. M. Berndt, 1944–47, on permanent loan from the Uni. of Sydney. Western Australian Museum: includes specimens collected by Dr H. Petrie in 1938.

SYDNEY:
Australian Museum: extensive collections including specimens from the expeditions of Prof. W. L. Warner, 1926, Rev. W. Chaseling, 1938–45, and Australian–American Scientific Expedition, 1948. AGNSW: important collections of Melville Island graveposts and bark paintings, most of which were collected for the gallery by Dr S. Scougall.

EXHIBITIONS
The first exhibition of Australian Aboriginal art held in a public art gallery, as distinct from the permanent ethnological displays in Australian museums, was opened at the NGV on 9 July 1929, costs being donated by R. D. Elliott, then treasurer for the gallery trustees. *The Jubilee Exhibition of Australian Art*, which toured Australian state capital cities in 1951, included 26 Aboriginal bark paintings, but the first fully documented, comprehensive travelling exhibition, *Australian Aboriginal Art*, was not put together until 1960. Organised by Tony Tuckson (q.v.), it toured the Australian state galleries during 1960–61. A selection of works from this splendid exhibition was sent later, under the auspices of the CAAB, to represent Australia at the 1961 *Bienal de São Paulo*, Brazil, where it created widespread interest. An exhibition of Australian Aboriginal art put together by F. D. McCarthy

Ellen Jose, The Cliffs, *1988. Linocut. (Old Tracks–New Land touring exhibition, Aus. and* USA, *1993–94.)*

was sent to the Commonwealth Arts Festival in 1965, when it was shown at Liverpool and London; in the same year a loan exhibition of bark paintings from the National Museum of Victoria was organised by Alan McCulloch for the Museum of Fine Arts at Houston, Texas. Significant exhibitions in the 1980s include *Koori Art 84* at the Contemporary Art Space, Sydney, which included 30 traditional artists such as Turkey Tolson Tjupurrula and those working outside traditional boundaries such as Trevor Nickolls and Jeffrey Samuels. In 1986 *Art from the Great Sandy Desert* at the AGWA focused attention on the work of the Balgo artists of WA. In 1989 six artists from Yuendumu produced a ground painting *Yam Dreaming* in the exhibition *Magiciens de la terre* at the Georges Pompidou Centre, Paris. In 1990 Rover Thomas and Trevor Nickolls represented Australia at the Venice Biennale while Melbourne dealer Gabrielle Pizzi took an exhibition of Papunya Tula artists' work to Rome. In 1993 *Images of Power* curated by Judith Ryan at the NGV focused on the work of Kimberley artists from both historical and contemporary perspectives, and the *Aboriginal Women's Exhibition* at the AGNSW and touring included a wide range of contemporary women's work. As well as these, an increasing number of exhibitions on aspects of Aboriginal art appear in public and private galleries and in each major survey show (such as *Australian Perspecta*; *Asia-Pacific Triennial*) as interest continues to grow.

GALLERIES AND CO-OPERATIVES
With the rise of interest in Aboriginal art (and helping promote it) the number of galleries specialising

in it mushroomed, as can be seen from the main street of Alice Springs where dozens of 'galleries' sport paintings of varied quality. A number of artists have formed their own co-operatives, sometimes establishing a gallery and employing an administrator (such as the Warringarri co-operative at Kununurra, owned by Kimberley and some NT artists) and the Central Desert Papunya Tula and the Utopia Women's Batik Group co-operatives. In many cases the sale of art helps the whole community, enabling the purchase of property, establishment of medical centres and schools and contributing towards living expenses. In Sydney the Boomalli Aboriginal Artists Cooperative was formed in 1987 to provide studio space and represent its members. Adelaide's Tandanya arts centre specialises in the display of Aboriginal art and craft. Commercial galleries in the major capitals specialising in Aboriginal art include Sydney's Utopia Art, which represents a number of well-known traditional and urban Aboriginal artists. In Melbourne, dealer Gabrielle Pizzi was one of the first to specialise in Aboriginal art and has taken a number of exhibitions overseas including Russia and the USA; Alcaston House represents several well-known tribal artists.

BIB: Catalogue essays exhibitions as above. Dr John Lhotsky, *A Song of the Women of the Monaro Tribe* Austin, Sydney, 1834 (?first published record of European interest in Australian Aboriginal culture). W. Blandowski, *Australia Terra Cognita*, 1857. R. Brough Smyth, *Aborigines of Victoria*, Vic. State Government, two vols, 1878. A. W. Howitt and Lorimer Fisson, *Kamilaroi and Kurnai*, 1880. Baldwin Spencer, *The Native Tribes of Central Australia, 1899; Northern Tribes of Central Australia*, 1904; *Native Tribes of the Northern Territory*, 1914; *The Arunta*, 1927; *Wanderings in Wild Australia*, 1928 (all pub. by Macmillan, London). A. W. Howitt, *The Native Tribes of South East Australia*, Macmillan, London, 1904. A. P. Elkin and C. H. and R. M. Berndt, *Art in Arnhem Land*, Cheshire, Melbourne, 1950. Ronald M. Berndt, *Kunapipi*, Cheshire, Melbourne, 1951. Charles P. Mountford, *Aboriginal Paintings – Arnhem Land*, UNESCO World Art Series, 1954. Charles P. Mountford, *Aboriginal Art*, Arts in Australia series, Longman, Melbourne, 1961. Alfred Butler, Terry Barrow, Charles P. Mountford, *Oceania and Australia*, Art of the World series, Methuen, London, 1962. Karel Kupka, *Un Art à l'état Brut*, Lausanne, Switz., 1962, English trans. Angus & Robertson, Sydney, 1965. Rex Battarbee, *Modern Australian Aboriginal Art*, Angus & Robertson, Sydney, 1951. Joyce D. Batty, *Namatjira, Wanderer Between Two Worlds,* Hodder & Stoughton, London, 1963. R. Edwards (ed) *Aboriginal Art in Australia* Ure Smith, Sydney, 1978. I. M. Crawford, *The Art of the Wandjina. Aboriginal cave paintings in the Kimberley, Western Australia*, OUP, 1968. N. Amadio and R. G. Kimber, *Wildbird Dreaming: Aboriginal Art from the Central Desert*, Greenhouse Publications, 1987. J. Isaacs, *Australia's Living Heritage, Arts of the Dreaming* Lansdowne Press, Sydney, 1984. J. E. Stanton, *Painting the Country: Contemporary Aboriginal Art from the Kimberley region*, University of WA Press, 1989. P. Sutton, *Dreamings: The Art of Aboriginal Australia*, Viking, NY, 1988. W. Caruana, *Windows on the Dreaming: Aboriginal Paintings in the Australian National Gallery, Canberra*, NGA and Ellsyd Press, 1989. J. Isaacs, *Aboriginality: Contemporary Aboriginal paintings and prints*, UQP, 1989. W. Caruana, *Aboriginal Art*, Thames and Hudson, World of Art series, London, 1993. Judith Ryan, introduction, *Images of Power*, Aboriginal art of the Kimberley, NGV 1993. A&A special issues 13/4/1976; 16/4/1979; 31/1/1993. AL Autumn/Winter 1990 (reprint 1992).

ABORIGINAL ARTISTS AGENCY
(Established 1978) 35 Jones St, Ultimo, NSW 2007 (PO Box 282, Cammeray 2062). Agency responsible for protecting copyright for Aboriginal artists in all art forms.

ABORIGINAL ARTS BOARD
See AUSTRALIA COUNCIL

ABRAHAM, Charles J.
(b. 1816; arr. Sydney 1843; d. 1885) Sculptor. STUDIES: Royal Academy Schools, London, with the sculptor Robert Sievier, 1833; Paris and Rome. A son of an architect, Robert Abraham, he made a 2.4-metre-high stone carving of the Duke of Wellington for the garden of J. N. Franklyn at Henbury Hill, near Bristol. One of the first sculptors to use the marble quarried from Abercrombie Cave, NSW, he carved a bust of Sir Thomas Mitchell and many other prominent Australians and was represented in Australia's first exhibition of sculpture (Royal Hotel, Sydney, 4 Oct. 1845), and at the first exhibition of the Society for the Promotion of Fine Arts, Sydney, 1847.
REP: Mainly in Sydney collections: Royal Australian Historical Society, Parliament House, Pioneers Club, Mitchell Library; also TMAG.
BIB: Moore, *SAA*; Gunnis, *DBS*, 1968; Scarlett, *AS*.

ABRAHAMS, Louis
(b. 1852, London; arr. Australia 1860; d. 1903, Melbourne) Painter, etcher.
STUDIES: Melbourne, NGV School, 1879–84. He was a leader of the student push for reforms at the NGV in 1881 and later one of the founders of the artists' camp at Box Hill. (See CAMPS). He modelled for the central figure in Roberts' famous picture 'The Artists' Camp', and himself painted a watercolour of the same subject. He was a member of the Buonarotti Society (q.v.) in the 1880s and exhibited with the Australian Artists Association. He also had a studio in the Grosvenor Chambers, Collins St, headquarters of a number of artists. His father imported sheets of cedar for the manufacture of cigar-boxes and from this source came the cedar lids on which the '9 × 5 Impressions Exhibitions' pictures were painted. McCubbin's first son, Louis, was named after Abrahams, who reciprocated by naming his first son Frederick. Abrahams made mostly etchings and watercolours. In 1903 his health declined and he suffered periods of depression that turned to melancholia resulting partly from frustration over his lost career as an artist. His illness reached a tragic end when in December of that year he descended to a cellar in his factory and shot himself dead. His work was included in *Golden Summers*, NGV and touring, 1986.
BIB: McCulloch, *AAGR*.
See also HEIDELBERG SCHOOL

ABRAHAMS, Peter

Painter.
AWARDS: Crouch prize, Ballarat, 1962.
REP: NGV; QAG.
NFI

ABSOLON, John de Mansfield

(b. c. 1843, England; d. 8/5/1879) Painter. Son of artist John Absolon. After a visit to the colony 1869–70, Absolon, who painted mainly marine pictures, returned with his wife (15 Oct. 1870) to settle in Perth and manage the shipping and mining interests of his father-in-law, Robert Mace Habgood. His work was seen in *The Colonial Eye* AGWA 1979.
REP: Royal Western Australian Historical Society; Mitchell Library.
BIB: Kerr, DAA.

ABSTRACTION

NON-OBJECTIVE, GEOMETRIC ABSTRACTION IN AUSTRALIA
The abstract art of Australia is both new and old. Its extreme antiquity is witnessed by the markings and signs of Australian Aborigines which contain a universe of meanings that have only from the 1980s begun to be better valued and understood. Aboriginal art remains Australia's supreme form of abstraction, utilising dots, lines, geometric patterns and shapes – often rhythmically applied – to describe mythic relationships between themselves, the land, and its climate, geography, flora and fauna. Aboriginal abstract art is loaded with content – specific, practical, mythic, expressive and awesome – but the beholder needs to be in the know to fully grasp its concepts. Until recently Australian Aboriginal artists worked outside western modernist traditions of representation and self-expression; instead they shared an *essential* abstract language necessary for communication and survival. Their art, and the manner in which it has developed through the late 1980s and 1990s, is of considerable interest to post-modern theorists – particularly those concerned with structural analysis, myth and cultural diversity.

THE MODERNISTS
Like their European counterparts, Australian modernists – from early abstractionists such as Margaret Preston to neo-abstract expressionists like Sydney Ball and John Walker – have responded to the powerful forms and arrangements of colour, line and shape of Aboriginal abstraction. The disclosure of a visual language based on abstract marks and minimal representation had great attraction for European non-figurative artists including Kandinsky, Mondrian and Malevich who believed, against the entrenched mimetic tradition of the west, that modern people would find value, beauty and meaning in universal abstract forms. They sought to override the crass, obvious and materialistic configurations of ordinary sense perceptions by substituting marks, signs, colours, symbols, shapes, and relationships between these, that convey personal and universal meanings or approximate the abstract thought applied in modern physics, science, industry and technology. They sought to share, with craftspersons, designers, architects, and the public, abstract frameworks which to them signified the richness of modern life. Like Aboriginal artists they abandoned the evidence of the eye for concepts of mind, whether anticipating futuristic travel in space or imbibing the mysticism of the ages.

Bernard Smith, tracing development towards the first non-objective painting in Sydney, tells us that in 1913 Norah Simpson brought back from Europe books on cubism which influenced Grace Cossington Smith and Roy de Maistre. Roland Wakelin was simultaneously very impressed by a newspaper reproduction of Marcel Duchamp's controversial *Nude Descending a Staircase* exhibited in the New York Armory Show in 1913. Experiments by Cossington Smith, Wakelin and de Maistre between 1914 and 1918 using heightened colour and simplified patterned forms led to the 'synchronism' demonstrated in de Maistre's painting *Rhythmic Composition in Yellow Green Minor* (1919). In the 1920s all three, like many who later experimented with pure abstraction, returned to stylised representational painting.

Between 1932 and 1937 Rah Fizelle and Grace Crowley set up an art school with teaching based on geometric organisation of form and American Jay Hambidge's ideas of 'dynamic symmetry'. Even then, 20 years after their exploration in Europe, cubism, futurism and non-figurative painting remained little known in Australia. Soon Ralph Balson became associated with the group. He exhibited with Dorrit Black whose Modern Art Centre in May Street, Sydney, showed and promoted the abstract/cubist/constructivist direction in contemporary art. So it was that about 1934 the constructivists Grace Crowley, Rah Fizelle, Dorrit Black, Frank Weitzel, Eleonore Lange, and Frank and Margel Hinder (who had just arrived from America), were all experimenting with forms of non-objectivity intended to reveal abstract knowledge of the universe. Australian abstractionists responded particularly to Mondrian's neo-plasticism, James Joyce's 'stream of consciousness' writing, and Einstein's relativity theory and various Theosophist and spiritualist writings. *Exhibition 1* at David Jones Gallery in 1939 abandoned representation to emphasise shape, tone, value, line and the flat picture plane. In the catalogue Eleonore Lange called it 'a new realm of visual existence'. The Sydney tendency to experimentation with constructivism and abstraction was further enhanced by the return of Eric Wilson from the Westminster School. That was in 1939, the year the influential *Herald Exhibition* of modern paintings selected by Basil Burdett was shown in Sydney and Melbourne. In Melbourne Sam Atyeo's *Organised Line to Yellow* (1934) was one of the first non-objective paintings to gain notoriety. Atyeo had renounced the Gallery School's teachings for an interest in Cézanne and Picasso. But wider acceptance of non-objectivity was somewhat eclipsed by George Bell's and William

Frater's arguments over modernism. After the establishment of the Contemporary Art Society (CAS) in 1938, and with John Reed's support, artists favouring cubism and abstract art felt more encouraged – though the Reeds always favoured figurative expressionism. In the second exhibition of the CAS, shown in Sydney and Melbourne, there were abstracts by Gordon Andrews, David and Geoffrey Collings and Leonard Crawford. Bernard Smith, and others after him, explained the slow acceptance of non-figuration as a factor of the interruption caused by two wars, the prolongation of academic teaching in art schools, and the fact that travelling scholarship winners frequently chose to go to England rather than Paris. The reasons have turned out to be more complex; pure abstraction continues to have a less favoured existence in Australia. Very few who take it up remain devoted to it, as many did in Europe and America. Bernard Smith thinks those Australians who did best at home and abroad were not 'simplifiers, reducers, primary-structure men'. This may be true, but looking back, the abstract works of Ralph Balson, Godfrey Miller, John Passmore, Ian Fairweather, Roger Kemp, Leonard French and George Johnson – all somewhat eccentric and often self-isolated painters who believed in the possibility of creating non-objective structures and relationships capable of universal communication – clearly constitute one of the most consistent and coherent expressions of modernism in Australian art.

THE 1950s

Exhibitions of non-objective paintings remained infrequent in Sydney and Melbourne prior to 1956, although Grace Crowley, Frank Hinder, Gerald Ryan and Ralph Balson exhibited *Constructive Paintings* at the Macquarie Galleries, Sydney, in 1944 and at David Jones Gallery in 1948. The Sydney CAS survived longer than the Melbourne branch, continuing its support of pure abstraction, if feebly. In 1953 when the Arts Council of Great Britain showed contemporary Australian paintings at the New Burlington Galleries, London, Miller, Hinder and Balson were included and throughout the 1950s geometric abstraction gained further strength under the enduring philosophical influence and teachings of the New Zealand mystic Godfrey Miller. He sought pictorial means of capturing the permanent essence of a world in flux by dividing his compositions into structural grids and facets of colour. Of similar impact were John Passmore, who had returned from Europe in 1950, and Ian Fairweather, whose bent towards abstraction was enriched by contact with the arts of Asia and Australian Aborigines.

In 1953 the exhibition *French Painting Today* toured Australia showing, alongside the better known 'School of Paris' painters, works by Manessier, de Stael, Soulages, Vieira da Silva and Hans Hartung. The show had a stong impact on Sydney's John Coburn, Tony Tuckson, William Rose and Stan de Teliga. In Melbourne, Roger Kemp, Leonard French, George Johnson (who arrived from New Zealand in 1951), James Meldrum and Leonard Crawford, each to varying degrees and at different times, favoured geometric abstraction as a means

of discovering and making visible universal truths. Each sought a world view rather than the more personally expressive and very popular abstract expressionism with which Donald Laycock, John Howley and Ian Sime and many Sydney painters were then experimenting. In 1956 when the Orient Line's *Orcades* sailed with the *Pacific Loan Exhibition* arranged by the AGNSW it carried – alongside figurative paintings – works by geometric abstractionists, French, Johnson, Miller, Passmore, Kemp, Balson and William Rose. It also included some emerging abstract expressionists, John Olsen, Lawrence Daws and Howley and Laycock. Bitter battles between figurative and non-figurative artists were about to erupt but when they did, on the occasion of the *Antipodean Exhibition* and its inflammatory *Manifesto* presented at the Victorian Artists' Society rooms in East Melbourne in August 1959, it was abstract expressionism and the increasing influence of New York which triggered the arguments. The earlier, European-inspired, geometric and non-objective abstraction remained the ongoing terrain of a committed minority.

The influential European migrant artists and scholars who arrived before and after the war tended to reinforce strands of expressionism and abstract expressionism rather than adding new zest to the search for a universal language of abstraction. This project was left to artists like Leonard French who developed a repertoire of geometricised shapes and images which he wove into a structured unity to convey myth and meaning. Leonard Crawford sought to capture musical notations in colour, line and plane, and Roger Kemp used a universe of recurring geometric symbols to understand something of the science of the cosmos. George Johnson still maintains consistent use of non-objective geometric forms and structure in his search to understand the structures of organic life and, more recently, societal machinations. James Meldrum, now living in Queensland, and Howard Taylor, working in Western Australian since the 1940s, are also very important contemporary Australian abstract artists.

MATERIALS

An interesting characteristic shared by most of these artists was their experimentation with non-traditional artists' materials. Struggling to survive the post-war years when art materials were scarce and expensive and sales a rare phenomenon, they used trade materials such as hessian, house-paints and masonite. They mixed their own gessos and glazes, and generally made do far from the main-streams of European and New York painting. In the 1960s most eventually converted to new materials like acrylics, but Leonard French continues to privilege the materiality of his paintings and processes.

THE RISE OF COLOUR-FIELD PAINTING — *THE FIELD* AND BEYOND

The mid-1960s, culminating with the NGV exhibition for its new building in 1968, *The Field*, saw the very rapid – perhaps premature – movement of abstract expressionism into colour-field painting (sometimes

called 'hard-edge' or 'minimalist') which was influenced by Americans Joseph Albers, Barnett Newman, Ad Reinhardt, Ellsworth Kelly, Kenneth Noland, Frank Stella and others. Though *The Field* artists often used geometric shapes and flat colour, their investigations represented a sharp break with the earlier generation of geometric abstractionists who on the whole continued to pursue their personal obsessions and meaningful world-views. In Melbourne the American James Doolin and young locals Robert Jacks, Robert Hunter, Alan Leach-Jones, Janet Dawson, Robert Rooney, Dale Hickey, Trevor Vickers, Mel Ramsden and Paul Partos Adelaide in Sydney Ball, and in Sydney Dick Watkins, Michael Johnson and artists associated with the Central Street Gallery, including Tony McGillick, Ron Robertson-Swann, Joseph Szabo, Gunther Christmann and Col Jordan, all exploited flat colour and geometric lines and shapes. They sometimes shaped their canvases.

Many of the painters chosen for *The Field* had either recently returned to Australia or migrated from England influenced by art there, and knowledgeable about New York developments. Patrick McCaughey, who championed their cause, thought *The Field* closed one period of Australian art and opened a new era. Other 'colourfield' painters, less inclined to strictly geometric divisions of surface, included David Aspden, John Peart and John Firth-Smith. All in all *The Field* painters had little in common with the earlier abstractionists and were certainly not interested in making do. Unlike the earlier artists they no longer professed particular interest in a universal language of art or the expression of personal or collective emotions. They avoided content meaning, expression and 'the accidental' in their efforts to orchestrate colour, shape and surface as pure aesthetic effect, making the painting – or art object – a thing unto itself, often bearing the elusive title *Untitled*. In the 1960s and 1970s Peter Booth and those listed above retained some geometric characteristics but their world was New-York-focused. In 1967, the two exhibitions *Aspects of British Art* and *Two Decades of American Painting* had given them an opportunity to study art from the big centres. Followed so closely by *The Field* they saw their direction confirmed until the onset of the pluralistic 1970s when minimalist works by artists like Ian Burn, Robert McPherson and others began to encompass more programmatic, and somerimes political, ideals consistent with the conceptualism of that decade.

THE 1980s ON

In 1983 when John Nixon's *Self Portrait (Non Objective Composition) Red, Black and White*, and the associated installation shown in the 1983 *Perspecta* at the AGNSW, made obvious reference to Kasimir Malevich, it was within the context of post-modern 'appropriation' which swept the world in the early 1980s. Robert Owen showed constructivist drawings at City Gallery, Melbourne, in 1992. Other artists, like New Zealanders George Johnson, Elizabeth Coates and Brent Harris, Sydney's John Plapp, Joe Felber and Andrew Christofides, and Lesley Dumbrell and Robert Jacks, continue to investigate geometric abstraction from an essentially modernist position.

An interesting recent development arising out of the later deconstructionist stages of post-modernism was heralded by *Room for Abstraction* at Heide in 1991, in which younger artists were seen to be re-experimenting with trade materials and geometric abstraction. Many of those represented in *Abstract Art* (curated by John Nixon for Roslyn Oxley9, Sydney) in January 1992 – including Stephen Bram, Eugene Carchesio and Melinda Harper – could also be described as 're-doing' geometric abstraction, now from a postmodern theoretical stance concerned not so much with communicating a world-view as exploiting the collision of several cultural moments.

EXHIBITIONS

Exhibitions which have traced the history of abstraction in Australia include:

1983: *Abstract Art in Australia: A Selection from the Past Thirty Years*, RMIT Gallery.

1986: *A Study Exhibition: Abstract Painting in Melbourne from the Mid 1950s to the Mid 1960s*, RMIT Faculty of Art Gallery, *A Resistant Spirit*, Roslyn Oxley Gallery, Sydney, and Realities, Melbourne; *20 Years of Abstraction Pt.2 – The Australians*, Ivan Dougherty Gallery, Sydney 1991: *New Directions 1952–62*, the Lewers Bequest and the Penrith Regional Art Gallery; *Room for Abstraction*, Heide 1992: *Abstract Art* curated by John Nixon for Roslyn Oxley 9, Sydney.

BIB: Catalogue essays exhibitions as above. Smith, AP. *West* Vol. 3, No. 2, 1991. *A&A* 18/4/1981; 23/4/1986.

JENNY ZIMMER

ABSTRACT EXPRESSIONISM
See EXPRESSIONISM

ACADEMY OF ART
See NEW SOUTH WALES ACADEMY OF ART

ACADEMY OF ARTS
(1895–1927) Founded by James Ashton in SA, 1895. The Academy continued until 1927.
See also SCHOOLS, NORWOOD ART SCHOOL

ACADEMY OF ARTS OF AUSTRALIA
(Active c. 1907) Short-lived group. Its members included Girolamo Nerli and P. Fletcher Watson, the first president, 1907.
BIB: *Argus*, Melbourne, 10 Aug. 1907.

ACKLAND, Margaret Lucille
(b. 11/8/1954) Painter.
STUDIES: NAS, 1973–76. Dip. Ed. Sydney Teachers College, 1977. She held approximately 20 solo and group exhibitions Sydney (including Wagner), Qld, (Delmar) and participated in Archibald Prize 1983, 86, 87, 88.
AWARDS: *Sydney Morning Herald* Travelling Scholarship 1984; Dyason Bequest, AGNSW 1985; Portia Geach Portrait Prize 1988; Royal Agricultural Society, modern figurative prize 1992.

APPTS: Secondary art teacher, NSW Department of Education 1978–81; part-time teaching Gymea TAFE, NSW 1975–91.
REP: Artbank; Mitchell Library; private collections including Robert Holmes à Court; Phillips Fox corporate collection.
BIB: Germaine, *AGA. A&A* 23/2/1985.

ADAM, *John Shedden*

(b. 14/7/1935, Sydney) Painter, teacher.
STUDIES: Melbourne Grammar School (with John Brack), 1951–52; Dip. Art Swinburne Tech. Coll., 1953–56; TTTC. In his first exhibitions at Toorak Gallery 1964 and VAS 1966, he combined impressionistic colour with flat, cubistic patterns. He held approx 11 solo exhibitions 1964–91 including three at Eltham Gallery (1981, 83, 85). Group shows in which he participated included with VAS 1960s, Eltham Gallery and Motor Works Gallery. He collaborated with artist/writer Robert Rooney (q.v.) in a series of satirical magazines, *Spon*, 1959–62 and published two satirical books (*The Journal of John Spon* 1976, *Drawing and Poems in Pie* 1971, both by Whole Earth Publications) and illustrated a book of poems.
AWARDS: Camden prize (VAS), 1963, Georges Commendation prize, 1967; Diamond Valley acquisition award 1981.
APPTS: Taught technical schools Vic. 1959–74 including as head of art dept McLeod, Preston East, Preston 1963–74; Melbourne Grammar director of art 1974–92.
REP: Sale regional gallery; State College of Vic.; Diamond Valley Shire.

ADAM, *Leonhard*

(b. 1891, Berlin; arr. Australia 1940; d. 1960, Berne, Switzerland) Anthropologist, sinologist, lawyer, authority on primitive art. Adam arrived in Victoria with many other distinguished German intellectuals in the prison ship *Dunera*. A short period of internment at Tatura, Vic., was followed by his appointment to the Uni. of Melbourne, where he established the archaeological and primitive art collections and secured for the university the Frederick H. Gray collection of bark paintings from Groote Eylandt. Author of *Primitive Art*, Penguin Books, Harmondsworth, 1949; *South Seas Studies*, Basle, 1951. He was commissioned to write a book on primitive art for the Pelican History of Art, but died while this important work was at an early stage of compilation and it was never published.
BIB: Catalogue exhibition Leonhard Adam Collection, University of Melbourne, 1973.
See also ABORIGINAL ART

ADAMS, *Dennis*

(b. 1914, Sydney) Painter, sculptor, teacher.
STUDIES: NAS 1931–34; Royal Academy Schools, London, 1935–39. He returned to Australia on the four-masted barque *Lawhill* in 1939, joined the army at the outbreak of war and in 1942 became an official war artist. In this capacity he served in New Guinea, the Middle East, Italy and England, and (after the war) in Canada and the Bahamas, producing more than 400 paintings and drawings. From 1947–66 he taught at the NAS, Sydney, and afterwards concentrated on commissioned work, mainly for the Australian War Memorial, Canberra. His completed commissions include the 12.19m × 3.96m mural in tempera, *Ships of the Royal Australian Navy*; a welded copper memorial to Robert Campbell (The Rocks, Sydney, 1978); a 6.40m × 3.05m mural, *Australian Wildflowers* (Wentworth Hotel, Sydney); Royal Australian Regiment Memorial in bronze (Regimental Square, Sydney, 1976); Royal Australian Corps of Signals bronze memorial (Watsonia, Vic., 1978).
AWARDS: Order of Australia Medal, 1989.
REP: AWM; other public collections
BIB: Scarlett, *AS*. Campbell, *AWP*. Felicity Baverstock, *Dennis Adams*, John Ferguson Publications, Sydney.

ADAMS, *Margaret Ruth*

(b. 1918, Kyabram, Vic.) Sculptor, teacher.
STUDIES: Melbourne, Swinburne Tech. Coll., 1936–39; Hobart Teachers Coll., 1940; Launceston Tech. School, 1941–42; RMIT, c. 1959–60. She designed puppets for the Australian Children's Theatre 1948–50, displays for the Victorian Dept of Agriculture 1954–58, and from 1959–61 was artist and model maker for the Inst. of Applied Science, Melbourne.
AWARDS: Mildura Prize for small sculpture (shared) 1961.
APPTS: Teaching, Charles Street Practising School, Tas., 1941–46; Methodist Ladies College, Melbourne, 1947.
REP: NGV; Geelong regional gallery.
BIB: Scarlett, *AS*. Sturgeon, *DAS*.

ADAMS, *Tate*

(b. 1922, Holywood, County Down, Ireland; arr. Australia 1951) Painter, printmaker, teacher.
STUDIES: Central School of Art, London (engraving with Gertrude Hermes), 1948. Basically Celtic in feeling, his painting and graphic work introduced to Melbourne a contemporary style that derived also from the lessons of cubism. He revisited London and Dublin, 1956–58, and on his return exhibited an impressive series of symbolistic portraits, entitled *The Warrior*, inspired by the writer Brendan Behan. Later he concentrated on printmaking. His students contributed decorative tailpieces in woodcuts to the quarterly *Meanjin* (1962), and in 1966 he established Melbourne's first print gallery, Crossley Gallery, which became a centre of Melbourne printmaking. He was also influential in establishing printmaking workshops, including the workshop conducted by George Baldessin (q.v.), and in many other ways contributed substantially to the development of the graphic arts in Australia. His own prints have been included in international print exhibitions in Dublin and Tokyo. He closed the Gallery in 1980 and retired from his lecturing position to enter fine art book publishing. He illustrated in lino-cuts J. M. Synge's *Riders to the Sea*, with illustrations ed. Robin Skelton, OUP, Melbourne, 1969.

APPTS: Lecturer in charge of printmaking RMIT, 1960–81.
REP: NGA; AGNSW; AGSA; AGWA; NGV; QAG.
BIB: PCA, Directory. *A&A* 1/4/1964.
See also ARTISTS' BOOKS

ADAMSON, *James Hazell*
(b. 1829, Scotland; arr. Aust. 1839; d. 1902) His view of *Melbourne, from the South Side of the Yarra, 1839* was engraved by J. Carmichael and is the earliest print of the city. Later he was awarded a ten-guinea prize for his *First Steamboat on the Murray* at the inaugural exhibition of the South Australian Society of Arts, held in the Legislative Council Chambers, Adelaide, 1857. His work appeared in *Graven Images in the Promised Land* AGSA 1981.
REP: AGSA; NLA
BIB: Moore, *SAA.* Kerr, *DAA.* Benko, *ASA.*

ADDISON, *George Henry Male*
(b. 1858, Llanelly, Wales; arr. Australia c. 1883; d. 6 Feb. 1922, Brisbane) Painter, architect.
STUDIES: Royal Academy Schools, London, 1881–. He arrived in Adelaide from London under contract to the SA Government, but in 1884 moved to Melbourne where he joined the architectural firm of Terry and Oakden, first as assistant before becoming a partner 1885. He opened a branch of the firm in Brisbane 1886 and in 1891 designed the Brisbane Exhibition Building. He painted genre and landscapes and made many architectural drawings.
APPTS: Teaching design, Melbourne 1884; art master, Brisbane Tech. Coll., 1891; president, QAS, 1917; chairman, New Art Society, Brisbane, 1904–06; Board member, QAG, 1906–08 and 1917–22.
BIB: Julie K. Brown and Margaret Maynard, *Fine Art Exhibitions in Brisbane 1884–1916*, Fryer Memorial Library, Uni. of Qld, 1980.

ADELAIDE FESTIVAL OF THE ARTS
See FESTIVALS

AINSWORTH, *Ruth*
Graphic artist, specialist in linocuts who studied with Thea Proctor c. 1927.
BIB: Moore, *SAA. AA*, 1927.
NFI

ALAND, *John*
(b. 5/2/1937, Brisbane) Painter, draughtsman, printmaker, curator.
STUDIES: Brisbane Central Tech. Coll. (art teachers' scholarship), 1958–59; private lessons with Jon Molvig. Surrealistic, expressionistic and formal design elements are features of his style which is particularly strong in drawing and seen in 20 individual exhibitions 1961–83 Brisbane (Johnstone Galleries 1971; Victor Mace 1978), Sydney (Bloomfield 1982). He has not held a solo exhibition since 1982 but has participated in many group exhibitions including *Drawings of Australian Painters*, Newcastle Art Gallery 1966; *Georges*

Invitation Art Prize, 1963, 64, 69; *Gifts from Patrick White*, AGNSW 1974; *Artists for Wildlife*, 1987–91; *Dobell Drawing Prize* AGNSW 1993.
AWARDS: Georges, Melbourne (commendation prize, 1963); L. J. Harvey Drawing Prize (1965); *Mirror-Waratah* prize, 1967; David Jones prize, Brisbane, 1969; VAB Special Grant, 1974. Gosford (drawing acquired), 1976; MPAC *Spring Festival of Drawing* (purchase award), 1977.
APPTS: Qld Education Department 1960–61; private teaching 1961– ; Union, Uni. of NSW 1974–81.
REP: NGA; AGNSW; QAG; several regional, university galleries NSW, Vic.
BIB: Catalogue essays exhibitions as above. Ursula Prunster, *Sydney Harbour Bridge 1932–82*, A&R & AGNSW 1984. Germaine, *AGA.* H. Fridemanis, *Artists and Aspects of the Contemporary Art Society Qld Branch*, Boolarong Publication, Qld, 1991. Bonython, *MAP. A&A* 9/1/1971; 16/4/1979.

ALBISTON, *Valerie (née Cohen)*
(b. 10/7/1911, Melbourne) Painter.
STUDIES: NGV School; RMIT; George Bell School. Daughter of painter Morris Cohen and sister of Yvonne Cohen (qq.v.), her modernist paintings became known through Melbourne Contemporary Artists and other group exhibitions. Her work appeared in group exhibitions with Charles Nodrum 1985–92; Eastgate Galleries 1988–91; Jim Alexander 1988; Shepparton Art Gallery 1989 and in *Classical Modernism: the George Bell Circle*, NGV 1992.
REP: Regional galleries Townsville, Warrnambool; Sydney Uni.
BIB: Ross Searl, *Artists in the Tropics*, 1991.

ALDENHOVEN, *W.*
(Active WA, c. 1910) Painter. Known mainly for watercolours. A collection of watercolours and other works was sold at the Aldenhoven Gallery by Gemell Tuckett and Co., Melbourne, 1907.
BIB: Henri Tebbit, 'W. Aldenhoven, West Australian Watercolour Painter', *Studio*, London, vol. 51, 1910–11; Elizabeth Hanks, *Bibliography of Australian Art, 1901–1925*, Library Council of Vic., Melbourne, 1976.

ALDER, *A.*
(Active Qld from c. 1890) Painter. Known mainly for landscapes and paintings of birds. His illustrations of Queensland birds appeared in the *Queenslander* 1895–96.
AWARDS: Queensland National Association prize 1895.
REP: QAG (painting *Not Game* purchased 1895).
BIB: Julie K. Brown and Margaret Maynard, *Fine Art Exhibitions in Brisbane 1884–1916*, Fryer Memorial Library, Uni. of Qld, 1980.

ALDERSON, *Alexandra Janet*
(b. 11/10/1934, Melbourne) Painter.
STUDIES: NGV School, 1957–59; Uni. of Melbourne (Fine Arts); travel studies 1961 UK and USA (Art Students League of New York), Spain 1962–66 and 1966–69. Her paintings in London included portraits of the actors Eric Porter and Keith Michell, but in

her Australian exhibitions of the 1970s she showed striped abstracts notable mainly for their colour. She held exhibitions also in Seville, Cordoba, Madrid (1962–66), Paris, London, Melbourne and Sydney, setting up teaching studios in Madrid (1974–76) and Paris (1978–91). She exhibits in London, Mexico and Australia regularly and once in the USSR (Moscow 1990) and alternates living between London and Queensland.

AWARDS: ESU scholarship, 1960; Dyason scholarship, 1961.

REP: AGNSW; NGV; several university collections Vic; Reserve Bank collection; public collections Spain, Mexico.

BIB: Germaine, AGA. *El Arte Abstracto de la Australiana Alderson*, Zeuras, Informaciones, Madrid 1964. Geoffrey de Groen, *Some Other Dream: The Artist, the Artworld and the Expatriate*, Hale & Iremonger, NSW, 1984.

ALDIS, Albert Edward

(Active c. 1890–1920) Painter. Botanical and landscape painter of European, Australian and New Zealand scenes. He exhibited in Nottingham in 1885 before going to Australasia.

REP: AGNSW.

BIB: Edward Craig, *Australian Art Auction Records, 1975–78*, Mathews, Sydney, 1978; J. Johnson and A. Greutzner, *Dictionary of British Artists, 1880–1940*, Antique Collectors Club, Woodridge, Suffolk, 1976.

ALDOR, Christine Gray

(b. 1913, SA; d. 1969, Warrandyte, Vic.) Painter, printmaker, teacher, journalist.

STUDIES: George Bell School, Melbourne. Married to painter Emil Aldor, she was a foundation member of *Melbourne Prints* (q.v.), a prominent member and teacher at the Warrandyte Arts Society and a writer of articles for CAE publications and for the Melbourne *Age*.

REP: AGSA; AGWA; NGV.

ALDRIDGE, Alexander

(b. 1908, Liverpool, UK; d. 1969) Painter, teacher.

STUDIES: NGV 1932; Art Teachers Certificate, Melbourne Tech. College, 1941. He held four exhibitions of impressionistic landscapes at the Athenaeum, Melbourne, 1946–49 and several with the Melbourne Arts League (a group of painters exhibiting together in the 1940s and early 50s) 1950–53 in which his work moved from the impressionism of earlier exhibitions to a more expressionistic style. His brother, Frederick Aldridge (1905–63), was a well-known journalist, caricaturist and illustrator.

APPTS: Senior art teacher, South Melbourne Tech. School.

ALEXANDROVICS, Judith

(b. 4/10/1944, Melbourne) Painter, printmaker.

STUDIES: Dip. Fine Art, RMIT, 1970; Dip. Technical Teaching (Hons), 1971; postgraduate dip., Phillip Institute 1984; travel studies Europe 1979, 81, New York 1985, 92; theoretical studies women in the arts, scriptwriting Australian Film School 1985–88;

Aboriginal field studies 1989–92. Often depicting crowds in city streets, her figurative paintings and graphics recall the words of Bertrand Russell as quoted in one of her catalogues, 'a pervasive tendency to dissolve the individual into his social functions'. She held around 20 individual exhibitions 1972–90 including at Warehouse/Standfield Gallery, Melbourne, Holdsworth, Sydney and Flinders Lane, Melbourne and has participated widely in group exhibitions including the Archibald, Wynne and Sulman prizes (1980, 83); MPAC *Spring Festival* 1985, 87 and several university collection exhibitions. She taught at various secondary and tertiary colleges, institutes and art groups in Victoria 1972–92.

AWARDS: Half-standard grant VACB, 1984; a number of awards for film scriptwriting and art direction 1988–92 USA and Australia, including an Awgie award in 1991.

REP: NGV; Parliament House; VACB; Artbank; regional galleries Mornington, Swan Hill; several university, corporate collections.

ALKINS, Horace F.

(Active Melbourne, Brisbane, c1880) Painter. He exhibited landscapes, portraits and genre paintings with the QAS.

BIB: Julie K. Brown and Margaret Maynard, *Fine Art Exhibitions in Brisbane 1884–1916*, Fryer Memorial Library, Uni. of Qld, 1980; *Table Talk*, Melbourne, 5 June 1891 (*Art and Artists*).

ALLAN, Micky

(b. 1/4/1944. Melbourne) Painter.

STUDIES: BA (Fine Art), Uni. of Melbourne, 1967; Dip. Painting, NGV School, 1968; travel studies Asia and Europe, 1970. Her early work consisted of photorealist paintings handpainted directly onto photographs. Her work developed and changed course significantly in the 1980s to include pastel sketches from a trip to Italy and France and geometric designs of mosaics and paintings of an imaginary world. Her late 1980s and 1990s work showed elements of surrealism and spirituality as seen in her installation at ACCA 1989 *For Love of the Divine* and an exhibition at Watters, Sydney 1992. She was artist-in-residence Karolyi Foundation, Vence 1983 and held around 23 exhibitions 1978–92 including Watters, Sydney; Deutscher Brunswick Street and Monash University Gallery 1987; ACCA 1990; in collaboration with Aleks Danko at Watters, Sydney and Contemporary Art Centre, Adelaide 1990. Numerous group exhibitions in which she participated included *A Decade of Australian Photography*, NGA 1983; *Shipwrecked*, 200 Gertrude St, 1986; *What is this thing called Science?*, Uni. of Melbourne Gallery, 1987; *Watters 25 Years* touring exhibitions regional galleries NSW 1989; *Out of Asia*, Heide and touring 1990. Her commissions include Bicentennial Print Portfolio, NGA 1988; painted tram for Vic. Ministry 1989.

AWARDS: Project grants VACB 1975, 79, 91; Maude Vizard-Wholohan Prize, AGSA 1982; residency Karolyi

Micky Allan, Detail of a Renaissance Landscape, *1985, oil on linen, 130 × 88.5cm. Courtesy Watters Gallery.*

Foundation, Vence, France 1983; residency Power Studio, Cité Internationale des Arts, Paris, Uni. of NSW 1985; Uni. of NSW Art Purchase Prize, 1987; Melbourne Savage Club Invitation Drawing Prize, 1990.
APPTS: Teacher, Preston Inst. of Technology, 1975–76; artist-in-residence, then teacher, Art Workshop, Uni. of Sydney, 1979–81; teacher, photography, SASA, 1981–82; lecturer, painting, VCA 1984–86; assessor and moderator, art courses at various institutions and departments (Victoria College, VACB), 1980s; lecturer, painting, Phillip Institute, 1990; lecturer, VCA, 1990; La Trobe Uni. College of Northern Vic., Bendigo 1987– .
REP: NGA; most state galleries; Parliament House; MOCA Brisbane; MCA, Sydney; Artbank; regional galleries Ballarat, Hamilton; many municipal collections; several tertiary, corporate collections including Baillieu Myer, Philip Morris.
BIB: Catalogue essays in exhibitions as above. *New Art Two.*

Burke, *Field of Visions: A Decade of Change: Women's Art of the Seventies,* Penguin, 1990. AL 1/3/1981; 2/1/1982; 2/5/1982. A&A 28/2/1990.

ALLCOT, *John C.*
(b. 13/11/1888, Derbyshire, UK; arr. Sydney 1912; d. 13 July 1973) Painter.
STUDIES: Liverpool School of Arts, UK (lithography). He was commissioned to paint HMS *Endeavour Entering Botany Bay, 29th April, 1770* and similar historical subjects, and became well-known for his impressionistic watercolours of sailing ships and liners, often viewed entering Sydney Harbour. He also painted occasional landscapes and still life.
REP: AGWA; Manly Art Gallery.
BIB: E.E.H. Archibald, *Dictionary of Sea Painters,* Antique Collectors Club, Woodridge, Suffolk, 1980.

ALLEN, *Davida*
(b. 20/10/1951, Qld) Painter.
STUDIES: Sturt Holme Convent, Qld (with Betty Churcher), 1965–69; Brisbane College of Art, 1970–72. The strength of Allen's work is in its bold expressionistic colour, texture and originality of a single, simple statement. Her 1986 Archibald prize-winning portrait of her father-in-law won her fame as well as the prize as did a series she created around the actor Sam Neill. She has written and illustrated two books, *The Autobiography of Vicki Myers: Close to the Bone,* Simon & Schuster, 1991 and *What is a Portrait?,* New Endeavour Press, Qld, 1991. She held numerous solo exhibitions including at Ray Hughes, Brisbane, 1973–88 and at MOCA, Brisbane (a survey of work 1978–88); AGNSW, 1952; Uni. of Tasmania, 1982; NGV 1983, 87. Her work was included in numerous group exhibitions 1970s–93 including *Biennale of Sydney,* AGNSW, 1984; *Australian Perspecta,* AGNSW, 1985; and overseas in USA, Japan, Ireland.
AWARDS: Archibald Prize, 1986.
REP: NGA; AGNSW; AGSA; AGWA; NGV; QAG; MOCA, Brisbane; MCA, Sydney; Artbank; Uni. of Qld Art Museum; Gold Coast City Council; MOMA, New York.
BIB: Catalogue exhibitions as above. Smith, AP. A&A 18/4/1981; 20/4/1983. AL 2/3/1982; 4/1/1984.

ALLEN, *George Henry*
(b. 1900, Bendigo; d. 1972) Sculptor, teacher.
STUDIES: Swinburne Tech. Coll., 1919–20; travel studies Europe and UK, 1937. He succeeded John S. Davie as head of the sculpture dept, RMIT. His sculpture commissions included the symbolic stone Pinkerton statue for Ballarat, 1952, which caused much local controversy, and the National War Memorial of Vic. stone carving completed and erected near the Shrine of Remembrance, 1955.
AWARDS: Commissions for Pinkerton Sculpture competition, Ballarat, 1949; Shrine of Remembrance Forecourt competition, Melbourne, 1952; War Memorial, Kew Town Hall, 1954.
APPTS: Head, sculpture dept, RMIT, 1933–65.
REP: AWM.

BIB: Lenton Parr, *Sculpture*, Arts in Australia series, Longman, Melbourne, 1961; AS.

ALLEN, Josiah

(b. UK c. 1773, arr. Aust. 1817, d. 1838) Miniaturist, painter, teacher. Arriving in Sydney having been convicted of forging banknotes, he established himself as a portrait painter as well as signmaker and decorater. He worked in Sydney until 1837 but none of his work is known to exist.

BIB: Moore, SAA. Eve Buscombe, *Artists in early Australia and their portraits*, Sydney, 1978. Kerr, DAA.

ALLEN, Joyce

(b. 1916, Brisbane; d. 1992) Painter, printmaker. STUDIES: Etching at Willoughby Art Centre, NSW. Her social commentaries in linocuts have been included in the *British Print Biennale*, Bradford, 1968 and 1970, and in PCA exhibitions in Australia as well as in other exhibitions. AWARDS: Prizes at Rockdale and Warringah, 1957. REP: AGNSW; QAG; regional gallery Launceston; Uni. of Sydney.

BIB: PCA *Directory*, 1976. A&A 30/3/93 (obituary).

ALLEN, Mary Cecil

(b. 2/9/1893, Melbourne; d. 7/4/1962, Provincetown, USA) Painter, critic, lecturer. STUDIES: NGV School; Meldrum School; Slade School, London; lecture courses at the People's Institute, New York (with Fritz Pfeiffer and Ernest Thurn). A leader of avant-garde thought, she did much to widen the appreciation of modern art in Australia. A member of a distinguished family of Melbourne intellectuals, she exhibited figure and landscape paintings at the VAS from 1917, and in 1927 made her home in the USA. During the next 31 years her energy in the cause of Australian art abroad, and in lecturing in Australia about the latest developments in Europe and America during her frequent visits home, made her a valuable unofficial ambassador. Soon after establishing her own painting school in America she accepted an appointment to teach art at a New York girls' school, which she inherited on the death of the principal. In 1927–28 she lectured for Columbia Uni. at the People's Institute, New York, and in 1930–31 organised an exhibition of 100 Australian paintings on which she lectured in 14 American cities. She painted in Central Australia in 1950, and lectured on this experience (see 'Notes on Central Australia', *Meanjin* 3/1950). Her last Australian lectures were given in 1960. A memorial exhibition of her work was held at the Lyceum Club, Melbourne, in 1962, and after her death the *Mary Cecil Allen Memorial Lectures* were initiated under the auspices of the Australian Society for Education through Art. REP: NGV.

BIB: Mary Cecil Allen, *Mirror of the Passing World, Painters of the Modern Mind*, lectures published by W. W. Norton, New York, 1928, 1929; Frances Derham, ADB 7.

ALLEN, Norma

(b. Newcastle, NSW) Painter. STUDIES: Newcastle Tech. Coll. (with John Passmore and Paul Beadle), 1945–58. She held four exhibitions at von Bertouch gallery, Newcastle 1965–85 and several other galleries, and participated in a number of group shows, largely in the Newcastle area 1960–85. AWARDS: Prizes at Cessnock, 1959, and Mt Gambier, 1961. REP: Several regional collections Maitland, Newcastle; several tertiary collections NSW.

ALLISON-LEVICK, Tony

(b. Qld, 15/6/1919) Sculptor. Self-taught sculptor who has won numerous regional and municipal sculpture prizes in Queensland since 1976. REP: Regional galleries Stanthorpe and Gold Coast; Logan Shire Council.

BIB: Germaine, AGA.

ALLPORT FAMILY

In 1981, two exhibitions were held in the State Library of Tasmania to commemorate the 150th anniversary of the arrival in Tasmania (then Van Diemen's Land) of Joseph Allport, his family and the succession of related Allports, who all contributed valuably to the development of the visual arts in Tasmania. The period covered begins in London in the 18th century with Henry Curzon Allport and ends with Henry Allport, whose generous gift in 1969 – added to the gift from Miss J. E. Allport in 1967 – led to the creation within the State Library of the Allport Library and Museum of Fine Arts. Amateur and professional artists seem inextricably mixed within the Allport succession. They are listed below, together with the known details of their careers.

BIB: J. L. Roget, *A History of the Old Watercolour Society*, Longmans Green, London, 1891. Henry Allport, *Early Art in Tasmania* Hobart, 1931. Moore, SAA. ADB 1. G. T. Stilwell, ADB 3. Clifford Craig, *The Engravers of Van Diemen's Land*, Foot & Playstead, Launceston, 1961. Bénézit, *Dictionnaire*, 1976. G. T. Stilwell, intro. exhibition catalogue, *Mary Morton Allport: A Commemorative Exhibition*, Allport Library and Museum of Fine Arts, State Library of Tasmania, Hobart, 11 Dec. 1981. Papers of Henry Allport, Allport Library and Museum of Fine Arts. Kerr, DAA.

ALLPORT, Cecil (Morton John)

(b. 1858, Hobart; d. 1926, Hobart) Solicitor, collector. Eldest son of Morton Allport. He wrote articles on Tasmanian history, and his library and collection of Tasmanian colonial pictures formed the nucleus of the Allport Library and Museum of Fine Arts. The Morton Allport Bequest – to acquire eighteenth and nineteenth century watercolours for the TMAG – was established under his will as a memorial to his father, Morton, and to his own son of the same name.

ALLPORT, Henry

(b. 1890, Hobart; d. 1965, Hobart) Solicitor, collector, authority on early Tasmanian art. Son of Cecil Allport. He bequeathed his magnificent library and

collection to form the Allport Library and Museum of Fine Arts, administered by the State Library of Tasmania as a memorial to the family.

ALLPORT, *Henry Curzon*

(b. 1788, Aldridge, Staffordshire; arr. Sydney 1839; d. 1854, Parramatta, NSW) Painter, administrator.
STUDIES: London, with John Glover. Brother of Joseph Allport. He exhibited with the RAS, London 1811–12 and the Old Watercolour Society 1813–20. In Australia he was, among other posts, agent to Edward Macarthur at Elizabeth Farm, Parramatta, around 1854 and continued to paint largely in watercolours the environs of Parramatta and the NSW countryside. His work was represented posthumously in the first exhibition of the NSW Academy of Art 1872. His work was represented in *The Art of John Glover*, NGV, 1980, and *The Artist and the Patron*, AGNSW, 1988.
REP: AGNSW; Allport, Mitchell, Dixson Libraries; British Museum.
BIB: Moore, *SAA*. *ADB* 1. Kerr, *DAA*. Campbell, *AWP*.

ALLPORT, *John*

(b. 1799; d. 1854) Painter.
STUDIES: Family studies with his brothers, Joseph and Henry Curzon, and sister, Mary Anne Allport. Not recorded as having visited Tasmania.

ALLPORT, *Joseph*

(b. 1800, Aldridge, Staffordshire; arr. Tas. Dec. 1831; d. 1877, Hobart) Solicitor, also distinguished as a naturalist and horticulturist. In Dec. 1826 he married Mary Morton Chapman, painter and miniaturist.

ALLPORT, *Lily (Curzona Frances Louise)*

(b. 1860, Hobart; d. 1949, Hobart) Painter.
STUDIES: London, with Hubert Voss; also in Paris and Rome. Second daughter of Morton Allport. She was prolific in lithography and linocuts, and painted mainly portraits and landscapes. A member of the Society of Painter Etchers, London, she exhibited at the Paris Salon, British Academy of Fine Arts, Rome, and in London and Tasmania.
REP: Allport Library and Museum of Fine Arts, Hobart; Ballarat Fine Art Gallery.

ALLPORT, *Mary Anne*

(b. 1790; d. 1865) Painter.
STUDIES: London, with John Glover. A sister of Joseph, Henry Curzon and John Allport, she is not recorded as having visited Tasmania.

ALLPORT, *Mary Morton (née Chapman)*

(b. 1806, UK; arr. Tas. 1831; d. Hobart, 1895) Painter, lithographer.
STUDIES: Aldridge, Staffordshire, where she received art lessons from Henry Curzon Allport at the school for young ladies conducted by his parents, William Allport and his wife Hannah, née Curzon. Later she studied in Hobart with J. S. Prout. A skilful lithographer, some of her work was printed in the *Illustrated London News*. She is best known as a miniaturist and natural history painter who, while she painted mainly for personal pleasure, did exhibit a chess table with 64 painted panels (whereabouts now unknown) in the Paris 1855 Universal Exhibition. The TMAG held a tribute exhibition of her work in 1981 and she was represented in the Bicentennial exhibition *The Great Australian Art Exhibition 1788–1988* and *A Century of Women Artists 1840–1940* Deutscher Fine Art, Melbourne, 1993.
REP: Ballarat Fine Art Gallery; Allport, Mitchell Libraries.
BIB: Tim Bonyhady *The Colonial Image; Australian Painting 1800–1880*, Sydney, 1981. C. Craig *The Engravers of Old Van Diemen's Land*, Hobart, 1961. C. Craig, *More Old Tasmanian Prints*, Launceston, 1984. Kerr, *DAA*.

ALLPORT, *Minnie (Mary Louise REID)*

(b. 1832, Hobart; d. 1871) Painter. Daughter of Joseph Allport.

ALLPORT, *Morton*

(b. 4/12/1830 Aldridge, Staffordshire, arr. Tas. 1831; d. 10/9/1878, Hobart) Solicitor, naturalist, artist, photographer.
STUDIES: Hobart with J. S. Prout. Eldest son of Joseph Allport. His photographs of Tasmanian scenery are among the earliest extant and he was a major force in organising exhibitions in Hobart during the 1850s including the *Hobart-Town Art Treasures* 1858. His work was represented in *Shades of Light* NGA 1988.
REP: TMAG; NLA; Allport, Crowther libraries.
BIB: *ADB* 3. Kerr, *DAA*.

ALLPORT, *Thomas*

A watercolour portrait by Thomas Allport, *Mrs Alice Monelly in her 73rd Year*, was included in Leonard Joel's auctions, Melbourne, Nov. 1977.
NFI

ALTSON, *Aby* or *Abbey (Abraham)*

(b. 21/8/1866, Middlesbrough, Eng.; arr. Aust. 1883; d. 1949, USA) Painter.
STUDIES: NGV School, 1885–90; Paris, Academie Colarossi, 1891–93. Brother of Meyer Daniel Altson. His best known student painting is *The Golden Age* in the NGV collection. He worked in London as an illustrator before turning to portraiture. Through London dealers he painted many portraits of Indian maharajas, notably of Ranga Singh, Maharaja of Nawanagar, and travelled much between England and India. He migrated to the USA in 1939 and died there. His work was represented in *Golden Summers* curated by the NGV, 1986.
AWARDS: NGV Travelling Scholarship, 1890.
REP: NGV.
BIB: McCulloch, *GAAP*.

ALTSON, *Meyer Daniel*

(b. 19/5/1881, Middlesbrough, England; arr. Australia 1888; d. 1965, London) Painter.

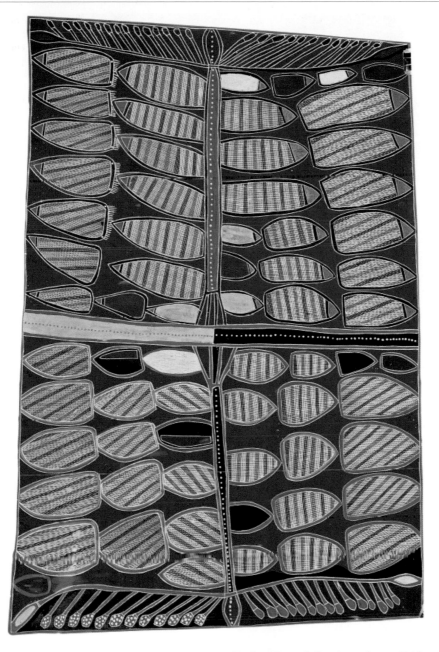

England Bangala Pandanus Story, *1992, ochres on paper. Maningrida, NT. Collection,* MAGNT.

Aboriginal Art

The transformation of the ancient forms of Aboriginal art into 20th century expression has been one of the great success stories of contemporary Australian art. Twenty years before, Albert Namatjira's Central Australian works had become famous and started a whole school of realist watercolourists. During the late 1970s and 1980s traditional iconography started being successfully portrayed through use of both modern and traditional materials ranging from bark and ochres to acrylics, canvas and board in Aboriginal areas throughout Australia. Artists such as Turkey Tolson Tjupurrula, Clifford Possum Tjapaltjarri, and many others tell 'dreaming' stories in a completely modern idiom while urban artists like Lin Onus and Fiona Foley combine their Aboriginal heritage with the 20th century Western experience. Aboriginal women's art as seen in the work of Emily Knagwarreye and Gloria Petyarre is distinctive in many styles throughout the country.

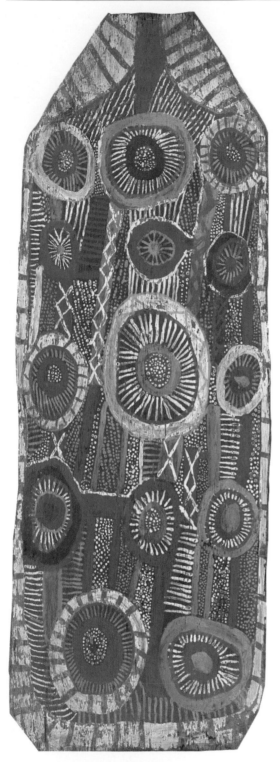

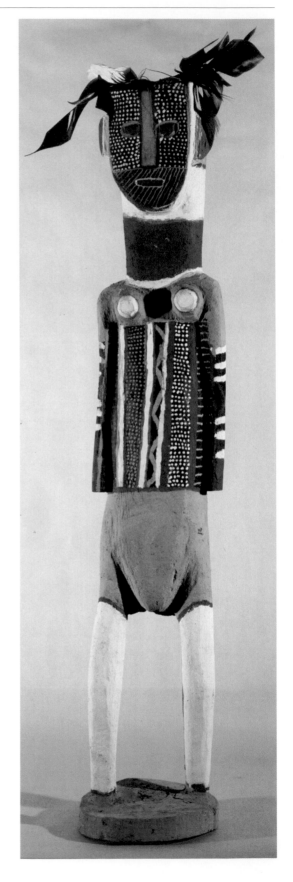

Above: *Toby Mungatopi,* Moon, sun, vines and stars, *c. 1968. Melville Island,* NT. *Collection,* MAGNT.

Right: *Benny Tipunguti* Sculpture of Wijai, *1975, Bathurst Island,* NT. *Collection* MAGNT.

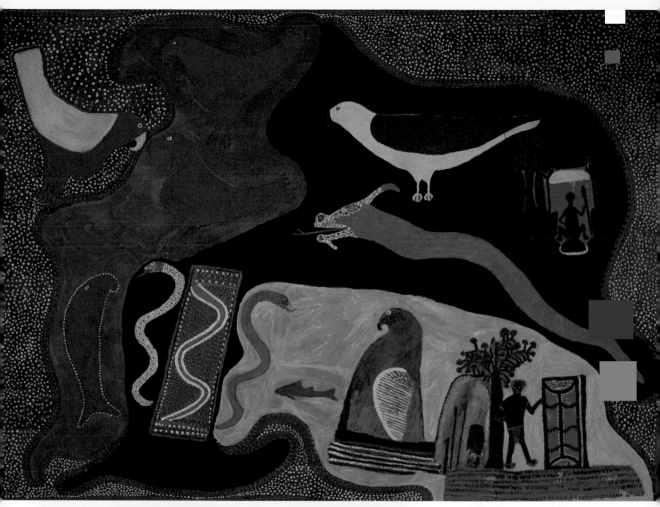

Above: *Turkey Tolson Tjupurrula*, Straightening spears at Ilyingaungau, *synthetic polymer paint on canvas, 181.5 × 243.5cm. Kintore,* NT. *Collection,* AGSA.

Top: *Ginger Riley Munduwalala*, Limmen Bight Country, *1988, acrylic on canvas. Courtesy Alcaston House Gallery, 1988.*

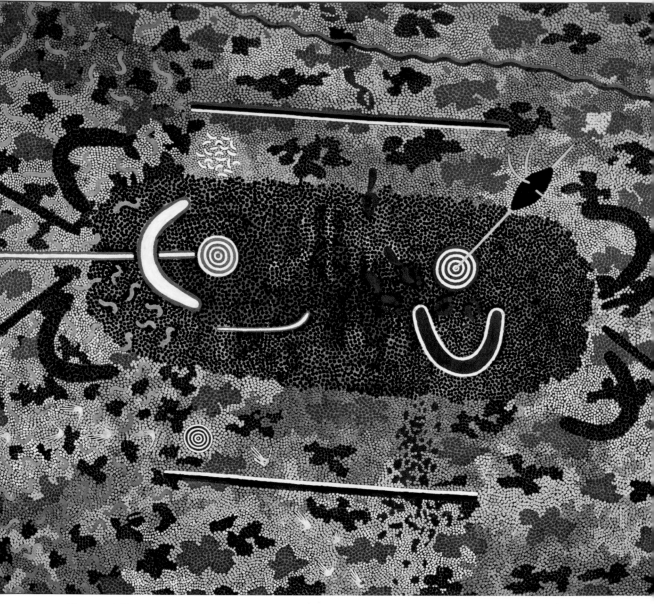

Above: *Clifford Possum Tjapaltjarri* Man's Love Story, *synthetic polymer paint or canvas, 1978, 214.5 × 257cm. Collection* AGSA.

Right top: *Lin Onus,* Ginger and my third wife check the mailbox, *1992, acrylic on linen, 91 × 152cm. Courtesy Painters Gallery, Sydney.*

Right: *Rover Thomas,* The Artist's Father's Country at Ngannjoo, *1991, natural ochres on canvas, 100 × 140cm. Courtesy Gallery Gabrielle Pizzi, Melbourne.*

Top: *Gloria Petyarre* Awelye, *acrylic on canvas, 1991,*
150 × 120cm. Courtesy Utopia Art.

Above: *Albert Namatjira,* White Gums, Central
Australia, *Courtesy Sotheby's, July 1988.*

Above: *Fiona Foley*, Black Cockatoo Feather, *1992 pastel on paper, 56 × 38cm. Courtesy Roslyn Oxley9, Sydney.*

Left: *John Mawandjul*, Nawarramulnul, *(Shooting star spirit), 1988, ochres and synthetic polymer on bark, 219.4 × 95cm. Near Maningrida, Arnhem Land,* NT, *Collection,* MCA.

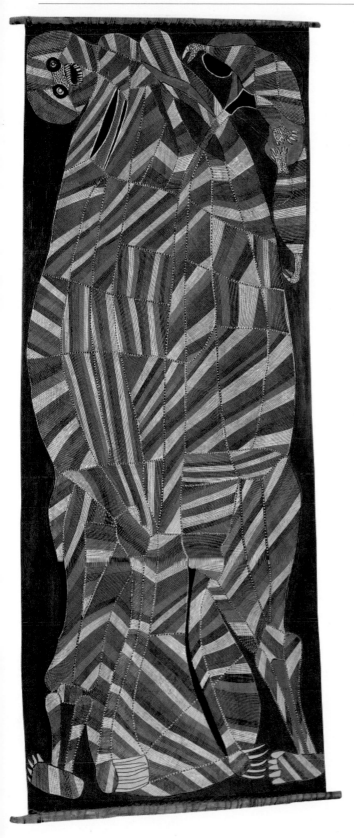

Above: *Emily Kngwarreye,* Arthukara Desert Grasses, *1991, acrylic on canvas. 152 × 122cm. Courtesy Gallery Gabrielle Pizzi, Melbourne.*

Left: *Jack Britten,* Country at the Bungle Bungles, *1992, natural ochres on canvas. Courtesy, Gallery Gabrielle Pizzi, Melbourne.*

Rick Amor, In Catalunya, *1992, oil on linen, 63.5 ×
79cm. Courtesy Niagara Galleries.*

STUDIES: NGV School, 1898–1902; Paris, Académie
Colarossi, Ecole des Beaux-Arts, Académie Humbert
(with M. Carriacere). Brother of Aby Altson. From
1902 Altson lived in Europe, painting portraits in
Florence before going to London where he painted
portraits of the British aristocracy and exhibited at
the RA, and Paris Salon. He lost his sight as result of
a wound received while serving as a gunnery inspec-
tor at Woolwich Arsenal during World War II. By
the 1950s he was calling himself Michael David Alston.
AWARDS: NGV Travelling Scholarship, 1902; silver
medal, Paris Salon, 1951.
REP: NGV.

AMOR, Rick
(b. 1948, Frankston, Vic.) Painter.
STUDIES: CIT, 1965; NGV School, 1966–68. From
1972, when he began work as a full-time professional
artist, he produced a continuous stream of paintings,
drawings, posters, illustrations and cartoons. His early
paintings reflect his formal training at the NGV, with
John Brack, but this influence was soon replaced by
social-realist interests deriving from natural sources
as well as from his studies of social problems as
expressed in the work of the modern Mexicans, Siqueros
and Orosco. His large, free-ranging exhibition at the
Trades Hall Gallery, Melbourne, 1978, was in effect

Abby Alston, Portrait, *oil on canvas, 59.5 × 49cm. Joels,
November 1991.*

a summary of his fine talents as painter, graphic artist, satirist and humanist. He was artist-in-residence at the Victorian Trades Hall Council in 1980. Since then his work has developed strength and maturity. His black and white drawings of Melbourne ports and docks were of particular note in the 1980s while in the 1990s, following time spent in Barcelona on a VACB grant, his painting developed an atmospheric, misty quality without diminishing its strong compositional structure. He held numerous solo shows in commercial galleries in Melbourne (especially at Niagara Galleries) and Canberra 1974–93; at ACCA 1990; a touring survey exhibition of five Victorian regional galleries; 3 exhibitions SA and Vic. regional galleries, 1991; as well as participating in numerous significant group exhibitions in public galleries.

AWARDS: NGV Gallery Society Drawing Prize (shared), 1967; NGV Travelling Scholarship, 1968; VACB grant, to work full-time for one year, 1975; MPAC *Festival of Drawing* (purchase), 1977; National Australia Bank Art Prize, 1989; VACB studio, Barcelona, 1991.

REP: NGA; NGV; TMAG; Artbank; regional galleries Ballarat, McLelland, Mornington, Mildura, La Trobe Valley, Riddoch; La Trobe, Melbourne, Monash Uni. collections; National Australia Bank Collection.

BIB: *New Art Three.* Daniel Thomas, *Outlines of Australian Art, The Joseph Brown Collection*, Macmillan 1989.

AMOS, Irene

(b. 27/7/1927, Brisbane) Painter, teacher.

STUDIES: Eight diplomas Central Technical College, Brisbane 1960–64; M. Creative Arts, Uni. of Wollongong 1986; Doctor of Creative Arts, Uni. of Wollongong, 1990; travel studies in UK, Europe and many other countries. Between 1966–86 she held over 35 solo exhibitions including some in Brisbane, Sydney and Melbourne, and participated in over 30 group exhibitions 1961–91 including *A Complementary Caste: Homage to Women Artists of Queensland Past and Present*, Centre Gallery, Gold Coast 1988; *Artists and Aspects of CAS, Brisbane*, City Hall and Museum 1991. Committee member of many societies, including life member RQAS 1961– ; Brisbane IMA 1980– ; Warana Festival Committee member; curriculum panel Queensland College of Art.

AWARDS: More than 45 prizes, largely in Queensland, 1961–88 including Godfrey Rivers Memorial 1961, Kenneth McQueen Memorial 1962; RNAGAQ, 1968, 69; and at Dalby, Grafton, Springbrook, Cairns, Townsville, Brookfield, Redland, Sandgate, Armidale, Innisfail; Order of Australia medal, 1991.

APPTS: Tutor, QAS, and for the Arts Council of Australia in various Qld centres, 1969–74; Australia Council board member 1991.

REP: QAG; Artbank; regional galleries, tertiary collections Qld, NSW including Armidale, Brisbane, Gold Coast, Toowoomba.

BIB: Catalogue essays in exhibitions as above. Fridemanis, *Artists and Aspects of the Contemporary Art Society 1961–73*, Boolarong Publications, Brisbane, 1988. Germaine, *DAWA*.

ANDERSON, Beryl

(b. 1927, Sydney) Painter, teacher.

STUDIES: ESTC, Sydney, 1946–50; travel studies Europe, UK, 1954–59 and 1961–64; Gordon Institute, Geelong (Dip. 1975). Her illustrative paintings in muted colours often depict interiors with cut-off figures.

AWARDS: Caltex prize, Flinders Art Show, 1976; *Artist of the Year* award, VAS, 1976.

ANDERSON Garry

(d. 31/12/1991) He operated his own gallery in Sydney 1981–91 which showed the work of a number of important contemporary and often younger artists and was on the staff of the NGA during its formative years.

BIB: *A&A* 30/1/92 (obituary).

ANDERSON, James

(Arr. Victoria c. 1852) He was on the committee to organise the Victorian Fine Arts Exhibition in 1853 to which he contributed works. He became a moderately successful portrait painter in Melbourne, country Vic. and Sydney 1850s–70s. His work was represented in *The Artist and the Patron* AGNSW 1988.

REP: Mitchell Library; Sydney University

BIB: Moore, *SAA*. Kerr, *DAA*.

ANDERSON, Lisa

(b. Qld, 25/2/1958) Painter, teacher.

STUDIES: Dip. of Teaching, Kelvin Grove CAE, Brisbane 1977–79; Grad. Dip. Professional Art Studies, City Art Institute, 1982; Master of Art (Vis. Art), City Art Institute, 1985–86; enrolled Doctor of Creative Arts (Wollongong), 1991– . Often working in environmental art area, she was the first artist-in-residence at the Australian Museum, Sydney, 1991. She held a solo exhibition *Memories on a Grand Scale*, City of Sydney & Australian Museum 1992 and participated in group exhibitions including *Another Page of the Diary*, EAF, Sydney, 1991; *You are Walking in the Shadows,* Australian Museum, Sydney 1991.

AWARDS: Residency, Moya Dyring Studio, Cité Internationale des Arts, Paris, AGNSW 1985; professional development grant VACB 1992.

APPTS: Lecturer in painting, Charles Sturt Uni., Wagga Wagga, 1988–89; lecturer, Catholic College of Education, 1989; lecturer, painting and drawing, SASA, 1990; lecturer, painting, Uni. of Western Sydney, 1992; project officer, VACB, 1993– .

REP: Australian Museum; Ipswich regional gallery; Uni. of Tasmania.

BIB: *New Art Six.*

ANDERSON, Wallace

(b. 1888, Dean, Vic.; d. 1975, Geelong, Vic.) Sculptor.

STUDIES: Gordon Tech. Inst., Geelong, 1907; VAS life classes conducted by C. Douglas Richardson (probably a decisive influence on his future as a sculptor); Chelsea Polytechnic, London, c. 1918–20. He served with the AIF in France from 1915 and in 1918 was appointed AIF Museums Officer in the War Records

Section at Earls Court, London. Returning to Australia in 1920 (after touring the battlefields of Europe and the Middle East), he worked at the AWM, Canberra 1920–30 and again c. 1940–46, to produce a large number of commissioned works relating to World War I. Later he achieved celebrity for his busts of Australian prime ministers for the Botanical Gardens, Ballarat, but the bronze for which he will always be remembered is popularly known as *Simpson and the Donkey*, in the Shrine of Remembrance gardens, Melbourne. He taught briefly at the Footscray Tech. School 1946–47 and at the age of 84 wrote an unpublished autobiography.
AWARDS: Competition for commemorative sculpture, *The Man with the Donkey*, Melbourne 1935.
REP: AWM; Science Museum of Vic.; State Library of Vic.; Geelong Art Gallery.
BIB: Scarlett, AS.

ANDERSON, Walter J.
(Active c. 1900–20, Melbourne) Painter. Known mainly for landscapes he exhibited at the VAS in 1901 and 1916–17, showing oils of Port Phillip Bay as well as landscapes. Mrs W. J. (Theo) Anderson (née Tuckett), his wife, was also a frequent exhibitor, showing landscapes and figure and flower compositions, 1888–1917. (Letter from grand-daughter B. Rideout 1985)

ANDERSON, William Nicholls
(b. 1873, Vic.; d. 1927, Mordialloc, Vic.) Painter, teacher.
STUDIES: NGV School (evening classes), 1894–96. He painted in the manner of the Heidelberg School painters, was secretary of the VAS 1915–19 and exhibited there 1901–27. He exhibited also with the Yarra Sculptors' Society 1901–10, and with the Australian Art Association 1918–20, 1923. Eighteen of his paintings of Melbourne and Port Phillip Bay scenes were included in the *Australian Art Exhibition* at the Guild Hall, Melbourne, Mar.–Apr. 1911.
REP: Dunedin Art Gallery, NZ.
BIB: Moore, SAA; VAS *Journals* nos. 1–83, July 1911–Feb. 1919. (Research paper by Joy French, 3 Oct. 1979.)

ANDREW, Carl Francis
(b. 3/7/1939, Melbourne) Curator.
STUDIES: RMIT (Dip. Art 1960); travel studies, mainly Greece and USA, 1964–67, Uni. of Melbourne, 1968–70. Son of the artist F. C. Andrew (q.v.), he worked first as a graphic designer 1961–63, then as a freelance artist and lecturer in Melbourne 1968–70 and since 1975 as gallery curator. He has been a member of a number of art committees and boards including Crafts Board of the Australia Council and Asian Arts Society. He has written a number of articles and catalogues on artists and the visual arts including for A&A and with Ann Galbally, *The Visual Arts in Victoria: A Survey*, Victorian Ministry for the Arts, 1975.
APPTS: Director, McClelland Gallery, Langwarrin, Vic., 1971–75; curator of art, TMAG, 1975–80; member Stamp Advisory Committee, Aust Post 1977–82; asst.

director, applied arts, Museum of Applied Arts and Sciences, Sydney, 1980–87; member, Crafts Board, Australia Council 1980–84; member Artbank board 1980–83; member Artworks Committee of Parliament House Construction Authority 1983–87; founding president Asian Arts Society of Australia 1991– ; senior curator, Collection Development, Powerhouse Museum, Sydney 1988– .

ANDREW, Francis Charles
(b. 4/4/1911, Melbourne; d. 13/9/1973) Painter, advertising artist.
AWARDS: 2nd prize, *Home Front* section, 3rd prize *War on Land* section, *Australia at War* exhibition, 1944.
APPTS: Secretary of Australian Commercial and Industrial Artists Association, 1936–42, president 1947; organising secretary of *Australia at War* exhibition, 1944.
REP: AGNSW; NGV; TMAG.

ANDREWS, William
(b. 1840, Sydney; d. 1887) Painter, draughtsman. Colonial school landscape and topographical watercolourist; draughtsman in the office of the government architect of NSW.
REP: Mitchell, Dixson Libraries; Manly art gallery; NLA.
BIB: Campbell AWP. Kerr, DAA.

ANGAS, George French
(b. 25/4/1822, Newcastle-upon-Tyne; arr. SA 1844; d. 1886, London) Illustrator, painter, topographical artist.
STUDIES: London, with Weaverhouse Hawkins, natural history artist. The eldest son of the shipping magnate and 'father of South Australia', George Fife Angas (1789–1879), Angas travelled to Adelaide on his father's ship, *Augustus,* on which also were two sons of the British artist Edward Calvert. His first expedition with Governor Grey was followed by a six-month visit to New Zealand, after which he rejoined Grey for his second South Australian expedition. Through Grey's influence the work done on these expeditions was shown in the Council Room, Adelaide, an unprecedented privilege, the exhibition being extensively advertised as 'the first exhibition in the colony'. This aroused much resentment, especially among the friends of S. T. Gill, and Angas came in for severe criticism, notably in a letter written by F. R. Nixon *(South Australian,* 17 June 1845). Angas was in London in 1846 to supervise the publication of his *South Australia Illustrated* and other books; he married there, returning to SA in 1850. When gold was discovered in NSW, he followed the rushes to record the scene at Ophir. He also made some illustrations of the Victorian goldfields but these are now thought to have been taken from photographs supplied by William Friend Bentley, who had been commissioned by Angas Snr to make pictorial records of SA. From 1860–63 George French Angas was chairman of the district council of Angaston. He returned to London finally in 1863,

published a number of volumes and died in England in 1886. His publications include: *A Ramble in Malta and Sicily in the Autumn of 1841*; *South Australia Illustrated*, 1846; *The New Zealanders Illustrated*, 1846; *Savage Life and Scenes in Australia and New Zealand*, 1846; *The Kafirs Illustrated*, 1848; *Australia: A Popular Account*, 1865; *Polynesia: A Popular Description*, 1866; and a book of verse, *The Wreck of the Admella*, 1874, all published in London. Books illustrated by Angas include the journals of the explorers John McDouall Stuart, c. 1860, and John Forrest, c. 1869. His work was seen in the touring exhibition, *South Australia Illustrated*, AGSA, 1976; the Bicentennial exhibition *The Great Australian Art Exhibition 1788–1988* and *The Artist and the Patron* AGNSW 1988.
APPTS: Official artist for Grey's SE expedition, 1844, and for his expedition to Port Lincoln and Kangaroo Island, 1845; secretary, Australian Museum, Sydney, 1853–59; first examiner, Sydney Mechanics School of Art, 1859–60.
REP: Most Australian state galleries and other important public collections.
BIB: McCulloch, AAGR. J. Tregenza, *George French Angas*, Adelaide, 1980. ADB 1. Benko, ASA.

ANGAS, John Howard
(b. 5/10/1823, Newcastle-upon-Tyne; arr. Adelaide 1843; d. 17/5/1904) Painter. Known mainly for his paintings of birds, flowers and insects he was the younger brother of George French Angas (q.v.). John's talents as an artist were sacrificed to the family's business interests. Having learned German in order to communicate with the Lutheran dissenters financed by George Fife Angas for settlement in South Australia, he developed the family properties and business interests, became very successful and generously endowed many institutions and properties in South Australia.
BIB: ADB 3.

ANGUS, Max Rupert
(b. 1914, Hobart) Painter.
STUDIES: Hobart Tech. College with Lucien Dechaineux, Mildred Lovett, Amie Kingston, Madge Walker, 1931; and after the war with rehabilitation training scheme with Jack Carington Smith. He moved to Melbourne and worked as a graphic designer before joining the army in 1941 and continuing to sketch and paint whenever possible. He returned to Hobart in 1948. He worked for the ABC for six months each year from 1956–73 (including conducting a series of television programs on early Tasmanian painters in 1963), painting the rest of the time. Founder of the Sunday Group of painters he has written books on the photographer Olegas Truchanas and the colonial artist Francis Simpkinson de Wesselow.
AWARDS: Minnie Crouch prize, Ballarat, 1962; Member, Order of Australia, conferred 1978.
APPTS: president, Art Society of Tasmania, 1956–60; fellow Royal Society of Arts 1987– .
REP: AGSA; TMAG; regional galleries Ballarat and Launceston.

ANGWIN, Robin Dale
(b. 1947, Melbourne; d. Dec. 1976) Painter, printmaker, sculptor, teacher.
STUDIES: RMIT 1969; NGV School 1971. His paintings were mainly large, colourful abstracts in which texture, colour and design were perhaps subservient to technological versatility, the element that prevailed also in his sculptures in steel. He held exhibitions in Melbourne 1971, 1973, Brisbane and Sydney 1972, Adelaide 1973. He was killed in a car accident while returning to Melbourne from the *Biennale of Sydney*, December 1976. A memorial exhibition of his work was held at the Warehouse Gallery, Melbourne, Feb. 1977.
AWARDS: Alcoa award for sculpture in aluminium, 1972; CIT study grant (for overseas study), 1976; British Council grant, 1976.
APPTS: Education officer, NGV, 1972–73; teacher of sculpture, CIT, 1973–76.

ANIVITTI, Giulio
(b. 1850, Rome; arr. Brisbane 1870; d. 1881, Rome) Painter.
STUDIES: Rome, Accademia di San Luca, with Alessandro Capalti. Known mainly for portraits, including those of Professor Badham, Canon Allwood and Archbishop Polding.
AWARDS: Gold medal for portraiture at annual NSW Academy exhibition.
APPTS: Teacher, NSW Academy of Art.
REP: Sydney Uni. College.
BIB: ADB 3.

ANNAND, Douglas
(b. 1903, Toowoomba, Qld; d. 1976, Sydney) Graphic designer, painter, illustrator, sculptor.
STUDIES: Central Tech. Coll., Brisbane, c. 1925–26. He worked for five years in a bank (1920–25) before joining an advertising agency and moving to Sydney, 1930, where he became Australia's most celebrated advertising designer. He designed the ceiling for the Australian Pavilion at the Paris Exposition, 1937, and in 1938–39 was art director of the Australian Pavilion at the New York World Fair. Later commissions included cover designs for *Meanjin*, the mural for the new Wilson Hall, Uni. of Melbourne, and murals and sculptures in widely varied media for a large number of business houses.
AWARDS: Sydney Harbour bridge poster competition, 1937; Sulman prize 1941, 47, 51; poster prize, Adelaide Festival of the Arts, 1960; international poster prize, Milan, c. 1968.
REP: NGA; AGNSW; NGV; QAG; AWM; uni. collections, Brisbane, Melbourne and Sydney.
BIB: Article, *Architectural Review*, special New York Fair number, 1939. *Gebrauchsgraphik*, Berlin, 1939. Sydney Ure Smith, ed., *Douglas Annand: Drawing and Painting in Australia*, Ure Smith, Sydney, 1944; *Who's Who in Graphic Art*, Graphis Press, Zurich, 1962. A&A 15/1/1977 (Lister G. Clark, tribute, *Douglas Annand*).

ANNANDALE IMITATION REALISTS

Group of three painters (Michael Brown, Ross Crothall and Colin Lanceley) from Annandale, NSW, whose colourfully decorated 'real' objects, such as stove pipes and various scrap-heap relics, made their first appearance at the Museum of Modern Art, Melbourne, 1962. Subsequent work represented the first Australian appearance of American Pop and assemblage influences.

ANNEAR, *Harold Desbrowe*

(b. 16/8/1865, Bendigo, Vic.; d. 22/6/1933, St Kilda) Architect, teacher, art patron, collector. Known for his highly individual designs of houses, some designed for artists, notably the house by the River Yarra at Darebin for the painter Norman Macgeorge, with garden design by Blamire Young (since the 1970s the artist-in-residency house for University of Melbourne). For many years Annear taught architecture and drawing at the Working Men's College, Melbourne (*see* SCHOOLS RMIT). He collected graphic art, including Australian drawings. The R. H. Bow collection given to the Mildura Arts Centre came from Annear's collection.

BIB: *ADB* 7.

ANNEAR, *Judy*

(b. 12/5/1951, New Zealand) Art writer, curator, administrator.

STUDIES: BA, Auckland Uni. She was assistant director (1979) then director (1980–82) of Ewing & George Paton Galleries, Melbourne Uni.; founding director, Artspace, Sydney 1982–83 and curator of numerous exhibitions including *Perspecta 85*; *Angry Penguins* Hayward Gallery, London, Tate Gallery, Liverpool; *Edge to Edge; Australian Contemporary Art to Japan* and *Zones of Love: 10 contemporary artists from Japan*, MOCA, Sydney, 1991–92; Australian Pavilion at Venice Biennale, 1993. She has written on the visual arts since 1979 including book reviews for *The Australian*; guest editor *Art & Text*, September 1991; contributor to art journals (*LIP*, *Art Network*, *Art & Text*, *Art & Australia*, *Art Monthly*, UK, *Studio International*, London).

ANNOIS, *Len (Leonard Lloyd)*

(b. 1906, Malvern, Vic.; d. 1966, Melbourne) Painter, graphic artist.

STUDIES: NGV School night classes, 1930–32; independent travel studies in Europe. As a council member of the VAS, founder of the magazine the *Australian Artist* and a president of the National Gallery Society of Victoria, Annois gave much valuable service to the development of art in Victoria, where he was unrivalled as a watercolourist working in the English tradition. A member of the RWS, London, he also studied the art of fresco in Italy, mainly to increase the size, scope and vitality of his watercolours. Later he executed many large murals in fresco, notably the 19m × 7m mural at the College of Pharmacy, Royal Parade, Melbourne. Towards the end of his life his horizons expanded. His style became freer and more colourful and consequently much sought after.

AWARDS: Prizes at Ballarat, 1949, 50; Bendigo, 1946, 49; Albury, 1948; Melbourne (VAS drawing prize), 1949; Perth, 1949; Melbourne (Dunlop), 1950, 53, 54; Adelaide (Vizard-Wholohan), 1960, 62; Maitland (watercolour and oil prizes), 1961; Sydney, Wynne prize for watercolours, 1961, 1964; Melbourne (VAS prize for watercolour), shared, 1962.

REP: Australian state and regional galleries and Australian uni. collections.

BIB: Catalogue NGV collections (watercolours), 1948; Bonython, *MAP*.

ANTIPODEANS

(Active Melbourne 1959–60s) A group of six painters, Charles Blackman, Arthur Boyd, David Boyd, John Brack, Robert Dickerson and Clifton Pugh, and the art historian Bernard Smith. It was formed in Melbourne early in 1959, in order to support figurative painting in opposition to the new forms of geometric abstraction. Only one exhibition was held at the VAS Galleries in August 1959. The catalogue to the exhibition contained a manifesto presenting their position, which in part stated: 'Let it be said in the first place that we have all played a part in that movement which has sought for a better understanding of the work of contemporary artists both here and abroad . . . As Antipodeans we accept the image as representing some form of acceptance of and involvement in life. For the image has always been concerned with life, whether of the flesh or of the spirit. Art cannot live much longer feeding upon the disillusions of the generation of 1914. Today dada is as dead as the dodo and it is time we buried this antique hobby-horse of our fathers.'

The name Antipodeans was adopted because it was intended initially to hold the exhibition in London and to avoid the implicit nationalism involved in the use of the word 'Australian'. For some years after 1959 the term Antipodean was used in a broader sense to refer to a good deal of Australian contemporary figurative art, and even Australian art in general. For example the catalogue of the Australian Exhibition held in the Tate Gallery, London in 1963 was entitled *Antipodean Vision*. The exhibition provoked considerable discussion in art circles throughout Australia. In 1976 the NGV assembled *The Antipodean Revisited*, a travelling exhibition of work by the group; in 1988 Lauraine Diggins Fine Art assembled *The Antipodeans Another Chapter* shown at her gallery in Melbourne as well as the Nolan Gallery, Lanyon, ACT and the S. H. Ervin Gallery, Sydney.

Most of the artists of the group were also associated at some stages of their lives with the Contemporary Arts Society, Melbourne. Work by members of the group was included in the Whitechapel Exhibition of 1961; *Rebels and Precursors* NGV 1962; *The Heroic Years of Australian Art* touring regional galleries Australia 1977–1979 and the inaugural exhibition of Heide, 1981.

See also EXHIBITIONS

ANTMANN, *Giselle*

(b. 9/5/1946, Munich, Germany; arr. Aust. 1955 Painter, ceramicist, writer.

STUDIES: Dip. Ed. Uni. of Sydney 1976; MA Ceramics, Cardiff Institute of Higher Education 1992. Copywriter in advertising (Sydney) and publishing (London), freelance writer for leading Australian magazines and tutor in English Lit. Sydney Uni. She participated in group ceramic, drawing and sculpture exhibitions at private galleries in Sydney and London, including *Perspecta*, AGNSW 1985 and degree show Cardiff, UK 1991.

APPTS: Tutor, English literature, Sydney Uni. 1969–70; Ceramics Dept, NAS, ESTC, 1992– .

REP: NGA; VACB.

BIB: Germaine, AGA.

Jean Appleton, Through the Window, *oil on canvas on board, 83 × 102cm. Joels, April 1992.*

APPLETON, *Jean*

(b. 1911, Ashfield, Sydney) Painter, teacher.

STUDIES: ESTC, Sydney (Dip. 1932); Westminster School of Art, London, 1936–39; travel studies in Europe. She taught at the Julian Ashton School 1947–50 and at the NAS, Sydney, 1948–55. Her well-designed paintings reflect the modernist trends of Sydney painting in the 1930s. Her 13 solo exhibitions 1949–85 were largely at Macquarie, Sydney; also Greenhill, Adelaide; Jim Alexander, Melbourne. Numerous group exhibitions include those with her husband, painter Tom Green, at Macquarie Galleries, Sydney, 1973, 74. She participated in two travelling exhibitions of Australian art to New Zealand and Malaysia.

AWARDS: D'Arcy Morris Memorial prize, 1960; Bathurst prize, 1961; Portia Geach portrait prize, 1965; Manly art prize 1977; Orange Prize 1977.

APPTS: Secondary teaching ACT, NSW 1940–46; schools lecturer AGNSW 1945–56; teacher Julian Ashton, NAS, Workshop Arts Centre Sydney 1947–68.

REP: AGNSW; AGSA; NGV; QAG; regional galleries Bathurst, Bendigo, Newcastle, Orange, Rockhampton, Wagga.

BIB: Badham, SAA. Colour reproductions, AA, 1940. *NSW Society of Artists Year Book* 1944 and 1947. Burke, AWA. Jean Campbell, *Early Sydney Moderns*, Craftsman House, Sydney 1988. Mary Eagle, *Australian Modern Painting Between the Wars*, OUP, 1990.

APPLEYARD, *Ronald George*

(b. 1920, Adelaide) Administrator.

STUDIES: SASA, Adelaide; travel studies Europe, UK and USA, 1964. With the exception of war service (AIF 1941–45), his professional career was based at the AGSA.

APPTS: AGSA, junior asst, 1937; Asst Keeper of Prints, 1948; Keeper of Prints, 1951; Asst Director, 1962; Deputy Director, 1973; foundation secretary Art Galleries (later Art Museum) Association of Australia, 1963–75, president 1976; president, Arts Council of Australia (SA division), 1974–77; convenor, Computer Cataloguing Committee, 1975.

AWARDS: Gulbenkian Foundation grant for overseas study, 1964; VACB travel grant, 1975.

ARAGO, *Jacques Etienne Vietor*

(b. 1790; d. 1855) Maritime artist. French maritime artist on de Freycinet's ship, *Uranie*, during her Pacific voyage (1817–20). Arago made romanticised paintings of Australian Aborigines and commented on the presence of naked savages in a comparatively civilised city (Sydney). His journal, *Promenade autour du monde*, was published in Paris in 1823.

REP: Mitchell Library, Sydney; NLA.

BIB: Moore, SAA. R. Rienits & T. Rienits, EAA. Smith, EVSP. Kerr, DAA.

ARCHER, *Hilary*

(b. 1934, Calcutta) Sculptor.

STUDIES: ESTC, 1950–55; travel studies UK, Europe, Far East and USA, 1965. She held several exhibitions of sculpture in the ACT and Sydney 1970s and 80s.

REP: ANU, Canberra; QVMAG.

BIB: AL 5/5/1983 (front cover).

ARCHER, *Suzanne*

(b. 17/12/1945, Surrey, England; arr. Aust. 1965) Sculptor, painter.

STUDIES: Sutton School of Art, England, 1961–64; travel studies New York, Paris, Europe 1978–79; Europe and Africa 1984–85, 88–89; Zimbabwe, 1991–92. Extensive use of collage, graffiti and other insignia are the characteristics of her large, quilt-inspired canvases which show also an interest in textures. Her work was described as 'compositions crammed full of bits and scraps; patches of paint, pieces of collage, passages of gestural paintwork . . . it is a world of confusion and of restless agitation; but its density allows no freedom of movement' (Christopher Allen, *SMH* 14/9/1990) and she held 20 exhibitions 1969–87 including four at Watters, Sydney; four at Rex Irwin,

Sydney and several at Powell St, Melbourne. Group exhibitions in which her work appeared included *Australian Perspecta 1985*, AGNSW 1985; *Faber Castell drawing prize*, 1985, 86, 87; *Inside the Greenhouse*, Tin Sheds 1990.

AWARDS: Over 40 regional, municipal prizes including at Dubbo, Gosford, Stanthorpe, and Faber-Castell Prize 1985; Trustees Art Prize and Spring Prize, AGNSW 1987; SMH Art Prize 1989; residency Power Studio, Cité Internationale des Arts, Paris, 1978 and VACB studio, New York, 1978; project grant VACB 1979, 87; travel grant VACB 1984.

REP: NGA; AGNSW; NGV; Artbank; VACB; many tertiary and regional collections all states including Bathurst, Camden, Darling Downs, Gosford, Mildura, Wollongong.

BIB: Catalogue essays exhibitions as above. Germaine, *AGA*. Virginia Hollister and Kathrin McMiles, *Contemporary Australian Figurative Ceramics*. McIntyre, *ACD*.

ARCHIBALD, Jules François (John Feltham)

(b. 14/1/1856, Kildare, Vic.; d. 10/9/1919, Sydney) Magazine editor. Founder of the Sydney *Bulletin* with John Haynes on 31 Jan. 1880. As editor in 1880, and 1887–1903, Archibald exerted enormous influence on the growth of a national school of writing and of black-and-white art, which lasted virtually until he left the *Bulletin* in 1914 for a brief period of work as advisory editor of the new *Smith's Weekly*. His complete biography is superbly written by Sylvia Lawson (*The Archibald Paradox*, Penguin, 1984.) His name is commemorated through his bequest for the famous Archibald prize, and also for the Archibald fountain, Hyde Park, Sydney. This classic bronze, which cost £16,000 in 1927, was made by the French sculptor François Sicard on the recommendation of the president of the Royal Academy, Sir Frank Dicksee; it commemorates Australia's association with France in World War I.

BIB: Joynton Smith, *My Life Story*, Cornstalk Publishing Co., Sydney, 1927. Fred Johns, *An Australian Biographical Dictionary*, Macmillan, London, 1934. *Memoirs of J. F. Archibald*, series of articles in the *Lone Hand*, Sydney, 1907. ADB 3.
See also PRIZES

ARIA, Aubrey

(b ? d. 1963) Cartoonist, illustrator. He directed a well-known art correspondence school in Sydney for many years. He was known also as a skilful watercolourist and portrait painter.

APPTS: Staff artist, *Evening News*, Sydney, 1923; *Woman's Mirror*, 1927; contributor *Bulletin*, c. 1930.

BIB: Exhibition catalogue *Fifty Years of Australian Cartooning*, Myer Mural Hall, Melbourne, Nov. 1964.

ARKVELD, Hans Morell

(b. 1942, Den Haag, Holland) Sculptor.
STUDIES: SASA 1964; Dip. Art, Perth Technical College 1966; travel studies Europe 1972. He held a number of solo exhibitions of his sculptures and prints from 1967 especially in WA and participated in a number

of group sculpture shows including *Australian Sculpture Triennial* Melbourne 1981.

AWARDS: Esso Award for painting, Sydney 1968; Manjimup Drawing Prize 1970; Waterway Sculpture Award 1973; grant VACB 1975.

APPTS: Teacher technical colleges WA 1969– .

REP: AGWA; tertiary colleges WA including WAIT.

BIB: Scarlett, *AS*. PCA *Directory*, 1982.

ARKLEY, Howard

(b. 5/5/1951, Melbourne) Painter.
STUDIES: Prahran CAE, 1969–72; Melbourne State Coll., 1973. His geometric abstracts of his first exhibitions from the early 1970s progressed into ironic Pop paintings of suburban interiors and exteriors in the 1980s and have been seen in numerous solo exhibitions in Melbourne (largely at Tolarno). His work has appeared in numerous group exhibitions 1975–93 including *Australian Perspecta* AGNSW 1981; *Meaning and Excellence* Edinburgh Festival of the Arts and travelling London 1984; *The Australians* CDS Gallery, New York, 1984; *Form, Image, Sign*, AGWA 1989. He completed a painted tram for the Vic. Ministry for the Arts in 1982 and was one of the artists commissioned to work on the Sydney Mural Project by the VACB, 1983.

AWARDS: Caltex Alva award, La Trobe Valley Arts Centre, 1974; Frankston, 1974; Bunbury, WA, 1974; Portland, 1975; Beaumaris (Inez Hutchison prize), 1975] residency Moya Dyring Studio, Paris, 1977; residency VACB studio NY, 1977; grant, VACB, 1983.

BIB: Catalogue essays exhibitions as above. Smith, *AP*. Chanin, *CAP*. *AGA* 24/3/1987.

ARMFIELD, David

(b. 11/1/1923, Brighton, Vic.) Painter, printmaker.
STUDIES: RMIT; NGV School 1940s. He worked as a process worker for newspapers until 1965 when he resigned to paint full-time. His low-keyed, tightly painted land and seascapes are often populated with related groups of small figures. He held 8 solo exhibitions 1960–91 including at Australian Galleries, Melbourne; Melbourne Contemporary Art and in Adelaide, Brisbane, Hobart, Sydney, Canberra. His work was included in Australian Graphics exhibition to Poland 1972; in Italy 1984. He held a 2-person show with Vic. O'Connor in 1987 at the VAS.

AWARDS: Ramsay prize, NGV School, 1945; prizes in competitions at Camberwell, 1967; Redcliffe, 1967; Wodonga, Albury, 1970; Eltham, 1980.

REP: AGNSW; NGV; TMAG; Bendigo, Rockhampton regional galleries; tertiary collections including Adelaide universities.

ARMSTRONG, Bruce

(b. 1957, Melbourne) Sculptor.
STUDIES: BA (sculpture), RMIT 1980; grad. dip. sculpture, RMIT 1981. He held four solo exhibitions 1986–90 largely at Powell St, Melbourne and Ray Hughes, Sydney, and participated in many sculpture survey and other exhibitions 1981– , including *Perspecta '85*, AGNSW

1985; *Site and Vision*, Carrick Hill, SA 1986; *Australian Sculpture Triennial*, 1987, 90; ICI *Art Collection*, Ballarat Fine Art Gallery and ACCA 1989. His commissions include those for Smorgon and Bardas families, Melbourne.
REP: NGA; several state galleries; a number of regional and public galleries Vic., Qld, SA; corporate collections including ICI.
BIB: Catalogue essays in exhibitions as above. A&A 23/4/1986; 26/1/1988; 28/1/1990. AL 9/2/1989; 10/4/1990–91.

ARMSTRONG, Edmund La Touche
(b. 1864, Geelong) He compiled *The Book of the Public Library, Museum and National Gallery of Victoria, 1856–1906* (Melbourne, 1906).
NFI

ARMSTRONG, Elizabeth Caroline
(b. 1860, SA; d. 1930, London) Teacher, painter.
STUDIES: Adelaide School of Design (with H. P. Gill). Known mainly for her landscape and flower paintings in oil and watercolour. A member of the SASA from 1892, she taught at the School of Arts and Crafts for 35 years, contributing much to art education in South Australia. She died during a holiday visit to London. The Elizabeth Armstrong Memorial Library at the SASA was established in her memory.
REP: AGSA.
BIB: Rachel Biven, *Some forgotten – some remembered*, Sydenham Gallery, Adelaide, 1976.

ARMSTRONG, Ian
(b. 30/12/1923, Malvern, Vic.) Painter, printmaker, teacher.
STUDIES: NGV School, 1945–50; George Bell School, 1945–48; Slade School, London 1951; RMIT, 1960–62. A painter of portraits, landscapes and genre, his work has appeared in many exhibitions since 1951; forty-six of his paintings and drawings were the subject of a special exhibition at the McClelland Gallery, Langwarrin, Apr.–May 1979. His earlier works are figurative; later they developed into abstract expressionism. He held solo exhibitions as Eastgate Gallery, Melbourne 1990, 93 and his work appeared in *Classical Modernism: The George Bell Circle* NGV, 1992.
APPTS: Art teacher for Vic. Education Dept, 1954–61; painting and drawing instructor, NGV School, 1961–66.
AWARDS: Commonwealth Jubilee Travelling Scholarship, NGV (shared with Michelle Wunderlich), 1951; Gibson prize, VAS, 1954; Crouch prize, Ballarat, 1964; Rockhampton prize, 1973; grant, VACB 1974; residency studio Cité Internationale des Arts, Paris, VACB 1988; self-portrait prize, Castlemaine Regional Gallery 1991.
REP: NGA; AGNSW; AGWA; NGV; TMAG; Armidale, Ballarat, Castlemaine, Geelong, Horsham, La Trobe Valley, Mornington, Rockhampton, Swan Hill, Warrnambool regional galleries.
BIB: Germaine, AGA. Kempf, *Printmakers*. June Helmer, *George Bell: The Art of Influence*, Greenhouse, Melbourne 1985. Patrick McCaughey, *Fred Williams*, Bay Books, Sydney 1980.

Ian Armstrong, Accordion Player, *1948, oil on canvas, 113 × 82cm. Private collection.*

Mary Eagle & Jan Minchin, *The George Bell School*, Deutscher Art Publications/Resolution Press, Melbourne 1981.

ARMSTRONG, John (Jihad Muhammad John (since 1984))
(b. 21/9/1948, Sydney) Sculptor.
STUDIES: NAS 1967–69; enrolled doctorate of creative arts, Wollongong Uni. 1989– . His 'object assemblages' made an immediate impression when they began to appear in Sydney exhibitions in the early 1970s and he has continued to produce innovative often three-dimensional works. He participated in John Kaldor's exhibition, *Art Project 2*, 1971, *Mildura Sculpture Triennial*, 1973, and NGV, *Object and Idea*, 1973, and with the painter Jan Senbergs was selected to represent Australian art at the *Bienal de São Paulo*, Brazil, 1973. He held over 30 solo exhibitions 1970–93 Sydney (largely at Watters) and other capital cities and a number in public galleries including QVMAG and QAG 1989 and Bendigo Regional Gallery 1993. His work appeared in sculpture and other survey exhibitions 1970–93 and he was artist-in-residence, University of Tasmania 1975.
AWARDS: Residency Power Studio, Cité Internationale des Arts, Paris, 1971; São Paulo, Brazil, 1973 (a first prize); Caltex Award, Ballarat, 1973; Stanthorpe prize (for sculpture), 1974; Sir William Angliss Memorial Prize, Melbourne, 1977; Marten Bequest 1983–84.

REP: NGA; AGNSW; QVMAG; TMAG; MCA, Sydney; Ballarat, Mildura, Stanthorpe, Wollongong regional galleries.
BIB: Donald Brook, article in *Studio International*, XV 11/8/1971; Elwyn Lynn, article in *Art International*, XV 11/8/1973. *A&A* 16/3/1979. Germaine, *AGA*. Sturgeon, *DAS*. Scarlett, *AS*.

ARMSTRONG, Warwick
(b. 1919, Melbourne) Painter, lecturer, stage designer. He exhibited first in annual CAS exhibitions, 1940–45, and his many designs for theatre included for Melbourne Theatre Guild; John Gielgud's *Julius Caesar*, Stratford-upon-Avon, 1949, and for ballet, opera and films, some produced by J. Arthur Rank. Returning to Australia in 1958 he designed sets for Borovansky's ballet *La Belle Hélène*, and for John Sumner's production of *Lola Montez* and later for the Australian Ballet Company. He held several exhibitions of his paintings 1962–87.
REP: Uni. collections, Melbourne and La Trobe, Vic.

ARMYTAGE, James Charles
(b. 1820, London; d. 1897, London) Engraver. He engraved mainly after Old Masters for Carton Booth's *Australia Illustrated*, including a number of Victorian subjects. He may have visited Australia, but there is no firm evidence for this.
BIB: McCulloch, *AAGR*.

ARNOLD, Ray
(b. 1950, Melbourne) Painter, printmaker.
STUDIES: Dip. Teaching, Melb. State College 1972; Dip. Art and Design, CIT, 1978; Grad. Dip. Art (Printmaking), CIT, 1981. A leading printmaker, landscape is often his subject matter and he held 13 solo exhibitions 1981–93 largely at Australian Galleries, Melbourne and participated in numerous group print exhibitions at public galleries including; *Spring Festival of Prints and Drawing*, MPAC 1978; *Australian Screenprints 1982*, PCA touring exhibitions state and regional galleries 1982–85; *Pre-settlement to Present*, NGA 1989; *Prints of the Decade*, NGA 1992. He had numerous print commissions including from PCA, NGA and was artist-in-residence at a number of colleges including Uni. of Western Sydney 1991 and community groups including at Savage River, Tasmania 1989. He also curated several exhibitions for Chameleon Contemporary Arts Space and Tasmanian Arts Advisory Board, and produced banners for Tasmanian Trades and Labour Council in conjunction with David Keeling in 1989.
APPTS: Secondary teaching Vic. Education Dept, 1972–79; tutor, printmaking, various tertiary colleges Melbourne, Tasmania (including Uni. of Tasmania) 1981– ; panel member, National Infrastructure Committee, VACB 1988–90; board member Tasmanian Arts Advisory Board 1988–90; committee member NETS Tasmania 1988–91; board member Contemporary Art Services, Tas., 1992.
REP: NGA; AGNSW: NGV; QAG; QVMAG; TMAG; Parliament House; Artbank; numerous regional gallery collections including Ballarat, Burnie, Mornington, Newcastle,

Ray Arnold, How is it Possible to Consider the Present? *Artificial Nature, etching, edition 10, 50 × 35cm. Courtesy Australian Galleries.*

Shepparton, Warrnambool, Wollongong; PCA; Monash, Tasmania universities; Arts Tasmania; several municipal, hospital and secondary school collections.
BIB: Backhouse, *TA*, Roger Butler, *Australian prints* NGA *A&A* 22/4/1985; *AL* 10/3/1990.

ARNOTT, Margaret
Printmaker. She exhibited linocuts at the exhibitions of the *Younger Group of Australian Artists*, Education Dept Gallery, Sydney, 1924–25. Her work was seen in *A Survey of Australian Relief Prints 1900–50*, Deutscher Galleries, Armadale, Vic., 1978.
BIB: *AA*, Oct. 1924, reproduction.
See also YOUNGER GROUP OF AUSTRALIAN ARTISTS

ARROWSMITH, Veda Joyce
(b. 14/3/1922, Sydney) Painter, printmaker.
STUDIES: Brisbane Tech. Coll., 1949; summer schools Uni. of New England 1962, 71, 74, 80. Her decorative, flat-pattern, semi-abstract paintings are well-known through appearances in numerous exhibitions and competitions, mainly in Queensland, and in Barry Stern Galleries, Sydney 1964, 87; Qantas Gallery, NY, San Francisco 1968; and in Melbourne, Adelaide, Wodonga, Canberra. She has conducted a number of workshops in Queensland, especially with Aboriginal artists, and her work has appeared in a number of

group exhibitions 1961–91 including with RQAS and *A Complementary Caste: A Homage to Women Artists in Queensland, Past and Present*, Centre Gallery Gold Coast, 1988.

AWARDS: Scone prizes 1969, 70; Shell Chemical Art Prize, Qld, 1969; RNAGAQ prize, 1969; Caltex award, La Trobe Valley, Vic., 1970; Townsville Pacific Festival prize, 1970; Westfield prize, Brisbane, 1971; Gold Coast City Art Prize 1976, 79, 80; OAM, 1992.

REP: Townsville Gallery; Gold Coast City Gallery; Darnell Collection, Uni. of Qld.

BIB: J. Millington, *Tropical Visions,* UQP 1987. H. Fridemanis, *Artists and Aspects of the CAS Queensland branch*, Boolarong Publications 1991. Germaine, AGA.

ART ASSOCIATION OF AUSTRALIA

Established Melbourne 1973 at a meeting at the NGV, 'to promote study and research in art . . .' bringing together (through seminars, special-purpose meetings and conferences) people who are engaged in the study, research and teaching of art and art history throughout Australia. Membership is in the hundreds and includes leading art academics, research students and other interested parties.

ART EXHIBITIONS AUSTRALIA

(Established 1980) 98 Cumberland St, The Rocks, NSW 2000. PO Box N222, Grosvenor Place, NSW 2000.

MANAGEMENT/STRUCTURE: Company limited by Guarantee. Board of 9.

STAFF: CEO (in 1993 Robert Edwards); 2 senior staff plus support staff. Art Exhibitions Austalia is the latest name of a body which was founded in 1977. Previously the Australian Art Exhibitions Corporation (1977–79), then International Cultural Corporation of Australia (1980–90), it became AEA in 1991. Like its predecessors, Art Exhibitions Australia is responsible for managing major international exhibitions in Australia and for touring Australian exhibitions abroad.

HISTORY AND DEVELOPMENT

The history of management of large-scale exhibitions in Australia's recent past dates to 1977 when the Australian Art Exhibitions Corporation Limited was established under the auspices of the Prime Minister, Malcolm Fraser, largely to stage and manage the first large-scale Chinese exhibition to visit Australia. This was a financial success netting around $516,000 profit. The Aus. Art Exhibitions Corporation also organised *El Dorado: Columbian Gold* in 1978, which was not financially successful, losing around $323,000. The AAEC was discontinued in 1979.

The business of organising similar-scale exhibitions then passed to the Australian Gallery Directors Council (q.v.), which had been in operation since 1948, organising among other activities visiting international exhibitions, although not on the same financial scale as those entered into by the AAEA. The losses from two such exhibitions organised by the AGDC, *French Art: the Revolutionary Decades* in 1979 and *Aboriginal Australia*, led to the demise of the AGDC in 1981.

The International Cultural Corporation, a company limited by guarantee and initially government-sponsored with a grant of $1 million in its first four years of operating, was established in 1980 and took over the role of managing and funding large visiting exhibitions and Australian exhibitions travelling abroad.

Pivotal to the success of large-scale exhibition management is the insurance indemnity of artworks, which is often a huge cost. The Australian Federal Government ensured such indemnity for ICCA exhibitions thereby enabling *The Entombed Warriors, Claude Monet: Painter of Light, Gold of the Pharaohs, Secret Treasures of Russia* and *van Gogh – his sources, genius and influences* to visit Australia. Art Exhibitions Australia became self-supporting in the late 1980s, raising its funds from sponsorship, admission charges and commercial operations.

ART FOUNDATION OF VICTORIA

See NATIONAL GALLERY OF VICTORIA

ART GALLERIES ASSOCIATION OF AUSTRALIA

See ART MUSEUMS ASSOCIATION OF AUSTRALIA

ART MUSEUMS ASSOCIATION OF AUSTRALIA

(Established 1965) Brunswick St. Fitzroy, Vic, 3065. An Art Galleries and Museums Association of Australia and New Zealand was formed in 1936 before becoming an association of scientific and historical museums only (the Museums Association of Australia). The Art Museums Association of Australia was founded in 1965 as the Art Galleries Association of Australia following a seminar in Melbourne in 1963 addressed by the director of the British Museum, Sir Frank Francis. The name changed to its present one in 1979. With a secretariat in Melbourne, key programs include regular conferences, publications, professional development seminars, information and advisory services. A directory of art museums and public galleries was published in conjunction with the Australian Studies Centre at Monash Uni. in 1990 (new editions 1991, 93), as well as a directory of independent curators and *The Money and the Means* in 1992.

MEMBERSHIP (1993): 800.

REVENUE: Several grants from foundations in its early years (Gulbenkian 1965, 66; Stuyvesant 1977/78); Australia Council subsidy 1986– ; membership dues, publication sales, programs and conferences with occasional support from other charitable trusts and foundations.

ART SOCIETY OF NEW SOUTH WALES

See ROYAL ART SOCIETY OF NEW SOUTH WALES

ART SOCIETY OF TASMANIA

Founded by Louisa J. Swan and Maria Evans in 1884. Permanent address from 1949: Lady Franklin Museum, Lenah Valley, Hobart. The Society holds annual exhibitions. Among early exhibitors were J. Haughton Forrest, W. C. Piguenit, G. V. Mann and Lucien Dechaineux. Maria Evans was the first secretary of the

society, which was originally known as the Art Association.

ART UNIONS

From the records, art unions appear to have started in the UK around 1837 when the most successful, the Art Union of London, began operations. They began in Australia in 1841 when Mr (Morris) Felton's Art Union was held in Sydney. The art unions were in effect lotteries aimed at distributing art works to subscribers and helping needy artists, while making money for the organisers. In 1845 (fostered by the Association for the Promotion of Fine Arts in Scotland and, four years later, by the Art Union of London), the idea took off with the first art union held in Melbourne. One guinea p.a. entitled a subscriber to the chance of a prize drawn at the annual meeting. The Victorian Art Union began in 1857, ceased operating in the 1860s and was successfully revived under new management in 1872, Robert Wallen, Thomas A. a'Beckett, F. S. Grimwade and H. E. Hart being members of its council. Cyrus Mason (q.v.) was one of the organisers and between 1872–83 1200 guineas distributed to needy artists. H. E. Davies, George Rowe, E. von Guérard, George Peck, G. F. Folingsby, J. Ashton, L. Buvelot, W. C. Piguenit, H. van den Houten, J. Mather, T. Roberts, A. Streeton, J.S. Mackennal and many others were helped by the art unions. Besides original paintings, subscribers received engravings and books of reproductions. The Art Union of NSW started in 1876. From then on art unions proliferated in various parts of the country and did much to publicise the cause of art generally. Their end came when they became involved in sharp practices. There was an outcry from the churches and by the end of World War I art unions as such had virtually ceased to exist.
BIB: Hesketh Hubbard, *100 Years of British Painting*, Longman, London, 1951; A&A 12/4/1975 (Mary Holyoake, *Art Unions: Catalysts of Australian Art*).

ARTBANK

(Established 1980) 50c Rosebery Ave, Rosebery, NSW 2018.
DIRECTORS: Graeme Sturgeon 1980–1988; Lesley Alway 1988– .
REVENUE: Self-funding federal government agency.
Created to 'encourage and assist Australian artists by buying their works' it was established by the Federal Government to acquire contemporary Australian art for rental to private and public sector clients. The collection in 1993 numbered over 7000 contemporary artworks by over 2500 artists and includes paintings, works on paper, photography, sculpture, tapestries, ceramics and Aboriginal art. These works, which include those by established, younger and emerging artists, can be rented by corporate and private clients and government agencies for 12 months to 3 years. As well, Artbank specialises in advising on development of personal or corporate collections and offers curatorial services including cataloguing and valuations.

With its strong acquisitions policy (buying works both direct from artists and through commercial gallery showings) and support from private sector and government agency clients, Artbank has proved a financial success and established itself as one of the most practical successes of government support of the visual arts.

ARTHUR, Tom (W. Thomas)

(b. 14/5/1946, Massachusetts, USA; arr. Australia 1974)
Sculptor, jewellery designer, teacher.
STUDIES: Art School, Boston Museum of Fine Arts, 1969; Tufts Uni. (grad. BS, 1969). Characteristics of his large, expertly crafted, environmental sculptures are expansion of microscopic forms and dialogue between materials that may be hard, soft, ancient, modern, natural or manufactured. His works incorporate boxes, glass, objects suspended from strings, symbols of death such as skeletons, as well as polished stones and metal, a legacy from his apprenticeship in jewellery making. His drawings crystallise his ideas on flat surfaces and emphasise his connections with the work of Duchamp, Tanguy, Matta and other surrealists. His work was seen in project exhibitions in Sydney (AGNSW 1975) and Melbourne (NGV 1979) as well as in group exhibitions including *Biennale of Sydney* 1979, 88; *Australian Perspecta* 1981.
AWARDS: USA scholarships, prizes and grants, including a Boston Museum of Fine Arts travelling scholarship, 1973.
APPTS: Lecturer, Sydney College of the Arts, 1976.
REP: NGA; AGNSW; NGV.
BIB: Catalogue essays exhibitions as above. Scarlett, AS. A&A 14/2/1976. Sturgeon, DAS. McIntyre, ACD.

ARTISTS' BOOKS

Artists' books are an increasingly popular art form which has undergone phenomenal development in Europe and North America where there have been hundreds of small presses established in the past several decades. They have only recently begun major development in Australia. When Geoffrey Farmer and the Book Collectors' Society of Australia published *The Literature of Australian Private Presses and Fine Printing: A Bibliography* (Sydney, 1986) the bias was towards the more usual finely printed limited edition collectors' volumes such as those printed by the Brindabella Press, Canberra. He did not include artists' books, art objects made by artists, or in collaboration with artists, which sometimes depart quite substantially from traditional book-making conventions to accommodate creative concepts and less predictable aesthetic sensibilities.

Major developments in Australia are attested by a growing number of exhibitions devoted to artists' books since *Words on Walls* curated by Barrett Reid at Heide, Melbourne, 1989 – *The Book and Print Show*, University of Wollongong, 1991; *Artists' Books Exhibition*, Grahame Galleries and Editions, Brisbane, 1991; *Exhibition of Books and Boats*, State Library of Victoria, Melbourne, 1991; *Artists Make Books*, Linden Gallery, Melbourne, 1991; *Exhibition of Artists' Books*, Australian

Print Workshop, Melbourne, 1992; and *Fragile Objects: Artists' Books and Limited Editions*, The Monash Studios, Melbourne, 1992 (the exhibition catalogue's glossary of technical terms is a useful reference). Studio 1 in Canberra also specialises in artists' books while the associated Raft Press provided letterpress printing.

In 1992 Peter Herel assisted in the establishment in Melbourne of the Centre for the Development of Artists' Books (CDAB) – a joint project of Monash University and the Australian Print Workshop – general editor, Jenny Zimmer. CDAB's first five editions were launched at the NGV, July 1993, and featured collaborations between more than 50 artists and writers including Graeme Peebles, Allan Mitelman, Peter Ellis, Henry Chopin, Nicholas Zurbrugg, Kevin Hart, Dinny O'Hearn and Mae Anna Pang.

Historical figures like William Blake belong to an earlier tradition, in which artists' original works were collected as folios or used to harmonise with literary texts. In Paris in 1911 Sonia Delaunay and Blaise Cendrars published the first, collaborative, *simultaneous book*, or poem set out in a visual/typographic format that simultaneously evoked the form and meaning of the verse. (A beautifully preserved copy from this edition is held in the NGA, where a major collection of artists' books from around the world was established during James Mollison's term as the Gallery's first director.)

Collaborations between French artists and literary figures are documented in Walter Strachan's definitive *The Artist and the Book in France* (1969). In America the production of artists' books was encouraged by publishers like Kenneth E. Tyler of *Tyler Graphics Ltd*, Mt Kisco, New York.

Details of its early history in Australia are scant. In 1905 Violet Teague used Japanese styled coloured wood-block prints to illustrate *Nightfall in the Ti-Tree* (a copy of which is held in the NGV). Between 1906–1909 Norman Lindsay illustrated the *Memoirs of Casanova* but was unable to find a publisher. His illustrations to Petronius's *Satyricon* were published, with text, in London. He went on to illustrate texts from Theocritus, Boccaccio, Rabelais, Balzac, Pepys, Gautier, Byron, Rossetti and Swinburne. In the 1930s, most printmakers, including Mervyn Napier Waller and Lionel Lindsay, made original bookplates – very popular at the time – and by the 1930s Noel Counihan and others were illustrating books and political texts. Roderick Shaw, a designer and book-illustrator, later turned to high quality printing. Tate Adams, established The Lyre Bird Press, operating from Queen Street, Melbourne, and brought out *Diary of a Vintage* (1981) and *Port of Pearls* (1989), both illustrated with wood-engravings. A major folio edition of John Brack's *Nudes*, with lithographs printed by the Druckma Press, furthered the concept. Others who have championed the art form are Gary Catalano in his book *The Bandaged Image: A Study of American Artists' Books*, 1983, and Noreen Grahame of Grahame Galleries and Editions, Brisbane.

Between 1967 and 1969 artist Bea Maddock combined words and images in her book *Being and Nothingness* a three-way dialogue between herself, Jean-Paul Sartre's text and the viewer. Maddock's book is a one-off, quite unique, but other artists – particularly printmakers – work in limited editions. Melbourne printmaker Bruno Leti began making books in 1980 after a stint at Giorgio Upiglio's Graphica Uno in Milan. Today he is one of Australia's most prolific book artists, frequently collaborating with studios in Milan and New York. A retrospective of his books, since 1981, appeared at Christine Abrahams Gallery, Melbourne, 1993.

In the 1960s and 1970s artists like Robert Rooney, Mike Brown, Aleks Danko and others used artists' books – often produced with cheap new printing technologies such as Xerox copying – to attack the contemporary status quo by making radical 'post object' artefacts. The books also operated as exhibitions outside the gallery space. Examples are Ian Burn's Xeroxed book, *Three Mirror/Structures* shown at Pinacotheca, St Kilda, in 1969, Mike Parr's *Blacked-out Book* (1971–72), and Dale Hickey's *White Walls* with black-and-white photographs arranged on data cards and stored in a circular file-box. They were shown in *Off the Wall: in the Air. A Seventies Selection* at ACCA and the Monash University Gallery, 1991.

Artists like Jane Kent whose *Letterlace* was shown at 200 Gertrude Street (1993) and Sydney-based Ruark Lewis who, like the French book artist Henri Chopin, composes with type, work from theoretical positions ideally suited to the art. The production of artists' books is likely to be a growth area in the arts in Australia in the 1990s.

BIB: Gary Catalano, *The Bandaged Image: A Study of Australian Artists Books*, Hale and Iremonger, Sydney, 1983; and the Australian and International Collections of the NGA.

JENNY ZIMMER

ARTISTS' STUDIOS OVERSEAS

Studios which have been available for Australian artists' use through grants have included those in Germany, Spain, France, USA and UK and are largely administered by the VACB of the Australia Council. Those available in 1993 included the following (Note: except where otherwise indicated these are all either owned or administered by the VACB, Australia Council and all enquiries should be directed to the Project Officer, VACB, PO Box 788, Strawberry Hills, NSW 2012.)

AMERICA
Greene St Studio, New York; Institute of Contemporary Art International Studio (as a fellowship residency); 18th St Arts Complex Studio, Santa Monica.

ENGLAND
Air and Space Studio, London.

FRANCE
VACB Studio, Cité Internationale des Arts, Paris. Power Studio, Cité Internationale des Arts, Paris (through University of Sydney). Moya Dyring Memorial Studio, Cité Internationale des Arts, Paris (through AGNSW)

ITALY
Besozzo Studio, Besozzo. Vercadaccio Studio, Sienna.

SPAIN
Barcelona Studio, Barcelona.
JAPAN
Tokyo Studio, Tokyo

ARTS ACCESS SOCIETY
(Established 1974) 109–111 Sturt St, Sth. Melb. Vic. 3205.
ADMIN: A committee of 12, including the President (in 1993 Judy Morton). A community-based non-profit organisation creating opportunities in the arts for people with disabilities and those disadvantaged by social conditions. Legally constituted as the Arts Access Society in 1979, the Arts Access Trust was established in 1992. The artistic program manages 30–40 arts projects annually in partnership with community groups and institutions in settings such as public hospitals, nursing homes, intellectual disability institutions, community centres, prisons and remand centres. There is a research unit which provides resources and training and an entertainment access service to distribute tickets to cultural events and lobby for improved access to facilities.

ARTS AND CRAFTS SOCIETY OF VICTORIA
(Established Melbourne, 1908) 37 Hardware St, Melbourne 3000. The society, which obtained Viceregal patronage, was formed to encourage the production of local arts and crafts, mainly by means of annual exhibitions. The first meeting was held at the studio of Bertha Merfield, 46 Collins St. Address of the society from 1964 was 313–315 Little Collins St, Melbourne; from 1967, 2 Crossley St, from 1980, 99 Cardigan St, and from 1981 Hardware St, Melbourne. Its activities include a shop and permanent displays of Australian crafts with occasional special exhibitions.

ARTS COUNCILS OF AUSTRALIA
(Established 1946) Established in Sydney, 1946, by Miss Dorothy Helmrich, OBE, it was modelled on the Arts Council of Great Britain, there are separate Arts Councils in most states. In 1964, grants from the Calouste Gulbenkian Foundation and Esso Australia Ltd enabled the Council to be established as a national body with divisions in all States; and on 8 Feb. 1966 it was constituted and incorporated under the NSW Companies Act and named the Arts Council of Australia. The Council is a private, non-profit organisation operated by professionals and volunteers in a national network of more than 250 branches and eight divisional offices. Traditionally the emphasis of Council activities is on 'touring performances to schools and adult communities,' but they include workshops, tutorials, festivals, seminars, art access and community arts activities.

STATE ARTS COUNCILS
The state arts councils are administered by a board and have affiliated local arts councils as members (numbering in the hundreds per state), with many individual members (for example 4000 in NSW in 1993).

ARTS INDUSTRY COUNCIL
(Established 1989) 117 Sturt St, South Melbourne 3205. Established to raise the profile of the arts in the political arena, it is open to any organisation, group or individual working in the arts.

ARTS LAW CENTRE OF AUSTRALIA
(Established 1983) The Gunnery, 43–51 Cowper Wharf Road, Woolloomooloo, NSW 2011. Open to any member of the Australian arts community or interested individual, the Arts Law Centre offers advice to artists on legal matters as well as holding seminars and lectures and referrals to other professionals such as accountants. The Centre has a reference and resource library and produces publications.

ARTS TRAINING AUSTRALIA
(Established 1983) The Cottage, Best St, Woolloomooloo, NSW 2011. With a membership of national employer and employee and professional organisations, Arts Training Australia services training needs of the arts industry, assists in developing the arts industry profile, advises governments on training matters, and assists tertiary institutions in developing arts courses and training. There are branches in each state and territory (except Tasmania).

ARTWORKERS UNION (NSW)
(Established 1979) PO Box A509, Sydney 2000. Formed to represent the professional and industrial interests of visual art and craft workers in the arts industry, the Union was registered as a trade union in NSW in 1989 and is affiliated with the Labour Council of NSW.

ARX (Artists' Regional Exchange)
(Established 1988) GPO Box L 914, Perth 6001. Established to support exchanges between Australian, South East Asian and NZ artists. It publishes a journal.
See also ASIAN-AUSTRALIAN ART LINKS

ASHBY, Alison M.
(b. 1901, Nth Adelaide) Botanical artist.
STUDIES: Adelaide (with Rosa Fiveash). She illustrated *Australian Wildflowers*, SA Museum series.
AWARDS: Honorary Associate, SA Museum; MBE conferred 1960.
NFI

ASHTON FAMILIES
Two separate families of Ashtons were distinguished in Australian art; the Australian origin of one family was in Adelaide, the other in Melbourne, and both moved to Sydney. Apart from their similar interests the families were not connected.

ASHTON, George Rossi
(b. 1857, Cornwall; arr. Melbourne 1879; ret. London, 1893) Painter, illustrator. Pictorial correspondent for *Illustrated London News* in South Africa (c. 1878). Married Blanche Brooke, daughter of the actor and entrepreneur George Coppin. He went to Melbourne to join his brother Julian on the staff of the *Illustrated*

Australian News, and later, the *Australian Sketcher*. Among the episodes covered jointly by the brothers was the capture of Ned Kelly at Glenrowan, 1880. George Ashton was a member of the Australian Artists' Association and the Art Society of NSW. He succeeded Phil May as staff artist for the *Bulletin*, 1888–93. The brothers Ashton may have quarrelled; there is no mention of George in Julian Ashton's autobiography.
BIB: George Ashton, *Australian Sketches*, London, 1895. ADB 7.

ASHTON, Howard (Julian Howard)

(b. 9/8/1877, London; arr. Melbourne 1878; d. 30/4/ 1964) Painter, critic, newspaper editor. Son of Julian Rossi Ashton. Art critic for Melbourne *Argus*, 1910–11, and for the Sydney *Sun* for 25 years; he was also editor of the *Sun*, 1924–26, and president of the Royal Art Society of NSW, 1942–45. His late impressionist oils often depicted coastal landscapes and views of Sydney Harbour. His work was seen in *Golden Summers*, NGV and touring, 1986.
AWARDS: Prize in State Theatre Art Quest, 1929; Sydney Sesquicentenary prize (for landscape), 1938.
REP: AGNSW; NGV.
BIB: ADB 7.

ASHTON, James

(b. 4/4/1859, Isle of Man; arr. Adelaide 11 Jan. 1884; d. 2/8/1935, Adelaide) Painter, teacher.
STUDIES: York School of Art, with J. Windass c. 1878; also with marine painter, Henry Moore c. 1895, during a visit to the UK. Father of Will Ashton. He founded the Norwood Art School, Adelaide, 1885, and is recorded as having founded art galleries in five SA towns, as well as the Academy of Arts, Adelaide (1895–1927). A fine painter of seascapes, his style was marginally influenced by impressionism.
AWARDS: Student prizes at South Kensington.
APPTS: Teaching, York School of Art; Prince Alfred College, Adelaide, 1887–1926.
REP: AGSA; regional galleries Broken Hill and Bendigo.
BIB: J. B. Mather, *Catalogue of the Art Gallery*, AGSA, 1913. ADB 7.

ASHTON, Julian Richard

(b. 7/12/1913, Sydney) Painter.
STUDIES: Julian Ashton School, Sydney 1930s. Son of Julian Howard Ashton, he was principal of the Julian Ashton School. He started exhibiting in 1935 and was a war artist in New Guinea with the AIF 1941–45. He was artist, writer and photographer with the NSW Dept of Tourism from 1945 and travelled and painted extensively in Europe and America, concentrating on marine painting.
AWARDS: North Shore Art Prize 1950; Mosman Art Prize 1953.
APPTS: War artist, AIF 1941–45; Art and Publicity Officer for NSW Dept of Tourist Activities and Immigration, 1948–63; principal Julian Ashton School 1963–85.
REP: NGA; AGNSW; AWM; New England Regional Art Museum.

ASHTON, Julian Rossi

(b. 27/1/1851, Alderstone, Eng.; arr. Melbourne Vic., 1878; d. 27/4/1942, Bondi, Sydney) Painter, teacher, writer.
STUDIES: London, West London School of Art; Paris, Académie Julian, c. 1873. Julian was the eldest of the five children of Thomas Briggs Ashton and his wife, a Florentine and daughter of an Italian count, Count Rossi. The death of his father in 1866 caused Julian to leave school and start work in the engineers' office of the Great Eastern Railway Company, while confining his art to spare-time studies. His art studies prospered, however, and in 1878 the Melbourne newspaper owner David Syme offered him £300 p.a. to move to Australia as illustrator for the *Illustrated Australian News*. He became friendly with Buvelot (q.v.) in Melbourne, and with his brother George covered the demise of the Kelly gang at Glenrowan. Differences with the management of the *News* brought about his move to a rival paper, the *Australasian Sketcher*, and in 1883 he accepted an offer to join the staff of the *Picturesque Atlas of Australasia*, Sydney, where after teaching at the Art Society of NSW School, 1892–96, he founded the Sydney Art School. In Sydney he became the central figure of a group that included Daplyn, Conder, Fullwood and Nerli (qq.v.), many of whom worked together in camps in the Hawkesbury River country where Ashton painted some fine riverscapes. His subject matter covered a wide range, extending from landscapes to portraiture and figure groups in oils and watercolours, all done in a workmanlike manner that successfully combined elements of impressionism and illustration.

His school attracted such students as G. W. Lambert, Sydney Long, John Passmore and many others to become, indeed, a teaching centre for all aspiring Australian painters. His influence extended to all departments of the Sydney art scene and was largely instrumental in transferring the focus of Australian art attention from Melbourne (where the Heidelberg School had long been dominant) to Sydney. He was president of the Art Society of NSW, 1886–92, and of its successor, the NSW Society of Artists, 1897–98 and 1907–21, and a trustee of the AGNSW, 1889–99. It was Ashton who bought for the Gallery Streeton's *Still Glides the Stream* in 1890, when, as a trustee, he proposed a resolution that was to bear a rich harvest, namely, that 'not less than £500 be spent annually on the purchase of Australian works of art'. At the same time he obtained the government grant that made possible the NSW Society of Artists' travelling scholarship. He organised the important Grafton Gallery Exhibition of Australian art, London, 1898, and in 1911 joined Harley Griffiths Snr and Hardy Wilson (qq.v.) to establish the Fine Arts Gallery in Bligh Street, Sydney. He also led the deputation to the Government that resulted in the establishment of the badly-needed Education Dept Gallery, Sydney, in 1913. He helped many younger artists and turned an exhibition by Blamire Young from failure to success by writing a letter to the Sydney *Daily Telegraph*. It was

Julian Ashton, By the fireside, *1876. oil on cardboard, 22.5 × 17cm. Collection, NGA.*

largely through Ashton's influence that Norman Lindsay was appointed to the staff of the Sydney *Bulletin*. He fought for the recognition of Australian art and artists all his life and published his autobiography at the age of ninety (*Now Came Still Evening On*, Angus & Robertson, Sydney, 1941).

AWARDS: NSW Society of Artists' medal, 1924; Sydney Sesquicentenary prize for watercolour, 1938; CBE 1930.

REP: Australian state and regional galleries.

BIB: *The Julian Ashton Book*, Ure Smith, Sydney, 1920. Articles and references, AA 1916–42. Extensive references in all books on contemporary Australian art. *Julian Ashton Sketchbook*, with essay by Dinah Dysart, NGA, Canberra, 1981.

ASHTON, *Robert Llewellyn*

(b. 11/8/1950, Vic.) Photographer.

STUDIES: Dip. Art & Design, photography, Prahran. He held several solo exhibitions 1973–90 including at United Artists and Luba Bilu and his work appeared in several books including *A Day In the Life of Australia* and *Into the Hollow Mountains: A Portrait of Fitzroy*.

REP: NGA; NGV; TMAG; various municipal collections.

ASHTON, *Will (Sir John William)*

(b. 1881, York, Eng.; arr. Adelaide 1884; d. 1963, NSW) Painter.

STUDIES: Adelaide (with his father, James Ashton); St Ives, Cornwall (with Julius Olsson and Algernon Talmadge); Paris, Académie Julian. On his return from his studies in England and Europe, Ashton held successful exhibitions of his impressionist pictures of Parisian street scenes, views of the quays at Dieppe and other tourist landmarks and resorts, and from then on spent much of his life travelling and repeating this initial success. He exhibited widely in London, at the RA and private galleries, and showed also at the Paris salon. Three Australian exhibitions of his work yielded £4000 in sales in one year (1925). As a prolific painter of this type of picturesque work Ashton became a strong and influential opponent of the modern movement in Australia.

AWARDS: Wynne prize 1908, 30, 39; Godfrey Rivers Bequest prize 1933, 38; NSW Society of Artists' medal, 1944; OBE conferred 1941, knighthood conferred 1960.

APPTS: Art adviser to the trustees, Art Gallery of SA, 1913–16; director-secretary, AGNSW, 1937–44; chairman, Commonwealth Art Advisory Board, 1953–63.

REP: Most Australian state galleries; many regional galleries.

BIB: Article in AA, June 1929; *The Life and Work of Will Ashton*, Legend Press, Sydney, 1960.

ASHWORTH, *John Simeon*

(b. 1915, Brighton, Vic.; d. 1979, Daylesford) Painter, teacher.

STUDIES: Melbourne Tech. Coll. Ashworth worked as an industrial designer from 1936 and after serving with the RAAF in World War II joined the Vic. Education Dept as an art teacher (1949–60). As an energetic art educationalist he made Hamilton Art Gallery a thriving communal art centre; in 1963 he was elected to represent Vic. on a four-person committee to discuss plans for the formation of a network of Australian public galleries.

APPTS: Teaching, Vic. Education Dept, 1949–60; Director, Hamilton Art Gallery, 1961–75; McClelland Gallery, Langwarrin, 1975–77.

ASIAN-AUSTRALIAN ART LINKS

Economic and cultural conditions which separated east and west virtually disappeared in the 1980s and most countries, including Australia, are increasingly aware of the need to develop world relations, particularly where understanding has previously been insufficient. Prominent Australian artists, among them Ian Fairweather, Donald Friend, Margaret Preston and Danila Vassilieff, were well acquainted with Asia. However, it has generally been to Europe and America that Australian artists have traditionally turned. This practice is now changing rapidly as Australians become more aware of the Asia–Pacific region.

Though the Australian Government, through the Department of Foreign Affairs and Trade and most particularly the South East Asia and Pacific Section (SEAP), has since the 1970s actively supported cultural exchange between Australia and Asia, it was

in the 1980s, at times in partnership with the VACB of the Australia Council, that specifically oriented contemporary art fact-finding missions first visited Asia – one in 1988 to China and in 1989 to the Republic of South Korea.

Asialink a non-profit organisation jointly initiated by the Myer Foundation, the Asian Studies Council and the Commission for the Future was established in 1991. It covers a diversity of areas – business, education and the visual and performing arts and film and television links institutions, academics, specialists, business and government.

In 1991 the Australia Council inaugurated a three-year *Australian Art to Asia Project* under the auspices of *Asialink* with development funding of $270,000 from the VACB and support of the Cultural Relations Branch of DFAT. It aims to show small to medium-scale exhibitions of contemporary Australian visual arts and crafts to in Asia. Venues are provided by Asian art schools, city councils, artist's organisations and museums; Australian artists and curators visit the various countries to gain knowledge of the context in which the work will be exhibited. Two exhibitions were initiated by *Asialink* 1990–93 – *Out of Asia* shown at Heide, Melbourne in 1990 and *Eight Contemporary Views* touring Asian countries 1990–91.

Residencies available in 1993 include those at Institut Teknologi Mara, Malaysia; Silpakorn University, Thailand; the University of the Philippines, Manila and the Zhijiang Academy of Fine Arts in Hangzhou, China. Other residencies including those in Beijing, Yogyakarta and in India are likely to be established during the 1990s.

In 1992 artists Geoff Lowe, Rozalind Drummond and curator Juliana Enberg established Australia's first contemporary art contact with Vietnam. Works by six leading printmakers curated by Anne Kirker were shown in Thailand and exhibitions of Australian painting, *Transculptural Painting*, photography, *Location*, and goldsmithing, *Australia Gold*, took extensive tours of major Asian centres. Artists who have completed residencies include Noelene Lucas, David Castles, Pat Hoffie, Dianne Mantzaris.

The Australia Abroad Council under the auspices of DFAT issues biannual lists of overseas initiatives. New Asian galleries have been installed in the AGNSW and NGA and are planned for the NGV. The Asian Arts Society of Australia has been established in Sydney under the presidency of Carl Andrew. *Art and Australia* started a new magazine-*Art and Asian Pacific* in 1993 and Australian-based journals *Crafts Arts International* and *Design World* are distributed in Asia. *Artlink* published a special Asian issue in 1993 and *Art Monthly Australia* runs regular Asian reviews and a column reporting on *Asialink*.

ASIA-PACIFIC TRIENNIAL OF CONTEMPORARY ART
Initiated by the QAG with a budget of around $1.5 million funded by the Qld government, DFAT and VACB and the QAG Exhibition Development Fund the inaugural Triennial in September–December 1993 hosted 77 artists from 13 countries. More than 200 major works of all media were displayed and it was complemented by an international conference, forums and publications. Australian artists were also represented and included Jon Cattapan, Bronwyn Oliver, Glora, Ada and Kathleen Petyarre, Giuseppe Romeo, Gareth Sansom and Judy Watson.
JENNY ZIMMER

ASPDEN, David
(b. 1/5/1935 Bolton, Lancs., Eng; arr. Australia 1950) Painter, lecturer.
STUDIES: No formal training. His early pictures were serialised hard-edge and composed predominantly of stripes. This geometricised format changed to 'colour-field' painting in the large impact pictures which he exhibited in the Travelodge and Transfield prize exhibitions in Sydney in Nov. 1970. The new pictures comprised wide, vertical bands of bright primaries joined at the edges with leafy patterns.

Between 1965–92 he held about 27 solo exhibitions including at Watters, Rudy Komon, Roslyn Oxley9, Sydney; Charles Nodrum, Realities, Melbourne. His work appeared in many group exhibitions 1965–92 including *Australian Landscape*, Adelaide Festival Centre and all state galleries, 1972; *Sydney Biennale*, AGNSW 1972; *Australian Perspecta*, AGNSW 1981; *The Field Revisited 1968–88*, Centre Gallery, Qld and touring 1988. In 1980 he was summer artist-in-residence, Bennington College, Vermont, USA and in 1984 artist-in-residence sponsored by the VACB at the Institute of Marine Science, Qld.
AWARDS: Wollongong 1963, 65; Muswellbrook 1967; Berrima 1967; VACB grant to assist full-time work for one year, 1975; VACB studio occupancy, New York, 1980.
APPTS: Lecturer, ESTC; City Art Institute.
REP: NGA; AGNSW; NGV.
BIB: Essays in catalogues for exhibitions as above. General texts on contemporary Australian art including Smith, AP. AI 9/3/1971. A&A 9/3/1971.

ASSOCIATION OF SCULPTORS OF VICTORIA
Formed July 1971, as a successor to the Victorian Sculptors Society. Annual exhibitions are held at the VAS galleries and the Association conducts the Tina Wentcher prize (for artists under 35), the Andor Meszaros prize, and the Shell Australia Acquisitive Sculpture Prize. Annual exhibitions are held in different venues including the AMP, National Bank, Commonwealth Bank and Rialto Plaza, and many smaller exhibitions by members are held in Melbourne and country centres.

ASTLEY, Charles
(Active 1868–1928) Painter. Known mainly for landscapes and bush life and characters.
NFI

ATHENAEUM
See GALLERIES; MECHANICS INSTITUTES

ATKINSON, Caroline Louisa

(b. 1834; d. 1872) Botanical artist. She wrote six novels, had a weekly column about country life in the *Sydney Morning Herald* and produced a number of paintings and sketches of animals and birds. Her work appeared in *The Artist and the Patron* AGNSW 1988.

REP: Mitchell Library; NLA

BIB: ADB 3. Margaret Swan, *Royal Australian Historical Society Journal*, vol. 15, pt 1, 1929. Kerr, DAA.

See also NATURAL HISTORY, ARTISTS

ATKINSON, Charles

(Arr. Hobart 1833; d. 1837, Tas.) Lithographer, architect. Atkinson was one of 99 survivors, of a full complement of 252, of the vessel *Hibernia*, which was burned off the coast of South America. The survivors were landed at Rio de Janeiro where the inhabitants subscribed the money for the charter of a ship which took them to their destination in Hobart, Tas. Atkinson, who claimed to be a qualified architect (his papers had been lost at sea), was appointed Superintendent of Roads and became involved in the construction of Tasmania's celebrated Ross Bridge, although the degree of his involvement has been disputed. His enemies described Atkinson as a trouble-maker and 'a person unsuited to have charge of convicts'; the colonial churches designed and built by him at reduced prices were the subject of hostile press criticism, and in fact they have failed to survive the test of time. His memorial was not in his architecture, as he had apparently hoped it would be, but in his well-known lithographs of Hobart Town. *Lithographic Illustrations of Hobart Town*, James Wood, Hobart, 1833; *Lithographic Drawings of Sydney and its Environments*, J. G. Austin, Sydney, 1836.

REP: TMAG; NLA; Mitchell, La Trobe, Allport Libraries.

BIB: Clifford Craig, *The Engravers of Van Diemen's Land, Old Tasmanian Prints* 1964; *More Old Tasmanian Prints* 1986 all published by Foot & Playstead, Launceston. Kerr, DAA.

ATKINSON, Robert

(b. 15/11/1863, Leeds, Eng.; arr. Sydney 1885; d. 1896, New Zealand) Painter, illustrator.

STUDIES: London (with Richard Waller); Antwerp (with Verlat). Known mainly for landscape, genre and figure paintings he worked in Sydney where he was a friend of A. H. Fullwood; he showed with the Art Society of NSW 1887–88 (landscapes, including New Zealand views), but returned to England in 1889. After visiting Egypt a number of times he finally went to New Zealand in 1895 and died there the following year.

BIB: R.A.S, *Fifty Years of Australian Art, 1879–1929*, Sydney, 1929; Edward Craig, *Australian Art Auction Records, 1975–78*, Mathews, Sydney, 1978.

ATKINSON, Yvonne

(b. 1918, Melbourne) Painter.

STUDIES: George Bell School, Melbourne, c. 1934. Daughter of Rupert Atkinson, poet and playwright (active late 1930s), she exhibited with the VAS, and with the CAS, her early work being well regarded by George Bell and Rupert Bunny. During these years she concentrated on figure studies and studio genre. After her marriage she lived in Townsville and for a brief period (1974–76) signed with her married name, Yvonne Daniell. She was represented in *Classical Modernism: The George Bell Circle* NGV 1992 and *A Century of Women Artists*, Deutscher Fine Art, Melbourne 1993.

REP: NGA; AGWA; Castlemaine, Warrnambool regional galleries.

BIB: Minchin & Eagle, *George Bell: His Circle and Influence* Deutscher Fine Art/ Resolution Press, Melbourne, 1981.

ATROSHENKO, Paul

(b. 28/8/1937, Hong Kong; arr. Aust. 1953) Painter, writer.

STUDIES: Dip. painting, NAS, 1959; private studies Europe with assistance of Gemini Cultural Trust, UK, 1963–68; M. Fine Arts, Uni. of NSW, 1991. He exhibited in London 1963–68 then Sydney including Prouds Gallery 1971, 74; Holdsworth 1976, 80, 92. He prepared discussion papers and submissions for various government inquiries into the arts and conducted an inquiry into public funding in the arts for the Federal Government in 1973. A large triptych satirising the political establishment was exhibited with other works at the Holdsworth Gallery, Woollahra, in 1976. He has written discussion papers, catalogue essays, general articles and book reviews on the visual arts and a book *Art?* on art theory (Lonely Arts, 1984).

APPTS: Part-time teaching, secondary schools, NSW 1961–62; lecturer part time, NAS 1971–74; lecturer College of Fine Arts Uni. of NSW 1975– .

ATYEO, Sam

(b. 1911, Melbourne; d. 1990, France) Painter.

STUDIES: NGV School with W. B. McInnes and L. Bernard Hall. As a student Atyeo achieved a *succès de scandale* when an abstract picture which he had entered for the Travelling Scholarship, 1932, was removed from the scholarship exhibition by Bernard Hall. The picture, which was the first abstract seen in such an exhibition, contravened requirements of the scholarship and Hall regarded it as a calculated affront to his teaching. Apart from his experiments with abstraction, Atyeo painted a limited number of landscapes during the 1930s, and became a versatile worker in the fields of industrial design and architecture as well as in painting; he was closely associated with Dr H. V. Evatt (a keen supporter of modern art, who purchased a Modigliani portrait from the 1939 *Herald Exhibition of French and British Painting*) during Evatt's term of office as Minister for External Affairs. In 1950 Atyeo abandoned painting for rose farming in the south of France but resumed his former career in 1960. An exhibition of his work, sent from France, was held under the auspices of the MOMAD at Georges Gallery, Melbourne, in 1963. It revealed some concentration on geometric abstraction but the firm structure of the oils differed from that of the watercolours, which were

more amorphous, with fluid forms emerging somewhat hazily from the paper. His work has been featured from the 1980s in exhibitions based on the Reed collection at Heide Gallery, Melbourne.
AWARDS: Grace Joel (student award), 1930.
REP: Most Australian state galleries.
BIB: Smith, *AP*.

AUDETTE, Yvonne.
(b. 22/4/1930, Sydney) Painter.
STUDIES: Julian Ashton School (with John Passmore), 1948–52; ESTC; Orban School; overseas travel study (USA, London, France, Spain and Italy), 1955–65. From 1958 she held a large number of exhibitions in various cities, including Florence, Milan and Rome, and in private galleries in Sydney and Melbourne (Lyttleton Galleries 1980s, 90s). Writing in her South Yarra Gallery exhibition catalogue in 1971, James Gleeson drew an analogy between her work and the palimpsest, but a later exhibition at the same gallery (1976) showed her as a figurative painter using warm sensuous colours, free line and flat patterns that related the work distantly to that of Matisse. Her work has appeared in a number of group exhibitions including *New Directions 1952–62*, The Lewers Bequest, Penrith Regional Gallery, 1991.
AWARDS: Two-year scholarship for study in New York, 1952.
APPTS: Private art schools, Florence, Milan, Rome 1958–65; RMIT 1988–92; Vic. College of the Arts 1990–92.
REP: NGV; MPAC; Artbank; regional galleries McClelland, Penrith; Lewers Bequest; Melbourne Uni.; private collections in Aust., US and Europe.
BIB: Horton, *PDA*. Bonython, *MAP* 1970 & 1975. McIntyre, *CAD*. McIntyre, *Collage*.

AULD, James Muir
(b. 19/6/1879, Ashfield, NSW; d. 8/6/1942, Camden, NSW) Painter.
STUDIES: Sydney, Ashfield Tech. School (evening classes); J. S. Watkins School c. 1907; Julian Ashton School. He began exhibiting with the RAS, Sydney, in 1902, was a member of the NSW Society of Artists and became well-known for his black and white contributions to the *Sydney Mail* and *Bulletin*. He spent about two years overseas c. 1909, mostly in London, studying the work of Constable, Steer and Turner and contributed to magazines such as *London Opinion*. Back in NSW c. 1911, he settled at Dee Why and joined the advertising firm of Smith and Julius. A subtle and sensitive painter of *plein air* landscapes and subject pictures, he also painted some fine portraits, including that of the poet Roderic Quinn in the collections of the AGNSW. But he suffered from poor health and eventually died of tuberculosis. Besides exhibiting with the societies, he held three exhibitions at Macquarie Galleries, 1928, 1936 and 1942. A memorial exhibition was held in the AGNSW in Dec. 1942.
AWARDS: Wynne prize, 1935.

REP: AGNSW; AGSA; TMAG; regional gallery Armidale; Manly Art Gallery.
BIB: *AA*, no. 3, 1917. Lloyd Rees, *The Small Treasures of a Lifetime*, Ure Smith, Sydney, 1969. ADB 7.

AUROUSSEAU, Georges Hippolyte
(b. 1864, Clarencetown, NSW; d. 1953, Sydney) Painter, teacher.
STUDIES: Sydney Mechanics School of Art; Sydney Tech. Coll. (with Lucien Henry). He painted many watercolours of landscapes but his accurate paintings of the flora of the Sydney region suggest the title 'botanical artist'. Some of his designs for architectural decorative features of the Hotel Australia, Sydney, the work he did on Lucien Henry's designs for Sydney Town Hall windows, as well as his writings, show that he inherited Henry's absorption with the decorative possibilities of Australian flowers and plants. His publications include 'Freehand Drawing of Ornamental Designs', *Technical Journal*, Sydney, vol. 3, 1899; 'Lucien Henry', *Technical Gazette*, Sydney, vol. 2, 1912; *The Analysis of Inanimate Form*, Sydney, 1907.
APPTS: Teaching, ESTC, 1885–1929.

AUSTIN, Graham P.
(b. 29/8/1941) Painter.
STUDIES: NAS 1958–63. A member, then president of the Australian Water Colour Institute, he has won numerous prizes for watercolours (approx. 31, 1962–93), mostly in NSW, including Royal Easter Show and at Lismore, Mudgee, Manly and Hunters Hill. His work has appeared in a number of group watercolour exhibitions including the 108th Annual Exhibition of the American Watercolour Institute. He has also organised several exhibitions of watercolours including those at Newcastle Regional Gallery 1991, Vancouver and Federation of Australian Artists 1992.
APPTS: Teaching, Drummoyne Art Society (of which he was a president), 1965–67; Meadowbank Tech. Coll., 1967–69; Kuring-gai Art Centre 1991.

AUSTIN, John Gardiner
(Arr. Aust., 1834) Lithographer, sketcher. He printed sketches including those after Robert Rusell (q.v.) and *The Profile Portraits* from pencil sketches of W. H. Fernyhough (q.v.). His work was represented in *The Artist and the Patron* AGNSW 1988.
REP: Mitchell Library.
BIB: Moore, *SAA*. Smith, *AP*. Kerr, *DAA*.

AUSTIN, William
(Active Vic., c. 1850) Engraver, watercolourist. A well-known work by Austin is the coloured lithograph *Arrival of the First Gold Escort, Melbourne, June, 1852* which he observed while employed at the Melbourne Survey office. He exhibited at a number of exhibitions in Melbourne, Brisbane and Sydney 1860s–80s including the 1879 Sydney *Intercolonial Exhibition*.
REP: La Trobe Library
BIB: Kerr, *DAA*.

AUSTIN, William S.

(b. 1867, Oxford; arr. Australia 1885; d. 1945, Brisbane)
Painter. Amateur painter, trained in England, who
specialised in pictures of buildings of significant his-
torical interest in the neighbourhood of Brisbane, win-
ning a special award at the Brisbane Exhibition of
1908.
BIB: *National Bank of Australasia Calendar*, Melbourne, 1960.

AUSTRALIA COUNCIL

181 Lawson St Redfern NSW 2016 (PO Box 788,
Strawberry Hills, NSW 2012) In Nov. 1967, Prime
Minister Harold Holt announced his Government's
intention to form an Australian Council for the Arts
'to be its financial agent and advisor on the performing
arts and other activities connected with the arts in
general'. The Council was formally announced by
Prime Minister John Gorton the following year and
met for the first time on 8 July 1968. A change of
government in 1972 broadened the scope and respon-
sibilities of the Council to encompass the functions
of the Commonwealth Literary Fund, the Common-
wealth Arts Advisory Board, the Commonwealth
Assistance to Australian Composers Scheme and the
Interim Council for a National Film and Television
Training School.

The aims and objectives of this new council were
'to encourage excellence in the arts; to foster a wider
spread of interest and participation; to help develop
a national identity through artistic expression and to
project Australia's image in other countries by means
of the arts' through its seven constituent Boards –
Aboriginal Arts, Crafts, Film Radio and Television,
Literature, Music, Theatre and Visual Arts (the
Community Arts Board was added in September 1977).
The chairpersons of each of these Boards were auto-
matically members of the governing Council. This
interim Council was also given the task of develop-
ing plans for the statutory authority which would
become the Australia Council.

The Australia Council was formally established as
a statutory authority by Act of Parliament on 13 March
1975 with substantial independence and policy-
making and funding roles extending well beyond its
earlier advisory role.

The Council receives an annual budget allocation
from the Commonwealth Government through the
Department of Finance. The allocation for 1992–93
was $56,873,000 to assist artists and arts organisa-
tions through the programs of its specialist artform
Boards and Committees. In April 1993 these were
the Aboriginal and Torres Strait Islander Arts Com-
mittee, the Community Cultural Development Board,
the Literature Board, the Performing Arts Board and
the Visual Arts/Craft Board.

In July 1987 the functions of the former Visual
Arts Board and Crafts Board were merged to become
the Visual Arts/Craft Board. The base support for the
arts budget allocation to the Visual Arts/Craft Board
for 1992–93 was $7,081,912.

THE VISUAL ARTS/CRAFT BOARD

Forms of assistance for the visual arts initiated within
the VACB include grants to assist the professional devel-
opment of artists and crafts people; annual awards to
visual artists and crafts people including the Emeritus
Award and Visual Art and Craft Emeritus Medal.
Funding is available to: organisations to support con-
temporary art and craft practice including exhibitions,
conferences, residencies and promotional activities;
support international recognition and appreciation of
contemporary visual art and craft including funding
of recurrent exhibitions such as the Venice Biennale,
Kassel Documenta, Indian Trienniale, São Paulo
Biennial, The Lausanne International Biennal of Textile
Arts, Ornamenta and Asia-Pacific Triennial of Con-
temporary Art; promote critical writing and special-
ist publications on contemporary visual art and craft;
organisations for development of contemporary art and
craft collections; museums and galleries to appoint
craft curators; encourage collaboration between artists,
designers and communities to enhance the quality of
the public environment.

The VACB also undertakes policy and advocacy work
on matters connected with the promotion of the arts
including such matters as public consultation, mar-
keting and promotion, professional and industrial rep-
resentations, legislative reform, ethics and health and
safety and education.

It also administers a number of studios available
for Australian artists in the USA, Europe and Japan
(*see* ARTISTS' STUDIOS OVERSEAS).

AUSTRALIAN ACADEMY OF ART

(1937–46) Formed Canberra, 1937, at a meeting
chaired by R. G. Menzies, then Attorney-General. The
first national exhibition was held at Sydney Education
Dept Gallery, 1938, and the second at NGV, 1939.
Annual exhibitions continued until 1946 when the
Academy ceased operations. During its brief existence
an effort was made to obtain a royal charter, a move
vigorously and successfully opposed by the Contem-
porary Art Society (q.v.) and other avant-garde groups.

AUSTRALIAN ART ASSOCIATION

(1912–c. 1930) Founded in Melbourne in 1912 for
the benefit of professional artists, whose activities in
other societies and associations such as the VAS had
frequently been obstructed by amateurs. The original
members included: F. McCubbin, J. Mather, M.
Meldrum, A. Patterson, W. Withers, A. McClintock,
C. Harcourt. Presidents: E. Officer, N. Macgeorge, W.
B. McInnes, G. Bell, J. Longstaff. Interest in the asso-
ciation waned as the original members died.

AUSTRALIAN ART EXHIBITIONS CORPORATION LIMITED

See ART EXHIBITIONS AUSTRALIA

AUSTRALIAN ART GALLERIES ASSOCIATION

See ART MUSEUMS ASSOCIATION OF AUSTRALIA

AUSTRALIAN ART SOCIETY

(1926–70) Its objective was 'to foster a true Australian outlook in art'. The first secretary of the group, which included Donald Commons and H. Pugmire, was William Montagu Whitney, one of the founders; the inaugural exhibition was held at the Education Dept Gallery, Sydney, in 1927.

AUSTRALIAN ARTISTS' ASSOCIATION

(Founded 1886) Breakaway group from the Vic. Academy of Arts; the severance was due to the prominence of amateurs within the VAA. The Association held three exhibitions at Buxton's Gallery, Melbourne, before reuniting with the VAA to form the Victorian Artists' Society. Members of the Australian Artists' Association included Tom Roberts, Arthur Streeton, Charles Conder, John Mather, John Ford Paterson, W. P. Spong, Percival Ball, Arthur Louriero, Ugo Catani.
BIB: Moore *SAA.*

AUSTRALIAN ARTS CLUB

(Founded 1919) Only two exhibitions were held.

AUSTRALIAN BICENTENNIAL PERSPECTA

See AUSTRALIAN PERSPECTA

AUSTRALIAN COMMERCIAL GALLERIES ASSOCIATION

(Established 1976) c/o Watters Gallery, 109 Riley St, East Sydney. Formed in Melbourne with the aim of furthering the interests of commercial galleries and the artists these galleries represent. The Association started the Australian Contemporary Art Fair (q.v.), held biennially since 1988 at Melbourne's Exhibition Building.

AUSTRALIAN CONTEMPORARY ART FAIR

(Established 1988) c/o J. Jones & Assoc., PO Box 5004, Carlton, Vic. 3053. Contemporary art fair held biennially at the Exhibition Building, Melbourne, at which Australian and international commercial galleries present work from artists they represent. Associated with the Fair is a sculpture exhibition in the grounds, and several forums on various aspects of contemporary art. In 1992 the first Georges Mora Memorial Lecture was presented in honour of one of Australia's leading gallery directors who died in 1992.

AUSTRALIAN EXHIBITIONS TOURING AGENCY

See TOURING AGENCIES

AUSTRALIAN EX-LIBRIS SOCIETY

(Founded Sydney, 1923) Formed as result of an exhibition of bookplates held at Tyrrell's Gallery, Sydney, 1923. The first president was John Lane Mullins; State vice-presidents included Edmund Jowett, Vic.; Fred Johns, SA; Aeneas J. McDonnell, Qld; G. Pitt Morison, WA; R. A. Clive, Tas. Annual *Brochure of Bookplates*; Camden Morrisby, *Bibliography of Ex-Libris Literature Published in Australia*, Ex-Libris Society Journal, 1930. *See also* BOOKPLATE DESIGN IN AUSTRALIA

AUSTRALIAN GALLERY DIRECTORS COUNCIL

(1948–81) The first meeting of Australian public gallery directors was at the NGV, 25–27 Aug. 1948. Three directors attended, Daryl Lindsay (NGV), Hal Missingham (AGNSW) and Louis McCubbin (AGSA). The title *Interstate Directors Conference* was adopted, and the meetings led to the formation of the AGDC as later constituted. The name of the organisation became Australian Gallery Directors Conference in 1973 (so as to include non-state galleries), and in 1976 the word *council* replaced *conference*. In 1977 the AGDC became formally incorporated as the Australian Gallery Directors Council Limited when the executive was reconstituted as a board of directors. In addition, it formally registered the Australian Exhibitions Trust (with AGDC as trustee), into which tax-deductible contributions from private sponsors could be deposited for use on projects specifically designated for the benefit of public institutions. The main function of the AGDC was the organisation of travelling exhibitions, large and small, from and to other countries, but with emphasis on international exhibitions of the calibre of *Master Drawings from the Alberta*, 1977; USSR *Old Master Paintings*, 1979; *America and Europe. A Century of Modern Masters from the Thyssen-Bornemisia Collection*, 1980; *Pompeii A.D. 79*, 1980. All these sprang from the co-operation of the AGDC with the Visual Arts Board of the Australia Council and the application of the Commonwealth Government Indemnity Scheme, formed to protect such exhibitions from loss or damage. Through its exhibitions, the AGDC provided a service of great benefit to the public. Moreover it changed the situations of public art galleries and museums throughout Australia in a number of ways, but mainly by creating a forum and giving the combined public art institutions the character of a national network. Its demise, at a time of great promise, came about through heavy financial losses incurred mainly on two large touring exhibitions, *French Art: the Revolutionary Decades* and *Aboriginal Australia*, 1981–82. *See also* EXHIBITIONS; ART EXHIBITIONS AUSTRALIA

AUSTRALIAN GUILD OF REALIST ARTISTS

(Established 1978) Guild House, 1 Inglesby Rd, Camberwell, Vic. 3124. Formed mainly for the benefit of painters painting in a representational manner. Meetings were held and a seminar was organised at CIT, 22 Sept. 1979, with demonstrations and lectures. In 1980 the Guild received a $10,000 state government grant towards establishment of a permanent headquarters in Melbourne (it now also has a NSW chapter). It holds an *Artascapade* annually during which artists from all over Australia join together in a week of painting, usually in a country venue such as Derwent,

Tas. and Robe, SA. An annual exhibition is also held, often at a public gallery (Caulfield Arts Centre, Mildura Regional Gallery), and in 1993 an exhibition of members' work toured Vic. regional galleries. Artists who have been associated with the Guild include Paul Fitzgerald, Kenneth Jack and Kathleen Ballard.

AUSTRALIAN INSTITUTE OF ARTS AND LITERATURE

(Founded 1921) Founded by Edward A. Vidler, art book publisher, in Aug. 1921. In *Smike to Bulldog* (Ure Smith, Sydney, 1946), R. H. Croll wrote that Streeton gave an illustrated lecture to the Institute at Queen's Hall, Melbourne, 1924. The Institute was short-lived.

AUSTRALIAN PAINTER-ETCHERS' SOCIETY

(1920–c. 1943) Founded by Gayfield Shaw, Sydney, Aug. 1920. Foundation members included L. Lindsay, J. Shirlow, Eirene Mort, D. Barker, S. Ure Smith, H. Fullwood, J. Barclay Godson, B. Robertson. Presidents: Lionel Lindsay, Bruce Robertson, Sydney Long. The first exhibition, a historical show of etchings, *Benjamm Duterrau to Hop*, held at the Education Dept Gallery, Sydney, in 1921, yielded £1600 in sales. Other exhibitions were held in Melbourne and Adelaide. In 1925 the committee formed the Australian Print Collectors' Club, and the following year established etching classes at the Attic Gallery, Callaghan House, George St, Sydney. The annual exhibitions continued for more than 20 years, but radical changes in the status and styles of the graphic arts during World War II brought the Society to an end.

AUSTRALIAN PERSPECTA

(Established 1981) AGNSW. Biennial exhibition focusing on the latest work of Australian contemporary artists. It appears each alternate year to the *Biennale of Sydney* (also at the AGNSW). Each Perspecta has a theme and the exhibition generally uses other venues as well as the core exhibition at the AGNSW and includes forums, installations and performances. The 1988 *Bicentennial Perspecta* was a watershed for 1980s Australian contemporary art enabling a comprehensive assessment of the work of 17 artists including Julie Brown-Rrap, Richard Dunn, Dale Frank, Bill Henson, John Nixon, Stieg Persson and Vivienne Shark Le Witt.
See also EXHIBITIONS

AUSTRALIAN PRINT WORKSHOP
See GALLERIES – PUBLIC

AUSTRALIAN SCULPTORS SOCIETY
See ASSOCIATION OF SCULPTORS OF VICTORIA

AUSTRALIAN SCULPTURE TRIENNIAL

(Established 1981) PO Box 436, Torquay, Vic. 3228. The Triennial was established to promote sculpture in galleries and public spaces throughout Melbourne as well as in regional centres and other capital cities. Seminars and forums are held in conjunction with the Triennial and it has become the leading survey exhibition for Australian contemporary sculpture since the Mildura Sculpture Triennial. Since 1990 it has been linked with the Melbourne International Festival and held in September.

AUSTRALIAN SOCIETY OF BLACK-AND-WHITE ARTISTS

(Founded Sydney, 1924) Short-lived society which aimed mostly at providing social facilities for members. First president was Cecil Hartt, the *Smith's Weekly* artist.
See also BLACK-AND-WHITE ART IN AUSTRALIA

AUSTRALIAN WATERCOLOUR INSTITUTE

(Established 21/8/1923) PO Box 158, Cammeray NSW 2062. Founded by artists B. E. Minns, M. Stainforth, G. E. S. Tindall, J. A. Bennett, A. H. Fullwood and A. J. Daplyn (qq.v.). The six were increased to 14 for the first exhibition at Anthony Hordern's Gallery on 25 Mar. 1924. Annual exhibitions have since kept the AWI alive, members numbering 66 (in Jan. 1993) of whom 40 resided in NSW. Exhibitions held at S. H. Ervin Gallery, Observatory Hill, NSW as well as others overseas. Members have included Frederic Bates, Hector Gilliland, Graham Austin, Margaret Coen, Claudia Forbes-Woodgate, Earle Backen, Peter Pinson.

AUSTRALIANA FUND

(Established 1978) GPO Box 4931, Sydney, NSW 2001. A charitable trust established to encourage direct public participation in the acquisition of works of art of all kinds for four official establishments – Admiralty House and Kirribilli House, Sydney, and Government House and The Lodge, Canberra. The Fund is allied directly to the Official Establishments Trust.

BACKEN TO BYRT

BACKEN, Earle
(b. 1/9/1927, Albury, NSW) Painter, printmaker, teacher.
STUDIES: Dattilo Rubbo; Julian Ashton School (with John Passmore); Central School of Arts, London 1954–55 (with Keith Vaughan); Slade School, London 1950s; Paris 1956–59 (etching and engraving with Henri Gaetz and S. W. Hayter). Backen's prints in both colour and black-and-white show notable control of mixed and varied techniques, and have been included in international print exhibitions in Philadelphia, Washington, Tokyo, Ljubljana, Lugano, Cracow, as well as the national exhibitions of the Print Council of Australia. His 1970s work was abstract and later developed figuratively, leaning towards realism in the 1980s. His subjects include objects from his studio showing light on drapes and architectural features. He has exhibited frequently at private galleries in Sydney (including Robin Gibson). Ivan Dougherty Gallery, Sydney, held a retrospective of his work in 1987.
AWARDS: NSW Travelling Scholarship, 1954; CAS, Sydney, prize for prints, 1960; Mosman prize, 1965; Maitland prize, 1966; Bicentennial Art prize, RAS 1988; project grant VACB 1974.
APPTS: Teaching, NAS, Sydney, from 1960; Alexander Mackie Coll., NSW (senior lecturer), 1975–87; foundation member, Sydney Printmakers.
REP: NGA; AGNSW; AGSA; AGWA; MAGNT; NGV; QAG; TMAG; several regional galleries including Newcastle; NSW Parliament House; many corporate collections; Cincinnati Art Museum, USA.

BACKHAUS-SMITH, Rex
(b. 23/1/1935, Surat, Qld) Painter, illustrator.
STUDIES: Brisbane Tech. Coll., 1962–63; travel studies Europe, UK and USA, 1972, 77, 88, 89, 90. Known mainly for his illustrations for books, notably Thomas Roy's *The Curse of the Turtle*, Bodley Head, London, and K. Langloh Parker's *Australian Legendary Tales*, Bodley Head, London, 1978; *Images* 1981; *On Reflection* 1983; *Impressions* 1987, all Wirra Publications; *The Plains of Promise*, Adrian Slinger Publications, 1988. He held numerous exhibitions 1967–89, mainly in Qld.

APPTS: Secondary schools and workshops, Qld; summer schools Qld, Canberra, NSW, NT.
REP: Several city and municipal collections; NLA and several other library collections.
BIB: John Keeble-Win, *The Art of Rex Backhaus-Smith*, Boolarong, 1986. Germaine, AGA.

BACKHOUSE, James
(b. 1794, Darlington, Eng.; arr. Aust. 1832; d. 1869, York, Eng.) Painter. Itinerant artist who spent six years in Australia and wrote *Narrative of a Visit to the Australian Colonies*, London, 1843, illustrated with his own and after others' sketches. It was an important source book for that period.
BIB: *Australian Encyclopaedia*, Angus & Robertson, Sydney, 1958. Smith, EVSP. Moore, SAA. Kerr, DAA.

BACKHOUSE, Sue
(b. 23/3/1955, Hobart) Curator, writer, painter, photographer.
STUDIES: Tasmanian School of Art, Hobart 1973–76. She participated in approximately seven group exhibitions at commercial galleries in Tasmania and Burnie Art Gallery, Fine Arts Gallery, Uni. of Tasmania 1976–82. She co-authored many catalogues for TMAG and was the sole author of *Jack Carington Smith Retrospective*, 1976. Her book *Tasmanian Artists of the Twentieth Century*, Pandani Press, Hobart, 1988, contains valuable biographical material on Tasmanian artists.
APPTS: Art teacher, Tas. Education Dept, 1977–78; part-time tutor then lecturer photography, School of Art, Hobart 1978–79; part-time tutor photography, Rosny College, Hobart 1981–83; part-time curator then acting curator of art, TMAG 1981– .
REP: TMAG; Burnie Art Gallery.

BACKLER, Joseph
(b. 1813, Eng.; arr Sydney 1832; d. 1895, Sydney) Painter. Convicted for forgery in London, he was transported for life and on arrival in Sydney assigned to the Surveyor-General's Dept at Port Macquarie for a year before being allowed to transfer to Sydney. He became well-known in Sydney in the 1840s for his portraits of prominent citizens, then having obtained

a second-class pardon travelled to country areas of NSW and Qld, setting up in a number of NSW towns and in Brisbane and completing portrait painting commissions. His work appeared in *The Artist and the Patron*, AGNSW 1988 and in a number of art auction houses in the 1980s.

REP: AGNSW; National Trust, NSW; Lanyon, ACT; Brisbane City Museum and Art Gallery; Bathurst regional gallery; Newcastle Library; Mitchell Library.

BIB: Eve Buscombe, *Artists in Early Australia and Their Portraits*, Sydney 1978. Joyce Hackforth-Jones, *The Convict Artists*, Melbourne, 1977. Kerr, DAA.

BADHAM, Herbert Edward

(b. 24/7/1899, Sydney; d. 1961, Sydney) Painter, teacher, writer.

STUDIES: Sydney Art School, 1925–28, 33, 38. His preferred subjects were figures, urban life and beach scenes and his work typifies the modernism of the 1930s and 40s. He exhibited with the Society of Artists for many years (1927–62) and participated in group exhibitions such as the retrospective exhibition of the Sydney Art School 1890–1933 in 1933; sesquicentennial exhibition of NSW at AGNSW 1938; and held a solo exhibition at Grosvenor Galleries 1939. During the 1940s he toured Australia seeking information for his book, *A Study of Australian Art* (Currawong Press, Sydney, 1949), for which he is well-known. He also wrote *A Gallery of Australian Art*, Currawong Press, Sydney, 1954. A retrospective exhibition of his work was held at the Wollongong City Gallery (and later S. H. Ervin Gallery, Sydney) in 1987.

APPTS: Head of intermediate art dept, ESTC; chief examiner in art and chairman of art syllabus committee, NSW Dept of Education; member of the NSW Society of Artists.

REP: AGNSW; NGV; regional galleries Bendigo, Newcastle, Armidale (Hinton Collection).

BAGGALEY, Norman Reginald

(b. 23/1/1937, UK; arr. Aust. 1978) Painter, lecturer, dean of art school.

STUDIES: Stoke-on-Trent College of Art, National Dip. Design (painting), 1957; Liverpool Uni., Art Teachers Diploma, 1958; Uni. of S. Illinois, USA, Master of Science in Education, 1975. Known mainly as an art educator, he held 18 solo exhibitions 1962–92 in Adelaide (Llewellyn 1970, 71, 73; Sydenham 1974, 76; Greenhill 1976–88), Melbourne (Christine Abrahams 1984; David Ellis 1987, 89, 91), Sydney (Holdsworth 1988–91) and Allyn Gallery, Uni. of S. Illinois, USA 1975. His work appeared in numerous group exhibitions in the UK and Australia 1962–92 including London Group, 1962; Grabowski Gallery, London, 1963; *Ten South Australian Painters*, touring exhibition to Vic. regional galleries, 1972; *Le Salon des Nations*, Centre International d'Art Contemporain, Paris, 1984; *Australian Painting*, Uni. of Vermont, USA, 1990.

APPTS: Principal lecturer in Art, head of division of Creative and Fine Arts, Salisbury College of Advanced Education 1969–78; Dean, School of Arts, Ballarat CAE 1978–80; Dean, School of Art & Design, Prahran CAE 1980–81; Dean, Faculty of Art & Design, Professor of Visual Arts, Victoria College, Prahran 1981–92; visiting lecturer, Cheltenham School of Art, UK, 1982–83; Dean, School of Art, Victorian College of the Arts, 1992– .

REP: Artbank; Deakin Uni.; Ballarat Uni. College; College of Fine Arts, Uni. of NSW; Adelaide Uni.; Uni. of SA; Westpac, Reserve Bank corporate collections.

BIB: *Who's Who in the World. Who's Who in the Commonwealth. Who's Who in Art*, Arttrade Press, UK. *Who's Who in International Art*, Lausanne. Germaine, AGA.

BAILEY, Mary Ann

(Active SA, c. 1895–1905) Painter. She painted portraits and genre, mainly of Aborigines on the Murray river.

REP: South Australian Museum.

NFI

BAILLIEU, Marianne

(b. Sweden, Danish nationality) Gallery director, painter.

STUDIES: Canterbury Uni., New Zealand (arts and psychology); Monash Uni. (politics and anthropology). She established Realities Gallery in Melbourne in 1971 and it soon became one of the leading and liveliest galleries in Australia showing contemporary work by many now well-established artists including George Baldessin, Jan Senbergs, Colin Lanceley, Inge King, Andrew Sibley, John Firth-Smith, Paul Partos and many others. In 1981 she sold the gallery in order to concentrate on her own art. Working in a variety of media, including three-dimensional, her work has moved from experimental three-dimensional in the early 1980s to oils – with no less exuberant approach to her subjects, which are often metaphysical. A frequent traveller to remote areas and drawing from the culture of the ancient primitives, her works have been described as 'spirited . . . significant . . . abstract' (Elwyn Lynn, *The Australian*, 13 Oct. 1990), and 'paintings concerned with energy, exhilaration and play . . . joyful paintings . . . affirming the pleasure and vitality of being' (Lynette Fern, Galleries, SMH, 26 Oct. 1990). In May 1992, she was guest curator of *The Living Mandala* exhibition of Tibetan Art, Access Space, NGV. She held seven solo exhibitions 1983–92 in Sydney (Yuill Crowley) and Melbourne (Tony Oliver; Karyn Lovegrove), and also exhibited with Imants Tillers 1983–92. Her work appeared in numerous group exhibitions including *Australian Perspecta*, AGNSW 1985; *Advance Australian Painting*, work of 16 Australian artists touring major public New Zealand Galleries, 1988; with Wilderness Society, Linden, St Kilda and *100 Artists Against Animal Experiments*, Deutscher Gallery, Melbourne 1990; *The Sublime Imperative*, ACCA, Melbourne 1992 and touring Canberra, Benalla.

REP: NGA (collaborative work Imants Tillers); Artbank; Monash Uni.

BIB: Catalogue essays in exhibitions as above.

BAILY, John (Harold John)

(b. 23/11/1927, Perth, WA) Gallery director, teacher, painter, valuer, dealer.

STUDIES: SASA; travel studies USA 1964, Europe 1970. As director of the AGSA, and later chairman of the Adelaide Festival Centre Trust, he made a valuable contribution to art development in SA before moving to Sydney to live. An accomplished watercolourist, he held numerous solo exhibitions 1964–92 including at Commonwealth Institute, London, 1962 and a retrospective at Wollongong Uni., 1984. He wrote the introduction to the book *Art Gallery of South Australia*, Adelaide, 1970.

AWARDS: Harkness Fellowship for study in the USA, 1964; Redcliffe prize, Qld, 1978; Membership of Order of Australia for services to art, 1987.

APPTS: Art teacher, lecturer and inspector of art for the Education Dept of SA; art critic, *Sunday Mail*, Adelaide, 1963–64; director, AGSA, 1967–75; president of the CAS, South Australia, of the Australian Society of Education Through Art, and of the Art Galleries Association of Australia; chairman, Visual Arts Board of the Australia Council, 1973–76; principal, Sydney Coll. of the Arts, 1976–87; painting workshops; manager, Bonython Meadmore 1986–88; Irving Fine Art 1988–90.

REP: NGA; AGSA; QAG; Parliament House; a number of university collections SA, NSW.

BIB: Campbell, *AWP. Bulletin, AGSA*, vol. 25, no. 3, Jan. 1964. *A&A*, 7/4/1970.

BAINES, Thomas (John Thomas)

(b. 27/11/1820, King's Lynn, Eng.; visited Aust. 1855–57; d. 1875, Durban) Explorer, painter.

A coach painter by training, he spent most of his life in South Africa where, by 1845, he was established as a marine and portrait painter. He accompanied expeditions to the interior before his appointment as a war artist with the British forces during the Kaffir War (1848–51), then returned to England before accompanying Augustus Gregory's expedition to the Northern Territory in search of Leichhardt. Working in a dual capacity as storeman and artist, he left a valuable record of a most hazardous expedition. Some of his drawings were engraved and others used as sketches for well-finished oils done at a later date. Another noted member of the expedition was Baron Ferdinand von Mueller, the botanist who later developed the Royal Botanic Gardens in Melbourne. By 1857 Baines was back in London where he became a Fellow of the Royal Geographical Society. In 1857 he accompanied Livingstone up the Zambezi but fell ill the following year; he also accompanied Chapman to the Victoria Falls (1861–64) and continued thereafter painting actively till he died of dysentery in 1875. His subject matter is broad and ranges from the marine paintings and portraits painted in the 1840s to the

landscapes of the 1850s and 1860s, into which he incorporated dramatic incidents from the military and exploratory expeditions with which he had been connected. His work was represented in *The Colonial Eye*, AGWA 1979; in Joseph Brown Gallery, Melbourne, *Winter and Spring Exhibitions*, 1973 and the Bicentennial exhibition, *The Great Australian Art Exhibition* 1988–89.

REP: NGA; regional galleries Ballarat, Geelong; NLA; Mitchell Library; collections of the Royal Botanical Gardens, and Royal Geographical Society, London; Norfolk Museum, King's Lynn.

BIB: Gregory's Australian Expeditions, *Geographical Journal*, vol. 10, no. 6, Dec. 1897. E. C. Booth, *Australia Illustrated*, London, 1873. *National Bank of Australasia Calendar*, Melbourne, 1963. Exhibition catalogue, ed. Helen Luckett, *Thomas Baines*, Norfolk Museum and Southampton Art Gallery, c. 1974. Kerr, DAA.

BAIRD, Bob

(b. 18/1/1948, NSW) Painter.

STUDIES: RAS; St George Technical College, Kogarah; Julian Ashton Art School; NAS, ESTC; Dip. Fine Art, Alexander Mackie CAE; Sydney Teachers College; Dip. Ed., Sydney Teachers College and Uni. of NSW. Living near the area where Streeton, Roberts and other impressionists based their *plein-air* Sydney school in the 1880s, Baird draws from his natural surrounding to create impressionistic-style traditional works reflecting the still beautiful bushland and coast. His other main subject, portraits, brought him some success and he was selected as a finalist in the Doug Moran portrait prize in 1982 and 1987. Solo exhibitions include two at Holdsworth, Sydney in 1988 and 1990. His work appeared in numerous group exhibitions at commercial galleries 1977–90 and with Print Council *100 × 100* portfolio exhibition 1988, *Heidelberg and Heritage 9 × 5 Centenary*, Linden Gallery, Melbourne 1985 and in University of Mexico 1990.

AWARDS: Numerous awards at RAS Royal Easter Show, Sydney (1973, 81, 83, 86, 90, 91, 92); Hunters Hill Art awards (1975, 88, 90).

APPTS: Private tutorials, Sydney 1974–79; workshops in Sydney and interstate 1983–92; secondary art schools, Sydney 1979–80; part-time then full-time teacher, School of Arts & Media, Seaforth College of TAFE 1979– .

REP: AGNSW; State Library of NSW; NLA; Bathurst regional gallery; City Art Institute; Dee Why Civic Centre; Warringah Shire and in Westmead Hospital, AWU (head office), Teachers' Credit Union, NSW, Reserve Bank collections.

BIB: Catalogue essays in exhibitions as above. *The Warringah Book*, 1988. *The Artists of Lane Cove*, 1988. Germaine, AGA.

BAIRD, John Forsythe

(b. 1902, Sydney) Painter, illustrator.

STUDIES: J. S. Watkins School, Sydney; Julian Ashton School; ESTC. He became a Fellow of the RAS, and an accredited war artist for Associated Newspapers, Sydney, 1943, for which group he worked as an illustrator for 30 years. He painted historical pictures and a number of portraits of World War II personnel.

REP: AGNSW; AWM; Howard Hinton Collection, Armidale, NSW.
NFI

BAKA, Peter

(b. 1958, SA) Painter. His work has included assemblages, collages and paintings and in his first exhibitions in Sydney in the early 1980s consisted of junk accumulated from the city streets. He moved into more conventional representations of natural forms in his paintings of the later 1980s. He participated in group exhibitions including *Still Life,* Ipswich City Gallery, 1986; *Dobell Foundation Exhibition*, Ivan Dougherty Gallery, Sydney, 1987; and commercial galleries, Sydney from 1986. He held one solo exhibition, at Contemporary Art Society, Adelaide, 1984 and some in Sydney galleries.
REP: NGA; AGSA; Bathurst City Art Gallery; Philip Morris Collection; Dobell Foundation.
BIB: *New Art Four.*

BAKER, Alan Douglas

(b. 1914, Sydney) Painter, teacher. Teacher of life drawing at J. S. Watkins School, Sydney, before World War II and a council member of the RASNSW, 1955–62. Best-known for paintings of flowers arranged on dark backgrounds, and for landscapes and portraits.
REP: NGA.
BIB: *Australian Art Illustrated*, RAS, Sydney, 1947.

BAKER, Christina Asquith

(b. 1868, London; d. 1960, Melb.) Painter.
STUDIES: NGV School (with F. McCubbin); Paris and privately with E. Phillips Fox; Julian School, Paris with Jean Paul Laurens, Baschet and Gabriel Ferris 1903; Charles Lasar, in Paris 1905 and London with Lasar 1905. She exhibited at the RA, London, Paris Old Salon, in VAS exhibitions in Melbourne 1896, 98 and 1916–18, and in exhibitions of *Contemporary Australian Artists* selected by Julian Ashton in Grafton Gallery exhibitions in London, 1898. She appears as the main figure in Fox's *The Art Students*, 1895 (AGNSW). She shared a studio in Paris with Ada Plante, living on the French coast in 1904 and returning to Paris in 1905, then to London and arriving back in Australia later that year. She was a member of the council of the VAS 1909–12 and travelled again to England and Paris 1912–14, exhibiting in London until the outbreak of World War I. Reviewers from the 1920s, including John Shirlow in the *Herald*, regarded her as an individual painter, and the *Age* critic described her works as having 'thoughtful and spirituelle aspects'. William Moore regarded her as having 'subtle insights' and in 1925 compared her work to David Davies. She exhibited at the Athenaeum Gallery in 1933 and 1935 and moved to Adelaide in the 1940s before returning to Melbourne and sharing a cottage with Ada Plante. At the age of 86 she undertook a painting trip to Alice Springs and held an exhibition at the Peter Bray Gallery, Melbourne, 1955, showing mainly lyrical landscapes and nocturnes. Jim Alexander

Galleries, Melbourne, held an exhibition of her work in 1986 and she was represented in *Completing the Picture: Women Artists and the Heidelberg Era* touring public galleries Vic., NSW, SA 1992.
REP: NGA; AGSA.

BAKER, David Edward

(b. 6/1/1945, NSW) Painter.
STUDIES: Teachers Certificate, Wagga Wagga Teachers College 1964; Dip. Art (Edn), NAS, ESTC 1971; MA Visual Arts (painting and drawing), College of Fine Arts, Uni. of NSW 1992– . He held 12 solo exhibitions in Sydney, Adelaide and Canberra 1972–92 and appeared in 11 group exhibitions at private galleries in Sydney, Newcastle, Adelaide and in *Sulman Award* exhibition, AGNSW 1972, 74; Sydney Opera House 1976, 77; Newcastle and Wollongong regional galleries 1985.
APPTS: Secondary art teacher 1970–73; lecturer art education, Riverina CAE 1973–75; part-time teacher, Wagga Wagga TAFE 1974–75; foundation lecturer visual arts, Macarthur Institute of Higher Education 1975–86; senior lecturer visual arts, Macarthur Institute of Higher Education 1986–87; art master, Scots College, Bellevue Hill, Sydney 1989– .
REP: MCA, Sydney; Charles Sturt, Wollongong and Uni. of Western Sydney uni. collections; AMP Society and Ansett Hayman Island collections.
BIB: *Archives of Australian Artists*, State Library of Victoria. Germaine, AGA.

BAKER, Dorothy

(b. 9/9/1914, Shepparton, Vic.) Painter, teacher.
STUDIES: NGV School; RMIT; George Bell School. She wrote and illustrated articles on art for *The Weekly Times* Melbourne in the 1960s and held numerous exhibitions at private galleries including Manyung, Vic. 1959–92.
AWARDS: Hon. Life Membership, Malvern Artists Society 1960; VAS Hon. Life Membership 1982; Fellow VAS 1989.
REP: NGV; Albury regional gallery; VAS; many private and art society collections in Aust. and overseas.
BIB: International *Who's Whos*. Germaine, AGA.

BAKER, Horace

See PICTURESQUE ATLAS OF AUSTRALASIA

BAKER, Jeanie

(b. Eng.) Illustrator, film-maker, collage artist.
STUDIES: Croydon College of Art, Surrey, UK 1969; BA (Hons) Art and Design, Brighton College of Art, Sussex, UK 1972. She is best-known for her colourful collage illustrations, largely on environmental themes for children's books one of which, *Where the Forest Meets the Sea*, won a number of awards and which she also wrote, directed and created as a 10-minute animated film (produced by Film Australia). Her work has appeared in numerous group exhibitions at private galleries in Sydney and London and at the Royal

Academy Summer Exhibition (London), Crafts Council of Australia, and regional galleries including Albury, Penrith and Noosa. She held six solo exhibitions 1975–92 in Sydney, New York and London; regional galleries at Newcastle, Noosa, Ipswich, Campbelltown, Penrith; Dromkeen, Vic.; NGV; Brisbane City Hall Art Gallery and Museum; Museum of Victoria; Adelaide Festival Centre; Craft Council of Australia galleries Sydney and Tasmania.

AWARDS: VACB grants 1978, 79; residency New York Studio, VACB 1980, 83; Crafts Board grant, Aust. Council 1982; Best Animated Film Award, Australian Film Industry 1988; Children's Picture Book of the Year Award, Australian Children's Book Council, 1988; Young Australians' Best Book Award, Picture Book Section 1988; *Parent* magazine Best Picture Book of 1988; Kids Own Australian Literature Award 1990; Honor Award for Illustration, International Board of Books for Young People, 1990.

REP: AGWA; QAG; Powerhouse Museum, Sydney; Dromkeen Museum of Children's Literature, Vic.; Qantas, James Fairfax, Ogilvy, Benson & Mather (London) collections.

BIB: Walter McVitty, *Authors and Illustrators of Australian Children's Books*, Hodder & Stoughton, 1989. *International Who's Who of Professional and Business Women*, 1988. Germaine, *AGA*.

BAKER, *Normand H.*

(b. 1908, Summerhill, NSW; d. 1955) Painter.
STUDIES: J. S. Watkins School, Sydney. Mainly a painter of portraits, interiors and street scenes.
AWARDS: Archibald Prize, 1937.
REP: AGNSW.

BAKER, *Richard Thomas*

(b. 1854; d. 1941) Botanist, painter, teacher. Pioneer in propagating the cause of the waratah, Australia's most heraldic bush flower, as a heraldic emblem, along with other native plants and flowers, for use in applied decoration, he wrote *Australian Flora in Applied Art: The Waratah*, Sydney, 1915, which was profusely illustrated by Lucien Henry and his students.
APPTS: Art Master, Newington College, Sydney, –1888; asst curator of botany, Sydney Technological Museum, 1888–98; curator and Government Economic Botanist, 1898–1921.

BAKER, *William Allan*

(b. 1921, Murwillumbah, NSW) Painter, administrator.
STUDIES: NGV School (with M. Griffin). His low-toned paintings showed him as a realist painter with a strong social consciousness. He was deputy director of the AGWA c. 1961.
AWARDS: Fremantle prize, 1961.
REP: AGWA.
NFI

BAKER, *William Kellett*

(b. 1806, Dublin, Ireland; arr. Sydney 1835; d. 1857, Maitland, NSW) Engraver, printer, publisher.

Lithographer and publisher of illustrated journals in Sydney 1835–c. 1852 he also collected some significant works including those by Frederick Garling (q.v.) and Joseph Fowles (q.v.) and moved to the Victorian goldfields c. 1853.
REP: NLA; Mitchell & Allport Libraries.
BIB: Kerr, *DAA*.

BAKER-CLACK, *Arthur*

(b. 10/1/1877, Boolaroo, SA; d. 1955, France) Painter.
STUDIES: France (with Rupert Bunny and Jean Paul Laurens). He was helped and encouraged by the French poster-artist, Steinlen. He began his working life as a reporter with the Perth *Morning Herald*, in which capacity he was sent to cover events on the Western Australian goldfields. He went to Paris in 1906 to study painting and lived in the Latin Quarter. He married a French art student, Edith, in 1910 and they eventually moved to the coastal village and art colony of Trepied d'Etaples. He served with the AIF in the Middle East and was a jury member and *Sociétaire* of the Salon d'Automne and of the Société Nationale des Beaux-Arts and a member of the London Group founded by Sickert. He exhibited at the New Salon, Salon des Indépendants, Autumn Salon, Paris, at the Beaux-Arts Academy, London 1924 and 1928; eight of his paintings were included in the Spring Gallery Exhibition of Australian Art, London 1925 and he exhibited at the Royal Academy, London 1929, 30. He once said 'the experience of twenty years' practice has led me to believe, with Bernard Shaw, that the only rule about art is that there is none'. His paintings and published statements show that he was a determined and enthusiastic modernist with particular interest in the work of Cézanne and Seurat. A posthumous exhibition of his work was held in Sydney in 1956.
BIB: *AA*, June 1925. George Patterson, *Arthur Baker-Clack*, *AA*, 3rd series, no. 21, Sept. 1927.
(Additional information supplied by John Wilson, Melbourne, July 1993)

BALCOMBE, *Thomas Tyrwhitt*

(b. 15/6/1810, St Helena; arr. Sydney 1824; d. 13/10/1861, Sydney) Painter, illustrator. As a son of the Colonial Treasurer in Sydney, he received whatever professional training existed in the colony, the evidence of such training being apparent in his work. Brought up on St Helena with his brother, Alexander Beatson Balcombe (later a pioneer settler and owner of National Trust property *The Briars* on the Mornington Peninsula, Vic.), he often saw Napoleon. He became known for his drawings and engravings of life on the NSW goldfields, notably for his portrait in watercolours of the discoverer of gold, E. H. Hargraves, 'receiving the salute of the miners', and worked as a draughtsman in the Colonial Treasurer's Dept (1831–61). He collaborated with the explorer Sir Thomas Mitchell, drew animals and birds, made lithographs of sporting subjects, contributed illustrated articles to the *Illustrated Sydney News* and received critical acclaim

for his contributions to the *Aboriginal Exhibition* 1848. He committed suicide by shooting himself at his home, *Napoleon Cottage*, Paddington, Sydney, during a fit of depression. His publications included *T. T. Balcombe*, in collaboration with G. F. Pickering, *Gold Pen and Pencil Sketches: The Adventures of Mr John Slasher at the Turzon Diggings*, W. Moffitt, Sydney, 1852; E. Winstanley, *Five Dock Grand Steeple Chase*, lithographs by T. T. Balcombe, Sydney, 1844. His work appeared in *The Artist and The Patron*, AGNSW 1988; *Early Australian Sculpture*, Ballarat regional gallery 1976; *Pastures and Pastimes*, Vic. Ministry for the Arts, VAS 1983.

REP: AGNSW; NLA (Nan Kivell Collection); Mitchell, Dixson Libraries; Queensland University; collection of *The Briars*, Mornington.

BIB: ADB 3. Eve Buscombe, *Artists in Early Australia and Their Portraits*, Sydney 1978. Smith, EVSP. Smith, PTT. McCulloch, AAGR. Scarlett, AS. Kerr, DAA.

(*See also* WINSTANLEY, Edward)

BALDESSIN, George

(b. 1939, N. Italy; d. 9/8/1978, Melb.) Sculptor, printmaker, teacher.

STUDIES: RMIT, 1958–61; Chelsea School of Art, London, 1962; Brera Academy of Fine Arts, Milan, with Marino Marini, 1962–63; travel studies Japan 1966–67, Paris 1975. From the time of his return to Melbourne and his first exhibition at the Argus Gallery in June 1964, he became a strong influence in local sculpture and its development. The exhibition occurred at a time when contemporary Italian sculpture had aroused admiration in Australia, partly from reproductions but also from the touring exhibition *Italian Art of the Twentieth Century* in 1956, which may have inspired Baldessin to study in Italy. The sculptures shown in his Argus Gallery exhibition, and at the *Mildura Sculpture Triennial* in the same year, combined the sensuality and archaic feeling of the Italians with a surrealistic penchant for fantasy that remained through to his final 'table sculptures', a series on the theme of food that stemmed ideologically from a seven-year period of his early life spent working as a waiter at Menzies Hotel. Between these periods of work as a sculptor, he attained a national reputation as a printmaker. In many of his etchings and aquatints voyeuristic features appear in company with dramatic contrasts of tone, reminiscent of Goya's *Disasters of War*. A man of prodigious energy, by 1970 Baldessin had become a master printmaker and the central figure of a select group of well-known artists and students working collectively in a large studio in the Olderfleet Buildings, Collins Street, Melbourne. His close associates at this time included Tate Adams, Les Kossatz, Andrew Sibley, Roger Kemp, Fred Williams, Jan Senbergs and many others. The paradox of Baldessin's life was that although he gave generously of his talents and his time, he remained introspective and isolated, unpredictable in his family and personal relationships and extremely sensitive to the slightest rebuff. He worked incessantly, won national sculpture

George Baldessin, Drawing, *1976, charcoal and conte pencil on paper, 120 × 80.5cm. Collection, Museum of Modern Art at Heide.*

awards and, in 1975, was selected to represent Australia at the *Bienal de São Paulo*, Brazil. Included in his São Paulo exhibit was one piece of sculpture in aluminium and 25 large etched plates printed on silver laminated paper and entitled *Occasional Images from a City Chamber*. The first survey exhibition comprising 214 examples of Baldessin's etched work was organised for the Mornington Peninsula Arts Centre in Oct. 1974. He was killed in a motor accident on the F19 freeway on the evening of 9 Aug. 1978 while on his way home from Melbourne to St Andrews, Vic. When he died, Australian contemporary art lost one of its most dedicated and remarkable artists. A memorial exhibition was held at Realities Gallery, Melbourne, in Nov. 1978 and the NGV organised a large memorial exhibition of sculpture and etchings for the NGV and touring state galleries 1983.

AWARDS: Alcorso-Sekers Travelling Scholarship Award for Sculpture, 1966; Maitland Prize (for prints), 1967,

70; prize at the *Ljubljana Biennale of Printmaking,* 1967; prize in the *Second International Biennale of Drawing Yugoslavia,* 1970; Geelong Print Prize, 1970; Comalco Invitation Award for Sculpture, 1971; VACB grant, 1973.

APPTS: Part-time lecturer, RMIT, 1963; lecturer, print-making, RMIT, 1968–74.

REP: NGA; all Australian state galleries; regional galleries Ballarat, Geelong, Mildura, Mornington, Sale, Warrnambool, Newcastle, Fremantle, Launceston; uni. collections Melbourne, Monash, Hobart; MOMA, New York.

BIB: Sturgeon, *DAS.* Scarlett, *AS. AI* 16/nos. 6–7/1972. *A&A* 7/2/1969 (Patrick McCaughey, *The Graphic Work of George Baldessin*); 16/3/1979 (*Death of George Baldessin*).

BALE, Alice Marian Ellen

(b. 11/11/1875, Richmond, Vic.; d. 14/2/1955, Melb.) Painter.

STUDIES: Melbourne, with May Vale; NGV School, with Bernard Hall and Fred McCubbin, 1895–1905. A prominent member of the VAS, she edited the VAS *Journal of the Arts* 1918–19. In 1933 a double portrait by her was exhibited at the RA, London, and her *Portrait of a Lady* was exhibited at the Old Paris Salon, 1939. A devoted follower of her contemporary, Max Meldrum, she reflected in her work the 'science of appearances' and tonal theories of that painter. She opposed modernism in painting but also the formation of the Australian Academy of Arts. On her death she left her estate (valued for probate at £46), her home at Kew and a scholarship 'for the benefit of young, traditional painters' which although not very well-known has become one of the richest art prizes in the country. The Castlemaine Art Gallery held a commemorative exhibition of her work in 1972 and she was represented in *Completing the Picture: Women Artists and the Heidelberg Era* 1992.

REP: QAG and other state galleries; regional galleries Ballarat, Benalla, Castlemaine.

BIB: Janine Burke, *Australian Women Artists 1840–1940,* Greenhouse, Melbourne, 1981. Refs and reprdns, *AA* Mar. 1924. *ADB* 7.

(*See also* PRIZES AND SCHOLARSHIPS, BALE SCHOLARSHIP)

BALFOUR, James Lawson

(b. 17/8/1870, Fitzroy, Vic.; d. 9/2/1966, Woy Woy, NSW) Painter.

STUDIES: London (with Herkomer); Paris (Cormon's Atelier, also at Julian's with Bougereau, Constant and Lefebvre). Son of an artist, James Balfour, he was taken to Scotland at the age of two, studied in London and Paris, and began his professional career in Ireland as a painter of babies and domestic animals. He migrated to NZ in 1900 and in 1912 moved to Sydney where he became noted as a portrait painter of prominent people and a member of the RAS and the Art Society of NSW, where he exhibited from 1913. In later years he was vice-president of the Manly Art Gallery. His commissioned portraits are conservative in style, and

his smaller landscapes and figure compositions combine a high-keyed palette with painterly brushwork to produce a personal and romantic result which is both intimate and beguiling.

REP: AGNSW; AGSA.

BIB: *Fifty Years of Australian Art 1879–1929,* RAS, Sydney, 1929. *AA* May 1923, illustration. *ADB* 7.

BALL, Adam Gustavas

(b. 4/4/1821; arr. Sydney 1838; d. 22/8/1882, Adelaide) Overlander, surveyor, artist. He travelled in the outback moving cattle and sketching outback life in SA, exhibited with the Society of Arts, Adelaide 1859 and 1860, and continued to sketch until his death. His work appeared in the Deutscher exhibition *Australian Paintings, Nineteenth and Twentieth Centuries,* Melbourne 1983 and *All but Forgotten Artists 1863–1880,* AGSA 1975.

REP: AGSA; NLA; Geelong Art Gallery

BIB: Kerr, *DAA.*

BALL, Percival

(b. 17/2/1845, London; arr. Aust. 1885; d. 4/4/1900, London) Sculptor.

STUDIES: RA Schools, London, c. 1861–65; Paris and Rome, c. 1866–74. An associate of Tom Roberts and the painters of the Heidelberg School, he assisted in the formation of the Australian Artists' Association in opposition to the Victorian Academy of Arts. Ball completed James Gilbert's statue in bronze of Sir Redmond Barry and, like Web Gilbert (q.v.), died while working on an important commission – in this instance the casting in London of *Phryne before Praxiteles* for the façade of the AGNSW. His work appeared in *Early Australian Sculpture,* Ballarat Fine Art Gallery 1977.

AWARDS: Gold Medal, RA, London (for a bas-relief), 1866.

REP: AGNSW.

BIB: Scarlett, *AS. ADB* 7.

BALL, Sydney

(b. 29/10/1933, Adelaide) Painter, printmaker, teacher.

STUDIES: Mainly self-taught; part-time, SASA, Art Students League of New York (with Theodore Stamos), 1963–65; travel studies Japan 1965; South Pacific 1975; Europe 1979; India 1985, 89; Korea 1990; China 1987, 91. He lived in New York 1963–65 and 1969–71 and in Europe 1979. During his first stay in New York he worked at the Pratt Graphic Centre (1964) and later taught lithography at the League Graphic Workshop. His contacts with New York artists included de Kooning, Guston, Motherwell and other members of the New York School. In response to the New York influence he returned to Australia as an early and influential representative of hard-edge abstraction. Using bright primary colours on black or dark blue fields, he painted a number of pictures on the theme of Persian architecture with emphasis on the

curved forms of the ogee. These pictures, with their vibrant colour surfaces, gained him several important national prizes, and in 1968 he was a key exhibitor in *The Field* exhibition at the NGV. His work continued its hard-edge abstraction until the 1980s when, responding to the international and local re-emergence of figuration, it changed to a more figurative, expressionist style, still based in abstraction. His imagery was now drawn from Western art historical sources and conflicts of cultures such as those of Aboriginal Australian, Melanesian and other Pacific cultures with white European. He held solo exhibitions annually in most capital cities 1965–90 and survey shows in which his work appeared included *Visions after Light 1836–1981*, AGSA 1981; *Biennale of Sydney*, 1982; *Australian Printmakers*, Bradford, UK 1988. His influence was strong, especially in South Australia in the mid late 1960s where he taught at his old school, the SASA. He featured in an ABC documentary, *Ten Australians – Sydney Ball 1975*.
AWARDS: Ford Foundation Scholarship, for study in the USA, 1964; *Mirror*-Waratah grand prize, 1965; Perth Festival Prize, 1967; Corio Prize, Geelong, 1967; Benalla purchase award, 1967; Georges Invitation Art Prize, Melbourne, 1968; VACB grant, 1973; Ford Foundation grant, 1974; Trustees Prize, QAG, 1973; purchase art awards, Alice Springs 1977, Caulfield 1978, Muswellbrook, Gold Coast 1984; British International Print Exhibition 1988.
APPTS: Lecturing, SASA 1965–69; NAS 1971; Alexander Mackie CAE 1975– .
REP: NGA and all state galleries; Parliament House; numerous regional collections; numerous university and other tertiary collections in all states; numerous corporate private collections including Robert Holmes à Court, National Australia Bank, ICI; international collections including MOMA, New York; National Museum of Contemporary Art, Seoul, Korea; Museum of Contemporary Art, Skopje, Yugoslavia.
BIB: Catalogue essays exhibitions as above. A number of general texts on Australian art including Bonython, MAP 1970 & 75; Smith, AP; Horton, PDA; Thomas, OAA, 1973. A&A 7/4/1970 (Patrick McCaughey, *Sydney Ball and the Sixties*); 24/1/1986 (Margaret Worth *Sydney Ball Descent from the Totem*).

BALLARAT LADIES' ART ASSOCIATION
Formed in 1890 as the first Australian women's art society. The object was to assist students and artists; by 1934 more than £1000 had been distributed, including an annual scholarship of £20. By 1978 this had increased to two annual scholarships, each of $100, available to young local artists.

BALLARD, *Kathlyn Margaret*
(b. 15/11/1929, Melb.) Painter, teacher.
STUDIES: Swinburne Tech. Coll., Melbourne, 1946–49. Her representational watercolours appeared in numerous exhibitions 1962–93, some in conjunction with her husband, Stanley Ballard. She also taught watercolour painting at Prahran Tech. Coll. and Malvern

Artists Society. A retrospective of her work was held at the Castlemaine Art Gallery in 1984.
AWARDS: Prizes in competitions at Camberwell, 1973; Portland, Vic., 1974.
REP: Artbank; several regional galleries including Castlemaine, Sale, Rockhampton.
BIB: Germaine, AGA. Campbell, AWP. Richardson, AA.

BALLARD, *Stanley*
(b. 25/2/1926, Melb.) Painter, advertising artist, graphic artist.
STUDIES: RMIT, 1942–44; NGV School, 1950 and 1952; travel studies Europe and UK, 1951. A frequent exhibitor of portraits and other representational paintings, some exhibited in conjunction with his wife, Kathlyn Ballard. He taught with local art groups and societies in Melbourne 1971–88.
AWARDS: Student prize for painting, NGV School, 1950; Camberwell prize, 1970; VAS portrait prize 1978; VAS Gustav Pirstite Award 1979; Toohey's *Paint-a-Pub* watercolour prize 1982.
REP: Sale Regional Arts Centre.
BIB: Germaine, AGA.

BALSAITIS, *Jonas*
(b. 1948, Germany; arr. Aust. 1949) Painter, filmmaker.
STUDIES: Preston Inst. of Technology, Melbourne, 1963–67; Prahran CAE, 1968; NGV School, –1969. Balsaitis combines films and painting. His painting is biographical, a summary of his Lithuanian origins, birth in a German refugee camp, varied experience in art schools and, finally, education and life as a painter. His early paintings attained a notable beauty of colour and dramatic tonal contrasts, but the main characteristics of his later 'border configurations' are the thoroughness with which problems are worked through, and their obvious relationships with a strongly held, personal aesthetic philosophy. In 1980 he returned from an overseas tour, stimulated to experiment with figurative drawings and 'constructed realities' used partly as a balance to the highly technical processes of film-making. He held solo exhibitions largely at Pinacotheca, Melbourne 1970–89 and participated in a number of group exhibitions in state galleries and contemporary art spaces.
AWARDS: Film, Radio and TV Board (Australia Council) grant, *Space and Time Structures*, 16 mm, 90 min., black-and-white and colour, 1976.
REP: NGA; AGNSW; NGV; National Film Library; regional and tertiary collections.

BALSON, *Ralph*
(b. 12/8/1890, Bothenhampton, Dorset; arr. Sydney 1913; d. 1964, Sydney) Painter, teacher.
STUDIES: Sydney Art School (night classes) with Julian Ashton and Henry Gibbons. Balson, who earned his living as a house painter, came to picture painting at the age of about 30, and partly because of this, meaningful recognition eluded him until late in life. His

real career began about 1934 when he joined Hinder, Crowley and Fizelle (qq.v.) at a Saturday morning life-class at 215a George Street, and heard about the European modern movements. Crowley's studies with Lhote and Gleizes in France, and Hinder's experience of New York (which paradoxically included studies of dynamic symmetry, a system in vogue among Melbourne students during the decade 1925–35), were relayed to Balson at this time. When the life-classes ended he continued painting on weekends at Grace Crowley's studio, and in August 1939 the group held a joint exhibition, *Exhibition 1*, which included, in addition to the work of the Crowley–Balson group, one painting by Frank Medworth and sculptures by Gerald Lewers, Margel Hinder and Eleonore Lange. *Exhibition 1* was in effect a cubist exhibition, and the precursor of Balson's first show (July 1941) of abstract paintings. Between 1949 and 1959 he conducted classes in abstract painting at the ESTC and in 1960 travelled overseas for the first time – to England, France and the USA – returning to Sydney in 1961. His painting had changed. Instead of the *Ecole de Paris* inspired abstracts, the mainstay of his exhibited work for the preceding two decades (1941–61), he now produced a succession of large paintings that clearly revealed kinship with the work of the New York School as represented by Pollock, Poons and Sam Francis. Pouring, spotting and shaking techniques were variously employed but used with an individuality that clearly revealed his intentions to create in paint 'A universe without beginning, without end. A continuous creating, destroying and expanding movement, its one constant the speed of light'. He was planning a second overseas trip when he died in 1964. The AGNSW held an exhibition, *Balson Crowley Fizelle Hinder*, in 1966 and his work was represented in the Bicentennial exhibition *The Great Australian Art Exhibition*. A retrospective of his work was held at Heide, Melbourne in 1989.
REP: NGA; most state galleries, notably the AGNSW; Newcastle Region Art Gallery.
BIB: Michel Seuphor, *A Dictionary of Abstract Painting*, Methuen, London, 1958. Badham, *SAA*. *A&A* 2/4/1965.

BALYCK, George

(b. 1950, Greta, NSW) Painter.
STUDIES: NAS, Sydney, 1970–71. Balyck, a painter of 'avant-garde' works, held his first exhibition at the Arts Council Gallery, Sydney, 1972.
AWARDS: Georges Art Prize, Melbourne (drawing purchased), 1974.
REP: NGV; Bendigo Art Gallery.
NFI

BANETH-GOODEY, Erica (Erica Baneth)

(b. 1928, Budapest, Hungary; arr. Aust. 1948) Sculptor.
STUDIES: RMIT (part-time), 1955–59; CIT, 1959–62; NGV School (part-time), 1963; Hammersmith School of Architecture and Arts, London, 1966, during travel studies Europe and UK. She travelled extensively in Japan, South America, Europe and the USA and in 1977 married, settled in Los Angeles and, after her second marriage, adopted the name Baneth-Goodey.
AWARDS: Prize at Moomba (Festival of Jewish Art), 1964; Vizard-Wholohan prize (for sculpture), 1965.
APPTS: Teaching, Monash Uni. Union, 1968.
REP: AGSA; Dallas Museum, USA.
BIB: Scarlett, *AS*.
NFI

BANKS, John

(b. 1883, Sydney; d. 1945) Painter.
STUDIES: J. S. Watkins School, Sydney (with Harry Garlick). Associate, RAS NSW, 1923–45. The principal subjects of his paintings were marine, seascape, landscape and figure compositions treated in an impressionistic manner.
REP: AGNSW; Manly Art Gallery.
BIB: *Fifty Years of Australian Art 1879–1929*, RAS, Sydney, 1929.

BANNERMAN, Cameron Laird

(b. 1919, Glasgow; arr. Sydney 1962) Painter, sculptor.
STUDIES: Glasgow School of Art, 1945–50; Académie Julian, Paris, 1950–51. Production artist for films and a teacher of art at Dumbartonshire before going to Australia where he taught at the ESTC and exhibited in group shows, including Archibald prize exhibitions.
AWARDS: Royal Scottish Academy awards (Chalmers bursary, 1950, and Sir Alexander Cross award, 1951).
NFI

BANNON, Charles George

(b. 1919, Edinburgh; arr. Aust. 1927 d. 1993) Painter, teacher.
STUDIES: Bendigo School of Mines; NGV School; Melbourne Tech. Coll. His early, figurative paintings revealed interest in flat-pattern cubist and 'section d'or' French painting. He directed the Paddington Print Studio, Sydney, 1965–71, and established a similar print studio in Adelaide, 1971. His work include broadcasts and telecasts, industrial design and design for theatre.
AWARDS: Blake prize, 1954; Barmera prize, 1956.
APPTS: Senior art master, St Peter's Coll., Adelaide, 1948–63; adviser on art education for Aborigines, NT Administration, 1963–65; lecturer, Mary White School, Sydney, 1965–69; lecturer, Bakery School, Sydney, 1969; project officer, Aboriginal Resources Division, SA, 1971; lecturer, Salisbury CAE, SA, 1976– .
REP: AGNSW; AGSA; TMAG; uni. collections Adelaide and Melbourne.
BIB: *AL* 1/1/1981.

BARAK, Bill (William)

(b. 1824, Vic.; d. 15/8/1903, Vic.) Called 'King Billy, last chief of the Yarra Yarra tribe', he was an accomplished painter in ochre and charcoal and an intelligent spokesman for Victorian Aborigines. Much of

the information published by A. W. Howitt and Lorimer Fisson (*Kamilaroi and Kurnai*) came from Barak. His work was represented in the Bicentennial exhibition *The Great Australian Art Exhibition*.

REP: NGV (two wash drawings of landscapes at Healesville, Vic., 1898).

BIB: *ADB* 3. Caruana, *AP*.

(*See also* ABORIGINAL ART)

BARAKI, *Bashir Hassen*

(b. 3/3/1943, USA; arr. Melb. via New Zealand 1977) Painter, printmaker.

STUDIES: Petersburgh School of Fine Arts, Commonwealth Uni. of Virginia, 1960–63; BA, CIT, 1987; MA (Fine Art), Monash Uni., 1992. Of Lebanese parentage, he visited Lebanon in 1963. Graduating from art school, he began teaching in Honolulu, held an exhibition there and, in 1966, migrated to New Zealand. He was in Europe in 1976 and arrived in Melbourne to settle in 1977. A competent painter of icons, he has completed many commissions for churches. He also curated several exhibitions. Using colour photocopies, laser printing and collage, his work has elements of religious mysticism and fantasy. He was artist-in-residence at Wesley Secondary College, Melbourne in 1990 and held approximately 20 solo exhibitions 1966–90 in Melbourne (including Australian, Pinacotheca), and at QVMAG 1980; Hamilton, Geelong regional galleries 1985, 86; ACCA survey show 1987. Group exhibitions in which his work appeared 1977–91 included *Blake Prize* 1977, 87; *Thousand Mile Stare*, ACCA 1988; *Twenty Contemporary Australian Photographers*, NGV 1990. He was the co-author of *Creating Laser Fine-Art Prints* (with Gill Smith), School Art Press, Monash Uni. 1991.

APPTS: Head of art dept, Xavier Coll. 1968–70; lecturer CAEs and several universities NZ and Australia 1972–90.

REP: Tertiary and library collections Vic., Qld.

BIB: Catalogue essays in exhibitions as above. Germaine, *AGA*.

BARBERIS, *Irene*

(b. 1953, London) Painter.

STUDIES: Dip. Fine Art, Prahran CAE, 1972–73; travel studies Europe, USA 1974–75; Dip. Art & Design, PIT, 1975–76; postgraduate dip., VCA, 1978; enrolled masters fine arts, Victoria Coll., Melbourne Uni., 1992– . Developed by six years of intensive training and experience, her expressionistic paintings and drawings gained her early recognition, resulting in commissions while still a student (costume designs, *Glimpses*, Australian Ballet Company, 1976; mural, *Art in the Streets*, Victorian Ministry for the Arts, 1977). She subsequently completed a number of commissions for theatre including for Playbox, Melbourne Theatre Works and Richmond Theatre. She was artist-in-residence at Mount Scopus, Melbourne 1990; Victoria College, Prahran 1990; Muka Studios, NZ 1991. She held seven solo exhibitions 1979–92 in Melbourne

(largely at Luba Bilu Gallery) and her work appeared in a number of group exhibitions 1976–92 including *Figures and Faces Drawn from Life*, Heide 1983; *Images of Religion*, NGV 1988–89; *Freedom of Choice*, Heide 1991.

AWARDS: Keith and Elisabeth Murdoch Travelling Fellowship, VCA, 1978; Eckersleigh Scholarship 1978; Glenfiddich Prize Acquisition; VACB grants 1979, 91; residencies Power Studio, Paris, Uni. of NSW 1980; Vence, France, VACB 1980; sculptors studio, Cité Internationale des Arts, Paris, VACB 1981; Dyason Bequest, AGNSW 1980.

APPTS: She taught regularly from 1984 at a number of tertiary colleges in Melbourne including Victoria College 1984–86; VCA 1987; and with ACCA and Linden galleries workshops and summer schools.

REP: NGV; Artbank; regional and public gallery collections including those at Ballarat, Mornington, Heide, Wollongong; tertiary collections including Monash Uni.; VACB; private and corporate collections including Budget; Murdoch, NY; Sol le Witt, Chesterfield, USA.

BIB: Catalogue essays exhibitions as above. McKenzie, *DIA*. Rosemary Crumlin, *Images of Religion in Australian Art*, Bay Books, 1988.

BARCLAY, *Dora*

Sculptor. She became known for her work at a time when little encouragement was given to Australian women sculptors and was married to the painter John Eldershaw. She exhibited at the Old Salon, Paris, and a study entitled *Portrait* was purchased for the AGNSW in 1914.

BIB: Sturgeon, *DAS*.

BARDA, *Wally*

(b. 1956, Sydney) Painter, architect.

STUDIES: B.Sc. (Arch.), Sydney Uni., 1978; B.Arch., Sydney Uni., 1980. His lyrical abstract paintings, while reflecting something of his architectural training (the profession in which he works) and concerned with the relationship between the built and the manmade environment, are freer and less technically oriented than many with similar formal training. They have a lush, elusive quality. He held nine solo exhibitions 1979–92 in Sydney (Watters) and Brisbane (Victor Mace 1988). His work appeared in about 18 group exhibitions 1980–91 at private galleries in Sydney (including Watters), Melbourne (David Ellis) and in the *First Australian Sculpture Triennial*, Melbourne 1981; *Invitation Art Purchase*, Newcastle Regional Art Gallery 1988; *Max Watters Collection*, Muswellbrook Art Gallery, NSW; *From the Landscape*, MOCA, Brisbane, 1991.

AWARDS: Residency, Power Studio, Cité Internationale des Arts, Paris 1983.

REP: Artbank; MOCA, Brisbane; Bathurst Regional Gallery.

BIB: Catalogue essays exhibitions as above. *New Art Two*. McIntyre, *ACD*. *A&A* 26/1/1988.

BARKER, Caroline
(b. 1894, Melb.) Painter.
STUDIES: NGV School; Byam Shaw School, London. She was a council member of the QAS, where she taught for 17 years.
AWARDS: Student prize for portraiture, Byam Shaw School, London.
REP: QAG.
BIB: Vida Lahey, *Art in Queensland 1859–1959*, Jacaranda Press, Brisbane, 1959.
NFI

BARKER, David
(b. 1888, Ballarat) Cartoonist, illustrator, painter, etcher.
STUDIES: RAS (with Norman Carter). Barker worked his passage to America as a deckhand on the ship *Makura* and later worked for the Curtis Publishing Co., Philadelphia. He served in Gallipoli, France and the Middle East during World War I and helped edit *The Anzac Book* and *Kiaora-Cooee*. After the Gallipoli campaign he joined the British Army on loan to work as a cartographer in Mesopotamia, and mapped Turkish positions in the area near the head of the Persian Gulf under orders from Colonel T. E. Lawrence. A versatile craftsman, Barker was a member of the first council of the Australian Painter-Etchers' Society. He also exhibited etchings and watercolours of oriental subjects and Sydney street scenes at the NSW Society of Artists exhibitions during the 1920s. He was the editor of *Australia in Palestine*, Angus & Robertson, Sydney, 1919; illustrations in T. A. White's *Diggers Abroad*, Angus & Robertson, Sydney, 1920.
BIB: Reproductions of etchings in AA no. 9, 1921.

BARKER, George W.
(b. 22/10/1942, Sydney) Printmaker, painter.
STUDIES: NAS, 1967–71. He held exhibitions in Sydney, Melbourne, Brisbane and Perth from 1969 and was represented in the 9th *International Biennale of Prints*, Tokyo, 1975. He held about nine solo exhibitions 1974–91, largely at Watters, Sydney. Group exhibitions 1969–90 in which his work appeared included *Contemporary Australian Prints*, AGWA 1977; *Contemporary Australian Drawings and Prints since 1975*, NGV 1981; *New Art: Selections from the Michell Endowment*, NGV 1984; *Portrait of a Gallery*, Watters 25th anniversary exhibition touring eight regional galleries 1989.
AWARDS: Student award for printmaking, 1971; VACB grant to study printmaking, Europe, UK, 1975.
REP: NGA; AGNSW; AGSA; NGV; MOCA, Brisbane; PCA; Artbank; many regional, uni. collections Vic., NSW, WA; corporate collections including BHP, Western Mining.
BIB: PCA, *Directory*.

BARKER, James
(b. 1931, Sydney) Painter, teacher.
STUDIES: ESTC 1951–55; Accademia dei Belle Arti, Florence; Salzburg, with Kokoschka, 1959. He lived in Florence 1957–68 and from 1966–68 taught paint-ing in collaboration with his wife, Elisabeth Cummings (q.v.), in their studio. Back in Australia in 1968 he held exhibitions in state capital cities and taught and tutored at the NAS, Uni. of NSW, Uni. of Sydney, and Willoughby Art Centre. His mostly conservative landscape paintings are often vertically structured, high-keyed in tone-colours and post-impressionist in style.
AWARDS: Prizes in competitions at the R.Ag.Soc.NSW (Human Image prize) 1973, Camden 1976, Leichhardt, Lismore and Berrima 1977.
REP: NGV.

BARKER, Leach
(b. 14/11/1897; d. 27/10/1967) Painter.
AWARDS: Perth watercolour prize, 1950; Claude Hotchin watercolour prize, 1962.
REP: AGWA; provincial collection, Busselton, WA.

BARKER, Neville
Painter. A member of the Contemporary Group, Sydney, c. 1920. He exhibited at the Blaxland Gallery, Sydney, in 1933.
NFI

BARLOW, Edward David
(b. 30/8/1836; arr. Sydney 1836. d. ?) Lithographer, printer. He produced black silhouetted profile portraits in Sydney in the 1830s, and became a printer of lithographs engraved mainly by William Nicholas (q.v.). Especially popular were the reworked representations by Baker of W. Fernyhough's drawing of Aborigines (q.v.).
REP: NLA; Mitchell Library.
REFS: Marguerite Mahood, *The Loaded Line*, Melbourne, 1973. Kerr, DAA.

BARLOW, Elsie (née Hacke)
(b. 1877; d. 1948) Painter.
STUDIES: Melbourne, privately, with Jean Sutherland; NGV School. Known mainly for watercolours, she was a sister of Dora Serle (q.v.). Her work was included in the *Exhibition of Australian Art*, RA, London, 1923. She married a police magistrate at Castlemaine, where an exhibition of her watercolours led to the foundation of the Castlemaine Art Gallery.
REP: Castlemaine Art Gallery.

BARNACOYLE HOUSE
House owned by Noel Sheridan of the Experimental Art Foundation, situated 40 km from Dublin. It was available to Australian artists (periods 3–12 months) at nominal rental. No longer applicable.

BARNES, Ethel
(b. 19/2/1876; d. 26/2/1980, New York) Painter.
STUDIES: No formal training. She exhibited her decorative-naive paintings with various Melbourne societies and groups and through her friendship gave great encouragement to many young artists. Painting until well into her nineties, she lived to the age of 104 and died while visiting her daughter in New York.

BARNES, *Gustav Adrian*
(b. 1877, London; arr. Aust. as a child; d. 1921)
Designer, painter, modeller.
STUDIES: Family studies with his father; Royal College
of Art, London.
APPTS: Art supervisor at South Australian Public
Library, Museum and Art Gallery, 1915–18; curator
of AGSA, 1918–21.
REP: AGSA.
BIB: J. B. Mather, *Catalogue of the Art Gallery*, Adelaide,
1913.

BARNES, *W. R.*
(Active Melb. c. 1850–60; d. 1898) Painter. Artist
on staff of Melbourne *Punch* who also painted Tasmanian
scenes.
REP: TMAG; Allport library.
BIB: Moore, SAA. Kerr, DAA.

BARNETT, *MICHAEL*
(b. 1957, Brisbane) Painter.
STUDIES: Design studies, Uni. of Qld, 1977; architecture, Uni. of Qld, 1983. He held four solo exhibitions 1985–91 in Brisbane, Sydney and one in
Tokyo. His work appeared in group exhibitions at
private galleries in Sydney and Brisbane 1982–92 and
at MOCA, Brisbane; Tin Sheds, Sydney; Dobell
Foundation, Ivan Dougherty Gallery 1987; *Seven
Queensland Artists*, Toowoomba Art Gallery, 1987;
Twenty Australian Artists, Galleria San Vidal, Venice;
QAG; Benalla Regional Art Gallery.
REP: QAG; MOCA, Brisbane; Gold Coast City Art Gallery;
Qld Uni. of Technology; Dobell Foundation.

BARNETT, *P. Neville*
Graphic artist. The honorary secretary of the Australian
Ex-Libris Society, 1923, he had a particular interest
in bookplates, was elected a life member of the
Australian Ex-Libris Society and in 1950 published a
large book of collected plates – P. Neville Barnett,
Australian Bookplates, privately published, Sydney, 1950.
BIB: Badham, SAA.

BARNEY, *George*
(b. 1792, London; d. 1862, Sydney)
Soldier, engineer, Surveyor-General of NSW, and an
amateur artist of distinction.
REP: Dixson Gallery of the Mitchell Library.
BIB: Moore, SAA. ADB 3.

BARNEY, *Maria*
See SCOTT, Maria Jane

BARON, *Syd*
(b. 1911, Sydney; d. 1973) Sculptor.
STUDIES: Central School of Arts and Crafts, London;
London Polytechnic (sculpture), 1935–39. He worked
as an orchardist and engineer in NSW and in 1964
completed three commissioned relief works in copper,
including a Royal Coat of Arms for the RAS, Sydney.
BIB: Scarlett, AS.

BARRATT, *Walter*
(Active 1890s) Painter. Known mainly for landscapes,
he is reported as being in Launceston in 1890 but
also painted in NSW.
NFI

BARRAUD, *Charles Decimus*
(b. 1822, Eng.; d. 1897) Painter. New Zealand landscape painter in watercolour. He arrived in Wellington
in 1849 and became a popular and prolific landscape
watercolourist. His sons Noel and William were also
painters. He is thought to have visited Australia in
1874 and Tasmania in 1891.
BIB: Edward Craig, *Australian Art Auction Records, 1975–78*,
Mathews, Sydney, 1978.

BARRETT, *Jeremy*
(b. 8/9/1936, Melb.) Painter.
STUDIES: NGV School, 1960–62; Central School of
Art, London, 1964; travel studies UK and Europe,
1963–66. Influenced by New York School painting,
his colourful mural-sized geometrical abstracts have a
restrained opulence of colour and texture. He held
about eight solo exhibitions 1971–86 including at
Tolarno and Niagara, Melbourne and in group exhibitions including *Georges Invitation Art Prize*, 1975;
William Angliss Art Prize, 1975, 76; *Artists' Artists*,
NGV 1975; *McCaughey Art Prize*, NGV 1975, 79.
APPTS: Part-time teaching, RMIT 1976–84; Melbourne
State College 1979–80; Chisholm Institute 1984;
Melbourne School of Art and Photography 1986–92.
REP: NGA; NGV; La Trobe Uni.; corporate collections
including NAB, BHP.

BARRETT, *Newell*
(b. 1952, WA) Painter.
STUDIES: Dip. Fine Art, RMIT, 1973. He held four
solo exhibitions at commercial galleries 1974–92 and
participated in five group exhibitions at commercial
galleries in Sydney, Melbourne, Perth 1974–93.
APPTS: Teaching adult education, Tasmania and
Melbourne, from 1970s; guest lecturer/tutor at Vic.
and some other art colleges from 1980s.
REP: NGV; Parliament House; Artbank.

BARRETT, *William*
Painter. An Australian watercolour landscape is recorded
by this artist dated 1925. He may have been the
Alfred W. Barrett who exhibited a still-life of fruit
at the Australian Academy of Arts, Melbourne, 1886.
NFI

BARRETTE, *Annette Pauline*
(b. 1929, Pakenham East, Vic.) Painter.
STUDIES: NGV School; Melbourne Tech. College c.
1948. She conducted the Eastside Gallery, Melbourne,
1961–63, the Carmyle Gallery and Art Library, 1966,
and in the 1970s started a gallery at *Charterisville*,
Ivanhoe (q.v.), the historic headquarters of Walter
Withers and other Heidelberg School painters of the
1890s.

BARRIE, *Colin*

Director, Industrial Design Council of Australia, 1957–69; Head of the Art School, RMIT, 1969–77, and Dean of the School, 1977–79. Author of *Design: The Part it Plays in Our Lives* (*Arts in Australia* series, Longman, Melbourne, 1962).

BARRINGER, *Ethel*

(b. 1884, Adelaide; d. 1925, Blackwood, near Adelaide) Painter, etcher, enamellist.

STUDIES: SA School of Design; privately, with Hans Heysen; London, St Johns Wood (with Speed and Fenn; etching with Lee Hankey). Sister-in-law of Gwen Barringer and sister of Herbert Barringer (qq.v.), her paintings are largely landscape and figure paintings. On her return from London she made etchings and watercolours of landscape and coastal scenes. In 1921 she was appointed to the SA School of Arts and Crafts. She exhibited at the South Australian Society of Arts Women's Exhibition and also held a show in Melbourne.

BIB: Rachel Biven, *Some forgotten . . . some remembered*, Sydenham Gallery, Adelaide, 1976.

BARRINGER, *Gwen (Gwendoline l'Avance, née Adamson)*

(b. 1883, Adelaide; d. 1960, Adelaide) Painter.

STUDIES: SA School of Design (with Gill and Collins), also with Hans Heysen; travel study in Europe, 1926. Watercolour painter of landscapes, still-life and blossom, she was married to Herbert and sister-in-law of Ethel Barringer. Her paintings were popular in Adelaide, especially between the wars, and she was on the council of the South Australian Society of Arts for over 30 years and was also well-known as a teacher. She concentrated mainly on flower studies but also painted a series of impressionistic views of Sydney Harbour in the 1930s.

REP: NGA; AGSA; NGV.

BIB: Rachel Biven, *Some forgotten . . . some remembered*, Sydenham Gallery, Adelaide, 1976. AA, Dec. 1928, illust.

BARRINGER, *Herbert*

Painter. Landscape watercolourist; Member of the Royal SA Society of Arts, c. 1920–30. Brother of Ethel Barringer and husband of Gwen.

BARRON, *Howard*

(b. 1900, Sidcup, Kent; arr. Sydney 1924; d. 25/1/1991) Painter.

STUDIES: Horsham, Sussex (with H. A. Rigby, RBA); Sydney (with Will Ashton). Barron practised as a portrait painter in London from 1962. His 1964 portrait of Dame Nellie Melba, painted from a photograph, hangs in the main hall of Australia House, London.

AWARDS: Silver medal, Paris Salon, 1954.

REP: AGNSW; QAG.

BARRY, *(Sir) Redmond*

(b. 1813, Cork, Ireland; arr. Aust. 1838; d. 1880, Melb.) Judge of the Supreme Court of Vic., whose

Geoffrey Bartlett, Sun God, 1989, painted bronze, 100 × 50 × 50cm. Courtesy Australian Galleries.

many interests included a life-long interest in art. In July 1853 he was appointed senior trustee to plan the State Library. The foundation stone was set by Governor Sir Charles Hotham, 1854, and in Feb. 1856 the library opened (to people over 14) with a collection of 4000 books. He was the first president of trustees of the National Museum, Library and Art Gallery, and was also a founder of the Uni. of Melbourne.

BIB: Manning Clark, *A History of Australia* vol. 4, MUP, 1978. Peter Ryan, *Redmond Barry: A Colonial Life 1813–1880*, MUP, 1980. ADB 3.

BARTLETT, *Geoffrey*

(b. 1952, Melb.) Sculptor.

STUDIES: Dip. Fine Art, RMIT 1973; postgraduate dip. Fine Art, RMIT 1976; MA Fine Arts (Hons), Columbia Uni., NY 1985. His timber constructions with open, metal 'drawing' first came to notice in a studio exhibition held in company with Anthony Pryor and

Augustine Dall'Ava in their Fitzroy, Melb. studio. The work of this trio subsequently became the subject of a touring VACB exhibition and they continued to share a studio and exhibit together until Pryor's death in 1992. A work of Bartlett's was commissioned by the NGV and stands in the moat outside the gallery. Other commissions include those for Chase Corporation, NZ; World Expo, Brisbane 1988. By 1993 his work as seen in his Australian Galleries exhibition, Melbourne had become less 'constructivist' and more organic. He held about nine solo exhibitions 1976–92 including at Macquarie, Sydney; Pinacotheca, Melbourne. His work appeared in numerous sculpture survey shows 1978–90 including *Australian Sculpture Triennials*, Melbourne 1981, 87, 90.

AWARDS: Project grants VACB 1975, 79; residency Tuscany studio VACB 1984; Harkness Fellowship 1983–85.

APPTS: Lecturer, Monash Uni. Caulfield campus, c. 1984– .

REP: NGA; AGNSW; NGV; Parliament House; Aust. Council; several regional galleries NSW, Vic.; private collections including Joseph Brown.

BIB: Catalogue essays exhibitions as above. Scarlett, AS. Sturgeon, DAS. Germaine, AGA.

BARTLETT, Henry Francis

(b. 8/3/1916, UK; arr. Aust. 1967) Arts executive, painter.

STUDIES: MA, Oxford; Ruskin School of Drawing, Oxford, 1934–38. He held solo exhibitions 1947–92 in Paris, London, Caracas, Mexico City and in the Town Gallery, Brisbane and his work appeared in numerous group exhibitions. He was also a diplomat for the British Government and has held a number of arts executive positions in Australia.

AWARDS: CMG; OBE conferred 1975.

APPTS: He held important British Government posts in many countries from 1940 before going to Australia as Deputy High Commissioner, Brisbane, 1967–69; Executive Officer for the Utah Foundation 1976–?; trustee, of the QAG 1977– ; trustee, Qld Cultural Centre Trust 1980–87.

REP: AGSA; QAG; Artbank; several university, regional gallery collections Vic., Qld.

BIB: *Notable Australians*, Hamlyn, Sydney, 1978.

BARWELL, Geoff

(b. c. 1920, Melb.; d. c. 1960) Teacher. A teacher of graphic art at RMIT, he played an important part in helping to raise standards of printmaking techniques at the Institute and took part in the exhibition *Prints by Ten Artists* at Peter Bray Gallery Melbourne, 1955. (*See also* MELBOURNE PRINTS)

BARWELL, Jenny

(b. 1932, Melb.) Painter, teacher.

STUDIES: NGV School, 1949–51; Uni. of Sydney c. 1979. She participated in the touring exhibition *Ocker Funk*, launched at Watters Gallery, Sydney, May–June

1975 and has since worked in a variety of media including film, installations of 'found objects', photography and painting. Watters Gallery, Sydney held a major retrospective of her work in 1985.

REP: NGA; AGNSW; regional galleries Mildura, Newcastle.

BIB: *New Art Two*.

BASKERVILLE, Margaret Frances Ellen

(b. 14/9/1861, Nth Melbourne; d. 6/7/1930, Brighton, Vic.) Sculptor, teacher.

STUDIES: NGV School, 1880–86; VAA with C. D. Richardson; Royal College of Art, London, c. 1903; travel studies in Europe. As a result of C. D. Richardson's influence she started making sculpture in 1897 and the following year became a foundation member of the Yarra Sculptors' Society. On her return from Europe she became studio assistant to her former teacher, Richardson, and in 1916 they married. She exhibited with the Yarra Sculptors' Society, the VAS, the Women's Art Club, in her own studio, and, in 1929, at the Arts and Crafts Society. Her public sculptures include the Sir Thomas Bent statue, Brighton, Vic., 1913, the James Cumming Memorial at Footscray, Vic. (carved from a single block of marble), and the Edith Cavell Memorial, St Paul's Cathedral, Melbourne.

AWARDS: Students' (second) prize for drawing, NGV School 1885; prizes in the *Women's Work Exhibition*, Exhibition Buildings, Melbourne, 1907.

REP: Brighton City Council collection, Melbourne.

BIB: E. A. Vidler, intro., *Margaret Baskerville, Sculptor*, privately published, Melbourne, 1929. Sturgeon, DAS. Scarlett, AS. ADB 7.

BASS, Tom (Thomas Dwyer)

(b. 1916, Lithgow, NSW) Sculptor.

STUDIES: Sydney, with Dattilo Rubbo, 1937–40; NAS, 1945–48; travel studies Europe and UK via India and Greece, 1962. Bass tramped the countryside carrying his swag during the depression years, and during World War II worked as an army records officer. He attained success after the war with a type of sculpture in which cubist and realist styles were discreetly mixed to express the theme. Among his well-known works are a large bronze relief for the façade of Wilson Hall, Uni. of Melbourne; a monumental statue, *Ethos*, for the civic square at Canberra; the *Children's Tree*, fronting the Colonial Mutual Insurance Company building in Melbourne; and the huge relief sculpture in copper for the NLA. He travelled extensively, completed commissions and gave radio talks, and in 1974 started his sculpture school at Broadway, Sydney. His son Tim is a Melbourne artist, book editor and lecturer.

AWARDS: Prize in the sculpture section, *Australia at War* exhibition, 1945.

APPTS: Teaching, NAS, Sydney, 1945–48 and 1950–53; assistant to Lyndon Dadswell, 1949–50; secretary, treasurer and finally president, Society of Sculptors and Associates, Sydney, 1951–64.

REP: NLA; uni. collections Melbourne, Sydney; Australian Capital Development Commission, Canberra.

BIB: Sturgeon, DAS. Scarlett, AS.

BASSETT, Arthur Wakefield

(b. 20/4/1869; d. c. 1960) Painter. Member of the Western Institute of Arts. Bassett was trained in Melbourne and took part in the first phase of art activity at *Charterisville* (q.v.). He moved to WA after the Victorian land boom disasters of 1893.
AWARDS: Perth Centenary Prize, 1930.
REP: AGWA.

BASTIN, Henri

(b. 1896, Belgium; arr. Australia 1921; d. Sept. 1979, Adelaide) Painter, opal miner. Bastin began painting while working on a Qld sheep-grazing property owned by Major H. de Vahl Rubin. Specimens of Bastin's naive painting, done in the manner of the Douanier Rousseau, were first shown at Brummel's Gallery, Melbourne, followed, in 1958, by two exhibitions at the Museum of Modern Art, Melbourne, one exhibition following the other within six months. The exhibitions established Bastin as a pioneer of naive painting in Australia, the inclusion of his palette and brushes in the second exhibition adding the final primitive touch in true Rousseau fashion. Early public appearances of his work included an exhibition at the Skinner Gallery, Perth, in connection with the Festival of Perth, 1960, and work shown in the *Herald* Outdoor Art Show, Melbourne 1963. In 1977 a Bastin painting was woven into a large tapestry at the Victorian Tapestry Workshop and exhibited throughout Australia. His last big work was the 2.7 × 3.6 m *Paradise Australia*, later acquired by public appeal for the Adelaide Festival Centre.
REP: AGWA; Adelaide Festival Centre.
BIB: Bianca McCullough, *Australian Naive Painters*, Hill of Content, Melbourne, 1977. A&A 17/3/1980.

BATEMAN, Edward La Trobe

(b. 1816, Derbyshire; arr. Melb. 1852; d. 30/12/1897, Rothesay, Scotland) Book illuminator and designer, draughtsman, landscape architect. He was connected with the Pre-Raphaelite Brotherhood from 1849, being friendly with Millais, Rossetti, Thomas Woolner and Bernhard Smith; it was in company with the last two that he left for Melbourne on the *Windsor*, their departure inspiring Ford Madox Brown's celebrated painting *The Last of England*. On arrival he visited his cousin, Lieut.-Governor Charles La Trobe, and joined William Howitt's party to the goldfields, where he sold sketches to the miners and local tradesmen for £5 each. After a rest period in Melbourne, he rejoined Howitt's party on their travels, but returned to the city when they embarked on the wild rush to the Buckland River. Bateman designed *Heronswood*, a private house for Prof. W. E. Hearns at Dromana, and is credited with planning the Botanic, Fitzroy and Treasury Gardens, Melbourne; he also designed the gardens of Chatsworth House in the Western District, Victoria. He made a number of fine topographical and landscape drawings, paying close attention to botanical and architectural detail, and painted a number of

portraits in watercolour. His watercolours of native wildflowers were exhibited at the Melbourne Public Library in 1869. In book design his work was influential. He designed the initials and headings (engraved by Samuel Calvert) for the Melbourne Public Library inscriptions. For Louisa Anne Meredith's (q.v.) *My Bush Friends in Tasmania* he designed the front cover (incorporating Australian flora) as well as the title page lettering. His return to England followed a buggy accident at Chatsworth which so damaged his right hand that he had to learn to write and draw with his left. In later years he was landscape architect to the Marquis of Bute in Rothesay, where he died.
REP: NGA; NGV; TMAG; NLA; Mitchell, La Trobe Libraries.
BIB: ADB 3. Bridget Whitelaw, *Australian Landscape Drawing*, NGV, Melbourne, 1976. McCulloch, AAGR. Kerr, DAA.

BATEMAN, H. M. (Henry Mayo)

(b. 1887, Sutton Forest, NSW; d. 1970, Eng.) Humorous artist, caricaturist, illustrator.
STUDIES: Westminster School of Art and New Cross Art School, London. He left Australia in childhood to become one of the most celebrated British humorous artists of his time. Basing his style on that of the French artist Caran d'Ache, he often carried distortion to outrageous extremes, so much so that E. M. Forster is recorded as having recoiled in horror when shown a Bateman drawing. He contributed to London *Punch* during the decades when that magazine was enjoying its greatest fame, and published more than ten books of his drawings as well as illustrating many others, including Rebecca West's *Rake's Progress*. He revisited Australia in 1939.

BATEMAN, Piers (Piers Maxwell Dudley-Bateman)

(b. 30/11/1947, Perth) Painter.
STUDIES: Largely self-taught; studies London 1966–68. His landscapes and coastal studies show the influence of Arthur Boyd and John Perceval. Although somewhat derivative of the Boyd/Perceval style, the often large and colourful works have attained considerable commercial popularity.
BIB: Alan Marshall, *Pioneers and Painters*. Germaine, AGA.

BATES, Frederic

(b. 6/4/1918) Painter.
STUDIES: Newcastle Tech. School (with R. Russom), 1935–39; ESTC, 1946. He served in the army 1941–46 including as a Lieutenant in parachute division and returned to art studies in 1946. A member and president of the RASNSW 1950– , his paintings have won many prizes. He has travelled widely, including teaching on a UK liner 1986, and acted as leader of painting groups to major museums in Europe. Heavily involved in the Australian Watercolour Institute, he arranged Australian touring watercolour exhibitions (New York 1974) and watercolour exhibitions to Australia. His work appeared in numerous exhibitions, solo and group, from 1950.

AWARDS: Prizes in Dunlop competition, Melbourne, 1954; Concord, 1956; Mosman, 1957; Albury, 1958; Tumut, 1958, 62; South Strathfield, 1959; in W. D. & H. O. Wills competition, 1960; Rockdale, 1960, 63; Ryde, 1963; AGNSW Trustees Watercolour Prize, 1965; Wynne Prize, 1970; *Spirit of the Nation* invitation prize 1973.

APPTS: Teaching, ESTC (part-time), 1963; NSW College of Art and Design, Meadowbank, 1963–78; fellow Aust. Watercolour Institute from 1957, vice-president 1962–72, president 1972–86; chair, judging panel Doug Moran portrait prize, 1987–88.

REP: AGNSW; numerous regional galleries including Albury, Bendigo, Bundaberg, Goulburn, Hamilton, Rockhampton, Stanthorpe; Waverley municipal collection.

BIB: Campbell, AWP. John Brackenreg, *Australian Artists in Oils and Watercolours*, 1984; Tom Roberts (compiler) & Geof Gaylard (editor), *Australian Impressionist and Realist Artist*, Graphic Management Services, Melbourne, 1990. Germaine, AGA.

BATT, Terry

(b. 11/1/1949, Bristol, Eng.) Painter, sculptor, teacher.
STUDIES: Higher Dip. Teaching, Melbourne Teachers College 1970; Dip. Visual Arts, Gippsland Institute of Adult Education; Grad. Dip. Visual Arts, GIAE; M. Fine Arts, Massachusetts College of Art, Boston 1982. He participated in an artists-in-residence program at the Hayden Gallery, Boston, and watercolours shown at the Standfield Gallery in April 1980 showed him as a painter of Klee-like abstractions. Later his totem-like sculptures using found domestic objects are described in catalogue essays for his exhibitions at Niagara Galleries, Melbourne as 'pertinent satirical comments and . . . above all . . . optimistic and fantastical'. He held 13 solo exhibitions 1974–91 largely at Niagara, Melbourne; DC Art Sydney and one in Boston, USA. Group exhibitions 1975–90 in which his work appeared included at Niagara; *A Horse Show*, Heide 1988.

AWARDS: Works acquired, Latrobe Valley Art Centre awards 1974, 76.

APPTS: Secondary teaching, Vic. 1971–80; visiting lecturer, Massachusetts College of Art, Boston 1981–82; lecturer, painting and drawing, Melbourne CAE 1983–88; senior lecturer, painting, RMIT 1989– .

REP: NGA; Artbank; several tertiary and regional gallery collections; Dobell Foundation.

BIB: *New Art Three.*

BATTARBEE, Rex E.

(b. 1893, Warrnambool, Vic.; d. 1/9/1973, Alice Springs) Painter, teacher.
STUDIES: No formal training. Beginning in 1928, Battarbee made several excursions through eastern and central Australia with John A. Gardner. On their second trip to the Centre in 1934, they held an exhibition of watercolours at the Finke River Mission at the request of Pastor F. W. Albrecht. When Battarbee returned to the mission alone two years later he gave

lessons to the Aboriginal painter Albert Namatjira (q.v.) of the Arunta tribe, and as these were successful he remained to teach other Aborigines and create an Arunta school of watercolourists. He wrote *Modern Australian Aboriginal Art* (Angus & Robertson, Sydney, 1951).

AWARDS: Melbourne Centenary prize for watercolour, 1934.

REP: AGSA; NGV.

BIB: *Rex Battarbee*, Legend Press, Sydney, n.d.

(*See also* ABORIGINAL ART, ARUNTA WATERCOLOURS)

BAUER, Ferdinand Lukas

(b. 20/1/1760, Feldberg, Austria; in Aust. 1801–05; d. 17/3/1826, Hietzing, Vienna) Draughtsman. Natural history draughtsman appointed for service with Captain Matthew Flinders on *Investigator* during Flinders's survey of the Australian coast, 1801–05. The topographer on *Investigator* was William Westall, both Westall and Bauer being appointed by Sir Joseph Banks at salaries of £300 per annum. Bauer, a son of the court painter to the Prince of Liechtenstein, was a master of detailed botanical drawing, and his work had a high degree of aesthetic content and an equally high degree of scientific accuracy. During his Australian assignment, which turned out to be as hazardous and exhausting as it was exciting, he made no fewer than 1541 drawings and sketches (Ferdinand Bauer, *Illustrationes Florae Novae Hollandiae*, London, 1813).

BIB: J. H. Maiden, *Sir Joseph Banks, the Father of Australia*, Sydney, 1909. Kerr, DAA. Rienits, *Early Artists of Australia*, 1963, contains a comprehensive account of Bauer's assignment. ADB 2.

(*See also* WESTALL, William)

BAXTER, Evelyn

(b. 1925, Melb.) Painter.
STUDIES: NGV School, Melbourne (with Septimus Power). Known mainly for flower paintings. She held successful exhibitions at the Seddon Gallery, Melbourne, c. 1946–47.

BAXTER, George

(b. 1804, Sussex; d. 1867, London) Printmaker. Inventor of the method of printing in oils using metal plates and woodblocks known as Baxter Prints, patented in 1835. Of Australian interest, he published *News from Australia* in 1853 and *Australia, News from Home* in 1854.

BAYLISS, Charles

(b. 1850, Hadleigh, Suffolk; arr. Melb. 1854; d. 1897, Sydney) Photographer. He completed Beaufoy Merlin's (q.v.) exhibition for the gold miner, Bernard Holtermann, for whom he continued to work in the 1870s producing a number of large photographic panoramas of Sydney, one of which was 10 m long. Holtermann exhibited these overseas and in Sydney. Bayliss continued as a photographer of landscapes and panoramas, some for Sydney's Garden Palace, 1879, and

Sydney GPO, 1886. His work appeared in *Australian Art in the 1870s*, AGNSW, Sydney 1976.

BAYLISS, *Clifford William*
(b. 1916, Melb.; d. 5/6/1989, UK) Painter.
STUDIES: NGV School, 1933–35; London, from 1935. Bayliss's meticulous drawings, modelled on the style of Leonardo, his vitality and his plastic approach to problems of form exerted great influence among his colleagues at the NGV. He was the leader of a fire unit in London during World War II, and after the war worked as production assistant in charge of the model room at Royal Covent Garden Opera House until 1965, when he became a teacher at Croydon Art School. An exhibition of drawings, at the Leveson Street Gallery, Melbourne, 1965, was his first.
AWARDS: NGV Travelling Scholarship, 1935.
REP: NGV.

BEADLE, *Paul John*
(b. 25/11/1917, Hungerford, Eng.; arr. Aust. 1944; moved to NZ, 1961) Sculptor, designer, teacher.
STUDIES: Cambridge Art School, 1933–35; LCC Central School of Arts and Crafts, 1937–38; travel studies Denmark, 1939. Widely known for his satirical 'bronzetti' on themes taken from history, literature and politics. He held exhibitions at the Bonython Gallery, Sydney, 1969, Adelaide, 1969; New Vision, Auckland, 1969 and Australian Galleries, Melbourne, until the mid-1970s.
AWARDS: LCC (London) Senior Scholarship in Sculpture, 1937.
APPTS: Lecturer, NAS, 1947–51; head of the Newcastle Art School, 1952–57; principal, SASA, Adelaide, 1958–60; Professor of Fine Arts, Uni. of Auckland from 1961.
REP: NGA; AGNSW; AGSA; AGWA; NZ National Gallery, Wellington.
BIB: Bonython, MAP, 1960. A&A 6/2/1968 (Gil Docking, *Dialogue with Paul Beadle*), 3/2/1965 (Peter Tomory, *New Zealand Sculpture*).

BEAMENT, *J.*
(Active from 1900, Melb.) Painter. He exhibited at the VAS from 1900, showing Cornish and Victorian landscapes, continuing to show regularly after World War I.
NFI

BEARD, *John*
(b. 1943, Aberdare, Wales; arr. Aust. 1983; living in NY 1990–) Painter.
STUDIES: Nat. Dip. Design, Swansea College of Art, Wales, 1965; ATC, Uni. of London, 1966; Dip. Art Education, University of London, 1976; MA, Royal College of Art, London, 1981. His expressionist abstracts from the 1980s on have a strong environmental basis and have developed in fluidity and confidence from his more figurative previous works. He became an Australian citizen in 1990 and while at Curtin University between 1983–90 his work appeared in a num-

ber of Australian exhibitions including with Macquarie Galleries, Sydney and in Pegasus Art Award, AGWA 1983; *Form-image-sign*, biennial survey of contemporary Australian art, AGWA 1984; *Western Australian Art Award*, Fremantle Art Gallery, 1984–85; *Australian Perspecta '85*, AGNSW, 1985; *Mindscapes*, AGNSW 1989; *Fremantle Print Award*, WA 1989. He received several commissions including for the Gold House, Perth, 1988; National Convention Centre, Canberra, 1989; AWP Building, Perth 1991. In 1986 he was artist-in-residence at Lalit Kala Akademia (Indian Arts Council), New Delhi, and undertook annual visits to US and Europe 1986–89. He established a working loft in Soho, NY, 1990– .
AWARDS: Welsh National Arts Scholarship, 5-year grant 1962; British Arts Council International Mural Prize 1965; Pegasus Art Award, AGWA 1983; Western Australia Art Award, Fremantle Gallery Invitation Exhibition, 1984; Aust. Council Fellowship, VACB, 1988; Sir Charles Gardner Print Prize 1989.
APPTS: Senior lecturer, Fine Art, Milton Keynes College/Open Uni., 1974–79; Member of Board of Studies for Art & Design, Uni. of Oxford, 1975–79; part-time lecturer, Middlesex Polytechnic (Hornesey College of Art), London, 1979–83; Senior Lecturer, Head of Fine Art, Curtin Uni., Perth, WA, 1983–89.
REP: NGA; AGNSW; AGWA; Parliament House; Alexander Library, Perth Cultural Centre; Artbank; Mount Gambier Regional Gallery; tertiary collections including Darwin Inst. of Technology, Uni. of WA, Murdoch Uni., Sydney CAE, Sydney Uni., Macquarie Uni.; corporate collections including Mobil Oil, Christensen Foundation, Shell Company, Rural & Industries Bank, Robert Holmes à Court, State Bank of NSW; SGIO of Australia; National Library of Wales; Arts Council, Great Britain; Royal College of Art, London; Buckinghamshire Education Authority, UK; Oxford Uni., UK; Lloyds Bank, UK.
BIB: Catalogue essays exhibitions as above. Chanin, CAP. *New Art Two*. A&A 24/1/1986 (Ted Snell, *John Beard and the Rites of Passage*).

BEATTIE, *John Watt*
(b. 1859, Aberdeen, Scotland; arr. Tas. 1878; d. 1930) Photographer. He collected the prints, paintings and drawings of Tasmania that formed the basis of the collection bought by the Launceston City Council in 1927; by 1930 he had accumulated a second collection.

BEATTIE, *Ray*
(b. 22/5/1949, Belfast; arr. Sydney 1967) Printmaker.
STUDIES: Dip. Fine Art, VCA 1978. The muted colours, careful placement and precise drawing of tools and domestic objects in his immaculate colour etchings make them outstanding in the category of new realist still-life. He held many solo exhibitions as well as contributing to PCA and Printmakers Association of WA shows. He was artist-in-residence at Griffith University, Qld 1981 and Aberdeen Art Gallery & Museum, Scotland 1984–85.

AWARDS: Fremantle Arts Centre print prize 1976.
REP: NGA; all Australian state and many regional galleries and university collections.

BEAUCHAMP, Robert Proctor
(b. 16/10/1819, Norfolk, Eng.; arr. NZ 1839; d. 1889, Tas.) Amateur artist, pastoralist, agriculturist.
He introduced merino sheep to New Zealand, where he lost a fortune owing to floods and earthquakes. He returned to England many times, was shipwrecked twice (once on an island off Brazil where he was rescued after several months). For a time he lived at Whittlesea, Vic., before returning to England, after which he went to Launceston, Tas. (1861), and finally settled on the West Tamar where he established a home, *Langley* and conducted one of the best orchards in northern Tasmania. He exhibited at the Victorian Academy of Arts in 1875–76 and is best known for his Tasmanian topographical watercolours. He also made oil paintings and drawings.
REP: AGNSW; TMAG; QVMAG; Dixson, Allport, Mitchell libraries.
BIB: Campbell, *AWP*. Moore, *SAA*. Kerr, *DAA*.

BEAUMARIS ART GROUP
(Established 1953) Community Centre, Reserve Rd, Beaumaris, Vic. 3193. Established by a group of artists and patrons who bought land and erected a large studio and community arts workshop to develop an important local centre of art activity. A regular feature is the annual (now biennial) Inez Hutchison Award for Painting which began in 1966. In addition, regular members' prizes are given, and classes and exhibitions are held.
(*See also* PRIZES)

BEAUMONT, Christopher
(b. 29/7/1961, Vic.) Painter.
STUDIES: Faculty of Medicine, Uni. of Melb., 1980–83; TOP, Art & Design, Prahran TAFE, 1984; B. Fine Art (painting), VCA 1987. His work appeared in several group exhibitions at public galleries 1988–90 including ACCA, Melbourne 1988; *Art with Text*, Monash Uni. Gallery and in *Moet & Chandon* Touring exhibition 1989, 90. He held two solo exhibitions 1990, 91 in Melbourne (Pinacotheca, Botanical).
REP: NGV (Margaret Stewart Endowment); Monash Uni.; Western Mining and AMP corporate collections.
BIB: Catalogue essays exhibitions as above. *Tension* no. 28. AM 34, 1990.

BECK, Deborah
(b. 14/10/1954, NSW) Painter.
STUDIES: Dip. Art, Alexander Mackie CAE 1976; ESTC (painting), 1973–74. Often consisting of mixed media including wash, stencils, hand-carved stamps, gouache and acrylic, her subjects since 1987 have frequently been interiors. Everyday life, such as shop interiors and details of Sydney's Chinatown, were the subject of her works in the late 1980s, while her 1992 works

comprised architectural details such as patterned ceilings and plaster friezes. In them she conveys the elements of space, depth, surface texture and colour. She held five solo exhibitions 1986–92 in Sydney and Melbourne (including Niagara). Her work appeared in group exhibitions at Blaxland and The Works Gallery, Sydney 1976–92 and at Goulburn (1982, 84) and Bathurst (1986) regional galleries.
APPTS: Tutor, painting, Riverina CAE, Goulburn 1982–84; part-time lecturer, drawing, Macarthur Institute of Higher Education, Milperra, 1989; part-time teacher, painting and drawing, Argyle College of TAFE, Goulburn, NSW 1979–84; part-time teacher, painting and drawing, St George College of TAFE, Kogarah; Meadowbank TAFE; NAS, 1986– .
REP: Artbank; Goulburn Regional Gallery; Uni. of Western Sydney; Maitland City Council.
BIB: Germaine, DAWA. *New Art Seven*.

BECK, Leonard
Black-and-white artist.
BIB: Exhibition catalogue, *Society of Artists Pictures*, AA 1920, *The Fountain*, pencil drawing.
NFI

BECKER, Ludwig
(b. 5/9/1808, Darmstadt, Germany; arr. Tas. 1851; d. 29/4/1861, Bulloo) Artist, naturalist, geologist, musician, explorer. His studies in Germany included with Johann Kaup, with whom he helped illustrate a book, and from 1829 he worked as a painter in a publishing firm. He became court painter to the Archduke at Mainz. He may have been involved in the liberal revolution in Germany in 1848 which caused his move to England in 1850 and subsequently Australia, where it was generally thought that he was a political refugee, a belief that conflicted however with his gentle and gregarious nature. In Tasmania his miniatures and topographical sketches earned him distinction before he left for Victoria in 1852, to make the sketches of the Bendigo goldfields exhibited at the Melbourne Mechanics Institute in April 1854. During his eight years in Victoria he made meteorological, botanical and ecological studies, some of which were later used to illustrate the books of McCoy and von Mueller. He contributed papers to the *Philosophical Institute of Victoria Journal*, served on the council of the Victorian Society of Fine Arts (1856), designed the medal for the *Paris Exhibition* and made a special study of the lyrebird and its habits and sent a paper on the subject to John Gould. He also helped form the Geological and Philosophical Societies and in 1856 published his volume of lithographs entitled *Men of Victoria*. He had a scientist's fascination with the unknown parts of the Australian continent and in 1860 was appointed official artist, scientist and geologist to the Burke and Wills Expedition at a salary of £300 p.a. It was Becker who pointed out the value of camels in exploration and who later warned the organisers, in his despatches, of the possible failure of the expedition. Like other members of the party, he

fell out of favour with Burke as the expedition went into decline. He died at Bulloo from the effects of dysentery and scurvy and was buried there. His work was seen in a number of historical exhibitions including the Bicentennial exhibition *The Great Australian Art Exhibition* 1988–89.

REP: NGA; NLA; Bendigo regional gallery; Mitchell, La Trobe, Crowther Libraries.

BIB: McCulloch, *AAGR. ADB* 3. Marjorie Tipping, ed. and intro., *The Journals of Ludwig Becker*, MUP, 1979. Tim Bonhady, *The Colonial Image: Australian Painting 1800–1880*, Sydney 1987. Kerr, *DAA*.

BECKETT, Clarice

(b. 21/3/1887; d. 6/7/1935) Painter.
STUDIES: Melbourne, with Max Meldrum. She became involved with the Meldrum school which included artists such as A.M.E. Bale, Colin Colohan, Percy Leason, Justus Jorgensen and John Farmer, exhibiting with the Society of Twenty Melbourne Painters and the Melbourne Society of Women Painters. An unpretentious painter, her early style was strongly influenced by the tonal paintings and theories of her teacher. Later she adopted a freer, more impressionistic style and produced many attractive seascapes of the bayside and night streetscapes. In 1919 her family moved to Beaumaris where she remained the rest of her life and, unlike many of her contemporaries, made no trips to Europe. Her work has a hazy, misty quality that is quite unique. An exhibition of her work, *Homage to Clarice Beckett*, was held at Rosalind Humphries Gallery, Melbourne in 1971 and her work was represented in *Women Artists 1840–1940*, Ewing & George Paton Gallery, University of Melbourne and touring state and regional galleries 1975–76; *The Great Australian Art Exhibition* 1988–89; *Important Australian Women Artists*, Melbourne Fine Art gallery 1993 and *A Century of Women Artists 1840–1940* Deutscher Fine Art, Melbourne 1993.

REP: NGA; regional galleries Ballarat, Benalla, Castlemaine, Latrobe Valley, Geelong.

BIB: Rosalind Hollingrake, *Clarice Beckett: The Artist and Her Circle*, Macmillan, Melbourne, 1979. Burke, *AWA*.

BEECHEY, Richard Bridges

(b. 17/5/1808; visited Aust. c. 1839; d. 1895) Son of portrait painter Sir William Beechey, he visited the Pacific including Australia and exhibited at RA and British Institution. An oil painting by Beechey in the Nan Kivell collection, NLA depicts Lieut. J. Lort Stokes speared in the lungs while discovering the Victoria River, NT, 1839.

REP: NLA (Nan Kivell collection).

BIB: Kerr, *DAA*.

BEER, Leslie H.

(Active c. 1900–25, Sydney) Painter, essayist. He exhibited at the Art Society of NSW from 1903, showing mainly watercolours of Sydney; Spanish, French and Italian views by him resulted from his trip to Europe c. 1908. He also exhibited in Melbourne at the VAS from 1917. His misty, romantic landscapes suggest contact with Hilder and Minns (q.v.). He wrote the introduction for *The Art of John Kaufmann*, Sydney, 1919.

BEERE, A.

Painter. Known for paintings of Australian pioneering subjects and a member of the Art Society of NSW, 1884, a work of his appeared in the exhibition and catalogue of Spink Auctions, Sydney, Mar. 1982.

BIB: *Fifty Years of Australian Art 1879–1929*, RAS, Sydney, 1929.

BEESTON, Mary Frances

(b. 14/1/1917, Melb.) Painter.
STUDIES: Newcastle Tech. College, 1954–61; travel studies Europe, UK, 1979. Her colourful studies of birds and other subjects have a pervasive charm.
AWARDS: Fairfax prize, R.Ag.Soc.NSW, 1963; prizes at Albury (City's Choice), 1964; Helena Rubinstein regional prize for portraits, Newcastle, 1966.
REP: Newcastle Region Art Gallery.
NFI

BEEVERS, Dianne

(b. 18/12/1946, Taree, NSW) Painter, curator.
STUDIES: Dip. Art, NAS, Newcastle Teachers College 1967. A teacher in NSW secondary schools 1968–75, she was the founding curator at the Children's Museum of Victoria 1985–88. One of the exhibitions she curated 1988–93 was Judy Chicago's *The Dinner Party* (Australian showing Royal Exhibition Building, Melb. 1988). She was a founding member of Bad Mothers artists' collective 1987 and held four solo exhibitions 1990–92 including at Access Sydney, as well as participating in about 22 group exhibitions 1977–92 including *The Romance Show*, Lake Macquarie Gallery and touring seven regional and public galleries including ACCA and EAF 1984; *The Twelve Days of Christmas*, ACCA 1989; *Bad Mothers*, Tin Sheds 1990.
AWARDS: Schools Commission Innovations Grant 1975.
APPTS: Secondary teaching NSW 1968–75; School of Art and Design, Newcastle TAFE and School of Visual and Performing Arts, Newcastle CAE 1982–84; Hamilton College of TAFE 1990.
BIB: Catalogue essays exhibitions as above. Germaine, *AGA*. Germaine, *DAWA*.

BEGG, Samuel

(b. 1854, London; arr. Sydney, 1877) Illustrator. He covered the Jolimont (Victoria) railway disaster for the *Illustrated Australian News* in 1878, and contributed to the Sydney *Bulletin* and *Town and Country Journal* until 1883, when he returned to London and worked as a staff artist on the *Illustrated London News* until 1919.

BEHAN COLLECTION

See COLLECTIONS

BEILBY, Marcus

(b. 20/11/1951, WA) Painter.
STUDIES: Dip. Fine Arts, Claremont Tech. Coll., 1975; travel studies USA, 1983–84. His photo-realist paintings were seen in five solo exhibitions 1975–92 including at Fremantle Arts Centre (1978, 88); *Artist in Focus*, AGWA 1987; Ipswich Regional Gallery 1992. His work appeared in about 20 group exhibitions 1976–93 including *Aspects of Realism*, NGV 1980; *Archibald Prize*, 1987, 90; *Field to Figuration: Australian Art 1960–86*, NGV 1986; *Portraiture and Biography*, NLA 1992. In 1993 he received the commission to paint the opening of the new Parliament House, Canberra by HM Queen Elizabeth II, from photographic record.
AWARDS: Grants, WA Arts Council 1979, 82; VACB 1982; Sulman Prize, AGNSW 1987.
APPTS: Lecturing tertiary colleges WA 1976–88 including Claremont Technical College, Curtin University.
REP: AGWA; NGV; AWM; NLA; Newcastle regional gallery; several tertiary collections including Curtin University; corporate collections including State Bank of SA, Holmes à Court, R&I Bank.
BIB: Catalogue essays exhibitions as above. *Contemporary Western Australian Painters and Printmakers*, Fremantle Arts Centre Press, 1979. Bill Hawthorn, *Some Contemporary Western Australian Painters and Sculptors*, Apollo Press, WA, 1982. Don Williams, *Look Again: An Appreciation of Art*, McGraw Hill Book Co, Sydney, 1990.

BELL, D. G.

(Active c. 1900, Tas.) Painter. He favoured simple bush and river scenes and was probably an amateur.
NFI

BELL, Edward C.

(Active 1850s and 1860s, Bendigo) Painter, photographer. Bell and his wife exhibited at the Bendigo Fine Arts Exhibition in 1869, where Mrs Bell's crayon sketches were especially commended.
BIB: McCulloch, AAGR. Kerr, DAA.

BELL, George Henry Frederick

(b. 1/12/1878, Kew, Vic.; d. 22/10/1966, Toorak, Vic.) Painter, draughtsman, teacher.
STUDIES: NGV School; Melbourne (with George Coates); Paris (with Jean Paul Laurens), 1904–06; Castelucha's Paris. Bell was elected a member of the Modern Society of Portrait Painters, London, in 1908, and exhibited at the RA and in Europe and America. After 17 years abroad, including a period spent working in munitions during World War I, and a further period as official war artist, he returned to Australia in 1920 and started teaching privately in 1922. He was appointed art critic for the Melbourne *Sun News-Pictorial* in 1923 (a position he held for 25 years), and in 1932 founded the Bell-Shore school, which soon became the centre of the modern movement in Melbourne. Bell's early students included Drysdale, Herman and other subsequently well-known painters. During a further 16-month refresher course of modern art study abroad in 1934–35, he became vitally interested in the work of the British artist Iain McNab. Arnold Shore maintained the school during his absence and also acted for Bell as art critic for the *Sun News-Pictorial* but when he returned, Shore wrote, they 'never regained the spirit of the first years of [their] partnership', and after another year the association was dissolved. As an 'avant-garde' leader and founder of the CAS, Bell was instrumental in preventing the Australian Academy of Art from obtaining a Royal charter. He was president of the Australian Art Association, Vic., 1924–26, vice-president of the NSW Society of Artists, and president of the CAS, Melbourne, 1938. Later he defected from the CAS to form his own group, the Melbourne Contemporary Artists (q.v.). A number of Bell School exhibitions were held in the 1980s and 1990s, notably *Classical Modernism: The George Bell Circle*.
AWARDS: Crouch Prize, 1928; OBE conferred, 1966.
REP: Australian state and regional galleries.
BIB: Moore, SAA. Arnold Shore, *Forty Years Seek and Find*, printed by McLaren & Co., Melbourne, 1957, and published privately. Catalogues of state galleries. A&A 4/2/1966 (Maie Casey, *George Bell in Bourke Street*). ADB 7.

BELL, John

(b. 1833, Glasgow; arr. Aust. ?early 1850s) Teacher, painter. He dug for gold in Ballarat before moving in 1861 to Bendigo, where he was appointed instructor in modelling and oil painting at the Sandhurst School of Design in 1871.
BIB: McCulloch, AAGR.

BELL, Ronald Charles

(b. 1918, Kangaroo Island) Painter, teacher.
STUDIES: SASA. A Fellow of the RAS, Adelaide, he painted mainly landscapes.
APPTS: Teaching, Thebarton and Norwood tech. schools, Adelaide Boys High School; senior lecturer, Torrens CAE.
REP: AGSA.
BIB: AGSA *Bulletin*, vol. 17, no. 4, Apr. 1956.
NFI

BELLETTE, Jean Mary

(b. 1909, Hobart; d. 16/3/1991) Painter.
STUDIES: Hobart Tech. School; Sydney Art School with Julian Ashton; Westminster Art School, London, with Bernard Meninsky and Mark Gertler; travel studies in Europe. Married to Paul Haefliger (q.v.), she returned to Sydney from overseas studies around 1939 and as well as painting, contributed articles on Italian old masters to the re-formed *Art in Australia* and became a foundation member of the Sydney Group and the Blake Prize Committee. She exhibited neoclassic paintings of figures grouped in landscapes, some in the manner of Poussin, and became a leader in the Sydney modern movement. She returned to Europe in 1957 and lived and worked alternately in Spain, Switzerland, Paris and Sydney. Her work appeared in many survey exhibitions including *Heroic Years of Australian Painting 1940–65*, Melbourne *Herald* 1977 and touring regional and state galleries 1977–79; *A Century*

of Australian Women Artists 1840s–1940s, Deutscher Fine Art, Melbourne 1993.
AWARDS: Sulman prize, 1942, 44; Metro-Goldwyn-Mayer prize, Sydney, 1952; prize in Commonwealth Jubilee Art Competition, 1951; Bathurst prize, 1955; award in Georges Invitation Art Prize, Melbourne, 1965.
REP: NGA; all Australian state galleries and many other public collections.
BIB: Smith, AP. *Meanjin* 4/1952 (Ursula Hoff, *The Art of Jean Bellette*).

BELLEW, Peter Richard
(b. 1912, Melb.; d. 14/10/1986, Paris) Critic, magazine editor, administrator. Founder and first secretary of the Contemporary Art Society, Sydney, 1939; art critic for the *Sydney Morning Herald*, 1939–42; editor, *Art In Australia*, 1939–42; head of the arts division of the headquarters staff of UNESCO, Paris, from 1947. Bellew married Helene Kirsova, prima ballerina of the de Basil Company during its Australian tour, and after World War II made his home in Paris.
BIB: AA 1939–42. A&A 24/3/1987.

BELLINGHAM, S. R.
(Active c. 1895, NSW) Painter. Known for landscapes.
NFI

BELTON, Louis
(Active c. 1880, Sydney) Artist. Contributor to the *Picturesque Atlas of Australasia*.
NFI

BENCE, Ronald Arthur
(b. 1937, Bombay; arr. Aust. 1939) Painter, sculptor, graphic artist.
STUDIES: RMIT; NGV School 1957–60; George Bell School; Central School of Art and Craft, London, c. 1962; travel studies Europe and UK, 1962–66. His paintings and prints were seen in his first exhibition at the Argus Gallery, Melbourne, 1960, and in the Italian Scholarship Exhibition (NGV), 1961. During his overseas studies he worked in Morris and Singer's bronze-casting foundry and exhibited with the Young Commonwealth Painters group at the Whitechapel Gallery, London, 1963. After his return to Australia he began to use a spray gun 'to develop his ideas on conflict, movement, space, and time'. He exhibited at Strines Gallery, 1970, and Tolarno Galleries, 1973.
AWARDS: Grace Joel prize, NGV School, 1958; Beaumaris Art Prize, 1972.
NFI

BENNETT, Anne
(b. 11/8/1962, Vic.) Painter.
STUDIES: BA (Painting), RMIT, 1983; MFA (Painting), Uni. of Tas., 1986. She held three solo exhibitions 1986–91 at Centre for the Arts, Hobart; Tolarno, Pinacotheca, Melbourne. Her work appeared in about

eight group exhibitions 1983–92 largely at public galleries including RMIT (1983, 84); Swan Hill (1984) and McClelland (1992) regional galleries; Spoleto Fringe Festival, Uffizi Galleries, Melb. 1987.
AWARDS: Desiderius Orban Art Award, 1987; project grant, VACB, 1987.
APPTS: Drawing tutor, Uni. of Tasmania, 1986; lecturer, Liberal Studies program, CAE, Melbourne, 1990; guest lecturer, Art Forum program, Monash Uni. College, Gippsland, 1990; tutor (painting, drawing and design), Northern Metropolitan College of TAFE, Vic., 1990–92.
REP: NGV, Uni. of Tasmania.
BIB: Germaine, DAWA. Germaine, AGA.

BENNETT, Charles S.
(b. 11/8/1869, South Yarra, Vic.; d. 22/4/1930, Mornington, Vic.) Painter, engraver.
STUDIES: Formal studies unknown. Painter Louis Buvelot and his wife were friendly with Bennett's parents and 'took a great interest in him'. Proficient in woodcuts, engravings and pen-and-ink work, he was employed by David Syme & Co. as an engraver for *Age* publications. He worked in his studio in High Street, St Kilda, where he lived. He lived also at Healesville and Yarra Glen. He married Miss Pyke (?Pike) of Bendigo, and their only son was killed in World War I. He was living in Mornington around the turn of the century and again from 1919 onwards, and it was there that much of his surviving work (mostly landscape drawings in pen-and-ink) was done.
REP: MPAC; Mornington Historical Society.
(*Information researched and kindly made available by Miss Doreen Townshend*)

BENNETT, Gordon
(b. 9/10/1955, Monto, Qld) Painter, multi-media artist.
STUDIES: BA (Fine Arts), Qld College of Art. He describes his background as an indigenous Australian as being fundamental to his view of life and henceforth expression in art. Realising early in life (through hearing himself and others described in racist terms) that language delineates, categorises and analyses, he based a series of works around derogatory terms such as 'Abo', 'Boong', 'Coon', 'Darkie', reducing them to the letters they start with – the first letters of the alphabet. 'I am interested in the ethnocentric boundaries implicit in language as a categorising system', he wrote in an artist's statement in 1992. 'The boundaries are as invisible as the perspective lines that create illusionist depth in Western painting. I see much of my work as history painting, not as documentary history painting but rather painting that investigates the way history is constructed after the event . . .' With a stated aim of influencing change to a more open concept of culture through his works, he uses fragments of historical references such as the much-documented violence against Aborigines by early colonists, and the 1990s deaths in custody of Aborigines throughout Australia, and contrasts these experiences with the seemingly unaware 'life as usual' attitude of

Australia's white culture. He held six solo exhibitions 1989–92 largely at Bellas Gallery Brisbane and IMA, Brisbane 1990 and AGWA 1991. He won the Moet & Chandon Fellowship in 1991 and his work appeared in a number of group exhibitions 1987–93 including *Australian Art of the Last Twenty Years*, MOCA 1988; *Perspecta*, AGNSW 1989; *Paraculture*, Artist Spaces, NY 1990; *Contemporary Aboriginal Art 1990*, Third Eye Centre, Glasgow, 1990; *Moet & Chandon Touring Exhibition*, 1990, 91; *Tyerabarrbowara-you: I shall never become a white man*, MCA, Sydney 1991; *Biennale of Sydney*, 1993; *Aratjara: Australian Aboriginal Art*, touring Europe and the NGV 1993–94. He was artist-in-residence at the University of Melbourne, 1993.
AWARDS: Moet & Chandon Fellowship 1991.
REP: NGA; AGWA; QAG; Artbank; Gold Coast, Townsville regional galleries; a number of tertiary collections including Qld, Griffith, Monash universities; Brisbane City Council.
BIB: Catalogue essays exhibitions as above. Liz Thompson, *Aboriginal Voices; Contemporary Aboriginal Artists, Writers and Performers*, Simon and Schuster, 1990. AL 10/1–2/1990. Caruana, AA.

BENNETT, *Jane*
(b. 1960, NSW) Painter.
STUDIES: Dip. Art, Alexander Mackie, 1981; Grad. Dip. Professional Art Studies, City Art Institute, Sydney 1982. Her contribution to *From the City to the Fringes*, curated by Arthur McIntyre at Holdsworth Galleries, 1991, was described by Elwyn Lynn in the Australian as '. . . views of the inner grey industrial suburbs in works of real substance'. She held four solo exhibitions 1986–92 including at Blaxland, Sydney; von Bertouch, Newcastle and participated in 14 group exhibitions in the ACT (Solander) and Sydney (Hogarth, Holdsworth) and in *Sulman Prize*, AGNSW 1986; *Wynne Prize*, AGNSW 1989, 90 and *Salon des Refusés*: S. H. Ervin Gallery, Sydney 1992.
AWARDS: Auburn Art Prize; John Fraser Memorial Watercolour Prize; Drummoyne Patron's Bicentennial Art Award; Caltex Watercolour Award; Drawing prize, Willoughby Art Award, all in 1988; Watercolour prize, Waverley Art Prize, 1989; Hunter's Hill Open Art Awards; John & Elizabeth Newman Pring Memorial Art Prize, 1990; Royal Rehabilitation Centre Art Prize; Willoughby Art Award, 1991.
APPTS: Painting and drawing teacher, Hornsby Evening College, Sydney 1987; painting teacher, Waverley-Woollahra Arts Centre, 1989–91; painting and drawing, part-time teaching, Seaforth College of TAFE, Sydney 1990–91.
REP: Auburn Council, NSW; Waverley Art Centre, NSW; Waverley Council; Department of Immigration, ACT; Ramada Renaissance International Hotel, Sydney.
BIB: Jan McDonald, *Australian Artists Index*, 1986. Germaine, AGA.

BENNETT, *Joseph Arthur*
(b. 1853, Ashton-under-Lynne, Eng.; arr. Sydney 1882; d. 1929) Painter.

STUDIES: Manchester School of Arts; Paris (with Leon Bonnat). Before coming to Australia he exhibited at the RA and visited Rome, Naples and Capri in 1881. In Sydney he was the vice-president of the Art Society of NSW, where he exhibited portraits, landscapes and still-life in the 1890s, concentrating on landscape in later years. He was an original member of the Australian Watercolour Institute.
REP: AGNSW.
BIB: *Fifty Years of Australian Art, 1879–1929*, RAS, Sydney, 1929.

BENNETT, *Portia*
(b. 1898, Balmain, NSW; d. 1/5/1989) Watercolourist.
STUDIES: RAS, with Dattilo Rubbo, 1913–14; Blackfriars Teachers College, 1915–19; Julian Ashton School. She moved to WA, 1932, and joined the Perth Society of Artists.
AWARDS: Hotchin prize, 1952.
REP: AGWA.

William Rubery Bennett, Burragorang Valley, *oil on canvas, 37.5 × 45cm. Joels, August 1989.*

BENNETT, *Rubery (William Rubery)*
(b. 1893, Brisbane; d. 10/3/1987) Painter.
STUDIES: RQAS School, Brisbane; Sydney (with John Salvana, Lawson Balfour and Fred Britten). Secretary-treasurer of the RQAS for some years, he moved to Sydney, where c. 1930–40 he conducted the Rubery Bennett Art Gallery, dealing mostly in Australian impressionistic painters. He was one of the first to exhibit the work of Tom Garrett (1929) and later himself became a popular painter of late impressionistic landscapes, his aim being to capture the pervading light of summer landscapes, his preferred subject

matter. He worked mainly in NSW. His paintings have become well regarded and a number appeared in leading art auction houses during the 1980s and 90s.

REP: NGA; NGV; QAG.

BIB: *The Art of Rubery Bennett*, Angus & Robertson, Sydney, 1954. Katherine Campbell Harper, *The Life and Work of Rubery Bennett*, Pot Still Press, Sydney, 1978.

BENNIE, Francis
(b. 1943, Pomona, Qld) Painter, film-maker.

STUDIES: NAS, 1964–67; St Martin's School of Art, London, 1972–74. He taught art at NSW schools 1968–71 and worked in Europe and UK 1972–74, specialising in films and prints. He exhibited at Hugh Stoneman's, London; Salle Sandoz, Paris (exhibition of drawings); Cité Internationale des Arts, Paris (group exhibition).

AWARDS: Student prizes for drawing and painting; Moya Dyring Studio scholarship, Cité Internationale des Arts, Paris, 1971.

NFI

BENSON, Eva E.
(b. c. 1885, Gawler, SA; d. 1949) Sculptor.

STUDIES: Perth Tech. College (with James Linton); London Polytechnic, c. 1915. She attained distinction as a student by winning the highest award given at the London Polytechnic for still-life painting and in 1917 turned her attention to sculpture, exhibiting busts and allegorical pieces at the RA, London, and Old Salon, Paris. Returning to Australia, she made Sydney her headquarters, where she completed commissions for the architect G. H. Godsell, including a Roman-style relief-frieze for the building of W. T. Waters and Co., King Street, and a relief work, *Cinderella*, for the entrance to the Ambassadors Cafe. Her largest work was the designing and modelling of the 4 × 6.7 m spandrells above the proscenium arch for the Prince Edward Theatre.

AWARDS: Perth Tech. College scholarship (enabled her to study in London); Lady Hackett prize for drawing from the antique, given by the WA Society of Arts; student prizes, Polytechnic, London.

REP: AGNSW; Royal Inst. of Fine Arts, Glasgow; Library Board of WA.

BIB: *Architecture Sydney*, vol. 15, no. 4, April, 1925. Lorna Barter, *Kalori*, Royal Society of Arts, SA, March 1967. Rachel Biven, *Some forgotten . . . some remembered*, Sydenham Gallery, Adelaide, 1976. Sturgeon, DAS. Scarlett, AS.

BENSON, George C.
(b. ?1886; d. 12/12/1960, Perth) Painter.

STUDIES: NGV School. He served as an artist during World War I and was an early arrival at the Dardanelles, where he was employed in making panoramic sketches of the western coast of Gallipoli prior to the landing. He was wounded and mentioned in despatches. After the war he left Melbourne, where he was well-known as an illustrator, and went to Perth, where he became known for his watercolours and the decorated beams in Winthrop Hall, Uni. of WA.

AWARDS: Claude Hotchin watercolour prize, 1949.

REP: NGA; AGWA; AWM (23 works); Castlemaine Gallery, Vic.

BENTLEY, William Friend
(b. 8/10/1836, Clements Dane, Eng.; arr. SA 1839; d. 1910, Burra Burra) Painter, photographer. He produced landscape, portrait and genre paintings in oils and watercolours and might have learned his craft in the classes conducted by S. T. Gill. Bentley's father became connected with the Burra Burra copper mines and it seems that Bentley spent most of his life in the district. He conducted a business in the town as a photographer and portrait painter, receiving commissions to make likenesses of prominent citizens. He also ran a school on the same premises and was commissioned by George Fife Angas to make pictorial records of South Australia. He probably visited the Victorian goldfields. Among his paintings is *Mount Alexander Gold Diggings from Adelaide Hill* (NLA). It is identical with the lithograph published as an extra by George French Angas in his *Six Views of the Gold Field at Ophir* and also with a painting by John Saddington Plush in the AGSA collections. It seems likely that all three artists copied their works from the same Bentley photograph.

REP: NAL.

BIB: Alan Davies & Peter Stanbury, *The Mechanical Eye in Australia*, Melbourne, 1985. Kerr, DAA.

BENWELL, Margaret (Meg)
(b. 16/6/1925, Vic.) Painter.

STUDIES: NGV School; George Bell School, late 1950s; travel studies, Italy, 1952. She held nine solo exhibitions 1950–91 in Melbourne (including Distelfink, 1984, 86, 88, 91; Drummond St, 1982) and a retrospective of her work was held at Shepparton Regional Gallery in 1993. Her work appeared in about 13 group exhibitions 1979–89 in commercial galleries (including Niagara; Eastgate); and in *Women's Art Forum*, Hawthorn City Gallery, Melbourne 1979; *Inez Hutchison Art Award*, 1984, 87, 89, 91; *Heritage Art Exhibition*, Linden Gallery 1989 and with Melbourne Society of Women Painters and Sculptors in 1950s, 60s, CAS 1950s, 60s and Melbourne Contemporary Art Society 1950s, 60s.

AWARDS: Norman's Watercolour Prize, VAS, 1959.

REP: Artbank; Shepparton regional gallery.

BIB: *150 Victorian Women Artists*, Women 150, 1978, Visual Arts Board of Aust. Council. Germaine, DAWA. Germaine, AGA.

BENWELL, Stephen
(b. 19/4/1953, Vic.) Ceramicist.

STUDIES: Dip. Art, VCA, 1974; Dip. Ed., Melbourne State College, 1976. He held 16 solo exhibitions 1975–91 in Melbourne (Powell St), Sydney and Adelaide and in *Benwell & Potter* survey show, Shepparton Art Gallery 1989; Gallery Tao, Tokyo 1992. His work appeared in numerous group shows 1985–92 including three Mayfair Ceramic Awards and *Quatre*

Artistes Australiens, Australian Embassy, Paris, 1985. His commissions include 50 bowls for the NGA shop; a float for the Melbourne City Council, 1988; small tapestries for the Vic. Tapestry Workshop, 1989. His work was seen in the Bicentennial exhibition *The Great Australian Art Exhibition*.

AWARDS: Mayfair Ceramic Award, 1980; Canberra Festival Craft Prize, 1981; Gold Coast Award 1990; five professional development grants, VACB; artist residency, Cité Internationale des Arts, Paris 1984–85.

REP: NGA; AGSA; AGWA; NGV; QAG; Parliament House; Powerhouse Museum; Artbank; regional galleries including Shepparton.

BIB: Catalogues exhibitions as above. *Australian Decorative Art*, NGA Press, Canberra, 1984.

BERGER, (Dr) George Martin

(b. 1913, Vienna; arr. Sydney Feb. 1939) Critic, art historian.

STUDIES: Vienna, Charlottenburg and Berlin, 1931–38; Paris, 1938–39. A member of the CAS, Sydney branch; foundation member of the Art Gallery Society of NSW; hon. secretary, Australian Division, International Association of Art Critics, he wrote critiques, letters and articles for many publications, including the Sydney *Jewish News* 1962–70, as well as *Franz Kempf*, Brolga Books, Adelaide, 1969.

Josl Bergner, Metho Drinker, *1939, crayon and ink, 46 × 41cm. Lauraine Diggins, Melbourne, 1992.*

BERGNER, Josl (Vladimir Jossif)

(b. 13/10/1920, Vienna; arr. Aust. 1937; migrated to Israel, 1950) Painter.

STUDIES: NGV School, 1940s. His father, Melech Ravich, a Yiddish poet and essayist, married Fanya Bergner, and their two children, Ruth, a dancer, and Josl, were brought up in Warsaw. Melech decided to migrate to Australia with his family because of a premonition about the fate of Jews in Europe. He founded (?the first) Yiddish school in Melbourne. Josl worked in factories before deciding to become a full-time painter. He exhibited first with Arthur Boyd and Noel Counihan at Melbourne Uni. in 1939. His early work combined influences derived from Daumier, Cézanne, and Courbet, whose work he had studied in Europe, and he began painting social-realist pictures. Demobilisation from service in the army (1942–46) gained him a rehabilitation scholarship at the NGV School, but his scholarship was terminated when he refused to accept the teaching. His still-life paintings and low-toned representations of the victims of persecution were arresting features of social-realist group exhibitions. He exhibited with the CAS in 1947. He left Australia for Paris in 1948 and arrived in Israel in 1950 where he has lived ever since, returning to Australia from time to time and becoming one of Israel's most famous painters. His work has been seen in a number of survey exhibitions in Australia including *The Heroic Years of Australian Painting 1940–65*.

REP: NGV; most Australian state galleries; Heide; many important overseas collections.

BIB: Most texts on 20th-century Australian art. Cecil Roth, *Jewish Art*, W.H. Allen, London, 1961.

BERKELEY, Martha S. (née Chauncey)

(b. 18/8/1813, Eng.; arr. SA 1837; d?) Amateur artist. She painted landscapes and buildings in the neighbourhood of Adelaide, and was also a miniaturist. She was married to cavalry officer, Charles Berkeley, of the Royal South Australian Militia, who is listed also as a JP in the *South Australian Directory* of 1851–52. A painting called *The First Dinner given to the Aborigines* 1838, in the collection of the AGSA, is the work for which she is best-known. Her work was seen in the Bicentennial exhibition *The Great Australian Art Exhibition*.

REP: AGSA.

BIB: McCulloch, *AAGR*. Shirley Wilson, *From Shadow to Light: South Australian Women Artists since Colonisation*, Adelaide, 1988. Kerr, *DAA*. *A&A* 24/4/1987.

BERKMAN, Christina (previously Christine)

(b. 5/12/1939, Brisbane) Painter, collage artist.

STUDIES: Brisbane Tech. College, 1956–58; Dip. Art, CIT 1965; RMIT 1958–61. Surrealism, Pop Art and extensive use of photographic collage are held together in her work by her talent for drawing, her greatest strength. She has been prominent in the Women's Art Movement. Her solo exhibitions 1966–91 include those at Ray Hughes, Brisbane, 1976, 80; Niagara, Melbourne, 1982, 84, 87. Her work was represented

in *Women and Art into the Eighties*, Monash University Gallery 1980.

REP: NGV; Artbank; several tertiary and municipal collections Qld, Vic.

BIB: *Women's Art Register*, Vic. H. Fridemanis, *Artists and Aspects of the CAS Qld Branch*, Boolarong, Qld, 1991.

BERKOWITZ, Lauren

(b. 1965, Melb.) Sculptor, installation artist.
STUDIES: BA Fine Arts (sculpture), RMIT, 1985; Grad. Dip. Fine Art (sculpture), VCA, 1989; M. Fine Arts, School of Visual Arts, New York, 1993. She held three solo installation exhibitions in Melbourne 1988–91 and at Heide and the Ministry of the Arts, Melbourne, 1990. Her work appeared in group exhibitions of works on paper at private galleries in Melbourne 1987, 88 and sculptures in seven group exhibitions at private galleries in Melbourne 1985–92 as well as in *Active Garden*, Heide, 1989; 2 × 7, Ian Potter Gallery, Melbourne Uni. 1989; ICI *Contemporary Art Collection*, touring regional Vic., NSW, Qld, ACT galleries 1989–91. Her private commissions include sculpture for Tract Consultants, landscape architects, Melb. 1986 and the Colonnade at the Austin Hospital, Melb. 1991.
AWARDS: David Rosenthal Prize, VCA, 1988; grant, VACB 1990, 91–92; Marten Bequest Travelling Scholarship, Dyason Bequest Travelling Scholarship, AGNSW 1991–92.
REP: Heide; corporate collections including ICI Contemporary Art Collection.
BIB: Catalogue essays exhibitions as above.

Ian Bettinson, Water Drawing IV, *1983/90, ink and acrylic on paper, 28 × 38cm. Private collection.*

BERNALDO, Allan Thomas

(b. 1900, Creswick, Vic.; d. 1988, Melb.) Painter.
STUDIES: Ballarat School of Mines. He exhibited frequently at the Kozminsky Galleries, Melbourne. His mainly watercolour paintings of horses and flowers gained wide popularity in Vic. during the 1930s and 1940s.
AWARDS: Albury prize, 1963 (two prizes).
REP: Shepparton Art Gallery.

BERRY, Philip Andrew

(b. UK, 1957) Painter.
STUDIES: Dip. Fine Art (painting), Claremont School of Art, WA. Working in a number of different media and venues, his work included a cover painting for the *Fremantle Arts Review*, May 1991; a mural at Prince Patrick Hotel, Collingwood, Melbourne 1984; artist-in-residence, City Arcade, Perth and backdrops for JJJ 200 celebrations. He described his 1991 work as 'currently undergoing change as I shake off the last vestiges of the romantic and melancholic preoccupations of youth . . . this is taking the form of the surrealist approach of unlocking the subconscious by simply drawing in a disturbed state of mind'. He held three solo exhibitions 1983–91 including two at Greenhill, Perth and his work appeared in about ten group

exhibitions 1982–91 at BMG gallery, Adelaide, and public galleries, including *West Australia Week Invitation Exhibition*, 1984 and *The Peace Show*, 1986, AGWA.

AWARDS: Channel 7 Young Artists Award, 1982; creative development grant, WA Dept for the Arts, 1991.

REP: AGWA; Royal Perth Hospital; Charles Gardner Hospital.

BERTHON, L. de C.

(Active c. 1880) Painter. He is recorded as having painted a pair of Melbourne scenes, one of the Yarra and the other of Sandringham. Several works of his were sold at Christie's, Mar. 1977.

BESEN, Marc

See COLLECTIONS

BETTINSON, Ian

(b. 1956, Eng.; arr. Aust., 1981.) Painter, sculptor.
STUDIES: Bradford College of Art, UK, 1973–75; BA (Hons) Fine Art, Wimbledon School of Art, London, 1979. He works as both a sculptor and painter, his abstract expressionist landscapes in particular demonstrating balance and a timeless quality. His work appeared in four solo exhibitions 1983–90 at Garry Anderson and Watters, Sydney and in about 24 group exhibitions 1983–91 in Sydney (Watters, Irving Sculpture) and in *Sculpture at Wimbledon Park*, London 1978; *Moet & Chandon Art Foundation Touring Exhibition*, 1986/87; *A New Romance*, 1987 and *A New Generation*, 1988, NGA; *New Acquisitions*, AGWA 1990; *Common Sense*, Uni. of SA Art Museum 1991; *Wynne Prize*, AGNSW 1987, 89. He also worked in galleries including Stockwell Depot Studios, London, 1978–81 and Watters, Sydney 1983–85 including curating one exhibition, *Spirit of Place*, 1986.

AWARDS: Wynne Prize, AGNSW 1987, 89; project development grant, VACB, 1989; residency, Cité Internationale des Arts, Paris, 1991.

REP: NGA; AGNSW; AGWA.

BIB: *New Art Two*. AM Nov. 1990.

BETTS, Mac

(b. 1932, London; arr. Perth 1970) Painter, teacher.
STUDIES: Kingston-on-Thames College of Art, 1953–57; Goldsmiths School of Art, London Uni., 1957–58; travel studies Spain and North Africa, 1967–68. His semi-abstract paintings lyrically express the spirit of the WA landscape in richly textured oils. After his first exhibition in Perth 1974 he exhibited regularly in most capital cities, mainly in WA.

APPTS: Senior lecturer in painting, WA Inst. of Technology.

REP: NGA; AGWA; NGV; a number of tertiary collections; corporate collections including Robert Holmes à Court.

BIB: *New Art Four*. A&A 22/3/1985.

BEVAN, Edward

(b. 1854, Bathwick, Somerset, Eng.; d. 7/3/1878, Galston, NSW) Surveyor, magazine editor, painter.

STUDIES: Sydney, where he was helped by Ashton, Roberts and many other of his artist friends. He exhibited with the RAS, Sydney from 1883 and in 1885 worked in Qld as a surveyor. Later he became an editor of the *Illustrated Australian News*.

REP: AGNSW (watercolour).

BEVAN, Margaret (née Stevens)

(b. 1913) Painter, teacher, illustrator.
STUDIES: School of Arts and Crafts, Adelaide (with Good and Harris), c. 1930. A founder of the CAS, Adelaide, in 1942, she exhibited regularly from 1953 as well as holding private art classes.

BIB: Rachel Biven, *Some forgotten . . . some remembered*, Sydenham Gallery, Adelaide, 1976.

BHP COLLECTION

See COLLECTIONS

BEZOR, Annette Thea

(b. 1950, Adelaide) Painter.
STUDIES: Dip. Fine Art, SASA, 1977. Her 1991 exhibition at the Contemporary Art Centre of SA in Adelaide, touring to regional SA country centres in 1991–92, consisted of 14 works from 1980–91. In these her work was concerned with expressing the female form of both anonymous and famous women through the centuries – from Eve to Marie Antoinette to Marilyn Monroe. Exploring the nature of female sensuality, she makes use of photographs as base images with which to create painted multi-layered works. Her materials include standard oil on linen and unusual materials such as mattress ticking and laser prints which give greater depth and intrigue to the surface qualities. She had six solo exhibitions 1983–93 including at Roslyn Oxley9, Sydney; Luba Bilu, Melbourne 1993; and at the Fine Arts Gallery, Uni. of Tasmania (1986), Contemporary Art Centre, Adelaide (1988). Her work appeared in about 20 group exhibitions 1977–93 including *John McCaughey Memorial Prize Exhibition*, NGV 1981, 83; *Australian Perspecta*, AGNSW 1983; *Against the Wall: Young Contemporary Artists Selected from the Michell Endowment*, NGV 1983; *Biennale of Sydney*, AGNSW 1984; *Adelaide Artists, New Words 1983/84*, Adelaide Festival Fringe Centre; *Voyage of Discovery: Australian Painting and Sculpture*, Dallas, USA 1987; *Here and There*, Monash Uni. Gallery, Melbourne 1987; *Advance Australia Painting*, Auckland City Gallery, NZ 1988.

AWARDS: John Christie Wright Memorial Prize for Life Drawing and Painting 1977; co-winner, Maude Vizard-Wholohan Art Prize, AGSA 1980; standard grant, VACB; Commission, Govt of SA (two paintings for entrance foyer, Law Courts, Adelaide), 1982; Power Studio, Cité Internationale des Arts, Paris, 1986; grant SA Dept. of the Arts 1988, 89; Australia Council Fellowship 1990.

REP: AGNSW; AGSA; NGV (Michell Endowment); Artbank; regional galleries, Broken Hill, Wollongong; private collections including ICI, John Sands corporate collections.

BIB: Catalogue essays exhibitions as above. Kirby, *Sightlines*. AL 3/2/1983.

BICKLEY, Wallace

(b. 1810; arr. WA 1830; d. 30/6/1876, Fremantle) Amateur artist, businessman. A prosperous Fremantle businessman, he left the colony, was appointed registrar in the secretariat of the government of Bengal, and later returned to WA where he bred horses for export to India at Kenwick Park, on the Canning River. His only known work is a hand-coloured aquatint engraving of Fremantle in 1832. It was seen in *The Colonial Eye*, AGWA 1979.

REP: AGWA; NLA; Mitchell Library.

BIB: Kerr, *DAA*.

BIENNALE OF SYDNEY

(Est. 1973) The Gunnery, 43–51 Cowper Wharf Road, Woolloomooloo, NSW 2011.

ADMIN: Company limited by guarantee with board of directors (15); patron (in 1992 The Hon. Bill Hayden AC, Governor-General of Australia), artistic director (in 1992 Anthony Bond) and chair (in 1992 Suzanne Davies).

REVENUE: The budget grew from $190,000 in 1979 to over $2m in 1992 with Australian federal, state and local governments providing $700,000; 45 foreign governments providing a total of $900,000 and over 60 corporations contributing in cash or kind. Artworks of the 1992 Biennale were valued at around $10m.

Until 1982 the title 'biennale' was a misnomer as the exhibition was held every three years (1973, 76, 79, 82), but since then it has been held, as the name indicates, every two years. It was initiated by Franco Belgiorno-Nettis, chairman of the Transfield group of companies, who also established the highly successful Transfield Prize (q.v.). With an international focus, the Biennale quadrupled in size from 1973 to 1983 to include the work of over 230 artists. Although the AGNSW is still the focal point of the exhibition, since 1986 other venues – notably the Gunnery at Cowper Wharf Rd and the Bond Store, the Rocks – have provided spaces in which often two-thirds of the works are displayed. Since 1976 each Biennale has had an artistic director who curates the exhibition on a theme. These have included Nick Waterlow's *European Dialogue*, 1979, *Origins, Originality and Beyond*, 1986, *From the Southern Cross: A View of World Art c. 1940–88* (in Australia's bicentennial year); Leon Paroissien's *Private Symbol, Social Metaphor*, 1984; Rene Block's *The Readymade Boomerang: Certain Relations in 20th Century Art*, 1990 and Anthony Bond's *The Boundary Rider*, 1992.

The Biennale was at its most controversial during the 1980s and while much interesting work continues to be seen it does not attract so much comment possibly because of its own success in bringing to Australia's viewing public contemporary visual art. Each exhibition is accompanied by an impressive catalogue.

BIGGS, J. R.

(Active c. 1885–1900, Vic.) Painter. Known mainly for landscapes. An oil dated 1886 was sold at Leonard Joel's, November 1973. He exhibited a painting, *Back Beach Sorrento*, at the VAS, 1900.

NFI

BILLICH, Charles

(b. 6/9/1934, Lovran, Italian–Croatian border; arr. Melb. 1954) Painter, advertising artist.

STUDIES: Academy of Applied Arts, Zagreb, 1950–52; art schools in Vienna and Salzburg, 1952; NGV School, 1955–58; Uni. of the Philippines Art School. Active as an advertising artist and art director, he conducted a commercial art gallery at St Kilda c. 1966 before becoming a full-time painter and art consultant. His work has been exhibited in various Australian states and internationally since 1966. He combines graphic, figurative and abstract elements in paintings which from the mid-1980s started to command considerably high prices and have been sufficiently popular to enable him to open four galleries showing his own work exclusively – three attached to leading hotels in Melbourne and Sydney and one in the Rocks area of Sydney and all well placed for the tourism market.

AWARDS: Spoleto Award, Italy 1987, 88; Victorian Heritage and Cultural Award 1988; Milan & Spoleto Award 1989.

REP: Exhibitions Building Trust, Melbourne; Rockhampton Art Gallery; New York State Government; a number of consular and diplomatic buildings in Australia, Germany, Japan.

BIB: Germaine, *AGA. A&A* 10/4/1972.

BILLINGHAM, S. R.

(Active c. 1880) Painter. He painted a fine *View of Albany*, as seen from the sea, collection Elder Smith-Goldsbrough Mort, Perth. His work was seen in *The Colonial Eye*, AGWA 1979.

BILU, Asher

(b. 1936, Tel Aviv; arr. Aust. 1957) Painter.

STUDIES: No formal training. He studied music from childhood and music has been important to his development in painting. European modernist movements, inherited Jewish symbolism and a natural penchant for technological experimentation held his interest from the beginning and since his first exhibition in 1959 he has remained faithful to these basic principles. He held exhibitions at MOMA, Melbourne (1961, 62), London (1963, 66) and Rotterdam (1964), and about 28 solo exhibitions in Melbourne (including at South Yarra Galleries 1960s–1973; Joseph Brown 1970, 71; Realities 1979; Tolarno 1981; United Artists 1982–85 and Luba Bilu 1988–). His 1979 work comprised monumental mosaics of plywood, cut with a fretsaw and painted and stuck together with enamels, casein and resin to create a kind of tumultuous harmony. Special music and lighting affirmed the mystical quality of the atmosphere. He has subsequently alternated more traditional canvas painting

with installations of this nature, including *Amaze*, where a maze was contructed on the gallery floor (shown Mt Gambier, Melbourne, Sydney, Armidale 1982–84), and *Escape* at Luba Bilu Gallery 1992 in which viewers were invited to immerse themselves in mounds of shredded paper. Group exhibitions in which his work appeared include *Images of Religion in Australian Painting 1942–88*, NGV; *Re:creation/Re-creation*, Monash Uni. Gallery 1989. He was commissioned in 1982 to produce four works for the Concert Hall at Vic. Arts Centre, Melbourne.

AWARDS: Blake Prize, Sydney, 1965; Henri Caselli Richards prize, Brisbane, 1965; First Leasing prize, Melbourne, 1970.

REP: NGA; NGV; Heide; Gold Coast regional gallery; several corporate collections including ANZ, BHP, Monash Medical Centre; CAS collection, London; Mertz collection, Corcoran Gallery, Washington, DC.

BIB: A number of general texts on Austalian art including Smith, AP; Thomas, OAA; Bonython, MAP 75. Laurie Thomas, *The Most Noble Art of Them All*, UQP, 1976. Rosemary Crumlin, *Images of Religion in Australian Painting*, Bay Books, 1988. *New Art Five*.

BINDER, Edward George

(b. 5/1/1938, Sydney) Painter, teacher.
STUDIES: NAS, 1961–66; travel studies Europe and UK, 1967–68. He held an exhibition at the Clytie Jessop Gallery, London, 1968, and contributed to exhibitions in Sydney, Melbourne and Hobart, 1971–74 and the *Archibald Prize*, AGNSW 1977, 78.
AWARDS: English Speaking Union Travelling Scholarship, 1966; Dyason Scholarship, 1967.
APPTS: TAFE, NSW 1970– ; head of NAS, East Sydney TAFE 1986– .
REP: AGSA.
NFI

Vivienne Binns, Tower of Babel (detail), *collaborative work of 49 artists, Watters Gallery, 1989.*

BINNS, Vivienne Joyce

(b. 6/11/1940) Painter, community artist.
STUDIES: NAS, ESTC 1958–62; television course, Gore Hill Technical College 1969. Her individual work includes enamels, environmental art and painting and she is equally involved as a well-known community artist. Feminism is a strong element of her work. She held about ten solo exhibitions 1967–92, largely at Watters, Sydney; several at Bellas, Brisbane. Her community art work includes a large project at Blacktown, NSW, *Mothers' Memories*, and as artist-in-the-community at Bowral, NSW. Her work appeared in numerous group exhibitions 1966–90, including *Australian Perspecta*, 1981, *Contemporary Australian Art*, ICA, London 1982; *Portrait of a Gallery*, Watters 25th anniversary exhibition touring eight regional galleries 1989; *Frames of Reference*, Artspace, Pier 4/5, Walsh Bay, Sydney 1991.

AWARDS: Order of Australia Medal 1983; Ros Bower memorial award for community art 1986; Australian Artists Creative Fellowship, Aust. Council 1990.

REP: NGA; AGNSW; MOCA, Brisbane; several university and corporate collections.

BIB: Catalogue essays in exhibitions as above. *New Art Two*. PCA, *Directory*. AL 2/2/1982, 2/3/1982, 9/3/1989, 10/3/1990.

BINZER, William

(b. c. 1850, Germany) Painter. A landscape painter in oils, he was working in New Zealand in the 1870s and in Australia in the 1880s and is believed to have returned to Europe in the 1890s. His paintings, none of which are dated, are usually rather dark and primitive in style.

BIRCH, Robert

(b. 1/5/1939, WA) Painter.
STUDIES: Harrow School of Art, UK, 1962–65. He travelled in the Middle East before returning to WA in 1967 where he worked on the staff of the AGWA, Perth, and taught art before becoming a full-time painter. He held exhibitions in Perth and participated in group shows in London, Singapore and Hobart.
AWARDS: Perth Prize for Drawing, 1969.
REP: TMAG; Fremantle Arts Centre.
BIB: ASEA *Bulletin*, 1970.

BIRKS, Edith Napier

(b. 1900, Adelaide; d. 1975, Adelaide) Teacher, painter.
STUDIES: Slade School, London. She founded the School of Fine Arts in Adelaide in 1921 and in the same year moved to rooms at the Uni. College. She married Basil Burdett (q.v.) but was divorced in 1930. In her later years she isolated herself from the Adelaide art world and unfortunately most of her work, in pastels and oils, which she had stored in a shed, was severely damaged by dampness.

BIB: Rachel Biven, *Some forgotten . . . some remembered*, Sydenham Gallery, Adelaide, 1976.

BIRMINGHAM, Karna Marea

(b. 3/12/1900, Sydney) Painter, illustrator.
STUDIES: Sydney Art School, with Julian Ashton, 1915–20. She exhibited with the NSW Society of Artists and from 1921 assisted as a teacher at the Sydney Art School. In 1938, however, her eyesight failed and except for a brief period when she recovered her sight in 1974, she did not paint again.
REP: AGNSW (pen drawing).

BISENIEKS, Ojars Aleksandres

See BLUE BRUSH

BISHOP, Ethel Alicia

(b. 1892, Bath, Eng.; arr. Aust. in childhood; d. 1958) Painter.
STUDIES: Adelaide, with James Ashton, 1906–11; NGV School. She won the NGV Travelling Scholarship in 1914 but remained in Australia during the war to teach at the South Australian School of Arts.
REP: AGSA.
BIB: Rachel Biven, *Some forgotten . . . some remembered*, Sydenham Gallery, Adelaide, 1976.

BISHOP, Tony

(b. 1940, Sydney) Sculptor, teacher.
STUDIES: Dip. Art, SASA 1961; travel studies London, Amsterdam, Munich, 1968–69, and USA, UK and Europe, 1976. Since his first exhibition in 1965 his work has appeared regularly in interstate exhibitions of contemporary sculpture. He uses arrangements of commonplace building materials and objects such as pipes, tables and bars with surfaces painted in alternating bright colours to attain a variety of modular ambiguities. He held eight solo exhibitions 1967–89, largely at Macquarie, Sydney, and his work appeared in a number of group exhibitions in Sydney, Melbourne, Adelaide, Newcastle, Mildura and Perth.
AWARDS: Perth Prize for drawing, 1969; work acquired, Mildura Sculpture Triennial 1973; VACB grants 1973, 74, 75; grant SA govt 1978.
APPTS: Teaching, SA secondary schools and Wattle Park Teachers College, 1961–64; lecturing, SASA, Adelaide, 1964– ; board member, AGSA, 1976–81; board member, deputy chair, VACB 1977–82; deputy chairman, 1st Aust. Sculpture Triennial 1981; member, art advisory committee, New Parliament House 1982–84; member, Australian Artists Creative Fellowships Scheme, Aust. Council 1989.
REP: AGSA; AGWA; Parliament House; Mildura Arts Centre; Adelaide Festival Trust collections.
BIB: Catalogue essays exhibitions as above. Sturgeon, DAS. Scarlett, AS. *New Art Two*. AL 2/4/1982, 3/1/1983, 4/2–3/1984, 6/5/1986, 9/2/1989.

BIZLEY, Roy

(b. c. 1930, Eng.; arr. Aust. 1957; returned Eng. 1961) Painter, teacher.
STUDIES: Slade School, London; Swindon Art School. Exhibited in Melbourne exhibitions, his semi-abstracts showed feeling for light, colour and pattern.

AWARDS: Cato prize, VAS, 1958; Perth prize, shared with Robert Juniper, 1959.
REP: NGV.

BLACK, Dorrit

(b. 23/12/1891, Burnside, SA; d. 13/9/1951, Adelaide) Painter, teacher, printmaker.
STUDIES: Adelaide School of Design, with H. P. Gill, c. 1909; Julian Ashton School, 1915– ; Grosvenor School of Art, London, 1927, with Iain McNab; Paris, with André Lhote and Albert Gleizes, 1927–29. She returned to Sydney late in 1929 from overseas studies inspired by the influence of the modern French painters with whom she had been associating. In September 1930, she held her first exhibition at the Macquarie Galleries, Sydney and in 1931 established the Modern Art Centre where she conducted exhibitions, taught and generally promoted the modernist cause in NSW. She travelled overseas again in 1934–35 and on her return to Adelaide became foundation vice-chair of the CAS in 1942, and in 1949 founded the modernist Group 9. Her early work in Sydney was influenced by the prevailing conservatism of Ashton and Gruner (qq.v.), but as she became aware of the changes that had taken place in Europe she responded by greatly simplifying her forms. Studies in Europe completed the processes of change in style and after her return, her 1930 Sydney exhibition contained some of the most advanced modernist painting seen in Australia to that time. The pre-war impressionism and conservative concepts had been replaced by innovations such as the flat-pattern cubist trend towards simplified, geometricised forms and bright, flat colours. At the same time she produced a series of linocuts similarly modernist in concept. However, after her return to Adelaide in the 1940s, her palette darkened and her forms became increasingly austere, in keeping perhaps with her association with the CAS, SA, but reflecting also her personal problems as a socialist undergoing religious doubts and questionings. She exhibited extensively throughout her professional life and when, tragically, she died following a car accident in 1951, Australian art lost one of its most courageous and innovative artists.

An exhibition of her work was held at the AGSA and her work was represented in *A Survey of Relief Prints 1900–1950*, Deutscher Galleries, Armadale, Vic., 1978; *Australian Women Artists 1840–1940*, Ewing & George Paton gallery and touring regional and state galleries 1975–76; the Bicentennial exhibition *The Great Australian Art Exhibition* and *A Century of Australian Women Artists 1840s–1940s*, Deutscher Fine Art, Melbourne 1993.
REP: NGA; Australian state and regional galleries; Victoria and Albert Museum, London.
BIB: Smith, AP. ADB 7. Burke, AWA. AL 1/4/1981.

BLACK, Margaret

(Active 1859–mid-1860s, Launceston and Melb.)
Two of her pencil sketches of views of Launceston were exhibited in exhibitions in Melbourne and

Launceston in 1859 and 1861; one was lithographed by F. Cogne (q.v.) in 1863.

REP: QVMAG; NLA; La Trobe & Crowther Libraries.
BIB: Clifford Craig, *Old Tasmanian Prints*, Launceston, 1964. Kerr, DAA.

BLACK, Stuart

(b. 20/2/1937, Vic.) Painter.
STUDIES: San Francisco, 1976–77. He studied also in Melbourne and held about 12 exhibitions 1967–93 including with Standfield; Gallery 101, Melbourne; in group exhibitions at ACCA and in prize exhibitions including *McCaughey Prize*, NGV 1965; *Perth International Drawing Prize*, 1975; MPAC *Print Prize*. He taught in primary, secondary and tertiary schools and colleges 1957–86.
REP: NGA; QAG; Indianapolis Museum of Art; Latrobe Valley Arts Centre; Melbourne Uni.; Ballarat Uni. College.

BLACK-AND-WHITE ART IN AUSTRALIA

Black-and-white illustration as an art form, distinct from painting, had its roots in Australia in the colonial imitations of London *Punch*. Melbourne *Punch*, founded in 1855 by James Smith, employed artists such as Nicholas Chevalier (the first staff cartoonist), 'Mr' Gill, Montagu Scott, O. R. Campbell, T. Carrington, Luther Bradley, George Dancey and Alec Sass. Their work, which was reproduced in engravings, successfully imitated the illustrations of Cruikshank, Du Maurier, Tenniel and other British artists of the time. *Punch* was acquired by the Melbourne *Herald* in 1924 and amalgamated with *Table Talk* two years later. Sydney *Punch*, which started in 1864, employed Montagu Scott and others; Adelaide *Punch*, started in 1868, employed W. J. Woodhouse and others; Queensland *Punch* employed A. V. Thomas, William Macleod, C. H. Hunt and Tom Durkin. A strong forward step in the quality of illustrative engraving occurred in 1883 when the *Picturesque Atlas of Australasia* began to attract the best local artists and engravers to Sydney (among them the Collingridge brothers, who probably introduced to Australia the work of the Spanish illustrator Daniel Vierge, with whom they had worked in Paris for *Le Monde Illustré*). Some of the *Picturesque Atlas* artists worked also for the *Illustrated Sydney News*, to which Charles Conder was attached (c. 1888) for a brief period as staff artist. Many of these artists transferred to the Sydney *Bulletin*, which J. F. Archibald and John Haynes founded in 1880. The introduction of photographic methods of line and half-tone reproduction focused attention on black-and-white art and helped build up an Australian school with standards laying claims to international status. Leader in the departments of technique and humour was Phil May, imported from London as *Bulletin* staff artist for a two-year period, during which he made more than 900 drawings. May's influence was decisive and his work became a prototype to which later

artists aspired, notably Alf Vincent and David Low. Meanwhile, the black-and-white development had fallen under the spell of world-wide art nouveau. *The Yellow Book* (London), Joseph Pennell's *Pen Drawing and Pen Draughtsmen* (London, 1889), and the Munich periodical *Die Jugend*, were important sources of inspiration. The pages of these books were filled with ornamental decorations in line based on plant forms, and illustrations of a macabre and erotic nature which found ready response among the *Bulletin* artists. George Ashton, A. H. Fullwood and Percy Spence were among the early leaders. Parallel with this development was the development of the comic cartoon, whose main early protagonist was the American, Livingston Hopkins. A gradual fusion of these two elements – art nouveau and the comic cartoon – led to a recognisable *Bulletin* style which took shape in the work of Frank Mahony and B. E. Binns, and reached its zenith in the work of Norman Lindsay and Percy Leason, both of whom produced strongly individual but differing types of bush idylls; a more stylised, more fanciful but much lighter type of illustration was created by the Scots-born D. H. Souter and Ruby Lindsay. The work of Will Dyson who, with his brother Ambrose, had made a reputation as staff cartoonist for Melbourne *Table Talk*, pointed to yet another influence, that of the draughtsmen of the German magazine *Simplicissimus*. As in other countries, the black-and-white era in Australian art siphoned off much talent which might otherwise have expressed itself in painting; this may well have been a powerful factor in causing the depressed standards of painting during the 1920s. Strong critical support from such authorities as Lionel Lindsay, the 'Joseph Pennell of Australia', gave additional emphasis to black-and-white development. The art standards of the *Bulletin* rose and fell with the first editor, J. F. Archibald; when, in 1919, just before his death, he transferred his talents and interests to a new paper, *Smith's Weekly*, the black-and-white standards went with him. Names that emerged with the new paper were those of George Finey, Stan Cross, Joseph Lynch, Syd Miller, Virgil Reilly and Joe Jonsson. In the vigorous work of this group, the refinements of 'art nouveau' were replaced by a lusty Rabelaisian bush humour, expressed with crude power in trenchant pen and brush strokes. While it lasted (1919–50), the *Smith's Weekly* school added considerable colour to the increasingly undisciplined bohemian climate of Sydney art life. The *Bulletin* standards declined steadily after Archibald's departure. The magazine ceased publication in its original form in 1961, when it was taken over by Consolidated Press, Sydney. It was amalgamated with the Sydney *Observer* and reformed as a review of opinion similar in format to the American magazine *Time*. Outstanding among the magazines in which attempts were made to maintain and even improve on the black-and-white traditions established by the early *Bulletin* was the new Melbourne *Punch* (1924–25), which attracted contributions from Percy Leason, Joseph Lynch, Hugh and Mahdi McCrae, D. H. Souter, and Unk White, a black-and-white artist

of considerable early brilliance. Its most memorable contributor was Will Dyson, who had accepted an invitation to return from London as chief cartoonist. Partly because of the high salaries paid, the new *Punch* lasted only a year, but Dyson's presence in Melbourne momentarily lifted the caricature and cartoon into the realms of high art and left an impression never to be forgotten. The imminent decline of the Australian black-and-white school became plain in the 1940s, despite the survival of *Smith's Weekly* until 1950 and the advent and subsequent demise of weeklies such as the wartime *Picture News* (*Herald* Melbourne, 1941) and the *Australasian Post* (*Argus* Melbourne, 1945–). The latter, an attempt to create a new national weekly from the traditional countryman's paper, the *Australasian*, replete with black-and-white contributions to challenge the highest *Bulletin* standards, attracted contributions of caricatures, cartoons and illustrations from Noel Counihan, Albert Tucker, Cedric Flower, Alan McCulloch (the art editor), a group of young German artists from the prison ship *Dunera*, the Norwegian Harald Vike, and a number of casual contributors. The collapse of the black-and-white era was a strangely swift, worldwide phenomenon brought about by changing economics, the upheaval of World War II and the transference of public interest to radio and television. The great magazines of the USA, invulnerable as they had seemed during the first three decades of the twentieth century, seemingly vanished overnight and with them went a great school of illustrators of world renown. Australians who had been accepted in the sacrosanct ranks of this school included Walter Jardine, Norman Lindsay and, most successful of all, Lindsay's star pupil, John Richard Flanagan. However if the black-and-white school thus died, the cartoon persisted. In Australia in the 1960s it began a strong upwards curve, to gain new meaning and standards.

(*See also* CARTOONS AND CARTOONISTS)

BIB: Joseph Pennell, *Pen Drawing and Pen Draughtsmen*, Macmillan, London, 1889, reprinted 1894. Moore, SAA. Marguerite Mahood, *The Loaded Line*, 1973. Vane Lindesay, *The Inked-In Image*, Hutchinson, Melbourne, 1979. Patricia Rolfe, *The Journalistic Javelin: An Illustrated History of the Bulletin 1880–1980*, Wildcat Press, Sydney, 1980. *The Bulletin*, centenary issue, 29 Jan. 1980.

BLACKBURN, David

(b. 1939, Yorkshire) Painter, printmaker, teacher.
STUDIES: Royal College of Art, London, 1959–62; travel studies in Europe, 1962–63. Blackburn's connections with Australia began when he worked as a lecturer in the art school at RMIT, 1963–66, and continued in his subsequent associations with the Uni. of Melbourne as visiting lecturer in the Dept of Architecture, 1971. Much of his activity has taken the form of fellowships at English and Australian universities. His technically competent, semi-abstract pastels and prints are often inspired by English and Australian landscape forms.
REP: AGSA; QAG.

BLACKMAN, Charles

(b. 12/8/1928) Painter.
STUDIES: ESTC, 1943–46. After a short period of work as a press artist for the Sydney *Sun*, 1945, he moved to Melbourne where he married, worked as a cook in restaurants and practised his art when he could. His impoverished situation began to change when he received the patronage of John Reed (q.v.), who drew the attention of newspaper critics to his work. He exhibited with the re-established CAS and at the new Mirka Gallery at 9 Collins Street, and his drawing *The Swimmer*, shown at the Peter Bray Gallery, caused a press controversy (*Herald* Melbourne, 12 and 19 May 1953) that further enhanced his reputation. But the inspiration that was to shape the future of his art came largely from writers like John Shaw Neilson:

> *Fear it has faded in the night,*
> *The bells all peal the hour of nine*
> *Schoolgirls hastening through the light*
> *Touch the unknowable divine.*

The schoolgirl and her flowers became for Blackman as the harlequin for Picasso or the guitar for Braque. His schoolgirl led to an Alice in Wonderland series and the schoolgirl remained a theme to which he returned for years. The success that launched him on his travels and studies overseas was the winning of the 1960 Helena Rubinstein Scholarship. His work was included in the Whitechapel and Tate Gallery exhibitions (1961–62), both of which helped to make the greater world of London familiar with the existence of contemporary Australian art. In 1965 a tour of northern France and Flanders led to a series of Blackman tapestries woven in Portugal and shown in Australia in Sydney, Melbourne and Adelaide. In the 1970s his paintings of cats and gardens inspired by Proust's writings revealed a softening of vision which occasioned some criticism. Of great importance to his early development was the influence of his first wife and early model, Barbara, who overcame the handicap of blindness later to embark on her own independent career as a writer. Throughout his career he has exhibited prolifically, the great strength of his work being his drawing. In 1993 a major retrospective was curated by Felicity St John Moore for the NGV and toured as well to AGNSW, Brisbane City Hall and Art Gallery and AGWA. This exhibition reinforced Blackman's great contribution to Australian art — especially through his works of the 1950s 70s. It included several examples of 1990–92 paintings which were much more in line with his works of the 1960s.
AWARDS: Rowney prize, Melbourne, 1959; Crouch prize, Ballarat, 1960; Helena Rubinstein Scholarship, Melbourne, 1960; Dyason endowment award, 1960; occupancy Australian studio, Cité Internationale des Arts, Paris; OBE, 1977.
REP: NGA; all Australian state and many regional galleries; university collections.
BIB: All major books on Australian art. Ray Mathew, *Charles Blackman – Monograph*, Georgian House, Melbourne, 1965; Thomas Shapcott, *Focus on Charles Blackman*, Uni. Qld Press, Brisbane, 1967; Nadine Amadio, *Charles Blackman: The Lost*

Domain, A. H. & A. W. Reed, Sydney, 1980. Nadine Amadio, *Charles Blackman's Paris Dreaming*, A. H. & A. W. Reed, Sydney, 1982. Nadine Amadio, *Orpheus the Song of Forever* Craftsman Press, Sydney, 1983. Thomas Shapcott, *The Art of Charles Blackman*, André Deutsch, London 1989. *A&A* 3/4/1966 (Ray Mathew, *London's Blackman*); 5/4/1968 (Barbara Blackman, *The Antipodean Affair*).

BLAIR, Oswald
(b. 1900, Tenterfield, NSW) Painter. He worked as a baker for 20 years, then in Sydney as a public servant until retirement in 1967, the year in which he started painting. His naive paintings of birds, kangaroos and other animals and vegetation done in bright colours are convincing in their innocence.
REP: NGV.
BIB: Bianca McCullough, *Australian Naive Painters*, Hill of Content, Melbourne, 1977.

BLAKE, Florence Turner (née Greaves)
(b. 1873, Armidale, NSW; d. 8/4/1959, Sydney) Painter. STUDIES: Julian Ashton School (where she was one of Ashton's first students); Slade School, London, 1925–29. She married William Mofflin in 1902, divorced him in 1916 and twelve years later changed her name to Blake (four of her paintings are in the AGNSW collection under the name of Mofflin). She bequeathed her estate (which in 1960 represented the income from £54,000) to the AGNSW for the purchase of works of art.
REP: AGNSW.
BIB: NSW Society of Artists catalogue, Ure Smith, Sydney, 1922.

BLAKE, W. S.
(Active c. 1802) Engraver. A *View of the Town of Sydney in the Colony of New South Wales* was engraved by Blake and published in London in 1802 from a painting done on the spot by an as yet unidentified artist. It was seen in *A Selection of Paintings and Prints*, Thirty Victoria Street Gallery, Sydney, 1974.

BLAKEBROUGH, Les
(b. 5/10/1930, Surrey, Eng.; arr. Aust. 1948) Painter, ceramicist, teacher.
STUDIES: ESTC (painting and ceramics); Mittagong 1957–59; Sturt Pottery with Ivan McMeekin; Kyoto, Japan, with Takeichi, 1963. Mainly a ceramic artist, his completed commissions include works for the Industrial Design Council and the Commonwealth Government (Expo 1967 and 1970). His work appeared in numerous group exhibitions 1961–90 in Australia and international craft exhibitions including *Australian Decorative Arts – 10 years*, NGA 1985. He held many solo exhibitions at Macquarie, Sydney and Distelfink, Melbourne.
APPTS: Manager of Sturt Pottery 1960–72; director, Sturt Workshops 1964–72; member, Crafts Board, Aust. Council 1973– ; senior lecturer, Tasmanian CAE 1973– ; Australian representative, World Craft Council conference, Dublin, 1970.

REP: NGA; all state galleries; several regional and tertiary galleries Qld, WA; private collections including the Reserve Bank and overseas embassies and collections.
BIB: Kenneth Hood, *Pottery*, Arts in Australia series, Longman, Melbourne, 1961. Borrman, Kunst & Handwerk, *Ceramics of the World*, Düsseldorf, 1985. Kenneth Hood, *Australian Pottery*, Macmillan, 1972.

BLANCHARD, Brian
(b. 28/6/1934, Lismore, NSW) Painter, teacher.
STUDIES: Julian Ashton School (with Henry Gibbons), 1952; City & Guilds of London School, 1962; 1967–70 with Graham Inson, Sydney; travel studies UK and Europe, 1970–72. He taught at the Julian Ashton School for 12 years and with the Royal Art Society of NSW then at his own studio for 20 years. He is a Fellow and exhibiting councillor of the Royal Art Society of NSW with whom he exhibited for over 30 years. He received a number of commissions including portraits and murals.
AWARDS: Prizes in competitions at Albury, 1962; Taree, 1964.
REP: NGA; Rockhampton Art Gallery.
BIB: Germaine, *AGA*.

BLANCHFLOWER, Brian
(b. 4/10/1939, Brighton, UK; arr. Aust. 1972) Painter, teacher.
STUDIES: Brighton College of Art, UK, 1956–61; Croydon College of Art, 1968–69. His huge paintings with dark backgrounds are filled with particles of colour like stellar explosions, the unstretched canvases on which they appear being an integral part of the work. Blanchflower has achieved recognition as a leading abstract painter since his first exhibitions in the mid-1970s. Solo exhibitions 1974–91 include those at University of WA 1979 & 89; a touring exhibition to AGWA, Ivan Dougherty, Sydney and NSW regional galleries 1985–86; at AGWA and AGNSW 1989; Curtin University of Technology 1991; PICA 1992. He was artist-in-residence, Air & Space studio, London, 1983–84 and Pier Art Centre, Orkney, 1984. Group exhibitions in which his work appeared included *The Great Australian Art Exhibition* 1988–89; *A Spacious Central Location*, PICA 1990.
AWARDS: VACB grants, 1975, 76; Georges Art prize (drawing acquired), 1978; studio grant VACB, 1983; grant VACB, 1988.
APPTS: Secondary art teacher, UK, 1965–71; lecturer, fine art, WAIT, 1972–81; visiting lecturer, WAIT, 1983–84.
REP: All state galleries and several university and regional collections in WA, Vic.
BIB: Catalogues for exhibitions as above. PCA, *Directory*. Chanin, *CAP*.

BLAND, William
(Active c. 1850, Sydney) He exhibited a portrait with the Society for the Promotion of the Fine Arts, Sydney, 1849.
BIB: Kerr, *DAA*.

BLANDOWSKI, William
(b. 21/1/1822, Silesia, 1822; arr. Aust. 1849. d. c. 1876) Naturalist, artist. He visited Adelaide, Sydney, Twofold Bay and Cape York and in 1852 joined the gold rush to Mt Alexander where he was fairly successful. He was instrumental in the founding of the National Museum of Vic. and in 1856 led an expedition to the junction of the Murray and Darling Rivers, collecting natural history specimens. Unfortunately he quarrelled with the committees of the expedition and when he returned to Germany took most of his fine sketches and drawings (about 4000) with him. Author of *Australia Terra Cognita*, ?1857.
REP: NLA; Mitchell, La Trobe Libraries.
BIB: ADB 3. McCulloch, AAGR. Kerr, DAA.

BLASHKI, Myer
See EVERGOOD, MILES

BLAYNEY, Peter
(b. 1920, NZ.; arr. Aust. 1929) Painter.
STUDIES: NAS, 1946–48; travel studies France, Italy and UK, 1949–67. He taught in London and later at the Uni. of NSW, NAS and City Art Institute. He held 16 solo exhibitions 1964–92, largely at Robin Gibson Gallery, Sydney, showing work with soft, lyrical colours and geometric abstract forms. His work was shown in a number of group exhibitions in Australia and internationally including in France, Spain and UK.
REP: Qld and Macquarie universities.

BLEACH, George
(Active c. 1914) Painter.
STUDIES: Julian Ashton School. During World War I he made a panoramic picture of the operations at Messines.
NFI

BLIZZARD, Liz (Elizabeth Henry)
(b. 1/12/1946, Vic.) Painter.
STUDIES: Prahran Inst. of Technology, Melbourne Teachers College, 1964–66; Dip. Painting, Ballarat CAE, 1978–79. She held six solo exhibitions 1982–92 in Melbourne (David Ellis, 1982, 90) and Ballarat and her work appeared in about 27 group exhibitions 1968–91 at private galleries in Melbourne (Princes Hill; 70 Arden St) and public regional galleries at Ballarat, Swan Hill, Muswell-brook, Warrnambool, Gold Coast.
AWARDS: Fletcher Jones Invitation Prize purchase, Warrnambool Art Gallery, 1984.
APPTS: Lecturer, painting and drawing (sessional), Ballarat Uni. College, 1986– .
REP: Regional galleries Ballarat, Warrnambool.
BIB: Germaine, AGA.

BLIZZARD, Peter Hugh
(b. 27/7/1940, Melb.) Sculptor.
STUDIES: Certificate of Art, Prahran CAE, 1965; Dip. Art, RMIT, 1967. He worked as a graphic designer before turning to sculpture in 1970 when his large steel constructions became well-known. In 1973 he completed a commission, *Stations of the Cross*, for St Mark's Church, Fawkner, Vic., a symbolic work for the Eucharistic Congress, Melbourne, and two symbols in bronze for the Vatican Museum, Rome. His abstract works on paper use collage and colours reminiscent of the Australian bush – soft greys, greens and browns. He held six solo exhibitions 1970–92 including at International Trade Fairs (New York, 1970; San Francisco 1970); works on paper, Gryphon Gallery, 1981. His work was included in numerous sculpture survey shows 1968–92 including *Mildura Sculpture Triennial*, 1978, 82, 88; *Australian Sculpture Triennial*, 1981.
AWARDS: Caulfield Invitation sculpture award, 1979; purchase 1st Australian Sculpture Triennial and Mildura Sculpture Triennial, 1981, 82.
APPTS: Lecturer/senior lecturer (head of sculpture), Ballarat Uni. College 1975– .
REP: Several municipal, regional gallery collections Vic., Qld; Vatican Museum.
BIB: Catalogue essays in sculpture survey exhibitions as above and several private galleries. Sue Kinealy and Peter Ward, *Australian Artists in Italy*, UQP, 1991. Germaine, AGA. Scarlett, AS.

BLOOMFIELD, John
(b. 2/8/1950, Surrey, Eng.; arr. Aust. 1960s) Painter.
STUDIES: Dip. Painting, NAS, 1973; Dip. Ed., NCAE, 1974. He held seven solo exhibitions 1972–91 in Sydney (Barry Stern, 1979; Robin Gibson, 1985; Rex Irwin, 1988, 91) and Brisbane (Philip Bacon 1974, 87), and at the Arts Council Gallery, Sydney 1972. His work appeared in about 27 group exhibitions 1972–91 at private galleries in Sydney and Adelaide; and in *Continuum*, Ivan Dougherty Gallery, Sydney 1981; *Faces*, AGNSW 1984; *Archibald in Retrospective*, S.H. Ervin Gallery, 1985.
AWARDS: Basil and Muriel Hooper Scholarship, AGNSW 1972, 73; Archibald Prize, AGNSW 1975 (decision reversed on technical issue); Moya Dyring Studio, AGNSW, Cité Internationale des Arts, Paris, 1977; Perth Portrait Prize, 1979.
REP: AGNSW; AGSA; MAGNT; AWM; Artbank; regional galleries Armidale, Rockhampton; Uni. of Sydney; Sydney Town Hall; Uni. of Illinois.
BIB: Bonython, MAP 80. Anna Waldman, *The Archibald Prize: An Illustrated History 1921–1981*, Ure Smith, 1982. Humphrey McQueen, *Suburbs of the Sacred*, Penguin Books, 1988. Donald Richardson, *Art in Australia*, Longman Cheshire, 1988. A&A 14/2/1976.

BLOXAM, Ethel D'Arcourt
(b. 1871, Mt Gambier; d. 1971, Adelaide) Painter. Known mainly for landscapes, she was a foundation member of the SASA in 1892 and continued to exhibit till she was ninety, showing mainly watercolours of the Adelaide Hills. She also did embroidery and tapestry.
BIB: Rachel Biven, *Some forgotten . . . some remembered*, Sydenham Gallery, Adelaide, 1976.

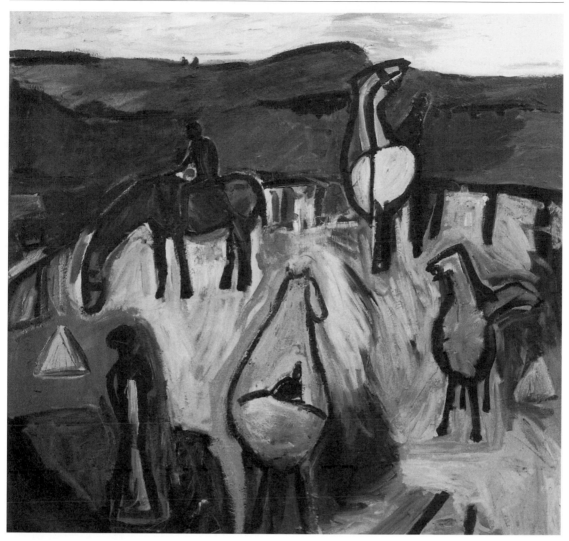

BLOXSOME, Henrietta

(Active c. 1830–60) Painter. There were two Henrietta Bloxsomes (senior and her daughter-in-law), both married to an Oswald Bloxsome (senior and son), which leads to some confusion as to who painted the two recorded works of 'H. Bloxsome' – *Mr Bloxsome's Sheep Farm* and *Sydney from the Rangers, Mosman c. 1849.* The former was sold at Christie's, Sydney, Oct. 1972.
BIB: Kerr, DAA.

BLUE BRUSH

(Active 1953–63, Melb.) Latvian group of painters, including O. Bisenieks, G. Jurjans, K. Mednis, G. Salins, L. Svikers, K. Trumpis and Erna Vilks. The group held regular annual exhibitions until 1963.

BLUETT, Thomas

(Arr. Hobart 1843) Lithographer.
STUDIES: London, with a firm of lithographers, Day and Haghe. He set up in business in Hobart in Oct. 1843, but gave up about a year later, after assisting Prout (q.v.) to print his *Sydney Illustrated*, lithographing six fine views of Hobart after H. C. Eaton (q.v.) and

Yvonne Boag, Riding Lesson, 1987, oil on canvas, 135 × 135cm. Courtesy Niagara Galleries.

making illustrations for a religious book, all published in 1844.
BIB: Clifford Craig, *The Engravers of Van Diemen's Land*, Foot & Playstead, Launceston, 1961.

BLUMANN, Elise

(b. 16/1/1897, Parchim, Germany; arr. Perth, WA, 1938) Painter, teacher.
STUDIES: Berlin Academy of Arts, with Liebermann and Kollwitz. She taught in Germany and later privately in Perth where she also assisted Robert Campbell (q.v.) in forming *The Art Group* to stimulate local interest in modern art. She travelled extensively in Northern and Central Australia and, from 1949, in Europe, returning to Perth finally in 1973. Large areas of open space and simplified tree forms are characteristic of her atmospheric landscapes. Her work appeared in *Western Australian Artists 1920–50*, AGWA 1980.
REP: NGA; AGWA.

BOAG, Yvonne

(b. 13/8/1954, Scotland; arr. Aust. 1964) Painter, printmaker.

STUDIES: Dip. Fine Art, printmaking, SASA 1977. Confident use of paint underpinned by strong drawing ability gave her semi-abstract works, seen in exhibitions in the 1980s, movement and energy. She held 13 solo exhibitions 1977–92 including at Niagara, Melbourne; Tynte, Adelaide; Coventry, Sydney and at Contemporary Arts Society, Adelaide 1980; Uni. Gallery, Melbourne 1982; Aberdeen Art Gallery, Scotland 1989. She participated in about 30 group exhibitions 1977–92 at private galleries including Tynte Gallery, Adelaide; Niagara, Melbourne; and *Women Artists: Works from the Collection*, Melbourne Uni. Gallery 1983; *Moet & Chandon Travelling Art Exhibition*, 1987; MPAC *Festival of Prints and Drawings*, 1987; *100 × 100*, PCA 1988; *Dissonance West*, Lewers Gallery, Penrith Regional Art Gallery 1991.

AWARDS: Moya Dyring/Denise Hickey Studio, Cité Internationale des Arts, Paris, AGNSW, 1990.

APPTS: Vic. Council of Adult Education, relief printing and etching, 1978–81; part-time lecturer, lithography, Uni. of NSW College of Fine Arts, Sydney 1986–89; part-time lecturer, lithography, Uni. of Western Sydney 1987–91; part-time lecturer, lithography, ESTC 1989; part-time lecturer, lithography, Sydney Uni., Sydney College of the Arts, 1991.

REP: NGA; Melbourne City Council; Australian Print Workshop; Artbank; Wagga Wagga Regional Art Gallery; La Trobe Uni.; Adelaide College of the Arts Collection; Melbourne Uni. Collection; Radio Australia; Telecom Australia; Vic. Education Dept.

BIB: Catalogue essays exhibitions as above. *New Art Three.*

BOAM, Paul

(b. 9/8/1938, Derbyshire, Eng; arr. Aust. 1964) Painter, lecturer.

STUDIES: Nottingham College of Art, UK 1957–62; Leeds College of Art, UK 1962–63. His geometric abstract squares within squares with centralised leaf-shaped motifs, as shown in his Melbourne exhibition, 1970, reflect his background interests as a designer. He exhibited with Jenny Boam in Tasmania and in group exhibitions largely in Tasmania. He also designed sets for the Tasmanian Conservatorium of Music.

APPTS: Lecturer, Tasmanian School of Art, 1970– .

REP: QVMAG; TMAG; Artbank; regional galleries Ballarat, Burnie; corporate collections including Reserve Bank, West German Landesbank, Hong Kong.

BIB: Germaine, AGA. Backhouse, TA.

BOARD, Leslie

(b. 1883, Sydney; d. 1935) Painter.

STUDIES: Sydney (with Phil Goatcher and John Gordan); London (with Joseph Harker); Paris. Scenic artist for J. C. Williamson, c. 1899.

REP: AGNSW.

NFI

BOCK, Alfred

(b. 1834, Hobart; d. 1921, Wynyard, Tas.) Painter, engraver, photographer.

STUDIES: With his father, Thomas Bock (q.v.), he engraved stamps, a portrait of Sir John Franklin and a number of Hobart street scenes. Subjects for his paintings were mainly portraits and landscapes, many of the latter in watercolours. He introduced daguerreotypes to Tasmania and ran a successful photography business for many years. His brother, William, also an engraver, migrated to New Zealand. His work was represented in the Bicentennial exhibition *The Great Australian Art Exhibition*.

REP: TMAG; NLA; Mitchell Library.

BIB: Henry Allport, *Early Art in Tasmania*, Hobart, 1931, quoted by Clifford Craig, *Engravers of Van Diemen's Land*, Foot & Playstead, Launceston, 1961. J. Cato, *The Story of the Camera in Australia*, Melbourne, 1955. Kerr, DAA.

BOCK, Thomas

(b. 1790, Sutton Coldfield, Eng.; arr. Hobart 1824; d. 1855, Hobart) Painter, engraver, teacher.

STUDIES: Engraving, Birmingham. A successful engraver and miniaturist with a wife and family, he was charged in 1823 at the Warwick Assizes and sentenced to transportation (not, as may be thought, for forgery, but for 'administering drugs to produce an abortion'). In Hobart he led an exemplary life; in Dec. 1824 he engraved government currency notes and made etchings of streets, landscapes and genre scenes. By 1831 he was running a gallery and giving art lessons. In 1833 he obtained a free pardon and gradually built up his reputation for portraiture, which he was the first to practise professionally in Tasmania and for which he is best remembered. He worked in oil and watercolour but most successfully in pencil; his sitters varied from the prominent citizens of the colony to Aborigines and bushrangers. He completed a fine series of Tasmanian Aboriginal portraits and, in a different vein, head studies of members of the Brady Gang during their trial in 1826. His portraits are refined and sensitive, their techniques occasionally showing his early preference for miniature painting. He died well respected, leaving 'a widow and a large family, we fear not too well provided for' (*Hobart Courier Mail*, 19 Mar. 1855). Of his five sons, Alfred (q.v.) became an artist and William worked for the New Zealand government as an engraver. An exhibition of his work was held at QVMAG 1991 and he was represented in *Shades of Light*, NGA 1988.

REP: TMAG.

BIB: Eve Buscombe, *Artists in Early Australia and their Portraits*, Sydney, 1978. Clifford Craig, *Engravers of Van Diemen's Land*, Foot & Playstead, Launceston, 1961. Kerr, DAA.

BODDINGTON, H.

Recorded as having painted a watercolour of *St James Church, Sydney*, 1892, sold at Christie's, London, May 1974.

NFI

BODDY, Janet R.

(b. 14/12/1935, Melbourne) Painter, teacher.

STUDIES: No formal training. Her atmospheric paintings were seen in 22 solo exhibitions 1965–92, mainly

in Melbourne, including at Gallery 99, Carlton; Hawthorn City Gallery 1972; ROAR Studios2 1985; and at the Gold Coast Gallery 1970. Her work was seen in numerous group exhibitions 1971–92 including *Sam Pees USA Travelling Aust-SE Asian Collection 1971–72*; Geelong Art Gallery 1972; MPAC 1976; Norwich Art Gallery, New York 1981. She was senior art teacher at Morongo Girls School, Geelong, and taught in a private studio on the Qld Gold Coast for three years with Laurie Paul before starting to paint full-time in 1969.

AWARDS: Prizes in competitions at Bundaberg, 1969; Warana (Caltex), 1969; Uni. of Tas., Hobart, 1971; Templestowe, Vic., 1974; Eltham, 1989.

REP: Uni. of Tasmania; several municipal collections; Toowoomba Hospital, Qld.

BIB: Germaine, AGA.

BOISSEVAIN, William

(b. 23/7/1927, New York; arr. Aust. 1949) Painter, teacher.

STUDIES: Central School of Arts and Crafts, London; Académie des Beaux-Arts, Paris. His father was a Netherlands diplomat appointed to posts in South America, Shanghai, East Africa, UK and France. His figurative work gained character from this sophisticated background and he painted a number of portraits of significant figures including Sir Douglas Kendrew, Governor of WA, and Professor Richard Joske. He held about 15 solo exhibitions 1964–89 in Perth (Skinner, Lister galleries) and Sydney (Holdsworth).

AWARDS: Rubinstein portrait prize, Perth, 1961; prize at Supreme Court Gardens exhibition, Perth, 1956; Claude Hotchin prize (oil), 1959; Perth Prize for Drawing International, 1971; OBE for services to the arts, 1978.

APPTS: Teaching, Wesley College, Perth; Adult Education, WA Uni. Extension.

REP: NGA; AGWA; TMAG; WA and Murdoch Uni. collections; WAIT, Perth, corporate collections including Orion Bank, London; Alcoa, Perth; R&I Bank, Perth.

BIB: Germaine, AGA. *Contemporary Western Australian Painters and Printmakers*, Fremantle Arts Centre Press, 1979.

BOLDEMAN, Beatrice

(Active c. 1895, Melbourne) Painter. Known for landscapes.

NFI

BOLES, Bernard

(b. 20/1/1912, Benalla, Vic.) Painter, sculptor, critic.

STUDIES: Melbourne Tech. Coll. with A. E. Davies, Napier Waller 1936–40; London with Laurence Gowing and M. Gillespie 1949–52; Courtauld Institute 1952–early 1960s. Boles acquired wide experience as an organiser and writer on art, as well as in painting, during his residency in London, Europe and the USA. His extensive overseas contacts included those with Henry Moore, 1948, with the Chicago Inst. of Design established by Moholy Nagy, 1946, and with UNESCO, 1955, as a delegate to its conference on the Plastic Arts. He exhibited in group and solo exhibitions in

London and wrote for art journals including ARI, *Painter* and *Painter and Sculptor*. He returned to Australia in 1964, and one year later an exhibition of his work, VAS, June 1965, showed a strong sense of fantastic imagery expressed in a forceful style based on the influences of cubism and surrealism. He subsequently held solo exhibitions with Niagara, Melbourne; La Trobe Uni. and participated in group exhibitions with Charles Nodrum, Melbourne. He also organised visiting exhibitions including the Henry Moore sculpture tour of Australia, 1947 and Milner Grey, designer royal, 1948. As art reviewer of *Nation Review* 1968–79, his writings on art attracted as much attention as any published in the contemporary Australian press.

REP: NGA; AGSA; Heide; regional gallery collections including Ballarat, Bendigo, Geelong, Mornington; tertiary collections including Adelaide, Deakin, Melbourne, Monash, Sydney, WA universities.

BIB: Scarlett, AS.

BOLGER, John

Early convict artist. His only known surviving work is a watercolour, *Walloomooloo.* (sic) *The Seat of Jno Palmer Esquire, Port Jackson*, 1803. It was seen in *The Art of Gardening in Colonial Australia*, AGDC touring exhibition 1979.

REP: Mitchell Library, Sydney.

BIB: Kerr, DAA.

BOMBACH, Bonney

(b. 23/5/1945) Painter.

STUDIES: BA and Dip. Soc. Studies, Melbourne Uni. 1966; Camden Inst. of Art, London, sculpture classes 1972–73; Dip. Art, Preston Inst. of Technology, Melbourne 1977; informal travel studies, emphasising early Christian art, Europe 1967–73; travel studies, 20th-century Mayan archaeological sites 1989–90. Concerned largely with the impact of civilisations on their environment, she has been painting professionally since the late 1960s. Her late 1980s works were praised by critics for their maturity and depth of imagery. Using mixed media which include natural pigments (charcoal, pastel oil stick), she overlays earth colours and textures on unstretched canvas, building up layers of diffuse images. She held ten solo exhibitions 1979–93 in Melbourne (including at Pinacotheca; Reconnaissance; MCA); Sydney (Mori); Lismore Regional Art Gallery 1984 and Gold Coast Regional Gallery, Qld 1993. Her work appeared in about 42 group exhibitions in public galleries 1979–93 including Pitspace Gallery, Preston Inst. of Technology 1979; *Women's Perspective*, Lismore Regional Art Gallery, NSW 1982; *Gold Coast City Art Prize*, 1984–87, 89; *Fisher's Ghost Acquisitive Prize*, Campbelltown, NSW 1990, 91; *Doors*, invitational theme show, Gold Coast Regional Gallery, Qld 1992.

AWARDS: Murwillumbah Art Prize, 1982, 84, 88, 90; Kyogle Festival Art Prize, NSW, 1984, 88; Ipswich City Acquisitive Art Prize, 1984; Byron Bay Art Award, 1985, 86; Caloundra Art Award, 1986; project grant, VACB, for solo show Melbourne, 1988.

APPTS: Life drawing at various Melbourne community arts organisations 1978–80; classes community organisations Lismore area, NSW; Visual Arts Tutor, Australian Flying Arts School, Qld 1990–91; part-time teaching, Murwillumbah TAFE 1992– .
REP: Footscray Community Arts Centre, Melbourne; Grafton & Tweed River Regional Art Galleries, NSW; Stanthorpe Regional Gallery, Qld; Artbank.

BOND, Anthony
(b. 1944, UK) Gallery director, curator, writer.
STUDIES: B. Ed., London Inst. of Education 1974; London Uni. 1970–74; enrolled PhD program, Fine Art, Uni. of WA 1989– . He edited and wrote many catalogue essays in Australia 1984–93 on artists for private galleries and curated exhibitions, and edited and wrote the catalogue essays for *Australian Perspecta*, 1987; *Surface for Reflexion*, AGNSW 1985; *Christo: The Real and the Revealed*, AGNSW 1990; *The Boundary Rider*, 9th Biennale of Sydney 1992. He held honorary positions on a number of art boards 1984–93. His contributions to books included *Contemporary Australian Painting*, ed. Eileen Chanin, Craftsman House, 1990.
APPTS: Director, Wollongong City Art Gallery 1978–81; chair, RGANSW 1978–80; assistant director, AGWA 1981–84; board member, AGDC 1979–80; member, VACB 1980–84 (deputy chair 1983–84); chair, Festival of Perth Visual Arts Committee 1983–84; board member, Museum Studies, Sydney Uni. 1984–87; member, curatorium, Biennale of Sydney 1984–88; curator, contemporary arts, AGNSW 1984–90; artistic director, Biennale of Sydney 1991–93.

BONE, Thomas Henry
(b. 1901, Bendigo, Vic.; d. 1953) Painter.
STUDIES: Travel studies in Europe and America, 1950. Known mainly for landscapes in watercolour; senior art teacher with the SA Education Dept.
AWARDS: Vic. government scholarship; gold medal, SA Centennial exhibition; Geelong prize for watercolour, 1946.
REP: AGSA; QAG; regional galleries Bendigo, Ballarat, Castlemaine.

BONYTHON, Kym (Hugh Reskymer)
(b. 15/9/1920, Adelaide) Gallery owner, entrepreneur, publisher.
STUDIES: St Peter's Coll., Adelaide. He founded important art galleries in Adelaide (1960) and Sydney (*see* GALLERIES – Commercial), advised BHP and the American gallery owner Harold Mertz on their Australian painting collections, and has served on a number of important art committees. His influence on Australian art affairs has been widespread. In 1960 he helped materially to restore the confidence of art book publishers by publishing, at his own cost, *Modern Australian Painting and Sculpture*, the first general art book to be published in Australia in 15 years. He achieved success also in the fields of car racing and jazz music. Books he wrote included *Modern Australian Painting*

and Sculpture, Adelaide, 1960; *Modern Australian Painting*, 1960–70; and *Modern Australian Painting 1975–80*, all published by Rigby, Adelaide.

BOOKPLATE DESIGN IN AUSTRALIA
Since bookplate design usually flourishes wherever the arts of engraving or etching are practised, the first Australian bookplates were probably made by early colonial artists. However they first came into fashion with professional artists in the 1890s, as, for example, when Percy F. S. Spence designed a bookplate for the Sydney collector, John Lane Mullins, in 1892. The Mullins collection included 1400 armorial plates in addition to many designed by leading Australian artists. Among early designers, Lionel and Norman Lindsay, Raphael Clint, John Carmichael, Irene Mort, Sydney Ure Smith, Roy Davies, E. Warner, Cyril Dillon, John Shirlow, George Perrottet and Neville Barnett were prominent, and later the bookplates of Adrian Feint were acquired for overseas collections. Eric Thake and James Flett designed excellent bookplates and Sydney bibliophile Patrick Corrigan commissioned bookplates from a large number of leading contemporary painters for his immense collection of Australian art books. The Australian Ex-Libris Society was formed in June 1923, and in 1930 published a journal containing a complete summary of literature on the subject published in Australia. No mention of the continued existence of the Society appears in published records after World War II.
COLLECTORS: John Lane Mullins, Lyster Ormsby, P. Neville Barnett, Bertram Stevens, G. L. Garnsey, P. J. Marks, John C. Flower, R. H. Croll, Patrick Corrigan.
BIB: Camden Morrisby, *Bibliography of Ex-Libris Literature Published in Australia*, Ex-Libris Society Journal, Sydney, 1930. Moore, SAA. P. Neville Barnett, *Australian Bookplates*, privately published, Sydney, 1950.
(*See also* AUSTRALIAN EX-LIBRIS SOCIETY)

BOOTH, Edwin Carton
Editor, journalist, historian. He compiled the two-volume *Australia* (better-known as *Australia Illustrated*) instalments, 1873–76. The work contains numerous engravings after John Skinner Prout and Nicholas Chevalier, as well as by S. T. Gill, Thomas Baines, Oswald Brierly and many others.

BOOTH, Peter
(b. 1940, Sheffield, Eng.; arr. Melbourne 1958) Painter.
STUDIES: Sheffield Coll. of Art, UK, 1956–57; NGV School, 1962–65. He taught painting at Melbourne tertiary colleges including Prahran Technical College and the NGV School from 1966 to 1986 and made his Melbourne debut with *The Field*, the opening exhibition at the new NGV, 1968. His large canvases, painted in viscous black sometimes edged with colour, appeared later in exhibitions at the Pinacotheca Gallery, St Kilda (Mar. 1969), and at the same gallery at irregular intervals after the gallery moved to Richmond.

In 1977 his painting became figurative without apparent disruption of style. Large, simplified black figures shown in burning cities or landscapes seemed logically to have burst through the viscous black skin of the earlier paintings as if forced from the subconscious by the social and political pressures of modern life. Added to this is a touch of the *weltschmerz* of German art, an influence that first appeared with the force of a new discovery in the exhibition *Australian Perspecta 1981*, AGNSW 1981. In 1982, Booth was one of two artists selected to represent Australian art at the *Biennale of Venice*. His work has remained in this vein in the 1980s and 90s and he held 30 solo exhibitions 1969–93 including many at Pinacotheca, Melbourne; a project show at AGNSW 1976; Monash Uni. Gallery 1976; CDS Gallery, New York 1986, 87, 88; Garry Anderson, Sydney 1985; Uni. of Melbourne Gallery 1986; Deutscher 1989, 90, 92 and a touring exhibition, *Getting to Know Mr Booth*, Mt Gambier, Ballarat regional galleries, Brisbane City Hall, Deutscher Brunswick St 1990. His works appeared in numerous significant group exhibitions 1967–93 including *Biennale of Sydney*, 1979, 84, 88; *Australian Perspecta*, 1981; *Project 40: Australian Artists at Venice and Kasssel*, AGNSW 1983; *From Another Continent: Australia: The Dream and the Real*, ARC/Musée d'Art Moderne de la Ville de Paris, Paris 1983; *Field to Figuration: Australian Art 1960–86*, NGV 1987; *Backlash: The Australian Drawing Revival*, NGV 1987; the Bicentennial exhibition *The Great Australian Art Exhibition* 1988–89; *Advance Australian Painting*, Auckland City Art Gallery, NZ 1988.
AWARDS: Prizes NGV School (2) 1964; grant VACB, 1975.
APPTS: Teaching, tertiary colleges, Vic. 1966–86 including Prahran, NGV School, VCA.
REP: NGA; AGNSW; AGSA; AGWA; NGV; QAG; TMAG; MCA, Sydney: MOCA Brisbane; Heide; a number of regional galleries including Ballarat, Bendigo Geelong, Mt Gambier, Mornington; Melbourne, Monash uni. collections; VACB collection.
BIB: Catalogue essays exhibitions as above. Smith, AP. Horton, *Aust. Painters of the 70s*. McIntyre, ACD. A&A 16/1/1978 (*Peter Booth*). AL 4/1/1984.

BOOTHBY, *Mabel Frances*

(b. 1870, SA; d. 1944) Painter. Known mainly for painting birds and flowers in watercolour on silk. She exhibited at the SA Society of Arts in the 1890s and at the *Australian Exhibition of Women's Art* in Melbourne in 1907.
BIB: Rachel Biven, *Some forgotten . . . some remembered*, Sydenham Gallery, Adelaide, 1976.

BOOTHROYD, *Arthur Sharland*

(b. 1910, Lancashire, Eng.; arr. Aust. 1923) Illustrator.
STUDIES: Swinburne Tech. Coll., Melbourne; RAS School; ESTC, 1927–31; Chelsea, London, 1945; travel studies Europe, Egypt, Cambodia, 1962. His early work particularly had a delicacy of touch that distinguished

it from the black-and-white illustrations of the period 1930–65.
AWARDS: Walkley awards, 1961, 63.

BORDASS, *Dorothy*

Painter. Member CAS of NSW c. 1940–50.
REP: AGNSW; AGWA.

BORGELT, *Marion*

(b. 1954, Nhill, Vic. Resident in Paris 1989–) Painter.
STUDIES: Dip. Painting, SASA, 1976; Dip. Ed., Underdale College, SA, 1977; postgrad. studies, New York Studio School, 1979–80. Her abstract paintings are distinctive for their interwoven multi-lined forms. Her 1980s and early 90s work is typified by her 1990 Moet & Chandon entry, *Shimmer*, described in the catalogue by Victoria Lynn: 'natural organic forms, glimpses of the body, furtive eyes and fantastic creatures have all been found in Borgelt's pictures . . . "Shimmer" . . . manifest[s] Borgelt's continuing interest in a metaphorical landscape which looks inward, beyond the skin of the earth/body to the psyche'. She held 16 solo exhibitions 1977–92 including at Bonython, Adelaide; Axiom, Christine Abrahams, Melb.; Roslyn Oxley9, Macquarie, Sydney; Milburn + Arte, Brisbane. Her work appeared in numerous group exhibitions at commercial galleries (including Roslyn Oxley9, Macquarie, Sydney; Greenhill, Perth) 1975–92 and in *New York Invitation Exhibitions*, 1979, 80; *South Aust. Centenary Exhibition*, AGSA 1980; *Form, Image, Sign*, AGWA 1984; *Isolaustralia*, Venice, Italy 1985; *Australian Perspecta '85*, Artspace, Sydney 1985; *Sixth Indian Trienniale*, Delhi, India and touring Aust. exhibition 1986; *Moet & Chandon Art Fellowship Touring Exhibition*, 1987, 88, 90; ICI *Contemporary Art Collection*, touring regional galleries 1989; *Abstraction*, AGNSW 1990; *Contemporary Australian Drawing*, AGNSW 1991. From 1989 she lived in Paris including collaboration with René Taze at Etching Atelier.
AWARDS: Harry S. Gill Award, SA School of Art 1976; Peter Brown Memorial Travelling Art Scholarship, New York Studio School 1978; Dyason Award for Postgraduate study in the US, 1979; Muswellbrook Drawing Prize, NSW 1983; Project Grant, VACB 1984; City of Lake Macquarie Art Prize 1986; 6th Ansett Hamilton Art Award, Vic. 1986; Gold Coast City Art Gallery Purchase Prize, Qld 1987; Uni. of Technology Purchase prize, 1988; Muswellbrook Open Prize, 1988; Faber-Castell Art Award 1988; Artists Development Grant, VACB 1988; Dyason Bequest for work and research in Paris, 1989; Campbelltown Purchase Prize 1990.
APPTS: Artist/tutor-in-residence, Canberra School of Art, 1986; tutor in drawing and painting, NSW Inst. of the Arts, 1987–89.
REP: NGV; AGNSW; AGWA; Parliament House; MOCA, Brisbane; Artbank; regional galleries Muswellbrook, Campbelltown, Hamilton, Gold Coast, Lake Macquarie, Newcastle; RMIT; Uni. of Technology, NSW; ICI Contemporary and Faber-Castell corporate collections.
BIB: Catalogue essays in exhibitions as above. McKenzie, DIA. Smith, AP. AL 6/2–3/1986.

BORLASE, Nancy

(b. 24/3/1914, NZ; arr. Aust. 1937) Painter, critic.
STUDIES: Canterbury Coll. of Art, NZ, 1936; ESTC (with Medworth and Dadswell), 1937–39; travel studies Europe and USA, 1956, USA, 1960. She joined the Contemporary Art Sociey of NSW in 1935 and was a committee member 1952–70. Her early important contacts were with Rah Fizelle and Grace Crowley and her early paintings were figurative but little exhibited until they were rediscovered in the mid-1980s. After her return from a second visit to the USA in 1960 her work revealed an interest in abstract expressionism and New York School painting. Her solo exhibitions included those with Macquarie, Sydney 1960, 66, 72; Wollongong City Gallery 1987. Group exhibitions in which her work appeared included *Sydney Avant-Garde Painting 1961*, Blaxland Gallery 1962; *Under a Southern Sun*, NGA travelling exhibition 1989; *New Directions 1952–62*, Lewers Bequest and Penrith Regional Gallery 1991; *A Century of Women Artists*, Deutscher Fine Art, Melbourne 1993. As an art critic for the *Bulletin* and the *Sydney Morning Herald* from 1973–81 she exercised considerable influence on art in Sydney. Her daughter, Susanna Short (q.v.), is also an art critic for leading newspapers and magazines.
AWARDS: Prizes in competitions at Mosman, 1961, and Berrima, 1967 (shared); AM for services to art, 1987.
APPTS: Art critic, Sydney *Bulletin*, 1972–73, *Sydney Morning Herald*, 1973–81.
REP: NGA; most state galleries and several regional galleries NSW; AWM; private collections including BHP, Commonwealth Bank.
BIB: John Reed, *The Arts in Australia: New Painting 1952–62*, Longman, Melbourne, 1962. Donald Richardson, *Art in Australia*, Longman Cheshire, 1988.

BORRACK, John Leo

(b. 5/11/1933, Preston, Vic.) Painter.
STUDIES: RMIT (with William Frater); travel studies Europe and UK, 1964 and 1975. Borrack's feeling for Australian landscape and light was largely developed by his teacher, William Frater, who directed him also to the study of Cézanne's theory that the forms of nature derive from the geometric shapes of cone, cylinder and sphere. In his own words, Borrack's objective is 'to infuse a powerful and dynamic personal feeling into a structural and poetic conception of nature'. He held about 41 solo exhibitions of his largely watercolour works 1958–91, mainly at Australian Galleries, Melbourne. Retrospective exhibitions of his work appeared at Morwell, Benalla regional galleries 1982, and he held solo shows at Horsham, Hamilton, Warrnambool galleries in the 1970s.
AWARDS: More than 14 awards for watercolours, including prizes at Yorick Club, Melbourne, 1958; Geelong, 1961; VAS (Norman Bros prize), 1961, 71.
APPTS: Secondary teaching, Melbourne 1954–69; lecturer, drawing and painting, Melb. State College 1970–82.

REP: NGV; QAG; a number of regional galleries Vic., Qld; several municipal collections Melb.
BIB: Bianca McCullough, *Each Man's Wilderness*, Rigby, Adelaide, 1980. Campbell, AWP. Germaine, AGA.

BOSTON, Paul

(b. 1952, Melb.) Painter.
STUDIES: Dip. Art, PIT 1973; travel studies Japan and SE Asia 1973–76; USA, UK, Europe 1980; China, Europe, USA 1985–86. 'Amid the neo-expressionist mêlée of the early 80s, Boston's work has retained a classical restraint and grace, embracing the new return to figurative concerns but proceeding with its own aura of unassuming intellectual exploration,' Ted Gott described Boston's drawings in the catalogue of the exhibition he curated, *Backlash: The Australian Drawing Revival*, for the NGV in 1986. Bostons' 1993 exhibition of dark-backgrounded clearly-defined abstracts showed the same consistency and rigour. He held six solo exhibitions 1983–93 in Melbourne (Reconnaissance; Deutscher; John Buckley; Niagara) and his work appeared in a number of group exhibitions 1972–91 including *A Survey of International Painting and Sculpture*, MOMA, NY 1984; *Backlash: The Australian Drawing Revival 1976–86*, NGV 1986; *Perspecta*, AGNSW 1983, 85; *Loti and Victor Smorgon Collection of Australian Art*, ACCA 1988; *Contemporary Australian Art to China*, four cities China 1990; *Sublime Imperative*, ACCA 1991.
REP: NGA; AGNSW; AGWA; NGV; MOCA, Brisbane; Heide; Artbank; private and corporate collections including Sussan, Loti and Victor Smorgon.
BIB: Catalogue essays exhibitions as above. A&A 23/4/1986.

BOSWORTH, Amy

(b. 1872, Riverton, SA) Painter.
STUDIES: School of Design, Adelaide (with H. P. Gill). Mainly a painter of flower pieces, specifically roses.
REP: AGSA.
BIB: J. B. Mather, *Catalogue of the Art Gallery*, AGSA, 1913.
NFI

BOULTON, Edward Baker

(b. 1812; arr. Sydney 1836; d. 1895) Painter, farmer.
He lived in NSW 1836–c. 1880s, exhibiting watercolours and oil landscapes in major exhibitions including the 1862 London *International Exhibition*, the 1879 Sydney *Intercolonial Exhibition* and during the 1870s with the NSW Academy of Art. His work was admired in Australia at the time with a watercolour view of Sydney Harbour being acquired by the AGNSW in 1882. He returned to England where he had settled his family of 18 children (he was married twice). His work was represented in *The Artist and the Patron*, AGNSW 1988.
REP: AGNSW; NLA; Mitchell Library.
BIB: Kerr, DAA.

BOURDIC, F.

(Active c. 1880) Madame Bourdic conducted art classes at her studio, 28 Queen Street, Melbourne, in

partnership with Mrs Farquharson; they had 70 pupils in July 1885.

NFI

BOURNE, George W. R.

(Active c1897–1902) Topographical artist. Arrived Fremantle on the *Daylight*, 16 Aug. 1876. He lived at Esperance Bay 1897–98 and Albany c. 1900–02, recording in watercolours the wreck of the *City of York* at Rottnest Island, 1899, and *Fremantle Lighthouse*, 1902. His work was seen in *The Colonial Eye*, AGWA 1979.

REP: WA Museum, Perth.

BOURNE, Shirley

(b. 1924, Brisbane) Painter.

STUDIES: NGV School; Europe, 1955–57; travel studies UK, Europe, Canada and South America, 1955–57. Known mainly for portraits. She exhibited with the VAS and Malvern Artists Society, Melbourne 1976– .

AWARDS: Dora Wilson scholarship, NGV School, 1952; VAS (Cato prize), 1961.

APPTS: Teaching, Malvern Art Society 1965– ; visiting tutor, Fremantle Arts Centre, 1978.

REP: AGNSW; AWM; regional galleries Bendigo, Langwarrin (McClelland Gallery), Rockhampton.

BOW, Ian

(b. 1914, Melb.) Sculptor, painter, teacher, lecturer.

STUDIES: Melb. Tech. Coll. c. 1931–34; travel studies, Europe 1950–51. An accomplished and versatile eclectic, and an inventive technician, Bow made his reputation first as a painter, then as a sculptor. He invented his own methods of lost wax casting in various metals and achieved successful results. Apart from his work as a practising artist, he became widely known as a lecturer and teacher for the Victorian Council of Adult Education. His career as a sculptor reached its zenith in the expressionistic works in cast aluminium produced c. 1958–69, and exhibited at the *Mildura Sculpture Triennial* 1961–70. From 1971 his output of work was severely curtailed as a result of injuries to his eyes and right hand suffered in a car accident. His father, J. R. Bow, was bequeathed the collection of Desbrowe Annear (q.v.). Ian Bow inherited the collection and in 1974 presented prints, paintings and drawings from it to the Mildura Arts Centre.

AWARDS: Robin Hood prize, 1956.

APPTS: Teaching, Victorian high schools, 1935; lecturer, Melb. Teachers Coll., 1942–44; Council of Adult Education, 1948–69; art master, Haileybury Coll., 1945–71.

REP: AGWA; NGV; QAG; Ballarat Gallery.

BIB: Clive Turnbull, *The Art of Ian Bow*, Cheshire, Melbourne, 1954. Scarlett, *AS*. Sturgeon, *DAS*.

BOWEN, Dean

(b. 5/2/1957, Vic.) Printmaker, painter.

STUDIES: Dip. Fine Art, RMIT, 1976. He is a community artist as well as holding solo exhibitions and his commissions include those for murals, including Moray St, South Melbourne 1981; Pickles St, Port Melbourne; Mary-borough Community Arts Centre 1982; Therapy Hotel Murals, North Melbourne 1982–83. He held five solo exhibitions 1983–92 including at Acland St, Australian Galleries, Melb.; St Christol de Rodières, France. His print commissions included PCA member print, 1989 & 91; ICI Print Commission, 1990; co-editions Lyon and Paris printmaking studios 1990/91. His work appeared in about 20 group exhibitions 1982–93 at private and community galleries including in Melbourne (Art Workers Union, St Kilda; United Artists; Acland St) and in MPAC *Spring Festival of Drawings and Prints*, 1976, 87, 88; *Transitional Times*, PCA touring exhibition 1991; *Fremantle Print Award*, 1991, and overseas including *Australian Prints*, Florida State University 1990; *Australian Contemporary Art A–Z*, Tokyo 1990; SAGA *Print Fair*, Paris 1991, 92; *5th International Biennial Print Exhibition*, Taipei Fine Arts Museum, Taiwan 1991; *Arco 92*, Madrid, Spain 1992.

AWARDS: Maryborough Arts Centre Award, 1978; MPAC Acquisitive, 1988; Henri Worland Memorial Print Award acquisition, 1991.

APPTS: Melbourne Uni. Inst. of Education, 1992.

REP: NGA; QVMAG; PCA; Australian Print Workshop; Artbank; MPAC; Maryborough Community Arts Centre; Fremantle Arts Centre; Brisbane City Hall Art Gallery; Melbourne Uni. Inst. of Education; Bibliothèque Nationale, France; URDLA Archives, Lyon, France; Channel 10, OTC and ICI corporate collections.

BOWEN, Stella (Esther Gwendolyn)

(b. 16/5/1893, Adelaide; d. 30/10/1947, London) Painter, writer.

STUDIES: Adelaide (with Margaret Preston), London and Westminster Schools of Art, UK (with Walter Sickert); Slade School, UK. She left Adelaide in 1914 and for the rest of her life lived mostly in England and France where many famous writers were numbered among her friends. Her remarkable career and nine-year association with the British writer Ford Madox Ford, with whom she had a daughter, Esther Julia Madox, is recorded in the papers of the writer Frank Dalby Davison. She made a successful visit to the USA in 1932, wrote critiques for the *News Chronicle*, taught, and painted a number of portraits, among them likenesses of Aldous Huxley, Edith Sitwell, Clifford Bax, Gertrude Stein and T. S. Eliot. Her autobiography, *Drawn from Life*, was published by Collins, London, in 1941. In 1944 she was appointed to record the activities of the RAAF and other Australian Forces in the UK. A memorial exhibition was held at the AGSA in 1953 and her work appeared in the Bicentennial exhibition *The Great Australian Art Exhibition*; *A Century of Australian Women Artists 1840s–1940s*, Deutscher Fine Art, Melbourne 1993 and *Important Australian Women Artists*, Melbourne Fine Art Gallery 1993.

REP: AGSA.

BIB: Frank Dalby Davison, 'Stella Bowen's Odyssey', *Age*, Melbourne, 17 Jan. 1967. Rachel Biven, *Some forgotten . . .*

some remembered, Sydenham Gallery, Adelaide, 1976. ADB 7. A&A 28/4/1991.

BOWES, Arthur

Early navigator and topographer, surgeon-artist. His real name was Arthur Bowes Smyth, but he called himself and became known as 'Bowes'. He was surgeon-artist on 'Lady Penrhyn' in the First Fleet, 1786–89, and thought to have made the first known sketch of an emu, but this was alleged later to be a copy of an emu by John Watts (q.v.).
BIB: K. A. Hindwood, article in *Emu*, July 1932. Arthur Bowes, manuscript journal, Mitchell Library.

BOWLES, William Leslie

(b. 16/2/1885, Sydney; d. 21/2/1954, Frankston, Vic.) Sculptor.
STUDIES: Brisbane Tech. School (with L. J. Harvey), 1902–08; South London School of Sculpture, RA Schools, 1910–14. Soon after his arrival in London as a travelling scholarship winner, he became an assistant to Sir Bertram Mackennal and, further encouraged by the sale of Mackennal's work *Dancer* to the AGNSW, he studied at the RA Schools in his spare time. When war broke out he enlisted in the Tank Corps and after demobilisation attended the RA Schools for a year's refresher training before returning to Australia. In 1926 he was elected to membership of the Royal Society of British Sculptors. Back in Australia he worked from 1925–31 as head sculptor for the AWM, Canberra, in succession to Web Gilbert. In 1931 he established a studio in Melbourne, where his works included memorials to King George V and Sir John Monash, as well as his best-known bronze, *Diana and the Hounds*, in the Fitzroy Gardens, Melbourne. In his later years he moved to the outer bayside suburb of Frankston, and became vocal in the press on many matters relating to sculpture and the lack of encouragement in Australia for this 'Cinderella of the arts', but he never allowed himself to become embittered.
AWARDS: D. R. McConnell Travelling Scholarship, Brisbane, 1910.
REP: NGA; AGNSW; AGSA; AWM.
BIB: Sturgeon, *DAS*. Scarlett, *AS. ADB* 7.

BOWMAN, Zenobia J.

(Active 1870s, Vic.) She exhibited Victorian landscape drawings at the NSW Academy of Arts in 1877 and possibly in 1876, simply as 'Miss Bowman'. J. S. Bowman, possibly her father, also exhibited in 1876, showing crayon drawings of Victorian landscapes and a portrait of Charles Dickens. Her work was seen in *Australian Art in the 1870s*, AGNSW, 1976.

BOWRING, Emily Stuart (née Cowrie)

(b. 1835, Brookstead, Tas.) Topographical artist. She lived with her husband at Panshanger, Tasmania, in 1855 and in Victoria for a few years; after this they are thought to have lived for some time in Ireland (where his sister was living in County Cork). She made fine pencil drawings in Tas., including a number of

views of pastoral properties, as well as a panoramic view of the Ben Lomond area.
REP: QVMAG; Allport Library, Hobart.
BIB: K. R. von Stieglitz, ed., *Early Van Diemen's Land*, Fullers Bookshop, Hobart, 1963. *Emma von Stieglitz: Her Port Phillip and Victorian Album*, preface Joseph Burke, intro. P. L. Brown, Fullers Bookshop, Hobart, 1964. Kerr, *DAA*.

BOWRING, Walter Armiger

(b. 1874, NZ; arr. Sydney 1925; d. 1931) Painter.
STUDIES: London (with Orpen and John). Known mainly for portraits, in Sydney he exhibited with the Royal Art Society of NSW from 1926.
BIB: *Fifty Years of Australian Art, 1879–1929*, RAS, Sydney, 1929.

BOX HILL CAMP
See CAMPS; HEIDELBERG SCHOOL

BOXALL, Arthur d'Auvergne

(b. 19/6/1895, Port Elliot, SA; d. 1944, Rose Park, SA) Painter, teacher.
STUDIES: Adelaide School of Mines; School of Arts and Crafts, Adelaide; Slade School, London, 1926–28. He won a scholarship at the Adelaide School of Mines, spent the first seven years of his working life in architecture and painted full-time before becoming an art teacher. After leaving the Slade School, London, he worked in Europe as recipient of the Robert Ross travelling scholarship, exhibited at the Paris Salon and RA and travelled extensively (Europe, Egypt, Fiji, New Zealand). A man of great versatility, he was equally proficient at painting portraits, landscapes, figure compositions and genre. He bequeathed a large part of his estate to the Art Gallery of South Australia.
AWARDS: Adelaide School of Mines, scholarship; Slade School, London, prizes in figure painting, anatomy, landscape and composition as well as the Robert Ross travelling scholarship.
APPTS: Head of the art school, ESTC, 1934–40; art master, St Peter's Coll., Adelaide.
REP: AGSA (10 works); AGNSW.
BIB: Catalogue collections, AGSA, 1960. Judith Thompson, *ADB* 7.

BOYD FAMILY

The Boyd family of artists originated in Australia mainly through the marriage of Arthur Merric Boyd with Emma Minnie a'Beckett in 1886. Their various descendants – sons Martin, Merric and Penleigh and their children including Arthur, David, Guy and Robin, and their children – have attained distinction in the fields of painting, writing, ceramics and architecture.

BOYD, Arthur Merric

(b. 19/3/1862, Opoho, NZ; arr. Aust. 1886; d. 30/7/1940, Murrumbeena, Vic.) Painter.
STUDIES: Unknown. Married to Emma Minnie a'Beckett, he exhibited at the RA in 1891 and was in London and Europe 1891–93. As a man of independent means he seems rarely, if ever, to have held exhibitions and is known to have been generous to his colleagues

Stella Bowen, Embankment Gardens, *c. 1943, oil on composition board, 63.5 × 76.2cm. Collection,* AGSA

Swanson's address in London, on at least one occasion, being given as 'c/o A. M. Boyd'. His sons, Martin, Merric and Penleigh, all attained distinction in the respective fields of literature, pottery and painting, and his own surviving paintings show him as an accomplished artist working in the impressionist manner of the Heidelberg School. He lived at Rosebud, Victoria from 1936, then at Murrumbeena.

REP: NGA; NGV; QAG; regional galleries Geelong, Mildura.

BIB: Catalogue NGV, 1948. ADB 7.

BOYD, *Arthur (Arthur Merric Bloomfield)*
(b. 24/7/1920, Murrumbeena, Vic.) Painter, potter, printmaker.

STUDIES: NGV School (intermittent attendance at evening classes for a short period), 1935–36. Principal studies were the family studies, through which he mastered many of the mysteries of oil painting, mainly via close association with his grandfather Arthur Merric, with whom he lived in his cottage at Rosebud, on the Mornington Peninsula, 1936–38. Prior to this,

during a painting excursion to Wilson's Promontory in the summer of 1934–35, he met Wilfred McCulloch (q.v.), who became a close friend and colleague. They frequently painted together, often at an artists' camp in the vicinity of Cape Schanck, near Rosebud, with Alan McCulloch and other friends. To other students the palette-knife technique with which Boyd (as well as Wilfred McCulloch) produced many of the landscapes and seascapes shown in his early exhibitions seemed particularly innovative. This period of Boyd's career ('some of the happiest years of my life', he wrote in a letter to Alan McCulloch years later) reached its climax with the *Herald* exhibition of *French and British Modern Art* of 1939 (*see* EXHIBITIONS), followed by the outbreak of World War II. The war had a devastating effect on Boyd's work. An unhappy period of army life ended with a brief interlude in a military hospital. But the period drew from him a remarkable series of psychological pictures expressive of his sufferings during the war years and of his particular interest in the writing of Dostoevsky.

Having met Josl Bergner in 1937, he now came in contact with the circle of John and Sunday Reed, whose patronage of mostly young artists included Nolan, Tucker, Perceval, the Russian émigré Vassilieff, and many others connected with the formation of the Contemporary Art Society (q.v.). From these

associations Boyd learned about expressionism, child art, primitivism and the value of studying old as well as modern masters. In 1945 he married Yvonne Lennie, a former student and prize-winner at the NGV School, and with her lived at Murrumbeena where he was making pots, tiles and other ceramics for a living. His studies of the old masters led to the discovery, with John Perceval, of reproductions of the work of Breughel in the public library. As a result, both artists painted a series of Breughel-inspired pictures of mining towns with crowd scenes, as well as religious pictures. In 1948 his uncle, Martin Boyd, novelist, commissioned him to paint a large mural in tempera covering the entire wall space in the dining room at The Grange, Harkaway, Victoria – an old a'Beckett house taken over by Martin Boyd on his return to Australia after an absence of 21 years. This remarkable work was followed by the Berwick and Wimmera landscapes that were to win him wide recognition. He visited Central Australia in 1951, designed and made the 9m high ceramic pylon for Melbourne's 1956 Olympic Swimming Pool, and in 1957 began his Chagall-inspired *Half-Caste Bride* series of paintings.

In 1959 he yielded to the pressing need to extend his horizons by moving with his family to London. It was a brave gamble that paid off. His first London exhibition (Zwemmer Galleries, July–Aug. 1960), comprising the *Bride* series on the theme of thwarted lovers, was a prelude to his representation in the Whitechapel and Tate Gallery exhibition (1961, 62).

Boyd has subsequently become one of Australia's most famous artists and international ambassadors, living and showing frequently in Europe, London and Australia. He returned to Australia in 1971 to take up an artist-in-residence position at the ANU. Two years later he and Yvonne purchased a house and property, Riverdale, at Shoalhaven on the south coast of NSW, followed a few years later by the nearby Bundanon, both of which were accepted as a gift for the nation in 1993 along with 2000 hectares. In 1975 he presented several thousand works to the NGA. He has also produced a number of series of lithographs and etchings as well as illustrating books such a limited editions and general books of poetry including that of A. D. Hope and Peter Porter. Many of his works of various periods are sited at Bundanon and the 'Shoalhaven' landscapes and riverscapes have become as famous as his earlier series. The Boyds spend time between their Suffolk house, a farmhouse in Tuscany, Italy and Australia. A feature film about him was made for London Weekend Television in 1986 and shown repeatedly in England and Australia. In 1993 the AGNSW mounted a major retrospective of his paintings, prints, drawings and ceramics touring Australian state galleries, 1994.

AWARDS: Dunlop prizes, Melbourne, 1950, 52; Kuring-gai, NSW prize, 1958; Henry Caselli Richards prize, Brisbane, 1963; Brittanica Australia award, 1971; artist-in-residence, ANU, 1971–72; AO (Officer of the Order of Australia) conferred 'for service to art', 1979; Companion of the Order of Australia, 1992.

REP: NGA; all Australian state and many regional, uni. and other public gallery collections.

BIB: All general texts on Australian art. Franz Philipp, *Arthur Boyd*, Thames & Hudson, London, 1967. Imre von Maltzahn, *Arthur Boyd Etchings and Lithographs*, Lund Humphries, London, 1971. Laurie Thomas intro., *Arthur Boyd Drawings 1934–70*, Secker & Warburg, London, 1973. Dobrez & Herbst, *The Art of the Boyds*, Bay Books, 1991. Ursula Hoff, *The Art of Arthur Boyd*, Deutsch, London, 1986. *Meanjin* 2/1951 (Alan McCulloch, *Drawings of Arthur Boyd*). A&A 22/1/1984, 24/2/1986, 24/4/1987; AL 4/1/1984.

BOYD, David

(b. 23/8/1924, Murrumbeena, Vic.) Painter, potter.
STUDIES: Family studies. Son of Merric and Doris Boyd, he began his professional career as a student of music before turning to pottery. His early exhibitions of pottery, some in conjunction with his wife, Hermia, gave vigorous impetus to local standards in this craft. Later he turned to painting, achieving great popularity with successive series of romanticised works based on historical themes (Tasmanian Aborigines, The Law, Church and State, Ben Boyd and the like). He was one of the contributors to the *Antipodean* exhibition (q.v.) and exhibited annually at CAS, Melbourne 1945–61 and in *Recent Australian Painting*, Whitechapel Gallery, London 1961. He held virtually annual exhibitions in various cities in Australia and overseas from 1950, including retrospective exhibitions in London 1969 and at Wagner Gallery, Sydney 1983; and exhibitions titled *Requiem for the Birth of a Nation*, Wagner 1987; *Beauty and the Beasts of the Land*, Wagner 1990.
AWARDS: Italian Scholarship, Melbourne, 1961.
REP: NGA; most state galleries; regional galleries Ballarat, Bendigo, Newcastle; Melbourne, Monash and Qld uni. collections.
BIB: Many books on Australian art including Bonython, MAP, 1970; Ross Luck, *Modern Australian Painting*, Sun Books, Melbourne 1969; Smith, AP. Dobrez & Herbst, *The Art of the Boyds*, Bay Books 1991.

BOYD, Emma Minnie (née a'Beckett)

(b. 1858, Melbourne; d. 13/9/1936, Melbourne) Painter.
STUDIES: NGV School, 1885–89. Married to Arthur Merric Boyd, she was the mother of Martin, Merric, Penleigh and Helen. Like her husband, she exhibited at the RA in 1891 but is not recorded as having held exhibitions of her own. Her watercolours have great charm and much of the lyricism reflected later in the work of her son Penleigh. She was represented in the Bicentennial exhibition *The Great Australian Art Exhibition*; and in *Completing the Picture, Women Artists and the Heidelberg Era*, Heide and touring 1992; *A Century of Australian Women Artists 1840s–1940s*, Deutscher Fine Art Gallery, Melbourne 1993 and *Important Australian Women Artists*, Melbourne Fine Art Gallery 1993.
REP: NGA; AGSA; regional galleries, McClelland, Bendigo.
BIB: *Emma Minnie Boyd Sketchbook*, NGA, 1982. Dobrez & Herbst, *The Art of the Boyds*, Bay Books 1991.

BOYD, *Guy (Guy Martin)*
(b. 12/6/1923, Murrumbeena; d. 26/4/1988) Sculptor.
STUDIES: No formal training. Family studies. Son of
Merric and Doris Boyd, he began his professional life
as a designer and manufacturer of commercial pottery
and was instrumental in rehabilitating the Boyd
family fortunes at a time of pressing need. In 1965 he
abandoned commercial pottery-making for a full-time
career as a sculptor and became successful with com-
missioned works done in a competent, pragmatic
and conventional manner. These included large relief
sculptures for Tullamarine and Sydney international
airports. He held Melbourne exhibitions at the
Australian Galleries from 1965. He was also active in
conservation and matters relating to the preservation
of historic buildings, and did much fine work in such
causes, particularly in the suburb of Brighton where
he lived.
REP: NGA; AGNSW; NGV; QAG.
BIB: Ann von Bertouch, *Guy Boyd Sculptures*, Lansdowne,
Melbourne, 1974. Dobrez & Herbst, *The Art of the Boyds*,
Bay Books 1991.

BOYD, *Hermia Sappho*
(b. 1931, Sydney) Ceramicist, sculptor.
STUDIES: ESTC, 1945–47. From 1964 to 1968 she
produced glass paintings and drawings, and held exhi-
bitions in London and throughout Australia, both solo
and with her husband David. She designed sets and
costumes for theatre productions, notably Peter
O'Shaughnessy's productions of *Pygmalion*, *The Four
Poster* and *Anatole*, in Dublin and Sydney in the 1950s
and 1960s. In 1970 she and David settled in France,
where they lived until returning to Australia in the
1980s, exhibiting in both countries almost annually.
She wrote a book, *Sappho of Lesbos*, in 1978.
REP: NGA; AGNSW; AGSA; AGWA; MAGNT; NGV; QAG;
TMAG; several overseas museums including Tokyo, UK.
BIB: Dobrez & Herbst, *The Art of the Boyds*, Bay Books 1991;
Scarlett, AS. Germaine, AGA.

BOYD, *Jamie*
(b. Nov. 1948, Vic.) Painter.
STUDIES: Central School of Art and Design, London;
music and composition, 1960s. Son of Arthur Boyd,
his decorative paintings show a similarity of style
with certain aspects of both his father's and uncle's
(David) work. A prolific and skilful painter, his work
has achieved popular success. He held 33 solo exhi-
bitions 1966–89 in Australian capital cities and in
London, Germany, Holland, Italy. His work appeared
in numerous group exhibitions, largely with com-
mercial galleries, in London and Australia 1966–91.
AWARDS: Painting award for study at Michael Karolyi
Foundation, southern France.
REP: QVMAG; Artbank; Unis. of SA and WA; Merz col-
lection, USA; Guild of Music and Dancing, London;
Boxer Collection and BHP corporate collections, Aust.
BIB: Bonython, *Contemporary Australian Art 1975–1980*,
Rigby 1980. *Jamie Boyd Paintings, 1965–1980*, Hillington

Press. Dobrez & Herbst, *The Art of the Boyds*, Bay Books
1991.

BOYD, *John*
(b. 5/6/1939, WA) Painter, printmaker.
STUDIES: Perth Tech. Coll., 1969–70; Associateship
in Art, fine art studies, WAIT 1975; printmaking, Perth
Tech. Coll., 1979–8. His figurative and abstract works
were seen in seven solo exhibitions 1976–92 in Perth
(Fine Arts Gallery, Alexander Galleries) and Fremantle
Arts Centre, 1986, and he participated in over 60
group exhibitions in private and regional galleries in
WA, NSW, Qld and NT 1969–92.
AWARDS: About 38 municipal and regional shire
awards for painting, drawing and prints WA 1970–92;
Sir Claude Hotchin Bequest, 1970; Tresilian Janet
Holmes à Court Prize for mixed media, 1984; Telecom
Acquisitive Art Exhibition, drawing, 1992.
APPTS: Host artist to WACAE students in 10-week stu-
dent practice, 1987.
REP: Uni. of WA; Murdoch Uni.; Kalamunda, Belmont
municipal collections; Busselton Art Society collec-
tion; National Crime Authority, Telecom Australia,
WA collections; David Jones, Sydney, collection.

BOYD, *Lynne*
(b. 20/4/1953, Melbourne) Painter.
STUDIES: BA, VCA, 1983; postgrad. studies, VCA,
1983–84. Of her exhibition at Powell St, Melbourne,
Robert Rooney wrote in the *Australian* (27 July 1991):
'Boyd makes paintings which are self-effacing in their
pictorial content and reserved handling of paint'.
Describing her literary allusions to Auden, Austen,
Margaret Drabble, Maupassant and others in hand-
written quotations, he concludes: 'At best, these notions
are barely visible as in the beautifully painted "Dusk
was falling", a work that proves her to be more than
a painter of atmospheric miniatures'. She held three
solo exhibitions 1986–91 in Melbourne at 70 Arden
St, 1986, 89; Powell St, 1991. Her work appeared in
about 60 group exhibitions 1984–91 including those
at private galleries in Melbourne (including 70 Arden
St, Powell St); award exhibitions including *Spring
Festival of Drawing*, MPAC 1985, 87, 89; *Gold Coast
Art Invitation Exhibition*, 1988; *Faber-Castell Drawing
Prize*, 1988, 89 and in *A New Generation*, NGA 1988;
New Art: Contemporary Australian Art Acquisitions, NGV
1990; *Art with Text*, Monash Uni., 1990.
AWARDS: Gold Coast Art Award Invitation Exhibition,
1984; BP Acquisitive Award, 1990.
APPTS: Part-time teaching, VCA, 1985–86; part-time
teaching, RMIT, 1989–91.
REP: NGA; AGWA; NGV; QVMAG; Parliament House;
Artbank; Melb., Deakin unis.; VCA; Lincoln Inst.;
municipal collections Waverley, St Kilda, Diamond
Valley; regional galleries Ballarat, Hamilton, Gold
Coast, Grafton, Latrobe Valley, Devonport; Shell, Myer
corporate collections.
BIB: Catalogue essays exhibitions as above. A&A 24/3/1987;
24/4/1987.

Penleigh Boyd, Portsea Pier, *1921, oil on canvas, 45 × 60cm. Private collection.*

BOYD, Merric (William Merric)

(b. 1888, St Kilda, Vic.; d. 1959, Murrumbeena, Vic.) Ceramicist.

STUDIES: Family training; NGV School (short period c1908); pottery, Australian Porcelain Works at Yarraville, Victoria with Fyansch, 'Australia's finest ceramicist', 1912–14. He established the Murrumbeena pottery (where his children Lucy, Arthur, Guy, David and Mary were brought up), the pots being decorated with soft and charming Corot-like designs by his wife Doris (née Gough, c. 1883–1960). In 1926 his studio and all its contents were destroyed by fire. Merric was also a prolific draughtsman, producing large quantities of 'naive' drawings of 'all creatures great and small', using mainly children's crayons. He became well-known and greatly loved in Melbourne art circles. After his death his pots gradually became highly prized collectors' items. The last ten or fifteen years of his working life were devoted entirely to drawing.

BIB: Christopher Tadgell, *Merric Boyd Drawing*, Secker & Warburg, London, 1975.

BOYD, Penleigh (Theodore Penleigh)

(b. 15/8/1890, Wiltshire, Eng.; d. 28/11/1923, Warragul, Vic.) Painter, etcher.

STUDIES: NGV School, 1907–09; travel studies in UK and Europe. Exhibited RA, London, 1911. He married a painter, Edith Susan Anderson (1880–1961). His early landscapes and seascapes had great brilliance, particularly in respect to effects of light. He served with the Mines Corps during World War I, was injured at Ypres and invalided home to Australia. During the immediate post-war years he worked to re-establish the place won in pre-war times as a leading Australian painter, renowned for his paintings of wattle and for the lyrical and poetic qualities that identified most of his early work. In this respect his drypoint etchings of the Australian bush are unique. But he never quite regained his early drive and enthusiasm. In 1923 he brought a special exhibition of British and European art to Australia in an attempt to introduce some comparative evaluations. But like Will Dyson he had become disillusioned by the war and its aftermath, and his death in a motor accident on the Sydney Road, near Warragul, in 1923, leaves open the question as to which way his work might have developed. His son Robin Gerard Penleigh Boyd (1919–71) became a distinguished architect and writer, and served on a number of important committees, including the Board of Trustees of the National Gallery of Victoria. Robin's books, *Victorian Modern*, 1947; The *Australian Ugliness*, 1960; *The Great Australian Dream*, 1972 (all published by Cheshire), exerted great influence on Australian architecture and its development.

AWARDS: Wynne prize, Sydney, 1914; 2nd Prize Federal Capital Site competition, Canberra, 1913.

REP: NGA; most Australian state and many regional galleries.

BIB: Exhibition catalogue, *European Art Exhibition for Australia*, Athenaeum, Melbourne, Aug. 1923. J. S. McDonald, intro., *Landscapes of Penleigh Boyd*, Alexander McCubbin, Melbourne, 1920. A&A 25/4/1988.

BOYD, Robert Max

(b. 1915, Gayndah, Qld.) Painter.
STUDIES: RAS, 1965–68; Graeme Inson studio, 1968–70. Grandson of Robert Alexander Boyd, elder brother of Arthur Merric Boyd I, he was in business until 1970 when he retired to live on the Gold Coast and work full-time at painting, specialising in paintings of historic homesteads, and became involved in the local regional gallery.
AWARDS: RAS annual prize, 1971.

BOYES, George Thomas William Blamey

(b. 1787, Stubbingbow, Hampshire; arr. Aust. 1824; d. 1853, Hobart) Colonial administrator, diarist, painter.
He made a sketching tour of Europe before sailing for Sydney in 1823, then transferring to Hobart in 1826 to become Colonial Auditor, later Colonial Secretary (1842–43). A watercolourist of some accomplishment, he is best remembered for his diaries, which give an interesting view of Hobart and its society. Over 100 of his drawings and his sketchbook are in the collection of the TMAG. The first volume of his diary (1820–1832) was published by OUP, Melbourne (ed. Peter Chapman) in 1985 and his work was represented in *Tasmanian Vision*, TMAG 1988.
REP: TMAG; NLA; Mitchell, Dixson, Allport Libraries.
BIB: ADD 1. Kerr, DAA.

BOYLE, Kathleen

(b. 6/3/1928, Melb.) Painter, sculptor, printmaker, teacher.
STUDIES: NGV School, 1952–57, Accademia di Belli Arti, Rome 1958–60; travel studies Europe, UK and Ireland; M. Fine Art, San Francisco Art Inst. 1975. The disciplines of abstract painting are felt in her figurative paintings and drawings which feature also spontaneity and economy of means. In the 1980s she used fabric such as clear plastic, hessian and linen twine for installations or collages. For her 1990 exhibition at Deakin University, critic and historian Bernard Hoffert wrote in the catalogue that she was 'Driven by commitment to the belief that there is a fundamental unity behind all the fragmentary components of sensory reality'. She held about 10 solo exhibitions 1961–90 including three at Hawthorn City Gallery 1978, 79, 81, and her work appeared in numerous group exhibitions 1957–90 at private and state galleries, including a number of works on paper and award exhibitions.
AWARDS: Five student prizes for painting and two for drawing at the NGV School; Italian Scholarship, 1958.
APPTS: Lecturer, CIT, 1961–87.
REP: MPAC; Monash and Deakin universities.
BIB: Germaine, DAWA. Germaine, AGA.

BOYNES, Robert

(b. 1942, Adelaide) Painter, printmaker, teacher.
STUDIES: SASA, 1959–64. From 1966 he held exhibitions in Adelaide, Melbourne, Sydney and Oxford (with the Arts Council of Great Britain, 1969) and by 1976, when a mural was commissioned for the Adelaide Arts Festival Centre, his work had become widely known for its successful blend of painting, drawing and photography. He has since made three films and a video documentary. He held about 35 solo exhibitions 1964–90 including a project exhibition, *Survey 7: Robert Boynes*, NGV 1979; and at Realities, Niagara (including a retrospective in 1989), Melbourne; Michael Milburn, Brisbane; Macquarie, Sydney and Canberra Contemporary Art Space 1990. His work was seen in numerous group exhibitions 1963–90 including *Australian Perspecta*, AGNSW 1983; *A Survey 1970–83: Recent Australian Painting*, AGSA 1983; *Field to Figuration*, NGV 1987, *Australian Prints: Pre-settlement to Present*, ANG 1989.
AWARDS: Ethel Barringer Memorial Prize for Etching, 1964; Barossa Festival prize, 1971; VACB grant for printmaking, 1973; Alice Springs prize, 1977; Mattarra Invitation purchase prize 1983.
APPTS: Teacher, lecturer, Wattle Park Teachers Coll., 1964–67; part-time, SASA, 1967; Maidstone Coll. of Art, Kent, 1967–68; Basingstoke Tech. Coll., Hants, 1969–70; lecturer, painting and printmaking, Wattle Park Teachers Coll., 1970–71; acting head (painting), SASA, 1972–77; lecturer in painting, Canberra School of Art, 1978– .
REP: NGA; most state galleries; Artbank; many regional galleries including Castlemaine, Mildura, Newcastle; Festival Theatre, Adelaide; many tertiary and uni. collections; several leading corporate collections including IBM, Westpac, NY.
BIB: Catalogue essays in exhibitions as above. Smith, AP. Bonython, MAP 80. Gary Catalano, *The Years of Hope: Australian Art and Criticism 1959–68*, OUP, 1981. McIntyre, ACD. A&A 21/2/1983; 23/3/1986; 26/3/1989. AL 6/6/1986–87.

BRACK, John (Cecil John)

(b. 10/5/1920, Melb.) Painter, teacher.
STUDIES: NGV School (part-time), 1938–40, (full-time with army rehabilitation scheme), 1946–49. After leaving school he worked as an insurance clerk, studying art at the evening classes of the NGV School. He served in the AIF as a lieutenant in the field artillery (1940–46), and resumed his art studies at the NGV School in 1946. This association with the NGV continued when he worked as an assistant in the Print Room (1949–51). Ronald Millar says that his first exhibited painting was *Barber's Shop*, shown at the Peter Bray Gallery in Feb. 1953, and purchased for the NGV collections. Known previously only for drawings rarely exhibited, Brack now had freedom to paint as a result of his appointment as painting master at Melbourne Grammar School. Later he gave occasional lectures at the Uni. of Melbourne (School of Fine Arts), and in 1958 wrote art reviews for the Sydney *Observer*.

Appointed Head of the Art School at the NGV in 1962, he resigned in 1968 to devote all his time to painting. From the beginning, Brack's aim as a painter and draughtsman was purity of style. In everything he drew or painted he tried for a perfect synthesis of line, colour, tone and carefully analysed subject. This was the basis of his development and it has remained consistent. His work often looks satirical but this is not the intention. As Gordon Thomson wrote in an introduction to an early Brack show, 'Brack has taken infinite pains to show that underneath the senseless conformity and tinsel of the suburban wedding, or the curious ritual of the ballroom dancing contest, can be found a human yearning for elegance, propriety and significance'. The same writer rightly referred to 'his fastidious sense of timing'. A later writer, Ronald Millar, singled out one of the show-window series for special attention.

If there is one painting that might be said to represent a painterly manifesto of Brack's intentions it is *Reflections in a Window*, a climax and a summary filled with half-seen and strongly-felt apprehensions, memories and prophecies. There is here a mysterious, even occult, three-way contact and interchange of identities.

Brack's colours are always carefully selected and limited, his tones correspondingly studied and the linear structure given the status of pictorial architecture. Surfaces are kept flat and long perspective lines used to create the illusory space in which his well-drawn figures elegantly act out their roles. An example is *John Perceval and his Angels*, one of Brack's most remarkable works, painted in 1962 and now in the collections of the NGV. In the 1970s and 1980s his work developed along its carefully considered lines, each exhibition consisting of a series of similar subjects (moving from figures to domestic utensils; pencils as armies) and demonstrating complex works of high finesse and artistic rigour. From 1965 he held exhibitions about every 18 months to two years, largely with Rudy Komon, Sydney; Joseph Brown and Tolarno, Melbourne. Four major retrospectives of his work have been held: at RMIT gallery and NGA (both in 1977); Monash University Gallery, 1981; NGV 1987; and his work has been represented in major survey shows such as the Bicentennial exhibition *The Great Australian Art Exhibition* 1988–89. The critic Gary Catalano reviewing his 1987 Tolarno exhibition in the *Age* (4/6/1987) said: 'Brack obviously possesses a mind of some incisiveness and distinction. This makes him an unusual figure in the history of art, as does the consistently high level of achievement he has maintained. His admirers are correct in claiming that he has not produced one uninteresting painting during 40 years of activity.'
AWARDS: Gallaher prize for portraits, 1965; Travelodge Prize, 1971.
REP: NGA; all state gallery collections and many regional gallery collections.
BIB: All general books on Australian art. Ronald Millar, *John Brack*, Lansdowne, Melb., 1971. Ronald Millar, *Civilized*

Magic, Sorrett Publishing, Melb., 1974. Margaret Plant, *John Brack: Nudes*, Lyrebird Press/Tate Adams, Melbourne 1981. A&A 2/4/1965 (Ursula Hoff, *John Brack*).

BRACKENREG, John
(b. 1905, Perth; d. 1986, Sydney) Painter, gallery director.
STUDIES: Julian Ashton School, 1922–30. Founding director, Artarmon Galleries, Sydney and publisher of Australian Artist Editions for Legend Press. Founder and secretary, Perth Society of Artists; secretary, Society of Artists, Sydney, 1938–40; foundation secretary, Australian Academy of Art, with Sydney Ure Smith, president; Fellow, Royal Society Arts, London; foundation member, Power Inst. of Fine Arts, Sydney.
AWARDS: MBE conferred 1962, OBE 1970 (for services to art); VACB grant.
REP: AGWA.
BIB: *ARTFORCE*, no. 10, Dec. 1976–Jan. 1977. A&A 24/4/1987.
(*See also* GALLERIES – COMMERCIAL)

BRADBEER, Godwin
(b. 1950, Dunedin, NZ; arr. Melb. 1955) Painter, photographer, teacher.
STUDIES: Higher Dip. Sec. Teaching, Melbourne State Coll., 1973; B. Ed., Melbourne CAE; enrolled MA course RMIT 1992. He taught at Victorian high schools from 1972, exhibited photographic prints and in 1976 held an exhibition of drawings in company with Warren Breninger (q.v.) entitled *Fragments of the Human Race* (Gryphon Gallery, Melbourne State Coll., June 1976). Featured was the obsessive interest of both artists in Italian Renaissance drawing and religious themes. Bradbeer's subsequent work as seen in about 10 solo exhibitions, including at Stuart Gerstman 1970s, 1980s and David Ellis/Lyall Burton 1990s, is consistent with these interests. Group exhibitions in which his work appeared 1980–93 included photography at AGSA 1980; *Michell Endownment*, NGV 1983; *Selected Contemporary Drawings*, Heide 1986.
AWARDS: Essendon Civic Centre prize 1976; Castlemaine State Drawing Prize 1990.
APPTS: Lecturer, painting and drawing, MCAE, VCA, RMIT, Uni. of Melbourne, Phillip Institute 1987– .
REP: NGA; AGSA; NGV; Parliament House; several govt departments and uni. collections; corporate collections including Philip Morris photographic collection.
BIB: McIntyre, ACD. McKenzie, DIA. Germaine, AGA.

BRADFORD, Dorothy Kathleen
(b. 7/11/1920, Hobart) Painter, commercial artist, teacher.
STUDIES: Hobart Tech. Coll.; ESTC; RA School, London; Ecole des Beaux-Arts, Paris; Italy. While travelling in Europe she worked for CIT, Touring Company of Italy. She exhibited with the Tasmanian group of painters 1940–57.
AWARDS: Tasmanian Travelling Scholarship, 1949.
APPTS: Art teacher, Hobart Tech. Coll., 1946–50.
REP: TMAG.
BIB: Backhouse, TA. Germaine, AGA.

BRADLEY, *Luther*

(b. 20/9/1853, New Haven, Connecticut, USA; arr. Aust. 1882–83; d. 9/1/1917, Illinois, USA) Cartoonist. A self-taught cartoonist, he worked for various Australian papers including Sydney *Bulletin*, and succeeded Tom Carrington (q.v.) as principal cartoonist for Melbourne *Punch* (1888–93), for which he featured the celebrated union symbol, *King Workingman* (created by Tom Carrington). His father's illness caused his return to America where he worked for the Chicago *Daily News*.

BIB: Marguerite Mahood, *The Loaded Line*, Melbourne, 1973. ADB 7.

BRADLEY, *William*

(b. 1757; arr. Sydney, 1788; d. 1833, Le Havre) Draughtsman, painter. First-lieutenant and draughtsman on HMS *Sirius*, with the First Fleet; author of *Bradley's Journal 1786–92*, a record of the British occupation of Australia. He painted the first views of Botany Bay and Port Jackson, *Sirius and Convoy going into Botany Bay 21 Jan. 1788*, and *Sydney Cove 1 Apr. 1788*. Bradley's Head, Sydney, was named after him. After returning to England in 1792 he served with distinction in the navy, rising to the rank of Admiral in 1812. He had an unfortunate end in being indicted for fraud, pardoned but exiled from England. He lived in exile from 1814 until his death.

REP: NLA; Mitchell Library.

BIB: Smith, *PTT*. Smith *EVSP*. Rienits, *Early Artists of Australia*, 1963. Kerr, *DAA*.

BRADY, *Margaret Mary (Sister Margaret Mary)*

(b. 1922, Tamworth, NSW) Painter, teacher.
STUDIES: No formal training. She taught art at high schools in NSW. Sent to *Australian Women's Weekly Portrait Prize* exhibitions, 1955, 1956, her pictures were among those selected for interstate showing.
AWARDS: Hunters Hill prize, 1957; Portia Geach Memorial prize for portraiture, 1966, 71, 75.
BIB: Germaine, *AGA*.

BRAGG, *Gwen (Gwendoline, née Todd)*

(b. ?1871, Adelaide; d. 1929, Eng.) Painter.
STUDIES: Adelaide School of Design, c. 1888. In 1889 she married Professor W. H. Bragg (later Sir William Bragg, OM, President of the Royal Society and Nobel Prize winner). They both painted landscapes in watercolours. Exhibiting at the SA Society of Arts in 1896, their paintings were praised in the press and pronounced virtually indistinguishable. Subjects ranged from quiet, open landscapes to more concentrated views with attention paid to foreground flora. The family moved to Yorkshire in 1909.
BIB: Rachel Biven, *Some forgotten . . . some remembered*, Sydenham Gallery, Adelaide, 1976.

BRAMLEY-MOORE, *Moyston*

(b. 25/2/1952, Wollongong, NSW) Painter, teacher.
STUDIES: BA, Uni. of Sydney, 1974; Dip. Ed., Sydney Teachers Coll., 1974; M. Fine Arts, Pratt Inst., NY 1977. His semi-abstract paintings have been seen in group exhibitions 1972–92 including *Artists Books: Book Works*, Ewing-Paton Galleries, University of Melbourne, 1978; Experimental Art Foundation, Adelaide, 1978; Modern Art Foundation, Brisbane, 1978; *A First Look*, and *A New Generation: Philip Morris Arts Grants Purchases*, NGA 1986, 88; many regional gallery survey shows and Watters Gallery exhibitions. He held about 20 solo exhibitions 1977–91 at Michael Milburn Brisbane, Watters Sydney and in UK galleries and museums and New England Art Museum 1989.
AWARDS: Several scholarships and fellowships Aust. and NY 1970–77; residency studio, Cité Internationale des Arts, Paris, Uni. of Sydney 1977–78; several regional awards including Latrobe Valley Schools Foundation award 1978; Herbert Johnson travel grant, Uni. of Sydney 1981–82.
APPTS: Lecturer, several tertiary art colleges Vic. 1980– ; head and acting dean, Visual Arts, Uni. of New England-Northern Rivers, 1991– .
REP: NGA; several state galleries; a number of municipal regional, tertiary collections; private collections including Baker & McKenzie; Allen, Allen & Hemsley.
BIB: Catalogue essays in exhibitions as above. *New Art Two*. Germaine, *AGA*. *A&A* 23/4/1986.

BRANDT, *Horace*

(Active c. 1911, Melb.) Painter. Contemporary of Melbourne painters Arnold Shore and William Frater, Brandt signed his freely-painted semi-abstract pictures with his mother's name, de Chimay. (H. A. Brandt, *Old Master Impressions in Galleries Abroad*, VAS. *Journal*, 1 July 1911.)
BIB: Arnold Shore, *Forty Years' Seek and Find*, privately published, Melbourne 1957.

BRASH, *Barbara*

(b. 3/11/1925, Vic.) Painter, printmaker.
STUDIES: Dip. Art, NGV School; printmaking, RMIT; George Bell School. Strong in design, colour and drawing, her mainly figurative prints have been included in numerous print survey exhibitions including those mounted by the PCA and international print exhibitions such as *Pratt Benefit International Exhibition*, New York 1969; *International Tokyo Biennial*; Miniature Print Exhibitions Seoul, Korea 1982, 88; *Contemporary Australian Printmakers*, West Coast, USA 1979, Sweden 1980, Singapore 1980 organised by Aust. Dept of Foreign Affairs and in *Artists' Artists*, NGV 1975; *100 × 100* print portfolio, PCA 1988; *Pre-settlement to the Present*, NGA 1989; *Classical Modernism: The George Bell Circle*, NGV 1992. She received a number of print commissions including member prints for PCA. She held a number of exhibitions at Eastgate Galleries, Melbourne in the 1980s and 90s.
AWARDS: Sara Seri Scholarship 1949; purchase awards at Warrnambool (1975), Gold Coast (1978), Stanthorpe (1980) Mornington (1981); Victor Harbor Drawing Prize 1984; selected award, 5th International Miniature Print Exhibition, Seoul, Korea 1988.

Barbara Brash, Native Dancer, *c. 1954, linocut, ed. 30.
21 × 14cm. Private collection.*

APPTS: Art teacher, School of Architecture, RMIT.
REP: NGA; AGNSW; AGSA; AGWA; NGV; QAG; Artbank;
numerous regional galleries including McClelland,
Mornington, Newcastle, Stanthorpe, Swan Hill,
Warrnambool; tertiary collections including Adelaide,
Flinders, Monash, Melbourne unis.; numerous corpor-
ate collections including AMP, ICI, BHP.
BIB: Catalogue essays exhibitions as above. Franz Kempf,
Printmakers of Australia, Adelaide. PCA, *Directory*. Germaine,
DAWA. Jan Minchin & Mary Eagle, *The George Bell School*,
Deutscher Fine Art/Resolution Press, 1981.

BRASSIL, Joan
(b. 8/8/1919, Sydney) Sculptor, painter, teacher.
STUDIES: Sydney Teachers College 1937–39; ESTC 1940;
Newcastle Tech. 1941–44; Power Inst., Uni. of Sydney
1969–71; Alexander Mackie CAE 1980–81; Wollongong
Uni. 1988–90. Her sculptures often deal with envir-
onment, nature and technology, and has developed
from largely organic works in the 1970s to more tech-
nologically-based ones in the 1980s. She held 14 solo
exhibitions 1975–91 in Sydney (Sculpture Centre
1976, 77, 78; Roslyn Oxley9 1982, 83, 84, 85, 88)
and Wollongong City Gallery, 1985; Araluen Art
Gallery, Alice Springs, 1987; retrospectives at ACCA,
Melbourne 1990 and Campbelltown City Art Gallery

1991. Her work appeared in about 23 group exhibi-
tions 1974–89 including at Roslyn Oxley9; Bonython,
Sydney and mainly public galleries including *Australian
Sculpture Triennials*, Melbourne 1981, 84; *A.U.S.T.R.A.L.I.A*,
Florence, Italy 1983. *Perspecta*, AGNSW, 1985; and at
Orange, Broken Hill, Riddoch (Mt Gambier) regional
galleries; *Origins, Originality and Beyond*, Sydney Biennale,
AGNSW, 1986.
AWARDS: Mosman Art Award 1973; Emeritus Award,
VACB 1988.
APPTS: Teaching, secondary schools 1940–45, 1955–73;
visiting lecturer, art colleges, Australia, Fiji, Thailand
1973– .
REP: Mosman City Council; Orange City Art Gallery;
Araluen Art Centre; Campbelltown City Art Gallery.
BIB: Catalogue essays in exhibitions as above. Scarlett, AS.
AM Nov 1990, 1991. A&T Sept, 1990. AL 7/2–3/1987,
10/4/1990–91.

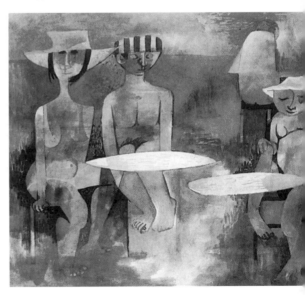

Dorothy Braund, Waiting for the Change, *1979, Gouache,
40 × 50cm. Christie's, August 1992.*

BRAUND, Dorothy Mary
(b. 1926, Melb.) Painter, teacher.
STUDIES: NGV School; George Bell School; travel stud-
ies Europe, 1951; Greece and Italy, 1958; Pakistan,
Persia, Turkey, Greece, 1961–62. Her flat, carefully
designed, small-scale paintings (mainly of people)
emphasise the silhouette and are usually either play-
ful or gently satirical. Equally important is her objec-
tive to 'attain the ultimate in simplicity', through the
play of light on black, white, brown, grey and other
tertiary colours. Her 1980s and 90s exhibitions have
largely been with Eastgate Galleries, Melbourne. Her
work was represented in *Classical Modernism: The George
Bell Circle* NGV 1992 and *Important Australian Women
Artists*, Melbourne Fine Art Gallery 1993.
AWARDS: Prizes in competitive exhibitions at Albury,
1962, Colac, 1964, Bendigo, 1966, Muswellbrook,
1972.

REP: NGA; AGSA; NGV; regional galleries Bendigo, Langwarrin (McClelland Gallery), Mornington.
BIB: Catalogue essays exhibitions as above. Jan Minchin & Mary Eagle, *The George Bell School*, Deutscher Fine Art/ Resolution Press, Melbourne, 1981.

BREES, Harold

(b. c. 1838; d. 1904, Sydney) Painter, lithographer, architect, surveyor. Known mainly for bush scenes. He exhibited at exhibitions in the 1870s and 80s including with the NSW Academy of Art from 1871 and the Art Society of NSW from 1881, and the 1870 Sydney Intercolonial Exhibition, concentrating on bush genre, incorporating Aborigines, pioneers, etc. into the landscape. He was also a successful architect/surveyor who produced standard designs for houses in Sydney in the 1860s. His work appeared in an exhibition of colonial art at Deutscher Galleries, Melbourne 1985 but few of his other works are known.
REP: NLA; Mitchell library.
BIB: Kerr, *DAA*.

BREES, Samuel Charles

(b. 1810, Eng.; arr. Aust. c. 1851; d. at sea 1865) Engineer, surveyor, author, topographical artist. He exhibited landscapes at the RA and at the Society of British Artists, 1832–37, before emigrating. He is best known for his work in New Zealand where he was Principal Surveyor in Wellington, 1842–45, and was responsible for a large number of important topographical watercolours. He returned to England and appears to have arrived in Australia around 1851. He travelled extensively around Victoria and in 1856 published *How to farm and settle in Australia – Rural Calendar and a Traveller's Map of the Squatting Stations, Townships and Diggings of Victoria. Beautifully illustrated on steel, with general observations, authentic account of the Gold Fields, etc. By an Old Colonist.* He lived in Keilor for a number of years and died during a return voyage to England.
REP: NLA; La Trobe Library; Alexander Turnbull Library, Wellington.
BIB: Gil Docking, *200 Years of New Zealand Painting*, Reed, Wellington, 1971. McCulloch, *AAGR*. J. A. Ferguson, *Bibliography of Australia* vol. 6, NLA, Canberra, 1977. Kerr, *DAA*.

BREMER, Percy (Percy Hieronimo)

(b. 1899, Hahndorf, SA; d. 1976, Hahndorf) Painter.
STUDIES: Self-taught save for a few lessons and encouragement from Hans Heysen (q.v.). Naive painter, mainly in watercolours. A coach painter by profession. A number of his works were auctioned at Leonard Joel's, Melbourne, in Nov. 1977. Subjects included landscape, genre, birds and animals (both Australian and overseas), all executed in a detailed manner indicative of his background as a trained craftsman.

BREN, Jeffrey

(b. 1944, Ballarat, Vic.) Painter.
STUDIES: NGV School (with John Brack), 1966–71; travel studies Europe, 1971–73. The originality of

Bren's vision manifested itself early. He was one of the few Brack students who learned much from his teacher without being victimised by his style. Nor did he ever succumb to the allure of the fashions that claimed so many artists of his generation. Bren held 16 solo exhibitions 1967–93 largely in Melbourne (Tolarno; South Yarra; Warehouse Galleries; Acland St; Owen Dixon Chamber; Australian; Flinders Lane) and Sydney (Rudy Komon). His work is rarely seen in group exhibitions largely because of his individual style which is not easily categorised.
AWARDS: Inez Hutchison Award, 1969; Georges Art Prize, 1970; Keith and Elisabeth Murdoch Travelling Fellowship (NGV School), 1971; Crouch Prize, Ballarat, 1974; Melbourne Exhibition Building Centenary prize, 1980; Beaumaris Art Prize 1983.
REP: NGA; NGV; regional galleries Ballarat, Benalla, Hamilton, Mornington.
BIB: Ronald Millar, *Civilized Magic*, Sorrett Publishing Melbourne 1974. *AI* vol. 14, no. 8, Oct. 1970.

Warren Breninger, The Sick Child No.3, *1987, mixed media, 78 × 48cm. Collection, NGV.*

BRENINGER, Warren Charles

(b. 14/3/1948) Painter, photographer, teacher.
STUDIES: Higher Dip., Sec. Teaching, Melb. State Coll., 1971; Dip. Art & Design, CIT, 1975. He held his first exhibition of drawings in company with Godwin Bradbeer (q.v.) in an exhibition entitled *Fragments of the Human Race* (Gryphon Gallery, Melb. State Coll., June 1976). Featured in this show was the obsessive interest of both artists in Italian Renaissance drawing and religious themes. Breninger's subsequent exhibitions, including *Faces*, Reconnaissance, 1987 and *The Expulsion of Eve: Series 111, 1980–88*, Contemporary Arts Centre, Adelaide, showed one photographic image reworked, while his 1990 exhibition at Charles Nodrum, Melbourne was still concerned with one image but broadened to include other shadowy atmospheric figues. He held about 10 solo exhibitions 1980–92 and his work was seen in numerous significant group exhibitions 1971–92 including *Shades of Light*,

NGA 1988; *Images of Religion in Australian Painting*, NGV 1988.

Oswald Brierly, Firing the Salute, *Isle of Wight, oil on canvas, 45.2 × 76.4cm. Private collection.*

AWARDS: Tina Wentcher prize, 1978; Alice Prize 1989; Blake Prize 1989; Castlemaine Festival Drawing Prize 1988; several photographic prizes including Muswellbrook 1988; project grants VACB 1982, 86, 88.

APPTS: Secondary teaching, Vic. 1972–77; part-time private teaching, 1978– .

REP: NGA; AGSA; AGNSW; QAG; NGV; Artbank; several regional collections.

BIB: R. Crumlin, *Images of Religion in Australian Art 1942–88*, Bay Books, Sydney 1988. Andres Sayers *Two Hundred Years of Drawing in Australia*, Bay Books, 1988. Germaine, AGA. A&A 18/1/1980; 18/2/1980; 26/4/1989. AL 6/1/1986.

BREWER, Henry

(b. 1743, London; d. 1796, Sydney) Provost-marshal, Sydney; topographical artist. He sailed with the First Fleet to Botany Bay and was known to have been a sketcher. Bernard Smith in *European Vision in the South Pacific* suggests that he 'possesses the strongest claims to be the Port Jackson Painter' (q.v.) which however is difficult to prove as almost nothing is known of his work.

REP: Mitchell Library.

BIB: Rienits, *Early Artists of Australia*, 1963. Smith, EVSP. ADB 1. T. McCormick, *First Views of Australia*, Sydney 1988. Kerr, DAA.

BRIERLY, (Sir) Oswald Walters

(b. 19/5/1817, Chester, Eng.; arr. Aust. 1841; d. 14/12/1894, London) Painter, topographical artist. Brierly came to Australia with Captain Boyd, commander and owner of the yacht *Wanderer*, to work as manager of a fishery at Boydtown, near Twofold Bay on the south coast of NSW. Boyd had built and staffed Boydtown, which comprised an inn, church, residence and a row of fishermen's houses designed after the style of Scottish crofters' cottages. (On a lonely part of the coast and hemmed in on three sides by a forest of tall eucalyptus, the village of Boydtown soon became a forgotten relic, but the residence remained occupied, and in the early 1950s Boydtown was sold and turned into a tourist resort.) Brierly stayed at Boydtown as manager for one year and painted his dramatic *South Sea Whaling off Twofold Bay*, which was later acquired for the AGNSW. William Moore writes that Brierly also painted what was probably the first mural done in Australia, *HMS Rattlesnake in a Squall off the Island of Timor*, for the dining-room of a private home at Mosman, Sydney. A copy of this work by C. E. S. Tindale is now in the Mitchell Library. Brierly also sailed on *Rattlesnake*, at the invitation of the master, Captain Owen Stanley, on a survey of the Great Barrier Reef, the Louisiade Archipelago and part of New Guinea. In 1867 Brierly returned to England as a member of the Duke of Edinburgh's staff, and, after a short stay, made further journeys to Australia. He was appointed marine painter to Queen Victoria in 1874 and became Curator of Painted Hall, Greenwich Hospital, in 1881. He was knighted in 1885. The largest collection of his work (200 paintings and drawings) is held in the Mitchell Library but he is well represented in many public collections.

His work has been seen in a number of historical survey exhibitions including the Bicentennial exhibition *The Great Australian Art Exhibition* and *The Artist and the Patron: Aspects of Colonial Art in NSW*, AGNSW 1988.
REP: NGA; most state galleries; a number of regional galleries; NLA; Mitchell Library.
BIB: Moore, *SAA. ADB* 3. Kerr, *DAA*.

BRISCOE, Kate
(b. 13/6/1944, UK; arr. Aust. 1968–69) Painter, printmaker, teacher.
STUDIES: Portsmouth Coll. of Art, 1960–64; Leicester Coll. of Art, 1964–65; M. Fine Arts, Uni. of NSW 1991. Luminous and direct, her abstract paintings have a poetic quality, reflected also in her colour prints. She held about 14 solo exhibitions 1968–91 in Sydney (Hogarth, Robin Gibson, Bloomfield, Bonyrhon/Meadmore) and Melbourne (Bartoni, Gabrielle Pizzi). Her work was seen in group exhibitions 1966–91 including with Sydney Printmakers 1970s, 80s and in *Blake Prize* 1987, 88, 91.
AWARDS: Cathay Pacific Prize, 1975; Cornelius Art Prize, 1976; several regional prizes including Wagga Wagga purchase prize, 1976; Maitland prize, 1979, 89; Gold Coast 1989.
APPTS: Teaching in Eng. 1965–68; at NAS, City Art Inst. 1969–90; workshop co-ordinator Campbelltown Regional Gallery 1989–90; teaching part-time, colleges in Sydney 1991– .
REP: Parliament House; Artbank; several regional collections NSW, Qld.
BIB: Bonython, *MAP* 75. Germaine, *AGA. New Art Four*. PCA, *Directory*, 1976.

BRITTEN, Jack (Warn-ngayirriny)
(b. 1921, Tickelara, South of Frog Hollow, WA). Of the Joolama tribe and Kija language group he lives at Frog Hollow (Woorreranginy) via Turkey Creek. Inspired by seeing Rover Thomas and Paddy Tjamintji painting he began painting, remembering his childhood experience when he watched his elders painting on the rock around Anne Springs. 'I paint about the Dreamtime stories and my country. It makes me feel good to paint about these things. When I am painting it is like how I paint the body markings on the young people for ceremonies. I think that by doing my painting I can teach them about the Dreamtime (Ngarranggarni). It is a way to make sure the young people don't lose their culture,' he stated. Using red, white and yellow ochres and boiled bark from the gum tree to create a black coloured paint he sometimes carves lines into the paint for greater textural effect. Group exhibitions in which his work appeared were held at the Aboriginal Artists Gallery, Sydney, 1988; Deutscher Gallery, Melbourne, 1989; Dreamtime Gallery, Perth, 1990; Hogarth Galleries, Sydney, 1991 and Lindsay Street Gallery, Darwin, 1991.
REP: NGA; NGV; AGWA.

BRITTON, Frederick Christian
(b. 1889, London; arr. Adelaide 1910; d. 1931) Painter, etcher, teacher.
STUDIES: Slade School, London, 1909–10. After war service with the AIF in France, Britton worked with the modelling group at Earl's Court, London.
APPTS: Teacher, SASA, 1911–14; first principal of School of Fine Arts, Adelaide; teacher at ESTC; member, Australian Painter-Etchers' Society.
REP: Australian state galleries; print room, British Museum (etching).
BIB: Reprdn, *AA*, Mar. 1925.

BROAD, Alfred Scott
(b. 1854, Adelaide; d. 1929) Illustrator, businessman. He contributed black-and-white drawings to early South Australian papers and eventually moved to NSW to become a staff member of the *Illustrated Sydney News*.
BIB: Mahood, *The Loaded Line*, 1973.

BROAD, Rodney
(b. 1947, Dannevirke, NZ; arr. Aust. 1969) Sculptor.
STUDIES: Dip. Fine Art, Uni. of Canterbury, NZ, 1968; Christchurch Teachers College, NZ 1969. Strongly textured and often representing fundamental human experiences such as the quest for power and death, Broad's bronzes have a strong organic quality. He held eight solo exhibitions 1969–90 including at Macquarie Galleries, Sydney and jointly with painter Peter Stephenson at Fine Arts Gallery, Uni. of Tasmania, 1984. His work has been seen in numerous group exhibitions at private galleries (including Macquarie, Sydney) and in group sculpture exhibitions at public galleries including *Mildura Sculpture Triennial*, 1975, /8; *Australian Sculpture Triennial*, NGV 1984; *Graven Images*, AGWA 1985; *Perspecta*, AGNSW 1986; *Contemporary Australian Painters and Sculptors*, QAG and Museum of Modern Art, Saitama, Japan, 1987. His commissions include for the Biomedical Library, Uni. of Tasmania, 1973; Commonwealth Law Courts, Hobart, 1984; Aust. Military Police Corps, Holsworthy, NSW 1990–91.
AWARDS: Guthrie Travel Award to study art in Australia, 1969; project grant, VACB, 1985; Gold Coast City Art Prize, 1989; residency, Besozzo Studios, Italy, VACB 1989.
APPTS: Sculpture teacher, Tasmanian School of Art, Uni. of Tasmania, 1971–88.
REP: NGA; QAG; QVMAG; TMAG; Artbank; regional galleries Burnie, Gold Coast, McClelland, Mildura, Newcastle; Uni. of Tasmania.
BIB: Catalogue essays exhibitions as above. Backhouse, *TA. New Art Two*. Scarlett, *AS*. Graeme Sturgeon, *Australian Contemporary Sculpture*, Irving Galleries and Craftsman House, 1987.

BROCK, John
(b. 15/7/1945) Painter, teacher.
STUDIES: TSTC, CIT 1969; Dip. Art & Design, Prahran CAE 1974; travel studies Europe, 1974–76. Often using pumice stone mixed with oils for texture, his landscape paintings, drawings and prints were seen in many solo exhibitions 1965–89 largely in Melbourne

and country Victoria including at Hawthorn City Gallery 1972; Flinders Lane 1989 and Araluen Arts Centre, Alice Springs 1989 as well as group exhibitions in most capital cities. As well, he has taught in secondary schools, adult education and private classes, owned and run galleries and antique shops and in 1991 became a partner and director in the printmaking press Port Jackson Press.

AWARDS: Several municipal arts festival prizes in Melbourne, 1967, 69.

APPTS: Teaching, Victorian high schools, 1966–68; Ballarat Grammar School, 1970–71; Haileybury Coll., 1973; Council of Adult Education, Melbourne, 1973–74; Wesley Coll., Melbourne, 1976: workshops Beaumaris art group, NGV 1980s– ; director, Studio Gallery, Carlton, Vic., 1976–87; director, Port Jackson Press 1991– .

REP: Parliament House; Artbank; regional galleries Hamilton, Latrobe Valley, Warrnambool; several municipal collections, Melb.

BROCKMAN, William Locke

(b. 1802; arr. WA 1830; d. 18/11/1872, WA) Amateur painter, landholder. One of the colony's largest landholders, a pen, ink and watercolour attributed to him, *Middle Swan Church* c. 1840s, has a naive character. He was Justice of the Peace and Magistrate for the Swan District, 1833 and first chairman of the Swan Roads Board, 1871. His work was represented in *The Colonial Eye*, AGWA, 1979.

REP: AGWA.

BIB: Kerr, *DAA*.

BRODYK, Andre

(b. SA) Painter.

STUDIES: Dip. Teaching, SACAE, 1979; B.Ed. (Art), Prahran Coll., 1980; painting and drawing, SASA, 1982–83; BA (Fine Art), 1984. He held six solo exhibitions 1984–91 at Tynte, 1987; Anima, 1989; Chesser, 1990 (Adelaide); Legge, 1991 (Sydney) and at Contemporary Art Centre, Adelaide 1984 and Adelaide Festival Centre, 1985. His work was seen in about 28 group exhibitions 1982–90 at private galleries in Adelaide, Sydney (including Legge Gallery) and public galleries and awards including *South Australian School of Art Painting* 1983, and *A Versions, Fakes of Picasso's Weeping Woman*, 1986, EAA, Adelaide; *Alice Art Prize*, 1987, 88; *Painting and Other Works*, Jam Factory, Adelaide 1988; *New Directions*, Adelaide Festival of Arts at Vincent Gallery, Adelaide 1990.

AWARDS: Whyalla Art Prize, 1987; project grant, Arts Development Division, SA Dept for the Arts, 1986, 88, 90.

REP: NGA (Philip Morris Grant); AGSA; MOCA, Brisbane; Arts Council of SA; Artbank; Uni. of SA; Flinders Uni.; Alice Springs Art Foundation.

BIB: *AL* 6/5/1986.

BRODZKY, Horace Ascher

(b. 30/1/1885, Kew, Vic.; d. 11/2/1969, London) Painter, graphic artist, writer.

STUDIES: NGV School; City and Guilds School, London. Second son of Maurice Brodzky, he became friendly with Pascin in New York, and in London with Gaudier-Brzeska whom he joined in supporting the modern art movements – notably the vorticist movement, whose supporters included also Epstein, Ezra Pound and Wyndham Lewis. A foundation member of the London Group, Brodzky became best known as a draughtsman and writer, in particular for his open line drawings of nudes. His low-toned paintings of grouped figures relate him also to social-realist painting. Author of *Gaudier-Brzeska*, Faber & Faber, London, 1933; *Drawings by Gaudier-Brzeska*, Faber & Faber, London, 1946; *Jules Pascin*, Nicholson & Watson, London, 1946.

REP: NGV; British Museum; Victoria and Albert Museum; Broadford Gallery; Aberdeen Art Gallery.

BIB: *Portfolio of Lino-cuts by Horace Brodzky*, Egmont Arens, New York, 1920. James Laver text, *Forty Drawings by Horace Brodzky*, Heinemann, London, 1935.

BRODZKY, Maurice

(b. 25/11/1850, East Prussia; arr. Aust. 1872; d. 1919, New York) Journalist, editor. He founded the Melbourne weekly *Table Talk*, in which he published an art column, *Art and Artists*, written by E. A. Vidler, between 1889 and 1902. Brodzky fought with the French armies in the Franco-Prussian war, spoke six languages fluently, and was a student of the humanities. He arrived in Australia from France soon after the Communard disorders of 1871; the ship on which he travelled, *Sussex*, was wrecked outside Sydney Heads and he lost everything, including a bag of gold coins. As founder of *Table Talk*, 1885, and in other ways within the limits of a bohemian way of life, he gave strong support to the visual arts until the magazine was sold in 1902.

BIB: Brian Elliott, *Marcus Clarke*, Clarendon Press, London, 1958. *ADB* 7.

BROINOWSKI, Gracius Joseph

(b. 7/3/1837, Walichnowy, near Wielun, Poland; arr. Vic. c. 1857; d. 11/4/1913, Mosman, NSW) Ornithological artist. He travelled Australia disposing of his work by means of art unions in country towns, his itinerary extending from southern Victoria to Cooktown, North Queensland. A man of versatile accomplishments, and a former student of languages at Munich Uni., Broinowski conducted art classes in Melbourne, and settled in Sydney in 1879 where he taught at Riverview College, St Aloysius College and Newington College. He also painted birds and mammals for NSW schools. His most important surviving work is *The Birds of Australia*, Charles Stuart & Son, Australia, 300 colour plates with text issued in 36 monthly instalments at 10s each, 1889–91. The aim of the book was to replace Gould's *Birds of Australia*.

BIB: *ADB* 3. Kerr, *DAA*.

BROMLEY, Viola

(b. 1915, Sydney) Painter.

STUDIES: Orban School, Sydney, 1955; ESTC, intermittent studies. Member of the first executive committee of the Regional Galleries Association of NSW, she was instrumental in developing the municipal art gallery at Muswellbrook, NSW, and bringing it to regional gallery status.
AWARDS: Seven prizes in Muswellbrook competitions, 1958–74.
REP: Newcastle Region Art Gallery.

BROOK, (Prof.) Donald

(b. 1927, Leeds, Yorkshire; arr. Aust. c. 1962) Teacher, philosopher, critic, sculptor.
STUDIES: BA (Fine Arts), King Edward VII School of Art, Uni. of Durham, UK 1953; postgraduate travel studies Greece and Crete (on scholarship), 1953–54; PhD, ANU, 1965. A university travelling scholarship took him to Greece. A year later he settled in Paris, and finally established a studio in London, where he stayed, apart from two years in Nigeria, until 1961. A successful exhibition of sculpture at the Woodstock Gallery, 1959, gained him a studio at the Digswell Art Trust, where he worked for two years. He migrated to Australia in 1962 and spent his first three years in the department of philosophy at the ANU's Institute of Advanced Studies, Canberra. Then followed a brief period of art teaching with the NSW Department of Technical Education, after which he returned temporarily to the practice of sculpture, notably in an exhibition in Canberra entitled *Serious Games in Relief* (1966), followed by similar exhibitions entitled *Postures and Predicaments*, at Gallery A in Sydney (1966), and Melbourne (1967). His studies of classic Greek sculpture, the contemporary British school and the primitive sculpture of Nigeria were all reflected in these exhibitions. A bronze reclining nude by him was cast by the lost-wax method at the newly set-up Transfield Foundry in Sydney. In 1968 he was appointed senior lecturer at the Power Inst. of Fine Arts, Uni. of Sydney, wrote art criticism for the *Sydney Morning Herald* (1967–73) and, in 1973, became Professor of Fine Arts at Flinders Uni., South Australia (on his retirement becoming emeritus professor). In 1974 he was instrumental in establishing the Experimental Art Foundation (q.v.) in SA.

He has travelled widely in SE Asia, Europe and UK. Between 1990 and 1992 he lived in Cyprus and returned to Australia permanently in 1992, becoming writer-in-residence for some months at PICA, WA with a grant from the Robert Holmes à Court Foundation. He has written several books including *Art in Architecture: A National Symposium*, with Christine Finnimore, Adelaide Festival Centre Trust 1977; several published by the EAF including *The Social Role of Art: Six Papers on Related Themes*, 1985 and for PICA *Art, Representation, Education*, 1992. He has contributed chapters to books on art and catalogue essays for a number of exhibition catalogues. The influence of his lectures and writings has been extensive, particularly in art education and at university level.
APPTS: Lecturer, sculpture, Nigeria 1954–56; Colchester College of Art (visiting) 1958–61; research, Inst. of Advanced Studies, ANU 1962–65; lecturer, Canberra Tech. Coll. 1965–66; full member, International Association of Art Critics 1969– ; correspondent, *Studio International* (1970–73) *Leonardo* 1972– ; art critic, *Canberra Times*, 1964–67, *Sydney Morning Herald* and *Nation Review*, 1967–73; senior lecturer, Power Inst., Uni. of Sydney 1967–73; professor, Visual Arts, Flinders Uni., SA 1974–89 (emeritus professor 1989–).

BROOKE HANSEN, Theo (Theodore)

(b. 1870, Melb.; d. 1945, Melb.) Painter.
STUDIES: NGV School, 1888–92; Colarossi's, Paris, 1896. Known mainly for landscapes, portraits and literary genre, mainly in oils, he began exhibiting at the VAS in 1893. By 1895 he was showing in Paris and the following year exhibited two figure paintings at the RA, London. He returned to Melbourne and continued to exhibit at the VAS until 1906 but does not seem to have been especially active thereafter. In his landscape paintings his palette retained the dark hues associated with the colonial school. This is less apparent in his portraits, whose colours and structure owe a certain debt to Whistler. His work was seen in *Spring Exhibition 1979*, Joseph Brown Gallery, Melbourne.

BROOKESMITH

(Active c. 1900–05, Melbourne) Painter. Sometimes given as Brooke-Smith he was a landscape painter in oils and watercolour, he exhibited a South Gippsland landscape at the VAS in 1902 from a South Yarra address where he was still living the following year. By 1907 he was exhibiting in New Zealand where he continued to show till 1918, his paintings receiving both favourable and, on one occasion, very caustic criticism.
BIB: Henry P. Newrick, *NZ Art Auction Records 1969–72*, Newrick, Wellington, 1973.

BROOMFIELD, Fred J.

(Active c. 1900–16, Sydney) Art writer. Broomfield conducted a regular feature called *The Modern Tendency in Art* for the Sydney magazine *The Salon*. The feature included numerous sympathetic and critical references to the contemporary European movements, notably post-impressionism and futurism, and did much to draw the attention of Sydney artists to the possibilities of the modern movements.

BROTHERHOOD, Harry

(Active 1890s, Sydney) Painter. Watercolourist, of landscape and bush subjects.
NFI

BROUGHTON, Owen

(b. 1922, Townsville) Sculptor.
STUDIES: ESTC, with Lyndon Dadswell, 1946–49; travel studies UK and Europe, 1950–52 (during this period he worked briefly as an assistant to Henry Moore and

Barbara Hepworth). Returning to Australia in 1952, he assisted Gerald Lewers and Lyndon Dadswell before joining the staff of the NAS Sydney (1954–62). He made a study tour of India in 1958, returning to live in SA and lecture at the SASA, Adelaide, from 1962. His large sculptures are cut usually from polished or painted steel and relate back to his training in England with Hepworth. They seem particularly well adapted to the aesthetic climate of South Australia. A fine example is *Sun Dial*, made 1973 for the upper plaza of the Adelaide Festival Centre.

AWARDS: VACB grant, 1973.

REP: AGSA; NGV; Mildura Arts Centre.

BIB: Catalogue *Mildura Sculpture Triennials*, 1961–78 – except 1970. *A&A* 12/1/1974 (Franz Kempf, *Sculpture in South Australia*). Scarlett, *AS*.

BROWN, Alfred John

(b. 1893)

REP: AGNSW (two drawings).

BIB: *Sydney Morning Herald*, 22 Dec. 1933.

NFI

BROWN, Bill (William)

(b. 1945, Cowra, NSW.) Painter, printmaker.

STUDIES: Part-time, NAS, 1961–64; Dip. Painting, NAS, 1967. His mainly figurative paintings and prints appeared in 15 solo exhibitions 1968–89, largely at Macquarie Sydney, also in a survey show at Wollongong City Art Gallery 1978, and Rex Irwin 1978. Group exhibitions in which his work appeared 1968–88 include *Australian Colourists '77*, WAIT 1977; *Drawn Decades*, travelling NSW regional galleries 1983; *Surface for Reflexion*, AGNSW and regional gallery tour 1987; *Wynne Prize*, AGNSW 1988.

AWARDS: NAS student prize; Park Regis painting prize; prizes at Berrima and Woollahra, 1968; Georges Invitation Art Prize (purchase award), 1973, 78; Gold Coast art prize 1982; standard grant, VACB 1983.

APPTS: Teaching NAS, 1969–72; assistant lecturer in design, SCA; lecturer, ESTC 1980–83.

REP: NGA; most state galleries and several regional, municipal collections.

BIB: Laurie Thomas, *200 Years of Australian Painting*, 1971. Bonython, *MAP* 70, 75, 80.

BROWN, F. Stringer

(Active c. 1850, Vic.) He worked with Thomas Ham (q.v.) and others on the *Illustrated Australian Magazine* and later went into partnership in an engraving business with David Tulloch (q.v.).

BIB: McCulloch, *AAGR*.

BROWN, Geoffrey

(b. 24/10/1926, Adelaide) Painter, printmaker.

STUDIES: SASA, 1946–48; Central School of Art, London, 1958–60. Monochromatic colours and themes of loneliness suggest surrealistic influences in his earlier works. Their mood extends to the graphics, whose tonal contrasts and configurations evoke a touch of the twilight world of Goya. In the 1980s and early 1990s

he concentrated on introducing the human figure to the landscape. He held about 25 solo exhibitions 1953–91 in Sydney, Adelaide and Melbourne galleries and with the CAS Adelaide 1967, 74, 80, 84. John Amery in the *Advertiser* (24 April, 1991) described him as a 'tireless worker of the Australian landscape', whose show 'explores earthiness [of works] which flicker between representation and abstraction'. His work appeared in numerous group exhibitions 1965–90 including many international print exhibitions and in Australia including *Graven Images of the Promised Land*, AGSA 1981; *Wynne Prize*, AGNSW 1989; and in Ibiza, Spain.

AWARDS: Maude Vizard-Wholohan print prize, 1966; Bathurst art prize purchase 1979.

APPTS: Secondary art teacher, Adelaide 1962; lecturer, SASA 1963–82; head, printmaking dept, SASA 1982–88; president, CAS 1971–76, 82–86, 91.

REP: NGA; AGNSW; AGWA; QAG; QVMAG; Parliament House; PCA; several government and education departments SA.

BIB: Smith, *AP*. PCA, *Directory* 1976. Germaine, *AGA*. Campbell, *AWP*. *A&A* 12/1/1974. *AL* 2/5/1982; Dec.–Feb. 1984–85.

BROWN, J. G.

Landscape painter in watercolour. Subjects include views of Brisbane, Sydney and Canberra with dates ranging from 1884 to c. 1920. A watercolour by this artist entitled the *First Survey Camp at Canberra* was exhibited at the Joshua McClelland Print Room, Melbourne, in May 1970.

NFI.

BROWN, Jan

(b. 29/4/1922, Sydney) Sculptor.

STUDIES: NAS; NDD Chelsea Polytechnic, London, 1949. Returning to Australia in 1956, she began teaching at the Canberra Art School the following year and from 1960–76 completed seven commissioned works for locations in Canberra, as well as one for Kingsgrove Convent, Sydney (*St Ursula*) and the *Captain Cook Memorial* in cement and bronze for Bowning, NSW. Many of her sculptures concern the theme of birds and animals. Other commissions include for the new Parliament House, ANU, Canberra Institute and Artbank. She held 11 solo exhibitions 1964–92 at Macquarie Galleries in Canberra and Sydney and retrospectives at the Drill Hall Gallery, NGA and ANU 1991, Dubbo and Orange regional galleries 1992. Her work appeared in group exhibitions 1966–91 including at private galleries in Canberra, Sydney and *Mildura Sculpture Triennial*, 1982, 85, 88. She is a member of various professional bodies including Arts Subcommittee, ACT Cultural Council 1992– .

AWARDS: AM, 1992; Emeritus Award, VACB 1992.

APPTS: Part-time lecturer, various tertiary institutions including Canberra School of Art and Canberra Institute of the Arts, ANU 1957–89.

REP: NGA; Parliament House; Artbank; ANU.

BIB: Catalogue essays exhibitions as above; Scarlett, *AS*. McKenzie, *DIA*.

BROWN, *Joseph*

(b. 30/3/1918, Lodz, Poland; arr. Aust. 1933) Art dealer, adviser, sculptor, painter, gallery director.
STUDIES: Brunswick Tech. Coll., Melbourne. He studied painting, then turned to sculpture (later exhibiting with the Victorian Sculptors Society, 1963–64), and at the same time engaged in business. His business success enabled him to realise a long cherished ambition to build a collection and start an art gallery. It materialised in 1967 as the Joseph Brown Gallery, 5 Collins Street, Melbourne. Historical research of Australian art was the speciality on which the policy was based and it soon gave the gallery strong individuality. The carefully documented, comprehensively illustrated catalogues in themselves have become valuable sources of reference. In 1976 the building at 5 Collins Street was marked for demolition and the gallery was moved to Caroline House, Caroline Street, South Yarra. By then Joseph Brown had become consultant to many important collectors. Over the years he has made numerous gifts to public galleries and in many other ways contributed valuably to art developments in Australia. A book on his collection, written by Daniel Thomas, had three editions 1973–93 (*Outlines of Australian Art*, Macmillan, Melbourne, 1973, 2nd edn 1980, 3rd edn 1989).
AWARDS: OBE 1973; Doctor of Laws Monash Uni. 1981 and Uni. of Melbourne 1986; Doctor of the Uni., La Trobe Uni. 1990; AO for services to art and the community 1990.
REP: MAGNT; nine regional galleries including Ballarat, Cairns, Carrick Hill, Geelong, Mornington, Newcastle.

BROWN, *Lyndell*

(b. 19/4/1961, Melbourne) Photographer, painter.
STUDIES: BA Fine Art (photography special study), VCA, 1988; travel studies USA, Europe, Canada, Paris 1988, 90; enrolled MA course VCA, 1991. Of one of her two joint exhibitions with Charles Green (Melbourne, Verity St 1991; Sydney, Annandale 1992), Elwyn Lynn in the *Australian* (21 March 1992) likens the shifts in the works from light to sombre dark to the Rubens school: 'juxtaposition of the modern world as represented by smoke plumes, skyscrapers and other images of today are overlaid with ornately garbed figures reminiscent of the baroque era'. Her work appeared in about nine group exhibitions 1988–91 in Melbourne including *The State of Things*, Vic. Ministry for the Arts, 1989; *Greenpeace*, Linden Gallery; BP *Acquisitive Art Award*, 1991; *Recently Seen: Recent Acquisitions for the NGV from the Margaret Stewart Endowment*, McClelland Gallery.
AWARDS: NGV Trustees Acquisitive Award 1988.
REP: NGV; Artbank; Uni. of Western Sydney; Heidelberg Repatriation Hospital.

BROWN, *Mike (Michael Challis)*

(b. 1938, Sydney) Painter.
STUDIES: NAS 1956–58. In 1959 he worked in Papua New Guinea as a member of a Commonwealth Film

Unit. His art first became known to a wider public when it appeared with that of two others – Colin Lanceley and Ross Crothall – in an exhibition at the MOMAD, Melbourne, entitled *Annandale Imitation Realists*, in 1962. It took the form of decorated junk from scrapheaps painted in the manner of American Pop, suggesting that Brown, in particular, might have made an ideal set-designer for Beckett's *Waiting for Godot*. More than either of his Annandale realist colleagues, Brown remained true to the inventive spirit of this show. The logical step forward was into Pop-inspired collage, which he applied to his picture *Mary Lou II*, a contribution to the touring exhibition, *Australian Painting Today*, 1963. The permissiveness of this work was a little ahead of its time and Brown was asked to remove it from the preliminary exhibition at the AGNSW, Sydney. Similarly, his *Painting a Go Go* exhibition at Gallery A, Sydney in 1965 earned him a charge of exhibiting 'grossly indecent' paintings and he was sentenced to three years' jail with hard labour (later changed to a small fine and a good behaviour bond). (Some 12 years later, his *Hard fast and deep* exhibition at Charles Nodrum Melbourne continued to portray frank sexuality and created controversy – this time earning feminist criticism.) His 1980s and 90s work continued with strong decorative elements complementing its controversial character. He was represented in a number of survey exhibitions including the Bicentennial exhibition *The Great Australian Art Exhibition* 1988–89.
AWARDS: Young Contemporaries Award, CAS, Sydney, 1966.
REP. Australian state and regional galleries.
BIB: Smith, AP. Chanin, CAP. A&A 13/4/1976 (Gary Catalano, *The 'Wreckings' of Mike Brown*); 30/1/1992 (Eroticism issue). AL 9/3/1989.

BROWN, *Vincent*

(b. 15/10/1901, Brisbane) Painter.
STUDIES: Soden Studios, Brisbane; Slade School (with Schwabe), Grosvenor School (with McNab) and Central School of Arts and Crafts (with Hutton), all in London, 1936–39; Ruskin School, Oxford, and Oxford Tech. Coll., 1939–40. Prior to leaving for London he gained a local reputation as a painter of romantic watercolour landscapes. During life in England his work expanded to absorb much of what was best in the British art of the 1930s. During the war he was variously occupied: as an art tutor for uni. exams, as a décor artist for the 3rd Division, AIF, and as an extramural lecturer in Fine Arts at the Uni. of Qld. He was also attached to the US Army, 1942–45 and the Dutch Army, 1945–48. Exhibitions in Brisbane, Canberra, Sydney and Melbourne preceded his departure for England in 1948 and from 1949 to 1964 he was head of the art dept of Gawr Grammar School, South Wales. Back in Brisbane he exhibited at the Verlie Just Town Gallery (1977) and at the Bloomfield Galleries in Sydney (1980); the latter included a selection of work from the 1940s – mainly firmly handled, high-keyed landscapes and still-life that show strong

contemporary European influences. The QAG presented a survey exhibition of his work in December 1990–April 1991, combined with a commercial exhibition at River house Galleries, both of which demonstrated the quality of his modernist paintings.

REP: NGA; AGNSW; NGV; QAG; regional galleries Armidale, Ballarat; Qld Uni.; British Museum, Victoria and Albert Museum, London.

BIB: Lin Bloomfield, ed., *Vincent Brown. Life and Work*, Odana, Sydney, 1980.

BROWNE, Andrew

(b. 10/2/1960, Melbourne) Painter, photographer, sculptor.

STUDIES: B.Ed. (art and craft), Melb. CAE, 1982; travel studies Europe 1986. Browne's photographs and large, somewhat sombre abstract paintings shown in Melbourne in the early 1990s were both neo-romantic and atmospheric. A co-director of the artist-run space Gotham City Gallery in 1981/82, he was also commissioned by the Howard Florey Institute at Melbourne University to paint a large work (completed 1991) for the foyer. He held six solo exhibitions 1984–93 in Melbourne (including at Reconnaissance, 1987, 88; 13 Verity St, 1990, 91; Gryphon Gallery, 1984). His work appeared in about 11 group exhibitions 1979–90 largely at public and community art venues including *Print Survey* and *Graduate Sculpture*, Gryphon Gallery, Melb. 1981; *St Kilda Arts Festival*, 1987; *Heidelberg and Heritage*, 1989; *Greenpeace Fundraising*, Linden Gallery, St Kilda, Melb, 1990; *Selections from the Margaret Stewart Endowment at the National Gallery*, McClelland Gallery, Vic. 1992.

REP: NGV; Artbank; Melb. CAE; Melb. Uni. (Graduate School of Business Studies); Western Mining, Australian Equity and National Bank corporate collections.

BIB: *New Art Three.* Germaine, AGA.

BROWNE, Richard

(b. 1776, UK; arr. Sydney 1810; d. 1824) Sketcher, artist. Transported to NSW for an unknown offence, he was sent to Newcastle penal settlement where he remained until 1817. Much of his work is indistinctly signed and appears as T.R., I.R. or J.R.; early works are signed Brown and later works add an 'e' – Browne. His first works in Australia were two views of Newcastle engraved by W. Preston (q.v.). He also made 27 watercolour drawings to illustrate *The Journal of Lieut. Thomas Skottowe* (unpublished manuscript, Mitchell Library, Sydney). Though somewhat primitive, suggesting a lack of formal training, these works are boldly designed and have considerable artistic merit. He served his sentence by 1817 and moved to Sydney where he remained the rest of his life. His work is most notable for his 'silhouette' caricature-like representations of Aborigines degraded by white civilisation and are early examples of the drift away from the 18th-century view of the Aborigine as a noble savage. His work was represented in *The Artist and the Patron*, AGNSW 1988.

REP: Mitchell Library.

Richard Browne, Natives Fishing in a Bark Canoe, *1819, watercolour, 32.3 × 24.9cm. Collection Mitchell Library, State Library of NSW.*

BIB: Moore, SAA. Smith, ESVP. Rienits, *Early Artists of Australia*, 1963. Jocelyn Hackforth Jones, *The Convict Artists*, Melbourne 1977. Geoffrey Dutton, *White on Black*, Macmillan, Melbourne 1974. Andrew Sayers, *Two Hundred Years of Drawing in Australia*, Bay Books, 1989. Kerr, DAA.

BROWNE, Thomas Henry Johnson

(b. 7/4/1818, London; arr. WA 1863; d. 1882) Artist, architect, civil engineer. He was a successful architect and civil engineer in Britain before being convicted of forgery and transported for 10 years. He worked as an architect/engineer in Fremantle, WA and remained in WA after gaining his freedom in 1872. Most of his few remaining works were done in his period of servitude and are representations of contemporary buildings done in pen, ink and watercolour which now have historical interest. He was represented in *The Colonial Eye*, AGWA 1979.

REP: Mitchell Library; WA Museum, Perth.

BIB: Kerr, DAA.

BROWNING, George

(b. 1918, Blackburn, Vic.) Painter, cyclorama artist.

STUDIES: NGV School, 1937–41; RMIT (part-time), 1938–39. He served as a war artist in New Guinea and Borneo, 1943–46, and after the war painted dioramas for the Museum of Victoria. Later his painting developed a regional character.

AWARDS: Ramsay prize (student award, NGV School).

REP: NGV; AWM; Museum of Victoria.

BROWN-RAP, Julie

(b. 9/11/1950, Lismore, NSW) Installation artist.

STUDIES: BA, Uni. of Qld, 1971; part-time painting and drawing, NAS, ESTC, 1974; Power Workshops, Fine Arts Dept, Uni. of Sydney, 1975; Photo-media Dept, City Art Institute, Sydney 1976. Working in

a variety of media, including photography, painting and drawing, her work is often installation. Curator/writer Tony Bond describes her work as emphasising 'the difficulty for women who wish to deal with matters of importance concerning gender, when the available history of signs and contexts has been created for and by men'. In answer she frequently mimics the style of old masters' representation of women. 'The sense of frustration which the works exude is relieved by her ironic wit and atmospheric quality of the installation', says Bond in *Realism in the Avant Garde* (*Contemporary Australian Painting*, ed. Eileen Chanin, Craftsman House, Sydney 1990). She worked with Mike Parr on films, videos, and performances and was a partner in an art photographic business. She held 10 solo exhibitions 1982–92 including at Roslyn Oxley9 and Mori, Sydney; Tolarno, Melbourne and eight in public galleries 1982–92 including George Paton, Melbourne; Artspace, Sydney; Australian Centre for Photography, Sydney; Monash Uni. Gallery, Melbourne and *Resistance*, an installation at QAG, Canberra Contemporary Art Space, Wollongong City Art Gallery, 1991; as well as in Grenoble, France; Ghent, Belgium; and Rouen, France.

Julie Brown-Rrap, Resistance, 1991, each 55cm square, photographic emulsion on milk glass. Doors of Galerie van Krimpen, Amsterdam.

Her work appeared in numerous group exhibitions largely at public galleries 1982–92 including *On Site*, Tasmanian School of Art Gallery, 1984; *Australian Perspecta '85*, AGNSW, 1985; *Australian Bicentennial Perspecta*, AGNSW 1987; *ICI Contemporary Art Collection*, touring exhibition, 1989; *Biennale of Australia*, AGNSW 1988, 92; *Australian Photography of the 1980s*, NGA 1988; *Field to Figuration: Australian Art 1960–1986*, NGV 1988; and overseas including *The Australian Show*,

Frankfurter Kunstverein, Frankfurt, 1988; *Edge to Edge: Australian Contemporary Art to Japan*, Harara Museum, Tokyo, 1988; *Elsewhere*, Institute of Contemporary Art, London, 1988; *French Australian Artists Exchange: 9 Australian Artists*, Paris, 1989; *The Australian Show*, Stuttgart, Germany, 1989; *Contemporary Australian Photography*, touring Canada 1990.
AWARDS: Lady Fairfax Open Photography Award, AGNSW, 1983; residency, Besozzo Studio, Italy, VACB, 1982–83; materials grant, VACB, 1984; residency, Cité Internationale des Arts, Paris, Power Institute, Uni. of Sydney, 1986; project grant, VACB, 1987; residency, L'Ecole des Beaux Arts, Grenoble, France, 1988; fellowship grant, VACB, 1989.
APPTS: Conducted courses in art and photography, Australian Centre for Photography, Sydney 1981–83.
REP: NGA; AGNSW; AGSA; QAG; MOCA, Brisbane; Wollongong City Gallery; tertiary collections including Sydney CAE, Griffith Uni.; ICI Contemporary Art Collection.
BIB: Chanin, CAP. A&T no. 29 June 1988. AL 4/2–3/1984.

BRUCE, Alice Joyce
Painter.
STUDIES: Sydney, with Dattilo Rubbo; London and Paris, 1936–38; China, 1946–49. On her return from China she taught art at Wahroonga, NSW.
REP: AGNSW.
NFI

BRUCE, Charles
(b. 1807, Eng.; arr. Tas. 1829; d. 1851) Engraver.
Bruce was a convict who provided illustrations for *Ross's Almanack*.
REP: NLA; Mitchell, Crowther Libraries.
BIB: Clifford Craig, *The Engravers of Van Diemen's Land*, Foot & Playstead, Launceston 1961, and *More Old Tasmanian Prints* 1984. Kerr, DAA.

BRUFORD, Frederick Horatio
(b. 28/1/1846, Hobart; d. 10/12/1920, Armadale, Vic.) Civil servant, amateur painter. Member VAA c. 1873–87 and VAS, of which he was president 1910–11. His paintings, many of historical interest, are owned mainly by his descendants. An oil by him, *Wreck of the Sierra Nevada off the Back Beach, Sorrento, May 1900*, was shown at the Joshua McClelland Print Room, Melbourne, in May 1970.
APPTS: Victorian customs official, c. 1864–94; Deputy Commissioner of Taxation, c. 1895–1911.
REP: Warrnambool Art Gallery.
BIB: VAS *Journal*, vol. 2, no. 2, *B. F. H. Bruford: A Retrospect*, 1911.
(*Letter from Bruford's grandson, F. B. Kitchen, CBE, of Merricks, Vic., 1980*)

BRUSH CLUB
See ROYAL ART SOCIETY OF NEW SOUTH WALES

BRUSHMEN OF THE BUSH
Amateur and professional group of painters formed at Broken Hill, NSW, 1973. Common interests are

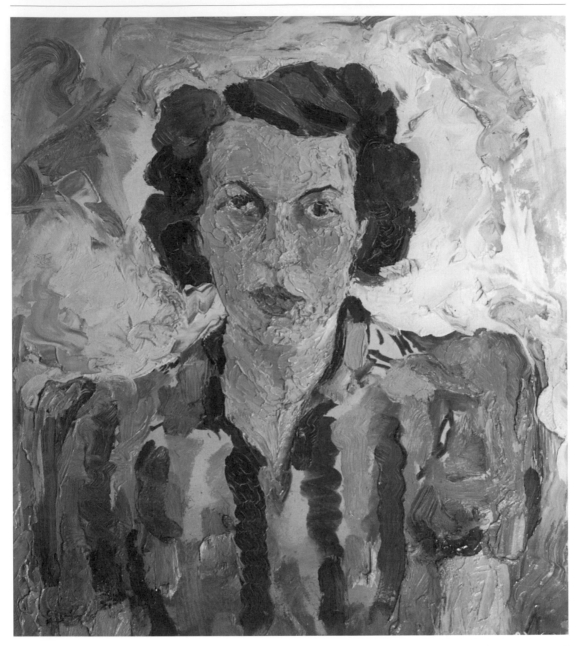

Lina Bryans, Head of a Woman (Alix Sobel), *c.1943–44, oil on masonite, 48.5 × 43cm. Private collection.*

depictive paintings of the area and incidents from its history. Widely advertised, their work has attained much popular success.

MEMBERS: J. Absalom, Pro Hart, E. Minchin, J. Pickup, H. Schultz, F. T. Offord.

BIB: Bianca McCullough, *Australian Naive Painters*, Hill of Content, Melbourne, 1977.

BRYANS, *Lina*

(b. 26/8/1909, Hamburg, Germany; arr. Aust. in childhood) Painter.

STUDIES: Melbourne, with Mary Cockburn Mercer and William Frater c. 1939. A generous supporter of art and artists, she formed close early friendships with many leading Melbourne painters including William Frater, Margaret Plante, Ambrose Hallen and Ian Fairweather. Her own paintings are freely conceived and boldly painted, with flat shapes and strong, expressionistic colours. She also has a fine sense of style and character, particularly in portraiture. Except for occasional contributions to group shows such as the Melbourne Society of Women Painters and Sculptors, she ceased exhibiting, but not painting, in the late 1960s. A large retrospective exhibition, organised for the NGV, was held at Banyule in October 1982 and her work has remained highly sought-after, appearing in survey exhibitions such as the Bicentennial

exhibition *The Great Australian Art Exhibition* 1988–89; *Classical Modernism: The George Bell Circle*, NGV 1992; *A Century of Australian Women Artists 1840s–1940s*, Deutscher Fine Art, Melbourne, 1993.

AWARDS: Crouch Prize, Ballarat, 1966; emeritus award Aust. Council 1989.

REP: NGA; AGNSW; AGSA; AGWA; NGV; QAG; TMAG; many regional galleries and corporate collections including ICI.

BIB: Catalogue essays exhibitions as above. Arnold Shore, *Studio*, London, May 1953. *Contemporary Australian Painting*, AA, Nov. 1938, June and Aug. 1941. Janine Burke, *Australian Women Artists*, Greenhouse, Melbourne, 1982. Jan Minchin & Mary Eagle, *George Bell*, Deutscher Fine Art/ Resolution Press, Melbourne 1989. A&A 21/2/1983.

BRYANT, *Charles David Jones*

(b. 11/5/1883, Enmore, NSW; d. 22/1/1937, Manly, NSW) Painter.

STUDIES: Sydney, with Lister Lister; London, with John Hassall, 1908– ; St Ives, Cornwall, with Julius Olsson. During his years in Europe he became a member of the RA, the Chelsea Arts Club, the Society of British Artists and Royal Inst. of Oil Painters, and the Salon des Artists Français. Attracted by the coastline and fishing fleets, he worked in Brittany, as well as in Paris and London, his impressionistic oils of the Seine and Thames being similar in style and quality to the work of his close friend, Will Ashton. He served as an official marine artist in World War I (England, France, the Western Front, the North Sea and the Channel) and in 1923 visited New Guinea as an official artist for the Commonwealth Government. Between 1924 and 1930 he ran a colour store in George Street, Sydney. As a successful marine artist, he was commissioned to paint a large oil of the American Fleet entering Sydney Harbour for presentation to the President of the United States. In 1924 he was a founder of the Manly Art Gallery and vice-president of the Royal Art Society of NSW (c. 1929).

REP: AGNSW; AGSA; NGV; AWM; Imperial War Museum, London.

BIB: *Fifty Years of Australian Art 1879–1929*, RAS, Sydney, 1929. ADB 7.

BUCKIE, *Harry*

(b. 8/10/1897, Melbourne; d. 17/4/1982, Hobart) Painter.

STUDIES: Kingston-upon-Thames, UK, 1919; NGV School, 1920–22 with W. B. McInnes. Known mainly for watercolours, he lived in Victoria, NSW, Qld and Tasmania and his activities included joining a sketching club which included Douglas Dundas, Arthur Murch and Eric Thake (qq.v.) 1929–33; working as an engineer attached to the Tasmanian Hydro-Electric Commission and becoming a founding member (and secretary) of the Tasmanian Group of Painters 1956. He was a member of the Art Society of Tas. and the Australian Watercolour Inst., Sydney.

REP: TMAG.

BIB: Backhouse, *TA*.

BUCKLAND FOUNDATION

See TRUSTS AND FOUNDATIONS: William Buckland Foundation

BUCKLEY, *John*

(b. 9/1/1941, Nhill, Vic.) Painter, teacher, gallery director, adviser, art dealer.

STUDIES: Dip. Fine Art RMIT, 1961; BA (Fine Arts), Uni. of British Columbia, Canada 1973; MA (Fine Arts), Uni. of British Columbia, Canada 1974. Independent consultant and curator from 1979, including for national touring exhibitions such as *Sidney Nolan: Works on Paper* for AGDC and for private galleries, notably Realities; Philip Guston and Keith Haring visits in 1980s. From 1986 he worked as a private consultant for many corporations, including the Loti and Victor Smorgon Collection of Contemporary Australian Art, SA Brewing Co, Potter Warburg and Bongiorno.

AWARDS: Several scholarships for study in Canada, 1970s; travel grant, VACB 1978.

APPTS: Lecturer, fine arts, Australia and Canada, 1961–73; exhibition research officer, Vancouver Art Gallery, 1974; Director, IMA, Qld, 1976–79; panel member, various boards, VACB 1980s; Australian Commissioner, Paris Biennale, 1983; director (founding), ACCA, 1984–85; hon. curator, Australian Elizabethan Theatre Trust.

BUCKLEY, *Sue (Edna May)*

(b. 1910, Perth, WA; d. 1985) Painter, printmaker, teacher.

STUDIES: Sydney, with Desiderius Orban, c. 1948. Married to painter James Sharp, she made her first linocuts and woodcuts in 1956, and in 1964 began to teach at Willoughby Arts Centre. She exhibited with the group Sydney Printmakers from 1961, and subsequently in many international exhibitions of prints.

AWARDS: Prizes for prints at Maitland, 1969; Berrima (shared), 1974.

REP: NGA; AGNSW; QAG.

BIB: PCA, *Directory*. A&A 24/1/1986 (obituary).

BUCKMASTER, *Ernest*

(b. 3/7/1897 Auburn, Vic.; d. 1968, Vic.) Painter.

STUDIES: NGV School, 1918–24. Painting with a square brush stroke, partly as a result of his training with Bernard Hall and W. B. McInnes at the NGV School, and partly from admiration for Streeton's later work, he developed great facility early in his professional career. He visited Europe in 1930 and again in 1938, but did not study there. His paintings of flowers and landscapes gained great popularity, particularly in Victoria, SA and, later, NZ. He painted 23 pictures for the AWM and in one year alone (in Perth, 1936) completed 11 portrait commissions. He also earned a reputation as a polemicist, launching many attacks on modern art in letters to newspapers. His son produced a book and presented and exhibition of his father's work at Vic. State Parliament, in October, 1993.

AWARDS: Ramsay prize for 'paintings from the nude', NGV School, 1922; Archibald prize, 1932; NGV Australian subject picture prize, 1941; Albury prize, 1950 and 1963.

REP: Australian state and regional galleries; public galleries in NZ.

BIB: A. H. Spencer, *The Art of Ernest Buckmaster*, Lothian Press, Melbourne, 1951. Bernard Smith, *Catalogue AGNSW*, 1953.

BUGG, Robert William

(b. 1853, ?Eng.; arr. Melb. 1857; d. 1937) Painter. STUDIES: Artisans' School of Design, Carlton, Vic.; NGV School. A portrait, marine and landscape painter in oil and watercolour, he exhibited at the Victorian Academy of Arts from 1878, showing marine pictures and (from 1883) Victorian landscapes in oil and watercolour. He continued exhibiting in Melbourne at the VAS until 1892, when he moved to Bendigo where he opened a photographic studio, and painted a number of portraits. An occasional work by him was still seen in Melbourne exhibitions during the 1920s.

BIB: McCulloch, AAGR.

BULL, Knud Geelmuyden

(b. 10/9/1811, Bergen, Norway; arr. Aust. 1846; d. 22/12/1889, Sydney) Painter. Known mainly for landscapes, he came from a talented and artistic family and may have received some art training. On a visit to London in 1845 he was convicted of forgery and sentenced to 14 years' transportation, arriving on Norfolk Island in 1846. By December 1850 he was in Hobart but absconded from service, only to be recaptured in Melbourne in January 1851. Following 20 days in solitary confinement he was assigned to the Reverend J. G. Medland in Hobart, also an artist, and obtained a ticket of leave in 1852 and a conditional pardon in 1853. He married and remained in Hobart where in this period some of his best-known works were done. They include views of Hobart Town and several portraits and his work was sent to the 1855 Paris Exposition as well as being seen in exhibitions in Tasmania. His landscapes are notable for their bold and dramatic skies handled with breadth and refinement, and his portraits show a taste for dramatic light, the faces of his sitters emerging strongly from dark backgrounds. The faces are finely painted with distinctive character, though hands and body are not so well handled and sometimes a little stiff. He left Hobart in 1856 for Sydney where he was listed as an artist and gave lessons (Gladstone Eyre (q.v.) was a pupil). He died at the home of his son, Alfred, in Sydney. Bull's Christian name Knud is often spent Knut or even, in early records, anglicised to Canute; his surname is occasionally spelt Buhl. His work was seen in *Tasmanian Vision*, TMAG 1988 and in Deutscher Fine Art exhibitions, Melbourne 1980, 83.

REP: AGNSW; QVMAG; TMAG; Mitchell, Dixson Libraries.

BIB: Jocelyn Hackforth Jones, *The Convict Artists*, Macmillan, Melbourne, 1977. Eve Buscombe, *Early Artists in Australia and their Portraits*, Sydney 1979. Kerr, DAA.

BULL, Norma

(b. 1906; d. Sept. 1980) Painter, etcher. Known mainly for landscapes, she was secretary of the Fellowship of Australian Artists from 1960.

AWARDS: 3rd prize, May Day competitions, Melbourne, 1958.

REP: Australian state and regional galleries (prints and drawings); Imperial War Museum, London.

NFI

BULL, Ronald

(b. 1942, Lake Tyers, Vic.; d. 1979, Melb.) Painter. STUDIES: NGV School, with John Brack. He was born on the Aboriginal mission at Lake Tyers in eastern Victoria and with an obvious talent for realistic-style landscapes was helped in his studies by Buckmaster and Heysen. His work gained a considerable following in Victoria through regular exhibitions in the 1960s and 70s but little has been seen of it since his premature death.

REP: MAGNT.

BULLEID, Anne E.

(Active c. 1920–32) Painter. Three works by this artist were included in the Faculty of Arts Gallery exhibition of Australian art, London, 1924; she also exhibited at the RA in 1932.

NFI

BUNBURY, Richard Hanmer

(Active Vic. 1838–57) He sketched a number of properties in country Victoria. His work appeared in *Colonial Crafts of Victoria*, NGV 1978 and *Victorian Vision*, NGV 1986.

REP: NGV; Mitchell, La Trobe Libraries.

BIB: Hugh McCrae, *Georgiana's Journal*, Melbourne 1934. Kerr, DAA.

BUNCE, D.

Natural history artist. Author of *A Guide to the Flora of Van Diemen's Land*, 1850.
(*See also* NATURAL HISTORY ARTISTS)

BUNNING, Neville Mirvane

(b. 1902) Sculptor, potter.
STUDIES: Camberwell Polytechnic, London. Prior to World War II he was a potter at ESTC, Sydney. He served with the RAAF during the war, when he wrote and illustrated a book on the salvage of aircraft; he later served with the Commonwealth Aircraft Corporation.

APPTS: Teacher, sculpture and pottery, School of Mines and Industry, Ballarat, 1945–64.

REP: NGA; Victoria and Albert Museum, London; Birmingham Art Gallery.

BUNNY, Rupert Charles Wulsten

(b. 29/9/1864, St Kilda, Vic.; d. 25/5/1947, Melb.) Painter.

STUDIES: Uni. of Melbourne (architecture and engineering); NGV School, 1881–84 (he was reported by Arnold Shore to have had lessons from William Ford, which would have been prior to his NGV studies); Calderons Art School, London, 1884–85; Paris, with Jean Paul Laurens, 1885–c. 88; brief studies with L. Glaize and Jean Joseph Constant. He first went to Europe with his father, Judge Bunny, in 1884, then to London and (1886) to Paris where he was to stay. He exhibited at the Old Salon in 1888; his painting *The Tritons*, earned a *mention honorable* in the Salon of 1890. In 1902 he married Jeanne Heloise Morel, a former model. His large, early canvases of Victorian idylls, inspired by the Italian and French masters, brought him more success than any of his Australian colleagues in Paris and he became a notable Australian link with French painting. Inevitably French impressionism affected his work and after World War I he concentrated on painting landscapes, mainly of Provence and based on the painting of Cézanne. He also made large numbers of open line drawings, inspired perhaps by Rodin's practice of drawing from models without looking at the paper. The last phase of Bunny's painting life concerned large, decorative allegories that owed something to Gauguin and the French love of the odalisque and other Islamic themes, and a little, perhaps, to the exotic illustrations of Edmund Dulac. A distinguished eclectic, Bunny had the right personality, appearance and attitude to fit him for the role of *grand seigneur*, as he appeared when he returned to live in Melbourne in 1933. Except for short visits home in 1911 and 1928 he had been away for 49 years. He became leader-elect of the modern movement, and in 1936 vice-president of the CAS, formed in opposition to the proposed Australian Academy of Art. But his age precluded too much involvement with local art politics. He spent the last few years of his life composing music in his South Yarra studio, and in 1946 was honoured with a full-scale retrospective exhibition at the NGV. Survey exhibitions in which his work appeared included the Bicentennial exhibition *The Great Australian Art Exhibition* 1988–89. A large-scale retrospective was held at the NGV and toured to other state galleries in 1991.

AWARDS: Honorable mention, Old Salon, Paris, 1890; bronze medal, 1900.
REP: NGA; state and regional galleries; Uni. of Melb. collections; public collections in France.
BIB: Catalogue essays exhibitions as above. David Thomas, *Rupert Bunny*, Lansdowne, Melbourne, 1970. AA. no. 5, Dec. 1918 (Norman Carter, *Rupert C. W. Bunny*). A&A 9/4/1972; 25/3/1988. ADB 7.

BUONAROTTI CLUB

(Founded c. 1880) Sketch and music club established by Cyrus Mason, to which many leading Melbourne contemporary artists belonged; conducted first on premises at Treasury Hotel, Spring Street, Melbourne, then in upstairs rooms at the Old Melbourne Coffee Palace. Songs, poems and recitations were given at the various functions. The club virtually began and ended with Mason, who was president for about three years.
BIB: Moore, SAA.

BURCHILL, Janet

(b. 1955, Melb.) Painter.
STUDIES: BA (Visual Arts), SCA 1983. She held about five solo exhibitions 1987–91 including at Mori, Sydney 1987; Yuill/Crowley 1988/89, IMA 1987 (Brisbane); ACCA, Melbourne 1991. Group exhibitions at public galleries in which her work has appeared 1984–91 included *Design for Living* (with Jennifer McCamley), Artspace, Sydney 1985; *Future Unperfect II*, George Paton Gallery, Melbourne University 1986; *Fortune*, Ivan Dougherty, IMA, EAF 1988; *Art with Text*, Monash Uni. Gallery 1990; *Australian Perspecta*, AGNSW 1989; *Adelaide Biennale of Australian Art*, Adelaide 1990; *Biennale of Sydney*, 1990.
REP: NGV; MOCA, Brisbane; ICI collection.
BIB: Catalogue essays exhibitions as above. A&T 26, 1987.

BURDETT, Basil

(b. 23/7/1897, Ipswich, Qld; d. 1/2/1942, Sumatra) Journalist, critic, gallery director. He served as a stretcher bearer in World War I and after the war worked briefly as a journalist and art critic for the Brisbane *Daily Mail* before moving to Sydney in 1921 to start the New Art Salon, 24 Bond Street, which later became the Grosvenor Gallery. In 1925 he formed a partnership with John Young and started the Macquarie Galleries. The following year he married Edith Birks, of Adelaide, but the marriage did not last. John D. Moore designed the house which Burdett built at Wahroonga, NSW. Fluent in French and Spanish, he spent some time in Europe and on his return in 1931 moved to Melbourne to join the *Herald* as art and drama critic. As a strong supporter of the modern movement, he attracted controversy for his art writings and also for his reviews of the Colonel de Basil ballets which were then causing much excitement, and at which Burdett cut an Oscar Wildean figure on opening nights. In 1939 the managing director of the *Herald*, Sir Keith Murdoch, who was also chairman of the trustees of the NGV, backed Burdett's idea of going to Europe to organise a big exhibition of European modern art to tour Australia. War became imminent while Burdett was still collecting the work, but finally the exhibition was put together, shipped to Australia and, after a brief showing in Adelaide, opened in Melbourne, 16 Oct. 1939. Entitled *Exhibition of French and British Contemporary Art* (see EXHIBITIONS), it was the most momentous exhibition in Australia's art history. But Burdett did not live to receive his due recognition. He was killed when a plane in which he was travelling as an administrative officer for the Red Cross crashed in Sumatra.
AWARDS: NSW Society of Artists medal, awarded posthumously, 1942.
APPTS: Journalist, Brisbane *Daily Mail*, 1918–19; art and drama critic, Melbourne *Herald*, 1931–40.
BIB: Lloyd Rees, *The Small Treasures of a Lifetime*, Ure Smith,

Sydney, 1969. A&A 17/4/1980 (Jan Minchin, *Basil Burdett*) ADB 7.

BURGESS, Arthur James Wetherall

(b. 1879, Bombala, NSW; d. 1957) Painter.
STUDIES: Sydney (with Lister Lister); St Ives, Cornwall (with Julius Olsson); London, 1901. Known mainly for his impressionistic marine pictures, he exhibited at the RA in London from 1904 and at the Paris Salon, and sent works to the VAS, 1910–11. The AGNSW trustees commissioned him to paint *The Australian Fleet entering Sydney Harbour October 4th 1913*, and during World War I he worked as an official naval artist for the Australian government. After the war, he became art editor of Brassey's *Naval and Shipping Annual* (1922–30) and carried out commissions for Vickers and other shipbuilding companies. He also contributed work for the 1924 exhibition of Australian art at the Faculty of Arts Gallery, London.
REP: AGNSW; AWM.

BURGESS, Ellen

(b. 1821; d. 1908, Hobart) Painter.
STUDIES: Tasmania with John Skinner Prout. Landscape and topographical artist, mainly in watercolour, she became a teacher at Horton College, Ross, Tas.
NFI

BURGESS, Peter

(b. 1952, Sydney) Painter, printmaker, teacher.
STUDIES: Alexander Mackie CAE, 1973–76; Pratts Graphic Centre, New York, 1977. He held five exhibitions 1978–88 in Sydney, including at Coventry and Garry Anderson. His work appeared in a number of group exhibitions 1976–88 including with Bonython Gallery and Pratt Graphics, NY.
AWARDS: VACB travel grant, 1978; residency Owen Tooth Cottage, Vence, VACB, 1985.
REP: VACB collection; regional galleries Armidale, Fremantle.

BURGESS, Ruth

(b. 1932) Printmaker, curator.
STUDIES: BA (art/music), Sydney Uni. 1954; woodcut printmaking, Workshop Art Centre, Sydney 1976–79. Originally interested in furthering her musical composition studies at the Paris Conservatoire, she became a printmaker specialising in woodcuts and taught in the medium from 1979, largely in Sydney but also during 1984–88 at Lucca and Florence where she studied wood engraving. In 1988 she curated the exhibition *Contemporary Australian Woodcuts* for the PCA and in that year was the Australian representative to a woodcut symposium in China sponsored by the Department of Foreign Affairs. She lectured in and visited China as artist-in-residence a number of times as well as holding four exhibitions in fine arts academies in Zhenjiang and Tianjin in 1989–91. In Australia she held three solo exhibitions 1984–89 and participated in international and national group exhibitions including in France, Germany and Korea,

and in print exhibitions with Sydney Printmakers 1983–91; and other print survey exhibitions at private and public galleries.
AWARDS: Grant, Australia–China Council, to take solo exhibition and lecture in four Chinese cities, 1991; Berrima Prize 1991.
APPTS: Woodcut teaching, Workshop Arts Centre, 1984–88; guest lecturer, Canberra School of Art 1988; lecturer, Central Arts Academy, Beijing, China 1990; lecturer, Wollongong City Art Gallery, 1990; teacher, woodcut printing, Tin Sheds, 1991.
REP: NGA; AGNSW; Parliament of NSW; Sydney Uni.; Australian Embassy, Beijing; Zhenjiang, Tianjin Academy of Arts, China; Central Art Academy, Beijing; corporate collections including IBM.

BURKE, Frances

(b. 1908, Melb.) Textile designer; furniture designer.
STUDIES: NGV School; Melbourne Tech. School. Under the name Burway Prints, she became the first textile screen printer registered in Australia in 1937. She was a foundation member of the Australian Inst. of Industrial Design and a council member of the Museum of Modern Art and Design, Melbourne. She provided illustrations for Maie Casey, *Verses*, privately published, Melbourne, 1963. Her work was represented in *Classical Modernism: the George Bell Circle*, NGV 1992.
AWARDS: Melb. Tech. School Scholarship.
REP: Textile prints hanging in many Australian embassies in the Pacific area, and in Paris; NGA; NGV.

BURKE, Janine Carmel

(b. 2/3/1952) Art historian, critic, author.
STUDIES: BA Hons, Uni. of Melb. 1974; MA, La Trobe Uni. 1983; travel studies, Europe and USA, 1976–77. A leader in the feminist art movement of the 1970s, she contributed to various publications, including *Meanjin, National Times* and A&A and curated a number of significant art exhibitions, most notable of which was *Australian Women Artists: One Hundred Years 1840–1940*. This exhibition, which toured major Australian galleries during International Women's Year 1975, enabled the work of many significant artists to be reassessed. Her book of the same name was published by Greenhouse Publications, Melbourne (since reprinted by Penguin Books) in 1980. The subject of her MA thesis, Joy Hester, became her second art-related book in 1983, preceded once again by a major retrospective of Joy Hester's work shown at the NGV 1981. Other exhibitions she curated included *Bea Maddock Survey II*, NGV 1989 and *Self Portrait/Self Image*, VCA and six regional and public galleries Vic., NSW, Tas. 1980. She resigned from art lecturing in 1982 to devote herself full-time to writing, living in 1983 at Arthur Boyd's studio at Paretaio in Tuscany, where she began her second novel. She published three novels 1980–87 (one of which won the Victorian Premier's Literary Award for Fiction) and *Field of Vision: A Decade of Change: Women's Art in the 70s*, a collection of her art criticism, in 1990. She was writer-in-residence at the University of New England, Armidale

1989 and teaches part-time, writes, lectures on art and writing, conducts workshops and reviews for a variety of media.

AWARDS: VACB grants 1976, 83; fellowships, Literature Board, Aust. Council 1986, 90; Premier's Literary Award for Fiction 1987.

APPTS: Lecturer, art history, VCA, 1977–82; founding member, LIP feminist arts journal, 1976; committee member, Writers Week, Melbourne International Festival, 1987; teaching part-time, postgrad. studies, VCA 1991–92.

BURKE, Joseph (Prof. Sir Joseph Terance Anthony)

(b. 14/7/1913, Ealing, London; arr. Aust. 1946; d. 1992, Melb.) Teacher, writer, historian, administrator.

STUDIES: Courtauld Institute, London; London Uni.; Yale Uni. He began his professional life as a private secretary to successive Lords President of Council, 1942–45, then to Prime Minister Clement Attlee, 1945–46. The first professor of Fine Arts appointed to an Australian university, he drew the attention of Sir Kenneth Clark (now Lord Clark) to the work of Sidney Nolan during Clark's visit to Australia in 1947. Under his leadership the Uni. of Melbourne art collections and School of Fine Arts were developed and the Uni. Gallery created. He has written extensively on Hogarth and his period and was recognised as a world authority on this subject. His books included *William Hogarth's Analysis of Beauty and Autobiographical Notes*, 1955; *Hogarth: The Complete Engravings*, 1968; *English Art 1714–1800*, 1976, all published OUP, London.

AWARDS: OBE conferred 1946; CBE 1953; knighted 1980.

APPTS: Asst Keeper, Victoria and Albert Museum, London, 1938–39; *Herald* Professor of Fine Arts, Uni. of Melbourne, 1947–78; member, Felton Bequest Committee, 1951.

BURLEIGH, Bertha Bennet

Cartoonist, illustrator. Regular weekly contributor to Sydney *Bulletin*, c. 1920–40.

BURN, Henry

(b. ?1807, Birmingham; arr. Vic. Jan. 1853; d. 1884, Melb.) Painter, lithographer.

STUDIES: Birmingham, UK, with Samuel Lines (1778–1863). Most of his work was devoted to views in and around Melbourne. He exhibited at the RA in 1830 and with the Birmingham Society of Artists in 1832. During the 1840s he travelled extensively in England making lithographic views of towns, including Weymouth, Nottingham, Halifax and Winchester, in which architectural detail is carefully delineated. Arriving in Victoria he made four views of Melbourne (lithographed between 1855 and 1862), exhibited with the Victorian Society of Fine Arts in 1857, lithographed portraits (including one of the Governor, Sir Henry Barkly), and painted a number of topographical views of Melbourne and suburbs. These works – mostly watercolours – are of historical interest and also show the artist's ability to handle the hazy effects of light that give his work its characteristic softness. He exhibited at the Victorian Academy of Arts in 1870 (views of Melbourne in oil and watercolour), 1872 and 1876–77. In that year he was admitted to the Benevolent Asylum; discharged in Dec., he was readmitted the following year and died there in 1884. His work was seen in *Pastures and Pastime*, Vic. Ministry for the Arts exhibition 1983; *Victorian Vision*, NGV 1985 and at an exhibition at Lauraine Diggins, Melbourne 1985.

REP: NGV; QVMAG; Castlemaine regional gallery; NLA; Mitchell, La Trobe Libraries; University of Melbourne.

BIB: Patricia Reynolds, *A Note on Henry Burn*, La Trobe Library *Journal*, Melbourne, vol. 3, Apr. 1973. Kerr, DAA.

BURN, Ian L.

(b. 1939, Geelong, Vic.; d. Sept. 1993, NSW) Painter, writer.

STUDIES: NGV School, 1961–62; travel studies in Europe, UK, and USA, from 1964. The drawings for which he was awarded the NGV Society Drawing Prize in 1962 had a Dufy-Matisse-like delicacy of touch. His interest in figurative drawing apparently declined after reading books by John Cage and Alain Robbe-Grillet and attending lectures by Cage and Buckminster Fuller. After moving to New York in 1967, he became increasingly involved in conceptual art, as evidenced in his *Two Glass/Mirror Piece*, exhibited in *The Field* in 1968 and, more deeply, in the exhibition *Two Xerox Books*, held in conjunction with Mel Ramsden and Roger Cutforth (q.v.) at Pinacotheca Gallery, St Kilda, Vic., in 1969. In America he exhibited as well as curating exhibitions, lecturing, teaching and writing. Returning to Australia in 1977 he taught (including at Sydney University), contributed articles to general press and art journals and became a journalist with Union Media Services from 1981. He curated an exhibition, *Working Art: A Survey of Art in the Australian Labour Movement in the 1980s*, at the AGNSW and AGWA 1986 and wrote *Dialogue: Writings in Art History*, Allen & Unwin, Sydney 1991. Exhibitions in which his work appeared 1977–91 included *A Melbourne Mood: Cool Contemporary Art*, NGA 1983; *Prints and Australia: Pre-settlement to Present*, NGA 1989; *L'Art Conceptuel, une Perspective*, Musée d'Art Moderne de la Ville de Paris (and touring Madrid, Hamburg) 1989; *Biennale of Sydney*, 1990; *Off the Wall, in the Air: A Seventies Selection*, Monash University Gallery and ACCA 1991. The AGWA held an exhibition of his work, *Minimal-Conceptual Work 1965–1970*, which demonstrated the range of his work from this period. He was tragically drowned off the southern NSW coast.

AWARDS: NGV Society Drawing Prize for students, 1962; grant VACB, 1976.

APPTS: Visiting lecturer several colleges USA including Queens College, City University of NY 1974 and University of California 1976; teaching School of Arts, New York. 1974; lecturer Sydney University & Alexander Mackie College 1977–80.

REP: NGA; MOMA; AGNSW; AGWA; NGV; MOCA, Brisbane; MCA, Sydney; regional galleries Ballarat, Geelong.
BIB: Catalogue essays exhibitions as above. Gary Catalano, *The Years of Hope*, OUP, 1980. Gary Catalano, *The Bandaged Image*, Hale & Iremonger, Sydney, 1983. Smith, AP. Charles Harrison, *Essays on Art and Language*, Blackwell, Oxford, UK. A&A 8/2/1970. AT no. 35, Summer, 1990. AM Nov. 1993 (obituary).

BURNS, Edward
(Active c. 1910–30) Black-and-white artist. He migrated to America where he became a contributor to *Scribner's Magazine*.
BIB: Moore, SAA.
NFI

BURNS, Hilary
(b. 1942, Wonthaggi, Vic.) Painter.
STUDIES: Orban School, Sydney. She participated in the exhibition *Ocker Funk*, Watters Gallery, Sydney; Realities, Melbourne, 1976.
REP: NGA; NGV; regional galleries Newcastle, Wollongong.
NFI

BURNS, Peter
(b. 1924, Geelong, Vic.) Architect, designer, typographer, painter.
STUDIES: No formal training. A vice-president of the CAS, Melbourne, and founder and first editor of *Architecture and Arts*, he held exhibitions at MOMA, Melbourne 1956–65 and until 1970 at a number of other galleries including Barry Stern Sydney; Strines Gallery, Melbourne. His work appeared in group exhibitions of the MOMA and CAS group in the 1960s, 70s.
AWARDS: Armitage Art Award 1974.
REP: NGV; Heide; Newcastle Region Art Gallery; RAIA.
BIB: *Modern Australian Art*, MOMA, Melbourne, 1958.

BURNS, Tim (Timothy David)
(b. 29/8/1947, Cunderdin, WA) Post-object artist.
STUDIES: WA Inst. of Technology, 1966–68; travel studies, USA, 1974–76. Working from the University of Sydney Fine Art Workshop from 1971, he became known as a leading exponent of 'non-object' arts. Venues for his exhibits have been Watters Gallery, Sydney; *Mildura Sculpture Triennial*; *Recent Australian Art*, AGNSW all in 1973. In 1973 he suffered an injury to his arm while checking a detonator in one of his creations, *Mine Field*, a loaded, roped enclosure of sand installed at Mildura *Sculpturescape*. He participated in group exhibitions including *Send a Postcard Today*, AGSA and Watters Tenth Anniversary Show, Sydney.
REP: NGA; AGNSW; NGV; Ballarat, Newcastle, Shepparton regional galleries.
BIB: Scarlett, AS.

BURRA BURRA, Sambo
(b. 1946, Bangardi Group, Roper River, NT) Painter. A leading painter of Ngukurr (the traditional name of Roper River Mission, changed back in 1968), his

early work reflected the techniques of bark painting in his use of cross-hatching and x-ray and consistently depicted animals as totems for people, occasionally weapons and infrequently the human figure. His later works developed into larger-scale pictures and, like the paintings of most Aboriginal people, tell a story – of epic hunts, memories of intertribal wars and ceremonial life. Group exhibitions in which his work appeared 1991–92 included *Aboriginal Art and Spirituality*, High Court, Canberra, 1991; National Museum of Tokyo, Japan, 1992. He holds solo exhibitions with Alcaston House, Melbourne.
REP: NGA; AGWA; National Maritime Museum.

BUSCOME, Eve
Art historian and curator, she was the author of *Artists in Australia and their Portraits*, Eureka Research, Sydney 1978 and the essay for *Australian Colonial Portraits*, TMAG 1979.

BUSH, Charles William
(b. 23/11/1919, Fitzroy, Vic.; d. Nov. 1989) Painter.
STUDIES: NGV School, 1935–40; London, with Bernard Meninsky, 1950–51; France, Italy and Spain. He exhibited at the RA in 1951 and was a member of an Australian cultural delegation to China in 1956; in 1961 he took part in an Australian Ministry of Air tour of Malaya, and later became widely known in Australia for his weekly television program, *My Lady Fair*. In partnership with Phyl Waterhouse and June Davies he founded the Leveson Street Gallery in 1962. His skilful, professional paintings include landscapes, seascapes, genre and portraits – including many portraits of celebrities. He travelled and exhibited widely in the UK, Spain, France, Israel, Turkey, Egypt, Mexico and the USA.
AWARDS: Grace Joel student prize, 1938; 2nd prize, War in the Air section, *Australia at War* exhibition, 1945; Crouch prizes, 1945, 54, 61, Crouch watercolour, 1947, 51, 52; Bendigo prize, 1947, 56, watercolour, 1952; Albury, 1947; Perth, 1948; British Council Grant, 1949; Dunlop prizes, 1950, 52, 54; Geelong, 1951; Melrose, 1952; Caselli-Richards, 1952, 53, 54; Harvey drawing prize, Brisbane, 1953; Wynne, 1952, 55; Vizard-Wholohan, watercolour, 1959; R.Ag.Soc.NSW, 1963, 66; Rycroft, SA ($1000 invitation award), 1972, 74; Rockhampton (purchase), 1973; *Mirror*-Waratah, Sydney, 1973; numerous Rotary, regional prizes 1961–88; ACTA Australian Maritime Award 1987, 88; Sir Hans Heysen Memorial Award, Adelaide Festival 1986; Dean's Bicentennial Awards, RASV (watercolour and oil awards of $5000 each), 1988.
APPTS: Official war artist, 1943–46; teacher of drawing, NGV School, 1954; Melbourne art critic for the *Australian*, 1966.
REP: NGA; most state and many regional galleries; AWM; Parliament House; some uni. and corporate collections.
BIB: Exhibition catalogue *Charles Bush: Two Summers*, Leveson

Gallery, Melb., Feb. 1980. Bonython MAPS 60; Bénézit, *Dictionnaire*, 1976.

BUSTARD, William

(b. 18/4/1894, Terrington, Yorkshire; arr. Aust. 1921; d. 24/8/1973, Labrador, Qld) Painter, illustrator, stained glass designer.
STUDIES: Battersea Polytechnic, Putney and Slade Schools, Scarborough School of Arts, London and UK; Powell's Studios (stained glass). Known mainly for late impressionist landscape, coastal and still-life studies, mainly in watercolour, he was also an illustrator and designer in stained glass. He served in Italy in World War I, exhibited at the RA, London, 1915, married in 1918, and in 1921 migrated to Australia. Settling in Brisbane, he soon earned a reputation as a designer of stained glass windows, as an illustrator and for his watercolours of the city. He was chairman of the Art Advisory Council, QAG, 1931–37, and president of the RQAS in 1932. The most notable of his achievements in stained glass are in St John's Cathedral, Brisbane, and in churches in Newcastle, NSW, and Rockhampton, Qld.
REP: QAG.
BIB: Moore, SAA. Vida Lahey, *Art in Queensland 1859–1959*, Jacaranda Press, Brisbane, 1959. J. Johnson and A. Greutzner, *Dictionary of British Artists 1880–1940*, Antique Collectors Club, Woodridge, Suffolk, 1976. ADB 7.

BUTLER, Daisy

(Active 1870s) Painter.
STUDIES: NGV School, 1874–76. She is not recorded as having exhibited at the principal art society of the time in Melbourne, the Victorian Academy of Arts, though her oil *The Heads to Port Phillip Bay 1876* (exhibited at the Joseph Brown Gallery, *Winter Exhibition – 1976*) shows her as an accomplished artist of the period.
NFI

BUTLER, Roger A.

(b. 4/6/1948) Sculptor, curator.
STUDIES: Dip. Art, Prahran CAE 1970; postgrad. studies, VCA 1971–72. In 1968 he exhibited in various competitive exhibitions and in 1970 was represented at the *Mildura Sculpture Triennial* by a 4.57 × 3.66 × 3.66 m structure in blackened, fabricated steel entitled *Monument*. In the late 1970s he turned more to art writing and curatorial activities and has since written a number of catalogue essays for private and public galleries including for Deutscher Galleries 1978–81 on Raymond McGrath, Christian Waller, Derwent Lees, Vera Blackburn and Thea Proctor, and numerous catalogue essays for exhibitions related to the print department of the NGA of which he became curator in 1981. He contributed essays on John Shirlow, Thea Proctor and Ernest Moffit to the *Australian Dictionary of Biography* and has written numerous articles on artists and art-related issues for art journals and the general media.
APPTS: Curator, Australian prints, NGA 1981– .

BUTLER-GEORGE, May

(Active c. 1910–33) Sculptor, painter. She exhibited with the Yarra Sculptors Society, Melbourne, 1910, the NSW Society of Artists, 1933, and the Royal Art Society, Sydney, in the same year. She is best-known for her two bronze reliefs for the pedestal of the Mont St Quentin monument, France, in honour of the AIF 2nd Division (World War I). The reliefs were removed by the Nazis during World War II, but afterwards copied by Wallace Anderson and replaced at Mont St Quentin.
BIB: Scarlett, AS.

BUVELOT, Abram Louis

(b. 3/3/1814, Morges, Vaud, Switzerland; arr. Aust. 1865; d. 30/5/1888, Vic.) Painter.
STUDIES: Lausanne Academy, Switzerland (with Wolmer); Paris (with Flers), 1834. Often referred to as 'the father of Australian landscape painting'. 'What the work of M. Corot is to France', reads the Melbourne catalogue foreword of the *Intercolonial Exhibition* of 1875, 'that of M. Buvelot is to Australia.' As this suggests, Buvelot was a pioneer of *plein air* tonal impressionism in Australia. He spent 18 years in Brazil under the patronage of Dom Pedro II, who bought his work and awarded one of his paintings a medal in an exhibition inaugurated by himself. The Emperor also conferred the Order of the Rose on Buvelot and gave him a studio in the palace. Buvelot left Brazil for health reasons and made a triumphant return to Switzerland. In 1859 he visited the East Indies and India, where he contemplated making his home at Calcutta, but again returned to Switzerland because of poor health. He found the Swiss winters too much for him and finally migrated to Australia in 1865. The impossibility of making an immediate living from his painting was obvious so he opened a photographer's shop in Bourke Street, Melbourne, where he was 'discovered' by James Smith, art critic for the Melbourne *Argus*. Madame Buvelot spoke English and taught French, but Buvelot himself spoke no English and his wife interpreted for him. His next-door neighbour, Julian Ashton, spoke to him in French, and although Ashton would have been about 29 at the time and Buvelot 65, Ashton became a close associate. He painted an excellent, if somewhat tight, portrait of Buvelot in 1880. Buvelot's painting was typical of the best landscape produced in the European academies of the time. He carried an 'Australian vision' further than it had ever been carried before, and was a main source of inspiration to the founders of the Heidelberg School (q.v.). The blue and gold palette of the Heidelberg artists was already implicit in the watercolours as well as the larger oils of Buvelot. The Buvelot Gallery at the old NGV was named after him. His work was represented in the Bicentennial exhibition *The Great Australian Art Exhibition* and *Swiss Artists in Australia 1777–1991*, AGNSW 1991.
AWARDS: Silver medal, Berne exhibition, 1856; Gold medal, London exhibition, 1872–73, 1880; silver medal, Intercolonial Exhibition, Melbourne, 1875.

REP: NGA; all Australian state and many regional galleries.

BIB: All general references on Australian art including Moore, *SAA*; Smith, *AP. ADB* 3. *A&A* 16/2/1978 (*Abram Louis Buvelot*).

BUXTON, *Jessamine Victoria Alexandrina*

(b. 1894, Adelaide; d. 1966, Adelaide) Painter, teacher. STUDIES: School of Arts and Crafts, Adelaide. She was a versatile artist able to turn her abilities to watercolour, sculpture and miniatures, as well as design for lace and needlework, though she is probably best-known for her pastel portraits and nudes (similar in treatment to the work of Cumbrae Stewart). She taught at the School of Arts and Crafts, Adelaide, from 1920; and in 1930 took over Elizabeth Armstrong's class and remained teaching till her retirement in 1954. She exhibited at the Royal South Australian Society of Arts, showing mainly watercolours of flowers, during the 1930s.

BIB: Rachel Biven, *Some forgotten . . . some remembered*, Sydenham Gallery, Adelaide, 1976.

BUZZACOTT, *Nutter*

(b. 1905, Perth, WA.; d. 1976, Qld) Illustrator, painter. STUDIES: NGV School; McNab School, London 1935; George Bell School early 1940s. His 1940s paintings show formal design elements of modernist art of the time combined with a 'story-telling' approach springing from his socialist political beliefs. His work was seen in *Bell School, Meldrum School*, McClelland Gallery, Langwarrin, Vic. 1981; *Art and Social Commitment*, S. H. Ervin Galleries 1984; *The Crouch Prize Winners*, Ballarat Fine Art Gallery 1990; *Classical Modernism: The George Bell Circle* and in exhibitions at the AGSA 1984; QAG 1985.

AWARDS: Crouch prize, 1940.

REP: Ballarat Fine Art Gallery.

BYRNE, *Sam (Samuel)*

(b. 1883, Barossa Valley, SA; d. 1978, Broken Hill) Painter.
STUDIES: No formal training. Naive painter. A former Broken Hill silver miner, Byrne began painting at the age of 73 and quickly earned a reputation as one of the country's leading naive painters, exhibiting at the MOMAD in Melbourne, and Rudy Komon's Gallery, Sydney, in 1959–60. His brightly-coloured paintings, usually in commercial oil paints or enamels, graphically depict the history and everyday life of the Broken Hill mines and the surrounding outback country.

AWARDS: Prizes in Broken Hill competitions, 1960, 76.

REP: AGNSW; NGV.

BIB: Bianca McCullough, *Australian Naive Painters*, Hill of Content, Melbourne, 1977.

BYRON, *Leslie Wallace*

(b. 24/4/1939, NSW) Painter, curator, conservator.

Sam Byrne, Mootoroo Bear Fill, The Miners with Agility, they sing and dance, *oil on board, 44.5 × 60.5. Joels, November 1992*

STUDIES: Two years, ESTC, 1960s. As well as painting, including several portraits and one mural commission, he has worked mainly as a gallery curator and conservator. He developed the first mobile conservation unit in Australia, based on a Canadian model, in the mid-1970s, which was taken over by the Art Galleries Association of NSW and with Bicentennial funding now operates statewide in NSW. He held a solo exhibition at Broken Hill Art Gallery in 1973 and his work appeared in group exhibitions at private galleries in Sydney in 1962 (Blaxland, David Jones) and Wollongong in 1975.

AWARDS: Schools Award, Goulburn, 1949; Goulburn Bicentennial Art Award, 1963.

APPTS: Art restorer, conservator, AGNSW 1964–68; conservator, AWM 1968–73; curator, Broken Hill regional gallery 1973–75; conservator, NLA 1980–83; curator, Shipley Galleries, Katoomba, 1984– .

REP: Regional galleries Goulburn, Broken Hill.

BYRT, *Roger*

(b. 24/2/1959) Painter.
STUDIES: BA (Fine Arts), CIT 1981. Strong surrealism is the basis of his work, which has been seen in six solo exhibitions 1985–92 in Melbourne (Pinacotheca, 1984, 85, 88, 90, 92) and Brisbane (Victor Mace), and in several group exhibitions including with the Geelong Art Gallery and *Postcards*, Linden, St Kilda, Melbourne 1991.

AWARDS: Diamond Valley Art Prize 1990; residency, Verdaccio studio, Italy, VACB, 1991/92.

APPTS: Part-time tutor/lecturer, CIT.

REP: Artbank; Monash Uni.; corporate collections including Western Mining.

BIB: *New Art Seven*.

C ADDY TO CUTHBERTSON

CADDY, Jo
(b. 12/1/1914, Seattle, USA) Painter, sculptor, ceramicist.
STUDIES: Vancouver School of Art, 1935–38; Montreal 1940; travel studies UK, 1940–46. Best known for her portrait paintings and modernist paintings and ceramics, and for her association with the CAS of which she was secretary for some years from 1963. Her solo exhibitions include those with Greenhill, Adelaide; Distelfink, Melbourne; RSASA, Adelaide and her work has appeared in many group exhibitions 1961–92 including many at CAS, Adelaide 1961–88 and in AGNSW and NGV.
AWARDS: Portia Geach memorial prize, 1967; regional SA portrait prizes Kadina 1981; Aust. Bicentennial Award for portraits 1988.
APPTS: Teaching, Adelaide, SASA; senior lecturer in art, Pembroke School; adult education classes and many summer schools.
REP: AGSA.
BIB: Nancy Benko, *Art and Artists of South Australia*, Lidums, 1969. *The Contemporary Art Society of South Australia*, Dean Bruton. Germaine, AGA.

CAFFYN, (Mrs) John C.
Artist who participated in the *Intercolonial Exhibition* of 1875; her seven pen-and-ink drawings were awarded a special Second Class Certificate. She may have been connected with the English novelist, Mrs Mannington Caffyn, resident in Melbourne and friend of George Gordon McCrae and Charles Conder.
BIB: ADB 3. Ursula Hoff, *Charles Conder*, Lansdowne, Melbourne, 1972.

CAIRE, Nicholas John
(b. 1837, Guernsey; arr. Adelaide c. 1860; d. 1918) Photographer. Based in Adelaide, he visited Gippsland in 1865, taking landscapes and portraits of Aborigines. He later moved to Clunes, Victoria then to Melbourne, 1876; in 1885 he gave up portraiture and specialised in landscape, becoming a friend, admirer and rival of Lindt (q.v.). His work was seen in *Australian Art in the 1870s*, AGNSW, Sydney, 1976 and the Bicentennial exhibition *The Great Australian Art Exhibition*.

REP: AGNSW; NGA; NLA; Mitchell Library.
BIB: Kerr, DAA.

CALDER, James Erskine
(b. 1808, England; arr. Tas. 1829; d. 1882, Hobart) Surveyor, painter.
STUDIES: Military Academy, Sandhurst, 1822–26; Ordnance Survey, c. 1826–28. From 1829 he was tirelessly surveying and building roads in Tas. till 1851 when overwork and rheumatism confined him to office work. He was appointed Surveyor-General in 1859 and was Serjeant-at-Arms in the Tasmanian Parliament from June 1870. He contributed many press articles on early Tasmanian history and made numerous topographical sketches of areas surveyed. Known mainly for Tasmanian landscapes he is also recorded as having painted a large oil of *Port Phillip Bay*, c. 1860. A work of his appeared in Christie's auction, Melbourne, Mar. 1973
BIB: Kerr, DAA.

CALKOEN, Alfred
(b. 1917, Amsterdam; arr. Aust. 1951) Painter, teacher.
STUDIES: Amsterdam, The Hague and Paris. His paintings are modernist in manner, skilfully adapted to teaching, and his work includes a large number of industrial murals, mostly in Victoria where he also frequently exhibits with his wife Yolande.
APPTS: Teaching, Melbourne, Council of Adult Education classes; RMIT (occupational therapy classes).
REP: NGV.
NFI

CALLINS, Charles
(b. 1887, Hughenden, Qld) Painter.
STUDIES: No formal training. His naive paintings, as shown at Gallery A, Sydney and Melbourne, from 1969, illustrate his experiences as journalist, sportsman and yachtsman in North Qld, the Great Barrier Reef and the Pacific Islands. He worked for newspapers in Cairns and Brisbane, served in the AIF in World War I, and began painting in 1947.
REP: NGA; QAG.
BIB: Bianca McCullough, *Australian Naive Painters*, Hill of

Content, Melbourne, 1977. A&A 1/4/1964 (John Olsen, *Naive Painters*)

NFI.

CALLOW, Maurice

(b. 4/9/1913) Collector, historian, gallery director. His collection of some 130 English nineteenth-century watercolours and graphic works by William Callow (1812–1908) and his contemporaries (all acquired in Melbourne during the decade 1968–78) have been the subject of special exhibitions, notably at the McClelland Gallery, Langwarrin, and the Hawthorn City Art Gallery (Oct. 1977). He also worked as acting director of the McClelland Gallery, Langwarrin, Vic., 1981. Founder of the Australian branch of the Old Watercolour Society's Club 1974 with instructions from the parent club (London) that it not be an exhibiting society. (*See* SOCIETIES). He has written several booklets and brochures for the Old Watercolour Society, including *Early Watercolours in Public Galleries throughout Australia*, 1988.

CALVERT, H. H.

(Active c. 1900–20, NSW) Painter. Known for watercolours, mainly of birds.

REP: AGNSW.

CALVERT, Samuel

(b. 21/11/1828, Brixton, UK; d. 1/1/1913, Berkshire, UK) Painter, engraver. Third son of the British artist and mystic Edward Calvert (1799–1884), he was trained as an artist and engraver. He left employment as a clerk at London East India House to join his two elder brothers, who had gone to SA in 1844. One of the brothers (John, b. 1824) subsequently became a millionaire miner and geologist. Samuel engraved some of the drawings of S. T. Gill (q.v.) in Adelaide before going to Melbourne where he became the principal engraver for Melbourne *Punch*. He worked as an engraver/illustrator for many Melbourne publications and designed stamps for the Victorian government. He vanished temporarily when he got into trouble for trafficking in stamps, then worked for a time in Tasmania. He worked in Fitzroy, Melbourne in 1865 (41 George Street, which in 1873 became the studio of Louis Buvelot) and in 1867–88 was working in Little Collins Street, Melbourne. Kerr (DAA) says he returned to UK in 1888, where he wrote *Memoir of Edward Calvert* (London, 1893), and then to Melbourne to open the Burlington Gallery at 90–92 Collins Street in 1894 before returning permanently to London in 1904 or 1905 where he remained until his death. A prolific exhibitor, he was a member of the Victorian Academy of Art with whom he exhibited 1875–83. He also exhibited with the Victorian Fine Arts Society (1853–56) as well as in many public exhibitions of the time. His best known works comprise large panoramic engravings of Australian cities such as his *View of Melbourne*, published 1871. His work was represented in the Bicentennial exhibition *The Face of Australia*.

AWARDS: Order of Merit for wood engraving, *International Exhibition*, Melbourne, 1880.

REP: AGSA; NLA.

BIB: J. Feldheim, *Australian Art in the Sixties*, Melbourne, 1914; Marguerite Mahood, *The Loaded Line*, Melbourne, 1973. McCulloch, AAGR. Kerr, DAA.

CAMBRIDGE, Enid Helen Gray

(b. 1903, Mosman, NSW; d. 1976) Painter, teacher.

STUDIES: Julian Ashton School; privately with Roland Wakelin; Salzburg, with Oscar Kokoschka, 1959. She attained distinction as a watercolourist during the period of the Sydney romantic movement led by Dobell, Drysdale, Friend, Herman and others, and for 35 years taught art at the Sydney Church of England Girls' Grammar School. Between 1939 and 1976 she held 12 exhibitions at the Macquarie Gallery, Sydney, and was a member of the Contemporary Group as well as the NSW Society of Artists.

AWARDS: Prizes at Bendigo, 1948; Mosman, 1954; Hunter's Hill, 1962.

REP: State and regional galleries.

BIB: *Society of Artists' Book*, Ure Smith, Sydney, 1945–46; Janine Burke, *Australian Women Artists 1840–1940*, Greenhouse, Melbourne, 1980. AA 1938, 1940. A&A 14/3–4/1977 (Lloyd Rees, *Enid Cambridge*, a tribute).

CAMERON, Donald James Gray

(b. 4/7/1927, Vic.) Painter, teacher.

STUDIES: Dip. Art, Caulfield Inst. 1969; TTTC, TSTC; Certificate, Slade School, London 1966. His conventional portraits and landscapes appeared in competitive and other exhibitions, including Archibald competitions since 1952. He was commissioned to paint numerous portraits of community and church leaders and various 'Miss Victoria' portraits. He wrote two books, one on art and one on his travels in France.

APPTS: Engraver for Commonwealth Bank, 1943–58; teacher, CIT, 1959–68, then head of art dept, CIT, 1969; Doveton Tech. School, 1970; Scotch Coll., Hawthorn, 1972–77.

AWARDS: Student prizes NGV 1951, 52; prizes at Albury 1961; Camberwell 1969; Burwood 1973; Waverley 1975; Ringwood 1977; Vic. Police Art Exhibition 1984; Marcellin College 1985; Killester College 1985; Bayswater 1987; Templestowe 1988; Melba Art Show 1989; Mt Waverley 1989; Kew 1990, 91; French government scholarship for four months technical study in France 1967.

REP: A number of regional galleries including Albury, Rockhampton, Sale; many secondary school, municipal collections Vic.

BIB: Germaine, AGA.

NFI

CAMM, Robert

(b. 1847, Eng.; arr. Melb. 1853) Painter.

STUDIES: NGV School, 1875–76; privately with J. H. Scheltema. Known for colonial landscapes his paintings depicting bush and coastal scenes of Apollo Bay,

Victoria were exhibited at the VAS, Melbourne, 1895–98.
REP: AGSA.
BIB: McCulloch, *AAGR*.

CAMPBELL, Annie J.

(Active c. 1897–1904) Painter. Her ink and gouache on wood, entitled *Kalgoorlie 1897*, was seen in *The Colonial Eye*, AGWA, 1979 and depicts Sir Alexander Cockburn Campbell sifting for gold and nearby his Indian servant with camels. The work is obviously that of a trained artist.
REP: AGWA.

CAMPBELL, Cressida

(b. 8/7/1960, NSW) Painter, printmaker.
STUDIES: ESTC 1978–79; Yoshida Hanga Academy, Tokyo 1980. She held about eight solo exhibitions of her decorative interiors, flower studies and landscapes 1979–92, including Sydney (Hogarth; Mori; Rex Irwin galleries) and Griffith Uni. 1986. They have won her several major awards and her work appeared in about 17 group exhibitions 1985–92 including *Perspecta '85*, AGNSW 1985; *Landscape*, Ipswich City Art Gallery, Qld 1986; *Archibald, Wynne & Sulman Prizes*, AGNSW and touring exhibition 1992; *9th British Print Biennale*, Bradford and London, UK 1986; *12th International Print Biennale*, Cracow, Poland 1989. She was artist-in-residence at Griffith Uni., Brisbane, in 1986 and has illustrated several book covers including Charmian Clift's books for Collins and the *Australian Flower Yearbook*.
AWARDS: Queen Elizabeth II Jubilee Award, 1985; MPAC Prints Acquisitive award 1987; Henri Worland Memorial Print Award, Warrnambool, 1987; St Gregory's Annual Art Award, 1988; *Sydney Morning Herald* Art Award, 1988; residency, Verdaccio, Italy, VACB, 1989; Mosman Art Prize, 1989; ACTA Australian Maritime Art Award, 1990; Wynne Prize for Watercolour, AGNSW, 1992; Pring Prize, AGNSW, 1992.
REP: AGNSW; NGV; State Library of NSW; Artbank; regional galleries Ipswich, Mornington, Warrnambool, New England; Griffith Uni.; Uni. of NSW; corporate collections include IBM, State Bank of NSW, Macquarie Bank, Australian Consolidated Press.
BIB: P. Jarrett, *Australians at Play*, Weldon, Sydney 1984. Geoffrey Dutton, *The Beach*, Mead & Beckett for Macmillan, 1985. *A&A* 23/2/1985.

CAMPBELL, Donald F.

Painter. Mainly a watercolourist, he was a member of the VAS and won Albury prizes for watercolour, 1953, 56, 59.
NFI

CAMPBELL, Fred A.

(Active, c. 1914, Sydney) Etcher, teacher. Member of the Australian Painter-Etchers' Society.
REP: AGNSW.
BIB: Reproduction, *AA*, 1921; other reproductions in the same magazine in articles about Australian etching.

CAMPBELL, Jean née Young

(b. 1913, Sydney) Writer, critic. The second daughter of John Young (q.v.), founder of Macquarie Galleries, she was art critic for Brisbane's *Courier Mail* and Adelaide's *Advertiser* for over twenty years (1952–74). She was a foundation member of the Australian Division of the International Association of Art Critics and wrote a number of texts on Australian art (firstly under the name Elizabeth Young) notably the introduction to the catalogue of the *Antipodean Vision* exhibition of Australian art in the Tate Gallery, London 1962; monographs on James Cant, George Lawrence and Dattilo Rubbo and *Australian Watercolour Painters* Craftsman House, 1989. She married gallery director and painter Robert Campbell (q.v.) with whom she made a number of trips accompanying significant art exhibitions.

CAMPBELL, John

(Active c1889–1918) Painter. He was working in Brisbane c.1889, NSW c.1890, WA c.1896, 1910, and again NSW c.1918. Possibly a member of a well-known family of Campbells of Parramatta, NSW, his work was seen in *The Colonial Eye* AGWA, 1979.
REP: Royal WA Historical Society; collections Swan Brewery Company.

CAMPBELL, Jon

(b. 5/8/1962, Belfast, Northern Ireland; arr. Aust. 1964) Painter.
STUDIES: BA (Fine Art), RMIT, 1984; Grad. Dip. (Painting), VCA, 1985; travel studies USA, UK, 1988. Moving from abstract style while a student, his works developed in style and subject matter into more realistic images in the 1980s, and represented both his immediate environment (such as the nightlife of St Kilda, Melbourne) and his youthful experiences in the western suburbs of Melbourne. He held one solo exhibition at Powell Street Gallery, Melbourne 1988 and was studio artist at Gertrude Street Artists Spaces, 1985 and artist-in-residence at Camberwell Boys Grammar. His work appeared in about 12 group exhibitions 1986–90, largely at public galleries including *Fears and Scruples*, Uni. Gallery, Melbourne, 1986; *Suburban Stomp*, (two-person exhibition), Gertrude St, 1987; *Young Australians*, NGV (national tour), 1987; *ICI Contemporary Art Collection*, Ballarat regional gallery and national tour, 1988.
AWARDS: Keith and Elisabeth Murdoch Travelling Scholarship, VCA, 1987; project grant, VACB, 1988.
REP: NGV; AGSA; VCA; corporate collections including ICI, Shell.
BIB: Catalogue essays exhibitions as above.

CAMPBELL, Marianne Collinson

(b. 30/6/1827, Hunter Valley, NSW; d. 2/5/1903, NSW) Painter, amateur architect. Daughter of amateur painter Edward Charles Close, she painted flower and portrait watercolours in NSW from about 1842. Married to George Palmer Campbell in 1894, they lived in Campbell's inherited property Duntroon, near Canberra (now the Royal Military College). An amateur

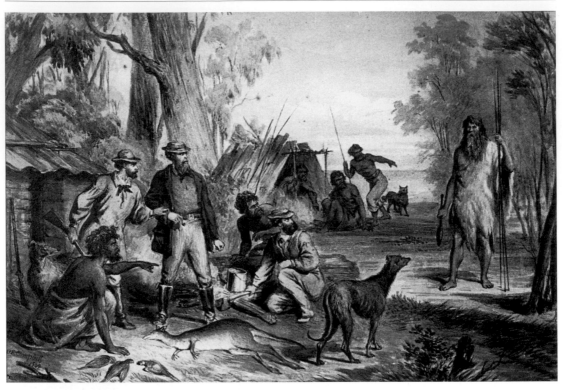

architect, she designed several additions to the house as well as the gardens and maze which stand today. An album of her diaries, sketches and notations is held in the Powerhouse Museum, NSW, although she never exhibited in her lifetime.

REP: Powerhouse Museum; Lanyon ACT; Royal Military College, Duntroon.

BIB: Kerr, *DAA.*

CAMPBELL, Oswald Rose

(b. 1820, Jersey, Channel Islands; arr. Aust. c. 1850; d. 18/3/1887, Melb.) Painter, cartoonist, illustrator, teacher, sculptor.

STUDIES: Trustees Academy, Edinburgh; RA Schools, London. His surviving oils and watercolours date from the 1850s. In 1856 he was honorary secretary of the Sydney Sketching Club of which Conrad Martens was president. He was cartoonist for Sydney *Punch*, 1864, then Melbourne *Punch*, 1865–66, after which he worked as an illustrator for the *Illustrated Australian News*. He was founding chairman, Victorian Academy of Arts, 1870, and drawing master at the NGV School, 1876–86. Campbell's reputation was apparently that of a competent but pedestrian artist whose range of work covered landscape, portraiture and genre, as well as illustrations and cartoons. During the 1870s he extended these activities to include the design and making of medals and other sculpture. His work was represented in *The Artist and the Patron* AGNSW, 1988 and *The Face of Australia*.

REP: AGNSW; Mitchell Library; Geelong Art Gallery.

BIB: Lionel Lindsay, *Conrad Martens*, Angus & Robertson, Sydney, 1920. ADB 3. Mahood, *The Loaded Line*, Melbourne, 1973. Kerr, *DAA.*

O.R. Campbell, Discovery of William Buckley, *watercolour and pencil. Collection, Geelong Art Gallery.*

CAMPBELL, Percy

(Active, NSW, c. 1890–1920) Painter. Known mainly for landscapes.

NFI

CAMPBELL, Peter

(b. 1946, Melbourne) Painter, teacher.

STUDIES: Prahran Tech. Coll., Melb.; RMIT, 1964–67. His work includes a fine portrait of George Baldessin exhibited in the Archibald Prize exhibition 1973. He appears not to have exhibited since his first exhibition at Avant Galleries in 1973 and *Ten Caulfield Artists*, Monash University 1975.

AWARDS: MPAC acquisition 1973; travel grant for studies in China, VACB, 1974.

APPTS: Teaching, CIT, 1973– .

REP: Regional galleries Castlemaine, Mornington.

NFI

CAMPBELL, Robert Richmond

(b. 18/7/1902, Edinburgh; arr. Aust. 1916; d. 1972, Adelaide) Painter, gallery director.

STUDIES: Edinburgh, with George Watson; travel studies, UK and Europe. A skilful and versatile painter in oils and watercolours, Campbell achieved his first major success with his Streeton-like paintings of Sydney Harbour in 1928 (a sell-out exhibition at Melbourne's Sedon Galleries). He was encouraged in this early work by the co-founding director of the Macquarie Galleries, John Young (q.v.), who commissioned him

to do a series of drawings of Sydney and Melbourne.

Campbell met Rupert Bunny in Melbourne in 1927 and stayed with him later in Paris; he worked also with John D. Fergusson, the Scottish impressionist. Returning to Australia in 1932, Campbell married the art writer Jean Young (q.v.), John Young's daughter, and painted for a year on islands off the Qld coast and in Townsville. He taught part-time in Sydney, including at Will Ashton's outdoor painting classes in 1937, and in 1941 became head of the Art Dept, Launceston Technical College, where he also acted as honarary adviser to the QVMAG.

His first notable exhibition of watercolours was at Kozminsky's gallery, Melbourne 1944, and he subsequently became director of both the Queensland and South Australian art galleries. His other achievements include organising the Tate Gallery exhibition of Australian art on behalf of the CAAB in 1962. His 1930s and 1940s work is strong and his landscapes lyrical and bordering on the expressionist. The AGSA curated a major retrospective of his work in May 1973 which toured state galleries for a year; McClelland Gallery, Langwarrin, Vic. held a retrospective in 1985 as did the QVMAG (*Robert Richmond Campbell, An Australian Impressionist*).

AWARDS: OBE 1958; CMG 1967.

APPTS: Director of Art, Launceston Tech. School, 1941–47; curator, AGWA, 1947–49; director (the first), QAG, 1949–51; director, AGSA, 1951–67; member, CAAB, 1953–c. 70.

REP: NGA; all state and many regional galleries and other public collections.

BIB: Campell, AWP. A&A 10/3/1973 (Daryl Lindsay, *Robert Campbell – in Remembrance*); 11/2/1973 (Ian North, *The Art of Robert Campbell 1902–72*).

CAMPS

From the time of the first settlements in Australia many different types of artists worked in bush camps The early topographers did this from necessity, journalistic artists such as S.T. Gill lived in goldfield areas where whole communities lived in camps, and painters such as W. C. Piguenit made lengthy painting excursions often into unexplored mountain territory. But the Australian impressionist schools which emanated from the artists' camps, c. 1883–1900, had special local significance because the painters, inspired by the *plein air* impressionist movement in France, adopted in principle the idea of completing their paintings spontaneously in the open air. Also, the low cost of living in camps suited the prevailing economic status of young artists for whose work no stable markets existed, added to which the idea of working in the open bush country identified the artists closely with a pioneering spirit and many of the conditions associated with life on the land.

HEIDELBERG GROUP

The work and activities of this group was to become identified as the Heidelberg School – the first indigenous Australian art movement. It began with the camp established by Tom Roberts, Frederick McCubbin and Louis Abrahams in 1885, at Box Hill, then a bush suburb of about 19km east Melbourne. The much younger Charles Conder and Arthur Streeton joined the camp later. It lasted until 1888 when a new camp was started by Conder and Streeton on the slopes overlooking the valley of the Yarra River at Eaglemont, much closer than Box Hill to the city. Headquarters of the camp was a house, loaned to the impoverished artists by the brother-in-law of David Davies (q.v.). Streeton and Conder attracted a number of students, mostly young women, to Eaglemont, and earned a precarious livelihood by teaching; Roberts, McCubbin, Abrahams and many other artists joined them at weekends and the camp attracted numerous visitors. On one occasion the veteran painter John Mather lectured to a gathering of more than 60 artists and students. The celebrated *9 × 5 Impression Exhibition* emanated mainly from the activities at Eaglemont. Walter Withers joined the group in the summer of 1889 and, because of the close proximity of the suburb of Heidelberg, the group became known as the Heidelberg School. Conder left for Europe in 1890, and Roberts and Streeton moved to NSW where, at Sirius Cove, they continued their camps around Sydney Harbour.

SYDNEY CAMPS

The Sydney camps had started at Edwards Beach, next to Balmoral, in 1883 when Livingstone Hopkins (q.v.) rented 24 hectares throughout which camps were established. Known as the *Artists' Camp* members or frequent visitors included Julian Ashton, Alfred Daplyn, Henry Fullwood, Charles Hunt, Robert Atkinson, Girolami Nerli, Charles Conder, William Lister Lister, John Mather, Sydney Long (qq.v.). Robert Louis Stevenson visited the Camp as did writer Ada Cambridge. The *Artists' Camp* continued through the 1890s but as more and more land became residential and improved transport lessened the isolation, its popularity declined and the camp was discontinued around the turn of the century. The Sirius Cove Camp called 'Curlew' had been established in 1875 by clothing manufacturer Reuben Brasch, and was near the site occupied by Taronga Park Zoo. Streeton and Roberts started visiting the camp in 1891 and returned at periods thereafter until Streeton left for England in 1897 and Roberts married in 1896. Others who lived or visited included Henry Fullwood, Alfred Daplyn, sculptor Nelson Illingorth (qq.v.). Composer William Marshall-Hall visited frequently as did teacher and journalist Frederick Delmer (who took a number of photographs of the camp). Numerous other artists visited 'Curlew' until around 1912 when with the establishment of Taronga Park Zoo the character of the area changed.

LATER CAMPS AND EXHIBITIONS

Various adaptations of the camp idea became common among the Australian artists who followed, especially those whose work aimed at spontaneous representation of the landscape and changing moods of nature, and included a camp on the deserted and wild coastline near Cape Schanck, Vic. which Arthur

Boyd, Wilfred and Alan McCulloch (qq.v.) and others established in the mid-1930s; and outback movable camps of artists such as Clifton Pugh, Frank Hodgkinson, Jeffrey Makin and others from the 1970s.

Three exhibitions during the 1980s and 90s focused attention on the work of the Impressionists and life in the early camps. They were *Golden Summers: Heidelberg and Beyond* curated by the ngv and touring state galleries 1986; *Bohemians in the Bush: The Artists Camps of Mosman* agnsw 1991 and *Completing the Picture: Women Artists and the Heidelberg Era* Heide Gallery, Melbourne and touring 1992. *See also* HEIDELBERG SCHOOL

CANBERRA ARTS SOCIETY
Formed mainly for the purpose of conducting regular local exhibitions, the first of which was held at the Civic Centre, Canberra, in 1927. For many years it was the only centre of visual arts activity in the ACT.

CANNIBAL CLUB – *Prehistoric Order of Cannibals*
Established as a club for young artists in the studio of George Coates over Peppa's fruit shop, Swanston Street, Melbourne, c. 1892, later in St James Building, William Street, Melbourne. Activities of the club gave Norman Lindsay material for his book *A Curate in Bohemia*, and during the same period he produced the set of *Boccaccio* drawings which later, through the influence of Julian Ashton, earned him employment on the *Bulletin.* Members included George Coates, 'Sonny' Pole, Lionel Lindsay, Percy Lindsay, Hugh McLean, Alec Sass, George Regan, Miles Evergood, Herman Kuhr (a Viennese artist and musician). Later

Curlew Camp, NSW, *photograph by Fred Delmar from* Bohemians in the Bush, *AGNSW. 1990.*

members included Norman Lindsay, Max Meldrum, Will Dyson, Hugh McCrae, Ernest Moffitt, Carl Archibald (half-brother of J. F. Archibald), Harry Weston, Jack Kilgour and Harry Hoyle.
See also COATES, George

CANNIZZO, *Phillip Joseph*
(b. 19/4/1945, Licordia, Eubea, Italy) Sculptor, printmaker, designer.
STUDIES: Prahran CAE and Melb. Teachers Coll., 1966–67; RMIT, 1968–69; travel studies Europe 1982, 85, 87, 91; Asia, Egypt, Turkey 1987. His first exhibition of motorised sculpture elicited a favourable response from critics; his second (Rudy Komon Gallery, Sydney, 1971) was more figurative and conventional, and his third (Melbourne, 1974) represented reversion to a type of academic work noted by critics mainly for its technical competence and high finish. Many commissions, including mural at Tullamarine Airport, Melbourne, and Queen Victoria Hospital, Melbourne. He held largely solo exhibitions 1967–87 including with Rudy Komon until 1984 and Australian Galleries, Melbourne 1980, 84 and in a group exhibition at Westpac Gallery, VAC, 1987.
AWARDS: Grant, VACB, 1973.
APPTS: Teaching at Victorian secondary schools, 1970– .
REP: NGA; AGNSW; Artbank; regional galleries Shepparton, Warrnambool.
BIB: Scarlett, AS.

CANT, James Montgomery
(b. 1911, Melbourne; d. 1983, Adelaide) Painter.
STUDIES: Sydney (with Dattilo Rubbo and Julian Ashton); ESTC; London School of Arts and Crafts, 1935–36. Soon after his arrival in London in 1932, Cant became a member of the London Group headed by Nash, Tunnard, Moore and Wadsworth. His early work in London showed surrealistic leanings which later, with the approach of World War II, changed to social-realism. He returned to Australia in 1939 and served with the AIF. In 1945 he married Dora Chapman (q.v.) and became a co-founder of SORA (Studio of Realist Art) (qq.v.). Cant exhibited in London, Toronto, São Paulo, Paris and Brussels, as well as in Australian capitals.

After a visit to London in 1949 he settled in SA, and his painting gradually assumed a romantic and regional character, the principal aim being 'to reveal the romance and drama of the ordinary phenomena of nature in its more intimate aspects'. Confined to a wheelchair because of advancing multiple sclerosis from the mid-1960s, his late series of works have a broad and often expressionistic style. He was not able to paint from the mid-1970s on but his wife Dora Chapman instigated a series of earthenware pots, which he decorated. His work was represented in the Bicentennial exhibition *The Great Australian Art Exhibition* and was the subject of two retrospectives – at the AGSA, 1984 and Niagara Galleries, Melbourne, 1993.
AWARDS: Vizard-Wholohan prize, 1961.
REP: NGA; most state and many regional galleries; British collections at Hornsey and Hertfordshire (Abbey Museum).
BIB: State gallery catalogues. Smith, PTT. Elizabeth Young, *James Cant*, Brolga Books, Adelaide, 1970. A&A 20/3/1983 (Ron Radford, *obituary*)

CANTLE, John Mitchell
(Active c. 1883, Sydney) Painter. He exhibited at the Art Society of NSW in 1883, showing an Illawarra landscape. He also painted birds.
NFI

CANTLON, Maurice
(b. 5/9/1926, Numurkah, Vic.; d. Jan. 1980, Bali) Painter, teacher.
STUDIES: BA, Uni. of Melbourne, 1946–48; CIT, Melbourne, 1962–64; travel studies 1955–56, 1960–66, 1967–68. He taught art in Victorian secondary schools 1949–64 and in about six exhibitions in Melbourne and Sydney became widely known for his illustrative paintings of Victorian historic homes. His books include *Homesteads of Victoria 1836–1900* (text and illustrations), Georgian House, Melbourne, 1967. He was killed by a falling branch cut from a tree, while holidaying at Bali.
AWARDS: Italian Government scholarship, 1962.
REP: Mitchell Library; McClelland Gallery, Langwarrin, Vic.

CAPON, Edmund
(b. 1940, Kent, UK; arr. Aust. 1978) Gallery director, sinologist, writer.
STUDIES: Courtauld Inst., London (part-time), 1965; London Uni., Chinese art and archaeology (grad. MA, philosophy, 1972). His publications include *Princes of Jade*, Sphere Books, London, 1973; *Art and Archeology in China*, Macmillan, Melbourne, 1977; *Chinese Painting*, Phaidon Press, Oxford, 1979; *Tang China: Visions and Splendour of a Golden Age*, Macdonald Orbis, London 1988.
APPTS: Victoria and Albert Museum, staff appointment, 1966, research asst. Far Eastern Studies, asst. keeper, 1973; ed., magazine *Oriental Art*, from 1974; director, AGNSW, 1978– .

CARABAIN, Jacques
(b. 1834, Amsterdam; arr. Melb. c. 1885) Painter.
STUDIES: Amsterdam Academy. Known for landscapes, streets and architectural subjects he travelled and painted extensively in Western Europe. He was recorded as having been based in Brussels from 1880 where he was again living in 1889. He exhibited Italian coastal landscapes at the Victorian Academy of the Arts in 1885 and may have been 'T. E. Carabain', who showed at the VAS in 1892. A fine oil of the Town Hall, Melbourne (1890) is in the La Trobe Library and a similar work, a view of King William Street, Adelaide (signed and dated 1907), was sold at Christie's in London, Mar. 1969.
REP: Ypres Museum, Town Hall, Brussels; La Trobe Library.
BIB: Bénézit, *Dictionnaire*, 1976.

CARDAMATIS, J. Wolfgang
(b. 1917, Berlin) Painter, designer.
STUDIES: Sydney (with Dattilo Rubbo and Norman Lindsay), ESTC, George Bell School, Melbourne. One of a group of artists who became prominent in Sydney during World War II and a member of the Sydney Group, he returned to Europe in 1946. His work was represented in *Classical Modernism: The George Bell Circle*, NGV, 1992.
REP: AGNSW.
BIB: Horton, PDA.

CAREW-SMYTH, Ponsonby May
(b. 7/8/1870, Cork, Ireland; arr. Aust. Jan. 1891; d. 9/10/1939, South Yarra, Vic.) Teacher, sculptor.
STUDIES: Belfast School of Art and Design; National Art Training School, South Kensington, UK; also in Paris. He designed the commemorative wall plaques for state schools after World War I.
APPTS: Teaching, National Art Training School, London; Rugby School, UK; Ballarat School of Art and Design, 1891– ; inspector of drawing, Vic. Dept of Education; chairman, Vic. State Schools Equipment and Decoration Society; acting director, NGV, Melbourne, 1936.
BIB: ADB 7.

CARINGTON SMITH, Jack

(b. 1908, Launceston; d. 19/3/1972, Hobart) Painter, teacher.

STUDIES: ESTC, 1936; RA Schools, London; Paris. Rated as an outstanding Tasmanian painter, his portraits with their modulated colours and general qualities of sensitivity and restraint ranked high in annual Archibald competitions for nearly 20 years before he finally won the prize. He was also a prolific painter of landscapes, still-life and genre, most of which show similar qualities of sensitivity. He exhibited with Macquarie Galleries, Sydney, 1939–71 as well as a number of galleries in Tasmania. A retrospective of his work was held at Macquarie Galleries, Canberra in 1975 and at TMAG and QVMAG 1975. Group exhibitions in which his work appeared included *Famous Australians by Famous Australian Artists* AGSA for Adelaide Festival of the Arts 1964; *100 Years of Watercolour Painting* inaugural exhibition McClelland Gallery, Langwarrin, 1971; *The Heroic Years of Australian Art* touring regional and public galleries 1978.

AWARDS: NSW Travelling Scholarship, 1936; Sulman prize, 1949; Tasmanian Sesquicentenary prize, 1954; Melrose prize, 1955; *Australian Women's Weekly* portrait prize, 1955; Archibald prize, 1963; Rubinstein portrait prize, 1966; Lloyd Jones Memorial prize for portraiture, 1969; Sir Warwick Fairfax (human image) prize, 1971.

APPTS: Teacher, Hobart Tech. Coll., 1940–61; head of the Fine Arts Dept, 1962–c. 71.

REP: Most state galleries; ANU; Uni. of Melb.

BIB: References in all general books on Australian art history. Backhouse, TA. A&A 10/1/1972 (John Brackenreg, *A Tribute to Jack Carington Smith*); 10/3/1973 (Douglas Dundas, *Jack Carington Smith*); 22/4/1985.

CARMENT, Tom

(b. 1/9/1954, NSW) Painter.

STUDIES: Julian Ashton Art School, 1973; travel studies Zimbabwe following independence 1981–83; France 1985–88. 'On one hand he is a very "straight" artist who paints landscapes, portraits and subject pictures from observation . . . but there is an edginess to his work that lifts him beyond all those honest toilers who just want to sell beautiful pictures', wrote John McDonald (SMH, 25 November, 1989). He held 11 solo exhibitions 1976–92 in Sydney, including Robin Gibson, 1980, 88, 89 (twice); Hogarth, 1983; Stephen Mori, 1985; Julie Green, 1991; and Paris (Galerie Cannibal, 1987). His work appeared in about 10 group exhibitions 1974–92 including *Archibald Prize*, 1974; *Wynne Prize*, 1975; *Heidelberg and Heritage*, Linden, Melb, 1989; *Salon des Refusés*, S. H. Ervin Gallery, 1992. He was artist-in-residence at Geelong College, Vic. 1984 and Wollongong Uni., NSW, 1992 and wrote and illustrated a book, *Days and Nights in Africa*.

AWARDS: Berrima District Art Prize, 1974; Mosman Art Prize (drawing), 1988; Woollahra-Waverley Art Prize 1988.

REP: AGNSW; Artbank; Wollongong City Gallery; Bibliothèque Nationale de Paris; Hyatt, Qld and Qantas corporate collections.

CARMICHAEL, John

(b. c. 1811; arr. Sydney 1825; d. 1857) Engraver.

STUDIES: Apprenticed to John Horsburgh, a Scottish engraver. Carmichael, who was deaf and dumb, did low-level caricatures of Aborigines and made the six plates for his *Select Views of Sydney, New South Wales* (1829), for the *New South Wales Calendar*, 1833, and the portrait frontispiece (after Richard Read) of the *Australian Almanack*, 1835. His work was represented in *The Artist and the Patron* AGNSW, 1988.

REP: NGA; NLA.

BIB: Rienits, *Early Artists of Australia*, 1963. Kerr, DAA.

Rod Carmichael, The Persistence of memory, *1988, oil on canvas, 200 × 200cm. Private collection.*

CARMICHAEL, Rod

(b. 1931, Edinburgh; arr. Aust. 1974) Painter, teacher, critic.

STUDIES: Edinburgh College of the Arts, 1948–53; British School in Rome 1957. He held shows in Edinburgh, Basle, Los Angeles, San Francisco, Middleborough, Bradford and York before moving to Australia. His art writings appeared in the Melbourne *Sun News-Pictorial* and the Geelong *Advertiser*. The colourful rubrics of the eighth-century *Book of Kells* inspired the style of his early iconography and gave his compositions luminosity and a timeless quality. He co-exhibited with David Turner in *Geelong Survey Exhibition No. 2*, Geelong Art Gallery, 1980 and at Realities, Melbourne 1982, 86; Macquarie, Sydney 1989; Gallery at Tolarno Restaurant 1993. He wrote several books published by Deakin University including *The Iconic Language of Painting*, 1981; *Orienteering, Painting in the*

Benjamin Duterrau Mrs Read, *1834, oil on canvas, 91.2 × 71cm. Collection,* TMAG.

COLONIAL ART 1770–c.1890

The first white artists to record the landscape and life in the new colony of Sydney were botanical artists on the First Fleet Joseph Banks and Sydney Parkinson and later the unidentified 'Port Jackson Painter.' Topographical artists who accompanied explorers such as Mathew Flinders making drawings of the landforms and coastline included William Westall, and the first landscape painter was the convict Thomas Watling. Early convict artists transported to van Diemen's land included Knud Bull and Thomas Bock. Later, free settler artists working in Tasmania included

Benjamin Duterrau, Louisa Anne Meredith, Robert Dowling and the wealthy pastoralist John Glover. S.T. Gill made hundreds of sketches of life on the Victorian goldfields from the mid 1850s. Eugene von Guérard, Louis Buvelot and William Charles Piguenit, three of the most significant landscape painters of the late 1800s, portrayed Australia's forests, coastline and countryside through eyes more accustomed to that of the lusher and more sombrely lit Europe and England.

Knud Bull, A General View of Sydney from the North Shore, *18/... (n.d), oil on board, 23 × 43cm. Sotheby's, April 1989.*

George Peacock, Port Jackson, New South Wales Showing the Observatory, *1845, 34 × 74.5cm. Sotheby's, Melbourne August 1991.*

Above: *Thomas Bock,* Mathina, *1842, watercolour, 30.1 × 24.6 (irregular) cm. Collection* TMAG

Above right: *Alexander Schramm,* Scene in South Australia, *1850, oil on canvas, 25.5 × 32cm. Collection,* AGSA.

Right: *William Strutt,* Opening of Princes Bridge, Melbourne, *c. 1850, colour engraving. Collection, Mitchell Library, State Library of* NSW.

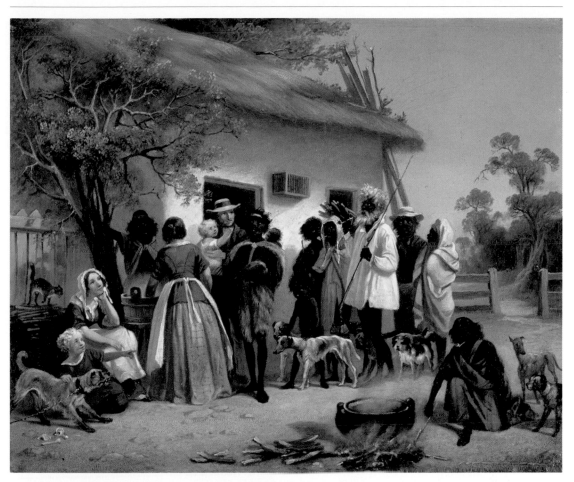

Right: *Henry Gritten,* Hobart Town, *1856, oil on canvas, 94 × 153.2. Collection,* TMAG.

Right: *Owen Stanley,* The Harbour Masters Boat Crew in a Mess, Moreton Bay, *1848, watercolour (from Capt. Owen Stanley's sketchbook). Collection, Mitchell Library, State Library of* NSW.

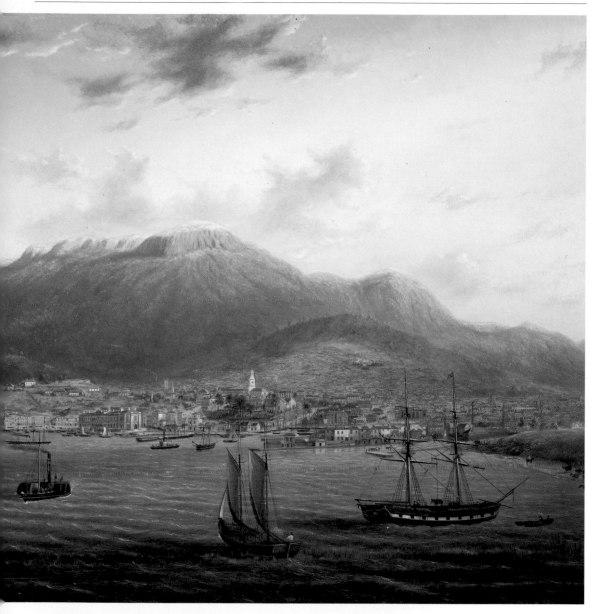

THE HARBOUR MASTERS BOATS CREW IN A MESS MORETON BAY

Left: *J. H. Carse* The Wentworth Falls, *1873, oil on canvas, 61.9 × 107.6. Collection Warrnambool Art Gallery.*

Far left below: *Louisa Anne Meredith,* A Cool Debate, *c. 1891, pencil, watercolour, gold paint and chinese white highlights, 27 × 38cm. Collection* TMAG.

Below: *Robert Dowling,* Group of Natives of Tasmania, *1860, oil on canvas, 45.6 × 91.4cm. Collection,* AGSA.

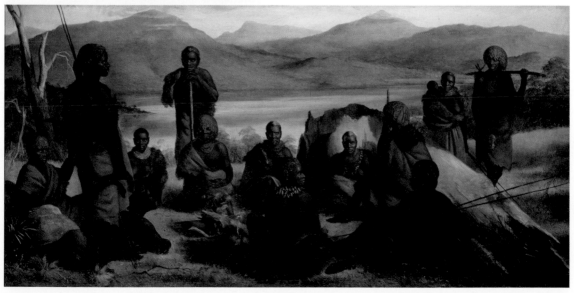

Above: *W.C. Piguenit,* Faith, Hope and Charity Islands, Port Esperance, Tasmania, *1887, oil on canvas, 61 × 91.5. Collection,* TMAG.

Above: *Eugene von Guérard,* Sydney Heads, *1866, oil on canvas, 72 × 123cm. Christie's (Dallhold Collection), Melbourne, July, 1992.*

Right: *S.T. Gill,* Lapstone Hill, *(n.d.) watercolour, 34.2 ×60cm. Collection Dixson Galleries, State Library of* NSW.

Top: *Louis Buvelot* Mt Elephant from Emu Creek, *1870, oil on canvas, 43.5 × 77cm. Collection Castlemaine Art Gallery.*

Above: *Jacob Janssen,* Sydney Harbour looking towards the heads, *1848, oil, 73 × 98.5cm. Collection, Mitchell Library, State Library of NSW.*

Landscape (co-author with Makin, Wolseley), 1984; *Art and Actuality*, 1984; *Artisan and High Technology*, 1985.

AWARDS: Travelling scholarship, Edinburgh School of Art, 1953; Rome scholarship, 1955; Royal Scottish Academy (Chalmers-Jarvies award), 1958; Fellowship, Salzburg School of American Studies, 1959.

APPTS: Visiting artist, Prahran CAE, 1974; head of Art and Design dept, Gordon Inst. of Technology, Geelong, 1974–78; principal lecturer, Dept of Art and Design, Deakin Uni., 1978– .

REP: NGV; Deakin University

CARNEGIE, Margaret
See COLLECTIONS

CARR, J.
See CARSE, J. H.

CARRICK, Ethel
See FOX, Ethel Carrick

CARRINGTON, Tom (Francis Thomas Dean)
(b. 17/11/1843, London; arr. Vic. c. 1860s; d. 9/10/1918, Toorak, Vic.) Cartoonist, critic.

STUDIES: London, with George Cruikshank. As staff cartoonist for Melbourne *Punch* from 1866–87, Carrington exercised a lot of influence. His early cartoons (including his initialled monogram) were done in the manner of Sir John Tenniel, but later he developed an individual style. Margaret Mahood tells us that in 1887 'he relinquished his interest in Melbourne *Punch* to join the *Argus* and *Australasian* as art editor and drama and art critic, and wrote with animation on these and other subjects until a fortnight before his death'. His books and writings include *History of the Berry Ministry* (book of cartoons); *Australian Art: Its Position and Prospects*, article in Melbourne *Argus*, 10 May 1913.

BIB: ADB 3. Marguerite Mahood, *The Loaded Line*, Melbourne 1973. Kerr, DAA.

CARROLL, Patrick
(b. 26/10/1949, Bathurst, NSW) Painter.

STUDIES: Bathurst Tech. Coll.; Royal Art Society, NSW. Traditional in style in the 1970s, in the mid-1980s Carroll's work developed into contemporary realism. Landscape has been his main subject matter and his acknowledged sources include the Australian and French impressionists and post-impressionists, Lloyd Rees, Arthur Boyd and Fred Williams. He held about 20 solo exhibitions 1975–93 including at Geo Styles, Sydney; Marsden Galleries, Brisbane; Hilton Art Gallery, Sydney; and his work appeared in about 30 group exhibitions largely at private galleries 1975–92 including Geo Styles, Sydney; Editions, Melbourne and in the *Blake Prize*, Sydney. He illustrated an edition of John O'Brien's *Around the Boree Log* (Angus & Robertson, Sydney, 1978).

AWARDS: Over 100 awards from 1965 to 1992 including Campbelltown Festival of Fisher's Ghost, Landscape 1973, 76, 80, 81, and Open 1978; Royal Easter Show First Prize (various categories) 1979, 81, 84, 85, 86 (Lady Fairfax Memorial Prize), 87 (two categories), 88 (two categories); ACTA Maritime Award, 1987; Doug Moran in search of excellence award, RAgSocNSW 1989; *Sydney Morning Herald* Art Prize, 1990.

REP: Regional galleries Campbelltown, Dubbo, Lismore; ACTA Maritime Award Collection; State Bank of NSW, *Sydney Morning Herald*, and other corporate collections.

BIB: Germaine, AGA.

CARSE, James Howe
(b. 1818 or 1819, Edinburgh; arr. Aust. c. 1867; d. 1900, Sydney) Painter.

STUDIES: Unknown. Probably undertook family studies and studies at the RA Schools, where his brother William (c. 1815–53) took a prize for drawing. In his excellent essay on Carse, Stephen Scheding writes that 'it is almost certain that Carse's father was the painter Alexander Carse ("Old Carse", c. 1801–38) and that Carse was named after the animal painter, James Howe (1780–1836)'. Scheding also mentions the possibility of Carse having arrived in Adelaide with the Duke of Edinburgh aboard the yacht *Galatea* in 1867, which would explain why Carse's name does not appear in shipping lists of the period. One of Carse's earliest Australian works is a watercolour sketch of the Kapunda Copper Mines, 1867, which were visited by the Duke. Prior to 1871, Carse travelled and painted extensively in Australia and New Zealand. He was a foundation member of the Victorian Academy of Arts, 1870, the NSW Academy of Art, 1871, and the Art Society of NSW, 22 June 1880, exhibiting ten pictures in the inaugural exhibition. He employed an agent and apparently sold his work well. Painting *en plein air* during painting trips (often on cigar box lids), he completed his larger canvases in the studio. Romantic vistas in the brownish manner of Scottish landscapes with small figures were among his favourite subjects; his best pictures are comparable with von Guérard's, but others are sketchily painted on paper and in later years his work became repetitive. Listed in *Sands' Sydney Directory* as J. H. Carr (1877), James Carr (1880), J. Cars (1882), and J. A. Carse (1883), his name was again misspelt as Carr on his contributions of Western Australian, Northern Territory, Queensland and Victorian scenes for Carton Booth's *Australia Illustrated*, engraved by J. C. Armytage, who seems also to have been credited occasionally for originals painted by Carse. Carse spent his last years in Mosman painting, drinking and frequenting artists' haunts around Sydney harbour. When he died in 1900 at his Mosman home 'from alcoholism and old age', his body was discovered by the patron and collector Howard Hinton. His work was represented in *The Artist and the Patron* AGNSW, 1988 and the Bicentennial exhibition *The Face of Australia*.

AWARDS: Certificate of Merit, NSW Academy of Art exhibition 1872; Hon. John Campbell prize, best oil (*Loch Oich and Inverary Castle*); certificate of merit,

1875; gold medal, 1876; first-class certificate, Philadelphia Exhibition, 1876.
REP: NGA; AGNSW; AGSA; AGWA; MAGNT; QAG; Mitchell Library; NLA; regional galleries Newcastle, New England (Armidale), Ballarat.
BIB: *A&A* 17/1/1979 (Stephen Scheding, *James Howe Carse*). Tim Bonyhady, *Images in Opposition* Melbourne 1985. Kerr, DAA.

CARSELDINE, George
(Active, Qld, c. 1919–20) Painter.
STUDIES: Royal College of Art, Edinburgh, 1919. He exhibited with the QAS, of which he was Hon. Sec., 1912–14, and also with the SASA, Adelaide, 1913.
BIB: Julie K. Brown and Margaret Maynard, *Fine Art Exhibitions in Brisbane 1884–1916*, Fryer Memorial Library, Uni. of Qld, 1980.

CARSTENS, Herbert
(b. 1904, Qld) Painter. A foundation member of the Toowoomba Art Gallery; exhibiting member of the Half Dozen Group and RQAS (qq.v.).
AWARDS: Royal National Association prize, Brisbane, 1964.
REP: QAG; Toowoomba Art Gallery.

CARTER, George
(Active c. 1780) Painter. One of several artists who painted contemporary pictures of *The Death of Captain Cook*.
REP: Mitchell Library.

CARTER, Maurice
(b. 1920; d. c. 1965) Painter. Carter exhibited with the social-realist group in Melbourne and held exhibitions at the VAS Galleries, 1953, and Argus Galleries, 1963.
AWARDS: May Day prize, 1954.

CARTER, Norman St Clair
(b. 30/6/1875, Kew, Vic.; d. 18/9/1963, Gordon, NSW) Painter, lecturer, stained glass designer.
STUDIES: NGV School, 1892–98; Melb. Art School (with Fox and Tucker), 1898–99. He also served an apprenticeship with a maker of stained glass. He designed the stained glass windows for Wesley College Chapel, Melbourne, moved to Sydney in 1903 and was a pioneer of mural painting there. He exhibited at the RA London, 1914, and his work was included in the Carnegie Corporation Exhibition, *Art of Australia*, touring USA and Canada, 1941. Informality, austerity and the fall of cool light on the figure are characteristic of the tightly painted portraits for which he became best known.
AWARDS: Medal, Old Salon, Paris, 1913.
APPTS: Lecturer, School of Architecture, ESTC, c. 1903–28; architecture and history of art, Uni. of Sydney, 1903–31; teaching, RAS classes, Sydney, 1912.
REP: AGNSW (13 works); AGSA; AGWA; NGV; QAG; AWM; regional galleries Bendigo, Mildura.
BIB: Reproduction, *AA*, no. 7, Mar. 1924. ADB 7.

CARTER, Tom
(Active, Vic., c. 1908–50) Teacher, painter. Best known as a teacher at Prahran Tech. School. Council member of the VAS, where his paintings of widely varied subjects appeared in seasonal exhibitions.

CARTOONS AND CARTOONISTS
Only very rarely in the history of the cartoon or caricature as used in the modern newspaper does art take precedence over propaganda. It happened in Australia during the black-and-white era, but after that (since World War II) the message conveyed by the ordinary newspaper cartoon was usually the quasi-comic propaganda message as required by the shapers of editorials. Art had little to do with it. The catalogue of the exhibition *Fifty Years of Australian Cartooning*, organised by the Australian Journalists Association (Myer Mural Hall, Melbourne, 9–13 Nov. 1964), lists about 140 Australian cartoonists, past and present. Only a small number of these (mostly artists from the past) deserve a mention as serious artists, but during the 1960s the Australian cartoon and its status took an upward turn, a phenomenon that is not easy to explain. True, the proliferation of little magazines and papers had a strong bearing. But that was not all. Perhaps the first generation of 'visually educated' people (the pioneer television generation of the 1950s) had something to do with it. Certainly the introduction of TV gave new meaning to the visual presentation of the message; but whatever the reasons the large number of cartoonists working in Australia since offer a variety of works very different in spirit from those offered in 1964. Present-day cartoonists may be divided roughly into three categories: (1) those who, like their predecessors, aim simply to express newspaper policies in return for well-paid jobs; (2) highly individual cartoonists such as Petty, Nicholson, Rigby and Tanner, who use satire as a distinctive language with its own rules, giving opportunities for original style and self-expression; (3) those who envisage the cartoon or caricature as a contribution to fine art such as Leunig and Spooner. The second and third categories are the more interesting, and include many talented and often inspired artists, satirists and humorists.

Many became known from the new weeklies that emerged in the 1960s, among them the *National Times* and the controversial *Nation Review*, which gave free expression to a large number of free-thinking writers, artists and journalists. The reputations of the cartoonists Leunig, Tandberg, Cook, Nicholson and a number of others all started at these sources and many later moved to daily newspapers to help change the character of the press cartoon in Australia. The artist/cartoonists see the cartoon as something more than the poor relation of high art. They have included the painters Counihan and Amor who contributed to leftist periodicals and magazines, but others, such as the Hungarian-born Molnar and the caricaturist and etcher Spooner, work for daily newspapers. But it is not

possible to make arbitrary judgements about such a subject as cartoons and cartoonists, and there is much overlapping of the categories. Cartoons or caricatures remarkable for wit, humour and brilliance of concept may appear in any of the three categories and frequently do. But it is only when art and propaganda are harmoniously married that great cartoons appear. A Daumier in France, a Hogarth or Rowlandson in England, a Grosz in Germany or a Dyson in Australia – these are the artists who enshrine the satire, the cartoon and the commentary as sources from which works of genius may emerge.

BIB: Mahood, *The Loaded Line*, Melbourne 1973. Vane Lindesay, *The Inked-in Image*, Hutchinson, Melbourne, 1979. Books of cartoons by May, Hop, Lindsay, Dyson, Low, Molnar, Petty, Cook, Tandberg, Leunig and Spooner.
See also BLACK-AND-WHITE ART IN AUSTRALIA

CARUANA, Wally
(b. 1/11952) Painter, curator, writer.
STUDIES: Dip Fine Art, Canberra School of Art, 1975. He has held several solo exhibitions since 1979 but is best known for his work as a curator and writer on Aboriginal art, mainly at the NGA where he has been curator of Aboriginal and Torres Strait Islander Art, since 1984. Exhibitions he has curated include *Ancestors Spirits: Painting from Arnhem Land in the 1950s and 60s*, 1987; *Aboriginal Art: The Continuing Tradition*, 1989; *L'été australien a Montpellier* at the Musee Fabre, Montpellier, France, 1990; *The Art of George Milpurrurru*, 1993. He has written a number of books including *Australian Aboriginal Art at the* ANG 1987; *Windows on the Dreaming: Aboriginal Painting in the NGA* 1989. His book *Aboriginal Art* World of Art Series, Thames and Hudson, London and New York, 1993 provides one of the most comprehensive overviews of Aboriginal art to date.

CASEY, Karen
(b. Hobart, 1956) Painter. An urban Aboriginal painter, her figurative work has attracted interest since her first representations in print exhibitions in 1987 and 88. Her work was seen in about 30 group exhibitions 1987–93 including *A Koori Perspective* Perspecta, Artspace, Sydney 1989; *Balance 1990 – Views, visions and influences* QAG, 1990; *Contemporary Aboriginal Art, The Robert Holmes à Court Collection* touring American tertiary galleries 1990; Aboriginal Women's Exhibition, AGSA and touring state galleries 1991; *Crossroads: Towards a New Reality Aboriginal Art from Australia* National Museums of Modern Art, Kyoto and Tokyo, Japan 1992; the RAKA *Invitational Award* Ian Potter Gallery, University of Melbourne 1993. She held two solo exhibitions at Gallery Gabrielle Pizzi, Melbourne 1991, 92 and received several commissions including member print for PCA and to produce a poster for Northern Land Council 1989.
AWARDS: Fellowship, Aboriginal Arts Board, Australia Council 1988; professional development grant, Aboriginal Arts Unit, Aus. Council 1989.

REP: NGA; AGSA; AGWA; NGV; QAG; Artbank; regional galleries including Ballarat, Devonport, Mt Gambier, Naracoorte; tertiary collections including Flinders University; State Library of Victoria; corporate collections including Robert Holmes à Court; Reserve Bank.
BIB: Catalogue essays exhibitions as above. Liz Thompson (ed.), *Aboriginal Voices*, Simon & Schuster, 1991; Jennifer Isaacs, *Aboriginality*, UQP, 1991. Caruana, AA. AL 10/1&2.

CASEY, Maie (Lady Casey, née Ethel Marian Sumner RYAN)
(b. 13/3/1891, Melb.; d. 20/1/1983) Art patron, writer, painter.
STUDIES: George Bell School, Melbourne, 1933–38; extensive travel studies. Married Richard Casey, later Lord Casey, Governor-General of Australia (1965–69). As a patron of great influence, she consistently helped young artists. Other participation in art affairs included service on many judging panels of art prizes, including the jury (as Commonwealth representative) for the Unknown Political Prisoner, international competition, London, 1953. She also wrote a number of books including *Early Melbourne Architecture*, 1953; *An Australian Story 1847–1907*, 1963; *Verses*, 1963; *Tides and Eddies*, 1966; *Melba Revisited*, 1975; *From the Night*, 1976. Her work was represented in *Classical Modernism: The George Bell Circle* NGV, 1992.

CASSAB, Judy
(b. 15/8/1920, Vienna; arr. Aust. 1951) Painter.
STUDIES: Prague, 1939; Budapest Academy, 1945–49. She married John Kampfner, 1938, and after a forced separation during the war they arrived in Australia with their two sons to make their home in Sydney in 1951. Already accomplished as a painter, she held the first of many exhibitions at the Macquarie Galleries in 1953. Expressionist influences give distinction to her portraits, which include likenesses of many distinguished Australian artists, writers, musicians and actors such as Joan Sutherland and Robert Helpmann and royalty such as Princess Alexandra, Queen Sirikit, Princess Marina and the Duke of Kent. She held numerous solo exhibitions 1953–92 including at Rudy Komon 1963, 82; New Art Centre, London 1978, 81; Australian Embassy, Paris 1981.
AWARDS: Perth prize, 1955; *Australian Women's Weekly* prize, 1955, 56; Archibald prize 1961, 68; Rubinstein portrait prize 1964, 65; R.Ag.Soc. NSW Easter Show prize 1965, 66, 71, 72, 73; CBE 1969; Sir Charles Lloyd Jones memorial prize 1971, 72, 73; Officer of the Order of Australia 1988.
REP: NGA; AGNSW; AGSA; AGWA; MAGNT; QAG; TMAG; Parliament House; MCA, Sydney; National Portrait Gallery, London; regional galleries Bendigo, Mornington, Newcastle; many other private and public collections.
BIB: A number of general texts on Australian art including Smith, AP; McKenzie, DIA; Bonython, MAP 70. *Judy Cassab: Places, Faces and Fantasies*, Macmillan, 1984.

CASWELL, Maurie Frank
(b. 8/8/1931) Painter.
STUDIES: Dip. Art, Qld Coll. of Art, 1981. He held 10 solo exhibitions 1980–92 at private galleries in Qld and at the RQAS (1979, 80, 83), and participated in numerous group exhibitions 1973–92.
AWARDS: Over 40 prizes 1973–92, mainly for watercolours at regional festivals.
APPTS: 12 years teaching, Qld Coll. of Art.
REP: Qld Parliament House; Armidale regional gallery; Qld Inst. of Technology.
BIB: *Paintings of Maurie Caswell: Kakadu and Other National Parks*, Boolarong Press, Brisbane, 1989.

CATALANO, Gary
(b. 1947, Brisbane) Critic. His work includes extensive writings on art subjects as a contributor to magazines, mainly *Art and Australia*, since July 1973. He was the art critic for the *Age* newspaper in the 1980s and the author of *The Years of Hope: Australian Art and Criticism 1959–1968*, OUP, Melbourne, 1981 and *The Bandaged Image – a study of artists' books*, Hale & Iremonger, Sydney, 1987.

CATANI, Ugo
(b. 1861, Florence; arr. Melb. 1885; returned Italy 1895) Painter, miniaturist.
STUDIES: Academy of Art, Florence, with Cioranfi, 1878–83. In poor health, Catani left Italy with Girolamo Nerli, a student colleague. They stayed at Mauritius and Bourbon before proceeding to Australia, where both became well-known painters. A foundation member of the Australian Artists' Association, Catani exhibited landscape, sea and genre subjects in VAS exhibitions, 1888–92, and painted subject pictures, including some on the theme of explorers, notably Burke and Wills, and A. C. Gregory, whose portrait by Catani hangs in the Masonic Museum, Brisbane. After his return to Italy he became known for miniatures painted in the style of Cosway and Isabey, whose work he admired. One of his subjects was Mark Twain.
BIB: Articles in *Table Talk*, Melbourne, 12 Oct. 1888, and *Studio Talk*, London, 15 Sept. 1903; copy of a letter to Joseph Burke from Bianca Catani Wyllie, of Circleville, Ohio, 21 Feb. 1972.

CATHELS, Sydney
(Active, c. 1890, Sydney) Painter. Sydney artist; a pupil of Lucien Henry.
NFI

CATO, E. T.
Melbourne doctor of medicine and an accomplished amateur painter. Donor of E. T. Cato prizes at VAS.
See also VICTORIAN ARTISTS' SOCIETY

CATTAPAN, Jon
(b. 15/4/1956, Melb.) Painter.
STUDIES: BA Fine Arts (painting), RMIT, 1977; travel studies USA, UK, 1979; Europe, New York, Los Angeles,

Italy 1985; Tokyo, Hakone district, Japan, 1986; New York, Ohio, 1989–90. Cattapan's expressionist works have attracted attention since his first postgraduate exhibitions in the late 1970s. Likened by a New York reviewer to continuing in the Tucker tradition 'malignant, brooding cityscapes enveloped in an air of threat', his work while living in the US in the mid-1980s acquired an atmospheric quality. While his subject matter (largely cities, industrial panoramas peopled with a solo or several floating observer-figures) changed little, a reserve and objectivity developed from his early more abundantly expressionist paintings. His 1992 works, however, showed such a refining of imagery that they became almost colour-tone abstracts. He held 16 solo exhibitions 1983–92 Melbourne (Realities 1983, 87, 89, 91, 92), Brisbane (Peter Bellas 1989, 91, 92), Sydney (Rex Irwin 1984, 86; D.C. Art 1989), Perth (Galerie Dusseldorf 1989) and Nathalie Karg, New York, 1991. His work appeared in over 60 group exhibitions 1978–92 at private galleries in Melbourne (including Drummond Street, Realities), Canberra (Solander) and numerous public, tertiary and regional galleries including *Emerging Painters*, RMIT 1982; *Melbourne Australia Printmakers*, PCA (touring Japan); *Young Australians*, The Budget Collection, NGV 1987; *Re:creation/re-creation: The Art of Copying*, Monash Uni. Gallery, 1989; *Between the Lines*, Australian Embassy, Washington DC 1992; and *Moet and Chandon Touring Exhibition*, 1987, 88, 89, 90, 92. He was visiting artist, Dept of Art, Ohio State Uni., Columbus, USA 1990.
AWARDS: Gold Coast Purchase Award 1987; MPAC Spring Festival of Drawing acquisition 1988; St Kilda Purchase Award 1989; residency, Greene St studio, NY, VACB, 1989–90.
APPTS: Part-time lecturer, RMIT and Melb. State Coll., 1982; RMIT, 1987–89; Monash Uni., 1991; foundation art studies, Inst. of the Arts, ANU, 1992– .
REP: NGA; NGV; AGNSW; QAG; Parliament House; MOCA, Brisbane; regional galleries Gold Coast, La Trobe, Mornington, Wagga Wagga, Warrnambool; ANU; Uni. of Tasmania; Victorian Uni. of Technology; Monash Medical Centre; corporate collections including ICI.
BIB: Catalogue essays in exhibitions as above. Smith, AP. McIntyre, ACD, Boolarong, Brisbane, 1989. Chanin, CAP.

CATTON, C. (Jnr)
A 1789 lithograph of a kangaroo by this artist is reproduced in the exhibition catalogue *Outlines of Australian Printmaking*, Ballarat Fine Art Gallery, Aug. 1976.
NFI

CAVELL, Paul Francis Louis
(b. 23/12/1946) Painter, printmaker, teacher, illustrator.
STUDIES: Architecture and fine arts, Melbourne Uni. 1965–66; illustration and graphic design, RMIT 1967. His meticulously drawn etchings, lithographs and other prints reflect the tradition of illustrative printmaking of 19th-century engravings. He held about

15 solo exhibitions 1974–92 in Victoria (including Wiregrass, Eltham 1980, 89, 90, 91) and was artist-in-residence at Geoghegan College, Broadmeadows, in 1980 and Melbourne Grammar in 1992. His work appeared in about 7 group exhibitions 1974–92 at private galleries in Vic. (including Distelfink, Melb.; Alpha, Daylesford) and in MPAC *Spring Festival of Drawing*, Mornington 1975; portrait exhibition, Bendigo Art Gallery, 1990.
AWARDS: Several regional prizes; *Canberra Times* National Art Award, 1980, 83; Eltham Commmunity Art Award 1986 ($15,000 purchase).
APPTS: Teaching art, graphic design, painting, drawing, illustrating, secondary colleges, Melb. 1975–79; co-ordinator, community access art workshop, Melb. 1983–85.
REP: Parliament House; NLA; Artbank; regional galleries Bendigo, Hamilton, Castlemaine, Swan Hill, Wangaratta.

CAWTHORNE, William Anderson
(b. 25/9/1825, London; arr. Aust. 1841; d. 1897) Author, teacher, painter. He briefly joined the Australian goldrush in 1852 and was headmaster at Pulteney Grammar School in Adelaide until 1855 when he opened his own academy. He wrote poetry and narratives as well as being proprietor of *Illustrated Adelaide Post* 1869–74. He lectured and published works on Aboriginal culture as well as producing watercolours of individuals and corroborees and made a set of views of SA and Vic. in the late 1840s as well as publishing a biography of Johann Menge, Adelaide, 1859.
REP: Mitchell and Dixson Libraries.
BIB: J. A. Ferguson, *Bibliography of Australia*, vol. 5, NLA, 1977. McCulloch, AAGR. Kerr, DAA.

CAYLEY, Alice M.
Painter. Known mainly for paintings of birds. Daughter of Neville Cayley, Snr and sister of Neville Cayley, Jnr (qq.v.). Like them, she worked mainly in watercolour.
See also NATURAL HISTORY ARTISTS

CAYLEY, Neville Henry Penniston
(b. 1854, Dover, Eng.; d. 1903, Sydney) Painter. Celebrated painter of birds who, with the more widely known British artist John Gould, helped to develop universal interest in the character of Australian birds. Father of Alice M. Cayley and Neville William Cayley.
AWARDS: Gold medal, *Chicago International Exhibition*, 1892.
REP: AGNSW; QAG.
See also NATURAL HISTORY ARTISTS

CAYLEY, Neville William
(b. 1886, Yamba, NSW; d. 1950) Painter. Known mainly for paintings of birds and insects he was the son of N. H. P. Cayley and brother of Alice M. Cayley. He signed his work Neville W. Cayley, and illustrated *What Butterfly is That?*, Angus & Robertson, Sydney,

1932; *What Bird is That?*, Angus & Robertson, Sydney, 1947.
See also NATURAL HISTORY ARTISTS

Harold Cazneaux, Children of the Rocks, *1912, gelatin silver photograph. 23.6 × 27.7 cm. Collection,* NGA.

CAZNEAUX, Harold
(b. 1878, New Zealand; arr. Australia 1889; d. 1953) Photographer. Employed as an artist-teacher from 1897 in the Adelaide firm of photographers that employed his father he soon became more interested in outdoor photography. He moved to Sydney in 1904 and began exhibiting successfully in local photographic competitions. His photographs of the poverty-stricken of Sydney in the early 1900s have become hallmark photographs of their time. His photographic career was long and distinguished and he was star photographer for *The Home* magazine. His work was represented in survey exhibitions including the Bicentennial exhibitions *The Great Australian Art Exhibition*, *The Face of Australia* and *Shades of Light*.
REP: NGA; a number of state galleries.
BIB: Catalogue essays exhibitions as above.

CELTLAN, Francis Matthew
(b. 1936, Sydney) Painter, teacher.
STUDIES: NAS, 1957–60; travel studies Europe and UK, 1968–72. He began his career as an advertising and industrial illustrator, 1950–57, before enrolling at the NAS to learn painting. The aim of his flat, luminous and often decorative paintings, as shown at the von Bertouch Galleries, Newcastle, 1972, is the transformation of commonplace, external and internal suburban architecture with figures. Clear, bright colours and ornamental detail help to sustain the mood. His work was seen largely in the Newcastle/Hunter Valley region of NSW 1978–88.
APPTS: Teaching, part-time, NAS, 1962–63; Newcastle,

1964–67, 1972–75; lecturer, Newcastle CAE, 1975–78.
REP: Regional galleries Newcastle, Gosford, Muswell-
brook.

CENTRE 5
Preceded by the exhibitions *Group of Four* and *Six
Sculptors*, Centre 5 was formed in 1961 at a meeting
in Melbourne convened by Julius Kane (Kuhn) (q.v.)
to help foster greater public awareness contemporary
sculpture in Australia. A program was drawn up to
promote exhibitions and lectures and to seek radio,
television and press coverage. Other aims included
better representation in state galleries, closer rela-
tionships with architects, the creation of scholarships
and foundations for sculptors and the employment
of sculptors on public buildings. The group held
exhibitions in Melbourne, Newcastle and Sydney and,
although the membership fluctuated, Centre 5 held
together long enough to fulfil many of its aims.
Members included Vincas Jomantas, Julius Kane
(Kuhn), Inge King, Clifford Last, Lenton Parr, Norma
Redpath, Teisutis Zikaras (qq.v.).

CERAMICS
See CRAFTS IN AUSTRALIA

CHAMBERS, Douglas Robert
(b. 12/3/1935, London; arr. Aust. 1970) Painter, teacher.
STUDIES: NDD, Royal College Walthamstow School of
Art, London; Associate, Royal College of Art, London.
Exhibiting first in the *Young Contemporaries* exhibitions
in London 1958–61, his work has been more based
in figuration than the Pop or abstract of his early con-
temporaries. With strong painterly style, his 1980
works show a vigorous expressive quality. His 14 solo
exhibitions (1974–91) have largely been held in WA
where he is best known and include a mid-career
survey exhibition at AGWA, 1991. He participated in
numerous group exhibitions 1965–91 in the UK and
Australia, many in WA at the Fremantle Arts Centre
and Albany Art gallery.
AWARDS: Several scholarships UK 1960s; Jamaica Gov-
ernment Painting Award 1968; grant VACB 1976–77;
Albany Invitation Exhibition Painting Award 1985;
West Australian Week Invitation Painting Award
1985; Holmes à Court Invitation Prize 1985; several
regional prizes WA 1986–90; creative development
fellowship, Dept for the Arts, WA 1989.
APPTS: Teaching, Charterhouse School, UK; Jamaica
School of Art; lecturer, WAIT, Perth, 1970– ; Darwin
Inst. of Technology.
REP: NGA; AGWA; MAGNT; NGV; regional galleries WA;
several uni. and tertiary collections; several corporate
collections including R&I Bank, WA.
BIB: *A&A* 26/4/1989.

CHAMBERS, Judith May
(b. 29/10/1937, Hong Kong; arr. Aust. 1970) Print-
maker.
STUDIES: Beckenham School of Art, UK, 1954–58;

Royal Coll. of Art, 1958–61; Ravensbourne Coll.;
Jamaica School of Art, West Indies; Perth Tech. Coll.
Her well-made, imaginative etchings have appeared
in group exhibitions, notably with the Printmakers
Association of WA, of which she was a foundation
member, 1973.
APPTS: Lecturing part-time at art schools in the UK
and Jamaica, and at Perth Tech. Coll.
AWARDS: MPAC Purchase award 1974.
REP: NGA; AGWA; Mornington regional gallery.
NFI

CHANDLER, Ian
(b. 1942, Wagga, NSW) Painter, teacher.
STUDIES: SASA, 1959–62. His modernist paintings
appeared in numerous group and solo exhibitions from
1963.
AWARDS: Georges commendation prize, 1969; SA
Grants Advisory Commission, grant for environmen-
tal kinetic work, 1975.
APPTS: Teaching, SASA, Adelaide, 1980.
REP: AGSA; NGV; regional galleries Ballarat, Albury;
ANU; Flinders Uni., SA.
BIB: *A&A* 6/2/1969.
NFI

CHAPMAN, Alice
(b. 1860, Inglewood, Vic., d. 1929, Melbourne) Painter.
STUDIES: NGV School 1876–86. A contemporary of
Roberts, Streeton, McCubbin and Longstaff at the NGV
School she was instrumental in questioning teaching
methods at the School. Invited to exhibit with the
Australian Artists Association in 1886 she displeased
the head of the School, George Folingsby, so much
by exhibiting with that group rather than the stu-
dent's exhibition he demanded that she be dismissed
from the School. (Following public outcry however,
the trustees overturned his decision.) She exhibited
regularly with the VAS 1888–92 and was a member
until the 1920s and received a number of public com-
missions for portraiture including a number of may-
ors of Melbourne suburbs and country towns. Her
work was represented in *Completing the Picture: Women
Artists and the Heidelberg Era* touring public galleries
Victoria, NSW, SA 1992.
AWARDS: gold medal figure painting, Bendigo Exhi-
bition, 1894; honorary life member, Bendigo Art
Gallery.

CHAPMAN, David (David Hammond)
(b. 5/8/1927, Ballarat; d. 8/12/1983) Painter, gallery
director.
STUDIES: Hobart Tech. Coll. with Carington Smith
1947; evening classes RMIT and NGV School, 1948–49;
George Bell School, 1953; travel studies Europe, 1968.
On his return from Europe he established the Powell
Street Gallery, Melbourne (1969–74), before moving
to Cressy, Tas., and a full-time career in painting. His
paintings are lyrical evocations inspired often by the
paintings of Bonnard. He held many solo exhibitions

1976–83 at private galleries, notably Powell Street, Melbourne. McClelland Gallery, Langwarrin, curated a retrospective of his work which toured to other Victorian regional galleries in 1986 and in 1987 a major retrospective of his work was held in QVMAG and TMAG.

REP: NGV; TMAG; Parliament House; many regional galleries and uni. collections Vic., Tas.

BIB: Graeme Sturgeon, *The Painter's Vision*, Bay Books, 1989. Backhouse, *TA. A&A* 22/4/1985.

CHAPMAN, Dora Cecil

(b. 1911, Mt Barker, SA) Painter, printmaker, teacher, critic.

STUDIES: SASA, 1936–41; travel studies, London, France, Italy, 1949–55. She achieved early recognition as a portraitist and in the mid-1940s married James Cant. With him, Hal Missingham, Bernard Smith and Roy Dalgarno she was a co-founder of SORA (Studio of Realist Art) in 1947.

After several years in Europe in the 1950s, she became a lecturer at the SASA (1958–69), and art critic for the Adelaide *Advertiser*.

AWARDS: Melrose Prize, 1961.

REP: NGA; AGSA; TMAG; regional gallery Hamilton, Vic.; uni. collections, Adelaide.

BIB: Rachel Biven, *Some forgotten . . . some remembered*, Sydenham Gallery, Adelaide, 1976.

CHAPMAN, Evelyn

(b. 1888; d. 1961) Painter.

STUDIES: Sydney (with Dattilo Rubbo); Paris; London. She painted a series of paintings of the Somme battle-fields, 1919–20.

REP: AGNSW (eight works).

NFI

CHAPMAN, Thomas Evans

(b. 1788, Eng.; arr. Hobart 1834; d. 1864, Hobart) Teacher, painter. Teacher at Mechanics Inst., Hobart, 1840 and teacher of drawing, 1846, he specialised in drawings of street scenes including hundreds of pencil sketches and watercolours, now mainly in public collections. He illustrated *Six Views of Hobart Town, 1844*, engraved by Thomas Bluett. He was represented by two watercolours in *Tasmanian Vision: The art of nineteenth century Tasmania* TMAG and QVMAG 1988.

REP: QVMAS; TMAG; Mitchell Library; NLA.

BIB: *ADB* 1. Moore, *SAA*. Kerr, *DAA*.

CHAPMAN, William Neate

(b. 1773, London; arr. Sydney 1791; d. c. 1837) Topographical artist, painter. He worked at Norfolk Island, 1796–1800, and Sydney, where he was also secretary to Governor King. His best-known work is a drawing of the settlement of *Sydney, Norfolk Island, 1796*. He returned to England in 1804.

REP: Mitchell Library, Sydney.

BIB: *ADB* 1. Kerr, *DAA*.

CHAPPLE, Arthur W.

(Active c. 1880–1915, Sydney) Painter. Known mainly for landscapes. He exhibited at the Art Society of NSW c. 1891–1900, showing landscapes and genre.

NFI

CHARSLEY, Fanny Anne

(b. 23/7/1828, Buckinghamshire, UK; arr. Aust. 1857; d. 21/12/1915, Sussex, UK) Painter. She produced a set of watercolours of wildflowers of the Melbourne area and published a book of lithographs of them in London, 1867, dedicated to Baron Ferdinand von Mueller, who helped with the work.

REP: NLA; La Trobe Library.

BIB: Kerr, *DAA*.

See also NATURAL HISTORY ARTISTS

CHARTERISVILLE

1890–1910. House situated at Heidelberg, Victoria, which became an artists' colony; it was first occupied by Walter Withers, in 1890. The name 'Charterisville' derived from the first owner, David Charteris McArthur, first manager of the Bank of Australasia, Melbourne, 1838, and a president of the Melbourne Public Library. The artistic history of Charterisville covers five phases.

FIRST PHASE: Withers lived in the house for nearly three years, during which period he sub-let three lodges in the grounds to a group comprising Hal Waugh, Arthur Basset, Fred Monteath, Thomas Humphrey, Fred Williams and Leon (Sonny) Pole.

SECOND PHASE: Occupants included Harry Recknall, Jack Gordon, Ernest (Heiner) Egersdorfer, Lionel and Norman Lindsay, Ernest Moffit, Will Dyson, James Quinn and Max Meldrum.

THIRD PHASE: Emmanuel Phillips Fox and Tudor St George Tucker started a summer school on the premises in 1893, as an adjunct to the Melbourne School (q.v.). They built a studio in the garden, taught on alternate months, and hired a cook, housekeeper and chaperon to look after the students.

FOURTH PHASE: When Fox and Tucker left for Europe, the house and studio had a floating population of artists which included the cartoonists Alf Vincent and Alec Sass.

FIFTH PHASE: The last artists to live at Charterisville were John Shirlow, etcher; Alexander McClintock, watercolourist; Alf Fisher, pastellist; Wallace Anderson, sculptor; W. S. Wemyss and Frank Crozier, painters. The end of the colony at Charterisville came about because of differences with the landlord. When the last group disbanded, the studio in the grounds was demolished and sold as building material. Later (1968) the original old house was converted into a commercial art gallery. It is worth recording that the original owner of the house, David Charteris McArthur (1810–87), succeeded Sir Redmond Barry as president of the trustees of the Public Library, Museum and NGV in 1881, and that the McArthur Gallery at the NGV was named after him. McArthur had built a winery at Charterisville above an archway of whalebones given to him by the Hentys; the winery was

further developed when Hubert de Castella (q.v.) bought the property after the death of McArthur's widow. McArthur was also president of the Melbourne Cricket Club for nine years.

BIB: Article in *The Age*, Melbourne, 13 Oct. 1956. Scott Murray, 'Portrait of a Banker', *Chequerboard*, Dec. 1964.

CHAUNCY, Theresa Susannah Eunice Snell

(b. 1807, Eng.; arr. Adelaide 1837; d. 1876, Vic.) Painter, sculptor. Married John Walker in Van Diemen's Land in 1837. They lived in Adelaide, Sydney and Launceston, John Walker dying in 1855. She then married Professor George Poole (1850) and went to the Victorian goldfields in the 1850s, then to Mauritius in 1865 before returning to SA in 1868, where Poole died in 1869. She became housekeeper to her brother. She had little formal training but learned from her father, William Chauncy, an amateur painter and sculptor, and produced many fine examples of wax models, including portraits of Ludwig Leichhardt now in the collection of the NGA. Her work was seen in *Early Australian Sculpture*, Ballarat Gallery, 1977.

REP: NGA; AGSA.

BIB: Kerr, *DAA*.

CHECK, J.

(Active, c. 1885, NSW) Topographical artist. His precise painting, *Residence of W. Hooken, Esq., Burren Creek, NSW* 1886, suggests professional training. A work of his appeared in the Joseph Brown Gallery exhibition, Melbourne, Winter Exhibition, 1977.

CHERRY, George

(b. c. 1820, UK; arr. Aust. 1849; d. 1878, Hobart) Photographer. Assistant superintendent of convicts on Norfolk Island, 1849 – c. 52, he moved to Van Diemen's Land where he exhibited daguerreotypes of Norfolk Island and later produced photographic portraits on paper, glass, ivory and canvas in his own gallery at Hobart from 1864. He was represented in *Shades of Light*, NGA 1988.

REP: TMAG; Allport Library, Hobart.

BIB: Kerr, *DAA*.

CHETTLE, Agnes Beatrice

(b. c. 1900, Eng.; arr. Aust. ?1920) Painter, wood carver.

STUDIES: Malvern and London, Eng. Known mainly for landscape watercolours, she exhibited with the SA Society of Arts in 1928.

REP: AGSA.

BIB: Rachel Biven, *Some forgotten . . . some remembered*, Sydenham Gallery, Adelaide, 1976.

CHEVALIER, Nicholas

(b. 9/5/1828, St Petersburg, Russia; arr. Vic. 1855; d. 15/3/1902, London) Painter, lithographer, cartoonist. STUDIES: Paris, with Jean S. Guignard, 1845; architecture in Munich, 1848; London, lithography with Louis Grüner, 1852; Rome, 1853–54. Chevalier's father,

a Swiss overseer working on the estates of a Russian nobleman, had unwisely invested money in a gold-mining venture in Vic.; he sent his son Louis to find out what had become of the money. Louis failed to return, so Nicholas was sent to find Louis. Nicholas's art studies in various cities had started when he was 17 and had their most fruitful result when he exhibited at the RA in 1852 and illustrated a book by A. H. Layard (*Discoveries in the Ruins of Nineveh*, London). He arrived in the gold city of Melbourne in Feb. 1855, and soon after located his brother at Bendigo. He made a limited number of paintings and drawings of the goldfields, some of which were published as engravings. When Melbourne *Punch* started in 1856 he became its first cartoonist, remaining in that position until 1861. He explored different parts of Vic. in company with his lifelong friend, Eugene von Guérard, and the two artists accompanied William Howitt on one of his expeditions. The multilingual Chevalier was tall, good-looking and apparently in every way impressive. These attributes contributed greatly to his success. For a time he and his wife conducted a salon at their home in Royal Terrace, Fitzroy. The first prize given for an Australian painting at the NGV (200 guineas), when the first picture gallery opened in 1864, was won by him, but in general his pictures were rather pretentious, grandiose representations of mountain scenery expressing little of the real character of the country. In 1865 Chevalier was painting in New Zealand and three years later he accompanied the Duke of Edinburgh on a world tour. On arrival in London he exhibited about 100 works (mainly drawings) done during the tour. His official commissions included pictures painted for Queen Victoria illustrating aspects of her reign, and the design for the setting of the Koh-i-noor diamond. He retired to Sydenham in 1893, wrote stories set to music and organised an amateur orchestra in which he played second violin. For the last 20 years of his life he acted as London adviser to the National Art Gallery of New South Wales (AGNSW). His work has been seen in a number of historical exhibitions including the Bicentennial exhibitions *The Great Australian Art Exhibition* and *The Face of Australia* and in *Swiss Artists in Australia 1777–1991* curated by the AGNSW and touring public galleries 1991.

REP: State and regional galleries; Wellington Art Gallery, NZ.

BIB: *ADB* 3. Marjory Tipping, *Eugene von Guérard's Australian Landscapes*, Lansdowne, Melbourne, 1975. McCulloch, *AAGR*. Kerr, *DAA*. *A&A* 18/3/1981 (Heather Curnow, *Nicholas Chevalier 1826–1902*).

CHICK, Lorna

(b. 1922, Wangandary, Vic.) Painter. Her naive *petit point* type painting first attracted attention in the Fairley Award exhibition in Shepparton, 1967.

REP: NGA; regional galleries Shepparton, Benalla.

BIB: Bianca McCullough, *Australian Naive Painters*, Hill of Content, Melbourne, 1977.

NFI

CHINNER, John Henry
(b. 1865, SA; d. 1933) Illustrator, cartoonist.
STUDIES: School of Design, Adelaide. Contributor to Sydney *Bulletin* and London *Punch*; Fellow of Royal South Australian Society of Arts.
NFI

CHRISTIE'S (Christie's Australia Pty Ltd)
Established 1969. 1 Darling St, Sth Yarra, Vic. 3141. In 1969 Christie Manson and Woods Aust. Ltd opened its branch of the celebrated London firm of fine art auctioneers establishing an office in Sydney and appointing an agent in Melbourne. Regular auctions of Australian paintings and artworks including prints and books were held in Sydney and Melbourne for nearly 10 years. Among important collections sold were those of Major H. de Vahl Rubin and Dr Clifford Craig. In 1989 a new subsidiary company was formed and established in Melbourne providing for auction and valuation services and absorbing the branch office functions of Christie Manson and Woods Australia Ltd. Christie's Australia sold in 1989 the renowned collection of the late Sir Leon and Lady Trout in a house contents sale in Brisbane; it reached over $7 million, figure that remains a record for any individual fine art auction held in Australia and indeed ranks among some of the major house sales conducted anywhere in the world. Other major collections sold to 1993 include the Dallhold Collection of Alan Bond's pictures (July 1992) and the Barry Byrne Collection of antiques and old masters paintings.

Regular sales are held of paintings, antiques, decorative arts, silver and jewellery, guns, cars, stamps and items of historical Australian interest.

Researched, illustrated catalogues accompanying the auctions are of great importance to research students as well as collectors.

CHRISTMANN, Gunter Sylvester
(b. 1936, Berlin; arr. Aust. via Canada 1959) Painter. STUDIES: NAS (part-time), 1962–65. His hard-edge abstract paintings became known through Central Street Gallery exhibitions, Sydney, 1966, 67, and *The Field* exhibition, NGV, 1968. Influences affecting his later work include the 'spot' paintings of the American Larry Poons, and German expressionism as applied to still-life and landscape. He has exhibited annually since 1967 including in Sydney (Coventry; Yuill/Crowley; Roslyn Oxley9; Garry Anderson), Melbourne (Tolarno; Niagara) as well as in NZ, Berlin and other Australian capital cities and regional centres. Group exhibitions in which his work appeared 1965–93 included *Perspecta* 81 AGNSW, 1981; *Biennale of Sydney* 1982; *Vox Pop* NGV 1983; *Field to Figuration* NGV 1987. REP: NGA; AGNSW; AGWA; NGV; QAG; Parliament House; regional galleries Armidale, Benalla, Geelong, Hamilton, Newcastle, Wollongong; European public collections including in Germany, Netherlands, Yugoslavia; corporate collections including Holmes à Court; Myer; Philip Morris.

Gunter Christmann, To Mexico City, *1989, acrylic on canvas, 168 × 137cm. Courtesy Niagara Galleries.*

BIB: Catalogue essays exhibitions as above. Mervyn Horton, PDA. *New Art Three.* Thomas, OAA 1989. Smith, AP. A&A 10/3/1973 (Elwyn Lynn, 'Gunter Christmann'). AI VI/3/1973.

CHRISTMAS, Ernest W.
(b. c. 1850, SA; d. 1918, Honolulu) Painter. STUDIES: Adelaide and Sydney. Painter. Known mainly for landscape oils, he painted South Australian and Murray River landscapes during the 1890s, exhibiting at the Art Society of NSW in 1894 as well as in Tasmania and WA. Between 1900 and 1910 he was in London showing at the RA, and Royal Society of British Artists, to which he was elected in 1909. In 1907 he was in New Zealand where his landscapes, exhibited at the NZ Academy of Arts, elicited the comment from a NZ *Times* writer that 'his hard sun-lights and lurid horizons are quite foreign'. After painting mountain and lake landscapes in Chile and Argentina, 1910–11, he was back in Sydney, 1911, showing NZ landscapes. His early Australian work is of varying quality and interest, the later paintings often being firmer in composition and appreciation of light, the result probably of impressionistic and other overseas influences.

BIB: Grant M. Waters, *A Dictionary of British Artists Working 1900–1950*, Eastbourne Fine Arts, Eastbourne, 1975; Henry P. Newrick, *NZ Art Auction Records, 1969–72*, Newrick, Wellington, 1973.

CHRISTO (Christo JAVACHEFF)

(b. 1936, Bulgaria; in Australia 1969) In Oct. 1969, Christo wrapped half a kilometre of Little Bay, NSW. This project had been organised by John Kaldor (q.v.) acting initially in the name of the Alcorso-Sekers Travelling Scholarship. Christo himself accepted responsibility for 51% of the costs ($120,000), $10,000 was contributed by the Aspen Centre of Contemporary Art, Colorado, and the proceeds of public admittance charges to view the completed work were donated to the Prince Henry Hospital, Little Bay. Materials included one million square feet (93,000 square metres) of polypropylene, ribbon-weave, agricultural fabric, 35 miles (56 km) of orange-coloured polypropylene, inch-and-a-quarter (3 cm) filmrope and 25,000 steel rivet-pins, fired from Ramset rivet-guns. Quantity surveying was in itself a major part of the undertaking. Professional mountaineers headed a staff of about 200 university and technical school students. Gales of up to 50 km/h, as well as damage by vandals, retarded the work, which attracted national and international publicity. Simultaneously, drawings for the project were included in Christo's exhibition at Central Street Gallery, Sydney, and later Christo visited Melbourne where he wrapped some bales of wool at the NGV. A retrospective of the event was held by the AGNSW in 1990 and he was represented in the Bicentennial exhibition *The Face of Australia*. His reputation has continued to be grow internationally for similar projects.

BIB: *AI* Jan 1970 (Alan McCulloch, *Letter from Australia*). *A&A* 17/2/1969 (Donald Brook, *The Little Bay Affair*).

CHRISTOFF, Ludmila

(b. 31/7/1950, Istanbul, Turkey; arr. Aust. 1970) Painter, jewellery designer.

STUDIES: Dip. Arts, Coll. of the Arts, Prague 1968; Dip. Art & Design, CIT 1976; Dip. Ed, Burwood Teachers Coll. 1977. In 1978 her well-drawn Pop-style paintings depicting scenes of crime were included in the CAS exhibition at Joan Gough Galleries, Melbourne. Later her work became more objective. A designer in pottery and jewellery as well, she held many group and solo exhibitions 1968–90 in Prague, Paris, Melbourne and Sydney including at Niagara, Monash Uni., MPAC, Hogarth.

AWARDS: Various student awards, 1965–77; CAS Award, Melb., 1978, 80; several municipal prizes 1970s Melbourne.

APPTS: Teaching art, Caulfield Arts Centre 1976–77; secondary art teaching, 1977–79; lecturer, co-ordinator, drawing and design studies, Monash Uni., Caulfield Campus 1988– .

REP: Several regional, tertiary collections Aust; Warsaw National Art Gallery; corporate collections including AMP.

CHRISTOFIDES, Andrew

(b. 13/4/1946, Cyprus; arr. Aust. 1951) Painter, printmaker.

STUDIES: Economics, Uni. of NSW, 1967–71; painting and drawing, Byam Shaw School of Drawing and Painting, London, 1974–75; BA (Hons), Chelsea School of Art, London, 1975–78. He held 6 solo exhibitions 1978–89 in London and Australia (including the Painters Gallery, Sydney) and his work appeared in numerous group exhibitions in Australia and London 1972–92 including *Rome Scholars 1970–80*, South London Art Gallery, London 1980; *The Subject of Painting*, AGNSW 1985; at Painters Gallery, Sydney (3 exhibitions); and *Fidelity: Four Abstract Artists*, New England Regional Art Museum, 1992. He curated and participated in *Pure Abstraction* exhibition at Painters Gallery, Sydney 1986.

AWARDS: Rome Scholarship (living and working in Rome), 1978–79; Picker Fellowship in Painting, Kingston Polytechnic, London 1979–80.

APPTS: Part-time lecturer, Canterbury College of Art and Bristol Polytechnic, UK 1980–81; part-time lecturer, NSW Dept of TAFE, 1982–88; lecturer, College of Fine Arts, Uni. of NSW, 1988– .

REP: Artbank; New England Regional Art Museum; Coll. of Fine Arts, Sydney; Phillip Inst., Melb.; Qantas and Ajax (Tokyo) corporate collections.

BIB: Catalogue essays exhibitions as above. Germaine, *AGA*.

CHUCK, Thomas Foster

(b. c. 1826, London; arr. Aust. c. 1860; d. 1898) Photographer, entrepreneur. He produced and exhibited a *Grand Moving Diorama of Victorian Exploring Expedition (Burke and Wills)* consisting of approximately 16 scenes of the Burke and Wills expedition which was exhibited in abbreviated form January 1862, at Kreitmeyers' Museum of Illustration, Bourke Street, Melbourne and later that year toured to Ballarat, Sydney and Hobart. He established galleries for his own photographic works in Daylesford, Vic. (c. 1866–68), Melbourne (1868–c. 1870s) and Ballarat (1880s). Specialising in the photography of well-known colonists and some landscape scenes, his most well-known work is *The Explorers and Early Colonists of Victoria*, 1872, (NLA) a huge mosaic of 700 photographic portraits, which took him three years to complete.

REP: NLA.

BIB: J. Cato, *The Story of the Camera in Australia*, Melbourne, 1955. Robert Holden, *Photography in Colonial Australia*, Sydney, 1988; Kerr, *DAA*.

CHURCHER, Betty (Elizabeth Ann)

(b. 11/1/1930, Qld) Gallery director, painter, writer, lecturer.

STUDIES: Royal College of Art, London 1956; MA, Courtauld Institute of Arts, London 1977. As teacher, writer, state and national gallery director she has been an influential force in art development and presentation of exhibitions in Australia since the early 1970s. Married to artist Roy Churcher (q.v.) she is the author of *Understanding Art* (Rigby, Adelaide, 1974), and *Jon*

Molvig: The Lost Antipodean (Penguin Books and Allen Lane, Ringwood, Vic., 1984).
AWARDS: RCA Travelling Scholarship, London, 1956; Qld Centenary Portrait prize, 1959.
APPTS: Lecturer in art, Kelvin Grove CAE, 1971–78; senior lecturer, School of Art and Design, Preston (later Phillip) Inst. of Technology 1978–86 (head of art school 1983–86); director, AGWA 1987–89; director, NGA 1990– .

CHURCHER, Roy
(b. 27/1/1933, London; arr. Aust. 1957) Painter, teacher.
STUDIES: Sutton School of Art, Eng. 1947–51; Dip. painting, drawing, etching, Slade School, London, 1956. Post-impressionist form and colour and a Bonnard-like interest in interiors invaded by sunlight are characteristic of his work. He exhibited with the CAS Brisbane 1962–71 and held frequent solo exhibitions 1971–92 including at Ray Hughes, Brisbane, Christine Abrahams, Melbourne and Solander, Canberra. Married to gallery director Betty Churcher (q.v.), he was artist-in-residence at the Vic. Tapestry Workshop in 1982 and has undertaken numerous trips teaching Aboriginal communities in Qld and WA.
APPTS: Teaching experience includes in private studio school with Betty Churcher in Brisbane 1957–62; Central Tech. Coll., Brisbane 1962–67; foundation member and vice-president, CAS, Qld; teacher, Australian Flying Art School 1970s; visiting lecturer at many institutions including Qld Uni., Curtin Uni., Phillip Inst., QIT.
AWARDS: R.N.Ag.A.Q. prize (modern rural), 1962; Redcliffe prize (non-representational), 1964; Georges Invitation Art Prize (drawing purchased), 1974; Australian-Italian Cultural Scholarship to Rome, 1972.
REP: NGV; QAG; Parliament House; Artbank; several regional and tertiary collections Vic., Qld.
BIB: Viday Lahey, *Art in Queensland*, 1959. Robert Hughes, *The Art of Australia*, 1966. H. Fridemanis, *Artists and Aspects of the Contemporary Art Society*, CAS, Qld, 1991. Smith, AP.

CHURCHILL FOUNDATION
See TRUSTS AND FOUNDATIONS

CHURCHLAND, Lindsay Sorel
(b. 1921, Colac, Vic.) Painter, teacher.
STUDIES: Dip. Art, ESTC 1949; Chelsea Polytechnic, London 1950–51. With a concurrent interest in the traditional guitar-making of Spain, where he lived in 1962 and again in 1974, he taught at the NAS, Sydney for 20 years, exhibited in group exhibitions especially with the NSW Society of Artists from 1955, lived in Europe 1976–83, and returned to Australia in 1983. He held three solo exhibitions with Robin Gibson, Sydney 1984–87.
APPTS: Teaching, NAS, Sydney, part-time 1953–55, full-time 1955–; City Art Inst. till 1976.
REP: AGNSW; Lismore regional gallery; City Art Inst.
BIB: John Kroeger, *Australian Artists*, Renniks, Adelaide, 1968.

CILENTO, Margaret (Phyllis Margaret)
(b. 30/12/1923, Sydney) Painter.
STUDIES: ESTC 1943; New York 1947–48; Paris 1949–50; Goldsmith College and Central School of Art, London 1957–60. Her 1952 exhibition at Macquarie Galleries, Sydney, showed interesting abstract works, at that time almost unheard of in Australia, derived from her contacts with Rothko and Motherwell in the USA. Her teaching introduced European and American modernist concepts and her work developed into a more figurative style from the late 1950s. She exhibited infrequently 1950–80s. The University Art Museum, Qld University held a retrospective of her work in 1990 and she held solo exhibitions at Garry Anderson, Sydney 1984; Adam Galleries, Melbourne 1990, 92.
AWARDS: 1st prize (Home Front Section), *Australia at War* exhibition, 1945; Qld Wattle League Scholarship, Brisbane, 1949.
REP: NGA; NGV; QAG; several university, regional and corporate collections including Holmes à Court.
BIB: H. Fridemanis, *Artists and Aspects of the Contemporary Art Society, Qld Branch 1961–73*, CAS, 1991.

CITÉ INTERNATIONALE DES ARTS
Established 1965 at 18 Rue d'Hotel de Ville, Paris 4, for the benefit of foreign students of painting, sculpture, music, choreography and architecture. The complex includes galleries, concert hall, restaurant, etc., as well as student studio flats owned by foreign governments and foundations. Australian owners include the Power Institute of Fine Arts and the AGNSW in the name of Moya Dyring and Dr Denise Hickey.
BIB: *Meanjin* 3/1966 (Alan McCulloch, 'Australia's Cultural Image'). Illustrated survey, *Dr John Power: the Power Bequest*, University of Sydney, 1975.
See also AUSTRALIA COUNCIL; SCHOLARSHIPS & AWARDS; OVERSEAS STUDIOS

CLARE, J.
Active c. 1900 in Australia and New Zealand. Colonial school landscape painter.
NFI

CLARK, James A.
(Active c. 1870–1900) Illustrator, etcher. William Moore records that he worked on the *Queens-lander* and produced the first etchings in Qld in the 1870s.
NFI

CLARK, Jane Evelyn Lindesay
(b. 26/9/1955). Curator, writer.
STUDIES: BA, Uni. of Melbourne, 1977; MA, Courtauld Institute, London, 1981. As curator of art at NGV she has been responsible for a number of significant exhibitions, for which she has written or co-written comprehensive catalogues, including *Golden Summers*; *Heidelberg and Beyond* 1986; *Ian Fairweather 1891–1874* 1991; *Constance Stokes 1906–91*, 1993; *Alan Sumner* 1993.

APPTS: Myer Curator Special Exhibitions, NGV, 1982– ; acting curator, 19th Century Australian art, NGV 1986; curator, prints and drawings, NGV 1987–88; visiting scholar, National Museum of Art, Washington, USA 1988–90; American Art Intern, MOMA, NY, 1989; Education Associate, National Building Museum, Washington, DC 1989–90; acting co-ordinator curator Australian Art, NGV, 1991–92; curator Australian art, NGV 1992– .

CLARK, John Heaviside

(b. c. 1770) Commercial artist, engraver. His ten well-known coloured plates of Aborigines hunting game, though of a quality to suggest they were done from nature, were probably made from drawings by another artist; Rex and Thea Rienits consider Lewin (q.v.) 'the most likely candidate'. His work was represented in the Bicentennial exhibition *The Face of Australia*. He wrote *Field Sports of the Native Inhabitants of New South Wales*, Edward Orme, London, 1813.

Rienits, *Early Artists of Australia*, 1963.

CLARK, John James

(b. 1838, Liverpool, Eng.; arr. Aust. 1852; d. 1915, Melb.) Architect, painter.
STUDIES: Melbourne, with Buvelot 1868–75; Oswald Rose Campbell, NGV School of Design. One of the most noted colonial architects, his designs include those of the Treasury, Customs House, Royal Mint, City Baths, Queen Victoria Hospital, and Government House, Melbourne; the Treasury in Brisbane, and the Public Library in Sydney. He was a competent sketcher, and painted watercolours mainly in the country areas surrounding Melbourne, especially the Dandenongs, Mt Macedon and the You Yangs.
REP: NGV.
BIB: Moore, *SAA. ADB* 3. Kerr, *DAA.*

CLARK, Marc

(b. 20/10/1923, Surrey, UK; arr. Aust. 1962) Sculptor, lecturer.
STUDIES: Canterbury School of Art, Eng., 1938–42; Dip. (1st class); MA, Royal College of Art, London, 1948–51; Paris, 1951–53, and later at La Dordogne, south-west France. From 1953 his work appeared in London group exhibitions including eight consecutive RA exhibitions. In Australia his work has been shown at *Mildura Sculpture Triennials* 1963, 66, 69, 73; Transfield Prize exhibition 1971; and special sculpture exhibitions at the TMAG 1972, 73. He also completed about 22 public commissions. Simple sensuous line with careful attention paid to the preservation of the block are characteristic of his sculpture, which ranges from solid, geometric forms inspired by ancient architecture to straight portraiture, unity of style being achieved through the application of classic disciplines.
APPTS: Lecturer (part-time), Watford, Croydon and Ravensbourne art colleges, UK; Melbourne, CIT, 1962; NGV School, 1962–72; senior lecturer, acting dean,

VCA, 1973–84; part-time tutor, Melb. CAE and Inst. of Education, Melbourne Uni. 1988–91.
AWARDS: Sculpture prize in the Captain Cook Bi-Centenary competitions, Melbourne, 1970; project grant, VACB 1977; fellow, The Art Foundation, NGV 1988.
REP: NGA; NGV; TMAG; Parliament House; Geelong Art Gallery.
BIB: *AI* 14/10/1970 (McCulloch, 'Letter from Australia'). *A&A* 8/1/1970. Sturgeon, *DAS.* Scarlett, *AS.*

CLARK, Thomas

(b. c. 1814, London; arr. Vic. c. 1852; d. 21/4/1883, Melb.) Teacher, painter.
STUDIES: Possibly with RA School, London. Clark was a dedicated teacher of wide experience. He first became known in Melbourne as a teacher at the Artisans School of Design, Collingwood, which started in 1856. More importantly, his letter of recommendation to the Victorian government resulted in the foundation of the NGV School which started in 1870. Clark was its first drawing master (1870) and remained so until declining health forced his resignation in 1876. Among his students were Tom Roberts and Frederick McCubbin. His surviving works show him as a fine landscape painter and portraitist working in a classic English tradition. He was represented in *Australian Art in the 1870s*, AGNSW, Sydney, 1976; the Bicentennial exhibitions *The Great Australian Art Exhibition* and *The Face of Australia*.
APPTS: Included anatomical draughtsman, King's College, London, from 1843; headmaster, School of Design, Birmingham (where Burne Jones was a pupil), 1846–51; director, Nottingham School of Art, 1851.
REP: State and regional galleries.
BIB: *Table Talk*, Melbourne, 9/1/1891. *ADB* 3. McCulloch, *AAGR.* Kerr, *DAA.*

CLARK, Tony

(b. 1954, Canberra) Painter.
He exhibited first with Art Projects Melbourne, in 1982 and held around 16 solo exhibitions to 1994 largely with Anna Schwartz, Melbourne and Roslyn Oxley9, Sydney. His work appeared in around 45 group exhibitions 1982–94 including *From Field to Figuration*, NGV, 1987 and *Documenta*, Kassel, Germany, 1992. His 1994 McCaughey Prize, NGV winning painting *Landscape* was of a series of panels depicting silhouetted trees and land forms.
AWARDS: McCaughey Prize, 1994.
REP: NGA; AGSW; NGV; university collections.

CLARKE, Cuthbert Charles

(b. 1818, Smyrna, Turkey; arr. Melb. c. 1851; d. 1863) Painter, illustrator. He signed his work *Clarke Ismer*, *C. Clark*, *C. Clarke Ismer*, and even on occasions two names on the one drawing. His drawings and watercolours form a valuable record of the history, topography and architecture of Castlemaine where he worked until about 1860. It is recorded that in 1856

he unsuccessfully applied for the position of Collector of Electoral Rolls, which went to H. G. Whitlam, great-grandfather of Gough Whitlam, Prime Minister of Australia, 1972–75. Many of his watercolours were done on David Cox paper, a paper which tends to darken with age. He contributed extensively to the *Illustrated Melbourne Post* 1862–63. His work was represented in *The Face of Australia* the Bicentennial exhibition touring 10 regional galleries Australia 1988–89.
REP: NLA; La Trobe Library.
BIB: *AAGR*; Kerr, *DAA*.

CLARKE, Denis Edwin
Painter.
STUDIES: Alexander Mackie CAE, 1974; St Martin's School of Art, London, 1975; Paris, 1976–77; Byam Shaw and Chelsea schools, London, 1977. He exhibited with groups in the UK and Europe and held an exhibition at the Holdsworth Galleries, Sydney 1981. He moved to Europe to live in the mid-1980s.
AWARDS: NSW Travelling Scholarship, 1974; Dyason Bequest, AGNSW; residency Moya Dyring Studio, Cité Internationale des Arts, Paris.
NFI

CLARKE, Hamilton
(Active, c. 1890, Melb.) Painter. Landscape watercolourist. He exhibited sepias at the VAS, 1890.
NFI

CLARKE, Joseph Augustus
(b. 1840, Kent, Eng.; arr. Aust. c. 1870; d. 1890, Brisbane) Painter, etcher, teacher.
STUDIES: RA Schools, London (South Kensington). He taught art in India (topographical drawing and sketching) before going to Australia, where much of his activity was devoted to teaching. He formed the drawing classes at schools of art in Woolloongabba and Fortitude Valley, Qld, and was the first teacher of drawing at the Brisbane School of Arts, 1881. He was also steward of the fine arts section of the Qld National Association, and drawing master at Brisbane Grammar School (girls' division), 1887. He taught at Brisbane Tech. Coll. (1884–90) and designed the school's emblem. He also designed the cover for the catalogue of the Qld court at the Sydney *International Exhibition*, 1879. His most well-known work is the 3.6 × 1.2 m panoramic painting of Brisbane commissioned for the Qld court and shown in the 1880 *International Exhibition* in Melbourne in which he was also represented by a number of other works. He also exhibited in the 1886 London *Colonial and Indian Exhibition* and the 1888 *Centennial International Exhibition* in Melbourne.
BIB: Margaret Maynard and Julie K. Brown, *Fine Art Exhibitions in Brisbane 1884–1916*, Fryer Memorial Library, Uni. of Qld, 1980. Vida Lahey, *Art in Queensland 1859–1959*, Qld 1959. Kerr, *DAA*.

CLARKE, Neil
(b. 13/9/1958, NSW) Painter, printmaker.
STUDIES: Dip. Art, Alexander Mackie CAE, 1980; Grad.

Dip. Art, City Art Inst., Sydney, 1982; BA (Visual Arts), City Art Inst., Sydney 1983. His abstract expressionist works were seen mainly in about seven group exhibitions 1985–89 at public and tertiary galleries including MPAC *Spring Festival of Drawing* and MPAC *Prints Acquisitive*, Mornington 1985, 86; *5th Seoul International Print Biennale*, 1986 and *Australians Celebrate the French Revolution*, Cannibal Peirce Gallery, Paris, 1989. He held a solo exhibition at Cité Internationale des Arts while in residency there in 1989. He was artist-in-residence at the Ludwig Forum für Internationale Kunst, Aachen, Germany 1993.
AWARDS: Warringah Art Prize (print), 1987; residency, Moya Dyring studio, AGNSW, Cité Internationale des Arts, Paris 1988–89.
APPTS: Part-time painting, printmaking, various Sydney TAFE colleges including Coll. of Fine Arts, Uni. of NSW; Meadowbank Coll. of TAFE; NAS, East Sydney Coll. of TAFE, 1986– .
REP: Uni. of NSW; Macquarie Uni.; Warringah Shire Council; Wentworth Law Chambers, Sydney; MLC Centre, Sydney.
BIB: Catalogue essays exhibitions as above. A&A 23/4/1986 (exhibit commentary); 24/3/1987.

CLARKE, Percy
(Active 1880s) He made 40 original sketches for his book *The New Chum in Australia* (1886).
NFI

CLARKE, Peter Warren
(b. 30/3/1935, Deloraine, Tas.) Painter, lecturer.
STUDIES: Prahran CAE, 1951–52; RMIT, 1953–54; European study tour, 1961–62; Europe and USA, 1974. He held over 20 solo exhibitions 1957–91, mainly in Melbourne (including at RMIT; Powell Street) and Sydney (Gallery A; Ray Hughes), as well as participating in a large number of group exhibitions, including the touring exhibitions *Contemporary Australian Painting*, shown in Los Angeles and San Francisco, 1966; *Australian Art Today*, SE Asia, 1970; *Survey of the Seventies*, Bendigo Art Gallery 1981. Beginning with small, Klee-like paintings, he moved gradually towards the large colour-field works for which he is best known. He designed a work made into a tapestry by the Victorian Tapestry Workshops for the Law Courts, Canberra, as well as members' prints commissioned by the PCA.
APPTS: Teaching, RMIT, 1967–c. 88.
AWARDS: Andrew Fairley prize, Shepparton, 1967; MAG prize, Launceston, 1967; Crouch prize, Ballarat, 1968; H. C. Richards prize, Brisbane, 1970; Gold Coast City (purchase), 1970; Darnell (de Gruchy) prize, 1972; QAG Trustees Prize 1975; Capital Permanent Award 1981.
REP: NGA; most state galleries; Artbank; regional galleries Ballarat, Shepparton, Launceston; tertiary collections.
BIB: Smith, *AP*. Bonython, *MAP*, 1970. Ronald Millar, *Civilized Magic*, Sorrett Publishing, Melbourne 1974.

CLARKE, Rod (Donald Roderick)

(b. 11/1/1927, Melb.) Painter, teacher.
STUDIES: NGV School; George Bell School; Chelsea and Slade Schools, London 1951–53; La Grande Chaumière, Paris, 1955. He has been mainly an art lecturer and exhibited little. He was involved in many committees in art and design fields including the Tertiary Art Education Study Committee, VACB 1979–80 which produced the report *Tertiary Art in Australia*, 1980. His work was represented in *Classical Modernism: The George Bell Circle*, NGV 1992.
APPTS: Teaching, NGV School, 1956–60; lecturing, RMIT, 1960–79, and head of the art school, 1979–81; Dean, Faculty of Art, RMIT 1981–91.
AWARDS: NGV Travelling Scholarship, 1950; VACB travel grant, 1975–76.
BIB: Mary Eagle and Jan Minchin, *George Bell School*, Deutscher Art/Resolution Press, Melbourne, 1981.

CLAUX, Eugene Crick

(b. 1929, Eng.; d. 1950, Sydney) Illustrator.
STUDIES: ESTC, 1944–48.
REP: AGNSW.

CLAXTON, Marshall

(b. 1813, Bolton, Lancashire; arr. Aust. 1850; d. 1881, London) Painter.
STUDIES: RA Schools, London, and with John Jackson. Known for portraits and biblical and historical genre, he exhibited at the RA and at the British Institute, 1832–75, winning several prizes in the 1830s. In 1850 he moved to Sydney to start an art school, bringing with him nearly 200 paintings for an exhibition. Sentiment and religion took precedence over art in his pictures and his exhibition was not a success. In Sydney he received several commissions, including one from Queen Victoria for a 'general view of the harbour and city of Sydney', but he felt that the artistic and economic climate of Sydney held little hope, and in 1854 he left for India, where he sold several of his paintings, arriving in England via Egypt and the Holy Land with many sketches of his travels. His portrait of James Cook, now in the collection of the Chief Secretary's Office, NSW government, was shown in the 1888 Centennial International Exhibition in Melbourne and several of his works commissioned in London following his return there in 1859, including his *General View of the Harbour and City of Sydney, Australia*, 1853, were presented to Queen Victoria. He exhibited at the Royal Academy, London until 1876. His work was represented in *The Artist and the Patron* AGNSW 1988 and the Bicentennial exhibition *The Face of Australia*.
REP: AGNSW; Geelong Art Gallery; Mitchell Library; Dixson Gallery.
BIB: *ADB* 3. Moore, *SAA*. Kerr, *DAA*.

CLAYDEN, James

(b. 1947, Vic.) Painter, sculptor, film-maker, performance artist.
STUDIES: Dip. Art & Design, PIT, Melb., 1978. A successful film and video-maker, Clayden's abstract paintings resemble the three-dimensional with built-up layers of paint (frequently enamel) through which the other layers are evident. He held 15 solo exhibitions 1969–91 in Melbourne (including Pinacotheca 1981, 83, 85; 312 Lennox St 1987, 88; Deutscher Brunswick St 1989; Girgis & Klym 1990, 91), Sydney (Ray Hughes 1989), Brisbane (Ray Hughes 1989). His installation films (separate from his feature films) have included *Re-Presentation: Still Life: Installation*, Ewing and George Paton Gallery, Melb Uni., 1977, and he has performed in theatre at La Mama, Melbourne. His work appeared in about seven group exhibitions 1978–92 including *A System of Differences: Some Recent Abstract Art*, 1988, *In House*, 1989, 200 Gertrude Street, Melb.; *John McCaughey Memorial Prize*, NGV 1991.
APPTS: Part-time lecturer, painting and drawing, PIT, Melb. 1989.
REP: NGA; NGV; Baillieu Myer Collection of Australian Art of the 1980s.
BIB: *New Art Three. Tension* 18 Oct. 1989. *AM*, March 1990.

CLAYTON, Samuel

(b. c. 1783; arr. Aust. c. 1816; d. 26/6/1853) Painter, silversmith. Transported to Sydney for 7 years from Dublin, he advertised his services in the Sydney *Gazette*, 4 Jan. 1817, as a miniaturist, portraitist and silver jeweller. He engraved the first issue banknotes for both the Bank of NSW, 1817, and Van Diemen's Land Bank, c. 1820. He received his ticket of leave in 1824 and rose to prominence in the colony, becoming one of the proprietors of the Bank of NSW in 1839, producing stamp designs, some painting and silverwork. His work was seen in *Australian Colonial Portraits*, TMAG, Hobart, 1979 and *The Artist and the Patron*, AGNSW, 1988.
BIB: W. Dixson, 'Notes on Australian Artists', *Journal of the Royal Australian Historical Society*, vol. 5, 1919. Moore, *SAA*. Kerr, *DAA*.

CLEMENTS, Bill (William) J.

(b. 1933, Bendigo) Sculptor.
STUDIES: ESTC (with Lyndon Dadswell), 1960–62; Japan (with Toru Mori and Shindo Tsuchi), 1964–67. He travelled in India and SE Asia in 1967 and during the same year held an exhibition in Kyoto, Japan. The influences of both Japan and India contributed to his *Reading for August 6th*, a piece in string and Xerox prints that gained him the 1970 Transfield prize. In 1970 Clements became increasingly interested in film-making and received financial assistance for film projects.
AWARDS: Japanese Government Scholarship for study in Japan, 1964; *Mirror*-Waratah Festival prize for sculpture, 1967; Transfield prize, Sydney, 1970; VACB grants, 1973, 76.
APPTS: Lecturer in sculpture, SASA, 1968–?
REP: AGNSW; AGSA; Mildura regional gallery.
BIB: *AL*, 1/5/1981.
NFI

CLEMENTS, Richard
(b. 10/8/1951) Painter. Self-taught, he exhibited in Melbourne at Rudolph Steiner School, 1987 and 13 Verity St 1989, 91 showing works of a surrealist dream-like nature.
REP: NGV; Western Mining Corp.
BIB: *New Art Three*. Germaine, AGA.

CLEVELAND, Charlotte
(b. 20/7/1819, London; arr. Aust. 1852; d. 1884, Tas.) Niece of Sir Charles Barry, architect of the British Houses of Parliament. In 1844 she married a trader, William Charles Cleveland, and moved to Tasmania in 1852 where she made pencil sketches of the town and countryside.
REP: Allport Library, Hobart.
BIB: *Papers and Proceedings, Royal Society of Tasmania*, vol. 100, 1966. Kerr, DAA.

CLEVELEY, James
(b. c. 1750, London) Artist. Unofficial artist and ship's carpenter on HMS *Resolution* during Cook's third voyage. He came from a well-known family of English marine painters, including his brothers John (who accompanied Joseph Banks on his voyage to Iceland) and Robert (Painter to the Prince of Wales). A competent artist, he is best known for his *Death of Captain Cook at Hawaii*, engraved by F. Jukes. This work, like other of his original drawings from the voyage, was redone by his brother John after his return from the Pacific.
REP: Dixson Gallery of the Mitchell Library, Sydney; NLA.
BIB: Bénézit, *Dictionnaire*, 1976. Kerr, DAA.

CLEWETT, George
(Arr. Aust. 1832; d. 1837) Sculptor. Mainly a carver of marble mantelpieces and church memorials, his work was seen in *Early Australian Sculpture*, Ballarat Fine Art Gallery, 1976.

CLIFFORD, James
(b. 26/10/1936, Muswellbrook, NSW; d. 25/12/1987) Painter.
STUDIES: Muswellbrook Tech. Coll.; Orban School and Ogburn School, Sydney. His work, which first appeared in group exhibitions at Watters Gallery, Sydney, 1963, combined painting with photography to produce kaleidoscopic effects related to imitation realism and Pop art. He held 11 solo exhibitions 1966–87, all at Watters except for two in Pondicherry, India, in the early 1970s. Group exhibitions in which his work appeared 1963–87 included *Portrait of a Gallery*, 25th anniversary annual touring exhibition; *A New Romance*, NGA 1987.
REP: NGA; AGNSW; AGWA; NGV; several regional galleries, tertiary and corporate collections NSW, Tas.
BIB: Horton, PDA. Smith, AP. Gary Catalano, *Years of Hope*, OUP, Melbourne, 1981. *New Art Two*. A&A 26/1/1988.

CLIFFORD, Samuel
(b. 1827, London; arr. Aust. 1848; d. 1890) Photographer. Kerr says he was 'the S. Clifford who arrived at Hobart Town from London, December 1848', where he exhibited his work and accepted photographic commissions. He specialised in stereoscopic photographs, largely of Tasmanian scenery, and was one of four official photographers commissioned to document the Duke of Edinburgh's 1867–68 tour of Australia. A work of his, *Burke, Wills and King at Cooper's Creek*, 1862, appears in Alfred Abbott's album of photographs, W. L. Crowther Library in the State Library of Tasmania. His work appeared in *Shades of Light*, NGA 1988.
REP: NGA; TMAG; Allport and Crowther Libraries, Tas.
BIB: Clifford Craig, *Old Tasmanian Prints*, 1955 and *More Old Tasmanian Prints*, 1984, Launceston. J. Cato, *The Story of the Camera in Australia*, Melbourne, 1955. Kerr, DAA.

CLIFTON, Louisa
(b. 1814, London; arr. WA 1841; d. 1880, Geraldton, WA) Amateur artist. Eldest daughter of Resident Commissioner Marshall Waller Clifton, and wife of George Eliot, Resident for the Bunbury district and later magistrate at Geraldton. One of seven children, four of whom (Elinor, Louisa, Mary and William) were artists – the sisters sketchers, the brother a photographer. Her surviving works suggest training in art and a natural talent for observation that helps greatly in their preservation as historical records of the early life of the colony of WA. Her work was seen in *The Colonial Eye*, AGWA, 1979.
REP: AGWA.
BIB: Nathaniel Ogle, *Colony of Western Australia*, 1839; diary of Louisa Clifton 1840, 1841. Lucy Frost, *No Place for a Nervous Lady*, Penguin, Vic. 1984. Moore, SAA. Kerr, DAA.

CLIFTON, Nancy
(b. 1907, Melb.) Painter, sculptor, printmaker.
STUDIES: NGV School; RMIT. She taught art at Ivanhoe Girls Grammar School, Vic., for 21 years. Compact composition and lyrical, impressionistic colour are features of her work, notably her watercolours.
AWARDS: Maitland prize for watercolours, 1966, 70.
REP: NGV; Newcastle Region Art Gallery.

CLIFTON, Romola
(b. 1935, WA) Painter.
STUDIES: Slade School, London, 1954–55; Europe, 1961. She worked as a medical artist in WA, 1959–60.
AWARDS: Hotchin prize for watercolour, 1956; Helena Rubinstein portrait prize, 1960.
REP: AGWA.
NFI

CLINCH, Robert
(b. 4/8/1957, NSW) Painter.
STUDIES: No formal training. Largely realist in style his work was seen in around 11 group exhibitions 1985–92 including Melbourne (Australian Galleries), Sydney (Robin Gibson), and in *Wynne Prize*, AGNSW 1985, 86, 87, 89, 91; *Portraits of Joseph Brown*, La

Trobe Uni. Gallery, 1991; *Uncommon Australians: Towards an Australian Portrait Gallery*, touring 5 state galleries 1992.
AWARDS: Royal Overseas League Art Award 1985; Wynne Prize for watercolour, AGNSW 1989, 93; Marten Bequest, NSW 1993.
REP: Artbank; ACTU; Linfox, Bank of Melbourne corporate collections; Joseph Brown collection.

CLINT FAMILY
The Clint family of Sydney artists originated with George Clint (1770–1854), well-known British portraitist who specialised in painting actors and other celebrities, exhibiting at the Royal Academy, 1802–35. His son Alfred Clint (1807–83) was a noted coastal landscape painter who also exhibited extensively at the RA. Another son, Raphael, went to Australia (arr. Sydney, 1840) to work as an engraver, lithographer and printer and was a member of the Society for the Promotion of Fine Art, Sydney, in 1849. Apparently he returned to London after the death of his father, the evidence being that he exhibited two figure studies in London (in 1857–58), giving his address as that of his brother Alfred. He may have incited his nephew, Alfred (1843–1924), to go to Australia. Alfred arrived in Adelaide in 1870, to become known for his cartoons for the *Mirror* and the *Lantern* before moving to Sydney and local celebrity as a cartoonist for Sydney *Punch*. In Oct. 1879, *Punch* issued 'a grand folio supplementary print', by Alfred Clint containing likenesses of over 100 colonial identities with inset portraits, allegorical figures and Sydney's coat of arms. Clint was one of the first cartoonists for the Sydney *Bulletin* when it started in 1880, and worked also for the *Tribune* and other papers. Later he became a scenic artist for the Prince of Wales Theatre, Sydney, and established a scenic studio at Camperdown, NSW, where he worked with his three sons. Of these, Alfred T. Clint (b. 1879; d. 5/9/1936) exhibited watercolours, some done on silk, with the NSW Society of Artists from 1914; George Clint exhibited with the NSW Society of Artists during the 1920s; and Sydney Clint died young.
BIB: Article, Sydney *Daily Telegraph*, 29/10/1922. AA, Nov. 1925. Marguerite Mahood, *The Loaded Line*, Melbourne, 1973. Kerr, DAA.

CLUTTERBUCK, Jock (Stanley John)
(b. 1945, Edenhope, Vic.) Sculptor, printmaker.
STUDIES: Sculpture and drawing, RMIT 1965–66. He exhibited at competitive exhibitions (Mildura 1967, 70; Comalco 1969; Cook Bicentenary 1970) and in 1968 participated in the New Zealand exhibition entitled *Form in Action: Survey of Australian Sculpture*. The simplified pyramidal or cylindrical forms in his sculptures are based often on water-forms, as in his *Niagara*, the monumental work in fabricated aluminium with which he won his first major award. His abstract prints, first shown regularly at the Crossley Gallery, Melbourne, then in a large number of important print exhibitions, complement the content and style of the sculptures. Group sculpture and print exhibitions in which his work appeared 1967–92 included *Mildura Sculpture Triennials* 1967, 70, 75, 78, 82, 85; *Aust. Sculpture Triennial* 1981, 87; with Ray Hughes, Sydney, in *They're Still Thinking Aloud*, 1987 and *Thinking Allowed*, 1991; and international print exhibitions in Poland 1991; Tokyo 1974; UK 1981, 82, 84. His work was represented in the Bicentennial exhibition *The Great Australian Art Exhibition*.
AWARDS: NGV Society drawing prize, 1966; Australian Print Council prize 1969, 73; Geelong print prize, 1972; State government Bicentenary award for sculpture, 1970; PCA print prize, 1973; Fremantle Art Centre print prize 1976; Caulfield Arts Centre sculpture award, 1979.
APPTS: Teaching, RMIT, 1970–73; lecturer in sculpture and printmaking, VCA, 1974–90.
REP: NGA; all state galleries; Parliament House; regional galleries Ballarat, Launceston, Newcastle, Mornington, Sale, Shepparton; many tertiary and govt dept collections Vic., NSW; MOMA, New York.
BIB: Catalogue essays in exhibitions as above. PCA, *Directory*, 1976. Scarlett, AS.

COASTAL ART GROUP
Tasmanian group of artists holding local exhibitions and meetings from c. 1950.

COATES, George James
(b. 9/8/1869, South Melb.; d. 27/7/1930, London) Painter.
STUDIES: NGV School, 1884–96; Julian's Academy, Paris, 1898. Apprenticed at 15 to the firm of Ferguson and Urie, makers of stained glass windows, he spent 12 years as a student at the NGV School before leaving for Paris in 1897 as a NGV travelling scholarship winner, travelling on the *Ophir* with David Davies. Between 1898 and 1913 he exhibited regularly at the Old Salon and from 1909 at the RA, London. He served as an official war artist during World War I, and in 1921 returned to Melbourne for an exhibition which he held jointly with his wife, Dora Meeson (q.v.), at the Athenaeum Gallery. Referring to this event in a letter to Roberts, Streeton wrote that 'the Coates had to pay duty on their work'. In his life abroad Coates became a member of the International Society of Painters in Oils, Royal Society of Portrait Painters, National Society of Portrait Painters, London; and the New Salon, Paris. A memorial exhibition of his work was arranged at the New Burlington Gallery, London, in 1931. From contemporary accounts Coates appears as a quiet influence on the contemporary Australian art scene, giving reliable support to his colleagues and acquiring the status in portraiture and other genres of a competent professional.
REP: AGNSW; AGSA; AGWA; NGA; TMAG; AWM; regional galleries Ballarat, Bendigo, Castlemaine.
BIB: Dora Meeson, *George Coates: His Art and Life*, Dent, London, 1937. Smith, AP.

George Coates, Nymph, *oil on canvas. Collection, Geelong Art Gallery.*

COATS, Liz
(b. 16/5/1946, NZ) Painter.
STUDIES: Dip. Fine Art, Elam School of Fine Art, Uni. of Auckland, 1968; Dip. Ed, Melb. State Coll., 1977. Her cool, well-balanced, formally-composed abstracts have echoes of women's crafts such as quilt-making, melding the best of the traditional with finesse of form and refined expression. She held about 12 solo exhibitions 1977–93 including at Ewing and Paton Galleries, Uni. of Melbourne 1977; Auckland Gallery 1978; in Sydney (Garry Anderson, Syme/Dodson; Annandale) and Melbourne (Charles Nodrum 1993). Her work appeared in about 8 group exhibitions 1977–92 including *Ten Years After,* Ewing and Paton Galleries, Uni. of Melbourne 1981; *Perspecta,* AGNSW 1983; *Tokyo Connection: 12 Australian Artists,* Tokyo 1990; *Frames of Reference,* AGNSW 1991.
AWARDS: VACB grants, 1981, 83, 86; studio residency, Tokyo 1987; artists' fellowship, 1989.
REP: AGNSW; Parliament House; Artbank; regional galleries Newcastle, New England; Uni. of Melbourne; private and corporate collections including National Bank of NZ, NZ Law Commission, Max Watters Collection, Baillieu Myer.
BIB: Chanin, CAP.

COBB, Victor Ernest
(b. 14/8/1876, Footscray, Vic.; d. 2/12/1945, Melb.) Etcher.
STUDIES: NGV School (evening classes), 1906. Cobb fought in the Boer War and on his return to Australia earned a living as a store detective, teaching himself the crafts of wood-engraving and etching in his spare time. By the 1920s he had mastered these crafts and with John Shirlow shared the distinction for many years of being one of the only Melbourne artists specialising in etchings. He made numerous carefully etched plates of city buildings in Melbourne and was commissioned by the Commonwealth government to make a series of plates in connection with the visit of the Prince of Wales to SA.
REP: Print collections in state galleries.
BIB: References in AA, no. 3, 1917, 1919, 1921. Robert C. Littlewood, *The Woodcuts of Victor E. Cobb,* Jester Press, Melbourne, 1981.

COBURN, Barbara (née Woodward)
(b. 1931, Sydney; d. 1986)
STUDIES: ESTC 1947–49. Best-known for her luminous and rare screen prints, she married artist John Coburn (q.v.) in 1953. Exhibiting little (Macquarie, Canberra 1968), she also printed editions of artists including Blackman, Rees, Nolan, Boyd, Olsen and Alun Leach-Jones.

COBURN, John
(b. 23/9/1925, Ingham, Qld) Painter, teacher, tapestry designer.
STUDIES: Dip. Painting, ESTC 1950. He studied the arts of India, Burma and China during war service in those countries, and in 1953 married silk screen printer, Barbara Woodward, who played an important part in his subsequent development. His paintings favour large, stylised shapes, simply designed and painted in glowing colours. 'My aim, he wrote, is to create formal harmonies of shapes and colours that exist in their own right and at the same time distil the essence of a place, a thing or an incident. Vital art must be a natural outpouring of one's experience disciplined by form'. These principles made his work readily adaptable to tapestry design. His tapestries were outstanding in the special exhibition of Aubusson tapestries shown at the 1968 Adelaide Festival of Arts, and later he was commissioned to design tapestries to be woven at Aubusson for the Sydney Opera House. He also designed a series on the theme of *The Seven Days* and supervised the weaving of many of his tapestries at Aubusson. His later work is somewhat repetitive. He exhibited widely in Australia and internationally, including a period living in Paris 1969–72 where he designed tapestries for the Aubusson workshop. He also designed tapestries for the John Kennedy Center for Performing Arts, Washington (7 tapestries, a gift of the Australian government). He held over 60 solo exhibitions 1957– 91 in all state capitals including Sydney (Macquarie, Barry Stern), Brisbane (Philip Bacon) and Melbourne (Australian Galleries). His early

John Coburn, Autumn, *1981, tapestry, 180 × 242cm. Courtesy Australian Galleries.*

1991 work was influenced by a trip to Kakadu and while still the stylised technique of works for which he has become famous the images were less formal and rigid with more figurative elements.

APPTS: Graphic designer for the ABC, 1956–59; teaching, NAS, 1959–67; head of Canberra Tech. Art School, 1967–69, and of NAS, Sydney, 1972–74; trustee, AGNSW, 1976–80.

AWARDS: Prizes at Bathurst, 1959; Tamworth, 1962; Young, 1963; Maitland, 1966; Blake prize, 1960; Darcy Morris Memorial prize, 1963; Order of Australia 1980; honorary doctor literature James Cook Uni., Townsville 1991.

REP: NGA; all state galleries; numerous regional, tertiary, government and corporate collections in every state.

BIB: Most general texts on Australian art. Sandra McGrath and John Olsen, *The Artist and the Desert,* Bay Books, Sydney 1981. Elwyn Lynn, *Contemporary Drawing,* Longman, Melbourne 1963. Terry Martin, *Masterpieces of Australian Painting,* Bay Books, Sydney, Longman, Melbourne 1967. Allen Rozen, *The Art of John Coburn,* Hamlyn, Sydney, 1980. Nadine Amadio, *John Coburn: Paintings,* Craftsman House 1988.

COCHRANE, *Grace Duncan*

(b. 29/9/1941, New Zealand; arr. Aust. 1972) Photographer, curator, art historian, writer.

STUDIES: Teacher's certificate, NZ, 1961; B.Ed., Tas. CAE, 1978; BA (fine arts), Tas. School of Art, Uni. of Tas., 1984; MA (fine arts), Uni. of Tas., 1986. She had

a solo exhibition, *Re-marking Time,* which travelled to Sydney, Adelaide, Townsville and NZ 1985–87; she worked as an art curator and wrote of *The Crafts Movement in Australia: A History* (Uni. of NSW Press, 1992). She was commissioned to document Parliament House, Canberra, by the Parliament House Construction Authority 1984–88 and to complete an art-in-working-life project at the James Nelson Textile Mill, Launceston, Tas.

AWARDS: Mt Nelson Prize, Tas. School of art, 1985; postgrad. scholarship, Uni. of Tas. 1984–85; professional development grant for overseas study, Art Museums Association of Australia through VACB, 1992.

APPTS: Primary and secondary teaching, NZ, 1961–70; part-time teaching, lecturing, Tas. School of Art, 1979–85; guest lecturer, art schools, conferences, 1986– ; curator, Australian Decorative Arts & Design post-1945, Powerhouse Museum, Sydney 1988– .

REP: NGA; QVMAG; Uni. of Tas.

COCKBURN, *(Major-General) James Pattison*

(b. 1779, New York, arr. Aust. c. 1837; d. 1847, London) Active NSW. Army officer and early topographic artist. Visiting Australia in the late 1830s he is better known for his Canadian sketches and paintings. The one Australian work attributed to him, a watercolour *The Fort on the Cox's River near Bathurst, New South Wales,* was sold at Christie's, London, May 1974.

BIB: Kerr, DAA.

COCKBURN-MERCER, Mary

(b. 1882, Scotland; arr. Aust. in childhood; d. 14/12/1963, Aubagne, France) Painter. Third daughter of William Cockburn-Mercer of Wannon, near Hamilton, Vic. As a teenager in Paris at the turn of the century, she had the good fortune to have independent means as well as the talent and opportunity of mixing with French modern painters during the most creative period in modern French history. Between 1900 and 1922 she was reported as having studied with Picasso and Chagall and worked as a studio assistant with Lhote and Waroquier. In 1922 she loaned the house she had built at Cassas in 1920 to friends and lived for a time at Capri. Eventually she moved from Capri to Spain where she was overtaken by the Civil War before escaping to Tahiti. She met the painter Ian Fairweather at Guam, and by 1939 was in Melbourne where she took a studio in St James Buildings and remained there until after World War II. Her artist associates in Melbourne included George Bell, William Frater, Lina Bryans and Arnold Shore, and her work appeared in the early CAS exhibitions; *Classical Modernism: The George Bell Circle* NGV, 1992 and *A Century of Australian Women Artists 1840s–1940s* Deutscher Fine Art, Melbourne, 1993. Her paintings reflect the spirit of the *Ecole de Paris* and the French painters whose company she had frequented. After the war she returned to Cassas, sold her house and made her headquarters in London. She died at Aubagne, France.

COCKS, Jane

(b. 8/9/1956, UK) Painter.
STUDIES: Dip. Art & Design (painting), Prahran CAE, 1979; Grad. Dip. (painting), VCA, 1982. She held five solo exhibitions 1980s–92 at Realities, Melb. and showed installations at Albury Regional Gallery, 1992 and Studio 666, Paris, 1986. Her work appeared in about 25 group exhibitions 1982–91 at private galleries (including Realities, Melb.) and at VCA Gallery, 1982; *Raising the Furies: 6 Melbourne Painters*, touring regional galleries, 1990; and *Trois Australiens*, Cité Internationale des Arts, Paris, 1986.
AWARDS: Grant, VACB, 1984; Keith and Elisabeth Murdoch Travelling Scholarship, NGV, 1985; residency, Cité Internationale des Arts, Paris, AGNSW, 1985; French government residency grant, 1986; residency, Greene Street Studio, NY, VACB, 1987.
APPTS: Lecturer, Charles Sturt Uni., Albury NSW.
REP: NGV; Artbank; Como; Monash Uni., VCA; State Bank of NSW corporate collection.
BIB: *150 Victorian Women Artists*, Vic. government 150 celebration, Globe Press, Melb. 1985.

COCKS, R. Sydney

Painter. colonial school landscape and seascape painter in watercolours; he exhibited with the Art Society of NSW, 1894–1902. His landscapes usually depict heavy bush country with trees, ferns, creeks, etc.
NFI

COEN, Margaret Agnes

(b. 4/4/1913, Yass, NSW) Painter.
STUDIES: RAS classes, Sydney, with Dattilo Rubbo and Sydney Long; watercolours with Norman Lindsay, 1930–40; travel studies Europe, 1954. Married to Douglas Stewart, poet and playwright, she exhibited her works, mainly of flowers and landscapes in watercolours, with the Australian Watercolour Institute and was a council member of the RAS, Sydney. She illustrated *Land of Wonder*, by Alec H. Chisholm (Angus & Robertson, Sydney, 1964). An exhibition of her work was held at the S.H. Ervin Gallery, Sydney 1991.
AWARDS: Goulburn prize, 1964; Pring prize, 1968; RAS prize for watercolours, 1972.
REP: NGA; AGNSW; QAG; regional galleries Armidale, Newcastle.
BIB: Douglas Stewart, *Seven Rivers*, Angus & Robertson, Sydney, 1966.

COFFEY, Alfred

(b. 1869, Ireland; d. 1950) Painter, teacher.
STUDIES: RAS School, Sydney. In 1897, when Julian Ashton left the RAS School to open his own school, Coffey went with him. His early work shows the influence of the Heidelberg School painters (who were in Sydney in the 1890s) and his large oil, *A Tail of Bushfire Smoke*, was exhibited at the AGNSW loan collection of Australian art, London, 1898. As a whole, his work evolves from the rich, subtle palette of the early impressionists to the softer tones of the romanticised painting of the 1920s and 1930s. He painted in the East Indies in 1922 and exhibited the pictures at Blaxland Gallery, Sydney, in 1923.
AWARDS: President's Prize, Art Society of NSW, 1892.
APPTS: Lecturer in history of art, Architecture School, Uni. of Sydney; teacher, Sydney Tech. School; official Australian representative at International Art Congress, Dresden, 1900.
REP: AGNSW; AGSA.
BIB: References and reproductions in AA, no. 9, 1921. *Fifty Years of Australian Art, 1879–1929*, RAS, Sydney, 1929.

COGNE, Francois

(b. 11/11/1829, Paris; arr. Aust. c. 1851; d. 1883, Paris) Artist, lithographer, teacher. An itinerant artist and lithographer, he went to London in 1848, taking up teaching positions, then to Ballarat and the goldfields via Melbourne in 1858. There he taught French and made engravings for Ballarat *Punch* from Aug. 1857, and in 1859 made a series of fine detailed lithographs of the town. Moving to Melbourne in 1862, he suggested the idea of lithographic views of Melbourne to the printer Charles Troedel (q.v.), which were produced in the *Melbourne Album*, 1863. He left Australia in 1864, returning via London to Paris.
REP: La Trobe Library; Dixson Library; NLA; Ballarat regional gallery; British Museum.
BIB: D. Bird, *On Australian Climates*, Melbourne, 1863. McCulloch, AAGR. Kerr, DAA.

Francis Cogne, Lydiard St, *1859, Ballarat West, lithograph, 27.7cm × 43.5cm. Joels, Nov 1991*

COHEN, Isaac Michael

(b. 1884, Ballarat, Vic.; d. 1951, London) Painter. STUDIES: NGV School, 1900–05; Paris. Known mainly for portraits, after initial successes in Australia, Cohen made his home in London, where he exhibited at the RA and became a member of the Royal Society of Oil Painters and Royal Society of Portrait Painters as well as the Pastel Society and Society of Graphic Art. AWARDS: NGV Travelling Scholarship, 1905; silver medal, Paris Salon, 1924, gold medal, 1932. REP: NGV.

COHEN, Morris Edwin

(b. 1866, Ballarat; d. 1931) Painter. He worked usually in pastels and was a friend of David Davies, Taylor Ghee and John Longstaff (qq.v.). He was drowned in a boating accident. His daughters, Valerie and Yvonne (qq.v.), became well-known painters and collectors. REP: Regional galleries Ballarat, Mornington. BIB: Exhibition catalogue, *Exhibition of Paintings by Australian Artists,* Fine Arts Society, Melbourne, 25 Oct. 1928.

COHEN, Valerie

See ALBISTON, Valerie

COHEN, Yvonne Frankel

(b. 28/6/1914, Melb.) Painter. STUDIES: RMIT; George Bell School, c. 1950. The daughter of Morris Cohen and sister of Valerie Albiston (qq.v.) she painted mainly semi-abstract landscapes. Her work appeared in exhibitions with Jim Alexander Gallery (1988); Charles Nodrum (1985, 86, 87, 88,

90); Eastgate Gallery (1988, 89, 91) and in *Classical Modernism: The George Bell Circle,* NGV 1992. AWARDS: A. H. Gibson prize, VAS, 1958; Portland prize, 1966. REP: Regional galleries Warrnambool, Townsville. BIB: Catalogue essays exhibitions as above. Germaine, AGA.

COHN, Anna

(b. Poland; arr. Sydney 1947) Sculptor. STUDIES: Académie des Arts Modernes, Paris, 1945–46; ESTC 1950–51; NAS (painting) 1955–60, (sculpture) 1960–62; Willoughby Arts Centre, 1963–64. She spent the war years, 1939–45, in German concentration camps. Her later travels to SE Asian, South American and European countries between 1963 and 1975 developed her taste for the primitive art forms that became characteristic of her ceramic sculptures. She held over 80 solo exhibitions 1947–93 and received many commissions including trophies for *Businesswoman of the Year* for Qantas (annually 1982–86) and *Torch of Learning* trophies, Hebrew Uni., Jerusalem, 1983, 91, 92; plaques and wall reliefs for public places including Royal Prince Alfred Hospital, Sydney. She lectured on Australian and international sculpture and has been a member of many professional bodies including International Critics Association 1977–84; John Power Foundation for Fine Arts, CAS, Sydney 1954–78; MCA 1991– ; sculpture advisory boards in South Sydney, Sydney councils 1991– . She was instrumental in establishing the Sculpture Centre in Sydney and President of the NSW Sculptors Society 1985–88. AWARDS: Twenty prizes for sculpture, notably the Great Synagogue prize, Sydney, 1964, 68, 70, and RASNSW prizes 1968–73; trophy competition Qantas-*Bulletin* Businesswoman of the Year 1982–86.

REP: AGNSW; QAG; MCA, Sydney; several regional sculpture collections including at Gosford; secondary, tertiary colleges NSW.

BIB: Ron Rowe, *Modern Australian Sculpture*, Rigby 1977. Scarlett, AS. *Women's Art Register*, Melb. 1983. Germaine, *DAWA*.

COHN, Ola (Carola)
(b. 1892, Bendigo; d. 1964, Melb.) Sculptor.
STUDIES: Bendigo School of Mines, 1909–19; Swinburne Tech. Coll., 1920–25; Royal College of Arts, London, 1926–30. She received much of her training at the RCA from Henry Moore. She also studied bronze casting in the evenings at the London School of Arts and Crafts, as well as wood-carving at South Kensington; later she travelled extensively, studying in European countries. In 1931 she returned to Australia as a prophet of the new movement in sculpture as represented by the work of Henry Moore. She taught briefly at Geelong Grammar School and for about 15 years (1940–54) lectured part-time at the Kindergarten Training College, Melbourne. During this time she became president of the Melbourne Society of Women Painters and Sculptors 1948–64. She was in Europe, UK, Sweden, Norway and Iceland, 1949–51, and in 1953 married H. J. Green. While her early work reflected the prevalent mood of British sculpture during her student days there, notably the Egyptian, Assyrian and Greek influences as derived from Epstein and Moore, its creative energy did not last and her work became sentimentalised and folksy. Her house at 41–43 Gipps St, East Melbourne, was bequeathed to the Melbourne Society of Women Painters and Sculptors, to become known as the Ola Cohn Memorial Centre (q.v.) and a venue for Council of Adult Education lectures. She was represented in *A Century of Australian Women Artists 1840s–1940s* Deutscher Fine Art, Melbourne, 1993.
AWARDS: Student prizes, NGA, 1920; Roman Catholic Centenary Prize, Melbourne, 1948; Crouch Prize, Ballarat (for sculpture), 1952; OBE conferred for services to art, 1964.
REP: NGA; AGSA; NGV; QAG; regional galleries Ballarat, Bendigo; uni. collections Qld and Melb.
BIB: Sturgeon, *DAS*. Scarlett, *AS*.

COLAHAN, Colin
(b. 1897, Woodend, Vic.; d. 1987) Painter, sculptor.
STUDIES: Uni. of Melbourne (medicine), 1915–16; Max Meldrum School, 1916–19; London; Paris. He was a foundation member of the Australian Academy of Art, and his early tonal portraits and landscapes show him as one of Meldrum's most gifted followers. He lived in England and Europe from c. 1920 and worked as an official war artist with the Australian forces in England in 1942. He exhibited at the Paris Salon, RA and with the Royal Institute of Oil Painters and Society of British Artists. When he moved to Italy in 1964 his main interest became sculpture. Author of *Max Meldrum, His Art and Views* (Alexander McCubbin, Melbourne, 1917). His work was represented in the Bicentennial exhibition *The Face of Australia*.
REP: AGSA; NGV; QAG.
BIB: Scarlett, *AS*.

COLCLOUGH, Edward
(b. 1866, Brisbane; d. 1950, Qld) Painter, photographer.
STUDIES: Brisbane Tech. Coll. with Joseph Clarke. He spent his working life in the record and correspondence section of the Qld Lands Dept and became known for landscape paintings in watercolours.
APPTS: Hon. secretary, QAS, 1900–03; New Society of Artists, 1904–07; Qld Authors and Artists Society, 1921–31; QAG, 1930–45.
AWARDS: Qld Centenary Art Prize, 1959.
BIB: Vida Lahey, *Art in Queensland 1859–1959*, Jacaranda Press, Brisbane, 1959. Julie K. Brown and Margaret Maynard, *Fine Art Exhibitions in Brisbane 1884–1916*, Fryer Memorial Library, Uni. of Qld, 1980.

COLE, Charles Frederic
(b. 1875; d. 1959) Painter. As an orchard inspector for the Victorian Dept of Agriculture, he wrote and illustrated books on the propagation of fruit trees. A keen birdwatcher, he contributed articles to the magazine *Emu*. His naive paintings have a dream-like quality and are often delightfully imaginative.
BIB: Bianca McCullough, *Australian Naive Painters*, Hill of Content, Melbourne, 1977.

COLE, Peter
(b. 1946, Bairnsdale, Vic.) Sculptor.
STUDIES: Prahran CAE, 1964–68; travel studies Mexico, South America, USA, 1976; NT 1982; Japan, Korea 1983; Philippines 1987. His work features surrealistic constructions in mixed media, as seen in 6 solo exhibitions 1981–88 at Ray Hughes Brisbane and Sydney. He participated in a number of group exhibitions 1970–91, among these many sculpture survey shows, including *Mildura Sculpture Triennial*, 1975, 78; *Relics and Rituals*, NGV 1981; *Continuum*, VACB touring exhibition to Japan, 1983; *Australian Perspecta '83*, AGNSW 1983; *Contemporary Art: A Review*, opening exhibition MOCA, Brisbane 1987. He also featured in many exhibitions with Ray Hughes Gallery, including *Seventeen Australian Artists*, Gallerie San Vidale, Venice in conjunction with Biennale 1987.
REP: Regional galleries Launceston, Mildura.
BIB: Scarlett, *AS*. Sturgeon, *DAS*.

COLE, Peter D.
(b. 1947, Gawler, SA) Sculptor.
STUDIES: SASA, 1965–68; travel studies, 1968–69 and 1973–74. He held 14 solo exhibitions 1969–91 largely at Macquarie Galleries, Sydney, and participated in a number of group exhibitions 1967–90 including with CAS, Adelaide; *Mildura Sculpture Triennial*, 1970, 85; *Australian Sculpture Triennial*, 1981, 84, 90; *Sculpture 111*, Lewers Bequest and Penrith Gallery 1987.
AWARDS: P. Gill medal, SASA; CAS Drawing Prize 1967.

APPTS: Lecturer in charge of sculpture, Preston Inst. of Technology, 1975– .

REP: NGA; Artbank; a number of university and regional collections NSW, Vic.

BIB: Catalogue essays in exhibitions as above. *New Art Two.* AL, 9/2/1989.

COLEBECK, James

(b. 1800, Dewsbury, Yorkshire; arr. Van Diemen's Land, 1828) Stone carver. He assisted Daniel Herbert with the carvings on the Ross bridge, Tas.

COLEING, Tony (Anthony John)

(b. 1/7/1942, Warrnambool, Vic.) Sculptor, painter, printmaker.

STUDIES: NAS 1958–59; England 1963–68. He went to England in 1963, and the following year he participated in exhibitions at the Whitechapel and Royal Institute galleries, London, and travelled in Europe. Returning to Sydney in 1968 he exhibited some of his new, experimental sculptures in plastic at *The Young Contemporaries* (Farmer's Blaxland Gallery) prior to showing similar works in *The Field*, Melbourne. In 1970 his 12.19m high *Wind Construction*, made from steel piping and colourfully painted propellers, created a sensation at the *Mildura Sculpture Triennial*. He held over 30 solo exhibitions 1969–91 including at Watters, Sydney; Ray Hughes, Brisbane and Sydney; Julie Green, Sydney; Venice Biennale, 1980; and a survey exhibition at MOCA, Brisbane in 1988. His commissions include those for Norwich Union, 1976 and a Bicentennial Print Commission, NGA 1987. He was artist-in-residence at the Uni. of Tasmania in 1990 and 1992 and has shown work in over 200 group exhibitions 1963–93 in Australia and internationally, including in print exhibitions and with CAS NSW; in *Mildura Sculpture Triennial*, 1970, 73, 75, 78; *Biennale of Sydney*, AGNSW 1976, 79; *Australian Perspecta*, AGNSW 1983; *Off the Wall, in the Air*, Monash Uni. and ACCA 1991. His 1991 exhibition titled *M.A.D.* (Mentally Assured Destruction) at Julie Green Gallery, Sydney was described by Lynette Fern in the 'Galleries' column, (*Sydney Morning Herald* 21/6/1991): 'the vibrant energy and colour . . . hold out promise . . . they do not disappoint but their continued impact is based on a paradox. For despite the attractive surfaces . . . their impact comes rather from Coleing's conviction that what humankind is playing is an endgame so that each work represents some potential apocalypse. Conveyed in the language of Pop Art and advertising come messages of doom.'

AWARDS: Kolotex award, Sydney, 1968; Flotta Lauro prize for sculpture, 1971; project grants, VACB, 1973, 74, 76; Muswellbrook Art Prize, print section, 1986; residency, NY Studio, VACB, 1987.

APPTS: Part-time, SCA, 1978–79.

REP: NGA; AGNSW; AGSA; AGWA; NGV; QAG; TMAG; many regional collections including Ballarat, Mildura, Warrnambool, Wollongong; AGNZ; several tertiary and corporate collections.

BIB: Catalogue essays in exhibitions as above. Sturgeon, DAS.

Chanin, CAP. A&A 10/4/1973 (Sandra McGrath, *Tony Coleing*); 11/1/1973 (Noel Hutchison, *Sculpturescape*). AL, 2/1/1982, 3/3/1983.

Tony Coleing, Portrait, *1990–91, acrylic on canvas, 16.7 × 122cm. Private collection.*

COLEMAN, Alannah

Painter, gallery director.

STUDIES: NGV School, c. 1934–39. Helped by a life-long association with many famous Australian painters, she opened the Alannah Coleman Gallery, London, for the promotion of Australian art in the late 1950s and in 1964 became director of Heal's Gallery. She helped to organise a number of important Australian exhibitions in London and Europe and went to Sydney as director of the Bonython Gallery in 1970, returning to London in 1971.

COLEMAN, Alfred

(b. c. 1890; d. 1952, Melb.) Painter. Known mainly for impressionistic landscapes. His work became well-known during the period 1930–50.

AWARDS: Albury prize, 1952.

COLLECTIONS: PRIVATE AND CORPORATE

See Appendix 1, p. 783.

COLLECTORS AND CONNOISSEURS' SOCIETY OF NEW SOUTH WALES

(1922–25) Established in Sydney to develop appreciation of the fine arts. President, F. J. Benson; secretary, C. F. Laseron.

BIB: Moore, *SAA*.

COLLINGRIDGE DE TOURCEY, Arthur

(b. 1853, Oxfordshire, Eng.; arr. Aust. 1877; d. 1907, Sydney) Painter, illustrator, teacher. Before migrating to Australia Collingridge was a staff artist for the *Illustrated London News* and *Graphic*, in Europe he worked for *Le Monde Illustré* and *L'illustration*, and was associated with the Spanish illustrator Daniel Vierge. In company with his brother, George, he fought with the Papal armies against Garibaldi, 1867–69. Arthur and George founded the Art Society of NSW; Arthur was staff artist for the *Illustrated Sydney News*, contributor to *Town and Country Journal* and Sydney *Mail*, and later helped start *Centennial Magazine*. He was also a trustee of the AGNSW, 1900–07, and art instructor at the technical schools at Bathurst, Orange and Lithgow.

REP: AGNSW.

COLLINGRIDGE DE TOURCEY, George Alphonse

(b. 29/10/1847, Oxfordshire, Eng.; arr. Sydney 1879; d. 1/6/1931, Sydney) Draughtsman, engraver.
STUDIES: Paris, Ecole des Beaux-Arts. Brother of Arthur Collingridge. The brothers rarely used the name de Tourcey. He studied architecture with Viollet-le-Duc and was apprenticed to an engraver in Paris. He made engravings for *Le Monde Illustré* and often worked in company with the French painters, Corot and Harpignies, sketching at Fontainebleau and Barbizon. In 1878 he was commissioned, as engraver, to accompany the Spanish illustrator Vierge to cover the wedding of the King of Spain in Madrid for *Le Monde Illustré*. This association with Vierge might well have inspired Australian black-and-white artists, notably Lionel Lindsay, in their high regard for the work of the Spaniard. George Collingridge fought for the Papal States against Garibaldi in 1867–69, and was awarded the Order of St Gregory, the Bene Merenti Medal and the Mentana Cross; he was also decorated by the Kings of Spain and Portugal. He was a teacher at Sydney Tech. Coll. for ten years and gave private lessons in art and French. An honorary member of the Royal Australian Historical Society of NSW, with his brother, Arthur, he founded the Art Society of NSW, and became its vice-president. He also founded the first branch of the Esperanto Club in Australia, sketched in the Windsor, Richmond and Bathurst districts of NSW and once made a trip by rowing-boat from Windsor to Broken Bay. Arthur Collingridge made a double-page drawing of the underground river at Jenolan Caves, which George engraved for publication in the *Illustrated Sydney News*, the first published picture of the caves. A man of great versatility, he spoke six languages and while living on the small property he owned at Berowra Creek, NSW, used his skill as a cartographer to add four or five miles of coastline to the maps of the Lands Dept. His 'magnum opus' is his *Discovery of Australia*, Sydney, 1895, published in support of his theory that the Portuguese had charted the entire Australian coastline, except the south, before 1530.

REP: AGNSW; Dixson Library.
BIB: *ADB* 8.

COLLINGS, Dahl and Geoffrey

Painters, designers, film-makers. The Collingses made their first joint films in Spain and Tahiti in 1937 and returned to Sydney in 1939. They became foundation members of the CAS, Sydney, and 1950–53 were in New York designing for the Australian Trade Commission. Back in Sydney in 1954, they held many group exhibitions and directed the series of films (sponsored by Qantas) on Australian painters and collections, notably Nolan, Dobell, Drysdale, Mertz Collection, etc., that were to win international awards. Their many exhibitions included *Dahl and Geoffrey Collings* (David Jones Gallery, Sydney, 1939) and an exhibition at the Macquarie Galleries in 1943.

BIB: Smith, *PTT*. Paul Rothka, *Documentary Film*, Faber & Faber, London, 1950. Smith, *AP*.

COLLINGS, Vi

(b. 23/9/1912, Devonport, Tas.) Printmaker, painter.
STUDIES: Drawing with Dattilo Rubbo, Sydney 1930–32; various classes 1959–73, Sydney. From 1970 her geometric abstract work appeared in many group print exhibitions including Sydney Printmakers 1970–90; *Pederson Memorial Print Prize exhibition*, QAG 1976; *Artists for Peace*, 1983–87.
AWARDS: Maitland prize (for prints), 1973.
REP: AGNSW; Reserve Bank collection.
BIB: PCA, *Directory* 1976, 82, 88. Germaine, *DAWA*.

COLLINGWOOD, Tom

(b. 1848, Glasgow; arr. Aust. 1866; d. 1937, Elsternwick, Vic.) Painter.
STUDIES: With J. H. Scheltema (c. ?1900). A schoolmaster by profession, he painted mainly landscapes in oils of the Dandenongs and Gippsland districts of Victoria.

COLLINS, Albert

(b. 1883, New Zealand; d. 1951, Sydney) Painter, commercial artist, teacher. As well as his art activities he conducted the *Argonauts* radio program for the Australian Broadcasting Commission until 1951.
AWARDS: NZ national competition for design.
APPTS: Teacher in NSW secondary schools, 1906–16; director of the advertising firm Smith & Julius, 1916–51.
REP: AGNSW; TMAG.
BIB: Reproductions, *AA*, no. 8, 1921.

COLLINS, Archibald

(b. 1853, Worcester, Eng.; arr. Adelaide 1899; d. 1922, Adelaide) Painter, teacher.
STUDIES: RA Schools, London. Teacher at the School of Arts and Crafts, SA, and Adelaide Art School, c. 1900.
REP: AGSA.

COLLINS, Lynn

(b. 13/7/1945, Adelaide) Painter, teacher.
STUDIES: Dip. Art (teaching), Western Teachers Coll. and SASA 1962–64; Advanced Dip. Teaching (tertiary), Fine Art, Torrens CAE 1978; Grad. Dip. Business Administration (Arts), SAIT. From 1965 she taught in various SA secondary schools and tertiary colleges as well as in London (1968–72), and in 1976 joined the committee of the CAS, Adelaide. Working in painting and assemblages, group exhibitions in which she participated 1965–91 included those with CAS Adelaide; *Georges Invitation Art Prize*, 1975; *Visions after Light*, AGSA 1981; and two-person exhibitions at Anima Gallery, Bonython-Meadmore galleries Adelaide 1984, 87. She held 10 solo exhibitions 1968–85 at Llewellyn Galleries, Adelaide; CAS and Ray Hughes, Brisbane.
AWARDS: Cornell prize for painting, 1965; Hayward prize for drawing, 1966; Georges prize (work acquired), Melbourne, 1975; standard grant VACB, 1977; Boans prize, Geraldton, WA, 1976; Australia/Japan travel grant, 1977; Alice Prize 1978.
REP: AGSA; NGV; TMAG; regional galleries Hamilton, Morwell.
BIB: Catalogue essays in exhibitions as above. Nancy Benko, *Art and Artists of South Australia*, Lidums 1969. Germaine, AGA.

COLLINS, William Gilbert

(b. 1889, Bealiba, Vic.; d. 1957, Melb.) Painter.
STUDIES: NGV School, c. 1925–30. Collins held his only exhibition at the Athenaeum Gallery, Melbourne, in April 1957.
AWARDS: NGV student awards including Ramsay prize.

COLLOCOTT, Michelle Frances (née Martin Francis)

(b. 1945, Sydney) Painter, teacher.
STUDIES: Dip. Art, NAS, 1960–65; travel studies Europe and UK, 1968–70. Bright colours, segmented shapes, flat patterns, and a wandering, map-like line reminiscent of Chinese landscapes, are the chief characteristics of her large, panoramic paintings. She held about 20 solo exhibitions 1970–92 at a number of galleries in Sydney (including Gallery A, Bonython, Coventry, Bloomfield), Canberra (Macquarie) and Brisbane (Victor Mace). Her work appeared in many group exhibitions at both private and public galleries from 1969, many of them at contemporary art spaces including *Mondo Faxo Wall Lords of the 20th Century*, Artspace 1989; *Porcelain Readymade*, Artspace 1990.
APPTS: Teaching, NSW secondary schools; NAS, 1970–75; visiting lecturer, Alexander Mackie CAE, 1975; lecturer, Mitchell CAE, Bathurst, NSW, 1977; guest lecturing at a number of tertiary colleges, NSW 1979– ; administrator, Artlet Window Gallery, Sydney 1990.
AWARDS: International Telephone and Telegraph Award, Australia (work acquired), 1972. (The ITT exhibition opened in Miami and toured the USA.)
REP: NGA; AGSA; Alice Springs Art Gallery; Araluen Arts Centre; a number of regional galleries including Armidale, Wagga Wagga; a number of tertiary collections including Macquarie Uni., Uni. of Technology, NSW; private and corporate collections including ITT (New York), BHP, Westpac.
BIB: Bonython, MAP 70; MAP 75. Germaine, AGA. A&A 9/4/1972; 19/2/1981; 20/4/1983; 22/4/1985.

COLQUHOUN, Alexander

(b. 15/2/1862, Glasgow; arr. Melb. 1876; d. 14/2/1941, Melb.) Painter, critic.
STUDIES: Glasgow, preliminary art studies; NGV School, 1877–79 and 1882–87. He painted after the admired style of the Glasgow School painters, notably Sir D. Y. Cameron, using a sombre palette touched occasionally with impressionistic accents. He was also influenced by Barbizon School painting and the work of his friend Max Meldrum. Favoured subjects were church interiors but he also painted landscapes and portraits. He taught at the Working Men's College c. 1910 and Toorak College 1930, and was highly respected as a critic. Writing for the Melbourne *Herald* (1914–22) and *Age* (1926–41), he exerted much influence on art affairs. He was secretary of the VAS, 1904–14, a foundation member of the Australian Art Association (exhibiting with both groups as well as with the Twenty Melbourne Painters), and a trustee of the NGV, 1936–41. His son, Archibald Douglas, was also a painter.
REP: NGA; NGV; regional galleries Bendigo, Castlemaine.
BIB: Alexander Colquhoun, *McCubbin: a Consideration*, and *The Art of W. B. McInnes*, both published by Alexander McCubbin, Melbourne, n.d. Alexander McCubbin, *Year Book of Victorian Art 1922*, Melbourne, 1923. ADB 8.

COLQUHOUN, Amalie Sara

(b. ?1894, Murtoa, Vic.; d. 16/6/1974, Vic.) Painter, teacher.
STUDIES: Ballarat Tech. School; Sydney Tech. School (pottery with F. J. Tarrant); Melbourne (with Max Meldrum and A. D. Colquhoun); travel study in Italy, France, UK and Greece. Married to Archibald Douglas Colquhoun (q.v.) she exhibited in London, taught at Melbourne Tech. Coll. and in partnership with her husband conducted an art school in Melbourne from 1927; she also designed stained glass windows for Ballarat churches.
REP: AGNSW; NGV; QAG; regional galleries Ballarat, Bendigo.

COLQUHOUN, Archibald Douglas

(b. 1894, Vic. d. 1983) Painter, teacher.
STUDIES: Melbourne, with his father, Alexander Colquhoun; NGV School (drawing classes), 1911; Melbourne (with C. Douglas Richardson and Max Meldrum);

travel study in France, Spain and England. He travelled in 1925 and exhibited at the Paris Salon, Société des Artistes Français and in London. Back in Melbourne in 1927 he started an art school; travelled again in Europe with his wife, Amalie, in 1935 and exhibited with the Royal Society of Portrait Painters, London Portrait Society and British Empire Society of Arts. The Colquhouns held a joint exhibition at a Bond Street gallery, returned to Melbourne in 1937 and continued teaching until 1950. Strongly influenced by the tonal theories of Max Meldrum, his paintings were often devoted to self-portraits and religious subjects.
AWARDS: Crouch prize, 1933; Melbourne Centenary Historical prize, 1934.
REP: AGNSW; QAG; NGV; a number of regional galleries including Ballarat, Geelong.

COLQUHOUN, Brett (Peter Brett)
(b. 1/4/1958, NSW) Painter.
STUDIES: Dip. Graphic Art, Swinburne College, Melb. His often monochromatic single-form abstracts have an attractive simplicity and were seen in 5 solo exhibitions 1982–92 in Melbourne (Art Projects, 1982; 200 Gertrude St, 1987; Pinacotheca, 1989, 91) and Sydney (Roslyn Oxley9, 1985), and in several group exhibitions 1982–92 including *Perspecta '83*, AGNSW 1983; *What is This Thing Called Science*, Melbourne Uni. 1987; *Moet & Chandon Touring Exhibition*, 1989, 92; *Biennale of SA*, AGSA 1990.
REP: NGV (Margaret Stewart Endowment); BP corporate collection.

COLVILLE, George Garden
(b. 1887, Aberdeen, Scotland; arr. Aust. 1892; d. 1970, Melb.) Painter.
STUDIES: NGV School. Known mainly for high-keyed, impressionistic landscapes and coastal scenes.
AWARDS: Albury prize 1951
REP: AWM; regional galleries Ballarat, Castlemaine, Mildura.

COMBES, Alice H.
(Active 1880s–1900s NSW) Painter. A landscape painter in watercolour she was the daughter of Edward Combes (q.v.), and recorded as having travelled widely and exhibited watercolours at Walker's Gallery, London, 1885–1912. She also exhibited extensively with the Art Society of NSW around the turn of the century.
BIB: J. Johnson and A. Greutzner, *Dictionary of British Artists, 1880–1940*, Antique Collectors Club, Woodridge, Suffolk, 1976.

COMBES, Edward
(b. 1830, Wiltshire, Eng.; arr. Aust. 1851; d. 1895) Painter, engraver; engineer, mine owner, politician, administrator. After prospecting for gold (apparently with success), he left to study engineering and art in Paris. He returned to Sydney in 1857, became a mine owner near Lithgow and, in 1872, an MLA. He was NSW Commissioner for the *Paris Exhibition* in 1878,

a director of the art section of the *International Exhibition*, Garden Palace, Sydney, and a trustee of the AGNSW (appointed 1881). In Sydney he exhibited watercolours (of Sydney and Devonshire) at the NSW Academy of Art, 1873 and 1877; in London he showed Australian scenes at the RA, and at the New Water Colour Society, 1884–92. He was President of the Art Society of NSW and a member of the Legislative Council from 1891. His work was seen in *Australian Art in the 1870s*, AGNSW, 1976.
AWARDS: CMG conferred.
REP: AGNSW.
BIB: ADB 3. Bénézit, *Dictionnaire*, 1976. Algernon Graves, *Dictionary of Artists*, Kingsmead, Bath, 1973.

COMMONS, Donald Gregor Grant
(b. 1/2/1855, Dunedin, NZ; arr. Sydney 1878; d. 1942, NSW.) Painter. Known mainly for seascapes. He taught drawing in Sydney while working as an engineering draughtsman in the NSW Dept of Public Works (18/8–1924). With other artists he formed a sketch club at Darlinghurst and after his marriage his home at Pymble became a meeting place for notable people, such as Conder, May, Ashton, Roberts, Streeton, Henry Parkes and J. F. Archibald. His work was represented in the *International Exhibition* at the Garden Palace, Sydney, 1879; he was a foundation member of the Art Society (later the Royal Art Society) of NSW the following year; and in 1926 a member of the Australian Art Society. His seascapes and other paintings are free, spontaneous and naturalistic, reflecting his interest in impressionism. An exhibition of his work was held at the McLeod Gallery, Sydney, in 1937 and at Villiers Gallery, Sydney, Sept.–Oct. 1972.
REP: NGA; AGNSW.
BIB: Moore, SAA.

COMMONWEALTH ART ADVISORY BOARD
(1911–72) In 1911 a committee was formed by Andrew Fisher, then Prime Minister, for consultation and advice concerning 'Votes for Historical Memorials for Representative Men'; this was followed in 1912 by the establishment of the Historic Memorials Committee of the Prime Minister (chairman), the President of the Senate, the Speaker of the House of Representatives, the Vice-President of the Executive Council, the Leader of the Opposition in the Senate and the Leader of the Opposition in the House of Representatives. In 1912 the government set up the Commonwealth Art Advisory Board to advise the committee on suitable artists to be commissioned to paint portraits of Governors-General, Prime Ministers, Presidents of the Senate, Speakers of the House of Representatives and other persons outstanding in the fields of the arts, science and literature, as well as recording important national events such as the opening of the first Commonwealth Parliament in Canberra in 1927, the opening of the Parliament by the Queen in 1954, etc. The Board was charged also with the responsibility of advising the Commonwealth government on the purchase of

paintings which would become part of a national collection to be housed in the NGA, when erected. In 1955 the Board was allocated an annual grant to purchase paintings for Australian embassies overseas. In the early 1960s its scope was gradually enlarged to permit the encouragement of Australian art, and it acquired a certain autonomy in purchasing paintings for the national collection, embassies, Department of Trade posts, etc., and in advising Commonwealth Departments on art matters. From 1960 the Board had authority to make contributions, within the framework of the amount of money approved by Parliament, towards overseas exhibitions of Australian art and circulating exhibitions in Australia. The annual allocation increased from £4,000 in 1958–59 to approximately £15,000 in 1961–62. During this period, exhibitions were sent to Malaya, India and Ceylon, Thailand, Vietnam, the Philippines, Paris (for the 2nd *Biennale des Internationale Jeunes Artistes*), New Zealand and South Africa. An exhibition of Australian sculpture was also sent to the Musée Rodin in Paris. An exhibition of Australian Aboriginal art to the *Bienale de São Paulo* in 1961; this exhibition was part of the comprehensive Tuckson exhibition of Aboriginal art collected from many sources and shown in every state gallery (*see* ABORIGINAL ART). Among the purchases, from 1959 to 1960, were works by Russell Drysdale, Sidney Nolan, Ian Fairweather and the younger painters Clifton Pugh, John Perceval, Andrew Sibley, etc., as well as paintings from an earlier Australian period by Streeton, Roberts, McCubbin and Withers. In 1962, at the invitation of the Tate Gallery, the Commonwealth Art Advisory Board assembled a large, mixed collection of past and current Australian paintings for exhibition in London. The exhibition, organised by Robert Campbell, had a preliminary showing in Adelaide to coincide with the Adelaide Festival of Arts in 1962. As a result of this showing, the exhibition was modified in some departments and extended in others. It was shown again in Perth as a contribution to the Commonwealth Games festivities before being sent to London, where it appeared at the Tate Gallery in Jan.–Feb. 1963. The Board co-operated with the Contemporary Art Society in 1962 in arranging an exhibition of modern Australian paintings for the *Commonwealth Art Today* exhibition held to inaugurate the new art gallery at the Commonwealth Institute in London, and with the state galleries in a comprehensive travelling exhibition, *Australian Painting Today*, organised by Laurence Thomas in 1963. The CAAB was disbanded in 1972 after the Whitlam Labor government came to power and responsibility for the arts passed to the Australia Council (q.v.).

COMMONWEALTH ARTBANK
See ARTBANK

COMMUNITY ARTS
This vast area of arts activity encompassing performing, visual arts and literature mushroomed into a huge industry in the 1980s. Spanning education, community groups, professional artists and performers, administrators and workplaces the activities are numerous and varied. With the establishment of the Community Arts Board of the Australia Council in 1978 and similar departments in most state arts ministries or equivalents the community arts became more highly organised and focused than ever before with the appointment of community arts officers in a large number of locations (including municipal councils). In the visual arts the main activites are those of artists-in-residence in an enormously diverse number of places including schools, local government, workplaces of many different types, with unions and the public service. Many joint mural projects have been completed in both public and privately-owned spaces.
See also PUBLIC ART

CONDER, Charles Edward
(b. 24/10/1868, London; arr. Aust. 13/6/1884; d. 9/2/1909, Virginia Water, Surrey) Painter.
STUDIES: RAS School, Sydney (night classes with A. J. Daplyn, where he won a three-guinea prize for the best painting from nature); NGV School (night classes with McCubbin), 1888–89; Julian's, then Corman's, Paris, 1890. He arrived in Sydney in the *Windsor Castle*, 13 June 1884, and started work with his uncle, William Jacomb Conder, in the Lands Dept of NSW. After eight months in that office he spent two years in a survey camp. He studied art at night and had his first success when his picture *Departure of the s.s. Orient* was purchased for 20 guineas from the Royal Art Society of NSW exhibition in 1888 for the AGNSW. Joining the staff of the *Illustrated Sydney News* he painted with Mahony, Minns, Fullwood and Julian Ashton in and around Sydney, and became influenced by the impressionistic art of Girolamo Nerli. In Oct. 1888 he went to Melbourne where he joined Roberts, McCubbin and Streeton at the Box Hill camp, to become permanently identified with the Heidelberg School (q.v.). In Melbourne he designed an *art nouveau* cover for the *9 × 5 Impressions Exhibition*. He exhibited also with the VAS, remaining in Vic. for about 18 months. Returning to Europe in 1890, he lived first in Paris, then in London where, in 1893, he became a member of the New English Art Club and attained celebrity for his paintings of Watteau-like fans done on silk. Sketches by Conder done in Paris have been mistaken for the work of his friend, Toulouse-Lautrec, whom he met at Corman's atelier and who painted a portrait of Conder which now hangs in the Aberdeen Art Gallery. Conder was also influenced by Whistler and the cult of *Japonais*. As a student in Paris he became friendly with William Rothenstein, and in 1891 they held a joint exhibition. His dissolute life in Paris did not prevent him from making progress with his art. Inspired by the sensuous paintings and drawings of Watteau (probably through his friend Anquetin) he began painting on silk, and painted a large wall decoration comprising a set of six panels for a back room in Samuel Bing's *La Maison de L'Art Nouveau*, Paris, 1895. His

Charles Conder, The Yarra, Heidelberg, *1890, oil on canvas, 49.9 × 90.2. Collection,* NGA.

first major success was a picture entitled *L'Oiseau Bleu,* 1895, done on silk in red chalk and watercolour. It seemed to critics 'luxuriously to sum up, in small scale, sensuality, nature and the idylls of a romantic past'. Through such works, as well as the fan paintings that later proliferated in his London studio, and his associations with Beardsley and the artists and writers of *The Savoy* and *The Yellow Book,* Conder became identified as a symbol of the *art nouveau* movement. In Paris in Dec. 1901 he married the socialite and widow Stella Maris Belford, and they made their home in London. He exhibited regularly with the New English Art Club, held joint exhibitions with his friend William Rothenstein and led a fashionable social life until incapacitated by his final illness in 1906. From contemporary accounts he rejected or was rejected by most Australian artists during his London years, one of the few to maintain contact being Streeton. Interest in his work declined rapidly after his death and in July 1927 an exhibition at Hordern's Gallery, Sydney, offered the public 121 of his works including oils, watercolours, drawings and lithographs for a total of about £782. However, as for his contemporaries, revival of interest and consequent prices for his work rose sharply from the 1970s and his works when obtainable command high prices. His paintings were represented in a number of significant survey exhibitions in the 1980s including *Golden Summers* NGV and touring state galleries 1987 and the Bicentennial exhibition *The Great Australian Art Exhibition.*
REP: NGA; all state and many regional galleries and other public collections; Jeu de Paume, Paris, and public collections in the UK and USA.
BIB: John Rothenstein, *The Life and Death of Charles Conder,* London, 1938. R. H. Croll, ed., *Smike to Bulldog,* Ure Smith,

Sydney, 1946. Ursula Hoff, *Charles Conder, His Australian Years,* NGV Society, Melbourne, 1960. *Charles Conder,* Lansdowne, Melbourne, 1972. ADB 3. A&A 2/1/1964 (Ursula Hoff, *Charles Conder*). Numerous references in general books and periodicals.

CONNELL, John Henry
(b. 1859, Collingwood, Vic.; d. Dec. 1952, Melb.) Hotel owner, grazier, collector, benefactor. He married Emily Baker, whose collection formed the nucleus of the magnificent collection of furniture, rugs, silver, ceramics, glass, engravings and various *objets d'art* (the Connell Collection) which he gave to the NGV in 1913. It was installed on the main floor of Buvelot Hall and opened to the public on 10 Sept. 1914. In 1929, Connell added to his gift a collection of old English china. The Connell Collection proved an inspiration to other, later collectors and resulted in other benefactions.
BIB: Percival Serle, *Catalogue of the Connell Collection,* 1925, rev. 1937. Leonard B. Cox, *The NGV 1861–1968,* NGV, Melbourne, 1970.
See also GALLERIES – NATIONAL GALLERY OF VICTORIA

CONNOR, Joseph Thomas
(b. 1874, Hobart; d. 1954, Hobart) Painter.
STUDIES: Hobart (with Mildred Lovett). His work, mainly of landscapes in watercolour, was included in the *Exhibition of Modern Art* at Grosvenor Gallery, Sydney, in Nov. 1926 (the first Australian modern exhibition). He later exhibited with the Society of Artists of NSW and at the RQ, London, 1928; Imperial Art Gallery, London; Old Salon, Paris.
REP: TMAG; QVMAG, Launceston.
BIB: Reproduction in AA, June 1925.

CONNOR, Kevin Leslie
(b. 15/8/1932, Sydney) Painter.
STUDIES: ESTC (night classes), 1948–49; Jos Holloway's

Sketch Club, Haymarket, 1950; overseas travel studies, 1954–57. He worked his way around the world, living and painting in the UK, USA and Canada, and held exhibitions on his return to Sydney. He also lived in Europe 1965–66, the USA 1966–68, and made shorter trips to Paris, London and Spain for 6 months in 1979; Egypt, Paris and London for 3 months in 1985; Paris, working with Jacques Champfleury in drawing and lithographs, in 1988; and several weeks in the Middle East drawing war-damaged areas in 1991.

His pictures incorporate a febrile expressionism with a deceptive spontaneity of line – deceptive as the works are well planned and considered, as aptly described by John McDonald in his review of Connor's 1989 retrospective at the AGNSW: 'I can think of few other Australian artists whose work denotes such a fierce and consistent struggle to distil a particular intensity from everyday experience. While Connor's paintings are full of intuitive leaps and vigorous brush-work, giving the evidence of spontaneity, I suspect that almost nothing in this exhibition has escaped long rumination and dogged reworking' (*SMH*, 23/9/1989). A prolific draughtsman, Connor's draw-ings are energetic and sure of line.

He held about 50 solo exhibitions 1962–93, includ-ing one in London, and participated in numerous group exhibitions in Australia including 13 Archibald Prize exhibitions (of which he won two). A number of retrospectives of his work have been held includ-ing at the Manly Art Gallery 1988; portraits at the Ivan Dougherty Gallery 1988; and in 1989 a major survey exhibition of his work was held at the AGNSW and toured to Heide, TMAG and Broken Hill art gal-leries.

AWARDS: Wollongong prize, 1961; *Mirror*-Waratah (grand prize), 1962; Harkness Fellowship, 1966; Sir William Angliss Memorial Prize, 1973; Archibald Prize, 1975, 77; *SMH* Art Prize 1979; Uni. of NSW Art Purchase, 1985; professional fellowship grant, VACB, 1988; Sulman prize, 1991; Dobell Prize for Drawing, AGNSW 1993.

APPTS: Lecturer, painting and drawing, NAS, Alexander Mackie CAE, City Art Inst. 1976–87; trustee, AGNSW, 1981–87.

REP: NGA; AGNSW; AGSA; AGWA; MAGNT; NGV; QAG; TMAG; AWM; MOCA, Brisbane; numerous regional, ter-tiary and corporate collections in all states; Aust. Embassy Washington.

BIB: Nancy Borlase, *Kevin Connor: Harbour Paintings 1964–87*, Manly Art Gallery and Museum 1988. M.A. Gilchrist, *Kevin Connor: Selected Portraits*, City Art Institute, 1988. Barry Pearce, *Kevin Connor*, Craftsman House, 1989. *Kevin Connor: The Haymarket Drawings*, Centaur Press, 1990 (limited edn). Bonython, MAP 70. Ronald Millar, *Civilized Magic*, Sorrett Publishing, Melbourne, 1974. Chanin, CAP. Smith, AP. A&A 4/3/1966.

CONSTABLE, Bill (William Henry Archibald)

(b. 1906, Eaglehawk, Vic.) Painter, stage designer.
STUDIES: NGV School, c. 1926; St Martin's School,

London 1930. Returning from studies overseas he worked in advertising before starting to design for theatre, becoming known for his décor and set designs for Borovansky ballets, notably *Façade*. Later his de-signs for the National Theatre included the décor for John Antill's *Corroboree*, 1951. He was working again in London in the late 1950s when his theatre work included for the London Festival Ballet (Noel Coward's *London Morning*, 1959) and art direction for the film *The Trials of Oscar Wilde*, 1960. Back in Australia he designed the tapestry curtain for a new theatre, Her Majesty's, Sydney, 1973. Later activities included exhi-bitions of paintings resulting from visits to Central Australia, Cambodia and the Great Barrier Reef. Author of *Flying Artist* (Legend Press, Sydney, 1952).
REP: AGNSW; NGV; MOMA, New York.
BIB: Horton, *PDA* Smith, AP. A&A 2/2/1964.

CONSTABLE, Christopher Roy

(b. 1941, Kempsey, NSW) Sculptor, painter.
STUDIES: Nottingham Coll. of Art, Eng., 1960–64; Hornsey Coll., London, 1964–66. An influence in his mostly figurative work is the *bronzetti* of Matisse. He held eight solo exhibitions 1978–89 including at Deakin University, 1979, and participated in a num-ber of group exhibitions 1978–89 including PCA print exhibitions; *Australian Sculpture Triennial*, 1984; *Mildura Sculpture Triennial*, 1985, 88; *Festival of Perth*, 1988.
AWARDS: Parmelia portrait prize (best WA entry), 1976; WA Arts Council grant, 1978; Rockingham prize, 1977; Canning Art Awards, 1981; Guy Grey-Smith Scholarship, 1984; grant, WA Arts Council 1985; Houghtons Wine Prize 1986.
APPTS: Visiting lecturer at various art colleges in the UK, 1966–73, and at WAIT, WA, 1975; Creative Arts Fellow, Geelong College and Deakin University, Vic., 1979.
REP: Fremantle Arts Centre; WA Uni.
BIB: *Western Australian Painters and Printmakers*, Fremantle Arts Centre Press, 1979. PCA, *Directory*. A&A 17/3/1980.

CONSTANTINI, Charles Henry Theodore
See COSTANTINI, Charles Henry Theodore

CONTEMPORARY ART SOCIETIES
Following the precedent of the CAS, London, the CAS movement in Australia began in Victoria, 1938, and spread rapidly to other states in a succession of inde-pendent societies (some still maintained as such) in capital cities. Federation of the state bodies in April 1961 led to the formation in Adelaide of the Contemporary Art Society of Australia (South Australia) Inc., which remains a thriving headquarters of avant-garde activity in the visual arts.
CONTEMPORARY ART SOCIETY OF SOUTH AUSTRALIA
14 Porter St, Parkside, Adelaide, SA 5063. Established Adelaide, 1942, largely through the initiative of Max Harris, the organisation received great impetus from the arrival in SA in the late 1940s of migrant artists

from Europe, among them the Dutkiewicz brothers, Stanislaus Rapotec and the brothers Dusan and Voitre Marek (qq.v.). The Cornell Prize and other prizes were conducted, and from the beginning the CAS, Adelaide, was more stable in its internal structure than the CAS in other states. When the state bodies federated in 1961, the CAS, Adelaide, became the national head-quarters and, in 1963, moved into its own building and gallery in Porter Street. Eearly significant exhibitions included the *Anti-Fascist Exhibition* in 1942 with works by artists including Dorrit Black, Ivor Francis, Jaqueline Hick, Douglas Roberts and Ruth Tuck. Administered by a council of 9 (minimum) elected by membership and funded by the SA Dept of the Arts and Cultural Heritage and the VACB, Australia Council.

CAS, BRISBANE

Contemporary Art Society, Brisbane, Qld. Formed 1963 with Dr Bernard Schaffer as president. Regular exhibitions and other activities were organised.

CAS, HOBART

Contemporary Art Society, Hobart, Tas. Formed 1963 with Barclay Erskine president.

CAS, MELBOURNE

PO Box 283, Richmond, Vic. 3121. Formed in 1938 with George Bell president, Rupert Bunny vice-president, John Reed lay vice-president and Adrian Lawlor secretary, in opposition to the reactionary spirit of the Australian Academy of Art (q.v.), which had been formed the previous year. The first meeting and election of office bearers of the Society took place at the VAS on 13 July 1938, and the first exhibition, which invited works from all states, was held at the NGV in June 1939. Three distinct groups emerged from the Victorian exhibitors: a group of students and adherents of the George Bell School, a group of avant-garde artists led by John Reed, and a social-realist group led by Noel Counihan and Josl Bergner. Differences soon arose between the groups and in 1940 George Bell seceded from the CAS, together with 83 other members, to form the Melbourne Contemporary Artists (q.v.). Similarly the social-realist group seceded to form its own body, and in 1947 the CAS, Victoria, suspended activities. It was revived in 1953 with Reed again as president, and in 1956 Reed established the Gallery of Contemporary Art, later the Museum of Modern Art and Design of Australia (q.v.), as a CAS headquarters. Contemporary artists donated pictures to an inaugural fund-raising exhibition and in 1957 the Victorian state government made available a grant of £250. The CAS broadsheet, published from 1954, was replaced by an illustrated magazine, *Modern Art News*, in 1959, but this failed after two issues.

The CAS Melbourne remains an active body receiving support from membership, holding monthly members' nights, workshops, talks by artists and critics, painting weekends, discussion groups and producing a bimonthly newsletter.

Presidents: 1938–40, George Bell; 1940–43, John Reed; 1943–47, Albert Tucker; 1947–53, organisation suspended; 1953–56, John Reed; 1957–59, Georges Mora; 1960, Bill Dye; 1961–63, David Boyd; 1963–64, Ron Greenaway; 1965–68, Robert Grieve; 1972–73, Heather Johnson; 1976–1980s, Joan Gough; 1993– , Robert Lee.

CAS, PERTH

Contemporary Art Society, Perth, WA. Formed at a meeting in Darlington, 7 May 1966, when the rent of premises was guaranteed for three years and lectures and exhibitions planned.

CAS, SYDNEY

Contemporary Art Society, Sydney, NSW (founded in Sydney, 1939). Initiated by Peter Bellew, secretary, with Rah Fizelle as president, this branch had the advantage of comparatively stable administration; it was particularly active from about 1960, and was then the most influential of the state bodies. A regular *CAS Broadsheet* was edited by Elwyn Lynn, who subsequently became president. A feature of the society's activities in NSW was the organisation within the group of a number of art prizes. (*See* PRIZES.)

BIB: CAS broadsheets and newsletters published Adelaide, Melbourne and Sydney. 'Contemporary Art Society', article in *The Critic*, Perth, vol. 7, no. 3, 1966.

CONTEMPORARY GROUP

(Active 1926–38) Established by George Lambert and Thea Proctor in Sydney for the encouragement of younger modern artists. The first exhibition (Grosvenor Gallery, Sydney) included work by Wakelin, De Maistre, Grace Cossington Smith and Margaret Preston. A Contemporary Art Group was formed also in Melbourne by George Bell, in 1932, to exhibit modern art as a counter to the local taste for academic art. It ceased to function with the formation of the CAS, Melbourne, in 1938.

CONVEY, Sylvia

(b. Apr. 1948, Germany) Painter.
STUDIES: B.Vis.Arts, Canberra Inst. of the Arts, 1985. As with her husband Tony Convey, Sylvia Convey's art is in the genre of 'sophisticated naive', or as it is designated, 'Outsider' artists, who are usually artists with little formal training, younger than most naive artists and present colourful images of slightly more sophistication than the child-like representations of more commonly seen naive art styles. She held 16 solo exhibitions 1972–92 in Melbourne (Avant Gallery) and Canberra (Bitumen, Ben Grady), and at MOCA, Brisbane 1989. Her work appeared in about 17 group exhibitions 1984–92 at private and regional galleries including *Seven Australian Outsider Artists*, Grafton Regional Gallery 1991; and in European galleries including Paris, Bayreuth and US (Minneapolis).
AWARDS: Three regional art awards (Albury 1978; Tallangatta 1980; Queanbeyan 1986).
APPTS: Teaching part-time, Canberra Inst. of the Arts, 1985–92.
REP: NGA; Albury regional gallery; *Outsider Archive*, London, Art Brut, Lausanne; Iwalewa Haus, Bayreuth.
BIB: Germaine, AGA. Germaine, DAWA. Judith Hoffberg, *Cross currents, bookworks from the edge of the Pacific*, Umbrella Assoc., California.

CONVEY, Tony

(b. 5/3/1946, Vic.) Painter, printmaker, sculptor. Self-taught, his work is of the same style as that of Sylvia Convey (q.v.) and was seen in 19 solo exhibitions 1981–92 including in Canberra (Kingston Art Space, Contemporary Art Space), Melbourne (Gallery Art Naive) and Hobart (Chameleon). He participated in approximately 20 group exhibitions 1981–91, often in the genre of 'Outsider', in regional galleries (as with Sylvia Convey) and *Raw Vision*, Lismore Regional Gallery, 1991.

AWARDS: Prizes at Wangaratta, 1976; Traralgon, 1977; Tallangatta, 1979; Queanbeyan, 1984; Canberra Religious Art Award, 1973; Victoria's 150th Anniversary Print Purchase, 1985; project development grant, VACB, 1988.

REP: NGA: Artbank; *Outsider Archive*, London; Art Brut Lausanne; Iwalewa Haus, Bayreuth.

BIB: *World Encyclopedia of Naive Art*, Harper & Row, NY 1985. Germaine, AGA.

COOK, Alfred Herbert

(b. 1907, Christchurch, NZ; d. 21/9/1970) Painter, etcher. Known mainly for watercolours. Teacher at ESTC from 1940; member of the Australian Watercolour Institute.

STUDIES: School of Art, Canterbury Uni., NZ, 1922–27.

REP: AGSA; QVMAG; Auckland Gallery.

COOK, Allon

(b. 11/5/1907, WA; d. 16/9/1971, WA) Painter.

AWARDS: Hotchin prize for oil, 1950, 51, 58.

REP: AGWA; Fremantle regional gallery.

COOK, Arthur Vollens

(b. 1909, Melb.; d. 1967, Melb.) Painter, critic.

STUDIES: Melbourne, with Max Meldrum. He was art critic for the *Age*, Melbourne, 1946–57.

COOK, Ebenezer Wake

(b. 1844, Essex, Eng.; arr. Melb. 1852; d. 1926) Painter, engraver.

STUDIES: Melbourne (with Chevalier); NGV School, 1872. Works by Strutt, von Guérard and Chevalier exhibited in a shop window, and Gill's watercolours in the foyer of the Theatre Royal, inspired him to become an artist. At 17, he studied painting, wood-engraving and lithography with Chevalier and later, 1870–72, became one of the first pupils at the NGV School of Design. The same year he was a foundation member of the Victorian Academy of Arts where he exhibited Macedon, Yarra and New Zealand landscapes. He showed NZ landscapes at the NSW Academy of Arts in 1872 and 1873, the year he exhibited Hobart views in Melbourne before returning to England. In London he was included with Strutt, Chevalier, Roper, Buvelot and Johnstone (qq.v.) in an exhibition, *Australian and New Zealand, American and Canadian*

Oil Paintings and Watercolour Drawing at the Burlington Gallery; he showed at the RA and at the Society of British Artists, 1874–1910, and continued to send European and Welsh landscapes to the Victorian Academy of Arts till 1883. Watercolours of the Swiss lakes, Italy and the Thames by Cook also appear frequently on the market. His work was seen in *Australian Art in the 1870s*, AGNSW, Sydney, 1976.

REP: AGSA; AGWA; NGV.

BIB: Christopher Wood, *Dictionary of Victorian Painters*, Antique Collectors Club, London, 1971. McCulloch, AAGR. Edward Craig, *Australian Art Auction Records, 1975–1978*, Mathews, Sydney, 1978. Moore, SAA. John Kroeger, *Rennicks Australian Artists*, 1968; Kerr, DAA.

COOK, H. N. E.

(Active, c. 1880, Melb.) His *Melbourne Town Hall, 1883* (from the Page Cooper Collection) was exhibited at the Joseph Brown Gallery *Winter Exhibition*, 1970.

NFI

James Cook, Two Tramps, *1932, pencil, 35.6 × 43.9cm. Collection, New England Regional Art Museum (Howard Hinton Collection).*

COOK, James

(b. 1904, Christchurch, NZ; d. 1960, Italy) Painter, teacher, curator.

STUDIES: Canterbury Art School, NZ; travel study in London, Edinburgh, Paris and Rome, 1924–27. A meticulous craftsman in paint and a critic of acknowledged

integrity, Cook was highly respected among his colleagues of the post-war art world in Sydney; a fine portrait of him by his friend William Dobell was one of his treasured possessions. He died of pneumonia while travelling in Italy in 1960. A memorial exhibition of his work was held at the Macquarie Galleries in Dec. 1960.

AWARDS: Sawtell Travelling Scholarship, Canterbury, NZ.

APPTS: Art instructor at Canterbury Uni. High School, NZ, 1927–33; official war artist; teacher at ESTC; curator of the AGWA, 1949–52; art critic for Sydney *Daily Telegraph*, 1952–59.

REP: State galleries; public galleries in NZ.

COOK, William Delafield
(b. 1861; d. 1931, Melb.) Painter.

STUDIES: Melbourne, with John Ford Patterson. Known mainly for landscapes and seascapes. He was a member of the council of the VAS and for many years a regular exhibitor in the Society exhibitions. Though basically conservative, his style often showed the influence of the French impressionist movement.

REP: AGWA.

COOK, William Delafield II
(b. 1936, Melb.) Painter.

STUDIES: CIT, RMIT, and Uni. of Melbourne, 1953–55; travel studies, Europe 1959; British School, Rome, 1960; Bath Academy of Art, UK (painting and photography), 1961–62. Grandson of William Delafield Cook I. He travelled extensively (Europe, Far East, Tahiti, USA, etc.) and held exhibitions as well as participating in *Australian Artists in Europe*, Folkstone and Frankfurt, 1963, *Relativerend Realisme*, Eindhoven and Brussels, 1972, and *Contemporary Art Society Art Fair*, London, 1975. He divides his time between his London home and Australia, which remains his visual stimulus and subject matter for the super-real paintings which have made his work well-known in Australia and the UK. Exhibiting infrequently, his work is sold through private dealership and was most recently seen in public showing in Australia at a retrospective exhibition at ACCA, Melbourne and AGNSW 1987.

AWARDS: Italian Government scholarship, 1960; resident scholarship, Bath Academy of Art, 1961; Georges Invitation Art Prize, 1971; guest artist, Künstlerprogramm, West Berlin, 1974; Wynne prize, 1980.

APPTS: Lecturer, Watford and Maidstone colleges of art, UK, 1963–65; lecturer, Prahran CAE, 1969.

REP: NGA; AGNSW; AGSA; NGV; regional gallery Newcastle; a number of public collections UK, Europe; private and corporate collections including Elton John, UK.

BIB: *A&A* 13/4/1976 (Graeme Sturgeon, *Realism Revisited – the paintings of William Delafield Cook*); AL 6/5/1986.

COOKE, Albert C.
(b. 1836, UK; arr. Aust. 1854; d. 1902, Melb.) Painter, illustrator.

STUDIES: Watercolours, lithography with James Dufield Harding, UK c. 1850s. Emigrating to Victoria (Ballarat) during the goldrush in 1854, his *Ballarat from the Black Hill 1868* was engraved by R. Bruce and forms an interesting topographical record of the city. His pencil drawing of Melbourne in 1858 is a detailed view of the city looking west. From 1870 to 1879 he exhibited watercolours at the Victorian Academy of Arts, subjects including views of Port Phillip Bay and Sydney as well as NSW and SA landscapes. He contributed to the *Picturesque Atlas of Australasia* (1883–86) as well as Tasmanian drawings to the *Illustrated Australian News* (Dec. 1886), and in 1890 exhibited an architectural drawing of St Paul's Cathedral, Melbourne. He also lithographed some fine panoramic views of Fremantle and Perth, published by Frearson and Brother, Adelaide, 1894.

REP: AGSA; AGWA; Ballarat regional gallery; NLA.

BIB: AGWA *Bulletin*, vol. 1, no. 4, 1962. Clifford Craig, *Old Tasmanian Prints*, Foot & Playstead, Launceston, 1963. McCulloch, *AAGR*. Kerr, *DAA*.

COOLEY, Peter
(b. 16/5/1956, Murwillumbah, NSW) Painter, ceramicist.

STUDIES: Dip. Art, City Art Inst.; associate dip. fine art, Coll. of Art, Seven Hills, Brisbane. Cooley's works, often comprising mixed media such as those painted on iron roofing sheets with bead construction, applique and ceramics, were seen in 10 solo exhibitions 1980–92 in Sydney (Hogarth 1980; Mori 1983, 84, 85, 86, 88, 89, 90) and Melbourne (Girgis & Klym 1988), and in about 17 group exhibitions 1977–92 including in Sydney (Mori) and Melbourne (Girgis & Klym); and in *Artworkers Union Exhibition*, Artspace, Sydney (1983, 85, 86, 87); *A First Look*, Drill Hall, and *A New Generation*, 1988, NGA; *Art with Text*, Monash Uni Gallery, 1990.

AWARDS: Philip Morris grant for NGA, to work with Chris Sanders to decorate pots, 1985.

REP: NGA; Philip Morris Collection; Allen, Allen & Hemsley corporate collection.

COOPER, Duncan Elphinstone
(b. c. 1813; arr. Aust. 1841; d. 2/11/1904, London) Squatter, painter. A partner in Challicum Station, Fiery Creek, near Buangor, Vic., from 1842 he painted topographical views of scenery and properties in the Western District in sepia and watercolour. He returned to Scotland, then England, c. 1855. He made topographical drawings and watercolours of the Western District of Vic. (including a 34-watercolour sketchbook of his property), Sydney Harbour and King George Sound, WA, as well as some in Tas. He also contributed a few drawings to Ham's *Illustrated Australian Magazine*, 1850–51.

REP: NGA; AGWA; NGV; La Trobe Library; Ballarat Fine Art Gallery.

BIB: McCulloch, *AAGR*. Kerr, *DAA*.

COPPING, Bruce

(b. 20/7/1934, Sydney) Sculptor, teacher.
STUDIES: Apprenticeship with S. T. Leigh Pty Ltd, lithographic printers, Sydney 1949–54; European travels, including Scandinavia, 1961–62; Sir John Cass School of Art, London, 1962; Central Street School of Art, then City and Guilds School of Art, part-time 1963, full-time 1964–68; BA (Hons) Newcastle Uni., NSW 1985. He returned to Australia in 1968, equipped with extensive experience of past and present-day sculpture gleaned from his travels and studies at London art schools. Exhibiting at Gallery A, Sydney and Melbourne, in 1969, his large bronze 'seeds' in pods showed the organic trend of his thinking but a later installation work erected outside Inhiboress Gallery, Sydney, in 1971, showed use of more abstract and more open forms. Group exhibitions 1969–92 include prize exhibitions at Muswellbrook, MPAC, and the *Blake*, and *Wynne* prizes. Solo exhibitions include with Gallery A, Sydney, Melbourne; Hogarth, Sydney; and Cooks Hill, Newcastle.
AWARDS: Project grant, VACB, 1970; several international sculpture prizes and competitions, 1980s; Maitland Fountain Competition, 1987; NSW Arts Council country program grant, 1990.
APPTS: Teaching, NAS, part-time, 1968–73; NAS, Newcastle, 1973; part-time, TAFE schools, NSW 1975–85; corrective services dept 1985– .
REP: Several regional collections.
BIB: Scarlett, AS.

CORBIN, Martin

(b. 1949, Hampshire, Eng.; arr. Aust. 1973) Wood artist.
STUDIES: BA (Biology), York Uni., Eng., 1970; self-taught wood crafts NZ 1980 and Aust. 1981– . He held eight solo exhibitions 1983–91 Melbourne, Sydney, Adelaide and Canberra and his work was seen in about 18 craft and woodworking group exhibitions 1983–90 at private galleries in Adelaide, Melbourne and Hobart and in QVMAG 1985; *Contemporary Craft in SA*, Festival Centre, SA 1988; the *Alice Prize*, 1990.
AWARDS: Two suburban art show awards (Brighton, SA and *Woodform*, exhibition, SA); professional development grant, VACB.
REP: AGSA; MAGNT; NGV; Powerhouse, Sydney; Artbank.

CORLETT, Peter Geoffrey

(b. 16/1/1944, Melb.) Sculptor.
STUDIES: RMIT (sculpture), 1961–64. Participating in many exhibitions of sculpture from 1968, he completed a number of works for public spaces, including Tarax play sculpture for the garden in the NGV; nine figures, *Everybody*, graphically demonstrating the working of the human body, Children's Museum, Museum of Vic.; *Phar Lap*, sculpture VRC. He is also known for his lissom and often erotic nude figures in highly finished, painted fibreglass. He has been artist-in-residence at Darwin Community Coll., 1977; Exeter Uni. and College of Art on a VACB grant, 1979–80. He has been a member of many advisory panels and

Peter Corlett, Simpson and the Donkey, *bronze, 1991.* Collection, AWM.

tertiary committees. In 1987 he curated *Personal Views* for the Westpac Gallery, Vic. Arts Centre. He held about 8 solo exhibitions 1972–92 in Melbourne (Gallery A, Realities, Meridian); and at MAGNT and Exeter, UK. Group exhibitions 1968–91 in which his work appeared included many sculpture survey exhibitions in Australia and the UK including *Mildura Sculpture Triennial*, 1975, 78; *Australian Sculpture Triennial*, 1980s.
AWARDS: Sydney Airport Sculpture Competition 1970; AWM, Simpson and His Donkey, 1986–88; grants VACB 1975, 78.
APPTS: Part-time lecturing, many tertiary institutions Vic., Qld 1970s– and Exeter Uni., UK.
REP: MAGNT; NGV; AWM; Parliament House; Museum of Vic.; many Vic. tertiary colleges and unis.
BIB: Scarlett, AS. Sturgeon, DAS. Patrick Hutchings, *Peter Corlett*, Deakin Uni. Press, 1992.

CORNISH, Campbell Frederick

(b. 8/8/1940, Hamilton, Vic.) Painter, sculptor.
STUDIES: Claremont Tech. School, WA, 1968–72. A foundation member of the WA Sculptors Association and lecturer in sculpture at Perth Tech. Coll., he was appointed Exhibitions Officer at the AGWA c. 1974.
AWARDS: Uni. of WA sculpture prize, 1971.
REP: AGWA.
NFI

CORNISH, Christine

(b. 24/1/1946, SA) Photographer.
STUDIES: TSTC (art and crafts), Melb. Teachers College, 1967; photography, PIT, Melb. 1977; MA (Vis. Art), City Art Inst., Sydney 1988. Elizabeth Cross, curator of *Interior Views*, the PCA touring exhibition in 1988, wrote of her prints and drawings in the catalogue: 'Not only does this mixture of drawing and photography produce images which are mysterious in appearance, but the objects themselves are barely decipherable as belonging to the "real world". . . . in silence and melancholy darkness, Cornish intrigues and troubles our vision with objects whose nature, form and substance often remain elusive, enigmatic'. She held 7 solo exhibitions 1977–91 in Sydney (Syme Dodson) and Melbourne (City), and at the Australian Centre for Photography, Sydney, and her work appeared in about 27 group (mainly photography) exhibitions 1978–91 including in Sydney (Garry Anderson), Melbourne (Photographers) and at the Australian Centre for Photography, Sydney; *Shades of Light*, NGA, 1988; *Australian Photography: The 1980s*, NGA 1988; *Australian Contemporary Art*, AZ Gallery, Tokyo 1990.
APPTS: Photography lecturer, Hornsby College of TAFE, 1979–87; NAS, East Sydney College of TAFE 1988– .
REP: NGA; AGNSW; NGV: Parliament House; Artbank; Griffith Uni., Qld; Hallmark cards Aust. Photographic Collection.
BIB: Anne Marie Willis, *Picturing Australia: A History of Photography*, A&R, Sydney 1988.

COSSINGTON SMITH, Grace

See SMITH, Grace Cossington

COSTANTINI, Charles Henry Theodore

(b. 1803, France; arr. Sydney 1824. d. ?.) Painter. His name is often misspelt Constantini, Constantine, or Costantine. He was brought up in Paris where his father was a teacher of Italian. Sentenced and transported first for forgery in 1824, he was pardoned by Governor Brisbane. Returning to England he was again sentenced to transportation at the Exeter Assizes, 21 Mar. 1827, and his conduct during the voyage was such that he was sent to Macquarie Harbour, Van Diemen's Land. On 12 Jan. 1828 the Commandant there, Major Butler, wrote to the Colonial Secretary: 'A prisoner who arrived here by the *Prince Leopold* on her last trip, named C. H. Theodore Constantini [*sic*], a French Man is a Draughtsman of which he has given me some proofs in Sketches taken at the Settlement. I would wish to employ him for some time in this Manner in order to afford his excellency an idea of this Station and its Localities – and as the Man states that there are two Boxes of his in the Commissariat Store, Hobart Town one of which contains pencils, brushes and some colours = I beg leave to request that these Boxes may be forwarded to the Ordnance Store at this Settlement = Both Boxes are Numbered 250 with his name.' The boxes were duly sent. Costantini was at Port Arthur 1831–32 where he

received severe punishment for general misconduct but nevertheless was given a Free Certificate on 21 Mar. 1834, and on 24 Feb. 1838 he advertised in the *Cornwall Chronicle* that he would 'paint portraits in the most correct style, also views, and sketches of gentlemen's farms, &c.' He painted landscapes, gardenscapes, architecture, figures and portraits, mainly in watercolours using a flat, primitive perspective. Among his surviving portraits are a likeness of William Buckley and a set of four small portraits of the Martin family, now in the Corowa Federation Museum, NSW. His work was represented in *The Art of Gardening in Colonial Australia*, AGDC touring exhibition, 1979 and *Tasmanian Vision* TMAG and QVMAG 1988.
REP: NGA; TMAG; Allport and Crowther Libraries, Tasmania; NLA.
BIB: Jocelyn Hackforth-Jones, *The Convict Artists*, Macmillan, Melbourne, 1977. *Australia's National Collections*, C. Lloyd, P. Sekuless, Melbourne 1980. Clifford Craig, *More Old Tasmanian Prints*, Launceston 1984. Kerr, DAA.

Olive Cotton, Teacup ballet, *1935, gelatin silver photograph, 37.5 × 29.5cm. Collection, NGA.*

COTTON, Olive

(b. 1911, NSW) Photographer. No formal studies. She worked with Max Dupain in his Bond St studio, established in 1934. Her technical polish, blend of New

Photography geometrics and surreal qualities led to a commission to design an advertisement for a tea service (*Teacup Ballet*) in 1935 which has become one of her most well-known works. She was the only female member of the Contemporary Camera Group in 1938, and from 1941–45 managed Dupain's studio while he was on war service and received her own war-related commissions. She curtailed her career after the war for parenthood but opened a portrait studio in Cowra in later years. In 1985 the Australian Centre for Photography held a retrospective exhibition from which the NGA acquired a large number of works. Her work was represented in the Bicentennial exhibitions *Shades of Light* NGA, 1988 and *The Great Australian Art Exhibition* as well as *A Century of Australian Women Artists 1840s–1940s* Deutscher Fine Art, Melbourne, 1993.

BIB: Catalogue essays as above.

COULSON, O. H.

Moore refers to 'a flying picture by O. H. Coulson', painted during World War I.

REP: AWM.

BIB: Moore, *SAA*.

COUNCIL FOR THE ENCOURAGEMENT OF MUSIC AND THE ARTS (CEMA)

(Active mid-1940s) The Council was formed during World War II, the first CEMA art exhibition being held in Sydney in 1946. It ceased after the War.

COUNCIL OF ADULT EDUCATION

(Established 1947) 3rd Floor, 256 Flinders St, Melbourne, Vic. 3000. Apart from the regular staff, the Council employs a large number of specialist tutors in a wide variety of subjects, with special emphasis on the arts in all forms.

HISTORY: Established as an independent statutory body in Victoria by the Victorian government in 1947, it evolved from the Workers' Education Association which by 1938 was active in all states. During 1941–45, the Australian Army Education Service had proved a successful nationwide experiment, and when the states resumed control of their own cultural activities after the war, the CAE, Victoria, was the first major development. It became involved in performing and visual arts tours throughout country Victoria during the 1950s and 1960s and in the 1970s pioneered the travelling Arts Train for those wishing to study arts-related subjects while travelling to work. Melbourne sculptor Ola Cohn bequeathed her property to the CAE for use as a creative arts studio.

The CAE provides practical and theoretical arts courses which include workshops and seminars in painting, drawing, graphics, ceramics, photography and sculpture. While the main focus is on non-formal education, the CAE is moving increasingly into the area of formal accredited provisions and provides an alternative pathway into arts programs in TAFE colleges and universities and facilitates adults'

preparation of portfolios of work which meet tertiary requirements.

COUNIHAN, Noel Jack

(b. 1913, Melb.; d. 5/7/1986, Melb.) Painter.
STUDIES: NGV School, 1930; travel studies Europe and UK, 1949–52. One of Australia's best-known social-realist/expressionist artists, he made a reputation as a pencil portraitist and press caricaturist, and freelanced extensively in Australia during the 1930s as well as in New Zealand, 1939–40, and Europe, 1949–52. He was staff artist for the Melbourne *Guardian*, 1945–49 and 1952–58, and worked for the World Trade Union Movement, London, 1950–52. In Melbourne he was a foundation member of the CAS, 1938, and a council member of the VAS, 1961–63. By 1950 he was acknowledged as a leading Australian social-realist painter, his paintings of miners and other workers, street scenes, demonstrations and portraits being featured in numerous exhibitions, including Archibald competitions. His work was shown extensively in overseas cities including London, 1951; Warsaw, 1951; Copenhagen, 1954; Moscow and Leningrad, 1960; and in exhibitions of drawings and prints in Poland and USSR, 1969. A semi-retrospective Counihan exhibition was held at the NGV, 1973, and in the same year a similar exhibition at the Commonwealth Gallery, London. This was followed in 1974 by a show at the Marjorie Parr Gallery, London, and participation in *Australian Artists in Britain* (Flinders bicentenary celebrations), Lincoln. Other representative showings include *Noel Counihan, Faces and Figures*, MPAC, 1978, and *Noel Counihan 1944–79*, Realities Gallery, Melbourne, 1979. An inveterate traveller, he lived in France during 1982 with his wife, Pat, educationist and teacher of French, producing a body of work on French villagers and village life based on the experience, shown at Realities Melbourne in 1983. Due to severe ill-health shortly after, this proved to be one of the last exhibitions he held. His work was represented in the Bicentennial exhibitions *The Face of Australia* and *The Great Australian Art Exhibition*.

AWARDS: Prizes in exhibition, *Australia at War*, 1945; Albury prize, 1948; Crouch prize, Ballarat, 1956, 57; McCaughey prize, Melbourne, 1958; VAS drawing prize, 1958; bronze medal, International Graphics, Leipzig, 1959; occupancy, Australian studio, Cité Internationale des Arts, Paris, 1974.

REP: NGA; most state and many regional galleries as well as uni. and other public collections.

BIB: Smith, *PTT*. Horton, *PDA*. Smith, *AP*. Max Dimmack, *Noel Counihan*, MUP, 1974. Robert Smith, *Catalogue Raisonee prints*. Vane Lindesay, *Noel Counihan Caricatures*, Hutchinson, 1985. Janet McKenzie, *Noel Counihan*. Bernard Smith, *Noel Counihan – Artist and Revolutionary*, OUP, 1983. *A&A* 20/3/1983; 24/2/1986.

COURIER, Jack

(b. 1915, Elwood, Vic.) Printmaker, painter, teacher.
STUDIES: George Bell School, 1942–46; Slade School, London, 1952–54. A foundation member of the PCA,

he exhibited in their touring shows for many years. Married to the painter Mary McGleish (q.v.) they exhibited together and he held a major exhibition of his semi-abstract works at Eastgate Galleries, Melbourne 1989. His work was seen in *Classical Modernism: The George Bell Circle*, NGV 1992.
AWARDS: Alice Springs prize (print acquired), 1975.
APPTS: Teaching, CIT and Prahran CAE.
REP: NGA; AGNSW; AGSA; NGV; regional galleries La Trobe Valley, Mildura and Warrnambool.

COUTTS, Gordon
(b. c. 1869, Glasgow; d. 1937, San Francisco) Painter.
STUDIES: NGV School, 1893–96; Glasgow; Royal Art School, London; Julian's, Paris. Known for landscapes and portraits he was art instructor at the Art Society of NSW, 1896–1900. He exhibited at the VAS, 1890–1900, showing mainly landscapes of Vic. and NSW but also portraits and genre. His style ranged from the careful delineation of Colonial School work to the broad brush work and lightened palette of the Heidelberg School. He returned to England and later worked in Morocco before finally making his home in San Francisco.
AWARDS: NGV School student prize, 1893.
REP: AGNSW; AGSA.

COVENTRY, Christopher Lionel
(b. 23/2/1944, Adelaide) Painter, writer, curator.
STUDIES: SASA 1966–69; M.Fine Arts, Uni. of Tasmania 1982. His abstract paintings appeared in 19 solo exhibitions 1969–91 in Adelaide (including Llewellyn; CAS), Melbourne (70 Arden St) and other capital cities. Group exhibitions in which he participated 1969–91 include *Visions After Light: Art in South Australia 1836–1981*, AGSA 1981; *The Upside Down River*, The Australia Gallery, New York 1991. He also wrote a number of essays and articles for catalogues for Macquarie Galleries, Sydney; SASA; Uni. of Tasmania; the *Mercury*, Hobart and the *Age*, Melbourne as well as curating a number of exhibitions 1983–91 including for CAS, Adelaide; SASA; Tasmanian School of Art.
AWARDS: Fellowship in Visual Arts, Burgmann College, ANU, 1977; fellowship in creative arts, Geelong College, Vic., 1980; direct assistance grant, VACB, 1980; Commonwealth Postgraduate Scholarship, 1982.
APPTS: Tutor, Tasmanian School of Art, 1981–82; lecturer, SASA and Adelaide TAFE College, 1983–84; lecturer, Monash Uni., Gippsland, 1985–91.
REP: AGSA; TMAG; Artbank; a number of tertiary, government dept regional collections Tas., ACT, NSW.
BIB: AL 6/6/1986–87.

COVENTRY, Lionel Ernest
(b. 1906, Broken Hill, NSW; d. 1986, Adelaide) Caricaturist. A completely self-taught artist, he was influenced by the *Bulletin* caricatures by Phil May and David Low. Beginning as a cadet journalist at *The News* in Adelaide in 1923, he subsequently worked for the *Register*, the *Advertiser*, the *Mail* and the *News*, as a journalist, cartoonist and portrait caricaturist. In his 50-year career, over 30,000 drawings of his were published in these newspapers and nationally, mainly in the *Bulletin*. His work appeared in *Fifty Years of Newspaper Cartoons in Australia 1923–73*, AGSA 1973. He also published three numbered editions of his works: *South Australian Centenary Celebrities 1936*; *South Australian Personalities 1949–50*; *Caricatures of English and Australian Test Cricketers 1946–47*.
REP: AGNSW.
BIB: William Feaver, *Masters of Caricature: From Hogarth and Gillray to Scarfe and Levine*, Knopf, New York, 1981.

COVENTRY, Virginia
(b. 1942, Melb.) Painter, teacher.
STUDIES: RMIT (painting) 1961–64; Slade School, London 1967–68; La Trobe Uni. (educational communication and media) 1973. Occasionally exhibiting photography and using photography as a reference for her abstract expressionist works, she held 10 solo exhibitions 1977–92 in Sydney (Watters, 1981, 82, 86, 89, 91), Melbourne (Art Projects, 1979, 81, 82) and at the EAF, Adelaide 1977; IMA, Brisbane, 1981. Her work appeared in about 31 group exhibitions 1969–92 including at Watters, Sydney and in *Three Women Photographers* (with Micky Allan and Sue Ford), 1975; *Frame of Reference*, 1980, both at Ewing and George Paton Galleries; *Australian Perspecta 1981*, AGNSW; *Big Pictures: Australian Photography 1975–85*, NGA 1986; *Australian Artists Books: The Eighties*, NGA 1989. She compiled and edited *The Critical Distance: Work with Photography, Politics, Writing*, Hale and Iremonger, Sydney 1986.
AWARDS: AFC Experimental Film Grant (group award), 1973; VACB overseas travel grant for study UK and West Germany, 1977–78; VACB project grant, 1983; VACB half standard grant, 1988.
APPTS: Lecturer, drawing and painting, College of Fine Arts, Uni. of NSW.
BIB: Catalogue essays in exhibitions as above. Janine Burke, *Field of Vision: Women's Art in the Seventies*, Penguin, Melb. 1991. *New Art Two*. A&A 18/3/1981.

COVENY, Christopher
(Active, 1880s, Sydney) Illustrator, painter. Artist of literary genre. In 1883 he published in Sydney *Twenty Scenes from the Works of Dickens. Designed and etched by Christopher Coveny*. The following year he exhibited numerous works on literary themes at the Art Society of NSW, including a series on the *Pied Piper of Hamelin*.
BIB: J. A. Ferguson, *Bibliography of Australia*, vol. 5, NLA, 1977.

COWAN, Theodora Esther
(b. 13/11/1868, Sydney; d. 27/8/1949, Vaucluse, NSW) Sculptor.
STUDIES: Sydney Tech. Coll. with Lucien Henry, 1887–88; Florence, 1889–94, with Prof. Rivalta. Daughter of Samuel and Elizabeth Cohen. She became known in Sydney for her busts of Sir Henry Parkes, F. L. du Faur and Sir Edmund Barton, and for her

memorial in the Campo Santa at San Miniato and the Australian medal for the Numismatic Society of New York exhibition, *Medals of all Nations*. Her work was seen in *Early Australian Sculpture*, Ballarat Fine Art Gallery, 1977.
AWARDS: Prize for sculpture, *Women Artists* Exhibition, London, c. 1899; gold medal, *Franco-British Exhibition*, Shepherd's Bush, London, 1908.
REP: NGA; AGNSW (bust of Sir Henry Parkes).
BIB: Scarlett, AS. ADB 8.

COWEN, Lionel J.
Painter. Annual exhibition of the Art Society of NSW, 1889, included eight paintings by this artist, who is listed in the catalogue as 'a member of the Royal Society of British Artists'. He was probably the Cowen referred to by Streeton in *Smike to Bulldog* (ed. R. H. Croll, Ure Smith, Sydney, 1946).
REP: AGNSW.

COWLAM, Keith Leslie
(b. 10/4/1946, UK) Painter, printmaker.
STUDIES: Croydon College of Art, UK, 1963–64: Ravensbourne College of Art, UK, 1964–65; BA (Fine Arts), SASA, 1980. He exhibited his realist works in Australia in 9 solo exhibitions 1982–90 in Melbourne (Australian 1983), Sydney (Robin Gibson, 1984; Bride St, 1990), Perth (Greenhill, 1983, 86) and Adelaide (Bonython 1982; Greenhill 1985; Studio 20, 1986), and won a number of awards before moving to France in the 1990s.
AWARDS: Regional awards at West Lakes, 1989; Victor Harbor, 1981, 88, 89; Whyalla, 1982; Fremantle (print award), 1983; Stirling, 1983; Clare Valley, 1988; Elizabeth, 1988.
REP: AGSA; Artbank; Fremantle Arts Centre; Adelaide City Council; Maitland, Whyalla, Hamilton, Victor Harbor council collections.

COWLING, Margaret Anne
(b. 19/7/1941, WA) Painter.
STUDIES: Dip. Art, illustration, RMIT 1960; private studies Shirely Bourne, 1971–72. Assistant to Harold Freedman (q.v.) 1977–78, working on transport murals at Spencer St Railway Station and History of Geelong Mosaic. She held five solo exhibitions 1981–87 and exhibited in many group exhibitions 1981–87.
AWARDS: Special award $10,000, AME Bale Trust, 1988; Artist of the Year, VAS, 1990.
REP: Sale regional gallery; Keilor, Oakleigh, Caulfield, Waverley council collections.
BIB: Campbell, AWP. Germaine, AGA.

COX, (Dr) Leonard B.
(b. 1894, Vic.; d. 1976, Melb.) Neurologist, collector, writer, administrator. He inherited a collection that began in 1912 and included furniture, drawings, engravings, etchings and paintings, to which he added the superb collection of Chinese ceramics that received its main impetus from the friendship he developed with the Orientalist H. W. Kent in 1937. Author of

The National Gallery of Victoria 1861–1968 (NGV, Melbourne, 1970).
APPTS: Trustee of the NGV, 1954–76; Chairman of Trustees, 1957–65; Honorary Curator of Oriental Art, 1956–65.
BIB: A&A 4/3/1966.

CRAFTS COUNCIL OF AUSTRALIA
(Established 1971) 5th Floor, 414–418 Elizabeth St, Surry Hills, NSW 2010. Aiming to position the professional craft industry at a national and international level, the Crafts Council was incorporated in 1973. Affiliated Councils operate in each state and the NT. The Crafts Councils are extremely active bodies promoting the crafts in a wide range of areas including presenting Australian crafts exhibitions; participating in major overseas events such as the Chicago New Art Forms Exposition; operating a computerised data base of craft information *Craftline*; publishing *Index to Craft Journals* and *Craft Export Guide* as well as a number of publications. Several Councils also operate their own retail outlets (*see* GALLERIES–PUBLIC). The Crafts Council of Australia membership consists of delegates from the state crafts councils who elect a board of directors.
FUNDING: Federal funding through the VACB of the Australia Council.
ADMIN: President and board of directors (elected by membership); executive director and support staff.
BIB: Grace Cochrane, *The Crafts Movement in Australia – A History*, NSW University Press, 1992.

CRAFTS IN AUSTRALIA
HISTORY AND DEVELOPMENT
Australia's first Art Council, founded in 1946 by Miss Dorothy Helmrich, was modelled on the Arts Council of Great Britain. From this grew the present national body, the Australia Council, which through its Visual Arts Crafts Board is the main provider of grants to artists and craftspeople.
This work is augmented by operation of the Craft Council of Australia which has branches in each state. One of the major objects of these craft organisations is to provide education and training experiences not available in teaching institutions. Craft councils throughout Australia have galleries in each state for the display and sale of artists' wares. Department stores play an important role in the exhibition and display of craft work. Since the 1970s the Crafts Council of Australia has become the central resource centre for the crafts. With a slide library of the work of thousands of Australian craftspeople it also undertakes market development and export projects and has an information service for the broader community.
The 1970s and 1980s were particularly vibrant years for Australian craft. During that time centres such as Sydney's Argyle Art Centre, Adelaide's Jam Factory, Hobart's Salamanca Centre and Melbourne's Meat Market (*see* GALLERIES–PUBLIC) were established and provide prominent craft venues where the crafts

through display, practice and education (often in conjunction with relevant university courses) flourish.

CERAMICS

William Moore records that in 1789 Governor Phillip sent clay dug from Sydney Cove to the British ceramicist Wedgwood, who modelled from it a symbolic Australian medallion (copy in the Mitchell Library collections); Moore goes on to tell us that the first examples of Australian pottery came from Tasmania, and cites 'the fine work' of Maud Poynter and Violet Mace at the Rotho Pottery, Bothwell, Tas. Later Brisbane became known as a centre of pottery through the work done by the painter, craftsman and teacher Lewis J. Harvey. The sculptor Theo Cowan made 'Koala pottery' in Sydney, where also an early group of potters flourished at Mosman under the guidance of Ada Newman. The painter and teacher L. H. Howie did much to promote interest in handmade pottery in South Australia, and Flora Landells performed a similar service for the cause of the craft in Western Australia. Merric Boyd, founder of the Boyd Pottery at Murrumbeena, was the best-known Victorian potter of the 1920–40 period, and Marguerite Mahood made and wrote extensively about ceramics and its possibilities. One of the finest collections of early Australian pottery is at the Shepparton Art Gallery, Vic., and recent research has revealed a past much richer in ceramic craft than was previously thought. The early Arts and Crafts Society developed branches in most states to become the chief promoter of pottery, and such private ventures as the Primrose Pottery Shop, Melbourne, provided much-needed marketing facilities. The Australian Ceramic Society was formed in 1945 and in the 1960s societies of all kinds for the promotion of the ceramic and other crafts began to proliferate.

RECENT DEVELOPMENTS

Ceramics, hitherto a functional craft, blossomed in the 1970s and 80s into sculptural ceramics, showing many and varied individual attitudes to society and the environment. In all Australian crafts this was an explosive time, fecund with ideas and personal exploration. In Sydney Marea Gazzard's hand-built sculptural forms pointed the way for many artists to break from the artificial confines of their craft. Bernard Sahm and Frederick Chepaux used human forms to explore the fantastic and whimsical. Alan Watt and Sandra Taylor added much humour as they juxtaposed their skills and unique visions with conventional scenes or objects. In Melbourne Noel Flood, Greg Wain, Peter Hook, Robyn Clarke, Mark Stoner and Ken Leveson were among those who used hand-building slab construction to form esoteric and surreal images. In South Australia Mark Thompson, Paul Greenaway, Margaret Dodd and Bruce Nuske used figurative images to express personal and social attitudes and in Perth Joan Campbell used landscapes as a theme to capture the textural and monumental character of her work.

In the 1990s ceramics developed two streams (which often interchange and cross over). Works of one are sculptural and fantastical; the other resembles Japanese-style utilitarianism, marked by attention to classical refinement, beauty of form and perfection of technique. Those in the first stream include Jenny Orchard, Deborah Halpern, David Potter and Alan Peascod and in the second, Peter Rushforth, Janet Mansfield, Col Levy and Mitsuo Shoji. With such fine work being produced it is a clear demonstration of how fine is the line between art and craft.

During the 1980s a number of exhibitions were sent overseas to Europe, the UK, the USA and SE Asia. Australians have long been prominent entrants for the prestigious Faenza ceramic awards in Italy and Minto awards in Japan. To complement these activities, many national and international symposiums are held each year and many overseas ceramic exhibitions were seen in Australia. Two significant tours of the 1980s were of the avant-garde Sodeisha Group of Japan and a British Council ceramics exhibition. Both had a lasting influence on Australian ceramics.

GLASS

Some early stained glass was imported, while some was made in Australia. Examples of the former include the windows of St Patrick's Cathedral, Melbourne; St Mary's and St Andrew's cathedrals, Sydney. Local production of tableware and novelty glass began in Australia as early as 1812 and was well established by the end of the century when Felton and Grimwade's 'Melbourne Glass Works Bottle Company' moved to the river bank at Spotswood, (it later developed into the giant Australian Glass Manufacturers; subsequently ACI). Local early stained glass firms which developed strongly in the gold boom years of the 1850s included Melbourne's 'Ferguson and Urie', 'Brooks Robinson & Co' and 'E.L. Yencken & Co'. Notable glass artists of the 1920s and 30s included Christian and Napier Waller (qq.v.) whose stained glass designs epitomised the the the 'art nouveau' style. Alan Sumner later introduced elements of modernism into his numerous glass commissions.

Notable glass artists of the 1920s and 30s were Christian and Napier Waller (q.v.) whose stained glass designs epitomised the *art nouveau* style. Flat glass as a creative artform was kept alive in the 1960s by Bill Gleeson and Les Kossatz. Leonard French's commission for the ceiling of the Great Hall in the NGV both focused attention on this field and demonstrated a new approach to it. David Wright and Klaus Zimmer had solo exhibitions in 1976 which were among the most innovative of their era. Around the same time Klaus Zimmer set up a seminal flat glass design course at the Caulfield Technical College, now Monash Uni. (Caulfield campus). An important hot glass studio was set up at the Jam Factory in Adelaide in 1978 and the Meat Market Craft Centre, Melbourne in 1982. Nick and Pauline Mount started their own studio in Gippsland in 1977, moving to Adelaide where they set up one of Australia's most successful and innovative craft centres, the Budgeree Glass workshop. More

creative development came as a result of American and Swedish glassblowers visiting Australia, a profusion of conferences and exhibitions, and Australians returning from overseas with valuable new techniques and trends. Richard Clements produces beautiful perfume bottles and small hand-blown glass vessels. The Wagga Wagga Regional Art Gallery (*see* GALLERIES–PUBLIC) became the main centre for the display of glass art in Australia. Warren Langley produced very exciting and abstract sculptural objects and the annual Arts Glass conference starting in Melbourne in 1981 continues to provide a focus for glass art in Australia.

JEWELLERY AND SILVERSMITHING

Apart from learning that Nicholas Chevalier designed the setting for the Koh-i-noor diamond and the gold hilt of a sword presented by the Australian Italian community to Garibaldi, one hears little about the work of early jewellery designers in Australia. It comes as a surprise, therefore, to learn that in his splendid little book on the subject, Kurt Albrecht lists more than 2000 jewellers and gold and silversmiths operating in Australia in the nineteenth century, among them many fine designers and craftsmen. He lists also the names of, and insignia used by, those identified by their work and punches. There were eight in New South Wales, two in Tasmania, five in South Australia and 25 in Victoria – mostly after the discovery of gold there in 1851. One of the first recorded as having worked in Victoria was C. Brentani and among the outstanding designers was the European-trained E. Leviny, whose technique in repoussé and elegant chasing 'places him among the great gold and silver smiths of the Colony of Victoria'. Two notable early designers working in South Australia were H. Steiner, who made a silver tree from some of the first silver mined from Broken Hill, and J. M. Wendt, who won two first prizes in the *Great Paris Exhibition* of 1878.

Much of the early work concerned the silver mountings for emu eggs used as vases, jewel boxes, centre pieces and so forth and many of the commissioned gold and silver objects found their way into the international and intercolonial exhibitions as evidence of the inspiration and high standard of craftsmanship to be found in the new country. The official record of the 1888 *Centennial International Exhibition* gives the names of a number of Victorian prize-winners: M. & J. Marks. J. J. Rowbottom, Stokes & Martin, P. H. Cadby, A. C. Bowman, P. Blashki, T. P. Lewis, W. Gartner, G. H. Armfield, H. M. Edwards & Kaul, J. P. Christie, S. W. Armfield.

In the twentieth century the increase in manufactured objects, and the more materialistic society that developed, gradually reduced the numbers of fine hand-craftsmen and artists working in the area of jewellery design. World War I further reduced the numbers and little was heard of artist-craftsmen in this medium in Vic. until after World War II, when the Renaissance-inspired silver work of Matcham Skipper began to attract attention. Even so, it was not until the early 1970s and the general revival of interest in the crafts as against manufactured objects, and subsequently the

beginning of the movement towards alternative lifestyles, that jewellery design as a creative art was restored to asemblance of its former pre-eminence. A comprehensive listing of all creative Australian jewellery designers, either old or new, is well beyond the scope of this brief summary, but mention should be made of the splendid school of jewellery design that developed at a number of tertiary colleges in the late 1960s, to produce a group of fine designers. Such colleges included RMIT, Uni. of NSW, WAIT, Qld College of the Arts, the Tasmanian CAE and at the Jam Factory, Adelaide. The national Jewellers and Metalsmiths Group of Australia was established in 1980.

In the 1980s jewellery design underwent many changes in style. Where European styles, usually Scandinavian, were once slavishly followed we now see Australian imagery with the use of Australian gems and semi-precious stones. There are many divergent styles from Matcham Skipper's art nouveau lost-wax technique to Alice Whish's clean, clear lines and lighthearted approach to her craft. Then there is the sculptural art jewellery of Carlier Makigawa and Kate Durham, the classic approach of Phillip and Kate Noakes and the pop-funk jewellery of Robyn Gordon, Peter Tully and Dinosaur Design's Louise Olsen, Stephen Ormandy and Liane Rossler.

In the 1980s workshops and studios developed throughout Australia and jewellers became involved not only in selling through regular outlets but also in direct selling and through links established with the fashion industry, craft centres and galleries. Changes and developments came with the various exhibitions and with visiting jewellers from overseas. Awards such as the De Beers Award which started in 1954 and evolved into the annual Diamonds Today award were key factors in the encouragement and recognition of Australian jewellery and jewellers. The biennial award established by Barbara Noble from Maker's Mark Melbourne in 1981, with voting by peers of the entrants, has been another great encouragement for practitioners. During the 1980s centres such as Melbourne's Meat Market Craft Centre and Adelaide's Jam Factory with their jewellery and silversmithing workshops also became focal points for the making, display and selling of hand-crafted jewellery.

TAPESTRIES, WEAVING AND FIBRE ART

Weaving and related crafts have been practised in Australia since colonial times and there are many fine surviving examples held mostly in family collections. However there was little professional interest in weaving until the revival of Jean Lurcat at Aubusson during 1930–50 which triggered off world-wide interest in tapestry-making. This world trend was followed in Australia where also in the 1960s a general reaction against machine-made objects was occurring. Mona Hessing was an important pioneer of weaving in NSW and weaving in the Lurcat tradition appeared in the work of Deana Conti in her Brudea Island studio off the Qld coast. Jutta Fedderson, trained in Germany, began to exert great influence on the art of weaving from her Mittagong workshop and studio while in SA

Pru Medlin established a high standard at the Jam Factory in Adelaide.

The Victorian Tapestry Workshop (*see* GALLERIES–PUBLIC) established in 1983 has remained a great success and receives commissions from all over the world. One of its major commissions was for the Arthur Boyd Tapestry for Parliament House which is the second largest tapestry in the world.

The growth of the Ararat Gallery (*see* GALLERIES–PUBLIC) in Victoria with its policy of collecting weaving and fibre art has given further stimulus to the craft as did *Crafts Victoria* 1975 – a whole year of craft promotion and events. The establishment of the Meat Market (q.v.) as Victoria's craft centre joined with those of the Jam Factory in Adelaide and Salamanca Place, Hobart, as a focus for the fibre arts as well as many other crafts.

Fibre art came into its own with educational courses offered in major colleges. Awards such as the Hoechst National Textile Award for recent graduates and the Ascraft Fabric Award for textile design helped elevate the status of fibre art. During the 1970s and 80s many exhibitions and shows demonstrated how diverse fibre art can be with the work of artists such as Heather Dorrough, Jutta Feddersen and Lorraine Hepburn.

Wall hangings and tapestry, rug-making and multimedia with embroidery were all seen in the work of David Green, Tori de Mestre, Kay Lawrence and Annamieke Mien. Liz Nettleton's rugs for Parliament House Canberra were a major commission. Art clothing too came into its own in the 1980s with fashion design students making hats, shoes and hand-printed fabrics. Many of these have grown into successful commercial enterprises ranging from limited ranges being sold in small boutique shops to the higher volume and well-known designers such as Annabelle Collett, Jenny Kee, Jenny Bannister and Linda Jackson.

WOOD

Because it was accepted practice among early colonists to import European timbers for interior work in country mansions and houses, in keeping with what they had known in the UK, general interest in the aesthetic possibilities of Australian timbers was delayed until after the period of the goldrush. The goldrush and its aftermath awakened widespread interest in the examination of local materials of all kinds. Australia was then found to be rich in timbers of unique quality and variety, extending from the Huon pine and hardwoods of Tasmania to the black-bean, cedars and native oaks of Queensland, the mountain ash, blackwood and red-gum of Victoria and the magnificent jarrah, karri and other hardwood timbers of Western Australia. The Australian eucalypts alone yielded hundreds of varieties of beautiful timber. The properties of much of this timber would doubtless have been discovered by anonymous craftsmen in Colonial times but the earliest recorded work in Victoria of significance was done by the wood-carver William Howitt (not to be confused with the writer, William Howitt, or his explorer son, Alfred William Howitt). Howitt arrived in Melbourne in 1887 to work on the interior carvings for St Paul's Cathedral. He brought with him much of the spirit generated by the Pre-Raphaelite artist-craftsman, William Morris, whose work in investigating the aesthetic possibilities of all forms of handcraft had caused a revival throughout the world. The beauty of Australia's local timbers was discovered also by the German cabinet makers and carvers, Robert Prenzel and his partner, J. Treede, and later by Prenzel's pupil, Nellie Payne, who drew particular attention to the beauty of Tasmanian woods, as did Sarah Todd of Hobart, and Hugh Cunningham and his pupil, Gordon Cumming, in their work for the Church of St John, Launceston. The traditions pioneered by such craftspeople were maintained and extended through the work of Robert Craig and his pupil, Edwin Newsham, in South Australia, L. J. Harvey in Queensland, and James R. Linton in Western Australia, although these artists are best remembered as painters and teachers. Many of the commercial wood-carvers and craftsmen who proliferated throughout the country around the turn of the century followed the example of Prenzel and Linton in applying motifs of bush-flowers, tree-foliage and native birds and animals, such as the kookaburra and koala, to create a body of work aptly described by one writer as 'Gumnut Nouveau' (Terry Lane, 'Gumnut Nouveau: A Suite of Furniture by Robert Prenzel', *Art Bulletin of Victoria*, 1973).

However the Gumnut style rapidly deteriorated into repetitive folksiness, and the originality and inventiveness of the pioneer artists, whose ranks would have included Lucien Henry and his students, was largely forgotten. Margaret Preston was one of the painters who helped to revive the tradition in the 1950s but the artist-craftsman who did most to restore Australian timber to its former prestige among craftsmen during and after World War II was Schulim Krimper (q.v.). Craftspeople working in the evolving 'alternative-lifestyle' communities of recent years have done much to assure continued recognition of native timbers. Even more importantly they are helping to preserve much of it from the threat of extinction. Interest in local wood and wood-carving has been greatly stimulated also by visiting craftsmen such as Stephen Hogbin (resident artist at the Melbourne State Coll., 1976–77), and in the exhibitions that followed, namely, *Ways with Wood*, Craft Association of Vic., North Melbourne, Mar. 1976. Finally, the greatest and most consistent recognition of the aesthetic qualities of Australian timbers has come from sculptors of the calibre of Gerald Lewers and Robert Klippel, in NSW, Stephen Walker, Tas., and Clifford Last, Vincas Jomantis, Norma Redpath, Tsutis Zikaras and Karl Duldig, in Vic. Mention may be made also of the carvings of the primitive artist Milan Todd, and the sculptures fashioned from fruit-tree prunings by Augustine Dall Ava.

Exhibitions in the 1970s had historical as well as recent work where survey-type shows aimed at showing the development in this field. The NGV, the Gryphon Gallery in Melbourne and the Tasmanian School of Art were among the institutions and galleries to hold such exhibitions. Wood can take

Sybil Craig, Study for Still Life Painting, *texta colours on newsprint paper, 15 × 21cm. Collection, Mornington Peninsula Arts Centre.*

many directions: traditional fine-finish furniture, non-functional decorative and expressive pieces, and the rough-hewn found timber which makes use of the natural defects and patinas of the wood. But wood reflects changes in fashion, especially architectural fashion, so post-modern angular and painted timber has arrived influenced by Italian craftspeople such as Mendini and Sottass.

Forerunners in Australian woodcraft included Peter Taylor, a sculptural woodworker, and Gay Hawkes, who uses found timber from old houses, boats and so forth in furniture resembling that of the pioneer days.

The first wood-oriented design courses in Australia were given at the Tasmanian School of Art, Hobart, by John Smith in the 1970s. Huon pine, under his influence, became a great inspiration to Stephen Walker and Donald McKinley, an academic who taught at TSA. From 1990 this school offered a Master's Degree through the centre of furniture design. It was and remains the leading institution of its type in Australia and its graduates include Tony Stuart, Donald Fortescue and Kevin Perkins, all leaders in their field.
ENTRY UPDATED BY ROBYN CLARKE

CRAIG, (Dr) Clifford

(b. 1896, Box Hill, Vic.; d. 5/9/1986, Adelaide) Collector, writer. His comprehensive collection of books, prints, paintings and other historical material relating to Tasmania began in the 1920s, and was auctioned by Christie's in 1975. He then amassed a second collection. His two books on Tasmanian prints, *The Engravers of Van Diemen's Land*, 1961, and *Old Tasmanian Prints*, 1963 (Foot & Playstead, Launceston), are standard works on the subject.
BIB: *A&A* 24/4/87 (obituary)

CRAIG, Sybil

(b. 18/11/1901, Enfield, UK; d. 14/9/1989, Melb.) Painter.
STUDIES: With John Shirlow, Melbourne 1920; NGV School, 1924–31; Melbourne Tech. Coll. (design, with Robert Timmings); George Bell, weekly lessons for 3 months, 1924; VAS classes, some study with Ian Bow, 1950s. From 1932 she exhibited with the New Melbourne Art Club, from 1933 with the Melbourne Society of Women Painters and Sculptors and from 1943 with the Twenty Melbourne Painters. In the 1940s she had a show of watercolours with Ethel Carrick Fox and Jean Sutherland. She was commissioned as a war artist in 1945 and in this capacity produced some interesting work. Though known mainly for her still-life paintings, her work covers a much broader spectrum, the emphasis being on her studies of French post-impressionism, transmitted (as early as 1923) by Jan Gordon in his book *Modern French Painters*. The full scope of her achievement was revealed in a large, retrospective exhibition at Important Women Artists Gallery, Melbourne (Mar.–May 1978). The catalogue included an introduction by Jim Alexander and a tribute to the artist by Lina Bryans (*Sybil Craig: Oil Paintings 1926–1970*). Other exhibitions in which her work appeared 1970–93 include *Australian Women Artists 1840–1940*, Ewing & George Paton Galleries, Uni. of Melbourne and touring public galleries 1975; *A Survey of Australian Relief Prints 1900–1950*, Deutscher Galleries 1978; *Sybil Craig*, Jim Alexander 1982 ; *Classical Modernism: The George Bell Circle*, NGV

1992; *A Century of Australian Women Artists 1840s–1940s* Deutscher Fine Art, Melbourne, 1993; *Important Australian Women Artists* Melbourne Fine Art, 1993.
AWARDS: OAM conferred, 1981.
REP: NGA; AGSA; NGV; AWM (group of 80 works); several regional gallery collections Vic.
BIB: Catalogue essays in exhibitions as above. J. Kroeger, *Australian Artists*, 1968. Janine Burke, *Australian Women Artists*, Greenhouse Publications, Melbourne, 1981. Mary Eagle and Jan Minchin, *The Bell School: Students, Friends and Influences*, Deutscher Fine Art/Resolution Press, Melbourne 1981. *A&A* 27/4/1990 (obituary).

CRAIG, William Harrison
(Arr. Sydney 1812) Convict artist, transported for unspecified crime. He arrived in Sydney and was sent to Van Diemen's Land in 1814.
REP: Mitchell Library.
BIB: T. & R. Rienits, *Early Artists of Australia*, 1963. Kerr, *DAA*. Joyce Hackforth-Jones, *The Convict Artists*, Melbourne 1977.

CRANE, Olive
(b. 1902; d. 1935) Painter. She married Qld painter Kenneth MacQueen, and exhibited genre pictures with the NSW Society of Artists from 1918.
BIB: Exhibition catalogue, *Society of Artists Pictures*, AA, 1920.

CRANSTONE, Lefevre James
(Arr. Qld c. 1880) Painter, etcher, illustrator. Known for figures, landscapes and genre in oil and watercolour. He exhibited genre paintings at the RA 1845–54, often in a style influenced by his contemporary W. P. Frith. Other recorded works, which suggest extensive travels, include a Perthshire landscape, *Slave Market in America, 1862*, and a group of inscribed but undated Qld watercolours probably done in the 1880s; they were sold by descendants of the artist at Christie's, Melbourne, Mar. 1973.
BIB: Christopher Wood, *Dictionary of Victorian Painters*, Antique Collectors Club, London, 1971. Bénézit, *Dictionnaire*, 1976.

CRAWFORD, Leonard Gordon
(b. 29/9/1920, Melb.) Painter, teacher.
STUDIES: Early encouragement by Gino Nibbi and Edith Holmes in the late 1930s, further developed by lessons from Mary Cockburn-Mercer, 1948–52. Themes of his paintings, inspired by music, are often given music titles, thus persuading some critics to ascribe a synthetic music content to his work. They are however most often resolved in pure formal abstract style. Crawford exhibited at early CAS exhibitions in Melbourne and held his first solo show at the Rowden White Library at the Uni. of Melbourne, 1948. After a period of inactivity due to eye trouble, his work reappeared with renewed vigour at the first *Herald* Outdoor Art Show, Melbourne, in 1953, where it gained immediate recognition. This was followed by a full-scale showing of his mature work at the MOMAD, Melbourne, in 1956. His *Captive Phoenix* was an outstanding picture in the Helena Rubinstein Scholarship exhibition at the NGV in 1960. He held 5 solo ex-

hibitions 1948–70 before recurrent eye trouble greatly retarded his output of paintings. His work was seen in group exhibitions of the Mertz collection, AGSA 1966; the Carnegie collection, NGV 1966; the Komon collection, Georges Gallery 1971; and in *Modern Australian Painting*, 1985, 88, Charles Nodrum, Melbourne.
APPTS: Art teacher, technical schools, Melb. 1959–62; lecturer, painting, RMIT 1964–85.
REP: NGA; NGV; National Art Gallery, Wellington, NZ.
BIB: Catalogue Mertz Collection, Griffin Press, Adelaide, 1966. *Modern Australian Art*, MOMAD, Melbourne, 1958. Smith, AP.

CRAWFORD, Roger
(b. 1949, Melb.) Painter, teacher.
STUDIES: Dip. Painting, NAS, 1973; postgrad. dip. visual art (sculpture, performance, installation), SCA 1990; travel studies SE Asia 1974; USA, Mexico, England 1975–76, USA, Central America, South America 1980; US 1982, 87. He held 13 solo exhibitions 1980–92 Sydney (including Rod Shaw Studio, 1980; Watters, 1986, 88, 91; First Draft, 1987, 92; Artspace, 1985) and at Canberra School of Art, 1987. His work appeared in about 51 group exhibitions 1973–91 at private galleries (including Mori, Macquarie, Hogarth, Watters, Sydney) and numerous public galleries and spaces including Performance Space, Artspace, Sydney and in *Blake Prize*, 1977, 88; *Inside the Greenhouse*, 1989, Tin Sheds, Sydney; *Australian Perspecta*, AGNSW 1989.
AWARDS: Reader's Digest Drawing Prize, 1973; NAS Prize, 1973; Basil & Muriel Hooper Scholarship, AGNSW, 1973; project grants, VACB 1975, 85; VACB special project grant 1985 and half standard grant 1987.
APPTS: Tutor, Arts Council of NSW, 1974–75 and 1978–80; painting and drawing teacher, Wollongong Art School, 1976; drawing teacher, ESTC, 1986–71; drawing teacher, CCA, 1990; guest lecturer, various institutions and events 1987– including First Draft, City Art Institute, Australian Perspecta '89, Wollongong Art School.
REP: NGA; MOCA, Brisbane; National Parks and Wildlife Service; Grafton regional gallery; Western Mining corporate collection.
BIB: *A&A* 23/3/1986.

CREAGH, Annie C. and Helen G.
(Active c. 1890–1910, Sydney) Painters. Impressionist landscape painters in oils and watercolours they exhibited at the Art Society of NSW from 1893, showing landscapes, beach and coastal scenes and genre, while living at the same address, so presumably were sisters.
NFI

CREAR, Johannah Clyne
Early amateur artist, her painting in the NLA, *Homestead in Australia*, is believed to be of Syndal, Ross, Tas. Her work was seen in *The Art of Gardening in Colonial Australia*, AGDC travelling exhibition, 1979.

Fred Cress Tell Tales 15, 1988, *charcoal, paint on paper, 61×91 cm. Private collection.*

CREASER, Marleen

(b. 1932, Sydney) Sculptor.
STUDIES: Julian Ashton and Desiderius Orban schools, Sydney, 1950–52; travel studies Europe, Spain (two years), North Africa, USA and Mexico, 1952–66. Her work in various media was exhibited at Gallery A, Sydney from 1972, at *Mildura Sculpturescape*, 1973, 75, and at the *Biennale of Sydney*, 1976. In the 1980s her work included an installation at Gryphon Gallery, Melbourne using clear plastics.
AWARDS: Award at *Mildura Sculpturescape*, 1973; VACB grant for equipment, 1975–76.
REP: AGNSW; Mildura Arts Centre; Uni. of Sydney.

CREATIVE SPACE

(Operated 1980s) Organisation of artists formed for purpose of locating low-cost work space for creative activity. Space was sought in empty buildings awaiting demolition or redevelopment and a register kept of artists needing space. In 1981 about 200 individual artists were listed.

CRESS, Fred

(b. 1938, Poona, India; arr. Aust. 1961) Painter.
STUDIES: Birmingham Coll. of Art, 1954–59; Dip. Art, RMIT 1968. Cress lived first at Wangaratta where he formed an art group and classes. He showed in *The Field* exhibition, NGV 1968 and showed figurative work in his first solo exhibition, at the Argus Gallery, 1965, before changing gradually to an abstract style that developed in later exhibitions into abstract expressionism and 'post-painterly abstraction'. The outcome of his assimilation of various reductive modes was to concentrate his attention on colour, tone, shape and texture as applied to large canvases. They formed the basis of the work that gained him a leading place in the Australian painting of the early 1970s. He worked in the USA in 1977, and on his return established his headquarters in Sydney. He was artist-in-residence at Curtin Uni., 1979–80. His 1980s work returned from abstraction to a more figurative style reminiscent of his early work, but with more powerful images especially his ironic satires of people.

He held about 31 solo exhibitions 1965–93 in Sydney (largely at Macquarie), Melbourne (Axiom, Christine Abrahams), Adelaide (BMG) and Canberra (Solander), and a survey exhibition at Orange Regional Gallery in 1987. His work appeared in numerous group exhibitions 1975–93 including *Artists Artists'*, NGV 1975; *Contemporary Australian Drawing*, AGWA and 2 other state galleries 1978; *Surface for Reflexion*, AGNSW and touring regional galleries 1986; *Field to*

Figuration, NGV 1987; *Backlash* NGV 1987; *Aspects of Australian Art*, Houston Int. Texas, USA 1988.
AWARDS: Prizes at Albury 1962, 63; Perth prize for drawing, 1966; Georges prize (purchase award), 1973; VACB grants, 1973, 77; Wollongong Purchase Award, 1977; Archibald Prize, AGNSW 1988.
APPTS: Teaching, CIT, from 1964, and later at Prahran CAE.
REP: NGA; AGNSW; AGSA; AGWA; NGV; QAG; TMAG; Parliament House; Artbank; numerous regional galleries including Albury, Ballarat, Broken Hill, Mornington, Newcastle; a number of tertiary collections including Melbourne, Monash, Macquarie, Queensland, NSW unis. and Bendigo, SCA, City Art Institute, Darwin Community colleges; corporate collections including State Bank of NSW, R&I Bank, Philip Morris and numerous corporate and private collections UK, USA, Europe.
BIB: Catalogue essays in exhbitions as above. A number of general books on Australian art including Bonython, MAP 70, 75, 80; de Groen, *Conversations with Australian artists*; McIntyre, *ACD*; Chanin, *CAP*. A Krell, *Fred Cress: Stages*, Wild & Woolley, Sydney 1989. *Art in America*, Sept. 1980. *A&A* 12/2/1974; 13/1/1975 (*Fred Cress and the New Painterliness*); 18/4/1981; 21/1/1983; 21/4/1984; 23/1/1985; 24/1/1986. *AL* 1982, 86/87.

CRICHTON, Richard
(b. 30/4/1935, Melb.) Painter, teacher.
STUDIES: CIT; Dip. Fine Arts, RMIT 1954. His work generally denotes a keen response to a wide diversity of influences ranging from that of Chagall (in his early work) to themes inspired by musical instruments, pottery and the primitive art of Australian Aborigines. He travelled and worked in Europe and the USA, 1966–70, and again in 1982, when he held a number of solo exhibitions at universities where he was artist-in-residence or visiting artist. He held about 22 solo exhibitions 1960–92 including at the Uni. Gallery, Uni. of Melbourne, July–Aug. 1978; Macquarie Galleries, Sydney. Group exhibitions in which his work has appeared 1956–92 included *McCaughey Prize*, NGV 1965, 75, 79; *Blake* and *Sulman* prizes AGNSW; *Animals and Animism in Art*, RMIT 1981; *Archibald Prize*, 1982. His commissioned work includes murals at H. J. Heinz head office, Melbourne and for Ballarat television station.
AWARDS: Georges commendation prize, 1965; commendation award, Alice Springs Art Prize 1970; Harkness Fellowship to the USA, 1967–69; standard grant, VACB, 1977; Gold Coast City Art Award 1987.
APPTS: Lecturer in Fine Art, RMIT, 1956–66, and 1970–80; senior lecturer 1981– .
REP: NGA; NGV; Parliament House; Gold Coast City Art Gallery; a number of tertiary collections including Uni. of Melbourne, Flinders Uni., Uni. of Adelaide; private and corporate collections including Reserve Bank; Mertz Coll., USA.
BIB: Bonython, MAP 70. Smith, AP. *The Australian Painters 1964–66*, Corcoran Museum, Washington DC 1967. *A&A* 17/3/1980.

CRIPPS, Peter
(b. 1948, Melb.) Sculptor.
STUDIES: RMIT, c. 1968–72. He first achieved prominence at the *Mildura Sculpture Triennial*, 1973, with a large, spectacular, open work in steel fabricated by engineer Robert Cripps (his brother), entitled *Blackbird*. A box kite mounted on wheels ran along rails on top of the structure, moving according to the direction and changes of the wind. Inventive works by Cripps have subsequently been shown at the Ewing Gallery, Uni. of Melbourne, 1974, 78; Watters Gallery, Sydney, 1977 and in group exhibitions including *Australian Perspecta*, AGNSW 1983; *What is This Thing Called Science?* Uni. of Melbourne Gallery 1987.
APPTS: Asst. Exhibition Officer, NGV, 1973–75; teaching, part-time, Tasmanian CAE, Hobart, 1976 ?.
REP: NGA.
BIB: Sturgeon, DAS.

CRISP, Henry J.
(Active from c. 1900, Sydney) Painter. He exhibited extensively at the Art Society of NSW from 1901, being a judge on the committee in 1909. He concentrated on portraits (mainly of women and girls) and landscapes, continuing to show till after World War I. Originally well received, his paintings are rarely seen today.
BIB: Royal Art Society of NSW catalogues, Sydney, 1908.

CRISP, James Alexander
(b. 1879, Sydney; d. 1962, Sydney) Painter, illustrator.
STUDIES: With J.S. Watkins and H. Garlick, Sydney. Younger brother of Henry Crisp (q.v.) he exhibited with the Royal Art Society of NSW from 1901 as well as in the USA where he lived from time to time. He contributed illustrations to magazines such as USA journals *Sunset* and *WASP* and, in Australia, the *Bulletin* for whom he illustrated many Henry Lawson stories. He exhibited with the Printmakers Society of California 1926–37; was a member of the Australian Painter-Etchers Society; and was represented in the 1924 Wembley Exhibition. His work included watercolours of birds and other fauna and oils of landscapes and rural life.
REP: NGA; AGNSW; Manly Art Gallery; New England Regional Art Gallery; public galleries NZ, New York, USA.
BIB: Moore, SAA. AA 1921.
(*New information from artists' daughter Mrs. M. Lawson, Sydney. Feb. 1994*).

CRITICS AND CRITICISM
Vital art begets vital criticism and the more vital the criticism the more is public awareness of and interest in the arts extended. It may even be said that the vitality of a nation's art may be measured by the criticism it produces. The power base of criticism is the daily newspapers. Before the great dailies started publishing regular art critiques, poverty among artists and lack of interest in what they did was widespread.

The first art criticism in Australia was published in Sydney in 1834. It came from Dr John Lhotsky, a versatile educator, writer, critic and scientist of insatiable curiosity, who examined with a keen eye many of the most elusive aspects of the new country. Lhotsky made the first translations of Aboriginal songs into English, criticised the absence of local content in the paintings of John Glover, and held that the light, atmosphere and landscape of Australia were capable of producing, at some future time, a Salvatore Rosa. But 'the mad Pole', as the British geologist Sir Impe Murchison dubbed him, was a voice crying in a real wilderness. Another such voice was heard in South Australia when the artist F. R. Nixon wrote a long letter of protest published in the *South Australian* on 17 June 1845. Subject of his protest was the official favours granted to G. F. Angas for his topographical drawings, as compared with the absence of official support given to the superior work of S. T. Gill (qq.v.).

The turning point that was permanently to mark the change from colonial to more enlightened attitudes towards art and art criticism came with the great *International Exhibitions* in Sydney (1879–80) and Melbourne (1880–81). From then on, regular art criticism began to be featured in many newspapers and periodicals. In the late 1880s a succession of small magazines – *Australian Art*, 1888, *Australasian Critic*, 1890–91, *Australasian Art Review*, 1899–1900 – introduced the art critiques of 'De Libra' (James Green), and Sydney Dickinson (qq.v.), both of whom gave informed support to the new movement – impressionism as imported from France. Impressionism held no attraction, however, for the most influential critic of the time, James Smith, who saw it as an ephemeral movement capable of producing nothing more than unfinished sketches. As art and drama critic for the great conservative daily the Melbourne *Argus*, for more than 40 years, Smith had enormous influence. He gave strong support to von Guérard, Buvelot, Julian Ashton and the entire contingent of goldrush painters and sculptors, and proposed the building of the NGV. But his failure to find merit in the work of the 9 × 5 *Impression Exhibition* of 1889, and the subsequent triumph of Heidelberg School impressionism, clouded his reputation until quite recent times when the full extent of his great contribution to Australian art was rediscovered. Smith's successor as *Argus* art critic was the cartoonist Tom Carrington, who also opposed impressionism but appreciated the qualities of both Manet and Cézanne (ref. *Argus*, 10 May 1913), thus anticipating the findings of George Bell (another anti-impressionist, though for different reasons) and other spokesmen for the Melbourne modern movement by nearly 20 years. Later *Argus* art critics included Arthur Streeton, Harold B. Herbert, Alan McCulloch, John Loxton and Arnold Shore (in that order), before the sudden, tragic collapse of the old newspaper c. 1956. Listed chronologically, daily newspaper critics include also Melbourne *Herald*: William Moore, James S. MacDonald, W. Blamire Young, Lionel Lindsay, Basil Burdett, Clive Turnbull, Laurie Thomas, Alan McCulloch, Ronald Millar, Susan McCulloch; *Sun News-Pictorial*: George Bell, Norman Macgeorge, Adrian Lawlor, Alan Warren, Jeffrey Makin, Rod Carmichael; *Age*: Alexander Colquhoun, M. J. McNally (casual), J. S. MacDonald, A. V. Cook, Arnold Shore, Bernard Smith, Ann Galbally, Patrick McCaughey, Maureen Gilchrist, Mary Eagle, Robert Rooney, Memory Holloway, Gary Catalano, Christopher Heathcote. Sydney critics, *Sydney Morning Herald*: Peter Bellew, Paul Haefliger, Wallace Thornton, Donald Brook, Nancy Borlase, Terence Maloon, Susannah Short, John MacDonald. Felicity Fenner. *Sydney Sun*: Howard Ashton, James Gleeson. *Telegraph*: W. E. Pidgeon, Daniel Thomas. The names of John Baxter Mather (Adelaide *Advertiser*), Ivor Francis (Adelaide *News, Sunday Mail* and *Advertiser*) and Brian Seidel (*Advertiser*) emerge with distinction from the files of daily newspaper critiques in South Australia, as do the names of Charles Hamilton, Salek Minc and Patrick Hutchings in Western Australia; Gertrude Langer (*Courier-Mail*) in Queensland and Sasha Grishin in Canberra. The *Australian* newspaper has published regular critiques by Elwyn Lynn, John Henshaw, Laurie Thomas, Ronald Millar, Graeme Sturgeon, Michael Shannon, Sandra McGrath and Robert Rooney and the *Bulletin* magazine' publishes reviews by Joanna Mendelssohn. Following the flurry of little magazines in the 1890s came the more substantial *Art and Architecture* (1904–11), *The Salon*, (1912–16), and *Art in Australia* (1916–42), all published in Sydney. In Melbourne there was *Stream* (1931), *Angry Penguins* (Adelaide and Melbourne, 1941–45), and *Meanjin* (1940–), the latter being the only magazine to publish regular features on the visual arts for many years after the demise of *Art in Australia*. In Perth there were the magazines *Westerly* and *The Critic*. Collectively, these publications produced a body of critical writing of great interest.

Of even greater interest was the criticism published in the periodical newspapers such as *Observer, Nation*, the new *Bulletin, National Times*, and the controversial *Nation Review*. These publications opened their columns to the critiques of such writers as Earle Hackett, Eneide Mignacco, the highly original Bernard Boles, and the ebullient Robert Hughes. In May 1963, *Art and Australia* appeared as a worthy successor to *Art in Australia*, to extend further the field of critical writing, and the formation of the Australia Council in 1972 led to the encouragement of a number of art magazines such as *Art and Text*, and *Art Monthly*. (*see also* MAGAZINES)

Other changes have occurred through television (whose early art proponents included 1962–65, a regular program, *The Critics*, chaired by Max Harris; and the 1980s Robert Hughes BBC/ABC *The Shock of the New*) and radio. The ABC has been the outstanding contributor to art criticism in the electronic media in the late 1980s/90s with the Peter Ross *Sunday* and *Review* on television and Mary Lou Jelbart's *Sightings* weekly programme on Radio National.

The changes affecting art criticism in Australia in the 1990s reflect a world situation and are every bit

as radical and extraordinary as the changes affecting other aspects of society. Where once it was the small voice of the few, art criticism is now the profession, or pastime, of the many, taught in schools and universities. Today's critic finds voice via the university or college lecture room, the television or radio, the columns of dozens of magazines, periodicals and newspapers, and a proliferation of art books. And in the general avalanche of words and pictures, and the battle for survival among critics, criticism feeds on criticism and art gets scant notice. However it is a consoling thought that art criticism, like art itself, is a dedication or it is nothing. And in the realms of dedicated criticism, Australia is no worse or better off than any other country.

See also INTERNATIONAL ASSOCIATION OF ART CRITICS; MAGAZINES, REVIEWS, PERIODICALS AND NEWSPAPERS

CROFT, Brenda

(b. 17/5/64, Perth, WA) Photographer, administrator, teacher.
STUDIES: Night courses, painting, life drawing, photography, Canberra School of Art 1981–83; BA (Visual Arts) 1 yr 1986 deferred; Koori women's video production course, Metro Television, Sydney 1990; MA Arts Administration, Coll. of Fine Arts, Uni. of NSW 1990–91; internship NGA 1991. Of the Gurindji people of the NT, her varied career includes as a photographer and installation artist showing in approximately 15 group exhibitions 1986–92 largely at public galleries and art spaces including *Inside Black Australia*, 1988, 89, Tin Sheds, Sydney; *A Koori Perspective* (alternative to Perspecta), Artspace 1989; *A Continuing Tradition; Directions in Aboriginal Art*, NGA 1989; *Aboriginal Women's Exhibition*, AGNSW 1991. She has broadcast and researched Aboriginal (especially women's) issues for the ABC, SBS radio and television and was a founding member of Boomalli Aboriginal Artists Co-operative in 1987.
AWARDS: Equipment grant, Aboriginal Arts Unit, Aust. Council 1989; research grant, Aust. Inst. of Aboriginal & Torres Strait Islanders 1990.
APPTS: Clerical asst., Aust. Taxation Office 1985–86; Aboriginal Services Section, Dept of Social Security 1986; consultant and photographer for various festivals and performances including 5th Festival of Pacific Art, Townsville 1987–88; researcher, SBS magazine program 1989; consultant ABC; Tranby Aboriginal Co-operative; Kudurru Aboriginal Resource Agency 1989; co-ordinator Boomalli Aboriginal Artists Co-operative 1990–91.
REP: NGA; Power Gallery, Uni. of Sydney; Mitchell Library; ATSIC.
BIB: Caruana, AA. A&A 31/1/1993.

CROFT, Christopher

(b. 1947, Melb.) Printmaker.
STUDIES: RMIT, c. 1970; Stuttgart, Germany, 1976–78. He earned a living briefly as a drover, waiter, cartoonist and copywriter before turning to printmaking. His etching *Burning Land* was commissioned by the PCA

in 1973. From this beginning his work developed a surrealistic and satirical twist as evidenced in many exhibitions.
AWARDS: Scholarship for study in Stuttgart, 1976.
BIB: PCA, *Directory* 1976.

CROLL, Robert Henderson

(b. 1869, Stawell, Vic.; d. 1947, Melb.) Librarian, journalist, writer. Croll, who amassed information and many anecdotes about his artist friends and colleagues, is remembered mainly for his biography of Tom Roberts. While working in the Victorian Public Library he performed many services for the NGV, both institutions at that time being served by a single body of trustees which also controlled the National Museum of Victoria. Croll organised the exhibition of art held to celebrate the Melbourne Centenary in 1934. He wrote *The Etched Work of John Shirlow*, Alexander McCubbin, Melbourne, 1920; *Tom Roberts, Father of Australian Landscape Painting*, Robertson & Mullens, Melbourne, 1935; *Life of R. W. Sturgess*, Melbourne, 1938; *I Recall: Collections and Recollections*, Melbourne, 1939.
BIB: ADB 8.

CROMBIE, Peggy

(b. 1901, Melb.; d. 1984) Painter.
STUDIES: Stotts Commercial Art Training Institute 1921; NGV school, with Bernard Hall and William McInnes, 1922–28; George Bell school 1940s. She exhibited 1927–59 with VAS and in *The Embryos* (with Constance Stokes, Herbert McLintock, William Constable and Eric Thake) 1930 and *The 1932 Group* (with John Vickery, Sybil Craig, Edward Heffernan and Jessie Mackintosh). They went on to become the New Melbourne Art Club in 1935 and exhibited for two years. Her work appeared in various other group exhibitions and in conjunction with other artists including Helen Ogilvie and Helen Boyd (qq.v.). From 1949 to 1976 she exhibited with the Melbourne Society of Women Painters (q.v.). Her paintings show strength of composition and those of the 1930s are modernist in style. They received mixed but encouraging reviews in the earlier exhibitions, in which her linocuts in particular were often singled out for attention. A major exhibition of her work was mounted by Jim Alexander Gallery, Melbourne, in July 1983.
REP: NGA.

CROOKE, Ray Austin

(b. 1922, Melb.) Painter, graphic artist.
STUDIES: Swinburne Tech. Coll., with Roger James and Allan Jordan, 1946–48. His preliminary studies at Swinburne were interrupted by army service in WA, North Qld and Borneo. After the war he worked at various occupations which included two years on Thursday Island working for the Diocese of Carpentaria, an experience that was crucial to his subsequent development as a painter. The cool, Gauguin-like portrayal of island life that emerged soon won him wide popularity. In his mature work figuration is mixed with

Ray Crooke, The Death of a Mining Town, *1963, oil on canvas. Private collection.*

a flat, decorative style given individuality by the attention paid to the fall of light. He served as an official war artist in Vietnam from 1966 and in 1969 won the Archibald Prize, Sydney, with a character study of the writer George Johnston. He has exhibited frequently in leading galleries in most capital cities and his work has been included in a number of significant group exhibitions and is frequently sold through leading auction houses.

AWARDS: Archibald prize, 1969.

REP: NGA; all state and many regional galleries: Vatican collections, Rome.

BIB: Rosemary Dobson, *Focus on Ray Crooke*, Uni. of Qld Press, Brisbane, 1971. James Gleeson, intro. *Ray Crooke*, Australian Artists Editions, Collins, Sydney, 1972; *A&A* 10/3/1973 (John Henshaw, *Ray Crooke Drawings*); 10/4/1973 (John Henshaw, *Ray Crooke Paintings*).

CROSS, *Elizabeth*

(b. 12/7/1943, Melb.) Printmaker, draughtsman, art critic.

STUDIES: TSTC, Melb. Teachers College, 1964; Dip. Art, RMIT 1969; fellowship dip. art, RMIT 1970; MA studies 1974–80; travel studies Europe 1979–80; 1983–84; 1987; 1990. A practising printmaker who

has held about 4 solo exhibitions in Melbourne 1969–88 and participated in a number of travelling and group print exhibitions she was also an art critic for newspapers including the *National Times, Art Network, The Age*. She was editor of the PCA magazine *Imprint* 1980–82 and has written for a number of art journals; curated exhibitions including *Crosscurrents* (with Maudie Palmer) for Heide, 1986; *Interior Views* for the PCA, 1989; *The City and Beyond* touring regional galleries 1990 and has given a number of public lectures.

APPTS: Secondary teaching Vic. and London, 1956–72; tertiary lecturing art history Melbourne (including Caulfiield, Phillip Institute) 1970–92; curator Art History dept, La Trobe University 1973–78.

REP: MOMA, NY; Victoria and Albert Museum ,London; NGA; AGSA; AGWA; NGV; QAG; Artbank; several regional galleries; a number of corporate and private collections including BHP; Margaret Carnegie; Myer collection.

CROSSLAND, *John Michael*

(b. 1800, UK; arr. Aust. 1851; d. 1858)

STUDIES: RA, London. Arriving in Adelaide he established a local reputation for portraiture, making his name with a series of portraits of Capt. Charles Sturt followed by those of many other colonial dignitaries including Sir Henry Young and Lady Young, George Fife Angus, and Justice Sir Charles Cooper. However it is his portraits of the Aborigines *Nanultera, a Young*

Cricketer of the Natives Training Institution and *Samuel Conwillan (Kandwillan) a Catechist of the Natives Training Institution, Poonwindie* (both in the Nan Kivell Collection, NLA, and on loan to NGA) which stand out. Commissioned by Archdeacon Mathew Hale in 1854, they graphically demonstrate the extraordinary cultural clash of Aboriginal Australians and colonial doctrinarians. The former of these two paintings was the first (in chronological order) of the touring exhibition *Towards an Australian Portrait Gallery*, 1992–93 and both works were included in the Bicentennial exhibition. *The Great Australian Art Exhibition*.

REP: AGSA; NLA; Parliament House, Adelaide; National Portrait Gallery, London.

BIB: Nancy Benko, *Art and Artists of SA*, Lidums, SA, 1969. A. Graves, *The Royal Academy of Arts*, London 1905. Kerr, *DAA*.

CROSTON, Douglas

(b. Brisbane, 1915) Painter, printmaker.
STUDIES: Martyn Roberts School, Brisbane, 1941; Brisbane Tech. Coll., 1942; vacation schools with S. Rapotec; travel studies Europe, UK, USA, 1973. He worked for 25 years as a photographer before turning to full-time painting in 1968. His Pop-style paintings and prints have appeared in exhibitions in state capital cities.
AWARDS: Stanthorpe prize, 1972; VACB grant for travel within Australia.
REP: QAG.
BIB: PCA, *Directory*, 1976.
NFI

CROTHALL, Ross

(b. 1934, New Zealand; arr. Aust. 1958) Painter.
STUDIES: NZ (with Theo Schoon), 1954–58. Crothall was one of three artists who exhibited at the MOMAD, Melbourne, in 1962, under the title *Annandale Imitation Realists*. Another exhibition by the same trio, titled *Annandale Subterranean Impressionist Realists*, was held in Sydney in the same year. One of his collaborative works (with Mike Brown) was included in the Bicentennial exhibition. *The Great Australian Art Exhibition*.

CROTHERS, Tanya

(b. 28/1/1941, NSW) Printmaker, multi-media artist.
STUDIES: B. Arch. Uni. of Sydney 1964; Dip. Ed., Uni. of New England 1972; lithography and etching, Willoughby Workshop Art Centre. Her prints have been seen in PCA and other group exhibitions 1970–93 and her mixed media sculptures and installations in eight solo or two-person exhibitions 1968–93. Daughter of Gerald and Margo Lewers and sister of Darani Lewers (qq.v.) her *Peace and Nuclear War in the Australian Landscape*, with its charred remains of once-living flora and fauna, caused interest when it toured four tertiary and public galleries in Melbourne, Sydney, Adelaide and Perth in 1985–86.
REP: Parliament House; Museum of Applied Arts & Sciences, NSW; NSW Parliament House; Artbank; ter-

tiary collections including Deakin Uni., QIT; Reserve Bank collection.

CROUCH, Richard Armstrong

(b. 19/6/1868, Ballarat; d. 7/4/1949, Point Lonsdale, Vic.) Politician, soldier, philanthropist. His gifts to the Ballarat Fine Art Gallery included bequests for the George Crouch prize (1926) in memory of his father, and the Minnie Crouch prize (1944) in memory of his sister. He also presented his fine collection of mediaeval and Renaissance manuscripts to the Gallery and initiated and helped to fund the avenue of sculptures of Australian prime ministers in the Ballarat Botanical Gardens.
BIB: ADB 8.

CROW, Eileen Maud

(b. Hobart, Tas.) Painter, commercial artist.
STUDIES: Hobart Tech. Coll. (with Lucien Dechaineux, Mildred Lovett). She exhibited with the NSW Society of Artists and with the Contemporary Group, Sydney, 1937–39, and was first honorary secretary of the Tasmanian Group of Painters, 1939.
REP: TMAG.

CROWE, Irwin

(b. 1903, Claremont, WA) Painter, engineer, prospector.
STUDIES: Melbourne Tech. Coll. (army rehabilitation course, 1947–50). Crowe's work was included in the *Painters from the West* exhibition at the MOMAD, Melbourne, in 1963.
AWARDS: Perth prize 1959, best WA entry (shared with Maurice Stubbs); special prize, Bunbury, 1961.
NFI

CROWLEY, Grace Adela Williams

(b. 28/5/1890, Cobbadah, NSW; d. 21/4/1979) Painter
STUDIES: Julian Ashton School, Sydney, c. 1915–18 (with Ashton and Elioth Gruner); Paris (1926), first at Colarossi's then privately with Louis Roger and, finally, with Andre Lhote (1927–29); she also studied briefly with Ozenfant and Albert Gleizes. Daughter of a grazier, Henry Crowley, of Glen Riddle, Barraba, she revealed artistic leanings early in life. Her childhood talents received professional encouragement when an uncle took her, once a week, to Julian Ashton's classes in Sydney. From this beginning she eventually became Ashton's assistant at the school (1918–23). After a visit to Melbourne and brief study with Bernard Hall at the NGV, she left Sydney for Marseilles in company with Anne Dangar who had recently become interested in the work of Cézanne. Crowley was already known for her work in annual NSW Society of Artists exhibitions and for her entry in the 1923 Travelling Scholarship of NSW (won by Roy de Maistre). Her importance to Australian art development is that, like her colleagues Dangar, Black, Balson, de Maistre, Fizelle and others, she had the opportunity, the talent and the perception to assimilate modern French

influences such as cubism and to introduce these influences with enthusiasm and dedication to the Sydney art of the decade 1930–40. She helped Dorrit Black with the Modern Art Centre in 1932 and held her only exhibition there. The geometric structure in a typical Crowley figure composition shows her indebtedness to *Section d'Or* theories as transmitted by her French teachers Lhote and Gleizes – but added to the structure is a painterly quality that gives the work strong individuality, especially in its application to Australian subjects. An exhibition *Balson, Crowley, Fizelle, Hinder*, was held at the AGNSW, 1966 and her work was the subject of *Project 4* at the AGNSW, Sydney, in 1975, and a similar show in July of the same year at the NGV, Melbourne. She was represented in *Australian Women Artists, One Hundred Years, 1840–1940*, Ewing and Paton Galleries, University of Melbourne, and touring 1975; *The Great Australian Art Exhibition* Bicentennial exhibition and *A Century of Australian Women Artists 1840s–1940s* Deutscher Fine Art, Melbourne 1993.

REP: NGA; AGNSW; NGV.

BIB: Michel Seuphor, *Dictionary of Abstract Painting*, Methuen, London, 1958. A&A 13/2/1975 (Bernice Murphy, *Project 4: Grace Crowley*).

CROXFORD, Thomas Swainson
(Active during last quarter of nineteenth century) Painter. Known for coastal landscapes. He exhibited at the RA, 1876–84, and worked in both oil and watercolour. Some of his paintings of rocky cliffs and coasts carry Australian inscriptions, though no other record of a visit to Australia has been found.

CROZIER, Frank R.
(b. 1883, Maryborough, Vic.; d. 1948, Warrandyte, Vic.) Painter, illustrator.
STUDIES: NGV School (with Alec Sass, C. Douglas Richardson), 1907; London; America, 1923–24. A war records artist during World War I, Crozier took part in the fifth phase of occupancy at Charterisville. His talented but careless painting was well-known during the middle period of Australian landscape painting; he exhibited extensively in Australia and also at the RA.
AWARDS: NGV School student prizes for landscape and drawing, 1907.
REP: NGV.
BIB: Article by J. S. McDonald, AA, Nov. 1921.

CULLEN, Max
(b. 1940, Wellington, NSW) Painter, sculptor, actor, producer.
STUDIES: Julian Ashton School, 1959–60; NAS (with Lyndon Dadswell) 1956. His early career included as a newspaper illustrator for magazines including the *Bulletin*. From 1957 he exhibited in competitive and other exhibitions in NSW. He joined the Ensemble Theatre Company in 1962 and studied acting with Hayes Gordon. In 1967 he held an exhibition of sculpture jointly with Barney Rahill at the Central Street

Gallery, Sydney, and the following year held another entitled *Max Cullen's Black Room Collection* of 'rare stamps, prints and sculpture' at the Pinacotheca Gallery, Melbourne. He exhibited at Watters, Sydney, 1989.

CUMBRAE-STEWART, Janet Agnes
(b. 23/12/1883, Brighton, Vic.; d. 8/12/1960, Melb.) Painter.
STUDIES: NGV School, 1904–08. She attained greatest success with her carefully drawn pastel studies of nudes, particularly during the 1920s. Her work has been seen in a number of survey exhibitions including *A Century of Australian Women Artists 1840s–1940s* Deutscher Fine Art, Melbourne, 1993 and *Important Australian Women Artists* Melbourne Fine Art, 1993.
AWARDS: Student prizes, NGV School, 1906; silver medal, *Panama Pacific Exhibition*, San Francisco, 1914.
REP: AGNSW; AGSA; NGV.
BIB: J. Shirlow, *The Pastels of Cumbrae-Stewart*, Vidler, Melbourne, 1921. ADB 8. AA June 1919.

CUMMINGS, Elisabeth
(b. 1934, Brisbane) Painter.
STUDIES: ESTC; Europe, c. 1958–61. She lived in Florence 1961–68 and on her return to Sydney in 1969 held a number of exhibitions in most capital cities.
AWARDS: Le Gay Brereton prize for drawing, 1957; NSW Travelling Scholarship, 1958; prizes in competitions at Redcliffe, 1964; Gold Coast City, Qld (work acquired), 1971; Grafton, 1971; Sydney (R.Ag.Soc.NSW), 1972; Cheltenham, 1972; Drummoyne, 1976; Lismore, 1977; Campbelltown, 1977, 84; Faber-Castell, 1987.
APPTS: Teaching, NAS, 1969–74; City Art Inst., 1975–86; TAFE, 1975.
REP: NGA; AGNSW; QAS; several regional galleries.

CUNNINGHAME, Fairlie
Painter.
STUDIES: Royal College of Art, London, with Professor Lanteri. She exhibited in Sydney with the RAS from 1905; Moore writes that she received a number of commissions in London.
BIB: Moore, SAA.

CUPPAIDGE, Virginia
(b. 14/8/1943, Brisbane) Painter, lecturer.
STUDIES: Orban School, Sydney, 1960–62; Mary White School, 1963–65: travel studies USA, 1969–75. Living in the USA as well as Australia, she lectures and exhibits frequently in both countries including at Michael Milburn, Brisbane; Gallery A, Sydney (1974–82); Bloomfield, Sydney 1985, 87; Australian Galleries, Sydney and Stephen Rosenberg, NY. In 1975 she was artist-in-residence at the University of California, Berkeley. Group exhibitions in which her work has appeared 1973–91 included *Voices for Choices*, Women's Caucus for the Arts, NY 1991; *Four Australian Painters Living in the USA*, Wagner Gallery USA 1992. Her hard-edge paintings were described by a New York critic

as 'an instinctive synthesis of Mondrian, Rothko and Hofmann'.

AWARDS: Macdowell Colony Fellowship, New Hampshire, USA, 1975; CAPS grant for painting, 1975; Guggenheim Fellowship, 1976; VACB special projects grant, 1977.

APPTS: Secondary art teaching, NSW, 1960–65; lecturing, Pratt Inst., Brooklyn, NY, 1980–82; Associate Professor of Art, Lehman College, Bronx, NY 1992– ; numerous guest lectureships at Australian and American universities, galleries and art colleges.

REP: AGNSW; QAG; MCA, Sydney; Australian Embassy loan collection; Newberger Museum, NY; several regional and uni. collections NSW, Qld.

BIB: H. Fridemanis, *Artists and Aspects of the Contemporary Art Society*, CAS, Qld, 1991. A&A 17/3/1980 (Kerrie Bryan, *Unbarring the Gates of Light: The Work of Virginia Cuppaidge*).

CURRIE, A.
Painter of a portrait of pioneer settler Sherbourne Sheppard, from whom Shepparton, Vic., received its name.

REP: Shepparton gallery.

NFI

CURRIE, Jane Eliza
(b. c. 1798; arr. WA 1829; returned Eng., 1832) Painter. Known for miniatures, wildflowers and landscapes. Wife of Captain Mark John Currie, first harbour master at Fremantle. Her best-known surviving work is the fine 26 cm × 304.8 cm *Panorama of the Swan River Settlement 1830–32*, a historical watercolour that took two years to complete. Her work was seen in *The Colonial Eye*, AGWA, 1979.

REP: Mitchell Library.

BIB: Kerr, *DAA*.

CURTIS, James Waltham
(b. 1839, Devonshire; d. 1901) Painter, illustrator. Curtis went to Vic. probably with the goldrush and worked in Melbourne, first as a colourist for the photographers Johnstone, O'Shannessy & Co., then as an illustrator for the *Illustrated Australian News*, having had experience in illustrating for the *Graphic* and the *Sketcher*, London. He is described in the catalogue of the *Intercolonial Exhibition*, Melbourne-Philadelphia, 1875–76, as 'the Australian Géricault', but his Australian reputation declined to the point where in 1946 the trustees of the AGNSW sold his *A Winter Morning* from the collections. Atonement was made in 1969 when they acquired his *McIntosh's Saw Mill at Echuca, Flood Time, 1887*. After Curtis's death 70 of his Australian landscapes were presented from his estate to the Leland Stanford Jnr Uni., California. His work was seen in *Australian Art in the 1870s* AGNSW, Sydney, 1976 and the Bicentennial exhibition *The Face of Australia*.

REP: AGNSW.

BIB: McCulloch, *AAGR*.

CURTIS, Robert Emerson
(b. 1899, Eng.; arr. Aust. 1924) Illustrator, painter.

Known mainly for industrial subjects. He wrote *A Vision Takes Form – Sydney Opera House*, A.H. & A.W. Reed, Sydney, 1967.

STUDIES: San Francisco; Chicago Art Inst., c. 1923–29.

REP: AWM (more than 200 works).

CURTIS, Robert Louis
(b. 4/12/1929, Sydney) Painter.

STUDIES: Orban School, Sydney; ESTC (sculpture); Joy Ewart School; Cornwall (with Peter Lanyon), 1958. Included in the CAS exhibit at the *Bienale de São Paulo*, Brazil, 1960, his work won him commissions in Papua New Guinea, 1964. He held about five solo exhibitions 1962–65 including at Macquarie, Sydney (1962, 65); von Bertouch, Newcastle (1963) and participated in a number of group exhibitions including *Abstract Expressionism in Sydney '56–64*, Alexander Mackie College 1980; *New Directions 1952–62*, Penrith Regional Gallery 1991.

AWARDS: ABM annual prize, Sydney, 1961; *King of Kings National Art Prize*, 1961; Henry Lawson Festival, 1966; Grenfell prize, 1966, 68.

REP: AGNSW; Sydney Uni.

BIB: John Kroeger, *Australian Artists*, Rennicks. Germaine *AGA*.

CURTIS, Sybil Rose
(b. 10/10/1943, Canungra, Qld) Painter.

STUDIES: B.Sc., Uni. of Qld 1967. Her super-real paintings of mining and other industrial subjects have been seen in six solo exhibitions 1983–92 in Brisbane (Victor Mace; Brisbane CAE) and Ipswich City Council, 1989, and in about 6 group exhibitions 1983–90 including *Queensland Works 1950–1985*, Uni. Art Museum, Uni. of Qld, 1985; *Queensland Women Artists in Profile*, Villanova College Brisbane, 1989.

AWARDS: Five Rotary and regional awards 1980–90; Caltex City of Brisbane Award, 1981, Gold Coast City Art Prize, 1990.

REP: Queensland Uni. of Technology; Redcliffe City Council; Ipswich regional gallery; Brisbane City Hall.

BIB: Germaine, *DAWA*.

CUSACK, Edith E.
(b. c. 1865; d. c. 1941) Painter.

STUDIES: Parramatta, NSW, with J. A. Bennett; Paris, with Bouguereau, Lefebvre and Fleury. She exhibited with the Art Society of NSW from 1893, and at the Paris Salon. Her subjects include portraits, landscape and flowers, all painted and drawn with skill. She gave private art lessons with Aline Cusack, presumably her sister, who exhibited with her. They ceased exhibiting in 1914. Her work *Wildflowers* was bought by the AGNSW in 1900 and sold in 1946.

BIB: Art Society of NSW catalogues c. 1905. John Kroeger, *Australian Artists*, Rennicks, Adelaide, 1968.

CUTHBERTSON, Arch
(b. 1/12/1924, Geelong) Painter, teacher.

STUDIES: Dip. Fine Art, RMIT, 1955; Fellowship, RMIT,

1969–70. Deriving from many modernist sources, Cuthbertson's early paintings showed cubist, abstract and finally texture painting influences. One of his best-known works is a large mural for the Commonwealth Bank, Ballarat. He also received several other ceiling mural commissions in Ballarat. He held about 26 solo exhibitions 1961–92 in Melbourne, Geelong, Adelaide and Sydney, including about six with Barry Stern, Sydney. He participated in a number of group exhibitions at private galleries 1959–91 and *Survey 8*, 4 Geelong Artists, Geelong Art Gallery 1987; *Scotchmans Hill* Prize, Geelong Art Gallery 1991.

AWARDS: Geelong prize for watercolour, 1964; Minnie Crouch prize, Ballarat, 1966; Bendigo (purchase award), 1968; Watercolour Australia Prize; Swan Hill Art Gallery 1988.

APPTS: Teaching, State Colleges, Geelong, Ballarat 1956–68; Gordon Inst. 1971–73; senior lecturer, Deakin Uni. 1974–84.

REP: AGSA; NGV; Parliament House; Artbank; many regional and tertiary collections Vic.

D
*D*ABRO TO DYSON

D*ABRO, Ante*
(b. 13/1/1938, Croatia; arr. Aust. 1967) Sculptor.
STUDIES: Academy of Fine Art, Zagreb, 1959–66. He completed a commission for a World War II sculpture for Bitrac, Yugoslavia, 1967, and held about 13 exhibitions of heroic-styled, expressionistic sculpture 1968–88 at Macquarie, Holdsworth, Sydney; Philip Bacon, Brisbane; Solander, Canberra. His other commissions included ACT Electricity Authority mural, 1968; sculptures for churches and public places including Aust. Government commission for French Bicentenary (sculpture of La Pérouse, now in Paris), 1989; Aust. Liberal Party bust of Sir Robert Menzies, 1990; and his work appeared in a number of group sculpture survey shows including *Mildura Triennial* 1982, 88.
AWARDS: Churchill Fellowship (study tour USA, Europe and UK), 1982.
APPTS: Part-time and full-time lecturing, Canberra School of Art, 1970– .
REP: TMAG; AWM; La Perouse Museum, Sydney; several tertiary collections ACT, Qld and City of Paris
BIB: Scarlett, AS. Germaine, AGA. NCDC, *Works of Art in Canberra*, 1st and 2nd editions.

D*ABRON, Jacqueline Helene*
(b. 11/9/1943, Springwood, NSW) Painter, teacher.
STUDIES: NAS, 1966–69; Dip. Art Education, 1969. Daughter of Jean Isherwood (q.v.), she exhibited in several private galleries in Tamworth and Walcha, and in Armidale City Gallery 1977; Tamworth City Gallery 1978, 91.
AWARDS: 28 prizes, largely regional, 1976–88 including Gosford 1976, Lismore 1977.
APPTS: Teaching, NSW high schools, 1970–72.
REP: A number of regional galleries NSW, Qld.
BIB: Germaine, AGA.

D*ABRON, John H.*
Inspector of art in NSW Education Dept; chairman of Australian UNESCO committee for visual arts; director of UNESCO seminar on art education, ANU, 1963. He married painter Jean Isherwood (q.v.).

AWARDS: USA Dept of State Program of Education Leaders and Specialists grant, 1963.

D*ADOUR, Vivienne*
(b. 2/5/1953, Sydney) Painter.
STUDIES: Dip. Graphic Design, NAS, 1974; B. Ed. (Visual Arts), Alexander Mackie CAE, 1980. Of her 1991 exhibition at Access gallery, Balmain, Sydney, Elwyn Lynn in the *Australian* (June 15–16, 1991) described her motion-filled semi-abstracts concentrating on body images as 'somewhat an heir of Pollock's linear notations and maybe of Mark Tobey's white writing . . . Dadour demands our time to find how the levels of her structures are connected.' She held four solo exhibitions at Willoughby Art Centre and one at Access Gallery Sydney 1985–92 and participated in 10 group exhibitions 1988–91 largely at artist-run galleries in Australia (Annandale Artists' Studio, Sydney) and the USA (Triangle Artists' Workshop, NY).
AWARDS: Fisher's Ghost Art Exhibition (works on paper), Campbelltown Regional Gallery, 1989.
REP: Campbelltown City Regional Art Gallery; overseas collections.
BIB: *New Art Eight*.

D*ADSWELL, Lyndon Raymond*
(b. 18/1/1908, Stanmore, NSW; d. 7/1/1986, Sydney) Sculptor, teacher.
STUDIES: With Julian Ashton, 1923–25; ESTC, with Rayner Hoff, 1926–29; after working as assistant to Paul Montford 1929–35, he was awarded a scholarship and studied at RA Schools, London 1935–36; travel studies Germany and Italy, 1936–37. Dadswell's valuable contribution to Australian sculpture mainly concerns his work as an educator and advocate for the changes that occurred after World War II. 'There is hardly a sculptor in Sydney who is not indebted to Lyndon in some measure,' wrote Margel Hinder in 1979. He wrote 'The Art of Sculpture', NSW *Society of Artists Book*, Sydney, 1944. Varied in their adaptations of modernist styles, Dadswell's own post-war sculptures aroused much public controversy, especially his prize-winning King George Memorial for Sydney, 1945, and the Newcastle Memorial ten years later.

He held solo exhibitions 1947–84 in Sydney (including at Rudy Komon; David Jones; Woolloomooloo galleries), Melbourne (including Niagara gallery) and other capital cities and completed a number of commissions including wall sculptures and free-standing sculptures for public buildings. An exhibition to mark his 70th birthday was held at the Sculpture Centre, Sydney in 1978 and a retrospective exhibition of his work was held at the AGNSW also in that year.
AWARDS: Wynne prize, 1933; King George Memorial prize, Sydney, 1945; Newcastle Memorial prize, 1955; Carnegie Foundation, Fulbright and Smith Mundt grants for study in the USA, UK and Europe, 1957–58; Sydney University prize, 1961; International Co-operation Art Award, 1967; Britannica Australia Award, 1967; Distinguished Artists Award, VACB 1973; CMG conferred, for services to art, 1978.
APPTS: Teaching, NAS, 1937–41; war service, 1941–42, followed by appointment as official war artist 1942–43; resumed teaching NAS, 1945–55; senior lecturer, NAS, 1955–66, head of the art school, 1966–67.
REP: NGA; AGNSW; AGSA; AGWA; NGV; QAG; AWM; Newcastle Region Art Gallery.
BIB: Sturgeon, DAS. Scarlett, AS. A&A 16/3/1979; 24/4/1987.

DAEN, Lindsay
(b. 1923, NZ; arr. Sydney in infancy) Sculptor. He held two exhibitions in Adelaide in 1946 and 1947, then worked in Sydney prior to leaving for the USA in 1949 where he participated in the inaugural exhibition for 1955 at the Whitney Museum, New York. Retrospective exhibitions of his work were held at the Uni. of Puerto Rico 1955, and Biblioteca de Jalixo, Mexico, 1958.

DAINTREE, Richard
(b. 1832?, Huntingdon, Eng.; arr. Aust. c. 1853; d. 1878, Qld) Photographer. He was a member of the Geological Survey of Vic. from 1854 and collaborated with Antoine Fauchery (q.v.) in a folio of photographs, *Australia*, in 1857. He left the Geological Survey in 1864 to take up land near Townsville, Qld and in 1872 published a photographically illustrated book, *Queensland*. Between 1872 and 1878 he published a number of folios of photographs depicting life in outback Qld and in 1879 over 200 photographs were shown posthumously at the Sydney International Exhibition. His work appeared in *Shades of Light*, NGA 1988.
REP: NGA; Qld Museum; NLA; Mitchell, La Trobe libraries.
BIB: *Treasures of the La Trobe Collection*, State Libary of Vic, 1986. J. Cato, *The Story of the Camera in Australia*, La Trobe 1955. Kerr, DAA.

DALE, Oliver James
(b. 1905, Melb.) Industrial artist.
STUDIES: NGV School. He worked as an art director in advertising in Australia, Canada and the USA before turning to full-time painting.
AWARDS: *Australia at War* exhibition, NGV, 1945 (first

prize shared); Olympic Arts Festival, Melbourne, 1956 (bronze medal).
NFI

DALE, (Lieut.) Robert
(b. Nov. 1810, Winchester, Eng.; arr. Swan River, WA, 8/6/1829; d. 1856, Bath) Topographical artist, explorer. Arriving in HMS *Sulphur* in Feb. 1829, he was appointed temporary assistant government surveyor, and explored the country beyond Canning River as well as the York district, Helena Valley and the region to the north of King George Sound where subsequently he was stationed (May 1832). Later in 1832 he became assistant to the acting administrator, Captain Irwin. Promoted lieutenant, he left WA in Oct. 1833 in HMS *Isabella* and accompanied his regiment to India. His *Panoramic View of King George Sound, Part of the Colony of Swan River*, with details of flora and fauna in the foreground, remains one of the earliest records of the area. It measures 17.78 cm × 274.32 cm and was engraved and published by Robert Havell, London, 1834.
REP: AGWA; Ballarat regional gallery; NLA; Mitchell Library.
BIB: Cedric Flower, *The Antipodes Observed*, 1974. Kerr, DAA.

DALGARNO, Roy Frederick Leslie
(b. 1910, Melb.; lived mainly in India from 1956) Painter, graphic artist.
STUDIES: NGV School, 1926–30; Sydney (with Dattilo Rubbo), 1930–32; ESTC, 1932–34; Paris, 1951–53. Dalgarno worked in Qld from 1936 until the outbreak of war in which he served as a camouflage officer for the RAAF. He taught art part-time at ESTC, 1946–49, and was one of the founders in Sydney of the Studio of Realist Art (SORA) before leaving for Europe in 1949. He illustrated George Farwell's *Down Argent Street: A Story of Broken Hill*, Frank Johnson, Sydney, 1949, travelled extensively in Europe, Asia and India and served on the Board of Studies of the Faculty of Fine Arts, Baroda Uni., India, 1968–75. After living in India he moved to Auckland, NZ, in 1978.
AWARDS: Second prize (Industrial Section), *Australia at War* exhibition, 1945; various prizes in Paris and India, mostly for graphics.
REP: NGA; AGNSW; QAG.

DALL'AVA, Augustine
(b. 24/1/1950, Grenoble, France; arr. Aust. 1955) Sculptor.
STUDIES: Dip. Fine Art (sculpture), RMIT, 1973; travel studies, Europe 1972–73; Japan, Europe 1976, 77; USA 1981; Europe 1984–85. He shared a studio in Gertrude Street, Fitzroy, with Anthony Pryor and Geoffrey Bartlett (qq.v.), and made an impressive debut in a joint exhibition there in which his slender constructions in aluminium, stainless steel and fruit-tree prunings contributed to the joint aim of using discarded materials. He held about 10 solo exhibitions 1982–90, largely at Pinacotheca Melbourne, and participated in many group exhibitions 1978–92

including *Mildura Sculpture Triennial*, 1978, 82, 88; *Aust. Sculpture Triennial*, 1981, 84, 87; *Sculptors as Craftsmen*, Meat Market 1984; *Sculpture 111*, Lewers Bequest and Penrith Gallery 1986; *On Site: Sculpture in City Spaces*, Sydney, 1990. His several commissions include Ian Potter sculpture commission for NGV and for the University of NSW 1981.
AWARDS: Special projects grant, VACB, 1975, 79; Alice Prize, 1982; residency, Tuscany studio, VACB, 1984.
APPTS: Teaching, several Melb. art schools, 1983–90; Monash Uni. sculpture, 1990–91.
REP. NGA; AGWA; NGV; Parliament House; Vic. Arts Centre; several regional and government collections Tas., Vic.
BIB: Catalogue essays for exhibitions as above. Scarlett AS. Sturgeon DAS.

DALLWITZ, David Frederick
(b. 25/10/1914, SA) Painter, printmaker, lecturer, musician.
STUDIES: SASA; Dip. Teaching, Adelaide Teachers College 1932–37. Equally talented jazz musician and composer as well as artist and teacher, he was a foundation member of the CAS of SA in the early 1940s and exhibited regularly from then with the CAS and privately, largely at Greenhill Adelaide. Group exhibitions 1939–92 in which his work appeared included those at AGSA: *Testament of Beauty*, 1939; *Graven Images in the Promised Land*, 1981; *Visions after Light: Art in SA 1881–1981*, 1981; *Adelaide Angries*, 1989. His musical talents took him to the 9th Annual Chicago Jazz Festival in 1987 and he made over 30 albums. Of his 1991 exhibition at Greenhill, Adelaide, John Neylon wrote in *The Adelaide Review*: 'Subject matter – inner rural environments, figure studies and still-lifes. Treatment – a characteristic slice of hard-edge illustration with post-impressionist echoes.'
AWARDS: Order of Australia (AO) for services to music, mainly jazz, 1986: bronze plaque, North Terrace, Adelaide, 'artist and musician', 1986.
APPTS: Secondary teaching, SA, 1938–62; lecturer, SASA, 1963–74; member, Secondary Schools Art Advisory Committee, 1950–62; foundation member, first president CAS, Adelaide, 1942.
REP: NGA; AGSA; Artbank; Flinders, SA unis.
BIB: Catalogue essays as above. Benko, ASA. Dean Bruton, *Recollections of the Contemporary Art Society of South Australia 1942–86*, CAS, Adelaide 1986.

DALLWITZ, John Christopher
(b. 3/3/1941, Adelaide) Painter, designer, lecturer, heritage consultant.
STUDIES: Uni. of Adelaide (architecture), 1959–62; Dip. Art, SASA, 1964; Dip. Teaching, SASA, 1965. From 1963 he worked with Ostoja-Kotkowsi (q.v.) on photographic and kinetic design as co-producer-director, *Sound and Image Experimental Theatre*, Adelaide Festival of Arts, 1964, 66, 68. His geometric abstract paintings appeared in exhibitions in Adelaide, Sydney, Melbourne and Perth from 1962 including at Powell St, Melbourne; Bonython, Adelaide; Barry Stern, Sydney.

He made frequent trips to the outback and was involved in many architectural restoration projects from the early 1960s including *The Biscuit Factory*, Adelaide. He is also a heritage consultant, his work including as a photographer for Oodnadatta Aboriginal community 1989 and Pitjantjara Land Rights historical exhibition 1991. Group exhibitions in which his work appeared 1970s–92 included *Visions after Light: Art in SA 1881–1981*, AGSA 1981; *The War Memorial Collection*, University of Adelaide 1992; *Adelaide Tibet Human Rights Exhibition*, 1992. He co-ordinated and curated several exhibitions including *Cross Currents*, 1988, 90. He also created large-scale sand sculptures from the mid-1980s, winning several competitions.
AWARDS: Caltex Art Prize, Adelaide, 1960; several municipal prizes 1960s; prizes for sand sculpture/castle competitions, Adelaide, 1986, 87.
APPTS: Secondary teaching, SA, 1965–66; part-time lecturer, painting and drawing, SASA, 1967–69; consultant conservator to Heritage Unit, SA Dept of Environment, 1978– ; consultant, Aboriginal Heritage Branch, SA Dept of Environment 1986– ; member of the National Parks and Wildlife Advisory Council of SA, 1976– .
REP: AGSA; Flinders Uni.; Uni. of Adelaide; several regional, secondary collections SA, Vic.
BIB: Catalogue essays exhibitions as above. Horton, PDA. Dean Bruton, *Recollections of the Contemporary Art Society of SA 1942–86*, CAS, Adelaide, 1986. Germaine, AGA.

DALY, Greg
(b. 20/5/1954, Vic.) Ceramicist.
STUDIES: Dip. Art (pottery), RMIT, 1974: Fellowship Dip. Art (pottery), 1976. He held five solo exhibitions 1976–90 at private galleries in Melbourne (Distelfink), Sydney (Macquarie), Brisbane (Victor Mace) and Canberra (Beaver), and participated in about 90 group exhibitions including *Australian Crafts 1983, 1984*, Meat Market Craft Centre, 1983; *Ten Years of Decorative Arts*, NGA, 1984; *Form and Function*, 1985; *Stuart Devlin Invitation Award Exhibition*, Meat Market Craft Centre, Vic. 1988; *National Survey Show*, Meat Market Craft Centre, 1989 and many international ceramic exhibitions in Europe.
AWARDS: Thirty awards nationally and internationally 1974–91 including Vic. Ministry for the Arts Craft Award, 1978; Caltex Ceramic Award, 1984; many awards France, Yugoslavia, Poland.
APPTS: Guest lecturer at many colleges and ceramic groups.
REP: NGA; AGWA; NGV; QAG; QVMAG; Parliament House; Artbank; Vic. Ministry for the Arts; Museum of Arts and Sciences, NSW; many overseas public collections UK, Europe and NZ.
BIB: Peter Lane, *Ceramic Form*, UK; *Studio Ceramics*, UK. Gottfried Borrman, *Ceramics of the World*, Germany. Harry Memmott, *The Australian Pottery Book*, 2nd ed. Janet Mansfield, *Modern Australian Ceramics*.

DALY, Herbert
See HEIDELBERG SCHOOL

DANCEY, George

(b. Eng.; arr. Aust. 1891) Cartoonist, painter, stained glass designer. Cartoonist for Melbourne *Punch*, 1894–1919. Dancey was obsessed with the work of Lord Leighton and made numerous studies of Leighton-like draped figures. Even in his *Punch* cartoons, he followed Leighton's procedure of starting with the anatomy of the figures, before putting in muscles and skin, and finally adding the clothing, a practice which, together with their Greek classic symbolism, caused the cartoons to be described as 'murals in miniature'. He left a successful career as a muralist and stained glass designer in London to go to Australia for health reasons and in Melbourne designed stained glass windows for the firm of Brooks Robinson. One of his best-known murals (done in tiles) was the entrance of the National Mutual Home Purchase Company building, 243 Collins Street.
BIB: Mahood, *The Loaded Line*, 1973.

DANCIGER, Alice

(b. 1914, Antwerp, Belgium; d. June 1991) Painter, stage designer, textile designer.
STUDIES: Sydney (with Dattilo Rubbo); Paris, 1935–38. She designed décor for the Kirsova Ballet, Sydney and exhibited at the Salon des Tuileries (1935–38); CAS, Sydney; and the NSW Society of Artists. She lived in Italy 1947–51 and exhibited in Rome, 1950. She held a successful exhibition of Italian paintings at Macquarie Galleries, Sydney, in 1951. She returned from Rome to Sydney in 1972.
REP: AGNSW.

DANGAR, Anne

(b. 1/12/1885, East Kempsey, NSW; d. 1951, Moly-Sabata, France) Painter, potter.
STUDIES: Sydney Art School with Julian Ashton, c. 1915–26; Académie André Lhote, Paris, 1927; Lhote's summer school, Mirmande, 1928. Colleagues at the Sydney Art School included Elioth Gruner, Dorrit Black, Rah Fizelle, Grace Crowley and with Crowley, who became a close friend, she became an assistant teacher at Ashton's school. In 1926 Dangar moved with her friend to Marseilles and Paris (visiting Cézanne *en route*), where they established a studio at Montrouge, and studied under Lhote. She returned to Australia in 1928 after a tour of Italy and resumed teaching at Ashton's school briefly before going back to France to join Albert Gleizes' student colony at Moly-Sabata on the Rhône. Moly-Sabata became her headquarters for the rest of her life until she died of cancer. Like many other artists working in the Rhône Valley, she was deeply influenced by Gleizes, who placed cubism at the service of strong religious beliefs, holding that movement, life and religious thought could be expressed in symbolic rhythms. She began working at the local pottery at St Dezirat, making traditional earthenware pottery decorated with abstract modernist decoration. She sent several consignments of her pots to Australia in the 1930s where they were exhibited at the Crowley-Fizelle School. Her paintings reflect Lhote's cubist style softened by a direct representation of nature and natural forms. Her work was seen in *Important Women Artists*, Jim Alexander Gallery, Melbourne 1977; *Australian Pottery 1900–50*, Shepparton Art Centre, Vic., 1978.
REP: NGA; AGNSW; Shepparton regional gallery; public collections, France.
BIB: Janine Burke, *Australian Women Artists*, Greenhouse, Melbourne, 1981. A&A 26/3/1989 (Helen Maxwell, *A Profile of Anne Dangar*).

DANIEL, George

(Active c. 1890–95, Sydney) Painter. Known for landscapes. He exhibited at the Art Society of NSW from 1892–94, showing mainly river scenes.
NFI

DANIEL, M. E.

Naive, or untrained, artist who painted a panoramic watercolour, *Mount Egerton, Victoria*, in 1883.
NFI

DANIELL, Jo

(b. 1945, Melb.) Photographer.
STUDIES: B. Economics, Monash Uni. 1969. Photographer who has travelled widely and exhibited his striking photographs of areas such as Central Australia, Africa, India, Nepal in solo and group exhibitions since 1977. Son of painter Yvonne Atkinson (q.v.).
REP: NGV; Artbank; City of Waverley.
BIB: A&A 18/2/1980; 30/2/1992.

DANIELL, Yvonne

See ATKINSON, Yvonne

DANKO, Aleksander

(b. 7/4/1950, Adelaide) Sculptor.
STUDIES: Dip. Fine Art (sculpture), SASA, 1971; Grad. Dip. Ed., Hawthorn Inst. of Education 1987; travel studies Europe, 1975, 77. Danko's forward thinking about sculpture was apparent from the first work he exhibited at the *Mildura Sculpture Triennial* (1970), a piece in cast brass and velvet entitled *Anxiety Switch*. The trend became more pronounced in his subsequent displays and his sense of irony increased, especially as seen in *A Child of His Times: Aleks Danko, Artist* at ACCA 1991; and in one work *Ambivalence: i love a sunburnt country* in his 1991 Deutscher Brunswick St, Melbourne exhibition which consisted of a galvanised iron tank – the symbol of outback Australia – surrounded by grinning halloween-like masks. Between 1975 and 1992 he held 8 solo exhibitions at Watters, Sydney; Deutscher, Melbourne and participated in numerous group exhibitions including *Irreverent Sculpture*, Monash Uni. Gallery 1984; *Field to Figuration*, NGV 1987; *Art with Text*, Monash Uni. Gallery 1990; *Off the Wall: In the Air*, Monash Uni. and ACCA 1991. He created a number of performance, film and documentary art pieces including *We should call it a living room*, a film project with Joan Grounds, David

Lourie and David Stewart, 1974, screened at many venues. His performance piece *I was just exhausted at the act of being polite* with a number of others was performed in Melbourne in 1983; and *Physical Culture/Psychic Trauma, parts 1 and 2* was performed at 200 Gertrude St in 1989. Several limited edition books on his work have been published and his commissions include a piece for the AGSA.

AWARDS: Transfield Prize (for sculpture), 1971; grants VACB 1973, 75, 77, 78–79, 81, 85 (including travel grants to Europe; residency Green St Studio NY); theatre board and film grants 1974, 83.

APPTS: Part-time tutor, Faculty of Architecture, Uni. of Sydney, 1972–73; resident artist and tutor at Uni. Art Workshop, 1972–74.

REP: NGA; AGNSW; AGSA; MOCA, Brisbane; numerous regional, municipal and tertiary collections Vic., SA, Qld.

BIB: Catalogue essays exhibitions as above. Ron Rowe, *Australian Sculpture: Mutlti-media with Clay*, Rigby 1978. Scarlett, AS. Sturgeon, DAS. A&A 12/1/1974 (Gary Catalano, *Aleksander Danko*); 29/4/1992.

DAPLYN, Alfred James

(b. 1844, London; arr. Melb. 1881; d. 1926, London) Painter, teacher.
STUDIES: Ecole des Beaux-Arts, Paris; Slade School, London; National Academy, NY. A dedicated *plein-air* painter, he exhibited English and Italian landscapes as well as figures and other genre at the Victorian Academy of Arts, Melbourne, 1882–84, before moving to Sydney to become the first art instructor at the Royal Art Society School, 1885–92. Sydney Long was one of his pupils. An even more celebrated pupil was Charles Conder, who attended the life classes and won a 3–guinea prize for the 'best painting from nature'. Daplyn painted in the Hawkesbury River area with Julian Ashton in 1884 and later with Ashton and Conder in the same area. He published *Landscape Painting from Nature in Australia* (W. C. Penfold and Company, Sydney) in 1902 and was a habitué of Livingston Hopkins' (q.v.) artists' camp at Mosman (also visited by Julian Ashton, Henry Fullwood, Charles Hunt, Charles Conder), painting many works in the area. He visited R. L. Stevenson at Vailima, Tahiti, but William Moore, who records this meeting, tells us that his personality made little impression on the writer. *The Moon is Up, Yet 'tis not Night*, by Daplyn (purchased 23 Aug. 1900), was sold from the collection of the AGNSW, 26 Nov. 1946. His work was seen in *Bohemians in the Bush: Artists' Camps of Sydney*, AGNSW 1990.
REP: Manly Art Gallery.
BIB: Catalogue of works in the Manly Art Gallery, NSW. (*See also* CAMPS)

DARGIE, (Sir) William Alexander

(b. 4/6/1912, Melb.) Painter.
STUDIES: Melbourne Tech. Coll., sculpture with George Allen, 1930–31, painting with Napier Waller, 1932–33; studio of A. D. Colquhoun, 1931–34. Success in

Archibald competitions (as winner of the prize on eight occasions) assured his place in Australia as a portrait painter. His numerous portraits include commissioned portraits of H.M. the Queen, Prince Philip and many other members of the Royal Family and British aristocracy as well as leading Australian figures in all areas of society. He is known also for his paintings of landscapes, ballet and theatre subjects and other genre. He wrote *On Painting a Portrait*, Artist Publishing Company, London, 1957 and his work was featured in the exhibition *Towards an Australian Portrait Gallery* which toured Australian state galleries and the NGA 1992–93.

AWARDS: Woodward prize, Bendigo, 1940; McPhillamy prize, Geelong, 1940; Archibald prize 1941, 42, 45, 46, 47, 50, 52, 56; OBE conferred, 1959; CBE, 1969; knighted (for services to art), 1970.

APPTS: Official war artist World War II, 1941–46; Head of the NGV School, 1946–53; member, Commonwealth Art Advisory Board, 1952–73, chairman, 1962–73; member, National Capital Planning Advisory Committee, 1970–73; Interim Aboriginal Arts Advisory Committee, 1969–71; trustee, Museum and Art Gallery, Papua New Guinea, 1970–74, and Native Cultural Reserve, Port Moresby, 1970–74; board member, McClelland Gallery, Langwarrin, 1980–82.

REP: NGA; all Australian state galleries and many other public collections.

BIB: A number of general books on Australian art including Smith, AP. *Who's Who in Australia*, Melbourne, from 1977.

DARNELL COLLECTION

See GALLERIES – Uni. of Queensland Art Museum

DARVALL, Charles George

(b. 1831, Eng.; arr. Vic. 1858, d. 1924, Bendigo) Painter, teacher. Known for watercolours, he was a textile designer by training. He was at the goldfields in the 1850s in Beechworth, Chiltern and Sandhurst (Bendigo), lectured at the Sandhurst School of Art and Design from 1889, and taught privately until shortly before his death.
REP: Bendigo Art Gallery (two watercolours).
BIB: McCulloch, AAGR. Kerr, DAA.

DASHWOOD, (Commander) George Frederick

(b. 20/9/1806, London; d. 15/3/1881) Topographical draughtsman.
STUDIES: Royal Naval College, Dartmouth, 1819– . He served in HMS *Challenger*, 1832–35, and HMS *Sulphur*, 1835–37. He was emigration agent for SA in London, 1855; on his return to Australia he was stipendiary magistrate, Adelaide, promoted to rank of Commander, 1878, and retired in 1879. His pencil and wash drawings in the AGWA show him as a capable topographical draughtsman. His work was seen in *The Colonial Eye*, AGWA 1979.
APPTS: Commissioner of Police, SA, 1847–52;

collector of customs, SA, and member of the Legislative Council.
REP: AGWA.

DATTILO RUBBO
See RUBBO, Dattilo

DAVENPORT, Robert
(b. 1816; d. 1896) Painter. A watercolour by Davenport, *Adelaide from the North bank of the River Torrens*, is in the collections of the AGSA, Adelaide.
BIB: Catalogue AGSA collections, 1976.
NFI

DAVID, Allen
(b. 1926, Bombay, India; arr. Aust. 1948) Painter, administrator, photographer.
STUDIES: Uni. of Melbourne (architecture). He held an exhibition entitled *Fine Arts Week* at the newly-opened Tasmanian Tourist Bureau Gallery, Melbourne in 1955 and from 1958–60 conducted a private gallery. He produced a book of photographs of Central Australian subjects with text by Russell Drysdale, *Form, Colour, Grandeur* (Grayflower Publications, Melbourne, 1962) and moved to Israel c. 1970s–80s.
AWARDS: Grafton prize, 1961.
REP: NGV; municipal collection at Grafton, NSW.

DAVIDSON, Bessie
(b. 1879, Adelaide; d. 1965, Paris) Painter.
STUDIES: Adelaide, with Margaret Preston, –1903; Munich, c. 1904, travel studies in Europe, 1904–07. On 2 July 1904 she left Adelaide for Genoa, Italy, on SS *Gera* in company with Margaret Preston. She spent three years in Europe, returning to South Australia and a joint exhibition with Preston in March 1907. In 1910 she returned to Europe where she made her headquarters in Paris, exhibiting at the New Salon with the Femmes Artistes Modernes, of which she was vice-president 1922, and as a foundation member of the Salon des Tuileries. During World War I she served with the French, was made a Chevalier of the Legion of Honour in 1931 and during World War II joined the French resistance movement. Between the wars she visited Russia, Finland, Morocco and Spain, spent many summer holidays in Scotland and, after World War II, made several visits home to SA where, reputedly, her strong French accent made her English difficult to understand. Her strong, direct and vital landscapes and still-life paintings clearly show her close affinity with the French art of her time. Her work appeared in *Winter-Spring Exhibition*, Joseph Brown Galleries, Melbourne 1977.
REP: AGSA; Jeu de Paume, Paris; Luxembourg, Paris; Rouen Gallery, France.
BIB: Badham, *SAA*.

DAVIDSON, Diana
(b. 16/7/1945, NSW) Painter, printmaker.
STUDIES: Painting, drawing, printmaking, ESTC, 1963–67. She opened a printmaking studio in Whaling Road, North Sydney in 1978 and printed works of many artists including David Rankin, John Peart, John Firth-Smith, Donald Friend and Russell Drysdale. She held two solo exhibitions at Realities Gallery, Melbourne 1988 and Australian Galleries, Sydney 1991, and participated in a number of group exhibitions at private galleries 1977–92 (including Barry Stern, Blaxland, Sydney; Dempsters, Melbourne; Bonython-Meadmore, Adelaide) and in *Artistes Australiennes Contemporaines*, Paris 1992.
APPTS: Teaching printmaking, ESTC, 1978–88; City Art Inst. (now College of Fine Arts, Uni. of NSW), 1984– .
REP: NGV; Artbank; Reserve Bank collection; collections Paris, New York, San Francisco, London.

DAVIE, John S.
(b. 1862, Edinburgh; arr. Aust. 1886; d. 1955) Sculptor.
STUDIES: Royal Scottish Academy, Edinburgh; assistant to sculptor John Hutchinson, RCA. He did stone carvings for architecture in Sydney, 1886 and in 1891 moved to Melbourne where he designed for a tile company before turning to teaching. Among his surviving works are the Queen Victoria statue, Botanical Gardens, Geelong, and the Burns Memorial, Canberra (1932–35).
APPTS: Teaching, Vic. Education Dept, c. 1896; instructor in modelling and casting, Working Men's College, Melbourne, 1897–1932.
BIB: Scarlett, *AS*.

DAVIES, David
(b. 21/5/1864, Ballarat West; d. 25/3/1939, Looe, Cornwall) Painter.
STUDIES: Ballarat School of Mines; NGV School, 1887–90; Académie Julien, Paris (with Jean Paul Laurens), 1891–93. Son of Thomas Davies, miner, and Mary Harris Davies. In 1890 he went to Paris and the following year married Janet Sophia Davies, a student at Julian's. Later they made their home at St Ives, Cornwall, where the prevalent romantic, Whistlerian style among the painters there held great appeal. He returned to Australia, to live at Templestowe, Vic., in 1893, where for the next three years he painted his famous 'moonrise' series. During this period he was closely associated with the Heidelberg School, and it was his brother-in-law (also named Davies) who made available the house at Eaglemont in which the group established their headquarters. David and Janet Davies moved to Cheltenham, Vic., in 1896 and in 1897 returned to St Ives with a one-year-old daughter. Cornwall and Wales was their home for the next 12 years; a son was born, and Davies exhibited at the New English Art Club and the RA, London. In 1908 he moved to France for health reasons, and settled in Dieppe, where he painted street scenes and landscapes in oil and watercolours. Apart from the war years, Dieppe remained their headquarters where Janet taught English at a girls' school and he taught and painted

until their return to England in 1932, and thence to Cornwall. His only major Australian exhibition was in May 1926 when 73 paintings in oil and water-colours were shown at the Fine Art Society Galleries, Melbourne. Many works were sold but according to Candice Bruce in *ADB* he may not have received payment. A large exhibition of his work was shown at the Plymouth City Art Gallery, UK, in 1932. Survey exhibitions in which his work appeared in the 1980s and 90s included *Golden Summers: Heidelberg and Beyond*, NGV and touring state galleries 1985–86; and *The Great Australian Art Exhibition* 1988–89.

REP: NGA; all state and many regional galleries and other public galleries.

BIB: J. S. MacDonald, *Art and Life of David Davies*, Alexander McCubbin, Melbourne, 1920. Exhibition catalogue, Emma Hicks intro., *David Davies*, Malvern Fine Art Gallery, Melbourne, 1978. *A&A* 16/1/1978 (Cameron Sparks, *David Davies, 1864–1939*). *ADB* 8.

DAVIES, Henry Easom

(b. 1831, Cornwall, UK; arr. Melb. c. 1855; d. 1868, St Kilda, Vic.) Painter. The son of a clergyman, Rev. W. H. Davies, after a roving life spent mostly in the UK, he was commissioned by the British government 'to record in words and pictures the colony of Victoria'. He was in Tas. before settling at St Kilda, Vic., where he painted a number of fine watercolours. In 1858 he married Emma Davis, a noted historian with a command of four languages, later appointed first Registrar of Vic. During his short life Davies made frequent changes of address, moving from St Kilda to Cheltenham, thence to the goldfield towns of Maryborough, Bendigo and Ballarat. His work was represented in most of the major art exhibitions 1855–68 and was well regarded. The *Argus* reviewer, in a review of the 1856 Victorian Exhibition of Art, described his style as 'characterised by great breadth and even massiveness'. Later reviews however were not so flattering. For a time he was thought to have been connected with David Davies (q.v.), but no relationship has been established. Examples of his work appear in auctions such as Christie's.

REP: La Trobe Library; State Library of Vic.

BIB: Kerr, *DAA*.

DAVIES, H. Edward

(b. 1853, Newport, Eng.; arr. Melbourne 1854; d. 1927, Adelaide) Architect, painter, curator. Appointed chief draughtsman for the SA Education Dept in 1876, he later went into partnership with James Cumming. He was hon. curator, AGSA, 1909–15, and later chairman of the Board of Management, Public Art Gallery and Museum of SA. An oil by him, *Siegersdorf Winery 1898*, was sold at Joel's auctions in May 1976. While lacking the refinement and finish of work by better-known colleagues, it showed Davies as an accomplished colonial landscapist.

REP: AGSA.

BIB: Catalogue AGSA, 1913.

DAVIES, H. Neville

(Active c. 1891) Hydrographer, surveyor, Qld Government; also a painter. A work of his was seen in *Horses and Riders*, NGV Women's Association, Georges Gallery, Sept.–Oct. 1975.

NFI

Isabel Davies, Dune Book, *1990, mixed media assemblage, 64 × 54 × 9cm. Private collection.*

DAVIES, Isabel

(b. 1/5/1929, Melb.) Painter, teacher, sculptor.

STUDIES: Swinburne Inst. of Tech., 1947–48; NGV School, with John Brack, 1966–67; travel studies Europe and UK 1977–78; Indonesia 1981; Asia, Europe 1985; Europe, USA 1991–92; outback Aust. 1983, 86, 87, 88, 89, 92. She first exhibited at Munster Arms Gallery, Melbourne, April 1969, then made constructions in aluminium and perspex (Australian Galleries, Dec. 1970) based on geometrical principles. Elements of painting, drawing, geometry, construction and satirical commentary are all utilised in her work. Drawing on her frequent outback travels she often uses material and images from the centre of Australia. Of her 1991 exhibition at Macquarie Galleries Elwyn Lynn in the *Australian* (21/9/1991) praised her inventiveness, describing some of the works thus: 'Rhythmical patterns reflecting the landscape flow across central boards that carry weathered wood, copper, wire, feathers and wire mesh . . . these are direct and discreet, tender and harsh, rough and delicate evocations and every one is admirable.' She held exhibitions at Christine Abrahams, Melbourne 1987, 89, 91 and Macquarie, Sydney 1988, 90, 91. Group exhibitions in which her work appeared include *MPAC Spring Festival*, 1975, 77, 79; many women's art exhibitions including *Women in Art*, WAIT 1975; *The Women's Show*, EAF, Adelaide 1977; *Women Artists*, Latrobe Valley Arts Centre 1988; and in *Mildura Sculpture Triennial* 1978, 88; *Aust. Sculpture Triennial*, 1981.

AWARDS: Grant to work in the Kimberley, VACB, 1991.

REP: NGA; NGV; QAG; Artbank; many regional, tertiary collections NSW, Vic., WA.

BIB: Catalogue essays in public exhibitions as above. Scarlett, AS. Germaine, *AGA*. Jennifer Isaacs, *The Gentle Arts*, Lansdowne, Melbourne, 1985. *New Art Two*. McIntyre, *Collage*.

DAVIES, Roy (Lewis Roy)

(b. 1897; d. 1979, Sydney) Painter, printmaker. He began wood engraving in 1921 and exhibited at Tyrrell's in 1923, later showing regularly with the NSW Society of Artists between the wars. First Principal of the NAS, Sydney (1960–61). His work was seen in *A Survey of Australian Relief Prints 1900–1950*, Deutscher Galleries, Melbourne, 1978.

BIB: AA 3rd series, no. 4, May 1923.

DAVIES, Violet

Exhibiting member, RAS of NSW, from 1918, her painting *The Squatter's Son* (reproduced in colour in *Fifty Years of Australian Art, 1879–1929*, RAS, Sydney, 1929, p. 47) shows her as an accomplished tonal impressionist.

NFI

DAVILA, Juan

(b. 6/10/1946, Chile; arr. Aust. 1974) Painter, editor, art writer.

STUDIES: Colegio Verbo Divino, Santiago, Chile, 1951–63; Law School, Uni. of Chile, 1965–69; Fine Arts School, Uni. of Chile, 1970–72. His often large paintings frequently depict exaggerated sexuality – a style which has caused his work to be the subject of considerable controversy. Beyond these arresting, shocking images Davila's deeper message, strongly based in his own Chilean culture, emerges – human freedom and the importance of a society (such as his new homeland, Australia) not becoming overly complacent. Writer/curator Tony Bond described the work *Echo*, appearing in *Australian Perspecta* 1988: 'The complexity and skill of the painting of this superficial web of images engages our attention for a considerable time before the underlying composition reveals itself to be built upon a series of variations upon the swastika. This is a superb metaphor for Davila's call to awareness of the hidden agenda within a seductive culture.' ('Realism in the Avant-Garde', in *Contemporary Australian Painting* ed. Eileen Chanin, Craftsman House, Sydney 1991.) He held about 28 solo exhibitions 1974–92, in Chile until 1979 and in Australia largely at Tolarno, Melbourne and Roslyn Oxley9, Sydney as well as contemporary art spaces in Adelaide, Sydney, Melbourne and Brisbane. His work appeared in numerous significant group exhibitions 1970–93 including in Chile and international festivals or biennales in France, 1975, 82; and in *Form-Image-Sign*, AGWA 1984; *POPISM*, NGV 1985; *Australian Perspecta*, AGNSW 1983, 87; *Biennale of Sydney*, AGNSW 1984; *Field to Figuration*, NGV 1987; *Stories of Australian Art*, Commonwealth Institute, London 1988; *The Australian Exhibition*, Frankfurt 1989; *Add Magic: A Billboard Project*, Aust. Centre for Photography, Sydney 1990; *America: Bride of the Sun*, Royal Fine Arts Museum, Antwerp 1992.

He wrote numerous articles for Australian and international art journals, and catalogue essays, as well as editing an art and criticism monograph series.

REP: NGA; AGSA; AGWA; NGV; QAG; MCA, Sydney; Heide, Melbourne; MOMA, NY; corporate collections including Robert Holmes à Court, Smorgon Family.

BIB: Catalogue essays exhibitions as above. Leon Paroissien, *Australian Art Review 2*, Warner Books, Sydney 1983. Paul Taylor, ed., *Hysterical Tears*, Greenhouse Publications, Melbourne 1985. Peter Fuller, *The Australian Scapegoat*, Uni. of WA 1986. Donald Richardson, *Art in Australia*, Longman Cheshire, Melbourne, 1988. Peter Quartermaine and Jonathon Watkins, *A Pictorial History of Australian Painting*, Bison Books, London 1989. Chanin, CAP. Smith, AP. Numerous references in art magazines including *Art International*. A&A 25/4/1988; 26/1/1988; 27/2/1989. AT 9/1983; 12/13/1984; 21/1986; 30/1988; 41/1982 AL 4/1/1984; 4/2–3/1984; 6/1/1986; 11/4/1991.

DAVIS, George Arthur David

(b. 1930, Hobart) Painter, teacher.

STUDIES: Hobart Tech. Coll. (with Carington Smith); Royal Art School, London, 1952–54. Known largely for his portraits (notably of 10 composers, commissioned by the Theatre Royal, Hobart), his realist work appeared in the Whitechapel exhibition of Australian art, London 1961 and in several prize exhibitions in Australia 1961–84 including *McCaughey Memorial Prize*, NGV; *Fremantle Art Prize*, WA. The TMAG held three exhibitions of his work 1978–86; in 1976 of drawings and paintings he had been commissioned to make of the islands off the Tasmanian coast; in 1985 of portraits of composers; and in 1986 of 73 portraits. He participated in a number of group exhibitions 1951–88 with the Tasmanian Group of Painters 1951–61 and in prize exhibitions including *Perth Prize for Drawing*, 1959, 60; *John McCaughey Memorial Art Prize*, NGV, 1981; *Fremantle Drawing Prize*, Fremantle 1984.

APPTS: Teaching, Hobart Tech. College.

REP: TMAG; QVMAG; several university and public collections Tasmania.

BIB: Backhouse, TA. Germaine, AGA.

DAVIS, James

(b. 3/5/1940, Sydney) Painter.

STUDIES: ESTC, 1956–59; Julian Ashton School 1958–59. During the 1960s Davis spent a number of years working in Berlin and Amsterdam and his works reflect European expressionism, especially the work of Max Beckman and Otto Dix. Much of his subject matter as seen in his five solo exhibitions in Melbourne (David Ellis/Lyall Burton 1989, 90, 91, 93) and Sydney (Holdsworth 1992) is of day-to-day scenes of inner suburban street life incorporated into dream-like surreal images. They are sombre works filled with shadowy figures. His work appeared in a number of group exhibitions including *Blake* and *Sulman* prizes in the 1960s and 1988–93 included *Castlemaine Drawing Prize*; *Australian Contemporary Art A–Z*, Tokyo 1991; *ACAF 2, 3*; *Sulman Prize* 1991.

REP: NGA; NGV; QAG; State Library of Victoria; regional

Jan Davis, Untitled, *1988, oil on board, 1820 × 1220cm.*
Courtesy Niagara Galleries.

galleries Bendigo, Castlemaine; Mallesons, Stephen Jacques & Sly and Weigall corporate collections.

DAVIS, Jan

(b. 1952, Bairnsdale, Vic.) Painter, printmaker.
STUDIES: Dip. Art, PIT, 1980; Postgrad Dip., printmaking, Phillip Inst., 1981. Her figurative paintings reflect her work as a printmaker with strongly graphic, striking solo images occupying almost all the canvas area. She held four solo exhibitions 1988–92 at Niagara, Melbourne (1988, 90, 92) and Roz McAllan, Brisbane (1989), and her work appeared in over 30 print and other survey shows 1980–92 including with PCA and in regional and tertiary galleries including *Landmarks* and *Elementalism*, both at Lismore Regional Gallery in 1988; *Art from Elsewhere*, Uni. of Tasmania; *The Jupiter Invitation Art Prize*, Centre Gallery, Gold Coast, 1992.
AWARDS: Project grants (2) VACB, 1992; Jacaranda Drawing Prize.
REP: Artbank; regional galleries Hamilton, Grafton; World Congress Centre, Melbourne; Art for Public Spaces, Melbourne; Western Mining corporate collection.
BIB: Catalogue essays exhibitions as above. *New Art Three.*

DAVIS, John Frederick

(b. 16/9/1936, Ballarat) Sculptor, teacher.
STUDIES: TSTC, Melb. Teachers College, 1957; Dip. Fine Art, Sculpture, RMIT, 1966; travel studies (world tour), 1972, India and Venice, 1973. One of the most well-known conceptual sculptors in Australia, his early sculptures in fibreglass and aluminium, many of highly polished, serialised handle or tap shapes, gained him success. By 1973, however, he had become more interested in the processes of creative activity (as represented by conceptual art) than the finished product, and his work became more along the lines of installations and environmental sculptures using twigs, wood and found objects. He was selected to represent Australian sculpture at the fourth *Indian Triennial* at New Delhi, 1977, and at the *Venice Biennale* during the same year. He held 32 solo exhibitions 1969–92 at Watters, Sydney; Inax Gallery Tokyo; IMA Brisbane (1980); Uni. of Southern California (1984); Heide Melbourne (1988) and with Luba Bilu from 1989. Group exhibitions in which his work appeared 1961–93 included *Mildura Sculpture Triennial*, 1961, 67, 70, 73, 75, 78; *Venice Biennale*, 1978; ACT *One*, ANU 1978; *Relics and Rituals*, NGV 1981; *Ten Years*, Ewing and George Paton Galleries, Uni. of Melbourne 1981; *Australian Sculpture Triennial*, 1981, 84, 90; *Field to Figuration: Australian Art 1960–1986*, NGV 1986; *Contemporary Art of the 80s: 100 Forms*, Inax Gall, Tokyo 1991. He was artist-in-residence, Monash University 1976 and in several other universities in Australia and three in California in the 1980s.
AWARDS: Prizes for sculpture, CAE, Melbourne 1960; Doncaster, 1967; Eltham, 1968; Comalco Invitation (for sculpture in aluminium), 1970; *Mildura Sculpture Triennial* (purchases), 1973, 75; grant (video equipment), VACB, 1975–76; Blake Prize, 1993.
APPTS: Secondary teaching, Vic., 1958–66; lecturing, several tertiary art colleges Vic., including Caulfield and Prahran 1967–80 and VCA 1981– .

REP: NGA; most state galleries; MOCA, Brisbane; Heide; numerous regional galleries; tertiary collections, government depts Vic., NSW, Qld, WA; private and corporate collections including Besen and Bankers Trust.
BIB: Catalogue essays exhibitions as above. Sturgeon, DAS. Scarlett, AS. Leon Paroissien, *Australian Art Review*, Warner & Assoc, Sydney, 1963. Ken Scarlett, *Places and Locations: The Sculpture of John Davis*, Hyland House, 1988. A&A 20/2/1982. AL 9/1/1989; 1/2/1981.

DAVIS, Ross

(b. 21/5/1938, Sydney) Painter, teacher.
STUDIES: Julian Ashton, 1954–57; ESTC, 1960–62 (with Desiderius Orban 1962–63 and John Ogburn 1963–65). Davis's colourful decorative works achieved popular success from his first exhibitions in the mid-1960s. He and his wife, artist Joy Beardmore, spend six months of the year on the island of Majorca, where they have a farmhouse, and six months on the south coast of NSW. He held about 30 solo exhibitions at numerous private galleries 1960s–92 (including Macquarie, Sydney; Wagner, Sydney; Solander, ACT) and at his own studio/gallery in Lane Cove, Sydney and in Spain. His work appeared in about 15 group exhibitions at private galleries (including Blaxland, Sydney; von Bertouch, Newcastle; Solander, ACT; Holdsworth, Sydney) and in *Joán Miró Invitation Exhibition*, Barcelona 1973; *Sweden Trosa*, Kvarn 1990.
AWARDS: CAS, NSW; Dubbo City Gallery Purchase Prize.
APPTS: Own teaching studio and gallery in Sydney, 1970; tutored in city and country areas through Sydney Uni. 1970–80; conducted own schools in country centres of NSW 1970– .
BIB: Germaine, AGA.

DAVSON, Sharon Silver

(b. 26/4/54, Gatton, Qld) Painter.
STUDIES: Assoc. Dip. Fine Art, Qld Coll. of Art 1974; Dip. Teaching, Kelvin Grove CAE, 1975; travel throughout Australia three years. She works on commission with a special interest in wildlife and was a founder director of *Artists for Life*, protecting endangered species. She received 38 commissions in public locations 1970s–92 such as World Book International Chicago, 1990; PNC Financial Services, Pittsburgh USA, and participated in several group shows in Brisbane and Sydney 1974–92.
AWARDS: Three regional arts festival awards 1986–92.
REP: MAGNT; regional galleries Bathurst, Bribie Island, Devonport, Gatton, Goulburn, Grafton, Lake Macquarie, Taree, Muswellbrook, Armidale, Sale, Stanthorpe, Townsville; city collections at Coffs Harbour, Cootamundra, Gosford, Taree, Port Macquarie, Katherine, Kempsey, Toowoomba, Young, Wyong; university collections at Canberra, Adelaide, Townsville, Darwin and Western Sydney.

DAWS, Lawrence

(b. 25/12/1927, Adelaide) Painter.
STUDIES: NGV School, 1949–53; Italy, 1957–60. Prior to his art training, Daws studied engineering and architecture at the University of Adelaide for three years and spent another two years on survey work in New Guinea. His work first became prominent through an exhibition shared with three colleagues, Pugh, Laycock and Howley, at the VAS gallery, Melbourne, 1955. His painting has been concerned from the beginning with problems of the division of space and the placing of expressive accents, as in his colourful *Manes Stone* series of the 1960s. His work become more romantic and more atmospheric as, for example, the *Glass House Mountain* series painted in the Qld district where he lives. He participated in the Whitechapel and Tate Gallery exhibitions of Australian art, 1961–62, and in the same year represented Australia with two others, Blackman and Whiteley, at the second *Biennale des Jeunes*, Paris. He had numerous solo exhibitions from 1955 in Sydney (including at Macquarie, Rudy Komon, Robin Gibson), Melbourne (including South Yarra), Brisbane (Philip Bacon) and Adelaide (Bonython-Meadmore), and participated in a number of group exhibitions including *Images of Religion*, NGV 1989. He received many commissions for churches, public areas and tertiary institutions including for the Performing Arts Complex, Brisbane.
AWARDS: Prizes in Dunlop contest, 1953, 54; Italian Scholarship, 1957; international award, *Biennale des Jeunes*, Paris, 1962; silver medal, *Bienal de São Paulo*, Brazil, 1963; Georges Art Prize, Melbourne, 1977.
APPTS: Secondary teaching, Vic., 1958–66; lecturing, several tertiary art colleges Vic., including Caulfield and Prahran 1967–80 and at VCA 1981.
REP: NGA; most state galleries; MOCA, Brisbane; Parliament House; Tate Gallery, London; Scottish National Gallery; V&A, London; Musée des Beaux-Arts de l'Ontario, Canada; Art Gallery of China, Beijing; regional galleries Ballarat, Mildura, Bendigo, Broken Hill, Newcastle; all state university and a number of other tertiary collections.
BIB: Neville Weston, *Lawrence Daws*, Reed, Sydney, 1982. A number of texts on Australian art including Laurie Thomas, *Australian Painting Today*, QAG 1963; Ursula Hoff and Margaret Plant, *The National Gallery of Victoria*, Cheshire 1968; James Gleeson, *Masterpieces of Australian Painting*, Lansdowne 1969; Bonython, MAP 1976, 80; Smith, AP. Gary Catalano, *The Years of Hope*, OUP, 1985. A&A 20/3/1983.

DAWSON, Janet

(b. 1935, Sydney) Painter.
STUDIES: NGV School, 1951–56; Slade School, London, 1957–58; Atelier Patris, Paris (lithography and etching); Anticoli Corrado, Italy (printing). She returned to Australia from Europe in 1961 where as well as painting, she installed a Bauhaus exhibition, directed Gallery A in Melbourne and conducted a print workshop and classes there, 1961–64, before moving to Gallery A, Sydney. She also designed sets and costumes for theatres in Melbourne, Adelaide and Hobart, and in Sydney worked at the Australian Museum in addition to painting, printmaking, designing theatre sets and posters, and tutoring and teaching. From

1961 she held a number of solo exhibitions and participated in many important group shows including *The Great Australian Art Exhibition* 1988–89. The range of her painting extends from straight portraiture (for which in 1973 she won the Archibald prize with a portrait of her husband, Michael Boddy) to soft geometric abstraction, often using pastel-coloured backgrounds which typifies her work from the 1970s onwards. The ANU held a major exhibition of her work in 1994.
AWARDS: NGV Travelling Scholarship, 1956; Boise Scholarship, London, 1959; Archibald prize, 1973; Gold Coast City purchase prize, 1975; Trustees (purchase) prize, QAG, 1977; Mosman and Uni. of NSW prizes, Sydney, 1979.
REP: NGA; most Australian state and many regional galleries.
BIB: A number of general texts on Australian contemporary art including Smith, AP. A&A 17/4/1980 (Margaret Plant, *Janet Dawson*).

DAWSON, Paula

Although her training was in sculpture, she is best known for her holograms, a number of which have been seen in public galleries since 1982. Her most famous is 'To Absent Friends' a scene of a bar and reputedly the largest hologram in the world.
AWARDS: Creative Arts Fellowship (four years), Australia Council, 1993.
REP: NGV and several other public galleries.

DAY, Elizabeth

(b. 28/1/1954, Lancashire, Eng.; arr. Aust. 1963) Installation artist.
STUDIES: B.Ed., Tasmania CAE, 1976; BA (Visual Arts), SCA, 1984; Grad. Dip. (Visual Arts), SCA, 1986. She held three solo exhibitions 1988–90 in Sydney and Greene Street Studio NY (1990), and participated in about 20 group exhibitions 1985–92 including at Artspace, Performance Space, Sydney and in *Perspecta*, AGNSW 1989. She was artist-in-residence at Riverina College in 1986, and at Canberra School of Art in 1990.
AWARDS: Grants, VACB, 1987, 91; staff development grant, NSW Dept. of Corrective Services, 1989; residency, Greene Street Studio, NY, VACB, 1989; Pat Corrigan Award, NAVA, 1991.
APPTS: Guest lecturer, several tertiary colleges, 1986– including Riverina College, Canberra School of Art; tutor, SCA, 1986; teaching (Art/Creative Writing), NSW Department of Corrective Services, Sydney 1987–90 and 1991; teaching (sculpture), Sculpture Dept, Uni. of NSW, Sydney, 1991.
BIB: Catalogue essays exhibitions as above. *Agenda*, November, 1991.

DAY, Peter William

(b. 28/10/1949, Sydney) Painter, teacher.
STUDIES: Dip. Industrial Design, NAS, Sydney, 1972; Postgrad. Dip. industrial design, Uni. of NSW, 1974; privately with RAS and Julian Ashton School 1970s;

Grad. Dip., Alexander Mackie CAE, 1980; MA (Visual Arts), SCA, 1986. He held about 15 solo exhibitions 1972–91 in Sydney (Kirk, Surry Hills, and Ivan Dougherty 1985), Lismore Regional Gallery 1987 and Eltham, Vic. and was involved in community art projects in Lismore, Wollongong and Sydney.
AWARDS: VACB grant, 1975; residency, Owen Tooth Memorial Cottage, Vence, France (Karolyi Foundation), VACB, 1978; Churchill Fellowship for Public Art, 1983; residency, Greene Street Studio, NY, VACB 1983; Design Institute Award for mural, The Rocks, Sydney, 1984; professional development grants, Community Arts Board, Aust. Council, 1985; several municipal prizes Melbourne, including City of Knox Bicentennial Heritage Award, 1988.
APPTS: Lecturer, various art colleges, Sydney, 1974– including Macarthur CAE; lecturer, NAS, 1989– ; guest lectureships UK, USA and Aust.
REP: Several tertiary and regional collections NSW, Vic.; international collections including Murchison Collection, Dallas, Texas; Travelodge; IBM; Michael Karolyi Foundation, Vence, France.
BIB: David Humphries and Robert Monk, *The Mural Manual*, Arts Council of NSW, 1982. *The Great Australian Annual*, Weldon, 1983; *Who's Who in Aust. and Far East*, 1988. *Australopedia*, McPhee Gribble, 1988. Germaine, AGA.

DAYES, Edward

(b. 1763; d. 1804) Painter, engraver. Known mainly for landscapes, Dayes, whose work is often associated with Australia, in fact never visited the country but produced engravings and mezzotints after the paintings of colonial artists such as William Chapman and John Eyre, including a fine aquatint of Eyre's *Sydney Cove* c. 1802. He also illustrated David Collins' *Account of the English Colony in New South Wales*. In London Dayes exhibited at the RA, where he was an Associate, 1786–1804, noted for his influence on the work of Girtin and Turner.
BIB: Iola Williams, *Early English Watercolours*, Kingsmead, Bath, 1970.

DEARING, H.

Primitive artist who signed his work with the pseudonym *Professor Tipper*. Clive Turnbull discovered his pictures in a Melbourne suburban bicycle shop in 1944. They were shown in early CAS exhibitions and later at the MOMAD, Melbourne.
BIB: *Angry Penguins*, article by Albert Tucker, 1944. *Modern Australian Art*, MOMAD, Melbourne, 1958.

DEBENHAM, Pam

(b. 1955, Launceston, Tas.) Printmaker.
STUDIES: B.Vis.Arts, SCA, 1982. She held three solo exhibitions 1990–92 in Canberra, Sydney and Brisbane and participated in a number of group exhibitions 1982–93 including *Continuum '83: Right Here – Right Now*, EAF, Adelaide and touring 1988; *Prints and Australia: Presettlement to Present*, NGA 1989. She was a member of Lucifoil Posters and Tin Sheds Posters at Sydney Uni. Art Workshop 1982–88.

AWARDS: VACB grant to conduct workshop to introduce Aboriginal artists to printmaking processes at Tin Sheds, 1987–88; individual artist grant, VACB, 1991.
APPTS: Tutor, Sydney Uni., 1982–88; part-time lecturer, Canberra CAE, 1989, 90, 92.
REP: NGA; QAG; AWM; several regional galleries including Mornington, Warrnambool; a number of tertiary collections including Sydney, Tasmania unis.; Mitchell Library, NSW; Musée d'Histoire Contemporaine, BDIC, Paris.
BIB: Catalogue essays exhibitions as above. *A&A* 28/4/1991.

DE CASTELLA, Hubert
(b. France; active c. 1860–90, Vic.) Member of the Victorian Academy of Arts; in commercial life a successful vintner who established the St Hubert vineyards at Yering, Vic. Later de Castella experimented with a vineyard at *Charterisville* (q.v.), and made the house available for an artists' colony. He wrote *Les Squatters Australiens*, Librairie de l'Hachette, Paris, 1861.
BIB: *John Bull's Vineyards*, Melbourne, 1886; McCulloch, *AAGR*, 1977.

DECHAINEUX, Florent Vincent Emile Lucien
(b. 15/7/1869, Liège, Belgium; arr. Aust. 1884; d. 4/4/1957, Hobart) Painter, etcher, sculptor, stained glass designer, teacher.
STUDIES: Sydney, ESTC, and with Julian Ashton, 1885–88. His parents moved to Australia after investing in 'a worthless citrus orchard and a salted gold mine'. Dechaineux became known as a painter, etcher and sculptor, and designer in stained glass, and attained distinction as 'the father of technical education in Tasmania'. He was still examining for the Tasmanian Education Dept in 1956. A portrait of his son, Emile, commander of HMAS *Australia*, killed in action 1944, is among three paintings representing Dechaineux in the TMAG, Hobart. His own portrait, painted by his successor at Hobart Tech. Coll., J. Carington Smith, an outstanding entry in the Archibald competition of 1952, is in the AGSA collections, Adelaide. Another portrait of Dechaineux by the same artist is in the TMAG.
APPTS: Lecturer in design at ESTC; art teacher at Launceston, 1896–1907; principal, and founder of the art dept, Hobart Tech. Coll., 1907–39.
REP: TMAG.
BIB: *ADB* 8.

DE CHIMAY
See BRANDT, Horace

DE CLARIO, Domenico
(b. 1947, Trieste; arr. Aust. 1956) Painter, teacher, sculptor.
STUDIES: Architecture, Uni. of Melbourne, 1966–69; Brera Academy, Milan and Urbino, 1967–68; town planning, Uni. of Melbourne, 1969–70. Lightness of touch, feeling for colour and texture and an urge to experiment have kept De Clario's work in a state of constant transition. His early drawings and large unstretched canvases as seen in about seven exhibitions, 1970–77, were later replaced by sculptural interests that moved rapidly from Caro-like weldings to alternative, throwaway works involving discarded materials. He held over 60 solo exhibitions (including a number of performance works) 1966–93 including at Pinacotheca, Powell St, Melbourne; Mori, Sydney; IMA, Brisbane 1991; Ian Potter Gallery, Uni. of Melbourne 1992; NGV 1993. His work appeared in numerous group exhibitions 1972–93 in Australia including *Mildura Sculpture Triennial*, 1975, 78; *Off the Wall: In the Air*, Monash Uni. and ACCA 1991; *Australian Sculpture Triennial*, Melbourne 1993; and in a number of international exhibitions in private galleries in NY, Europe, the UK and at *Chicago Art Fair*, 1991; *Rediscovery: Australian Artists in Europe 1981–91*, Seville, Paris, Berlin, Amsterdam 1992.
AWARDS: Italia Prize (Italian Government scholarship), 1969; Perth International Drawing Prize (Australian section), 1971, 73; Crouch prize (for watercolour), Ballarat, 1973; Corio prize, Geelong, 1973; *Mildura Sculpture Triennial* (award for non-permanent sculpture), 1973, (acquisition award) 1975; travel grant, VACB (to attend Anzart), 1981; Diamond Valley prize 1982, 85; Alice Springs Art Prize, 1982; Myer Foundation Grant, 1986; Uni. of NSW Acquisitive Prize, 1987; residencies VACB, Paretaio, Italy 1984, Greene St, NY 1990; grant VACB 1987.
APPTS: Lecturer, Phillip Institute, Melbourne, 1973– .
REP: NGA; AGNSW; AGWA; NGV; MOMA, NY; regional galleries Hamilton, Geelong, Mildura, Ballarat; several tertiary collections including Melbourne and Monash universities; corporate collections including Robert Holmes à Court, Smorgon Collection.
BIB: Catalogue essays exhibitions as above. Sturgeon, *DAS*. Scarlett, *AS*. Chanin, *CAP*. *A&T* May 1986; June 1991; 1992.

DE GROEN, Geoffrey
(b. 10/12/1938, Brisbane) Painter, teacher, critic.
STUDIES: Julian Ashton School, 1957–58; North Sydney Tech. Coll., 1960–61; ESTC, 1962–66; travel studies UK, Europe, Canada 1968–73. Rhythm, colour and simplicity of form are the main attributes of his semi-abstract still life and other drawings and abstract paintings. He produced a series of black paintings in the early 1980s but from around 1984 his works returned to the use of colour applied thinly and in many layers, soaked into the surface. He held about 33 solo exhibitions 1966–91 in Sydney (Watters; Bonython; Coventry), Melbourne (39 Steps; Europa; Charles Nodrum), Brisbane (Michael Milburn) and Canberra (Narek; Solander), and in England and Canada. Twenty of his paintings were included in *The Subject of Painting* group exhibition at AGNSW 1985. His commissions included a mural for the NCDC, Canberra 1975 and one from the NLA to interview Australian artists, published in book form as *Conversations with*

Australian Artists (Quartet Books 1978). He also wrote *Some Other Dreams* (Hale and Iremonger, 1984).
AWARDS: Residency, Power Institute studio, Cité Internationale des Arts, Paris, 1969; special project grants, VACB, 1975, 76; grant, Australia-Japan foundation, 1977.
APPTS: Teaching, schools in England, 1969–70; Fanshawe College of Applied Art, Ontario, Canada, 1970–72; art critic, *Canberra Times* and *National Times*, 1973–77.
REP: AGNSW; QAG; New England Art Gallery; several tertiary collections Qld, NSW.
BIB: Horton, PDA. Bonython, MAP. Rodney Hall, *Australians Aware*, Ure Smith 1975. Germaine, AGA. A&A 22/3/1985 (Tony McGillick, *Geoffrey de Groen: Recent Work.*)

DELACOUR, John Anthony
(b. 1948, Sydney) Photographer, lecturer.
STUDIES: Science, Uni. of Sydney, 1966–69; travel studies Europe, USA, 1979. Self-taught photographer who started as a photographer of art works for reproduction (books, catalogues, etc.) and later moved into exhibiting his own work. He held five solo exhibitions 1982–89 in Sydney (Watters 1982, 84, 87; Manly Art Gallery and Museum, 1988), and joint exhibitions at the Tasmanian School of Art Gallery, Hobart, 1983, and Christine Abrahams, Melbourne, 1985. His work appeared in about 12 group exhibitions 1977–92 at private galleries in Melbourne and Sydney, and in *Australian Photographers: The Philip Morris Collection*, Philip Morris, Melbourne, 1979. *Australian Art Photography*, touring to various Middle Eastern countries for Dept of Foreign Affairs, 1979; *Australian Perspecta '83*, AGNSW.
AWARDS: VACB travel grant, 1979.
APPTS: Secondary teaching (science), 1970–73; advanced courses, Australian Centre for Photography Workshop, 1980–82; part-time lecturer, photography, SCA, 1981; part-time lecturer (1982) then full time lecturer (1903), photography, City Art Inst.
REP: NGA; NGV; Griffith Uni.; Bibliothèque Nationale de Paris.
BIB: A&A 21/3/1984.

DELAWARR, Valentine
(Active c. 1890–98; believed to have been of Dutch extraction) Painter. He lived in Sydney 1890–96 and Perth 1898–99, exhibiting in the third annual exhibition of the WA Society of Arts, 1898. He worked also in NZ and Tas. His oil paintings, many featuring reflections in water, are painted in a contemporary Dutch manner. His work was seen in *The Colonial Eye*, AGWA, 1979.
REP: AGWA.
BIB: *National Bank of Australasia Calendar*, Melbourne, 1962.

DELECCA, Bill (William Alfred)
(b. 6/3/1929, Bendigo, Vic.) Painter, teacher.
STUDIES: Art Teachers Secondary Certificate, Prahran Tech. Coll., 1950; TTTC, 1965. A Bendigo-based teacher and painter, he exhibited largely in the local area from

1951, including a retrospective in Bendigo Art Gallery, 1990. Author of an Education Department report to the Australia Council, 1987.
AWARDS: Bendigo Art Prize (watercolour), 1963.
APPTS: Teaching, Bendigo Tech. Coll., 1959–66; head of dept, art and design, Bendigo CAE, 1966–87.
REP: Regional galleries Bendigo, Castlemaine, Shepparton.
BIB: Germaine, AGA.

DELOHERY, Cornelius
(b. London; arr. Aust. c. 1830; d. 1866, Sydney) Painter. Government employee in various departments in Sydney including the Police Department, his first known artistic activity was 1847 when he exhibited at the Society for Fine Art exhibition. He became a portrait painter and a self-portrait by him is in the collection of the Mitchell Library, while several other oil portraits, including one in the Newcastle Library, have been attributed to him. His work was seen in *The Artist and the Patron*, AGNSW, 1988.
BIB: Kerr, DAA.

DELPRAT, Paul Ashton
(b. 22/3/1942, Sydney) Painter, lecturer, administrator.
STUDIES: Julian Ashton School, Sydney, 1962. A great-grandson of Julian Ashton, his work as exhibited mainly at the Holdsworth Galleries, Sydney, is widely varied, ranging from antipodean-style landscapes to formal nudes and decorative works. In 1968 he made paintings, drawings and sculpture of island subjects for Michael Powell's film *The Age of Consent*, based on a book by Norman Lindsay. He held around 21 solo exhibitions in Sydney 1960s–93 and illustrated articles for newspapers and magazines.
AWARDS: *Mirror*-Waratah Festival prizes, 1962, 63; Le Gay Brereton prize for drawing, 1962.
APPTS: Univ., colleges 1960s, 70s, principal, Julian Ashton Art School, 1988– .
REP: NGA; BHP.
BIB: Bonython AP. Germaine, AGA.

DE LUTIIS, Jo
(b. 1953, Italy; arr. Aust. 1957) Painter. He held solo exhibitions in Melbourne 1974–90 including at Hawthorn City Gallery, Tolarno and Powell Street.
AWARDS: Elaine Targett Drawing Prize, 1974; Ansett acquisition prize, Hamilton regional gallery, 1980; VACB grant, 1980.
REP: NGV; MAGNT; Artbank; regional galleries Hamilton, Alice Springs; several tertiary and municipal collections Vic., Qld.

DE MAISTRE, Roy (Leroy Leveson Laurent Joseph)
(b. 27/3/1894, Bowral, NSW; d. 1/3/1968, London) Painter.
STUDIES: RAS School, Sydney, with Dattilo Rubbo; Sydney Art School with Julian Ashton; also studied music at the Sydney Conservatorium. Born de Mestre,

Roy de Maistre, Untitled – Still Life, *1933, oil on canvas, 91.4 × 60.5cm. Collection* NGA.

son of horse trainer E. L. de Mestre, he signed this name on some of his early work. Later he changed his name to de Maistre. In company with Wakelin, Cossington Smith, Crowley, Norah Simpson and others, he became a pioneer of post-impressionism and cubism in NSW. He held his first exhibition, with Wakelin, in Sydney, 1918, during a period of experiment with music-painting relationships and the psychological effects of colour. He travelled to Europe in 1923, and exhibited at the Paris Salon the following year and at the Venice *Biennale,* 1926. Back in Australia the same year he held a show at the Macquarie Galleries, returning to Europe in 1929. A show at the Beaux Arts Gallery, London, 1930 was followed by two years spent in Paris, after which he returned to London, his headquarters for the rest of his life. His friends in England included Patrick White (who for ten years lived in a flat in the same building and collected his paintings), John Rothenstein and Francis Bacon, who designed some of his studio furniture. In 1943 a retrospective exhibition of his work was held in conjunction with work by the British sculptor Gaudier Brzeska at Temple Newsam, Leeds; a similar exhibition followed at Birmingham in 1946, and another retrospective at the Whitechapel Gallery, 1960. Included in his commissioned work was his *Stations of the Cross* for Westminster Cathedral. The early cubist influences remained in his work which reverted, logically, to a neo-Gothic style as thematically it became more and more involved with religion. A memorial de Maistre

exhibition (with works from his estate) was held at the Joseph Brown Gallery, Melbourne in 1971 and his work has since been seen in a number of significant survey exhibitions of Australian art including *The Great Australian Art Exhibition* 1988–89.

AWARDS: Travelling scholarship of NSW, 1923; CBE conferred, 1962.

REP: NGA; AGNSW; AGSA; AGWA; MAGNT; NGV; QAG; QVMAG; TMAG; many regional and other public galleries; Tate Gallery, London.

BIB: All standard Australian art histories. Grant M. Waters, *A Dictionary of British Artists Working 1900–1950,* Eastbourne Fine Arts, Eastbourne, 1975. ADB 8. Heather Johnson, *Roy de Maistre: The Australian Years,* Craftsman House, 1988. A&A 2/1/1964 (Ross Morrow and Kerry Dundas, *Roy de Maistre*), 4/4/1967 (John Rothenstein, *Roy de Maistre*).

DE MESTRE, Roy

See DE MAISTRE, Roy

DENHAM, Henry (Admiral Sir Henry Mangles)

(b. 1800; visited Aust. 1856) Naval officer, painter. Royal Navy captain in command of HMS *Herald* during her charting, surveying and hydrographical cruises in the Western Pacific, 1852–61. The ship visited Sydney in Feb. and again in Nov. 1856. A watercolour of marine and topographical interest, *Sydney, when approaching the Anchorage, 1856,* was offered at Leonard Joel's, May 1977.

DEN HARTOG, Harry (Henricus Marie)

(b. 1902, Rotterdam; arr. Aust. 1923) Painter.
STUDIES: No formal training. President of the CAS, Melbourne, 1940–41, and a council member 1940–45.

Harry den Hartog, Still Life, *oil on canvas. Private collection.*

One of the first painters in Melbourne to be influenced by cubism, he exhibited with the Melbourne social-realists led by Counihan, Bergner and O'Connor. Later he became an orchardist.

BIB: AA Nov. 1938. *Angry Penguins,* Sept. 1943 ('Fascism in the Making'). Smith, AP.

DENNIS, C. Elwyn (Clayton Elwyn)

(b. 1941, Upland, California; arr. Aust. 1965) Sculptor, curator, teacher, lecturer.
STUDIES: Uni. of Redlands and Uni. of California at Berkeley (BA 1965), USA. His fastidious and sensitive sculptures and drawings have qualities of symbolism, mysticism and perhaps introversion that often defy analysis and definition. His work appeared in a number of solo exhibitions Melbourne 1966–80s (Gallery A, Realities, Gryphon Gallery) and in group sculpture exhibitions including *Mildura Sculpture Triennial*. He was sculptor-in-residence at University of Melbourne's Dept of Architecture in 1977 and artist-in-community at Daylesford, Vic. in the mid-1980s where he created a sculptural landscape around the town's scenic lake.
AWARDS: Mildura Sculpture Triennial (purchase), 1967; Ampol Sculpture Prize (special award), 1970.
APPTS: Assistant curator, decorative arts, NGV, 1966; curator of sculpture and ethnic art, 1968–70; lecturer, Prahran CAE, 1968; lecturer (part-time), NGV School, 1970–71; senior tutor, Uni. of Melbourne (Dept of Architecture), 1974–76.
REP: NGV; Mildura Arts Centre; Uni. of Melbourne.

BIB: Sturgeon, DAS. Scarlett, AS. A&A 1/4/1964/; 6/4/1969; 7/4/1970.

DENNIS, Joseph Tracton

(b. Ireland; arr. Aust. 1838) Painter, actor. Scene painter with Sydney's Royal Victoria Theatre c. 1940 and later the new City Theatre, he is best-known for landscapes and portraits, a number of which were exhibited 1847–61 in important contemporary exhibitions. His best-known surviving work is his 1840 life-sized portrait of Sir James Dowling, Chief Justice of NSW, in the collection of the Mitchell Library (which also holds his 1846 *Portrait of Henry Smithers Hayes*). An unsigned, undated portrait, *Robert Pitt Jenkins*, attributed to him, was seen in *The Artist and the Patron*, AGNSW, 1988.
REP: Mitchell Library.
BIB: Kerr, DAA.

DENNYS, Joyce

(Active c. 1918, NSW) Painter. She exhibited designs and genre pictures with the NSW Society of Artists from 1918.
BIB: Reprdns, AA 1920.
NFI.

DENT, Aileen Rose

(b. 1890, Deniliquin, Vic.; d. 1979) Painter.
STUDIES: NGV School, 1909–16. Known mainly as a portrait painter, she held regular exhibitions at the Athenaeum Gallery, Melbourne, from 1921. Her capable tonal-impressionist portraits included likenesses of many identities in the local art world. Her work was seen in *Australian Women Artists: One Hundred Years 1840–1940*, Ewing-Paton Galleries, Uni. of Melbourne, and touring public galleries 1975.
AWARDS: Student prizes, NGV, 1912, 13.
REP: NGV.
BIB: Janine Burke, *Australian Women Artists 1840–1940*, Greenhouse, Melbourne, 1980.

DENT, John Harold

(b. 3/3/1951, Sydney) Painter, printmaker.
STUDIES: Dip. (painting, printmaking), RMIT, 1973; travel studies in Europe; postgrad. painting studies, St Martin's School of Art, London, 1973–74; Accademia Britannica, Rome, 1974. He researched printmaking materials and techniques in Europe, and exhibited his work in England and Italy before returning to Australia to help establish the Crossley Print Workshop with George Baldessin, Tate Adams and Jan Senbergs. He held his first exhibition in his nearby studio in Highlander Lane, Melbourne, in Nov. 1976 and held about 17 exhibitions in Melbourne, Canberra, Sydney and Perth 1976–92, including at Rudy Komon, Stuart Gerstman, Robin Gibson, Lauraine Diggins. His paintings, like his drawings and prints, are decorative and in their concentration on interiors and still-life, their muted colours and seductive textures, reveal admiration for the intimist works of Vuillard and Bonnard.

Group exhibitions in which he participatéd included print survey shows internationally and in Australian regional, tertiary and state galleries. He lived in Paris 1983–86 and represented France in a group exhibition, *Paris-New York* in Holland, 1985.
AWARDS: VACB grant, 1973; PCA print acquisition, 1973; Georges Art Prize acquisition, 1977, 79.
REP: NGA; AGNSW; NGV; Parliament House; many regional, tertiary galleries.
BIB: PCA, *Directory*, 1976. Campbell, AWP.

DENTON, Enid
(b. Newcastle, NSW) Painter.
STUDIES: Studio of Alastair Gray (watercolours) and William Frater, Melbourne. Chief characteristic of her watercolours is their vibrant luminosity.
AWARDS: Portland prize for watercolour, 1963; VAS (Ron Crawford prize), 1972; Brighton City (acquisition) prize, 1972.
NFI

DE OLSZANSKI, George
See OLSZANSKI, George

DERHAM, Frances (née Anderson)
(b. 1894, Malvern, Vic.; d. Nov. 1987, Melbourne) Painter, teacher.
STUDIES: NGV School 1911–13; Swinburne Tech. Coll., 1911–13; George Bell School, 1930 & 1936–39. Lecturer in art at Mercer House Associated Teachers Training Coll., Melbourne, and Kindergarten Training Coll., Kew, she played a leading part in the development of an enlightened approach to art education at pre-school and primary school level. The Frances Derham Scholarship, administered by the Australian Pre-School Association, was given for research on and integration of child art. She wrote numerous articles on child art for magazines and newspapers and *Art for the Child Under Seven*, Australian Preschool Association, Melbourne, 1961.
AWARDS: MBE conferred (for services to art education), 1952.
BIB: Bernard Smith, *Education Through Art in Australia*, MUP 1958. A&A 25/4/1988.

DE OLSZANSKI, SAINSON, Louis Auguste
(b. 26/4/1800; arr. Aust. 1826; d. 1887) Topographical draughtsman. A clerk in the naval administration, he joined Dumont d'Urville's expedition which left France for Australia in 1826. The *Astrolabe* visited King George Sound, WA, Sydney, Jervis Bay and Hobart as well as New Zealand, returning to France in 1829. De Sainson's drawings of geological features, coastal views and Aborigines were lithographed by Langlume, Lemercier and others to illustrate the account of the voyage. He continued his career as an illustrator, contributing to various publications, including the *Voyage dans la Russie méridionale et la Crimée* (1840–42). His work was seen in *The Colonial Eye*, AGWA, 1979.
REP: Most Australian state libraries and galleries; Société de Géographie, Paris.

BIB: J. S. C. Dumont d'Urville, *Voyage Pittoresque autour du monde*, Paris, 1834. Smith, EVSP. *Early French Voyages to Australia*, portfolio of reproductions, Banque Nationale de Paris, to celebrate the centenary of its establishment, Mar. 1981. Kerr, DAA (as Sainson, Louis Auguste de).

DESIGN INSTITUTE OF AUSTRALIA
(Established 15/8/1958) c/- 50 Burwood Rd, Hawthorn, Vic. 3122. Formerly known as the Industrial Design Institute of Australia, this is the professional association for interior, industrial, product and graphic designers.

DE SILVA, Francis Kenneth
(b. 1913, Newcastle, NSW; d. 1981, Qld) Painter, teacher.
STUDIES: Sydney (correspondence course); Central Tech. Coll., Brisbane. Best-known for his paintings of Qld cattle country landscapes, his aim was to capture 'a true Australian image in his own style'. He was killed in a road accident.
AWARDS: Prizes at QAG (H. Caselli Richards), 1957; Redcliffe, 1958, 66; NGV (McCaughey), 1960; Toowoomba, 1960, 65; Warana, 1965; Dalby, 1966; Brisbane (David Jones), 1967; R.N.Ag.A.Q., 1968.
REP: NGA; NGV; QAG; Toowoomba Art Gallery; James Cook Uni. collections.

DE TELIGA, Sarah
(b. 1957, Sydney) Painter.
STUDIES: NAS, 1972–76; theatrical design, Drama Studio, Sydney, 1980–83. She held six solo exhibitions 1982–91, largely at Mori Sydney and Realities Melbourne, and participated in several group exhibitions 1976–90 including *Printmakers Exhibition*, Bonython 1974, 75, 76; *Young Painters*, Macquarie Galleries 1973, 74, 75, 76; *Artworkers Union Fundraising* exhibitions, 1984, 85, 86 and ACCA, Melbourne 1988. She received several commissions including for the restaurant of the AGNSW in 1987 and set designs for Kinselas theatre/restaurant, Sydney, 1983–84.
REP: NGA; Artbank; Hamilton regional gallery; Aust. Film Commission; OTC corporate collection.
BIB: A&A 21/3/1984.

DE TELIGA, Stan
(b. 1/4/1924; arr. Aust. 1926) Painter, teacher.
STUDIES: Dip. Art, NAS, 1951. He served in the RAAF during World War II and began his professional career as a tutor in art at the Uni. of Sydney, 1951–54. He held about 20 solo exhibitions 1958–89 largely at Macquarie, Sydney, which show his commitment to various modernist movements such as post-impressionism and cubism. The decade 1962–72 brought him success in many art prizes. In 1984 Ivan Dougherty Gallery, Sydney, held a retrospective of his work.
AWARDS: Australian Fashion Fabric Design award, 1963; Manila Art Prize, 1967; Flotta Lauro Travelling Scholarship, 1968; Myer Foundation Travel grant, 1969; British Council study grant, 1970; prizes at

Westfield, 1969, Southern Cross, 1969, and Rockdale, 1972; British Council Study grant 1978.

APPTS: Keeper, TMAG, Hobart, 1954–60; director, Blaxland Gallery, Sydney, 1960–66; teacher, NAS, Sydney, 1966–74, and Head of the Art School, 1974–75; senior lecturer, Alexander Mackie CAE, 1975 and City Art Inst., 1982–84.

REP: NGA; AGNSW; AGSA; TMAG; Parliament House; Artbank; a number of tertiary and regional collections Qld, NSW, Tas.

BIB: Horton, *PDA*. Bonython, *MAP* 1960, 70. Horton, *Australian Painters of the 1970s*, Ure Smith, 1975. Germaine, *AGA*. Chanin, *CAP*.

DEUTSCH, Herman

(b. c. 1833, Prussia; arr. Aust. 1857) Engraver, lithographer. Lived in Ballarat, where he established a lithography business and published a number of folios of local scenes 1854–70.

REP: NGA; NLA; La Trobe, Dixson, Mitchell Libraries.
BIB: Kerr, *DAA*.

DEVEREUX, Alan

(Active c. 1900) Painter, writer. Itinerant painter and writer, whom William Moore records as an Australian who travelled in Europe and America, making 'sketches and recorded impressions in prose, verse and picture'. An A. Devereux is recorded as living in Ireland and showing a painting at the Royal Hibernian Academy in 1925. A work of his was seen in *Winter Exhibition*, Joseph Brown Gallery 1971.

BIB: *AA* Sept. 1926, illustration. Moore, *SAA*. J. Johnson and A. Greutzner, *Dictionary of British Artists, 1880–1940*, Antique Collectors Club, Woodridge, Suffolk, 1976.

DEVLIN, Stuart Leslie

(b. 1931, Geelong, Vic.; d. 1986) Sculptor, industrial designer, teacher.

STUDIES: Gordon Inst. of Technology, Geelong; Melb. Tech. Coll.; Royal College of Art, London, 1958–60; Columbia Uni., NY, 1960–62. Devlin exhibited his sculpture in the USA during 1962–63; he returned to Australia in 1963 and took charge of a class in experimental materials at Prahran Tech. School, Melbourne. In 1964 he designed the coins for Australia's new decimal currency, using themes of Australian fauna. Soon afterwards he went to London, where he achieved success as a designer of silverware.

AWARDS: Harkness Fellowship for study in the USA, 1960.

DE WESSELOW, Francis Guillemand (Simpkinson)

(b. 26/5/1819, London; arr. Aust. 1844; d. 4/12/1910, London) Painter, diarist, naval officer. Nephew of Sir John Franklin, he was born Simpkinson and changed his name by deed poll to de Wesselow in 1869, after his great-grandfather, ambassador to Peter the Great of Russia, at the court of Vienna. Simpkinson, or de Wesselow, was one of a fashionable Hobart group devoted to the arts during the 1840s; among his numerous watercolours, which were closely modelled on the style of John Skinner Prout, with whom he travelled around Tasmania, is a panoramic view of Hobart, painted in 1845.

REP: TMAG; Mitchell, Allport Libraries.
BIB: W. R. Rawnsley, *Life of Jane, Lady Franklin*, family history, London, 1923. Kerr, *DAA* (under Simpkinson (de Wesselow) Francis Guillemard). *AA* 1929.

DEXTER, Caroline (née Harpur)

(b. 6/1/1819, Nottingham, Eng.; arr. Aust. 1854; d. 19/8/1884, Brighton, Vic.) Writer, feminist. Married to artist William Dexter, she was a friend of George Sand (Amandine Aurore Lucile Dupin, 1804–76) and seems to have been permanently influenced by the French writer. Because of her life with Dexter, whom she married in 1843, she gained great sympathy as the prototype of a poverty-stricken artist's wife. She lectured in London on 'the Bloomer costume' and completed a novel, *The Immigrant*, during the voyage to Australia on the *Marie Gabrielle*. Arriving in Sydney in 1854, she joined Dexter to conduct a Gallery of Arts and School of Design, before moving in 1856 to Vic. and a short period of farming life in Gippsland. It is recorded that the ship, *Meg Merrilees*, on which she arrived at Port Albert, Vic., was lost at sea together with its captain two days later. After separating from Dexter in Melbourne in 1857, she compiled her *Ladies Almanack: Australian Album and New Year's Gift* (printed and published by W. Calvert, Neaves Buildings, Collins St East, Melbourne, 1857, with illustrations by Dexter) and became associated with the suffragette Harriet Clisby. Her tragic romance with Dexter ended when he died in Sydney and in 1861 she married the lawyer William Lynch, 21 years her junior and Dexter's former pupil at Lyndhurst. The marriage was successful. Their home, *Bombala*, at Brighton, Vic., became an important centre where artists, musicians and writers mixed socially at regular parties. The Lynch collection of art was sold by Gemmel Tuckett & Co., Melbourne, in 1903, and at least one of the pictures found its way into the NGV collections: Bonnington's *Low Tide at Boulogne* (bequeathed by Alfred Felton, 1904).

BIB: *ADB* 4. McCulloch, *AAGR*.

DEXTER, William

(b. 1818, Melbourne, Derbyshire, Eng.; arr. Aust. 1852; d. 4/2/1860, Redfern, NSW) Painter. He served an apprenticeship with the Derby china factory painting birds, animals and flowers, and visited France working as a royal vase painter in 1839 and 1840. In 1843 he married the feminist Caroline Harpur, and in 1851–52 exhibited paintings (*Dead Birds* and *The Lark and Her Young*) at the RA, before embarking in the *Bank of England* for Australia, arriving Sydney in Oct. 1852. This journey seems to have been prompted partly for health reasons, partly by the lure of gold. For a time he taught at Lyndhurst College, Glebe, but by 1853 was at the Bendigo goldfields participating in the Red Ribbon agitations for which he designed the diggers' flag. William Howitt wrote him

down as an undesirable revolutionary. In 1854 he was back in Sydney to meet Caroline, and together they launched a Gallery of Arts and School of Design, at which Dexter taught painting and drawing while Caroline taught elocution, grammar, composition and other subjects. The project failed and in 1856 the Dexters moved to Stratford-on-Avon, Gippsland, to try their luck at farming. They became friendly with the founder of Gippsland, Angus McMillan, but the farm failed, Dexter's paintings (nine pictures exhibited in Melbourne with the Victorian Society of Fine Arts, 1856) did not sell and the unlucky pair finally separated in 1857, when Dexter returned to Sydney where he set up in business as a sign-writer at 768 George Street South, in a last desperate attempt to

BIB: William Howitt, *Land, Labour, and Gold*, London, 1855, republished by Lowden, Kilmore, Vic., 1972. ADB 4. McCulloch, AAGR. Kerr, DAA. AA 8/1921 (W. Hardy Wilson, *The Dexter Mystery*); Feb. 1931 (Dora Wilcox and William Moore, *The Wife of the Artist*); A&A 24/3/1987 (Michael Watson, *William Dexter, forget him was impossible*).

DIBDEN, Thomas Coleman

(b. 1810, London; d. 1893, London) Painter, lithographer. Painter of landscapes and architectural subjects. He exhibited at the RA, London, 1832–74, and may have confined his Australian interests to reproducing the work of other artists such as Louisa Clifton.

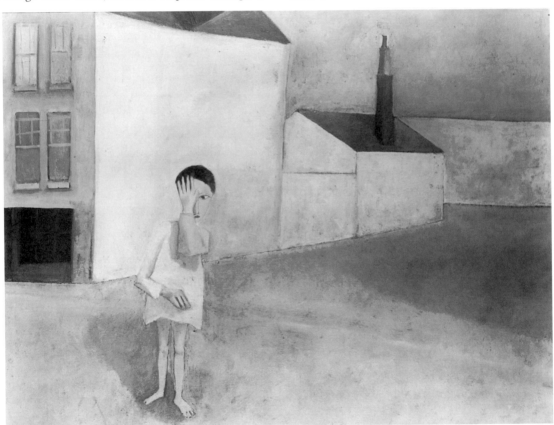

Robert Dickerson, Boy in Street, *oil on board, 92 × 122cm. Private collection.*

restore their fortunes. Most of his surviving paintings symbolically depict dead birds, often with eggs and nests and surrounding foliage, grass and flowers. This choice of subject, combined with the reputation he must have gained as a revolutionary from William Howitt's published account of his activities in Bendigo, might explain his lack of material success (which as so often happens was redressed posthumously), contemporary public demand, such as it was, being limited to portraits and topographical landscapes. His work has appeared regularly in fine art auctions since the 1970s and was seen in *The Artist and the Patron*, AGNSW, 1988.
REP: NGA; AGSA; NGV; QAG; NLA; Bendigo regional gallery; Joseph Brown collection.

DICKERSON, Bob (Robert Henry)

(b. 28/3/1924, Hurstville, NSW) Painter.
STUDIES: No formal training. Dickerson left school at 14 and, after working in factories, spent four years, 1940–44, as a professional boxer – which he described later as 'the cruellest life on earth'. He joined the RAAF at 18, and served on the ground staff in Darwin, Dutch East Indies and at Morotai. He started to paint seriously in 1950 and became known first through his exhibitions at the MOMAD, Melbourne, and later in Sydney. His monumentally conceived, two-dimensional

drawings of figures attain notable stylistic simplicity, their haunted look being accentuated by the surrounding empty spaces. The paintings are complemented, and their qualities confirmed, by a regular output of large charcoal drawings. He held over 100 solo exhibitions 1949–88 and travelled to the UK, Europe (1973, 89, 91), USA (1979) and Japan (1984). A retrospective of his work was held at Caulfield Arts Centre, Melbourne, in 1993.

AWARDS: Clint prize, 1954; Darcy Morris memorial prize, 1958; Tumut prize, 1959; RAS NSW (human image prize), 1965; *Mirror*-Waratah (shared grand prize), 1966; Gold Coast prize (acquisition), 1974; DDB Needham Inaugural Art prize 1990.

REP: NGA; most state and many regional galleries; ANU collection; many significant private collections including Joseph Brown and Holmes à Court.

BIB: *Modern Australian Art*, MOMAD, Melbourne, 1958. All standard works on Australian modern art history including Smith, AP.

DICKINSON, Sidney

(b. 1851, Massachusetts, USA; d. 1919, Ohio, USA) Critic. In Australia for several periods, beginning Sydney 28 June 1888, ending 1891, he became known for his lectures and for his critical support of the Heidelberg School artists in the *Australasia Critic*, 1890. In 1889 he delivered a lecture on art in Australia at the AGNSW. He was secretary of the VAS from 1890, and between 1892 and 1902 contributed articles on Australia, New Zealand and Fiji to American magazines, notably *Scribner's* and *The Scientific American*. He held a Master of Arts degree, and was a Fellow of the Royal Geographic Society.

BIB: *Art Lectures*, John Sands, Sydney, 1889. Smith, PTT. Smith, AP. ADB 8.

DICKSON, James A. C.

(b. 1836; arr. Adelaide 1865) Painter. He arrived in Adelaide on the *Norman Morrison*, 21 Aug. 1865, with his wife and two children. *Cameron's Farm 1866* (AGSA collections) shows him as a capable colonial painter of rural life.

REP: AGSA.

BIB: AGSA, *Bulletin*, July 1966.

DIGBY, Desmond Ward

(b. 1933, Auckland, NZ; arr. Aust. 1959) Painter, illustrator, stage designer.

STUDIES: Elam School of Art, Auckland; Auckland Uni., 1949–52; Slade School, London, 1954– . As assistant to Hugh Skillen, leading theatrical property maker in London, Digby worked on theatre productions for Glyndebourne and Covent Garden. He returned to Australia in 1959 to design sets for the Elizabethan Theatre Trust, and remained to design sets for opera, plays by Patrick White, ballets by the Australian Ballet Company and many other works. His work as an illustrator includes the prize-winning illustrations for Banjo Paterson's *Waltzing Matilda*, and two books by S. A. Wakefield – *Bottersnikes and Gumbles*, 1967, and *Gumbles on Guard*, 1968.

AWARDS: Picture Book of the Year award, 1971; Brooklyn Art Books for Children citation, 1973.

REP: AGNSW; NGV.

BIB: A&A 4/1/1966.

DIGGLES, Sylvester

(b. 24/1/1817, Liverpool, UK; arr. Aust. Nov. 1853; d. 21/3/1880, Brisbane) Naturalist, painter, musician. He taught drawing and music, made natural history drawings, including 325 plates for *The Ornithology of Australia* (Brisbane, 1863–75), as well as sketches of Brisbane. He was organist at St Mary's Cathedral, Brisbane, and was called 'the father of music in Brisbane'.

REP: NGA; NGV; QAG; Mitchell Library.

BIB: Vida Lahey, *Art in Queensland 1859–1979*, Jacaranda Press, Brisbane, 1959. ADB 4.

DILLON, Cyril

(Active c. 1880–1970, Melbourne) Etcher. Dillon made etchings of *Coombe Cottage* for Dame Nellie Melba, and sets of etchings of Melbourne public schools. A prominent member of the Savage Club, Melbourne, and friend of many leading artists, he was a vice-president of the Australian Painter-Etchers' Society for ten years.

REP: NGV; Castlemaine Art Gallery.

BIB: AA May 1923, reprdn.

DIMMACK, Max

(b. 1922, Adelaide; d. c. 1983) Painter, teacher, writer.

STUDIES: RMIT, 1947–49; evening classes with Alan Warren, 1950–51. An informed and energetic campaigner for better art education in primary schools, his own paintings are more theoretical than sensuous and show keen appreciation of cubism and constructivism. He was the author of several books including *Modern Art Education in the Primary School*, 1958; *Dictionary of Creative Activities for School Use*, 1962; *Art Techniques for Students*, 1969, all published by Macmillan, Melbourne; *Clifford Last*, Hawthorn Press, Melbourne, 1972; *Noel Counihan*, MUP, 1974.

APPTS: Lecturer in art education, Melbourne Teachers Coll., 1949–51; Burwood Teachers Coll., 1954–63; head of the art dept, Coburg Teachers Coll., 1964–75.

REP: AWM; Vic. State Coll. collections.

DISTON, J. Swinton

(Active c. 1900–30, Vic.) Painter. He was a prominent member of the VAS, where he exhibited 1914–17, showing Port Phillip Bay, Indian and Japanese scenes. Most of his work on the market today comprises coastal landscapes in watercolour painted in a conservative style. He reputedly signed many of his works Deschamps. It is not known if he was related to another Diston who exhibited at the Victorian Academy of Arts in 1888.

DOBELL, (Sir) William

(b. 24/9/1899, Newcastle, NSW; d. 13/5/1970, Lake Macquarie, NSW) Painter.

STUDIES: Apprentice architect to Wallace J. Porter, Newcastle, 1916–24; Julian Ashton's School, Sydney (evening classes), 1924–29; Slade School, London, 1929; Holland, The Hague, 1930; the continent and London, independent study, 1931–39. When Dobell returned to Sydney in 1939, after ten years abroad, his portrait and genre paintings added a new dimension to the stature of Australian painting. The assimilation of varied influences – the chiaroscuro of Rembrandt, satire and simplicity of Daumier, wit of Hogarth, Renoir's feathery brushstroke, and other features – appealed to all schools. The fact of having exhibited at the RA gained Dobell a certain conservative following which remained until increasing numbers of returning Australian expatriates, and a growing body of migrant artists, claimed him as the figurehead of the Sydney modernist wartime movement. The circumstances and pressures of the time, the life and environment of Sydney, soon gave his work a new, added vitality. With two other painters, James Cook and Joshua Smith, he engaged in war service, first in a camouflage unit and then in the Civil Construction Corps as a labourer before receiving an appointment as an official war artist. The CCC experience, particularly, provided a succession of portrait subjects that gave full scope to talents expressed with an underlying quality of Cockney whimsicality already evident in his pictures of London costermongers. His best portraits, *The Billy Boy, The Strapper, Scotty Allan, The Cypriot*, all resulted from this wartime period of inspiration. In 1944 he made a final sensational break with local academic tradition by winning the 1943 Archibald prize with a portrait of his colleague, Joshua Smith. The notoriety resulting from this award (*see* PRIZES, ARCHIBALD PRIZE) made his name known throughout Australia, but it had an inhibiting effect on his work because of the disproportionate publicity attached to everything he painted afterwards. He was offered tempting commissions, many of which represented subjects quite alien to his temperament; after a life of comparative poverty in London for ten years, the sudden accession to fame and wealth did his work more harm than good. In 1948 he attained further celebrity by winning the Archibald and Wynne prizes simultaneously, the Archibald with a baroque-styled portrait, *Margaret Olley*, the Wynne with a landscape, *Storm Approaching, Wangi*. He visited and worked in New Guinea, 1950–51, and on his return was commissioned by the Commonwealth Government to paint a landscape in celebration of Commonwealth Jubilee year. Towards 1956 his health deteriorated and seemed in danger of total collapse; he celebrated his recovery with a third successful Archibald painting in 1959, the subject being his surgeon, Dr Edward McMahon. Dobell won the £1500 *Australian Women's Weekly* portrait prize with a portrait of Helena Rubinstein in 1957, and *Time* magazine commissioned a cover portrait of the Prime Minister, the Rt Hon. Robert G. Menzies, in 1960. These events were to be the precursors of great changes not only in Dobell's own affairs but also in the local status of all artists; by 1962 the economic status of artists throughout Australia bore little relationship to the conditions of 1939. Dobell was affected rather more than his contemporaries. In 1962 he had the experience of seeing pictures for which he would probably have accepted £50 at the time they were painted sold at auction for prices up to £7000. The crowning touch to Dobell's career was a large retrospective exhibition held at the AGNSW in July 1964: it comprised 224 pictures from all periods. The last years of his life were spent living alone in his house at Lake Macquarie, the only diversion from painting being the visits of his more intimate friends and drinks in the evening at the local pub. After his death the whole of his estate went to the creation of the Dobell Foundation (q.v.).

AWARDS: Society of Artists Travelling Scholarship, 1929; prize in State Theatre Art Quest, 1929; Archibald prizes, 1943, 48, 59; Wynne prize, 1948; *Australian Women's Weekly* portrait prize, 1957; *Britannica Australia* award, 1964; knighted, 1966.

REP: NGA; AGNSW; AGSA; AGWA; MAGNT; NGV; QAG; QVMAG; TMAG; AWM; many regional galleries; uni. and other public collections.

BIB: Catalogue essays exhibitions as above. All standard books on Australian art. *The Art of William Dobell*, Ure Smith, Sydney, 1946. James Gleeson, *William Dobell*, Thames & Hudson, London, 1964. Cat. paintings and drawings from the studio of Sir William Dobell, Sotheby sale at Sydney Opera House, Sir William Dobell Art Foundation, 1973. Brian Adams, *Portrait of an Artist*, Hutchinson, Melbourne, 1983. A&A 2/2/1964 (Dobell special issue); 8/1/1970; 14/3/1976; 14/4/1976.

DOBELL FOUNDATION
See TRUSTS AND FOUNDATIONS

DOBLE, Gilbert
Sculptor. He made a statue of the Surveyor-General, discoverer of Bathurst, George William Evans, for Bathurst (completed 1913), and carved a lion for the Bathurst Soldiers Memorial.
BIB: Scarlett, AS.
NFI

DOCKING, Gil (Gilbert Charles)
(b. 1919, Bendigo, Vic.) Administrator, writer.
STUDIES: Industrial design 1938–39, painting 1946–47, RMIT; BA Fine Arts, Uni. of Melbourne, 1951. Outstanding achievements are his books on New Zealand painting, *Two Hundred Years of New Zealand Painting* (Lansdowne, Melbourne, 1971), and on Desiderius Orban, *Desiderius Orban: His Life and Art* (Methuen Australia, 1983). He also wrote several catalogues of retrospective exhibitions (Henry Salkauskas, Douglas Dundas) for AGNSW and many essays on artists for art journals such as *Art and Australia*.
APPTS: Senior Education Officer, NGV, 1952–57; Director, Newcastle Region Art Gallery, 1958–65; Director, Auckland City Art Gallery, NZ, 1965–72; Senior Education Officer 1972–74, Deputy Director, AGNSW 1974–82.

Shay Docking, Tree Totem, PVA. *Collection, Hamilton Art Gallery.*

DOCKING, Shay (née Lawson)
(b. 29/11/1928, Warrnambool, Vic.) Painter.
STUDIES: Swinburne Tech. Coll., 1947–50; NGV School, 1954–55. Strong in flat pattern design and tonal contrasts, her landscapes were included in many touring exhibitions of Australian art, including SE Asia, 1962; Europe, 1964, 66; Japan, 1970; Indonesia, 1978. She held over 40 solo exhibitions 1955–93 in Sydney (including Rudy Komon, Barry Stern), Melbourne (Niagara) and Newcastle (von Bertouch). A major exhibition of her work was curated by Warrnambool Art Gallery and toured various regional galleries Vic., NSW, 1975–76, and a solo exhibition, *Tower Hill and Other Volcanoes*, was held at S. H. Ervin Gallery, Sydney 1976. Group exhibitions in which she participated included *Looking Back*, NGV and touring 1975; *Landscape and Image: A Selection of Art in the 1970s*, Indonesian travelling exhibition 1978; *On the Beach*, travelling art exhibition, AGNSW 1982; *Tower Hill and its Artists*, Warrnambool Art Gallery 1985; *A Gift to the Gallery: Bicentennial Exhibition*, S. H. Ervin Gallery 1988; *60th*

Anniversary Exhibition, Blaxland Sydney 1989.
AWARDS: Maitland prize (local artist), 1959; Gold Coast Purchase Award 1979; Peter Sparks Pastel Award, Newcastle 1986.
REP: NGA; AGNSW; AGSA; AGWA; MAGNT; NGV; QAG; QVMAG; TMAG; numerous regional galleries SA, Vic., NSW, including Bathurst, Benalla, Hamilton, Latrobe Valley, Sale, Shepparton, Swan Hill, Warrnambool, Rockhampton; public galleries in NZ.
BIB: Exhibition catalogues as above and numerous others. Ursula Prunster, *Shay Docking: The Landscape as Metaphor*, AH & AW Reed, Sydney 1983. Lou Klepac & Hendrik Kohlenberg, *Shay Docking Drawings*, Beagle Press, 1990; and limited edition with print. All major texts on Australian and NZ art including Bonython, MAP 1970, 75, 80 editions; Gil Docking, *Two Hundred Years of New Zealand Painting*, Lansdowne, Melbourne, 1971; Donald Richardson, *Art in Australia*, Longmans, 1988; Germaine, AGA; Germaine, DAWA. Sandra McGrath & Robert Walker, *Sydney Harbour: Paintings from 1794*, Jacaranda 1979. Geoffrey Dutton, *The Myth of the Beach*, OUP, 1985. A&A 13/2/1974.

DODD, Margaret
(b. 1941, Berri, SA) Ceramicist, sculptor.
STUDIES: Adelaide Teachers College, 1958–60; SASA, 1961–62; California, with Robert Arneson, 1966–67; Uni. of California (grad. BA), 1968; travel studies Europe, 1974–75. She held exhibitions at the Memorial Union Gallery, Davis, California, 1968; Watters Gallery, Sydney, 1971; Llewellyn Gallery, Brisbane, 1972. Best-known for her hand-moulded stoneware sculptures depicting motor cycles and Holden cars, her work was seen in a number of group exhibitions 1966–83 including *The Road Show*, Shepparton regional gallery 1976; *The Women's Show*, Adelaide 1977; *Perspecta*, AGNSW 1983.
REP: NGA; AGNSW.
BIB: Alison Littlemore, *Nine Artist Potters*, Murray Book Distributors, Sydney 1973. Scarlett, AS. A&A 10/4/1973; 10/4/1911.

DOLAN, David
(b. 1949, Renmark, SA) Critic, teacher, curator.
STUDIES: Flinders Uni.; Adelaide Uni. In 1975 he held exhibitions at the Experimental Art Foundation and CAS, Adelaide and he works as a museum/art curator.
APPTS: Lecturer in art theory, SASA and Torrens CAE, 1973; editor, *CAS Broadsheet*, Adelaide, 1974–76; art critic for Adelaide *Advertiser*, 1977; advisor, Dept Prime Minister and Cabinet 1980–83; curator, Lanyon Historic Home 1989–90; curator Powerhouse Museum, Sydney 1990– .
REP: VACB.

DOLESCH, Susanne
(b. 1932, Hungary; arr. Aust. 1970) Painter, illustrator, stained glass designer, tapestry designer, wrought iron designer.
STUDIES: Art Gimnazium, Budapest, 1948–52; Academy of Fine Arts, Budapest, 1952–56. From 1957–70 she lived and worked in the USA, completing

a large number of commissioned works there and in Canada, including illustrating about 30 books. In Sydney from 1970 her commissions included large tapestries for the AMP Building and St James Centre as well as a 2.44 m × 11.58 m mural for the publishers Angus & Robertson. Her several Australian exhibitions have been at Bonython Gallery, Sydney, and Australian Galleries, Melbourne (nine in the 1970s). Typical of her tapestries and open-line drawings is a Miró-like sense of fantasy.
AWARDS: AMP tapestry commission, 1972.
NFI

DONALD, Will

(Active from c. 1906, Adelaide) Black-and-white artist. Contributor to Adelaide *Cadfly*, in which the work of Ruby Lindsay and Ambrose and Will Dyson also appeared.
BIB: Vane Lindesay, *The Inked-In Image*, Hutchinson, Melbourne, 1979.

DOOLIN, James

(b. 1932, Hartford, Connecticut, USA; arr. Aust. 1965; returned USA, 1967) Painter.
STUDIES: Philadelphia College of Art (grad. 1954); travel studies Europe, 1961–62. As an exponent of New York School hard-edge painting, and teacher at Prahran Tech. Coll., Melbourne, 1965–67, Doolin received a certain reflected glory from the exhibition *Two Decades of American Painting*, 1966–67, his work being featured in *The Field*, the inaugural exhibition at the new NGV, Melbourne, 1968. However his style changed radically after his return to the USA, and a later exhibition at the VCA Gallery, Melbourne, featuring urban planning as the theme, bore little resemblance to his former exhibitions of hard-edge painting.
REP: NGV.
BIB: *Other Voices* 1/2/1970 (P. E. McGillick, *James Doolin's Artificial Landscapes*). A&A 16/3/1979 (Geoff Wallace, *James Doolin: Artist at the Crossroads*). Smith, AP.

DORAHY, Les

(b. 27/4/1950, NSW) Sculptor, printmaker.
STUDIES: Dip. Painting, ESTC 1973. His figurative works have been based on environmental concerns especially to do with the destruction of forests. He held 9 solo exhibitions 1988–92 including at Michael Milburn, Brisbane; Christine Abrahams, Melbourne; and in Paris and *Centre des Arts Plastiques*, Villefrance, France 1988. Group exhibitions in which his work appeared 1988–92 included those at private galleries including Michael Milburn, Brisbane and Annandale, Sydney and in *Face of Australia*, Bicentential touring exhibition 1988; *Tenth Mildura Sculpture Triennial*, Mildura regional gallery 1988; *France/Australia*, Galerie Bourdin, Lebon, Paris 1989.
AWARDS: Several regional purchase prizes 1981–86 including Warrnambool, Stanthorpe; residency Besozzo studio, Italy, VACB, 1988.
APPTS: Tutor, drawing, Sydney Uni., 1973; lecturer, printmaking, 1981–92; head of sculpture, Uni. of New England, Northern Rivers, 1992– .

REP: Artbank; several regional galleries Australia; several French public collections.
BIB: Catalogue essays exhibitions as above.

DORN, Karl
See VEALE, Laurie

DOUGLAS, Neil

(b. 1911, NZ) Painter, potter, ecologist.
STUDIES: NGV School (evening classes), 1927–28. A keen student of botany and zoology, he combined these subjects with meteorology during his army service, World War II, and after the war became known for his work as a conservationist and as an enthusiastic advocate for alternative living. In 1964 he held an exhibition of his bush paintings done in late impressionist style somewhat in the manner of John Perceval and other contemporaries. Inspiration came from the theme of the environment and historic themes such as the wreck of the *Loch Ard* 1973.
AWARDS: MBE for services to conservation and the arts, 1975.

DOUTNEY, Charles

(b. 1908, Brisbane; d. 1957, Sydney) Painter.
STUDIES: Sydney, J. S. Watkins school; ESTC. Known for romantic-realist pictures. Doutney's early death resulted from an illness contracted in New Guinea during World War II.
AWARDS: Sulman prize, 1952; *Australian Women's Weekly* portrait prize, 1956.
REP: AGNSW; AGWA.

DOWIE, John Stuart

(b. 15/1/1915, Prospect, SA) Painter, sculptor, teacher.
STUDIES: SASA, part-time, c. 1925–30; Sir John Cass College, London, 1950–53; Florence Academy (sculpture), 1951–52. After a period of war service in the army, he assisted Lyndon Dadswell in the military history section of the Department of War Records, 1941–43. He travelled extensively during 1964, 1966 and 1968, and from c. 1955 completed a large number of sculpture commissions (including of HM the Queen, Hans Heysen, Lloyd Rees, Sir Zelman Cowan) done in the style of Rodin and contemporaries. His public sculptures include the *Pan* fountain, Veale Gardens, Adelaide; *Three Rivers* fountain, Victoria Square; *Girl on Slide*, Rundle Mall; and *Ross Smith and Crew*, Adelaide airport.
APPTS: Lecturer, SASA, 1954–62; president, RSASA, 1960– 62.
REP: AGSA; AGWA; NGV; TMAG; AWM.
BIB: Sturgeon, DAS. Scarlett, AS.

DOWLING, Henry

(Active c. 1835–60) Printer, bookseller. A noted printer and bookseller of Launceston, not to be confused with his contemporary, the Rev. Henry, father of Robert Dowling (q.v.). He printed a pirated edition of *The Pickwick Papers*, using local engravers, in 1838.

BIB: C. Craig, *Old Tasmanian Prints*, Foot & Playstead, Launceston, 1963.

DOWLING, Robert Hawker

(b. 4/7/1827, Essex, UK; arr. Launceston, Tas., 1839; d. 8/7/1886, London) Painter.

STUDIES: Hobart, with Thomas Bock and amateur painter the Rev. Medland. Son of the Rev. Henry Dowling, first Baptist minister at Launceston, he painted in Tasmania and Victoria 1850–57 and in London at the RA and the Society of British Artists 1859–82, showing scriptural and Oriental subjects. A number of his works were sent from London to various colonial exhibitions in Australia during this period and he returned to Melbourne in 1884 with a well-established reputation. He visited Tasmania, exhibited in important exhibitions in Victoria and NSW and obtained a number of significant portrait commissions including the Governor of Victoria, Sir Henry Loch (now in the collection of the La Trobe Library), 1885, and Sir Redmond Barry (Supreme Court Library, Melbourne), 1886. Other works include *Group of Natives in Tasmania*, 1859 (QVMAG). A painting of 1870 titled *Minjah in the Old Time* (Warrnambool Art Gallery) shows Dowling as an artist with a fine lyrical sense of composition in the manner of the Old Masters. He returned to London in April 1886 where he died three months later. His work was seen in *Tasmanian Vision*: TMAG and QVMAG 1988 and *The Great Australian Art Exhibition* 1988–89.

AWARDS: Bursary (raised in Launceston by public subscription), 1856.

REP: NGA; most state galleries; several regional galleries including Ballarat, Launceston, Warrnambool; NLA; Mitchell, Dixson Libraries; Joseph Brown collection.

BIB: *ADB* 1. Kerr, *DAA. A&A* 25/1/1987.

DOWLING, William Paul

(b. c. 1824, Dublin, Ireland; arr. Tas. 1849; d. 1875, Launceston, Tas.) Painter. An Irish political prisoner sent out for sedition and pardoned in 1857, he became a well-known and successful portrait painter in Launceston 1851–53 and Hobart 1853–58. He produced hand-coloured photographic portraits with his brother 1859–69 and solo from then, becoming well-known for his oil over-painting of photographs, exhibiting in such exhibitions as the *Intercolonial Exhibition*, Sydney 1866. His early work includes a pencil and watercolour drawing of the four Crowther children 1851 (collection Crowther Library), formerly attributed to Thomas Bock, and included in his portraits is one of Sir Richard Dry (1815–69), Premier of Tas.

REP: QVMAG; Ballarat Fine Art Gallery; Mitchell, Allport, Crowther, Launceston Libraries.

BIB: C. Craig, *Old Tasmanian Prints*, Foot & Playstead, Launceston, 1963. J. Cato, *The Story of the Camera in Australia*, Melbourne 1955. Eve Buscombe, *Artists in Early Australia and Their Portraits*, Sydney 1979. Kerr, *DAA*.

DOWNER, Una Stella (née Russell)

(b. 9/5/1871, Sydney) Painter.

STUDIES: Julian Ashton's, Sydney, c. 1890; London, with W. Bayes, c. 1930. She painted watercolours of Sydney, the NSW coast and Tasmania in the 1880s, and exhibited in Sydney in 1896 before marrying Sir John Downer and moving to SA, where she continued to paint. After her husband died in 1915 she travelled extensively till 1919 when she married D'Arcy Addison of Hobart (where she lived till 1928). She then went to London to continue her studies and painted in Europe and England during the 1930s, returning to SA in 1935; thereafter she painted little. She signed 'Una S. Downer' while married to Downer and 'Una Addison', or 'U.A.', during her second marriage.

BIB: Rachel Biven, *Some forgotten . . . some remembered*, Sydenham Gallery, Adelaide, 1976.

DOYLE, Clint (Clinton James)

(b. 26/9/1960, Sydney) Painter.

STUDIES: BA (Visual Arts), SCA, 1988; Grad. Dip. (Visual Arts), SCA, 1989; enrolled MA (Visual Arts), SCA, 1992– . He held one exhibition at First Draft West, Sydney 1990, and participated in seven group exhibitions at private galleries (including Roslyn Oxley9, Sydney; Milburn + Arte, Brisbane; Yuill Crowley, Sydney) and *The New Naturalism*, IMA, Brisbane 1989.

AWARDS: William Dobell Scholarship, SCA, 1987; Basil and Muriel Hooper Scholarship, AGNSW, 1988.

DREDGE, Margaret

(b. 1928, Murrumbeena) Painter.

STUDIES: Melbourne, with Nancy Grant and Robert Grieve. Her large abstract-expressionist canvases appeared in exhibitions in Victoria as well as in many competitive exhibitions, notably in the annual Inez Hutchison prizes. Member of Melbourne Contemporary Artists, and CAS, Melbourne.

AWARDS: Shire of Flinders Award (shared), 1976; TMAG acquisitions award, 1978.

REP: TMAG; Monash Uni.

DREW, Dudley Joseph

(b. 20/3/1924, Warrnambool) Painter. Largely self-taught painter of portraits, landscape and still-life. His popular landscapes show the influence of Buckmaster and his portraits that of late impressionism in Melbourne in the 1930s. He holds yearly exhibitions at his own studio/gallery and painting commissions included one of Sir Edward ('Weary') Dunlop.

AWARDS: A number of regional and municipal art prizes including at Albury 1963, Woodend, Werribee, Keilor, Waverley.

REP: Several regional collections; corporate collections including VSO, State Bank, Melbourne.

DRIDAN, David Clyde

(b. 15/12/1932) Painter, administrator, teacher.

STUDIES: SASA, 1949–51; ESTC, 1956; London Polytechnic, 1961; travel studies UK, Europe and USA,

1961–62. From 1969 he devoted all his time to painting and teaching privately and became interested in viticulture. Meticulous in observation and representation of grass, sand, foliage and wildlife, his mostly medium-sized oils on canvas offer a convincing, detailed view of the pastoral and coastal regions of SA. He is the author of *The Art of Hans Heysen*, Adelaide, 1966.

AWARDS: British Council grant, 1961 (for studies at the Victoria and Albert Museum, London).

APPTS: Professional assistant, AGSA, 1959–61, keeper of paintings, 1962–64; teaching, senior art master, St Peter's College, Adelaide; artistic director, John Martin & Co., 1964; started the North Adelaide Galleries in 1966; member, Commonwealth Art Advisory Board, c. 1970, Canberra.

REP: NGA; AGSA; AGWA; QAG; QVMAG; Launceston regional gallery.

BIB: Arthur Rhymill, *David Dridan*, Hyde Park Press, Adelaide, 1972.

DRYSDALE, (Sir) George Russell

(b. 7/2/1912, Bognor Regis, Sussex, Eng.; arr. Aust. in childhood; d. 29/6/1981, NSW) Painter.

STUDIES: With George Bell, Melbourne, 1931 and 1935–38; Grosvenor School, London, 1938–39; Le Grand Chaumière, Paris, 1939. Formally educated at a preparatory school in England, then at Geelong C. of E. Grammar School, Vic., Drysdale began his working life as a jackeroo, working afterwards in Qld in the family sugar mills of which eventually he became a director. In 1933 he married Elizabeth Stephen. Meanwhile his preliminary studies with George Bell had been followed by full-time studies (1938–39), climaxed by the experience of London, Paris, and the 1939 Melbourne *Herald* exhibition of French and British Modern Art (*see* EXHIBITIONS). But the catalyst that really shaped his career was his experience of World War II. Defective eyesight kept him out of the armed services that indirectly claimed the life of his best friend, Peter Purves Smith (q.v.), whose widow was to become his second wife. What he could contribute to the war effort had to be through his art. He was now living in Sydney where his friends included Dobell, Friend, and the critic Haefliger. The French influences were now modified by what he learned from the work of the British wartime painters Sutherland and Piper, whose techniques and wartime vision led to the formation of a personal Drysdale style, strongly expressive of contemporary tensions and portents. Formerly despised materials such as crayons and coloured inks (resorted to also as a wartime economy measure) made it possible to obtain dramatic acidity of colour, strongly expressive of the spirit of the times. The period yielded subjects such as aeroplane hangars at night, fire-devastated ruins and grouped figures in uniform, the latter deriving also from the influence of Henry Moore's studies of figures in the London underground shelters. In 1944 Drysdale applied these lessons to the expression of a different kind of tragedy, that of the drought conditions in northern NSW. As a preliminary to later paintings he made a series of line-and-wash drawings commissioned by the *Sydney Morning Herald*. These drawings of erosion, decay and the bleached carcasses of animals represented the beginnings of a new era of Australian regional art; the subjects were soon extended to include deserted outback towns and landscapes in which long low horizon lines were opposed by the verticality of trees, buildings and figures. Paintings of ghost towns and pubs, each with its complement of elongated figures of stockmen, station hands and half-caste families occupied Drysdale's energies for some years. As time went on the dry reds and yellows, with accompanying browns, blacks, greys and whites, became allied to the rich tonal range of the Venetian masters whom Drysdale had studied in the Louvre in company with Peter Purves Smith during their joint early studies in Paris.

Drysdale made further trips overseas in 1950, 1957 and 1965, and between 1957 and 1965 toured by caravan through Central and Western Australia. This period produced some of his most dramatic canvases; in place of the former eloquent spaces, the large, full figures of Aborigines began to fill the foregrounds. *Snake Bay at Night*, 1959, and *Ceremony at the Rock Face*, 1963, are among the paintings of this period. In 1960 his work was the subject of a large retrospective exhibition at the AGNSW; and a later retrospective was held at John Martin Galleries, Adelaide, in 1964 to coincide with the Adelaide Festival of Arts. Throughout his career his first love had been drawing. The hundreds of drawings that fill his sketchbooks are like signposts pointing to the people, places, and events that gave him his unique place in the Australian art of his time.

APPTS: Member, Commonwealth Art Advisory Board, Canberra, 1962–72; member, Board of Trustees, AGNSW, 1963–76.

AWARDS: Wynne prize, 1947; Melrose prize, 1949; Britannica Australia award, 1965; knighted, 1969; AC (Companion of the Order of Australia) conferred, 1980.

REP: NGA; AGNSW; AGSA; AGWA; MAGNT; NGV; QAG; QVMAG; TMAG; many regional galleries; Tate Gallery, London; MOMA, New York.

BIB: Joseph Burke, *The Paintings of Russell Drysdale*, Ure Smith, Sydney, 1951. Geoffrey Dutton, *Russell Drysdale*, Thames & Hudson, London, 1964. All major Australian art books, reviews and catalogues. A&A 1/1/1963; 19/2/1981; 20/4/1983; 25/1/1987.

DUBOIS, C.

Graphic artist. Awarded first prize (Special Frontline Sketch section), *Australia at War* exhibition, NGV, 1945.

NFI

DU CANE, (Sir) Edmund Frederick

(b. 23/3/1830, Colchester, Eng.; arr. WA 1851; d. 7/6/1903, London) Amateur artist, engineer, prison administrator. Son of a major, he was commissioned to the Royal Engineers in 1848 and came to WA to superintend works for the convict establishment. During an exploratory expedition to Geraldton in about 1851

he produced some watercolours of the coastline and sketches of Aborigines and the coast. His watercolours of buildings, bridges and colonial life were often humorous accompaniments to letters home. He returned to London in 1856, was appointed to the board of directors of convict prisons and became an authority on penology for which he was knighted in 1877. He wrote a book on prevention of crime, enlightened for its time, as well as recollections of the Swan River Colony in the *Cornhill Magazine*, 1897. His work was seen in *The Colonial Eye* AGWA, 1979.
BIB: A. Hasluck, *Royal Engineer: A Life of Sir Edmund Du Cane*, Cremorne, NSW 1973. Kerr, *DAA*.

DUCHÉ De VANCY

(d. 1788) Painter, draughtsman, engraver. He worked in Paris, where he was known mainly for his figure and portrait prints, before accompanying La Pérouse on his ill-fated voyage to the Pacific.
BIB: Smith, *EVSP*. Bénézit, *Dictionnaire*, 1976.

DUCKETT, Thomas

(b. 1839, Kendal, UK; arr. Aust. 1866; d. 26/4/1868, Sydney) Sculptor, painter. Friendly with von Guérard in Melbourne in the 1860s, he modelled von Guérard's portrait in a medallion and produced a pencil sketch of him in 1866, the medallion being exhibited in the Melbourne *Intercolonial Exhibition* of that year. He modelled medallions and plaster portrait busts in Launceston and Sydney and received a commission to produce a series of 11 portrait transparencies of famous explorers in honour of Prince Alfred's visit to Sydney in 1868. Never completed, some of the sketches for these survive and are with other sketches in the Harris Museum and Art Gallery, Preston, UK.
BIB: Kerr, *DAA*.

DUDLEY, Rod

(b. 1935, Melb.) Sculptor, painter.
STUDIES: Dip. Art and Craft, Melb. State Coll., 1961; Brera Academy, Milan, with Marini, 1965. He taught art in Victorian high schools, 1962–64 and in 1965 an Italian Government grant took him to Italy where he achieved considerable success and has since lived. Constructed of polished, laminated wood, leather, fur and synthetic materials garishly painted, his macabre nudes appear as grotesque symbols of society ladies outrageously glimpsed in distorting mirrors. Dudley's exhibitions included approximately 30 solo exhibitions 1969–93 in Europe (Amsterdam, Milan, Rome, Paris, Brussels, Besozzo, Genoa, Ravenna), as well as several in Australia at Bonython-Meadmore, Sydney; MCA, Melbourne; Canberra School of Art; and Adelaide Festival Centre.
AWARDS: Italian Government grant, 1965; Dyason scholarships, AGNSW (two grants), 1965.
REP: AGSA; QAG; AWM; MCA, Sydney; Adelaide Festival Centre; corporate and private collections including Transfield, Philip Morris, Elton John and a number of European collections.
BIB: Scarlett, *AS*.

DU FAUR, Eccleston Frederick

(b. 1832; d. 1915) Foundation trustee of the AGNSW, with E. L. Montefiore. He also organised the artists' and photographers' camp in the Grose Valley of the Blue Mountains, 1875, attended by such painters as William Charles Piguenit (q.v.).

DUHIG, (Dr) J. V.

(b. 1889, Brisbane; d. 1963, Brisbane) Lecturer, critic. Lecturer in Pathology, Uni. of Qld, 1937–46; art critic, president of RQAS, 1937–46. He added a collection of books and pictures to the Darnell Collection, Uni. of Qld.
AWARDS: Luffman Memorial prize for literature, 1934.
BIB: Vida Lahey, *Art in Queensland 1859–1959*, Jacaranda Press, Brisbane, 1959.

DUKE, William

(b. 1817?, UK; arr. Sydney 1840; d. 17/10/1853, Tas.) Painter. Originally a carpenter, he was also a scene painter for Sydney theatres for a time before visiting NZ and arriving back in Australia, at Hobart, in 1845. He became a portrait painter and scene painter for Hobart Town Royal Victoria Theatre c. 1846, as well as producing lithographs of buildings and the whaling industry, engraved by R. V. Hood (q.v.), 1848. Other works include paintings of landscapes and views of properties. A work of his was included in the Christie's sale of the Clifford Craig Collection in 1975 and his work appeared in *Tasmanian Vision*, TMAG 1988 and *The Great Australian Art Exhibition* 1988–89.
REP: QVMAG; TMAG; Geelong regional gallery; Mitchell, Crowther Libraries; NLA.
BIB: Kerr, *DAA*.

DULDIG, Karl

(b. 1902, Przemysl, Austria; arr. Aust. via Singapore, 1941; d. 1986, Melb.) Sculptor, teacher.
STUDIES: Kunstgewerbe Schule, Vienna; privately with Anton Hanak, 1921–25; Academy of Fine Arts, Vienna, 1926–33. Interrupting his art studies was his success in sport, first as an international soccer player (as goalkeeper for Vienna's Hakoah), then as a tennis player and, finally, as title-holder, on two occasions, of the Austrian open table-tennis title. His studies with Hanak had taught him the value of letting materials such as marble or steatite suggest their own forms. Inspired by the carvings of antique Greece and Egypt, he produced some of his best work during his late student period. His Australian work was widely varied, often involving the use of local materials. In 1982–83 McClelland Gallery held a retrospective of his work, and works by him are in a number of public locations in Melbourne including City of Caulfield Municipal Offices; Carlton War Memorial; Melbourne General Cemetery; Raoul Wallenberg Monument at Kew Junction. In 1986 the NGV mounted an annual lecture on sculpture in his name, in 1988 the Caulfield Arts Centre held a retrospective of the ceramics of Karl and Slawa Duldig (q.v.) and in 1990 the NGV

included a large component of his sculptures in *Vienna and the Early Twentieth Century*.

APPTS: Teaching (part-time), Mentone Grammar School, 1945–67; elected president, Association of Sculptors of Victoria, 1976–c. 1980s.

REP: NGA; NGV.

BIB: Eric Westbrook, *Karl Duldig*, intro. Pamela Ruskin, Cheshire, Melbourne, 1966. Sturgeon, *DAS*. Scarlett, *AS*.

DULDIG, Slawa (née Horowitz)

(b. 1902, Horocka, Poland; arr. Aust. 1941; d. 1975, Melb.) Sculptor, inventor, teacher.

STUDIES: Academy of Fine Arts, Vienna, 1925–29. Soon after leaving art school she invented the folding umbrella. Manufactured in Austria and Germany, the umbrella sold more than 10,000 in the first year of production, Slawa Duldig drawing annual royalties until 1938, when she sold the patents and escaped from the Nazi occupation of her country. With her baby, Eva, she joined her husband in Singapore where the family stayed for three years. She taught art and languages at Korowa C. of E. Girls Grammar School, 1945–47, and art and crafts at St Catherine's from 1947 (in 1992 the Duldigs' daughter, Ewa de Jong-Duldig, mounted an exhibition of these students' work found in her home). Classic in style, her drawings and sculptures were the subject of a retrospective, memorial exhibition at the McClelland Gallery, Langwarrin, in Oct. 1977 and in the Duldig Ceramics at Caulfield Arts Centre 1988. She was represented in *Vienna and the Early Twentieth Century*, NGV 1990.

DUMBRELL, Lesley

(b. 14/10/1941, Melb.) Painter.

STUDIES: RMIT, 1959–62. Her early exhibitions in Sydney, Melbourne, Brisbane and Canberra from 1969 introduced personal variations of a style of stripe painting based on the work of the painter she most admired, Bridget Riley. Beginning with restrained forms and colours, she gradually varied her palette and her abstract stick-like forms became freer and lighter, a style which she retained in her work of the 1980s and 1990s. She held over 20 solo exhibitions 1969–92 largely at Christine Abrahams, Melbourne; Ray Hughes, Brisbane; Macquarie, Sydney and at Monash Unviersity Gallery 1977, and participated widely in group exhibitions at public galleries including *Australian Colourists '77*, WAIT 1977; *Australian Perspecta '81*, AGNSW 1981; *A Melbourne Mood: Cool Contemporary Art*, NGA 1983; *Colour and Transparency* (with Robert Jacks and Victor Majzner), touring to NGV, AGNSW, AGWA and Venice 1986; *Australian Biennale 1988*, AGNSW 1988; *Drawing in Australia 1770s–1980s*, NGA 1988. She was artist-in-residence at Monash Uni. 1977 and has been a member of several professional bodies and committees including Member of Council, VCA, 1985– .

AWARDS: Georges prize (purchase awards), 1974, 77, 79; Camden City prize (purchase), 1979; Hamilton Art Award (R. M. Ansett), 1980; Alice Prize, 1983.

APPTS: Teaching part-time, including lecturing, VCA 1980–83, 84–85.

REP: NGA; most state galleries; regional galleries Hamilton, Sale.

BIB: Catalogue essays exhibitions as above. Chanin, *CAP*. *A&A* 18/1/1980. Smith, *AP*.

DUNCAN, George Bernard

(b. 7/1/1904, Auckland, NZ; d. 1974, Sydney) Painter, gallery director.

STUDIES: RAS, with Dattilo Rubbo, –1926; travel studies UK and Europe, 1934–39. Throughout his working life he maintained a close working relationship with his wife, Alison Refisch (q.v.). They held joint exhibitions, appeared in many of the same group shows, and responded to the same impressionist-cubist influences. Returning to Sydney in 1939 he worked as a camouflage artist and became a member of the CAS, Sydney (treasurer 1950, president 1953). He was also president of the Australian Watercolour Institute, 1958. In 1947 the Duncans' George Street studio was destroyed by fire and they moved to Newcastle and Berrima, returning to Sydney when George became director of David Jones Art Gallery (1953–64). Their last joint exhibition was held in 1958. A memorial exhibition was held at the Macquarie Galleries in April 1976.

AWARDS: Students' prize, RAS, Sydney, 1926.

REP: NGA; AGNSW; AGWA; NGV; QAG; Qld Uni. collections.

DUNDAS, Dorothy

(b. 1910, Eng.; arr. Aust. via NZ, 1929; d. 15/5/1987, Sydney)

STUDIES: ESTC, 1930s; RA, London, 1930s. She returned to Australia in 1935 and became highly regarded as a life-drawing teacher at ESTC, exhibiting her own work simultaneously. In 1941 she married Douglas Dundas (q.v.), with whom she occasionally exhibited.

DUNDAS, Douglas Roberts

(b. 1900, Inverell, NSW; d. 1981, NSW) Painter.

STUDIES: Sydney Art School (with Julian Ashton and Henry Gibbons); London Polytechnic (with Harry Watson and W. Matthews); Paris (with André Lhote), 1929. He exhibited largely in Sydney and with the NSW Society of Artists from the 1940s and his work became well-regarded for its strong modernistic style and portrayal especially of the streets and houses of inner Sydney. He contributed frequent articles to magazines such as *Art in Australia*.

APPTS: Teaching, ESTC, 1930–61; head of NAS, 1961–65; trustee of the AGNSW, 1948–69; president of the NSW Society of Artists from 1948.

AWARDS: NSW Society of Artists Travelling Scholarship, 1927; Wynne prize, 1943.

REP: AGNSW; most state galleries; Armidale Teachers College collection.

BIB: Horton, *PDA*, Refs. *AA* 1937, 1938 and 1940.

DUNKLEY-SMITH, John

(b. 16/6/1946, Ballarat, Vic.) Painter, lecturer, administrator.

STUDIES: Trained Primary Teachers Certificate, Ballarat Teachers College, 1965; TSTC, Melb. State Coll., 1966; Dip. Art (painting), Ballarat School of Mines, 1973; postgrad. dip., Film and Television, Hornsey Coll. of Art, London, 1975; MFA (painting), VCA, 1991. Working largely in the areas of film and installation art, he held usually three to six showings/exhibitions annually 1976–93 including in London, NY, Melbourne (including at Art Projects, RMIT, Uni. of Melbourne Gallery, ACCA), Sydney (including with Yuill/Crowley, Artspace, Roslyn Oxley9) and at IMA Brisbane. His work appeared in a number of group exhibitions 1971–92 largely at contemporary art spaces, including *Film London*, Third International Festival of Avant Garde Film, London 1981; *Biennale of Sydney*, AGNSW 1982, 86; *Australia: Nine Contemporary Australian Artists*, Los Angeles Institute of Contemporary Art, 1984; *The Elusive Sign*, Australian avant-garde program, Australian Film Institute, Sydney and Melbourne 1990; *Location*, ACCA 1992. He was commissioned for an integrated artwork for the new Melbourne Cricket Ground stand in 1991 and was artist-in-residence and visiting artist at a number of tertiary colleges including SCA, Darwin Institute of Technology, SACAE.
AWARDS: Grants, Experimental Film and Television Fund, 1976; Aust. Film Commission, 1978; VACB, 1981, 87.
APPTS: Lecturer, various tertiary colleges including PIT, SCA, VCA; deputy dean and co-ordinator postgrad. studies, VCA, 1992– .
REP: NGA; AGSA; NGV; Film Collection, NLA.
BIB: Catalogue essays as above. Paul Taylor, *Anything goes: Australian Art in the Seventies*, Art and Text, Melbourne 1984. A&A 17/3/1980; 21/2/1983; 24/3/1987. A&T Spring 1981; no. 28, March–May 1988.

DUNLOP, Brian James
(b. 14/10/1938, Sydney) Painter.
STUDIES: Dip. Art, ESTC, 1954–59; travel studies, southern Europe, 1960; Europe and UK, 1963–68. His large, realistic interiors with light falling on nudes and figures have a touch of the sensuousness of Balthus, a characteristic reflected also in his drawings. His paintings, especially of interiors with a solitary figure, became during the 1970s and 80s increasingly atmospheric, enhanced by technical finesse. He held numerous exhibitions 1963–92 including Sydney (Barry Stern, Macquarie), Melbourne (Australian) and all other capitals. Group exhibitions in which his work appeared 1970s–90 included *Australian Realists*, AGSA 1977; *What is This Thing Called Science?*, Melbourne Uni. Gallery 1987 and at the NGA and many state, regional and other public galleries. He was artist-in-residence at the Uni. of Melbourne in the early 1980s and his many portrait commissions include Victoria's sesquicentenary portrait of HM Queen Elizabeth II.
AWARDS: Le Gay Brereton prize for drawing, AGNSW, 1958; Hamilton Gallery (R. M. Ansett purchase award), 1976; MPAC Spring Festival of Drawing purchase, 1977; Civic Permanent award, Canberra, 1976, 77; Sulman prize, 1980.

APPTS: Teaching, part-time various art colleges 1968–80s including ESTC, Uni. of NSW (architecture school), Alexander Mackie.
REP: NGA; all state galleries; Parliament House; Artbank; most regional galleries Vic., NSW, SA, WA, Tas.
BIB: Bonython, MAP 1980. Paul William White, *The Art of Brian Dunlop*, Craftsman Press, 1984. Lynne Strahan, *Brian Dunlop*, Craftsman House, 1990. A&A 16/3/1979 (Jeffrey Smart, *Brian Dunlop's Room*); 18/4/1981; 19/4/1982.

DUNN, E. C.
(Active c. 1852, Ballarat, Vic.) Goldfields artist (one of the earliest on the Ballarat goldfields). He made a series of sketches for the *Illustrated London News*, 22 May 1852.
BIB: McCulloch, AAGR.

DUNN, Noel
(b. 1933, Melb.) Sculptor, architect.
STUDIES: Uni. of Melb. (architecture), 1951–58; travel studies UK and Europe, 1961–65. In 1967 he exhibited in the Alcorso-Sekers Sculpture Competition in Sydney and became associated with the new abstractionist painters and sculptors at the Central Street gallery. His painted, pyramidal sculpture, reductive in style and cut from sheets of steel in right-angled patterns, appeared also in *The Field*, NGV 1968.
REP: Uni. of New England.
BIB: Scarlett, AS.
NFI

DUNN, Richard
(b. 13/9/1944, Sydney. Painter, installation artist, administrator)
STUDIES: School of Architecture, Uni. of NSW, 1962–64; NAS (part-time), 1963; Mary White School, with John Olsen, 1963–64; MA, Royal College of Art, London, 1969. He visited New York in 1968 and after his return to London became a guest tutor at St Martin's School of Art. He was a contributing editor of *Rolling Stone* and *Friend's* magazines, London, 1969–70. Many exhibitions made his work known in Sydney, Melbourne and Adelaide as well as in London. Simple, contrasting tone-colours and sensuous textures are features of the large canvases that relate his work to New York School painting. His subjects in the 1980s were concerned with events in Australian history and the power relationships in society and he held about 20 solo exhibitions 1972–91 including at IMA, Brisbane (1979, 85); Yuill/Crowley, Sydney; and Tolarno, Melbourne. Group exhibitions in which he participated included *POPISM*, NGV 1982; *D'Autre Continent: L'Australie, Le Rêve et le Réel*, ARC/Musée d'Art Moderne de la Ville de Paris, 1983; *Biennale of Sydney*, 1979, 90; *Field to Figuration*, NGV 1987; *Australian Perspecta*, AGNSW 1988, 90 and many international exhibitions including *The Australian Exhibition*, touring Germany 1988–89; *Art from Australia: Eight Contemporary Views*, touring SE Asian public art galleries 1990–91. The AGNSW held an exhibition of his work, *The Dialectical Image: Selected Work 1964–92*, in 1992.

AWARDS: NSW Travelling Scholarship, 1966; Dyason scholarship, 1967; VACB grants 1975, 77, 80; PSI Fellowship, ICA, New York 1989.

APPTS: Lecturer and senior lecturer 1977–87, head of school of visual art 1987, director 1988, SCA; professor, SCA, Uni. of Sydney 1990– .

REP: NGA; AGNSW; AGSA; NGV; MCA, Sydney; Royal College of Art, London; New Museum, New York; regional galleries including Ballarat, New England; corporate collections including Myer Foundation; NAB collection; Chase Manhattan Bank, NY.

BIB: Catalogue essays exhibitions as above. *A&T* Spring 1983. *A&A* 23/3/1986. *AM* October 1988. Smith, *AP*.

DUNNE, Frank

(b. c. 1897; d. 23/12/1937) Cartoonist. During World War I he served with the First Field Ambulance and afterwards succeeded Cecil Hartt as a staff artist for *Smith's Weekly*. His work was seen in *Fifty Years of Australian Cartooning*, Myer Mural Hall, Melbourne, Nov. 1964.

DUNNETT, Frank

(b. 1822, Scotland; arr. Melb. 1856; d. 12/10/1891) Painter, engraver, teacher. He studied at the RA Schools, London with J. M. W. Turner before coming to Australia, first to Melbourne then shortly afterwards to Hobart where one of his co-workers in the Hobart Town Survey Office was William Charles Piguenit whom he later instructed in painting. An experienced lithographer, he produced lithographs and watercolours of Hobart and surrounding areas as well as portraits, including Governor Gore Browne. His work was seen in *Tasmanian Vision*, TMAG & QVMAG, 1988.

REP: TMAG; Mitchell and Crowther libraries.

BIB: C. Craig, *The Engravers of Van Diemens Land*, Foot & Playstead, Launceston 1961. H. Allport, *Early Art in Tasmania*, Hobart 1931. Kerr, *DAA*.

DUPAIN, Max (Maxwell Spencer)

(b. 1911, Sydney; d. Nov. 1992, Sydney) Photographer. STUDIES: ESTC; Julian Ashton School. His career in photography began with work in the commercial studios of Cecil Bostock, a founding member of the Sydney Camera Circle, and Dupain opened his own studio in 1934. His training in the visual arts and contacts with Sydney artists soon gave his photographs unique distinction. During World War II he was a camouflage officer in the RAAF and became a photographer with the Department of Information. Returning to Sydney after the war he resumed his photographic career. His versatile approach spanned many fields including portraiture, landscape and architecture. He held numerous solo exhibitions from 1930 in Australia and internationally and his work was the subject of a number of retrospectives including at NGA 1975, 91; Aust. Centre for Photography 1975, 80, 87; AGNSW 1980; NGV 1975. He was commissioned to produce photographs for a number of books including *Sydney Builds an Opera House*, Zeigler, Sydney, 1973; *Architecture of the New World: The Work of Harry Seidler*, Horwitz,

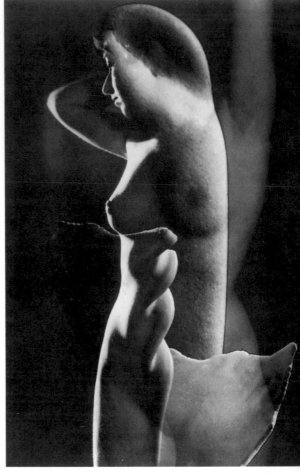

Max Dupain, Impassioned Clay, *1937, gelatin silver photograph, 46 × 32.9cm. Collection, NGA.*

Sydney, 1974. His work was represented in two Bicentennial exhibitions — *Shades of Light: Photography in Australia*, NGA 1988 and *The Great Australian Art Exhibition* 1988–89. Collections of his works have appeared in a number of books including *Max Dupain Photographs*, Ure Smith, Sydney, 1948; *Max Dupain's Australian Landscapes*, Viking, Melbourne, 1988.

APPTS: Camouflage officer in Australia and New Guinea, 1939–45; photographer for the Dept of Information, 1945.

AWARDS: OBE, 1982; honorary fellow, RAIA, 1983.

REP: NGA; most state galleries.

BIB: A number of standard texts on Australian art and photography. *A&A* 13/2/1974; 30/2/1992.

DUPREE, Geoffrey

(b. 23/2/1947, UK; arr. Aust. 1955) Painter. STUDIES: Dip. Fine Art (painting), City and Guilds of London Art School, 1975; advanced painting certificate, St Martin's School of Art, London, 1977. Super-realistic images of largely urban landscapes characterise his work and he held four solo exhibitions at

Australian Galleries, Melbourne (1979, 82, 89) and a touring exhibition to four Vic. regional galleries 1991–92. Group exhibitions in which his work appeared 1977–92 in London and Australia include *Trustees Purchase Exhibition*, QAG, 1979; *Seven Painters: Different Viewpoints*, Uni. of Melbourne 1982; *The Face of Australia*, Bicentenary exhibition; *Archibald Prize*, 1990.

AWARDS: Three UK prizes.

APPTS: Part-time tutor and senior tutor, Gippsland Inst. of Advanced Education, 1979–83; part-time principal tutor and lecturer, Chisholm Inst. of Technology (now Monash Uni.), 1981– .

REP: NGV; Artbank; Latrobe Valley Arts Centre.

BIB: Catalogue essays exhibitions as above. McKenzie, DIA.

DURACK, Elizabeth

(b. 1915, Perth, WA) Painter, illustrator, writer.

STUDIES: Loreto Convent, Perth; London Polytechnic, 1936–37. Her life on Argyle and Ivanhoe cattle stations, WA, where she was brought up with her sister, writer Mary Durack, gave her an intimate knowledge of Western Australian Aborigines and their culture, the themes of most of her work as a painter and illustrator. Later her extensive travels brought her into contact with other cultures. First of her many exhibitions was in the AGWA, 1946, and a large retrospective of her work was held in the same gallery in 1965.

AWARDS: OBE conferred, 1966.

REP: NGV; AGNSW; AGSA; AGWA; QVMAG; a number of tertiary collections including Murdoch Uni.; WAIT; corporate collections.

BIB: *Australian Art Today*, MacRobertson Miller Airlines, Perth, 1963. *Australian Aboriginal Heritage*, Berndt and Phillips 1973. *Contemporary Western Australian Painters and Printmakers*, Fremantle Arts Centre Press 1979. *The Art of Elizabeth Durack*, A&R, 1983.

DURHAM, Kate (Katherine Burgoyne)

(b. 9/1/1957, Vic.) Decorative artist.

STUDIES: Dip. Fine Art, Chisholm Inst., 1978; postgrad. dip. Fine Art, VCA, 1980. A jeweller, illustrator, interior designer and sculptor, Durham's design talents have been turned to projects as diverse as individual pieces of jewellery and clothing; murals and interior designs theatre costumes and sets; stationery design; and frequent talks, lectures and seminars. She is a member of various cultural advisory boards including the Fashion Design Council of Australia. She held about six solo exhibitions 1979–92 including at Barry Stern, Sydney, and Daimaru Gallery, Melbourne, 1991. Her work appeared in about 40 group exhibitions 1979–91 at craft galleries in Melbourne, Sydney, Canberra and numerous public and regional galleries including *Art Clothes*, 1980–81, *Sydney Harbour Bridge*, 1982, *Art Knits*, 1988, all at AGNSW; *Australian Crafts*, Meat Market, Melbourne 1984; *Sydney Exhibition 1991*, Powerhouse Museum, Sydney 1991. International group exhibitions include those at department stores (Nieman Marcus Store, Dallas, USA 1987; LOFT Store opening

and exhibition Seibu Department Stores, Osaka, Japan 1990).

REP: NGA; AGNSW; NGV; Powerhouse Museum.

DURKIN, Tom

(Active c. 1874–1900, Brisbane and Melb.) Cartoonist. Contributor to many periodicals, mainly in Melbourne. He gave lessons to Ambrose and Will Dyson, and was sole illustrator of a paper called *The Bull-Ant*, which he founded with Edward Dyson, a brother of Ambrose and Will, who supplied all the text. Among papers to which he contributed were *Sam Slick in Victoria*, 1879; *Tomahawk*, 1880; *Life*, 1885; Sydney *Bulletin* (from 1889); *Bull-Ant*, Melbourne, 1890–92.

BIB: Mahood, *The Loaded Line*, 1973.

DURRANT, Ivan John

(b. 1947, Melb.) Painter, photographer, performance artist.

STUDIES: BA, Monash Uni., 1969. From the age of seven he lived in an orphanage (1954–62), where he developed a passion for birds and animals often during time spent on farm holidays. Re-united with his family in 1962, he developed his interest in painting, and in April 1970 held his first exhibition at Tolarno Galleries, St Kilda. Painted in semi-primitive style, his pictures of pigeons, Friesian cattle and other domestic animals reflected his interest in farm life and the animal considered as produce. His 1971 Tolarno exhibition revealed a considerable talent for pattern-making. Later, to demonstrate his concern for the fate of farm animals, he began an intermittent series of public performances, some of a macabre and sensational nature. His 'shot cow', 'severed hand', 'pigeon dinner' and other performances, developed also through his growing skills in photography, attracted wide publicity and some caused police intervention, especially the occasion when he dumped a dead cow on the steps of the NGV in both an animal rights and artistic statement. He held about 25 solo exhibitions 1970–93, largely at Tolarno and United Artists, Melbourne; also at Hogarth, Sydney and Benalla Regional gallery survey exhibition 1989. Group exhibitions in which his work appeared included *Animal Images in Art*, touring regional Vic. galleries 1989; *Thinking Allowed*, Ray Hughes 1991; *The Great Australian Art Exhibition*, touring state galleries 1988–89.

AWARDS: Caulfield Art Centre acquisition, 1976; Maude Vizard-Wholohan prize, Adelaide, 1977; VACB overseas travel grant, 1978.

REP: NGA; AGSA; NGV; regional galleries including Benalla, Latrobe Valley, Geelong; Caulfield Arts Centre.

BIB: Catalogue essays exhibitions as above. A number of reference books on contemporary Australian art including Smith, AP.

DUTERRAU, Benjamin

(b. 1767, London; arr. Hobart 1832; d. 1851, Hobart) Engraver, painter, etcher, sculptor. Trained as an engraver, he had six portraits in RA exhibitions 1817–23 before coming to Tasmania where he had been offered

a teaching position (filled by the time he arrived belatedly). Arriving in Tasmania late in life (aged 65), he gave the first lecture in Australia on the subject of painting to a small audience at Hobart Mechanics Institute, in 1833. He contributed 'The School of Athens as it Assimilates with the Mechanics Institution' to a series of seven published lectures delivered at the Institute during the first part of the session conducted in 1849. He is best-known for his paintings of Tasmanian Aborigines, which he completed 1833–43. The largest of these is called *The Conciliation*, painted between 1833 and 1835 (TMAG collection) as a result of George Robinson's achievement in rounding up, at government expense, all known remaining Tasmanian Aborigines with the object of accommodating them on a large government reserve. William Moore describes this work as Australia's first historical picture and goes on to say that as the Aboriginal models came into Hobart, Robinson took them to the studio where Duterrau was working. Duterrau also completed a series of high relief sculptures of Aborigines in plaster, as well as etchings of the same subject (c. 1835–36), some of the earliest known to have been produced in Australia. A number of his portraits of early settlers are now also in public collections. His work appeared in *Tasmanian Vision*, TMAG 1988; *The Tasmanian Aboriginal in Art*, TMAG 1976 and *The Great Australian Art Exhibition* 1988–89.

REP: NGA; QVMAG; TMAG; NLA; Mitchell, Crowther Libraries; British Museum.

BIB: ADB 1. Eve Buscombe, *Artists in Early Australia and their Portraits* Sydney 1978. C. Craig, *The Engravers of Van Diemen's Land*, Foot & Playstead, Launceston, 1961. Moore, SAA. Scarlett, AS. Kerr, DAA.

Dutkiewicz, Ludwik
(b. 2/2/1921, Poland; arr. Aust. 1949) Painter, stage designer, film director.
STUDIES: Lopoh's Tech. Coll., School of Art, Poland, c. 1939. A leading member of the CAS, SA, Dutkiewicz's works are largely formal abstract pictures. His brother is Wladyslaw Dutkiewicz (q.v.). He worked as a plant illustrator at the Botanical Gardens, Adelaide, 1953–62, and his illustrations appeared in several books on the flora of SA. He was a part-time teacher for one year at the SASA and the artistic director of several films, one of which, *Transfiguration*, is represented in MOMA, New York.
AWARDS: Cornell prizes, 1953, 54.
REP: AGSA; TMAG; Artbank; several uni. and art society collections SA.
BIB: Benko, ASA. Dean Bruton, *Recollections of the Contemporary Art Society of SA 1942–86*, CAS, 1988.

Dutkiewicz, Wladyslaw
(b. 21/2/1918, Poland; arr. Aust. 1949) Painter, sculptor, stage designer, theatre director.
STUDIES: Academy of Fine Arts, Cracow, Poland; Paris, 1936–37. Brother of Ludwik Dutkiewicz, he was taken prisoner and held by both the Russians and the Germans during World War II. His exhibitions of abstract expressionist pictures 1946–91 included many solo and group exhibitions including *50 Years of South Australian Art 1928–1978*, AGSA 1978; *Painting in SA Today*, AGSA 1981 and two and three person exhibitions at MOMA, Melbourne 1961 and Kensington Gallery, Adelaide 1991. For several years from 1956 following injuries received in a traffic accident he was forced to give up painting and turned to stage production, forming the Art Studio Players in Adelaide. He appeared as an actor in many television programs and was a set designer for theatre (and later film and television), first in Germany as a displaced person in the war years, then later in Adelaide. The Contemporary Art Society of South Australia held a retrospective of his work in 1993.
AWARDS: Cornell prizes, 1951, 55; shared *Adelaide Advertiser* prize with Erica McGilchrist, 1956; grant, SA govt, 1976.
APPTS: Lecturer in Art, Dept of Adult Education, 1950s and 60s; SASA; Workers' Education Association of SA, 1960s, 70s.
REP: AGSA; TMAG; Newcastle Region Art Gallery.
BIB: Bonython, MAP. Smith, AP. Benko, ASA. Dean Bruton, *Recollections of the Contemporary Art Society of SA 1942–86*, CAS, 1988.

Dutruc, John
(b. 1909, Eng.; arr. Aust. 1932) Painter.
STUDIES: Brighton Art School, England (with Charles Knight), 1927–30; Melbourne (with Ambrose Hallen and William Frater). His abstract paintings appeared in the NSW section of the CAS *Interstate Exhibition* at Preston Motors, Melbourne, 1954, and at Gallery A, Melbourne, in July 1959. He led a roving existence, droving cattle in the NT, scrub-cutting, mining for gold and tin at Tennant Creek and the Tate River. During this period he contacted Aboriginal tribes and became friendly with the writer Bill Harney, coming to a halt when he settled finally near Narrabeen, NSW. After this he worked in isolation, partly to protect himself against 'the latest trends', but also to develop a strongly individual kind of abstract painting reflecting mainly his changes of background. He held his first solo exhibition with Ray Hughes in Sydney, 1987.
REP: Grenoble Art Museum, France.

Dutton, Geoffrey Piers Henry
(b. 2/8/1922, Anlaby, SA) Writer, critic.
STUDIES: Geelong Grammar School, Vic.; Uni. of Adelaide; Magdalen College, Oxford. He wrote numerous articles, essays and books on Australian art 1962–93 including *The Paintings of S. T. Gill*, Rigby, Adelaide, 1962; *Russell Drysdale*, Thames & Hudson, London, 1964; *On My Island (Poems)*, illust. John Perceval, Cheshire, Melbourne, 1967; *S. T. Gill's Australia*, Macmillan, Melbourne, 1981; *The Myth of the Beach*, OUP, 1985; *The Innovators: Sydney Art of the 1940s*, Macmillan, 1986.
AWARDS: AO (Officer of the Order of Australia), conferred 1979.

APPTS: Senior lecturer in English, Uni. of Adelaide, 1955–62; Board member, Australia Council, 1968–70, Literature Board, 1972–74.

DUTTON, H. Orlando

(b. 1894, Staffordshire, Eng.; arr. Aust. 1920; d. 1962, Melb.) Sculptor.

STUDIES: Elementary art training at local school in Staffordshire was followed by an apprenticeship to an architectural firm in Lichfield before enlistment in World War I. Migrating to Australia in 1920 he went into partnership with a monumental stone mason in Adelaide and exhibited at the RSASA in 1923, before settling permanently in Melbourne. From c. 1929 he worked as a stonemason on the Shrine of Remembrance. By the time of the outbreak of World War II (in which he served), his commissioned work included four figures for the tower of St Paul's Cathedral, Melbourne, c. 1929; a large figure group for the Manchester Unity building, 1930–31; the façade for the Castlemaine Art Gallery; and panels for Anzac House, Melbourne, 1937. In *Australian Sculptors* Ken Scarlett lists no commissions completed by Dutton after World War II. As president of the VAS, 1946–47, he worked hard to get recognition for sculptors; he spent five years in England, 1955–60, returning to Melbourne after the death of his wife. At some time (period not known) he taught at Prahran Tech. Coll. for about six years. In 1962 he joined a deputation to the Premier of Victoria in an unsuccessful attempt to have an artist appointed to the Board of Trustees of the NGV. In the same year he died by drowning, his body being recovered from the river Yarra some days after he disappeared from his home in Kew.
AWARDS: Melrose prize, Adelaide, 1938.
REP: AGSA; NGV; regional gallery Castlemaine.
BIB: Sturgeon, *DAS*. Scarlett, *AS*.

DYRING, Moya

(b. 1908, Melb.; d. 1967, London) Painter.
STUDIES: NGV School, 1930–32. In conjunction with such NGV students as Sam Atyeo and Dominic Leon (Leo Burn) (qq.v.), she was one of the first in Melbourne to respond to cubist influences, notably in her exhibition at the Riddell Gallery, Melbourne, 1934. From 1935 she made her home in Paris and gradually adopted a more pictorial style of painting reminiscent of the work of Utrillo, returning briefly for exhibitions in Melbourne and Sydney in 1953, 1956 and 1963. She bequeathed a studio apartment (the Moya Dyring Memorial Studio) administered by the AGNSW, at the Cité Internationale des Arts, Paris, for the benefit of Australian artists (*see* ARTISTS' STUDIOS).
BIB: *Modern Australian Art*, MOMAD, Melbourne, 1958. *A&A* 4/4/1967 (David Strachan, *Moya Dyring: A Tribute*).

DYSON, Ambrose Arthur

(b. 1876, Alfredtown, near Ballarat, Vic.; d. 1913, Melb.) Cartoonist, illustrator.
STUDIES: NGV School; he also took lessons from the cartoonist Tom Durkin. Cartoonist for Melbourne *Table Talk*, 1907–10; first sports cartoonist for Melbourne *Herald*, and a contributor to Sydney *Bulletin*, the *Champion* (1895–96), the *Critic* (1897), and other papers. Ambrose Dyson's early death cut short a promising career; his achievements were largely overshadowed by the brilliance of his younger brother, Will Dyson.
BIB: Mahood, *The Loaded Line*, 1973.

DYSON, Edward Ambrose, Jnr

(b. 1908, Melb.; d. 1953, Melb.) Cartoonist. Nephew of Will Dyson and Ambrose Dyson (Snr). He contributed social-realist war cartoons to various Melbourne publications during World War II.
AWARDS: First prize in the graphics section and second prize in the Civil Construction Corps section, *Australia at War* competitive exhibition, 1945.
BIB: Ambrose Dyson, *Gold*, folio of drawings with introduction by Eric Lambert, published privately in Melbourne, 1951.

DYSON, Will (William Henry)

(b. 3/9/1880, Alfredtown, near Ballarat, Vic.; d. 21/1/1938, London) Cartoonist, caricaturist, writer, draughtsman.
STUDIES: Melbourne, with George Coates, c. 1896; he may have had some lessons from the cartoonist Tom Durkin, who had taught his older brother, Ambrose, and would almost certainly have been helped by Ambrose. The brothers contributed to many of the same papers and appear to have been very close. Will Dyson submitted his first cartoon to the Sydney *Bulletin* in 1897, and during the same year exhibited in the inaugural exhibition of the NSW Society of Artists. In 1906 he provided fifty illustrations for Edward Dyson Snr's *Fact'ry Ands* Melbourne. The year 1909 was crucial to his development. In May of that year he held an exhibition of caricatures at Furlong's Rooms, Bourke Street, Melbourne; in Sept. he married Ruby Lindsay at Creswick and one month later the pair left for London, accompanied by the bride's brother Norman, Dyson's friend. The friends quarrelled in London and never made it up. Norman Lindsay went on to become Australia's most controversial artist of the period and Dyson to attain international celebrity for his cartoons. His London success began when he attracted the admiration and friendship of A. R. Orage of the *New Age*. From 1912–16 he revitalised the Labour newspaper, the *Daily Herald* with his cartoons, to gain a large following in a literary world that included H. G. Wells, G. K. Chesterton and G. B. Shaw. His *Kultur Cartoons* extended his reputation, and in Dec. 1916 he was appointed official war artist for the AIF with the rank of lieutenant. He began his war work at Pozières, 1916, and was wounded at Messines, 31 July 1917, and again at Zonnebeke, Dec. 1917. His *Australia at War* (1918) remains one of the most moving documents resulting from either of the two World Wars, and his cartoon deriding the Treaty of Versailles, 'I seem to hear a child crying' (*Daily Herald*, London, 17 May 1919), was a powerfully prophetic work. But

after the war his situation deteriorated. Greatly saddened by Ruby's death from the influenza epidemic of 1919 and disillusioned by the general atmosphere of post-war London, he accepted an offer to return to Australia from John Dalley, editor of Melbourne *Punch*, which had been taken over and revitalised as 'the new national weekly' by the Herald and Weekly Times. His return home with his young daughter, Betty, was front-page news and his illustrated lecture, *Pictorial Satire*, given at the NGV soon after arrival, attracted a large and enthusiastic audience. However, the new *Punch* failed after about 12 months and Dyson's contract was transferred to the Melbourne *Herald*. During his five years in Melbourne he had considerable influence on Melbourne's art world. He attended the life class conducted by Clive Stephen (q.v.), drew a series of portrait-caricatures of visiting celebrities including Pavlova, Chaliapin and Maurice Moscovitch, and held an exhibition of his work at the Athenaeum Gallery. His best *Herald* work was probably the series entitled *Literary Reflections*, but otherwise he did not enjoy working for the newspaper and often descended to slapdash solutions to the problems of daily cartoon work. Before he left Australia in 1930 he had become greatly interested in etching, mainly in making the series of drypoints subsequently exhibited in New York and London under the title *Our Moderns*. Before leaving Melbourne he tied up most of his work in bundles which he distributed to his friends, the result of this excessive generosity being that much important work was irretrievably lost. The acclaim that greeted his drypoints in New York also heralded his return to the art world of London. But while his new work for the *Daily Herald* was at first warmly received, it soon became clear that his best days were over.

Later, much of his energy was dissipated in interesting but irrelevant activities such as making puppets and supporting the Douglas Credit system, a subject on which he wrote a book. He died in London in 1938, a lonely and disillusioned man. Dyson's life and career contain many ambiguities. His work was never appreciated in Australia as it was in London but it was in Australia that its character was formed. Its raw colonial beginnings were tempered by German, French and British influences and his natural sensitivity and idealism were at first hidden beneath a veneer of 'inspired larrikinism'. This often verged on crudity, but from this source much of Dyson's toughness and strength derived. During his last period in Melbourne he did some painting; it was brilliant in expressionist colour but in his own view not sufficient to earn him the status of painter, and none of the paintings are known to have survived. Books of his cartoons include *Cartoons, Daily Herald*, London, 1913 and 1914; *Kultur Cartoons*, with foreword by H. G. Wells, Stanley Paul & Co., London, 1915; *Australia at War*, with intro. by G. K. Chesterton, Cecil Palmer & Hayward, London, 1918; *In Memory of a Wife*, memorial book of poems to Ruby Lindsay, London, 1919. The Bendigo Art Gallery held an exhibition of his works in 1980.

REP: NGA; AGNSW; AGSA; NGV; AWM; regional galleries Ballarat, Castlemaine, Hamilton, Mornington; British Museum, Victoria and Albert Museum; Imperial War Museum, London.

BIB: *AA* no. 6., 1919 (Charles Marriott, *Will Dyson's War Drawings*). *Meanjin* 4/1949 (Vance Palmer, *Will Dyson*); Sept. 1980 (Ross McMullin, *Will Dyson*). *Overland* Spring, 1962 (Vane Lindesay, *Will Dyson*); Dec, 1981 (Alan McCulloch, *Dyson*, commemoration Dyson centenary).

E
ADIE TO EYRE

EADIE, Robert William
(b. 8/8/1941, Sydney) Painter, teacher.
STUDIES: Dip. Fine Arts, NAS, 1966. He organised
the Arts Council Gallery, Sydney, 1971–73, and held
exhibitions there and at the Toorak Gallery, Melbourne,
1975. Beginning with impressionistic colour, his paint-
ings have become abstract and geometric, with some
concentration on the study of the square. He held
around 14 solo exhibitions 1966–91 at private gal-
leries and took part in over 50 group exhibitions
(including seven Archibald Prize exhibitions). He com-
pleted mural projects at Woolloomooloo; foyers of
buildings including Johnson & Johnson; Crippled
Children's Association, Sydney and Sydney Billboard
Project. He suffered a stroke in 1989 at the age of
48 which required him to learn many of the basics
of life again – his 1990 exhibition, *Recovery*, attracted
favourable reviews from Sydney critics including John
McDonald who said: '. . . the deliberation only adds
to the effectiveness of each picture. One feels he is
not trying to discipline the sensual aspects of his art
but to painfully and hesitantly test out the limits of
his abilities . . . a stroke is a hard way to forge a new
path but the strength of these works is a testimony
to an artist of great character and ability' (*Sydney
Morning Herald* 11/8/1990).
AWARDS: Reader's Digest drawing award, NAS, 1965;
grant, VACB, 1975–76; purchase prizes Hamilton, 1978,
Campbelltown, 1984; Sydney Heritage Art Award,
1986.
APPTS: NAS, 1968–74; tutor, Arts Council of Australia,
1969–74; tutor in art, Uni. of NSW, 1974; lecturer,
various other colleges including ESTC, Alexander Mackie
CAE 1975– .
REP: State and regional galleries and private collec-
tions.

EAGER, Helen
(b. 27/9/1952, Sydney) Printmaker, teacher.
STUDIES: SASA, 1972–75; Kala Inst., Berkeley, USA,
1981–82; MA Visual Arts, City Art Inst., 1989. Her
carefully worked 'intimist' lithographs and etchings
are rich in pattern and texture. Her respect for artists
such as Bonnard and Matisse is evident in her use of
clear colour and choice of often domestic objects and
interiors as subjects. She held about 15 solo exhibi-
tions 1977–90 largely at Watters, Sydney and Michael
Milburn, Brisbane and participated in numerous group
exhibitions at private and public galleries 1976–92,
including *Drawn and Quartered* AGSA, 1980; *Art in the
Making*, AGNSW, 1980; *Perspecta*, AGNSW, 1983; *Moet
& Chandon Touring Exhibition*, 1987; *A New Romance*,
NGA, 1987; *Off the Wall*, Monash University Gallery,
1991; *Her Story: Images of Domestic Labour in Australian
Art*, S. H. Ervin Gallery, 1991; *Contemporary Australian
Drawing*, MOCA, Brisbane 1992.
AWARDS: VACB travel grant, 1980; residency, New
York Studio, VACB, 1988.
APPTS: Part-time lecturer, College of Fine Arts, Uni.
of NSW, 1990– .
REP: NGA; AGSA; AGNSW; Artbank; a number of regional
and tertiary collections NSW, SA, Vic. including at
Bathurst, Broken Hill, Albury; corporate collections
including Baker & McKenzie, Robert Holmes à Court,
State Bank, NSW.
BIB: Numerous catalogue essays in exhibitions as above. *New
Art Two*. McKenzie, DIA.

EAGLE, Mary
(b. 1944, Bairnsdale, Vic.) Curator, critic.
STUDIES: BA, Uni. of Melb., 1975. She was art critic
for the *Age*, Melbourne, 1977–80, has written a num-
ber of catalogues and books on Australian art and
curated a number of exhibitions. Catalogues she has
written include *Adelaide Bicentennial of Australian Art*
for AGSA, 1990; and *Rupert Bunny* works in the NGA
collection, NGA. Books she has written include (with
Jan Minchin) *The George Bell School*, Deutscher Art
Publications, Melbourne, 1981; *Australian Modern
Painting Between the Wars 1919–1939* Bay Books,
1990; *A Story of Australian Art: the ICI collection* Pan
Macmillan, 1993.
APPTS: Art critic, *The Age*, Melbourne 1977–80; cura-
tor, Australian painting and sculpture, NGA 1982– .

EAGLES, Percy
(b. 1900, Eng.) Painter, cartoonist.
STUDIES: RAS, Sydney (on a three-year scholarship).

Augustus Earle, Dr. R. Townson, *oil on canvas. Collection, Mitchell Library.*

Eagles contributed black-and-white drawings to the *Bulletin* and *Smith's Weekly.*
REP: QAG.

EARLE, *Augustus*

(b. 1/6/1793, London; arr. Hobart 1825; d. 10/12/1839, London) Painter, traveller. Son of an American painter, James Earle (1761–96), and nephew of American portrait painter Ralph Earle (1751–1801), he studied at London, RA Schools, exhibiting there from the age of 13. He began travelling in 1815, with visits to North Africa, Sicily, Malta and Gibraltar, then extended to the USA, Peru, Chile and a four-year sojourn in Brazil. Subsequently, during a voyage to India in 1824, he was marooned on the island of Tristan da Cunha for eight months until finally rescued by the captain of the *Admiral Cockburn* bound for Hobart, where he arrived on 18 Jan. 1825. At the end of the year he moved to Sydney where he stayed until 1828. Soon becoming regarded as the best artist of the time in Sydney, he received many important commissions including portraits of the colonial secretary Frederick Goulburn and Captain John Piper and family. He

opened a gallery in George St, showing his work and offering lessons and started making lithographs at about the same time. His Australian work includes views of Van Diemen's Land, a number of portraits and eight panoramic views of Sydney, exhibited by Robert Burford, London, and later published in his *Australian Scrap Book* (1830). The dedication in a complementary publication *Views in New South Wales and Van Diemen's Land* (J. Crofts, London, 1830) states that his departure from Sydney for New Zealand in Oct. 1827 went unnoticed. Greatly attracted to the Maoris, he recorded his meetings with them in a number of fine historic pictures before returning to London to supervise the publication of his Australian and New Zealand works, including *A Narrative of a Nine Months' Residence in New Zealand in 1827* (London, 1832). But he was overtaken by illness and before this work appeared in print he had accepted a post as draughtsman on HMS *Beagle* with Charles Darwin, under the command of Captain FitzRoy. The move did little to restore his health and he handed over to his successor, Conrad Martens (q.v.) at Montevideo in 1832. He was back in London in 1833 and from then until his death five years later he worked on his publications and exhibited at the RA. He was represented by six works in the Bicentennial exhibition *The Great Australian Art Exhibition* and his work appeared in *Tasmanian Vision* TMAG and QVMAG 1988 and *The Artist and the Patron*, AGNSW 1988.
REP: NGA; AGSA; NGV; NLA (161 watercolours from the Nan Kivell collection); Mitchell and Dixson Libraries.
BIB: Smith, *EVSP*. Augustus Earle, *Narrative of a Residence in New Zealand*, originally 1832, ed. E. H. McCormick, and republished by Clarendon Press, Oxford, 1966. *New Zealand Painting*, Reed, Sydney, 1969. Gil Docking, *Two Hundred Years of New Zealand Painting*, Lansdowne, Melbourne, 1971. Margaret Weidenhofer, *The Convict Years 1788–1868*, Lansdowne, Melbourne, 1973. ADB 1. Kerr, *DAA*.
(*See also* BURFORD, ROBERT).

EARLE, *Stephen*

(b. 26/5/1942, Sydney) Painter.
STUDIES: North Sydney Tech. Coll., 1960–61; NAS, 1962–64. His work was included in the Commonwealth government sponsored exhibition *Young Australian Painters*, which toured Australia and Japan in 1965. From this beginning emerged the type of flat-pattern colour painting that distinguished his work during the period 1965–70, as a regular exhibitor at Watters Gallery, Sydney. He held 15 solo exhibitions (largely at Watters) 1967–83 and participated in a number of group exhibitions 1965–88 including *Australian Colourists 77*, WAIT 1977; *Continuum*, Ivan Dougherty Gallery, Sydney 1978; *Acquisitions*, AGNSW 1982; *Max Watters Collection*, Muswellbrook Art Gallery and touring 1988. Little was seen of his work in the years following the mid-1980s.
AWARDS: Young Contemporaries prize, CAS, Sydney, 1965; Launceston (purchase award), 1967; Hunter Douglas prize, CAS, Sydney, 1969; Gold Coast City (purchase award), 1970; Corio prize, Geelong, 1970;

Sun Herald prize, CAS, Sydney, 1970; Muswellbrook prize, 1971; VACB grant, 1975.

REP: NGA; AGNSW; AGSA; QVMAG; VACB; regional galleries Geelong, Gold Coast, Latrobe Valley, Newcastle; corporate collections including BHP; Allen, Allen & Hemsley.

BIB: Bonython, MAP 1970 & 75. Smith, AP. Horton, PDA. Gary Catalano *The Years of Hope*, OUP. Noel Hutchinson, *Stephen Earle – paintings 1963–69*, privately published Sydney 1969. A&A, 14/4/77. AI, 14/4/70 (McCulloch, *Letter from Australia*).

EARLES, Chester

(b. 18/8/1821; arr. Aust., 1864; d. 1905, Melb.) Painter. Studying at the RA Schools, London, 1842–45 and in Paris, 1846, he exhibited extensively at the RA and at the Royal Society of British Artists, 1842–63. In Australia he was in charge of the Bankers Clearing House for many years and from 1870 exhibited with the Victorian Academy of Arts (president in succession to O. R. Campbell) showing mainly portraits and literary genre. He also sent paintings to the NSW Academy of Art, 1872, 1873 and 1876, and contributed to the *Intercolonial Exhibition* sent to Philadelphia in 1875. His painting remained basically conservative in style and English in content. Inspired often by the literature of Milton, Tennyson and others, his work tended to look anachronistic at a time of rapidly growing general interest in Australian landscape. In the 1880s he exhibited designs for an altarpiece and a stained-glass window for two South Yarra churches. He was represented in *Australian Art in the 1870s*, AGNSW 1976.

REP: NGA; NGV; Bendigo regional gallery.

BIB: C. Christesen, *The Gallery on Eastern Hill*, Melbourne 1960. *A Dictionary of Artists*, originally published 1901, London; republished 1973, Bath. Thomas, OAA. Kerr, DAA.

EAST, John R.

(Arr. Sydney, 1830s) Miniaturist. Probably exhibited at RA, London (although some confusion with artist 'T.B.' East) and in Sydney became established as a portrait painter including a watercolour and pencil portrait of Sir James Dowling in 1834. Little work can be attributed to him and his most significant is the oil portrait of Billy Blue (collection Mitchell Library), the Jamaican boatman living in Sydney in the 1830s. East left for India c. 1835, where he died. A work of his appeared in *The Artist and Patron*, AGNSW 1988.

BIB: Moore, SAA. Kerr, DAA.

EASTAUGH, Stephen

(b. 20/7/1960, Melb.) Painter.

STUDIES: BA Fine Arts, VCA, 1979; Cert. of Achievement, Uni. of Oslo, Norway, 1982; Dip. Ed., Uni. of Tas., 1985; travel studies Scandinavia 1982; Europe, North and West Africa 1983; Asia, northern Aust. 1984; USA, Europe, South America 1989; Hong Kong, Philippines, 1990. His first solo exhibition was in 1987 at 200 Gertrude St and he held five solo exhi-

bitions 1988–91 at 13 Verity St, Melbourne and Syme Dodson, Sydney. Small caricature-like figures or objects on textured backgrounds create the element of surprise in his whimsical works as typified by his 1989 *Moet & Chandon* entry *Fret*, made, as many of his 1980s works were, from mixed media – in this case encaustic wax, braid, and oilstick on wood. His work appeared in a number of group exhibitions 1982–91 including invitation art prizes at Gold Coast 1988, Swan Hill 1991 and in *Moet & Chandon Touring Exhibition*, 1989; *A New Generation*, NGA 1988; *10 + 10*, Access Gallery, NGV 1991; *The Corporeal Body*, NGA 1991.

AWARDS: Faber-Castell Drawing Award 1991.

APPTS: Secondary (emergency teaching), Melb. alternative schools, 1986–90.

REP: NGA; AGWA; NGV; MOCA, Brisbane; Gold Coast regional gallery; corporate collections including Myer, Smorgon, Faber-Castell.

BIB: catalogue essays in exhibitions as above. *New Art Three*. AL 9/2/1989.

EASTAWAY, Lynne

(b. 1949, Sydney) Painter, printmaker, teacher.

STUDIES: NAS, 1970–73. Basic interests in her work include graffiti and abstract expressionism. She held around five solo exhibitions 1973–83 including at Powell St, Melbourne and DC Art, Sydney, and her work appeared in group drawing, print and other survey shows 1972–82.

AWARDS: Prizes at Muswellbrook, 1974; Leichhardt, 1974; Drummoyne, 1977; Alice Springs (purchase), 1977; VACB grant, 1982.

REP: NGV; Alice Springs Art Gallery; several municipal and tertiary collections.

APPTS: Teaching, printmaking, Uni. of New England summer school, 1975; lecturing, Alexander Mackie CAE, 1976; ten-week Saturday program (with Michael Shannon), SCA, 1977.

BIB: Germaine, AGA.

NFI

EATON, Henry Green

(b. c. 1811, London; arr. Tas. c. 1844; d. 29/10/1887) Lithographer. A landscape and topographical artist, six of his views of Hobart street scenes were lithographed by the Hobart lithographer Thomas Bluett (q.v.), 1844. He settled in Queensland in the 1850s where he continued to work as an artist lithographer.

BIB: C. Craig, *Old Tasmanian Prints*, Launceston 1964; *More Old Tasmanian prints*, 1984. Kerr, DAA.

EBELI, Gerard

(b. 1928, Haarlem, Holland; arr. Aust., 1949) Painter.

STUDIES: Amsterdam, Royal Academy of Fine Art, 1954–57; Melbourne, with Max Meldrum. Ebeli also also studied violin and musical composition for six years at the Conservatorium of Music, Amsterdam and taught with the Victorian Education Dept 1967–71. Member of the CAS, Sydney in the 1970s, he moved to Tasmania in the early 1980s.

Awards: *Mirror*-Waratah Prize, Sydney 1964; Royal Easter Show, 1967.
REP: TMAG
BIB: Backhouse, *TA*.

EBERT, Max
See McCLINTOCK, Herbert

EDEN, Eva (formerly Schramm)
(b. 1956, North Germany; arr. Aust. 1968) Painter. She held 5 solo exhibitions 1981–93 of installations and paintings Melbourne (Reconnaissance), SA (Adelaide University Union) and Berlin including sculptures based on time spent in Alice Springs and Central Australia 1981–82. Group exhibitions in which she participated 1980–93 included *Perspecta '83* AGNSW; *Continuum '83* Tokyo 1983; *Crimes of Passion* Munich, 1985. She became co-ordinator of Melbourne's *Art Around Town* project in 1991.

EDGAR, William
(Active Brisbane) Painter and sailor who raffled his work on the wharves, c. 1920–30.
BIB: Moore, *SAA*.
NFI

EDGECOMBE, Henry
(b. 1881, Sydney) Painter, commercial artist, teacher. STUDIES: ESTC; Colarossi's, Paris. He was a member of the RAS, Sydney, and Australian Art Society, exhibited at the Paris Salon, and from 1905 taught painting and drawing at Kingsbury Academy, Buenos Aires. He returned to Sydney in 1918, and taught lettering at ESTC.
REP: AGNSW.
NFI

EDKINS, Cathleen Elizabeth
(b. 1922, Mt Gambier, SA) Painter. STUDIES: Melbourne, with Septimus Power, 1936–39 and 1945–49; NGV School, 1947. She exhibited in Melbourne and Adelaide from the early 1950s. Her commissioned paintings of horses achieved wide popularity among lovers of the turf.
NFI

EDWARD, John
(b. 1929, WA) Printmaker. His extensive experience in silk-screen, wood-cut and other relief mediums included participation in the *Ljubljana International Biennale*, 1969, a commission for PCA members print edition, 1972, and about 10 awards for printmaking.
REP: Regional galleries Albury, Newcastle, Wollongong; Uni. of Tas. collections.
BIB: PCA, *Directory*, 1976. Germaine, *AGA*.
NFI

EDWARD, Lindsay Maurice
(b. 26/8/1919) Painter, teacher. STUDIES: NGV School, 1938–41; Dip. Art, RMIT; Fellowship Dip. Fine Art, RMIT; travel studies, Europe

and UK 1947–48. He held around 20 solo exhibitions 1944–93 Melbourne (including at Realities, Powell St, David Ellis), Sydney (including at Holdsworth) and Perth (Quentin Gallery). His work included several major mural commissions to which his semi-abstract style adapted well and included mosaics and an award-winning mural for the exterior of the Brisbane Public Library, 1958. He combined exhibiting with full-time lecturing, 1954–79.
AWARDS: Brisbane Public Library competition for a mural, 1956.
APPTS: Head of the painting school, RMIT 1954–67, head of the Dept of Fine Art, 1967–79.
REP: NGA; NGV; Artbank; several tertiary and regional gallery collections Vic.; corporate collections including AMP, BHP.

EDWARDS, Margery
(b. 1933, Newcastle, NSW; d. 1989, New York) STUDIES: BA (nursing), NSW, 1956; private art studies with Dora Jarret, Rodney Milgate, Desiderius Orban, Sydney, 1959–60; Brera Academy of Art, Milan, 1969; Morley College of Art, London, 1970; travel studies USA, UK, East Africa, Italy, Australia. She exhibited at Macquarie Galleries in 1972 and 1974 as well as in Milan where she was living. She moved to New York in 1974 where she lived until her death in 1989, exhibiting there and in Australia (Roslyn Oxley9, Ray Hughes, Holdsworth). Her work appeared in a number of group exhibitions from 1963 to 1989 including *Power Gallery Acquisition*, 1981, 83; *Australia at Meridian House*, Washington DC 1984; *Juried Show*, Summit Art Centre, NY 1984, 85; *Three Australian Artists*, The Nippon Club Gallery, NY 1984. Holdsworth Gallery held a major exhibition of her 'black' paintings 1986–88 in 1990 which showed works built up by layer on layer of paint creating density and depth.
REP: AGNSW; Parliament House; MCA, Sydney; Artbank; tertiary colleges including Alexander Mackie, Darwin Community; Rutgers University Art Museum, New Brunswick, USA; private corporate collections including Best Collection, Virginia, USA; National Westminster Bank, NY; BHP Aust.
BIB: *A&A* 21/3/1984. Germaine, *AGA*.

EDWARDS, Mary
(b. 1894, Sydney; d. 1988, Fiji) Painter. STUDIES: ESTC; Colarossi's, Paris. Known mainly for portraits she was a regular contributor to Archibald prize contests and was one of the plaintiffs, with J. Wolinski, in the Dobell Joshua Smith case (*see* ARCHIBALD PRIZE). She exhibited at the Paris Salon and travelled and lived extensively in the South Pacific area, including Java, New Caledonia, Fiji and Tahiti. From 1955 she called herself Mary Edwell-Burke.
AWARDS: Prizes in State Theatre Art Quest, 1929.
REP: AGNSW; TMAG.
BIB: *AA* May 1940 (*A Balinese Pavlova*); *Fifty Years of Australian Art, 1879–1929*, RAS, Sydney, 1929.

EDWARDS, Robert (Bob)

(b. 7/4/1930) Curator, administrator, museum director. With a broad knowledge of anthropology, archaeology and Aboriginal culture he has been a curator, director of the Aboriginal Arts Board of the Australia Council, museum director and executive director of a large arts exhibition management body. His archaeological and anthropological work in the 1960s included leading field studies to the NT, Tas., Vic. and SA to evaluate Aboriginal art and sacred sites and policy development with the SA Museum. His knowledge of Aboriginal culture led to his appointment as deputy principal of the Australian Institute of Aboriginal Studies and as director of the Aboriginal Arts Board of the Australia Council. As director of the Museum of Victoria he aimed to present its activities to a wider general public and worked towards the establishment of a new museum. As administrator for Australia's largest exhibitions touring agency he oversaw the bringing to Australia of many significant exhibitions including *Gold of the Pharaohs*, and the life-size terracotta *Entombed Warriors*, 1987. He has been a member of over 80 arts bodies, including consultant to a number of government and state arts bodies (including the Bicentennial project); adviser to Australian and international museums; and head of numerous judging panels and awards. He has written numerous papers and catalogue essays as well as contributing to books, magazines and periodicals.
AWARDS: Order of Australia; hon. doctorate of laws, Monash Uni.
APPTS: Curator, anthropology, SA Museum, 1965–73; deputy principal, Australian Inst. of Aboriginal Studies, 1973–75; founding director Aboriginal Arts Board, Aust. Council, 1975–80; founding executive director, International Cultural Corporation of Australia, 1980–84; director, Museum of Victoria, 1984–90; chief executive and director, Art Exhibitions Australia Ltd 1990.

EDWELL, Bernice

(b. 1880, Newbury, Berkshire, UK; arr. Sydney in youth; d. 1962) Painter.
STUDIES: RAS School, Sydney, with A. H. Fullwood, c. 1899–1900; Colarossi's, Paris. She became widely known for her miniatures, exhibited in Sydney at the RAS, NSW Society of Artists and Society of Women Painters (of which she was a council member), and in London at the RA, 1921, 1923. Her work was included in *Art Nouveau in Australia*, AGDC touring exhibition, 1980.
REP: AGNSW; NGV.

EDWELL-BURKE, Mary

See EDWARDS, Mary

EGERSDORFER, Heiner

Painter, cartoonist. He exhibited with the Art Society of NSW from 1887 and contributed a weekly cartoon to the Sydney *Bulletin*. Later he lived with Lionel and Norman Lindsay at Charterisville. Dyson and the Lindsays might well have derived much of their interest in German black-and-white art from Egersdorfer, who eventually migrated to South Africa.

EIDLITZ, Frank

(b. 1938, Hungary) Industrial designer, sculptor.
STUDIES: Royal Academy of Art, Budapest. First exhibition of his optical painting was held at the MOMAD, Melbourne, 1965. His work was subsequently reproduced in international graphic magazines. He exhibited in Melbourne, New York, Germany and London in the 1970s and was represented in the 1980 *Biennale of Sydney*.
AWARDS: Winston Churchill Fellowship (the first given), 1966, to enable Eidlitz to study visual communications under Gyorgy Kepes at the Massachusetts Inst. of Technology.
BIB: Smith, AP.
NFI

ELDERSHAW, John Roy

(b. 1892, Sydney; d. 20/5/1973, Nimmitabel, NSW) Painter.
STUDIES: Julian Ashton School, Sydney, and with J. S. Watkins; Central School of Arts and Crafts, London, 1928–30; Paris. Married to sculptor Dora Barclay (q.v.) he painted mainly landscapes in watercolours which he exhibited at the RA, London, and Old Salon, Paris, 1927. He was a member of the NSW Society of Artists, Australian Art Association and Australian Watercolour Institute of which he was president (1949–52). He lived in Tasmania for 20 years, toured Australia by caravan, 1939–41, and during World War II served as a camouflage officer with the RAAF in Victoria. He was commissioned by the Duke of Gloucester in 1946 to paint 'an Australian landscape', and in 1959 his work was featured in a special exhibition at the QVMAG, Launceston.
AWARDS: Commonwealth Centenary prize, 1950, Albury prizes, 1954, 60; prize at R.Ag.Soc. NSW, 1960; W. D. & H. O. Wills watercolour prize, 1961; 2nd prize, Blue Mountains art competition, 1962; shared Tumut prize, 1963; Berrima prize, 1963; Taree prize, 1964.
REP: AGNSW; AGSA; NGV; QAG; TMAG; regional gallery Launceston.
BIB: Moore, SAA.

ELENBERG, Joel

(b. 1948, Melb.; d. 10/7/1980, Bali) Painter, sculptor.
STUDIES: No formal training. Extensive travel studies. He started painting soon after leaving school in 1962. During 1966–67 he travelled in the Middle East and in 1969 held an exhibition at the Australian Galleries, Melbourne, comprising saturnine figures drawn in a bold, scratchy style and reflecting an interest in the Italian Renaissance masters and a preoccupation with the violence and cruelty of his time. In a similar exhibition at the same gallery two years later his themes were sex, birth, murder, etc., deriving from

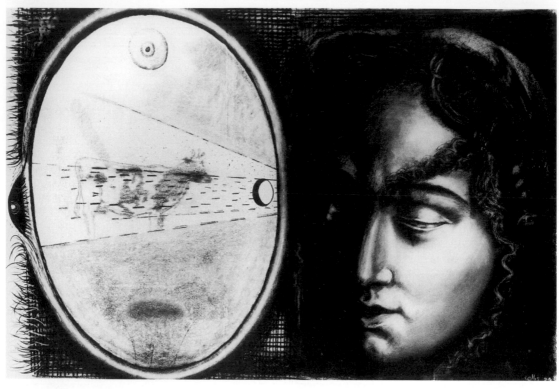

Peter Ellis, Eye, *1989, charcoal on paper. Private collection.*

the tragedies of the drug scene and the war in Vietnam. The excesses of this early work gave way later to a series of painted, decorative screens, beautifully made, with the leaves and fronds of native plants providing the theme. He began sculpting in marble in 1972, visited South America in 1975 and by 1977 had produced a series of works in white marble carved in his studio at Carrara, Italy.
REP: Dunedin Art Gallery; mural in Union House, Uni. of Melbourne.
BIB: Scarlett, AS.

ELISCHER, *John (Johan Wolfgang)*
(b. 1891, Vienna; arr. Aust. 1935; d. 1966) Sculptor.
STUDIES: Vienna, with the sculptor Bitterlich; Academy of Vienna, 1908–11; Paris, with Rodin, c. 1910–11. After war service 1914–18, he freelanced as a sculptor, designed figures and animals for porcelain factories and, 1924–27, worked as art director for Ditmar-Brunner light-fitting and novelty manufacturers. During his early years in Australia he worked as an industrial designer for pottery, later receiving commissions for sculptures. His Australian commissions included the King George V Memorial for Bendigo, 1938; bronze fountain for Sir Russell Grimwade, Toorak; bust of Archbishop Mannix for Newman Coll., Uni. of Melbourne.
AWARDS: Prix de Rome, 1909; international competition for South African Memorial to General Botha, 1926; Commonwealth Government Jubilee prize for medal design, 1951.
BIB: Scarlett, AS.

ELLIOT, *Frederick*
(Active c. 1890–1930, Sydney) Painter. Marine painter, usually in watercolour. A prolific artist, he painted liners, cargo and sailing ships, depicted in Sydney Harbour and in the open sea; his watercolours are high-keyed and often echo the romantic effects of soft light and mist popularised by J. J. Hilder (q.v.).

ELLIOTT, *John*
(b. 1943, UK; arr. Aust. 1970) Sculptor, teacher.
STUDIES: Gravesend School of Art, UK, 1958–61; RCA, London, 1961–65. His work was seen in group exhibitions in Australia 1972–85 including in *Mildura Sculpture Triennial*; *Six New Directions*, QAG 1985.
AWARDS: VACB grant, 1975.
APPTS: Teaching at colleges in London, 1965–69; ESTC, 1971–73; Adelaide, 1973–75; Darling Downs IAE, 1976–?.
BIB: Scarlett, AS.

ELLIS, *Peter William*
(b. 27/6/1956, Sydney) Painter.
STUDIES: BA, RMIT, 1978; travel studies UK, Europe, USA, 1979. Influences of Dada and surrealism and, more locally, his teacher Andrew Sibley could be seen in his early works. His 1990 Powell St, Melbourne exhibition consisted of multi-layered collages, often with hair or fur attached and peep holes cut into canvases, with use of the laser colour copier. Jenny Zimmer (*Sunday Herald* December, 1990) described the works as: '. . . impossible to categorise in terms of dominant fads and fashions of contemporary art. He is simply a surrealist. . . . and uses surrealism to discredit so-called reality, to challenge reason, to externalise

deep personal obsessions and to celebrate the unsettling power of the subconscious to conjure disturbing images'. He held around 10 solo exhibitions 1983–92 largely at Powell St, Melbourne and DC Art, Sydney and participated in over 60 group exhibitions 1975–91 including *Diversity in Contemporary Art*, MOMA, Japan 1987; *Field to Figuration*, NGV 1987; *Prints and Australia*, NGA 1989; *The Intimate Object*, Gertrude St 1989; *Artists under Saturn*, University of Melbourne Museum of Art 1989. He was artist-in-residence at the VCA in 1986.
AWARDS: Fremantle Drawing Prize 1986; VACB project grant 1986; Newcastle Invitation Art Purchase 1988.
APPTS: Painting and drawing, RMIT 1982– ; VCA 1985–89; guest lecturer, various art colleges Australia-wide.
REP: NGA; AGNSW; AGWA; NGV; Artbank; regional galleries including Mildura, Wagga, Warrnambool; tertiary collections Vic.; corporate collections including Budget transport, ICI, Robert Holmes à Court.
BIB: Catalogue essays exhibitions as above. Smith, AP. A&A 23/3/1986; 24/1/1986.

ELLIS, William

(Active c. 1777–80) Painter. The surgeon's mate on *Discovery*, sister ship to *Resolution*, on Captain Cook's third and last voyage. He painted four excellent studies of Tasmanian birds at Adventure Bay, Tas. (Jan. 1777) and published *Authentic Narrative of a Voyage Performed by Captain Cook and Captain Clerke in HMS Resolution and Discovery during the years 1760–1780*.
REP: Mitchell, La Trobe Libraries; British Museum.
BIB: Rienits, *Early Artists of Australia*, 1963. B. Smith & R. Joppien, *The Art of Captain Cook's Voyages*, vol. 3., Melbourne, 1987. U. Platts, *Nineteenth Century NZ Artists*, Christchurch 1980. Kerr, DAA.

ELLYARD, Heather

(b. 1939, Boston, USA; arr. Aust. 1970) Painter.
STUDIES: B.Sc. Simmons College, Boston, USA, 1961; Boston School of Museum of Fine Arts, 1961–63. Her artistic concerns include portraying and preserving the natural world which she does through use of collage incorporated in her abstract paintings. She lived in Canberra 1974–76; Papua New Guinea 1976–78 and in Adelaide 1980–88 before moving to Melbourne. She held 10 solo exhibitions 1974–91 including at Abraxas, Canberra; Bonython-Meadmore, Adelaide; Painters, Sydney; Luba Bilu, Melbourne. Group exhibitions in which her work appeared included *The Lovely Motherhood Show*, EAF 1981; *Ten South Australian Paintings*, RASA 1982; *Australian Art Now*, AGSA 1986. Her commissions included those for the amphitheatre, Sculpture Garden, Canberra and outdoor painting, South Australian Museum, Adelaide.
AWARDS: Alice prize, 1983; *Canberra Times* National Art Award, 1983, 84; Whyalla Prize special prize, 1987; artists' grant, SA Dept for Arts, 1985; VACB project grant, 1989.

APPTS: Lecturer, Canberra School of Art, 1971–73; SACAE 1986–87; involved in a number of public and community art events including Public Art Forums, Canberra 1973; art reviewer, ABC Canberra, 1974–76; board member, Artbank, 1985– .
REP: AGSA; Parliament House; Artbank; several public service collections including Office of the Premier, SA, Commonwealth Dept of Arts; a number of tertiary collections including Canberra CAE, Monash Medical Centre; corporate collections including Commonwealth Bank.
BIB: AL 1/3/81, 1/6/81–82; 2/4/82, 2/5/82; 3/5/83; 3/6/83–84; 4/2–3/84; 5/6/85.

ELTON, W. H.

(Active c. 1810, Sydney) Painter. Perhaps a convict artist his watercolour *Sydney Harbour, 1810*, was sold from the collection of Sir Thomas Ramsay, at Christie's, Melbourne, 3–5 Mar. 1977.
NFI

ELWES, Robert

(Arr. Tas. c. 1849) He drew and lithographed two Tasmanian views – *Hobarton* and *Gum Forest* – for his illustrated *Sketcher's Tour Round the World*, London, 1854.
BIB: Clifford Craig, *Old Tasmanian Prints*, Foot & Playstead, Launceston, 1963. Kerr, DAA.

ELY, Bonita

(b. 17/8/1946, Mildura) Environmental artist, printmaker.
STUDIES: CIT, 1965–66; Prahran CAE, 1968–69; Grad Dip. Prahran CAE; M Fine Arts, SCA, Uni. of Sydney; travel studies UK, Europe, North Africa, 1970–73; New York, 1973–75. She held around 17 solo exhibitions 1971–92 including at Performance Space, Sydney; Roslyn Oxley9; Bellas, Brisbane. From 1971 she participated extensively in exhibitions concerned with the environment and women's art, notably *Three Statements on Environment*, Ewing-Paton Galleries, Melbourne, 1976; and the *Women's Show*, EAF, 1977 as well as *Perspecta*, AGNSW 1981, 85; *Continuum* Tokyo 1983; *Bicentennial Print Portfolio*, NGA 1988; *Unfamiliar Territory*, Adelaide Biennale 1992.
AWARDS: Special project grants, VACB, 1976, 77, 78; Henri Worland print prize (purchase), Warrnambool, 1979; literature grant, Vic. Ministry of the Arts, 1981; Kiffy Rubbo Memorial Art Award, 1985.
APPTS: Senior tutor, head study area of sculpture, College of Fine Arts, Uni. of NSW, 1990– .
REP: NGA; AGNSW; QAG; Artbank; MOCA, Brisbane; several municipal, tertiary collections NSW, Vic., Qld.
BIB: Catalogue essays in exhibitions as above. Sturgeon, DAS. McIntyre, ACD. AL 1/1/1981; 1/5/1981; 3/3/1983.

ELYARD, Samuel

(b. 9/5/1817, Isle of Wight; arr. Sydney 1821; d. 23/10/1910, Nowra, NSW) Painter.
STUDIES: Sydney, with Conrad Martens and John Skinner Prout. His father was a surgeon on the convict

ship *John Bull* and Samuel grew up in Sydney where he became a clerk in the Colonial Secretary's Dept and studied art in his spare time. Later he taught drawing and exhibited with the Society for the Promotion of Fine Arts, 1847 and 1849, largely watercolour views of Sydney harbour and landscapes. In 1857 he started a journal, the *Salem Standard*, and advocated the conversion of Jews to Protestantism. For much of his life he suffered from mental disturbances from which he sought peace in religion. Towards the end of his life he became a lay preacher and a justice of the peace. He was represented in *Australian Art in the 1870s*, AGNSW, 1976, *The Artist and the Patron*, AGNSW, 1988 and an exhibition of his work was held at S. H. Ervin Gallery, Sydney 1982.
REP: AGNSW; NLA; Wollongong City Gallery; Dixson, Mitchell Libraries.
BIB: *ADB* 4. McCulloch, *AAGR*. Robert Holden, *Photography in Colonial Australia*, Sydney 1988. Kerr, *DAA*.

EMANUEL, *Cedric*

(b. 1906, NZ; arr. Aust. in childhood) Painter, printmaker, illustrator.
STUDIES: Julian Ashton Art School; with Dattilo Rubbo. Working as a commercial artist until the 1920s, he had his first book of etchings published in 1945 during his RAAF service. He produced Christmas and other greeting cards and became well-known for his pencil sketches of terrace houses, landscape and watercolours. He illustrated some 50 books 1952–92 including a number of popular sketchbooks, and received a number of mural commissions. He exhibited frequently in solo exhibitions 1952–92 in Australia and the USA and in 1980 a limited edition of his etchings was published by Angus & Robertson.
AWARDS: Scsquicentenary National Art Competition, 1938; Order of Australia medal, 1981.
REP: Most state galleries; AWM; Mitchell Library; NLA; Art Gallery of NZ, Wellington.

ENES, *Albert*

(b. 1876) Painter.
STUDIES: NGV School, 1892–96; Melbourne Art School (with Fox and Tucker), c. 1896–99. Writing about Enes, William Moore records that 'after his sensational *Pan* he never realised the promise of his youth'. The reference is to a pastoral study exhibited by Enes at the VAS, Melbourne, where he exhibited 1904–16. Another contemporary of Enes, William Frater, recalled that Enes went to Cornwall where he painted with the founder of the Newlyn School, Stanhope Forbes. Three works by Enes (*Girl with a Fan, Howard Ashton* and *The Violinist*) were hung in the Archibald prize exhibition, 1944.
REP: NGV.

ENGLUND, *Ivan Oscar*

(b. 1915, Liverpool, NSW) Potter, sculptor.
STUDIES: ESTC; Brighton Coll. of Art, England. Two sculptures in fibreglass and resin were exhibited by him in the *Mildura Sculpture Triennial*, 1970. A retro-spective of his work was held at Wollongong City Gallery in 1990.
AWARDS: Prizes for pottery at Wollongong, 1962; Hunters Hill, 1964; *Mirror*-Waratah, 1965.
APPTS: Teacher of ceramics at Canberra Tech. Coll., 1953–54; head of the art dept at Wollongong Tech. Coll.; part-time lecturer at Sydney Uni.
REP: NGA; AGNSW; AGSA; AGWA; NGV; QAG; a number of regional galleries.
BIB: Kenneth Hood, *Pottery*, Arts in Australia series, Longman, Melbourne, 1961.

ENGLUND, *Patricia*

(b. 1922, NSW) Painter, potter.
STUDIES: Julian Ashton School, Sydney, with Henry Gibbons. Part-time teacher of ceramics, Wollongong Tech. Coll., NSW, from 1958.
AWARDS: Hunters Hill prize for pottery, 1961, 66; *Mirror*-Waratah prize 1965; Wollongong, 1965.
REP: AGWA; NGV.
BIB: Kenneth Hood, *Pottery*, Arts in Australia series, Longman, Melbourne, 1961. Campbell, *AWP*.

ERSKINE, *Douglas Elliott*

(b. 1949, Sydney; d. 1988) Sculptor.
STUDIES: ESTC (part-time), 1970–71; Newcastle CAE, 1972–76. His work was seen in solo exhibitions at the Sculpture Centre, Coventry and Hogarth galleries, Sydney in the 1970s and in 34 group exhibitions including the first exhibition with the Gay & Lesbian Mardi Gras at Watters Gallery 1978.
REP: NGA; VACB; Milperra CAE.
BIB: *A&A* 16/1/1978.

ESAM, *Arthur*

(b. 24/7/1850, London; arr. Melb. 1870) Painter, drover, surveyor, explorer. He was employed in the SA Dept of Lands, 1878–82, secretary to a brewery in Coolgardie, 1893, and worked on the staff of the *Kalgoorlie Miner*. He also joined a SA expedition party to look for fresh water, Sept. 1881–Aug. 1882, and in 1884 overlanded 87 camels to Normanton for use on stations in the Gulf country. Well-known as a contributor to illustrated papers, including *Freason's Weekly* and the *Sydney Mail*, he painted a large number of watercolours, many of horse teams and bush genre spontaneously drawn. He settled in Melbourne. His work was seen in *The Historical George Page Cooper Collection*, Leonard Joel, Melbourne, 21–22 Nov. 1967.

ESLING, *Gordon*

(b. 1897, Inverell, NSW) Painter.
STUDIES: Julian Ashton School, Sydney. Landscape painter, also painter of theatre scenery he exhibited at the Society of Artists and RAS from 1918, showing landscapes; by the 1930s he was also painting interiors and coastal scenes. His work shows the firm modelling of contemporaries, notably Elioth Gruner (q.v.) with whom he worked, though Esling often pays greater attention to detail.

ESSON, Michael

(b. 19/3/1950, Aberdeen, Scotland; arr. Aust. 1974)
Draughtsman, sculptor.
STUDIES: Gray's School of Art, Aberdeen, Scotland,
1968–70; Dip. Art, Edinburgh College of Arts,
Scotland, 1972; postgrad. studies, Edinburgh School
of Arts, 1972–73; MA, Royal College of Art, London,
1977. Living alternately between Australia, London
and Scotland from the mid-1970s he held four solo
exhibitions 1986–91 at Coventry, Sydney and two in
Scotland (Crawford Art Centre, St Andrew; Artspace,
Aberdeen, 1990). He uses Scottish symbolism such
as 'clooties' (cloth) tied up as a memorial to events
(e.g. Culloden) which need catalogue explanations for
an Australian audience. *Our identity is our discomfit*, the
catalogue/book published for exhibitions of the same
name in Scotland 1990, shows images of cloth-wrapped
meticulously-drawn figures including surgeons per-
forming anatomical operations as well as three-
dimensional sculptural objects. Group exhibitions in
which his work appeared 1973–89 included at pri-
vate galleries (Holdsworth and Coventry, Sydney) and
in *Attitudes to Drawing*, Ivan Dougherty, Sydney 1980
as well as in MOMA, NY and the Victoria and Albert,
London.
APPTS: Tutor, CIT, 1974–75; lecturer, City Art Inst.,
1977; College of Fine Arts, University of NSW, 1990.
REP: Sydney CAE; Ararat regional gallery; Aberdeen
Art Gallery; Corning Museum, NY; Scottish Arts
Council.
BIB: *New Art Five.*

EUSTACE, Alfred William

(b. 1820, Ashbury, Berkshire, Eng.; arr. Aust. 1851;
d. 1907, Chiltern, Vic.) Painter, taxidermist. He earned
a living as a shepherd in Victorian gold districts while
teaching himself to paint. From about 1856 his paint-
ings on gum leaves became known in the district and
by 1869, when two of his gum leaf paintings were
shown at the *Art and Art Treasures Exhibition*, his rep-
utation had spread to Melbourne where his work con-
tinued to attract notice until the 1880s. Understandably
few of the gum leaf paintings survive, though oils on
board or canvas still appear in Melbourne auctions;
the majority of these are small river landscapes of the
Chiltern and Beechworth districts. He exhibited at
the Victorian Academy of Arts in 1877. He was also
a skilled taxidermist, known in this field for his pre-
paration of the birds and animals in the Beechworth
museum. His work was seen in *Australian Art in the
1870s*, AGNSW, Sydney, 1976 and *Australian Art
1820–1920*, Deutscher Galleries, Melbourne, 1980.
BIB: Kerr, DAA.

EVANS, Edith R.

Painter.
STUDIES: NGV School, c. 1890. Her painting *Doomed*,
purchased in 1903 for the AGSA, was described by
J. B. Mather as 'one of the best painted heads in the
colonial section'.
REP: AGSA.

BIB: J. B. Mather, *Catalogue of collections*, AGSA, Adelaide,
1913.

EVANS, George Francis

(b. 1809, Cardiff, Wales; arr. Hobart c. 1826; d. 1895,
Hobart) Painter, businessman, politician. Son of George
William Evans (q.v.) he migrated to Tasmania where
he worked in the public service before becoming a
wine merchant. In 1855 he was sentenced to death
for shooting an intruder but was pardoned by the
Governor. Appointed Usher of the Black Rod to the
Legislative Council, he retained this position till his
death. Only three paintings are positively attributed
to him – all of similar size and subject. His *View of
New Town, Tasmania, from Queen's Domain* (exhibited
Deutscher Galleries, 1981), though slightly stiff in
the foreground composition, is nevertheless of con-
siderable topographical and historical significance. His
work was seen in *Australian and European Paintings*
Deutscher Galleries Melbourne, May 1981 and
Tasmanian Vision TMAG and QVMAG 1988.
REP: Allport Library, Hobart.
BIB: Rienits, *Early Artists of Australia*, 1963. Kerr, DAA.

EVANS, George William

(b. 5/1/1770, Warwick, Eng.; arr. Sydney 1802;
d. 16/10/1852, Hobart) Artist, explorer, surveyor. His
professional career began in England when he was
apprenticed to an engineer and architect from whom
he learned the rudiments of cartography. Migrating
to the Cape of Good Hope in 1796, he moved on to
Sydney where he became acting surveyor-general and
storekeeper at Parramatta, only to be dismissed by
Governor King soon afterwards for fraud. He sup-
ported Bligh in 1808 and in 1809 was appointed
surveyor at Dalrymple, where he arrived in 1812.
In 1813 Macquarie recalled him from Tas. to lead an
expedition over the Blue Mountains. A second simi-
lar expedition followed, Evans' reward for success being
a grant of 1000 acres in Van Diemen's Land and the
post of deputy surveyor there. In 1817 he joined Oxley
and served under him in two expeditions, his sketches
for *Oxley's Journal* being redrawn for publication by
Major Taylor. Among Evans' best-known works are
two aquatints of Hobart published in London in 1820
and 1829. His work was represented in *The Artist and
the Patron*, AGNSW, 1988.
REP: NLA; Mitchell, Dixson Libraries.
BIB: G. W. Evans, *Description of Van Diemen's Land*, London,
1822; repr. Heinemann, Melbourne, 1967, intro. note by
K. R. von Stieglitz. C.M.H. Clarke, *A History of Australia*,
vol. 1, MUP, 1962. Rienits, *Early Artists of Australia*, 1963.
ADB 1. *George William Evans. Explorer*, Angus & Robertson,
Sydney, 1966. Margaret Weidenhofer, *The Convict Years
1788–1868*, Lansdowne, Melbourne, 1973. C. Craig, *Old
Tasmanian Prints*, Foot & Playstead, Launceston 1964. Kerr,
DAA.

EVERGOOD, Miles (Myer BLASHKI)

(b. 10/1/1871, Carlton, Vic.; d. 3/1/1939, Melb.)
Painter.

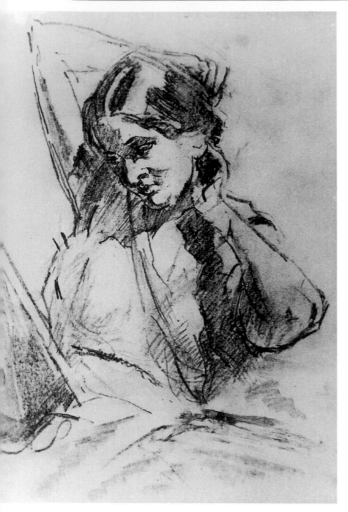

Miles Evergood, Woman Fixing Her Hair, *pencil, 24 ×
17.7 cm. Collection Castlemaine Art Gallery and Historical
Society.*

STUDIES: NGV School; England; Europe; USA, 1898–
1931. His real name was Myer Blashki, the name
under which he competed for the NGV Travelling Scholar-
ship in 1896. He left Australia after two years in
Sydney, 1896–98, and spent the next 40 years over-
seas, mostly in America, where his son, Phillip Evergood
(d. 1973) later became a leading American social-real-
ist painter. Miles Evergood cut a unique figure in the
conventional Australian art world, to which he unex-
pectedly returned in 1931. His work, exhibited in
Melbourne and Sydney, 1933, introduced a vivid, well-
balanced palette of primary colours which belonged
neither to the accepted categories of Australian paint-
ing nor to the modern European schools then in process
of gaining local recognition.
REP: NGV; QAG.
BIB: AA Apr. 1933.

EWART, Joy (Joyce Vera Mary)
(b. 1916, NSW; d. 1964, NSW) Painter, teacher.

STUDIES: ESTC, 1936; also with Dattilo Rubbo and
Desiderius Orban; England and Europe, 1949–52;
USA, 1959. Well-known in Sydney for her painting
and graphic art, she taught in various private schools
as well as conducting tutorial classes in art at Sydney
Uni. In 1960 she opened her own art school and soon
afterwards started the Workshop Arts Centre at Wil-
loughby, NSW. Among her varied, successful activities
was the production of a 16 mm film directed by
Laurence Collings, *Youth Creates,* on the teaching of
art to children and young people.
AWARDS: Mosman prize, 1948; Fulbright grant for
study in the USA, 1949.
REP: AGNSW.
BIB: A&A 2/4/1965 (memorial article).

EWERS, Ray (Raymond Boultwood)
(b. 1917, Wyalong, NSW) Sculptor.
STUDIES: Working Men's Coll. (RMIT), commercial art,
1936–40. Worked with Leslie Bowles as a third, sec-
ond, then first assistant on the King George V and
Monash memorials, Melbourne, c. 1938–41. Enlisting
in an engineering unit in 1941, he served as an official
war artist in Papua, Java, Borneo, 1943–45, and after
the war worked on 32 dioramas pertaining to World
War II action for the AWM, Canberra, in studio space
made available in the Exhibition Buildings, Melbourne.
His many subsequent commissioned works include
soldiers, sailors and airmen memorials, and the restora-
tion of the Suez Anzac Memorial, completed by Web
Gilbert, Paul Montford and Bertram Mackennal
(1923–31), which had been badly damaged during
riots at Port Said.
AWARDS: Scholarship for Working Men's Coll., 1937;
Australia at War exhibition (prize for sculpture), 1945;
Matthew Flinders Bicentenary fountain project, 1975.
REP: AWM.
BIB: Sturgeon, DAS. Scarlett, AS.

EWINS, Rod
(b. 27/12/1940, Fiji; arr. Sydney 1956) Painter, print-
maker.
STUDIES: Julian Ashton School, Sydney, 1961–62; City
and Guilds of London Art School, UK, 1963–65; travel
studies in Europe, 1965; USA, 1976. A fourth-gener-
ation member of a family of British settlers in Fiji,
Ewins' art was shaped largely by his background, re-
flecting island primitive, Italian old master and mod-
ern influences. His work has been shown in solo and
group exhibitions including those with the PCA 1967–
88; international print shows and at the Royal Society
of Painter-Etchers, London.
AWARDS: Tasmanian Arts Prize, 1968; joint and sole
winner several print prizes including Shell Award, WA
1980, Spain 1983; Gold Coast City Art Prize, 1984.
APPTS: Scientific illustrator, CSIRO, Canberra, 1966;
teaching, Canberra Tech. Coll., 1966; lecturer in print-
making, Tas. CAE, Hobart, 1967– .
REP: AGNSW; QAG; TMAG; Artbank; several regional
galleries inclduing Benalla, Burnie.
BIB: PCA, *Directory,* 1988. Backhouse, TA.

EXHIBITIONS
See Appendix 2, p. 787.

EXPERIMENTAL ART FOUNDATION
(The Jam Factory)
See GALLERIES – PUBLIC

EXPRESSIONISM IN AUSTRALIA
Australian expressionism can be divided into two main streams – 'abstract expressionism' and 'figurative expressionism'.

ABSTRACT, POST-PAINTERLY AND NEW (NEO) EXPRESSIONISM
Abstract expressionism in Australia was the result of a complex amalgam of influences from Europe, England and America and can be divided into three main phases: abstract expressionism in Sydney and Melbourne prior to the mid-1960s and influenced more by European painting than American; its continuation in New York and English influenced 'colour painting' from the mid 1960s to the 1970s; and the various survivals, revivals and conversions to neo-abstract expressionism in the 1980s and 90s.

In February 1957 Sydney critic Paul Haefliger, reviewing *Direction 1*, an exhibition of works by John Passmore, John Olsen, Bill Rose, Eric Smith and Robert Klippel at Macquarie Galleries in December 1956, announced that abstract expressionism had arrived. The artists rejected the association with abstract expressionism pointing out that their works were in fact 'structurally' abstracted rather than 'expressed'. Structural abstraction, as in the works of European painters Manessier, de Stael, Soulages, Vieira De Silva and Marchand, all seen in the 1953 exhibition *French Painting Today*, was also known as tachism. The term described those who worked in flat planes and textures with strong vertical and horizontal compositional elements.

Earlier, an exhibition at Sydney's Contemporary Art Society in November 1956, with works by Margo Lewers, Carl Plate, Iam Sime, Tom Gleghorn and Elwyn Lynn did evidence the new American influence. In March 1956 Lynn had distinguished between European tachism and abstract expression. The latter depends on restless, emotive loosely flowing lines and shapes analogous to emotions and inner realities which were supposedly non-referential to the outer world of sense-data experience.

In the 1959 *Antipodean Manifesto* Bernard Smith attacked abstractionists: 'Today's Tachistes, Action Painters, Geometric Abstractionists, Abstract Expressionists and their innumerable band of camp followers threaten to benumb the intellect and wit of art with their bland and pretentious mysteries . . . the art which they champion is not an art sufficient for our time'. Such sentiments were against the tide, particularly in Sydney where abstract expressionism with its energetic lines, masses of colour which fuse and spread, spontaneous applications of paint and accen-

tuated brush line palette-knife marks, was enthusiastically accepted. The young John Olsen and the older Ralph Balson adopted it simultaneously in a bat 1960.

Some artists adhered to the style briefly, for their own reasons and not always in harmony with its official history and mythology.

In Melbourne, artists were aware of abstract expressionism but it was Peter Upward's rapidly executed linear abstractions influenced by Zen and bebop jazz, and painted without preliminary drawings or corrections and shown at the Museum of Modern Art and Design in 1959, that best exemplified its influence. Upward and sculptor Clement Meadmore soon relocated to Sydney where other general abstract expressionists included Stanislaus Rapotec, Leonard Hessing, Henry Salkauskas, Eva Kubbos, Hector Gilliland, Ron Lambert, Daryl Hill, Rodney Milgate, Ross Morrow, Nancy Borlase and, briefly after 1962, John Coburn. All had, by the 1960s, a good knowledge of European painting – some having migrated from there – and a passing acquaintance with American developments through international art magazines.

Their ranks were re-informed by the American Charles Reddington, the young Robert Hughes and Michael Taylor who returned to Australia in 1963. A significant though low key influence was Tony Tuckson – then deputy director of the AGNSW – whose cursive linear style was influenced by Ian Fairweather and Jackson Pollock and, from 1958, by the art of Australian Aborigines. In South Australia new arrivals Stanislav Ostoja-Kotkowski, the brothers Ludwik and Wladyslaw Dutkiewicz, Anton Holzner and American Gordon Samstag reinforced the movement, while Stanislaw Halpern, who settled in Melbourne, later contributed to its continuation in Paris.

By the early to mid 1960s, new influences heralding the colour-field phase assumed the avant-garde position. Collectively, the 1960s generation rejected the figurative expressionism of the Antipodeans though the latter's success in London in the early 60s helped develop their confidence and esteem. Breaking with the landscape and its myths, they looked to New York painters Hofmann, Motherwell, de Kooning, Guston, Pollock, Kline, Gorky, Gottlieb, Slill, Rothko, Newman, Louis and Kelly, who, championed by critics Clement Greenberg and Harold Rosenberg, had ceased to think of abstraction as structure but rather as colour, line and expression.

In 1968, adherents of a style variously known as hard-edge, post-painterly abstraction, new abstraction and colour-field painting (see ABSTRACTION) were drawn together for *The Field* exhibition at the NGV. Though the paintings were non-objective and sometimes geometrically abstracted, philosophically they had little in common with European inspired abstraction or expressionism, but much to do with American abstract expressionism as it metamorphosed into minimalism. The painters' immediate and continuing careers have often continued to refer to abstract expressionism as in the 1980s and 1990s many have strived to place

their ongoing individual development within the postmodern context of neo-expressionism.

1970S AND BEYOND

The leading figures, much assisted in the 1960s by the growth of commercial gallery and art school systems, a spate of lucrative prizes, an accepting press and their own undaunted egos, enjoyed rapidly acquired reputations as modernist 'rebels and heroes'. Their position was difficult to sustain in the pluralistic, political, conceptual 1970s. Their champion, Patrick McCaughey, quippped, 'No ambitious art bureaucrat, curator or art critic is going to make their reputation by supporting them'. Though their careers have not always been continuously devoted to abstract expressionism, the best of the *Field* painters developed more loose painterly modes and were joined, in the 1970s, by others including John Peart and Lesley Dumbrell. Though the 1980s revival of figurative expressionism also brought new opportunities for abstractionists, their contribution has been problematical. Branded as anti-intellectual archetypal mainstays of modernism, surviving abstract expressionists have been unsympathetically targeted as having little in common with post-modern theory.

With various defections and changes of direction, and the inclusion of additional exponents variously versed in post-modernism – like Ann Thomson, Denise Green, Sandra Leveson, Lesley Dumbrell, Elizabeth Gower, Marion Borgelt, Janet Lawrence, Marianne Baillieu, Aida Tomescu, John Walker, Brian Blanchflower, James Clayden, Richard Larter, Tim Maguire, Paul Boston and Victor Sellu – the painterly neoabstract expressionism of *Field*-generation painters Michael Johnson, Alan Leach-Jones, David Aspen, Robert Hunter, Paul Partos, Robert Jacks, Allan Mitelman and John Firth-Smith, remains a force to be reckoned with in the 1990s.

FIGURATIVE AND NEO-EXPRESSIONISM

Figurative expressionism, which originated in Europe before the First World War, was more effectively assimilated and appropriated by Australian artists of the 1940s to 1960s than its sister movements, surrealism and abstraction. It springs from anxiety, and knowledge of the loneliness that would prevail without means of communicating ideas, emotions and feelings through art. In Germany, where it has informed the visual arts since the Middle Ages, it reappeared in pre-war activities of the Dresden and Munich groups 'Die Brücke' and 'Der Blaue Reiter'.

The two pre-eminent eras of figurative expressionism in Australian art have been the 'Antipodean' movement of the 1940s and '50s and 'new figuration', also known as trans-avantgardism and neo-expressionism, which developed from the early 1980s.

Elements of expressionism are present in most art. They communicate information pertaining to the emotions and feelings. They can be detected in paintings by artists of the Heidelberg School (q.v.), when they used bright high-keyed colours and expressive brushwork in response to the landscape. More than 'impressionism' they documented an emotional involvement with the landscape and its colonial and pastoral myths. The influence of post-impressionism arrived in Sydney shortly after the First World War while Melbourne was in the grip of 'Meldrumism' and tonal academic painting. The 1920s and 30s were cautious with intermittent independence displayed by painters like William Frater, Arnold Shore and Margaret Preston, who were more inclined to compose for expressive effect than to copy from nature.

The influential exhibitions of modern masters in 1939, and the development of Contemporary Art Societies in Melbourne (1938), Sydney (1939), and later Adelaide, indicate a general striving towards art which would give expression to contemporary thought and life.

The Melbourne CAS, according to Bernard Smith, fell into three groups: George Bell's followers whose painting organised colour and form in terms of personal experience and the influence of post-impressionism; the social realists who used expressionism to validate social commitment and promote political views, and the avant-garde group championed by John and Sunday Reed. This group was variously attuned to European modernism and the changing psychological, social and political forces active before and after the war.

At the Reeds' home Sidney Nolan, Albert Tucker, Arthur Boyd, John Perceval and Joy Hester collided with the Russian Danila Vassilieff who, from 1936 and his second arrival in Australia, had been painting the inner urban streets in a vital, passionate, expressionistic manner. His influence, the heady debates encouraged by the journals, *Meanjin*, *Angry Penguins* and *Art in Australia* and the pre-war arrival and return from Europe of migrants and expatriates knowledgeable and anxious about events overseas and their possible repercussions here, all encouraged a local brand of expressionism focusing on social injustice encountered in the cities and a vast landscape settled by pioneering battlers.

Alan McCulloch called figurative expressionism in Australia 'The Antipodean School'. In the previous edition of the *Encyclopedia* he wrote: 'Isolation, drought, crime in colonial times, exploration, pioneering frontiers, the whole wide, newly discovered spectrum of *Australiana*. Drysdale's drawings and paintings of the drought-plagued north-west of NSW and his use of the coloured inks and crayons as discovered by the British war time artists Piper, Sutherland and Henry Moore. Nolan's lyrical use of a ghastly medium – ripolin on hardboard – in his paintings around the military camps of Dimboola and the Wimmera, and the beginnings of his reincarnation of the bushranger, Kelly. Albert Tucker's discovery of German expressionism and its application to his "images of evil". Child art as introduced by Danila Vassilieff and swiftly adapted by Nolan. John Perceval and the former impressionist, Arthur Boyd, and their grotesque

melanges of expressionism, child art and the hysteria of war. Such were the components of what finally became known as the Antipodean School. Its key theme was *Australiana* and its catalyst, World War II.

'Antipodeanism was never a concerted movement like its illustrious predecessor, the Heidelberg School of the 1880s. The only thing Drysdale and Nolan had in common was the theme, and there were vast differences between the ways of thinking and of painting of most of the others.

'The name "antipodean" seems first to have been applied by English critics, who may have had it from the early annual magazine, *The Antipodean*, published by Chatto and Windus, London, 1892, 1893 and 1897. It was used by these critics in comments on Australian painting in the 1950s, and c. 1957 Albert Tucker used the title *Antipodean Head* in his work exhibited in London. In August 1959, Bernard Smith used it in an exhibition, *The Antipodeans*, which he organised in defence of figurative as opposed to abstract painting then gaining popularity among Australian painters and students. Smith wrote a manifesto in support of figuration [and critical of abstract art] and the exhibition was held at the Victorian Artists' Society, Melbourne.'

McCulloch goes on to include artists James Wigley, Jacqueline Hick, Clifton Pugh and Fred Williams before concluding that by 1975, Antipodeanism was finished. It had given Australian painting a strong and rugged identity, great individuality and was 'the most creative period in the history of Australian art.'

The precise definition of groups, movements and schools of art is difficult because artists frequently, and thankfully, reorder their styles, attitudes and allegiances in the course of a lifetime – particularly in the 20th century, one of unprecedented cultural change. As early as 1943 the social realists Noel Counihan, Yosl Bergner and Vic O'Connor criticised the individually oriented expressionism of Nolan and Tucker. Tucker used the pages of *Angry Penguins* to attack the social realists' political stance. Henceforth, the Reeds, Max Harris, Nolan, Boyd, Tucker and Perceval became the doyens of Melbourne-based figurative expressionism – differentiated from Russell Drysdale and William Dobell whose work also carried expressionist tendencies and social awareness.

After the war the 'Angry Penguins' and the Melbourne Contemporary Art Society ceased to exist, and the former identities went different ways. After them came a more provincial and folksy group including Gil Jamieson, Ray Crooke, Douglas Stubbs and Sam Fullbrook. They continued to seek the 'outback' myth.

Figurative expressionsism did not abate; it was sustained through the 1960s and '70s by Melbourne painters Fred Williams, John Brack, Clifton Pugh, Ken Whisson, Jan Senbergs, Richard Crichton, George Baldessin, Michael Shannon, Andrew Sibley, and later Peter Booth; by Queensland painters Lawrence Daws and Jon Molvig; by Kevin Connor, Tim Storrier, Brett Whiteley, Keith Looby and Gunter Christmann in Sydney and by Robert Juniper and Guy Grey-Smith

in Western Australia. In fact, Williams, Brack, Booth and Senbergs developed spectacularly in the 1970s, keeping faith in figurative expressionism alive during a pluralistic decade noted for decline in formal studio-based activities.

The figurative painters continued to be supported by the commercial gallery circuit, but modernism, including its expressionist exponents, became increasingly embattled. When the 1970s ended, critics like Robert Hughes made much of their passing, predicting the end of the avant-garde and, possibly, the end of painting. After the conceptual 1970s, a more intellectual mode and successive interpretive theories could no longer be ignored. But no-one predicted the wholesale return to the easel and the rebirth of figuration which would characterise much of the 1980s.

The new-figuration, or neo-expressionist, painters emerging in Australia after the Italian 'trans-avant-gardism', and the German 'Zeitgeist', reassessed their own 'histories' and the cultural 'texts' of modernism. Earlier styles, like expressionism, were raided for images and effects which were appropriated and reworked from differing perspectives. Former figurative expressionists and abstractionists including Peter Booth, John Walker, Bill Brown, Janet Dawson, Sydney Ball, Guy Warren, Fred Cress, Robert Boynes and many others joined the resurgence of expressive figuration which featured elements of historicity and personal paranoia. Painting had a bonanza. Neo-expressionism appealed particularly to younger artists anxious to unload their private fears and doubts in styles borrowed from the vital years of modernism. Australia's Aboriginal history received attention and there was an exodus of painters travelling north to acquire first hand experience of Aboriginal art.

Those who could be said to fall into an expressionistic category in the 1990s include Peter Booth, Jan Senbergs, Gareth Sansom, Jenny Watson, Arthur Boyd, John Brack; Susan Morrio, Caroline Williams, Vivienne Shark-LeWitt, Geoff Lowe, Lindy Lee, Adrienne Gaha, Imants Tillers, Juan Davila and Richard Dunn.

As well Jan Murray, Susan Rankine, Mandy Martin, Davida Allen, Julie Brown Rrap, Kim Donaldson, Carolyn Fels, Deborah Walker, Nora Sumberg, Rosie Weiss, Pat Hoffie, Rick Amor, Ted May, Jeffrey Makin, Victor Majzner, David Keeling, Stephen McCarthy, Noel McKenna, Joe Furlonger, George Foxhill, Tony Clark, Stephen Bush and many others could be included.

While all the foregoing work figuratively, it is sometimes questionable whether they are expressionists in any coherent sense of the term. Their interests and references are so diverse and obscure – 'texts' rich in visual puns, metaphor, historicity and literal references. Post-modern paintings can be so artificially constructed that they reject interpretation and devalue emotional involvement. Other artists deliberately confuse the communication process.

Thus the return to figurative painting – though it has enriched the interplay of symbol, metaphor and narrative – has moved away from uncomplicated

expression and communication of emotions to art forms which are answerable to, and derived from, art and its theory. This new theoretical direction coincided with the decade of the 1980s when patronage and opportunities for artists now included many women and younger artists. Outstanding was Melbourne's 'ROAR' group – including David Larwill, Sarah Faulkner, Wayne Eager, Jill Noble, Mark Schaller and Mark Howson. A decidedly different and richer, if more competitive, cultural context exists from the 1980s on.

The younger artists and many of their predecessors have been prepared to re-evaluate figurative traditions in Australia and elsewhere. They have responded to the arts of the Aborigines and taken inspiration from the city, the landscape, and the human psyche in their efforts to perpetually re-invent figuration.

JENNY ZIMMER

EYRE, *Gladstone*

(b. 1863, Brunswick, Vic.; d. 1933, Sydney) Painter. STUDIES: Melbourne, with van den Houten; Sydney, with Knut Bull. A member of the Art Society of NSW, 1883– , he exhibited a portrait of Mrs Langtry in that year and became known for his portraits of government officials. His posthumous reputation depends more, however, on his landscape, bush and coastal paintings.

REP: Mitchell Library; QVMAG.
BIB: McCulloch, *AAGR*.

EYRE, *Hal*

(Active c. 1890, Qld) Black-and-white artist. He contributed to *The Comic Australian*, Sydney, and was staff artist for the *Queenslander*. He married the ceramic artist Vi Hodginson.

BIB: Vane Lindesay, *The Inked-In Image*, Hutchinson, Melbourne, 1979.

EYRE, *John*

(b. c. 1771, Coventry, Eng.; arr. Sydney 1801) Painter, engraver. Between 1801 and 1812 as a convict, Eyre produced many paintings and engravings, including panoramic views of Sydney, and four well-known aquatints of Sydney Cove. Nothing is known of Eyre after he left the colony as a free man in 1812.

REP: Dixson Gallery of the Mitchell Library; Nan Kivell Collection, NLA.

BIB: *Present Picture of New South Wales*, Mann, London, 1811. A. West, *Fourteen Views of New South Wales*, Sydney, 1812. Rienits, *Early Artists of Australia*, 1963. ADB 1. Jocelyn Hackforth-Jones, *The Convict Artists*, Lansdowne, Melbourne 1977. Smith, *EVSP*. Kerr, *DAA*.

FABIAN TO FURNEAUX

FABIAN, Erwin

(b. c. 1915, Berlin; arr. Aust. 1940) Industrial designer, graphic artist, sculptor. He arrived in Australia on the prison ship *Dunera* and after a period spent at Tatura, Vic., went to Melbourne where he became a leader among a group of young German artists, several of whom contributed to *Argus* publications (1944–47). He worked at advertising art and contributed drawings and cover designs to Army Education publications. Returning to London in 1950 he worked as a designer and lecturer (at the London School of Printing). Back in Melbourne in 1962 he commenced his work as a sculptor, exhibiting in state capital cities as well as in London.

REP: NGA; NGV; QVMAG.

BIB: Scarlett, AS.

See also FRIEDEBERGER, Klaus; SCHONBACH, Frederick.

FABYC, Deej

(b. 26/8/1961, UK) Installation artist.

STUDIES: BA, ANU, 1980; B. Fine Arts, Canberra School of Art 1982; BA Fine Arts, Preston Inst. of Technology, 1983; BA Fine Art, Uni. of New England, 1987–88; Grad. Dip. Visual Arts, Uni. of NSW 1990. She held three solo exhibitions at Legge Gallery, Redfern 1990, 91 and Signal Box, Museum Station, Sydney 1990. Her work appeared in about 22 group exhibitions 1982–92 at private galleries in Sydney (Legge) and Canberra (Bitumen River), and public galleries and performance spaces including in *Women's Art Show*, Pier 2, The Rocks 1987; *Beauty and the Beast*, Tin Sheds 1991.

AWARDS: National Women's Consultative Council Competition, International Women's Decade 1975–85; Union Art Prize, Uni. of New England; OTC Technical Art Prize, 1991; residency Power Studio, Cité Internationale des Arts, Paris, 1992; VACB project/travel grant, 1992; NAVA materials grant for installation costs.

REP: NGA; Canberra Contemporary Art Space; State Library of Vic.; Uni. of New England; Ballarat regional gallery.

FAED, William C.

(Active c. 1892) Painter. He exhibited at the RA, London and was in Melbourne, 1892, when he exhibited portraits and figure compositions at the VAS. The style of his work suggests a relationship with the Scottish 'story telling' painters John (1820–1902) and Thomas Faed (1826–1900).

FAERBER, Ruth

(b. 1922, Sydney) Printmaker, critic.

STUDIES: ESTC (part-time); Orban's School; Pratt Centre for Contemporary Printmaking, NY, 1968. She held solo exhibitions in most capital cities from 1964, received a number of print commissions (including member prints for PCA; and *100 × 100* print portfolio, 1988) and participated in a number of group print survey exhibitions 1964–90 including *1st International Paper Biennale* Düren, West Germany, 1986; *Paper Present* 1st National Paper Conference, Hobart, 1988. She was artist-in-residence, Bezalel Art Institute, Jerusalem, 1987.

AWARDS: Scholarship for study, New York, 1968; grant VACB 1975, 81; Qantas Freight Grant (London) 1981.

APPTS: Secretary of Sydney Printmakers, 1970–73; treasurer PCA, 1974; art critic, *Australian Jewish Times*, 1970– ; Australian delegate, International Association of Art Critics convention, Yugoslavia, 1973.

REP: Print collections in AGNSW; NGV; QAG; QVMAG; TMAG; Bezalel Museum, Israel; PCA archives; a number of international collections including Thyssen-Bornemisza, Switzerland; Israel Museum.

BIB: PCA, *Directory*. Kempf, *Printmakers*.

FAIGAN, Julian Goodrich

(b. 24/10/1944, NZ) Gallery director, curator.

STUDIES: BA (Auckland), 1966; MA (Auckland), 1970; MA (Melbourne Uni.), 1984.

APPTS: Director, Hamilton Art Gallery; director, *Uncommon Australians* exhibition touring state galleries and the NGA 1992–93; director, Nutcote House 1993– .

FAIR, Fraser Grant

(b. 24/9/1949, Hobart) Painter.

STUDIES: Prahran CAE and RMIT, 1968–71; travel studies, Europe, 1971. Beginning with luminous, large-scale abstracts, his work gradually became more

figurative, as for example in his exhibition of nudes done in pastels (Stuart Gerstman Galleries, Nov. 1979). He exhibited at Melbourne and Sydney galleries (including Rudy Komon) 1970s and 80s and group exhibitions in which his work appeared included *McCaughey Prize* 1975, 79; Michell Endowment, 1983; *Vox Pop* 1983 all at NGV.

AWARDS: Travelodge prize, 1972; Darnell de Gruchy (purchase award), 1977.

REP: NGA; NGV; QAG; Benalla, Rockhampton regional galleries; University of Melb; corporate collections including NAB, ICI, ANZ.

BIB: Backhouse, *TA*. Germaine, *AGA*.

FAIRBAIRN, David Cautley

(b. 28/12/1949, Zambia; arr. Aust. 1981) Painter, printmaker, lecturer.

STUDIES: Wimbledon and Central School of Art & Design, London, 1969–70; BA Hons (Fine Art), West Surrey College of Art & Design, UK, 1971–74; post-grad. study painting, RA Schools, London, 1974–77; travel studies Middle East 1973, 75; West Africa 1974; USA 1976; USA, Europe, Africa 1984–85; Europe, Africa 1988–89; Zimbabwe 1991–92. He held joint exhibitions with his wife, Suzanne Archer, (q.v.) 1981–92 including at Wollongong City Gallery 1982, and eight solo exhibitions 1974–88 in Sydney including at Roslyn Oxley9 (1982), Mori (1984), Hogarth (1986), DC-Art (1988), and in Melbourne (Powell St, 1984). His paintings are abstract expressionist, often portraits and he used collage in his earlier work, less frequently since the mid-1980s. He was represented in about 31 group exhibitions 1975–92 including Royal Academy exhibitions, UK, 1975, 76, 77 and Slade School, 1977; in Australia in private galleries (including Mori, Hogarth, Holdsworth, Sydney) and regional and public galleries including *Sydney Biennale* 1986; *The Portrait Today*, Westpac, Vic. Arts Centre 1986; *Archibald Prize*, AGNSW, 1983, 84, 85, 86. He was artist and tutor-in-residence, Canberra School of Art, 1987.

AWARDS: Several Royal Academy of Arts, UK, awards 1975, 76; many regional prizes Australia including Bathurst, 1981, 87; Camden, 1987, 88, 89; Gold Coast, 1984, 89; Fisher's Ghost Prize, Campbelltown, 1989.

APPTS: Inner London Education Authority and Wimbledon School of Art Foundation, UK, 1976–81; visiting lecturer, part-time, Coll. of Fine Arts, Uni. of NSW; NAS; St George Tech. Coll., 1981– ; also SCA, Nepean CAE, Newcastle Uni., 1981– ; Uni. of New England Summer School, 1982; Kingston Arts Workshop, Canberra, 1985, 86; summer school, Coll. of Fine Arts, Uni. of NSW, 1988–92; Tamworth Art Camp, 1989–92.

REP: City council collections including Bathurst, Port Stephen, Gold Coast, Hunters Hill, Waverley-Woollahra, Camden, Warringah, Mudgee; regional galleries including Bathurst, Broken Hill, La Trobe Valley; corporate collections including Myer, State Bank.

BIB: Germaine, *AGA*. McIntyre, *ACD* and *CC*.

FAIRFAX FAMILY

The Fairfax family of Sydney newspaper owners has traditionally given strong support to Australian art in broad, general areas of art patronage and administration. Many members of the family have made large, important collections. Sir Vincent Charles Fairfax served on the council of the Art Gallery Society of NSW, 1953–69; Sir Warwick Fairfax served on the Elizabethan Theatre Trust (vice president 1969), and his wife, Lady Mary Fairfax, OBE, was elected to the board of the AGNSW, 1972. James Fairfax was elected to the board of the AGNSW, 1972. James Fairfax, OBE, was elected to the International Council of the MOMA, New York, in 1971, and to the Council of the NGA, 1982.

BIB: A&A 3/3/1965 (James Gleeson, 'The Art Collectors 3: James O. Fairfax, Part 1'); 3/4/1966 (Daniel Thomas, 'The Art Collectors: James 0. Fairfax, Part 2').

FAIRSKYE, Merilyn

(b. 4/1/50, Vic.) Painter, lecturer.

STUDIES: Dip. Art, Alexander Mackie CAE, 1975; Dip. Ed., Sydney CAE, 1987; MA (Visual Arts), SCA, 1989. She uses a variety of techniques and media including installations, photography and paint. Her 1980s work was concerned with feminism and the feminine in art and language. Her 1992 exhibition at Roslyn Oxley9, *In Camera*, consisted of a series of monochrome diptychs of famous and infamous personalities with women significant in their lives, including Himmler and daughter; John Kennedy and daughter Caroline. She frequently quotes apposite texts in her work, which is often large, multi-panelled and complex. She held 18 solo exhibitions 1985–93 in Sydney (Roslyn Oxley9 1985, 88, 89, 91, 92) and Melbourne (William Mora 1992, 93), and in public galleries including Filmmakers Cinema, Sydney 1982; *Conducting Bodies*, IMA Brisbane, ACCA, Melbourne, Praxis, Fremantle 1987; and in PSI, NY 1989. Her work was seen in about 44 group exhibitions 1980–91, mainly at public galleries including; *Australian Perspecta*, AGNSW 1983, 85; *The Romance Show*, touring regional galleries and Contemporary art spaces, Sydney 1984; *ICI Contemporary Art Collection*, touring regional galleries 1989; *Dissonance: Aspects of Feminism and Art 1970–91*, Artspace 1991. She received seven mural commissions 1979–84 in Sydney and Tasmania.

AWARDS: Japan-Australia Foundation Hozumi Momota memorial Award, 1980; VACB full standard grant, 1984; residency, Cité Internationale des Arts, Power Inst. of Fine Art, Uni. of Sydney, 1985; fellowship, PSI, New York, VACB, 1989; residency, Rockefeller Foundation, Bellagio Conference and Study Centre, Italy, 1992.

APPTS: Art tutor, Arts Council of NSW, 1976–78; art tutor, Community Support Scheme, Sydney, 1980–81; lecturer, painting, drawing, School of Art and Design, ESTC, 1978–86; tutor, painting, drawing, public art, Art Workshop, Uni. of Sydney, 1980–84; lecturer, painting department, SCA, 1984–86; lecturer, painting, drawing, art survey, Dept TAFE, Sydney, 1987–88; lecturer, painting workshop, Canberra Inst. of the Arts,

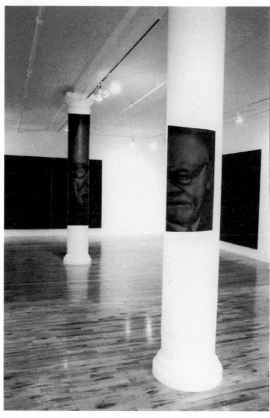

Merilyn Fairskye, Blue-Green (Sigmund Freud, Vienna, 1938), *diptych, acrylic and oil on plastic columns. Private collection.*

ANU, 1988–89; adjunct professor, SENHAC, New York Uni., NY, 1991– .

REP: NGA; AGNSW; AGWA; NGV; QAG; AWM; James Hardie Library of Fine Arts, State Library of Qld.

BIB: Catalogue essays in exhibitions as above. Sue Cramer & Bob Lingard (eds), *IMA 1975–89; A documentary history of the IMA,* IMA Brisbane, 1989.

FAIRWEATHER, Ian

(b. 29/9/1891, Bridge of Allan, Scotland; arr. Melb. Feb. 1934; d. 20/5/1974, Brisbane) Painter.
STUDIES: Hague Academy, Holland (briefly), 1918, then privately with van Mastenbroek; Commonwealth Forestry Inst., Oxford (forestry), 1919, School of Oriental Studies (Japanese), 1921; Slade School, London (intermittently), 1920–24; travel studies throughout his life. Brought up by various relatives in Scotland and destined for a career in the army through family tradition (his father was a Doctor-General in the Indian army), Fairweather received his early schooling at Jersey, London, and Chamery, Switzerland, before attending an officer training school at Belfast (1912–14) where he attained the rank of second lieutenant. Soon after the outbreak of World War I he was captured by the Germans near Dour, France (24 Aug. 1914) and spent the next four years in POW camps. His life in the camps, though interspersed with various attempts at escape, permitted studies in Japanese and drawing

as well as illustrations for POW magazines. After the war he studied art in Holland, London and Munich before continuing the wandering existence (which had been his lot from childhood) in Canada, Shanghai, Bali and Colombo. By Feb. 1934 he was in Melbourne where he made contact with the bookseller Gino Nibbi, and the painters Frater and Bell, as well as other Melbourne modernists, and partly completed a mural on brown paper for Menzies Hotel. In Sept. he left abruptly for the Philippines via Sydney and Brisbane. Murray Bail lists the places in which he lived during the 1930s – Shanghai, Peking, Tokyo, Formosa, Hong Kong, Jakarta, Macassar, Tawau, Zamboanga, Manila, Brisbane (1938), Cairns (1939), Saigon, Bangkok, Singapore, Calcutta, Bangalore. After service with the British army, mainly in India (1941–43), he visited Melbourne, Brisbane, Cairns and Cooktown, and in Oct. 1945 settled in Melbourne in a studio in a converted hotel at Darebin, owned by the painter Lina Bryans. His paintings had become widely known, having been acquired by the CAS, London, the Tate and Leicester galleries and included in the exhibitions *British Painting Since Whistler* and *Exhibition of 20th Century Art* at the National Gallery, London. In 1947 he moved to Qld and thence overland to Darwin where, after living in the hulk of an old boat on the beach, he built a raft and embarked on the hazardous journey to Timor that brought him into the spotlight of world news. The year was 1952. Deported by the Indonesian authorities he went to London via Singapore, returning to Brisbane in 1953. Some years previously

he had discovered Bribie Island, then an isolated, rural retreat, and there he built a bush hut where, except for visits to India (1965) and London (1966), he lived and worked for the rest of his life. Though primitive in feeling there is nothing primitive in the general iconography, rhythms and colour modulations of his paintings. They reflect rather the influence of his Slade School studies but more importantly the ancient paintings of the Chinese, the people whose language, culture and character remained very close to his heart. (He illustrated with original paintings *The Drunken Buddha*, translated from the original Chinese, and published by the University of Qld Press, Brisbane in 1965.) As one of the few European-trained painters to have successfully assimilated the exotic and primitive influences of the islands of the Pacific, Fairweather invites comparison with Gauguin, and indeed he is the only European-trained painter ever successfully to have assimilated the art of Australian Aborigines – partly because his way of life and theirs had much in common. His work was included in the exhibition *Australian Painting Today* at the Tate Gallery, London, in 1963, and in the same year was selected to represent Australian art at the *Bienale de São Paulo*. But the loneliness of his life continued to the end. He drank whisky and played chess with his occasional rare visitors and fed his pet goanna at his bush hut, to become known locally as 'the hermit of Bribie Island'. When he died after a short illness at the age of 82, the rural character of the island died with him. It is now a tourist resort. Survey exhibitions in which his work appeared include the Bicentennial exhibitions *The Great Australian Art Exhibition 1788–1988* and *The Face of Australia* and *Classical Modernism: The George Bell Circle* NGV, 1992.

AWARDS: Student prize, Slade School, London, second prize for figure drawing, 1922; W. D. & H. O. Wills Prize, Sydney, 1965; John McCaughey Prize, Sydney, 1965.

REP: MGA; AGNSW; AGSA; AGWA; MAGNT; NGV; QAG; QVMAG; TMAG; many regional and other public galleries; Tate Gallery, London; Leicester Art Gallery; Ulster Museum, Belfast.

BIB: Norma Abbott Smith, *Ian Fairweather: Profile of an Artist*, Uni. of Qld Press, 1978. Murray Bail, *Ian Fairweather*, Bay Books, Sydney, 1981. A&A 1/1/1963 (Laurie Thomas, *Ian Fairweather*); 12/1/1974 (Mary Turner, *Ian Fairweather: An Appreciation*); 21/3/1984.

FALLET, *Francois*

(Active c. 1860–70, Melb.) Sculptor, stone carver. He arrived in Vic. during the goldrush. Among work attributed to him is some of the carving on Scots Church, Melbourne; Christ Church, South Yarra; and the sandstone coat of arms at the entrance of Government House, Melbourne. Two small marble reliefs by Fallet (the *Prospectors* and the *Landing of Captain Cook*) were owned by the Atyeo, family whose ancestor Frederick Atyeo had worked with Fallet. A work of his appeared in Joseph Brown Gallery *Spring Exhibition* 1979.

BIB: McCulloch, AAGR. Scarlett, AS.

FALLS, *Roger Eykyn*

(Active 1880s–90s) Painter. One of seven artists represented in the 9 × 5 *Impressions Exhibition* at Buxton's Gallery, Melbourne, in 1889. He exhibited three pictures. He was represented in *Golden Summers* NGV and touring 1986.

REP: Geelong Art Gallery.

FANNING, *Charles*

(b. c. 1815) He contributed two paintings, *A Fir Tree* and a biblical scene, to the Society for the Promotion of Fine Arts, Sydney, 1849 and was listed as a practising artist in Sydney in 1849.

BIB: Kerr, DAA.

FANTL, *Tom (Thomas)*

(b. 16/1/1947, Prague, Czechoslovakia; arr. Melb. 1949) Painter, printmaker, sculptor, teacher.

STUDIES: Prahran CAE; CIT; Melb. State Coll., 1967–70; travel studies UK and Europe, 1974–77. A strong draughtsman, his prints and drawings often have a linear quality with spare, open use of line, colour and form. He held about 20 solo exhibitions 1972–92 in Melbourne (including at Leveson St, Christine Abrahams, Distelfink, Gretz, MCA) and Sydney (including Coventry; Holdsworth), and a number in Belgium, London, 1970s. He participated in many group exhibitions at private and public galleries 1971–91, including MPAC *Spring Festival of Prints and Drawings*, Mornington 1983, 85, 87, 89. Commissions include paintings for Elders-IXL; Pacific Dunlop.

APPTS: Secondary teaching, Vic. Education Dept, 1970–74; Melb. State Coll., Caulfield Arts Centre, 1977; art teaching, Pentridge Prison, 1982; Wesley College, 1983–87 (head of Vis Arts, 1984–85); CAE, 1983– ; Moorabbin Coll. of TAFE, 1988–90; established own art school, 1991– .

REP: NGA; MPAC; several secondary college collections; corporate collections including Elders-IXL; Arnold Bloch Leibler; public collections in Paris, Belgium.

FARDOULYS, *James Nicholas*

(b. 1900, Kythera, Greece; arr. Aust. 1914; d. 1975, Brisbane) Painter. He accompanied his wife, a ventriloquist, on her show business travels (mostly in Qld), conducted his own troupe of performers, and later became a cafe proprietor and taxi driver. He began painting full-time about 1960. His naive paintings, inspired by recollections of his childhood in Greece, gained him a number of art prizes.

REP: AGNSW.

BIB: Bianca McCullough, *Australian Naive Painters*, Hill of Content, Melbourne, 1977.

FARLEY, *Stanley*

(b. 15/8/1942, Vic.) Painter, lecturer.

STUDIES: Dip. art and design, Preston Inst. of Technology, 1975. His whimsical, surreal images including fragments of pottery, cars, and surreal farm landscapes were seen in four solo exhibitions 1972–90, Melbourne (Tolarno 1986, 88, 90; Gerstman 1972), and about

five group exhibitions 1987–91 including at the NGV in 1987.

AWARDS: Project grant, VACB, 1987.

APPTS: Lecturer, drawing, La Trobe Uni. College, Bendigo.

REP: Artbank; Bendigo regional gallery; Brighton City Council; Ansett and Myer corporate collections.

FARMER, John MacCormack

(b. 1897) Painter.

STUDIES: NGV School; privately (with Max Meldrum); studies in Japan, China, England. He served in a camouflage unit in Australia during World War II. An honorary life member of the Twenty Melbourne Painters, he remained throughout his career devoted to the teachings of Max Meldrum.

REP: NGV.

FAUCHERY, Antoine Julien

(b. 15/11/1827; arr. Vic. 1852; d. 27/4/1861, Japan) Photographer, painter. Brought to Australia by the attraction of the goldfields following a colourful and artistically motivated early life in France where he associated with many leading writers and artists, his skills were many and he was described by French writer Theodore de Banville as 'a painter, engraver, architect, writer and photographer'. Fauchery recorded the life of the goldfields in his writings and in 10 volumes of 'stereo-monoscopes'. He ran a restaurant in Melbourne and a store on the goldfields, neither of which resulted in success but from which he learned much. The written account of his experiences first appeared in 15 instalments, beginning 9 Jan. 1857, in the Paris journal *Le Monitor Universel*. He returned to Paris for a year (1856–57) before coming back to Melbourne where he became a photographer, operating from a Collins St studio first alone then in collaboration with Richard Daintree (q.v.), with whom he published an album called *Australia* in 1858. He left Melbourne for Manila in 1859, thence to China as a French war correspondent where he became ill, transferred to Japan and died there in 1861. His work was represented in *Shades of Light*, NGA, 1988.

BIB: Antoine Fauchery, trans. A. R. Chisholm, *Letters from a Miner in Australia*, Georgian House, Melbourne, 1965; original French edn, Paris, 1857. ADB 4. McCulloch, AAGR. Dianne Reilly and Jennifer Carew, *Sun Pictures of Victoria: The Fauchery-Daintree Collection 1858*, Currey O'Neil, Melbourne, 1983. Kerr, DAA

FAULKNER, Sarah

(b. 1959, Hobart) Painter.

STUDIES: RMIT (painting), 1977–78; Dip. Art and Design, Prahran CAE, 1981. A founding member of the artists' co-operative ROAR Studios in 1982, her work has followed the new-expressionist style of that group. She held five solo exhibitions in Melbourne 1986–92 (Realities; Australian) and her work appeared in about 10 group exhibitions 1981–92 including a number at ROAR and in *New Acquisitions Show*, NGV 1990; *Young Artists*, Heide 1982 and *ROAR Studios at*

Heide, Heide 1992. Her commissions include for the NGA *Eight Group Murals* for the restaurant, a mural for the VRC restaurant and Portsea resort mural, 1990. She was artist-in-residence, Glamorgan, Geelong Grammar, Toorak, Vic., 1986.

AWARDS: Residency, Greene St Studio, NY, VACB, 1984.

REP: NGA; NGV (Michell Endowment); Monash Uni.; Uni. of WA; corporate collections including State Bank of NSW, Western Mining, Macmillan Publishing, Lieberman family collection.

FAULKS, Philip

(b. 1959, St Albans, UK) Painter.

STUDIES: Dip. Fine Arts (painting), VCA, 1980. He held five solo exhibitions in the 1980s at Ray Hughes, Sydney and Brisbane and *Fell in Love* at 200 Gertrude St, Melbourne, 1986. His work appeared in about 14 group exhibitions 1983–91 including at Ray Hughes, Sydney and Brisbane, and public galleries including *Contemporary Art in Australia*, opening show, MOCA, Brisbane 1987; *Young Australians: The Budget Collection*, NGV and touring regional galleries and other state galleries 1987; *Selected works from the Loti and Victor Smorgon Collection*, ACCA, Melb. 1988; *Twenty Australian Artists'*, Galleria San Vidal, Venice, QAG, Bendigo Regional Art Gallery 1990. He was commissioned to do a work for the Playbox/Malthouse theatre, Melbourne, 1990.

AWARDS: Overseas travel grant, VACB, 1985.

APPTS: Part-time painting and sculpture teacher, Adult Education, Box Hill City Council, 1982–83; part-time, VCA, 1988, 89.

REP: NGV (Budget Collection); MOCA (Brisbane); World Congress Centre, Melb.; Smorgon family collection.

BIB: A&A 23/4/1986.

FAWCETT, George

See ROWE, George Fawcett

FEARN, Francis

(b. 25/3/1835; arr. Aust. 1852; d. 23/12/1896, Bendigo.) Painter. He worked at the Princess Theatre, Melbourne, and at the Royal and Lyceum Theatres in Bendigo. After some years of moving around in Vic. he settled in Bendigo in 1884, where he became known for illuminated addresses. While living at Dunolly, he made the official drawing of the giant nugget, *Welcome Stranger*.

BIB: AAGR. Kerr, DAA

FEDDERSEN, Jutta

(b. 5/8/1931, Germany; arr. Aust. 1957) Fibre artist, sculptor, lecturer.

STUDIES: Dip. Fibre Art, Bremen, Germany 1953; MA (Visual), City Art Inst., 1988. She came to Australia to teach weaving at Sturt workshops, Mittagong. A leading creative weaver, her tapestries often take the form of woven structures or soft sculptures. In 1987 she displayed 80 white-plastered life-size organic forms, each surmounted by other material (feathers, twigs) while her animal sculptures, including pigs, form satirical, wry statements on animal/human life. Her

1991 Coventry Sydney show consisted of 22 'grind stones', legs and feet covered in rags, denoting the suffering in wars and inhumanity. She held about 15 solo exhibitions 1967–91 Sydney (including at Bonython; Roslyn Oxley9; Coventry) and Melbourne (Realities), and at McClelland Galleries, Melbourne; Ivan Dougherty Sydney and New England Regional Art Museum, Armidale 1988. Group exhibitions 1969–91 in which her work appeared included fibre and sculpture survey exhibitions such as *The Age of Collage*, Holdsworth 1987; *Mildura Sculpture Triennial*, 1988. She had a number of major commissions including for Sydney Opera House.

AWARDS: VACB grant, textiles in Africa, 1974; Warringah Shire prize, 1978; Diamond Valley Art Prize, 1981; residency, Paretaio, Tuscany studio, 1982.
APPTS: Lecturer, various tertiary colleges Sydney and NSW, including NAS, Alexander Mackie, 1962– ; senior lecturer, Hunter Inst. of Higher Education (Uni. of Newcastle) 1980– .
REP: AGWA; NGV; QAG; several tertiary, hospital, regional collections NSW, Vic.; corporate collections including Westpac.
BIB: Scarlett, AS. Sturgeon, DAS.

FEHLBERG, Tasman Julius August
(b. 15/9/1912, Hobart; d. 14/3/1971, Cronulla, NSW) Painter.
STUDIES: SASA; Hobart Tech. Coll; BA, Adelaide Uni., 1932. Known mainly for landscapes he exhibited solo only three times 1954–65 in Hobart and Adelaide as well as teaching at Adelaide Boys High School. He held offices with the SA Society of Artists 1944–47 before moving back to Tasmania to work at the ABC and later in Vic and NSW. His work appeared in several group exhibitions 1934–54 including with the Art Society of Tas and Tasmanian Group of Painters.
AWARDS: Tas. Sesquicentennial Prize for Painting, 1951.
APPTS: Supervisor of education ABC Tas. 1947–56; asst. supervisor education, ABC, Vic. 1957–61; supervisor of education, ABC, NSW 1961–69.
REP: AGSA; TMAG.
BIB: Backhouse, TA.

FEINT, Adrian George
(b. 29/6/1894, Narrandera, NSW; d. 25/4/1971) Painter, designer.
STUDIES: Sydney Art School, with Julian Ashton, 1919. He served in the AIF in France and Belgium during World War I. After studying with Ashton in Sydney, he worked as an artist specialising in commercial art, illustration and book-plate design. From 1924 to 1928 he directed the Grosvenor Galleries. In 1930 he held an exhibition of his book-plates at the Library of Congress, Washington, DC. Later his landscapes, and particularly his flower paintings, developed the modernist, surrealistic quality that brought him prominence during the romantic realist period of the mid-1940s in Sydney. He was represented in *The Face of Australia* Bicentennial exhibition.

REP: NGA; AGNSW; AGSA; NGV; Armidale regional gallery.
BIB: Horton, PDA. *Flower Paintings* Ure Smith, Sydney, 1948. A&A 9/1/1971 (Douglas Dundas, *Adrian Feint*).

FELLOWSHIP OF AUSTRALIAN ARTISTS
(Established 1950, Melbourne) Formed for the purpose of representing 'all schools of thought' in painting. The first exhibition was held at Tye's Gallery, Melbourne, 1951; decline in public interest reduced activities of the group.
BIB: Exhibition cat. *Fellowship of Australian Artists Royal Tour Exhibition*, Lower Town Hall, Melbourne, 1954.

FELS, Carolyn
(b. 8/12/1941, Melb.) Painter.
STUDIES: NGV School, 1959–60; George Bell School, 1961, 62; BA, Uni. of Melb., 1979; BA (Fine Arts), VCA, 1986; grad. dip. fine arts (painting), VCA, 1986–88. She held four solo exhibitions 1988–93 at 13 Verity St, Melb. (1988, 90, 93) and Coventry, Sydney (1989) of oils typified by 'paintings within paintings – new-romantic' style landscapes and figures in the landscape surrounded by a painted panel frame, creating simultaneously both a focal point for the inner work and a feeling of distance of the whole work. Her work was seen in about 20 group exhibitions 1988–92 at private galleries Melbourne and Adelaide and in public galleries including *A New Generation – Philip Morris Collection*, NGA 1988; *New Art: Contemporary Australian Art Acquisitions*, NGV 1990; *National Australia Bank Collection: Rivers in Australian Art*, Heide, Melbourne 1991.
REP: NGA; NGV; Artbank; Heidelberg Repatriation Hospital; Western Mining, National Bank, Sussan Corporation corporate collections.
BIB: *New Art Three*.

FELTON, Alfred
(b. 1831, Essex, Eng.; arr. Vic. 1853; d. 1904, Melb.) Philanthropist, art patron. His bequest (Felton Bequest) raised the purchasing power of the NGV in 1904 to international level. In 1867 Felton joined F. S. Grimwade to establish the company of Felton Grimwade, wholesale druggists, and so founded the business which made his fortune. A bachelor of modest tastes, he left an estate of net value £383,163, the income from which was to be divided equally between charities, and for the purchase of works of art for the NGV. Value of the estate appreciated rapidly and by 1963 the capital value had grown from the original amount to approximately £2 million, the amount of £1,260,000 income from the bequest having been spent on the acquisition of works of art. Famous works acquired through the bequest include paintings by Rembrandt, *Self-Portrait* (£21,500); Tiepolo, *Banquet of Cleopatra* (£25,000); Flemish contemporary, after van Eyck, *Madonna and Child* (£31,395); Van Dyck, *Countess of Southampton, as Fortune in the Clouds* (£17,800); Tintoretto, *Portrait* (£14,000); Turner, *Walton Bridges* (£7,250); Corot, *Bent Tree* (£5,750); 36 drawings by William

Blake (£7,605); Goya, *Portrait of a Lady* (£5,500); Daumier, *Don Quixote* (£1,450); Poussin, *Passage of the Red Sea* (£14,000); Courbet, *The Wave* (£350); Pissarro, *Boulevard Monmartre* (£300), and the complete Barlow collection of Dürer engravings, woodcuts and books (£45,000). All these and many other masterpieces were acquired at a time when world prices were low. By the time the NGV had been moved to its new building in St Kilda Road, Felton's bequest had endowed the institution with one of the finest collections in the Southern Hemisphere. During the 1980s and 90s the Felton Bequest continued to provide considerable sums annually for purchases (in 1992 some $300,000 with the privately sponsored Art Foundation providing $500,000 and a percentage of the entrance fee, a further $300,000).

BIB: Daryl Lindsay, *The Felton Bequest: an Historical Record, 1904–1959*, OUP, Melbourne, 1963. Leonard B. Cox, *The National Gallery of Victoria, 1861–1968*, NGV, Melbourne, 1970. ADB 4.

FELTON BEQUEST
See FELTON, Alfred; GALLERIES, National Gallery of Victoria

FELTON, (Dr) Maurice Appleby
(b. 1803, Hinckley, Leicestershire, UK; arr. Aust. 1839; d. 30/3/1842, Sydney) Painter. A surgeon, he came to Australia as a ship's surgeon but soon after arrival in Sydney transferred his occupation to the art of portrait painting. A friend of Conrad Martens (q.v.), he was represented in the exhibition of the Society for Promotion of Fine Arts in Australia, Sydney, 1847. He painted many of the leading citizens of the time as well as a study of Queen Victoria, landscapes and other views of Sydney. His work appeared in *The Artist and the Patron*, AGNSW 1988.

REP: AGNSW; Mitchell Library.

BIB: Eve Duscombe, *Artists in early Australia and their portraits*, Sydney 1978. Kerr, DAA

FELTON, Myra
(b. 15/4/1835, UK; arr. Aust. 1839; d. 13/7/1920) Photographer, painter. Daughter of Dr Maurice Felton (q.v.), she had some lessons from Marshall Claxton (q.v.) in Sydney in the early 1850s and opened her own photographic studio in 1859, becoming one of the first independent professional women in Sydney. She produced mainly highly-skilled portrait photographs coloured over in oils as well as originals in oils and pastels. Her coloured photographs were much praised and her oil portraits include a commission of the Qld governor, Samuel Wensley Blackall, for the Qld Legislative Assembly. She taught painting at her own school in Sydney from around 1870 and also had published a novel, *Word Pictures of Home-Life in NSW*, in 1887. Little of her work other than that in public collections survives, the rest having been destroyed following the death of her niece to whom it was bequeathed in 1955.

Susan Fereday, Clarendon, Tasmania, c. 1850, watercolour, 24.2 × 32.4. Private collection.

REP: QVMAG; Mitchell Library; Qld Parliament.

BIB: Alan Davies & Peter Standbury, *The Mechanical Eye in Australia*, Melbourne 1985. Kerr, DAA.

FEREDAY, Susan
(b. c. 1810, UK; arr. Tas. 1846; d. 21/10/1878) Painter. Wife of the Reverend John Fereday, clerk, master of arts, photographer and one of the Ministers and Chaplains within the Diocese of Tasmania, from Sept. 1846. Her watercolour drawings including portraits and landscapes show sensitive feeling for the character of the subject. Five of her drawings were in the Joseph Brown Gallery, *Spring Exhibition*, 1979, and one in Lauraine Diggins exhibition, June 1985.

REP: Latrobe Valley regional gallery; NLA; Allport Library.

BIB: S. Ducker, *The Contented Botanist*, Melbourne 1988. Kerr, DAA.

FERGUSON, Andrew
(b. 1959, Melb.) Painter.
STUDIES: Dip. Art, Phillip Inst., 1983; travel studies Turkey, Greece, Egypt, 1988. A founding member of ROAR studios in Melbourne, his work was seen in three group shows 1982–84 at ROAR and Realities,

Melbourne and in *A New Generation: Philip Morris Collection*, NGA 1988, as well as in several solo exhibitions at Coventry, Sydney 1985–92.
REP: NGA; Parliament House.
BIB: *New Art Five*.

FERGUSON, *Anne Elizabeth*

(b. 13/4/1939, Broken Hill, NSW) Sculptor.
STUDIES: Julian Ashton School, Sydney, 1958–59; CIG Welding Inst.; travel studies, 1965; ESTC, 1967–70; travel studies Europe, UK, USA, Greece, Yugoslavia, 1970, 73, 76. Her commissions include a memorial to Lindsay Robertson, Mosman playgrounds, Sydney, 1974–75; carving for the Uni. of NSW and marble finials and RSL Memorial at Parliament House, Canberra, 1988. She exhibited in group exhibitions with Irving Sculpture, Sydney 1982, 84; Gallery A, Sydney 1982, 83 and *Australian Sculpture Triennial*, NGV 1984. Member of the Society of Sculptors and Associates, Sydney (since 1972), and CAS, Sydney (since 1975).
APPTS: Part-time teaching with Uni. of NSW; summer school, All Saints Coll., Bathurst; visiting lecturer, Meadowbank Tech., Newcastle Art Coll.
REP: Parliament House; Washington National Museum of Women in the Arts, USA; several tertiary collections including Macquarie, NSW unis.
BIB: Germaine, *AGA*. Scarlett, *AS. A&A* 19/4/1982; 22/2/1984.

FERGUSON, *Peter John*

(b. 1956, Melb.) Painter, stained glass designer.

William Henry Fernyhough, Ombres Fantastique, 1836, lithograph, 25.3 × 33.8cm. Collection Mitchell Library, State Library of NSW.

STUDIES: Dip. Art, VCA, 1979. A founding member of ROAR studios, 1982–85, his abstract expressionist works with echoes of Klee, Kandinsky and Leonard French were seen in three solo exhibitions 1989–91 at William Mora, Melbourne and Coventry, Sydney. He participated in about eight group exhibitions 1982–92 including a number at ROAR, and with William Mora, Melbourne, Coventry, Sydney and in *A New Generation: Philip Morris Collection*, NGA 1988. He was one of the eight artists commissioned to do a mural at the restaurant at the NGA in 1988.
REP: NGA (Philip Morris); William Dobell Foundation; Shepparton Art Gallery; World Congress Centre, Melbourne; NAB.
BIB: *New Art Five*.

FERGUSON, *William James*

(b. 4/1/1932, Melb.) Painter.
STUDIES: RMIT, –1962; travel studies overseas, 1970. Allusive symbolism inspired by Aboriginal art endowed his first colourful paintings with mystery. His work is distinguished otherwise for refinement of texture, notably his large pastels, a medium in which he specialises. He held 20 solo exhibitions 1962–93 including at Holdsworth, BMG, Sydney; Stuart Gerstman, Distelfink, Realities, Flinders Lane, Melbourne; Solander,

Canberra; and in West Germany, 1986. Group exhibitions in which his work appeared 1962–93 include a number of private gallery group shows including von Bertouch, Newcastle; Stuart Gerstman, Distelfink, Melbourne; BMG, Adelaide; prize exhibitions including McCaughey Prize, NGV 1977; William Angliss, NGV 1977; and public galleries including *Artists Artists*, NGV 1975. He received commissions for several murals including for Endeavour and Woodside oil companies and ANZ Bank, Darwin. Of his 1990 exhibition at BMG, Sydney, Elwyn Lynn described the works in the *Australian* (17–18 Mar. 1990) as 'gently radiant works . . . they must be the best lyrical, vaporous abstractions around . . . fragile delicacy strengthened by purposeful, iconic forms is overdue for reassessment'.
AWARDS: Prizes at Colac (Kanyana), 1963; English-Speaking Union, Melbourne, 1966; Doncaster, 1967; Beaumaris (Inez Hutchison), 1974.
APPTS: Secondary school teaching, Vic., 1953–71; head of dept art & design, Melbourne State Coll., 1972–81; senior lecturer in charge of painting, RMIT, 1982–88.
REP: NGA; TMAG; Parliament House; Artbank; VACB; MPAC; several tertiary collections including Melb. and Monash unis and Melb. State Coll.; West German Ministry, Bonn; corporate collections including Rothschilds Bank, London, Holmes à Court.

FERN, Harry L.
(b. 1892, Ballarat, Vic.; d. 1945, Melb.) Painter.
STUDIES: Ballarat School of Mines; Melbourne (under M. J. McNally). Mainly a watercolourist. Secretary of the Victorian Artists Society, 1933–45.

FERNTREE GULLY ART SOCIETY
(Founded 1944) Victorian Society with a large membership of professional and amateur artists of all kinds, including writers and crafts workers.

FERNYHOUGH, William Henry
(b. 17/3/1809, Eng.; arr. Sydney 1830s; d. 15/8/1849, Sydney) Painter, illustrator, surveyor, architect. Fernyhough succeeded E. R. Govett as assistant surveyor and architect to Sir Thomas Mitchell. His published lithographs present the Aborigine as a subject for ridicule, in striking contrast with the image of 'the noble savage' presented by earlier artists and printed in *A series of twelve profile portraits of the Aborigines of New South Wales*, W. Baker, Sydney, 1836. He illustrated a *Narrative of a Voyage to Torres Straits*, W. E. Brockett, Sydney, 1836 and was also a successful portraitist, lithographer and architectural draughtsman. His work was represented in *The Artist and the Patron*, AGNSW 1988.
REP: NLA; Mitchell, Dixson Libraries.
BIB: Moore, SAA. Smith, EVSP. Kerr, DAA.

FERRAN, Anne
(b. 10/5/1949, NSW) Photographer, installation artist, teacher.
STUDIES: BA, Sydney Uni.; Dip. Ed., Mitchell CAE, BA (visual arts), Sydney Uni.; postgrad dip. (visual arts),

SCA. She held 14 solo exhibitions largely at public galleries and contemporary art spaces 1981–92 (including Performance Space, Sydney; ACCA, Melbourne; EAF, Adelaide; Canberra School of Art) and Mori, Sydney. Her work was seen in about 18 group exhibitions at mainly public galleries 1985–92 including *Perspecta*, AGNSW 1985; *Australian Photography of the 80s*, NGV 1988; *Twenty Contemporary Australian Photographers*, NGV and AGNSW 1990 and in overseas public galleries in London, NY and Montreal.
AWARDS: Project grant, VACB, 1985; SCA Postgraduate Scholarship, 1986; travel grant, VACB, 1986; residency, Power Studio, Cité Internationale des Arts, Paris, Uni. of NSW, 1987; project grant, VACB, 1989; Canada Council Foreign Visiting Artist Grant, 1990.
APPTS: Head, Photomedia Workshop, Canberra School of Art, 1992– .
REP: NGA; AGNSW; AGSA; NGV; Monash Uni.; Uni. of Western Sydney.
BIB: Catalogue essays for exhibitions as above.

FERRARINI, Guiseppe
(b. 1846, Parma, Italy) Painter. Ferrarini lived and worked in Sydney, c. 1886, but after a few years returned to Rome. He painted murals on the theme of the four seasons for the Casino at Nice and was represented in the *Berlin International Exhibition*, 1891.
REP: AGSA.
BIB: Catalogue AGSA, 1946.

FERRIE, Cathie
(b. 1912, NZ) Sculptor, painter, printmaker.
STUDIES: NAS, Sydney, 1934–35; SASA, 1956–57; Julian Ashton School and Orban School, Sydney, 1958–61; Workshop Arts Centre, Willoughby (printmaking) with Joy Ewart, Jim Sharp and Sue Buckley. Her printmaking experience includes participation in a large number of important group exhibitions.
REP: Regional gallery Warrnambool.
BIB: PCA, *Directory*.

FERRIES, James
(b. 1875, Red Creek, SA; d. 1951) Painter, farmer.
STUDIES: SASA (with H. P. Gill and A. Collins); Slade School, London, 1922–25 (with Prof. Henry Tonks and Wilson Steer). He painted mostly landscapes with architecture.
REP: AGSA.
BIB: AGSA catalogue of paintings, 1960.

FESTIVALS
See Appendix 3, p. 796.

FETTER, Sidney
(b. 1945, Melb.) Painter, teacher, printmaker.
STUDIES: NGV School. Strong in design, texture and colour, his iconographic relief prints, like his paintings, reveal cubist as well as surrealistic influences.
AWARDS: Ben Uri Gallery prizes, 1965, 66; Beaumaris prize (shared), 1970.

Maximillian Feuerring, Homage to Silence, *mixed media on board, 89.5 × 120cm. Christie's, September 1991.*

APPTS: Teaching, Trinity Grammar School.
REP: NGV; Jewish Museum of Art, Israel.
BIB: PCA, *Directory,* 1976.

FEUERRING, Maximilian

(b. 1896, Lvov, Poland; arr. Aust. 1950 d. 1986) Painter, teacher, lecturer.
STUDIES: Berlin, with Prof. A. Knapp, 1919; Academy of Fine Arts, Rome, 1923–26. He was a prisoner of war in Poland during World War II, in which his entire family, including his wife, had died in a concentration camp. Liberated in 1945 he became a professor of art at Munich, before migrating to Australia. In Sydney he was a founding member of the CAS (Sydney) from 1951–1960s and represented Australia in the *São Paulo Biennal* in 1961 with the CAS and in 1965 was invited to exhibit alone at the *Biennal*. He held 45 solo exhibitions 1950s–1978 in Australia and overseas. As well as in Munich he taught at Lvov, 1927, then at the Lic. Academy of Fine Arts, Warsaw, 1934–39; and Sydney (WEA and Adult Education classes, Uni. of Sydney), 1959–66. Post-impressionist and expressionist influences shaped his painting style.
AWARDS: About 16 prizes in Australian competitive exhibitions including Taree, 1956; Goulburn, 1958; Hunters Hill and Rockdale, 1959; Tumut, 1962; Sydney (Transfield prize), 1963; Bathurst, 1966; Sydney (Darcy Morris), 1968; Sale, 1970; Albury, 1970.
REP: AGNSW; AGSA; AGWA; NGV; QAG; TMAG; regional galleries Newcastle, Sale; a number of public collections Europe, Israel.
BIB: Smith, *AP.* Robert Hughes, *The Art of Australia,* Penguin Books, Harmondsworth, 1966, 1970. *A&A* 24/1/1986 (*obituary*).

FFARINGTON, Richard Atherton

(b. 23/12/1823, UK; arr. Aust. 1841; d. 1855, Lancashire, UK) Painter. Kerr lists him as coming to Australia as ensign in the 51st Regiment and remaining in Australia until 1847. He produced a sketchbook *From Australia,* 1841 with 8 pencil drawings and diary notes of the voyage out; as well as watercolours and sketches of WA environs – including Aboriginal portraits, corroborees and coastal scenes which were published in London journals, including *Illustrated London News.* He sailed for India in 1847 and from there to UK where he died. His work appeared in a 1985 Sotheby's London auction.
BIB: Kerr, *DAA.*

FIDLER, Rupert C.

(Active c1920, Sydney) Painter. Landscape and coastal watercolourist he was a member of the RAS, Sydney, from 1910. He exhibited also at the NSW Society of Artists from c. 1914, showing landscapes and nocturnes, some of which show the influence of J. J. Hilder (q.v.).

FIGUEROLA, Alma

(b. c.1895; d. 1969) Painter.
STUDIES: Family studies with her father, Juan Figuerola, then with Oscar Binder and Tom Carter before working for four years in the studio of Max Meldrum. Honorary secretary of the Twenty Melbourne Painters group from c. 1940 and a member of the Fellowship of Australian Artists she conducted classes in her studio for many years and painted figure studies and portraits, mainly in the manner of Max Meldrum.

FILLANS, James D.

(Active c.1870, Sydney) Sculptor. A number of needy Sydney sculptors were assisted by Sir Henry Parkes with commissions for work on public buildings, among them James Fillans. With White, MacIntosh, Sani and Illingworth, he helped to carve figures of prominent people for the façade of the Lands Dept building, and apparently, with MacIntosh, did carvings for the Museum of Applied Arts and Sciences and the Sydney Tech. Coll. buildings. He is listed also as having been a member of the Art Society of NSW from 1895.
BIB: Scarlett, *AS.*

FINE ARTS SOCIETY

See VICTORIAN FINE ARTS SOCIETY

FINEMORE, Brian

(b. 1925; d. 1975, Melb.) Curator.
STUDIES: BA, Uni. of Melb. Curator of Australian art at the NGV, 1959–75, he wrote a number of catalogue essays on art as well as *Painting* (Arts in Australia series, Longman, Melbourne, 1961) *and Australian Impressionists* (Longman, Melbourne, 1967). He was found murdered in his East Melbourne flat on 25 Oct. 1975. A memorial exhibition was held at the NGV from 12 May 1977.
BIB: *A&A* 13/3/1976 (Frances McCarthy and Jennifer Phipps, *Brian Finemore*).

FINEY, George Edmond

(b. 1895, Auckland, NZ; d. c. 1987) Caricaturist, painter.

STUDIES: Elam School, Auckland, NZ; Polytechnic, London. Finey served with the NZ Forces in France in World War I. After the war he came to Australia and with other talented black-and-white artists of the time joined the staff of the newly launched *Smith's Weekly* in Sydney. His aggressive and energetic mind found full scope for expression in this journal and he soon became pre-eminent in the field of caricature in Australia. When *Smith's Weekly* ceased publication he turned to painting, in which field he used a colourful, expressionistic style and was probably the first Australian painter to exploit the possibilities of collage. From 1945 he held annual exhibitions of his modernist paintings and constructions, mostly in Sydney.

AWARDS: Bathurst prize for watercolour, 1959.

REP: Depts of Prints and Drawings in most state galleries.

BIB: *AA* June 1924, article and reprdns; Finey, special number of *AA*, Ure Smith, Sydney, June 1931.

FINLAY, Ernest

(c. 1890–1930) Painter, potter.

STUDIES: J. S. Watkins School, Sydney. A pioneer of pottery in NSW, he experimented with Aboriginal and native plant motifs. His brother, Alan, was also a potter and studied at the Bendigo School of Mines c. 1902. He researched Victorian clays and the brothers worked together at Moreland, Vic., and exhibited with the Arts and Crafts Society of Vic.

BIB: *AA* no. 8, 1921.

FINLEY, Fred

(Active 1922–23, Sydney) Etcher. Member of the Australian Painter-Etchers' Society.

REP: AGNSW.

FIRTH-SMITH, John

(b. 8/7/1943, Melb.) Painter.

STUDIES: NAS, Sydney, 1961; travel studies Europe and USA, 1971; USA, 1982. Beginning with figurative paintings of yachts on Sydney Harbour, his style became increasingly abstract from 1968, tending gradually towards colourfields of opaque blue or green bisected by long diagonal lines. His works have been included in *The Japanese Forum* exhibition, Tokyo 1967; *Twenty Years of Australian Painting*, London 1972; *Biennale of Paris*, 1973; *Contemporary Australian Art to Indonesia*, 1978; *Sydney Harbour Bridge 1932–82*, AGNSW 1982; *Perspecta*, AGNSW 1983; *Surface for Reflexion*, AGNSW and travelling NSW 1987. In Dec. 1981 he completed a huge commissioned work of 32 panels occupying the two principal walls enclosing the reception area on the first floor of the ANZ Bank, Collins Place, Melbourne. He held about 25 solo exhibitions 1966–93 in Sydney (including at Gallery A; Roslyn Oxley9) Adelaide. He was artist-in-residence Melbourne Uni. 1983. Several films about his work including by the ABC (two documentaries) and his other commissions include a tapestry for Parliament House, Canberra, 1987.

AWARDS: Young Contemporaries Award (CAS, Sydney), 1963–64, 68; prizes at *Mirror*-Waratah Festival, Sydney, 1962, 64; R.Ag.Soc.NSW, 1968; Trans-Australia Airlines competition, 1970; Georges (purchase) prize, 1972; standard grant, VACB, 1978; *SMH* Art Prize 1978; Civic Permanent Art Award, Canberra 1978; Broken Hill Art prize 1978.

APPTS: Teaching, high schools, 1960s; architecture faculty, Sydney Uni., 1970s; ESTC, 1973–78; Alexander Mackie CAE, 1978–84; trustee AGNSW 1987– .

REP: NGA; AGNSW; AGSA; AGWA; MAGNT; NGV; QAG; QVMAG; TMAG; MOCA, Sydney; Artbank; VACB; numerous regional galleries all states; many tertiary collections including Monash, Melbourne, WA unis.; numerous corporate collections including BHP, Georges, Qantas.

BIB: Catalogue essays for exhibitions as above. A number of major texts on Australian art including Bonython, MAP. *A&A* 12/1/1974 (Janine Burke, *John Firth Smith*).

FISCHER, Alfred

(Active c. 1900–14, Melb.) Painter. A landscape and figure painter, in pastel and in watercolour, he exhibited at the VAS, 1904–14, showing mainly landscapes in watercolour as well as lithographs. Titles of his works include *Nocturne, Winter, The Nymph's Bath, The Sea Serpent, The Cloud*, etc. He was at Charterisville around 1910 with Shirlow and others. As with A. J. Fischer, to whom he may have been related, his name is sometimes given as 'Fisher'.

FISCHER, Amandus Julius

(b. 1859, Ophir, NSW) Painter, illustrator, cartoonist.

STUDIES: NSW Academy of Art, Sydney (under Anivitti), 1875; Westminster School of Art, London; Julian's and Colarossi Ateliers, Paris. From 1883 he exhibited with the Art Society of NSW (RAS), and later with the NSW Society of Artists, landscapes and figure studies. He also worked as a staff artist for the *Illustrated Sydney News* and *Bulletin*, Brisbane *Boomerang*, 1888–91, and illustrated Steele Rudd's *On Our Selection*. His name is sometimes spelt 'Fisher'. One of his works was seen in Christie's auction, Melbourne, 1 March 1973.

REP: AGNSW.

FITCHETT, Gordon Heath

(b. 22/9/1953, NSW) Painter, illustrator.

STUDIES: Dip. Graphic design, Swinburne Coll. of Technology, Melb., 1973. Fitchett's quirky realist works – their titles often based on word-play (*Salmon Chanted Evening*; *Moo with a View*) – adapt well to children's book illustrations and his realist-with-a-twist watercolour and colour pencil works on paper are imaginative and skilful. His work was seen in about 11 solo exhibitions 1985–92 including at Barry Stern, Sydney and in about eight group exhibitions at Dempsters, Melb., 1985–92.

REP: Juniper Hall, collection of children's illustrations, Sydney.

FITLER, William Crothers
(b. 1857, USA; arr. Aust. 1886; d. 1915, USA) American artist, one of the illustrators for *The Picturesque Atlas of Australasia*, together with W. T. Smedley, F. B. Schell and others.

FITTS, David Russell Hamilton
(b. 8/1/1946, Melb.; d. 7/2/1980, Melb.) Painter, teacher.
STUDIES: Melbourne, with Ronald Millar at Melbourne Grammar School, c. 1961–64; Uni. of Melbourne, 1964–68 (BA Fine Arts); NGV School, 1968; travel studies, Europe and UK, c. 1977. He taught at Victorian secondary schools, 1969–72, then at Melbourne Grammar School. He also lectured at CAE classes in Melbourne. From 1972 his paintings, many on religious themes, appeared in about five exhibitions, including a special exhibition, *Stations of the Cross*, at St Paul's Cathedral; another was of paintings of Carlton houses in the foyer of the Ministry for the Arts, Melbourne. A memorial exhibition of his work was held at the Mornington Peninsula Arts Centre in Aug.–Sept. 1980 and it was represented in *The Changing Face of Melbourne* Lauraine Diggins; Charles Nodrum, 1993.
AWARDS: Prizes at Flinders, 1976; Mornington (purchase), 1977.
REP: Regional galleries Mornington and Langwarrin (McClelland Gallery); Uni. of Melb. collection.

FITZGERALD, Florence
Painter
REP: AGWA.
NFI

FITZGERALD, Gerald
(b. 1873, Hunters Hill, NSW; d. 1935) Painter, farmer.
STUDIES: RAS School, Sydney, with Lister Lister; Colarossi's and Académie Moderne, Paris, with Eugene Carriere. He served on the committee of the Art Society of NSW (RAS), exhibiting with the Society (c. 1893–1902) vigorously painted impressionistic landscapes, but is said to have abandoned painting for farming.
REP: Manly Art Gallery.

FITZGERALD, Paul
(b. 1922, Melb.) Painter.
STUDIES: NGV School, 1940s; travel study in Europe 1949–57. Son of Frank Fitzgerald, journalist-art-critic for Melbourne *Argus*, c. 1940, he is a well-known traditional portrait painter whose numerous portraits include those of H. M. The Queen, Sir Robert Menzies, Dr Mannix, Pope John XXIII, Lew Hoad and many other well-known people. He was the first president of the Australian Guild of Realist Artists; is a Knight of Malta and a trustee of the AME Bale Scholarship.
BIB: *Who's Who in The Commonwealth/ Australia*. Debrett's, *Handbook of Aus and NZ*.

FITZGERALD, Robert David
(b. 1830, Ireland; arr. Sydney 1856; d. 12/8/1892, Hunters Hill, NSW) Botanical artist. He produced drawings of flora and fauna in Sydney during the mid-1800s and became a fellow of the British Linnaean Society and the Royal Society of NSW.
BIB: *ADB* 4. Kerr, *DAA*.

FITZJAMES, Michael
(b. 1948, Melb.) Illustrator, painter.
STUDIES: Dip. Fine Arts, Tasmania School of Art, Hobart, 1976. Known for his strong block-like black and white prints and drawings and stylised representations of Australian flora and fauna, as well as in beastic and other illustrations and graphic designs, his work featured in four group exhibitions at private galleries 1984–92, and in *Black and White Tradition*, the Lewers Bequest and Penrith Regional Art Gallery 1987. His 11 solo exhibitions 1970–92 were mainly at Macquarie Galleries, Sydney.
APPTS: Illustrator, *Guardian*, London, 1978–80; *National Times*, 1980–89; SMH 1990– .
See also BLACK AND WHITE ART; CARTOONING IN AUSTRALIA

FIVEASH, Rosa (Rosa Catherine)
(b. 1854, Adelaide; d. 1938, Adelaide) Painter, illustrator.
STUDIES: SA School of Design, Adelaide; also with Louis Tannert. She illustrated works on SA flora, including J. Ednie Brown, *Forest Flora of South Australia*, Adelaide, 1882–90, a large folio vol. issued in nine parts, each with coloured plates by Fiveash and R. S. Rogers, *South Australian Orchids*, Adelaide, 1974. As well she introduced china painting to South Australia. The SA Museum has 227 of her works.
BIB: Rachel Biven, *Some forgotten . . . some remembered*, Sydenham Gallery, Adelaide, 1976.

FIZELLE, Rah (Reginald Cecil Grahame)
(b. 4/9/1891, Baw Baw, NSW; d. 24/10/1964, Sydney) Painter, teacher.
STUDIES: Julian Ashton's, Sydney, 1921–26; Polytechnic and Westminster Art Schools, London, 1927. A leading supporter of the cause of avant-garde painting in Sydney in the 1928–38 period, Fizelle served with the AIF in World War I, and was a teacher specialising in art in the Education Dept of NSW before the war and later, in 1919–21. He returned to London in 1927 and spent three years studying in Europe, after which he came back to Australia to start Sydney's first modern art school. Obliged to earn a living as a house painter, he worked at his art in his spare time, developing the ideas stimulated by his contact in Europe with cubism and futurism. In 1934 he started an art school at 215a George St, Sydney, with Grace Crowley and Frank Hinder, which continued until 1937. After the war Fizelle taught abstract painting at ESTC, Sydney, and in 1960–61 travelled in the UK, France and the USA. In his own painting he practised

what he preached, his high-keyed colours and semi-abstract forms showing the cubist and futurist influences to which he most consistently responded. His work appeared in important modernist exhibitions in Sydney dating from the early 1930s and in the Whitechapel exhibition of Australian painting in London, 1961 and in *Balson, Crowley, Fizelle, Hinder* AGNSW, 1966. It has been seen since in a number of leading auction house sales.
APPTS: Lecturer in art, Sydney Teachers Coll.; president, Australian Watercolour Inst., 1948–50.
REP: NGA; most state and many regional galleries and many uni. collections.
BIB: Smith, AP. A&A, 3/2/1965.

FLANAGAN, John Richard

(b. 1894, Sydney; d. 1964, New York) Illustrator.
STUDIES: Royal Art Society of NSW School (evening classes with Dattilo Rubbo, for five years). Also received help and criticism from Norman Lindsay and some of his early work became indistinguishable from that of this mentor. Flanagan departed from Sydney for the USA in 1916; he became famous in the USA for his scraper-board illustrations for magazines *Cosmopolitan, Colliers*, etc. He revisited Sydney in 1927 and held a successful exhibition.
REP: AGNSW; NGV; Manly Art Gallery.
BIB: Arthur W. Guptil, *Drawing with Pen and Ink*, Pencil Points Press, New York, 1928. *Fifty Years of Australian Art, 1879–1929*, RAS, Sydney, 1929.

FLAXMAN, Mollie

(b. Sydney) Painter.
STUDIES: ESTC; RAS School; watercolours with G. K. Townshend.
AWARDS: Prizes for watercolours at Concord and Albury, 1955; Goulburn, 1956, 57, 60; Bega, 1964, 71; North Shore Historical Society, 1960; Northside Festival, 1963, Cheltenham, 1969, Ryde, 1968, 71; R.Ag.Soc.NSW, 1975.
REP: NGA; AGNSW.

FLEAY, Maude Glover

(b. 1869; d. 1965) Painter.
STUDIES: NGV School, 1891. Known mainly for paintings of flora and fauna of the Australian bush. The Maude Glover Fleay Bursary ($1,000 for an art student) was presented by her daughter, Mrs Mary Beasy, at the VCA, 1980.

FLEISCHMANN, Arthur John

(b. 5/6/1896, Bratislava, Czechoslovakia; arr. Aust. 1939; left Australia 1948; d. 2/3/1990, Tenerife) Sculptor.
STUDIES: Prague Uni. (medicine), 1921; Art Academy of Prague, with Jan Sturza, 1921; Art Academy of Vienna, 1922–29; travel studies, Italy and France, 1932–36. From 1934 to 1937 he taught at the Women's Art Academy of Vienna (ceramics), and before arrival in Australia visited South Africa, USA, South America

Arthur Fleischmann, Motherhood, *bronze, 62.5 (height), Christie's, August 1992.*

and Bali. He became a leading figure among Sydney sculptors during the period 1938–45, when his commissioned work included relief heads of explorers for the bronze doors of the Mitchell Library (1941); a fountain for Frensham Coll., Mittagong, NSW (1940); a bust of Dr E. L. Bainton for the Sydney Conservatorium of Music (1943); a fountain for Government House, Canberra (1945); and a memorial for the Botanical Gardens, Sydney (1946). Except for visits to USA, Japan and South America, London was his headquarters from 1948. He exhibited in Australia with the Merioola Group, Sydney, 1986 and David Jones, Sydney, 1988 and in London until his death in 1990. He was commissioned to produce a perspex sculpture for the opening of the NSW State Library, 1989.

REP: AGSA; AGWA; NGV; TMAG; Mitchell Library, Museum of Science and Technology, Canberra.

BIB: Sturgeon, *DAS*. Scarlett, *AS*.

FLEMING, Margaret

(Painter) She exhibited at the annual exhibitions of the Art Society of NSW, 1894, at the first exhibition of the NSW Society of Artists, 1895, and at the exhibition of Australian art in London, 1898.

REP: AGNSW.

NFI

FLETCHER, Bruce

(b. 1937, Melb.) Painter, teacher.

STUDIES: Prahran CAE, 1950–56; privately with William Dargie; travel studies, Singapore, Borneo and Europe, 1963. He held exhibitions at the Athenaeum Gallery, Melbourne, in 1964 and 1967, painted portraits of notable Australians and in 1969 was appointed official Australian war artist in Vietnam. Seriously wounded on his second day in Vietnam, he nevertheless completed a seven-month tour of duty to produce over 40 paintings and 220 drawings. On his return to Australia he was appointed lecturer in painting at the CIT, Melbourne and subsequently turned to portrait painting, receiving many commissions.

AWARDS: Prizes in competitive exhibitions in Dandenong, Albury, Doncaster, Camberwell, Malvern, Vic.

REP: NGA; AWM; Buckingham Palace, London; Benalla, Rockhampton regional galleries; a number of secondary, hospital and tertiary collections.

FLETCHER, William Ernest

(b. 27/10/1924, Bellbird, NSW; d. 22/1/1983) Painter.

STUDIES: ESTC (part-time) 1949; Julian Ashton Art School 1952. Living a reclusive life he was a painter of Australian flora which he exhibited in Sydney (including Artarmon Galleries), Melbourne (including at Russell Davis; Editions) and other capital cities. He also contributed to group exhibitions including with the CAS, NSW 1950–53. The Wiliam Fletcher Trust set up after his death funds a variety of art activities.

(*See* TRUSTS AND FOUNDATIONS).

REP: NGA.

FLETT, James

(b. 1906, Dunolly, Vic.; d. 1986) Painter, graphic artist, writer.

STUDIES: NGV School (evening classes), 1927–28.

He won most of the available student prizes at the NGV School and two of his prints were purchased for the NGV collections. Later, inspired by the watercolours of Blamire Young and the romanticised subjects of Norman Lindsay, he produced a series of large watercolours, many on the theme of pirates. He also experimented with etchings, built up a large and valuable reference library of art books, started an art magazine and became absorbed with a number of inventions, including an aeroplane designed to fly by bicycle propulsion. In 1932 he visited the UK but returned discouraged about his possible future in art. He held no more of the exhibitions through which his work had become known, devoted himself to business affairs and became involved in writing and the historical research that remained his chief interest. Books he wrote included *Dunolly: Story of an Old Gold Diggings*, Poppet Head Press, Glen Waverley, Vic., 1956; *The History of Gold Discovery in Victoria*, Hawthorn Press, Melbourne, 1970; *Maryborough Goldfields History*, Poppet Head Press, Glen Waverley, Vic., 1976; *A Pictorial History of the Victorian Goldfields*, Rigby, Adelaide, 1977; *Old Pubs*, Hawthorn Press, Melbourne, 1979.

AWARDS: Many student prizes at the NGV School.

REP: NGV; Castlemaine Art Gallery and Historical Museum.

FLEURY, Adrian Thomas

(Active c. 1880, Hobart and Sydney) Graphic artist. He made a set of drawings of old buildings in Hobart and produced many prints of the streets and buildings in old Sydney. Brother of Joseph Luke Fleury.

FLEURY, F. C.

See TERRY, Frederick Cusemero

FLEURY, Joseph Luke

(b. 1872, Hobart) Painter, teacher.

STUDIES: Hobart Tech. Coll.; Julian Ashton's School, Sydney. Known mainly for religious pictures and ornaments, Fleury decorated Catholic churches throughout Australia including the Pope's Oratory, North Sydney. His work for this project gained him a decoration from Pope Pius XI. An exhibition of his frescoes was held in Sydney in 1928. He was assistant art master at Hobart Tech. Coll. and brother of Adrian Thomas Fleury. Paintings by Fleury sold in auctions reveal his style as late colonial and his subjects extending to street scenes and other genre.

BIB: Moore, *SAA* 1934. Backhouse, *TA*

FLEXMORE, John

(b. 1911, Melb.) Painter.

STUDIES: NGV School, 1930–36; Europe, 1964. Flexmore held regular annual exhibitions of his representational watercolours at the Athenaeum Gallery, Melbourne, from c. 1950.

FLINTOFF, Thomas

(b. c. 1809, Newcastle-upon-Tyne, UK; arr. Ballarat, Vic. early 1850s; d. 1891, Melb.) Painter. He worked in England, California, Mexico, Texas and the Society Islands prior to going to Australia where he set up the Tyne-side Photographic Gallery in Sturt St, Ballarat, advertising the superiority of his 'infallotype' to photography. This variation of the daguerreotype attracted the wealthy citizens of Ballarat and he made portraits of many leading citizens of the colony, including a crayon drawing of John Basson Humphray. He established a studio in Melbourne in 1872, exhibited with the Victorian Academy of Arts, 1872–73, and produced portraits of leading citizens. His work appeared in *Australian Colonial Fine Arts*, Lauraine Diggins Gallery, Melbourne, 1986 and the Bicentennial exhibition *The Face of Australia*.
REP: NGV; Ballarat Fine Art Gallery; Dixson, La Trobe Libraries.
BIB: Alan Davies & Peter Standbury *The Mechanical Eye in Australia*, Melbourne 1985. Pinkney, *Painting in Texas: the Nineteenth Century*, University of Texas Press, Austin, 1967. McCulloch, *AAGR*. Kerr, *DAA*.

FLOISTAD, Lise

(b. 1956, Calcutta, India; arr. Aust. c. 1984) Painter, installation artist.
STUDIES: Norway and Rhode Island School of Design, New York, before coming to Australia; MA (Visual Arts), Sculpture, SCA, 1986. Her multi-material assemblages have elements of the natural world combined with use of rich paints (such as gold leaf) and draw on symbolic reference from cultures she has experienced including Norway, the Americas, India and Spain, giving them an icon-like quality. Her work was sufficiently spiritual to earn her the *Blake Prize* (for religious art) in 1988. She held about 11 solo exhibitions 1976–92 at private galleries in NY, Norway, Germany, Spain and Sydney (Coventry, Macquarie) and at Uni. of Sydney and Penrith Regional Gallery. Her work appeared in about 14 group exhibitions 1975–92 in private galleries in Norway, NY and Sydney (Macquarie, Coventry) and in *Mildura Sculpture Triennial*, 1985; *Perspecta*, AGNSW 1985; a two-person show *Mapping the Edge of Enchantment*, Penrith Regional Art Gallery 1988.
AWARDS: Textron Award, USA, 1982; Commonwealth Postgraduate Award, 1985; project grant, VACB, 1987; Blake Prize for Religious Art, 1988; artists' residency, Künstlerhaus, Bethanien stuio, VACB, 1989.
REP: Artbank; Power Collection, Uni. of Sydney.
BIB: Catalogue essays exhibitions as above. *New Art Two*.

FLORA AND FAUNA ARTISTS

See NATURAL HISTORY ARTISTS

FLOWER, Cedric

(b. 22/8/1920, Sydney.) Painter, designer, writer.
STUDIES: Sydney (with Dattilo Rubbo). Flower's versatile activities include painting, illustration, book

Cedric Flower, Girl & Terrace, *oil. Private collection*

and stage design as well as writing radio plays, features and film scripts in collaboration with his wife. The aim of his painting is to delight and, as this suggests, his work is decorative and whimsical, based on influences such as those of Raoul Dufy and the illustrator Ludwig Bemelmans. Overseas from 1950 to 1955, his first Australian exhibition was at Macquarie Galleries in 1941. Between 1941 and 1991 he held about 41 solo exhibitions in Sydney, Adelaide and Melbourne. He wrote six books on aspects of Australia including *Illustrated History of NSW*, 1981; *The Antipodes Observed*, 1974; *Erotica*, 1977; *Picture Book of Australia When . . .* , 1978; *Illustrated History of New South Wales*, 1981 and was the general editor of Sun Academy Art Monographs 1976–78.
REP: NGA; AGNSW; NGV; several municipal, regional collections NSW and Qld including Manly, Armidale.
BIB: Smith, *AP*. Germaine, *AGA*.

FLUGELMAN, Herbert (Bert)

(b. 28/1/1923, Vienna; arr. Aust. Nov. 1938) Sculptor, painter, lecturer.
STUDIES: NAS (with Paul Beadle, Frank Hinder and Wallace Thornton), 1947–50; travel studies, England, Europe, USA, 1951–56. He became known first as a painter, then as a sculptor, largely through his success in winning the major prize at the *Mildura Sculpture Triennial*, 1967, with a large, Marini-type equestrian piece in cast iron. By 1970 he had earned a reputation for indefatigable energy (despite the handicap of having been crippled as a result of poliomyelitis) and as an artist with a fine sense of style and occasion, and with rare understanding of space and how to use it. Among his commissioned works are the cast bronze

sculpture for Goldstein Hall, Uni. of NSW (1964), and the copper and ceramic mosaic fountain for Bruce Hall, ANU, Canberra; *Wave*; Uni. of Wollongong 1985; Penrith Gallery 1985. He held about 23 solo exhibitions 1953–91 including at Watters, Sydney; Irving Sculpture; BMG; Macquarie, Sydney. He participated in numerous group survey exhibitions of sculpture and paintings including *Mildura Sculpture Triennial*, 1964, 67, 70, 73, 75, 78, 88; *Australian Sculpture Triennial*, 1980; *Expatriates and Exiles*, Festival Centre, Adelaide 1986; *Sculptors at the Table*, Craft Centre Gallery, Sydney and touring NSW regional galleries 1989/90. He is a member of many professional bodies and accreditation committees including VACB committees; judging panel, Inst. of Architects, 1988. Several films on his work were made, including one by SA Film Corporation, 1979. His works were used on the covers of many art and education magazines and books.
AWARDS: RA grants to enable him to work at Ibiza, Balearic Isles, 1951; prizes for sculpture at the R.Ag.Soc.NSW, 1958, 67, 68; Mildura Sculpture Triennial, 1967; SA Sculpture Prize, 1978; VACB grant for equipment, 1976; competition, Adelaide Shopping Mall, 1977, Martin Plaza, Sydney 1978; Maude Vizard-Wholohan prize, AGSA, 1983; Lawrence Hargrave Memorial Competition, 1988.
APPTS: Lecturer, many tertiary colleges, 1961–92 including SASA; City Art Inst., Sydney; Uni. of Wollongong; professional fellow, Uni. of Wollongong, 1991– .
REP: NGA; AGNSW; several regional gallery collections including Orange, Wollongong, Geelong, Penrith; several tertiary collections NSW, Tas.; corporate collections including Comalco.
BIB: Catalogue essays in exhibitions as above. Sturgeon, *DAS*. Scarlett, AS. *A&A* 21/3/1984. *AI.* 1/4/1981, 2/6/1982–83, 3/1/1983, 3/4/1983, 9/2/1989, 10/4/1990–91.

FLUKE, Roy George Herbert
(b. 12/11/1921, London; arr. Sydney 1925) Painter, teacher.
STUDIES: ESTC, c. 1941. While serving in the army, 1941–46, he lost his left leg, and after demobilisation resumed his studies with the Commonwealth Rehabilitation Scheme. He worked part-time teaching and in television and in 1960 joined the staff of the National Art School. His geometric-abstract pictures with their intricate shapes and bright colours attain a feeling of carefully controlled and precise order. He was represented in the Bicentennial exhibition *The Face of Australia*.
AWARDS: Prizes at Mosman, 1954, 58; Taree, 1956 (2nd); Maitland, 1957, 58; Cessnock, 1958; Muswellbrook, 1961; R.Ag.Soc.NSW, 1958 (shared modern industrial prize with H. Flugelman); Sulman prize, 1963.
REP: AGNSW.

FOARD, Patsy (Patricia Jessop)
(b. 1935, Bairnsdale, Vic.) Painter, teacher.
STUDIES: RMIT, 1952–56; travel studies, Europe, 1958–60; Academy of Art, Florence, 1958; Uni. of Melbourne (Fine Arts), 1966; Uni. of Hawaii, 1977–79. She held her first exhibition at the Gallery of Modern Art, Florence, in 1958, visited Iceland in 1959 and held an exhibition of her Icelandic paintings at the Commonwealth Inst., London, in 1959. After visiting Spain and the USA, she returned to Melbourne in 1960. Her capable painting reflects the many changes in her career, together with attendant influences.
APPTS: Teaching, CIT, 1960–63; NAS, Sydney, 1968–69; SASA, 1970; and Prahran CAE, 1971–77, 1979– .

FOGG, Sarah Anne
(b. 29/11/1829; arr. Launceston 1850; d. 1/1/1922, South Africa) Painter. She produced sketches and watercolours of Tasmanian flora and topography from around 1860, her 1865 views of Launceston being of special interest. She left Tasmania in 1878 for Italy and was back in Australia in 1880 when she was in Qld, once again sketching the environs of Gladstone and Rockhampton, and Tasmania in the 1880s. She left Australia c. 1881 to join her brother in South Africa where she lived for some 40 years. Her work *Quamby Buff from Westbury, Tas.*, was shown in the Joseph Brown Gallery, Melbourne, Winter Exhibition, 1977 and her work was represented in *Tasmanian Vision*, TMAG & QVMAG, 1988 and *A Century of Australian Women Artists 1840s–1940s* Deutscher Fine Art, Melbourne 1993.
REP: QVMAG; NLA; Mitchell Library.
BIB: Kerr, *DAA*.

FOLEY, Fiona
(b. 20/3/1964, Maryborough, Qld) Curator, painter, sculptor, printmaker.
STUDIES: Certificate of Art, ESTC, 1983; B. Visual Arts, SCA, 1986; Dip. Ed., Sydney Uni., 1987; travel studies, St Martin School of Arts, London, 1983; Northern Territory 1988. She held five solo exhibitions 1988–92 at Roslyn Oxley9 (1988, 89, 91) and Griffith Art Works, Griffith Uni. 1988. Her work appeared in many Aboriginal and other group exhibitions 1984–92 including *Koori Art 84*, Artspace, Sydney 1984; *Australian Perspecta*, AGNSW 1989; *A Continuing Tradition*, NGA 1989; and several overseas exhibitions including *Paraculture*, Artists Space, New York; *Contemporary Aboriginal Art*, several American universities including Harvard and in Third Eye, Glasgow, Scotland, 1989. She was artist-in-residence at Griffith Uni., Qld, and Maningrida, NT, and co-ordinator of a silk screen printing workshop at Ramingining, NT, all in 1988. She completed a mural for the Darwin Post Office with Pady Dhangu's supervision and was artist-in-residence at Cleveland St Intensive Language Centre, Sydney, in 1990. Her commissions include for the Aboriginal Islander Dance Theatre, National Aboriginal Artists Awards posters 1987; seven oils for St Stephen's Cathedral, Brisbane, 1987; lithograph edition, ANU, 1990.
AWARDS: Grants, Aboriginal Arts Board, 1988 and Aboriginal Arts Unit, Australia Council 1990.

G.F. Folingsby, Woman Picking Blossom, *oil, 94 ×
58.5. Private collection.*

APPTS: Many guest lectures, public and tertiary, 1988–
including Biennale Forum, 1988; Darwin Task Force,
1988; ESTC; Canberra School of Art; MOCA, Brisbane
and Sydney; Adelaide Arts Festival.
REP: NGA; AGNSW; AGSA; QAG; Aust. National Museum;
Artbank; Gold Coast regional gallery; tertiary collec-
tions Flinders, Griffith unis. and Darling Downs Inst.;
Robert Holmes à Court collection.
BIB: Catalogue essays exhibitions as above. Caruana, AA. AL
vol. 10 nos. 1 & 2 1990. AM no. 30, 1990.

FOLINGSBY, George Frederick
(b. 23/8/1828, Wicklow, Ireland; arr. Melb. 1880;
d. 4/1/1891, Kew, Vic.) Painter, teacher.
STUDIES: New York, c. 1849; Munich, 1852–54; Paris
(with Thomas Couture), c. 1855; Munich Academy
(with Carl Theodor von Pilotz), 1855–60. He went
from Ireland to Canada in 1848, then to New York
where he studied drawing and became an illustrator
working for *Harpers Magazine* and *Cassells Illustrated
Magazine of Art*, of which, briefly, he was pictorial
editor. After travels in Asia Minor, Greece and Europe,
he settled in Munich. Except for six months of study
in Paris and visits to Belfast (1862), and London
(1871), Munich remained his headquarters for 25 years.
Many of his paintings took the form of historical illus-
tration, a legacy perhaps from his days in the USA as
an illustrator. His paintings were hung in exhibitions
at the RA, London, and in many international exhi-
bitions, his first contact with Australia being when
his *Bunyan in Prison* was acquired for the NGV (one
of its first acquisitions). In 1878 the NGV trustees
commissioned another painting and, acting on the
advice of Sir Charles Gavan Duffy, Folingsby decided
to migrate, arriving in the summer of 1879–80, with
his commissioned picture – *The First Meeting between
Henry VIII and Anne Boleyn*. His first Australian paint-
ing was a commissioned portrait of Sir Redmond
Barry, and in 1882 he succeeded von Guérard as direc-
tor of the NGV, and head of the art school. His teach-
ing methods were based on those of the Munich
Academy. His use of bitumen and vermilion as the
base colours of portraiture was criticised by painters
such as Streeton; but his teaching otherwise seems to
have been sound enough, one advantage being that it
ended von Guérard's practice of requiring the stu-
dents to copy the pictures in the gallery collections.
Folingsby became an outspoken critic of the local art
societies but his death in 1891 precluded the possi-
bility of a lasting influence on Australian art. His
work was represented in *Australian Art in the 1870s*,
AGNSW, 1976.
AWARDS: Awards in the international exhibitions at
Vienna, 1873, and Philadelphia, 1876.
REF: AGNSW, NGV.
BIB: ADB 4. Leonard B. Cox, *The National Gallery of Victoria,
1861–1968*, NGV, 1970.

FONTANA, Giovanni
(Active c. 1879–90) Sculptor. His work was exhib-
ited in the Australian Court at the international exhi-
bitions of 1879–80 where it attracted praise, along
with work by Simonetti and Perceval Ball. His best-
known work is possibly the bust of Sir Henry Parkes
for Parkes Council Chambers, NSW.
BIB: Sturgeon, DAS.

FORBES, Clem (Clement Patrick)
(b. 1948, Bowen, Qld) Painter, teacher, gallery
owner.
STUDIES: No formal training. From 1966 he held exhi-
bitions, conducted art classes and, in 1972, estab-
lished the Bakehouse Gallery, Mackay, followed in
1979 by the Forbes Gallery Studio.
AWARDS: Prizes at Cairns, 1967; Mackay, 1971, 72,
73; Cloncurry, Ernest Henry Memorial, 1974.

REP: Rockhampton City Art Gallery; Townsville Uni. collection.
NFI

FORBES, Louisa Lillias

(Active c. 1870–75) Painter. Topographical and landscape painter in watercolour who painted a number of views of Sydney and Hobart.
NFI

FORBES, Rodney

(b. 14/7/1951, Vic.) Painter.
STUDIES: Dip. Arts (Visual Arts), Gippsland Inst., Vic, 1982; Grad. Dip. Arts (Visual Arts), Gippsland Inst., 1983. He held three solo exhibitions 1987–92 at Australian Galleries, Melb. and *Out of the Bay/Into the Valley*, Latrobe Valley Arts Centre 1987. His work appeared in five group exhibitions 1985–92 including *Regional Artists: Gippsland*, Vic. Ministry for the Arts 1985; *100 × 100*, PCA Bicentennial Touring Exhibition.
AWARDS: Project grant, VACB, 1990.
REP: NGA; PCA; Artbank; Latrobe Valley Arts Centre; Latrobe Regional Arts Board; Monash Uni. Coll. Gippsland; Box Hill Council, Vic.
BIB: Karen Bensley & David Hansen, *Contemporary Gippsland Artists*, Latrobe Valley Arts Centre, 1990.

FORBES-WOODGATE, Claudia

(b. 1925, Melbourne) Painter.
STUDIES: Privately, SA, 1940–42; with John Godson, Henry Edgecombe, 1946–48, and with G. K. Townshend, 1948–58, Sydney; travel studies, Europe, UK, USA, Turkey, 1971. A member of the RAS, Sydney, from 1950, and Australian Watercolour Inst. from 1964, she won many prizes, mostly for watercolours and exhibited with the Australian Watercolour Institute in a number of exhibitions including in USA, NZ.
AWARDS: Prizes at Taree, 1960, 62–64; Goulburn, 1964; R.Ag.Soc.NSW, 1966, 67, 74; Campbelltown, Killara, Cheltenham, Vic., all in 1972; Northside Festival, 1973; Kuringai, 1979.
APPTS: teaching privately; treasurer Australian Watercolour Institute 1975– .
BIB: Campbell, AWP. Germaine, AGA.

FORD, Sue

(b. 1943, Melb.) Photographer, film-maker.
STUDIES: RMIT (photography), 1961. Her photographs were seen in 12 solo exhibitions 1971–92 at private galleries in Melbourne (Christine Abrahams 1982, Melbourne Contemporary Art Gallery 1989, Niagara 1992) and Sydney (Watters 1984, 92); and at Hawthorn City Art Gallery, Melbourne 1971; NGV 1974, 87; Australian Centre for Photography, Sydney 1975, 87; AGNSW 1982; NGA 1989; Tiwi Cultural Museum, Bathurst Island, NT 1990. She participated in about 20 group exhibitions 1974–92, mainly at public galleries, including *Three Women Photographers*, Ewing and George Paton Galleries, Uni. of Melbourne, 1975; *Biennale of Sydney*, AGNSW 1981; *A Decade of Australian*

Photography 1972–1982, NGA 1983; *Shades of Light* NGV 1988; *Twenty Contemporary Australian Photographers*, NGV and touring 1990; exhibitions of Australian photographs touring Spain, 1990–91. She made seven films and videos 1971–85 including interviews with women artists and two books of her work were published.
AWARDS: Film grant, Experimental Film Fund, 1970– ; ILFORD Scholarship (two years postgraduate study), VCA, 1973; grant, Australian Film Commission, 1974; special project grant, VACB, 1975; special project grant, VACB, 1981; residency, Tuscany, Italy, VACB, 1983; photography fellowship, Vic. Council of the Arts, 1987; development grant, VACB, 1991.
REP: NGA; NGV; AGNSW; City of Melbourne; municipal collections Waverley, St Kilda, Vic.; Philip Morris and Hallmark corporate collections.
BIB: Geoffrey de Groen, *Conversations with Australian Artists*, Quartet Books, 1978.

FORD, William

(b. c. 1820, UK; arr. Vic. c. 1871; d. c. ?1886) Painter. He worked as a designer of Paisley shawls and exhibited at the RA before going to Australia. In Melbourne he gave private lessons at his studio at Inkerman Rd, St Kilda (one of his pupils being Rupert Bunny), and became a council member of the Victorian Academy of Art (around–1875). A letter written by Mrs Ford to the VAA (25 May 1883) reveals that Ford went blind. His most celebrated picture is *Picnic Party at Hanging Rock* (near Mt Macedon), which inspired the book by Joan Lindsay and subsequently the film made from it. Exhibited at the NSW Academy of Art, 1876, the picture was one of two representing Ford's work in the *Intercolonial Exhibition*, Philadelphia, 1876. He was represented in *Australian Art in the 1870s* AGNSW, Sydney, 1976 and by two pictures in the Bicentennial exhibition *The Great Australian Art Exhibition 1788–1988*.
AWARDS: First-class certificate, Philadelphia Intercolonial Exhibition, 1876.
REP: NGV.
BIB: McCulloch, AAGR.

FORDE, Helena

See SCOTT, Harriet and Helena

FORREST, (Lieut.) Charles

(Active c. 1880) A set of four small pencil drawings of Mornington, Vic., c. 1880, is the only known work of this late colonial artist.
REP: MPAC.

FORREST, Haughton

(b. 28/12/1826, Boulogne, France; arr. Tas. 1876; d. 20/1/1925, Hobart) Painter. Educated in Jamaica and Germany, his early married life was spent in England where he engaged in a military career and was commissioned in the Light Infantry in 1852. He visited South America in 1875, returned to England and went to Tas. the following year. Prior to his arrival he had

Haughton Forrest, Lake Marion, Tasmania, *oil on board,*
30 × 46cm. Private collection.

painted marine pictures in Britain (the Prince of Wales
is believed to have bought seven of his yachting pic-
tures) and shortly after arrival he had two paintings
on show at the gallery conducted by R. V. Hood (q.v.).
He was appointed Superintendent of Police at Sorell
but did not remain there long and retired to Hobart.
He painted prolifically, his subjects including Tasmanian
lake and mountain landscapes, ship portraits, fishing
boats off the English and French coasts (from pho-
tographs) and dark, stormy seascapes with wrecks.
Typical of his work is a high standard of finish and
close attention to nautical, topographical and botan-
ical detail. He exhibited two paintings at the Victorian
Academy of the Arts in 1887. His work was seen in
a number of survey exhibitions in the 1970s and 80s
including *Selected Australian Works of Art* Lauraine
Diggins Fine Art, Caulfield Vic., 1981; *Australian Art
in the 1870s,* AGNSW, 1976; *Tasmanian Vision,* TMAG
& QVMAG, 1988 and the Bicentennial exhibition *The
Face of Australia.*
REP: NGA; AGSA; AGWA; QAG; TMAG; QVMAG; NLA;
Mitchell, La Trobe Libraries; corporate collections
including Cascade brewery, Hobart; ICI.
BIB: J. Feldheim, *Australian Art in the Sixties,* self-published
Melbourne, 1915. D. Brook Hart, *British 19th Century Marine
Painting,* Antique Collectors Club, Woodbridge, Suffolk,
1974. Geroge Deas Brown *Haughton Forrest* Malakoff Fine
Art, Caulfield, Vic., 1982.

FORSTER, George (Johann Georg Adam)
(b. 1754, Germany; d. 1794, Paris) Writer, traveller,
philosopher, draughtsman. Natural history draughts-

man in *Resolution* during Cook's second voyage, when
his father, Johann Reinhold Forster (1729–98) served
as official scientist on the same ship. Forster's work
as draughtsman included drawings of the crested pen-
guin and the white goshawk. He packed a vast range
of varied activities into his short, adventurous life; he
taught languages, made translations and earned last-
ing fame for his books on travel, botany, geography,
ethnography, literature, aesthetics, philosophy and pol-
itics. He was professor of natural history at the Uni.
of Vilna, Poland, from 1784, and because of the research
facilities became librarian at Mainz, Germany, in 1788.
When Mainz was taken by the French in 1792, he
joined the Jacobites and two years later, exiled and
friendless, he died in Paris.
BIB: *ADB* 1.

FORSTER, Paton
(b. Perth, WA) Sculptor, administrator.
STUDIES: First in Perth, then Melbourne (RMIT). He
exhibited in numerous mixed exhibitions, notably at
Victorian Sculptors Society shows, VAS galleries, and
at the *Mildura Sculpture Triennial,* 1970. As secretary
of the National Gallery Society of Vic. (1968–c. 1985)
he was instrumental in building the Society into the
largest and most active gallery society in Australia.
BIB: *Artforce* special feature, no. 29, June–July 1980.

FORSTER, W.
Colonial school marine painter, mainly in watercolour.
Paintings by this artist, which often appear in auc-
tions, come usually from Adelaide (where it seems he
worked). Dates range from c. 1880–90, subjects being
mostly ships. No connection with Charles William

Foster (q.v.) has been established, though confusion often occurs between the two.

FORSYTH, A. W. (?Arthur William)
(Active c. 1900) Colonial School landscape painter. A. William Forsyth and Arthur W. Forsyth appear to be the same artist, though they are often listed separately. Subjects include New Zealand and Victorian scenes.
NFI

FORSYTH, George
(Active c. 1895, Sydney) Painter. He began exhibiting at the Art Society of NSW in 1896, showing oils and drawings, including figure and genre paintings; later works include views of Sydney.

FORSYTH, George Andrew
(b. ?UK; arr. Aust. 1866) Sketcher. A godson of the cartoonist George Cruikshank, he was employed in Fremantle, WA, as a pilot, harbour master and commander of the Fremantle Naval Volunteers. His paintings of Fremantle installations, done in pen, ink and watercolour, have historical interest. His work was represented in *The Colonial Eye*, AGWA 1979.
REP: WA Museum; Fremantle City Library.
BIB: R. Erickson, *The Bicentennial Dictionary of Western Australians pre-1829–1888*, Nedlands, 1988. Kerr, DAA.

FORTHUN, Louise
(b. 7/2/59, Port Macquarie, NSW) Painter.
STUDIES: B. Fine Art, painting, RMIT, 1981; postgrad. dip. painting, VCA, 1986; BA, La Trobe Uni., 1991; travel studies, NY, 1985; Europe, NY, 1989; Japan, 1992. Her abstract works, often composed of small interlocking shapes, were seen in six solo exhibitions in Melbourne 1985–92 including at Pinacotheca 1985; Tolarno 1990, 92 and in George Paton Gallery, Uni. of Melbourne 1987. She participated in about 30 group exhibitions 1982–92 largely at public, tertiary or artists' spaces including at Canberra School of Art 1984; International House, Columbia Uni., NY 1985; *Performance Work*, VCA Gallery 1986; *Angry Young Penguins*, Church Theatre, Melbourne 1987; *Physical Culture*, 1989 and *Witness*, 1990, 200 Gertrude St; Scotchmans Hill Vineyard Art Prize, Geelong Art Gallery 1989, 90; *Moet & Chandon Touring Fellowship*, 1990, 92; *Adelaide Biennale*, AGSA 1992. In 1986 she was artist-in-residence at Camberwell Boys Grammar School, Melbourne.
AWARDS: National Gallery Women's Association, 1985, 86; BP Acquisitive prize, 1989, 91; project grant, VACB, 1989; Gertrude St Artists Space, Vic. Ministry for the Arts, 1991; residency, Tokyo studios, VACB, 1991.
APPTS: Guest tutorials, RMIT, VCA, 1988; tutor, VCA, 1990– .
REP: Artbank; Melb. City Council; corporate collections including BP, CRSA, Sam and Minnie Smorgon.
BIB: Catalogue essays exhibitions as above.

FOSTER, Charles William
(b. 1840, Boston, USA; arr. Aust. c. 1856; d. 1920, NZ) Painter. He was in Bendigo by 1856 and from 1873 to 1887 exhibited marine paintings at the Victorian Academy of Arts. He was living in Collins St from 1878, went to New Zealand in 1895 and there appears to have concentrated on coastal landscapes.
REP: Auckland City Art Gallery.
BIB: McCulloch, AAGR. Henry P. Newrick, *NZ Art Auction Records 1969–72*, Newrick, Wellington, 1973.
See also FORSTER, W.

FOSTER, Una
(b. 1912, Sydney) Printmaker, designer.
STUDIES: ESTC, c. 1934; Central School of Arts and Crafts, London, 1950–51; Workshops Art Centre, Willoughby, NSW, 1969. Best-known for her Op style, abstract serigraphs which won her a number of awards from 1971.
REP: Regional galleries Maitland, Townsville, Warrnambool.
BIB: PCA, *Directory*, 1976.
NFI

FOULKES, Garrey
(b. 1944, Melb.) Painter.
STUDIES: RMIT (advertising), 1960; Ealing Art School, London, 1961. He travelled in Europe and Asia before returning to Australia in 1962. A large *Untitled* acrylic on canvas (1.85 m × 2.74 m) by Foulkes appeared in *The Field* and later he held an exhibition at the Pinacotheca Gallery, St Kilda, Vic. In this exhibition his tonal nuances of rust, red and brown were divided into subtly arranged geometric shapes, such as squares and rectangles.
BIB: Smith, AP.
NFI

FOUNDATIONS
See TRUSTS AND FOUNDATIONS

FOWLES, Joseph
(b. 1810, UK; arr. Sydney 1838; d. 25/6/1878, Sydney) Painter. He was the ship's surgeon on the voyage to Australia and sketched the ship and life at sea. He was a farmer in Hunters Hill (leasing Mary Reibey's farm) and opened a studio in 1847, exhibiting in the same year with Society for the Promotion of the Fine Arts. In 1848 he published 40 illustrations of the streets of Sydney. In 1859 he became the first instructor of drawing at the Sydney Mechanics School of Art. He also taught and examined for the National Board of Education at Sydney Grammar School, the King's School and Lyndhurst College. He became well-known as a painter of marine subjects, racehorses and jockeys, as well as landscapes of Sydney and the harbour and environs; he also showed English landscapes. He was represented in *Australian Colonial Portraits*, TMAG 1979; *Pastures and Pastimes*, exhibition VAS 1983 and *The Artist and the Patron* AGNSW, 1988.

REP: Newcastle regional gallery; NLA; Mitchell, Dixson Libraries.

BIB: Moore, SAA. ADB 1, Kerr, DAA.

FOX, Alexander

(b. c. 1830, Norwich, UK; arr. Aust. c. 1852; d. c. 1870?) Photographer. He dug for gold in Bendigo, also producing panoramic views of Bendigo 1856–59 before moving to Melbourne in 1859. Having married Rosetta Philips, he established a photographic company in 1862 which failed dismally by 1866. He turned to painting but returned to photography, moving to Sydney in c. 1867. It is not known what became of him after this time, and where and when he died. His second youngest son was E. Phillips Fox (q.v.). His work appeared in *Shades of Light*, NGA 1988.

REP: Bendigo Art Gallery; Mitchell, La Trobe, Dixson Libraries.

BIB: Alan Davies and Peter Standbury, *The Mechanical Eye in Australia*, Melbourne 1985. Len Fox, *E. Phillips Fox and Family*, Sydney 1985. Marguerite Mahood, *The Loaded Line*, Melbourne 1973. A. Glover, *Victorian Treasures from the La Trobe Collection*, State Library of Vic., 1980. Kerr, DAA.

FOX, Emanuel Phillips

(b. 12/3/1865, Fitzroy, Vic.; d. 8/10/1915, Melb.) Painter.

STUDIES: NGV School, 1881–86; Académie Julian, Paris, then Ecole des Beaux-Arts with Bourgereau and Gérome 1887. Son of Alexander Fox, photographer, Phillips Fox was linked in name with Rupert Bunny as one of the two great Australian expatriate painters of the period. After exhibiting at the Old Salon and Salon des Artistes Français, 1890, he returned to Melbourne, held an exhibition there in 1892, and started the Melbourne Art School in partnership with Tudor St George Tucker. In 1900–01 he was commissioned by the trustees of the NGV to paint *The Landing of Captain Cook at Botany Day* under the terms of the Gillbee bequest which required the work to be painted in London. Fox went to London in 1902 and in 1905 married the painter Ethel Carrick (q.v.) and they settled in Paris. Travels in Spain and Italy, 1906, and work in Paris, earned him election as associate of the Société Nationale des Beaux-Arts in 1908 and membership 1910. During these and succeeding years he twice visited Melbourne (1908, 1913), was elected a member of the International Society of Painters, Sculptors and Gravers, London (1912) and sold a picture *(My Cousin)* to the Musée du Luxembourg. He had by this time become known as a fine post-impressionist type painter of figures in dappled sunlight. Inspired perhaps by the example of Gauguin he visited Tahiti in 1914. One of his last acts was organising the purchase of a lorry for the Red Cross in 1915. Survey exhibitions in which his work appeared in the 1980s included the Bicentennial exhibitions *The Great Australian Art Exhibition 1788–1988* and *The Face of Australia*.

AWARDS: Student prize for landscape, NGV School, 1885; gold medal, Old Salon, Paris, c. 1909.

REP: NGA; state and regional galleries and many other Australian public collections.

BIB: Len Fox, *E. Phillips Fox: Notes and Recollections*, privately published, Sydney, 1969. McCulloch, GAAP. ADB 8. References in all historical works on Australian painting.

FOX, Ethel Carrick (née Carrick)

(b. 7/2/1872, Uxbridge, Middlesex; d. 17/6/1952, Melb.) Painter, teacher.

STUDIES: Brook Green, drawing with Francis Bate; Slade School, London, with Henry Tonks and Frederick Brown (1898–99 and 1902–03). During her post-student days she worked at an artists' colony at St Ives, Cornwall, and there met Emanuel Phillips Fox. After their marriage they painted together in France, North Africa and Spain, visited Australia in 1908 and again in 1913. They had been married only ten years when Phillips Fox died, after which Ethel Carrick travelled frequently between Australia and Europe, painting and conducting an art school in Paris for Australian and American students. Her post-impressionistic paintings, beautiful in colour, strong in design and often depicting crowded cafe and beach scenes have great clarity. She exhibited at the Salon d'Automne 1904–30 and Société des Beaux-Arts 1906–37, as well as in many British and Australian group exhibitions. A tireless worker for art and artists, she did much to extend the recognition of her husband's work in Australia, notably by promoting a joint exhibition of their work (Athenaeum Gallery, Melbourne, 1934), and during two world wars organised art unions for the relief of artists. During the 1930s she deplored the absence from Australian collections of work by Ecole de Paris artists, and strongly recommended to the NGV that 'now is the time to buy works by such artists as Degas, Renoir, Lautrec and Bonnard'. Her work was the subject of a retrospective at the Geelong Art Gallery and travelling 1979 and has been seen in a number of survey exhibitions during the 1980s and 90s including the Bicentennial exhibitions *The Great Australian Art Exhibition 1788–1988*; *The Face of Australia* and in *A Century of Australian Women Artists 1840s–1940s* Deutscher Fine Art, Melbourne 1993; *Capturing the Orient: Hilda Rix Nicholas and Ethel Carrick in the East* Waverley City Gallery and touring 1993.

AWARDS: Many European prizes and awards, including Dip. of Honour, International Exhibition, Bordeaux.

REP: Australian state and regional galleries.

BIB: D. H. Souter, *Parisian Paintings in Melbourne: Ethel Carrick*, Art and Architecture, Sydney, vol. 5, 1908. Article in Melbourne *Herald*, 9 May 1933. Janine Burke, *Australian Women Artists 1840–1940*, Greenhouse, Melbourne, 1980. ADB 8.

FOX, Len

(b. 1905, Melbourne) Writer. Known for his work on Australian history and related subjects, including recollections of his relative, E. Phillips Fox (q.v.). He wrote *Eureka and its Flag*, Mullaya Publications, Canterbury, Vic., 1973 and *E. Phillips Fox: Notes and Recollections*, privately published, Sydney, 1969.

FOXHILL, George

(b. 18/9/1921, Salzburg, Austria; arr. Aust., 1956)
STUDIES: Salzburg Art School, 1947–48; Dip. Art, Melb., 1961. His distinctive figurative expressionist works have elements of German expressionism and were seen in 13 solo exhibitions 1963–92 in Canberra (including Gallery Nunda 1963, 67; Solander 1975; Ben Grady 1988), Sydney (Coventry 1989, 90), Melbourne (Luba Bilu 1990, 92) and the Arts Council Gallery Canberra, 1985. He participated in about 15 group exhibitions 1962–89 largely at public galleries including *Transfield Prize*, 1962; *Trustees Prize*, QAG 1972, 73, 82; *Blake Prize*, 1979, 80; *National Art Award*, Canberra 1986.
AWARDS: Residency, Landesatelier, Künstlerhaus, Salzburg, 1979, 81, 86/87; grant, VACB, 1983.
REP: Parliament House; several public galleries Australia; ANU; Commonwealth Bank, Canberra; Allen, Allen & Hemsley.
BIB: *New Art Five*.

FRANCIS, Dorothea

(b. 1903, Melb.; d. 1975) Painter.
STUDIES: Private lessons including with George Bell 1941–55 and Alfred and Yolande Calkoen 1958–60. Sister of Margaret Francis (q.v.), she exhibited at the Women's Art Club (later Melbourne Society of Women Painters) 1922–75; VAS 1939–44, 48, 53; Melbourne Contemporary Artists 1942–65. Some of her works have overtones of Modigliani, Matisse and Picasso, with a personal interpretation of modernism, while others are fairytale-like watercolours. She was a close friend of and influenced by Treania Smith (founder director of Macquarie Galleries, Sydney). An exhibition of her work with that of her sister Margaret was held at Jim Alexander Gallery, Melbourne, 1987.
BIB: Mary Eagle and Jan Minchin, *The George Bell School*, Deutscher Fine Art/Resolution Press, 1985. (Information from J. Alexander catalogue *Dorothea and Margaret Francis*, 1987)

FRANCIS, Ivor Pengelly

(b. 13/3/1906, Uckfield, Sussex; arr. Aust. 1924 d. 6/11/1993 S.A.) Painter, writer, teacher, critic.
STUDIES: SASA, 1929–39. A pioneer of surrealism in SA, he held many exhibitions from 1948, with the CAS, Adelaide from the 1940s and several solo and two-person shows in Adelaide in the early 1950s. In the 1950s and 1960s he was employed by the ABC as supervisor of education in Adelaide, and was also art critic for the *News, Sunday Mail* and *Advertiser*, as well as publishing his own monthly art journal, *Ivor's Review* (1956–60). His work over the years included surrealism, social-realism, abstraction and a number of other styles. Group exhibitions in which his work appeared included *Aspects of Australian Surrealism*, 1976; *Visions After Light: Art in SA 1836–91*, AGSA 1984; *Art and Social Commitment: An End to the City of Dreams*. Major retrospectives of his work were held at AGSA 1987 and Charles Nodrum, Melbourne, 1988 and a smaller exhibition at Nodrum, 1993. His work was

represented in the Bicentennial exhibition *The Great Australian Art Exhibition 1788–1988*.
AWARDS: John White Prize for Landscape 1939; McGregor Memorial Prize 1956; Emeritus Award, VACB, 1988; Medal, Order of Australia, 1989.
APPTS: President, CAS, Adelaide; vice-president, RSASA, Adelaide; teaching, SA School of Mines and Industry, Adelaide Tech. School, 1943–47; Supervisor of Education, ABC, Adelaide; lecturer in art history and art appreciation, Uni. of Adelaide (Dept. of Architecture), 1970– ; art critic, *News*, 1944–56; *Sunday Mail*, 1965–74; *Advertiser*, 1974–77.
REP: NGA; AGNSW; AGSA; NGV; AWM; several tertiary and regional galleries Vic., WA.
BIB: Catalogue essays in exhibitions as above, especially Charles Nodrum exhibition 1988. Smith, AP. Ivor Francis, *Ivor's Art Review*, monthly, 1956–60; *History and Appreciation of Art*, four booklets, RAAF Educational Services, Adelaide, 1945. Benko, ASA. Richard Haese, *Rebels and Precursors* Viking, Melbourne 1983. Dean Bruton, *The Contemporary Art Society of South Australia*, Adelaide, 1992.

FRANCIS, Margaret

(b. 1909, Melb.; d. 1987, Melb.) Painter.
STUDIES: With her older sister Dorothea and with George Bell 1941–43, Alfred and Yolande Calkoen 1960. She exhibited with Melbourne Contemporary Artists 1940–44, 48 and the Melbourne Society of Women Painters 1962, 64–67, 70–75. She converted to modernism earlier than her sister and during World War II made hand-stuffed animals, the proceeds of the sale of which went to the Red Cross. They became highly popular and much sought-after. She exhibited in the Australian section of *Arts and Crafts Various Nations* in NY, 1953, and returned to painting in the late 1950s. She exhibited with her sister until Dorothea's death in 1975. A joint exhibition of their work was held by Jim Alexander in Melbourne in 1987. She was represented in *Classical Modernism: The George Bell Circle* NGV, 1992.
BIB: Mary Eagle & Jan Minchin, *The George Bell School* Deutscher Fine Art/Resolution Press, Melbourne 1985. (Information from J. Alexander catalogue *Dorothea and Margaret Francis*, 1987)

FRANK, Dale

(b. 26/8/1959, NSW) Painter.
STUDIES: Several weeks SCA, 1977 and CAE Art School, 1977. An extraordinarily prolific painter and draughtsman, Frank's early 1980s drawings revealed a skilful talent. Previously he had gained attention through his performance works. The body remained a focus of his 1980s works which included self-portrait drawings, and amoebic-like textured shapes rather like oil on water patterns based on interior body canals. He occasionally adds objects to the work's surface and uses bright almost fluorescent colours in clashing tones. He held 56 solo exhibitions including performance shows 1979–91 including in Sydney (Roslyn Oxley9; Mori), Melbourne (Realities; Deutscher Brunswick St; Karyn Lovegrove) and Brisbane (Milburn + Arte) and in EAF, Adelaide 1979; Uni. Gallery, Melbourne 1982;

Dale Frank, The Wounded Painting that Tempted to Look in the Mirror, *1985, acrylic on canvas, 200 × 179cm. Private collection.*

Uni. Gallery, Uni. of Melbourne 1984; IMA, Brisbane 1990; Tamworth City Gallery, Tamworth, NSW 1991; Newcastle Regional Gallery, Newcastle 1992; Contemporary Art Centre of SA, Adelaide 1992 and many exhibitions in the USA (New York, Chicago), Italy (Bologna, Milan, Naples), Zurich, Basel, Amsterdam and Brussels. His work appeared in over 70 group exhibitions 1974–92 largely at public galleries including *Biennale of Sydney*, 1982, 90; *Recent Australia Painting*, AGSA 1983; *Vox Pop*, NGV 1983; *Form, Image, Sign*, AGWA 1984; *Recent Australian Art: An American Perspective*, Guggenheim, NY 1984; *Australian Vision*, touring five state galleries 1985; *Backlash*, NGV 1987; *Australian Drawing*, NGA 1988; *A New Generation: Philip Morris Art Grant Purchase*, NGA 1988; and in many international survey exhibitions in Italy, Canada, France and the USA.
REP: NGA; AGNSW; AGSA; AGWA; NGV; QAG; MCA, Sydney; regional galleries Burnie, Townsville, Newcastle, Tamworth, Wollongong; Melbourne, Griffith unis.; Guggenheim, NY; Zurich and Liège museums; National Gallery of New Zealand; private collections include Exxon, New York; Allen, Allen & Hemsley, Sydney; ICI; Hugh Jamieson, Sydney; Smorgon Family, Melbourne; many others in Australia, New York and Europe.
BIB: Catalogue essays in exhibitions as above. Smith, AP. McIntyre, ACD. Jane Mangan *Dale Frank*, Craftsman House, Sydney 1992. *A&A* 25/2/1987.

FRANK, Louis

(Active c. 1880–85, Sydney) Painter. Itinerant colonial school painter, he exhibited with the Art Society of NSW, 1880–85, showing landscapes of the Grose Valley, NSW, as well as views of the Himalayas and other Indian scenery. He painted also in New Zealand, being attracted to effects of light and colour on mountains. He may have been related to W. Frank (q.v.).

FRANK, W.

(Active c. 1866, Sydney) Painter. Two watercolours of early Australian homesteads dated 1866 by this otherwise unknown painter were sold at Leonard Joel's auctions, Melbourne, May and Nov. 1977.

FRANKLAND, George

(b. 1797; arr. Tas. 1827; d. Dec. 1838, Tas.) Painter, surveyor. He recorded natural history of Tasmania while travelling through it in his capacity as Surveyor-General from 1827 to 1838 and devised comic-strip drawing, affixed to bark throughout the bush, depicting the meeting of the two races and penalties of hanging for Aborigines who speared a white and vice-versa. The most well-known of these, *Lieutenant-Governor Arthur's Proclamation to the Aborigines 1829*, was shown at the 1866 Melbourne *Intercolonial Exhibition* and the 1867 *Paris Universal Exhibition* and is now in the collection of the TMAG. His illustrations appeared in *Ross's Almanack*, 1830. His work was seen in *Tasmanian Vision*, TMAG & QVMAG, 1988.
REP: QVMAG; TMAG; Parliament House; NLA; Mitchell Library; Museum of Archeology and Ethnology, Cambridge.
BIB: ADB 1. *Australian Encyclopaedia*, Angus & Robertson, Sydney, 1958. C. M. H. Clark, *A History of Australia*, vol. 2 (reprdn), MUP, 1968, 1975. Tim Bonyhady, *Images in Opposition*, Melbourne 1985. Kerr, *DAA*.

FRANKLIN, (Sir) John and (Lady) Jane

Art patrons. Governor of Tas. (1837–43) and his wife, Jane, née Griffin. The impetus given to the arts in Tas. by the presence of Governor and Lady Franklin helped to make Hobart a centre of colonial culture and education. Lady Franklin, a keen patron of the arts, gave assistance to such artists as Thomas Bock, John Gould and J. E. Chapman. As a midshipman Franklin was wrecked in Flinders' ship *Porpoise* (17 Aug. 1803) and spent nearly eight weeks marooned on a sandbank in company with William Westall (q.v.) and others. His liberal administration and humane and enlightened attitude towards the convicts while governor of Tas. did not suit the authorities in England and he was recalled. Two years later he led the Arctic expedition in which he and his crew perished in 1847.
BIB: Rienits, *Early Artists of Australia*, 1963. C. M. H. Clark, *A History of Australia*, vol. 2, MUP 1968, 1975. ADB 1.
See also GALLERIES, LADY FRANKLIN MUSEUM

FRANSELLA, Graham

(b. 3/6/1950, Harrow, Eng.; arr. Aust. 1975) Printmaker.

STUDIES: Bradford School of Art, Yorkshire, Eng., 1970–73. A leading printmaker, his work is in the tradition of European printmaking, is often monochromatic with finely balanced composition. He took part in international and Australian print exhibitions 1972–91 including at Macquarie, Sydney, and Henri Worland Print Prize, Warrnambool regional gallery, 1980, 81, 83; *Australian Prints*, NGA 1989. He held about 18 solo exhibitions 1978–92 at private galleries including Gerstman and Gerstman Abdullah, Melbourne and Cologne, Germany, and Macquarie, Sydney, 1983, 84, 86, 88–91.
AWARDS: Bradford School of Art Travelling Scholarship 1972; Maitland Print Prize 1985.
APPTS: Lecturer, printmaking, VCA, 1975– .
REP: NGA; NGV; Artbank; many regional and tertiary collections.
BIB: PCA, *Directory*.

FRASER, Alison Hartley

(b. 5/9/1945, Lancaster, UK; arr. Sydney Feb. 1965) Gallery director, painter, administrator.
STUDIES: Glasgow School of Art, 1963–65; Dip. Fine Art, NAS, 1968. She exhibited in students' exhibitions including *Farmer's Young Contemporaries*, Farmer's Gallery, Sydney, 1967. She was a secondary art teacher and gallery director in the 1960s and 1970s and from 1984 was attached to Arts Victoria (previously the Victorian Ministry for the Arts). She also has reviewed art for the ABC and the *Australian*, was a contributor to art journals and was a member of the course advisory and accreditation committees of several Victorian art schools. She contributed to the *Australian Dictionary of Biography* and co-authored a community arts curriculum and slide kit on the history of Australian art.
APPTS: Teaching, Ascham School, Sydney, 1968–73; Education Officer, AGNSW, 1974–76; VACB consultant, 1977–78; director, VCA Gallery, Melbourne, 1978–82; assistant to dean, VCA, 1983–84; co-ordinator, Community Arts Training Programme, 1984–86; visual art/craft executive, 1986–88; public art executive, 1988–90; manager, visual arts unit, Arts Victoria, 1990– .

FRASER, Edward

(Active c. 1888–1920, Melb.) Painter. He exhibited at the VAS, 1888–90 (river scenes, mainly of the Yarra and the Maas), and again 1916–17, when he showed drawings of Scottish subjects as well as the Yarra Valley and Pakenham landscapes. E. Fraser, quite likely the same person, exhibited in Glasgow in 1884. A misty street scene in watercolour, *Spring Street, Melbourne*, by Fraser, was included in Leonard Joel's auctions, Melbourne, Nov. 1973.

FRASER, Peter Gordon

(b. 31/3/1808; arr. Tas. May 1839; d. 27/4/1888, UK) Painter. Known mainly for watercolours Fraser was the Sheriff of Tas. 1840–3, colonial treasurer 1843–56, colonial secretary 1851–52 and a member of the

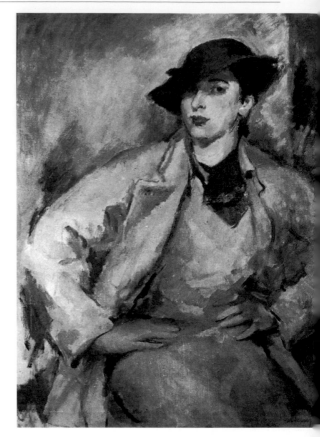

William Frater, The Red Hat, 1942, oil on canvas. Collection, NGV.

Executive and Legislative councils. He was a keen amateur sketcher and member of the Hobart Sketching Club in the 1840s. He accompanied John Skinner Prout (q.v.) on a number of journeys thoughout Tasmania and helped organise art exhibitions in the Legislative Chamber 1845, 46. A number of his works are in public collections in Tasmania and one was represented in *Images of Children*, Burnie Art Gallery 1979 and in *Tasmanian Vision*, TMAG & QVMAG, 1988.
REP: QVMAG; Allport Library.
BIB: *ADB* 1. Kerr, *DAA*.

FRATER, William

(b. 31/1/1890, Ochiltree, Linlithgow, Scotland; arr. Aust. 1910; d. 28/11/1974, Melb.) Painter.
STUDIES: Glasgow School of Art (with Maurice Griffenhagen), 1905–09 and 1912–13; London, stained-glass design (with R. Anning Bell); Paris. After his initial visit to Australia in 1910, he returned four years later to continue his five-year contract with the firm of Brooks Robinson as a designer of stained glass and there made the acquaintance of Arnold Shore, a junior in the same firm. Later he assisted at the modern art school conducted by Shore and George Bell, and with them became widely known as a pioneer of modernism in Vic. Although his painting was, and

remains, sensuous rather than intellectual, he was a consistent protagonist for the theories and principles of Cézanne. A compulsive painter, he adapted Cézanne's 'apricot palette' to problems of representing the Australian landscape. He applied these principles also to portrait painting. One of his most celebrated portraits is the *Red Hat* (NGV), a study of his pupil and colleague Lina Bryans; another is his 1930 portrait, *Adrian Lawlor* (AGNSW), the painting that most clearly reveals his admiration for, and understanding of, the painting of Cézanne. Long after the battle between academics and moderns had been fought and won he was elected president of the VAS, remaining president until shortly before his death. His place in the history of modern Australian art is that of a link artist joining the modernist movements of the 1930s in Vic. with the work of the 1950s figurative artists and their discovery of the outback country. Ada Plante and Isobel Tweddle were among the many painters who responded to his influence. His painting represented a liberation and a freedom from convention that made it widely acceptable also to the emerging generation. His work was represented in *Classical Modernism: The George Bell Circle*, NGV, 1992.

AWARDS: Prize in Dunlop competitions, 1950; Eltham Art Award, 1965.

REP: NGA; most state and many regional galleries.

BIB: Arnold Shore, *Forty Years*, *Seek and Find*, privately published, Melbourne, 1957 Ursula Hoff and Margaret Plant, *National Gallery of Victoria: Painting, Drawing, Sculpture*, Cheshire, Melbourne, 1968. *A&A* 18/4/1980 (Anne Gray, *William Frater-Reconsidered*).

FRAWLEY, John

(b. 1915, Melb.) Painter, printmaker.
STUDIES: NGV School, 1939– ; RMIT; Prahran CAE. He served in the army signals corps during World War II, became an official war artist and painted a number of portraits of army personnel.
AWARDS: Student prize, NGV School, 1939.
REP: AWM.
NFI

FREEDMAN, Harold Emanuel

(b. 1915, Caulfield, Vic.) Painter, illustrator, teacher.
STUDIES: Melb. Tech. Coll. (RMIT), 1929–35. From 1936 he worked as a freelance illustrator and cartoonist, contributing to Melbourne weeklies. As a teacher, he initiated the Melbourne Print Group within the RMIT (1951), and from 1963 completed a series of detailed topographical views of Melbourne for a book *Views of Melbourne* (Grayflower Publications, Melbourne, 1963). Such work led to a commission to paint a large mural depicting the history of aviation for the AWM, Canberra. Completing this work, 1967–72, he was appointed state artist for Vic., his first commission being the large mural on the theme of transport for the Spencer St railway station. He has since completed a number of of other murals including that on the theme of regional history for the new state offices, Geelong, Vic.

APPTS: Official RAAF war artist, 1944–45; teacher, later senior lecturer, RMIT, 1945–67; state artist for Vic., 1973– .
REP: AGNSW; AGSA; AGWA; NGV; QAG; TMAG; AWM.

FREEMAN, Arthur

Painter.
AWARDS: NSW Society of Artists' Travelling Scholarship, 1933.
NFI

FREEMAN BROTHERS (James & William)

(James b. 1814, UK; arr. Aust. 1854; d. 1870, UK. William b. 1809, UK; arr. Aust. 1853; d. 1895, Newcastle, NSW) Photographers. Two of the best-known and most successful photographers in Sydney 1854–c.1869, they photographed, as well as numerous portraits of dignitaries, the first government of NSW and one of the first photographic panoramas in Australia, in 1851, of ten views of Sydney. They held exhibitions of their own work in Sydney as well as participating in the London *International Exhibition* in 1862, and a number of their photographs were used as the basis for engravings reproduced in Sydney newspapers. The photographer Cazneaux was one of their pupils and they opened a gallery and studio for a year (1867–68) with Victor Prout (q.v.), in Castlereagh St North. James returned to the UK, where he died, and William, who had accompanied him, returned to Australia where he continued to work in the 1870s and 1880s.
REP: Most state galleries, and other public collections.
BIB: ADB 4. Alan Davies & Peter Standbury, *The Mechanical Eye in Australia* Melbourne 1985. Kerr, DAA.

FREEMAN, George John

(b. 17/1/1842, London; arr. SA 1861; d. 5/4/1895, Adelaide) Photographer. A leading photographer in Adelaide in the 1870s, he moved to NSW in 1884, working in Newcastle, Balmain, Parramatta before returning to Adelaide c. 1892. He produced photographic panoramas including several of Adelaide sent to the 1876 Philadelphia Centennial Exhibition, USA. His work was represented in *Shades of Light*, NGA 1988.
REP: AGSA; NLA.
BIB: Alan Davies & Peter Standbury, *The Mechanical Eye in Australia* Melbourne 1985. Kerr, DAA.

FREEMAN, Jack

(b. 1921, Melb.) Painter.
STUDIES: Melbourne (with A. D. Colquhoun), 1940; Army rehabilitation course at NGV School, 1946–49; Europe, 1961–62. Member of the Melbourne group of social-realist painters. Freeman's exhibition at Frederick's Showroom Gallery, St Kilda, 1962, showed him as a lyrical painter of street scenes, buildings and landscapes done in a social-realist manner.
AWARDS: Robin Hood prize, 1959; Yorick Club prize, 1960; Portland prize, 1961.

FREEMAN, Madge (Frances Margo)

(b. 1895, Bendigo; d. 1977, Melb.) Painter.
STUDIES: School of Mines, Bendigo, with Arthur Woodward, 1911–15; NGV School, 1916–21; Slade School, London, 1924; Paris, with Adolphe Millich, 1925–26. In 1926 she married an engineer, Lanfear Thompson, who took her to live on the African Gold Coast until his premature death in 1929, after which she led a wandering life in Europe, returning to Australia, 1935, and lived in Bendigo from 1938 until her marriage, in 1940, to Basil Davies. She revisited Europe in 1952–53. Her paintings of street scenes, interiors, forgotten corners and similar genre had a touch of post-impressionism that raised them above pedestrian level. She exhibited with Melbourne groups such as the Independent Group and Melbourne Society of Women Painters and Sculptors. She gave a £100 prize to the Bendigo Art Gallery in memory of her mother in 1956 and bequeathed her collection to the Gallery in 1977. Before his death in 1979 her husband, Basil Davies, established the Madge Freeman Prize. The Bendigo Art Gallery held a retrospective exhibition of her work in 1981.
AWARDS: Bendigo Art Prize, 1956.
REP: NGV; Bendigo Art Gallery.

FREEMAN, Peter

(b. 1933, Surrey, Eng.; arr. Aust. 1958) Painter.
STUDIES: Royal College of Art, London, 1953–56. He painted in Spain 1957–58 and held exhibitions in London, Brisbane, Sydney and Melbourne, 1965, of mainly semi-abstract pictures.

FRENCH, Joy

(b. 1917, Melb.; d. 1980s) Graphic artist, teacher.
STUDIES: RMIT; George Bell School. Her drawings in VAS and CAS exhibitions established her reputation as a graphic artist. She was the first wife of Leonard French (q.v.).
AWARDS: Prizes VAS (*Herald* prize for figure drawing), 1948, watercolour prize 1970, 71, special prize 1972; Albury (graphics), 1972.
REP: NGV.

FRENCH, Leonard William

(b. 8/10/1928, Brunswick, Vic.) Painter.
STUDIES: Melb. Tech. Coll., c. 1944–47; independent study in England, Ireland and Belgium, 1949–51; Asia, 1960–61; Greece, Italy, Spain, France and England, 1962–63; America, 1965. As the creator of large-scale symmetrical designs in a wide variety of media, he occupies a unique place in Australian art. Basically romantic, his concept of art fitted him from the beginning for the demands of large architectonic projects in stained-glass, mosaics, tapestry and mural painting. His first mural was an Orozco-style work done for a Brunswick church when he was nineteen; the style was soon abandoned but it showed his innate capacity for large scale-design. Brought up in the Melbourne industrial suburb of Brunswick, he left the state school at the official school-leaving age to work on farms and as a signwriter. He worked his passage to the UK late in 1949 and spent a brief period in London before working in Ireland. He also spent several hungry weeks on the waterfront at Amsterdam where he saw pictures by the French painter Marcel Grommaire, and the Belgian Constant Permeke. He returned to Melbourne early in 1951 and a year later the first of his *Iliad* pictures appeared at the Peter Bray Gallery, Melbourne. These pictures were followed by a larger exhibition on the *Odyssey* theme at the VAS galleries in 1955. He painted a large mural for the Legend espresso bar, Melbourne, in 1956, and in the same year completed a monumental mural for the Beaurepaire Physical Education Centre at the Uni. of Melbourne. About this time he abandoned signwriting for teaching and in 1959 won an Asian scholarship which took him to Indonesia, India, China and Japan, and led towards the major source of his later inspiration – the study of Byzantine art. Towards the end of 1960 he unsuccessfully contested the Rubinstein Scholarship with a series of remarkable paintings on the theme of *Genesis*, which earned him the enthusiastic patronage of the Sydney dealer Rudy Komon. A later series on the theme of the 16th-century martyr Edmund Campion was exhibited by Komon in Sydney, then Melbourne, before French left for Greece to study Byzantine art at its source. In 1963 he returned to Melbourne, where he received the commission that would change the course of his career – the huge ceiling in stained glass for the new NGV. His travels were resumed in Apr. 1965, when he visited Japan en route for the USA on a Harkness Fellowship. He exhibited approximately every two years in the 1980s including at Australian Galleries, Powell St, Melbourne; Philip Bacon, Brisbane; Greenhill, Adelaide. From 1970 he devoted his time mainly to large-scale, commissioned works in stained glass such as the circular window for Monash Uni., 1971; glass panels, La Trobe Uni., 1978; 47 windows and altar painting, Haileybury College, Keysborough, Vic., 1987/88; St James the Less Anglican Church, window, Mt Eliza 1988/89.
AWARDS: Asian travelling prize, judged in Melbourne, 1959; Crouch prize, 1959; Perth prize, 1960; Blake prize, 1963, 80; Georges Invitation Art prize, 1964; W. D. & H. O. Wills prize, 1964; Harkness Fellowship, 1965; OBE conferred 1969; Doctor of Laws (*honoris causa*), Monash Uni., 1972.
APPTS: Teaching, Melbourne School of Printing and Graphic Arts, 1952–56; Sir William Angliss School of Experimental Cooking, c. 1956; Exhibitions Officer, NGV, 1956–60; member, CAAB, Canberra, –1972; NGA Board, Canberra, –1982.
REP: All Australian state galleries; Uni. of WA collection; Ballarat Gallery; MOMA, New York; Hamilton Art Centre, Canada.
BIB: All general books on contemporary Australian art including Smith, AP. *The Campion Paintings*, intro. Vincent Buckley, Grayflower Publications, Melbourne, 1962. *Meanjin* 2/1951 (Alan McCulloch, *Leonard French, Artist of Promise*). A&A 1/2/1963 (William Hannan, *Leonard French*); 6/3/1968 (Alan McCulloch, *Carpet in the Sky, Leonard French's Ceiling*); 7/4/1970

(John Baily, *Leonard French and Recent British Painting* Adelaide Festival); 12/4/1975 (Patrick McCaughey, *Leonard French's Raft Series*).

FRENCH, Margaret (Margaret Anne)
(b. 1860, Adelaide; d. 1927, ?Mt Gambier) Painter. Known mainly for landscapes in watercolour. She exhibited at the SASA and is best known for her paintings of the area around Mt Gambier where she lived.
BIB: Rachel Biven, *Some forgotten . . . some remembered*, Sydenham Gallery, Adelaide, 1976.

FREYCINET, Louis-Claude Desaulses de
(b. 1779, France; arr. Aust. c. 1801; d. 1842) Sketcher, cartographer. A member of Nicolas Baudin's 1800–04 expedition to Australia, he made maps of the voyage but is best remembered for the account of a later (1817–20) voyage from France to Australia, *Voyage autour du monde*, while on a ship of his own command.
BIB: Reinits, *Early Artists of Australia*, 1963. ADB 1.

FRIEDEBERGER, Klaus
(b. 1922, Berlin; arr. Aust. on the prison ship *Dunera*, 1940; returned to UK, c.1950) Graphic artist, painter.
STUDIES: ESTC, 1947–50. Friedeberger was a member of a group of European graphic artists who worked in Melbourne (c. 1940–49); he went to live and work in London in 1950.
AWARDS: Mosman prize, 1949; prize at Ostend (gold medal), 1964.
BIB: *The Arts Review*, London, 26 Jan.–9 Feb. 1963.
See also FABIAN, Erwin

FRIEDENSEN, Thomas
(b. 1879, Leeds, Eng.; arr. Sydney 1921; d. 1931, Cannes, France) Etcher.
STUDIES: RCA, UK (South Kensington). Friedensen, a capable and prolific etcher in a contemporary Dutch manner, travelled extensively all his life visiting North and South America, South Africa, France, Belgium, Spain and Italy. He exhibited at the RA, London, New English Art Club, and Royal Inst., and was one of the founders of the Graphic Art Society, London. Member of RAS of NSW and Australian Painter-Etchers' Society.
REP: Australian state galleries; Manly Art Gallery.
BIB: Manly Art Gallery catalogue of works. AA, December 1928, reprdns.

FRIEND, Donald Stuart Leslie
(b. 1915, Sydney; d. 17/8/1989) Painter, writer.
STUDIES: RAS, Sydney, and Dattilo Rubbo's School, 1933–34; Westminster School, London, 1935–36. He worked in Nigeria 1938–40 and acted as an adviser to a local prince before returning to Sydney, where (c. 1940) he lived at Merioola and his drawings and paintings earned him a leading place among the new generation of Sydney painters. Two illustrated books written while serving as an artillery gunner (in Borneo and Moratai), World War II, further enhanced his reputation for versatility and wit, and additional lustre

was added when he won two important national prizes (1951 and 1955). His travels now took him to Ischia, the Torres Strait islands, Colombo and Ceylon where (1962) he experimented with sculpture, using sheet aluminium and copper to produce a whole series of small works of great wit and charm. In 1967 he settled in Bali where he built a house and studio and sent regular exhibitions of his work to Australia, namely to the Macquarie, Holdsworth and Australian Galleries, moving back to Australia in 1982. In April 1989 he held a mini-retrospective at Philip Bacon, Brisbane, and in February 1990 a major retrospective was organised by the AGNSW and toured to several other state galleries. Books by Friend include *Gunner's Diary*, 1943; *Painter's Journal*, 1946; *Hillendia*, 1956 – all published by Ure Smith, Sydney; *Donald Friend's Bali*, Collins, London, 1972; *The Cosmic Turtle*, Carroll's, 1976; *Birds from the Magic Mountain*, BAP Sanur, Bali, 1977; *Bumbooziana*, 150 limited edition copies, 1978; *Art in a Classless Society*, Richard Griffin, Sydney, 1985.
AWARDS: Flotta Lauro prize, 1951; Blake prize, 1955; Bunbury prize, 1962; university medal for services to art, Uni. of Sydney 1988.
REP: NGA and all state galleries; many regional and other public galleries; numerous public and corporate collections.
BIB: All general books on Australian art including Smith, AP; Bonython, MAP, 1976. Robert Hughes, *Donald Friend*, Edwards & Shaw, Sydney, 1965. A&A, 8/1/1970 (Peter Brown, *Donald Friend in Bali*); 27/2/1989 (*obituary*).

FRIEND, Ian
(b. 1951, UK; arr. Aust. 1980s) Painter, printmaker, sculptor, stage designer.
STUDIES: Exeter Coll. of Art, 1969–70; Birmingham Coll. of Art, 1970–73; Slade School of Fine Art, Uni. Coll., London, 1973–75. As well as performance works in collaboration with various directors and musicians in Melbourne, 1989–91 his solo exhibitions included those at, William Morris Gallery, London 1985; School of Art, Launceston, Tasmania 1989; Christine Abrahams, Melbourne; Macquarie, Sydney, 1989. His work appeared in about 30 group exhibitions 1975–91 including at Courtauld Inst. of Art, London 1975; *Hayward Annual*, Hayward Gallery, London 1982 and many British and international print exhibitions and in many regional, public and tertiary exhibitions including *A New Generation*, NGA 1988; *Monash Uni. Collection*, 1990.
AWARDS: Arts Council and fellowship awards UK (4), 1975–82.
REP: NGA; NGV; Tate Gallery, London; many tertiary, regional collections all states.
BIB: Catalogue essays exhibitions as above. A&A 28/2/1990.

FRIEND, Mary Ann
(b. c. 1800; arr. Hobart Apr. 1830; d. 27/12/1838, George Town, Tas.) Sketcher, lithographer. Wife of Commander Matthew Curling Friend, captain of the merchant ship *Wanstead*, on which the Friends arrived at Swan River in Jan. 1830, she made a fine historical

lithograph of the encampment (inscribed 'taken on the spot & drawn on stone by Mrs M. C. F., March 1830'). The Friends later went to Launceston (1832). Her work appeared in *The Colonial Eye*, AGWA 1979.
REP: Mitchell Library.
BIB: *The Diary of Mary Ann Friend*, journal Royal WA Historical Society, vol. 1, pt 10, 1931. Kerr, DAA.

FRIES, Ernest

(b. 21/12/1934, Würzburg, Germany; arr. Aust. 1959) Sculptor, silversmith.
STUDIES: Trained first in engineering, he studied silversmithing part-time in Zurich and Karlsruhe, Germany and RMIT, 1962; travel studies, Europe, 1971 and 1976. In Australia he worked first as an engineer then, from 1964, as a freelance silversmith. His sculpture, with its simple, geometric shapes and highly polished surfaces, reflects his early training. A member of the Association of Sculptors of Victoria, he was secretary 1976–77, and president 1978. He held about 16 solo exhibitions 1965–91 including at Irving, Sydney, Solander, Canberra and in Germany. His work appeared in several group sculpture survey exhibitions.
AWARDS: Association of Sculptors of Vic. *Sculptor of the year* award, 1977; VACB special projects grant, 1977; a number of municipal awards in Melbourne, 1975–91.
APPTS: Teaching gold and silversmithing, RMIT, 1968–76.
REP: Artbank; several regional galleries including Horsham, Geelong, Latrobe Valley.
BIB: Catalogue essays in several survey and solo shows including *Mildura Sculpture Triennial* 1978. Scarlett, AS.

FRISTROM, Carl Magnus Oscar

(b. 16/1/1856, Sturko, Sweden; arr. Brisbane c. 1884; d. 26/6/1918, Brisbane) Painter, sculptor, photographer.
STUDIES: No formal studies. Son of a teacher at elementary schools and brother of Claus Edward Fristrom. Associate (probably resident artist) in the firm of Hutchison, Fristrom and Company (Elite Photographic Company), and a foundation member of the Qld Art Society, 1887 (president, 1918). He gave private lessons in painting and photographic retouching and worked for a time as a pictorial artist in the signwriting firm of Victor Day. He helped form the New Society of Art in 1904 and became its first president. As a painter he was best known for his portraits, specifically his portraits of Aborigines. Apart from about a year spent in Adelaide (1894–95), he appears to have spent all his married life in Brisbane.
REP: AGSA; QAG.
BIB: Julie K. Brown and Margaret Maynard, *Fine Art Exhibitions in Brisbane 1884–1916*, Fryer Memorial Library, Uni. of Qld, 1980.

FRISTROM, Claus Edward

(b. 1864, Carlskrona, Sweden; arr. Brisbane c. 1888; d. 1942, Carmel, California) Painter, sailor.
STUDIES: Carlskrona, Royal Art School (local branch). The careers of the brothers Fristrom were closely related. Both painted portraits and landscapes, both served on sailing vessels, both settled in Brisbane and married daughters of the same tug master, Captain Johnson. Claus is first recorded in Brisbane in 1887 and listed the following year as an employee of the Elite Photographic Company. He was a council member of the Qld Art Society 1896 and, c. 1902, finally separated from his brother when he moved to New Zealand, where he was soon exhibiting with the Auckland Society of Arts. He travelled extensively in NZ and c. 1909 was apparently back in Brisbane where he exhibited 14 NZ paintings with the QAS, returning to Auckland to teach at the Elam School of Art from c. 1911. Among his pupils were Robert Johnson and George Finey (qq.v.). Reputedly he was an inspiring teacher; Gil Docking records also that an *art nouveau* element was perceptible in his colour and composition but that his painting was otherwise strong and expressionistic. He left Auckland c. 1915 and stayed in Wellington for a short time before migrating to California.
REP: QAG; Auckland and Dunedin public galleries, NZ.
BIB: Gil Docking, *Two Hundred Years of New Zealand Painting*, Lansdowne, Melbourne, 1971. Julie K. Brown and Margaret Maynard, *Fine Art Exhibitions in Brisbane 1884–1916*, Fryer Memorial Library, Uni. of Qld, 1980.

FRITH, Clifford

(b. 1/10/1924, London) Sculptor, painter, teacher.
STUDIES: Camberwell School of Art, London; St Martin's School of Art, London, 1939. He held several solo exhibitions 1954–90 including at Irving, Sydney, and group exhibitions including at Jam Factory, SA, and AGSA. He was a finalist in the Doug Moran portrait prize 1988.
AWARDS: grants, VACB, 1976, 91; Maude Vizard-Wholohan Prize AGSA, (painting) 1980, (drawing) 1982.
APPTS: Teaching, Sutton, Rochester, Camberwell schools of art, UK; Goldsmiths' Coll., UK, 1942–59; Head of Fine Art, Ahmadu Bello Uni., Zaïre, Northern Nigeria, 1952–62; Head of Fine Art, Croydon Coll. of Art, London, 1962–70; Bedford Park Teachers Coll., SA, 1970; head of first year studies, SASA, Adelaide, 1980–91.
REP: NGA; AGSA; Flinders Uni; Adelaide Festival Centre Trust.
BIB: Scarlett, AS.

FRITH, Frederick

(b. c. 1819; arr. Aust. ?; d. 1871, Melb.) Painter, photographer. Mainly a portrait painter, he was a member of and exhibited with the Victorian Fine Arts Society in Melbourne in 1853 and moved to Hobart where he continued painting in oils and watercolours and set up as a photographer around 1855. He was joined by his brother Henry (q.v.) in 1857 and Frederick moved back to Victoria in the early 1860s where he worked as both a painter and photographer. He exhibited a portrait of Sir Henry Barkly, the governor of

Victoria, at the Melbourne *Intercolonial Exhibition* in 1866 and his representation of the 1865 Melbourne Cup was engraved and published in the *Illustrated Australian News*. His work was represented in the Clifford Craig collection at Christie's auctions 1975 and in *Shades of Light*, NGA 1988.

REP: TMAG; Ballarat Fine Art Gallery; Mitchell, Allport, Crowther libraries.

BIB: Eve Buscombe, *Artists in Early Australia and their Portraits*, Sydney 1978. Kerr, DAA.

FRITH, Henry Albert

(b. ?; arr. Tas. c. 1854; d. ?) Photographer. He worked with his brother George (q.v.) in Hobart for some years.

BIB: Clifford Craig, *Old Tasmanian Prints* Foot & Playstead, Launceston 1964. Alan Davies & Peter Standbury, *The Mechanical Eye in Australia*, Melbourne 1985. Kerr, DAA.

FROME, (Captain) Edward Charles

(b. 17/1/1802, Gibraltar; arr. Adelaide Sept. 1839; d. 12/2/1890, Surrey, Eng.) Soldier, engineer, surveyor, artist.

STUDIES: Royal Military Academy, Woolwich, 1817–25. Appointed Surveyor General of SA, he had successfully surveyed land available to the anxiously waiting settlers by 1841, and during the next few years explored and mapped much new territory to the north and south-east of Adelaide. He also undertook the duties of Colonial Engineer, supervised the construction of Adelaide gaol and designed bridges across the Torrens River. He was a member of the Council of Government, 1839–43, and served on many other public bodies. Returning to England in 1849, he served in Mauritius, 1852–58, Heligoland, 1858, Scotland, 1858–59, Ireland, 1859–60, Gibraltar, 1862–68 and Channel Islands, 1869–74. By 1874 he had attained the rank of General. Frome applied himself to his art with the same aptitude and zeal that he applied to his many other vocations, and left a large collection of topographical and other watercolours and drawings. The AGSA acquired 152 of his sketches of inland journeys and other sketches of life in SA 1839–49 which provide a valuable record of the time. They were seen in the Bicentennial exhibition *The Great Australian Art Exhibition 1788–1988*.

REP: AGSA; Mitchell Library.

BIB: Kerr, DAA. 'Captain E. C. Frome, R.E., and his sketches of South Australia, 1839–1849', R. G. Appleyard, quarterly *Bulletin of the Art Gallery of South Australia*, vol. 34, nos. 1 and 2, July and Oct. 1972.

FROUDIST, Henri E.

(b. 1902; d. ?1968 or 1969, Perth, WA) Painter. Known for portraits.

REP: AGWA.

NFI

FRY, Edith M.

(Active c. 1908–24) Painter, art writer. She founded the Panton Club, London, exhibited at the New Salon, Paris, organised the exhibition *Australian Artists in*

Europe (Faculty of Arts Gallery, London, 1924), and wrote articles on Australian art for various publications including 'Australian Artists in Paris', *Argus*, Melbourne, 27 June 1908.

FRY, Ella

(b. 1916, Brisbane) Painter. She held an exhibition (Skinner Galleries, Perth) in 1960. A member of the board of trustees, AGWA.

REP: AGWA; Perth Uni.

FRY, John V.

(Active c. 1852–62, Bendigo) Painter, actor. He exhibited a panorama of the main incidents of the Burke and Wills expedition in Bendigo, 1862, and left shortly afterwards, possibly for New Zealand.

BIB: McCulloch, AAGR. Kerr, DAA.

FRY, Merrick

(b. 1950, Bathurst, NSW) Painter.

STUDIES: NAS, Sydney, 1971–73; travel studies, SE Asia, Europe and UK, 1978. In 1975 he was selected by Peter Powditch for *Artists Choice* exhibition, Gallery A, Sydney, and held his first exhibition at the same gallery in 1978. He held nine solo exhibitions 1978–89 including at Bloomfield, Sydney; Solander, Canberra. His work appeared in a number of group exhibitions 1975–89.

REP: VACB; Uni. of NSW collections.

FRY, R. Douglas

(b. 1872, Ipswich, Eng.; arr. Sydney 1899; d. 1911) Illustrator, painter.

STUDIES: London, horse anatomy; Julian's, Paris. From 1905 he was a member of the Society of Artists of NSW, where he exhibited sporting pictures. A keen horseman (he taught Norman Lindsay to ride), he is recorded by Julian Ashton as having 'added to his excellent drawing of the horse a quality of movement and a high degree of finish which made him popular amongst the owners of bloodstock'. Fry contributed to the *Lone Hand*, the *Sydney Mail* and other magazines. Among the racehorses he painted was Poseidon.

BIB: *Fifty Years of Australian Art, 1879–1929*, RAS, Sydney, 1929; AA, Sydney, 1920; articles in the *Lone Hand*, sydney, Nov. 1911; *Art and Architecture*, Sydney, vol. 7, 1910.)

FRYER, James John Robertson

See TRANTHIM-FRYER, James John Robertson

FULLBROOK, Sam (Samuel Sydney)

(b. 14/4/1922, Sydney) Painter.

STUDIES: NGV School, 1946–48. He began his working life as a timber cutter and stockman in the Gloucester district of NSW. He joined the AIF and served in the Middle East and New Guinea during World War II. After the war he joined the NGV School as a Commonwealth Rehabilitation student. He then worked in Qld and the NT where he joined the McLeod Aboriginal Co-operative at Pilbara, and painted a number of pictures of Aboriginal life. Between 1948 and 1971 he held a large number of exhibitions mostly

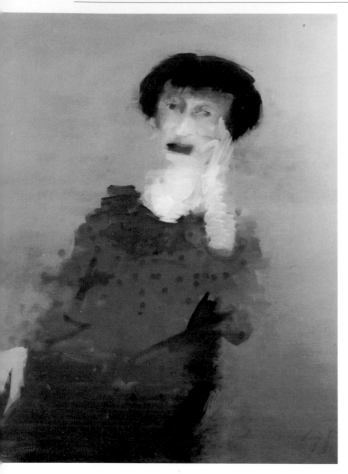

Sam Fullbrook, Ernestine Hill, *1972, oil on canvas, 96.8 × 76.3. Collection,* QAG.

in NSW and Qld but this activity was severely curtailed when a fire burned out his studio and most of his work was lost. Features of his painting are its lightness, airiness, and the use of high-keyed, translucent colours such as lime, viridian, rose and violet. His landscapes and seascapes are poetic in feeling and because of their flatness often look abstract. He was adept at 'catching nature on the wing', but the illusory effects gave his portraiture, for example, an ephemeral look that put his dependability as a painter of commissioned portraits at risk. His painting of Sir John Kerr was rejected from hanging in Parliament House, Canberra. This ephemeral quality sometimes extends to his drawings which are superb in quality but lose much when the touch becomes too light. The artist's credo, as passed on from his gallery director, is 'to paint good pictures that children will love, to combine in my work tenderness, sweetness, charm, clarity, succinctness, love, passion and religion'. He held about 40 solo exhibitions 1948–92 including in Brisbane (Moreton 61, 62, 65, 67), Sydney (Macquarie 61, 62, 68; David Jones 70, 71; Rex Irwin 78, 82, 92), Melbourne (Australian 60, 79, 85) and New York (112 Greene St, Soho, 1989). The QAG held a trib-

ute exhibition of his work in 1976 and he was represented in a number of survey exhibitions including the Bicentennial exhibitions *The Great Australian Art Exhibition 1788–1988* and *The Face of Australia.*

AWARDS: Wynne prize, 1963, (shared) 1964; David Jones prize, 1966; H. C. Richards Memorial prize, 1967, 69; Townsville prize, 1967; L. J. Harvey prize for drawing, 1969; Maude Vizard-Wholohan prize, 1970; Archibald prize, 1974.

REP: NGA; most Australian state and many regional galleries, including MPSV (20 drawings).

BIB: Smith, AP. Ronald Millar, *Civilized Magic*, Sorrett Publishing, Melbourne, 1974.

FULLER, *Florence Ada*

(b. 1867, Port Elizabeth, South Africa; arr. Aust. in childhood; d. 17/7/1946, Gladesville, NSW) Painter.

STUDIES: NGV School (drawing classes), 1888; travel studies, Europe, UK, 1894–1904. Known for portraits and landscapes, she won the prize for the best portrait for an artist under 25 at the first exhibition of the VAS. Travelling to the Cape of Good Hope in 1892 she then went to France and England where she exhibited at the RA, London, 1897 and 1904, at the Manchester City Art Gallery; Royal Inst. of Oil Painters and the Paris Salon. She exhibited six works with the VASS in the Australian Federal International exhibition, Melbourne, Nov.–Jan. 1903. In 1904 she moved to Perth and exhibited with the WA Society of Arts, and between 1908 and 1911 lived at the headquarters of the Theosophical Society in India before revisiting England. The last part of her life was marred by mental illness. During the 1920s, she was painting miniatures at Mosman Bay. Her work was seen in *The Colonial Eye* AGWA, 1979 and *Completing the Picture: Women Artists and the Heidelberg Era*, Heide Gallery and touring public galleries Vic., NSW and SA 1992.

REP: AGSA; AGWA.

BIB: Cat. AGSA, Adelaide, 1913.

FULLWOOD, *Albert Henry*

(b. 15/3/1863, Birmingham, UK; arr. Sydney 1881; d. 1/10/1930, Waverley, NSW) Painter, illustrator.

STUDIES: Birmingham Inst. Fullwood exerted an important influence on art developments in Sydney, particularly during his early days there as staff artist for the *Picturesque Atlas of Australasia* and black-and-white contributor to the *Bulletin, Town and Country Journal,* and other magazines. He practised etching with Livingstone Hopkins, shared a studio with Frank Mahony, and painted in company with Julian Ashton and others at the Roberts–Streeton camp at Sirius Cove. In 1895 he helped to establish the NSW Society of Artists, but the bank crisis of 1893 had embarrassed him financially and in 1900 he auctioned his work and went to the USA, where he stayed for a year before going to London to work as a freelance artist for the *Graphic* and other magazines and to send paintings to the RA and Paris Salons. During World War I he worked at Wandsworth Hospital in company with

Roberts, Streeton, Evergood and Coates, and in 1918 was commissioned to paint pictures of scenery and action on the Western Front for the Australian War Memorial Museum. He returned to Australia in 1920 and lived there until his death ten years later. A *Henry Fullwood Memorial Exhibition* was held at the Joseph Brown Gallery, Melbourne, 26 Feb.–15 Mar. 1973; an auction of his work at Geoff Gray auctions, Rosebery, NSW 1974 and his work was represented in *Tasmanian Vision*, TMAG & QVMAG, 1988 and the Bicentennial exhibition *The Face of Australia*.

REP: AGNSW; NGV; AWM; print collections of the British Museum; public galleries in Dresden, Brussels, Budapest, Johannesburg.

BIB: *ADB* 8. *AA* no. 8, 1921.

FUNDING
See Appendix 4, p. 798.

FURLONGER, *Joseph Maxwell*
(b. 1952, Cairns, Qld) Painter, printmaker.
STUDIES: Associate dip. painting, Qld Coll. of Art, Brisbane, 1976; Dip. Art, Alexander Mackie CAE, 1978. Described in the 1988 *Moet & Chandon Fellowship* catalogue of 1988 as 'a new kind of Australian landscape painter' his strong expressionistic figures 'almost like landforms' are powerful and direct, striding across the canvas, the sea frequently as background. He held nine solo exhibitions 1982–91 largely at Ray Hughes, Brisbane and Sydney, and in France, 1989; Uni. of NSW, 1991. Group exhibitions in which he participated 1976–91 included *They're still thinking aloud*, 1969; *Thinking Allowed*, 1991 Ray Hughes, Brisbane and Sydney; and exhibitions in numerous state, tertiary and public galleries including *Past and Present*, IMA, Brisbane 1986; *Moet & Chandon Touring Art Exhibition*, AGWA and touring major state galleries 1987; *Twenty Australian Artists*, Galleria San Vidal, Venice, QAG and Benalla regional gallery 1990.

AWARDS: Moet & Chandon Fellowship, 1988.

REP: NGA; NGV; QAG; MOCA, Brisbane; Powerhouse, Sydney; a number of regional, municipal and corporate collections Qld, NSW.

BIB: Catalogue essays in exhibitions as above. Chanin, CAP. Smith, AP.

FURNEAUX, *(Capt.) Tobias*
(b. 1735; d. 1781) Commander of *Adventure*, sister ship to Cook's *Resolution* on Cook's second voyage, Furneaux, an amateur artist, made a rough drawing of the southern side of Adventure Bay, Tas., the first drawing made there by a European.

BIB: Smith, *EVSP*. Rienits, *Early Artists of Australia*, 1963. R. Joppien and B. Smith, *The Art of Captain Cook's Voyages*, vol. 2, OUP, Melbourne 1985. Kerr, *DAA*.

GAHA TO GYE

GAHA, Adrienne
(b. 1960, Sydney)
STUDIES: Higher Art C ESTC, 1982; BA, SCA, 1985.
Her 1980s work was characterised by monochromatic,
monumental-scale figures occupying a large propor-
tion of the canvas, as seen in three exhibitions 1986–90
in Sydney (Mori; First Draft). Her 1993 exhibition
at Charles Nodrum Melbourne showed a radical change
of style to small paintings featuring images taken
from Victorian illustrations. Her work appeared in
about 12 group exhibitions 1982–92 including *Young
Contemporaries*, ACCA, Melbourne 1985; *The Golden
Shibboleth*, Gertrude St, Melbourne 1987; *Backlash*,
NGV 1988; *re-Creation/ Re-creation*, Monash University
Gallery, Melbourne, 1989.
REP: AGWA; NGV; University of Tasmania.
BIB: Catalogue essays exhibitions as above. Chanin, *CAP*.

GALBRAITH, Anthony
(b. 1951, Philippines) Assemblage artist.
STUDIES: NAS, 1973–74; Alexander Mackie CAE,
1975–77; NY Studio School, 1979–80; MA, City Art
Inst., 1984–85. His geometric, abstract, architec-
turally based constructions and paintings of similar
style were seen in one exhibition at Macquarie Sydney,
1987, in conjunction with Paul Hopmeier (q.v.) at
the same gallery in 1989 and in several group exhi-
bitions 1980–93 including in New York, Sydney and
Still Life Heide, 1993.
AWARDS: Peter Brown Memorial Scholarship, NY Studio
School/VACB, 1978; Dyason Bequest, AGNSW, 1979;
Fisher's Ghost Prize, Campbelltown Art Gallery, 1988;
Herron, Todd, White Valuers Award, Gold Coast,
1989; Mosman Art Prize, 1991; residency, Cité
Internationale des Arts, Paris, AGNSW, 1991.
REP: AGNSW; Artbank; regional galleries including
Campbelltown, Gold Coast, Lake Macquarie; Mosman
Council; State Bank, NSW.
BIB: *New Art Two*. Chanin CAP.

GALBRAITH, William
(b. 1822; arr. Aust. 1848; d. 1911) Printer, litho-
grapher. He established an art printing firm with John
Penman (q.v.) in Adelaide c. 1850 and printed a num-
ber of sheets and albums including several series of
S. T. Gill's (q.v.).
REP: AGSA; NLA; Mitchell, Mortlock Libraries.
BIB: Kerr, *DAA*.

GALLERIES: PUBLIC AND PRIVATE
See Appendix 5, p. 799.

GAME, Stewart Burrell
(b. 14/7/1915, Melb.) Architect, teacher, painter.
STUDIES: Architecture, Adelaide Uni., 1934–40; SASA,
1934–36; travel studies England, France, Italy,
1950–53. He served in the AIF, 1940–44, and was
president of the RSASA, 1962–66. He tutored archi-
tecture at Adelaide Uni. in the 1950s and RSASA draw-
ing and composition in the 1970s and 1980s. He
exhibited largely with the RSASA from 1945 and held
several solo exhibitions in Adelaide as well as receiv-
ing several private and public commisions including
Government House, SA, 1986.
REP: AGSA; SA Government House; corporate collec-
tions including ANZ, State Bank of SA.
BIB: Benko, *ASA*. Germaine, *AGA*.

GARDE, Owen John
(b. 1919, SA) Painter.
STUDIES: SA School of Arts and Crafts, 1932–36;
Melbourne (with John Longstaff, 1936–38, Max
Meldrum, 1942–48). Garde's portraits are well-known
in WA, where he established his own art school, called
the Western Australian Academy of Fine Art. He has
also painted commissioned portraits in the USA.
AWARDS: Student scholarship SA School of Fine Arts.
REP: Uni. collections in WA, NZ and the USA.

GARDEN PALACE
(1879–82) Built for the early international exhibi-
tions in Sydney. A vast, ornate, iron, glass and con-
crete structure situated in the Botanic Gardens, it was
the venue also of exhibitions of the NSW Academy of
Arts. The building and the Academy exhibition of
that year were destroyed by fire in Sept. 1882.

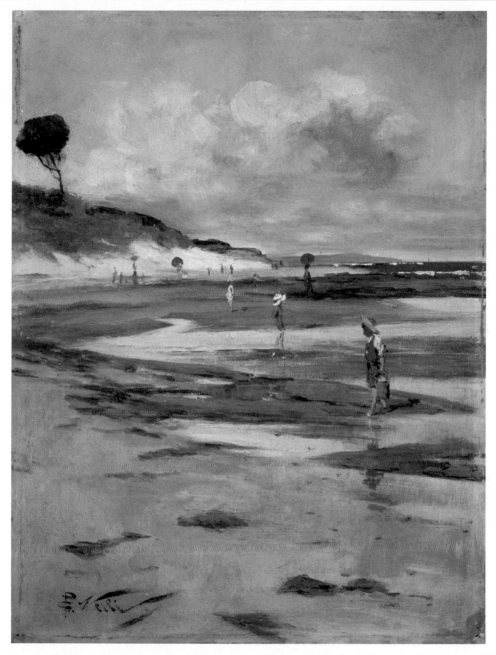

Girolami Nerli, Beach Scene, Sandringham, *c. 1888–89, oil on canvas, 29.5 × 22cm. Christie's, Melbourne, November 1993.*

IMPRESSIONISM 1885–1910

Painting in the open air which typified the school of painting known as 'Impressionism' was introduced to Australia by artists of the Heidelberg School, Tom Roberts, Frederick McCubbin and Louis Abrahams, who established an artists camp at Heidelberg, Vic in 1885. Later members of the group included Charles Conder, Arthur Streeton, and David Davies. The most famous exhibition by this group was the 1889 9 × 5 *Impression* exhibition. Although they did not exhibit with the group artists such as Jane Sutherland and Jane Price were significant members. Other well known

Impressionist artists included the Sydney based Girolami Nerli and Melbourne's Walter Withers. Almost a century later in the 1970s, the contribution by women artists such as Emma Minnie Boyd to the art of this era was re-evaluated. Impressionism was followed in the early part of the 1900s by post-impressionism which while it was never as significant in Australia as in France, was a style practised by several major artists until the advent of WWII and the expressionism of that era.

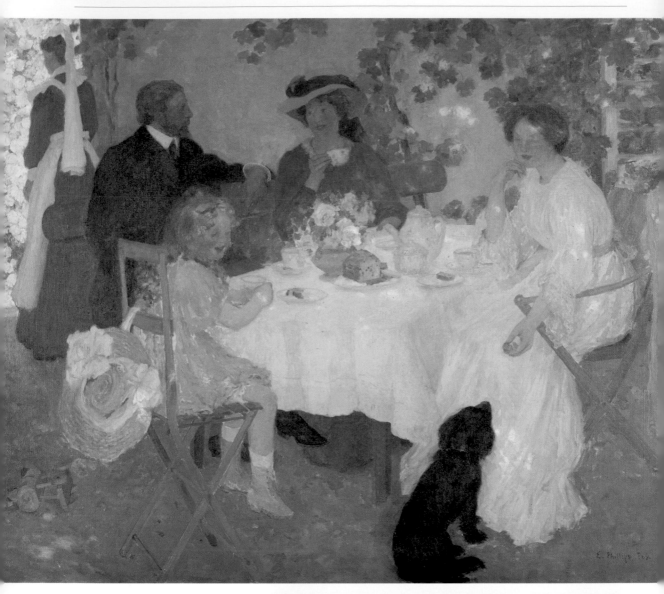

Left: *E. Phillips Fox* Al Fresco, *oil on canvas, 153.6 ×
195.6cm. Collection,* AGSA.

Below left: *Ethel Carrick Fox,* In a Park, Paris, *oil on
board. Courtesy, Melbourne Fine Art.*

Bottom: *Arthur Boyd snr,* Waiting for the Tide, *1890,
oil on canvas, 91.5 × 135cm. Private collection.*

Below: *David Davies,* A Summer Evening, *c. 1895,
oil on canvas on hardboard, 71.5 × 91.2cm. Collection,*
AGNSW.

Below: *Elioth Gruner,* The Bellingen River, *1937, oil on canvas, 60.5 × 73.5cm. Sotheby's, Melbourne, August, 1991.*

Above: *Tom Roberts,* Mosman's Bay, *1894, oil on canvas,
64.7 × 97.8cm. Collection New England Regional Art
Museum, Armidale, NSW.*

Left: *Fred McCubbin,* Rainbow over the Yarra, *1913,
oil on canvas, 91.5 × 183cm. Collection, NGA.*

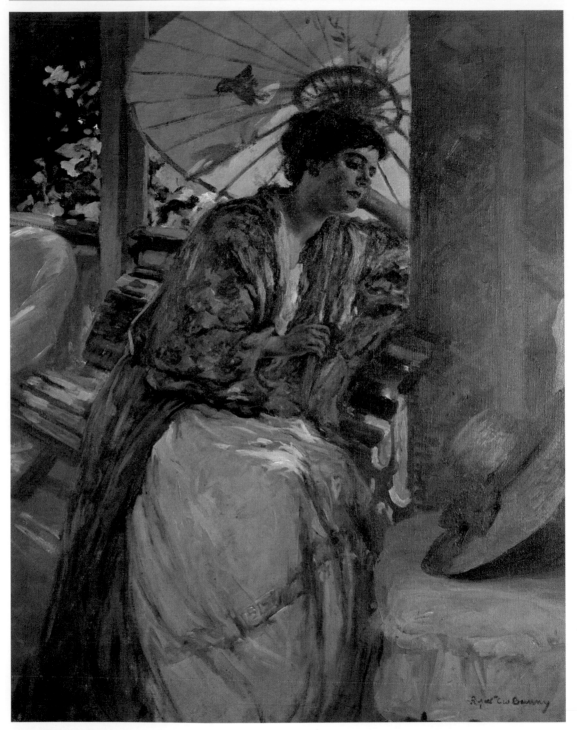

Above: *Rupert Bunny*, The Parasol, *oil on canvas, 81 ×
65cm. Private collection.*

Top right: *Walter Withers*, The Cherry Tree on the
Yarra, *1892, oil on canvas, 49.5 × 59.5. Courtesy
Christopher Day Gallery, Sydney.*

Right: *Jane Sutherland*, Little Gossips, *1888, oil on
canvas, 48.5 × 36cm. Private collection. Courtesy Deutscher
Fine Art, Melbourne.*

Far right: *Emma Minnie Boyd*, Afternoon Tea, *1888,
oil on canvas, 41 × 35.8. Collection, Bendigo Art Gallery.*

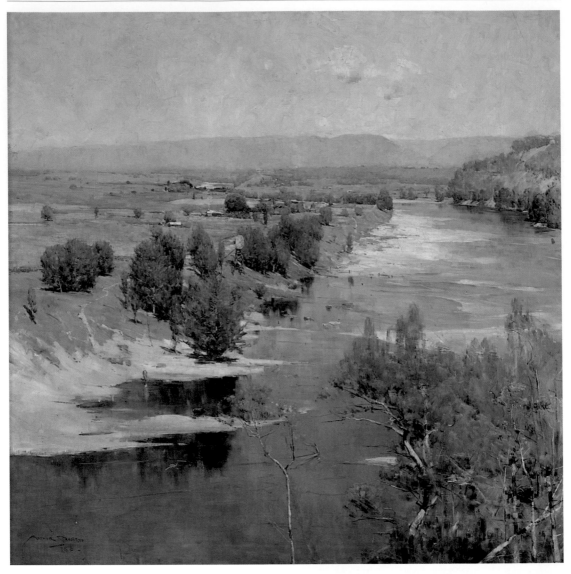

Above: *Arthur Streeton,* Purple Noon's Transparent
Might, *1896, oil on canvas, 121.8 × 122cm. Collection,*
NGV.

Right: *John Peter Russell,* Cruagh en Mahr, Matin, Belle
Ile en Mer, *n.d., oil on canvas, 60.4 × 73.5cm. Christie's,
April 1992.*

GARDINER, Ian David
(b. 22/6/1943, Melbourne) Printmaker.
STUDIES: Dip. Art, Swinburne Tech. Coll., 1964; TTC; Tokyo National Uni. of Fine Art and Music, 1973; enrolled MA course Monash Uni. 1992– . He held exhibitions in Tokyo, 1971, 73, 74, participated in group exhibitions (Japan Print Association, 1972, Tokyo Uni. Foreign Students exhibition, 1973), and in 1973 work by him was acquired for the MOMA, New York. In Australia his solo exhibitions include those in Sydney (including Clive Parry) and Melbourne (Tolarno; Stuart Gerstman) and he participated in a number of group exhibitions largely with the PCA. He travelled extensively to Japan, USA, Central Russia, India, Portugal, England and Europe and produced a print for the *100 × 100* print portfolio for the PCA, 1988.
AWARDS: Acquisitive prizes MPAC, Box Hill; Henri Worland Print Prize, Warrnambool Art Gallery.
REP: NGV; QVMAG; regional galleries Mornington, Shepparton; Tokyo, National Uni.; MOMA, New York.
BIB: PCA *Directory*, 1976, 88. Franz Kempf, *Contemporary Australian Prints*. Germaine, AGA.

GARDINER, Marie
(b. 1918; d. 1966) Painter. Two pencil drawings by this otherwise unknown artist are in the collections of the AGNSW.
NFI

GARDNER, John A.
(b. 1906, Vic.) Painter, farmer
STUDIES: NGV School. Artist and dairy farmer, principally a painter of bush landscapes. In company with Rex Battarbee, Gardner made many caravan trips and worked extensively in Central and Eastern Australia. He relinquished a successful career as a commercial artist to devote his time to painting. In 1960 he lost the use of his right hand in a car accident and learned to paint with his left hand. He exhibited with Athenaeum Gallery 1929–71 and a retrospective exhibition was held at Geelong Art Gallery in the early 1970s.
REP: AGSA; NGV; QAG.
(*See also* ABORIGINAL ART, ARUNTA WATERCOLOURS)
NFI

GARLICK, Henry Glede
(b. 1878, Orange, NSW; d. 1910, Sydney) Painter.
STUDIES: Sydney (with G. Collingridge, J. Ashton, J. S. Watkins and F. Mahony); he also made a special study of horse anatomy. An animal painter and painter of impressionistic landscapes, Garlick earned a precarious living as a solicitor's clerk; he exhibited at the Art Society of NSW from 1894. When it was exhibited at the NSW Society of Artists exhibition, 1909, his painting *The Last Furrow*, which showed the figure of death as the ploughman, created a stir because of its macabre feeling. Garlick died a few months later.
REP: AGNSW; Wellington Art Gallery, NZ.

GARLICK, Rosa
(b. 2/4/1914, Daylesford, Vic.) Painter, printmaker.
STUDIES: SATC; Caulfield Tech; NGV school: RMIT, c. 1969. Beginning with an exhibition of semi-abstract paintings, Leveson Street Gallery, 1962, she changed gradually to the bold, rhythmic type of environmental painting shown in a later exhibition at the Hawthorn City Art Gallery, Sept. 1977. She is best known for her woodcuts. She exhibited with the VAS 1960–64, Melbourne Contemporary Artists (George Bell Group) 1960–64, CAS 1963 – and annually in Sydney, Perth, Hobart, Newcastle, Geelong, and in Launceston, Shepparton, Latrobe Valley and Warrnambool. Group exhibitions include at Caulfield Arts Centre, Vic. regional galleries, exhibitions of women's art at the Lyceum Club, Melbourne, 1979 and Niagara Galleries, Melbourne, MPAC *Spring Festival* 1984, 85, 86, 87, 89, 91, with the PCA and in Inez Hutchison Prize, Beaumaris Art Group 1970– .
AWARDS: Deans Prize 1967; Inez Hutchison Prize 1970; CAS Hanover Holdings Prize 1974.
REP: Latrobe Valley Arts Centre; Uni. of Melb.
BIB: PCA, *Directory*, 1988. Franz Kempf, *Contemporary Australian Printmakers*. *150 Women Artists*, Vic. Government 1985. Germaine, AGA.

GARLING, Frederick
(b. 23/2/1806, London; arr. Sydney; 1815, d. 16/11/1873, Sydney) Painter. He was a landing waiter in the Customs Office, Sydney, till retirement. He specialised in marine subjects done in watercolour. After he settled in Sydney he was reported to have painted the picture of every ship that came into Sydney Harbour for 40 years. He painted in watercolours, rarely signing his work. He exhibited in a number of leading exhibitions of the 1840s but hardly any others except the 1870 Sydney *Intercolonial Exhibition*. His work was seen in *The Colonial Eye*, AGWA 1979, *The Artist and the Patron*, AGNSW 1988.
REP: AGNSW; AGSA; AGWA; regional galleries Ballarat, New England; NLA; Aust. National Maritime Museum; Mitchell, Dixson Libraries; Manly Art Gallery; private collections including Joseph Brown, Robert Holmes à Court.
BIB: Moore, SAA. Campbell, AWP. Thomas, OAA. Kerr, DAA. ADB 1.

GARLING, William
(Active c. 1860, Sydney) Painter.
STUDIES: Sydney, with S. T. Gill. Son of Frederick Garling, his known works are mainly of animals and his best-known work is a portrait of Gill 'as he was in the 1850s', done from memory.
BIB: K. Macrae Bowden, *Samuel Thomas Gill, Artist,* Maryborough, 1971. Geroffrey Dutton, *S. T. Gill's Australia,* Macmillan, Melbourne, 1981. Kerr, DAA.

GAROFANO, Clinton
(b. 15/6/62, Sydney) Painter, installation artist, multimedia artist.

STUDIES: BA, City Art Inst., Sydney, 1983; travel studies North Africa, Italy, USA, Japan, 1985; New York, 1986; Europe and New York, 1988. He held 11 solo exhibitions 1983–92 including in Sydney (Mori 1983, 84, 86, 89, 91, 92), Melbourne (Karyn Lovegrove 1992) and at George Paton, University of Melbourne, 1990; Phillip Dash, New York, 1986; Spiral Wacoal Art Centre, Tokyo, 1991. His work was seen in about 27 group exhibitions 1982–92 at some private galleries (Mori, Sydney) but mainly at public galleries including *A First Look: Philip Morris Arts Grant Purchases 1983–86*, NGA; *A New Generation*, NGA 1989; *Australian Drawing 1983–88*, Drill Hall, NGA 1989; *Abstractions*, AGNSW 1990; *Reference Points*, QAG 1991.

AWARDS: Residency, Tokyo studio, VACB, 1989; overseas development grant, VACB, for travel to Japan, 1990.

REP: NGA; AGWA; Uni. of Western Sydney; News Limited (London); Philip Morris collection.

BIB: Catalogue essays exhibitions as above. *A&A* 25/3/1988; 28/1/1990

GARRETT, Tom (Thomas Balfour)

(b. 20/12/1879, Hobart; d. 27/8/1952) Painter.
STUDIES: Hutchins School, Hobart. He moved to Melbourne in 1900 and read for holy orders with the Anglican Church until about 1929 when he became a professional painter, producing large numbers of small jewel-like blue and green monotypes that recalled often the romantic watercolours of J. J. Hilder, whose work Garrett admired greatly. He exhibited with the RAS of NSW, and at various group exhibitions, but his work became known mainly through his exhibitions in various cities, notably in Melbourne at the Kozminsky Galleries.

REP: AGSA; NGV.

BIB: Terry Ingram, intro. *Tom Garrett: the Rogowski Collection*, Moorabbin, Vic., 1976.

GASCOIGNE, Rosalie Norah King

(b. 1917, Auckland, NZ; arr. Aust. 1943) Painter, sculptor. With no formal training, her art evolved largely through her passion for collecting wildflowers, shells, stones and pebbles, and all kinds of natural objects as well as scrapbooks, cuttings and, later, discarded bits of machinery and thrown-away material. Arranging dried flowers led her to Japanese ikebana, which in turn led to pictorial arrangements of other objects, leading finally to the analysis of the found material and its synthesis in pictorial form. Her three-dimensional works using painted galvanised iron are especially powerful for their strong evocation of the Australian bush and the outback. She held her first exhibition at the Macquarie Galleries, Sydney, 1974, and her work was included in the exhibition *Artists' Choice*, Gallery A, Sydney, 1975. In 1978 it was the subject of *Survey 2* at the NGV. She held 14 exhibitions 1974–93 including at Macquarie, Roslyn Oxley9, Sydney; Pinacotheca, Melbourne and in the National

Art Gallery, Wellington, NZ 1983; Tasmanian School of Art 1985. Her work appeared in over 22 group exhibitions 1975–92 including *Biennale of Sydney*, 1979, 88, 90; *Australian Sculpture Triennial*, 1981, 84, 87; *Project 40: Australian Artists at Venice and Kassel*, NGV and AGNSW 1983; *A New Romance*, Drill Hall, NGA 1987; *The Great Australian Art Show*, touring state galleries 1988; *Rosalie Gascoigne–Colin McCahon: Sense of Place*, Ivan Dougherty Gallery, Ian Potter Gallery, Melbourne Uni. 1990; *Diverse Visions*, QAG 1991. International exhibitions in which her work appeared 1982–90 included *Venice Biennale*, 1982; *Continuum '83*, Tokyo 1983; *What is Contemporary Art?*, Sweden 1989; *L'été Australien à Montpellier*, Provence 1990.

REP: NGA; AGNSW; AGSA; AGWA; NGV; QAG; QVMAG; Artbank; Parliament House; a number of regional galleries including Ballarat, Burnie, Geelong, Newcastle, Wollongong; corporate collections including Philip Morris.

BIB: Catalogue essays exhibitions as above. Janine Burke, *Field of Vision*, Penguin Books, 1990. NGA: *An Introduction*, Daniel Thomas, NGA 1982. Scarlett, AS. *A&A* 24/4/1986. AL 8/3 1988; 10/4/1990–91.

GASKING, John Cecil

(b. 1861, Plymouth, Eng.; arr. Sydney 1889) Cartoonist, illustrator. Staff artist for the *Illustrated Sydney News; Boomerang*, Qld, 1891–92; *Queenslander*, 1892–97; *World's News*, 1901–27. He designed the cover of the Qld Art Society catalogue, 1892, exhibited with the Society, 1892 and 1898, and worked in Charters Towers, 1900–01.

BIB: Margaret Maynard and Julie Brown, *Fine Art Exhibitions in Brisbane 1884–1916*, Fryer Memorial Library, Uni. of Qld, 1980.

GATISS, David

(b. 18/1/1949, UK; arr. Melb. 1959) Printmaker, painter.
STUDIES: Dip. Art, PIT, 1976; Dip. Ed., State Coll. of Vic., Hawthorn, 1977; Grad. Dip. Visual Arts, Gippsland Inst. of Advanced Education, 1986; MA (Visual Arts), Monash Uni. Coll., Gippsland, 1988–90. Freelancing and working at various labouring jobs were followed by a period of teaching at Daylesford High School, 1977–80, before he was able to devote himself full-time to drawing and printmaking. Apart from his own work he made prints for many leading Melbourne artists. His exhibition at Hawthorn City Art Gallery, 1980, revealed admiration for the drawings of David Hockney. He had four solo exhibitions 1980–89 in Melbourne, London and Gippsland and participated in a number of group exhibitions including MPAC Spring Festival, 1979–84 (annually); *Andrew and Lilian Pedersen Memorial Prize for Drawing*, 1982; touring print exhibitions USA (1985–86) and Cuba (1986); international print shows, England 1989, 90.

AWARDS: Elaine Targett Drawing prize, Hawthorn City Art Gallery, 1974; grant, experimental films, Aust. Film Trust, 1974; Henri Worland Print Award, 1981.

APPTS: Lecturer, drawing and printmaking, Box Hill College of TAFE.

REP: MAGNT; PCA; several Vic. regional galleries including Shepparton, MPAC; various schools and tertiary institutions Vic., Qld.

BIB: PCA, *Directory*. Germaine, *AGA*.

GAZZARD, Barry

(b. 1936, NSW) Painter, printmaker, teacher.
STUDIES: Julian Ashton Art School and ESTC, 1955–56; Central School, London, 1957; National Dip. of Design, Chelsea Art School, London, 1962; grad. studies and Japanese aesthetics, Kyoto Uni. of Fine Arts, 1965–67; Master of Creative Arts, Wollongong Uni. He held 32 solo exhibitions 1967–92 in Sydney (including Barry Stern; Bloomfield; Holdsworth), Adelaide (Greenhill) and Perth (Greenhill), at Kiku Gallery, Kyoto (1967–73) and Yamada, Tokyo (1967–73) and in private regional galleries at Bathurst, Katoomba, NSW; touring exhibition to regional galleries in NSW, 1985; Bathurst Regional Gallery, 1986; Intaglio, London 1982; Uni. of Wollongong 1989 and Western Sydney 1991. His work appeared in about 29 group exhibitions 1961–92, mainly print exhibitions, including *Kanagawa Independents Print Exhibition*, Yokohama, Japan 1982, 84, 86; *Sydney Printmakers*, 1987, 88; *Young Contemporaries*, ICA, London 1961; *Young Commonwealth Artists*, ICA, London 1962; *Endangered Species*, Artspace, Sydney 1989. He curated many exhibitions while on the staff of various colleges, notably Mitchell CAE.

AWARDS: Postgrad. scholarship, London, 1962; Sydney Jaycees Prize, 1963; four regional and suburban art prizes including Manly, Campbelltown, Orange, 1963–81.

APPTS: Teaching at a number of colleges including ESTC, 1974; Uni. of NSW, 1974; Faculty of Architecture, Uni. of Sydney, 1974; Mitchell CAE, 1975–85; Macarthur Inst., 1986–89.

REP: Artbank; regional galleries Bathurst, Stanthorpe, Manly, Orange, Goulburn, Griffith; Dept of Education, Vic.; Dept of Education and Youth Affairs, Canberra,; Hawkesbury Community Centre; Uni. of Western Sydney; Clark Art Centre, Chicago, USA.

BIB: Germaine, *AGA*. *A&A* 20/3/1983; 22/1/1984.

GAZZARD, Marea

(b. 1928, Sydney) Sculptor.
STUDIES: NAS, 1953–55; Central School of Arts and Crafts, London, 1955–58; travel studies Europe, Canada, USA, 1959–60; Mexico, 1976; USA, 1976. Her 1972 exhibition with fibre artist Mona Hessing (q.v.) at the NGV entitled *Clay and Fibre* focused attention on her large, abstract ceramic sculptures and her work was included in a large number of important group exhibitions, including *Mildura Sculpture Triennial* (1967, 70); *Australian Ceramics*, touring USA, Dept of Foreign Affairs and Aust. Council 1984; *A Changing Relationship: Aboriginal Themes in Australian Art 1938–88*, S. H. Ervin Gallery, Sydney 1988; *Australian Decorative Arts*

1900–1985, NGA 1988. Her work came into further prominence with the bronze sculpture for one of the courts of the new Parliament House, Canberra based on Aboriginal dreamings of the Olgas. She held about 14 solo exhibitions 1960–90 in Sydney (including at Gallery A, Coventry), Melbourne (South Yarra) and Brisbane (Johnstone Gallery), with Mona Hessing at NGV 1973, and solo at Vic. Arts Centre 1987.

AWARDS: Senior fellowship, VACB, 1978; Order of Australia (AO), 1979; residency, Denise Hickey Studio, Cité Internationale des Arts, Paris, 1988; fellowship, VACB, 1990.

APPTS: First chair, Crafts Board of the Aust. Council, 1973–76; guest artist, Haystack Mountains School of Crafts, Deer Isle, Maine, USA, 1976; visiting lecturer, Alexander Mackie CAE, 1977–79; lecturer, Renwick Museum, Washington, USA; Central School, Art and Design, London; part-time lecturer, City Art Inst., Sydney.

REP: NGA; AGNSW; AGSA; AGWA; NGV; QAG; Parliament House; High Court of Australia; Powerhouse Museum, Sydney; a number of regional galleries NSW, Vic; several tertiary collections NSW; Robert Holmes à Court corporate collection.

BIB: Kenneth Hood, intro. cat. AGDC touring exhibition *Australian Ceramics*, 1974–76; 'Honour for Australian Craftswoman', *Artforce*, no. 30, Aug.–Sept. 1980.

GEACH, Portia Stranston

(b. 1873, Melb.; d. 1959) Painter.
STUDIES: NGV School, 1890–96; RA Schools, London; travel studies Paris, UK to 1900. She returned from European and UK travels and studies in 1900 and set up her studios at 245 Collins St, Melbourne. She exhibited regularly with the VAS from 1901, and with the Art Society of NSW from 1906, her subjects including portraits, mural designs, and Australian and European landscapes and street scenes. In 1905 she painted a banner for the suffragette movement and became an advocate and active worker for social change in many areas – from women's exploitation to preservatives in foodstuffs and better farming practices. In 1922 she moved to Sydney, living at Cremorne Point. Her later paintings concerned more decorative effects. She also exhibited in London, Paris and New York. In 1965 the Portia Geach Memorial Award was established in her memory by her sister, Florence; the annual award is for 'the best portrait painted from life by any female artist resident in Australia' (*see* PRIZES). Her work was seen in *Completing the Picture: Women Artists and the Heidelberg Era* touring exhibition public galleries 1992.

AWARDS: Second prize for painting from the nude, NGV School, 1895.

BIB: Janine Burke, *Australian Women Artists*, Greenhouse, Melbourne, 1980.

GEE, Aly (Annie Laura Vernon)

(b. 1860, NSW; d. 1935, Adelaide) Painter.
STUDIES: SASA, with H. P. Gill. She painted portraits and landscapes but the main focus of her work was

on birds and wildflowers. She was represented in the *Federal Exhibition*, 1901.

REP: AGSA.

BIB: Rachel Biven, *Some forgotten . . . some remembered* , Sydenham Gallery, Adelaide, 1976.

GEIER, Helen

(b. 1946, Sydney) Painter, teacher.
STUDIES: Grad. Dip. Ed., 1968; NAS, Sydney; St Martin's School, London, –1973. The focus of her abstract paintings is often on texture. She held regular exhibitions in Sydney, Canberra and Melbourne from 1974, and her work appeared in numerous print and other survey exhibitions 1974–89, including *Tokyo Print Exhibition*, 1976; *Works on Paper*, AGSA 1980; *A New Generation 1983–88*, NGA 1988.
APPTS: Prahran CAE (lecturer in painting), 1974– .
REP: NGA; NGV; regional galleries including Ballarat, Newcastle, Warrnambool; RMIT.
BIB: PCA, *Directory*.

GEMELLI, Adrian

(b. 1946, Melb.) Painter, printmaker, sculptor.
STUDIES: Self-taught and with Clifton Pugh and Frank Hodgkinson, Melbourne 1970–71; ceramic casting, CIT 1981. His first solo exhibitions were at the VAS 1972–73 and he held a number of solo exhibitions in Melbourne, Sydney and Toowoomba during the 1970s and 80s. He participated in sculpture survey shows including *Australian Sculpture Triennial* and *Mildura Sculpture Triennial*, received a number of commissions including for mirror mosaics on walls of Melbourne public buildings, and was artist-in-residence at several institutions.
AWARDS: Grants, Vic. Ministry for the Arts 1982, 83.
REP: NGV; regional galleries, municipal collections and tertiary colleges.

GENTLE, Christopher

(b. 17/7/1939, Sussex, UK; arr. Aust. 1967) Painter, lecturer, writer.
STUDIES: West Sussex College of Art, UK, 1958–61; ATD (art education), Inst. of Education, London Uni., 1962; travel studies West Indies, Canada, NZ, 1965–67. His work was seen in several group shows in Sydney following his arrival in 1967, before he started teaching at the NAS. His abstract expressionist oils are concerned with nature and natural forms. He participated in a number of group exhibitions 1967–93 including at Bonython-Meadmore in Sydney. While director of the Ivan Dougherty Gallery he travelled to the NT for a three-month commissioned painting and drawing trip and was part of the *Young Contemporaries Lord Howe Island Art Project* where commissioned works were later displayed at Stadia Graphics, Sydney (1984). He wrote several articles and catalogue essays for art journals (including *Art and Australia*).
APPTS: Teaching, NAS, 1969–74; senior lecturer, Alexander Mackie CAE, 1975–77; senior lecturer, Coll. of Fine Arts, Uni. of NSW, 1987– ; director, Ivan Dougherty Gallery, 1977–86.

REP: NGA; AGNSW; QAG; Artbank; NSW Inst. of the Arts; corporate collections including *New York Times*.
BIB: Germaine, AGA. *New Art Four*. Nevill Drury, *Images in Contemporary Australian Art*, Craftsman House, 1992. *Artfile*.

GENTLE, Ian

(b. 1945, Healesville, Vic.) Painter, sculptor, printmaker.
STUDIES: NAS, 1970–73; Dip. Art, Alexander Mackie CAE, 1978. Using materials of the bush (where he lived for many years as a copper miner) to create creature-like sculptures, he held 13 solo exhibitions in Sydney 1981–90 largely at Macquarie Galleries. His 1979 Blake Prize-winning entry of a 'bush altar-piece' caused some controversy. He participated in numerous group exhibitions 1974–91 including *Continuum*, Ivan Dougherty Gallery 1981; *Three Aspects*, installation with Maria Kozic, Adelaide Festival Centre 1982; *Perspecta*, AGNSW 1985; *Mildura Sculpture Triennial*, 1988; *Contemporary Australian Art*, Houston International Festival, Texas, USA 1988; *Green Art*, S. H. Ervin Gallery, Sydney 1991. Commissions include *The Dance of the Drover's Dream*, Red Hill Primary School, ACT and ten sculptures for Neiman Marcus Store, Dallas, USA. He was artist-in-residence at Praxis, Fremantle, in 1983.
AWARDS: Several regional prizes NSW including Ashfield, 1974, 75; Wollongong, 1980; Randwick, 1984; shared the Blake Prize with A. Trompf, 1979; VACB grants, 1982, 89.
REP: AGNSW; AGSA; AGWA; Artbank; several tertiary colleges and regional collections NSW; corporate collections including IBM.
BIB: Catalogue essays exhibitions as above. *New Art Two*.

GEORGE, May Butler

See BUTLER-GEORGE, May

GEORGE, Phillip

(b. 1956, Sydney) Painter, photographer, computer graphic artist.
STUDIES: NAS, Sydney, 1974–75; Dip. Art, BA (Visual Arts), Alexander Mackie School of Art, 1976–78; travel studies Europe, 1979–80; New York, Istanbul, Northern Greece, 1988. He held seven solo exhibitions 1986–92 at Breewood, Blue Mountains 1986, 88, 90; ROAR 2 Studios, Melbourne 1990; Rex Irwin, Sydney 1982, 86; Solander, Canberra 1982. He participated in about 32 group exhibitions 1976–92, some at private galleries in Sydney and Melbourne but mainly at prize exhibitions and public or access spaces, including *Archibald Prize*, AGNSW 1978; *Soft Attack*, Artspace, Sydney; *National Photographic Exhibition*, Albury Regional Art Gallery 1989; *Wynne Prize*, AGNSW 1990, 91; *Coded*, AUSGRAPH 1990; *Salon des Refusés*, S. H. Ervin Gallery, Sydney 1992.
AWARDS: Arts development grant, VACB, 1991.
APPTS: Computer graphics workshops at NSW Uni. and Coll. of Fine Arts; lecturer, photography, Aust. Centre for Photography.

REP: Artbank; National Art School, Canberra; City Art Inst., Sydney.

BIB: Catalogue essays exhibitions as above. Germaine, AGA.

GERALDES, Luis

(b. 15/5/1957, Portugal; arr. Aust. 1985) Painter, sculptor.

STUDIES: Art and Design, IADE, Lisbon, Portugal, 1984; Dip. Ed., Victoria Coll., Melb., 1989. Portuguese-born, he went to Angola at the age of four and flew back to Portugal as a refugee from war in Angola. He was in the Portuguese army, visited Israel 1981, then became an art and design teacher in Portugal. Arriving in Australia in 1985 he became an Australian citizen in 1987. He was a member of artists' co-operatives in Melbourne 1986–91 including Maribyrnong River Edge Art Movement 1986–90. Describing himself as a 'metaphysical artist exploring the third dimension of man in relation to the spiritual universe' he held numerous group and solo exhibitions in Portugal, Canada, France and the USA. His Australian exhibitions have mainly been in Melbourne including at Gretz, Raya, ROAR Studios, Alliance Française, and Footscray Art Centre.

AWARDS: About six awards for painting, design, sculpture, Portugal, 1972–84.

APPTS: Art and design, secondary and technical schools in Portugal, 1980–85; lecturer, art and design, RMIT, 1989– .

REP: National collections of Israel, Portugal, Angola.

BIB: PCA, *Directory*. Germaine, AGA. *Who's Who of Australian Visual Artists*, NAVA/D. W. Thorpe, 1991.

GERBER, Matthys

(b. 1956, Delft, Holland; arr. Aust. 1956) Painter.

STUDIES: Julian Ashton Art School and Hornsby Tech. Coll., 1974–76; enrolled M. Fine Arts, Uni. of NSW, 1991– . He held 11 solo exhibitions 1980–92 including at Coventry, Mori, Yuill/Crowley, Sydney; George Paton, Karyn Lovegrove. His work, which has been described as ironic and self-parodying, includes images from contemporary popular culture such as film posters and advertisements, and appeared in about 13 group exhibitions 1986–92 including with Yuill/ Crowley and in *Art with Text*, Monash Uni. Gallery 1990; *Out of Asia*, Heide and touring regional galleries 1990; *Paraculture*, Artists' Space, NY 1990; *Association City*, Gertrude St, Melbourne 1991.

REP: NGA; NGV; MCA, Sydney; regional galleries Broken Hill, Newcastle, Wollongong; corporate collections including Allen, Allen & Hemsley; News Ltd.

BIB: Smith, AP. AM August 1992.

GHEE, Robert Edgar Taylor

(b. 1872, Vic.; d. 1951) Painter.

STUDIES: NGV School, 1889–92. A capable impressionistic painter, mainly of landscapes. His oil painting *Bourke Street, Melbourne, 1905* invites comparison with Tom Roberts' painting of the same subject.

REP: NGV.

GIARDINO, Pasquale

(b. 28/12/1961, Melb.) Painter, sculptor.

STUDIES: Vic. Coll., Prahran, 1981–82. He held two solo exhibitions in Melbourne 1988–91 at William Mora and Australian Galleries, and his work appeared in six group exhibitions 1982–89 including with ROAR Studios; Realities; Coventry, Sydney and in *A New Generation*, NGA 1989.

REP: NGA; NGV; Benalla regional gallery; William Dobell Foundation; NAB collection.

GIBB, John

(b. 1831, Stirlingshire, Scotland; arr. Aust. c. 1880; d. 1909) Painter.

STUDIES: Greenock, Scotland, with John MacKenzie. He migrated to NZ in 1876 and settled at Christchurch. The fine marine and coastal paintings on which his reputation rests were exhibited extensively throughout NZ art society exhibitions and in 1879 or 1880 he went to Australia where he became an exhibiting member of the Art Society of NSW, Sydney. His son, W. Menzies Gibb (1859–1931), learned from his father and studied in Melbourne at the NGV School, 1880–81. John Gibb painted pictures of the Yarra River and Williamstown. The Gibbs were back in NZ by 1892.

REP: Melbourne Town Hall collection; public galleries in NZ.

BIB: Gil Docking, *Two Hundred Years of New Zealand Painting*, Lansdowne, Melbourne, 1971; Henry P. Newrick, *NZ Art Auction Records, 1969–72*, Newrick, Wellington, 1973.

GIBBES, Francis Blower

(b. 1815, Scotland; arr. NSW c. 1840; d. 1904, Melb.) Painter. In 1872 he exhibited watercolours at the Victorian Academy of Arts, of which he was secretary, 1875–88, and also with the NSW Society of Artists. Subjects of his watercolours include views of the Western District, Port Phillip, the Dandenongs, Mt Buffalo, Gippsland, the You Yangs and Macedon, as well as views of NSW, NZ and Scotland. Works by him seen in auctions from the 1970s include bush scenes with creeks and ferns, as well as lighter, more open beach scenes. Exhibitions in which his work appeared 1970–93 include at Block Galleries and Deutscher Galleries, *Nineteenth and Twentieth Century Australian Art*, Melbourne, 1979; Joseph Brown Gallery, *Winter Exhibition*, 1974; Joel's November auction, Melbourne 1982.

BIB: E. Craig, *Art Auction Records*, Sydney 1981 & 84. *Nineteenth Century New Zealand Artists*, U. Platts, NZ 1979. Kerr, DAA.

GIBBONS, Henry Thomas George Cornwallis

(b. 1884, Balmain, NSW; d. 1972) Painter, teacher.

STUDIES: ESTC (Ashfield branch), 1902; Art Society of NSW school; privately with Frank Mahony; NGV School, 1908–11; USA, 1911–14; Sydney (with George Lambert), after World War I. Gibbons worked in Vancouver, Philadelphia, New York, Boston and Halifax; he enlisted in the Canadian Forces in 1914, attained the rank of lieutenant and was twice wounded. After

convalescence in 1918, he returned to Australia to become an art teacher at ESTC, from which he transferred to the Sydney Art School to join Julian Ashton, whose eyesight was beginning to fail. Gibbons continued teaching for 40 years (1923–63), and on the death of Ashton, in 1942, he took over the school, which he renamed the Julian Ashton School. Gibbons' competent representational pictures were shown regularly at the NSW Society of Artists exhibitions.
AWARDS: Student prizes, NGV School, 1908.
BIB: AA Oct. 1924, reprdn.
(*See also* SCHOOLS, SYDNEY ART SCHOOL)

GIBBONS, Tom
(b. 1928, Salford, England) Painter, critic.
STUDIES: No formal training. Gibbons' painting is two-dimensional, with bright, flat colours used decoratively. He contributed critiques to the *Critic*, Perth, from 1961. He was senior lecturer in English, Uni. of WA.
REP: Uni. of WA collection.
BIB: A&A 15/2/1977.

GIBBS, Cyril Gordon
(b. 1906, Yackandandah, Vic.) Painter, teacher.
STUDIES: Ballarat School of Mines. A partner in the commercial art firm, Gibbs-Smith Studio, 1938– , he was a delegate to a large number of art education conferences and painted watercolours.
AWARDS: Prizes in competitive exhibitions at Redcliffe, 1957, 65.
APPTS: Teaching, Swinburne Tech. Coll., Melbourne, 1929–31; head of the art school, Central Tech. Coll., Brisbane, 1938–72; member, board of trustees, QAG, 1940–59.
REP: QAG; Darnell Collection, Qld Uni.

GIBBS, Denyse
(b. 1950, Melb.) Painter.
STUDIES: Uni. of Melbourne (Fine Arts), 1970; VCA, (Grad. Dip., 1973); travel studies Europe and UK, 1974– . Her work, shown first at Tolarno Galleries, Melbourne, 1972, equates art and science, specifically entomology, as in her enlarged, detailed studies of the common house fly. Her work appeared in *Perspecta*, AGNSW 1983.
AWARDS: VACB grant, 1973; Myer Foundation grant, 1973; VACB grant (for research in Italy), 1975; Myer Foundation grant (for research in Italy), 1975; Potter Foundation grant, 1976; assistance grant, Aust. High Commission, London, 1977.
REP: NGA; NGV; Artbank; Ballarat Art Gallery; corporate collections including Philip Morris.
BIB: Denyse Gibbs, 'Art Works based on Entomology', *Leonardo*, London, vol. 2, 1978.
NFI

GIBBS, Herbert William
(b. 21/11/1852, Hardway, near Portsmouth, England; arr. Adelaide 1881; d. 4/11/1940, South Perth, WA) Painter.

STUDIES: South Kensington and with Phillip Sydney Holland. Employed in the Civil Service, 1870–81, he migrated to SA with his brother George, and after a brief attempt at farming joined the Lands Dept. In 1885 he moved to Harvey, WA, and thence to Perth where he was drawing master at Perth Grammar School, 1890, and a clerk and draughtsman in the WA Lands Dept, 1891–1917. He was a prominent member of the Wilgie Club and the WA Society of Arts for many years and father of the artist and illustrator May Gibbs. His work was seen in *The Colonial Eye*, AGWA 1979.
REP: AGWA.

GIBBS, Julian J.
(Active 1880–87, Melb.) Painter.
STUDIES: NGV School, 1880, where he was one of Folingsby's first students. He exhibited watercolours at the Victorian Academy of Arts, 1883–87, showing views around Melbourne and Port Phillip Bay as well as landscape and river scenes. He died in a railway accident.

GIBBS, May
(b. 1876, Surrey, England; arr. Aust. 1881; d. 1969, Sydney) Illustrator.
STUDIES: London, c. 1895–1903 (Cope and Nichol School, Chelsea Polytechnic, Henry Blackburn School of Black and White). Known mainly for illustrations in her own books for children, she was the daughter of Herbert W. Gibbs. She worked as an illustrator for Harrap, London, married B. J. Ossoli Kelly, c. 1918, and returned to Australia to live in Sydney where she became famous for her 'Gumnut' series of books for children. Her *Snugglepot and Cuddlepie* has been in print continuously since its first printing in 1918.
AWARDS: MBE conferred, c. 1955.
BIB: M. Muir, *Australian Children's Book Illustrators*, Sun Books, Melbourne, 1977; Ron Radford, *Art Nouveau in Australia*, catalogue AGDC touring exhibition, 1980.

GIBSON, Aubrey Hickes Lawson
(b. 1901, Melb.; d. 1975, Melb.) Art patron, collector.
STUDIES: NGV School, 1920. The Aubrey Gibson collection includes paintings by Soulages, de Silva and Sutherland, as well as many important Australian paintings and sculptures, Oriental works and a fine collection of silver. In 1967 Gibson bought Tom Roberts' historic picture *Coming South* for $20,000, and presented it to the NGV. He wrote *The Rose Bowl*, Cheshire, Melbourne, 1952.
AWARDS: NSW Society of Artists' medal 'for services to Australian art', 1965.
APPTS: Trustee of the NGV from 1956, treasurer 1957–59, deputy chairman 1960–62; councillor of the VAS, 1951–56, trustee from 1956; member of the Britannica Australia Awards committee from 1966.
BIB: Ronald Millar, 'The Art Collectors: Colonel Aubrey Gibson', *A&A*, vol. 2, no. 3, Dec. 1964.

GIBSON, Bessie (Elizabeth Dickson)

(b. 16/5/1868, Ipswich, Qld; d. 13/7/1961, Brisbane)
Painter.
STUDIES: Central Tech. Coll., Brisbane, with Godfrey
Rivers; Paris, with Mlle Debillemont-Chardon (minia-
tures), Colarossi and Castelucho, c. 1907. She left
Brisbane in 1905, settled in Paris in 1906 and stayed
there for 40 years, returning to Brisbane in 1947. Her
first success was with miniatures but the scope of her
work broadened rapidly to include portraits, land-
scapes, still-life and other subjects painted in oils and
watercolours. She exhibited at the Old Salon, Paris,
RA, London, and in many other exhibitions. A memo-
rial exhibition of her work was curated by the Univer-
sity of Qld in 1978 and toured through the AGDC,
and her work was included in *A Century of Women's
Art 1840s–1940s*, Deutscher Fine Art, Melbourne
1993.
AWARDS: Australian Exhibition for Women's Work,
Melbourne, 1907 (prize for miniatures).
REP: NGA; AGNSW; AGSA; NGV; QAG.
BIB: A&A 17/1/1979. Janine Burke, *Australian Women Artists
1840–1940*, Greenhouse, Melbourne, 1980. ADB 8.

GILBERT, George Alexander

(b. 3/12/1815, Eng.; arr. Vic. Nov. 1841; went to NZ
c. 1857) Lithographer, inventor. He married the widow
of Sir John Brierly and went to Victoria where he
became active in a wide variety of cultural enterprises.
He was the first secretary of the Mechanics Inst. and
School of Arts, lectured on lithography and taught
drawing and also dancing at the seminary for young
ladies conducted by his wife at their home in Collins
Street. Among the institutions he helped to establish
were: the Melbourne Hospital, Horticultural Society,
Chamber of Commerce, Vic. Industrial Society, Society
of St George and the first Masonic lodge. Reputedly
he held the first art exhibition in the colony and was
one of the first photographers. In 1844 he became
insolvent. By 1850 he was conducting spiritualist
seances, and in 1851 he became an assistant gold com-
missioner on the Bendigo goldfields where he gained
great popularity with the diggers. Described by William
Howitt as 'a tall, handsome man in his early forties',
he accepted a testimonial from the diggers compris-
ing mainly 'a gold pint cup filled with gold dust and
nuggets'. Reported to the Vic. government, the cir-
cumstances of his acceptance of this gift caused his
resignation. Some of his drawings were lithographed
by Thomas Ham, and others were printed in the
monthly *Port Phillip Gazette* which he had launched
in collaboration with the Melbourne coroner, Dr
Wilmot, in 1843. He separated from Mrs Gilbert and
was last heard of in NZ where he painted a picture
entitled *Rotorua 1857*.
REP: Geelong Art Gallery; Mitchell, Dixson, La Trobe
Libraries.
BIB: William Howitt, *Land, Labour, and Gold*, London, 1855,
republished by Lowden, Kilmore, Vic., 1972. Frank Cusack,
Bendigo: A History, Heinemann, Melbourne, 1973. McCulloch,
AAGR. Kerr, DAA.

GILBERT, James

(Active c. 1880, Melb.) Sculptor. His work included
a statue of Sir Redmond Barry, the first president of
trustees of the NGV (1853–80). Gilbert made the work
in clay but died before it was completed; it was finished
by Percival Ball, cast in bronze, and finally presented
to the NGV by subscribers in 1887.

GILBERT, Web (Charles Webster)

(b. 1867, Cockatoo, Vic.; d. 1925, Melb.) Sculptor.
STUDIES: Melbourne, drawing lessons from Sayer;
NGV School (evening classes), 1888–91; VAS life classes,
Melbourne. Trained as a pastry cook, he was employed
at Parer's Restaurant, Melbourne, for 25 years, study-
ing art in his spare time. Intent on becoming a sculp-
tor, he exhibited first at the VAS in 1893, and in 1898
was a foundation member of the Yarra Sculptors Society.
Influenced by James White, he began casting in bronze
from 1905 and soon became expert, although marble
remained his favoured material. His first exhibition,
mainly of carvings in marble, was held in his Fitzroy
studio in 1910, followed in 1913 by another at the
Robertson & Moffat Gallery in Bourke Street. He
went to London in 1914 and was appointed sculptor
in charge of modelling for the War Records section
of the AIF, completing the war memorial to the AIF
Second Division at Mont Saint Quentin, France. In
1915–18 he exhibited at the RA and in 1917 attained
his greatest success when his sculpture *The Critic* was
purchased for the Tate Gallery through the Chantrey
Bequest. He returned to Melbourne in 1920. Gilbert
was a natural carver and modeller with an innate sense
of plasticity. Among his best-known works are the
colossal figure of an Australian soldier at Broken Hill,
and the memorial bronze sculpture of Bass and Flinders
outside St Paul's Cathedral, Melbourne. He died sud-
denly, one month before the unveiling of this local
masterpiece, while working on the ANZAC Light Horse
Memorial for Port Said. His work was seen in *The
Great Australian Art Exhibition 1788–1988*.
AWARDS: ANZAC Memorial prize, 1923.
REP: NGA; most state and some regional galleries; AWM;
Tate Gallery, London.
BIB: Sturgeon, DAS. Scarlett, AS.

GILES, J. (?James William)

Topographical artist. J. Giles painted a watercolour,
Kincardine, dated 1847 and James William Giles painted
an oil, *Ercildoun Tower from the Eildon Peaks*. Craig
records a SA landscape by J. W. Giles and Moore
records him as making a lithograph after S. T. Gill's
watercolour of *The Departure of Captain Sturt, August,
1844*.
BIB: Catalogue Leonard Joel auctions, Nov. 1975.

GILES, John

(b. 1885, SA) Painter.
STUDIES: Adelaide, with Will Ashton; Sydney, with
J. S. Watkins. Known mainly for seascapes and land-
scapes, he exhibited with the Art Society of NSW,
c. 1918.

REP: AGNSW.

NFI

GILES, Patricia Helen

(b. 23/6/1932, Hobart) Painter.
STUDIES: Hobart Tech. Coll.; Tasmanian School of Art
with Carington Smith (Dip. Fine Art, 1968). A mem-
ber of the Australian Watercolour Inst., Sydney, and
Art Society of Tas., her watercolours have been exhib-
ited many times (over 30 solo exhibitions 1956–92)
in Tas. and once at the Hamilton Gallery, Vic., in
1974. She taught at the Tasmanian School of Art and
several other adult art classes until 1975 when she
took up painting full-time.
AWARDS: Devonport prize, 1962; watercolours acquired,
TMAG exhibitions, 1972, 73; several regional water-
colour awards Tas.; City of Hobart Art Prize, 1990;
Sheraton Invitation Spring Exhibition Prize, 1990.
REP: QVMAG; TMAG; VACB.
BIB: James McAuley, *A World of Its Own*, poems with paint-
ings by Patricia Giles, ANU Press, Canberra, 1978. Campbell,
AWP. Backhouse, *TA*. Germaine, *AGA*.

GILES, Rosemary

See MADIGAN, Rosemary Wynnis

GILFILLAN, John Alexander

(b. 1793, Jersey; arr. Aust. 1848; d. 11/2/1864, Melb.)
Painter. The son of a soldier, he served in the Royal
Navy for eight years before starting his career as an
artist. In Oct. 1830 he was appointed professor of
painting and drawing at the Andersonian Uni., Glasgow,
and held that post until May 1841, three months
before migrating to NZ to make his home in the Hutt
Valley on the outskirts of Wellington. His family fell
victim to the Maori disorders of Apr. 1847, when his
wife and four of his eight children were massacred
and Gilfillan badly wounded. He arrived in Sydney
with his surviving children and remained there three
years before making a new home in Adelaide where,
in 1852, he married Matilda Witt by whom he had
a second family. The exodus of South Australians for
the Victorian goldfields caused a severe economic
depression in SA and in Mar. 1852 Gilfillan joined
the SA contingent of diggers at Forest Creek. His suc-
cess as a gold digger is not recorded, and perhaps he
spent most of his short time at Forest Creek (Mar.–May
1852) drawing. A series of illustrations by him of
goldfields subjects appeared in the *Illustrated London
News* of 26 Feb. 1853. He was well-known in Melbourne
as a painter and illustrator at a time when the visual
arts in Australia received little encouragement. Forced
to earn a living as an employee of the Customs Dept,
he still managed to produce a considerable body of
fine work. His surviving Australian work includes
Waterhouse's Corner Adelaide, Adelaide in 1851, and a
number of history paintings, the best known of which
is *Captain Cook taking possession of New South Wales*,
engraved by Calvert (q.v.).
REP: AGSA; Mitchell Library (three works); NLA (16
works); Glasgow District Art Galleries (four works);

Scottish National Portrait Gallery; Alexander Turnbull
Library, Wellington, NZ (six works); Hocken Library,
Uni. of Otago, Dunedin, NZ (Gilfillan's sketchbooks);
Sarjeant Gallery, Wanganui, NZ (11 works).
BIB: Gil Docking, *Two Hundred Years of New Zealand Painting*,
Lansdowne, Melbourne, 1971. R. G. Appleyard, *Waterhouse's
Corner, 1849–51*, Bulletin of the AGSA, vol. 30/2/1968. Kerr,
DAA.

GILKES, Herbert Samuel

(b. 1876, Brighton, Eng.; arr. Aust. 1920; d. c. 1952)
Collector. Keeper of prints, NGV, 1927–39. A keen
collector of prints, he presented many to the NGV
before being made honorary Keeper. Items from his
collection were included in the sale of the Spencer
Jackson Collection at Kozminsky's Lower Gallery,
9–20 June 1958.

GILKS, Edward

(Active 1850s, Melb.) Painter, lithographer. Known
mainly for landscapes. He engraved the work of *Clarke
Ismer* (Cuthbert Clarke, q.v.) and contributed to Troedel's
(q.v.) *Melbourne Album* as well as producing some ori-
ginal watercolours and pencil sketches.
REP: NLA; Mitchell, La Trobe Libraries.
BIB: McCulloch, *AAGR*. Kerr, *DAA*.

GILL, Harry Pelling (?Pelham)

(b. 1855, Eng.; arr. Adelaide 1882; d. 1916) Painter,
teacher, curator.
STUDIES: Brighton, UK, –1877; RA School, South
Kensington (later the Royal College of Art), 1877–81.
Mainly a painter of watercolours, he visited Europe
in 1899 and, acting in concert with a committee,
spent £10,000 of Elder Bequest funds on acquisitions
for the AGSA; he also compiled the first catalogue of
the collections, 1903. He wrote *The Straight and Devious
Paths of Studentship*, Adelaide, 1894. His health began
to deteriorate in 1914 and in 1916 he died on his
way to England and was buried at sea.
APPTS: Master, School of Design, SASA, 1882; direc-
tor of technical art, 1889–1914; honorary curator,
AGSA (then the National Art Gallery of SA), 1892–1909;
president, SA Society of Arts, also of SA Art Teachers
Association.
REP: AGSA.
BIB: Moore, *SAA* (under 'Pelham Gill').

GILL, Justin Moray

(b. 1903, Bendigo) Painter, graphic artist.
STUDIES: Bell-Shore School, Melbourne. His work
reflected the modernist influences of the Bell School
of the 1930s.
AWARDS: Stafford Ellinson prize, Bendigo, 1979.
REP: Regional galleries Ballarat, Bendigo, Mildura,
Warrnambool.
NFI

GILL, Lou

See GILLINI

GILL, Naylor

(b. 1873; d. c. 1945, Melb.) Painter. Known mainly for paintings of bush life and landscape, some in the Mooroolbark area, he exhibited with the VAS c. 1900.

GILL, Samuel Thomas

(b. 21/5/1818, Perriton, Devonshire, UK; arr. SA 1839; d. 27/10/1880, Melb.) Painter, draughtsman.

STUDIES: Family studies with his father, a clergyman, schoolteacher and amateur artist; with various teachers in Plymouth and London. Most famous of all graphic chroniclers of life on the Vic. goldfields. At the age of 17 or 18 he went to London to work at the Hubard Galleries. Hubard cut portrait profiles with scissors and Gill's work comprised painting backgrounds for these. The decision by the Rev. Gill to move his family to Australia was prompted partly by the death from smallpox of his two youngest boys. The only daughter died from typhoid soon after arrival in SA and Mrs Gill survived her by only a few months, leaving Samuel Thomas and his brother, John Rowland, as the comforters of their father. The Rev. Gill successfully started a boys' school and Samuel Thomas set up a studio and soon became well-known in the colony. His watercolours of Adelaide life and architecture are superb examples of colonial art and remain among his most memorable works. However, personal tragedy continued to dog his footsteps, greatly to contribute to his ultimate misfortune of becoming an alcoholic. As official artist for the Horrocks expedition in 1846, he was devastated when Horrocks was involved in a shooting accident from which subsequently he died. In 1847, on 3 Feb., Gill organised *An Artists' Exhibition* (described by William Moore as 'the first movement in Adelaide') and in the same year raffled his work from the expedition. However the tragedy of Horrocks continued to haunt him; he sought solace in drink and suffered a severe decline in health.

His rivalry with George French Angas did nothing to help him, but in 1849 his set of lithographs, *Heads of the People*, brought him some success. He made many drawings in the Mt Gambier district in 1850 but addiction to drink was beginning to affect his vitality. He became insolvent in 1851, and broke irrevocably with his father, who had remarried. In 1852, anxious to start a new life, Gill joined his brother John and a friend when they shipped on the brig *Hero*, bound for Port Phillip and the Victorian goldfields. At the rip-roaring gold centre of Mt Alexander he found the subject that was to bring him his greatest fame. Before the year was out he had published the first of two volumes of lithographs entitled *A Series of Sketches of the Victorian Goldfields as they Really Are*. Described by a contemporary as habitually dressed in a top hat, cutaway coat and carrying a riding crop, he became a well-known figure in Melbourne's new luxury bars. Other volumes followed the first in quick succession. In May 1856 he sailed on the *London* for Sydney, taking a 'Mrs Gill' with him. His sojourn in Sydney produced several volumes

of work and his marital life there lasted for eight years before he returned to Melbourne in 1864. During that year he was to produce his most celebrated volume, *The Australian Sketchbook*, but it was to be his last. His drinking habits proved disastrous and gradually he 'fell into obscurity'. Julian Ashton records that when he met Gill in 1878–79 he was 'a broken old man in very bad shape'. His last appearance among artists was probably on the premises of the monumental mason G. K. Parker, where the sculptors Scurry, Fallet and Mackennal, and the painters Ashton and Buvelot, occasionally met. On the afternoon of 27 Oct. 1880, when he fell down the steps of the Elizabeth Street post office and died in the street, he was not identified. An inquest was held and he was buried in a pauper's grave. His body remained there until Apr. 1913, when the remains were exhumed and removed to another, private part of the Melbourne General Cemetery and a headstone erected. A major exhibition of his work was held at the AGSA in 1986 and he was represented in *The Great Australian Art Exhibition 1788–1988* and *The Artist and the Patron*, AGNSW 1988.

REP: NGA; AGNSW; AGSA; NGV; QAG; Ballarat Fine Art Gallery; NLA; Mitchell, La Trobe, Dixson Libraries.

BIB: Geoffrey Dutton, *The Paintings of S. T. Gill*, Rigby, Adelaide, 1962 and *S. T. Gill's Australia*, Macmillan, Melbourne, 1981. K. M. Bowden, *Samuel Thomas Gill, Artist*, Maryborough, Vic., 1971. McCulloch AAGR. Smith, PTT. Kerr, DAA. A&A 19/1/1981. Andrew Sayers, *Drawing in Australia*, NGA, 1989.

GILLILAND, Hector Beaumont

(b. 30/12/1911, Launceston, Tas.) Painter, teacher.

STUDIES: ESTC night classes, 1935–40; Canberra Uni. Coll., 1946–48; travel studies UK and Europe, 1953–54. He helped to establish the art classes at Canberra Tech. School where he was a part-time teacher from 1948 to 1952. From 1952 to 1953 he was president of the Canberra Art Society, and at the end of that period he resigned his position with the Commonwealth Public Service, and visited Europe. The big geometric shapes in his semi-abstract paintings, while retaining all the translucence and delicacy of the medium, help greatly to align the development of the contemporary watercolour in Australia with that of more robust mediums. Gilliland also played an active part in teaching at the various CAE summer schools and taught graphic communication at the School of Architecture, Uni. of NSW, 1959–77 and design and painting (part-time) at the NAS, Sydney, 1970–74. He participated in numerous group exhibitions 1937–91 including with the Australian Watercolour Institute (touring NZ 1977); *Abstract Expressionism in Sydney 1956–64*, S. H. Ervin Gallery 1980; *Opening Exhibition*, NGA 1982; *Drawing in Australia*, NGA 1988; *The Private Eye: Australian Artists' Sketchbooks*, NGA 1992. He is a member of the Australian Watercolour Inst.

AWARDS: Approximately 50 prizes 1952–77 including at Yorick Club, Melbourne, 1955; Bathurst, 1955, 57, 60; Perth, 1956; Maude Vizard-Wholohan

(Adelaide), 1958; Rockdale, 1958; Albury, 1960, 62; *Mirror*-Waratah Festival, Sydney, 1961, 64; Minnie Crouch, Ballarat, 1961; Leeton Festival, 1962; Grenfell, 1962; Young, 1962; Grace prize, Northside Arts Festival, Sydney, 1963; Tumut, 1963; Berrima, 1963, 64; Grafton, 1963, 65; R.Ag.Soc.NSW Easter Show (modern industrial), 1964 (shared with Raft); Wellington, 1964; VACB grants, for exhibition purposes, 1975, 77.
REP: NGA; AGNSW; AGSA; AGWA; NGV; QAG; QVMAG; TMAG; many regional galleries, tertiary collections NSW, Vic, Qld, SA.
BIB: Catalogue essays exhibitions as above. Elwyn Lynn, *Contemporary Drawing*, Arts in Australia series, Longmans 1963. Campbell, AWP. Smith, AP. Germaine, AGA. A&A 24/2/1986.

GILLINI (Lou GILL)
(Active last quarter of 19th century, Melb.) Painter. Known mainly for oils of landscapes, sunsets, ruins, cathedrals, etc. He signed with the pseudonym *Gillini*, painting numerous small, rather sombre paintings with a strongly European flavour. He may have been related to Naylor Gill.

GILMOUR, Guy
(b. 18/2/1955, NSW) Painter.
STUDIES: Dip. Art, Alexander Mackie CAE, 1978; BA (Visual Arts), City Art Inst., Sydney, 1985. Bruce Adams, in the Galleries column of the *Sydney Morning Herald* (20 March 1987), described his exhibition at Robin Gibson as 'Typical scenes in a local environment, from backyards at Bronte to sizzling sausages at a family barbecue, are arrested by Gilmour's realistic style. Clear light and heavy shadow give everyday objects an uncanny, static airlessness.' He held ten solo exhibitions 1981–92 at regional private galleries in Armidale, Walcha, Coffs Harbour, Tamworth and Sydney (Hogarth, 1984; Robin Gibson 1987, 89, 90, 92). Group exhibitions in which his work appeared include *New England Regional Artists Survey*, New England Regional Art Museum, Armidale and Tamworth City Gallery 1982–83.
AWARDS: Regional art prizes at Inverell, Moree, Nambucca, 1981–90.
REP: Artbank; Tamworth regional gallery; Abbott Tout Russell Kennedy, corporate collection.

GITTOES, George
(b. 7/12/1949, Sydney) Painter, printmaker, photographer, sculptor.
STUDIES: Uni. of Sydney, 1968; Art Students League and with Joe Delaney, NY, 1969; travel studies NT, 1977, 84; UK, US, Europe, 1984; Philippines, 1984. He exhibited in Sydney and New York, and in 1969 co-founded, with Martin Sharp, the Yellow House, a 'revolutionary multi-media environmental gallery and performance space complex', in Macleay Street, Sydney. Since then his work has concerned mainly performances and film-making. His 1980s work included holograms, installations and performance, often focus-

ing on environmental subjects from underwater photography and films to industrial pollution. He has travelled and worked much in the outback. He held about 28 solo exhibitions of paintings and photographs 1975–92, largely at Sydney galleries, including a touring exhibition, *Heavy Industry*, to NSW, SA and NT in 1992. He participated in group exhibitions including *Archibald, Wynne and Sulman*, 1988, 89 and touring exhibition 1992; *The Yellow House*, AGNSW 1990; and was artist-in-residence at Tennant Creek 1983; Wollongong, Newcastle, Broken Hill galleries 1989; Whyalla 1990.
AWARDS: Fisher's Ghost Art Prize, 1974, 90; VACB development grant, 1991; Blake Prize 1992.
REP: Armidale City Art Gallery.
BIB: Catalogue essays exhibitions as above. Laurence Le Guay, *Australian Photography*, Sydney 1976, 80. Lyn Coots, *Performance Arts Yearbook*, Showcase, Sydney 1982. Jean-Marc Le Pechoux & Peter Beilby, *The Australian Photography Yearbook*, Thomas Nelson 1983. Maeve Vella & Helen Rickards, *Theatre of the Impossible*, Craftsman House 1989. *Decorative Arts and Design from the Powerhouse Museum*, Powerhouse Museum, 1991. AL 5/2/1985.

GLAISTER, Thomas Skelton
(Active 1850s–70s, Sydney) Photographer. He worked as a photographer in New York before coming to Australia and setting up a studio in Sydney. One of the first to use the stereoscopic daguerreotype, he was an innovative and successful portrait photographer who also produced portraits hand-tinted on glass, and whose works were used as the basis for engravings for books. His work was seen in *Shades of Light*, NGA 1988; *The Artist and the Patron*, AGNSW 1988 and *Masterpieces of Australian Photography*, Joseph Lebovic Gallery 1989.
REP: NGA; Mitchell Library; Sydney Uni.
BIB: J. Cato, *The Story of the Camera in Australia*, Melbourne 1955. R. Holden, *Photography in Colonial Australia*, Sydney 1988. Kerr, DAA.

GLASER-HINDER, APRIL
(b. 1928, Sydney) Sculptor.
STUDIES: NAS 1967–71; Sydney Teachers' College, 1974. By 1977 she had moved to Switzerland where her steel ribbon sculptures became well-known. She returned to Australia in 1984 for a commemorative exhibition of her work with Michael Buzacott at the Irving Sculpture Galleries, Sydney.
BIB: A&A 21/4/1984.

GLASS, Peter
(b. 1917, Melb.) Painter.
STUDIES: Melbourne, with Max Meldrum; London and Paris, 1951–55. Known mainly for his skilfully painted pictures of landscapes with houses.
AWARDS: Yorick Club prize, 1963; Camden Art Centre prize (VAS), 1962; shared Tumut prize with J. Eldershaw, 1963; Redcliffe, 1967; Camberwell (Rotary Club prize), 1970; CTA prize, 1970.
REP: NGA.

GLEESON, Bill (William James)

(b. 30/1/1927, Mildura, Vic.) Painter, teacher, stained glass designer.

STUDIES: NGV School, 1945–50; George Bell School, 1950–53; Melb. Tech. Coll., 1953–58. He began his working career in the stained-glass dept. of Brooks Robinson, Melbourne, 1945–55, studied art at night and practised printmaking. His graphics were included in international graphic exhibitions at Cincinnati, USA, 1958 and Toronto, 1974. In 1967 he held an exhibition at the Cité Internationale des Arts, Paris, in conjunction with John Perceval. He held solo exhibitions 1967–89 including at Leveson St, Acland St, Hawthorn Art Gallery, Melbourne and a retrospective exhibition at Mildura and other regional galleries in 1989.

APPTS: Teaching, Vic. Education Dept schools, 1955–61; lecturer in figure drawing, painting and stained-glass design, RMIT, 1962–81.

REP: NGA; AGSA; AGWA; NGV; several regional galleries; La Trobe Uni. collection.

GLEESON, James Timothy

(b. 21/11/1915, Hornsby, NSW) Painter, critic, lecturer, curator.

STUDIES: ESTC, 1936; travel studies Europe and UK, 1947–49 and Europe 1958–59. Represented in the first CAS exhibition held in Melbourne (1938) by a Dali-inspired painting, Gleeson may be called Australia's first surrealist and has continued to work in that style. He is also known as an author, having been a critic and writer on art for newspapers and art magazines, and written several major texts on Australian art as well as a book of his own poems. His paintings over the course of some fifty years of productive work have developed a heroic quality with imagery ranging from the violent and disturbing to the lyrical and almost ethereal. In 1993, due to the NGA's exhibition of works from around the world, *Surrealism: Revolution by Night* (*see* EXHIBITIONS), interest in surrealism in Australia increased enormously (something that Gleeson had been working towards in his writings for years) with a consequent focusing of interest in his work. He held over 35 solo exhibitions 1950–92, first mainly at Macquarie then Watters, Sydney; Pinacotheca, Melbourne. Numerous group exhibitions include CAS exhibitions, Sydney, 1939–46; *110 Years of Australian Art*, Blaxland Gallery 1950; *33 Male Artists*, Heide Park and Art Gallery 1986; *Drawing in Australia from 1770s to 1980s*, NGA 1988; *The New Romantics*, Penrith Regional gallery and touring regionals Vic., NSW, Qld 1988; *The Great Australian Art Exhibition 1788–1988*; *Modern Muses: Classical Mythology in Australian Art*, S. H. Ervin Gallery, Sydney 1989; *Contemporary Australian Drawing*, MOCA, Brisbane 1992; *Clemenger Triennial*, NGV 1992. He wrote a number of books on art including *William Dobell*, Thames & Hudson, London, 1964; *Masterpieces of Australian Painting*, Lansdowne, Melbourne, 1969; *Colonial Painters 1788–1880*, Lansdowne Press, 1971; *Impressionist Painters 1881–1930*, Lansdowne Press 1971; *Ray Crooke*,

Collins, Sydney, 1972; *Robert Klippel*, Bay Books, 1983.

AWARDS: CAS prize (shared with Eric Thake), 1941; AM (Member of the Order of Australia), 1975; honorary Doctor of Letters, Macquarie Uni. 1989; Officer Order of Australia 1990.

APPTS: Lecturer in art, Sydney Teachers Coll., 1945–46; lecturer, Orient Line exhibitions of Australian painting, 1956, 64, 67; art critic, Sydney *Sun*, 1949–72, *Sun-Herald*, 1962–72; director, Sir William Dobell Art Foundation, 1971– ; member, judging panel, eleventh *Bienale de São Paulo*, Brazil, 1971 (Australian commissioner, 1972); member, Commonwealth Art Advisory Board, 1972; deputy chairman, VACB, 1973–76; council member, NGA, 1976–82, chairman of the acquisitions committee, 1973, visiting curator 1975.

REP: NGA; AGNSW; AGSA; AGWA; MAGNT; NGV; QAG; QVMAG; TMAG; most regional galleries and other public collections.

BIB: Catalogue essays exhibitions as above. All major texts on Australian art including Smith, AP; Horton, PDA; Bonython, MAP 19/0 & 75. A&A 5/3/1967. Renée Free, *James Gleeson: Images from the Shadows*, Craftsman House, 1993.

GLEGHORN, Tom

(b. 2/6/1925, Thornley, Eng.; arr. Aust. 1929) Painter, gallery director, teacher.

STUDIES: No formal training; some help from William Dobell; travel studies, UK and Europe, 1962–63 and 1970. He started painting at the age of 24 and between 1957–73 won about 30 major as well as many smaller art awards. His painting reflects the general changing pattern of international styles. He held about 34 solo exhibitions 1959–92 in most capital cities including at Macquarie, Sydney; Tynte, Adelaide and von Bertouch, Newcastle. He has participated in many group exhibitions, largely at private galleries, sometimes in conjunction with several others including Dickerson, Makin, Borrack, Coburn.

AWARDS: Blake Prize, 1958; Muswellbrook Prize, 1958, 60; Rockdale Art Prize, 1957, 61; Sir Charles Lloyd Jones Industrial Art Award, 1959; Helena Rubinstein Travelling Scholarship, 1961; grant, British Council, 1962; plus approximately 25 other art awards.

APPTS: Artist designer for Grace Bros, then Farmers, Sydney; director, Blaxland Galleries, Sydney, 1958–60; teaching, NAS, Sydney, 1960; head of the Canberra Art School, 1968–69; lecturer in art, Bedford Park Teachers Coll., Adelaide, from 1969, senior lecturer from 1973.

REP: NGA; most state and many regional galleries; many corporate collections including IBM, ICI, State Bank, Perth, Sydney, London, Hong Kong.

BIB: Most major texts on Australian art including Gleeson, AP; Bonython, MAP, 1970; Gary Catalano, *The Years of Hope*, OUP; Smith, AP.

GLICK, Rodney Albert

(b. 23/4/1961, WA) Sculptor, installation/performance artist.

STUDIES: BA Fine Arts (Sculpture), WAIT, 1985; Grad. Dip. Art and Design (Sculpture), Curtin Uni., 1986; Master Fine Arts (Sculpture), Uni. of Tasmania, 1990. In partnership with freelance writer, advertising executive and ABC producer David Soloman he formed *The Glick International Collection*, which produced a number of writings and publications sending up artists' theories through the words of a fictional philosopher, 'Bernard Klus'. He held six solo exhibitions, largely of installations, 1988–92, including in Perth (Dusseldorf 1988, 89, 92), Melbourne (Niagara 1991) and Sydney (Roslyn Oxley9 1991), and *We are no wiser today than yesterday*, AGWA and Westpac Gallery, Melbourne 1991–92; *The Alice Black Theory of Emerging Art*, Adelaide Festival Centre 1992. His work appeared in about six group exhibitions 1988–92 in Perth (Galerie Dusseldorf, Lawrence Wilson).
AWARDS: Research grant 1991, research and development fund 1992, Curtin Uni.; conferences, seminars and special events grant, special projects fund, WA Dept for the Arts, 1991; project fund, VACB, 1991.
APPTS: Tutor, sculpture, Curtin Uni. of Technology, 1987–88; tutor, sculpture, Uni. of Tasmania, 1989; senior tutor, sculpture, Curtin Uni., 1991–92.
REP: AGWA; Curtin Uni.
BIB: *No Substitute: Prose, Poems, Images*, Terri-Anne White (Editor), Fremantle Arts Centre Press, Perth, 1989. AL Vol. 11, Winter 1991.

GLOVER, Alan C.

Printmaker, mainly an etcher; president of the Royal South Australian Society of Fine Arts, 1956–58.
AWARDS: Maude Vizard-Wholohan prize for prints, 1957.
NFI

GLOVER, Harry C.

(Active 1850–60, SA) Painter. The publican of the Stag Inn, Rundle St, Adelaide, and later listed in the SA directory as an artist. A fine portrait in watercolours of William Baker Ashton, first governor of the Adelaide gaol, is attributed to Glover and was seen in *South Australia Illustrated*, AGSA 1976. He also painted other portraits and watercolour views of Adelaide.
REP: AGSA; NLA; Mitchell, Mortlock Libraries.
BIB: Benko, AAS. Kerr, DAA.

GLOVER, Henry Heath, Jnr

(Arr. Melb., 1848) Engraver, lithographer. He worked for the engravers De Gruchy and Leigh, Melbourne, 1848–51 and thence probably in the goldfields until 1856 when he was in Adelaide. He is best-known for his lithograph of the NSW v. Vic. cricket match of 1858. He went to NZ in 1864 were he worked for the *Lyttelton Times*, and returned to Australia to become a foundation member of the Victorian Academy of Arts in 1870. He moved to Sydney about 1870 to take up a job as chief draughtsman of a printing firm. He worked for a number of Sydney printing firms

and on his own until his death some 30 years later.
REP: Mitchell, Dixson, La Trobe Libraries; Canterbury Museum, Christchurch, NZ.
BIB: McCulloch, AAGR. Kerr, DAA.

GLOVER, John

(b. 18/2/1767, Leicestershire, Eng.; arr. Tas. 1831; d. 1849, Tas.) Painter.
STUDIES: London (with William Payne, and possibly John 'Warwick' Smith). Glover established a gallery in Bond St, London, in 1820, for exhibitions of his own works, and was equally successful financially as dealer, painter and teacher. He was a skilful and prolific painter of landscapes with a reputation extending to France, where he attracted the interest of Louis XVIII. The French king bought Glover's pictures, presented him with a gold medal, and was said to have aroused his interest in migrating to Australia. A man of considerable wealth, Glover embarked from Gravesend on 20 Sept. 1830, arriving Launceston, 18 Feb. 1831, Hobart, 1 Apr. 1831. In Mar. 1832 he set off by wagon for Mills Plains to occupy his holding – a government grant of 2560 acres (1037 hectares). He bought an additional 5098 acres (2064 hectares), built a large house, *Patterdale*, a church at the nearby village of Deddington and lived a happy family life as country squire and successful painter. John Skinner Prout, who visited him there, made a drawing of Glover which was reproduced in the *Art Journal* (London, 1850). Glover made regular return visits to England, where he exhibited at the RA but was never elected. His work was the subject of what was probably the first criticism published in Australia. A visiting critic, Dr John Lhotsky, attacked Glover's neglect of local characteristics; this contrasts with what another critic, G. T. W. B. Boyes, Tasmanian Colonial Auditor, wrote in his diary in 1831, that the trees in the foreground of Glover's *Mount Wellington* were painted 'with hideous fidelity to nature'. The truth was that what Glover had accomplished in England and what he was to accomplish in Australia were two quite different things. His European landscapes, mountainscapes and formal classical compositions had made no stylistic advances on the work of mentors such as Salvator Rosa or Claude, and perhaps because they were too imitative they failed to gain him election to the RA. However in Tas. he discovered a new landscape, light, foliage and atmosphere and responded to the raw and primitive features of the new country perceptively enough to attain new individuality and distinction. The rusticity of his new work became its greatest strength. He was also unique among Australian painters of his time for painting in oils. A large, heavy man with two club feet, Glover became a patriarchal figure. Two of his four sons, John Richardson Glover and William Glover (qq.v.), were also painters. A major exhibition of his work toured state galleries in 1977; his work was also seen in many exhibitions of colonial and other works in the 1980s and 90s including *Tasmanian Vision*, TMAG & QVMAG, 1988; *The Great Australian Art Exhibition 1788–1988*; *Stories of Australian Art*,

Commonwealth Inst., London 1988; and in a number of leading auction houses including Sotheby's April 1989 sale.
AWARDS: Gold medal presented by Louis XVIII (stolen while on loan to QVMAG, in 1904).
APPTS: A foundation member of the Society of Painters in Watercolour, 1804, president in 1807; foundation member of the Royal Society of British Artists, 1823.
REP: NGA; most state, many regional galleries and other public collections; Tate Gallery, London.
BIB: Most general books on Australian art. John McPhee, *The Art of John Glover*. Kerr, DAA. ADB 1. A&A 3/2/1965; 16/3/1979. AL 5/1/1985.

GLOVER, John (Richardson), Jnr

(b. 1790, Eng.; arr. Tas. 1831; d. 1868) Painter, farmer. STUDIES: Family studies. The eldest son of John Glover (q.v.), he is recorded as having exhibited at the RA, London, 1808–29. If this is correct it suggests a painter of precocious talents. His subjects were all landscapes (of Wales and, the Lake District, and later, Tasmania). Having accrued debts in England, he accompanied his father to Van Diemen's Land (Tas.), his three brothers, Henry, James and William, having preceded them by about one year. Like his father, John Richardson Glover had received a grant of land at Mills Plains. BIB: Kerr, DAA.

GLOVER, William

(b. c. 1791, Eng.; arr. Tas. 1829; d. Tas.) Painter. Son and pupil of John Glover and brother of John Glover Jnr (qq.v.), he taught drawing in Birmingham in 1808 and exhibited frequently in London, 1813–33. BIB: Bénézit, *Dictionnaire*.

GOATCHER, James

(b. 13/8/1879, Philadelphia; arr. Sydney 1890; d. 29/7/1957) Painter.
STUDIES: Family studies with his father, a scene-painter for theatre; RAS classes, Sydney; also in Melbourne. Apprenticed as a scene-painter to the J. C. Williamson Comic Opera Company, he painted in his spare time, mainly conventional watercolours. In 1906 he moved to WA where he became a member of the WA Society of Arts (vice-president, 1952), and exhibited his watercolours annually at Newspaper House, 1944–54. His work was seen in *The Colonial Eye*, AGWA 1979.
AWARDS: Claude Hotchin prize for watercolours, 1950.
REP: Royal WA Historical Society.

GODDARD, Barrie Frederick

(b. 25/6/1941, Adelaide) Painter, lecturer, printmaker, photographer.
STUDIES: Dip. Art, SASA, 1960, printmaking course (part-time), 1961–63; travel studies Europe, UK and USA, 1970; UK, Europe, Egypt, Iran, India, 1976; NZ, 1982; New Caledonia, UK, Europe, Morocco, 1988. He held his first exhibition at the Llewellyn Gallery, Adelaide, in 1970, and from then on his work appeared in competitive and other group exhibitions. His figur-

ative style embodies influences derived from Op, hard-edge and other modernist movements worked in harmony with more traditional forms such as panoramic strip painting. He held about 14 solo exhibitions 1963–90, mainly in Adelaide, and participated in numerous group exhibitions 1963–92 including with CAS Adelaide, 1960s–90s; *Print as Object*, PCA 1985; many staff exhibitions, SACAE 1980s. Public art work includes poster design and murals at Whyalla, 1987. He is a member of many course/accreditation committees.
AWARDS: H. P. Gill medal and prize, SASA, 1960; Georges prize, Melbourne (work acquired), 1979; McCaughey Prize, 1975, 79, 81.
APPTS: Secondary art teacher, SA, 1960–63; at SASA: lecturer, 1963–85; senior lecturer and head of dept, 1986–90; course co-ordinator, 1990– .
REP: NGA; AGSA; QAG; TMAG; Parliament House; High Court, Canberra (photographic works); a number of regional and tertiary collections SA, Vic., NT; corporate collections including BHP, BP.
BIB: Catalogue essays exhibitions as above. Benko *Art and Artists of SA*.

GODDEN, Walter

(Active c. 1895–98) Draughtsman, mining surveyor. Worked as a draughtsman with the Dept of Public Works, Perth, 1895, and Coolgardie, 1897. His map of the Bulong deep-lead mine was published in 1898. He lived in Kalgoorlie until about 1903. His watercolour of the Kanowna Mine with horse and figures in the foreground, seen in *The Colonial Eye*, AGWA, 1979, shows him as an able draughtsman.
REP: AGWA.

GODSON, John Barclay

(b. 1882, Eng.; arr. Sydney 1914, after three years in NZ; d. 1957) Painter, etcher, teacher.
STUDIES: Leeds School of Arts, RCA, London. Godson was assistant art master at Auckland Tech. School, NZ, from 1911; teacher at ESTC, Sydney, and an original member of the Australian Painter-Etchers' Society from 1921.
REP: AGNSW; NGV; Print Room, British Museum.
BIB: AA no. 9, 1921, refs and reprdns.

GOERG, Edouard Joseph

(b. 1893, Sydney) Painter, etcher.
STUDIES: Académie Ranson, 'a centre of activity for the Nabi movement, founded under Gauguin's influence', 1912. Born of French and Irish parentage, he left Australia in childhood for England and in 1900 went to France where he made his permanent home. His paintings and etchings have a haunting, dreamlike quality that suggests close studies of the great satirists and moralists such as Goya, Daumier and Rouault. The combination made him eminently suited to illustrate such books as Baudelaire's *Les Fleurs du Mal*.
AWARDS: International Hallmark prize, 1948; Légion d'Honneur, 1965.

BIB: Gaston Diehl, *Edouard Goerg,* Edns de Clermont, Paris, 1947. Carlton Lake and Robert Maillard, general eds, *A Dictionary of Modern Painting,* Methuen, London, 1956. Waldemar George, *Edouard Goerg,* Pierre Cailler, Geneva, 1965; Hal Missingham foreword, Jean Cassou intro., *French Painting Today,* Australian touring exhibition, Jan.–Sept. 1953.

GOLD, (Lieut. General) Charles Emilius

(b. 1803, Eng.; visited Tas., 1846–47; d. 1871) Army officer, topographical artist. In 1846 he was posted to Wellington, NZ, to the British 56th Regiment which he commanded for part of the Maori Wars. Dated watercolours of Hobart suggest he was in Tas. in Dec. 1846 and in 1847. By 1855 he was back in Wellington where he stayed until 1858.

BIB: Henry P. Newrick, *New Zealand Art Auction Records 1969–72,* Newrick, Wellington, 1973. Kerr, DAA.

GOLDCOAST GROUP

(Active from c. 1960.) Formed by painters living at Surfers Paradise, Qld. Members included Petra Klepel, Billo Munro, Laurie Davies, P. Winter-lrving, Veda Arrowsmith.

GOLDFINCH, Duncan Alexander Macarthur

(b. 20/9/1888, St Marys, NSW; d. 25/9/1960) Painter. Self-taught realist, mainly *plein-air* painter. He made many field trips to outback SA from Sydney in the early 1900s, with others including Sydney Long (q.v.), Lister Lister (q.v.), Dattilo Rubbo (q.v.), Tom Roberts (q.v.) and Norman Lindsay (q.v.). President of Royal South Australian Society of Artists (q.v.), 1953. He painted Ayers Rock and Mt Olga in 1951, after five years' negotiation with the Australian Government to enter the Aboriginal reserve. Goldfinch claimed he was the first to paint the 'Rock', although that claim was made by at least one other – Hans Heysen. Arnold Shore in the *Australasian Post* wrote in 1952: 'one of the latest to try to catch its bulk and character is a South Australian, Duncan Goldfinch', continuing, 'granted he suggested something of the idea of a big bulk ... he stopped off thinking of rhythm and bulk though when he painted the tree and the foreground. These are flat and stereotyped ... Goldfinch says that some praise he received for his work in Adelaide made every bone-shaking mile of his trip worthwhile. That must have been nice but I wish he could get one more bump that would make him aware of how trees, little rock and desert are just as vital as "one feller big rock".' Woomera Base invited him to organise a visiting art group in 1952, which happened on a regular basis. Goldfinch was a prolific artist with many sell-out shows, mainly at the RASA, 1940s–50s.
(Letter from artist's son 1992)

GOLDWERTH, Frederika Foric

Mosaic artist who exhibited at the VAS in 1955. She studied with the Italian futurist Severini, and exhibited at the Salon d'Automne, Paris.
NFI

GOOD, Gladys K.

(b. 1890, Adelaide; d. 1979) Teacher.
STUDIES: School of Arts and Crafts, Adelaide, 1906– . She moved straight from study to teaching and spent most of her life as a teacher at the SASA, retiring in 1960. Among her students were Ivor Hele, Jacqueline Hick and Jeffrey Smart.
BIB: Rachel Biven, *Some forgotten . . . some remembered,* Sydenham Gallery, Adelaide, 1976.

GOODCHILD, Doreen (née Rowley)

(b. 1900, SA) Painter, potter.
STUDIES: SASA, Adelaide; Sydney, with Dattilo Rubbo; Central School of Arts and Crafts, London. Married to John Goodchild (q.v.), she painted mainly landscapes and made porcelain and earthenware figures.
REP: AGSA.
BIB: Rachel Biven, *Some forgotten . . . some remembered,* Sydenham Gallery, Adelaide, 1976.
NFI

GOODCHILD, John Charles

(b. 1898, London; arr. SA 1913; d. 1980) Painter, etcher, teacher.
STUDIES: SASA, Adelaide, 1941–46; Central School of Arts and Crafts, London, 1921. Known principally as an etcher and watercolourist, he depicted mainly landscapes with architecture. While serving in France during World War I, he contributed to the field paper, *Digger,* and after the war was commissioned by the Commonwealth Government to do 36 pen drawings of Australian cemeteries in France. He was a prolific worker and a member of the Australian Painter-Etchers' Society as well as the Senefelder Club and Graphic Art Society, London. His books included *Where Diggers Rest,* 1921; *Adelaide in Pen and Ink,* 1921; *Drawings of Adelaide,* 1924; *In and about Adelaide,* 1933 – all published by Tyrrells Ltd, Sydney and Adelaide.
APPTS: Teaching, Central School of Arts and Crafts, London, 1928–29; SASA, Adelaide, 1934; principal of the SASA, 1941–45; official war artist, World War II, 1945; member of the board of trustees, AGSA, 1940–53 and 1961–68.
REP: Australian state galleries (depts of prints and drawings); British Museum (watercolours and etchings).

GOODHART, Joseph Christian

(b. Feb. 1875, Adelaide; d. 1954, Victor Harbor, SA) Painter, etcher.
STUDIES: No formal training in art. He was helped with his etchings by John Goodchild (q.v.). Educated at St Peter's Coll., Adelaide, the death of both parents caused him to leave school early and assume responsibility for three younger brothers. He became a window dresser and display artist, first in Adelaide, at John Martin's, then, 1896, at Boan Bros, Broken Hill, before starting his own small shop (which was to become one of the largest in Broken Hill). He painted in oils, pastels and watercolours before experimenting with etching learned from books. A chance

visit from John Goodchild helped his studies and his first press was made in a fitting shop. In the late 1920s, a set of etchings was bought by Herbert Hoover (later President Hoover), then working at Broken Hill for his mining manager's ticket. The set is now in the White House archives. In 1929, two of Goodhart's etchings were accepted and hung 'on the line' at the Paris Salon. Described by William Moore as 'the only artist doing mining subjects to-day', he joined the Australian Painter-Etchers' Society and the SA Society of Arts, to attain distinction in the boom period of early Australian etching, 1925–45.

AWARDS: Gold medal for window dressing, given by the *Draper of Australia*, 1905.

REP: NGA; AGSA; NGV; TMAG; regional gallery Broken Hill; British Museum (five prints).

BIB: *AA*, Dec. 1926. Moore, SAA.

(Information from the artist's son, Brian Goodhart, 26 May 1981)

GOODSIR, Agnes Noyes

(b. 1864, Portland, Vic.; d. 1939, Paris) Painter.
STUDIES: Bendigo School of Mines, with A. T. Woodward; Paris, with Jean Paul Laurens and Lucien Simon. A painter of landscapes, portraits and still-life, she exhibited at the RA, London and lived in Paris, 1900–27. She is reported as having painted a portrait of Mussolini in the mid-1920s, was elected an Associate, New Salon, Paris, 1924, Member, 1926, and was represented in the exhibition *150 Years of Australian Art*, AGNSW, 1938.

AWARDS: Silver medal, Paris Salon, 1924 (for her painting *The Red Cloak*).

REP: AGNSW; NGV; QAG; TMAG; regional galleries Bendigo, Geelong.

BIB: Janine Burke, *Australian Women Artists 1840–1940*, Greenhouse, Melbourne, 1980.

GOODWIN, William Lushington

(Arr. Launceston, 1821) Sea captain, caricaturist. He commanded the convict ship *Kains* (c. 1831). As editor of the *Cornwall Chronicle* he became known for his fearless publishing of often scurrilous caricatures, for which he was twice sued for libel. The best-known were the 19 woodcuts he made and titled the *Gallery of Comicalities* (1836–37). A trained wood-engraver and etcher, he is said to have been Australia's first newspaper cartoonist. His work was included in *Shades of Light*, NGA 1988.

BIB: Clifford Craig, *Engravers of Van Diemen's Land*, Foot & Playstead, Launceston, 1961. ADB 1. Mahood, *The Loaded Line*, Melbourne 1973. Kerr, DAA.

GORDON, Jack

See CHARTERISVILLE

GORDON, Jeremy (Hugh)

(b. 22/1/1947, Adelaide) Painter.
STUDIES: SASA, 1961–63; ESTC, 1963–65; also private lessons from William Dobell; Hammersmith Art School, London, 1966; Dip. Art, Byam Shaw School, London, 1968; travel studies Europe, including Greece, Turkey,

1968. Though related to flat-pattern cubism as well as surrealism, his canvases, painted in bright, largely primary colours with emphasis on red, blue and green, have a sense of fantasy that gives them strong individuality. His work appeared in nine solo exhibitions 1971–91 including at Joseph Brown Gallery (1971) and Bloomfield, Sydney. Group exhibitions in which his work appeared were largely in private galleries in Adelaide, Sydney, Melbourne and several at AGSA and Vic. regional galleries.

AWARDS: Student prize at Byam Shaw School.

REP: Artbank; Flinders Uni. collections; BHP; Reserve Bank.

BIB: Bonython, *MAP*, 1975 & 1980. Germaine, AGA.

GORDON, L. F.

Sculptor, surveyor. One of the modelling group at Earl's Court, London, after World War I. Assistant sculptor at AWM, Canberra. Before the war he was growing sugar in Qld.

BIB: Moore, SAA.

GORDON-FRASER, C. E.

(Active c. 1890, ?Melb.) Painter. Colonial School landscape and portrait painter. His *Children in Rain Forest*, 1889, as seen in Joel's auction, Melbourne 1977, showed this little-known painter as a competent minor artist of his period, and similar in painting style to Robert Camm (q.v.).

REP: NGV (*Portrait of Benjamin Cowderoy*).

GOSS, Michael

(b. 1942, Melb.) Painter, teacher, executive officer.
STUDIES: Melbourne, c. 1960; Europe, from 1964. Black-and-white drawings exhibited at the South Yarra Galleries, 1962–63, showed Goss as a draughtsman with a flair for large-scale decorative design. He exhibited until 1972 and then continued his work as a printmaker. He has been an arts administrator since the late 1970s, first as executive officer with the NSW RGAV and since the 1980s with the NSW Ministry for the Arts.

GOSSE, Thomas

(b. 1765; d. 1844, London) Engraver. He made a mezzotint of the *Founding of the Settlement of Port Jackson in NSW in 1799* seen in *Outlines of Australian Printmaking*, Ballarat Fine Art Gallery, Aug. 1976.

GOUGH, Craig Alan

(b. 15/9/1938, Perth) Painter, lecturer.
STUDIES: Art Teachers Associateship, Perth Tech. Coll. and WAIT, 1958–65; Dip. Teaching, Graylands Teachers College, 1981. Abstract expressionist in style and strong in colour and movement, he paints often large, lyrical works. The sea, urban beaches and boats were the subject of much of his 1980s work, which he displayed in successful exhibitions at Christine Abrahams Gallery, Melbourne. In 1974 he moved from Perth to Melbourne to take up a position as senior lecturer at Monash Uni. (then CIT). He had about 18 solo

exhibitions 1969–92 including at Old Fire Station Gallery, Quentin Gallery, Perth; Stuart Gerstman and largely Christine Abrahams, Melbourne. He participated in numerous group exhibitions including at AGWA, Fremantle Arts Centre, WAIT and in *Inez Hutchison Art Awards*, NGV 1974, 75, 76; *John McCaughey Memorial Art Prize* (co-winner), NGV 1983; *Faber-Castell, Gold Coast* and *Scotchman's Hill Vineyard* prize exhibitions, 1980s, 90s. In 1988 he made his first trip outside Australia with a three-month residency at the VACB studio in Tuscany followed by extensive European, UK, USA travels as well as travel in 1992 to Paris and Spain, visiting galleries.

AWARDS: Guild prize, WA, 1965; Rothmans prize, WA, 1966; Bunbury art prize, 1970, 86; Beaumaris/ Sandringham art award 1978; John McCaughey Memorial Prize, NGV (co-winner Mandy Martin), 1983; several other municipal art awards Vic., 1985, 86; MPAC acquisitive award, 1985; Gold Coast Art Prize, 1986; residency, Paretaio studio, Tuscany, VACB, 1988.

APPTS: Teaching, WA high schools, 1959–67; lecturer in Fine Art at Claremont Tech. School, 1969–73; President, CAS, Perth, 1969–70; art critic for the Perth *Sunday Times*, 1972–73; member of the Festival of Perth Arts Committee, 1973–74; senior lecturer, painting, Monash Uni. (previously CIT), 1974– .

REP: NGV; Artbank; a number of regional galleries Vic., NSW including MPAC, Newcastle; several municipal, tertiary collections WA, Vic., NSW; corporate collections including Robert Holmes à Court, Mark Besen/Sussan, Price Waterhouse.

BIB: Germaine, *AGA*.

GOULD, Elizabeth

(b. 18/7/1804, Ramsgate, Eng.; d. 15/8/1841) Illustrator. Married to naturalist John Gould (q.v.), she illustrated a number of his books of birds including *A Century of Birds from the Himalayas*, 1830–31, and *Birds of Australia*. She completed around 600 illustrations for books before her untimely death at the age of 37. During the 12 years of her married life with Gould she had six children and her name is commemorated in that of the 'Gouldian finch' of tropical Australia.

REP: Mitchell Library.

BIB: *ADB* 2. Kerr, *DAA*.

GOULD, John

(b. 14/9/1804, Lyme Regis, Dorset, Eng.; d. 3/2/1881, London) Ornithologist, painter. He was official taxidermist to the London Zoological Society from 1827. Gould spent from 1838 to 1840 in Australia, mostly in Tas., SA and NSW. In his *European Vision and the South Pacific*, Bernard Smith tells us that Gould left England for Tas. with Elizabeth, his collector, John Gilbert, his son, nephew and two servants, and that he was helped by Sir John and Lady Franklin. After extensive travels in Tas. he went to NSW and travelled 644 km inland in search of specimens. Of his 2999 colour plates of birds, 895 were birds of Australia and New Guinea; altogether he added 300 new species to the numbers of Australian birds already known. Gould's

Birds of Australia, London, 1840–48, published in 36 quarterly parts, was available to a limited number of subscribers at £115. A supplement appeared later, issued in five parts over a period of 18 years. *The Mammals of Australia*, London, 1845–63, was published in 13 parts, and included 182 illustrations in colour.

BIB: *ADB* 1. Gordon C. Sauer, *John Gould the Birdman: A Chronology and Bibliography*, Lansdowne, Melbourne, 1982. Kerr, *DAA*.

GOULD, Strom (Charles Sidebotham)

(b. 1910, UK; arr. Aust. 1935) Painter, illustrator, printmaker, teacher.

STUDIES: St Albans School of Art, St Martin's School of Art, Central School of Arts and Crafts, London; Reiman School of Design, Berlin; travel studies UK, 1946–60 (philosophy and psychology). He worked with distinction as a cartoonist and illustrator for the *Sydney Morning Herald*, 1935–40, and later worked as a freelance artist in a wide variety of media.

AWARDS: Prizes in exhibitions at Mosman, 1961; Ryde, 1961; Gundagai, 1960; Wollongong, 1962; Bathurst, 1962, 63; Sydney (*Mirror*-Waratah), 1963, 64; Rockdale, 1963, 67; Cheltenham, NSW, 1967, 68; Scone, 1967; Grenfell (Henry Lawson Festival), 1967, 70; Castle Hill, 1970; Carrabubula, 1969, 1970; Rylstone, 1970.

APPTS: Teaching, ESTC, 1951– .

REP: AGNSW; AGSA; QAG.

GOULD, William Buelow (William Buelow Holland)

(b. 8/11/1803, Liverpool, Eng.; arr. Tas. 1827; d. 11/12/1853, Hobart) Painter.

STUDIES: With Mulready; at Spode Potteries, Staffordshire; and as assistant to the London lithographer Ackermann. Gould, whose real name was Holland, was an alcoholic, and sentenced to transportation for seven years for the theft of clothing. He arrived in Hobart in the *Asia* on 7 Dec. 1827, having left his wife and family in Staffordshire. Sent to Port Macquarie, he was transferred (for repeated drunkenness) to Port Arthur in 1833 and finally received his freedom on 25 June 1835. In 1836 he married Amy Reynolds and led a comparatively stable life for some years before succumbing again to continual drinking and related problems of poverty and minor offences for which he received several jail sentences. Withal he managed to paint many small, still-life studies containing flowers, fruit and fish (many done in return for liquor), as well as a few excellent portraits. In addition, his sketches of Macquarie Harbour, made during confinement there, are a unique topographical record of the settlement. He also painted portraits of some of the Aborigines for George Augustus Robinson. His work has featured in a number of exhibitions including *Australian Colonial Portraits*, AGDC touring exhibition 1978; *William Buelow Gould*, Burnie Art Gallery 1980; *Tasmanian Vision*, TMAG & QVMAG, 1988; *The Great Australian Art Exhibition 1788–1988*.

W.B. Gould, Tasmanian Wildflowers, *c. 1840s, oil on canvas, 66.3 × 56.3cm. Collection* TMAG.

REP: NGA; most state galleries and a number of regional galleries.

BIB: *ADB* 1. G. Darby, *William Buelow Gould: Convict Artists of Van Diemen's Land*, Sydney 1981 Kerr, DAA.

GOULDSMITH, Edmund

(b. 1852, Chatham, Bristol; arr. Aust. 1883; d. 1932, Eng.) Painter.

STUDIES: School of Art, Bristol, 1875; Royal Coll. of Art, London, from 1876. He worked in Adelaide from 1883–86 where he became a member of the RSASA. From 1886–89 he taught in Christchurch, NZ, before returning to England where he continued to exhibit for many years, mainly at the RA.

REP: AGSA.

BIB: J. B. Mather, *Catalogue of the AGSA*, Adelaide, 1913. Grant M. Waters, *A Dictionary of British Artists Working 1900–1950*, Eastbourne Fine Arts, Eastbourne, 1975.

GOUPIL, Ernest Auguste

(b. ?Paris; d. 1841, Paris) Draughtsman. He made drawings of Port Essington and New Victoria between 1837 and 1840 while serving in *Zelee*, sister ship to the ill-fated *Astrolabe*, during Dumont D'Urville's second voyage. Bénézit records him as exhibiting at the Paris Salon from 1834 and as also having travelled around the world on the frigate *La Bonite*.

REP: AGSA; NLA; Mitchell Library; Toulon Museum.

BIB: Smith, *ESVP*. Bénézit, *Dictionnaire*, 1976. Kerr, DAA.

(*See also* LEBRETON, Louis)

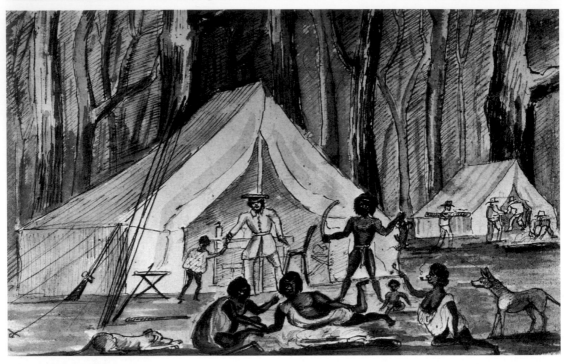

GOVETT, William Romaine

(b. 3/10/1807, Tiverton, Devon, Eng.; arr. Sydney 1827; d. 22/8/1848, London) Surveyor, painter.

STUDIES: Blundell's School, Tiverton, c. 1823–26; he may also have had lessons in Sydney from Charles Rodius. Appointed to the colonial survey dept of NSW, Govett went on his first expedition in 1829, his most notable surveying achievement being his survey of the Blue Mountains road, when he became the first white man to ascend Mount Hay. In 1831 he discovered a waterfall plunging into one of the gullies of the Grose River. Later it was named by Sir Thomas Mitchell, Govett's Leap or Cataract. However his contraventions of Mitchell's instructions earned him a reputation for wildness. What saved him from retribution apparently was Mitchell's high regard for his capabilities. Their association ended when Govett returned to London in 1834. Back in England he contributed a series of 20 illustrated articles entitled 'Sketches of New South Wales' to John W. Parker's *Saturday Magazine*. Not much is known of his subsequent life, his only other contribution to the *Saturday Magazine* being an unsigned article entitled 'The Black and Red Ants of Australia'. The original watercolours and drawings for the *Saturday Magazine* series represent a valuable record of early NSW. In later years a legend developed that Govett's Leap had been named after a bushranger chased to his death in a chasm. Annette Potts convincingly refutes this legend in her account of Govett's life published by Gaston Renard.

REP: Mitchell Library, Sydney; NLA (Nan Kivell collection).

BIB: Gaston Renard & Annette Potts, *Sketches of New South Wales by William Romaine Govett*, Gaston Renard, Melbourne, 1977. ADB 1. Kerr, DAA.

William Govett, Surveyor's Camp, 1835, watercolour, 19.2 × 30.1cm. Collection, Mitchell Library, State Library of NSW.

GOWER, Elizabeth Ann

(b. 28/10/1952, Adelaide) Painter.

STUDIES: Prahran CAE, 1970–73. Maintaining a commitment to abstractionism since she started exhibiting in the 1970s, her paintings are distinctive for their vibrancy emanating from interlocking straight-edged lines and shapes, forming works of detail yet overall cohesion. During the mid-1970s she began using textiles, creating large wall hangings using embroidery and multi-layered different-textured fabrics to create soft, flowing backgrounds with objects of everyday life painted or drawn often in minute detail. She held 17 solo exhibitions 1975–93 in Melbourne (Powell St 1977; Christine Abrahams 1980, 82, 83, 84; Lennox St 1987; Luba Bilu 1990; Sutton, 1993), Brisbane (Bellas 1991, 92) and Sydney (Central St 1976; Coventry 1981), and at Hawthorn City Art Gallery 1975; Ewing and George Paton Gallery, Uni. of Melbourne 1976; IMA, Brisbane 1982; QAG 1991. Her work was seen in a number of group exhibitions 1975–92 including *Lost and Found Objects and Images*, Ewing-Paton Galleries, Uni. of Melbourne, Oct. 1978; *Australian Perspecta*, AGNSW 1981, 85; *Recent Australian Painting: A Survey*, AGSA 1983; *Domestic Contradictions*, Power Gallery of Contemporary Art 1987; *Moet & Chandon Touring Exhibition*, 1988; *Off the Wall, In the Air*, Monash Uni., Melbourne 1991; *Inherited Absolute*, ACCA, Melbourne 1992. International exhibitions in which her work appeared include Belgrade and Venice 1984. Commissions she received include those for a painted tram for the Vic. Ministry for the Arts 1988;

World Congress Centre, Melbourne 1989; banners for the MCG Great Southern Stand; painting, foyer Southgate building, Melbourne 1992.

AWARDS: Lynch prize, Prahran CAE, 1973; VACB travel grant, 1975, special projects grant, 1978.

REP: AGNSW; NGV; regional galleries Ballarat, Sale, Shepparton.

APPTS: Lecturer, various art colleges, 1978– including painting, Uni. of Tasmania, 1985–86, 1987–89; senior lecturer, VCA, 1991– .

REP: NGA; AGWA; AGNSW; NGV; Artbank; Uni. of Qld; MOCA, Brisbane; regional galleries Ballarat, Newcastle, Sale, Shepparton.

BIB: *New Art Three*. McIntyre, CC. A&A 18/4/1981; 21/1/1983. *Meanjin* 3/1977. Janine Burke, *Field of Vision. A Decade of Change: Women's Art in the '70s*, Penguin, Vic, 1990. Sandy Kirby, *Sightlines: Women's Art and Feminist Perspective in Australia*, Craftsman House, 1992.

ing Praxis, Fremantle; the Museum of WA and Australian Centre for Photography. Her work was seen in group exhibitions 1983–90 including *Australian Perspecta* AGNSW 1985; *The Biennale of Sydney* 1987 and *Australian Sculpture Triennial*, Melbourne 1987.

AWARDS: Travel scholarship, UK 1974–75; grant WA Council 1976; grant VACB 1982.

REP: Parliament House; tertiary collections including WAIT, Perth Technical College; corporate collections including Transfield Collection and ICI Contemporary Art Collection.

BIB: Catalogue essays exhibitions as above.

GRAHAM, Anne Marie (née Haas)

(b. 17/1/1925, Vienna; arr. Vic. 1939) Painter, sculptor, lecturer.

STUDIES: Vienna, with Prof. Cizek; RMIT, 1939–43; NGV School, 1948; George Bell School, 1949–50;

Elizabeth Gower, Scatter, 1990, acrylic on canvas, 122 cm × 244cm. Private collection.

GRAHAM, Anne

(b. 1949, Buxton, Derbyshire. UK; arr. Aust. 1975) Sculptor, installation artist, painter.

STUDIES: Dip. Art and Design, Manchester Polytechnic, UK 1971; MA Royal College of Art, London 1973; postgrad. dip. ed., WAIT, 1983. Her early interests while at art college in the UK were those of set construction, performance art and creating total environments within which her performances became part of the whole. Her sculpture was described in the ICI collection catalogue thus: 'the iconography of her sculpture revolves around themes of sexuality, balance and aggression. She often employs phallic shapes with highly polished and sensuous surfaces, their erotic power enhanced by her choice of materials and by her use of colour.' She also turned to photography as a further medium for her work and held about 8 solo exhibitions 1983–90 at contemporary art spaces includ-

travel studies Europe (including lessons from Emilio Greco and Oscar Kokoschka), 1959. She lectured at the School of Architecture, Uni. of Melbourne, 1960–64. Her open line drawings and naive-sophisticate paintings have appeared in many exhibitions, including those in London, 1970, and Zurich, 1973. Her best-known commissioned sculpture is the fountain for the Southern Cross Hotel, Melbourne. She held over 30 solo exhibitions 1966–91 in Sydney (including Holdsworth), Melbourne (including a retrospective at Georges Gallery 1982), Canberra (Solander), Brisbane, Adelaide and Perth and at a number of regional galleries in NSW and Vic. including Benalla, McClelland, Shepparton. She went as the artist with the Uni. of Sydney archaeological survey on the Greek island of Andros 1970 and is a member of several artists' groups including CAS, *Essentialists*, *Figuratives Now*, and council of NGV Society 1965–67. She illustrated a number of book covers and books and her works have been made into greeting cards. A number of documentary films have been made on her work.

AWARDS: Italian Scholarship, 1959; Springbrook Prize, Qld, 1966; Jacaranda Art Prize, 1976; Carlo Levi Art Prize, 1976; Latrobe Valley Acquisitive Prize, 1976; Melbourne International Centenary Exhibition, 1980.
REP: AGWA; NGV; QAG; several regional galleries Vic., Qld; a number of tertiary collections.
BIB: Ronald Greenaway, *Paintings of Anne Graham,* Aldine Press, Melbourne, 1969. Elizabeth Young, *Figuratives Now,* Aldine Press, Melbourne, n.d. Bianca McCullough, *Australian Naive Painters,* Hill of Content, Melbourne, 1977. Lister & Williams, *Twentieth Century British Naive and Primitive Artists,* Astragal, 1977. *World Encyclopedia of Naive Artists,* Frederick Muller, 1988. Joan Ackland, *An Essential Vision: The Art of Anne Graham,* Greenhouse Publications, Melbourne 1988. Germaine, AGA. Germaine, DAWA.

GRAHAM, Peter Benjamin

(b. 4/6/1925, Melb.; d. 15/4/1987) Painter, printmaker.
STUDIES: Melb. Tech. Coll., 1939–46; Abbey Arts Centre, Herts., Eng., 1947–48. He studied lithography, served an apprenticeship in photogravure, worked in Sydney, 1951–53, Alice Springs, 1954–56, then in Fiji before returning to Melbourne where he established his own printing press in Queensberry Street, conducted a gallery on the premises, 1972–78 and assisted, as a committee member, in setting up the Victorian Printmakers Group. He exhibited with the Social Realist Group and the VAS 1944–47 and his work appeared in *Australia at War,* NGV 1945. He held five solo exhibitions 1960–78 largely at his own gallery in Carlton, Vic. Posthumous exhibitions of his work were held at Lyttleton Gallery, Castlemaine 1987; ROAR Studio2, Melbourne and Lyttleton Gallery, Melbourne 1992, 93. He worked as a graphic designer and conceived the idea of a visual notation system for painting, 'Notation Painting', which his sons Philip and Euan Graham continue. His early 1950s paintings of Alice Springs and the outback are of particular significance in showing a similar style made better-known and on a grander scale by painters such as Drysdale and Boyd who painted the same areas shortly after.
REP: Castlemaine, Mornington regional galleries.

GRAINGER, Percy Aldridge (George Percy)

(b. 1882, Brighton, Vic.; d. 1961, White Plains, New York) Musician, but also a painter.
STUDIES: Frankfurt, 1895–1901; London. To most people, the exhibition *Objects, Documents and Pictures selected from the Grainger Museum Collection* (Uni. of Melbourne Gallery, 1978) came as a revelation. It revealed that Australia's celebrated pianist and composer Percy Grainger was trained early in painting and drawing and for a time was undecided whether to devote himself to painting or music as a career. He began his professional career in music in London in 1901, moved to the USA in 1914 and 20 years later (1934) founded the Grainger Museum, Uni. of Melbourne. His early drawings and paintings, particularly, are delightfully imaginative and inventive.
BIB: Kay Dreyfus, introduction to catalogue *Percy Grainger Exhibition,* Uni. Gallery, Melbourne, Feb.–Apr. 1978.

GRANT, Gwendolyn Muriel (née Stanley)

(b. 1878, Ipswich, Qld; d. 1968, Brisbane) Painter.
STUDIES: NGV School, with Bernard Hall; Brisbane Tech. Coll. Grand-daughter of the Scottish artist Montague Stanley, and wife of William Gregory Grant. She painted landscapes, portraits and genre, and in 1914 was runner-up to Daphne Mayo in the Qld Wattle League travelling scholarship.
REP: QAG.
BIB: G. Stanley, 'Art Scholarships', *Daily Mail*, Brisbane, 5 July 1924. J. Sheldon, *Art in Brisbane.* AA series 3, no. 7, 6 Aug. 1939. Margaret Maynard and Julie K. Brown, *Fine Art Exhibitions in Brisbane 1884–1916,* Fryer Memorial Library, Uni. of Qld, 1980.

GRANT, Nancy

Painter.
STUDIES: NGV School, c. 1944; Melbourne Tech. Coll., c. 1945; George Bell School, c. 1945. She worked in munitions during World War II and after the war travelled and studied in India and Europe. She taught adult classes at the Beaumaris Art Centre and her work is known for its continuous output of spontaneous drawings in line and wash.
AWARDS: Student prizes at the NGV School.
REP: MPAC.

GRANT, William Gregory

(b. 1876, Brisbane, Qld; d. 1951, Brisbane) Accountant, painter.
STUDIES: Night classes conducted by Godfrey Rivers at Brisbane Tech. Coll. A trustee of the QAG, 1946–51, he married a painter, Gwendolyn Stanley. Grant's early work was conservative in style but changed somewhat after a visit to the tropic regions of Northern Australia. He illustrated Qld *School Readers*, was honorary treasurer of the QAS, and with his wife was among the Qld artists represented in the exhibition *Present Day Australian Art*, held in the Lower Melbourne Town Hall in Feb. 1945.
REP: QAG.
BIB: Vida Lahey, *Art in Queensland 1859–1959,* Jacaranda Press, Brisbane, 1959.

GRAY, Alastair Cameron

(b. 1898, Dunedin, NZ; arr. Aust. 1911; d. 1972, Melb.) Painter.
STUDIES: Uni. of Melbourne (grad. in Architecture, 1924); Melbourne, lessons in watercolour painting from Harold B. Herbert. Known mainly for watercolours, he was chief draughtsman for the Anglo American Mining Trust in South Africa, 1926. From c. 1950 he was a regular exhibitor at the VAS, of which he was secretary, 1956–59. His watercolours have the deft touch of a trained draughtsman and attain also a notable freedom and iridescence, the main theme being landscape, often with architecture.
AWARDS: Corio Art Society prize, 1958; VAS (watercolours), 1961; Bendigo (watercolours), 1962; VAS (Norman Bros prize), 1969.
REP: NGV; ANU, Canberra.

GRAY, Anne
(b. 12/9/1947, WA) Curator, writer.
STUDIES: MA, University of WA. She has curated a number of exhibitions and written a number of catalogues and texts for institutions by which she was employed. Books she has written include *Masterpieces of the Australian War Memorial* (with Gavin Fry), Rigby, Adelaide, 1982; *Letters from Smike: The Letters of Arthur Streeton* (with Ann Galbally), OUP, Melbourne, 1989; introduction to *Kenneth Jack: World War II Paintings and Drawings*, Boolarong, Brisbane, 1990. She contributed *Artists' Visions of Vietnam* to *Vietnam Days*, Penguin, Melbourne, 1991.
AWARDS: Winifred Cullis grant, 1973; scholarship for studies in the British Museum, 1991.
APPTS: Education officer, AGWA 1975–80; curator pre-1939 art 1980–83; senior curator of art, AWM 1983– .

GREEN, Charles Douglas
(b. 18/10/1953, Melb.) Painter, critic.
STUDIES: Dip. Art, NGV School, 1973; Dip. Ed., Melb. State Coll., 1980; BA Fine Arts (Fine Art), VCA, 1981; BA (Hons), Melb. Uni., 1987; travel studies Europe, North Africa, Asia, 1967–77; USA, Canada, India, Sikkim, 1984; USA, Europe 1988; USA, Canada, Europe, India, 1990; enrolled MA, Monash Uni. Coll., Gippsland, 1991– . A writer and critic as well as an artist, he held nine solo and joint (with Lyndall Brown) exhibitions 1979–92 at private galleries in Melbourne (Powell St 1979; Pinacotheca 1982, 85, 87, 89; William Mora 1991; 13 Verity St 1991) and Sydney (Annandale 1992) and at the Australian Centre for Photography 1991. Of their 1992 exhibition at Annandale Galleries, Sydney, Elwyn Lynn in the *Australian* (21 March 1992) commented: 'juxtaposition of the modern world as represented by smoke plumes, skyscrapers and other images of today . . . overlaid with ornately garbed figures reminiscent of the baroque era'. His work appeared in about 18 group exhibitions 1975–91 at private galleries in Melbourne (including Powell St, Pinacotheca) and Brisbane (Ray Hughes) and at public galleries including *Maps and Charts*, CAS Gallery, Adelaide 1980; *Seven Artists*, VCA 1983; *Bright Abyss*, George Paton Gallery, Melbourne Uni. 1987; *Images of Fantasy and Surreal*, Heide, 1991; *From the Landscape*, MOCA, Brisbane 1991; *Recently Seen: Recent Acquisitions for the NGV from the Margaret Stewart Endowment*, NGV 1992. He contributes to art magazines including *Art Monthly* and *Art and Australia*, and wrote a number of catalogue essays.
AWARDS: UNESCO AIEE National Award, 1971; Sir Lindsay Clark Award, NGV School, 1973; 50 artists Art/Craft, 1988, Melbourne; artist development grant, VACB, 1990; fellowship, VACB, 1992.
APPTS: Teaching foundation year, Prahran Coll. of TAFE, 1981; Victoria Coll., Prahran, 1990–91; fine art dept, Box Hill Coll. of TAFE, 1982– .
REP: NGV; MOCA, Brisbane; Artbank; Uni. of Western Sydney; World Congress Centre, Melbourne; corporate collections including Allen, Allen & Hemsley.
BIB: Catalogue essays exhibitions as above.

GREEN, Denise
(b. 1946, Melb.) Painter.
STUDIES: Sorbonne, Paris, 1969; MFA, Hunter College, NYC, 1976. Her abstracts have followed a similar style – overlapping circular motifs overlaid with squares, triangles and other geometric shapes and liberal use of vibrantly colourful oils – since the 1970s. Most arresting and intriguing are those which contain an element of mystery with feather-like brushstrokes of stronger colour marks on paler backgrounds. She lived and worked in NY and Australia from 1972 exhibiting widely and prolifically (over 45 solo exhibitions 1972–91) in New York and several other main US cities, as well as in Europe, India and Australia. Her major solo exhibitions included a project show at the AGNSW 1980; *Ellipses*, Anderson Gallery, Virginia, Commonwealth Uni., Richmond 1981; *Paintings and Drawings*, 1975–85, Centre for the Arts, Muhlenberg College, Allentown PA 1985. In Australia she exhibits in Melbourne (Christine Abrahams), Sydney (Roslyn Oxley9), Brisbane (Peter Bellas) and Perth (Delaney). Her work appeared in numerous group exhibitions 1972–92 at public galleries in the USA, including *Young American Artists*, Guggenheim NY 1978; *Surfaces/Textures*, MOMA, NY 1981; *Contemporary Still Lives*, MOMA 1982; *Emerging Artists 1978–86: Selections from the Exxon Series*, Guggenheim 1987; as well as numerous significant exhibitions in Australian public galleries including *Australian Perspecta 81*, AGNSW 1981; *Surface for Reflexion*, AGNSW 1986; *Window on Japan*, 1986; *Backlash: The Australian Drawing Revival*, NGV 1987; *Balance 1990: Views, Visions and Influences*, QAG 1990.
REP: NGA; AGNSW; NGV; QAG; Guggenheim, NY; MCA, Sydney; tertiary collections including Qld, NSW unis.; a number of corporate collections including American Can Co; First Bank, Minneapolis; Commodities Corporation, Minneapolis; Sony Corporation, NY; Chase Manhattan Bank, NY,
BIB: *Art in America*, Feb 1981 & July 1986. AI Sept, 1979. Chanin, CAP.

GREEN, Douglas A.
(b. 1921, Ballarat, Vic.) Painter, teacher.
STUDIES: Melb. Tech. Coll.; NGV School, c. 1944–47; George Bell School, 1946–47; London County Council School of Arts and Crafts; travel study in Europe. He returned to Australia in 1952 and worked first as an advertising designer, then as an art teacher with the Vic. Education Dept. Later he exhibited some *trompe l'oeil* paintings of plant forms. His work was seen in the Bicentennial exhibition *The Face of Australia*, and in *Classical Modernism: The George Bell Circle*, NGV 1992.
AWARDS: NGV Travelling Scholarship, 1947.
REP: NGV; Ballarat, Warrnambool regional galleries.

GREEN, James
See DE LIBRA

GREEN, Mike
(b. 1941, Auckland, NZ; arr. Aust. 1945) Painter.

STUDIES: Self-taught first, then School of Museum of Fine Arts, Boston, USA. He held 21 solo exhibitions largely of realist and semi-realist interiors 1975–91 in Melbourne (Australian 1978; Realities 1980, 85, 88; David Ellis 1991), Adelaide (Bonython 1979, 80, 83, 86) and overseas including Boston, USA (Clarke Gallery 1982, 84, 85, 87, 89) and NY (Kathryn Merkel 1986). Group exhibitions in which his work appeared 1984–88 include *Larry Rawlins, Printmaker*, ACCA 1987; *Interior Motives*, Westpac Gallery 1988; *Mitchelton Print Exhibition and Tour*, 1988.

REP: MPAC; corporate collections BHP, James Hardy, Freehill Hollingdale & Page, Wesfarmers, First National Bank of Boston.

GREEN, Olive Dutton

(b. SA; d. 1930, London) Painter. Known mainly for landscapes in watercolours, she left Australia as a child in the 1880s but exhibited in the 1911 *Federal Exhibition*. On her death, a watercolour prize was established under the terms of her will; among winners were Max Ragless and Dora Chapman.

BIB: Rachel Biven, *Some forgotten . . . some remembered*, Sydenham Gallery, Adelaide, 1976.

GREEN, Tom (Alfred Thomas)

(b. 16/6/1913, Warwickshire, Eng.; arr. NZ 1924; arr. Sydney, Jan. 1949; d. 27/1/1981) Painter, graphic artist, teacher.

STUDIES: Canterbury College of Art, NZ, 1929–30; Wellington Technical Art School, NZ, 1935; Julian Ashton School, Sydney, 1949–51, Orban School, 1950; travel studies UK and Europe, 1951–52. He taught at the NAS, Sydney, and the Uni. of NSW, 1961–70, and held joint exhibitions with Jean Appleton. His flat-pattern, abstract paintings and prints sometimes recall the visual metaphors of Max Ernst and Paul Klee. He participated in international travelling exhibitions of Australian art in both mediums. He held exhibitions 1963–78 in NSW, often at Macquarie Galleries and later Holdsworth, and joint exhibitions with Jean Appleton (q.v.) at Artarmon and Blaxland galleries in Sydney in the 1970s.

AWARDS: Prizes at Campbelltown, 1965; Grafton, 1966; Goulburn regional gallery.

REP: NGA; AGNSW; AGWA; several regional and tertiary collections Vic., NSW; Smithsonian Inst., USA.

BIB: Catalogue essays with joint exhibition with Jean Appleton, Langsam Galleries, Melbourne, Oct.–Nov. 1973. PCA, *Directory*. Germaine, AGA.

GREENAWAY, Ronald Leslie

(b. 11/6/1932, Melb.) Painter, author.

STUDIES: Swinburne Tech. Coll., 1950s; BA, Melb. Uni.; MA, Melb. Uni. Greenaway's paintings are strong in formal design and sometimes surrealistic in character. He held seven solo exhibitions 1953–69 mainly in Melbourne. His work was seen in group exhibitions in most capital cities 1953–78 and in travelling exhibitions to SE Asia and South Africa 1962. He was secretary of the CAS, Melbourne, 1961–63,

president 1963–65; editor of CAS broadsheet, and a member of the Australian Guild of Realist Artists and the VAS. He is the author of *The Paintings of Anne Graham*, Aldine Press, Melbourne, 1969.

AWARDS: Gold medal, Accademia of Italy, 1980; hon. life member, CAS, 1971.

REP: NGV; regional galleries including Newcastle, Swan Hill.

BIB: Elizabeth Young, *Figuratives Now*, Aldine Press, Melbourne.

GREENAWAY, Vic

(b. 1/10/1947, Sale, Vic.) Ceramicist.

STUDIES: Dip. Art, RMIT, 1967; with Ian Sprague, Mungeribar Pottery, Upper Beaconsfield, 1969–73; Japan, with Tatsuzo Shimaoka (two months), 1974. Following his time in Japan as the recipient of a Churchill Fellowship he established the Broomhill Pottery, Upper Beaconsfield, Melbourne, with the assistance of a Crafts Board grant. He has since trained a number of ceramicists on a one-to-one basis at the Pottery as well as teaching at colleges. He held 38 solo exhibitions 1968–93, including at Macquarie Sydney, Craft Centre, Clive Parry, Distelfink, Melbourne and in other capital cities and country centres. His work was seen in a number of invitational group exhibitions including *Australian Craft '83*, London, Hong Kong 1983; *Tachikichi Corporation*, Tokyo and Kyoto, Japan 1990, *Australian Design Academy*, SE Asian exhibition touring 1992; and in about 30 group exhibitions 1970–93 at private and public galleries including *Nine Potters*, McClelland Gallery 1974; *Ceramics 88*, Uni. of NSW 1988. He exhibited in numerous craft expos (with the Crafts Council of Australia) and award exhibitions including at the Meat Market, Vic. A member of numerous craft and art groups, and accreditation and examination committees for tertiary colleges, he has also been a visiting craftsman in numerous colleges in most Australian states and in the mid-1970s a teacher of pottery with the Australian Flying Arts School.

AWARDS: Kelvin award, 1966; Made in Australia design award, 1967; Shell award, 1972; Churchill Fellowship, 1974; VACB grants 1974, 75; Mayfair Ceramic award, 1976; Potters Cottage award, 1979; Fletcher Brownbuilt award of merit, 1980; BP Australia Ceramic Award 1980; Stuart Devlin Craftsman Award, ceramics 1981, 83.

APPTS: Teaching, ceramics, Footscray Inst. of Technology, 1968; CIT, 1969–70; Prahran CAE, 1971–77.

REP: NGA; NGV; QAG; QVMAG; Artbank; a number of regional galleries including Alice Springs, Ararat, Horsham, Newcastle, Sale, Shepparton, Langwarrin (McClelland Gallery); a number of tertiary collections including ANU, WAIT, Melb. Teachers Coll.

BIB: Catalogue essays exhibitions as above. Most books on ceramics in Australia including Janet Mansfield, *The Potter's Art*, Cassell, 1981; Allan Moult, *Craft in Australia*, Reed, 1984. Janet Mansfield, *A Collector's Guide to Modern Australian Ceramics*, Craftsman House 1991. Frequent illustrations/reviews *Craft Australia*, and other craft magazines.

(See also CERAMICS)

GREENE, Anne Alison

(b. 1878, Wynnum, Qld; d. 1954, Qld) Painter.
STUDIES: Brisbane Tech. Coll. with Godfrey Rivers; South Kensington Art School, London; Paris, with Edwin Scott. She was elected Associate of the Société des Beaux-Arts, 1924, Member, 1928. She spent the years of World War II in London, returned to Australia 1946 and held an exhibition in Brisbane.
REP: QAG.
BIB: Vida Lahey, *Art in Queensland 1859–1959*, Jacaranda Press, Brisbane, 1959.

GREENHALGH, Audrey Edith

(b. 1903, Ravensthorpe, WA) Painter.
STUDIES: Perth, with James Cook and Robert Campbell. Vice-president of the Perth Society of Artists (six times between 1948–61), she painted mainly semi-realistic seascapes and landscapes.
REP: AGWA; Fremantle City Art Gallery.
NFI

GREENHALGH, Victor E.

(b. 1900, Ballarat, Vic.; d. 1983, Qld) Sculptor, teacher.
STUDIES: Ballarat School of Mines, 1914 (studies interrupted by World War I); Working Men's College, 1919–22. He exerted great influence on tertiary art education, and was one of the first Vic. sculptors to adopt a modern style. His commissioned work includes the King George V statue, Ballarat, and portrait busts of eight Australian prime ministers for placement in the Ballarat public gardens.
AWARDS: Ballarat City Council scholarship, 1919; Commonwealth Jubilee prize for sculpture (Vic.), 1957.
APPTS: Teaching, Bendigo School of Mines, 1922; Ballarat School of Mines, 1927–37; RMIT, 1938–55, head of the art school, 1955–65.
REP: NGV; regional galleries Ballarat, Wagga Wagga.
BIB: Lenton Parr, *Sculpture*, Arts in Australia series, Longman, Melbourne, 1961. Sturgeon, DAS. Scarlett, AS.

GREENHILL, Harold

(b. 6/12/1914, Sydney) Painter, teacher.
STUDIES: RAS classes with Dattilo Rubbo, Sydney, 1934–39; NAS, 1943–44; travel studies UK, 1947–50; Europe, Iran, 1972; Europe, England, 1980. His best-known work is the compact, rather tightly composed figurative painting that won him the Sulman prize in 1950. He held an exhibition, *Art in the Family*, with Harold, Kay and Joy Greenhill, at Manly Art Gallery in 1983 and a retrospective exhibition at Woolloomooloo Gallery in 1990.
AWARDS: NSW Society of Artists Travelling Scholarship, 1942; Sulman prize, 1950, 56; prize in Dunlop competition, 1952.
APPTS: Teaching at NSW Dept of Education schools, 1954–60; lecturing, Alexander Mackie CAE, 1961–74.
REP: AGNSW; NGV; AWM; Newcastle regional gallery; Manly Art Gallery; Armidale City Art Gallery.

GREENWAY, Francis Howard

(b. 20/11/1777, Gloucestershire, Eng.; arr. NSW 1814; d. 1837) Architect, painter. He was employed in Britain as an architect but seems not to have had a building completed, although some drawings appear to have been exhibited in the 1800 RA exhibition. He was accused of forging a document and transported for 14 years. In Sydney he was lucky to have been present when Governor Macquarie needed a trained architect to undertake projects for the new colony. He designed a number of outstanding buildings including Hyde Park Barracks, St Luke's, Liverpool and St James's, Sydney. A self-portrait believed strongly to be by Greenway is in the Mitchell Library, although few other works can be definitely attributed to him. His architectural career fell out of favour due to excessive demands he made for payments and an arrogant personal manner.
BIB: AA no. 10, 1921 (special number *The Macquarie Book*). M. H. Ellis, *Francis Greenway; His Life and Times*, Shepherd Press, Sydney, 1949. *Australian Encyclopaedia*, Angus & Robertson, Sydney, 1958; Morton Herman, *Early Colonial Architecture*, Arts in Australia series, Longman, Melbourne, 1963. ADB 1. Kerr, DAA.

GREENWOOD, Edward Alister

(b. 1930, Melb.) Painter, illustrator.
STUDIES: RMIT, 1959. Craft critic for the *Age*, Melbourne, 1977–81. The colours in his paintings, exhibited Argus Gallery, Melbourne, 1963, resemble those in Pompeian frescoes.
APPTS: Lecturer, Toorak Teachers Coll., 1960–68.
REP: AGWA.

GREGORY, Arthur Victor

(b. 1867, Melb.; d. 1957, Melb.) Painter. Second son of G. F. Gregory, younger half-brother of G. F. Gregory Jnr. He began taking small commissions for ship portraits as a boy, while assisting his father and half-brother with large compositions, the father sketching in the work, the boys colouring in the sea and sky and the father adding the finish. A. V. Gregory's reputation had been established in Melbourne by the early 1880s and he continued producing ship portraits in great numbers for the next fifty years. This specialisation limited his possible development and he rarely went beyond representation of the ships' profiles. His seas and skies are often over-dramatised. He inherited his father's business c. 1890, eventually to leave a valuable record of the maritime traffic on Port Phillip Bay, ferries, cargo ships, liners all being painted with careful attention to detail. Photographic competition does not seem to have affected him and in the 1920s business was brisk, especially in respect to the last phase of the wheat and wool ships, many from Scandinavian countries where some of his works are still held in collections. He retained all his working sketches and was thus enabled to repeat earlier watercolours and make numerous copies of the same ship. For security reasons he ceased painting during World War II and finally retired from business in 1948. Inexplicably he died in greatly reduced circumstances in 1957.

(Information from Peter Williams, secretary of the Maritime Trust, Melbourne, 1980)

GREGORY, Bill (William A.)
(b. 1942, Windsor, Eng.; arr. Aust. 1966) Sculptor, teacher.
STUDIES: Loughborough Coll. of Art, UK, 1961–64. His imaginative sculptures and ceramics are inventive and he has become well-known as an art lecturer.
AWARDS: Law School sculpture prize, Monash Uni., 1970; VACB grant, 1975.
APPTS: Teaching (ceramics), Dept of Fine Art, Uni. Newcastle-upon-Tyne, 1964–66; ceramics, SASA, 1966–68; lecturer, Bedford Park CAE, Adelaide, 1969–70; designer with Inter Erg Design Group, Melbourne, 1970–73; lecturer, Preston Inst. of Technology, 1975–c. 1980s; RMIT, 1980s– , head of dept, 1989– .
REP: AGNSW; AGSA; Monash Uni.
BIB: Scarlett, AS.

GREGORY, Charles
(b. 1850, London; arr. Aust., 1851; d. 1920, UK.) Painter. He spent 22 years of his early life in Australia and was a founding member of the Victorian Academy of Fine Arts in 1870, before returning in 1873 to London to study at the RA Schools. He produced a large volume of work while in Australia including watercolours of marine subjects (a large collection of which is in the La Trobe Library) and also painted birds.
REP: AGNSW; AGSA; NGV; TMAG; La Trobe Library.

GREGORY, Charles Dickson
(Active from c. 1890, Melb.) Painter, jeweller. He worked for the business firm of Alfred Felton (q.v.). Known for marine paintings, most of his paintings of ships were done for pleasure. There are similarities of style but his work lacks the finish of G. F. Gregory. The two were not related.
(Information supplied by Peter Williams, secretary, Maritime Trust, Melbourne, 1980)

GREGORY, George Frederick
(b. Eng.; arr. Aust., 1852; d. c. 1890, Melb.) Painter. He served in the Royal Navy as a boy then sailed to China on the *Nemesis* of which he made several paintings. Arriving in Port Phillip Bay in 1852, he jumped ship to join the gold-rush but had no luck on the fields. However the increase in shipping brought a demand for marine pictures and he was able to make a living painting ship portraits, port scenes, naval vessels and reviews as well as historical scenes of battles. His business in Melbourne grew to include huge numbers of photographic reproductions of his watercolours, originals going to captains or owners and photographs to the crew. His paintings of Port Phillip Bay have historic interest, to which is often added a fine sense of composition and atmosphere achieved without compromise of accuracy. However his work is repetitive and fine large paintings such as those depicting the

visit of HMS *Galatea*, ships of the Victorian navy and views of early Williamstown tend to be exceptions rather than the rule. G. F. Gregory had two sons (by different wives), A. V. Gregory who inherited the business, and G. F. Gregory Jnr who worked in Melbourne until c. 1890 then moved to Adelaide and thence to Sydney. The Gregory family make an interesting group of specialist marine painters somewhat similar to the Jacobsen father and son, active in New York, c. 1880–1920.
BIB: E. Craig, *Australian Art Auction Records*, Sydney 1982. Kerr, DAA.
(Original information supplied by Peter Williams, secretary, Maritime Trust, Melbourne, 1980)

GREGORY, Ina (Georgina Alice)
(b. 18/10/1874, East Melb., d. 1964, Melb.) Painter.
STUDIES: NGV School c. 1893–c.1898; Melbourne School of Art with Fox and Tucker 1890s; summer school *Charterisville*, Melb. She exhibited at the VAS, 1898–1912, initially showing portraits, and later, impressionistic bush landscapes and lush green garden scenes. She produced book illustrations with Violet Teague (q.v.), another *Charterisville* student, and contributed to the First Australian Exhibition of Women's Work in 1907. She wrote a novel, *Blue Wings*, referring to her days as a student at the Melbourne School. She lived largely with her sister Ada and in later life shared her house with artist Jane Price (q.v.). Few of her works have been traced.
REP: Castlemaine Museum and Art Gallery.
BIB: Moore, SAA.

GREGSON, Thomas George
(b. 1798; d. 1874) Politician, painter, cartoonist. This leading Hobart politician and advocate for the liberty of the press exhibited his paintings in early exhibitions in Hobart, 1845, 1846, and contributed cartoons to Tasmanian *Punch*. An equestrian sketch of the Rev. Knopwood, first chaplain of Van Diemen's Land, by Gregson, is in the Beattie Collection, Launceston.
REP: QVMAG.
BIB: *Australian Encyclopaedia*, Angus & Robertson, Sydney, 1958. Marguerite Mahood, *The Loaded Line*, Macmillan, 1973. ADB 1. Kerr, DAA.

GREIG, Edward Jukes
(b. 1839, Melb.; d. 4/10/1864, Sydney) Cartoonist, illustrator. He painted in Melbourne in the 1850s and 1860s and became the first cartoonist for Sydney *Punch*. He was appointed in 1864, but drowned in Sydney Harbour a few months later. His last cartoon appeared 8 Oct. 1864 and his 'epitaph' was published in *Punch* the following week, lamenting the loss of 'the hand that erst adorned this page, whose pencil featly swayed the limner's art'.
REP: Mitchell Library.
BIB: Marguerite Mahood, *The Loaded Line*, Macmillan, 1973. Kerr, DAA.

Guy Grey-Smith, South of Roebourne, 1961, oil on board. Private collection.

GREIG, Mary Augusta

(b. 1845, Hobart; d. 1917, Launceston) Painter.
STUDIES: With Samuel Prout Hill, and Robert Beauchamp, Tasmania. President of Launceston Art Society and a member of the Tasmanian Art Society, Hobart. Work by Mary Greig was included in the *Panama Exhibition*, San Francisco, 1914.
REP: TMAG.

GREN, Nils A.

(b. c. 1893, Norway) Painter.
STUDIES: Sydney, with Dattilo Rubbo, c. 1914–18. He migrated to the USA, 1918.
REP: AGNSW.
BIB: Kroeger, AA, Renniks, Adelaide, 1968.
NFI

GREY, Frederick Millward

(b. 1899, London; d. 1957) Etcher, teacher.
STUDIES: Central School of Arts and Craft, London. While living in London he worked as a guide for American tourists visiting art galleries. An exhibiting member of the Australian Painter-Etchers' Society, he belonged also to the American Bookplate Society

and the Designers and Collectors Society, Washington.
APPTS: Teacher, then director, School of Fine Arts, Adelaide (c. 1923); principal, SASA, 1946–56.
BIB: F. Millward Grey, 'Art in South Australia', *Australian Art Annual*, Ure Smith, Sydney, 1939. Moore, SAA.

GREY, (Sir) George

(b. 1812, Portugal; d. 1898, Eng.) Explorer, governor of SA; painter. An amateur artist of distinction, he illustrated in part his *Journals of Two Expeditions of Discovery in North-West and Western Australia*, 1837–39. He discovered the rock-paintings at the Glenelg River near Hanover Bay, WA, in 1837. Official artist during Grey's later expeditions in SA was George French Angas (q.v.).
BIB: *ADB* 1. Kerr, DAA.

GREY-SMITH, Guy Edward

(b. 1916, Wagin, WA; d. Aug. 1981, WA) Painter, printmaker, ceramicist.
STUDIES: Chelsea School of Art, London, with Ceri Richards, Robert Medley and Henry Moore, 1945–47; pottery at Woolwich, with Hebe Matthews; fresco at Central School of Arts and Crafts, with Louis Le Brocquy, 1952–54. While serving in World War II as a RAAF pilot he transferred to the RAF and was shot down over Germany and imprisoned, an experience that left him with tuberculosis. During convalescence in London he began painting. He married a colleague student (Helen) in London and returned to WA in 1947. Grey-Smith's journeys across the Nullarbor and to the sparsely settled regions of the north-west made him a skilled bushman with first-hand knowledge of some of Australia's most interesting country, the effect on his painting being to give freshness and brilliance to colour that seemed to derive from the natural flora, and later, from the desert itself. The AGWA held a retrospective of his work in 1976 and by 1980 his painting and graphic art had gained in breadth, resonance and freedom. His work at the time of his death was achieving considerable recognition and it continues to be well regarded although rather more in art circles than popularly.
AWARDS: Perth prize (for WA entries), 1955, 63; Murdoch prize, 1959; Robin Hood prize, Sydney, 1962; Perth Prize (open), 1964; VACB grant, 1974; Georges Invitation Art Prize, 1978.
REP: NGA; AGWA; Swan Hill and other regional galleries.
BIB: References in most standard Australian art books. A&A 15/1/1977; 20/2/1977. AN no. 5, Autumn–Winter, 1982 (obit).

GREY-SMITH, Helen Dorothy

(b. 26/5/1916, Coonor, S. India; arr. Aust. 1947) Painter, printmaker.
STUDIES: London College of Design, 1937–39; Hammersmith School of Art (textile printing), 1952–53. She first gained distinction for her printed textiles and from 1954 for her serigraphs. She was married to Guy Grey-Smith with whom she exhibited regularly from 1954 until his death in 1981. One of her

commissions included 914 metres of textiles for the Council House, Perth.

REP: AGNSW; QAG.

BIB: PCA, *Directory*.

GRIER, Louis (Monro)

(b. 1864, Melb.; d. 1920, St Ives, Cornwall) Painter. Known for landscapes and beach scenes, usually in oils. He left Australia when young, was educated in Toronto and London, lived in England for most of his life and worked mainly as a teacher at St Ives, exhibiting at the RA, 1888–1918, and Paris Salon, 1891. He was in Australia in 1892 when he exhibited Yarra landscapes at the VAS.

AWARDS: Medal, Paris Salon (for his painting *The Night Watch*).

BIB: Grant M. Waters, *A Dictionary of British Artists Working 1900–1950,* Eastbourne Fine Arts, Eastbourne, 1975.

GRIERSON, Maxwell Donald

(b. 23/10/1941, Melb.) Painter, printmaker, teacher. STUDIES: RMIT, 1963; BA, TSTC; SATC; grad. dip. ed. Work by Grierson was included in the Australian Print Survey exhibition which toured the Australian state galleries, 1963–64. He held two solo exhibitions in Melbourne, 1967 and 1983, and his work was seen in four group exhibitions in Victorian country centres and Melbourne, 1963–82.

APPTS: Secondary art teaching Vic., 1963–66 and 1970–82; Inner London Education Authority, 1967–70; Melb. School of Art, 1983–84; head of art, Caulfield Grammar School, 1985– .

GRIEVE, Alan Robert Colquhoun

(b. 22/4/1910, Manly, NSW; d. 22/3/1970) Painter. STUDIES: Julian Ashton School, Sydney; ESTC, and with Herbert Badham, 1928–34. Painter of landscapes and harbour scenes, he exhibited with the RAS, Sydney, c. 1947, and was vice-president of the Australian Art Society.

AWARDS: Prizes in exhibitions at Rockdale, 1956; Taree, 1957; *Mirror*-Waratah Festival, 1961.

REP: AGNSW.

BIB: *Australian Art Illustrated*, RAS, Sydney, 1947. Badham, SAA.

GRIEVE, Bob (Robert Henderson)

(b. 30/11/1924, Melb.) Painter, printmaker, teacher. STUDIES: Regent Polytechnic, London (lithography with H. Trivick). He spent some time in Japan, held an exhibition in Tokyo and took part in international print biennials (1960 and 1962). His work is distinguished by a harmonious fusion of Japanese with modernist European influences and includes elements of calligraphy and a use of subtle colours and rhythmic abstract forms. His prints are notable for their complex use of colour. He held about 25 solo exhibitions 1962–90 in most Australia capital cities, most recently at David Ellis/Lyall Burton, Melbourne and Holdsworth, Sydney. He participated in many group exhibitions, notably international print surveys in Tokyo, New York, California and SE Asia.

AWARDS: Prizes in exhibitions at VAS, Melbourne (Cato prize), 1960; Adelaide (Vizard-Wholohan, for prints), 1959; Gundagai, 1960; Wollongong, 1962; Portland, 1962; CAS Prize, 1963; Bendigo (watercolour), 1964; Geelong, 1965; Warrnambool (print acquired), 1971, 76; Maitland, 1971, 72; Mornington (MPAC *Spring Festival of Drawing*, drawing acquired), 1975; Gold Coast (painting acquired), 1976; Gold Coast Print Prize, 1979; Diamond Valley Art Award, 1983; Toowoomba Purchase Award, 1984.

APPTS: Teaching, lithography, Swinburne Tech. Coll., 1956–58.

REP: NGA; most state galleries and many regional galleries NSW, Vic., Tas; tertiary collections Vic., SA; Mertz Collection, Washington; NZ public collections; Art Museum, Vilnius, Lithuania.

BIB: Ronald Millar, *Civilized Magic*, Sorrett Publishing, Melbourne, 1974. Franz Kempf, *Contemporary Australian Printmakers*, Lansdowne 1976. Smith, AP, 1990.

GRIFFEN, Peter

(b. 30/7/1948, Adelaide) Painter. STUDIES: Dip. Teaching and Advanced Dip. Teaching, Sturt CAE, SA, 1969 and 1972; BA Visual Arts, City Art Inst., 1985; postgrad. dip. studies, City Art Inst., 1986; travel studies Europe, 1980; USA, Europe, 1990–91. He curated several exhibitions for Holdsworth Gallery, Sydney in the 1980s and was director of Flight Gallery, SA, 1977–80. Sasha Grishin, in the *Canberra Times*, Aug. 1991, describes his work: 'he has always worked on the edges of the art establishment acquired by the private sector rather than public galleries . . . he works in . . . abstract-expressionism as mainly applied to landscape . . . the expressionist virtues of spontaneity, the emotionally charged brushwork and the portrayal of energy are all central concerns.' He held 13 solo exhibitions 1975–91 in Sydney (Holdsworth 1987, 89, 91), SA (Vargas 1975; Flight 1978, 80; Greenhill 1988) and Canberra (Solander 1991), and at Orange Regional Gallery 1990 and Paris, France 1991. His work was seen in about 28 group exhibitions 1972–92 at private galleries in NSW, SA and many regional prize exhibitions as well as *Sulman Prize*, AGNSW 1989 and overseas exhibitions including *Biennale International du Pastel*, France 1990; *Lineart*, Ghent Art Fair, Belgium 1991.

APPTS: Secondary teaching (maths, geography), SA, 1973–80; part-time secondary teaching (maths, art, science), NSW, 1982–88.

REP: Regional galleries New England, Muswellbrook; corporate collections including Westpac, Potter Partners, Park Royal, Regent, Hyatt Coolum; Massachusetts Education Dept, USA.

GRIFFIN, Ambrose Sylvester

(b. 1912, Vic.) Painter. STUDIES: NGV School; also with Septimus Power. Member of the RAS of NSW. His representational paintings of landscapes, many with animals, achieved popularity, mainly in Vic.

REP: AGNSW.

GRIFFIN, Jane L.
Painter. A member of the Art Society of NSW from 1886– .
REP: AGNSW (two pictures presented by J. G. Griffin, 1918).
NFI

GRIFFIN, Murray (Vaughan Murray)
(b. 1903, Vic.) Painter, graphic artist, teacher.
STUDIES: NGV School, 1919–23. He spent three and a half years as a POW in Malaya, recording this experience in the series of drawings exhibited on his return. Best-known for his colourprints (mainly of birds and animals), they helped to form a bridge between modern and pre-World War II printmaking in Vic. A sympathetic teacher, he had much influence on his students. His work appeared in *A Survey of Australian Relief Prints*, Deutscher Galleries, Armadale, Vic., 1978 and with Eastgate Gallery, Melbourne in the 1980s and 90s.
AWARDS: Prizes in exhibitions at Ballarat (Crouch prize), 1935; Geelong (F. E. Richardson prize), 1939; Melbourne (Dunlop prizes), 1952; Adelaide (Vizard-Wholohan).
APPTS: Teaching, Scotch Coll., Hawthorn, Vic., 1934–36; RMIT, 1936–40; official war artist, Malaya, 1941–45; teacher of drawing, NGV School, 1946–53; senior lecturer, RMIT, 1954– .
REP: AGSA; NGV; AWM; regional galleries Ballarat, Geelong.

GRIFFIN, Walter Burley
(b. 24/11/1876, Maywood, Chicago; arr. Aust. 1913; d. 13/2/1939, India) Architect. Designer of Australia's federal capital, Canberra. In the USA he worked for Frank Lloyd Wright's company, 1900–05, formed his own company, and in 1912 won a competition to design the city of Canberra. His wife, Marion (née Mahony), was his artist, drawing up many of his plans on silk. Apart from his Canberra work, his controversial designs earned him a special place in the history of Australian architecture. His last commission was for a building in India where he died in 1939. A commemorative touring exhibition of his work, with many designs drawn by his wife, was organised and held at the NGV and toured in 1979–80.

GRIFFITH, Pamela Ann
(b. 26/8/1943, NSW) Painter, printmaker, teacher.
STUDIES: NAS and Sydney Teachers Coll., 1961–64; B. Art Ed., Alexander Mackie CAE, 1983; travel studies Europe, 1972–73, 1981–82. Her work was seen in numerous group print survey exhibitions 1980–92, mainly in private galleries in Sydney, and with the PCA. She is involved in art teachers' associations and syllabus committees for Art Teachers Association and Education Dept, NSW, and was artist-in-residence at Bundaberg Art Gallery. Commissions include portraits commissioned by the Great Synagogue, the Australian Youth Orchestra, and the Joan Sutherland Society (an etching, 1992).

AWARDS: Rotary Vocational Service Award.
APPTS: Secondary school teacher, tech. coll. teacher; lecturer, Sydney Inst. of Advanced Education; guest lecturer, institutions and service clubs.
REP: NGA; AGNSW; Parliament House; Artbank; regional galleries Bathurst, Bundaberg, Tamworth, Wollongong; Uni. of NSW; Macarthur and Riverina CAEs; La Pérouse Museum, France; corporate collections including Regent Hotel, Sydney; Hilton Hotel, Cairns; Jupiters Casino, Brisbane; Commonwealth Bank; AMP; Qantas; Nissan Australia; Advance Bank; RACV.
BIB: *New Art One*. PCA, *Directory*. Germaine, AGA.

GRIFFITH, William
(Arr. Sydney, 1838; d. 1870) Painter.
STUDIES: Studied in France. In 1839 he married Susan Duffus, sister-in-law of a Polish count, Lucien de Broel Plater, who may have arrived in Sydney on the same ship in 1838. Described by William Moore as 'the pioneer painter of Parramatta', he received a record price (£200) for a large portrait of Sir William Westbrook Burton. However his success was shortlived. The introduction of the daguerreotype wrecked his practice as a portrait painter and he ended his life in poverty. His work was represented in *Australian Colonial Portraits*, AGDC touring exhibition 1979, and *The Artist and the Patron*, AGNSW 1988.
REP: AGSA; Mitchell Library.
BIB: Moore, SAA. Eve Buscombe, *Artists in Early Australia and their Portraits*, Sydney 1978. Kerr, DAA.

GRIFFITHS, Harley
(b. 3/6/1878, Brighton, Vic.; d. 21/12/1951) Painter.
STUDIES: NGV School (with Hall and McCubbin) 1894–99. Griffiths exhibited regularly with the NSW Society of Artists from 1907; his work was included in the exhibition *150 Years of Australian Art*, Sydney 1938. He shared a studio in Melbourne with Max Meldrum in 1914 and was joint manager with Julian Ashton and Hardy Wilson of the Fine Arts Society, Sydney, 1911–14. His son, Harley Cameron Griffiths, became a painter and conservator.
REP: AGNSW; AGSA; Parliament House; Castlemaine regional gallery; Wellington Gallery, NZ.
BIB: AA, no. 4 1918, refs and reprdns.

GRIFFITHS, Harley Cameron
(b. 13/4/1908, Sydney; d. Apr. 1981) Painter.
STUDIES: Melbourne (with A. D. Colquhoun); travel studies Europe and UK, 1950, 55, 60, 68. A son of Harley Griffiths Snr, he held intermittent exhibitions in Australian capital cities from 1933 to the mid-1970s, as well as showing with groups such as the Twenty Melbourne Painters. His careful interiors and still-life paintings show admiration for the work of the Dutch masters. He wrote *The Literary Parasites of Art*, Lowden Publishing Co., Kilmore, Vic., 1980.
AWARDS: Bendigo prize, 1946; J. H. McPhillimy prize, Geelong Art Gallery, 1947; Dunlop prize (shared second place), 1954; Nuffield Foundation grant for

conservation study overseas, 1950; life membership, NGV, 1977.

APPTS: Adviser on conservation of painting, NGV, 1950–77.

REP: NGA; AGNSW; AGSA; QAG; regional galleries including Bendigo, Castlemaine, Geelong; National Gallery of NZ, Wellington.

GRIGG, May (Mabel)

(b. 1885, Adelaide; d. 1969) Painter.

STUDIES: SASA, with H. P. Gill; SA, with Hans Heysen, 1904–07; travel studies in Europe; Adelaide, with Margaret Preston. An exhibiting member of the RSASA, 1915–30, she painted portraits, landscapes and still-life in a post-impressionist manner.

APPTS: Teaching (privately in her Adelaide studio); senior art teacher, Ballarat School of Mines, 1930–46.

AWARDS: Melrose prize, 1921, 22.

REP: AGSA.

BIB: Rachel Biven, *Some forgotten . . . some remembered*, Sydenham Gallery, Adelaide, 1976.

GRIMSHAW, John Atkinson

(b. 1836, Leeds; d. 1893) Painter. He visited Australia for health reasons and is believed to have painted about four pictures while visiting – notably *A View of Collins Street* (private collection).

BIB: Christopher Wood, *Dictionary of Victorian Painters*, Antique Collectors Club, London, 1971.

GRIMWADE FAMILY

In the area of patronage, collecting and practical administration, the Grimwade family has traditionally given strong support to the arts, principally through long association with the NGV. Alfred Felton's partner, the Hon. F. S. Grimwade, was chairman of the first Felton Bequest Committee in 1904. Maj. Gen. H. W. Grimwade and Norton Grimwade served on the same committee, as did Sir W. Russell Grimwade, chairman for many years. All made valuable gifts to the NGV and other public collections, as did Lady Grimwade, who also made the initial large cash donation to the building fund for the new NGV in St Kilda Road. Sir Andrew Grimwade, a member of the Felton Bequest Committee, became a member also of the NGV Committee of Trustees and was chair of the NGV Trustees 1979–92.

BIB: Leonard B. Cox, *The National Gallery of Victoria 1861–1968*, NGV, Melbourne, 1970.

GRISHIN, Sasha

(b. 18/4/1950, Vic.) Art historian, critic.

STUDIES: BA (Hons), Uni. of Melb.; MA, Uni. of Melb.; postgrad. studies, Universities of Moscow, Oxford, Harvard, Courtauld Inst.; PhD, ANU. He established the Fine Art program at ANU in 1977, which became Dept of Art History in 1987. He wrote several major books on Australian artists including *Genesis: The Seven Days of Creation by Leonard French*, Heidelberg Company, Melbourne, 1984; *The Art of John Brack*, 2 volumes, OUP, 1990; *S. T. Gill's Doyle Sketchbook*, Mitchell Library,

1993; *Andrew Sibley: The Divided Image*, Craftsman House, 1993. He contributed to many art journals and magazines and was art critic for the *Canberra Times*, 1977– .

APPTS: Melb. Uni. Fine Art Dept; art history, ANU 1977– .

GRITTEN, Henry C.

(b. 1818, Eng.; arr. Aust. 1853; d. 15/1/1873, Launceston.) Painter. The son of a London art dealer, he exhibited extensively in London at the RA, British Inst. and Society of British Artists, 1835–49, showing mainly landscapes. By 1853 he was at the Bendigo goldfields, having travelled via the USA, and possibly via the Californian goldfields. He dug for gold in Ballarat before visiting Tas. where he painted oils and watercolours of Hobart and the Derwent. He visited Sydney, c. 1854 and lived in Hobart and Launceston, Tas. c. 1858–63 but was back in Melbourne later in 1863 where he contributed views to Troedel's *Melbourne Album*, 1863, and over the next years painted views of the city and surrounding area *(Hanging Rock, 1867)* and central Vic. *(Crossing the Goulburn 1868)*. He was a founding member of the Victorian Academy of Arts in 1870, exhibiting a Rhine river landscape (presumably from an early sketch) and views of Melbourne. However he did not exhibit again and died two years later, having suffered all his life from epilepsy. His style is typical of his period and he was well regarded in his day, one of his works being accepted as a gift to the NGV in 1866. Today his paintings are also seen as having historical and topographic interest. He occasionally worked from other painters' sketches, and is known to have done several versions of the same painting a number of times – his views of Sydney, Hobart and Melbourne all exist with different dates and in varying forms. He was represented in *Australian Art in the 1870s*, AGNSW 1980; *Tasmanian Vision*, TMAG & QVMAG, 1988; *The Artist and the Patron*, AGNSW 1988.

REP: Most Australian state galleries; La Trobe Library; NLA.

BIB: McCulloch, AAGR. John Cato, *The Mechanical Eye in Australia*. Kerr, DAA.

GROSMAN, Barbara

(b. 18/9/1944, Georgia, former USSR; arr. Aust. 1958) Painter.

STUDIES: Dip. Art, Swinburne Tech. Coll., 1964. She lived in Lodz, Poland, from 1946. Married to painter John Hopkins (q.v.), she held her first exhibition at Osborne and Polak Gallery, South Yarra, 1971, and participated in Georges Invitation Art Prize, Melbourne, 1973. Her surrealistic paintings of machine-like shapes later appeared in group exhibitions, notably *Five Women Painters*, MPAC 1971. She has taught at several Victorian art schools 1975– including VCA; Chisholm Inst. She held four solo exhibitions in Melbourne 1971–90 and participated in a number of group exhibitions at private and some public galleries 1969–93 including *Still Life: Eight Women Realists*, VCA gallery 1978; *Australian Art of the Past 10 Years*, NGA 1982; *Modern*

Australian Paintings, Charles Nodrum Gallery 1989; *Contemporary Mornington Peninsula Artists*, MPAC 1992; *Still Life*, Heide, 1993. She was artist-in-residence, VCA, 1978.

AWARDS: MPAC Acquisition Festival of Drawing, 1979; Sheila Kirk Award for Drawing, 1983.

REP: NGA; Artbank; MPAC; several tertiary collections Vic.; ICI corporate collection.

GROSSE, Frederick

(b. 1838; d. 1894) Artist, vintner. He engraved and published Chevalier's drawings and paintings of Bendigo, became government engraver and held that position until Black Wednesday (8 Jan. 1878), so called because of the drastic purge of the Civil Service by the Berry administration. Grosse then turned to wine growing but in 1893 phylloxera 'was discovered in Grosse's Toowonga vineyard at Emu Creek', and his vineyard was destroyed.

BIB: McCulloch, AAGR. Marguerite Mahood, *The Loaded Line*, Melbourne 1973.

GROUNDS, Joan Dickson

(b. 31/8/1939, Atlanta, Georgia; arr. Aust. 1968) Sculptor.

STUDIES: Newcomb College, New Orleans, 1957–62; Uni. of California, Berkeley, Cal., 1962–66. She exhibited ceramics and sculptures (sample bags with contents) at Watters Gallery, Sydney, 1972 which were described by critic Donald Brook as 'the most amusing, most elegant, most inventive ceramic sculptor for some distance'. She branched out into installations and films as part of her work which continues to include ceramics as well as a variety of other media.

AWARDS: VACB grant 'to participate in *Biennale de Jeunes*', Paris, 1976–77.

REP: NGA.

BIB: Scarlett, AS.

GROUNDS, Marr Roy

(b. 1930, Los Angeles; arr. Aust. 1968) Sculptor, lecturer. STUDIES: B. Arch., Uni. of California, Berkeley, 1965; MA (sculpture), Uni. of California, 1966; teaching certificate, California Junior Coll., 1966. He exhibited extensively in California and visited Australia three times before settling there in 1968. From 1973, he showed abstracts, conceptual works and video at the *Mildura Sculpture Triennial* (including a large earth structure). He held about 15 individual exhibitions including at Avago Gallery, Los Angeles and Sydney; Ivan Dougherty Gallery and Watters, Sydney. He participated in numerous group exhibitions 1964–92 in the USA, Australia and Germany including video and installation performance art. The exhibitions include *Australian Video Art Festival*, Centre for Art & Communications, Buenos Aires, Argentina 1979; *Perspecta*, AGNSW 1981, 83; *Contemporary Art in Australia: Australian Art in the Last 20 Years*, MOCA, Brisbane 1988; *Off the Wall, In the Air*, Monash Uni. and ACCA 1991; film and video festivals in several capital cities. He has made approximately 16 films.

AWARDS: VACB grants, 1975, 76, 78, 80, 81, 82, 84; resident artist, Australian studios, Cité Internationale des Arts, Paris, 1977; New York City, 1977; Künstlerhaus Bethanien, Berlin, 1982.

APPTS: Lecturer in architecture, Kumasi, Ghana, 1966–68; senior lecturer in architecture, Uni. of Sydney, 1968–86.

REP: NGA; most state galleries; Parliament House; MOCA, Brisbane; several tertiary collections NSW, Vic.

BIB: Catalogue essays exhibitions as above. Paroissien, AAR, 1982. Sturgeon, DAS. Scarlett, AS. A&A 14/3/1977; 14/4/1977.

GROVE, James

(b. 1769; arr. Hobart 1804; d. 1810, Hobart) Painter, engraver. Sentenced to death, commuted to transportation for life, for forging Bank of England notes in 1801, Grove received favoured treatment because of his talents, disposition and subsequent exemplary behaviour. Taking with him his wife and child, he left England in the *Calcutta* (Apr. 1803), with Lieut.-Governor Collins on the expedition to found a settlement at Port Phillip. Collins soon moved the expedition from Port Phillip to Van Diemen's Land there to found the city of Hobart. Grove had become Collins' devoted friend and the friendship extended to the chaplain to the expedition, the Reverend Robert Knopwood. Grove had made a number of watercolour drawings during the voyage and may have made the first known watercolour of the settlement at Hobart (*Sullivan's Cove*, Dixson Gallery of the Mitchell Library) but no engravings by him of Australian subjects have been recorded. His friendship with Collins and Knopwood continued (he was pardoned in 1806 through the influence of these friends), and when Collins died suddenly in 1810 Grove engraved the silver plaque for his coffin. The circumstances of Collins' funeral have been graphically described by Manning Clark in his *History of Australia*, vol. 1. Grove's grief at the loss of his friend and benefactor was intense and contributed greatly to his own death, which occurred 24 days later.

REP: Dixson Gallery of the Mitchell Library.

BIB: James Grove, *Lost and Found*, letters from a convict in Van Diemen's Land, London, 1859. Clifford Craig, *The Engravers of Van Diemen's Land*, Foot & Playstead, Launceston, 1961. Rienits, *Early Artists of Australia*, 1963. ADB 1.

GRUNER, Elioth

(b. 16/12/1882, Gisborne, NZ; arr. Aust. 1883; d. 1939, Sydney) Painter.

STUDIES: Julian Ashton's, Sydney, 1894. Beginning at the age of 12, he worked at Ashton's School as an assistant and in 1913 began to exhibit at the NSW Society of Artists. Later he exhibited in London at the RA and in Paris at the New Salon. Gruner's paintings of green rolling pastures and farmyard animals, seen through the dewy mists of early morning, made him one of the most successful and popular painters of the 1910–38 period. Style and colours reflected Gruner's mixed Norwegian and Irish parentage. He won the Wynne prize for landscape painting seven

times, and in 1921 was commissioned by the trustees of the AGNSW to paint a large picture, *The Valley of the Tweed*, which was painted entirely in the open air and took four months to complete. In his landscapes of rolling hills and pastures, he favoured the cool blues, greens and greys of winter. As a leading member of the Australian Art Association and the NSW Society of Artists, he managed the exhibition of Australian art arranged through the Society of Artists for showing at the Royal Academy, London, in 1923. An exhibition of his work was held at the AGNSW in 1983 and his work was included in *Swiss Artists in Australia*, AGNSW 1991; *The Great Australian Art Exhibition 1788–1988*.
AWARDS: Wynne prize, 1916, 19, 21, 29, 34, 36, 37.
REP: NGA; AGNSW; AGSA; AGWA; MAGNT; NGV; QAG; QVMAG; TMAG; many regional galleries as well as other public collections.
BIB: *Elioth Gruner*, Ure Smith, Sydney, 1923. Numerous refs in *AA* 1922–23. Norman Lindsay foreword, *Elioth Gruner*, Shepherds Press, Sydney, 1947.

GUDE, Gilda
(b. 1918, Ballarat) Painter, teacher.
STUDIES: Ballarat School of Mines. Like her sister, Nornie Gude, she worked in varied media, favouring figure and flower studies.
APPTS: Lecturing in art, RMIT, 1961– ?.
REP: NGV.
NFI

GUDE, Nornie
(b. 1915, Ballarat) Painter.
STUDIES: Ballarat School of Mines; NGV School, 1936–39; travel studies UK and Europe, 1958. Known mainly for watercolours of children, she married Scott Pendlebury and is the sister of Gilda Gude.
AWARDS: NGV Travelling Scholarship, 1941; prize for watercolours at Geelong, 1948; Bendigo, 1950; Albury, 1951; Perth, 1954; Ballarat, 1957, 59; Dunlop competitions, 1955; VAS (Voss Smith prize), 1958, 59; Robin Hood, Melbourne, 1959; Pring prize, 1970.
REP: AGWA; NGV; regional galleries Bendigo, Ballarat, Castlemaine, Geelong.

GUDIPI, Willie
(b. 1916, Ngukurr (Roper River Mission)) Painter. A traditional artist from the Roper River area of the Northern Territory, Willie Gudipi has been painting since 1988, mostly with his wife Moima. His work was seen in three solo exhibitions 1990–92 in Melbourne (William Mora; Alcaston House) and Sydney (Aboriginal Arts Australia) and in a number of group exhibitions including *Aboriginal Art and Spirituality*, High Court, Parliament House, Canberra, Ballarat Fine Art Gallery, Waverley City Gallery 1991; *Flash Pictures* NGA 1991.
REP: NGA; NGV; private collections including Margaret Carnegie.

GUÉRARD, Eugène Von
(*See* VON GUÉRARD, Eugène)

GUEST, Nancy
(b. c. 1904, Vic.) Painter.
STUDIES: NGV School, 1923–26; UK, Europe, –1931. On her return from her studies overseas she exhibited with the VAS, c. 1931.
AWARDS: Student prizes, NGV School, 1923–26; NGV Travelling Scholarship, 1926.
REP: NGV; Mornington regional gallery.
NFI

GUILFOYLE, William Robert
(b. 1840; d. 1912) Landscape gardener, botanist, designer, watercolourist. Curator, Botanical Gardens, Melbourne, 1873–1909, his work was seen in *The Art of Gardening in Colonial Australia*, AGDC travelling exhibition, 1979.
REP: National Herbarium, Royal Botanical Gardens, Melbourne.
BIB: R. T. M. Pescott, *W. R. Guilfoyle 1840–1912: Master of Landscaping*, OUP, Melbourne, 1974. ADB 4.

GULLY, John
(b. 1819, Bath, Eng.; arr. NZ 1852; d. 1888, NZ) Painter. He worked as a clerk in NZ before becoming a teacher of drawing at Nelson Coll., Nelson (1863–78). A meticulous draughtsman, he painted mainly New Zealand landscapes which he exhibited at the Victorian Academy of Arts, Melbourne, 1872–84. He became well-known in Australia for the engravings published in the *Australasian Sketcher*, Melbourne, 1873–74, and the *Picturesque Atlas of Australasia*, Sydney, 1883–86.
BIB: Gil Docking, *Two Hundred Years of New Zealand Painting*, Lansdowne, Melbourne, 1971.

GUM, Maude
(b. 1885, Amyton, SA; d. 1973, Adelaide) Painter.
STUDIES: Adelaide, with James Ashton, from 1915; Sydney, with Will Ashton, 1925. She exhibited with the RSASA, c. 1926, taught at a private school near Adelaide till her retirement c. 1955, and continued teaching privately for many years after. A retrospective of her works was held at the Malvern Fine Art Gallery, Melbourne, in 1969.
NFI

GUPPY, James Justin
(b. 28/1/1954, UK; arr. Aust. 1982) Painter, teacher.
STUDIES: BA (Hons), economics and art, Lancaster Uni., UK, 1976; M. Litt. including research into mural painting, Lancaster Uni., UK, 1982; travel studies USA, 1990–91. He held six solo exhibitions 1989–91 mainly at Qld and northern NSW galleries and with Access Gallery, Sydney. He is known mainly for his murals for schools, colleges, hospitals and other public and private buildings in the UK and Australia, having completed 25 between 1975 and 1987. His work was seen in seven group exhibitions 1987–91 including *Archibald Prize*, AGNSW 1987; *Blake Prize*, 1989.
AWARDS: Prizes at Waverley (Windsor & Newton prize), 1990; Tweed River, 1990; North Coast, Qld, 1991; Stanthorpe, 1992.

APPTS: Lecturer, Lancaster Uni., UK, 1979–81; part-time summer school teaching, UK and Aust., 1980–89; facilitator, mural workshop, National Conference on *Youth and the Arts*, Brisbane, 1985.

REP: Artbank; Tweed River regional gallery; several tertiary collections including Lancaster Uni., UK; Uni. of NSW.

GURDON, Nora
(b. ?c. 1885, Melb.) Painter.
STUDIES: NGV School, 1901–08. Known mainly for late impressionist landscapes and portraits in oils, she exhibited at the VAS in 1907 (landscapes, street scenes and portraits) and was later a member of the Australian Art Association and of the Melbourne Society of Women Painters and Sculptors. She went to England in 1914 and spent two years nursing in the French Red Cross Hospital at Le Croisic during World War I. She returned to Melbourne in 1920 and revisited Europe in 1927 and 1937. Her painting *Under the Window* was included in the *Exhibition of Australian Art*, London, 1923.
REP: Regional galleries Bendigo, Shepparton.

GURVICH, Rafael Daniel
(b. 14/2/1949, Melb.) Painter, printmaker.
STUDIES: School of Architecture, Uni. of Melb., 1967–68; Dip. and Fellowship Dip., RMIT, 1967–72; travel studies Italy, Spain and UK, 1974–75; Indonesia, Singapore, Hong Kong, Macau, 1981; Japan, 1984. His exhibition at the Avant Galleries, South Yarra, May 1977, was like a backwards look to the surrealism of Tanguy, Matta and Wilfredo Lam. However, in his joint exhibition with John Dent at the Highlander Lane studio-gallery, Melbourne, 1979, green, white or blue, tipped with pink and purple, allusive, biomorphic forms seemed to burst from a tableland of rich brown earth, like the shoots of exotic plants. He held about 14 solo exhibitions 1974–90 in Melbourne (largely Powell St) and Sydney (Macquarie), and several joint exhibitions with Victor Rubin, John Dent and Jennifer Plunkett (qq.v.). Group exhibitions in which his work appeared 1974–92 include *Blake Prize*, 1978; drawing and print survey exhibitions largely at major private galleries; *Proofs*, Victorian Print Workshop, McClelland Gallery, Langwarrin 1985.
AWARDS: Elaine Targett Drawing prize, 1972; Kenneth Smart prize, 1975; standard grant, VACB, 1976; MPAC *Spring Festival of Drawing* (work acquired), 1979.
REP: NGA; NGV; TMAG; Parliament House; PCA; a number of regional galleries, tertiary collections Vic., NSW.
BIB: *Directory of Artists Producing Print*, PCA 1988. Germaine.

GUTH, Erwin Albert
(b. 14/11/1926, Saarbrücken, Germany; arr. Aust. 1954) Sculptor.
STUDIES: Academy of Fine Arts, Berlin, 1940–42;

Saarbrücken, Germany, 1946–52. Guth was a teacher of sculpture at the Ministry of Public Worship and Instruction of the Saar, 1950–53, before moving to Australia, where most of his work was done for churches in Qld. He was a member and exhibited with the Half Dozen Group of Artists, Brisbane 1955–70.
REP: QAG.

GUTH, Henk (Henk Gerrit)
(b. 19/10/21, Holland; arr. Melb. 1961) Painter.
STUDIES: Arnhem Academy of Arts, 1938–41. Active in Alice Springs since 1966 and known for his *Panorama*. Some 6.1 m in height, this huge artificially lit oil painting extends for 61 m around the walls of a circular room. It has become a popular tourist attraction.

GUTHRIE, Tim
(b. 30/9/1933, Melb.; d. 11/7/1991) Painter.
STUDIES: Geelong Grammar School (with Hirschfeld Mack); NGV School, 1960–61; City and Guilds of London Art School (etching and lithography), UK, 1963–64; travel studies Europe and UK, 1962–64. His strongly designed geometricised landscapes are concerned mainly with pattern and effects of light.
AWARDS: English-Speaking Union prize, 1967; Alice Springs prize (for landscape), 1972.
REP: NGA; MAGNT; Gold Coast City Collection; Alice Foundation; several corporate collections including Westpac and NAB.
BIB: Elizabeth Young, *Figuratives Now*, Aldine Press, Melbourne.

GWYNNE, Marjorie Campbell
(b. 1886, Adelaide; d. 1958, Adelaide) Painter.
STUDIES: Adelaide, SASA; later with Hayley Lever. She became known for her impressionistic landscapes, but influenced by Dorrit Black changed to a more modern idiom. Her later of still-lifes with their bold brushwork and emphasis on pattern clearly mark the change. She exhibited with Black's Group 9 in 1951.
REP: AGSA (four paintings).
BIB: Rachel Biven, *Some forgotten . . . some remembered*, Sydenham Gallery, Adelaide, 1976.

GYE, Hal (Harold Frederick Neville)
(b. 22/5/1888, Sydney; d. 1967, Eltham, Vic.) Cartoonist, illustrator, painter.
STUDIES: Melbourne, with the cartoonist, Alec Sass. He drew cartoons for Melbourne *Punch*, for the daily newspapers *Herald*, Melbourne, and *News*, Adelaide, drew for the *Gadfly*, Adelaide, and for many years was theatre caricaturist for the Sydney *Bulletin*. He became famous for his illustrations to the books of C. J. Dennis including *Songs of a Sentimental Bloke*, 1915; *The Glugs of Gosh*, 1917 – both published by Angus & Robertson, Sydney.
REP: AGNSW; Mitchell Library.

H AAS TO HUYGHUE

HAAS, Juli

(b. 26/4/1952, Vic.) Painter, printmaker.
STUDIES: Fine arts, CIT, 1971–74; BA Visual Arts, Gippsland Inst. of Advanced Education, 1989; Grad. Dip. of Arts (Visual Arts), Monash Uni. Coll., Gippsland Coll., 1990. She held two solo exhibitions to 1993 and her work appeared in many group exhibitions and attracted favourable critical reviews. Christopher Heathcote in the *Age* (27 Feb. 1991) reviewing the *Young Artists: New Works* exhibition at Flinders Lane Gallery, March 1991, described her works as 'anything but empty vessels . . . not only compositionally superior, but loaded with a rich narrative cargo'. Her work appeared in about 20 group exhibitions 1988–92, largely at public galleries, including *Swan Hill Print and Drawing Show*, Swan Hill Regional Gallery 1990, 91; *Spring Festival of Drawing*, MPAC 1989, 91; *Gippsland Prints and Printmakers*, Sale Regional Gallery 1988, 89; and *Young Artists: New Works*, Flinders Lane Gallery, Melb. 1991.
APPTS: Tutor, school of Visual Arts, Monash Uni. Coll., Gippsland; St John's Regional Coll., Dandenong, Vic. 1975–77.
REP: Latrobe Valley Arts Centre; Grafton Regional Gallery; Monash Uni. Coll., Gippsland.

HABBE, Nicholas Francois

(b. 10/4/1827, Copenhagen; arr. Vic. 1855; d. 1889, Sydney) Painter. Also well-known as a scene-painter, he painted portraits, allegorical scenes and theatre subjects in Sydney and Melbourne from the 1860s to the late 1880s. He exhibited in the 1888 *Centennial International Exhibition*.
REP: AGNSW; Mitchell Library.
BIB: Kerr, *DAA*.

HABGOOD, William

(b. c. 1805; arr. WA 1830; d. Perth, 1845) Painter. Amateur artist and merchant. A landholder on the Swan and Murray rivers, he was a foundation director of the Bank of WA, 1837, and a member of the Northam Trust. His historically interesting watercolours show an amateur's passion for detail. His work was represented in *The Colonial Eye*, AGWA 1979.

Juli Haas, The Fitting, *1991, drypoint, 52 × 33.5cm. Private collection.*

REP: NLA.
BIB: Kerr, *DAA*.

HADLEY, Basil

(b. 6/5/1940, London; arr. Aust. 1965) Painter, printmaker.

STUDIES: Ealing Coll. of Art, 1957–58; Prahran CAE, 1973. His capable work, seen in annual exhibitions since 1971, follows both figurative and non-figurative international trends. He exhibited in many leading international print exhibitions and Australian prints touring in Japan, Singapore, SE Asia and Spain. His commissions include those for leading hotels (Sheraton), and the London, New York and Hong Kong offices of the SA State Bank.

AWARDS: Prizes at Beaumaris (Inez Hutchison), 1973; Bunbury, 1974; Perth (David Jones prize), 1974; Albany, 1975; Hamilton (Ansett award), 1976; Gold Coast City (purchase award), 1977, 84; VACB grant, 1977; Whyalla prize, 1978; Bathurst prize, 1979; *Examiner*-Albert Hall Art Purchase Prize, Tasmania, 1980; Broken Hill Art Prize, 1981; Westlakes Art Prize, SA, 1981; City of Elizabeth Watercolour Prize, 1982; Kernewek Lowender Art Prize, 1989.

REP: NGA; AGNSW; AGSA; AGWA; MAGNT; NGV; QAG; QVMAG; TMAG; PCA; numerous regional galleries; many tertiary, municipal collections most states; corporate collections including Qantas, Telecom, BHP, AMP, CBA.

BIB: David Dolan, *Basil Hadley*, Craftsman House, 1991. *New Art Four* Nevill Drury, *Images in Australian Contemporary Painting*, Craftsman House, 1990. Bonython, MAP. Germaine. AGA. A&A 21/3/1984.

HAEFLIGER, Paul

(b. 1914, Hamburg; d. Mar. 1982, Switzerland) Painter, critic.

STUDIES: Julian Ashton School, Sydney, c. 1928; Westminster Art School, London, with Bernard Meninsky and Mark Gertler; travel studies Europe, India and Japan. Married to painter Jean Bellette (q.v.), he returned to Sydney in 1939 and with his wife assisted Peter Bellew with the reformed *Art in Australia* until wartime conditions brought the publication of that journal to an end. About 1941 Haefliger was appointed art critic for the *Sydney Morning Herald*, a position he held for 16 years. While greatly concerned with art history as transmitted largely by the writings of the French historian Eli Faure, he strongly supported the modernist ideas brought back to Sydney by returning expatriates such as Dobell, Drysdale, Friend and Passmore, and migrant artists such as the Hungarian Desiderius Orban and the Swiss Sali Herman. He attacked the reactionary and academic cliques which had held sway in official art in NSW for several decades and appeared as chief witness for the defence in the Dobell–Joshua Smith case. He wrote the introduction to *Russell Drysdale*, Ure Smith, Sydney, 1960 and *Duet for Dulcimer and Dunce*, with illustrations by Russell Drysdale, Bay Books, Sydney, 1979. The long concentration on writing, however, frustrated his own development as a painter and in 1957 he resigned from art criticism and went with his wife to live in Majorca, Spain. Their living quarters alternated between Spain, France, Switzerland and Australia. In painting,

Haefliger proved a natural eclectic with a love for the romantic past accompanied by an ironic appreciation of the not-so-romantic present. His work was seen in *Swiss Artists in Australia*, AGNSW 1990.

REP: NGA; AGNSW; AGWA.

BIB: A&A 20/2/1982; 21/3/1984.

(*See also* BELLETTE, Jean Mary)

HAGHE, Louis

(b. 1806, Tournai, Belgium; d. 1885) Itinerant lithographer and painter. Member of the British Inst. and a president of the New Watercolour Society, London, 1873–84. His published topographical illustrations 1840–52 include several of Tasmania. His work was seen in *The Art of Gardening in Colonial Australia*, AGDC travelling exhibition 1979.

HAINES, Robert Keith Reeve

(b. 1916, St Kilda, Vic.) Gallery director, administrator, collector.

STUDIES: Courtauld Inst., London. As director of the QAG, he obtained for the gallery the magnificent Rubin collection; later he established the David Jones Fine Art Gallery, Sydney, as a venue for many fine exhibitions. Between 1970–79 he lived and studied in Italy. He wrote essays for a number of catalogues including *French Art from Australian Collections*, 1959, *Recent Acquisition of French Paintings*, QAG, Brisbane, 1959.

AWARDS: British Council Scholarship, 1950.

APPTS: Director, Georges Gallery, Melbourne, 1945–46; assistant director, NGV, 1947–51; director, QAG, 1951–60; director, David Jones Fine Art Gallery, Sydney, 1960– ; member of the board of trustees, AGNSW, from 1979.

(*See also* GALLERIES – Commercial)

HAINSELLIN, Henry

(b. 20/4/1810, Devonport, Eng.; arr. Aust. c. 1840) Painter, lithographer. He exhibited genre paintings at the RA, London, from 1843 to 1853, and from 1853 was at Ballarat, digging for gold as well as recording the scene in watercolours. He moved to Melbourne then back to the country at Beechworth where he lived 1857–79; from 1879 he lived in St Kilda. In 1884 he exhibited *Herdsman of the Common Collecting Fees*, at the VAA. He illustrated George Hamilton's *Experiences of a Colonist 40 years Ago*, Adelaide, 1879 and in 1886 returned to England.

BIB: Bénézit, *Dictionnaire*, 1976. A. Ferguson, *Bibliography of Australia*, vol. 5, NLA, 1977. McCulloch, AAGR. J. Johnson and A. Greutzner, *Dictionary of British Artists 1880–1940*, Woodbridge, UK 1976. Kerr, DAA.

HALF DOZEN GROUP OF ARTISTS

(Founded 1941) Formed by Lilian Pedersen (Hon. Sec., 1941–71), Frank Sherrin, Mona Elliott (first president), Rosalie Wilson, Anne Ross and Leonard G. Shillam, the objective being to infuse vitality into Qld art affairs. A policy 'to conduct exhibitions of high standards, develop the use of Australian materials and designs, and promote individual methods

of expression' was formulated at the first meeting (9 Apr. 1941). The Group obtained Vice-Regal patronage, organised scholarships and prizes for artists, and gifts of art works to public institutions. In 1946 the Group assumed some of the responsibilities of the Qld Wattle League which, in return, contributed £400, used later to establish scholarships. It established the L. J. Harvey Memorial Prize for Drawing (*see* PRIZES) in 1951, and was valuable in promoting art in Qld by, as well as the annual exhibitions, holding workshops in drawing, painting, ceramics and other crafts at the Group's studio. Distinguished early members included Donald Friend, Hal Missingham, Kenneth MacQueen, Margaret Preston, Lloyd Rees and G. K. Townshend.

HALL, Bernard (Lindsay Bernard)

(b. 1859, Liverpool; arr. Melb. 1892; d. Feb. 1935, London) Painter, teacher, gallery director.
STUDIES: RCA, London; Antwerp and Munich Academies. Director of the NGV and head of the NGV Schools for 43 years, 1892–1935. Before moving to Australia, Hall drew for the *Graphic*, the *Illustrated London News* and other British magazines. Austerity and eroticism are evenly mixed in his paintings of quasi-classic nudes and studies of figures grouped in interiors; his other subject pictures add to these qualities the illustrative manner of the Munich Academy. A disciplinarian in his teaching methods at the Melbourne National Gallery Schools, he continued the Munich traditions already established there by his predecessors, Folingsby and von Guérard. Hall's tastes as a conscientious buyer for the Gallery collections were often liberal and perceptive. As first purchaser for the Felton Bequest, he visited London in 1905 and bought Pissarro's *Boulevard Montmartre* (for £300) from Durand-Ruel's exhibition of French Impressionist pictures at the Grafton Galleries. (R. H. Wilenski, in *Modern French Painters*, Faber & Faber, London, 1939, tells us that the authorities of the National Gallery, London, had little respect for this exhibition and reluctantly accepted a Boudin landscape presented by a group of subscribers.) On 27 Feb. 1934 Hall again went to London as adviser to the Felton Bequest Committee, and his successful recommendations subsequently included two Rowlandson drawings and a miniature, a bronze group by Barye and a Van de Heem and Van de Gelder (acquired in Holland). This buying expedition was to be his last. In Jan. 1935 he developed a cold that turned into double pneumonia from which he died early in Feb. Among the obituaries in the Melbourne papers was one written by Harold B. Herbert for the *Star*: 'There will never be another Bernard Hall and I doubt whether the country can ever replace him'. Memorial exhibitions were held at the NGV in 1961 and the Block Galleries, Melbourne, Aug. 1971 and his work was seen in *The Great Australian Art Exhibition 1788–1988*.
AWARDS: NSW Society of Artists medal, 1929.
REP: NGA; AGNSW; AGSA; AGWA; MAGNT; NGV; QAG; QVMAG; TMAG; many regional galleries and other public collections.

BIB: Moore, *SAA*. All major texts on Australian art history. Leonard B. Cox, *The National Gallery of Victoria, 1861–1968*, NGV, Melbourne, 1970.

HALL, Douglas Grant

(b. 29/8/1954, Vic.) Gallery director.
STUDIES: Dip. Fine Arts, VCA, 1976. As director of Bendigo Art Gallery, he made a significant contribution in helping to consolidate the collection, implementing touring exhibitions programs and initiating the visit of a French scholar to assess a number of works in the collection to establish their authenticity. He became a state gallery director in 1987 and was a member of a number of state and federal visual arts bodies including the ICCA (now Art Exhibitions Australia); Queensland Council of Art Museums of Australia; chairman, Council of Australian Art Museum Directors and the Queensland Cultural Centre Trust.
APPTS: Director, Warrnambool Art Gallery, 1977–80; Bendigo Art Gallery, 1980–87; QAG, 1987– .

HALL, Edward

(b. 1930, Sydney) Painter, teacher.
STUDIES: NAS, 1950–56; travel studies, England and Germany, 1972–74. From 1960 his paintings with their expressionistic contrasts of tone won him a number of prizes. Group exhibitions in which his work appeared 1973–89 include with the Royal Society of Marine Painters, London, 1973 and Wollongong Uni., 1985, and he held numerous solo exhibitions 1962–89 including with Macquarie Galleries in the 1960s.
AWARDS: Over 20 prizes at local competitions 1960– .
APPTS: Teaching, NAS and ESTC, 1962– .
REP: TMAG; Bendigo Art Gallery.
BIB: Germaine, *AGA*.

HALL, F. V.

(b. 1897, Eng.) A painting by this artist is in the AGWA (purchased from the Perth Society of Artists in 1938 under the terms of the Hackett bequest).
NFI

HALL, Fiona

(b. 1953, Sydney) Painter, photographer.
STUDIES: NAS, Sydney 1975; MFA photography Visual Studies Workshop, Rochester, NY 1982. Her work encompasses paintings, photography, installations and drawings, most of which have a Breughel-like complexity. She has become best known for her photographs which are created by assembling multifarious objects on surfaces and photographing them. In photographing them rather than simply displaying them as assemblages the objects are transformed and spaces created. Describing one of the works in her 1987 series *Apocalypse*, Timothy Morell writing in *Art and Australia* (25/2/1987) says: 'Like many of her photographs . . . the mundane, the otherworldly, the hideous and the funny thrash about in perpetual confusion'. Her solo exhibitions 1980–93 include those in London, Italy, Aust. Centre for Photography, Sydney and her work was included in a number of group exhibitions

Pam Hallandal, The Artist's Mother, *1979, charcoal, 80 × 60cm. Collection Mornington Peninsula Art Centre.*

1980–93 including *Biennale of Sydney*, 1982; *What is this thing called science*, University of Melbourne Gallery 1987; Australian Centre for Photography exhibitions; at ACCA, Melbourne and *The Great Australian Art Exhibition 1788–1988*.

REP: NGA; AGSA; NGV; a number of tertiary, public collections.

BIB: Chanin, CAP. A&A 25/2/1987. AL 3/4/1983; 4/1/1984; 5/6/1985–86; 6/1, 6/4, 6/5/1986; 6/6/1986–87; 7/1/1987; 7/4/1987–88; 8/1/1988; 10/4/1990–91.

HALL, Oswald

(b. 1917, Melb.; d. 1991) Painter, printmaker.
STUDIES: NGV School, 1934–38 with Charles Wheeler and W. B. McInnes; RMIT, ?1939. Son of NGV director L. Bernard Hall (q.v.), his rigorous training in drawing was evident in many early works including portraits (for which he won an award at the NGV School) and figure studies. His 1930s work has elements of social realism and concurrent with his wartime work in a munitions factory in the 1930s and 1940s he designed a series of linocuts and was a foundation member and later a council member of the CAS. His work from the 1940s on developed into a type of surrealist expressionism, still with formal tonal elements and often a dream-like quality. He exhibited largely in group exhibitions 1938–91 including *Survey of Australian Relief Prints*, 1978; *Aspects of the Unreal: Australian Surrealism, 1930s–50s*, Geelong Art Gallery 1983. A retrospective of his work was held by Niagara Gallery in conjunction with Waverley City Gallery in Melbourne, 1991. Hall donated his collection to the NGA in 1991.

AWARDS: Bernard Hall prize for portraiture (NGV School); NGV Travelling Scholarship, 1938.
REP: NGA; Ballarat Fine Art Gallery; Heide.

HALLANDAL, Pam

(b. 16/1/1929, Aust.) Sculptor, draughtsman.
STUDIES: Assoc. Dip., RMIT, 1950; Central School of Arts and Crafts, London, 1956–57; travel studies in Europe, 1957; TTTC, Melb., 1960; fellowship (sculpture), RMIT, 1964. Her first works were of figurative sculptures in ceramics and wood, as appeared in group exhibitions including the Jubilee exhibition, 1951; Olympic exhibition, Melbourne, 1956; and *Mildura Sculpture Triennial* 1961 and 1964. From the mid-1960s she concentrated exclusively on drawing, and her powerful black and white figurative drawings appeared in a number of significant group exhibitions including *Backlash*, NGV 1987; *The Portrait of the Nude*, AGNSW 1990; *The City and Beyond*, NGV and touring state galleries Qld, NSW 1990–91; *The Face of Australia: Bicentennial Touring Exhibition*, 1988 and *Contemporary Australian Drawing*, AGNSW 1992. She held two solo exhibitions at Pinacotheca and Stuart Gerstman, Melbourne. She visited Indonesia 1970, Thailand 1972, USA and Mexico, 1974.
AWARDS: Acquisitive prizes at Mornington, 1979, 81, 83, 85; Diamond Valley, 1986; Gold Coast, 1986; Castlemaine State Festival of Drawing Prize, 1986.
APPTS: Teaching, Prahran CAE, drawing, sculpture and ceramics, 1958–66; senior lecturer, drawing, 1970–90; senior lecturer (drawing), VCA, 1991– .
REP: AGNSW; NGV; QVMAG; TMAG; a number of regional and public galleries including Heide, MPAC, Gold Coast; a number of tertiary collections including Deakin, La Trobe unis.; State Library of Vic.; World Congress Centre.
BIB: Catalogue essays exhibitions as above. Scarlett, AS. McKenzie, DIA. Elizabeth Cross, *Art Bulletin of Tas.*, 1987.

HALLEN, Ambrose Lance

(b. 1886, NSW; d. 1943, Box Hill, Vic.) Painter.
STUDIES: Travel studies, mainly in France (1905–); Paris, with Frances Hodgkins, c. 1907. A great-grandson of the explorer Lieut. William Lawson, Hallen went to France at the age of 19, and in Paris became friendly with Modigliani, Kisling, Soutine and other *Ecole de Paris* artists. He joined a small colony of artists at Belle Isle, home of John Peter Russell (q.v.), where he converted an old mill into a studio. His only son, Robert, was killed in World War I. During the late 1930s he returned to Sydney and then went to live in Vic., where he held an exhibition at the Riddell Galleries (4 Nov. 1938), gave lessons to John Dutruc and became friendly with William Frater and Lina Bryans. His watercolours and drawings have a light, Matisse-like touch but when shown in Melbourne were ahead of their time. He was virtually unknown when he dropped dead on the Box Hill railway station in 1943. The old hotel rented by him at Darebin, Vic., was eventually bought by Lina Bryans and became a home for the painters Ada Plante, William Frater

Stacha Halpern, Landscape, *1962, oil on canvas, 113 ×
145.5cm. Private collection, courtesy Charles Nodrum, Melb.*

and Ian Fairweather and a meeting place for many
other artists.

HALLIDAY, Madeleine
Awarded Robert Le Gay Brereton prize for drawing,
Sydney, 1960.
NFI

HALLIGAN, Harriette Victoria
Painter.
AWARDS: Medals at *International Exhibition* in 1880,
and *World Exposition in Colombia, 1892–93.*
REP: TMAG.
NFI

HALPERN, Deborah Dorothy
(b. 7/9/1957, Vic.) Sculptor.
STUDIES: Apprentice, Sylha Ceramics, Melb., 1976;
Postgrad. Dip., Visual Arts, Gippsland Inst. of Advanced
Education, 1987–88. Her colourful, imaginative ceramic
sculptures were seen in eight solo exhibitions 1981–92,
largely at Christine Abrahams, Melbourne, and in over
50 group exhibitions 1978–94 including many of the
Australian Craft survey exhibitions at the Meat Market;
at Potters Cottage, Warrandyte; and in state and re-
gional galleries. She received seven commissions 1987–
92, ranging from the large bicentennial sculpture
Angel, standing in the moat outside the NGV, to a
float (with Stephen Benwell) for the Moomba parade,
to designs for T-shirts for the NGV shop and the
Australian Ballet. She was artist-in-residence at two
schools in Victoria, 1982, 84.
AWARDS: VACB grants, 1981, 85, 87, 89; grant, Myer
Foundation, 1988; award Art Foundation, NGV, 1989;
Gold Prize, Japan Association for the International
Garden and Greenery Exposition, Osaka Expo, Japan,
1990; Sidney Myer Fund Australia Day Ceramics
Award, Shepparton Art Gallery, 1993.
APPTS: Tutor, Potters' School, Warrandyte, 1981; lec-
turer, Victoria Coll., Prahran, 1990; workshops CAE,
1990– .
REP: NGA; AGSA; AGWA; NGV; QAG; Victorian State
Craft Collection; Artbank; regional galleries includ-
ing Ballarat, Shepparton, Geelong; tertiary collections
including Uni. of Melbourne, Box Hill Coll. of TAFE.
BIB: Catalogue essays exhibitions as above. John Gollings,
Paul Greene, Edward Hopkins, *Melbourne,* Heinemann,
Australia 1990. Grace Cochrane, *The Crafts Movement in
Australia: A History,* NSW Uni. Press, 1992. Numerous ref-
erences in *Craft Australia* and other craft magazines. *A&A*
28/1/1990 (front cover and article).

HALPERN, Stacha (Stanislaw)
(b. 1919, Zolkiev, Poland; arr. Aust. 1939; d. Jan.
1969, Melb.) Painter, potter.

320

STUDIES: School of Fine Arts, Lwow, Poland; RMIT (sculpture), 1948 (one term of part-time study only); George Bell School (painting and drawing), 1948–49. In a foreword to the retrospective memorial exhibition of Halpern's work (NGV, Sept.–Oct. 1970), Arthur Boyd wrote: 'In 1945 Stacha's approach to his work in both painting and clay was original, vigorous and always arresting. His work of the 40s and early 50s influenced and awakened a new interest in the craftsmanship of ceramics in Melbourne. In his canvases the forms were robust and earthy and the painting, done at great speed, was arresting perhaps because the vivid line contrasted so much with the solidity of form.' Halpern returned to Europe in 1951, held nine exhibitions (1951–62) and exhibited in a large number of group exhibitions in Holland, France, Italy and Switzerland. He became well-known in Paris and was indeed the only Australian-domiciled painter to achieve that honour in the immediate post-war decade. In 1966 he returned to live for the rest of his life in the bayside suburb of Beaumaris. Partly because of the timing of his sojourn in the country, Halpern's work as a painter never received its due recognition in Australia until after his death. His livelihood in Australia came mostly from his pottery, which has a vigour, strength, and vibrancy derived from his early acquaintance with Polish peasant work. A retrospective of his work was held at the NGV, 1970 and Charles Nodrum, Melbourne 1993 and he was represented in *Classical Modernism: The George Bell Circle* NGV 1992.
REP: NGV and other Australian state galleries.

HAM, Thomas
(b. 17/2/1821; arr. Melb. 1842; d. 1874, Brisbane) Engraver, publisher. Son of the Rev. John Ham, first minister of the Collins Street Baptist Church, Thomas Ham established Melbourne's first engraving business. Backed by his three brothers (all successful later in business), he started the *Australian Illustrated Magazine* in 1850, thus creating employment in the colony for illustrators and engravers. The most celebrated contributor was William Strutt, who was hired within days of his arrival in Melbourne. The magazine ran for 22 issues (July 1850–Aug. 1852). Ham also published sets of engravings of life on the goldfields and maps. Many of the drawings for these were done by David Tulloch (q.v.) and some by Ham himself. Ham moved interstate c. 1860 to concentrate on business interests and lived the last part of his life in Qld.
REP: AGSA; regional galleries Ballarat, Geelong; NLA; La Trobe, Mitchell Libraries.
BIB: T. Darragh, *Engraving and Lithography in the Time of the Goldrush*, Sydney 1990. McCulloch, AAGR. Kerr, DAA. ADB 4.

HAMBIDGE FAMILY
Three sisters – Helen (1857–1937), Alice (1869–1947) and Milly (Millicent; 1872–1938) – who worked mainly in watercolour and pastel; they lived, painted and exhibited together and it is difficult to separate the threads of their individual lives. All three studied in Adelaide in the 1880s, Helen at the SASA (with Gill), Alice and Milly at the School of Design. They began exhibiting with the SA Society of Arts in the 1890s, showing mainly landscapes and street scenes, but also flower pieces, portraits of prominent people such as state governors, and figure studies, continuing to exhibit till the 1920s. All three exhibited portraits at the VAS, 1905–09. Their work was well regarded and included in the *Exhibition of Australian Art*, Grafton Gallery, London, 1898, and also in the *100 Best Pictures of the NSW Society of Artists*, 1906. They concentrated on careful drawing and precise delineation, in direct contrast to the more painterly results attained by contemporaries such as the Heidelberg School painters. By the 1920s the Edwardian flavour of the Hambidges' work was looking a little dated, and around 1930 they ceased exhibiting. Alice Hambidge's work was included in *The Great Australian Art Exhibition 1788–1988* and Helen Hambidge's work was included in *A Century of Australian Women Artists 1840s–1940s* Deutscher Fine Art, Melbourne 1993.
REP: AGNSW.
BIB: M. E. Farr, 'Three Adelaide Artists', *Lone Hand*, no. 2, 1914; Rachel Biven, *Some forgotten . . . some remembered*, Sydenham Gallery, Adelaide, 1976.

HAMEL, Julius
(Active 1853–73, Vic.) Engraver, painter, teacher. He was on the goldfields in 1853, became a partner in the engraving firm of Hamel and Ferguson and from 1873 was Superintendent of the St Kilda School of Industrial Art.
BIB: McCulloch, AAGR. Kerr, DAA.

HAMILTON, Charles
(b. 1874, NSW; d. 1967, Perth) Painter, teacher, critic. STUDIES: Perth Tech. Coll. (with J. W. R. Linton). Art critic for the *West Australian*; teacher with WA Education Dept, 1907–20. Foundation and honorary life member of the Australian Division of the International Association of Art Critics.

HAMILTON, George
(b. 12/3/1812, Herefordshire, Eng.; arr. Sydney c. 1838; d. 1883, Adelaide) Artist, writer, overlander. He went from Sydney to Adelaide in 1839, having overlanded cattle from Port Phillip, Vic., and rode in a horse race on the day of arrival. He painted bush and sporting subjects, had some engraved, contributed illustrations to the journals of Grey and Eyre, and produced three illustrated volumes of his own. From 1848 to 1853 he worked in the SA Treasury, was a foundation member of the Adelaide Club and, in 1867, became Commissioner of Police, a job he held until 1882. His work appeared in *Graven Images of a Promised Land*, AGSA 1981.
REP: Mitchell Library.
BIB: Adelaide, *Register*, 4 Aug. 1883, full account of his life. Moore, SAA. H. M. Green, *History of Australian Literature 1789–1923*, A&R, Sydney, 1961. McCulloch, AAGR. Kerr, DAA. Benko, ASA.

HAMLYN, *Rhonda*
(b. 18/4/1944, Sydney) Painter.
STUDIES: NAS. Characteristics of her figurative paint-ings include elongated forms, intimist shapes and colours, and attention to light. Her work has appeared in group exhibitions at Watters Gallery since 1965 and in several other drawing exhibitions including *Contemporary Australian Drawings and Prints*, AGNSW 1980; *Contemporary Australian Drawing*, MOCA 1992.
REP: NGA; AGNSW; NGV; MOCA, Brisbane; Fremantle Art Gallery.
BIB: *A&A* 8/2/1967, reprdn.

HAMMON, *G. H.*
(Active c. 1895–1905, Sydney) Painter. Known mainly for Sydney Harbour views in watercolour.

HAMMOND, *Charles*
Six illustrations in watercolour to A. B. Paterson's *The Man from Snowy River* by this otherwise unknown artist were exhibited at the Joshua McClelland Print Room, Melbourne, Mar. 1967.

HAMMOND, *Mary*
(b. 21/9/1928, WA) Painter, printmaker.
STUDIES: Fremantle Tech. Coll., 1943–45; NGV School, 1950–55. Her drawings and watercolours are notable for a sure impressionistic line and soft colours and were seen in five exhibitions in Melbourne 1986–92, includ-ing at Raya and Bridget McDonnell galleries, and at Hamilton regional gallery, 1991. Her work appeared in about 43 group exhibitions Melbourne 1953–92.
REP: NGV; AWM; Artbank; Museum of Vic.; tertiary collections including Phillip Inst., La Trobe Uni.

HAMMOND, *Stanley James*
(b. 1/8/1913, Trentham, Vic.) Sculptor.
STUDIES: Daylesford Tech. School, with John Grant, 1926; Prahran Tech. School (evening classes), 1930–34; Melbourne Tech. Coll. (evening classes), 1933–36; travel studies, UK, Europe, South Africa, USA and Mexico, 1968. He worked as an assistant to Paul Montford on various works, including the Shrine of Remembrance, 1930–36, also to Orlando Dutton (AMP emblem), 1932. He completed some 100 works in bronze and stone for public places 1936–92 includ-ing bronze statues of John Batman in Collins St, Melbourne; Capt. James Cook, Cooktown, Qld; Henry Lawson, Nicholson Park, Footscray; with George Allen the 125–tonne basalt *Fallen Warrior*, at Melbourne's Shrine of Remembrance in the 1950s; and the Australian Memorial, Mont St Quentin, France, to replace the original work by Web Gilbert (destroyed during World War II). A long-serving member of the VAS council (1952–89; president 1972–77), he was awarded the VAS Hon. Life Membership in 1971; Medal of Honour, 1979; Distinguished Service Award, 1991. One of the gallery rooms at the VAS is named after him.
APPTS: Teaching sculpture (part-time), RMIT, 1936–60; president, Victorian Sculptors Society, 1953–56; Association of Sculptors of Vic. Inc, 1972–74.

AWARDS: MBE conferred, for services to sculpture and the arts, 1974.
REP: NGA; AWM; regional galleries Rockhampton, Sale; Heidelberg, Waverley city collections.
BIB: Sturgeon, *DAS*. Scarlett, *AS*.

HAMPEL, *Carl*
(b. c. 1887; d. 1942, London) Painter.
STUDIES: Melbourne, with Max Meldrum, c. 1914–22. He began his working life in the post office at Bendigo, then in 1914 moved to manage the family farm in the Mallee where he was encouraged by his mother to observe nature and study art. With his close friend, A. E. Newbury, and other members of the Meldrum school, he was a member of the Australian Art Association and Twenty Melbourne Painters group. He exhibited also at the VAS and in 1922 moved to Tas., married and went to live in the UK, 1923, where he spent the rest of his life. He wrote the introduc-tion to *The Paintings of A. E. Newbury*, Alexander McCubbin, Melbourne, 1916. He exhibited in London at the RA and attained some success. With his wife and one of their children he was killed in London during an air raid in 1942.
REP: TMAG; regional galleries Bendigo, Broken Hill.
BIB: *AA*, Nov. 1940. (A. Colquhoun, *Carl Hampel, Man and Artist*).

HANDASYDE, *Stewart*
(Active c. 1890–1920, Melb.) Painter. One of a group who worked with Frederick McCubbin at Blackburn, Vic., after the dissolution of the Box Hill camp. He exhibited at the VAS, 1893–1916, showing oils and watercolours of NSW and Victorian pastoral and coastal landscapes and produced *Album of Melbourne Cup Winners 1861–98*, Mason, Melbourne, 1898. He was working as a lithographic artist in Melbourne c. 1920.

HANKE, *Henry Aloysius*
(b. 1901, Sydney) Painter.
STUDIES: J. S. Watkins School, Sydney, c. 1918. In 1922 he became an exhibiting member of the Royal Art Society of NSW, painting portraits, landscapes and still-life. He served in the Military History section of the AIF during World War II, 1943–45. Best-known in Sydney for his exhibitions and contributions to group exhibitions, including Archibald and Sulman prize exhibitions.
AWARDS: Archibald prize, 1934; Sulman prize, 1936; prizes at the R.Ag.Soc.NSW 1960 and 1963; Northside Festival, Albury, Katoomba, Drummoyne, 1963; Rockdale, 1964; Goulburn, 1965.
REP: AGNSW; AWM; Newcastle regional gallery.
BIB: *Australian Art Illustrated*, RAS, Sydney, 1947, reprdn.

HANRAHAN, *Barbara*
(b. 6/9/1939, Adelaide; d. Dec. 1991) Printmaker, novelist, painter, teacher.
STUDIES: Dip. Art Teaching, Teachers Coll., Adelaide, 1960; Dip. Etching, Central School of Art, London, 1964; Advanced Dip. Printmaking, Central School of

Barbara Hanrahan, Nightmare, *1975, mixed media, /6 × 56.5. Collection, Mornington Peninsula Arts Centre.*

Art, London, 1966. Maori art and the fantastic designs on playing cards are strong influences in her prints, to which is added her own brand of erotic symbolism, and strong decorative qualities – a combination that won her considerable success. She held about 22 solo exhibitions 1964–92 largely at Bonython Adelaide and in all other capital cities as well as in London and Florence. Her work appeared in many significant group exhibitions 1964–92, especially print survey shows, including *Australian Printmaking 1780–1985*, NGA 1985; *Graphic Identity: Australian Prints 1969–85*, QAG 1987; *Bicentennial Print Portfolio* (prints by 25 artists), NGA 1988; *Prints and Australia: Pre-settlement to Present Day*, NGA 1989; *Contemporary Australian Printmaking*, Birmingham Art Festival, USA 1990. As well as a successful artist and printmaker, she was a highly regarded novelist with 15 novels published. She died of cancer prematurely at the age of 52.
AWARDS: Cornell prize (CAS, Adelaide), 1961; PCA (member print published), 1974; MPAC Prints, Mornington (print acquired), 1974; Pedersen prize (for prints), QAG, 1976.
APPTS: Teaching, SASA, 1957–60; Falmouth Coll. of Art, Cornwall, UK, 1966–67; Portsmouth Coll. of Art, 1967–70; Salisbury CAE; Torrens Coll. of Art, 1970s–80s.
REP: NGA; AGNSW; AGSA; AGWA; MAGNT; NGV; QAG; QVMAG; TMAG; many regional galleries including Bendigo, Fremantle, Mornington, Newcastle.

BIB: Catalogue essays as above. Brian Seidel, *Printmaking*, Arts in Australia series, Longman, Melbourne, 1965. Benko, ASA. Candida Baker, *Yacker 2*, Picador, 1987. Pam Gilbert, *Coming Out from Down Under*, Pandora, 1988. Alison Carroll, *Barbara Hanrahan*, Wakefield Press, 1986. A&A 29/4/1992 (obituary). AL 3/6/1983–84; 5/1/1985; 6/5/1986.

HANSEN, *Allan Adolf Peter*
(b. 31/5/1911, Copenhagen) Painter.
STUDIES: ESTC, 1931–36; privately, with H. Justelius. He paints in a traditional and late impressionist manner, mostly landscapes.
AWARDS: Prizes at Ryde, 1961, Katoomba, 1963, Campbelltown, 1972; Liverpool, 1978; Ashfield, 1981; Kogarah, 1981; Geo. Styles Award for Traditional Painting, 1982.
APPTS: Teacher, RAS NSW and director of art school, 1968–90.
REP: NGA; AGNSW; muncipal collections Liverpool, Campbelltown; tertiary collections including Uni. of NSW.
BIB: John Brackenreg *The Australian Landscape*, Sydney. Tom Roberts, *Australian Impressionist and Realist Artists*.

HANSEN, *Theodore Brooke*
See BROOKE HANSEN, Theo.

HANSON, *Albert J.*
(b. 1866, Sydney; d. 1914) Painter.
STUDIES: RAS School, Sydney, c. 1884. He became an exhibiting member of the Art Society of NSW (RAS) in 1889, but moved to New Zealand in the same year, conducted an art school in Dunedin and is recorded as having designed a house for Robert Louis Stevenson (never built). He returned to Sydney and was in London, 1892–96, where he exhibited at the RA and was elected a member of the Royal Society of British Artists. Back in Australia in 1896 he showed English landscapes and other genre at the VAS as well as at the Art Society of NSW where he continued to show until c. 1910. Throughout his career he varied his subjects widely to include capably painted allegories, country and particularly coastal scenes.
AWARDS: Wynne prize, 1905.
REP: AGNSW; AGSA; many public galleries in New Zealand.
BIB: *Fifty Years of Australian Art, 1879–1929*, RAS, Sydney, 1929. Moore, SAA.

HARCOURT, *Clewin Simon Vernon*
(b. 1870, Dunolly, Vic.; d. 1965, Heidelberg, Vic.) Painter.
STUDIES: NGV School (with Folingsby), 1886–90; Westminster Art School, London; Académie des Beaux-Arts, Antwerp. Known mainly for portraits, he was also a flautist and maker of musical instruments and foundation member of the WA Society of Arts and Crafts, and Australian Art Association, 1912. Harcourt exhibited at the RA, London, from 1909, and at the Paris Salon. Family responsibilities prevented him from devoting all his time to art until 1900. A fine craftsman, he made about a dozen Boehm flutes and

piccolos in wood, ebonite and silver. Increasing deafness restricted his participation in music, and towards the end of his life he lived as a recluse in the studio which he built at Heidelberg where he died, in 1965, at the age of 94.
AWARDS: Silver medal for figure painting, Académie des Beaux-Arts, Antwerp, 1901.
REP: AGSA; AGWA; NGV; Geelong Art Gallery.
BIB: *AA* no. 8. 1919 (R. H. Croll, *Clewin Harcourt*).

HARDING, Bill (Arthur William)
(b. 18/5/1930, Albert Park, Vic.) Painter, teacher.
STUDIES: RMIT; privately, with William Frater; travel studies Europe 1974–75; Spain and UK, 1986; China 1988, 89, 91. His landscapes and figure paintings are modelled on the style of his teacher, William Frater. He held about 11 solo exhibitions VAS 1967–91 and about five other joint or solo exhibitions including Leveson St, Melbourne 1965, 85; Benalla 1970 and Barry Newton, SA 1989.
APPTS: Teaching, Vic. secondary schools, at Burwood Teachers Coll., and from c. 1974 at the Melbourne CAE (senior lecturer in painting and drawing); president, VAS; external adviser, Alexander Mackie and Townsville CAEs, 1973–75.
AWARDS: Prizes at Geelong, 1961, 62; VAS, 1962, 66, 69, 74 including Artist of the Year, 1992.
REP: Regional galleries Bendigo, Benalla, Geelong; tertiary collections including Deakin, Monash unis.; NAB.
BIB: L. J. Blake, ed., *Vision and Realisation*, vol. 1, Education Dept of Vic., 1973.

HARDY, Cecil
(b. 1929, Kyabram, Vic.) Painter, printmaker, teacher.
STUDIES: RMIT, 1951–52; travel studies, Mexico, USA, UK and Europe, 1972. Exhibitions in which his prints were shown include *Australian Imprint* (SE Asian tour), 1971; *Australian Graphics* (Poland), 1972–73; fifth *International Print Biennale*, Cracow, 1974.
AWARDS: English-Speaking Union prize, Melbourne, 1968; Barossa Valley prize, 1969; Vizard-Wholohan prize, Adelaide, 1970; Caltex prize, Warrnambool, 1974.
APPTS: Lecturer in painting, SASA, 1976– ; head of school, 1980– .
REP: NGA; AGSA; QAG; regional galleries Newcastle, Hamilton, Shepparton, Warrnambool.
BIB: PCA *Directory*, 1976.
NFI

HARFORD, Patrick
(Active c. 1920–30, Melb.) Painter. Associated with the Frater Shore group during the beginning of 'modernism' in Melbourne.
BIB: Smith, *AP*.
NFI

HARGREAVES, John
(b. 1897, Horsham, Vic.; d. 1978) Painter.
STUDIES: Melbourne, with Frederick McCubbin, 1916.

Mainly a landscape painter in watercolours. He earned a living working for the PMG's Dept, started painting in watercolour in 1918 but never exhibited during his lifetime, although much of his work matched that of many well-known contemporaries. A commemorative exhibition was held at Russell Davis Gallery, Armadale, Vic., Feb.–Mar. 1981.

HARPUR, Royston
(b. 15/9/1938) Painter, printmaker, conservator, lecturer, critic.
STUDIES: Sydney, with Maximilian Feuerring, 1956–59; travel studies, UK, Europe, Malta, Asia, Japan. His work includes performance, minimal art, modern Japanese calligraphy and many other forms and he also works as a curator, critic and art writer. He works largely in black and white. He held about 13 solo exhibitions 1961–85 in most capital cities including a retrospective of his work 1967–80 at Charles Nodrum, Melbourne 1985. His work appeared in over 45 group exhibitions 1967–90 including with the CAS, WA, SA, Vic., and in London and Japan. He won many awards (nearly all in NSW), including a VACB grant for study in Japan, 1975–76.
APPTS: Art critic, *Observer*, Sydney, 1960; assistant, restoration dept, AGNSW, 1961–63; adult education lecturer, Sydney, c. 1964: gallery manager, Inst. of Contemporary Art, London, 1965; co-director, Central Street Gallery, Sydney, 1966; exhibitions assistant, then curator, European and American painting after 1800, NGV, 1968–69; art critic, *Australian*, 1971; teaching, NAS, 1973– .
AWARDS: Twelve awards Sydney and NSW, 1967–77, including Muswellbrook, 1974; Maitland, 1977.
REP: AGNSW; regional galleries Newcastle, Maitland, Muswellbrook.

HARREX, David Montague
(b. 2/6/1929, Hobart) Painter, graphic artist, teacher.
STUDIES: Hobart Tech. Coll. (with J. Carington Smith, 1952–56). Harrex worked as a press artist, 1948–51, before joining the Tasmanian Education Dept and becoming senior graphic designer, Curriculum Resource Centre, Dept of Education and the Arts. He held several solo exhibitions in Tasmania 1968–88 and his work appeared in group exhibitions, largely in Tasmania (including CAS 1962, 64, 67, 69), and the *Wynne Prize*, 1964, 65, 66.
AWARDS: Minnie Crouch prize, Ballarat, 1965; prizes at Taree (drawing), 1966; Bendigo (watercolour), 1967; Muswellbrook (drawing), 1969; Springbrook, Qld, 1969; Bathurst, 1969; Drummoyne, 1970; Hobart (acquisition drawing prize, TMAG), 1972; many other regional awards Tasmania, 1979–91; Bathurst Art Prize, 1990; ANZ Bank open art prize, 1991.
APPTS: Instructor, School of Art, Hobart, 1959–67; graphic design, Hobart Tech. Coll., 1976–89; drawing and watercolour teacher, adult education, 1991– ; senior graphic designer, Tasmania Media Centre, 1990– .
REP: QVMAG; TMAG; Artbank; several regional galleries including Bathurst, Ballarat, Bendigo, Muswellbrook;

several tertiary collections Tas.; corporate collections including ANZ Hobart.

HARRIS, George Prideaux Robert

(b. 1775, Eng.; arr Vic. 1803; d. Hobart, 1810) He arrived to set up a colony at Port Phillip and was the surveyor of the expedition led by Lieutenant Governor Collins which established white settlement in Van Diemen's Land in 1804. He made topographic sketches of his journeys, including six watercolour drawings of Tasmanian birds with scenic backgrounds (Mitchell Library, Sydney).
REP: NLA; Mitchell Library; British Museum.
BIB: Rienits, *Early Artists of Australia* 1963. ADB 1. R. Gibbon, *The Early History of Tasmania*, OUP, 1938. Kerr, *DAA*.

HARRIS, Mary Packer

(b. 1891, Yorkshire; d. 1977) Teacher, painter.
STUDIES: Coll. of Art, Edinburgh, 1913. An exhibitor with the RSASA and NSW Society of Artists, she is best remembered as an influential teacher at the SASA, Adelaide (1922–53), where, in the 1930s and 1940s, she introduced students to the work of Cézanne, Picasso and other modern masters. She was the author of *The Cosmic Rhythm of Art and Literature*, Frank Cork, Adelaide, n.d.; *Art the Torch of Life*, Adelaide, n.d.
BIB: Rachel Biven, *Some forgotten . . . some remembered*, Sydenham Gallery, Adelaide, 1976.

HARRIS, Max

(b. 1921, Adelaide) Writer, poet, critic. Founder and co-editor with John Reed of *Angry Penguins*, 1941–44, in which was published the early work of Nolan, Perceval, Tucker and other subsequent leaders of the expressionist movement in painting. Later Harris chaired *The Critics* (ABC television program), 1962–65; edited *Australian Letters* and *Australian Book Review* and became a controversial columnist for the *Australian*. He subsequently became the successful proprietor of the Mary Martin Bookshop (Adelaide and Melbourne) and a director of the publishing house, Macmillan Company of Australia Pty Ltd. His writings include *Gift of Blood, Dramas from the Sky* and *The Vegetative Eye* (novel).

HARRIS, Pamela

(b. 13/9/1946, NSW) Multi-media artist.
STUDIES: Dip. Fine Arts, SACAE, 1977; Postgrad Dip. (printmaking), SACAE, 1981; MFA candidate, Uni. of Tas., 1987; MVA, Uni. of SA, 1992. Her work appeared in seven group exhibitions and events 1985–92 including performances at *Australian Perspecta '85*, AGNSW; *Adelaide Festival of Art*, 1986; *Woop Woop National Performance Event*, EAF, Adelaide 1991; *Right Here, Right Now: Aboriginal and White Printmakers' Work*, touring for Bicentennial Adelaide Festival of the Arts, 1988. She was artist-in-residence at Praxis, WA, in 1982.
AWARDS: Project development grant, VACB, 1983.
APPTS: Lecturer, Uni. of SA, 1980–89.

REP: NGA; AGNSW; AGSA; AGWA; MCA, Sydney; PCA; Artbank; Uni. of Tasmania.
BIB: *AL* Dec 1985; June/July 1986.

HARRIS, William Edward Strelley

(b. 1818, Eng.; arr. WA 1833; d. Midland, WA, 1901) Amateur artist. Except for a brief visit to the Victorian goldfields in the summer of 1852–53, and a visit to England on the occasion of his second marriage, 1896, Harris spent most of his life on his WA properties. His first marriage was to Mary Gregory, sister of the explorers, H. A. and A. C. Gregory. One of Harris's best-known watercolours dramatically depicts the rescue of the Hamersley family during the floods of 1872. His work was represented in *The Artist and the Patron*, AGNSW 1988.
REP: AGWA.
BIB: Kerr, *DAA*.

HARRISON, Birge

(Active 1889–91, Aust.) Painter. An article in the *Australasian Critic*, 1891, records an exhibition of works by Mr and Mrs Birge Harrison prior to their departure for California. It comprised 'a number of works which they brought with them from Europe as well as others they have painted during their residence in the colonies'.

HARRISON, David Mackay

(b. 1941, Lismore, NSW) Painter, gallery owner.
STUDIES: No formal training. Awarded about 10 prizes in NSW for his representational oils and watercolours, including prizes at Albury, 1970; Ballina, 1974–76 and 1980; and Dubbo, 1975.
REP: Regional galleries Albury, Grafton, Hamilton.

HARRISON, Harry (Henry Bromilow)

(b. 10/5/1878, Geelong, Vic.; d. 1948) Painter, cartoonist
STUDIES: South Brisbane Tech. Coll., c. 1896; Melbourne, with Max Meldrum. He went to Qld as a youth, studied in Brisbane and became a cartoonist working for the *Queenslander, Courier* and *Observer*; he also exhibited paintings with the Qld Art Society. In Melbourne he studied with Max Meldrum but, according to Moore, never became a Meldrumite. He was a foundation member of the Australian Art Association and wrote freelance art criticism for the *Argus* and *Australasian*. He also did some commercial art.
AWARDS: Honourable mention, Philadelphia exhibition, 1876.
REP: AGNSW; NGV; QAG.
BIB: *AA* no. 7, 1919; vol. 30, 1930 (James S. Macdonald, *Harry B. Harrison*). Moore, *SAA*.

HART, Conway Weston

(Active c. 1850, Melb.) Painter, photographer. Hart received a £300 commission to paint a large 9 ft (2.75 m) high portrait of the first Premier of Tas., Sir Richard Dry, for Parliament House, Hobart. A picture by him, *The Finding of Moses*, was shown at the 1853 exhibition of the Fine Arts Society, Melbourne, where, Moore

tells us, 'he was the first portrait painter to practice'.
REP: TMAG; Parliament House; Parliament House, Hobart; Sydney Uni.; La Trobe, Allport libraries.
BIB: Moore, SAA. *Art in Victoria, Illustrated Journal of Australasia*, vol. 4, Jan.–June 1958. Eve Buscombe, *Artists in Early Australia and their Portraits*, Sydney 1978. C. Wood, *Dictionary of Victorian Painters*, Woodbridge, 1978. Kerr, DAA.

HART, Eleanor

(b. 10/7/1946, Melb.) Painter.
STUDIES: Fellowship Fine Art, RMIT, 1975; Dip. Art & Design, CIT, 1974; Dip. Ed, 1976. She was represented in the PCA travelling exhibition, 1973, and her large, strong, abstract-expressionist etchings have been featured in many group exhibitions. Ronald Millar, in a review (*Herald*, 2 May 1990), described her as 'simply an intuitive and talented decorator'. She held 13 solo exhibitions 1975–92 in Melbourne (including at Niagara, Melbourne Contemporary Art), Sydney, Brisbane (Roz McAllan) and Latrobe Valley, Horsham regional galleries. She participated in numerous group exhibitions 1973–92 including print touring exhibitions internationally and in Australia. Some of these were PCA exhibitions; *Sulman Prize*, AGNSW 1984.
AWARDS: Warrnambool Print prize, 1973; residency, Moya Dyring studio, Paris, NSW, 1983.
REP: Artbank; Warrnambool Art Gallery; US Consulate, Melbourne; Education Dept of Vic.
BIB: PCA, *Directory*, 1976. *Australian Printmakers*, Lansdowne Press 1976. Germaine, AGA.

HART, Pro (Kevin Charles)

(b. 1928, Broken Hill) Painter, inventor, gallery owner.
STUDIES: Broken Hill Tech. Coll. A tireless promoter of his own work and energetic populariser of visual art, with a prolific output of small paintings mostly connected with the history of Broken Hill. In the realm of sculpture, one of his most notable works is a giant steel ant mounted on a 6 m high mine poppet head outside the Stephens Creek hotel, north of Broken Hill. His almost fluorescent-hued works are unique in style and highly popular with some buyers but are rarely seen in curated exhibitions or survey exhibitions of contemporary Australian art.
REP: NGA; AGSA; regional gallery Broken Hill; Adelaide Uni. collection.
BIB: Bianca McCullough, *Australian Naive Painters*, Hill of Content, Melbourne, 1978.
(*See also* BRUSHMEN OF THE BUSH)

HARTT, Cecil L.

(b. c. 1894; d. 1930, Moruya, NSW) Cartoonist. Best-known as a cartoonist for *Smith's Weekly*, Hartt was wounded at Gallipoli during World War I, and after convalescence contributed drawings to London *Bystander, Passing Show* and *London Opinion*. A book of cartoons by Hartt, *Humorosities*, published in Sydney after World War I, sold 60,000 copies. He was the first president of the Australian Society of Black-and-White Artists (formed 17 July 1924).
BIB: Moore, SAA.

HARVEY, Edmund Arthur

(b. 20/2/1907, Newcastle-upon-Tyne, Eng.; arr. Aust. 1909) Painter, teacher.
STUDIES: SAS, Sydney (with Julian Ashton); ESTC; Chelsea Polytechnic, London, 1925– ; Académie Julian and Colarossi's, Paris; Florence and Rome. On his return to Sydney in 1928, Harvey became assistant to George Lambert and in 1935 founded the School of Decorative Art (Sydney) with Arthur Murch. He held his first exhibition in Sydney in 1933, won a design competition for decorations for the Queen Victoria Building for the 150-year celebrations in 1935, and exhibited with the NSW Society of Artists and at Macquarie and Artarmon galleries (which held a retrospective of his work in 1988).
APPTS: Part-time teaching at ESTC 1936–40; full-time 1940–71; head of the North Sydney Annex of ESTC and senior head teacher 1971–?
REP: AGNSW; TMAG; Manly Art Gallery; regional galleries Bendigo, Geelong.
BIB: *New South Wales Society of Artists*, Ure Smith, Sydney, 1944, reprdn. John Kroeger, AA. Badham, SAA.

HARVEY, Geoffrey Allan

(b. 24/2/1954, Sydney) Painter, sculptor, printmaker.
STUDIES: NAS, 1974; Dip. Art, Alexander Mackie CAE, 1977; MFA, City Art Inst., Sydney, 1987. His paintings, ranging from early photo-realism to abstract expressionism, show a sure use of colour and technique. He has also occasionally made primitive-like wooden sculptures of birds and animals. He held about 18 solo exhibitions in Sydney (including Rex Irwin, 77, 78, 79, 80, 83; Robin Gibson 85, 87, 88, 89, 90, 91) and Adelaide (BMG 1988). His exhibition *Something Real* was shown at Broken Hill Regional Gallery, 1983, Uni. of Western Sydney, 1990, 91 and at the Australian Embassy, Paris, France, 1991.

He participated in about 23 group exhibitions 1979–91 including *Works on Paper*, Burnie Art Gallery, Tasmania 1979; *Australian Art of the Last Ten Years*, ANU 1982; *Dobell Foundation Travelling Exhibition*, 1987; *Wires*, Australian Museum, Sydney 1987; a print exhibition at NGA 1989, and in several group shows in the USA.
AWARDS: RAS Modern Figurative Prize, 1978; VACB project grant, 1979; Blake Prize (shared), 1983; RAS Painting Prize, 1989.
APPTS: Teaching, ESTC, 1979–92; Nepean CAE, 1980–84; SCA, 1984–86; City Art Inst., 1987–89; Uni. of Western Sydney, Macarthur, 1990–92.
REP: NGA; AGSA; NGV; TMAG; Parliament House; PCA; Artbank; Dobell Foundation; regional galleries Rockhampton, Wagga Wagga, Wollongong, Gold Coast, Broken Hill, Maitland, Bathurst, Warrnambool, Dubbo, Burnie, Hamilton; Fremantle Arts Centre; Dept Foreign Affairs, Canberra, WAIT; Flinders Uni; Uni. of NSW; Uni. of Western Sydney; corporate collections including BHP, Faber-Castell, Pancontinental.
BIB: *New Art Four*.

HARVEY, L. J. (Lewis Jarvis)

(b. 1871, Wantage, Berkshire; arr. Aust. 1874; d. 1949, Brisbane) Craft worker, teacher, sculptor.
STUDIES: Brisbane, wood-carving with Madley, and Vickers; Brisbane Tech. Coll. (part-time), with J. A. Clarke, Godfrey Rivers and Mathew Fern. Established the L. J. Harvey School of Applied Art, 1937. His influence on art and craft in Qld was widespread and his qualities as a teacher were acknowledged by Leslie Bowles, Daphne Mayo, Douglas Annand, Lloyd Rees and many others. He built the first art pottery in Qld and through his experiments with local clays made Brisbane a centre of Australian pottery. His work as a sculptor was centred on wood-carving, a medium in which he attained great competence, completing numerous commissions, many for churches. He was a member of the advisory board of the QAG, a life member of the Qld Art Society and the Arts and Crafts Society of Brisbane, and a foundation member of the Half Dozen Group (1940). After his death the Half Dozen Group provided the money for the L. J. Harvey Memorial Prize, a national biennial event conducted at the Qld Art Gallery.
AWARDS: Gold medal, *Franco-British Exhibition*, 1908; gold medal, *British Empire Exhibition*, Wembley, 1924.
APPTS: Teaching, part-time, Brisbane Tech. Coll., 1910–15, full-time, 1915–37.
REP: QAG; Museum of Applied Arts and Sciences, Sydney; regional galleries Ballarat, Tamworth.
BIB: Moore, *SAA*. Scarlett, *AS*. Margaret Maynard and Julie K. Brown, *Fine Art Exhibitions in Brisbane 1884–1916*, Fryer Memorial Library, Uni. of Qld, 1980.

HASSALL, Ian

(b. 1899, London) Painter, sculptor, illustrator.
STUDIES: London School of Art, 1921–24; travel studies in Europe, USA and the Far East. Before migrating to Australia, Hassall was a staff artist for the firm of Winsor & Newton, artists' supplies, London, for seven years. Director of Hassall's Roadside Gallery, Eltham, Vic.
REP: NGV.

HATCH, Brian Morton

(b. 24/9/1934, Pomona, Qld) Printmaker, painter.
STUDIES: Brisbane Tech. Coll. 1959–62; Pratt Graphics Centre, NY (silk screen and lithography), 1966; Armidale Uni, Qld Arts Council, Uni. of Qld Art Schools, 1968–71; travel studies Europe, 1958. He held about nine solo exhibitions in Queensland 1968–90 and participated with large, colourful abstract silkscreen prints in competitive exhibitions. He established the Printmakers Gallery and Workshop, 1978.
AWARDS: Include prizes at Redcliffe, 1968, 69; Dalby, 1969; *Telegraph* Art Contest, 1972; Westfield Art Prize, 1973; VACB grant, 1975.
APPTS: Tutor, RQAS and Brisbane Coll. of Art, 1973; teacher, printmaking, Printmakers Workshop, Brisbane, 1978–82.
REP: QAG; many school and some university collections Qld, NSW, Vic.

BIB: PCA, *Directory*. Helen Fridemanis, *The Contemporary Art Society of Qld*, Boolarong, Qld, 1991.

HATTAM, Hal (Harold Bickford)

(b. 14/1/1913, Edinburgh; arr. Aust. 1920; d. 8/2/1994.) Painter.
STUDIES: No formal training. A doctor of medicine by profession, his association from the 1950s with a number of Melbourne painters, including Boyd, Blackman, Perceval, French, Kemp and Williams, led him to abandon medicine for a time to concentrate on painting. His large, simplified, atmospheric seascapes reflect his admiration for the work of Fred Williams, described by Patrick McCaughey in 1973 (*Age*, 9 May) as 'a new and compelling image of the landscape . . . sure sense of a basic truthfulness of experience . . . the marvellous creation of deep space is firmly anchored to the flatness of the picture surface'. He held about 11 solo exhibitions 1962–88 including at Joseph Brown, Melbourne; Philip Bacon, Brisbane; Solander, Canberra; David Jones, Sydney; a three-person exhibition at McClelland Gallery with Blackman and Perceval. He participated in a number of group exhibitions with CAS Melbourne; MOMA, Melbourne and regional galleries, 1960s–91.
REP: Mt Gambier regional gallery.
BIB: Catalogue essays exhibitions as above. Janine Burke, *Joy Hester*, Greenhouse Publications, 1984.

HATTAM, Katherine

(b. 14/12/1950, Melb.) Painter.
STUDIES: BA (Hons), Melbourne Uni. No formal art training. Daughter of Hal Hattam (q.v.), her work is especially strong in decorative drawing and appeared in about 14 solo exhibitions 1978–91 in Melbourne (including with William Mora), Sydney (including with Ray Hughes) and the ACT, and at Ewing and George Paton Gallery, Melbourne Uni., 1978; Warrnambool City Gallery, 1988. Group exhibitions in which her work appeared 1984–91 include with Tynte Gallery, Adelaide; 70 Arden St, Melbourne; Ray Hughes, Sydney; and in *Shipwrecked*, 200 Gertrude St 1986; Hamilton City Art Prize, 1988; *Splash: The Cutting Edge*, Warrnambool, Mt Gambier regional galleries; *Recent Acquisitions*, NGA 1990 and NGV 1991.
AWARDS: MPAC Spring Festival of prints and drawings (acquisitive), 1986; Box Hill Drawing Prize, 1987.
REP: NGA; NGV; Artbank; regional galleries Hamilton, Warrnamboool, Mornington; Box Hill City collection; Shell, Sportsgirl corporate collections.
BIB: Germaine, *AGA*. Germaine, *DAWA*.

HAVEKES, Gerard

(b. 11/12/1925, Holland; arr. Aust. 1950) Sculptor, painter. Exhibitions in Sydney from 1958 showed Havekes as a competent sculptor, and a painter with a feeling for rich colour and texture. A well-known work by him is the large F. J. Walker monolith and fountain in Hyde Park, Sydney, 1962. Other commissions include four carved ceramic murals and a

fountain at Grace Bros, Chatswood; other ceramic carved murals at Williamstown Library, Melbourne; Darwin Casino; RSL clubs at Foster and Taree, NSW; Broken Hill Council Chambers; St Georges League Club and Westpac head office, Brisbane.

HAVELL, Robert

English engraver active during the first half of the nineteenth century, he was responsible, often in collaboration with his brother, Daniel, for many topographical Australian plates including Lieut. Dale's *Panoramic View of King George's Sound – Western Australia* (engraved in 1834), and Colonel William Light's *A View – near the site of the Proposed Town of Adelaide* (aquatint, 1837). His work was seen in *The Great Australian Art Exhibition 1788–1988*.

HAVYATT, Richard Salisbury

(b. 18/1/1945, Melb.) Painter, teacher.
STUDIES: Uni. of Melbourne (Architecture), 1962–64. Self-taught painter. Havyatt's large, modernist abstracts first attracted attention in three exhibitions held in Melbourne and one in Ballarat, 1967–72. He held about 11 solo exhibitions 1967–90, largely at Melbourne galleries including Pinacotheca and United Artists. He participated in group exhibitions 1964–87 including *Artists' Artists*, NGV 1975; *Works on Paper*, regional development program, VACB 1978; *John McCaughey Memorial Art Prize Exhibition*, NGV 1987.
AWARDS: Georges Art Prize (commendation award), 1966, 68; Minnie Crouch prize (watercolours), Ballarat, 1968, 69; Ronald award, Latrobe Valley Arts Centre, 1973; Alice Prize, 1975.
APPTS: Lecturer, painting, VCA, 1974– .
REP: NGA; NGV; Parliament House; regional galleries Ballarat, Latrobe Valley; several tertiary collections Vic.; Alice Springs Art Foundation.
BIB: Catalogue essays exhibitions as above and booklets *Australian Abstract Art*, Patrick McCaughey, NGV 1975; *Freedom from Prejudice: Brian Finemore*, eds. J. Phipps, S. Murray-Smith, NGV. Horton, PDA. Bonython, MAP 1980.

HAWKE, Ronald Lloyd

(b. 22/12/1933, Sydney) Painter.
STUDIES: Dip. Fine Art (painting), NAS, 1952–54. His solutions to problems of attaining light and atmosphere, and compact, two-dimensional presentation of the urban scene of houses and hilly landscape, have freshness and originality. He held about five solo exhibitions 1970–86 in Adelaide, Newcastle and Sydney.
AWARDS: Prizes at Muswellbrook (drawing), 1967; Georges, Melbourne, 1979 (painting and drawing acquired); grant for equipment and travel, VACB, 1975–76.
APPTS: NAS, Newcastle, 1967–69; senior lecturer, SASA, 1969– .
REP: AGSA; NGV; Artbank; regional galleries Ballarat, Bendigo, Broken Hill, Muswellbrook, Newcastle, Swan Hill; Flinders Uni. collection.

HAWKES, David

(b. 1/12/1956) Painter.

STUDIES: Kogarah Tech. Coll.; Alexander Mackie CAE, 1976–78; Dip., Canberra School of Art, ANU, 1992. He established and helped co-ordinate Sylvester Studios Inc., an artist-run gallery and studio complex, Redfern, 1985–90, as well as collaborating in music/performance groups in various venues in Sydney, Adelaide and Brisbane. His work as seen in the 1987 *Moet & Chandon* exhibition showed elements of cubism, surrealism and neo-expressionism. He held ten solo exhibitions 1980–91 in Sydney (Mori 1983, 85; DC Art 1989; EMR 1990; Syme Dodson 1991) and Canberra (Ben Grady 1988, 90; Canberra School of Art 1990), and his work appeared in about 20 group exhibitions 1979–89 in Sydney (including Mori, Garry Anderson, Holdsworth) and in *First Look*, Drill Hall, NGA 1986; *Selected Affinities*, Jam Factory, Adelaide 1987; *Moet & Chandon Touring Exhibition*, 1987; *New Generation*, NGA 1988; *Endangered Species*, Artspace 1989.
AWARDS: Campbelltown Art Prize, 1976, 80; Rural Bank Prize, 1976; Mosman Art prize, 1980; Dyason Bequest, 1980; SMH Travelling Art Prize, 1980; travel grant, VACB, 1985; project grant, VACB, 1988.
APPTS: Part-time teaching, Canberra School of Art, 1990–92.
REP: NGA; NGV; Artbank; Gold Coast regional gallery; SMH, Allen, Allen & Hemsley, Faber-Castell corporate collections.

HAWKES, Gay

(b. June 1942, Burnie, Tas.) Sculptor, wood artist.
STUDIES: BA, Uni. of Tas., 1962; Assoc. Dip., Tas. School of Art, 1980. A part-time teacher, she has also worked in theatre and been artist-in-residence at a number of secondary schools in Victoria and New Zealand. Her unique wood furniture is notable for its highly imaginative, often quirky qualities. It is more reminiscent of sculpture than utilitarian objects and is frequently made from wood found in the bush and driftwood from the beaches of her native Tasmania. She held six solo exhibitions 1983–91 including at Ray Hughes, Sydney, and Australian Galleries, Melbourne and Sydney, and participated in a number of group exhibitions including *Australian Crafts*, Easter exhibitions at Meat Market, Melbourne 1983, 84, 85; *Australian Decorative Arts: The Past 10 Years*, NGA 1984; *Neiman-Marcus Aust. Exhibition*, Neiman-Marcus store, Dallas, USA 1986; *A New Generation*, NGA 1988; *Australian Decorative Arts*, NGA 1989. A film on her work, *Out of Wood*, was made when she was artist-in-residence in Swan Hill, Vic., 1985.
AWARDS: VACB professional development grant, 1982; special development grant, 1986.
REP: NGA; AGSA; Parliament House; AWM; Victorian State Craft Collection; MOCA, Brisbane; Artbank; public museum Norway.
BIB: Allan Moult, *Craft in Australia*, Reed Books, 1984. Elwyn Lynn & Laura Murray, *Considering Art in Tasmania*, Fine Arts Press 1985. Michael Bogle & Peta Landman, *Modern Australian Furniture*, Craftsman House 1989. Tom Darby, *Twelve Australian Woodworkers*, The Guild of Master Craftsmen Publications, East Sussex, UK 1991.

HAWKINS, *Harold Frederick Weaver*

(b. Sydenham, London, 28/8/1893; arr. Australia 1935; d. Willoughby, NSW, 13/8/1977) Painter, graphic artist. STUDIES: Bristol Art School UK; Westminster School of Art, 1919–22; Royal Coll. of Art (etching), 1921–22. He began painting during convalescence from severe wounds sustained during World War I. At the battle of the Somme, 1 July 1916, he was left for dead at Gommecourt but crawled back to safety two days later. A series of 20 operations saved his life and his arms from amputation, although he never regained the use of his right hand. He began painting, with his left hand, as a therapeutic measure, and on leaving hospital began serious art studies at the Bristol School of Art. On 15 Sept. 1923 he married Irene Villiers and they went to France where they lived at St Tropez, 1923–24, before moving to Sienna, Italy, 1925, and thence to Sicily and Barcelona before returning to England. They were in Malta, 1927, and again in France 1930–33 before moving to Tahiti 1933–34, thence to Australia via New Zealand, arriving Sydney in Mar. 1935. His stylised, cubistic manner of painting landscapes and figures became well-known through many Sydney exhibitions and competitions. Towards the end of his life, in 1976, his work was the subject of a tribute exhibition, *Project 11: Weaver Hawkins*, AGNSW and in 1977–79 a touring exhibition of his work at state and regional galleries was organised by Ballarat Fine Art gallery and toured by the AGDC. His work was seen in *The Great Australian Art Exhibition 1788–1988*.
AWARDS: Prizes at Albury, 1950, 59; Taree, 1955; Warringah, 1956; Mosman, 1958, 60; Muswellbrook, 1966; Hunters Hill, 1971.
REP: NGA; AGNSW; AGSA; QAG; regional galleries Ballarat, Bendigo, Geelong, Newcastle.
BIB: Catalogue essays exhibitions as above. *A&A* 16/1/1978 (Douglas Dundas, obituary).

HAWKINS, *Norman H.*

(Active c. 1892–1904) Topographical artist, surveyor. Born and educated in Bendigo, Vic., he moved to WA in 1892, where he became assistant surveyor to the Albany municipality. In 1894 he walked to the goldfields, prospected near Kalgoorlie and served on the Kalgoorlie Municipal Council, 1899–1903. In 1904 he was president of Kalgoorlie's first art society. He migrated to Canada where he is believed to have earned a living as a cartoonist and painter. His work was seen in *The Colonial Eye*, AGWA, 1979.
REP: AGWA; Mitchell Library.

HAWKINS, *Sheila*

(b. c. 1910, Melb.) Illustrator.
STUDIES: NGV School. She worked in London (c. 1964) as a poster artist and illustrator of children's books.
REP: NGV.
NFI

HAWTHORN, *George*

Shipping Master at Hobart, 1856–1905. He made a series of topographical drawings of Hobart and surrounding areas.
BIB: Clifford Craig, *The Engravers of Van Diemen's Land*, Foot & Playstead, Launceston, 1961.

HAXTON, *Elaine Alys*

(b. 1909, Melb.) Painter, stage designer, illustrator. STUDIES: ESTC (with Rayner Hoff), c. 1928; London, with Iain McNab, 1931–39; travel studies USA, Mexico, 1939; USA and UK, 1946–48 (including short studies in theatre design, New School, New York); Paris (with Hayter); and Kyoto, Japan; Workshop Art Centre, Willoughby, NSW. Her decorative paintings, theatre designs and illustrations became well-known in Sydney in the 1940s when she was also the subject of a famous portrait by William Dobell.
AWARDS: Sulman prize, 1943; Crouch prize, Ballarat, 1946.
REP: NGA; most state galleries; regional galleries Ballarat, Bendigo, Geelong, Newcastle.
BIB: Horton, *PDA*. Janine Burke, *Australian Women Artists, 1840–1940*, Greenhouse, Melbourne, 1980.

HAY, *Bill*

(b. 1956, Melb.) Painter, printmaker.
STUDIES: RMIT, 1974–76; VCA, 1982–83. He painted six murals 1980–87 including at St Kilda Esplanade; Pickles St, South Melbourne; Middle Park Hotel, Melbourne; VCA; and designed sets for five Barry Dickins plays at St Martin's and La Mama 1987–90. His four solo exhibitions 1985–93 included at Linden, and Australian Print Workshop, Melbourne; Ray Hughes, Sydney, and his work appeared in about 14 group exhibitions 1989–91 including at Ray Hughes, Sydney; Acland St, Melbourne and in *St Kilda Council Acquisitive Prize*, 1980, 81, 87, 88; *Exquisite Corpse*, 200 Gertrude St, Melbourne, 1987.
AWARDS: Project development grant, VACB, 1988.

HAYDON, *George Henry*

(b. 26/8/1822; arr. Melb. 1840; d. 1891, ?London) Artist, illustrator, teacher, architect, author, lawyer. He contributed to the *Port Phillip Gazette* and other papers, and illustrated his own book, *Five Years Experience in Australia Felix*, published in Exeter and London, 1846. After his return to London in 1844 he contributed to London *Punch* but reverted to the study of law and was called to the Bar in 1865. He was sketched by his friend Henry Hainsellin (q.v.) in the late 1840s.
BIB: *ADB* 4. Eve Buscombe, *Artists in Early Australia and Their Portraits*, Sydney 1978. Kerr, *DAA*. McCulloch, *AAGR*.

HAYES, *Philip*

(b. 7/2/1963, Vic.) Printmaker, sculptor.
STUDIES: Dip. Fine Art, Ballarat, 1983; Grad. Dip. Education, Ballarat, 1984; Grad. Dip. Fine Art, Uni. of Tasmania, 1989. He held five solo exhibitions 1989–91 in Hobart, Launceston and Eltham Gallery, Vic., 1991. His work appeared in about 40 group exhibitions 1985–92 including at Linden, Melbourne

and in *Middle Earth 84: Contemporary Art in Regional Victoria and South Australia*, Warrnambool, Mt Gambier regional galleries, 1984; MPAC Spring Festival of Prints and Drawings, Mornington 1988, 90; *Swan Hill Print and Drawing Show*, Swan Hill 1991 and several international print exhibitions in Belgium, Spain, Poland and Lithuania. His commissions include those for Ballarat Fine Art Gallery and Office of the Status of Women, Canberra.
AWARDS: Pat Corrigan Artists grant, NAVA, 1991.
APPTS: Teacher, printmaking, Ballarat Grammar School, 1985–88; tutor, printmaking, Ballarat CAE, 1988; lecturer, printmaking, Uni. of Tasmania, 1990– .
REP: Geelong Art Gallery; Aust. Print Workshop; Commonwealth Bank; Royal Hobart Hospital; Uni. of Tasmania; various state collections Belgium, Canada.

HAYMAN, Karan Ann
(b. 18/10/1959, Melb.) Painter.
STUDIES: Dip. Fine Art, Phillip Inst., 1982; postgraduate Phillip Inst., 1992. A founding member of ROAR Studios Melbourne, she held four solo exhibitions 1988–92 in Melbourne (William Mora 1988, 90, 92) and Tokyo (1989). Her work appeared in a number of ROAR-related exhibitions 1981–92 including *ROAR Studios Benefit*, 1981; *ROAR Studios Opening Exhibition*, 1982, 83, 84; *Seven ROAR Artists: Ten Years On*, Gallery 2, Launceston 1991; *ROAR Studios Touring Exhibition*, Heide 1992; and in *A First Look*, Drill Hall, NGA 1986; *A New Generation*, Philip Morris Arts Grant, NGA 1988; *Heidelberg and Heritage 9 × 5*, Linden, Melbourne 1989; *Artists Against Animal Experimentation*, Deutscher Brunswick St 1990. She was one of the four artists commissioned to paint a mural for the restaurant at the NGA.
REP: NGA; NGV; Parliament House; Gadens and Myer collections.

HAYNES, George
(b. 1938, Kenya; arr. Aust. 1962) Painter.
STUDIES: Chelsea School of Art, London, 1958–62. His exhibitions at the Skinner Galleries, Perth, 1964–74, established his name as a leading WA painter. In their spaciousness and freshness his large, early abstracts are a celebration of the West, its sunshine and landscape. His well-drawn, low-toned drawings of heads reflect his early training and add strongly to his growing reputation. He made his debut in the eastern states in the *Artists from the West* exhibition (MOMAD, Melbourne, 1963) and subsequently held many solo exhibitions in Sydney (Hogarth, Rudy Komon, David Jones); Melbourne (South Yarra, Powell St); Canberra (Solander); and many with Greenhill Galleries, Perth. His work appeared in a number of group exhibitions including *Ten Western Australian Artists*, AGWA 1976; Perth Festival of Arts, 1985.
AWARDS: Uni. of WA painting prize, 1966; Sir William Angliss prize, Melbourne, 1972; Murdoch Uni. Prize, WA, 1975; Fremantle Drawing Prize 1983, 84.

REP: NGA; AGSA; NGV; uni. collections in Perth and Adelaide.
BIB: Smith, *AP*. *A&A* 16/4/1979.

HAYSOM, Melville
(b. 1900, Melb.; d. 1976, Brisbane) Painter, teacher, critic.
STUDIES: NGV School. Haysom, who went to Qld in 1929, became president of the Qld Art Society (1923–24) and wrote art critiques for the Brisbane *Observer*. Army service, 1940–44, interrupted his painting career. In 1948 he became instructor in painting at the Brisbane Central Tech. Coll. Moore mentions his coastal scenes ('distinguished for free, bold brushwork').
AWARDS: Godfrey Rivers Bequest prize, 1935.
REP: QAG.
BIB: Vida Lahey, *Art in Queensland 1859–1959*, Jacaranda Press, Brisbane, 1959.

HAYWARD, F. J. (née Pickering)
(Active c. 1885–1910, Melb.) Painter.
STUDIES: Heidelberg, Vic., with Walter Withers. As Miss F. J. Pickering (the daughter of the Rev. A. J. Pickering, Vicar of St John's, Heidelberg, 1874–80), she exhibited at the VAA in 1885 and, as Mrs F. Hayward, at the VAS, 1898–1906. Her subjects (in oils) include landscapes of Heidelberg and Healesville as well as portraits and still-life. In her later work the influence of Withers can be clearly seen in both tonality and brushwork.

HAYWOOD, John
(b. 17/8/1929, Hobart; d. 24/10/1987, Hobart) Painter, sculptor.
STUDIES: Hobart Tech. Coll. (with J. Carington Smith); Royal Coll. of Art, London (with Professor Skeaping); Stockholm; Copenhagen (with Gottfried Eickhoff), c. 1951. He exhibited with the Tasmanian Group of Sculptors, 1950–68; CAS, Tasmania, 1962–72 and in several group exhibitions at the TMAG.
AWARDS: ESU Prize (open section), 1967.
APPTS: Head of Dept of Art, Hobart Tech. Coll.; Supervisor of Art for Tasmanian Education Dept from 1962; president of the CAS, Tas.
REP: TMAG.
BIB: Backhouse, *TA*.

HEADLAM, Kristin
(b. 1953, Launceston, Tas.) Painter.
STUDIES: BA, Uni. of Melb., 1976; painting, VCA, 1980–81. Photographic-like, atmospheric cloud images formed the majority of her works at several of her four solo exhibitions 1984–91, including those at Charles Nodrum, Melbourne, 1989, 91. Her work appeared in six group exhibitions 1982–91 including at Tricycle Theatre Arts Complex, London 1982; and in *Spirit of the Times*, Bicentennial Touring Exhibition, 1988; *Scotchmans Hill Prize*, Geelong Art Gallery 1989, 90; *Spring Festival of Drawing*, MPAC 1991.

AWARDS: Gold Coast City Conrad Jupiters Art Prize, 1991.
REP: NGA; Artbank; regional galleries Gold Coast, Tamworth.

HEATHCOTE, Christopher
(b. 1959, Vic.) Painter, critic, art historian.
STUDIES: Dip. Art, Prahran CAE, 1980; BA (Hons), Uni. of Melb., 1987; Ph.D. (art history), La Trobe Uni., 1993.
APPTS: Tutor, Uni. of Melb., 1988; La Trobe Uni., 1989–91; lecturer (part-time), Australian art, La Trobe Uni., 1992; Melb. Inst. of Education, 1992; art critic, *Art Monthly* (Australia) and *Art Monthly* (International), 1989–90; advisory editor, *Art Monthly*, Australia, 1989– ; art critic, the *Age*, 1991– .

HEDSTROM, Newton Samuel
(b. 2/7/1914, Sydney) Illustrator, painter.
STUDIES: NAS, 1932–34; J. S. Watkins School, 1934–35; RMIT, 1943–45; travel studies UK, Europe, 1976, 80, 83. His portraits were entered in *Archibald Prize* competitions from 1945; *Australian Women's Weekly Portrait Prize*, 1955–57; *Gallaher Portrait Prize*, 1965; *Wynne* and *Blake* prizes, 1978. A capable traditionalist figurative painter, he is a member of the Australian Watercolour Inst. with whom he exhibited annually from 1967. He first exhibited with the Society of Artists in 1940. He participated in the *Australia at War* exhibition at the NGV, 1945, and was a finalist in the Doug Moran National Portrait Prize, 1988.
AWARDS: Mosman prize for watercolour, 1948; Manly Art Gallery prize, 1969, 70; Caltex prize, 1971; several art society prizes Sydney 1975, 78, 85; Mercantile Credits Ltd Competition, 1985.
REP: AWM; Manly Art Gallery; Tweed River Gallery.
BIB: Robin Brown, *Milestones in Australian History 1788–1988*, Collins 1986. James Hays, *Australian Painters Series*, Golden Press 1967. *Warringah 1988. A Celebration by Its Artists and Writers*, Warringah Shire Council, 1988.

HEFFERNAN, Edward Bonaventura
(b. 1912, Melb.; d. 14/12/1992) Painter, teacher, industrial designer.
STUDIES: NGV School, 1928–31; George Bell School, 1932. Known principally for his drawings and paintings of nudes and other figure studies exhibited in solo and group exhibitions, notably in VAS exhibitions Melbourne.
AWARDS: Prizes in competitions at Heidelberg, Vic., 1930; Broken Hill, NSW, 1963.
APPTS: Lecturer (art and design), RMIT, 1946–58; head of dept of art and design, Gordon Inst. of Technology, Geelong, 1959–74; art critic, *Geelong Advertiser*, 1966–74; president, VAS, 1974–c. 85.
REP: NGV; regional galleries Castlemaine, Geelong, Hamilton, Shepparton.

HEGARTY, Kevin
(b. 11/12/1952, Fremantle, WA) Painter, teacher, printmaker.

STUDIES: Dip. Fine Arts, Claremont School of Art, Perth, 1972; postgrad. course, VCA, 1973; Dip. Ed., Hawthorn State Coll., 1979; B. Ed., Melb. CAE, 1982; study tours SE Asia, 1981, 82; Europe, UK, Hong Kong, China, 1991, 92. He held his first exhibition at the Inst. of Contemporary Art, Sydney, followed by two exhibitions of prints in Melbourne, 1978–79, and one in Canberra, 1979. His capable prints and drawings are done with panache and a certain flair for emphasis on essentials. He held about 10 solo exhibitions 1977–89 in Melbourne, Canberra and Sydney (Coventry Gallery) and at Claremont School of Art, WA 1989. He participated in a number of group (mainly prize) exhibitions including *Archibald Prize*, 1974; *Henri Worland Art Prize*, Warrnambool Gallery 1975; *Georges Invitation Art Prize*, 1980; *Blake Prize*, 1981, 82 and *Seoul International Print Bienniale*, 1983.
AWARDS: Armidale Art Gallery Purchase Award, 1975; Maitland Prize Purchase Award, 1981; Gold Coast City art purchase award, 1981; export market development grant, 1982.
APPTS: Tutor, CAE classes, Melbourne, 1974–78; secondary and TAFE teacher Vic., 1979–89; head, arts and media, North Coast Inst. of TAFE, Forster, NSW, 1990– .
REP: Regional galleries Gold Coast, Lismore, New England, Warrnambool; Uni. of WA; National Art Gallery, Malaysia.
BIB: PCA, *Directory*, 1976, 88. *Who's Who of AVA*, Thorpe/NAVA 1991. Germaine, AWA.

HEGEDUS, Lazlo
(b. 7/1/1920, Budapest; arr. Aust. 1949; returned Europe, 1976) Painter, graphic artist.
STUDIES: V. Aba Novak Studio, Budapest, 1938–40; Royal Hungarian Fine Art Academy, 1940–44. A teacher of artistic anatomy at the Uni. of Budapest 1940–46, he travelled in the Middle East in 1941. In 1948 he was granted political asylum in Austria and Italy before migrating to Australia. His low-toned, expressionistic paintings and drawings enjoyed a mixed reception in some 20 solo exhibitions in Australia and in 1976 he held a *Lazlo Hegedus Farewell Exhibition* at the Hawthorn City Art Gallery, Melbourne, and returned to Europe.
REP: NGA; NGV; uni. collections Melbourne, Monash; Museum of Fine Arts and State Museum, Budapest.

HEIDELBERG SCHOOL
Established 1885, at Box Hill, Vic. Initiated by Tom Roberts, Frederick McCubbin and Louis Abrahams when they established an artists' camp at the Melbourne bush suburb of Box Hill. Their work there was tantamount to a celebration of the introduction of *plein air* impressionism to Australia. Later members were Charles Conder, whom Roberts met in Sydney and persuaded to join the Box Hill group, and Arthur Streeton, whom Frederick McCubbin met by chance while painting on the beach at Beaumaris in 1887. During the summer months the group painted at Mentone and other Port Phillip Bay beach resorts. They also painted

in the country around Heidelberg, closer to the city than Box Hill, and in 1888 the brother-in-law of David Davies (q.v.) offered them the use of a cottage on a property at nearby Eaglemont. Streeton and Conder lived in the cottage and gave painting lessons, mainly to young women students from the NGV. Roberts, who worked in his studio in the city, joined them when he could and the general activities at Eaglemont attracted many visitors. On one occasion, the veteran painter John Mather lectured there to a gathering of more than 60 people, and before long the increase in attendances became an embarrassment. At Box Hill, Roberts had talked much about the new movements in France and what he had learned of impressionism during his European studies (1881–85). Many of his ideas were confirmed by the younger Conder who had learned something of the new movements in Sydney, mainly from the itinerant Italian Girolamo Nerli (q.v.). Box Hill was mainly deep-forested, bluegum country, but the much lighter atmosphere of the undulating landscape at Eaglemont and Heidelberg, through which flowed the clear waters of the Yarra River, had a special, lyrical quality well suited to the mood of impressionism. It soon became an important preoccupation with the Eaglemont group to record swift, on-the-spot impressions of the changing light and atmosphere, many of these 'impressions', being seen in the 9 × 5 inch (22.8 × 12.7 cm) cedar cigar-box lids of the 1889 *Impression Exhibition* (See EXHIBITIONS) – the most controversial exhibition in early Australian art history. Another important painter, who had just returned from Europe, Walter Withers, joined the Eaglemont Group after the 9 × 5 show, and it was his continued activity, and that of many other painters in the Heidelberg area after the dissolution of the original Eaglemont group in 1890, that caused the whole of the activities at Box Hill, Mentone, Heidelberg and Eaglemont to be categorically named the 'Heidelberg School'. A major exhibition *Golden Summers: Heidelberg and Beyond* concentrating on artists from the School was initiated by the NGV in 1986 and toured to other state galleries, bringing huge attendances at all its venues. *Completing the Picture: Women Artists and the Heidelberg Era*, first seen at Heide Gallery, Melbourne 1992 then touring five regional and public galleries, created much interest and focused attention on women artists associated with the School.
BIB: All Australian contemporary art histories. McCulloch, *GAAP*. Ann Galbally, *Arthur Streeton*, 1969, 1979; Virginia Spate, *Tom Roberts*, 1972, 1978; Ursula Hoff, *Charles Conder* – all published by Lansdowne. See also catalogues of *Golden Summers* exhibition, Jane Clark and Bridget Whitelaw, NGV, 1986 and *Completing the Picture*, Victoria Hammond and Juliet Peers, Artmoves, Melbourne 1993.

HELE, (Sir) Ivor Henry Thomas
(b. 13/6/1912, Edwardstown, SA; d. 1/12/1993, Adelaide) Painter.
STUDIES: SASA, with James Ashton, –1916; Biloul School, Paris; Heyman School, Munich. His sesquicentennial prize-winning picture, *Sturt's Reluctant*

Decision to Return, created a minor sensation when shown in Sydney in 1938. During World War II, Hele was appointed official war artist while serving first as a private soldier then captain with the 9th Australian Division in the Middle East. His grimly realistic paintings of the actions in which he participated as artist-soldier are outstandingly the most impressive of any work produced by an Australian official war artist during World War II. In 1952, after a prolonged period of work at his home at Aldinga, SA, he was appointed an official artist to the Australian forces in Korea. He was commissioned to paint the opening of Federal Parliament by the Queen in 1954 and in 1956 became a member of the board of trustees of the AGSA. He was also a renowned portrait painter, having won the Archibald Prize five times in the space of seven years. His work was represented in *The Great Australian Art Exhibition 1788–1988*.
AWARDS: South Australian centennial prize, 1936; Melrose prizes 1935, 36, 39; Sydney sesquicentennial prize, 1938; Archibald prizes, 1951, 53, 54, 55, 57; OBE conferred 1955; knighted 1983.
REP: NGA; AWM; AGNSW; AGSA; AGWA; MAGNT; NGV; QAG; QVMAG; TMAG; many regional galleries and other public collections.
BIB: A number of general books on Australian art. V. W. Bransom, *The Art of Ivor Hele*, Rigby, Adelaide, 1967.

HELLIER, Dermont James John
(b. 23/2/1916, Albury, NSW) Painter.
STUDIES: Sydney, with Scottish artist Sarah Kyle, 1925; NGV School, (with Charles Wheeler) 1932, (with Septimus Power) 1947; Dip. Art, CIT; TTTC. He served in World War II in Australia and New Guinea and after the war continued his studies with Septimus Power. He was a secondary art teacher for the Education Dept, Vic., and held an exhibition at the Athenaeum Gallery, Melbourne and one in the Qantas Gallery, London, in 1966. By 1976 his deft pictures of street scenes and landscapes had appeared in numerous solo exhibitions in Victorian country areas as well as in NSW, Alice Springs and Qld. His mural and painting commissions include six paintings of the area for the Gold Coast City Council.
AWARDS: Prizes at Albury, Bright, Mornington, Shepparton.
REP: QAG; several regional galleries including Albury, Geelong, Shepparton, Swan Hill.

HELYER, Nigel Lloyd William
(b. 14/12/1951, Hampshire, Eng.; arr. Aust. mid-1980s) Sculptor, sound artist, lecturer.
STUDIES: BA (Hons), sculpture, Liverpool Coll. of Art, UK, 1974; MA (environmental media), Royal Coll. of Art (London), 1979. Described as a 'sound architect', he produces sculptures that transmit sounds, ranging in size from an installation at the ABC building in Ultimo (Sydney) of miniature Buddha sculptures fitted with radio transmitters hanging from the atrium's scaffolding, to an architectural scale work in Olympic Park for the Seoul Olympics. His commissions include

those for Uni. of San Jose, USA; Olympic Park, Seoul, 1988; ABC Radio *Bell Transfer*, and ARS Electronica (Vienna), opera *Semi Automatic Writing*, ABC radio, 1991. He made about five solo installations 1990–93 including at AGNSW; PICA, Perth; and for the Biennale of Sydney.

AWARDS: Residency, Greene St Studio, NY, VACB, 1988; residency, Cité Internationale des Arts, Paris, AGNSW, 1990; fellowship to develop practice, VACB, 1992.

APPTS: Head of sculpture, performance art, installation studio, SCA, 1985– .

REP: AGWA; Uni. of WA; public museums Seoul, Uni. of San Jose.

BIB: Catalogue of installations including *A Symphony for Other Cultures*, 1987; *A Big Bell Beta*, 1992; *Siren Song*, 1992.

HENDERSON, E. A.

Sculptor.

STUDIES: SASA. A member of the Earl's Court modelling group of Australian soldier-artists in London after World War I. Later he worked on the AWM at Canberra.
NFI

HENDERSON, (Sir) Edmund Yeamans Walcott

(b. 19/4/1821, Muddiford, Hampshire; arr. Perth 1850; d. 1896, London) Administrator, soldier, painter. As Comptroller of Convicts in WA, 1850–63, he is recorded as having been a capable and humane administrator; he returned to England after his wife died in 1855, remarried 1857 and resumed his office in WA in 1858. Several of his sketches were engraved and published in the *Illustrated London News*, 1857. His residence, *The Knowle*, Fremantle, was built by convicts in 1856 from local limestone with floors and staircases of Singapore cedar. The house became the Fremantle Hospital and is now the administrative centre of the hospital. His work was included in the exhibition *The Colonial Eye*, AGWA 1979.

BIB: *ADB* 4. Kerr, *DAA*.

HENDERSON, John Black

(b. 5/6/1827, London; arr. Vic. 1851; d. 1918) Painter. He studied in Edinburgh and London before going to the Ballarat goldfields in 1851. He joined the Survey Dept, Melbourne, surveyed the town of Beechworth, and worked in the Government architect's office, Sydney, from 1877 to 1903. He exhibited landscapes in oils of north-eastern Vic. at the VAA, 1870–72, but his principal claim to fame is a small watercolour in the Mitchell Library depicting the Eureka Stockade. It was painted from sketches done on the spot a few hours after the event. His work was seen in *From the Beginnings of European Settlement*, Ballarat Fine Art Gallery 1983; Joseph Brown exhibition, Autumn 1979 and in *Selected Australian Works of Art*, Lauraine Diggins Gallery 1985.

REP: Ballarat Fine Art Gallery; NLA; Mitchell, La Trobe, Dixson Libraries.

BIB: Campbell, *AWP*. Moore, *SAA*. McCulloch, *AAGR*. Kerr, *DAA*.

HENG, Euan

(b. 26/2/1945, Oban, Scotland; arr. Aust. July 1977) Painter, printmaker, teacher.

STUDIES: Dip. art and postgrad. study, Duncan of Jordanstone Coll. of Art, Dundee, Scotland, 1970–75; enrolled masters degree, RMIT, 1991– . Working as a merchant seaman for 10 years before taking up art studies, his paintings have a deliberation gained by preworking the images in pastel or pencil before committing to paint. Contemporary symbolism and flat pattern-making are features of his work described by Gary Catalano (*Age* 27/9/1989): 'the changes Heng makes as he reworks and perfects an idea are all directed at deepening his work's emotional resonance. In Heng's art connotations count for much.' He held 10 solo exhibitions 1974–91 including in the UK, at Australian Galleries, Melbourne, and at Latrobe Valley Arts Centre (1987, 91). Group exhibitions in which his work appeared include some in Scotland, and print survey exhibitions including *Contemporary Australian Printmakers*, QAG 1984; *Australian Prints '85*, touring USA 1985; and PCA exhibitions including *100 × 100*, 1988; *Transitional Times: 25th Anniversary Print Commissions*, 1991.

AWARDS: Student prizes for painting and printmaking, 1971–76.

APPTS: Tertiary teaching from 1976, including lecturer, Clackmannan Coll. of Further Education, Stirling; lecturer in drawing and printmaking, Riverina CAE, Wagga Wagga, NSW; senior lecturer, School of Visual Art, Monash Uni. Coll., Gippsland.

REP: NGA; NGV; TMAG; Parliament House; PCA; Artbank; numerous regional gallery collections including Bathurst, Bendigo, Latrobe Valley, Wagga Wagga; a number of tertiary collections including Griffith, Charles Sturt unis.; Scottish Arts Council.

BIB: Catalogue essays exhibitions as above. *A&A* 27/1/1989.

HENIGAN, Patrick

(b. 1925, Staffordshire, Eng.; arr. Aust. 1950) Painter.

STUDIES: Coll. of the Arts, Qld, 1976; Prahran CAE, 1977–78. A member of the Franciscan order of brethren, his art has been strongly influenced by religion. His drawings, first shown at Pinacotheca Gallery, Melbourne, 1981, 82 were on the theme of 'self, all done at *La Verna*, a Franciscan house of prayer', and attracted attention for their intensity of feeling. This quality is further enhanced by the placement of the figure within the frame and rich, sombre colours. He held seven other solo exhibitions 1984–92 at Niagara Galleries, Melbourne and at the Mornington regional gallery 1989. His work appeared in about 18 group exhibitions 1982–91 including at Niagara, Melbourne and in *Art from Elsewhere*, Uni. of Tasmania 1989; *Correspondences*, QAG 1991.

AWARDS: MPAC *Festival of Drawing*, work acquired, 1981.

Patrick Henigan, Untitled – (Boxing series), *1988, charcoal on paper, 56 × 76cm. Courtesy Niagara Galleries.*

REP: NGA; NGV; MOCA, Brisbane; regional galleries Latrobe Valley, Mornington; tertiary collections including La Trobe Uni., Victoria Coll.; Joseph Brown collection.
BIB: Daniel Thomas, *Outlines of Australian Art: The Joseph Brown Collection,* 3rd edition, Macmillan, 1989. *New Art Three.*

HENN, M. L.
Early engraver of Van Diemen's Land, c. 1800.
NFI

HENNESSY, John
(Active c. 1910, Melb.) Painter. He exhibited oils, watercolours and pastels at the VAS, 1900–15. Subjects included portraits, figure studies and genre.
NFI

HENNING, Rachel Biddulph
(b. 23/4/1826, Bristol, UK; arr. Aust. 1854; d. 1914, Sydney) Sketcher, writer. Although now known mainly for her letters of rural colonial life which have been published in several books, she also made sketches.
BIB: *ADB* 4. Kerr, *DAA.*

HENNINGS, John
(b. 6/7/1835, Germany; arr. Aust. 1855; d. 1898) Painter. Studying decorative art in Düsseldorf, he painted some sets for the Vienna State Opera before migrating to Victoria. He painted scenery for most of Melbourne's leading theatres including the Queen's, Princess, Olympic and Haymarket and exhibited a number of still-lifes and portraits in exhibitions such as the 1866 *Melbourne Intercolonial Exhibition.* He was commissioned by the trustees of the Exhibition Buildings to paint a large cyclorama of Melbourne (now in the La Trobe Library collection) based on that previously painted by the architect Samuel Jackson (q.v.). He is regarded as having made a major contribution to the development of Australian theatre.
REP: La Trobe Library.
BIB: E. Irwin, *Dictionary of Australian Theatre 1788–1984,* NSW 1985. Moore, *SAA.* McCulloch, *AAGR.* Kerr, *DAA.*

HENRY, Lucien Felix
(b. 1850, Sisteron, France; arr. Sydney 1880; d. 10/3/1896, France) Painter, sculptor, designer, teacher.
STUDIES: Paris (with Viollet-le-Duc, architect); Ecole des Beaux-Arts (with Gerome). A French *communard,* Henry was active in the commune of 1871 for which he was sentenced to death, but was later reprieved and sent to New Caledonia. At the end of his sentence he went to Sydney, where he became instructor at the first modelling school in Australia, and in 1883 the first lecturer in art at the school established when the Board of Tech. Education took over the former Sydney Mechanics School of Art (*see* SCHOOLS). He published *The Legend of the Waratah,* and dedicated it

to a prominent figure in Australian Labor politics, Fred Bloomfield, directing special attention to 'the great decorative possibilities in the forms of Australian wildflowers'. Henry was intensely interested in Australian flora and, through his strong, engaging personality, imbued his students with much of his own power of perception. Among his pupils were: James Nangle, a superintendent of technical education in NSW; G. H. Aurousseau, Gregory Macintosh, Alexander Murray, instructors at ESTC; J. R. Tranthim-Fryer, first director, Swinburne Tech. School, Melbourne; Lucien Dechaineux, director of Hobart Tech. Coll.; A. G. Reid, sculptor; B. E. Minns; G. W. L. Hirst; Sydney Cathels. Henry designed the *Captain Cook* and *Australia* subject stained-glass windows in the Town Hall, Sydney, and the chandelier in the Hotel Australia, Sydney; he also painted many portraits and modelled many busts. His pioneering ideas and the opposition to them are given in an article in *Australian Art*, 1888. He returned to Europe in 1889.

BIB: R.T. Baker, *Australian Flora in Applied Art: the Waratah*, Sydney, 1915. Lucien Henry, article in *Australian Art*, 1888. ADB 4.

HENRY, Thomas Shekleton

(Active c. 1890–1920) Painter. Known mainly for watercolours, he exhibited a Katoomba landscape at the Art Society of NSW in 1894. Recorded works include an Illawarra beach scene and a view of Hobart; later works dated 1920 suggest his emphasis shifted towards bush genre in the intervening years. Ferguson records his book *Spookland! A record of research – spiritualistic phenomena*, by T. Shekleton Henry, ARIBA (Sydney, 1894).

REP: AGWA.

BIB: Edward Craig, *Australian Art Auction Records, 1975–78*, Mathews, Sydney, 1978. J. A. Ferguson, *Bibliography of Australia*, vol. 5, NLA, 1977.

HENRY, Victor

(Active c. 1900, Melb.) Painter. Late colonial school landscape painter, he exhibited watercolours and oils of WA as well as Victorian landscapes at the VAS, 1901–03. New South Wales landscapes have also been recorded.

NFI

HENSHAW, John George

(b. 2/2/1929, NZ) Painter, critic, editor, writer.

STUDIES: Elam School of Art, NZ, 1948; Julian Ashton School, with John Passmore, 1951–54; Central School of Arts and Crafts with Keith Vaughan, 1957–58; British School, Rome, 1959; sculpture studies, Basle, 1959; travel studies Europe, Africa, USA, and Pacific Islands, 1959. His versatile talents, extensive interests and experience, as well as involvement with a wide variety of art activities, have somewhat militated against his recognition as a fine painter and draughtsman. Travelling widely, including trips to Iran, Mexico, India, Egypt, Europe, USA and UK, he held about six solo exhibitions 1962–92 largely in Sydney (including at Artarmon Galleries 1964,

Darlinghurst Gallery 1967, David Jones 1979) and Melbourne (Niagara 1992). His work also appeared in several group exhibitions, including with the CAS, Sydney in the 1950s and in *Archibald Prize*, 1973; *Wynne Prize*, 1974. His books and catalogues include several definitive works on the art of Godfrey Miller (*Drawings by Godfrey Miller*, Edwards & Shaw, Sydney, 1962; *Godfrey Miller*, Darlinghurst Galleries, Sydney, 1965; Godfrey Miller catalogues for Newcastle Art Gallery, 1968, Niagara Galleries, 1982, David Jones, 1990) and Frank Hinder (catalogues for lithograph exhibition Bloomfield Gallery, Sydney 1979 and co-author with Renee Free of a book, as yet unpublished, on Hinder). He contributed widely to art journals and magazines and in 1989–91 was instrumental in training craftspeople in India in the art of stained glass art.

AWARDS: Travelling scholarship of NSW, 1956; Warringah Prize, 1956; Bendigo prize, 1964.

APPTS: Teaching, NAS, 1960–70; senior lecturer, SCA, 1975–86; visiting lecturer, various colleges, 1975– , including RMIT, 1975, Newcastle Uni., 1990; general ed., Lansdowne *Australian Art Library*, 1966–70; art critic, *Australian*, 1969–70; manager in Australia for Christie Manson and Woods, 1970–75; senior lecturer in visual arts, SCA, 1976– .

REP: NGA; AGNSW.

HENSON, Bill

(b. 1955, Melb.) Photographer, self-taught, whose work is notable for a grand scale and melding of art and photography. David Malouf, in a catalogue essay (Deutscher Fine Art exhibition 1984), describes his works as portraying a 'mysterious and compelling world . . . A Bill Henson photograph sets what it looks at in a new light, the light of a city we have never been in, or a city on another planet'. He held over 35 solo exhibitions 1975–93 in Australia (including Deutscher; Garry Anderson; Roslyn Oxley9), New York, San Francisco, Paris, Wellington, NZ, Rotterdam, and at the NGA, 1987; Tasmanian School of Art, 1987; IMA, Brisbane, 1987; and in public galleries in Vienna, 1989; Denver, USA, 1990; Paris, 1990. His work appeared in numerous exhibitions in Australian public galleries 1975–93 including *Australian Perspecta*, AGNSW 1981, 89; *Biennale of Sydney*, 1982, 86; *Shades of Light*, NGA 1988; *Ten Years of Australian Photography*, NGA 1988; *The Great Australian Art Exhibition 1788–1988*, touring 1988–89; and many European, British and American group exhibitions including *ARCO 2*, Paris 1983; Guggenheim Museum 1984; *Elsewhere: Photobased Work from Australia*, Inst. of Contemporary Art, London 1988; *Photo Kunst*, Stuttgart Staats Gallerie 1989; *Passages de l'Image*, Centre Georges Pompidou, Paris 1991 and touring USA, Spanish museums, 1991.

REP: NGA; AGNSW; AGSA; AGWA; NGV; QAG; QVMAG; TMAG; MOCA, Brisbane; Artbank; several regional galleries including Ballarat, Horsham; High Court of Aust.; several tertiary collections including Darwin Community Coll., Phillip Inst. of Technology, Griffith,

Harold Herbert, Bather under a Tree, 1943, watercolour, 27.5 × 33.5cm. Christie's, September 1991

Monash unis.; Loti and Victor Smorgon private collections; Guggenheim Museum, New York; San Francisco Art Museum; Denver Art Museum; MOMA, Vienna.

HENTY, *Ruby Perchard*

(b. 1884, Adelaide; d. 1972, Adelaide) Painter.
STUDIES: School of Design, Adelaide (with Gill and Collins). She spent some time in Sydney in the 1920s and was a member of various societies including the SASA, the CAS (in Vic.) and the NSW Watercolour Inst. Basically modern in outlook, she was associated with Dorrit Black's Group 9 which exhibited in Adelaide from 1944–51.
BIB: Rachel Biven, *Some forgotten . . . some remembered*, Sydenham Gallery, Adelaide, 1976.

HERBERT, *Harold Brocklebank*

(b. 1892, Ballarat, Vic.; d. 1945, Melb.) Painter, teacher, illustrator, critic.
STUDIES: Ballarat School of Mines, c. 1907. Herbert worked in the tradition of Australian impressionism and became noted for extraordinary skill in the manipulation of watercolour washes. He was a member of the Commonwealth Art Advisory Board and of the Australian Artists' Association, Australian Watercolour Inst., NSW Society of Artists and the VAS; also art teacher for the Victorian Education Dept from 1912 to 1919, and from 1915 to 1919 he taught at his old school, the Ballarat School of Mines. He painted in Europe and Morocco in 1922 and on his return established the 'Herbert watercolour tradition', which affected a whole school of later representational watercolourists. From c. 1936 he illustrated stories for the *Sun News-Pictorial* and wrote critiques for the *Australian*

and subsequently for the *Argus*. Herbert's personal popularity and contacts gained him a prestige and influence far in excess of his knowledge of art and art history, of which he was never a student. It was said of him that he took little or no interest in the collections in the Louvre during his visit to Paris, and still less in other European collections. He was the first official war artist appointed, in 1941, to the Australian Imperial Forces in the Middle East, and he served in that capacity for six months. A memorial exhibition of his work was held at the National Gallery of Victoria in 1945.
REP: Australian state and regional galleries.
BIB: AA, 1920 (*The Watercolours of M. J. McNally and Harold Herbert*); special number of AA, 1928. Moore, SAA.

HERBERTE, *Sandy (Alexander)*

(b. 1960, Taree, NSW) Painter.
STUDIES: BA (Visual Arts), SCA. He curated *Some Young Sydney Painters* for Ray Hughes Gallery, 1987 and held four solo exhibitions 1987–91 including at Ray Hughes, Brisbane and Sydney. His work appeared in about 12 group exhibitions 1982–90 including Nicholson St Gallery, Sydney; *Australian Perspecta*, AGNSW 1989; *Twenty Australian Artists*, Galleria San Vidal, Venice, QAG, Benalla Regional Art Gallery 1990.
REP: QAG.

HERBST, *Gerhard (Paul Gerard)*

(b. 1/2/1911, Dresden; arr. Melb. Mar. 1939) Designer, teacher, lecturer.

STUDIES: Germany, Industrie und Handelskammer (Dip. 1930). Exhibiting in Berlin and Munich, his designs came under the notice of Moholy Nagy after the closure of the Bauhaus by the Nazis. Escaping to Australia in 1939, he established studios for Victorian industry, served in the AIF, 1939–45, and after the war worked as an industrial designer before his appointment as lecturer in charge of industrial design at RMIT (1960–76). He lectured in the USA, Italy, and Mexico 1969–70, was design consultant to the Industrial Design Council of Australia and, from 1979, to Deakin Uni. He contributed to several books and journals including *Visual Education*, ed. C. E. Moorhouse, Pitman Australia, Melbourne, 1974; *Visual Language*, Deakin Uni., Geelong, 1979. He curated a number of international poster exhibitions for Australian galleries 1984–93 including *Visionnaire Schweiz*, with the Prahran City Council, 1992. His work appeared in *Pioneers of Design*, Ivan Dougherty Gallery, NSW 1992.
AWARDS: Documentary film award (shared with Geoff Thompson), Ciné Service, 1951–52.

HEREL, *Petr*

(b. 19/5/1943, Horice, Czechoslovakia; arr. Aust. Mar. 1973) Painter, printmaker, teacher.
STUDIES: Prague Coll. of Visual Arts, 1957–61; MA and Dip. Ed., Prague Academy of Applied Arts, 1964–69. First Australian showing of his work was at the Crossley Gallery, Melbourne, in May 1973, when his etchings evoked the surrealistic fantasies of a Bosch or Callot. Later his work lightened, developing a lost-and-found look in which imagination and sensuousness are mixed with poetic sensibility. He held about four solo exhibitions 1980–93 including with Rudy Komon, Sydney 1983; Powell St, Melbourne 1984 and in Paris. Group exhibitions in which his work appeared 1980–93 include *Artists' Books*, NGA, Tasmanian Uni. 1989; *Mitchelton Print Award*, 1992; and many international print exhibitions 1983–93 including Europe, Japan. In the 1990s he was instrumental in the promotion of the *Artists' Books* project at the NGA and later with Professor Jenny Zimmer from the Monash University Dept of Art (Caulfield Campus). (*See* ARTISTS' BOOKS.)
AWARDS: Scholarship, French Government, Paris, 1971; Hamilton Invitation Award, 1980; Henri Worland Print Prize, 1983; Interprint Honorary Medal, Lvov, 1992.
APPTS: Teaching, CIT, 1974–76; Dijon Ecole des Beaux-Arts, 1977–78; Canberra School of Art, 1979–85; Orléans Institut des Arts Visuel, 1985–86; Canberra Inst. of the Arts, ANU, 1986– .
REP: NGA; NLA; state galleries Czechoslovakia, Prague, Vienna; Bibliothèque Nationale, Paris.
BIB: Catalogue essays exhibitions as above. Anne Gray, *Petr Herel: Artists' Books*, NLA, 1989.

HERMAN, *Sali (Yakubowitsch)*

(b. 1898, Zurich; arr. Aust. 1937; d. 3/4/1993) Painter.
STUDIES: Zurich Tech. School, 1914–16; Paris, 1920–23; George Bell School, Melbourne, 1937.

Herman began art dealing in 1923 and travelled extensively in Europe, USA, South America and Africa before coming to Australia. He settled in Sydney in 1938 and was appointed an official war artist, 1945–46. His paintings, particularly those of the façades of inner city buildings in the suburbs of Paddington and Woolloomooloo, became noted for the tactile qualities of their surfaces. With their muted colours, they are carefully worked over by extensive scraping down and the use of scumbling and transparent glazes. His style was successfully applied also to landscape, still-life and portraiture. A generous supporter of other artists and the art world, he donated the entire prize money of the Opera House lottery he won to the AGNSW for purchase of works of art. A major retrospective of his work, curated by the AGNSW, was toured to state galleries in 1981 and his work was represented in *Swiss Artists in Australia* AGNSW, 1991.
AWARDS: Wynne prize, 1944, 62, 65; Sulman prize, 1946, 48; prizes at Bendigo, 1948, 49; Geelong, 1948; Brisbane (Caselli-Richards), 1958; Maitland, 1959, 60, 62; Wagga Wagga, 1958; Melbourne (McCaughey), 1959; Tumut, 1959; Newcastle, 1962; R.Ag.Soc.NSW, Easter Show prize, 1964; OBE conferred, 1971; CMG, 1982.
REP: NGA; AGNSW; AGSA; AGWA; MAGNT; NGV; QAG; QVMAG; TMAG; many regional galleries and other public collections.
BIB: Daniel Thomas, *Sali Herman* in *Australian Art Monographs*, Georgian House, Melbourne, 1962; *Sali Herman*, Collins, Sydney, 1971. A&A 24/4/1987.

HERN, *Charles Edward*

(b. 1848, Eng.; arr. Aust. 1873; d. 1894, Eng.) Landscape painter in watercolour. Hern lived in Sydney where he was an active member of the NSW Academy of Arts, 1873–80, and of the Art Society of NSW, 1880–83. His carefully finished and detailed watercolours include views of *Careening Cove*, a panorama of Sydney Harbour, the *Grosse Valley from Govett's Leap*, etc. Chromolithographs were made from his original *Six Views of the Hawkesbury River* and *Six Views of the Blue Mountains*, the latter published by John Sands in the early 1880s. He returned to England in 1883 and became instructor in watercolour painting to the daughters of Edward VII, then Prince of Wales. He exhibited landscapes at the RA and at the Royal Society of British Artists, 1884–93. His work appeared in *A Selection of Paintings and Prints*, Thirty Victoria Street, Sydney, 1974.

HESLING, *Bernard*

(b. 1905, Yorkshire; arr. Aust. 1928) Painter, cartoonist.
STUDIES: No formal training. Hesling started painting after meeting Léger, Vlaminck, Marie Laurencin and other leading French painters while working in Paris as a house painter and marbler. He began work as a primitive and modelled himself after the pattern of the Douanier Rousseau, before moving into more sophisticated fields of activity. In 1929 he held an

exhibition of abstracts in Sydney and from 1933 until 1938 was an advertising director at Elstree Studios, Sydney. Cartoons and writings by him appeared in the *New Yorker, Manchester Guardian, Listener, Sydney Morning Herald, Telegraph, Smith's Weekly, Meanjin, Quadrant, Nation* and other papers. He also wrote art criticism for the Sydney *Observer*, and between 1950 and 1955 painted a number of murals besides pio-

APPTS: Lecturer in art at the School of Architecture, Sydney Uni., 1959.
REP: AGNSW; NGV; QAG; regional galleries Ballarat, Launceston, Newcastle.

BIB: Elizabeth Young, *Antipodean Vision*, Cheshire, Melbourne, 1962. Exhibition catalogue of *The Australian Painters*, Mertz collection, Corcoran Gallery, Washington, DC, 1966. Smith, AP. A&A 9/3/1971.

Joy Hester, Reclining woman, *pencil, pen and ink on paper, 12.6 × 20.2cm. Collection, Warrnambool Art Gallery.*

neering in Australia the use of vitreous enamels and holding exhibitions in this medium in Adelaide, Sydney and Melbourne. He has published a number of booklets illustrated with his own paintings and drawings, including *Around the World on an Old Age Pension*, Lynton Publications, Adelaide, 1974.

HESSING, Leonard

(b. 1931, Romania; arr. Aust. 1951) Painter, lecturer.
STUDIES: Paris (with Fernand Léger), 1950–51; grad. with a degree in Architecture from Sydney Uni. After World War II, Hessing travelled through Russia, the Middle East and the Mediterranean islands before going to Australia. He founded the Atoll Group in Sydney, 1957, and was vice-president of the CAS, NSW division, 1960–61. His painting reflects many of the sophisticated trends of abstract-expressionist painting in Europe and America. His first wife, Mona, is a distinguished weaver and his mother, Perle Hessing, a naive painter. About 1966 he moved to the UK.
AWARDS: Board of Architecture prize, NSW, 1958; Robin Hood prize, 1961; Rockdale prize, 1961; R.Ag.Soc.NSW Easter Show (rural modern) prize, 1962; Taffs prize (CAS), Sydney, 1962.

HESTER, Joy

(b. 21/8/1920, Elsternwick; d. 1960) Painter.
STUDIES: Brighton Tech. School (commercial art), 1936; NGV School, 1937–38. In 1941 she married Albert Tucker with whom she had one son, Sweeney (1944–79), and from whom she separated in 1947. Her second marriage was to another Melbourne painter, Gray Smith, with whom she had two children. From 1947 she suffered from Hodgkins disease, the cancer that was prematurely to end her life, but which gave her drawings the *fleur de mal* quality that became their trademark. The unique quality of these drawings, done usually with a brush loaded with Indian ink, derived also from her interest in poetry. She read avidly, wrote her own poems, some of which she illustrated, and came to understand, as few Australian artists of her generation did, the ways in which poetry and drawing are linked through metaphor. She drew incessantly, exhibiting her work in Melbourne and in the

annual exhibitions of the CAS, of which she was a foundation member (1938). During her lifetime her great talents were apparent only to the few confined mainly to the circle of artists and writers in which she moved but after her death these talents became more widely recognised. A large commemorative exhibition, *Joy Hester*, was held at Georges Gallery, Melbourne, in 1963, and another at the NGV, Sept.–Dec. 1981, and Lauraine Diggins curated an exhibition of her work for her Melbourne gallery and touring regional galleries Vic., and S. H. Ervin, Sydney 1993. Her work was included in *Australian Women Artists: 1840–1940* Ewing & George Paton Galleries, University of Melbourne 1975; *The Great Australian Art Exhibition 1788–1988*; *A Century of Australian Women Artists 1840s–1940s*, Deutscher Fine Art, Melbourne 1993.
REP: NGA; AGSA; AGWA; NGV; regional gallery Ballarat; Uni. of Qld (Uni. Art Museum).
BIB: Gino Nibbi, *Joy Hester*, Modern Australian Art, MOMAD, Melbourne, 1958. Janine Burke, *Australian Women Artists 1840–1940*, Greenhouse, Melbourne, 1980 and *Joy Hester*, Greenhouse Publications, Melbourne 1985. A&A 4/1/1966; 18/1/1980.

HEXT, *(Captain) C. S.*

(b. 5/2/1816, Cornwall; visited Tas. 1842) Naval officer, topographical artist. He made drawings of Hobart, Port Arthur, Eaglehawk Neck, as well as of Aborigines and one of Sydney; these were lithographed by C. Hutchins and probably published in 1845. Though amateur works, the detail is of considerable historical interest.
REP: Melbourne Uni.; NLA; Dixson, Allport Libraries.
BIB: Clifford Craig, *Old Tasmanian Prints*, Foot & Playstead, Launceston, 1961. Kerr, DAA.

HEYSEN, *(Sir) Hans*

(b. 8/10/1877, Hamburg, Germany; arr. Adelaide 1883, d. 2/7/1968, Hahndorf, SA) Painter.
STUDIES: Norwood Art School, Adelaide (with James Ashton); Adelaide School of Design (with Harry P. Gill); Paris, 1899 (with Jean Paul Laurens and Benjamin Constant), Académie des Beaux-Arts (with Leon Bonnat). From the time of his first exhibition, at the Guild Hall, Melbourne, 1908, Heysen's work gained steadily in popularity. He made his home at Hahndorf, SA, and became prolific in watercolours of Australian bush landscapes dominated by massive, strongly drawn gum-trees, coloured in delicate pinks and blues. Many of these paintings portrayed the stand of gum-trees on his own 60-hectare (150-acre) property at Hahndorf, and the Flinders Ranges, Mount Lofty Range, and the regions near Hahndorf became favourite subjects. From 1908 a wide section of the public began to see these works as symbols of the Australian landscape. Heysen won the Wynne prize for landscape nine times between 1904 and 1932, and is generally rated as the chief protagonist in charcoal and watercolour of the monumentality of the Australian gum-tree. He was a member of the board of trustees of AGSA, 1940–68. The AGSA held a retrospective of his work in 1977 and

Nora Heysen, Self Portrait, *1932, oil on canvas on stretcher frame, 76.2 × 61.2cm. Collection, AGNSW.*

survey exhibitions in which his work appeared in the 1980s included *The Great Australian Art Exhibition 1/88–1988*.
AWARDS: Wynne prize, 1904, 09, 11, 20, 22, 24, 26, 31, 32; Crouch prize, 1931; Vizard-Wholohan prize, 1957; OBE conferred, 1954; knighted, 1959.
REP: AGNSW; AGSA; AGWA; MAGNT; NGV; QAG; QVMAG; TMAG; many regional galleries; British Museum (two etchings in the print collections).
BIB: AA special Heysen number 1920, *The Art of Hans Heysen*. Lionel Lindsay, *Hans Heysen's Watercolours and Drawings*, Legend Press, Sydney, 1952. A&A 6/4/1969 (Robert Campbell, *Sir Hans Heysen*).

HEYSEN, *Nora*

(b. 1911, Ambleside, SA) Painter.
STUDIES: Family studies; School of Fine Arts, Adelaide, with F. Millward Grey, 1926–32; Central School of Arts and Crafts, London, 1934–36; Byam Shaw School with Bernard Meninsky, 1935–37. While still in her teens she became known for her impressionistic still-life studies and portraits and her work was acquired for three state galleries. She won an Archibald prize at the age of 27, was appointed an official war artist and worked in New Guinea, 1944–46. Her work

became highly regarded as the years progressed, especially in the 1980s and 90s with the revival of interest in women artists of the 19th to mid 20th century. Her work was seen in *Australian Women Artists 1840–1940*, Ewing & George Paton galleries, University of Melbourne and touring public galleries 1975; *A Century of Women Artists*, Deutscher Galleries, Melbourne 1993.
AWARDS: Archibald prize, 1938; L. J. Harvey Memorial prize, QAG, Brisbane, 1973; emeritus award, VACB, 1991.
REP: AGNSW; AGSA; QAG; AWM; regional galleries Armidale, Ballarat, Hamilton, Newcastle.
BIB: Janine Burke, *Australian Women Artists 1840–1940*, Greenhouse, Melbourne, 1980. Lou Klepac, *Nora Heysen*, Beagle Press, Sydney, 1989. A&A 27/3/1990.

HICK, Jacqueline
(b. 8/12/1919, Adelaide) Painter.
STUDIES: SASA; TSTC, SA Teachers Coll., 1941; Central School of Art, London; Fernand Léger Studio, Paris; travel studies UK, Europe, 1948–51. Her dramatic pictures of regional subjects won wide acclaim from c. 1950 and made her one of the leading SA painters working in this field. She was a foundation member of the CAS, SA and a Fellow of RASA. Exhibitions in which her work appeared included *A Century of Australian Women Artists 1840s–1940s*, Deutscher Fine Art, Melbourne 1993.
AWARDS: Prize in Dunlop competitions, 1955; Melrose prize, 1958; Cornell prize, 1960; Adelaide Arts Festival (Caltex) prize, 1960; Vizard-Wholohan prizes, 1962, 64.
APPTS: Teaching, SA School of Arts and Crafts, 1942–46, and with Adult Education Dept, Uni. of SA, 1958–62; council member NGA; member, Board of Trustees, AGSA, 1968.
REP: NGA; AGNSW; AGSA; AGWA; MAGNT; NGV; QAG; QVMAG; TMAG; numerous regional gallery, municipal and tertiary collections; London Guild Hall; Mertz Collection, USA; Raymond Burr Collection, USA.
BIB: Bonython, MAPS. Benko, ASA. Germaine, AGA.

HICKEY, Dale
(b. 31/7/1937, Melb.) Painter, teacher.
STUDIES: Swinburne Tech. Coll. (graphic design), 1954–57; Melb. Teachers Coll. 1960–63; travel studies, UK, Europe and USA, 1971 and 1977. The expressionistic paintings which he exhibited in his first show, at Toorak Gallery, Melbourne, in 1964, led to his first competitive entry in Georges Art Prize in 1965. His style changed radically in later exhibitions to abstractionism. Summarising his work in *The Field*, Patrick McCaughey wrote: 'The tough image is a central preoccupation in Dale Hickey's work.' Like Doolin his abstractions grow out of a physical context which he then patterns obsessively in a *trompe l'oeil* manner. Hickey's serialised, multiple-imaged, environmental abstracts changed, logically enough, to 'conceptual constructivism' in a series of variously sized picket fences which he erected in separate galleries at Pinacotheca in Oct. 1969. His continued stylistic

metamorphosis arrived at pure conceptualism at the new Pinacotheca, Richmond, in 1970. In later exhibitions, however, he changed to more representational and abstract paintings and in these has attained his greatest success. He held about 20 solo exhibitions 1964–92 including a retrospective organised by NGV and touring Vic. regional galleries, Manly Art Gallery and MOCA, Brisbane 1988–89. His work appeared in numerous group exhibitions 1965–93 including *Australian Perspecta*, AGNSW 1978; *The Field Now*, Heide 1984; *Field to Figuration*, NGV 1987; *Free Styles: Australian Art 60s to Now*, NGV 1989; *Off the Wall, In the Air: A Seventies Selection*, Monash Uni. Gallery and ACCA 1991. He completed a number of commissions including a design for a tapestry for the NAB with the Vic. Tapestry Workshop 1980; and he designed and illustrated a book by Morris Lurie.
AWARDS: Ferntree Gully prize, 1956; Hugh Williamson Prize, Ballarat Fine Art Gallery, 1986; VACB grants, 1974, 75, 81; creative fellowship, Aust. Council, 1991.
REP: NGA; AGNSW; AGSA; AGWA; NGV; QAG; QVMAG; TMAG; MOCA, Brisbane; several regional gallery collections including Ballarat, Latrobe Valley; a number of tertiary collections including Monash, Melbourne unis.; Vic. Tapestry Workshop; Westpac Art Collection; NAB; Philip Morris.
BIB: Catalogue essays as above. A number of general Australian art texts including Chanin, CAP; Horton, PDA; Smith, AP. A&A 17/3/1980 (Gary Catalano, *On Dale Hickey*).

HIGGINS, J. Thomas
(b. 1943, Margaret River, WA) Painter, teacher, printmaker.
STUDIES: Claremont Teachers Coll., Perth, 1961–62; Perth Tech. Coll., 1962–66; WAIT, 1967; Further Education Centre, Subiaco, 1968–69. First secretary of the Printmakers Association of WA (which in 1973 he helped to form), 1974. His embossed etching-serigraph, *Clouds*, was commissioned for PCA members' edition, 1975.
APPTS: Lecturer, Perth Tech. Coll., 1968– ; member of the PCA.
REP: AGWA; QAG; regional galleries Newcastle, Warrnambool.
BIB: PCA, *Directory*.

HIGGINS, Roma
(b. 1908, Eng.; arr. Aust. 1914) Painter. Subject of her naive paintings reflects her experience of life on a farm at Bangalow, NSW.
AWARDS: Albury prize, 1976.
BIB: Bianca McCullough, *Australian Naive Painters*, Hill of Content, Melbourne, 1977.

HIGGS, Joshua
(Active c. 1880, Tas.) Painter. Known mainly for watercolours. A well-known historical picture by Higgs depicts the Old Toll Gate at the mouth of Cataract Gorge, Launceston.
NFI

HIGGS, Paul David
(b. 26/12/1954, UK; arr. Aust. 1978) Painter.
STUDIES: Sutton Coldfield Coll. of Art, UK, 1974; BA
(Hons) fine art, Winchester School of Art, UK. Heavy
paint (described by Elwyn Lynn as 'a heavy conges-
tion') typifies his abstract oils, consisting of many
shapes and resembling collages. They were seen in
nine solo exhibitions 1980–87 in Sydney (Coventry),
Canberra (Solander) and Wollongong City Art Gallery.
He participated in about 24 group exhibitions 1979–92
including at Coventry, Sydney; *Wollongong Art Purchase
Prize*, Wollongong City Gallery 1979, 80; *Twenty Years
of Australian Abstraction*, Ivan Dougherty Gallery,
Sydney 1986; Newcastle Regional Art Gallery 1987.
AWARDS: Lloyd Rees Drawing Prize, Port Kembla
Art Gallery, 1978; NSW Travelling Art Scholarship,
AGNSW, 1983.
APPTS: Painting/drawing teacher at a number of ter-
tiary colleges NSW, 1978– , including Coll. of Fine
Art, Uni. of NSW; School of Creative Arts, Wollongong
Uni. 1983–84 and 1991– .
REP: AGNSW; regional galleries Wollongong, New
England, Newcastle.
BIB: *New Art Five*. A&A 21/3/1984; 21/4/1984; 27/1/1989;
28/3/1991.

HIGSON, Shayne
(b. 18/1/1960, Sydney) Photographer, teacher.
STUDIES: Cert. of Art, ESTC, 1979; BA (Visual Arts),
City Art Inst., Sydney, 1982. *Canberra Times* art critic
Sasha Grishin, reviewing her exhibition at aGog Gallery
in 1990, describes her work as involving 'play with
words, images and techniques that are designed to
shock and disturb . . . Her large sombre images
present a social commentary dealing with alienation,
exploitation and urban decay.' She held 15 solo exhi-
bitions 1981–92 in Brisbane (Milburn + Arte),
Melbourne (Realities) and Sydney (Roslyn Oxley9 and
Mori), and a joint exhibition with Joy Youngen, *The
Manipulated Image: A New Vision in Photography*, tour-
ing for Qld Arts Council, 1988. Her work appeared
in about 36 group exhibitions 1982–92 including at
Roslyn Oxley9, Garry Anderson, Sydney; *Delineations:
Exploring Drawing*, Ivan Dougherty Gallery, Sydney
1988; *Inside the Greenhouse*, Tin Sheds, Sydney; *Photo-
graphy: Recent Acquisitions*, NGA 1990; *Tony Coleing and
Friends*, NGA 1992.
APPTS: Photography teacher, several tertiary colleges,
1986– , including NAS, 1986–90; Coll. of Fine Arts,
Uni. of NSW, 1990–92.
REP: NGA; MOCA, Brisbane; Sydney CAE; Griffith Uni.;
Ipswich regional gallery.
BIB: *Contemporary Australian Collage and its Origins*, Arthur
McIntyre, Craftsman House 1990.

HILDER, Bim (Vernon Arthur)
(b. 1909, Parramatta, NSW) Sculptor, teacher.
STUDIES: ESTC, 1925–26; RAS School (evening classes),
1927; etching with Sydney Long, 1928. The eldest
son of J. J. Hilder, he worked as a carpenter for the
architect Walter Burley Griffin; then as a designer for
theatre, shop windows, film and puppet sets and, dur-
ing World War II, as a camouflage artist. He began
carving while convalescing from a broken ankle, and
made his reputation as a wood carver and for his relief
sculptures in metal. He was twice president of the
Society of Sculptors and Associates, of which he was
a foundation member in 1951. Included in his com-
missioned work is a fountain at Castlecrag, Sydney
(memorial to Walter Burley Griffin), and a large mural
sculpture in metal for the Reserve Bank, Sydney,
1962–64.
AWARDS: Wool Board prize, 1953; Reserve Bank prize
for a wall feature, 1962.
APPTS: Teaching, part-time, ESTC, 1962; sculpture
classes for the Student Union, Uni. of NSW.
REP: AGNSW; Armidale City Art Gallery; uni. collec-
tions NSW.
BIB: Scarlett, AS. A&A 22/2/1984.

HILDER, Brett
(b. 1911, Epping, NSW; d. 1981) Sea captain, painter.
STUDIES: Family training. Known mainly for water-
colours of marine subjects. The second son of J. J.
Hilder, during his 50 years at sea he produced a large
number of paintings of the Pacific Islands as well as
illustrations for magazines and books. His books include
Navigator in the South Seas, Marshall, London, 1961;
The Heritage of J. J. Hilder, Ure Smith, Sydney, 1966;
and *The Discovery of Torres Strait*, Uni. of Qld Press,
Brisbane, 1979.
AWARDS: Prizes for portraits in New Guinea art com-
petitions, 1962, 65; MBE, for services to navigation,
1971.
BIB: A&A 22/2/1984.

HILDER, Jesse Jewhurst
(b. 23/7/1881, Toowoomba, Qld; d. Apr. 1916, Hornsby,
NSW) Painter.
STUDIES: Qld, encouragement and help from Isaac
Jenner; Sydney, night classes with Julian Ashton, c.
1904–07. From 1898 until 1909 Hilder was a clerk
in various branches of the Bank of NSW. According
to an account written by Bertram Stevens (p. 13, *The
Art of J. J. Hilder*), Hilder enrolled at Ashton's night
classes under the name of Joyce because he did not
want the bank to know of his spare-time activities as
a painter; Brett Hilder (p. 67, *The Heritage of J. J.
Hilder*) contradicts this and gives the *nom de plume* as
'Anthony Hood', the name with which Hilder signed
his work between 1904 and 1908. Hilder suffered
from tuberculosis; he resigned from the bank when
his health finally broke down in 1909 and in the same
year he married. He painted in the style of Corot,
whose work he greatly admired, but used a greatly
heightened palette and worked always in watercolour
– usually on a small scale. He also admired the work
of J. W. Tristram (q.v.). Twenty-one of his pictures
were sold at the annual NSW Society of Artists' exhi-
bition in Sydney in 1907 and 14 out of 19 at the
same exhibition the following year, but his real suc-
cess began in 1910 with his association with the dealer

Adolf Albers, who sold 273 Hilder paintings during the next six years. The comparatively low prices of Hilder's work, however, and the expenses of his illness and family responsibilities kept him poor until the end. After his death his work became much sought after and it swiftly appreciated in value. A commemorative, anniversary travelling exhibition was organised by Laurie Thomas at the QAG (opened 21 Apr. 1966) and toured Australian state and regional galleries and his work was seen in *Mirage*, Ballarat Fine Art Gallery, July 1973, and *The Great Australian Art Exhibition 1788–1988*. His two sons, Bim and Brett (qq.v.), were both well-known artists.

REP: AGNSW; AGSA; AGWA; MAGNT; NGV; QAG; QVMAG; TMAG; many regional galleries.

BIB: Bertram Stevens, *The Art of J. J. Hilder*, Angus & Robertson, Sydney, 1918; Brett Hilder, *The Heritage of J. J. Hilder*, Ure Smith, Sydney, 1966; numerous refs in *A.A.*, between 1916 and 1938. *A&A* 4/1/1966 (Lloyd Rees, *J. J. Hilder*); 22/2/1984 (*The Hilders: a Family Trilogy*).

HILL, Andrew

(b. 27/3/1952, Adelaide) Painter, printmaker, photographer, oral historian, editor, designer.

STUDIES: Dip. Fine Art, Torrens CAE; grad. dip. secondary art teaching, Torrens CAE, 1971–74; Flinders Uni., 1974–76. From 1977 he participated in a large number of print exhibitions and his early involvement in theatre broadened to an interest as artist-in-the-community. He worked on projects including with United Trades and Labour Council (SA), Working Women's Centre, Trade Union Authority, Community Media Association in *All Our Working Lives*, 1983; directed several plays including *A Bitter Song* (with variety of SA, Vic. and NSW unions 1986–88) and *Shoulder to Shoulder*, with Multicultural Artworkers Committee Campaign Against Racial Exploitation; and worked with several Aboriginal study and community groups 1989–90. He also exhibited in numerous poster, multicultural and community-art based exhibitions; designed many brochures, posters, handbills; directed a number of projects and festivals and was a committee member of many art organisations in SA such as CAE, Community Arts Network, Community Media Association.

AWARDS: 13 project grants 1978–92 largely from Australia Council (Community Arts Board, Literature Board, VACB), also from SA Dept for the Arts and Aust. Bicentennial Authority.

APPTS: Contract teaching, SA Education Dept, 1978; tutoring, WEA, Adelaide, 1976–79; lecturer, Uni. of SA, 1979–92.

REP: NGA; AGNSW; AGSA; QAG; AWM; Artbank; Uni. of Sydney; regional galleries Alice Springs, Maitland, Warrnambool.

BIB: *Art and Working Life in Australia*, Australia Council 1983. *Multiculturalism and the Arts*, Australia Council 1986.

HILL, Charles

(b. 1824, Coventry, Eng.; arr. Adelaide, 1854; d. 1916) Painter, engraver and teacher. He studied engraving

at Newcastle and London, where he worked on engravings for the *Great Exhibition* of 1851 with the engraver S. W. Reynolds the younger. He taught art at various schools in Adelaide, conducted his own art school, and in 1856 helped to establish the (Royal) South Australian Society of Arts, of which he became the first president. When the South Australian School of Design was founded in 1861, Hill was appointed art master and held the post until 1881. In the same year he completed his best-known picture, *The Proclamation*, painted during the preceding 15 years from information supplied by eye-witnesses and from sketches made on the site. Depicting the official proclamation of the colony of SA in 1836, it contains 79 portraits for which Hill obtained sittings. He was represented in *Graven Images in a Promised Land*, AGSA 1981.

REP: AGSA.

BIB: R. G. Appleyard, *Charles Hill 1824–1916*, *Bulletin of the National Gallery of South Australia*, vol. 28, no. 3, Jan. 1967. *A&A* 19/1/1981. Kerr, DAA.

HILL, Daryl (Hill-Harrison)

(b. 10/12/1930, Alexandra, Vic.) Painter, sculptor, teacher.

STUDIES: Hobart Tech. Coll; ESTC, 1951–52; Académie Ranson, with Singier, Paris, 1953; assistant to Henry Moore, UK, 1955–58; independent studies, Spain, 1959. Prominent among the Sydney abstract expressionists of the 1960s, his work was included at the *Bienale de São Paulo*, Brazil, 1961. His first solo exhibitions were in London, Paris and Spain 1957–59 until returning to Australia in 1960. He held 13 solo exhibitions 1960–89 in Perth, Melbourne, Hobart, Adelaide and Sydney. Equally involved in film-making, he and his wife started a film company in London in 1973 and from 1973 to 1986 travelled extensively through Europe, Africa, Iran, Arabia and India producing documentary films and painting. They returned to Australia in 1987 after an extended trip through India, Thailand, Malaysia and Bali.

AWARDS: New Vision prize, London, 1958; Robin Hood prize (for watercolours), 1961.

APPTS: Teaching, NSW Education Dept; Tasmanian Education Dept, 1960; supervisor, Children's Library and Craft Centre, Sydney, 1962–3; Mary White School of Art, Sydney, 1965.

REP: AGNSW; AGWA; Uni. of WA.

BIB: *The Australian Painters*, catalogue Mertz collection, Griffin Press, Adelaide, 1966. Smith, AP.

HILL, Robin

(b. 1932, Brisbane) Painter, teacher, typographer, book designer.

STUDIES: Wimbledon School of Art, London, 1945–47; NGV; RMIT. Hill's interest in birdlife began in England where he grew up. He achieved his first success with the publication of his *Australian Birds* (1967), followed by an exhibition of the original works at the South Yarra Gallery, Melbourne.

HILL, Samuel Prout

(b. 1821; arr. Hobart 1842; d. 1861, Hobart) Painter, writer, journalist, lecturer. A cousin of John Skinner Prout (q.v.), he lived in Sydney where he was secretary of the Mechanics Inst. School of Arts, 1845–48, and exhibited marine paintings with the Society for the Promotion of Fine Arts in 1847. He wrote poems, including *Tarquin the Proud and Other Poems*, 1843, and illustrated Carton Booth, *Heads of the People*, Sydney, 1847. Later he settled in Hobart and worked in the Survey Office before joining the staff of the *Cornwall Chronicle*, Launceston.

He worked also as a leader-writer for the Hobart *Mercury* and finally accepted a position on the *Advertiser*. An eloquent speaker, he lectured on Shakespeare, Dickens and the fine arts, entered politics and was elected a member of the House of Assembly in 1860 but died the following year.

REP: TMAG; QVMAG; NLA; Mitchell, La Trobe, Dixson Libraries.

BIB: Moore, SAA. ADB 1. Kerr, DAA.

(*See also* MECHANICS INSTITUTES AND SCHOOLS OF DESIGN)

HILLER, Christine Mary

(b. 24/7/1948, Hobart) Painter, printmaker. She held 12 solo exhibitions 1982–92 in Tasmania (including Salamanca Place, Hobart; Masterpiece, Hobart; and at Burnie and Devonport regional art galleries). Her work appeared in about 33 group exhibitions 1982–92 including *Archibald Prize*, 1982, 83, 84, 85, 86; *Portia Geach Memorial Award*, 1980–81, 83–91; and at private commercial galleries in Tasmania. She also illustrated book covers for magazines and books.

AWARDS: Portia Geach Memorial Award, 1986, 87; Tasmanian of the Year, 1987; Tasmania Day Award.

APPTS: Art teaching, Burnie High School, Tas, 1969–71.

REP: Queen's, Hob., Allport, Uni. of Tasmania, regional galleries Devonport, Burnie; private collections including Robert Holmes à Court and Telecom.

HILTON, Juliana Louise

(b. 9/7/1940, Seymour, Vic.) Painter. STUDIES: Prahran CAE, Melbourne; RMIT, 1958–63; printmaking (with Bea Maddock), Bendigo CAE, 1982. Living in New Guinea, WA and Victoria, she became known for her paintings of interiors shown in exhibitions at Leveson Street Gallery, 1966, 73, 74, 78. One of her paintings was acquired for the Commonwealth Art Advisory Board, 1966. She held nine solo exhibitions 1966–92 including two at David Ellis, Melbourne and exhibited in several group exhibitions including *9 × 5 Centenary Exhibition*, Castlemaine Art Gallery 1989.

AWARDS: Prizes at Bacchus Marsh, 1974; Camberwell, 1979; Mornington, 1980; Maryborough, 1982; Pioneer Art Awards, Swan Hill 1979 (oil), 81 (watercolour).

REP: Swan Hill regional gallery; Commonwealth collection.

HINDER, Frank (Henry Francis Critchley)

(b. 26/6/1906, Summer Hill, NSW; d. 31/12/1992, Sydney) Painter, teacher.

STUDIES: Family lessons with his father, an amateur painter; RAS School, Sydney, 1924; ESTC, 1925–27; Art Inst. of Chicago, 1927–28; New York School of Fine Arts, 1929; Master Inst. of Roerich Museum, New York, 1930–31. His experience of overseas art started early when in 1925 he toured Europe with the Young Australia League. In 1930 he married Margel Ina Harris, and during 1931–34 taught at the Child-Walker School of Fine Art, Boston. He studied and exhibited at Taos, New Mexico (with Emil Bisttram) in 1933 and in 1934 returned to Sydney, where he joined Crowley, Fizelle and Balson in 'the second phase of the modern art movement'. His work introduced to Sydney cubist and futurist influences encountered in the USA, particularly from the example of such celebrated works as Duchamp's *Nude descending a Staircase*. His well-known *Escalator* clearly derives from this source. Theatre design, advertising art, graphic art, teaching and the general business of earning a living from art in difficult times absorbed much of his attention during the decades 1934–64. In 1969 he experimented with a series of luminal kinetics. Organisations attracting his membership included the CAS, Sydney (foundation member and president), Australian Watercolour Inst., Sydney Printmakers, Australian Stage Designers Association. The AGNSW held an exhibition *Balson, Crowley, Fizelle, Hinder* 1966 and a retrospective exhibition of Frank and Margel Hinder's work in 1980. His work was seen in *The Great Australian Art Exhibition 1788–1988*.

AWARDS: Adelaide Poster Design prize, Royal Industrial Show, Adelaide, 1951; Blake prize, 1952; Leroy Alcorso Textile Design prize, 1954; Perth prize (watercolour), 1954; Mosman prize (drawing), 1956; Irene Mitchell Award for Theatre Design, Melbourne 1958.

APPTS: Camouflage artist, World War II, 1939; teaching, NAS, Sydney, 1948–58; head of the art dept, Sydney Teachers Coll., 1958–64; member of the board of trustees of the AGNSW, 1975.

REP: NGA; AGSA; AGWA; NGV; AWM; MCA, Sydney; MOCA, Brisbane; regional galleries Ballarat, Hamilton, Newcastle, Broken Hill.

BIB: A number of general texts on Australian art including Smith AP. Scarlett AS. John Henshaw, intro. *Frank Hinder Lithographs*, Odana Editions, North Sydney, 1978. A&A 29/3/1992; 30/4/1993 (obituary).

HINDER, Margel Ina (née Harris)

(b. 4/1/1906, New York; arr. Aust. 1934) Sculptor. STUDIES: She began her studies in the children's classes at the Albright Art Gallery, Buffalo, NY, 1911; Albright Art School, Buffalo, NY, 1925; Boston Museum School of Art, 1926–28; New Mexico (with Emil Bisttram), 1933; Sydney (with Eleanor Lange). She married Frank Hinder 1931, came to Australia in 1934 and became an Australian citizen in 1939. She worked in the Department of Home Security during World War II, and became one of Sydney's best-known sculptors. Her

constructions in metal became a feature of the new movement in sculpture in Australia. Among her many important commissions is the sculpture for the Woden Town Square, Canberra, 1972 (from her entry in the Comalco Prize competition, 1969) and the fountain for North Point, North Sydney, 1976 (with water jets by Frank Hinder). The AGNSW held a retrospective exhibition *Frank and Margel Hinder* in 1980 and her work was represented in *A Century of Australian Women Artists 1840s–1940s*, Deutscher Fine Art, Melbourne 1993.

AWARDS: Third prize in International Unknown Political Prisoner Competition, 1952; Sydney Water Board building prize, 1939; CAS Madach prize, 1955; CAS Clint prize, 1957; Anzac House competition, Sydney, 1959; Blake prize for sculpture, 1961; Newcastle, NSW Civic Fountain competition, 1961; Commonwealth Reserve Bank prize, Sydney, 1962; VACB grant, 1973.
APPTS: Teacher at NAS, Sydney, 1949–50.
REP: AGNSW; QAG; Newcastle Region Art Gallery.
BIB: A number of general texts on Australian art and sculpture including Smith, AP; Lenton Parr, *Sculpture*, Arts in Australia series, Longman, Melbourne, 1961; Sturgeon, DAS; Scarlett, AS. Numerous refs in A&A including 29/3/1992.

HINDMARSH, Mary
(b. 1817, Kent; arr. Adelaide 1836; d. 1887, London) Painter. Youngest daughter of the first Governor of SA, she made sketches of the young colony largely between 1836 and 1840. She married her drawing teacher George Milner Stephen (q.v.) and with him had 13 children. She continued to paint some quite significant works following her marriage. The Stephens lived in SA, England and on an island off the European coast and her work was shown in exhibitions including the 1870 *Sydney Intercolonial Exhibition* and the NSW *Academy of Arts*. Her sketch of the first Government House of SA, 1837, was reproduced in the *Sydney Mail*, 24 Oct. 1928.
REP: AGSA; Mitchell Library.
BIB: S. Cameron Wilson, *From Shadow to Light*, Adelaide 1978. Benko, ASA. Kerr, DAA.

HINDS, John Alexander
(b. 3/9/1950, Melb.) Painter, illustrator, designer.
STUDIES: Cert. Advanced Interior Design, SAIT, Adelaide, 1970; fellowship dip. interior design, RMIT, 1974; travel studies USA 1988; England, France, Italy 1990. As graphic designer/illustrator he has illustrated six David Malouf book covers for Penguin Books and merchandise for MCA, Sydney. His prints and mixed-media paintings are colourful and decorative and reflect his design training. He held 9 solo exhibitions 1979–92 in Adelaide (Roundspace 1980, 82; Bonython Meadmore 1985, 87), Sydney (Exiles 1981) and Melbourne (Profile 1982, 84; Reconnaissance 1987; ROAR2 1989, 91), and participated in about 35 group exhibitions 1979–92 including *Maude Vizard-Wholohan Invitation Exhibition*, AGSA 1981; *On and Off the Wall*, invitation exhibition, 1984; *Beyond the Portrait: Unprintable Books*, 1986; *Members Christmas Show*, 1987; *Members' Exhibition*,

1988; all at CAS, Adelaide; *Fresh Cut*, EAF 1985; and in ROAR II Studio shows in Melbourne, 1986, 87, 92.
AWARDS: Travel grant, Australia-Japan Foundation, 1983; grant, SA Dept for the Arts, 1985.
REP: AGSA; Artbank.
BIB: *New Art Four*. PCA, *Directory*, 1988. Germaine, AGA.

HINGSTON, Arthur James
(b. 1874, London; d. 1912) Painter, cartoonist.
STUDIES: Brisbane Tech. Coll. (with Godfrey Rivers). Illustrator and cartoonist for Brisbane *Truth*, the *Worker*, and later for the London *Daily Mail*, 1902–03. He had considerable success as a cartoonist in London. He also worked in oils, watercolours and pastels.
REP: QAG; Brisbane Uni. (Darnell Collections).
BIB: Moore, SAA.

HINTON, Howard
(b. 1867, Surrey, UK; arr. Aust. 1892; d. 1948, NSW) Shipping magnate, collector. As a young man he lived in one of the Roberts–Streeton artists' camps at Balmoral and became friendly with the artists of the Cremorne and Curlew camps. He gave paintings to the AGNSW and over the years endowed the Armidale Teachers Coll. with the Hinton Collection comprising 1000 paintings and 700 books (later to form the basis of the collections of the New England Regional Art Museum).
AWARDS: NSW Society of Artists medal, 1932; OBE conferred.
APPTS: Trustee, AGNSW, 1919–48.
BIB: *Howard Hinton, Patron of Art*, Angus & Robertson, Sydney, 1951. *Focus on the Hinton Collection*, VAB touring exhibition catalogue Sydney, 1979. A&A 17/4/1980 (Joanna Mendelssohn, *Focus on the Hinton Collection*).

HINTON, M.
(Active c. 1870, NSW) Painter. His *Coogee Bay* (1870) was auctioned at Christie's, Sydney, Nov. 1974; in style it was close to the work of Isaac Whitehead (q.v.).
NFI

HIRSCHFELD-MACK, Ludwig
(b. 1893, Frankfurt, Germany; arr. Aust. 1940; d. 1964, Vic.) Painter, teacher.
STUDIES: Debschitz Art School, Munich; Munich Uni. (with Professor Woefflin), 1912–14. Also studied colour theorics (with Professor Holzel) at Stuttgart, 1918–19. Teacher at the Bauhaus, Germany, where he made experiments with colour theory as related to music. His work was represented in *Bauhaus, 1919–1925*, MOMA, New York, 1938 and in 1942, two years after arriving in Australia, he became art master in charge of the art school at Geelong Grammar School, Vic., where he taught until 1957. When Walter Gropius, founder of the Bauhaus, visited Australia after World War II, he made a special trip to Geelong to visit his former colleague. Hirschfeld-Mack's small Klee-like paintings appeared in exhibitions in Australia but it was not until the memorial exhibition mounted at the Uni. Gallery, Melbourne, 1981, that the full scope

of his highly inventive talents became widely realised. He wrote *The Bauhaus: An Introductory Survey*, Longman, Melbourne, 1963 and was represented in *The Great Australian Art Exhibition 1788–1988*.

APPTS: Foundation member of the Bauhaus at Weimar, Germany, 1920–25; art teacher at Freie Schulgemeinde Wickersdorf, 1926–29; professor of art at the Teachers Training Coll. (Pädagogisch Akademie) at Frankfurt and Kiel, 1930–33; art and craft teacher at Subsistence Production Society, Cwavon, South Wales, 1936–38; art master at Dulwich Coll. Preparatory School, London, 1938–40.

REP: AGNSW (lithograph); Bauhaus archives, Darmstadt, Germany; Uni. Gallery, Uni. of Melb. (extensive collection).

HIRST, C. G. S.

(Active c. 1870s) Painter. Itinerant painter of naive pictures painted mainly in south-eastern Qld and NSW, c. 1870–80. A well-known picture by him is *Claremont House. The Property and Residence of Mr C. Bashford and Family at Limestone near Ipswich, Qld*.

REP: NLA.

HIRST, George W. L.

(Active c. 1900–30, Sydney) Sculptor.

STUDIES: ESTC (with Lucien Henry); Art Society of NSW School (with Julian Ashton). He exhibited with the Society of Artists and later with the Art Society of NSW from 1902; he also showed a bust at the *British Empire Exhibition* in London in 1924. In later life he seems to have given up professional sculpture after accepting an appointment as the Commonwealth Government Registrar of Pensions, Canberra. His work was seen in *Early Australian Sculpture*, Ballarat Fine Art Gallery, 1977.

AWARDS: Wynne Prize, 1907 and 1923 (both for sculpture – bust of *Harry Garlick* and *Head of an Old Man*, respectively).

REP: AGNSW.

BIB: Moore, SAA. Scarlett, AS.

HISTORIC MEMORIALS COMMITTEE

Established Dec. 1911, originally to obtain portraits of Australians connected with Federation (as commemorated in Tom Roberts' painting of the official opening of parliament). Function of the Committee was extended later to include portraits of politicians, members of the judiciary and other distinguished Australians.

HITCHEN, J.

(Active 1840s, SA) Lithographer. His best-known work is a lithograph made after a drawing by Col. Gawler, *J. Barton Hack Esq's Farm near Echunga Springs, Mount Barker*, SA.

REP: AGSA.

HITCHINS, F.

(Active c. 1850s) Painter. A self-portrait by Hitchins was included in the Fine Arts Society exhibition,

Melbourne, 1853. A watercolour of a cockatoo by Hitchins was included in Joel's auctions, Melbourne, in May 1978.

BIB: Kerr, DAA.

HJORTH, Noela Jane

(b. 5/12/1940, Melb.) Printmaker, teacher.

STUDIES: Prahran CAE, Melbourne, 1958–60; RMIT, 1961–63; Chelsea School of Art, London (etching and lithography), 1969–71; travel studies India, Thailand 1980–81; Europe, USA, Indonesia 1983; Indonesia 1985, 86, 87; USA 1990, 91. Her exhibitions include two in London, 1970, 71, and 26 in Australia, 1972–92, including two retrospectives (Hawthorn City Art Gallery 1980, Wagga Wagga City Art Gallery 1981). Classical subjects with figures based on Greek and biblical mythology are often dramatically depicted in her prints and in the 1980s she produced a full-size series of 'body prints' using her body as the impression on printing plates. Group exhibitions in which her work appeared 1970–92 included *Victorian Printmakers Travelling Exhibition*, all states 1981; *Contemporary South Australian Painting*, AGSA 1988; and in Victoria and Albert Museum, London 1992. Several films and videos were made of her work in the late 1970s and early 1980s.

APPTS: Lecturing, part-time, CIT, 1973–74; teaching printmaking at Box Hill Tech. Coll., 1975–78; vice-president of PCA, 1976; foundation member and co-ordinator of Victorian Printmakers Group, 1976–78.

REP: NGA; AGNSW; AGSA; AGWA; MAGNT; NGV; QAG; QVMAG; TMAG; numerous regional galleries including Araluen Arts Centre, Burnie, Latrobe Valley, Swan Hill, Stanthorpe, Wagga Wagga; a number of tertiary collections including Queen Mary Coll., London; WAIT; Riverina CAE; private collections including Christensen Foundation.

BIB: PCA, *Directory. Noela Hjorth – Journey of a Fire Goddess*, Craftsman House, Sydney 1989. Germaine, DAWA. Germaine, AGA. *Noela Hjorth*, V. Pauli & J. Rodriquez, Granrott Press, SA, 1984. A&A 10/3/1973; 22/2/1984.

HOBBS, Marie Louise

(b. 27/4/1933, Renmark, WA) Painter.

STUDIES: Part-time, Claremont School of Art, 1974; Southampton School of Art, UK, 1975; Byam Shaw School of Art, UK, 1981. Her abstract expressionist works have been well received in 13 solo exhibitions in Perth (including Old Fire Station 1974, 76; Delaney 1987, 88, 91) and Adelaide (Bonython 1979), and at Fremantle Arts Centre 1986 and AGWA (*Artist in Focus 3*, 1988). She participated in about 33 group exhibitions 1981–92 largely in WA including *Landscape Images*, Fremantle Arts Centre 1981; *Critics' Choice*, AGWA 1982; *Works on Paper*, Fremantle Art Gallery and UK 1985; *The Maritime Gateway*, Fremantle Arts Centre Poster Design; *Spring Peace Festival*, AGWA 1987; *Robert Holmes à Court Invitation Exhibition*, 1989; ACAF2, Melbourne 1990; *The Western Australian Painters Exhibition*, Sanyo Gallery, Tokyo 1991.

AWARDS: Pegasus Art Award, 1982; WA Art Week

Painting Prize, 1983, 84; Albany Art Prize, 1985, 88; travel grant, VACB, 1987; Matilda Bay Restaurant Prize, 1988; RAS prize, 1989.

APPTS: Part-time tutor, drawing, Curtin Uni., 1983, 84.

REP: NGA; AGWA; NGV; municipal collections Albany, City of Fremantle, New Norcia; Uni. of WA; WACAE; Curtin Uni.; numerous corporate collections including Robert Holmes à Court, Malleson, Stephen Jacques, Woodside Petroleum, Wesfarmers.

BIB: Catalogue essays exhibitions as above.

HOBDAY, James Mayall

(Active c. 1878–1907, Brisbane) Painter.
STUDIES: England. Known mainly for watercolours. From 1899 he exhibited with the Qld Art Society of which he became honorary secretary, 1905–07, vice-president, 1908. He was also a vice-president of the Brisbane Sketching Club, 1904; and his work was included in the *Sydney International Exhibition* of 1879. His son, Percy Stanhope Hobday (q.v.), was also a painter and William A. Hobday, who showed with the QAS in 1905, may have been another son.

BIB: Margaret Maynard and Julie K. Brown, *Fine Art Exhibitions in Brisbane 1884–1916*, Fryer Memorial Library, Uni. of Qld, 1980.

HOBDAY, Percy Stanhope

(b. 1879, Brisbane; d. 1951, Brisbane) Painter, graphic designer, teacher.
STUDIES: Brisbane, with his father, James Hobday; Brisbane Tech. Coll. He painted landscapes and miniatures, conducted classes, and did commercial illustration, caricatures and photographic retouching as well as writing on art. He also designed the first cover for the quarterly magazine *Meanjin*.

APPTS: Visiting art master, Brisbane Grammar School; president, Qld Art Society, 1928–31; president of the Authors and Artists Association and of the Qld Wattle League.

REP: QAG.

BIB: Margaret Maynard and Julie K. Brown, *Fine Art Exhibitions in Brisbane 1884–1916*, Fryer Memorial Library, Uni. of Qld, 1980.

HODDLE, Robert

(b. 20/4/1794, London; d. 24/10/1881, Melb.) Artist, surveyor. First Surveyor-General of Vic. He revised the surveys of Robert Russell, Melbourne's first surveyor, and was responsible for planning Melbourne's broad streets as well as a system (changed by later speculators) of wide boulevards to the suburbs. However, as William Howitt pointed out in his *Land, Labour, and Gold*, no provision was made for a city square, which may have been Hoddle's mistake. Described as an accomplished artist, he was also an organist, flautist and translator of writings from the Spanish. He conducted Melbourne's first land sales, amassed a considerable fortune and built himself a magnificent house and garden at the corner of Bourke and Spencer Streets, Melbourne. His daughter, Agnes, painted a portrait

of him believed still to be in the possession of one of his descendants. His work was represented in *Victorian Vision: 1834 Onwards*, NGV 1985.

REP: Mitchell, La Trobe, Dixson Libraries.

BIB: *Australian Encyclopaedia*, A&R, Sydney, 1958. ADB 1. McCulloch, AAGR. Kerr, DAA.

(*See also* MOGENSEN, Diana Hoddle)

HODGES, Christopher

(b. 1954, Sydney) Painter, gallery director.
STUDIES: Dip. Art Ed., Alexander Mackie. CAE. He held 16 solo exhibitions 1979–92 largely at Coventry Galleries, Sydney and several at Michael Milburn, Brisbane, and participated in over 20 group exhibitions including at Ben Grady Gallery, Canberra; Michael Milburn, Brisbane and in *A New Generation*, NGA 1988; *Expressive Space*, Drill Hall, NGA. 1989; *Balance 1990*, QAG. In 1988 he established the Utopia Art Gallery which has become one of the leading galleries specialising in the work of contemporary Aboriginal artists.

APPTS: Lecturing part-time various tertiary colleges, Sydney including City Art Institute, SCA 1980–88; director Utopia Art 1988– .

REP: NGA; NGV; QAG; Parliament House; Artbank; regional galleries including New England, Grafton, Wollongong; tertiary collections including University of New England; corporate collections including Robert Holmes à Court; Philip Morris; Westpac, New York.

HODGES, William

(b. 28/10/1744, London; visited Norfolk Island 1774; d. 1797, London) Painter.
STUDIES: With Shipley and Richard Wilson, London. Hodges, a Royal Academician, was probably the most widely travelled British painter of his time and his work depicted many formerly unknown subjects in the Pacific area. He was on the *Resolution*, on Captain Cook's second voyage, 1772–75. Although the second ship on the voyage, the *Adventure*, visited Tas. after being separated from the *Resolution* during a storm, Hodges never set foot in Australia. Of all Cook's artists he was the best trained, and apart from their topographical value his paintings are of great interest for their accurate depiction of effects of light and weather. After his voyage to the Pacific, he painted extensively in India, 1778–83. He published folios and illustrated books of his travels, e.g., his *Travels in India: Select Views in India*, London, 1786, and folios of engravings of his work in the Pacific.

BIB: Smith, EVSP. B. Smith & R. Joppien, *The Art of Captain Cook's Voyages*, Melbourne 1985. Kerr, DAA.

HODGKINS, George

(b. 1921, Eng.; arr. Aust. 1923) Painter.
STUDIES: No formal training. He paints, in a naive manner, subjects of early mining days. Designed Tarcoola Art Gallery, Mt Tarcoola, WA, for the sale of his own works.

AWARDS: Tom Wardle prize, Geraldton Festival, 1967.

REP: AGWA.

NFI

Frank Hodgkinson, Escarpment, *1991, mixed media on canvas, 188 × 180cm. Private collection.*

HODGKINSON, *Frank George*

(b. 28/4/1919, Sydney) Painter.

STUDIES: RAS School (with Sydney Long), Dattilo Rubbo Atelier, Sydney, 1936–38; Central School of Art and Craft, London, 1947–48; Académie Grand Chaumière, Paris, 1948–50. He supported his studies with freelance illustrations for magazines and from 1954 painted full-time. He served in the AIF 1940–46 in North Africa, Syria and Kokoda trail, PNG, and as war artist covered the assault landings in Borneo. His interest in Goya drew him to Madrid in 1947 to which he returned in 1958 having won the Helena Rubinstein travelling scholarship. Then and again in 1963–67 he found himself temperamentally in tune with the work of Canogar, Vela, Suarez, Tapies and other Spanish moderns whose spirit and example taught him to paint big, and experiment with the expressive possibilities of texture while escaping the dangers of 'belle matière'. This period included exhibitions in Barcelona (1960, 61), Madrid (1962, 64, 66), London (1960–65), New York and LA (1961–62) as well as Australia and produced many admirable paintings. Since returning to Australia in 1971 he has concentrated on painting the remote areas of the country including the Coorong, Flinders Ranges, Lake Eyre and the Kimberley, with Arnhem Land becoming an annual trip from 1978 to 1987, either alone or as leader of the artist-in-field scheme organised by the MAGNT. In 1987–89 he painted a series of abstract waterfronts exhibited in all state capitals and in 1990 undertook a safari on foot in Zimbabwe followed by an exhibition of resultant images in Sydney. He was artist-in-residence, National Arts School of Papua New Guinea, 1977, and Uni. of Melbourne, 1979, and published a number of diaries with illustrations, some in limited editions (as in *Sepik Diary*, Richard Griffin, 1982) and some in more general form (Reed

Books 1985), and *Kakadu and Arnhem Landers*, Weldon 1987 (reprinted 1990, 92).
AWARDS: Hunters Hill, 1957, 58; Australian-American Association, Sydney, 1958; Helena Rubinstein scholarship, 1958; W. D. & H. O. Wills prize, 1962; VACB grant, 1976; ACTA prize, 1988.
REP: NGA; AGNSW; AGSA; AGWA; Newcastle Region Art Gallery; uni. collections.
BIB: Most general references on Australian art including Bonython, MAP; Smith, AP; Horton, PDA. Laurie Thomas, *200 Years of Aust. Painting*, Bay Books 1979. Bianca McCullough, *Each Man's Wilderness*, Rigby 1980. Robert Hughes, *The Art of Australia*, Penguin, Harmondsworth, 1966, rev. 1970.

HODGKINSON, Roy Cecil
(b. 1911, Sydney) Illustrator.
STUDIES: RAS, Sydney (with Dattilo Rubbo); Central Tech. School (with Rayner Hoff); Europe, 1938–39. Brother of Frank Hodgkinson. He worked as illustrator on the *Daily Guardian* and *Sun* in Sydney, 1929–31, and from 1932 to 1976 on the staff of the Melbourne *Herald*. He held exhibitions of his drawings of ballet dancers of the De Basil company in 1939 and served as an official war artist in New Guinea during World War II.
REP: NGV; AWM.

HODGMAN, Vernon Wilfred
(b. 12/8/1909, Burnie, Tas.; d. 31/5/1984, Hobart) Painter, teacher, curator.
STUDIES: Hobart Tech. Coll., with Lucien Dechaineux, Mildred Lovett, Margaret Walker, 1928–30 and part-time, 1932–35. He began his career as a commercial artist, 1928–40, and after serving with the AIF in the Middle East, 1941–44, returned to work as a commercial artist for a year before joining the Tasmanian Education Dept. He was a foundation member of Group Ten, Hobart. He exhibited regularly with the Art Society of Tasmania 1937–64, Launceston Art Society 1946–60 and the Tasmanian Group of Painters 1948–67.
APPTS: Teaching, head of the art dept, Launceston Tech. Coll., 1945–60; examiner for the Tasmanian Education Dept; keeper of the art gallery, TMAG, Hobart, 1960–75.
REP: TMAG; QVMAG.
BIB: Germaine, AGA. Backhouse, TA.

HOFF, George Rayner
(b. 1894, Douglas, Isle of Man; arr. Sydney 1923; d. 1937, Sydney) Sculptor, teacher.
STUDIES: Family studies with his father, a stonemason and carver; Nottingham School of Art, 1910–15; RCA, London, 1919–22. While studying in Rome as recipient of a *Prix de Rome* from the RCA, London, he accepted an offer to move to Sydney as teacher at the ESTC; he remained with the school until the time of his premature death in 1937. As a leading sculptor in Sydney during the period now known as Art Deco, Hoff's position and influence were matched by his

industry. In his *Australian Sculptors*, Ken Scarlett lists 150 commissioned works. Best-known of these are the sculptures for the Anzac Memorial, Hyde Park, Sydney, and the carved figures for the SA War Memorial, Adelaide. He designed the NSW Society of Artists medal and made busts of many of his contemporaries such as Norman Lindsay and Dame Mary Gilmore. His work was represented in *The Great Australian Art Exhibition 1788–1988*.
AWARDS: Student prizes at Nottingham School of Art; *Prix de Rome*, RCA, London, 1921; Wynne prize (for sculpture), 1927.
APPTS: Instructor in drawing and sculpture, ESTC, 1924–31, head of the art school, 1931–37.
REP: NGA; AGNSW; AGSA; regional galleries Ballarat, Geelong, Armidale.
BIB: Moore, SAA. Sturgeon, DAS. Scarlett, AS. A&A 24/1/1986.

HOFF, (Dr) Ursula
(b. 1909, London; arr. Aust, 1939) Art historian, lecturer, writer, curator.
STUDIES: History of art in the universities of Frankfurt, Cologne, Munich, Hamburg and London (Ph.D., Hamburg, 1935); extensive travel studies, mostly in Europe, from 1949. She worked in London 1933–34 and 1939, and began her working life in Australia as secretary at the University Women's Coll., Melbourne, 1939–43 before becoming art tutor and subsequently curator and senior art adviser. She wrote numerous texts and catalogue essays on art including *Rembrandt and England*, privately published, Hamburg, 1935; *Charles I, Patron of the Arts*, Collins, London, 1942; *Masterpieces of the National Gallery of Victoria*, in collaboration with Alan McCulloch and Joan Lindsay, Cheshire, Melbourne, 1949; *Charles Conder, His Australian Years*, NGV Society, Melbourne, 1961; *National Gallery of Victoria, Paintings, Drawings and Sculpture*, in collaboration with Margaret Plant, Cheshire, Melbourne, 1968; *Charles Conder*, Lansdowne, Melbourne, 1972. Her book on Arthur Boyd, *The Art of Arthur Boyd* (Andre Deutsch, London, 1986; paperback edition Fischer Fine Art, London), is widely regarded as the definitive text.
APPTS: From 1948, part-time tutor, later lecturer in fine arts, Uni. of Melbourne; assistant Keeper of the Prints, NGV, 1941–47; keeper, 1947–56; curator, 1957–67; assistant director and senior curator, 1968–70; assistant director, 1970–75; member of the NGV Board of Trustees, 1973–74; London adviser to the Felton Bequest Committee, 1975– .
AWARDS: Dutch Ministry of Education scholarship (to Netherlands Inst. of Art History), 1963; Britannica Australia award, 1966; OBE conferred, 1969.

HOFFIE, Patricia
(b. 27/12/1953, Edinburgh, Scotland; arr. Aust. 1957) Painter, installation artist.
STUDIES: Dip. Teaching, Kelvin Grove CAE, 1973; Dip. Fine Art, Qld Coll. of Art, 1975; Master Creative Arts, Wollongong Uni., 1986; enrolled Ph.D. program, Wollongong Uni., 1991– ; travel studies SE

Asia, 1974, 82; Middle East, Asia, 1978–79; India, Nepal, Thailand, 1980, 81, 84; Egypt, Israel, Sinai, 1987. Her figurative works are ambitious in concept, drawing on Eastern and Western symbolism, and are frequently concerned with the dichotomy of cultures and male/female perspectives. Her *The Three Graces* (*Women Rise from the Rubble*) in the 1987 *Moet & Chandon* prize exhibition typify her 1980s work with its representation of a cultural or social issue in a style that combines both formality of composition and mystery. She held about seven solo exhibitions 1974–80 in Brisbane (including at Cellars Gallery, Brisbane CAE) and Sydney (Coventry). Her work appeared in about 30 group exhibitions 1982–92 including *Australian Painters of the Seventies*, QAG 1986; *Moet & Chandon*, travelling exhibitions 1986, 87; *Australian Perspecta*, AGNSW 1989; *Art Exciting*, MOMA, Saitama, Japan 1989; *Out of Asia*, Heide, Melbourne and Nolan Gallery, Canberra; *Frames of Reference*, Artspace, Sydney 1991.

APPTS. Secondary teacher, Qld Ed. Dept, 1974–77; instructor, Qld Coll. of Art, 1979–87; instructor, Flying Arts School, 1982–83; lecturer, QCA, Griffith Uni., 1990–92; member, selection panel, *Moet & Chandon Fellowship*, 1987; national executive, NAVA, 1989– .

BIB: Catalogue essays exhibitions as above. *New Art Five.* Kirby, *Sightlines*. Germaine, *AGA*.

HOGG, Geoffrey Vernon
(b. 8/1/1950, Tatura, Vic.) Painter.
STUDIES: Cert. of Art & Design, PIT, 1969; Dip. Painting, NGV School, 1971; TTSC, State Coll., Hawthorn, 1972; Mural Studios, National Academy of San Carlos, Mexico, 1974; Chicago Public Art Workshops, USA, 1974. Best known as a banner, community and mural artist, he taught at Victorian schools in the early 1970s before travelling in the US, UK and Mexico. His interest in mural projects began in the mid-1970s when he worked on the Nottinghill Mural project in London in 1974 followed by the Lygon Street Mural, Melbourne, in 1975 – the first public art style mural in Australia. He was instrumental in establishing the Community Art Workers Organisation which linked the talents of artists and studio organisation with diverse community groups including trade unions, local residents, historians, ethnic and other groups instigating and working on about 25 such mural projects 1975–92 including in Melbourne, Xian Yang, China 1988, Parliament House, Canberra 1989, and Australian Workers Heritage Centre, Barcaldine, Qld 1990–91. From 1982 to 1990 he helped establish and ran the Victorian Trades Hall Council Art Workshop, which developed art projects of relevance to workers and their families. Works included murals, banners, installations, sculpture and works on paper and under Hogg's direction, it became an important centre for banner and other community arts projects. Community art work overshadowed his solo work for some years, but he held about six solo exhibitions 1980–91 in Melbourne, Sydney and Adelaide and

contributed to a number of *Working Art* and other group exhibitions. He lectured and developed courses on public art and mural painting for tertiary colleges in Victoria, SA, Qld and China and was a member of many community arts, urban planning and art and working life government committees.
REP: NGA; Parliament House; Museum of Victoria; a number of tertiary collections including Melbourne and Qld unis., VCA.
BIB: *New Art Two.* S. Cassidy, *Art and Working Life in Australia*, Community Arts Board, Australia Council 1983. McKenzie, DIA. A. Reeves and A. Stephen *Badges of Labour, Banners of Pride*, Allen & Unwin 1984.

HOHAUS, Herman
(b. 1920, Silesia, Germany; arr. Melb. 1954) Sculptor.
STUDIES: School of Applied Art, Bad Warmbrunn, Silesia, 1938–40; Hochschule der Bildenden Kunste, Munich (Uni. of Fine Art), 1946–52. The bronze castings for which he is best known are modest in scale and modelled along Greek classic lines reminiscent also of the work of the post-World War II Italian sculptors. He published a book on his own work (*Herman Hohaus Sculptures*, Hawthorn Press, Melbourne, 1971).
APPTS: Lecturer in sculpture, RMIT, 1961– .
REP: AGSA; AGWA; NGV; QAG; regional galleries Hamilton, Mildura; NCDC, Canberra.
NFI.

HOILE, H.
(Active c. 1855, Sydney) Colonial school landscape painter. Two oils by him, *Cockatoo Island* and *Lake Albert*, were sold at Christies, London, Feb. 1973.
NFI.

HOILE, Henri
(Active c. 1910–1930s) Landscape painter, mainly in watercolour. He exhibited Dandenong and Warrandyte landscapes at the VAS in 1916. Moore records a Harry Hoyle as a member of the Cannibal Club (q.v.), and in a memoir written by Clara Southern (q.v.) on artists working in the Warrandyte area in the 1920s, Henri Hoile is described as 'a tall, interesting figure . . . still working away at his watercolours'.
BIB: Moore, SAA.

HOLDEN, Margot P.
(Active c. 1905–30) Sculptor.
STUDIES: Sydney (with Dattilo Rubbo); London School of Animal Painting (with Frank Calderon). Known mainly for animal subjects. She exhibited with the Art Society of NSW from 1905.
REP: AGNSW (study of a greyhound).

HOLDSWORTH, Gordon
(b. 1886, Hampshire, Eng.; arr. WA 1900; d. 1965) Sculptor.
STUDIES: Perth Tech. Coll. (with James Linton). Known for ecclesiastic subjects. He completed many small works for WA churches.

AWARDS: Medallist at Wembley Exhibition.
REP: AGNSW.
BIB: Moore, SAA.

HOLDSWORTH, W. P.
Painter. Mainly a watercolourist. Member of the Art Society of NSW from 1919, and NSW Society of Artists.
BIB: AA 1920 (*The Society of Artists Pictures* – reprdns of *The Open Door, St James, Sydney* and *Running Before the Breeze*).

HOLLIE
(b. 20/8/1958, Brisbane) Painter, performance artist.
STUDIES: Self-taught. Her abstract works draw on natural elements, sometimes with elements of Aboriginal mythology and design as seen in her 1990 winning entry for the *Moet & Chandon* touring exhibition, *I saw the serpent's blood dancing*, with its painted ribbons in basket-weave pattern created by tiny dots and stripes of reds, blues and ochres. She organised her own exhibitions at first and held six solo exhibitions 1982–89 largely in Brisbane (also with Michael Milburn and Milburn + Arte). She participated in about 12 group exhibitions 1983–90 including *Past and Present*, IMA, Brisbane 1986; *A New Generation*, NGA 1988; *A Complementary Caste: Homage to Women Artists*, Centre Gallery, Gold Coast 1988; *Australia Beyond the Mundane*, touring exhibition, China.
AWARDS: Moet & Chandon Fellowship, 1990.
REP: NGA; QAG; Brisbane City Hall; tertiary collections including Darling Downs IAE, Griffith Uni.
BIB: Catalogue essays exhibitions as above. Kirby, *Sightlines*.

HOLLINGWORTH, Robert
(b. 15/5/1947, Vic.) Painter, printmaker.
STUDIES: Dip. Art, Gordon Tech. Coll., Geelong; travel studies USA, UK, France. His strength as a draughtsman is notable in his paintings of objects, figures and landscapes as well as in black and white prints and drawings, which were seen in ten solo exhibitions 1980–92 in New York (Keane Mason Gallery), Melbourne (including Niagara, Peter Gant, Christine Abrahams) and Sydney (DC Art). His work appeared in about 50 group exhibitions 1980–92 at regional galleries (including Swan Hill, Newcastle, Gold Coast, Muswellbrook, Castlemaine, Mornington) and in *Views by Contemporary Artists*, touring Vic. regional galleries 1985; *Asia Pacific Show*, Tokyo, Hong Kong 1991; *Sulman Prize*, AGNSW 1986, 90.
AWARDS: Corio Shire Acquisition Prize, Geelong Art Gallery, 1983; Fletcher Jones Art Purchase Prize, Warrnambool Art Gallery, 1988; Sulman Prize, AGNSW, 1990; Swan Hill Drawing Acquisition, 1991; Spring Festival of Drawing Acquisition, MPAC, 1991.
APPTS: Private art tutor, 1975–85; guest lecturer, various tertiary colleges.
REP: Regional galleries Geelong, Mornington, Swan Hill, Warrnambool; La Trobe, Deakin unis.
BIB: Germaine, AGA.

HOLLIS, Neil
(b. 1954, Perth) Painter, printmaker.

STUDIES: Perth Tech. Coll., 1970–75; WAIT, 1975. In company with Jeff and Ashley Jones, he formed the Fine Art Printmaking Studio, Perth, 1974, attracting a VACB supportive grant, 1975. An untitled etching by him was commissioned for the PCA member print edition, 1974.
APPTS: Lecturer, Perth Tech. Coll., 1976– .
REP: QAG; regional galleries Fremantle, Mornington.
BIB: PCA, *Directory*, 1976.
NFI

HOLLOWAY, Memory
(b. 1946, Decatur, Illinois, USA; arr. Melb. 1970; lives NY) Art historian, critic.
STUDIES: BA, Uni. of Redlands, USA, 1968; MA, Uni. of Melb., 1972; MA, Courtauld Inst., London 1979. She tutored and lectured at the Uni. of Melbourne and Monash Uni. 1972–81 and was art critic for the *Australian* (1978–81) and the *Age* (1982–86) before returning to the USA with her husband, painter John Walker (q.v.).

HOLLY GROUP
Melbourne group of painters. Annual exhibitions were held at the Athenaeum Gallery, Melbourne, 1957–65. Members: Reshid Bey, W. V. Manders, Graham Moore, Don Morrow, F. M. S. Rossiter, R. W. Rowed, Colvin Smith, Gordon A. Speary.

HOLMAN, Francis
Painter. Early maritime artist who painted pictures of the exploration ships *Resolution* and *Adventure*, 1772.
REP: Dixson Gallery of the Mitchell Library.
BIB: Moore, SAA.

HOLMES, Edith Lilla
(b. 1893, Hamilton, Tas.; d. 26/8/1973, Hobart) Painter.
STUDIES: Hobart Tech. Coll. with Lucien Dechaineux and Mildred Lovett; Julian Ashton School, Sydney. A member of the Art Society of Tas. and the Tasmanian Group of Painters, she shared a studio in the mid-1930s in Hobart with other artists including Mildred Lovett (q.v.), Florence Rodway (q.v.) and Dorothy Stoner (q.v.) and held her first exhibition in Melbourne in 1938. Combining naive art with a Bonnard-like intimism, her paintings of interiors, figures and landscapes reflect a sensuous delight in impressionistic colour and light. The TMAG held a retrospective exhibition, *Edith Holmes and Dorothy Stoner*, October 1983.
AWARDS: Hobart sesquicentenary awards (special prize), 1954.
REP: NGA; NGV; QVMAG; TMAG; Devonport regional gallery; University of Tasmania.
BIB: Janine Burke, *Australian Women Artists 1840–1940*, Greenhouse, Melbourne, 1980.

HOLZNER, Anton
(b. 1935, Innsbruck; arr. Aust. 1955) Painter, graphic artist, stage designer.
STUDIES: Innsbruck, 1950–53 (theatre design); Linz Art School, 1953–54; refresher studies in Austria,

1962. The son of an academic painter at Innsbruck, Austria, Holzner held his first exhibition in Adelaide in 1957, and from 1956 to 1961 taught drawing and sculpture at the SASA. His abstract painting aims at a geometric interpretation of related mass in movement, expressed often in thin, luminous veils of colour. He held 15 solo and joint exhibitions 1958–88 in Melbourne (including South Yarra, Powell St galleries), Adelaide (Bonython Galleries) and a number at Salamanca Place, Hobart. Group exhibitions in which his work appeared 1961–88 included *South Australian Painters*, MOMA, Melbourne 1961 and a number at TMAG including *Six Contemporary Artists*, 1988. A major exhbition of his work was held at TMAG in 1988.

AWARDS: Robin Hood prize, Sydney 1963; Para Hills prize, 1963; acquisitions to TMAG purchased through Blue Gum Festival 1975, 76.

APPTS: Teaching SASA 1956–61; 64–69; senior lecturer Tasmanian CAE 1971–79.

REP: NGA; AGSA; NGV; QVMAG; TMAG; Artbank; Flinders University; University of SA; corporate collections including NAB.

BIB: Catalogue essays exhibitions as above. A number of general texts on Australian art including Bonython, *MAP*; Smith, *AP*; Benko, *ASA*; Campbell, *AWP*; Backhouse, *TA*. Hendrik Kolenberg, *Holzner Paintings*, TMAG, 1988. *A&A* 22/4/1985.

HOMER, Irvine
(b. 1919, New Lambton, NSW) Painter. Naive painter. He took his themes from memories of childhood spent in the bush.

REP: NGA.

BIB: Bianca McCullough, *Australian Naive Painters*, Hill of Content, Melbourne, 1977.

HONEY, C. Winifred
Painter.

STUDIES: NGV School. Exhibited at the Royal Academy, London, 1929. Her work was seen in *A Century of Australian Women Artists 1840s–1940s*, Deutscher Fine Art, Melbourne 1993.

AWARDS: NGV Travelling Scholarship, 1911.

BIB: Moore, *SAA*.

HOOD, Kenneth Edwin
(b. 10/2/1928, Melb.) Painter, administrator.

STUDIES: RMIT, 1944 (full-time) and 1950s (part-time); travel studies UK and Europe, 1967. His able paintings of still-life and interiors have an elegance that connects them with contemporary French painting. He ceased exhibiting soon after joining the staff of the NGV where during his tenure he curated many exhibitions, wrote a number of catalogue essays and several books including *Pottery, Arts in Australia series,* Longman, Melbourne, 1961; *English Pottery from the Fifteenth to the Nineteenth Century*, NGV booklets, OUP, Melbourne, 1966; *Australian Pottery* (with Garnsey), Macmillan, 1972.

APPTS: Assistant curator, dept of decorative art, NGV,

1961–72; senior curator, 1973–74; acting deputy director, 1974–75; deputy director, 1976–92.

AWARDS: Robin Hood prize, 1957; Crouch prize, Ballarat, 1963; Churchill Fellowship, 1967.

REP: NGA; AGSA; AGWA; NGV; QAG; QVMAG; TMAG.

HOOD, Robin Vaughan
(b. 1802, Eng.; arr. Tas. 1833; d. 1888) Lithographer. As well as a lithographer, Hood was also proprietor of the first picture gallery in Australia, established in Hobart in 1846 as a result of the success of an exhibition arranged by John Skinner Prout at the Hobart Legislative Council Chambers the year before. Hood bought Prout's equipment when Prout left Tas., using the equipment to print his own works (including a number of marine subjects), and also the work of other artists. He exhibited the work of Glover, Forrest and Wainewright (qq.v.) in his gallery and after his death the business was carried on by his son, R. L. Hood.

BIB: Clifford Craig, *Old Tasmanian Prints*, Foot & Playstead, Launceston, 1963 and *More Old Tasmanian Prints*, 1984. Kerr, *DAA*.

HOOK, Richard
(b. 1945, Melb.) Painter, printmaker.

STUDIES: BA, Uni. of WA, 1968; postgrad. cert. of education, London Uni., 1971; Associateship in Fine Art, WAIT, 1974; MFA, Tas. School of Art, 1982. He held 11 solo exhibitions 1976–89 including in Perth (Gallery 52), Sydney (Holdsworth) and Melbourne (Editions), and at the Tasmanian School of Art Gallery 1982. Group exhibitions in which his work appeared 1979–92 include PCA exhibitions and prize exhibitions including Fisher's Ghost, Campbelltown regional gallery; ACTA Maritime Award 1989; and at the Uni. of Wollongong. His commissions include prints for Hyatt Hotel, Adelaide, and a boardroom table for Wollongong City Council.

AWARDS: Shell-Fremantle Print Award 1982; Commonwealth Postgrad. Scholarship 1982; bicentennial grant to design children's opera, 1985.

APPTS: Secondary art teaching, UK, Helsinki, WA and at Fremantle Arts Centre, 1962–72; lecturer, several tertiary colleges including Tasmanian School of Art, Newcastle CAE, Wollongong Uni., 1984– .

REP: AGWA; Parliament House; Fremantle Art Gallery; a number of municipal, hospital and other public collections; tertiary collections including Uni. of Wollongong, Victoria Uni. of Technology.

HOOKEY, Mabel Madeline
(b. 29/1/1871, Rokeby, Tas.; d. 1953) Farmer, painter, writer.

STUDIES: Sydney, with A. H. Fullwood. Brought up at Rokeby House, Rokeby, she received her formal education in Tas. before becoming active as an art student. She managed her estate and exhibited with the Tasmanian Art Society, the Society of Women Artists, Sydney, and in 1928 in Paris, at the Old Salon, in company with two other Tasmanians, Isobel Oldham and Joseph Connor. She wrote *Romance of*

Tasmania, with illustrations by L. Dechaineux, J. Connor, Blanche Murphy (Hobart, n.d.) and *The Edge of the Field*, with decorations by L. Dechaineux (The Bookfellow, Sydney, 1913).
REP: AGNSW; TMAG.

HOPE, Edith Amy

(b. Aust.; moved to UK in childhood) Etcher.
REP: Etchings in print collections of Australian state galleries.
BIB: AA, no. 9, 1921, ref. and reprdns. Moore, SAA.

HOPE, Emily

(b. 1940, Sydney; d. 1979, Melb.) Painter, sculptor, writer, jewellery designer.
STUDIES: Dip. Art, RMIT 1967. Daughter of poet A. D. Hope, she made the murals in enamelled copper for Uni. Women's Coll. and the Anglican Chaplaincy, Uni. of Melbourne, and became best-known for her imaginative jewellery in cast silver. She also wrote *The Queen of Nagas*, with illustrations by the author, privately published, Melbourne, 1978.

HOPE, Laurence

(b. 1928, Sydney) Painter, teacher.
STUDIES: ESTC, 1943–46; travel studies, UK and Europe, from 1962. Exhibited in Brisbane, 1947, and Melbourne, 1954, his early paintings have an introspective, dream-like quality derived from themes of love, sleep and loneliness. His London exhibitions included shows at the New Vision (1965), Zwemmer (1966), Australian Artists (1966), Clytie Jessop (1968), Commonwealth (1972), and London Hilton (1971) galleries. He returned to Australia in 1974, holding a retrospective exhibition at Holdsworth, Sydney, in 1975.
AWARDS: Robin Hood prize, 1958; VACB grant, 1974.
REP: NGA; Newcastle regional gallery: Heide.
BIB: *Modern Australian Art*, MOMAD, Melbourne, 1958.
NFI

HOPGOOD, Hoppy (Charles)

(b. at sea, 1917) Painter.
STUDIES: No formal study. Naive painter. An army officer by profession, he began painting while recovering from a stroke in 1966.
BIB: Edward Craig, *Australian Art Auction Records, 1975–78*, Mathews, Sydney, 1978.

HOPKINS, John William

(b. 24/12/1943, Melb.) Painter.
STUDIES: Swinburne Tech. Coll., 1960–64. His early work was as a commercial draughtsman, technical illustrator and graphic designer, and secondary schoolteacher, 1970–72. He painted full-time for the succeeding year before taking up a creative arts fellowship at the ANU, 1973–74. His large, new-realist canvases in which his wife, Barbara Grosman (q.v.), is often featured as his model, were among the outstanding entries in national competitions from 1971, notably Gold Coast City, 1971, and Georges, 1972. Described

by one critic as 'the most interesting figure painter of his generation because of his "coolness"', he was an invited exhibitor at the Opera House *Biennale of Sydney*, 1973. He held about six solo exhibitions 1970–90, largely at Tolarno Melbourne, and participated in group exhibitions including prize exhibitions (Gold Coast, Georges, McCaughey, MPAC Spring Festival of Prints and Drawings, Faber-Castell, Alice) and in *Australian Realist Painters*, AGSA 1977; *Australian Art of the Last 10 Years*, NGA 1982; *Field to Figuration*, NGV 1987; *Green Art*, S. H. Ervin Gallery, 1991.
AWARDS: Caltex Alva prize, Latrobe Valley Arts Centre, 1972; Georges Art Prize (acquired), 1972; Crouch prize, Ballarat, 1974; Creative Arts Fellowship, ANU, Canberra, 1973; MPAC acquisitive prize, 1983.
REP: NGA; NGV; regional galleries Ballarat, Geelong, Latrobe Valley, Newcastle; several tertiary collections Vic., ACT; corporate collections including Alcoa (USA), IBM, ICI.
BIB: Catalogue essays exhibitions as above. Alison Small, *Art & Artists of Australia*, Macmillan. McKenzie, DIA. AI 6/7/1972.

HOPKINS, Livingston

(b. 1846, Ohio, USA; arr. Aust., 1883; d. 1927, NSW) Cartoonist. Hopkins fought in the American Civil War. He was working in New York as a successful cartoonist when invited by W. H. Traill to join the staff of the Sydney *Bulletin*. His pseudonym 'Hop' became famous throughout Australia. As an etcher and watercolourist as well as cartoonist he was active in the art life of Sydney, and started an artists' camp with Julian Ashton, at Balmoral, NSW. The camp attracted many leading artists and visitors, the most celebrated of whom was R. L. Stevenson. His book of cartoons, *On the Hop*, was published by the *Bulletin*, Sydney, 1915.
REP: Australian state galleries, departments of prints and drawings.
BIB: Dorothy June Hopkins, *Hop of the Bulletin*, Angus & Robertson, Sydney, 1929. Vane Lindesay, *The Inked-In Image*, Hutchinson, Melbourne, 1979. Catalogue essay *Bohemians of the Bush* exhibition, AGNSW 1990.

HOPMEIER, Paul

(b. 1949, Westmead, NSW) Sculptor.
STUDIES: Dip. Art (sculpture), NAS, 1976; New York Studio School, New York, 1978–79; travel studies Europe 1979; USA 1981, 83. He held nine solo exhibitions 1980–92 in Sydney (Gallery A, Macquarie), Brisbane (Michael Milburn) and Melbourne (Powell St), and participated in about 13 group exhibitions 1977–90 including New York Studio School sculpture show, 1977, 78; ESTC survey show, 1978; *Objects*, Lewers Bequest and Regional Gallery, Penrith 1981; *Mildura Sculpture Triennial*, 1982; *Australian Sculpture Triennial*, Melbourne 1984.
AWARDS: Marten Bequest, 1977; travel grant and residency, New York Studio, VACB, 1978; studio equipment grant, VACB, 1982.
APPTS: Part-time teacher, sculpture, TAFE colleges, 1976–86.

REP: NGV; regional galleries Penrith, Mildura; ANU; Colac Sculpture Park, Vic.

HOPWOOD, Henry Silkstone

(b. 1860, Leicester, Eng.; arr. Sydney 1888; d. 1914) Painter.

STUDIES: Julian's Academy, Paris. During the passage out from England on the sailing ship *Thomas Stevens*, he made a number of shipboard sketches and paintings, one of which was later bought for the AGNSW. 'A big, genial Bohemian who could sing and tell a yarn with the best', he did much to enliven the depressed art climate of NSW. As W. Lister Lister wrote in his memoir: 'It was a great time for black and white artists but a poor one for painters. The arrival of H. S. Hopwood from England in 1888 brought a welcome change, and later on when Streeton and Roberts came over from Victoria, things seemed to go ahead.' During his two or three years stay, Hopwood exhibited with the Art Society of NSW, and was a prominent member of the Society's sketch club.

REP: AGNSW; Tate Gallery, London.

BIB: *Fifty Years of Australian Art, 1879–1929*, RAS, Sydney, 1929. Moore, *SAA*.

HORE, Curtis

(b. 10/11/1958, Vic.) Sculptor.

STUDIES: Dip. Art & Design, Prahran CAE, Melb., 1979, Meridian Sculpture Foundry, Melb., 1980–83; postgrad. studies (sculpture), Tasmanian State Inst. of Technology, Launceston, 1983; Dip. Ed., Uni. of Tasmania, 1986. Christopher Heathcote, in a review of Curtis's painted bronze and welded steel sculptures at Christine Abrahams Gallery (*Age*, 10 Apr. 1991), wrote: 'Few works are artificial and machine-like; instead they allude to organic and natural forms. . . . At no point in these does Hore lower sculpture to a structural exercise, but introduces into this formerly inflexible format an uncommon sensitivity and, perhaps, tenderness.' He held five solo exhibitions 1983–93 in Tasmania (Cockatoo, Launceston; Salamanca, Hobart) and Melbourne (Christine Abrahams), and his work appeared in about 12 group exhibitions 1979–91 in Tasmania and in the graduate shows, Gryphon Gallery, Melbourne 1979; QVMAG, Launceston 1983; *Works All Ways*, Uni. of Tasmania.

AWARDS: Project grant, VACB, 1980; workshop development grant, Tasmanian Arts Advisory Board, Hobart, 1985; artists-in-schools program, Kingston, Tas., 1987; workshop development grant, TAAB, 1988; Diamond Valley Acquisitive Art Award, 1991.

REP: NGV; Uni. of Tasmania; tertiary colleges Melbourne, Launceston, Devonport.

BIB: *A&A* 24/3/1987; 28/1/1990.

HOREAU, Thomas Georg

(b. 26/3/1961, SA) Painter.

STUDIES: BFA, Curtin Uni., 1981. His interiors appear almost as holograms in which figures, walls and other objects seem almost transparent, while much of the his other subject matter include changes (demolition in particular) and domestic objects. Throughout there is a haunting sense of abandonment, dispossession and absence. He held six solo exhibitions 1984–91 in Perth (Galerie Dusseldorf 1984, 88, 90, 91; PICA 1990; AGWA 1991), and his work appeared in approximately 33 group exhibitions 1981–92 in Perth (including Galerie Dusseldorf) and in Albany Art Gallery 1986; Praxis, Fremantle 1987; Uni. of WA 1987; AGWA 1987; *Local Talent: Urban Living*, Undercroft Gallery, Uni. of WA 1990. He received many commissions including a banner for May Day march, THC, Perth, 1985, was artist-in-residence at Praxis, Fremantle 1986 and Metropolitan Coll. of TAFE 1990 and presented a performance and reading at PICA and AGWA in 1991.

AWARDS: TVW 7 Young Artists' Award, 1981; Guy Grey Smith Memorial Travelling Grant, 1983, 85; Fremantle Drawing Prize, 1987; residency, Greene St Studio, New York, VACB, 1991–92.

APPTS: Temporary curator of art works, Royal Perth Hospital, 1990; Queen Elizabeth II Hospital, curator art works, 1991– ; teacher at various institutions including Edith Cowan Uni., Uni. of WA and Metropolitan Coll. of TAFE, 1980s.

REP: NGA; AGWA; Uni. of WA; Curtin Uni. of Technology.

BIB: Catalogue essays exhibitions as above.

HORGAN, John Columbia

(b. 1886, County Cork, Ireland; arr. Perth c. 1910; d. 1952) Painter. Known mainly as a watercolourist. Migrating from Ireland to WA, where he became friendly with Linton and Whyte (qq.v.), he joined the WA Art Society and began farming. Failing to make a living, he moved to Canberra where later (in 1927) he founded the Canberra Artists Society. He painted along the east coast and held exhibitions in Canberra and Melbourne (1932). His paintings of Canberra's beginnings have considerable historical interest for collectors. Rosalind Humphries Gallery, Armadale, Vic held an exhibition of his work in 1972.

HORNE, George

Assistant Commissary General, Norfolk Island; he made an annotated topographical drawing of King's Town in 1853.

NFI

HORNE, Richard Henry

(b. 31/12/1802, London; arr. Aust., 1852; d. 1884) Sketcher, writer. A colourful personality whose early life included fighting for Mexican Independence in 1825–26 and self-publishing a long poem in London, he arrived in Melbourne as the most famous poet to visit the colonies. One of the founders of the Garrick Club, he mixed with literati and artists of the day and also produced sketches and watercolours. His exhibited works include one in the 1867 *Paris Universal Exhibition*.

BIB: *ADB* 4. Kerr, *DAA*.

HORNEL, Edward Atkinson

(b. 1864, Bacchus Marsh, Vic.; moved to the UK in childhood; d. 1933, Scotland) Painter.

STUDIES: Edinburgh and Antwerp, 1881–83. He became a member of the Glasgow School, the International Society of Painters, Gravers and Sculptors, and in 1901 declined an offer of election to the Royal Scottish Academy. He travelled widely: Japan, 1893–94; Ceylon and Australia, 1907; Burma, Japan and America, 1920–21, and became well-known for his coastal paintings and landscapes, many with figures of girls reclining on grass.

REP: AGSA.

HORSE AND SPORTING ARTISTS

The nineteenth century, the century of the horse and the horse-drawn vehicle, was a time of great concentration on specialist paintings of horses and riders as well as sporting prints with emphasis on racehorses. This speciality attracted a large following in Australia, and as art teaching developed studies of the horse, inspired mainly by the work of the eighteenth-century British artist and anatomist George Stubbs, had many devotees. William Strutt and S. T. Gill both knew about the horse and its anatomy and so did later painters like G. W. Lambert, Frank Mahony and Septimus Power. Before photography replaced their work other specialist nineteenth-century Australians concentrated on racehorse portraits. Best known of these were members of the Woodhouse family (q.v.), who concentrated on Melbourne Cup winners, and Martin Stainforth (q.v.). Other later painters who became known for this kind of work include Daryl Lindsay. Many of the paintings and prints in which horses are featured and which frequently appear at art auctions are by artists otherwise unknown. Among these may be mentioned Angela Clare (pastels), David Dalby, Brian Emery, J. J. Forseca or Foneca (c. 1860), Harry Parris (1877), R. Taylor (humorous chromolithographs, c. 1880), B. Taylor (c. 1885), Peter Brinkworth (c. 1890), Mark Garwen (1861–1943), B. G. Stottard (c. 1896) and R. S. Alexander (nineteenth-century primitive). Exhibitions of this subject have included *Horses and Riders*, NGV Women's Association, Georges Gallery, Melbourne, Sept.–Oct. 1975 and *Pastures and Pastimes* Victorian Ministry for the Arts, held at VAS Gallery, Melbourne 1983.

HORSEMAN, Mollie

(b. Rochester, Vic.) Illustrator.

STUDIES: Sheffield, UK; also in Germany; ESTC. She studied in company with Joan Morrison, working in a similar style in pen, ink and wash. Both joined the staff of *Smith's Weekly* in 1929 to become nationally celebrated for their drawings of girls.

BIB: Vane Lindesay, *The Inked-In Image*, Hutchinson, Melbourne, 1979.

HORSLEY, Malcolm

(b. 1925, Sydney) Painter.

STUDIES: Sydney (with D. Orban). Horsley lived in Europe from 1951 and was represented in the 1963 Berlin exhibition of work by Australian artists in Europe.

NFI

HORTON, E.

Painter. A landscape by Horton, *Near Chineford* (oil, dated c. 1860), was exhibited at the Joseph Brown Gallery, *Autumn Exhibition*, 1969.

NFI

HORTON, Mervyn

(b. 1917, Sydney; d. 1983) Editor, art writer, entrepreneur. Best-known as the hard-working foundation editor of Australia's leading art magazine, *Art and Australia*, 1963– , he was professionally associated with a large number of Sydney art organisations including Ure Smith Publications (as editor); NSW Society of Artists (secretary and exhibitions manager for 12 years); AGNSW (trustee, 1973–76); AGNSW Gallery Society (honorary secretary, 1962–72); National Trust of Australia (council); Friends of the Australian Ballet (council). He wrote a number of books on Australian art including *Australian Painters of the '70s*, 1975, and *Present Day Art in Australia*, both published by Ure Smith, Sydney.

AWARDS: AM conferred, 1982.

HOTCHIN, (Sir) Claude

See GALLERIES, Hotchin Gallery; PRIZES

HOUTEN, Henricus (Henry) Leonardus van den

(b. 1801, The Hague, Netherlands; arr. Aust., 1853; d. 1879) Painter, teacher. He arrived in Victoria with eleven of his children and worked on the Victorian goldfields 1853–55. He then became an art teacher at Scotch College, Melbourne and started exhibiting in Melbourne exhibitions including the Victorian Fine Arts Society, the 1861 *Victorian Exhibition* and the 1866 *Melbourne Intercolonial Exhibition*. A prolific painter of landscapes in the colonial style, he also exhibited works frequently in Sydney exhibitions continuing to show in both Sydney and Melbourne regularly until 1875. His work was shown in a number of exhibitions in the 1970s–90s including *Australian Art in the 1870s*, AGNSW 1976; *Thirty Australian Paintings*, Deutscher Fine Art 1983.

REP: AGNSW; NGV; QAG; Benalla regional gallery; La Trobe Library.

BIB: McCulloch, *AAGR*. Kerr, *DAA*.

HOWARD, Ian Gordon

(b. 28/8/1947, Sydney) Multi-media artist, teacher.

STUDIES: NAS; Alexander Mackie CAE, Sydney, 1965–68; postgrad. dip., film and television, Middlesex Polytechnic, London, 1976; MFA, Montreal, Concordia Uni, 1976; enrolled Ph.D., Uni. of NSW, 1992– . Concerned with broadening art into the wider context of contemporary life (especially the impact of and dangers of war), he employs a number of media to impart his message. These include (in the 1970s) gaining access to restricted miltary sites and taking rubbings of objects that have been significant in 20th-century conflicts, such as the *Enola Gay* (the plane that bombed Hiroshima) and the Berlin Wall. He uses familiar

Ian Howard, Man with aeroplane wing, *1992, bronze, 18.5cm high. Private collection, courtesy Charles Nodrum, Melb.*

domestic objects and settings (kitchens, living rooms and their furniture and fittings) juxtaposed with militaristic references, thereby creating thought-provoking 'theatre of war in the home' images. He held about 15 solo exhibitions 1968–93 largely at Watters, Sydney and Charles Nodrum, Melbourne and in three tertiary galleries in Hobart, Adelaide and Perth, 1989. His work appeared in a number of group exhibitions 1966–90 including *Drawing in Australia 1770s–1980s*, NGA 1988; *Australian Art of the Last 20 Years*, MOCA, Brisbane 1988; *Towers of Torture*, 1988 and *Inside the Greenhouse*, 1989, Tin Sheds Gallery, Sydney.
AWARDS: NSW travelling scholarship 1972; Dyason Bequest, 1973; Concordia Uni. Graduate Fellowship, 1975.
APPTS: Teaching, Casino High School, Qld, 1968–73; Alexander Mackie CAE, 1977– ; head, school of arts education and theory, Coll. of Fine Arts, Uni. of Sydney 1992– .
REP: NGA; AGNSW; AGWA; NGV; MOCA, Brisbane; Musée d'Art Contemporain, Montreal.
BIB: Catalogue essays exhibitions as above. Gary Catalano, *The Bandaged Image. A Study of Australian Artists' Books*, Hale & Iremonger, 1983. McIntyre. ACD. *New Art Two*. G. Sullivan, *Seeing Australia: Views of Artists and Art Writers*, Harcourt Brace Jovanovich, 1992. A&A, 27/1/1988; 28/4/1991. AL 8/4/1988; 9/1/1989; 10/1–2/1990.

HOWARD, *Melanie Adel*
(b. 24/12/1952, UK) Painter.

STUDIES: Dip. Fine Art, painting, SASA, 1975; Grad Dip. Fine Art (painting), SASA, 1985. She held eight solo exhibitions 1984–93 in Perth (Greenhill 1990), Adelaide (Anima 1989), Sydney (Irving 1992) and Melbourne (Charles Nodrum 1993), and at the Adelaide Festival Fringe, Women's Switchboard, 1984, CAS Adelaide, 1988; and in Paris, 1991. Group exhibitions in which her work appeared 1988–91 include *A New Generation 1983–88*, NGA 1988; *Perspecta*, AGNSW 1989; *But Never by Chance*, MCA Sydney 1992. She completed a mural for the Port Lincoln Aboriginal organisation with Kerry Giles in 1989 and covers for the Adelaide Festival of Arts Collection in 1988.
AWARDS: Exhibition grant, SA Visual Arts Board, 1988; residency, Paris studio, VACB, 1990.
APPTS: Part-time lecturer, painting, Aboriginal Community Coll., SA, 1984–88; part-time lecturer, painting, TAFE coll., SA, 1983–86.
REP: NGA; Artbank; Philip Morris Collection.
BIB: A&A 26/1/1988.

HOWES, *W. H.*
(Active c. 1880–1910, Sydney) Painter. Colonial school landscape painter. He exhibited at the Art Society of NSW in 1884, showing harbour views. Other subjects are restricted mainly to Sydney and the surrounding country and coast, all painted with care in an academic manner, in opposition to the free brushwork and light palette of Australian impressionism.

HOWIE, *Laurence Hotham*
(b. 1876, Adelaide; d. 1963, Adelaide) Painter.
STUDIES: SASA; Westminster School, London; RCA. Mainly a painter of landscapes in watercolours. After

World War I he worked in the War Records Office, London, before returning to Adelaide where, after joining the staff as a teacher, he became principal of the South Australian School of Arts and Crafts, 1920–41. He was president of the RSASA, 1927–31, and again, 1935–37.

REP: AGSA; AWM.

HOWITT, *William*

(b. 1847, Manchester, Eng.; arr. Melb. 1887; d. 1929,

Prize, Melbourne 1971; *Qdos Australian Painters*, Japan and Hong Kong 1991. In 1980 he started the Acland Street Gallery, St Kilda, moving it to his Williamstown studio in 1989. He completed several murals including for Melbourne Airport, and Royal Children's Hospital, Melbourne, and a commission of 12 paintings for the Regency Hotel, Melbourne, 1982.

AWARDS: VACB grants, 1972, 73.

REP: NGA; AGWA; NGV; uni. collections in Melbourne, Perth.

Perth) Wood carver, sculptor, furniture designer. Not to be confused with the writer William Howitt, or his explorer son, A. W. Howitt. His decorative carvings helped to gain recognition for the qualities of Australian hardwoods. He exhibited wood carvings in Paris, 1902; Glasgow, 1902, 1905; Franco-British Exhibition, 1908; and won medals on all these occasions. He spent five years on the wood carvings for St Paul's Cathedral, Melbourne, and in 1898 settled in Perth.

REP: St Paul's Cathedral carvings, Melbourne.

BIB: Moore, SAA.

HOWLEY, *John Richard*

(b. 30/12/1931, Melb.) Painter.

STUDIES: Dip. Art, NGV School, c. 1949–53. His work first became known through an exhibition shared with three NGV student colleagues, Daws, Laycock and Pugh (qq.v.), at the VAS galleries in 1956. He taught at CAE classes and for the Victorian Education Dept, 1955–56. A car accident retarded his progress towards the end of the 1950s but by 1960 he was in Europe where he worked and travelled until 1965 when he moved to Israel to live for the succeeding two years. He held five shows in Israel before returning to Australia. Concerned often with anti-war protest themes, his colourful, expressionistic paintings and spontaneous line drawings appeared in 23 solo exhibitions 1951–92 in Melbourne, Brisbane, Sydney, Japan, USA and Hong Kong, and in group exhibitions including *Georges Art*

J. B. Hoyte, Sydney Harbour from the North Shore looking East, *watercolour, 34.2 × 70.5. Private collection.*

BIB: All general books on contemporary Australian painting including Smith, AP; Bonython, MAP; Germaine, AGA. A&A 8/4/1971 (John Olsen, *John Howley*).

HOWSON, *Mark Henry*

(b. 12/3/1961, UK; arr. Aust. 1969) Painter, sculptor, jewellery designer.

STUDIES: TOP Art & Design, Prahran CAE, 1980; painting, VCA, 1981–82; sculpture, Phillip Inst., 1992; travel studies Europe, 1983–84; Japan, 1989. A founding member of ROAR Studios, Melbourne, his work developed from the vigorous expressionism that characterised the work of the early ROAR collective into abstracts with distinct influences of Cubist artists, including Picasso, then into semi-abstract, more romantic works of huge shapes and landscapes of eerie stillness. He held five solo exhibitions at William Mora (1988–93), his 1990 show attracting the following comments from Christina Lew in *Tension* (Jan.–Feb. 1990–91): 'Howson's work is designed and operates to create a contemplative stillness and peace, the distorted monumental scale of his subjects combined with the recurring motif of water. The Elysian atmosphere and subdued and sombre palette all contribute to the pacific quality in the work.' His work appeared in about 26 group exhibitions 1981–92 including in Melbourne (Realities, Reconnaissance, William Mora)

and Sydney (Coventry), and at ROAR Studios exhibitions 1981, 82, 83; and in public galleries including *A New Generation: 1983–88 Philip Morris Arts Grant*, NGA 1988; *Heidelberg and Heritage: 9 × 5*, Linden Gallery, Melbourne 1989; *Roar Studios Touring Exhibition*, Heide and touring Vic. regional galleries 1992. He was one of the four ROAR artists commissioned to paint the mural at the NGA restaurant.
AWARDS: Trustees of the NGV Initial and Intermediate Year Painting Award, 1981.
REP: NGA; NGV; Parliament House; Artbank; Launceston CAE; Monash Uni.

HOYTE, John Barr Clarke
(b. 1835; arr. Sydney 1879; d. 1913, Mosman, NSW) Painter.
STUDIES: In London. Known mainly for landscapes in watercolours. He spent five years in the West Indies (c. 1854–59), married in London and migrated to New Zealand (c. 1861) where he taught drawing at the Auckland Coll. and Grammar School and became active in the formation of local art societies. Well-known in NZ for his watercolours of mountain scenery, he migrated to Sydney in 1879, to become the foundation president of the Art Society (later the RAS) of NSW, 1880. His subsequent exhibits in Art Society shows helped to establish his reputation as a painter of Australian scenery.
REP: Manly Art Gallery; Auckland City Art Gallery, NZ.
BIB: F. Myers, *The Coastal Scenery of New South Wales*, with illustrations by John C. Hoyte, Gov. Printer, Sydney, 1886. Gil Docking, *Two Hundred Years of New Zealand Painting*, Lansdowne, Melbourne, 1971. Henry P. Newrick, *New Zealand Art Auction Records, 1969–72*, Newrick, Wellington, 1973.

HUDSPETH, Elizabeth
(b. 2/2/1820, Eng.; arr. Tas. c. 1837; d. 1882 Canary Islands) Painter. She arrived in Tasmania as a child and made many sketches and watercolours of the local scenery 1840s–early 1850s, after which time she returned to England, living late in life in the Canary Islands where she died. Her known work includes many sketches of Tasmania and the south coast of NSW and in England five of her views, *Ben Lomond, The Derwent, The Customs House at Eden, Twofold Bay* and *Boydtown*, were lithographed by M. & N. Hanhart in London.
REP: TMAG; NLA; Mitchell Library.
BIB: Clifford Craig, *Old Tasmanian Prints*, Foot & Playstead Launceston, 1963. Kerr, DAA.

HUGGINS, William John
(b. 1781; d. 19/5/1845) Painter. He exhibited at the RA, London, 1817–44; the Royal Society of British Artists, 1824–45; and at the British Institution and Suffolk Street. While serving at sea for the British East India Company he made drawings of Tas. and WA from which prints were made in London. In 1834 he was appointed marine painter to William IV. He was represented in *The Colonial Eye*, AGWA 1979.
REP: Hampton Court Palace and National Museum, Greenwich.
BIB: Nathaniel Ogle, *Colony of Western Australia*, London, 1839.

HUGHAN, Harold Randolf
(b. 1893, Mildura, Vic.; d. 1987, Vic.) Ceramicist. Said to have been the first to produce stoneware in Australia he became a well-respected potter whose work retained a simplicity of form and subtle colouration. Two retrospectives of his work were held at the NGV in 1969 and 1987.
BIB: Kenneth Hood, *Pottery*, Arts in Australia series, Longman, Melbourne, 1961. A&A 6/1/1968.

HUGHES, John E.
(b. 1936, Sydney) Sculptor, teacher.
STUDIES: NAS, Sydney. He held an exhibition at Watters Gallery, Sydney, 1966, and participated in competitive sculpture exhibitions from 1966, notably Alcorso-Sekers, Transfield and *Mildura Sculpture Triennial*, 1967. His 1.22 m (48 in) high steel *Prometheus Bound* was among those selected from the Mildura exhibition for display at Georges Gallery, Melbourne, in 1967.
APPTS: Teaching, sculpture, part-time, NAS, 1967– .

HUGHES, Robert Studley Forrest
(b. 1938, Sydney) Art critic, writer, painter.
STUDIES: Uni. of Sydney (architecture); extensive travel studies UK, Europe and USA from 1959. During 1959 he began writing art critiques for the London *Observer* and *Sunday Times*, made his first appearances on BBC television and in 1970 was appointed art critic (and later a senior member of the editorial staff) of *Time* magazine, New York. He made more than 20 TV documentaries on the visual arts, including the series *The Art of Australia* 1975, his BBC series *The Shock of the New*, and the book that followed under the same title. His professional career began when he left the Uni. of Sydney without completing his course in architecture, to work briefly as a cartoonist and illustrator for the Sydney *Telegraph*. His eclectic freelance art critiques introduced a new dynamism into art writing in Sydney, and his similarly eclectic paintings were the subject of successful exhibitions in Sydney and Melbourne before he finally decided to devote his energies exclusively to art criticism. As an art writer he became internationally celebrated for his scintillating style, his wit, his far-ranging knowledge of world art and art history and his remarkable memory. His book *The Shock of the New* reveals also a depth of perception and a humanism that marked the emergence of his mature style, further deepened by his re-evaluation of Australia's history in his award-winning, *The Fatal Shore. Nothing if not Critical* (Harper Collins, 1991) provides an excellent selection of his art criticism of the 1980s.
APPTS: Freelance art critic for papers and magazines, including Sydney *Observer* 1958–59, *Nation* 1959–mid 1960s, *Sunday Mirror, Art and Australia*, from 1963; art critic, *Time* magazine, NY 1970– .

HULME, Edward
(b. 1818, London; arr. Aust. 1855; d. 1904) Painter.
STUDIES: RA School, London. Kerr gives him as a professional portrait painter and muralist in England who arrived to seek gold in Victoria. He lived in Melbourne before going to the Ovens River goldfields from where he sent paintings to exhibitions of the day, including the 1866 *Melbourne Intercolonial Exhibition*, the 1876 *NSW Academy of Art* exhibition and the 1879 *Sydney International Exhibition*. About 70 works of his, most in private collections, are known. An exhibition of his work was held at Albury City Art Gallery in 1979.
REP: Mitchell Library.
BIB: Kerr, DA.

HUMBLE, Brenda
(b. 1/10/1933, Brisbane) Painter, sculptor.
STUDIES: Dip. painting, NAS, 1960; travel studies Sri Lanka, 1981. She held 13 solo exhibitions 1973–92 in Sydney (including Bondi Pavilion 1980, 81, 82; Access 1988, 89, 90), and her work appeared in about 43 group exhibitions 1960–92 at private galleries including Access Gallery, Sydney, and in prize exhibitions including *The Alice Prize*, 1974; *Portia Geach Memorial Award*, 1980, 81, 82, 83, 85, 86, 88; *Blake Prize*, 1984; ACAF2, 1990.
AWARDS: South Sydney prize, 1976, 77, 78, 80; Arthur Phillip Cumberland Award, 1st and 2nd prize, 1981; Portia Geach Memorial Award, 1982.
REP: Parliament House; Artbank; Uni. of NSW; Reserve Bank; IBM collection.
BIB: Germaine, AGA. A&A 20/3/1982; 22/2/1983.

HUMPHREY, Tom (Thomas)
(b. 1858, Aberdeen; arr. Aust. 1869; d. 1922, Armadale, Vic.) Painter.
STUDIES: NGV School, with O. R. Campbell. He worked as a photographer and manager for the firm of Johnstone, O'Shannassy & Falk and in 1890 set up his own business. He was a member of the Buonarotti Club, and painted with the Heidelberg School painters (nocturnes and landscapes), exhibiting his work at the VAA, 1885 and VAS, 1888–1913. Symptoms of the illness (tuberculosis) which finally killed him appeared first in 1902 and from then on his work was severely handicapped. Between 1910 and 1919 he painted at Mornington, the bayside resort where he spent his summer holidays. In the words of Tom Roberts, his lyrical, impressionistic painting 'expressed the intimate and tender spirit of the Bush in its quiet moods'. During his lifetime he never held a solo exhibition. An exhibition of his work was held at the Fine Arts Society Gallery, Melbourne, in 1925, and in July 1979, a commemorative exhibition, *Tom Humphrey: 1858–1922*, was held at the Warrnambool Art Gallery. His half-sister, Elizabeth, married John Ford Paterson (q.v.).
REP: AGNSW; NGV; regional galleries Ballarat, Bendigo, Castlemaine, Mildura, Warrnambool; Uni. Gallery collections, Melbourne.
BIB: Moore, SAA.

HUMPHRIES, Barry (John Barry)
(b. 17/2/1934, Melb.) Satirist, artist. Although better-known for his 'alter-egos' Dame Edna Everage, Barry McKenzie and Sandy Stone, he once contemplated a career in painting and held several exhibitions of Dada-surrealist-type works including *Ten Little Australians* (a satire on Australian prime ministers), Myer Mural Hall, July 1968, and *Forkscapes*, VAS. As well he collected the works of Charles Conder at a time when they were little regarded and in 1993 promoted and appeared in the NGA's exhibition *Surrealism Revolution by Night*.

HUNT, Charles Henry
(b. 1857; arr. Sydney c. 1878; d. 1938) Painter, illustrator.
STUDIES: Heatherley's School, London. He was a foundation member of the Art Society of NSW, where he exhibited regularly for many years subjects ranging from Oriental scenes (1883) to genre and garden scenes (1884), trees in blossom, etc. As a black-and-white artist, he was associated with Arthur Collingridge (with whom he collaborated in an art union, 1892) and Ernest Blackwell in establishing the *Centennial Magazine*; he also drew for the *Illustrated Sydney News*, and for the Qld *Punch*, 1878–94. The *Illustrated Sydney News*, 1885, contains double-page drawings by Hunt of the embarkation and return of Australian troops for the Sudan. Though not directly associated with the Sydney impressionism of the 1890s, his work forms an identifiable link between the earlier Colonial School of the 1870s and that of artists such as Julian Ashton and A. H. Fullwood (qq.v.) of the 1890s.
REP: AGNSW.
BIB: Moore, SAA.

HUNT, Colin
(b. 1898, Drouin, Vic.; d. 1952) Painter.
STUDIES: Ballarat School of Mines and Melbourne Tech. Coll. Known mainly for landscapes. Art teacher at Castlemaine Tech. School and secretary of Castlemaine Art Group.
REP: Castlemaine Gallery, Vic.

HUNT, Diana
(b. London; arr. Aust. c. 1950) Sculptor.
STUDIES: Southern School of Art, Essex; St Martin's School, London; NAS, Sydney, 1963–67. She held a show of 'domestic sculpture' in Sydney in 1965 and was commissioned to produce a commemorative wall-sculpture at Basser Coll., NSW, a fountain for Kippax Park, Sydney, 1966, and *Don Quixote* (a memorial to Sir Lionel Lindsay) for Wahroonga Park, Sydney. A carving in willow by her, entitled *Flight*, was included in the *Mildura Sculpture Triennial* in 1967.
REP: Manly Art Gallery.
BIB: Scarlett, AS.

HUNT, Percy Ivor
(b. 19/3/1903, Fremantle; d. 30/8/1971, Swanbourne, WA) Painter, teacher.

STUDIES: Perth Tech. Coll. (evening classes), also with James W. R. Linton, 1924–29; Central School of Arts and Crafts, London, with Bernard Meninsky, 1930; Regent Street Polytechnic with Harry Weston and Stuart Tresillian, 1930–34; brief travel studies, Paris, 1930. After working as a commercial artist in Singapore, 1935–38, he returned to Perth, 1938, and from 1941 to 1964 taught at Perth Tech. Coll. (head of the art dept, 1954–64). Member of the Perth Society of Artists, 1940; vice-president, 1951–53; president, 1953–54. His highly-skilled, figurative watercolours painted in the English tradition, often of waterfront subjects, are noted for their luminosity, lyricism, atmosphere and economic use of colour. The AGWA held an exhibition of his work in 1980.

AWARDS: Dunlop prize, 1952; Festival of Perth prize, 1958, and 1964 (shared); prizes at Narrogin, 1961; Bunbury, 1966, 68 (all for watercolours).

REP: AGWA; Uni. of WA; WAIT.

HUNTER, John (Captain, later Admiral Sir John)

(b. 1737, Leith, Scotland; d. 1821, London) Ship's officer, painter, cartographer. Second captain of *Sirius* in the First Fleet. Governor of the colony of NSW in succession to Phillip, 1795–1800. He was shipwrecked at Norfolk Island, which he surveyed. His journal, *An Historical Journal of the Transactions at Port Jackson and Norfolk Island*, was published in London in 1793 and his album of 100 watercolours of Australian birds, animals and plants (Nan Kivell Collection, NLA) is of significant historical importance. A facsimile book of it was produced by the National Library in 1989 and his work was seen in *The Great Australian Art Exhibition 1788–1988*.

REP: NLA; Mitchell, La Trobe Libraries.

BIB: Smith, EVSP. Rienits, *Early Artists of Australia*, 1963. McKenzie, DIA. ADB 1. Kerr, DAA.

HUNTER, Philip

(b. 1958, Donald, Vic.) Painter.
STUDIES: Dip. Art, Prahran CAE, Melb., 1979. He held ten solo exhibitions 1981–91 in Melbourne (Axiom, Christine Abrahams, City Gallery, Monash Uni. Gallery) and his work appeared in about 16 group exhibitions 1980–91 including *Six Young Melbourne Painters*, Monash Uni. 1982; *Ansett Art Award*, Hamilton regional gallery 1982; *Australian Perspecta*, AGNSW 1983; *Recent Acquisitions*, NGV 1990. His work was selected for two *Moet & Chandon* touring exhibitions 1988 and 1991, the latter called *Visit VI*, being part of a series of neo-romantic works based on images of Rubens.

AWARDS: Ansett Art Award, 1982; project development grant, VACB, 1984.

APPTS: Lecturer, VCA, 1982–86; lecturer, Phillip Inst. of Technology, Melb., 1984; visiting lecturer, artist-in-residence, Canberra School of Art, 1987; lecturer, Victoria Coll., Prahran, 1988– .

REP: NGA; NGV; regional galleries Benalla, Hamilton, Warrnambool; Monash Uni.; Victoria Coll.; Myer and Shell corporate collections.

BIB: Catalogue essays exhibitions as above.

HUNTER, Robert

(b. 1947, Melb.) Painter.
STUDIES: Preston Tech. Coll., Melb., 1964–65; RMIT (industrial design, then painting), 1966–67. He participated in exhibitions from 1966, and in 1968 with groups including *The Field*. In his essay in the catalogue Patrick McCaughey wrote: 'Perhaps the most crucial example in the exhibition of the central role of the onlooker's experience as the key to understanding the force of the new abstraction is Robert Hunter's white painting . . . It is the continuous paradox of a wide spectrum of different imaginative persuasions within the new abstraction that . . . create complex and ambiguous experiences for the spectator'. Hunter's simplifications appeared also as unstretched, unframed canvases painted in a single off-white at the Pinacotheca Gallery, Richmond, 1970. Grey was added to the white in a later show (1970) representing identical geometrical patterns stencilled onto the wall of the same gallery. Since then his work has remained true to the minimalist style he first evinced but the paint has become more subtly shaded and within the shapes flecks, stripes and other patterns appear – often visible only in excellent light – giving the works depth. Group exhibitions in which his work appeared 1968–92 include *Second Indian Triennial*, New Delhi 1974; *Australian Perspecta*, AGNSW 1983; *The Field Now*, Heide 1984; *Field to Figuration*, NGV 1987; *Surface for Reflexion*, AGNSW 1988; *The Great Australian Art Exhibition 1788–1988*; *Australian Biennale*, AGNSW 1988; *Advance Australian Painting*, Auckland City Art Gallery, NZ 1989.

AWARDS: Eltham prize, 1966; residency, Gertrude St Artists Spaces, 1987–88.

REP: NGA; most state gallery collections; a number of regional, tertiary and other public collections.

BIB: A number of books on contemporary Australian art including Chanin, CAP; Smith, AP. A&A 16/3/1979; 17/1/1979.

HUNTER, William

(b. c. 1900; d. 1963, Vic.) Painter, graphic artist, teacher. Well-known for his colourprints and watercolours and as a member of the VAS and Peninsula Art Society, Frankston. He was killed in a car accident in 1963.

BIB: Moore, SAA.

HUNTINGTON, Isobel

(d. 1971, Melb.) Painter.
STUDIES: Ballarat Tech. Coll.; RMIT. Teacher of art at Rosanna High School, Vic. Director of handicrafts for Red Cross; member of the Melbourne Society of Women Painters and Sculptors.

AWARDS: Albury prize, 1965; Caltex prize, Flinders, 1970.

REP: MPAC.

HURRY, Polly (Mary Farmer)

(b. 1883; d. 1963, Vic.) Painter.
STUDIES: Melbourne, with Max Meldrum; Paris, 1923–24; London, 1933–34. Exhibited at the Paris Salons and with the Royal Society of Portrait Painters, London. Wife of John Farmer.
REP: Castlemaine Gallery, Vic.

HUTCHESON, Margot

(b. 15/6/1952, London; arr. Aust. 1974) Painter.
STUDIES: St Martin's School, London, 1970–71. She held five solo exhibitions at Watters Gallery, Sydney (1981, 83, 85, 87, 89) and participated in about six group exhibitions 1983–89 at private galleries in Sydney (including Watters) and Albury Regional Art Gallery 1983; *Portrait of a Gallery*, Watters Gallery 25th anniversary exhibition touring eight regional centres, 1989–91; *From the Landscape: A Review of the Influence of the Landscape in Contemporary Art*, MOCA, Brisbane 1991.
REP: NGV; Artbank; MOCA, Brisbane; IBM, Allen, Allen & Hemsley corporate collections.

HUTCHINGS, Patrick Alfred

(b. 26/10/1929, NZ) Philosopher, critic, writer.
STUDIES: MA, Uni. of NZ; B. Litt., Oxford Uni., UK. University lecturer, author of several Australian art monographs and contributor to various art journals including *Art International*; *The Critic*, Perth; *Ascent*, *Islands*, NZ; *Art & Australia*; and general press including *The Bulletin*, *The Australian*, 1960s– . His books include: *Guy Boyd*, with Anne von Bertouch, Lansdowne Press 1976; *Kathleen O'Connor: Artist in Exile*, with Julie Lewis, Fremantle Arts Centre Press, 1987; *Peter Corlett: Sculptures*, Deakin Uni. Press, 1992.
APPTS: Hon. Research Fellow in Aesthetics, Uni. of London; art critic for *The Critic*, Perth; senior lecturer in philosophy, Uni. of WA.

HUTCHINSON, Allen

Sculptor. Itinerant sculptor who arrived in Sydney in 1896 via Canada, Honolulu and New Zealand. He exhibited at the RA in 1883, made a bust of R. L. Stevenson in Honolulu in 1893 and in Sydney exhibited with the Society of Artists of NSW.
REP: AGNSW (bust of Sir Alfred Stephen, first president of Trustees, acquired 1899).

HUTCHINSON, (Dr) John

(b. 1811, Newcastle-upon-Tyne; arr. Bendigo goldfields 1852; d. July 1861, Fiji) Doctor, painter, sculptor, musician. His work as a doctor did much to alleviate suffering from respiratory ailments on the goldfields, and this as well as his personality and versatile accomplishments as an artist made him a noted personality in Bendigo. His mineral collection was purchased to form the nucleus of a local public collection. His sculptures took the form of bas-reliefs but none of these or any of his paintings are known to have been preserved in Australia.
BIB: McCulloch, AAGR.

HUTCHISON, Inez

(b. 1890, Essendon, Vic.; d. 1970, Beaumaris) Painter.
STUDIES: George Bell School, Melbourne, 1956–59. Member of Melbourne Contemporary Artists' Group. Best-known as a painter of expressionistic flower paintings. The Inez Hutchison award was created in 1966 in her honour by the Beaumaris Art Group.
(*See also* PRIZES)

HUTCHISON, Noel Stewart

(b. 10/4/1940, St Leonards, NSW) Sculptor, teacher, art writer.
STUDIES: BA (Hons), Uni. of Sydney, 1969. He began his working life as a plumber, a trade that equipped him with some of the metal-working skills that were later to affect his abstract sculptures, many constructed from pipes. He held about four solo exhibitions largely at Watters, Sydney, 1971–83 and participated in *Mildura Sculpture Triennial* and *The Tasmanian Series*, touring six regional and private galleries in Tasmania, Sydney and Melbourne, 1984–88. Combining sculpture with full-time lecturing in various colleges, he was also a member of many art advisory groups including adviser, art purchases, VACB, 1976; member, various accreditation committees including for Newcastle CAE (1980–81), Prahran CAE and VCA 1974– ; book reviewer for various newspapers, 1971– ; author of several books and catalogues including *Stephen Earle: Painting*, catalogue, War Memorial Gallery, Uni. of Sydney, 1969; *Bertram Mackennal*, OUP, 1973; *Early Australian Sculpture*, catalogue, Ballarat Fine Art Gallery, 1976. He contributed to many journals and general magazines including CAS (NSW) Broadsheet, *Art & Australia*, *Arts Melbourne*, and to *Australian Dictionary of Biography* (three biographies).
APPTS: Teaching, ESTC and Randwick Tech. Coll., 1969–70; tutor, adult fine arts classes, Uni. of Sydney, 1969–71; tutorials, lectures, Power Inst., 1973; lecturer, Newham CAE, Tas., 1973–74; principal lecturer in Fine Art, Victoria Coll., Melb., 1982–91; Acting Dean, Prahran Faculty Art & Design, 1982–83 and 1989; critic for *Honi Soit*, 1968; *Union Recorder*, 1969; *Sydney Morning Herald*, 1968, 71, 73; *Examiner*, Launceston, 1975–80; associate professor, Victoria Coll., 1991; head of art history/co-ordinator undergraduate studies, VCA/Uni. of Melb., 1992– .
AWARDS: Prize for sculpture, R.Ag.Soc.NSW Easter Show, Sydney, 1970; Mildura acquisition, 1970.
REP: NGA; Mildura Arts Centre.
BIB: Catalogue essays exhibitions as above. Scarlett, AS. Sturgeon, DAS. Germaine, AGA. A&A 12/3/1975.

HUTTON, Francis Frederick

(b. 4/8/1826, Bideford, Devon; arr. Vic. c. 1854; d. 1859, at sea) Painter.
STUDIES: King's Coll., London; Cambridge Uni., UK (matric. from Trinity Coll., June 1845). In 1850 he was official artist for an expedition led by Sir Henry Young to the junction of the Murray and Darling Rivers. He painted portraits in Melbourne 1854–55, Sydney 1855–56, Hobart 1858, and participated in

an exhibition there in that year. He was drowned in the wreck of the *Royal Charter* off the Welsh coast in 1859. He was represented in *Australian Colonial Portraits*, touring exhibition to state galleries, 1979.
REP: AGSA; Allport Library.
BIB: Eve Buscombe, *Artists in Early Australia and their Portraits*, Sydney 1978. Kerr, DAA.

HUXLEY, Thomas Henry

(b. 1825; d. 1895) Scientist, painter, draughtsman. In addition to being a scientist and champion of the theories of his friend Charles Darwin, Huxley was a distinguished amateur painter and natural history draughtsman. He visited Australia as assistant naturalist on HMS *Rattlesnake*, on which Oswald Brierly was also a passenger; Huxley acted as surgeon during the survey of the east coast of Australia (July 1847 to Feb. 1850). Illustrations by Huxley were published in *Narrative of the Voyage of H.M.S. Rattlesnake*, by John McGillvray, London, 1852.
BIB: ADB 1.

HUYGHUE, Samuel Douglas Smith

(b. 1815, Prince Edward Island, Canada; arr. Vic. 1852; d. 1891, Melb.) Painter, sketcher. He became Clerk of the Office of Mines, Ballarat, in 1853, and in 1862, Collector of Imposts, until 1872, when he became Clerk of Petty Sessions at Graytown, retiring from the public service to live in Melbourne in 1874. His watercolours and drawings of goldfields subjects included some (?done from memory) of the Eureka Stockade.
REP: Ballarat Fine Art Gallery; Mitchell, La Trobe Libraries.
BIB: McCulloch, AAGR. Campbell, AWP. Kerr, DAA.

I LIC TO IWANOFF

ILIC, Dragan
(b. 1948, Serbia; arr. Aust. Nov. 1971) Painter, sculptor, performance artist.
STUDIES: Interior design, fine art, Belgrade, 1967–69; Academy of Fine Art, Vienna, 1971; NAS., 1975. He designed the sets for Dorothy Hewett's *Joan of Arc* (Canberra) 1975. After participating in exhibitions with sculpture and painting in Canberra and Sydney he began the series *electronic pencils*, for which he is best-known. The series was performed at the Adelaide Festival Centre Gallery, EAF and Adelaide Coll. of the Arts and Education in March 1978.
NFI

ILLINGWORTH, Nelson
(b. 1862, Portsmouth, Eng.; arr. Sydney 1892; d. 1926) Sculptor.
STUDIES: Lambeth Art School, London. Known mainly for busts of prominent citizens, including Sir Henry Parkes and other politicians, businessmen and officials. Illingworth worked at Royal Doulton potteries as model-maker and modeller before going to Australia. He exhibited with the Society of Artists from 1895 and with the Art Society of NSW, and was in Christchurch, NZ, for the *International Exhibition*, 1906–07. He worked usually on a small scale, an exception being a large bronze of J. C. Manifold for the square at Camperdown, Vic. He is also remembered as one of Sydney's more colourful Bohemians.
REP: NGA; AGNSW; AGSA.

IMPRESSIONISM
See HEIDLELBERG SCHOOL

INDEPENDENT GROUP
(Active, c. 1940–50, Melb.) Annual exhibitions were held, usually at the Athenaeum Gallery. Members included: James Quinn, Norman MacGeorge, Dora Wilson, Dora Serle, James D. Watson, Charles Bush.
BIB: Exhibition catalogues, Independent Group.

INDEPENDENT SCULPTURE SCHOOL
Name adopted by Melbourne sculptors, c. 1970. The group included Clive Murray White, Ti Parks, Roger Butler, John Davis, Kevin Mortensen and Andrew Coplan (qq.v.).

INDUSTRIAL DESIGN INSTITUTE OF AUSTRALIA
(Established 1959) Incorporated organisation of professional designers in Australia. The Institute absorbed the Society of Designers for Industry (est. 1948) and the Interior Designers Association.

INGHAM, Alan
(b. 19/8/1920, Christchurch, NZ; arr. Aust. 1956) Sculptor, teacher.
STUDIES: Christchurch School of Art (part-time), 1939–41; Dip. Fine Art, ESTC (with Lyndon Dadswell), 1946–48; Central School of Arts and Crafts, London, 1949, with RA Grant. Assistant to Henry Moore, 1950–53. In 1954 he returned to New Zealand where he built a small bronze foundry before moving to establish a studio in Sydney. His commissioned works include sculpture for the Snowy Mountains Authority, NSW, bronze motif for Phoenix House, Sydney, 1959; the aluminium *Spirit of Botany*, done in the style of Moore, for the Bankstown Civic Centre, 1964; university medal North Qld Uni. and CSR presentation 1979; Royal College of Surgeons *Cini Clinic*, Award 1971–74; Australian Inst. of Chemistry 1987–88; 3M company award for excellence, lithography 1964–67; Australian Library Association awards 1977, 78, 88. He held about 20 solo exhibitions 1948–89 in London, NSW and Brisbane.
APPTS: Teaching, part-time, 1960– , various art colleges including ESTC, Meadowbank and Seaforth TAFES, and Uni. of NSW School of Architecture.
REP: Auckland Art Gallery, NZ.
BIB: Scarlett, *AS*.

INGRAM, Terry (Terence John)
(b. 29/5/1942, UK; arr. Sydney 1964) Art writer.
STUDIES: Leeds Uni., fine art, 1960–63. From around 1968, his writings for the *Australian Financial Review* and other periodicals have given a well-written, common sense view of many important Australian art

affairs. He is the author of *A Matter of Taste: Investing in Australian Art,* Collins, Sydney, 1976 and *A Question of Polish*, Collins, Sydney, 1979.

INSLEY, W.
Early topographic artist who made careful, primitive-style pictures of colonial streets and buildings, mostly in Melbourne, c. 1861.
REP: Dixson Gallery of the Mitchell Library.

INSON, *Graeme*
(b. 8/2/1923, Cootamundra, NSW) Painter.
STUDIES: Melbourne (with Max Meldrum). Inson, a leading exponent of the methods of the Meldrum school and a regular contributor to Archibald contests, later became a Fellow of the RAS and established his own school in Sydney in 1955. He held around 40 solo exhibitions 1950–92, frequently at Verlie Just, Brisbane and in Sydney (including at David Jones; Wagner) and has been commissioned for many official viceregal and other public figure portraits. He was a finalist in the Doug Moran portrait prize in 1990 and 1992.
AWARDS: Troy Roche prize, Tumut competitions, 1961; R.Ag.Soc.NSW Easter Show (rural traditional), 1966, 67.
REP: NGA; AGNSW; QAG; QVMAG; Artbank; several regional galleries Qld, NSW.

INSTALLATION ART
See PERFORMANCE INSTALLATION AND ASSEMBLAGE ART

INSTONE, *Roland*
(b. 1890, near Invercargill, NZ; d. 1956) Collector. He amassed a large collection which he hung in his home in Sydney. Many of the Australian works were acquired from the Macquarie Galleries, Sydney. The main emphasis of the collection is on graphic art, including examples by Rembrandt, Rowlandson and Augustus John.
BIB: *A&A* 6/2/1968 (Daniel Thomas, *The Art Collectors: Roland Instone*).

INTERIOR DESIGNERS ASSOCIATION
See INDUSTRIAL DESIGN INSTITUTE OF AUSTRALIA

INTERNATIONAL *and* INTERCOLONIAL EXHIBITIONS
See EXHIBITIONS

INTERNATIONAL ASSOCIATION OF ART CRITICS *Australian Division*
AICA (Association Internationale des Critiques d'Art), the world organisation, was formed in Paris in 1948, when national delegates were asked to form branches in their own countries. Australian unofficial delegate was Alan McCulloch, and the second Congress (1949) was attended by him and two other Australians, Albert Tucker and Peter Bellew. Difficulties of distance, of getting interstate critics to attend meetings, delayed formation of the Australian Division until 1962, when

Australian critics were circularised by the Australian Advisory Committee to UNESCO with requests to form the division so as to make Australian artists eligible for international Guggenheim prizes. The Australian Division was finally formed in Adelaide that year at a meeting attended by Alan McCulloch, Wallace Thornton and Elizabeth Young. With assistance provided by Australian newspapers and the sponsors of Georges Invitation Art Prize (q.v.), the first interstate meeting was held in Melbourne at the NGV board room, 9 May 1963. Fourteen critics attended from all states. Since then, Australian delegates have attended the international congresses in various Europe cities. Presidents have included Alan McCulloch, Bernard Smith, James Gleeson, Gertrude Langer, Graeme Sturgeon.

INTERNATIONAL CULTURAL CORPORATION OF AUSTRALIA
See ART EXHIBITIONS AUSTRALIA

IRELAND, B.
Artist who painted *Eureka Stockade*, a detailed, bird's-eye-view depiction of the epic events at Ballarat, 3 Dec. 1854. A print made by T. Welch and I. Watson is in the collections of the La Trobe Library of the State Library of Vic. Another picture (oil on canvas) by Ireland, *Melbourne from the Back of the Victoria Barracks 1898* (included in the Arthur and Caroline Howard Bequest collection), reveals Ireland as a lyrical painter of considerable talent.
BIB: McCulloch, *AAGR*.

IRONSIDE, *Adelaide Eliza Scott*
(b. 1831, Sydney; d. 1867, Rome) Painter.
STUDIES: Family studies with her mother, a philologist. She studied Latin and German as well as art and literature. Known for imaginative religious pictures which echoed the manner of the Italian masters and were greatly influenced by the work of the Pre-Raphaelites. In Sydney she contributed articles and verse to local papers and in 1855 moved with her mother to London. She studied fresco painting at a monastery (Order of Camaldoli) at Perugia, Italy, and lived in Rome, 1856– , where she became known as a painter and also as a medium who painted the visions seen in crystal balls. During a visit to London in 1865 she met Ruskin with whom subsequently she corresponded. A large picture by her, exhibited in the NSW Court of the Kensington *International Exhibition* in 1862 was bought by the Prince of Wales for £500, and another went to William Charles Wentworth (1790–1872) for the same price. In Italy she was granted an audience with Pope Pius IX and given permission to copy pictures in the Vatican. When she died from tuberculosis in Rome at the age of 36, a memorial poem was written by James Brunton Stephens, and she was described in the London Athenaeum (11 May 1867) as the 'impersonation of genius'. Her work was seen in *The Artist and the Patron*, AGNSW, 1988.
REP: AGNSW; St Paul's Coll., Sydney Uni.

BIB: Janine Burke, *Australian Women Artists 1840–1940*, Greenhouse, Melbourne, 1980. ADB 4.

IRVINE, Greg (Gregory John)
(b. 26/9/1946, Melb.) Painter, ceramicist.
STUDIES: NGV School, 1963–66. He first exhibited at the South Yarra Gallery, 1965, ceramics modelled in the style of John Perceval's ceramic angels; later exhibitions of his paintings have been decorative and exotic. His flair for decoration earned him a commission to design the sets for an Australian Ballet Company production of *Firebird* and invitations to participate in two Angliss Prize exhibitions. In 1975 he travelled in Bali and Sulawesi. He held annual exhibitions 1964–89 in most Australian capital cities and in France, where he was based from the mid-1980s.
AWARDS: Junior prizes in *Sun* Youth Art exhibitions 1960, 62; Albury prize, 1964; Grand Prix, Cannes, France 1985.
REP: NGA; several regional galleries; overseas public collections.

IRVINE, John
(b. 1805, Lewick, Scotland; arr. Aust. c. 1855; d. 1888, Dunedin, NZ) Painter. He exhibited portraits at the RA, London, 1842. Records of the Royal Scottish Academy, where he exhibited from the late 1830s, state that he worked in Australia in the late 1850s and early 1860s.
BIB: Bénézit, *Dictionnaire*, 1911–23.

IRVING, Henrietta
See CHARTERISVILLE

IRVING, Julie
(b. 1953, Melb.) Painter.
STUDIES: Dip. Art, NGV School, 1973; BA studies, Uni. of Melb. 1971–72; postgraduate dip., VCA, 1975. Exhibiting in group exhibitions from 1973 she attained prominence with a series of exquisitely textured works shown at the Pinacotheca Gallery, Melbourne, 1979. She held five solo exhibitions 1976–89 in Melbourne (Pinacotheca; Realities) and Canberra (Abraxas) and participated in a number of group exhibitions including *A Room of One's Own* (with Lesley Dumbrell, Anne Newmarch), Ewing Gallery, Uni. of Melb. 1973; *Selected Works from the Michell Endowment*, NGA 1980; *Young Australians*, NGA 1987; *Print and Drawing Show*, Swan Hill Regional Gallery 1989. She received several commissions including works for the Park Royal Hotel and World Congress Centre, Melbourne.
AWARDS: Alliance Française scholarship, Paris 1977; Georges prize, 1980 (major award and in addition work acquired for Mildura Arts Centre).
APPTS: Part-time lecturer, various art colleges, Melb. 1977–86 including Prahran, VCA; lecturer, Victoria Coll. 1981–91.
REP: NGA; NGV; Artbank; VACB; World Congress Centre; Mildura Arts Centre; corporate collections including Bongiorno, Budget.

IRVING, Tony (Anthony)
(b. 22/8/1939, Eng.) Painter, printmaker.
STUDIES: Dip. Art, Swinburne Tech. Coll., 1955–59. A group exhibition at the South Yarra Gallery, 1963, and a social-realist exhibition followed by a show at the Australian Galleries, 1965, paved the way for Irving's debut in the John McCaughey Memorial Art Prize exhibition (NGV), 1966. He won the prize with a promising figurative painting entitled *Uncle John's 1919 Homecoming*. Lyrical in feeling, it expressed the spirit of the prize to represent 'some aspect of an Australian way of life', and consequently stood out from other entries. Combining painting with graphic and book design and illustration he held about 10 solo exhibitions 1965–93 in Melbourne (Australian; South Yarra), London and Sydney. In 1982–83 he was artist-in-residence with the Victorian Trades Hall, his main task being to depict life on the workshop floor. He produced a sketchbook of Melbourne published by Greenhouse Publications, Melbourne, in 1984.
REP: NGA; NGV.

IRWIN, Elizabeth
(b. c. 1814; arr. WA 22/8/1837; d. 14/5/1882, Clifton, Gloucestershire) Amateur artist. Wife of Captain Frederick Chidley Irwin. They lived in St George's Terrace, Perth, then at Henley Park near Guildford, returning to England, Mar. 1854. Her *View of the Tunnel under the Roundhouse from the Sea, c. 1840s*, in *The Colonial Eye*, AGWA, 1979. shows her as a competent and sensitive topographical artist.
REP: J. S. Battye Library of WA History, Perth.
BIB: Kerr, DAA.

ISHERWOOD, Jean de Courtenay
(b. 17/4/1911, Sydney) Painter, teacher.
STUDIES: ESTC, 1926–28 (evening classes), 1931–36; RAS classes with Dattilo Rubbo. Influenced by prevailing modernist movements of the 1930s, she exhibited first in 1934 with the Australian Watercolour Inst., of which she became a member in 1947. Between 1950 and 1980 she won 19 prizes for watercolours and 37 for oil paintings. She married John Dabron (q.v.) in 1940. Their daughter, Jacqueline Dabron (q.v.), is also a painter with whom she has exhibited. She held about 12 solo exhibitions 1946–92 in Sydney (including Artarmon Gallery), Brisbane and in NSW regional centres.
AWARDS: Over 50 awards 1950–89, mainly municipal, regional prizes including at Stanthorpe, Gunnedah, Port Macquarie, RAG Easter Show, Scone.
APPTS: Teaching, ESTC 1961–74; tutorials, Art Council of Australia.
REP: NGA; AGNSW; regional galleries NSW, Qld including Dubbo, Gosford, Griffith, Lismore, Stanthorpe, Taree.
BIB: Campbell, AWP. John Brackenreg, *Australian Landscape in Oil and Watercolours*, Artarmon Galleries.

ISHERWOOD, R.
(Active from c. 1920, Tas.) Painter. Known for

watercolours he taught at Friends School, Hobart 1934–35, won a prize at the Launceston Art Society exhibition of 1931 and exhibited with the Art Society of Tas 1916 and with the Launceston Art Society 1927–36.
REP: TMAG.
BIB: Backhouse, *TA*.

ISHMAEL CLUB
(Operative c. 1892) Melbourne artists' club, similar to the Cannibal Club (q.v.), formed by a group attending George Coates's studio lifeclasses

ISMER, CLARKE
See CLARKE, Cuthbert

ITALIAN CULTURAL INSTITUTE
(Established 1961) 233 Domain Rd, South Yarra, Vic. 3141. Sydney branch (established 1979), 10th Floor, Dymock's Building, 428 George St, Sydney NSW 2000. Established to promote and develop cultural relations between Italy and Australia, to organise Italian language courses and courses on Italian culture and to assist cultural needs of Italian-speaking people in Australia.

IVANYI, Bela
(b. 30/5/1936, Hungary) Painter, teacher.
STUDIES: Dip. Fine Arts (painting), NAS, 1968. His oils, predominantly of the landscape, were exhibited in about 20 solo exhibitions 1969–93 Sydney (including Hogarth, Robin Gibson), Brisbane (Philip Bacon), Newcastle (Cook's Hill) and Canberra (Solander). Group exhibitions include several prize exhibitions including the *Tasmanian Invitation Open*, 1969; and the *Wynne Prize*, 1978, 81, 82, 83, 84.
AWARDS: *Reader's Digest* Drawing Prize 1968.
APPTS: Senior tutorials, Kelvin Grove CAE (Australian Flying Art School), Brisbane; own 10-day workshops for advanced artists, Qld, 1975– , teaching painting, drawing, design Newcastle CAE to 1980 and City Art Inst., Sydney 1980– .

REP: NGA; Artbank; corporate collections including Transfield, Citicorp; Hilton.
BIB: Bonython, *MAP* 1975. *A&A* 11/2/1973, reproduction.

IVERS, T. H.
Painter. An official war artist during World War I and a close associate of G. W. Lambert, who painted his portrait.
REP: AWM.

IWANOFF, Michael
(b. 1954, Perth) Painter.
STUDIES: Associateship Fine Art, WAIT, 1975; postgraduate studies and Masters Degree, Staatliche Kunstakadamie, Düsseldorf, Germany, 1977–80. His abstract expressionist work shows the influence of his European training and was seen in six solo exhibitions 1982–90 in Perth (Galerie Düsseldorf), Sydney (Macquarie) and *Origins-Identity*, PRAXIS, Perth 1987. His work appeared in over 30 group exhibitions 1975–92 including with Macquarie, Sydney; Galerie Düsseldorf, Perth; *Acquisitions*, 1983 and *The Rural and Industries Bank Collection*, AGWA; and *A New Generation: The Philip Morris Arts Grant Purchases*, NGA.
AWARDS: Postgraduate scholarship, German Academic Exchange Service, 1977; study scholarship, Düsseldorf 1979–80; Tresillian Art Award, mixed media section 1984, 85, 86, 91; Pegasus Art Award, 1984; Albany Art Competition, *Caltex Art Award*, 1985; Geraldton Sunshine Festival art prize, 1985; Mandorla Art Prize, 1987; Holmes à Court Invitation Prize 1987; Williams Art Prize 1990.
APPTS: Part-time tutor, Fine Art, WAIT 1981–87; lecturer, Fine Art, Curtin Uni. of Technology, 1986– .
REP: NGA; AGWA; Artbank; regional galleries Wollongong, Fremantle; tertiary collections including UWA, UNSW, Curtin Uni.; corporate collections including Holmes à Court, Leeuwin Estate, R&I Bank.
BIB: Chanin, *CAP*. T. Snell, J. Goddard, W. Marcon (eds), *The Painted Image; 20 contemporary WA painters*, Curtin Uni. of Technology, 1991.

JACK TO JUST

JACK, Kenneth William David

(b. 5/10/1924, Caulfield, Vic.) Painter, printmaker, teacher.

STUDIES: Drawing Teacher's primary and secondary certificates; Art Teacher's Certificate; Art Teacher's Diploma, RMIT 1951; Trained Teacher's Certificate, Melbourne Teachers Coll. 1947. He spent the war years 1942–45 as a survey draftsman with the RAAF in New Guinea, Borneo and Morotai. A competent and prolific watercolourist and printmaker, he won over 50 awards 1950–92. His commissioned works include a mural for the Australian Pavilion, Expo 67, Montreal, and a tapestry bearing the Australian coat of arms for Expo 70, Osaka. He held numerous solo exhibitions in every capital city 1975–91 including three retrospectives – two at the Adelaide Festival in 1970 and 1978 and one at Australian Galleries, Melbourne 1988. He was commissioned by Australian Artist Editions to complete three portfolios of limited edition prints and has illustrated many books including *The Melbourne Book*, Ure Smith, Sydney, 1948; *The Charm of Hobart*, Ure Smith, Sydney, 1949; seven colour prints, *Australian Gold and Ghost Towns*, Porpoise Bookshop, San Francisco, 1962.

AWARDS: Numerous regional, municipal prizes all states; Trustees Prize for watercolours, AGNSW, 1967, 1972; Vizard-Wholohan prize, Adelaide, 1961, 63; RAS, NSW, 1967, 68, 69, 70; Crouch prize for watercolours, 1960; medal of honor, American Biographical Institute, 1987.

APPTS: Teaching, with Vic. Education Dept, 1948–68; senior lecturer, CIT, 1956–67; deputy head of dept, 1968; vice-president, Australian Guild of Realist Artists; foundation member, Artbank board, 1980–83; patron and member, council, CIT, 1969–76; life patron, International Biographical Association and Old Watercolour Society Club (London).

REP: NGA; most state and many regional galleries and other public collections including 500 works with AWM.

BIB: Douglas Dundas, *Kenneth Jack*, Collins, Melbourne, 1972. Lou Klepac, *Kenneth Jack*, Bay Books 1988. *Kenneth Jack: World War II Paintings and Drawings*, Boolarong 1990. Numerous references in general books on Australian art.

JACK-HINTON, Colin

(b. 1/1/1933, UK) Museum director, gallery director, historian, archaeologist.

STUDIES: MA, Aberdeen Uni.; PhD, ANU. He was the foundation director, MAGNT, 1970–93 and organised numerous local, national and international exhibitions. He has written widely in the fields of SE Asian and Pacific history, art and material culture.

JACKS, Robert

(b. 8/3/1943, Melb.) Painter, printmaker, sculptor.

STUDIES: Prahran Tech. Coll (sculpture), 1958–60; RMIT (painting), 1961–62. He held his first exhibition at Gallery A, Melbourne, in 1966 and exhibited in *The New Generation* at the MOMAD and in *The Field*, NGV 1968. He has remained true to the style of his first works – partitioned and bordered colourfield abstracts. The highly individual delicacy of touch distinguished them from other geometrical abstracts and although they have developed from minimalism to more involved works, remained true to his original vision. He lived in Canada and New York 1969–78, teaching and exhibiting (including in the New York Cultural Centre and Whitney Museum Artist Resource Centre). On his return to Australia he continued to exhibit and teach. As well as his Canadian and American exhibitions he held about 47 solo exhibitions 1966–93 Sydney (including Rex Irwin; Ray Hughes; Roslyn Oxley9), Melbourne (including Realities; Australian; Deutscher) and at IMA, Brisbane 1980 and ACCA, Melbourne 1984. He participated in numerous group survey exhibitions 1968–92 including *Third Annual Contemporary Reflection*, Aldrich Museum of Contemporary Art, Connecticut 1974; *Perspecta*, AGNSW 1981; *Continuum '83: Australian Contemporary Art in Japan*, 1983; *The Field Now*, Heide, 1984; *Surface for Reflexion*, AGNSW 1987; the Bicentennial exhibition *The Face of Australia*. In 1991 he also held a solo exhibition of small abstract-formed bronze sculptures.

AWARDS: Standard grant, VACB, 1974.

APPTS: Teaching, Australia, Canada, UK, USA.

REP: NGA; AGNSW; AGSA; AGWA; MAGNT; NGV; QAG; TMAG; Parliament House; Artbank; many tertiary, regional and municipal collections in most states;

corporate collections including BHP, Reserve Bank; Sony Corporation, USA.

BIB: Catalogue essays in exhibitions as above. Bonython, *MAP* 60. Horton, *PDA*. Smith, *AP*. Chanin, *CAP*. *A&A* 18/1/1980.

JACKSON, A. L.

Artist represented in the NSW section of the *International Exhibition* of 1880.

NFI

JACKSON, Carlyle

(b. 1891; d. 1940) Painter.

STUDIES: Sydney, with Julian Ashton and J. S. Watkins. A skilful and prolific painter of landscapes and street scenes in watercolours, his practice of selling his work in the bars of hotels militated against the wider recognition to which he was entitled.

REP: AGSA; regional galleries Castlemaine, Geelong.

JACKSON, James Ranalph

(b. 3/7/1882, Palmerston, NZ; arr. Aust. 1894; d. 1975, Sydney) Painter, teacher.

STUDIES: RAS School, Sydney; NGV School; Colarossi's, Paris; London (with Frank Brangwyn); Europe, 1925–26. Foundation member of Australian Academy of Art; one of the first Fellows of the RAS of NSW, and a teacher at the RAS School, 1917–26; member of the Australian Art Association. His early impressionistic paintings of Sydney Harbour, painted in the fluent manner of Streeton, were greatly superior to the work that later gained great popularity in Australia and New Zealand.

AWARDS: Manly Art prize, 1924, 62; prize in State Theatre Art Quest, 1929; prizes at R.Ag.Soc.NSW Easter Show, Sydney, 1960, 61; Grafton prize, 1962.

REP: Australian state galleries; New Zealand public galleries.

JACKSON, John Alexander

(Active 1047, Adelaide) Member of a group that included S. T. Gill, Edward Frome, Alexander Tolmer, Martha S. Berkeley and 18 others represented in an early group exhibition in South Australia.

BIB: McCulloch, *AAGR*. *ADB* 2.

JACKSON, Roy

(b. 23/7/1944, London; arr. Aust. 1959) Painter.

STUDIES: ESTC 1960–61; Nat. Dip. Design, Sutton School of Art, Wimbledon Coll. of Art, 1961–65; travel studies, Greece, SE Asia, Middle East, USA, Europe. His abstract-expressionist paintings appeared first at CAS shows, Sydney, 1965–72. He held about 15 solo exhibitions 1976–92 in Sydney (Stephen Mori and largely Watters), Melbourne (Powell St), Brisbane (Milburn + Arte) and Canberra (Abraxas). His work appeared in a number of group exhibitions 1978–92 including *Figures and Faces Drawn from Life*, Heide 1983; *Portrait of a Gallery*, Watters 25th Anniversary Touring Exhibition 8 regional centres 1989–91.

AWARDS: Prizes at Scone, NSW, 1967; Campbelltown, 1977, 88; VACB travel grant, 1977; special project,

1978, residency Power Bequest, Cité Internationale des Arts, Paris, 1978; MRCC Jubilee Purchase Prize 1980; Faber-Castell Drawing Prize 1986.

REP: AGWA; NGV; Artbank; regional galleries Campbelltown, Wollongong; corporate collections including Faber-Castell, Baker & McKenzie.

BIB: Catalogue essays in exhibitions as above. *New Art Two*. *A&A* 22/2/1984.

JACKSON, Samuel

(b. London; arr. Melb. 1835; d. 1875, London) Cycloramic artist, architect. Melbourne's first practising architect, he returned to London in 1860. A cycloramic drawing of Melbourne, measuring 5.4m by 46cm, is in the historical collection of the State Library of Vic. It was done by Jackson from the partly completed walls of the first Scots Church, 30 July 1841. John Hennings, a scenic artist, painted a cyclorama of early Melbourne from this work, after which it was forgotten for 26 years. In 1888, 13 years after the artist's death in London, it was bought by the Victorian Government for 400 guineas.

REP: State Library of Vic.

BIB: *ADB* 2. McCulloch, *AAGR*. Kerr, *DAA*.

JAGO, Lionel

(b. 1882; d. 1953) Painter.

REP: AGWA.

NFI

JAKSIC-BERGER, Mimi

(b. 1936, Pomazatin, Serbia; arr. Aust. 1959) Painter.

STUDIES: Petch Art Inst., 1951–56. She taught art at Belgrade high schools, 1956–57, and worked for magazines, 1957–58, before going to Paris and thence to Australia. She designed the Churchill medallion for the Sydney Coin Club and the Dobell medallion for Newcastle and has won more than 40 art prizes, mainly in NSW. Her large watercolours are skilfully painted in the manner of contemporary New York lyrical abstractionists.

REP: AGNSW; QAG; MAGNT; TMAG; MCA, Sydney; municipal and regional collections including Gosford, Lismore, Muswellbrook, Ryde, Taree, Wollongong; several tertiary collections NSW; Phillips Collection, Washington; several public collections Europe; corporate collections including Qantas; ANZ.

BIB: Bonython, *MAP* '75.

JAM FACTORY

See GALLERIES — PUBLIC

JAMES, C. E.

Painter. His work was included in the exhibition of Australian art at the Faculty of Arts Gallery, London, 1924.

NFI

JAMES, D.

(Active, c. 1885, Vic.) Engraver. He engraved the

plates for Edmund Thomas's *Victorian Views* (1854).
BIB: McCulloch, AAGR.

JAMES, Jimmy (Richard Haughton)
(b. 1906, Sussex, Eng.; arr. Aust. 1939) Industrial designer, painter, advertising executive.
STUDIES: Various (painting, graphics, industrial design and advertising management) in London, Paris and Rotterdam. James gave evidence for the defence in the Dobell case (*see* PRIZES, ARCHIBALD PRIZE) and in his many lectures and writings helped to develop in Australia a more enlightened attitude towards modern art problems, particularly in the field of industrial design. His greatest influence on Australian art affairs was exerted in 1947–48 when he edited the *Australian Artist*. James retired from the advertising business in 1964 to devote himself to painting (which he began in 1962), and in 1965–66 held successful exhibitions in Melbourne and Sydney. He moved to live in Positano, Italy, in 1966, revisited Australia several times and in 1979–80 was given retrospective exhibitions of his paintings at the McClelland Gallery, Langwarrin; and Gryphon Gallery, Melbourne State College. Books he wrote included *Art Appreciation*, Cheshire, Melbourne, 1948; *Commercial Art*, Arts in Australia series, Longman, Melbourne, 1963.
APPTS: Fellow of the Royal Society of Arts, London; fellow, Australian Commercial and Industrial Artists Association; president, Society of Designers for Industry; council member, CAS of NSW, VAS and National Gallery Society of Victoria.

JAMES, Louis Robert
(b. 22/9/1920, Adelaide) Painter.
STUDIES: No formal training; travel studies, UK and Europe, 1949–64, and again (including USA), 1978. Employed as a draughtsman in the Lands Dept of SA, 1938–39, he served with the AIF, 1939–44, began painting in 1946 and held his first exhibition in Adelaide (John Martin Gallery) in 1949. In the same year he moved to the UK, where he spent most of the next 15 years. He exhibited with the London Group and in exhibitions at the Redfern Galleries (1956–64), and became known as a hard-working professional responding to contemporary French trends. Returning to Adelaide in 1964, he moved to Sydney the following year and won a number of important prizes. He held some 41 exhibitions 1949–88 in the UK and Australia including at Bonython and Macquarie galleries, Sydney, and BMG, Sydney and Adelaide. Group exhibitions in which he participated 1950–88 included at Redfern Gallery London and *Australian Painting*, Whitechapel London 1961; exhibitions of same name in Los Angeles 1961; Birmingham, UK 1961; the Tate gallery, London 1963; Frankfurt 1963; *McCaughey Prize Exhibition*, NGV, 1975, 79.
AWARDS: Maude Vizard-Wholohan Prize, 1957; prizes at Wollongong, 1964; R.Ag.Soc.NSW Easter Show prize, 1965; Geelong (Corio prize), 1965; Newcastle, 1967; Maitland, 1972; Drummoyne, 1973; Georges

Art Prize, Melbourne (second award), 1966; Georges (first prize), 1967; Sulman Prize 1966, 69.
APPTS: Lecturing, Faculty of Architecture, UNSW 1967.
REP: NGA; AGNSW; AGSA; NGV; QAG; many regional galleries NSW, Vic., Qld including Albury, Bendigo, Geelong, Newcastle, Wagga Wagga; uni. galleries Melbourne, Newcastle, Qld and Sydney; public galleries in the UK.
BIB: Most general works on contemporary Australian art, including Bonython, MAP '75; Nancy Benko, *Art and Artists of SA*, 1970. Barry Pearce, *Louis James Painting*, Beagle Press, 1986.

JAMES, Roger Paton
(b. 1/9/1914, Johannesburg, South Africa) Painter, teacher.
STUDIES: George Bell School, Melbourne, 1929–35; Swinburne Tech. Coll., 1932; Slade School, London (with Randolph Schwabe), 1935–37; London (with Algernon Newton). He practised as a commercial artist in London and travelled in Norway, Sweden, Denmark, France and Switzerland, returning to Australia to enlist in the army in 1940. After the war he turned to art teaching and taught at Swinburne Tech. Coll. from 1945.
REP: AGNSW; NGV.

JAMIESON, Gil
(b. 1934, Monto, Qld) Painter.
STUDIES: Central Tech. Coll., Brisbane, with Melville Haysom. His large, figurative paintings have a life force and movement that derives largely from German expressionism but also strongly from their environment – the Qld bush country. First exhibited at the MOMAD, Melbourne, in 1961, his work was selected by gallery owner Kym Bonython to be shown in the Corcoran, USA exhibition of the Merz collection. In the mid-1970s he produced a remarkable series of panels depicting Jay Creek which evoked a total environment to give audiences the sensation of standing in the centre of a raw and remote outback landscape. Continuing in this vein, much of his subsequent large-scale painting has been done at Monto where he has lived for most of his life.
AWARDS: McCaughey Prize, Melbourne, 1965; prizes at Maryborough 1977; Bundaberg, 1977; Rockhampton 1978.
REP: NGA; NGV.
BIB: Most general books on contemporary Australian art including Smith, AP.

JANSSEN, Jacob
(b. 1779, Elbing, Prussia; arr. Sydney 1840; d. 1856, Sydney) Painter. He arrived in the *Louisa Campbell* from Manila on 5 Dec. 1840, exhibited *The Election of a Village Magistrate, East Prussia* at the Society for the Promotion of Fine Arts, Sydney, 1847, and is remembered for his fine view of *Sydney Harbour Looking Towards Sydney, 1848* in the Mitchell Library. He also painted miniatures and still-lifes as well as scenes of events, landscapes and ships in harbour. His work

appeared in *The Artist and the Patron* AGNSW 1988; the Bicentennial exhibition *The Great Australian Art Exhibition 1788–1988*, and *Stories of Australian Art* Commonwealth Art Institute, London 1988.
REP: AGSA; TMAG; NLA: Mitchell Library.
BIB: Sandra McGrath and Robert Walker, *Sydney Harbour*, Jacaranda Press, Brisbane, 1979. Kerr, DAA. A&A 26/3/1989.

JARDINE, Walter
Black-and-white artist. Sydney illustrator who attained fame in America for his pen-and-ink drawings on scraper-board.
BIB: Arthur L. Guptil, *Drawing with Pen and Ink*, Pencil Points Press, New York, 1928.

JARRET, Dora
(b. 1904, Sydney. d. 1983) Painter, teacher.
STUDIES: Dattilo Rubbo School, Sydney; Paris, with Andre Lhote. Regular exhibitor with the Australian Watercolour Inst., Sydney.
REP: AGNSW; regional galleries Newcastle, Armidale.

JARRET, William
(Active Tasmania and Melbourne 1840s–70s) Painter, sketcher. He produced the first known drawing of Pentridge Stockade (later Gaol) in 1853 as well as a number of oil paintings of Tasmanian and Victorian landscapes, exhibiting in exhibitions in Melbourne and Sydney including the 1866 Melbourne *Intercolonial Exhibition* and the 1870 Victorian and NSW acadamies of the arts. A large oil of Hobarton and the Derwent river was sold at Christies in 1989.
REP: Mitchell, Dixson, La Trobe Libraries.
BIB: Kerr, DAA.

JARVIS, Arnold
(b. 30/3/1881; d. 20/8/1960) Painter. His popular watercolours of gum trees, in the manner of Hans Heysen, were in vogue in the 1920s and still appear often in Melbourne auctions. Block Gallery catalogue on the Bernard Hall commemorative exhibition, Aug. 1971, quotes Arnold Jarvis also as having written on Hall's work for the Melbourne *Age*, 1959.

JARVIS, Hubert
(b. 1882, Devonshire, Eng.; arr. Aust. 1915) Painter.
STUDIES: London (with George Sherringham). Qld Government entomologist at Stanthorpe; member of the RQAS, where he exhibited watercolours in 1912 and 1915.
REP: QAG.

JARVIS, Katherine Munro
(b. 24/1/1910, Peterhead, Scotland; arr. Aust. 1930) Painter, teacher.
STUDIES: Dip. Art, Gray's School of Art, Aberdeen, Scotland, 1930; Central School of Art, London, 1961. She exhibited regularly with the Perth Society of Art and held a number of two and three person exhibitions, largely at Newspaper House Gallery, 1934–51.

AWARDS: Hotchin prizes, 1953, 55; Dunlop prize, 1953 (all for watercolours).
APPTS: Secondary art teaching and some adult education classes, 1955–70.
REP: AGWA; regional galleries Kalgoorlie, Narrogin.

JAUGIETIS, Regina
(b. 14/2/1923, Latvia) Sculptor.
STUDIES: Architecture in Riga, Latvia, and Darmstadt, Germany; SASA (sculpture); BA, NAS (ceramics) Sydney. Ceramic sculptures were the feature of her work in her first exhibitions, SA Society of Art, in the late 1950s. She exhibited with the SASA, the CAS (SA) and Gallery A, Melbourne and participated in numerous group sculpture and survey exhibitions 1961–92 including *Mildura Sculpture Triennial*, 1961, 64, 67; *New York International Art Horizons Competition Winners* Exhibition, 1991, 92. Of her 1991 Adelaide exhibition at Reade Art, John Neylon, in the *Adelaide Review* (August 1991), described her ceramic technique as 'volcanic glazes – the brooding pitted surfaces, the crawling and skinning and the interplay of matt and shiny areas . . . the fruits of over 30 years of commitment to ceramic glaze and aesthetic formulae which are unswerving in their search for technical perfection and aesthetic excellence'. She completed many commissions for city sites in Adelaide (including RDC Building, City Arcade; Marion Shopping Centre), Sydney and New York, and was one of 50 winners in the 5000-entry worldwide *New York Art Horizons International Art Competition*, 1991, 92.
AWARDS: Clarkson's memorial prize for sculpture, Adelaide, 1958; New York International Art Horizons Competition, Ceramics section 1991, 92.
APPTS: Lecturer, Uni. of SA, 1961–89.
BIB: Catalogue essays in exhibitions as above. Nancy Benko, *Art and Artists of South Australia*, Adelaide, 1978. *Latvian Artists in Australia*, Society of Latvian Artists, 1979.

JAY, Virginia
(b. 1946 Sale, Vic.) Painter, teacher.
STUDIES: SASA; travel studies, UK and Europe, 1972. Her large geometric abstracts appeared in solo and interstate competitive exhibitions from 1968, notably Transfield, Sydney, 1968; and Georges prize exhibition, Melbourne, 1971.
APPTS: Lecturer, Torrens CAE.
REP: NGA; AGWA; QAG; TMAG; regional galleries Ballarat, Castlemaine, Geelong, Shepparton.
NFI

JEFFREYS, (Lieut.) Charles
(Arr. Hobart, 1817) Naval officer, topographical artist. He drew a view of Hobart which was lithographed several times – in 1820 (for his book on Tas.) and again in 1900 and 1904. In what is apparently the original version, 1817, the buildings are annotated.
REP: TMAG.
BIB: Moore, SAA. Clifford Craig, *The Engravers of Van Diemen's Land*, Foot & Playstead, Launceston, 1963. Kerr, DAA.

JALLET, Colin
(b. 12/11/1946, Vic.) Painter, teacher.
STUDIES: Dip. Art, Ballarat CAE; TTTC. Known for environmental abstracts, he held about 9 solo exhibitions 1970–89 largely at Standfield Gallery, Melbourne.
APPTS: Lecturer, RMIT, 1975– .
REP: NGA; NGV; High Court of Australia; VACB.

JENKINS, Constance L.
(b. c. 1885) Painter.
STUDIES: NGV School, where she was the first woman to win the Travelling Scholarship in 1908. Known mainly for portraits. As C. L. Jenkins, she exhibited portraits, beach scenes and other oils at the VAS 1905–08, and was a prize-winner for a 'striking portrait' at the *Australian Exhibition of Women's Art*, Melbourne, Oct. 1907. She married fellow student Spencer Macky (q.v.) and by 1930 had moved to California where they were in charge of the Californian School of Arts, San Francisco. William Moore spells her name Jenkyns.
BIB: Moore, SAA.

JENKINS, Robert
(Arr. Melb. c. 1890; d. 1895, Melb.) Painter. He exhibited watercolour landscapes at the VAS, 1892–95, while living in East Melbourne. Subjects included views near Melbourne, harvesting and river scenes.
NFI

JENNER, Isaac Walter
(b. Mar. 1836, Godalming, Surrey; arr. Qld 1883; d. 1/3/1902, Brisbane) Painter, sailor. He served in the British Navy at the time of the Crimean War and began painting after retirement from the Navy in 1865. He contributed to exhibitions at Brighton, England, 1872–82, and soon after settling in Brisbane petitioned the government to build a public gallery. He was a foundation committee member of the Qld Art Society (1887), taught art at Miss O'Connor's school, Oxley, and at the Brisbane Tech. Coll. from 1887. His studio at Taringa was a centre which attracted leading Qld artists of the time, and among the artists he encouraged was J. J. Hilder.
REP: QAG; Darnell Collection, Brisbane Uni.; Brighton Gallery, England.
BIB: Vida Lahey, *Art in Queensland, 1859–1959*, Jacaranda Press, Brisbane, 1959. *A&A* 15/4/1978 (I. Jenner, *Isaac Walter Jenner, pioneer artist of Qld*).

JENUARRIE
(b. c. 1960, Qld?) Batik artist and printmaker.
STUDIES: Aboriginal & Islander Arts & Crafts, TAFE, Rockhampton, 1984–85. Her work appeared in 6 group exhibitions including *Down to Earth*, Cairns Museum, 1985; *Dalkuna Mnunuway Nhe Rom*, Foreign Exchange International Centre, Melbourne, 1987; *Aboriginal Australian Views in Print and Poster*, PCA and touring, 1987–88; Arts Council, Sydney, 1987; *Ageless Art*, QAG, 1988.

AWARDS: Lillian Pedersen Memorial Prize for printmaking.
REP: NGA; QAG; NGV; SA Museum, Qld Museum; National Trust of Australia; Robert Holmes à Court Collection; French Embassy.

JENYNS, Bob (Robert Stanley)
(b. 1944, Melb.) Sculptor, ceramicist, teacher.
STUDIES: CIT, 1961–64; ACTT, Hawthorn Tech. Teachers Coll., 1972. Pop and naive art influences have contributed to many of his bizarre configurations which relate also to the theatre, specifically to mime and the ballet. Also in his work is a touch of folk art. Behind the innocent melange, however, is the haunting, much more sinister presence of the real world, a presence that does much to support the claim of many critics for Jenyns as a considerable satirist. He held about 11 solo exhibitions 1974–91 largely at Watters, Sydney and in *The Jenyns Show* (with Lorraine Jenyns) touring Vic regional galleries and Watters, Sydney 1976–77. Group exhibitions in which his work appeared 1972–92 include *Mildura Sculpture Triennial*, 1973, 78; *Australian Perspecta*, AGNSW 1981; *Aust Sculpture Triennials*, 1984, 90; *Graven Images*, AGWA 1985; *Off the Wall, In the Air: A Seventies Selection*, Monash Uni. Gallery and ACCA 1991; *Contemporary Australian Drawing*, MOCA, Brisbane 1992. Commissions he received included for Collingwood Education Centre, Melbourne 1976 and a tram for Vic. Ministry for the Arts, 1988. He also curated a number of exhibitions including Michael Leunig drawings, Uni. of Tasmania 1986; a play and installation by Peter Cripps for Centre for Arts Gallery, Hobart; ACCA, Melbourne; AGNSW 1988/89; Carol Jerrems photographs, NGA and touring Sydney, Melbourne 1990/91.
AWARDS: Launceston purchase prize, 1973; VACB grants 1975, 78, 82; Alice Springs purchase prize 1976; Capital permanent award 1980.
APPTS: Lecturer, sculpture, Uni. of Tasmania School of Art.
REP: NGA; AGNSW; QVMAG; MOCA, Brisbane; VACB; regional galleries Ballarat, Alice Springs, Geelong; uni. collections including Deakin; ICI corporate collection.
BIB: Catalogue essays exhibitions as above. *New Art Two*. Sturgeon, DAS. *A&A* 10/4/1973.

JENYNS, Lorraine Dawn
(b. 1945, Melb.) Ceramic and textile sculptor.
STUDIES: CIT, 1963–64; RMIT, 1965. Her brightly coloured ceramic sculptures are often satirical and humorous representations of allegorical subjects, often using animal imagery in semi-functional objects (vases, bowls) as well as non-functional shapes. Her first exhibition was held at Powell Street Gallery, 1973 and she held 7 solo exhibitions 1973–92 largely at Watters Gallery, Sydney and *The Jenyns Show* (with Bob Jenyns) touring Vic regional galleries. The Ballarat Fine Art Gallery held a retrospective of 25 years' work in 1992. Her representation in significant group shows includes the *Mildura Sculpture Triennial*, 1975, 78; *Australian*

Sculpture Triennial, 1981; *Australian Perspecta*, AGNSW 1981; *Australian Decorative Arts: The Last 10 Years*, NGA 1983 and the Bicentennial exhibition *The Great Australian Art Exhibition 1788–1988*. She was commissioned in 1986 for an Art in Public Places Project, Tasmania, for a work for the Royal Hobart Hospital.
AWARDS: Caltex Ceramic Award, Shepparton, 1974; VACB grants, 1974; Uni. of Tasmania, 1985; Tasmanian Arts Advisory Board, 1986.
REP: NGA; AGSA; AGWA; NGV; QVMAG; VACB; regional galleries including Latrobe Valley, Muswellbrook, Newcastle, Shepparton; Manly Art gallery.
BIB: Catalogue essays in exhibitions as above. *New Art Two*. Germaine, AGA. Scarlett AS. A&A 10/4/1973.

JESSOP, Clytie
(b. 1929, Sydney) Painter, gallery director.
STUDIES: Julian Ashton School, Sydney, 1945; ESTC (dip. 1949); Chelsea School of Arts, London, 1952. She exhibited at the CAS in Sydney and later with the CAS, London, and in 1951 established Capricornia, a ceramics gallery in Blandford St, London. Her poetically conceived paintings often concern themes of birth and death. She held exhibitions in New York (Collectors Gallery), 1960; Sydney (Dominion Gallery), 1963; Melbourne (Argus Gallery), 1964; and in 1966 held an exhibition jointly with her sister, Hermia Boyd, at the Clytie Jessop Gallery which she established in Sloane Ave, London, 1966. She returned to Australia in May 1977 and was director, S. H. Ervin Museum and Art Gallery, Sydney 1979–82.

JESSUP, Frederick Arthur
(b. 1920, Talbot, Vic.) Painter.
STUDIES: Sydney (with Dattilo Rubbo); ESTC, 1945–48; travel studies in France, Italy and Spain from 1948. He served with the AIF during World War II and after the war resumed his art studies at the ESTC. In 1948 he moved to France which then became his headquarters. He revisited Australia in 1959 and 1962 when his paintings, exhibited at the Australian Galleries, Melbourne, were redolent with the spirit of a Gallic world of grand-scale decoration.
AWARDS: NSW Travelling Scholarship, 1945; first prize (for the best front-line sketch), *Australia at War* exhibition, 1945.
REP: Bendigo Art Gallery.
NFI

JEWELLERY DESIGN AND DESIGNERS
See CRAFTS IN AUSTRALIA – JEWELLERY

JOEL, Grace
(b. 26/5/1865, Dunedin, NZ; d. 1924, London) Painter.
STUDIES: Dunedin, NZ, –1888; NGV School (with Folingsby, Hall and McCubbin), 1888–94; Julian's Academy, Paris (with Bashet and Schommer), c. 1899. Mainly a portrait painter. As a prize-winning student at the NGV School during the period of the first artists' camps and the rise of the Heidelberg School, she would certainly have been influenced by Roberts, McCubbin (her drawing teacher), Streeton (whose portrait she painted), and possibly Conder and Nerli. She returned to Dunedin to teach, and in 1895, in company with Nerli and a breakaway group from the Otago Art Society, helped form the Easel Club. Her portrait of Nerli (AGNSW) was probably painted at this time. In 1899 she went to Paris to study and make her home, moving later to Chelsea where she became friendly with the Bellocs, whose daughter she painted. In a letter to a friend, Mlle Belloc referred to her as 'a pupil of Renoir'. She took an interest in the suffragette movement, and exhibited at the RA, the Royal Scottish Academy and the Paris Salon. Exhibited in the 1921 Salon, her *Portrait of a Musician* attracted the attention of the reviewer for *La Revue Moderne* who found it exceptional in 'psychological understanding', added to which were qualities that 'lift this work right above the general level of portraits of the Salon'. However her work did not receive due acknowledgement in either Australia or New Zealand, owing largely to the fact that she had independent means and as she got older (like John Peter Russell), she became increasingly reluctant to part with any of her paintings under any circumstances. She bequeathed portraits to all Australian galleries whose administrators had attempted to buy her work. The galleries included the AGNSW, which got the portraits of Nerli and Streeton, but no New Zealand galleries benefited. The Grace Joel Prize for paintings from the nude was established in her memory at the NGV School as a memento of her student days.
AWARDS: Student prizes for painting and drawing from the nude, NGV School.
REP: Several state galleries including AGNSW.
BIB: Frances Lindsay, introduction to exhibition catalogue *Von Guérard to Wheeler*, VCA, 6–21 Apr. 1978; Gil Docking, *Two Hundred Years of New Zealand Painting*, Lansdowne, Melbourne, 1971.

JOEL'S AUCTIONS
(Founded 1920) 1195 High St, Armadale, Victoria 3143. One of the three specialist auctioneers of fine art and Australiana, along with Christie's and Sotheby's (qq.v.) in addition to furniture and general effects. Historic art sales include estates of George L. Lansell (middle 1930s), E. Phillips Fox (early 1950s), George Page Cooper, Charles Ruwolt, and studio collection, Hans Heysen. The connection with fine art and books was started and maintained 1920–59, by Thomas Dwyer, father of Paul Dwyer who became the fine art director in 1959 followed by his son Jon Dwyer in the 1980s.

JOHNS, Greg
(b. 14/11/1953, Adelaide) Sculptor.
STUDIES: Dip. Fine Arts, SASA, 1978; travel studies USA, Europe 1980s. He held 10 solo exhibitions 1980–92 of his geometric shaped and rounded metal sculptures, in Adelaide (Bonython 1980, 83; Roundspace 1981; Bonython-Meadmore 1983, 91, 92),

Sydney (Robin Gibson 1983, 87; Bridge St, 1992) and Canberra (Solander 1991). Sasha Grishin, in the *Canberra Times* (October 1991), describes several of the works in his Solander show as: 'tapping into the spiritual in art, finding archetypal forms that somehow reflect the "universal spirit" . . . not an easy exhibition full of gimmicks or aesthetically pleasing compromise, it is a demanding show which provokes and rewards the beholder'. He received many commissions from 1978 for councils, parks and gardens, city buildings, and Benalla Gallery 1980 and his work appeared in about 30 group exhibitions 1977–92 including *Australian Sculpture Triennial*, Melbourne 1981; *Mildura Triennial*; *World Expo*, Brisbane 1988; *Echoes of Tienanmen*, Artzone, Adelaide 1989; and in New York Sculptors Guild exhibitions 1991, 92. He was artist-in-residence at Rhode Island School of Art, USA, 1990.

AWARDS: Whyalla Sculpture Prize, 1980; project grant VACB, 1980; part-time arts assistance grants, SA arts ministry grants 1981, 83, 86, 88; SA Arts Ministry to exhibit 3 works in New York, 1991.

REP: Artbank; Benalla Gallery; Whyalla Arts Council; several municipal and regional council collections; Commonwealth Bank, Adelaide; Robert Holmes à Court and Manchester Unity private collections.

BIB: Catalogue essays exhibitions as above. Germaine, AGA. New Art Four. A&A 27/2/1989; 29/1/1991.

JOHNSON, George Henry

(b. 18/8/1926, Nelson, NZ; arr. Aust. 1953) Painter, teacher.

STUDIES: Tech. Coll., Wellington, NZ, with Theo Schoon and Gordon Walters, 1943–47; Cert. Art, RMIT, 1956; TTTC, Melb., 1965; Dip. Art, RMIT, 1968; travel studies Europe, London, New York, 1971; Peru, Europe, 1974; Europe, London, 1979. Johnson's formalised abstractions, comprising usually a pattern of small related geometrical shapes, give life, luminosity and fluidity to forms which might otherwise be mechanical and lifeless. From 1960 he became absorbed in the study of the circulatory system of life beneath the earth's surface, and the brown, white, grey and blue paintings with their hessian collages and Capagrossi-like cogwheel shapes are graphically expressive of this theme. Later his forms became much larger and more architectonic with greater emphasis on shape and placement – a style which he has maintained since. His work made its Melbourne debut at the *Herald Outdoor Art Show* in 1953, and was included in the *Orcades Exhibition of Australian Art* which toured the Pacific in 1956; *Georges Invitation Art Prize*, 1965, 70, 75; *20 Years of Abstraction*, Ivan Dougherty Gallery, Sydney 1986; *Modern Australian Paintings*, Charles Nodrum 1986, 88, 89, 90. He held about 20 solo exhibitions 1956–92 including at Pinacotheca, Realities and largely Charles Nodrum, Melbourne; Rudy Komon, Coventry, Sydney and several regional galleries including Ararat 1969; Hamilton 1970; Shepparton 1970.

AWARDS: Albury prize, 1966; Orange prize, 1971; BACB grants, 1973, 77, 86; Georges prize (acquisition), 1975; Gold Coast Art Purchase Prize 1984.

APPTS: Art instructor, tech. schools, Melb., 1955–66; lecturer, painting, CIT, 1966–68; part-time teaching, RMIT, 1970–75 and 1978–84; experi-mental studies lecturer State Coll. of Vic. 1976–77; exhibitions officer, RMIT Gallery and RMIT Faculty of Art Gallery, 1982–87.

REP: NGA; NGV; MAGNT; Heide; Artbank; MOCA, Brisbane; regional galleries including Benalla, Geelong, Hamilton, Mornington, Newcastle, Warrnambool; several tertiary collections including Uni. of Melb, Ballarat and Bendigo Teachers Colleges.

BIB: John Reed, *New Painting 1952–62*, Arts in Australia series, Longmans 1963; Smith, AP. *New Art Five*. AI 14/1/1970 (*Australia*). A&A 24/3/1987.

See also ABSTRACT ART

JOHNSON, John

(b. 1939, Middlesex, Eng.; arr. Aust. 1960) Painter, ceramicist.

STUDIES: Willesden Tech. Coll., London, 1955–59 (architecture and art); WAIT, Perth, 1973–75. He was a foundation member of the CAS, Perth, 1966, curator of collections, WAIT, 1974–76, visiting lecturer in ceramics, 1974–78, and resident craftsman, 1977. He held five exhibitions in Perth from 1966 and his ceramics were shown in Melbourne in 1978 and 1979.

REP: AGWA; Uni. of WA.

NFI

JOHNSON, J. C. F. (Joseph Colin Francis)

(b. 1848, Adelaide; d. 1904) Journalist, illustrator, politician. He worked on the literary staff of the *Register* in the 1870s and in 1880 became proprietor and editor of the Adelaide *Punch*, to which he contributed comic and satirical drawings. He was an accomplished draughtsman whose interests ranged from gold mining to the theatre, and from politics to art collecting. He entered Parliament in 1884 and was Minister of Education, 1887–89. His work was seen in *Australian Colonial Art*, Deutscher Fine Art Gallery, Melbourne, 1980 and the Bicentennial exhibition *The Face of Australia*.

JOHNSON, Ken

(b. 1950, NSW) Painter, sculptor.

STUDIES: Dip. Graphic Design, NAS. He held 18 solo exhibitions 1976–92 of largely realist-style landscapes Sydney (Barry Stern, 1979, 81, 83, 84, 90), Perth (Greenhill 1986), Melbourne (Editions) and the USA (Munsons Gallery, Chicago 1988; IMG, New York, 1988), and his work appeared in 8 group exhibitions 1970–91 at private galleries in Sydney (Barry Stern) and the USA (Los Angeles, New Mexico, New York), and in *Wynne Prize* 1982, 83; *Archibald Prize*, 1983.

AWARDS; Gosford Art Prize, 1980.

REP: Gosford Council; James Cook Uni., Qld; numerous private collections including Peat Marwick Mitchell and Co, Qantas (murals), BP, Wesfarmers, News Limited, Legal & General.

BIB: Germaine, AGA.

JOHNSON, Mathew

(b. 1963, London; arr. Aust. 1975) Painter.
STUDIES: Dip. Higher Art Certificate, NSA, 1984; travel studies Europe and UK 1989. He lived in New York, 1969–75 and in Australia held five solo exhibitions 1989–92 including at his own studio 1989, 90, 91 and at Christine Abrahams 1989, 92. His work appeared in 11 group exhibitions 1985–92 including *New South Wales Travelling Art Scholarship*, 1985, 88; *William Dobell Foundation Art Prize*, 1989.
AWARDS: Faber-Castell Prize for Drawing, 1988.
APPTS: installation staff member, MCA, Sydney, 1991– .
REP: Artbank; Robert Holmes à Court, Faber-Castell, Allen, Allen & Hemsley and various other corporate collections.

JOHNSON, Michael

(b. 1938, Sydney) Painter.
STUDIES: Julian Ashton School, Sydney, 1954–59; Dip. Art, NAS, 1959; travel and study in Europe (mostly in London), 1960–67, including working as studio assistant to Anthony Caro 1964–65. He exhibited in *Commonwealth Festival Biennale*, London, 1962–65, and in *Australian Painting and Sculpture in Europe Today* at Folkestone and Frankfurt. Soon after his return to Sydney in 1967 his exhibition at Central Street Gallery, Sydney, placed him as a leader of the new generation abstractionists, epitomised in *The Field* at NGV in 1968. His huge, related canvas blocks of primary colours repeated the lessons of scale and colour saturation as demonstrated in the 1967 exhibition, *Two Generations of American Painting*. In a foreword to the catalogue of Johnson's exhibition at Gallery A (Sydney and Melbourne, 1969), Patrick McCaughey wrote: 'Johnson's distinctness as a painter comes from his readiness to match the attitude of the important American modernist painters, not simply mirror their styles . . . Johnson's art at its best, no matter where he keys his colour, opens up to us the country of the marvellous and the splendid'. In 1969 Johnson left Australia for New York where he lived and worked, including exhibiting at the Max Hutchinson Gallery, until 1975. In 1969 his work represented Australia at the *Bienal de São Paulo*. His 1980s work softened somewhat, with more fluid lines and brush strokes, and his colours became more those of the Australian bush and outback, yet his commitment to abstraction remained constant. Group exhibitions 1969–92 in which his work appeared included *Australian Painting and Tapestries of the Past 20 Years*, NSW House, London 1972; *The Field Now*, Heide 1984; *Field to Figuration 1960–86*, NGV 1987; *Australian Biennale*, AGNSW 1988. He held at least one and often two or three shows annually from 1967 in Sydney (largely Gallery A and Macquarie Galleries), New York and Melbourne (Pinacotheca; Christine Abrahams). In 1989 the AGNSW held a survey of his work 1968–88. He was artist-in-residence at James Cook Uni., Townsville 1975 and Uni. of Melbourne 1986.
AWARDS: R. H. Taffs Prize, CAS Annual Interstate

Exhibition, Sydney, 1967; Travelodge Invitational prize, Sydney, 1970; VACB grants, 1974, 75; residency, New York studio, VACB, 1981.
APPTS: Lecturer at many tertiary art colleges, 1963–85, including St Martins and Croydon schools of art, London; Birmingham School of Art, UK; Alexander Mackie CAE; SCA; Newcastle CAE; Uni. of NSW; Silkapoprn Uni., Thailand.
REP: NGA; AGNSW; AGSA; AGWA; MAGNT; NGV; QAG; TMAG; Parliament House; Artbank; many regional collections including Burnie, Gold Coast, Wollongong; tertiary collections including James Cook Uni., Monash Uni., ANU; corporate collections including NAB, CBA, Chase Manhattan, NY, Robert Holmes à Court, OTC, Hyatt Melb. and Adelaide.
BIB: Catalogue essays exhibitions as above; many general books on Aust. art including Bonython, *MAP*; Smith, *AP*; Horton, *PDA*; Germaine, *AGA*; Chanin, *CAP. AI* 13/7/1969. *A&A* 24/3/1987.
See also ABSTRACT ART

JOHNSON, Robert

(b. 1890, Auckland, NZ; arr. Sydney 1921; d. 1964, Sydney) Painter.
STUDIES: Elam School of Art, Auckland, 1910–14 (with A. F. Nicoll and E. Fristrom). A member of the RAS of NSW from 1921 (later a Council member) he became well known for his landscapes and paintings of Sydney Harbour, skilfully painted in a popular impressionist manner. Among his many commissions was one from the Commonwealth Government to paint a picture of Canberra for presentation to the new art gallery at Wellington, NZ, in 1936.
AWARDS: Queen's Coronation Medal, 1953; R.Ag.Soc. NSW Easter Show (rural traditional) prize, 1961; 2nd prize, same contest, 1962.
REP: Most Australian state galleries; public galleries in NZ.
BIB: *The Paintings of Robert Johnson* Legend Press, Sydney, 1948. *New Zealand, Land for the Artist*, Legend Press, Sydney, 1953. *AA* (special number), Ure Smith, Sydney, Feb. 1934.

JOHNSON, Roger

(b. 1922, Eng.) Painter, architect, town planner. Associate consultant architect, Uni. of WA. His work was included in *Artists from the West* exhibition, MOMA, Melbourne, 1963.
REP: Uni. of WA collections.

JOHNSON, Tim

(b. 1947, Sydney) Painter, sculptor, teacher, film-maker.
STUDIES: Uni. of NSW (philosophy and political science), 1966–69; travel studies, India and SE Asia, 1974–75. Between 1969 and 1976 he became known in Sydney and Melbourne for his experiments with conceptual art and later with video and performance art, as in his *Voyeur, Diary Fittings*, performed Pinacotheca Gallery, Melbourne, June–July 1976 and his 11 films on conceptual art and his own work, 1971–76. From the mid-1970s his work developed

almost entirely into painting and Aboriginal imagery, incorporated as part of the experiences of his living amongst Aboriginal people, predominated. Writer/curator Tony Bond describes his work: 'Johnson has an emotional and philosophical affinity with both the oriental and Aboriginal attitudes towards existence. His work brings them together in a form which at an abstract level is equally capable of being understood as modernism . . . he draws our attention to a more complex world of feeling and language than is sometimes represented through ideological dogma and simplistic dualisms'. (Tony Bond, 'Realism in the Avant-Garde' in *Contemporary Australian Painting* ed. Eileen Chanin, Craftsman House, Sydney, 1990). He held over 30 solo exhibitions 1970–93 largely at Mori, Sydney, Bellas, Brisbane and Tolarno, Melbourne and at IMA, Brisbane 1986; Ian Potter Gallery, University of Melbourne, 1993. His work appeared in numerous survey exhibitions 1970–92 including *Stories of Australian Art*, Commonwealth Institute, London 1988; the Bicentennial exhibition *The Great Australian Art Exhibition 1788–1988*; *Out of Asia*, Heide and regional galleries Vic. 1989; *Off the Wall/In the Air*, Monash Uni. and ACCA 1991; *Biennale of Sydney*, 1986, 92; *Documenta*, Kassel, Germany 1992.
AWARDS: Woollahra prize, 1969; Young Contemporaries prize, Sydney, 1973 (shared).
APPTS: Teaching, Education Dept of NSW, 1972–74, (part-time) 1975–77; member, VACB, 1973–75.
BIB: Catalogue essays in exhibitions as above. Chanin, CAP. Smith, AP. P. Quartermaine and J. Watkins, *A Pictorial History of Australian Painting*, P. Quartermaine and J. Watkins, Bison Group, London 1989. Daniel Thomas, *Outlines of Australian Art*, Macmillan, 1991. Gary Catalano, *The Bandaged Image*, Hale & Iremonger, 1983. A&A 29/1/91.

JOHNSON, (Sir) William Elliot

(b. 1862, Newcastle-upon-Tyne; d. 1932) Lithographer, politician. Amateur artist who made lithographic views of Melbourne; also the first drawings of the Government camp and other features of early Canberra. Member of Parliament, Speaker, House of Representatives, 1913–14, 1917–23. Before going to Australia he assisted his father as a scenic artist at Covent Garden.
REP: NLA.

JOHNSTON, Diana

(b. 17/5/1941, Eng.) Painter. Self-taught painter of Australian landscapes, still life and portraits. She held about 8 solo exhibitions 1978–92 in Perth.
AWARDS: Mundaring prize, 1972; artist of the year award, Perth, 1972; Spinifex prize, 1973, 74.
REP: AGWA; MAGNT; Uni. of WA; Murdoch Uni., Perth; Rhodes National Gallery, Rhodesia; a number of secondary colleges and public collections WA; corporate collections including Robert Holmes à Court; CRA.

JOHNSTON, T. E.

(d. 1905) Painter. Colonial school landscape painter. His *Two Swagmen in the Bush* (Christie's auctions,

H. J. Johnstone, Fetching Water from the Creek, oil on board, 27 × 18cm. Private collection.

Melbourne, Apr. 1976) is basically conservative in style though showing the influence of Buvelot.
NFI

JOHNSTONE, Henry James

(b. 1835, Birmingham; arr. Vic. 1853; d. 1907, London) Painter, photographer.
STUDIES: Birmingham; Melbourne, with Louis Buvelot, 1867– ; NGV School, 1870– ; RA Schools, London, c. 1881. He worked in his father's photographic business in Birmingham, went to Victoria with the goldrush and did well enough to buy the Duryea and McDonald photographic studio (1862), changing the name to Johnstone and O'Shannessy two years later. It became the leading photographic business in Melbourne. Rich and handsome, Johnstone was described by Frederick McCubbin as 'quite a personality', as well as being one who helped struggling artists and students. He exhibited regularly with the

VAA from 1872, his landscapes, many with rivers, being understandably low-toned and photographic in concept. He left Australia for the USA and England c. 1880–81, enrolled at the RA Schools, London, and exhibited at the RA between 1887 and 1900. He was represented in *Australian Art in the 1870s*, AGNSW, 1976.

REP: NGA; most state galleries; Ballarat Fine Art Gallery; Mitchell, La Trobe libraries.

BIB: T. Bonyhady, *Images in Opposition* Melbourne 1985. J. Cato, *The Story of the Camera in Australia*, Melbourne 1955. E. Craig, *Australian Art Auction Records* Sydney 1987. Kerr, DAA.

JOHNSTONE, Ruth
(b. 1955 Vic.) Painter, printmaker

STUDIES: Dip. Art, Warrnambool IAE 1979; grad. dip., RMIT 1982. Her semi-abstract black and white prints and drawings show a good imagery and a strong drawing ability as seen in three solo exhibitions Powell St, Melbourne 1984–91. She received a number of print commissions and her work appeared in about 20 group exhibitions (largely print surveys) public galleries 1982–93 including *A New Romance* NGA, 1987; *100 × 100 Print Portfolio* PCA, 1988; *Margaret Stewart Endowment* NGV, 1993.

AWARDS: Acquisitive awards 1982–93 MPAC, Warrnambool, Diamond Valley, Ipswich.

REP: NGA; NGV; Fremantle Arts Centre; a number of regional galleries including Benalla, Bendigo, Hamilton, Ipswich, Mornington; tertiary collections including University of Tasmania.

BIB: PCA, *Directory*, 1989.

JOMANTAS, Vincas
(b. 24/9/1922, Kaunas, Lithuania; arr. Aust. 1949) Sculptor, teacher.

STUDIES: Family training with his father, Vilus Jomantas; School of Fine Arts, Vilnius, Lithuania, 1942–44; Academy of Fine Art and School of Applied Art, Munich, 1946–48. On arrival in Australia he worked first in a timber mill in WA, then as a house-painter in Victorian country districts (1949–52), also in the furniture trade, and as a draughtsman. From the time his work first appeared in a group exhibition at Brummels Gallery in 1957, it was clear that a new, vital talent had emerged with his superbly finished abstracts, mostly in wood or metal. A foundation member of the group Centre Five (1960), Jomantas completed his first commission (for the Physics Building, ANU) in 1958. His other commissions include a wall sculpture in wood for the Forestry School ANU 1968, a large screen in aluminium for the Australian Chancery, Washington, DC (1969), a coat of arms for the State Government Offices, Melbourne (1971); a feature for the Administrative Building, Asian Inst. of Technology, Bangkok, Thailand, and screens for NGA. He held 6 exhibitions 1967–90 with Rudy Komon, Sydney, in the 1970s and at RMIT gallery 1982, and a retrospective of his work was held at McClelland Gallery, Langwarrin in 1990.

AWARDS: Mildura Sculpture Triennial (sculpture acquired), 1964; Comalco prize for sculpture, 1968.
APPTS: Lecturer, sculpture, RMIT 1960–87.
REP: NGA; AGNSW; NGV; QAG; regional galleries McClelland, Mildura, Newcastle; uni. collections ANU.
BIB: Lenton Parr, *Sculpture*, Arts in Australia series, Longman, Melbourne, 1961. Sturgeon, DAS. A&A 1/1/1963 (*Sculpture in Australia since 1945*).

JONES, Angus
(b. 1962, Melb.) Painter.

STUDIES: Prahran Coll., 1980–81; Phillip Inst., 1983–84. One of the early members of ROAR Studios, his work appeared in 21 group exhibitions 1983–91 including at Rhumbarellas, Lennox St, John Buckley, Melbourne; ROARS Studios 1983, 84; and in *Loti and Victor Smorgon Collection of Australian Art*, ACCA 1988; *New Art: Contemporary Art Acquisitions*, NGV 1990; *Freedom of Choice*, Heide 1991. He held five solo exhibitions 1986–92 Melbourne (Rhumbarellas 1986; Girgis & Klym 1987, 90, 91) and Canberra (Ben Grady 1987).

REP: NGA; NGV (Margaret Stewart Endowment); Artbank; Phillip Inst.; Smorgon, Myer, Budget corporate collections.
BIB: Catalogue essays exhibitions as above.

JONES, Arthur Edgar
(b. 1871, Moreland, Vic.; d. 1960, Melb.) Painter.

STUDIES: Melbourne, with Walter Withers, c. 1911– . He earned his living as a French-polisher then as a signalman for the Victorian Railways, and held his first exhibition at the Leighton Gallery, Little Collins St, Melbourne in 1939. Commenting in the *Sun*, George Bell wrote: 'Painted in the impressionist tradition, lyrical and romantic, with the accent on the light effect, [his paintings] are brave and rich in colour and show a knowledge of the necessity of picture construction'. The Rosalind Humphries Gallery, Armadale, Vic. held an exhibition of his work in September 1972.

JONES, Ashley
(b. 20/1/1951, Perth) Painter, printmaker.

STUDIES: Cert. Graphic Design, Perth Tech. Coll., 1971; Dip. Fine Art, Claremont School of Art, 1973; Associateship Fine Art, WAIT, 1974; travel studies, 1979. Jones' photo-realist work appeared in a large number of exhibitions including the interstate touring *Ten Western Australian Printmakers*. He held about 6 solo exhibitions 1975–86 including two at Fremantle Arts Centre. Group exhibitions in which his work appeared 1975–92 included *Woman in Art*, WAIT 1975; *Aspects of New Realism*, NGV and touring 1981; *Living Together, Bicentennial Banners*, Uni. of WA 1988; *9 × 5*, Uni. of WA 1988; *Wesfarmers Collection*, AGWA 1989.

AWARDS: Student awards 1974, 77; VACB special projects grant, 1977, travel grant 1978, 85.
APPTS: Part-time teaching, Fremantle Arts Centre, 1975–79; WAIT (printmaking); Claremont Tech. School, from 1975.

Geoff Jones, White Poppies, *oil on perspex, 76 × 55cm. Private collection. Courtesy Australian Galleries.*

REP: NGA; AGWA; NGV; Artbank; VACB; several tertiary collections Perth; corporate collections including Robert Holmes à Court, Wesfarmers, Rural & Industries Bank.
BIB: Collection catalogues of R&I Bank; WAIT; Wesfarmers. *Contemporary Western Australian Painters and Printmakers,* Fremantle Arts Centre Press 1979. *The Artist's Rottnest,* Fremantle Arts Centre Press, 1988. *Artforce* no. 10, Dec. 1976–Jan. 1977.

JONES, Clifford Malcolm
(b. 1939, Eng.; arr. Perth 1958) Graphic artist, painter, printmaker.
STUDIES: Claremont Tech. Coll., Perth, 1967–69; travel studies, Europe and UK, 1971. He held two exhibitions in Perth in 1971 and 1973. His finely detailed, semi-figurative drawings done with Indian ink in a stippling technique came into prominence when Professor Bernard Smith awarded him the prize for the best Australian entry in the Perth Prize for Drawing International, 1970. He held 10 solo exhibitions 1971–86 and participated in over 50 invitation group exhibitions including for PCA, and other print survey exhibitions.

REP: AGWA; Bunbury Art Gallery; Uni. of WA collections; Artbank; Fremantle Arts Centre; corporate collections including R&I Bank.

JONES, Clytie Lloyd
See JESSOP, Clytie

JONES, David John
(b. 1943, Melb.) Sculptor, teacher.
STUDIES: Graylands Teachers Coll., WA, –1962; WAIT, –1970; RCA, London, 1977–79. He taught in WA schools from 1963.
AWARDS: Student prizes in Perth art schools.
REP: Fremantle Arts Centre; WAIT collections.
BIB: Scarlett, AS.

JONES, Geoffrey
(b. 1909, Melb; d. August 1993) Painter.
STUDIES: Melbourne, with George Bell; travel studies in England, Egypt, 1950–53. He served with the British army in World War II. Repatriated home to Australia, 1946, he resumed work as a tally clerk at Port Melbourne, devoting his spare time to painting. His exhibitions include shows in Sydney and Paris as well as Melbourne, and inclusion in Melbourne Contemporary Artists group shows in the 1960s. Personal development of the basic principles of his early training gave his work a great individual lyricism and charm. He usually painted still-life in small scale. Australian Galleries, Melbourne held a retrospective of his work in 1989 and he was represented in *Classical Modernism: The George Bell Circle,* NGV 1992.
REP: NGA; NGV; Adelaide Uni.; New England Regional Art Museum.

JONES, Henry
(Active c. 1860s, Adelaide) Photographer. Remembered for his 'mosaic of portraits' of the pioneer women of SA, photographed in Adelaide's new Town Hall at the Banquet to the Pioneers (for the surviving first white settlers of 1836). Jones' photographic 'mosaic' differed from those of Thomas Chuck, who originated the idea with 400–500 small portraits of colonists in Melbourne, in that his portraits were all of women. He was represented in *Australian Art in the 1870s,* AGNSW, Sydney, 1976 and in *Shades of Light* NGA 1988.
BIB: Kerr, DAA.

JONES, Henry Gilbert
(b. 1804, Swansea, Wales; arr. Melb. 1841; d. 1887, Eltham) Artist, engraver. An apothecary by profession, Jones, who had private means, never practised as an apothecary in Australia but devoted his talents to art and to Aboriginal welfare as Deputy Protector of Natives. He is recorded by Moore as making the earliest etchings in Vic. (Melbourne street scenes) in the 1840s. He built himself a log hut at Eltham where he was the first resident, and engraved a set of 12 plates of early Melbourne for use as personal letterheads, c. 1840s. A work of his was sold in the F.G.

Cole's Australiana Collection, Joel's auctions, Melbourne, 1965
BIB: Moore, *SAA*. McCulloch, *AAGR*. Kerr, *DAA*.

JONES, Jonah
(b. 25/1/1944, Vic.) Gallery director, art consultant.
STUDIES: B. Comm. (major fine art), Melb. Uni. The founding director, Araluen Arts Centre, Alice Springs, 1980–85 he is a freelance consultant to various art foundations and events including *Moet & Chandon Touring Exhibition and Prize*, ACAF 2&3, for the Australian Commercial Galleries Association, Christensen Fund (*see* TRUSTS AND FOUNDATIONS) with whom he has toured contemporary Australian collections in Europe, USSR, Turkey, Canada and USA. He contributed to *Albert Namatjira: Life and Work of an Australian Painter*, Nadine Amadio (ed.), Macmillan, 1987.
AWARDS: Merito di Benemerenza, Italian govt.

JONES, J. Llewellyn
(Active c. 1880–1924, Vic.) Painter, photographer, teacher.
STUDIES: NGV School, 1883–89. He began his working life in photography before turning to painting. He painted with the Heidelberg School painters from 1885, exhibited at the VAS from 1889 and was an early member of the Australian Watercolour Inst., Sydney, 1924. His work was included in the exhibition of Australian art at the Grafton Gallery, London, 1898, and in *150 Years of Australian Art*, AGNSW, Sydney, 1938. He is recorded also as having spent two years painting and teaching at Bendigo.
AWARDS: Student prize for landscape, NGV School, 1885.
REP: AGNSW.
BIB: Smith, *Catalogue AGNSW*, 1953; Frances Lindsay, intro. exhibition catalogue *Von Guérard to Wheeler*, Vic. Coll. of the Arts, Melbourne, 1978. Moore, *SAA*.

JONES, Lyndal
(b. 1949, Sydney) Performance/installation artist, theatre director.
STUDIES: BA, Dip. Ed., Monash Uni., 1968–71; mime, modern dance, puppetry, London, 1974–76; movement/Ideokinesis, NY 1980–82; Feldenkrais system of movement, Melbourne and Sydney 1979–90 (qualified Feldenkrais practitioner). She has performed and produced about 20 solo performances and installation pieces at theatres and gallery venues 1978–93 including at La Mama, Melbourne; IMA, Brisbane; Performance Space, Sydney; the Studio, Vic. Arts Centre, and contributed performance, video and installations in numerous group exhibitions and theatre festivals 1979–93 including *Works by Australian Video Artists*, Japan tour 1983; *Australian Perspecta '83*, AGNSW; *Biennale of Sydney*, AGNSW 1988. Her performance work is notable for its representation of women's issues, including domestic experiences, and the effects of language delineation, and has included *At Home*, (1977–80) and *Prediction Pieces* (1981–91) a series of 10 works concerned with the individual's ability to effect change.

She was artist-in-residence at the Tasmanian School of Art in 1979 and the Performance Space, Sydney 1988 and has reviewed a number of commission including those for Biennale of Sydney, Elizabethan Theatre Trust, ACCA, IMA. She has given numerous conferences and seminars on dance, performance and visual arts subjects and directed a number of plays, largely for tertiary colleges; choreographed and danced in a number of works and wrote and performed with groups such as *Still Life Theatre* (later *Cunning Stunts*) in Australia and community festivals in London and Edinburgh.
AWARDS: Myer Foundation Travel Grant 1975; grants (travel and project) Theatre Board, Aust. Council 1976, 79, 80, 86; Kiffy Rubbo memorial fellowship, VACB, 1983; grants Performing Arts Board, Aust. Council 1988 (creative fellowship and project), 90; project grant, Vic. Ministry for Arts, 1988; Australian Artists Development Project Grant, Federal Govt, 1992.
APPTS: Lectured and tutored in movement, writing, directing, number of tertiary colleges Vic. including Melb. State Coll., 1978–80; VCA, 1985–88; staff representative various boards, VCA 1983–86; chair, National Conference on Youth Theatre, Theatre Board, Aust. Council, 1984; committee member, various arts and education projects and committees including Bicentennial Arts Projects, 1987; exhibitions committee, ACCA, 1987–88; accreditation committee, MFA, VCA; examiner, MA, visual art, SCA, 1988.
BIB: Catalogue essays exhibitions as above. *Agenda* no. 5, June 1989; *A&T*, no. 6, 1982; 16, 84/85; *AN* 3/4/1980.

JONES, Marion
(b. c. 1897, Bendigo; d. 1977, Melb.) Painter.
STUDIES: NGV School, 1912–17. She won the NGV scholarship in 1917 and subsequently exhibited at the RA, London, Paris Salon (1923), and with the London Portrait Society. Her portrait commissions in London included Billy Hughes (the painting was later presented to Parliament House, Melbourne) and *Viscount Novar, Governor-General of Australia*. After her return to Melbourne she exhibited at the VAS for a time, after which little was seen of her work until after her death in 1977.
AWARDS: NGV Travelling Scholarship, 1917.
REP: NGV; Bendigo Art Gallery.
BIB: Frances Lindsay, intro. exhibition catalogue *Von Guérard to Wheeler*, VCA, Melbourne, 1978.

JONES, Paul Osborne
(b. 12/6/1921, NSW) Painter.
STUDIES: Julian Ashton Art School; ESTC with H. C. Gibbons. He exhibited with the NSW Society of Artists from 1940 and served with the AIF in New Guinea as art instructor in the Army Education Service during World War II. His reputation rests largely on his *trompe l'oeil* paintings of camellias, consolidated by an exhibition of New Guinea subjects in Sydney and Melbourne, 1966–67. He held about 10 solo exhibitions 1966–78 and his commissions include a series of 30 flower paintings for Lord McAlpine. He designed

floral emblems for Australia Post and for fabric design, Sydney 1985, and illustrated several books on flowers, including *Camellia Quest* (1947) and *Camellia Trail* (1952), both by E. G. Waterhouse, Ure Smith, Sydney and *Flora Superba* and *Flora Magnifica*, Tron Gallery, London 1971,76.

AWARDS: RAS NEW Easter Show, 1965; OBE conferred 1970.

REP: NGA; AGNSW; AGSA; AGWA; MAGNT; NGV; QAG; TMAG; Hunt Inst. for Botanical Documentation, Pittsburgh.

JONES, Tim
(b. 7/2/1962, North Wales; arr. Aust. 1984) Printmaker, sculptor.

STUDIES: Early family studies in wood engraving; BA, Newcastle-upon-Tyne Polytechnic, 1983; travel studies Europe, New Hebrides, Ireland; postgrad. dip. (sculpture), VCA, 1985. Jones' father was a woodwork teacher and restorer of gypsy caravans from whom he learnt of Celtic history and Romany life as well as the traditional art of wood engraving. These have been the cornerstones of his printmaking and drawing which show the acknowledged influence of the 18th-century wood engraver and naturalist Thomas Bewick. Jones travelled throughout Europe, the New Hebrides and Ireland before arriving in Australia to study at the VCA with John Walker. He studied, travelled widely in Australia, lectured at the VCA and was artist-in-residence at Gippsland Inst. of Advanced Education in 1986. He started exhibiting sculpture in *New Sculptors: New Directions*, Uni. Gallery, Uni. of Melbourne 1985, and from then his sculptures, drawings and prints have been seen in a number of group exhibitions including *Alternative Sculpture Triennial*, 1985; *Fears and Scruples*, Uni. Gallery, Uni. of Melbourne 1986; MPAC *Spring Festival of Prints and Drawing* 1986, 87; *Freestyle: Australian Art 60s to Now*, NGV 1989. Exhibitions in the UK include *British Society of Woodengravers 51 Exhibition*, touring UK 1987. He returned to Wales in 1986 before travelling to the USA in 1987 to work with John Walker for several months, then to London, New Hebrides, New Mexico, Mexico, Iceland and back to Australia in 1989. He was artist-in-residence at Macgeorge House (Uni. of Melbourne) in 1989. His solo exhibitions 1986–93 include at Latrobe Valley Arts Centre 1986; Arden Street, 1987; Uni. Gallery, Uni. of Melbourne 1990 and Tolarno 1989, 92.

APPTS: Part-time engraving and sculpture teaching, VCA, 1986.

REP: NGV; Uni. of Melb.; Latrobe and Mildura regional galleries.

BIB: *A&A* 28/1/1990.

JONES, William
(Active c. 1848, Tas.) Engraver. His marine engraving, *The Halcyon*, published in 1848, was auctioned in the Craig sale (Christie's, Launceston, Nov. 1975).

BIB: Clifford Craig, *The Engravers of Van Diemen's Land* 1963 and *Old Tasmanian Prints* 1964 both published by Foot & Playstead, Launceston. Kerr, *DAA*.

JONES, William Lorando
(b. c. 1820, Merthyr Tydfil, Wales; arr. Aust. c. 1856; d. c. 1890) Sculptor, painter, photographer. Brother of sculptor Watkin D. Jones he studied in the London studio of Welsh sculptor Joseph Edwards (1814–83) and exhibited busts of prominent people at the RA, London, 1843–55 achieving success with his statue, *The Prince of the Bards*, reproduced in the *Illustrated London News* 1845. He may have gone to Victoria for the goldrush but there is no record of him on the goldfields and in 1857 he exhibited a bust with the Victorian Society of Fine Arts, Melbourne.

He travelled as a photographer throughout NSW and Qld and settled at Granville, NSW. He modelled the relief medallion of Daniel Henry Deniehy, now in the collections of the Public Library, Sydney, and showed eight works at the *Intercolonial Exhibition*, Sydney, 1870. His career was ruined by his public avowals of atheism, and in 1871, a jail sentence (two years, reduced to one month) for blasphemy. For the rest of his life he worked mainly as a stonemason. Later in the 1870s, through the influence of Sir Henry Parkes, his statue *Flora* was placed in the Botanical Gardens, Sydney, where it remained for some years. He was represented in *Early Australian Sculpture*, Ballarat Fine Art Gallery, Dec. 1976.

BIB: Moore, *SAA*. Scarlett, *AS*. Gunnis, *Dictionary of British Sculptors* London.

JONES-ROBERTS, Gareth
(b. 24/2/1935, Wales; arr. Aust. 1949) Painter, teacher.
STUDIES: Melbourne Uni. for three years before turning to painting, in which he had no formal training. A grandson of the Welsh poet Owen Parry Owen, he taught art for four years at Eltham High School, Vic., and, from 1961, held several exhibitions of large abstract paintings at the Australian Galleries, Melbourne. Later paintings, shown at the South Yarra Gallery in 1967, were luminous semi-abstracts dealing with the theme of swimmers. He held about 26 solo exhibitions 1959–87 in Melbourne (including South Yarra; Manyung), Sydney (largely Mavis Chapman; Wagner), Brisbane (Johnstone), Adelaide (White Studio) and Perth (Lister). Group exhibitions in which his work appeared 1961–91 included a number at private galleries and *World Wilderness Congress Exhibition*, Sydney Opera House 1980; several *Archibald, Wynne, Sulman, Transfield, McCaughey* and *Blake* prize exhibitions. He and his wife Norma Sherriff (q.v.) were exchange artists to China in 1989 and he was artist-in-residence at La Trobe Uni. in 1989.

AWARDS: Darcy Morris prize, 1965; Sulman prize, 1965; Albury prize, 1965; CAS. Vic. ICI prize, 1966; RAS NSW Easter Show prize, Sydney (human image), 1966; St Kevin's College prize, 1991.

REP: NGA; Artbank; uni. collections ANU, La Trobe.

BIB: Many texts on Australian painting including Ross Luck, *A Guide to Modern Australian Painting*, Sun Books; Ninette Dutton, *The Beautiful Art of Enamelling*, Sun Books; Horton, *PDA*; Alison Small, *Art & Artists of Australia*, Macmillan, 1981; Smith, *AP*.

Col Jordan, Song, *1987, acrylic on canvas, 100 × 100cm. Private collection.*

JONSSON, Joe
(b. 1890, Halmstad, Norway; d. 1963, Sydney) Cartoonist, black-and-white artist.
STUDIES: J. S. Watkins School, Sydney, 1918–20. He began life as a sailor (1908–17) and became nationally celebrated as a humorous artist working for *Smith's Weekly* from 1924–50. When *Smith's Weekly* ceased publication, Jonsson's creations continued as comic features in daily newspapers.
BIB. Vane Lindesay, *The Inked-In Image* Hutchinson, Melbourne, 1979.

JORDAN, Allan
(b. 1898, Melb.; d. 1982, Melb.) Painter, printmaker, teacher. He made designs and illustrations for Hawthorn Press, Melbourne, notably five wood engravings for Joseph O'Dwyer's *The Turning Year,* 1944. His work was seen in *A Survey of Australian Relief Prints 1900–1950,* Deutscher Galleries, Melbourne, Apr.–May 1978.
APPTS: Teaching, Swinburne Tech. Coll. (retired as principal, 1959).

JORDAN, Ben
(Active 1909–10, Sydney) He illustrated a number of books including Steele Rudd's *On an Australian Farm* 1910.
NFI

JORDAN, Col (Colin George)
(b. 13/10/1935, Sydney) Painter, sculptor, teacher.
STUDIES: NSW Teachers Certificate, Balmain Teachers

Coll., 1954–55; BA, Uni. of Sydney, 1962. Shown in solo and many group exhibitions in capital cities from 1966, including the *Mildura Sculpture Triennial* 1967, 70, 73, his early large abstracts revealed Op art influences (in his painting) moving logically towards minimal influences in sculpture. Outstanding features in both are colour, light and simplicity of form. As well as full-time lecturing he held about 23 solo exhibitions 1966–90 in Melbourne (including Tolarno, Warehouse, Standfield), Sydney (including Bonython; Macquarie; Holdsworth; Bloomfield) and Canberra (Solander). Group exhibitions in which his work appeared 1966–86 include with CAS Sydney, Melbourne, Adelaide, Perth, Hobart and Brisbane, and in *The Field Now,* Heide, 1984; *Abstraction: The Australians,* Ivan Dougherty Gallery. Overseas group exhibitions include CAS *Australian Painting,* Los Angeles and San Francisco 1969; *Australian Art,* PNG 1971; *Young Australian Painters,* Auckland, NZ 1973.
AWARDS: H. C. Richards Memorial prize, Brisbane; RAS, Sydney (for abstract painting), 1967, 69; prizes at Maitland, 1968, Muswellbrook, 1968, Wollongong, 1965, 73; TAA *Australian* prize, 1970; Gold Coast, Qld (work acquired), 1971; Flotta Lauro travelling scholarship, 1971.
APPTS: Teaching, NSW Education Dept., 1960s; lecturer, Wollongong Inst. of Education, 1970, senior lecturer, 1971–74; principal lecturer, Alexander Mackie CAE, Sydney, 1975–82; Dean of Academic Services, City Art Inst., 1982–87; asst director, City Art Inst. 1988–89; associate professor and deputy director 1990 and professor, Coll. of Fine Arts, Sydney, 1991– .
REP. NGA; AGNSW; NGV; QAG; several regional collections including Ballarat, Mornington, Newcastle, Wollongong; uni. collections ANU, Uni. of Sydney, Uni. of WA; corporate collections including BHP, CBA, IBM, CBC.
BIB: Most major texts on Australian art including Scarlett, AS; Horton, PDA; Smith, AP; Germaine, AGA; Edward Craig, *Australian art auction records,* Philip Mathews 1978.

JORGENSEN, Justus
(b. 1893, Mordialloc, Vic.; d. 15/5/1975, Melb.) Painter.
STUDIES: Architecture, as apprentice to his uncle, Robert Shrieber, 1908; NGV School, 1915–17; Melbourne (with Max Meldrum), 1918–24 (first as a pupil, then assistant); Paris, London, Burgundy, Spain, 1924–28. Between 1930 and 1950 Jorgensen taught in Melbourne. In 1935 he moved his living-quarters to Eltham where he started an artists' colony and the construction of the group of buildings known as Montsalvat. The buildings were erected on a site of 6 hectares; stone, iron and pisé were the principal materials used and all members of the colony contributed to the employment and study of the variety of handicrafts needed for the proper use of these materials. By 1963 several large studios, a two-storey house in the style of a French chateau, swimming pool and other amenities had been built. Montsalvat gradually became a tourist attraction in the Eltham district and has been home to artists including Matcham Skipper.

Although Jorgensen took no part in public exhibitions between 1950 and 1967, he produced more than 1000 self-portraits painted in the style of Rembrandt.

JOSE, Ellen

(b. 17/5/1951, Cairns, Qld) Painter, printmaker, photographer, lecturer.

STUDIES: Cert. of Fine Art, Seven Hills Art Coll., 1976; Dip. Fine Art, Preston Inst. of Technology, 1978; Dip. Ed., Melb. State College, 1979. A versatile artist who was artist-in-residence at a number of different venues including Cairns TAFE College, 1990; she ran a printmaking workshop at Canberra Coll. of Art and a lithography workshop at Griffith Uni., both in 1990. She was a member of a number of advisory boards including interim committee, Vic. Koori Arts and Craft Association 1990–91; Vic. Council of the Arts, 1991– . Her photographs give a harsher portrait of the Aboriginal experience than her prints and paintings, which include bright coloured woodblocks of the land, animals and ocean. Her exhibition *In Search of Lost Innocence*, at William Mora Gallery, 1991, portrayed her childhood experiences and were described by Martin Flanagan in the *Age* (27/5/91) as able to be 'read like poems'. Her commissions include PCA patron print, 1988; teaching assistant to Lin Onus on cultural exchange between Yokohama, Japan and Port of Melb. Authority, 1990. She illustrated seven books, including *Rainbow Serpent* by David Gulpilil. Her work appeared in about 25 group exhibitions 1986–92 including *Recent Acquisitions*, NGV and NGA 1989; *A Myriad of Dreaming: Twentieth Century Aboriginal Art*, Lauraine Diggins Fine Art, 1990; *Inside Black Australia*, Museum of Victoria 1988, 90, 91; *Aboriginal Art the Continuing Tradition*, NGA 1989; *Aboriginal Women's Exhibition*, AGNSW 1991. She held five solo exhibitions 1987–93 Melbourne (including Aboriginal Artists Gallery; William Mora).

AWARDS: Grant, Aboriginal Arts Board 1987; Williamstown Art Award, 1989; project grant, Aboriginal/ Islander Arts Unit 1990.

APPTS: Guest lecturer, Monash Uni. 1986–90; lecturer, Arts Dept, Koori Unit, Deakin Uni., Vic, 1991– .

REP: NGA; state libraries of NSW and Vic.; Qld Museum; PCA; Ballarat regional gallery; Flinders Uni.; private collections including Robert Holmes à Court corporate collection.

BIB: Catalogue essays exhibitions as above. Jennifer Isaacs *Aboriginality: Contemporary Aboriginal Painting*, 1989. Caruana, *AA*.

JOSELAND, Richard George Howard

(b. 1860, Worcester, Eng.; arr. Sydney 1888; d. 1930, Sydney) Architect, painter. Joseland painted the first landscapes of Canberra shown in Sydney, and exhibited with the RAS of NSW from 1893. Best known as an architect for his large new Sydney buildings designed up to 1927. Author of *Angling in Australia and Elsewhere*, illustrated with watercolours by the author, *Art in Australia*, Sydney, 1921; 'Domestic Architecture in Australia', *Centennial Magazine*, vol. 5, no. 11, 1890. REP: AGNSW.

JOYCE, Ena Elizabeth

(b. 1925, Sydney) Painter.

STUDIES: ESTC, –1946; London School of Arts and Crafts. Travel study in England, France, Italy and Spain, 1947–50. She exhibited Sydney galleries from 1946–90 (including Macqaurie; Painters) and her work appeared in a number of group exhibitions 1956–88.

AWARDS: NSW Travelling Scholarship, 1946; Portia Geach prize, 1977; prizes in competitions at Drummoyne, 1977; Lane Cove, 1977.

REP: AGNSW; AGWA; NGV; TMAG; Artbank; Manly Art Gallery.

BIB: Germaine, *AGA*.

JUBELIN, Narelle

(b. 1960, Sydney) Installation artist, printmaker.

STUDIES: Alexander Mackie CAE, 1979–82; B. Ed. Art, City Art Inst., 1983; grad. dip. Professional Art Studies, SACAE 1988. Her 1980s installations and prints were concerned largely with places she worked in or visited and the cultural differences of races and the history of their co-development. Her exhibitions consisted usually of prints, objects and ornaments from the cultures and created, as Dianne Losche in *Art and Australia* (29/4/1992) described the artist herself as a 'spellbinding story'. She held 11 solo and joint exhibitions 1985–92 in Sydney (largely Mori galleries), and at Adelaide CAE Gallery 1988; George Paton Gallery, Uni. of Melbourne 1989; Wollongong City Gallery 1991; Centre for Contemporary Art, Glasgow 1992; and in Vienna, 1992. Her work appeared in about 20 group exhibitions 1983–93 including *Frames of Reference*, Pier 4, Sydney 1991; *Perspecta*, AGNSW 1989; Spoleto Festival, USA 1991; *Paraculture*, Artists Spaces, NY 1990; *Biennale of Sydney*, 1992–93. She was artist-in-residence at SACAE in 1988 and the Uni. of Wollongong in 1990.

AWARDS: Residency, Tokyo Studio, VACB 1991.

REP: NGA; AGSA; AGNSW; NGV.

BIB: Catalogue essays exhibitions as above. *AL* 8/3/1988. *A&A* 29/4/1992.

JUDELL, Anne

(b. 1942, Melb.) Painter.

STUDIES: Dip. Design, RMIT, 1962; travel studies Europe and USA 1965/66; 74; 79–80 (New York). Her abstract pastels and oils were seen in 12 solo exhibitions 1976–91 in Sydney (Barry Stern; Macquarie), Melbourne (Christine Abrahams; Charles Nodrum) and Canberra (Solander,) and in about 20 group exhibitions 1983–93 largely at private galleries in Sydney (David Jones; Macquarie) and Melbourne (Charles Nodrum), and in *Faber-Castell Drawing Prize* 1983, 85, 86, 88; *Blake Prize* 1985, 90, 91; *Margaret Stewart Endowment* NGV, 1993. Of her 1986 pastels at Macquarie Galleries, Sydney, Joanna Mendelssohn wrote (*SMH* 12/9/1986): 'They glow jewel-like out of the

surface, their luminosity enhanced by their contrasting colour . . . a self-conscious spirituality . . . but spiritual awareness owing more to the traditions of Eastern art than Western iconography.'

REP: AGNSW; NGV; Parliament House; ABC; Artbank; regional galleries Campbelltown, La Trobe Valley; private collections including Hyatt Hotels, State Bank of NSW; Western Mining.

BIB: Germaine, AGA. *New Art Two*. A&A 22/2/1984.

JULIUS, Harry
(b. 15/11/1885, Sydney) Caricaturist.
STUDIES: Julian Ashton School, Sydney. Theatre caricaturist for the Sydney *Bulletin*. He also drew strip drawings in colour for the *Comic Australian* and worked in advertising. In partnership with Sydney Ure Smith, Julius established the advertising company of Smith & Julius; he was also a director of the magazine *Art in Australia*. William Moore wrote that Julius was the first artist to invent animated cartoons for the cinema and that he secured a patent for it.
BIB: Moore, SAA.

JUNIPER, Bob (*Robert Litchfield*)
(b. 7/1/1929, Merredin, WA) Painter, teacher.
STUDIES: Beckenham School of Art, Kent, UK, 1943–46. He worked as a commercial artist in England before returning to WA in 1948 and a life in a farming district. He soon moved to Perth where he held his first exhibition in 1953 and taught for some years at Hale School. Painting mostly landscapes (often with figures and buildings) in muted colours with well-drawn, linear accents, he made his name by winning a number of local prizes. As a leading WA painter his position was soon consolidated when his work was included in the Whitechapel (1961) and Tate Gallery (1962) exhibitions of Australian art in London. He helped to form the Perth Group with Guy Grey-Smith, Brian McKay and Tom Gibbons in 1957 and has exhibited annually since 1962 in major commercial galleries in capital cities and in Japan in 1964. He has completed numerous commissions including murals, poster designs, theatre and set designs, stained glass windows, prints and sculpture. The AGNSW held a retrospective of his drawings 1980.
AWARDS: Prizes in Perth contests, 1954, 59, 60, 62; McKellar-Hall prize in Commonwealth Games competition, 1962; Wynne prize, Sydney, 1976, 80; Mona McCaughey prize, 1980; Honorary Doctorate (D. Litt.), Uni. of WA, 1984; Kingfisher Prize, NSW, 1988.
APPTS: Teaching, Perth Coll., 1954–56; Hale School, 1956–64; Guildford Grammar, 1964–84.
REP: NGA; AGNSW; AGWA; MAGNT; NGV; NGV; QAG; Fremantle Arts Centre; Wollongong City Gallery; several tertiary collections including Curtin and WA unis.; numerous corporate and private collections including BHP, Christensen Fund, Robert Holmes à Court, Mertz Collection (USA), Wesfarmers.
BIB: Several general books on contemporary Australian painting and *Each Man's Wilderness: Reflections by Australian Artists*, Rigby, Adelaide 1980. Graeme Sturgeon, *The Painter's Vision*,

Bay Books, Sydney 1989. Robert Walker, *Painters in the Australian Landscape*, Hale & Iremonger, 1988. Elwyn Lynn, *The Art of Robert Juniper*, Craftsman House, 1986. Philippa O'Brien, *Robert Juniper*, Craftsman House, 1992. A&A 16/4/1979 (Salek Minc, *Of Robert Juniper*).

JURASZEK, Paul
(b. 8/8/1953, Vic.) Sculptor.
STUDIES: Fine arts, CIT, 1976–79; postgraduate sculpture, VCA, 1980–81. Working often on a huge scale and in stone, marble, wood and metal, his representational sculptures are impressive for their scale and presence created by his choice of subject – frequently links with ancient civilisations and Greek and Roman mythology. He held 6 solo exhibitions 1981–90 in Melbourne (McCormack, 1981; Rhumbaralla, 1985, 86; Luba Bilu, 1990) and Sydney (Irving Sculpture, 1989), and his work appeared in about eight group exhibitions 1979–90 including group and postgraduate exhibitions, VCA 1979, 80; *Australian Sculpture Triennial*, Melbourne 1987; ACAF 2 and 3, 1989, 90. His commissions include those for the Malvern Council, Melbourne, and installations at Caulfield Arts Centre 1985, 87. He was artist-in-residence at two Melbourne primary schools in the 1980s.
AWARDS: VACB special project grant, 1983, 85.
APPTS: Tutor, CAE.
REP: NGA; AGWA; MOCA, Brisbane; Mount Gambier regional gallery; Malvern City Council.
BIB: Catalogue essays as above. AL 7/4/1987–88.

JURJANS, Gunars
(b. 29/4/1922, Riga, Latvia; arr. Aust. 1950) Painter, stage designer, television designer.
STUDIES: Tilberg's Art School, Latvia, 1939–41; Academy of Fine Art, Latvia, 1942–44; Royal School of Decorative Art, Copenhagen, 1948–50. A talent for geometric design gives Jurjan's painting a strong formal basis; combined with a scheme of tertiary colours, it suggests the influence of French analytic cubism. A founding member of the Blue Brush group of artists (q.v.), he exhibited annually with them 1953–64 and held four solo exhibitions 1964–79 at Latvian Art Gallery, Melbourne. His work was included in a European travelling exhibition of Baltic artists living in Australia, 1959, and his commissions include a mosaic decorative panel for Latvian House, Melbourne and a stained glass window for the Commonwealth Bank, Clifton Hill, Vic.

JUST, Verlie
(b. 22/7/1922, Qld) Painter, jewellery designer, gallery director.
STUDIES: Brisbane Tech. Coll., 1937–40; travel studies USA, 1969. She held solo exhibitions Moreton Gallery and Design Arts Centre, Brisbane and Barry Stern Sydney 1961 and opened her own gallery in Brisbane.
AWARDS: Order of Australia Medal, 1992.
REP: Jewellery in NGA; QAG.
BIB: Germaine, AGA. H. Fridemanis, *The Contemporary Arts Society of Qld*, Boolarong, Brisbane, 1990.

K AHAN TO KY

KAHAN, Louis
(b. 25/5/1905, Vienna; arr. Aust. via the USA, 1947)
Painter, printmaker, stage designer.
STUDIES: Academie Colarossi, Grande Chaumière, Paris
(printmaking), 1946; Hornsey Coll. of Art, London
(stained glass), –1958; he was first encouraged to paint
by Albert Marquet and the illustrator Edy Legrand
in Algiers, 1941. The son of a Viennese tailor, he
learned the trade and went to Paris in 1925 where
he worked as a master tailor, then as a designer for
Paul Poiret and finally as an illustrator. During World
War II he served with the French Foreign Legion and
from 1942 to 1945 worked as a war artist in North
Africa. An important feature of his work is his skill
as a journalistic draughtsman. He covered the trial of
Petain's Ministers for *Le Figaro*, Paris, 1946, and later
studied printmaking. Arriving in Australia, he began
a program of frequent exhibitions (about 50 between
1947 and 1991), worked in Perth, 1947–50, and from
1950 mainly in Melbourne, freelancing as a painter
and designing décor for the National Theatre and
Australian Opera. His series of portrait drawings of
writers published in *Meanjin*, the *Age* and in books,
brought him prominence. After his marriage in 1954
he studied and worked in Paris and London (includ-
ing designing for the Welsh Opera Company) return-
ing to continue his work in Melbourne in 1958. From
1969 he taught with the Council of Adult Education,
Melbourne, and became well-known as a painter. He
designed stained glass windows for churches and syn-
agogues in Melbourne and Sydney. A collection of his
work commissioned by the *Age*, *Artists in Profile*, was
presented to the NGV by the *Age* in 1965. He had six
solo exhibitions in public galleries 1955–92 includ-
ing at NGV 1965; *The Great Music Makers*, portraits
of 100 musicians at Vic. Arts Centre 1987, and a ret-
rospective at AGWA 1992.
AWARDS: Prizes at Albury, 1953; Mosman, 1959;
Archibald Prize, Sydney, 1962; R.N.Ag.A.Q., Brisbane,
1964, 66, 67; Bendigo, 1965; Kinsella, 1976; Henri
Worland Print Prize, 1976; Pedersen Prize, 1976;
Caulfield drawing purchase, 1980; Drummoyne Print
Purchase; Order of Australia (OA) 1993.
REP: NGA; AGNSW; AGSA; AGWA; MAGNT; NGV; QAG;
QVMAG; TMAG; regional galleries Albury, Ararat, Ballarat,
Bendigo, Devonport, Geelong, Hamilton, Horsham,
Langwarrin, Launceston, Mornington, Newcastle, New
England, Rockhampton, Warrnambool; uni. collec-
tions in Adelaide, Melbourne, Perth and Sydney; col-
lections in Paris, Vienna, NZ, Israel, USA and UK.
BIB: John Hetherington, *Australian Painters: Forty Profiles*,
Cheshire, Melbourne, 1963. Smith, AP. J. Zimmer, *Stained
Glass in Australia*. R. Crumlin, *Images in Religion in Australia*,
Bay Books, Sydney, 1988. Lou Klepac, *Louis Kahan*, Beagle
Press, Sydney, 1990. J. Campbell, AWP.

KAHLER, Carl
(b. 1855, Linz, Austria; arr. Melb. 1885; d. 1906, San
Francisco) Painter.
STUDIES: Munich Academy. Kahler, a painter of soci-
ety portraits, exhibited in Berlin (1880), Dresden,
Vienna and Paris (Salon 1882). He went to Australia
probably at the instigation of Carl Pinschof, publisher
and noted patron of the Heidelberg School painters
(q.v.). Kahler's most celebrated work in Australia
consisted of three pictures of Melbourne Cup race-
meetings, notably *The Betting Ring*, in which each
member of the crowd was an individual portrait. The
pictures were photographed, engraved by Goupils,
Paris, 1887, and published, together with identity
key, by Carl Pinschof, Melbourne, 1890. One of the
series, *Flemington Lawn on Cup Day*, was described in
the Sydney *Bulletin*, 19 Jan. 1889, as 'a veritable page
in the history of Australia'. Kahler's paintings and
pastels were auctioned in Melbourne, 7 May 1890;
he went to San Francisco, c. 1906, where he is believed
to have fallen victim to the earthquake. An exhibi-
tion of his work held in New York, 1907, would
therefore have been posthumous.
BIB: Article in *Table Talk* Melbourne, 11 Jan. 1889; J. Smith,
Herr Kahler's The Lawn at Flemington on Cup Day, McCarron,
Melbourne, ?1889. (*Information researched and made available
by Alan Benjamin*)

KAIN, Robert
(b. 1948, Melb.) Environmental artist, teacher.
STUDIES: Melb. State Coll., 1968–71. He began teach-
ing for the Victorian Education Dept, 1972, lectured
on drama, Melbourne State Coll., 1975, and from

1976 was teaching at Numurkah High School. He made an inflatable for Myers, Melbourne, 1971, and created a total environment from mirrors and plastic, Tolarno Gallery, Melbourne, 1972.

BIB: Scarlett, *AS*.

KAISER, *Peter Christian*

(b. 17/6/1918, Berlin; arr. Aust. 1940; moved to France, c. 1951) Painter.
STUDIES: Berlin Academy, 1936–38. Kaiser worked in Melbourne before moving to Sydney where he joined the Merioola Group, and in 1948 taught illustration and applied art at ESTC. In 1951 he moved to Tourettes-sur-Loup, France, and subsequently maintained his Australian connections through exhibitions and visits. Abstract in feeling though based on the visible phenomena of nature, his paintings have notable beauty of surface texture and colour. From 1951 Kaiser exhibited in many cities around the world and held Australian exhibitions at the Peter Bray Gallery, Melbourne; Clune Gallery, Sydney, 1959; and South Yarra Gallery, Melbourne, 1961, 62 and with Charles Nodrum, Melbourne since the 1980s.
REP: AGNSW; Rhode Island Museum; Museum of Fine Arts, Boston; Seattle Museum; Peggy Guggenheim Collection, Venice.

KALDOR, *John*

(b. 1936, Hungary; arr. Aust. 1949) Businessman, collector, entrepreneur. His tastes in art developed through his studies and experience in the textile industry. In 1966 he initiated the Alcorso-Sekers Sculpture Scholarship and, three years later (1969), the visit to Australia of Christo Javacheff (to wrap the coast at Little Bay, Sydney). He also initiated the visit of Harald Szeemann, director, Kassel Documenta, 1971. His collection includes works by leading European, American and Australian artists.
AWARDS: Grant VACB to stage Project No. 4, a conceptual art event', Sydney, 1976; grant, VACB Sol Lewitt tour, 1976–77.
BIB: *A&A* 8/4/1971 (Daniel Thomas, *The Art Collectors 10: John Kaldor*).

KALDOR, *Stephen Ernest*

(b. 2/2/1938, Hungary) Painter.
STUDIES: B. Med. (Surgery), Uni. of Sydney, 1961; NAS, 1971–74. He held about five solo exhibitions 1979–91 at private galleries in Sydney, and participated in numerous prize exhibitions 1971–91 including *Archibald Prize*, 1975, 76; *Blake Prize*, 1976–90 (8 times); *Sulman Prize*, 1984, 85; *Alice Prize*, 1989–91.
AWARDS: R.Ag.Soc.NSW, (landscape) 1976, (portrait) 77; prizes at Campbelltown, 1978; Stanthorpe (work acquired), 1992.
APPTS: Private classes, Sydney; arts lecturer on cruise ship *Achille Lauro*.
REP: Regional galleries Wollongong, Bathurst, Cairns, Stanthorpe; Uni. of NSW.
BIB: Germaine, *AGA*.

KANE, *Julius (Julius KUHN)*

(b. 1921, Budapest; arr. Aust. 1949; d. July 1962, Melb.) Sculptor.
STUDIES: Budapest Uni. (law and economics); Academy of Fine Arts, Munich, 1946–49; Ontario Coll. of the Arts, Canada, 1960–61. Shown first in a Vic. Sculptors Society exhibition at the VAS, Melbourne in Nov. 1952, Kuhn's warmly sensuous, stone *Equestrienne* was one of a group of works by new artists who were jointly to revitalise Australian sculpture, the common motivating principle being Brancusi-like awareness of the organic nature of materials. Kuhn became naturalised as an Australian citizen in 1956 and simultaneously changed his name to *Kane*. His work was more abstract by 1960, the year in which he energetically helped to found the group Centre 5 (q.v.). Meanwhile his work had achieved acclaim in successive CAS exhibitions. In 1959 a Canada Council Fellowship took him to Canada, the USA and Mexico, an experience from which he learned much. His large wood-carving, entitled *Group Organism*, was an outstanding entry in the first *Mildura Sculpture Triennial*, 1961. His personal life however was not so happy. Despite the warm regard of his colleagues, he remained a lonely and introspective man whose intense yearning for the unattainable was a contributing factor to his suicide in July 1962.
AWARDS: Canada Council Fellowship, 1959.
REP: NGA; NGV; Uni. of Montreal.
BIB: Lenton Parr, *Sculpture*, Arts in Australia series, Longman, Melbourne, 1961. Sturgeon, *DAS*. Scarlett, *AS*.

KAPOCIUNAS, *Vytas Bronius*

(b. 23/12/1943, Lithuania; arr. Aust. 1950) Painter, printmaker, sculptor.
STUDIES: SASA, c. 1964; travel studies, UK and Europe, 1966–67, 74, 78–79, 81; USA, Europe, 1985; India, 1988. His German expressionist-type work appeared annually in exhibitions in various capital cities from 1965. He had about 12 solo exhibitions 1970s–92 including at CAS, SA, 1980; Uni. of Adelaide and National Museum of NSW 1988. Group exhibitions include at AGSA, PCA, several regional art galleries and private galleries in Adelaide. In 1988 he spent some time visiting Community Aid Abroad projects in India.
AWARDS: Commonwealth scholarship, 1962; Goya prize, 1964.
APPTS: Teaching, SASA, Adelaide (part-time), 1966–68, lecturer (full-time) from 1968.
REP: AGSA; NGV; Hamilton Regional Gallery; ANU uni. collection.
BIB: Nancy Benko, *Art and Artists of SA*, Adelaide. PCA, *Directory* 1976, 89. Germaine, *AGA*. E. Craig, *Australian Art Auction Records 1975–78*, 1978. Smith *AP*.

KAREDADA, *Lily*

(b. c. 1937, Kalumburu, WA) Painter. From the Woonambal group in the far north-west of the Kimberley, Lily Karedada paints the *Wandjina* (waterspirits) on bark and canvas. Using only ochres her

paintings are traditional representations yet refined in imagery. Her work was seen in *Images of Power* NGV 1993. Her husband, Jack, and sister-in-law Rosie Karedada are also painters working at Kalumburu.

REP: NGA; NGV; MAGNT.

See also ABORIGINAL ART

KAROLYI MEMORIAL FOUNDATION
See OWEN TOOTH MEMORIAL COTTAGE

KAY, *Barry*
(b. 1932, Melb.; d. 1985, London) Stage designer.
STUDIES: RMIT, c. 1950; Académie Julian, Paris; travel studies, UK and Europe, –1954. He designed sets for the National Theatre, Ballet Guild and other Melbourne groups before moving to London to settle in 1956. Theatres and companies for which he designed include the Old Vic., Sadler's Wells, Royal Ballet Company, Covent Garden; Royal Shakespeare Company; Theatre de la Monnaie, Brussels; Vienna State Opera; Staatsoper, Berlin; Australian Ballet Company. Artists with whom he worked include Nureyev and Kenneth Macmillan. Separate exhibitions of his work were held in London from 1966; Berlin, 1967; New York, 1970; Melbourne, 1972, 84; Athens, 1972. In 1989 a scholarship fund, *The Barry Kay Memorial Scholarship for Design*, administered by the Australian Ballet, was established to assist young Australian designers.

REP: NGA; AGWA; NGV; Victoria and Albert Museum, London.

KAY, *William Porden*
(b. 1809, England; arr. Aust. 20/5/1842; d. c. 1870, England)

Watercolourist, draughtsman, architect, surveyor, engineer and public servant. The son a of prominent English family of architects, Kay first worked in London, and through his connections with Sir John Franklin who married his aunt, Eleanor Anne Porden, was invited to Van Diemen's Land as Colonial Architect. There he designed many public buildings including the asymmetrical Tudor-style New Government House, Hobart (1853–58). He belonged to a sketching club initiated by John Skinner Prout (q.v.) and was secretary for the organising committees for the Hobart Town art exhibitions, 1845 and 1846 and a committee member of the *Art Treasures Exhibition* held in 1858. Due to deteriorating eyesight he retired in 1858 and the following year sailed to England. His work was included in *Tasmanian Vision* TMAG and QVMAG 1988.

REP: Allport Library.

BIB: Kerr, DAA,

KEDEM, *Rimona*
(b. 17/5/1937, Israel) Painter.
STUDIES: Avni Art Academy, Tel Aviv, 1955–58; Art Academy, Mexico City, 1962–65; BA Fine Arts, Flinders Uni., SA, 1974–77; preliminary MA, Melbourne Uni.; travel studies, Middle East, 1978–79; Dip. Ed., La Trobe Uni., 1979–80; B. Ed., La Trobe Uni., 1980–83.

She exhibited in Mexico 1962–65 and Israel 1966 before coming to Australia in 1967. Her first Australian exhibitions were at Rudy Komon Gallery, Sydney, in 1967 and she had about 20 solo exhibitions 1967–92 in Australia (including Macquarie, Sydney; Powell St, Niagara, Wiregrass, Melbourne) and in Mexico City and Jerusalem. She had commissions for stained-glass windows, often for synagogues, in Melbourne, Sydney and Mexico City, and designed costumes for leading opera and dance companies. Expressionistic, decorative and richly textured, her painting style concerns allusive images of life and death, conflict and a strong underlying content of social realism and cabalistic ritual. Her 15 stained-glass memorial windows for the Melbourne Synagogue, fabricated by Yencken Glass, represent a significant contribution to religious art in Melbourne.

REP: NGV; museums in Mexico City, Israel.

BIB: *150 Victorian Women Artists*, 1985.

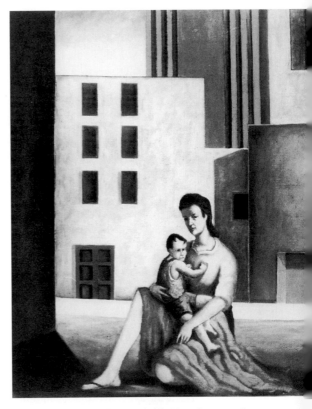

David Keeling, Mother and Child, *oil on wood, 70 × 61cm. Courtesy Niagara Galleries.*

KEELING, *David*
(b. 11/7/1951, Tas.) Painter.
STUDIES: B. Visual Arts, Tas. School of Art; Postgrad. Dip., professional art studies, Alexander Mackie CAE; Dip. Art Teacher Ed., Tas. CAE. Surrealist images and a sense of unease with humankind's relationship to the built environment characterise his finely honed and statically atmospheric paintings. He held seven

solo exhibitions 1987–93 largely at Niagara, Melbourne and Dick Bett, Hobart. Group exhibitions in which his work appeared include at Chameleon Gallery, Hobart; *Witness*, 200 Gertrude St and Artspace 1990; *Rediscovery: Australian Artists in Europe*, Seville and Paris 1992.
AWARDS: Residency, Verdaccio studio, Tuscany, VACB, 1988; artists' development grant, VACB, 1991; City of Hobart Art Prize, 1991.
APPTS: Secondary teaching, Tasmania, 1977–80, 83–90; Messerli Studio School, Sydney, 1981–82.
REP: NGA; NGV; Artbank; Tas. Uni.
BIB: *New Art Three.*

KEELING, Dorothea
(b. 23/6/1907, Tas.) Painter.
STUDIES: NGV School 1929–32. She won several prizes at the NGV School and became known, mainly in Tas., during the 1930s for her decorative paintings of animals and birds; lived in Melbourne 1936–41 and 1944–72 before returning to Tasmania to live and exhibit.
REP: QVMAG.

KEKY, Eva
(b. 1931, Hungary; arr. Sydney 1962) Graphic artist.
STUDIES: Hungary, 1955–56; Paris (with Friedlander), 1960.
REP: AGNSW.

KELLOCH, D. Taylor
Stained-glass designer, teacher.
STUDIES: Edinburgh, Scotland. Teacher of art at Hobart Tech. Coll., 1939–41. Among the many stained-glass windows designed by Kelloch is the war memorial window for Scotch College chapel, Hawthorn, Vic.

KELLY, Harry Garnet
(b. 10/7/1896, Hobart; d. 1967) Painter, advertising artist.
STUDIES: Hobart Technical College with Mildred Lovett, 1922–31, 34,35; NGV School 1945. Known mainly for landscapes, he served with the AIF, 1914–18, was a member of the Art Society of Tas., Tasmanian Group of Painters, Australian Water Colour Inst. and NSW Society of Artists, and in commercial life the advertising manager for a confectionary factory until 1948.
REP: TMAG.

KELLY, Margaret Elizabeth Walloscheck
(b. 1890, ?SA) Painter, teacher.
STUDIES: SA School of Arts and Crafts, Adelaide (with Gill). Best-known as a teacher, she taught at her old school, the SASA, for nearly 50 years.

KELLY, Tim (formerly Anthony James)
(b. 17/2/1945, Sydney) Printmaker, photographer, administrator.
STUDIES: Randwick Tech. Coll., Sydney, 1971; Arts Council of Australia printmaking classes; Dip. Arts,

Alexander Mackie CAE, 1977–79; grad. dip. gallery management, City Art Inst., 1986. He held seven solo exhibitions 1974–80 at private galleries in Sydney, Canberra and Wollongong.
AWARDS: VACB special purpose grant, 1975.
APPTS: Tutor in printmaking, Arts Council of Australia classes, 1975–78; technical officer, Power Inst., Uni. of Sydney; guest lecturer, printmaking, Alexander Mackie cae, 1977.
REP: QAG; regional galleries Fremantle, Wagga Wagga, Wollongong; Waikato Art Museum, NZ.
BIB: PCA, *Directory* 1976, 89. Germaine, AGA.

KELLY, Wendy Louise
(b. 17/5/1942, Vic.) Painter.
STUDIES: Dip. Art & Design/Fine Art, CIT; Grad. Dip. Art, Monash Uni. Coll., Gippsland, 1991– . Taking up painting in her 30s her paintings are often ambitious in concept and of individual style. She held six solo exhibitions 1981–93 Melbourne (Pinacotheca 1985; Judith Pugh 1990; MCA, 1993) and at Hawthorn City Art Gallery, Melbourne 1981; Chisholm Coll., La Trobe Uni. 1985; Power Gallery of Contemporary Art, Sydney and touring to ACT Arts Council Gallery, Canberra, Shepparton Art Gallery, EAF, Adelaide 1987.
AWARDS: Pioneer Art Award, Swan Hill Art Gallery, 1981; project grant, VACB, 1989.
APPTS: Lecturer short courses, La Trobe Uni. and Holmesglen TAFE.
REP: Swan Hill Regional Gallery; La Trobe Uni. collection.
BIB: Germaine, AGA.

KELLY, William J.
(b. 4/5/1943, Buffalo, USA; arr. Aust. 1968) Painter, printmaker.
STUDIES: Philadelphia Coll. of Art, –1968; NGV School. He came to Australia as a Fulbright graduate scholar under the auspices of the Australian-American Education Foundation, 1969, took up residency at Prahran CAE and the NGV School, Melbourne, and held his first Australian exhibition at Strines Gallery, Carlton, in June 1969. His realistic paintings and drawings from the nude were photographic in conception in accord with his interest in photography, but illustrated also his aim of presenting the nude as a commonplace object seen in perspective from all points of view. After his initial experience of Australia (1969–70), he returned in 1975 to take up an appointment as Dean of the School of Art, VCA, a position he held until 1981, when he resigned to work full-time as a painter. From 1989–93 he worked on a large series of work which included prints, drawings and paintings entitled *The Peace Show* aimed at counteracting violence in society. The works were seen at MOMA, Heide in 1993 with a book and video of the project produced later. He held about 30 solo exhibitions 1969–93 in the USA, Italy and Australia, including a number at tertiary and public galleries including Mildura regional gallery 1982; VCA gallery 1990; Westpac Gallery, Vic. Arts Centre 1990; Seymour

William Kelly, Targets (from Prints from the Peace Project folio), *screenprint.*

Centre, Sydney 1990; Drill Hall, ANU 1991. He participated in many significant group exhibitions in the USA, Asia, Europe and Australia including *Modern Art II: International*, Budapest, Hungary 1987; *Contemporary Australian Art*, QAG and Museum of Modern Art, Saitama, Japan 1987; *Art of the Eighties*, Western Carolina Uni., USA 1989. In the 1980s he also designed a number of theatre sets and posters, made several films and initiated a number of urban arts and environmental design projects including Westage Park, Footscray Wharves and Environs and Barwon Heads Village Park, Vic. with local and state government planning departments.
AWARDS: Student awards in the USA (James Roberts, Fulbright postgrad. grant; grant, Australian film Commission; grant, Myer Foundation.
REP: NGA; VCA; many tertiary collections, some regional galleries Vic., NSW, Qld, USA; public collections USA; archival collections, leading print workshops Aust., USA; theatres; Vic. Tapestry Workshop.
BIB: Catalogue essays for exhibitions as above. McKenzie, DIA.6. *Who's Who in American Art. Dictionary of International Biography.* Germaine, AGA. A&A 24/1/1986 (Janet McKenzie, *William Kelly*)

KEMBLE, Herbert
(b. 1894, NZ; arr. Sydney 1920) Painter, illustrator.
STUDIES: No formal training. After serving at Gallipoli in World War I, he settled in Sydney where he worked as a window-dresser and painted in his spare time. By 1928 he was working at commercial art and contributing to annual Society of Artists exhibitions. From 1941 he worked as a newspaper and magazine illustrator and exhibited in *Archibald*, *Wynne* and *Blake* prize exhibitions. He was elected to the committee of the CAS, Sydney, in 1952 and in 1955 held a retrospective exhibition at David Jones Gallery, Sydney. In Europe in 1959 he exhibited with the Royal Watercolour Society, London, at the Paris Salon, and in the British section of the Guggenheim Prize primaries in 1958.
AWARDS: Bathurst prize, 1968.
REP: Bathurst regional gallery.
(Information from the artist, 1 Oct. 1979)

KEMP, John
(Active from 1872, Melb.) Painter. Known mainly for portraits. He exhibited with the Victorian Academy of Arts in 1872.
NFI

KEMP, Michel
(b. 17/2/1951, Melb.) Printmaker, film-maker. Daughter of Roger Kemp, after her preliminary studies in Melbourne she had a brief career in film-making in London before going to Israel where (1973–74) she produced a series of surrealistic etchings and aquatints symbolising the terrors of the Israeli–Palestinian disorders. She participated in group exhibitions in Tel Aviv and London, and held her first Melbourne exhibition in Aug. 1974 and from then participated in several group exhibitions including *Contemporary*

Australian Printmakers, PCA/Oregon Uni. 1980; *Survey 8*, Geelong Art Gallery 1987; *A Personal Line in History*, Shepparton Art Gallery 1992.

BIB: PCA, *Directory* 1976,89.

KEMP, Roger

(b. 4/7/1908, Bendigo, Vic.; d. 14/9/1987) Painter, printmaker, teacher.

STUDIES: Dip. painting, NGV School, 1933–35; Melb. Tech. Coll.; Space Studios, London; travel studies New York, 1980. 'The aim of my work has been to develop in relation to the central discipline of aesthetic and structural balance, and from this formal plastic and creative centre, to express through a realised symbol, my experience and knowledge of humanity.' In these simple words, Kemp summed up the attitude which through constant and determined application made him a vital force in Australian contemporary painting. The Gothic matrix upon which his painting structure is based provided a perfect vehicle for his symbolism while retaining within its abstract structure strong links with a twentieth-century spirit. Other aspects of his work included the belief that colour is achieved only through tone, and a natural urge towards self-expression through grand-scale decoration, e.g., the great stained-glass windows of Chartres. Obliged to work for some years in factories, and hampered further by lack of facilities and materials, Kemp still managed to maintain a large and steady output of work. Although admired by colleagues such as Leonard French and often praised by critics, his work did not attract substantial patronage until after 1961, when he won the McCaughey prize, Melbourne, followed by the Darcy Morris prize, 1964, and Georges Invitation prize, 1965. He had his first trip overseas in 1966 and lived and worked in London 1970–72. A major factor in stabilising and giving direction to his career was his marriage to Merle McCrohan, a colleague student at the Melbourne Tech. Coll. during the late 1930s.

Around 1968 Kemp began a series of works on paper which added further to his great productivity. He began teaching at Prahran CAE and in 1970 joined the group of etchers working with George Baldessin in the Olderfleet buildings in Collins Street, Melbourne. In 1978 his seventieth birthday was celebrated in four huge simultaneous exhibitions held at the NGV, the Uni. of Melbourne Gallery, Monash Uni. Gallery and Realities Gallery, and organised by Patrick McCaughey. Several of his works were woven by the Vic. Tapestry Workshop – a group of three of large scale being endowed in 1992 by Dame Elisabeth Murdoch to hang in the Great Hall of the NGV.

From the 1980s group exhibitions in which his work appeared included *Blake Prize: The First 25 Years, a Survey*, Monash Uni. Gallery 1984; *The Australians: Three Generations of Drawings*, CDS Gallery, New York 1984; *Surface for Reflexion*, AGNSW 1986; *What is This Thing Called Science?*, Uni. of Melbourne 1987; *Drawing in Australia 1870s–1880s*, NGA 1988; the Bicentennial exhibitions *The Great Australian Art Exhibition* and *The Face of Australia*; *Classical Modernism: The George*

Bell Circle NGV, 1992; *Two Hundred Years of Australian Painting: Nature, People and Art in the Southern Continent*, National Museums of Western Art, Tokyo and Kyoto, Japan 1992. In 1986 an exhibition of his work, *Sacred Images*, was held at the NGV and in 1990–91, *Roger Kemp: Etchings*, was curated by the AGNSW and toured to five public galleries in NSW, Vic., Qld and Tas.

AWARDS: John McCaughey Memorial prize, 1961; Darcy Morris prize (Blake prize competitions), 1964; Albury prize, 1964; Georges Invitation Art prize, 1965; Transfield prize, 1965; Blake prize, 1968, 70; International Cooperation Art Award, 1968; VACB grant (for distinguished artists and scholars), 1973; OBE, 1978; hon. doctorate of laws, Monash Uni., 1984; life membership of NGV for service to art, 1984; Painters and Sculptors Award for outstanding contribution to Aust. art, 1986; Officer, Order of Australia (OA) 1987.

APPTS: Part-time lecturer, Prahran CAE, 1976–80.

REP: NGA; AGNSW; AGSA; AGWA; MAGNT; NGV; QAG; QVMAG; TMAG; Parliament House; Artbank; many regional galleries including Ballarat, Bendigo, Castlemaine, Mornington, Newcastle, Burnie, McClelland; uni. collections Melbourne, Monash, WA, Deakin, ANU, Macquarie; many corporate collections including CBA, NAB, ANZ.

BIB: Catalogue essays in numerous solo and group exhibitions as above. Most major texts on Australian art including Hilde and Hans Knorr, *Religious Art in Australia*, Longman, Melbourne, 1967; James Gleeson, *Masterpieces of Australian Painting*, Lansdowne, Melbourne, 1969; Patrick McCaughey, *Australian Abstract Art*, OUP, Melbourne, 1969; Rosemary Crumlin, *Images of Religion in Australian Art*, Bay Books, Sydney 1988; Smith, AP. *Meanjin* 1/1951 (Alan McCulloch, *Roger Kemp*) A&A 8/2/1970 Patrick McCaughey, *Roger Kemp*); 19/2/1981 (Alwynne Mackie, *Roger Kemp and Meaning in Art*); 24/3/1987 (Gillian Forward, *Roger Kemp and the Example of Rupert Bunny*); 25/3/1988.

KEMPF, Franz

(b. 26/6/1926, Melb.) Painter, printmaker, teacher.

STUDIES: Prahran Tech. Coll., 1942; Swinburne Tech. Coll., 1944–45; NGV School, 1946–47; Uni. of Perugia, 1956; Salzburg, with Kokoschka, 1957; travel studies (printmaking) Israel, 1965; Israel, Europe, England, 1975. Best-known for his meticulous, abstract, firmly structured paintings and prints, he exhibited in many important exhibitions and worked as a film designer and advertising director. He was president of the CAS, SA, 1965–68. He held about 17 solo exhibitions 1966–92 in private galleries in most Australian capital cities including Charles Nodrum, Melbourne; Kensington, Adelaide; and touring exhibition of graphic works, Vic. regional galleries 1992. Group exhibitions in which his work appeared include numerous print survey shows in Australia and internationally and general survey exhibitions including *Recent Art from SA*, CAS Adelaide 1974; *Twelve Australian Lithographers*, PCA travelling exhibition 1975; *Australian prints 1980*, PCA touring; *Painting in South Australia Today*, AGSA 1981; *Mini Prints*, PCA Melbourne 1984; *Australia: A Different Vision*, Landell Studios, Carmel, California 1987. Author

of *Contemporary Australian Printmakers*, Lansdowne, Melbourne, 1976.

AWARDS: Prizes, mainly for graphics in Adelaide (Cornell CAS), 1964; Geelong, 1965; Sydney (Great Synagogue), 1965; Albury, 1966; Sydney *(Mirror-Waratah*, and Associated National Insurance), 1967; Adelaide (Vizard-Wholohan, watercolour and print prizes), 1967; Zamel prize (painting), 1968; Alice Springs (Alice prize), 1972; Mornington (MPAC Prints), 1974; Dorothy Douglas Bequest, Swan Hill, 1991.

APPTS: Lecturer, RMIT, 1960–61; SASA, 1961– ; senior lecturer, printmaking, SASA, 1973– ; guest lecturer including art, Slade School of Art, London, Edinburgh Coll. of Art 1979, 81.

REP: NGA; AGNSW; AGSA; AGWA; MAGNT; NGV; QAG; QVMAG; TMAG; Parliament House; Artbank; many regional galleries, tertiary collections all states; Victoria and Albert Museum, London; public collections Israel; corporate collections including BHP, Hilton International, Adelaide.

BIB: Catalogue essays in numerous exhibitions as above. Most major texts on Australian art including Nancy Benko, *Art and Artists of South Australia* Adelaide; Campbell, *AWP*; Smith, *AP*. George Berger, *Franz Kempf*, Brolga Books, Adelaide, 1969. N. Weston, *Franz Kempf; Graphic Works*, Wakefield Press, Adelaide 1984. PCA, *Directory*, 1976, 1989. *A&A* 14/1/1976 (David Dolan, *Franz Kempf*)

KEMPSON, Michael
(b. 1961, Kapunda, SA) Painter, printmaker.
STUDIES: BA Visual Art, City Art Inst., 1982; postgrad. dip., City Art Inst., 1983; Dip. Ed., Sydney CAE, 1986–87; enrolled MFA, Coll. of Fine Arts, Uni. of NSW, 1992– . He held seven solo exhibitions 1983–90 largely at Rex Irwin, Sydney and Riverina Galleries, Wagga Wagga. He participated in numerous group exhibitions 1981–92, largely print survey shows including with Sydney Printmakers; Seoul International Print Biennale 1986, 88; Fremantle Print Award 1990; *Sun, Smoke, Steel*, national travelling print exhibition, Studio One Print Workshop, Canberra 1990; MPAC Print Prize 1990, 91.

APPTS: Head of printmaking dept, Meadowbank Coll. of TAFE, 1986.

REP: Artbank; regional galleries Burnie, Broken Hill, Hamilton, Orange, Rockhampton, Wagga Wagga; several tertiary colleges including Sydney CAE; Vic. Dept of Education; Sir William Dobell Foundation; Commonwealth Bank; Faber-Castell collection.

BIB: *A&A* 21/1/1983.

KENNEDY, Peter
(b. 1945, Brisbane) Environmental artist, performance artist.
STUDIES: Brisbane, drawing with Jon Molvig, 1964–66; NAS, Sydney, 1965–66. He exhibited in avant-garde exhibitions in Brisbane, Sydney and Melbourne, notably the Dr Harald Szeemann exhibition at the Bonython Gallery, Sydney, in which he changed the sounds of wind in a tree by tying down the branches and using foam pads. In another exhibition (at Gallery A, Sydney, 1971) he was identified in the catalogue as a 'per-

former-composer with AZ music'. From 1971 he conducted Idea Demonstrations with Mike Parr, first in Sydney, then in Canada and Switzerland. Since, he has become a leading post-conceptual, installation and video artist exhibiting widely in numerous survey exhibitions including *Bienale of Sydney* 1979, 84; *Australian Perspecta*, 1981; and in contemporary art spaces such as EAF, Adelaide; Artspace, Sydney.

REP: AGNSW; AGSA; NGV; Tate Gallery, London; ICA, London; uni. collections, including Flinders, SA.

BIB: Smith, *AP*. Sturgeon, 'DAS'. *AI* June 1973 (Donald Brook, *Idea Demonstrations*).

KENYON, George
Artist of the Victorian goldfields. From the primitive style of his work generally considered to have been an amateur.
REP: La Trobe Library (set of watercolours of the goldfields).
BIB: McCulloch, *AAGR*.

KEOGH, Rex
(b. 1943, Vic.) Sculptor, painter.
STUDIES: RMIT (industrial arts), 1963–64 and 1972–73; Bendigo Inst. of Technology, 1967–69; travel studies, Europe and UK, 1975; Japan, 1978. From 1974 he lectured on sculpture and metal studies at RMIT and held exhibitions in Melbourne, Sydney, Fremantle and Shepparton. His sculptures are abstractions in which the character of the materials used and their interaction determine the results. Stainless steel and other metals, cloth, wood and glass are used, sometimes symbolically and sometimes purely as construction materials.

AWARDS: VACB grant, 1974; Winston Churchill Fellowship (for overseas study), 1975; grants for travel and work in Japan and WA, 1978, 79.

REP: NGA; NGV.

BIB: Scarlett, *AS*.

KERMODE, W. A.
Painter. Assistant at biological laboratory, Uni. of Tas. He studied and practised painting after settling in London in 1911, exhibited his linocuts and served in the Tank Corps, World War I. His work was included in the exhibition, *Australian Paintings and Sculpture*, Faculty of Arts Gallery, London, 1924.

BIB: *Studio* London vol. 87, no. 234, 1924 (*W. A. Kermode*, Notes overseas). Moore, *SAA/*

See EXHIBITIONS

KERR, Alexander
(b. 1875, Inverness, Scotland; arr. Melb. in childhood; d. 1950, Melb.) Painter, picture framer. A capable watercolourist in the Australian manner developed by Streeton, Herbert, Gruner and many others in the 1920s, he was a well-known, popular personality who conducted a picture-framing business at the Eastern Market, Melbourne. He was also a musician; his son, Colin, became a member of the Melbourne Symphony Orchestra.

KEWLEY, Brian David

(b. 21/1/1933, Melb.) Painter, lawyer.
STUDIES: No formal training. Well-known for his colourful, panoramic paintings of cities and seaside suburbs he was vice-president of the CAS, Vic., 1962–68; runner-up McCaughey Prize 1965. He held about 13 solo exhibitions 1965–90 mainly in Melbourne (Pinacotheca, Warehouse, Niagara, Clive Parry, Flinders Lane). In 1989 he retired as partner in law firm to devote himself full-time to painting.
AWARDS: Prizes in CAS exhibitions, Melbourne, 1964, 66; VAS exhibitions, 1965; Flinders Art Prize exhibitions, 1981, 82, 91.
REP: NGV; QAG; Artbank; Reserve Bank.

KEYES, Eileen

(b. 1903, NZ) Ceramicist, teacher.
STUDIES: School of Art, Christchurch, NZ; Chelsea School of Arts and Crafts, London; travel studies, Sweden, Japan and USA.
APPTSP: Teaching, Armadale High School, WA, –1976– .
REP: AGNSW; AGWA; NGV; QAG.

KEYS, David

(b. 1925, Newcastle-upon-Tyne, Eng.) Painter.
STUDIES: RMIT, –1959– ; London, 1965. As exhibited during the 1960s his hard-edge paintings concerned the harmony of colour and pattern. He exhibited in Georges first Invitation Art Prize, 1963, and after his return from the UK started the artists' materials business, Art Stretchers, in Carlton, Vic.
AWARDS: British Council grant, 1965.
REP: NGV.

KEYWAN, Orest Nicholas

(b. 19/12/1944, Germany; arr. Aust. 1951) Sculptor.
STUDIES: NAS, Sydney, 1966. He was brought up in Canada, held his first exhibition at the Bonython Gallery, Sydney, in 1969, and participated in the *Mildura Sculpture Triennial* in 1970. Of his exhibition at Annandale Galleries in 1991, Lynette Fern (SMH, 24 May 1991) wrote: 'sculptural pieces explore the ambiguities of space and matter . . . very tactile but deceptive in what they proffer to the touch . . . nothing is quite as it seems to be. Even the surfaces of the metallic elements have been altered . . . The signals to sight and touch are deliberately set up to confuse.'

KILBURN, Douglas Thomas

(b. c. 1813, England; d. 1871) Painter, photographer.
Daguerreotype photographer who worked in Melbourne; Sydney and Tasmania 1847–1870 also member of parliament and wealthy property owner. He exhibited in contemporary exhibitions including the 1855 Paris Universal Exhibition. He photographed views of local landmarks, and Aboriginal inhabitants.
REP: NGV; TMAG; NL.
BIB: J. Cato, *The story of the Camera in Australia*, Melbourne

1955. C. Craig, *More Old Tasmanian Prints*, Foot & Playstead, Launceston, 1984. Kerr, DAA.

KILGOUR, Jack (John Noel)

(b. 3/10/1900, Melb.; d. Sept. 1987) Painter, teacher, commercial artist.
STUDIES: RAS, Sydney, 1919; Sydney Art School (with Julian Ashton and Henry Gibbons), 1924–30; St Martin's School of Art, Chelsea Polytechnic, and Royal Art School, London, 1938. Kilgour, a competent painter of figures and landscapes at illustrative level, exhibited at the New English Art Club and the RA, London, where he and his wife, Nancy, supported themselves by illustrating books. He returned to Australia in 1939 and taught at the ESTC, 1939–70. He held about ten solo exhibitions in most capital cities 1940–83 including at Macquarie, Sydney; Philip Bacon, Brisbane and Stanley Coe, Melbourne; a retrospective at Newcastle Regional Art Gallery in 1977; and joint exhibitions with Arthur Murch (1972), Nancy Kilgour (1943, 46, 50) and H. V. Justelus (1967).
REP: NGA; AGNSW; AWM; regional galleries Ballarat, Newcastle.
BIB: *New South Wales Society of Artists*, Book, Sydney, 1942. A&A 16/2/1978 (Joanna Mendelsohn, *J. N. Kilgour*).

KILLICK, Stephen

(b. 26/9/1947, London) Sculptor, stage designer.
STUDIES: SASA, 1965–67; NGV School, 1971–72. He designed for productions at the Pram Factory and La Mama Theatre, Melbourne, 1976, 1977. His painting is concerned with mystic symbolism. He held 17 solo exhibitions 1970–92, including at Irving Sculpture, Sydney and Michael Milburn Brisbane. Sculpture commissions include for Heide Park and Art Gallery 1975; World Expo, Brisbane 1988 and Adelaide Festival Centre 1989; *Third Sculpture Triennial*, Melbourne 1990 and his work appeared in *Mildred Endowment*, NGV, Melbourne, 1981; *Diversity in Australian Art*, QAG 1987.
AWARDS: Residency, Air & Space studio, London, VACB, 1972; Kangaroo 4th annual sculpture award, 1990.
APPTS: Lecturer, painting, Brisbane School of Art, 1974; Northern Riverina CAE, Wagga Wagga, 1978.
REP: NGA; AGSA; NGV; QAG; Parliament House; Heide Park and Art Gallery; Brisbane Town Hall.
BIB: Sturgeon, *Contemporary Australian Sculpture*, Craftsman House, Sydney, 1991.

KING, Grahame

(b. 23/2/1915, Melb.) Painter, printmaker.
STUDIES: NGV School, 1934–39; George Bell School; Central School of Art, London, 1947–49; Paris and Rome, 1949–50; British Council study tour Europe, USA, 1969–70; travel study Japan (1974, 76, 82), Europe (1976, 82), USA (1990). Apart from producing strongly designed, abstract painting, King played a leading part in helping to raise the standards of printmaking in Melbourne. He worked as a lithographer and photolitho colour etcher, 1938–42, and

was a foundation member and first honorary secretary of the PCA, 1966, president c. 1979–1984. A retrospective exhibition of his prints was held in Victorian regional galleries, 1975–76. His 1993 exhibtion of monotypes at Melbourne's Eastgate Galleries showed an undiminished quality and some finely-controlled complexity of colours and shapes. He often exhibits jointly with his wife, Inge King. He held about 7 solo exhibitions 1975–93 including at Tynte Gallery, Adelaide and Realities, Eastgate, Melbourne and participated in numerous group exhibitions, especially touring print exhibitions (often PCA-organised) internationally and in Australia including *Second South Pacific Print Biennale*, touring 12 countries 1978; *Twelve Melbourne Printmakers*, Oxford, UK 1982; *Recent Australian Prints*, RMIT gallery 1984; *Classical Modernism: The George Bell Circle*, NGV 1992.

AWARDS: British Council travel grant, UK and USA, 1969–70; PCA member print commissioned, 1971; AM for service to art education, 1991.

APPTS: Lecturer, art, RMIT, 1966–88.

REP: ANG; AGNSW; AGSA; AGWA; MAGNT; NGV; Parliament House; many regional galleries; BHP corporate collection; Victoria and Albert Museum, London; Aust. Embassy, Washington.

BIB: Catalogue exhibitions as above. PCA, *Directory* (all editions).

KING, Inge

(b. 26/11/1918, Berlin; arr. Aust. 1951) Sculptor.
STUDIES: Berlin Academy, 1937–38; RA Schools, London (scholarship), 1940; Glasgow School of Art (bursary), 1941–43; travel studies, France, Italy, ISA, 1949–50. She taught art in Glasgow and London, 1944–49, married painter and printmaker Grahame King, and worked as a jewellery maker and sculptor during her first years in Australia. She made her name as a modernist sculptor with large commissioned works from 1953 and exhibitions as well as her winning design for the RAAF Memorial, Canberra, 1971. Her monumental pieces in black welded steel have appeared in most important Australian sculpture exhibitions since 1950 to establish her as a leader in contemporary Australian sculpture. She held some 20 solo exhibitions 1949–93 in London, Melbourne (including Powell St, Realities, Uni. Gallery, Melbourne Uni., Australian), Sydney (Coventry, Bonython-Meadmore) and Adelaide (BMG), and at Deakin Uni., Geelong 1990, and numerous exhibitions jointly with Grahame King. In 1975–76 a major exhibition of the Kings' work toured regional galleries and in 1992 a retrospective of her work was held at the NGV. Some notable commissions include *Forward Surge*, the *Wave* sculptures outside the Victorian Arts Centre, Melbourne; the Lawn of Uni. House, Canberra and Union Lawn, Uni. of Melbourne; ICI House, Melbourne.

AWARDS: Eltham prize, 1965, 67; Adelaide Festival prize, 1968; British Council Travel Grant, 1969; RAAF Memorial prize, Canberra, 1971; Uni. of Qld Schonell Memorial Fountain prize, 1971; *Mildura Sculpture Triennial*, 1975 (work acquired); VACB travel grant,

1980; Order of Australia (AM), 1984; Alice Prize, 1984; Royal Blind Society Sculpture Award, 1987; D. Litt., Deakin Uni., 1990.
APPTS: Inst. of Early Childhood Education, Melb. 1961–75; sculpture, RMIT, 1976–87.
REP: NGA; NGV; MAGNT; QAG; TMAG; Parliament House; Artbank; regional galleries Mildura, Newcastle, Geelong, Gold Coast, McClelland; many uni. and other public collections; Aust. Embassy, Washington DC.
BIB: Catalogue essays in exhibitions as above. Lenton Parr, *Sculpture*, Arts in Australia Series, *Longman*, Melbourne, 1961. Sturgeon, *DAS*. Scarlett, *AS*. Germaine, *AGA*. *New Art Four*. *A&A* 4/2/1966 (Centre 5).

KING, Philip Gidley

(b. 1758, Cornwall; d. 1808, London) Governor of NSW, 1800–06, also a skilful amateur artist.
REP: Mitchell Library.
BIB: Rienits, *Early Artists of Australia*, 1963. ADB 2. Jonathan and John King, *Philip Gidley King: a Biography of the Third Governor of New South Wales*, Methuen, Sydney, 1981. Kerr, *DAA*.

KING, (Rear Admiral) Phillip Parker

(b. 13/12/1791, Norfolk Island; d. 15/2/1856, Sydney) Topographical artist. Third son of Philip Gidley King (q.v.) from 1818 to 1822 he commanded surveying expeditions of the areas of the Australian coast not covered by Matthew Flinders in 1801–03. He was in England from 1823 preparing the text and plates of his *Narrative of a Survey of the Intertropical and Western Coasts of Australia* (London, 1827), which included topographical views of the coast of WA. He also made drawings of Raffles Bay, Southwest Bay, Goulburn Island, Asaph Bay and Port Essington. From c. 1827 to c. 1830 he surveyed the Pacific coast of South America, after which he retired from the Navy, returning to Australia in 1832. In 1837 he drew a view of the house of Captain Lonsdale, the first government residence in Melbourne (J. A. Panton, q.v., made an oil painting from the sketch in 1880). At King's death Conrad Martens recorded the official naval funeral in a painting. His work was seen in *The Colonial Eye*, AGWA, 1979; Christie's, *Australian Paintings*, Sydney, 24 Sept. 1969.
REP: AGWA; Mitchell Library; J. S. Battye Library of WA History, Perth.

KING, Theodore K.

Painter. Artist of the Victorian goldfields. The picture by which he is best known is a small oil painting in the Bendigo Art Gallery entitled *The First Parliamentary Election, Bendigo, 1855*. It celebrates the success of the local candidate, Dr John Downes Owens (1809–66) and his crowd of supporters outside the Criterion Hotel, Bendigo. He exhibited in the 1866 *Intercolonial Exhibition* and was represented in *The Face of Australia* Bicentennial exhibition drawn from regional gallery collections, touring 10 regional galleries Australia 1988–89.
BIB: McCulloch, *AAGR*, 1977. Kerr, *DAA*.

KINGSLEY, Garrett

(b. 1915, Sydney; d. 1981) Painter.
STUDIES: Julian Ashton School, Sydney; ESTC. Known for portraits, he was a regular contributor to the Archibald competitions. Fellow of the RAS of NSW and a member of the Australian Art Society. A portrait by Kingsley, submitted for the *Australian Women's Weekly* portrait prize, 1955, was among those selected for interstate exhibition.
AWARDS: Bathurst prize (oil), 1963; Blue Mountains prize (portrait or figure painting), 1963.
REP: AGNSW.

KINGSTON, Amie

(b. 29/11/1908, Hobart) Painter, teacher, printmaker, stage designer.
STUDIES: Hobart Tech. Coll., 1924–27, with Mildred Lovett, Lucien Dechaineux; Julian Ashton School, Sydney, 1932–33; privately with Thea Proctor; Central School of Art and Craft, London; Westminster School, London; Slade School (stage design with Vladimir Polunin), London. She made ballet costumes for Sadler's Wells Ballet Company before returning to Sydney in 1940 where, 1942–45, she designed for the Helene Kirsova Ballet Company and opera studio of the Sydney Conservatorium. She exhibited with the Sydney Society of Artists in the 1940s and leading Sydney galleries including Macquarie, Irving, Woolloomooloo and Blaxland.
AWARDS: Betty Malcolm scholarship for stage and decorative painting, Uni. of London, 1939.
APPTS: Teaching, Hobart, Tech. Coll., 1930–38; Sydney Design School, 1948–53; ESTC children's classes, 1951–64; NSW correspondence schools, 1958–76; NSW Arts Council junior art summer schools, 1966–70.
REP: NGA; AGMSW; TMAG; regional galleries Ballarat, Armidale.
BIB: Horton, *PDA*. Backhouse, *TA*. Germaine, *AGA*. Campbell, *AWP*.

KINKA, Arpad

(b. 1952, Hungary; arr. Aust. 1968) Painter.
STUDIES: NAS, Sydney, 1970–74; travel studies, Europe, 1976–77. He was artist-in-residence at the Power Inst. studio, Cité Internationale des Arts, Paris, and Owen Tooth Memorial Cottage, Vence, 1976–77, after his first exhibition at the Griffith Gallery, Canberra, 1975. From 1971 his Op style, striped paintings have appeared in many group exhibitions, including exhibitions at the AGNSW and ICA, Sydney, and the MPAC *Spring Festival of Drawing*, 1979.
AWARDS: VACB grant for studies overseas, 1976; prizes in competitions at Penrith, 1975; Liverpool, 1975; Campbelltown, 1975; Wollongong, 1976.
REP: Regional gallery Wollongong.

KIRK, Peter

Painter.
STUDIES: Artisans School of Design, Carlton, Vic., 1867; NGV School, 1870– . He was a prizewinner at the Statewide *Exhibition of Students' Work*, Melbourne,

12 July 1863, and first president of the Past NGV Gallery Students Society, 1916.
BIB: Moore, *SAA*.

KIRK, Ronald Hugh

(b. 1920, Melb.) Painter.
STUDIES: RMIT. Kirk was secretary of the Independent Group, Melbourne, 1960–63. Part regional and part romantic in conception, his capably painted, middle-of-the-road pictures have appeared in many competitive and VAS exhibitions.
AWARDS: Moomba Motif competition, Melbourne, 1954; Bendigo prize, 1955; Wagga Wagga prize, 1957.
REP: Bendigo Art Gallery; Monash Uni. collections.

KIRWAN-WARD, Jeremy

(b. 13/7/1949, WA) Painter.
STUDIES: Graphics and Fine Art, Perth Tech. Coll., 1967/68; associateship Fine Art, Curtin Uni. of Technology, 1971; travel studies Asia, Middle East, Europe, 1969–70; worked in England, Netherlands 1972–74. He participated in about 15 group exhibitions 1971–91 at private galleries in Perth (Greenhill) and Sydney (Holdsworth), and in public exhibitions including *Ten Young WA Artists*, Undercroft Gallery, Uni. of WA 1976; *Australian Colourists*, Curtin Uni. of Technology 1977; *BP Invitation Award*, AGWA 1986; *The Fremantle Dozen*, Fremantle Art Gallery 1987. His 11 solo exhibitions 1971–91 were at private galleries in Perth (Skinner; Greenhill Perth Galleries), at Fremantle Art Gallery 1989 and in India (Ahmedabad 1990).
AWARDS: Regional awards at Geraldton 1985; Tresillian Drawing prize, Nedlands, 1986; Katanning Drawing Award, 1987; fellowship, WA Creative Development Fund, 1987.
APPTS: Tutor, drawing and painting, Curtin Uni. of Technology, 1982–86; tutor, drawing and painting, Edith Cowan Uni., 1988–89, 90–91.
REP: NGA; AGWA; Artbank; ANU; Uni. of WA; Edith Cowan Uni.; Royal Perth Hospital; Rural & Industries Bank, Woodside Petroleum, IBM, Robert Holmes à Court corporate collections.
BIB: Catalogue *Rural and Industries Bank of Western Australia Art Collection*, 1988. Murray Mason, ed., *Contemporary Western Australian Painters and Printmakers*, Fremantle Arts Centre Press, 1979.

KITCHING, Michael Digby

(b. 1940, Hull, Eng.; arr. Aust. 1952) Sculptor.
STUDIES: No formal art training. His early works, such as *The Last Supper – Premonition*, with which he won the Blake Prize in Sydney in 1964, were junk assemblages. His interests had changed by 1967 when his *Phoenix II* was shown at the *Mildura Sculpture Triennial*. It was made from aluminium and coloured perspex and illuminated by electricity. A still later work, entered for the Transfield Prize in 1970, showed the use of greatly simplified, monolithic forms. The solidity of his cross, sphere and cube shapes in aluminium suggested that Kitching was moving finally

towards a new kind of monumentality, a trend that continued in his Comalco prize exhibit of 1971. During 1978–79 he turned to industrial design, specifically the design of the computer selected as a finalist in the 1979 Prince Philip awards for industrial design.
AWARDS: Prizes in competitive exhibitions in NSW; Blake, 1964; CAS, Taffs, 1964; Young Contemporaries, 1965; R.Ag.Soc.NSW, 1966; Muswellbrook, 1966; Berrima, 1966; Flotta Lauro, 1967; *Mildura Sculpture Triennial* (work acquired), 1967; Alcorso-Sekers travelling scholarship, 1967.
REP: NGA; AGWA; regional galleries Ballarat, Mildura, Launceston.
BIB: Sturgeon, *DAS*. Scarlett, *AS*.

KLEIN, Deborah Lee

(b. 4/12/1951, Melb.) Painter, printmaker.
STUDIES: BA Fine Art, Chisholm Inst. of Technology, 1984; grad. dip. fine art, Gippsland Inst. of Advanced Education, 1988; lived London, 1973–80. Her work was seen in about 20 group exhibitions 1984–92 including PCA exhibitions; MPAC *Spring Festival of Prints and Drawings*, 1984, 86, 88, 91; *Visions of Australia*, Gryphon Gallery, Uni. of Melbourne, 1990. She held four solo exhibitions 1984–85 at private galleries in Adelaide (Tynte 1987) and Melbourne (Port Jackson Press 1988; Australian 1992), and a touring exhibition *The Pirate Jenny Prints*, published by Port Jackson Press touring regional galleries 1990.
AWARDS: Arches Rives, 1984; Henri Worland Print Award, Warrnambool gallery, 1989; residency, Paris studios, VACB, 1993.
REP: QVMAG; Artbank; PCA; Aust. Print Workshop; SLV; regional galleries Hamilton, Ipswich, Warrnambool, Devonport; Fremantle Arts Centre; municipal collections Diamond Valley, Box Hill, St Kilda; tertiary collections including Uni. of Tasmania; Melb. CAE; Brisbane CAE; corporate collections including OTC, Comalco.
BIB: Catalogue essays in print exhibitions as above. PCA, *Directory* 1988. *150 Victorian Women Artists*, 150 celebrations, Melbourne 1985. Germaine, *AGA*. Germaine, *DAWA*.

KLEPAC, Lou

(b. 1/9/1936, Yugoslavia; arr. Perth 1950) Museum curator, art historian, publisher.
STUDIES: BA, Uni. of WA, 1955–57. As curator of paintings at the AGSA, he organised the exhibition *Sickert Paintings* in 1968 and became known in Adelaide for his critiques for the *News*. Later, as Deputy Director of the AGWA, he organised a series of fine exhibitions. He lived in Sydney from 1980, where he established the Beagle Press to publish fine art books. He wrote and published books on Russell Drysdale, Louis James, Kenneth Jack, Nora Heysen, Shay Docking Drawings, Louis Kahan and *James Gleeson; Landscape out of Nature*; *Judy Cassab: Artists and Friends*. He has also produced some of the AGNSW major catalogues including retrospectives on Donald Friend and Arthur Boyd.

Exhibitions he curated and produced catalogues or books on 1992–93 included *David Strachan* S.H. Ervin Gallery and touring and *The Road to Berry* of the drawings of Whiteley and Rees.
AWARDS: Appointed Cavaliere by Italian Govt for contribution to understanding of Italian art and sculpture, 1983.
APPTS: Curator of paintings, AGWA, 1964–66; curator of paintings, AGSA, 1966–70; art critic, the *News*, Adelaide, 1967–70; senior curator, then deputy director, AGWA, 1974–80.

Robert Klippel, No 785, 1988, painted wood, 89 × 114 × 81cm. Courtesy Watters Gallery.

KLIPPEL, Robert Edward

(b. 19/6/1920, Sydney) Sculptor, artist, teacher.
STUDIES: ESTC, 1944–46; Slade School, London, 1947. He served in the Royal Australian Navy during World War II and began making models, the activity that foreshadowed his involvement with sculpture. Crucial to his development was his first trip overseas. Among his London friends were Oliffe Richmond, and James Gleeson whom he met while living with other Australians at the Abbey Art Centre. In Paris his work excited the interest of André Breton, who arranged for his exhibition at the Nina Dausset Gallery in June 1949. Klippel's sculptures at this time took the form of wooden rod constructions joined by reels, some painted. Contacts made in Paris ultimately resulted in his first teaching job in the USA. His marriage took him back to Australia in 1950 when, to earn a

living, he worked for four years as a salesman, then three as an industrial designer. In 1957 he went to New York where he worked at his sculpture before taking up his first teaching appointment at Minneapolis. Another period in New York followed and it was then that he started experimenting with welded metal junk sculpture, the work exhibited in Sydney after his return in 1963. Unlike his Sydney exhibitions of 1951 (Macquarie Galleries), his 1963 exhibition (Terry Clune Galleries) created widespread interest and was in fact a prelude to his recognition as one of the most vital Australian sculptors of the post World War II era. In 1988 he was commissioned by the SA Dept for the Arts for a bronze sculpture in the Adelaide Plaza. He held some 35 solo exhibitions 1949–92 including several major retrospectives in state and other public galleries (AGMSW 1975, 83, 89; Heide Park and Art Gallery 1987). His work appeared in most major sculpture and general survey exhibitions of Australian art from 1948 including *Australian Sculpture Triennials*, 1984, 90; the Bicentennial exhibition *The Great Australian Art Exhibition*; *Diverse Visions*, QAG 1991; *Contemporary Australian Drawing*, MOCA, Brisbane 1992. The NGA held a retrospective of his work in 1993.
AWARDS: *Minnesota Biennial* (second prize), 1961; *Mildura Sculpture Triennial* (work acquired), 1964.
APPTS: Instructor in sculpture, Minneapolis School of Art, 1958–62; visiting professor, 1966–67; teaching, ESTC, 1967–68 (part-time, 1968–75); Alexander Mackie CAE, 1975–79.
REP: NGA; AGNSW; AGSA; AGWA; MAGNT; NGV; QAG; QVMAG; TMAG; most regional galleries; Museum of Applied Arts and Sciences, Sydney.
BIB: Catalogue essays in exhibitions as above and many others including solo exhibitions at Watters 1979; 1990. Lenton Parr, *Sculpture* (Arts in Australia) series, Longman, Melbourne, 1961. Sturgeon, *DAS*. Scarlett, *AS* Smith, *AP*. *A&A* 2/1/1964; 24/1/1986; 25/3/1988. *AL* 7/4/1987–88.

KLUGE-POTT, Hertha

(b. 16/12/1934, Berlin; arr. Melb. 1958) Printmaker, teacher.
STUDIES: Braunschweig School of Applied Art, Germany, and Berlin Academy of Art, 1953–58; Dip. Fine Art, RMIT, 1960–63; travel studies, Spain, Italy and Germany, 1964–65; Germany, Italy and UK, 1974–75. She became known as an accomplished printmaker while still a student at RMIT and her intaglio and other prints appeared regularly after that time in many important exhibitions of Australian prints. She established a printmaking workshop at the Melbourne State Coll. where she lectured in printmaking and drawing 1968–78. She held about seven solo exhibitions 1972–90 in Melbourne (including at Stuart Gerstman, Powell St), Brisbane, Canberra and Geelong and participated in a number of group exhibitions, largely printmaking, including award exhibitions at Fremantle 1985–91; MPAC Spring Festival 1984, 86, 88, 90; Henri Worland, Warrnambool 1981, 87, 90, 91, 92; and in touring exhibitions organised by PCA.
AWARDS: Geelong Print prize, 1966; Henri Worland

acquisitive prize, Warrnambool Art Gallery 1987, 89, 91; MPAC acquisitive 1982, 84, 88.
APPTS: Lecturer, printmaking, Melb. State Coll., 1968–78; RMIT, 1979–92.
REP: NGA; AGNSW; AGSA; NGV; QAG; PCA; Artbank; a number of regional galleries including Ballarat, Geelong, Newcastle; tertiary and government collections ACT, NSW, Vic.; corporate collection BHP; Ostrow City Museum, Poland.
BIB: Franz Kempf, *Contemporary Australian printmakers*, Lansdowne 1976. *Women 150*, 1987. PCA, *Directory* 1976. Germaine, *AGA*.

KMIT, Michael

(b. 1910, Stryj, western Ukraine, 1910; arr. Sydney 1950; d. July 1981, Sydney) Painter.
STUDIES: Academy of Fine Arts, Cracow. Kmit taught painting in Lvov, Poland, and Landeck, Austria, after World War II (in which he served) and worked in Italy, Paris and Vienna before arriving in Australia where his paintings, based on traditional acquaintance with the Byzantine icon, soon brought him into prominence. At the height of his Sydney success in 1958 Kmit left for the USA, where he spent seven years before returning to Sydney in 1965. During this period his work developed a new command of form in which the early influences of Byzantine iconography combined with peasant craft to produce a powerful architectonic unity.
AWARDS: Blake prize, 1953; Perth prize, 1954; Critics' prize for contemporary art, 1955; Darcy Morris Memorial, 1956; Sulman prize, 1957, 70; Melrose, 1967.
REP: NGA; AGNSW; NGV; TMAG; uni. collections in Sydney and Brisbane.
BIB: Bonython, *MAPS*. *AI* vol. 14, no. 4, Apr. 1970. *A&A* 19/3/1982.

KNGWARREYE, Emily Kame

(b. c. 1916, Alalgura, NT) Painter of the Eastern Anmatyere tribe. A brilliantly successful blending and merging of colours imbues her paintings with a glowing abstract quality and she has become one of the most well known and highly regarded Aboriginal painters of the 1980s. She held solo shows with Coventry, Sydney, 1990; Gabrielle Pizzi, Melbourne, 1990, 91, 92 and Hogarth, Sydney, 1991 and her work was included in numerous group exhibitions nationally and overseas including in *Contemporary Aboriginal Art*, Carpenter Centre for the Visual Arts, Harvard Uni, Massachusetts, USA, 1990; *Aboriginal Paintings from the Desert*, touring Russia, 1992; *Crossroads, Towards a New Reality, Aboriginal Art from Australia*, National Museum of Modern Art, Kyoto and Tokyo, 1992; *Aratjara – Australian Aboriginal Art*, touring Germany, London (Hayward Gallery) and Denmark (Louisiana regional gallery) 1993, NGV, 1994.
AWARDS; Australian artist's creative fellowship, VACB 1992.
REP: NGA; NGV; QAG; AGWA; AGSA; Araluen Arts Centre, Alice Springs, Benalla regional gallery; Auckland City

Art Gallery, NZ; Robert Holmes à Court Collection.
BIB: Catalogue essays exhibitions as above. Most books on contemporary Aboriginal art including Caruana, AA.

KNIGHT, Warren

(b. 1941, Minneapolis, USA) Painter, printmaker.
STUDIES: Minneapolis School of Arts. From 1969 he held a number of exhibitions in Melbourne (Pinacotheca and Tolarno galleries 1969, 70) and Sydney (Watters Gallery, 1971) and was among those selected for a special modernist exhibition by Dr Harald Szeemann during his Australian visit, 1971. Painted with acrylic modelling paste on canvas, his abstract paintings show thick, script-like meshes of black over white, alternating with white over black. In Oct. 1970 he participated in *The Garden Party* (Happening) together with Guy Stuart and Ti Parks at the *Age* Gallery, Melbourne. He returned to the USA in the 1980s and has not exhibited in Australia, and little at all, since.
REP: AGNSW; regional galleries Ballarat, Newcastle; Tas. CAE.

KNIGHT, William

(b. 15/3/1809, London, UK; arr. Aust. 1827; d. 30/6/1877, Hobart) Watercolourist, merchant. An amateur painter and collector he contributed works to the 1846 and 1858 Hobart Town art exhibitions and was represented in *Tasmanian Vision* TMAG and QVMAG 1988.
REP: Allport Library, Hobart.

KNIGHTS, Samuel

(b. c. 1818. England; arr. Vic. 1852; d. 1880) Painter His name is often misspelt Knight. He became known in Melbourne as the painter of prize animals for wealthy squatters in the 1850s and exhibited in contemporary exhibitions including *Geelong Mechanics Institute Exhibition* 1857. His work was seen in *Pastures and Pastimes* Vic. Ministry for the Arts, VAS, 1983.
REP: NGA; NLA; La Trobe Library.
BIB: Kerr, DAA.

KNORR, Hans

(b. 1915, Bamberg, Bavaria; arr. Aust. 1946) Sculptor.
STUDIES: Bavaria, with Deuerling. He lived in South Africa, 1934–46, before settling in Vic. where he completed many sculptures in bronze, wood, stone and mixed media, many commissioned for churches. With his wife, Hilde, and son, Michael, he conducted the Emerald Gallery, Vic., from 1961 and wrote *Religious Art in Australia* (with Hilde Knorr), Arts in Australia series, Longman, Melbourne, 1967.
BIB: *Sculpture of Hans Knorr*, Spectrum Publications, Melbourne, 1976. Scarlett, AS.

KNOX, William Dunn

(b. 1880, Adelaide; d. 1945, Melb.) Painter, businessman.
STUDIES: NGV School. Knox became the manager of the Eagle and Globe Steel Co. He was a council member of the Australian Art Association and VAS, and a foundation member of the Australian Academy of Art. His paintings of landscapes and harbour scenes attained a jewel-like quality of surface, and on a modest scale matched the best work of the post-Heidelberg School painters of Vic. and NSW.
REP: NGA; AGSA; AGWA; NGV.

KNY, Louis

(Active c. 1895, Melb.) Painter.
STUDIES: NGV School, c. 1893–96. William Moore writes that 'Quinn handed [the symbolic travelling scholarship mug] on to Louis Kny who justified the choice by winning most of the prizes the following year [?1894]'. He also quoted Lionel Lindsay recounting that: 'Living was cheap and rents were small in those days. The whole of the top floor of the North Melbourne Town Hall was occupied by George Coates, James Quinn, Leon Pole and Louis Kny, the rent for all being 10/6d per week'. Kny did not complete the course at the NGV School 'but having acquired the necessary funds went to London'.
BIB: Moore, SAA.

KOHLHAGEN, Lisette

(b. 1890, Adelaide; d. 1969, Adelaide) Painter, printmaker.
STUDIES: Adelaide, with Leslie Wilkie and Gwen Barringer; Sydney, with Maud Sherwood and Adelaide Perry; Melbourne, with George Bell. She travelled and exhibited extensively, showing in Adelaide, Sydney and Melbourne as well as in London. A member of the CAS in three cities, she also wrote critiques for the Adelaide *News* as well as being official guide lecturer at the AGSA. Best-known for her woodcuts and linocuts, subjects including street scenes and flower pieces.
REP: AGSA.
BIB: Rachel Biven, *Some forgotten . . . some remembered*, Sydenham Gallery, Adelaide, 1976.

KOLENBERG, Hendrik Cornelis Gysbertus

(b. 31/7/1946, Rotterdam; arr. Aust. 1952) Gallery curator.
STUDIES: Dip. Art Teaching, Western Teachers Coll., Adelaide and SASA, 1965–67. He was the curator of and writer and production co-ordinator for the catalogues of a number of significant exhibitions at the public galleries of which he has been on the staff, including at AGWA: *Ten Western Australian Printmakers*, 1978; *Robert Juniper Drawings 1950–80*, 1980; at TMAG: *Fred Williams: Bass Strait Landscapes 1977–78*, 1981; *Edith Holmes and Dorothy Stoner: Two Retrospectives*, 1983; (with Sue Backhouse) *Jan Senbergs Mining Landscapes, Mt Lyell*, 1984; *Tasmanian Vision: The Art of Nineteenth Century Tasmania*, 1988; for AGNSW: (with Barry Pearce) *Francis Lymburner Retrospective*, 1992; *Kevin Connor paintings and drawings* (with Barry Pearce); *Roger Kemp: The Complete Etchings; George Lambert drawings* (with Ann Gray). He wrote many exhibition catalogues for these and other exhibitions and several books including *Lloyd Rees: Etchings and Lithographs: A Catalogue Raisonné*, Beagle Press, 1988; *Kevin Connor: Haymarket Drawings*, Centaur Press, 1990.

APPTS: Education officer, AGSA, 1972; curator, prints and drawings, AGWA, 1976–80; editor *AGWA Bulletin*, 1979; curator of art, TMAG, 1980–88; editor *Art Bulletin of Tasmania*, 1983–86; curator of Australian prints, drawings, watercolours, AGNSW, 1989– .
AWARDS: Netherlands Government Scholarship, 1974; Harold Wright and Sarah William Holmes scholarship British Museum, 1982.

KOLLER, Christopher

(b. 9/9/1943, Yorkshire, Eng.; arr. Aust. 1952) Photographer.
STUDIES: Dip. art & design (photography), Prahran CAE, 1978–80; travel studies and work Europe, Asia, South America, Africa, USA, 1968–76; Japan, 1982–84; Mexico, 1988–89. He held 12 solo exhibitions 1981–91 in Melbourne (United Artists 1986, 88; Photographers Gallery 1981, 84), Sydney (Aust. Centre for Photography 1985, 88), Adelaide, Japan, London and Mexico. His work appeared in ten group exhibitions 1979–91 including *Twenty Contemporary Photographers*, NGA, AGNSW and touring regional galleries 1990–91; *A Constructed Reality*, NGV 1991.
AWARDS: VACB travel grant, 1982; VACB half-standard grant, 1985.
APPTS: Lecturer, Photographic Studies Coll., Melbourne, 1991– ; senior lecturer, photography, VCA, 1992.
REP: NGA; NGV; Bibliothèque Nationale, Paris; collections in Japan, Mexico.
BIB: Catalogue essays exhibitions as above. *Aust. Photography Yearbook*, 4 Seasons Press, Melbourne, 1983.

KOMON, Rudy

(b. 1908, Vienna; arr. Sydney, 1953; d. 27/10/1982, Sydney) Art dealer, gallery director, entrepreneur, oenologist. He began his professional career as a journalist in Czechoslovakia where he served with the Czech resistance movement during World War II. Arriving in Sydney, he opened an antique shop in Waverley and in 1958 converted a former wine shop in Woollahra into an art gallery, to begin his long career as promoter of contemporary Australian art and artists. Previously unknown in Australia, the European methods he applied to his entrepreneurial activities changed the situations of many of the younger artists of the 1950s, among them Brack, French, Jomantis, Kemp, Molvig, Olsen, Redpath and Williams. He also greatly advanced the interests of many older artists, notably Dobell, Drysdale, Nolan and Boyd, and later, a new generation of painters, including Whiteley, Aspden, Powditch and many others. A connoisseur of and expert in Australian wines, he entertained a long list of distinguished visitors in his gallery. He also made generous gifts of art works to art institutions and in many other ways made a valuable contribution to post-World War II development of Australian art.
BIB: *A&A* 20/3/1983 (Alun Leach Jones, *memorial tribute*).

KONG SING, Justine

(b. 1868; d. 1960) Painter. Known as a miniaturist.

REP: AGNSW.
BIB: John Kroeger, *Australian Artists*, Renniks, Adelaide, 1968.

KONING, Theo

(b. 24/9/1950, Avenhorn, Netherlands; arr. Aust. 1953) Sculptor, painter.
STUDIES: Dip. Fine Art (sculpture), Claremont School of Art, 1971–74. He participated in *Drawn and Quartered: Australian Contemporary Paperworks*, AGSA, 1980, in which his exhibit was made with colour Xerox, felt pen, stamps and 12 postcards. He taught sculpture at several art schools from 1976 including WAIT and Curtin Uni. of Technology (formerly WAIT) and from 1990 was lecturer in art and design at Central Metropolitan Coll., Perth. He was a member of several artists' organisations including WA Artworkers Union, 1980–84, and Artworks in Public Places Working Party, Fremantle City Council 1989. He held about 12 solo exhibitions 1975–92 largely in Perth (Galerie Düsseldorf) and in 1991–92 in touring exhibitions to WA and Qld regional centres. He participated in a number of group exhibitions including *Festival of Perth Exhibition*, Undercroft Gallery, Uni. of WA 1981; *Australian Perspecta*, AGNSW 1985; *Among the Souvenirs: WA Art in the 80s*, AGWA 1987; *Backward Glance: A Survey of WA Sculpture 1960s–90*, PICA 1991. He received a number of commissions including for the foyer of AGWA 1989 and fabric and poster designs.
AWARDS: Award of Merit, Waterway Farm Studios, 1973; undergraduate sculpture prize, Uni. of WA, 1974; VACB grants, 1976, 78, 80, 85; Guy Grey-Smith Memorial Travelling Fellowship, 1985; Mandorla Art Prize, 1985; BP Art Award, 1986.
REP: NGA; AGSA; AGWA; Parliament House; VACB: several tertiary, regional collections WA; corporate collections include Robert Holmes à Court, Christensen Foundation.
BIB: Catalogue essays in exhibitions as above and many others. *Contemporary Western Australian Painters and Printmakers*, Fremantle Arts Centre Press, 1979. B. Hawthorn, *Some Contemporary WA Painters and Sculptors*, Apollo Press, 1982. Scarlett, *AS*. Ted Snell, *Cinderella on the Beach, A Source Book of WA's visual culture*, Uni. of WA Press, 1991. *A&A* 22/3/1985.

KORN, Tibor

(b. 15/12/1926, Janoshida, Hungary; arr. Aust. 1950) Sculptor, ceramicist, teacher.
STUDIES: Dip. Art, Torino-Iurea, Italy (ceramics); Cert. Art, CIT, 1960–62 and RMIT, 1963; TTTC, Tech. Teachers Training Coll., 1967. He had about 10 solo exhibitions 1964–88 at smaller galleries in Vic. and at Shepparton Art Gallery in 1966 and 1973. Group exhibitions in which his work appeared include exhibitions at Eltham, Corio, Geelong and Bacchus Marsh and he was artist-in-residence for a number of secondary and community groups in Vic.
AWARDS: Prizes for painting and sculpture, Wodonga competitions, 1972, 73.

APPTS: Teaching, Victorian secondary schools 1965–88; part-time tutor, Inst. of the Arts, Deakin Uni. 1989– .

REP: Shepparton Art Gallery; several secondary schools, colleges Vic.

BIB: Scarlett, AS. Germaine, AGA.

KORWILL, Ferdinand G. (Ferry)

(b. 30/9/1905, Vienna; arr. Aust. 1938) Painter. Self-taught painter who started painting in 1950. He held a number of solo exhibitions in WA from 1955 (a work by him was included in *Artists from the West* exhibition, MOMAD, Melbourne, 1963) and from 1972 largely in the studio of his garden in Perth. Fremantle Arts Centre held a retrospective of his work in 1992 which showed his development from the landscape, city spaces and buildings of the 1950s to the broader-focus of works of 1960s due to travels in Asia and Europe. His 1970s and 1980s works are concerned more with the expressionist treatment of social issues.

AWARDS: Grant for retrospective exhibition, Govt of WA Dept of Arts, 1992.

APPTS: President of the AGWA, 1964– .

REP: AGWA; Uni. of WA; Curtin Uni.

KOSKIE, Jack Louis

(b. 23/7/1914, Yorkshire, Eng.; arr. Aust. 1939) Painter, printmaker, teacher, graphic designer.

STUDIES: Hull Coll. of Art; art studies Paris, Rome; ESTC; Dip. Art, Hobart Tech. Coll. He served with camouflage engineers in World War II, and afterwards worked as a commercial artist in Sydney. His mainly representational paintings are regularly exhibited in VAS exhibitions and in group exhibitions such as Sulman and Wynne Prizes, AGNSW and with Art Society of Tasmania, 1957–61. As graphic designer his work includes as the chief designer of Commonwealth Office of Education in Sydney and the Tasmanian Government Printer. He wrote and illustrated a book, *The Ships that Shaped Australia*, A&R, 1987.

AWARDS: *War at Sea* section of *Australia at War Exhibition*, 1945; a number of private company and municipal prizes; Cato prize, VAS, 1971; Roland prize, Latrobe Valley Arts Centre, 1971.

APPTS: Lecturer, painting, graphic design, printmaking, various colleges, 1954–79 including Hobart Tech. Coll. 1954–61, Mount Scopus 1961–75, Deakin Uni. 1975–79; printmaking at Gordon Inst. of Technology, –1974.

REP: TMAG; AWM; regional galleries Broken Hill, Latrobe Valley; public collections including NSW Govt House; Parliament House, Hobart; several tertiary collections including Hawthorn Inst. of Ed.

BIB: Germaine, AGA. PCA, *Directory*, 1988. Backhouse, TA.

KOSSATZ, Les

(b. 10/1/1943, Melb.) Painter, printmaker, sculptor, stained-glass designer.

STUDIES: Dip. Art, RMIT, 1964; TSTC, Melb. He became known for his designs in stained glass, exhibited in early MOMAD exhibitions, Melbourne. He also adapted his style to experiment with modernist ideas expressed in works ranging from paintings of semi-abstract figures with flags, arrangements of heaped beer cans, constructions of various kinds, environmental pieces and finally the large, cellular leaf picture awarded the Cook Bicentenary prize for painting, VAS, Melbourne, 1970. From 1967–73 he completed a number of commissioned works in stained glass, notably the windows for the Interdenominational Chapel, Monash Uni., 1968. His lasting reputation, however, centres around the series of sculptures of sheep, made from real sheepskin and metal and first shown in Perth, 1975. These realistic symbolic works attain a remarkable balance between reality, the world of imagined images and social commentary. Included in his major commissioned works are the ornate doors in silvered bronze and laminated plate glass for the High Court building, Canberra, completed 1980. He held about 20 solo exhibitions in most capital cities 1967–89 including Realities, Melbourne; Robin Gibson, Sydney at IMA, Brisbane 1977; Latrobe Valley Arts Centre 1984 and in 1988 a large exhibition toured Vic. regional galleries as part of the Bicentenary. He participated in many significant survey group exhibitions at public galleries from 1963 including *Mildura Sculpture Triennials*, 1970, 85; *Singular & Plural: Aust. Sculpture 1975–85*, AGSA 1985; *Australian Sculpture Triennial*, 1987; *Diversity in Contemporary Australian Art*, QAG 1987; *Field to Figuration*, NGV 1987; *Diversity in Contemporary Australian Art*, MOMA, Saitama, Japan 1987. Commissions include prints for PCA; ALP *Bodford Terrace*, suite; AWM; Darling Harbour, Sydney; Klaus Groenke collection, Idaho, USA; Ed & Nancy Kienholz Collection, Idaho.

AWARDS: Cook Bicentenary prize for painting, VAS, Melbourne, 1970; VACB grants (for stained-glass studies) 1973, (for sculpture equipment) 1975–76; Lilian Pedersen sculpture prize, 1978; Ian Potter Foundation sculture prize, 1980.

APPTS: Teaching in Victorian secondary schools, 1965–69; lecturer, RMIT, 1968–90.

REP: NGA; AGWA; MAGNT; NGV; QAG; QVMAG; Parliament House; PCA; MCA, Sydney; several regional collections NSW, Vic.; tertiary collections all states; corporate collections including Bond, Comalco, BHP.

BIB: Catalogue essays in exhibitions as above. Many major texts on Australian art including Bonython, MAP; McKenzie, DIA; Scarlett, AS. J. Zimmer, *Stained Glass in Australia*, OUP 1985.

KOTKOWSKI, S. Ostoja

See OSTOJA-KOTKOWSKI, Joseph Stanislaw

KOZIC, Maria

(b. 1957, Melb.) Painter, sculptor.

STUDIES: Dip. Art, PIT, 1978; postgrad. dip., PIT, 1980. Her early exhibitions were of Pop-art style animal sculptures which started as quirky representations of horses in stables etc. They progressed into more sinister portrayals notably the *Wolf Pack* series based on the horror movie genre and described by Merryn

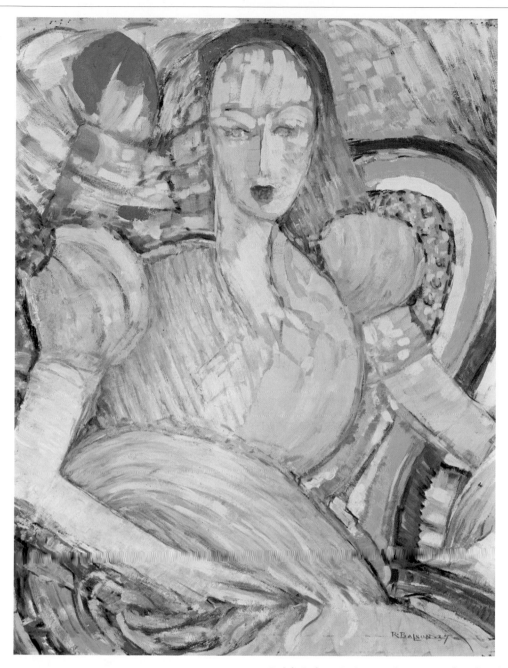

Ralph Balson, Girl in Pink, *1937, oil on board, 70cm × 55cm. Collection AGNSW.*

1920s–40s

Following the freeing up of styles largely initiated by the Impressionists, artists in Australia, like those of the rest of the Western world experimented widely in the decades 1900–mid 1940s. Clarice Beckett's misty streetscapes contained echoes of Impressionism; George Bell's paintings demonstrated the traditional tenets of his teaching; the South Australian Hans Heysen concentrated on watercolours of the Australian eucalypts which were to make him famous and Margaret Preston's woodcuts, and Napier Waller's paintings and stained glass reflected Art Deco elements of design

and colour. Excited by the European schools of cubism and fauvism Australian artists Rah Fizelle, Grace Cossington Smith, Frank Hinder, Harold Weaver Hawkins, and others developed theories of painting based on colour, shape and form. Their 'modernist' style (*see MODERNISM*) became the dominant one of the period and was a precursor of one of the most vibrantly creative periods in Australian art of the twentieth century.

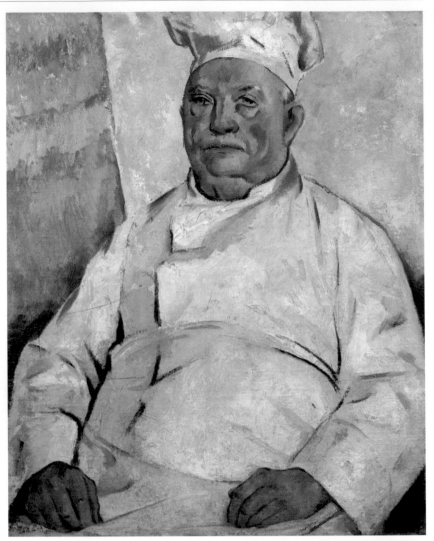

Above: *Hans Heysen,* In the Wonoka Country with the Arkaba Ranges, *1927, oil, charcoal and chalk on canvas, 39.5 × 125.5cm. Sotheby's, August 1991.*

Left: *Raynor Hoff,* The Kiss, *1923, Rome bronze, 28cm high. Collection* AGSA.

Top far left: *George Bell,* The Chef, *1934, oil on canvas on board, 75.7 × 61.6cm. Private collection.*

Below far left: *Clarice Beckett,* Boatshed, Beaumaris, *c. 1928, oil on academy board, 30.5 × 36cm. Collection Castlemaine Art Gallery.*

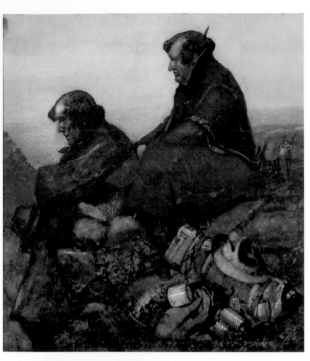

Above: *Blamire Young,* The explorers, *watercolour, 73.3 × 68.7, Collection New England Regional Art Museum, Armidale,* NSW.

Above right: *Sydney Long,* Flamingo Pool *watercolour, 31 × 74cm. Private collection.*

Right: *Napier Waller,* The knight and the ring, *1924, watercolour, 48.9 × 38.3cm. Collection New England Regional Art Museum, Armidale,* NSW.

Far right: *Harold Weaver Hawkins,* Boatsheds, Newport, *1943, oil on canvas, 51 × 60cm. Sotheby's, Melbourne, April, 1990.*

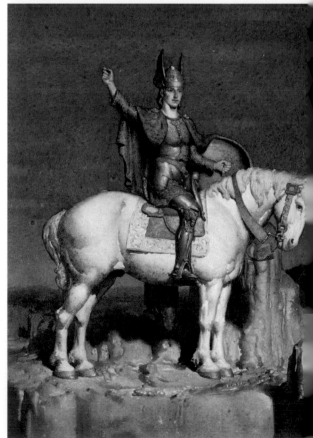

Right: *Rah Fizelle,* Interlude, *oil on canvas, 74.9 ×
101.9cm. Collection Bendigo Art Gallery.*

Below: *Herbert Badham,* Hyde Park, *1933, oil on
cardboard, 40.7 × 50.3cm. Collection New England Regional
Art Museum.*

Right: *Frank Hinder,* Advance, *1942, watercolour, 36.6
× 24.2cm. Courtesy Martin Browne Fine Art, Sydney.*

Right centre: *Ethel Spowers* School is out, *1936, linocut
on rice paper, 35.2 × 27.8. Collection New England
Regional Art Museum, Armidale,* NSW.

Far right: *Freda Robertshaw* Standing Nude, *1938, oil
on board, 110.6cm × 71cm. Private collection. Courtesy,
Deutscher Fine Art.*

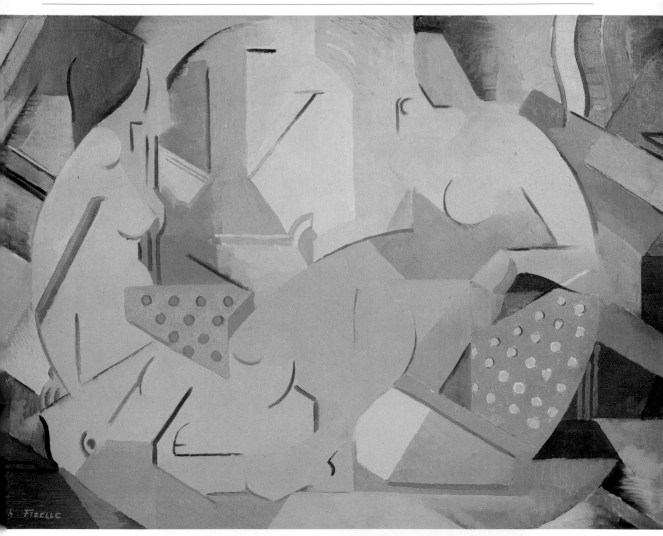

Above: *Grace Cossington Smith,* The Curve of the Bridge, *1928–29, oil on cardboard, 110.5cm × 82.5cm. Collection, AGNSW.*

Right: *Margaret Preston,* Circular Quay, *1925, handcoloured woodblock print, 24.7 × 24.8cm. Courtesy Martin Browne Fine Art, Sydney.*

Gates in the 1991 *Perspecta* catalogue (AGNSW) as 'a unique and modern bestiary'. Her 1980s and 90s work included also a number of other installation pieces combining painting and three-dimensional elements as well as videos. Her 1991 Melbourne exhibition (City Gallery) was accompanied by several huge billboard cut-outs of herself dressed in black underwear and leather on various advantageous advertising sites around the city and suburbs. She held 15 solo exhibitions 1978–92 including Sydney (Roslyn Oxley9), Melbourne (Reconnaissance; City Gallery) and IMA, Brisbane; MCA, Sydney 1992. Her work appeared in numerous group exhibitions 1978–92 including *Biennale of Sydney* 1981; *Popism*, NGV 1982; *Venice Biennale*, 1986; *Australian Sculpture Triennial*, ACCA 1988; *Moet & Chandon Touring Art Exhibition*, 1989; *Art with Text*, Monash Uni. Gallery 1990; *Opening Transformations*, MCA 1991; *Australian Perspecta* AGNSW, 1991. Her commissions include a Christmas tree for the NGV, 1984, and installation for the Bicentennial Travelling Pavilion, 1988. From 1978 she was involved with performance, music, video and installations and made three films of her work 1981–88, widely screened 1982–92 at venues such as the Aust. Film Inst.; Artspace; NGA; State Film Centre, Melbourne; in Zurich and as part of *Continuum* 83, Tokyo. She produced a number of publications including *Things*, 1, 2, 3, 4, 1988–89 and *Dynamite*, March 1991.

REP: NGA; AGWA; NGV; MCA; Artbank; corporate and private collections including Smorgon Collection.

BIB: Catalogue essays exhibitions as above. Smith, AP. A&T no. 2. 1981; no. 6, 1982; no. 15, 1984; no. 16, 1985. A&T monograph series no. 2, 1987. *Tension*, #13, 1988. AL, 2/1/1982; 2/4/1982.

KRAHE, Steven

(b. 1952, Box Hill, Vic.) Painter.

STUDIES: Dip. Art, VCA, 1977–79; Grad. Dip. Fine Art, VCA, 1987–00. He participated in about six group exhibitions 1987–89 including student exhibitions at VCA and at private galleries in Melbourne (Girgis & Klym), and in *Anonymous Collaboration*, 200 Gertrude St, 1987. He held two solo exhibitions at Girgis & Klym, 1988, 89.

AWARDS: Joseph Brown drawing prize, 1977; NGV Trustees award, 1979; Keith and Elisabeth Murdoch Travelling Fellowship, 1989.

KREFFT, Gerard (Johann Ludwig Gerard)

(b. 17/2/1830, Brunswick, Germany; arr. Melb. 1852; d. 19/2/1881, Randwick, NSW) Zoologist, artist. He worked on the goldfields till 1857 when he joined Blandowski's expedition to the Lower Murray and Darling. A competent artist, he contributed illustrated articles to the *Sydney Mail;* themes of his drawings include Aborigines, landscape and natural history. Appointed to the Australian Museum in Sydney in 1860 and made curator in 1864, he built up the museum's collection and became an internationally noted scientist, publishing works on snakes and mammals. He quarrelled violently with the Museum Trustees and in 1873 was dismissed for alleged involvement in the disappearance of some specimens of gold. The ensuing legal wrangle occupied most of his remaining life and ruined his career. He published *The Snakes of Australia* in 1869 and *The Mammals of Australia* in 1871.

BIB: ADB 5. McCulloch, AAGR. Kerr, DAA.

See also SCOTT, Harriet and Helena

KRIEGEL, Adam

(b. 1912, Poland; arr. Aust. 1947) Painter, teacher, musician.

STUDIES: Warsaw, Brussels, Paris and Sydney. Concert violinist and a teacher at Sydney Uni. Conservatorium of Music, 1951–54; teacher of art with SA Education Dept; lecturer, SASA, Adelaide. His remarkable *Vincent van Gogh* series of heads shown at the Munster Arms Gallery, Melbourne, in Mar. 1973, showed him as an expressionist painter of great sensibility. He held about 12 solo exhibitions 1972–89 Melbourne (Judith Pugh; David Ellis), Adelaide (Richard Llewellyn; Greenhill).

REP: NGA; NGV; WAIT; Hamilton Art Gallery.

KRIMPER, Schulim

(b. 1893, Bukovina, Austria; arr. Aust. 1939; d. 1971, Melb.) Craftsman, artist.

STUDIES: Apprenticed first to a mastercraftsman in the Austrian dukedom of Bukovina, he studied and worked in Berlin, as well as Weimar, Gotha and Eisenach. Escaping from Hitler's Germany in 1938 without money or tools, he supervised the building of a refugee camp in England before moving, with his wife, to Australia. Discovered as a craftsman in wood by Robert Haines (q.v.), he can truly be said to have revived public interest in Australian timber during the immediate post-war years. An exhibition of his work was sponsored by the Commonwealth Dept of Trade for Rockefeller Centre, New York, in 1956, and another, of selected pieces, was held at the NGV, Melbourne, 1959. A Krimper memorial exhibition was held at the NGV in Apr.–May 1975.

KRIVS, Dzem

(b. 1924, Latvia) Painter, graphic artist.

STUDIES: ESTC, 1949–53. He worked as an advertising artist until 1957, exhibited with the group Six Directions (q.v.) and conducted two commercial galleries, 1965–69.

AWARDS: Prizes at Latvian Arts Festivals, Sydney, 1959, 74.

REP: AGNSW.

KRUGER, Elisabeth

(b. 15/4/1955, Nouméa, New Caledonia) Painter, printmaker.

STUDIES: B. Visual Arts (printmaking), Canberra School of Art. Her paintings have links with both her training as a textile artist and European Renaissance art. Delicately-wrought in often sombre but clear colours, the works glow with clarity. Her 1990 winning Moet & Chandon Fellowship painting of a section of intricate

frieze caused comment for its small size and classical painting style in contrast to the majority of entries which were considerably more expressionistic. Group exhibitions 1987–91 in which she participated included *Made in Canberra*, Contemporary Art Space, Canberra 1988; *Moet & Chandon Touring Exhibition*, 1989; *Adelaide Biennale of Australian Art*, AGSA 1990. Her 6 solo exhibitions 1978–92 included quilts and paintings, Wollongong City Gallery 1989; Deutscher Fine Art Melbourne 1992 and at Hautvillers, Cham-pagne, France 1990.

AWARDS: Residency, Sturt Workshops, Mittagong, NSW, Crafts Council of Australia, 1980; Moet & Chandon Australian Art Fellowship, 1989; residency and overseas grant, Besozzo, Italy, VACB, 1990.

APPTS: Teacher, printmaking, 1986–89, life drawing, 1992, Canberra School of Arts.

REP: NGA; NGV; several tertiary and corporate collections including Moet & Chandon, Epernay, France.

BIB: Catalogue esssays exhibitions as above. AL 9/2/1989.

KRUGER, John Friederich Carl (Fred)

(b. 18/4/1831, Berlin; arr. Victoria c. 1863; d. 1888) Photographer. He photographed Aboriginal cricket teams from 1868 and was commissioned to produce an album of portrait photographs of the Aboriginals of Coranderrk Mission, near Healesville, Vic. He was also a successful landscape photographer, commissioned by land-owners to take photographs of their properties as well as early development of towns such as Geelong and Queenscliff and leading businessmen, especially of the Geelong area. The NGV held an exhibition of his photographs in 1983, largely from a large collection of his given in 1979 and his work appeared in *Geelong on Exhibition* in 1987.

REP: NGV; La Trobe Library; Geelong Art Gallery.

BIB: Kerr, DAA.

KRUM, Les (Eleazer)

(b. 1948, Paris) Painter.

STUDIES: Dip. Painting, NGV School, 1971; TTC, Hawthorn Institute, 1972. He went to Israel where he set up a studio in Tel Aviv in 1973. He was in London by 1974 and exhibited with a group at the Aberbach Gallery, 1978, having already shown at a group exhibition at the Notheler Gallery, Berlin, 1977. Returning to Australia in 1979, he held 8 solo exhibitions 1980–92, largely in Melbourne (including Standfield; Terra Australis). His abstract, colour paintings feature firm sculptural form and expressionistic movement.

KRZYWOKULSKI, John

(b. 12/7/1947, Germany; arr. Aust. 1950) Painter, sculptor.

STUDIES: CIT, Melbourne, 1965–68. Energetically promoted by the gallery director Sweeney Reed from 1969, he burst suddenly on the local Melbourne scene with successive exhibitions of polished, hard-edge paintings and minimal, painted sculptures, most of which incorporated a beguiling felicity of form that

intrigued some critics while antagonising others. Three of his sculptures done in Duco enamel sprayed onto fibreglass were entered for the *Mildura Sculpture Triennial* 1970. He held four solo exhibitions 1969–91 Melbourne including at Reflections, 1991 and his work appeared in about 23 group exhibitions 1969–91 including MPAC *Festival of Prints and Drawings* 1987, 89; *Five Decades of Modern Australian Art from the Heide Collection* Heide, 1989.

AWARDS: Eutectic Competition for sculpture, 1975; Shire of Flinders (acquisition award), 1976.

REP: NGA; AGWA; TMAG; Heide; Ballarat, Mornington regional galleries; Myer collection.

BIB: Bonython, MAP 1980. Scarlett, AS. A&A 9/2/1971 (John Reed, *Visual Experience – and John Krzywokulski's painting*); 19/1/1981.

KUBBOS, Eva

(b. 8/2/1928, Lithuania; arr. Aust. 1952) Graphic artist, painter.

STUDIES: Hochschule für angewandte Kunst, Berlin, 1946–51; RMIT, 1952. Known mainly for watercolours; advertising manager, Cann's dept store, Melbourne, 1957–60; member of Sydney Printmakers.

AWARDS: *Mirror*-Waratah prize (contemporary watercolour), 1963; Armidale watercolour prize, 1963; Trustees watercolour prize, 1963, 70, 71, 81; prize at Maitland (watercolour), 1964; Rockdale (contemporary), 1964; Mosman, 1964, 66; Wollongong, 1964; Melbourne (Lithuanian Arts Festival), 1964; Wollongong, 1965; Ryde, 1965; Rockdale, 1965; Robin Hood, 1965; Hunters Hill, 1966; Pring prize, 1970, 71, 74, 75, 77, 79, 81.

REP: NGA; AGNSW; AGWA; Newcastle Region Art Gallery; National Gallery, Kuala Lumpur.

BIB: Elwyn Lynn, *Drawing*, Arts in Australia series, Longman, Melbourne, 1963.

KUCZYNSKA, Maria

(b. Poland; arr Aust c. 1981) Ceramicist, sculptor.

STUDIES: M. Fine Arts, Academy Fine Arts, Gdansk, Poland, 1971. She lectured in Poland where her early work was mainly in ceramics which she exhibited in Poland, Italy, West Germany before arriving in Australia in the early 1980s. She was artist-in-residence at Canberra School of Art, 1982; WAIT, Perth, 1983 and Meridian Sculpture Foundry, Melbourne, 1989. She has held around five solo exhibitions in Australia including with Macquarie, Sydney and Christine Abrahams, Melbourne and a major touring exhibition throughout Australia 1982–83. She continues to exhibit in Europe and group exhibitions in which her work appeared 1976–91 included international and Australian ceramic exhibitions. Her sculptures since the mid 1980s have consisted of finely-formed semi-abstract torsos, often with wings, evocative of mythical creatures.

AWARDS: Student prizes, Poland, Italy 1976, 77; gold medal, Faenza International Ceramic Art Competition, Italy, 1979.

REP: AGWA; NGV; Shepparton regional gallery; tertiary

Maria Kuczynska, Thrusted Leg Figure, *1988, 1090 × 400 × 44cm.*

collections including Canberra School of Art; a number of European public collections including national museums in Poland, Germany, Italy.

BIB: V. Hollister and K. McMiles, *Contemporary Australian Figurative Ceramics*, 1988.

KUHN, Maria
(b. Melb.) Sculptor, teacher.
STUDIES: Melb. Tech. Coll., 1937–40. She taught at Melbourne Tech. Coll. (c. 1942) and later produced works in collaboration with her husband, a specialist in wrought iron.
REP: Statue of E. Hanlon, Premier of Qld, in the grounds of Brisbane General Hospital.

KUO, Graham
(b. 1948, China) Printmaker.
STUDIES: NAS, Sydney. His colourful, abstract serigraphs appeared in group exhibitions, notably in PCA and Sydney Printmakers shows, from 1974.
AWARDS: Prints purchased from competitive exhibitions in Drummoyne, Mosman and Mornington.
REP: AGNSW; Mornington regional gallery; Uni. of Sydney; Uni. of NSW.
BIB: PCA, *Directory 1976*.

KY, Carmen
(b. 28/2/1946, NSW) Painter, printmaker, photographer, teacher.
STUDIES: Dip. Painting, ESTC, 1966; Grad. Dip. Printmaking, Coll. Fine Arts, Uni. of NSW, 1983; Assoc. Dip. (printmaking), Canberra School of Art, 1988. She participated in numerous group exhibitions 1966–92 including at Blaxland Gallery and Scotland Island artists exhibitions and AGOG, Canberra 1990; prize exhibitions including Portia Geach, Blake and Sulman. She held four solo exhibitions 1968–89 in Sydney (3) and Perth.
AWARDS: Six regional prizes 1968–90 including Campbelltown Art Prize, 1973; Macquarie Towns Acquisitive Prize, 1989, 90.
APPTS: Part-time teaching, several Tech. Colls and Sydney Uni. 1972–92 including NAS, ESTC, 1991– .
REP: Several uni. and regional galleries.
BIB: PCA, *Directory 1988*. Germaine, *AGA*.

*L*A BILLARDIERE TO LYTTLEON

LA BILLARDIERE, Jacques-Julien Houtou de
(b. 1755; d. 1834) French botanist, artist. He made
265 drawings of Australian plants for the books on
Admiral d'Entrecasteaux's voyage in search of La
Pérouse, c.1792. His name has been given to an
Australian shrub, 'billardiera'. Péron, another artist
on the same ship, contributed 12 illustrations to the
two volumes he wrote about the voyage published in
Paris in 1800–04, *Relation du Voyage à la Recherche de
La Pérouse*.
BIB: Smith, *EVSP*. *ADB* 2. Kerr, *DAA*.

LACY, George
(b. c.1816, London; arr. Australia c.1842; d. 12/3/1884,
Bathurst, NSW) Painter, illustrator, teacher. He lived
in Victorian goldfield towns and camps before mov-
ing to Albury where he wrote articles for the *Southern
Courier*, 1860. He then spent five years in England
before settling permanently in Australia as a school
teacher in Bong Bong, then Braidwood, NSW, to become
known for his contributions (articles and drawings)
to the *Illustrated Sydney News*, and watercolours of
comic 'Australiana' subjects. A 'George Lacy', pre-
sumably him, was contributing political articles and
letters to the *Australasian*, Melbourne, 1881, and
Bulletin, Sydney, 1883. His work is often seen at auc-
tions, a group of 25 being included in Joel's sales,
Melbourne, March 1970. His finest work is probably
the watercolour *The First Gathering of the Bendigo
Caledonian Society Jan. 6, 1860*, now in the NLA col-
lection. He was represented in the Bicentennial exhi-
bition *The Face of Australia*.
REP: QAG; NLA; Mitchell, La Trobe Libraries; Bendigo,
Castlemaine regional galleries.
BIB: Rex and Thea Rienits, *A Political History of Australia*,
Hamlyn, Sydney, 1969. Kerr, *DAA*.

LAEUBLI, Annis
(b. ?; d. 1948, Sydney) Sculptor.
STUDIES: ESTC. Member of the NSW Society of Artists.
Her works included a 5.5m high concrete figure for
the Royal Agricultural Society of NSW, and a plaster
group for the Spastic Centre, Mosman, NSW. She was
represented in *A Century of Australian Women Artists*

1840s–1940s Deutscher Fine Art, Melbourne, 1993.
REP: AGNSW.

LA GERCHE, Geoff
(b. 28/7/1940, Sale, Vic.) Painter, printmaker and
teacher.
STUDIES: Dip. Art, CIT, Melbourne, 1961; postgrad-
uate studies, RCA, London 1967. His paintings range
from expressionistic landscapes to photo-realist, as
in his larger-than-life portraits entered for Archibald
prizes. He held about 22 solo exhibitions 1963–92
Sydney (largely with Coventry) Melbourne (Tolarno,
Christine Abrahams) and in MAGNT 1979. His work
has appeared in a number of group exhibitions 1967–92
including with Coventry Galleries and in *Contemporary
Australian Printmakers I & II* touring USA 1979; *Rivers
in Australian Art* NAB collection, Heide 1990. He was
artist-in-residence at Darwin Community College 1979
and has had a number of commissions including from
Coopers and Lybrand; Deighton Corporation.
AWARDS: Warrnambool Print prize, 1974; Darnell de
Gruchy purchase prize, Brisbane, 1975; Alice prize,
Alice Springs, 1976; Gold Coast City purchase prize,
1976; prizes at Benalla, 1977; Rockhampton, 1977;
Toowoomba, 1978; Maitland, 1978; grant VAB 1981;
Mitchelton Print Purchase 1982; Western Mining
Acquisition Prize 1982.
APPTS: Senior lecturer Monash University, Caulfield.
REP: NGA; AGNSW; AGSA; AGWA; NGV; QAG; Dunedin
Art Gallery, NZ; a number of regional galleries includ-
ing Alice Springs, Benalla, Gold Coast, Mildura,
New England, Rockhampton, Warrnambool; a number
of tertiary collections including Macquarie, South
Australian, NSW, Qld, WA universities; corporate &
private collections including IBM; Vincent Price
Collection USA; Besen collection, Melb; James Fairfax.
BIB: Catalogue essays exhibitions as above. PCA, *Directory*
1976. Bonython, *MAP*. *New Art Five*. Germaine, *AGA*. Nevill
Drury, *Images*, Craftsman House 1992. *A&A* 14/2/1976;
19/3/1982.

LAHEY, Frances Vida
(b. 26/8/1882, Pimpana, Qld; d. 29/8/1968, Brisbane)
Painter, teacher.
STUDIES: Brisbane Tech. Coll. with Godfrey Rivers;

Vida Lahey, Monday Morning, *1912, oil on canvas, 152 × 123cm. Collection, QAG.*

NGV School, 1905–09; watercolour painting with Walter Withers; Colarossi's, Paris, 1919; St Ives, Cornwall, with Frances Hodgkins, 1920. She began studying watercolour painting at boarding school at Southport, Qld, and after her art school studies in Melbourne returned to Brisbane where she taught privately before going to London and war work in 1915. Her work was exhibited at the Paris Salon and New English Art Club during this period. Returning to Brisbane in 1920 she taught, held her first exhibition in 1921, and spent two years in Tasmania working with Mildred Lovett. An 18-month period of travel study in Europe followed (1928–29) before she settled in Brisbane where, with Daphne Mayo, she initiated the Queensland Art Fund for the benefit of the QAG. Other activities included membership of the Contemporary Group, Sydney, the NSW Society of Artists, the RQAS and the Art Advisory Committee of the QAG (1931–47). She wrote several books including *Art For All*, Qld National Art Gallery, Brisbane, ?1941; *Art in Queensland 1859–1959*, Jacaranda Press, Brisbane, 1959. She was represented in *A Century of Australian Women Artists 1840s–1940s* Deutscher Fine Art, Melbourne, 1993.
AWARDS: NSW Society of Artists medal, 1945; MBE conferred 1958 (for services to art).

REP: AGNSW; AGSA; QAG; NGV; Armidale regional gallery; Uni. Art Museum, Brisbane.
BIB: Janine Burke, *Australian Women Artists 1840–1940*, Greenhouse, Melbourne, 1980.

LAHIFF, Trevor
(b. 1938, Melbourne; d. 1962, Melbourne) Painter. His expressionistic paintings were shown in three Melbourne exhibitions, the last at the South Yarra Gallery (6 Sept. 1961), a few months before his death from leukemia.
REP: NGV.

LAING, Alec
Black-and-white artist. Contributor to Melbourne *Punch* and the *Champion,* a radical Melbourne paper, 1895–96, whose contributing cartoonists included also Duncan Max Meldrum, Ambrose Dyson and Blashki (Miles Evergood). Laing drew also for the *Critic*, 1897.
BIB: Mahood, *The Loaded Line*, 1973.

LAKE, Florence Thorne
(b. 1873, Adelaide) Painter.
STUDIES: Brisbane (with Ada Ellwood); Adelaide (with Will Ashton); England (with Lamorna Birch), 1922.
REP: AGSA; Manly Art Gallery.
BIB: *Catalogue of AGSA.*

LAKE, Joshua
(b. 1848, Ilford, Sussex; d. 1908, Melbourne) Teacher, administrator, adviser
APPTS: Art teacher, Melbourne C. of E. Grammar School; headmaster, Hamilton College; adviser to Ballarat Fine Art Gallery, NGV, AGSA, AGWA; General Superintendent of Fine Arts for the *Centennial International Exhibition*, Melbourne, 1888–89.

LAMB, Henry
(b. 1883, Adelaide; d. 1960, England) Painter.
STUDIES: A student at Manchester Uni. Medical School, Lamb left at the age of 20 to study art in Paris at La Palette with Jacques Emile Blanche, 1907–08. This distinguished British artist went to England in childhood when his father, Dr (later Sir) Horace Lamb, who had been professor of mathematics at Adelaide Uni., was elected to the corresponding chair in his native city of Manchester. Returning to England in 1912 he became a foundation member of the Camden Town Group and eventually qualified in medicine during World War I. Later in the war he became an official artist in Palestine and Macedonia, 1916–18, and during World War II he worked as an official artist for the army. He exhibited at the RA from 1921, was elected RA, 1949 (ARA, 1940), and served as a trustee of the National Portrait Gallery from 1942, and of the Tate Gallery, 1944–51.
REP: Tate Gallery (notably by his portrait of Lytton Strachey); Manchester Art Gallery and most provincial galleries in England as well as Australian collections including AGWA, AGSA.

LAMBERT, George Washington

(b. 1873, St Petersburg, Russia; arr. Aust. 1887; d. 1930, Cobbity, NSW) Painter, sculptor.

STUDIES: Académie Julian, Sydney (with Julian Ashton), 1896–1900; Colarossi's and Atelier Delecluse, Paris, 1900–01. Between 1920 and 1930 the work of Lambert may truly be said to have dominated the Australian scene; his name meant to Australia what the names of Orpen and John meant to Britain during the same period. As Lionel Lindsay wrote long after his death: 'Lambert was possessed of a Renaissance ambition to excel in all media, including sculpture'. He was Julian Ashton's favourite pupil, and remained, for the rest of his life, Ashton's greatest triumph in teaching; it took more than an epoch before the virtuoso aspects of his accomplishments were brought into perspective. His mother was English; his father, an American engineer employed on the Tsar's railways, died in Russia just before he was born. When Lambert was two, the family moved from St Petersburg to Wurttemberg, and six years later to Somerset, England, where they lived for a further six years before going to Australia, in 1887, to live with Mrs Lambert's uncle, Robert Firth, on his station property at Eurobla, near Nevertire, NSW. After an unsuccessful attempt to become a clerk in Sydney, Lambert began a career as a black-and-white artist contributing to the Sydney *Bulletin*. In 1896, when Lambert was 23, B. E. Minns, staff artist on the *Bulletin*, introduced him to Julian Ashton, who had just started his own art school in Sydney (Académie Julian). Lambert enrolled at the school and four years later won the first NSW Travelling Scholarship. He travelled to England with Hugh Ramsay, who shared his passion for Velazquez' work; both enrolled at Colarossi's, Paris, where Lambert remained a year before moving to England and further success. He was soon exhibiting at the RA and New Salon exhibitions and subsidising his income with continued contributions to the Sydney *Bulletin*. His painting style now reflected the influence of the Florentine mannerist painter, Bronzino. With his flamboyant appearance and extrovert personality, he also gained a reputation as an after-dinner speaker. The crowning laurels to his reputation came, however, when he worked as a war artist with the Australian Light Horse Brigade in Palestine to produce a succession of brilliant drawings, paintings and sculptures. He returned to Australia in 1921 to be enthroned as a leading figure in the art world, one who seemed to have brought with him the spirit of such luminaries as Lawrence of Arabia and Augustus John. Lambert's successes would thus seem to be complete, but there was another, entirely different, side to his character, a side which suggested that the apparent self-confidence which had taken him so far concealed a very different type of man. In the catalogue of the *Australian Jubilee Exhibition*, 1951, Roland Wakelin wrote: 'In 1926 Lambert and Thea Proctor, who were disgusted with the lack of appreciation shown the moderns, invited de Maistre, Wakelin, Cossington Smith and others to exhibit with them at the Grosvenor Galleries

. . . There was further evidence that Lambert was by no means confident of the infallibility of his own work and attitude. His picture *Important People* earned him the censure of reactionary critics, and before his death at Cobbity, NSW, in 1930, he was reputed to have been an embittered rather than a self-satisfied man'. The evidence of his later work is that he had become conscious of the academic milieu in which he had become enshrined, and bitterly regretted the consequent curtailment of his creative spirit. This is borne out in a letter introducing his pupil, Arthur Murch, to his son, Maurice Lambert: 'This will introduce Mr Murch who has won the Travelling Scholarship, the damn thing that ruined my life'. His work has been included in many group exhibitions such as the Bicentennial exhibitions *The Great Australian Art Exhibition* and *The Face of Australia* and the AGNSW held an exhibition of his drawings 1993. Works in bronze include the figure of the unknown soldier, St Mary's Basilica, Sydney (which bears also Arthur Murch's signature).

AWARDS: NSW Society of Artists' Travelling Scholarship (the first awarded), 1900; London, ARA, 1922.

REP: A large collection of Lambert's paintings and drawings is in the AGNSW (owing mainly to the Lambert purchase fund organised by the NSW Society of Artists after his death); all Australian state and many regional galleries and public collections abroad.

BIB: J. S. McDonald, *The Art and Life of George W. Lambert*, McCubbin, Melbourne, 1920. Amy Lambert, *Thirty Years of an Artist's Life*, Society of Artists, Sydney, 1938. Smith, AP. Andrew Motion *The Lamberts: George, Constance & Kit*, Chatto & Windus, London 1986. Numerous references and special numbers of *Art in Australia*, from 1921.

LAMBERT, Ronald

(b. 6/7/1923, Sydney) Painter.

STUDIES: NAS, 1954–57; Oskar Kokoschka School, Salzburg, 1960–61; travel studies Greece, Turkey, Spain, Italy. His early style derived largely from New York School painting, specifically the early striped paintings of Morris Louis, moving into abstract expressionism and strong use of painterly surfaces which style he has maintained and expanded into the 1990s. He held around 22 individual exhibitions 1963–93 largely at Watters, Sydney and Charles Nodrum, Melbourne. He participated in a number of group exhibitions in public and private galleries 1956–92 including *Abstract Expressionism in Sydney 1956–64*, Ivan Dougherty Gallery 1980; *Max Watters Collection*, Muswellbrook Art Gallery 1988.

AWARDS: Over 12 prizes in NSW competitions 1955–83, including the first Le Gay Brereton prize (1955), Bathurst Sesquicentenary, 1965 and Hunters Hill Mondrian prize 1983.

REP: NGA; NGV; MOCA, Brisbane; a number of regional and tertiary collections NSW including Bathurst and Wollongong; Centre for Contemporary Art, New Zealand.

BIB: Catalogue essays in exhibitions as above. *New Art Two*.

LANCASHIRE, John William

(Active 1798–1806, Aust.) Convict artist. Sentenced 6 Apr. 1796 to seven years' transportation for an unspecified crime. He arrived in NSW on 18 May 1798 on the ship that brought also Absolom West, Australia's first publisher of topographical views. Lancashire's *View of Sydney, 1803* shows an artist of unusual talent. In this work primitive ingenuousness and a strong decorative sense are allied to careful attention to topographical detail. Reputed to be a notorious troublemaker, Lancashire was, in Governor King's opinion, 'possessed of every art and cunning that human invention could turn to the worst of purposes'. He was granted conditional freedom, became a draughtsman and painter, but committed further crimes and was eventually sentenced to three years' hard labour in Van Diemen's Land. With other convicts he mutinied during the voyage south (1806) and took possession of the ship, the brig *Venus*. No records exist of what became of either mutineers or ship. He was represented in *The Artist and the Patron* AGNSW, 1988.
REP: Dixson Gallery of the Mitchell Library.
BIB: Rienits, *Early Australian Artists*, 1963. John Kroeger, *Australian Artists*, Renniks, Adelaide, 1968.

LANCASTER, Charles Henry

(b. 1886, Melbourne) Painter.
STUDIES: NGV School. Exhibitor with the Qld Art Society from 1914, later president, RQAS, c.1934; trustee of the QAG, –1959.
REP: QAG.
BIB: Moore, *SAA*.

LANCELEY, Colin

(b. 6/1/1938, Dunedin, NZ; arr. Aust. 1940) Painter, sculptor, printmaker.
STUDIES: Dip. Painting, NAS, 1954–60 with Passmore, Miller, Olsen and Laverty. He became known first which seen in Annandale Imitation Realists (q.v.) shows which had their first showing at the MOMAD, Melbourne, 14 Feb. 1962, the common aim being painted decorations on waste material such as empty tins, bottles, rusted piping and so on. His brightly coloured paintings have since become well-known for their characteristic additions of three-dimensional tubular shapes. He travelled to Italy in 1965 as a recipient of the 1964 Helena Rubinstein Travelling Scholarship, and lived in London in the 1960s and 1970s where he became associated with the Marlborough Galleries, and established a London reputation. He visited Mexico, revisited Australia in 1970 and since then held regular exhibitions in Australia, returning to live in Sydney in the 1980s. He held annual exhibitions in the UK, Australia, New York and Europe from 1962, including a solo print exhibition at the Tate, London, 1976, and a large survey exhibition at the AGNSW in 1987. He participated in numerous group exhibitions at private and public galleries including *Perspecta*, AGNSW 1983; *Biennale of Sydney 1986*; and the Bicentennial exhibition *The Great Australian Art Exhibition*. In 1988 a film directed by Andrew Saw

for the ABC was made on his work.
AWARDS: Young Contemporaries prize, MOMAD, 1963; Helena Rubinstein Travelling Scholarship, 1964; Scottish Arts Council prize, Edinburgh Festival, 1967; Cracow International Print Biennale, 1968 (two prizes); Order of Australia (AO), 1990; creative arts fellowship, Australia Council, 1991.
APPTS: Lecturer in painting and drawing, UK and Australia 1966–86, including Bath Academy of Art, Wiltshire and Gloucestershire Coll. of Art; Chelsea School of Art; ESTC; CAI.
REP: NGA; most state and many regional galleries; numerous public collections UK, USA, Europe including Tate Gallery; Victoria and Albert Museum, London; MOMA, New York; Los Angeles County Museum, Los Angeles, USA; Guggenheim Museum, New York.
BIB: Monograph by Charles Spencer, Editions Alecto, London 1973. Robert Hughes and William Wright, *Colin Lanceley*, Craftsman House, Sydney, 1987. References in most general Australian books and writings on contemporary Australian art. AGA 1/3/1963 (Elwyn Lynn, *Pop Goes the Easel*); 8/2/1970 (Sandra McGrath, *Where am I up to? An article on Colin Lanceley*); *Other Voices*, 1/2/Aug.–Sept. 1970 (*Interview: Colin Lanceley*); 19 Aug. 1976.

LANDELLS, Flora

(b. 1888, Adelaide; d. 1981) Painter, potter.
STUDIES: Perth Tech. Coll. From 1904 she exhibited with the WA Society of Arts and in 1925, assisted by her husband, opened the Maylands School of Art. She taught art also at MLC, Perth, for 40 years.
REP: AGWA.

LANDER, Cyril George

(b. 1892, Melbourne) Painter, furniture maker.
STUDIES: Gordon Inst. of Technology, Geelong (Applied Arts), c.1909–14. Member of the Perth Society of Artists; Fellow of the Royal South Australian Society of Arts.
AWARDS: Hotchin prizes for watercolours, 1957, 59; Bunbury prize, 1959.
REP: AGSA; AGWA; WA municipal collections.
NFI

LANE, Harold Vincent

(b. 22/6/1925, Sydney) Painter.
STUDIES: Brisbane, with F. J. Martyn-Roberts, 1939–41; ESTC (part-time), 1948–51. His commissioned works include a mural (triptych) for the Law Courts building, Darwin. From 1965 he held exhibitions in Brisbane, Sydney and Adelaide.
AWARDS: Prizes in competitions in Brisbane 1965; Redcliffe, 1965, 66: Westfield, 1971; Rockhampton, 1972.
REP: QAG; regional galleries Rockhampton, Toowoomba.
NFI

LANE, Henry Bowyer

Artist of the Victorian goldfields. He worked at Mt Egerton. Drawings of north-eastern Victorian landscapes, signed H. B. Lane, and dated 1853 and 1862, are in the La Trobe Library, State Library of Vic.

LANG, Alexander Denistoun
(Active Victoria 1840s) Sketcher, photographer, etcher. He made a number of etchings of rural life, one of which was published in London in 1847. His sketchbook in the collection of the La Trobe Library, Vic also contains drawings of Aboriginals and he compiled an album of photographs. His work was seen in *Victorian Vision: 1834 Onwards* NGV 1985.
REP: La Trobe Libary.
BIB: Kerr, *DAA.*

LANGE, Eleonore
(b. 1893, Frankfurt-am-Main, Germany; arr. Australia 1930; d. 1990) Sculptor, teacher.
STUDIES: Kunstgerwerbeschule, Frankfurt-am-Main. She lived on Qualto Island, Papua New Guinea, before moving to Sydney. In 1932 she organised the Marionette Theatre, Sydney, and held the first performance on 29/11/1932. She also lectured on modern art at Rah Fizelle's and in her own studio, 1934, then at the AGNSW, University of Sydney and CAS, Sydney, 1935–39. From the time of her arrival in Sydney she played an important part in the rise of the modern movement, completing a number of commissioned works, some concerned with theories of light in which her experiments with materials such as perspex anticipated the work of later local constructivists. She wrote the foreword for *Exhibition 1* (David Jones Gallery, Sydney, 1939) and contributed articles to *Art in Australia* 1936 and 1941.
APPTS: Lecturer, Frensham School, Mittagong, NSW, 1934; joined the staff of the School, 1947, art mistress (full-time), 1949–54.
REP: Sydney Teachers Coll. and Frensham School collections.
BIB: Sturgeon, *DAS.* Scarlett, *AS. A&A* 28/3/1991 (obituary).

LANGER, Gertrude
(b. 1908, Vienna; d. 19/9/1989) Critic, teacher, administrator.
STUDIES: Ph.D., History of Art, Uni. of Vienna, 1933; Sorbonne, Paris, with Prof. Henri Focillon. A leading critic, and curator she wrote numerous articles and catalogue essays and was involved in a number of contemporary art activities in Brisbane.
AWARDS: OBE 1968.
APPTS: Art critic, *Courier-Mail*, Brisbane, 1953– ; president, Qld Arts Council, 1961–75, director, 1975–79; founder and honorary director, Vacation Schools of Creative Arts, 1962–? ; president, QAG Society, 1965–66, and 1974–75; executive member, Darnell Fine Arts Committee, Qld Uni., 1968–70; vice-president, Arts Council of Australia, 1970–72; president, Australian Division, International Association of Art Critics, 1971–78; member, Convocation, ANU, Canberra, 1975–?; Patron, Inst. of Modern Art, Brisbane, 1975–89; member, Australian Federation of Uni. Women.
BIB: Smith, *AP.*

LANGKER, (Sir) Erik
(b. 1898, Sydney; d. 3/2/1982) Painter.
STUDIES: Sydney Art School (with Julian Ashton); RAS School. Marine and landscape painter.
AWARDS: OBE, 1961; knighthood, 'for services to art', 1968.
APPTS: President of trustees of the AGNSW, 1962–75; president, RAS of NSW, from 1946; also a member of Marshall Bequest and Travelling Art Scholarship committees and a trustee of the Sydney Opera House.
REP: AGNSW; TMAG; Sydney Uni. collection.

LANGLEY, Jean
(b. 11/1/1926, Melbourne) Graphic artist, painter. Best-known for her botanical illustrations and wildflower drawings, she has illustrated several books including *Australian Bush Flowers*, Lansdowne Press, Melbourne, 1970 and *To a blue flower*, 1983. Original watercolours for both books were acquired by the National Australia Bank. She held a joint exhibition with her brother Robert Langley (q.v.) at the MOMAD, Melbourne in 1958 and exhibited at several private galleries including Libby Edwards, 1988.
REP: MPAC; NAB.
BIB: Barrie Reid, ed., *Modern Australian Art*, MOMAD, Melbourne, 1958.

LANGLEY, Robert Savige
(b. 29/4/1929, Mentone, Vic.) Sculptor, ceramicist. He makes mainly terracotta figurines in unglazed clay. He assisted Arthur Boyd in the construction and firing of his ceramic pylon for the Melbourne Olympic Swimming Pool in 1956, and held annual exhibitions of his own small sculptures from 1960 in Melbourne (including Distelfink 1985, 89, 90), SA (including Greenhill 1975, 78), WA and Qld. Held joint exhibitions with his sister, watercolour artist Jean Langley (q.v.), at several galleries 1958–80.
BIB: Scarlett, *AS.*

LANGLEY, Warren (Vincent)
(b. 6/7/1950, NSW) Glass artist/sculptor.
STUDIES: B.Sc.(Hons), Uni. of Sydney, 1972; various glass studies Australia, UK, USA, 1972–78. Many commissions including for Parliament House, Canberra; Darling Harbour Project, private corporations. He held about six solo exhibitions, 1986–91 including at Robin Gibson, Painters, Sydney 1986 and 1989, and in Paris, Antibes and Zurich. He participated in numerous glass exhibitions worldwide 1984–91 including *International Exhibition of Glass Art*, Kanazawa, Japan 1988; *Australian Glass Biennial*, Wagga Regional Gallery 1989; *World Glass Now*, Hokkaido Museum of Modern Art, Japan, 1988, 91.
AWARDS: Project grant VACB, 1983; Silver medal, International exhibition of glass art, Japan 1988.
APPTS: Workshops, sculptural glass techniques, USA, UK, France, Switzerland, Japan, Australia, 1978– .
REP: NGA; NGV; QAG; public museums Switzerland, Japan, New York.
See also CRAFT IN AUSTRALIA

LANGSHAW, *Yvonne*
(b. 1938, NSW) Painter.
STUDIES: NAS, four years; Chatswood Evening College. Traditional-style artist, mainly watercolour painter. She held about five two-person and group shows in private galleries in Sydney (Gallery 8, Gallery 680) and a solo exhibition at North Sydney Contemporary Gallery in 1990.
AWARDS: Grace Bros. Art Competition, 1968, 70; Ryde Art Award (open traditional), 1981, 84; several of the sections of shire awards (Kuring-gai, Lane Cove), 1984–90.
APPTS: Teacher painting and watercolour, Willandra Art Centre, Ryde; art teaching, Roseville Community Art Centre.
REP: Shoalhaven Shire Council.

LANSELL, *G. Ross*
Critic.
STUDIES: Uni. of Melbourne (fine arts). He wrote regular critiques for *Nation*, Sydney, 1966–67; *Daily Telegraph*, Sydney, 1967–68. A contributing Melbourne editor for *Other Voices*, 1970, he contributed also to the *Age*, *Australian Book Review*, the ABC *Broadside*, and other magazines and reviews. The controversial nature of his critiques brought him into prominence in the 1960s.

LANYON *Gallery*
See GALLERIES – PUBLIC; NOLAN, Sidney

LARSEN, *Helge*
(b. 1929. Copenhagen, Denmark; arr. Australia 1961) Jeweller, lecturer, curator, head of art department.
STUDIES: National Diploma, College of Craft & Design, Copenhagen, 1950s; four years apprenticeship jewellery, Denmark, 1940s–50s; exchange student trainee, University of Colorado, Denver, USA 1953–55. He participated in and curated many jewellery exhibitions often in conjunction with Darani Lewers (q.v.). He also participated in many Australian and international master workshops in silversmithing and is frequently guest professor and lecturer at a number of international art schools. His work was included in about 35 group exhibitions 1961–90 including Transfield Sculpture Prize exhibition 1965; *Australian Jewellery* national tour, Crafts Board of the Australia Council, 1974; *International Jewellery* Tokyo, 1986; *Contemporary Jewellery in Australia & Japan*, Japan, 1991. A retrospective of his and Darani Lewer's work organised by NGV toured to public galleries throughout Australia 1986–88 and to Austria and Germany in 1988.
AWARDS: Moya Dyring Studio, Cité International des Arts, Paris 1972.
APPTS: Senior instructor, Department of Industrial Arts, University of NSW, 1962–74; head of jewellery and silversmithing department, Sydney College of the Arts, 1977–85; principal lecturer, Sydney College of the Arts, 1986– ; deputy director 1988, acting director, 1990; associate professor, Uni. of Sydney, 1990–91;

head of school, School of Visual Arts, Sydney College of the Arts, 1991– .
REP: NGA; NGV; AGSA; Museum of Applied Arts & Sciences, Sydney; AGWA; QVMAG; and in overseas public collections Austria, Czechoslovakia, Germany and in Australian Embassy, Tokyo.
BIB: F. Bottrell, *Artist Craftsmen in Australia*, Murray Books 1972. *Crafts of Australia*, Crafts Council of Australia, 1974.

Richard Larter, Untitled, *1963, expoxy on hardboard. Courtesy Watters Gallery.*

LARTER, *Richard*
(b. 19/5/1929. London; arr. Aust. 1962) Painter.
STUDIES: St Martin's School of Art, London c.1945; travel studies Algiers 1950; evening classes, Toynbee Hall, London, 1952–53; Shoreditch Teachers Training College, Egham, Surrey 1954–57. The Pop-style paintings (especially the frank paintings of female nudes) for which he is best known evolved through a technique of applying small dots of colour with hypodermic syringes. In conjunction with these he has, since the 1980s also painted abstract landscapes and other subjects. He held about 30 solo exhibitions 1965–93 including at Watters, Sydney and Niagara, Melbourne and a survey exhibition in 1985 at Queensland University Art Museum and touring and at MOCA, Brisbane 1991. He has participated in numerous significant group exhibitions in public galleries 1973–91 including *Recent Australian Art* AGNSW 1973; *Australian Painting and Sculpture 1956–81* AGNSW 1982; *Perspecta* AGNSW 1983; *Field to Figuration* NGV 1987; the Bicentennial exhibition *The Great Australian Art Exhibition*; and *The Face of Australia*; *Prints and Australia*; NGA 1989; *L'été Australien à Montpellier* France 1990. He was artist-in-residence at several tertiary colleges and universities NSW 1978, 79.
AWARDS: Berrima Prize 1965; Perth prize (for drawing) 1967. Teaching experience: visiting lecturer painting University of Auckland, NZ 1974;
REP: NGA; most state galleries and many regional galleries all states; Parliament House; Artbank; MOCA, Brisbane; many tertiary collections NSW, SA, Vic, Qld;

corporate collections including Robert Holmes à Court; Estée Lauder, New York; NAB.

BIB: Catalogue essays in exhibitions as above and many others. Many major texts on Australian art including Horton PDAIA 1969; *Australian painters of the Seventies* Ure Smith 1969; Smith *AP*; Bonython *MAP* 1976 & 80. G. Catalano *Years of Hope* OUP, 1981. *New Art Two*.

LARWILL, David

(b. 1956 Ballarat, Vic.)

STUDIES: Prahran CAE 1975; painting PIT 1980; travel studies Europe and USA 1975–77; Arnhem Land (with Michael Leunig) 1991. One of the founding members of ROAR Studios, Melbourne he achieved considerable success in the 1980s with his large neo-expressionist paintings. Often using reds, blacks and yellows, simplified figures overlaid the loosely squared painted grid on a white background. He held 10 solo exhibitions 1982–91 first at ROAR then with other galleries Melbourne (including United Artists, Realities and William Mora), Sydney (Coventry) and Launceston. His work has appeared in a number of group exhibitions including survey shows of ROAR Studios artists and in *Vox Pop*, 1984; *Modern Masters* 1986 at NGV; *A Horse Show* Heide 1988. His commissions include a mural for ACCA, Melbourne: painted tram for Vic. Govt 1985; restaurant commission with other ROAR Studios artists for mural at NGA restaurant 1986.

REP: NGA; NGV; Parliament House; Dobell Foundation; corporate collections including Holmes à Court; ICI; Myer.

LASPAGIS, PAUL

(b. 1949, Greece) Painter, printmaker.

STUDIES: Dip. Art, NGV 1971. His expressionist paintings while often based on everyday domestic objects are abstract and show an energetic yet deliberate handling of paint. He held about 9 solo exhibitions 1975–93 Melbourne (including at Tolarno, VAS, Pinacotheca, Vic. Print Workshop, Niagara, MCA) and participated in a number of group exhibitions 1981–92 largely at private galleries in Melbourne including Niagara, Charles Nodrum, MCA.

REP: NGV; Artbank; National Gallery of Athens; several tertiary collections including Melbourne and La Trobe Universities; corporate collections including Myer; NAB.

BIB: *New Art Three*.

LAST, Clifford

(b. 1918, Pookes Green, Hampshire, England; arr. Australia, Jan. 1947) Sculptor.

STUDIES: Hammersmith School of Wood Sculpture, 1946; scholarship to City and Guilds School of Sculpture, London; RMIT, 1947. He held his first exhibition at Georges Gallery, Melbourne, 1948, and in 1951 travelled in England, France and Spain, responding enthusiastically to the work of the French and British modern sculptors, in particular to that of Robert Adams whose simplified, geometric forms were destined to have a lasting influence. Back in Australia

in May 1952, he went through a lean period before turning to teaching and lecturing at Mercer House Teachers College, 1955–62. He was a foundation member of the Group of Four, 1953–55 and Centre Five, 1963–65 and during this time established his reputation. His carvings in wood and stone are noted for elegance of form, clear understanding of the organic nature of natural materials and a refined sense of style. The NGV held a retrospective of his work 1989–90.

AWARDS: Crouch prize, Ballarat, 1965; British Council grant for overseas study, 1967; Captain Cook Bicentenary (second prize), VAS, 1970; OBE conferred, 1977.

APPTS: Member, Commonwealth Art Advisory Board 1970–? (q.v.).

REP: NGA; NGV; regional galleries at Ballarat, Benalla, Castlemaine, Launceston, Mildura and Newcastle.

BIB: Max Dimmack, *Clifford Last*, Hawthorn Press, Melbourne, 1972. Lenton Parr, *Sculpture*, Arts in Australia series, Longman, Melbourne, 1961. Sturgeon, *DAS*. Scarlett, *AS*. *A&A* 2/2/1964 (Hal Missingham, *Mildura Prize for Sculpture*).

LATELLA, Diego

(b. 1948, China) Sculptor and painter.

STUDIES: ESTC (etching with Rose Vickers); Ultimo Tech. School (window dressing, with S. Lee), 1973–74. His minimal sculptures were shown in the *Mildura Sculpture Triennial*, 1978 and he subsequently held solo exhibitions Sydney (Robin Gibson; Irving Sculpture Centre) and participated in a number of group exhibitions including *Perspecta* AGNSW 1983.

AWARDS: Prizes at the RAGSNSW, 1975, 1977; Camden Festival competitions, 1975, 1977; Dyason grant, AGNSW, 1978; New York Studio School (Peter Brown Memorial scholarship), 1978–79; scholarship, Pratt Graphic Centre, New York, 1978; scholarship, Pennsylvania Academy of Fine Art, 1979; residency Moya Dyring Studio, Cité Internationale des Arts, Paris, 1979.

REP: AGNSW.

BIB: Germaine, *AGA*.

LATIMER, Bruce

(b. 4/4/1951, Sydney) Painter, printmaker.

STUDIES: Dip. Fine Arts, NAS, 1973; Dip. Ed., Sydney Teachers College, 1974. Made often on handcut paper, with lacron paper stencils combined with photo-stencilled line drawings, his Pop-style, figurative prints have appeared in many print exhibitions. He lived and worked in New York 1976–91, returning to Sydney in 1991. He held six solo exhibitions 1974–88 at Watters, Sydney; Ray Hughes, Sydney and Brisbane, and PACA Gallery, New York and his work has appeared in group exhibitions including several print survey exhibitions such as *Contemporary Australian Printmakers*, Uni. of Oregon, USA 1980; *Australian Screenprints*, travelling Australian exhibition 1985; *Prints and Australia* NGA 1989; *Off the Wall/In the Air*, Monash Uni. 1991; *Tony Coleing and Friends*, NGA 1992.

AWARDS: NAS Students Union prizes, 1970–71; Rowney prize (for prints), 1973.

APPTS: Part-time lecturer in painting, postgrad. dept, SCA, 1991.

REP: NGA; AGNSW; AGSA; AGWA; NGV; QAG; TMAG; MCA, Brisbane; regional galleries including Ballarat, Latrobe Valley, Newcastle, Shepparton; National Art Gallery of NZ; tertiary collections including Tasmanian CAE, WAIT; corporate collections including Philip Morris.

BIB: G. de Groen, *Some other Dreams*, Hale and Iremonger, 1984. PCA, *Directory* 1976. Germaine, AGA. A&A 15/1/1977 (Geoffrey Legge, *Bruce Latimer's prints*).

LATIMER, Murray (Murray Hugh Latimer Triggs)

(b. 1919, Wallaroo, SA; d. 1974) Painter, teacher. STUDIES: SASA, –1939; NGV School, c.1945–48; RMIT; travel studies, UK and Europe; India, 1958, 1959. He studied art while working on the staff of the SA Public Library. Wounded in Syria while serving with the AIF, he transferred to AIF Middle East headquarters as a draughtsman, and after the war resumed his art studies in Melbourne. Painted usually in oil using a palette knife technique.

REP: AGSA.

BIB: *AGSA* catalogue, 1960.

LATOS-VALIER, Paula

(b. 6/2/1946. Philadelphia, USA; arr. Australia 1978) Gallery director. STUDIES: BA, University of New Hampshire, 1967; M. Phil, Yale University 1971; 1963–67; University of Dijon, France, 1966; Ecole des Beaux Arts 1965–66; Diploma International School of the Hague, Netherlands, 1963; Melbourne State College, 1978. She completed many commissioned works in the USA, and became celebrated for her mural-sized banners done in nylon and wool felt. Her experience includes teaching, administrative, curatorial and design work. APPTS: Tutor design CIT, Melbourne, 1978; 1979 staff of AGDC; 1981–88 assistant director and from 1989–90, executive officer, Biennale of Sydney; 1985–88 staff of Australian Bicentennial Authority including as exhibition design manager for *The Face of Australia*; director, AGWA 1990– .

LA TOUANNE

See TOUANNE, E. de la

LA TROBE, CHARLES JOSEPH

(b. 30/3/1801, London; arr. Aust. 1839; d. 1875, England) Colonial administrator, sketcher. He made a number of sketches of his travels in Europe before coming to Australia. Superintendent of the Port Phillip District 1839–50, then first governor of the colony of Victoria 1851–4, he was responsible for the establishment of Melbourne's Botanical Gardens and for appointing von Mueller as government botanist. A number of his watercolour sketches survive and have been exhibited in exhibitions such as *Victorian Visions: 1834 onwards* NGV 1985 and in the La Trobe Library which holds the only public collection of his works (on loan from the National Trust).

LA TROBE LIBRARY of the STATE LIBRARY OF VICTORIA

La Trobe St., Melbourne, Vic. 3000. Named after the first governor of Victoria, Charles Joseph La Trobe (1801–75), the Library houses the great Australiana collections of the State Library of Victoria. The collections include paintings, drawings, prints, books, letters and other documents dating from the earliest times of Colonial settlement. Special exhibitions are held in the Library's gallery, Irving Benson Hall.

BIB: Catalogues of La Trobe Library exhibitions.

LAUGHTON, Annie Watson

(b. 1858, Adelaide; d. 1903) Painter. STUDIES: School of Design, Adelaide (with L. Tannert), and in Sydney. REP: AGSA.

LAUNCESTON ART SOCIETY

(Founded in 1891, as the Launceston Drawing Club) PO Box 1476, Launceston, Tas. 7250. Walch's *Red Book* makes the first reference to the Launceston Art Society in 1899, and lists Mrs M. Greig as the first president, although Moore gives Lady Hamilton, married to the Governor, as the holder of that office. Annual exhibitions of the Society (membership 150 in 1993) are held at various venues. Centenary exhibition held Oct. 1991.

BIB: Moore, *SAA*.

LAURENCE, Janet

(b. 1949, Sydney) Installation artist, painter, sculptor. STUDIES: University of Sydney; Alexander Mackie College, City Art Institute, Sydney; Perugia; New York Studio School. Often using building materials (wood, tin) her sculptures resemble the frame of a building, a style which is reflected in her abstract expressionist paintings in which she also uses mixed media on canvas to create texture. She held 16 solo exhibitions 1981–91 Sydney (including Garry Anderson); Melbourne (United Artists; University of Melbourne; City galleries) and other capital cities. Group exhibitions in which her work was seen 1982–92 included *A Contemporary Australian Art* London, 1985; *Isolaustralia* Venice, 1985; *Perspecta* AGNSW 1985; *Frames of Reference* Sydney 1991.

AWARDS: Residencies at Paretaio, Italy, VACB studio, 1983; Tokyo Studio, VACB 1988; grant VACB, 1986; prizes at Campbelltown, Camden, Maitland, Port Macquarie 1982–87; Newcastle Invitation Purchase Painting Prize, 1988.

REP: NGA; Parliament House; regional galleries

BIB: Chanin, *CAP*. Kirby *Sightlines*. McIntyre, *CC*.

LAURIE, Ross Campbell

(b. 1961, NSW) Painter, sculptor. STUDIES: SCA, 1979; Mitchell College, Bathurst (painting, printmaking) 1983; Foundation course, St Martins

School of Art, London, 1984–85; Newcastle-upon-Tyne Polytechnic, UK, 1984–85; Victoria College, Prahran 1986. His work includes printing and sculpture as well as painting and often relates to rural Australia such as his sculptures or mini-reproductions of farmyard scenes and rural icons including windmills, tankstands, etc. His paintings show a broad imagination and are both figurative and surrealist. His work was included in about 15 group exhibitions 1982–92 in private galleries Sydney (Syme Dodson), Melbourne (Acland St; William Mora) in *Moet & Chandon Foundation Touring Exhibition* 1987, 88 and public and community galleries including *New Art Melbourne* Ivan Dougherty Gallery, Sydney, 1988; *10 Square works for Wilderness* Linden Gallery, St Kilda, 1992. He held 10 solo exhibitions 1981–92 in country NSW (Walcha 1981, 86) Melbourne (Girgis & Klym, 1988; William Mora, 1991) and Tamworth City Gallery (1981, 91) and Linden, St Kilda (1990).
AWARDS: Project grant, VACB.
APPTS: Drawing workshop, Prahran, 1987; CAE, Walcha (life drawing; Aboriginal class; young children) Walcha, 1991; teacher (painting) Tamworth TAFE, 1992– .
REP: NGA; Artbank, Benalla regional gallery; La Trobe University.
BIB: Catalogue essays exhibitions as above.

LAUVERGNE, Barthelemy

(Active c.1820–30) Maritime artist. Secretary to Dumont D'Urville in *Astrolabe* which visited Tas., 1827. Some of Lauvergne's views were lithographed for D'Urville's book. He also made sketches of *Vooloomolo* (Woolloomooloo) while attached to the ship *Favorite*.
REP: Mitchell, Dixson, Allport Libraries.
BIB: Dumont D'Urville, *Voyage de la Corvette l'Astrolabe*, 5 vols, Paris, 1830. KETT, DAA.

LAVERTY, Peter Phillip

(b. 10/10/1926, Winchester, England; arr. Aust. 1951) Painter, teacher, gallery director.
STUDIES: Winchester School of Art, UK. He held exhibitions, some jointly with his wife, Ursula (q.v.), from 1959, mainly of semi-abstract paintings stylistically related to contemporary British painting. His work appeared in several significant group exhibitions including survey exhibitions of Australian art in USA, 1966; NZ, 1965; *São Paulo Bienale*, Brazil, 1961. He is a member of a number of art societies including Australian Watercolour Institute and International Society of Art Critics and served on a number of art committees including NSW Travelling Scholarship 1976–78; Churchill Fellowship Arts Selection 1971– ; Sydney Biennale Committee 1975–77. He was on assessment committees for many tertiary colleges in NSW including City Art Inst., Wollongong Inst. of Education and SCA, and was a judge for numerous art competitions including Transfield; Sulman, Blake prizes; Portia Geach Memorial Award. He wrote for *A&A* and many other art journals and gave numerous art lectures.
AWARDS: Prizes in competitions at Warringah, 1957; Grenfell, 1960; Mosman, 1961, 62; Maitland, 1965;

Campbelltown, 1966; Rockdale, 1966; Berrima, 1966; Grafton, 1969.
APPTS: Teaching, NAS, then head of the school and State Supervisor of Art, 1952–71; director, AGNSW, 1971–78.
REP: AGNSW; AGWA; NGV; TMAG; regional galleries Bendigo, Castlemaine; uni. collections in Brisbane.
BIB: Germaine, AGA. *International Who's Who in Art and Antiques. Dictionary of International Biography*, Vol. 15; Smith, AP. Campbell, AWP.

LAVERTY, Ursula Airlie

(b. 18/12/1930, London; arr. Aust. 1949) Painter.
STUDIES: Southern Coll. of Art, Winchester, UK; ESTC 1950–52. She held several solo exhibitions from 1968 including at Macquarie, Sydney; Arts Council Gallery, Sydney; Artarmon Galleries, Sydney and Design Arts Centre, Brisbane and joint exhibitions with her husband, Peter Laverty (q.v.). A foundation member of the Sydney Printmakers group, she exhibited regularly with them until 1985 and is a life member of the NSW Society of Artists and one time member of the CAS.
AWARDS: Sixteen municipal and regional awards including Mosman drawing prize, 1957; Journalists' Club Award (for graphic arts), 1957 and George Galton memorial print Prize, Maitland, 1980.
REP: AGNSW; NGV; Newcastle Region Art Gallery.
BIB: Franz Kempf, *Australian Printmakers*. PCA, *Directory* 1982, 89. Germaine, DAWA. *A&A* 19/4/1982; 28/1/1990.

LAW, Benjamin

(b. 1807, England; arr. Hobart 1834; d. 1890, Westbury, Tas.) Sculptor. His busts of the Tasmanian Aborigines – *Woureddy* and *Truganini* (1836) – show a humanity and understanding that was rare in the European population of the time. Sturgeon informs us that 'He produced about 30 casts of the two busts, some hand-coloured, and offered them for sale at four guineas each'. He taught at the Infant School, Hobart, 1837 and was represented in *Early Australian Sculpture* Ballarat Fine Art Gallery, 1977; the Bicentennial exhibition *The Great Australian Art Exhibition* and *Tasmanian Vision* TMAG and QVMAG 1988.
REP: TMAG; QVMAG.
BIB: Moore, SAA. Sturgeon, DAS. Scarlett, AS.

LAWLOR, Adrian

(b. 25/8/1889, Marylebone, UK; arr. Aust. 1910; d. 6/9/1969, Repatriation Hospital, Heidelberg, Vic.) Painter, critic, writer.
STUDIES: NGV School (evening classes), 1929; with Alexander Colquhoun, 1930. He married Eva Nodrum (b.1869, New York) in 1916 and on 22 Nov. 1916 enlisted in the AIF in which he served until demobilised, 15 June 1919. He settled at Warrandyte and from April 1921 to December 1923 wrote six articles for the Sydney *Bulletin*. He wrote also for *Vision* (three articles), 1923, *Art in Australia*, 1927, *New Triad*, 1927. A period of art study in Melbourne preceded a succession of exhibitions (Little Gallery 1930,

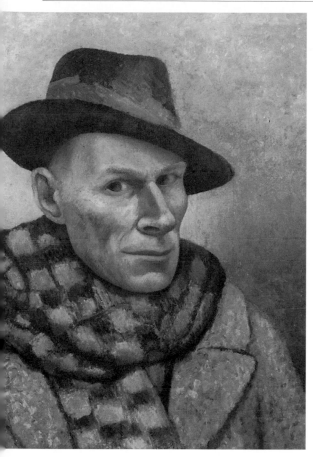

Adrian Lawlor, Self Portrait, *c. 1937, oil on cardboard, 61.5 × 48cm. Collection, Museum of Modern Art at Heide.*

31; Fine Arts Society 1933; Cynthia Reed Gallery 1935; Athenaeum 1936; Riddell Gallery 1937, 38; Athenaeum 1940). He exhibited also as an invitee with the Contemporary Art Group 1932, 1933 and 1937, became the foundation secretary of the CAS (q.v.), 1938, and the following year its artist vice-president. In 1939 his Warrandyte house and more than 200 paintings were destroyed by fire. His reputation as an art critic was established by his writings for various publications, particularly the critiques he wrote for the *Sun News-Pictorial* while deputising for the regular *Sun* critic, George Bell, and for his radio broadcasts on art, which began in 1936 and ended in 1951. The most articulate of all critical protagonists of Burdett's 1939 exhibition of *French and British Contemporary Art*, Lawlor practised what he preached, but his Cézanne-inspired paintings received little recognition during his lifetime. Even his more avant-garde colleagues did not take these little works as seriously as they should have, with the result that fewer than 60 are now known to have survived. His first wife died in Jan. 1953, and his second marriage three years later lasted only a few weeks. The failure of his novel, *The Horned Capon* (1949), helped to ruin him financially and led to a collapse in his health.

His memory failed and, unable to complete any kind of creative work, he accepted manual work on a farm and then worked at the St Kilda post office during his final years of decline. He received some consolation from the retrospective exhibition of 54 of his works at the Argus Gallery, Melbourne, Aug. 1966, when 18 paintings were sold. His work was represented in the Bicentennial exhibition *The Face of Australia*. His books include *Arquebus*, Ruskin Press, Melbourne, 1937; *Eliminations*, Ruskin Press, Melbourne, 1939; and *The Horned Capon*, Oberon Press, Melbourne, 1949 (edition of 350 copies).
REP: NGA; AGSA; AGWA; NGV; Ballarat Fine Art Gallery.
BIB: A number of general texts on Australian art including Smith, AP.

LAWRENCE, George Feather
(b. 14/6/1901, Annandale, NSW; d. 1981) Painter.
STUDIES: Sydney Art School with Julian Ashton; travel studies, Europe and UK, 1951, 52, 62, 68. He worked as an advertising artist and exhibited with the Contemporary Group, Sydney, and NSW Society of Artists as well as holding regular exhibitions, notably at the Macquarie Galleries, from 1945. Early in his career he developed great facility and during the 1950s his free, expressionistic paintings of city streets and buildings attracted a large following. His works are seen frequently in Joel's, Christie's and Sotheby's auctions.
AWARDS: Wynne prize, 1949; Crouch prize, Ballarat, 1949; Bendigo prize, 1950.
REP: AGNSW; AGSA; NGV; QAG; TMAG; regional galleries Armidale, Ballarat, Bendigo, Broken Hill.
BIB: Roland Wakelin, *George Lawrence*, Legend Press, Sydney, 1963. Jean Campbell, *George Lawrence*, Aust. Artist's Editions, Sydney 1980.

LAWSON, Bernard John
(b. 9/3/1909, Carlton, Vic.) Painter, teacher.
STUDIES: NGV School, 1926; George Bell School, 1938–40 and 1956–61. He taught at the classes conducted at the VAS, 1965–70. An accomplished draughtsman and painter, he frequently changed his allegiances, moving from studies of the work of William Dobell to School of Paris painting styles from Modigliani to Picasso. He held several individual exhibitions in Melbourne including Hawthorn City Art Gallery 1977 and Distelfink Gallery 1988.
AWARDS: Mornington Peninsula Art prize, 1967; Dean prize (VAS), 1970; Cato prize (VAS), 1971; Camden Art Prize 1970.
REP: NGV.

LAWSON, J. Webster
(b. 1855, Sheffield, England; arr. Aust. 1895; d. 1941, Sale, Vic.) Painter, sculptor.
STUDIES: South Kensington, London; the studio of F. Cormon, Paris. He was a contemporary of Rupert Bunny, who may have interested him in Australia. His first commission in Melbourne was designing theatre sets for J. C. Williamson. Later he opened an art

school at Nhill where his pupils included Percy Leason (q.v.). For 30 years he taught at Education Dept tech. schools in Vic. His surviving works include a bust of Father Geoghan, Kyneton, a Stations of the Cross at the Roman Catholic Cathedral at Sale, an oil owned by O. S. Green of Melbourne, and a watercolour owned by Mrs Cross, of Bundalaguah, via Sale, Vic.

(Information in a letter from O. S. Green, 30 June 1971)

NFI

LAWSON CLARKE, Lesley

(b. 1930, Melbourne) Painter, teacher.

STUDIES: NGV School, 1947–53; RMIT, 1955–56 (evening classes in printmaking with Harold Freedman); George Bell School; one year, Fine Arts, Uni. of Melbourne, 1947; travel studies Europe, 1951 and USA, 1988. A member of the Melbourne Contemporary Artists Group she exhibited with that group and with the George Bell School. Her work was represented in *Classical Modernism: The Bell Circle*, NGV 1992.

AWARDS: Grace Joel scholarship, NGV School, 1951; VAS drawing prize, 1954.

REP: NGA; NGV.

BIB: Henry Rasmussen, *Printmaking with Monotype*, Pitman, London 1960. M. Eagle & J. Minchin, *The George Bell School: students, friends, influences*, Deutscher Fine Art/Resolution Press, 1981.

LAYCOCK, Donald

(b. 4/4/1931, Melbourne) Painter.

STUDIES: NGV School, 1949–53; with Charles Reddington, 1959; travel studies Europe (principally Spain), 1966–67. His work first attracted attention in a group exhibition shared with Clifton Pugh, John Howley and Lawrence Daws (qq.v.) at the VAS galleries, 1955. His early interest in surrealist painting was succeeded by a later phase in which he sought to interpret in paint problems relating to space and time. From 1961 he held regular exhibitions at the South Yarra Gallery, Melbourne, and Bonython galleries in Sydney and Adelaide. Among his commissioned works is a mural, *Night Sky*, for the Australian pavilion at Expo '67, Montreal, and another for the Australian pavilion at Osaka, Japan, 1969. He exhibited infrequently from the late 1970s.

AWARDS: Travelodge prize, 1970.

REP: NGA; AGSA; AGWA; NGV; regional galleries Benalla, Castlemaine, Newcastle; uni. collections ANU, NSW, Monash.

BIB: References in most general books on contemporary Australian painting. Gleeson, MAP. Ronald Millar, *Civilized Magic*, Sorrett Publishing, Melbourne, 1974. A&A 13/2/1975 (Janine Burke, *Donald Laycock*).

LAYTON, George F.

Secretary and superintendent, AGNSW, 1895–1905.

LEACH-JONES, Alun

(b. 1937, North Wales, UK; arr. Aust. 1959) Painter, printmaker, teacher.

STUDIES: Liverpool Coll. of Art (evening classes), 1957–59; SASA (evening classes), 1960–63; travel studies, UK and Europe, 1964–65. In 1964 he began to develop the system of painting small, vermicular shapes within a circle within a square, which became known as his 'Noumenon format' or series, shown in a large number of exhibitions both in Australia and overseas including representation in the *Bienale de São Paulo*, 1969 and *The Field*, NGV, 1968. Ultimately the format became restrictive and he changed to a freer style. His abstract form-filled circular motifs became extremely distinctive and he transformed them into both prints and tapestries with great success. He held about 50 solo exhibitions 1964–91 in Australia (initially at Rudy Komon then Macquarie, Sydney; Powell St, Melbourne), UK, Europe and USA including a retrospective print exhibition at New England Regional Art Museum (Armidale) in 1986. He participated in many significant group print and painting exhibitions in Australia and other countries including Europe, Japan and USA from 1963, including *Australian Prints*, PCA, Cracow, Poland 1970; international print biennales in New York, Italy, Norway; *Tapestry and the Australian Artist*, NGV 1977; *The Field Now*, Heide 1984; *Field to Figuration*, NGV 1987; *Backlash*, NGV 1987; *Sightings*, Institute of American Studies, Barcelona, and Pratt Manhattan Gallery, New York, touring Spain 1988–89; *Aspects of Australian Art*, Houston Inter-national Festival, USA 1988. He was artist-in-residence at Macquarie Uni., Sydney, 1977; Künstlerhaus Bethanien, West Berlin, 1980; State Uni. of New York, 1981; Fremantle Arts Centre WA, 1985 and visiting artist at Claremont School of Art WA, 1981.

AWARDS: Patron print, PCA, 1967; Benalla Art Gallery (acquisition award), 1967; Wangaratta prize, 1968; Georges Art Prize (second award), 1970; Henri Worland Memorial Art prize, Warrnambool Art Gallery, 1979; grant, VACB, 1980; Fremantle Print Award, 1985; grant British Council, London, 1990.

APPTS: Teacher, Prahran CAE, then NGV School, 1969–71; VCA, 1972–77.

REP: NGA; AGNSW; AGSA; AGWA; MAGNT; NGV; QAG; TMAG; Parliament House; Artbank; many regional galleries; many tertiary and university collections most states; all major corporate collections including the Christensen Foundation; NAB; BHP; Reserve Bank; Faber-Castell; Robert Holmes à Court.

BIB: Catalogue essays in exhibitions as above and many others including for solo exhibitions at Monash University Gallery, 1976; Macquarie Galleries, 1986, 91; Fremantle Arts Centre, 1987 and for Luise Ross Gallery, New York 1987, 91. Graeme Sturgeon, *Alun Leach-Jones*, Craftsman House, Sydney 1988. J. Eisenberg, *A Studio Book: Alun Leach-Jones: First Etchings*, Gwalia Press, Sydney 1987. Most major texts on Australian art including Gleeson, MAP; Smith, AP. A&A 11/1/1973 (Patrick McCaughey, *The Popularity and the Problem of Alun Leach-Jones*).

LEASON, Percy (Percival Alexander)

(b. 25/2/1889, Kaniva, Vic.; d. 11/9/1959, New York) Painter, cartoonist, illustrator, teacher.

STUDIES: NGV School (evening classes), 1907–10; with Max Meldrum, 1924– . He drew all his life. Brought up on a farm, his first studio was a converted piano case in which he drew pictures of farm life. At the age of 17 he was apprenticed to the lithographers Sands & McDougall, Melbourne, and later shared a studio in Queen Street with the painters McInnes, Frater and Crozier. He seems to have spent some time in Qld during this period and is listed as an exhibitor with the Qld Art Society, 1913 and 1914. In 1916 he married his cousin, Isabel Chapman, and the following year moved to Sydney to join the advertising firm of Smith and Julius. The pen-and-ink illustrations to Henry Lawson's poems and of explorers (AGNSW) were done about this time (*Selected Poems of Henry Lawson*, Angus & Robertson, Sydney, 1918). He became known for his cartoons in the Sydney *Bulletin*, nationally famous for his *Wiregrass* cartoons, and as staff artist for the new Melbourne *Punch*, was the most highly paid contemporary black-and-white artist in Australia. In 1924 he met Max Meldrum and fell greatly under his influence as a painter, his best-known paintings of Australian subjects being a series of portraits of the surviving Aborigines of the Lake Tyers settlement in Vic. Later landscapes and paintings of European architecture, painted in a tonal impressionist manner, revealed him as one the most accomplished of Meldrum's many followers. In 1939 he moved to the USA where he worked as an illustrator in New York before settling on Staten Island where he taught at the Inst. of Art and Science. In 1957 he realised a life-long ambition to study prehistoric cave paintings in Europe, an experience that resulted in the work for his last exhibition, at the Chase Gallery, New York. Unable to overcome the shyness which was a legacy from his isolation as a child, he did not capitalise on his many successes and died comparatively poor. A memorial exhibition of his work was held at the Staten Island Inst. in Jan. 1962, and another at the Joseph Brown Gallery, Melbourne, 1972.
REP: AGNSW; NGV.
BIB: Vane Lindesay, *The Inked-In Image*, Hutchinson, Melbourne, 1979. Marshall, *Pioneers and Painters*, Thomas Nelson Australia. References and reproductions, *AA* no. 4, 1918.

LE BIHAN, E.

Early Qld artist. First staff artist for the *Queenslander* (c.1890).
BIB: Moore, *SAA*.

Le BRETON, Louis

(b. c.?1800; d. Paris, 1866) Marine and topographical artist in *Astrolabe* during Dumont D'Urville's second voyage, 1837–40. He made numerous drawings and watercolours, many of which were later lithographed in Paris by Sabatier, Blanchard and others. Of Australian interest are his views of Port Essington and New Victoria, NT, as well as five views of Hobart. He exhibited at the Paris Salon in 1841 and 1849.
REP: QVMAG; Mitchell Library; public collections France.
BIB: J. S. C. Dumont D'Urville, *Voyage au Pole Sud et dans*

L'Océanie sur les corvettes L'Astrolabe et la Zélée etc., 23 vols, Paris, 1841. Smith, *EVSP*, 1960. Bénézit, *Dictionnaire*, 1976. Kerr, *DAA*.
(*See also* DE SAINSON, Louis Auguste; GOUPIL, Ernest August)

LECKIE, Alexander J. K.

(b. 1932, Glasgow; arr. Aust. 1955) Sculptor, ceramicist, teacher.
STUDIES: Glasgow School of Art, 1950–55; Central School of Arts and Crafts, London, 1966. While often evoking the pastiche, his large ceramic sculptures are presented with wit and a sense of style. He was artist-in-residence, Melbourne State Coll., 1978–79.
APPTS: Teacher, ceramics and sculpture, SASA, 1956–62; senior lecturer in ceramics, Glasgow School of Art, 1966.
REP: AGNSW; AGSA; AGWA; Newcastle Region Art Gallery.
BIB: Scarlett, *AS*.
NFI

LECKIE, Mal (Malcolm John Stuart)

(b. 4/1/1952, Perth, WA) Sculptor, draughtsman, teacher.
STUDIES: Associateship Fine Art (sculpture), WAIT, 1974; Grad. Dip. Ed., WAIT, 1977. His landscape drawings in charcoal have a strong, sculptural look. He held about 11 solo exhibitions 1980–91 (largely in Qld) and from 1973 participated in a number of group exhibitions also largely at private galleries in Qld.
AWARDS: Uni. of WA Undercroft Gallery prize (for sculpture), 1973; Bundaberg Drawing Prize, 1978; St Albans Drawing Prize, 1980; Gold Coast City Art Prize (purchase award), 1981; about 20 prizes Qld 1981–91 including Gold Coast City Art prize 1985, 86, 87 and Suncorp Biennial Award 1987; Southern Cross Drawing Prize 1991.
APPTS: Art master, Southport School, Qld, 1974–88; art critic, *Gold Coast City Bulletin*, c.1978.
REP: Regional collections Qld including Tweed River, Gold Coast City Art Gallery and Brisbane City collection.
BIB: John Millington, *Tropical Visions*, UQP, 1987. Germaine, *AGA*.

LEE, Lindy

(b. 1954, Brisbane) Painter.
STUDIES: Dip. Ed. (art, secondary school), Kelvin Grove CAE, 1975; Chelsea School of Art, London, 1979–80; BA (Vis. Arts), Postgrad. Dip. (painting), SCA, 1981–84. Lee came to prominence in the 1980s with her distinctive paintings based on images from past masters including El Greco, Rembrandt, Delacroix etc. Her technique involved coating the surface with black oil and wax, scraping back the black to reveal the underlying image often in glowing reds, blues and greens. Thus the figures appear as if through a dark, streaky fog. Due to the often poignant human subjects and the underlying colours contrasting with the streaky black overlay, her works have a lyrical luminosity. Her

work was included in almost all significant survey exhibitions in the 1980s and early 1990s in some private galleries Sydney (Roslyn Oxley9) and Melbourne (13 Verity St) but mainly in public galleries including *History*, 1988, IMA, Brisbane; *Australian Perspecta 85*, AGNSW 1985, *Biennale of Sydney*, AGNSW, 1986; *Moet & Chandon Art Foundation Touring Exhibition*, 1987; *Dis/appearance*, touring contemporary art spaces Melbourne, Adelaide, Sydney, Perth, 1991. She held 14 solo exhibitions 1985–93 Sydney (Roslyn Oxley9 1986, 87, 88, 89, 90, 91), Melbourne (13 Verity St 1988, 90, 93), Brisbane (Bellas, 1990) and Contemporary Art Centre of SA, Adelaide, 1991. Performance *Pipe Dream*, written and directed Lyndal Jones, Studio Theatre, Vic. Arts Centre, 1989.

APPTS: Canberra School of Art, 1988; SCA, 1986– .

REP: NGA (general and Philip Morris Coll.); AGNSW; NGV (Budget Collection, Michell Endowment); QAG; MCA, Sydney; Griffith and Melbourne unis.; regional galleries Benalla, Geelong, Wollongong; Smorgon and ICI corporate collections.

BIB: Catalogue essays in exhibitions as above. Smith AP. *Collecting Art: Masterpieces, Markets and Money*, Craftsman House, Sydney, 1990. Kirby, *Sightlines*. AL 11/4/1991 (R. Grayson, *Terrible/Sublime or Perverse*). A&T no. 36, May 1990 (D. Losche, *Paraculture, Artists Space*). *Agenda* Dec. 1990 (J. Gregory, *Lindy Lee, Black + Black + Black*).

LEE, P.

(Active c.1890, NSW) Painter. Known for oils, mainly of mountain landscapes, often in a naive manner. Frequently painted the Blue Mountains and probably lived in Sydney.

NFI

LEES, *Derwent*

(b. 23/11/1885, Melbourne; d. 28/3/1931, London) Painter.

STUDIES: Uni. of Melbourne; travel studies, Italy and France; Slade School, London, 1905–08. Early in life, a severe riding accident caused concussion and the loss of his right leg, a misfortune that led finally to mental disorder and his premature death. His success at the Slade (with Brown and Tonks) was such that he continued at the school from 1908 to 1918 as assistant drawing-master. His close associates in London included Augustus John (whose model, Euphemia Lamb, he married in 1913), J. D. Innes, Henry Lamb (q.v.), George Moore, Lytton Strachey and Ambrose McEvoy from whom he learned to use sponges in watercolour painting. He exhibited with the New English Art Club and held his first exhibition at the Chenil Galleries, London, c.1913. Painted in the spirit of the New English Art Club, his figure paintings, portraits and drawings became well-known in London. He exhibited at the Friday Club until 1916, and at the New English Art Club until 1919, but by 1921 his declining health reached a stage when he was unable to work. He was hospitalised for the last 10 years of his life. Retrospective exhibitions were held at the Redfern Gallery in 1934 and 1939. Represented in many important public collections in England, his work went to Australia in travelling group exhibitions in 1933, 1935, 1939 and 1947–48, but remained virtually unknown here until Nov.–Dec. 1978, when an Australian commemorative exhibition was held at the Deutscher Galleries, Armadale, Vic.

REP: AGNSW; AGSA.

BIB: *Studio*, London Oct. 1933 (A. Zander, *Derwent Lees: His Life and Work*); Oct. 1946 (G. Charlton, *The Slade School of Fine Art*). *Burlington Magazine*, Jan. 1943 (R. Schwabe, *Reminiscences of Fellow Students*). AA, Feb. 1933. (A. Zander, *Derwent Lees*).

LEGGE, *(Colonel) William Vincent*

(b. 1841, Tas.; d. 1918, Tas.) Soldier, scientist, amateur painter. Educated in England, he was commissioned in the Royal Artillery in 1862 and from 1883 was responsible for the Hobart Battery defences. His interest in birds, begun in Ceylon in the 1870s, continued in Tas. where he read papers on ornithology, flora, forestry, etc. He was the friend and biographer of W. C. Piguenit (q.v.).

LE GRAND, *Henri*

(b. 1921, Amsterdam; arr. Aust. 1949) Potter, teacher.

STUDIES: Academy of Art, Amsterdam.

APPTS: Head of the art dept, Canberra Tech. School.

REP: AGWA; NGV; QAG; regional collections.

BIB: Kenneth Hood, *Pottery*, Arts in Australia series, Longman, Melbourne, 1961.

LEIGH, *William*

(b. 1829, England; arr. Aust. c.1852; d. 1905) Sketcher. A prolific sketcher, he was in Australia for about 18 months and made sketches of buildings and landscapes in SA, NSW, Vic. and Qld. Three volumes of his watercolour sketches are in the Mitchell Library, Sydney. His work was represented in *Gothic in South Australian Churches* Flinders University 1984 and *Victorian Vision* NGV 1985.

BIB: Kerr, DAA.

LEIST, *Frederick William*

(b. 1878, Sydney; d. 1945) Painter, illustrator, teacher.

STUDIES: Julian Ashton School; London, 1908. Leist began as a black-and-white artist, contributing drawings to the Sydney *Bulletin* and *Sydney Mail*, and later to the London *Graphic*. He was appointed an official war artist in France, and after World War I painted two large murals for the Australian Pavilion at the Wembley exhibition. This resulted in commissions for work at St Augustine, Florida, after which he toured Texas, New Mexico and Arizona. His paintings were hung at the RA exhibitions, London, in 1911 and 1925. He returned to Australia in 1926.

APPTS: Member of the Royal Society of British Painters in Oils; head teacher of painting, ESTC, 1926; NSW Society of Artists; RAS, Australian Watercolour Inst.

REP: NGA; AGNSW; NGV; QAG; AWM; regional galleries Bendigo, Mornington, Newcastle; England, Sheffield and Bradford galleries.

BIB: Moore, SAA. AA. no. 8. June 1924 (Edith M. Fry, *The Work of Fred Leist*).

LEMPRIERE, *Helen Dora*

(b. 1907, Melbourne d. 1991) Painter.
STUDIES: Melbourne, with A. D. Colquhoun and later with Justus Jorgensen, 1930–45; Paris, with Fernand Leger, 1950, later with Fred Klein. A great-granddaughter of T. J. Lempriere (q.v.) and niece of Dame Nellie Melba, she inherited a strong urge towards aesthetic self-expression. After her studies in Melbourne, then Paris (where her work was greatly influenced by Fred Klein, the father of Yves), she exhibited at the Salon des Surindependents, 1953–55, and other group exhibitions and in 1954 began an intensive program of solo exhibitions that took her from France to the UK, Germany, USA, Holland and, in 1966, back to Sydney. Her colourful, symbolistic painting derived inspiration from Aboriginal myths and legends. Woolloomooloo Galleries held an exhibition of her work, 1993.
REP. AGNSW; QAG; TMAG; public galleries in Israel and the USA.
BIB: Exhibition catalogues, Leicester Galleries, London, 1963, 1965; David Jones Gallery, Sydney, 1966.

LEMPRIERE, *Thomas James*

(b. 11/1/1796, Hamburg, Germany; arr. Van Diemen's Land 1822; d. 1852, at sea) Merchant, writer, portrait painter. Assistant Commissary-General of Tasmania he was largely a portrait painter although he did paint some allegorical scenes, decorations such as fire screens and maps. His work was seen in *Australian Colonial Portraits*, TMAG, 1979.
REP: TMAG; Mitchell, Allport, Dixson Libraries.
BIB: William Dixson, 'Notes on Australian Artists', *Journal of Royal Australian Historical Society*, vol. 7, pt 3, 1921. Moore, SAA. ADB 2. Kerr, DAA.

LENDON, *Nigel*

(b. 14/9/1944, Adelaide) Sculptor and teacher.
STUDIES: Dip. Fine Art (sculpture) SASA, 1969. His work first came into prominence at the *Mildura Sculpture Triennial*, 1967, in a minimal piece described later by Graeme Sturgeon as 'the most advanced in the show'. He showed also a painted, minimal work in *The Field* exhibition 1968, and in his contribution to *The Situation Now – Object or Post Object Art* (CAS, Sydney, July–Aug. 1971) moved closer still to the ultimate objective of creating a total sculptural environment. Later this was realised in his exhibition at Watters Gallery, Sydney, Mar. 1971. His work has appeared in a number of largely group exhibitions since the 1960s including Comalco Sculpture Award 1970s; Transfield Prize 1970; *Australian Drawing* NGA 1988; *Dick Watkins in context* NGA 1993. He has been involved in an honorary capacity on numerous art boards, committees, professional associations since 1973 including as member of the VAB, member of Board and National Executive, NAVA and guest curator of the exhibition *The Painters of the story of the Wagilag sisters* NGA 1992; has writ-

ten a number of articles, essays and biographical essays including *The Necessity of Australian Art* (with Ian Burn, Charles Merewether, Ann Stephen) Power Institute, Sydney 1988; and for art magazines including *Art Monthly*, *Photofile*.
AWARDS: H. P. Gill (student prize), SASA, 1969; Mildura Sculpture Triennial (work acquired), 1970; Harkness Fellowship for studies in the USA, 1974–76; grant for database art chronology project VACB 1986.
APPTS: Lecturer, fine art, Gippsland Inst. of Advanced Education, 1971–74; member, Visual Arts Board, Australia Council, 1973–74; lecturer Sydney Coll. of the Arts, 1977–88 (head of dept 1986–88); deputy director Canberra School of Art, 1988– .
REP: NGA; AGNSW; AGSA; NGV; regional galleries Ballarat, Latrobe Valley, Mildura.
BIB: Catalogue essays as above. Sturgeon, DAS. Scarlett, AS.

LEON, *Dominic (Leo Burn)*

(b. c.1910; d. 1932) One of the first Melbourne artists to be influenced by cubism; his cubistic woodcuts appeared on covers of the Melbourne review, *Stream*, 1931. He died in a street accident.

LESTER, *Kerrie*

(b. 1953, Sydney) Painter.
STUDIES: NAS, 1971–74; Alexander Mackie CAE, 1975. From 1975 Lester's serialised paintings began to appear in exhibitions at the Hogarth Galleries, Sydney. She held 11 solo exhibitions 1976–92 largely at Macquarie Galleries, Sydney and participated in such group exhibitions as *Perspecta*, AGNSW 1981; *Continuum*, Ivan Dougherty Gallery 1981; the Bicentennial exhibition *The Face of Australia*; *Archibald, Wynne, Sulman* prizes, 1988, 89, 90; *Portia Geach Memorial Prize* 1990; *Off the Wall, In the Air*, Monash Uni. and ACCA 1991. Commissioned as participant in *A Portfolio of Women Artists*, Cancer Council of NSW, 1990.
AWARDS: VACB grant, 1977, 78; Georges Art Prize (work acquired), 1978.
REP: Regional galleries Horsham, Wollongong; Philip Morris Collection; State Bank of NSW.
BIB: *New Art Two*. Chanin, CAP. Elwyn Lynn, *Sydney Harbour Bridge 1932–82*, Angus & Robertson, 1982.

LESUEUR, *Charles Alexandre*

(b. 1/1/1778, Le Havre, France; d. 12/12/1846, St Adresse, near Le Havre) Zoological artist.
STUDIES: Royal Military School, 1787–96. Initially appointed as a novice helmsman with Baudin's expedition, Lesueur assisted the official artist, Nicholas Petit (q.v.), after three other artists withdrew in Mauritius. By the end of the voyage he had become an accomplished zoological artist specialising in marine fauna. His drawings of the platypus, kangaroo and dingo form an interesting early record as do also his detailed drawings of Aborigines. Péron and Freycinet published the first two volumes of the account of the voyage (François Auguste Péron and Louis Freycinet, *Voyage de Découvertes aux Terres Australes . . . sur les*

Corvettes *le Géographe, le Naturaliste, et la goélette le Casuarina – 1800–1804*, Paris, 1807, 2 vols and the first part of the atlas; after Péron's death in 1810 Lesueur assisted Freycinet to publish the second part of the atlas (1812) and the third vol). The huge collection of specimens made by Péron and Lesueur (over 100,000 specimens, of which over 2500 represented new species) was praised by the scientific committee: 'Péron and Lesueur alone have discovered more new animals than all the travelling naturalists of modern days'. Lesueur subsequently exhibited animal paintings, and in 1816 went to the USA where he was curator of the Academy of Natural Sciences in Philadelphia until 1825 and taught drawing in New Harmony, Indiana, 1826–37, before returning to France. He was appointed director of the Natural History Museum, Le Havre, 1845, but died shortly after. His work was represented in *The Colonial Eye*, AGWA, 1979 and *Tasmanian Vision* TMAG and QVMAG 1988.

REP: TMAG; Mitchell Library; Natural History Museums, Le Havre and Paris.

BIB: Smith, *EVSP*. J. A. Ferguson, *Bibliography of Australia*, vol. 1, NLA, 1975. Bénézit, *Dictionnaire*, 1976. Kerr, *DAA*.

LETHBRIDGE, *John*

(b. 1/3/1948, Wellington, NZ; arr. Australia 1975) Performance artist and printmaker.
STUDIES: Wellington Design School; Elam School of Fine Arts, Uni. of Auckland. He held exhibitions in NZ before moving to Australia. Conceptual art, process art, have all influenced his work which in 1993 at City Gallery, Melbourne consisted of photographic installations suspended from the walls by fine wire. His solo exhibitions 1975–93 included those at Coventry Gallery, Sydney 1975, 77; IMA, Brisbane, 1977; Australian Centre for Photography, Sydney 1979, 90; Yuill/Crowley 1982, 83, 86, 88, 89; Tolarno Melbourne 1982, 87; City Gallery 1990, 93; MCA, Brisbane 1988 and in Tokyo 1983 and Berlin 1985. His work was the subject of *Survey 4* (NGV, Melbourne, July–Aug. 1978) and has appeared in numerous group exhibitions 1970–93 including *Frame of Reference* George Paton Gallery, University of Melbourne 1980; *Eureka! Artists from Australia* Serpentine Gallery and Institute of Contemporary Arts, London 1982; *Biennale of Sydney*, AGNSW 1982, 90; *Continuum '83* 15 galleries in Tokyo 1983; *Visual Tension* ACCA, Melbourne 1983; *Backlash* NGV 1986.

REP: NGA; AGSA; AGNSW; NGV; QAG; regional galleries, Mildura; university collections, Sydney (Power Inst.), Monash, Vic.

BIB: Catalogue essays exhibitions as above. *A&T* Autumn 1981.

LETI, *Bruno*

(b. 1941, Roccantica, Italy; arr. Aust. 1950) Painter, printmaker.
STUDIES: TSTC, Melbourne Teachers College, 1963; Fellowship Dip., RMIT 1975; travel studies Europe, Canada, USA, 1968–70; Brazil, Peru, Argentina, 1975; USA and Italy 1977. He taught at the Scott Park Art

Bruno Leti, Holy Mountains, *woodcut, ed. 20. 1989, 41 × 38cm.*

School, Ontario, was Education Officer, NGV, 1971–73 and worked 1988 and 1991 in New York and Milan. A leading printmaker his semi-abstract etchings, woodcuts, aquatints and collagraphs have become well-known in Australian exhibitions, notably in those organised for the PCA. His paintings are based on the same abstract style as his prints and show a restrained use of often dark colour and balanced compositional aspect. He has also made a number of original books (*see* ARTISTS' BOOKS). He held about 30 solo exhibitions 1967–92 including at Melbourne (Gerstman Abdullah; Christine Abrahams; Editions) Sydney (Rudy Komon) and Deakin Uni., Geelong; Solander, Canberra; and survey exhibition Westpac Gallery, 1988. He participated in a number of group exhibitions 1976–92 including international and Australian print survey exhibitions such as *Mitchelton Print Touring Exhibition*, 1982, 86; *Oz Drawing Now*, Sydney Biennale, 1986; *Artists' Books*, Australian Print Workshop 1992.

REP: NGA; AGNSW; AGSA; AGWA; NGV; QAG; TMAG; Parliament House; Artbank; regional galleries including Benalla, Burnie, Fremantle, Ipswich, Launceston, Mount Gambier; municipal collections including Caulfield, Box Hill, Melbourne City Council; uni. collections including Melbourne, Canberra, Tasmania, WA; library collections WA, Qld; a number of corporate collections including Philip Morris; Westpac; BHP; AMP; Hirshhorn Museum, Washington DC; Museum of Art, Iowa City; Hamilton Museum and Art Gallery, NZ.

BIB: Catalogue essays exhibitions as above. V. B. Smith, *Dictionary of Contemporary Artists*, Clio Press, Oxford 1981. B. Hoffert, *Two Decades on Paper 1972–92*, (monograph), Dale Rock Publishers, Melbourne 1992. Germaine, AGA. PCA *Directory* (all editions).

LEUNIG, Michael

(b. 1945, Melbourne) Cartoonist, painter. With no formal training he has become one of Australia's foremost artist/cartoonists. His work was first seen in *Nation Review* in the early 1970s and later in the Melbourne *Age*, where it developed a large following for its poignant whimsy and unique humour often focusing on the foibles of human behaviour. Several collections of his cartoons have been published by Penguin, Australia. During the 1980s his talents as a painter also became developed with introduction of colour first tentatively in his newspaper work then more boldly in canvases. A retrospective entitled the Michael Leunig 'introspective' was held at the NGV, 1993.
REP: NGA; a number of state galleries including NGV.

LEVER, Richard Hayley

(b. 1876, Adelaide; d. USA, 1958) Painter, teacher.
STUDIES: Adelaide (with James Ashton); St Ives, Cornwall (with Julius Olsson, and A. M. Talmadge); Paris; New York, Art Students' League. He left Australia in 1902, and after study in Cornwall and Paris, went to America, where he became instructor of seascape painting at the Art Students' League of New York, and had a successful career as a marine painter. A member of the National Academy of Design, American Painters and Engravers, Connecticut Academy of Fine Arts, Royal British Artists.
AWARDS: A large number of awards won by Lever in the USA included the Carnegie prize, awarded by the National Academy of Design, New York, 1914.
REP: AGNSW; AGSA; Metropolitan Museum New York
BIB: Smith, *Catalogue AGNSW*, 1953. Article and reproductions in AA, no. 5, 1918.

LEVESON, Kenneth

(b. 13/2/1945. Melbourne) Ceramicist, lecturer.
STUDIES: Dip. Graphic Design, CIT, Melbourne, 1965; gold & silversmithing studies CIT, 1965–68; TSTC, State Coll., Toorak, 1968–69; Dip. Art, RMIT, 1969–72; New York Experimental Glass Workshop, NY, 1978–79. From 1972 he became known for his ceramic sculptures as shown in many solo and group exhibitions, mainly in Australian capital cities, and later in New York. He held three solo exhibitions Realities, Melbourne and Bonython, Sydney, 1972–75 and participated in a number of group exhibitions, 1968–92 including at NGV; AGSA; in New York; and in Newcastle area 1980s. A member of many committees and panels for ceramic and tertiary colleges he has given numerous guest lectures and was artist-in-residence, Melbourne State College, 1975, 80. Commissions include ceramics for the Park Hyatt Hotel, Sydney.
AWARDS: Grant VACB, 1974; grant Parks Commission, NY City, 1979; grants for Clayworks Pottery, NY State

Council for the Arts and National Endowment for the Arts 1977, 78, 79, NY City.
APPTS: Teaching, in ceramics (part-time), Prahran CAE, 1973; Preston CAE, 1973; La Trobe Uni., 1973; Hunter Coll., New York City, 1974–78; Baldwin Pottery, New York City, 1978–79; Mercer Coll., New Jersey, 1978; Prahran CAE, 1980; Newcastle CAE, 1981–84; head of dept, Uni. of Newcastle, 1985–89; ceramics critic (*Newcastle Herald*, 1981–83; *Age*, 1990); head of ceramic design dept, Associate Professor, Monash Uni. Caulfield, 1990– ; member Crafts Board of the Australia Council 1973–76.
REP: NGA; AGSA; a number of tertiary collections including Victoria College; Kalgoorlie College; Curtin Uni.; Uni. of Melbourne; Newcastle Uni.; regional galleries including Campbelltown.
BIB: F. Bottrell, *Artist Craftsmen in Australia*, Murray Books 1972. Germaine, AGA. Scarlett, AS. A&A 10/4/1973 (Barrie Reid, *The New Ceramics*).

LEVESON, Neil

(d. 1992) Printmaker, administrator. As director of the Australian Print Workshop (previously the Victorian Print Workshop: *see* GALLERIES – PUBLIC) from 1987 until his premature death in 1992, he lifted that organisation to new levels of professionalism and public profile.
BIB: A&A 30/2/1992 (obituary).

LEVESON, Sandra

(b. 1944, Melbourne) Painter, printmaker, teacher.
STUDIES: CIT, 1959–63; NGV School, 1959–63; overseas study 1974 and 1976. Her screen paintings gained her a reputation as a colourist when they appeared first at Pinacotheca Gallery, Melbourne, in 1968 which has been sustained by her coolly restrained abstracts often characterised by pastel blues and pinks divided by a horizon-like line. She held about 20 solo exhibitions 1969–93 including at Realities, Melbourne; Macquarie, Sydney; and *Decade of Sandra Leveson*, Uni. of Melbourne gallery, 1977. Group exhibitions 1969–92 included *Decade of Australian Painting*, McClelland Regional Art Gallery 1971; *Georges Invitation Art Prize*, 1973; *Australian Screenprints*, touring state and regional galleries 1983; *Aspects of Australian Art*, Houston International Festival exhibition, Houston 1988. She had a number of painting and print commissions including for PCA (patron print), 1978; painted tram, VACB, 1978; Bicentennial Darling Harbour Project, 1988.
AWARDS: Corio Prize, Geelong Art Gallery, 1971; Alice Painting Prize, Alice Springs, 1972; Trustees Award, QAG, 1972; Tasmanian Art Prize, TMAG, 1975.
REP: NGA; AGNSW; AGSA; MAGNT; NGV; QAG; TMAG; Parliament House; Artbank; most regional galleries Vic., NSW; a number of tertiary collections including Melbourne, WA, unis.; many corporate collections USA including Texas American Bank, Woodmont Corporation, Texas; corporate collections Australia including Robert Holmes à Court, NAB, Comalco.
BIB: F. Bottrell, *Artist Craftsmen in Australia*, Murray Books

1972. Bonython, MAP. G. de Groen *Conversations with Australian Artists*, 1978. Fiona Holt and Maurice Rinaldi, *Australian Women: Successful Lives*, Macmillan 1985. *Sandra Leveson* Craftsman House, 1993.

LEVI, Sara
(Active c.1905–20, Melbourne) Painter. She exhibited at the VAS from 1907 on. Her subjects included still-life of flowers and landscapes of the Melbourne area, including beach scenes of Port Phillip Bay. She was also a member of the Women's Art Club and the Bendigo Art Society.
BIB: Leon Caetoni, *The Art of Sara Levi*, E.A. Vidler, Melbourne, 1922.

LEVICK, T.
Instructor of drawing and painting at Working Men's Coll., Melbourne (RMIT), 1903–16; Head of Art School, RMIT, 1923–31.
(*See also* SCHOOLS: ROYAL MELBOURNE INSTITUTE OF TECHNOLOGY)

LEVIDO, Alfred
(Active, WA, c.1904–17) Architectural draughtsman, painter, teacher. He exhibited with the WA Soc. of Arts in 1905, 1906, 1908 and 1910. In 1908 he took over Linton's (q.v.) position at the Perth Tech. School. His architectural background served him well in the depiction of buildings and constructions such as his *Old Bridges, Fremantle*, 1904. His work appeared in *The Colonial Eye*, AGWA, Perth, 1979
REP: AGWA.

LEVIDO, Brad
(b. 18/2/1953, Cessnock, NSW) Painter.
STUDIES: Dip. Art (painting), Newcastle CAE, 1976. He held six solo exhibitions 1977–91, four at Coventry, Sydney. His work has been included in group exhibitions 1976–91 including at Coventry, Sydney and in *Australian Realists*, Ivan Dougherty Gallery 1978; *Philip Morris Arts Grant*, Canberra 1982; *Lake Macquarie Art Prize*, 1991.
AWARDS: Dattilo Rubbo Prize, 1976.
APPTS: Lecturer, SCA; Newcastle CAE, 1979–81.
REP: NGA; QAG; several regional collections.
BIB: *New Art Five*.

LEVY, Col (Colin Eric)
(b. 1933) Ceramicist.
STUDIES: Sydney, ESTC. He has held solo exhibitions largely at his pottery/studio in NSW and was represented in the Bicentennial exhibition *Great Australian Art Exhibition*.
REP: AGNSW; NGV.

LEWERS, Darani
(b. 4/4/1936, Sydney) Jeweller, sculptor.
STUDIES: Apprenticeship in jewellery, ESTC, 1957; trainee to Nina Ratsep, Anina Pty Ltd, Sydney, 1958 and Helge Larsen (q.v.), Solvform, Copenhagen, 1959. A daughter of Margo and Gerald Lewers and sister of Tanya Crothers (qq.v.) she formed a partnership with

Helge Larsen in 1961 and since then they have worked in collaboration on many jewellery exhibitions and workshops, both as artists and curators nationally and internationally.
AWARDS: Grant, VACB, Moya Dyring studio, Cité Internationale des Arts, Paris, 1972; AO, 1982.
APPTS: Member, SCA Council, 1976–80; guest craftsperson, World Craft Council, 1978, Kyoto, Japan; part-time lecturer, City Art Inst., Sydney, 1980–83; member, Canberra School of Arts Council, 1980–82; trustee, Museum of Applied Arts and Sciences, Sydney, 1981–90; member, Lewers Bequest and Penrith Regional Art Gallery, 1981; member, Artworks Advisory Committee, Parliament Construction Authority, ACT, 1982–86.
REP: NGA; AGSA; AGWA; NGV; QAG; QVMAG; Museum of Applied Arts and Sciences, Sydney; Museum of Decorative Arts, Prague; Museum of Decorative Arts, Copenhagen; Jewellery Museum, Pforzheim, Germany; Australian Embassy, Tokyo; MIM Holdings, Qld.

LEWERS, Gerald Francis
(b. 1905, Hobart; d. Aug. 1962, North Qld) Sculptor.
STUDIES: ESTC (part-time), 1924–26; with Dattilo Rubbo (evening classes), 1926–29; Kunstgewerbeschule, Vienna, with Koenig, 1931; Central School of Arts and Crafts, London, with John Skeaping, 1934. He married Margo Plate in 1933 and worked for the construction firm of Farley and Lewers until 1950 when he devoted himself full-time to sculpture. His travels included participation in a zoological expedition to the Great Barrier Reef, 1924, a visit to China with an Australian cultural delegation, 1956, and a visit to the Far East and Europe, 1959. His contribution to Australian sculpture was particularly notable for his use of Australian timbers in woodcarving. Ken Scarlett in *Australian Sculptors* lists about 27 commissioned works in different media, among them a memorial headstone for the grave of Christopher Brennan, 1945; a fountain for the ICI Building, Melbourne, 1958; a memorial fountain to Scottish sculptor John Christie Wright, Bridge St, Sydney; and a wall-relief for the Reserve Bank, Canberra, completed by Margo Lewers after her husband's untimely death in a riding accident while on holiday in North Qld. He was represented in the Bicentennial exhibition *The Great Australian Art Exhibition*.
REP: NGA; AGSA; AGWA; NGV; QAG; National Capital Development Commission, Canberra.
BIB: Lenton Parr, *Sculpture*, Arts in Australia series, Longman, Melbourne, 1961. Sturgeon, DAS. Scarlett, AS.

LEWERS, Margo (née PLATE)
(b. 1908, Sydney; d. 1978, Sydney) Painter, designer, sculptor.
STUDIES: Sydney, with Dattilo Rubbo and later with Desiderius Orban; Central School of Arts and Crafts, London, 1933. Sister of painter Carl Plate, she married Gerald Lewers in 1933 and during their studies in London both were influenced by the work of Moore, Hepworth, Nicholson and other leaders of the modern movements then affecting British art. Returning

John Lewin, The Ground Parrot of New South Wales, *c. 1810, watercoulour, 23.6 × 23.6cm. Collection, Mitchell Library, State Library of* NSW.

to Sydney in 1934 she joined the staff of the Sydney *Daily Telegraph* as a cadet artist, then freelanced, making a name as a fabric designer and contributing paintings to group exhibitions, notably with the CAS. A busy family life did not retard her progress and by 1959 she had become a leader in Sydney avant-garde painting. She was one of four women painters represented in the Tate Gallery exhibition of Australian art, London, 1963. After her death in 1978, the Lewers' home and collections were given by the Lewers' daughters to the city of Penrith, NSW, for development as a regional gallery in honour of their parents. (*See also* GALLERIES — PUBLIC)

AWARDS: Prizes in competitions at Hunters Hill, 1958; Mosman, 1959, 60; Muswellbrook, 1959; Sir Charles Lloyd Jones Memorial Prize, RAgSocNSW, Sydney,

1960; Henry Caselli Richards prize, Brisbane 1962; Rockdale, 1962; Wellington, NSW, 1962.

REP: AGNSW; AGWA; NGV; ANU.

BIB: Exhibition catalogue, Tate Gallery exhibition of Australian Art, 1963. References in most general books on Australian contemporary art. *A&A* 7/3/1969 (Alister Brass, *Talking with Margo Lewers*); 16/2/1978 (John Henshaw, *Margo Lewers*).

LEWIN, *John William*

(b. 1770, London; arr. Sydney 1800; d. 1819 Sydney) Zoological and botanical artist.

STUDIES: Hoxton, London; family training (Lewin's father, William Lewin, a fellow of the Linnean Society was the author of a 7-volume work, *Birds of Great Britain*, London, 1789–94). John Lewin went to Australia to record the ornithological and entomological life for a British patron, Dru Drury, a task which was subjected to frequent interruptions owing to the misfortunes by which Lewin was habitually

beset. His studies of birds as well as butterflies and other lepidopterous insects show him as a meticulous craftsman with a faithful eye for colour and his publications include *A Natural History of the Lepidopterous Insects of New South Wales*, London, 1805 and *A Natural History of the Birds of New South Wales*, London, 1822. However his career proved somewhat unlucky with domestic troubles, shipwreck and involvement in a native war in Tahiti. Attached to Governor Macquarie's 'progress of the Blue Mountains' enterprise, he was nominated by Macquarie as the colony's first official artist, but the appointment failed to get the endorsement of the British government, and in 1810 Macquarie appointed him city coroner. He started the first art school in Sydney in 1812, but without success. His work was represented in the Bicentennial exhibition *The Great Australian Art Exhibition* and *The Artist and the Patron* AGNSW, 1988.
REP: AGNSW; NLA; Mitchell, Dixson Libraries.
BIB: Rienits, *Early Artists of Australia*, 1963. ADB 2. Smith *EVSP*. Andrew Sayers, *Drawing in Australia* NGA 1985. Kerr, *DAA*. *A&A* 26/4/1989; 27/4/1990.

LEWIS, Aletta
Painter, writer, illustrator. A teacher at Julian Ashton's Sydney Art School. She took part in the second exhibition of modern art at the Grosvenor Gallery, Sydney, 1927, as well as exhibiting in Archibald prize competitions. She wrote and illustrated *They Call Them Savages* (Methuen, London, 1938).
BIB: Moore, *SAA*.

LEWIS, Jon
(b. 1950, Maryland, USA; arr. Aust. 1951) Photographer.
STUDIES: Self-taught. With Martin Sharp, George Gittoes, Brett Whiteley and Alby Thoms and others lived in Yellow House, Potts Point early 1970s and worked as a social photographer and film-maker. A founding member of Greenpeace he made a film on dolphins (now in NGA collection). His photographs of Bondi Beach in 1980s attracted attention as art photographs followed by a series in 1988 of twice life-size portraits. His work was the subject of SBS documentary 1990. He was artist-in-residence at two secondary colleges country NSW 1978 and he held 14 solo exhibitions 1974–92 mainly at Coventry, Sydney also 13 Verity St, Melbourne, Solander Canberra and in Jakarta 1988. Group exhibitions in which his work appeared 1975–91 included at Hogarth, Coventry galleries, Sydney; Australian Centre for Photography, Sydney; *Five Years On* AGNSW 1986; *Yellow House Exhibition* AGNSW 1989; *Portrait Photography* NGA 1989 and in Paris, Amsterdam and Germany.
AWARDS: Grants VACB & Experimental Film Fund, Aust. Film Corporation 1974; international program Australia Council 1989.
APPTS: Teaching two schools of design Paris 1990, 91.
REP: NGA; AGNSW; Parliament House; and in several public and private photographic collections France, USA, Netherlands.

LEWIS, Mari Ann
(b. 2/8/1934, Qld) Administrator.
APPTS: Director, later executive director, Gallery A, Sydney, 1964– ; council member, Art Gallery Society of NSW, 1970–81, president 1978–80; member, International Council, MOMA, New York, 1972; member, VACB, 1973–76, chairman, 1980–83; director, Aboriginal Arts and Crafts company, 1977–80; director, International Cultural Corporation of Australia, 1980–c.1985; board member, James McGrath Foundation, Sydney, 1981– ; director Australian Exhibitions Touring Agency, 1992– .

LEWIS, Ruark Adrian
(b. 6/2/1960, Sydney) Draughtsman, writer, performance artist.
STUDIES: BA, Visual Arts, SCA, 1983. He produced sound works and performances for NGA, AGNSW, High Court of Australia and mounted exhibitions *Transcription Drawings of Music and Poetry*, Melbourne and Sydney, 1987, 89, 91. A co-founder of Writers-in-Recital, AGNSW, 1984–90 he participated in group exhibitions largely in state and public galleries including a survey show at ACCA 1991 and at NGA; AGNSW; university galleries Melbourne, Sydney. He held three solo exhibitions 1987–92 at Syme Dodson, Sydney; King Street Studios, Sydney and ACCA, Melbourne.
AWARDS: Special project grants, Performing Arts & Literature Board, Aust. Council, 1984, 85, 88, 89, 90; grant, Moya Dyring Studio, Cité Internationale des Arts, Paris, VACB, 1991.
REP: NGA; AGNSW; MOCA, Brisbane.
BIB: *AM* no. 46, 1992. *A&T* no. 31, 1989.

LEWIS, Thomas H.
(Active NSW 1840s) Painter. Son of Mortimer Lewis, the NSW government architect, his watercolour of a cricket match played in Hyde Park, Sydney, c.1842–43 is in the collection of the Mitchell Library.
REP: Mitchell Library.
BIB: Moore, *SAA*. *National Bank Calendar*, Melbourne, 1966. Kerr, *DAA*.

LHOTSKY, (Dr) John
(b. 27/6/1800, Poland; arr. Sydney 1832; d. 1866) Scientist, writer, critic. Impelled by a powerfully developed sense of curiosity (he was described by the geologist Sir Roderick Impey Murchison as 'the mad Pole'), he visited a number of unexplored regions and reported extensively on many aspects of the Australian scene, including its old and new art and culture. As the first recorded writer of art criticism in Australia, he castigated John Glover 'for failing to select really primitive and original Australian nature'. His translation of 'A Song of the Women of the Monaro Tribe' published in Sydney in 1834, has been noted as the first recorded specimen of indigenous Australian music, and his interest in ethnology inspired also an unpublished vocabulary of the Tasmanian Aborigines. Other publications include *A Journey from Sydney to the Australian Alps*, Sydney, 1835; *Illustrations of the Present*

State and Future Prospects of the Colony of New South Wales, five parts, Sydney, 1835–36; The State of Art in New South Wales and Van Diemen's Land, *Art Union*, London, July 1839. Unlike many of his British colleagues, he had a keen eye for the true character of the new country and even prophesied that it might 'produce a Daniell, and in succession a Salvator Rosa, and, perhaps, such as will even exceed them' (quoted by Bernard Smith).
BIB: Smith *PTT*. ADB 2. Elizabeth Hanks, *Australian Art and Artists to 1950*, Library Council of Victoria, Melbourne, 1982. Kerr, *DAA*.

LIARDET, Wilbraham Frederick Evelyn
(b. 1799, London; arr. Vic. 1839; d. 1878, NZ) Naive painter, army officer, inn-keeper, musician, writer. After losing a considerable fortune because of his way of life, he migrated to Australia with his wife and sons. Preferring the white sands of Port Phillip to the rocks of Sydney Harbour, he settled on the beach, built an inn and a jetty and the area became known as Liardet's Beach (later Sandridge and finally Port Melbourne). Notoriously Bohemian in their way of life, the family eventually prospered as a result of the Victorian goldrush – from trade (his sons owning hotels on the goldfields) rather than gold itself – and Liardet was able to devote his time to writing and illustrating the early history of Victoria of which he has left so colourful an account. (Many of the watercolours for this are in the La Trobe Library collection.) His work was seen in *Victorian Vision* NGV 1985.
REP: Mitchell, La Trobe Libraries.
BIB: A. W. Greig, biographical note on Liardet, *Journal of the Victorian Historical Society*, Melbourne, 1916. ADB 2. Susan Adams, intro., Weston Bate, Ed., *Liardet's Water-colours of Early Melbourne*, La Trobe Library, Melbourne, 1972. McCulloch, *AAGR*. Kerr, *DAA*.

LICHA, Barbara
(b. 2/7/1957, Poland; arr. Aust. 1982) Painter.
STUDIES: State Academy of Fine Arts, Wroclaw, Poland, 1979–81; BA, City Art Inst., Sydney, 1989; Grad. Dip. Fine Art, City Art Inst., 1989; travel studies Europe 1981, 90, 91. Her expressionist paintings are vigorous and interesting. She participated in group exhibitions 1979–92 in Poland and print exhibitions in Sydney, and MPAC *Spring Festival of Drawing*, Mornington 1988. She held six solo exhibitions 1979–91, three in Poland and three at Access Galleries Sydney.
REP: Artbank; PCA; various tertiary and regional collections.
BIB: PCA, *Directory*, 1988. Nevill Drury, *Images in Contemporary Painting*, Craftsman House, 1992.

LIGHT, (Colonel) William
(b. 1786, Malaya; arr. SA, 1836; d. 1839, Adelaide) Artist, musician, seaman, soldier. Appointed (1835) first Surveyor-General of SA, he selected the site for Adelaide. A talented watercolourist, draughtsman and oil painter a number of his SA and European works are in Australian public collections, his best-known work being *View of Proposed Town of Adelaide* 1838

(Mitchell Library collection). His work was seen in *Graven Images in the Promised Land* AGSA 1981 and in *W. Light: Pre-Australian Paintings* City Hall, Adelaide 1984.
REP: AGSA; Adelaide Town Hall; Mitchell, Mortlock Libraries.
BIB: *National Bank of Australasia Calendar*, Melbourne, 1961. ADB 2. C. M. H. Clark, *A History of Australia*, vol. 3, MUP, 1973, 1978. Kerr, *DAA*. A&A 19/1/1981.

LIIBUS, Vaike
(b. 29/4/1922, Estonia; arr. Aust. c.1920s) Painter.
STUDIES: ESTC; Julian Ashton. She exhibited widely since the early 1950s, largely in group exhibitions with Royal Art Society, Sydney until 1965; the Contemporary Art Society of Sydney and in competition prizes such as Blake, Royal Easter Show and received numerous portrait commissions including Sir Charles Moses; Harold Mertz, USA; and numerous other public figures.
AWARDS: Philip Musket prize 1945; Portia Geach portrait prize 1969; Estonian Cultural Art Prize 1973.
REP: Estonian National Gallery; secondary school collections Australia; corporate and private collections including Mertz, Sears Roebuck, USA.

LIIRI, Peter
(b. 13/9/1954, Finland) Painter.
STUDIES: RMIT 1975; B. Arts PIT 1989. His works are often small and graphic-based with cartoon-like primitive stylized figures. He held six solo exhibitions 1981–91 including at Pinacotheca, United Artists, Charles Nodrum Melbourne; Chapman, Canberra.
REP: NGA; MOCA, Brisbane; PIT; St Kilda Council

LIKIC, Jean
(b. 1934, France; arr. Aust. 1959) Sculptor.
STUDIES: Zagreb Art School, Yugoslavia. Likic's work first attracted attention when he exhibited head studies modelled in an archaic Italian style. He lived in Brisbane from 1971.
AWARDS: Shared first prize for an indoor sculpture, Mildura Sculpture Triennial, 1961.

LILLECRAP-FULLER, Helen Leslie
(b. 18/3/1949, Adelaide) Multi-media artist.
STUDIES: SASA, 1967–68; Dip. Teaching, Western Teachers Coll. 1969–70; Dip. Fine Art, Torrens CAE, 1978; MA (visual arts), Uni. of SA 1992– ; travel studies Europe and UK 1976, 79, 84, 85, 86; Indonesia 1990. She began using all kinds of materials, including coloured pencils and photographs, to create the collages for which she is known. She held about 11 solo exhibitions 1979–92 including *A Visual Diary 1979–91*, QAG and Perc Tucker Regional Gallery, Townsville, 1991. She worked as a graphic illustrator and artist-in-residence in several Qld tertiary colleges and as an archaeological illustrator for the Thai Ceramic Archaeological Project organised by AGSA 1986. She participated in numerous group exhibitions 1978–91 including *Drawn and Quartered*, AGSA 1982;

Moments in Qld Contemporary Art, QAG 1986; *A New Generation: Philip Morris Arts Grant Purchases 1983–88*, NGA 1988; staff exhibitions at Qld Uni. of Tech.

AWARDS: SAS 10 Young Artists Award, 1977; grants, VACB, 1982, 86; Trustees Purchase Exhibition, QAG, 1982; residency, Zhejing Academy of Fine Arts, Hangzhou, China 1992.

APPTS: Secondary teaching in schools in SA and Qld 1972–88; lecturer in painting Qld Uni. of Tech., 1989–91.

REP: NGA; AGSA; NGV; QAG; Parliament House; Artbank; MCA, Brisbane; regional and municipal collections Gold Coast, Ipswich, Brisbane City Hall; a number of tertiary collections including Qld Uni. of Tech., Uni. of SA.

BIB: Catalogue essays for exhibitions as above. McIntyre, *CC*.

Kevin Lincoln Figs and Reflected Head, *oil on linen, 101.5 × 111.5cm. Courtesy Niagara Gallerieis, Melbourne.*

LINCOLN, Kevin
(b. 20/3/1941, Hobart) Painter.

STUDIES: Hobart Tech. Coll. (part-time); RMIT, 1957–60; travel studies Europe 1986. His work was first seen at VAS exhibitions then in Realist Group exhibitions, 1957–60, followed by a series of 'cloth paintings', Stuart Gerstman Galleries, Melbourne, 1979, in which white cloths were represented on dark grounds. Later exhibitions of self-portraits shown at the same gallery affirmed his status as a draughtsman of unusual power and perception. He held about 21 solo exhibitions 1975–93 including at Stuart Gerstman Galleries, 1970s and 1980s; Niagara, Melbourne, 1990– and a survey exhibition at MPAC, 1988–89; Latrobe Valley Arts Centre, 1988–89; and QVMAG and Devonport Art Gallery, 1990–91. Group exhibitions include prize

exhibitions at MPAC *Spring Festival of Drawing*, 1975, 80, 84; *Henri Worland Prize*, Warrnambool, 1978, 80; print exhibitions including *British International Print Biennale*, 1984; *Mitchelton Print Exhibition*, 1988; and *Six Contemporary Artists*, TMAG 1985.

AWARDS: MPAC Spring Festival of Drawing (drawing acquired), 1979.

REP: NGA; AGNSW; NGV; QVMAG; TMAG; Parliament House; Artbank; regional galleries including Campbelltown, Latrobe Valley, Mornington, Warrnambool; tertiary collections including State College of Vic., La Trobe Uni.; corporate collections including NAB.

BIB: Catalogue essays for exhibitions as above. McKenzie, *DIA*. Backhouse, *TA*. PCA *Directory* 1988.

LINDESAY, Vane
(b. 2/10/1920, Glebe, Sydney) Cartoonist, writer, book designer. Contributor of cartoons and illustrations to various newspapers and magazines since the 1940s. He is also a well-known book designer and author of a number of art and black-and-white art related titles including *The Inked-In Image* (Hutchinson, 1979); *It's Moments Like These* (Macmillan, 1979); *Australian Popular Magazines* (OUP, 1983); *Noel Counihan Caricatures* (Hutchinson, 1985); *Aussie-osities* (Greenhouse 1988). He has contributed a number of artist entries (including on Will Dyson) to the *Australian Dictionary of Biography* and reviews books for the ABC and leading print media. His cartoons and illustrations have largely been exhibited in group exhibitions at State Library of NSW and Vic; Westpac Gallery and in group exhibitions in Canada and Japan.

AWARDS: *The Bulletin* Black and White Artists Award 1988; Award of Honour, Aust. Book Publishers Association 1991.

LINDSAY, Arthur J.
Painter.

STUDIES: George Bell School, Melbourne, c.1942; advice and encouragement from Rupert Bunny. In his early pictures he showed promise as a painter of still-life.

NFI

LINDSAY, Daryl (Ernest Daryl)
(b. 31/12/1889, Creswick, Vic.; d. 1976, Mornington, Vic.) Painter, illustrator, gallery director.

STUDIES: Family studies at Creswick; Slade School, London, with Professor Henry Tonks, c.1918. He earned a living first in a bank at Ballarat (c.1905), then as a jackaroo on cattle and sheep stations in south Qld and the Riverina, NSW (c.1906–15). Enlisting in the AIF in 1915 he served in France with the war artist Will Dyson (his brother-in-law), until transferred (1917) to work as an artist for plastic surgery at the Queen Mary Hospital, Sidcup, Kent. He returned to Australia in 1919 to work as a freelance illustrator and painter. In 1922 he married Joan à Beckett Weigall and they moved to London where he developed his talents as a watercolourist; later he did many drawings of ballet dancers. As director of the NGV he

started the quarterly *Bulletin* and the NGV Gallery Society and introduced staff reforms and a more enlightened policy of collecting. He also did much to revitalise the regional galleries of Vic. The strong support of his wife and the warmth of his personality greatly expanded the sphere of NGV influence. After retirement from the NGV, he generously devoted much of his time to the development of the Lindsay room at the Ballarat Fine Art Gallery, the institution that had meant so much to the early art education of the Lindsay family. Author of *The Felton Bequest: An Historical Record, 1904–1959*, OUP, Melbourne, 1963; *A Leafy Tree*, Cheshire, Melbourne, 1965.
AWARDS: Knighthood conferred, 1956.
APPTS: Keeper of the Prints, NGV, Melbourne, 1940–41, director, 1941–56; president of the NGV Gallery Society, 1956; member of the National Trust of Australia; member Commonwealth Art Advisory Board, chairman 1962–70.
REP: Most state galleries; Ballarat Fine Art Gallery and many other regional galleries.
BIB: Franz Philipp and June Stewart, eds, *In Honour of Daryl Lindsay*, OUP, Melbourne, 1964. A&A 15/4/1978 (Colin Caldwell, *Obituary: Sir Daryl Lindsay*). ADB 10.

LINDSAY, Frances

(b. 10/2/1946, NSW) Curator, museum director.
STUDIES: BA, Uni. of Melbourne, 1967. She was guide lecturer then associate curator of Australian art, NGV, 1968–72, assistant curator of Australian Art, AGNSW, 1972–76, and director, VCA gallery, 1976–78. Since 1984 she has been director, Uni. of Melbourne Art Gallery.

LINDSAY, Jack

(b. 1900, Melbourne; d. March 1990, UK) Writer.
STUDIES: Brisbane Grammar School, 1917; Honours grad. Classics, Uni. of Qld, 1919–21. Of all members of the Lindsay family, Norman Lindsay's oldest son, Jack, had the highest claims to top international honours. His writings include poetry, translations from Greek, Latin and Russian, 'a series of major assessments of Australian writers', superb monographs on Turner (1966), Cézanne (1969), Courbet (1972), William Morris (1975), Hogarth (1977) and Blake (1978), and so many other books and other writings that, as Michael Wilding writes, 'there are very few writers in a position to discuss the full range of his work'. His first published writing appeared in 1917 in the Brisbane Grammar School magazine, which he edited. He also edited the Qld Uni. magazine, and from 1921–26 worked in Sydney as a freelance journalist and as editor of *Vision*. He left Australia in 1926, organised the Fanfrolico Press in London, and made his home and his name in the UK.
BIB: *Overland*, Apr. 1981 (Michael Wilding, *Jack Lindsay*).

LINDSAY, Joan à Beckett
(née WEIGALL)

(b. 16/11/1896; d. 30/12/1984, Baxter, Vic.) Painter, writer. From c.1921 she exhibited with the VAS,

Lionel Lindsay, Owls, *woodcut, 23.2 × 17.1cm. Collection, New England Regional Art Gallery (Howard Hinton Collection.)*

Melbourne, and the NSW Society of Artists, and in 1922 married Daryl Lindsay. Apart from assisting him in his work for the NGV, she developed her own talents as a writer independently, wrote a number of books and won international acclaim for *Picnic at Hanging Rock*, which later was made into a film. Her books included *Through Darkest Pondelayo* (by 'Serena Livingstone-Stanley'), Chatto & Windus, London, 1936; *Masterpieces of the NGV*, in conjunction with Ursula Hoff and Alan McCulloch, 1949; *Time Without Clocks*, 1962; *Facts Soft and Hard*, 1964; *Picnic at Hanging Rock*, 1967 – all published by Cheshire, Melbourne.
REP: MPAC.

LINDSAY, Lionel Arthur

(b. 18/10/1874, Creswick, Vic.; d. 22/5/1961, Hornsby, NSW) Painter, graphic artist, writer, critic.
STUDIES: NGV School. The most influential art writer of his time, he was the chief protagonist for the cause of the Australian black-and-white school and of post-impressionist and modernist painting. Brother of Percy, Norman, Daryl and Ruby Lindsay. He started his working life at the age of 15 as pupil-assistant at the Melbourne Observatory, 1889–92. On leaving the Observatory he worked as a freelance artist and journalist and contributed black-and-white drawings to

the Sydney *Bulletin* and other magazines. He made the first of several visits to Spain in 1902 and learned to speak Spanish fluently. An inveterate traveller and talker, he wrote for the Sydney *Evening News*, 1903–26, and travelled in Europe, North Africa and India. By 1927 the basis of his reputation was established and he had become widely known for his watercolours and etchings, and particularly for his woodcuts of Australian animals and birds. An exhibition of his work held at Colnaghi's, London, in 1927 yielded $2500 in sales. A keen admirer of the work of Charles Keene, Adolf Menzel and Daniel Vierge, his writings on black-and-white art came to mean in Australia what the writings of Joseph Pennell meant in England and America. As an art critic he was often inconsistent but his views were always expressed energetically, and, when he felt strongly on a particular subject, with great vehemence. When art critic, briefly, for the Melbourne *Herald*, 1935, he launched a spirited attack on the teaching methods at the Melbourne National Gallery School, which he called 'the school of smudge'. He gave strong critical support to the Melbourne modern painters exhibiting in the 1935 exhibition of the Twenty Melbourne Painters. Also, as a trustee of the AGNSW, he warmly supported the award of the 1943 Archibald Prize to William Dobell. On the other hand, the views expressed in his polemical pamphlet *Addled Art* (1943) showed him as a bitter antagonist of the School of Paris and everything which the term 'modern art' connoted, and his own painting and drawing, which was rigidly conventional and often colourless, supported this attitude. He made many gifts of etchings and drawings to public collections. His gift to Toowoomba, Qld, resulted in the foundation of the Lionel Lindsay Gallery and Library, Toowoomba, 1959. His work was included in the Bicentennial exhibitions *The Great Australian Art Exhibition* and *The Face of Australia*. Publications include *A Consideration of the Work of Ernest Moffitt*, Atlas Press, Melbourne, 1899; *Conrad Martens: The Man and his Art*, Angus & Robertson, Sydney, 1943; *Lionel Lindsay: Etchings in Spain*, Ure Smith, Sydney, 1949; forewords to many of the books of Norman Lindsay's etchings. A limited edition of a book of his prints was published by Jester Press, Melbourne, 1985.

AWARDS: NSW Society of Artists' medal, 1937; knighthood conferred 1941.

APPTS: Trustee of the AGNSW, 1918–29, and 1934–49.

REP: NGA; all state and many regional galleries British Museum (complete set of woodcuts).

BIB: Catalogue essays exhibitions as above and all general books on Australian art history. ADB 10. Joanna Mendelssohn, *Lionel Lindsay: an artist and his family*, Chatto & Windus, 1988.

LINDSAY, *Norman Alfred Williams*

(b. 23/2/1879, Creswick, Vic.; d. 21/11/1969, Springwood, NSW) Pen-draughtsman, etcher, painter, writer.
STUDIES: Family training; lessons from Walter Withers at Withers' open-air studio at Creswick. A natural eclectic, with a genius for adapting the styles to which

he was attracted, Lindsay assimilated the influences of Menzel, Vierge, Böcklin, Beardsley, Sandys, May, Keene, Schwabe and Rubens, and many others. Keenly promoted by his brother Lionel, his work developed at a time when the invention of the line-block, new methods of photographic reproduction and the publication of large numbers of illustrated books and periodicals drew the attention of artists throughout the world to the advantages of black-and-white illustration. In his early days in Melbourne he led a Bohemian life with other members of the Cannibal Club (q.v.). During this period he lived at 'Charterisville' with his brother Lionel, Ernest Moffitt and others, and the activities of the group resulted in one of his first written and illustrated books, *A Curate in Bohemia*. Another early venture was a set of illustrations to the *Decameron* of Boccaccio which led, through Julian Ashton, to a staff job on the Sydney *Bulletin*. He engaged in a life-long private campaign against hypocrisy and 'wowserism', and introduced to Australia an arcadian 'hyperborean' world inhabited by nude nymphs and satyrs and modelled on the voluptuous paintings of Rubens, and the Swiss, Arnold Böcklin. The uninhibited nature of Lindsay's work earned the censure of religious organisations and moralists, but its eroticism was widely overlooked in official quarters, on account of its technical virtuosity. His first novel, *Redheap*, was banned in Australia, not on moral grounds but because of the resemblance of its characters to living persons. He illustrated many of the Roman and Greek classics as well as the works of Rabelais and Casanova, travelled extensively in Europe, and while in America illustrated stories for leading magazines. He bequeathed his home, furniture and collections to the state of NSW. His publications number in the hundreds and include *Norman Lindsay's Book*, nos. 1–2, NSW Bookstall Co., Sydney, 1912–15; *The Magic Pudding*, Angus & Robertson, Sydney, 1918; *Creative Effort*, Art in Australia, Sydney, 1920 and Palmer, London, 1924; *Hyperborea*, Fanfrolico Press, London, 1928; *Madam Life's Lovers*, Fanfrolico Press, London, 1929; *Redheap*, Faber & Faber, London, 1930; *The Cautious Amorist*, Farrar, New York, 1932; *Pan in the Parlour*, Farrar, New York, 1933; *Saturdee*, Endeavour Press, Sydney, 1933; *The Flyaway Highway*, Angus & Robertson, Sydney, 1936; *Age of Consent*, Laurie, London, 1938; *The Cousin from Fiji*, Angus & Robertson, Sydney, 1945; *Halfway to Anywhere*, Angus & Robertson, Sydney, 1947; *Dust or Polish?*, Angus & Robertson, Sydney, 1950. During the 1980s his work was even more heavily promoted especially by Sydney art dealer Trevor Bussell who held many exhibitions of his work which was similarly featured in the sales of Sotheby's, Christie's, Joel's and other auction houses. He was represented in *The Great Australian Art Exhibition* and a film based on his life was made in 1993.

REP: NGA; all state and many regional galleries with large holdings of 'Lindsayana' in AGNSW; AGWA; NGV; Ballarat Fine Art Gallery; Toowoomba Gallery; Uni. of Melbourne gallery.

BIB: All general books on Australian art. Douglas Stewart,

Norman Lindsay: a Personal Memoir, Angus & Robertson, Sydney, 1975. A&A 11/2/1973 (Eric Rowlison, *Olympus at Springwood: the Sculpture of Norman Lindsay*). *Meanjin* 1/1974 (Jack Lindsay, *The Life and Art of Norman Lindsay*). ADB 10.

LINDSAY, Percy (Percival Charles)

(b. 1870, Creswick, Vic.; d. 21/9/1952, Sydney) Painter, illustrator.
STUDIES: Creswick (with Walter Withers); NGV School (with F. S. Sheldon). After studying at the NGV he worked with Walter Withers, and later settled in Roseville, NSW, in 1917 where he contributed black-and-white drawings to the Sydney *Bulletin*. As a painter he attained distinction mainly for his watercolours. However since his death his paintings, particularly his oils, have appreciated greatly in value. The Ballarat Fine Art Gallery held a memorial exhibition of his work in Nov. 1975. His work was represented in *The Face of Australia* 1988–89.
REP: State and regional galleries.
BIB: AA, no. 11, 1921. ADB 10.

LINDSAY, Raymond

(b. 1904, Sydney; d. 1960, Sydney) Painter.
STUDIES: Julian Ashton School. Son of Norman Lindsay. He became known for his illustrative pictures of pirate subjects.
BIB: Badham, SAA, 1949. AA, Dec. 1928 reproductions.

LINDSAY, Robert

(b. 1945, Epping, NSW) Curator, administrator.
STUDIES: NAS; Alexander Mackie CAE, 1962–66; Power Inst., Uni. of NSW, 1969–74. As curator of Australian art at the NGV 1978–89 he organised successive *Survey* exhibitions of the work of contemporary Australian artists. He left the NGV in 1989 to become a director of Powell St Gallery, Melbourne until its closure in 1993 following which he became a freelance curator.
APPTS: Assistant curator of Australian Art, NGV, 1977–79; curator of Contemporary Australian Art, NGV, 1979–89.

LINDSAY, Ruby (Ruby LIND)

(b. 1887, Creswick, Vic.; d. 12/3/1919, Chelsea, England) Painter, illustrator.
STUDIES: NGV School. Her delicate, 'art nouveau' drawings gained her distinction in Australia. She married Will Dyson in 1909 and they went to London where they had a daughter, Betty, who also became a talented artist. Ruby's premature death from influenza during the epidemic in 1919 was commemorated in a book published by Will Dyson.
REP: NGV; Ballarat Fine Art Gallery.
BIB: Will Dyson, *Poems in Memory of a Wife*, Palmer, London, 1919. Cecil Palmer, *The Drawings of Ruby Lind*, London, 1920. Article in the *Bulletin*, Sydney 2 Feb. 1938. ADB 10.

LINDT, John William

(b. 1845, Frankfurt-am-Main, Germany; arr. Brisbane 1862; d. 1926, Healesville, Vic.) Painter, photographer. He worked in Grafton, NSW, where he became

known for his portraits of Aborigines. He moved to Melbourne in 1876 where he was a successful society photographer until the financial depression of the 1890s. His albums included *Picturesque New Guinea*, London, 1887 and several books on the technique of photography in the 1860s and 70s. His work was represented in *Australian Artists of the 1870s* AGNSW 1976 and the Bicentennial exhibition *The Great Australian Art Exhibition*.
BIB: ADB 5. Kerr, DAA.

LINEGAN, E.

Sculptor. He made one of the bronze bas-relief panels for the centre door of the Mitchell Library, Sydney (c.1925); the other 17 panels were done by Ralph T. Walker, Frank Lynch, Arthur Fleischmann and Daphne Mayo.

LINES, Benedict (Geoffrey Richard)

(b. 4/9/1962, SA) Painter, printmaker, sculptor.
STUDIES: Dip. Fine Art (sculpture), CIT, 1983; Postgrad Dip. Fine Art (sculpture), CIT, 1988; travel studies Europe, Asia Minor, 1986. He held two solo exhibitions of totem-like wooden sculptures at 13 Verity Street Gallery, in 1989 and 1991 after his debut exhibition with Ted Parrit at Linden, Melbourne, 1985.
AWARDS: Travel grant, VACB, 1986.
REP: NGA; NGV; several tertiary, regional and private collections.
BIB: *New Art Three*. Germaine, AGA.

LINTON, James Walter Robert

(b. 14/6/1869, London; arr. WA 1896; d. 29/8/1947, Perth) Painter, enamellist, modeller, carver, leatherworker, furniture and jewellery maker, teacher.
STUDIES: Slade School, London (with Alphonse Legros), 1885–88; architecture as articled pupil to a firm of London architects, c.1888–91; Westminster School of Art (with Frederick Brown), c.1891–92; Sir John Cass Tech. School, 1907–08 (crafts and bronze casting). Linton played a vital part in the development of art in WA. His father, Sir James Dromgole Linton, a president of the Royal Inst. of Painters in Watercolours, 1884–98 and 1909–16, was knighted in 1885 for his services to British art. James Linton went to Australia to look after the family interests at Miners Dream Gold Mine, Broad Arrow, near Kalgoorlie, in 1896, but contracted typhoid the following year, convalesced in Perth, and from then on devoted his life to art. He established the Linton School of Art in Hay St in 1899 and in 1902 succeeded Frederick Williams as art instructor at Perth Tech. School, a position retained until his retirement in 1931. Elected vice-president of the WA Society of Arts in 1902 and later president c.1919–22, he was a trustee of the Public Library, Museum and Art Gallery of WA, 1922–36. In 1902 he married Charlotte Bates Barrow with whom he had three children (Jamie, b. 1904; John, b. 1905; and Kathleen, b. 1910). Linton's fine watercolours were matched by his skilled and versatile craft work, which included the design and

making of a casket for presentation to the Duke and Duchess of Cornwall and York when they visited Perth in 1901. A *Self Portrait* painted in 1908 shows that he was equally impressive as a painter in oils. He exhibited with the Royal Inst. of Painters in Watercolours, London, 1890–93, and contributed to the exhibition *150 Years of Australian Art*, AGNSW, 1937. The AGWA held an exhibition of his work in 1977 and he was represented in *Western Australian Artists 1920–50*, AGWA, 1980.

REP: AGNSW; AGWA; Western Australian Museum.

BIB: Moore, SAA. Badham, SAA. AA, special number, 1920. A&A 16/4/1979 (Anne Gray, *James R. Linton*).

LISSENDEN, Anne

Bird artist who illustrated J. A. Leach, *An Australian Bird Book*, Whitcombe & Tombs, Melbourne, 1958. (*See also* NATURAL HISTORY ARTISTS)

LISTER, Matilda

(b. 1889; d. 1965, Young, NSW) Painter. Known for naive or primitive pictures, many of Hill End mining subjects.

AWARDS: Darcy Morris memorial prize, Blake competition, Sydney, 1959.

REP: AGNSW.

LISTER, William Lister

(b. 27/12/1859, Sydney; d. Nov. 1943, Sydney) Painter. STUDIES: Bedford School of Art, England; France. He was taken to England in 1867 and began his working life in the drawing office of the Fairfield Engineering Works. After his art studies at Bedford, then France for two years, he moved to Glasgow where he joined the St Mungo Art Club and, in 1876, at the age of 17, exhibited at the Royal Scottish Academy. He returned to Sydney to live in 1888. He exhibited with the British Empire Society of Artists, the Royal Society of Painters in Oils and the Royal Society of British Artists, London. He was celebrated in Australia mainly as a painter of large, shimmering seascapes and coastal vistas, and as a 7 times winner of the Wynne Prize. He was killed in a street accident in Nov. 1943.

AWARDS: Wynne prize, 1898, 1906, 10, 12, 13, 17, 25; Canberra (Commonwealth Government Prize), for a picture of the Federal Capital site, 1913.

APPTS: President, RAS of NSW, 1897–1941; member of the board of trustees, AGNSW, 1900–43.

REP: AGNSW (8 works); AGSA; NGV; NZ National Gallery, Wellington.

BIB: Smith, *Catalogue AGNSW*, 1953. Moore, SAA. *Australasian Art Review* no. 1 and no. 9, vol. 10, 1899. (*Wm. Lister Lister*). ADB 10.

LITHERLAND, Victor W.

(b. 16/4/1897, Odessa, S. Russia; d. 1978) Painter. A carpenter by trade, his careful painting of portraits and landscapes have much of the stylistic purity of naive art.

AWARDS: Bendigo prize, 1957.

REP: NGV; regional galleries Ballarat, Bendigo.

LITTLEJOHN, Vivienne

(b. 1948, Tas.) Printmaker.

STUDIES: Prahran Inst. of Tech, 1967–69; Dip. Art, Alexander Mackie CAE, 1976; travel studies Egypt, 1984. She showed her woodcut prints in group printmaking exhibitions largely in regional galleries 1983–91 and participated in international print exhibitions and biennales in the UK 1986, 88; as well as in Australian exhibitions including *Woodcut 1905–1989*, Lewers Bequest and Penrith Regional Gallery 1989; *200 Years of Australian Prints*, NGA 1989. She held 8 solo exhibitions 1982–91, largely at Powell St, Melbourne; Macquarie, Sydney.

AWARDS: Project grant, VACB, 1985.

APPTS: Secondary art teaching, Tasmania, 1970–72; part-time teacher, various colleges Sydney, 1986–88; part-time lecturer, Uni. of Western Sydney, Milperra, 1989.

REP: NGA; AGNSW; NGV; QAG; QVMAG; Artbank; several regional galleries, tertiary and private collections including Smorgon.

BIB: PCA, *Directory*, 1989. A&A 20/4/1983.

LITTLER, Frank Anthony

(b. 1/11/1947, Kogarah, NSW) Painter, cartoonist, wood carver, printmaker.

STUDIES: NAS, 1964–71. He served an apprenticeship in woodcarving, before turning to teaching, first in NSW high schools then at the NAS, Sydney, 1972–73. From 1974 he worked as a cartoonist and painter, exhibiting at Watters Gallery. His style is expressionistic and his work often satirical in content. Group exhibitions 1972–92 included *Ocker Funk*, May–June 1975 at Watters; *Contemporary Australian Prints and Drawing*, AGNSW 1980; *Continuum*, Ivan Dougherty Gallery 1981; *Portrait of a Gallery*, Watters 25th anniversary touring exhibition, 8 regional centres 1989–91; *From the Landscape*, MCA, Brisbane 1991. He held 12 solo exhibitions 1974–93, largely at Watters Sydney and Pinacotheca, Melbourne.

AWARDS: English-Speaking Union prize, 1969; NAS student prizes for painting, 1969, 70; VACB grant, 1975–76.

REP: NGA; AGNSW; AGSA; NGV; QVMAG; MCA, Brisbane; regional galleries including Gold Coast, Shepparton, Warrnambool, Newcastle, Latrobe Valley; tertiary collections including Griffith Uni.; corporate collections including Allen, Allen & Hemsley, Baker & McKenzie, Philip Morris.

BIB: Catalogue essays in exhibitions as above. *New Art Two*. PCA, *Directory*. A&A 12/4/1975.

LIVERMORE, Reg

(b. 1938, Parramatta, NSW) Entertainer, stage designer, painter.

STUDIES: No formal training. He received encouragement from Tom Gleghorn, William Fletcher, Sheila McDonald and Joy Ewart. Mainly an entertainer and stage personality but also an artist and a designer for theatre. His work includes stage design for *Betty*

Blockkbuster Follies, *Wonder Woman*, *Ned Kelly* and *Sacred Cow*.
(*See also* THEATRE ART)

LIVINGSTON, Mary H.
(Active c.1870s, Vic.) Painter.
STUDIES: NGV School, 1871–79. She lived on a property, 'Comodai', between Bacchus Marsh and Gisborne, Vic., where Buvelot visited and gave lessons. In 1875 she was sending pictures to the NSW Academy of Art (including copies of paintings by Webb and Bedford), and in 1875 to the Victorian Academy of Art. A photograph of her painting, *The Bush Home*, was offered to subscribers to the Art Union of Vic., 1875–76. Her work appeared in *Australian Art in the 1870s*, AGNSW, 1976.

LLOYD, Charles Salis
(b. 1902, Melbourne; d. c.1960, Melbourne) Painter.
STUDIES: NGV School with Bernard Hall. Known mainly for late impressionistic landscapes, portraits and still life. He held regular exhibitions at the Athenaeum Gallery for many years, continuing to show till the mid-1950s. He was a friend and admirer of Ernest Buckmaster whose influence can be seen in his work but whose financial success he never managed to emulate.
AWARDS: Student prizes, NGV School, 1918.

LLOYD, Henry Grant
(b. 1829, Chester, England; arr. Tas. 1840; d. 1904, Tas.) Painter.
STUDIES: Sydney, with Conrad Martens, c.1846. Eldest son of Major Henry Lloyd who retired from the East India Company in 1840 and migrated with his family to Van Diemen's Land. Described by Moore as 'Australia's peripatetic artist', H. G. Lloyd was an inveterate traveller, finding his subjects in all Australian states except Western Australia and the Northern Territory and painting on the spot. Thousands of his watercolours survive, the bulk of which are in the Mitchell and Dixson Libraries (1500 works). He may have accompanied John Skinner Prout on some of his journeys and was reputedly the first artist to reach what is now Canberra; he spent some time also in New Zealand. His work was seen in *Australian Art in the 1870s*, AGNSW, 1976.
REP: NLA; Mitchell, Dixson, Allport Libraries.
BIB: Moore, SAA. ADB 5. Clifford Craig, *Old Tasmanian Prints* Foot & Playstead, Launceston 1969. Kerr, DAA.

LLOYD, Norman
(b. 1897, Sydney) Painter.
STUDIES: Sydney, with Julian Ashton. Seriously wounded in France during World War I, he resumed painting during convalescence and in 1924 exhibited in Sydney with the Younger Group of Australian Artists, formed by Julian Ashton. Later he went to live in France.
REP: AGWA, Perth.
BIB: AA Sept. 1926, reproductions.

LLOYD JONES, Charles
(b. 1878, Strathfield, NSW; d. 1958, Sydney) Painter, art patron, collector.
STUDIES: Julian Ashton School, Sydney.
As a successful business executive and chairman of the board of David Jones Ltd, Sydney, he put together an important collection of contemporary Australian paintings and served as a trustee, for a time vice-president, of the AGNSW, 1934–58. Early in his career he helped Sydney Ure Smith and Bertram Stevens to launch the magazine *Art in Australia*. A commemorative prize is awarded in his name at the RAgSocNSW Easter Show competitions.
AWARDS: Knighthood conferred, 1951.
REP: AGNSW; NGV.
BIB: AA, numerous refs, reproduction, Sept. 1926. A&A 9/2/1971 (Douglas Dundas, *The Art Collectors 11: The Lloyd Jones Collection*). ADB 9.
(*See also* GALLERIES, DAVID JONES GALLERY)

LOANE, John David Duncan
(b. 23/6/1950. Melbourne) Printmaker, publisher.
STUDIES: Grad. Dip. Fine Art (printmaking) VCA 1977; travel studies, Europe and USA. Exhibitions at Crossley Street Gallery, 1972, and Powell Street Gallery, 1974, showed his etchings as calligraphic, varied in textural effects and surrealistic. In the late 1970s he established his first press, Molesworth Press, for printing limited editions from artists' plates and during the 1980s was director of the Victorian Print Workshop until re-establishing his own press Viridian Press in Melbourne in 1988
AWARDS: Prizes for prints at Geelong (1972) and Warrnambool (1977).
APPTS: Lecturer Printmaking Tas. School Art 1980; director, Vic. Print Workshop 1981–87.
REP: NGA; NGV; regional galleries at Geelong, Morwell (Latrobe Valley), Shepparton and Warrnambool.

LOBLEY, J. Hodgson
Australian painter who exhibited at the RA, London, in 1924, and at the exhibition of Australian art at the Spring Gardens Gallery, London, 1925.
(*See also* EXHIBITIONS)
NFI

LOCKYER, (Major) Edmund
(b. 1784, Devon, England; arr. Sydney April 1825; d. 1860) Painter, landholder. Military officer in charge of the settlement of Frederickstown (later renamed Albany), at King George Sound, WA. His watercolour, *The Settlement, King George Sound*, is dated 1827, which was also the year he returned to Sydney. He took up land at Marulan, near the junction of the Murrumbidgee and Goodradigbee rivers. Iron ore mined from his estate was used to construct the first NSW railway.
REP: AGWA.
BIB: AGWA *Bulletin*, vol. 1, no. 4, 1962. C. M. H. Clark, *A History of Australia*, vol. 3, MUP, 1973, 1978. *National Bank Calendar*, Melbourne, 1973. ADB 2.

LOJEWSKI, Steven

(b. 1952, England; arr. Aust. 1969) Photographer, lecturer.

STUDIES: Dip. Art & Design (photography), Prahran CAE, 1975; MA (visual arts), SCA, 1987; candidate Doctorate Creative Arts, Uni. of Wollongong 1988– . He curated a number of exhibitions including for the State Library of NSW and Aust. Centre of Photography. His commissions included for Parliament House, Canberra and he participated in numerous group exhibitions 1973–92, largely in public and tertiary galleries including Ewing and George Paton, Melbourne Uni.; Gryphon Gallery, Melbourne State College; Benalla and Mildura regional galleries and in major photography survey shows including *A Decade of Australian Photography*, NGA 1983; *Shades of Light*, NGA 1988; *Souvenirs of Sydney*, AGNSW 1992. He held 12 solo exhibitions 1976–91 including at Photographers Gallery, Melbourne; Australian Centre for Photography, Sydney; Syme Dodson, and Stills Galleries Sydney.

AWARDS: Project grant, VACB, 1976; Bicentennial Photography Project, Aust. Bicentennial Authority, 1988.

APPTS: Part-time teaching, photography, several tertiary colleges, Melbourne, 1975–77; lecturer, photography, SCA, 1978, head of dept, SCA, 1984 and 1987–91.

REP: NGA; AGNSW; AGSA; NGV; TMAG; Parliament House; Artbank; many regional, tertiary and corporate collections.

BIB: Catalogue essays in exhibitions as above. Peter Turner (ed) *Creative Camera*, Coo Press, London 1978. *Time Life Annual 1978*, Time Life, NY 1978. Jean Marc Le Pechoux (ed.) *Australian Photography Year Book 1983*, Roscope Publishing, Melbourne 1982. Anne-Marie Willis, *Picturing Australia*, A&R, Sydney 1988.

LONG, D.R.

(Active, Sydney, c.1870) Topographical painter in watercolours.

REP: NLA.

LONG, Leonard H.

(b. 1911, Summer Hill, NSW) Painter.

STUDIES: ESTC. Long began his career as a watchmaker, became interested in landscape painting in 1939 and between 1946 and 1950 held three exhibitions at the Grosvenor Gallery, Sydney. He subsequently became a popular exponent of traditional landscape painting. Member of the RAS of NSW.

REP: AGNSW; regional galleries Armidale (Hinton Collection), Rockhampton.

BIB: *Leonard Long: Australian Artist*, Waite & Bull, Sydney, 1971.

LONG, Ludwig

(Arr. Vic. c.1850s) Engraver. He engraved plates for a number of well-known artists of the goldrush period.

BIB: McCulloch, AAGR.

LONG, Olive

Early member of the CAS, Melbourne.

AWARDS: 3rd prize (War at Sea section), Australia at War exhibition, 1945.

NFI

LONG, Sydney

(b. 20/8/1871, Goulburn, NSW; d. 23/1/1955, London) Painter, etcher, teacher.

STUDIES: Art Society of NSW, Sydney (later RAS) school, with A. J. Daplyn, Frank Mahony and Julian Ashton, c.1892–96; London, with Malcolm Osborne, 1910. From 1913 he exhibited regularly at the RA and began to practise etching. After 15 years in London he returned to Sydney in 1925 to become a leading figure in the Australian art world, particularly in the field of etching. He painted and etched pastoral subjects and romanticised and stylised Australian bush subjects to which he introduced the decorative forms of fauns and other mythical creatures, as well as birds and foliations borrowed from European art nouveau. He was represented in the Bicentennial exhibitions *The Face of Australia* and *The Great Australian Art Exhibition*.

AWARDS: Wynne prize, 1938, 40.

APPTS: President, NSW Society of Artists, 1899–1901; Associate, Royal Society of Painter-Etchers, London, 1920; foundation member and first secretary, Society of Graphic Art, London; president, Australian Painter-Etchers' Society, Sydney; director, RAS School, Sydney; member of the board of trustees, AGNSW, 1933–49.

REP: NGA; AGNSW; AGSA; AGWA; MAGNT; NGV; QAG; QVMAG; TMAG; many regional and other public collections.

BIB: All general books on Australian art history. Dorothy Ellsmore Paul, ed., *The Etched Work of Sydney Long*, Attic Press, Sydney, 1928. Joanna Mendelssohn, *The Life and Work of Sydney Long*, McGraw Hill, 1979. Numerous references in the magazine *Art in Australia*. A&A 15/2/1977 (Joanna Mendelssohn, *Sydney Long*).

LONGELY, Dianne

(b. 8/6/1957, NSW) Printmaker.

STUDIES: Dip. Art, Newcastle CAE, 1978; BA (visual arts), Newcastle CAE, 1987. She held 9 solo and joint print exhibitions 1979–91, Australia and Scotland 1985 and in *100 × 100*, PCA 1988; *People, Print and Paper*, NLA.

AWARDS: Travel grant, VACB, 1984; residence Tokyo, VACB, 1989; Sadach studio development grant, 1991; several print prizes 1984–87 including Award of Excellence, Korean Miniature Print Exhibition, 1980.

APPTS: Part-time lecturer, printmaking, SASA, 1985–87; full-time lecturer, printmaking, Uni. of Newcastle and Uni. of SA, 1989–92; part-time lecturer, printmaking, Adelaide Central School of Art, 1992– .

REP: AGSA and several collections Korea, Scotland, Belgium.

BIB: *CAC Broadsheet*, vol. 17, no. 4, AL, vol. 11, no. 3.

LONGSTAFF, (Sir) John Campell

(b. 1861, Clunes, Vic.; d. 1941, Melbourne) Painter.

STUDIES: NGV School, with Folingsby, 1883–87;

Sir John Longstaff Burke and Wills at Cooper's Creek.
Collection, NGV.

Corman's, Paris, from 1888. Longstaff, a man of exceptional physical well-being who could say, at the age of 75, that 'he had never felt physically tired in his life', remained throughout his career happy to develop and extend the methods and principles imparted to him in the schools. He had a natural penchant towards historical painting and much natural skill; these attributes, combined with personal charm, brought him official success. He studied at Corman's, Paris and through his friendship with John Russell came in contact with some of the most forceful modern painters of the time, including Toulouse-Lautrec and Louis Anquetin. He remained loyal however to the influences of the official French Salons and the RA. His interpretation of *The Sirens*, a popular subject of the era, was exhibited at the Salon of 1892 and RA, 1893, and acquired, under the terms of the Travelling Scholarship, for the NGV in 1894. This picture typified his attitude; painted in transparent, smoky blues and bottle greens, it was one of the most popular pictures in the gallery collections for more than a decade. Another work, the Gilbee Bequest picture of Burke, Wills and King, painted in 1907, measures 2.8 × 4.3 m, and is one of the largest Australian pictures in state gallery collections; as this suggests, its completion called for the exertion of considerable physical effort. Longstaff's string of official portraits included commissioned likenesses of Australian war-leaders during World War I and many colleagues among the Australian painters and writers, as well as members of the Royal Family.
AWARDS: NGV Travelling Scholarship, 1887; honorable mention, Paris Salon, 1891; Archibald prizes 1928, 29, 31, 35; shared Melbourne *Herald* 'best picture of the year', award (£50), Athenaeum Gallery, 1937; knighthood conferred, 1928.
APPTS: London adviser to the AGNSW, trustee of the NGV, 1927–41.
REP: NGA; AGNSW; AGSA; AGWA; MAGNT; NGV; QAG; QVMAG; TMAG; many regional and other public collections.
BIB: Moore, SAA. Smith, PTT. Nina Murdoch, *Portrait in Youth. A Biography of Sir John Longstaff*, Angus & Robertson, Sydney, 1948. Badham, SAA. AA (*The Art of Sir John Longstaff*) Apr. 1931. ADB 10.

LONGSTAFF, Ralph

(b. 1880, Paris; d. 1967, Southwick, UK) Painter.
STUDIES: RA Schools, London. Son of Sir John Longstaff. He served with the Artists' Rifles and Yorkshire Rifles during World War I, was badly wounded, was awarded the Military Cross and attained the rank of major. His father painted his portrait in 1917 (now in the AGNSW), but he tended to repudiate family connections and his own painting bears no resemblance to that of his celebrated parent, being reticent, lyrical, monochromatic and often done in pastels. After the war he married Edith Hoskins, a colleague at the RA Schools, and lived at the Mall Studios where they became friendly with John Skeaping and his wife Barbara Hepworth. Longstaff taught at the London School of Art, the Richmond School of Art and privately, and exhibited at the RA. He rejected 'modernism', rarely exhibited his work, and lived a very private life. A commemorative exhibition of his work was held at Tolarno Galleries, Melbourne, in Aug. 1982.

AWARDS: Student prizes at the RA Schools.

BIB: Nina Murdoch, *Portrait in Youth: A Biography of Sir John Longstaff*, Angus & Robertson, Sydney, 1948. ADB 10.

LONGSTAFF, Will (William Frederick)

(b. 1879; d. 1953, London) Painter. Known for allegorical pictures, many of them on the theme of World War I. A cousin of Sir John Longstaff, Will Longstaff became interested in painting while serving as a soldier in the Boer War. He exhibited landscapes at the VAS, 1911–13. Appointed official war artist in World War I, he worked with the Australian forces as officer-in-charge of camouflage during the 8 August 1918 offensive. After the war, he worked at St John's Wood,

LOOBY, Keith

(b. 1940, Sydney) Painter.

STUDIES: NAS, 1955–60; travel studies, Europe and UK, 1960–67. The pink, tumescent figures in his large, early surrealistic paintings gave them the look of Flemish primitives. A prolific worker, he made a large number of paintings, as well as an extensive, on-going series of drawings in pen-and-ink entitled *History of the World*. This first phase reached its apogee in his large tapestry-like composition *Our Many Happy Returns to God*, entered for the Transfield prize, Bonython Gallery, Sydney, 1978. His later paintings included a series of large relief works entitled *The Student*. He held about 34 solo exhibitions 1964–92, including

London, where he painted pictures for the Australian National War Museum (now AWM). He achieved spectacular success with his picture *The Ghosts of Menin Gate*, which was bought by Lord Woolavington for £2000 in 1928, and presented to the Australian Government. Reproductions of this picture were sold in large numbers, crowds attended the exhibitions at which it was shown, and, as with later similar work by the same artist, it received constant newspaper publicity.

REP: AWM.

BIB: ADB 10.

Keith Looby, History of the World. *Pen and ink.*

exhibitions in Rome, 1964; Turin, 1965; Sydney and Canberra, 1967; Melbourne, 1968 and with Ray Hughes, Brisbane; Roslyn Oxley9, Sydney; *Drawings of our Artworld: Arthole, Gazers, Artrooters and Bumrubbers*, Ray Hughes, Sydney 1989, *Tree of Man Split Mural*, Ray Hughes, Sydney 1990. In 1978 he was selected to represent Australian painting at the fourth *Indian Triennial*. Other group exhibitions in which he participated included the opening exhibition for MOCA,

Brisbane, 1987; Venice Biennale, 1988; *Thinking Allowed*, Ray Hughes, Sydney 1991. As well he frequently writes on Australian art issues and artists for newspapers and art journals.
AWARDS: Darcy Morris Memorial Prize, 1969, 71, 72; Georges purchase award, 1971; Blake Prize, 1973; Sulman prize, 1974; VACB grant, 1976–77; Archibald Prize, 1984.
APPTS: Resident Creative Fellow at ANU, 1973–74.
REP: NGA; AGSA; AGWA; TMAG; regional galleries Geelong, Latrobe Valley, Mornington, Newcastle, Swan Hill; Philip Morris.
BIB: A number of general texts on Australian contemporary art including Smith, AP. H. McQueen, *Suburbs of the Sacred*, Penguin, Sydney 1988. A&A 12/4/1975 (Terence McMullen, *Keith Looby: The Artist as Idealist*). AI vol. 15, no. 3, 1971 (Alan McCulloch, *Letter from Australia*).

LORD, Anne

(b. 27/5/1953, Qld) Painter, printmaker, installation artist.
STUDIES: Dip. Art, Alexander Mackie CAE, 1978; Grad. Dip. Ed., Sydney Teachers College, 1979; Postgrad. Printmaking Studies, Monash Uni. College Gippsland 1991– . She participated in group exhibitions 1988–91, including at QAG; IMA; Araluen Centre, Alice Springs and Warrnambool regional gallery. She held five solo exhibitions 1986–91, including at Holdsworth, Sydney; Town Gallery, Brisbane; Umbrella Studio, Townsville, 1990 and Perc Tucker regional gallery.
AWARDS: A number of regional awards mainly Qld, 1988–91.
APPTS: Instructor 1980–89 and from 1990– lecturer, School of Art & Design, James Cook Uni., Townsville.
REP: QAG; Parliament House; a number of uni., regional and corporate collections.
BIB: J. Millington (ed.) *Tropical Visions*, UQP. *Eyeline*, vol. 11, 1990 (exhibition review by Helen Jones).

LORIMER, Vernon

Between 1921 and 1925, he illustrated a large number of small books, all published by the NSW Bookstall Co.
BIB: Elizabeth Hanks, *Australian Art and Artists to 1950*, Library Council of Vic., Melbourne, 1982.

LORMER, M.E.

Painter.
STUDIES: George Bell School, Melbourne, c.1950–60. Romantic in conception, her soft-edged paintings of still life were a feature of Melbourne Contemporary Artists exhibitions during the decades 1940–60.
NFI

LORRI (Lorraine WHITING, née Fraser)

(b. 1927, Melbourne) Painter, sculptor.
STUDIES: RMIT, c.1947. She left for the UK in 1952, showed in mixed exhibitions and in 1955 moved to Rome. She subsequently exhibited in Rome, 1958, 59, 61, and London, New York, Milan and Basle, 1961. Married to writer B. R. Whiting, she is the sister of former Australian Prime Minister, Malcolm Fraser.
REP: NGV.
BIB: Grosvenor Gallery exhibition catalogue, London, 1961.

LO SCHIAVO, Virgil

Painter. Lo Schiavo's work included two large, allegorical murals for the original Commonwealth Bank, Melbourne. He was assisted in this work by Betty Morgan.
AWARDS: Sulman prize, 1945.

LOUREIRO, Arthur Jose de Souza

(b. 11/2/1853, Oporto, Portugal; arr. Melbourne 1884; d. 7/8/1932, Terras de Bouro, Portugal) Painter.
STUDIES: Academy of Fine Arts, Oporto, Portugal; Académie des Beaux-Arts, Paris. He exhibited at the Paris Salon, 1880–82, and lived at Fontainebleau, London and Surrey before moving, with his Tasmanian wife, to Australia. In Melbourne he was 'discovered' by Louis Buvelot and James Smith while painting in the Fitzroy Gardens. He taught in Melbourne, where his work (mainly landscapes but also portraits and history paintings) gained the respect of other artists for its breadth and freshness, and his personality brought him wide popularity. A foundation member of the Australian Artists Association, he joined Roberts, Streeton and Conder in their opposition to the Victorian Academy of Art. His life in Australia was ruined by the death in World War I of his son, Vasco (also a painter), who studied at the NGV School, 1902–05, and he left Australia in 1904. His work was represented in *Golden Summers* curated by the NGV and touring 1986.
AWARDS: Prix de Rome, c.1879.
REP: NGA; NGV.
BIB: ADB 5. *Table Talk*, Melbourne, Oct. 1888.

LOVETT, Mildred E.

(b. 1880, Hobart; d. 1955, Hobart) Painter, teacher.
STUDIES: Hobart Tech. Coll., c.1896; Julian Ashton School, 1898–99; Westminster School, London; Paris, with Andre Lhote, 1929. After teaching china painting at the Hobart Tech. Coll. she went to Sydney to succeed Sydney Long as assistant to Julian Ashton at the Sydney Art School (1910–15). She married Stan Paterson in 1915 and lived in Brisbane where she worked with Vida Lahey before returning to Sydney and thence to Hobart where she taught privately as well as at her old school. In 1924 her work was chosen to represent Tas. in the *British Empire Exhibition*, London. She became a member of the Sydney Contemporary Group in 1926, and her interest in modernist art was greatly stimulated by her visit to Europe and the UK in 1929, when she responded to cubist influences derived mainly from her studies at the summer school conducted by Andre Lhote. Exhibitions in which her work appeared 1970– included *Mildred Lovett (1880–1955) and her students: Grace Crowley, Jean Bellette, Amie Kingston, Important Women Artists*, Melbourne 1978 and *An Exhibition of Art Nouveau in Australia*, Ballarat Fine Art Gallery, 1980.

REP: AGNSW; TMAG.

BIB: Moore, *SAA*. Janine Burke, *Australian Women Artists* Greenhouse, Melbourne, 1980. *ADB* 10. Caroline Ambrus, *The Ladies Picture Show*, Hale & Iremonger, Sydney 1984. *Art & Architecture*, 1909 (J. R. Ashton, *Miss Mildred Lovett: Some Notes on her China Painting*); *Lone Hand*, May 1913. *AA* Sept. and Dec. 1929, reproductions.

LOW, (Sir) David

(b. 1892, Dunedin, NZ; d. 1963, England) Cartoonist. He made his name in Australia with his contributions to the Melbourne page of the Sydney *Bulletin*, of which journal he was a staff member from 1914 to 1920. He had no formal training, his early drawings being carefully modelled on the style of the artist he most admired, Phil May. His first published drawing appeared in *New Idea*, Melbourne, 1903. Many of the *Bulletin* cartoons which established his reputation depicted the Australian Prime Minister, William Morris Hughes. In London in 1920 he became top cartoonist for the Beaverbrook press, working successively for the *Daily News* and *Star*, 1920; *London Daily Express*, 1926; *Evening Standard*, 1927–50. His most celebrated British cartoon character was Colonel Blimp. His work featured in many books of cartoons including *The Best of Low*, Jonathan Cape, London, 1928.

REP: Print and drawing collections of state galleries.

BIB: Vane Lindesay, *The Inked-In Image*, Hutchinson, Melbourne, 1979.

LOWCAY, Rose

(b. 1889, Stellenbosch, South Africa; arr. Adelaide 1890; d. 1968, Adelaide) Painter.

STUDIES: Adelaide, with James Ashton; London, with Talmadge and Vicat Cole; Newlyn School, with Stanhope Forbes. Known mainly for late impressionist landscapes in oils, she exhibited at the RAS of NSW and VAS from 1908, and in 1912 held an exhibition of her European paintings in Melbourne.

REP: AGSA.

BIB: Rachel Biven, *Some forgotten . . . some remembered*, Sydenham Gallery, Adelaide, 1976.

LOWE, Geoffrey

(b. 1952, Melbourne) Painter, teacher.

STUDIES: RMIT, 1969–72; travel studies, Europe 1974–75. He lived at Colebrook, Tas., 1973–74, and came under the influence of the surrealist painter Dusan Marek. Others who influenced his early work included Laurence Peterson, Raphael Gurvich and David Lloyd. Later his style broadened to include large paintings of interiors and a series of brilliant, open, line drawings. He held 17 solo exhibitions 1952–93, including at Powell Street, Melbourne; Roslyn Oxley9, Sydney; IMA, Brisbane; ACCA; Sutton Gallery, Melbourne and regional galleries in Warrnambool, Mt Gambier and Hamilton. His work appeared in about 50 group exhibitions 1976–93 including *New Generation Victorians*, MPAC 1976; *Figures and Faces Drawn from Life*, Heide, 1983; *Australian Perspecta*, AGNSW 1985; *Backlash* and *Field to Figuration*, NGV 1987; *Stories of*

Geoff Lowe (with John Nixon) There is a hole in the ozone layer, 1992, acrylic, conte and colour laser copy on linen, 152 × 122cm. Courtesy Roslyn Oxley9.

Australian Art, Commonwealth Inst., London; *Two Hundred Years of Drawing*, NGA 1988; *The Inherited Absolute*, ACCA 1992.

AWARDS: Elaine Target Drawing Prize, 1971; VACB grant, 1974; MPAC Spring Festival of Drawing (drawing acquired), 1979.

REP: NGA; AGWA; NGV; QAG; Artbank; regional galleries Castlemaine, Newcastle, Mornington, Warrnambool; Uni. of Melb; Monash Uni.; RMIT; Phillip Inst.

BIB: Catalogue essays for exhibitions as above. *AM* no. 35, 1991 (J. Watkins, *The Export of Australian Art*) *A&T* no. 36, 1990 (R. Benjamin, *Re: Creation? Re-Creation: The Art of Copying 19th and 20th Centuries*).

LOWE, Georgiana (née ORRED)

(Arr. Sydney Oct. 1842; d. 1884) Painter. Skilful amateur painter of watercolours. Married to politician Robert Lowe, who was a member of the NSW Legislative Council, later Chancellor of the Exchequer (1868), and in 1880 was made Viscount Sherbrooke. Lowe and Georgiana married in 1836 and they went to Australia for health reasons. They lived at Bronte House where Georgiana devoted much time to painting. Her best-known work is the charming set of watercolours entitled *Album of Watercolour Scenes in New South Wales, 1847–1850* and she was represented

in *The Art of Gardening in Colonial Australia*, AGDC touring exhibition 1979.
REP: Mitchell Library.
BIB: C. M. H. Clark, *A History of Australia*, vol. 3, MUP, Melbourne, 1973, 1978. Kerr. *DAA*.

LOXTON, John Samuel

(b. 1903, Adelaide; d. 1971) Painter.
STUDIES: NGV School; Swinburne Tech. Coll. A skilful painter in the impressionist watercolour tradition of Harold Herbert (q.v.), Loxton travelled in Europe, 1948–50, and in 1965 held an exhibition at the Qantas Gallery, London. Subjects include Victorian landscapes, snow scenes, coastal and harbour views.
AWARDS: Prizes for watercolours at Geelong, 1940, Albury, 1947.
APPTS: Art critic for the Melbourne *Argus*, 1947–48; president of the Fellowship of Australian Artists, 1961.
REP: State and regional galleries.
BIB: *The Art of John S. Loxton*, Osboldstone & Co., Melbourne, 1956.

LUCAS, Noelene

(b. 12/5/1948, Melbourne) Sculptor.
STUDIES: Dip. Teaching, Melbourne Teachers Coll., 1968–71; Dip. Art, Prahran CAE, 1978; MA Fine Art, Uni. of Sydney 1992– . She held 7 exhibitions 1981–92, including at Gryphon Gallery, Melbourne; Lunami Gallery, Tokyo; Gore St Gallery, Melbourne; Garry Anderson, Sydney. Group exhibitions include *Mildura Sculpture Triennials*, 1973, 75, 78, her work in the last of these exhibitions being a large circular earthwork; *Australian Perspecta*, Sydney 1985; several exhibitions in Tokyo; *Three Installations*, AGNSW 1991; *Artists Regional Exchange*, AGWA 1992.
AWARDS: Residency, VACB studio, Tokyo, 1987; development grant, VACB, 1991.
APPTS: Part-time tutor, Melbourne State Coll., 1979; head of study area of sculpture, School of Visual and Performing Arts, Uni. of Western Sydney, Nepean, 1992– ; artist-in-residence, VCA, 1980; visiting artist, British School in Rome and at Cité Internationale des Arts, Paris, 1988 and Silpakorn Uni., Bangkok, 1991.
REP: MAGNT; Darwin Community College; Mildura Arts Centre; Uni. of Western Sydney.
BIB: Sturgeon, *DAS*. Scarlett, *AS*. *AN*, Spring, 1982. *AM*, May, 1992; June, 1992.

LUCK, Ross

Industrial designer, designer for theatre and art writer. Vice president, 1950, later president, CAS, Adelaide, his work included sets for Australian theatre productions and introductions to a number of books and catalogues including to Kim Bonython's *Modern Australian Painting and Sculpture* 1960; and *Modern Australian Painting* 1970, 1980 and the text and design for exhibition catalogue *The Australian Painters* 1964–66, Mertz Collection for Corcoran Gallery, Washington, DC, Griffin Press, Adelaide, 1966. His son, Peter Luck, is a television documentary maker and producer.

LUKE, George

(b. 1/2/1920. Melbourne) Sculptor, painter.
STUDIES: NGV School, 1937–40; RMIT, 1938–41; travel studies in Europe, 1948–51. He served with the AIF (1940–45), spent three years in Europe after the war and for a time worked as a television designer for Channel 2, Brisbane. His Daumier-like sculptures identified him with social-realism when they appeared in his first show at the Argus Gallery, Melbourne, 1964, but an exhibition of paintings (Australian Galleries) five years later revealed interest also in cubism and the French 'Section d'Or' painters. He exhibited with the Half Dozen Group, Brisbane, 1963, and held solo exhibitions 1963–90 largely in Brisbane (Johnstone; Reed galleries) and Gallery Schubert, Gold Coast, 1990.
REP: NGA; AGSA; AWM; Rockhampton Gallery; Flinders Uni. collections; Australian War Memorial, Canberra.
BIB: Scarlett, *AS*.

LUMB, Frank

(b. 1910, Sydney) Sculptor, teacher.
STUDIES: ESTC, c.1930. With Lyndon Dadswell he assisted Rayner Hoff. His work was shown at Society of Artists of NSW exhibitions, and at the Society of Sculptors and Associates of which he was a foundation member. His commissioned works include a cast concrete piece for a baby health centre at Campsie, NSW, 1954, and a metal relief work for the Commercial and General Acceptance Building, Bent Street, Sydney, 1960. Guiding principle of his sculpture is its relationship to architecture.
APPTS: Teaching, NAS, Sydney, c.1961; Canberra School of Art, –1971.
BIB: Lenton Parr, *Sculpture*, Arts in Australia series, Longman, Melbourne, 1961. Sturgeon, *DAS*. Scarlett, *AS*.

LUNGHI, John

(b. 1912, London; arr. Aust. 1937) Painter.
STUDIES: Central School of Arts and Crafts, London. A president of the Perth Society of Artists, his abstract work was included in the Whitechapel Gallery exhibition of Australian art, 1961.
AWARDS: WA Festival of Arts Painting Prize, 1958.
REP: AGWA.
NFI

LUPP, Graham

(b. 1946, Bathurst, NSW) Painter, teacher.
STUDIES: B. Arch., Uni. of Sydney, 1964–69; foundation year, Ealing Tech. Coll., London, 1972–73; BA (Hons), Hornsey Coll. of Art, 1973–76; MA, Chelsea School of Art, 1977. His exhibitions include photorealist work in about 13 exhibitions 1977–92 in London, Sydney, regional NSW and Brisbane. Group exhibitions in which his work appeared 1982–90 included *Bathurst Scenes Seen*, Bathurst Regional Gallery 1982; *The New Romantics*, Macquarie Galleries 1987. He completed a number of commissions including for Parliament House; Charles Sturt Uni.; James Hardie; Embassy, People's Republic of China, Canberra.

AWARDS: Bathurst Art Purchase 1985, 91.

APPTS: Lecturer, Mitchell CAE, Bathurst.

REP: NGV; Parliament House; Artbank; Bathurst Regional Gallery; corporate collections including Qantas.

BIB: Catalogue essays for exhibitions as above. *A&A* 21/4/1984; 23/1/1985.

The resulting views are rather more picturesque and tidy than the real landscape. His work was included in *Tasmanian Vision* TMAG and QVMAG 1988; *The Artist and the Patron* AGNSW, 1988; and the Bicentennial exhibitions *The Great Australian Art Exhibition* and *The Face of Australia.*

REP: NGA; AGNSW; NGV; AGSA; TMAG; ALMFA; NLA.

Joseph, Lycett, View on the Wingeecarrabe River, New South Wales, *1825, coloured lithograph, 17 × 27cm. Joels, April 1992.*

BIB: Rienits, *Early Artists of Australia*, 1963. ADB 2. Jocelyn Hackforth-Jones, *The Convict Artists*, Macmillan, Melbourne, 1977.

LYCETT, *Joseph*

(b. 1774, Staffordshire; arr. Sydney 1814; d. 1828, England) Painter, miniaturist, engraver. Convicted for forgery in 1811, he arrived in Sydney in 1814 on the *General Hewitt* after a voyage in which one in nine of 300 male convicts died; also on board was Captain James Wallis (q.v.). The following year he was again convicted of forgery and sent to Newcastle; but in 1816 Wallis took over as commandant and employed him to draw up plans for a new church. Back in Sydney he made many paintings and drawings, including landscapes (many with Aborigines), views of Sydney and of the mansions built by the free settlers and members of the Rum Corps, as well as a few botanical drawings. Governor Macquarie, for whom he made topographical drawings, secured a pardon for him and after his return to London he prepared and published the 50 aquatints of his *Views in Australia and Van Diemen's Land* (13 monthly parts, 1824–25). The work, dedicated to his patron, Lord Bathurst, was accompanied by 'exact and faithful descriptions' of each view, one of the objects being to advertise life in the colony.

LYLE, *Max W.*

(b. 23/2/1935, Melbourne) Sculptor, teacher.

STUDIES: Dip. Art, RMIT, with George Allen, Victor Greenhalgh and Stanley Hammond, 1951–54; travel studies, Europe, 1968–69; USA, Mexico and Canada, 1976; Malaysia, Indonesia 1990; Canada, USA, UK, Europe 1991. The development of his work has been subject to frequent changes of style and direction, its most consistent feature being relationship to environment. His commissioned work for the Adelaide Festival Theatre, 1973, shows interest in minimal sculpture but returned to more structural but nevertheless simple forms in the 1980s–90s. He has had a number of sculpture commissions including a 7.6 m high work for Broken Hill Administrative Centre and *Performance*, a two-part 8.5m steel/stainless steel sculpture for Mt Gambier, SA.

AWARDS: Victorian Sculptors' Society (Aubrey Gibson award), 1954; VACB grants, 1973, 76.

APPTS: Lecturer in sculpture, Caulfield Tech. Coll., 1957–59; Gordon Inst. of Technology, Geelong, Vic., 1960–62; senior lecturer, sculpture, SASA 1972– ; consultant artist, Thebarton Community Centre, Adelaide

Francis Lymburner, Girl with Lute, *1950, oil on canvas on composition board, 41 × 50.7cm. Collection* QAG.

in 1974 and artist-in-residence, VCA (funded by Aust. Council and VCA), 1981.
REP: NGA; AGSA; Adelaide Festival Centre; regional galleries Geelong, Mildura; Sydney and Adelaide unis.
BIB: Sturgeon, *DAS.* Scarlett, *AS.*

LYMBURNER, Francis

(b. 11/6/1916, Gympie, Qld; d. 10/10/1972) Painter, draughtsman.
STUDIES: Brisbane Tech. Coll., with Martyn J. Roberts; travel studies, Europe and UK, 1950–63. Early in his career his outstanding talent for drawing animals inspired Sydney Ure Smith to publish his work in book form. Clarity of expression saved his work from the threatened 'plunge into the abyss of formlessness' predicted by some critics. He lived in England 1952–64 exhibiting rarely with a notable exception being inclusion in the 1961 Whitechapel Exhibition (*see* EXHIBITIONS). On his return to Sydney he exhibited widely in most capital cities until suffering a cerebral haemhorrage in 1966, following which he was unable to paint again. A second book of drawings was published in 1970 and in 1992 the AGNSW held a retrospective of his paintings and drawings, which assisted in giving him a more significant place in Australian art than he had been accorded previously.

AWARDS: Mosman Prize, 1951.
REP: NGA; most state galleries.
BIB: Vida Lahey, *Art in Queensland 1859–1959,* Jacaranda Press, Brisbane, 1959.

LYNCH, Guy (Frank)

(b. 1895, NZ; d. 1967) Sculptor.
STUDIES: Royal Coll. of Art, London. Brother of Joseph Lynch, cartoonist. Sculptures by Guy Lynch include one of the panels for the bronze doors of the Mitchell Library, Sydney; Amiens bronze group at the Australian War Memorial, Canberra; Masterton Memorial, Wellington, NZ; memorial at Devonport, Auckland, NZ. Lynch exhibited at the RA, London. In 1924 his *Faun* caused a press controversy when it was exhibited at the NSW Society of Artists' Younger Group exhibition, the objections raised being that it was a 'pagan work', unsuitable for exhibition in a public gallery.
REP: AGNSW; AWM.
BIB: Moore, *SAA.* Scarlett, *AS. AA.,* no. 9, 1924 (William Moore article).

LYNCH, Joseph

(b. NZ) Cartoonist. Brother of Guy Lynch. Contributor to Sydney *Bulletin, Smith's Weekly* and Melbourne *Punch,* c.1925. Lynch, a brilliant and original thinker, and an artist of outstanding talents, was drowned when

he attempted to win a wager by swimming ashore from a ferry in Sydney Harbour. The tragedy of his death became the subject of a poem by Kenneth Slessor, 'Five Bells', and later of John Olsen's mural for the Sydney Opera House.

Elwyn Lynn, Posted, *1966, mixed media on canvas, 102 × 102cm.*

LYNN, Elwyn Augustus

(b. Canowindra, NSW, 1917) Painter, critic and gallery curator.
STUDIES: BA, Dip. Ed., Uni. of Sydney 1941; extensive travel studies from 1958. As a painter (which he started in the mid 1940s) he has became known for his colourful, expressionistic work awarded the Blake prize in 1957. In his later work, expressionism gave way to the informalism and texturology of modern Spanish painting, and he began to use collage such as wood, rope and other materials imbedded in heavily impastoed surfaces. As curator of the Power Institute, his buying affirmed the catholicity of his tastes and his writing/editorial has included as editor of *Art and Australia*; art critic for several newspapers including the *Weekend Australian* 1983– . He has written a number of books on Australian art including *Contemporary Drawing*, Arts in Australia series, Longman, Melbourne, 1963; *Sidney Nolan: Myth and Imagery*, Macmillan, London, 1967; *Australian Landscape and its Artists*, Bay Books, Sydney, 1977; *Sidney Nolan: Australia*, Bay Books, Sydney, 1979; *The Art of Robert Juniper*, Craftsman Press 1986. He has held over 40 solo exhibitions 1958–94 including at von Bertouch, Newcastle; Bonython, Robin Gibson Sydney; Niagara, Gerstman Abdullah, Melbourne and participated in numerous group exhibitions in public galleries including *Contemporary Australian Drawing* AGWA, 1978; *20 Years of Australian abstraction* Dougherty Gallery 1986. In 1991 the AGNSW held a retrospective of works 1956–1990.
AWARDS: Blake, Mosman and Bathurst prize, 1957; Wagga Wagga and Campbelltown prizes, 1962;

Muswellbrook, Young and Grafton prizes, 1963; Rockdale, 1964; Wollongong, 1963, 1964; USA Government Leader grant, 1964; CAS Melbourne prize, 1965; R.Ag.Soc.NSW., 1965; Robin Hood prize, 1966; AM (Member, Order of Australia) 1975; Trustees Watercolour Prize, AGNSW 1980, 83; Wynne Prize, AGNSW 1985; Purchase prize University of NSW 1987.
APPTS: Teaching, NSW high schools, 1941–68; curator, Power Gallery of Contemporary Art, Power Inst., Sydney, 1969–1983; advisory ed. *Art International*, Lugano, Switz., 1971– ; chair, Visual Arts Board of the Australia Council, 1976–79; board member, Australian Art Exhibitions Corporation, 1976–78; council member, Alexander Mackie CAE., 196– .
REP: NGA; all state and many regional galleries and many other public collections including tertiary, municipal; corporate collections icluding BHP, NAB.
BIB: Most general books on Australian art including Bonython MAP 1970, 76, 80; Gary Catalano, *The Years of Hope* OUP; Eileen Chanin CAP. A&A, 1/3/1963; 8/1/1970; 23/2/1985; 23/4/1986.

LYSAGHT, P. J.

(Active c.1875, Vic.) His *View of the Murray River at Echuca*, 1876, showing paddle steamers, the wharf and a boating party, was exhibited at the Joseph Brown Gallery, *Autumn Exhibition*, 1971.

LYTTLETON, Thomas Hamilton

(b. 1826, Tas.; d. 1876) Painter, mainly of sporting scenes, administrator. He was the son of William Thomas Lyttleton (q.v.). In Victoria he worked as a superintendent of police in various towns in the 1860s and as a painter seems to have concentrated on hunting scenes, racehorses, etc. He exhibited at the VAA, 1870–72, showing a portrait, a coaching scene near Woods Point and paintings of the horse 'Sheet Anchor' and other horses. Works of the 1860s appear to show a slightly more refined finish and attention to detail than later works. His work was seen in *Pastures and Pastimes* Ministry for the Arts exhibitions, Victoria 1983; and the Bicentennial exhibitions *The Great Australian Art Exhibition* and *The Face of Australia*.
REP: La Trobe Library; a number of racing clubs, Vic., NSW
BIB: Kerr, DAA.

LYTTLETON, William Thomas

(b. c.1786; arr Aust. 1809; d. 1839) Army officer, painter. He worked in Sydney before going to Launceston, Tas., as a police magistrate. A talented architect and painter, he designed houses including probably 'Hagley House', near Longford, and painted pastoral scenes such as *Panshanger, Tasmania, The Seat of Joseph Archer, Esq.*, 1835. His son, T. H. Lyttleton (q.v.), became a competent painter of landscapes and racing scenes. His work appeared in *The Art of Gardening in Colonial Australia*, AGDC touring exhibition, 1979.
REP: TMAG; Mitchell, Crowther, Allport Libraries.
BIB: ADB 2. Cedric Flower, *The Antipodes Observed*, Macmillan 1974. Moore, SAA. Kerr, DAA.

McARTHUR, *John*

(b. 1790, England; d. 1862, England) A captain in the Royal Marines, later a major-general. McArthur was commandant of the first settlement at Port Essington, Northern Australia (1838–49). He was also an accomplished amateur painter. Among the artists who visited the settlement was Captain Owen Stanley (q.v.) in 1839. Stanley painted the scenery for a play produced at the settlement.
REP: NLA.
BIB: National Bank Calendar, Melbourne, 1963. *ADB* 2. Kerr, *DAA.*

McAUSLAN, *Gordon Stuart*

(b. 1913, Riverton, NZ; arr. Australia 1936) Painter, teacher, illustrator, ceramicist, sculptor.
STUDIES: ESTC (evening classes), 1938; Edinburgh Art Coll. (pottery), Sussex, with Edward Wadsworth, 1947–49. From 1938 he contributed illustrations to Sydney magazines and from 1947 held exhibitions in NSW as well as contributing to group exhibitions, including with the GAG, Sydney, and *Mildura Sculpture Triennials,* 1961 and 1964. He lived in NZ during the late 40s where he also exhibited.
APPTS: Draughtsman, Australian Army Intelligence, 1941–46; teaching, King Edward Tech. Coll., Dunedin, 1949–51; ESTC (part-time teacher), 1951–59; art master, Sydney Grammar School, 1959–76.
REP: NGV; AGNSW; Auckland City Gallery; Invercargill City Gallery NZ.
BIB: Scarlett, *AS.*

MacCALLUM, *Polly*

(b. England; arr. Australia 1960) Sculptor, collage artist.
STUDIES: Part-time studies at Willesden Art School and Royal Academy of Music (speech and drama), UK; Dip. Art, CAI, 1970; MA, CAI, 1986. MacCallum's work has moved from mainly painting in the 1970s and early 1980s through to collage, wall constructions and free-standing sculpture. Her initial responses to the issue of violence in society were a series of inward-looking works using geometric symbols and clear perspex to create a fourth dimension through shad-

owy images and reflections. Her 1990 series broadened the subject to include a historical context from mythical figures to martyrs, especially women. She held 7 solo exhibitions from 1980–1990 mainly at Coventry, Sydney (1985, 86, 88, 90) and also at Holdsworth (1980); and regional galleries in Fremantle, 1983 and Wollongong, 1986. She participated in 15 group exhibitions mostly in private galleries in Sydney including Ivan Dougherty, 1979, 82; Garry Anderson, 1982, 84; Coventry 1986, 87, 88. She was also included in *Contemporary Collage,* Wollongong City Art Gallery and *Blake Prize,* Blaxland, 1982; *Sydney Morning Herald Art Prize,* 1984; *The Age of Collage,* Holdsworth, 1987; Mildura Sculpture Triennial, 1988.
AWARDS: Studio grant, VACB Besozzo Studio, Italy, 1983.
REP: Artbank; Parliament House; Fremantle, Mildura and Wollongong regional galleries; CAI; Uni. of Wollongong.
BIB: McIntyre CC. *A&A,* 23/1/1985 (exhibition commentary). *AI* May/June, 1982.

McCANN, *Richard Matthew*

(b. c. 1889, Melb.) Painter.
STUDIES: RMIT; VAS evening life classes, 1906–14; NGV School, –1916– ; travel studies in UK and Europe, 1924–26. He began exhibiting landscapes in oil at the VAS, Melbourne in 1912, sometimes signing his work 'R. Greville McCann'. He exhibited also with the Qld Art Society, 1914, and later at the RA, London, also at Liverpool and at the Paris Salon.
AWARDS: Prize in Dunlop contests, Melbourne, 1951.
REP: Castlemaine Art Gallery.
BIB: R. M. McCann, *The Fable of the Stuffed Lion* illus. by Clarence Rigby, Waterways, New York, 1915. Refs in the *Bulletin,* Sydney, 4 Sept. 1929; *Table Talk* Melbourne, 2 Apr. 1925.

McCARTHY, *Stephen*

(b. 1/10/1954, Melbourne) Painter.
STUDIES: RMIT (painting), 1975–1977; VCA, 1978–80. His 1980s paintings showed a strong response to social issues such as pollution and overpopulation, which he portrayed in a surreal expressionistic style. He held 10 solo exhibitions, 1982–92, in private galleries,

Melbourne (Reconnaissance; 13 Verity St), Sydney (Coventry) and ROAR Studios, 1982 and Amsterdam (1984, 90). He participated in about 30 group exhibitions 1976–91, in private galleries in Melbourne (Verity St; Rhumbarallas); Sydney (including Coventry); ROAR Studios exhibitions 1981, 82, 83; *A New Generation 1983–1988, Philip Morris Arts Grant Purchase* NGA, 1988; ROAR *Touring Exhibition*, Heide and touring regional galleries, 1992. His commissions include for RMIT (Bowen Lane mural) 1976; Witte Rues, Amsterdam, 1984.
AWARDS: Grant, VACB, Sarah Levi Folio Award, 1980.
REP: NGA; NGV.
BIB: Catalogue essays in exhibitions as above. *New Art Three.*

MCCAUGHEY, Patrick (Arnold Patrick)
(b. 10/2/1943, Belfast, Ireland; arr. Australia c. 1953) Professor of fine arts, art critic, gallery director.
STUDIES: BA (hons) Fine Arts, English, Uni. of Melbourne, 1965; D. Letters, Monash Uni., 1978. His controversial art writings for newspapers and many other publications won him acclaim and a position of great influence and he had a significant effect on the development of visual art in Australia in the 1970s and 80s. His articulate presentation and enthusiasm made him one of the most colourful and well-known public gallery directors during his six-year term as director of the NGV and he contributed greatly to fostering and promoting contemporary Australian art. Books he has written include *The Australian Impressionist Painters of the Heidelberg School – the Jack Manton Collection* OUP, 1979; *Fred Williams*, Bay Books, 1980; *The Spirit of Genius: Art at the Wadsworth Atheneum*, Hudson Hills Press, USA, 1992. He has written newspaper reviews and many articles for art magazines as well as numerous catalogue essays for major exhibitions including those on Roger Kemp, Fred Williams, Picasso, and *200 years of American Painting: From the Collection*, 1989; *Goya to Matisse*, 1991 for the Wadsworth Museum.
AWARDS: Harkness Fellowship for study in USA, 1969.
APPTS: Fellow in Fine Arts, Uni. of Melbourne 1972–73; foundation member of the VACB of the Australia Council, 1973–75, and a member of the interim council of the NGA; art critic, *Age*, Melbourne, 1966–69, 1971–74; teaching Fellow, Monash Uni., 1969–75; Foundation Professor of Visual Arts, Monash Uni., 1975–81; director, International Cultural Corporation of Australia, 1985–87; director, NGV, 1981–88; director, Wadsworth Atheneum, Hartford, Connecticut, USA 1988– .

MCCLINTOCK, Alexander
(b. 1869, Westport, County Mayo, Ireland; arr. SA 1879; d. 1922, Melbourne) Painter.
STUDIES: Melbourne, with John Mather whose assistant he became. Brought up in Adelaide, he went to Melbourne to learn to be a Hansard reporter but soon changed to become a cub reporter for *Age*. He then joined a firm of importers of farm machinery, remaining their employee for the rest of his working life.

Influenced by the work of the British painter Lamorna Birch, he painted mostly in watercolours, exhibiting with the VAS from 1895 until, in 1912, he joined the breakaway group, including Mather, Harcourt, Meldrum and Withers, to form the Australian Art Association (q.v.). He maintained a large output of fine landscapes in watercolours which gained him the respect of his colleagues, but because of his daily work and family commitments he never attained the professional status to which his talents entitled him. His son, Remy (Rembrandt) became an artist and so did his nephew, Herbert (q.v.). His portrait was sculpted by C. Web Gilbert, and a memorial exhibition of his work was held at the Athenaeum Gallery, Melbourne, in 1922.
REP: AGNSW; Perth Uni. collections.
BIB: Alexander Colquhoun, *Australian Artists of the Past: Alexander McClintock, The Age*, Melbourne, 21 Jan. 1933. Arnold Shore, *Alexander McClintock: Australian Watercolourist of Distinction, The Age*, Melbourne, 9 Apr. 1960.

MCCLINTOCK, Herbert ('Max EBERT')
(b. 1906, Perth d. 1985) Painter, singer.
STUDIES: NGV School, 1925–27 and 1929. Nephew of painter Alexander McClintock. Undecided, in mid-career, whether to pay major attention to painting or singing, and to avoid confusing his separate reputations, he signed many of his early paintings 'Max Ebert'. He earned a living as an advertising artist while still a student, joined the Communist Party, drew appropriate cartoons and art-edited a paper, *Strife* (one number only), 1930. He married in Perth, 1933, and after a few years there moved to Sydney where he continued painting with the Max Ebert pseudonym. An oil from this period, *Streetscene*, is reproduced in Bernard Smith's *Place, Taste and Tradition*. McClintock's work did not live up to its early promise, although a large retrospective (Niagara Lane Galleries, 1980) brought out many unexpected facets.
REP: AGNSW.
BIB: Smith, PTT. Smith AP. Max Dimmack, *Noel Counihan* MUP 1974. Don Watson *Brian Fitzpatrick; A Radical Life* Hale & Iremonger 1978.

MCCOLL, Mitzi
(b. 1913, Vienna; arr. Australia 1939) Sculptor.
STUDIES: ESTC, with Lyndon Dadswell, 1953–59. She joined the Society of Sculptors and Associates, 1963, worked as an assistant to Douglas Annand, 1962–64, then with Margo Lewers and Bim Hilder, 1965–66, after which she taught part-time at technical colleges. During 1971–72 she travelled to the USA west coast, visited art schools and worked in Mexico City for six weeks.
AWARDS: Sculpture prize *Mirror* Waratah Festival, Sydney, 1962.
APPTS: Teacher, ESTC, 1969–72; Meadowbank Tech. Coll., 1972–76; Sculpture Centre, Sydney, 1972 of which she became head teacher, 1976 and chief administrator, 1980.
REP: Commonwealth Government Collection, Canberra;

private collections in Australia, USA and Mexico; Fairfield Girls High.

BIB: Scarlett, *AS. A&A* 19/3/1982.

McCOMAS, *Francis John*

(b. 1874, Tas.; d. 1938, Fingal) Painter.
STUDIES: Julian Ashton School, Sydney. He migrated to the USA in 1898, settled in Monterey, California, and became a successful painter in New York and Philadelphia.
AWARDS: Dana gold medal, also prize for most original watercolour shown at the *Exhibition of the American Society of Painters in Watercolour*, Pennsylvania Academy of Fine Arts.
REP: Metropolitan Museum, New York; AGNSW (watercolour).
BIB: D. H. Souter, *Francis McComas*, illustrated article in *Art and Architecture*, Sydney, vol. 5, no. 3, 1908. AA., no. 7, 1919.

McCONNELL, *Carl*

(b. 1926) Queensland ceramic artist.
STUDIES: Central Tech. College, Brisbane; Chicago Art Institute; travel studies, China, Japan, USA and South America.
REP: QAG

MacCORMAC, *Andrew*

(b. 1826, County Down, Ireland; arr. Melbourne 1854; d. 1918, Adelaide) Portrait painter.
STUDIES: Leigh's Academy, London, 1852. A foundation member of the Victorian Society of Fine Arts, 1856, he exhibited in the Melbourne Exhibition in 1854 as well as participating in landscape sketching trips organised by Buvelot. In the early 1860s he studied for the Church, was ordained, and in 1867 was appointed pastor of Newstead, near Castlemaine. He moved to South Australia in 1868 and two years later exhibited portraits and figure paintings at the SA Society of Arts. In 1880 he relinquished his ministry to paint full time. He painted numerous commissioned portraits of civic leaders as well as other notables, such as the explorers Stuart and McKinlay. He continued a vigorous output of portraits, exhibiting widely both in Adelaide and interstate, and was still showing at the SASA in 1908.
AWARDS: Gold Medal, International Exhibition, London, 1852.
REP: AGSA; Town Hall and Parliament House collections, Adelaide; Joseph Brown collection.
BIB: Moore, *SAA*. Kerr, *DAA*. J. B. Mather, *Catalogue of the Art Gallery*, AGSA, Adelaide, 1913. Rachel Biven, *Andrew MacCormac*, unpublished manuscript, Adelaide, 1979.

McCRAE, *George Gordon*

(b. 29/5/1833, Leith, Scotland; d. 15/8/1927, Hawthorn, Vic.) Writer, artist. Son of Georgiana McCrae and father of Hugh McCrae (q.v.). Elected honorary secretary of the Victorian Society of Fine Arts in 1856, and exhibited at its only exhibition in 1857. Deeply involved in literature and the visual arts, he was part of a circle frequenting the Bourke Street premises of the bookseller Henry Tolman Dwight. He has been called 'the father of Victorian poetry'.
BIB: *Australian Encyclopaedia*, Angus & Robertson, Sydney, 1958. ADB 5. McCulloch, AAGR. Kerr, DAA.

McCRAE, *Georgiana Huntly*

(b. 15/3/1804, London; arr. Australia 1/3/1841; d. 1890, Melbourne) Painter, writer.
STUDIES: England, with John Varley, John Glover and M. D. Serres. A woman of outstanding talents and personality, she married Andrew Murison McCrae. Their descendants formed a small dynasty of artists and writers, among them: George Gordon McCrae, son; Hugh and Dora Frances McCrae, grandchildren; Mahdi McCrae, great-granddaughter. Georgiana painted mainly miniatures and wildflowers and worked steadily on the diary that was to be her main legacy to posterity – *Georgiana's Journal*. The original McCrae homestead, *Arthur's Seat* at McCrae, Mornington Peninsula, Vic., became a small historical museum in 1961. Her work appeared in *A Century of Australian Women Artists 1840s–1940s* Deutscher Fine Art, Melbourne, 1993.
REP: NGV; La Trobe Library; National Trust.
BIB: Hugh McCrae, ed., *Georgiana's Journal*, Angus & Robertson, Sydney, 1934. ADB 2. McCulloch, AAGR. Kerr, DAA.

McCRAE, *Hugh Raymond*

(b. 1876, Melbourne; d. 1958) Poet, journalist, editor, illustrator. Son of George Gordon McCrae and grandson of Georgiana Huntly McCrae; friend and confidant of Dame Mary Gilmore and many other writers and artists. Known mainly as a poet and bon vivant, McCrae was a staff artist for Melbourne *Arena* and Melbourne *Punch,* and contributed for many years to the Sydney *Bulletin* and other journals. His books include *Satyrs and Sunlight, Columbine, Idyllia, DuPoissy Anecdotes*, and many other works, some illustrated by Norman Lindsay and published mostly by Angus & Robertson, Sydney, c. 1920–40. His daughter, Mahdi McCrae, also contributed black-and white drawings to these publications, c. 1925–30.
BIB: AA, Dec. 1931. *Southerly*, no. 1, 1959.

McCUBBIN, *Charles Wilson*

(b. 24/8/1930, Melb.) Painter, natural history artist.
STUDIES: RMIT; privately with Murray Griffin; travel studies UK, 1972. A grandson of Frederick McCubbin, his travels in search of local flora and fauna include a crossing of the Simpson Desert in company with Warren Bonython (July–Aug. 1973). General activities include exhibitions in Melbourne, Joshua McClelland Print Room, 1962, 1965, 1968, London, 1973, and ABC telecasts. He held about six solo exhibitions, 1962–80, at Joshua McClelland; Australian Galleries and participated in several group shows London and Pittsburg, USA, largely on the theme of wildlife. He has had numerous commissions for leading corporations including Comalco; APM and a stamp series for Australia Post. His publications include

Butterflies of Australia, Thomas Nelson, Melbourne, 1971.
AWARDS: Wildlife Arts Society (Lloyd O'Neil Award and Hutchinson Award for drawing), 1982; Robert Brown Award (shared) Matthew Flinders Bicentenary Literary Awards for *Australian Butterflies* book, 1988.
REP: Sale regional gallery; La Trobe Uni.; Wollongong Uni.; Vic. State Collection; Hunt Botanical Library, Pittsburg, USA.

MCCUBBIN, Frederick
(b. 25/2/1855, West Melbourne; d. 20/12/1917, South Yarra) Painter, teacher.
STUDIES: Artisans School of Design, Carlton, 1867–70; NGV School, with Thomas Clark, E. von Guérard and G. F. Folingsby, 1872–86. Son of a West Melbourne baker, he worked first in his father's business, studying art in the evenings until 1877, when he decided on a fulltime career as a painter. Still involved with the affairs of the bakery in 1884, he earned extra money illustrating animal stories for the *Australian Journal* until, in 1886, he succeeded O. R. Campbell as teacher of drawing at the NGV School. His marriage to Anne Moriarty in 1889 and subsequent family responsibilities (7 children) were strong inducements for keeping a steady job. In 1885, in company with his gallery school friends, Tom Roberts and Louis Abrahams, he established in the bush at Box Hill the first of the artists' camps that would lead to what has become known in Australian art history as the Heidelberg School (q.v.). At the time he was painting mainly large subject pictures, some inspired by the poems of Henry Lawson and all set in the blue gum country around Box Hill. Later, inspired by Roberts' interest in European Impressionism, he adopted the prismatic palette and broken brushstrokes characteristic of his large landscapes and cityscapes and, later, after his only visit to Europe in 1907, he got closer still to impressionism in his small-scale paintings of city streets. *The Pioneers* (triptych), *Down on His Luck*, *Bush Burial*, *The Lost Child* and such narrative works were the masterpieces of his Box Hill period. A genial, uncomplicated man whose songs, sung in a silvery tenor voice, were often features of artists' smoke nights, he had neither the forceful, organising character of Roberts, nor the gnawing ambition of Streeton. He lived a happy, family life, moving house frequently from Melbourne suburb to suburb before settling finally in South Yarra in 1907. The principal complication of his life was probably his unsympathetic relationship with the director and head of the NGV School, L. Bernard Hall, which lasted for 25 years. He was much loved by his students who gave him a send-off and a purseful of sovereigns at the VAS on the occasion of his leaving for Europe. Two of his children, Louis and Sheila, became painters. Another son, Alexander, became a publisher of art books; another, Hugh, a businessman, married a painter. He was represented in *Golden Summers* curated by the NGV and touring 1986; *Tasmanian Vision* TMAG and QVMAG 1988; and the Bicentennial exhibitions *The Face of*

Australia and *The Great Australian Art Exhibition*. An exhibition of his 'smaller works' toured regional and public galleries Vic., 1991–93.
AWARDS: NGV School, £30 prize for 'an original landscape', the first prize given at the School, 1882.
APPTS: Teacher of drawing, NGV School, 1886–1917; president, VAS, 1893, 1902–04, 1908–09, 1911–12; president, Australian Art Association, 1912.
REP: NGA; NGV; AGNSW; QAG; AGSA; AGWA; TMAG; MAGNT; many regional galleries as well as other public collections.
BIB: All general books on Australian art history. J. S. MacDonald, foreword, *The Art of Frederick McCubbin*, Lothian Press, Melbourne, 1916. *McCubbin. A Consideration by Alexander Colquhoun*, Alexander McCubbin, Melbourne, n.d. McCulloch, GAAP. Ann Galbally, *Frederick McCubbin*, Hutchinson, Melbourne, 1981. Bridget Whitelaw, *The Art of Frederick McCubbin* NGV, 1991. A&A 7/1/ 1969 (David Thomas, *Frederick McCubbin*) AL, 1/1/1981. Numerous refs and reproductions AA. ADB 10.

MCCUBBIN, Louis Frederick
(b. 1890, Melb.; d. 1952, Adelaide) Painter, gallery director, teacher.
STUDIES: NGV School, 1906–11. Son of Frederick McCubbin. In 1920 he was commissioned by the Commonwealth Government to paint backgrounds for dioramas of battle scenes for the AWM. The work took 9 years to complete. He also painted a series of pictures of the Great Barrier Reef for the Australian National Travel Association.
AWARDS: ANA Landscape Prize, 1914; Crouch Prize, 1929; OBE conferred c. 1948.
APPTS: Official war artist, WWI; instructor in drawing and painting at Swinburne Tech. Coll., Melbourne, from 1935. President of the VAS; director of the AGSA, 1936–50; deputy director of camouflage in SA during WWII; member of the Commonwealth Art Advisory Board, and Art Committee of the AWM.
REP: NGA; NGV; AGNSW; QAG; AGSA; AGWA; TMAG; MAGNT; many regional galleries.

MCCUBBIN, Sheila
Painter.
STUDIES: NGV School, 1914–17. Daughter of Frederick McCubbin. Mainly a painter of landscapes and still life, she exhibited at the Athenaeum Gallery, Melbourne, in Nov. 1971.

MCCUBBIN, Winifred
Painter. Wife of Hugh McCubbin. Member of the Melbourne Society of Women Painters and Sculptors.
AWARDS: First prize (Women's Services Section), *Australia at War* exhibition, 1945.
REP: Bendigo Art Gallery.

MCCULLOCH, Alan McLeod
(b. 5/8/1907, St Kilda, Vic.; d. 21/12/1992, Melb.) Cartoonist, painter, writer, gallery director, critic.
STUDIES: Family studies with his brother, Wilfred; special teaching from – Sheldon at Scotch Coll., Hawthorn, 1922; evening classes, NGV School, 1926–27;

RMIT, 1930–35; travel studies USA, Europe and UK, 1947–49. He received the greater part of his early art education studying art books and periodicals (such as the Sydney *Bulletin*, and the German *Simplicissimus* and *Jugend*) in the Melbourne Public Library. He also received help and encouragement from Will Dyson. His career included contributions of drawings and writings to Australian papers from 1927, American magazines 1947, a tandem tour of France and Italy, 1948, an exhibition (paintings and drawings), St Georges Gallery. London, 1949; organising *Aboriginal Bark Paintings from Australia*, exhibited Museum of Fine Arts, Houston, Texas, 1965; founding judge *Georges Invitation Art Prize*, Melbourne, from 1963–84; curator, touring exhibition, *The Heroic Years of Australian Painting 1940–65*, 1977–78. His compilation of the *Encyclopedia of Australian Art* began as a loose-leaf filing system soon after he started writing art criticism in 1944. His publications were *So This Was the Spot*, written and illustrated jingles published by author, Melbourne, 1934; *Ballet Bogies*, collaboration, Wilfred McCulloch and Lionel Smalley, Melbourne, 1938; *Masterpieces in the National Gallery of Victoria*, collaboration, Ursula Hoff and Joan Lindsay, Cheshire, Melbourne, 1949; *Trial by Tandem*, Cheshire, Melbourne, 1950; *Highway Forty*, Cheshire, Melbourne, 1951; *Encyclopedia of Australian Art*, Hutchinson, London, 1968 (with corrections, Hutchinson, Melbourne, 1977; revised edition, two volumes, 1984; third edition (with Susan McCulloch) Allen & Unwin, 1994); *Golden Age of Australian Painting: Impressionism and the Heidelberg School*, Lansdowne, Melbourne, 1969; *Artists of the Australian Gold Rush*, Lansdowne, Melbourne, 1977.

He painted and drew throughout his life and his contribution to Australian art can be seen in his many reviews for the Melbourne *Argus*, *Herald* and other journals and his promotion of the regional galleries of Victoria, notably that of Mornington of which he was director from its inception until illness forced his retirement in 1991. Christopher Heathcote in the *Age* wrote in his obituary (22 December 1992): 'Alan McCulloch was one of the great supporters of Modern Australian art. For more than 30 years he attempted to foster advanced painting and sculpture. . . . The contemporary art scene as we know it today would not have developed without his resolute dedication to contemporary Australian culture. . . . His writing may not have been concerned with complex ideas but this quiet and gentle man was arguably the most influential art critic to have practised in this country.'

AWARDS: Scholarship visits, France and Holland, 1965; Australia Council (VACB) grant, 1973; Order of Australia (AO) conferred, 1976. Australia Council (VACB and Literature Board) grant, 1982; honorary doctorate laws, Melbourne University, 1987; emeritus medal, Australia Council, 1992.
APPTS: Art critic, *Argus*, Melbourne, 1944–47; *Herald*, Melbourne, 1951–81; associate editor (art), *Meanjin Quarterly*, 1951–63; foundation president, International Association of Art Critics (Australia), 1963–66; Australian correspondent, *Art International*, Lugano, Switz.,

1970–73; director, Mornington Peninsula Arts Centre 1970–91.
REP: NGA; NGV; AGWA; AWM; MPAC.
BIB: *A&A* 30/4/1993 (S. McCulloch, obituary).

McCULLOCH, George
(b. 1848, Glasgow; d. 1907, London) Mining magnate, art collector. A nephew of Sir James McCulloch (twice Premier of Victoria, 1862–77), and a founder of Broken Hill. He gave pictures to establish the Broken Hill Art Gallery and amassed a huge collection which realised £136,000 at a sale in 1913. To decorate his mansion at Queens Gate, London, he had copies made of five of the magnificent tapestries from the *Quest of the Holy Grail* set designed by Burne-Jones for McCulloch's friend, William D'arcy of Stanmore Hall, Middlesex, and woven by Morris and Co. in 1894.

McCULLOCH, Rosamond Anna Veitch
(b. 1905, Scotland; d. 1971, Hobart) Painter.
STUDIES: Edinburgh (with her father, William McCulloch, 1927); Hobart Tech. Coll. (with Lucien Dechaineux). Her skilful, semi-abstract paintings were featured in many comprehensive exhibitions of Tasmanian contemporary art.
APPTS: Art teacher at Hobart Tech. Coll.; member of the advisory committee to the TMAG, Tasmanian Group of Painters, Contemporary Art Society, Tas., and Australian Watercolour Inst.
BIB: Monograph in *Origins of Art in Tasmania*, Queen Victoria Museum Publications, Hobart, 1948. Backhouse, *TA*.

McCULLOCH, Wilfred Arthur
(b. 17/8/1910, Drummoyne, Sydney; d. 10/2/1942, Singapore) Painter.
STUDIES: Family studies with his brother Alan (their father, Alexander, 1865–1917, was a mining and marine engineer and amateur painter and writer); NGV (evening classes), 1930–32; RMIT, 1932–35. He earned a living as a commercial artist, and painted at weekends and holidays. During a painting excursion to Wilson's Promontory he met Arthur Boyd, who became a close friend. They painted much together and for nearly six years, in company with Alan McCulloch and others, attended an artists' camp at Cape Schanck (1934–40) during weekends and holidays. 'Those were among the happiest years of my life', wrote Boyd in a letter in 1963. He illustrated *Ballet Bogies*, in collaboration with Lionel Smalley and Alan McCulloch, Melbourne, 1938. Like other artists of the time, Wilfred McCulloch was stimulated and influenced by the French post-impressionists whose original paintings he saw for the first time at the *Herald Exhibition of French and British Art*, 1939. His work developed a sudden surprising maturity, influenced by the work of Manet, Van Gogh and Seurat. He held three exhibitions, 1938, 39 and 40 – two at the Riddell Galleries, and one at the Athenaeum, Melbourne. Soon after the outbreak of war he enlisted in a military unit as an unofficial artist, and in 1941, after failing to get an

appointment as an official war artist, and again to pass an officers' training course at Duntroon Military Coll., transferred to an AMC unit of the ALF as a stretcher-bearer, together with another of the Cape Schanck group, Arnold Gardner, a promising poet (b. 1921). Both were killed. In 1992 his niece, Susan McCulloch, discovered about 50 of his watercolours and oils and numerous pencil sketches and sketchbooks, a number of which she had restored and exhibited at the Melbourne Fine Art gallery, Melbourne and Savill Galleries, Sydney.

REP: AGWA; MPAC.

BIB: Catalogue essays Daniel Thomas *Wilfred McCulloch: Works 1934–41*, Melbourne Fine Art, 1992. *CAS Broadsheet* Sydney, October 1963 (C. B. Christesen, *Arthur Boyd and the Last of the Artists' Camps*).

McCULLOUGH, Bianca

(b. Germany; arr. Australia 1949) Advertising artist, editor, writer. She worked as an advertising artist in India for two years, 1947–49, served as a governor on the board of the Prahran CAE, and in 1980 was appointed director of art exhibitions for the World Wilderness Congress, Qld, 1980. She wrote *Australian Naive Painters*, Hill of Content, Melbourne, 1977 and *Each Man's Wilderness*, Rigby, Adelaide, 1980.

McCULLOUGH, Tom

(b. 8/7/1936, Belfast, Nth Ireland; arr. Australia 1956) Museum director, educationist.
STUDIES: TSTC, Melb. Teachers College, 1961; B.Ed, Uni. of Melbourne, 1983; Grad. Dip. Museum Studies, Deakin Uni. 1984. As director of the Mildura Arts Centre, he added *Sculturescape* to the *Mildura Sculpture Triennial* (q.v.) and gave the event an avant-garde character. In 1975 it was the subject of controversy when the Mildura Council banned the display of some of the works and officially burned the book *Exhibition Exposition* that explained the background to the exhibition. At Mildura he also initiated some 20 artists-in-residence (including critics, dealers, artists) funded by the VACB. He became the inaugural director of the Australian Gallery of Sport & Olympic Museum at MCG, Melbourne. He has written numerous essays for exhibition catalogues. Boards on which he has served include the AGDC, Crafts Board of the Australia Council and Art Galleries Association of Australia and has been a guest lecturer at international forums including International Olympic Academy, Greece, 1991; World Convention for Directors of Sports Museums, Lausanne, 1985, 88.
AWARDS: Calouste Gulbenkian Foundation annual travel award, 1969/70.
APPTS: Teaching, Vic. Education Dept schools, 1965; director, Mildura Arts Centre, 1965–78; director, *Biennale of Sydney*, 1967; lecturer and organiser of the sculpture gallery, Pitspace, Preston Inst. of Tech., 1978; director, 1979–82; organiser, *Australian Sculpture Triennial*, Preston Inst. of Tech., and La Trobe Uni., 1980; director, Australian Gallery of Sport and Olympic Museum, MCG, Melbourne, 1983–90.

McDIVEN, Bryant

(b. 1923, Mildura, Vic.) Painter, teacher.
STUDIES: RMIT (commercial art), –1939; Claremont Teachers Coll., Perth, 1945–47; WAIT, 1947–49. He served as a pilot in the RAAF, 1940–45, and after the war settled in Perth where he held five exhibitions at the Skinner Galleries in addition to contributing to interstate group exhibitions.
AWARDS: *Southwest Times* Prize, Bunbury, 1961; Hotchin Prize (for watercolour), Perth, 1961.
APPTS: Teaching, Claremont Teachers Coll., 1951–58; head of the dept of art education, Graylands Teachers Coll., 1959–69; Mt Lawley CAE, 1970– .
REP: NGA; TMAG; WAIT.

MacDONALD, Anne

(b. 1960, Launceston, Tas.) Photographer, printmaker, teacher.
STUDIES: BA, TSA, 1981; MA, TSA, 1983. She held ten solo exhibitions (1983–92, including at Roz MacAllan, Brisbane, 1987; First Draft, Sydney, 1987, Roslyn Oxley9, 1987, 1992 and participated in about 20 group exhibitions 1984–92, including *Recent Australian Photography: from the Kodak Fund*, NGA, 1985; *The Naked Image*, Adelaide Festival and ACCA, Melbourne, 1986; *Australian Photography: The 1980s*, NGA, 1988; *Photodeath*, NGA, 1991.
AWARDS: Project grant, VACB, 1985, 88; project grant, TAAB, 1987, 89; overseas studio grant (Paris), VACB, 1990; research grant, Australian Research Council, Uni. of Tas., 1991.
APPTS: Tutor, photography, TSA, 1984; administrator, Chameleon Contemporary Art Space, Hobart, 1985, assistant director, 1986; tutor, photography, TSA, 1988, lecturer, photography, 1990.
REP: NGA; AGSA; TAAB; MCA, Brisbane; Artbank; Uni. of Tas.; Derwent Collection.
BIB: Catalogue essays exhibitions as above. Backhouse, *TA*.

McDONALD, Danny

(b. 11/10/1949, Vic.) Printmaker, art educator.
STUDIES: BA, VCA; travel studies Indonesia 1979, 80; Italy, France, 1980, 81; New York, Germany Italy, 1985; France, 1989; Italy, France, 1990. He held five solo exhibitions 1982–91 Melbourne (Gallery 18, photographs; Stuart Gerstman, prints 1988, 92), Canberra (Solander, photographs) and his work was included in about 20 group exhibitions 1981–92, including PCA exhibitions in the USA, 1985–76; *Henri Worland Print Prize*, 1986, 87, 89, 90, 91; MPAC *Spring Festival of Prints and Drawings*, 1990.
AWARDS: Worland Print Prize, Warrnambool regional gallery 1991.
APPTS: Head of visual art, Ruyton Girls School.
REP: Artbank; Uni. of Melbourne; VCA; PCA; municipal collections Caulfield, Diamond Valley, Vic.; Mornington, Tamworth, Warrnambool regional galleries.

McDONALD, Dawson

(b. 30/11/1920, Melb.) Painter, printmaker, teacher.

STUDIES: Dip. Art, RMIT. McDonald served with the Royal Signals Corps and worked as a draughtsman during WWII. His stylised depictions of buildings and street scenes attained recognition in Melbourne from c. 1950. He held four solo exhibitions 1967–88.

AWARDS: Aubrey Gibson Prize, VAS, 1955; Bendigo Prize, 1958, 1962; Caltex Prize, 1970, 72; Swinburne Annexe Prize, 1972.

APPTS: Lecturer in graphic illustration, RMIT, from 1962–1982.

REP: NGA; Bendigo, Swan Hill regional galleries; corporate collections including Caltex.

BIB: Germaine, AGA.

NFI

MACDONALD, *Fiona Melanay*

(b. 27/5/1956, Qld) Photographer, collage artist.

STUDIES: BA, SASA, 1976; Assoc. Dip. Fine Art, College of Art, Brisbane, 1979. She held about six solo exhibitions Mori Gallery, Sydney, 1983–88 and in Studio 666, Paris, 1987 and participated in about 14 group exhibitions 1981–92 including at Uni. of Tas, 1985; QAG, 1985; *Australian Perspecta*, AGNSW, 1985; IMA, Brisbane, 1986; 200 Gertrude St, 1987, 87; *A New Generation 1983–88*, NGA, 1988.

AWARDS: Alice Art Prize, 1955.

APPTS: Teaching, photography, CAI, 1988–89.

REP: NGA; NGV; QAG; AGWA; Araluen Arts Trust; National Gallery of NZ: Artbank; Allen, Allen & Hemsley, News Ltd; Zurich (Aust), institutional and private collections, UK, Europe and Australia.

McDONALD, *Harry (Henry Reginald)*

(b. 1914, Armidale, NSW) Painter, teacher with the Education Dept of NSW.

STUDIES: Sydney, with Dattilo Rubbo; ESTC. His oils and watercolours included portraits, landscapes and genre.

REP: NGV.

BIB: NGV catalogue, 1948.

MACDONALD, *James Stuart*

(b. 1878, Melbourne; d. 1952, Melbourne) Gallery director, art critic, painter, draughtsman.

STUDIES: NGV School; London, Westminster School of Art; Julian's, Paris. Completing his studies overseas, he exhibited at the Old Salon, Paris, and the RA, London. He was wounded early in World War I, became an official war artist, and when the war ended, he went to New York, where he exhibited at the Academy of Arts, and taught art for four years. During his professional career he became involved in two court cases. The first, in which he successfully conducted his own defence, concerned a libel suit brought against him, as art critic for the Melbourne *Herald*, by a dealer whose wares he had denounced in the paper as forgeries. His second appearance in court was about 20 years later, at the famous 1943 Archibald prize trial (*see* PRIZES), in which he appeared as chief witness for the plaintiffs. The case completed the decline in his status which had begun with his appointment to the NGV in 1936. The appointment was made by a state Labor government in opposition to the recommendation of the gallery committee of trustees, whose nominee was Hardy Wilson. The position in which MacDonald was thus placed was aggravated by his own attitude and views on art, which came into sharp conflict with the views of the chairman of trustees, Sir Keith Murdoch. Affairs reached a climax when MacDonald violently attacked the 1939 *Exhibition of Modern French and British Art*, which Murdoch's newspaper, the Melbourne *Herald*, had sponsored, and in 1941 an untenable situation ended with MacDonald's resignation. He returned to art criticism, as art critic for the Melbourne *Age*, the post which he held until his sudden death in 1952. His publications include *The Work of Frederick McCubbin*, Lothian, Melbourne, 1916; *The Art and Life of David Davies*, 1920; *The Art and Life of George W. Lambert*, 1920; *The Landscapes of Penleigh Boyd*, 1920, all published by Alexander McCubbin, Melbourne; *The Art of Charles Wheeler*, Lothian, Melbourne, 1952.

APPTS: Official war artist WWI; teacher in New York, 1919–23; art critic, Melbourne *Herald*, c. 1923–28; director-secretary, AGNSW, 1928–36; director, NGV, 1936–41; art critic, *Age*, Melbourne, 1941–52.

REP: AGNSW; NGV.

BIB: Smith, AP.

McDONALD, *John*

(b. 1961, Cessnock, NSW) Critic, writer.

STUDIES: University of NSW. He has written reviews for a number of Australian newspapers including the *Australian*, *National Times*, *Independent Monthly*. He was art critic for the *Sydney Morning Herald* 1985–90. He has lectured widely and contributed a number of essays to anthologies and exhibition catalogues, and to Australian and international art journals and written two monographs – *Jeffrey Smart* 1990 and *Ari Purhonen* 1992 – both published by Craftsman House, Sydney. In 1992 he edited the late Peter Fuller's *Modern Painters*, an anthology of essays.

McDONALD, *Sheila Lethbridge*

(b. 1902, St Mary's, NSW; d. ?/3/1971) Painter, committee member of the CAS, Sydney.

STUDIES: Sydney, painting with Julian Ashton and D. Orban; ESTC (sculpture with Lyndon Dadswell); travel studies in Europe, Asia and Pacific Islands. She converted a house in Sydney into studios occupied by painters, sculptors and other practising artists, and in 1949 started a private sketch club. Influenced by the Antipodean movement of the 1960s her painting during this period was concentrated on abstracted landscapes of Australian outback country seen from above, sensuous in feeling and colour.

AWARDS: Maitland Prize, 1963 (shared with W. Peascod); RAgSocNSW Prize, 1967.

REP: NGA; AGNSW; Newcastle Region Art Gallery.

BIB: *Meanjin* 3/1961 (Elwyn Lynn, *Avant-garde Painting in Sydney*). A&A 9/1/1971 (Lesley Pockley, *Sheila McDonald – An Appreciation*).

McDONNELL, *Aeneas John Lindsay*

(b. 1904, Toowoomba, Qld; d. 1963, London) Art collector, connoisseur. Partner in Macquarie Galleries, Sydney (c. 1928). London adviser to the Felton Bequest trust for the NGV, 1947–63.
AWARDS: French Legion of Honour (for services with Occupation Forces, Germany, during WWII).
BIB: Daryl Lindsay, *The Felton Bequest*, OUP, Melbourne, 1963.

McDONOUGH, *Jack Henry*

(b. 1916, Parramatta, NSW) Painter, weaver, teacher. STUDIES: NAS (part-time), 1935–36. He taught in NSW teachers colleges, 1951–70, before appointment as Head of Creative Arts, Mitchell CAE, Bathurst, NSW. AWARDS: Prizes at Bathurst 1958, 1961, 1962, 1966, and Wellington, NSW, 1962.
REP: Regional collection, Bathurst, NSW.

McEACHARN, *Neil*

(Arr. Australia 1940; d. ?Italy, 1964) His real home was at the Villa Taranto on the shores of Lake Maggiore, Northern Italy, where he developed the superb gardens later presented in about 1939 to the Italian government. While living in Australia he made a fine collection of modern Australian painting.
BIB: A&A 2/3/1964 (Helen Blaxland, *An Appreciation of Captain Neil McEacharn*).

McFADYEN, *Kenneth Charles*

(b. 1939, Preston, Vic.) Painter.
STUDIES: Dip. Fine Arts, BA, NGV, 1954–60. He served as an official war artist in Vietnam 1967–68, held many solo exhibitions in Australia and overseas including SE Asia 1968, and has won 24 awards. In 1973 he became a member of the VAS council, Melbourne. He also worked as a set designer for theatre and television including with the ABC and completed many commissions. A member of a number of art societies and clubs including Australian Guild of Realist Artists.
REP: AWM.
BIB: Gavan Fry & Ann Gray, *Masterpieces of the AWM*, Canberra, Rigby, 1982.

MacFARLANE, *J.*

Painter. He made dramatic, historical drawings of Australian exploration subjects including the expeditions of Sturt, Mitchell, Henty, Leichhardt, McDouall Stuart, Forrest, Eyre, etc. He illustrated *At the Races – the Melbourne Cup, 1892*, Thompson, Melbourne, 1892 and G. Dwithdale, *The Book of the Bush*, Ward, London, 1898.
BIB: Moore, SAA.

MacFARLANE, *Pamela*

(b. 1926, Dunedin, NZ) Painter.
STUDIES: MA, Otago Uni. (zoology), NZ, 1943–48; Dunedin School of Art (part-time), 1938–46; (part-time with Melville Haysom) Brisbane School of Art, Qld, 1950–51; (graphic workshop) Art Students League, New York, 1951–52 and 1958; travel studies, USA

and Europe, 1951–52; Mexico and UK, 1958. Her painting has been shaped by her studies of Cézanne, Etruscan and Pre-Columbian art, and the psychology of C. G. Jung; she sometimes made use of symbols related to the game of chess. She held about 15 solo exhibitions in Dunedin 1954, 1968; Brisbane 1956, 1959, 1967; Melbourne 1961; Adelaide 1966; Canberra 1967; ANU Gallery, Canberra, 1986. She participated in many group shows in Australia and overseas including *Australian Graphics*, Poland, 1972– 73; *Australian Prints*, New York, 1973; *Australian Prints to Poland and USA*, 1979–80; *A Homage to Women Artists in Queensland*, The Centre Gallery, 1988.
REP: NGA; AGSA; QAG; TMAG; university collections in Brisbane and Canberra; Wellington and Dunedin art galleries, NZ; private collections Australia, Canada, UK, Japan, and USA.

Stewart MacFarlane, Risk, *oil on canvas, 1991, 160 × 160cm. Private collection.*

MacFARLANE, *Stewart Angus*

(b. 24/11/1953, Adelaide, SA.) Painter, printmaker, teacher.
STUDIES: Dip. Fine Art, SASA, 1974; BA Fine Art, School Visual Arts, New York City, 1977; postgrad. studies (painting), VCA, 1984. While at art school in New York and visiting arts centres along the east coast, MacFarlane made contacts with American realists and photo-realists and subsequently worked as studio assistant for a number of artists including Alex Katz, Janet Fish and Chuck Close. In his characteristic dramatic style he juxtaposes people against modern images (motels, rooms, television sets) or transit situations such as highways, bikes, or cars, in a colourfully confrontationalist manner. His subject matter

reinforces the sense of narrative drama portrayed in a voyeuristic manner giving a sense of 'the uncensored dream'. He held 9 solo exhibitions, 1986–93, Melbourne (Arden St; Australian Galleries) Sydney (Rex Irwin) and Roswell Museum and Art Centre, New Mexico, USA (where he was artist-in-residence, 1987–88 & 1990–91).

AWARDS: Artist-in-residence, Showhegan School of Painting and Sculpture, USA, 1976; fellowship, Fine Arts Work Centre, Provincetown, 1977; artist-in-residence, MacDowell Colony, New Hampshire, USA, 1978; residency, Besozzo Studio, Italy, VACB 1986; artist-in-residence, Roswell Museum and Art Centre, New Mexico, 1987, 88, 90, 91; Edith Cowan Uni., 1992.

APPTS: Painting and drawing lecturer in several tertiary colleges 1985 – including Gippsland Institute; RMIT; Charles Sturt Uni., Wagga.

REP: NGA; NGV; Artbank: Wagga City Gallery; Uni. of WA.

BIB: *AL*, 9/2, 1989.

MACGEORGE, James
See ROYAL SOUTH AUSTRALIAN SOCIETY OF ARTS

MACGEORGE, Norman
(b. 1872, Adelaide; d. 1952, Darebin, Vic.) Painter, lecturer and critic.

STUDIES: School of Design, Adelaide, with Harry P. Gill; NGV School, 1897–99; travel studies, Europe and UK. His painting is lyrical in feeling, particularly in the landscapes and seascapes, as, for example, the large, high-keyed canvas, *Mother of Pearl*, acquired for the NGV in 1906. As a critic he adopted a strong, avant-garde attitude in which he supported George Bell and others in vigorous opposition to the institution of an Australian Academy of Art. His lifelong absorption with the arts extended to literature, music and ballet and with the sympathetic support of his wife (*née* May Hepburn, daughter of Vic. pioneer settler, Captain Hepburn), turned their home on the Yarra River at Darebin, Vic. into a lively rendezvous for artists of all kinds. On the death of May Macgeorge the property was bequeathed to the Uni. of Melbourne for use by an artist-in-residence. His publications include *The Borovansky Ballet in Australia*, 1946 and *The Arts in Australia*, 1947 both published by Cheshire, Melbourne.

APPTS: President, Australian Art Association; lecturer, Uni. of Melbourne Extension Classes; occasional critic for the Melbourne *Herald* and *Sun News-Pictorial*, c. 1940.

REP: NGV; Government House collection, Canberra.
(*See also* GALLERIES – PUBLIC, University of Melbourne)

McGILCHRIST, Erica
(b. 1926, Mt Gambier, SA) Painter, printmaker, teacher.
STUDIES: SASA, 1936–46; Adelaide Teachers Coll., 1945–46; RMIT (part-time), 1952–55; postgrad. Academy of Fine Arts, Munich, 1960–61. Her regular art studies began when she was 10 and lasted for nearly 20 years. Beginning at the Bookclub Gallery, Melbourne, in 1951, her solo exhibitions numbered more than 40 by 1993, and her modern, figurative paintings and prints have been featured in a large number of important group exhibitions in Australia and overseas. Recent solo exhibitions include Monash Uni., 1980; Caulfield Arts Centre, 1986 and a retrospective at the Springvale Library, Vic., 1988. Sources of inspiration include cubism and German expressionism, the latter especially after her studies in Munich. Since 1973 she has made costume and set designs for the Australian Ballet and Ballet Victoria and illustrations and cover designs for various publications, nationally and internationally.

AWARDS: Students Landscape Award, SASA, c. 1944; Adelaide *Advertiser* Prize (shared), 1956; Helena Rubinstein Prize for mural, Women's Uni. Coll., Melbourne, 1958; German scholarship for study in Munich, 1960–61; Dyason grant, AGNSW, 1961; German Academic Exchange Service grant, 1963; VACB standard grant, 1973; Caltex Masters Choice Award, 1978; painted a tram for the Vic. Ministry for the Arts; grant, VACB, 1981; grants, VACB, Vic. Ministry for the Arts, ACTU, Myer Foundation and Reichstein Foundation for Women's Art Register activities, 1978–87.

APPTS: Co-ordinator, Women's Art Register, 1978–87.
REP: NGA; NGV; AGNSW; university collections, Monash, Vic., Uni of WA; regional gallery at Ararat.
BIB: References in most books on contemporary Australian art.

MACGILL, Walter
(Active c. 1850–74) Sculptor, stonemason. He carved the columns for the Australian Museum, Sydney, c. 1864, and the statue of Captain Cook for Randwick, NSW, Oct. 1874. Most of his work was done at Port Fairy, Vic., including a head of John Wesley for the Methodist Church and a font for the Church of England.
BIB: Moore, *SAA*. Scarlett, *AS*.

McGILLICK, Tony (Antonov)
(b. 22/2/1941; d. Dec. 1992, Sydney) Painter.
STUDIES: Julian Ashton School, 1955–59. Between 1960–65 he worked in London and soon after his return to Sydney via New York (1965) established the Central Street Gallery, in collaboration with John White and Harald Noritis (sponsors), and Royston Harpur and Rollin Schlicht (qq.v.). Through his interest in this gallery and the work he exhibited there, he helped greatly to extend the colour-form abstract styles that had their roots in the New York School and became known to the Australian public through the exhibition *Two Decades of American Art* shown in Melbourne and Sydney in July–Aug., 1967. The shape he favoured was the square. In his geometric, hard-edge canvases in *The Field*, the square was repeated in shaped, joined and overlapping configurations in which were established ambiguous axial points of balance. Disliking aspects of the art market he held few

exhibitions following the demise of the Central St School (q.v.) and from 1970 to his death in 1992 held only six solo exhibitions including at Pinacotheca, Charles Nodrum, Melbourne; Ray Hughes, Sydney. He wrote frequently for art magazines such as *Art and Australia*. His work was the subject of survey exhibitions held at the NGV, 1978; AGNSW, 1973, 85 and Sherman Galleries, Sydney, 1993. This last small retrospective included the last picture he painted based on a *Time* magazine cover and demonstrated the vigour and strong painterly aspects of his 1970s abstracts.
REP: NGA: AGNSW: NGV; Ballarat Art Gallery.
BIB: Catalogue essays exhibitions as above. Smith, AP.

McGRATH, Eileen
(b. 1907, Parramatta, NSW) Sculptor, illustrator.
STUDIES: ESTC, with Rayner Hoff, 1923–31; London, carving, with John Skeaping, 1934; travel studies Germany, Holland, Denmark, Sweden, 1935. Sister of Raymond McGrath (q.v.). In 1936 she began making humorous illustrations for London publications, including London *Punch*, in which the jokes she illustrated (1936–38) were supplied by Albert Frost, whom she married. She taught art at a girls' school in Carlisle, England, 1939, and moved to the USA when her husband was appointed to the British Embassy at Washington, DC. An apt and brilliant student during her early days, her later sculptures recall the rhythms and tactile surfaces of Skeaping's models of animals.
AWARDS: Student awards, ESTC, 1930.
REP: Manly Art Gallery.
BIB: G. Rayner Hoff, ed., *The Work of Eileen McGrath*, ESTC, Sydney, 1931. Scarlett, AS.

McGRATH, Marilyn
(b. 1939, Sydney) Sculptor.
STUDIES: Newcastle Tech. College Art School, 1958–60; NAS (sculpture), 1960–62; Japan (temple sculptures), 1963. A member of the Society of Sculptors and Associates, she travelled in Europe, Iran, India and Asia, 1976–77, assimilating the influences that shaped the large, sensuous abstracts (resembling tropical plant forms) characteristic of her style. She held about 7 solo exhibitions 1973–91 including at Bonython, Sydney and Von Bertouch, Newcastle and participated in many survey sculpture exhibitions, 1972–91, including at Robin Gibson, Sydney and AGNSW.
AWARDS: Project fellowship Dept Technical and Further Education to study sculpture departments in New York, 1988; residency, Cité Internationale des Arts, Paris, AGNSW, 1988.
APPTS: Teaching, NAS, Newcastle, 1970–74; Newcastle Uni. School of Architecture, 1976; NAS, Newcastle (part-time), 1977; Seaforth College of TAFE 1980–89.
REP: AGNSW; QAG; several regional gallery and tertiary collections NSW.
BIB: Scarlett, AS.

McGRATH, Raymond
(b. 7/3/1903, Sydney; d. 23/12/1977, Dublin) Painter, writer, architect.
STUDIES: Grad. Architecture, Sydney Uni., 1921–26;

Julian Ashton School; modelling with Rayner Hoff, bookbinding with Walter Tavlor (c. 1921–26); Westminster School of Art, London. Brother of Eileen McGrath (q.v.). His versatile talents led to his interest in woodcuts, etchings, illustrations, bookbinding and magazine editing, but his main achievements were in architecture. In London in 1926 a chance meeting with Mansfield Forbes established the course of his career and he was offered the position of first Research Student of Architecture at Clare College, Cambridge. He visited Italy and Spain and contributed articles, short stories and poems to the *Architectural Review*, and the *Lady Clare Magazine*, of which he later became editor. From 1930–35 he was design consultant to the BBC, London. He designed also for Poole pottery, and in 1937, in collaboration with his brother-in-law, A. C. Frost, published his monumental *Glass in Architecture and Decoration*, a standard work on the subject. From 1940 he was an official war artist making mostly drawings for aircraft production, and 1948–68 worked as principal architect for the Office of Public Works, Dublin. Appointed Professor of Architecture at the Royal Hibernian Academy, 1970, he held that position until his death. Books he wrote and/or illustrated included *Seven Songs of Meadow Lane*, written, illustrated and published by the artist, Sydney, 1924; *Twentieth Century Houses*, Faber & Faber, London, 1934; *Glass in Architecture and Decoration*, with A. C. Frost, Architectural Press, London, 1937, revised 1961; James W. Mill, *The Labyrinth and Other Poems*, with wood engravings by McGrath, William & Norgate, London, 1930; Elizabeth Montizambert, *London Adventure*, illustrations by McGrath, London Passengers Transport Board, 1939. Deutscher Galleries, Melbourne held an exhibition of his prints April 1979.
AWARDS: *Daily Mail* Modern Art and Electric Light competition, 1930; *Architectural Review* competition for a lounge room, designed for an imaginary Lord Benbow, 1930.

McGRATH, Sandra
(b. Birmingham, Alabama, USA) Art critic, historian.
STUDIES: BA, Vassar Coll., NY; Uni. of Sydney.
APPTS: Art critic, the *Australian*, 1972– . Contributions to other publications include critiques for *Bulletin*, Sydney; *Vogue*, Sydney; *Art and Australia*, Sydney; and *Art International*, Lugano, Switzerland. Books she has written include *Brett Whiteley*, Bay Books, Sydney, 1979; *Sydney Harbour Paintings from 1794*, Bay Books, Sydney, 1979.

MacGREGOR, Graeme D.
(b. 13/6/51, Vic.) Painter.
STUDIES: Self-taught. Attended first year of Dip. Art, Ballarat Uni. College, 1984. He held five solo exhibitions, 1986–91 including at 13 Verity Street, Melbourne, 1989, 91. He was guest curator for *Image – defined & altered*, Ballarat Fine Art Gallery, 1988.
AWARDS: Buninyong Shire Council Acquisition Award, 1982; Fletcher Jones Memorial Purchase Award, Warrnambool regional gallery, 1988.

REP: NGV; regional galleries at Ballarat, Horsham, Shepparton and Warrnambool; Buninyong Shire Council.
BIB: Germaine, AGA *New Art Three*.

Fellowship of Australian Painters, showing mainly still-life and flower studies.
(*Information from the artist's daughter, Jean Phillips, 9 June 1981*)

W.B. McInnes, Cottage Amongst the Trees, *1912, oil on board, 23.5 × 28.5cm. Joel's, November 1992.*

MacInnes, Colin

(b. 1914, Melbourne, d. 1976, London) Art critic, essayist, novelist. The son of baritone James Campbell MacInnes and novelist Angela Thirkell (herself the granddaughter of the English artist Sir Edward Burne-Jones), he used in early life the surname of his step-father, – Thirkell, but on leaving Australia reverted to his own surname – MacInnes. Educated at Scotch College, Melbourne, he also studied languages in Europe, and was art critic for the London *Observer*, 1948–50. He helped many Australian painters to gain recognition in London. His many books and essays include a number dealing with Australian art such as (with introduction by Kenneth Clark and Bryan Robertson) *Sidney Nolan*, Thames & Hudson, London, 1961.

McInnes, Violet (née Musgrave)

(b. 18/1/1892, East Prahran, Vic.) Painter, photographic artist.
STUDIES: NGV School. She married W. B. McInnes in Feb. 1915. She exhibited with the VAS, the Melbourne Society of Women Painters and Sculptors and the

McInnes, William Beckwith

(b. 18/5/1889, St Kilda; d. 1939, Melbourne) Painter, teacher.
STUDIES: NGV School, 1909–11; travel studies Europe and UK, 1911, 1933, 1935. Painting with great facility, often with the square brushstroke made popular by Streeton, and greatly assisted by his success in winning Archibald prizes, he made his name as a portrait painter. His landscapes have a poetic feeling and reflect the charm and sensitivity that won him the affection of his students at the NGV School. In 1927 he was commissioned, with Septimus Power, to paint the opening of the Federal Parliament at Canberra by HRH the Duke of York (later King George VI). Memorial exhibitions to McInnes were held in the NGV and AGNSW in 1940.
AWARDS: Archibald Prize, 1921, 1922, 1923, 1924, 1926, 1930, 1936; Wynne Prize, 1918.
APPTS: Teacher of drawing, NGV School, 1917–34; head of the NGV School, 1934–39; acting director NGV, 1935–36.

REP: NGA; NGV; AGNSW; QAG; AGSA; AGWA; TMAG; MAGNT; regional galleries at Ballarat, Bendigo, Castlemaine and Mildura; Uni. of Melbourne.

BIB: All general works on contemporary Australian art history. Alexander Colquhoun, introduction *The Art of W. B. McInnes*, Alexander McCubbin, Melbourne, 1920.

McINTOSH, William P.

(b. 1857, Ayr, Scotland; arr. Sydney 1880; d. 1930, Sydney) Sculptor, teacher at ESTC, Sydney.
STUDIES: Edinburgh (anatomy) with Dr Andrew Wilson; Mechanics School of Arts, with Lucien Henry, Sydney, 1880–82; Italy in 1898–99. McIntosh was one of a group of sculptors commissioned by the Parkes government to do work for various public buildings in Sydney. These included the Museum of Applied Arts and Sciences (carved sandstone pillars), Lands Dept building and marble figure groups for the Queen Vic. Market, Sydney.
AWARDS: Student prize (the first awarded), Sydney Mechanics School of Art, 1882; Queen Vic. Market competition, 1897.
BIB: Scarlett, AS.

McINTYRE, Alan Lester

(b. 21/11/1913, Hobart, Tas.) Art critic, painter, teacher.
STUDIES: Dip. Fine Arts, Hobart Tech. Coll., 1949. An art critic and writer he held several solo exhibitions in Adelaide, Melbourne and Qantas Gallery, London, 1978 and participated in a number of group exhibitions including with the Launceston Art Society from the 1970s and Handmade Gallery, Hobart 1990–91. He produced a book of poems, *Red and Green*, illustrated by James Meldrum in 1979.
APPTS: Lecturer, Launceston Tech. Coll., 1962–77; art critic of the Launceston *Examiner* and contributor to the Sydney *Bulletin*.
REP: NGA; TMAG; QVMAG.

McINTYRE, Arthur Milton

(b. 31/10/1945, Katoomba, NSW) Painter, teacher and critic.
STUDIES: Dip. Art, NAS, 1962–66; part-time, Contemporary Art History, Uni. of Sydney, 1971–73; travel studies Europe and UK, 1975, 78, 79. In the 1970s his ongoing series *Survival and Decay* began with an obsession with the decay of the human body, and he said 'drawing is fundamental to all of my work as is my fascination with the paradoxes of the human condition'. He held about 21 solo exhibitions, 1970–91, including at Cité Internationale des Arts, Paris; Holdsworth and Mori galleries, Sydney; Tolarno, Melbourne. He contributed art critiques to the *Australian*, Sydney, 1977–78, and Sydney reviews for the *Age*, Melbourne 1980. He was guest professor, Rollins College, Florida, USA, 1981. He has curated a number of exhibitions including *The Age of Collage*, 1987; *Intimate Drawing*, 1989; *Sydney – from the City to the Fringes* 1991 and wrote *Australian Contemporary Drawing* Boolarong Publications, 1988 and *Contemporary*

Australian Collage, Craftsman House, 1990. He participated in numerous group exhibitions, especially drawing survey shows in public and private galleries including *Drawing in Australia*, NGA, 1988; *Assembled Art*, Centre Gallery, Qld, 1989; *Artists in Hospitals* Drill Hall, NGA 1991.
AWARDS: RASNSW Prize (contemporary section), 1971; prize in *Mirror*-Waratah competitions, Sydney, 1972; grants, VACB, 1975, 80, 86; residency Power Studio, Paris, 1975; American College, Paris, 1981.
APPTS: Taught in NSW schools from 1974; lecturer in drawing, NIDA, Uni. of NSW, 1979–88.
REP: NGA; AGNSW; AGWA; QAG; MCA, Sydney; Artbank; VACB; numerous regional, tertiary collections most states; corporate collections including IBM; Faber-Castell; Phillips Fox; NAB.
BIB: Catalogue essays in exhibitions as above. A number of texts on Australian art including Bonython, MAP 1979; *The Visual Arts* Jacaranda Wiley, 1980, 87. *New Art Seven*. AM, Nov., 1990.

McKAY, Brian

(b. 18/3/1926, Meckering, WA) Painter.
STUDIES: No formal training. McKay's early painting showed abstract-expressionist influences. He formed the Perth Group of artists with Guy Grey-Smith, Robert Juniper and others in 1961 and joined the Praxis Group in 1976. He spent 10 years lecturing in printmaking at TAFE Central College, WA and held about 12 solo exhibitions, 1962–90, largely in WA at Skinner Galleries, 1963–72; Galerie Dusseldorf, 1979– and Fremantle Arts Centre, 1984, 90. He has participated in a number of WA art group shows including at Galerie Dusseldorf and *10 WA Artists*, AGWA, 1976; *Fremantle Dozen* Fremantle Arts Centre, 1987. He became chairman of PICA in 1990.
AWARDS: David Jones Art Prize, 1977; Perth Festival of Arts Poster, 1981; WA Week Art Award, 1983, 84; Mandorla Prize, 1986; emeritus award VACB, 1990; Order of Australia, 1991.
REP: AGNSW; AGWA; Perth Uni.; Artbank; several tertiary and regional gallery collections, largely WA; corporate collections including Robert Holmes à Court; Rural and Industries Bank.
BIB: Bonython, MAP 1975, 80. Murray Mason, *West Australian Printmakers and painters* Fremantle Arts Centre Press, 1979. Lucielle Harley and Niek Waterlow *Brian McKay, Painter*, Fremantle Arts Centre Press, 1991. *Westerly*, nos. 2, 3, 1962. A&A 18/4/1981 (Hendrik Kolenberg, *Printmaking as Painting – Brian McKay's Recent Work*).

MacKAY, Ian Hugh

(b. 1936, Pt Augusta, SA) Sculptor, teacher.
STUDIES: ESTC, 1959–61; travel studies, Europe and UK, 1961–64. His brightly coloured sculptures welded from flat steel plates and girders or unpainted pipes, in the style of Anthony Caro, have appeared in successive *Mildura Sculpture Triennials* as well as in exhibitions, mainly in Sydney. Commissioned works by him are at Cooma, NSW (*Man from Snowy River*), Dee Why, NSW (sandstone *Hovering Bird Touchdown*, for Roche Products), Bradfield Park, Sydney (outdoor piece

for CSIRO). The AGNSW held a survey of his work 1984.
AWARDS: Mildura Purchase Award, 1973; VACB grant, 1974.
APPTS: Part-time teacher, NAS, 1966–74; St Martin's School of Art, London, 1976.
REP: AGNSW; AGSA; TMAG; Mildura Arts Centre.
BIB: Scarlett, *AS. A&A* 24/2/1986.

MacKay-Harrison, *David Ian*

(b. 16/8/1941) Sculptor, gallery manager.
STUDIES: Self-taught; Dip. Ag; studied sculpture, Toowoomba Summer School. He held a number of solo exhibitions of realist work including at his own gallery in Ballina, NSW.
AWARDS: A number of Rotary art awards 1970–76 at Albury/Wodonga, Ballina, Lismore, Nerang.
REP: Albury, Hamilton, Grafton, Rockhampton regional galleries.
BIB: Germaine, *AGA*.

McKenna, *Noel Vincent Joseph*

(b. 5/8/1956, Brisbane) Painter, printmaker.
STUDIES: BA (Architecture), Uni. of Qld, 1974–75; Brisbane College of Art, 1976–78; CAI, 1981. He held 16 solo exhibitions, 1978–91, including five at Kelvin Grove CAE; Garry Anderson, Sydney; Niagara, Melbourne. Often works in small scale. In his review of McKenna's 1990 show (*Australian*, 26–27 May) Rooney describes him as 'a gentle ironist who with apparent indifference to all that goes into producing big statements can make even the most ordinary domestic scene . . . seem both comical and hauntingly strange'. His work has appeared in numerous group exhibitions from 1980–93 including *Wynne* and *Sulman* prize exhibitions, AGNSW, annually 1982–90; *Fremantle Print Award*, 1986; *A Horse Show*, Heide, 1988; *Moet & Chandon Touring Exhibition*, 1991.
REP: NGA; AGNSW; QAG; Parliament House; Artbank; regional galleries including Mornington; Latrobe Valley; Gold Coast; Warrnambool; tertiary collections including Uni. of WA; Logan TAFE, Brisbane; corporate collections including Western Mining; Joseph Brown; Allen, Allen & Hemsley.
BIB: *New Art Three*. Thomas OAA 1989. *A&A* 26/4/1989. *AM* June 1991.

Mackennal, *Edgar Bertram*

(b. 1863, Melbourne; d. 1931, Devon, England) Sculptor.
STUDIES: Family studies with his father, John Simpson Mackennal; NGV School, 1878–82; RA Schools, London, 1883. In 1884 he married Agnes Spooner, a colleague student at the RA Schools, visited Rome and set up a studio in Paris where he was helped through a financial crisis by John P. Russell, who also introduced him to Rodin. In 1886 he was appointed head of the modelling and design departments of Coalport Potteries, Shropshire where he stayed until his return to Melbourne in 1888 to complete work for the façade of Parliament House, Melbourne. Subsequent local commissions kept him travelling between Australia, France and England

Bertram McKennal, Salome, *c. 1900, bronze. Private collection.*

for the rest of his working life, the turning point of his career having been the exhibition of his bronze, *Circe*, at the Paris Salon in 1893. Works by him were purchased for the Tate Gallery, London (through the Chantrey Bequest), in 1907 and 1908; he was the first Australian artist to be elected to the RA, 1909, and the first to be knighted (1921). Ken Scarlett gives an extensive list of commissioned works (*Australian Sculptors*, 1980) and rightly cites him as Australia's

most successful visual artist of the period. As Graeme Sturgeon suggests in his *Development of Australian Sculpture* (1978) Mackennal lost his chance of greater posthumous fame when he met Rodin; though greatly influenced by that master, he absorbed only the superficial aspects of his work. He was represented in the Bicentennial exhibition *The Great Australian Art Exhibition*.

AWARDS: Competition for relief carvings, Vic. State Parliament House, 1887; honourable mention for *Circe*, Paris Salon, 1893; Royal Victorian Order conferred, 1912; created Knight Commander, 1921.

REP: NGA; NGV; AGNSW; QAG; AGSA; Ballarat Fine Art Gallery; many other Australian public collections; Tate Gallery, London, and other British collections.

BIB: Moore, *SAA*. Sturgeon, *DAS*. Scarlett, *AS*. ADB 10.

MACKENNAL, John Simpson

(b. 1832, near Stranraer, Ayrshire, Scotland; arr. Vic. 1852; d. 1901) Sculptor.

STUDIES: Apprenticed to Liverpool sculptor, Goodall. Father of Sir Bertram Mackennal, he is also listed as student 'modeller and sculptor' at the NGV School, 1877–79. He went to Vic. with the goldrush and worked on the diggings before returning to Melbourne where he formed a partnership with James Scurry in architectural modelling. They worked jointly on commissioned works for banks and other commercial buildings and completed most of the ornamental plaster work for Parliament House, Melbourne. François Fallet also assisted with this work, which was directed, initially, by Charles Summers. Much of Mackennal's work concerned portrait busts and medallions but he received also commissions for carvings for the Law Court and Vic. Market buildings. Later he weathered a depressed period with help from the Art Unions of Vic. (q.v.). He was a foundation member of the VAA and whenever possible sent work to exhibitions overseas. During the 1870s he met regularly with Scurry, Fallet and others at the premises of G. K. Parker in Swanston Street, Melbourne.

REP: Ballarat Fine Art Gallery.

BIB: McCulloch, *AAGR*. Sturgeon, *DAS*. Scarlett, *AS*. *Table Talk*, Melbourne, 8 Mar. 1889.

McKENNAL, W.

First instructor of modelling and casting at Working Men's Coll. (now RMIT), Melbourne, 1889. It seems likely that he too was related to John Simpson Mackennal. (*See also* SCHOOLS, ROYAL MELBOURNE INSTITUTE OF TECHNOLOGY)

McKENZIE, Alick

Theatre designer, notably of the décor and costumes for the National Theatre, Melbourne, production of *The Barber of Seville*, 1951. McKenzie migrated to London in 1953.

McKENZIE, Graham William

(b. 8/12/1943, Orange, NSW) Painter, printmaker, set designer.

STUDIES: Prahran CAE; RMIT; TSTC, Melbourne State College. He taught at Victorian secondary schools, 1964–67 and 1972–76, and in Canada (Northern Alberta), 1968–70, before moving to London where he designed exhibitions for the Whitechapel Gallery. Travelling in the UK, Europe and North Africa, he returned to Melbourne in 1972, to paint, design jewellery, and design décor for the Australian Ballet, Melbourne State Dance Theatre and Human Veins Dance Theatre, Canberra. He painted in northern Qld and Mornington Island, 1978, and held around 11 solo exhibitions, 1969–92, including *Terra Australis*, Melbourne and Araluen Gallery, Alice Springs, 1992 and participated in many group exhibitions, largely prize exhibitions, including *Alice*; MPAC *Drawing*; and private galleries 1963–91.

REP: Several secondary school collections Vic. and ANZ Bank, Civic Advance Bank collections.

BIB: Germaine, *AGA*.

MacKENZIE, Isabel

(b. Melb.) Painter, teacher.

STUDIES: Sydney, RAS classes, 1920–27; landscape with Will Ashton, 1924–33. She exhibited with the RAS, Sydney, the NSW Society of Artists and the Society of Women Painters, London. From 1933 she held shows at the Macquarie Galleries, Sydney.

AWARDS: RAS student prizes.

APPTS: Teacher of art, NSW Education Dept, 1922– ; lecturer in art, Sydney Teachers Coll., 1941– . She wrote *The Why and How of Child Art*, Angus & Robertson, Sydney, 1955.

REP: AGNSW

BIB: Smith, *Catalogue AGNSW*, 1953.

McKENZIE, Laurel

(b. 2/12/1948, Vic.) Printmaker, art educator, consultant on health & safety in the arts.

STUDIES: Dip. Fine Art, printmaking, RMIT 1970; teachers certificate, Hawthorn State College, 1972; grad. dip., visual arts, Gippsland Institute of Advanced Education, 1986. She held four solo exhibitions, 1979–85 in Sydney (Robin Gibson); Geelong (Works Gallery); ACT (Bolitho) and Hawthorn City Gallery, 1979. She participated in about 50 group (mainly print) exhibitions, 1982–92 including PCA exhibitions to Sweden, 1982; Japan, 1984; USA, 1985; and in *100 × 100 Print Portfolio* 1989; *Henri Worland Print Prize*, Warrnambool 1978, 79, 80, 82, 84; MPAC *Spring Festival* 1976, 78; *Fremantle Print Award*, 1981, 82, 83, 84, 86, 87. She has also given many seminars and lectured on printmaking and occupational health and safety in printmaking including 'safe practice' booklets.

AWARDS: Residency, Moya Dyring Studio, Cité Internationale des Arts, Paris, AGNSW 1981.

APPTS: Teacher, Vic. Education Dept, 1972–92; lecturer in fine art, co-ordinator of printmaking, Box Hill College of TAFE 1978–88; part-time lecturer in print-making, CIT, 1987–88; consultant to Arts Training

Australia, Health and Safety in the Visual Arts Curriculum project, 1989–90.
REP: Artbank; Hawthorn & Geelong Institutes of Education; Latrobe regional gallery.
BIB: PCA, *Directory* 1982, 85.

McKINLAY, Miguel

(b. 1896) Represented in the 1924 exhibition of Australian art at the Faculty of Arts Gallery, London. (*See* EXHIBITIONS)

McKINNON, Ian

(b. 1886; d. 1960) Painter, mainly a watercolourist.
REP: NGV.
NFI

MacKINNON, Leah

(b. 1943, Canberra) Painter.
STUDIES: Canberra Tech. Coll. (evening classes), c. 1962–69; CSA, 1973–76. She held six exhibitions of minimalist paintings and drawings in Canberra, Sydney and Melbourne, 1976–77, and exhibited in group shows in which her use of fragile, diaphanous materials gave her work a distinctive lyricism. In July 1979 she was elected third artist-in-residence at the Uni. of New England, 1979–80. Since 1990 she has lived in outback Queensland becoming the co-proprietor of a hotel in Isisford but still holds solo exhibitions (about 16, 1975–89) including at First Draft, Sydney and Photospace Gallery, Canberra School of Art, 1992. She participated in numerous group exhibitions, 1976–92, including *The Radiant Core* David Jones Art Gallery, Sydney, 1990; *Frames of Reference* Artspace, Sydney, 1991 and curated two exhibitions on the themes of women (in the city and sexual differences in paintings) 1982, 83.
AWARDS: Georges Prize (work acquired), 1976; Australia Japan Foundation grant, 1977 (for travel to Japan); grant, VACB (for travel to New York and Paris), 1977.
REP: NGA: NGV; Parliament House; Artbank; a number of regional gallery collections including Benalla, Tamworth.
BIB: Catalogue essays in exhibitions as above.

McKINNON, Michael

(b. 1940, Beulah, Vic.) Sculptor.
STUDIES: Uni. of Melbourne, 1959–61; RCA, London, 1965–68. Co-founder of light and motion group Continuum. In 1966–67 in company with Robert Janz he developed a low-relief, kinetic sculpture or painting (for hanging on a wall) which he called *Tumbledisc* – a reference to its constantly changing patterns created by tumbling forms activated by a small, silent motor.
AWARDS: English-Speaking Union travelling scholarship, 1965; British Council Travel grant, 1965; Dyason scholarships, 1965, 1967, 1968; Multiples Competition, Ikon Galleries, Birmingham, England, 1969; Lorne Fellow, Uni. Coll., London Uni., 1976.

REP: Overseas collections, Arts Council of Great Britain and London Natural History Museum.
BIB: Scarlett, *AS*.
NFI

MacKINTOSH, Jessie Macqueen

(b. 1892, d. 1958) Painter.
STUDIES: NGV School, 1908–1911; George Bell, 1920s–30s. NGV School, 1927–1931. She exhibited with the VAS, 1928–31, and the Melbourne Society of Women Painters, 1931–58. Her modernist work appeared in the *1932 Group* exhibition with others including Peggy Crombie, Sybil Craig, Edward Heffernan and John Vickery who went on to found the *New Melbourne Art Club* in 1933. She exhibited with the club until about 1942 as well as with the *Students of George Bell* exhibition in 1939 and a joint exhibition with Marjorie Woolcock in 1946. A joint exhibition with Peggy Crombie was held by Jim Alexander Gallery, Melbourne in 1990.

MACKY, Spencer

(b. c. 1883, Auckland, NZ; arr. Australia c. 1903) Painter, teacher.
STUDIES: NZ, with C. F. Goldie; NGV School, with Bernard Hall, c. 1903. He married an NGV Scholarship winner, Constance Jenkins (q.v.), and left for Europe in 1908. They travelled in the UK and Europe and after WWI moved to San Francisco where he became head of the Californian School of Art.
BIB: Brian Sherrif, *Old New Zealand Artists*, Te Anau Press, Te Anau, South Island, NZ, n.d.

McLEAN, Andrew

(b. 1946, Bairnsdale, Vic.) Painter and teacher.
STUDIES: Prahran CAE and RMIT, 1964–67. Painted usually in muted pastel colours and carefully arranged, his still-life studies of studio objects have attracted attention in many exhibitions in Vic. since 1967. He held four solo exhibitions, 1972–85, including Stuart Gerstman, 1976 & 79, and Australian, 1985.
AWARDS: Caltex-Alva Prize, Latrobe Valley, 1973, 1974; Naracoorte acquisitions award, 1975.
APPTS: Lecturer in painting and drawing, CIT, 1974–84.
REP: NGV; AGWA; Parliament House; Latrobe Valley Arts Centre; Naracoorte Gallery, SA; corporate collections including Philip Morris, BHP, Comalco, ICI.

McLEAN, Bridgid

(b. 1946, NSW) Painter and sculptor.
STUDIES: Dip. Art, painting, ESTC, 1968; travel studies, USA, Europe, 1970, Japan and USA, 1977. She held her first exhibition at Watters Gallery, Sydney, 1973 and another three solo shows in the same gallery, 1976, 82, 90; participated in the *Ocker Funk* exhibition at the same gallery, and in Melbourne, 1976. Her work has been included in 15 group exhibitions, 1975–90, including *Fire and Ice – Aspects of Contemporary Australian Surrealism*, Manly Art Gallery and Museum, 1989; *Portrait of a Gallery*, Watters 25th anniversary touring exhibition 1989.

AWARDS: Prizes in competitions at Cowra, NSW, 1969, 1970, 1971; Northside Festival, 1971.

REP: NGA; MOCA, Brisbane; several regional gallery collections, NSW & Qld; corporate collections including Allen, Allen & Hemsley; Rheem Australia.

McLEAN, Margaret

Painter. Her small, capably painted pictures appeared in VAS and numerous other Melbourne group exhibitions, c. 1920–60.

REP: Castlemaine Art Gallery.

Euan MacLeod, Glenbrook 2, *1992, oil on canvas, 83.9 × 122cm. Courtesy Niagara Galleries.*

MacLEOD, Euan

(b. 1956, Christchurch, NZ; arr. Australia 1981) Painter. STUDIES: Certificate, graphic design, Christchurch Tech. Institute, 1975; Dip. Fine Arts (painting) Canterbury Uni., Christchurch, 1979. His expressionistic figurative works have a sense of movement and immediacy, especially those of his portraits as seen in some 18 solo exhibitions, 1982–91 Sydney (Watters, 1982, 83, 85, 87, 89, 90); New Zealand, and Brisbane (Victor Mace, 1987,90). He participated in about 32 group exhibitions 1980–91, at Holdsworth and Watters, Sydney and in many public galleries including *Uni. of NSW* Art Purchase Exhibition, Uni. of NSW, 1987; *Max Watters 25th anniversary Touring Exhibition* regional centres NSW, 1989–91; *Green Art,* S.H. Ervin Gallery, 1991; *Moet & Chandon Touring Exhibition,* 1991.

REP: NGA; NGV; AGWA; Parliament House; Burnie,

Gold Coast, New England, Wollongong, regional galleries; Heide; Uni. of Qld Art Museum; Australian Museum; Centre for Contemporary Art, NZ; and in Allen, Allen & Hemsley; Baker & McKenzie; Western Mining corporate collections.

BIB: Catalogue essays in exhibitions as above. *New Art Two. A&A* 23/4/1986. *AM* April 1990.

McLEOD, John

Sculptor and teacher. Art instructor with the Dept of Education, WA, c. 1925. He made the well-known statue of Patrick Hannan for Kalgoorlie, and the centenary tablet for the façade of Perth Town Hall.

BIB: Moore, *SAA.* Records of the Kalgoorlie Council, 13 Nov. 1928, quoted by Ken Scarlett, *AS.*

MACLEOD, William

(b. 1850, London; arr. Australia 1855; d. 1929, Sydney) Artist, businessman.

STUDIES: School of Arts (with Edmund Thomas and F. E. Terry), Sydney. A man of widely diverse talents, he was known principally as the manager of the Sydney *Bulletin,* 1886–1929. Macleod was an early contributor to Sydney *Punch,* and the first Australian artist elected to work for the *Picturesque Atlas of Australasia,* of which enterprise he eventually became chairman of directors. It was while on a travelling assignment for the *Picturesque Atlas* in Ballarat that he received the offer of managing the *Bulletin* from J. F. Archibald. During his association with this magazine, he painted portraits of Livingston Hopkins and Percy Leason. Another well-known painting by him was the *Landing*

of Captain Cook, painted for the Christmas supplement of *Town and Country Journal* in 1899. His work was represented in *The Artist and the Patron*, AGNSW, 1988.
AWARDS: Student awards given by the RAgSocNSW, and NSW Academy of Art.
REP: NGA; AGNSW; Mitchell Library, Sydney.
BIB: Conor Macleod, *Macleod of the Bulletin*, written by his wife, Snelling, Sydney, 1931. Margaret Maynard, *The Sketchbooks of William Macleod, 1850–1929*. A&A 18/1/1980.

McMAHON, Bettina

(b. 28/6/1930) Painter, printmaker.
STUDIES: Julian Ashton School, Sydney, 1946–49; travel studies, Europe and UK, 1950–53 and 1960–61; advanced etching at Goldsmiths Coll., London Uni., 1972. Her work is abstract and decorative, with emphasis on geometric pattern. She taught etching at various art and community centres in Sydney, 1976–82, and held about 15 solo exhibitions, 1978–91, including at Susan Gillespie, Canberra; Tynte Gallery, Adelaide; Barry Stern, Sydney. Group exhibitions in private galleries include Barry Stern, Leveson St, Melbourne 1967– .
AWARDS: Prizes at Bathurst, 1962; Ryde, 1967; Portia Geach Prize, 1968; Hunters Hill, 1970; Drummoyne, 1974, 89; residency, Moya Dyring Studio, Cité Internationale des Arts, Paris, AGNSW, 1982; residency Cité Internationale des Arts, Paris, VACB, 1987.
REP: NGA: AGNSW; Parliament House; Artbank; several regional gallery collections including Bathurst, Geelong; several tertiary collections NSW.
BIB: *New Art One*. A&A 23/3/1984.

McMANUS, Jean

(b. 1920, Sydney) Painter.
STUDIES: ESTC; Julian Ashton School; Central School of Arts, London; travel studies in Spain, France, Italy. She spent 15 years overseas, mostly in London, where she held several exhibitions of her semi-abstract paintings before returning to Australia in 1965. Her work was shown at the Argus Gallery, Melbourne, 1965.

McMILLAN, Alex

(b. 1910, Strathfield, NSW) Painter. Mainly a watercolourist.
STUDIES: ESTC, also at Orban and Bissieta Schools, Sydney. Member of the RAS and Australian Watercolour Inst., Sydney.
AWARDS: Prizes in competitive exhibitions in Bendigo, 1958; Drummoyne, 1964; Hunters Hill; Goulburn, 1971; Kogarah; Ryde, 1974; Ashfield, 1976.
REP: Bendigo Art Gallery.

MacNALLY, Matthew James

(b. 5/7/1874, Wangaratta; d. 1943, SA) Painter, art critic.
STUDIES: Melbourne, watercolours with John Mather; Bushey, UK, with Hubert von Herkomer. A member of the Australian Art Association, foundation member of the Australian Water Colour Inst. and a member of the Royal Inst. of Painters in Water Colour,

London, he painted much in company with Harold B. Herbert at Malmsbury, Vic., and other favourite painting grounds. Both exhibited with the Fine Art Society Gallery and Sedon Galleries, Melbourne, and they sometimes exhibited jointly. MacNally's watercolours stand midway between Herbert's skilled watercolours and the more poetic work of romanticists such as J. J. Hilder. Apart from his painting, MacNally wrote occasional critiques for the Sydney *Daily Telegraph*, Melbourne *Age*, Adelaide *News* and Adelaide *Mail*. Outspoken in his comments, he accused Streeton of 'commercialism' on the occasion of Streeton's 1924 Melbourne exhibition. Benalla Art Gallery held an exhibition of his work in 1974.
REP: Most state and many regional galleries.
BIB: AA 1920 (*The Watercolours of M. J. MacNally and Harold Herbert*).

McNAMARA, Frank

(b. 1916, Perth) Painter, mainly a watercolourist.
STUDIES: Sydney (with G. A. Daniel), 1928–31. McNamara's spontaneous and iridescent watercolours have the swift, journalistic touch typical of the painter who successfully invokes the aid of time and place for variety of inspiration. From 1945, when he won his first art prize, his work gained a firm following, particularly in NSW. He published *Landscape in Watercolour – Frank McNamara* (introduction by Hal Missingham), Legend Press, Sydney, 1950.
AWARDS: First prize (War on Land), third (Open Section), *Australia at War* exhibition, 1945; Perth Prize, 1948; Hunters Hill, 1964; Drummoyne, 1966 (all for watercolours).
REP: Most state and many regional galleries.

McNAMARA, Leila Constance

(b. 1894, Williamstown, SA; d. 1972, Adelaide) Painter.
STUDIES: Adelaide, with James Ashton and Leslie Wilkie, Sydney, with Dattilo Rubbo and James R. Jackson. She exhibited her late impressionist landscapes at the RSASA from 1916, winning landscape and still-life prizes in 1926 and 1945, respectively. She also showed in London, Sydney and Melbourne, where her work was favourably reviewed.
REP: AGSA.
BIB: Rachel Biven, *Some forgotten . . . some remembered*, Sydenham Gallery, Adelaide, 1976.

McNEIL, Keith

(b. 1907, Hobart, Tas.) Artist, typographer.
STUDIES: Hobart Tech. Coll. McNeil's wife, Margaret McNeil, a member of the RQAS, helped to pioneer a creative approach to the art teaching of children in Brisbane and Hobart. Work by McNeil was represented in the *British Empire Exhibition*, 1938.

McNEILAGE, Ian

(b. 1932, Melb.) Painter, printmaker, teacher.
STUDIES: CIT; travel studies, Europe, 1954. A member of the PCA, he began making screen-prints in 1957, holding exhibitions in Melbourne, 1963 and 1971. His wife, Moonyeen, is a painter and ceramicist.

APPTS: Teaching, art dept, Swinburne Coll. of Tech., Hawthorn, Vic., 1961–64; deputy head of dept, 1964–; dean of visual arts, –1979– .
REP: NGV; AGNSW; AGSA.
BIB: PCA, *Directory* 1976.

McPHAIL, Janet

Assistant secretary of the Art Society of NSW for 40 years, 1885–1925.
BIB: Moore, SAA.

McPHERSON, Margaret Rose

See PRESTON, Margaret Rose

MacPHERSON, Robert

(b. 14/2/1937, Brisbane) Painter.
STUDIES: Travel studies, Europe, 1973. Dada and technological innovation have been the main sources of his inspiration since c. 1958. He held over 40 solo exhibitions, 1975–93, including at IMA, Brisbane (including survey exhibition, 1985); Q Space, Brisbane;

Sydney; regional galleries including Ballarat, New England; Fremantle Arts Centre; tertiary collections including Griffith, Qld universities.
BIB: Catalogue exhibitions as above. *Drawings in Australia: Drawings, watercolours, pastels and collages from the 1770s to the 1980s*, OUP, 1989. *IMA 1975–1989: A Documentary History*, IMA, Brisbane, 1989. Thomas, *OAA* 1989. *A&A* 15/4/1978; 17/2/ 1979. *A&T* no. 6 1982. *AL* no. 3 1988; no. 36., May 1990. *Tension* vol. 18. 1989; no. 21. June 1990.

MACQUARIE, Elizabeth Henrietta
(née Campbell)

(b. 13/6/1778, Scotland; arr. Sydney 1809; d. 11/3/1835) Sketcher, architectural and landscape designer. Married to Lachlan Macquarie, 16 years her senior and the governor of NSW 1809–21. She was an active supporter of the arts and artists in the colony as well as being a sketcher, landscape painter and diarist. With a special interest in architecture she was instrumental in choosing the designs for a number of the colony's finest buildings, many by Francis Greenway (q.v.).
BIB: *ADB* 2. Kerr, *DAA*.

Mary MacQueen, Crater Country, lithograph. Public and private collections.

and since early 1980s with Yuill/Crowley, Sydney. His work appeared in numerous group exhibitions in public galleries, 1976–91, including *Biennale of Sydney*, 1979, 90; *Recession Art and other Strategies*, Artspace, Sydney, 1986; *Australian Drawings 1983–88*, NGA, 1988; *Transit Zone*, Ivan Dougherty Gallery, 1991.
AWARDS: VACB standard grant, 1974; USA travel grant, 1976.
REP: NGA; AGNSW; AGSA; AGWA; NGV; QAG; MCA,

MacQUEEN, Kenneth Robertson

(b. 1897, Ballarat; d. 1960) Painter, farmer.
STUDIES: Slade and Westminster Schools, London. Member of the RQAS, NSW Society of Artists, Australian Watercolour Inst. and Contemporary Group, Sydney. On his return to Australia, after serving in France

during WWI, MacQueen became a farmer in the Darling Downs district, Qld, and painted in his spare time, often in collaboration with his wife, Olive Crane (q.v.). He was one of the first Australian watercolourists to paint in a modern style; his formalised, semi-abstract landscapes are noted for simplicity of construction. He exhibited at the RA and at the New English Art Club, London and his work appeared in the Bicentennial exhibition *The Great Australian Art Exhibition*. He wrote *Adventures in Watercolour*, Legend Press, Sydney, 1948.
REP: Most state galleries; Ballarat Gallery; Wanganui Gallery, NZ.
BIB: A&A, 19/4/1982.

MacQueen, Mary McCartney

(b. 1912, Melbourne) Painter, printmaker, teacher.
STUDIES: George Bell School, 1946–47; RMIT (print-making), 1957–58. Her open line drawings of birds and animals spontaneously observed and recorded have won her a place in this genre second to none in contemporary Australian drawing. She has held about 26 solo exhibitions 1945–91 including at Crossley Galleries in the 1960s; Powell St, Melbourne; Ray Hughes, Sydney and Charles Nodrum Melbourne. Group exhibitions she has participated in include those with VAS, 1943–57; CAS, Melbourne, 1960 64; print exhibitions organised by PCA Australia and internationally; *The Collage Show* organised by the VACB touring regional NSW galleries 1982; *Perspecta*, AGNSW, 1983; *Ten Australians* CDS Gallery, New York, 1984; the Bicentennial exhibition *The Face of Australia*; and *Classical Modernism: The George Bell Circle* NGV, 1992.
AWARDS: Numerous prizes including Drawing prize, VAS, 1957; May Day prize, for drawing, 1958; Portland prize, 1965; MPAC Spring Festival of Drawing (work acquired), 1973; Ronald award, Latrobe Valley Arts Centre, 1973; Maitland prize for prints, 1974; F. E. Richardson prize (for watercolours), Geelong, 1976.
APPTS: Teacher, freehand drawing and printmaking, at RMIT.
REP: NGA; NGV; AGNSW; QAG; AGSA; AGWA; MAGNT; TMAG; many regional galleries including Ballarat, Bendigo, Castlemaine, Ipswich, Mornington, Shepparton, Tamworth.
BIB: Catalogue essays exhibitions as above. References in a number of art magazines including A&A, *Imprint*. Brian Seidel, *Printmaking*, Art in Australia series, Longmans 1965. M. Eagle & J. Minchin *The George Bell School* Deutscher Fine Art, Melbourne 1981. Franz Kempf *Contemporary Australian Printmakers* Lansdowne, 1981. A&A 1/4/1964; 16/3/1979; 19/2/1981.

McRae, Rod

(b. 13/2/1950, UK; arr. Australia 1982)
STUDIES: Medicine, UCHMS, London 1968–74; foundation course, St Martins School of Art, London, 1975–76; BA Hons, St Martins School of Art, 1979; Higher dip. painting, Slade School, London, 1982; travel studies Japan, Russian, Iran, Afghanistan, Europe, Sudan, Ethiopia, Kenya, 1968–82. He held six solo

exhibitions, 1985–1991, Melbourne (Pina-cotheca 1985, 87, 89, 91) and Watters 1986, 90, Sydney. He participated in about 7 group exhibitions, 1986–90 Sydney (including Watters) and Melbourne (Pinacotheca) and in *Treading Classic Ground*, Manly Art Gallery and Museum, 1986; *Hugh Williamson Prize*, Ballarat Fine Art Gallery, 1986; *New Art*, NGV, 1990.
REP: NGV; MOCA, Brisbane; Artbank; World Congress Centre, Melbourne and in Allen, Allen & Hemsley, Budget and IBM corporate collections.
BIB: *New Art Three*.

McSherry, William

Painter of sporting subjects. *The Finish of the Sydney Cup*, c. 1880, by McSherry, is in the La Trobe Library collection, Melbourne. Moore describes him as 'a well known animal painter in his time'.
BIB: Moore, SAA.

McWhannel, Isabel

(Active, Sydney, c. 1880–1910) Painter. A member of the Society of Artists of NSW, where she showed pastoral scenes in 1907, and of the Art Society of NSW, where she exhibited from 1903 (as Isabella McWhannel), subjects including flower pieces. Her work was included in the *Exhibition of Women's Art*, Exhibition Building, Melbourne, 1907.
REP: Geelong Art Gallery.
BIB: AA 1920 (*Society of Artists Pictures*).

McWilliams, Peter

(b. 27/10/1940) Sculptor, teacher.
STUDIES: Dip. Art, painting, SASA, 1967. Advanced Dip. Teaching, Torrens CAE, 1978; B. Ed, Adelaide College of the Arts and Education, 1981; MA, visual arts, Flinders Uni., SA, 1988. Large constructions by him in steel, concrete and fibreglass were exhibited in *Mildura Sculpture Triennials* 1975, 1978 and first *Australian Sculpture Triennial*, NGV, 1981. His Adelaide commissions include sculptures for City Cross (off Rundle Street), 1968; Hooker building, King William and Hindley Streets, 1970; National Bank, King William Street, 1970; Adelaide House, Waymouth Street, 1970; Inst. of Engineers, Sturt Street, 1972; Terrace Hotel, North Terrace, 1990.
APPTS: Lecturer, SASA, 1972–74; Murray Park CAE, 1975; Uni. of SA, 1975–90; senior lecturer, head art discipline, Uni. of SA, 1990– .
BIB: Catalogue essays in exhibitions as above. N. Benko, *Art and Artists of South Australia*, Lidums, 1969. Scarlett, AS.

Maddock, Bea (Beatrice Louise)

(b. 13/9/1934, Hobart) Painter, printmaker, teacher.
STUDIES: Hobart Tech. Coll., 1952–56; Slade School, London, 1959–61; travel studies, UK and Europe, 1962. She became interested in hard-edge and colour-field painting, before turning, in about 1970, towards the kind of work with which she has since become identified – serialised imagery, both painted and photographed and accompanied often by lettering. Her commissioned work includes an external wall plaque,

No. 1 Court, High Court Building, Canberra. She held over 25 solo exhibitions 1964–93 in public and private galleries in Tasmania, Melbourne, Sydney, Canberra, Ballarat and Launceston and a major exhibition of her work toured state galleries and the NGA 1992–93. She participated in about 65 group exhibitions 1964–1993 in Australia, Europe, SE Asia, Canada, and South America including many international print biennales; *Field to Figuration: Australian Art 1960–1987*, NGV, 1987; the Bicentennial exhibitions *The Great Australian Art Exhibition* and *The Face of Australia*; *Pre-settlement to Present: Survey of Printmaking in Australia*, NGA, 1989; *Joan and Peter Clemenger Triennial Exhibition of Contemporary Art*, NGV, 1993.
AWARDS: Tasmania Prize for Drawing, 1968; F. E. Richardson Print Prize, Geelong, 1969; VACB grant, 1973; PCA members print commission, 1974; Alice Prize, 1979; QAG Purchase Prize, 1982; ANU, Canberra, Creative Arts Fellowship, 1976; Hugh D. T. Williamson Foundation for a painting for the NGV, 1988; Centennial print for QVMAG, 1991; Clemenger Award for Contemporary Art, 1993.
APPTS: Lecturer, Launceston Teachers Coll., 1962–63; Launceston Tech. Coll., 1965–69; NGV School, 1970–73; senior lecturer in printmaking, VCA, 1973–81, acting dean, 1980; opened Access Studio (private tutoring), Macedon, Vic., 1982; part-time lecturer in printmaking, Bendigo CAE, 1982–83; lecture tour of NZ, 1983; head of School of Art, TCAE, Launceston, 1983–84; chairperson, board, Ritchies Mill Arts Centre, Launceston, 1984–85; member, Council of NGA, 1985–88; artist-in-residence, Alberta Uni., Canada, 1978, SCA, 1979, Artists in Antarctica program, 1987.
REP: NGA; NGV; AGNSW; TMAG; QAG; AGSA; AGWA; QVMAG; regional galleries at Ballarat, Bendigo, Geelong, Newcastle and Shepparton; Uni. of Tas., Uni. of Qld, Qld. Uni. of Tech.; VCA; Melbourne State Coll.; MOMA, NY; NGNZ; BHP; Philip Morris.
BIB: Catalogue essays for exhibitions as above. A number of general texts on Australian art including Smith, AP. PCA, *Directory* (all eds.). Backhouse, TA. J. Burke, *Field of Vision* Viking, 1990. A&A 13/4/1976; 16/2/1978 (Janine Burke, *Portrait of the Artist: Bea Maddock's Prints*). AL, 10/4/1990–91.

MADIGAN, *Rosemary Wynnis*
(b. 5/12/1926, Glenelg, SA) Sculptor.
STUDIES: ESTC, Sydney, –1948; John Cass Coll., London, 1951; travel studies, Europe and India, 1952–53. Her work appeared in the Bicentennial exhibition *The Great Australian Art Exhibition*.
AWARDS: NSW Travelling Scholarship (as Rosemary Giles), 1950; VACB grant, 1976; Wynne Prize, 1986.
APPTS: Teaching, SASA, 1964; ESTC, 1973–75; Sculpture Centre, 1975– . Her commissioned work includes a fountain for St Mark's College, Adelaide.
REP: NGA; AGNSW; Rockhampton Art Gallery.

MAGAZINES, JOURNALS AND NEWSLETTERS
See Appendix 6, p. 835.

MAGUIRE, *Tim*
(b. 1958, Chertsey, UK; Arr. Australia 1959) Painter.
STUDIES: Grad. Dip. Painting, CAI, 1982; grad. studies, SCA, 1983; Düsseldorf Kunstakademie, under Jan Dibbets, 1984–85. His 1980s work was abstract, characterised by his 1990 series of dark backgrounds spliced by a brilliantly coloured flame-like horizontal or vertical light. His 1993 winning *Moet & Chandon* entry however was in the neo-romantic style and featured oversized detail of lushly coloured flowers. He held 10 solo exhibitions, 1980–93, including Sydney (Mori; Performance Space) Melbourne (Tolarno); Greg Shepherd and in NY and London. In 1991–93 his solo exhibition *Canal* toured London and Australia. He participated in many group exhibitions including *Third International Drawing Triennial*, Nuremburg, 1985; *Sydney Biennale*, 1986; *A New Generation 1983–86*, NGA, 1988; *Stories of Australian Art*, Commonwealth Institute, London, 1988; the Bicentennial exhibition *The Face of Australia*; *Australian Perspecta*, AGNSW, 1989.
AWARDS: Peter Brown travelling scholarship, 1984; travel grant, VACB, 1984; Third International Drawing Triennial Prize, 1985; Faber-Castell Drawing Prize, 1985; Hugh Wiliamson Prize (emerging artist), Ballarat Fine Art Gallery, 1986; exhibition grants London Arts Board, Arts Council Great Britain, VACB 1992; Moet & Chandon Fellowship 1993.
REP: NGA; NGV; AGNSW; institutional and private collections in Australia, UK, Europe and USA.
BIB: Smith, AP (as *Macquire*). Chanin, CAP.

MAHONY, *Frank Prout*
(b. 1862, Melbourne; d. 1917, England) Painter.
STUDIES: NSW Academy of Art (with Anivitti). A painter of outback subjects, black-and-white illustrator and teacher, he taught at the RAS School, Sydney, worked on the staff of the *Picturesque Atlas* and contributed drawings to the Sydney *Bulletin* for many years. Books he illustrated included stories by Henry Lawson (*On the Track and Over the Sliprails*, Angus & Robertson, Sydney, 1923; *While the Billy Boils*, Angus & Robertson, Sydney, 1924), poems by Barcroft Boake and 'Banjo' Paterson's *Geebung Polo Club* for the *Antipodean*. He went to London in 1904, but the raw, colonial vigour which gained him success in Australia had no appeal for the British public, and he died in obscurity in Middlescx 13 years later.
REP: AGNSW; TMAG.
BIB: AA. no. 4, 1918, (refs and reproductions).

MAHOOD, *Marguerite Henriette (née Callaway)*
(b. 29/7/1901, Melbourne; d. 14/10/1989, Melbourne) Painter, illustrator, ceramic artist, art historian.
STUDIES: NGV School; RMIT (ceramics); Uni. of Melbourne (MA, PhD 1973). She became known for her pottery and for her black-and-white drawings contributed to magazines. From 1926–29 she gave weekly broadcasts on history, techniques and other aspects of the visual arts on ABC radio. Her major work was her

Hilarie Mais, The Grid, 1984, wood, oil paint, 195 × 195 × 6cm. Collection, Wollongong City Art Gallery.

London, 1975–77. She held 13 solo exhibitions, New York, 1977–81; Roslyn Oxley9, Sydney, 1984, 87, 88, 90; Christine Abrahams, Melbourne, 1986, 89, 92. Group exhibitions include *Australian Sculpture Triennials*, 1984, 87; *Australian Perspecta*, AGNSW, 1985; *Biennale of Sydney* AGNSW, 1986, 88.

AWARDS: Hampshire Award, UK, 1973; HFC Scholarship, UK, 1977; Boise Scholarship, 1977; fellowship New York studio school 1977, 78; visiting artist, SUNY Purchase, New York, 1979–80.

APPTS: Carnegie Lecturer, Pratt Institute, Brooklyn, NY, 1980.

REP: NGA; AGNSW; NGV; AGWA; Artbank; Heide Park & Art Gallery; Parliament House; Uni. of NSW; Wollongong regional gallery; Loti & Victor Smorgon; Baillieu Myer; ICI; Medibank and SA Brewery corporate collections and in Slade School of Fine Art London; Liszt Collection, NY.

BIB: *A&A* 23/2/1985.

MAJZNER, Victor.

(b. 6/2/1945, Ufa, USSR; arr. Australia 1959) Painter, printmaker, lecturer.

STUDIES: Dip. Art (painting) CIT, 1962–67. He lived in Poland, 1946–58, and France, 1958. Exhibiting, mainly in Melbourne, since about 1971, he established his reputation as a painter of monumental canvases in which barbaric colour is often modified by soft and varied texture. His strong expressionist abstract style continued into the 1980s and 1990s and although he frequently paints the landscape, his paintings are at their strongest when the subject has to do with people – such as his late 1980s exhibitions of suburban life. He held about 40 solo exhibitions, 1971–93 most capital cities including Melbourne (Powell St; Christine Abrahams; Australian; Luba Bilu); Sydney (Coventry; Macquarie); Brisbane (Victor Mace) Canberra (Solander); Perth (Greenhill). His work was seen in numerous group exhibitions largely in public galleries, 1969–91, including *Colour and Transparency*, NGV; *Shipwreck* Gertrude St, Melbourne, 1985; *Voyage of Discovery, Recent Australian Art*, Crescent Gallery, Dallas, USA, 1987; *Surface for Reflexion*, AGNSW, 1987; *Loti and Victor Smorgon Collection of Contemporary Art*, ACCA, Melbourne, 1987.

AWARDS: Mordialloc Art Festival Prize, 1970; Georges Invitation Art Prize (purchase), 1973; Corio Prize (purchase), 1974; Alice Prize (purchase), 1974; Armidale Art Society (purchase), 1975; Taree Council Purchase, NSW, 1975; special purpose grants, 1974, 86 & travel grant, 1976, VACB; Dalby Art Purchase 1976; travel grant British Council, 1977; Pioneer Art Award, 1978; Gold Coast City Art Prize, 1983.

APPTS: Lecturer in painting, CIT, 1968–73, Prahran CAE 1973–90; VCA, 1990– .

REP: NGA; NGV; AGNSW; QAG; AGSA; AGWA; MAGNT; TMAG; many regional collections including at New England (Armidale), Gold Coast; Geelong; Wollongong; many tertiary and municipal collections; corporate collections including Myer Foundation; Wesfarmers; NAB.

BIB: Catalogue essays in exhibitions as above. Bonython, MAP

book on Australian political cartoons *The Loaded Line*, MUP, 1973 written as a thesis for her PhD. Between 1977 and her death in 1989 she contributed articles on colonial cartoonists for *Australian Dictionary of Biography* and held several solo exhibitions at Lyceum Club and Jim Alexander Gallery, Melbourne. Her work appeared in *A Century of Australian Women Artists 1840s–1940s* Deutscher Fine Art, Melbourne, 1993.

REP: NGV; Shepparton Art Gallery (ceramics).

BIB: Catalogue essays exhibitions as above.

MAINWARING, Geoffrey Richard

(b. 29/10/1912, SA) Painter, teacher.

STUDIES: Unley School of Arts, SA. Mainly worked as a portraitist.

APPTS: Art teacher, Thebarton Tech., SA, 1928–36; official war artist, Papua New Guinea and Pacific Islands, WWII; instructor, Royal Aust. Engineers, Wagga Wagga, 1940–46; lecturer, SASA; 1947–49; art teacher, Ballarat School of Mines from 1949–75.

REP: AGSA; AWM.

BIB: *Who's Who in Australia*, Melbourne, 1950.

MAIS, Hilarie

(b. 17/1/1952, Yorkshire, England) Sculptor.

STUDIES: Bradford School of Art, 1970–71; BA 1st Class Honours, Winchester School of Art, 1971–74; higher diploma, Slade School of Fine Art, Uni. College,

1975, 80. Franz Kempf *Contemporary Australian Printmakers,* Lansdowne, 1976. G. de Groen, *Conversations with Australian Artists* Quartet, 1978. Chanin, CAP. A&A, 12/2/1974; 18/4/1981; 20/3/1983 (Leigh Astbury, *Victor Majzner*); 22/3/1985; 23/4/1986.

MAKIGAWA, Akio
(b. 29/10/1948, Japan; arr. Australia 1977) Sculptor, installation artist.
STUDIES: BA, Nihon Uni., Tokyo, 1971; BA fine arts, Curtin Uni., WA, 1979; grad. dip., sculpture, VCA, 1982; travel studies/work Carrara, Italy, 1989–90. His early sculptures were delicate constructs of ribbon-like metal and wood which later marble forms predominated and he held about 22 solo exhibitions 1977–93, Melbourne (including Christine Abrahams; City Gallery); Sydney (Irving, 1991) and public galleries including Fremantle Arts Centre, WA, 1979, 80, 85; VCA, 1981; Adelaide Festival Centre, 1983; Noosa Regional Gallery, 1990 and in Inax Gallery, Tokyo 1983, 89 & Osaka, 1989. His work appeared in about 15 group exhibitions of sculpture 1981–90, including *Australian Sculpture Triennial*, 1981, 84, 90; *Australian Perspecta '85*, AGNSW, 1985; *Pleasure of the Gaze*, AGWA, 1985; *Australian Contemporary Art*, Saitama Museum of Modern Art, Japan, 1987. His many commissions include the City of Sale, 1983; Australian Embassy, Tokyo, private corporations including Emery Vincent Associates; Norwich Union; Azcorp Limited, Melbourne.
APPTS: Artist-in-residence, Wagga Wagga City Gallery, 1982, CSA, 1990; Noosa Regional Gallery, 1990; part-time lecturer, VCA, 1984–88.
REP: AGNSW; AGWA; MAGNT; NGV; QAG; regional galleries at Fremantle and Noosa; Uni. of WA, Curtin Uni.; VCA.
BIB: Catalogue essays in exhibitions as above.

MAKIN, Jeffrey
(b. 13/5/1943, Wagga, NSW) Painter, lecturer, critic.
STUDIES: NAS, 1961–66. He travelled in New Caledonia, Europe, UK, USA, and South Sea Islands, 1975, 1976, 1977. His large, strongly designed paintings (mostly landscapes or seascapes), with their dark colours and flat forms, often have a sculptural look. His subject matter is largely landscapes especially waterfall and lush bush scenes. He held about 40 solo exhibitions, 1967–93, largely with Macquarie and Rex Irwin in Sydney; Tolarno and Realities, Melbourne and Victor Mace, Brisbane. He participated in numerous group exhibitions, 1972–79, in private galleries including Joseph Brown, Melbourne and Bonython, Sydney; Georges and McCaughey Prize exhibitions; *The Australians*, CDS Gallery, New York, 1984; and in several public gallery exhibitions including *Artists Artists*, NGV, 1975; *Green Art*, S. H. Ervin Gallery, 1991; and at art fairs, Melbourne, Chicago, 1988–92. Commissions include a painted tram for the Vic. Ministry for the Arts, 1987; large mural for Hilton International Hotel, Brisbane, 1991.
AWARDS: Student scholarship, NAS; prizes at *Mirror-*

Waratah Festival, Sydney, 1965; Drummoyne, 1966; Rockdale, 1967; Southern Cross, 1968; Gold Coast, 1971; Townsville, 1976; Rockhampton, 1976; Tattersalls, Qld, 1991.
APPTS: Tutor, NAS, 1966–70; lecturer, Prahran CAE, 1971–82; principal lecturer, Phillip Institute, 1983–85 and RMIT, 1986; art critic *Sun News-Pictorial*, 1972–90.
REP: NGA; NGV; AGNSW; QAG; AGWA; Parliament House; many regional gallery and tertiary collections including at Benalla, Geelong, Rockhampton, Sale, Townsville; tertiary collections including La Trobe and Melbourne Uni.; Artbank; corporate collections including ICI; NAB; R&I Bank, WA.
BIB: Catalogue essays for exhibitions as above. Bonython MAP McKenzie, DIA. A&A 21/1/1983; 21/4/1984.

MALANGI, David
(b. 1927, Central Arnhem Land, NT) Aboriginal bark painter, designer. Of the Ramingining area, his work was selected for reproduction on the 1966 Australian one dollar note. He participated in group exhibitions including *Australian Perspecta*, AGNSW, 1983 and in private galleries in New York, 1988 and Roslyn Oxley9, Sydney, 1989.
REP: NGA; AGSA.
BIB: W. Caruana, *Windows of the Dreaming* NGA, 1989. Caruana, AA.

MALLYON, Greg
(b. 1/2/1954, Qld.) Painter, printmaker.
STUDIES: Dip. Art, fine art, Qld; Grad. dip., teaching (art education), Qld; BA Fine Art, Uni. of Melbourne; BA, fine art (Italian language) Uni. of Perugia, Italy. He held 13 solo exhibitions, 1982–92, Australia, USA, and Europe and participated in a number of group exhibitions largely in private galleries.
REP: Artbank; tertiary collections including Footscray Institute of Tech., CAE, Melbourne; private collections including BHP.
BIB: Germaine, AGA

MALONE, Neil
(b. 20/10/1950, Melb.) Painter, printmaker.
STUDIES: Dip. Art, 1971; Fellowship of Painting, 1972; Fellowship of Printmaking, 1973 all at RMIT; Royal College of Art, London, 1974–75; travel studies, Europe and Asia, 1976–77. He worked with George Baldessin in the co-operative artist print workshop in the Olderfleet Building, Melbourne. He held 5 solo exhibitions, 1979–90, including at Stanfield and Acland St galleries, Melbourne and participated in a number of group exhibitions, including PCA touring print exhibitions from 1976; MPAC *Prints Acquisitive*, 1984.
AWARDS: Travel grant, VACB, 1974; MPAC Prints Acquisitive (work acquired), 1984.
APPTS: Printer at Crossley Printmaking Workshop, 1973–74; lecturer in printmaking at several tertiary colleges, 1973– including RMIT, CIT, Vic. College, Prahran, VCA.
REP: NGV; regional gallery collections including Bathurst,

Devonport, Mornington; tertiary collections including Uni. of Qld; SCA.
BIB: PCA, *Directory* (all eds.)

MALONEY, Ellen
(b. 1900, Toowoomba, Qld; d. 1976) Naive painter. Painting the life of the countryside where she lived, she completed an art diploma course by correspondence and held her first exhibition at the Darling Downs IAE, 1975.
REP: Toowoomba Art Gallery.
BIB: Bianca McCullough, *Australian Naive Painters*, Hill of Content, Melbourne, 1977.

MALSEED, Nancy
(b. 1913, Vic.) Painter, printmaker. Melbourne painter of whimsical regional subjects and semi-abstracts.
AWARDS: Portland Prize, 1965.
REP: Hamilton Art Gallery.

MANBERG, Karl
(b. 1914, Tallinn, Estonia; arr. Australia, 1947) Sculptor.
STUDIES: Sydney, St George Tech. Coll., 1962–63; ESTC, 1964–66. He earned his living as a toolmaker, joined the Society of Sculptors and Associates in 1964 and since 1962 has won a number of prizes for sculpture.
AWARDS: Prizes at Rockdale, 1962; RAgSocNSW (various minor awards between 1966–76); Royal Melbourne Show, 1975.
BIB: Scarlett, AS
NFI

MANION, Margaret
(b. 7/3/1935, Nowra, NSW) Professor, historian, lecturer, writer.
STUDIES: BA, MA and BEd, Uni. of Melbourne, 1956–62; PhD, Bryn Mawr Coll., Pennsylvania, USA, 1972. An art lecturer at tertiary level since the mid 1960s, her special interests are in Medieval and Renaissance art. In 1979 she was engaged in a three-year research project funded by the Australian Research Grants Committee, to compile a comparative catalogue of medieval illuminated manuscripts in Australian collections. Her books include *The Wharncliffe Hours*, Sydney Uni. Press, 1972; *Medieval and Renaissance Manuscripts in Australian Collections* (with Vera Vines), Thames and Hudson, London 1984; *Medieval Texts and Images, Studies in Medieval Manuscripts*, Harwood Academic and Craftsman House, Sydney and New York 1991.
AWARDS: Dwight Prize, Uni. of Melbourne, 1959; M. Farley Scholarship for Foreign Students, together with Fulbright travel grant to study art history at Bryn Mawr, Penn., USA, 1972; Australian Research Council grants 1978–82; Officer of Order of Australia, 1989.
APPTS: Member of the Council of Trustees, NGV, 1975–90; chairman, NGV publication and library sub-committees, member, Victorian Arts Centre Trust (VACT) building committee, 1979–80 and member of VACT, 1981–90; Herald Professor of Fine Arts, Uni. of Melbourne, 1979– ; member of the Australia Council

1981–84; pro-vice-chancellor and chairman of Academic Board, Melbourne Uni. 1985–88; deputy chairman of CAE, 1989– .

MANN, Gother Victor Fyers
(b. 1863, Sydney; d. 1948, Sydney) Architect, painter, gallery director.
STUDIES: Sydney, with Julian Ashton, 1886; also with Roberts and Streeton. The son of John Frederick Mann and grandson of Sir Thomas Mitchell, Mann, whose first official assignment in art work was to catalogue the collection of the AGNSW, attained a position of great influence. As a painter he exhibited with the NSW Society of Artists from 1898, and held an exhibition at the Macquarie Galleries, Sydney, May, 1930. William Moore records that 'artists who saw the exhibition were surprised at the breadth and freedom of the work'.
AWARDS: Inst. of Architects of NSW gold medal, 1887; NSW Society of Artists medal, for services to art, 1928; CBE conferred, 1929.
APPTS: Secretary and superintendent of the AGNSW, 1905–12, director and secretary from 1912–19; member of Commonwealth Art Advisory Board, 1911–48; chairman of the National Memorials Committee, 1922–48; director of MacLeod Gallery, George Street, Sydney.
REP: AGNSW; Mitchell Library.
BIB: Moore, SAA.

MANN, John Frederick
(b. 1819, Kent, England; arr. Sydney 1841; d. 1907, Sydney) Artist, surveyor. Father of Gother Victor Fyers Mann, he was second in command of Leichhardt's second expedition in 1846–47. In 1884 he went to New Guinea with the Protectorate Commission.
REP: Mitchell Library.
BIB: ADB 5. Kwii, DAA.

MANSELL, Byram (William Arthur Byram)
(b. 1899, Sydney; d. 1977) Painter, designer. He became widely known for his murals and designs adapted from Aboriginal bark paintings. His extensive travels took him from Paris, where he designed fabrics, to Hollywood, USA, where he worked for Cecil B. de Mille. The adaptations from Aboriginal art began in 1948 as a result of artefacts seen after the return of the Australian-American Arnhem Land Expedition. Designs by him have since been used in luxury hotels, airports and tourist centres of all kinds.
BIB: Roman Black, *Old and New Aboriginal Art*, Angus & Robertson, Sydney, 1964. A&A, 24/1/1986.

MANSELL, George
Painter. Mainly a watercolourist specialising in paintings of old buildings and street scenes he was a council member of the VAS.
AWARDS: Prizes for watercolours at Bendigo, 1953; A. H. Gibson Prize (VAS), 1958.
REP: Bendigo Art Gallery; Perth Uni.

MAREK, Dusan Tomas

(b. 7/3/1926, Bitouchov, N. Bohemia, Czechoslovakia; arr. Aust. Oct. 1948; d. 1993) Painter, film-maker, teacher.

STUDIES: Schools of Applied Art, Turnov and Jablonec; Academy of Fine Art with Prof. Frantisek Tichy, Prague, 1942–48; travel studies in USA, UK and Europe, 1979; Italy and France, 1982; France, 1985. He lived in Port Moresby and Rabaul, Papua New Guinea from 1954–59. The influence of Tichy, who admired the works of the Ecole de Paris artists as well as surrealists such as Max Ernst, while deprecating the Russian realist art exhibited in Prague in 1947, was crucial to Marek's development. Leaving Prague in 1948 he spent nearly five months (Mar.–July) in a West German refugee camp before embarking for Australia, arriving at a migrant camp at Bathurst, in Oct., thence in Dec. to Adelaide. His first Australian exhibition was held jointly with his brother, Voitre, at the Uni. of Adelaide, after which his work appeared in numerous exhibitions throughout Australia. His interest in *objet trouvé*, his inherent preference for painting on scrap materials and his deep and lasting commitment to surrealism, impelled him to a solitary course in Australian art, but the impact of his work and personality was considerable. Apart from his work as painter, he produced 10 films between 1952–71, notably *Adam and Eve* (1962) which won awards in Australia and overseas. In Feb. 1973, he moved from SA to Hobart, Tas., to an appointment as lecturer in painting and film-making at the Tasmanian School of Art, Uni. of Tasmania, 1973–82, and established the film-making department at the same school. He held about 24 solo exhibitions, 1939–91, in most capital cities including Macquarie, Sydney; Bonython-Meadmore, Adelaide; AGNSW, 1976; Mornington Peninsula Arts Centre, 1975. He was the subject of *Project 10*, AGNSW, 1975–76 and he participated in numerous group exhibitions including *Tasmania Visited* TMAG and QVMAG, 1981; *Perspecta '83*, AGNSW *Adelaide Angries; South Australian Paintings of the 1940s*, AGSA; *Modern Australian Paintings* Charles Nodrum 1988, 89.

AWARDS: Grand Prix and first Gold Medal winner, Australian Film Awards, 1963; several film awards 1967–71 including certificate of outstanding merit, Chicago Film Festival, 1967; grant, Experimental Film and Television Fund, Australian Film Inst., 1970; *Advertiser* Award Adelaide International Film Festival, 1971; resident fellowship, ANU, Canberra, 1977; travel grant, Arts Council of Australia, 1979;

REP: AGNSW; AGSA; TMAG; Parliament House; several regional gallery collections including Burnie, MPAC; QVMAG; VACB; tertiary collections including Adelaide and Tasmania Uni.; corporate collections including Westpac; CBA and Hobart.

BIB: Catalogue essays in exhibitions as above. *Australian painters 1964–66, The Mertz Collection*, Griffin Press, Adelaide, 1967. Bonython, MAP 1980. N. Benko, *Art and Artists of SA* Lidums, 1969. A&A 31/1/1993 (obituary).

MAREK, Voitre

(b. 1919, Bitouchov, Czechoslovakia; arr. Australia 1948) Sculptor.

STUDIES: Trained first as an engineer, then as an artist, at Prague Academy of Fine Art, c. 1939–44. Brother of Dusan Marek, he settled in SA where his commissioned work included sculptures for Adelaide schools and churches (St Aquinas Coll., St Alban's Church, Stella Maris Church) and murals, notably for Birks Gallery (CAS exhibition, Adelaide Festival of the Arts, 1962) and Marion Shopping Centre, 1967. He travelled overseas to further his studies in 1970.

AWARDS: Churchill Fellowship (for overseas study), 1970.

BIB: Scarlett, AS.

MARINE PAINTING

In Australia marine painting – of ships, as opposed to coastal landscapes and sea pieces giving emphasis to sea, sky and changes of weather – began with the arrival of the first ships. Large numbers of artists have left records of early ships and shipping. Oswald Brierly was one of the first to turn this speciality into a profession, and Frederick Garling is recorded as having painted virtually every ship that tied up in Sydney Harbour during the course of his professional life. Best-known Australian painters of ships are the Gregorys (A.V., C., C.D., and G.F., (q.v.)). Shipwrecks and other maritime incidents inspired many nineteenth and early twentieth century painters, but after the days of sail marine painting tended to become more pictorial, with many painters working in Australia responding to the influence of the Anglicised impressionism of Julius Olsson (1864–1942), and William Lionel Wyllie (1851–1931). Among these may be mentioned Allcot, Jenner, Burgess, Bryant and Hansen (q.v.). Marine painting as a profession went into decline even before WWII and the process was hastened by the advent of air travel in the 1950s. In the 1980s a major award 'The Australian Maritime Award' was established boosting interest in this area (see PRIZES).

BIB: Moore, SAA.

MARINELLI, Pasquale

(b. 4/2/1946, Italy) Sculptor.

STUDIES: Dip. Art (sculpture) RMIT, 1966; TTTC, Technical Teachers College, 1969. He exhibited with the Victorian Sculptors Society and two of his abstracts were exhibited at the *Mildura Sculpture Triennial*, 1967. He lectured in sculpture at Prahran CAE, 1968 and has been a secondary art teacher in Victoria 1970– . His commissions include relief bronze panels for Dunlop House, Melbourne 1968.

BIB: Sturgeon, DAS.

MARKS, Rae

(b. 1945, Vic.) Painter.

STUDIES: Swinburne Inst. of Technology, Melbourne. Her decorative, naive-sophisticate paintings have appeared in exhibitions at the Avant and George Paton Galleries, Melbourne in the 1960s and 70s.

BIB: Bianca McCullough, *Australian Naive Painters*, Hill of Content, Melbourne, 1977.
NFI

MARKS, Stella (née Lewis)

(b. c. 1888, Vic.) Miniaturist, portrait painter.
STUDIES: NGV School (with Bernard Hall and Frederick McCubbin), 1906–11; and in London. She returned to Melbourne in 1913 and held a joint exhibition with her husband, Montague Marks. She lived in the USA, 1914–36, then in England, becoming a member of the Royal Miniature Society of London and the American Society of Miniature Painters. Among her commissioned works were miniatures of members of the Royal Family.
REP: NGV.
BIB: References in the *Studio*, London, vol. 69, no. 204, 1917; vol. 73, no. 35, 1918; vol. 83, no. 53, 1922.

MARMOL, Ignacio

(b. 1934, Andujar, Spain; arr. Australia 1962) Painter.
STUDIES: School of Arts and Crafts, Madrid, 1945; Royal Academy of Ceramics, 1947, Academy of San Fernando, 1953. He travelled in Italy, USA and Portugal, 1955–58, and from 1960–62 was Secretary General of the UNESCO Centre, Madrid. His symbolic abstracts reflect the influence of the modern Spanish school of texture painters.
REP: NGA; AGNSW, Sydney; Newcastle Region Art Gallery; ANU, Canberra.
BIB: A&A 4/2/1966; 6/4/1969 (Ian Bassett, *Ignacio Marmol – with Poems by the Painter*).

MARQUES, Charles

(Active, Castlemaine, c. 1890) Naive painter, mainly of mining company claims and operations.
BIB: McCulloch, *AAGR*.
NFI

MARQUET, Claude A.

(b. 1870, Moonta, SA; d. 1920, Sydney) Artist contributor to illustrated papers *Quiz* and *Sporting Life*, Adelaide. Cartoonist for *Table Talk*, Melbourne, 1903–04; Melbourne *Punch*, also chief cartoonist for *Sydney Worker* (c. 1920).
BIB: A. Marquet, *Cartoons: A Commemorative Volume*, The Workers Trustees, Sydney, 1920. Vane Lindesay, *The Inked-In Image*, Hutchinson, Melbourne, 1979.

MARRINON, Linda

(b. 1959, Melbourne) Painter.
STUDIES: Dip. of Fine Art (painting), VCA, 1979–81; Degree in Conservation, VCA, 1982. She held 7 solo exhibitions from 1983–1991 including George Paton and Tolarno, Melbourne; Roslyn Oxley9, 1987, 89, Sydney, IMA, Brisbane, 1987 and Cannibal Pierce Galerie Australienne, Paris, 1989. She participated in 22 group exhibitions, 1982–1990, including *Australian Perspecta*, AGNSW, 1983; *Moet & Chandon Touring Exhibition*, AGNSW, 1988; *Annotations*, 200 Gertrude St, Melbourne, 1989; *Art with Text*, Monash Uni.,

1990 and *Self Portraits*, Cannibal Pierce Galerie Australienne, Paris, 1990.
REP: NGA; AGSA; Museum of Contemporary Art, Sydney; ANU, Canberra; Uni. of Melbourne.
BIB: Catalogue essays for exhibitions as above. Kirby, *Sightlines*.

MARRIOTT-WOODHOUSE, Archibald

(b. 1884, Sydney; d. 1930) Portrait genre painter.
STUDIES: RAS School, Sydney. He exhibited at the *Empire Exhibition*, London.
REP: AGNSW; Manly Art Gallery.
BIB: Catalogue, Manly Art Gallery.

MARSDEN, Theodore

(Active, Vic., c. 1860–90) His only known work is a capably painted oil, *Cobb & Co. Coach, Forest Creek & Bendigo Line* (Christie's auctions, Melbourne, Mar. 1974, illustrated in catalogue). A later work, *Timber Gatherers* (attributed to N. Marsden, 1890), brought $400 at auction (Christies 1974). It may have been by the same painter.

MARSH, Dale

(b. 1940, Brisbane) Painter.
STUDIES: Brisbane, with Vida Lahey, 1949–51; Brisbane Central Tech. Coll., 1954–60; RMIT, 1964–65. A foundation member of the Australian Guild of Realist Artists, 1974. His paintings of rural subjects, many with animals, have appeared in capital city exhibitions since c. 1972.
REP: QAG; regional galleries, Latrobe Valley, Benalla; AWM.
BIB: Germaine, *AGA* 1979.

MARSHALL, Helen

(b. 14/3/1918, N. Ireland; arr. Australia. 1935) Painter, ceramicist.
STUDIES: George Bell School, 1948. She travelled and lived in Europe (esp. Italy) and India from 1950–1970s. She worked in ceramics with Stascha Halpern in 1946 and held a number of exhibitions from 1951. In 1979 she moved to Sydney. In Australia she exhibited with Holdsworth, Irving Sculpture, Richard King and Coventry galleries and in group exhibitions with European and Australian private galleries. Her work was included in *Classical Modernism: The George Bell Circle* NGV, 1992.
REP: NGV; Museum of Domona, Israel.
BIB: M. Eagle & J. Minchin, *The George Bell School* Deutscher Fine Art/Resolution Press, Melbourne 1981. *New Art Five*.

MARSHALL, James Miller

(Active, Australia, c. 1885–90) Painter. He exhibited at the RA, London and may have gone to Vic. with the goldrush. In 1888 he gave lessons in watercolours to Lionel Lindsay. By 1891 he was back in England living in Devon.

MARSHALL, Jennifer Patricia

(b. 25/3/1944) Adelaide. Painter, printmaker, lecturer.
STUDIES: Dip. of Fine Art (painting), SASA, 1959; BA

(hons) Fine Arts, Sydney Uni. 1973; enrolled MA program Monash University 1991– ; travel studies Germany and Australia, 1978; UK, 1982–83. She held over 20 solo exhibitions, 1975–1993, including Bonython, Stadia Graphic, Sydney; Powell St Graphics, Realities, Melbourne; and in other capital cities. Her work has appeared in numerous Australian and international print and other survey exhibitions including with the PCA and in *Printmakers of NSW*, London, 1982; *The Subject of Painting* project exhibition, AGNSW, 1984; *Abstractions*, Ivan Dougherty Gallery, 1986; *Three Australian Painters*, Webster University Gallery, St Louis, USA, 1992; *Black and White*, Tin Sheds Gallery, Uni. of Sydney, 1992. She judged a number of print prizes including those at Mornington and Warrnambool (Henri Worland) and *Moet & Chandon Australian Art Fellowship* as well as being a committee member of a number of visual arts organisations including the Australian Print Workshop.

AWARDS: Residency, Power Studio, Cité Internationale des Arts, Paris, Uni. of NSW, 1974; grant, VACB, 1977; British Council grant, 1983; residency Moya Dyring Studio, Cité Internationale des Arts, Paris 1987.

APPTS: Secondary school art teaching, 1963–73; lecturer in printmaking, SCA, 1977–82; senior lecturer, head of printmaking, SCA, 1982–89; visiting lecturer, Glasgow School of Art, 1982, 84, 91; sessional lecturer, Ballarat Uni. College, 1989–92; sessional lecturer, RMIT (Bundoora campus) and Monash Uni. (Caulfield campus), 1992– ; Board member Australian Print Workshop, 1989–92.

REP: NGA; AGNSW; AGSA; NGV; QAG; Artbank; Latrobe Valley, Wagga regional galleries; a number of tertiary institutions including Darling Downs Inst. of Advanced Ed; City Art Institute; Gryphon Gallery, Melbourne; private & corporate collections including BHP; Westpac; SA Brewing; Telecom.

BIB: Catalogue essays for exhibitions as above. *A&A* 19/3/1982. *Aspect*. Vol. 5/4/1984.

MARSTON, *Suzie*

(b. 11/5/1952, Sydney) Painter.
STUDIES: Wollongong Tech. Coll., 1981; self-taught; travel studies in India, 1981–83. Many of her paintings in 10 solo exhibitions, 1982–91, showed a surrealist fantasy world peopled with animals and humans, Sydney (Watters); Melbourne (Pinacotheca) and at Wollongong City Art Gallery, 1983; CAS, Adelaide, 1984. She participated in about 34 group exhibitions 1982–91, in private galleries in Sydney (including Watters) and public galleries including *Blake Prize Touring Exhibition*, 1982–83; *Figures and Faces Drawn from Life*, Heide, 1983; *Urban Anxieties*, NGA, 1987; *Selected Acquisitions*, MOCA, Brisbane, 1991.

AWARDS: Blake Prize (co-winner), 1982; residency Power Studio, Cité Internationale des Arts, Paris, 1984.

APPTS: Teacher of painting, drawing, colour and design, Illawarra Grammar, Wollongong, 1981–83; lecturer in painting, CSA, 1985–86, lecturer in painting, Uni. of Wollongong, 1988.

REP: NGA; MOCA, Brisbane; Burnie, Newcastle, regional galleries.
BIB: McKenzie, DIA. *New Art Two*.

MARTENS, *Conrad*

(b. 1801, Crutched Friars, London; arr. Sydney 1835; d. 21/8/1878, N. Sydney) Painter.
STUDIES: London (with Copley Fielding) from c. 1816. Son of J. C. H. Martens, German-born consul for Austria in London; two of Conrad Martens' brothers, Henry and J. W. Martens, were also artists. He left England when Captain Blackwood of the *Hyacinth* offered him a three-year cruise to India, and transferred to the *Beagle* at Montevideo, after hearing that its captain wished to engage an artist in succession to Augustus Earle. Charles Darwin, who became his close friend during the ensuing two-year voyage, described Martens' arrival in a letter quoted by Bernard Smith: 'Poor Earle has never been well since leaving England, and now his health is so entirely broken up that he leaves us; a Mr Martens, a pupil of C. Fielding and an excellent landscape painter, has joined us, and like all birds of that class, full up to the mouth with enthusiasm.' The influence of Darwin, and the commander of the *Beagle*, Captain FitzRoy, a keen student of meteorological phenomena, did much to provide Martens' work, which had formerly reflected the romantic qualities of his teacher, Copley Fielding, with scientific precision, particularly in the recording of topographical detail. Martens' engagement ended at Valparaiso, and he shipped on the *Peruvian* for Tahiti, and thence on the *Black Warrior* for Sydney, where he arrived on 17 Apr. 1835. He settled in Sydney in Cumberland Street in the area known as the Rocks, set up a studio and took pupils, among them Robert Russell, first surveyor of Melbourne. Martens married in Sydney two years later, and supported his wife and two children entirely from his painting until he became Parliamentary Librarian in 1863, a post which he held until his death. As well as painting prolifically, he designed the font for St Thomas's Church of England (North Sydney) of which he was verger, and is thought to have designed the new St Thomas's Church. He covered a considerable amount of territory as landscape and seascape painter, but Sydney Harbour and its environs remained his favourite, permanent source of inspiration. His large watercolours had much of the drama and poetry of Turner's maritime paintings. Despite his great talents and high rating as a painter, Martens had a hard time earning a living in the colony; the depressed era of the 1840s was particularly trying. To make ends meet, he published a set of lithographs, *Sketches in the Environs of Sydney*, during 1850–51, and on another occasion considered himself lucky when he received £60 from the proceeds of an Art Union. He was the first professional artist to paint in Brisbane and gave his picture *View of Brisbane, 1861* to his friend Darwin as a memento of the *Beagle* days. Darwin left the picture to his own son, who subsequently bequeathed it to the Qld Art Gallery. His work appeared in *The Artist and the Patron*, AGNSW, 1988;

the Bicentennial exhibitions *The Great Australian Art Exhibition* and *The Face of Australia*.

REP: NGA; NGV; AGNSW; AGSA; AGWA; QAG; MAGNT; TMAG; many regional galleries and other public collections.

BIB: Lionel Lindsay, *Conrad Martens, The Man and His Art*, Angus & Robertson, Sydney, 1920. S. de Vries-Evans *Conrad Martens* Pandannus Press, 1993. Douglas Dundas, *Conrad Martens*, illustrated article in the quarterly bulletin of the AGNSW, Oct. 1963. Smith, *EVSP. ADB* 2. McCulloch, *AAGR*. Kerr, *DAA*. *A&A* 16/2/1978 (Helen Topliss, *Conrad Martens at Observatory Hill*); 21/4/1984.

MARTIN, Alan Albert

(b. 22/8/1923, Melb.; d. 19/10/1989) Painter, teacher. STUDIES: Melbourne, with Max Meldrum, 1938–58; NGV School, with William Dargie, 1964; RMIT, design with Murray Griffin. His tonal painting reflects his background training. He established his own private painting classes at Eltham and Kew.

AWARDS: Prizes in competitions at Toowoomba, Qld, 1965; Bacchus Marsh, Moe and Sherbrooke, Vic.

REP: Regional galleries at Castlemaine and Rockhampton; La Trobe Uni.

MARTIN, Florence Beresford

(b. 1908, Ballarat) Painter, designer for theatre. STUDIES: Melbourne, with A. D. Colquhoun; New York, with Serge Londeikine, 1945–46; American Art School, 1951. A member of the United Scenic Artists of America, she designed for theatre and ballet in the USA and Australia besides holding exhibitions of still-life and flower paintings. A paraplegic as a result of a motor accident in youth, she travelled extensively in company with her sister, Kathleen.

REP: NGA.

MARTIN, Jesse

Painter. Prisoner of war during WWII. On his return to Australia he shared an exhibition at the Macquarie Galleries, Sydney, with Justin O'Brien, in 1944.

REP: Newcastle Region Art Gallery.

NFI

MARTIN, John Anthony

(b. 26/5/1942, Sydney) Painter, teacher. STUDIES: NAS, 1960–61; travel studies, Europe and UK, 1972–73. Teaching, NAS, Newcastle from 1973. His work has appeared in exhibitions and, from 1970, in CAS exhibitions.

REP: AGNSW; Newcastle Region Art Gallery.

BIB: *A&A* 24/1/1986.

NFI

MARTIN, (Martin-Cremiere) Louis Marcellin

(b. 1841, Tours, France; arr. Aust. 1860; d. 1908) Cartoonist, caricaturist. Founder of a satirical weekly paper *The Laughing Jackass* in Rockhampton, Qld in 1881 for which he produced numerous cartoons and caricatures. As well he painted the scenery around Rockhampton and town buildings.

MARTIN, Mandy

(b. 18/11/1952, Adelaide) Painter, printmaker, teacher. STUDIES: Dip. of Fine Art, SASA, 1975. Her screenprints in the exhibition *Lost and Found Objects and Images* (Ewing-Paton Galleries, 1978) showed a strong social content and sense of satire. Her 1980s work was often of industrial landscapes and the outback, on a large scale and using glowingly bright colours. Typical is the huge work *Red Ochre Cove* (probably the largest painting ever made in Australia) commissioned by New Parliament House, Canberra to hang in the main Committee Room. She held about 25 solo exhibitions, 1977–91, in leading galleries in Sydney (including Roslyn Oxley9); Brisbane (Michael Milburn); Canberra (Ben Brady); Melbourne (Christine Abrahams) and in IMA, Brisbane, 1984; Latrobe Valley Arts Centre, 1990; Missouri Botanical Garden, St Louis, USA, 1990. She participated in numerous significant group exhibitions in public and many state galleries & NGA including *Visions after Light; Art in South Australia 1836–1981*, AGNSW, 1981; *Australian Perspecta*, AGNSW, 1981, 83; *Australian Visions*, Gug-genheim Museum, New York, 1984; *Backlash*, NGV, 1986; the Bicentennial exhibition *The Face of Australia*.

AWARDS: John McCaughey Prize, NGV, 1983; Hugh Williamson Art Prize, Ballarat Fine Art Gallery, 1985; half-standard grant VACB, 1985–86; Alice Prize, 1990. APPTS: Lecturer, Canberra School of Art, 1978–92.

REP: NGA; NGV; AGNSW; AGSA; AGWA; QVMAG; Parliament House; Artbank; AWM; many regional gallery collections including Broken Hill, Newcastle; New England, Mt Gambier; Warrnambool; a number of tertiary collections including RMIT; Qld and Melbourne Uni.; Guggenheim Museum, NY; corporate collections including IBM; Price Waterhouse; CRA.

BIB: Catalogue essays exhibitions as above. Numerous references in art magazines including *A&A*; *AM*; *A&T*. Smith, *AP*. Eileen Chanin, *Collecting Art*, Craftsman House, 1990. *New Art Four*. Nancy Hall, *Women Artists: An illustrated History*, Abbeville Press, NY, 1991. *A&A* 28/2/1990. *AL* 2/1/1982; 3/5/1983; 6/1/1986; 6/2–3/1986.

MARTIN, Max

(b. 1889, Fitzroy, Vic. d.?) Painter. STUDIES: Collingwood School of Art (with Ambrose Pratt); St Martin's School of Art, London. In 1912 Martin was earning a living in Sydney making lightning sketches for Bennan's Amphitheatre. Soon afterwards he left for London where he earned a precarious living renovating old inn-signs. He designed sets for musical comedies and became a pioneer of animated cartoon techniques when he worked as a black-and-white artist for Pathé Frères. He earned a London reputation soon after WWI, when the paintings he exhibited at the 1924 and 1925 exhibitions of Australian art in London (*see* EXHIBITIONS) gained high praise from newspaper critics. While not breaking with tradition, they exhibited many of the cubist influences already discernible in the work of British painters such as C. R. W. Nevinson, Wyndham Lewis and the Nash brothers. Martin was a member of the Royal Society

of British Artists, from 1919 and exhibited at the New English Art Club, RA, Salon d'Automne, Paris, and at the Royal Hibernian Academy. He went to Ireland in 1928 and stayed 20 years, after which he returned to Australia where, apart from a single, virtually unnoticed exhibition at the VAS in 1950, and an occasional picture sent to competitive exhibitions, he lived and worked in comparative seclusion.

AWARDS: Bronze medal, painting from the nude, Victoria and Albert Museum, students' exhibition.

MARTIN, Phillip

(b. 1/6/1927, Essex, UK; arr. Australia 1969) Painter.
STUDIES: Italy, 1952–56; France, 1956–62; India, 1926–69. Largely self-taught, Martin travelled and lived in Europe extensively including periods in Ireland, Italy, Spain, Belgium and India before arriving in Sydney in 1969. Based in Sydney since the 1980s, he still travels frequently and exhibits in Paris, Ireland and New York. Works first seen in Australia in the 1970s were explosive, semi-abstract, symbolistic pictures. He continues to use found objects and collages and is noted for an ability to infuse familiar images with symbolic elements. He held about 37 solo and two-person exhibitions (with Helen Marshall) from 1951–91, the majority of which were in European cities and in Sydney with Richard King, Irving Sculpture & Coventry galleries. His work has appeared in many group exhibitions in Europe including in Venice, Paris, Milan, Brussels, and in Australia with Coventry and Charles Nodrum and Tolarno Galleries.
REP: Many art museums in Europe, UK & USA including Contemporary Art Society, London; San Francisco Art Museum; Guggenheim Museum, Venice; MOMA, New York.

MASON, Cyrus

(b. 1830, London; arr. Melbourne 1855; d. 1915) Illustrator, draughtsman. Secretary of the Victorian Art Unions, 1872–75 and founder of the Buonarotti Club he made drawings and lithographs of life at the gold-diggings, of which he had practical experience. After losing everything as a digger at Star Mine, Woods Point, he gave up hope of finding gold and walked to St Kilda, Vic. Much of his subsequent life was spent in trying to improve local conditions for artists. He became a draughtsman in the Victorian government railways, and the Art Unions which he organised provided some 1200 guineas for distribution among impoverished Victorian artists. Mason was an enthusiastic and vigorous protagonist of art causes; among those who benefited from his lectures was Frederick McCubbin. He exhibited with the Victorian Academy of Arts in 1870 and wrote and illustrated a children's book *The Australian Christmas Story* in 1871 (republished by the NLA, 1988).
REP: NGA; Mitchell, Dixson, La Trobe Libraries.
BIB: McCulloch, AAGR. Kerr, DAA.

MASON, Frank Henry

(b. 1870, County Durham; visited Australia c. 1934;

d. 1965) English marine and coastal painter and etcher; railway poster designer. He exhibited at the RA from 1900, served in the navy in WWI and travelled extensively. A watercolour of Melbourne, signed and dated '34, was sold at Leonard Joel's, Nov. 1965.

MASON, Heather

(b. Port Arthur, Tas.) Sculptor.
STUDIES: Slade School, London, 1897. She became a successful designer and modeller of medallions, exhibited at the New Salon, Paris, and RA, London, 1907–11. Her sister, Veronica, was a writer of verse and prose, notably of *I Heard a Child Singing and Other Verses*.
BIB: Moore, SAA.

MASON, Joe

(b. 1923) Sculptor. Foundation member of the Society of Sculptors and Associates, 1951. He worked as an assistant to Tom Bass before moving from Sydney to Western Australia during the 1970s.
REP: AGNSW.
BIB: Scarlett, AS.

MASON, Walter George

(b. 8/2/1820, Holloway, Middlesex, England; arr. Sydney 1852; d. 1866) Illustrator, wood-engraver.
Son of Abraham John Mason, a well-known English wood engraver, he was one of the four proprietors of Sydney's *Illustrated Sydney News* in the mid 1850s and engraved most of its illustrations. Artists from whose work illustrations were taken included George French Angas, Louisa Atkinson and Conrad Martens (qq.v.). He was also involved with the *Sydney Punch* from 1856–88 and produced *Australian Picture Pleasure Book* with 200 wood engravings of the architecture, scenery and development of the colony of NSW. He also made portrait engravings and illustrated a number of books. Despite the high regard for his work in the colonies he died in reduced circumstance in Sydney.
BIB: Moore, SAA. M. Muir, *A History of Australian Children's Book Illustrations* Sydney 1982. Kerr, DAA.

MATASSONI, Terry

(b. 15/8/1959, Melbourne) Painter.
STUDIES: Dip. of Fine Art (painting), VCA, 1980; postgrad. dip. in painting, VCA, 1981–82. He held 6 solo exhibitions, 1984–91, Melbourne (Realities, 1984, 86, 89); Sydney (Irving 1991) and Swan Hill Regional Gallery of Contemporary Art, 1991. Group exhibitions in which he participated 1985–91 included private galleries Melbourne (John Buckley, Realities) and *A Horse Show*, Heide, 1988; *Popular Front*, ACCA, 1989; *Raising the Furies* regional galleries touring exhibition, 1990.
AWARDS: Sir Russell Drysdale Memorial Prize for Drawing, 1981; travel grant, VACB, 1982; artist development grant, Vic. Ministry for the Arts, 1985; Broadford Prize, 1987; grant, Vic. Health Promotion for theatre arts project.
APPTS: Part-time lecturer in art, VCA, 1986–87; lecturer Australian College of Photography, 1990–92.

REP: NGV; Heide; Swan Hill regional art gallery; Vic. Ministry for the Arts; VCA; Northern Territory Uni.; Monash Medical Centre; Monash Uni.; World Congress Centre, Melbourne and in A. V. Jennings, Victor and Loti Smorgon Contemporary Art collections.

MATHER, James

(Active, Sydney, c. 1883) Painter. He exhibited with the Art Society of NSW from 1883.
REP: AGNSW.
BIB: *Fifty Years of Australian Art, 1879–1929*, RAS, Sydney, 1929

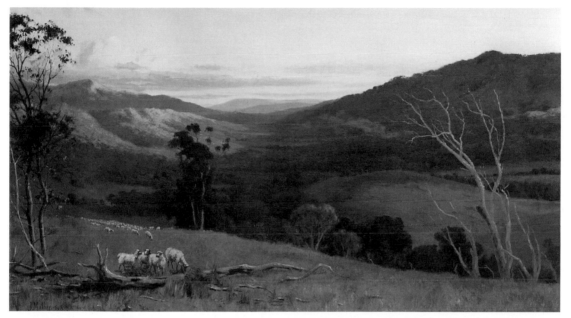

John Mather, Panoramic Landscape, *1889, oil on canvas, 49.5 × 89.8cm. Private collection.*

MATHER, John

(b. 1848, Hamilton, Scotland; arr. Australia 1878; d. 18/2/1916, Melb.) Painter, etcher, teacher.
STUDIES: Glasgow, with watercolourist Fairnarn; Edinburgh, National Gallery School; Paris. Mainly a painter of landscapes working in a Scottish tradition, he painted at Healesville and on the eastern shores of Port Phillip. One of his first commissions in Melbourne was to help decorate the dome of the Exhibition Building. He became popular as a teacher and on occasion extended his lectures to the Heidelberg School gatherings at Eaglemont. He was the first artist trustee of the NGV involved with a number of art organisations. Despite his considerable reputation and influence however, he is represented by only one painting in the NGV, and none in the AGSA and AGNSW. He sometimes collaborated in joint paintings with the animal painter J. H. Scheltema. His work was represented in *Golden Summers* NGV and touring, 1986 and *Tasmanian Vision* TMAG and QVMAG 1988.
APPTS: Trustee, NGV, 1893–1916, member, Felton Bequest Committee, 1905–16; president, VAS, 1893–1901, 1905–09, 1910–11; foundation member, Australian Art Association, 1912.
REP: NGV; TMAG; AGWA; regional galleries, Ballarat, Castlemaine, Geelong, Launceston, Mornington.
BIB: Moore, SAA. Smith, AP. Article *Table Talk*, Melbourne, 2 Nov. 1888; AA no. 9, 1921.

MATHER, John Baxter

(b. 1853, Edinburgh; arr. Australia 1860; d. 1940) Etcher, critic, journalist. After working as a journalist at Mount Gambier and Warrnambool he became staff artist for the Adelaide *Advertiser and Express*, 1893–99, and wrote art criticism for the paper for 15 years. An associate of the South Australian Society of Arts, he became well known as a landscape and marine painter and is stated by Moore to have been the first etcher in SA. In 1913 he revised H. P. Gill's 1903 catalogue of the AGSA. His career closely parallels that of his countryman, John Mather of Vic., but the two artists were not related.
BIB: Moore, SAA.

MATHEWS, Gregory Macalister

(b. 1877, Briamble, NSW; d. 1949 England) Bird artist. His classic book on Australian birds, *Birds of Australia* (published in 13 volumes in an edition of 225 signed copies, H. R. & G. Witherby, London, 1910–27), took 20 years to complete. In 1939 his £30,000 gift of drawings and bird books to the Commonwealth Government of Australia made the ornithological section of the NLA unique.
AWARDS: CBE conferred, 1939.

MATHEWS, Marjorie McChesney

(b. 1908, Williamstown, Vic.) Painter, sculptor, teacher.
STUDIES: Melbourne (painting, with A. D. Colquhoun and M. Meldrum; sculpture, with Ola Cohn). She taught art at Toorak Coll. and Huntingtower School,

Vic., and for four years after WWII was Red Cross officer in charge of handicrafts at Stonnington Convalescent Hospital. In 1969 she completed 20 large icons for St George's Serbian Orthodox Church at St Albans, Vic.

AWARDS: Prize at Albury art competitions, 1963.
APPTS: Secretary of the Melbourne Society of Women Painters and Sculptors, c. 1964.
BIB: Article and reproduction, *Architects Journal*, 1939.

MATTHEWS, Nevil

(b. 19/4/1930, Ayr, Qld) Painter, printmaker, sculptor, designer of stained-glass.
STUDIES: Brisbane Tech. School, 1948–50; Brisbane, with Jon Molvig, 1951–53, also with Clement Meadmore; travel studies, UK, Europe, 1966–67. Known mainly as a painter of hard-edge pictures, many with stripes and circular compositions, he has completed commissions for Mayne Hall, Uni. of Qld (stained-glass) and Griffith Uni., Brisbane (sculpture).
AWARDS: Australian Fabric design, 1966; TAA award, 1970; Darnell de Gruchy prize, 1970; Launceston (work acquired), 1970.
APPTS: Part-time lecturing, Darling Downs IAE, –1979– .
REP: QAG; regional galleries at Launceston and Newcastle; universities, James Cook, Uni. of Qld and Griffith Uni.
BIB: Bonython, MAP, 1970, 1980.

MATTINSON, Lance

(b. 1892, Sale, Vic.; d. 1953) Black-and-white artist. Mattinson became known during WWI for his drawings for the AIF paper *Aussie*. After the war he contributed to *London Opinion, Passing Show* and London *Punch*, before returning to Australia to join the staff of *Smith's Weekly*, 1936.
BIB: Moore, SAA. Vane Lindesay, *The Inked-In Image* Hutchinson, Melbourne, 1979.

MAUDSLEY, Helen

(b. 1927, Melbourne) Painter.
STUDIES: RMIT; NGV School. Her work appeared first in VAS seasonal exhibitions (from 1943) and from 1957 in solo exhibitions in Melbourne. Small in dimensions, carefully designed and painted in muted colours, her paintings incorporate surrealistic and decorative elements expressive also of a strong personal attitude. She is married to painter John Brack.
REP: NGV; Newcastle Region Art Gallery.

MAUGHAN, Jocelyn

(b. 26/12/1938, NSW)· Painter, draughtsman.
STUDIES: Dip. of Fine Art (hons, painting), National Art School; travel studies Europe, England. She held solo and two-person exhibitions at the Watercolour Society, 1987; Wall Gallery, Sydney, 1991 and Petronga Bakehouse Gallery, 1992. Group exhibitions include district art shows and Portia Geach Award from commencement of award until 1989; Archibald Prize entries annually 1962–1980s and Aust. Watercolour Society Annual Members Exhibitions.

AWARDS: Portia Geach Award, 1976; many prizes RAS and local art awards.
APPTS: TAFE teaching 1960– ; head of Meadowbank School of Art & Design, TAFE; frequent lecturer & demonstrator, art society workshops, NSW.
REP: Grafton regional gallery.

MAURIN, N. A.

French lithographer who prepared illustrations for Dumont D'Urville's *Voyage de l'Astrolabe*.
(*See* DE SAINSON, LOUIS AUGUSTE)

MAXWELL, Stuart

(b. 1925, Qld) Painter and advertising artist.
STUDIES: George Bell School, Melbourne; RMIT; St Ives, Cornwall (with Peter Lanyon and William Redgrave), 1954–56. Post-impressionism, expressionism and finally surrealism and new realism have all influenced his painting. His *Christ and Emmaus*, which shared the Blake Prize with Ken Whisson's *Tobias and the Angel* in 1974, depicted a hand opening a door into an interior with a jacket, bread, wine and other still-life objects painted in meticulous trompe l'oeil fashion.
AWARDS: Prizes at Mosman, 1969; Ashfield and Ryde, 1972; Tamworth, 1973; Blake Prize for Religious Art (shared with Ken Whisson), 1974.

MAXWELL, William J.

(b. Scotland; arr. Australia c. 1880) Sculptor. Before leaving England he did restoration work for Westminster Abbey. He went to Australia for health reasons and is stated by Moore to have modelled the heads of six prominent South Australians for the façade of the SA House of Parliament 'about 1885'. He also carved the marble statue of Robert Burns in North Terrace, Adelaide, the model for which had won him a silver medal at Kilmarnock before he left England. Much of the sculpture work on other public buildings in Adelaide and also in Melbourne and Sydney was done by Maxwell. He also participated in a Melbourne competition for public sculpture in 1891.
BIB: *Table Talk*, 17 July 1891 (*Art and Artists*). Moore, SAA. Scarlett, AS.

MAY, Maggie

(b. 26/11/1944, Warrnambool, Vic.) Printmaker, ceramicist, sculptor, teacher.
STUDIES: Dip. of Fine Art, RMIT, 1964; fellowship in ceramics, RMIT, 1976; Dip. of Graphic Communication, Hawthorn State Coll., 1981. Her strengths are her draughtsmanship and fine ceramics which are at once delicate and convoluted as seen in her *Bell Jar* series of the late 1970s, early 1980s and throughout her semi-abstract drawings. She held three solo exhibitions, 1978–1993 in Melbourne and participated in about 25 group exhibitions including *Contemporary Australian Ceramics*, NGV, and touring NZ and USA, 1982; *Australian Decorative Arts: The Past 10 Years*, NGA, 1984. She has been a member of a number of arts committees including Course Advisory, Fine Art,

RMIT, 1987; Vic. Print Workshop, 1986–87 and since 1987 has been based in Wales, UK.

AWARDS: John Childian Award, RMIT, 1964; Diamond Valley Art Award, 1978.

APPTS: Part-time lecturer various tertiary colleges Melbourne 1971–87 including Lincoln Inst; RMIT (School of Architecture), VCA.

REP: NGA; NGV; AGWA; Powerhouse, Sydney; regional galleries at Ballarat, Geelong, McClelland, Wollongong; Monash Uni; Uni of Melb.; Diamond Valley.

BIB: Catalogues for exhibitions as above. McKenzie, *DIA*

MAY, Phil (Philip William)

(b. 27/4/1864, Leeds, England; d. 5/8/1903, London) Black-and-white artist.

STUDIES: No formal training. May was largely responsible for setting the high standard of draughtsmanship attained by the black-and-white artists of the Sydney *Bulletin*. He was induced to go to Australia as artist for the Sydney *Bulletin* by W. H. Traill, and during his stay, 1886–88, produced more than 900 drawings. He shared a studio with Blamire Young at Katoomba, in the Blue Mountains, NSW. A perceptive student of character, May was a fine portraitist as well as cartoonist, and it was the powerful relation of truth to life that gave his cartoon characters distinction. Among the visitors to the Katoomba studio, which was subsequently burned down, were Godfrey Rivers and Theodore Fink, who became a noted patron of the arts in Melbourne and chairman of the Melbourne *Herald*. May's life after he left Australia was successful but apparently unhappy, as this passage from the autobiography of Julian Ashton, indicates: 'May was the life and soul of the art circle in Melbourne during the last months he spent in Australia [but] when I met him again in London he had greatly changed. I saw him in Fleet Street one day when he was at the height of his fame, and he told me he was the most miserable man in London.' The basis of his great reputation was his strong and sympathetic sense of identification with people and understanding of character. But he owed much also to adaptability to the new line-block technology and to the apprenticeship served during his early formative days in Australia. The many books of drawings and cartoons published by the artist in London include *Westminster Annual*, published 1892–1903, and numerous *Phil May Annuals* and *Sketchbooks*.

REP: Most state galleries.

BIB: *Australian Encyclopaedia*, Angus & Robertson, Sydney, 1958. Julian Ashton, *Now Came Still Morning On*, Angus & Robertson, Sydney, 1941. ADB 5. Vane Lindesay, *The Inked-In Image*, Hutchinson, Melbourne, 1979.

MAY, Stephen

(b. 10/9/1940, Melb.) Painter.

STUDIES: Ravensbourne Coll. of Art and Design, UK, 1957–60; NGV School, 1965–67. He held 13 solo exhibitions, 1970–1993, including with Tolarno, 1970; Macquarie Galleries, Sydney, 1972; Greenhill, Adelaide, 1976; Niagara, 1985, 87, 88 and Christine Abrahams,

Melbourne, 1993. Group exhibitions include Stuart Gerstman Gallery, Melbourne, 1982 and *Niagara at Watters*, Sydney, 1989. His metamorphic paintings, in which often the nude becomes the landscape, convey a pleasant feeling of rhythm, space and well-placed accent. He was artist-in-residence, Elwood High School, 1981, Warrnambool High School, 1988, Mount Waverley High School, 1990.

APPTS: Part-time teacher, Prahran CAE, 1971–81, PIT, 1989–91; sessional lecturing, Dandenong TAFE, 1990, RMIT, 1992.

REP: NGA, Prahran CAE; A. V. Jennings, private collections in Australia and abroad.

MAY, Ted (Edward)

(b. 1939, Ryde, NSW) Painter, teacher.

STUDIES: ESTC, –1963; travel studies, 1973–74. He held solo exhibitions in Sydney, Canberra and Melbourne from the mid 1970s as well as taking part in a large number of group exhibitions, the main thrust of his work being 'investigation of the figure in space within the modernist tradition of Picasso to de Kooning and beyond'. He has exhibited little since the mid 1980s but continues to paint.

AWARDS: Prizes in competitions at Maitland, NSW, 1967, 1968.

APPTS: Teaching, NSW Education Dept secondary school, 1964; NAS, 1965–72; CIT, Vic., 1974; RMIT, 1978–91.

REP: NGV; a number of regional and tertiary collections including Uni. of Melbourne.

MAYO, Daphne (Lilian Daphne)

(b. 1/10/1895, Sydney d. 1982) Sculptor.

STUDIES: Brisbane Central Tech. Coll. (drawing with Godfrey Rivers, modelling with L. J. Harvey), 1911–12; Sydney Art School, with Julian Ashton, c. 1915–16; Polytechnic, London, 1919; RA Schools (sculpture), 1920–23; France and Italy, 1924–25. Her experience as a sculptor during her studentship included working with monumental masons in Qld (Frank Williams & Co., Ipswich, and Lowther & Sons, Petrie Bight), 1916 and studio assistant to John Angel, St John's Wood, London, 1920. She returned to Brisbane in June 1925 to become a distinguished sculptor as well as undisputed leader of art development in Qld. Working in the Greek tradition she completed the 18m long stone carving for the tympanum of the Brisbane Town Hall (1928–29), as Sturgeon notes, 'in situ', a memorable performance. Other commissions included busts, portraits, reliefs, religious works of various kinds for churches, all done with a high degree of professionalism. She also taught in Brisbane. More importantly, her role in the evolving pattern of Australian sculpture is as a link artist, joining the old academic traditions to the new spirit that would emerge after WWII. Her sense of style can clearly be seen in her most masterly work, the female figure entitled *The Olympian* (NGV collections, Melbourne), reflecting, as it does, the French influences of Rodin, Malliol and Despiau.

AWARDS: Qld Wattle League Travelling Scholarship,

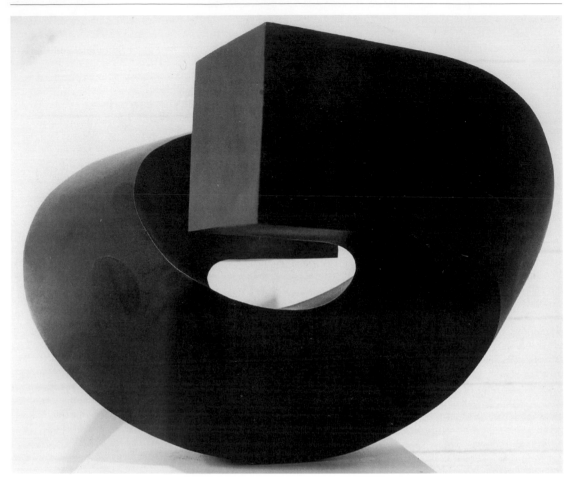

Clement Meadmore, Janus, *1968, steel, 36cm × 40cm × 39cm. Private collection.*

1914; RA (Landseer Scholarship), 1921, bronze, silver and gold medals, 1921–23, and Edward Stott travelling studentship, Dec. 1923; Coronation medal and RQAS Jubilee medals, 1937; NSW Society of Artists' medal, 1938; Carnegie Corporation grant, 1940; MBE, 1959.

REP: NGV; AGNSW; QAG; AGSA; AWM; Uni. of Qld.

BIB: All general books on Australian art history. Sturgeon, *DAS.* Scarlett, *AS.* Julie K. Brown and Margaret Maynard, *Fine Art Exhibitions in Brisbane 1884–1916,* Fryer Memorial Library, Uni. of Qld, 1980. *A&A* 20/3/1983 (Judith McKay, *Daphne Mayo and a Decade of Public Monuments for Brisbane*).

MAYO, Eileen Rosemary
(b. 1906, Norwich, England; arr. Australia 1953) Graphic artist, illustrator, writer, teacher.

STUDIES: Slade School (with Henry Tonks), London; Central School of Arts and Crafts (with Noel Rooks, John Farleigh); Westminster (sculpture with Eric Schilsky); Chelsea Polytechnic (with Robert Medley, H. W. Williamson and Henry Moore); Paris, Académie Montmartre (with Fernand Léger). She illustrated many books, including *The Story of Living Things,* 1944; *Shells and How They Live,* 1944; *Little Animals of the Countryside,* 1945; *Animals on the Farm,* 1951, all published in London; contributed to English and Australian periodicals such as *Apollo,* London and *Art News and*

Review, London as well as designing Australian postage stamps, 1959–62; she also designed tapestry for exhibition during the Festival of Britain and worked on murals in Sydney. Her work was seen in *Important Australian Women Artists* Melbourne Fine Art Gallery, 1993.

AWARDS: Vizard-Wholohan (prints) Prize, 1962.

APPTS: Teacher, St Martin's School of Art, and Sir John Cass Coll., London, and at the NAS, Sydney. Member of the Society of Wood Engravers, London, and Sydney Printmakers.

REP: V&A Museum, London; NAG; NGV; AGNSW; QAG; AGSA; AGWA; TMAG.

MAYSON, Andrew
(b. 1919, Smyrna, Turkey; arr. Australia 1936) Sculptor, teacher.

STUDIES: Sydney Art School; NAS (crafts course), 1948–52; travel studies, 1962; 1973–74. A vertical unit abstract entitled *Sydney Cove* represented his work at the *Mildura Sculpture Triennial,* 1970. He held his first solo exhibition in London, 1974, after which he exhibited at the Sculpture Centre, Sydney, 1976, then at Macquarie, Holdsworth and again with the Sculpture Centre in 1988.

AWARDS: RAgSocNSW Easter Show Prize (for sculpture), 1970, 1972, 1973; WAIT Prize (commission), 1974; Japan Sculpture Prize, 1986; *Book of History*, Japan, 1987; Japan Museum Prize, 1987.
APPTS: Teaching, Cranbrook School, NSW, 1952–76, and director of art, 1976– ; ESTC, 1976; guest lecturer, NSW Education Dept and Sculpture Centre, 1975–84.
BIB: Scarlett, AS.

MAZELL, P.

An undated lithograph, *Black Flying Opossum*, by this otherwise unknown artist is reproduced in the exhibition catalogue *Outlines of Australian Printmaking*, Ballarat Fine Art Gallery, Aug. 1976.

MEADMORE, Clement

(b. 9/2/1929, Melbourne) Sculptor.
STUDIES: RMIT (industrial design and engineering). He started making sculptures in 1949, experimenting with tensional constructions (in accord with what he had learned in engineering). Similarly, he experimented with mobiles, 1950–53, then made monumental abstract works in welded steel and bronze. He visited Europe in 1953, and on his return directed Gallery A for Max Hutchinson (1959–61), after which he moved to Sydney where he established his reputation as a leading modernist sculptor. After a visit to SE Asia he moved to the USA in 1963, and in New York discovered new sources of inspiration. The monumental dimensions, geometric concepts and simplicity of the new American movements were readily assimilated and projected into a series of huge welded metal pieces that seem to contain and simplify the spirit of the new sculpture. In 1969 his work was included in the Rockefeller collection shown at the MOMA, New York, at the Mexican Olympics and at the Whitney Annual, in which it appeared again in 1973. It was included also in *Monumental Art*, Cincinnati, Ohio, 1970, and the *City is for People*, Fine Arts Gallery of San Diego, 1973. It has since been seen in numerous solo and group exhibitions in Australia, UK, Europe and USA.
AWARDS: Hunters Hill Prize, 1961; Taffs Prize for Textile Design, Sydney, 1963; American Academy of Arts and Letters award, 1973.
REP: NGA; NGV; AGNSW; many public collections in the USA.
BIB: Lenton Parr, *Sculpture, Arts in Australia series,* Longman, Melbourne, 1961.
Sturgeon, DAS. Scarlett, AS. AI 14/4/1970; 14/9/1970.

MEADOWS, J. E.

A topographical view of Bendigo, 1886, by this otherwise unknown artist is in the Bendigo Art Gallery collections.
BIB: McCulloch, AAGR.

MEAT MARKET CRAFT CENTRE

See GALLERIES – PUBLIC

MECHANICS INSTITUTES AND SCHOOLS OF DESIGN

(Established 1826, Hobart, Tas.) The Hobart initiative followed the Mechanics Institute Movement established in London by George Birbeck in 1823 as 'a means to wider adult education in science and the industrial arts'. The scheme was logically applicable to Australia, for as well as providing universal education, it met the need for the growing numbers of artisans required for the development of the colony. The building of the Hobart Mechanics Institute was followed by the building of the Sydney Mechanics Institute in 1833, the initiative having come from a group of Scottish mechanics led by the schoolmaster Henry Carmichael (arr. Sydney in *Stirling Castle*, 1831). The Melbourne Mechanics Institute and School of Art (later the Athenaeum) was built in 1839. The Sydney Mechanics School of Arts (later the National Art School), founded in 1859, sprang from the Mechanics Institute program and so did the Artisans Schools of Design in the Melbourne suburbs of Carlton and Collingwood. These represented the only public institutions providing facilities for instruction in the visual arts for many years. As late as 1871 the Preston School of Design, Melbourne, could be cited as 'the first building erected in the colony devoted to the purpose of art culture alone' (*Argus*, 31 Oct. 1871), notwithstanding that the Melbourne National Gallery School was founded in 1870. The Preston school, where Hiram W. Paterson presided as instructor of art, attracted 96 pupils. Meanwhile the Mechanics Institute ideals had been actively propagated in Hobart in a series of lectures which began in 1849 and included: 'The Perception of the Beautiful as an Element in Civilization', delivered by John Lillie; 'The Principles of Taste', by Samuel Prout Hill; 'The School of Athens as it Assimilates with the Mechanics Institution', by Benjamin Duterrau; 'Expression as Applied to the Fine Arts', by Dr John Bedford; 'The Philosophy of Botany', by J. E. Bicheno. In 1857 a wide comprehensive national program was launched and by the end of the century a Mechanics Institute building had been established in virtually every country town in Australia. The buildings and the libraries which they housed provided the inhabitants with their only cultural contacts, but there was no individual leadership available, and soon the presence of the buildings was taken for granted. Their influence rapidly declined; a whole generation grew up not even knowing why they had been built or what the name Mechanics Institute stood for, and by the 1920s most of them had been converted into cinemas or cheap concert halls. The Munn-Pitt report on Australian libraries, published in 1935, contained this statement: 'These institutions have deteriorated to such an extent that they add relatively little to the educational and cultural life of the community'. Despite this ignominious conclusion, however, the Mechanics Institutes contributed much to art and education. The artisans Schools of Design in Melbourne, for example, provided preliminary teach-

ing for many of the Heidelberg School painters, and the Working Men's College (offering full, liberal education for the working man), which subsequently became the RMIT, grew from the Mechanics Institute ideal, as did the tech. colleges at Collingwood and Richmond.

BIB: Smith, *PTT*, 1945; and *EVSP*, 1960; C. M. H. Clarke, *A History of Australia*, vol. 2, MUP, 1968. S. Murray-Smith, *A History of RMIT*, c. 1989.

J.G. Medland, The first convict station in the penal colony of Tasmania. c. 1848, *pencil, 19 × 27.2cm. Private collection.*

MEDLAND, James Gould

(b. c. 1817; arr Hobart, November 1844; d. 1899, London) Painter, sketcher, clergyman. He was the religious instructor with the Church of England at convict settlements at Buckland and Brown's River, Van Diemen's Land from 1844 before becoming a chaplain in Hobart in 1848. Married to Eliza Leakey, daughter of artist James Leakey and sister-in-law of novelist Caroline Leakey, he exhibited copies of old master paintings as well as originals in exhibitions in Hobart in the 1840s and made sketchbooks of his observations in the colony. He moved to Melbourne in 1854 and returned to Britain in 1859. His work was seen in *Tasmanian Vision* TMAG and QVMAG, 1988.
REP: TMAG; Allport, Mitchell Libraries.
BIB: *ADB* 5 (ref under Caroline Leakey). Kerr, *DAA*.

MEDNIS, Karlis

(b. 1/4/1910, Penza, Russia; arr. Australia 1949) Painter, stage designer.

STUDIES: Riga School of Art, Latvia, 1937–40. Between 1950–71 he held more than 40 exhibitions in Australia and the USA. He also conducted classes in his private art school in Melbourne, 1972–75. His work is characterised by brightly lit cityscapes. He is a member of various art societies including Australian Guild of Realist Artists; Old Watercolour Society Club; council member of the VAS where he taught from 1960–71; member of the Blue Brush Group.
AWARDS: Latvian Festival Prizes, 1958, 1963; E. T. Cato Prize (VAS), 1960; Albury Prize for watercolour, 1964; Rotary Prizes including at Camberwell 1966, 80, Mordialloc, 1981, Croydon, 1984; VAS, Artist of the Year 1979; Academician Art Academy of Italy, 1980.
REP: NGA; several state and regional galleries; Artbank; several tertiary collections including Melbourne and La Trobe uni.; many private and corporate collections.
BIB: International *Who's Whos*. Tom Roberts, *Australian Impressionist and Realist Artists – 70 living Australian artists* 1990.

MEDWORTH, Frank

(b. 22/8/1892, London; arr. Australia 1939; d. 1947 Mexico City) Painter, etcher, teacher, illustrator.
STUDIES: City and Guilds of London Inst. and Royal Coll. of Art, London. He served with the British army in France and East Africa, 1914–19, and exhibited at the RA, London, 1923–27, before changing to a modernist viewpoint. As head of Sydney's principal art school, he gave considerable impetus to the modern movement in Australia, and did much to keep it active during WWII. He died tragically in Mexico City

during a visit as a delegate to the United Nations Educational Scientific and Cultural Council. Books he wrote included *Animal Drawing*, Faber & Faber, London, 1935; *Perspective*, Chapman & Hall, London, 1936; *Figure Drawing*, Faber & Faber, London, 1940.

APPTS: Teaching, Westminster School of Art; head of the drawing and painting school, Hull Coll., 1935–38; head of the art school and chief lecturer in art, ESTC, 1939–47.

REP: NGV; AGNSW; QAG; AGSA; AGWA; TMAG; regional galleries, Bendigo, Mornington; Newcastle; AWM, Canberra; Perth Uni.; V&A Museum, London.

BIB: *Meanjin*, 2/1943 (Margaret Preston, *The Art of Frank Medworth*). Smith, *Catalogue* AGNSW, 1953. John Kroeger, *Australian Artists*, Renniks, Adelaide, 1968.

MEDWORTH, Muriel

(b. 1903, England; arr. Sydney 1939) Painter, mainly a watercolourist. Married to Frank Medworth. Member of the Contemporary Group and the Australian Watercolour Inst.

AWARDS: Mosman watercolour prize, 1953.

REP: AGWA.

NFI

MEEK, James

(b. 1815; arr. Australia c. 1851; d. 1899) Draughtsman and illuminator. After digging for gold in Ballarat, he went into business, though with limited success. He developed great skill as an illuminator; his *Ballarat Historical Gumtree* earned him a certificate from Queen Victoria, pronouncing him 'the best penman in Australia', and his map of Australasia won first prize at the Intercolonial Exhibition, 1861.

BIB: McCulloch, *AAGR*, 1977. Kerr, *DAA*.

MEEKS, Arone Raymond

(b. 30/11/1957, Sydney) Painter, printmaker, sculptor, illustrator.

STUDIES: Cert. Art, Kogarah College of Art, Sydney, 1976–77; Dip. Art, CAI, 1978–80; post-graduate studies, Mornington Island traditional methods of art and culture, 1981; BA (visual arts), CAI, 1984; travel studies India, 1988, Paris, 1989. An Aboriginal painter, he held solo exhibitions in the Australian Embassy, Paris, 1989, 92; Centro Cultural Recoleta, Buenos Aires, Argentina, 1990; Coo-ee Gallery, Sydney, 1991. He participated in about 50 group exhibitions, 1978–91, including *Contemporary Aboriginal Art Exhibition*, Bondi Community Pavilion, 1983; *Koori Art '84*, Art Space, 1984; *Perspecta*, AGNSW, 1991. His commissions include many murals, graphic design for posters, book markers, logos including for UN, commercial group hotels, Australian Elizabethan Theatre Trust poster; murals at Bondi Beach (mosaic); Dept of Aboriginal Affairs; posters for Aboriginal National Theatre Trust; land rights groups; Belvoir Theatre. His book illustrations include *There is Still Rainbow Snake Country*, ENORA (Ashton Scholastic); *Pheasant and Kingfisher*, Martin Educational, 1987;

Arone Meeks, Shot in the Dark, *1990, linocut with caustic etching, 61 × 50cm.*

AWARDS: Crichton Award for Children's Book Illustration, 1988; study grant, Aboriginal Arts Board, Australia Council, 1988; fellowship Aboriginal Arts Board, Australia Council, 1989; Award for Recognition of Excellence in Visual Art, Aboriginal National Theatre Trust, 1990.

APPTS: Artist-in-residence, CSA, 1985,88; Cairns TAFE, 1988; Cité Internationale des Arts, Paris, Feb.–April 1992; Consultant to Festival of Pacific Arts, Townsville, 1988 and later delegate for the same festival held in the Cook Islands, 1992.

REP: NGA; AGNSW; AGWA; National Museum, Canberra; Australian Museum, Sydney; Uni. of NSW & Qld; National Gallery of Japan; Australia Post; Bibliothèque Nationale de Paris; Robert Holmes à Court collection.

BIB: Caruana, *AA*.

MEERE, Charles (Matthew Charles)

(b. 1890, London; d. 1961, Sydney) Painter, illustrator.

STUDIES: West Ham Tech. Coll., UK; Royal Coll. of Art, London; Colarossi's, Paris. He exhibited with the NSW Society of Artists from c. 1940, his landscapes showing something of the transition from the Australian impressionist style of the 1930s to the more firmly

structured work of the Sydney school in the post-war years. He also painted a number of decorative panels, concentrating on the formal placement of figures. He worked as a freelance commercial artist before joining the staff of the *Sydney Morning Herald* as an illustrator. The formal style of his painting extended to his newspaper illustrations which thereby gained considerable distinction. His work appeared in the Bicentennial exhibition *The Great Australian Art Exhibition.*

AWARDS: Sulman Prize, 1938; Wynne Prize, 1951.

MEERTENS, *Victor*

(b. 1955, Seymour, Vic.) Sculptor.
STUDIES: Dip. of Art (painting), RMIT, 1977–79; Grad. Dip. of Fine Art, VCA, 1984. He held six solo exhibitions of sculpture, 1985–92, including at 75 Arden St; City Gallery, Melbourne; Deakin Uni., Geelong.

MEESON, *Dora*

(b. 7/8/1869, Melbourne; d. 1955) Painter.
STUDIES: Slade School (with Henry Tonks), London; NGV School; Julian's (with Jean Paul Laurens and Benjamin Constant), Paris. Best known for her paintings of the River Thames, and of landscapes and coastal views, she exhibited at the RA and at the Old Salon, Paris, 1899, as well as in Australia. Married to painter George Coates (q.v.) in England in 1903; they lived in England and Paris until 1921 both illustrating for the *Encyclopaedia Britannica*. They revisited Australia several times including in 1921 for a year and held several successful exhibitions in various capital cities. They returned to London and held regular exhibitions, and obtained painting commissions until their deaths (George Coates in 1930; Dora Meeson, 1955). She was the first Australian woman member elected to the Royal Inst. of Painters, 1919. Jim Alexander

Dora Meeson, The Pioneer's Hut, 1894, oil on canvas, 42 × 60cm. Joel's November 1992.

His large metal sculptures have appeared in a number of sculpture survey exhibitions, 1987–92, including *Australian Sculpture Triennials*, Melbourne, 1987, 90; *ICI Contemporary Art Collection*, ACCA & touring 1989; *Diversity in Contemporary Australian Art*, QAG, 1987; *Australian Biennale*, AGNSW, 1988; *A New Generation – Philip Morris Collection*, NGA, 1988. He was artist-in-residence Chameleon Artists Space, Hobart 1989.
AWARDS: Grant, VACB, 1986, 89.
REP: NGA; AGNSW; NGV; QAG; Auckland City Gallery, NZ; Monash Uni.; Uni. of Melbourne; private & corporate collections including Valentine Sands; ICI.
BIB: Catalogue essays exhibitions as above. *A&A* 23/3/1986; 24/2/1986; 26/2/1988.

Galleries, Melbourne held a joint exhibition of their work in 1984 and Meeson was represented in *A Century of Australian Women Artists 1840s–1940s* Deutscher Fine Art, Melbourne, 1993.
REP: NGV; AGNSW; QAG; AGSA; AGWA; TMAG; regional galleries at Ballarat, Bendigo and Castlemaine; AWM, Canberra (12 works); London War Museum; provincial galleries UK.
BIB: John Kroeger, *Australian Artists*, Renniks, 1968. Moore, *SAA*. E. D. Craig, *Australian Art Auction Records (1973–75)*, 1975.

MEILERTS, Ludmilla

(b. 1908, Latvia) Painter.
STUDIES: Academy of Fine Arts, Riga, Latvia, 1929–40. She travelled and painted in Europe and exhibited in Germany, 1944–47, before migrating to Australia, where her street scenes, landscapes and flower paintings done in a post-impressionist manner have gained her work great popularity.
AWARDS: Dunlop Prize, 1950; prize in competitions in Bendigo, 1951, Gosford 1971, Portland 1971, Morwell 1973.
REP: NGV; AGWA; Uni. of WA collections.
NFI

MELBOURNE ART CLUB

Moore states that Septimus Power 'first exhibited at the Melbourne Art Club at the age of seventeen', which would have made the date 1895. He makes reference also to 'the new Melbourne Art Club [which] had its beginnings in [1933]'.
BIB: Moore, SAA.
NFI

MELBOURNE CONTEMPORARY ARTISTS

(1940–c. 66) Group formed by George Bell when he seceded from the Contemporary Art Society, together with 83 other members. The Melbourne Contemporary Artists gradually settled into a conservative pattern of activity, supported mainly by past and present students of the George Bell School. Annual exhibitions were held, first at the VAS then at the Argus Gallery. The group ended, virtually, with the death of its founder in 1966.

MELBOURNE GRAPHIC ARTISTS

See MELBOURNE PRINTS

MELBOURNE PRINTS

Formed Nov. 1951, at a meeting called by Harold Freedman. About 40 Melbourne artists attended, the aim being to extend the use of RMIT printmaking facilities and thereby infuse vitality into the languishing art of local printmaking. From this came the group Melbourne Prints, foundation members being Harold Freedman, Lionel Harrington, printer, and Geoffrey Barwell, assist. lecturer. Associated with the group were: Ian Armstrong, Barbara Brash, Harry Rosengrave, Jennifer Purnell, Florence Higgs, Christine Aldor, Fred Williams, Kenneth Jack, Walter Gheradin, Fred Morgan, Allen David, Kenneth Hood. Work by seven selected members of the group was exhibited at the NGV in Sept. 1963. Over-crowding by RMIT students curtailed the activities but in 1961 the teacher of printmaking, Tate Adams, organised his students into a group making wood-block decorations for the quarterly Magazine, *Meanjin*, and continued this activity for about 12 months. Melbourne Prints was an important milestone in the story of modern printmaking in Victoria.

MELBOURNE SOCIETY OF WOMEN PAINTERS AND SCULPTORS

(Established 1909, Melbourne) Most of Victoria's leading women artists were members during the early 1900s. Annual exhibitions were held at the VAS and headquarters of the Society was the Ola Cohn Memorial Centre.
BIB: Moore, SAA. Janine Burke, *Australian Women Artists*, Greenhouse, 1980.

MELDRUM, Duncan Max

(b. 1875, Edinburgh; arr. Melb. 1889; d. 6/6/1955, Melb.) Painter.
STUDIES: NGV School (with Bernard Hall), 1892–99. He earned some money as a freelance illustrator and cartoonist contributing to Melbourne papers such as the *Champion*, a socialist weekly published 1895–96, and in 1900, as winner of the NGV Travelling Scholarship, went to Paris where he studied and copied the works of masters in the Louvre and responded to the influence of the Barbizon School painters but not to the work of the painters then laying the foundations of the great French modernist movements. The only painter of this school whose work he conceded as having great merit was J. L. Forain. He lived in Paris for 13 years, married a French woman and returned to Australia just before World War I. His philosophy of tonal painting, expressed in many writings and lectures as well as in his teaching, linked his ideas to those of the Barbizon School and brought him into direct opposition with the increasingly popular Australian impressionist school. Sales of his work brought £2000 in 1922 (his best year). His formidable ego, accompanied by a powerful spirit of dedication and gift for rhetoric, made him a storm centre of Australian painting for several decades. In 1931 he embarked on a lecture tour of the USA, and afterwards revisited Europe. The cult of Meldrumism spread throughout Australia, and its adherents became widely known as 'Meldrumites'. He was appointed a trustee of the NGV in 1937, but was deposed in a reshuffle in 1945. In an interview he said, 'If I could expunge my name from the history of Australian art, I would gladly do so tomorrow'. Apart from the many paintings of portraits and landscapes which supported his theories, Meldrum left a legacy of notable early paintings such as *Picherite's Farm, A Peasant of Pace* and the portrait of his mother, all in the NGV. He wrote *The Science of Appearances*, Shepherd Press, Sydney, 1950. A large retrospective of his work toured the state galleries in 1954 and he was represented in the Bicentennial exhibition *The Great Australian Art Exhibition*.
AWARDS: NGV Travelling Scholarship, 1899; Archibald Prize, 1939, 1940.
APPTS: President of the VAS, 1916–17, and a foundation member of the Australian Art Association.
REP: NGA; NGV; AGNSW; QAG; AGWA; AGSA; MAGNT; TMAG; many regional galleries; other public collections.
BIB: Colin Colahan, (ed.) *Max Meldrum. His Art and Views*, Alexander McCubbin, Melbourne, 1917.

James Meldrum, Grand Ziggarut, *1988, acrylic on canvas, 72cm × 72cm, Private collection.*

MELDRUM, *James Michael*

(b. 15/4/1931, Melb.) Painter, teacher.
STUDIES: Dip. of Art (painting), Swinburne Tech. Coll., Melbourne, 1945–49; Fellowship, RMIT, 1972; travel studies in UK, 1951–52; Europe (Italy and Spain), North Africa, Afghanistan, Pakistan, India, 1955–56; Japan, 1959–60; Japan, Persia, Europe, Mexico, 1969–70; Asia Minor, Japan, India, 1970–80. A lecturer at RMIT and Swinburne Tech. Coll., 1960–85, his paintings were shown first in London (Gimpel Fils) then at Kozminsky Galleries, Melbourne, 1953. His large, colourful, surrealistic canvases depicting non-functional furniture have appeared in many exhibitions. He held about 30 solo exhibitions, 1951–91, in private galleries in London, Sydney (including at Macquarie, Holdsworth), Melbourne (Pinacotheca, Charles Nodrum) and a retrospective exhibition at RMIT, 1980. Group exhibitions include *Abstract Painting in Melbourne,* RMIT gallery, 1986. He has travelled widely in Japan, Mexico, Europe, India and completed a number of mural commissions for architectural firms in Melbourne and Brisbane. Since the mid 1980s he has been based in Qld.
AWARDS: Italian Scholarship, 1955; prizes in competitions at Bendigo, 1968; Maitland, Benalla, 1970; Sulman Prize, 1971; Alice Springs Prize, 1979; Canberra Art Prize, 1979.
APPTS: Lecturing RMIT 1970s–c. 1985.
REP: NGA; regional galleries at Bendigo, Benalla, Manly, Newcastle; Alice Springs Gallery; various private collections in USA, UK, Europe and Australia.

MELLICK, *Ross*

(b. 22/1//1934, Goondiwindi, Qld) Sculptor, painter, doctor of philosophy, lecturer.
STUDIES: PhD (neurobiology), Uni. of London, 1966; no formal training in art. He held several solo exhibitions, 1962–80, including at St Martin's, London; Bonython, Sydney; Gallery A, Sydney, 1980. He participated in group exhibitions including *Sulman Prize,* AGNSW, 1978, 80, 82, 83; *Australian Perspecta,* AGNSW, 1985; a three-person show of installation sculptures at the AGNSW, 1991. His 1991 project show at the AGNSW with Noelene Lucas included the use of natural materials including hair, bamboo, wool and a demountable building, a yurt from Mongolia, to represent journeys/a place of rest/a prison. His interests are strongly towards the environment and tribal cultures. Graeme Sturgeon in *Contemporary Australian Sculpture* says 'in contrast to the logical and analytical art of the 1970s, Mellick's work returns sculpture to the irrational and the subconscious – the symbolic rather than the literal'.
APPTS: Lecturer, CAI; NSW Conservatorium of Music; Uni. of NSW.
REP: NGA; AGNSW; AGWA; several tertiary and regional gallery collections.
BIB: Catalogue essay in exhibitions as above. Germaine, *AGA.* AN Spring, 1985. A&A 23/1/1985. Sturgeon, *Contemporary Australian Sculpture,* Craftsman House, 1991.

MELLISH, *Raoul Oakeley John*

(b. 1928, Qld) Gallery director, painter.
STUDIES: St Joseph's Coll., Brisbane.
APPTS: Assist. director, Queensland Art Gallery, 1968–74; director, 1974–86. He worked in the public service until 1968, and as director of the QAG served on many committees.
AWARDS: Churchill Fellowship, 1973.

MELVILLE, *Harden Sydney*

Maritime artist on the survey voyage of HMS *Fly* and HMS *Bramble,* 1842–46. He made sketches of Australia and neighbouring islands, some published in the journal of the voyage as *Sketches in Australia and the adjacent Islands* (25 lithographic plates), London, 1849 and *The Adventures of a Griffin,* London, 1867. He also provided the majority of illustrations for (but did not accompany) Ludwig Leichhardt's expedition in *Journal of an Overland Expedition in Australia from Moreton Bay to Port Essington 1844–45* as well as showing oils at the Society of Fine Arts, Sydney 1849 and in England at the RA in 1864–65; the British Institution 1848–65 and the Society of British Artists 1848–65 (only one of those shown in London being of an Australian subject).
REP: NGA; British Museum; NLA; Mitchell Library.
BIB: Moore, *SAA.* T. Bonyhady, *Australian Colonial Paintings in the Australian National Gallery,* NGA, 1986 and *The Colonial Image: Australian Painting 1800–1880,* Sydney 1987. C. Wood, *The Dictionary of Victorian Painters* 2nd ed. Woodbridge, Suffolk, UK, 1978. Kerr, *DAA.*

MELVILLE, Henry Alfred

Artist; brother of Harden S. Melville.; teacher. Due to the similarity of their names confusion has existed as to the provenance of several works by 'H. Melville' although both signed their work as either 'H.S.' (Harden) or 'H.A.' (Henry).

BIB: Moore, SAA.

MENDELSSOHN, Joanna

(b. 18/6/1949, Hurstville, NSW) Curator, writer, critic, lecturer.

STUDIES: BA Hons, Sydney University (with Bernard Smith), 1972. She worked as curatorial assistant at the AGNSW in the 1970s with Daniel Thomas and Tony Tuckson and started writing art reviews for the university paper *Honi Soit*. She has since written art criticism and articles for a number of art journals and general press (including *A&A*; *SMH*; *Independent Monthly*). She has written several books including *The Life and Work of Sydney Long* (McGraw-Hill, 1979); and several on Lionel Lindsay including *Lionel Lindsay; an artist and his family* (Chatto & Windus, 1988). Catalogues she has written include *The Yellow House* exhibition, AGNSW, 1990.

AWARDS: Travel grant, VACB, 1980; fellowship, Literature Board, Australia Council, 1984, 86; Geraldine Pascall Prize for art criticism, 1991; George Munster Prize for Freelance Journalism, 1992.

APPTS: Curatorial assistant, AGNSW 1972–76; assistant director, Newcastle Region Art Gallery 1976–79; curator, S. H. Ervin Museum and Art Gallery, 1980; researcher, *Dictionary of Australian Artists*, University of Sydney, 1980; art critic *Bulletin* 1989– ; lecturer College of Fine Arts, University of NSW, 1990– .

MENDOZA, June

(b. Melb.) Painter.

STUDIES: Swinburne Tech. Coll., Melbourne; St Martin's School of Art, London. Daughter of pianist and composer, Dot Mendoza. A member of the Royal Society of Portrait Painters, she is best known for portraits of prominent people, notably Prince Philip and the Archbishop of Canterbury. She moved to London in the 1950s.

MENPES, Mortimer

(b. 1855, Port Adelaide, SA; d. 1938) Painter, etcher.

STUDIES: School of Design, Adelaide; London, South Kensington (with Poynter). Menpes went to London at the age of 19 and became celebrated as an etcher. An inveterate traveller, he held more exhibitions in London than any other painter of his day. Sketches of Japanese people brought him fame in 1889. He presented 50 of his copies of old masters 'to form the nucleus of a Commonwealth National Gallery'. During the 1890s he was proud to be known as the follower and devoted admirer of Whistler. He wrote a number of biographies of famous people (including *Whistler as I Knew Him*, A. & C. Black, London, 1904), illustrated many books and conducted the Menpes Press, London.

REP: TMAG.

BIB: Fred Johns, *An Australian Biographical Dictionary*, Macmillan, London, 1934.

MERCER, Mary

See COCKBURN-MERCER, Mary

MEREDITH, Lousia Ann (née Twamley)

(b. 20/7/1812, Birmingham, England; arr. Sydney 1839; d. 21/10/1895, Melb.) Botanical artist, writer. In his *European Vision and the South Pacific*, Bernard Smith cities Louisa Ann Meredith as the chief Australian representative of a new literary genre, the sentimental flower book. (The genre had spread to the English-speaking world through the English translation of Charlotte de Latour's *Le Langage des Fleurs*, 1833.) The books were well publicised and brought her wide renown. Later she wrote and illustrated more pithy commentary books on life in the colony of NSW and of an isolated bush life which have become important historical documents. Before arriving in the colonies, she had written and illustrated five books by the age of 27, written a number of articles, exhibited frequently in leading art exhibitions and was supporting herself by means of her work. She married her cousin Charles Meredith, a son of George Meredith, pioneer settler on the east coast of Van Diemen's Land. The couple went first to Sydney then to Van Diemen's Land in 1840 where they settled at Spring Vale on Oyster Bay. Here she wrote *Notes and Sketches of NSW during a residence in that colony from 1839 to 1844*; *My Home in Tasmania* 1852 and a number of others including *Over the Straits* 1856; *Some of My Bush Friends in Tasmania* 1860; *Tasmanian Friends and Foes* 1881. She had four sons, published a total of 21 books (most of which she also illustrated) and exhibited oils and watercolours at intercolonial, international and Tasmanian exhibitions until the late 1880s. The major collection of her work is with the TMAG and contains original watercolours for her books. Her work appeared in *Tasmanian Vision* TMAG and QVMAG 1988; *Shades of Light* NGA, 1988; *A Century of Australian Women Artists 1840s–1940s* Deutscher Fine Art, Melbourne, 1993.

AWARDS: Medals (for botanical drawings) at the London Exhibition, 1862; Tasmanian Government pension of £100 p.a.

REP: TMAG; QVMAG; NLA; Mitchell, Allport, Crowther, La Trobe Libraries.

BIB: Smith, EVSP. V. R. Ellis, *Louisa Anne Meredith: A Tigress in Exile*, Blubber Head Press, Hobart, 1979. ADB 5. Kerr, DAA.

MERFIELD, Bertha Elizabeth

(b. c. 1869, Melb.; d. 20/9/1921, Melb.) Painter.

STUDIES: Melbourne School (with E. Phillips Fox and Tudor St George Tucker), c. 1899. Recorded by Moore as a pioneer of mural painting in Vic., she exhibited also bush scenes, portraits, figure compositions and still-life at the VAS from 1900. The first meeting of the Arts and Crafts Society of Vic. was held in her studio.

BIB: *Lone Hand*, Sydney, July, 1920 (*An Australian Decorative Artist – Miss Bertha Merfield*). Moore, SAA.

MERIOOLA GROUP

(1945–50) Group brought together through communal life in an artists' boarding-house, Merioola, Sydney. Exhibitions were held at the Myer Gallery, Melbourne (Sept.) and David Jones Gallery, Sydney (Nov.) in 1947. Members included Friend, Sainthill, O'Brien, Ritchard, Kaiser, Jocelyn Rickards, sculptor Arthur Fleischman and the writer Harry Tatlock Miller. The group dissolved c. 1950 as various members left for Europe. Work by the Merioola painters and others was later lumped together by the critic Robert Hughes with the title 'Sydney Charm School', a name retained by other art writers. An exhibition of the group's work was held at S.H. Ervin gallery, 1986.

BIB: Robert Hughes, *Donald Friend*, Edwards & Shaw, Sydney, 1965.

MERLIN, Henry Beaufoy

(b. 1830, England; arr. Australia c. 1849; d. 1873, Sydney) Artist, photographer. By 1866 he was in Vic., photographing mainly houses (with the owners shown standing in front) and landscapes. In 1869 or 1870 he began touring the country districts of NSW with his assistant Charles Bayliss (q.v.). He visited N. Qld in 1871, Hill End and Gulgong in 1872 and Bathurst, Orange, Dubbo, Carcoar and Goulburn in 1873, photographing views of the country for Bernard Holtermann, a miner and businessman, who planned to mount a travelling exhibition. Merlin died before the exhibition was completed. He is considered one of the finest documentary photographers of his day. His work appeared in *Australian Art in the 1870s*, AGNSW, Sydney, 1976 and *Shades of Light* NGA 1988. REP: Mitchell Library (Holtermann Collection).

BIB: Keast Burke, *Gold and Silver*, Heinemann, Melbourne, 1973. Kerr, DAA. J. Cato, *The Story of the Camera in Australia*, Melbourne 1955.

MERTZ COLLECTION

(1964–66) Australian contemporary painting collection made by Kym Bonython for American connoisseur and collector Harold Mertz. The collection, comprising 200 pictures by 84 Australian painters, took nearly two years to assemble, the aim being to show representative Australian art in the USA. Mertz took it to America and launched it at a gala exhibition opening at the Corcoran Gallery, Washington DC, on 10/3/1967. A copiously illustrated catalogue contained an introduction by Richard A. Madigan, assistant director of the Corcoran Gallery, and a comprehensive text, complete with historical background and biographical notes on the artists, by Ross K. Luck of Adelaide.

BIB: Exhibition catalogue, Ross K. Luck introduction, *The Australian Painters 1964–66*, Griffin Press, Adelaide, 1966.

MERYON, Charles

(b. 1821; d. 1868) This subsequently famous French etcher visited Australia as an ensign on the French corvette *Le Rhin*. He was in Hobart, Dec. 1842–Jan. 1843, Sydney in Nov.–Dec. 1843, and Sydney again in Oct. 1845–Jan. 1846. During these visits as well as coastal sketches he made a drawing of a pet dingo, which later became an etching (*Tête de Chien de la Nouvelle Holland*), and his existing works include a portrait of an Aborigine (held in Paris), and a view of Sydney Harbour (Mitchell Library). By far the majority of his work was done in New Zealand where he was based during the 1840s and in France from 1846 and include a large number of New Zealand subjects, the South Pacific islands as well as of 19th century Paris.

REP: AGNSW; AGSA; NLA; Mitchell Library; National Art Gallery of New Zealand and a number of public and state collections in USA, Canada, Paris.

BIB: Moore, SAA. Kerr, DAA.

MESKENAS, Vladas

(b. 1916, Baku, Russian Caucasus; arr. Australia 1949) Painter.

STUDIES: Lithuania and Vienna. An outstanding contender for the 1961 Archibald Prize, in which he entered a portrait of Weaver Hawkins. Another excellent double portrait of the same sitter, with his wife, was entered for the Sulman Prize in 1963. In 1993, he came to public attention when he sued AGNSW director Edmund Capon for comments Capon had made regarding Meskenas's entry in the 1992/93 Archibald Prize. He won damages in the amount of $100 and costs, appealed by Capon. (*See also* ARCHIBALD PRIZE)

AWARDS: Rubinstein Portrait Prize, Perth, 1963; RAgSocNSW Prize, 1975.

REP: AGNSW.

BIB: *Meanjin* 1/1963, article on the Archibald Prize.

MESTON, Emily

(b. c. 1864. Vic.; d. 1914) Painter.

STUDIES: NGV School, 1885–92. Mainly a painter of portraits. Her sitters included Sir Thomas Anderson Stuart, Sir George Reid, James Ashton, MLC. Her *Study of Grapes* was bought for the AGNSW from the first exhibition of the NSW Society of Artists in 1895. It was included also in the *Exhibition of Australian Art*, Grafton Galleries, London, 1898. She was also a foundation member of the Society of Women Painters, Sydney, 1910.

REP: AGNSW; QAG.

MESZAROS, Andor

(b. 1900, Budapest, Hungary; arr. Australia 1938; d. 1972, Melb.) Sculptor.

STUDIES: Budapest, Vienna and Paris. Specialising in medallions, he was president of the Victorian Sculptors' Society (1955–56 and 1962). He designed a silver altar-piece for Canterbury Cathedral, England, and executed many commissions for large monumental works in Australia.

AWARDS: Many prizes for medallions, including a first

Bill Meyer, Through the Gap Darkly, *1984, detail of room piece, charcoal on cartridge paper, 10 × 8 × 8 × 3m. Installation, Riverina* CAE.

prize at the Madrid World Exhibition of Medallions in 1951.

REP: State galleries (medallion collections).

BIB: Kelman Semmens, *Andor Meszaros*, Hawthorn Press, Melbourne, 1972.

MESZAROS, *Michael Victor*

(b. 11/4/1945, Melbourne) Sculptor.

STUDIES: B. Arch, Uni. of Melbourne, 1967; La Scuola dell' Arte della Medaglia, Rome, 1968. Sculptor specialising in medallions. Son of Andor Meszaros. He works mainly on commission having had over 100 medallion commissions since 1970 including Bicentennial Schools & official souvenir medallions. He held about six solo exhibitions, 1970–86, largely at VAS and participated in group exhibitions with the Association of Sculptors of Vic. since 1963. His 13 major public sculptures include the large welded copper piece, *Birds*, for St James Plaza, St Kilda Road, Melbourne, 1974, and a bronze portrait statue of John Pascoe Fawkner for the Melbourne City Council, site, National Mutual Plaza, Collins Street, Melbourne.

AWARDS: Churchill Fellowship 1969; about 70 purchase prize awards, 1968– in Europe and Australia including joint winner of the French-Austra-lian Bicentenary Medal competition, 1987.

APPTS: Member, VACB, Australia Council, 1976–79.

REP: TMAG: Castlemaine Art Gallery; British Museum; Budapest National Gallery.

BIB: Ray Jewell, *Journal of the Numismatic Association of Australia*, vol. 2, 1986. Scarlett, AS.

MEYER, *Bill*

(b. 10/12/1942, Melbourne) Painter, printmaker, sculptor, film-maker.

STUDIES: BA, Uni. of Melbourne, 1974; NGV School, 1968–72; Royal Coll. of Art, London, 1972; travel studies, Israel, 1976, 89, 91; USA, 1977–78, UK, 1979; India 1984, 86. Photography and film-making have been important studies in his development. However, the photographic abstract image-making for which he first made a name in his screen-print gave way, in later work, to the rich and vigorous line drawing of natural forms. He completed many print commissions including for PCA, and held about 24 solo exhibitions, 1971–92, including at Crossley, Realities, Gretz, Melbourne; London and Europe, Victorian Arts Centre, 1986 and touring exhibition *Gapscape* to 23 regional galleries, 1982–84. He participated in numerous group exhibitions, 1971–92, including MPAC *Spring Festival of Drawing*; Henri Worland Print Prize; *Survey 4*, Geelong Art Gallery, 1982; *A View of Colour*, prints by 8 major Australian printmakers, Gryphon Gallery, Uni. of Melbourne, 1989.

AWARDS: NGV student prize for sculpture, 1972; Australian Film Inst. award for film, 1971; grants British Council 1974, 76; grant, VACB, 1982.

APPTS: Lecturer, Deakin Uni., 1981–82; guest artist, Mishkenet Shaananim, Jerusalem, 1989, 91; printmaker Port Jackson Press 1987–93.

REP: NGA; NGV; QAG; Artbank; many regional galleries and tertiary collections Vic., NSW, Qld; Tate

Gallery, London; corporate collections including ANZ; Westpac; BHP; ABC, SA.
BIB: Catalogue essays exhibitions as above. PCA, *Directory* (all edns). Germaine, AGA.

MEYNELL, Kevin
(b. 1929, Vic.; d. 1957, Vic.) Painter. Meynell, a young modernist painter of outstanding promise, was tragically killed in a car accident. A commemorative exhibition was held at the Gallery of Contemporary Art, Melbourne, 20/8/1957.

MEZAKS, Margaret
(b. 1945, Russia; arr. Australia 1949) Painter.
STUDIES: Travel studies, Europe and USA, 1972–73. Her strongly structured landscapes began to appear in VAS exhibitions in 1964.
AWARDS: W. & G. Dean Prize, VAS, 1964, 1967; Bundaberg Prize, 1969; Commendation prize, Captain Cook Bicentenary Prize for Painting, VAS, 1970; Italia Art Prize, 1971; Camberwell Rotary Club Prize, 1971 (shared).

MIDDLE PERIOD 1914–40
Name occasionally applied to Australian art of the period between the two world wars, when the art produced seemed to symbolise the general complacency of the era and the 'Fools' Paradise' that went with it. Much emphasis was given to official art, much of the art writing concerned publicity and description rather than objective analysis, and teaching in art schools was academic and uninspiring. The Mecca of the successful student was the RA, London, and the fermenting spirit among the younger and unsuccessful had not yet been given expression. The Middle Period ended with the rise of the modern schools in Sydney and Melbourne and the drastic changes brought about by the events of WWII.

MIDDLETON, Max
(b. 22/10/1922, Melbourne) Painter.
STUDIES: NGV School, 1938–42; with Harold Septimus Power, 1939–44; Heatherly's School, London 1951; School of Fine Arts, Florence, 1952. He held several exhibitions annually from 1946 including at David Jones, Sydney; Kozminsky's, Athenaeum, Five Ways, Melbourne. He conducted art classes at Camden Art Centre before running his own school in 1964–68 and paints traditional 'light' landscapes both scenic and farm, forest subjects, still life and figures. The Caulfield Arts Centre held a major exhibition of his work in 1993.
AWARDS: Prize at Tumut, 1960.
REP: QAG; regional galleries at Bendigo and Benalla.
BIB: *The Art of Max Middleton*, limited edition, 1982. Germaine, AGA.

MIDWOOD, Tom
(b. 1855, Hobart; d. 1912.) Cartoonist. William Moore relates that at one stage of his career, Midwood, caricaturist for the Tasmanian *Mail* and the *Critic*, toured America as a guitarist with a travelling musical show. During his years in Hobart, he reputedly drew every well-known person in the city as well as engraving scenes of Hobart.
REP: Van Diemen's Land Folk Museum, Hobart: collection presented by the artist's son, E. Midwood.
BIB: Moore, SAA. Mahood, *The Loaded Line*, 1973.

MILDURA SCULPTURE TRIENNIAL
Conceived and organised by the first director, Ernst van Hattum, this unique event began in 1961 as the Mildara Prize for Sculpture (in honour of the first sponsor, the Mildara Winery). What made it unique was its precedence as the first full-scale promotion of Australian contemporary sculpture to be held by any public art institution. The Mildura Arts Centre became celebrated throughout Australia because of its sculpture prize and its initiative brought great prestige to the entire Victorian regional galleries development program. The name of the prize was changed to the Mildura Prize for Sculpture in 1964, and in 1970 it became the Mildura Sculpture Triennial. (An exception was in 1975, when the triennial sequence was interrupted in support of Arts Victoria 75 and the title changed to Mildura Sculpture Exhibition.) In 1975, van Hattum's successor, Tom McCullough, introduced an additional title, *Sculpturescape*, when he extended the exhibition area to include half a square kilometre of fenced, untended land on the river flats below Rio Vista. But this ambitious project was a little ahead of its time. It was a great piece of organising and generated a lot of excitement; but its dependence on the student body and on the avant-garde, and consequently the ephemeral nature of the work shown, meant that public interest could not be sustained for anything like the full period of the exhibition. The subsequent unfortunate disagreement with the Council led to McCullough's resignation and the Triennial went through a period of crisis. McCullough's successor, Michel Sourgnes, restored the original triennial sequence which continued until its cessation in 1988.

MILGATE, Rodney Armour
(b. 30/6/1934, Kyogle, NSW) Painter, teacher, writer, actor.
STUDIES: NAS and Sydney Teachers Coll. 1952–55; BEd (art), CAI, Sydney, 1981; MA, CAI, Sydney, 1984; PhD (creative arts), Wollongong Uni. 1989; travel studies, UK and USA, 1969. Between 1956–61 he worked as a teacher at high schools, NSW, then as an actor, and from 1962–91 held about 28 exhibitions largely at Macquarie Galleries, Sydney. He has written various books including *Art Composition, A Contemporary View*, A&R, 1966, as well as approximately 20 stage plays and a novel. The ABC made a film on his work in 1983 and he participated in numerous group exhibitions including CAS exhibitions, Sydney, 1962–73; Blake Prize (approximately 20 times, 1960–1992); and at Ivan Dougherty Gallery, Uni. of NSW, 1992. He paints in muted colours, using firmly

knit, abstract designs covering the whole picture space.
AWARDS: RAgSocNSW, Fairfax Human Image Prize, 1964; Blake Prize, 1966, 75, 75 (with John Coburn, 1977); D'Arcy Morris Prize, 1970; Gold Coast Purchase Prize, 1972; residencies, Vence, France, 1978 & studio Cité International des Arts, Paris, 1978; Gosford City Art Prize, 1986; *Herald* Heritage Art Award, 1987; Mosman Art Award, 1991.
APPTS: Director of summer schools for the Arts Council (NSW Division), 1971; senior lecturer, Prahran CAE, Vic., 1970–74; art critic in Melbourne for *The Australian*, 1970– ; principal lecturer, School of Art, CAI, 1974–78; Dean, School of Visual Arts, CAI, Sydney CAE, 1982; Dean, School of postgraduate studies, CAI, 1983; Associate Professor of Art, College of Fine Arts, Uni. of NSW 1990– .
REP: NGA; AGNSW; AGWA; AGSA; MOCA, Brisbane; Artbank; many regional galleries including Geelong, Newcastle; university collections, Brisbane and Canberra; Mertz collection, USA.
BIB: Catalogue essays exhibitions as above and many texts on Australian art including all editions of Bonython, MAP; Germaine, AGA. R. Crumlin, *Images of Religion in Australian Art*, Bay Books, 1988. *The Oxford Companion to Australian Literature* OUP, 1985. *New Art Four*. A&A 4/3/1966.

MILLAR, Ronald Grenville

(b. Dec. 1927, Donald, Vic.) Painter, teacher, writer, critic.
STUDIES: No formal studies; travel studies, Europe and UK, 1975–76 and 1978–79. He began his professional life as a freelance country journalist and started painting after seeing the works of Ambrose McEvoy and Cézanne in the NGV. From 1956–80 he held 12 solo exhibitions of paintings. Conservative at first, his paintings became distinguished for their high-keyed sensuous colours – notably pink, blue, green and violet and voluptuous forms. He held around 23 solo exhibitions 1956–90 first with the VAS then largely with Realities, Melbourne and participated in around 24 group exhibitions 1959–90 including McCaughey Prize, NGV; Joseph Brown exhibitions. His books include a monograph on John Brack, (Lansdowne Press, 1970); *Civilised Magic* (Sorrett Press, 1974); and he was contributing editor to the visual arts section of *A Nation Apart* collection of essays (Longman Cheshire, 1984). He has written numerous reviews and articles for the general media, as well as lecturing and presenting papers at numerous seminars, conferences, and groups; judging exhibitions and travelling. He retired from full time lecturing in 1991, moving to country Victoria and devoting himself to painting and writing.
AWARDS: Fairley Prize for Painting, Shepparton Art Gallery, 1968; Gold Coast City Art Prize, 1970; travel grant, VACB, Australia Council, 1975; Rockhampton Prize, 1975, 1977; Swan Hill Prize, 1984.
APPTS: Master in charge of the art department at Melbourne Grammar School, 1961–73; lecturer in painting, RMIT, Melbourne, 1974–80; senior lecturer, 1981–91; Melbourne art critic, *Australian*, 1965–70;

casual critic, Melbourne *Herald*, 1965; art critic, Melbourne *Herald*, July 1981–93; lecturer for the Australia Council, Uni. of New England, 1977–78; casual radio and television art programs for the ABC.
REP: AGWA; QAG; MAGNT; regional galleries at Mornington, Horsham, Rockhampton, Shepparton, Southport; City of Waverley; Artbank; corporate collections including NAB.
BIB: AI 13/9/1969. Germaine, AGA.

MILLEN, Ronald

(b. 1922, Sydney) Painter, writer.
STUDIES: Julian Ashton School; ESTC; Europe, from 1957. Millen's painting became widely known in Australia through a work which appeared in an interstate exhibition, *Australian Contemporary Painting*, which toured the state galleries in 1955. It was called *National Landscape, Summer No. 2* and showed an original approach to problems of colour and texture. Millen held exhibitions at the Macquarie Galleries, Sydney, in 1951 and 1953, and while living at Majorca sent pictures to a joint exhibition with John Olsen at the Museum of Modern Art, Melbourne. His writings on European art, contributed to *Art and Australia* as European member of the advisory panel, from 1963, showed him as a perceptive and discriminating observer.
REP: NGA; AGNSW; AGWA.
NFI

MILLER, Charles A.

(b. 1920, Melbourne) Painter, sculptor.
STUDIES: Brighton Tech. Coll., Melbourne, 1935–37; RMIT evening classes (sculpture), 1945–55. A member of the Victorian Sculptors' Society, he contributed monumental abstract sculptures to the *Majorca Sculpture Triennial* exhibitions from 1961–70. He was president of the Victorian Sculptors' Society, 1966, and from c. 1970 has specialised in calligraphy.
BIB: Scarlett, AS.

MILLER, Everard Studley

(b. 26/10/1866, Melbourne; d. 5/7/1956). His interests included astronomy, archaeology, photography, architecture, Greek and Roman history and art. In 1956 about £200,000 was bequeathed by Everard Studley Miller to the NGV 'for the purchase of portraits painted, sculpted or engraved prior to 1800, of persons of merit in history'. As a result, the collections of Old Master portraits in the NGV were greatly enriched, additions including portraits by Rubens, Bernini, Gainsborough, Wilson, Boucher, and a large number of portrait engravings.
BIB: *Bulletin*, National Gallery Society of Vic., Feb. 1982 (Caroline Coffey, *The Everard Studley Miller Bequest*). ADB 10. (*See also* GALLERIES – NATIONAL GALLEY OF VICTORIA)

MILLER, Godfrey Clive

(b. 20/8/1893, Wellington, NZ; arr. Australia 1919; d. 10/5/1964, Paddington, Sydney) Painter.
STUDIES: Architecture, Victoria Uni., Wellington c. 1910–12, grad. 1917; Slade School, London, 1929–31,

and part-time 1933–38. Described by John Henshaw as 'anchorite, contemplative, teacher, writer, philosopher and friend' his architectural studies were interrupted by the outbreak of WWI in which, after preliminary training at Trentham, he was sent with the NZ Light Horse to Egypt, then to Gallipoli where he was badly wounded in the right arm. After convalescence in hospital at Rotorua, 1917, he completed his studies in architecture and worked with a firm on designs for the Grand Pacific Hotel, Suva. The event that changed the course of his career was his meeting with the Dunedin painter A. H. O'Keefe, who advised him to paint. The influence derived from this meeting remained with him forever. In the summer of 1919–20, after extensive travels in the Philippines, China and Japan, he moved to Vic. to settle at Warrandyte and begin his career in painting. Independent means enabled him also to spend two years studying in London, 1929–31, and after a further session in Vic., mainly in Melbourne, 1931–33, he returned to London and intermittent study at the Slade. Extensive European travels with his brother, Lewis, followed the death of their father in 1934. Using London as a headquarters, he engaged also in travels that included Greece and the Middle East, until the outbreak of WWII returned him to Australia to settle in Sydney, in comparative seclusion, at 54 Young Street. The complex influences that contributed to Miller's mature style now included, as well as his early legacies from building and architecture and his knowledge of scantling timbers, tie-rods, ceiling beams on churches and the like, the ancient art and architecture of Giza, Luxor and Karnak, as remembered from his soldiering days and the Eastern influences from his travels through the Orient in 1919. These were revived in his mind by the Chinese exhibition which he saw at Burlington House, London, in 1935. Added to these experiences were those absorbed during travels in Greece and the Mediterranean basin. He had developed an inexhaustible curiosity about the cellular composition of the universe and about all aspects of biological study, both ancient and modern. Composed of fine, ruled lines that criss-crossed the canvas from corner to corner, forming small squares, oblongs and triangles in a modified cubistic grid, touched in with monochromatic or Mediterranean colours, his paintings were an expression of the belief that the cellular secrets of the universe are contained in a drop of water, and that art is a generative and indefinable force. Invited to teach at the National Art School, Sydney, in 1945, he taught mainly by the example of developing his own concepts of drawing and talking to those students who listened. In 1957 his first exhibition at the Macquarie Galleries, Sydney (10 paintings and 9 drawings) affirmed his position in Sydney as a painter of unusual distinction. He flew to Paris in the same year but a street accident put him in hospital and frustrated his intention of a Paris exhibition. In 1959 a large retrospective show of 22 paintings and 9 drawings at the NGV extended and confirmed his Australian reputation. He revisited London in 1960 for the Picasso exhibition at the Tate Gallery, and a year later the Tate Gallery trust bought his *Triptych* from the Whitechapel exhibition of Australian art. About 1954 he had moved from his studio in a former chandler's quarters near Circular Quay to Sutherland Street, Paddington, and Paddington remained his home for the rest of his life. A large, post-humous memorial exhibition of 37 paintings was held at the Darlinghurst Galleries, Sydney, in 1965 and his work was included in the Bicentennial exhibitions *The Face of Australia* and *The Great Australian Art Exhibition*.

REP: NGA; most state galleries (the AGNSW holds 13 works); many regional galleries and other public collections hold drawings; Tate Gallery, London.

BIB: John Henshaw, *Forty Drawings by Godfrey Miller*, Edwards and Shaw, Sydney, 1962. John Henshaw, ed., *Godfrey Miller*, Darlinghurst Galleries and Ure Smith, Sydney, 1965. Gil Docking, *Two Hundred Years of New Zealand Painting*, Lansdowne, Melbourne, 1971. Alan McCulloch, *Contemporary Art in Australia*, Prisme des Arts, Paris, 15/4/1956. A&A 2/2/1964 (Alan McCulloch *In Memorium, Godfrey Miller*); 24/4/1987.

MILLER, Harry Tatlock
Writer and gallery director. Member of the Merioola Group, Sydney, and a lifelong friend of the theatre designer, Loudon Sainthill. He moved to London c. 1947, became a director of the Redfern Gallery and with Rex Nan Kivell was the first to show in London the work of Sainthill, Nolan, Friend, Annand and other contemporary Australian artists. He was editor and publisher of *Manuscripts*, Geelong, Vic., 1931–35; editor, with Sainthill, *Royal Album*, 1951, and *Undoubted Queen*, 1958, both published by Hutchinson, London.

MILLER, Max John
(b. 29/11/1940, Wellington, NSW.) Painter, printmaker and teacher.
STUDIES: Julian Ashton School, 1963–64; ESTC, 1965; etching, American School of Arizona, La Bottega, Florence, 1967; Hammersmith Coll. of Art, London, 1967–68; grad. dip. of art in painting and printmaking, St Martins, London, 1968–72. In 1978–79 he studied print and papermaking workshops in Europe and Japan. Immaculately made, his firmly structured, semi-abstract paintings and prints are subtle in form and colour, reflecting the influences of his Asian and European studies. He held solo exhibitions in St Martins College of Art, London, and the Commonwealth Institute Gallery, Edinburgh, in 1970 and held around two exhibitions annually including Sydney (Coventry; Ray Hughes; Macquarie); Melbourne (Powell St; Stanfield; David Ellis; Australian). He participated in numerous group exhibitions in public galleries including invitation print biennales in Yugoslavia, Norway, USA, made frequent trips to the outback and with Clif Pugh presented *Green as a Rainforest*, touring exhibition Hobart, Sydney and Melbourne, 1983; *Contemporary Views of New England*, New England Regional Art Museum, Armidale, 1988; *Twentieth Century Australian*

Watercolours, AGNSW, 1989. He produced prints at his own print workshop at East Kangaloon, NSW, printing editions of many leading artists including Lloyd Rees, Clifton Pugh, John Olsen, Frank Hodgkinson.
AWARDS: Phillip Musket student prize at Julian Ashton School, 1964; prizes at the RAgSocNSW, 1973, 74; Mosman Print Prize, 1976; Hamilton Watercolour Prize, Vic., 1976; AGNSW Trustees Watercolour Prize, 1977; grants, VACB, 1976 and 1978; acquisition awards at Wollongong (1979); Camden (1981, 840; Berrima (1982); Warrnambool (1983).
APPTS: Part-time teacher at ESTC and Randwick Tech. College, 1973–75; co-director, Zero Print Workshop, later known as Miller St Workshop, Sydney, 1975–76; established his own printmaking workshop, 1977.
REP: NGA; NGV; AGNSW; QAG; AGWA; AGSA; TMAG; numerous regional gallery and tertiary collections; Artbank; Parliament House; Skopje Museum of Contemporary Art, Yugoslavia; Norwegian Museum for International Contemporary Art, Fredrikstad; VACB; High Court; private collections including Philip Morris, Mobil, WA Bank.
BIB: PCA, *Directory* 1976.

MILLER, Peter Fletcher
(b. 1921, Sheffield, England; arr. Australia 1924) Realist painter; head of the art dept, Brunswick Tech. School.
STUDIES: Perth Tech. School, 1937; NGV School, 1945–48; RMIT, 1961.
AWARDS: May Day Prizes, 1955, 57.
REP: Uni. of WA collection.

MILLER, Robert Thomas
(b. 7/11/1916, Windsor, Vic.) Painter.
STUDIES: RMIT, 1933–36. In 1934 he began a long association with Australian Consolidated Industries as an industrial designer. As an exhibiting member of the VAS, and the Australian Watercolour Inst., he is well known for his large, atmospheric watercolours.
AWARDS: Over 70 awards for watercolours including Camberwell Rotary 1973, 76; VAS Artist of the Year, 1973; Bright Art Festival, four times.
REP: NGA; Bendigo Art Gallery; private collections including Suzuki Motor Co., Japan.
BIB: Campbell, AWP. Germaine, AGA. *Australian Impressionist and Realist Artists*, Roberts & Gayland, 1990.

MILLINGTON, John Douglas
(b. 12/1/1942, Sydney) Painter, printmaker, art columnist, writer.
STUDIES: NAS, 1961–66. He held about 20 solo exhibitions, 1979–91, largely in the Gold Coast area of Qld and participated in a number of group shows at private galleries and the bicentennial exhibition, *In Search of Gold*, Gold Coast City Art Gallery, 1988; and *Printmakers Exhibition*, Tweed River Regional Gallery, Murwillumbah, NSW, 1989, 90. He is author of *Tropical Visions* UQP, 1987.
AWARDS: Blue Mountains Prize, 1972; Bundaberg, 1977; St Albans (purchase), 1978, 80, 83; Ipswich,

1980, 81; Seven Hills, 1980; numerous regional prizes since 1980 including Gold Coast City Art Purchase Award, 1985; Southern Cross Prize, Ballina, 1988, 91; Heritage Festival, Stanthorpe Purchase Award, 1991.
APPTS: Teaching, NSW Education Dept schools, 1967–69; lecturer in drawing, part-time, Wollongong Tech. Coll., 1967–69; head of art dept, Blue Mountains Grammar School, 1970–73; head of art dept, Southport School, Qld, 1974–78; art columnist, *North Coast Advocate* and *Opinion* newspapers (NSW), 1979–80; *Gold Coast City Bulletin*, 1977– .
REP: Artbank; regional galleries at Gold Coast, Tweed Heads, Stanthorpe, Cloncurry civic collection; private collections including BHP; a number of secondary schools collections.
BIB: Germaine, AGA.

MILLWARD, Clement
(b. 20/11/1929, Melbourne) Painter, teacher.
STUDIES: (evening classes) ESTC, 1945–47; Julian Ashton's, 1948–49 (evening classes), 1950 (full-time); Nicolae Grigorescu Inst. of Plastic Arts, Bucharest, 1951–55. He accepted a scholarship to Romania while attending a youth festival in East Berlin, 1951, returned to Australia in 1956 and worked as a labourer on the Sydney waterfront until 1960, when he began teaching. His romanticised landscape paintings include the deployment of techniques such as pouring, staining and speckling.
AWARDS: Prizes at Rockdale, Harden, Murrumburrah, Campbelltown (all 1972); Cowra, Grenfell, Miranda, Leichhardt, Blackheath (1973); Wynne Prize, Sydney, 1973; Grenfell, 1974.
APPTS: Teaching, NAS, 1961–65; travelling tutor, Arts Council (NSW Division), 1963–70; teacher, Kogarah, 1966–68; teacher, Wollongong, 1969–71; and from 1972 senior head teacher, Hornsby Tech. Coll.
REP: AGNSW; MAGNT; QAG; regional galleries at Gold Coast, Manly, Rockhampton.
BIB: Germaine AGA. John Henshaw, *Clem Millward*, Australian Artist Editions, 1993.

MILOJEVIC, Milan
(b. 1964, Hobart, Tas.) Printmaker, teacher.
STUDIES: Tas. School of Art, 1972–75; apprenticed as master printer, Landfall Press, Chicago, USA, with support of a VACB grant, 1977–79; Peter Milton Summer School of Etching, 1982. He held solo exhibitions at the Art Poster Gallery, Hobart, 1984, and in the Australian Visual Arts Gallery, Sydney, 1984. He participated in numerous group shows from 1979 including at Cadaques, Spain, 1985; ACP travelling show to Canada, and USA, 1984; Brazil, South America and Lodz, Poland, 1985; PCA Show to USA, 1985; *Outgrowing Assimilation*, Uni. of Tas., Arts Centre, 1988.
AWARDS: Grants, VACB, 1976, 86; QVMAG Prize, 1980; DAAD, Federal Republic of Germany grant, 1985; Henri Worland Print Award, 1987.
APPTS: Guest lecturer, Adelaide Coll. of the Arts and Education, 1980; tutor, Tas. School of Art Summer Schools, 1979, 81; tutor in printmaking, Tas. School

of Art; commissions, Royal Hobart Hospital, 1986 and Launceston Community Coll., 1988.
REP: Artbank; Parliament House.

MILPURRURRU, George
(b. 1934, NT) Bark painter. A member of the Gurrumba Gurrumba clan from Central Arnhem Land near Ramangining and a member of the Ganalbingu language group. A prolific painter, Milpurrurru lives a traditional Aboriginal lifestyle within a bush environment and is an important leader in his community's secular life. Mortuary rites, hunting and gathering expeditions and the ancestral figures of his people are common themes in his work. He participated in numerous group exhibitions including *Aboriginal and Melanesian Art*, AGNSW, 1973; *The Art of Black Australia*, Aboriginal Arts Board, 1976; *Art of the First Australians*, Australian Exhibit Organisation, Canada, 1976; *Exhibition of Aboriginal Art of North Australia*, Aboriginal Arts Board, 1977; *Biennale of Sydney*, AGNSW, 1979; *Aboriginal Art at the Top*, MAGNT, 1982; NGA, 1989; the Bicentennial exhibition *The Great Australian Art Exhibition*. He was the first Aboriginal artist to be accorded a solo exhibition at the NGA in 1993.
REP: NGA; MAGNT; AGSA; Australian Embassy, Paris.

MINCHAM, Jeffery Dean
(b. 26/2/1950, Milang, SA) Painter, ceramic artist, teacher.
STUDIES: Art teacher training, Western Teachers Coll., 1970–72; post grad. studies (ceramics), Advanced Diploma of Teaching, SASA, 1973; postgrad. studies, Tas. School of Art, 1974. A prolific ceramicist he held 39 solo exhibitions 1976–1991, in private galleries including Blackfriars 1978, 79, Australian Craftworks, 1984, BMG, 1988, 90, Sydney; Distelfink, 1983, Realities, 1985, 87, 88, 91 Melbourne; and at the Jam Factory, Adelaide 1976, 80, 90 and in numerous regional and private galleries. He participated in numerous group exhibitions, 1973–1991, including *Australian Crafts*, Meat Market, 1981, 82, 83, 84; and numerous touring exhibitions of Australian crafts to Japan, USA, Europe and UK.
AWARDS: Grants VACB, 1973, 77, 82; SA Government, 1987; and VACB, 1989; fellowship, VACB, 1990; about 12 pottery awards, 1976–90, including Mayfair Ceramic Award, 1982, 84; Fletcher Challenge Award, Auckland, NZ, 1989.
APPTS: Part-time lecturer various tertiary institutions including SASA, 1975, 78; Murray Park CAE, 1979; SA School of Design, 1988, 89;
REP: NGA; AGNSW; AGWA; NGV; QVMAG; MAGNT; Artbank; Parliament House; Meat Market; and over 24 regional, municipal and tertiary collections in each state; Robert Holmes à Court and several other corporate collections.
BIB: N. Ioannou, *Ceramics in SA 1936–86*, Wakefield Press, 1988. P. Dormer, *The New Ceramics: Trends and Traditions*, Thames and Hudson. J. Mansfield, *The Collectors Guide to Modern Australian Ceramics*, Craftsman House. *New Art Four*.

MINCHIN, Richard Ernest
(b. 5/3/1831, Tipperary, Ireland; arr Adelaide 1851; d. 4/1/1893, Mt Barker, SA) Painter, draughtsman, zoo director. A draughtsman at the Land Office in Adelaide from 1859 and drawing master at a boys school in Adelaide he produced watercolours which often won prizes at the SA Society for the Arts exhibitions in the 1850s–early 1870s. He visited NZ in the late 1860s exhibiting paintings of NZ subjects back in Adelaide in the 1870s and became the director of the Adelaide Zoological Gardens in 1883. His work appeared in *Graven Images in the Promised Land* AGSA 1981.
REP: AGSA; Mitchell Library.
BIB: ADB 5. Nancy Benko, *Art and Artists of South Australia*, Lidums, Adelaide, 1969. Ursula Platts, *Nineteenth Century New Zealand Artists* Christchurch, 1990. Kerr, DAA.

MINIATURES
Notable among colonial and late colonial painters of miniatures working in Australia were Richard Read, Jnr, Georgiana McCrae and Ludwig Becker. Ugo Catani made a name as a miniaturist after his return to Europe and numbered Mark Twain among his sitters, and Stella Lewis Marks became a member of the Royal Miniaturist Society, London. Others distinguished in this field include: Josiah Allen, T. B. East, George Milner Stephen, Richard H. Ramsden, Bernice Edwell, Margaret Butterworth, Gladys Laycock, Bess Norris Tait, Bessie Gibson, Ada Whiting, and Bess Golding.
BIB: Moore, SAA.

MINISTRIES for the Arts
See ARTS FUNDING

MINNS, Benjamin Edwin
(b. 1864, NSW; d. 1937) Painter, cartoonist, illustrator.
STUDIES: Sydney (with Lucien Henry, A. J. Daplyn and Julian Ashton). Minns, whose early drawings appeared in the *Sydney Mail*, was an associate of Charles Conder, who drew for the same magazine. The freshness of colour and romantic quality of Minns' watercolours was sometimes spoiled by a tendency to be careless about the definition of edges. He drew for the Sydney *Bulletin* for more than 40 years, and became known throughout Australia for his humorous outback drawings of Aborigines. Minns visited London in 1895 and contributed drawings to London *Punch*, the *Strand* and the *Bystander*.
AWARDS: Sydney Sesquicentennial prize for histor-ical painting (awarded posthumously, 1938).
REP: NGV; AGNSW; QAG; regional galleries at Bendigo, Castlemaine, Newcastle.
BIB: AA Dec. 1932 (*B. E. Minns Number*).

MINOGUE, James
(b. c. 1890; d. 1955, Melbourne) Painter, graphic artist.
STUDIES: Melbourne (with Max Meldrum). Minogue's best-known works were simple, crisp drawings of

animals. He was secretary of the Victorian Artists' Society (c. 1950–55). A memorial exhibition of his work was held at the VAS, 14/11/1955.

MISSINGHAM, Hal
(b. 8/12/1906, Claremont, WA; d. 9/4/1994) Painter, photographer, gallery director.
STUDIES: Perth, with J. W. R. Linton and A. P. Webb, 1922–26; Julian and Colarossi Académies, Paris, 1926; Central School of Arts and Crafts, London, with Meninsky and Roberts, 1926–32. An artist of wide experience and versatile talents working in varied media, he became interested in photography in 1933. The friend of many leading British artists, he visited Canada from 1927–28, where he worked as a teacher and freelance artist. He returned to Australia to live in Sydney in 1941. After war service with the AIF, 1943–45, he was a foundation member of SORA (Studio of Realist Art), Sydney, 1944, and in 1945 he succeeded Will Ashton as director of the AGNSW to enter the period of administrative work for which he is best known. He introduced enlightened policies of Australian art collecting and the international exhibitions organised by him (*French Painting Today*, 1953; *Italian Art of the Twentieth Century*, 1956; *French Tapestries*, 1956) represented outstanding contributions to contemporary Australian art development. His long administrative career (1945–71) was climaxed by his supervision of the new building extensions to the Gallery. When he reached retiring age he refused all inducements to continue with administrative work, mainly because of a long-cherished ambition 'to see Australia' in all its aspects. Operating from headquarters established in WA, his subsequent written and photographic records have been published in a number of books including *Hal Missingham Sketch Book*, Dymocks, Sydney, 1954; *My Australia*, Collins, Sydney, 1969; *Australia Close Focus*, Ure Smith, Sydney, 1970; *They Kill You in the End*, Angus & Robertson, Sydney, 1973, *Blackboys and Blackgins*, Arts Centre Press, Fremantle, 1978; *Design Focus*, Van Nostrand Reinhold, Mitcham, Vic., 1978. He was represented in the Bi-centennial exhibition *The Face of Australia*.
AWARDS: AO (Officer of the Order of Australia) conferred 1978; many honours bestowed by other countries.
APPTS: Teaching, Central School of Arts and Crafts, London; occasional teaching, Westminster School of Arts, Goldsmiths Coll. and Chelsea Polytechnic, 1933–40; director, AGNSW, 1945–71.
REP: NGA; NGV; AGNSW; QAG; MAGNT; AGWA; AGSA; TMAG.
BIB: A number of general texts on Australian art including Smith, AP.

MITCHELL, Donald C.
(b. 14/1/1930, Sydney) Painter, teacher.
STUDIES: NAS, 1946–51; Central School of Arts and Crafts, London, 1952–53; Perugia Uni., 1953–54. He designed and manufactured Australian wallpapers, and held exhibitions in private galleries including Barry

Stern, Canberra; Holdsworth and Woolloomooloo, Sydney; and in London, Perugia, and Bali.
APPTS: Head of the NAS, School of Art & Design, 1980–85; lecturing part-time, Java and Bali, 1985– .
REP: AGNSW.

MITCHELL, Harry Reuben
(b. 1906, Melbourne) Painter, cartoonist.
STUDIES: Swinburne Tech. Coll., 1920–22; NGV School, 1923–26; Bell School (with George Bell and Arnold Shore), 1930–32; with George Bell, 1948–52. Treasurer and exhibiting member of the Melbourne Contemporary Artists, he worked as a cartoonist for the *Sun News-Pictorial*, Melbourne, for many years before retiring to devote his time to painting.

MITCHELL, John Herbert
(b. 4/7/1885, Launceston, Tas.; d. c. 1954, Foster, Vic.) Pharmacist, amateur painter. He travelled in Australia and NZ over several years and for a time lived at Mount Gambier. His works are principally of historical interest and were seen in *The Colonial Eye*, AGWA, Perth, 1979.
REP: AGWA.

MITCHELL, (Sir) Thomas Livingstone
(b. 15/6/1792, Scotland; arr. Sydney 1827; d. 1855, Sydney) Explorer, artist, surveyor. Mitchell illustrated his own journals of exploration, and did many fine paintings, mostly in watercolour. His talents as a landscape painter were of great assistance to his work as a surveyor. His work appeared in *The Artist and the Patron*, AGNSW, 1988 and the Bicentennial exhibition *The Face of Australia*.
APPTS: Deputy Surveyor-General of NSW; Surveyor-General in succession to Oxley in 1828.
REP: William Dixson Gallery of the Mitchell Library, Sydney.
BIB: ADB 2. Smith, EVSP. Histories of Australia including C. M. H. Clark, *A History of Australia*, vol. 3, MUP, 1973, 1978. Kerr, DAA.

MITCHELL LIBRARY
Founded Sydney, 1907, when David Scott Mitchell bequeathed his collection of 61,000 books, manuscripts, letters, prints, engravings, paintings and miscellaneous objects, including coins, medals and other items comprising, collectively, a magnificent representation of Australiana. He left also £70,000, the income to be used for binding and for the purchase of new books. A splendid new state library building was erected in Macquarie Street and opened to the public in 1910 with the Mitchell Library situated in the north-west corner. Decorative features of the building include interior relief maps in mosaic and three large bronze doors, each containing 18 panels separately designed by sculptors Daphne Mayo, Arthur Fleischmann, Frank Lynch, E. Linegan and Ralph T. Walker. The William Dixson Library and Gallery were added to the building in 1929, further increasing the

importance of the collections, which by 1993 numbered over 500,000.

MITELMAN, Allan

(b. 6/8/1946, Poland; arr. Australia 1953) Painter, printmaker lecturer.
STUDIES: Prahran CAE, 1965–68; travel studies, Middle East and Europe, 1969–70. A lecturer at the VCA, Melbourne, since 1972, he first became known for his large prints exhibited at the Crossley Gallery, 1969. Like his paintings, the prints have a sensuous refinement of surface enlivened with accents, their quality often being complemented by evocative titles. He held annual exhibitions from 1969 including at Crossley St, Powell St, Pinacotheca, 312 Lennox St, Deutscher Brunswick St, Melbourne; Macquarie, Garry Anderson, Sydney. Group exhibitions in which he participated 1969–93 included many print surveys and graphic exhibitions, internationally and in Australia, including *East Coast Drawings*, ICA, Brisbane, 1976; *Prints and Australia: Pre-settlement to Present*, NGA, 1989; *Reference Points: A New Perspective*, QAG, 1992.
AWARDS: Geelong Print Prize, 1970; Henri Worland Print Prize, Warrnambool Art Gallery, 1972; grant, VACB, 1973; Corio Art Prize, 1974; Fremantle Arts Centre Print Prize, 1976; Wollongong Art Purchase Prize, 1976; Bathurst Art Award, 1977; fellowship, VACB, 1989.
APPTS: Lecturer, NGV School, 1972; VCA, 1973–83; senior lecturer, VCA 1983– .
REP: NGA; NGV; AGNSW; QAG; AGSA; QVMAG; Parliament House; many regional galleries including Ballarat, Geelong, Hamilton, Shepparton, Warrnambool and Newcastle; several tertiary galleries, NZ; MOMA, New York; private collections including Myer Foundation.
BIB: Catalogue essays in exhibitions as above. Bonython, *MAP* 1976, 80. Franz Kempf, *Contemporary Australian Printmakers*, Lansdowne Press, 1976. *New Art Three*. Thomas OAA 1979. Chanin, *CAP*.

MIZZI, Denis Mario

(b. 30/10/1949, NSW) Painter, installation artist, photographer, curator, gallery director.
STUDIES: Dip. Sculpture, ESTC, 1969–1971; BA (visual arts), CAI, 1979; grad. dip. (professional art studies), CAI, 1987. He held about 8 solo exhibitions, 1980–92, in private galleries including Mori, 1980, Images, 1985; First Draft, 1986, Sydney; Contemporary Art Spaces, ACT, 1988; Tin Sheds, 1989, EMR, 1990, Sydney; A. V. Gallery, Osaka, Japan, 1986; Artemisia Arte Contemporanea, Italy, 1992. He curated *Soft Attack: Artists Against Militarism*, Artspace, 1984 and since 1987 has been co-director, Camera Lucida Gallery, Sydney.
REP: AWM; Sydney Uni.; Hiroshima Peace Museum, Japan; Institute of Culture, Sao Paulo, Brazil.
BIB: McIntyre *CC*.

MODERNISM

While the term modernism is applied to a wide spectrum of cultural pursuits, in the visual arts it is identified in styles which respond and contribute to modern society, its technological progress and an underlying appreciation of modernity. Representations of modernity in Australian art have generally taken one of two broad and opposing directions. One is the expression of pessimism and despair at urbanisation and the technological change which led to the supposed imprisonment of the human soul and alienation from the natural world. The other reflects exhilaration at the scientific and technological development of the time. Albert Tucker's 1940s 'images of modern evil' expressing despair at the darker side of urban life, could be said to represent the former; Ralph Balson's portrayal of abstract scientific notions, the latter.

Modernist visual art emerged in France at the beginning of the century when the 'art of the eye' or representations based on visual evidence and culminating in French impressionism, was overtaken by various avant garde movements seeking to replace 'realism' and 'naturalism' with more abstract revelations reflecting artists 'inner visions' as determined by imagination, beliefs and intentions. Members of the modernist avant garde were regarded as trail blazers and their works as cultural constructs fundamental to the life and thought of the times, and seen even as possessing valid moral values. Modernism was represented in post–First World War Europe and the USA by many 'ism's—including cubism, fauvism, expressionism, surrealism, dadaism, abstract expressionism. Starting spasmodically, modernism finally received more orchestrated recognition in Australia in the late 1930s with the development of the Contemporary Art Societies (q.v.) in Melbourne, Sydney and Adelaide.

EARLY AUSTRALIAN MODERNISTS
Nora Simpson is often credited with having introduced modernism to Australia when she returned to Australia in 1913 bringing back reproductions of work by French painters. Such works influenced Grace Cossington Smith (whose painting *The Sock Knitter* is probably Australia's first modernist work) and Roy de Maistre. Other 1930s modernists included Roland Wakelin, Ralph Balson, Frank and Margel Hinder, Dorrit Black, Grace Crowley amd Eleonore Lange. It was characterized by an overriding passion for experimentation, innovation, invention and change which encouraged artists to devise and explore an ever greater variety of forms and technical means such as cubism's spatial relationships or expressionism's gestural brushtrokes. Modernists exploit tone, colour, shape, line, texture according to formal principles of repetition, contrast, harmony and discord. By means of composition, play, construction or pure psychic automatism they organise their inventions according to their stated or unstated individual intentions. Dorrit Black's Modern Art Centre in Sydney featured such principles as did Rah Fizelle's and Grace Crowley's art school and the 1939 exhibition at David Jones Gallery *Exhibition 1* (with a catalogue by Eleonore Lange).

During the 1940s and 50s modernism was dramatically extended by the activities of groups like the

Sydney abstractionists and Melbourne's so called 'rebels and precursors' who included Sidney Nolan and others gathering around John and Sunday Reed's home, Heide.

MID 20TH CENTURY

Modernism's capacity to be new and to change and shock diminished as the century progressed, developments in Australia following at a more leisurely pace those overseas especially New York.

Modernism's high point coincided with the development of the post-war New York School and its mentor critic, Clement Greenberg, who considered formal modernist painting to be the most authoritative representation of value in modern art. He promoted the popular idea that the work of art, if good will speak for itself and will find a receptive audience. Artists valued for challenging tradition and exploiting the unpredictable consequences of individual thought and action came to be known as the avant garde and were popularly thought to struggle unrewarded for the greater cause. They were expected to die, like the popular (not entirely true) mythology surrounding Vincent van Gogh has it, alienated and unknown. Because the modernist avant garde of the 1960s and 70s encompassed rebels, heroes and individuals promoted as being of elevated creativity, its members were mythologised as being so far in advance of the masses that alienation and misunderstanding were inevitable. Creative individuals were portrayed as god–like and selfless. Yet as Suzi Gablik asked in her 1984 book *Has Modernism Failed?* how did the lonely alienated avant garde support New York City's annual two billion dollar, highly bureaucratised art market? By the end of the 1970s Greenberg's 'autonomous art works' those in which content was completely dissolved into form were being redone or 'deconstructed' by post-modern artists and theorists intent on a better understanding of the social conditions that bred modernism. The originality and authority of such works and those who made them were challenged by a new generation intent on theory before practice. Thus the social and intellectual change which created modernism also undermined it. Some aspects of modernism in Australia are found in texts by Janine Burke, Richard Haese, Robert Hughes, Humphrey McQueen and Bernard Smith – a comprehensive history, however, is yet to be written.

BIB: Charles Harrison and Paul Wood, *Art in Theory 1900–1990: an antholgy of changing ideas*, Blackwell, Oxford, 1993. John Russell, *The Meaning of Modern Art*, Thames and Hudson, London, 1981. Suzi Gablik, *Has Modernism Failed?*, Thames and Hudson, New York, 1984. Smith, AP. Richard Haese, *Rebels and Precursors*, Viking, 1983.

JENNY ZIMMER and S. McC.

MOET & CHANDON – FELLOWSHIP; FOUNDATION
See PRIZES; TRUSTS AND FOUNDATIONS

MOFFITT, Ernest
(b. 1870, Bendigo, Vic.; d. 1899) Draughtsman, painter, musician, scholar. Moffitt was one of the second group of artists at *Charterisville* and the close friend of Lionel and Norman Lindsay. Like the Lindsays, he worked in pen-and-ink, and etching. He also showed watercolour views of Melbourne at the VAS, 1893–98. He was a member of the Cannibal Club and 'discovered' Fasoli's Café, which subsequently became a celebrated Bohemian rendezvous in Melbourne. Moffitt designed the title-page for Marshall Hall's *Hymn to Sydney*, 1897.
BIB: Lionel Lindsay, *A Consideration of the Art of Ernest Moffitt*, Atlas Press, Melbourne, 1899. AA no. 4, 1918, reference and reproduction.

MOFFLIN, Florence
See BLAKE, Florence Turner

MOGENSEN, Diana Hoddle
(b. 18/06/1929, Melbourne) Painter, printmaker.
STUDIES: BA, Uni. of Melbourne, 1953; CIT (with Noel Counihan), 1964–65; Académie de la Grande Chaumière, Paris, 1967–69; postgrad. studies (fine art), Uni. of Melbourne, 1978–80. She travelled widely including in Asia, Europe, Torres Strait Islands, Morocco, Central Australia, Tahiti, China, Egypt, Tokyo, Vietnam. The great-granddaughter of Robert Hoddle, artist and first Surveyor-General of Vic., she studied fashion-design in Paris and after visiting Canada, the USA and Mexico, directed a 'couture' business in Melbourne before encouragement from Noel Counihan induced her to turn her full attention to painting and drawing. Attracted particularly to line drawing, she developed her strong, Matisse like style during her studies in Paris. She held about 7 solo exhibitions, 1965–91, including at Australian, Niagara, and Dempsters, Melbourne and at Ararat Regional Gallery 1973. Group exhibitions include MPAC *Spring Festival of Drawing* and MPAC *Prints Acquisitive* biennales, 1985–90; *Backlash: The Australian Drawing Revival*, NGV, 1986. She has had several commissions for cover illustrations for books.
AWARDS: MPAC Spring Festival of Drawing, 1977, 1981; Sheila Kirk Award for drawing, Flinders Art Prize, 1980; Gold Coast City Art Prize, 1981; Swan Hill Print and Drawing Show Acquisition Award, 1990.
REP: NGV; several regional galleries including Gold Coast, Hamilton, Mornington, Swan Hill; La Trobe Collection, SLV; Musée Léon Dierx, Saint Denis de la Réunion.
BIB: Catalogue essays in exhibitions as above. PCA *Directory* 1988. Germaine DAWA.

MOKETARINJA, Richard
(b. 1916, Hermannsburg, NT.) Aboriginal watercolour painter. He studied with Rex Battarbee and Albert Namatjira in Alice Springs during the 1950s. He exhibited in group shows with the Collectors Gallery of Aboriginal Art, Sydney and more recently with Bloomfield Galleries, 1989.
REP: NGA; QAG; AGSA; TMAG; Bendigo regional gallery.

MOLDER, August
See SIX DIRECTIONS

MOLLISON, James
(b. 1932, Vic.) Curator, writer, gallery director.
STUDIES: Melbourne Teachers Coll. Appointed as curator of the CAAB national collections on the recommendation of the chairman, Sir Daryl Lindsay, then by the McMahon Government as director-designate, NGA, he rejected many of the old purchases made by the CAAB and established a forward-thinking policy of collecting based largely on his experience as director of Gallery A. In August 1973, this led to the acquisition of the $1.34 million *Blue Poles* by the American painter Jackson Pollock, a purchase that made Mollison's name known throughout Australia and in many other countries. Besides modernist works, his acquisitions policy included also old master paintings, drawings and sculpture, as well as Oriental and Primitive art, work by Rodin, Bourdelle, Brancusi, Malliol, Moore, Courbet, Degas, and many other famous Europeans, work by contemporary international leaders and a large body of Australian sculpture, paintings, drawings and other works relevant to the development of a great, representative, national collection. He left the NGA in 1989 to become director of the NGV. Books and catalogues he has written include *Fred Williams Etchings*, Rudy Komon Gallery, Sydney, 1968; touring exhibition catalogue *Genesis of a Gallery*, NGA, 1978.
AWARDS: AO (Order of Australia), 1992.
APPTS: Teaching with the Vic. Dept of Education; education officer, NGV, 1961–63; director, Gallery A, Melbourne, 1964–66; director, Ballarat Fine Art Gallery, 1967–68; curator and researcher, National Collection, Canberra (then controlled by the Commonwealth Art Advisory Board), 1968–71; director-designate, Australian National Gallery, 1971; director, 1977–1989; director NGV, 1989– .

MOLNAR, George
(b. 1910, Hungary; arr. Sydney 1939) Architect, cartoonist, illustrator, teacher.
STUDIES: BA, architecture, Uni. of Budapest, 1932. From his own account he became a cartoonist by accident, drawing first for the Sydney *Telegraph* then, regularly from 1953–84, for the *Sydney Morning Herald*. His cartoons differ from those of other Australian cartoonists in that they affirm his belief that a cartoon should first of all be well designed and well drawn, a belief that brings them into the category of fine art. He held solo exhibitions at Holdsworth, Sydney, 1984, 87, 89. Books of his works include *Statues*, Phoenix House, London, 1954; *Insubstantial Pageant*, Angus & Robertson, Sydney, 1959; *Postcards*, Angus & Robertson, Sydney, 1961; *Molnar at Large*, Argus & Robertson, Sydney, 1968; *Molnar 1970–76*, John Fairfax, Sydney, 1976; *Moral Tales*, Hutchinson, Melbourne, 1976.
APPTS: Lecturer in architecture, Uni. of Sydney, –1967; associate professor, Uni. of NSW, 1967– .
BIB: *A&A 2/2/1964*.

MOLVIG, Jon
(b. 27/5/1923, Newcastle, NSW; d. 15/5/1970) Brisbane. Painter, teacher.
STUDIES: ESTC (with CRT Scheme), 1947–49. His father was a Norwegian steel worker, his mother died while he was a child and he left school at 14 to earn a precarious living in Newcastle, first in a garage, then in the steel works, then, after the outbreak of WWII, in a factory making steel helmets, one of which he would later wear during army service in New Guinea and the Philippines, 1942–46. These hard beginnings left him prey to the melancholia from which he suffered all his life. After his studies in Sydney, he managed to get to England and thence to France and Norway, where he saw originals of many of the post-impressionist and expressionist paintings from which his style would later evolve. He earned his living as he went and in 1953 returned to Australia first to work at the Newcastle steel works then to spend a year on the dole.

His professional career may be said to have started when he moved to Brisbane in 1954 and began teaching at St Mary's Church Studio, Kangaroo Point. His first exhibition (Macquarie Galleries, Sydney, 1955) was followed by his portrait of Paul Beadle shown in the Archibald Prize exhibition, AGNSW, 1956, and a year later he held an exhibition at the MOMAD, Melbourne. All these won varied degrees of critical acclaim and Molvig was launched as a national figure. Chief characteristics of his work are expressionistic savagery, cubistic monumentality and superb draughtsmanship. While the interlocking of these elements is often clumsy, atonement is ever present in the vigour of the attack. An additional influence appeared as a result of a journey to Arnhem Land with the anthropologist Dr Stuart Scougall in 1962. The influence of Aboriginal bark paintings thereafter affected his painting with a haunting presence. Early in his career his work and personality attracted the interest of Rudy Komon, who was to remain his most consistent and loyal patron. His work appeared in the Bicentennial exhibitions *The Face of Australia* and *The Great Australian Art Exhibition*.
AWARDS: Lismore Prize, 1955; Rowney Drawing Prize, Melbourne, 1960; Transfield Prize, Sydney, 1961; Perth Prize, 1963; Corio Prize, Geelong, Vic., 1966; Archibald Prize, 1966; Gold Coast City Prize, 1969.
REP: NGA; NGV; AGNSW; QAG; MAGNT; AGWA; AGSA; TMAG; QVMAG; regional galleries, Geelong, Mornington, Newcastle; Uni. of Qld.
BIB: Vida Lahey, *Art in Queensland 1859–1959*, Jacaranda Press, Brisbane, 1959. B. Churcher, *Molvig: The Lost Antipodean*, Perguin, 1984. Smith, *AP. A&A 8/2/1970* (Pamela Bell, *Jon Molvig*); 16/4/1979 (John Aland, *Molvig*).

MOMONT, Marek
(b. 3/5/1940, Poland; arr. Australia 1960) Painter, graphic artist.
STUDIES: Dip. Art & Design, Prahran CAE; TTTC, Hawthorn Institute of Education. His paintings, as exhibited at the Leveson Street Gallery, 1971, emphasise

themes of sex and loneliness in a surrealistic way made stronger and more decorative in his etchings. He held about three solo exhibitions, 1971–89, in Melbourne and participated in a number of print and prize exhibitions including MPAC *Spring Festival of Drawing*, MPAC *Prints Acquisitive* and *Polish Art Exhibition*, Melbourne, 1982.

APPTS: Art teacher (including special methods lecturer, art, craft, design), Vic. Ministry of Education; Hawthorn Institute of Education, 1977–78.

REP: Warrnambool Art Gallery.

BIB: PCA, *Directory* 1976, 82, 88.

MONCRIEFF, Greg (Gregory Kenneth)

(b. 12/6/1950, Melbourne) Mainly a printmaker.

STUDIES: RMIT, 1969–73. Pop art and the photo montage are among many elements that have influenced his work. His screenprints were included in the fifth *International Print Biennale*, Cracow, 1974, and *Artists' Artists* exhibition, Sydney, 1975.

AWARDS: PCA Print Prize, 1973; Caltex Award (painting), 1973; travel grant, VACB, 1975; special projects, grant, VACB, 1975, 81; Henri Worland Print Prize, Warrnambool Art Gallery, 1978.

REP: NGA; NGV; regional galleries, Ararat, Ballarat, Shepparton, Geelong, Mornington, Warrnambool; Artbank; VACB collection; RMIT.

BIB: PCA, *Directory* 1982.

MONEY, John

(b. 1953, Melbourne) Painter.

STUDIES: Swinburne Inst. of Technology, 1970; CIT, 1971–75. He inherited his love of painting and drawing from his father, Alan Money, artist and actor. His realist drawings and paintings have a strong sense of style in which careful attention to detail in no way militates against the power of the work. As shown in Adelaide, 1980, and at Realities Gallery, Melbourne, May–June 1981, his drawings in wax crayon on scraper board place him as a draughtsman of outstanding ability.

REP: NGA; QVMAG, Launceston.

NFI

MONKHOUSE, T. S.

First instructor of painting and drawings, Working Men's College, Melbourne (RMIT), 1887. (*See* SCHOOLS, ROYAL MELBOURNE INSTITUTE OF TECHNOLOGY)

MONTAGU, Fearnleigh L.

(Active, Australia, c. 1870–80) Painter. Many of his works bear inscriptions. For example, *A Lagoon near Camden (Morning hazy)*, exhibited NSW Academy of Art, 1875, bears the additional information, 'An Artist not an Amateur . . . Presented by the Artist as a prize in the Academy's Art Union this year'. Also *Scene on the Warragamba River, NS Wales*, 'by Fearnleigh L. Montagu –1875– Price 50 gns. An Original – No Duplicate exists F.M.' He exhibited also with the VAA, 1877–78. His compositions are repetitive, often with

side and background mountains sloping to water in the middle foreground with figures fishing or enjoying the view. His work was seen in *Australian Art in the 1870s*, AGNSW, Sydney, 1976; *Joseph Brown Spring Exhibition*, Melbourne, 1971. Some pictures show him as an uneven painter.

REP: AGNSW.

MONTEATH, Fred

See CHARTERISVILLE

MONTEFIORE, E. L. (Eliezer Levi)

(b. 1820, West Indies; arr. Adelaide 1843; d. 1894, Sydney) Painter, etcher, gallery director, collector, businessman. He was in business in Melbourne by 1849 where he practised as one of the first etchers. A trustee of the NGV, 1870–71, he was also a foundation member of the Victorian Academy of Arts in 1870 where he exhibited Tahitian and NZ landscapes. He moved to Sydney in 1871 and was a founder and vice-president of the NSW Academy of Arts where he exhibited drawings on a regular basis, though styling himself an amateur. He was a trustee of the AGNSW, 1876–92, and first director, 1892–94. He was represented in *Australian Art in the 1870s*, AGNSW, Sydney, 1976.

BIB: ADB 5. Kerr, DAA.

MONTEFIORE, John

(b. 1936, Paddington, NSW) Painter.

STUDIES: Cranbrook School with Justin O'Brien; NAS, 1954–59; Byam Shaw School of Painting and Drawing, London, 1964–67, NY, 1985. His first exhibitions in Sydney (Clune Galleries 1961) were panels depicting crowds of libidinous nudes painted in Renaissance style. Subjects of later exhibitions include landscapes and Japanese-style flower and bird compositions. He held about 13 solo exhibitions, 1961–86, largely at von Bertouch, Newcastle and a retrospective at the Maitland City Art Gallery, 1980. He participated in group shows largely in the Newcastle area of NSW including with Newcastle Uni. and Maitland City Art Gallery. Commissions include altarpieces and stained glass windows for churches in NSW and a mural for the concert hall, City Hall, Newcastle. He also illustrated several books.

AWARDS: Travelling Scholarship of NSW, 1964; visiting professor studio grant, Queens Coll. NY, 1985; Muswellbrook Art Prize, 1980; Sulman Prize, 1993.

APPTS: Teacher, various art schools, NSW, 1960– including NAS, 1960–61; Newcastle CAE, 1962–64, 1975–85, 86– (now Uni. of Newcastle).

REP: AGNSW; Muswellbrook Art Gallery; Newcastle Region Art Gallery; Uni. of Newcastle.

MONTFORD, Paul Raphael

(b. 1868, London; arr. Melbourne 1923; d. 1938) Sculptor. President of the VAS, 1930–32.

STUDIES: RA School, London, 1887–91. He moved to Australia to carve the four buttress groups in granite for the Melbourne Shrine of Remembrance. He made

some notable works in bronze during his stay in Australia, namely the seated statue of Adam Lindsay Gordon for Spring Street Gardens, Melbourne, 1932, and greatly influenced the direction of Australian sculpture, partly by example and partly through his pupil-assistants, notably Lyndon Dadswell. His wife, Marion, was also a painter and sculptor.

AWARDS: Gold medal and many other prizes at RA School, London; gold medal awarded by the Royal Society of British Sculptors for the Adam Lindsay Gordon memorial, 1934.

APPTS: Modelling master at the London Polytechnic, 1898–1903.

BIB: AA Mar. 1924. Sturgeon, *DAS*. Scarlett, *AS*.

women artists of the time including Josephine Muntz-Adams and Dora Serle; her brother, Richard, and half-brother, 'Mont' (William Jnr.) Montgomery, were both artists. As well as formal training at the NGV school she studied mural painting with Napier Waller, working with him on several commissions as well as obtaining numerous solo mural commissions from the early 1930s. She started teaching in 1935 at RMIT painting school, then the architecture school from 1937–73. She started printmaking in the 1930s producing decorative aquatints, and coloured etchings. Her work was seen largely in group exhibitions with the Bell School in the 1950s and she exhibited regularly in solo exhibitions (including at Georges Gallery, 1947) then in

Anne Montgomery, Still Life, *1958, oil on cardboard, 26 × 37.7. Courtesy Eastgate Gallery.*

group or with several other artists including Edith Wall, Mary Macqueen, Maidie McGowan, and Marjorie Woolcock. Her work appeared in *The Printmakers,* Important Women Artists Gallery, Melbourne, 1978. In 1992 Eastgate Galleries, Melbourne held a retrospective exhibition which showed some strong modernist paintings, fine line work and delicate, well-composed and often lyrical watercolours. Her work appeared in *Classical Modernism: The George Bell Circle* NGV, 1992 and *A Century of Australian Women Artists 1840s–1940s* Deutscher Fine Art, Melbourne, 1993.

APPTS: Lecturer, RMIT, 1935–73.

REP: NGA; AGNSW; NGV; several regional gallery collections in Vic.; several tertiary collections including Uni. of Melbourne, Deakin.

BIB: Catalogue essays exhibitions as above. M. Eagle and J. Minchin, *The George Bell School,* 1981. Smith, *AP.*

MONTGOMERY, Anne

(b. 14/9/1908, Melbourne; d. 8/10/1991, Melbourne) Painter, printmaker, teacher.

STUDIES: NGV School, 1927–32; RMIT (mural painting with Napier Waller), 1934–35; George Bell School, 1938–39, also c. 1950; privately with J. C. A. Traill (etching); overseas travel studies, 1967. Anne Montgomery came from an artistic family. Her father, William, an artist of various media including stained glass (he ran a studio of note in the early 1900s), was a trustee of the NGV and president of the VAS; her mother, May Rowed Montgomery, painted with many

MONTGOMERY, William

(b. 1850, Newcastle-upon-Tyne, UK; arr. Melbourne 1887; d. 1927, Melbourne) Designer of stained glass, also a painter of watercolours.
STUDIES: Art School, Newcastle-upon-Tyne; South Kensington School of Art, London. He joined the London firm of stained-glass makers, Clayton and Bell, and later (1880–86), taught stained-glass design in Munich where he helped to rehabilitate local traditions in the craft. In Australia his many commissions for stained glass included the windows at Geelong Grammar School and Bathurst Cathedral. He was a foundation member of the VAS, Society president, 1912–16, and a trustee of the NGV, 1916–27. He was also a member of the War Memorial Committee. His son, William, and daughter, Anne (q.v.), both became artists. William studied at the NGV School, showed great promise as a painter and stained-glass designer but was killed in action while serving with the AIF in France in Nov. 1918.

MONTSALVAT

See JORGENSEN, Justus

MOON, Milton

(b. 29/10/1926, Melbourne) Ceramic artist, lecturer.
STUDIES: Brisbane Central Tech. Coll., 1949–51.
His ceramics have been exhibited in state capital cities since 1959 and represented in international ceramic exhibitions in the USA, Japan, England and Germany. Three pieces by him, all entitled *Wheel Thrown Form,* were included in the *Mildura Sculpture Triennial,* 1970. He held annual solo exhibitions from 1959, most capital cities including Johnstone Gallery, Brisbane; Bonython, Adelaide & Sydney; Solander, Canberra; Greenhill, Perth; Christine Abrahams, Melbourne. He participated in numerous group ceramic shows in Australia and internationally including *Contemporary Australian Ceramics* touring Australia, NZ, and USA, 1983; *First International Ceramics – 1986,* Mino, Japan, 1986. His commissions include sculptures for AGSA & SAIT and a fountain for Festival Theatre, Adelaide.
AWARDS: Churchill Fellowship for study in the USA and Europe, 1966; Myer Foundation Fellowship for study in Japan, 1974; Mayfair Ceramic Award, 1978; Member Order of Australia (AM), 1984; Advance Australia Foundation Award, 1992; Creative Arts Fellowship, Australia Council for five years, 1994–99.
APPTS: Senior pottery instructor, Central Tech. Coll., Brisbane, 1962–69; art tutor, Dept of Architecture, Qld Uni., 1967–68; senior lecturer, head of ceramics dept., SASA, 1969–75.
REP: NGA; NGV; AGNSW; QAG; AGWA; AGSA; TMAG; many regional galleries and other public collections including Parliament House, Powerhouse Museum; Artbank; many tertiary and overseas collections.
BIB: K. Hood & J. Garnsey, *Australian Pottery.* F. Bottrell, *The Artists Craftsman in Australia,* Murray Books, 1972. H. Fridemanis, *Artists and Aspects of the CAS* Boolarong, Brisbane, 1989.

MOORE, Alan

(b. 1915. Melbourne) Painter, teacher.
STUDIES: NGV School; Sydney (with J. S. Watkins). Moore served as an official war artist during WWII stationed in Europe and New Guinea, and after the war spent some years in Europe.
AWARDS: Grace Joel Prize, NGV School, 1942; Ferntree Gully Prize, 1946.
APPTS: Teacher of painting, Swinburne Tech. Coll., c. 1963– .
REP: NGV; Shepparton Art Gallery.

David Moore European migrants arriving in Sydney 1960, gelatin silver photograph. 20.2 × 30.7cm. Collection, NGA

MOORE, David

(b. 6/4/1927, Sydney) Photographer.
STUDIES: Sydney, with Max Dupain, 1948–52; travel studies, UK and Europe, c. 1950. With colleague Wesley Stacey, he helped to establish the Australian Centre for Photography, Sydney. As a photographer, he has made an important contribution to the visual arts in Australia and has held about 32 solo exhibitions, 1953–92, including Macquarie, Sydney; Museum of Modern Art, 1959, Christine Abrahams, Melbourne; and internationally including the CRA *Pilbara Project* exhibition in China, Korea and Japan, 1985. In 1988 the AGNSW held a major retrospective of his work which toured to a number of NSW regional galleries. He participated in many group exhibitions including *Australian Landscape Photographed,* AGNSW, NGV and regionals, 1986; *Australia Built,* Design Arts Board of the Australia Council; international touring exhibitions, 1982–85; the Bicentennial exhibitions *The Face of Australia* and *The Great Australian Art Exhibition; Souvenirs of Sydney,* AGNSW, 1992. His work has appeared in a number of books published 1964–92, including *Australia: Image of a Nation, 1850–1950,* Collins, 1983; *The Australian Functional Tradition,* Five Mile Press, 1987 and several monographs including *David Moore,* Richmond Hill Press, 1980.
AWARDS: New York World's Fair Special Award, 1965;

five first prizes, Pacific Photographic Fair, Melbourne, 1967; Nikon International Photographic Competition, first prize in colour section, 1971; Commonwealth award for services to professional photography, 1979; Denison Award for Architectural Photography, 1985; Honorary fellowship, Australian Institute of Professional Photography, 1989.

REP: NGA; NGV; AGNSW; AGSA; many public collections including State Library of NSW, Parliament House, Canberra, National Maritime Museum, Sydney; MOMA, New York; Smithsonian Institution, Washington, USA; corporate collections including Polaroid; Perron Group, 'Sydney; Hamersley Iron Ore, Canberra; Bibliothèque Nationale, Paris; Australian Embassy, Beijing, China.
BIB: A&A 14/1/1976 (John Williams, *David Moore*).

MOORE, Graham Hinton
(b. 1916, New Jersey, USA; arr. Australia 1920) Painter, member of the Holly Group.
STUDIES: NGV School; Swinburne Tech. Coll; privately with A. D. Colquhoun; Europe, 1958–59. Moore exhibited with the Royal Society of British Painters and the Royal Society of Portrait Painters, London.
AWARDS: Prize at Dunlop competitions, 1954; Dandenong Festival prize, 1955.

MOORE, Herbert
An architectural draughtsman, he illustrated *Links With Other Days*, book of pen-drawings of old buildings in Melbourne, C. J. Harvey & Co., Melbourne, 1927.

MOORE, John Drummond MacPherson
(b. 6/9/1888, Sydney; d. 1958) Sydney. Painter, architect.
STUDIES: Articled pupil to McCredie and Anderson, architects, 1906–12; Sydney Art School; also in classes conducted by A. W. Chapple and Norman Carter; London Polytechnic (drawing); Architectural Association School. Member of the NSW Society of Artists and Contemporary Art Society. Moore went to the USA in 1913 and after work there as an architect, moved to London in 1915 before serving with the Royal Engineers in France in WWI. Returning to Sydney via the USA in 1920, he began practising as an architect and in 1927 joined the firm of Wardell, Moore and Dowling. He also spent much time painting and became a member of the NSW Society of Artists, Australian Art Association and the Contemporary Group. His colourful, post-impressionist style paintings of Sydney and environs gained him a highly respected place in the Sydney modern movement.
AWARDS: Prize at State Theatre Art Quest, 1929.
REP: NGA; NGV; AGNSW; QAG; AGWA; AGSA; TMAG; regional galleries, Ballarat, Bendigo, Castlemaine and Newcastle; V&A Museum, London.
BIB: Moore, SAA. AA, Aug. 1923, Oct. 1933. A&A 11/4/1974 (Brian Dunlop, *John D. Moore*).

MOORE, John Stirling
(Active c. 1880–1920) Landscape and genre painter

in oils. He exhibited at the VAS, 1887–1916, while living in Wangaratta; subjects included N. Victorian landscapes, Tasmanian and coastal scenes and a Central Australian landscape. At times his work connects with the style of A. W. Eustace (q.v.).

MOORE, Kenneth
(b. 1923, Melbourne) Painter.
STUDIES: St Martin's School of Art, London, 1956– . Son of Albert Edward Moore, teacher of painting at Geelong Grammar School, Vic. He migrated to England and participated in the *Commonwealth Biennale of Abstract Art*, London, 1963. An exhibition of Moore's work was held at the Museum of Modern Art, Melbourne, 1962.
(Letter from John Offen, of Toronto, Canada, 1/11/1975)
NFI

MOORE, Mary
(b. 25/6/1957, WA) Painter, printmaker.
STUDIES: Dip. of Fine Art, Claremont Tech. Coll., 1973–75; Associateship Fine Art, WAIT, 1976–77; printmaking studies, Royal College of Art, London, 1979–80; BA (fine art), Curtin Uni. of Tech., 1991. Her work as seen in the *Moet & Chandon* touring exhibitions 1990 & 91 alludes to art history in its use of Renaissance-style profile figures and gilded frames, combined with a 'psychological portrait' of two figures. She held seven solo exhibitions 1977–91, largely in public galleries in WA including Undercroft Gallery, Uni. of WA, 1977; Fremantle Arts Centre, 1979; AGWA, 1989; and in Gallery A, Sydney, 1982, 83. She participated in around 32 group exhibitions 1978–92, including *Critics Choice*, AGWA, 1982; *Painter's Papers*, Fremantle Arts Centre, 1982; *Western Australian Paperworks*, AGWA, 1983; *Rural and Industries Bank Collection*, AGWA, 1989; *Moet & Chandon Touring Exhibition*, 1991, 92; *The Loaded Image – Satire in Contemporary Art*, AGWA, 1992.
AWARDS: Undergraduate and other prizes for drawing, 1975–77, including Rural and Industries Bank; grant for London study, WA Arts Council, 1979; grant to work with youth unemployment scheme, Maylands, WA Arts Council, 1979; Sir James Cruthers Fellowship, 1982; residency grant, Paretaio, Italy, VACB, 1983; travel grant, VACB, Italy, 1983; artists development grant, VACB, 1986; creative development fellowship, WA Dept of Arts, 1989.
APPTS: Part-time lecturer, Fremantle Tech. Coll., 1977–79, Applecross Special Art Course, 1977–79, Child Care Certificate Course, 1978–79, Rocky Bay Village, 1981; part-time lecturer, School of Art and Design, WAIT, 1981–83; part-time lecturer, drawing, Curtin Uni. of Tech., 1987; part-time tutor, printmaking, Curtin Uni. of Tech., 1988– .
REP: AGWA: Uni. of WA; Curtin University; Edith Cowan Uni. and in corporate collections including Rural & Industries Bank; Robert Holmes à Court collections.
BIB: Catalogue essays exhibitions as above. Murray Mason

(ed.), *Contemporary Western Australian Painters and Printmakers*, Fremantle Arts Centre Press, 1979. Ted Snell (ed.) *The Painted Image: Western Australian Art No: 1*, Curtin Uni. of Technology, WA, 1990. A&A 16/4/1979; 19/4/1982.

MOORE, Robert
(b. 1964, Brisbane) Sculptor, painter.
STUDIES: Dip. of Visual Arts (major in sculpture), Darling Downs Inst. of Advanced Education. He held 4 solo exhibitions, 1988–91, all at Ray Hughes Gallery, Sydney, and participated in numerous group exhibitions, 1985–91 including at Ray Hughes, 1987, 89, 90, 91, Sydney; *Fourth Australian Sculpture Triennial*, NGV, 1990 and *Twenty Australian Artists*, Galleria San Vidal, Venice, QAG and Benalla Regional Art Gallery, 1990.
REP: NGA; NGV; MCA, Brisbane; Centre Gallery, Gold Coast; Ipswich Regional Art Gallery and Holmes à Court Collection.

MOORE, Ross
(b. 1954, Broken Hill, NSW) Painter, writer. No formal training. He participated in group exhibitions at Australian Galleries, 1977, Gallery Art Naive, 1978, Powell St Graphics, 1985, Melbourne and Greenhill Galleries, Adelaide Festival of the Arts, 1978. Author of a book on naive painter Sam Byrne, he also exhibited with Powell St Gallery, Melbourne in the 1980s and in 1993 showed some paintings on the subject of homosexuality at Melbourne's Linden gallery.
AWARDS: Young writer's fellowship, Literature Board of the Australia Council, 1979.
REP: Swan Hill Regional Gallery.
BIB: Bianca McCullough, *Australian Naive Painters*, Hill of Content, Melbourne, 1976.

MOORE, William
(b. 11/6/1868, Bendigo; d. 1937) Art critic, historian, author of the first comprehensive study of Australian art, art and drama critic for the Melbourne *Herald*, 1905–12. His life's work, The Story of Australian Art, began with an article, Beginnings of Art in Victoria, written for the Melbourne *Herald* in 1905. Other articles, 'City Sketches', 'Studio Sketches', 'Glimpses of Melbourne Studio Life', written in 1906, continued the series and formed the basis of material gathered over a period of 30 years. The two volumes which resulted (*The Story of Australian Art*, Angus & Robertson, 1934 and reprinted several times) represented for many years the only available comprehensive information on the subject of Australian art, and formed the basis of reference for all subsequent studies. Moore was in London in 1912 and served in the British Army Service Corps in WWI. He organised play readings of Australian plays in London (c. 1916–18), wrote several one-act plays and appeared in a play, *Hardy's Dynasts*, produced by the Berker-Vedrenne company at Royal Court, London. He married a New Zealand poet, Dora Wilcox, in London, about 1922. On his return to Australia he joined the staff of the Sydney *Daily Telegraph*. He was also a reg-ular contributor to the Brisbane *Courier*. A portrait of Moore, by George Coates, is in the NLA.
AWARDS: NSW Society of Artists' medal, 1934.
BIB: Most books on Australian art history notably Smith, AP. A&A 19/4/1982.

MOORE-JONES, Horace Millichamp
(b. 1868, Malvern Wells, England; d. 1922, Hamilton, NZ) Painter, draughtsman.
STUDIES: Sydney and London. He was a council member of the Art Society of NSW from about 1890, exhibiting portraits, literary genre and landscapes. His wife was also a professional artist and they exhibited together and conducted joint art classes until c. 1906 when they appear to have left Sydney, possibly for London. He served with the ANZACS at Gallipoli where he made the series of topographical drawings acquired for the AWM after the war. He died while helping guests escape from a fire at the Hamilton Hotel, NZ.
REP: AWM.
BIB: Brian Sherrif, *Old New Zealand Artists*, Te Anau Press, NZ, n.d.

MOORFIELD, John H.
(d. 1945) Sculptor.
STUDIES: Sydney, with Rayner Hoff. Pupil assistant to Hoff during his work on the Anzac Memorial for Hyde Park, Sydney, c. 1930. Moorfield completed the King George V Memorial, Parkes Place, Canberra, 1937, from the design by Rayner Hoff, who died before completing the work.

MOORHEAD, Tim
(b. 1943, Penna, USA; arr. Australia 1968) Painter, ceramicist, lecturer.
STUDIES: Highland Uni., New Mexico, 1961–63; Santa Anna Coll., 1964; Santa Monica Coll., Cal., 1965; BA, California State Coll., 1965–68; MA, Gippsland IAE, 1984–86. His Pop-style work reflects his training in the USA. He held about 18 solo exhibitions, 1966–86 including at Los Angeles, 1966, 67; Hawthorn City Gallery, 1971; Sydney (Clive Parry; Macquarie); Melbourne (Distelfink); Adelaide (Jam Factory; Bonython); Canberra (ANU; Solander) and participated in numerous group shows including at Wollongong City Gallery, 1982; Narek Gallery, ACT, 1982; Adelaide Festival, 1986; NGA, 1987; World Craft Centre, Sydney, 1988; Powerhouse Museum, 1988; Albury Regional Gallery, 1988.
APPTS: Lecturer, Prahran CAE, 1969–72, head of fine arts, 1972–73; education officer in charge Crafts Dept, Dept of Further Education SA, 1973–74; creative arts fellow, ANU, Canberra, 1977–79; education officer, Crafts Council of Australia, 1979–81; part-time lecturer, Canberra CAE, 1979; art critic, *Canberra Times*, 1979; part-time lecturer, RMIT, 1982, CSA, Canberra, Bega, NSW, 1984, Gippsland IAE, PIT, Riverina Murray Institute Higher Education, 1985; head, Centre for Visual Arts, 1987– .
REP: NGA; NGV; AGSA.

MORA, Georges

(b. Paris; arr. Australia 1951; d. 1992, Melb.) Gallery director, restaurateur, patron of the arts. Married to artist Caroline Williams (q.v.), with his first wife, Mirka Mora (q.v.), he established the Mirka Gallery, Collins Street East, in 1953, as a headquarters of the revived Contemporary Art Society, and in 1955 moved this headquarters to a coffee-shop which he established in Russell Street, Melbourne. He subsequently conducted the Balzac restaurant in East Melbourne, for which he commissioned a mural from the Annandale Imitation Realists, and in 1967 started the Tolarno Galleries adjoining a new bistro and restaurant conducted by him at 42 Fitzroy Street, St Kilda. The gallery moved to new premises in River Street, South Yarra, in 1980 and his son, William, was a partner in the gallery from 1980–87 before opening his own gallery. Many of the exhibitions at Tolarno Galleries were of top international standard, particularly in respect to the work of modern French masters, the exhibitions of which made Mora a valuable emissary of French art in Australia. Following Mora's death in 1992 Tolarno Galleries continued under the directorship of Jan Minchin, moving to new premises in 1993. Mora's collection of paintings was sold by Christie's in 1993.
APPTS: Vice-president of the Council of the Museum of Modern Art and Design; president of the Contemporary Art Society, Victoria, 1956–60. A gallery was named after him at the new Museum of Modern Art, Heide, and the Australian Commercial Gallery Directors Council established a lecture series in his name in conjunction with the Aust. Contemporary Art Fair (q.v.).
(*See also* GALLERIES-COMMERCIAL)

MORA, Mirka Madeleine

(b. 1928, Paris; arr. Australia 1951) Painter, doll-maker, embroiderer.
STUDIES: Jean Vilar and J. L. Barrault School of Theatre, Paris, 1945–47; self-taught 'for fun and art'. A vivacious protagonist for the cause of modern art, specifically that centred around the early activities of the Contemporary Art Society and Museum of Modern Art and Design, Melbourne. In the best of her work, which is done mostly in black-and-white, a certain Chagall-like *joie de vivre* is mingled with the decorative qualities found in folk and child art. Her voluminous output of paintings, drawings, designs, etc., include designs painted on trams and refrigerators, murals and soft sculptures (dolls). She has conducted many highly popular workshops around Australian schools and CAE classes and held many solo exhibitions since 1956 including at Tolarno, Melbourne and in her son William Mora's gallery since 1987. A book on her work was published in 1980 by Macmillan, Melbourne. She was represented in the Bicentennial exhibition *The Face of Australia* and was a participant in the group work *Tympan* commissioned by Marianne Baillieu for Realities Gallery which was purchased by the QAG in 1992. Her colourful murals remain as an integral part of the character of the Tolarno restaurant, Melbourne.
REP: NGA; NGV; various regional galleries; Uni. of Qld collection.
BIB: Barrie Reid, editor, *Modern Australian Art*, MOMAD, Melbourne, 1958. McKenzie, DIA. Elwyn Lynn, *Australian Drawings*, Longmans, 1963. Geoffrey Dutton and Max Harris, *The Vital Decade*, Sun Books, 1968. F. Bottrell, *The Artists Craftsman in Australia*, Murray Books, 1972. Germaine, AGA.

MORANT, George

(b. 1934, Qld) Prospector turned painter.
STUDIES: No formal training. He worked on wheat and sheep properties in the Riverina before turning to prospecting for tin and gold in the Northern Territory and, in 1964, for opals at Lightning Ridge. Influenced by Aboriginal bark paintings, he began painting seriously in 1973 and participated in about 12 exhibitions, 1975–92, including at Russell Davis, 1975, Warehouse, 1977, *Georges Invitation Art Prize*, 1978, Melbourne; Holdsworth, 1979, 80, 84, 86, 92, Sydney; Community Arts Centre, 1980, 81, 83, Brisbane. His work has primitive vigour and simplicity. It is figurative, painted in bright, flat colours, and often attains originality of design.

MORCOM, Verdon Langford

(b. 8/12/1926, Kew, Vic.) Painter, graphic and advertising artist.
STUDIES: RMIT, 1943–46, where he won prizes and a one-year scholarship. From 1952–54 he travelled in Europe and worked for one year as artist with *News Chronicle*, London. Morcom's paintings and graphic art have appeared mostly in the group exhibitions of the Melbourne Contemporary Artists and Melbourne Graphic Artists (c. 1960–64).
REP: AGWA.

MORGAN, Glenn William

(b. 22/10/1955, Warrnambool, Vic.) Painter, sculptor, printmaker.
STUDIES: Dip. of Fine Art, Warrnambool IAE, 1976; postgrad. studies (printmaking), VCA, 1978–79; Dip. Ed, Hawthorn State College, 1980. He held 7 solo exhibitions, 1983–91, at Pinacotheca 1983, 85, 87, 89, 91, Melbourne and Ray Hughes 1988, 90, Sydney. He participated in around 28 group exhibitions, 1979–91, at Pinacotheca and largely in tertiary, public galleries including *Graduation Show*, VCA, 1979; *Male Sensibility*, Heide Park and Art Gallery, 1986; *100 × 100*, PCA, 1988; *Naked City*, ACCA, 1989; *Mortality*, Canberra Contemporary Art Space, 1991.
AWARDS: Graham Brown Works on Paper Prize, VCA, 1979; Henri Worland Print Prize, Warrnambool Art Gallery, 1979, 81, 83; Tamworth Tapestry Prize, 1984.
APPTS: Art teacher, Warrnambool Technical School, 1981–84; art teacher, South West College of TAFE, Warrnambool, Vic. 1985– .
REP: NGA; Tamworth, Warrnambool regional galleries; PCA; VCA; Artbank; Australian Craft Council.
BIB: Catalogue essays exhibitions as above.

MORGAN, *James Squire*

(b. 1886, Sydney; d. 1974) Etcher, Fellow of the Royal Art Society of NSW, president, Australian Painter-Etchers' Society, 1931, member of the London Society of Graphic Arts.

STUDIES: Sydney (with Julian Ashton and Sydney Long).

REP: NGV; AGNSW.

BIB: *Art and Architecture*, Sydney, vol. 5, no. 5, 1908 (*NSW Society of Artists Exhibition*).

MORGAN, *Margaret*

(b. 30/7/1958, NSW) Painter.

STUDIES: Dip. of Art, CAI, 1980; Dip. Ed, Sydney Teachers Coll., 1981; BA (Fine Arts), SCA, 1983; independent study program, Whitney Museum of American Art, 1990. Her 1980s work included drawing, painting and installation and was largely concerned with the portrayal of women in society; her 1989 *Moet & Chandon* entry was a multi-panelled painting on the theme of love as depicted in soap operas. She held 14 solo exhibitions 1980–93 Sydney (Mori; Uni. of Sydney, 1986); Melbourne (William Mora); Drew Gallery, Canterbury, England, 1982; Jon Gerstad Gallery, NY, 1987. She participated in about 35 group exhibitions 1982–93, largely in public, tertiary galleries including *Australian Perspecta*, AGNSW, 1983, 85; *Heartland*, touring regional galleries and Ivan Dougherty Gallery, Sydney, 1985; *A New Romance*, NGA, 1987; *From Margaret Preston to Margaret Morgan*, AGWA, 1988; *Moet & Chandon Art Fellowship*, 1989, 91; *At Least It's Gone to a Good Home, Women's Patronage of Australian Women Artists 1970–1991*, Tin Sheds, 1991 and several shows in the US since 1990. She was artist-in-residence, Canberra School of Art 1989 and received a mural commission for Woolloomooloo Housing Commission.

AWARDS: Travelling Art Prize, Uni. of NSW, 1981; residency, Cité Internationale des Arts, Paris, Power Institute, Uni. of Sydney, 1982; project grant, VACB, 1982, 83; Dyason Bequest, AGNSW, 1982; residency, Greene St Studio, NY, VACB, 1987; residency, Moya Dyring Studio, Cité Internationale des Arts, Paris, AGNSW, 1991.

APPTS: Tutor & lecturer tertiary colleges 1985 – including Uni. of Western Sydney, SCA, Leichhardt Community Arts Centre; guest lecturer at a number of tertiary and general public institutions, 1984–89, including Ivan Dougherty Gallery, 1985, *Sydney Biennale*, 1986 and at SCA, Uni. of Western Sydney, RMIT, Canberra Institute of the Arts.

REP: NGA; NGV; AGWA; Artbank; Griffith Uni. and universities of NSW, Qld; Myer Foundation, Melbourne.

BIB: Catalogue essays in public exhibitions as above. McIntyre, *ACD*. Germaine, *AGA*. Smith, *AP*. *A&A* 23/2/1985; 27/4/1990.

MORGAN, *Sally*

(b. 1951, Perth) Writer, painter, printmaker.

STUDIES: BA, Uni. of WA, 1974; postgrad. dip. (counselling psychology), WAIT (now Curtin Uni.), 1975; postgrad. dip. (computing and library skills), WAIT, 1976. Drawing from an early age, she drew inspira-

tion from her distant relative Solomon Cocky, who drew his ancestral stories incessantly on paper. Her 1987 autobiography tracing her Aboriginal heritage, *My Place*, Fremantle Arts Centre Press, Fremantle won many awards. Her colourful, blocked prints and drawings have since become well-known through over 20 solo exhibitions, 1989–93, including at Birukmarri Gallery, Fremantle, 1989; Chapman, Canberra, 1989; Wenniger Graphics, Boston, USA, 1989, 92; Framed Gallery, Darwin, 1989; Cooee Gallery, Sydney, 1989; Rebecca Hossack Gallery, London, 1990; Painters Gallery, Sydney, 1990; Caulfield Arts Complex, 1993. She participated in numerous group exhibitions, 1986–93, including *Aboriginal Australian Views in Posters and Prints*, PCA and touring, 1987; *Australian Perspecta: A Koori Perspective*, Artspace, Sydney, 1989; *Aboriginal Art: The Continuing Tradition*, NGA, 1989; *Contemporary Aboriginal Art – A Selection from the Robert Holmes à Court Collection*, Carpenter Center for the Visual Arts, Harvard Uni., USA, 1989; *Contemporary Australian Visions*, Hamburg Museum, Germany, 1991; *Mysterious Presence*, Jan Weiss Gallery, NY, 1992. She has also completed a number of commissions for poster designs, journal cover designs and in 1993 was commissioned by the United Nations for the Human Rights Stamp Series for which she produced *Outback*, a multi-coloured screenprint. She is also a successful playwright, having had several plays performed at festivals and other venues.

AWARDS: Human Rights and Equal Opportunities Commission Award for Literature 1987, 1989; WA Week Literary Award, 1988, 1990; Braille Book of the Year, 1988; Aberdare Arts Prize, 1989; Logan Art Award, 1990.

REP: NGA; AGNSW; AGWA; QAG; Powerhouse Museum; regional galleries at Naracoorte, Tweed River, Warrnambool; many tertiary collections including Flinders Uni., La Trobe Uni., Monash Uni., universities of Tas., Western Sydney; Artbank; Dobell Foundation; Robert Holmes à Court Collection; Christensen Fund; Parliament House, Zimbabwe; Museum of Ethnology, Osaka, Japan; Newark Museum, Newark, New Jersey, USA; Richard Kelton Foundation, Santa Monica, California, USA.

MORIARTY, *Mervyn Gregory*

(b. 28/11/1937, Brisbane) Painter, teacher.

STUDIES: Central Tech. Coll., Brisbane, and privately with Jon Molvig and Andrew Sibley. Beginning professional life as a display artist, he held his first exhibition of paintings jointly with Gordon Sheperdson in 1959, his work reflecting interest in the local scene and, increasingly, the influence of international trends such as Optical art. He established the Australian Flying Art School (Eastaus) in 1971 (see SCHOOLS). In this work he performed the invaluable service of taking art into the remote areas of northern Australia. He held annual exhibitions from 1960 in many capital cities including Bonython, Adelaide; Rudy Komon, Bridge St, Sydney; Powell St, Melbourne; Verlie Just's, Brisbane. During the 1980s he exhibited less

frequently but travelled frequently, often to outback areas of WA, SA and the NT occasionally leading small tours of artists on working trips.

AWARDS: Johnsonian Club Prize, 1962; RNAgAQ, 1963; Gold Coast (purchase), 1969; Cairns, 1969; Dalby, 1970; Cook Bicentenary, Brisbane, 1970; Ballandean Estate, 1989.

APPTS: Teacher, Brisbane Tech. Coll., 1960–63; Uni. of Qld, 1970–71 and 1974.

REP: NGA; AGNSW; QAG; Uni. of Qld; Brisbane City Gallery; Brisbane CAE; Artbank.

BIB: Betty Churcher, *Understanding Art*, Rigby, Adelaide, 1973. *A&A* 9/1/1971 (reproduction).

MORISON, George Pitt

(b. 31/8/1861, Melb.; d. 4/9/1946, Melb.) Painter. STUDIES: NGV School evening classes, 1880– ; Académie Julian, Paris, 1890–93. Like Tom Roberts he worked for a living in Melbourne in a photographic studio. He became friendly with Tom Humphrey and in his company joined the Heidelberg School painters at weekends. A legacy from his father took him to Paris (1890) where he shared a studio with the British painter, William (later Sir William) Nicholson (1872–1949). His Australian associates in Paris included Longstaff and Phillips Fox; he studied with Lefebvre and Bourguereau and went to Spain to study the work of Velazquez. The collapse of the banks and consequent loss of his income took him back to Melbourne in 1893. Returning to photography, he shared a cottage with Tudor St George Tucker at Blackburn, and renewed his acquaintance with Frederick McCubbin. He moved to WA in 1894 to manage a photographic studio at Bunbury. A period spent prospecting for gold at Coolgardie and Menzies, 1896, was followed by employment as a draughtsman in the Land and Surveys Dept, Perth, and in 1906 he was appointed assistant in the art section of the Museum and Art Gallery. Appointed Assistant in Charge, Art Collections, 1922, he became Curator in 1922 and held that post until retirement (1942). His other WA activities included participation in the Fine Arts course (?the first in Australia), Uni. of Western Australia, 1927–32, the painting of *The Foundation of Perth* for the WA Centenary celebrations (1929), and designing the centenary stamp. He was president of the WA Society of Arts in 1906, a foundation member of the Perth Society of Artists, 1932, and his naturalistic landscapes were included in most representative exhibitions of WA art of the period (including *The Colonial Eye*, AGWA, 1979; *Western Australian Artists 1920–50*, AGWA, 1980). He returned to live in Melbourne in 1945 and died there the following year.

AWARDS: Perth Centenary Prize, 1930.

REP: AGWA.

MORRELL, Richard

(b. 29/1/1809, England; arr. Fremantle 19/1/1832; d. 29/4/1863, Northam, WA) Amateur artist, builder, farmer. He followed many varied vocations, starting life as a farmer, then turned to building (of a church

in Perth, 1840) and later became a toll keeper (c. 1850). In Northam from 1855 he was a publican, a hotel owner and finally postmaster. His topographical drawing is of fine quality, a lithograph being published by J. Wilson, London, of his *View of Fremantle, Western Australia, . . . 1832*. His work was seen in *The Colonial Eye*, AGWA, 1979.

REP: AGWA; J. S. Battye Library of WA History, Perth.

BIB: AGWA *Bulletin*, vol. 1, no. 4, Nov. 1962. *National Bank Calendar*, 1974.

MORRIS, Colleen (née Zeeng)

(b. 24/2/1948, Mildura, Vic.) Painter. STUDIES: Dip. of Art, RMIT, 1967–68 with Peter Clarke and Jan Senbergs; Fellowship Dip. of Art, RMIT, 1972; Technical Teacher's Certificate, State Coll. of Vic., Hawthorn, 1970; travel studies, Indonesia, 1971; Europe and UK, 1975. She started exhibiting hard-edge paintings in Melbourne in 1970, and held about 7 exhibitions, 1970–92, all in Melbourne including at Ewing Gallery, Uni. of Melbourne, 1974; Warehouse, Powell St and Stuart Gerstman. She participated in several group exhibitions including *Artist's Artists*, NGV, 1975; *Women in Art*, Women's Electoral Lobby, 1980; *Postcards for Peace*, PND exhibition, Universal Theatre, Melbourne, 1984; Painters Gallery, Sydney, 1985.

AWARDS: Dandenong (prize for drawing), 1966; Perth International Drawing Prize (for drawing by an Australian), 1973; American Bicentennial Painting Prize, Brisbane, 1976.

APPTS: Tutor, CAE, Melbourne, 1973–75; art workshop, Horsham, painting and drawing classes, 1973; tutor in painting and printmaking, Melbourne State College, 1975–76; teacher of art, various Vic. secondary schools since 1971.

REP: AGWA; QAG; Artbank; Vic. Council for the Arts.

BIB: *Women in the Visual Arts*, Women 150 Survey catalogue. Bryony Cosgrove, *Who's Who of Australian Women*. Germaine, AGA.

MORRIS, Frank

(b. 1936, Glasgow; arr. Sydney 1948) Painter, writer. STUDIES: RMIT (part-time), 1953–56. He began painting in 1957 and started collecting material for his first book on birds in 1959. In 1964 he was commissioned to paint two dioramas for the National Museum of Vic., and in 1969 devoted all his time to painting and writing on his chosen subject. His first show was at the Australian Galleries, Collingwood, Vic., 1973 where he has exhibited regularly and is best represented. His publications include *Birds of Prey of Australia*, 1973; *Birds of the Australian Swamps*, vol. 1, 1979; Pencil *Drawings*, 1979; *Robins and Wrens of Australia*, 1979; all Lansdowne, Melbourne.

REP: NGA; QVMAG, Launceston.

MORRIS, Kent Hugh

(b. 19/4/1964, Qld) Sculptor. STUDIES: BA (Fine Art) CIT, 1984; postgrad. dip. of Art (Sculpture), VCA, 1986. He held 8 solo exhibitions

Melbourne (70 Arden St; Christine Abrahams; Luba Bilu); Irving Sculpture, 1988, Sydney; and 200 Gertrude St Melbourne, 1985 and participated in about 20 group exhibitions 1984–90, including *Sculpture '85*, World Trade Centre, Melbourne, 1985; *Ninth Mildura Sculpture Triennial*, Mildura Arts Centre, 1985; *Third Australian Sculpture Triennial*, Heide, 1987; *Proposals*, George Paton Gallery, Uni. of Melbourne, 1989, CACSA, Adelaide, Artspace, Sydney, 1990.
AWARDS: Arches-Rives Drawing Award, 1984; Desiderius Orban Youth Art Award, VACB, 1985; Queen Elizabeth II Silver Jubilee Award, 1986.
APPTS: Lecturer, CIT, 1988.
REP: NGV; MOCA, Brisbane; Heide Park and Art Gallery; VCA; City of St Kilda.
BIB: Catalogue essays exhibitions as above.

MORRIS, Robert J.
(b. 1949, Mt Barker, SA) Painter, sculptor.
STUDIES: With Betty Churcher, 1964; with Mervyn Moriarty, 1965–70; travel studies, Europe, 1986–87. He held 9 solo exhibitions, 1970–90, at Reid Gallery, 1970, 74, Ray Hughes, 1983, 85, MOCA, Brisbane, 1988; Ray Hughes, Sydney, 1986, 89, 90; Space Studio Gallery, London, 1987. He participated in many group shows including at Rudy Komon, Sydney, 1969; Georges Gallery, Melbourne, 1969; Uni. of Qld, 1985; numerous shows at Ray Hughes. International exhibitions include *Australian Fortnight* Dallas, Texas, 1986; and at MOMA, Saitama, Japan, 1987; Galleria San Vidal, Venice, 1988, 90; London Art Fair, 1989; Australian Embassy, Brussels, 1990; Marta Hewett Gallery, Cincinnati, Ohio, 1991.
REP: QAG; Gold Coast City Art Gallery; Artbank; Parliament House; Canberra Centre Gallery; Qld Uni. of Tech.
BIB: Catalogue essays exhibitions as above. Betty J. Smith, *Success Stories in Spite of Early Learning Problems* self-published, Brisbane, 1990. Germaine, AGA.

MORRISON, Alistair Ardoch
(b. 21/9/1911, Melbourne) Painter, industrial designer, commercial artist.
STUDIES: NGV School; London, 1935–39. Morrison worked as an assistant to Lazlo Moholy-Nagy in London in 1935 and brought to his work in Australia many of the avant-garde ideas of the famous Bauhaus professor.
APPTS: President, CAS, NSW, 1953.
REP: NGA: AGNSW: Powerhouse Museum: V&A Museum, London.

MORRISON, G. E. M.
Colonial artist. His only known work is a pencil portrait of Alexander Tolmer (q.v.).
REP: AGSA.
NFI

MORRISON, Joan
(b. 1911, Wrotham, Kent; arr. Tas. 1914; d. 1969) Illustrator.

STUDIES: ESTC. She began her career as an illustrator for children's pages of Tasmanian newspapers before joining *Smith's Weekly*, Sydney, 1929, to become celebrated for her drawings of girls.
BIB: Vane Lindesay, *The Inked-in Image*, Hutchinson, Melbourne, 1979.

MORROCCO, Leon Francesco
(b. 1942, Edinburgh, Scotland; arr. Melbourne 1980) Painter, teacher.
STUDIES: Duncan of Jordanstone Coll. of Art, Dundee, 1959–60; Slade School, London, 1960–61; Edinburgh Coll. of Art, 1961–64; travel studies, Italy, Greece, Turkey, 1964–65; Majorca, 1979; USA, Mexico, 1983; Europe, Japan, 1985. Sensuous, richly textured paint surfaces, high-keyed colours and careful placement of figures and objects are characteristic of his large, Bonnard-like canvases. He held annual exhibitions from 1965 first in the UK and since 1982 in Australia largely at Australian Galleries, Melbourne and Sydney. In 1992 he left Melbourne to live in London for an indefinite period.
AWARDS: Italian Government Travelling Scholarship, 1968; Guthrie Award, Royal Scottish Academy, 1970; Caulfield Arts Centre Acquisition Award, 1980.
APPTS: Lecturer, Edinburgh College of Art, 1965–68; Glasgow School of Art, 1969–79; head of dept of fine art, CIT, 1979–83.
REP: QAG; Artbank; Caulfield Arts Centre; many public collections UK including Edinburgh City collections, Bradford Art Gallery, Uni. of Liverpool, Scottish Arts Council, HRH Princess Margaret.

MORROW, Romola (née Clifton)
(b. 1935, Perth) Painter, illustrator, teacher.
STUDIES: Slade School of Art, London, 1954–55; travel studies, Europe, 1961. She held solo exhibitions at Skinner Galleries, Perth 1959–78
AWARDS: Hotchin Prize, 1956; Helena Rubinstein Portrait Prize, 1960.
APPTS: Teacher, Claremont Tech. Coll., Fremantle Arts Centre.
REP: AGWA; WAIT; QE Hospital, Perth.

MORROW, Ross
(b. 1932, Bar Beach, NSW; d. 1987) Painter, teacher.
STUDIES: NAS (with Commonwealth Art Scholarship), 1955–57; Newcastle School of Art (with John Passmore and John Beadle), 1959–60; travel studies, Europe, 1962–66; Ireland, 1965; Europe, 1984. Morrow's colourful, semi-abstract paintings of Central Australia, a subject which he studied during a tour made in 1960–61, made an impressive debut in an exhibition at the Terry Clune Galleries, Sydney. He was represented in the Whitechapel exhibition of Australian art in 1961, and selected as a competitor for the Rubinstein Scholarship in 1962. He held one and two-man shows at Gallery A, 1968, Powell St, 1969, Melbourne; Holdsworth, 1970, Sydney; Skinner, 1974, 76, Perth and participated in numerous group exhibitions including *Biennale de Paris*, 1963; *Australian*

Contemporary Painting, Japan, 1965; *11 by 7*, Manchester City Gallery, UK, 1965; *The Australian Painters 1964–66*, Corcoran Gallery, Washington DC, 1967; *Perth Prize for Drawing*, AGWA, 1962, 67, 75.
APPTS: Lecturer, Manchester Coll. of Art and Design, 1964–65; NAS, 1968–69; teacher, Arts Council of Australia (Qld Division) Summer School, Brisbane, 1967; teacher, Claremont Tech. Coll., Perth, 1972–75; Newcastle CAE, 1977–82; lecturer, CAI, 1984–.
REP: NGA; NGV; AGNSW; Newcastle Region Art Gallery; Fremantle Arts Centre; Uni. of WA; Mertz Collection; Uni. of Texas, Austin, USA.
BIB: K. Bonython, *The Australian Painters 1964–66* (*Mertz Collection*), Griffin Press, Adelaide, 1966. Smith, AP.

MORT, Eirene

(b. 1879, Sydney; d. 1977) Etcher.
STUDIES: London, at various colleges and schools, including South Kensington School of Art, Grosvenor Life School and at London County Council Central School (etching) with Luke Taylor. Returning to Sydney in 1906 she shared a studio with Nora Weston and started art teaching. Her pupils included Sydney Ure Smith to whom she taught etching. In 1912 she produced the first of a series of bookplates (she was to produce over 100 in her career) and continued printmaking until 1934 when she retired to Bowral, NSW. She was a foundation member of the Arts and Crafts Society of NSW in 1907 and of the Painter-Etchers' Society in 1920. She held her first exhibition in 1927 and illustrated various books including on wildflowers and an illuminated manuscript on the History of the Uni. of Qld in the 1950s. Some of her designs were used for the famous London *Liberty Prints* in the early 1900s. Her own competent work was in conformity with the etching fashions of the 1910–30 period. Jim Alexander Gallery, Melbourne held an exhibition of her work in 1982 with that of Dora Wilson and Alma Roach.
REP: AGNSW; NLA; Mitchell Library.
BIB: AA no. 9, 1921; no. 5, 1923.

MORTENSEN, Kevin C.

(b. 1939, Melbourne) Sculptor, teacher.
STUDIES: Melbourne Teachers Coll. and Prahran Tech. Coll. (art teaching), 1957–60; RMIT, part-time sculpture, 1962–66. From the time of his first exhibition (Argus Gallery, 1966) and the *Twenty-Four Point Plug Show* (Argus Gallery, 1967), his determination to come to grips with contemporary avant-garde problems was evident. In his three large pieces in mixed media at the 1970 *Mildura Sculpture Triennial* his absorption was with the problem of uniting sculptural form with natural phenomena, and the works he exhibited in other exhibitions, notably at the opening show of the new Pinacotheca Gallery, Richmond, included objects and materials such as wire, sand and stuffed seagulls, in an attempt to reconstruct a total environment. He received critical acclaim also for his construction in the *Mildura Sculpture Triennial* entitled *Delicatessen*. He held solo exhibitions, 1964–79, mostly at Pinacotheca

and participated in many group shows from 1964 including at NGV, 1968, 75, 79; Venice, 1988; sculpture triennials; *Australian Perspecta*, AGNSW, 1981.
AWARDS: Mildura Sculpture Triennial (work acquired), 1973, temporary works award (shared), 1975; grant, VACB, 1975.
APPTS: Lecturer (sculpture and art education), Burwood State Coll., 1971–.
REP: AGSA; Mildura Arts Centre; Burwood State College.
BIB: Sturgeon, DAS. Scarlett, AS, 1980. A&A 17/1/1979 (Graeme Sturgeon, *Kevin Mortensen Icons and Images*).

MOUNT, Nicholas (Nick)

(b. 1952, Adelaide) Painter, glass artist.
STUDIES: SASA, 1970–71; visual arts, Gippsland IAE, 1972–74. He received many commissions for trophies, display cases and lights and held 12 solo exhibitions, 1978–86, including at Robin Gibson, 1981, Macquarie, 1986, Sydney; Jam Factory, 1980, Bonython-Meadmore, 1986, Adelaide; Latrobe Valley Arts Centre, 1978, Ararat Regional Art Gallery, 1978, Distelfink, Melbourne, 1981. He participated in around 20 group shows 1979–92, including *National Contemporary Australian Glass Exhibition*, Wagga, NSW, 1981; *Contemporary Glass*, Uni. of Tas., Hobart, 1982; *Second National Ausglass Exhibition*, Jam Factory, Adelaide, 1983; *World Glass Now 1985*, Hokkaido MOMA, Sapporo, Japan, 1985; *Australian Crafts*, Meat Market Craft Centre, 1982, 83, 84, 85, 87, 88.
AWARDS: Research grant, VACB, 1980.
APPTS: Tutor in ceramics, CIT, 1976; teaching assistant Pilchuck School, Washington State, USA, 1985, 87.
REP: NGA; NGV; AGSA; QAG; Parliament House; Powerhouse Museum; Ararat, Sale, Latrobe Valley, Wagga regional galleries.
BIB: Allan Moult, *Craft in Australia*, Reed Publishing, 1984. *First International Design Yearbook*, Thames and Hudson, Europe, Abbeville Press, USA, Japan, 1985. Marie Appleton, *Made In Adelaide*, Savvas Publishing, 1987. AL, 5/5/1985.

MOYLE, T. C.

(Active c. 1865–85) Naive artist of the goldfields. His scrupulously detailed and highly keyed watercolours of mining companies' shafts and claims at Ballarat are of considerable historical interest and combine the naive's attention to content with a grasp of perspective. Like his contemporary Tibbits (q.v.), he also painted private houses, probably on commission. His work appeared in the Bicentennial exhibition *The Face of Australia*.
REP: Ballarat Fine Art Gallery; Castlemaine regional gallery; Creswick Historical Museum; La Trobe Library, Melbourne.
BIB: McCulloch, AAGR. Kerr, DAA.

MOYNIHAN, Daniel Charles

(b. 8/4/1948, Melbourne) Painter, printmaker.
STUDIES: Dip. of Art (painting and printmkaing), RMIT, 1967; travel studies, France, 1984. His large, brightly-coloured canvases showing Renaissance angels hovering in Hesperidian gardens first appeared in a

show at the Powell St Gallery, Melbourne, in 1969. Archways and fragments of Renaissance architecture gave the work a sense of scale, and the general structure and the care with which the paintings were done further showed him as an artist of individuality and inventiveness. His subject also include animals and sporting subjects, especially football. He has held annual exhibitions since 1969 including at Powell St, Melbourne: Bonython, Sydney: Roz MacAllan, Brisbane. He participated in numerous group, especially print survey exhibitions, 1967–92, including *Australian Printmaking Today*, V&A Museum, London, 1972; *Artist's Artists*, NGV, 1975; *Australian Etching Exhibition* touring all state galleries, 1978; several international print biennales in Yugoslavia, Poland, Belgium, USSR; *The City and Beyond* touring 7 regional galleries in Vic. and NSW, 1990–91.

AWARDS: Minnie Crouch Prize for Watercolours, Ballarat, 1967; acquisition prizes, Mornington 1976, 87, Box Hill, 1985, Diamond Valley, 1985, Gold Coast City, 1987; residency Power Studio, Cité Internationale des Arts, Paris, Sydney Uni., VACB, 1983; Fremantle Print Award, 1988; Kedumba Print Award, 1993.

APPTS: Lecturer at various art colleges from 1973 including Prahran, 1973–76, PIT, 1977– ; RMIT, 1993– .

REP: NGA; NGV; Artbank; Parliament House; a number of regional galleries in Vic., NSW, Qld, WA; a number of tertiary and municipal collections in several states.

BIB: Franz Kempf, *Australian Printmaking Today*, Lansdowne, 1975. PCA, *Directory* 1976, 88. Rob Steward *The Australian Football Business*, Kangaroo Press, 1983.

MPETYANE, Lindsay Bird

(b. c. 1945, NT) Traditional Aboriginal painter of the Mulga Bore area of the NT, his solo exhibitions include *Lindsay Bird, Utopia NT*, Syme-Dodson Gallery in association with Utopia Art Sydney, Sydney, 1989; *Desert Dreaming*, Nogizaka Arthall, Tokyo, 1992 and *Il Tempo del Sogno del Deserto*, regional gallery tour of Italy, 1992. His work was seen in around 20 group exhibitions, 1988–92, including *Contemporary Aboriginal Art*, Harvard University, USA, 1990; *Tagari Lia; My Family*, Third Eye Centre, Glasgow, Scotland, 1990; *Australian Aboriginal Painting*, Austral Gallery, St Louis, USA, 1992; Gallery Rai, Tokyo, 1992.

REP: NGA; QAG; AGWA; AGSA; Powerhouse Museum; Museum of Vic.; Robert Holmes à Court Collection; Allen, Allen & Hemsley.

BIB: A. Brody, *Utopia – A Picture Story*, Heytesbury Holdings, Perth, 1989. A. Brody, *Contemporary Aboriginal Art*, Heytesbury Holdings, Perth, 1990. R. Crumlin, *Aboriginal Art and Spirituality*, Collins Dove, Melbourne, 1990. M. Boulter, *The Art of Utopia*, Craftsman Press, Sydney, 1991. Caruana, AA.

MUDFORD Grant

(b. Sydney) Photographer.

STUDIES: BA Architecture, Uni. of NSW, 1963–64. Mudford worked as a commercial photographer in Sydney from 1965–74 after which he travelled to the

USA in 1974 and again in 1977. He is currently resident in Los Angeles. He held numerous solo exhibitions from 1972 at Bonython, Roslyn Oxley9, Macquarie, Sydney; Realities, Powell St, Christine Abrahams, Melbourne; and at Light Gallery, New York, 1976, 77, 79; Photographers Gallery, London, 1977; Los Angeles, 1979, 83, 84, 86 and has participated in many group shows in Australian and the USA.

AWARDS: Travel grant, VACB, 1974, 77.

REP: NGA; NGV; AGNSW; AGSA; V&A Museum, London; MOMA, NY.

MUDIE, Charles F.

(Active c. 1900–35) Late impressionist painter in oils of landscapes and coastal scenes in Vic. As C. F. Moodie he exhibited a still life at the VAS in 1901, from an address in Albert Park. The following year, as Charles F. Mudie, he exhibited landscapes. He was still painting and living in Williamstown in 1930.

MUIR AULD, James

See AULD, James Muir

MULTICULTURAL ARTS

Though pre-war Australia had small Chinese, Italian, Greek, German and other subcultures, the culture was predominantly Anglo-Celtic and the minorities, including indigenous people, were expected first to assimilate and later integrate. With the volume and acceleration of post-war immigration it gradually became clear that Australia could not maintain cultural homogeneity. 'Non-English-speaking background' (NESB) citizens began retreating into ethnic communities when their cultural expression faced policies of exclusion practised in the 1950s and 60s. For instance, overseas trained artists were required to retrain to teach art in Australia.

A generation of artists such as Judy Cassab, Ludwig and Wladyslaw Dutkiewicz, Maximilian Fuerring, Stanislaw Halpern, Sali Herman, Louis Kahan, Franz Kempf, Inge King, Eva Kubbos, Ignacio Marmol, Desiderius Orban, Jan Senbergs and Salvatore Zoffrea had arrived from Europe just before or after the war. Today it is impossible even to briefly list artists with a non-English-speaking background.

People of non-English-speaking backgrounds constitute 35 per cent of Australia's population, creating an increasing complexity of iconographies, cross-influences and background history – all of which must be considered in defining Australia's cultural identity. Perhaps the most obvious area of change has been in the reassessment of the contemporary art of Aboriginal Australians in which Western concepts of meaning may not be adequate.

It was not until the 1980s and 90s that the issues of ethnicity, cultural diversity and arts policy for a multicultural Australia were debated. Numerous conferences took place, papers were written and state and federal funding bodies established departments dealing specifically with multicultural arts.

In 1989 the National Agenda for a Multicultural Australia was launched by the Prime Minister and in 1990 a Consultative Committeee on Cultural Heritage in a Multicultural Australia was set up to prepare strategies to assist cultural institutions to reflect cultural diversity. Arts for a Multicultural Australia is an Australia Council priority – its programs offering assistance to NESB artists to consolidate and develop innovative work within Australia and overseas, to arts organisations and galleries to provide opportunities for NESB artists and projects. The status of multicultural arts in the 1990s is the subject of a 254-page report commissioned by the National Association of Visual Artists (NAVA) (q.v.) entitled *Outside the Gum Tree: The Visual Arts in Multicultural Australia 1992*. Researched by Helen Andreoni, it seeks to identify current levels of participation by NESB artists; indicate their past, present and potential contribution to Australia's cultural development and to define and exemplify the problems they face.

As can be seen from the individual artists' entries in this work, a high proportion of artists currently recognised as contributing magnificently to the culture have claim to the label 'multicultural' should they wish to assume it. Whether they choose to or not, it is certainly evident that the visual arts in Australia offer constantly changing interpretations of tradition – thus interlocking, past, present and future in the definition of cultural identity.

BIB: *AL* Autumn/Winter, 1991. *A&A* 30/3/1993 (Emigré issue).

JENNY ZIMMER

MUNDUWALAWALA, *Ginger Riley*
(b. c. 1937 Mara) Aboriginal painter in synthetic polymer on canvas from Ngukurr, NT. He uses bright, primary colours and naive realistic figures depicting ancestral beings of his country – the far north-east of Australia beyond Arnhem Land. He held five solo exhibitions, 1991–92, at William Mora, 1990, 91, Melbourne; Hogarth, 1991, Sydney; Tandanya, 1991, Adelaide; the Australian Gallery, Soho, New York, 1991. He participated in about 15 group exhibitions, 1989–91, including Melbourne (Gabrielle Pizzi; Alcaston House); Dreamtime Gallery, WA, 1989 and in *Contemporary Aboriginal Art from the Holmes à Court Collection*, touring USA and AGNSW, 1990; *Flash Pictures*, NGA, 1991; Araluen, Alice Springs, 1992; National Museum of Modern Art, Kyoto, Japan, 1992; *Heritage of Namatjira*, travelling exhibition, 1992.
REP: NGA; NGV; AGNSW; QAG; MAGNT; AGWA; Victorian Tapestry Workshop; Robert Holmes à Court Collection; National Bank; Australian Embassy, Beijing; Australasia Post.
BIB: Caruana, *AA*.

MUNDY, *Godfrey Charles*
(b. 10/3/1804, London; arr. NSW 1846; d. 1860) Deputy adjutant-general of the colonial forces, 1846–51 he, like many others of his time and class, was proficient in the arts. Among other things, he wrote and illus-

trated a book *Our Antipodes*, Bentley, London, 1852 (the proof plates for which are in the NLA collection).
BIB: *ADB* 2. Kerr *DAA*.

MUNDY, *Henry*
(b. c. 1798; arr. Hobart, 1831; d. 1848) Painter, teacher. He became a portrait painter in Launceston painting a number of well-known identities – although his works are hard to identify as he neither signed nor dated them. He also painted landscapes and although he was moderately successful with commissions until the early 1840s, the economic depression of 1844 caused his work to decline in popularity and hence reduce his income and he suicided in 1848.
REP: TMAG; Allport Library.
BIB: *ADB* 1 (ref under B. Duterrau). Eve Buscombe, *Early Artists and their Portraits* Sydney 1979. Kerr, *DAA*.

MUNGMUNG, *George*
(b. ? WA) Aboriginal painter in natural ochres on canvas from the Turkey Creek region of the East Kimberleys, a traditional camp site for the Kija and Miriwung language groups. He exhibited at Bloomfield Galleries, Sydney, 1989 and in the same year with Deutscher Fine Art, Melbourne.
REP: NGA; AGWA.
BIB: Caruana, *AA*.

MUNTZ-ADAMS, *Josephine*
(b. 1862, Barfold, near Kyneton, Vic.; d. 1950, Melbourne) Painter, teacher.
STUDIES: NGV School, 1884–89; Julian's, Paris, c. 1900; Herkomers School, Hertfordshire, England. She married Samuel Adams in 1898 and after her European studies returned to Australia to spend most of her life in Vic., where she became known as a capable professional working in a variety of genre.
AWARDS: Gold medal for portraiture, *Greater Britain Exhibition*, London, 1898.
APPTS: Council member, VAS, Melbourne, 1905–08, 1912–13, 1916; teaching (painting), Brisbane, Central Tech. School, 1917–22.
REP: NGV; AGNSW; QAG; AGWA; regional galleries, Ballarat, Bendigo, Geelong; Perth Uni. collections.
BIB: Moore, *SAA*. Janine Burke, *Australian Women Artists 1840–1940*, Greenhouse, Melbourne, 1980.

MURATORE, *Antonio*
(b. 1947, Calabria, Italy) Painter, printmaker, teacher.
STUDIES: PIT, Melbourne, 1968; RMIT, 1969–72; travel studies, Europe and India, 1979–84. Since 1970 he has held over 20 solo exhibitions including at Hogarth, Sydney, 1986; Town Gallery, Brisbane, 1987; York St, Melbourne, 1988. Group shows include Blond Fine Art, London, 1979; Stuart Gerstman, 1981; Victorian Printmakers, 1986; Images, 1985; York St, 1988.
AWARDS: Diamond Valley, 1977; commission portrait, Mr Gordon Bryant, MHR.
APPTS: Artist-in-residence, Loyola Coll., Melbourne, 1985; lecturer in printmaking, RMIT, 1986–87.
REP: QAG; QVMAG, Melbourne City Council; Artbank;

Arthur Murch, The Fisherman's Daughter, *c. 1950, oil on canvas. Private collection.*

MOMA, New Delhi; Australian High Commission, New Delhi.

MURCH, *Arthur James*

(b. 8/7/1902, Croydon, NSW; d. 1989) Painter, sculptor.

STUDIES: Sydney, apprenticed to a firm of engineers he became an engineering draughtsman but abandoned engineering in 1924; RAS School with Datillo Rubbo and James R. Jackson, 1921–25; ESTC, with Rayner Hoff, 1923–25; Chelsea Polytechnic, London; Rome, with Prof. Sciotino, 1925–27. Murch returned to Australia in 1927 and became well known as a sculptor-assistant to George Lambert, 1928–30, during which time he produced a considerable volume of work after the style of Lambert. He responded to modernist influences during a later visit to Europe, 1936–40, and his painting moved to a more cubistic form of expression in which the rounded forms of nudes and other figures are painted in bright, diffused colours, predominantly yellow, pink and blue. He held solo exhibitions largely at Macquarie Galleries, 1933–57, and many other galleries in Sydney, Brisbane, Adelaide, and Melbourne until 1976. He participated in many significant group exhibitions, 1938–78, including *Art of Australia 1788–1941*, National Gallery of Art, Washington, DC, and 28 gallery tour to USA and Canada, 1941–45; *The Herald Exhibition of Australian Present-Day Art from NSW and other States*, Lower Town Hall, Melbourne, 1945; *Jubilee Exhibition of Australian Art* touring Australia, 1951; *The Australian*

Landscape, Peking, Nanking, AGNSW, 1975; *Landscape and Image*, Indonesia, 1978, organised by the Gallery Directors Council of Australia and the Bicentennial exhibition *The Great Australian Art Exhibition*. Murch received a large number of sculpture and mural commissions including for the Uni. of Adelaide; Wool Pavilion, Glasgow Empire Exhibition, 1938; *The Arts of Peace*, Uni. of Qld, mural 1963; *Trigg Memorial Fountain*, Uni. of Sydney 1967. A tribute exhibition in 1990 was held at the AGNSW and a retrospective exhibition of his work toured to regional galleries in NSW, 1992 including Armidale; Campbelltown and S. H. Ervin, Sydney.

AWARDS: NSW Society of Artists' Travelling Scholarship, 1925; Archibald Prize, 1949; RAgSocNSW (rural) Prize, 1958; Emeritus Award, VACB, 1989.

APPTS: Official war artist during WWII.

REP: NGA; NGV; AGNSW; QAG; AGWA; AGSA; TMAG; many regional galleries including Ballarat, Bendigo, Castlemaine and Howard Hinton Collection, Armidale, NSW; AWM, Canberra.

BIB: All general books on contemporary Australian art history including Moore, SAA; Horton, PDA. Jean Campbell, *Early Sydney Moderns,* Craftsman House, Sydney, 1988. Mary Eagle, *Australian Modern Painting* Bay Books 1989. Ian Burn, *National Life and Landscapes* Bay Books 1990.

MURDOCH, *(Dame) Elisabeth Joy (née Greene)*

Patron of the arts. Widow of Sir Keith Murdoch and mother of Rupert Murdoch. She served as a trustee on the Council of the NGV, 1968–77, and on the Board of the Victorian Tapestry Workshop from 1976. In 1971 she initiated the Keith and Elisabeth Murdoch

Travelling Fellowship to replace the ailing original travelling scholarship at the NGV School, Melbourne. The scholarship is now given at the VCA. Through the family trust (The Murdoch Trust) she has also funded a number of other visual arts ventures – the most significant being the Keith and Elisabeth Murdoch Court at the NGV dedicated to the showing of contemporary art. (*See* GALLERIES – PUBLIC) In numerous other ways she has given generous support to the arts community including as chairperson for the McClelland Regional Art Gallery, Vic.

MURDOCH, Keith Arthur

(b. 1885, Melbourne; d. 1952, Melbourne) Newspaper executive, art collector, trustee of the NGV, 1933–39, chairman 1939–52. As chairman and managing director of the Herald and Weekly Times, he was the first chairman of the NGV after its administrative separation from the National Museum and Library trusts. In accord with established *Herald* policy, he maintained and greatly increased *Herald* support for the arts. Through his influence, Basil Burdett was able to organise, in 1939, the *Herald* exhibition, *French and British Contemporary Art.* Murdoch also initiated the first school of fine arts in an Australian university – the *Herald* Chair of Fine Arts at the Uni. of Melbourne, and was responsible for the old Wirth's Olympia site being reserved by the government as the site for the new Victorian Arts Centre. His wife, (Dame) Elisabeth (q.v.), strongly supported his views, and their son, Rupert, has carried on the tradition, first with the Murdoch Art Prize in WA and then by giving generous coverage to the arts in his newspapers.
AWARDS: NSW Society of Artists medal, 1940; knighthood conferred, 1933.
BIB: *Keith Murdoch, Journalist, 1886–1952, Herald,* Melbourne, Dec. 1952. John Hetherington, *Australians: Nine Profiles,* Cheshire, Melbourne, 1960; Leonard B. Cox, *The National Gallery of Victoria, 1861–1968,* NGV, Melbourne, 1970.

MURPHY, Ashton

(b. 1874, Qld) Black-and-white artist.
STUDIES: No formal training. Murphy and Arthur Hoey Davis ('Steele Rudd') founded *Steele Rudd's Magazine,* 1904–07, and *Steele Rudd's Annual,* 1917–22. Murphy's special talent was for interpreting bush life.
APPTS: Contributor to the Sydney *Bulletin,* 1897–1934 and also honorary treasurer Qld Authors and Artists Association.
BIB: Moore, *SAA.*

MURPHY, Blanche

Colonial artist. Prominent member of a sketch club established in Hobart, Tas., by Lady Franklin. William Moore refers to her 'fine sense of colour'. She contributed illustrations to Mabel Hockey's *Romance of Tasmania* and participated in the *Australian Exhibition of Women's Work,* Exhibition Building, Melbourne, 23/10/1907. The TMAG held an exhibition *The Misses Hookey-Murphy Oldham-Swan,* 1990–91.
BIB: Moore, *SAA.*

MURPHY, Fiona

(b. 1958, Melbourne) Ceramicist.
STUDIES: Dip. of Art, Prahran CAE, 1980; postgrad., PIT, 1984; travel studies, Europe, 1983. She held 7 solo exhibitions, 1981–88, at Distelfink, 1981, 82, 84; Macquarie, 1985, 87, 88; Christine Abrahams, 1987, and participated in numerous group shows from 1980.
AWARDS: Prahran CAE Award of Excellence in ceramics, 1980; travel grant, VACB, 1983; grant, VACB, 1986; Bathurst Regional Gallery Prize, 1986.
REP: NGA; NGV; Geelong Art Gallery; Vic. State Craft Collection; Artbank.

MURPHY, Idris

(b. 1949, Sydney) Painter, printmaker, teacher.
STUDIES: Dip. of Fine Art, NAS, 1971; Winchester Coll. of Art, UK, 1975–79; travel studies UK, Europe, USA, 1975–79; USA, 1979, 85. He paints mainly landscape in an abstract expressionist style and held 10 solo exhibitions, 1972–92, largely at Macquarie, Sydney and participated in a number of group exhibitions, 1978–91, including Sulman & Wynne Prizes, AGNSW; *Green Art*, S. H. Ervin Gallery, Sydney, 1991. He was artist-in-residence, AGNSW, 1983 and commissioned by AGNSW Art Gallery Society to produce two limited edition prints.
AWARDS: Hunters Hill Art Award, 1972, 73; Keith & Elisabeth Murdoch Travelling Fellowship, 1975; Rockhampton Art Prize, 1976; Arts Council Special Travel Grant, 1976; Dyason Bequest Fund for Australian Artists Overseas, AGNSW, 1977–79; residency, Moya Dyring Memorial Studio, Cité Internationale de Arts, Paris, 1978, 79.
APPTS: Part-time lecturer, School of Creative Arts, Wollongong Uni.; CAI; Wollongong TC, 1980– .
REP: NGA; Parliament House; Artbank; NLA; NSW State Library; Rockhampton Art Gallery; tertiary collections including Wollongong Uni.; Bibliothèque Nationale de Paris.
BIB: Catalogue essays exhibitions as above. *New Art Two. A&A* 10/2/1972; 20/2/1982.

MURRAY, Alexander

(b. 25/9/1803, Scotland; arr. SA 1803; d. 1880) Painter, member of the South Australian Parliament (1867–68). He made watercolours of the countryside around his farm in Morphett Vale, SA – a number of which he exhibited in Glasgow in 1845. Two portraits of him (by Sr? Danile McNee and Thomas Ritchie, both of Glasgow) are in the collection of the AGSA as well as a number of his watercolours.
REP: AGSA.
BIB: Kerr, *DAA.*

MURRAY, A. S.

Topographical artist.
STUDIES: Mechanics School of Art with Lucien Henry, Sydney. He became an instructor at ESTC, and wrote *Tasmanian Rivers, Lakes and Flowers,* George Robertson, Melbourne, 1900.

MURRAY, David
(b. 1829; d. 1907) He bequeathed a large collection of prints to the AGSA, Adelaide, plus £3000 to establish a Print Room.

MURRAY, Ebenezer
(b. 1848, Edinburgh; d. 1913) Painter, cartoonist. Moore tells us that he had a successful career as a painter (of landscapes) until he went to Brisbane in 1887. Unable to make a living there from landscape painting, he turned to commercial work and cartooning. First contributor to the *Boomerang*, Qld (1887).
BIB: Moore, SAA.

MURRAY, Jan
(b. 1957, Ballarat) Painter.
STUDIES: Ballarat CAE, 1976–78; VCA, 1980–81. Objects floating in a spacious background concered with illusion were the subjects of her *Moet & Chandon* entries of 1988, 90. She held 7 solo exhibitions, 1983–91, largely at Roslyn Oxley9, Sydney, and also at Künstlerhaus Bethanien, Berlin, 1985 and Uni. of Melbourne the same year. She participated in numerous group exhibitions including *Australian Visions*, Guggenheim Museum, New York, 1984; *Emerging Artists*, Guggenheim Museum, New York, 1987; *Images of Religion in Australian Art*, NGV, 1988–89; *Moet & Chandon Fellowship Exhibition*, 1989, 90.
AWARDS: Grant, VACB, 1982; travel grant for residency at the Künstlerhaus Bethanien, Berlin, VACB, 1984.
APPTS: Lecturer, VCA, 1986– .
REP: NGA; NGV; AGNSW; Latrobe Valley Arts Centre; Uni. of Melbourne; Uni. of Qld; Artbank, Robert Holmes à Court Collection; Metropolitan Museum, New York; Solomon R. Guggenheim Museum, New York; First National Bank of Chicago.
BIB: Catalogue essays for exhibitions as above. AL 6/2–3.

MURRAY-WHITE, Clive
(b. 20/2/1946, Walton-on-Thames; arr. Australia 1959, and settled permanently, 1965) Sculptor, teacher.
STUDIES: Brisbane Central Tech. Coll., 1961–62; Guildford School of Art, Surrey, UK, 1962–64; RMIT, 1970–71; Dip. of Art, Preston Inst. of Technology, 1972. Since 1967 his work has been featured in avantgarde sculpture exhibitions throughout Australia. One of the younger artists demonstrating the new thought in sculpture at the Argus Gallery, Melbourne, later he experimented with installations before settling for the welded steel pieces for which he is best known. He held at least one exhibition annually from 1967 including at Argus, Pinacotheca, Powell St, Christine Abrahams, Melbourne; Macquarie, Sydney. He participated in numerous group exhibitions, 1966–91, including at *Sydney Biennale*, 1974; sculpture triennials at Mildura 1973, 77, 82, 85; *A Melbourne Mood*, NGA, 1983; *Australian Prints*, NGA, 1987. He has had several works commissioned for Monash Uni., Sale City Council and Adelaide Festival of the Arts.
AWARDS: Mildura Sculpture Triennial (purchase), 1973; travel grants, VACB, 1976 (USA, UK, Europe), 1978 (Canada), 1986 (Paretaio, Italy); individual artists grant, VACB, 1980; artist-in-residence, Riverina CAE, 1980, City of Lismore, NSW, 1986.
APPTS: Teaching, first in tech. schools 1966–67, then Prahran CAE, 1968–69; high schools, 1970–71; lecturer (sculpture), Melbourne State Coll., 1971–81; lecturer in charge of sculpture Gippsland Institute, 1983–87.
REP: NGA; NGV; Parliament House; Sir William Dobell Foundation; a number of regional gallery and tertiary collections; VACB; corporate collections including Philip Morris, ICI.
BIB: Catalogue essays for exhibitions as above. B. Churcher, *Understanding Art* Rigby 1973. Geoffrey de Groen, *Conversations with Australian Artists* Quartet Books, 1978. Scarlett, AS. Sturgeon, DAS. A&A 13/4/1976; 23/3/1986.

MURRELL, Michael
(b. 1941, Hobart) Ceramicist, painter, teacher.
STUDIES: Launceston TC, 1962–65; Hobart School of Art, 1966–69; TCAE, Newnham, 1976. He held a solo exhibition at the Little Gallery, Devonport, 1972 and participated in group shows including at TMAG, 1973; Salamanca Place, Hobart, 1975; Uni. of Tas., 1978, 80.
APPTS: Teacher, Devonport TC, 1970–72; TCAE, Newnham, 1973–75.
REP: TMAG; QVMAG; Devonport Art Gallery; Uni. of Tas.

MUSKETT, Alice J.
(Active 1886–1930) Painter.
STUDIES: Second student at the classes started by Julian Ashton, Sydney, 1886; Colarossi's, Paris. She exhibited in the first exhibition of the NSW Society of Artists exhibition, 1895, as one of the breakaway artists from the Royal Art Society with whom she had shown from 1893. During WWI she worked in a canteen in London. Her subjects in painting included still life, genre, figure compositions and paintings of old buildings. In 1902 the government bought and presented her *Cumberland Street* and 14 other works of old Sydney to the AGNSW; in 1920 they were transferred to the Mitchell Library. In 1928 she gave £250 to the Sydney Art School to start a prize as a memorial to her brother.
REP: Mitchell Library, Sydney.
BIB: Moore, SAA.

MYER, Sidney (Sidney Myer Charity Trust)
See TRUSTS AND FOUNDATIONS

MYRNIONG GROUP
Group of businessmen/amateur painters, conducting regular annual exhibitions at the Athenaeum Gallery, Melbourne, from c. 1960–67.

N AIVE ARTISTS TO NUTTALL

NAIVE ARTISTS

The relentless search for new 'primitives' that followed the fashion for 'naive' or untutored painting caused by the publicity attending the rise of the Douanier Rousseau and his work in the early part of the 20th century found a following in Australia. The art of colonial times was rich in primitive and amateur artists. However these while perhaps amateurish in technique, lacked the main distinguishing quality of the true naive artist – innocent and childlike vision. Probably Australia's first true naive painter was H. Dearing ('Professor Tipper'), whose work was discovered in the 1940s. In the 1950s the painter and opal miner Henri Bastin became the forerunner of contemporary Australian naive painters. Among the best of these may be mentioned Sam Byrne, Charles Callins, Selby Warren, Douglas Stubbs. The 1970s saw the introduction of a new style of conscious naive art practised by often trained artists called 'Outsider' art.

NAMATJIRA, Albert

(b. 1902, Hermannsburg, NT; d. 1959, Alice Springs) Painter.
STUDIES: Hermannsburg Mission, with Rex Battarbee, 1936. A member of the Arunta tribe, he became interested in painting when the Melbourne painters Rex Battarbee and John A. Gardner visited the Hermannsburg Mission in 1932, 1934 and again in 1936. After learning the watercolour technique Namatjira agreed to an exhibition of his work at the Fine Art Society Gallery, Melbourne, in 1938. Within two days of the opening all his pictures were sold at prices ranging from one to six guineas and a fashion for his work was created that soon extended to the whole of Australia. Namatjira became a national celebrity and the income from his work was such that soon it had to be administered by a special trust created at Hermannsburg. In accordance with tribal practice, Namatjira distributed his new-found wealth among members of the Arunta tribe. But his gifts included the illegal distribution of liquor. He was arrested and sentenced to imprisonment, and although the sentence was commuted he never recovered from the experience and

died one year later. Since his death, his work has continued to be highly regarded, both in its own right and as an important linking step in the development of Aboriginal art as a professsional art form. His work has been included in a number of survey exhibitions including the Bicentennial *The Great Australian Art Exhibition*.
REP: NGA; several state and some regional galleries.
BIB: Rex Battarbee, *Modern Australian Aboriginal Art*, Angus & Robertson, Sydney, 1951; Joyce D. Batty, *Namatjira, Wanderer Between Two Worlds*, Hodder & Stoughton, Melbourne, 1963. Caruana, AA. N. Amadio (ed) *Albert Namatjira – The Life and work of an Australian Painter*, Macmillan, 1986; Hardy & Megaw (eds) *The Heritage of Nomatjira*, Heinemann, Melb. 1992.
(*See also* ABORIGINAL ART, ARUNTA WATERCOLOURS)

NAN KIVELL, Frank

(b. Aust.) Cartoonist, painter, etcher. He made his name in New York as a staff artist for *Puck* magazine, 1896– . Later his interest turned to portrait painting and etching.
BIB: Moore, SAA.

NAN KIVELL, (Sir) Rex de Charembac

(b. 9/4/1899, Canterbury, NZ; d. 7/6/1977, London) Gallery director, archaeologist, collector.
STUDIES: New Brighton School and Canterbury Coll., NZ. During World War I he served in France (at the age of 16), was invalided out of the army and began collecting early Australian art before becoming director of the Redfern Gallery, London, where he assisted many modern Australians with exhibitions of their work, and remained for the rest of his career. He researched the La Tene bronze and iron period in England (from third century BC) and later presented his archaeological collection to the Devizes Museum, Wiltshire. More important for Australia was the huge collection of Australiana which he presented to the NLA in 1957. Comprising approximately 16,000 items, it includes paintings, prints, books, photographs, maps and associated material. The NLA occasionally tours a selection from the collection and often lends items for use in other exhibitions.
AWARDS: Order of Dannebrog (Danish), 1935; CMG conferred, 1966; knighthood, 1976.

BIB: Rex Nan Kivell, *Portraits of the Famous and Infamous*, London, 1974. A&A 5/4/1968 (Maie Casey, *An Introduction to the Nan Kivell Collection*); 15/3/1978 (Pauline Fanning, *A Tribute to Sir Rex de Charembac Nan Kivell*).

NAPIER, Thomas

(b. 11/7/1802, Marykirk, Scotland; arr. Van Diemen's Land 5/11/1832; d. 1881, Moonee Ponds, Vic.) Painter.
STUDIES: RA Schools, London, including the British Museum. He arrived in Hobart on the *Lavinia* and obtained permission to paint Tasmanian Aborigines under the protection of G. A. Robinson. Several important works date from this period notably *Wooreddy and Trugganini* (TMAG collection) and *Alphonse the Tasmanian* (QVMAG collection). Later he moved to Victoria and made his permanent home at Moonee Ponds, where he purchased 100 acres of land.
REP: QVMAG; TMAG; Savage Club, Melbourne.
BIB: *Victoria and its Metropolis*, vol. 2, McCarron, Bird & Co., Melbourne, 1888. *Camperdown Chronicle*, 11 Feb. 1881. Kerr, DAA. (Letter and information from George Chalmers, April 1983)

NAROZNY, Michael

(b. 15/3/1957, Warsaw, Poland) Painter.
STUDIES: RMIT, 1975–76. Meticulous and surreal his work was seen in solo exhibitions at Realities, Melbourne, 1988, 90. and in about 23 group exhibitions, 1975–91, in private galleries (including Realities, Melbourne; Von Bertouch, Newcastle; D.C. Art, Sydney), and public galleries including *The Show with No Name*, four-person show, Linden, Melbourne, 1988; MPAC *Spring Festival of Drawing*, MPAC, 1987; *Castlemaine Drawing Prize*, Castlemaine regional gallery 1988; *Blake Prize*, 1989; *Moet & Chandon Touring Exhibition*, 1989.
AWARDS: St Kilda Art Prize, 1988; Swan Hill Drawing Prize, 1989.
REP: City of St Kilda; Swan Hill regional gallery; Allen, Allen & Hemsley corporate collection.

NATHAN, Jerrold

(b. Apr. 1899, London; arr. Aust. 1924; d. 1979) Painter.
STUDIES: RA Schools with J. Singer Sargent and William Orpen, London, c. 1918; Paris. He served in World War I before studying at the RA Schools, then moved to Australia to become known as a painter of portraits and landscape. He was president of the Australian Art Society, 1945–52, a member of the RQAS and a contributor to Archibald Prize exhibitions.
AWARDS: Medal for portrait painting, RA Schools, London.
BIB: Smith, *Catalogue AGNSW*, 1953.

NATIONAL ASSOCIATION FOR THE VISUAL ARTS (NAVA)

(Founded 1983) 1/245 Chalmers St, Redfern, NSW 2016 (PO Box 336, Redfern, NSW 2016) In 1983 the Visual Arts Lobby convened to establish a representative national advocacy and service organisation for the visual arts in Australia. After broad national consultation, State Management Committees were formed and representatives were elected to a National Board which first met in Feb. 1984. This meeting determined the role and function of NAVA. An independent lobby group, NAVA is dedicated to advocating the importance of the visual arts in Australia. It represents and promotes the collective interest of over 60,000 members including national and state art museums, visual arts organisations, contemporary art spaces, commercial galleries, educational institutions, art publications, artists' co-operatives, individual artists and allied services. NAVA promotes policies, undertakes research and develops strategic plans for issues identified by the industry including the status of the artist, the economic benefits of the visual arts industry, art education and training, copyright and taxation. Working with government, federal and state agencies, the commercial sector and the community, NAVA aims to increase the consciousness of Australia's cultural heritage and to foster the growth of the visual arts. NAVA regularly compiles, analyses and distributes visual arts industry statistics and legislative news, and addresses topics of professional interest in its quarterly newsletter. NAVA also acts as the administrative base for the Pat Corrigan Artist Grant and the Australian Visual Artists Benevolent Fund. (*See also* GRANTS) NAVA publications 1993: *Money for Visual Artists*; *Contacts: A Directory of Australian Visual Artists*.
STAFF: Founding chairperson, David Throsby, Professor of Economics at Macquarie Uni. and an internationally recognised authority on the economics of the arts, 1983– .

NATIONAL CAPITAL DEVELOPMENT COMMISSION

(1957–80) Formed 'to plan, develop and construct Canberra as Australia's national capital'. Its functions included the construction of public buildings, public squares and gardens, schools, playgrounds and centres of various types of national significance and the commissioning and purchase of works of art to enhance these constructions. Art advisers to the Commission were various individual authorities as well as the CAAB, and the VACB of the Australia Council. Among many major works commissioned were Norma Redpath's bronze fountain and sculpture for the courtyard of the Treasury Building, Canberra, and Leonard French's stained-glass windows for the National Library, both completed 1967. The Commission was disbanded by the Fraser Government in 1980.

NATIONAL TRUST OF AUSTRALIA

(Founded 1956) National Trust responsibilities include a number of properties containing art collections, most of them curated as historical museums. Included among them are also those curated as independent art museums or galleries, for example, the Norman Lindsay Gallery and Museum at Faulconbridge, NSW, and the S. H. Ervin Museum and Art Gallery, Sydney.
(*See also* GALLERIES – PUBLIC)

NATURAL HISTORY ARTISTS

Biology and natural history engaged the attention of the first artists to arrive in Australia and the greater proportion of the first pictorial records depicts the plant and animal life of the country. The first known representation of an Australian animal was published in Antwerp in 1593; it appeared on the title page of a book on geography, *Speculum Orbis Terrae*, by Cornelis de Jode, in the form of an inaccurate but unmistakable likeness of a kangaroo with two young in its pouch. The published history of Vlamingh's voyages around the west coast of Australia, 1726, contains illustrations of black swans on the Swan River, and the published accounts of Dampier's voyages (London, 1703) are illustrated with engravings of Australian birds, plants and fish. Cook's voyages (1770–77), followed by the arrival at Botany Bay of the First Fleet (1788) and British settlement, brought a steady flow of artists to record the plant, animal and bird life. The leading patron and authority on this activity was the naturalist Sir Joseph Banks (1743–1820), whose influence and enthusiasm created a fashion in London for collecting rare plants and other specimens from the Antipodes. Scientific interest in Australia's natural history grew steadily through the colonial and exploration periods and virtually every expedition was accompanied by an official artist. German scientists and artists were particularly active in Vic. during the period of the gold rush and its aftermath, an outstanding example being Baron von Mueller and his development of Melbourne's Botanical Gardens. Two outstanding figures in the late 19th century in NSW in pioneering the decorative application of Australian native plants were Lucien Henry and Richard T. Baker (qq.v.), the latter as curator of Sydney's Technological Museum. In the early part of the twentieth century natural history was a subject widely taught in schools, and the names of the bird artist Neville Cayley, the botanical artist Marian Ellis Rowan, and many others became widely known. Natural history therefore was a subject of special interest to Australian artists long before there was any thought of the threat to the environment brought about by the boom days of industrial development. The environmental issues that began to stir up public feeling in the 1960s soon led to an unprecedented degree of interest in natural history drawing and painting of all kinds.

Important exhibitions of Australian flora in applied art include three entitled *Australian Flora Applied to Art*, the first organised by R. T. Baker for the Sydney Technological Museum in 1906 (in which some 200 adaptations of bush flowers by engravers, ceramicists and modellers were listed). The second, organised by Margaret Betteridge for the Museum of Applied Arts and Sciences, was shown at Elizabeth Bay House, Sydney, in 1977, and from this came a third, also organised by Margaret Betteridge, the AGDC touring exhibition, 1979. In the 1980s and 1990s artists contributed to highly successful exhibitions such as *Artists against Animal Experimentation*, Melbourne and exhibitions organised by Greenpeace and Friends of the Earth in Melbourne. An exhibition, *Green Art*, selected by science broadcaster Robyn Williams, was held at S. H. Ervin Gallery, Sydney, in 1991.

NEAGLE, J.

Engravings by this (presumably) male artist of Aborigines were published in London in 1798.
NFI

NEDELKOPOULOUS, Nicholas

(b. 29/3/1955, Melb.) Painter, printmaker, photographer.
STUDIES: Prahran CAE, 1973–75; PIT, 1975–76; VCA, 1977; RMIT, 1979. His work is based strongly in graphic tradition which can be seen throughout his work in all media. He held 11 solo exhibitions 1977–91 in private galleries in Brisbane (Ray Hughes, 1982, 85, 87), Melbourne (Deutscher Gertrude St, 1988; Deutscher Brunswick St, 1990; Realities, 1991) and Sydney (Garry Anderson, 1990); and at VCA, 1977; NGA Drill Hall, 1991. He participated in approximately 45 group exhibitions 1982–92 including with Ray Hughes, Sydney; Deutscher, Melbourne and in many public galleries including *Australian Perspecta*, AGNSW 1983; *Victorian Vision*, NGV 1984; *Sam Neill Celebrity Choice*, AGNSW 1986; *Urban Anxieties*, NGA 1987; Gallery 1988; *Australian Drawings, Watercolours and Pastels*, NGA 1989; *Tony Coleing and Friends*, NGA 1992; and in *Seventeen Australian Artists*, Galeria San Vidal, Venice 1988; *5th International Biennale Exhibition of Drawings and Graphics 1988*, Yugoslavia 1988.
APPTS: Guest lecturer in various secondary and tertiary institutions Vic., Tas., NSW and Qld, 1970–90; artist-in-residence, Brisbane CAE, Kelvin Grove, 1984.
REP: NGA; AGNSW; AGSA; NGV; QAG; MOCA, Brisbane; Warrnambool regional gallery; Tasmanian Inst. of Advanced Education; Griffith Uni.; Uni. of Tasmania; shire collections in Diamond Valley, Waverley, Box Hill; La Trobe Library; Anglican Church, Brisbane; Trinity Coll. (Melbourne); City of Melbourne; MOMA, NY; National Art Gallery, Wellington, NZ; private collections, Loti and Victor Smorgon and Crestknit.
BIB: Catalogue essays in exhibitions as above. *The Australian People: An Encyclopedia of the Nation, its People and their Origins*, James Jupp general editor, Angus & Roberston, Sydney, 1988. Thomas OAA 1989. A&A 28/3 1991.

NEEDHAM, Frederick Miller

(b. 1840, UK; arr. Aust. 1857; d. 1910, Renmark, SA) Surveyor, painter, illustrator. Son of the Rev. R. W. Needham, first Anglican minister at Mt Gambier, he worked in the surveyors' dept. of SA. He drew and painted often in the south-east area of SA, and c. 1890 illustrated the literature for Chaffey's Murray Irrigation Scheme. His signature has been wrongly attributed as 'J. M.' Needham.
REP: AGSA.
BIB: Moore, SAA. Kerr, DAA

NEESON, John

(b. 1948, Melb.) Painter, printmaker.

STUDIES: Fellowship Dip. Fine Arts, RMIT, 1967–72; Dip. Ed., State Coll. Hawthorn, 1972. He produced some fine prints using silkscreen, lithography and etching, and held several solo exhibitions including at Pinacotheca 1970; Crossley 1970, 72; Powell St, Melbourne 1984, 87; Macquarie, Sydney 1979; Tynte, Adelaide 1981, 84, 87. International exhibitions in which his work appeared include Victoria and Albert Museum, London 1972, and print biennales at Cracow, 1972, and Tokyo, 1974; *Australian Printmakers to USA*, 1979 and to Scotland, 1980; *PCA to Canada*, 1984; Intaglio, London 1984; *German Print International*, Nuremburg 1988.

AWARDS: PCA Student Printmaker award, 1969; Geelong Purchase, 1970; Shepparton Purchase, 1970; Warrnambool Purchase, 1972; Portland Purchase, 1974; Minnie Crouch Prize, 1975; Henri Worland, 1977; PCA members print, 1979.

REP: NGA; AGNSW; AGSA; NGV; TMAG; regional galleries Geelong, Mildura, Shepparton, Warrnambool; MOMA, NY; Auckland City Art Gallery, NZ.

BIB: *A&A* 23/3/1986; 25/2/1987.

solidity to images which began to move and inhabit a cinema screen panorama'. He held about 15 solo exhibitions 1973–92 largely at Pinacotheca, Melbourne, Roz MacAllan, Brisbane and Macquarie Galleries, Sydney. He participated in numerous group exhibitions in public galleries 1967–92, including *Artists' Artists*, NGV 1975; *Artbank's Big Paintings*, Ivan Dougherty Gallery, Sydney 1987; *Inherited Absolute*, ACCA 1992. He designed a tapestry for the Victorian Tapestry Workshop, 1981, and painted a tram for the Vic. Ministry for the Arts, 1988. He also curated several exhibitions for the Uni. of Tasmania while lecturing there in the mid-1980s.

APPTS: Lecturer in art, various art colleges including lecturer in charge of painting, School of Visual and Performing Arts Education, Uni. of Melbourne, 1987– .

REP: NGA; NGV; Parliament House; MOCA, Brisbane; VACB; Artbank; several regional gallery and tertiary collections Vic., Qld, Tas.; corporate collections including ICI.

BIB: Catalogue essays in exhibitions as above. McIntyre, ACD Chanin, CAP. New Art Two.

John R. Neeson, Small Monochrome, *1990, oil on canvas, 101 × 66cm. Private collection.*

NEESON, John R.

(b. 24/10/1946, Melb.) Painter.

STUDIES: Fellowship Dip. Fine Arts (painting), RMIT, 1967; TSTC, Secondary Teachers Coll., Melbourne, 1970. Of the same name and being of similar age, John Neeson (q.v.) and John R. Neeson are frequently taken for the same person. John Neeson is largely a printmaker and John R. Neeson a painter. His 1980s meticulously crafted paintings have a surreal quality described by Robert Lindsay in the ICI Contemporary Art Collection catalogue as evolving 'an illusionist space with shafts of light and cast shadows giving a

NEILD, James Edward

(b. 1824, Yorkshire; arr. Aust. 1853; d. 1906, Melb.) Pathologist, drama critic, topographical artist. In Vic. for the gold rush, he dug for gold at Mt Alexander (Castlemaine), practised as a pharmacist, 1855–61, and conducted a medical practice, 1861–64, before becoming a university lecturer in Melbourne, 1865–1904. An artist of versatile talents, he wrote plays,

was theatre critic for the *Australasian*, Melbourne, 1865–90, and was a good friend to Marcus Clarke, Henry Kendall and other Melbourne literati. He left a volume of fine pencil drawings of scenes in and around Melbourne, done during a sketching tour with his wife.

BIB: *ADB* 5. Kerr, DAA.

NEILL, Robert

(b. 1801, Edinburgh; arr. Tasmania 1820; d. 1852) Painter, etcher. He arrived in Tasmania as an employee of the army and went to the Swan River settlement, WA in 1839. He made paintings of flora and fauna of WA (now in the collection of the British Museum) and provided illustrations for Eyre's *Journals*, published in London in 1845 (wrongly attributed at the time to a 'J.' or 'John' Neill). He collected Aboriginal artefacts in both Tasmania and WA (later given to the Uni. Museum, Edinburgh) and made a number of paintings and drawings of Aborigines including a lithograph, *Indigenes des deux sexes, van Diemen*, published in Dumont D'Urville's journal of the *Astrolabe* journey in 1830. His work was seen in *Outlines of Australian Printmaking*, Ballarat Fine Art Gallery, 1976; *The Tasmanian Aboriginal in Art*, TMAG 1976 and *Tasmanian Vision* TMAG and QVMAG 1988.

REP: TMAG; Mitchell, Allport Libraries.

BIB: Clifford Craig, *Old Tasmanian Prints*, Foot & Playstead Launceston 1964. Kerr, DAA.

NELSON, Jan

(b. 15/1/1955, Melb.) Painter.
STUDIES: BA Fine Arts, VCA, 1981–83. Many of her 1980s works were concerned with the landscape and how it had been interpreted by artists from colonial to contemporary times. She held five solo exhibitions 1984–91, including in Melbourne at Christine Abrahams, 1984, 86; 70 Arden Street, 1987; Realities, 1989, 91. She participated in a number of group exhibitions including *Australian Perspecta '85*, AGNSW; *Moet & Chandon*, 1987; *Shipwrecked*, Monash Uni. Gallery, 1987; *A New Generation*, NGA 1988; *Re-Creation/Recreation*, Monash Uni. 1989.
AWARDS: Travel grant, VACB, Vence, France, 1983; Sir Russell Drysdale Drawing Prize, 1983; Potter Foundation grant, 1983; VACB project grants, 1984, 87, 90; Vic. Ministry for the Arts grant, 1985.
REP: AGWA; NGV; QAG; Monash Uni.; ACTU collection; Monash Medical Centre.
BIB: Catalogue essays exhibitions as above.

NELSON, Michael Tjakamarra

(b. 1949, Vaughan Springs, NT). Of the Warlpiri tribe he began painting in 1981 and held solo shows at Gabrielle Pizzi Gallery, Melbourne in 1989 & 90. His work appeared in approximately 20 group exhibitions 1984–92 including *Papunya Tula Artists*, Araluen Arts Centre, Alice Springs, 1984; *Biennale of Sydney*, Sydney, 1986; *Dreamings, The Art of Aboriginal Australia*, Asia Society Galleries, New York, 1988;

with Centro Cultural Arte Contemporaneo, Mexico City, Mexico, 1989; NGA, 1989, 91; Utopia Art, Sydney, 1990, 91; Auckland City Art Gallery, NZ, 1991; Araluen Arts Centre, Alice Springs, 1992; Ballarat Fine Art Gallery, 1992. His commissions include a mural and mosaics for Parliament House, Canberra – the mosaic becoming the focus of publicity in 1993 when Michael Nelson started removing it as part of a demonstration against the Federal government's proposed native title legislation.
AWARDS: National Aboriginal Art Award, 1984; Order of Australia, 1990.
REP: NGA; QAG; AGWA; AGSA; MAGNT; Austalian Museum; Broken Hill regional gallery; Parliament House; Robert Holmes à Court Collection.
BIB: Caruana, AA. Smith, AP.

NEMEC, Jane Ann

(b. 27/6/1934, Melb.) Painter, graphic artist, teacher.
STUDIES: Swinburne Tech. Coll., 1950–52; part-time, NGV School, George Bell School, 1955–58. She taught art in Victorian secondary schools for six years, lived in England and Italy, 1968–73, and designed fabrics and murals from 1973. Her solo exhibitions include Churchill Galleries, Perth, 1978; and Melbourne at the Lyceum Club, 1980, 87, and Niagara, 1982. She participated in several group shows 1978–90, including MPAC *Spring Festival of Drawing*, 1979–90; *Diamond Valley Art Award*, 1985; *Invitation Art Exhibition*, Shepparton regional gallery, 1988.
REP: Regional galleries Horsham, Mornington.
BIB: *Women's Art Forum Annual*, Melbourne, 1978.

NERLI, Girolamo Pieri

(b. 12/2/1860, Siena; arr. Aust. 1885; d. 1926, Nervi, near Genoa) Painter.
STUDIES: Academy of Arts, Florence, with Ciseri and Muzzioli. A protagonist of Impressionism, he inherited the title 'Marchese' from his Italian father; his mother was the daughter of Thomas Medwin, biographer of Shelley and author of *Conversations with Lord Byron*. Nerli left Italy with a student colleague, Ugo Catani (q.v.), visited Mauritius and Bourbon, and went on to Melbourne and thence, in 1886, to Sydney, where his personality and work greatly influenced the youthful Charles Conder. By 1889 he was in Dunedin, NZ, with the NSW contribution to the *South Seas Exhibition*. His gifts as a promoter were highlighted by the inclusion of 9 of his own paintings among the 37 representing NSW. By 1892 he was in Samoa painting a portrait of Robert Louis Stevenson, who wrote a jingle: 'Did ever mortal man hear tell sae singulur a ferlie / As the coming to Apia here of the painter Mr Nerli?' There were 27 sittings for the life-size portrait which was done in oils, pastel and charcoal. The original in oils was sold by Nerli to Lord Guthrie, in 1907, for 350 guineas. Numerous other studies and adaptations were also disposed of by Nerli. A pencil portrait was presented by him to Lord Guthrie; a replica was bought in NZ for 100 guineas by Mrs James Turnbull and bequeathed to the Scottish National

Gallery. Another replica was bought by a Mr Wright for £40, and a third was sold by Nerli to Angus & Robertson Ltd for publication, and afterwards bought by Sir Anderson Stuart for £40. In addition, a charcoal drawing went to Lord Rosebery; a pastel was bought by Scribner & Sons, New York, about 1923, and a replica of the pastel (in oils) remained in possession of Marchesa Nerli, widow of the artist. Stevenson had been painted by Sargent and many other painters, but regarded the original portrait by Nerli as the best. After this sojourn in Tahiti, Nerli returned to NZ in 1893, teaching at the School of Art, Dunedin, and giving private lessons to such students as Frances Hodgkins, as well as assisting in the formation of the Easel Club. Grace Joel was also influenced by him. He left for Auckland in 1896 where he exhibited with the Auckland Society of Arts. Two years later he married Cecilia Josephine Barron. He was in Sydney in 1899 before moving to Melbourne where he showed portraits and other work at the VAS (1902–03), before returning to Italy where he settled at Nervi, near Genoa. Gil Docking tells us that, according to tradition, Nerli became Court Painter at the Vatican. He was in London in 1904 and in Italy 1905–6; London 1910 and Italy c. 1923. Nerli's sojourn in Australia happily coincided with the arrival there of the French impressionist influences and, although his influence should not be overestimated, there is little doubt that his work and personality vitally helped the new movement and the general development of the Heidelberg School. His surviving paintings include, beside the portraits, Monet-like scenes of figures and traffic, often shown reflected in wet city streets, and the broad beach and coastal scenes painted in New Zealand. His work was seen in *Golden Summers:* NGV and touring, 1986; *Bohemians in the Bush:* AGNSW, 1991 and the Bicentennial exhibition, *The Face of Australia*.

REP: NGA; AGNSW; NGV; QAG; regional galleries Ballarat, Newcastle.

BIB: McCulloch, GAAP. Gil Docking, *Two Hundred Years of New Zealand Painting*, Lansdowne, Melbourne, 1971. A&A 16/1/1978 (Betty Currie, *Signor Nerli*).

NETTLETON, Charles

(b. 1826, Eng.; arr. Melb. 1854; d. 1902, Melb.) Photographer. His government-commissioned views of streets, public buildings, etc. in Melbourne form a true historical record. He also photographed country towns and bush scenes. He was very successful and extremely prolific. His work was seen in *Australian Art of the 1870s*, AGNSW 1976; *Masterpieces of Australian Photography*, Joseph Liebovic Gallery, Sydney 1989 and *Shades of Light*, NGA 1988.

REP: NGA; most state galleries and public libraries.

BIB: ADB 5. J. Cato, *The Story of the Camera in Australia*, Melbourne 1955. Kerr, DAA.

NEVILLE, George W.

(b. 1889, Cheltenham, Vic.; d. 1955, Glenhuntly, Vic.) Painter.

STUDIES: NGV School, c. 1910. A member of the VAS, he earned a living from painting in the first years of his marriage in the early 1900s. Inspired by the European vogue for Oriental art, he developed a keen interest in Chinese art and painted small, decorative fan designs on silk in a painstakingly slow technique. He exhibited these and other works at Fine Art Societies Galleries in 1926 and 1927 from which Dame Nellie Melba purchased two fans (according to a contemporary newspaper report she gave to Toti Del Monte). Several commissions followed from the exhibitions, most notable of which was for the foyer of the Regent Theatre. This was exhibited for several years before being taken down during World War I and stored in the basement, where it was subsequently burnt during a fire. He worked for *The Argus* as an etcher from the 1940s until his death.

REP: NGV (watercolours, *The Chinese Fan* and *The Argonauts*, both fan designs, 1924).

(Information Joyce McGrath, retired former director, La Trobe Library, 1992)

NEW ART SOCIETY

(1904–16) Formed in 1904 by a group seceding from the RQAS, Brisbane. Led by Oscar Fristrom, it lasted 12 years before reuniting with the RQAS.

NEW SOUTH WALES ACADEMY OF ART

(1871–80) On 25 Apr. 1871 a meeting was convened by Edward Reeve to form the New South Wales Academy of Art. The first president was T. S. Mort; vice-president, E. L. Montefiore; secretary, Edward Reeve. The first exhibition, held in rooms at the Sydney Chamber of Commerce, was opened on 5 Mar. 1872, with a representation of works by Nicholas Chevalier, S. Elyard, G. Podmore, E. L. Montefiore and E. Wake Cook. Cook was awarded a medal for the best watercolour; at the second exhibition, held in 1873, two 25-guinea prizes, given by the Hon. John Campbell, were won by J. Carse (oil) and J. Deering (watercolour). Among the medallists at succeeding annual exhibitions, which continued until 1879, were Anivitti, Martens, Carse, Simonetti (gold medals); MacLeod (silver medal). An Academy School of Design had been established in 1875 by Montefiore and Du Faur at Clark's Assembly Rooms, Elizabeth Street; Giulio Anivitti was appointed instructor of drawing and painting at the school, and Achille Simonetti instructor of sculpture. The school was equipped with a collection of plaster casts brought from the Royal Coll. of Art, London. Early students included F. Mahony, A. J. Fisher, W. T. Butler, Percy Williams. The classes flourished until the secession of the professional artists from the Academy in 1880, to form the Art Society of NSW, which later became the Royal Art Society of NSW. The breakaway group was led by Arthur and George Collingridge. The principal result of the work done by the NSW Academy of Art was that it led to the foundation of the AGNSW, the final inspiration having been provided by the *International Exhibition* of 1879.

(*See also* GALLERIES — PUBLIC, ART GALLERY OF NEW SOUTH WALES; EXHIBITIONS)

NEW SOUTH WALES SOCIETY OF ARTISTS

(Founded 1895, Sydney; ceased to function as an exhibition venue between 1961–64) Founded when Fullwood, Roberts, Mahony, Long, Souter and Watkins seceded from the Art Society of NSW to form the council of the NSW Society of Artists.

IMPORTANT EVENTS: 1895 First exhibition at Skating Rink, York St, Sydney; 28 Sept. 1897: Vickery's Chambers, 76 Pitt St, became headquarters and site of exhibitions; 1899: Lambert's *Across the Black Soil Plains* exhibited; 1900: Travelling Scholarship, £150 per annum for three years, awarded (first winner, G. Lambert), and government subsidy of £400 per annum granted; 1901: Australia-wide exhibition to mark the founding of the Commonwealth of Australia, and the Society amalgamated with the Royal Art Society of NSW in order that both societies should benefit from government grants; 1907: Society seceded for the second time from the Royal Art Society, the Hon. John Lane Mullins being elected honorary secretary; Norman and Lionel Lindsay, J. J. Hilder, Douglas Fry and Sydney Ure Smith made their debut in the annual exhibition, Hilder's reputation being established when 21 of his watercolours were sold; 1921: Ure Smith elected president, and Lambert returned to Australia, the latter's *Important People* causing discussion because of a 'modernist' bias; 1923: Ure Smith organised a NSW Society of Artists *Exhibition of Australian Art* at the RA, London.

SOCIETY OF ARTISTS MEDAL: In 1924 it was decided to strike a NSW Society of Artists silver medal for presentation to outstanding contributors to the cause of Australian art. The medal was designed by Rayner Hoff. Winners: 1924, Julian Ashton; 1926, Sir Baldwin Spencer; 1928, Gother Victor Fyers Mann; 1929, L. Bernard Hall; 1931, Sydney Ure Smith; 1932, Howard Hinton; 1936, Alexander Melrose; 1937, Sir Lionel Lindsay; 1940, Sir Keith Murdoch; 1944, Sir Will Ashton; 1965, Colonel Aubrey Gibson.

PRESIDENTS: 1895–97, Tom Roberts; 1897–99, Julian Ashton; 1899–1901, Sydney Long; 1901–02, D. H. Souter; 1907–21, Julian Ashton; 1921–47, Sydney Ure Smith; 1948–61, Douglas Dundas; 1961–65, Lloyd Rees.

BIB: *Society of Artists Book*, five annual issues, Ure Smith, Sydney, 1942–46. Lloyd Rees, *The Small Treasures of a Lifetime*, Ure Smith, Sydney, 1969.

(*See also* ART SOCIETY OF NSW; PRIZES AND SCHOLARSHIPS; NSW TRAVELLING ART SCHOLARSHIP; ROYAL ART SOCIETY OF NSW)

NEW YORK STUDIO SCHOOL FOR DRAWING, PAINTING AND SCULPTURE

By arrangement with the VACB, the NY Studio School makes available to Australian graduate students, of painting or sculpture, two places annually for a period of two semesters. This scholarship is known as the Peter Brown Memorial Scholarship in honour of the late Peter Brown, an early VACB project officer.

(*See also* ARTISTS STUDIOS)

NEWBURY, Albert Ernest

(b. 29/1/1891, Middle Park, Vic.; d. Apr. 1941) Painter, teacher.

STUDIES: Gordon Tech. Coll., Geelong, with Tranthim Fryer; NGV School, with Frederick McCubbin and Bernard Hall, 1909–14; also with Max Meldrum. He married fellow student Ruth Trumble, and they built a home at Eltham, Vic., where he did most of his painting. Popular impressionism and the tonal impressionism taught him by Max Meldrum were evenly combined in the lyrical landscapes for which he became best known. His son, David, became a painter and teacher. A retrospective exhibition of Newbury's work was held at the Castlemaine Gallery in 1976.

AWARDS: Student prizes, NGV School, 1913.

APPTS: Teaching, Swinburne Tech. Coll., 1936–39; drawing teacher, NGV School, 1939–41.

REP: AGNSW; AGWA; AGSA; NGV; regional galleries Ballarat, Bendigo, Benalla, Geelong, Langwarrin (McClelland Gallery), Armidale.

BIB: Carl Hampel, *The Paintings of A. E. Newbury*, Alexander McCubbin, Melbourne, 1916. Moore, SAA.

NEWBURY, David

(b. 1925, Eltham, Vic.) Painter, teacher.

STUDIES: Associate and Fellowship, RMIT. Son of A. E. Newbury. His large abstract and semi-abstract paintings appeared in exhibitions at the Argus Gallery, Melbourne, from c. 1960, and at the Leveson Street Gallery. In the 1970s he reverted to an impressionistic style of landscape painting.

APPTS: Part-time painting instructor, RMIT, 1955–59; lecturer at Bendigo Teachers Coll., 1959–61; Melbourne Teachers Coll., 1962–63.

REP: Several tertiary colleges Vic. including Melbourne State College, Burwood, Frankston, Melbourne and Toorak; Deakin Uni.

NFI

NEWELL, Lucy

(b. 29/9/1906, Castlemaine, Vic.) Painter, textile designer, printer.

STUDIES: NGV School, 1927–32. A committee member of the Arts and Crafts Society, Melbourne, 1950–65, she worked principally as a textile printer using Australian motifs, 1934–65. Her work was the subject of a special exhibition at the Castlemaine Art Gallery in 1971 and appeared at the same gallery in a family exhibition, 1978.

AWARDS: Prize for watercolours, Woodend, Vic., 1980.

REP: NGA.

NFI

NEWMAN, Elizabeth

(b. 1/3/1962, Vic.) Painter.

STUDIES: BA Fine Art, VCA, 1983; postgrad. (painting), VCA, 1984. She held five solo exhibitions at City

Gallery, Melbourne 1988, 89, 90; George Paton Gallery, Uni. of Melbourne 1986; Roslyn Oxley9, Sydney 1989. Moving from figuration in the early 1980s her works became abstract, and concerned with the illusory aspects of painting – paintings within paintings, rectangles and squares within a single colour 'frame.' Her work appeared in about 21 group exhibitions 1985–91, mainly in public galleries, including *Other People: Victorian Women Artists*, ACCA 1985; *Fears and Scruples*, Uni. Gallery, Uni. of Melbourne 1986; *The New Generation: Philip Morris Collection*, NGA 1988; *Frames of Reference* Pict 4–5, Sydney 1991.

AWARDS: Vitrex Camden Award, 1984; overseas fellowship, Besozzo, Italy, VACB, 1986; Gold Coast Art Prize, acquisition, 1988.

APPTS: Part-time teaching, Dept of Fine Art, RMIT, 1988; part-time teaching, postgrad. program, VCA, 1988–89; drawing teacher, Dept of Industrial Design, RMIT, 1991.

REP: NGA; Artbank; William Dobell Foundation; Gold Coast regional gallery; ICI corporate collection.

BIB: Catalogue essays exhibitions as above. *Agenda* 1 May 1988. *A&T* Dec. 1986; Dec. 1988; 14 Jan. 1992. *Tension* April 1990; AM March, 1990.

NEWMAN, Nicole

(b. 1/1/1949, Paris; arr. Aust. 1951) Sculptor.
STUDIES: Dip. Art, VCA, 1967–70; San Francisco Art Inst., 1972; postgrad., VCA, 1973–74. Her kitsch sculptures, satires on the glib vulgarity of advertising and fashion have been seen in a number of Melbourne galleries 1972–93, including Realities, Avant and MCA.

REP: NGA; NGV.

BIB: Scarlett, AS. Germaine, AGA.

NEWMARCH, Ann Foster

(b. 9/6/1945, Adelaide) Painter, sculptor, lecturer.
STUDIES: SAA, 1964–67. With a particular interest in community, feminist, environmental and Aboriginal land rights issues, her art reflects these concerns. She held numerous solo exhibitions 1969–93 in Adelaide, Brisbane and Sydney and her work appeared in many significant group exhibitions including *Women in Society*, Hogarth Galleries 1976; *Perspecta*, AGNSW 1981; *Continuum 83*, Tokyo 1983; *The Great Australian Art Exhibition*, touring Australian galleries 1988; *Balance 1990*, QAG 1990; *Bad Mothers*, Reconnaissance, Melbourne 1989 and Tin Sheds, Sydney 1990; *Dame Edna regrets she is unable to attend*, Heide and touring 1992. She has been prominent in a number of community and art-in-working-life projects including Prospect Mural Group, SA; anti-rape mural with Women's Art Movement, Adelaide 1980; *Museum Views*, mural project for SA Museum, 1988 and as a consultant to various government environmental projects.

AWARDS: Grant, VACB, 1976; fellowship, Community Arts Board, 1984; cultural exchange program to China (with muralist Anne Morris); Order of Australia, 1989.

APPTS: Lecturer, SASA, 1969– ; consultant Northern Gateway Project, Dept of Planning and Environment, SA, 1990.

REP: NGA; AGNSW; AGSA; AGWA; MAGNT; NGV; QAG; TMAG; Flinders Uni.; Uni. of SA; VACB.

BIB: Catalogue essays exhibitions as above. Shirley Cameron, *From Shadow to Light – South Australian Artists*, Adelaide, 1989. P. Sutton, *Dreamings: Art of Aboriginal Australia*, 1988. Janine Burke, *Field of Vision*, Viking 1991. Kirby, *Sightlines*. Artforce, no. 10, Dec. 1976–Jan. 1977. Numerous references in AL 1983–93.

NEWSHAM, Edwin

(b. 1891, Chester, Eng.; arr. Adelaide 1923) Painter, carver, etcher, teacher.
STUDIES: Adelaide School of Arts and Crafts, 1925. He married Anne Louise Barnes, sister of Gustav Barnes (q.v.).

APPTS: First principal of the Mt Gambier Tech. School; Deputy Principal, Adelaide School of Arts and Crafts, 1947– .

NEWSOME, Mary

(b. 24/6/1936, Melb.) Printmaker, textile designer, lecturer, curator.
STUDIES: BA, Uni. of Melb., 1957; City & Guilds Certificate, London, 1967; Dip. Art & Design, Prahran CAE, 1977; Grad. Dip. Art Education, Toorak SCV, 1978; Grad. Dip. Museum Studies, Vic. Coll., 1989. She held three solo exhibitions 1978–85, and her work appeared in a number of group exhibitions 1979–93, including *100 × 100*, print folio, PCA 1988; *Letterboxes*, GPO, Melbourne. She was also a member of several education advisory and textile art committees.

APPTS: Tutor, several tertiary colleges Melbourne, 1979–86 including senior tutor, art, Vic. Coll. (now Deakin Uni.), 1984–86; curator, Vic. Coll. Art Collection, 1986–91.

REP: AGSA; QAG; SLV; a number of tertiary collections including ILEA (London), Deakin Uni.

BIB: *150 Women Artists*, Vic. 150. *Fibre Arts Design Book 3*, USA 1988.

NEWTON, Max (Thomas Maxwell)

(b. 1919, Melb.) Painter.
STUDIES: George Bell School, Melbourne; London County Council School; travel studies, Europe and USA. He served with the RAAF as a war artist during World War II, and later exhibited in group exhibitions, mainly in Melbourne.

REP: AGWA; NGV; QAG; TMAG; AWM; Geelong regional gallery.

NFI

NIBBI, Gino

(b. 1896, Fermo, Italy; arr. Aust. 1930; d. Dec. 1969, Rome) Writer, critic, bookshop proprietor, entrepreneur, art writer. Art correspondent for Rome *Il Giornale d'Italia*, Madrid *Goya* and Tokyo *Japan Times*. Nibbi visited Australia in 1928 and returned to settle in 1930 to conduct the Melbourne bookshop which quickly became a centre of avant-garde art activities,

Hilda Rix Nicholas, Market Women of Morocco, *1912–14, coloured crayon on paper, 53 × 36.5cm. Private collection.*

including in 1931 the distribution of the magazine *Stream*. Police action to remove a display of prints by Modigliani gave further celebrity to the shop. Nibbi provided Ian Fairweather with contacts with artists soon after his arrival in Melbourne and helped him to get commissions. He played an active part in the CAS movement in 1939 and soon after World War II returned to Italy and opened, in Rome, a combined bookshop and art gallery called *Galleria ai Quattro Venti*. Sidney Nolan and Albert Tucker held a joint exhibition at the gallery in 1953. Nibbi returned to Australia in 1954, visited Japan, 1960–61, and attended the first meeting of the Australian division of the International Association of Art Critics in Melbourne in 1963, prior to his return to Italy.

NICHOL, *Keith James Craig*
(b. 11/2/1921, Harkaway, Vic.; d. 1/8/1979, Melb.)
Painter.

STUDIES: NGV School, 1946–49; travel studies Europe and UK, –1953. He became friendly with Arthur Boyd at the Murrumbeena state school, accompanied him on painting trips by bicycle and, in 1939, held an exhibition jointly with Boyd at the Athenaeum Gallery, Melbourne. His landscapes are modest in scale and romantic in style. From 1953 to 1967 he exhibited with the Social Realist group in Melbourne and held exhibitions in Qld, SA and Vic.
AWARDS: First prize (best by a serviceman section), *Australia at War* exhibition, 1945; third prize (shared), Dunlop competitions, 1950.
REP: NGV; Swan Hill regional gallery.
(Letter from Russell Davis, Armadale, Vic., 28 July 1979)

NICHOLAS, *Hilda Emma (née RIX)*
(b. 1884, Ballarat, Vic.; d. 1961, Tombong, NSW)
Painter, pastellist.
STUDIES: NGV School, with Frederick McCubbin, 1902–05; Paris, 1908– ; travel studies UK, Europe and North Africa. Known as 'Hilda Rix Nicholas' or 'Hilda Rix', she exhibited the pastel drawings made during her travels in Paris and in 1911 a large canvas was hung in the Paris Salon and a work was acquired for the Luxembourg. The outbreak of World War I caused her to abandon her studio and belongings at Etaples. In 1916 the paintings were discovered and admired by an Australian soldier, Major G. N. Nicholas, who subsequently met the artist. They were soon married. Six weeks after the marriage he was killed in action. Hilda Rix Nicholas returned to Australia after the war to be acclaimed at her exhibitions in Sydney and Melbourne as an important Australian artist. She painted in the Monaro district of NSW, often realistic romanticised scenes of riders. Back in England and France in 1924 her work was bought for the City of Leicester gallery and the Jeu de Paume; 9 of her paintings were hung at the Paris Salon of 1925 and she was made an Associate. She married a second time on her return to Australia, Edgar Wright, of Tombong. They made their home at Tombong and she remained there for the rest of her life. Her last exhibition was at David Jones Gallery, Sydney, in 1945. Failing eyesight limited her output during her declining years. In the main her work reflected the prevailing spirit of the British art of the 1920s as represented by Orpen, John, Brangwyn and Laura Knight. The Joseph Brown Gallery, Melb., held an exhibition of her work in July 1971 and she was represented in the Bicentennial exhibition *The Face of Australia* and *A Century of Australian Women Artists 1840s–1940s* Deutscher Fine Art, Melbourne, 1993. The Waverley City Gallery Melbourne held a touring exhibition, curated by John Pigot, *Capturing the Orient – Hilda Rix Nicholas and Ethel Carrick* in 1993 which highlighted her fine drawing and sketching ability.
REP: NGA; AGNSW; AGSA; AGWA; NGV; MAGNT; QAG; TMAG; regional galleries.
BIB: Catalogue essays exhibitions as above. AA no. 6, 1919

1940s–70s

William Dobell, The Cypriot *1940, oil on canvas, 123.3 × 123.3cm. Collection,* QAG.

The mid to late 1940s heralded the most innovative, lively and controversial periods of Australian art since the Impressionist period of the late 1800s and saw Australian art develop a strong individual identity. Largely focused in Melbourne, figurative expressionism (q.v.), deriving from Europe, was effectively assimilated by Australian artists including Sidney Nolan, Albert Tucker, Arthur Boyd, John Perceval and Joy Hester. Russell Drysdale painted strong evocative images of lonely country town streets and houses, Noel Counihan graphically portrayed the life of the everyday in strong social-realist images, William Dobell took portrait painting into an individuality it had never before experienced and the Antipodean group (q.v.) held an exhibition in 1959 to reinforce their commitment to expressionism.

Aspects of surrealism (q.v.) were also portrayed in many artists work in this era most consistently in the work of James Gleeson.

Left: *Roy de Maistre* Interior Artists Studio, *n.d., oil on board, 80 × 60cm. Sotheby's, April 1990.*

Below left: *Wilfred McCulloch,* The Restless Sea, *1941, oil on canvas, 56 × 85. Private collection.*

Below: *Albert Tucker,* Images of Modern Evil series (Watcher on the Balcony), *1945, 63.5 × 53.2. Private collection.*

Above: *Sali Herman,* Suburbia, Paddington, *1947. oil on board, 54.5 × 75cm. Joels, August 1992.*

Above left: *Norman Lindsay,* Adventure, *1944, oil on canvas, 88.5 × 75cm. Private collection.*

Left: *Noel Counihan,* Miners working in wet conditions, *1942, oil on composition board, 61.5 × 79.3cm. Collection, NGA.*

Above: *Sidney Nolan,* Pretty Polly Mine, *1948, enamel on hardboard 91 × 122.2cm. Collection,* AGNSW.

Above: *Alan Sumner,* The Cabbage Patch, *1947, silkscreen print. ed.40. 37 × 43cm. Courtesy Eastgate Galleries, Melbourne.*

Top: *Edith Holmes,* Mt Direction, *1949, oil on canvas on cardboard, 52.5 × 60.7. Collection,* TMAG.

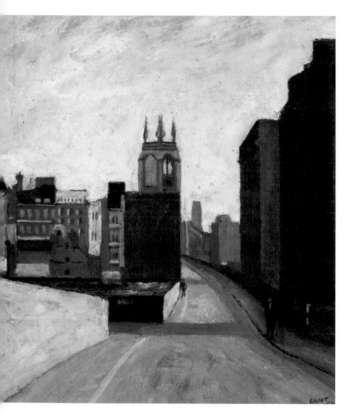

Above: *James Cant,* Islington Street, *1954, encaustic on hardboard, 48 × 42.5cm. Private collection.*

Above: *Russell Drysdale,* George Ross of Mullengrandra, *1950, oil on canvas, 64.1 × 100.3cm. Courtesy Martin Browne, Sydney.*

Right: *James Gleeson,* Funeral Procession in a Wounded Landscape, *1945, oil on canvas, 117 × 176cm. Courtesy Martin Browne Fine Art, Sydney.*

Above: *Charles Blackman,* It's always Teatime, *1956, oil on enamel on board, 148 × 106.6cm. Private collection.*

Top: *Lloyd Rees,* The Coast near Kiama, *1952, oil on canvas, 89.8 × 118.7. Collection,* QAG.

Above: *Godfrey Miller,* Trees in moonlight, *c. 1959, oil on canvas on wood, 62.5 × 85.7cm. Collection,* QAG.

Above: *Leonard French,* Ancient Sun, *1963, enamel and gold leaf on board, 137 × 122cm. Joel's, November, 1992.*

Top right: *Arthur Boyd,* The Phantom Bride, *1958, oil and tempera on board, 160 × 137cm. Private collection.*

Right: *Clifton Pugh,* Cruxification on the Salt Pans III, *1961, oil on board, 90 × 105cm. Joel's, November, 1992.*

John Perceval, Romulus and Remus with Wolf Mother, *1961, glazed earthware, 31 × 30c. Collection, Powerhouse Museum, Sydney.*

John Olsen, Summer in you beaut country, *1963, oil
on hardboard, 137 × 180cm. Collection,* TMAG.

Above: *Fred Williams,* You-Yang Pond, *1968, oil on composition board. Collection, AGSA.*

Left: *Judy Cassab,* Desiderius Orban, *1965, oil on canvas, 120 × 120cm. Private collection.*

(Ruth Sutherland article). Janine Burke, *Australian Women Artists* Greenhouse Publication, Melbourne, 1981.

NICHOLAS, Michael Geoffrey

(b. 19/3/1942, Hayes, Middlesex; arr. Aust., Feb. 1960) Painter.
STUDIES: Qld, with Arthur Evan Read; travel studies Europe and UK, 1971–72. He held about three solo exhibitions 1970–89, largely in Qld and Cooks Hill, Newcastle, NSW. In 1992 he was the first artist to be appointed to the Qld Govt program of *Artists in Parks*, completing a residency in Girraween National Park.
AWARDS: Prizes at Redcliffe, 1970; RNAgAQ, Brisbane (landscape prize), 1971; Charters Towers, 1974; Qld Rugby League, 1975; Beenleigh, 1976, 77; QAG Trustees Prize, 1982; Suncrop Art Prize, 1983; Stanthorpe, 1984; Aberdare, 1984.
REP: QAG; Artbank; Brisbane City Gallery; regional galleries Townsville, Stanthorpe; tertiary collections including Qld Uni. of Technology, Griffith Uni., Uni. of New England.

William Nicholas, Hannah Tompson (Mrs Charles Tompson Junior) nee Morris (1803?–1874), *watercolour, 36.2 × 29.2. Collection, Mitchell Library.*

NICHOLAS, William

(b. 1809, UK; arr. Sydney 1836; d. 1854) Draughtsman, engraver, lithographer. He became known as Sydney's 'society artist', specialising in watercolour portraits 1830s–50s and participated in a number of art unions and exhibitions of the day, including the Society for the Promotion of Fine Arts 1847, 1849. He drew portraits for Baker's *Heads of the People*, including a likeness of Ludwig Leichhardt. His work was seen in the Bicentennial exhibition *The Face of Australia*; *The Artist and the Patron*, AGNSW 1989 and at exhibitions at Bridget McDonnell Gallery, Melbourne.
REP: Ballarat Fine Art Gallery; NLA; Mitchell Library; a number of historic properties including Vaucluse House and Duntroon.
BIB: Moore, SAA. Eve Buscombe, *Artists in Early Australia and their Portraits*, Sydney 1978. F. Connell, *The Mystery of Ludwig Leichhardt*, MUP, 1980. Kerr, DAA.

NICHOLLS, Michael

(b. 5/10/1960, Melb.) Painter, sculptor.
STUDIES: CIT, 1980–83. His 1980s expressionistic works were typical of the style characteristic of a number of founding members of ROAR Studios, Melbourne, of which he was one. He held 8 solo exhibitions 1986–91 Sydney (Coventry, 1986, 88, 90, 91) and Melbourne (13 Verity St 1987, 89, 91, 93). About 21 group exhibitions in which his work appeared 1982–91 included Coventry, Sydney, ROAR Studios 1982, 83, 84 and in *A New Generation 1983–88: The Philip Morris Arts Grant Purchases*, NGA; *Greenpeace*, Linden, Melbourne 1990. He was commissioned for a sculpture by Playbox, and a painting, Malthouse Theatre, Melbourne, 1990.
REP: NGA; Sir William Dobell Art Foundation: regional galleries Campbelltown, Grafton; Myer, Philip Morris, Allen, Allen & Hemsley, Gadens Ridgeway, Robert Holmes à Court, Pan Continental Mining and other corporate collections.
BIB: *New Art Three*.

NICHOLLS, W. A.

(Active c. 1850) Sketcher. Referred to by Moore (SAA., 1934) as 'an artist who did a number of sketches of the goldfields'.
BIB: Moore, SAA. McCulloch, AAGR.
NFI

NICHOLS, Ethel Maud

(b. 1866; d. 1956, Hobart) Painter. She excelled as a painter of street scenes.
REP: TMAG.
BIB: Moore, SAA.

NICHOLS, Gary

(b. 1950, Hobart) Painter.
STUDIES: Dip. Fine Arts, Alexander Mackie CAE, 1974–77; New York Studio School, NY, 1978–85; Skowhegan School, Maine, USA, 1982. He held solo exhibitions in New York, 1991, and Macquarie Galleries, Sydney, 1992, and was nominated by Alan Oldfield for the exhibition, *Artists' Choice*, Gallery A, Sydney, 1976. He participated in many group exhibitions from 1976 including a number in New York where he was

based 1984–88, and *Contemporary Australian Drawings from the Collection*, AGNSW 1992.
AWARDS: Marten Bequest Travelling Scholarship, 1977; Dyason Scholarship, AGNSW, 1977; Peter Brown Scholarship to New York Studio School, VACB, 1980; merit scholarships, New York Studio School, 1981, 82; Skowhegan Scholarship, New York Studio School, 1982.
APPTS: Visiting artist and lecturer, City Art Inst., Sydney, 1987; teacher, painting, Parsons School of Design, New York, 1989–90.
REP: AGNSW; NGV; Artbank; Burnie Museum; Westpac Bank, NY; Samual P. Harn Museum of Art, Uni. of Florida.

NICHOLSON, Max (Maxwell Leigh)

(b. 14/2/1945, Adelaide) Painter.
STUDIES: SASA (part-time), 1961–64. His landscape paintings of outback areas with wildlife became known through solo exhibitions annually from 1973 largely at Manyung, Vic.; Kensington Galleries, Adelaide and Allerton Gallery, Melbourne. He exhibits with the VAS.
AWARDS: Prizes at Flinders, Vic., 1975; VAS (Applied Chemicals prize), 1976, and Lismore, NSW, 1978.
REP: Artbank; a number of regional gallery collections including Mornington, Rockhampton, Lismore; several tertiary institutions; corporate collections including Shell, Kraft, Mobil, Mitsubishi.
BIB: Germaine, *AGA*.
NFI

Peter Nicholson, Rubbery Figures. *Animated puppets.*

NICHOLSON, Peter Harvey

(b. 27/9/1946, Melb.) Cartoonist. Well-known political cartoonist for *The Age* since 1976, his cartoons had previously appeared in *Nation Review*, *National Times* and *Australian Financial Review*. His sculptures, often in bronze and his *Rubbery Figures* animated television series from 1989 arose from his cartoons. His first solo exhibition of caricature sculpture and drawings toured Victorian regional galleries 1982–83, and

his next solo show (including his *Rubbery Figures*) was held in the Access Gallery of the NGV, 1993. He also exhibited in two-person shows at Powell St, Melbourne, 1985 and Solander, Canberra, 1986. He participated in numerous group exhibitions 1987–93, including *Mildura Sculpture Triennial*, 1987; *Uncommon Australians: Towards a National Portrait Gallery*, touring state galleries and the NGA, 1992 and *Rubbery Figures*, Old Parliament House, Canberra 1993, curated by the Australian National Museum.
AWARDS: Walkley Award for best Australian cartoon, 1982, 92; Walkley Award for best Australian illustration, 1991–92.
REP: NGV; State Library, Vic.; regional galleries Ballarat, Latrobe Valley.
BIB: Catalogue essays exhibitions as above. *Twenty-seven Deadly Sins (A collection of cartoons from 1976–1983)*, Penguin, Australia, 1983.

NICHOLSON, William Michael

(b. 1916, Newark-on-Trent, Nottinghamshire, UK; arr. Aust. 1960) Sculptor, film-maker, lecturer.
STUDIES: RMC, Sandhurst, UK, 1933–36; City and Guilds School of Arts and Crafts, London, 1938–39; Camberwell School of Arts and Crafts, 1947–48. He served in France and Burma during World War II, attained the rank of major and resumed his art career in 1947. From 1960 he completed commissions for decorative works for large office buildings in Sydney, designed and supervised the sculpture and fountain court for the Jesmond Centre, Newcastle, and from 1966 was president of the Society of Sculptors and Associates, Sydney. In 1968 his minimal sculptures were included in the NGV exhibition, *The Field*. He has also made films and video, some shown at the *Mildura Sculpture Triennial*.
AWARDS: Wall relief commission, Commonwealth Works Dept Building (jointly with Leonard Hessing), 1962 (the work was never completed); R.Ag.Soc.NSW (for sculpture), 1964; Mildura Sculpture Triennial Awards, 1973, 75; Australian Film Inst. grant, 1973.
APPTS: Teaching, Central School of Arts and Crafts, UK, 1948–51; visiting lecturer, School of Art and Design, Auckland Uni., NZ, 1951–53; senior tutor, School of Architecture, Uni. of NSW, Sydney, 1962–69; temporary lecturer, Power Inst. of Fine Arts, Uni. of Sydney, 1974; artist-in-residence, Northern Rivers CAE, 1976–77.
REP: AGNSW; Auckland City Art Gallery, NZ.
BIB: Catalogue essays exhibitions as above. Sturgeon, *DAS*. Scarlett, *AS*.

NICKOLLS, Trevor

(b. 1949, Adelaide, SA) Painter, graphic artist.
STUDIES: SASA, Adelaide, 1970s. Wally Caruana describes Nickolls (*Aboriginal Art*, Thames and Hudson, 1993) as being one of the two 'pioneers in establishing a place on the Australian scene for artists working outside the classical Aboriginal traditions' whose achievements 'opened the way for others to follow'. He studied Western art in SA before moving to the NT for several

years, learning of desert and other Aboriginal painting, before returning to live in Sydney. His paintings are, as Caruana describes, about 'expressing in paint the dilemmas facing the individual caught between two cultures and isolated from both'. He held 13 solo exhibitions 1978–91 at various galleries in Canberra, Sydney, Brisbane, Adelaide and at the MAGNT, 1982. He was represented in numerous group exhibitions including *Koori Art '84*, Contemporary Art Space, Sydney; *Art and Aboriginality*, Exhibition Hall, Sydney Opera House, NSW and Aspex Gallery, Ports-mouth, England, 1987; the Bicentennial exhibition *The Face of Australia*; *A Koori Perspective: Australian Perspecta*, Artspace, Sydney, 1989; Venice Biennale, Italy, 1990; *Crossroads: Towards a New Reality*, Museum of Modern Art, Kyoto and Tokyo, Japan, 1992.
AWARDS: Alice Springs acquisition art award, 1976; Canberra Civic permanent art award, 1980; Jacaranda Art Society acquisition drawing prize, Grafton Aboriginal gallery, 1988; grants, creative arts fellowship, ANU, Canberra, 1981, Aboriginal Arts Board, 1981, 84.
REP: NGA; NGV; AGSA; AGWA; NT Museum of Arts & Sciences; ANU; Flinders Uni.; James Cook Uni; Canberra CAE; Melbourne CAE; NSW Institute of Tech.
BIB: Catalogue essays exhibitions as above. Uli Beir, *Dreamtime-Machine Time: The Art of Trevor Nickolls*, Robert Brown & Associates, Bathurst, NSW, in association with the Aboriginal Arts Agency, 1975. J. Isaacs, *Aboriginality: Contemporary Aboriginal Paintings and Prints*, UQP, 1989. P. Sutton, *Dreamings: The Art of Aboriginal Australia*, Viking Press, New York, 1988. Caruana, *AA*. Smith, *AP*. *Aspect* 34, Sydney.

NIGRO, Jun (Mrs Elizabeth Nigro)
(b. 16/4/1920, NZ; arr. Melb. 1948) Painter.
STUDIES: Elam School of Art, Auckland; George Bell School, Melbourne, 1948–52. Her work was exhibited at the Stanley Coe Gallery, Melbourne, 1950. She returned to NZ in 1952, settled at Rotorua, and became known for her modernist, metamorphic paintings noted for their strong emotional content. Member of the CAS and VAS, Melbourne.
AWARDS: Prizes in Dunlop contest, 1950.
REP: NGV.
BIB: Gil Docking, *Two Hundred Years of New Zealand Painting*, Lansdowne, Melbourne, 1971.

NIKOLESKI, Vlase
(b. 17/2/1948, Ohrid, Macedonia; arr. Sydney 1966) Sculptor.
STUDIES: Bitola Uni., Macedonia (mechanical engineering), 1961–65; Moscow Uni. (Faculty of Hydraulics), 1965–66; Tasmanian School of Art, Hobart, 1970; NGV School, 1971–72; VCA, 1972–75; MA (sculpture), City Art Inst., Sydney, 1985–87; travel studies, France and UK, 1973–74; USA, 1977. He held about 12 solo exhibitions 1973–90, including at Tolarno, Melbourne; Solander, Canberra; Macquarie, Sydney and Ivan Dougherty Gallery, Sydney, 1987. His first exhibition (Tolarno Galleries, 1974) marked him as a sculptor of great promise. He showed large-scale minimal sculptures in stainless steel at the *Mildura Sculpture Triennial*,

1973 and 1975, and since, participated in numerous group sculpture exhibitions including and a number of international exhibitions including in Macedonia and USA. His commissioned works include the commemorative Captain Cook Bicentenary sculpture for the Hobart City Council, 1970.
AWARDS: Vitorio and Fernando Foundry Sculpture Prize, 1973; VACB grants, 1973, 75; Keith and Elisabeth Murdoch Travelling Fellowship, VCA, Melbourne, 1977; International Sculpture Prize, winner, International Sculpture Symposium, Macedonia, 1980; research grant, Hunter Inst. of Higher Education, 1989.
APPTS: Lecturer in sculpture and drawing since 1975 at various tertiary colleges, Australia, including Canberra School of Art, 1976–84; Newcastle CAE, 1984–89; senior lecturer in sculpture and drawing, Dept. of Fine Art, Uni. of Newcastle, 1992– .
REP: NGA; NGV; Heide; VCA; Mildura Arts Centre; public museums and collections in Macedonia, Indonesia.
BIB: Catalogue essays in exhibitions as above. Scarlett, *AS*. Sturgeon, *DAS*.

NIMMO, Lorna Muir
(b. 1920, Katoomba, NSW; d. 1991, Murrunundi, NSW) Painter, graphic artist.
STUDIES: ESTC, 1936–40; Paris; Slade School of Art and Courtauld Inst., London, 1952–54; travel studies, Europe, UK and USA, 1969–70. She exhibited with the Australian Watercolour Institute 1940s–c. 1980 (president 1955–58), and the Society of Artists 1941–42. Her work was included in *100 Years of Australian Painting* Centenary of Public Education in NSW, AGNSW, 1948; *Australian Women Painters 1950s–60s*, Lewers Bequest and Penrith Regional Art Galleries, 1982; *Twentieth Century Australian Watercolours*, AGNSW, 1989.
AWARDS: NSW Travelling Scholarship for landscape painting, 1941; Wynne prize, 1941.
APPTS: Teacher, ESTC, 1945–52; Lecturer in contemporary art, and in charge of graphics, School of Architecture, Uni. of NSW, 1955–80; president, Australian Watercolour Institute, 1955–58.
REP: NGA; AGNSW; AGSA; regional galleries at Armidale, Newcastle.
BIB: Smith, *Catalogue AGNSW*, 1953; Campbell, *AWP*. Germaine, *AGA*.

NIND, Isaac Scott
(b. 1797, Tewkesbury, Eng.; arr. NSW c. 1826; d. 6/8/1868, Campbelltown, NSW) Topographical artist, surgeon, writer. He was appointed Colonial Assistant Surgeon at King George Sound, WA, 1826, but returned to NSW in 1829 and to England soon after. In London, Robert Brown read a paper by Nind on WA Aborigines to the Royal Geographical Society (14 Feb. 1831). His watercolour views of King George Sound show him to be a competent topographical artist. He returned to NSW in 1833 and remained there till his death. His work was seen in *The Colonial Eye*, AGWA 1979.
REP: AGWA.
BIB: AGWA *Bulletin*, vol. 1, no. 4, Nov. 1962. Kerr, *DAA*.

NINE × FIVE EXHIBITION
(9 × 5 Impressions Exhibition)
See HEIDELBERG SCHOOL; EXHIBITIONS

NISBETT, *Herkis Hume*
(b. 1849, Scotland; arr. Aust. 1865; d. 1923) Painter, author, teacher. Widely travelled, he appears to have spent considerable time in Australia; a sunset of Sydney Harbour, dated 1874 (Christie's, Sydney, Nov. 1975), and a suite of three watercolours of bush scenes, dated 1879 (Joseph Brown Gallery, *Exhibition of Nineteenth Century Australian Paintings*, 1969), suggest a long stay. A prolific writer and illustrator, he published more than 23 books and illustrated several by other writers. He returned to Scotland in 1879 or 1880 and exhibited at the Royal Scottish Academy, 1880–85.
BIB: J. Johnson and A. Greutzner, *Dictionary of British Artists, 1880–1940*, Antique Collectors Club, Woodridge, Suffolk, 1976.

NIVISON, *Angus*
(b. 1/2/1953, Walcha, NSW) Painter.
STUDIES: NAS, ESTC, 1972–74; Alexander Mackie CAE, 1975; travel studies UK, Europe, 1979, 83, 88. Abstract expressionist in style, his paintings are frequently seen in his local area of New England, NSW, at Walcha as well as six solo exhibitions 1982–91, mainly in Sydney (Gallery A; Bloomfield; Coventry). He participated in a number of group exhibitions 1974–91, largely with Bloomfield, Sydney and from 1991, Coventry, and in the New England area of NSW (New England Art Museum, Armidale, Tamworth City Art Gallery). He had several commissions for murals in local public spaces, including the Armidale Festival, 1980 and Tamworth City Council, 1983.
AWARDS: *Sydney Morning Herald* Travelling Scholarship, 1979; residency, Owen Tooth Memorial Cottage, Vence, France, 1979; several regional prizes including Maitland, 1976; Narrabri, 1977; Gold Coast, 1989; Muswellbrook, 1991.
REP: Parliament House; Artbank; several regional collections including Gold Coast City, Maitland, New England, Tamworth; Uni. of NSW; corporate collections including Consolidated Press and *Sydney Morning Herald*.
BIB: *Artforce*, no. 23, May–June, 1979. *New Art Five*.

NIXON, *Anna Maria*
(Active 1830s–60s, Hobart) Sketcher, painter. The second wife of the Bishop of Tasmania, Francis Russell Nixon (q.v.), she was a prolific sketcher of the landscape, town and domestic scenes around Hobart before returning to England in 1862.
REP: QVMAG; TMAG; NLA; Mitchell Library.
BIB: *ADB* 6. Kerr, *DAA*.

NIXON, *(Dr) Francis Russell*
(b. 1803, Kent; arr. Hobart 1843; d. 1879, Italy) Painter, photographer. First Bishop of Tasmania, he was a noted painter of Tasmanian landscapes in water-colour. Not to be confused with Frederick Robert Nixon (q.v.), of SA, he illustrated *The Cruise of the Beacon*, an account of a visit to Bass Strait, 1857, and also made a number of lithographs and photographs. He returned to England in 1862 for health reasons. His work was seen in *Shades of Light*, NGA 1988 and *Tasmanian Vision* TMAG and QVMAG 1988.
REP: QVMAG; TMAG; Mitchell, Dixson, Allport Libraries; National Portrait Gallery, London.
BIB: *ADB* 2. Kerr, *DAA*.

NIXON, *Frederick Robert*
(Active c. 1836–45, SA) Surveyor, artist. Employed in the SA Surveyor General's Dept, 1836–43, he drew, etched and printed a volume of views in and around Adelaide. His spirited support of the work of S. T. Gill as opposed to that of G. F. Angas gives him also a fair claim for recognition as South Australia's only remembered Colonial art critic. On 17 June 1845 he published a long letter in the *South Australian* attacking the work of George French Angas, who had been granted the rare privilege of a solo exhibition in the Council Room. The substance of Nixon's comment was that if such support for art was forthcoming it should have been given to the work of S. T. Gill. His letter evoked the following editorial response in a rival newspaper, the *South Australian Register*, 18 June 1845: 'Mr N.F.R. is known to be Mr F. R. Nixon who some time ago practised a gross imposition on the colonists by the publication of 12 views around Adelaide at a guinea, which were not intrinsically worth a farthing . . . our opinion of Mr Nixon as a mere "bastard" has long been formed . . . We have long wished to have our guinea's worth out of him but are sorry to say no opportunity has ever presented itself.' Accepted well in their day, however, the quality of these paintings has been confirmed by the test of time.
REP: AGSA; NLA; Mortlock Library.
BIB: Moore, *SAA*.. McCulloch, *AAGR*. Benko, *Art and Artists of SA*, Lidums, Adelaide. Kerr, *DAA*.

NIXON, *John*
(b. 1949, Sydney) Installation artist, painter.
STUDIES: PIT, 1967–68; Dip. Art, NGV School, 1970; Dip. Ed., Melb. State Coll., 1973; frequent travel studies from 1976, UK, Europe, USA, Asia. A leading conceptual artist his work as shown in Melbourne first at the Pinacotheca Gallery, 1973–77, then in NGV, AGSA, Experimental Art Foundation, Adelaide, and ANU, 1976–79, concerned multi-media art and art as language, some conducted in collaboration with Peter Kennedy. He ran his own gallery in partnership with Jenny Watson (q.v.) 'Art Projects', in Melbourne, 1979–85, and wrote numerous essays for catalogues and art journals. From 1980 all of his work has related to the title *Self-Portrait* (*Non-Objective Composition*), described by Terry Smith in *Australian Painting* (OUP, 1992) as using 'only the techniques, materials and compositional modes of the Constructivists. . . . [he] does this not in order to make a naive fantasy self-fulfilling, but to dramatize its impossibility.' Largely

due to the film and video media in which he worked in the 1970s and 80s he held an extraordinary number (up to 37) of exhibitions annually at contemporary galleries including IMA, Brisbane; Roslyn Oxley9, Sydney; City Gallery/Anna Schwartz, Melbourne. His work appeared in numerous group exhibitions from 1975 including *A Melbourne Mood*, ANU 1983; *Perspecta*, AGNSW 1983, 85, 87; *Biennale of Sydney*, 1979, 88, 90; *Australian Visions*, QAG and touring state galleries 1985; *Emerging Artists 1978–86: Selections from Exxon Series*, Guggenheim, NY 1987; *Field to Figuration*, NGV 1987; *Edge to Edge: Contemporary Australian Art to Japan*, National Museum of Osaka and touring Japan 1988; *Opening Transformation*, MCA, Sydney 1991; *Strangers in Paradise*, Museum of Contemporary Art, Seoul, Korea 1992.

AWARDS: VACB grants 1975, 76, 77, 84, 89; grant, Theatre Board, Aust. Council, 1984; residency, Villa Arson, Nice, France, Aust./French artists exchange program, 1988.

REP: NGA; AGNSW; AGSA; AGWA; NGV; QAG; MCA, Sydney; Geelong Art Gallery; a number of tertiary collections including Deakin, Griffith, Monash, Melbourne unis; Guggenheim Museum, NY; a number of European state collections including Lodz, Poland, Paris, France.

BIB: Catalogue essays exhibitions as above. R. Crumlin, *Images of Religion in Australian Art*, Bay Books, Sydney, 1988. Smith, AP. Artforce, no. 10, Dec. 1976, and Jan. 1977. Numerous references in A&T from 1981– and AM from 1986. *Tension* no 10, 1986; no. 14, 1988.

NOBLE, Jill

(b. 1962, Adelaide) Painter.
STUDIES: SASA, 1980–82. In 1982 she moved to Melbourne and became a founding member of ROAR studios. Her 1980s work adopted the style of 'Art Brut' or 'Outsider' art with its 'naive-sophisticate' style. She held three solo exhibitions at Coventry, Sydney (1987, 88, 90) and participated in about 19 group exhibitions 1982–92 in private galleries (Coventry, Sydney); ROAR Studios, and *A New Generation: Philip Morris Arts Grant Purchases*, NGA 1988.
REP: NGA; NGV; Artbank; Uni. of WA; William Dobell Art Foundation; IBM, Baker & McKenzie, Gadens Ridgeway and other corporate collections.
BIB: *New Art Five*.

NOBLE, Richard

(b. c. 1812; arr. Sydney, 1847) Painter.
STUDIES: RA Schools, London, 1828– . He exhibited with the Society for the Promotion of Fine Arts (landscape of East Malling, Kent) at its first exhibition at the Australian Library, Sydney, 1847. He painted mainly sentimental, romanticised portraits of prominent colonists and their children, including one of Lady Mary FitzRoy (Government House, Parramatta). Reputedly, he had only one arm. He is believed to have left Sydney for the USA, 1865. He was represented in *Australian Colonial Portraits*, TMAG 1979 and *The Artist and the Patron*, AGNSW 1988.

REP: NGA; AGNSW; AGSA; Joseph Brown Collection.
BIB: Thomas, OAA 1973. Eve Buscombe, *Artists in Early Australia and their Portraits*, Sydney 1978. Kerr, DAA.

NOLAN, Cynthia (née REED)

(b. c. 1910; d. 1976, London) Writer, connoisseur. Sister of John Reed, married to Sidney Nolan, to whom she gave lifelong help and encouragement. She wrote *Open Negative*, with jacket and endpapers by Sidney Nolan, Macmillan, London, 1967.
BIB: A&A 5/2/1967 (Nolan Issue) (*Extracts from Open Negative*).

NOLAN, Sidney Robert

(b. 22/4/1917, Carlton, Vic.; d. 29/11/1992, London Painter.
STUDIES: NGV School, evening classes, 1934 and 1936; various Melbourne technical schools; Atelier 17, Paris, engraving and lithography with S. W. Hayter, 1957. He earned a living in the art department of a hat factory, 1934–38, and during this period shared a studio near the NGV with John Sinclair (later Melbourne *Herald* music critic), and Arthur Evan Read (q.v.). In 1939 his views on modern art, known formerly from reproductions of works by Cézanne, Van Gogh, Picasso, Miró and other masters seen at the bookshop of Gino Nibbi (q.v.) were stimulated and affirmed by the *Exhibition of French and British Contemporary Art*, which opened at the Melbourne Town Hall, 16 Oct. 1939. (*See* EXHIBITIONS) Other influences that were to shape his art came from Danila Vassilieff, and from his first patrons, Sunday and John Reed. Nolan exhibited annually with the CAS, 1939–47, and held his first solo exhibition in 1940. He designed décor for Serge Lifar's ballet, *Icare*, in 1941, took an editorial interest in *Angry Penguins*, and completed his war service with the army, 1942–45, during which time he produced a series of naive sophisticate pictures painted mainly at Dimboola, Victoria, based on child art and primitive art. These pictures gained him the patronage of the Melbourne *Herald* critic, Clive Turnbull, one of the first to buy his work. In 1946 he began a whole series of paintings on the theme of the bushranger Ned Kelly, whose legendary exploits had come to him via his grandfather, a member of the Victorian police force. Nolan toured the Kelly country in company with the writer and editor Max Harris in 1946, absorbing the atmosphere; four of the Kelly works were reproduced in the *Australian Artist*, and the Kelly legend-in-paint that was to make Nolan's name was launched. Other early series concerned Fraser Island, which he visited in 1947, and the time-ravaged landscape of Australia's 'dead heart' as observed from the air. His greatest encouragement now came from a visitor, Sir Kenneth Clark, who pronounced Nolan Australia's 'only real painter'. By then he had married Cynthia Reed, his first patron's sister, and in 1948 John Reed took the Kelly paintings to Paris where, in 1949, they were exhibited at UNESCO. Two other paintings by Nolan were bought for the AGNSW in 1949; he won the Dunlop Prize in 1950, exhibited

in Sydney and Rome, and went to London for his first exhibition there, at the Redfern Gallery, in 1951. Successive series of works, including themes of Leda and the Swan, African animals, and Gallipoli and the ANZACS, further enhanced his reputation and earned him the right to be called 'Australia's most internationally celebrated painter'. The Nolan story may be a rags to-riches story, but it is not true to say (as has often been said) that he did not receive adequate support during his early career from both patrons and critics. John and Sunday Reed became his most valuable patrons, his wife Cynthia became a great driving force, and having once been launched his successes followed swiftly, one after another. After Cynthia's death in 1976, he married Mary Perceval, divorced wife of his old friend and colleague John Perceval, and sister of Arthur Boyd (qq.v.), thus linking together three outstanding figures in the story of post-World War II Australian art development.

His widely varied activities included designs for ballets and plays, illustrations and dust jacket designs for books, notably the novels of Patrick White, Alan Moorehead, Colin McInnes and George Johnston. He acted as adviser to and organiser of the Australian contribution to the *Biennale of Venice*, 1954, and in 1974 donated his Gallipoli series of paintings and drawings to the Australian War Memorial, Canberra, in honour of his brother, killed in World War II. Much of Nolan's late career involved travelling, being photographed, interviewed, written about and filmed. In 1978 a television film, *Nolan at Sixty* was made by the BBC working in concert with a West German television company and the ABC. He was knighted in 1981 and in that year he also had resumed his interest in designing for theatre. He designed the décor for Stravinsky's *Rite of Spring* for Covent Garden in 1962, and in September 1981 his designs for Saint-Saëns' opera *Samson and Delilah*, for the Royal Opera House, were well received in London. He also designed the décor for Edward Cowie's opera *Ned Kelly*, the subject with which his own reputation as a painter really began. During his last years he made a number of important gifts to federal and state government instrumentalities, notably the Kelly paintings to the NGA, housed at 'Lanyon', and the large set (1320 individual works) of flower paintings, *Paradise Gardens*, installed in the foyers of the Concert Hall and the State Theatre at the Victorian Arts Centre, Melbourne in 1982. In 1985 he and Mary Nolan acquired the property adjoining Arthur and Yvonne Boyd's on the Shoalhaven River, NSW, and in 1986 he donated some 50 paintings to Ireland after purchasing some land in County Clare. Major exhibitions 1986–92 include his Antarctic and African series at 'Lanyon', 1986 and a large retrospective, *Sir Sidney Nolan: Landscapes and Legends: A Retrospective 1937–77*, NGV, AGNSW, AGSA, AGWA 1987–88; Australian Galleries, Melbourne, 1992. He was represented in Bicentennial exhibitions *The Great Australian Art Exhibition* and *The Face of Australia*. A book and film, conceived, written and produced by Brian Adams were released in 1987, the film being

shown on television in London and the UK, Australia, Hong Kong and Ireland.

AWARDS: Dunlop Prize, 1950; Italian Government scholarship, 1956; Harkness Fellowship for study in the USA, 1958–60; resident fellowship, ANU, 1965; hon. D. Litt., ANU, 1965; Britannica Australia award, 1969; CBE conferred, 1963; knighthood (Knight Bachelor), 1981; hon. member, American Academy of Arts and Letters, NY, 1985.

REP: NGA; AGNSW; AGSA; AGWA; MAGNT; NGV; QAG; TMAG; AWM; many regional and university galleries; Tate Gallery, London; MOMA, NY; Mertz collection; many private and commercial collections Australia and overseas.

BIB: References all general books on contemporary Australian art history and catalogue essays exhibitions as above. Colin McInnes, introduction *Sidney Nolan*, Thames & Hudson, London, 1961. Elwyn Lynn, *Sidney Nolan. Myth and Imagery*, Macmillan, Melbourne, 1967. Brian Adams, *Sidney Nolan – Such is Life*, Century Hutchinson, 1987. Jane Clark *Sidney Nolan: Landscapes and Legends* ICCA and Cambridge University Press, Sydney, 1987. *A&A* 3/2/1965 (Charles S. Spencer, *Myth and Hero in the Paintings of Sidney Nolan*): 5/2/1967 (Nolan issue); 19/4/1982; 25/2/1987; 30/4/1993 (obituary).

NORITIS, *Haralds*

(b. 1928, Latvia; arr. Sydney 1951) Painter, teacher.
STUDIES: State Inst. of Technology, Riga, Latvia; ESTC, 1951–54; John Ogburn Art Studio, 1964–66. Geometric abstraction, colour-form and hard-edge painting form the basis of his gentle abstractions. As a leader of the Central Street Group he participated in *The Field*, NGV 1968.
APPTS: Teaching (part-time), NAS, 1954–55; art director, K. G. Murray Publishing, Sydney, 1955–58; a founder of Central Street Gallery, 1966; foundation member and chairman, Inst. of Contemporary Art, Sydney; organiser, Latvian Arts Festival, Sydney, 1971.
BIB: Essays exhibitions as above. *Other Voices* vol. 1, 1970 (Terry Smith, *Colour-form Painting: Sydney, 1965–70*).
NFI

NORLING, *Robin Carl*

(b. 1/5/1939, Windsor, NSW) Painter, teacher.
STUDIES: Dip. Art (painting), ESTC, 1960; Royal Coll. of Art, London, 1966; Teachers Certificate, Sydney Teachers Coll., 1961; travel studies, North Africa and Europe, 1962–63; Europe, Middle East and India, 1966. He presented television programs on art for children including *Young World* for ABC radio, 1970–73 and for GTV 9, 1980–84. He wrote several books on Australian art including *Australian Artists*, Macmillan, 1989 and was consulting editor for *A Young Person's Guide to Art in Australia*, Macmillan, 1986. In 1992 he presented a retrospective of his work, *Nudes 1960–92*, at several NSW regional galleries.
AWARDS: Robert Le Gay Brereton prize for drawing, 1961; Sulman Prize, 1961; Dyason Bequest, AGNSW Travelling Scholarship, 1962; Cook Bicentenary (*Sun-Herald* prize for painting), 1970: Lady Fairfax prize for painting, 1990.
APPTS: Teaching, Dept of Education NSW, 1967–69;

tutorials in painting, Arts Council of Australia, 1968–71; lecturer in art, Alexander Mackie CAE, 1970–75, and acting program director of art education, 1978; education officer, AGNSW, 1978–86; teacher of painting and drawing, TAFE, Meadowbank 1986– .
REP: AGNSW; Goulburn and Sydney CAE collections; private collections in Australia, Europe and USA.

NORMAN, Desmond
(b. 31/1/1930, Melb.) Painter, teacher, art therapist, art restorer.
STUDIES: With Max Meldrum, 1945; Melb. Tech. Coll., 1946. His early paintings comprise stylised realist pictures of buildings and landscapes. In 1966 he held an exhibition of regional pictures on the theme of the celebrated Aboriginal-welfare worker, Daisy Bates. He exhibited with a number of art groups from the 1950s including Independent Group of Artists, Fellowship of Australian Artists and Victorian Artists Society. His exhibited at Toorak Gallery, 1966, 67, 69, 70; Bonython, Adelaide, 1967 and Leveson St Gallery, Melbourne, 1972. Commissions include a catwalk mural for ICI building, Melbourne, 1954 and Icon of St Peter, Melbourne Grammar, 1988. He worked as a restorer of artworks and restored several altar pieces and worked with Melbourne Grammar and Melbourne Uni. collections in the early 1980s. He also illustrated several books including sketch books of Port Phillip Bay, Geelong and South Gippsland.
AWARDS: South Melbourne Centenary Prize, 1955; Australia and New Zealand Bank Prize, VAS, 1956; Chamber of Commerce Prize, 1958; Churchill Fellowship for study of Byzantine iconic art, England, Russia, Greece, 1984.
APPTS: Art therapist with Mental Hygiene Authority, Melbourne, 1959–62; teacher of art, Melbourne Grammar School, 1964–91; art adviser, Carlton Fiesta, 1981–82.
REP: NGA; NGV; IMAG.
BIB: Leonard Cox, *National Gallery of Victoria 1861–68*, NGV. Geoffrey Dutton, *White on Black*, Macmillan/AGSA. Don Fabun, *Australia 2000*, Cassell Australia. Elizabeth Salter, *Daisy Bates*, Angus and Robertson, Sydney. Germaine, AGA.

NORRIE, Mary
(b. Melb.) Painter, printmaker.
STUDIES: BA, Uni. of Melbourne; Central Tech. Coll., Brisbane, with Melville Haysom; Uni. of New England, Armidale, NSW, summer vacation classes with George Baldessin. She exhibited with the RQAS and CAS, Brisbane and from 1964 won more than 45 prizes, mostly in Qld competitions.

NORRIE, Susan
(b. 1/7/1953, Sydney) Painter, teacher.
STUDIES: NAS, 1973; VCA, 1974–76; travel studies, 1987–88. Her illusory re-created colonial-style landscapes of the 1980s drew attention to her work which has developed consistently with widely varied imagery but always on the theme of illusion/reality and fantasy. Her works are strongly painterly, with subjects ranging from landscape, to a 'moods of women' series in the mid 1980s, to her prize-winning work for the 1987 *Moet & Chandon Fellowship fête* with its extraordinary Disneyland images, to more surreal lyrical abstracts characterising her early 1990s painting. She held about 9 solo exhibitions 1981–93, at Mori Gallery, Sydney; Wollongong City Gallery (1989), and, following her year as a recipient of the Moet & Chandon Fellowship, in France (1987, 88); Nancy Hoffman Gallery, New York (1990, 91) and Wellington City Gallery, NZ (1993). Her work appeared in numerous group exhibitions 1983–93, including *Australian Perspecta*, AGNSW 1983, 85; *Biennale of Sydney*, AGNSW 1986; *A New Romance*, NGA, 1987; *Emerging Artists 1978–86: Selections from the Exxon Series*, Guggenheim Museum, NY 1987; *Strangers in Paradise*, Museum of Contemporary Art, Korea 1992.
AWARDS: *Sydney Morning Herald* Sydney Heritage Award, 1983; Moet & Chandon Fellowship, 1986.
APPTS: Part-time lecturer, SCA; artist-in-residence, Uni. of Melbourne, 1984.
REP: NGA; NGV; AGNSW; AGWA; QAG; Wollongong City Gallery; Guggenheim Museum, NY; private collections in NY; the Baillieu Myer collection, Melbourne.
BIB: Essays exhibition catalogues as above. A&A, 23/2/1985. AL, 6/1/1986. A&T no. 31, 1989.

NORRIS, Bess
See TAIT, Bess Norris

NORTH, Ian
(b. 15/4/1945) Painter, photographer, curator, lecturer.
STUDIES: BA, Uni. of Melbourne; MA, Flinders Uni., SA; MFA, Uni. of New Mexico, USA. He held 9 solo exhibitions 1970–92, including with Contemporary Art Centre, Adelaide; Roslyn Oxley9, Sydney; Australian Centre for Photography, Sydney; and participated in a number of group exhibitions 1970–92, including *On the Wall, off the Wall*, Centre for Contemporary Art, Santa Fe 1986; *Stories of Australian Art*, Commonwealth Inst. Gallery, London & Usher Gallery, London 1988; *Location*, ACCA and Asian tour 1992. He did not exhibit between 1971 and 1985 while a curator for state galleries and the NGA and he was involved as a committee member of a number of visual arts organisations including EAF, Artists Week of Adelaide Arts Festival, Arts Grants Advisory Committee, SA Government, committees of the VACB and Art Museums Association of Australia, for whom he wrote and edited a number of booklets on art museums and art practice. He also wrote and edited a number of other books and essays for art journals including on Dorrit Black, Margaret Preston and Hans Heysen.
APPTS: Director, Manawatu Gallery, Palmerston North, NZ, 1969–71; curator of paintings, AGSA, 1971–80; foundation curator of photography, NGA, 1980–84; head, SASA, 1984– .
REP: NGA; AGNSW; Artbank; Flinders and Griffith unis.; Mt Gambier regional gallery.
BIB: Catalogue essays exhibitions as above. Numerous references in AL 1984– .

NORTH, Marjorie
(b. Melb.) Painter.
STUDIES: NGV School; George Bell School. Known mainly for still-lifes and landscapes.
BIB: Basil Burdett, *Australian Art Today*, *Studio*, London, Jan. 1938; *AA*, Christmas number, 1938.

NORTHCOTE, John Carter
(b. 1817; arr. Bendigo 1851; d. 1883) Painter. Artist of the goldfields. He moved to Tas. to become a partner in an unsuccessful timber business before his appointment as drawing-master at Hutchins School, Hobart, 1870. He is not recorded as having done any paintings after leaving Bendigo, and he finished his working life as host of the Royal Exchange Hotel, Hobart. His work appeared in the Bicentennial exhibition *The Face of Australia* touring 10 regional galleries Australia 1988–89.
REP: Bendigo Art Gallery.
BIB: McCulloch, *AAGR*. Kerr, *DAA*.

NORTHFIELD, James
(d. Melb., c. 1975) Poster artist, painter. He became well-known in Melbourne as a poster artist and, towards the end of his life, painted broadly impressionistic landscapes in a popular style.

NORTON, Alice E.
(Mrs F. A. G. STEPHENS)
(b. 1865, Sydney; d. 1958) Painter. Known mainly for rural scenes in watercolour.
REP: AGNSW; Manly Art Gallery.
BIB: Catalogue of the Manly Art Gallery.

NORTON, Charles
(Active 1840s–70s, Vic.) Sketcher, architect. Although there is no record of his having practised as an architect, he was listed as one in Melbourne 1850s–70. He was known to have sketched and painted watercolours exhibited in the Melbourne Exhibition of Fine Arts, 1862 and flower studies as well as views of his own house (designed by John Gill, q.v.). His work was seen in *Lost Images of Geelong*, Geelong Art Gallery 1986; *Victorian Vision*, NGV 1988 and *Squatter Artist: Charles Norton*, State Library of Victoria 1989.
REP: La Trobe Library.
BIB: Kerr, *DAA*.

NORTON, Charles Frank
(b. 1916, Gisborne, NZ; arr. Aust. c. 1917) Painter, teacher, gallery director.
STUDIES: ESTC, 1931–36 (with Fred Leist); London, 1939. He was an official artist with the RAN and RAAF during World War II. He taught at the ESTC, 1945–58, after which he was director of the AGWA, 1958–76. As gallery director he concentrated mainly on building up the contemporary Aboriginal sculpture collections.
REP: AGWA; AWM.

NORTON, Rosaleen
(b. 1917, NZ; arr. Aust. as a child) Illustrator, painter.
STUDIES: ESTC. Contributor to *Smith's Weekly*; painter of murals in cafés at Kings Cross, Sydney. Her exhibition at the Uni. of Melbourne, 1949, was closed by the police; later she was acquitted on an obscenity charge.
BIB: *The Art of Rosaleen Norton*, with poems by Gavin Greenlees, Walter Glover, Sydney, 1952.
NFI

NOTT, Andrew
(b. 1946, Sydney) Painter.
STUDIES: Camberwell Art School, UK, 1962. Domiciled in London, 1959–63, he returned to Sydney to exhibit his hard-edge and colourfield paintings at Gallery A in Sydney and Melbourne. As recipient of a Flotta Lauro scholarship he went to Italy in 1970, revisited the UK and returned to Australia via New York.
AWARDS: Flotta Lauro scholarship, 1970; prizes at Stanthorpe, Townsville and Lismore (all in 1974); Civic Permanent Award, 1975.
REP: NGA; AGNSW; municipal collections Stanthorpe, Townsville, Lismore.
NFI

NUTTALL, Charles
(b. 6/9/1872, Melb.; d. c. 1950, Melb.) Black-and-white artist, etcher, illustrator.
STUDIES: NGV School (c. 1895). Cartoonist for *Table Talk*, Melbourne, 1904–05, he drew for Melbourne *Punch* and Sydney *Bulletin*, and in 1905 went to the USA where he became staff artist on the *New York Herald* and a contributor to *Life, Century* and *Harper's* magazines. Nuttall was colour-blind. The reproductions of a monochrome by him, *The Final Test*, 1904, sold in hundreds throughout Australia; another popular reproduction of a monochrome by Nuttall was of the opening of the first Commonwealth Parliament. The original was acquired by the trustees of the Exhibition Building, Melbourne, the scene of the event: it contains 400 likenesses of those present, and makes an interesting comparison with Tom Roberts's big picture on the same subject. After five years in America, Nuttall returned to Australia in 1910. He conducted classes in Melbourne and became popular for his illustrations for the boys' weekly *Pals*, published by the Melbourne *Herald*.
BIB: *Charles Nuttall, Representative Australians*, McCarron Bird, Melbourne, 1902. Moore, *SAA*.

OAKLEY TO OZANNE

OAKLEY, A. E.
Painter. Known for flower paintings.
BIB: Edward A. Vidler, *An Australian Flower Painter, A. E. Oakley*, Melbourne, 1923.
(*See also* NATURAL HISTORY ARTISTS)

OATES, Denese
(b. 1955, Orange, NSW) Assemblage artist.
STUDIES: CAI, 1974–77. Using handmade paper, cotton fibre and an assortment of other materials, her three-dimensional paper works include masks and sculptures of clothing such as Japanese kimonos. She held 7 solo exhibitions at Macquarie Galleries, Sydney 1979–89 and Fremantle Art Gallery, Penrith Regional Gallery, 1983 and participated in approximately 20 group exhibitions 1976–92, in private galleries in Sydney (including Hogarth, Blaxland, Macquarie) and in *Sulman Prize*, AGNSW 1978; *Archibald Prize*, AGNSW 1979; *The Paper Show*, Women and Arts Festival, Wollongong City Art Gallery 1982; *The Kimono Show*, Crafts Council Gallery, ACT 1985.
AWARDS: Project development grant VACB, 1979.
REP: Artbank; regional galleries Burnie, Rockhampton, Wollongong; City Art Inst.; Christchurch City collection.
BIB: *New Art Two.*

O'BRIEN, George
(b. 1821, Drumoland Castle, County Clare, Ireland; arr. Aust. c. 1839; d. Dunedin, NZ, 1888) Artist, architect. Son of Admiral Robert O'Brien, RN. During his 24 years in Melbourne, he painted watercolours of the city and environs and designed a number of houses. Best-known of his Australian works is the *Panoramic View of Melbourne and Williamstown, 1862*. In 1863 he migrated to NZ where he practised as an architect and became well-known in Dunedin for his fine watercolours of the region. His work appeared in *Victorian Visions*, NGV 1988.
REP: NGA; NGV; La Trobe, Allport Libraries; several NZ public collections.
BIB: Gil Docking, *Two Hundred Years of New Zealand Painting*, Lansdowne, Melbourne, 1971. McCulloch, *AAGR*. Kerr, *DAA*.

O'BRIEN, Justin Maurice
(b. 2/8/1917, Hurstville, NSW) Painter, teacher.
STUDIES: Sydney, with Edward Smith, 1930–36; travel studies, Europe, 1947–49, Greece, 1964, 74. During war service with the AAMC, beginning 1940, he was sent to Palestine and Greece, taken prisoner at Ekali, and after six months' internment in Athens was sent to Torun, Poland, where he arrived on New Year's Eve, 1941. In 1944 he was among a group of prisoners of war sent to Barcelona in exchange for German prisoners, returning to Australia soon afterwards for demobilisation. During the period of captivity he had taken every opportunity to study the Byzantine art of the countries in which he was held, and the pictures he managed to paint in Torun, with materials supplied by the Red Cross, formed the nucleus of his first Australian exhibition, held in Sydney in collaboration with another ex-prisoner, Jesse Martin. The Byzantine influence which gave his early work individuality and style continued in his mature painting. In 1967 he moved to Rome where he has lived ever since, returning to Australia with exhibitions every two years. His work was represented in the Bicentennial exhibition, *The Great Australian Art Exhibition*.
AWARDS: Blake Prize, 1951; Darcy Morris Prize, 1962.
APPTS: Teaching, first at convent schools in NSW, then, after World War II, at Cranbrook School, 1945–67.
REP: NGA; AGNSW; AGSA; AGWA; NGV; TMAG; regional galleries Castlemaine, Hamilton, Mornington; Sydney Uni. and ANU; Vatican Museum of Contemporary Art, Rome.
BIB: All books on contemporary Australian art history. Hilde and Hans Knorr, *Religious Art in Australia*, Arts in Australia series, Longman, Melbourne, 1967. *The Art of Justin O'Brien*, Craftsman House, Sydney, 1982. Christine France, *Justin O'Brien: Image and Icon*, Craftsman House, 1987. A&A 7/3/1969 (Kenneth Hood, *Justin O'Brien*); 18/4/1981 (Brian Dunlop, *Justin O'Brien: Composition*); 21/4/1984 (Anthony Bradley).

O'CARRIGAN, Patrick
(b. 1918, Northern Ireland, near Belfast; arr. Aust. 1928) Priest, painter.
STUDIES: Woollahra, Sydney, with portrait painter, Edmund Smith; Accademia Belli Arte and Scuola del Nudo, Rome, with Franco Gentilini, 1969–70. His

Vic O'Connor, The Yellow Bar – Paris, *1976. Oil. Private collection.*

skilful watercolour landscapes won him a number of prizes and helped to lift the standard of the watercolour section in VAS regular exhibitions in Melbourne.
AWARDS: Southern Memorial Hospital Festival Award, 1973; prizes in art competitions at Caulfield, Latrobe Valley, 1973; Mornington, Mt Waverley.
REP: NGV; MAGNT; regional galleries Hamilton, Horsham, Latrobe Vallcy.
BIB: Germaine, AGA.

O'CONNELL, Michael

(b. 7/8/1897; arr. Aust. 1920; d. Dec. 1976) Textile designer. Master craftsman in the design of hand-blocked fabrics. He made his early reputation in Melbourne where he conducted an interior design and decorating business with Cynthia Reed and Frederick Ward; later he moved to London where his modern designs became well-known.
BIB: Moore, SAA.

O'CONNOR, Ailsa Margaret (née Donaldson)

(b. 1921, Melb.; d. 1980, Melb.) Sculptor, teacher.
STUDIES: RMIT, 1937–38, sculpture, 1962–64; George Bell School, intermittently, 1940–62; travel studies, Italy, 1979. Beginning with paintings and drawings influenced by the work of Kathe Kollwitz, she exhibited in the *Anti-Fascist Exhibition*, Melbourne, 1942, and generally developed her art in a social-realist milieu. She married the painter V. G. O'Connor, devoted much time and energy to the cause of recognition for women artists and, in 1975, held her first exhibition of sculpture. Her bust in hollow-cast, ciment fondu, *Mary Gilbert: First Migrant Woman Settler*, completed

1974, was acquired by the Melbourne City Council for the Fitzroy Gardens. Apart from Kollwitz, Maillol was the artist to whom she looked for much of her inspiration, but beyond this was her own strong individuality and belief in what she was doing.
APPTS: Teaching at Victorian high schools, 1939–43 and 1955–70.
BIB: Exhibition catalogue *Ailsa O'Connor*, Russell Davis Gallery, 6 Mar. 1975. Scarlett, AS.

O'CONNOR, Kate (Kathleen Letitia)

(b. 14/9/1876, Hokitika, NZ; d. 24/8/1968, Perth) Painter.
STUDIES: Perth Tech. School, with James Linton; Bushey School of Art, London, with von Herkomer and Brangwyn, c. 1905. The daughter of engineer C. Y. O'Connor (who designed and constructed the first 150km water pipeline to Kalgoorlie), she made several visits to Europe before settling in Paris in 1910. Her Paris associates included many famous painters such as Israels, Vuillard, Sickert, Modigliani, Chagall, van Dongen and Segonzac. Her Australian and New Zealand friends in France included Frances Hodgkins, Roy de Maistre and Rupert Bunny. She visited Perth and Sydney 1927–28, sent notes from Paris to the WA weekly, *Town Talk*, 1928–29, and spent the World War II years in England, having lost her Paris studio and many of her belongings. She spent 1948–51 in Perth and Fremantle, revisited Paris and London and finally settled in Perth in 1955. By

then she had become thoroughly French in her attitude, habits, language and painting style. Her paintings of still life, portraits and genre had the soft colours and much of the charm of the intimist paintings of Vuillard and Bonnard. To Australians who knew her in Perth, she appeared to have stepped out of a painting by Manet. In her early career she exhibited at the Salon d'Automne (1911–32), and in the *Exposition des Femmes Artistes d'Europe*, at the Musée de Jeu de Paume, 1937, as well as in many other exhibitions. Her work was represented in *Western Australian Artists 1920–50*, Perth, 1980; the Bicentennial exhibition, *The Great Australian Art Exhibition*; and *A Century of Australian Women Artists 1840s–1940s* Deutscher Fine Art, Melbourne, 1993.

AWARDS: Perth Prize (WA section), 1958; BP Prize, Commonwealth Games art competition, 1962.

REP: NGA; AGNSW; AGSA; AGWA; NGV; QAG; MAGNT; TMAG; regional galleries and uni. collections.

BIB: *The Studio*, London 15 Sept, 1916 (William Moore, *The National Galleries of Queensland and Western Australia*). Hutchings and Lewis, *Kathleen O'Connor: artist in exile*, Fremantle Arts Centre Press, 1984. A&A 3/4/1966 (Max Harris, *Kate O'Connor*).

O'CONNOR, Vic (Victor George)
(b. 21/12/1918, Melb.) Painter.
STUDIES: Saturday afternoon classes at George Bell School, 1939. He practised as a lawyer before turning to painting full-time. He married Ailsa Donaldson and from 1939 exhibited with the Melbourne Social-Realist group to attain, in his low-toned paintings of processions, street scenes and landscapes, a notable richness and luminosity. Later he concentrated on landscape and his palette changed and became lighter, particularly after working in Cornwall, 1974. His work was shown in frequent solo and group exhibitions of Australian art in Canada, Russia and the UK as well as Australia. Exhibitions include the bicentennial exhibition *Angry Penguins and Realist Painting in Melbourne in the 1940s*, shown initially at the Hayward Gallery, London then Tate and touring to other UK centres and Australian state galleries, 1988–89. His work was included in *Classical Modernism: The George Bell Circle*, NGV 1992 and in 1993 he showed a selection of his latest work at Bridget McDonnell Gallery, Melbourne reminiscent in style of his early scenes of inner-city street life.

AWARDS: CAS Prize (shared with Donald Friend), 1941; May Day contest, Melbourne, 1958; Swan Hill Art Prize, 1972.

REP: NGA; AGWA; NGV; QAG; TMAG; a number of regional galleries including Mornington, Swan Hill, Warrnambool; uni. collections in Brisbane and Melbourne.

BIB: Many major texts on Australian art including Smith, AP. Richard Haese, *Rebels and Precursors* Allen Lane, 1981. Mary Eagle & Jan Minchin, *The George Bell School*, Deutscher Fine Art, Melbourne 1981.

ODDIE, James
(b. 31/3/1824, Clitheroe, Lancs., UK; arr. Vic. June 1849; d. 3/3/1911, Ballarat) Businessman, gold-digger, storekeeper, painter, benefactor, collector. The son of a Lancashire innkeeper, he started a foundry in Geelong soon after arriving in Victoria, and in 1851 became one of the original gold-diggers at Buninyong. After joining the rushes to Mt Alexander and Bendigo, he opened a store at Smythesdale, Ballarat, in 1852. He supported the diggers against the gold licence and at the time of Eureka witnessed from his store 'the massacre of innocent diggers'. Eventually one of Ballarat's wealthiest citizens, he was the first chairman of the Ballarat Municipal Council, 1856–58, founder and patron of the Ballarat Gallery, patron of Eugène von Guérard, and was responsible for obtaining the monumental statue of his friend, Peter Lalor, for Sturt Street, Ballarat. In 1884 he commissioned von Guérard's most famous painting, *Ballarat 1853–54*, for a figure of £1000. Later it was presented to the gallery, but his greatest gift to the gallery was the Eureka flag, remnants of which he had received from the widow of King, the trooper who hauled the flag down. Presented by Oddie in 1895, it is the Ballarat Gallery's most priceless possession.

BIB: Len Fox, *Eureka and Its Flag*, Mullaya Publications, Canterbury, Vic., 1973. ADB 5. McCulloch, AAGR.

O'DOHERTY, Chris (also know as Reg MOMBASSA)
(b. 14/8/1951, NZ; arr. Aust. 1969) Painter, graphic artist, musician.
STUDIES: NAS, 1969–70. Designer for Mambo Graphics and guitarist for *Mental as Anything* (from 1976) and *Reg & Pete's Dog Trumpet* (from 1991). He participated in about 13 group exhibitions 1975–92, largely at Watters, Sydney, also in *The Challenge of the Landscape*, New England Regional Art Museum 1986; *Green Art* S. H. Ervin Gallery, Sydney 1991. He held a solo exhibition at Watters, 1991.

REP: AGNSW.

O'DONNELL, Terence Paul
(b. 4/7/1942, NSW) Painter, teacher.
STUDIES: Dip. Painting, NAS, ESTC, 1966; travel studies, Canada, USA, Mexico, Europe, India, 1967–69. From 1966, when he received an English-Speaking Union travelling scholarship, his figurative paintings, some of animals, were shown in group exhibitions and competitions, notably *Four Younger Artists*, Bonython Gallery, Sydney 1973, and in the exhibition of Australian paintings at Expo '74, Washington, DC. He held about 9 solo exhibitions 1971–91, largely at Robin Gibson, Sydney, and participated in a number of group exhibitions including graphic survey shows at Ivan Dougherty Gallery, Sydney; *Blake Prize*, finalist, 1988 and *Wynne Prize*, 1992.

AWARDS: English-Speaking Union travelling scholarship, Sydney, 1966; Stock and Holdings Painting Prize, 1966; Park Regis Canadian Pacific Painting Prize, 1966; Ashfield Prize, 1970, 71; Gosford Drawing Prize, 1985; Delmzar Galleries Drawing Prize, 1991.

APPTS: Teaching, Canada, 1967; NAS, Sydney, 1969–75; CAI, 1975– ; senior lecturer, Fine Arts, Uni. of NSW. REP: AGNSW; MAGNT; Artbank; a number of regional gallery, municipal and tertiary collections in NSW; corporate collections including Regent Hotel, Sydney; Commonwealth Bank, Sydney.
BIB: Bonython, *MAP* 1975. Germaine, *AGA*.

OFFICER, Edward Cairns
(b. 1871, Swan Hill, Vic.; d. 1921, Macedon, Vic.) Painter.
STUDIES: NGV School, 1893–94; Académie Julian, Paris. Known mainly for landscapes. Officer received advice and help from Harpignies in Paris and exhibited at the Paris Salon, Royal Inst., London, and Royal Society of British Artists, 1892–1904. He was first president of the Australian Art Association, 1912–21, and a trustee of the NGV, 1916–21.
AWARDS: Wynne prize, 1903.
REP: AGNSW.
BIB: Smith, *Catalogue AGNSW*, 1953. Reference and reproduction, *AA*, no. 4, 1918. D. H. Souter, *Edward Officer*, illustrated article in *Art and Architecture*, Sydney, vol. 5, no. 2, 1908.

OGBURN, John
(b. 1925, St Arnaud, Vic.) Painter, research chemist, teacher.
STUDIES: Julian Ashton School (with John Passmore); also with D. Orban and Lyndon Dadswell; travel studies in UK and Europe, 1953–57. He exhibited at the Macquarie Gallery, Sydney 1953; Coffee House, London 1956; São Paulo, Brazil 1961 and Adelaide Festival of Arts, 1962. From 1965 he held private exhibitions of his work in his studio and in the Harrington Street Gallery, and wrote articles for *A&A*.
AWARDS: Muswellbrook Prize, 1962.
APPTS: Vice-president of the CAS, Sydney, 1958–62; teacher at Orban Studio, Sydney, 1961–62.
BIB: Exhibition catalogue, Gallery A, 1959.

OGILVIE, Helen
(b. 1902, NSW; d. 1/8/1993, Melb.) Painter.
STUDIES: NGV School, 1919–21. She was well-known for her small, meticulously observed paintings of old country buildings for which she received many commissions. She was the first director of Peter Bray Gallery, Melbourne 1949–55 and her exhibitions included two successful shows of small paintings, *Australian Country Dwellings*, at the Leicester Galleries, London, 1963 and 1967, as well as many in Australia. Her work appeared in *A Survey of Australian Relief Prints*, Deutscher Galleries, Melbourne, 1978.
REP: NGA; AGNSW; NGV; regional galleries Ballarat, Castlemaine.
BIB: *AM* number 63 Sept. 1993 (obit).

O'HARRIS, Pixie
(b. 1903, Cardiff, Wales; arr. Sydney 1921) Illustrator, painter.

STUDIES: Julian Ashton School, 1922–23. By 1975 she had written and illustrated more than 10 children's books and decorated more than 50 children's hospital wards, nurseries, clinics and schools.
AWARDS: MBE, 1976; Coronation Medal for services to art, 1977.
REP: NGA; Uni. of NSW collection.

OHLFSEN, Dora (Dorothea Ohlfsen-bagge)
(b. 1867, Ballarat; d. 1948) Sculptor, musician, writer.
STUDIES: Studies in music, Berlin; French Academy, sculpture with Pierre Victor Dautel, engraver of medals, Rome. Forced to abandon a promising career as a pianist in Berlin because of neuritis, she turned to music teaching, working in Germany then in Russia where her extensive knowledge of languages enabled her to do secretarial work for the American Ambassador and to write on arts and history subjects for Moscow and American newspapers. She travelled in various Baltic countries, including Finland, did paintings and caricatures, and began studying sculpture when she moved to Italy with a Russian family. She visited Sydney in 1912 and during World War I worked as a Red Cross nurse in Italy. In 1916 she produced and paid for an Anzac Memorial medal (sold in London for the benefit of Australian soldiers) and during 1921–22 was in Australia where she made medallion portraits of Billy Hughes, Nellie Stewart and other notable people. Her Italian work included a medallion of d'Annunzio and, later, one of Mussolini, as well as a war memorial, *Sacrifice*, made at Formia, the only work of its kind in Italy known to have been done by a female artist. Her work was seen in *Early Australian Sculpture*, Ballarat Fine Art Gallery, 1976.
REP: AGNSW; Ballarat Fine Art Gallery; Uni. of Sydney; British Museum; Petit Palais, Paris; Uni. of Glasgow.
BIB: Carol Sylva, *Dora Ohlfsen – Sculptress: Australian yet a thorough Cosmopole*, *Woman's World*, vol. 1, no. 3, 1922. Moore, *SAA*. Sturgeon, *DAS*. Scarlett, *AS*.

OLA COHN MEMORIAL CENTRE
41–43 Gipps St, East Melbourne, Vic. 3002. Bequeathed in 1964 by the sculptor Ola Cohn to the CAE and used as a meeting place for the Society of Women Painters and the Vic. Association of Sculptors. Exhibitions, meetings, classes, lectures and other functions are held there.
(*See also* COHN, Ola)

OLD WATER COLOUR SOCIETY CLUB
(Established 1974) Formed on 8/12/1974 at the instigation of Maurice Callow, the club held its first meeting at the VAS in early 1975 as an Australian branch of the Old Water Colour Society Club, London, the supporting organisation for the Royal Society of Painters in Water Colour. Meetings are held in the VAS, 430 Albert Street, Melbourne. Patrons include Sir Daryl Lindsay, 1975–80 and Kenneth Jack, 1980– . President: Robert Miller, 1975; Michael Blanche, 1976–77; Kenneth Jack, 1978–80; Maurice Callow, 1980–81; Robert Wade, 1982–85; Kathlyn Ballard, 1986–88;

Harold Farey, 1989–91; Louise Foletta, 1992– . Maurice Callow was foundation secretary and Stanley Ballard foundation treasurer. Successive secretaries: Peter Rosenhain, Patricia Marshall, Noel Stevenson, Andrew Orr, Margaret Cowling and Joan Richard.

OLDFIELD, Alan
(b. 30/12/1943, Sydney) Painter, lecturer.
STUDIES: NAS, 1962–66; travel studies, Europe and USA, 1970; Rome, 1974–75; MA, Sydney CAE. He was represented by a hard-edge painting entitled *Mezzanine* in *The Field*, NGV 1968 and held 16 exhibitions in Sydney, Melbourne and Canberra, 1966–89, including *Project 35*, AGNSW 1981. His work became more figurative in the 1970s and 1980s, notably in his paintings of chairs and other furniture casting strong shadows, and in his Hockney-like open line drawings of interiors. Group exhibitions in which he participated 1966–90 include *Recent Australian Painting*, AGSA 1983; the Bicentennial exhibition *The Face of Australia*; *The Field Now*, Heide and touring 1984 and in the *Blake Prize*, several times, winning twice. His commissions include set and costume designs for the Sydney Dance Company and the Australian Ballet, and he was artist-in-residence at Linacre Coll., Uni. of Oxford, 1988–89.
AWARDS: NAS Student Prize for Painting, 1966; Young Contemporaries Prize, CAS, Sydney, 1970; Mosman Art Prize, 1974; VACB grant, 1974; Sulman Prize, 1975; Maude Vizard-Wholohan Prize, Adelaide, 1976; Civic Permanent award, 1977; Townsville Pacific Festival award, 1977; Dalby Prize, 1978; Gold Coast Art Prize, 1981; Blake Prize, 1987, 91.
APPTS: Associate professor, Coll. of Fine Arts, Uni. of NSW.
REP: NGA; AGNSW; AGSA; AGWA; NGV; many regional galleries including Armidale, Ballarat, Gold Coast, Newcastle; many tertiary collections in most states; corporate collections including Reserve Bank, SMH.
BIB: Catalogue essays in exhibitions as above. Smith, AP. G. de Groen, *Conversations with Australian Artists*, Quartet. R. Crumlin, *Images of Religion in Australian Art*, Bay Books Sydney 1988. A&A 18/4/1981 (Peter Haynes, *Alan Oldfield*); 25/4/1988.

OLDHAM, Isobel
(b. 1867; d. 1958) Tasmanian painter of landscapes and flowers; exhibited at the Old Salon, Paris, 1928. The TMAG held an exhibition misses *Hookey-Murphy Oldham-Swan* in 1990.

O'LEARY, Shirley
Painter, stained glass designer.
STUDIES: Bissietta School, Sydney; Academy of Art, Rome; London.
AWARDS: Italian Scholarship, 1955.

OLIVER, Bronwyn
(b. 22/2/1959, NSW) Sculptor, teacher.
STUDIES: B.Ed. (Art), CAI, 1980; MA (sculpture), Chelsea School of Art, London, 1983. Her tubular sculptures and similarly based paintings were seen in 10 solo exhibitions 1986–92 in Sydney (Roslyn Oxley9) and Melbourne (Christine Abrahams), and at the Adelaide Festival Centre, Adelaide 1992 and Auckland City Gallery, Auckland, NZ 1992. Her work appeared in about 23 group exhibitions 1981–92 in private galleries (including Roslyn Oxley9; Irving Sculpture, Sydney) and many sculpture surveys including *Young Contemporaries*, ICA and Artspace, London 1983; *Mildura Sculpture Triennial*, Mildura Arts Centre 1985, 88; *Australian Perspecta*, AGNSW 1985, 91; *Correspondences*, QAG 1991. She was artist-in-residence, Meridian Foundry, Melbourne, 1989 and Auckland City Gallery, 1991.
AWARDS: NSW Travelling Art Scholarship, 1981–83; Dyason Bequest Scholarship, 1982–83; fellowship in sculpture, Gloucester Inst. of Art, Cheltenham, England, 1983–84; Moya Dyring Bequest Studio, Cité Internationale des Arts, Paris, AGNSW, 1984; French/Australian artist exchange program, 1988; Power Bequest Studio, Sydney Uni., Cité Internationale des Arts, Paris, 1989; Marten Bequest Scholarship for Sculpture, 1989–90; VACB project grant, 1990; *Moet & Chandon* Fellowship, 1994.
APPTS: Part-time lecturer (fine art), Gloucester Inst. of Art & Technology, Cheltenham, England, 1983–84; part-time lecturer (fine art), CAI and SCA, 1985–89; part-time lecturer (visual arts), Uni. of Western Sydney, 1991–92; part-time teacher of art, Cranbrook Preparatory School, Sydney 1985–92.
REP: AGNSW; NGV; QAG; Artbank, NSW Uni. Inst. of Art; State Craft Collection, Meat Market; ICI and Freehill, Hollingdale and Page corporate collections.
BIB: Sturgeon, *Contemporary Australian Sculpture*, Craftsman House, 1991. A&A 26/1/1988.

OLIVER, Charles Frederick
(b. 1896, Palmerston, NZ; d. 1957) Sculptor.
STUDIES: Said to have studied in the UK with Paul Montford after World War I. He served with the NZ Forces in World War I, and with the AIF in World War II. After the first war he settled in Melbourne, working in a studio at 19 Collins St, as well as at his home in Osborne St, South Yarra, his best-known work being a bust of George Gordon McCrae. He made a mace (no longer in use) for Federal Parliament, Canberra, and bookends and reliefs in plaster of native flora and fauna. He also worked as an assistant to Paul Montford on the Shrine of Remembrance, Melbourne, c. 1930–34, an association that may have led to confusion about his early studies.
REP: NGV.
BIB: Moore, SAA. Scarlett, AS.

OLLEY, Margaret Hannah
(b. 24/6/1923, Kyogle, NSW) Painter.
STUDIES: ESTC, 1945, with Frank Medworth; La Grande Chaumière, Paris, 1949; travel studies, Italy, Spain and Portugal, 1949; Papua New Guinea, 1966–68; Malaysia, Cambodia, Thailand and Bali, 1969; UK, Europe, USA, China and Russia, 1980–89. Her

Bernard Ollis, Nightlife, 1984, oil pastel, 61 × 80cm. Private collection.

portrait was painted by Dobell and Drysdale and her own painting developed in the atmosphere of Sydney wartime romanticism, from which evolved the impressionistic style of work for which she became known. Her colourful paintings of interiors and still lifes are especially notable for their use of brilliant, clear colours. She held at least one exhibition annually from 1948 including at Macquarie, Holdsworth, Sydney; Philip Bacon, Brisbane; Greenhill, Adelaide; Australian Galleries, Melbourne and Sydney; and Solander, Canberra. She participated in numerous group exhibitions from 1944 including CAS, Sydney, 1940s; *Contemporary Painting and Sculpture*, QAG 1967; *A Survey of Eighty Painters: Qld Works, 1950–85*, Uni. of Qld 1985; *Justin O'Brien and Friends*, S. H. Ervin Gallery 1987; *A Changing Relationship: Aboriginal Themes in Australian Art 1938–88*, S. H. Ervin Gallery 1988; *The Self Portrait*, David Jones, Sydney 1989.

AWARDS: Prizes at Mosman, 1947; Lismore, 1958; Redcliffe, 1962, 63; Helena Rubinstein Portrait Prize, 1962; Finney Centenary Prize, Qld, 1963; Johnsonian Club Prize, 1964; Toowoomba Art Society Competition, 1965; prizes at Bendigo and Redcliffe, 1965; Aberdare Prize for still life, 1986; Order of Australia, 1991; hon. doctorate Literature, Macquarie Uni., 1991; life governor, AGNSW, 1992.

REP: NGA; AGNSW; AGWA; NGV; QAG; TMAG; many regional galleries including Lismore, Maitland, Gold Coast, Wollongong; many tertiary and municipal collections.

BIB: Vida Lahey, *Art in Queensland, 1859–1959*, Jacaranda Press, Brisbane, 1959. Smith, AP. Christine France, *The Art of Margaret Olley*, Craftsman House, 1990.

OLLIS, Bernard David

(b. 25/4/1951, Eng.; arr. Aust. 1976) Painter.
STUDIES: Foundation studies, graphic design, sculpture, painting, printmaking, photography, textiles, ceramics, Cardiff Coll. of Art & Design, Wales, 1969–70; Dip. Art & Design, Cardiff Coll. of Art & Design, 1970–73; BA (Hons), Cardiff Coll. of Art & Design, 1973; MA (painting), Royal Coll. of Art, London, 1973–76. Ollis's 1980s work was on a grand scale with allegorical expressionism described by Sandra McGrath in *The Weekend Australian*, (18/2/1984): 'While the simplification of shapes and humorous content of the paintings suggest life-size cartoons, the paintwork, colour, composition and lack of overt satiric content forces the viewer into a more subtle relationship with the painter and the painting than with the more explicit cartoon format.' His 1993 exhibition at the Botanical, Melbourne however while of the same style was of much smaller works with lesser impact. He held 19 solo exhibitions 1973–92 in the UK (1973–76), including Coll. of Art Gallery, Cardiff, 1973, and in Australia (1976–92), in Melbourne (Warehouse, 1978; Powell Street, 1985, 87, 91; Botanical, 1993), Sydney (Macquarie, nine exhibitions,

1981–92), Brisbane (Roz MacAllan, 1988) and an Australian solo exhibition organised by the VACB touring 12 regional, tertiary and municipal galleries 1984–86. He participated in approximately 30 group exhibitions in the UK, 1970–76 and in Australia, 1976–92, including at private galleries (Macquarie, Sydney; Solander, ACT) and in public galleries including *On the Beach*, Arts Council of NSW touring exhibition 1985; *9 × 5 Centenary* exhibition touring NSW, Qld, 1989.

AWARDS: Artist-in-residence, Studio Cité Internationale des Arts, Paris, 1974; British representative, artist-in-residence, Maltese Studio, International Youth Arts Festival 1975; drawing and painting prizes, London, 1976, 77; Australian regional prizes including Gold Coast, 1982, 88.

APPTS: Lecturer and occasionally head of dept, Darwin Community Coll., NT, 1976–82; head of painting, Fine Art Department, Bendigo CAE (now La Trobe Uni.), 1982– ; guest lecturer many tertiary venues UK and Australia, 1973–92; foundation committee member of Artspace co-operative, Bendigo.

REP: NGA; NGV; QAG; Artbank; Parliament House; Darwin Inst.; Phillip Inst., Melbourne; regional galleries Gold Coast, Orange, Bathurst, Grafton, Bendigo, Toowoomba; UK public collections.

BIB: Catalogue essays exhibitions as above. *New Art Two*. Chanin, *CAP*.

O'LOUGHLIN, Geoff

(b. 27/4/1923, Melb.) Painter, sculptor, biologist.
STUDIES: Melbourne with Ian Bow. Biologist at the Victorian Plant Research Inst., he started painting at the age of 35 and held exhibitions at the Richman and Australian Galleries, Melbourne, during the 1960s and showed also with the VAS and CAS, Melbourne. His commissions include stained glass, notably for the Victorian Plant Research Inst., 1977.

REP: AGWA; TMAG; regional gallery Castlemaine.
BIB: Germaine, *AGA*.
NFI

OLSEN, John

(b. 21/1/1928, Newcastle, NSW) Painter, teacher.
STUDIES: Julian Ashton School (with Passmore); Orban School, 1950–56; Paris, 1957–60 (engraving with Hayter); independent study in Spain. Olsen's independent outlook became evident when he took part in an anti-Archibald Prize demonstration at the AGNSW in 1953. He gained his first official success in Melbourne, 1955–56, when a small painting was bought for the NGV from the *Herald Outdoor Art Show*. By 1957 the Sydney critic Paul Haefliger had recognised his potential and private subscribers raised a fund to send Olsen abroad. He sent exhibitions to Sydney and Melbourne, 1958–59, and returned after three years to introduce an expressionistic type of painting reflecting the combined influences of the Dutch painter Corneille and the Scots painter Alan Davie. The first impact of this work was felt when, with other young Sydney painters, Olsen took part in the *Sydney Nine*

inaugural exhibition, 1961, to introduce to the vocabulary of Australian art a new title, *You Beaut Country*. This title was crucial to his subsequent success. European influences in his work were fused to produce individual child-art type imagery expressed with a sophistication and panache, added to which was a strong, natural feeling for his Australian environment. A wandering, child-like scrawl of linear superstructure was imposed on a rich, free, colourful scumble of underpainting of alternating opaque and transparent passages. The colloquially titled series, which began with *Journey into You Beaut Country*, summed up the attitude and drew attention to Olsen's Irish-inspired wit and his affection for the general character of Sydney and environs. In 1963 he designed a series of tapestries made in Portugal and the following year went to Europe to further his work in this field, returning to Sydney in 1967. Until 1970 he conducted the Bakery Art School, Sydney, and in the same year received a commission from the Dobell Foundation to paint the Sydney Opera House mural *Salute to Five Bells*, inspired by a poem by Kenneth Slessor and completed 1973. One year later he began a number of tours of Central Australia (1974–76) in company with the naturalist Vincent Serventy, an experience that gave his map-like drawings a lyrical and ecological character. In 1978 he extended these travels to include Egypt, Kenya and South Africa. He became a trustee of the AGNSW in 1978 and both as practising artist and administrator has continued to exert great influence on art affairs in NSW. His work was represented in the Bicentennial exhibition *The Great Australian Art Exhibition* and a major retrospective of his work was curated by the NGV and toured to other state galleries 1991–92.

AWARDS: Prizes at Rockdale, 1960; Brisbane (Caselli-Richards), 1961; Perth, 1961; Sydney (Royal Easter Show), 1961; Melbourne (Georges Invitation Prize), 1963, Launceston, 1964, Sydney (Wynne Prize), 1969; OBE, 1977; creative arts fellowship, Australia Council, (five years), 1993.

REP: NGA; state galleries and many regional galleries including Ballarat, Mornington, Orange, Newcastle.

BIB: All general books on Australian contemporary art history. Virginia Spate, *John Olsen*, Australian Art Monographs, Georgian House, Melbourne, 1963. Sandra McGrath, *Lake Eyre – the Desert Sea*, Lansdowne, Melbourne, 1979. *John Olsen: My Complete Graphics 57–79*, Gryphon Books and Australian Galleries, Melbourne, 1980. Deborah Hast, *John Olsen*, Craftsman House, 1992. *A&A*. 14/2/1976 (Sandra McGrath, *A Remote Eden*) 24/3/1987. *AL*, 2/2/ 1982.

OLSZANSKI, George
(George D'Olszanski-Ronikier)

(b. 1919, Poland; arr. Aust. 1948) Painter, gallery director.
STUDIES: Poland, 1935–39; RA School, Rome, 1945–47. During World War II he joined the British army in India and served with the Policy Unit in Europe. In Sydney he exhibited briefly with the Merioola Group and, 1950–59, was director of David Jones Gallery.

Later he held exhibitions of his colourful, semi-abstract paintings at the Clune Galleries and, 1978, at David Jones Gallery.

REP: AGWA; QAG; TMAG

NFI

O'MALLEY, Terry

(b. 7/8/1949, Hull, UK; arr. Aust. 1983; left Australia for Ireland 1993) Painter, performance artist.

STUDIES: BA Hons. (first class), Leeds Polytechnic, Yorkshire, UK, 1974; MA (fine arts), Reading Uni., UK, 1976. He held 14 solo exhibitions 1976–92 in UK galleries (1976–82) including Leeds Polytechnic 1976; ICA, London 1976; Midland Group Gallery, Nottingham 1979, 82; and at private galleries in Australia including Sydney (Roslyn Oxley9, 1983) and Hobart (Salamanca Place, 1987, 89; Freeman, 1990, 91). He participated in 24 group exhibitions 1973–92 in the UK (including *Masquerade*, Welsh Arts Council touring exhibition, Cardiff Museum 1975), and in Australia at private galleries (including Macquarie, Sydney; Chameleon, Hobart), public galleries and performance spaces from 1982, including *First York Theatre Festival*, Uni. of WA 1984; *Australian Perspecta*, AGNSW 1985; *Blake Prize*, Blaxland Gallery, Sydney 1985, 87, 90. His commissions include a large mural for the Cygnet Council, Tas., 1991 and Jennings Pty Ltd, for eight drawings on the settlement of Hobart, 1991.

APPTS: Research assistant, Trent Polytechnic, Nottingham, 1978–81; head of sculpture, Uni. of Tasmania, 1982–85; art teacher, Lambert Cottage School, Hobart, 1990– .

REP: NGA; QAG; TMAG; Artbank; Derwent Collection.

ONUS, Lin

(b. 4/12/1948, Melb.) Painter, sculptor.

STUDIES: Self-taught. His work underwent a considerable change following a pilgrimage to Arnhem Land in the early eighties. To its illustrative qualities derived from Western culture was added imagery evolved from his Aboriginal heritage. His 1990s series which comprised both super-real and semi-abstract styles were based on the lush landscape of the forest and showed new stage of lyricism and subtlety in his work. He held 14 solo exhibitions 1975–92 in Melbourne (including Aboriginal Advancement League, 1975; Taurinius, 1976; Gallery 333, 1978; Gabrielle Pizzi, 1988, 89, 91, 92), Sydney (Holdsworth, 1978; Painters, 1990, 92). He participated in approximately 30 group exhibitions in public galleries 1984–92, including *Aboriginal Art: The Continuing Tradition*, NGA 1989; *Balance 1990: Views, Vision, Influences*, QAG 1990; *Australian Perspecta*, AGNSW 1991; *Tagari Lia: Contemporary Aboriginal Art from Australia*, Third Eye Centre, Glasgow, regional galleries at Swansea and Sheffield, UK 1990. He was artist-in-the-community, Koori Information Centre, Vic., 1983–84 and artist-in-residence, Sherbrooke Community School, 1987; Yokohama City Board of Education, Japan, 1989.

AWARDS: National Aboriginal Art Award, Darwin, 1988; Maude Vizard-Wholohan Art Prize Purchase Award, AGSA, 1988; Shire of Sherbrooke, Community Service Award for Cultural Achievement, 1991; RAKA Award, the Australian Centre, Melbourne, 1993.

APPTS: Co-ordinator, mural project, Aboriginal Health Service, Melbourne, 1984–85; member, Aboriginal Arts Board, 1986–88; chair, Aboriginal Arts Committee, Australia Council, 1989.

REP: NGA; AGWA; AGSA; NGV; MAGNT; QAG; City of Melbourne; Museum of Victoria; Aboriginal Advancement League; Flinders Uni.; Port of Melbourne Authority; Holmes à Court, Coles-Myer, Qantas, Podgor corporate collections.

BIB: Catalogue essays exhibitions as above. J. Isaacs, *Aboriginality – Contemporary Aboriginal Painting and Prints*, UQP, 1989. R. Crumlin and A Knight, *Aboriginal Art and Spirituality*, Collins Dove, 1991. *Criss Cross*, Collins Dove, 1991. *The Encyclopedia of Aboriginal Australia*, Australian Inst. of Aboriginal and Torres Strait Islander Studies, 1993. Caruana, AA. AL, 10/1–2, 1990. AM, May, 1990. A&A 31/1/1993.

OOM, Karin

(b. 15/8/1933, Mosman, NSW) Painter, teacher.

STUDIES: NAS, 1949–54; travel studies, UK and Europe, 1954–58; Dip. Ed., Uni. of Sydney, 1959; printmaking studies, 1977–78. Her drawings have won acclaim in 10 Sydney and Melbourne exhibitions, 1963–89. She participated in a number of group shows, largely in private galleries in Sydney (Macquarie; Woolloomooloo), with *The Print Circle*, 1978–84, and in the PCA's *100 × 100, 1988*.

AWARDS: Dubbo Art Prize, 1977; MPAC Spring Festival of Drawing, purchase award, 1981.

APPTS: Teaching, NSW high schools, 1960–62; UK schools, 1967–69; part-time teaching, 1972– .

REP: AGNSW; MPAC; institutional and private collections.

OPIE, Roy

(b. 1909; d. 1968, Paris) Painter.

STUDIES: Melbourne, with A. D. Colquhoun and George Bell. His studies with such disparate teachers and his participation as a founding member of the CAS, Melbourne in 1938, while associating with Justus Jorgensen's colony at 'Montsalvat', Eltham, suggest the ambiguities characteristic of Opie's attitude. He left Melbourne for Europe in 1960 and, apart from two lengthy visits home, spent the rest of his life in Paris. His work there included several ink portraits of Picasso, whom he met in 1961. Subsequently his work followed Ecole de Paris trends with emphasis on cubist and surrealist painting. He was preparing for his first exhibition in Paris in 1968 when he was killed in a street accident. A retrospective exhibition was held at the NGV, Dec. 1978.

ORBAN, Desiderius

(b. 26/11/1884, Gyor, Hungary; arr. Sydney 1939; d. 4/10/1986, Sydney) Painter, teacher.

STUDIES: Uni. of Science (mathematics), Budapest; Julian's Academy, Paris, 1906. Crucial to his development were the Saturday evening gatherings at the

Desiderius Orban, Yachts, c. 1942, oil on canvas, 40 × 50.5cm. Courtesy Christie's.

studio of Gertrude Stein where he was taken by the colleague with whom he shared a studio, Robert Bereny. Apollinaire, Duchamp, Matisse, Picabia, Picasso and many others were among Stein's regular guests and their influence on the young Hungarian was immense; it provided the foundations of the aesthetic philosophy which went with Orban to Sydney, there to affect the careers of several generations of painters. His arrival coincided with the return from war-threatened Europe of a number of Australian expatriates who would radically change the character of art in Sydney. Orban played an important part in the change. His low-toned oils and pastels matched the spirit of the emerging Sydney Romantic School and were important factors in its creation. Much of Orban's subsequent influence was transmitted through the Orban School (*see* SCHOOLS). Books he wrote included *A Layman's Guide to Creative Art*, Edwards & Shaw, Sydney, 1957; *Withstanding Art*, Ure Smith, Sydney, 1968; *What is Art All About?*, Hicks Smith, Sydney, 1975. In 1980, with the help of sponsorship from the NSW Government and NSW House, London, he held his first London exhibition. He was 96. The following year (Apr. 1981), he held a large retrospective at the

Niagara Lane Galleries, Melbourne. The exhibition covered 70 years, revealing a strong and consistent line of development that linked the early dark figurative work to the much lighter, open line work of the 1980 pictures. He continued teaching and painting almost until his death at the age of 101.

AWARDS: Gold medal, International Exhibition, Barcelona, 1929; Blake Prize, 1967, 71; Wollongong Prize, 1971.

APPTS: Head of Arts and Crafts Atelier, Budapest Academy, 1933–39; president, CAS, Sydney, 1945–48; chairman, UNESCO Committee for the Visual Arts in Australia, 1953.

REP: NGA; AGNSW; AGSA; AGWA; NGV; QAG; MAGNT; TMAG; regional galleries Ballarat, Bendigo, Geelong, Mildura, Newcastle; public galleries in Budapest.

BIB: Passuth Kristina, *Orban Desco*, Budapest, 1977. Smith, AP. A&A 3/1/1965 (John Ogburn, *Desiderius Orban*); 22/2/1984; 24/3/1987 (obituary).

ORCHARD, Christopher Robin
(b. 24/4/1950, SA) Painter.
STUDIES: Advanced Dip. Fine Art (sculpture, painting), SACAE. He held six solo exhibitions 1984–91, including at the Adelaide Festival Centre (1984, 88); Reade Gallery, Adelaide 1987, 91; Adelaide Central Gallery 1992. He participated in several group exhibitions 1979–92, including PCA 1979; SA *Paperworks*, survey

exhibition, AGSA 1981; *Adelaide Artists in Japan*, 1989. APPTS: Lecturer, Adelaide Central School of Art. REP: AGSA; Artbank; Adelaide Uni.; BP London.

ORCHARD, Jenny

(b. 19/11/1951, Turkey; arr. Aust. 1975) Ceramicist. STUDIES: CAI, 1977–79. Mainly self-taught. Her highly decorated and colourful pots and sculptures draw on the African mythology of Zimbabwe – the country in which she grew up. She held 8 solo exhibitions 1981–93 in Sydney (Blackfriars, 1981; Macquarie, 1986, 87, 88, 90, 91), Melbourne (Distelfink, 1985; Christine Abrahams, 1989), and touring Tasmanian public galleries in 1985. Her work appeared in approximately 30 group exhibitions 1981–91, including at private galleries in Sydney (Macquarie) and Melbourne (Distelfink), and ceramic survey exhibitions including *Australian Crafts*, Meat Market Craft Centre, Melbourne 1981, 82, 83, 84, 85; *The Patterned Edge*, Crafts Council Centre Gallery, Sydney 1985; and in Tao Gallery, Tokyo 1990.
AWARDS: Stuart Devlin Award Exhibition, Meat Market Craft Centre, 1988.
APPTS: Part-time tutor, CAI, 1986; part-time tutor, Randwick Tech. Coll., NSW, 1988–89; lecturer, CAI, 1990; lecturer, Sydney Uni., 1991; lecturer, ESTC, 1991; lecturer, SCA, 1992; part-time tutor, ceramic design, ESTC and Tin Sheds Workshop, Sydney Uni.
REP: NGA; AGSA; NGV; QAG; QVMAG; TMAG; Powerhouse Museum; Uni. of NSW; Darling Downs Inst.; Qld Inst. of Technology; regional galleries Orange, Shepparton.
BIB: *A Collector's Guide to Modern Australian Ceramics*, Craftsman House, 1988. *New Art Two*. John Gibson, *Pottery Decoration*, A. C. Black, London 1989. Lina Tessorrero & Helga Nilson, *Aspects of Art*, Science Press, 1989.
(*See also* CRAFTS IN AUSTRALIA)

ORCHARD, Kenneth Leslie (Ken)

(b. 1959, Keith, SA) Sculptor, printmaker, painter, curator.
STUDIES: BA (Fine Arts), SACAE, 1982; MA (Fine Arts) SCA, 1988. Orchard has worked in a variety of media including installations and photocopied, collage art. Printmaking is the basis of much of his art. In his exhibition *White Terrace*, Roslyn Oxley9, Sydney and touring to NZ, 1990–91, he used collage and photocopied woodblocks to extend the media of watercolour, drawing and engraving. His work also reveals the influence of Max Ernst and James Gleeson (some of whose images he uses). He held 14 solo exhibitions 1987–92 at Roslyn Oxley9 (1990, 92) and public galleries including Contemporary Art Centre of SA, and ACCA, Melbourne 1988; Works Gallery, CAI, Sydney 1989; AGWA 1991 and NZ public galleries including Wellington 1989; Dunedin 1990; Centre for Contemporary Art, Hamilton 1991. He participated in about 25 group exhibitions 1983–92, including *Recent South Australian Sculpture*, AGSA 1983; *net-work*, two person exhibition, Artspace, Sydney 1987; *10th British International Print Biennale*, Bradford Museum and Galleries, UK 1988; *Australian Perspecta*, AGNSW 1989; *Recent Acquisitions*, QAG 1992.

AWARDS: Maude Vizard-Wholohan Acquisition Prize, 1982; Pedersen Memorial Prize for Printmaking, QAG, 1987; creative project grant, Arts Council of NZ, 1990; project grant, VACB, 1990.
APPTS: Artist-in-residence, Griffith Uni, 1987; Wellington City Art Gallery, 1989; Edith Cowan Uni., Perth, 1991.
REP: NGA; AGSA; AGWA; QAG; Griffith Uni. collection; Robert Holmes à Court collection.
BIB: Catalogue essays exhibitions as above. AL, 1/4/1981; 6/6/1986–87; 8/1/1988.

ORR, Fiona

(b. 1955, Melb.) Sculptor.
STUDIES: Prahran CAE, 1972–75, VCA, 1976–78. Delicacy and lightness combined with strength are features of her abstract sculptures, done usually with slender rods of willow or steel bedded in ciment fondu. She held 10 solo exhibitions 1979–91 Melbourne (including Christine Abrahams), Sydney (Irving Sculpture) and participated in a number of group exhibitions including *Mildura Sculpture Triennial* 1978, 82, 85; *Australian Sculpture Triennial* 1981, 84, 87.
AWARDS: Australian Sports Women award (commission), Sydney, 1979.
APPTS: Visiting lecturer, Gippsland IAE, 1978; organiser, sculpture workshops, National Gallery Society of Vic.; part-time teacher, sculpture, VCA, 1978–83; lecturer VCA and Melbourne CAE 1987– .
REP: NGV; VACB; tertiary collections including Monash University

ORR, Jill

(b. 1952, Melb.) Performance artist, painter.
STUDIES: Melb. CAE, 1970–75. Having studied dance as well as painting, one of her first works combined both when she plastered with clay, painted over and adorned her body with leaves. Her paintings are distinctive for their heavy layers of oil and simple images, often of domestic subjects. They were seen in solo exhibitions in Melbourne, Brisbane and Sydney from 1979 and in a number of group exhibitions 1980–93 including *Mildura Sculpture Triennial* 1978, 87; *Continuum* 1983.
REP: NGV.
BIB: *New Art Three*. AL 3/2/1983; 4/5/1984. Kirby, *Sightlines*.

OSTOJA-KOTKOWSKI, Joseph Stanislaus

(b. 1922, Poland; arr. Aust. 1949; d. 9/4/1994) Painter, draughtsman, film-maker, industrial designer.
STUDIES: Poland (with O. Vetesco); Academy of Arts, Düsseldorf, 1946–49 (on a four-year scholarship); NGV School, 1950–51. His versatile activities include many large-scale mural works in mosaic, metal work, bas-relief and theatre décor as well as photography, film and glass work. His decorations and illustrations have enlivened the typography of reviews and magazines and his easel paintings in a variety of media appeared throughout Australia in group exhibitions and solo shows. His numerous experiments in advanced techniques include the production of Op and kinetic

pictures as well as electronic images and designs for productions for theatre. His experimental productions for Adelaide Arts Festivals include *The Oldest Continent*, 1970, and Janacek's *The Excursions of Mr Broucek*, 1974. He has also designed a 36.58 m chromasonic tower for Adelaide, 1970; a laser chromasonic tower for the Festival of Arts and Sciences, Canberra, 1975, and a 24.38 m chromasonic tower for the SA Chamber of Commerce, 1978, as well as many other works requiring the amalgamation of art and science. His experiments in electronics have made him outstanding as an artist working in this field.

AWARDS: Cornell Prize, 1957, 59; mural competition conducted by British Petroleum Co., Melbourne, 1963; Churchill Fellowship, 1967; Creative Arts Fellowship, ANU, 1971–72; Australian-American Education Fellowship, 1973; Visiting Artist Fellowship, Vic. Ministry for the Arts, 1976; Order of Australia, 1991; Order of Merit, Polish Government, 1991.

REP: NGA; AGSA; AGWA; NGV; TMAG; Mertz Collection, USA; Society of Fine Arts, Cracow, Poland; Peter Stuyvesant Trust, USA; a number of tertiary collections including ANU, Monash Uni.

BIB: A number of general texts on Australian art including John Reed, *New Painting 1952–62*, Longmans 1963. Craig McGregor, *Australian Art and Artists in the Making*, Thomas Nelson 1969. Nancy Benko, *Art and Artists of SA* Lidums, Adelaide; Thomas OAA; Smith, AP. Laurie Le Guay, *Australian Photography – a contemporary view*, Globe Press 1979. *Meanjin* 3/1951 (Alan McCulloch, *Drawings of Ostoja-Kotkowski*). AI 14/6/1970 (*Letter from Australia*). A&A 19/3/1982. AL 7/2–3/1987.

OUTHWAITE, Ida Rentoul
(b. 1888; d. 1960) Illustrator.
STUDIES: No formal training. The first book of the fantasy and fairy illustrations for which she became locally celebrated appeared in 1904. She married Grenby Outhwaite in 1909 and held exhibitions in Melbourne, 1916, Sydney, 1917, London, Paris, c. 1919. Books she illustrated included *Mollie's Bunyip*, Robert Jolley, Melbourne, 1904; *Elves and Fairies*, Lothian, Melbourne, 1916. Her work appeared in *Art Nouveau in Australia*, travelling AGDC exhibition, 1980; *A Century of Australian Women Artists 1840s–1940s* Deutscher Fine Art, Melbourne, 1993.
REP: TMAG; Mitchell Library, Sydney.
BIB: M. Muir, *Australian Children's Book Illustrators*, Sun Books, Melbourne, 1977;

OVERBURY, Mary
(b. 1860, Adelaide; d. 1932, Adelaide) Teacher, painter. She lectured at the SA School of Design from 1892 and exhibited in the *Australian Exhibition of Women's Work*, Melbourne, 1907.

OWEN, Gladys Mary
(b. 1889, Sydney; d. 1960) Painter.
STUDIES: Sydney, with Gerald Fitzgerald and Dattilo Rubbo; Grosvenor School, London, and in Europe. A member of the Australian Watercolour Inst., she painted mainly landscapes and street scenes in watercolour.

An exhibition of her work was held at the Macquarie Gallery, Sydney, 1955, and a commemorative exhibition at the Mitchell Library, Sydney, 1977.
AWARDS: OBE conferred (for work with the Red Cross during World War I).
REP: AGNSW; Manly Art Gallery.

OWEN, Robert
(b. 29/6/1937, Sydney) Painter, sculptor.
STUDIES: NAS, 1958–62; travel studies, Europe and UK, 1963–66; USA, 1966–74. He travels for often extended periods to Japan, Europe and the UK to study and work, with a special interest in computer graphics and installation art. Shown at the Tolarno Gallery, Melbourne, in 1972, as well as in later exhibitions, his 'kinetic reliefs' in stainless steel showed him as an artist of outstanding talent in this genre. He worked with a group of constructionists (Ernest, Hill and Wise) in London, 1967, and made models for *Cybernetic Serendipity Exhibition*, ICA Gallery, London 1968; New York, 1969. He held solo exhibitions from 1971 in Melbourne (Tolarno, Art Projects), Sydney (Coventry, Roslyn Oxley9, Annandale), London's Air and Space studio, Ivan Dougherty and the Australian Centre for Photography. He also exhibited in group exhibitions in Birmingham, Oxford, Liverpool, London and Edinburgh, notably in the show *Four Australian Artists: Nolan, Boyd, Hessing, Owen*, 1970, as well as in New York. Other group exhibitions 1969–91 include several in the UK; a number of sculpture survey shows in Australia including *Australian Sculpture Triennial*, 1981, 87; and a number of public gallery exhibitions including *What is this thing called Science?*, Uni. of Melbourne 1987; *Deux ex Machina*, Monash Uni. Gallery 1989 and Powerhouse Museum, Sydney 1990; *Off the Wall – In the Air: A Seventies Selection*, ACCA 1991; *Three Installations: Echo*, AGNSW 1991; and in Paris, London and other European cities. He was artist in residence at several institutions including Air and Space Studio, London, 1985; VCA, 1987; Gertrude St, 1988; Centre European d'Actions Artistiques Contemporaines, Strasbourg, France, 1988. He completed a number of commissions and curated several exhibitions including *Inland, Corresponding Places*, ACCA 1990.
AWARDS: Prize at John Moore's *Liverpool Exhibition*, 1969; grants VACB, 1976, 78 (to participate in 38th Venice Biennale), 83 (to participate in *d'Autre Continent*, ARC/Musée d'Art Moderne, Paris), 88.
APPTS: Lecturer in sculpture, drawing and painting, various tertiary colleges, 1972– including Winchester Coll. of Art, 1972; CAI, 1975–87; RMIT, 1989–91; associate professor of sculpture, RMIT, 1991– .
REP: NGA; AGNSW; AGSA; AGWA; NGV; QAG; MAGNT; TMAG; numerous public collections including Parliament House; MOCA, Sydney; MOMA, New York; numerous public collections in Europe, UK, Asia, Canada, India, Africa; corporate collections including NAB, Comalco, BHP, Banque Nationale de Paris.
BIB: Catalogue essays for exhibitions as above. *Art in America*, 1970 (John Russell, *New Names in Britain*). A&A, 24/2/1986. AL, 6/1/1986.

OWEN TOOTH MEMORIAL COTTAGE

(Founded 1971) Michael Karolyi Memorial Foundation, Vence, South France. This studio-cottage was built by Mary Egan as part of the Michael Karolyi Memorial Foundation, to serve as a memorial to her artist son, Owen Tooth (q.v.). Available to Australian artists by application to the VACB, resident artists have included Irene Barberis, Rod Withers, Angus Nivison, Dawn Sime, Eric Westbrook, Edgar Snell, Rodney Milgate, Stephen Roach, Tim Storrier.

OXLEY, Kevin George

(b. 13/12/1941, Hay, NSW) Painter, printmaker, gallery director, sculptor, poet.

STUDIES: Self-taught; travel studies, USA, 1981. He held about 26 solo exhibitions 1969–92 in Victoria (including Munster Arms, Melbourne, 1975; Manyung, Mt Eliza, 1986), Sydney (Holdsworth, 1977, 92; Barry Stern, 1982) and regional galleries, and participated in numerous group exhibitions in Sydney. His sculpture commissions include a concrete and copper bas-relief, IXL Building, Sydney, 1976; polyester resin panels for St Martin's Tower and St Martin's Grosvenor Building, Sydney 1977, 79; bas-relief panels for National Mutual Insurance building, London Circuit, Canberra, 1978; tapestries, AMA, 1982. A traditional-based artist, his other artistic occupations have included gallery director and judge of a number of regional art prizes. He runs his own art school in Maryborough, Qld.

APPTS: Founder Hawkesbury Community Arts Workshop, Uni. of Western Sydney; director, Wyreena Community Arts Centre, Croydon, Vic., 1985–87; Tweed River Regional Gallery, 1988–89; national co-ordinator, Doug Moran Portrait Prize, 1988–89; tutor, aesthetics and creativity, Education Dept, Uni. of Western Sydney, Richmond, NSW; tutor, painting and drawing, Murwillumbah TAFE.

OZANNE, Nicholas

Draughtsman on La Pérouse's expedition to the Pacific. (*See also* DUCHE DE VANCY; PRÉVOST)

PACHUCKA TO PYKE

PACHUCKA, Ewa (née JAROSZYNSKA)
(b. 17/2/1936, Lubin, Poland; arr. Aust. Apr. 1971)
Sculptor, painter, printmaker.
STUDIES: Lyceum of Plastic Arts, Lubin, 1951–57;
Academy of Fine Arts, Lodz, 1957–58. She exhibited
paintings and prints in group exhibitions in Poland,
contributed tapestry to the Warsaw Festival of Arts
tapestry exhibition, 1968, and attained prominence
when her crocheted sculptures were included by Mildred
Constantine in the exhibition *Wall Hangings* at the
MOMA, New York, 1967–68. Her hairless, Neanderthal-
looking figures, crocheted in string, have become well-
known and she became a leader in the art of soft
sculpture done in fibre. Her first Australian exhibi-
tion was at the Rudy Komon Galleries, Sydney, Sept.
1972. She contributed to the *Mildura Sculpture Triennial*,
1973, and in 1974 represented Australia in the *Triennial
of Contemporary Art*, New Delhi. Her work was the
subject of *Survey 5: Ewa Pachucka*, NGV 1978 and com-
missions include for Parliament House Canberra, 1987.
REP: NGA; AGNSW; NGV; TMAG.
BIB: Scarlett, AS. Germaine, AGA. Backhouse, TA.

PAGE-COOPER, George
(b. c. 1895; d. 1967, Melb.) Gallery director, collec-
tor. Director of Tye's Gallery, Melbourne, c. 1945–54.
After serving in World War I, he became deeply inter-
ested in collecting Australiana, especially paintings,
drawings and documents. Amongst his collection was
a large holding of drawings by Robert Russell, first
surveyor of Melbourne. He dealt in art and held no
fewer than eight sales of old furniture and paintings;
the final sale from his estate (Leonard Joel's Auctions,
Nov. 1967) included material covering all periods of
Australian art, especially late nineteenth century.

**PAINTER-ETCHERS AND GRAPHIC ART
SOCIETY**
See AUSTRALIAN PAINTER-ETCHERS' SOCIETY

PAISIO, Franco
(b. 12/11/1936, Milan; arr. Aust. 1958) Painter, sculp-
tor, poet.
STUDIES: Piero Vannucci Academy, Perugia, Italy

(painting and sculpture); Bissietta School, Sydney; ESTC
(ceramics). His abstract paintings have spontaneity,
delicacy and movement and are often based on nat-
ural forms or conditions such as wind in the trees and
clouds. He held around ten solo exhibitions 1961–91,
largely in Sydney (including at Barry Stern, Hogarth,
BMG, Bridge St), and participated in a number of
group exhibitions including prize exhibitions (*Blake,
Transfield*) and with BMG Gallery, Sydney. He also pub-
lished two books of poems in Italy, to receive a first
prize from the Italian Society of Authors in 1961.
REP: Artbank; regional galleries Newcastle, Swan Hill;
corporate collections including Philip Morris.
BIB: Germaine, AGA. *New Art Four*.

PALMER, Ethleen
(b. 1908, Johannesburg; arr. Sydney 1921; d. 1965,
Sydney) Printmaker.
STUDIES: ESTC. Exhibiting in Sydney and Melbourne,
and from 1935–50 with the NSW Society of Artists,
she became known for her decorative prints of birds
and animals. They received praise for their sense of
design and strong colour. During and after World
War II she produced mainly cards, calendars, etc. Her
work appeared in *A Survey of Australian Relief Prints*,
Deutscher Galleries, Armadale, Vic., 1978 and *A
Century of Australian Women Artists 1840s–1940s*
Deutscher Fine Art, Melbourne, 1993.
APPTS: Teacher of printmaking, ESTC, 1938– .
BIB: AA Aug. 1939.

PALMER, Maudie
(b. 1944) Gallery director.
STUDIES: RMIT; Camberwell Art School, London; Prahran
Coll. of Art; Phillip Inst.; Uni. of Melbourne. Inaugural
director Heide Park and Art Gallery 1981– (since
1992 The Museum of Modern Art at Heide) and a
member of a number of professional art groups in-
cluding International Advisory Council; International
Sculpture Exposition Atlanta Ltd, USA; Public Art
Galleries Association of Melbourne.

PALMER, Roger John
(b. 9/7/1933, UK) Painter, printmaker, graphic artist,
critic.

STUDIES: RMIT, 1955; North Melbourne School of Graphic Arts, 1956; BA (Hons), La Trobe Uni., 1990. Painter, art writer, critic. Art reviewer for the ABC in the 1980s and the *Melbourne Report* monthly magazine from 1986. He held solo exhibitions at Melbourne Arts League, 1956, 57; Tasmanian Tourist Bureau, 1966; Niagara Galleries, 1982.

APPTS: Teacher, various adult courses; Swinburne 1958–59; private courses, La Trobe Uni., Melbourne Arts League.

REP: La Trobe Uni. Collection; Geelong Regional Art Gallery; High Court of SA.

PANTON, Alice
(b. c. 1870) Painter.
STUDIES: NGV School, 1890–95. Daughter of J. A. Panton (q.v.), she painted mainly landscapes and portraits, and exhibited at the VAS, 1893–1913; she also exhibited in England. Her impressionistic portrait study of her father, *Sketch at Night*, is signed in monogram, the 'A', attached to the lower right side of the 'P'.

REP: La Trobe Library, Melbourne.
BIB: McCulloch, *AAGR*.

PANTON, Joseph Anderson
(b. 2/6/1831, Knockiemil, Scotland; arr. Aust. 1851; d. 25/10/1913, St Kilda, Vic.) Painter, military administrator.
STUDIES: Uni. of Edinburgh, Scotland; Scottish Naval and Military Academy; Paris, c. 1856, with Nazon. Having developed a keen interest in drawing, he outraged his traditionally military family by leaving the Academy without obtaining a degree, and was subsequently shipped off to work on an uncle's sheep station at Mangalore, Vic., in 1851. He joined the gold rush to Mount Alexander soon after gold was discovered. Apparently he found little gold but his application for work with the gold escort resulted in an appointment as Assistant Gold Commissioner at Kangaroo Gully, near Bendigo. A man of commanding presence (standing 'well over six feet in height') he was rapidly promoted to the job of Resident Warden of the Sandhurst gold district, where he 'handled the diggers' protest movement with tact and discretion', established a Chinese protectorate and became one of the best-loved commissioners in the service. In 1854 he organised the *Bendigo Exhibition*, and in the following year was a commissioner for the first Melbourne *International Exhibition*. Soon afterwards he realised a long-held ambition to study art in Paris where he went with his friend and relation by marriage, Hubert de Castella. Later (Dec. 1860) he was restored somewhat to family favour by marrying the daughter of an Indian army officer, Colonel John Fulton. Back in Vic. with his wife, he resumed administrative work as a warden, first at Jamieson, then at Andersons Creek, at Heidelberg, and finally at Geelong. In 1874 he became Senior Police Magistrate in Melbourne, a position held until his retirement in 1907. Panton's interests included wine growing, exploration and yacht-

ing, as well as art. A member of the Victorian Academy of Arts, he was first president of the VAS, and in 1895 declined the honour of a knighthood. The contingencies of his career and his upbringing, as well as the versatility of his interests, militated against his becoming much more than a distinguished dilettante in painting, but after his death his drawings developed considerable historical value. His daughter, Alice (q.v.), became well known in Melbourne as a painter. His works appeared in exhibitions and auctions including Christie's, 1969 (where his oil *Commandant's House, Melbourne, 1886* fetched the then extraordinarily high price of $20,000) and at Deutscher Fine Art exhibition, 1980.

AWARDS: CMG conferred, 1895.
REP: NGV; Bendigo Art Gallery; Mitchell, La Trobe Libraries; Melbourne Club.
BIB: *ADB* 5. McCulloch, *AAGR*. Kerr, *DAA*.

PARAMANTHAN, Nathan Thambu
(b. 1929, Malaya) Painter, teacher.
STUDIES: Uni. of Melbourne; RMIT (Dip. 1963, Fellowship 1966). His expressionistic landscapes, painted usually in a limited range of soft, monochromatic colours, are noted for their lightness and rhythmic linear structure.
AWARDS: Applied Chemicals prize (shared), VAS, Melbourne, 1973; 3rd prize, Asian Art Exhibition and Competition, 1976.
APPTS: Senior lecturer in art at the State Coll. at Coburg; chairman of the Inst. of Art Education and Victorian State representative of ASEA.
NFI

PARAMOR, Louise
(b. 1964, Sydney) Sculptor.
STUDIES: BA (painting), Curtin Uni., Perth, 1985; Postgrad. Dip. sculpture, VCA, 1988. Her sculptures are often well-considered effective site-specific pieces as seen in the sculpture display *Gasworks*, Melbourne in conjunction with the Australian Sculpture Triennial, 1993. She participated in around 14 group exhibitions 1986–92 in Melbourne (Girgis & Klym), Sydney (Ray Hughes) and in public galleries including *An Incongruous Marriage*, Praxis, Fremantle 1986; *Site of Execution*, ACCA 1988; *Backward Glance*, PICA, 1991. Her solo exhibitions were at Ray Hughes (Brisbane, 1988; Sydney, 1989; Melbourne Temporary Space, 1991); 200 Gertrude St, Melbourne, 1991; Girgis & Klym, Melbourne, 1993.
AWARDS: Studio grant, Barcelona, VACB, 1991.
REP: Curtin Uni.; MOCA, Brisbane.
BIB: *AM*, no. 44, Oct. 1991. *A&A* 26/2/1988.

PARAMOR, Wendy
(b. 1938, Melb.; d. 1975) Painter, sculptor.
STUDIES: NAS, 1956–59; Julian Ashton School, 1959–60; travel studies in Europe and the USA, 1960–63. She exhibited in London, New York and Portugal, and after her return to Sydney in 1963 exhibited at the Dominion, Watters, Blaxland and Central Street

galleries and became a committee member of the CAS. A brief visit overseas in 1965 and an exhibition of drawings at the Bognor Gallery, Los Angeles, were accompanied by a change of style from abstract expressionism to the kind of unit abstraction evident in her one painting and two sculptures in *The Field* exhibition, NGV, 1968. The sculptures comprised painted, modular forms in which the interchangeable units were drawn together like the separate parts of giant magnets.

AWARDS: Gulbenkian grant for study in Portugal, 1961; prize for painting at Young Art Festival, NSW, 1964.

BIB: *A&A* 14/1/1976.

PARKER, Colin Ross

(b. 1941, Lindfield, NSW) Painter.

STUDIES: RAS classes, Sydney. Numerous exhibitions have made his paintings known mainly in NSW, his best-known work being a mural depicting outback Australia for Tullamarine airport, Vic.

AWARDS: Prizes in art competitions at Braidwood, 1965; Scone, 1965; Sydney, RAgSocNSW, 1971, 78; Hawkesbury, 1976, 77, 78.

REP: AGNSW; Rural Bank and Westpac Collections.

PARKER, G. K.

(Active c. 1860–80) Stonemason, carver. His Melbourne premises (corner Swanston St and Flinders Lane) became a meeting place for painters and sculptors, including Buvelot, Scurry, Mackennal, Fallet, Ashton and S. T. Gill.

BIB: McCulloch, *AAGR*.

PARKER, Harold

(b. 1873, Aylesbury, Eng.; arr. Brisbane, 1876; d. 1962) Sculptor.

STUDIES: Brisbane Tech. Coll., 1888, drawing, modelling, with Frank Clarke and Godfroy Rivore, wood carving with C. Vickers; City and Guilds Art School, London, with W. S. Frith, 1896–1902. William Moore writes that he painted landscapes in Qld before going to London and subsequently exhibited watercolours in Sydney, Melbourne and Paris, but he is known otherwise exclusively as a sculptor. In 1890 he was selected to do carvings for the NSW Forestry Dept for exhibition at the *Chicago Exhibition*, 1893, and by 1896 he was in London where, two years later, he won a scholarship for sculpture, followed by work in the studios of Sir Thomas Brock, Sir Hamo Thornycroft and Goscombe John. Towards the end of this period of apprenticeship with three eminent RA's, which lasted until 1908, he secluded himself in his studio with a supply of food, to emerge six weeks later with his masterpiece – the marble carving *Ariadne*. Purchased for the Tate Gallery through the Chantrey Bequest, *Ariadne* made his name. His interest in the nude interpreted through classic themes is typical of the RA and Paris Salon sculpture of the period, but in his marble carvings particularly he added expressiveness, elegant finish and delicacy of texture to fine craftsmanship. Among his commissioned works are the carved figure groups for Australia House, London, completed 1915–18. He visited Australia in 1911, again in 1921–22 and returned to settle permanently in Brisbane in 1930. His work appeared in the Bicentennial exhibition *The Great Australian Art Exhibition*.

AWARDS: Gilbert Garret competition and; 100 pounds, two-year scholarship for sculpture, City and Guilds Art School, 1898; honourable mention, Paris Salon, 1910; medal (for *The Pioneer*), Paris Salon, 1928.

REP: NGV; QAG; Uni. Art Museum, Uni. of Qld; John Oxley Library, Brisbane.

BIB: Moore, *SAA*. Scarlett, *AS*. *AA* May 1922 (*Harold Parker's Sculpture*, article and reprdns); Feb. 1931.

PARKER, Reg

(b. 1925, Melb.) Sculptor, teacher.

STUDIES: Melbourne Teachers Coll., 1948–50; RMIT, 1958–60 and 1971. From 1973 he produced a large number of sculptures designed in large, simple, geometric forms, minimal in style and done usually in welded steel variously surfaced. Many were commissioned and others contributed to exhibitions such as the *Mildura Sculpture Triennial*, 1964, 75, 78; *Sculpture and Performing Arts Festival*, La Trobe Uni. 1978.

AWARDS: VACB grant, 1975.

APPTS: Teaching, Vic. Dept of Education schools, 1951–61; lecturer, Burwood Teachers Coll., 1961–68; lecturer in sculpture, Melbourne State Coll., 1969– .

REP: Regional galleries Mildura, Langwarrin (McClelland Gallery); ANU, Canberra; State colleges at Ballarat and Burwood.

BIB: Scarlett, *AS*. Germaine, *AGA*.

NFI

PARKER, Stanley

(b. c. 1908, Melb.) Black-and-white artist. He specialised in pencil drawings of celebrities connected with the theatre; contributor to Melbourne *Table Talk*, London *Bystander*, *Sketch* and *Tatler*. He lived in London from 1936 and revisited Australia in 1952.

PARKIN, Constance

See STOKES, Constance

PARKINSON, Roy Phillip

(b. 1901, Brisbane; d. 1945) Painter.

STUDIES: Brisbane Tech. Coll. Known mainly for watercolours. A member of the RQAS, he exhibited at the *Coronation Exhibition*, London, 1937, and in the USA. He wrote *Praise Life and Practice Art*, William Brooks, Brisbane, 1946.

REP: AGSA; NGV; QAG; Castlemaine Gallery.

PARKINSON, Sydney

(b. 1745, Edinburgh; arr. Aust. 1770; d. 1771) Draughtsman. Natural history draughtsman on the *Endeavour* on Captain Cook's first voyage. Two other artists, Alexander Buchan and John Reynolds, were also attached to this expedition and all three artists

died during the voyage. An engraving of two Aborigines advancing to combat, published in Parkinson's journal of 1784, is the first known pictorial record made by an Englishman in Australia. During this voyage he made 680 sketches and 280 finished drawings; one of his important Australian works is *The Careening of the Endeavour*, done after the vessel had struck a rock off the Qld coast on the southern bank of the Endeavour River.
REP: NLA; British Museum.
BIB: Rienits, *Early Artists of Australia*, 1963. Smith, EVSP. R. Joppien & B. Smith, *The Art of Captain Cook's Voyages*, vol. 1, OUP, 1985. Kerr, DAA.

PARKS, Ti (Theodore)
(b. 1939, UK; arr. Melb. 1964; lived London, 1974–) Experimental artist.
STUDIES: Bromley Coll. of Art, Kent, UK, 1956–61; Slade School, London, 1961–63. He worked as a scenic artist for television, 1964, and held an exhibition at the Argus Gallery, Melbourne in the same year. Constructivist, conceptual, happening, primary, World Theatre, environmental and ecological art were all a part of his early work. He exhibited during the 1970s at Hawthorn City Gallery, Pinacotheca, Mildura Arts Centre, and Lennox Street, 1978 and received favourable reviews from Donald Brook in the *Sydney Morning Herald* and Elwyn Lynn in the *Bulletin*. Parks went to NZ as visiting lecturer in sculpture, Uni. of Auckland, in 1974 and returned to England the following year.
AWARDS: Work acquired, Mildura Sculpture Triennnial, 1975.
REP: NGA; AGNSW; NGV; regional galleries Ballarat, Mildura.
BIB: Sturgeon, DAS. Scarlett, AS. A&A 16/1/1978 (Gary Catalano, *Ti Parks*).

PAROISSIEN, Leon Francis
(b. 5/3/1937, Gisborne, Vic.) Art museum director, lecturer.
STUDIES: BA, Uni. of Melb.; TSTC, Melb. Teachers Coll., 1954–56; CIT, 1961–62; travel studies, Europe and UK, 1967; BA, Uni. of Melb., 1968. In 1974 he became the first director of the Visual Arts Board of the Australia Council, from which he resigned in 1980 and travelled overseas. Later he joined former AGDC director, William Warner, in a publishing venture, *Australian Art Review*, a book surveying the year's art which had several editions. He has been a member of a number of professional bodies including Biennale of Sydney, International Committee for Museums and Collections of Modern Art as well as founding director Sydney's Museum of Contemporary Art (*see* GALLERIES – PUBLIC).
APPTS: Art teacher in Victorian and English secondary schools until 1968; lecturer in art history, Melb. Teachers Coll., 1969–71; senior lecturer, Tasmanian School of Art, 1972–73; Uni. of Sydney, 1984–86; editor, *Art in Australia*, 1987–92, and senior adviser to the journal 1992– ; acting director, 1986, then director, 1989– , MCA, Sydney.

PARR, Bob (Robert PARADINSKI)
(b. 1923, Adelaide) Sculptor, lecturer.
STUDIES: Trained as an engineer, he studied drawing at the evening classes at Wollongong Tech. Coll., then in Melbourne (part-time) at RMIT 1940; self-educated in sculpture. Involving welding and joining techniques and the use of a wide variety of old and new materials, his sculptures owe much to his training in engineering. Though sometimes bewildering in their range of expression, they attain a certain unity of concept through the dialogue consistently evoked between nature and the machine. He held around 22 solo exhibitions 1964–91, largely at Watters, Sydney; Pinacotheca, Melbourne. His work appeared in numerous sculpture and other survey exhibitions at public galleries 1964–92, including *Mildura Sculpture Triennial*, 1967, 70, 78, 82, 85, 88; *Australian Sculpture Triennial*, 1981; *Portrait of a Gallery*, Watters 25th anniversary touring exhibition to eight regional centres 1989; *Off the Wall, In the Air: A Seventies Selection*, Monash Uni. and ACCA, 1991. His commissions include works at Wollongong Leagues Club and Darling Harbour, Sydney.
AWARDS: Sculpture prizes in competitions in Wollongong, 1963, 65, 74; Dattner Award, Eltham, 1965; Hunters Hill, 1965, 66; Sydney (RAgSocNSW), 1965, CAS, 1971; Glenfiddich Art Award, 1979.
APPTS: Part-time teaching, Wollongong Tech. Coll., 1966–69, and at the NAS, Sydney, 1970– ; teacher-in-charge of dept of sculpture, Canberra Art School, 1973– .
REP: NGA; AGNSW; AGSA; AGWA; NGV; MOCA, Brisbane; VACB; tertiary collections including Melbourne Uni.; regional galleries at Mildura, Wagga; corporate collections including Allen, Allen & Helmsley.
BIB: Catalogue essays exhibition as above. Sturgeon, DAS. Leon Paroissien, *Australian Art Review* Warner, 1982. Scarlett, AS. New Art Two. A&A 14/1/1976; 17/1/1979 (G. Legge, *Robert Parr's Sculpture*).

PARR, Geoffrey
(b. 6/1/1933) Painter, graphic artist, photographer, teacher.
STUDIES: ESTC, 1953–54. His solo exhibitions include Lloyd Jones Gallery, Hobart 1965; Uni. of Tasmania 1973; QVMAG 1976; *Developed Image*, Adelaide 1982. He participated in many group shows including *Australian Perspecta*, 1983.
APPTS: Head of Graphic Design, School of Art, Tas., 1972–78; head, School of Art, Uni. of Tas., 1979; member, VACB, 1974–77; TAAB, 1980–83; fine arts committee, Uni. of Tas., 1983–84.
REP: NGA; AGSA; NGV; QVMAG; TMAG; Devonport Art Gallery.
BIB: John Kroeger, *Australian Artists*, Renniks, Adelaide, 1968. Backhouse, TA.

PARR, Lenton
(b. 1924, Melb.) Sculptor, teacher.
STUDIES: RMIT, 1951–54; UK, with Henry Moore 1955–57. He served in the RAAF in World War II

from 1943 and in 1951 was invalided from the force after protracted illness. Privileged to work as a pupil-assistant to Henry Moore, 1955–57, he responded to the spirit of the emerging British school of modern sculpture with enthusiasm, returning to Vic. in 1957 to become, three years later, a leading figure in the Melbourne group known as Centre 5. His welded steel work from this period has the crustacean look of the sculptures of a Chadwick or a Meadows. Later his formal structure inclined more towards the welded steel work of Caro and the St Martin's School – a style which he continued to refine. He has completed over 30 commissions and held around 20 solo exhibitions 1956–91 in Sydney and Melbourne, including at Powell St, Christine Abrahams. He wrote *Sculpture* for the *Arts in Australia* series, Long-man, Melbourne, 1961. A retrospective of his work was held at NGV, 1984–85.

AWARDS: Member, Order of Australia, 1977.

APPTS: Teaching, RMIT, 1957–64; head of sculpture school, 1964–66; head of the art school, Prahran Tech. Coll., 1966–68; head of the art school, NGV, 1969–72; dean of the school of art, VCA, 1973, director, VCA, 1974–84.

REP: NGA; most state galleries; a number of regional gallery collections including Geelong, McClelland, Mildura, Warrnambool; a number of tertiary collections including Deakin, La Trobe unis.

BIB: Sturgeon, *DAS*. Scarlett, *AS*. Smith, *AP*. *A&A* 6/4/1969 (C. Elwyn Dennis, *Lenton Parr – an Australian Asset*).

PARR, Mike

(b. 1945, Sydney) Sculptor, video artist, performance artist.

STUDIES: Qld Uni., c. 1965; ESTC. In company with Peter Kennedy he conducted the Inhibodress Co-operative Gallery in Woolloomooloo, Sydney, 1970–72, becoming widely known as an energetic protagonist of avant-garde art including performance art. He was born with a deformed left arm and his performances often have to do with self-mutilation (to such effect members of the audience have been known to faint). He described the intent of his 1992 *Haemorrhage Performance* in WA to 'escape the straitjacket of style', and himself as being 'interested in complexity' and challenging 'appropriate' ways of expression. In *Alphabet Haemorrhage* he posed the question of the connection between body and self-portrait: 'Performances', he said, 'are a condensed form of memory of experience . . . the basis for didactic, instructional contract, dilated and ballooned according to audience perception' (ABC Radio National *Sightings*, Dec. 1992). Another strong element in his work is drawing in which he excels. He held over 40 solo exhibitions 1970–92 including at Roslyn Oxley9, Sydney; City Gallery, Melbourne; Drill Hall, NGA; Ian Potter Gallery, University of Melbourne. His work appeared in numerous significant group exhibitions 1970–92 internationally (including in Amsterdam, Paris, London, Venice, Germany, Japan, USA) and in Australia including *Biennale of Sydney*, AGNSW 1979, 82, 88, 90; *An Australian Accent: The*

Artists, Mike Parr, Imants Tillers, Ken Unsworth, IMA 1984; *Australian Perspecta*, AGNSW 1985, 87; the Bicentennial exhibitions, *The Great Australian Art Exhibition* and *The Face of Australia* and in *The Corporeal Body*, Drill Hall, NGA, 1991. In 1989 the IMA, Brisbane presented an exhibition of the *Inhibodress* gallery work from the early 1970s.

AWARDS: grant, VACB, 1976–77.

REP: Many films, works on paper and paintings in collections of NGA; AGNSW; AGSA; AGWA; NGV; Parliament House; NLA; MCA, Sydney; regional galleries including Burnie, Hamilton, MPAC; tertiary collections including Griffith, WA, Flinders unis.; corporate collections including Chase Manhattan, First National Bank, USA.

BIB: Catalogue essays exhibitions as above. Leon Paroissien, *Australian Art Review {1 & 2}*, Warner Publications, Sydney 1982, 83. Chanin, *CAP*. Smith, *AP*. *Aspect* Sept. 1975; 3/3/1978; 3/4/1978; 5/3/1980; no. 26–27, 1987. *A&T* no. 10, 1983; no. 35, 1989; no. 35, 1990. *A&A* 13/4/1976; 17/2/1979; 20/4/1983.

PARSONS, Elizabeth

(b. 1831, England; d. 1897, Victoria) Painter. She exhibited at the Victorian Academy of Arts, 1870–87, and Art Society of NSW, 1880– , showing mainly English and Scottish watercolours and Victorian landscapes. She also exhibited with the Australian Artists' Association, 1885–87, and with the VAS, 1888–96. Her oil paintings, in popular colonial style, are characterised by an unusual clarity. She held an exhibition *E. Parsons, historical watercolour drawings of early Melbourne*, at Decoration Galleries, 15–20 Mar. ?1920. Her work was represented in *Australian Art of the 1870s*, AGNSW, Sydney, 1976; the Bicentennial exhibition *The Face of Australia* and *A Century of Australian Women Artists 1840s–1940s* Deutscher Fine Art, Melbourne, 1993.

REP: NGV

BIB: Catalogue essays exhibitions as above.

PARTOS, Paul

(b. 1943, Czechoslovakia; arr. Aust. 1950) Painter.

STUDIES: RMIT, 1959–62; travel studies in Europe and UK, 1965–66; USA, 1970–72. The paintings and drawings in his first exhibition (Gallery A, Melbourne, 1965) showed the influence of Picasso's early cubist and double-image portrait periods. His painting style changed gradually to environmental abstraction and no traces of figuration remained in his exhibits in *The Field* exhibition in 1968. Later he experimented with conceptual art before settling to the style of painting in which small rectangular shapes, thick, rich textures and kaleidoscopic colours predominate. He held about 18 solo exhibitions 1965–93, Melbourne (Gallery A, Pinacotheca, Realities, Christine Abrahams); Sydney (Garry Anderson, Sherman galleries). His work appeared in numerous group exhibitions 1968–92, including *Australian Perspecta*, AGNSW 1981; *The Field Now*, Heide 1984; *Surface for Reflexion*, AGNSW 1986. In 1989 he was resident artist at Ian E. Joye Foundation, Sydney.

AWARDS: Corio Five Star Whisky prize, Geelong, 1969; McCaughey prize (shared with Ken Whisson), NGV, 1979; fellowship, VACB 1992.
APPTS: Lecturer in painting, VCA, 1978– .
REP: NGA; AGNSW; AGSA; AGWA; MAGNT; NGV; QAG; Artbank; regional galleries including Ballarat, Geelong; private and corporate collections including Philip Morris, NAB, Loti & Victor Smorgon.
BIB: Catalogue essays exhibitions as above. Smith, AP. Gary Catalano, *The Years of Hope* OUP, 1981. Chanin, CAP. A&A 17/4/1980.

PASCO, John William
(b. 23/1/1949, Melb.) Painter.
STUDIES: Warrnambool Inst. of Technology, 1966–67; WAIT, 1968–69. From 1968 he participated in group exhibitions in Perth and held a solo exhibition at the Old Fire Station Gallery, Perth, in 1974. Group exhibitions include NGV, 1979.
AWARDS: Undergraduate prizes, WAIT, 1968–70.
REP: NGA; AGWA; WAIT; Uni. of WA; Bunbury Art Gallery.

PASSMORE, John Richard
(b. 4/2/1904, Sydney; d. 9/10/1984) Painter.
STUDIES: SAS, with Julian Ashton, intermittently between 1918 and 1933, and with George Lambert; independent study in Europe, 1933–50. When Passmore returned to Sydney after 17 lean years overseas, his work appeared as a strange phenomenon on the Australian scene; its felicity of colour and texture concealed the struggle to break with the early, student influences of Lambert and his British counterpart, Orpen. In his search for a personal idiom Passmore seemed to be attempting a union of Cézanne's principles of cubistic form, and form achieved through colour, with the graphic power of a Rembrandt. And while at first this suggested the kind of eclecticism through which an artist may move from one point of historical influence to another, it soon became apparent that there was much more to it. His work touched the inner spirit of his mentors, nourishing his own spirit and providing the strength necessary to continue the search. This period of Passmore's work attracted the attention of critics and gained him a considerable following. The first manifestation of what seemed at the time like an abrupt change of direction occurred in his 1959 Rubinstein Scholarship painting entitled *Jumping Horse Mackerel*. The change was in fact a move away from the cubistic forms and palette of Cézanne, and colours indigenous to the Côte d'Azur, towards a range of tertiary colours including brown, orange, grey, white and black, to which he imparted a luminosity eloquently evocative of his own, specific environment. Like the enlarged scale of the canvas on which he had painted the Rubinstein work, and like his drawing, which now moved towards a new calligraphic freedom reminiscent of Chinese or Japanese art, his apparent change of painting style was a contrapuntal exercise that sought to equate with the scene he knew best – the Sydney harbour front.

The jumping horse mackerel became a theme that was to occupy him for some years. In it the symbols of sun, sand, sea, fish, figures, jetties and changes of weather were brilliantly transcribed to produce a rare kind of visual excitement. The theme is recurrent and surfaces often in his later work. It should be added that the finest qualities of Passmore's paintings were anticipated and summarised in his vivid and spontaneous drawings. They seemed to pour from his heart and hand in a never-ending stream to take their place among the most remarkable series of graphic documents produced by any of his generation of Australian painters. Like Ian Fairweather and Godfrey Miller before him, Passmore was an artist working in isolation and his work is by no means easy to come to grips with. In the general assessment of his accomplishments, the Sydney critic Paul Haefliger was the first to recognise the qualities inherent in his 'Cézanne period'; his 'Oriental period' was brilliantly analysed by another painter-critic, Ronald Millar, in his book *Civilized Magic*. A major retrospective exhibition curated by Barry Pearce was held at the AGNSW in 1984 and his work appeared in the Bicentennial exhibition *The Great Australian Art Exhibition*.
AWARDS: Helena Rubinstein Travelling Scholarship, 1959.
REP: NGA; AGNSW; AGSA; AGWA; MAGNT; NGV; QAG; QVMAG; TMAG; many regional galleries, uni. galleries and other public collections.
BIB: Catalogue essays exhibitions as above and all general texts on Australian art including Smith, AP. Ronald Millar, *Civilized Magic*, Sorrett Publishing, Melbourne, 1974. A&A 22/3/1985.

PASZTHORY
A Hungarian artist who painted in Melbourne including portraits of Nellie Melba and the Lord Mayor, Gillot.

PATE, Klytie
(b. 1912, Vic.) Ceramicist.
STUDIES: NGV School, c. 1931 (drawing with W. B. Innes and Charles Wheeler); Melb. Teachers Coll., c. 1938–45. Her interest in art was encouraged by her aunt, the artist Christian Waller, who introduced her to the art deco style and classical mythology, both of which were to become major themes in her work. She exhibited regularly from 1941 in Melbourne, Sydney, Brisbane and Adelaide including with Macquarie Galleries, Sydney, and in 1983 a retrospective of her work was held at NGV. Her work appeared in the Bicentennial exhibition *The Great Australian Art Exhibition*.
REP: NGA; NGV; Powerhouse Gallery, Sydney; regional galleries including Ballarat, Shepparton.
BIB: John McPhee, *Australian Decorative Arts*, NGA, 1982.

PATERSON, Betty
(b. Melb. active 1930s) Painter, illustrator.
STUDIES: NGV School. A specialist in child portraiture. Niece of John Ford Paterson (q.v.), sister of

Esther Paterson (q.v.). Her work appeared in *A Century of Australian Women Artists 1840s–1940s* Deutscher Fine Art, Melbourne, 1993.
AWARDS: Prize in Albury competitions, 1958.
REP: Shepparton Art Gallery.

PATERSON, Esther
(b. 1896, Melb.) Painter.
STUDIES: NGV School, 1907–12. Fellow of the Royal Society of Arts, London; member of the Melbourne Society of Women Painters and Sculptors; council member of the VAS. Her competent paintings included advertising artwork and illustrations for books.
REP: NGV; Geelong Art Gallery.

PATERSON, Ethel M.
(Active from c. 1900, Melb.) Bird artist.
STUDIES: Melb. Art School (with E. Phillips Fox and Tudor St George Tucker). She illustrated 177 plates for John Leach's *Australian Bird Book*, Vic. Education Dept, Melbourne, 1911.
AWARDS: Prize for her illustrations to Dr John Leach's bird book in a competition conducted by the Vic. Education Dept.

PATERSON, Jim Robert
(b. 3/7/1944) Painter, printmaker, sculptor.
STUDIES: Prahran CAE, 1968–69. He held his first exhibition at the Pinacotheca Galleries, Melbourne, 1975, followed by six others at Pinacotheca to 1986, three with Ray Hughes, Brisbane; Macquarie Galleries, Sydney, 1982 and Tolarno Galleries, 1988. Although sculpture and some fine landscapes were shown in two of his exhibitions, the strength of his work is in his large, monochromatic, frontal studies of heads. His method of modelling rather than drawing with the paint helps to give these larger-than-life studies great vitality and character. Group exhibitions in which his work appeared include *Australian Perspecta*, AGNSW 1983; *Portraits*, Heide 1984; the Bicentennial exhibition *The Face of Australia*.
AWARDS: Georges Art Prize (acquisitive), 1972, 76, 78, 82; MPAC Spring Festival of Drawing (acquisitive), 1975, 87; VACB grants, 1975, 78, 81.
APPTS: Teaching, part-time, 1978–80.
REP: NGA; AGWA; NGV; Parliament House; several regional galleries including Geelong, McClelland, MPAC; several tertiary collections and corporate collections including NAB.
BIB: Catalogue essays exhibitions as above.

PATERSON, John Ford
(b. 1851, Dundee, Scotland; arr. Melb. 1872; d. 1912) Painter.
STUDIES: Royal Scottish Academy, Edinburgh. After three years in Australia he revisited Scotland (1875–84), before returning to live permanently in Melbourne. He was friendly with Louis Buvelot and from 1884 closely associated with the members of the Heidelberg School. His painting is lyrical and romantic, linked with contemporary Scottish painting and in Australia forming a bridge between the paintings of Piguenit and the impressionist paintings of the Heidelberg School (q.v.). His work appeared in the Bicentennial exhibition, *The Face of Australia*.
APPTS: President of the VAS, 1892–93; trustee of the NGV, 1903–12.
REP: State and regional galleries.
BIB: All general books on Australian art history including Moore, SAA. ADB 5. AA, Aug. 1919, and Aug. 1933. A&A 21/4/1984.

PATERSON, Mildred E.
See LOVETT, Mildred E.

PATTERSON, Ambrose McCarthy
(b. 29/6/1877, Daylesford, Vic.; d. 8/10/1967, Seattle, USA) Painter, teacher.
STUDIES: NGV School, then Melb. Art School, with Tudor St George Tucker and E. Phillips Fox, 1896–98. In 1898, inspired by what he had learned of French painting from Fox and Tucker, he left Melbourne for Paris where he studied at the Académie Julien (?with J. S. Macdonald) before moving to Colarossi's and Académie Delecluse, where Macdonald and Hugh Ramsay were both students. The three shared a studio near that of the Sydney travelling scholarship winner, G. W. Lambert. Ramsay painted a fine portrait of Patterson and both Lambert and Patterson responded to Ramsay's influence, Patterson noticeably in his *Self Portrait*, c. 1902, now in the NGA collections. By 1903, however, Patterson had discovered impressionism, specifically Pisarro's bird's-eye views of Paris streets. He returned to Australia in 1910 and two years later joined the VAS breakaway group to form the Australian Art Association. He left Australia for Hawaii in 1917. In 1919 he was appointed professor of painting at the Uni. of the State of Washington, Seattle. He had a distinguished career in the USA both as painter and teacher, retiring from the university as professor emeritus in 1947. He returned to Australia for a visit in the 1950s but his reception was cool because nobody knew who he was, his name being confused with that of the Paterson sisters, Esther and Betty. An exhibition of his work was held at Joshua McClelland Print Room, 18 Nov. 1969 and he was represented in *Aspects of Australian Art*, travelling exhibition, 1978–79. A touring exhibition of his work throughout regional galleries was seen in 1992.
REP: NGA; AGSA; NGV.
BIB: Collection catalogues of NGV and AGSA.

PATTERSON, W. H.
(Active c. 1854–60, Bendigo) Painter. He contributed drawings to the *Illustrated Sydney News,* c. 1854.
BIB: McCulloch, AAGR.

PAUL, Emily Letitia
(b. 1866, Bathurst, NSW; d. 1917) Painter.
STUDIES: Julian Ashton School, Sydney; Slade School, London; Académie Julian, Paris. Contestant for the Federal seat of Cook in 1914 parliamentary elections.

Mother of Sydney *Bulletin* artist, Mick Paul, she was an original member of the NSW Society of Artists, 1895.

PAUL, John
(b. 14/9/1953, WA) Painter.
STUDIES: Graphic Design, St James College, WA, 1970–72; Fine Arts, Claremont Tech. Coll., WA, 1972–73. Concerned largely with the environment, his work was seen in two solo exhibitions 1984–92 including one at Fremantle Arts Centre and in a number of group exhibitions largely in WA including *Art and Social Commitment*, AGWA 1985; *Recent Acquisitions*, AGWA 1991. He was artist-in-residence at Claremont School of Art.
AWARDS: Grant, AGWA; *Mandorla Art Prize*, 1990.
APPTS: Relief and other tertiary teaching, 1980– , including at Perth Tech. Coll., Claremont School of Art.
REP: AGWA; Notre Dame Uni; New Norcia Gallery; corporate collections including Western Mining.
BIB: Ted Snell (ed) *The Painted Image*, Vol. 1. 1991.

PAUL, Laurie
(b. 20/8/1928, Richmond, NSW) Painter.
STUDIES: Summer schools, Uni. of New England, Armidale, and Uni. of Qld, Brisbane with Rapotec, Orban, Reddington, Laycock and Daws; studied and painted in UK, Europe and USA, 1979–83. An abstract expressionist and surrealist painter, she held around 22 solo exhibitions 1978–90, largely on the Gold Coast, Qld. Her work was seen in *A Homage to Women Artists*, Gold Coast City Art Gallery, 1988.
AWARDS: Prizes at Springbrook, 1965, 67; Grafton, 1965; Cowra, 1966; Warana, 1970, 72, 74, 77; Maryborough, Qld, 1976; Trinity Purchase, 1986.
REP: TMAG; regional galleries Grafton, Gold Coast.

PAUL, Mick
Black-and-white artist. Illustrator on the staff of the Sydney *Bulletin*. Son of Emily Letitia Paul. Member of the Dee Why group, NSW.
REP: Mitchell Library, Sydney (etching purchased 1928).

PAYNE, Frankie (Frances Mallalieu)
(Active c. 1900–30) Painter, commercial artist.
STUDIES: Brisbane Central Tech. Coll. with Godfrey Rivers; Ecole des Beaux-Arts, Paris; London, with Frank Brangwyn. She drew for the *Brisbane Courier* and painted landscapes and portraits, exhibiting with the Qld Art Society, 1902–15, before moving to Sydney where, from 1923, she exhibited with the RAS. Her work appeared in *A Century of Australian Women Artists 1840s–1940s* Deutscher Fine Art, Melbourne, 1993.
REP: QAG.
BIB: Julie K. Brown and Margaret Maynard, *Fine Art Exhibitions in Brisbane 1884–1916*, Fryer Memorial Library, Uni. of Qld, 1980.

PEACOCK, George
(Active c. 1875–1900, Melb.) Painter. He exhibited

a number of works at the VAA, 1877–85, concentrating on oil paintings of views and landscapes in and around Melbourne. Works by him offered at Leonard Joel's auctions, Melbourne, May 1979, included oils of *St Kilda Pier*, and the *Yarra at Heyington*, the latter a relatively low-keyed, traditional landscape, dated 1898. It is recorded that G. E. Peacock (q.v.) was followed to Sydney by his wife and young son in 1837, and it is thus possible that George was the son of George Edward Peacock.

PEACOCK, George Edward
(b. 4/9/1806, Eng.; arr. Sydney 1837; d. ?post 1890, Sydney) Sketcher, painter. A London attorney convicted for forgery in 1836, he was transported the following year and sent to Port Macquarie as an educated convict; his wife and son followed him shortly after. In 1839 he obtained the position as assistant to the astronomer at South Head, Sydney, and following his conditional pardon in 1846 he remained there as meteorologist till 1856 when the station was apparently closed. He had an unhappy domestic life, exacerbated it seems by his severely reduced circumstances and enforced simplicity of lifestyle which he felt unsuitable for his wife. According to Kerr he appears to have started painting around 1840 when he painted various views of the Harbour from South Head and also copied in a smaller version sketches of Conrad Martens (q.v.), the colony's leading artist. A number of his works were seen in contemporary exhibitions including the Society for the Promotion of Fine Arts, 1847 and 1849. Little appears known of him after 1857 when he may have left Sydney to visit Victoria. Works by the George Peacock done in the 1870s almost certainly are those of a different artist. His paintings are usually small in scale and painted on canvas, board or copper; their subject matter is almost wholly limited to views of the harbour with its bays, landmarks and buildings, though occasional landscapes and street scenes are recorded and his drawing of the crowds at the opening of the *First Australian Railway, July 3rd, 1850* (lithographed by J. Allen) is an interesting exception. Stylistically his work has a stillness, intimacy and softness of colour which contrasts strongly with the bolder brushwork and greater sophistication of his contemporary, Conrad Martens, and although he occasionally lapsed into prettiness, he remains one of the principal painters of this period whose works retain historical and topographical interest. His work was seen in *The Art of Colonial Gardening*, an AGDC touring exhibition, 1979.
REP: QAG; NLA; Mitchell, Dixson Libraries.
BIB: Jocelyn Hackforth-Jones, *The Convict Artists*, Macmillan, Melbourne, 1977. Edward Craig, *Australian Art Auction Records 1975–78*, Mathews, Sydney, 1978. Moore, SAA. Kerr, DAA.

PEARCE, Barry
(b. 9/5/1944, Adelaide) Curator, author, art historian.
STUDIES: SASA, University of Adelaide, Western Teachers College, Adelaide, 1962–66; Harold Wright Scholar,

British Museum, London 1971–72. He returned to Australia in 1975 to become curator of prints and drawing at AGSA. In that and subsequent positions he has organised many exhibitions, lectured and published texts on Australian art. Exhibitions he organised 1975–93 included *Paul Nash: Photographer and Painter*, AGWA, 1977; *A Century of Australian Landscape: Mood and Moment*, touring China 1983; *The Artist and the Patron*, AGNSW 1988; *Terra Australius: The Furthest Shore*, AGNSW 1988; *Swiss Artists in Australia 1777–1991*, AGNSW 1991; *200 Years of Australian Painting*, touring Japan, 1988. Individual retrospectives he has organised for the AGNSW 1978–93 included those of Sali Herman (1981), Elioth Gruner (1983), John Passmore (1984), Kevin Connor (1989), Donald Friend (1989), Francis Lymburner (1992), Arthur Boyd (1993). He wrote catalogue essays for most of these as well as books on Kevin Connor (Craftsman House, 1989) and David Strachan (with Lou Klepac and John McDonald) (Beagle Press, 1993) and *Australian Artists, Australian Birds*, Bow Press, 1989.
APPTS: Education officer, AGSA 1967–70; curator prints and drawings AGSA 1975–76; curator paintings AGWA 1976–78; curator Australian art, AGNSW 1978, senior curator, 1988– .

PEARCE, G.
Painter. The only known work by this Victorian goldfields artist is a watercolour, *The Myers Creek Rush – near Sandhurst, Victoria*, c. 1859, in the Nan Kivell Collection, NLA.

PEARCEY, Eileen
(b. Melb.) Painter, stage designer.
STUDIES: NGV School, c. 1923–26. Pearcey's work was included in a special exhibition *Theatre Arts Display*, organised for the National Theatre at the NGV, 1951; she exhibited also at the Peter Bray Gallery, Melbourne, 1955.
AWARDS: Ramsay prize (shared), NGV School, 1926.

PEARSON, Ian Howard
(b. 24/7/1951, Lancashire, Eng.; arr. Aust. 1960) Painter, printmaker.
STUDIES: Fine Arts, Uni. of Sydney, 1970–73; Dip. Art, Alexander Mackie CAE, 1973–76. He held 12 solo exhibitions 1978–92 mainly at Robin Gibson Gallery, Sydney.
APPTS: Part-time lecturer in drawing, painting and printmaking, ESTC, 1978–85 and again at Uni. of New England and Northern Rivers, 1987–92.
REP: NGA; Parliament House; regional galleries Maitland, Wagga Wagga; Gold Coast City Gallery; Griffith Uni.; Alexander Mackie CAE; corporate collections including Philip Morris, Banque Nationale de Paris, CBA Bank, BHP.
BIB: McIntyre CC.

PEARSON, (Dr) Joseph
Director, TMAG, Hobart, 1934–52.
NFI

PEART, John
(b. 10/12/1945, Brisbane) Painter.
STUDIES: Brisbane Tech. Coll., 1963–64; travel studies, USA, Europe and UK, 1969–71. In 1964 he moved to Sydney where three years later he collaborated with the composer Nigel Butterley in the production of *Interactions*, an ABC film entry for the Italia Prize. After his initial travels, he lived in England, 1970–71 and returned to Sydney in the mid-1970s. His large canvases have varied enormously over the years but maintained their abstract quality and are noted for their chromatic and textural delicacy and charm. He held around 30 solo exhibitions 1967–92, largely at Watters, Sydney; Powell St, Melbourne; Victor Mace, Brisbane. His work appeared in many group exhibitions from 1965 including *The Field*, NGV 1968; *Recent Australian Art*, AGNSW 1973; *The Field Now*, Heide, 1984; *Portrait of a Gallery*, Watters Gallery 25th anniversary exhibition touring eight regional centres 1989–91; *Surface for Reflexion*, AGNSW 1989; *Field to Figuration*, NGV 1986.
AWARDS: Pacesetter Prize, *Mirror*-Waratah Prize, NBN 3 prize, Newcastle Prize, Transfield Prize (all in 1968); Myer Foundation Grant, 1969; VACB grant, 1976.
APPTS: Teacher of painting, ESTC, 1978–86.
REP: NGA; AGNSW; AGSA; AGWA; NGV; QVMAG; TMAG; Parliament House; MOCA, Sydney; MOCA, Brisbane; many regional galleries including Albury, Ballarat, Dalby, Orange; many tertiary collections including ANU, Uni. of Sydney; numerous corporate collections including ICI, NAB, BHP, Robert Holmes à Court.
BIB: Catalogue essays exhibitions as above. Many general texts on Australian art including Bonython, MAP; Smith, AP Horton, PDA; Chanin CAP. *New Art Two*. PCA, *Directory* 1989. A&A 7/1/1969; 9/4/1972.

PEASCOD, William
(b. 3/5/1920, Ellenborough, Cumbria, Eng.; arr. Aust. 1952, d. 17/5/1985) Mining engineer, painter.
STUDIES: Wollongong Tech. Coll.; Seika Coll. of Art, Kyoto, 1971–72. He worked in coal mines in the UK for fifteen years, spent his spare time mountaineering and in Jan. 1953 moved to Wollongong. His early experience in geology and mining are reflected in his early paintings, which are otherwise abstract expressionist, but his style softened and changed after his visit to Japan, 1971–72.
AWARDS: Prizes at Wollongong, 1961; Maitland, 1963; Adelaide, Vizard-Wholohan, 1963; Armidale, 1963; Muswellbrook, 1965.
APPTS: Teaching, Canberra School of Art, –1979.
REP: AGNSW; AGSA; regional galleries Armidale, Newcastle; Uni. of Qld.
BIB: A&A 23/2/1985 (obituary).

PECHELL, Charles
(b. 1810) Naval commander, painter. Amateur artist who painted views of Fremantle, WA, probably while serving in HMS *Conway*, 1838. His work was reproduced in the National Bank Calendar, Melbourne, 1962.

PECK, George W.

(Active c. 1830–54) Engraver, musician. A versatile worker in many different art forms including music and engraving. He set up a business in Hobart, *Peck's Repository of Arts*, and as a former pupil of Paganini gave violin lessons and concerts. In the late 1830s he constructed a model of Hobart Town which won great praise in London; and in 1857 he conducted Mr George Peck's Art Union at the Mechanics Inst., Melbourne.
BIB: George W. Peck, *Melbourne and Chinsha Islands*, Scribners, New York, 1854.

PEDERSEN, Lilian Ella (née GLOVER)

(b. 1898, Leicester, Eng.; arr. Aust. 1921) Painter, craftworker.
STUDIES: Manchester School of Art, 1915–21. Known for her paintings in oils and watercolour, her versatile accomplishments include also weaving, leatherwork, jewellery design and book illumination. A foundation member and honorary secretary for 31 years of the Half Dozen Group, Brisbane (1940–71), she established in 1975 the Andrew and Lilian Pedersen Memorial Art Prizes, administered by the QAG (*see* PRIZES).
AWARDS: Manchester City Council Art Scholarship.
REP: QAG.
BIB: Reproduction, *Meanjin*, Spring 1943. 25th annual exhibition catalogue, *Half Dozen Group of Artists*, Aug.–Sept. 1965.

PEDVIN, Albert A.

(b. 1874, SA; d. 1900) Sculptor, painter.
STUDIES: Adelaide School of Design, with H. P. Gill. He exhibited annually with the SASA, Adelaide, 1893–98. During his short life he made a reputation as a skilful painter and modeller as well as a designer of jewellery.
REP: AGSA.
BIB: J. B. Mather, *Catalogue of the Art Gallery*, AGSA, Adelaide, 1913. Scarlett, *AS*.

PEEBLES, Graeme

(b. 22/1/1955, Melb.) Printmaker, lecturer.
STUDIES: Printmaking, RMIT, 1973–75; travel studies, Europe and UK, 1976–77, 84, 86. Best known for his mastery of the difficult printmaking art of mezzotint as applied to still-life subjects, he held around 14 solo exhibitions 1980–90 in Melbourne (Stuart Gerstman, Powell St, Australian Galleries), Canberra, Brisbane and in Europe (Vienna and Italy) as well as at Wollongong City Gallery, 1982. He participated in numerous international print survey exhibitions 1978–92, including in *British Print Biennale*, 1982, 84, Europe, Singapore and Thailand.
AWARDS: Churchill Fellowship, 1977; grants VACB, 1977, 86, 91; acquisition prizes at Mornington, 1980, Gold Coast, 1989, Henri Worland (Warrnambool), 1983; Queen Victoria Print Prize, 1981; prizes at Diamond Valley, 1983; Box Hill, 1987; Gold Coast, 1989; Aberdare prize, 1989.
APPTS: Lecturer in printmaking, RMIT, 1981–86.
REP: NGA; AGNSW; AGSA; AGWA; MAGNT; NGV; QAG; QVMAG; TMAG; Parliament House; Artbank: other public collections; a number of regional galleries and tertiary collections in all states; several public collections in Italy, Los Angeles, USA.
BIB: PCA, *Directory* 1988.

PEELE, James

(b. 1847, Geelong, Vic.; d. 1905, Christchurch, NZ) Painter. He migrated to New Zealand in 1865 and, after a career in banking, took up painting. By 1876 he was exhibiting NZ landscapes at the VAA, continuing to show there till 1878. He is recorded as having returned to Australia as a painter and teacher, and in 1889 exhibited at the VAS from a St Kilda address. However the bulk of his work is New Zealand in subject, competently handled with emphasis on mountain and lake scenes and views of noted landmarks.
BIB: Henry P. Newrick, *NZ Art Auction Records 1969–72*, Newrick, Wellington, 1973.

PEERLESS, Thomas

(Active late 19th century, Aust. and NZ) Painter. Colonial school painter of landscapes done mainly in watercolours. Although recorded as painting in NSW and Tas., the majority of his paintings are of New Zealand scenic landscapes.
NFI

PEIR, Clifton Thomas Almont

(b. 1905, Marrickville, NSW) Painter, advertising artist.
STUDIES: Julian Ashton School, 1929–32. He travelled in Europe, 1952, and painted a number of Drysdale-like pictures of Aborigines as a result of visits to Central Australia.
AWARDS: Phillip Muskett prize for figure drawing, Julian Ashton School; prizes at Kogarah, NSW, 1946, 74, Campbelltown 1974–76, Rockdale, 1977.
APPTS: President of the Australian Art Society, 1951–67; art critic for Sydney *Mirror*, 1961–62.
NFI

PEIRCE, Augustus Baker

(b. 7/10/1840; arr. Aust. 1859; d. 1919) Sketcher, photographer, entrepreneur. He jumped ship at Port Phillip and went to the Victorian goldfields where he painted signs and pictures and performed as a vaudeville entertainer. He took up photography in Melbourne and once again travelled to the goldfields and country Victoria where he also sketched and painted scenery for theatres. He was hired to chart the Murray River from Albury to Goolwa, SA, the resulting work being nearly 200m long, wound on rollers and installed on a river boat to chart the journey as it progressed. He produced a panoramic view, so popular at the time, of ambitious scale (65.8m) and content (a journey round the world) which toured Victoria and NSW in 1871. After a colourful life in Melbourne and country Victoria he left for the USA in the late 1870s where

he died some 40 years later. His sketches, although small in scale, are prolific and frequently feature himself with others, in caricature form. He was represented in *Painters of the Past*, Geelong Art Gallery, 1991.
REP: Geelong Art Gallery; La Trobe Library.
BIB: Kerr, *DAA*.

PEISLEY, Wilfrid John
(b. 1916, Bathurst, NSW) Painter.
STUDIES: ESTC and New York. In 1945 he went to New York to study at the art school at Yale Uni. with Professor Theodor Sizer. He married in New York and subsequently taught art at American schools, including the Uni. of New York, and became well-known as a portrait painter. He entered a painting for the *Australian Women's Weekly* prize competitions, Sydney, in 1955.
AWARDS: NSW Government Travelling Scholarship, 1943 (for landscape).
REP: AGNSW.
NFI

PELLION, J. Alphonse
A topographical draughtsman, he accompanied Freycinet in *Uranie* (1817–20) on his voyage to Australia to observe the west coast and chart areas omitted by Baudin (*see* LESUEUR, Charles Alexander), and then visit Sydney (1819). With Arago he made the drawings around Sydney, later lithographed for the book, *Voyage autour du Monde*. His work was seen in *The Colonial Eye*, AGWA, Perth, 1979.
REP: Nan Kivell Collection, NLA.
BIB: *Banque Nationale de Paris*, centenary souvenir publication, 1981. Kerr, *DAA*. Colin Finney, *To Sail Beyond the Sunset*, Rigby, Adelaide 1984.

PENBERTHY, Wesley
(b. 1920, Broken Hill) Painter, teacher.
STUDIES: Perth Tech. Coll., 1935–38; NGV School, 1945–47; ESTC, 1955. He was assisted in his studies also by Norman Lindsay, at Springwood, NSW, 1939. His many commissioned works include industrial and other murals done in styles varying from traditional figuration to modernist abstraction. He conducted art classes for the Peninsula Arts Society, Frankston, Vic. (c. 1958–63), and through his association with Norman Lindsay was instrumental in getting a large collection of Lindsay's works (mostly paintings) for the Uni. of Melbourne collections.
AWARDS: Sulman prize, 1955.

PENDLEBURY, Laurence Scott
(b. 21/4/1914, Melb. d. 1986, Melb.) Painter, teacher.
STUDIES: NGV School, 1932–38; Swinburne Tech. Coll. He served with the AIF, 1941–45, began teaching after the war and held three exhibitions as well as contributing to group shows. His competent paintings, mostly landscapes, are conservative in style, briskly painted in a restrained range of colours. Travels in

Europe with his wife Nornie Gude (q.v.) in 1958 resulted in some of his best work.
AWARDS: Dunlop Prize, 1950, 51, 53, 54; Gibson Prize, VAS, 1956; Wynne Prize, 1956, 57, 60 (shared with John Perceval); Caltex Prize, 1957; VAS Artist-of-the-Year award (shared), 1975.
APPTS: Teaching, Swinburne Tech. Coll., 1946–63, head of the art school, 1963–74; President, VAS, 1961–63.
REP: Most state galleries; Bendigo regional gallery.
BIB: *Who's Who in Australia*, 1983. Richard Haese, *Rebels and Precursors*, Allen Lane, 1981.

PENGILLEY, Vivienne
(b. 1944, Eng.; arr. Aust. 1970) Painter, collage artist, tapestry designer.
STUDIES: Sutton School of Art, UK, 1962–64. She held her first exhibition at the Pinkney Gallery, London, in 1968, and soon after arriving in Australia held a joint exhibition with Chica Lowe at Gallery A, Sydney, 1971. Her art derives from traditional peasant patchwork to which is added a touch of modernist kitsch. Themes are mythological, zoological and biological. She held 15 exhibitions 1972–82, and was commissioned in 1974 to make three collage tapestries for the Uni. Union, Macquarie Uni., Sydney. She participated in numerous group exhibitions 1972–82 in state and regional galleries including *Fabric Art*, AGNSW 1977; *Australian Crafts*, national touring exhibition, 1978; *Australian Perspecta*, AGNSW 1981 and *Women Artists*, Gallery A, Sydney, in conjunction with the Women and Arts Festival, NSW, 1982.
AWARDS: AM conferred for services to the arts, 1988.
REP: NGA; Ararat Gallery; Macquarie Uni.; VACB.
BIB: *A&A* 9/4/1972.

PENGLASE, Marjory
(b. 11/5/1922, Echuca, Vic.; d. 1989) Painter, stage designer.
STUDIES: RMIT, 1940–45; travel studies, UK, Europe, 1976; Europe, 1980; China, 1982. Married to painter Newton Hedstrom (q.v.) she moved to Sydney where she exhibited with SORA, the NSW Society of Artists and in competitive exhibitions.
AWARDS: Prizes at Warringah, 1978; Lane Cove Open, 1986; Young NSW Open, 1986.
APPTS: Teaching, RMIT, 1945–46 and in several community centres, NSW, to 1985.
REP: AGNSW; Armidale Regional Gallery; Manly Art Gallery; Sydney Uni.

PENTSTONE, Charles C.
Black-and-white artist. Contributor to Adelaide *Punch* and *Frearson's Weekly*, SA, c. 1878–84.
BIB: Moore, *SAA*.

PERCEVAL, Celia
(b. 13/6/1949, Vic.) Painter.
STUDIES: Self-taught; travel studies London, 1963–66; UK, France and Italy, 1967–71; UK, 1970s and 1980s.

Daughter of John Perceval and Mary Nolan (*née* Boyd), her paintings reflect the style of the Perceval/Boyd genre – landscapes and bush scene predominate, the oils applied in short brush-strokes or with a palette knife. She held 17 solo exhibitions 1971–93, including in Melbourne (Australian, 1973, 76, 79), Sydney (Bonython, 1975; Barry Stern, 1980; Wagner, 1990), Newcastle (Cooks Hill, 1990, 91) and at the Hilton Gallery, London 1971; Armidale City Art Gallery, NSW 1977; Marches Gallery, Wales 1978; Qantas Gallery, London 1983; *Border Arts Festival*, Wales 1986. Her work appeared in around 11 group exhibitions 1966–91, including at private galleries in Australia, London and Wales including Qantas Gallery, London 1981; *Border Arts Festival*, Wales 1983, 84, 85, 87.
REP: Regional galleries Bendigo, Armidale.

PERCEVAL, John de Burgh

(b. 1/2/1923, Bruce Rock, WA) Painter, ceramic artist.
STUDIES: No formal training. As a boy he contracted poliomyelitis which left him permanently lame. His work attracted attention in early CAS exhibitions in which his precocious talents were boldly expressed in surrealistic paintings, some reproduced in *Angry Penguins*. During the 1940s he joined the Boyd family at Murrumbeena (he and Mary Boyd married), assisted in rehabilitating the family pottery and, having temporarily abandoned painting, returned to the exhibition scene in Aug. 1954 with some Breughel-inspired pictures, and later, 1958, with a remarkable exhibition of ceramic 'angels' at the MOMAD. His spontaneous drawings of family life, his paintings of bush and coastal scenes, with ships and seagulls, or of figures partially lost in thick whorls of colourful paint, combined with his ceramic work, soon gained him a large following. In 1962 he visited London, whence after three eventful years, he returned home as the first recipient of a Creative Arts Fellowship at the ANU, Canberra. During the late 1960s his following increased with every new exhibition and prices of his work rose dramatically. By the middle 1970s, however, his family affairs had fallen into disarray and for a number of years he stopped painting. He married former student Anne Hall and started painting again in the mid to late 1970s and has continued to exhibit intermittently from that time. His work has been represented in a number of survey exhibitions during the 1980s, notably the Bicentennial exhibitions *The Great Australian Art Exhibition* and *The Face of Australia*. In 1992 a major retrospective of his work was curated by the NGV.
AWARDS: McCaughey Prize, Melbourne, 1957; Maude Vizard-Wholohan Prize, Adelaide, 1959; Wynne Prize, (shared), 1960; ANU Creative Arts Fellowship, 1965.
REP: NGA; AGNSW; AGSA; AGWA; MAGNT; NGV; QAG; QVMAG; TMAG; many regional galleries and uni. collections.
BIB: All general books on contemporary Australian painting. Margaret Plant *John Perceval*, Lansdowne, Melbourne, 1970. Traudi Allen, *John Perceval*, MUP, 1992. A&A 5/1/1967; 23/3/1986.

PERCEVAL, Matthew

(b. 21/8/1945, Melb.) Painter.
STUDIES: Self-taught; travel studies south of France, 1967–79; Paris 1979–81. Living since the early 1980s in Newcastle, NSW, while his works have the similar use of free-flowing paints of most of the self-taught Perceval/Boyd clan, his subjects extend from landscape into lesser-known territories. He held 24 solo exhibitions 1969–92 in London (Clytie Jessop, 1969; Qantas Gallery, 1979), Melbourne (South Yarra, 1972, 75), Sydney (Wagner, 1982, 86; Bridge St, 1989), Newcastle (von Bertouch, 1974, 77, 82, 89, 92), Canberra (Solander, 1985, 91), Perth (Green Hill, 1984), Adelaide (Green Hill, 1984) and France (Paris, Nimes, Marseilles, Villeneuve, Carnon). His work was seen in around 20 group exhibitions 1968–92, in France including *Salon de Mai* and *Salon d'Automne*, Grand Palais, Paris 1979; London including *Australian Paintings and Drawings*, Australia House 1973; *Australian Artists of Fame and Promise*, NSW House 1979, and Australia from 1985 in private galleries (including Wagner, Bridge St, Sydney; Solander, Canberra; Cooks Hill, von Bertouch, Newcastle).
REP: Regional galleries Bathurst, Horsham; Uni. of Newcastle; corporate collections including National Australia Bank, St George Investment and McAlpine collections.
BIB: Germaine, AGA. E. D. Craig, *Australian Art Auction Records*, 1991. P. Dubrez and P. Herbst, *The Art of the Boyds*, Bay Books, Sydney 1990.

PERCIVAL, C. H.

Cartoonist, illustrator. He contributed to *Aussie*, a paper for troops in the trenches during World War I, also to London *Punch*, worked with the War Records section in London and later became principal cartoonist for the Sydney *Bulletin* (1920–40).
BIB: Moore, SAA.

PERFORMANCE, INSTALLATION AND ASSEMBLAGE ART IN AUSTRALIA

When neo-Dada 'happenings' and 'environments' as they were known in America and Europe arrived in Australia in the 1970s, they provided radical alternatives to traditional studio arts. Soon renamed 'performance', 'installation' and 'assemblage' they constituted an experimental 'cutting edge' for younger artists and diverted some established artists either temporarily or permanently.

Thus the late 1960s exhibitors in *The Field* exhibition (q.v.) for the first time on the crest of an international wave, were confronted by 1970s conceptually based art forms which eventually led to doubts about the relevance of art and predicated the demise of the avant-garde. Precursors of this attitude included Barry Humphries' late 1950s political satires, the activities of Colin Lanceley, Ross Crothall and Mike Brown as the *Annandale Imitation Realists* (q.v.) and Martin Sharp, Garry Shead and Mike Brown as founders of *The Yellow House* (q.v.) and *Oz* magazine. Their assemblages and irreverent pop-art 'kitsch' were

Stelarc, Sitting/swaying:event for rock suspension, *Tamura Gallery, Tokyo, 1980.*

intended to erode the distinctions drawn between art and life in popular mass culture. The *Mildura Sculpture Triennial* (1967–78) (q.v.) also evidenced the development of alternative art forms through pop and neodada works by Mike Kitching, Col Jordan, Nigel Lendon in 1967 and funky installations by Ti Parks and Tony Coleing in 1970.

Performance art was soon encouraged by Geoffrey Legge at Watters gallery, Sydney and Bruce Pollard at Pinacotheca Melbourne. In the 1970s Pinacotheca showed Ti Parks, Ian Burn, Mel Ramsden and Joseph Kosuth and introduced photographs by Dale Hickey, Roger Cutforth, Robert Rooney, Bill Henson and others. Stelarc performed his 'body suspensions' there. Sydney's *Inhibodress* was founded in 1972 by Mike Parr, Peter Kennedy and Tim Johnson and artists' collectives proliferated around the country. They included branches of the *Women's Art Movement*, the *Artworkers Union* and co-operatives like Sydney University's Tin Sheds, Melbourne University's George Paton Gallery and South Australia's Experimental Art Foundation (*see* GALLERIES – CONTEMPORARY ART SPACES).

Precursors of 'performance art' included Europeans F. T. Marinetti's 'theatre pieces', and Vladimir Myakovsky's 'street pieces'. German Dada artist Kurt Schwitters, who filled his Hanover apartment with an assembled column of wook, plaster and found objects was an early progenitor of 'installation art'. During the 1930s and 40s, artists such as Salvador Dali, Marcel Duchamp and others continued the spirit of Dada art – Dali's 1936 London lecture for example being delivered in a diving suit with a loaf of French bread strapped to his helmet and Duchamp's contribution

to the *Surrealist Exhibition* in Paris in 1938 being 1200 coal sacks filled with paper suspended from the ceiling.

In the 1960s, American pop artists appropriated gallery spaces for their installions – Oldenburg's 1961 *Store*, Andy Warhol's 1964 *Boxes* and Ed Kienholz's 1965 *Beanery*. Art 'consumers' began to lose their grip on what constituted a work of art – a situation soon exploited by artists who were prepared to declare anything art if they intended it so. An example is Christo (q.v.) who disrupted hierarchical beliefs by involving the public in his 'wrappings' of buildings, landforms and other structures.

Australia's early history of performance and installation art was encapsulated in Tom McCullough's Mildura *Sculpture-scapes* (1973 and 75) which established a close association between sculpture and alternative art forms. These installations, including those of Peter Cole, Kevin Mortensen, Tony Coleing, Ken Unsworth, Domenico de Clario, Terry Smith, Peter Tyndall and Dale Frank have become legendary in Australian art history.

By the end of the 1970s Australia had hosted important international artist visitors through such exhibitions as the *Biennale of Sydney* as well as sending artists to major contemporary art biennales including the *Paris Biennale* and the *São Paulo Biennal*. Thus many Australian artists reflected the international mood of the late 1960s. When Ivan Durrant deposited a dead cow at the door of the NGV it was a subversive act intended to shake art institutions out of their supposed conservatism and oblivion to social realities.

It was, however, museums and art spaces which hosted the most radical 'conceptual art' of the 1970s especially the text-based works of artists like Robert Rooney and Ian Burn.

From the 1970s much art has deliberately confronted formal definitions of artist, spectator, curator and consumer, attempting to subvert them. Ephemeral events recorded by photography, photocopiers and video as non-saleable expressions of radical ideas have proved highly collectable as proxy works of art. With the new art forms came new breeds of dealers and collectors.

The 1970s art practice was divided into a plurality of strands defined by the conceptual leanings of its major figures. Performances and installations by Ross Grounds, John Davis, Jill Orr, Robert MacPherson, Bonita Ely and Kevin Mortensen were linked by the ecological concern for the landscape. Inspired by Europe's *Fluxus* artists, Australians Peter Tyndall, Aleks Danko and John Nixon began questioning the status of the art object and the cultural rituals of museums. Community involvement was explored by Peter Kennedy, Vivienne Binns and others. Documentary text-based 'conceptual art' was practised by Ian Burn, Terry Smith and others of the *Art and Language* group active internationally in the mid 1970s as well as the photographic documentary art of Micky Allan and Sue Ford.

The greatest notoriety however was reserved for those like Stelarc and Mike Parr who explored the tolerances of human mind and body. Stelarc suspended himself from the ceiling by means of numerous fish hooks and performed technological experiments with internal body functions; Mike Parr put his spectators through tests of endurance with performances such as *Cathartic Action/Social gesture* (1977) in which he appeared to hack off his arm in an effort to achieve therapeutic release from psychic anxieties. Aside from these, heated controversy was in fact little found – the 1975 sit-in at the NGV when Domenico de Clario's installation work was removed and a row over Sydney Biennale's insufficient inclusion of women artists being the exceptions.

Comprehension of the differences between the 1970s and 1990s 'performance' and 'installation' is made more clear by the almost universal return to mainstream studio painting and sculpture which occurred in the early 1980s as an outcome of the deconstructionist urge to 'appropriate' and 're-do' modernism and art of other historical eras. Many of the 1970s avant-garde artists have recast their ideas for the 1990s. The content of contemporary works by artists including Ian Burn, Mike Parr, Aleks Danko, Robert Rooney, Stelarc, Joan Grounds, John Nixon and Dale Hickey can sometimes appear similiar to earlier interests but the conceptual base has usually changed. In the 1990s 'performance', 'installation' and 'assemblage' have been reintegrated into visual arts practice. Artists of many theoretical persuasions have appropriated installation and performance as a means of assembling aspects of their work, reflecting on its content and enabling the spectator to create new content. With so many practitioners it is virtually impossible to comprehensively acknowledge all those working in 'performance' and more particularly, 'installation' in the 1990s. Artists active in these areas include Micky Allan, Howard Arkley, Gordon Bennett, Vivienne Binns, Karen Casey, Aleks Danko, John Dunkley-Smith, Ian Howard, Susan Fereday, George Gittoes, Charles Green, Pat Hoffie, Tim Johnson, Janet Lawrence, Ruark Lewis, Dianne Mantzaris, Rosslynd Piggott, Steig Persson, Hossein Valamanesh and Ania Walwicz.

BIB: Catalogues of *Off the Wall: In the Air, A Seventies Selection*, Monash Uni. Gallery, 1991; *8th Biennale of Sydney* AGNSW, 1990. AL 13/2/1993. Many other issues of AL and AT, which have reviewed these art forms continuously.
JENNY ZIMMER

PERICLES, Leon
(b. 22/3/1949, Perth) Painter, printmaker, sculptor. STUDIES: Dip. Art, Perth Tech. Coll., 1968–70; Assoc. of Fine Art, WAIT, 1972; Postgrad. Dip. Art, Birmingham Coll. of Art, UK, 1973–74; travel studies, UK, 1973. A prolific painter and printmaker his works have elements of naturalism and surrealism and include text and wide historical references. He held around 34 solo exhibitions 1970–93 in most Australian capital cities, and in Tokyo and London as well as a number in WA regional centres and his prints and collages appear frequently in galleries all over Australia. A retrospective of his work was held at the AGWA in 1989. From the mid-1980s he became involved in art kite-making, winning several awards and receiving numerous commissions. He published a book on his work, *Works from the North Wing* in 1992.
AWARDS: A number of print and painting awards 1968–93 including Bunbury Prize (1971), Camden Print Award (1988); ABC Set Design prize, 1968; prizes at Bunbury, WA, 1971, Albany, 1972; Uni. of WA, prints, 1972; WA Arts Council grant for studies overseas, 1973; travel grant, Australia-Japan Foundation, 1979.
APPTS: Part-time tutor, WAIT and Fremantle Arts Centre, 1975, 76; part-time lecturer in drawing, painting, sculpture and printmaking, WA Secondary Teachers College, 1975–81; part-time lecturer in painting and printmaking, Perth Tech. Coll., 1982–88.
REP: NGA; AGNSW; AGSA; AGWA; MAGNT; NGV; QAG; QVMAG; TMAG; Birmingham Art Gallery, UK; collections of prime ministers, London, Japan; a number of corporate collections including Robert Holmes à Court, Rural and Industries Bank, Wesfarmers.
BIB: A. H. Russell, preface, Frank Norton, foreword, *Pericles Etchings*, Perth, 1976. M. Mason, *Contemporary West Australian Painters and Printmakers*, Fremantle Arts Centre Press, 1979. Bill Hawthorne, *Some Contemporary West Australian Painters and Sculptors* Apollo Press 1982. *New Art One*. AL 9/3/1989.

PÉRON, François
(b. 1775, France; d. 1810) French artist attached to Baudin's scientific expedition to the South Seas (1800–04). Péron was appointed as a zoologist, not as an official artist, but together with Lesueur and Petit (qq.v.) he made important graphic records including with Louis de Freycinet, *A Voyage of Discovery to the Southern Hemisphere*, London, 1809. His work was seen in *Terra Australis*, AGNSW 1988.

BIB: Rienits, *Early Artists of Australia*, 1963. *Early French Voyages to Australia*, portfolio of reproductions published by Banque Nationale de Paris to celebrate the centenary of its establishment in Australia, 1881–1981. ADB 1. Smith, EVSP. Kerr, DAA.

PERRY, Adelaide E.

(b. 1891, Melb.; d. 1973) Painter.
STUDIES: NGV School, 1914–20; RA Schools, London; Paris. After her overseas studies she settled in Sydney, taught drawing at Julian Ashton's school, exhibited with the young modern group at the Grosvenor Gallery, 1927, NSW Society of Artists and in Archibald prize exhibitions, and was a foundation member of the Australian Academy of Art. Her work appeared in *A Century of Australian Women Artists 1840s–1940s* Deutscher Fine Art, Melbourne, 1993.
AWARDS: NGV Travelling Scholarship, 1920.
REP: AGNSW.
BIB: *AA*, June 1927, reproduction. Moore, SAA.

PERRY, (Captain) S. A.

(b. c. 1792, Wales; arr. Sydney 1829; d. 1854) Painter, sea captain. He exhibited NSW watercolour landscapes with the Society for the Promotion of the Fine Arts, Sydney, 1849, as well as French and Spanish scenes, and in 1857 he showed a view of Mauritius. Many of his works were destroyed by flood in a descendant's home at Walcha, NSW in the 1930s, with only a handful being in public collections.
REP: NLA; Mitchell Library.
BIB: ADB 2. Kerr, DAA.

PERSSON, Stieg

(b. 1959, Melb.)
STUDIES: BA (painting), VCA, 1981. He held 14 exhibitions 1983–92, at City Gallery, Melbourne and Yuill/Crowley, Sydney, of abstract expressionist works notable for their subtle monochromatic shadings — mostly very dark greys to black. He participated in numerous group exhibitions at public galleries 1983–92, including *Australian Perspecta*, AGNSW 1985; *Backlash*, NGV 1987; *Field to Figuration*, NGV 1987; *A New Generation*, NGA 1988; *The Corporeal Body*, NGA 1991; *The Black Show* Geelong Art Gallery and touring, 1993. He was artist-in-residence, Heidelberg Repatriation Hospital, 1987 and received a painted tram commission from the Vic. Ministry for the Arts, 1987.
AWARDS: Keith & Elisabeth Murdoch Travelling Fellowship (secondary award), 1985; H. V. Evatt Foundation Prize, AGNSW, 1987.
REP: NGA; AGNSW; AGWA; NGV; MCA, Sydney; Artbank; MOMA, New York; several regional gallery collections; corporate collections including ICI.
BIB: Catalogue essays in exhibitions as above. Chanin, CAP. AM, No. 36, Nov. 1990. A&A 25/1/1987. A&T 23/4/1987. AN no. 14, 1985.

PERTH SOCIETY OF ARTISTS

Founded in 1936 by a group led by John Brackenreg, which seceded from the Western Australian Society of Arts and Crafts. First president: G. Pitt Morison; hon. secretary, J. Brackenreg. Regular spring and autumn exhibitions were held and in 1962 the society conducted an important art competition as part of the festivities connected with the Commonwealth Games.
(*See* PRIZES, PERTH SOCIETY OF ARTISTS PRIZE)

PETERSON, Laurence

(b. 21/12/1946, Melb.) Painter, teacher.
STUDIES: Prahran CAE, 1963–64; RMIT, 1965; privately with Roger Kemp, 1975–76. He worked as a freelance graphic designer, 1966–68, and during 1969–70 taught art at Victorian technical schools. His work was exhibited first at Gallery 99, Aug. 1971, then at the Gallery de Taste, 1977. His painting is large in scale, dynamic in form and colours and charged with sensuous energy. He exhibited intermittently during the 1980s and at Flinders Lane, Melbourne, 1990, 93.
AWARDS: Inez Hutchison Prize, Beaumaris, 1971; VACB grant, 1973.

PETIT, Nicolas-Martin

(b. 1777, Paris; d. 21/10/1804, Paris)
Painter. French portrait painter; one of four official artists attached to Nicolas Baudin's scientific expedition to the South Seas (1800–04). The other three official artists, Milbert, Lebrun and Garnier, remained at Mauritius when the ships, *Geographe* and *Naturaliste*, arrived there, leaving the work to Petit and two unofficial artists, Lesueur and Péron (qq.v.). His work appeared in *Tasmanian Vision* TMAG and QVMAG 1988.
BIB: Rienits, *Early Artists of Australia*, 1963. ADB 1. *Early French Voyages to Australia*, Banque Nationale de Paris, Melbourne, 1981. Kerr, DAA.

PETTINGER, Charles Firth

(b. 11/11/1897, Lithgow, NSW) Painter.
STUDIES: Newcastle Art School, 1953–60; travel studies, UK and Europe, 1961–62. Member of the Australian Watercolour Inst., Sydney, and tutor in watercolour, WEA, Uni. Extension, Newcastle.
AWARDS: Newcastle (NBN 3 prize for watercolour), 1968; Maitland Prize, 1974.
REP: Newcastle Region Art Gallery.
NFI

PETTY, Bruce Leslie

(b. 1929, Melb.) Cartoonist, caricaturist.
STUDIES: London and Europe, 1954–58; USA, 1959; Asia, 1961. He contributed drawings to London *Punch*, *New Yorker*, *Esquire* and Sydney *Bulletin*, and from 1964–c. 1980 was chief cartoonist for the *Australian* before joining the Melbourne *Age* and the Sydney *Morning Herald* for whom he contributes at least one major cartoon weekly. His work became renowned for a strong sense of satire and he is one of the most prolific of the leading Australian cartoonists. He wrote and illustrated a number of books including *Australian*

Artist in South East Asia, with introduction by Ronald Searle, Grayflower Publications, Melbourne, 1962; *Petty's Australia Fair*, Cheshire, Melbourne, 1967; *The Best of Petty*, Horwitz, Melbourne, 1968; *The Penguin Petty*, Penguin Australia, Ringwood, Vic., 1972 and animated films including *The Money Game*, 1971.
BIB: A&A 10/4/1973 (Robert Smith, *The Imagery of Bruce Petty*). AL, 6/2–3/1986.

PETYARRE, Ada Bird

(b. c. 1930) Painter. Batik painter. She lives and works at Akaye Soakage, Mulga Bore, NT. One of the leading batik painters she often represents women's ceremonies in her intricate works. She held a solo exhibition at Utopia Art, Sydney in 1990 and her work appeared in about 35 group exhibitions 1977–93, including *A Picture Story*, Tandanya, Adelaide and touring to The Royal Hibernian Academy, Dublin, Ireland; *Contemporary Aboriginal Art*, Harvard Uni. and touring USA and Australia, 1990; *Flash Pictures*, NGA, and *Aboriginal Women's Exhibition*, AGNSW and touring, 1991; *My Story My Country: Aboriginal Art and the Land*, AGNSW 1992.
REP: NGA; AGSA; Uni. of NSW; Museum of Contemporary Art, Los Angeles, USA; Robert Holmes à Court, Allen, Allen & Hemsley.
BIB: Catalogue essays for exhibitions as above. A. Brody, *Contemporary Aboriginal Art*, Heytesbury, Perth, 1990. A. Brody, *Utopia – A Picture Story*, Heytesbury Holdings, Perth, 1990. M. Boulter, *The Art of Utopia*, Craftsman House, 1990. Caruana, AA.

PETYARRE, Gloria Tamerre

(b. c. 1945) Painter. Batik painter living and working at Mulga Bore, NT. Her solo exhibitions include those at Utopia Art, Sydney, 1991, 93 and Australian Galleries, Melbourne 1991 and in New York. Her work appeared in approximately 30 group exhibitions 1980s–93 including *Time Before Time*, Austral Gallery, St Louis 1988; *A Summer Project*, S. H. Ervin Gallery 1989; *Utopia Men and Dogs*, Austral Gallery, St Louis 1990; *Tagari Lia: My Family*, Third Eye Centre, Glasgow 1990; *Aboriginal Women's Exhibition*, AGNSW 1991; *New Tracks Old Lands*, Boston and touring, 1992; and *Aboriginal Art: Utopia in the Desert*, Nogizaki Arthall, Tokyo 1992.
REP: NGA; MAGNT; QAG; Powerhouse Museum, Sydney; Museum of Victoria; Gold Coast City Gallery; Uni. of NSW; Griffith Uni.; Robert Holmes à Court; Allen, Allen & Hemsley; Westpac, New York.
BIB: Catalogue essays for exhibitions as above. Caruana, AA.

PHELAN, Tom

(Active c. 1900, Melb.) Painter. Member of VAS; he went to America.
BIB: Moore, SAA.
NFI

PHILIP, Enid A.

(b. 1898, Williamstown, Vic.) Painter.
STUDIES: NGV School, 1918–23 (with McInnes and Hall). Known mainly for flower pieces in watercolour. She was runner-up to Jean Sutherland (q.v.) for the Travelling Scholarship in 1923; after the latter's return from Europe the two painted landscapes together in the Dandenongs c. 1930. Later she concentrated on still life, exhibiting at the Kozminsky and later the Block Galleries, Melbourne.

PHILIPP, Franz Adolf

(b. 1914, Vienna; d. 1970, London) Art writer.
STUDIES: Uni. of Vienna, Kunsthistorisches Institut, 1934–38; Uni. of Melbourne, Arts Degree, 1946; travel studies in Europe, 1956, Europe and USA, 1963. Reader at the Dept of Fine Arts, Uni. of Melbourne, 1964–70. He arrived in the ship *Duneru*, 1940 and the integrity of his taste and the depth and thoroughness of his scholarship gained him the respect of artistic and academic circles throughout Australia; in 1967 his monograph on Arthur Boyd (*Arthur Boyd*, Thames & Hudson, London) appeared as a model of what an artist's monograph should be. He also wrote (with June Stewart) *In Honour of Daryl Lindsay*, OUP, Melbourne, 1964 and many articles in *Meanjin* and the *Bulletin* of the NGV.
AWARDS: Wilson Scholarship and Dwight Prize (Uni. of Melbourne), 1946; Senior Research Fellowship, Warburg Inst. (Uni. of London) 1956; Carnegie Corporation Travel Grant, 1963.
BIB: A&A 8/3/1970 (Patrick McCaughey, *Franz Philipp – a Tribute*).

PHILLIPS, Amelia Mary

(b. Cornwall; arr. Aust. in infancy) Painter.
STUDIES: NGV School (with Hall and McCubbin); travel studies in England, 1952. Known mainly for light impressionistic landscapes and seascapes. Teacher of fine art at Swinburne Tech. Coll. until 1920.
AWARDS: Prize at Albury competitions, 1957.

PHILLIPS, James Grainger

(b. 1915, Perth) Painter, illustrator.
STUDIES: J. S. Watkins' School, Sydney. Phillips' illustrations for *Smith's Weekly* (c. 1937) showed qualities derived from his studies of Daumier which gave him a high ranking among contemporary Sydney black-and-white artists.
AWARDS: Journalists Club Art Award, 1958; Walkley awards, 1960, 62; prize at RAgSocNSW Easter Show art competition, Sydney, 1962; Mosman Prize, 1962.

PHILP, James Buckingham

(Active c. 1863, Melb.) Topographical artist. He contributed plates to Charles Troedel's *The Melbourne Album*, 1863, and was a lithographic draughtsman for the Department of Crown Lands. He left Melbourne in 1865 having stolen money from both a bank and a charitable fund.
REP: QVMAG; Mitchell, La Trobe Libraries.
BIB: Clifford Craig, *Old Tasmanian Prints*, Foot & Playstead, Launceston, 1964. McCulloch, AAGR. Kerr, DAA.

PHILPOT, Ernest Sidney

(b. 1906, London; arr. Aust. 1913; d. 1985) Painter, teacher.

STUDIES: NGV School, 1937. A president of the Perth Society of Artists, he held exhibitions in London 1960 and 1967 and more than 12 in Perth 1936–84. His commissioned work includes two murals for Perth hospitals.

AWARDS: Hotchin Prize, 1948; Perth Prize for landscape, 1952.

APPTS: Lecturer, WA Adult Education schools; art teacher, Wesley Coll., WA, 1957–68; art critic, Perth *Sunday Times*, 1961–65.

REP: AGWA; Bunbury regional gallery.

BIB: *Art News and Review*, London, vol. 12, no. 24, 1960.

PHOTOGRAPHY IN AUSTRALIA

Not long after L. J. M. Daguerre (1789–1851) invented the daguerreotype in France (1839), his invention was put to practical use in Australia when Samuel Thomas Gill imported one of the machines (1846) to become 'the first professional photographer in South Australia', according to his principal biographer, Keith McCrae Bowden. Gill, it seems, made better use of the equipment than did Beard, its London agent; but he tired of it quickly and sold it to Robert Hall who took it to Perth where he made the first photographic records. Equally swift to arrive in Australia was the more sophisticated kind of photography brought about by the use of collodium (1851). Photography came with the Australian goldrush and was part of the scene at Bendigo, Ballarat and Mt Alexander (Castlemaine) in the 1850s, notably in 1857 in the photographs taken by Antoine Fauchery (q.v.). Nineteenth-century photographers like Fauchery were nearly all trained as painters, which explains why nineteenth-century photographs are rich in aesthetic content. Photographers flourished in fairly large numbers in the early goldfield towns and cities of Victoria and New South Wales, to leave a fine body of work, much of which has been lost. Alexander Fox, father of E. Phillips Fox (q.v.), was a Bendigo photographer, while in Melbourne, Louis Buvelot began his Australian career as a photographer before encouragement from the critic James Smith returned him to the world of painting. Tom Roberts began his working career as a retouch artist for the photographer Richard Stewart, and like a number of other artists, J. W. Curtis worked for the photographic firm of Johnstone and O'Shannassy. Later Johnstone (Henry James Johnstone (q.v.)) himself became well-known as a painter, although he was never quite able to shake off the haunting presence of the photographic image.

Among the many fine photographers working in Sydney in goldrush times was Holtermann's photographer, Charles Bayliss. One of his surviving works is a remarkable panoramic view of Sydney Harbour taken from Holtermann's tower. The exhibition catalogue *Australian Women Photographers 1890–1950* (George Paton Gallery, Uni. of Melbourne, 1981) lists 27 women photographers of this transitional period, among them three at least who began as students of painting in art schools. The *Dictionary of Australian Artists 1780–1870* edited by Joan Kerr (OUP, 1992) contains comprehensive information on hundreds of professional and amateur photographers working in that period.

After World War I, with the increase in the marketing of the camera as an object easily accessible to all, there was inevitably a swift decline in aesthetic standards. 'Photographic' soon became a term rigorously to be avoided by all painters – and it still is. There is plenty of evidence to show that the further painters keep away from photographic aids the better their painting is likely to be. In respect to photography as a separate art form, the mistake of confusing it with painting, or worse still, considering it as a substitute, prevented its due recognition as an independent art form for more than half a century. The situation only began to change in the 1960s, and in 1968 there was an important breakthrough when, through the efforts of Athol Shmith and John Cato, a department of photography was established at the NGV, with Jennie Boddington as curator. Another big step forward was the establishment of a similar department at the NGA. The Australian Centre for Photography in Sydney came into being in 1974, having been preceded by a number of notable, small commercial galleries of photography. Among these may be listed Peter Gabelles' Photographers' Gallery which operated at Bondi, NSW, during 1972; Brummels Gallery, established by Rennie Ellis at South Yarra, Vic., in the same year; Paul Cox and John Williams' Photographers' Gallery, also at South Yarra, 1974; and the Church Street Photographic Centre, which operated in Richmond, Vic., from 1977– c. 1984. (*See also* GALLERIES)

A comprehensive listing of contemporary and near contemporary photographers who have produced aesthetically valid works is impossible within the context of this work. Much good work has been done by press photographers, commercial photographers and amateurs, and there is no end to the numbers. Among those who have regularly exhibited are Robert Ashton, John Cato, Jon Conte, Paul Cox, John Delacour, Max Dupain, Rennie Ellis, Sue Ford, Duncan Frost, Carol Jerrems, Mark Johnson, Laurie le Guay, Jon Lewis, Grant Matthews, David Moore, Grant Mudford, Dieter Muller, Axel Poignant, Athol Shmith, Wesley Stacy, Mark Strizic. Some important photography exhibitions include *Fifty Years of Press Photography*, NGV, Nov.–Dec. 1972; many at state galleries and the NGA and at the Australian Centre for Photography, Sydney. The Bicentennial exhibition *Shades of Light* at the NGA 1988 and its accompanying catalogue provided a most comprehensively researched history of Australian photography.

PICK, John

(b. 1866, Port Fairy, Vic.; d. 1949) Amateur painter. Mayor of Shepparton, Vic., 1937–39.

REP: Shepparton Art Gallery.

PICKERING, F. J.
See HAYWARD, F. J.

PICKING, A. S. H.
Painter.
STUDIES: NGV School. During World War I, Picking contributed to AIF publications, *From the Australian Front* and *Abroad with the Fifth*. A painting by him was included in the *Australian Art Exhibition*, Spring Gardens Gallery, London, 1925.
BIB: Moore, *SAA*.

PICTURESQUE ATLAS OF AUSTRALASIA
Published Sydney, 1883–86. A book-publishing venture conceived by an American book canvasser, Silas Lyon Moffetts, it comprised an outline of discovery, geography and general development of Australasia, written by the most authoritative writers available and illustrated with 800 engravings by leading Australian artists. Published in Sydney over a period of three years (1883–86), in 42 parts, it was issued finally in three bound volumes. The various sections were written by James Smith, Vic. and Tas.; Rev. H. T. Burgess, SA; W. H. Traill, Qld; Sir T. Cockburn Campbell, WA; and H. Brett, New Zealand. Frank J. Donohue was in charge of administrative sections and wrote the section *The People of Australasia*, in which he attributed the 'origins proper' of the AGNSW to the international exhibitions, in Melbourne and Sydney, of 1880: 'From the International Exhibitions really dates the beginnings of anything like an intelligent public interest in the progress of Art in Australia'. STAFF: F. B. Schell, the American art editor of the *Atlas*, brought two American artists with him – W. T. Smedley and W. C. Fitler – and his own engravers such as Horace Baker (not thinking to find any in Australia). Australian artists who contributed included Julian Ashton, Frank Mahony, W. C. Piguenit, Henry Fullwood, Marian Ellis Rowan, Tom Roberts, Louis Belton, George Collingridge (engraver) and William McLeod, who did most of the portraits. McLeod became also chairman of directors of the company formed to publish the *Atlas*, which was a financial failure (Moore writes that the shareholders lost 2s. 6d. in the pound), but an artistic success. The 800 wood-engravings were undoubtedly the best produced in Australia to that time, and the high standards of the *Atlas* greatly assisted in developing the high standards of the early Sydney *Bulletin*. It is reasonable to assume that the Australian black-and-white school received great impetus from the *Atlas*, and that the influence of Daniel Vierge was spread in Australia through the Collingridge brothers (who had worked closely with the Spanish illustrator), that of the British draughtsmen through Ashton and Fullwood, and the influence of famous American illustrators through the American staff artists. (*See also* BLACK-AND-WHITE ART IN AUSTRALIA)

PIDGEON, Harry
(b. 6/7/1943) Painter, graphic artist.
STUDIES: Dip. Art, NAS, 1965; travel studies, USA,

1989; USA, Italy, Spain, 1990. A landscape painter known mainly for watercolours, his work reveals elements of strong graphic design. He held eight solo exhibitions at private galleries in regional NSW and the Gold Coast, Qld, 1981; Sydney (Sylvania, 1986; Kenthurst, 1992) and Tamworth City Art Gallery, 1982; Lismore Regional Art Gallery, 1982. Group exhibitions in which his work appeared 1983–92 include private galleries in Sydney (Holdsworth, Q, Painters) and New England Regional Gallery, 1983–85; Biota Gallery, West Hollywood, 1990, 91.
AWARDS: Around 13 regional prizes 1978–84; Brisbane Warana Festival (watercolour), 1982; Tamworth City Art Prize, 1983.
APPTS: Occasional guest lecturer, Armidale CAE, 1984–91.
REP: Artbank; regional galleries Lismore, Tamworth, Narrabri; Cloncurry and Wide Bay art societies; The Armidale School and HRH Prince Edward collections.
BIB: Germaine, *AGA*.

PIDGEON, William Edward ('WEP')
(b. 1909, Paddington, NSW; d. Feb. 1981, Sydney) Cartoonist, painter, illustrator, critic.
STUDIES: J. S. Watkins School, Sydney; ESTC. He became nationally famous for his cartoons signed with the initial letters of his name, WEP. He began his professional career in 1925 as a cadet artist on the *Evening News*, Sydney, drew also for the *Daily Guardian*, the *Sun* and the *World*, and made his name with a comic strip, *In and Out of Society*, and with his illustrations to the humorous column written by Lennie Lower, both published in the *Australian Women's Weekly*. He also wrote art critiques for the *Daily Telegraph*, and became well known as a portrait painter. Books he illustrated included Nino Culotta's *They're a Weird Mob*, Ure Smith, Sydney, 1957 and Cyril Pearl's *So You Want to Buy a House?*, Cheshire, Melbourne, 1961.
AWARDS: Prizes in the *Australia at War* exhibition, AGNSW and NGV, 1945; Archibald Prize, 1958, 61.
REP: AGNSW; AGWA; AWM; Newcastle Region Art Gallery.
BIB: Vane Lindesay, *The Inked-In Image*, Hutchinson, Melbourne, 1979.

PIGGOTT, Owen
(b. 1931, Worcestershire, UK; arr. Melb. 1950) Painter, teacher.
STUDIES: Dudley School of Art, UK, 1948–50; RMIT, Uni. of Melbourne, 1950–59; travel studies, UK and Europe, 1961, 71. His early paintings were abstracts, heavily textured with geometric shapes, while works from the 1980s onward concentrated on landscape with a much more lyrical approach. He held around 28 solo exhibitions 1963–93, including one in London, 1991 and participated in a number of group exhibitions largely with private galleries including Pinacotheca and Clive Parry, Melbourne; Allegro, Sydney.
AWARDS: Municipal prizes at Eltham, 1967; Flinders, 1974; Brighton, 1975; Mornington Rotary, 1978.

APPTS: Lecturer, several campuses, Monash Uni. art school 1963–86, including Gippsland Inst.

REP: QAG; several regional gallery collections including Benalla, Castlemaine, Mornington, Sale; a number of tertiary collections including ANU, Monash, La Trobe Uni.; corporate collections including Reserve Bank.

BIB: Germaine, *AGA*. *A&A* (reproductions) 25/1/1987; 26/4/1989; 27/3/1990; 27/4/1990; 29/2/1991.

PIGGOTT, *Rosslynd*

(b. 6/7/1958, Frankston, Vic.) Painter, installation artist, teacher.

STUDIES: B.Ed., Inst. of Education, Uni. of Melb., 1977–80. Her work has a deliberate delicacy with an element of surrealism and often focuses on flora, as typified by her 1991 *Moet & Chandon* entry *Shadow* – a work showing a fine sense of individualism and space. She held six solo exhibitions 1987–92, including at 200 Gertrude St, Melbourne, 1987; Ian Potter Gallery, Uni. of Melbourne, and Contemporary Art Centre of SA. Her work appeared in a number of group exhibitions 1986–92, with a number at 200 Gertrude St, Melbourne including *Slouching towards Bethlehem*, 1986; *The Intimate Object*, 1989 and in *Recent Acquisitions*, NGA 1989; *Outlines of Australian Art: The Joseph Brown Collection*, AGNSW 1989; *Moet & Chandon Art Foundation Touring Exhibition*, 1991.

AWARDS: St Kilda City Council Acquisitive Prize, 1986; residency Pareteio, Italy, VACB, 1988; grants VACB, 1988, 90.

APPTS: Part-time painting, printmaking teacher, tertiary colleges, Vic., 1984– including Uni. of Melbourne; Monash Uni. Vic. College (Prahran campus); Phillip Inst.

REP: NGA; NGV; Monash Uni.; St Kilda Council; corporate and private collections including Joseph Brown, Smorgon, BHP, Budget Transport.

BIB: Catalogue essays exhibitions as above. Thomas obit,1989. AM, no. 30. May 1990. *Agenda*, June 1990. *Tension 21*, June 1990.

PIGUENIT, *William Charles*

(b. 27/8/1836, Hobart; d. 17/7/1914, Hunters Hill, NSW) Painter, amateur explorer.

STUDIES: W. S. Smith's Cambridge House Academy, Hobart, where, in 1849, he won the prize for drawing. His father, Frederick Le Geyt Piguenit, of French ancestry, came from Kent; Moore gives it that Piguenit was 'the first Australian-born professional painter'. He joined the Lands Dept, Hobart, as a draughtsman in Sept. 1850 and resigned 23 years later (1873) to devote himself to painting. A colleague draughtsman in the Lands Dept (Frank Dunnett) helped him with his art. His early work was concentrated on lithographed views of the Derwent and environs (notably the *Salmon Ponds*, New Norfolk), and in the late 1860s his enchantment on discovering the south-west highlands turned him towards painting. He explored the Valley of the Huon in 1871, and painted around Lake St Clair in 1873 and Lake Pedder, 1874, and in 1875 joined an artists'

camp organised by Eccleston Du Faur in the Grose Valley, near Hartley, NSW. He exhibited with the NSW Academy of Arts, held an exhibition, 1875, settled in Sydney in 1880 and contributed illustrations of mountain scenery to the *Picturesque Atlas of Australasia* (q.v.). He visited England in 1898 and 1900 and had three English landscapes engraved by Henry Graves and Company. He also exhibited at the Old Salon, Paris. A regular exhibitor at the Art Society of NSW (later the Royal Art Society of NSW) from 1880 (in which year also listed among exhibitors is Miss H. V. Piguenit), he resigned from the Society because of the advent of impressionism to which he was strongly antagonistic. His work *Mount Olympus* was the first work purchased for the AGNSW in 1895. In 1902 he received £175 plus £25 travelling expenses to paint a picture of Mount Kosciusko for the AGNSW. *The Valley of the Murray* is generally rated as his masterpiece; his painting is exacting in detail, composed on strict, classical lines though somewhat lacking in colour. He was represented in a number of survey exhibitions including *Australian Art in the 1870s*, AGNSW, 1976; *Tasmanian Vision* TMAG and QVMAG 1988; *The Artist and the Patron* AGNSW, 1988 and the Bicentennial exhibition *The Great Australian Art Exhibition*. His work appears in leading auction house sales where it always fetches high prices. A major exhibition of his work was mounted by the TMAG in 1992.

AWARDS: Bronze medal for his photographs, *Intercolonial Exhibition*, Sydney, 1870; Wynne Prize for landscape (*A Thunderstorm on the Darling*), 1901.

REP: NGA, most state galleries (the TMAG has 62 works, mostly in five folios).

BIB: Catalogue essays exhibitions as above and most general books on Australian art history including Moore, *SAA*, Smith, *EVSP*, Kerr, *DAA*. An obituary and appreciation of Piguenit was published by his friend, W. V. Legge, Launceston, 1914. Bernard Smith, *Documents on Art and Taste in Australia*, OUP, Melbourne, 1975. ADB 5. *A&A* 29/4/1992.

PIKE, *Jimmy*

(b. c. 1942, Great Sandy Desert, WA) Painter. One of the most well-known Aboriginal artists of the Great Sandy Desert area of WA his prints and paintings have been included in exhibitions since 1987.

REP: NGA; AGNSW; AGWA; NGV; Robert Holmes à Court Collection.

BIB: PCA *Directory* 1988. Germaine, *AGA*. Caruana, *AA*. *A&A* 26/4/1989.

PILLIG, *Gustave Michael*

(b. 1877, Germany; arr. Aust. 1913; d. c. 1940) Artist, well-known Melbourne personality. Some of Pillig's work was acquired for the foyer of the Plaza Theatre, Melbourne. He exhibited with the NSW Society of Artists.

PILVEN, *Neville*

(b. 1939, Melb.) Painter.

STUDIES: George Bell School, Melbourne; NGV School,

1965–68; travel studies, Europe and UK, 1970–73. Painted usually in a colour range of dusty browns, pinks and blues, his well-composed landscapes (many of lakes and rivers) interpret the subjects poetically. AWARDS: Travelodge Prize, 1972; Angliss Prize, 1976; McCaughey Memorial Prize, 1975, 79.

NFI

PINSCHOF, Carl

(Active 1881–1914, Melb.) Art patron, publisher, consul-general for Austria-Hungary. He first arrived in Melbourne with the Austria-Hungary exhibit for the *International Exhibition* 1880–81, and returned later to live in Melbourne, to be listed in the Melbourne telephone directory, 1886, as 'Pinschof, Carl, Consul for Austro-Hungaria, 312 Little Flinders Street'. He published the monochromatic engraving of Carl Kahler's *Flemington Lawn on Cup Day*, and was later influential in arranging the publication of Tom Roberts' *Opening of the First Federal Parliament*. He was one of the first (and best-loved) patrons of the painters of the Heidelberg School. It was Frau Pinschof, a former opera singer, who arranged the introduction of Nellie Armstrong (Dame Nellie Melba) to Madame Mathilde Marchesi, whose influence was to prove crucial to the famous diva's career. Portraits of the Pinschof family were painted by Tom Roberts, and their home at *Studley Hall* (later a preparatory school boarding-house for Xavier College) became a famous centre of Melbourne art life. The outbreak of World War I sadly brought this era to an end.

BIB: McCulloch, *GAAP*.

(Pinschof story researched and kindly made available by Alan Benjamin, 1981)

PINSON, Peter

(b. 1943, Sydney) Painter, printmaker, lecturer.
STUDIES: NAS, and Sydney Teachers Coll., 1961–64; Royal Coll. of Art, London, 1969–71; Ph.D., Wollongong Uni., 1988. Geometric abstracts exhibited on his return to Australia showed the influence of Zen Buddhism, as studied at the RCA. His paintings, shown at the Warehouse Galleries, Melbourne, 1977, comprised colourful box shapes shown juxtaposed on spotted backgrounds. In 1986 he was the first peacetime war artist to be appointed by the Australian Defence Forces. He wrote numerous catalogue essays for individual and group exhibitions including on Rodney Milgate (retrospective, Macquarie Galleries, 1982), Col Jordan (Bloomfield Gallery, Sydney, 1991), Eric Thake as War Artist (ICA, Sydney, 1991), Pater Laverty, and Peter Hardy. He held a number of solo exhibitions in the 1980s, largely at Painters Gallery, Sydney and Lewers Bequest and Penrith Regional Gallery, of drawings as a war artist, 1992.
AWARDS: *Mirror*-Waratah Prize, 1964; Grenfell Prize, 1964; Wilson Stinson Prize, 1967; Drummoyne Prize for Graphics, 1968; NSW Travelling Scholarship, 1968; Power Bequest studio occupancy, Cité Internationale des Arts, Paris, 1969; Dyason Bequest grants, 1969, 70, 71; AWM research grant, 1976; Campbelltown

Watercolour Prize, 1979, 80; Drummoyne Prizes, (3) 1980 and watercolour 1981; Windsor Prize, 1981; Lady Jane Fairfax Memorial Prize, 1983; Capron Carter Drawing Prize, 1983; Manly Art Purchase Prize, 1983; Pat Corrigan Artists Grant, 1992.
APPTS: Lecturer, Wollongong Inst. of Education, 1972–74; councillor, Council of Adult Education, Melbourne, and education officer, NGV, 1974–77; senior lecturer, Alexander Mackie CAE, 1977–90; Official Military Artist (honorary), Australian Defence Forces, 1986; Assoc. Professor, College of Fine Arts, Uni. of Sydney 1991– .
REP: AGNSW; Artbank; VACB; several regional gallery and tertiary collections.
BIB: Catalogue essays for exhibitions as above.

PIRON

Cartographer. Bruny d'Entrecasteaux's artist on the voyage in search of La Pérouse, 1791–94. The naturalist J. J. H. de La Billardiere (q.v.) wrote an account of the voyage for which Piron made the illustrations (engraved by Copia). The expedition visited Tas. and the book contains prints of Aborigines (6), birds (2), botany (7), and a catamaran (1). Some of the botanical prints were redrawn by the noted French flower painter, P. J. Redoute. Piron also drew charts and coastal profiles for the account of the voyage by E. P. E. Rossel, d'Entrecasteaux's successor as senior officer of the expedition.
BIB: Rienits, *Early Artists of Australia*, 1963. Kerr, DAA.

PITKETHLY, G.

Principal of the art school, Working Men's Coll., Melbourne, 1916–23.
(*See* SCHOOLS, ROYAL MELBOURNE INST. OF TECHNOLOGY)

PITT, William

(Active 1850s–70s, Melb.) Architect, scenic artist, painter. A foundation member of the Victorian Academy of Arts, 1870, he was an accomplished scene painter for Melbourne and Sydney theatres, made panoramas and exhibited in exhibitions including the Victorian Exhibition of Fine Arts, 1861. His *Victorian House with Figures in the Foreground* was included in the Joshua McClelland Print Room exhibition in May 1970.
BIB: Moore, *SAA*. Kerr, DAA.

PITT-MORISON, George

See MORISON, George Pitt

PLACEK, Wes

(b. 25/12/1947, West Germany; arr. Aust. 1950) Painter, photographer.
STUDIES: Preston Tech. Coll. (screen printing with Normana Wight), 1967–68; RMIT (etching with Udo Sellbach), 1968–69; travel studies in Europe and USA, 1975, 78–79, 80, 84. His large, abstract-expressionist paintings appeared first in an exhibition at the Pinacotheca Galleries, Melbourne, 1971; in later exhibitions his style fluctuated between small-scale paintings

of still-life and medium-sized works with emphasis on textures created by skeins and dribbles of paint, his 1980s works using photography. He started Artists Space Gallery, Melbourne, 1979 and held around 23 solo exhibitions 1971–91, many at Artists Space and also Developed Image, Adelaide, La Trobe Uni. College of Northern Vic. and Uni. of Wisconsin, 1991. He participated in a number of group exhibitions including *Australian Sculpture Triennial*, 1981; *The Thousand Mile Stare*, ACCA 1988; *Australian Photography*, The City of Waverley Collection, 1990.

AWARDS: Grants, VACB, 1973, (travel grant) 75, Georges Invitation Art Prize, 1974.

REP: NGA; NGV; Artbank; Mildura Arts Centre; Waverley City Gallery; Darwin Community College; Monash Uni. Collection (Gippsland); La Trobe Uni. College Northern Vic.; Uni. of Wisconsin.

BIB: Catalogue essays for exhibitions as above. PCA, *Directory* 1976. Germaine, AGA. AL Vol. 2, No. 3, 1982. *Agenda*, No. 5, June, 1989.

PLANT, (Prof.) Margaret

(b. 1940, SA) Professor of fine arts, lecturer, writer, art historian.

STUDIES: Uni. of Melbourne, grad. BA, MA. Books she has written include *The National Gallery of Victoria: Painting, Drawing, Sculpture* (with Ursula Hoff), Cheshire, Melbourne, 1968; *French Impressionists and Post-impressionists*, NGV, Melbourne, revised edition, 1977; *John Perceval*, Lansdowne, Melbourne, 1970; *Paul Klee: Figures and Faces*, London, 1978.

APPTS: Tutorials, Uni. of Melbourne, 1962–65; lecturer/senior lecturer, RMIT, 1968–75; senior lecturer, Uni. of Melbourne, Dept of Fine Arts, 1975–82; Prof. of Fine Arts, Monash Uni., 1982– .

PLANTE, Ada May

(b. 1875, Temuka, NZ; d. 1950, Vic.) Painter.

STUDIES: NGV School, 1894–99; UK, c. 1902; Académie Julian, Paris, 1903. She shared a studio in Paris with Christina Asquith Baker and towards the end of her life (1950) spent several months with the same artist in her cottage at Research, Vic. After studies in Europe she returned to Vic. c. 1912, exhibited with the VAS, and later shared a studio with her life-long friend, Isobel Tweddle. Through the influence of the Frater, Bell, Shore group both artists became interested in post-impressionism and the work of Cézanne, and took part in the inaugural exhibition of the Contemporary Group, Melbourne, 1932. Later Ada Plante lived in a studio at Darebin in the converted hotel owned by Lina Bryans (q.v.), and there painted many of the high-keyed, post-impressionist landscapes with houses with which her name is usually associated. A memorial exhibition was held at the Stanley Coe Gallery, Melbourne, 1951 and she was represented in *A Century of Australian Women Artists 1840s–1940s* Deutscher Fine Art, Melbourne, 1993.

AWARDS: Student prizes at the NGV School, 1894, 98.

REP: NGV; AGNSW; AGWA.

BIB: Catalogue essays exhibitions as above. Janine Burke, *Australian Women Artists 1840–1940*, Greenhouse, Melbourne, 1980.

PLAPP, Jon

(b. 1938, Williamston, Vic.) Painter.

STUDIES: BA, Uni. of Melbourne, 1959; Ph.D. (Psychology), Washington Uni., St Louis, USA, 1967; painting and life drawing classes, Washington Uni., St Louis, 1966–69. He lived in Toronto, Canada, 1968–77 and returned to Australia (Sydney) in 1977. His abstract works are characterised by a concentration on squares within squares, a style he has maintained over some 25 years of constant exhibiting and seen in some 16 solo exhibitions 1979–93 in Sydney (Watters, 1979, 81, 84, 86, 88, 90, 92), Brisbane (Milburn + Arte, 1989; Michael Milburn, 1991), Melbourne (Charles Nodrum, 1991, 93), the Uni. Gallery, Uni. of Melbourne, 1984 and Burnie Art Gallery, Tasmania, 1984. He participated in approximately 25 group exhibitions 1980–92, at private galleries (including Watters, King St, Sydney; Powell St, Melbourne) and public galleries including *Study for Reflexion*, AGNSW 1986; *Selected Acquisitions*, MOCA, Brisbane 1991.

REP: NGA; MOCA; Artbank; Newcastle, Burnie Art Gallery; Uni. of Toronto; Robert Holmes à Court; Allen, Allen & Hemsley; Western Mining.

BIB: Catalogue essays exhibitions as above. *New Art Two*.

PLATE, Carl Olaf

(b. 1909, Perth, WA; d. 1977) Painter.

STUDIES: ESTC, 1930–34; travel studies, USA and Mexico, 1935–36; St Martin's School, London, with Vivian Pitchforth, 1937–38, Central School of Arts and Crafts, with Bernard Meninsky, 1939. Brother of Margo Lewers (q.v.). He visited Scandinavian countries and Russia, and returned to Australia in 1940 to establish the Notanda Gallery, a business enterprise dealing mainly in *objets d'art* and souvenirs, in Sydney. His early paintings, of complex compositions containing plant forms, fish, insects and other forms of wildlife, were modelled on the style of the French painter André Masson, but later he changed to a broad, abstract-expressionist type of painting which depicted stark, skeletal shapes painted often on a very large scale. He exhibited at the Leicester Galleries, London, 1959, the Knapik Gallery, New York, 1962, and held exhibitions in Sydney and Melbourne as well as participating in many important exhibitions and competitions. A memorial exhibition was held at Zanders Bond Gallery, Armadale, Vic., in May 1979.

AWARDS: Prizes at Mosman, 1951; Kuringai, 1951; Bathurst, 1956; Perth, 1958; RAgSocNSW Easter Show, 1959; Tamworth, 1960; Young (shared with T. J. Santry), 1963; *Mirror*-Waratah Festival, 1963; Georges Invitation Art Prize (second place), 1964; Taff's Prize, CAS, Sydney, 1964.

REP: Many state and regional galleries; Cornell Uni. collection, New York.

BIB: *A&A* 7/2/1969 (Elwyn Lynn, *Carl Plate*); 16/2/1978 (John Henshaw, *Carl Plate*).

PLATTEN, Anna
(b. 24/11/1957, SA) Painter.
STUDIES: BA Fine Art, SACAE. She held one solo exhibition in 1992 at Uni. of SA and her work appeared in several group exhibitions 1986–92, including *The Nude Show*, travelling arts program, AGSA 1991; *This Mortal Flesh*, Festival exhibition, Adelaide Town Hall 1992. Her commissions include a portrait commission through the Dept of the Arts, SA, and a mural for the SA Museum (one of twelve artists selected). She was artist-in-residence, EAF, 1985.
AWARDS: Postgraduate award, SACAE, 1983; Chanter Bequest, SACAE, 1987; residency, Cité Internationale des Arts, Paris, VACB, 1989.
APPTS: Lecturer, Adelaide Central School of Art.
REP: NGA; NGV; Artbank; SACAE.

PLUMMER, Lyn
(b. 28/4/44, Qld) Sculptor, installation artist.
STUDIES: Brisbane School of Art, 1960–61; Dip. Art (Visual), Canberra School of Art, 1981; Grad. Dip. Fine Art (Sculpture), VCA, 1983; masters candidate, MA (Visual Arts), Monash Uni. Coll., Gippsland, 1992; travel studies, Philippines and Hong Kong, 1975; UK, Europe and USA, 1988. She works in a variety of media including wood, polyurethane, paint and found objects. Of her work in her 1988 exhibition at Roz MacAllan Gallery, Brisbane, the *Courier Mail* critic Michael Richards said 'perfectly resolved and balanced works . . . cleverly combines her pieces of dolls, . . . within a structural framework'.

She was founder and president of LINK Artist Access Studios, Albury/Wodonga 1985. Her 12 solo exhibitions 1974–91 include with the Arts Council of Port Moresby, PNG, 1974, 76, 77 and in Brisbane (Ray Hughes, 1982; Roz MacAllan, 1988), Sydney (Gallery A, 1982) and Albury Regional Art Gallery, 1986; Artel Studio Workshop, Albury, 1990, 91. She participated in approximately 20 group exhibitions 1975–92, in some private galleries but mainly in public and tertiary galleries including *Mildura Sculpture Triennial*, 1985; *New Art Six*, MOCA, Brisbane 1992.
AWARDS: Several prizes, PNG, 1974–76; Maude Glover Fleay Scholarship, 1983; project grant VACB, 1983; grant for Link Artist Access Studios, VACB, 1983; professional experience program, six-month study tour, Charles Sturt Uni., 1988; research grant, Friends of the Murray Campus Art Centre, Charles Sturt Uni., 1991.
APPTS: Secondary art teacher, PNG, 1981; part-time lecturer (sculpture and drawing), VCA, 1984; artist-in-residence, lecturer, Cheltenham School of Art, UK, 1988; visiting lecturer, VCA, Bendigo CAE, 1987; Uni. of Newcastle-upon-Tyne, UK, 1988; lecturer (visual arts), School of Creative Arts, Charles Sturt Uni. 1985– .
REP: Wollongong City Art Gallery; Charles Sturt Uni.; PNG Government Collection, Port Moresby.
BIB: Catalogue essays exhibitions as above.

PLUNKETT, Jenny
(b. 4/4/1950, Melb.) Painter, part-time conservation framer.
STUDIES: Graphic Design, CIT, 1968–69; Dip. Art (painting), RMIT, 1971–75; Dip. Technical Teaching, Hawthorn Teachers College, 1977; travel studies Japan, 1973; Europe and UK, 1976; Indonesia, Singapore, Hong Kong, Macau, 1981; Japan, 1984. Drawing is a strong element of her work, described by Ronald Millar in the Melbourne *Herald* (15/6/1987) as 'sharp'. She held six solo exhibitions 1979–92, including at Melbourne Uni. Gallery, 1979; *The Swimming Pool*, ROAR Studios 1987; Lyttleton Gallery, Melbourne 1992, and participated in about seven group exhibitions 1977–91, including the MPAC Spring Festival of Drawing, 1977 and *The ROAR 2 Summer Salon*, ROAR 2 Studios 1989. She held joint exhibitions with Rafael Gurvich (q.v.) at their Melbourne studio, 1981, 83.
AWARDS: Commonwealth of Australia grant to visit Japan as an observer of the International Design Conference in Kyoto, 1973.
REP: RMIT; Melbourne Uni.; Australian Print Workshop; Vilnius Uni. Library, Lithuania.

PLUSH, John Saddington
(b. 1808; d. 1892) Sketcher. A watercolour by Plush, entitled *Mount Alexander Gold Diggings from Adelaide Hill,* is in the collections of AGSA. Identical pictures by the photographer and painter William Friend Bentley, in the NLA, and another, published by George French Angas as an extra in his *Six Views of the Gold Fields at Ophir*, cause doubts about the originality of this work. The evidence suggests that all three artists painted their pictures from a photograph by Bentley.
REP: AGSA.
BIB: McCulloch, *AAGR*.
(*See also* BENTLEY, WILLIAM FRIEND)

POCIUS, Ieva
(b. 1923, Lithuania) Sculptor, teacher.
STUDIES: SASA, 1962. Beginning with prizes for figures at two RSASA exhibitions 1962, 65, she had won six prizes for sculpture by 1969. Her free forms in welded steel exhibited at Mildura 1967, 70, equate her work with contemporary international trends.
REP: AGSA.

POCKLEY, Lesley Haselwood
(b. 14/4/1919, Sydney) Painter.
STUDIES: Chelsea Polytechnic, London; Julian Ashton School, Sydney, privately with Jean Bellette, Judy Cassab and M. Feuerring; summer schools, Uni. of New England, Armidale, NSW. From 1963 she held exhibitions of her abstract-expressionist paintings in Sydney, Tokyo and Melbourne and was a judge for several art shows including RAS, NSW, 1977, 86, 89.
AWARDS: Prizes in competitions at Wollongong, 1967; Scone, 1969; RAgSocNSW, Sydney, 1974, 86, 87, 90; Berrima, 1978; Mosman, 1978; Macquarie Award, 1986; Wyong, 1988; Portia Geach portrait prize, 1974.

PODMORE, George

(b. 1829, London; arr. Aust. c. ?1870; d. 1916) Painter, teacher. Known for portraits, landscapes and natural history paintings. Noted as a painter of fish for the NSW Fisheries Commission. In 1875 and 1877 he exhibited with the NSW Academy of Arts, showing portraits (often of children) and marine paintings. Landscapes of the Sydney area have appeared on the art market in recent years, including an oil dated 1898.

AWARDS: Gold Medal, *Fisheries Exhibition*, London.

POGANY, Margit

(b. 1880, Hungary; arr. Aust. 1948; d. 1964, Melb.) Painter.

STUDIES: Hungary and France. Favourite model of the Romanian sculptor Constanin Brancusi. Her paintings are typically central European in style and theme. They were shown at two exhibitions at Georges Gallery in 1951 and 1955. Brancusi made many variations of the head of Mlle Pogany between 1912 and 1931; one was included among the five works sent to the New York Armory Show, 1913. Margit Pogany owned one of the heads, which she offered to the NGV before sending it to New York, where it was bought, on the recommendation of James Johnson Sweeney, for the Museum of Modern Art.

AWARDS: Honourable mention, Robin Hood competition, 1957.

POLE, Sonny (Leon)

(Active 1888–94, Melb.) Painter, caricaturist, musician.

STUDIES: NGV School, 1888–92. He was a fine player of the piccolo and is recorded also as having great facility as a muralist, as evidenced by his work for the Palace Theatre, Sydney. Moore quotes Lionel Lindsay as listing Pole, Coates, Quinn and himself as joint tenants of a studio on the top floor of the North Melbourne Town Hall, for which they paid 10s. 6d. per week. Pole, a foundation member of the Cannibal Club, was also one of the original artist tenants at *Charterisville* (q.v.). He went to Canada where, reputedly, he was successful as a muralist. A pen-and-ink drawing of Pole by Lionel Lindsay was exhibited at Deutscher Fine Art, Melbourne, May, 1981. The most well-known of his works, a naturalistic oil, *The Village Laundress*, 1891, was first exhibited in the NGV students' exhibition of 1891 (for which he received second prize of ten pounds), and included in *The Artists' Camps: Plein Air Painting in Melbourne 1885–1989*, curated by Helen Topliss for Monash Uni. Gallery 1984, in Joel's auctions in 1983 and in *The Changing Face of Melbourne 1840–1993* Lauraine Diggins Fine Art, 1993.

BIB: Moore, *SAA*.

POLOMKA, Kim

(b. 8/4/1951, SA) Painter.

STUDIES: Dip. Fine Art, SAAS, 1972. Known mainly as a watercolourist, he was commissioned to paint 12 panels for the 1974 Adelaide Festival of Arts. His work has been described as 'surrealist landscape' or 'landscape redefined'. It has strong graphic elements. He held eight solo and joint exhibitions 1974–92, in Adelaide (Sydenham, 1974, 76; Kensington, 1986; Greenhill, 1987; Chesser, 1988), Sydney (Bloomfield, 1981), Perth (Greenhill, 1983) and Newcastle (von Bertouch, 1986), and participated in about five group exhibitions in private galleries in Adelaide (including North Adelaide, Greenhill), Sydney (Hogarths), at the AGSA and Festival Centre, Adelaide, and in Wynne Prize 1973, 76, 77, 89.

AWARDS: Kim Bonython Prize for Painting, 1971; Grace Bros on Broadway Prize, 1978; Stirling Festival, Adelaide, 1981; City of Elizabeth, SA, 1982.

APPTS: Lecturer, RSASA 1978.

REP: Artbank.

POOLE, G. Temple

Architect, painter. Western Australian government architect; also a landscape painter and a member of the Wilgie Club, Perth, c. 1890.

BIB: Moore, *SAA*.

POPLE, Rodney

(b. 6/9/1952, Launceston) Painter, sculptor.

STUDIES: Dip. Fine Arts (photography), Tasmanian School of Art, 1974; postgrad. (sculpture), Slade School of Art, London, 1978; postgrad. (sculpture), New York Studio School, NY, 1979. His large expressionist works and occasional sculptures were seen in about 17 solo exhibitions 1981–91 in Sydney (Art Empire Industry, 1981; Roslyn Oxley9 1982, 85; Ray Hughes 1986, 87, 88, 89), Melbourne (Tolarno, 1983; William Mora, 1989), Tasmania (Salamanca, Hobart 1987; Cockatoo, Launceston, 1987; Dick Bett, Hobart, 1992). He participated in about 31 group exhibitions including at Ray Hughes, Sydney; Michael Milburn, Brisbane; *Young Contemporaries*, ICA, London 1978 and public, regional galleries Australia including *First Australian Sculpture Triennial*, Melbourne, 1981; *Australian Perspecta '85*, AGNSW 1985; *Moet & Chandon Touring Exhibition*, 1987, 88; ICI *Contemporary Art Collection*, ACCA, Melbourne 1989.

AWARDS: Tasmanian Arts Advisory Board Grant, 1978; project grant, VACB, 1984, 88; Lake Macquarie Art Prize, 1988; residency, Mora Dyring Studio, Cité Internationale des Arts, Paris, AGNSW, 1990.

APPTS: Guest lecturer, SCA, 1982, 84; Uni. of Tas., 1984; life drawing, CSA, 1988; VCA, 1990, Bendigo TAFE, 1990.

REP: NGA; NGV; QAG; MOMA, Brisbane; Artbank; Lake Macquarie Gallery; Ansett, Budget, ICI corporate collections.

BIB: Catalogue essays exhibitions as above. Chanin, *CAP*. Backhouse, *TA*.

PORCELLI, Pietro

Sculptor. Italian sculptor who modelled statues in Perth (c. ?1887) of Alexander Forrest (cnr St Georges Terrace and Mount St) and C. Y. O'Connor (Fremantle

Harbour entrance, 1911), the father of Kathleen O'Connor (q.v.).

BIB: Scarlett, *AS*.

PORT JACKSON PAINTER

(Active c. 1790, Port Jackson) The recordings of life at the first settlement at Port Jackson sent by Governor Phillip to Sir Joseph Banks are preserved in the British Museum as Banksian MS. 34. Among them are some 250 unidentified drawings which Prof. Bernard Smith ascribes (in his book, *European Vision and the South Pacific*) to 'the Port Jackson painter'. The Port Jackson painter might have been several people, but a certain naive quality which persists in the style, particularly in the fantastic drawings of Aborigines, suggests that they are the work of one person – Bernard Smith suggests either Henry Brewer (q.v.) or Francis Fowkes (q.v.). An exemplary work appeared in the Bicentennial exhibition *The Great Australian Art Exhibition*.

BIB: Smith, *EVSP*. Rienits, *Early Artists of Australia*, 1963. T. Bonyhady, *First Views of Australia*, Sydney, 1987. Kerr, *DAA*.

POSSUM *Clifford Tjapaltjarri,*

(b. c. 1943, Napperby Station, north west of Alice Springs) Artist of the Papunya region. His paintings of traditional stories are amongst the largest and most intricate of the 'dot' style of paintings typical of Central Desert Aboriginal art (*see* ABORIGINAL ART). He has become one of the most highly regarded painters of the area and has exhibited widely since the 1970s including in group exhibitions such as *Art of the Western Desert* Peter Stuyvesant Foundation and touring Australian state galleries, 1983; *Australian Perspecta*, AGNSW, 1981; *The Great Australian Art Exhibition* Bicentennial exhibition 1988–89.

REP: NGA; AGNSW; AGSA; NGV; QAG; MAGNT; tertiary collections including Flinders Uni.; corporate collections including Robert Holmes à Court.

BIB: W. Caruana (ed.), *Windows on the Dreaming*, NGA/Ellsyd Press, 1989. G. Bardon, *Papunya Tula, Art of the Western Desert*, McPhee Gribble, Melbourne, 1991. Caruana, *AA*. Caruana, *AA*. Smith, *AP*.

POST GALLERY STUDENTS SOCIETY

Started in 1916 by ex-students of the NGV School. The first president was Peter Kirk and the second John Longstaff. Moore states that (by ?1934) there were over 200 members.

BIB: Moore, *SAA*.

POST-MODERNISM

Modernism, though it sought to break with traditional visual conventions and overturn time-honoured attitudes to the arts, is usually accommodated by 20th century British and American aesthetics. Aesthetic judgements pertaining to modernism, and the criteria on which they were made, were generally descended from western philosophical tradition, going back to Plato and Aristotle. Critics had a tendency, perhaps even a program, to elevate art and artists judged to

be excellent above other objects and most mortals. It went thus: artists 'conceived' and 'made' art-works, and in so doing 'felt self-affirmed'. Good art-works were intended to 'communicate' to a public which 'received' their genius with pleasure and enlightenment. Works by universally recognised modern artists like Picasso, or in Australia Sidney Nolan or Arthur Boyd, fit within this ethos. But post-war European critical theory, chiefly emanating from France from the 1960s and early 1970s, has irrevocably altered the way art is conceived, made, communicated and evaluated.

A precise history of the development of post-modernism is impossible to outline, though Stuart Sim (*Philosophical Aesthetics: An Introduction*, Blackwell, 1992) provides a succinct and useful account which is referred to here. Post-modernism has occurred as a stage-by-stage process over four decades in which 'structuralism', and later 'post-structuralism' or 'deconstructionist theory', undermined the desire and ability of many artists and critics to make value judgements about art. Artists are now divided into those who follow post-modern theory, and those who still adhere to some notion of an essential system of values. Theories developed to explain or interpret cultural change, rather than the extension of western metaphysics in its quest for universal truths, have so dominated post-war intellectual life that some critics have indicated alarm at the excessive and rapidly transforming theorisation which is often unduly dismissive of other legitimate practice.

Anglo-American criticism has been a little more resistant to the imposition of theoretical world-views on the conceptualisation, production and evaluation of art than in some post-colonial cultures, like Australia, where post-modern attitudes – understood to varying degrees – have tended to play decisive roles in decisions as to which artists and art practices are judged to be at 'the cutting edge' and which are not. This has sometimes had the unfortunate consequence of favouring those who appear to exemplify the latest theory over those whose conceptual base is more 'readable'.

Though structuralism insisted on authoritative patterns of meaning consistent with a self-contained, rule-governed language system, it introduced a tendency to downgrade the importance of selected art objects as possessing intrinsic, lastingly valuable qualities of excellence. This undermined the individual prestige of modernist artists who, like Jackson Pollock for instance, had come to be thought of as rebels and heroes whose genius and creativity were both momentous and permanently valuable.

With no clear criteria by which works could be judged – rather than described or classified – the notion of evaluation became increasingly outmoded and art writers ever more inclined to demonstrate complexity of meaning and density of coding. In Australia, publications like the journal *Art and Text* (*see* MAGAZINES) encouraged the use of 'textual analysis' to uncover and construct multiple meanings and

to use texts to produce additional meaning rather than simply absorbing meaning from them. Under such circumstances the spectator can become more important to the text than its originator. The artist experiences diminished control over the work as it makes its way in the world.

It was the lack of a role for chance associations and random insights that led influential 'post-structuralists' or 'deconstructionists', like Jacques Derrida (Ref: *Positions*, University of Chicago Press, 1981), to renounce structuralism as sterile and rule-governed. Derrida and others, like Geoffrey Hartmann and members of the Yale School, prefer puns and word games. Derrida's famous *différance* – a play on the meanings of 'to differ' and 'to defer' – does not conform to logically constructed language or conventional systems of meaning.

Post-modernism's dismissal of authority and tradition contributes to a state in which it is finally acceptable to renounce theories of explanation (grand narratives) along with metaphysical belief systems, logic and aesthetic criteria. Previous judgements on art are often treated as 'rhetorical' or self-serving'. The post-modernist looks to small narratives or sequences of events which exist simply because they happen. Narratives, such as those explored by painters Jon Cattapan or Linda Cottrell, for instance, might be banal, but the post-modernist will find them interesting and effective because they exist at a remove from previous rhetoric. The post-modern individual is thus freed from 'grand narratives' of past art which are seen as having robbed individuals of opportunities to exercise creativity. The effect on art practice has been to legitimise and reassess the creative activities of previously marginalised groups such as women, Aborigines, minority groups in multicultural societies, the disadvantaged, the disabled and so on. The result is a considerable enriching of the culture and an exponential growth of arts-related activities which focus on pluralistic, post-colonial and regional aspects of Australian culture. Artists like Gordon Bennett, Narelle Jubelin, Stephen Bush, Tom Risley, Carol Rudyard, Tim Johnson and others are important in this context.

One of the responses to post-modernism that has been particularly evident in the visual arts has been the practice of 'appropriation' from past art. Visual traditions are revisited and reassessed. Using pastiche and other methods, post-modern artists like Juan Davila, John Nixon, Adrienne Gaha and Susan Norrie have given contemporary meaning to earlier histories. This tendency can also be noted in works by Janet Burchill, Imants Tillers and many others. Ironically, numerous modernist and romantic assumptions are still usefully at work within Australian culture, helping to support a visual arts culture on which post-modernists are also dependent. The interactions of opposite world-views, traditional and anarchic, help keep cultural issues on the boil.

The post-modern state of affairs – good, bad and simply passing – is but another episode in the flux of relativity and change which perpetually subsumes individual lives. For all that it has opened up – for instance the challenges of post-industrialisation, post-colonialism, diversity, a reordering of old hierarchies – the question remains, has post-modernism so far found a better way of defining culture than those philosophies which depended on the search for eternal truths and other value systems? The evolution of thought goes on and the production of art is one of its consequences.

BIB: Oswald Hanfling (ed), *Philosophical Aesthetics: An Introduction*, Blackwell/The Open University, Oxford, 1992. A. Grosz et al. (eds) *Futur-Fall: Excursions into Postmodernity*, Power Institute, Sydney, 1986. Charles Harrison and Paul Wood, *Art in Theory, 1990–1990: An Anthology of Changing Ideas*, Blackwell, Oxford, 1992. Jean-François Lyotard, *The Postmodern Condition: A Report on Knowledge*, Minnesota and Manchester, 1984. Claude Lévi-Strauss, *The Raw and the Cooked*, Jonathan Cape, 1969. Jack Burnham, *The Structure of Art*, Braziller, 1973. Ludwig Wittgenstein, *Philosophical Investigations*, Blackwell, 1967. Roland Barthes, *Image-Music-Text*, Hill and Wang, 1977. Jacques Derrida, *Positions*, University of Chicago Press, 1981. Jean Baudrillaud, *America*, Verso, 1988.

JENNY ZIMMER

POTTER FOUNDATION
See TRUSTS AND FOUNDATIONS

POTTS, Frank Waldo
(b. 1888, Sandgate, Eng.) Painter.
STUDIES: Brisbane Tech. Coll. (with G. Rivers). He exhibited in Brisbane.
REP: QAG.
BIB: Vida Lahey, *Art in Queensland 1859–1959*, Jacaranda Press, Brisbane, 1959.
NFI

POW, Lindsay
(b. 1955, Fremantle, WA) Painter.
STUDIES: WAIT, 1974–76. By 1979 he had held three exhibitions and won prizes in three states. He favours large Pop-style paintings with screen dots and photographic images.
AWARDS: Prizes at the Uni. of WA (Guild Print Prize, 1976); Manjimup, 1976, 77; Rockingham, 1976; Melville, 1977; Port Hedland, 1977; Alice Springs, 1977; Broken Hill, 1977; Fine Arts Gallery Prize for Landscape, shared, Perth, 1978; Kalamunda, 1978; Warringah, 1978; Shire of Flinders, Vic., 1978; VACB travel grant, and occupancy VACB studio, Dublin, 1979.
REP: NGV; AGWA; TMAG.
NFI

POWDITCH, Peter Allen
(b. 1942, Sydney) Painter, teacher.
STUDIES: NAS, with Lyndon Dadswell, as well as part-time studies at Orban's School (with John Olsen), Mary White School, and at a small school at The Rocks conducted by Passmore, Klippel and Olsen, 1960–63; travel studies, USA, 1974. His cool, flat pattern, monochromatic paintings of Sydney sunbathers and related subjects refer to his early training in sculpture and

occasionally, as in his *Sun Torso* series, to the *Great American Nude* paintings of the American Tom Wesselman. His work has become widely known, first through his exhibitions at Gallery A, Sydney and Melbourne, then at the Rudy Komon Gallery, Sydney and in 30 solo exhibitions 1970–93. His work was included in approximately 55 group shows 1970–93 including *Australian Prints*, V&A, London 1972; *Print Council of Australia Exhibition*, touring Australian public galleries and Poland; *The Australian Landscape*, AGNSW and touring Peking, China 1975; *Seventeen Australian Artists*, Galleria San Vidale, Venice 1988; *Australian Prints*, NGA 1989.

AWARDS: *Mirror*-Waratah Watercolour Prize, 1963; Taree Prize (drawing), 1969; Lismore Prize, 1969; Maude Vizard-Wholohan, Georges Invitation (purchase), Taree, Gold Coast City (purchase), Wollongong, Sulman Prizes, all in 1972; travel grant VACB, 1974; Darnell de Gruchy, Sir William Angliss Memorial, Corio Five Star Whisky Purchase, all in 1974; Latrobe Valley Purchase Award, 1975; AM conferred, 1981.

APPTS: Part-time lecturer, sculpture dept, NAS, 1968–73, and Uni. of NSW, 1969; lecturer in visual communication, SCA, 1976– ; lecturer in painting, SCA, 1981–82.

REP: NGA; most state galleries; Parliament House; Artbank; regional galleries Ballarat, Geelong, Gold Coast, Horsham, Mildura, Newcastle, Shepparton, Wollongong; Uni. of Qld; Uni. of WA; Philip Morris; Western Mining.

BIB: Catalogue essays exhibitions as above. Bonython, MAP. Smith, AP. A&A 11/4/1974 (Peter Brown, *Peter Powditch*).

POWER, *Harold Septimus*

(b. 1878, Dunedin, NZ; d. 1951) Painter.
STUDIES: Académie Julian, Paris, 1905–07. His early studies and date of arrival in Australia are not recorded. J. B. Mather described him as 'practically a self-taught artist', and Moore states that he exhibited first with the Melbourne Art Club at the age of 17 before settling in Adelaide in 1898. He is known to have made special studies of the anatomy of the horse. These studies were the basis of his subsequent great success and wide popularity. In Adelaide he drew for the *Register* and other papers and in 1904 was commissioned by the trustees of the AGSA, through the Elder Bequest, to paint an animal picture (*After the Day's Toil*). After his Paris studies he settled in London, became a member of the Royal Inst. of Painters in Oils and Society of Animal Painters, exhibited at the RA, and served as an official war artist with the AIF during World War I. Most of his war painting pertained to cavalry engagements. His commissioned work included the *Opening of Federal Parliament House, Canberra, by H.R.H. The Duke of York, 1927* (outside ceremony), and three huge panels entitled *War* for the stairwell of the Melbourne Public Library, 1924.

REP: NGV; AGNSW; AGSA; AWM; regional galleries Ballarat, Bendigo, Geelong; Imperial War Museum, London.

BIB: Catalogues AGSA 1913, NGV 1943 and AGNSW 1953. Moore, SAA.

John Power, Orchestre, *1927, gouache, 33 × 71cm. Collection,* MCA, *Sydney.*

POWER, *John Joseph Wardell*

(b. 1881, Sydney; d. 1/8/1943, West Hill, Jersey, Channel Islands) Painter, doctor of medicine.
STUDIES: Uni. of Sydney (grad. BMSc, 1905, MMSc,

1906); London, further medical study, 1907; Atelier Araujo, Paris, 1920–22. Power, the son of a Macquarie Street specialist and a grandson of William Wardell, architect of St Mary's Cathedral, Sydney, St Patrick's Cathedral, Melbourne, and many other famous buildings, served in the RAMC with the rank of captain during World War I. His father had died in 1906, leaving him financially independent for life, and after the war he gave up medical practice for a career in art. In 1923 he settled at Bournemouth and joined the London Group where, in 1924, his work attracted the attention of the *New Statesman* critic, Osbert Sitwell. In 1926 he held his first exhibition at the Independent Gallery in Grafton Street with considerable success. In Paris he joined the Abstract Creation Group, became friendly with many leading Ecole de Paris painters, including Picasso and Léger, and compiled an important book on synthetic cubism, the form with which his own painting became closely associated. He moved to Jersey in the Channel Islands in 1939, partly because of low taxation, and died there during the German occupation. In Oct. 1961, Power's widow died in Jersey and it was announced that he had bequeathed shares in the Mutual Life and Citizens Assurance Company, worth approximately £2 million, to the Uni. of Sydney, to be used for the foundation of a Faculty of Fine Arts, 'to make available to the people of Australia the latest ideas and theories in the plastic arts by means of lectures and teaching and by the purchase of the most recent contemporary art of the world'. This magnificent bequest led to the establishment of the Power Institute of Fine Arts and later the Museum of Contemporary Art.
REP: Nottingham Municipal Gallery, England; Power Inst., Uni. of Sydney.
BIB: Smith, AP. *Meanjin* 1/1964 (Bernard Smith, *Sir Herbert Read and the Power Bequest*). A&A 2/1/1964; 13/2/1975 (Donna Lee Brien, *John Power: A private iconography*; 29/2/1991 (Bernice Murphy, *The Power Collection: development in the 90s*) (*See also* UNIVERSITIES; GALLERIES – PUBLIC (Museum of Contemporary Art, Sydney)

PRATT, Douglas Fieldew
(b. 6/5/1900, Katoomba, NSW; d. 1972) Painter, etcher.
STUDIES: RAS School, Sydney, –1928; also etching with Sydney Long. Jackeroo, insurance broker and surveyor, he became a full-time artist in 1929, exhibiting with the RAS, Sydney, and Australian Painter-Etchers' Society. He served in New Guinea during World War II, attaining the rank of captain. Between 1953 and 1972 he was a member of the Commonwealth Art Advisory Board, Canberra. His work comprised mainly carefully detailed etchings and impressionistic landscapes in oils.
REP: NGV; AGNSW; AGWA.
BIB: John Kroeger, *Australian Artists*, Renniks, Adelaide, 1968.

PRESS, (Captain) Henry
(b. c. 1860, Eng.) Maritime pilot, painter. After his life in the pilot service at Williamstown, he retired to paint full-time in his studio *The Coach House* at 96 Balwyn Road, Balwyn. He exhibited two marine paintings and a landscape at the VAA, 1887.
BIB: Moore, SAA.

PREST, Cedar
(b. 1940, Vic.) Stained glass designer.
STUDIES: NGV School; Uni. of Melbourne, grad. BA, 1960; Wimbledon Coll. of Art and Hornsey Coll. of Art, UK (stained-glass), 1965–66; Germany, 1973; travel studies, USA, 1973–74. In 1974 she worked at the glass-blowing workshop at the Jam Factory, Adelaide, with Sam Herman, taught at the Craft Association of SA, summer schools and lectured at schools in the USA and UK. Her commissions include stained glass windows for the Uni. of Adelaide, St Michael's Ukrainian Church, Croydon; St Anne's Church, Maitland, SA.
AWARDS: VACB grant for study in Germany, 1973.
BIB: AL, 6/5/1985; 10/3//1990.

PREST, Trefor
(b. 26/6/1945, South Wales; arr. Aust. 1961) Sculptor.
STUDIES: Croydon College of Art, UK, 1960; Dip. Art (sculpture), VCA, 1973; welding and structural drawing, RMIT, 1972–74; graduate studies, VCA, 1974–75; travel studies UK, Europe, 1974; UK, Europe, Middle East, Asia, 1976. He held four solo exhibitions 1990–92 in Melbourne (Pinacotheca 1990, 92), Castlemaine Art Gallery (1990), Australian Galleries, Sydney (1991) and participated in around 21 group exhibitions 1972–92, including *Mildura Sculpture Triennial*, 1975, 78; *Australian Sculpture Triennial*, 1981; *Sculptors as Craftsmen*, Meat Market Craft Centre, Melbourne 1985.
AWARDS: Project grant, VACB, 1977; half standard grant, VACB, 1980.
REP: NGA; QVMAG; Artbank; Newcastle Regional Art Gallery; NCBC, Canberra.
BIB: Sturgeon, DAS. Scarlett, AS. AI 11/5–6, 1978. A&A 16/1/1978.

PRESTON, David
(b. 2/5/1948, Sydney) Painter, printmaker.
STUDIES: Julian Ashton Art School, 1966–67; NAS, ESTC, 1968–71. His decorative hand-coloured linocuts of Australiana and still-lifes, predominantly flowers have proved popular in 23 solo exhibitions 1971–92 Sydney (Mosman, 1971; Barry Stern, 1977, 78, 79, 84; Robin Gibson, 1981, 83; Bridge St, 1984, 91, 92; Wagner, 1988, 90), Adelaide (Greenhill, 1985), Perth (Greenhill, 1985), Melbourne (Australian, 1980), Canberra (Studio One, 1992), and New York Art Expo, 1992.
AWARDS: CUB Prize, 1974; Caltex Prize, Mackay, 1974; Brisbane Festival Prize, 1974.
APPTS: Teacher, HSC Art, Fort Street Boys High School, 1972.
REP: NGA; AGWA; Parliament House; Artbank; regional galleries Wollongong, Rockhampton; a number of uni. collections; World Trade Centre; Arbitration

Commission; international collections including Pompidou Centre, France.
BIB: Germaine, *AGA*.

PRESTON, Harley

Gallery director, curator. Assistant curator of prints and drawings, NGV, 1962–67; curator, Maritime Museum, Greenwich, England 1970s–1980s. In his latter capacity, he organised the exhibition *300 Years of Painting* for Somerset House. His contributions to the *Australian Dictionary of Biography*, notably his article on Robert Russell, were outstanding pieces of biographical research.

PRESTON, Margaret Rose
(née McPHERSON)

(b. 29/4/1875, Port Adelaide; d. 28/5/1963, Mosman, NSW) Painter, teacher.
STUDIES: Sydney, with W. Lister Lister, 1888; NGV School, 1893–94, 1896–97; Adelaide School of Design, 1898; travel studies, Germany, France, Spain, 1904–07. In 1899 she leased a studio in Adelaide and began teaching, and on her return from Europe in 1907 resumed her teaching in company with Bessie Davidson with whom she shared an exhibition; she took the classes also at PLC, St Peter's, SA, and joined the RSASA as a council member. In 1912 she went to London, then to Europe, remaining overseas until 1919 when she married William George Preston (1881–1978). In 1920 the Prestons made their home at Mosman. They were in New Caledonia and the New Hebrides, 1923, travelled in SE Asian countries and China, 1924–26, North Qld, 1927. She energetically developed her individual concept of modernist art, the strength of her work being strong design, glowing colour and the influences of French and primitive art, especially Australian Aboriginal art, which she recognised long before most other artists as emanating from a rich and ancient culture of exceptional depth. The AGNSW trustees commissioned a self-portrait in 1929 and in 1942 organised at the Gallery a Dobell–Preston exhibition. Apart from her painting she had a prodigious capacity for writing and lecturing. A vigorous crusader for the cause of modern art, she remained an inveterate traveller all her life, her last travels being through Ceylon, Africa and India, 1956–58. After her death in 1963 her influence both as teacher and painter became widely recognised. The AGSA curated a touring exhibition of her work in 1980 and paintings, prints and ceramics from the AGNSW collection were shown 20 December 1985–2 Feb. 1986. She was represented in the *Australian Women Artists 1840–1940*, Ewing & George Paton Galleries and touring, 1975; the Bicentennial exhibitions *The Great Australian Art Exhibition* and *The Face of Australia* and in *A Century of Australian Women Artists 1840s–1940s* Deutscher Fine Art, Melbourne, 1993.
AWARDS: Medal, International Exhibition, Paris, 1937.
REP: NGA; AGNSW; AGSA; AGWA; NGV; QAG; TMAG; MAGNT; many regional galleries and other public collections.

BIB: All general books on Australian contemporary painting and catalogue essays exhibitions as above. Margaret Preston, *Monotypes*, 1949; *Present Day Art in Australia*, 1945, both published by Ure Smith, Sydney. Elizabeth Butel, *Margaret Preston: the art of constant rearrangement* Penguin, Melbourne, 1985. Janine Burke, *Australian Women Artists*, Greenhouse, 1980. A&A 1/2/1963 (Hal Missingham, *Margaret Preston*); 18/3/1980 (Ian North, *Model of an Era*). AL, 1/2/1981; 3/1/1983.

PRESTON, Reg (Reginald)

(b. 1917, Sydney) Ceramicist.
STUDIES: RA Schools, London, –1939; Melb. Tech. Coll., 1945–47. His early work was influenced by Chinese pottery and the work of the English ceramicist Bernard Leach. His work appeared in numerous solo and group exhibitions including all major ceramic surveys at public galleries.
REP: AGWA; NGV; Shepparton regional gallery.
BIB: Kenneth Hood, *Pottery*, Arts in Australia series, Longman, Melbourne, 1961.

PRESTON, Walter

(b. 1777, England; arr. Sydney 1812) Convict artist, engraver. The death sentence passed on Preston at Middlesex Assizes, 1811, for the crime of highway robbery, was commuted to transportation for life. Preston, a skilled engraver, engraved the works of Brown, Eyre and Lewin. In Sydney also he engraved eight of the first 12 plates of views of the settlement, issued by the publisher Absolem West (q.v.) (to whom he may have been assigned as a servant). Further trouble with the authorities earned him a transfer to Newcastle. The commandant was Captain James Wallis. Preston engraved the plates for Wallis's *Historical Account of New South Wales*, published by Ackermann, London, 1821. Preston's pardon, which came soon afterwards, was probably a reward for this work. He was represented in the Bicentennial exhibition *The Face of Australia*.
BIB: Moore, *SAA*. Rienits, *Early Artists of Australia*, 1963. Kerr, *DAA*.

PRÉVOST

Two Prévosts, uncle and nephew, were appointed natural history draughtsmen on La Pérouse's voyage to the Pacific. Prévost 'l'aîné' (presumably the uncle) is recorded as exhibiting portraits and flower pieces in Paris in 1774. Most of the drawings were lost when the expedition was wrecked at Vanikoro, c. 1788, though a number had been sent back to France from ports visited on the way. Contact with Australia was limited to a short stay at Botany Bay, Jan.–Feb. 1788.
BIB: Smith, *EVSP*. Bénézit, *Dictionnaire*, 1976.

PRICE, F.

(Active c. 1850, Vic.) Illustrator, engraver. He worked for Thomas Ham on the *Illustrated Australian Magazine* and may have been connected with a later Price who painted impressionistic pictures of outback subjects.
BIB: McCulloch, *AAGR*.

PRICE, *Jane R.*

(b. 18/2/1860, England; arr Aust. 1880; d. 1948, Melb.) Painter.

STUDIES: RA School, South Kensington, London. She first came to Sydney before settling in Melbourne in 1882, becoming close friends with Clara Southern, Jane Sutherland and Tom Roberts. She exhibited with the VAS, 1882–1906, and like Tom Roberts and other artists, had a studio at Grosvenor Chambers, a Collins St building specially designed for artists' studios and built in 1888. She painted some fine impressionistic pictures, was a frequent visitor at the Eaglemont camp of the Heidelberg School painters, and c. 1906 moved to Sydney, where she became a foundation council member of the Society of Women Painters. During World War I she lived in Melbourne, returned to Sydney in the mid 1920s and came back to Melbourne in the late 1930s to share the house *Rosedale* with fellow artist Ina Gregory. Her work appeared in *Completing the Picture: Australian Women Artists of the Heidelberg Era* Heide and touring, 1992 and *A Century of Australian Women Artists 1840s–1940s* Deutscher Fine Art, Melbourne, 1993.

REP: NGV; Bendigo Art Gallery.

BIB: Catalogue essays exhibitions as above. Moore, *SAA*. John Kroeger, *Australian Artists*, Renniks, Adelaide, 1968. McCulloch, *AAGR*. Janine Burke, *Australian Women Artists 1840–1940*, Greenhouse, Melbourne, 1980.

PRICE, *Thomas*

(Active c. 1860s–80s, Sydney, then Vic.) Painter. He painted miniatures in Sydney from 1866 as well as portraits, exhibiting them in exhibitions such as the 1870 Sydney *Intercolonial Exhibition*. In Ballarat c. 1880s he, with local businessman James Oddie (q.v.), organised the first major exhibition of paintings and became a foundation member of the committee for a local art gallery which became the Ballarat Fine Art Gallery (see GALLERIES PUBLIC).

BIB: Kerr, *DAA*.

PRIEST, *Margaret Kennedy*

(b. 1922, Barrhead, near Glasgow; arr. Aust. 1951) Sculptor, teacher.

STUDIES: Glasgow School of Art, 1939–43; Jordanhill Training Coll., 1944; studies in Paris, 1947; travel studies, India, 1958, and UK, Europe and USA, 1974–75; sculpture and language, Japan, 1982. From c. 1955 she completed a large number of commissioned sculptures for schools, churches and public buildings in WA, including a fountain for Terrace Arcade, Perth, 1966, and the Arts Building, Uni. of WA, 1968, and a memorial to pioneer women of Australia, King's Park, Perth, 1967. She participated in group exhibitions 1954–74 including at the Mildura Arts Centre, 1961; Newcastle Regional Art Gallery, 1962; *Transfield Prize*, 1966; and AGWA, 1974.

AWARDS: Benno Schotz Prize, UK, 1940; postgraduate scholarship, Glasgow, 1943; Guthrie Award, Glasgow, 1944; Keppie Travelling Scholarship, France, 1947.

APPTS: Teaching, Allan Glen's School, Glasgow, 1944–46; Queen's Park School, Glasgow, 1947–49; Christchurch West High School, NZ, 1950; lecturer (part-time) in art history, Uni. of WA, 1952; teaching, Penrhos Coll., Perth, 1962–63; visiting lecturer in sculpture, WAIT, 1969–73 and 1975.

REP: AGWA; TMAG; Uni. of WA.

BIB: Scarlett, *AS*.

NFI

PRIEST, *Maude*

(b. 1885, ?Adelaide; d. 1945) Painter, teacher.

STUDIES: SA School of Design (with H. P. Gill), also with James Ashton. She painted portraits, seascapes (round Port Elliot), and landscapes in the Blue Mountains and around Woodside.

BIB: Rachel Biven, *Some forgotten . . . some remembered*, Sydenham Gallery, Adelaide, 1976.

PRINGLE, *John Douglas*

Journalist, editor, writer. Editor, *Sydney Morning Herald* c. 1950–60 and author of *Australian Painting Today*, Thames & Hudson, London, 1963.

PRINSEP, *Augustus & Elizabeth*

(Arr. Tas. 1829) Travel writers, topographical artists. Augustus Prinsep and his wife made a number of fine landscape sketches during a visit to Tasmania in 1829–30, eight of which were lithographed by various engravers and printed by Hullmandel with the title *Journal of a Voyage from Calcutta to Van Diemen's Land* (London, 1833). The text is by Augustus and on the plates, mainly views of Hobart and New Norfolk of which they form a good early record, the inscription reads: 'Mr and Mrs Prinsep . . . united their powers in the production of these drawings'.

REP: TMAG; Dixson Gallery of Mitchell Library.

BIB: Clifford Craig, *Old Tasmanian Prints*, Foot & Playstead, Launceston, 1963. Kerr, *DAA*.

PRINSEP, *Charles Henry*

(b. 5/9/1844, Calcutta; arr. Fremantle 1866; d. 20/7/1922, Busselton, WA.) Businessman, civil servant, painter.

STUDIES: RA, London, with G. F. Watts; Dresden, Germany. He grew up in a cultured family friendly with Alfred Tennyson, and went to WA to inspect family property. There he bred horses till 1874 when he joined the Lands and Surveys Dept, becoming head of the Mines Dept in 1894. He visited England c. 1910, was Mayor of Busselton for some years and also a prominent member of the Wilgie Club (president, 1904–05). His watercolour of the *Salt Lake and Salt House, Rottnest* (AGWA) shows an interest in both topography and history as well as being firmly constructed. His work was represented in *The Colonial Eye*, AGWA 1979.

REP: AGWA; J. S. Battye Library, Perth, WA.

BIB: National Bank Calendar, Melbourne, 1962. Kerr, *DAA*.

PRINT COUNCIL OF AUSTRALIA INC.

Founded 1966. 459 Swanston Street, Melbourne, Vic. 3000. Formed 'to promote the production and enjoy-

ment of handprinted graphics in Australia', the PCA has organised and toured print exhibitions by Australian printmakers annually since 1967. These have been toured to state, regional and university galleries throughout Australia, and special exhibitions have been toured to the USA, UK, Europe and SE Asia. The work of advanced students from about 16 schools has also been placed on tour in special exhibitions since 1971, and in 1976 the *Western Pacific Print Biennale* was organised, greatly to extend the sphere of PCA influence. In the first decade of operations, the PCA was responsible for some 23 exhibitions of very high standards. Prints for distribution to patrons and members are commissioned annually. It also publishes (since 1966) the quarterly magazine *Imprint* and the *Directory of Australian Printmakers* – editions to 1993 have been: Lillian Wood, ed., *Directory of Australian Printmakers*, PCA, in association with Lansdowne Editions, as a supplement to Franz Kempf, *Contemporary Australian Printmakers*, Melbourne, 1976, 82; Ann Verbeek, ed., *Directory of Australian Artists Producing Prints*, PCA, 1988.

ADMIN: President and members. President: 1968, Ursula Hoff; 1968–70, John Brack; 1970–72, Noel Counihan; 1973–78, Robert Grieve; 1978–81, Geoff La Gerche; 1981–82, Graham King; 1982–83, James Taylor; 1983–85, Suzanne Davies; 1986–89, Roger Butler; 1991– Michael Maloney. Executive Officer: 1966–74, Lillian Wood; 1974–75, Maggie Mackie; 1975–80, Judith Schiff; 1986–89, Diane Soumilas; 1989– , Di Waite.

MEMBERSHIP: In 1993, 850 including 180 educational organisations.

FINANCE: Membership fees, donations, publications, federal and state government grants.

PRIOR, Elizabeth

(b. 21/11/1929, Ormond, Vic.) Painter.
STUDIES: Studied privately 1952–66 with a number of artists including Ian Bow and William Frater; travel studies SE Asia and Bali, 1973, 83; Europe, 1977, 84; USA, Canada, UK and Europe, 1988. Member of the VAS, and CAS (vice-president 1972–73). She started painting in 1952 and from 1962 participated in many competitive exhibitions. Her large, energetic and well-composed landscapes have won her a number of prizes.
AWARDS: Prizes include Mordialloc, 1965; Gold Coast, 1971; Healesville, 1971; Brighton, 1974; Camberwell Rotary, 1974; Flinders, 1974; Clayton, 1978; St Kilda, 1982; Sandringham, 1982; Tallangatta, 1984; Mordialloc, 1985; Atelier Acrylic, 1989; VAS exhibition prizes, 1966, 76, 78, 79, 82, 85.
REP: Artbank; Gold Coast regional collection; La Trobe Uni.

PRIZES, AWARDS AND SCHOLARSHIPS
See APPENDIX 7, p. 842.

PROCTOR, Thea (Althea Mary)
(b. 1879, Armidale, NSW; d. 1966, Sydney) Painter, teacher.

Thea Proctor, Summer, *coloured woodcut, 17.5 × 23cm. Christie's, April 1992.*

STUDIES: Julian Ashton School, Sydney, 1895– ; St John's Wood School, London, 1903. She first exhibited with the NSW Society of Artists, 1897. In 1903 she went to London, where she was tutored by G. W. Lambert (who painted her portrait), became closely associated with the Lambert family, and painted many fan designs in watercolours in the manner of Charles Conder. Except for a visit to Sydney in 1912 with an exhibition of her fan paintings, she remained in London for 18 years, exhibiting with the RA, New English Art Club, International Society, Senefelder Club, and with groups at the Goupil Gallery. She contributed also to international exhibitions in Venice, Rome, Paris, Berlin and Ghent. Returning to Sydney in 1921, she did much to stimulate interest in linocuts, lithography and other printmaking media, founded the Contemporary Group in company with Lambert and others, and gave great encouragement to younger artists. She also drew attention to the neglected work of her cousin, John Peter Russell. Her work was represented in the Bicentennial exhibition *The Great Australian Art Exhibition* and *A Century of Australian Women Artists 1840s–1940s* Deutscher Fine Art, Melbourne, 1993.

AWARDS: Prizes at Bowral Art Competition (judged by Arthur Streeton), 1895; Franco-British Exhibition, London (shared prize in women's section with Frances Hodgkins); State Theatre Quest, Sydney, 1929; NSW Society of Artists medal, 1946.

APPTS: Teaching, drawing and design classes, Julian Ashton's Sydney Art School from c. 1925; she also conducted private classes in Sydney.

REP: NGA; AGNSW; AGSA; AGWA; NGV; QAG; TMAG; regional galleries Castlemaine, Geelong, Newcastle.

BIB: All general books on contemporary Australian art history and catalogue essays exhibitions as above. Roger Butler and Jan Minchin, *Thea Proctor–The Prints*, Resolution Press, Sydney, 1980. Janine Burke, *Australian Women Artists 1840–1940*, Greenhouse, Melbourne, 1980. A&A 4/4/1967 (Dorothy Dundas, *Thea Proctor–an Appreciation*). AL 3/1, 1983 (12).

PROUD, Geoffrey Robert

(b. 1946, Adelaide) Painter.
STUDIES: No formal training. He held his first exhibition at Watters Gallery, Sydney, 1967, and by 1978 his work had become known in Melbourne, Adelaide, Perth and Brisbane. Many of his early Pop-style, surrealistic images were painted on the reverse side of perspex. His later, large paintings on canvas are more conventional. He has produced a number of cover illustrations for books including Shirley Hazzard's *Transit of Venus*.
AWARDS: Georges Art Prize (acquisition), 1976.
REP: NGA; AGWA; regional galleries Horsham, Morwell (Latrobe Valley), Armidale.
BIB: Horton, PDA. Bonython, MAP 1975. A&A 17/3/1980 (Gary Catalano, *Geoffrey Proud*).

PROUT, John Skinner

(b. 19/12/1805, UK; arr. Sydney 1840; returned Eng. 1848; d. 29/8/1876, London) Painter, lithographer. Nephew of British watercolour painter Samuel Prout (1783–1852) and cousin of Samuel Prout Hill (q.v.), he was a lithographer and painter in England and had a number of volumes of lithographs published before coming to Australia to visit his uncle – the under-sheriff of NSW. He attempted to organise an exhibition in Sydney but had more success with his two series of lectures (each of six) at the Mechanics Inst., which was filled to capacity (500 seats) on each occasion. He also painted scenery for the Olympic Theatre and published a set of lithographic views, *Sydney Illustrated*, before moving to Hobart, where he again lectured, and with the help of a committee organised the colony's first exhibition, which opened in the Legislative Council Chambers, 6 Jan. 1845. The success of this exhibition led to Robert Vaughan Hood's Colonial Picture Gallery, built in 1846. During his stay in Tas., Prout imported a complete lithographing plant from England and issued a series of lithographic views, *Tasmania Illustrated*, in two parts, 1844, 1846. Before leaving Hobart he had started a local fashion for painting in watercolours. He made numerous sketching trips all over Tasmania with Peter Fraser and Francis Simpkinson (q.v.) in the mid-1840s and he spent three months in Vic., making sketches for his *Views of Melbourne and Geelong*, 1847, and the following year returned to London. Later, the publication of his *A Magical Trip to the Gold Regions*, London, 1853, claiming 'sketches on the spot', suggests that he might have made another, later visit to Vic., but there is no other evidence of this and, equally, the sketches could have been done from photographs or from the work of another artist. He also produced a 'moving panorama' of painted glass slides which achieved considerable success, being exhibited in England over 600 times 1852–53. He wrote of his Australian travels in the *Art Union of London*, 1 Nov. 1848 and published the *Journal of a Voyage from Plymouth to Sydney*, London, 1844. In 1851 he was sketching in Europe with Morton Allport. In London he was made a member of the New Watercolour Society (later

the Royal Institute of Painters in Watercolour), exhibiting with the Institute for the rest of his life. His son, Victor Albert Prout (b. 1835), was a successful photographer in London and Sydney, becoming a partner of Freeman Bros (q.v.) in Sydney the 1860s. The TMAG mounted a large exhibition of John Skinner Prout's Australian work in 1986. He was represented in *Tasmanian Vision* TMAG and QVMAG 1988; *The Artist and the Patron* AGNSW, 1988; and the Bicentennial exhibitions, *The Great Australian Art Exhibition* and *The Face of Australia*.
REP: NGA; AGNSW; AGSA; QVMAG; TMAG; regional galleries including Ballarat; NLA; Dixson, La Trobe, Allport Libraries; Sydney Uni.; British Museum and a number of other British public collections.
BIB: A number of books on Australian art history including Moore, SAA; Kerr, DAA and catalogue essays exhibitions as above. ADB 2. McCulloch, AAGR. *Drawing in Australia*, Andrew Sayers, NGA 1989. A&A 22/4/1985.

PRYOR, Anthony Denis

(b. 1951, Melb.; d. 26/10/1991, Melb.) Sculptor, teacher.
STUDIES: Dip. Fine Arts (sculpture), RMIT, 1973; Fellowship Fine Arts, RMIT, 1974; travel studies in Japan, 1975, 76. His work first came to notice when it appeared with that of Geoffrey Bartlett and Augustine Dall'ava in an impressive show of constructivist sculpture at their studio at 108 Gertrude St, Fitzroy. In 1978 the work of this trio became the subject of a VACB touring exhibition. He held six solo exhibitions 1982–90, largely at Realities, Melbourne, and received many public and private sculpture commissions. His work appeared in a number of significant group sculpture survey exhibitions including *Australian Sculpture Triennials*, Melbourne; *2 Sculptori Australiani*, Florence, Italy 1984; and in Saitama, Japan 1987. His work developed in finesse and strength and he was one of the most highly regarded sculptors in Australia before his untimely death of cancer at the age of 39. A lasting memorial to his skill is the large sculpture commissioned by architect Daryl Jackson to stand outside the new southern stand of the MCG.
APPTS: Part-time lecturer in sculpture, RMIT, 1975–76.
AWARDS: VACB travel grants, 1974, 75.
REP: NGA; AGWA; NGV; Parliament House; Artbank; Vic. Arts Centre; Alice Springs Art Gallery; Lismore regional gallery; tertiary collections including Canberra CAE; corporate and private collections including Shell.
BIB: Scarlett, AS. AL 9/4/1989–90.

PRYOR, Oswald

Black-and-white artist. Pryor came from a Cornish mining district and settled in SA, where he made black-and-white drawings for illustrated papers, contributing to the *Critic*, Adelaide, 1897, *Gadfly*, Adelaide, and to Sydney *Bulletin*. Pryor's drawings of Cornish miners were a feature of the *Bulletin* for many years (c. 1910–30).
BIB: Mahood, *The Loaded Line*, 1973.

PUBLIC ART

Few art controversies are as spectacular as those sur-rounding public art. The first large-scale public statue cast in the colonies, Charles Summers' *Burke and Wills Monument* (1862–65) (in 1993 resited in Melbourne's City Square), caused a furore (*see* SUMMERS, Charles).

Sculptor of Melbourne's *Shine of Remembrance* Paul Montford (q.v.) found in the 1930s similar contro-versy with both that building and many of his 70 other public sculptures.

Forty years later, public art controversy reached its zenith with Ron Robertson-Swann's (q.v.) 1978 sculp-ture *Vault* commissioned by the Melbourne City Council (*see* PRIZES & AWARDS). Subsequent public sculptures such as Inge King's *Forward Surge* outside the Arts Centre have proved popular but suffered problems with siting as did several early ceramic murals by Tom Sanders which were demolished.

The monuments adorning most Australian capital cities from the 1800s included those similar to Hans Thornycroft's *General Gordon Monument*; Sir Bertram Mackennal's *Edward VII Monument* and Charles Gilbert Web's *Mathew Flinders Monument*.

As well as sculpture however public art includes stained glass, mosaic, tapestry and murals by indi-viduals and from the 1970s a number of community groups.

During the 1940s Christian and Napier Waller (qq.v.) produced stained glass, mosaics, and murals for public spaces including the AWM and the Melbourne Town Hall. In Sydney modernists Gerald Lewers, Lyndon Dadswell and Tom Bass promoted public sculpture as did Daphne Mayo in Brisbane. The 1956 Olympic Games did little to promote public art although a ceramic sculpture by Arthur Boyd was commissioned for the swimming pool and Leonard French's mural appeared at Melbourne University.

The 1970s boom in corporate architecture meant a corresponding need for 'foyer' art. The Victorian Tapestry Workshop (q.v.) produced many large-scale tapestries from the work of leading artists for foyers and public spaces (such as Arthur Boyd's huge tap-estry in the Great Hall of Parliament House Canberra). Other 'foyer' works include John Firth-Smith's mural for Collins Place, Melbourne and Brian McKay's work for the Central Tower, Perth.

During the 1970s public art was boosted by efforts to connect art with community and working life result-ing in colourful collectively painted murals on fac-tory walls, railway stations and other highly visible sites. In Melbourne the efforts of Geoffrey Hogg (q.v.) and others have led to public art projects sited in the new ACTU headquarters and elsewhere; in Sydney the *Public Art Squad* has produced a range of site-specific work; in Adelaide projects have included Cedar Prest's (q.v.) work with community groups in creating glass murals for the *Parks Project* in 1974.

Debate intensified over art for public places in the 1980s and brought recognition of a holistic approach, engendering a rash of conferences, publications, exhi-bitions, commissions, collaborations and the develop-ment of agencies to facilitate them. Issues such as commissioning guidelines on fees, health and safety conditions, copyright, de-accessioning, repair and main-tenance policies were part of the agenda. A percent-age of capital works spending devoted to art was legislated for in Tasmania and recognised by Griffith and Monash universities.

In many ways South Australia has been the leader of public art in the 1980s. The *Art for Public Places Committee* was established in 1984 and to 1993 had overseen more than 40 projects while the *Adelaide Station Environs Redevelopment* (ASER) project devoted $2m for public art.

In Victoria, Arts Victoria's *Art and Public Spaces Strategy* was boosted by the 1988 *Creative City Conference* which addressed the problems of humanising the mod-ern city. Arts Victoria has also taken an active role in arranging commissions for artists with architects, gov-ernment departments and corporations – for example Anthony Pryor's huge 15m high sculpture *The Legend* outside the new southern stand of the MCG.

The Western Australian *Public Art Directory*, an initiative of the Dept for the Arts, offered project co-ordination and advice and by the end of the 1980s had registered some 180 artists.

A similar service was offered by the *Tasmanian Development Authority*. In Brisbane *World Expo '88* com-missioned a number of major sculptures. The *Australian Sculpture Triennial* (q.v.) established in 1981 raised the profile of sculpture in Melbourne with literally hun-dreds of works on view in public spaces and com-mercial and public galleries for several months.

If the drive in the 1980s in Australian cities may have been towards development, the 1990s are more concerned with conservation, pollution, noise control and making more livable cities. There is conscious-ness of a need to both protect and conserve the pub-lic art of the past through committees such as the National Trust's *Public Art Committee* and integrate art even more into our everyday life through initiating new projects.

BIB: *Artfile: Artists and Designers/Makers of Australia* Craft Arts International, Sydney, 1992. AL vol. 9, no. 2, 1989; vol. 13, no. 2. 1993; A&A 28/1/1990. *The Role of the Common-wealth in Australia's Cultural Development: A Discussion Paper* Commonwealth of Australia, Canberra, April, 1992.
JENNY ZIMMER

PUGH, Clifton Ernest

(b. 17/12/1924, Richmond, Vic.; d. 14/10/1990, Cottles Bridge, Melb.) Painter.

STUDIES: NGV School, with William Dargie (Common-wealth Rehabilitation Training Scheme), 1947–50. During World War II he served with the AIF in New Guinea, 1943–45, then with the occupation forces in Japan. Two portraits exhibited in group shows in 1954 (*A. Thornton* and *Self Portrait*) marked him as a young painter of great promise. This promise was affirmed by his work in an exhibition shared with NGV School colleagues Laycock, Daws and Howley (qq.v.) at the VAS galleries, 1955. Pugh's work, which concerned the

Artists Geoff Hogg and Tessa Jasper work on the Museum Station mural, Melbourne, 1984.

integration of native animals and birds with their bush environment, corresponded with his evolving lifestyle at the bush property at Cottles Bridge, Vic., where, in company with his first wife, Marlene, he built an adobe, mud-brick and timber house, and further developed the area as a sanctuary for wildlife. His bush paintings linked him with the Antipodean School painters (q.v.), his portrait painting developed as a separate activity and both equated with the Labor Party politics to which he became attached, and which led him, in 1971, to formulate an ALP arts policy. Already a member of the Commonwealth Arts Advisory Board, he was elected to the Visual Arts Board of the Australia Council when the ALP assumed office in 1972. Meanwhile his reputation as a portrait painter had grown rapidly, especially after his initial success in the Archibald competitions in 1965 (*R. A. Henderson*), followed by a similar success in 1971 (*Sir John McEwen*). His portraits of other artists, writers and university leaders had already earned him high ranking in this field; these were now joined by a series of portraits of political leaders, some controversial, and most distinguished by Pugh's innate ability to bring out character. He travelled extensively and in company with his third wife, Judith, engaged in a wide variety of highly publicised activities, adapted his work to set designs and dust jackets for books, and published books of his own work (including with Ivan Smith,

Death of a Wombat, Wren, Melbourne, 1972; and *Dingo King*, Wren, Melbourne, 1977) as well as taking part in a vast number of exhibitions. These include representation in the important Whitechapel and Tate Gallery exhibitions of 1961 and 1963 and many exhibitions of representative Australian contemporary art in other countries. Throughout his extremely busy career he never lost his love for the bush, outback and desert country and its people and continued to travel (with his fourth wife, artist Adriane Strampp, and later other companions) and exhibit frequently in Australia and internationally until his death of a heart attack at his Cottles Bridge home.

AWARDS: Maude Vizard-Wholohan Prize, SA, 1958; Minnie Crouch Prize, Ballarat, 1958; RAgSocNSW Prize, 1965; Archibald Prizes, 1965, 71, 72; Master's Choice: Caltex Prize, 1976; Albury-Wodonga Prize, 1976; Order of Australia 1985.

REP: NGA; AGNSW; AGSA; AGWA; MAGNT; NGV; QAG; TMAG; many regional galleries, uni. galleries and other public collections.

BIB: All general books on contemporary Australian art history. Noel Macainsh, *Clifton Pugh*, Australian Art Monographs, Georgian House, Melbourne, 1962. Andrew Grimwade, sponsor, Geoffrey Dutton, introduction, *The Portraits of Clifton Pugh and Mark Strizic*, Sun Books, Melbourne, 1968. Traudi Allen, *Patterns of a Lifetime – a biography of Clifton Pugh*, Thomas Nelson, Melb., 1981. AL, 2/2/1982. A&A 28/4/1991 (obituary).

PULLEINE, Robert
(b. 1911, Adelaide) Painter.

STUDIES: North Adelaide School of Fine Arts; George Bell School, Melbourne. His career was interrupted by war service during World War II. Best known for his paintings of flowers.

REP: AGSA.

BIB: John Kroeger, *Australian Artists*, Renniks, Adelaide, 1968.

PURHONEN, Ari

(b. 2/11/1953, Finland; arr. Aust. 1966) Sculptor.
STUDIES: B.Sc. (architecture), Uni. of NSW, 1975; B.Arch., Sydney Uni., 1982. His well-poised works appear delicately constructed and are often made of steel, glass and aluminium. His works as shown at the Auckland project exhibition while he was artist-in-residence there in 1990 were on the theme of *Cell* – both as a confinement and basis of life – and consisted of geometric boxes often with the swastika emblem either on its own or counterbalanced by fluid, graceful, ribbon-like circular shapes. He held 15 solo exhibitions 1980–91, largely at Mori and Ivan Dougherty, Sydney, 1990; Auckland City Art Gallery, 1991. Group exhibitions in which his work appeared 1982–93 include *Australian Sculpture Triennial*, NGV 1984, 90; *Australian Perspecta*, AGNSW 1985, 91; *Museum of Accidents*, Performance Space, Sydney 1993. He had several maquettes commissioned including for University of NSW; Sydney City Council.
AWARDS: Mildura Sculpture Triennial (work acquired), 1985; grants VACB, 1987, 89, 90; residency, Power Studio, Cité Internationale des Arts, Paris, AGNSW, 1991.
APPTS: Lecturer in sculpture, several tertiary colleges, NSW including Nepean CAE, 1986–88; Sydney Uni., 1986–92; sculpture/jewellery lecturer, College of Fine Arts, Uni. of NSW, 1990–92; director, AVAGO (Window Gallery), Sydney Uni., 1986–89.
REP: AGNSW; AGSA; NGV; QAG; MOCA; Mildura regional gallery.
BIB: Catalogue essays exhibitions as above. Sturgeon, AS.

PURLTA, Mary Anne

(b. c. 1940, desert country south of Bililuna, WA) Painter, printmaker. Married to Jarinyanu David Downs (q.v.), she participated in eight group exhibitions 1989–93, including *Old Land New Tracks: Aboriginal Art of the Kimberley*, travelling exhibition to the USA, 1993; *Images of Power*, NGV 1993.
REP: NGV.

PURVES SMITH, Peter (Charles Roderick)

(b. 26/3/1912, Melb.; d. 21/7/1949, Melb.) Painter.
STUDIES: Grosvenor School, London, c. 1935; George Bell School, Melbourne, 1936–38; La Grande Chaumière, Paris, 1938–39. An artist of exceptional imagination and inventiveness, he returned to Melbourne from his first studies armed with the modernist influences absorbed at the Grosvenor School. Colleague students at George Bell's School in Melbourne recall their pleasure at his imaginative, Rousseau-like drawings and paintings of animals at the Zoo. He made

Peter Purves Smith, Promenade, *oil on canvas. Private collection.*

a second journey overseas in 1938, and with his friend Russell Drysdale attended life classes at La Grande Chaumière. Soon after the outbreak of World War II he enlisted in the British Army, attained the rank of captain and was posted to West Africa, then to Burma, where he became very ill. Invalided home to Australia in 1946, he died three years later. His premature death deprived Australian art of a painter whose influence had already been widely felt. His widow, Maisie (*née* Newbold), married Russell Drysdale in 1964. Joseph Brown, Melbourne held an exhibition *Homage to Peter Purves-Smith*, 12–28 July 1976 and his work appeared in *The Great Australian Art Exhibition* Bicentennial exhibition and *Classical Modernism: The George Bell Circle* NGV, 1992.
REP: NGA; AGNSW; NGV; QAG; regional galleries Ballarat, Mornington; MOMA, New York.
BIB: All general books on contemporary Australian art history and catalogue essays exhibitions as above. John Kroeger, *Australian Artists*, Renniks, Adelaide, 1968.

PURVIS, Ian

(b. 1916, Melb.) Naval officer, painter.
STUDIES: Painting classes with J. Wynn Morgon,

London, 1961–64; RMIT (etching), with Tait Adams, 1966; Prahran CAE (silk-screen), 1966; travel studies, UK and Europe, 1961–64; UK, Europe and Morocco, 1974–76. RAN officer from 1929, retiring as Commodore, Flinders Naval Depot, Vic., 1971. He began painting in 1950, became a full-time painter, mainly in watercolours, in 1971 and held ten solo exhibitions 1974–93, including at Hamilton Regional Art Gallery, 1974; City of Hawthorn Gallery, 1979; MAGNT, 1984.

APPTS: Executive Officer, RGAV, 1977–81.

REP: MAGNT; Benalla Art Gallery; Uni. of NSW; Uni. of New England.

PYE, Mabel
(b. 1894, Melb.; d. c. 1960) Painter, printmaker.
STUDIES: NGV School, 1912–21. Member, VAS, 1918–38; also of Melbourne Society of Women Painters and Sculptors, 1938–57. Still life, flowers and street and beach scenes are the favoured subjects in her linocuts and watercolours. Her work appeared in *A Survey of Australian Relief Prints*, Deutscher Galleries, Melbourne, 1978.

PYETT, Christopher Thornton Wills
(b. 1/5/1943, Melb.) Painter, teacher, administrator.
STUDIES: Dip. Fine Art (painting), Tasmanian School of Art, 1964; travel studies, Europe and UK, 1967. He held six solo exhibitions in Tasmania 1966–69, and three in Melbourne 1970–79, showing mainly expressionistic canvases inspired by Aboriginal art. Later he turned more to representational landscapes and held around another eight solo exhibitions 1979–92, including with Stuart Gerstman, John Buckley, Melbourne. Group exhibitions in which his work appeared 1974–92 include with Stuart Gerstman galleries; *Staff Artists*, Chisholm Inst.; *New Generation Victorians*, MPAC 1976; *Interpretations: The Woven Language of the Victorian Tapestry Workshop*, 1991.

AWARDS: Prizes at TMAG (purchase award), 1974; Georges Prize (purchase), 1975; Latrobe Valley, 1979; Diamond Valley Watercolour Prize, 1980; Caulfield Art Prize (work on paper), 1983.

APPTS: Teaching, Devonport Tech. Coll., 1965–69; Melbourne State Coll., 1971–73; CIT, 1973– ; head of dept, 1986– ; assoc. professor, fine arts, Monash Uni. (Caulfield campus), 1990–92; deputy director, Vic. Tapestry Workshop, 1992– .

REP: TMAG; a number of regional galleries including Alice Springs, Burnie, Hamilton, Mornington, Warrnambool; Monash and La Trobe Uni. collections.

BIB: Backhouse, *TA*. Germaine *AGA*. *Artfile* 1993.

PYKE, Guelda
(b. Melb.) Painter.
STUDIES: NGV School, 1957; RMIT; George Bell School; travel studies, UK, Europe, USA, Middle East and Asia. She worked in Bali, and in 1961 travelled by caravan through Greece, Iran, Pakistan and India in company with Nancy Grant and Dorothy Braund (qq.v.). Her spontaneous paintings have a sensuous, decorative quality. She exhibited frequently from 1961 and her exhibitions during the 1980s include at Niagara, 1984; Eastgate Galleries, Melbourne, 1992.

REP: NGA; NGV; MPAC.

BIB: Catalogue essays exhibitions as above.

QUEENSLAND ART FUND TO QUINN

QUEENSLAND ART FUND
(Established 1930) Organised by Vida Lahey and Daphne Mayo to promote public interest in the QAG. Their precedent was the National Arts Collections Fund for the National Gallery, London. A carnival was organised on the roof of the new Brisbane City Hall to finance a loan exhibition of art from the southern States, which was held in the vacated QAG premises in the Executive Buildings. Through purchases and gifts, the Fund acquired paintings, books and a collection of 2000 photographs given by the Carnegie Corporation, New York. In addition, a total of £20,000 was raised; this amount came from a bequest of £10,000 from John Darnel with the proviso that pound for pound be publicly subscribed within five years of his decease, half to go to the QAG and half to the Brisbane City Council for housing for the Randall Collection. When Art Fund activities ceased the collections were divided among the QAG, the Queensland Uni. and other public bodies.
BIB: Moore, *SAA*.

QUEENSLAND ART SOCIETY
See ROYAL QUEENSLAND ART SOCIETY

QUEENSLAND ARTS COUNCIL
See ARTS COUNCIL of Australia.

QUEENSLAND AUTHORS AND ARTISTS SOCIETY
(Founded 1921) Founded for the benefit of writers and artists. The president was Professor J. S. Stable.
BIB: Moore, *SAA*.
NFI

QUEENSLAND WATTLE LEAGUE
Formed originally 'to establish the wattle as the national flower and emblem of Australia', the League provided (in 1914) the first travelling art scholarships in Qld. Two awards were made, one for sculpture, which went to Daphne Mayo, the other for architecture, which went to R. P. Cummings. The League finally ceased to function and in 1949 its funds were merged with those of the Queensland Half Dozen Group (*see* HALF DOZEN GROUP).

BIB: *Rules of the Queensland Wattle League*, Brisbane, 1932; Vida Lahey, *Art in Queensland 1859–1959*, Jacaranda Press, Brisbane, 1959.
(*See also* HALF DOZEN GROUP OF ARTISTS)

QUINN, James Peter
(b. 4/12/1869, Melb.; d. 18/2/1951, Prahran, Vic.) Painter.
STUDIES: NGV School, 1886–93; Julian's, Colarossi and Delacluse Academies, and Ecole des Beaux-Arts with Jean Paul Laurens, Paris, c. 1894–1902. He married a French student, Blanche Guernier, moved to London c. 1902 and exhibited at the RA. The years 1903–05 saw the birth of two sons, René Robert and Roger, and the family group became a subject that Quinn painted many times. His *Mother and Sons*, painted in 1910, won an honourable mention at the French Salon of 1912. He served as an official war artist during World War I and in 1919 he was appointed as an official artist, Canadian War Records, together with the British artists Augustus John, William Orpen, Paul Nash, Wyndham Lewis, and another Australian, George Coates. He established an impressive London reputation as a portrait painter of notable people, including military and political leaders and members of the aristocracy, his only apparent disadvantage being his lifestyle, 'that of "bon vivant", with just a touch of the larrikin'. He became a member of the Royal Inst. of Painters in Oil and Royal Society of Portrait Painters, and generally enjoyed a successful career in London. This came to an end with the tragic death of his son René. This event appears to have wrecked his family life and when he returned to Australia, where he spent the remainder of his life (from c. 1937), he went alone. Back in Melbourne he was elected president of the VAS, 1937, and with the exception of one year (1946–47), remained so until his death in 1950. He mixed freely in the local art world, opposed the formation of the Australian Academy of Arts, became a member of the Savage Club, a member of the steering committee of the 1951 National Theatre Arts Festival, and completed a number of portrait commissions. Nevertheless he appeared as an isolated and lonely figure. He taught briefly at his old school, the NGV, became 'Jimmy Quinn' to the

students (for whom he had great affection), led a Bohemian life that seemed often to border on poverty and in numerous ways estranged himself from his contemporaries. This tended to obscure his true status as a painter and it was not until the commemorative exhibition organised by Alison Fraser for the VCA in 1980 that his real command of the formal elements of portrait painting became generally known and acknowledged. Strong in structure and in drawing, his portraits have a lyricism and show a capacity for character analysis that lifts them well above the academic standards of his time.

AWARDS: NGV Travelling Scholarship, 1893; honourable mention, Old Salon, Paris, 1912; Crouch Prize, Ballarat, 1941.

REP: NGA; AGNSW; AGSA; NGV; QAG; AWM; regional galleries Ballarat, Bendigo, Castlemaine, Fremantle, Geelong, Hamilton, Newcastle, Shepparton.

BIB: Most general books on Australian art history including Moore, SAA.

R ADFORD TO RYDE

RADFORD, Ronald Warwick
(b. 3/12/1949, Warragul, Vic.) Painter, gallery director, curator.
STUDIES: RMIT, 1967–70. He exhibited his abstract paintings at the Warehouse Gallery, Melbourne in 1972, but is best known as a designer and gallery director. As director of the Ballarat Fine Art Gallery, he organised a number of important, original and well-researched exhibitions as well as initiating the formation of the RGAV Conservation Centre. In 1980 he moved to the AGSA, first as curator and senior curator, and in 1991 became director.
AWARDS: Travel grant, VACB, 1983; Churchill Fellowship, 1989; Huntington Research Fellowship, 1990; fellowship in British Art, Yale Center for British Art, 1990.
APPTS: Education Officer, NGV, 1971–72; director, Ballarat Fine Art Gallery, 1973–80; board member, AGDC, 1977–80; curator of painting and senior curator of Australian and European Art, AGSA, 1980–90; director AGSA 1991– .

RAE, Iso (Isobel)
(b. 1860, Melbourne; d. ?) Painter.
STUDIES: NGV School 1877–87 and life classes with George Folingsby. Her student work in Melbourne, along with that of her sister Alison received favourable comments. Their family moved to Etaples, France in 1887 where they became friends with artists including Rupert Bunny and exhibited in Paris and London 1891–92. During World War I she worked at Etaples, France. Her known work shows her as a capable painter working in a romantic tradition. Nothing is known of her life following the First World War. She was represented in *Completing the Picture: Women Artists of the Heidelberg Era* Heide and touring, 1992 and *A Century of Australian Women Artists 1840s–1940s* Deutscher Fine Art, Melbourne, 1993.
BIB: Catalogue essays exhibitions as above. Janine Burke, *Australian Women Artists 1840–1940* Greenhouse, Melbourne, 1981. A&A 14/3/1977.

RAE, John
(b. 1813; arr. Sydney 1838; d. 1900) Painter. Appointed commissioner for the exhibitions of the Society for the Promotion of the Fine Arts, Sydney, 1847 and 1849, he exhibited landscapes, portraits and views of Sydney in the first but was not represented in the second. His painting in the Dixson Gallery, *Supreme Court and St James Church from Elizabeth Street*, 1842, is precise and somewhat mechanical in style. He also published a number of books (including *The Shield and Hammer Won*, Hutchinson, London, 1882; *Stanley Cordon*, Scott, London, 1889) and became a photographer in the 1850s, displaying his 'panoramic views' at several contemporary exhibitions including the Melbourne 1888 *International Exhibition*. His work was represented in *Shades of Light*, NGV 1988 and *Tasmanian Vision* TMAG and QVMAG 1988.
REP: Dixson Gallery of the Mitchell Library, Sydney.
BIB: *ADB* 6. Kerr, *DAA*.

RAFT, Emanuel (Emanuele RAFTOPOULOS)
(b. 1938, Suez, Egypt; arr. Aust. 1956) Painter, jewellery designer.
STUDIES: Brera Academy, Milan (with Luciano Minguzzi); Italy, 1959–60; M. Arts, City Art Institute, 1986. Raft's abstract-expressionist paintings appeared first in Sydney exhibitions, as stark, white, skeletal shapes painted on dark grounds; as his work developed, his colours gradually softened, became more varied and the painted surfaces were often enlivened with areas of collage. He contributed monolithic abstract sculptures to *The Field* (NGV, 1968), and has since held a number of exhibitions of jewellery, paintings and sculptures including four with Coventry, Sydney 1986–90.
AWARDS: Young Contemporaries award, CAS, Sydney, 1964; RAS, NSW Easter Show prize, 1964; Rural Bank, John F. Kennedy Memorial prize, Sydney, 1964; residency Cité des Arts Internationale studio, Paris, VACB, 1989.
REP: NGA; AGNSW; AGSA; NGV; QAG; Parliament House; Bathurst regional gallery; Mertz Collection, NY.
BIB: *New Art Five*.

RAGLESS, Maxwell Richard Christopher
(b. 10/8/1901, Adelaide; d. 1981) Painter.
STUDIES: No formal training. From 1920–51 he kept

a vineyard in SA, and taught himself to paint in his spare time. He became a camouflage officer, Dept of Home Security, 1941–43, during World War II and, from 1945, an official war artist. His landscapes and oil paintings of coastal scenes and boats are painted in a vigorous and direct style.

AWARDS: Prizes at Ballarat, 1944; Bendigo, 1945; Ferntree Gully, 1945; Dunlop contests, Melbourne, 1952, 53; Albury, 1954; Caselli Richards, Brisbane, 1959; Taree, 1964.

REP: AGNSW; AGSA; AGWA; NGV; QAG; TMAG; AWM; regional galleries Ballarat, Castlemaine, Shepparton.

BIB: John Kroeger, *Australian Artists*, Renniks, Adelaide, 1968.

RAGUS, Aurel (John)

(b. 1923, Bucharest, Romania; arr. Aust. 1950) Sculptor. STUDIES: Switzerland; Italy, marble carving at Milan and Carrara. His Australian commissions include a fountain for John Curtin House, Barton, ACT, 1975, and three sculptures for ANU, Canberra.

BIB: Scarlett, *AS*.

RAIMONDE, Rene

(Active 1880s, Tas.) Painter. Known for paintings of Tasmanian pastoral landscapes with houses. His work was seen in the AGDC touring exhibition *The Art of Gardening in Colonial Australia*, 1979.

REP: QVMAG.

RAMSAY, Gwen and Jean

See TURRAMURRA WALL PAINTERS

RAMSAY, Hugh

(b. 25/5/1877, Glasgow; arr. Aust. 1878; d. 5/3/1906, Vic.) Painter, organist, choirmaster.

STUDIES: NGV School, 1894–99; Académie Colarossi, Paris, 1900–02. He was organist and later choirmaster at the Congregational Church, Ascot Vale. Runner-up for the NGV travelling scholarship, 1899, he travelled to Europe in the same ship as the winner of the NSW travelling scholarship, G. W. Lambert, with whom later he spent much time copying old master paintings in the Louvre. An artist of great talent and sensitivity, he responded strongly to the example of Velazquez and to the influence of near contemporaries such as Whistler. Four of his five paintings submitted were hung in the New Salon of 1902 and his work appeared also in the *British Colonial Exhibition* and at the Royal Inst. Galleries, London. However his health, never robust, broke down, largely because of the severity of the Paris winters and straitened financial circumstances. It is recorded that Nellie Melba (later Dame Nellie) contributed £100 for his fare back to Vic. and subsequently paid the costs of his first exhibition there. During the remaining four years of his life his paintings included more than 20 full-length portraits, including portraits of Arthur S. McKenzie and his wife, of Barnawatha Station, Vic., where he spent much of his time. Widely considered

Hugh, Ramsay, David Mitchell esq., *1903, oil on canvas, 122 × 91cm. Collection Castlemaine Art Gallery (gift of Dame Nellie Melba, 1924).*

to be the most brilliant prospect in the Australian art of the decade, he was able to endow the portrait with a felicity, poetic feeling and an objectivity that fully endorses that claim. Most of his canvases have the silvery quality of his admired masters – all portrait painters and including Manet. His work appeared in the Bicentennial exhibition *The Great Australian Art Exhibition*. An exhibition of his work was held at the NGV 1992.

AWARDS: NGV School prizes, (painting from the nude) 1896, 98, 99, (drawing figure from life) 1898.

REP: NGA; AGNSW; AGSA; AGWA; MAGNT; NGV; QAG; QVMAG; TMAG; regional galleries Ballarat, Castlemaine, Geelong.

BIB: All general books on Australian art history and catalogue essays exhibitions as above. Edward A. Vidler, foreword, *The Art of Hugh Ramsay*, Fine Art Society, Melbourne, 1918. John Kroeger, *Australian Artists*, Renniks, Adelaide, 1968. A&A 4/3/1966 (Patricia Gourlay, *Two Portraits Re-examined*).

RAMSDEN, Melvyn

(b. 1944, Nottingham, Eng.; arr. Melb. 1963) Conceptual artist.

STUDIES: NGV School, 1963. In 1964 he left Melbourne for London and from 1967 lived in New York where his interests included exhibitions of conceptual art at the Dwan Gallery. In 1969 he held an exhibition of conceptual art in company with Ian Burn and Roger Cutforth (qq.v.) at the Pinacotheca Gallery, St Kilda, Vic. His *Secret Painting*, comprising an unequal division of dark and light areas, bore an explanatory note pinned on the light side and headed 'Secret Painting (2)': 'The context of this painting is invisible, the character and dimensions of the content is to be kept permanently secret, known only to the artist.' One of his conceptual paintings (gloss enamel on canvas) was included in *The Field* (NGV, 1968), and his influence on his Melbourne colleagues – specifically Paul Partos and Trevor Vickers (q.v.) – was noted in the catalogue of that exhibition.

NFI

RANDALL, Alfred

(b. 1831, Somerset; arr. Tas. c.1853; d. 1912) Painter. A nephew of Mary Ann Piguenit (q.v.), he lived in Tasmania and visited the Victorian goldrush where, c.1855, he painted *Newstead Hotel, 1855* (collection Castlemaine Gallery). He moved to New Zealand in the late 1850s until c.1865, then returned to Hobart to become director of the public service. He continued to paint, including a map of the landscape of the water works at Hobart and a number of other graphic works (book title pages, illuminated addresses), as well as lithographing a number of other artists' work (notably W. C. Piguenit (q.v.), with whom he maintained a close association).

BIB: C. Craig, *More Old Tasmanian Prints*, Foot & Playstead, Launceston, 1984. McCulloch, AAGR. Kerr, DAA.

RANDALL, Richard John

(b. 7/2/1869, South Brisbane; d. 15/10/1906, Birkdale, Qld) Painter.
STUDIES: South Brisbane Tech. Coll., with Joseph Clarke, c.1890–91; Herkomer's School of Art, Bushey, UK, 1891–95. He exhibited at the RA, completed portrait commissions in his London studio, visited Europe, and returned to Brisbane in 1899 to conduct classes in South Brisbane in a studio built for him by his father. He was vice-president of the Qld Art Society, 1902–06, and of the Brisbane Sketching Club, 1904–06. An energetic and prolific painter, his sudden death at the age of 37 short a career marked by exceptional early success. In 1914 the Randall Gallery was created on the first floor of the South Brisbane Public Library (later transferred to the City Hall, Brisbane) as a memorial, housing 600 Randall works presented by his father.
AWARDS: Scholarship at Herkomer's School, c.1894.
REP: AGNSW; QAG.
BIB: Henry A. Tardent, *Life and Work of Australia's Greatest Artist, Richard John Randall*, Government Printer, Brisbane, ?1914. Julie K. Brown and Margaret Maynard, *Fine Art Exhibitions in Brisbane, 1884–1916*, Fryer Memorial Library, Uni. of Qld, 1980.

RANKIN, David

(b. 19/12/1946, Plymouth, Eng.; arr. Aust. 1949) Painter, teacher.
STUDIES: No formal training. He taught art, 1966–74, and between 1968 and 1990 held over 70 exhibitions in Sydney (including Watters, Macquarie), Brisbane (including at Ray Hughes, Michael Milburn), Melbourne, (including at Charles Nodrum, Realities, Tolarno), Canberra (Abraxas) and New York. His early paintings concerned mainly technological innovation and its application to observed natural phenomena. Landscape has always been an important part of his work and his 1980s abstract works are distinctive for their use of strong brush strokes, swirling, dribbled paints and earthy colours. He founded Port Jackson Press. In the mid-1980s his work also encompassed the Jewish world of his wife, poet Lily Brett, with a series of paintings based on her poems, *The Auschwitz Poems*, 1987; *The Paintings of Lily*, 1987 and *The Jerusalem Paintings*, 1989. His work appeared in numerous group exhibitions in public and private galleries including *Figures and Faces Drawn from Life*, Heide, 1983; *Surface for Reflexion*, AGNSW 1986 and in a number of art fairs in the US and Australia. He illustrated a number of books of Lily Brett's poems and other writings and in 1989 he and his family moved to New York where he regularly exhibits, continuing also to exhibit in Australia.
AWARDS: Prizes in competitions at Campbelltown, 1970; Brisbane (L. J. Harvey drawing prize); Armidale, NSW; Ballarat (purchase of drawing), 1971; Gold Coast City, Leichhardt, 1972; Orange, Muswellbrook, Westfield Miranda Fair, Brisbane (Darnel de Gruchy), Wollongong (purchase), Berrima, 1973; Stanthorpe, Qld, 1974; Maitland, 1975; Cairns, 1976; Fremantle Print Award, 1978; Alice Prize, 1979; Uni. of NSW Art Prize, 1980; Wynne Prize, AGNSW, 1983; Gold Coast City Art Prize, 1986; Borough National Drawing Prize, Bendigo, 1988.
REP: NGA; AGNSW; QAG; TMAG; a number of regional gallery collections including Armidale, Ballarat, Gold Coast, Newcastle; many tertiary collections including ANU, Qld and Sydney unis.; corporate collections including Robert Holmes à Court, NAB, Loti and Victor Smorgon, BHP.
BIB: Many general texts on Australian art including Horton, AP; Bonython MAP, 1976; McIntyre, ACD. Gary Catalano, *The Years of Hope*, OUP, Melbourne, 1981. A&A 18/2/1980 (Gary Catalano, *David Rankin*).

RANKINE, Susan

(b. 1954, Adelaide) Painter.
STUDIES: Dip. Fine Art, SASA, 1974; Dip. Ed., Torrens CAE, 1975; Grad. Dip. Fine Art (painting), VCA, 1981. She held five solo exhibitions 1981–88, largely at Realities Melbourne and Gippsland Inst. of Technology, 1984. Her work appeared in numerous group exhibitions 1981–91, largely at public galleries including graduate exhibitions at the VCA and NGV in the early 1980s; *Australian Perspecta '83*, AGNSW 1983; *A First Look: Philip Morris Arts Grant Purchase 1983–1986*,

NGA; *Young Australians: The Budget Collection*, NGV 1987; *A New Generation*, NGA 1988. She was artist-in-residence at the VCA in 1984 and curated an exhibition, *Bone*, at 200 Gertrude St, 1988.

AWARDS: VACB project grant 1984; residency, Greene Street Studio, NY, 1986.

REP: NGA; NGV; Artbank; several tertiary and corporate collections in Aust. and overseas.

BIB: Catalogue essays exhibitions as above. Leon Paroissien, *Australian Art Review 2*, Warner Associates Sydney 1983. AL 6/2–3/1986; 5–6/1986.

RANSOME, *Joanna*

(b. 18/8/1957, London) Painter, critic.
STUDIES: Grad. Dip. Art Education, Victoria Coll., 1980; Postgrad. Dip., Chelsea School of Art, London 1980; BA (Fine Art), Monash Uni., 1983. She held six solo exhibitions 1980–92 at Melbourne galleries including VCA 1980, ROAR Studios 1984. Her work appeared in several group exhibitions 1977–91 including local art prizes and *Take A Seat*, designers' and artists' exhibitions, Blaxland Gallery, Sydney 1990. She reviewed the visual arts for the ABC, *Geelong Advertiser* and *Melbourne Times*, 1984– .

AWARDS: Caltex Prize (painting) 1980.

APPTS: Lecturer painting, drawing several tertiary colleges in Vic. including Ballarat, RMIT.

REP: Artbank; tertiary colleges Vic.

BIB: Germaine, DAWA. Germaine, AGA.

RAPER, *George*

(b. 1768 or 1769; arr. Aust. 1788; d. 1797) Draughtsman, ship's officer. Early maritime draughtsman, midshipman and later lieutenant on HMS *Supply*. He is known for his paintings of Port Jackson, Norfolk and Lord Howe Islands, and for his studies of birds. Seventy-three watercolour drawings by Raper (Godman collection) are on loan to the British Museum; two volumes of drawings of flowers, plants and fish are in the Mitchell Library, Sydney; 66 watercolours in the Alexander Turnbull Library, Wellington, NZ.

BIB: Rienits, *Early Artists of Australia*, 1963. ADB 2. Smith, EVSP. Kerr, DAA.

RAPOTEC, *Stanislaus*

(b. 4/10/1913, Trieste; arr. Adelaide 1949) Painter, teacher.
STUDIES: Uni. of Zagreb (economics, history of art), 1933–39; travel studies, Vienna, Prague, Venice, Sofia, Istanbul. During World War II he served in the Yugoslav army in Bulgaria, Romania, Greece, Italy and the Middle East, attaining the rank of captain. Migrating to Australia, 1949, he resumed his career as a painter in Adelaide where he became a leading figure in the modernist movement before moving to Sydney (1955), where he finally abandoned figurative painting for more abstract, more dynamic forms of expression. In 1961 he won the Blake prize with a large, mural-sized painting entitled *Meditating on Good Friday*. The award caused a press controversy from which he emerged as a leader of Sydney's new school

Stan Rapotec, Experience in Seville Cathedral, *1966, synthetic polymer paint on composition board, 182.8 × 137.3cm. Collection QAG.*

of abstract-expressionism. His painting remained consistently abstract-expressionist from that time, its large, rolling forms and spacious rhythms being seen as complementary to the artist's personality. Judy Cassab's portrait of him was awarded the Archibald Prize in 1960. For many years he taught privately in Sydney and conducted summer schools for the Uni. of New England at Armidale, NSW, and held a number of exhibitions in Australian capital cities and London. In 1976 the death of his wife upset the sequence of his life, and from then he spent much time travelling and working in Europe where he exhibits and occasionally in Australia – his work most often being seen in survey shows of Sydney abstract-expressionists of the 1960s.

AWARDS: Blake Prize, 1961; *Mirror*-Waratah Festival, two prizes, 1961, (for graphics) 1962; RAgSocNSW Easter Show (modern landscape), 1963.

REP: NGA; AGNSW; AGSA; AGWA; QAG; Newcastle Region Art Gallery; Vatican Museum for Contemporary Art, Rome.

BIB: All general books on contemporary Australian art including Smith, AP; Chanin, CAP. A&A 8/2/1970 (Laurie Thomas, *Stanislaus Rapotec*).

RATAS, Vaclovas (Vaclovas RATAISKIS)

(b. 1910, Lithuania; arr. Aust. 1949; d. 1973) Graphic artist; printmaker.
STUDIES: Kaunas School of Art, 1935. Ratas was curator at M. K. Curlionis Museum, Kaunas, 1937–44, and principal of the art school at Augsburg, Germany, 1945–49. His abstract prints are bold and dynamic in style.
AWARDS: Diploma of honour at the *International Exhibition*, Paris.
REP: AGNSW; AGWA.

RAWORTH, William Henry

(b. c.1820, Eng.; arr. NZ 1850; d. 1905) Painter. He produced numerous watercolour views of Australian and New Zealand places of interest, exhibited in Christchurch, 1871, and in Melbourne the following year. He travelled extensively and his work often appears in fine art auctions. He was represented in the Bicentennial exhibition *The Great Australian Art Exhibition* 1988–89. He produced a series of advanced drawing copies of *Sydney Harbour and Neighbourhood*, Sydney, ?1875.

RAYNER, Henry Hewitt

(b. 1903, Brighton, Vic.; d. 1957) Etcher.
STUDIES: Melbourne (with Charles Nuttall); RA Schools, London (with Walter Sickert). Rayner migrated to England in 1924 and worked in comparative obscurity until his drypoint etching of King George VI brought him into prominence when it was bought by Queen Mary in 1939.
REP: Print collections at the National Portrait Gallery; Ashmolean Museum; British Museum and Royal Collection, Windsor.

READ, Arthur Evan

(b. 1911, Melb.; d. Aug. 1978, London) Painter, teacher.
STUDIES: NGV School, c.1935. After training in Melbourne, he went to Sydney in 1943, thence to northern Qld and finally to Brisbane, working his way as farmhand, fisherman, cane-cutter, etc. He became a leading representational painter of Qld subjects and contributed regularly to the Wynne Prize competitions and NSW Society of Artists annual exhibitions in Sydney. He was an art teacher at Brisbane Tech. Coll. In 1969 he became a member of the committee of trustees of the QAG and was its acting director during the absence of Raoul Mellish overseas (six months), 1973.
AWARDS: Wynne prize, 1954; Henry Caselli Richards prize, 1955; Harvey drawing prize, 1957; Brisbane Eisteddfod Centenary prize, 1959.
REP: AGNSW; AGSA; QAG; TMAG; uni. collections in NSW, Qld and Canberra.
BIB: Vida Lahey, *Art in Queensland 1859–1959*, Jacaranda Press, Brisbane, 1959.

READ, Charles Rudston

(b. 16/5/1818; arr. Aust. 1838; d. 1854) Sketcher,

naval officer, administrator, author. He first visited Australia as a naval officer in 1838. His journeys took him to NZ and many other places in the South Pacific and by 1851 he had joined the gold rush to NSW. Later he was assistant gold commissioner at Mt Alexander, Vic., and probably returned to England in 1853 for the publication of his book, *What I Heard, Saw and Did at the Australian Gold Fields*, which he wrote and illustrated with coloured lithographs and wood engravings.
REP: NLA; Dixson, Mitchell Libraries.
BIB: J. A. Ferguson, *Bibliography of Australia* vol. 7, NLA, 1969. McCulloch, AAGR. Kerr, DAA.

READ, Richard (I)

(b. ?1765, Eng.; arr. Sydney 1814) Painter.
STUDIES: ?With Sir Joshua Reynolds. Convict artist; portrait painter and painter of allegories. Sentenced to 14 years transportation for unspecified crimes, Read claimed to have been taught by Sir Joshua Reynolds, and was indeed a prolific worker in various fields of painting practice. He conducted a school in Sydney from 1813, having been granted a ticket of leave by Governor Macquarie soon after his arrival. Read opened a drawing and painting school and painted portraits including several of Governor Macquarie and his wife as well as views of Sydney. Granted an absolute pardon in 1826, he may have returned to the UK. A portrait of Read's of Macquarie is in the Mitchell Library, Sydney, another of Mr and Mrs Macquarie in the collection of the TMAG. His style of portraits was rather in the 'grand manner', with backgrounds of allegorical scenes against which the faces were detailed finely, while his views of the Harbour and Sydney environs were more literal. He was represented in *The Artist and the Patron*, AGNSW 1988 and the Bicentennial exhibition *The Great Australian Art Exhibition*.
REP: TMAG; Newcastle regional gallery; NLA; Mitchell Library.
BIB: Rienits, *Early Artists of Australia*, 1963. ADB 2. Marjorie Wymark, *Governor Macquarie and the Case of the Court House Portrait*, Hawkesbury Press Printers, Windsor, NSW, 1979. Kerr, DAA. AA no. 10, 1921 (*The Macquarie Book*).

READ, Richard (II)

(b. 1796, Ireland; arr. Sydney 1819; d. 16/1/1862, Melb.) Painter. Son of the first Richard Read, he arrived in Sydney as a free settler. There was apparently rivalry between father and son as the first Richard Read advertised that 'he had no connection whatever with any other person in the same profession' (*Sydney Gazette*, 24 Feb. 1821). His portraits were more straightforward than the first Richard Read's and the subjects were the middle class of the colony. He had a long and successful career as a portraitist in Sydney and was exhibiting in the 1849 Society for the Promotion of Fine Arts in Australia. William Moore says that Read II was painting miniatures in 1850, six years after the daguerreotype had put his colleagues out of business. He moved to Victoria in the late 1850s, where he died. His work appeared in *The Artist*

and the Patron, AGNSW 1988 and *The Great Australian Art Exhibition* 1988–89.
REP: NGA; Ballarat Fine Art Gallery; NLA; Mitchell, La Trobe Libraries.
BIB: Rienits, *Early Artists of Australia*, 1963. ADB 2. Eve Buscombe, *Artists in Early Australia and their Portraits*, Sydney 1978. Kerr, DAA.

REARDON, Raymond Edward
(b. 10/12/1939, Gundagai, NSW) Painter, printmaker, lecturer.
STUDIES: TPTC, Bendigo Teachers Coll.; Dip. Art, Gordon Inst., 1972; travel studies, Europe, UK and USA, 1974. His colourful abstracts appeared in exhibitions in Adelaide and Melbourne as well as in group exhibitions. He held about 13 exhibitions from 1974 to the mid-1980s, including while artist-in-residence at Melbourne Uni. and a touring exhibition to regional galleries in Vic. He had several commissions including a series of paintings for Pyramid Building Society and Deakin Uni. as well as collaborating on a film. His other activities include producing a number of stress management videos and seminars.
AWARDS: Inez Hutchison award, 1968; Bacchus Marsh prize, 1972.
APPTS: Part-time senior lecturer, Deakin Uni.
REP: Regional galleries including Albury, Geelong, Sale; Pyramid Building Society.

RECKNALL, Harry
See CHARTERISVILLE

RECORD, A. C.
(b. ?Tas.) Sculptor.
STUDIES: Blackheath School of Art, UK, c.1919. During World War I, after service with the AIF, he made plaster casts from drawings by Daryl Lindsay at the military hospital at Sidcup, Kent.
BIB: Moore, SAA

REDDINGTON, Charles
(b. 1929, Chicago; arr. Aust. 1959) Painter.
STUDIES: Chicago Art Inst.; Uni. of Chicago. The nude which becomes the landscape was the main theme of his semi-abstract, symbolic landscapes. Flat forms and a range of colours, including mainly black, white, yellow and red, relate his work distantly to Antipodean School painting. He returned to the USA during the late 1960s.
AWARDS: Poster prize, Adelaide Festival of Arts, 1962; W.D. & H.O. Wills prize, 1963; Mosman prize, 1963; Tumut prize, 1964; Maitland prize, 1964.
APPTS: Lecturer, RMIT, 1959–60; SASA, 1960–63; teaching in Sydney, 1963.
REP: NGV.
BIB: Exhibition catalogue, Mertz Collection, *Australian Painters 1964–66*, Griffin Press, Adelaide, 1966.

REDPATH, Norma
(b. 1928, Melb.) Sculptor.
STUDIES: Swinburne Tech. Coll., 1943–44 and 1946–48; RMIT, 1949–51; travel studies in Europe, 1956–57. Immaculate in finish and stylistically related to the work of the British sculptor Barbara Hepworth, her early work attracted attention at Centre Five exhibitions and at the annual exhibitions of the Vic. Sculptors Association, of which she was a council member and vice-president. An Italian scholarship took her overseas again in 1962, when she worked in bronze-casting foundries and established a headquarters in Milan. From then she travelled much between Italy and Australia and Italian became her second language. The strength of her development became widely known through her first major Australian exhibition of bronze castings at Gallery A, Melbourne, 1963. From 1951 she was awarded many commissions, a number being of major importance, including bronze reliefs for BP offices in Melbourne and Westernport, 1964; the *Treasury Fountain*, Canberra, 1965–69; Vic. State Coat of Arms, façade, NGV, 1968; sculpture column, Reserve Bank, Brisbane, 1969–72; Sydney Rubbo memorial, Uni. of Melbourne, 1970–74; *Extended Column*, Canberra New School of Music, 1972–76. A dedicated artist of prodigious energy throughout her career, her contribution to the development of Australian sculpture has been far-reaching and continuous.
AWARDS: Stanley Hammond prize (Vic. Sculptors Society), 1953; Baillieu Library mural competition (Uni. of Melbourne), 1958; Italian Scholarship, 1962; Dyason Scholarship (AGNSW), 1961; Mildura prize for sculpture, 1961, 64; Transfield prize for sculpture, 1966; Myer Foundation grant, 1970; Creative Arts Fellowship, ANU, 1972; OBE conferred, 1970.
APPTS: Teaching, Korowa C. of E. Girls Grammar School, Melbourne, 1953–54; Swinburne Tech. Coll., 1958.
REP: NGA; AGNSW; AGWA; NGV; regional galleries Mildura, Newcastle; Uni. of Melbourne; many works for public buildings.
BIB: A number of general texts on Australian art including Scarlett, AS; Sturgeon, DAS. Lenton Parr, *Sculpture*, Arts in Australia series, Longman, Melbourne, 1961. *Norma Redpath*, Grayflower Publications (for Gallery A, Melbourne), 1963. A&A 6/3/1968 (A. McCulloch, *Norma Redpath's Bronze Coat of Arms*).

REED, John
(b. 1901, Tas.; d. Dec. 1981) Art patron, gallery director. Founder and first director of the Museum of Modern Art and Design of Australia, Melbourne, 1958–65; joint editor and publisher (with Max Harris) of *Angry Penguins*; president of the Contemporary Art Society, Melbourne, 1940–43 and 1953–58; founder of the Gallery of Contemporary Art, 1958. John Reed and his wife Sunday (*née* Baillieu) jointly presented their entire collection of Australian art, including Sidney Nolan's first series of Kelly paintings, to the Museum of Modern Art and Design in 1958 to provide a nucleus for the Museum collections. The collection reverted to the Reeds when the MOMAD ceased operations in 1966, and was subsequently given, in part, by Sunday Reed to the NGA. Reed wrote many

articles on artists including in A&A (4/2/1966, *Danila Vassilieff, Cossack and Artist*); (5/1/1967, *John Perceval*); (5/2/1967, *Nolan's Kelly Paintings*). In 1979 the Reeds sold the rest of their collection and property, *Heide*, at Bulleen, to the Victorian state government for development as a public art gallery. John and Sunday Reed both died soon after the gallery was opened. Their life has since been documented in books such as Richard Haese's *Rebels and Precursors* (Viking, 1981) and in a number of monographs on artists associated with their circle, notably *Sidney Nolan: Such is Life*, Brian Adams (Hutchinson Australia, 1987) and *Joy Hester*, Janine Burke (Greenhouse Publications, Melbourne, 1987).

BIB: Publications as above. A&A 6/2/1968 (Neil Clerehan, *Heide*); 20/1/1982 (obituary)

(*See also* GALLERIES – PUBLIC, MUSEUM OF MODERN ART AT HEIDE PARK AND ART GALLERY)

REED, Joseph

(b. 1822, Cornwall; arr. Vic. 1853; d. 1890) Architect. Reed arrived in Victoria with the gold rush and remained to shape the character of Melbourne's city architecture in elegant, old-world style. Among Reed's many important buildings are the original State Public Library, Museum and Art Gallery, the Exhibition Building, Melbourne Town Hall, Wesley Church, Independent Church, Scots Church, the old Eastern Market (demolished), and Ormond Coll., Uni. of Melbourne.

REED, Sweeney

(b. 1945, Melb.; d. 1979, Melb.) Gallery director, painter. The son of Albert Tucker and Joy Hester, he was adopted by John and Sunday Reed when his natural parents separated. His heritage and lifelong association with artists shaped his career. From 1966 to 1970 he conducted Strines Gallery in Faraday Street, Carlton, providing a valuable outlet for the work of young, modernist artists, and from 1972 to 1975 the Sweeney Reed Gallery in Brunswick Street, Fitzroy. He held an exhibition of his own work, entitled *Moments of Mind*, at Tolarno Galleries, 25 May 1977. A posthumous exhibition held at Tolarno some time after his tragically premature death showed him as a lyrical painter of small works on paper.

REES, Lloyd Frederic

(b. 17/3/1895, Yeronga, Qld; d. 2/12/1988) Painter, teacher.

STUDIES: Brisbane Tech. Coll., with Godfrey Rivers, Martyn Roberts and L. J. Harvey, day-classes 1910, evening-classes 1911–14, day-classes 1916; travel studies, UK and Europe, 1923–24 (he drew from the model at the Chelsea Polytechnic and attended a life class in Rome). At the age of 13 he copied some reproductions of drawings of Italian towns and villages by Joseph Pennell, discovered in an omnibus volume of *The Century Magazine*. The careful, analytical and, at the same time, sensuous approach that prompted him to make these copies remained central to his art. From

1912 he worked in the Qld government printing office and in 1917 he moved to Sydney to join the advertising office of Smith and Julius. He exhibited with the RAS and NSW Society of Artists, and in Europe, 1923, discovered for himself the landscape of Tuscany, familiar from his early studies of Pennell's drawings. He married Marjorie Pollard in 1931 and in the same year held his first exhibition with the Macquarie Galleries, Sydney. His son, Alan Lloyd Rees, was born in 1934. He travelled again in Europe 1952–53, 1959–60 and 1966–67. Throughout his long career his work was widely accepted by all factions, largely because of its underlying sincerity and unpretentiousness. As well as painting and drawing he wrote several books (including *The Small Treasures of a Lifetime*, Ure Smith, Sydney, 1969). In 1942 its status was affirmed by a large retrospective exhibition at the AGNSW, and again (1969–70) by a national exhibition that toured all state galleries and one regional gallery (Newcastle). Painted, drawn, etched or lithographed, his work has in it a quality of monumental grandeur that comes from careful investigation of a new experience, presented as if for the first time. In his later years he renewed his energies with excursions into printmaking, notably with a folio of softground etchings of Sydney Harbour, 1978, and a folio of 17 large lithographs, *The Caloola Suite*, 1980. In 1981 the Uni. of Melbourne Gallery organised a retrospective exhibition of his work and in 1987 he revisited Paris when the city of Paris awarded him the Medaille de la Ville de Paris, in recognition of his standing as an artist. In 1988 he was included in the Australian Bicentennial Authority's *Two Hundred People who made Australia Great*; *The Great Australian Art Exhibition The Face of Australia*. His autobiography, *An Artist Remembers*, was published by Craftsman House in 1987. He remained actively painting and drawing until his death in Hobart, at the age of 93. In 1993 an exhibition *The Road to Berry* linking his drawings with those of his friend and admirer Brett Whiteley was held at Heide and the AGNSW.

AWARDS: Silver medal, *Paris Exposition*, 1937; Godfrey Rivers prize, 1941; Wynne prize, 1950, 82; Commonwealth Jubilee prize, 1951; Dunlop prize, 1954; RAgSocNSW Easter Show prize, 1958; Henry Caselli Richards prize, Brisbane, 1964; Hon. Doctorate of Letters, Uni. of Sydney, 1970 and Uni. of Tasmania, 1984; CMG conferred, 1977; Companion of Order of Australia (AC), 1985; Medaille de la Ville de Paris 1987.

APPTS: Lecturing and teaching (part-time), history of art, and teaching painting and drawing, Uni. of Sydney, 1946–70; Sydney adviser to Felton Bequest, NGV; adviser to Bendigo Art Gallery, 1949; president, NSW Society of Artists, 1961–65; member, National Advisory Committee for UNESCO and chairman of the Visual Arts Committee, 1964–69.

REP: NGA; AGNSW; AGSA; AGWA; MAGNT; NGV; QAG; QVMAG; TMAG; many regional galleries, as well as uni. collections; numerous corporate and private collections.

BIB: All general texts on Australian art history including Smith, AP and catalogue essays exhibitions as above. Renee Free, *Lloyd Rees*, Lansdowne, Melbourne, 1973; Hendrik Kolenberg, *Lloyd Rees: Etchings and Lithographs: a catalogue raisonné*, The Beagle Press, Sydney 1986. A&A 18/2/1980 (Lou Klepac, *Homage to Lloyd Rees*); 26/3/1989 (obituary).

REEVE, Alan
(b. 1910, NZ; d. 1962, Sydney) Caricaturist, journalist.
STUDIES: No formal training. Itinerant caricaturist and journalist who worked and exhibited in Australia, 1934–36. His work appeared in American magazines including *Fortune, Town and Country* and *Vogue* and he wrote a book (text and illustrations) *Africa I Presume?*, Macmillan, New York, 1948.

REEVE, Edward
A founder of the New South Wales Academy of Arts in 1871; Reeve compiled a gazetteer of central Polynesia and wrote a treatise on education in NSW. He was also curator of the Nicholson Museum of Antiquities at the Uni. of Sydney, and compiled the first catalogue.

REGIONAL GALLERIES ASSOCIATION OF NEW SOUTH WALES
(Established 1972) c/o Art Gallery of New South Wales, Art Gallery Rd, Sydney, NSW 2000. Initiated in 1972 by David Thomas, director of the Newcastle Region Art Gallery, the RGANSW is a non-profit company established to promote the development of professionally designed and managed public art museums and galleries. It assists the galleries' collection, conservation and documentation of the visual arts for the education and enjoyment of the public. It is assisted by the Government of NSW through the Ministry for the Arts, the AGNSW, the VACB and gallery membership.

REGIONAL GALLERIES ASSOCIATION OF VICTORIA
(Founded 1957) c/o NGV, 180 St Kilda Rd, Melbourne. In 1944 or 1945, the director of the NGV, Daryl Lindsay, held a meeting at the NGV to discuss the state of the provincial art galleries at Ballarat, Geelong and Bendigo. The galleries which had begun so bravely during the 1880s were in a very depressed condition, receiving no official help of any kind and attracting little local interest. One of the first, Warrnambool, was no longer operative, and the others seemed about to close their doors. Present at the meeting were Daryl Lindsay, Alan McCulloch (art critic for the *Argus*) and Clive Turnbull (art critic for the *Herald*). Lindsay outlined the situation and it was unanimously decided to make every effort to try to restore the situation. Lindsay again approached the government and finally received, on behalf of the galleries, enough money to keep open the doors of these institutions. However it was not until some years later that a properly concerted move was made to try to establish all the provincial galleries on a sound financial footing.

In 1956 the Mildura Art Gallery was established, bringing the total number of provincial galleries to six – Ballarat, Bendigo, Castlemaine, Geelong, Mildura and Shepparton – and in 1957, at the suggestion of the new director of the NGV, Eric Westbrook, representatives of the six galleries met with him at the NGV to form the Victorian Public Galleries Group. From that grew the RGAV.

Key figure in the formative history of the RGAV and its development was its first hon. secretary and chairman (for 20 years), Donald Webb. Equally dedicated were many of the early delegates who gave him loyal support. Prior to the formation of the Victorian Public Galleries Group and the RGAV, the separate galleries had no funds, no voice and no muscle, and for a time seemed in great danger of being lost to the state of Victoria, along with their great collections. The work of the RGAV changed all that and indeed set an example to the whole of Australia. By 1980 there were 16 RGAV member galleries, namely: Ararat Gallery, Ballarat Fine Art Gallery, Bendigo Art Gallery, Benalla Art Gallery, Castlemaine Art Gallery and Historical Museum, Geelong Art Gallery, Hamilton Art Gallery, Horsham Art Gallery, Latrobe Valley Arts Centre, Mildura Arts Centre, Mornington Peninsula Arts Centre, McClelland Gallery, Sale Regional Arts Centre, Shepparton Art Gallery, Swan Hill Art Gallery, Warrnambool Art Gallery (see GALLERIES). The total value of the assets of the 16 galleries cannot be assessed in terms of money. The existence of the RGAV and its affairs had an important bearing on the formation of the Vic. Ministry of the Arts in 1975, and conversely the Ministry has had a vital influence on RGAV affairs.

A significant innovation in the 1980s was the establishment of the *Bank of Melbourne – Victorian Government Art Foundation* which funds purchases of up to $100,000 per year until 1995.

CONSERVATION CENTRE
12a Lydiard St North, Ballarat, Vic. 3350. The need for conservation of art works held in the regional galleries had long been obvious and in 1976 a move was initiated by the director of the Ballarat Fine Art Gallery, Ron Radford, to build an RGAV Conservation Centre in converted premises at Ballarat. The premises, originally the old Call Room of the Mining Exchange, adjoined the gallery and on 12 Nov. 1977, the new Conservation Centre was opened by the Mayor of Ballarat, Cr J. A. Chisholm. Funding for the conservation work came from the state government through the Ministry for the Arts, the Visual Arts Board, contributing RGAV galleries and the private sector (William Buckland, Utah, Ian Potter foundations and the Sidney Myer Charity Trust). Conservators have been 1977–79, Matthew Moss; 1979–83, David Lawrence (acting); 1981, Ian Fulton (paper conservator); 1983– , Mohammed Aman Siddique.

BIB: Annual reports of the RGAV; *The Visual Arts in Victoria. A Survey*, Vic. Ministry for the Arts (Arts Victoria), 1975. A&A 12/3/1974 (Donald Webb, *Regional Galleries Association of Victoria*).

Alison Rehfisch, The Patio, *oil on board, 49.5 × 39.5cm. Christie's, August 1992.*

REHFISCH, Alison Baily

(b. 1900, Sydney; d. 1975, Sydney) Painter.
STUDIES: Sydney, with Ashton and Rubbo; Grosvenor School, London, with Iain MacNab: travel studies, Europe, 1933–39. Known mainly for still-lifes. Throughout her career she collaborated with her husband, George Duncan (q.v.). After their first joint exhibition at the Macquarie Galleries in 1933, they exhibited at the Cooling Galleries, London (1934), together with Elaine Haxton and Gerald Lewers. She exhibited also in London with the Society of Women Artists and the Royal Oil Painters Inst. Returning to Sydney in 1939, she became an active member of the CAS and was included in the exhibition *Australian Women Painters* (AGNSW, 1946). The following year the studio she shared with her husband was destroyed by fire and they spent the next few years in Newcastle and Berrima. She died a few months after her husband's death and a memorial exhibition to the two artists was held at the Macquarie Galleries in 1976. In later years her work appeared in group exhibitions including a retrospective, *Duncan and Rehfisch* Macquarie Galleries, 8–25 Apr. 1976; *Australian Women Artists: One Hundred Years,* 1840–1940, Ewing and George Paton Galleries, Uni. of Melbourne and touring

1975–76; *Important Australian Women Artists,* Melbourne Fine Art Gallery 1993 and *A Century of Australian Women Artists 1840s–1940s* Deutscher Fine Art, Melbourne, 1993.
REP: AGNSW; QAG; Newcastle Region Art Gallery.
BIB: Catalogue essays exhibitions as above.

REID, A. G.

Sculptor.
STUDIES: Sydney, modelling classes conducted by Lucien Henry. A member of the RAS of NSW from 1894. His modelled and cast figure, *Defiance,* was acquired for the AGNSW.
BIB: Moore, *SAA.*

REID, David G.

(b. Scotland; d. 1933) Painter.
STUDIES: Lancastrian School, Edinburgh; RAS School, Sydney (with Daplyn and Ashton). Member of the RAS of NSW from 1890. He exhibited extensively in Sydney, showing mostly river landscapes which, though usually somewhat conventional in structure, were in the mainstream of local impressionist art.
REP: AGNSW; Manly Art Gallery.
BIB: Catalogue Manly Art Gallery. Moore, *SAA.*

REILLY, Henry

See RIELLY, Henry

REILLY, Virgil Gavan

Illustrator. Worked under the pseudonym *Virgil;* he worked as an advertising artist for films and became nationally famous for his drawings of women for *Smith's Weekly,* c.1920–40. He illustrated Kenneth Slessor's *Darlinghurst Nights,* with Frank C. Johnson, Sydney, 1933 (reprinted Angus & Robertson, Sydney, 1981).
BIB: Vane Lindesay, *The Inked-In Image,* Hutchinson, Melbourne, 1979.

REINHARD, Ken

(b. 17/3/1936, Mudgee, NSW) Painter, sculptor, lecturer.
STUDIES: NAS, 1954–56; Sydney Teachers Coll., 1957. His combination of conventional, sensuously presented female nudes with Optical and Pop art assemblages and Conceptual art backgrounds and accents, such as arrows and lettering, became well-known in modernist group exhibitions from the 1960s. Kinetic art was a later influence and helped in his shift of focus into the realms of abstract sculpture. Among his commissioned sculptures are those for Marland House, Melbourne, 1971, and Kingsgate Hotel, Kings Cross, Sydney, 1972. He exhibited frequently 1964–72 (about 16 exhibitions) in Sydney (Bonython, Bloomfield), Melbourne (South Yarra, Realities), Perth and Adelaide and participated in a number of group exhibitions 1959–92 including *Mildura Sculpture Triennial,* 1970; CAS, NSW exhibitions and many competitions including the *Wynne, Sulman* and *Transfield* prizes. However his exhibitions became less frequent in the 1970s and 1980s and his 1991 exhibition *Signs,* at Bloomfield

Galleries, Sydney, was the first major one for a number of years. While of current work, the well-presented catalogue that accompanied it included photographs of his work over the previous 20 years. His strong, clean images contain satire and social comment and his 1980s work was described by Betty Churcher in the exhibition catalogue: 'sensuous, glossy and vivid surfaces of the nude, the automobile or the freeway are the tools with which the artist manipulates formal relationships between two- and three-dimensional pictorial space . . . [he] is interested in signs and their ability to communicate – by scrambling his signs he both invites interpretation and resists it.'

AWARDS: Prizes at Ryde, 1963, 64; Drummoyne, 1964; second prize, Rural Bank, John F. Kennedy Memorial competition, 1964; Sulman prize, 1964; Sydney Trade Fair Art Award, 1965; Darcy Morris, 1966; Mosman, 1966; Mildura (purchase), 1970; Marland House sculpture award, 1971.

APPTS: Teaching, NAS, 1968; Industrial Design, Uni. of NSW, 1969–70; Dean, School of Art, Alexander Mackie CAE, 1974–81; member, VACB, 1980–83; director, City Art Inst., 1982–89; dean and director, Coll. of Fine Arts, Uni. of Sydney, 1990–

REP: NGA; AGNSW; AGWA; NGV; Artbank; a number of regional collections including Burnie, Wollongong, Mildura, Newcastle.

BIB: Sturgeon, DAS. Scarlett, AS. Catalano, *The Years of Hope* OUP, 1981. Smith, AP Germaine, AGA. AI 15/8/1972; 25/5–6/1980. A&A 5/4/1968; 9/4/1972.

RENDALL, W. G.

(Active c.1860–1900, Vic.) Painter. A landscape painter, his paintings seen in auctions include *The Digger's Home, Ballarat*, 1863, and *Aborigines on the Murray* (c.1893–96) at Leonard Joel, *Australian Paintings*, Nov. 1973, May 1975.

REVELEY, Henry Willey

(b. c.1779, Eng.; arr. Perth 1829; d. 27/1/1875, Reading, Eng.) Architect, engineer, amateur artist.
STUDIES: Pisa Uni. (engineering), c.1818. He formed a friendship with Shelley in Italy and later, in London, married Amelia, the sister of the painter Copley Fielding (*see* MARTENS, Conrad). In WA he worked as the civil engineer responsible for all public buildings until 1838. Interest of his watercolours is mainly historical. His work appeared in *The Colonial Eye*, AGWA 1979.
REP: NLA (Nan Kivell Collection).
BIB: Kerr, DAA.

REYNELL, Gladys

(b. 1881, Reynella, SA; d. 1956) Painter, printmaker, potter.
STUDIES: Adelaide, privately with Margaret Preston; Ecole des Beaux-Arts, Paris, 1914; London, pottery during World War I. She exhibited at the RA and at the Paris Salon before returning to SA, where initially she concentrated on pottery. Married in 1922, she

lived in Vic. and continued with painting and pottery as well as making decorative woodcuts. Her work appeared in *The Great Australian Art Exhibition* 1988–89.
BIB: Rachel Biven, *Some forgotten . . . some remembered*, Sydenham Gallery, Adelaide, 1976.

REYNOLDS, Frederick George

(b. 1880, London; arr. Aust. 1899; d. 1932, Melb.) Painter.
STUDIES: London, South Kensington schools. Son of painter G. G. Reynolds (1828–1922), he began exhibiting with the VAS in 1906, and became known in Melbourne as a painter of conventional portraits, nudes, landscapes and river scenes with boys bathing. He also made a few woodcuts and etchings. His work appeared in *A Survey of Australian Relief Prints 1900–1950*, Deutscher Galleries, Armadale, Vic., 1978.
REP: Castlemaine Art Gallery.
BIB: Edward A. Vidler, *Frederick G. Reynolds*, Melbourne, 1924.

RHODES, Jon

(b. 1947, Wagga Wagga, NSW) Photographer.
STUDIES: Two year photographic course, Ultimo Tech. College, Sydney, 1970–71; travel studies, 1977–78. From 1968–70 he worked as photographer and assistant cinematographer for the Uni. of NSW. After studies he joined Film Australia and as a cinematographer made many documentary films in Australia, Papua New Guinea and India. He held 12 solo exhibitions 1976–92 including with the George Paton gallery, Melbourne and NGV, 1977; NGV and QAG, 1991; AGNSW and AGWA, 1992. He was represented in 10 group exhibitions 1975–91 including *Recent Australian Photography*, Dept of Foreign Affairs touring exhibition to Asia, 1975–76; *Australian Photography: Living in the 70s*, NGA, 1987. He received CSR commissions for photographic projects on the Pyrmont Sugar Refinery, 1978, and Hunter Valley Coal, 1982.
AWARDS: Travel grant, VACB, 1978; grants, VACB 1980, 89; Australian Institute of Aboriginal Studies photographic projects to Yaruman, Yuendumu and Kiwirrkurra Aboriginal Communities, 1986, 87, 90.
REP: NGA; NGV; AGNSW; AGSA; TMAG; Parliament House; Macquarie Uni.; Art Bank.
BIB: Catalogue essays exhibitions as above. References in numerous magazines and journals including *London Magazine*, vol. 21, no. 12, 1982. *History of Photography*, UK, 1991.

RICARDO, Geoffrey (John)

(b. 7/9/1964, Vic.) Printmaker, sculptor.
STUDIES: BA (printmaking), Chisholm Inst.; Grad. Dip. (printmaking), Monash Uni.; travel studies London, Paris, Spain, New York, 1989. He held two solo exhibitions 1990, 92 and participated in several group exhibitions 1986–91 including at Chisholm Inst.; *Affiliations*, Monash Uni. Gallery 1987; *Australian Contemporary Art Exhibition*, Tokyo 1990; *Transitional Times*, PCA travelling exhibition, 1991.
AWARDS: Several regional gallery acquisitive print

prizes including Mornington, Warrnambool, 1988; National Student Art Prize, 1989.
APPTS: Part-time lecturing, printmaking, Monash Uni. Caulfield, 1990–92.
REP: QVMAG; PCA; a number of secondary, tertiary, regional and municipal collections Vic., NSW, Qld.

RICHARDSON, *Charles Douglas*
(b. 1853, UK; arr. Vic. 1858; d. 1932, Melb.) Sculptor, painter.
STUDIES: Scotch Coll., Melbourne (special lessons from Van den Houten, c.1862); Artisans School of Design, Carlton, c.1870; NGV School, 1871–80; RA Schools, London, 1881–86. A close associate of Roberts, McCubbin and other Heidelberg School painters, he studied with Roberts and Streeton in London and shared a studio with another RA Schools student, Bertram Mackennal. Returning to Melbourne in 1889, he took part in the *9 × 5 Impressions Exhibition*, contributing 'plastic sketches', and became known as a sculptor. His first commissioned work was the monument for the Golden Jubilee of the Discovery of Gold at Bendigo, Vic., 1902–06, and it was to represent the zenith of his accomplishment. From 1890 he conducted the life classes at the VAS and in 1914 married one of his pupils, Margaret Baskerville (q.v.). Thereafter they worked much together, sharing their studio at Brighton and completing many local commissions. As president of the VAS in the late 1920s, Richardson cut a venerable and distinguished figure at the openings and other functions. Cast in the quasi-romantic mould of the British establishment sculpture of the early 1900s, his work maintained these early ideals and gradually settled into a well-respected formal style. He was represented in *Early Australian Sculpture*, Ballarat Fine Art Gallery, 1976; *The Great Australian Art Exhibition* 1988–89.
AWARDS: Student prizes in Melbourne, 1873; first prizes for both painting and sculpture, RA Schools, London, 1884.
APPTS: Teaching, Trades Hall school, Carlton, c.1870; foundation president, Yarra Sculptors Society, 1898; president, VAS, 1917–24, 1925–30.
REP: NGA; regional galleries Ballarat, Bendigo.
BIB: Moore, SAA. Sturgeon, DAS. Scarlett, AS.

RICHMOND, *Oliffe*
(b. 8/11/1919, Hobart, Tas.; moved to the UK, 1948; d. 1977, London) Sculptor.
STUDIES: Hobart Tech. Coll., 1938–40; ESTC, 1946–48; Royal Coll. of Art, London, 1948. After his studies at the RCA, London, he spent three months in Italy where he joined Alan McCulloch on a sketching tour of villages south of Naples. As an assistant to Moore he was brought into contact with an epic period of British sculpture, his own work reflecting the influence of Rodin and even more the figurative sculptures of Picasso (e.g., Picasso's famous *Man Carrying a Sheep*), as revealed in his first London exhibition (Molton Gallery, 1962). He exhibited also at the Australian

Oliffe Richmond, Figure Group 64, 1964, bronze, 20 × 30 × 15cm. Courtesy Watters, Gallery.

Sculpture Centre, Canberra, June 1967. An exceptionally modest man, he made no attempt to promote his own work, and because of his long sojourn overseas his work was little recognised in Australia until in 1980, at the instigation of his lifelong friend, Robert Klippel, a commemorative, touring AGDC exhibition was organised. This was followed by a retrospective at Watters, Sydney and Niagara, Melbourne in 1989 and in 1990 the Brisbane City Hall Art Gallery held *Oliffe Richmond Drawings: The Australian Years 1937–48*. His work also appeared in a number of group exhibitions including *Modern Muses: Classical Mythology in Australian Art*, S. H. Ervin Gallery 1989; *Portrait of a Gallery*, Watters 25th anniversary exhibition touring eight regional centres, 1989.
AWARDS: Travelling Scholarship of NSW, 1948.
APPTS: Assistant to British sculptor Henry Moore, 1949–50, intermittently, 1950–56; lecturer, Chelsea School of Art, London, 1956–77.
REP: AGNSW; NGV; Mildura Arts Centre; Arts Council of Great Britain, London; Kroller-Muller Museum, Otterlo, Holland.
BIB: Catalogue essays exhibitions as above. Sturgeon, DAS. Scarlett, AS. A&A 2/4/1965; 22/1/1984; 22/4/1985.

RICKETTS, William
(b. 1899, Richmond, Vic.; d. 1993) Sculptor, conservationist.
STUDIES: Melbourne, violin lessons from Stanislaus de Tarczynski; no formal training in sculpture. He played the violin in cinemas c.1924–35, and when talking films eliminated this kind of work, he took up forest land at Olinda, modelled Aboriginal heads in terracotta and began placing these and related works in the bush garden that he turned into a sanctuary, which later (with assistance from the Victorian government) became the William Ricketts Sanctuary. Ricketts considered himself more conservationist and worker for human rights (specifically the cause of Australian Aborigines) than sculptor.
REP: AGSA; Museum of Applied Arts and Sciences, Sydney.
BIB: Scarlett, AS.

RIDER, Thomas W.
(Active c.1850, NSW) Topographical artist. He worked in Sydney in the 1840s and was especially noted for his watercolours and engravings of the Aborigines of the Lake Macquarie area. A pair of detailed *Views of the Honourable East India Company's Depot at Bungarabbee, New South Wales* was sold at Christie's, London, 17 May 1974.
REP: NLA; Dixson Gallery, Mitchell Library.
BIB: M. Mahood, *The Loaded Line*, Melbourne 1973. Kerr, DAA.

RIDLEY, Jennette Alice (née ROGERS)
(b. c.1865, London; arr. Fremantle 11/2/1887; d. 23/6/1929, Perth) Painter. Her landscapes showed an interest in local flora and are of historical or topographical interest. She was represented in *The Colonial Eye*, AGWA, 1979.

RIEDE, Anton David
(b. 1905, Cottesloe, WA) Painter.
STUDIES: SASA, and North Adelaide School of Fine Arts, with Millward Grey. Mainly a landscape painter, he earned a living from signwriting and commercial art and during World War II worked in camouflage in Darwin and north-west Australia.
AWARDS: Scholarship to the SASA; prize in Dunlop competitions, Melbourne, 1951.
REP: AGSA; TMAG.
BIB: John Kroeger, *Australian Artists*, Renniks, Adelaide, 1968.

RIELLY, Henry (Henry REILLY)
(Active 1870–1902) Painter. He exhibited at the VAA, 1870–95, subjects being landscapes of the Melbourne area and north-eastern Vic. (1878), and occasionally genre pictures such as his *News from Home*, 1875. He showed at the NSW Academy of Art in 1874 and 1876 and was assisted by the Art Union of Vic. along with Buvelot, with whom he was associated, and other Melbourne painters. Later he moved to Qld where he exhibited with the Qld Art Society, 1892–1902. His work was seen in *Australian Art in the 1870s*, AGNSW, Sydney, 1976.
REP: NGV.
BIB: Julie K. Brown and Margaret Maynard, *Fine Arts Exhibitions in Brisbane, 1884–1916*, Fryer Memorial Library, Uni. of Qld, 1980.

RIENITS, Rex and Thea
Art writers. Collaborators in writing *Early Artists of Australia* (Angus & Robertson, Sydney, 1963), a distinguished work of research covering the period from the earliest times to 1821. Rex Rienits (d. 1971) was known as a writer on many subjects.

RIGBY, Jeff
(b. 1948, Sydney) Painter.
STUDIES: Dip. Art, Alexander Mackie CAE, 1967–68; ESTC, 1971–74; Dip. Ed., Sydney Teachers Coll., 1975. His realist paintings were shown first at the Bonython Galleries, Sydney, 1976, then at Macquarie, 1976–91 (9 solo exhibitions) and subsequently in group exhibitions, including *Recent Australian Painting, 1970–83*, AGSA 1983; *Green Art*, S. H. Ervin Gallery 1991. He was commissioned also to paint a landscape by the National Capital Development Commission, Canberra and the High Court, Canberra in 1984 and had several other private commissions.
REP: AGNSW; QVMAG; Artbank; regional galleries Launceston, Rockhampton.
BIB: Germaine, AGA.

RIGBY, John Thomas
(b. 9/12/1922, Brisbane) Painter, teacher.
STUDIES: ESTC, 1948–51; travel studies, Italy and UK, 1957–58. His colourful figurative paintings of rainforests, landscapes and portraits feature regularly in Archibald, Wynne and other national exhibitions as well as in his own exhibitions (approximately 30, 1954–92) in Qld, Sydney and Melbourne. He was a cartoonist for the *Sunday Mail* and held and participated in a number of group exhibitions.
AWARDS: Italian prize, 1958; *Australian Women's Weekly*, 1958; H. C. Richards, 1960; RNAGAQ, 1961; Sulman, 1962; Melrose, 1963; David Jones, Brisbane, 1965, 68; Albury, 1968; Armidale, 1969; Gold Coast (purchase), 1971; Naracoorte (purchase), 1972; finalist, Doug Moran Portrait Prize 1987.
APPTS: Senior instructor, Coll. of Art, Brisbane, 1974–84; trustee, QAG; Fellow of the Royal Society of Arts, London.
REP: NGA; AGNSW; AGSA; AGWA; MAGNT; QAG; QVMAG; TMAG; regional gallery collections including Albury, Gold Coast; several tertiary collections.
BIB: Vida Lahey, *Art in Queensland 1859–1959*, Jacaranda Press, Brisbane, 1959. Geoffrey Dutton, *White on Black*, Macmillan, 1974. Geoffrey Dutton *The Australian Collection*, A&R 1985. Betty Churcher, *Molvig: The Lost Antipodean*, Penguin, 1984. J. Millington *Tropical visions*, St Lucia, Qld, 1987.

RIGBY, Paul Crispin
(b. 1924, Melb.) Cartoonist, illustrator, painter.

STUDIES: NGV School; travel studies, UK, Europe, USA and the Orient. Celebrated for his political cartoons in the Perth *Daily News*.

AWARDS: Walkley award, 1963.

BIB: Vane Lindesay, *The Inked-In Image*, Hutchinson, Melbourne, 1979.

RIGGALL, Louise

(b. Bendigo; d. 31/8/1918, France) Painter.

STUDIES: Bendigo School of Mines with A. T. Woodward; Académie Julian, Paris. She had a work hung at the Old Salon, Paris. After her return to Vic., she exhibited at the VAS, Melbourne, and during World War I served for four years as a nurse, first in Vic., then at the hospital at the Palace, Heliopolis, Egypt, then as a British Red Cross Society representative at the 1st Australian General Hospital, Rouen. She was mentioned in dispatches and died suddenly while still on active service, shortly before the Armistice.

REP: Castlemaine Art Gallery.

BIB: Moore, SAA.

RINTOUL, Gordon

(b. 27/8/1931, Young, NSW) Painter, teacher, critic.

STUDIES: Dip. Art, NAS, 1951; STC, 1952; Dip. Art, Newcastle CAE, 1978; M. Fine Arts, State Uni. of NY, 1981. He held solo exhibitions with Sydney galleries 1966–69 including Barry Stern and Macquarie, and his work appeared in a number of group exhibitions 1979–92 largely in regional NSW including Lake Macquarie, Muswellbrook, Newcastle regional galleries and in NY 1982.

APPTS: Lecturer, senior lecturer at a number of tertiary colleges, 1970–92 including Alexander Mackie CAE, 1972–73; Power Inst., Uni. of Sydney, 1973–74; Newcastle CAE, 1975–89; part-time, State Uni. of NY, 1979–81; Uni. of Newcastle, 1991–92; critic, *The Australian*, 1976–79; review program, regional television, NSW, 1982.

RISH, Adam (Cameron)

(b. 6/12/1953, UK) Printmaker, painter, sculptor, filmmaker.

STUDIES: B. Med. Sc., MB, BS, Uni. of Tas., 1978; Dip. Sculpture, ESTC, 1992; BA (hons), Fine Arts, Uni. of Sydney, 1991; travel studies, USA, Europe, Asia, PNG, 1970s, 80s. He held about 21 solo exhibitions 1975–91 in Tasmanian galleries and at Rex Irwin, Mori, Sydney; Christine Abrahams, Melbourne; Solander, Canberra as well as working in a number of other fields including as an environment officer, medical practitioner, art teacher, film scriptwriter and graphic artist. He illustrated three books including one with Garry Shead, *Vence upon a time*, RYZ Press, 1982 and made two short films exhibited in capital cities (including film festivals) in 1984 and 1986.

AWARDS: Special purpose grant, 1979, artist's grant, 1991, VACB; residency, Karolyi Foundation, Vence, 1981, Besozzo, Italy, 1984, VACB; comedy fund grant, Australian Film Commission, 1984.

REP: NGA; AGNSW; QAG; TMAG; Artbank; several regional and tertiary collections in Tas., Vic.

BIB: Germaine, AGA.

RISKE, Jan

(b. 1933, Holland; arr. Aust. 1952) Painter. Member of the CAS, Melbourne. He revisited Holland in 1962 and helped to form the Baroque Abstractionists group before returning to Australia in 1965 to live in Hobart. His massive, heavily textured paintings were exhibited at the Museum of Modern Art and Design, Melbourne, June 1965, and at Gallery A, 1967.

REP: AGNSW; NGV.

BIB: John Kroeger, *Australian Artists*, Renniks, Adelaide, 1968.

RISLEY, Tom

(b. 1947, Rockhampton) Sculptor.

STUDIES: With no formal training his 15 solo exhibitions 1981–91 included works made from parts of car bodies and other artificial objects and were held mainly at Ray Hughes, Brisbane and Sydney, and at Auckland City Gallery, NZ 1990; Townsville and Gold Coast regional galleries 1991. Group exhibitions in which his work appeared included *Australian Sculpture Triennial*, 1981, 84, 87, 90; *Diversity in Australian Art*, QAG & Museum of Modern Art, Saitama, Japan 1987; *The New Generation*, NGA 1988; *The Great Australian Art Exhibition* 1988–89; *Adelaide Biennale*, AGSA 1989; *Twenty Australian Artists*, Galleries San Vidal, Venice, QAG; Benalla regional gallery 1990 and Ray Hughes group exhibition *Thinking Allowed*, 1991.

REP: NGA; AGSA; AGWA; NGV; QAG; Parliament House; Artbank; numerous regional, tertiary and corporate collections in all states.

BIB: Catalogue essays exhibitions as above. Sturgeon, DAS. A&A 23/4/1986; 27/4/1990.

RITCHARD, Edgar

(b. 1908, Sydney; d. 1984, London) Painter, muralist, graphic artist.

STUDIES: Sydney Art School with Julian Ashton and Thea Proctor; Chelsea Polytechnic with Henry Moore and Graham Sutherland, 1928; Slade School with Henry Tonks. He designed costumes for a number of stage productions in London before serving with the RN during World War II. After returning to Australia he became a member of the Merioola group (q.v) c.1946, then travelled again to London in 1948. From 1957–68 he spent part of each year in Portugal and painted several murals including for the restaurant of the Royal Shakespeare Theatre, Stratford-on-Avon (since destroyed); the Little Oratory at Brompton Oratory, London and at Longstowe Hall, Cambridgeshire. He held solo exhibitions at Macquarie Galleries while with the Merioola group and later at Qantas Gallery, New York, 1968 showing Portuguese portraits and landscapes. His work was seen in *Merioola and After*, S. H. Ervin Gallery, Sydney, 1986.

REP: NGA: AGNSW.

BIB: AA 1928 (reproduction).

RITCHIE, Charles E.

(b. Tas.) Painter.
STUDIES: Paris. A barrister by profession, he gave up law to study art in Paris. From 1895 he exhibited at the RA, London, and with groups in Scotland, the West Country and Liverpool, continuing to show till c.1940. After World War I he returned to Tasmania.
REP: QVMAG; Royal Collections at Windsor Castle (portraits of Sir George White, Lord Lister, and Sir William Huggins).
BIB: Moore, SAA. Grant M. Waters, *Dictionary of British Artists Working 1900–1950*, Eastbourne Fine Arts, Eastbourne, 1975.

RITCHIE, F. H.

(Active c.1903–07, Melb.) Painter. He exhibited watercolours of views in and around Melbourne at the VAS, 1903–07.

RIVERS, Richard Godfrey

(b. 1859, Plymouth, UK; arr. Aust. 1889; d. 1925, Hobart) Painter, teacher.
STUDIES: Slade School with Legros, London, 1877–83. He taught painting, modelling, design, ornament and even art needlework, was the prime mover in the establishment of the QAG, toured overseas 1893, 1898, and served on the Qld selection committee for the *Commonwealth Exhibition of Australian Art*, Sydney, 1901. He exhibited landscape, genre and portraits with the QAS, 1892–1916, and represented Qld painting in the *Adelaide Jubilee International Exhibition*, 1887, and the *Australian Art Exhibition*, Grafton Gallery, London, 1898.
AWARDS: Prize for landscape, Slade School, London, 1883.
APPTS: Art master, Brisbane Tech. Coll., 1890–1910; (part-time teacher), 1910–15; president, Qld Art Society, 1892–1901, 1904–08, 1911; hon. curator, QAG, 1895–1914; president, Brisbane Sketching Club; drawing and painting master, Girls Grammar School.
REP: AGNSW; QAG; TMAG; Uni. of Qld.
BIB: Moore, SAA. Julie K. Brown and Margaret Maynard, *Fine Art Exhibitions in Brisbane 1884–1916*, Fryer Memorial Library, Uni. of Qld, 1980.

ROACH, Gilbert Thomas Meredith

(b. 1895, Adelaide; d. 1972) Painter.
STUDIES: Adelaide, SASA, c.1910. A contributor to the *Anzac Book* during World War I of drawings described by Moore as 'important from a historical point of view'.
REP: AGSA; QAG.
BIB: Moore, SAA.

ROBERTS, Douglas

(b. 1919, Kadina, SA; d. 1976) Painter, teacher.
Foundation member of the South Australian branch of the CAS. His work appeared in the Bicentennial exhibition *The Face of Australia*.
AWARDS: Cornell prize, 1953; prize in Caltex competition, Adelaide Festival of Arts, 1960; Vizard-Wholohan, 1965; and prizes at Yalumba and Barossa.
APPTS: Senior lecturer, SASA; acting principal, 1957–58, principal from 1964.
REP: NGA; AGSA; Hamilton Art Gallery.

ROBERTS, Frederick James Martyn

(b. 28/5/1871, Plymouth, UK; arr. Brisbane 1880s; d. 3/6/1963, Brisbane) Painter, teacher.
STUDIES: Brisbane Tech. Coll., with Clarke and Rivers; Sydney, with Julian Ashton, c.1897. Served on Qld selection committee, *Commonwealth Exhibition of Australian Art*, Sydney, 1901. He exhibited landscape and genre at Qld National Association, 1886–87, and Qld Art Society, 1894–1912.
AWARDS: Student awards; Qld Art Society prizes, 1899.
APPTS: Part-time teacher of geometry and perspective, South Brisbane Tech. Coll., 1894; assistant art teacher, Brisbane Tech. Coll., 1896; teaching, Ipswich Tech. Coll., 1896; acting art master, Brisbane Tech. Coll., 1898–99; art master, South Brisbane Girls High School, 1896, and South Brisbane Tech. High School, 1904; temporarily in charge of art classes, Brisbane Tech. Coll. from 1910 (when Richard Rivers, q.v., became a part-time teacher), acting supervisor of art, 1915; supervisor Central Tech. Coll. (formerly Brisbane Tech. Coll.), 1916–36.
BIB: Julie K. Brown and Margaret Maynard, *Fine Art Exhibitions in Brisbane 1884–1916*, Fryer Memorial Library, Uni. of Qld, 1980.

ROBERTS, John Rider

(b. c.1820, UK; d. 1868, Sydney) Painter, architect, surveyor, illustrator. He provided topographical views for plans of land to be sold in the colony and large views of Sydney for the *Illustrated Sydney News*, 1853–55 and 1863–68. A watercolour of his was included in the NSW section of the Paris *Universal Exhibition* in 1867, and four posthumously in the 1870 Sydney *International Exhibition*.
REP: Geelong Art Gallery; Dixson, Mitchell Libraries.
BIB: Kerr, DAA.

ROBERTS, Lisa

(b. 1949, Norfolk Island) Painter, teacher, film-maker.
STUDIES: NGV School, 1969–71. Great-granddaughter of Tom Roberts, her drawings and paintings have a light, lyrical touch. She made a film entitled *Still Lives*, completed with the aid of a grant from the Experimental Film and Television Fund.
APPTS: Teaching, art dept, Wesley Coll., Melbourne, 1976– .

ROBERTS, Samuel Hartley

(Active c.1860–80, Melb.) Painter. He helped to establish the Artisans' School of Design, Carlton, 1867, and the NGV Art School and published *Drawing Copies of Ornament*, based on plant forms of Australia, Artisans' School, Melbourne, 1879.

BIB: Moore, SAA. Elizabeth Hanks, *Australian Art and Artists to 1950*, Library Council of Victoria, Melbourne, 1982.

ROBERTS, Tom (Thomas William)

(b. 9/5/1856, Dorchester, UK; arr. Melb. 1869; d. 14/9/1931, Kallista, Vic.) Painter.
STUDIES: Collingwood Artisans' School of Design, Melbourne, with Thomas Clark and Louis Buvelot; NGV School, with Thomas Clark, 1875–80; RA Schools, London, in company with C. D. Richardson and Bertram Mackennal, 1881–82. A pioneer of plein-air impressionism in Australia, he became known, after his death, as 'the father of Australian landscape painting'. With Frederick McCubbin and Louis Abrahams he founded the first of the artists' camps, at Box Hill, from which would develop the Heidelberg School (q.v.). He was a foundation member of the Australian Artists Association, 1886; the VAS, 1888; and NSW Society of Artists, 1895; first president, 1895–97.

His father, Richard Roberts, editor of the *Dorchester County Chronicle*, died in 1868, leaving his widow and three children, Tom, his sister, and brother Richard (1860–1903), in straitened circumstances. Mrs Roberts decided to take her family to Australia where her brother was a leather merchant in Melbourne, Vic. To earn money she made schoolbags for her brother while Tom worked as an assistant to a city photographer, Richard Stewart, and studied art in the evenings. Later he contributed illustrations to Melbourne papers and, as an early student at the NGV School, met Frederick McCubbin and Louis Abrahams. By 1881 he had saved enough to pay his fare to England; on board ship he made a new friend John Peter Russell. He studied at the RA Schools, London, in company with other Australians, maintained his meagre resources by drawing for the *Graphic* and other magazines, absorbed the influence of Whistler and the brilliant Bastien Lepage, and in 1883 joined John Peter Russell and his brother Percy, and Will Maloney (later Dr Maloney, a leader in Vic. Labor politics) in a great adventure – travels with a donkey through Spain (?inspired by R. L. Stevenson). During their epic journey from Bordeaux to Granada, they met two Spanish artists who told them about the revolutionary art movements in Paris. French impressionism, once so vehemently resisted by the official salons, was gaining a strong hold. (One of the Spaniards was Barrau and the other Casas, who later attained eminence in Barcelona as portrait painter, editor, revolutionary modernist and mentor of younger artists – among them, Pablo Picasso.) Full of what he had learned from his European experience, Roberts returned to Melbourne in 1885 and with his friends, McCubbin and Abrahams, established the first artists' camp at Box Hill. In the city, inspired by Monet's bird's-eye views of Paris streets, he painted *Bourke Street Melbourne 1885–86*, and from sketches made at Box Hill, *The Artists' Camp* (1886), done in the tonal manner of the painters of the French Barbizon School. He became active in local art politics and led the breakaway group from the amateur-controlled Vic. Academy of Arts to form the Australian Artists Association (q.v.). Through his influence, Charles Conder, whom he met in Sydney in the spring of 1887, returned with him to join McCubbin and Streeton at Box Hill shortly before the group moved to Eaglemont. It was Roberts who organised the climactic *9 × 5 Impressions Exhibition* (see EXHIBITIONS).

In 1888 he visited Brocklesby Station, near Corowa, NSW, and there did the sketches for one of his most famous paintings *Shearing the Rams*, a classic, realist work painted in the spirit and style of a Courbet. NSW provided material also for his celebrated *The Breakaway*, and the bush-life series continued with *Bailed Up* which was painted on-the-spot on a Victorian hillside. To finish this work he hired models, complete with coach and horses, and worked from a platform specially built out from the roadside. Several of these large rural-life canvases were bought by the AGNSW and AGSA. He moved to Sydney where he did illustrating work for the *Picturesque Atlas of Australasia* and established a camp at Sirius Cove, Sydney Harbour, with Arthur Streeton (see CAMPS). During their work there between 1891 and 1896, the two artists were said to have existed for part of the time on a joint income of ten shillings per week. In 1896 he married Elizabeth Williamson; their son, Caleb, was born at Balmain, Sydney, 1898. Elizabeth studied wood carving and later carved many of Roberts' frames. In 1901 Roberts was commissioned by the Australian Art Association Pty Ltd to paint a huge picture of the opening of the first Federal Parliament in Melbourne. Included in his contract was a clause requiring scores of life-sized portraits. He expected 'the big picture', as he called it, to be the grand culmination of his career, but in fact it took great toll of his energies and spelled the end of his best, creative period. It entailed a vast amount of enervating travel before, finally, it was finished in London in 1903. Afterwards he visited Holland, 1905–06, and Italy 1913–14, returning to London just before the outbreak of World War I in which he served as an orderly at Wandsworth Military Hospital. He gained a modest reputation as a painter in London before finally returning to Australia in 1923 to settle at Kallista, Vic. He visited Tas. and painted there a good deal; he also had some success from reworking his *Bailed Up* which was bought by J. W. Maund for 500 guineas and given on permanent loan to the AGNSW. However his pleasure in this success was spoiled by the death of his wife (1928). The only picture by Roberts purchased for the NGV during his lifetime was a portrait study, *Penelope*, bought through the Felton Bequest in 1922 for £84. He married again and the rest of his working life was spent mostly at Kallista, Vic., where he died, one year after his old friend, John Peter Russell, had died unnoticed in Sydney.

During his lifetime Roberts received no official honours. But his work lived on and as the legend of his life and career grew, his work began to appreciate in value. Through the Felton Bequest the NGV purchased *Shearing the Rams* in 1932, in the mid-1960s Col. Aubrey Gibson (q.v.) paid £20,000 for his *Coming South* (1885–86) and presented it to the NGV; later his finest coastal picture *Mentone, 1887* was added to the Manton Collection, which also went to the NGV. He was represented in the important survey exhibitions of the 1980s – *Golden Summers: Heidelberg and*

Beyond NGV and touring 1986; *Tasmanian Vision* TMAG and QVMAG 1988; *The Great Australian Art Exhibition* 1988–89; and *The Face of Australia* 1988–89.
AWARDS: Student prize for drawing, Artisans' School of Design, Collingwood, 1875.
REP: NGA; AGNSW; AGSA; AGWA; MAGNT; NGV; QAG; QVMAG; TMAG; many regional galleries and other public collections.
BIB: All books on Australian art history and catalogue essays exhibitions as above. R. H. Croll, *Tom Roberts, Father of Australian Landscape Painting*, Robertson & Mullens, Melbourne, 1935. *Smike to Bulldog*, Ure Smith, Sydney, 1946; McCulloch, GAAP. Virginia Spate, *Tom Roberts*, Lansdowne, Melbourne, 1972, rev. 1978. A&A 18/3/1981 (Imants Tillers, *Tom Roberts – Some Impressions*)
(*See also* HEIDELBERG SCHOOL)

ROBERTS-GOODWIN, Lynne
(b. 1958, Sydney) Painter, photographer, computer/electronic artist.
STUDIES: BA, Uni. of Sydney, 1975; Dip. Art Alexander Mackie CAE, 1978; MFA, Manchester Polytechnic, UK, 1980; Assoc. Dip. teaching, SCAE, 1987. She held about 13 solo exhibitions/installations 1980–91 in Manchester, London, Paris galleries (1980s) and Sydney and Melbourne galleries including Camera Lucida, Sydney 1989, 90. Her work appeared in a number of group exhibitions 1977–91 including student exhibitions at Alexander Mackie and in *Spirit of the Times*, touring three states, 1988; *Scanning the code*, Ivan Dougherty Gallery 1990.
AWARDS: Basil and Muriel Hooper Travelling Art Scholarship, AGNSW, 1978; Dyason Bequest, AGNSW, 1979, 80; overseas travel grant, VACB, 1983; Moya Dyring Studio, Paris, AGNSW, 1983; research grant, Australian Film Commission, 1989.
APPTS: Teaching, UK and Australian tertiary colleges, 1980s; lecturer, photography, TAFE Sydney, 1988–92.
REP: AGNSW; Artbank; several tertiary and regional collections; Paris, London, US private and gallery collections.
BIB: Catalogue essays exhibitions as above.

ROBERTSHAW, Freda
(b. 1917, Sydney) Painter.
STUDIES: ESTC, –1937. Her work as exhibited at the NSW Society of Artists, Royal Art Society and Australian Watercolour Inst. showed her as a capable painter of atmospheric landscapes and related subjects. Her painting *Standing Nude* (1938) was included in *A Century of Australian Women Artists*, Deutscher Fine Art, Melbourne, 1993 and described by curator Victoria Hammond in the catalogue as standing in a class apart, 'a convergence of the academic tradition with the spirit of modernism . . . the only known self-portrait as nude by an Australian woman artist prior to the 1970s. The concept of the work contains a wealth of material for feminist discussion'. Describing the painting as showing 'extraordinary skill' she continues that 'Robertshaw could have become a leading

figurative painter of her generation, but she renounced the style in favour of impressionism.'
REP: AGNSW; QAG; TMAG.
BIB: *Society of Artists Book*, Ure Smith, Sydney, 1945–46 (reprdns)

ROBERTSON, Andrew
(Active c.1880, Melb.) Painter. He exhibited at the Victorian Academy of Arts, 1870–83 (council member, 1875–78 and 1881–85), showing watercolour views of the eastern suburbs of Melbourne.

ROBERTSON, Bruce
(b. 1872, Newcastle, NSW) Painter, etcher.
STUDIES: London Polytechnic; Westminster School; Central School of Arts and Crafts. Moore records that Heysen spent a summer in company with Bruce Robertson and Gustave Barnes at West Wemyss, Fifeshire, c.1903. Robertson worked in Scotland, exhibited RA, London, 1905, and returned to NSW in 1912 to build himself a studio beside a waterfall at Dee Why. He exhibited at the RAS, Sydney, from 1912 and succeeded Lionel Lindsay as president of the Australian Painter-Etchers' Society (q.v.). His panoramic view of Newcastle was presented to the Prince of Wales (later Edward VIII) in 1920.
REP: AGNSW.
BIB: AA Mar. 1917, Sept. 1921. Moore, SAA.

ROBERTSON, Christian Clare
(b. 29/9/1946, Oxford, Eng.; arr. Aust. 1946) Painter, lecturer.
STUDIES: Dip. Fine Art, SASA, 1966; travel studies, Europe, 1972; Iceland, 1983; Hawaii, 1988; Antarctica, 1989; Kimberley region, Aust., 1990–92. Dynamic and colourful expression of natural phenomena is characteristic of her paintings, as first shown at the North Adelaide Galleries, Aug. 1968. She held about 17 solo exhibitions 1968–91 including at Tynte, Adelaide; Macquarie, Sydney. Engaged in an ongoing series, *Extreme Landforms* (Iceland/Greenland; Hawaiian volcanoes; Antarctica; Pilbara/Kimberley; African Rift), she contrasts the differences in landforms researching and travelling to each area. In 1991 an exhibition of her Antarctica paintings was held at Parliament House, Canberra, and travelled to MAGNT and Alice Springs.
AWARDS: Ronald prize (Latrobe Valley Arts Centre), 1971; Flotta Lauro travelling scholarship, 1972; Caltex Prize, Alice Springs, 1981; VACB research grants, 1989, NTU, 1989, 90, 91.
APPTS: Assistant curator, prints and drawings, AGSA, 1970–75; art lecturer, Caulfield (1975), Preston (1976), Northern Territory Uni. (1977–); director, Northern Territory Uni. Gallery, 1992– .
REP: NGA; QAG; Artbank; Museum of Arts and Sciences, Darwin; Australian Antarctic Division; tertiary colleges including Adelaide, Flinders unis.; regional gallery including Alice Springs, Latrobe Valley.
BIB: Nancy Benko, *Art and Artists of South Australia*, Adelaide 1969. Shirley Cameron, *Women Artists in South Australia*, 1987.

Ron Robertson-Swann, Chez Chares Swann, painted steel, 109.2 × 145.8 × 90cm. Private collection.

ROBERTSON, James

Painter. Landscape watercolourist. A former police magistrate, he was elected secretary of the Victorian Academy of Arts (q.v.) when it was formed at his house in St Kilda, 10 Jan. 1870. He exhibited profusely with the Academy till 1887, showing watercolours of Melbourne, Port Phillip and English landscapes. He continued to show with the VAS, 1888–1905, when his watercolours included Sydney scenes.

BIB: McCulloch, AAGR.

ROBERTSON, Thomas

(b. 1819, UK; arr. Aust. c.1853; d. c.1873, Yokohama, Japan) Painter. A ship's captain by profession, he was the master of the clipper *Lightning* on the Australia–New Zealand run, c.1861–62. Few other facts about his life are known. He painted on board ship in harbour, awaiting cargo and passengers. Turn-around times varied from a few days to several weeks and this may explain the variation in the scope of his work. Most of his ship portraits are simple in composition and concentrate on nautical accuracy; however he could also handle larger and more ambitious compositions with the skill characteristic of British marine painters

of the period. Known works include *The Red Jacket, Lightning and James Baines in Hobson's Bay*, c.1856 (collection Australian Maritime Museum); *Citizen* (ship entering Corio Bay), c.1857; *Portland 1858 with the Ship Francis Henty* (collection with several others in La Trobe Library). He was represented in *Victorian Vision 1834 Onwards*, NGV 1985 and a work appeared in the Deutscher, Melbourne exhibitions *30 Australian Paintings*, 1980 and *Australian Art 1790–1970s*, 1988.

REP: NLA; Aust. National Maritime Museum; Mitchell, La Trobe Libraries; Joseph Brown Collection.
BIB: Catalogue of the La Trobe Library. Kerr, DAA.

ROBERTSON, Toni

(b. 1953, NSW) Poster artist, printmaker, teacher.
STUDIES: BA, Uni. of Sydney, 1975; honours fine arts, Uni. of Sydney, 1980. She held 12 solo exhibitions 1980–92 including at Cité Internationale des Arts, Paris; Manchester, UK; Linden Gallery, Melbourne and First Draft West, Sydney. Her work appeared in over 50 group exhibitions 1975–91 at private galleries including Hogarth, Watters, Sydney and in many

community arts activities including *Walls Sometimes Speak: An Exhibition of Political Posters*, touring regional, tertiary galleries NSW, Vic., SA 1977–79; film posters USA and international poster exhibitions; *Continuum 83*; *Eureka: Artists from Australia*, Arts Council of Great Britain, 1982; *Sites of Power*, Watters gallery and several public, tertiary galleries NSW, Qld, SA 1985–87. APPTS: Tutor, Uni. of Sydney, 1975–79; lecturer, printmaking, photomedia, Canberra School of Art, 1982–85; member VACB, 1984; art forum co-ordinator, Canberra School of Art, 1984.
REP: NGA; AGNSW; AGSA; NGV; AWM; Artbank; MCA, Sydney; numerous tertiary, state library and union collections.
BIB: Catalogue essays exhibitions as above. Virginia Coventry (ed) *The Critical Distance*, Hale & Iremonger 1986. M. McMurchy & J. Thornley, *For Love or Money*, Penguin Australia 1983. AL 1/3/1981. A&A 20/1/1982.

ROBERTSON-SWANN, Ron (Ronald Charles)
(b. 20/2/1941, Sydney) Sculptor, painter, teacher.
STUDIES: NAS, with Lyndon Dadswell, 1957–59; St Martin's School of Art, London, with Anthony Caro and Phillip King, 1962. He worked as an assistant to Henry Moore after leaving St Martin's School (1963–65), exhibited in London and returned to Sydney in 1968. In that year he exhibited three 'unit abstractions' (paintings) in *The Field* exhibition (NGV 1968), and the following year won the prestigious Transfield Prize with a large painting composed of vertical columns of fused, primary colours. However his main activity continued in the tradition of the painted steel primary structures inherited from his studies with Caro and King. He held about 22 solo exhibitions 1968–91 in Sydney (including at Rudy Komon, Gallery A, Painters galleries) and Melbourne (Powell St, Charles Nodrum), and was artist-in-residence at various institutions including ANU and Devon Community Coll., Tasmania. He was represented in the Bicentennial exhibition *The Great Australian Art Exhibition*.

He exhibited in most national competitive exhibitions and in 1978–79 completed a large steel sculpture, *Vault*, painted a brilliant yellow, for Melbourne's new City Square. When placed in the square this work caused the most prolonged controversy of any Australian public sculpture in a hundred years. It dominated a space already overcrowded with artificial waterfalls, a lake, concrete garden tubs, arcades, stairways, walks, bridges and Charles Summers' large historical bronze of the explorers Burke and Wills, which had itself been the subject of controversy more than a century before. Most vehement of Robertson-Swann's detractors were members of the Melbourne City Council, who dubbed his work *Yellow Peril*. Many suggestions were made about the future of the sculpture until finally it was removed to its present site near the Yarra river, where it remains the subject of controversy. (*See also* PUBLIC ART)
APPTS: Teaching, St Martin's, 1963; teaching, East Ham Tech. Coll.; lecturing, West Ham Coll. of Technology, 1965–66; teaching, Goldsmith Coll.,

London Uni., 1967; teaching, part-time, Dept of Architecture, Uni. of NSW, 1969; NAS, 1969–74; board member, VACB, 1973–75.
AWARDS: John Moore's Painting Prize, Liverpool, UK, 1965; Comalco sculpture prize, 1969; Transfield prize, 1969; Mildura prize (work acquired), 1970; Townsville Pacific Art Festival prize, 1976; VACB grant, 1976–77; Bathurst prize, 1977; creative arts fellowship, ANU, 1986; Stanthorpe Purchase prize, 1992.
REP: NGA; most state galleries; Parliament House; a number of regional galleries and tertiary collections in all states.
BIB: Scarlett, AS. Catalano, *The Years of Hope* OUP, 1981. Sturgeon, DAS. Germaine, AGA. AI 10/4/1966; 14/9–10/1981. A&A 10/2/1972; 20/1/1982; 25/2/1987.

ROBINSON, Edwin
(b. 1917, Melb.) Painter.
STUDIES: Melb. Tech. Coll.; George Bell School. From 1940 he exhibited with the Melbourne Contemporary Artists and from 1965 in VAS exhibitions, where his work reflected the influence of early modernist training with Bell.
REP: NGV.

ROBINSON, John Harold
(b. 4/11/1940, Melb.) Painter, printmaker, teacher.
STUDIES: TSTC, Melb., 1961; Dip. Art, RMIT, 1962; travelled and worked in Europe, 1967–69, 1975–76. His capable, photo-realist paintings were first exhibited at Realities Gallery, Melbourne, 1974 and his work then moved into the abstract typified by use of fragmented small shafts of colour. He held about 13 exhibitions 1966–91, largely at Realities. He helped establish and ran a lithographic printing workshop, Drukma Press, from 1978 to 1983 and between 1983 and 1988 ran his own press, Lithos Press, printing editions for many well-known artists. He participated in numerous group exhibitions from 1962 including international and Australian print exhibitions, such as *12 Melbourne Printmakers*, Oxford Uni., UK 1982; the Bicentennial exhibition *The Face of Australia*; MPAC *Print Biennale*, 1990. He was external assessor for many painting and printmaking courses at tertiary colleges.
AWARDS: Geelong print prize, 1974; VACB grant (special projects), 1975.
APPTS: Lecturer, printmaking, CIT; teaching (photography), Maryborough Tech. Coll., 1970–74; part-time lecturer, RMIT, 1974; teaching, RMIT, and Prahran CAE, 1976–77.
REP: NGA; QAG; MAGNT; Parliament House; a number of regional gallery and tertiary collections Vic., NSW, Qld.
BIB: PCA, *Directory*. 1988.

ROBINSON, Max
(b. 1934, Melb.) Painter, industrial designer.
STUDIES: Melb. Tech. Coll., 1951; travel studies, UK, Europe, India, Egypt, Malaya, Malta, 1961–64. He worked as an industrial designer and from 1960 his modernist paintings became well-known in Melbourne.

His work was included in the Whitechapel Gallery exhibition, *Recent Australian Painting*, 1961, and other group exhibitions of Australian art in London and Europe.

REP: National Gallery, Wellington, NZ.

BIB: Germaine, AGA.

ROBINSON, Sally

(b. 1952, Eng.; arr. Aust. 1960) Painter, printmaker. STUDIES: NAS, 1970–73. Her prints comprise montage photographs hand-painted in bright colours, often of Australian birds, animals, outback and sporting scenes. She held about ten solo exhibitions 1976–89 in Adelaide (Bonython), Sydney (Robin Gibson), Brisbane (Ray Hughes), Melbourne (Stuart Gerstman), Perth and Adelaide as well as at the AGSA, 1976. Her work appeared in numerous print and other survey exhibitions 1976–92 including *Perspecta '83*, AGNSW 1983; *Australian Screenprints*, state and regional galleries 1982–83 and *The Face of Australia* Bicentennial exhibition 1988–89.

AWARDS: Gosford prize, 1972.

REP: NGA; most state galleries; Geelong Art Gallery; uni. collections.

BIB: Germaine, AGA.

ROBINSON, William Francis (Bill)

(b. 16/4/1936, Qld) Painter, teacher. STUDIES: Central Tech. Coll., Brisbane, 1955–61. While the subject of most of his works is almost exclusively the animals and scenery on his farm in Qld, he weaves them into an abstract or surreal context that gives his work great originality. In 1987 he won the Archibald Prize with a striking self-portrait as a horse-rider. He held 14 solo exhibitions 1967–91, largely with Ray Hughes, Brisbane and Sydney, and participated in a number of group exhibitions including *Australian Perspecta '83*, AGNSW 1983; *Thinking Allowed* and *They're Still Thinking Aloud*, Ray Hughes; *Seventeen Australian Artists*, Venice Biennale, 1988; *The Face of Australia* 1988–89; *Twenty Australian Artists*, Galleria San Vidal, Venice, QAG, Benalla 1990; *Green Art*, S. H. Ervin Gallery 1991.

AWARDS: RNAGQ prize (watercolour), 1965; David Jones prize, 1970; Schonell prize, 1969, 72; Archibald Prize, 1987; Wynne Prize, 1990.

APPTS: Teaching, Kedron Park Teachers Coll., 1971– ; senior lecturer in art, Kelvin Grove Teachers Coll., –1974– , North Brisbane CAE, 1979– .

REP: NGA; most state galleries; Parliament House; a number of regional gallery collections including Armidale, Gold Coast; several tertiary collections including unis. of Qld, NSW; MOMA, New York; Waikato Art Museum, NZ.

RODIUS, Charles

(b. 1802, Cologne, Germany; arr. Sydney 1829; d. 8/4/1860, Liverpool, NSW) Painter, illustrator, lithographer, architect. STUDIES: Academy of Paris for eight years. Sentenced to seven years' penal transportation for the theft of an opera glass, perfume bottle, handkerchief and a silk bag, he received a certificate of exemption in July 1832 and full pardon July 1841. Assigned on arrival in Sydney to the Dept of Public Works, he taught drawing to military officers and became tutor to the children of Chief Justice Forbes (later Sir Francis Forbes). He also drew plans for buildings, acted as a translator of languages and painted portraits of well-known people, including Henry Parkes, George Robert Nichols and, during a visit to Port Phillip, the actress Sara Flower. He painted a portrait also of the murderer Knatchbull. Besides teaching and painting portraits, he was an accomplished singer. He produced views of Sydney (for engravings in London) and lithographs of Aborigines. Books his work appeared in included *Portraits of Aborigine Kings*, J. G. Austin, Sydney, 1834. His work was represented in *Australian Colonial Portraits*, TMAG 1979; *The Artist and the Patron*, AGNSW 1988 and the Bicentennial exhibition *The Great Australian Art Exhibition*.

REP: TMAG; Dixson, Mitchell Libraries; British Museum.

BIB: Catalogue essays exhibitions as above. *National Bank Calendar*, Melbourne, 1965; Eve Buscombe, *Artists in Early Australia and their Portraits*, Eureka Research, Sydney, 1978. ADB 2. Kerr, DAA.

RODRIGUES, Frank (Francis S.)

(b. 1884, Sydney; d. 1968, Sydney) Painter. STUDIES: ESTC; travel studies in Europe and Russia, 1936. Mainly a watercolourist and advertising artist. He introduced Alan McCulloch, with whom he had a lifelong, family friendship, to Rah Fizelle and his modernist group in the 1930s. A meticulous painter of illuminated addresses, he was also responsible for the small and detailed pictures of birds' eggs that appear in the *Australian Encyclopaedia* (A&R, 1958).

BIB: AA 3rd series, no. 81, 1940 (reproduction).

RODRIGUEZ, Judith

(b. 1936, Perth, WA) Writer, graphic artist. From 1961 she published poems, stories and review articles, some illustrated with her own linocuts. She held an exhibition of linocuts at the Bookshelf Gallery, Melbourne, 1978.

AWARDS: South Australian biennial prize for literature, Adelaide Festival of Arts, 1978.

RODWAY, Florence

(b. 1881, Hobart, Tas.; d. 23/1/1971) Painter. STUDIES: Hobart Tech. School; Sydney, with Sydney Long; RA Schools, London. Her fellow students in Hobart included Mildred Lovett and Jean Spong and in London visiting teachers included Sargent, Bacon, Soloman. She settled in Sydney on her return to Australia in 1906, joining the evening classes at Julian Ashton School. She exhibited with the RAS, Sydney, from 1906 and was a council member of the Society of Artists, 1912. Known as a pastellist and portraitist she received many commissions including official portraits of Dame Nellie Melba, Henry Lawson, J. F. Archibald, Julian Ashton and William Charles Wentworth. She married Walter Moore in 1920 and

went with him to live in Hobart, 1922 to c.1950 when she was in Melbourne, painting commissioned portraits with her daughter, Susanne. She exhibited at the Athenaeum, Melbourne in 1914; with Edith Holmes in Westminster Gallery, Melbourne 1948 and in 1953 in Hobart. Her work was seen in group exhibitions with the RA 1923, 24; the Tasmanian Group of Painters 1940–62; and in the *Sesquicentenary Art Exhibition* TMAG, 1954.

AWARDS: Scholarship (four years study) RA.

REP: NGA; AGNSW; TMAG; AWM; Castlemaine regional gallery; Mitchell Library, Sydney.

BIB: Backhouse, *TA*. Caroline Ambrus, *The Ladies Picture Show*, Hale & Iremonger, 1984. *ADB 2*. *AA* first number Sydney 1916 (article with reproduction). Moore, *SAA*.

ROGERS, Aileen Jesse

(b. 5/12/1916, Wagga Wagga, NSW) Painter.
STUDIES: Desiderius Orban Art School, 1964–77; travel studies, UK, Europe. Although she did not start painting until the age of 45, her work shows a sense of perspective and drawing ability. Her teacher Desiderius Orban described her in 1973 as 'not a present fashion but refreshingly original, a genuine artist'. Her work was seen mainly in group exhibitions 1972–93 including the *Archibald*, 1972, 73, 75, 86; and *Maritime Award* (in which she was a finalist in 1990 and winner 1991).

AWARDS: Mosman Art Prize, 1977; Don Pring Memorial Prize, 1985; Australian Maritime Award, 1991.

REP: National Trust of Australia.

ROGERS, John

(b. 1928, Ceylon; arr. Aust. 1941) Painter, printmaker.
STUDIES: NGV School, 1945–48; George Bell School, 1946–48; Fernand Léger Studio, Paris, 1949. He exhibited in Melbourne (1953–67) and taught at RMIT and the Uni. of NSW before leaving for overseas. He held exhibitions in Australia of work done in Spain in 1960, and from 1980 lived in London.

REP: AGSA; AGWA (print collections); Leicester Education Authority collection, UK.

ROGGENKAMP, Joy

(b. 1928, Roma, Qld) Painter.
STUDIES: Brisbane Tech. Coll.; privately with Stanhope Hobday, Melville Haysom and Jon Molvig. A prolific and skilful painter of watercolours, she exhibited in most Australian capital cities from c.1958 and especially in the Gold Coast (Qld) area.

AWARDS: Prizes (mainly for watercolours) in competitions at Lismore, 1958; Redcliffe, 1959, 62, 64; Half Dozen Group Centenary, Brisbane, 1959; L. J. Harvey (drawing), Brisbane, 1959; AGNSW (Trustees Watercolour), 1962; AGNSW, Sydney, Pring prize, 1966, 67.

REP: NGA; AGNSW; regional gallery, Ballarat; Qld Uni. collection.

ROLANDO, Charles

(b. 1844, Italy; arr. Aust. 1885; d. 8/7/1893, St Kilda, Vic.) Painter.

STUDIES: Florence. He went to England, 1870, completed frescoes for a Liverpool church and in 1874 married Frances Webb, sister of the English portraitist. He moved to South Africa, 1883, and thence to Australia, and later conducted a 'fashionable' art school in St Kilda as well as exhibiting with the Victorian Academy of Arts, the Australian Artists Association and the VAS. He often painted in collaboration with J. H. Scheltema (q.v.), Rolando painting the landscape and Scheltema the cattle and horses. His own landscapes are dextrous and facile and are mainly large bush scenes in oils, but show feeling for light and atmosphere.

REP: Regional galleries Ballarat, Bendigo, Warrnambool.

BIB: *Table Talk* 30 Jan. 1891. Moore, *SAA*. *ADB 6*.

ROMEO, Giuseppe

(b. 1958, Melb.) Painter, sculptor.
STUDIES: VCA, 1978–81; travel studies, Europe 1979, 82; Europe and USA, 1986, 89, 90. His 1980s and 1990s figurative paintings, seen in five solo exhibitions 1986–92 at United Artists then Luba Bilu, Melbourne, were concerned with symbolism of our recent and ancient past. He also participated in a number of group exhibitions 1981–93 including *Australian Sculpture Triennial*, 1981, 84, 87; *A New Generation*, NGA 1988; *Moet & Chandon Touring Exhibition* 1992. He also received a number of sculpture, illustration and painting commissions including *Instruments for Human Solidarity*, a sculpture for the World Congress Centre; a sculpture for the cafeteria of the NGA and a Christmas tree for the NGV, 1991.

AWARDS: Tina Wentcher prize for Sculpture, 1981; grant, Vic. Ministry for Arts, 1986; grants, VACB, 1986, 88, 89, 90; Heide/Savage Club Invitation Drawing Prize (joint winner), 1987; acquisition, Gold Coast City Gallery Prize, 1990; Diamond Valley Art Award, 1990; Andrew & Lillian Pedersen Memorial Prize for Drawing, 1991.

REP: NGA; NGV; QAG; Centre for Contemporary Art, Hamilton, NZ; MCA, Brisbane; several municipal and regional collections including at Diamond Valley, Mt Gambier; corporate collections including Philip Morris, Smorgon, Bankers Trust.

BIB: Catalogue essays exhibitions as above. Sturgeon, *DAS*.

ROONEY, Elizabeth Ursula

(b. 1929, Sydney) Painter, etcher.
STUDIES: ESTC, –1949; etching with Herbert Gallop, 1948–49. She helped Joy Ewart to establish etching facilities at the Workshop Art Centre, Willoughby, NSW, and held her first exhibition of etchings there in 1963. By 1976 she had made about 250 prints in widely varied media. Group representation includes National Arts Club exhibition, New York, 1958; *Australian Prints*, Smithsonian Inst., Washington, DC, 1966; *British Print Biennale*, 1968–69; and many group exhibitions within Australia. Much of her interest is concentrated on social commentary expressed in open line drawing.

AWARDS: Mosman print prize, 1966.
BIB: Germaine, *AGA*. PCA, *Directory*, 1988. *A&A* 6/4/1969; 9/4/1972.

ROONEY, Robert

(b. 24/9/1937, Melb.) Painter, photographer, critic.
STUDIES: Swinburne Coll. of Technology, 1954–57; Preston Inst. of Technology, 1972–73. Hard edge painting, photography, colour-field painting, serial art, conceptual art and other forms have all been assimilated by Rooney in his aim to give aesthetic meaning to the commonplace, as in the well-known stencils cut from Kelloggs cornflake packets and arranged in series entitled *Slippery Seals, Kind-Hearted Kitchen Gardens, Canine Capers* and the like. From about 1980 photography began to replace painting as his main interest. His work was included in the exhibition *The Field* (NGV, Aug.–Sept. 1968), and ten years later it was the subject of a special NGV Survey exhibition organised by Robert Lindsay. He held about 18 solo exhibitions 1960–90, largely at Pinacotheca, Melbourne and in *Project 8: Robert Rooney*, AGNSW 1978; and *From the Homefront: Robert Rooney Works 1953–88*, Monash Uni. Gallery 1990. His work has appeared in many group exhibitions including *POPISM*, NGV 1982; *A Melbourne Mood*, Monash Uni. Gallery 1984; *The Field Now*, Heide 1984; *Field to Figuration*, NGV 1987; *The Great Australian Art Exhibition* 1988–89; *Freestyle: Australian Art 60s to Now*, NGV 1989; *Biennale of Sydney*, AGNSW 1990. He started art criticism in 1980, first with the Melbourne *Age* (1980–82), then the *Australian* (1982–), becoming one of the most widely read critics in Australia in the 1980s and 1990s. He has written and contributed articles to many leading art journals, including *A&A*, and written catalogue essays for survey exhibitions and individual artists.
APPTS: Art critic, *Age*, Melbourne, 1980–82, *Australian*, 1982– .
REP: NGA; AGNSW; AGSA; AGWA; NGV; QVMAG; TMAG; Fremantle Arts Centre; VACB; several regional gallery collections including Geelong, Wagga Wagga, Warrnambool; a number of tertiary collections including Flinders, Monash unis.; Smorgon Collection.
BIB: Catalogue essays exhibitions as above and most general texts on Australian art including Smith, *AP*. G. Catalano, *The Years of Hope*, OUP, 1981. D. Richardson *Art in Australia*, Longman Cheshire 1988. Thomas, *OAA*. Elwyn Lynn, *Australian Art Monographs; Drawing*, Longmans. *A&A* 14/1/1976. *AL* 2/4/1982.

ROPER, Edward

(b. c.1830, Sutton Valence, Stapleton, UK; arr. Aust. 1854; d. 1909) Painter, writer. Itinerant field artist and writer. He travelled extensively in Canada, NZ and Australia, where he painted on the Victorian goldfields and did paintings of kangaroo hunting. His signature is usually in monogram with the left vertical stroke of the 'R' elongated to look like a 'J'. His best-known painting, entitled *Gold Digging, Ararat*, is in the Dixson Gallery of the Mitchell Library, Sydney. Fifty works by him are listed in the catalogue of an early group exhibition at the Burlington Gallery, London, many of Australian and NZ subjects. He wrote and illustrated several books – *By Track and Rail*, 1891; *A Claim on the Klondike*, 1899; *Ice Bound, or the Anticosti Crusoes*, 1902; *Fred Seagood: His Travels and Triumphs*, 1904 – all published in London. He lived in the UK from about 1888 until his death. Works by him appeared in Deutscher's *Colonial and Impressionist Paintings*, 1981 and in Sotheby's October 1985 sale and he was represented in the Bicentennial exhibition *The Face of Australia* 1988–89.
REP: NLA; regional galleries Ballarat, Benalla; Dixson, Mitchell Libraries; ICI collection.
BIB: McCulloch, *AAGR*. C. Craig, *More Old Tasmanian Prints*, Foot & Playstead, Launceston, 1984. E. Craig, *Australian Art Auction Records*, Sydney 1987. Kerr, *DAA*.

ROSE, David

(b. 1936, Melb.) Painter, printmaker, teacher.
STUDIES: B.Sc. (forestry), Uni. of Melb., 1959; Escuela Lonja, Barcelona (etching), 1964. Working in a representational style, he began full-time painting and printmaking in 1960 and by 1993 had held over 40 solo exhibitions. His work appeared in a number of group exhibitions 1961–93, largely with private galleries (Greenhill, Adelaide; Editions, Melbourne), as well as in touring international exhibitions such as *Australian Etching*, PCA travelling exhibition 1978; *Contemporary Australian Printmakers*, Tokyo 1984. He drew on his knowledge of landscape and original forestry training to produce colourful landscapes including a graphic series on the devastation and rebirth following bushfires in the late 1980s.
AWARDS: Prizes at Ryde (oils), 1962; Wollongong (drawings), 1962.
APPTS: Teaching, part-time, NAS, 1967–74; Alexander Mackie CAE, 1975–76; North Shore Art Workshop.
REP: NGA; AGNSW; AGWA; NGV; QAG; a number of regional galleries; MOMA, NY.
BIB: PCA, *Directory* 1988.

ROSE, Herbert

(b. 1888, Windsor, Vic.; d. 1937, India) Painter, etcher.
STUDIES: NGV School, 1914–18; travel studies in Europe and the USA. Known mainly for landscapes. The youngest son of George Rose, founder of the Rose Stereograph Company, he assisted in the photographic department of the business and during the depression years designed birthday greeting cards. Financed by his father, he travelled extensively, visiting North Africa, Syria, Persia and India. Many of his paintings, drawings and etchings are of Eastern subjects and have a light Whistlerian touch that earned him a distinguished place in the Australian art of the period 1920–37. He died of smallpox while travelling in India.
REP: Graphic art collections, NGV and other state galleries.
BIB: *AA*, Sept. 1921, ref. and reprdns; special Melbourne number, 1928, reprdns.

ROSE, Joe
(b. 1915, Woldenberg, Germany; arr. Aust. 1957) Painter.
STUDIES: Berlin and Sydney. Imprisoned in concentration camps at Sonnenberg and Buchenwald, he escaped in 1938, fled to England with his wife in 1939 and served as an NCO with the British army in England and France. His paintings reflect the prevailing influences in German art (Dada and expressionism) between the two World Wars. He established his own art school in Sydney in 1966.
AWARDS: Prizes at Wagga, 1961; Bathurst, 1964; Parramatta, 1965; Mosman, 1967; Sydney (Great Synagogue prize), 1967; Rockdale, 1968; Cheltenham, NSW, 1969; Currabubula, 1969; Robin Hood, Sydney, 1969.
REP: Regional galleries Bathurst, Wagga Wagga; Sydney Uni.
NFI

ROSE, William
(b. 29/9/1929, Newcastle, NSW) Painter.
STUDIES: Newcastle Tech. Coll., 1948; ESTC and Julian Ashton School, –1949. He tried, briefly, a seafaring life at the age of 17, then worked in factories, studying art in the evenings at Newcastle, before moving to Sydney where, after further studies, he became a member of what Bernard Smith has described as 'the Victoria Street Group' of Sydney abstract expressionists. However his painting reveals distinctive differences, its vignetted structure disclosing a fine relationship between structure and idea calligraphically expressed rather in the molecular grid tradition of a Vieira da Silva. His work was included in significant important national exhibitions in the early 1960s, notably *Recent Australian Painting*, Whitechapel Gallery, London, 1961, and *Antipodean Vision*, Tate Gallery, London, Jan. 1963. He held approximately 20 solo exhibitions 1957–91 in Sydney, Melbourne and in Everson Museum of Art, Syracuse, New York 1982 and Lewers Bequest, Penrith Regional Art Gallery 1991.
AWARDS: RAS, NSW Easter Show (industrial landscape), 1961; Transfield prize, 1967.
REP: NGA; AGNSW; AGSA; AGWA; MAGNT; NGV; QAG; QVMAG; TMAG; regional galleries Newcastle, Rockhampton.
BIB: All general works on Australian contemporary art including Smith, AP; Bonython, MAP and catalogue essays exhibitions as above. John Kroeger, *Australian Artists*, Renniks, Adelaide, 1968.

ROSEBRAY, Alvah Earlington
(Active c.1903–10, Sydney) Painter. He exhibited a number of wash drawings at the RAS of NSW, 1904–10. Works sold at auctions include watercolours, landscapes and oil paintings of birds.

ROSENGRAVE, Harry
(b. 1899, Locksley, Vic.) Painter.
STUDIES: NGV School, 1941–48; George Bell School, 1946–60; Melbourne Tech. Coll., 1951–59. He earned a living as a civil servant in the Postal Dept and in the Dept of the Army, while studying art in his spare time. For 19 years he helped in organising student activities, first becoming known as a painter at an exhibition held jointly with Fred Williams and Ian Armstrong (Stanley Coe Gallery, Melbourne, 1951). Much of his work, part of his large collection, and valuable equipment were lost in a fire in his studio in June 1968. His work bears elements of surrealism and is largely modernist, typical of many students of the Bell School in the 1940s and 1950s. He held exhibitions of his own work and one including many works from his collection at the Hawthorn City Art Gallery in 1973 and 1979. He was represented in *Classical Modernism: The George Bell Circle*, NGV 1992.
AWARDS: Caltex prize, Portland, 1972.
REP: NGV; AGWA.

ROSMAN, Peter
(b. 22/2/1944, Melb.) Sculptor.
STUDIES: Architecture, Uni. of Melb., 1963–67; St Martin's School of Art, London, 1968–70; Dip. Art, PIT, 1973; Dip. Ed., State College of Vic., 1974. His early work included steel and concrete 'book' sculptures at the Coventry Gallery, Sydney, 1976, Warehouse Gallery, Melbourne, 1977 and AGSA, 1978. He held 16 solo exhibitions 1977–93, largely at Standfield, Melbourne; Coventry, Sydney; Ray Hughes, Brisbane and while he was artist-in-residence at Griffith University, Qld 1981 and Claremont School of Art, 1983. His work appeared in a number of group exhibitions 1978–93 including *Australian Sculpture Triennial*, 1984, 87, 90; *Recent Australian Art*, MOCA, Brisbane 1989. He was Australian representative at the Sculpture Symposium in Portugal, 1993.
AWARDS: VACB grants, 1975, 78.
REP: NGA; NGV; Parliament House; Heide; MOCA, Brisbane; regional galleries including Geelong, Wollongong; tertiary collections including North Brisbane CAE; Griffith Uni.; corporate and private collections including Philip Morris.
BIB: Catalogue essays exhibitions as above. Paroissien, *Australian Art Review*, Warner, 1986. Scarlett, AS.

ROSS, Christine Alexandra
(b. 5/7/1944, Newcastle, NSW) Painter, critic, teacher.
STUDIES: NAS, Newcastle, 1962–63; NAS, Sydney 1964–66; travel studies, Thailand 1969, New Guinea 1971, Japan and Europe 1973, Indonesia and Philippines 1978, USA, UK, Europe 1979–80. Her work has been shown in exhibitions since 1967, mostly connected with Newcastle and Newcastle groups. In 1989 she received study leave from Uni. of Newcastle in order to travel to northern NSW and the Flinders Ranges to pursue the theme of arid zones from which an exhibition evolved and was shown at von Bertouch Galleries, 1991.
AWARDS: Prizes at Cowra, 1968; Kurri Kurri, 1968; Bradmill, 1970; Maitland, 1971; Raymond Terrace,

1973; Scone, 1977; VACB grant, 1983; research grant Uni. of Newcatle, 1991.
APPTS: Teaching, NAS, Newcastle, 1967–74; lecturer, Newcastle CAE, 1975; senior lecturer, Uni. of Newcastle, 1989; art critic, ABC, Newcastle, 1968, *Newcastle Morning Herald*, 1971– .
REP: Artbank; Dobell Foundation; several regional gallery and municipal collections including Newcastle, Maitland, Scone; a number of tertiary collections including ANU, SACAE.
BIB: Germaine, AGA.

ROSSI, Daisy
(b. 18/1/1879, Auburn, SA; d. 1974) Painter.
STUDIES: Adelaide School of Design; Perth (with Florence Fuller), c.1905; Grosvenor School, London; Paris, 1909–10. She exhibited in Perth from 1905 with the WA Society of Arts and held a show at the Karrakatta Club; she was also included in the *Exhibition of Women's Art*, Melbourne, 1907. She became head of the art department, Fremantle Tech. School. She married George Temple-Poole, a noted Perth architect, in 1918, and later became the first woman on the Town Planning Board. She contributed various articles to magazines and radio and was included in the *British Empire Exhibition* in London in 1924. Her paintings are primitive in style and conception and far removed from the conventional art of her time. They were seen in *The Colonial Eye*, AGWA, Perth, 1979.
REP: AGWA; Royal WA Historical Society.

ROTH, (Madame) H. Constance
Painter. She conducted a salon in her Sydney studio where musicians, actors and artists met. Roberts met Conder at her home in 1887. Listed by Moore among the first Australian women painters to distinguish themselves as landscape painters, she is also described by him as 'a clever artist who afterwards settled in South Africa'.
BIB: Moore, SAA.

ROUBOUS, Leon
(b. 13/1/1959, Sparta, Greece; arr. Aust. 1956) Painter.
STUDIES: BA, RMIT, 1982; travel studies, Europe, 1982, 88. His entries *Moet & Chandon Touring Exhibition* 1989 and 1990 showed meticulously detailed minute figures set in a flat sparse expanse of canvas. The isolation and super-real style creates a similar effect to the work of Jeffrey Smart. He held seven solo exhibitions 1985–92 at Melbourne Contemporary Art Gallery; Barry Stern, Sydney and George Paton Gallery, Melbourne Uni. (1989) and participated in a number of group exhibitions 1985–92 including award and prize exhibitions at regional galleries.
AWARDS: Henri Worland Acquisitive Print Prize, Warrnambool Gallery, 1989.
REP: NGV; several regional galleries in Vic.; corporate collections; National Gallery of Greece.

ROUGHSEY, Dick (Goobalathaldin)
(b. 1924, Nth Qld; d. 1985) Painter.

STUDIES: No formal training. An elder of the Lardill tribe of Aborigines, Mornington Island, Gulf of Carpentaria, he painted and illustrated a number of books (including *Moon and Rainbow*, Reed, Sydney, 1971; *Giant Devil Dingo*, Collins, Sydney, 1973) mostly of Aboriginal legends, in a semi-primitive manner.
APPTS: Chairman, Aboriginal Arts Board of the Australia Council, 1973–76; member, Inst. of Aboriginal Studies.
BIB: Bianca McCullough, *Australian Naive Painters*, Hill of Content, Melbourne, 1977. Caruana, AA.

ROUSEL, Jules Henry Roy
(b. 1897, Sydney) Painter.
STUDIES: RAS School, Sydney, 1912–18; Slade School, London, 1935, RA Schools, 1935–38. Vice-president and life member of the Royal Art Society of NSW. He exhibited at the RA and Royal Portrait Society, London, and at the Paris Salon and Société des Beaux-Arts, Paris, his subjects being conventional figure compositions.
AWARDS: Scholarship for drawing, RAS School, Sydney; honourable mention, Paris Salon, 1949.
REP: AGNSW; AWM.

ROWAN, Marian Ellis (née RYAN)
(b. 1848, Melb.; d. 1922, Macedon, Vic.) Painter.
STUDIES: No formal training; her grandfather, John Cotton, was a natural history painter. She married Captain Frederic Rowan in 1873 and lived in NZ till 1878 when she returned to Melbourne. From the 1880s she travelled widely both overseas and within Australia, studying and painting flowers in their native habitat. She was in north WA with Lady Forrest in 1889 and by 1895 was in London where she exhibited at the Dowdeswell Galleries. She afterwards visited, in Germany, Baron Ferdinand von Mueller, who had previously catalogued a number of her wildflower studies. This period was followed by several years spent in America illustrating books on American flora by Alice Lounsberry whom she accompanied on expeditions to all parts of the country in search of material. After visiting the West Indies she returned to Melbourne c.1905. Next she went to WA, where she painted wildflowers on the goldfields before setting out for New Guinea and the adjacent islands, where she spent two years and painted 45 of the 52 known Birds of Paradise. She contracted malaria in the interior and the natives, reputedly cannibals, carried her many miles to the coast. Biographers remember her as a woman of small and delicate stature but of boundless energy, courage and spirit. Her prolific output was mainly confined to watercolours, ranging from the large, boldly coloured and carefully detailed flower studies through to small, more intimate garden scenes and the birds of New Guinea. Her oils are rare but show considerable refinement. Her work appeared in *The Colonial Eye*, AGWA and *A Century of Australian Women Artists 1840s–1940s* Deutscher Fine Art, Melbourne, 1993.
REP: QAG (125 works); NLA (947 studies of Australian and New Guinean flora and fauna).

BIB: H. J. Samuel, *Wild Flower Hunter*, with illustrations by Maie Casey, Constable, London, 1961. Janine Burke, *Australian Women Artists 1840–1940*, Greenhouse, Melbourne, 1980. Margaret Hazzard, intro., Helen Hewson, botanical notes, *Flower Paintings of Ellis Rowan*, NLA, 1982.

ROWBOTHAM, Marjory

(b. 2/10/1923, Vic.) Painter. Art instructor at Perth Tech. Coll. from 1946.

REP: AGWA.

ROWBOTHAM, Walter

(b. 1879; d. 24/4/1951) Painter. Art instructor at Perth Tech. Coll., 1934–46.

REP: AGWA.

ROWE, Fawcett (George Curtis FAWCETT)

(b. 24/7/1832; arr. Vic. 1853; d. 29/8/1889) Painter, actor, entertainer. Son of George Rowe, he arrived with his father on the goldfields at Ballarat in 1853, where, contributing to their financial support, he became known as an entertainer in the theatres and booths of Ballarat and Bendigo as well as for his watercolours. He also painted theatre scenery. He appeared as a supporting artist with Lola Montez. Taking the surname *Fawcett* to distinguish himself from his father's work (he signed 'George Fawcett'), he became a part-owner of Melbourne's Princess Theatre. He went from Melbourne to NZ in the early 1860s to become active in art circles in Wellington, and afterwards to England and America, becoming well-known in both countries as an actor and producer. He died in New York and was buried in the actors' plot at Evergreen Cemetery.

REP: Alexander Turnbull Library, Wellington, NZ.

BIB: S. Blake, *George Rowe, Artist and Lithographer*, Cheltenham Art Gallery and Museum catalogue, UK 1982. AAGR, 1977. ADB 6. Kerr, DAA.

ROWE, George

(b. 1796, Dartmouth, Eng.; arr. Aust. 1853; d. 2/9/1864, Exeter, UK) Painter, lithographer, etcher. Commissioned by the British Government to make watercolour drawings of the Victorian goldfields, Rowe arrived at Port Phillip in *Blorenge* in company with his son, Fawcett Rowe (q.v.), 25 Nov. 1852, and proceeded to the goldfields at Ballarat. He was soon active and making 'two guineas per day from the sale of sketches'. An accomplished watercolourist, he is best known for his fine panoramic views of Ballarat, Bendigo and Melbourne. As in other topographical drawings of the period, the landmarks, buildings and groups of figures are arranged so as to produce a pleasing composition, convey the maximum information and give the viewer a sense of being 'on the spot'. Examples of such work, all done in the classic English manner (and apparently painted on David Cox paper, which would account for the darkening of areas not covered with paint) include: *Richmond Hill and the River Yarra Flats*, 1857; *Old Bendigo*, 1857; *Victorian Race Meeting near Sunbury*, 1858; *Ballarat*, 1858; and *Hobart*, 1858. Fifty works by him were exhibited in an art union, Bendigo, 1857.

Rowe returned to England via Sydney in 1859. His work was seen in *Victorian Visions*, NGV 1986 and *Tasmanian Vision* TMAG and QVMAG 1988.

AWARDS: Medal at the Kensington *International Exhibition*, 1862.

REP: Regional galleries Ballarat, Bendigo, Warrnambool; Dixson Gallery of the Mitchell Library, Sydney (Sir William Dixson acquired Rowe's watercolours, including those listed above, in London); NLA; La Trobe Library.

BIB: Moore, SAA. S. Blake, *George Rowe, Artist and Lithographer*, Cheltenham Art Gallery and Museums catalogue, UK 1982. McCulloch, AAGR. Kerr, DAA. ADB 6.

ROWE, Graeme

(b. 7/12/1952, Vic.) Painter.

STUDIES: Dip. Art & Design, Deakin Uni.; Grad. Dip. Painting, Canberra School of Art. He held three solo exhibitions 1988–91 in Victoria (including Flinders Lane Gallery 1991), and his work appeared in group exhibitions 1988–92 at regional galleries in Swan Hill, Broken Hill, Mildura, Geelong and Mt Gambier.

REP: NGV; Artbank; Deakin Uni.

BIB: *New Art Five*.

ROWE, Ron

(b. 1944, Broken Hill) Sculptor, painter, teacher.

STUDIES: SASA, 1962–64; travel studies, UK and USA. He lived and worked in London, 1968–70, and after his return to Australia, 1972, held exhibitions and contributed to Mildura Sculpture Triennials. He made use of assemblage and performance art including using a nude model to parody Duchamp's *Nine Malic Moulds* at the opening of an exhibition. He is the author of *Modern Australian Sculpture Multi-media with Clay*, Rigby, Adelaide, 1977.

AWARDS: VACB grant, 1976–77.

APPTS: Lecturer, Teachers Coll., Columbia Uni., New York, 1970–71; SASA, 1972–73, lecturer in sculpture, 1980– .

REP: AGSA; regional galleries Latrobe Valley, Mildura, Langwarrin.

BIB: Scarlett, AS. A&A 13/4/1976.

NFI

ROWE, S. V.

Lecturer. Successor to J. W. Wright as lecturer at Sydney Mechanics School of Arts, 1923–33. When Rowe was appointed in 1923, the Sydney Mechanics School of Arts moved from Ultimo to East Sydney, where it became known as the East Sydney Technical Coll.

BIB: Moore, SAA.

(*See also* SCHOOL–NATIONAL ART SCHOOL)

ROWED, Reginald Wilfred Whiting

(b. 1916, Melb.) Painter, teacher.

STUDIES: RMIT, 1934–38. He served with the AIF, 1940–45, and after the war became known in Melbourne for his epic paintings of mountain and coastal scenery.

AWARDS: Prize in Dunlop competitions, 1950.
APPTS: Official war artist with the AIF (Military History Section), 1945, then with the British Commonwealth occupation forces in Japan until 1947; lecturer in textile design, RMIT, 1948–76.
REP: NGV; AWM; Geelong Art Gallery.

ROWELL, John Thomas Nightingale

(b. 18/1/1894, Carlton, Vic.; d. 1973, Mornington, Vic.) Painter, teacher.
STUDIES: Working Men's Coll., Melb.; NGV School, 1913–16; travel studies Europe and USA., 1937–38. A skilful painter of sunlit landscapes of great popular appeal, he was selected to paint the coronation of King George VI at Westminster Abbey. Though conservative in his tastes, he did much to promote the cause of art in Vic. His work appeared in *The Face of Australia* 1988–89.
AWARDS: State Theatre landscape prize, 1929; Crouch prize, Ballarat, 1927, 37; Carnegie grant for travel study, 1937; Bendigo prize, 1938; H. Caselli Richards prize, Brisbane, 1951.
APPTS: Teaching, Ballarat School of Mines, 1919–27; art dept, Melbourne Grammar School, 1928; RMIT, 1929–47; senior member, Vic. Education Dept Board of Examiners for painting diploma; vice-president, National Theatre movement, Melbourne, 1950s.
REP: AGNSW; AGWA; NGV; QAG; regional galleries Ballarat, Bendigo, Castlemaine.
BIB: All general books on Australian art history. John Kroeger, *Australian Artists*, Renniks, Adelaide, 1968.

ROWELL, Kenneth

(b. 1920, Melb.) Stage designer, painter.
STUDIES: Melb. Tech. Coll. (evening classes), 1942–43; ballet with Edouard Borovansky, 1940–41; theatre design, London, 1950–51. His first designs for theatre were done for the Little Theatre and the Uni. of Melbourne Marlowe Society, with his first commission coming from the Adelaide Ballet Society, 1947. He went to London in 1950 and a year later designed décor and costumes for Walter Gore's television ballet *Hoops* (BBC). By 1992 he had designed over 140 ballet, opera and other theatre productions in England and Australia.
AWARDS: British Council scholarship for study in London, 1950.
REP: NGA; AGNSW; NGV; V&A Museum, London; Manchester City Art Gallery.
BIB: A&A 5/3/1967.

ROWELL, William Nicholas

(b. 1989, Melb.; d. 1946, Melb.) Painter, teacher.
STUDIES: NGV School, 1913–15; also with Max Meldrum. He painted mainly portraits and landscapes in a capable, impressionistic manner and was a foundation member of the Australian Academy of Art.
AWARDS: Melbourne Centenary prize (for landscape), 1934; Melrose portrait prize, 1937; Crouch prizes, Ballarat, 1939, 42.

APPTS: Drawing teacher, NGV School, 1941–46, acting head of the School, 1945–46.
REP: AGSA; NGV; QAG; regional galleries Castlemaine, Ballarat, Geelong.

ROWLISON, Eric Bjorn

(b. 13/11/1939, Norwalk, Connecticut, USA) Gallery director, administrator.
STUDIES: St Luke's School, Connecticut; Lafayette Coll., Easton, Philadelphia; New York Uni., NY. His special areas of interest were primitive art, especially Australian Aboriginal art and the art of Oceania and while with the Vic. Ministry for the Arts, he provided valued support to Victoria's 16 regional galleries. He wrote *Rules for Handling Works of Art*, Art Galleries Assoc. of Aust., Adelaide, 1973 and, with Theresa Veveris, the *Cataloguer's Manual for the Visual Arts*, AGDC, Sydney, 1980.
APPTS: Registrar, AGNSW, 1971–73; registrar, MOMA, New York, 1973–75; director, NGV, 1975–80; chairman, AGDC, 1975–78; Assistant Director (Special Projects), Vic. Ministry for the Arts, 1980–c.1983.

ROXBURGH, M.

Recorded by William Moore as an Australian prizewinner at *Panama Pacific International Exhibition* at San Francisco, 1914.

ROYAL ART SOCIETY OF NEW SOUTH WALES

Founded 1880 by a group led by the Collingridge brothers which broke away from the NSW Academy of Art. Known first as the Art Society of New South Wales, it was incorporated in 1887 and in 1903 granted a Royal Charter, to become the Royal Art Society of New South Wales. Among the founding members were Arthur and George Collingridge, W. C. Piguenit, L. Henry, C. H. Hunt, J. H. Carse, A. Clint, G. Podmore, C. E. Hern, W. Macleod, J. T. Richardson, J. Dalgarno, C. W. Minchin, P. Williams, A. Steffani. When the Society was founded, the artists exhibited their work in music shops until helped by Sir Henry Parkes to find space in the Garden Palace for exhibitions. During the third exhibition in 1882, however, the Garden Palace was burned down and the pictures destroyed. The fourth exhibition was held at the Sydney Town Hall and subsequent exhibitions appeared there until 1886; afterwards they were held at 70 Pitt St, Sydney, and Vickery's Chambers, 76 Pitt St, until 1914, when the Education Dept gallery was built and made available. Distinguished artist members of the Royal Art Society included Conder, Mahony, Long, Streeton, Roberts, Minns, Lambert, Ethel Stephens (the first woman council member), Hopkins, May, Nerli, Fullwood. In 1883 a government grant of £250 p.a. was given to establish a school. Among the early activities was the formation of clubs within the parent society. The Brush Club was founded for members under 26; it was established by D. H. Souter and its members included: Percy F. S. Spence, Thomas Gatward, Richard Tarrant, Victor Tarrant and H. M. S.

Atcherley. Monthly meetings were held and criticisms given by Ashton, Fullwood and other leading artists. Other clubs within the RAS included the Supper Club and Brother Brushes. This early period was recorded in a book, *Those Were the Days*, by George Taylor. A division occurred in 1895 when, at a special meeting, Fullwood moved that amateurs and laymen be excluded from the council. The motion was lost, but the professional artists then held a meeting at which Roberts suggested forming a new society to be called the Society of Artists with membership confined to professional artists. Led by Roberts the group then seceded from the Royal Art Society, and the New South Wales Society of Artists was formed. An RAS Artists' Ball was held at Paddington Town Hall in 1897 and from then on conducted annually for some years as a means of raising funds. In 1902 the Minister of Education, the Hon. John Perry, threatened to discontinue annual subsidies, which had been made available to the rival societies, unless they amalgamated; this was done and the Royal Art Society and the New South Wales Society of Artists received £800 per annum jointly until 1907, when they again divided, this time permanently. In 1922 the constitution of the Royal Art Society was amended to include the creation of Fellows and Associates. In 1929 a jubilee retrospective exhibition was held at the Blaxland Gallery, Sydney. The Society is still active (1993) with regular exhibitions by members, scholarships awarded, and the RAS school conducted at the historic premises in North Sydney.

PRESIDENTS: 1880–81, J. C. Hoyte: 1881, E. Coombes; J. Ashton, J. Abbott; R. Bloxham; W. Lister Lister; 1946– , E. Langker.

BIB: *Fifty Years of Australian Art, 1879–1929*, RAS, Sydney, 1929, to mark the jubilee celebrations. George Taylor, *Those Were the Days*, Tyrrells, Sydney, 1918. *Australian Art Illustrated*, RAS, Sydney, 1947.

ROYAL QUEENSLAND ART SOCIETY

(Established 1887) Established as the Queensland Art Society, it was granted a Royal Charter in 1927. Founding members included Oscar Fristrom, Isaac Jenner, L. W. K. Wirth and Godfrey Rivers (president, 1890–1906). Regular exhibitions began in 1888 and prizes were given from 1898. Small grants from the Qld government helped the Society; a building fund was started and in 1911 a specially organised Coronation Pageant added £500 to Society funds. In 1904 a group led by Fristrom seceded from the Society but rejoined it in 1916. An art library, which opened in 1936, added to the amenities provided for members. Present day activities include regular art classes and exhibitions.

BIB: Vida Lahey, *Art in Queensland 1859–1959*, Jacaranda Press, Brisbane, 1959.

ROYAL SOUTH AUSTRALIAN SOCIETY OF ARTS

(Established 1856) 122 Kintore Ave, Adelaide 5000. The oldest Australian art society, the RSASA was initiated by Charles Hill; Hill was elected president, the

Anthony Dattilo Rubbo, Man's Portrait, *charcoal on board, 42.9 × 32cm. Howard Hinton Collection, New England Regional Art Museum, Armidale, NSW.*

secretary being James McGeorge. Interest in the Society declined during the presidencies of successive state governors, 1867–88, and during 1889–91 vice-presidents only were appointed. The general meeting of 1890 was attended by the secretary and one other member, and only the efforts of Harry P. Gill saved the Society from oblivion. Part of the trouble was caused when a breakaway group formed the SA Academy of Art in 1885. When later a similar kind of split occurred at the Academy, one of the two groups reverted to the Society. Internal friction again occurred in 1942 when the dissenting faction left the RSASA to form the Contemporary Art Society, SA. Functions of the Society include exhibitions and regular daily art classes and tutorials and the production of a journal, *Kalori*.

PRESIDENTS: 1856–67, Charles Hill; Sir Dominick Daly; Sir James Fergusson; Sir Anthony Musgrave; Sir W. F. D. Jervois; –1889, Sir W. C. F. Robinson; 1892–1908, Samuel J. Way; 1908–10, Harry P. Gill; 1910–13, John White; 1913–17, James Ashton; 1917–20, John White; 1920–22, Edward Davies; 1922–26, John White; 1926–32, L. H. Howie; 1932–35, Leslie Wilkie; 1935–37, L. H. Howie; 1937–40, John C. Goodchild; 1940–49, George Whinnen; 1949–53, Duncan Goldfinch; 1953–56, H. Milward Gray; 1956–58, Alan C. Glover; 1958–59, Paul Beadle; 1959–64, John S. Dowie; 1964–66, Stewart Game; 1966–67, Max Lyle; 1967–70, Mervyn Smith; 1970–72, Don Noyce; 1972–74, Harry Marchant; 1974–81, Elizabeth Manly; 1981–85 Jeffrey Mincham; 1985–92 Stephanie Schrapel; 1992– Adam Dutkiewicz.

RUBBO, Anthony Dattilo

(b. 1870, Naples; arr. Sydney 1897; d. 1955, Sydney)
Painter, teacher.
STUDIES: Royal Academy, Naples, 1893–97 (with Domenico Morelli). He founded an art school in Sydney in 1898 and maintained it for 43 years, while teaching also at the RAS for 28 years. Although academic in his methods, he was never restrictive. His students included de Maistre, Wakelin, Cossington Smith, Friend, Murch and many others who went on to become successful painters. He was elected a member of the Council of the Royal Art Society in 1900 and a member of the War Memorial Advisory Board in 1919. A large collection of his work is in the Manly Art Gallery. His work was represented in the Bicentennial exhibition *The Great Australian Art Exhibition 1988–89*.
AWARDS: Created Knight of the Order of the Crown of Italy, 1932.
REP: AGNSW; AGSA; QAG; Wellington and Dunedin galleries in NZ.
BIB: *AA*, Aug. 1921, (reprdn). Erik Langker, *Anthony Dattilo Rubbo*, AGNSW *Bulletin*, vol. 6, no. 2, Jan. 1965.

RUBBO, Ellen Christine (née GRAY)

(b. 1911, Sydney; d. 1977, Melb.) Designer, painter.
STUDIES: Julian Ashton School, Sydney; Westminster School, London (with Iain McNab), 1934. Member of the Melbourne Contemporary Artists group. She worked as an advertising artist with the firm of Smith and Julius, Sydney, and in 1937 married Dr Sydney Rubbo, son of Dattilo Rubbo, and settled in Melbourne, where her colourful, illustrative paintings became well-known in exhibitions. Her work appeared in *The Face of Australia* 1988–89. Their son, Michael, became a film-maker, and their daughter, Kiffy (b. 1943, Mclb.; d. 1980, Melb.), was director of the Ewing-Paton Galleries, Uni. of Melbourne, 1971–80.
REP: AGNSW; NGV.

RUBIN, Harold de Vahl

(d. 1964, NSW) Collector, art dealer. Millionaire collector and art dealer who gave a number of valuable French post-impressionist paintings to the Queensland Art Gallery. Major Rubin, who owned extensive grazing properties in Qld, was an art dealer at 20 Brook St, London, for some years. A man of eccentric habits, he made a practice of buying entire exhibitions of work by young painters, and from about 1958 amassed a large collection of Australian paintings. After his death his collection went to Israel.
(*See also* GALLERIES, QUEENSLAND ART GALLERY)

RUBIN, Victor

(b. 1950, Sydney) Painter.
STUDIES: Bakery Art School, Paddington with John Olsen, William Rose, 1967–69; ESTC and Alexander Mackie CAE, 1970–73. His complex, image-laden, Breughelesque representations of modern disasters such as overpopulation and pollution are sometimes extended through collage. He held 25 solo exhibitions 1971–91

in Sydney (largely Mori, Roslyn Oxley9), Melbourne (Warehouse, Christine Abrahams, Realities) and Brisbane (Michael Milburn). He participated in numerous group exhibitions 1983–91 including at Watters, Mori, Macquarie, Sydney and major survey shows at public galleries including *A Different Perspective*, Artspace 1983; *The Male Sensibility*, Heide 1986; *Urban Anxieties*, NGA 1987; *A New Romance*, NGA 1987; *Mindscapes*, AGNSW 1989.
AWARDS: Half-standard grant, VACB, 1986.
REP: NGA; AGNSW; NGV; QAG; several regional and corporate collections Vic., NSW including ICI.
BIB: Catalogue essays exhibtions as above. Chanin, *CAP*.

RUMLEY, Katrina Le Breton

(b. 24/11/1946, Melb.) Painter, gallery director, administrator.
STUDIES: RMIT, 1964–67; travel studies, Europe and UK, 1971–72.
AWARDS: West German government scholarship for study in Germany, 1972.
APPTS: Lecturer in painting and art history, Gordon Inst. of Technology, Geelong, 1970–71; director, Geelong Art Gallery, 1972–75; senior projects officer, VACB, 1975– ?.

RUSCONI

Sculptor, monumental stonemason. He carved the *Dog on the Tucker Box* at Gundagai, NSW (c.1929).
NFI

RUSHFORTH, Peter

(b. 1920, Sydney) Ceramicist, potter.
STUDIES: RMIT, 1947–48; NAS, 1950–51; travel studies, Japan.
AWARDS: Churchill Fellowship, 1967; Bendigo award, 1974; VACB grant, 1974.
REP: Most state galleries.
BIB: Kenneth Hood, *Ceramics*, Arts in Australia series, Longman, Melbourne, 1961.

RUSSELL, Arthur Clarence

(b. 11/3/1927, Wickepin, WA) Painter, film-maker.
STUDIES: BA, Uni. of WA; travel studies, Europe, 1956–58; NAS, –1959. Information received gives him as 'painter changing to film', which would account for the absence of information about him as a painter since his exhibitions at the Old Fire Station, Perth, 1969, 70, and Gallery A, Sydney, 1971. His abstract expressionist paintings were shown also in the exhibition *Art from the West*, MOMAD, Melbourne, 1963.
APPTS: Teaching, Education Dept of WA, lecturer, Fine Art, Perth Tech. Coll., also WAIT, –1969; teaching, Yirara Coll. (for Aborigines), Alice Springs, 1971.
REP: AGWA.
NFI

RUSSELL, (Captain) Charles Robert Tylden

(Active c.1886–1902, Perth) Naval officer, painter. While serving as OIC, Harbour and Light Dept (from 1886), he painted some fine seascapes, exhibiting with the Wilgie Club at the *First Annual Art Exhibition* in

1890. His *Mouth of the Swan River, Fremantle, showing the Lighthouse* (probably painted in the 1890s) shows a capacity for portraying light and reflection. He returned to England in 1902. His work was seen in *The Colonial Eye*, AGWA, 1979.

REP: AGWA; WA Museum; Royal WA Historical Society.

BIB: *National Bank Calendar*, Melbourne, 1962.

RUSSELL, Elsa

(b. 18/1/1909, Sydney) Painter.

STUDIES: ESTC; also with Dattilo Rubbo, Sydney; Paris. Her work shows special interest in circus and ballet subjects, as for example in her exhibition in the foyer of His Majesty's Theatre, Melbourne, 1951.

AWARDS: Tumut prize, 1961.

REP: NGA; AWM; regional galleries Dubbo, Newcastle; Manly Gallery.

RUSSELL, James Newton

(b. 1909, Campsie, NSW) Illustrator, cartoonist.

STUDIES: Julian Ashton, 1924–30. He worked as an office boy in the office of the newspaper *Smith's Weekly* from 1924, and after studying at Ashton's school was promoted to the art staff in 1931 to become well-known for his illustrations and cartoons. He took over *The Potts*, a comic strip started by his colleague Stan Cross, and by the 1970s it was being syndicated to 35 newspapers in the USA, and had earned him the honour of election to the American National Cartoonists Society.

AWARDS: Voluntary Services section prize, *Australia at War*, NGV, Melbourne, 1945.

BIB: Vane Lindesay, *The Inked-In Image* Hutchinson, Melbourne, 1979.

RUSSELL, John Peter

(b. 16/6/1858, Darlinghurst, NSW; d. 30/4/1930, Randwick, NSW) Painter.

STUDIES: Slade School, London, with Legros (intermittently), Jan. 1881–84; Cormon's Academy, Paris, 1885–88. The son of an owner of a prosperous engineering firm, he had a natural talent for painting and a powerful urge to make painting his career though trained to take his place in the family engineering works. To this end he was sent as a 'gentleman apprentice' to the firm of Robey & Co., Lincoln, UK, 1876–79, but soon after his return to Sydney in 1880 his father died in the UK leaving him a handsome income for life, and the opportunity of a career in art, an opportunity he was quick to adopt. In the summer of 1881–82 he returned to London, and is recorded as having travelled in s.s. *Garone* with Tom Roberts. The two artists became fast friends. A brief period of study at the Slade was followed by a further sojourn in Sydney, when Russell wound up his business and family affairs and joined the Art Society of NSW, exhibiting in the annual exhibitions in 1882–83. He then returned to London, in company with his brother, Percy, and further study at the Slade. In the summer of 1883 John and Percy Russell joined Tom Roberts and their friend, Will Maloney (later Dr Maloney, a

leader in Vic. Labor politics), on a walking tour through Spain. Russell made another trip home to Sydney, spent a further short period of study at the Slade, painted in Cornwall, and in 1884 moved to Paris and enrolled at Cormon's Academy. There he made friends with the French artists Anquetin, Bernard, Guillaumin, Toulouse-Lautrec and Van Gogh, whose portrait, painted in 1886, was to become his most famous and enduring work. In Paris he became friendly also with Bizet, Forain, Steinlen and many others, including Rodin, whose favourite model, Marianna Antoinetta Mattiocco, he was to live with in his Paris studio. They married in Feb. 1888, and moved to Belle Isle, off the coast of Brittany, where Russell had built a splendid house and where their family (six sons and one daughter) grew up. Russell painted his most celebrated seascapes at Belle Isle, where also he entertained Monet, Van Gogh and many other artist friends. Among the visitors were the Australians Will Maloney, John Longstaff and Bertram Mackennal. The Russells lived an idyllic life but it was not to last. When Marianna died in 1908 Russell was bereft. He foolishly burned many of his paintings, sold *Le Chateau Anglais* without ascertaining its value and left Belle Isle for ever. In 1912 he married Caroline de Wit Merrill, an American singer and friend of his musician daughter, Jeanne. A period of work at Portofino, Italy, produced many fine, impressionistic watercolours but his work never regained the impetus that distinguished the paintings of his first Paris period, nor did he ever find, as his second wife recalled, the 'grand modern style' for which he sought. He worked in a London hospital during World War 1 and afterwards settled one of his sons on the land in NZ before returning to Sydney to live for the rest of his life at Watsons Bay. His cousin, Thea Proctor, described his garden there: 'From the street you could see nothing, but when you entered the gate leading through the high stone wall, the beauty of it took your breath away. For there, surrounded by flowering oleanders and delicious frangipani, you felt suddenly transported into the world of Monet.' At the bottom of the terraced garden Russell had blasted a small boat harbour out of the rock and at the end of a small wharf built his studio. Many of his paintings of the harbour were painted from his boat. One of his ambitions had been to establish the nucleus of a great impressionist collection for Sydney. But the idea was discouraged by local art authorities and his collection (stored in Paris) was lost to Australia. What it contained will never be revealed; it is believed to have included works by Rodin, Sisley, Guillaumin, Bernard. Van Gogh had offered 'some pictures of mine if your plan for an impressionist collection in your own country comes off'; and Russell's daughter, Jeanne Jouve, told the critic Basil Burdett in 1939 that 'Renoir had offered her father a number of works for Sydney'. Russell took little part in the art life of Sydney after his final return, and when he died following a heart attack in April 1930, all the attention he received was a formal death notice in the newspapers. His wife, Caroline, was visiting her sick

mother in New York at the time. Caroline died in Florida in 1962. Since the mid 1970s his work has become sought after and his oil paintings especially fetch high prices in auctions. His work is also often represented in Impressionist survey exhibitions.

REP: NGA; AGNSW; AGSA; NGV; Dixson Gallery of the Mitchell Library; Rijkmuseum, Amsterdam.

BIB: Nina Murdoch, *Portrait of a Youth*, Angus & Robertson, Sydney, 1948. Elizabeth Salter, *The Lost Impressionist*, Angus & Robertson, Sydney, 1976. Ann Galbally, *The Art of John Peter Russell*, Sun Books, Melbourne, 1977. *Meanjin* 4/1956 (Bernard Smith, *John Russell, Australia's Unknown Artist*). McCulloch, GAAP. A&A 3/1/1965 (Donald J. Finley, *John Peter Russell and his Friends*).

RUSSELL, Robert

(b. 13/2/1808, London; arr. Sydney 1832; d. 1900, Melb.) Surveyor, painter, architect, collector.

STUDIES: Edinburgh, articled to a firm of surveyors and architects; Sydney, with Conrad Martens, 1835 (he was Martens' first pupil in Sydney). In 1835 he went to Melbourne as surveyor but soon fell out with the administration. A man of strong ideas, he opposed the razing of Batman's Hill, with its forest of casuarinas, to make way for Spencer Street Railway Station. His differences with the administrator, Captain Lonsdale, ended when he was replaced as surveyor by Robert Hoddle and returned to Sydney in 1837. He was in Sydney for a year but an appointment as Clerk of Works returned him to Melbourne. He finally resigned from the public service in 1838 to go into private practice as a surveyor, architect and artist. During his versatile career, he produced many paintings, etchings, drawings, poems, translations from French writings and an unpublished novel entitled *The Shipwreck*. He also experimented with glass prints, heliogravure and daguerreotypes, and became known as a print collector and authority on old master paintings. He married Mary Ann Collis Smith (1839) and their daughter, Helen, achieved local celebrity as a singer. The family lived in England 1856–60, when Russell acted as a gallery guide for visiting colonial friends. He corresponded with Conrad Martens for 36 years. He left a large number of small sketches and paintings, many of the city from the south side of the Yarra River, and all highly professional in style. His work was represented in *Shades of Light*, NGA 1988.

REP: NGV; Ballarat Fine Art Gallery; NLA; Mitchell, Dixson, La Trobe Libraries.

BIB: Moore, SAA. ADB 2. McCulloch, AAGR. Kerr, DAA.

RUSSOM, Reginald

(b. 1887; d. 1952, Newcastle, NSW) New South Wales painter who worked for some years in America as a staff artist for the *New York Times*. A memorial exhibition of Russom's work was held in Newcastle in 1952.

BIB: Moore, SAA.

RUST, Bernard

(b. 21/7/1929, Berlin; arr. Aust. 1949) Painter.
STUDIES: School of Applied Art, Berlin, 1946–48;

part-time, ESTC, 1950–57; Certificate of Art, Swinburne Tech. Coll., 1965. He earned a living as a clerk in the NSW Railways until 1951, then, in Melbourne, in an insurance company until 1967 when he became a full-time painter. Later he taught part-time at RMIT. He exhibited regularly with the Social Realist group, held his first exhibition at Leveson Street Gallery, Melbourne, in April 1967, and later acted as secretary for the Malvern Artists Society. The character of the Social Realist painting of the 1950s remains in his work. He held about 13 solo exhibitions 1966–91 in Melbourne including at Wiregrass, Eltham and participated in a number of group exhibitions with the Realist Group at VAS in the 1960s and in social realist survey shows at private galleries in the 1970s, and 1980s.

AWARDS: E. T. Cato Prize, VAS, 1964.

APPTS: Teaching painting, CAE, Melbourne, 1970–91; part-time lecturer, RMIT.

REP: Commonwealth Art Advisory Board; several tertiary collections including teachers' colleges at Bendigo, Melbourne; several municipal collections including Diamond Valley.

RUTLEDGE, William

(b. 1924, Sydney) Musician, painter.
STUDIES: No formal training in art. Living in London from 1951, he held his first exhibition on the Victoria Embankment in 1956 and sold every picture. Since then his popular abstract paintings have brought him financial success. He was severely handicapped in 1965 when he lost his right arm in an accident. He lived in Switzerland from 1980.

RUWOLT, Charles

(b. 1873, Mt Gambier; d. 1946, Melb.) Engineer, businessman, collector. He retired to his property *Yarramundee*, Mulwala, NSW, where his house contained his large collection of mainly Heidelberg School, late colonial and modernist Australian paintings, a number of which were sold by Joel's auctions in *Charles Ruwolt Collection of Australian Paintings*, Melbourne, 17 Nov. 1966.
(*See also* COLLECTIONS)

RYAN, David

(b. 1951) Painter.
STUDIES: Several tertiary colleges in Vic., 1967–73; postgrad. studies, VCA, 1975; travel studies, India, 1977–78, 82, 84, 86. He held 12 solo exhibitions 1977–90, largely at Ray Hughes, Brisbane and Sydney. His work appeared in group survey shows 1970–91 at private galleries including Ray Hughes (*Thinking Aloud Again*, 1989; *Thinking Allowed*, 1991) and public galleries including regional galleries at Shepparton, Dalby, Qld and in *Perspecta*, AGNSW 1985; *Moet & Chandon Touring Exhibition*, 1987.

AWARDS: VACB travel grant, 1977.
REP: NGA; NGV; Artbank; several tertiary and regional collections Qld.

RYAN, *Rosemary*

(b. 1926, Tas.) Painter.
STUDIES: NGV School, 1950–51; George Bell School, 1950–52; Chelsea Polytechnic, London, 1954–55. From 1963 her work became known through exhibitions at the MOMAD, Melbourne, and at the South Yarra; Australian; Powell Street and Libby Edwards galleries. Her paintings poetically evoke memories of country life in Australia in pre-World War II times and occasionally allegorical scenes. She was represented in *Classical Modernism: The George Bell Circle*, NGV 1992.
BIB: Backhouse, *TA*. Germaine *DAWA*.

RYDER, *Mona*

(b. 1945, Brisbane)
STUDIES: Assoc. Dip. Visual Arts, QUT, Kelvin Grove, 1980; BA, QUT, Kelvin Grove, 1991. Her art often reflects issues such as the relationship between the sexes and domestic violence. Using found objects in her 1990s paintings she vividly portrayed the intrinsically beautiful native bush surroundings of the Gold Coast area juxtaposed with the garishness of modern development. She held about 12 solo exhibitions in Qld 1980–92, including several at regional galleries (Gold Coast City; Perc Tucker, Townsville) and the Uni. Art Museum, Uni. of Qld. Her work appeared in a number of group exhibitions 1976–91, first in Qld including at IMA; Michael Milburn; Uni. Art Museum, Uni. of Qld, then more generally including *Perspecta '85*, AGNSW 1985; *Book Works*, PICA 1989.
AWARDS: Residency, Vence, France, VACB, 1985; Gold Coast Art Prize, 1986; Andrew and Lilian Pedersen Memorial Prize, 1986; Caloundra Art Prize for watercolour, 1990.
APPTS: Teaching, several tertiary colleges, 1981–91, Qld, WA including QUT; Curtin Uni.; Griffith Uni.
REP: NGA; QAG; several regional gallery collections Qld; several tertiary collections Qld; tertiary library collections Uni. of Melbourne; James Hardie Library, State Library of Qld; British Library.
BIB: Catalogue essays exhibitions as above. *New Art Six*. Sandy Kirby, *Sightlines*, Craftsman House 1992.

RYDGE, *Albert*

Painter.
STUDIES: Meldrum school, Melbourne. A Fellow of the Royal Art Society of NSW.
AWARDS: Goulburn prize, 1962.
REP: AGNSW.

SABINE TO SZIGETI

SABINE, Patricia

(b. 22/1/1954, Melbourne.) Curator, gallery director.
STUDIES: NAS; EST, Sydney Teachers College, 1962–65.
She was an exhibition officer with touring organisations and public galleries and freelance consultant as well as co-ordinator for the arts section of the Melbourne City Council before becoming director of the TMAG in 1992.
APPTS: Education officer, TMAG and AGNSW 1976–79; executive assistant Australian Art Exhibitions Corporation, 1978; exhibition co-ordinator then manager, Cultural Development Branch, Melbourne City Council, 1985–91; director, TMAG 1992– .

SACHS, Bernhard

(b. 12/4/1954, SA) Painter, draughtsman.
STUDIES: BA; Dip. Ed., Uni. of Adelaide, 1976; BA (Fine Arts), SASA, 1980; Staatliche Akademie de Bildende Kunst, Stuttgart, Germany, 1982; Postgrad. Dip. Art, VCA, 1985; travel studies, Europe, USSR, Far East, 1982; Germany. Sachs' monochromatic drawings and paintings are often darkly brooding and reflect his European training and origins, especially that of German expressionism. Curator Tony Bond, writing in *Contemporary Australian Painting* (ed. Eileen Chanin, Craftsman House, 1989), describes his work as using 'the surrealist technique of doubling the images, layering one over another . . . [and] is committed to understanding the history of European hopes and failures.' He held 17 solo exhibitions and installations 1978–92 in Melbourne, including Reconnaissance, Deutscher Brunswick St (1990) and a number of tertiary and regional galleries including 200 Gertrude St (1987). He participated in numerous group exhibitions 1979–91, some at private galleries including Tynte, Adelaide; Deutscher Brunswick St, Melbourne, but largely at public galleries including EAF, Adelaide 1979, 80; and in *Blake Prize*, Blaxland Gallery 1986; *1000 Mile Stare*, ACCA 1988; *Perspecta*, AGNSW 1989; Joye *Adelaide Biennial of Australian Art*, AGSA 1990.
AWARDS: VACB overseas development grant, 1990; residency Power Studio, Cité Internationale des Arts, Paris, Power Inst., Uni. of Sydney, 1990.
APPTS: Lecturer, VCA and RMIT 1986– .

REP: NGA; AGNSW; AGWA; NGV; QAG; several tertiary, regional and municipal galleries Vic., NSW and SA.
BIB: Catalogue essays in exhibitions as above. Chanin, CAP. Smith, AP. A&A 27/2/1989; 30/1/1992. AL 10/4/1990–91.

SADLO, Alex

(b. 1927, Czechoslovakia; arr. Aust. 1951; moved to London 1972) Painter, jewellery designer.
STUDIES: Prague School of Art, 1948–49. He worked as a set designer at the State Theatre of Pilsen, Czechoslovakia, 1940–42 and in Australia first with Stan Ostoja-Kotkowkski (q.v.) and Wlad Dutkiewicz (q.v.) in Adelaide in the mid-1950s. His work is formalist abstract with expressive overtones. He also produced carvings from opals in the 1950s and 1960s. In 1968 his interest in three-dimensional work grew and he made stereoscopic photographic strips, and also worked in vitreous enamels and etched copper. His exhibitions in Australia before moving to London in 1972 included those with the CAS, 1950s, 1960s.
REP: NGA; AGSA.

SAGES, Jenny

(b. 19/9/1933, Shanghai, China) Painter, illustrator.
STUDIES: ESTC, 1950–51; Franklin School of Art, New York, 1951–54; with John Olsen, Mary White, 1956–57. She held two solo exhibitions 1988–92 at Blaxland Gallery, Sydney and participated in a number of group exhibitions with that gallery and in several award exhibitions including *Archibald*, *Wynne* and *Bathurst*. She won the 1992 Portia Geach Portrait Prize for a painting of art critic Nancy Borlase (q.v.) and her husband, unionist Laurie Short.
AWARDS: Bathurst Art Purchase Prize, 1991; Portia Geach Art Award, 1992.
REP: Artbank; NSW State Library; Bathurst regional gallery; private collections including Coles Myer, IBM.

SAHM, Bernard

(b. 1926) Ceramicist, teacher.
STUDIES: ESTC; travel studies, Europe and UK. He held numerous solo exhibitions 1955–92 and participated in many group exhibitions including at V&A, London, 1972 and Mildura Sculpture Triennial.

AWARDS: Several municipal awards for ceramics including Hunters Hill, Bathurst, 1972; project grant, VACB, 1976.
APPTS: Teaching, ESTC; lecturer in ceramics, Sydney Coll. of the Arts, 1978–84.
REP: AGNSW; NGV.
BIB: Kenneth Hood, *Australian Pottery*, Macmillan. A&A 3/3/1962. Germaine, AGA.

SAINTHILL, Loudon

(b. 1919, Hobart; d. 1969, London) Stage designer.
STUDIES: Melb. Tech. Coll., c. 1936. He refused formal schooling because of a severe stammer and, with the exception of the period spent at the Tech. Coll., was self-educated. An important influence was his lifelong friendship with the writer Harry Tatlock Miller. A natural designer, he received great stimulus from the arrival in Melbourne in the mid-1930s of the Colonel De Basil Russian Ballet Company. He held his first exhibition at the Australia Hotel, Melbourne, travelled to England in 1939 as a member of the Company, and held a successful exhibition at the Redfern Gallery, London. Later, with Harry Tatlock Miller, he assembled a large and important exhibition of theatre art for showing in Sydney and Melbourne. He served with the RAMC during World War II, and with Miller formed the Merioola Group of artists in Sydney. His set of designs entitled *A History of Costume from 4000 BC to 1945 AD* was shown at the AGNSW and subsequently acquired for the NGA, by public subscription. In 1949 he returned to England where he spent the rest of his life. Success in London was immediate, his first production of décor being for *The Tempest* at the Shakespeare Memorial Theatre, Stratford-upon-Avon. Designs for Sadler's Wells and many other theatres followed, and by 1954, when he designed the decor for *Le Coq D'Or* for the Royal Opera House, Covent Garden, he was established as a major designer for theatre. His wide range of interests, particularly in history and travel, made him, as Miller wrote, 'a designer who could not be type-cast'. He influenced a whole succession of Australian designers and established a tradition of Australian theatre design. Realities Gallery, Melbourne held a memorial exhibition of his work 29 April 1973 with a catalogue introduction by Harry Tatlock Miller – the proceeds from which went towards establishing the Loudon Sainthill Memorial Scholarship for Theatre Design, to enable young Australian designers to study in England. His publications include *Royal Album*, ed. with H. Tatlock Miller, and *Undoubted Queen*, both published by Hutchinson, London, 1951, 1958.
REP: NGA; many state and regional collections; Victoria and Albert Museum, London.
BIB: Catalogue essays exhibitions as above. Horton, PDA. A&A 7/3/1969 (Treania Smith, *Loudon Sainthill: a Tribute*); 10/2/1972 (Bryan Robertson, *Loudon Sainthill, in Grateful Memory*).

SALINS, Gunars

See BLUE BRUSH GROUP

SALKAUSKAS, Henry (Henrikas)

(b. 1925, Kaunas, Lithuania; arr. Aust. 1949; d. 1979, Sydney) Painter, graphic artist.
STUDIES: Paris, L'Ecole des Arts et Métiers; Germany, Freiburg Uni., 1946–49. Salkauskas earned his living as a house painter when he first arrived in Australia, and he continued to do so all his life, believing that this would help his absolute independence of spirit as an artist. His talent for simplicity and use of space gave small-scale mediums, such as watercolour and printmaking, remarkable depth and spaciousness. His calligraphic brushstroke, monochromatic colours and bold presentation were simple, direct and powerful, and his work was included in virtually every touring exhibition of Australian graphic art for 30 years. During the same period, 1950–79, he won a vast number of prizes for watercolours and printmaking. The AGNSW held a retrospective in 1981.
AWARDS: Many prizes including in Perth, 1962, 63; Adelaide (Vizard-Wholohan), 1964; Sydney (Robin Hood), 1962, 63, 64, 66; Wollongong, 1962, 63, 64; Geelong, 1966.
REP: NGA; AGNSW; AGSA; AGWA; NGV; regional galleries Bendigo, Geelong, Wollongong.
BIB: Most books on contemporary Australian art history. Exhibition catalogue *The Australian Painters, 1964–66*, Mertz Collection, Griffin Press, Adelaide, 1966. PCA, Directory 1976. A&A 19/3/1982; 20/2/1982.

SALMON, A. J.

(b. c. 1890, Melb.; d. c. 1970, Melb.) Painter. Late impressionist painter in oils, mainly of views in and around Melbourne. He exhibited at the VAS, Melbourne, from 1913, subjects including landscapes of the Dandenongs, mountain and bush scenes, etc. He also painted a few seascapes, probably at a later date.

SALMON, William Arthur

(b. 9/4/1928, Geelong, Vic.) Painter, teacher.
STUDIES: Swinburne Tech. Coll., 1946–49; Slade School, London, 1950–52; George Bell (Saturday classes), 1968; RMIT (industrial design), 1969. He wrote critiques for Sydney *Bulletin*, 1961, and conducted radio and television programs for children. His landscapes appeared regularly in *Wynne* prize exhibitions from 1958 and he held several exhibitions 1961–91 in Sydney (including at Macquarie; Robin Gibson), Brisbane (Philip Bacon) and Melbourne (Leveson St; Toorak in the 1970s).
AWARDS: Prizes at Grenfell, 1961; Rockdale, 1966; Hunters Hill, 1964; RAgSocNSW Easter Show, 1970; Dubbo, 1973; Lithgow, 1975; Portland, Grafton, Gosford, 1976; Portland, 1978.
APPTS: Teaching, SASA, 1953–58; ESTC, 1958–64; visiting lecturer, Alexander Mackie CAE, 1975–77.
REP: NGA; AGSA; AGNSW; QAG; NSW Parliament House; Auckland Art Gallery, NZ; several corporate collections including Reserve Bank, Esso, BHP.
BIB: Elwyn Lynn, *Australian Landscape and its artists*, Bay Books. *Australian Artists, Australian Birds*, Angus & Robertson. Germaine, AGA. A&A 3/1/1965; 19/2/1981.

SALNAJS, Venita
(b. 1945, Zwickau, Germany) Painter, teacher.
STUDIES: ESTC and Alexander Mackie CAE, 1963–66. She held around nine solo exhibitions 1977–89, largely at Holdsworth Gallery, Sydney; von Bertouch, Newcastle.
AWARDS: Prizes for watercolours in competitions at Ryde, 1967; Hunters Hill, 1968; Castle Hill, 1971; Drummoyne, 1972; RAgSocNSW Easter Show, 1976; Pring prize, AGNSW, 1976.
APPTS: Teaching, part-time, in NSW secondary schools.
REP: Uni. collections, James Cook Uni., Qld.
BIB: Reinis Zusters, *Spiral Visions*, Bay Books, Sydney, 1981. Germaine, AGA.

SALVANA, John
(b. 1873, Ironbark, NZ; d. 1956, Wyong, NSW) Painter.
STUDIES: RAS School, Sydney, 1897; Frank Calderon's Art School, London, 1912. His impressionistic landscapes were modelled somewhat in the manner of Streeton in his later period. Salvana worked as a theatre artist in Brisbane and became hon. secretary of the Qld Art Society, 1916–18, and a Fellow of the RAS, Sydney. In 1919 he presented a collection of paintings and a library of art books to the town of Tamworth, NSW, 'to encourage art in the country'.
AWARDS: Reeves prize, Sydney, 1936; National Roads and Motorists Association prize, Sydney, 1947; Albury prize, 1949.
REP: AGNSW; QAG; regional galleries Armidale, Newcastle; Manly municipal gallery.
BIB: Julie K. Brown and Margaret Maynard, *Fine Art Exhibitions in Brisbane 1884–1916*, Fryer Memorial Library, Uni. of Qld, 1980.

SAMEK, Tom
(b. 1950, Prague, Czechoslovakia) Painter, printmaker.
STUDIES: Bregenz, Czechoslovakia, with Eric Smodics, 1973. His work includes a large mural for the Engineering School, Uni. of Tas., 1977. His figurative work has been shown mainly in Tasmania, where he lives.
REP: AGSA; TMAG; QVMAG; VACB; Burnie, Devonport regional galleries.
BIB: Backhouse, TA. Germaine, AGA.

SAMSON, Horace
(b. ?c. 1818, Eng.; arr. Fremantle, WA, 14/3/1841; d. c. 1906, Eng.) Topographical draughtsman. A draughtsman and lithographer with the Land and Survey Dept, Perth, c. 1848–54, when he moved to Vic. where he held a similar position, becoming Deputy Registrar General, Crown Law Office, in the 1880s. He retired to England. He was known for his carefully painted atmospheric landscapes and topographical drawings. His work appeared in *The Colonial Eye*, AGWA 1979.
REP: AGWA; J. S. Battye Library of WA History, Perth; Mitchell Library.
BIB: Kerr, DAA.

SANDEMAN, H. G. H.
(Active 1880s, Sydney) Painter. Listed as R. Sandeman, he exhibited with the RAS, Sydney, from 1881, becoming known as a painter of horses, sporting, military and coaching scenes.

SANDERS, Christopher
(b. 1952, Vic.) Ceramicist.
STUDIES: With father, Tom Sanders, then Mungeribar Pottery, Vic., with Ian Sprague, 1972–78; travel studies, USA, Canada, England, 1978; Europe, 1985. He held 11 solo exhibitions 1977–89 including at Macquarie Galleries, Sydney 1986, 87, 89, and his work appeared in several group exhibitions 1978–87, including at Distelfink; Craft Council Gallery, Sydney 1987.
AWARDS: Arts & Crafts Society of Vic. Annual Award, 1981; trainee and workshop assistance grants, VACB, 1979, 84.
APPTS: Part-time lecturer, Prahran CAE, 1979–81.
REP: NGA; AGWA; NGV; Artbank; state craft collections; regional galleries Vic., Qld, NSW.

SANDERS, Tom
(b. 1925, Vic.) Ceramicist, muralist, tapestry designer.
STUDIES: ESTC, 1947–49; Europe, 1959–61. Well-known for his large ceramic murals for airports and city buildings and for his mural-sized, silk tapestries woven in Japan.
REP: AGNSW; NGV.
(*See also* PUBLIC ART)

SANDLER, John
(b. 1945, Birlystock, Poland; arr. Vic. 1949) Painter, printmaker, teacher.
STUDIES: Architecture, Uni. of Melbourne, 1964–66; printmaking, Prahran CAE, 1968–70. Best-known for his paintings, drawings and prints of themes carefully worked in series such as teapots, dolls' heads, boots, etc. His prints have been shown in international print exhibitions, notably at Bradford, UK, 1972, and in West Germany; they are also well-known through Australian interstate print exhibitions.
AWARDS: Prizes at Warrnambool (print acquired), 1973; Mornington (drawing acquired, MPAC *Spring Festival of Drawing*), 1973; Georges Art Prize, Melbourne (work acquired), 1974.
APPTS: Art teacher, Peninsula Boys School, Mornington Peninsula, Vic., 1972– .
REP: Regional galleries Mornington, Warrnambool; Uni. of Qld.
BIB: PCA, *Directory* 1976. Germaine, AGA.

SANI, Tommaso
(b. 1839, Florence, Italy; arr. Aust. 1870s; d. 28/8/1915, Paddington, NSW) Sculptor.
STUDIES: Trained in Italy as a sculptor's pointer. He exhibited a sculpture in the Italian section of the *International Exhibition*, Melbourne, 1880–81 (first public appearance of his work in Australia), and in 1882 was commissioned to carve the spandrels for the new Sydney Post Office, Pitt Street. Commissioned by Sir Henry Parkes to make the bronze *Footballer* for Centennial Park, Sydney, 1891 (removed 1951), he

Gareth Sansom, Friendship's Road/Crucifixion, *1985, mixed media on linen, 182 × 243.8cm. Collection,* MOMA, *New York.*

later made statues of prominent people for the Lands Dept building, Bridge St, Sydney, 1891.
BIB: *ADB* 6. Scarlett, AS.

SANKEY, Olga
(b. 4/10/1950, SA) Printmaker.
STUDIES: BA (Hons), Uni. of Adelaide, 1971; BA Fine Arts, SASA, 1980; Dip. Lithography, State Inst. of Art, Urbino, Italy, 1981; Grad. Dip. Fine Arts, SASA, 1982. Her prints were seen in three solo exhibitions 1981–91, in Bologna 1981; Tynte Gallery, Adelaide 1985; Holdsworth Gallery, Sydney 1990, and in a number of print survey exhibitions including international exhibitions at Seoul 1982, 84, 88, 90; Osaka 1991 and *100 × 100,* PCA 1988.
AWARDS: Grand Prix International Miniature Print Exhibition, Seoul, Korea, 1982 and Award of Excellence, (same) 1988.
APPTS: Lecturer, printmaking, SASA, 1984–87; Uni. of Newcastle, 1988–89; SASA, 1989–92.
REP: AGSA; Parliament House; Artbank; regional galleries Devonport, Hamilton, Perc Tucker; Uni. of Adelaide; WAIT; Deakin Uni.
BIB: PCA, *Directory* 1988. A&A 22/2/1984.

SANSOM, Gareth Laurence
(b. 1939, Melb.) Painter, lecturer.

STUDIES: Dip. Fine Art, RMIT, 1959–64; travel studies, USA, UK and Europe, 1967. Influences of Pop, expressionism, assemblage, photo-montage and other international modes have all contributed to the development of his large-scale paintings which often incorporate sociological and satirical references. He held about 30 exhibitions 1959–93 in Melbourne (including at Sweeney Reed Galleries, Realities, Luba Bilu), Sydney (Roslyn Oxley9) and Brisbane (Ray Hughes), with the most significant being large survey exhibitions at Charles Nodrum, Melbourne 1986; Uni. Gallery, Uni. of Melbourne 1986; Seventh Triennale, New Delhi, India; Melbourne Uni. Museum of Art and touring three other tertiary and state galleries, 1991. His work was seen in over 100 group exhibitions 1962–92 including Biennale of Sydney 1982, 86; *From Field to Figuration,* NGV 1987; *Painters and Sculptors: Diversity in Australian Art,* QAG and touring Japan 1987; *The Face of Australia* Bicentennial exhibition 1988–89; *Word as Image, Art as Text,* Monash Uni. Gallery 1990; *Off the Wall, In the Air,* Monash Uni. gallery and ACCA 1991; *Diverse Visions,* QAG 1991. Commissions include a tapestry for the Vic. Tapestry Workshop. He was a visiting artist to Stedeljik Museum, Amsterdam, 1982.
AWARDS: Grants, VACB, 1975, 76, 81, 84; Hugh Williamson Prize, Ballarat Gallery, 1984.
APPTS: Lecturer in art, various tertiary colleges, 1960–91; Dean, School of Art, VCA, 1986–91.
REP: NGA; AGNSW; AGSA; AGWA; NGV; QAG; QVMAG;

TMAG; Artbank; MCA, Brisbane, Sydney; MOMA, New York; National Art Gallery, Wellington, NZ; Heide; many regional galleries including Ballarat, Bendigo, Geelong, Newcastle, Latrobe Valley; many tertiary colleges and unis. including Griffith, Melbourne, Monash; many corporate collections including Loti and Victor Smorgon, Mertz Collection, NY.

BIB: Catalogue essays exhibitions as above and most general books on Australian contemporary art history including Bonython, *MAP*; Smith, *AP*; McIntyre, *ACD. A&A* 15/2/1977.

STUDIES: ESTC evening classes, c. 1951–57. He worked as an architectural draughtsman and designer for television, and later as a theatre artist, before receiving numerous commissions to make sculpture features in widely varied materials for buildings nationally and internationally. Known for his Royal Shakespeare Theatre's mirror curtain and the suspended centrepiece sculpture at the Barbican Arts and Cultural Centre, London and the dazzling *Arcturus* light sculpture suspended through a six storey atrium in the

John Santry, Near Edgecliffe Station, *1970, oil on board, 58.5 × 89cm. Christie's, August, 1992.*

SANTRY, John (Terence John)

(b. 1910, Sydney; d. 1990, Sydney) Painter, illustrator. STUDIES: Sydney, part-time, with Dattilo Rubbo; ESTC; Westminster School, London, 1937–39. He worked as a black-and-white artist with newspapers including the *Daily Telegraph, Labor Daily* during the 1930s before going to London to study. Returning to Australia in the 1940s he combined cartooning with painting – his paintings being in the post-impressionist style.
AWARDS: Prizes in Dunlop competition, Melbourne, 1954, 55; Rockdale, 1955; RAgSocNSW Easter Show, 1958, 66; Wagga Wagga, 1959; Katoomba (Blue Mountains Centenary), 1962; RANgAQ, Brisbane, 1961; Young, NSW (shared with Carl Plate), 1963; Drummoyne (watercolour), 1964; Hunters Hill, 1966.
APPTS: Secretary of the NSW Society of Artists; lecturer in art at Sydney Uni. and ESTC, 1950s and 60s.
REP: AGNSW; NGV; QAG; Bendigo Gallery, Vic.
BIB: *A&A* 28/4/1991 (obituary).

SANTRY, Michel John

(b. 1936, Sydney) Designer, sculptor. Son of John Santry.

entrance foyer of the Melbourne Concert Hall. He has completed many commissions in Europe, the Middle East, China, SE Asia and Australia.

SARGENT, G. F.

Artist of the Victorian goldfields. Moore says that 'a number of sketches of goldfields were made by W. A. Nicholls and G. F. Sargent'.
BIB: Moore, *SAA.* Kerr, *DAA.*
NFI

SASS, Alec (Alec WILLIAMS)

(b. c. 1870, UK) Painter, cartoonist.
STUDIES: NGV School, c. 1897. His real name was Williams. He exhibited paintings with the Art Society of NSW from 1902 and later with the NSW Society of Artists but became celebrated as a cartoonist, using the pseudonym Alec Sass. He drew for the Melbourne *Punch*, Sydney *Bulletin* and other papers, worked in

New York for the *New York World*, c. 1915–17, and returned to Sydney to join the advertising firm Smith and Julius. He became the art editor of *Smith's Weekly* when that paper started, and gave George Finey (q.v.) his first regular job.

BIB: Moore, SAA. Lloyd Rees, *The Small Treasures of a Lifetime*, Ure Smith, Sydney, 1969. M. Mahood, *The Loaded Line*, 1973.

(*See also* CHARTERISVILLE)

SASSE, Edmund
(b. 1819, Brussels; arr. Aust. 1852) Painter. The first art teacher at Geelong, he taught at Geelong Grammar School from 1854 and had two daughters who continued to teach art in Geelong. His work *Banquet to mark the Turning of the First Sod for the Geelong and Melbourne Railway 1853* is in the collection of the Geelong Art Gallery and he showed etchings and watercolour sketches in a number of exhibitions in Geelong 1850s–70s.

BIB: Kerr, DAA. W. Brownhill, *The History of Geelong and Corio Bay*, Melbourne 1955.

SATCHELL, Edgar
Graphic artist. Exhibited at an exhibition 'to promote interest in the medium of woodcuts' at Tyrrell's Gallery, Sydney, in 1923.

BIB: Moore, SAA.

NFI

SAWREY, Hugh David
(b. 3/3/1923, Forest Glen, Qld) Painter, sculptor.
STUDIES: No formal training. Son of a teamster, he worked on NT and Qld cattle stations, began painting, attained popular success, and turned to painting full-time in 1964. His subsequent large output of oils, depicting the life he knows best, attracted a large following in Qld and he is recognised as the leading painter of horses of this type in Australia. He exhibits largely at galleries on the Gold Coast, Qld and has completed a number of commissions including a painting of the USA Embassy in Canberra. In 1974 he established the *Stockmen's Hall of Fame and Outback Heritage Centre*, Longreach, Qld.

AWARDS: Rockhampton prize, 1970; Gold Coast City art prize (popular vote), 1969, 70; CBE for services to art 1988.

REP: NGA; QAG; regional galleries Benalla, Rockhampton; Dunedin Gallery, NZ; Menzies Foundation.

SCARLETT, Kenneth William
(b. 27/11/1927, Melb.) Sculptor, gallery director, teacher, writer, freelance curator.
STUDIES: CIT (as a secondary art-craft teacher), 1947–48; Melb. Teachers Coll., 1949; travel studies, UK and Europe, 1954. He travelled extensively in Europe, Russia, India, SE Asia, Japan, Mexico, Guatemala, Greece, Algiers and Egypt and from 1958 his sculptures were exhibited in group and solo exhibitions. He began his book *Australian Sculptors* (Thomas Nelson, 1980), the omnibus volume for which he is best

known, in 1972, and during his research contributed the biographies of Perceval Ball, Margaret Baskerville and Ola Cohn to the *Australian Dictionary of Biography*. He developed a special interest in Australia–Japan exchange and fostered many cross-cultural exhibitions including a large exhibition (*Continuum '83*) of contemporary Australian art in Japan and of contemporary Japanese art in Australia (in eight Melbourne galleries). Retiring from the Gryphon Gallery in 1987, he became secretary of the Australian Sculpture Triennial and executive manager 1986–90 and curated several significant sculpture exhibitions including *Dame Edna Regrets She Could Not Attend*, an exhibition of satirical sculpture, Heide, 1992. His other books include a monograph on the sculptor John Davis (q.v.) – *John Davis: Places and Locations*, Hyland House, Melbourne 1988 and *Sculpture in Public Gardens*, Craftsman House, 1993.

AWARDS: VACB grants, 1972, 76, 82.
APPTS: Teaching, Victorian secondary schools, 1950–52, high schools, 1955–58; education officer, NGV, 1958–60; teaching, high schools, 1961–63; CIT, 1964–68; Melb. State Coll., 1969–76; director, Gryphon Gallery, Melb. State Coll., 1976–87.

SCARVELL, Jessie E.
(Active 1890s, Sydney) Painter. Landscape painter in oil and watercolour. She exhibited regularly at the Art Society of NSW from 1892, her subject matter usually being restricted to river, lake and coastal scenes in NSW. Her work was included in the Exhibition of Australian Art, Grafton Gallery, London, 1898.

REP: AGNSW.

BIB: John Kroeger, *Australian Artists*, Renniks, Adelaide, 1968.

SCHALLER, Mark
(b. 1962, Hamburg, Germany; arr. Aust. 1962) Painter.
STUDIES: VCA, 1980–82. One of the members of the ROAR collective, he exhibited with ROAR in Melbourne 1981–83 and Coventry, Sydney 1985, 87, 88. He held four solo exhibitions in Melbourne 1982–89 including at ROAR 1982; United Artists 1983; Australian Galleries 1989, and was one of the artists commissioned to paint a mural for the NGA restaurant as well as those for Tasmanian CAE, Launceston; Victoria Racing Club; Portsea Resort.

REP: NGA; several tertiary, regional galleries Vic., Tas.

SCHAPEL, Dennis
Teacher, painter.
STUDIES: Dip. Secondary Art Teaching, Adelaide CAE, 1964; SATC; Dept of Education, SA, 1965; Dept of Education, Vic., 1966; Grad. Dip. Visual art, Adelaide CAE, 1977; MFA, Maryland Inst. of Art, USA, 1984. Member of many professional bodies including art adviser to NT Dept of Education; Heads of National Art Schools Association. He held 13 solo exhibitions 1969–90 in the NT, Adelaide and Sydney including at the NT Museum of Arts and Sciences 1984, 86, 90. He was artist-in-residence at Georgia Fine Art

Jan Hendrick Scheltema, Cattle By a Pond, *oil on board, 49 × 74.5cm. Christie's, August 1992.*

Academy, USA 1985, 88 and his work appeared in around 20 group exhibitions 1980–92 including *Artists Maps and Walks,* CAS, SA 1980; staff exhibitions, Northern Territory Uni. 1990, 91, 92.

APPTS: Teaching and lecturing, tertiary institutions, since 1977 including Darwin Inst. of Technology, 1984– ; Head of NT School of Art, 1991– .

REP: MAGNT; Northern Territory Uni.; Maryland Inst. of Art, Baltimore Design Centre, USA.

SCHARF, Theo

(b. 1899, Melb. d. ?) Painter, teacher.

STUDIES: Bulgaria, c. 1914; Munich, with von Habermann, 1916–24. Son of Eduard Scharf (musician friend of Marshall Hall) and Olive de Hugard, pianist, he was hailed by Melbourne artists Blamire Young and E. Phillips Fox as an infant prodigy when he held an exhibition at the Athenaeum, Melbourne, 1914. His portrait, as a child artist with brushes and palette, was painted by Violet Teague (NGA collection). Because of his German antecedents he was taken to Europe soon after the outbreak of World War I and studied briefly in Bulgaria before moving to Munich. In the early 1920s Dame Nellie Melba brought a set of his etchings back to Australia. Mostly of figures in interiors, they are typical of the prevailing Munich style; later his painting, though remaining figurative, strongly reflected the influence of cubism. As a professor of art, he was one of the artists who hosted the visit to Munich of the French artists who accepted Hitler's invitation made through the Pétain administration during the German occupation of France. After the war his Australian passport made it possible for him to leave Germany, and in 1950 he returned to Victoria where he stayed for six years, exhibiting with the CAS, Melbourne, lecturing to CAE classes and conducting

art classes at Box Hill. He returned to Munich in 1956.

AWARDS: Student prizes, Munich Academy, 1917–18; Bendigo prize, 1953.

APPTS: Professor of painting and drawing, Munich Academy of Applied Art, 1934– , and 1956–?

REP: NGA; AGSA; NGV; Bendigo Gallery.

BIB: *VAS Journal,* Melbourne, 1 Mar. 1914.

NFI

SCHELL, Frederic B.

(b.?/3/1838, USA; arr. Sydney 1886–9; d. ?/05/1902, USA.)

See PICTURESQUE ATLAS OF AUSTRALASIA

SCHELTEMA, Jan Hendrik

(b. 1861, The Hague, Holland; arr. Vic. c. 1890; d. 1938) Painter.

STUDIES: Three years at the Royal Academy, Brussels. Known mainly for paintings of cattle and horses. Scheltema painted mostly in monochrome, and was said to have been colour-blind. He lived for some years at Gouda, Holland, and practised as a portrait painter before moving to Vic., where he became known chiefly as a painter of domestic animals, painting often in conjunction with other painters, e.g., John Mather, and Charles Rolando – Scheltema painting the cattle, and Rolando, his chief collaborator, the landscape. His paintings became popular in auction houses such as Joel's, Christie's and Sotheby's during the 1980s with the rise in popularity of colonial-style paintings.

REP: AGNSW; AGSA; NGV; TMAG.
BIB: Catalogue *National Gallery of South Australia*, Adelaide, 1946.

SCHEPERS, *Karin*

(b. 1927, Cologne; arr. Aust. 1955) Printmaker, teacher.
STUDIES: Kölner Werkschulen, Cologne, 1946–53; travel studies, Israel, 1969, Israel, Holland, France and UK, 1975. Between 1960 and 1964 she made about 40 etchings but from 1964 concentrated on art education and studies in art history.
APPTS: Teaching, SASA, Adelaide, 1959– ; lecturer, Kingston CAE, 1976– .
REP: AGSA; NGV; Newcastle regional gallery.
BIB: PCA, *Directory 1976*.
NFI

SCHERER, *Rodney James*

(b. 24/2/1951, Campbelltown, NSW) Painter, curator.
STUDIES: Canberra School of Art, 1973–75; Dip. Art, Gippsland Inst. of Advanced Education, 1978; Grad. Dip. Art (painting), 1985. He curated several exhibitions in the Latrobe Valley 1990–92 including *Contemporary Gippsland Artists*, touring regional galleries 1990–92, and participated in about ten group exhibitions 1984–92 including *First Australian Sculpture Triennial*, La Trobe Uni. 1981; *Middle Earth*, Warrnambool, Mt Gambier regional galleries 1984; *Contemporary Gippsland Artists*, touring 1990–92; *2 at W*, two-person exhibition, Vic. Ministry for the Arts foyer 1992. He held two solo exhibitions, at Latrobe Valley Arts Centre (1985) and Artenbrug, Brazil (1988).
APPTS: Technician, School of Visual Arts, Gippsland IAE, 1979–80; education officer, Latrobe Valley Arts Centre, Morwell, 1987–90; curator, 1990– .
REP: Latrobe Valley Arts Centre; SEC, Vic.; La Trobe Regional Commission.

SCHIPPERHEYN, *Peter Martinus*

(b. 31/5/1955, Melb.) Sculptor.
STUDIES: Dip. Fine Arts, CIT, 1978; Accademia di Belle Arti Roma, four months, 1976; Accademia di Belle Arti Carrara (Scultura), nine months, 1979; travel studies, Japan, France, Italy, 1989; Italy, France, Belgium, USA, 1990. Working often in marble and on a large scale, his works include huge torso and portrait sculptures and were seen in six solo exhibitions 1981–91 in Melbourne (Australian Galleries 1981, 88), Sydney (Holdsworth 1986, 88) and Galleria della Arte Biennale, La Spezia, Italy 1982. Group exhibitions in which his work was seen 1979–90 included; *Esibizzione di tre Scultori*, 1982; *Wynne Prize*, AGNSW 1982, 92; *Frederick R. Wiesman Travelling Collection*, ongoing worldwide travelling exhibition of sculpture, paintings and graphics 1985; *Bronze Figurative Sculpture*, Dieleman Gallery, Brussels 1990. His many commissions include those for Whitefriars Coll., 1982; RSL St Kilda, 1983; CUB, 1985; Sydney Town Hall (Dame Joan Sutherland), 1988; St Stephen's Catholic Cathedral, Brisbane, and a portrait bust of Dr Eric Westbrook for the NGV, 1991.

AWARDS: Abercrombie Sculpture Prize, 1978; municipal art prizes (Camberwell Rotary, 1978; Dandenong Festival, 1978); Italian Government Scholarship, nine months Accademia di Belle Arti, 1979; artist development grant, Vic. Ministry for the Arts, 1983; Wynne Prize, AGNSW, 1992.
REP: AGNSW; NGV; Geelong Art Gallery; Vic. Arts Centre.

SCHLICHT, *Rollin*

(b. 1937, Ocean Island; arr. Aust. 1939) Painter, architect.
STUDIES: Part-time, Winchester School of Art, UK, 1956–58; Dip. Architecture, Kingston School of Art, 1959–65. He returned to Sydney, 1966, exhibited at Central Street Gallery and Pinacotheca Gallery, Melbourne, 1968, 70, and participated in *The Field* exhibition, NGV 1968. The scale of his work and his use of flat, primary colours and separate asymmetric shapes related his painting to that of Matisse. Rehabilitation of the Baroque style as profound grand-scale decoration may have been one of his aims in painting, in accord with his work in architecture, the profession to which he is mainly committed. He is also a fine draughtsman.
AWARDS: Aubusson Tapestry award, Hungry Horse Gallery, Sydney, 1967.
REP: NGV; Mornington regional gallery.
BIB: Smith, AP.

SCHLUNKE, *David*

(b. 1942, Temora, NSW) Painter.
STUDIES: ESTC; also with Arthur Murch, 1959–64. His semi-abstract, atmospheric landscapes have appeared in around 22 solo exhibitions 1972–90 including Hogarth, Sydney and a retrospective at Wagga Wagga regional gallery, 1988.
AWARDS: R AGSOCNSW Easter Show prizes, 1964, 67, Trustee's Purchase Prize, QAG, 1978.
REP: NGA; QAG; Reserve Bank; Manly Art Gallery; Artbank.
BIB: Germaine, AGA.

SCHMEISSER, *Jorg*

(b. 1942, Germany; arr. Aust. 1976) Printmaker, lecturer.
STUDIES: Academy of Fine Arts, Hamburg. He graduated as an art teacher and became assistant to Paul Wunderlich before a scholarship took him to Japan, where he taught 1969–72. He lectured in Hamburg, Germany, 1972–73, and as artist for the Uni. of Missouri expedition to Israel and Greece developed an interest in archaeology. He travelled extensively in the Far East, gave lectures and held exhibitions in Australia, 1976, and the following year went to the Bezalel Academy of Fine Arts and Design, Jerusalem, as guest lecturer before returning to Australia in 1978 as senior lecturer at the Canberra School of Art. Meticulous in their making, his detailed etchings (many in colour) testify to the thoroughness of his

training, talents and observation. Natural phenomena, microscopic and macroscopic forms and elemental forces are so composed as to give a feeling of existence in infinite space and time. To such subjects Schmeisser adds depictions of ancient and imaginary cities and references to famous nudes by old masters, a legacy perhaps from his early association with Wunderlich. He held at least one (and frequently two or three) solo exhibitions annually from 1969 in Japan, USA and Australia, and participated in numerous important international group print exhibitions. He was represented in *The Face of Australia* Bicentennial exhibition 1988–89. His works have developed seamlessly in complexity and depth and have earned him a significant international reputation.

AWARDS: German Academic Exchange Service scholarship to Japan, 1968; Aldegrever-Gesellschaft scholarship, Hamm, 1974.

APPTS: Teacher, Design Inst., Kyoto, 1969–71; lecturer, printmaking departments, various tertiary colleges, 1972 – including Hamburg Fine Art Academy, 1972–78; senior lecturer, Canberra School of Art, 1978– ; professor, Kyoto Seika Uni., 1988.

REP: NGA; AGSA; NGV; many public collections in Europe, Israel and the USA including Bibliothèque Nationale, Paris; Kunsthalle, Hamburg; Israel Museum, Jerusalem; MOMA, New York; Princeton Uni. collection.

BIB: PCA, *Directory,* 1988. Monograph on his work *Jorg Schmeisser Etchings 1974–1979*, Okamura Printing Industries, Nara, Japan, 1980.

SCHMIDT, Karl
He worked in Sydney, c.1899.

REP: AGNSW (enamel, the drawing for which is in the Manly Gallery).

NFI

SCHOENFIELD, Frederick
(b. c. 1810, Switzerland; arr. Vic. 1858; d. 1868) Illustrator, engraver. Also known as 'Fritz Shonfeld', he worked in Melbourne as a freelance artist and was employed by the director of the National Museum of Victoria, Frederick McCoy, to engrave plates for his books of flora in the 1860s. He also lithographed portraits for editions of books and is notable for the lithograph of Ludwig Becker (q.v.) produced for the Melbourne German Club in 1861 (collection La Trobe Library). However, depressed by money problems, he committed suicide in a water-filled quarry in Richmond, Melbourne.

REP: Mitchell, La Trobe Libraries.

BIB: Kerr, DAA.

SCHOLARSHIPS
See PRIZES AND SCHOLARSHIPS

SCHONBACH, Frederick
(b. 1920, Vienna; arr. Melb. 1938.) Graphic artist, illustrator. One of a group of artists who arrived on the prison ship *Dunera* and later contributed drawings to the *Australasian Post*, Melbourne, 1945–46. Schonbach migrated to Brazil, c. 1946.

AWARDS: Prize, *Australasian Post* black-and-white art competition, 1945.

(*See also* FABIAN, Erwin)

SCHOOLS AND UNIVERSITIES
See APPENDIX 8, p. 864.

SCHRAMM, Alexander
(b. 1814, Berlin; arr. Adelaide 1849; d. 1864, SA) Painter. He showed in exhibitions regularly in Adelaide, 1857–64, and his known work includes portraits of the Stow family, lithographs of Aborigines and landscapes, and the oil *The Gilbert Family* (collection AGSA), unusual for its portraying a domestic scene with both whites and Aborigines. His work appeared in the Bicentennial exhibition *The Great Australian Art Exhibition*.

REP: AGSA.

BIB: *Bulletin* of the AGSA, vol. 28, no. 1, July 1966 and vol. 39, 1979. Kerr, DAA.

SCHRAPEL, Stephanie
(b. 27/12/1944, SA) Painter, photographer, curator, art writer, critic.

STUDIES: Dip. Teaching, Adelaide Teachers Coll., 1965; BA, Uni. of Adelaide 1968; Dip. Ed., Uni. of Adelaide, 1971; PhD, 1987. She was a secondary teacher in SA and a member of many artists' societies and educational bodies, 1966–92 including RSASA, PCA, CAS, and Art Museums Association of Australia. She undertook many field trips including to China, UK, India, Europe, Japan, and the Australian outback, 1968–91. She gave numerous lectures and wrote numerous articles and booklets, largely for the Education Dept of SA, on art and craft as well as curating exhibitions for Flinders Uni. and the Crafts Association of SA. She held around 22 solo exhibitions 1982–92, some at private galleries in Adelaide but largely at tertiary and public gallery annexes, community centres and in *South Australian Heritage*, touring six SA regional centres, 1987. She participated in numerous group exhibitions, often photographic survey shows, 1966–90, including RSASA; SA Centre for Photography.

AWARDS: Bronze medal, Australian Bicentennial Authority, 1988; Wildlife Art Award, 1993.

APPTS: President, RSASA, 1985–92; co-ordinator, Heritage Week, National Trust of SA, 1987–88; art critic, Adelaide *Advertiser*, 1988–89.

BIB: PCA, *Directory* 1982; 1988. Joy Redman, CAS *Workshop, the First Years*, 1985. Germaine, AGA.

SCHWARTZ, E. George
(b. 1935, Zurich) Film-maker, painter, printmaker, teacher.

STUDIES: Ecole des Arts et Métiers, Vevey, Switzerland. He held exhibitions of his surrealistic paintings in Lausanne, 1962, Basle, 1962, Munster, 1963, before coming to Australia where he exhibited at the Sebert Galleries, Sydney, 1970, prior to concentrating mainly on teaching and film-making.

AWARDS: Experimental Film Fund grant, 1970; Australian Film Inst. special award for lighting, 1971; Sydney Tech. Coll. School of Graphic Arts prize for photomechanical reproduction, 1976, 77.
APPTS: Lecturer, NAS, 1970; Alexander Mackie CAE, 1976; partner in Printworkshop Zero, Sydney, 1974– .
REP: VACB collections, Sydney; Alexander Mackie Collection.
BIB: C. Flower, *Erotica: Aspects of the Erotic in Australian Art*, Sun Books, Melbourne, 1977. Germaine, *AGA*.
NFI

SCOTT, *Eric G.*

(b. c. 1898, Bega, NSW) Etcher.
STUDIES: Sydney Art School; Académie Julian, Paris, 1920. Scott earned a precarious living in Paris by making commercial pen-drawings. Assistance from an American women's club in Paris resulted in an exhibition of etchings with which he established a reputation in the USA.
REP: Chicago Gallery.
BIB: *AA.*, Dec. 1926 (reference and reproduction). Moore, *SAA*.

SCOTT, *E. Montagu (Eugene Montagu)*

(b. 1835, London; arr. Aust. via NZ c. 1856; d. 1909) Painter, cartoonist, illustrator, photographer. Chief cartoonist for Melbourne *Punch*, Mar. 1861–Mar. 1865, and for Sydney *Punch* for 20 years, 1865–85. On arrival in Victoria, he conducted a photographic salon, and when the Duke of Edinburgh visited Vic., Scott was commissioned to paint his portrait for a fee of 250 guineas. He drew for the Sydney *Bulletin* when it started and contributed cartoons also to the *Boomerang* and the *Worker*, Brisbane. He published a series of chromolithographs entitled *Our Collection of Worthies*, 1877, became well-known as a painter of animals and late in life turned to painting racehorses. He was represented in *Masterpieces of Australian Photography*, Joseph Lebovic Gallery, Sydney 1989 and in *The Artist and the Patron*, AGNSW, 1988.
REP: NLA; Mitchell, La Trobe Libraries.
BIB: Moore, *SAA*. Mahood, *The Loaded Line*, 1973. Kerr, *DAA*.

SCOTT, *Harriet & Helena*

(b. 1830 and 1832 respectively, Sydney; d. 1907 and 1910 respectively) Illustrators. Working mainly in watercolour and pen, both sisters were accomplished natural history illustrators, first near Newcastle, NSW, then in Sydney, 1846–1890s. During the 1860s they illustrated almost all the scientific publications produced at that time, and they also produced the first Australian Christmas card in 1879. Their work can be seen in natural history books of the mid-1800s in libraries including Mitchell, La Trobe Library collections. They were represented in *A Century of Australian Women Artists 1840s–1940s* Deutscher Fine Art, Melbourne, 1993.
BIB: Moore, *SAA*. Kerr, *DAA*.

SCOTT, *James Fraser*

(b. 1877, NZ; d. 1932, London) Painter.
STUDIES: Académie Julian, Paris, 1898 (J. S. MacDonald was a fellow student). During World War I he was one of a group of soldier artists transferred to the War Records Section under Major Treloar for the purpose of recording the action in France. To this end it is recorded by Moore that Scott sketched the scene at Mont St Quentin one hour after it was recaptured from the Germans. After the war, Scott, who reached the rank of captain, became one of a group employed in a studio at St John's Wood painting war pictures. Besides a picture of Mont St Quentin, painted from the sketches, Scott depicted 'the scene at Bayonvillers on the third day of the big offensive', as well as other works for the Australian War Memorial, Canberra. Later he lived in London on a small government pension and died in poverty soon after receiving the news that his paintings had at last been accepted at the RA.
REP: AWM.
BIB: Moore, *SAA*.

SCOTT, *Margaret Cochrane (née LITTLE)*

(b. 1825, Liverpool; arr. SA 1853; d. 1919, Adelaide) Painter. Beginning as an amateur, she turned to professional painting of wildflowers after the death of her husband in 1891. She developed great skill as a floral miniaturist, becoming well-known for this work in London. Her patroness was Viscountess Kintore, who bought her work and brought it to the notice of the Glasgow Gallery and the Royal Family.
REP: Victoria and Albert Museum, London; Glasgow Art Gallery.
BIB: Rachel Biven, *Some forgotten . . . some remembered*, Sydenham Gallery, Adelaide, 1976. Shirley Wilson, *From Shadow into Light*, Adelaide 1988. Kerr, *DAA*.

SCULPTORS SOCIETY AT THE SCULPTURE CENTRE

(Founded 1951) The Warehouse, Bennett Place, Surry Hills, NSW 2010. After a preliminary meeting at the home of Gerald Lewers, the Society was formally established as the Society of Sculptors and Associates at a general meeting on 10 Feb. 1951. The first executive of seven included Prof. Denis Winston (President), Lyndon Dadswell (Vice-President), Paul Beadle (Secretary), Gerald Lewers (Treasurer), John D. Moore, Charles Salisbury, Tom Bass. The first exhibition by members, entitled Open Air Exhibition of Sculpture, included 34 works shown in the Sydney Botanic Gardens, Nov.–Dec. 1951, and was reputedly the first outdoor exhibition of sculpture ever staged in Australia. Early exhibitions reached a climax in the national exhibition for the international competition for the Unknown Political Prisoner memorial held at the AGNSW, Dec. 1952, and won by Tom Bass. The organisation became the Sculptors Society at the Sculpture Centre when it moved to an address in the Rocks in 1970. The Society was managed by a professional staff,

1970–80, when it reverted to control by a committee and volunteer staff.

MEMBERS: In 1993, 150.

BIB: Sturgeon, *DAS*. *Artforce*, Jan.–Feb. 1976.

SCULPTORS SOCIETY OF AUSTRALIA

(1933–39) Initiated in Melbourne by the sculptor Leslie Bowles. One of its important functions was the initiation of the competition for the Anzac memorial, *The Man with the Donkey*, 1935. It was won by Wallace Anderson.

BIB: Scarlett, *AS*.

(*See also* PRIZES, MAN WITH THE DONKEY)

SCULPTURE CENTRE

See SCULPTORS SOCIETY AT THE SCULPTURE CENTRE

SCULPTURE

Australia's sculpture has enjoyed a much less continuous history than its painting. As Ken Scarlett in his comprehensive *Australian Sculptors* points out, isolation, great distances, high cost of production, small population, an almost non-existent market, insufficient production experience and few exhibition opportunities have hampered its development. Australia's first sculpture exhibition was in Sydney in 1847. By 1865 when Charles Summers (q.v.) designed Melbourne's *Burke and Wills* monument, the first cast in large-scale bronze, local sculptors were working within the western tradition of monumental public sculpture popular throughout Europe. This tradition underwent various revivals as colonial outposts of the 'new world' expressed their first pangs of nationalist pride. Of the few sculptors working here in the late 1800s most were born and trained overseas and included Charles Abrahams, Perceval Ball, Margaret Baskerville, William Leslie Bowles, Theodora Cowan, Dora Barclay, Orlando Dutton, C. Web Gilbert, Bertram Mackennal, Charles Douglas Richardson and Thomas Woolner. Most were competent portraitists with good production skills and styles close to those of Europe and especially England. The establishment of state and the federal government, rise in commerce and industry and the advent of two world wars enabled many sculptors to be employed on civic monuments and war memorials. While Daphne Mayo's works for the Brisbane Town Hall, Rayner Hoff's Adelaide and Sydney War Memorials and Paul Montford's sculptures for Melbourne Shrine of Remembrance were historic and fairly conservative in style, they did constitute large and much publicised commissions and raised the level of debate over modern sculpture. Sculptors working in the early to mid 1900s included George Allen, Wallace Anderson, Tom Bass, Paul Beadle, Eva Benson, Ian Bow, Ola Cohn, Lyndon Dadswell, Victor Greenhalgh, Stanley Hammond, Margo and Gerald Lewers, Margel Hinder, Bim Hinder and George Lambert. After World War II improved transport and faster communication provided Australian sculptors with access to overseas trends. Their numbers had also been dramatically increased by numbers of European-born sculptors (see

MULTICULTURAL ARTS) who helped bolster the ranks of the Victorian Sculptors' Society (q.v.) established in Melbourne in 1948 as a continuation of the Australia Sculptors' Society and the Sydney-based Society of Sculptors (q.v.) established in 1951. New arrivals were prominent in Melbourne's Centre Five (q.v.) formed in 1961 and comprising Clifford Last, Vincas Jomantas, Julius Kane, Lenton Parr, Tsietus Zikaris and Inge King. The group made it its business to embark on serious dialogue with architects involved with post-war buildings, and although commissions were rare, it was able to establish a consciousness of the need for sculpture to be incorporated into buildings and public environments. As an outcome sculptors like Norma Redpath and Clement Meadmore gradually developed opportunities for large-scale commissions. Other European-born sculptors prominent in the post-war era included Slawa Duldig, Herman Hohaus, Vincas Jomantas, Ludwig Hirschfield Mach and Tina Wentcher while those like Robert Klippel returned from overseas with up-to-date ideas. In 1961 the first *Mildura Sculpture Triennial* (q.v.) was held. Between 1961–1978 these Triennials provided a forum for the rapid transformation of sculptural ideas of the times. Favouring an experimental edge, the Triennial, under the directorship first of Ernst van Hattam then Tom McCullough, focused on the expression of landscape and environment. Sculptors like Tony Bishop, Tim Burns, Marc Clark, Tony Coleing, Aleksander Danko, John Davis, Marr Grounds, Les Kossatz, Kevin Mortensen and Ti Parks expressed new ideas. Simultaneously Australian sculptors became engaged in the international art dialogue of the 1970s helped along by visitors such as Christo and those involved in the early years of the *Sydney Biennale* (q.v.). Some, like Imants Tillers, George Baldessin and Robert Owen worked abroad for extended periods. In the 1970s sculpture prizes like the *Comalco* and *Transfield* contributed to the establishment of the *Sydney Biennale*, *Perspecta* and the *Australian Sculpture Triennial* and a new determination arose to include sculpture more prominently in art school curricula. A new generation of sculptor/teachers including Marc Clark, Jock Clutterbuck, John Davis, Bonita Ely, Herbert Flugelman, Joan Grounds, Noel Hutchinson, Vincas Jomantas, Inge King, Les Kossatz, Max Lyle, Kevin Mortensen, Ron Robertson Swann, Peter Taylor, David Wilson, Clive Murray White and later Geoffrey Bartlett, Augustine Dall'Ava and Bruce Armstrong revitalized the pioneering teachings of Anita Aarons, Lyndon Dadswell, Victor Greenhalgh and Raynor Hoff. A new professionalism also developed with the establishment of foundries such as Stephen Walker's in NSW and Tas and Meridian Foundry in Melbourne. During the 1980s Australia experienced a re-awakening of interest in sculpture as public art (*see* PUBLIC ART) and for the first time since the 1800s some sculptors were able to live by their art. Public galleries such as the NGA, NGV, AGNSW reinvigorated their sculpture purchasing programs while other public galleries created 'sculpture parks' such as those at the Museum of

Modern Art at Heide and McClelland Gallery, Langwarrin, Vic. Gradually sculpture received more critical appraisal and major publications on it were produced following those of Ken Scarlett and Graeme Sturgeon. With the rise of installation and performance art, and the development of contemporary craft, 'sculpture' in the 1990s covers an extremely broad range of styles and concepts. Some artists prominent in this field include Hans Arkeveld, Robyn Backen, Peter Blizzard, Joan Brassil, Peter Cole, Peter, D. Cole, Peter Corlett, Peter Cripps, Domenico de Clario, Rosalie Gascoigne, Richard Goodwin, David Jensz, David Jones, Paul Juraszek, Stephen Killick, Maria Kuczynska, Lou Lambert, Hilarie Mais, Akio Makigawa, Victor Meertens, Wendy Mills, Robert Morris, Bronwyn Oliver, Fiona Orr, Tom Risley, Peter Schipperheyn, Howard Taylor, Jennifer Turpin, Hossein Valamanesh, Toni Warburton.
BIB: Sturgeon, *DAS.* Scarlett, *AS.* Graeme Sturgeon, *Contemporary Australian Sculpture*, Craftsman House, 1993. Catalogues of the *Mildura Sculpture Triennial* 1961–78; *Australian Sculpture Triennial* 1981. *AL* Vol. 13. No. 2. 1993.
See also MULTICULTURAL ARTS; PERFORMANCE AND INSTALLATION ART; PUBLIC ART.
JENNY ZIMMER

SCURRY, James
(Arr. Vic., c. 1855; d. ?Eng.) Sculptor. He exhibited at the RA, London, 1850–52 and at the Vic. Academy of Fine Arts in 1857. By the 1860s he was in partnership with J. S. Mackennal (q.v.), working on the ceilings of Parliament House, Melbourne. From 1862 he was included in many international exhibitions and was a founding member of the Victorian Academy of Arts, 1870. He exhibited a bust of his colleague, Charles Summers, and one of Judge Fellows at the International Exhibition, Melbourne, 1880–81, and returned to England in 1885. His work was seen in *Early Australian Sculpture*, Ballarat Fine Art Gallery, 1976.
REP: QVMAG; National Museum of Vic. (Aboriginal portrait busts); Parliament House, Melbourne.
BIB: Moore, *SAA.* McCulloch, *AAGR.* Scarlett, *AS.* Kerr, *DAA.*

SCURRY, John
(b. 1947, Melb.) Painter, printmaker, musician.
STUDIES: Prahran CAE, 1966–69. He toured Europe and the UK as a jazz musician in 1967, and again in 1970. In 1978 he was commissioned to paint a portrait of Prof. H. Atkinson for the Dental School, Uni. of Melbourne, and after this became known for his prints exhibited in PCA group exhibitions and as a painter specialising in still-life themes. He exhibited in the 1980s but is better known as a teacher at Prahran and, since 1992, the VCA (Melbourne University).
APPTS: Teaching, printmaking and drawing, Preston Inst. of Technology, 1973–75; Prahran CAE, 1976–92; VCA, 1992– .

SEARLE, Ken
(b. 6/8/1951, Sydney) Painter.
STUDIES: No formal training. His work is a mixture of realism and surrealism and a semi-naive style that developed from his *Ocker Funk* contribution in 1975. His paintings often depict historical subjects from a twentieth century viewpoint. He held 12 solo exhibitions 1976–91 at Watters, Sydney, EAF, Adelaide and Lennox St, Melbourne, and in the Lewers Bequest and Penrith Regional Gallery. He participated in around 30 group exhibitions 1976–91 at Watters, Sydney and largely at public galleries including *Visions After Light*, Centenary exhibition, AGSA 1981; the Bicentennial exhibition, *The Face of Australia*; *Portrait of a Gallery*, Watters Gallery 25th Anniversary exhibition touring 8 regional galleries 1990; *Her Story: Images of Domestic Labour in Australian Art*, S. H. Ervin Gallery.
AWARDS: Residency, Besozzo Studio, Italy, VACB, 1985.
REP: NGA; AGNSW; AGSA; MOCA, Brisbane; regional galleries Qld, NSW, Vic.; several leading corporate collections.
BIB: Bonython, *MAP* 1980. *New Art Two.*

SEEHUSEN, Walter
(Active c. 1880–95, Melb.) Painter. He lived in Carlton and at Bairnsdale, Vic., and exhibited landscapes and bush genre with the Vic. Academy of Arts, 1881–93.
NFI

SEFFRIN, Nickolaus Johannes
(b. 16/1/1931, Heidelberg, Germany; arr. Aust. 1951) Sculptor.
STUDIES: Brisbane Tech. Coll.; Coll. of Fine Arts, Gdansk, Poland, 1972. His early work comprised small, decorative pieces fabricated in wire, and he held around 13 exhibitions 1963–92 mainly in Sydney (including at Holdsworth, Barry Stern, Eddie Glastra galleries) and Brisbane (Philip Bacon gallery). He completed a number of commissions including fountains for the Post Office, Brisbane, and church items including a life-size crucifix for Newman Coll. Chapel, Uni. of Melbourne.
REP: AGSA; QAG; AWM; Government House, Canberra.
BIB: Hilde and Hans Knorr, *Religious Art in Australia*, Collins Dove, 1989. Scarlett, *AS.*

SEIDEL, Brian
(b. 30/8/1928, Adelaide) Painter, printmaker, teacher, critic.
STUDIES: SASA, 1948–53; Uni. of Iowa, USA, 1961; Slade School, London, 1961–63. His paintings and prints of figures, interiors and landscapes have a lush, decorative quality and his 1989 exhibition at Chapman Gallery was described by *Canberra Times* art critic Sasha Grishin as 'full of glowing gems'. Grishin attributes the success of the works to solid grounding in the crafts of his art and Seidel's respect for tradition, and says his art is 'devoid of gimmicks and trendy fads. . . . light and spontaneous surfaces conceal a compositional, structural toughness with carefully thought through colour reflexes.' He held around 25 solo exhibitions 1964–92 largely at Victor Mace, Adrian Slinger galleries, Brisbane; Greenhill, Adelaide and Perth;

Chapman gallery, Canberra; Lauraine Diggins, Melbourne. His work was included in a number of print and drawing prize exhibitions in public galleries in Australia and internationally, including *Figures and Faces Drawn from Life*, Heide, 1983; *Prints of Australia: Pre-Settlement to Present*, NGA 1989. Maintaining a continuous interest in the development of printmaking in Australia he wrote *Printmaking* for *The Arts in Australia* series, Longmans, 1966 and in 1993 became co-owner (with Jeffrey Makin) of the printmaking firm, Port Jackson Press.

AWARDS: Many prizes for prints. Other awards include: Fulbright Scholarship, 1961; English-Speaking Union Travelling Scholarship, 1961; British Council grant, 1962; Geelong prize, 1963; Maude Vizard-Wholohan prize for painting, 1965.

APPTS: Lecturer in printmaking, SASA, 1964–66; art critic, Adelaide *News*, 1963–66; head of the dept of art, Bedford Park Teachers Coll., SA, 1968–70; head of the school of art and design, Preston Inst. of Technology, Vic., 1971–81; council member Victorian Council of the Arts, 1976; board member, Victorian Print Workshop c. 1980–83.

REP: NGA; AGNSW; AGSA; AGWA; NGV; QAG; QVMAG; TMAG; Parliament House; Artbank; a number of regional gallery collections including Geelong, Newcastle, Riverina; a number of tertiary collections including ANU, Flinders, Griffith, New England unis.; Des Moines Museum, Iowa, USA; corporate collections including Dunlop, State Bank of SA, Hilton Hotel, Brisbane.

BIB: Many general texts on Australian art including Smith, AP; Horton, PDA; Bonython, MAP; McKenzie, DIA. Peter Quartermaine, *Brian Seidel,* Beagle Press, 1993. A&A 22/3/1985.

SELLBACH, Udo

(b. 1927, Cologne, Germany; arr. Aust. 1955) Painter, printmaker, teacher.

STUDIES: Kölner-Werkschulen, Cologne, 1947–53; travel studies, Europe, 1963–64. He organised a print workshop, *Kölner Presse*, in Cologne, and after moving to Australia established a reputation as a fine printmaker in joint exhibitions held with Karen Schepers (q.v.). His adaptability in keeping abreast of the times gives his work a look of permanent freshness and vitality, whether its antecedents be Goya, as in his etchings of 1966, or hard-edge as in his paintings in the exhibition *The Field*, NGV, 1968. He has since become well-known as a printmaker and teacher.

AWARDS: Cornell prize, Adelaide, 1962; second award, Georges Invitation Art Prize, 1968; fellowship, VACB, 1992.

APPTS: Lecturer in printmaking, SASA, 1960–63; RMIT, 1965–71; head of the school of art, Tasmanian CAE, Hobart, 1972–78; head of the Canberra School of Art, 1978– ; foundation member, PCA, 1966; foundation member, VACB, 1973; foundation member, Tasmanian Arts Advisory Board.

REP: AGNSW; AGSA; AGWA; NGV; regional galleries Geelong, Newcastle.

BIB: PCA, *Directory* 1976, 88. Smith, AP. A&A 2/2/1964.

SELLHEIM, Gert

(b. 1901, Estonia) Graphic artist, industrial designer. He moved from Germany to Australia during the 1930s. He was one of the first poster artists to work in a semi-abstract style in Melbourne. Later he adapted Aboriginal art to advertising purposes.

AWARDS: Sulman prize, 1939.

BIB: Roman Black, *Old and New Aboriginal Art*, Angus & Robertson, Sydney, 1963.

SELLS, (Reverend) Alfred

(b. 1824, Eng.; arr. Aust. 1876; d. c. ?1910, Eng.) Painter. Topographical watercolourist. He spent twelve years in SA and painted numerous watercolours of the Adelaide area; an album of sketches suggests that he spent time at Lyndoch and Mitcham parsonages. He also visited Vic. and Tas.

BIB: Edward Craig, *Australian Art Auction Records, 1975–78,* Mathews, Sydney, 1978.

SELWOOD, Paul Owen John

(b. 20/6/1946, Sydney) Sculptor, painter.

STUDIES: NAS, 1964–65; travel studies, Europe and UK, 1965–70. His painted steel sculptures were shown at *Mildura Sculpture Triennial*, 1973, 75 and *Australian Sculpture Triennial* 1981, 84, and in a number of other group sculpture, drawing and other survey exhibitions including Bicentennial exhibition *The Face of Australia*; *Portrait of a Gallery*, Watters 25th anniversary touring exhibition; *Contemporary Australian Drawing*, MCA, Brisbane 1992. He held ten solo exhibitions 1972–92, largely at Watters, Sydney.

AWARDS: Sculpture prizes at Armidale, NSW, 1971; Liverpool, 1974; Townsville, 1977; VACB grant, 1988.

APPTS: Technical assistant, RCA, London, 1965–68; teaching sculpture, Bath Academy of Art, UK, 1969; visiting sculptor, Wolverhampton Coll. of Art, UK, 1970; teaching sculpture, NAS, 1972; Woollahra Art Centre, 1972; Macquarie Uni. Union, 1972; lecturer in sculpture at a number of tertiary colleges 1977– including Darling Downs IAE, Qld; Newcastle Tech. Coll.; City Art Inst.; NAS; Newcastle Uni.

REP: MCA, Brisbane; Heide; several regional gallery collections including Bathurst, Armidale, Mildura; tertiary collections including Griffith and Macquarie unis.; Townsville City Council.

BIB: Catalogue essays exhibitions as above. Scarlett, AS. Sturgeon, DAS. Germaine, AGA.

SENBERGS, Jan

(b. 29/10/1939, Riga, Latvia; arr. Aust. 1950) Painter, printmaker, teacher.

STUDIES: No formal training as a painter. Served apprenticeship as a screen-printer and attended one day a week at the Melbourne School of Printing and Graphic Arts, 1956–60. His dark, strongly constructed paintings are poignant reminders of the encroachment of the machine at the expense of human values and of the general industrialisation of the landscape. In his independent studies he was helped by Leonard French (q.v.) and he held his first exhibition at the

Richman Gallery, Melbourne, in 1960. Four years later his painting *A Detached Figure* was bought from Georges Invitation Art Prize exhibition for the Museum of Fine Arts, Houston, Texas, and by 1973 his paintings and screen-prints had been included in eight international exhibitions. He held around 25 solo exhibitions 1960–92 with Rudy Komon, Sydney (in the 1960s and 1970s); Powell St, Melbourne; Australian Galleries, Sydney and Melbourne, and in a number of tertiary and public galleries including a touring exhibition organised by RMIT in 1984–85 and with TMAG 1984; Newcastle Region Art Gallery 1990. From 1973 his work appeared in many significant international and Australian survey exhibitions including *70th Anniversary Exhibition*, Commonwealth Serum Laboratories, Parliament House and touring 1986; *Painters and Sculptors of Australia*, QAG and MOMA, Saitama, Japan 1987; *The Face of Australia* Bicentennial exhibition 1988–89. He was a Creative Arts Fellow at the ANU, 1975; artist-in-residence at AGWA 1988 and in 1989–90 visiting professor, Chair of Australian Studies, Harvard Uni., Boston, Massachusetts. Among his major commissioned works are two murals, each made up of six panels, for the High Court building, Canberra, 1980; three tapestries for the State Bank of NSW, 1984–86; ANZ Bank Bicentenary Series of paintings for TMAG, 1987, and a large relief structure and painting on the site of the first Government House for the Governor Phillip Towers development in 1992. In 1987 he visited Antarctica as guest of the Antarctic Division, Dept of Science, resulting in a series of large works.

AWARDS: Georges Invitation Art Prize (commendation award), 1964, first prize, 1969, 82; Helena Rubinstein Travelling Scholarship, 1966; prizes in competitions at Hobart (Tasmanian print), 1968, Morwell (1968), Newcastle (1969), QVMAG (1970), Shepparton (1971), Ballarat (Crouch Prize, 1972); Creative Arts Fellowship, ANU, Canberra, 1975; Sir William Angliss Prize, Melbourne, 1976; L. J. Harvey Drawing Prize, QAG, 1983; Fremantle Drawing prize, WA, 1984; hon. Doctorate of Laws, RMIT, 1986.

APPTS: Lecturer in fine arts, RMIT, 1966– ; member, VACB, 1984–87; trustee, NGV, 1984–89; visiting professor, Chair of Aust. Studies, Harvard Uni., Boston, Massachusetts, USA, 1989–90.

REP: NGA; AGNSW; AGSA; AGWA; NGV; QAG; QVMAG; TMAG; Artbank, MOMA, New York; Museum of Fine Arts, Houston, Texas, USA; National Gallery, Washington, USA; numerous regional galleries including Ballarat, Geelong, Latrobe Valley, Mornington, Sale; a number of public collections including High Court, Canberra, Federal Court, Melbourne; numerous tertiary collections; corporate collections including NAB, Bond Uni., State Banks of NSW and Vic., Myer collection.

BIB: Many general texts on Australian art including Smith, AP. PCA, *Directory* 1976. A&A 14/1/1976; 22/2/1984.

SERELIS, Vytas Antanas
(b. 10/2/1946, Germany (Lithuanian); arr. Aust. 1946) Painter, musician, graphic designer, illustrator.

STUDIES: Dip. Fine Arts, SASA, 1966. He made instruments and lived in London 1967–70. A realist painter, his work appeared in group exhibitions with Adelaide galleries (Greenhill; Bonython) and at Bloomfield, Sydney. His solo exhibitions include those at Greenhill and Adelaide Uni., where he was artist-in-residence, 1990.

AWARDS: Alice Springs Prize 1974; Robin Hood prize 1975.

REP: AGSA; AGWA; MAGNT.

SERLE, Dora (née Hacke)
(b. 1875, South Melbourne; d. 1968, Melb.) Painter.

STUDIES: Privately, Melbourne with Jane Sutherland; NGV School, with Bernard Hall and Frederick McCubbin, 1895–1902; Melbourne School, with E. Phillips Fox; Cornwall, with Stanhope and Elizabeth Forbes, Newlyn, 1902; travel studies in France. Inspired by her contacts with Phillips Fox and Walter Withers, she responded enthusiastically to the influence of French impressionism, and the many high-keyed oils and watercolours that preoccupied most of her working life were the result. After her first trip to Europe, she ran an art school at Geelong and loaned pictures for exhibitions at the Geelong Art Gallery. Her sister was Elsie Barlow, her husband Percival Serle (qq.v.) and her son the historian, writer and editor, Geoffrey Serle. She exhibited with the Melbourne Society of Women Painters and Sculptors from 1929, and was a foundation member of the Independent Group, 1939. In 1928 she revisited Europe, and again in 1954, when she was greatly attracted to the work of Bonnard. A retrospective of her work was held at McClelland Gallery, Langwarrin, 1979 and she was represented in *Completing the Picture: Women Artists and the Heidelberg Era* Heide and touring, 1992.

REP: NGA; NGV; regional galleries Ballarat, Castlemaine, Geelong, Langwarrin (McClelland Gallery), Mildura.

SERLE, Percival
(b. 1871, Melb.; d. 1951, Melb.) Writer, curator. Biographer to the Melbourne Public Library; guide lecturer, NGV, 1929–38, and acting curator of the art museum, 1934–36; council member of the Victorian Artists' Society, for more than 30 years. He compiled *A Bibliography of Australasian Poetry* (1925) and the two-volume *Dictionary of Australian Biography* (1949).

SHANNON, Michael (David Michael)
(b. 1927, Kapunda, SA; d. 17/10/1993) Painter.

STUDIES: NGV School, 1945–48; George Bell School; Central School of Arts and Crafts, London; Paris (with Fernand Léger); Académie Florence, 1949–52. He first became known for his de Buffet-like portraits and cityscapes painted in a basic range of colours such as red, yellow, black and white. Later his palette lightened, and his interiors with period décor, freely painted in impressionistic colours over well-drawn structures with hatchings of ink or pencil, gained a following

Michael Shannon, Marshalling Yards V, *1971, oil on canvas, 76 × 102cm. Christie's, September 1991.*

that was further extended by his large, high-keyed, panoramic paintings of cities and suburbs seen as if from above. His 1980s work concentrated largely on representations of the Axedale quarry and surrounding bush areas. His first exhibition was in 1952 at Melbourne's Peter Bray Gallery, and he held annual exhibitions 1958–90 including in Sydney (Macquarie), Melbourne (Powell St), Adelaide (Bonython), Brisbane (Victor Mace) and at RMIT gallery 1986. His work has appeared in a number of group exhibitions 1960s–90s at leading private and public galleries including *Classical Modernism: The George Bell Circle*, NGV 1992.
AWARDS: Crouch Prize, Ballarat, 1953, 55; Minnie Crouch Prize, 1954; Winemakers' Prize (shared with Andrew Sibley), 1965; John McCaughey Memorial Prize, 1968; Muswellbrook Art Prize, 1970; the *Australian-TAA* National Art Award, 1970; Member Order of Australia 1979.
APPTS: Melbourne art critic for the *Australian*, 1973–75; member of the VACB, 1975–79; Melbourne adviser to *Art and Australia*, 1966–79; lecturer, Prahran CAE, 1970–74.
REP: NGA; AGNSW; AGSA; AGWA; MAGNT; NGV; QAG; QVMAG; TMAG; a number of regional galleries including Ballarat, Newcastle, Muswellbrook, Gold Coast; numerous corporate collections including BHP, CBA, Alcoa, CRA, Mertz Collection, USA.
BIB: All general books on contemporary Australian art history. *A&A* 12/4/1975; 24/2/1986.

SHARK LE WITT, *Vivienne*
(b. 1/9/1956, Vic.) Painter.
STUDIES: Uni. of Adelaide, 1974–75; Dip. Fine Art, Tasmanian CAE, 1978; Postgrad. Dip. Fine Art, Alexander Mackie CAE, 1981; Uni. of Melbourne, 1987–88. Her small allegorical paintings reflecting Renaissance, Medieval and Baroque styles depict subjects from Roman and Greek myths to novels and contemporary issues. Finely technically executed, her work has a distinctive ironic quality capable of, as aptly described in the 1988 *Bicentennial Perspecta* catalogue, 'placing the viewer in the position of both looking at and being looked at.' She held six solo exhibitions 1984–92 mainly at Roslyn Oxley9; IMA Brisbane and Tolarno, Melbourne. Her work appeared in many group exhibitions 1982–91 including with Roslyn Oxley9, Sydney and at public galleries including *The End of Civilization Part II: Love Among the Ruins*, George Paton Gallery, Melbourne 1983; *Australian Visions*, Guggenheim Museum, NY 1984; *Sydney Biennale*, 1985, 87; *The Australian Bicentennial Perspecta*, AGNSW 1987; ICI *Contemporary Collection*, touring regional galleries 1989; *Rivers in Australian Art*, Heide, 1991.

AWARDS: VACB travel grant, 1982.
APPTS: Co-ordinator, visual arts, Women 150 Festival, 1985; gallery assistant, Ewing and George Paton galleries, Uni. of Melbourne, 1982–84 and 1986; tutor, Gippsland CAE, 1982–84; part-time lecturer, Prahran TAFE, 1985 and tutor 1987, 89.
REP: NGA; AGNSW; Guggenheim, NY; MOCA, Sydney; many significant corporate collections including ICI, NAB, Smorgon.
BIB: Peter Cripps, *Interviews with Artists*, IMA, Brisbane 1986. Chanin, *CAP AL* 4/2/1984. *AT* 29/1988.

SHARP, James Campbell
(b. 1905, Sydney; d. 1985) Painter, printmaker, teacher.
STUDIES: Desiderius Orban School, Sydney, 1949–50. While in his early forties he abandoned a successful career in banking to become a painter. Subsequently he lectured in the tutorial dept at Sydney Uni., taught painting at Newington Coll., and from 1951 held exhibitions in Sydney. A foundation member of Sydney Printmakers, 1961, he was honorary art director of the Workshop Arts Centre, Willoughby, NSW, in the 1960s. Meticulous in the order of its component abstract parts, his work was included in the sixth *Bienale de São Paulo*, Brazil, 1961.
REP: Uni. of NSW collections.
BIB: PCA, *Directory*, 1976.

SHARP, John Mathieson
(b. 1823; d. 1899) Photographer. He worked in Hobart from the mid-1800s photographing a number of Tasmanian politicians and leading citizens, and with his partner, Frederick Frith (q.v.), produced what is considered to be the earliest panorama print produced in Australia, in 1856. Kerr says he abandoned photography in the mid-1860s. His work appeared in *Shades of Light*, NGA 1988.
REP: NGA; TMAG; Crowther library.
BIB: Eric Duscombe, *Artists In Early Australia and their Portraits*, Eureka Productions, Sydney 1978. Kerr, DAA.

SHARP, Martin
(b. 21/1/1942) Painter, cartoonist, art director. From 1962–64, with Richard Neville and Richard Walsh, he conducted the Sydney satirical magazine *Oz*. The magazine ceased publication in Sydney in 1964 because of obscenity charges, after which Sharp and Neville left for the UK where they published a new version of the magazine in London (1966–73). Sharp also published a book of collected cartoons, and in 1969 his *Magic Theatre Oz* was published in London. In the same year he held an exhibition at the Sigi Krauss Gallery, entitled *Sharp Martin and his Silver Scissors cartoons*, and after his return to Sydney exhibited *The Art Exhibition: A Yellow House Production*, at the Bonython Galleries. Sharp had contracted new allegiances, his method being to cut out and paste up in a new context reproductions of paintings by modern masters. As Bernard Smith succinctly wrote, 'With Sharp the spirit of Dada moves from form towards meaning, like a cat among the iconographical pigeons of tra-

ditional art'. The NGV held a survey exhibition of his work in 1981 and he exhibited in Sydney (with Roslyn Oxley9) in 1986 and 1989 and his work was included in Bicentennial exhibitions *The Great Australian Art Exhibition* and *The Face of Australia*. In 1990 the AGNSW held an exhibition – *The Yellow House* a survey of the art produced by inhabitants of the Sydney house in which Sharp and a number of others lived in the 1970s based on van Gogh's 'Yellow House' at Arles.
AWARDS: *Mirror*-Waratah prizes for graphics (by an artist under 22), 1962–63.
REP: NGA; AGNSW; Victoria and Albert Museum, London.
BIB: Smith, AP. Bonython, MAP, 1975.

SHARPE, Alfred
(Active 1905, NSW) Painter. He was active 1856-1905 in NZ, where his watercolours of rural coastal scenes and landscapes (now in the Auckland City Art Gallery) have the detailed clarity and precision of a Douanier Rousseau. Details of his career are unknown but the date (1856) and the fact that he was on the Coromandel goldfields c. 1870, suggests that he might have been one of the many Victorian gold diggers who went to NZ when gold was discovered there. His watercolour *Wallaby Rock on the Hawkesbury*, 1905 indicates that he was in NSW.
REP: Auckland City Art Gallery, NZ.
BIB: Gil Docking, *Two Hundred Years of New Zealand Painting*, Lansdowne, Melbourne, 1971.

SHARPE, Wendy
(b. 24/2/1960, NSW) Painter.
STUDIES: Art certificate, Seaforth TAFE; BA Visual Art, City Art Inst.; Grad. Dip. Ed., Sydney Inst. of Education; Grad. Dip. Art, City Art Inst.; MA Fine Arts, Uni. of NSW; travel studies, Europe and NY, 1987–88; Israel, Egypt, Greece, Italy, 1989. She held seven solo exhibitions 1983–91 in Sydney, including two at DC Art, and her work appeared in several group exhibitions 1989–91 including *Fresh Art Survey Show*, 1989; *Modern Muses: Classical Mythology in Australian Art*, S. H. Ervin Gallery 1990; *The Intimate Experience*, Ivan Dougherty Gallery 1991.
AWARDS: Sulman Prize, AGNSW, 1986; Marten Bequest, Travelling Scholarship, 1986; residency, Cité Internationale des Arts, Paris, VACB, 1986; Mercedes-Benz Art Scholarship, 1989; postgrad. research award, 1991; many local prizes.
APPTS: Teaching art part-time, community centres, TAFE colleges and Julian Ashton School, 1983– .
REP: Uni. of Sydney.

SHARPLES, Geoff
(b. 7/1/1945, Adelaide) Sculptor.
STUDIES: Dip. Fine Art, SASA, 1964; travel studies, UK and Europe, 1972–74. He held seven solo exhibitions 1968–89, all in Darwin except for one in Adelaide 1968, and participated in a number of sculpture survey exhibitions including *Mildura Sculpture Triennials* 1964, 78, 82, 85, 89 and many in the

Northern Territory and with Darwin tertiary colleges including staff exhibitions.

AWARDS: Goya award (SA section), 1964; Alice prize (work acquired), 1974, 86; Tennant Creek Art Award, 1986; Northern Territory Art Award, 1991.

APPTS: Lecturer in sculpture, several colleges in Darwin, NT, 1971– including Darwin Community Coll.; Darwin Inst. of Technology and since 1989, Northern Territory Uni.

REP: MAGNT; Mildura Arts Centre; Alice Springs Art Foundation; Tennant Creek municipal collection; NT Uni.

BIB: Scarlett, AS.

SHATIN, Georgina

(b. 1913; d. 1977) Painter.

STUDIES: NGV School, with William Dargie and Alan Sumner. Her modernist, neo-Gothic-style paintings of people and still-life became known through group exhibitions in Melbourne. A memorial exhibition was held at the VAS, Melbourne, in Aug. 1979. Later, many of her works were presented by her doctor husband to Vic. public galleries.

REP: MPAC; Uni. of Melbourne.

SHAW, George Baird

(b. 23/3/1812, Dumfries, Scotland; arr. Aust. 1851; d. 1833) Painter, engraver, illustrator. Elder brother of James Shaw (q.v.), he followed his brother to South Australia via NZ before settling in Sydney in the late 1850s. He produced landscapes, portraits and topographical scenes in oils and watercolours and exhibited in the 1870 Sydney *Intercolonial Exhibition* and the 1877 NSW Academy of Art exhibition. Several of his works are in NZ public collections.

BIB: Kerr, DAA.

SHAW, Gerrard Gayfield

(b. 1885, Adelaide) Etcher.

STUDIES: School of Design, Adelaide; J. S. Watkins School, Sydney. He became known in Sydney for his bookplates and etchings of landscapes and street scenes. He also conducted a gallery, the Gayfield Shaw Art Salon, in Elizabeth Street, Sydney, founded the Australian Painter-Etchers' Society in 1920 and in 1924 took an exhibition through NSW by caravan.

BIB: Moore, SAA.

SHAW, James

(b. 12/1/1815, Dumfries, Scotland; arr. Adelaide 1850; d. 1881, Adelaide) Painter, engraver. He studied with his father, an engraver, lithographer and amateur painter, as well as undertaking law studies in Scotland. He spent ten years as a planter in Jamaica before moving to Adelaide where he worked as a clerk in a post office then as a full-time painter, with income derived from painting pictures of colonial homes and gardens. Together with his friend and colleague, Charles Hill, he was a foundation member of the South Australian (later Royal South Australian) Society of Arts. Many

of his works show an unusual combination of painting and photography, as in the painting of the South Australian Parliament 1867 (collection AGSA) in which the faces of the members are photographs stuck onto the canvas, the rest having been painted in oil. His work was represented in *The Art of Gardening in Colonial Australia*, travelling exhibition state galleries 1979; *Graven Images in the Promised Land*, AGSA 1981; Bicentennial exhibitions, *The Great Australian Art Exhibition* and *Shades of Light*, NGA 1988.

REP: AGSA.

BIB: Catalogue essays exhibitions as above. Kerr, DAA.

SHAW, Peggy Perrins

(b. 1917, Vic.) Painter.

STUDIES: NGV School, 1948–50; George Bell School, 1949–50; St Martin's School of Art and Chelsea Polytechnic, London, 1952; La Grande Chaumière and Atelier Andre Lhote, Paris, 1953–56; Orban School, Sydney, 1956–64. She presented a number of her abstract paintings to public galleries.

REP: NGA; NGV; TMAG; regional and uni. galleries.

SHAW, Richard H.

(b. 1832; d. 1895) Painter. His known paintings are watercolours of Aborigines, notably *Blacks in Full War Dress*, AGSA collections, *Aborigines in a Landscape*, sold at Leonard Joel auctions, Melbourne, 1974 and *Aboriginals on the Murray River*, sold in Sydney, 1989.

REP: AGSA.

BIB: Benko, *Art and Artists of South Australia*. E. Craig, *Australian Art Auction Records 1973–75* and *1982–85*, Sydney 1975, 85. Kerr, DAA.

SHAW, Roderick Malcolm

(b. 17/9/1915, Drummoyne, NSW) Painter, illustrator, industrial designer, publisher.

STUDIES: ESTC, 1932–37. He worked as an advertising artist from 1936, and in 1938 joined Richard Edwards to establish the publishing company, Edwards & Shaw. A foundation member of the Windsor Group, Sydney, 1937– 40; CAS, Sydney, 1939; and SORA (Studio of Realist Art), 1945, he worked in the RAAF as a camouflager 1941–44. He wrote *The Windsor Group 1935–1945*, Edwards & Shaw, NSW, 1990.

AWARDS: Prize at *Australia at War Exhibition* (State galleries in Sydney and Melbourne), 1945.

REP: AGNSW; NGV; Armidale regional gallery.

BIB: John Kroeger, *Australian Artists*, Renniks, Adelaide, 1968.

NFI

SHAW, Stuart

Cartoonist. Shaw was art editor and designed the cover for the World War I trench magazine, *Aussie*, Jan. 1918–Apr. 1919. The publication continued as a humorous magazine after the war and at its peak attained a circulation of 100,000.

BIB: Moore, SAA.

(*See also* MATTINSON, LANCE)

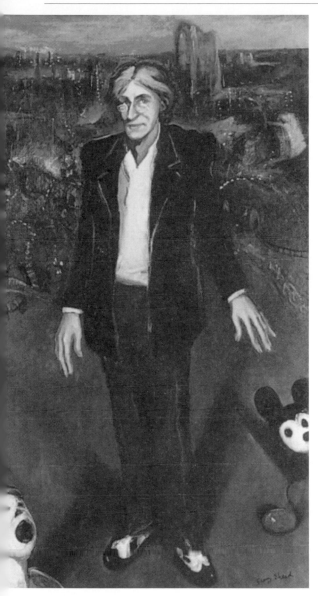

Garry Shead, Portrait of Martin Sharp, *oil on canvas with fabric attachment, 197 × 121cm. Christie's, August 1992.*

SHEAD, Garry

(b. 24/6/1942) Painter, film-maker.
STUDIES: NAS, 1961–62; travel studies, Europe, 1973. With Martin Sharp (q.v.), he edited a publication called *Arty Wild Oat* (1962), which led to the founding of *Oz* magazine. After working as a scenic artist for the ABC 1963–66, he was assistant film editor, 1967–68. Shead, like Martin Sharp, in the 1960s and 1970s was a satirist, his satirical comments on Sydney society being adapted from influences that owe much to both British and American Pop. He showed a series in 1993 based on D. H. Lawrence's book *Kangaroo* of a young British couple's experiences in a NSW country town in the late 1800s. He is known also for portraiture, including the 1993 Archibald Prize-winner

of the publisher Tom Thompson. He held around 17 solo exhibitions 1966–93 in Sydney (including at Watters, Hogarth, Garry Anderson, Artmet), Melbourne (William Mora; Lyall Burton) and Brisbane (Ray Hughes), and his work appeared in a number of group exhibitions 1961–91 including at Charles Nodrum, Greenhill galleries; and public galleries including NGA, and *The Yellow House*, AGNSW, 1990.
AWARDS: Young Contemporaries prize, CAS, Sydney, 1967; Power studio grant, Cité Internationale des Arts, Paris, 1973; Karolyi Foundation studio, Vence, VACB, 1982; Archibald Prize, AGNSW, 1993.
REP: NGA; AGNSW; AGSA; regional galleries Mildura, Wollongong.
BIB: Smith, AP. Mervyn Horton, *Australian Painters of the 70s*, Ure Smith 1976. *Garry Shead: The D. H. Lawrence Paintings*, Craftsman House, Sydney, 1993.

SHEARSBY, Edward Jayes

(Active c. 1900–30, Melb.) Painter. Known mainly for watercolours. Moore refers to his 'nice sense of tone'. He exhibited at the VAS, 1905–15, and again from 1920, showing farming and coastal scenes sometimes influenced by the watercolours of Alexander McClintock or, alternatively, Blamire Young (qq.v.)
BIB: Moore, SAA.

SHELDON, Frederic S.

(b. 1853, London; arr. Aust. c. 1889; returned London, 1891) Painter, sculptor.
STUDIES: Studio Leon Bonnat (c. 1872–75), Paris, with Isadore and Rosa Bonheur. For a time he was animal painter to François II, ex-King of Naples, and exhibited sculpture at the RA, London (1885–86). He went to Australia for health reasons, taught at the Ballarat Fine Art Gallery (where Percy Lindsay was one of his pupils), and painted many pictures of racehorses, including *Carbine* for Donald Wallace. According to Moore, this commission was the reason for Sheldon's move to Australia.
REP: NGV (statuette of George Watson on *Cavalier*).
BIB: Moore, SAA.

SHELDON, Pearl

(b. Armidale, NSW) Painter.
STUDIES: Sydney (with Lister Lister); London (with G. Vernon Stokes). She exhibited at the RA, London, and at the Paris Salon.
REP: Manly Art Gallery.
BIB: Moore, SAA.

SHELDON, Vincent

(b. 1895, Brisbane; d. 1945) Etcher, commercial artist.
STUDIES: Commercial art in USA, 1920, and in England, 1924. On his return to Australia Sheldon became interested in etching and held an exhibition of his work. He returned to England to study etching with W. P. Robins in 1929.
REP: QAG; British Museum; Victoria and Albert Museum.
BIB: AA Dec. 1928, (reproduction). Vida Lahey, *Art in Queensland 1858–1959*, Jacaranda Press, Brisbane, 1959.

SHEPHARD, Richard

(Active c. 1870) Lithographer. Government lithographer and a foundation member of the Victorian Academy of Arts, 1870.
BIB: Moore, *SAA*.

SHEPHERD, Charles

According to Moore, this Australian artist painted pictures on London pavements and was brought out of obscurity by fellow Australian John Barry, the actor.
BIB: Moore, *SAA*.
NFI

SHEPHERD, Richard

(b. 6/4/1825, Cumberland, UK; arr. Aust. 1835; d. 1885, Melb.) Lithographer. Kerr says he arrived in Geelong via Melbourne, visiting the Steiglitz goldfields c. 1855 and returning to Melbourne. He lithographed a number of views of Melbourne and most of the geological maps issued by the Geological Survey and Mining Department 1860–85. He served as art juror in the 1880 Melbourne International Exhibition, for which he received a bronze medal.
REP: NLA; Mitchell, La Trobe Libraries.
BIB: Moore, *SAA*. Kerr, *DAA*.

SHEPHERDSON, Gordon

(b. 1934, Brisbane) Painter.
STUDIES: Brisbane, at classes conducted by Caroline Barker, 1960, then at drawing and painting classes conducted by Molvig and Sibley (q.v.). His early, dark paintings focused on the obsessive theme of the slaughtered animal as observed at the abattoir where he worked. In 1977 he began making etchings and produced a series of plates representing biomorphic images of woman and bull. From 1964 he held exhibitions in Brisbane (Johnstone Gallery), Sydney (Komon Gallery) and Melbourne (Georges Gallery), and in 1978 his work was the subject of an important survey exhibition at the Uni. of Qld.
AWARDS: Georges Art Prize, Melbourne (painting acquired), 1980.
REP: NGA; QAG; regional galleries Ararat, Mornington; uni. collections, Brisbane; VACB collections.
BIB: *A&A* 15/4/1978.
NFI

SHEPPARD, Benjamin

(b. 1976, London; arr. Tas. 1896; d. 1910, Capetown) Sculptor, teacher.
STUDIES: Cope-Nichols School, South Kensington, London, c. 1890; RA Schools, c. 1893–96. He returned to London, 1903, and later moved to Capetown, where he died of tuberculosis. He made the South African Memorial in the Domain, Hobart, and completed two large murals for St Joseph's Church, Hobart. His sister, Mary E. Southern, established the Arts and Crafts Depot in Perth after World War I.
APPTS: Teaching, Hobart Tech. Coll., 1900–03.
REP: TMAG; South African National Gallery, Capetown.
BIB: Scarlett, *AS*.

SHEPPARD, Catherine Elizabeth (Kate)

See STREETER, Catherine Elizabeth

SHERLOCK, Max

(b. 1925, Caulfield, Vic.) Painter.
STUDIES: With Max Meldrum, Melbourne, 1941; NGV School, evening classes, 1941–42; with Clifton Pugh and Frank Werther, 1958–60; travel studies, Europe and USA, 1964, 73, 76. He served with the RAN during World War II, and after the war began exhibiting his paintings of romanticised, expressionist landscapes with birds, at Leveson Street and other Melbourne galleries, as well as in Sydney, Perth and Canberra. He has exhibited regularly at the VAS.
AWARDS: RNAgAQ, Brisbane, 1966; VAS (Cato prize), 1968; artist of the year, VAS, 1974, 75.
REP: NGA; Bendigo Art Gallery.

SHERMAN, Albert T.

(b. 1882, Cornwall, Eng.; arr. Aust. after World War I) Painter.
STUDIES: Central Technical School, Truro, Cornwall (with W. A. Rollason). Known mainly for flower pieces; member, RAS, Sydney, from 1928. A book on his work, *The Flower Paintings of Albert Sherman*, was published by Angus & Robertson, Sydney, 1955.
REP: Manly Art Gallery.
NFI

SHERRIF, Alexander

Sculptor. One of a group of NSW artists helped by Sir Henry Parkes with work on public buildings and monuments, notably the Lands Dept building, Bridge Street, Sydney, for which statues of local identities were made, 1891–1902.
BIB: Badham, *SAA*. Scarlett, *AS*.

SHERRIFF, Norma Jean

(b. 6/9/1931, Melb.) Painter.
STUDIES: RMIT, 1963–65. Best-known for her work in vitreous enamel, she exhibited in the French Biennial in 1968, and in 1989 with her husband, painter Gareth Jones-Roberts, visited China with a La Trobe Uni. art delegation.
AWARDS: Eltham prize, 1966.
REP: NGA; NGV; several tertiary collections including Sydney and Melbourne unis.; Reserve Bank collection.
BIB: Germaine, *AGA*.

SHERRIN, Frank

Painter. A trustee of the QAG until 1959; president of the Half Dozen Group, Qld.
REP: QAG.

SHERWOOD, Maud

(b. 1880, Dunedin, NZ; arr. Sydney 1915; d. 1956, Sydney) Painter.
STUDIES: Wellington Tech. Coll., with James Nairn; Sydney; Paris; –1924. A foundation member of the Australian Watercolour Inst. in 1924, she returned home to NZ during the same year before moving in

1925 again to Paris, where she lived for the next eight years. On her return to Australia in 1933 she held an exhibition at the Macquarie Galleries, Sydney, was elected to the NSW Society of Artists and settled in Sydney. Her extremely able work in oils was included in the 1923 *Exhibition of Australian Art*, London, but later she became better known in Sydney for her watercolours.

REP: AGNSW.

BIB: Moore, SAA. Gil Docking, *Two Hundred Years of New Zealand Painting*, Lansdowne, Melbourne, 1971.

SHEW,
Instructor in model drawing at the Artisans' School of Design, Carlton, Vic., 1867.

BIB: Moore, SAA.

SHILLAM, Kathleen (née O'Neill)
(b. 25/5/1916, Devonshire, UK; arr. Aust. 1927) Sculptor. STUDIES: Brisbane Tech. Coll., 1932–33; Accademia di Firenze, Italy, also Royal Coll. of Art in London (bronze casting), 1961–64. Married to Leonard Shillam (q.v.), she worked as an advertising artist in Brisbane, 1934–38, also in Sydney, c. 1938–40, before returning to Brisbane to begin her career full-time in sculpture, from 1950. Basic to her art is drawing and interest in animals and insects. Her work in bronze extends to portrait plaques including those commissioned by Qld Uni.; Cane Growers Association; Gatton Coll., while other commissions include the fountain for St Paul's Coll., Sydney Uni. and with Len Shillam the Coat of Arms for Qld Parliament. She held about 11 solo or two-person exhibitions 1949–91 in Brisbane and Sydney, and participated in a number of group sculpture exhibitions including *Mildura Sculpture Triennials*, 1964, 67 and others in NSW, Vic., Qld.

AWARDS: L. J. Harvey drawing prize, Brisbane, 1951, 1955; Redcliffe prize, 1988; Order of Australia (AM), 1986.

APPTS: Teaching, summer schools in Qld, 1955; Stuartholme Convent, Brisbane, 1958–59; drawing, Dept of Architecture, Uni. of Qld, 1960s; numerous summer workshops, Qld, including with Society of Sculptors, Qld.; Brisbane Tech. Coll., 1975.

REP: AGNSW; AGWA; QAG; QVMAG; several regional gallery collections including at Newcastle, Dalby, Redcliffe, Gold Coast; uni. collections Brisbane, Hobart.

BIB: Vida Lahey, *Art in Queensland 1859–1959*, Jacaranda Press, Brisbane, 1959. Lenton Parr, *The Arts in Australia – Sculpture*, Arts in Australia series, Longmans, Melbourne, 1961. Scarlett, AS. Germaine, AGA.

SHILLAM, Leonard George
(b. 15/8/1915, Brisbane) Sculptor, teacher. STUDIES: Brisbane Tech. Coll., 1931–34; Westminster School, London (sculpture with Eric Schilsky), 1938; St Martin's School of Art (drawing with Leon Underwood), 1938; Central School of Arts and Crafts, 1938–39; travel studies, Greece, Italy and UK, Accademia di Firenze and Royal Coll. of Art (bronze casting), 1961–64. Married Kathleen O'Neill, a col-

league student. He earned a living as a poultry farmer, 1939–49, became a full-time sculptor in 1950 and worked jointly with his wife, sharing in studies as well as exhibitions. His style reflects the influence of the contemporary British school, as for example, in stone carvings of birds or animals, the compact look of sculpture by Skeaping, with whom he studied at the Central School of Arts and Crafts. Many of his commissioned works have been for Qld churches and schools. He held about 11 solo and two-person exhibitions 1949–91 in Brisbane and Sydney and participated in a number of sculpture survey exhibitions in regional, tertiary and state galleries including *Mildura Sculpture Triennial*, 1964, 67.

AWARDS: Carnegie Inst. grant, 1938; Qld Centenary Prize for Sculpture, 1959; Gold Coast Sculpture competition, 1986; Order of Australia (AM), for services to sculpture, 1986.

APPTS: Teaching, various summer schools, 1955– ; head of sculpture dept, Coll. of Art, Brisbane, 1975–80.

REP: AGNSW; QAG; QVMAG; several regional gallery collections including Dalby, Stanthorpe; several tertiary collections including Townsville, Qld unis.

BIB: Vida Lahey, *Art in Queensland 1859–1959*, Jacaranda Press, Brisbane, 1959. Lenton Parr, *Sculpture*, Arts in Australia series, Longman, Melbourne, 1961. Scarlett, AS. Germaine, AGA.

SHILLITO, Phyllis S.
(b. Eng.) Painter, teacher. STUDIES: Schools in Liverpool and London, UK. She painted mainly in watercolours and directed the Shillito Design School at 36 Grosvenor Street, Sydney.

APPTS: Teaching, Brisbane Tech. Coll.; ESTC (design).

REP: AGNSW.

BIB: Moore, SAA.

SHIMMEN, Heather (Jane)
(b. 8/11/1957, Vic.) Painter, printmaker. STUDIES: BA Fine Art, RMIT, 1978. Strongly based on drawing and inspired by poetry and history, her figurative works were seen in 8 solo exhibitions 1982–93 in Melbourne (Realities, Lyall Burton), Canberra and Adelaide. She participated in over 50 group exhibitions 1972–93 including many print survey and prize exhibitions including *Henri Worland Memorial Print Award*, Warrnambool Gallery 1979, 81, 82, 92; MPAC *Spring Festival of Prints and Drawings*, Mornington 1979, 81; PCA exhibitions, and in *Young Australians*, Budget Collection, NGV 1987; *Heidelberg and Heritage*, Linden 1988; *Transitional Times*, Australian Print Workshop, 1991; *Henri Worland 20th Anniversary Exhibition*, Warrnambool Regional Gallery 1992.

AWARDS: VACB grants, 1983, 89; PCA member/patron prints, 1983, 91.

APPTS: Teacher, printmaking and art, various Melbourne community centres, Lincoln Inst. and Northern Metropolitan Coll. of TAFE.

REP: QVMAG; AWM; regional galleries including Tamworth, Bendigo, Mildura; a number of secondary, municipal and tertiary collections including ANU; PCA.

BIB: PCA, *Directory* 1982; 1988. Germaine, *AGA*. Germaine, *DAWA*.

SHIRLEY, Eric
(b. 1919, Sydney) Painter, advertising executive.
STUDIES: NAS, 1937–39 and 1946–48; (drawing) Julian Ashton School, 1959; John Ogburn Art Studio, 1963–65. He served with the RAN, 1940–45, and after the war resumed his studies in Sydney at the NAS and other schools. In 1968 he participated in the *21st Show* at Central Street Gallery, Sydney, and in *The Field*, Melbourne, in which he exhibited a hard-edge painting, *Encore*, designed in broad undulating stripes of pure colour.
NFI

SHIRLEY, William T.
(Active c. 1920–29) Sculptor, stonemason. Wounded at Bullecourt during World War I, he later contracted tuberculosis and was invalided to the Lady Davidson Home, Turramurra, NSW. During convalescence, he undertook and completed carving a replica of the Sphinx of Giza from a rock 3.6m high in the bush at Kuring-gai Chase.
BIB: Moore, SAA.

SHIRLOW, Florence
(b. 1/3/1903, Melb.; d. 1987) Painter.
STUDIES: NGV School, 1925–32; George Bell school, c. 1948–39. Daughter of John Shirlow, she exhibited with CAS exhibitions in late 1930s, 40, 42. In 1989 Jim Alexander Melbourne, held an exhibition of around 40 of her paintings which showed works from the late 1940s demonstrating a strong commitment to modernism and influence of Picasso, Braque and Modigliani as seen in Australia in the *Exhibition of French and British Contemporary Art* in 1939. Her work appeared in *Classical Modernism: The George Bell Circle* NGV, 1992.
AWARDS: NGV painting prize, 1932.

SHIRLOW, John Alexander Thomas
(b. 1869, Sunbury, Vic.; d. 1936, Melb.) Etcher, teacher.
STUDIES: NGV School, 1891–94; with Arthur Loureiro, Melbourne. Moore says that Shirlow 'revived the art of etching in Australia', having become interested first in the Whistler etchings at the NGV collections in 1892. A member of the VAS and one of the last occupants of the studios at *Charterisville* (q.v.), he was foundation vice-president of the Australian Painter-Etchers' Society in 1920 and became celebrated for his etchings of city buildings. He was circumspect in his style of work but Bohemian in his habits, and though educated in etching techniques knew little about art history and less about the art of painting. As a trustee of the NGV he violently opposed the purchase of paintings by both Manet and Renoir and all 'that kind of thing'. APPTS: Art master, Scotch Coll., Melbourne; assistant examiner in drawing, Uni. of Melbourne; trustee, NGV, 1922–36 and member, Felton Bequest Committee, 1933–36; founder of classes in etching, Working Men's Coll. (RMIT), 1929.

REP: Print collections in all state and many regional and other public collections; print collections, British Museum.
BIB: Sydney Ure Smith, intro., *John Shirlow Etchings*, Angus & Robertson, Sydney, 1917. R. H. Croll, *The Etched Work of John Shirlow*, Alexander McCubbin, Melbourne, 1920. Moore, SAA. Leonard B. Cox, *The National Gallery of Victoria 1861–1968*, NGV, Melbourne, 1970.

SHOMALY, Alberr
(b. 10/2/1950, Bethlehem; arr. Aust. 1965) Printmaker.
STUDIES: NGV School, 1968–71; travel studies, UK (Leeds), 1972–73. Shomaly's large colour-prints depicting male and female nudes, some with the heads of wolves in double-image, had immediate appeal for a fashionable public when seen in exhibitions in the 1960s, partly because of their libidinous subjects and partly for smoothness and simplicity of presentation. They were selected for inclusion in *Australian Prints* (Victoria and Albert Museum, London, 1972), and for the *8th International Biennial Exhibition of Prints*, Tokyo, 1972. His work was later seen in a number of solo and group exhibitions including international print exhibitions and *Australian Printmakers*, McClelland Gallery, Langwarrin, 1982.
REP: NGA; AGNSW; AGSA; AGWA; NGV; TMAG; Ballarat regional gallery; print collections, Victoria and Albert Museum, London.
NFI

SHORE, Arnold Joseph Victor
(b. 5/5/1897, Windsor, Vic.; d. 22/5/1963, Melb.) Painter, teacher, critic.
STUDIES: NGV School, 1912–17; also with Max Meldrum. In 1932 he joined George Bell to establish the Bell–Shore School in premises in an upstairs studio, cnr Bourke and Queen Sts, Melbourne. The school quickly became a centre of instruction in modern painting, and during Bell's absence overseas Shore maintained it alone. Differences between the two artists caused their separation soon after Bell's return, 1934. Shore earned a living first working for the firm of Brooks Robinson, designers and makers of stained glass, and there established a lifelong friendship with William Frater. He adapted his post-impressionist painting style to depict the Australian bush as well as still life, and occasional portraits, and attained a fine feeling of spontaneity and freshness of colour. Atmosphere and light and the lush texture of roughly laid on paint are characteristic of his work. He was a pivotal part of the *Classical Modernism: The George Bell Circle* exhibition, NGV 1992.
AWARDS: Melbourne *Herald* picture-of-the-year prize (shared with Longstaff), Athenaeum Gallery, 1937; Crouch prize, Ballarat, 1938; McPhillimy prize, Geelong, 1939; medal of honour, VAS, 1961.
APPTS: Art critic, *Sun News-Pictorial*, Melbourne, 1934–35 (during absence overseas of regular critic, George Bell); guide lecturer, NGV, 1947–57; art critic, Melbourne *Argus*, 1950; Melbourne *Age*, 1957–63; president, VAS, 1958–61.

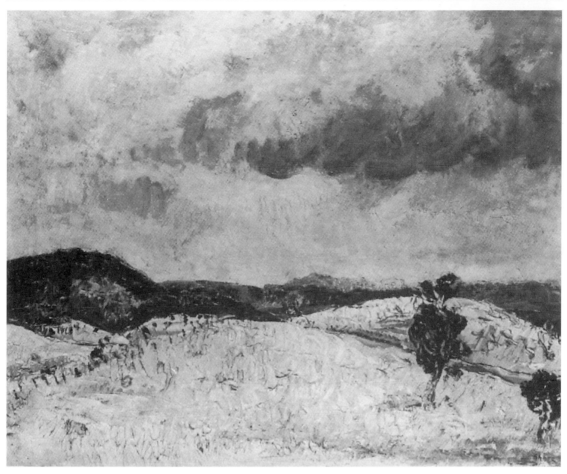

Arnold Shore, Summer Landscape, *1952, oil on canvas, 50.5 × 60.5cm. Joel's November 1992.*

REP: NGA; AGNSW; AGSA; AGWA; NGV; QAG; TMAG; regional galleries Ballarat, Bendigo, Castlemaine.
BIB: *Meanjin* vol. 9. 1950 (A. Cook, *The Art of Arnold Shore*). M. Eagle and J. Minchin *The George Bell School: Students, Friends, Influences*, Deutscher Fine Art/Resolution Press, Melbourne 1981.

SHORE, Ivy
(b. 1919) Painter.
STUDIES: Sydney, with Graham Inson.
AWARDS: Portia Geach Prize, 1979.
NFI

SHORT, Ernest
(b. 1875, Melb.; d. 1959, Eng.) Art writer, lecturer, journalist.
STUDIES: Independent studies at the British Museum. He lived in England from the age of nine and wrote many books on art including *The Painter in History*; *William Blake*; *G. F. Watts*; *A History of Religious Architecture*; *A History of British Paintings*; *A History of Sculpture* – all published by Eyre & Spottiswoode, London. He worked in the London office of the Melbourne *Argus.*

SHORT, Henry
(b. 1807, Eng.; arr. Melb. 1852; d. 1865, Melb.) Painter. Father of William Short, Snr, he showed in exhibitions in Melbourne in the 1850s, including still-lifes and paintings of Aborigines. He donated one of his works to the NGV. One of his works was in *Australian Art in the 1870s*, AGNSW 1976.
REP: NGV.
BIB: T. Bonyhady *The Colonial Image: Australian Painting 1800–1880*, Sydney 1987. J. Phipps, *Artists' Gardens*, Bay Books, Sydney 1987. Kerr, DAA.

SHORT, Susanna Borlase
(b. 23/8/1944, NSW) Author, critic.
STUDIES: BA, Uni. of Sydney, 1965; postgrad. studies, Slade School of Fine Art, Uni. Coll., London, 1967–68. A critic, writer on the arts she was the author of a biography of her father, *Laurie Short: A Political Life*, Allen & Unwin, 1992. Her mother is critic Nancy Borlase (q.v.).
APPTS: Journalist and feature writer for *Daily Telegraph* Sydney, 1967; London correspondent for Australian Consolidated Press; feature writer, *Daily Mirror* London, 1970–73; art critic, *National Times* Sydney, 1977–81; SMH, 1981–86; SBS television, 1985.

SHORT, William Henry
(b. 1875, Melb.; d. 1947, Melb.)

STUDIES: Family studies with his father, William Short, Snr (q.v.), and in Tas. The work of both father and son is close in style and confusion occasionally arises as to attribution. The younger Short usually signed W. H. Short. He began exhibiting in Melbourne before World War I, though he appears to have been painting from about the turn of the century. Like those of his father, his oils are rather sombre. He also painted watercolour seascapes and still life. In 1940 he bequeathed £1000 to the NGV for the purchase of paintings (the W. H. Short Bequest). His work appeared in *Australian Art in the 1870s*, AGNSW.
BIB: Edward Craig, *Australian Art Auction Records, 1975–78*, Mathews, Sydney, 1978. Kerr, DAA.

SHORT, William, Snr (William Wackenbarth)
(b. 1833, Surrey, UK; arr. Melb. 1851–52; d. 1917, Ballarat) Painter, photographer. A son of Henry Short (q.v.), after a brief stint on the goldfields he set up a photography studio in Melbourne in 1852 which he ran till 1880. He was a member of the Vic. Academy of Arts, exhibiting numerous landscapes in oils (and occasionally in watercolour), 1877–87, from various addresses – initially Melbourne and later from Bendigo and Woodend; subjects were usually views around Melbourne, priced at approximately five guineas. In 1887 he moved back to Bendigo, set up a studio in Pall Mall, and became a strong supporter for the establishment of the Bendigo Art Gallery. Dated works of Heidelberg (1878) and Mount Macedon (1897) suggest he travelled frequently or possibly worked from sketches. He usually signed William, or Wm. Short, though early in his career he rather confusingly signed Short Junr., presumably to distinguish himself from his father. His paintings are often rather dark and lack the professional touch of the major artists of his day. From the turn of the century he concentrated on watercolours. His work appeared in *Australian Art in the 1870s*, AGNSW 1976; *Colonial Bendigo*, Bendigo Art Gallery 1984 and in Deutscher exhibitions, Melbourne, *Australian Painting*, November 1984 and April 1986.
REP: Regional galleries Castlemaine, Bendigo; Royal Historical Society of Vic; NLA.
BIB: McCulloch AAGR. Kerr, DAA.

SIBLEY, Andrew J.
(b. 1933, Kent, Eng.; arr. Aust. 1948) Painter, teacher. STUDIES: Gravesend School of Art, UK, 1946; ESTC, 1951–53; RCA, London, 1954–55. He lived in Papua New Guinea, 1957, then in Qld, where he became associated with Jon Molvig, 1958–63, then Sydney, where he taught at the Mary White School of Art, 1964–65, before moving to Melbourne in 1966 with his wife, Irena, an artist and teacher. His figurative painting is bold, with emphasis on controlled distortion; it is also symbolic, satirical and technically inventive. Not the least of his accomplishments is in portraiture, notably in portraits entered in Archibald competitions which have included paintings of the artists Jon Molvig and Mirka Mora and Alan McCulloch. His exhibitions are frequently based on the mythol-ogy and culture of an ancient civilisation such as Greece or India, or urban life; and is strongly based on human reaction and interreaction. His work has remained consistently distinctive over 40 years of productive output. He held annual exhibitions 1959–93 in Melbourne (including at Realities, Australian, David Ellis/Lyall Burton), Sydney (Macquarie, Rudy Komon, Sherman), Perth, Brisbane and Canberra as well as several in Germany. Group shows in which he participated 1961–93 included the Whitechapel and Tate Gallery exhibitions, London, 1961, 62, *Australian Artists*, Japan 1965; and Jack Manton Invitation Exhibition, QAG 1989.
AWARDS: Transfield prize, 1962; Winemakers prize (shared with Michael Shannon), 1965; Bathurst, 1967; Georges Invitation, Melbourne, 1968; Launceston (QVMAG purchase), 1969; Shepparton, 1969; Gold Coast City (purchase), 1970; Townsville (purchase), 1972.
APPTS: Lecturer in Fine Arts, RMIT, 1966–90; senior lecturer, Caulfield campus, Monash Uni., 1990– .
REP: NGA; AGNSW; AGSA; AGWA; MAGNT; NGV; QAG; a number of public collections including Parliament House; a number of regional galleries including Ballarat, Bendigo, Launceston, Mornington, Shepparton, Townsville; Australian Embassy, Washington; state libraries in Vic., NSW, Qld.
BIB: A number of general texts on Australian art including Smith, AP; Bonython, MAP. Rodney Hall, *Focus on Andrew Sibley*, UQP, 1968. Sasha Grishin, *Andrew Sibley*, Craftsman House, 1993. A&A 21/4/1984.

SIERP, Allan Frederick
(b. 1905, Adelaide) Painter, teacher, printmaker.
STUDIES: SASA. He published about ten technical booklets on art subjects, including lettering, drawing, perspective and photography.
APPTS: Principal, SASA, 1961–64; inspector of art for the Dept of Education of SA, 1964– .
REP: Melbourne State Coll. print collections.

SILAS, Ellis
Painter, writer. He lived and worked at Kiriwina, in the Trobriand group of islands, and published a book about island life, *A Primitive Arcadia: being the Impressions of an Artist in Papua*, London, 1926, as well as *Crusading at Anzac*, with collection of drawings, London, 1916. He received the DCM during World War I, and later painted pictures of the Gallipoli campaign for the Australian War Museum.
BIB: Moore, SAA.

SIME, Dawn Frances
(b. 1932, Melb.) Painter.
STUDIES: RMIT, 1948; Preston Inst. of Tech. Her first exhibition was with Julius Kane and her first husband, Ian Sime, at the Mirka Gallery in Jan. 1954. She subsequently taught part-time in Vic. schools and lectured at CAE classes. She held a number of solo exhibitions 1954–93 in Melbourne (including at South Yarra, Powell St, Australian and David Ellis), Adelaide,

Canberra and Auckland, NZ galleries and a retrospective at Hawthorn City Gallery. She was represented in the Tate Gallery exhibition of Australian art, London, 1962 and in a number of other survey exhibitions including *Five Women Painters*, touring Victorian regional galleries. Geometric abstraction influenced her early work and its lessons were still evident in her late 1970s and early 1980s work, while later she developed a more fluid style of abstraction. Married to Eric Westbrook (q.v.).

AWARDS: Minnie Crouch prize, Ballarat (watercolours), 1964; Carnegie Fellowship travel grant, 1965; Ian Potter Foundation grant; Karolyi Foundation (artist-in-residence).

REP: NGA; AGWA; NGV; regional galleries Benalla, Castlemaine; Auckland City Art Gallery, NZ; corporate and private collections including Reserve Bank, Joseph Brown collections.

BIB: Catalogue essays exhibitions as above. Smith, *AP*.

SIME, Ian

(b. 1926, Melb.; d. 17/6/1989) Painter.
STUDIES: Ueno Uni., Japan (with Prof. Sorano and Charles Monimoto). He served as an army lecturer in Japan, c. 1948, and held his first exhibition at the Mirka Gallery, Melbourne, with Dawn Sime (q.v.) in 1954. He was a council member of the CAS, Melbourne, vice-president, 1956–62. Interested equally in the philosophy and technology of painting, he adopted surrealist methods and ideas from about 1940, his aim being, as he expressed it, 'to reconcile intellectual control learned in Japan to the subconscious expression of surrealism'. His exhibition held at the Australian Galleries in 1965 was divided between surrealistic and abstract types of expression.

BIB: Barrie Reid, ed., *Modern Australian Art*, MOMAD, Melbourne, 1958. *A&A* 5/1/1967; 27/3/1990 (obituary).

SIMONETTI, Achille

(b. 1838, Rome; arr. Brisbane 1871; d. 1900, Birchgrove, NSW) Sculptor.
STUDIES: St Luke's Academy, Rome. Son of sculptor Louis Simonetti. Trained as a religious sculptor, he migrated to Australia at the instigation of Dr James Quinn, Roman Catholic Archbishop of Brisbane, and moved to Sydney in 1874 to join Giulio Anivitti as a teacher at the NSW Academy of Art, 1875. He made the statue of Governor Phillip for the Botanic Gardens, Sydney, at a cost of £13,000, and completed other commissions for public works. His bust of Commodore J. G. Goodenough was shown in 1876 at the RA, London, where his name became confused with that of the painter, Attilio Simonetti. His work was also included in the NSW sections of the Sydney and Melbourne *International Exhibitions* of 1879–80 and, almost a century later, in *Early Australian Sculpture*, Ballarat Fine Art Gallery, 1976 and *Australian Art in the 1870s*, AGNSW, Sydney, 1976.

AWARDS: Sculpture prizes, NSW Academy of Art, 1874, 75, and at the *International Exhibition*, Sydney, 1879.

REP: AGNSW; Uni. of Sydney, Uni. of Adelaide; State Parliament Houses, Brisbane and Sydney.
BIB: *ADB* 6. Sturgeon, *DAS*. Scarlett, *AS*.

SIMONETTI, Alfonso

(b. 1840, Naples; d. 1892, Castrociello) Painter. A genre, portrait and landscape painter, he is recorded as exhibiting in Melbourne.
BIB: Bénézit, *Dictionnaire*, 1976.

SIMPKINSON, Francis Guillemard

See de WESSELOW, Francis Guillemard Simpkinson

SIMPSON, Herbert Clarke

(b. 1879, Casino, NSW; d. 1966, Brisbane) Painter.
STUDIES: Brisbane Tech. Coll., with Godfrey Rivers. Known as a prolific painter of popular watercolours and regular exhibitor at the RQAS, Brisbane, 1901–26. (Information from Boyd Robertson, Mermaid Beach, Qld, 13 May 1983)
NFI

SIMPSON, Norah Cassan

(b. 1895, Sydney; d. 1974) Painter.
STUDIES: Sydney, with Dattilo Rubbo, 1911–12, and 1913–15; Westminster School, London, 1912, and again, with Walter Sickert, 1915. During her first visit to London she became friendly with the Camden Town Group, including Charles Ginner, Harold Gilman and Spencer Gore, from whom she learned much about the modernist movement in Paris. Moving briefly to Paris, she saw originals by Van Gogh, Cézanne, Gauguin and many others, and the reproductions she took back to Sydney and circulated at Rubbo's classes had a powerful effect on friends such as Wakelin, de Maistre and Cossington Smith. She moved permanently to the UK in 1915, re-enrolled at the Westminster School with Sickert and resumed her acquaintance with Ginner and Gilman, who jointly conducted a small school of their own. She worked in Glasgow in 1919, Paris in 1920, married, and after the birth of her son, gave up painting.
REP: AGNSW.
BIB: Janine Burke, *Australian Women Artists 1840–1940*, Greenhouse, Melbourne, 1980.

SIMPSON, Ronald Albert

(b. 1929) Poet, painter, sculptor.
STUDIES: RMIT; George Bell School; travel study in Europe, 1957–58. He taught with the Vic. Education Dept, and was an early member of the CAS and the author of *The Walk Along the Beach*, book of poems, Edwards & Shaw, Sydney, 1960.
NFI

SINCLAIR, Alfred (Alfred WADHAM)

(b. 1866, Liverpool, Eng.; arr. Aust. 1877; d. 1938) Painter.
STUDIES: Liverpool Academy of Arts. Landscape watercolourist. The brother of W. J. Wadham (q.v.), he adopted the professional name of Sinclair. He exhibited

a Melbourne landscape at the VAA in 1887 and probably went to Adelaide shortly after, most likely to join his brother, William Joseph Wadham, foundation president of the Adelaide Easel Club, whose members had seceded from the Royal South Australian Society of Arts (q.v.). Sinclair is recorded as living in North Wales 1899–1902, and exhibiting in London. Watercolours of New Zealand views suggest a short stay there, possibly with his brother in the early 1920s.

SINCLAIR, Margaret
(b. 1918, Adelaide) Sculptor.
STUDIES: SASA, c. 1937; travel studies, UK and Europe, 1956; SASA (part-time), 1957–60, (full-time studies in sculpture), 1962–64; travel studies in Mexico, South America, USA, Europe, Greece, Italy (including five months' work in a bronze foundry in Milan, 1966); Italy again, 1972; UK and Spain, 1974. She was a member of the CAS, Adelaide 1960–70, the RSASA 1959–65, and held numerous solo exhibitions 1959–89 including with Bonython/Meadmore Adelaide (1984, 88, 89).
AWARDS: CAS, SA, prizes for sculpture, 1962, 63, 64; Churchill Memorial fellowship, 1966; Mildura Sculpture Triennial (purchase award), 1967.
APPTS: Teaching, summer schools at Albany for the WA Adult Education Board, and one at the Perth Uni., 1964–66.
REP: AGSA; MPAC; Uni. of Flinders, SA; Festival Centre, Adelaide; Churchill House, Canberra.

SINCLAIR, T.
(Active c. 1851) Painter. His only known painting depicts the River Yarra steamer *City of Melbourne*, which ran aground at King Island, 1853.
BIB: McCulloch, AAGR.
NFI

SINGLETON, Judi Louise
(b. 21/3/1963, NSW) Painter, ceramicist.
STUDIES: Self-taught. A member of ROAR Studios Melbourne from 1983, she exhibited with ROAR Studios 1983, 84, and in group exhibitions with Coventry, Sydney and in *A New Generation: Philip Morris Arts Grants*, NGA 1988; *9 × 5, Wilderness Exhibition*, Linden St Kilda 1989. Her four solo exhibitions 1987–91 were with William Mora (1987, 89, 90) and Australian Galleries (1989). She was one of the artists commissioned to paint a mural for the NGA restaurant.
AWARDS: Shepparton Ceramic Prize, Shepparton Art Gallery, 1991; Sydney Myer Fund Australia Day Ceramics Award, 1992.
REP: NGA; Parliament House; Artbank; several regional galleries, Vic.; several corporate collections.

SISLEY, Thomas A.
Secretary of the Victorian Artists' Society in the 1890s he is said to have been related to Alfred Sisley. He wrote *Stray Thoughts in the Sydney Art Gallery, Australasian Builders and Contractors News*, 1891.
NFI

SIX DIRECTIONS
(Established 1953) Group formed by Latvian, Lithuanian and Estonian artists living in Sydney. The first exhibition, mainly of abstract painting, was held at the Bissietta Gallery, Sydney, in 1957. Group members included: G. F. Bissietta, Edgar Aavik, August Molder, Uldis Abolins, Dzem Krivs, Jurgis Miksevicius and Henry Salkauskas.
BIB: Smith, AP.

SKILLITZI, Stephen
(b. 30/8/1947, UK) Glass artist.
STUDIES: Ceramics Certificate, NAS, 1966; MA (Fine Art), Uni. of Massachusetts, USA, 1970. He held over 30 solo exhibitions 1966–91 including at Studio 20 and Bonython, Adelaide; Holdsworth, Sydney; Realities, Melbourne and internationally. He participated in numerous group exhibitions 1975–90 including craft exhibitions internationally and in *Australian Sculpture Triennial*, Mildura Art Gallery 1988.
AWARDS: VACB grants, 1971, 74, 75; several scholarships USA and several clay art prizes Aust.
APPTS: Part-time teaching, ceramics, glass-blowing, USA and Aust., 1969–73; full-time lecturer, ceramics, glass design, B. Design Degree, SACAE, 1976–87.
REP: NGA; NGV; most state and regional galleries; several USA art museums.

SKINNER, Rose
(d. Sept. 1979, Perth) Gallery director, entrepreneur, collector. Encouraged by her husband, Joseph Skinner, she established the Skinner Galleries, Perth, 1958, to make it a centre of modern art in Western Australia. Throughout her career she worked for the benefit of art and artists in Australia.
BIB: A&A 12/2/1974 (Patrick Hutchings, *The Art Collectors 13: The Rose Skinner Collection*); 17/2/1979 (Elizabeth Riddell, *Rose Skinner – A Remembrance*).

SKIPPER, John Michael
(b. 12/7/1815, Norwich, UK; arr. Adelaide 1836; d. 7/12/1883, Kent Town, SA) Solicitor, painter. Interested mainly in art, he abandoned his law studies and served in the East India Company's ship *Sherbourne* during a voyage to Calcutta, later writing and illustrating his impressions. In 1836 he migrated to South Australia, made sketches during the voyage and met Frances Amelia Thomas whom he married in Adelaide in Dec. 1839. Articled to the Advocate General, Charles Mann, and Judge E. G. Gwynne, he practised law, 1843–51, became known as an artist in SA and joined the gold rush to Victoria in 1851, making many sketches of the goldfields. His mostly small, skilful drawings and paintings of South Australian life, its people, landscape and natural history have great historical interest. His illustrations for almanacs and for his own journals extend also to illustrations for Sturt's expeditions done from descriptive notes loaned by the explorer. He was the grandfather of M. G. Skipper (q.v.).
REP: AGSA; SA Museum; Royal Empire Society, London.

Peter Powditch, Not Dawn Again, *1969/70, oil, enamel, 'Wundercoat', on masonite, 150 × 145cm. Courtesy Niagara Galleries.*

1970s–80s

Australian art in the late 1960s and 70s became increasingly part of the international art movements. Annandale Imitation Realists (q.v.) Mike Brown and Colin Lanceley epitomised 1960s 'funk/pop' art while figurative expressionism initiated in the 1940s and 50s was carried through into the 1960s and '70s by Clifton Pugh, Jan Senbergs, Andrew Sibley, Susan Norrie, Peter Booth, Ken Whisson, Kevin Connor, Tim Storrier, Brett Whiteley and many others. Abstraction (q.v.) became an equally important art movement in the 1960s as was seen in the work of artists like Tony Tuckson, Peter Powditch, Roger Kemp and Robert Jacks. Jeffrey Smart's empty city scapes, Justin O'Brien's medieval-like interiors, John Brack's meticulously placed people and objects and Brian Dunlop's figures re-interpreted the realistic with a new style of super-realism.

Above: *Ian Fairweather*, Monastery, *1961, polyvinyl acetate on cardboard, 142.8cm × 185.8cm. Collection,* NGA.

Left above: *Tony Tuckson*, White lines (horizontal) on Black and Pink, *1973, synthetic polymer paint on composition board, 213.5 × 122cm. Collection,* AGSA.

Left: *Mike Brown*, Abstract III, *1969, oil on plywood, 91.4 × 91.4cm. Collection, Museum of Modern Art at Heide.*

Right: *Brett Whiteley,* The balcony II, *1975, oil on canvas, 203.5 × 364.5cm. Collection,* AGNSW.

Above: *Ken Reinhard,* A Call 4 Parking in WI, *1982, mixed media, 154.5 × 174.8cm. Private collection.*

Right: *Selection of works by John Nixon from 1968–86 at the* MCA, *Sydney.*

Far right: *Justin O'Brien,* The Sacred Concert, *1974, oil on canvas, tripytch, 112 × 144.5cm. Joel's. April, 1992.*

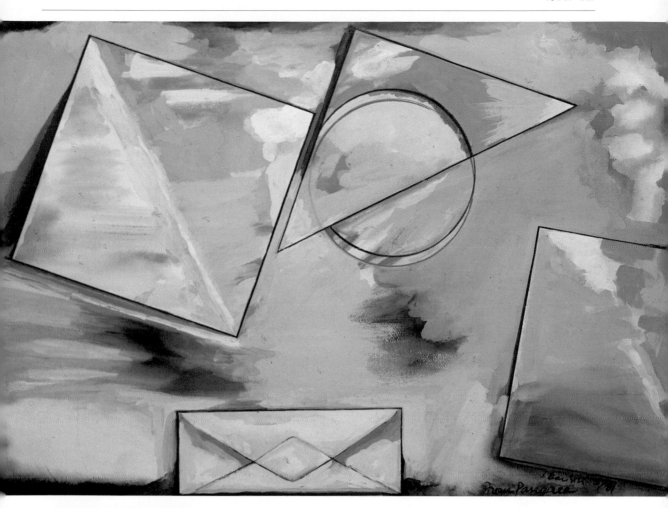

Above: *Janet Dawson*, From Pangaea, *1981, gouache, 51 × 76cm. Private collection.*

Left: *Jeffrey Smart,* Arrezzo Turnoff, *1973, oil and synthetic polymer paint on canvas, 120 × 81cm. Christie's, November 1993*

Above left: *John Brack,* NO, *1984, oil on canvas, 182 × 152. Collection, Parliament House, Canberra.*

Far left: *Roger Kemp,* Mechanics of the Mind, *n.d. oil on paper, 205 × 330cm. Private collection.*

Below left: *Ken Whisson,* Suburban Light Pale Faces and Kitchen Tables, *1987/88, acrylic on canvas, 99 × 119cm. Courtesy Watters Gallery, Sydney.*

Left: *Colin Lanceley,* Songs of a Summer Night, (Lynne's Garden), *1985, oil colours on canvas and carved wood, 165 × 222cm. Collection, AGNSW.*

Below: *Andrew Sibley,* Black Hug, *ink, wash and watercolour on paper, 69 × 47.5. Private collection.*

Below left: *Tim Storrier,* Ceremonial Still Life, *1986, construction, 121 × 151cm. Courtesy, Australian Galleries, Melbourne.*

Below: *Kevin Connor,* King Street, Newtown, *1987, oil on canvas. Private collection.*

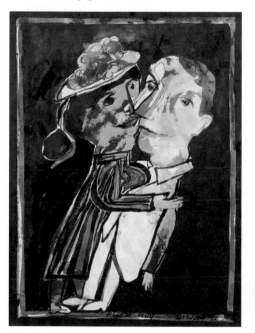

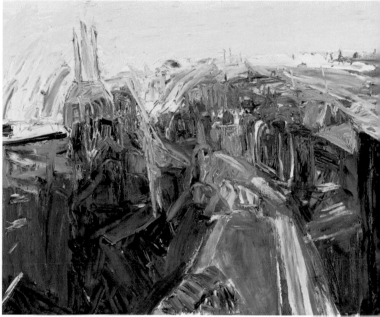

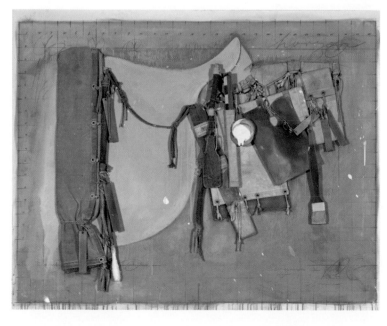

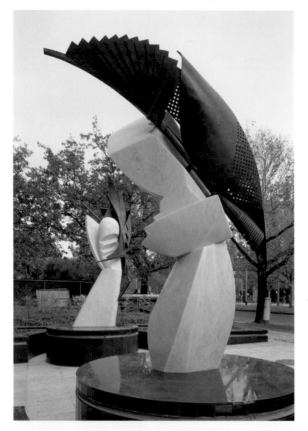

Above: *Jan Senbergs* Voyage Six - Antarctica, *1987, acrylic on linen, 197 × 306cm. Collection,* QAG.

Top right: *Brian Dunlop* Morning Aair, *1989, oil on canvas, 84 × 49cm. Courtesy Australian Galleries, Melbourne.*

Top left: *Tony Pryor* The Performers, *1989, two of seven sculptures for the American Embassy, Melbourne, marble, bronze and painted steel.*

Above: *Robert Jacks* Past Unfolded, *1986, oil on canvas,* Top: *Margaret Olley* Clivias, *1984, oil on canvas, 76 ×*
168 × 251cm. Private collection. *102cm. Private collection.*

Peter Booth Painting 1989 (Mountain landscape with snow), *1989, oil on canvas, 167.5 × 304.5cm. Collection,* TMAG.

Susan Norrie Fete, *1986, oil on ply, 213.25 × 152.5cm. Courtesy Moet & Chandon Fellowship (winner, 1987).*

BIB: Adelaide *Register*, 8 and 13 Dec. 1883. Moore, SAA. McCulloch, AAGR. ADB 6. Kerr, DAA.

SKIPPER, Matcham

(b. 1921, Melb.) Sculptor, jewellery designer; film director. Son of Mervyn Skipper (q.v.), he learnt metal craft work at the Jorgensen colony at Eltham. Skipper's early reputation was made through his designs in silver, based on study of Italian Renaissance art; from 1963 he concentrated on sculpture. He travelled in Europe, 1970–71. His commissioned work includes sculptures in wrought iron for universities, schools and churches, and jewellery presentation pieces for the Duke of Edinburgh. Five documentary films have been made about Skipper and his work, and he directed *The Prize*, an award-winning film at Venice.
AWARDS: Italian government scholarship (renounced), 1962; sculpture awards, Eltham, 1966; Churchill Fellowship, 1970; prize at *International Medallion Exhibition*, Cracow, Poland, 1974.
REP: AGWA; NGV.
BIB: Scarlett, AS.

SKIPPER, Mervyn G.

(b. c. 1884; d. c. 1950) Cartoonist. Melbourne correspondent of the Sydney *Bulletin;* father of Matcham Skipper. Member of the Jorgensen colony, Eltham. He wrote and illustrated *The Meeting-pool: A Tale of Borneo*, London, 1929.
BIB: Moore, SAA.

SKIPPER, Peter

(b. c. 1929, Juwaliny country in the Great Sandy Desert, WA) Aboriginal painter of the Juwaliny/Walmajarri language group. Originally from the Great Sandy Desert he followed a traditional life-style until, in the mid 1960s, he moved to Fitzroy Crossing, the Kimberley. He started painting on canvassed boards for the local tourist market in the early 1980s but since 1987 has been working on large scale stretched canvas for the fine art market. His paintings focus on personal identity, expressed in terms of a particular inheritance of Aboriginal law, belief and territory. He has held a number of solo exhibitions and his work was included in 9 group exhibitions 1988–90, in particular *Dreamings*, Asia Society, New York, 1988; *Abstraction*, AGNSW, 1990; *Tandanya Contemporary Art South to North*, Edinburgh, 1990, *Tarinoita*, Keravan Taidemuseo, Helsinki, 1993; *Crossroads: Towards a New Reality*, Museum of Modern Art, Kyoto and Tokyo, Japan, 1993.
REP: NGV; AGWA; AGSA; SA CAE; corporate collections including Robert Holmes à Court.
BIB: Catalogue essays exhibitions as above. Caruana, AA. A&A 26/4/1989 (Peter Sutton & Judith Newman *Dreamings . . .*).

SKOTTOWE, Elizabeth

(b. 1912, Adelaide; d. 1970) Illustrator, writer.
STUDIES: SASA (with Wilkie). She began as an illustrator in Adelaide in the 1930s, but after 1935 (apart from a visit to Sydney in 1937) she spent her time

in England, her children's books being published there from 1952.
BIB: Rachel Biven, *Some forgotten . . . some remembered*, Sydenham Gallery, Adelaide, 1976.

SLADE, George Penkivil

(b. 1832, Eng.; arr. Sydney 1858; d. 1896) Painter.
STUDIES: With Conrad Martens, Sydney. He painted in both Tas. and NSW. Though typical of the nineteenth-century amateur artist, his topographical watercolours have a refinement and quality equal to that of many of his professional contemporaries. He exhibited with the NSW Academy of Arts, 1874–77, showing NSW coastal and landscape watercolours, the subjects for which he is best-known today. His work was included in *Tasmanian Vision*, TMAG 1988; *The Artist and the Patron*, AGNSW, 1988 and one of his works was in Christie's September 1984 sale.
REP: Mitchell Library, Sydney.
BIB: E. Craig, *Australian Art Auction records*, Sydney 1987. Andrew Sayers, *Drawing in Australia*, NGA, 1988. Kerr, DAA.

SLA(E)GER, Philip ('Sligo')

(Arr. Sydney 1807) Engraver, sketcher. Assigned as a servant in the Parramatta and Hawkesbury area, Slager or Slaeger drew and engraved five plates for Absolom West's Views of New South Wales (1814). These are well finished and finely detailed, though occasionally lacking accurate perspective.
BIB: J. Hackforth Jones, *The Convict Artists*, Macmillan, Melbourne, 1977. Rienits, *Early Artists of Australia*, 1966. Kerr, DAA.

SLAGMOLEN, Rein

(b. 1911, Utrecht, Holland; arr. Aust. 1949) Stained glass designer.
STUDIES: Some formal training in Holland, travel studies in Europe, Uganda, Tanganyika and Kenya 1937. He served in the British army from 1943, and served in Australia (1945), Africa and Holland. In 1949 he settled in Australia and his first work, in faceted stained-glass, comprised the 12.2m high windows for the Church of the Holy Eucharist, Chadstone, Melbourne. Another well-known work is his glass mosaic wall in the foyer of Qantas House, Melbourne and his other commercial works in stained glass, enamels, and metal can be seen in several hundred buildings, mainly in Vic.
NFI

SMART, Jeffrey (Frank Jeffrey Edson)

(b. 26/7/1921, Adelaide; moved to Rome, Italy, 1965) Painter.
STUDIES: SASA, 1937–41; Académie Montmartre, Paris with Fernand Léger, 1949, and also at La Grande Chaumière. His first ambition was to be an architect, and love of the created environment and relationship between buildings and other man-made structures and people has been the focus of his art for over 40 years. His own regular exhibitions began in 1957 and

continued annually from then. Clear, cool light, long shadows, showing the scene lit as if from the side, relate his surrealism to de Chirico's. Shown in isolation, his plebeian figures of people set in meticulously painted landscapes with dark, encroaching clouds, or against concrete buildings with freeways, signs, signals and space-age constructions, reflect the disquieting atmosphere of the times. He held over 25 solo exhibitions 1957–92 from which especially in the 1980s his work fetched high prices and was highly sought-after. Significant group exhibitions in which his work appeared 1962–90 included Whitechapel and Tate Gallery exhibitions of Australian art, 1962, 63; Corcoran Gallery Washington, 1966; *Survey*, NGV 1966; *Australian Paintings and Tapestries of the last 20 years*, NSW House, London 1972 and the Bicentennial exhibition *The Great Australian Art Exhibition*.
AWARDS: Commonwealth Jubilee Art Prize, 1951.
APPTS: Art critic, *Daily Telegraph*, Sydney, 1952–54; creator of ABC radio and television children's art session under the pseudonym 'Phidias', 1956–63; teaching drawing, NAS, 1962–63.
REP: NGA; AGNSW; AGSA; AGWA; MAGNT; NGV; QAG; QVMAG; TMAG; Metropolitan Museum of Art, New York; regional galleries Ballarat, Newcastle; Vic. Arts Centre; tertiary collections including ANU, Sydney and Yale, USA unis.; corporate collections including Mertz, Washington, von Thyssen; de Beers; Lugano collections.
BIB: Most general books on Australian contemporary art including Smith, AP; James Gleeson, *Masterpieces of Australian Painting* Lansdowne, Melbourne, 1969; John McDonald *Jeffrey Smart; paintings of the 70s and 80s*, Craftsman House, 1990. A&A 7/1/1969; 22/3/1984.

SMART, Sally
(b. 26/3/1960, Quorn, SA) Painter.
STUDIES: Dip. graphic design, SASA, 1981; Grad. Dip. Fine Art (painting), VCA, 1988; MA (fine art), VCA, 1991. Her paintings draw on traditional women's crafts such as quiltmaking and patchwork and resemble collages, as shown in her 1991 and 1992 *Moet & Chandon* entries *Inheritance* (using a stylised gum tree covered with painted bandages, strips and squares of cloth to symbolise a family tree). She held ten solo exhibitions 1983–92 including in Sydney (Roslyn Oxley9), Melbourne (Luba Bilu and 200 Gertrude St 1989) and at the Geelong Art Gallery and touring 1993/94. Group exhibitions in which her work appeared 1986–92 included *Artbank Big Paintings*, Ivan Dougherty gallery 1987; *Imaging Aids*, ACCA 1989; *Moet & Chandon Touring Exhibition*, 1991, 92, 94; *Skin*, CAC, Adelaide 1992.
AWARDS: Student prizes at SASA, VCA (3) including ANZ travelling scholarship, 1989; St Kilda acquisition, 1988; VACB grant, 1991.
APPTS: Part-time lecturing, tertiary colleges Gippsland and VCA, 1985–90.
REP: NGA; NGV: Artbank; several regional, tertiary and municipal collections, Vic.
BIB: Catalogue essays exhibitions as above.

SMEDLEY, John
(b. 4/3/1841, Sydney; d. 1903, Shanghai) Architect, painter.
STUDIES: With his cousin William Dexter (q.v.) he worked on several projects including Dexter's prize-winning design (Smedley came second) for a presentation gold cup in 1856. He copied several of Dexter's works and others from photographs and became an architect in 1866. He went to Hong Kong as an architect and painted scenery for the theatre as well as panoramic views and other decorative works, returning to Sydney in 1880 to continue his practice as a succesful architect (his buildings included the Sydney Trades Hall). He exhibited in major exhibitions in Sydney and Melbourne (including the 1888 *Centennial Exhibition* in Melbourne), went to Japan in 1891, thence to Shanghai where he practised as an architect for six years before his death. His work was represented in *The Artist and the Patron*, AGNSW 1988.
BIB: E. Craig, *Australian Art Auction Records*, Sydney 1982. Kerr, DAA.

SMEDLEY, William Thomas
(b. 1858, USA; arr. Sydney c. 1886–7; d. USA, 1920) Painter, black-and-white artist.
STUDIES: Pennsylvania Academy; Paris, with Jean Paul Laurens. He went to Sydney by invitation to work on the *Picturesque Atlas of Australasia* (q.v.), the work for which he is remembered in Australia. Returning to America, he made a reputation as a painter of landscape, portraits and genre.
REP: AGNSW; Metropolitan Museum, New York; National Gallery, Washington.

SMITH, (Prof.) Bernard William
(b. 1916, Sydney) Historian, lecturer, teacher, critic.
STUDIES: Sydney Teachers Coll., 1934–35; Julian Ashton School, 1936; Uni. of Sydney, 1945–53, grad. BA; Courtauld Inst. of Art and Warburg Inst., London, 1948–49; ANU, 1953–54, grad. Ph.D. His name was established with the publication of *Place, Taste and Tradition*, 1945, the first book on general Australian art history to appear since William Moore's *Story of Australian Art*, 1934. He began his professional career in teaching and, 1940–41, contributed paintings to Teachers Federation Art Society and CAS exhibitions. He compiled the first complete catalogue of Australian oil paintings in the AGNSW (1953), and during his work as Education Officer did much to establish throughout the State the art prizes that led, eventually, to the building of the NSW network of regional art galleries. In 1960 the publication of his *European Vision and the South Pacific* firmly established his position as historian and research scholar. He served as president of the Glebe Society, 1968–70, and International Association of Art Critics (Australian Division), 1966-69, and is a Fellow of the Australian Academy of the Humanities (president 1977–80), and Society of Antiquaries, London. His publications include *Place, Taste and Tradition*, Ure Smith, Sydney, 1945; rev. edn, OUP, Melbourne, 1979; *A Catalogue*

of Australian Oil Paintings in the National Art Gallery of New South Wales, 1875–1952, AGNSW, Sydney, 1953; ed., *Education Through Art in Australia*, Herbert Read intro., MUP, 1958; *European Vision and the South Pacific, 1768–1850*, Clarendon Press, Oxford, 1960; *Australian Painting, 1788–1960*, OUP, Melbourne, 1962; *1788–1970*, 2nd edn, OUP, 1971; *1788–1990*, 3rd edition (with Terry Smith) 1992; *The Architectural Character of Glebe, Sydney*, in collaboration with Kate Smith, Uni. Co-operative Bookshop, Sydney, 1974; *Documents on Art and Taste in Australia: the Colonial Period, 1770–1914*, OUP, Melbourne; ed., *Concerning Contemporary Art: the Power Lectures, 1968–73*, OUP, Melbourne, 1975; *The Antipodean Manifesto: Essays in Art and History*, OUP, Melbourne, 1976; *The Boy Adeodatus*, OUP 1985; *The Art of Captain Cook's Voyages* (with R. Joppien), 3 vols., OUP, 1985–87; *The Critic as Advocate* OUP 1989; *Imaging the Pacific* MUP, 1992; *Noel Counihan, Artist and Revolutionary*, OUP, 1993. He established The RAKA (Ruth Adeney Koori Awards) in 1992 in honour of his late wife (*See* PRIZES).
AWARDS: Ernest Scott prize for history, Uni. of Melbourne, 1962; Grenfell Festival (Henry Lawson award for verse), 1964.
APPTS: Teaching, Enmore Activity School, 1941–44; education officer, AGNSW, 1945–52; lecturer, 1955, senior lecturer, 1956–63, reader, 1964–66, Dept of Fine Arts, Uni. of Melbourne; art critic, *Age*, Melbourne, 1963–66; professor of Contemporary Art and director of the Power Inst. of Fine Arts, Uni. of Sydney, 1967–77.

SMITH, Bernhard

(b. 1820, Greenwich, UK; arr. Vic. 1852; d. 1885, Alexandra, Vic.) Sculptor, police magistrate.
STUDIES: RA Schools, London, 1840; Paris, with M. Ramey, 1840–41. He exhibited busts and medallion portraits at the RA, 1842–51, shared a studio with Thomas Woolner, and went with him and Edward La Trobe Bateman to the Victorian goldfields in 1852. In 1854 he was appointed Gold Commissioner, Ballarat, and in 1855, Protector of Chinese. He became Commissioner of Lands, Stawell, c. 1860 and in 1874 Police Magistrate at Smythesdale. Dismissed during the purge of civil servants by the Berry Government in 1878, he was reinstated and posted to Alexandra, where he remained for the rest of his life. He is recorded as having produced only one medallion in Australia (1877), but towards the end of his life he wrote poems and produced a series of drawings after the manner of Blake or Fuseli, based on the works of Shakespeare and Longfellow. He is also known for producing Australia's first fairy picture, later to become a popular subject. One of his daughters, Minnie Bernhard Smith, became a sculptor. His work was seen in *Australian Art in the 1870s*, AGNSW 1988.
REP: NGA; La Trobe Library; National Portrait Gallery, London.
BIB: Smith, *PTT.* McCulloch *AAGR.* Scarlett, *AS.* ADB 6. Kerr, *DAA.*

(*See also* SMITH, Minnie Bernhard)

SMITH, Edward M.

(b. 1883, Eng.; arr. Perth c. 1914) Painter, sculptor, teacher.
STUDIES: RA Schools, London; travel studies, France and Italy, 1903–04. He started teaching in 1903 and, after migrating to Australia, served with the AIF in World War I. He taught at the ESTC from c. 1923, was supervisor of art in NSW, c. 1933, wrote critiques for the Sydney *Telegraph* and exhibited his paintings (mostly portraits) at RAS exhibitions.
BIB: *Australian Art Illustrated*, RAS exhibition cat., Sydney, 1947.

SMITH, Eric John

(b. 5/8/1919, Melb.) Painter.
STUDIES: Brunswick Tech. School, Melb. (commercial art), 1936–37; Melb. Tech. Coll. (RMIT), 1947–51. He served in the army, 1941–46, and studied under the Commonwealth Rehabilitation Training Scheme, having already become known for his fine self-portrait entered for the Archibald prize in 1944. During the post-war years he was greatly influenced by the colour and iconography of Rouault and the religious paintings that evolved included successful entries for the Blake Prize on six occasions. Later his palette lightened and he began to paint more abstract works on large canvases and to experiment with abstract expressionist concepts before returning to figuration. Among numerous group exhibitions he was represented in *Uncommon Australians; Towards an Australian Portrait Gallery*, privately funded exhibition touring Australian state galleries 1992–93.
AWARDS: 2nd prize, *Australia at War* exhibition (War on Land section), 1945; Catholic Centenary prize, 1948; *Herald* (drawing prize, VAS), 1950; Berrima (mural), 1953; Sulman, 1953, 73; Adelaide *Advertiser*, 1955; Bathurst, 1956; Blake, 1956, 58, 59, 62, 69, 70 (shared); RAgSocNSW (industrial landscape), 1962, (portraits), 70; Rubinstein scholarship, 1962; CAS (Taffs prize), 1965; Archibald prize, 1970, 81, 82; Wynne prize, 1974; Muswellbrook, 1975.
REP: NGA; AGNSW; AGSA; NGV; QAG; regional galleries Bendigo, Mildura; Perth Uni. collections.
BIB: All general books on contemporary Australian art history and references in A&A (a number of editions) 1963, 64.

SMITH, Ernest Walter

(b. 18/12/1928, Melb.) Painter, gallery director, critic.
STUDIES: NAS, 1944–49; Perugia, Italy, 1961; Toorak Teachers Training Coll., Melbourne, 1963; Washington Uni., St Louis, Missouri, USA, 1965–67. Expressive and often of romantic themes with horses and riders, his paintings, as exhibited in Melbourne from 1963, strike a balance between abstract and figurative styles.
AWARDS: Italian scholarship, 1961; Geelong (F. E. Richardson) prize, 1962; grad. Fellowship, Washington Uni., St Louis, 1965–67.
APPTS: Teaching, lecturer in art, Gordon Inst. of Technology, Geelong, 1962–63; art critic, Adelaide *Sunday Mail*, 1963; SASA, 1964–65; lecturer in art history and director, Loretto-Hilton Gallery, Webster

Coll., St Louis, Mo., 1967–70; prof. of art history and director of Dalhousie Uni. Gallery, Dalhousie Uni., Halifax, NS, Canada, 1970–74; director, Auckland City Art Gallery, 1974–79; lecturer and exhibitions officer, Dunedin Public Art Gallery, NZ, 1980; director, Swan Hill Regional Art Gallery, Vic., 1981–93.
REP: NGV; Geelong Art Gallery.

SMITH, Frances
(b. 1938, Sydney) Painter.
STUDIES: ESTC. She travelled extensively in Central Australia, 1960–61, and her work was included in both Whitechapel and Tate exhibitions of Australian art, London, 1961, 62.
NFI

SMITH, Frederick C.
(b. 1819; d. WA, 1837) Amateur explorer-artist with Grey's expedition. One of Smith's drawings was reproduced in Sir George Grey's *Journals of Two Expeditions in North West and Western Australia, 1837–1839.*

SMITH, Grace Cossington
(b. 22/4/1892, Neutral Bay, NSW; d. 1984, Sydney) Painter.
STUDIES: Sydney, school studies with Albert Collins and Alfred Coffey; Dattilo Rubbo's school, 1909–12; travels in UK and Europe, 1912–14; returned to study at Rubbo's school, Sydney, 1914–26. Her reputation as a leader among the Sydney modernist painters of the period (1925–35) was slow in evolving. Her painting *The Sock Knitter*, painted in 1915, is now considered a key picture in the modernist movement; it was painted at Rubbo's school under the influence of Nora Simpson (q.v.). However it was not until her work with Roland Wakelin and Roy de Maistre and the formation of the Contemporary Group in 1926 that the real character of her contribution to modern painting in Sydney began to take shape. She exhibited in London at the Walker Gallery, 1932, and at the New English Art Club, Redfern Gallery and RA in 1950, and between 1932–72 held about 12 exhibitions at the Macquarie Galleries, Sydney, as well as contributing to many group exhibitions. Beginning with post-impressionism her style gradually developed a Bonnard-like intimacy and lightness of colour expressed often in paintings of sunny interiors. By 1970 she had become widely recognised as an important Australian painter and in that year a large, retrospective exhibition was organised to tour Australian state galleries. Her work has appeared in numerous survey exhibitions since including *Australian Women Artists* Ewing & George Paton Galleries, University of Melbourne and touring public galleries 1975; the Bicentennial exhibition *The Great Australian Art Exhibition* and *A Century of Women Artists 1840s–1940s* Deutscher Fine Art, Melbourne 1993. A retrospective of her work was held at S. H. Ervin Gallery, Sydney in 1984.
AWARDS: Bathurst prize, 1958, 60; Mosman prize, 1952; OBE conferred for services to art, 1973.

REP: NGA; most Australian state and many regional galleries.
BIB: Catalogue essays exhibitions as above and most general books on Australian art history including Smith, AP. Bruce James, *Grace Cossington Smith* Craftsman House, 1984. A&A 4/4/1967 (Daniel Thomas, *Grace Cossington Smith*).

SMITH, Gray
(b. 1919) Painter, poet. He held his first exhibition of paintings in 1957; these were simple, figurative statements expressive of 'the drama of the Australian bush'. Later he turned to stained-glass designing. He was Joy Hester's (q.v.) second husband.
BIB: Barrie Reid, ed., *Modern Australian Art*, MOMAD, Melbourne, 1958.

SMITH, Guy Grey
See GREY-SMITH, Guy Edward

SMITH, Helen Grey
See GREY-SMITH, Helen Dorothy

SMITH, Henry Robinson
(Arr. Aust. c. 1847) Painter. He exhibited in exhibitions in Sydney from 1847 to c. 1860 and received a number of portrait commissions including one for the governor, Sir Charles FitzRoy, in 1855 and the merchant David Jones.
REP: Mitchell Library.
BIB: Eve Buscombe, *Artists in Early Australia and their Portraits*, Sydney 1978. Kerr, DAA.

SMITH, Ian
(b. 1950, Cairns) Painter, teacher.
STUDIES: Uni. of Qld (architecture), 1968; Prahran CAE, 1970–72. He held numerous solo exhibitions 1972–89, largely at Ray Hughes, Brisbane, and a survey show at MOCA, Brisbane, 1988. His work was seen in a number of group exhibitions including at tertiary institution galleries in Qld and at the NGV.
AWARDS: Prizes in competitions at Cairns, 1974; Kingaroy, 1976; Gold Coast (purchase), 1977, 84; Townsville, 1977, 79; Bundaberg, 1978; Toowoomba 1980; Stanthorpe 1982.
APPTS: Lecturing, Brisbane Coll. of the Arts, 1979–?.
REP: NGA; NGV; QAG; VACB; Artbank; Gold Coast City Gallery; tertiary collections including ANU, Uni. of Qld.
BIB: A&A 18/4/1981.

SMITH, Jack Carington
See CARINGTON SMITH, Jack

SMITH, James
(b. 1820, Eng.; arr. Melb. 1854; d. 1910) Journalist, critic, magazine editor. Smith is widely quoted for his critical attacks on the work of the Heidelberg artists, namely the 9×5 *Impressions Exhibition*, 1889, in which he described some of the work as resembling 'the first essays of a small boy who has just been apprenticed to a house painter'. But there was another, more constructive, side to James Smith's activities

which is not so well-known. In his *Australian Painting 1788–1960*, Bernard Smith writes: 'He [James Smith] had written books on Wilton and its associations, on English poetry and rural life, [also] plays including one on Garibaldi produced in 1860, interested himself in the Alliance Francaise, and became president of the Dante Society'. He was a trustee of the Public Library and the NGV, and for fifty-six years worked tirelessly for the improvement of local culture. It was James Smith who first advocated, in a speech at a meeting of the Victorian Society of Fine Arts, the establishment of the National Gallery of Victoria. He was the first art authority to support Louis Buvelot and the first to encourage Julian Ashton. He also assisted von Guérard, Chevalier, Woolner, Gill and Summers. In an article in *Table Talk*, 18 Mar. 1886, Maurice Brodzky wrote: 'For breadth and subtlety of knowledge [James Smith] would hold his own in art circles in any city in Europe'.
APPTS: First editor of *Leader*, Melbourne; founder, second editor, then proprietor of Melbourne *Punch* (1855); art, drama and literary critic, *Argus*, Melbourne, 1856–96.
BIB: Moore, SAA 1934. Bernard Smith, PTT. Smith, AP. Mahood, *The Loaded Line*, 1973. McCulloch, GAAP. McCulloch, AAGR.

SMITH, James (Cook)
(b. 1813, UK; arr. Tas. *c.* 1839; d. 1881, West Melbourne, Vic.) Sailor, painter. His oils included portraits, ships and panoramas as well as views of Tasmania and Melbourne, 1840s–60s, exhibiting in several exhibitions in Melbourne in 1853, 56 and in Launceston 1856. His work appeared in *Tasmanian Vision*, TMAG 1988 and *The Artist and the Patron* AGNSW, 1988.
REP: QVMAG.
BIB: Eve Buscombe, *Artists in Early Australia and their Portraits*, Sydney 1978. Kerr, DAA.

SMITH, John
(b. 1952, Sydney) Painter, lecturer.
STUDIES: BA, Sydney Uni., 1974; Dip. Ed., Sydney Teachers Coll., 1974. He held nine solo exhibitions 1983–91 in Sydney (Mori, Painters, DC Art), Brisbane (Michel Milburn) and Lismore regional gallery. Group exhibitions in which his work appeared 1981–91 include at Lismore Regional Gallery; *Sulman Prize*, AGNSW 1987; *A New Generation: The Philip Morris Arts Grant*, NGA 1988.
AWARDS: Six regional prizes, Vic., NSW, 1983–92.
APPTS: Lecturer, painting, drawing, art theory and foundation, Uni. of New England, Northern Rivers, NSW, 1986.
REP: NGA; MOCA, Brisbane; Artbank.
BIB: A&A 24/3/1987.

SMITH, John Firth
See FIRTH-SMITH, John

SMITH, Joshua (William Joshua)
(b. 1905, Sydney) Painter.

Joshua Smith, Portrait group, oil on canvas, 109 × 88.9cm. Collection, AGNSW.

STUDIES: ESTC (modelling), with Rayner Hoff; Julian Ashton School (drawing and painting), with Henry Gibbons; also with Adelaide Perry. During World War II he worked on mobile camouflage in company with William Dobell and James Cook and, like Cook, became the subject of Dobell drawings and paintings. In Jan. 1944, his portrait by Dobell (q.v.) was awarded the 1943 Archibald Prize which subsequently became the subject of a famous law case (*see* PRIZES, ARCHIBALD PRIZE). The publicity attracted reflected unfairly on Smith, whose painted image swiftly became known throughout Australia, and who himself won the Archibald Prize the following year with a portrait, *The Hon. H. S. Rosevear, Speaker in the House of Representatives*. Smith exhibited with the NSW Society of Artists, and with the Royal Art Society of NSW, of which he was a Fellow. His best-known work was the fine realist portrait of his parents, painted in 1942 and acquired for the AGNSW in 1943.
AWARDS: Archibald prize, 1944; Katoomba (Blue Mountains prize), 1962.
REP: AGNSW; AGSA; QAG; AWM; Perth Uni.
BIB: *Present Day Art in Australia*, Ure Smith, Sydney, 1945. Badham, SAA. Smith, AP. John Kroeger, *Australian Artists*, Renniks, Adelaide, 1968.

SMITH, Ken
(b. 11/5/1951, Vic.) Painter.
STUDIES: Dip. Arts, VCA, 1974; Grad. Dip. Fine Art, VCA, 1981. A realist painter showing strong strength in line drawing, his 1980s paintings included maritime subjects. He held four solo exhibitions at Australian Galleries, Melbourne (1979, 82, 85, 91) and participated in a number of group exhibitions including *Seven Artists: Different Viewpoints*, Uni. of Melbourne Gallery, 1983; MPAC *Spring Festival of Prints and Drawings*, 1983, 89, 91; *Australian Maritime Award 1986*.
APPTS: Lecturer, Monash Uni. Caulfield, 1984– .
REP: NGV.
BIB: McKenzie, DIA.

SMITH, Ludlow
(Active c. 1850, Tas.) Painter. Known for landscapes. Listed by Moore as an amateur.
BIB: Moore, SAA.

SMITH, Mervyn Ash.more
(b. 1904, Sydney) Architect, painter.
STUDIES: Newcastle Tech. Coll., NSW. He married Ruth Tuck (q.v.), and his work is best-known for showing a vigorous handling of the medium of watercolour. He held around 22 solo exhibitions 1947–88 and his work was included in a number of group exhibitions including at AGSA; McClelland Gallery; Tynte and Greenhill galleries, Adelaide in the 1980s. A retrospective of his work was held at Greenhill in 1988.
AWARDS: Perth prize, 1955, 57, 58, 64 (shared); Bendigo prize, 1961; Maude Vizard-Wholohan prize, 1966 (all for watercolours); L. J. Harvey prize 1967.
APPTS: Fellow, Royal Aust. Inst. of Architects; Associate, Royal Inst. British Architects; member, Royal Australian Planning Inst., president, CAS, Adelaide, 1958–59; president, RSASA, 1967–70.
REP: NGA; most state galleries; Alice Springs, Naracoorte collections; a number of tertiary collections including Uni. of Adelaide.
BIB: John Kroeger, *Australian Artists*, Renniks, Adelaide, 1968. Germaine, AGA, 1979.

SMITH, Minnie Bernhard
(Active c. 1918) Sculptor, writer. Daughter of Bernhard Smith. A letter written 26 July 1918 from Minnie Bernhard Smith of 68 Pakington Street, Kew, to Mrs Walter Sproule of Chatto, Flinders, Vic., writes about her own model of Edward Wilson (?of the *Argus*), shown apparently at the Women's Exhibition (?1907) and acquired with two other works by her for the Prahran Town Hall. The manuscript for her own book, *Bernhard Smith and his Connection with Art, or The 7 Pre-Raphaelite Brothers*, is in the archives of the Mitchell Library.
(Letter as above made available by Mrs Mary Broughton of Shoreham, Vic., 1982)

SMITH, Robert
Designer, photographer, lecturer, art writer. He was the founding head of art studies at Flinders University in 1966; founding editor of *Westerly* magazine and the *Australian Journal of Art* and has written several books on Australian art including a catalogue raisonné of Noel Counihan's prints.
BIB: Germaine, AGA.

SMITH, Sydney Ure
See URE SMITH, Sydney George

SMITH, Terence
(b 14/8/1944) Writer, critic, lecturer.
STUDIES: BA, University of Melbourne, 1966; MA, University of Sydney 1976; doctoral studies, NY University, Columbia University, Whiteney Museum, NY 1973–74; PhD, University of Sydney, 1986. He has written for many art magazines, catalogue essays for solo and group exhibitions and books including the years 1970–1990 for Bernard Smith's *Australian Painting* (OUP, 1992). He has been a member of numerous art education boards, consultant to tertiary institutions, and a member of boards including MCA, Sydney 1988– . As a critic he has written for *The Bulletin*, *Nation Review* and *Times on Sunday*.
AWARDS: Harkness Fellow, NY 1972–74; H. V. du Pont fellow, Hagley Museum, Wilmington, Delaware, USA 1993.
APPTS: Tutor, Power Inst., Uni. of Sydney, 1970, lecturer, 1975–86; acting director, Power Institute, 1983, 86, 90, 93; assoc. professor, Dept of Fine Arts, Uni. of Sydney 1988– ; visiting professor, Dept of Vis. Arts, University of California 1991.

SMITH, Timothy
(b. 26/8/1952, Tas.) Printmaker, photographer.
STUDIES: BA (Visual Art), Tasmanian CAE, 1975; Dip. Ed., Uni. of Tasmania, 1975. His photographs appear in several publications including for the ACF and National Trust. He participated in group exhibitions of photographs and prints 1974–92 at state and regional galleries in Tas., WA and Vic., including *100 X 100*, PCA 1988; AGFA *National Photographic Exhibition*, Albury Regional Gallery 1991. His three solo exhibitions 1984–91 were at Images Gallery, Sydney; Cockatoo, Launceston; Northern Territory Uni. Gallery.
AWARDS: Special project grant, VACB, 1976.
APPTS: Secondary art and art history teacher, Tas., 1976–78; lecturer, printmaking, photography, print media, tertiary colleges Tas., Perth, 1981–90; lecturer, photography, video, Northern Territory Uni., 1991– .
REP: NGA; NGV; QVMAG; PCA; several regional, uni. collections.
BIB: Backhouse, TA. PCA, *Directory*.

SMITH, Treania Bennett
(b. 23/12/1901, Brisbane; d. 1990) Painter, gallery director.
STUDIES: Max Meldrum School, Melbourne; Edinburgh Coll. of Art; travel studies in Europe. She exhibited

with the Society of Artists, Sydney, 1932–49, and in 1938, with Lucy Swanton, she took over the Macquarie Galleries, Sydney, from its founder John Young. During her almost 40 years of directing the gallery she was influential in the art life of Sydney. She sold the gallery in 1976.
REP: TMAG; Newcastle regional gallery.
(*See also* GALLERIES – COMMERCIAL)

SMITHIES, *John Geoffrey*
(b. 2/9/1954, Tas.) Sculptor, installation artist.
STUDIES: Dip. Fine Art, TAS, 1975; BA Fine Art, SASA, 1979; guest student, Staatliche Akademie Der Bildenden Kunst, Karlsruhe, Germany, 1981–82. He held two solo exhibitions 1988–91 at Reconnaissance, Melbourne; Irving, Sydney. He gave performances in Germany and was represented in *Australian Perspecta*, AGNSW 1985.
AWARDS: Lake Macquarie Gallery prize (drawing), 1990.
REP: AGNSW; City of Lake Macquarie.

SNELL, *Edgar William (Ted)*
(b. 25/3/1949, WA) Painter, critic, teacher, curator.
STUDIES: Teachers certificate, Secondary Teachers Coll., WA; associateship Art Teaching, WAIT; Grad. Dip. Art Education, Birmingham Polytechnic, UK. He held eight solo exhibitions 1968–92, largely at Galerie Düsseldorf, Perth and Gore St Gallery, Melbourne (1992). He contributed many essays and chapters for books and is the author of seven books (1975–91) including *The Painted Image: Western Australian Art No. 1*, Curtin Uni., 1991; *Cinderella on the Beach: A Source Book of Western Australia's Visual Culture*, Uni. of WA Press, 1991. He also contributed many articles to art and literary journals including *Praxis* and *Art & Australia*, and wrote regular articles and reviews for *The Australian*, *Western Mail* and *National Times* from 1982. He was art critic for the *Western Mail*, 1982 and *The Australian*, 1984– . He curated exhibitions for Praxis, Fremantle Arts Centre, Perth Inst. of Contemporary Art and was a member of Praxis and editor of the *Artworkers Union Newsletter*.
AWARDS: Perth Prize for drawing under 21 section, AGWA, 1970; travel grant, VACB, 1990.
APPTS: Senior art master, secondary private school, WA; senior tutor and lecturer, art education, WAIT, 1975–79; lecturer and senior lecturer, fine arts, Curtin Uni., 1982– ; member, Fremantle Arts Centre Management Committee, 1991– .
REP: NGA; AGWA; Artbank; several uni. collections; a number of corporate collections including Robert Holmes à Court.
BIB: *A&A* 29/1/1991.

SNELL, *Edward*
(b. 1820, Devon, UK; arr. Adelaide 1849; d. 15/3/1880, UK) Sketcher, diarist, surveyor. He was a draughtsman in the UK before coming to Australia, where he was a professional artist making sketches of colonial landscapes, Aborigines and some caricatures and figure studies. He joined the Victorian gold rush in 1852 and, settling in Geelong, became an engineer on the railways. He exhibited works in exhibitions in Geelong in the 1850s before making enough money to return to England.
REP: Mitchell, La Trobe Libraries; a number of historical collections Geelong, UK.
BIB: Kerr, *DAA*.

SOCIAL REALISM IN AUSTRALIA
Social realism began to flourish in Australian painting in Melbourne in the late 1930s, specifically in the work of Bergner, Counihan and O'Connor (qq.v.). As in other countries, its themes derived from poverty, strikes, work in coal mines, economic depression and the situation of underprivileged people such as Australian Aborigines. The movement produced some fine paintings and drawings, became the subject of great controversy during the early days of the CAS, Melbourne, and received an approximation of its due recognition after Russia's entry into the war as an ally. Later painters prominent in the Melbourne movement were James Wigley and Bernard Rust. The movement became active in Sydney late in 1945, when a group led by Herbert McClintock, James Cant, Roderick Shaw, Hal Missingham, Roy Dalgarno and Dora Chapman formed the Society of Realist Artists.
BIB: Exhibition catalogue *Anti-Fascist Exhibition*, CAS, Melbourne, 1942; Smith, *PTT*. Smith, *AP*.

SOCIETY FOR THE PROMOTION OF THE FINE ARTS
(1847–c. 57) The first Australian art society established in Sydney. Three exhibitions were held. The first, presided over by Sir Charles Nicholson, founder of the Nicholson Museum, Uni. of Sydney, and a committee of prominent citizens, was held in the Australian Library in Bent Street and opened 22 June 1847. It comprised loan works, as well as paintings by Angas, Brierly, Elyard, Garling, Martens, Nicholas, Prout and Rodius. Richard Read's work was added in the second exhibition, in Barrack Square, 1849, and in the third exhibition (Mechanics School of Art, Jan. 1857) works by O. R. Campbell, Claxton, Dexter, S. T. Gill and Terry were included.
BIB: Moore, *SAA*.

SOCIETY OF ARTISTS, NSW
(1895–c. 1940s) Formed as a breakaway group from the Royal Art Society of NSW (q.v.) by Tom Roberts, Arthur Streeton, Henry Fullwood (qq.v.) and others. Membership was confined to professional artists. It held regular exhibitions 1895–1902 until the promise of an £800 travelling scholarship by the NSW government if the Society and the Royal Art Society amalgamated, caused the joining of the two. The amalgamation however lasted only until 1907 when previous Society members again broke away. The Society once again held annual exhibitions 1907–1940s after which time it too suffered a more or less natural attrition with the emergence of modernism and

the establishment of first the Australian Academy of Art then the Contemporary Art Society (qq.v.).

BIB: Moore, SAA. Smith, AP.

SOCIETY OF ARTS AND CRAFTS OF NEW SOUTH WALES

(1906–c. 1970) Founded by Dorothy Wilson (Mrs Wardell) for the purpose of making known the arts and crafts of New South Wales. Beginning with eight members, the membership had grown to around 200 by 1934.

BIB: Moore, SAA.

See CRAFTS IN AUSTRALIA

SOCIETY OF DESIGNERS FOR INDUSTRY

(1948–59) Absorbed in 1959 by the Industrial Design Council of Australia (q.v.).

SOCIETY OF REALIST ARTISTS (SORA)

See SOCIAL REALISM IN AUSTRALIA

SOCIETY OF WILDLIFE ARTISTS OF AUSTRALASIA

(Established 1974, Melbourne) It holds regular exhibitions and prizes, largely at the VAS, Melbourne.

(*See also* NATURAL HISTORY ARTISTS)

SOCIETY OF WOMEN PAINTERS, NEW SOUTH WALES

(1910–c. late 1930s?) Foundation members included Lady Chelmsford (president), Aline Cusack (vice-president), Emily Meston (treasurer), Lilian Chauvel (secretary), Florence Rodway, E. W. Parsons, Gertrude Williams, Bernice Edwell, Jane Price. The Society held meetings, classes and exhibitions at its headquarters in Queen Victoria Buildings, Sydney.

BIB: Moore, SAA.

SOLLIER, Andre

(b. 1922, France; arr. Aust. 1970) Painter.

STUDIES: Japan, studies in Sumiie painting, also Zen Buddhism.

REP: NGV.

NFI

SOLLY, Benjamin Travers

(b. 24/8/1820, UK; arr. Adelaide 1840; d. 1906, Adelaide) Painter. Known mainly for watercolours. He was assistant colonial secretary in SA, 1857–94, and produced sketches from the 1840s until about 1894. His work was seen in the 1879 Sydney International Exhibition and in exhibitions in Hobart in the 1850s. His work *The Main Shaft of the Whim Kapunda Copper Mine, SA* 1845, is in the AGSA collection.

REP: AGSA; TMAG; Allport Library.

BIB: McCulloch, AAGR. Kerr, DAA.

SOLOMON, Lance Vaiben

(b. 27/1/1913, Liverpool, NSW; d. 1989) Painter.

STUDIES: ESTC; RA Schools, London. A Fellow of the Royal Art Society of NSW, his paintings are mainly skilful depictions of bush scenery. One of these was presented to H.M. the Queen Mother during her visit to Australia in 1958.

AWARDS: NSW Government Travelling Scholarship for landscape painting, 1939; Wynne prize, 1946, 53; prizes at Dunlop contests, 1951; RAgSocNSW Easter Show, 1961, 62, 64, 65.

REP: AGNSW; AGSA; AGWA; NGV.

BIB: *Australian Art Illustrated*, RAS, Sydney, 1947. A&A 27/3/1990 (obituary).

SOMMERS, John

(Active 1870–1910) Painter.

STUDIES: NGV School, c.1899–1900. He exhibited at the VAS, Melbourne, 1888–1910. His son, John Archibald Douglas Sommers (d. 1934), was a portraitist and landscape painter trained at the NGV School, of which he was said to have been temporary director. He exhibited at the VAS (fan and decorative panels in watercolour) in 1902 and 1905. His daughter, Dora L. Sommers, also studied at the NGV School, 1900–06, and showed a portrait at the VAS in 1906. He was represented in *Golden Summers: Heidelberg and Beyond* NGV and touring, 1986.

AWARDS: Ramsay prize, NGV School, 1899, 1900.

REP: NGV (drawing of Frederick McCubbin, aged 21).

SOTHEBY'S AUCTIONS

(Established Australia 1973) 13 Gurner St, Paddington, NSW 2021. The British-based firm of auctioneers of art works formed an Australian company (Sotheby & Co., Australia, Pty Ltd), which opened in Sydney in 1973. Outstanding among the auctions held 1973–93 included the sale of 126 works from the Sir William Dobell Foundation 19 Nov. 1973, the collections of Professor Bernard Smith, G. K. Cowlingshaw and from the family of Sir Russell Drysdale. It holds three or four fine art auctions annually in Melbourne and one in Sydney with the decorative and other auctions being held in Sydney.

SOUTER, David Henry

(b. 1862, Aberdeen; arr. Sydney 1886; d. 1935, Sydney) Illustrator, cartoonist, art editor.

STUDIES: South Kensington, London. In 1880, aged 18, he joined the staff of the Aberdeen magazine, *Bon Accord*, and after about one year moved to Natal where he worked for five years (1881–86) before moving to Sydney. There he worked for John Sands, and William Brooks and Co., and drew cartoons for the *Tribune*, until 1892, when he joined the staff of the Sydney *Bulletin*. During the succeeding several decades he became famous for his decorative art nouveau style drawings, many of women with cats. He founded the Brush Club within the Art Society of NSW, 1887, was president of the NSW Society of Artists, 1901–02, and art editor of *Art and Architecture*, 1904–11.

REP: AGNSW; NGV; Ballarat Fine Art Gallery; Mitchell Library, Sydney.

BIB: AA Aug. 1923. Moore, SAA. Vane Lindesay, *The Inked-in Image*, Hutchinson, Melbourne, 1979.

SOUTH AUSTRALIAN ACADEMY OF ART

(Founded 1885) Breakaway group from the Royal South Australian Society of Arts. President of the Academy was W. R. Hunt. The Academy was short-lived; it divided into two groups, one reverting to the Royal South Australian Society of Arts, the other under the leadership of Alfred Sinclair forming the Adelaide Easel Club, which lasted several years.

(*See also* ROYAL SOUTH AUSTRALIAN SOCIETY OF ARTS)

SOUTHALL, Andrew

(b. 1947, Melb.) Painter, printmaker.
STUDIES: No formal training. His strong sense of pattern links him with cubism. Using largely bright, often primary colours his subject matter of the 1980s included domestic subjects and landscapes, seen in exhibitions in Melbourne 1975–93 (Warehouse; Realities; Charles Nodrum), Sydney (Macquarie), Canberra (Solander) and in a number of group exhibitions with those galleries as well as public galleries and in London where he lived for a time in the late 1980s.
REP: NGV; regional gallery Armidale, NSW; VACB.

SOUTHERN, Clara

(b. 3/10/1860, Kyneton, Vic.; d. 1940, Vic.) Painter.
STUDIES: NGV School, 1883–87. She shared a studio at Grosvenor Chambers, Collins St with Jane Sutherland and Tom Roberts, was elected to the Council of the Vic. Artists Society 1902–06 and was among the first women to be elected to the Buonarroti Society (q.v.) in 1886. She married John Flinn in 1905. Shortly after, she moved to Warrandyte, her 'Arcady', and her love and knowledge of the countryside is clearly seen in her landscapes which are notable for their lyricism and charm. Many are of the farm buildings painted near Warrandyte where her work and presence attracted a number of other artists to instigate an artists' colony, among them Penleigh Boyd, Louis McCubbin, Charles Wheeler (qq.v.). Along with Jane Sutherland, she was regarded as one of the foremost women artists of the era and continued to paint and live at Warrandyte until her death at the age of 79. Her work was represented in *Australian Women Artists 1840–1940* George Paton and Ewing Galleries Melbourne, 1975 and touring; *Golden Summers: Heidelberg and Beyond* curated by the NGV and touring state galleries 1986 and *A Century of Australian Women Artists 1840s–1940s*, Deutscher Galleries, Melbourne 1993.
REP: NGV; Ballarat Fine Art Gallery.
BIB: Catalogue essays exhibitions as above. Janine Burke, *Australian Women Artists*, Greenhouse Publications, Melbourne 1980.
(Correct birth date supplied by Jane Clark, NGV)

SPARKS, Cameron Morbey

(b. 1930, Narrabri, NSW) Painter, teacher.
STUDIES: NAS, 1949–53 and 1956; Hobart Tech. Coll.,
1954–55; travel studies, Europe, 1956–58. Known mainly as a watercolourist, he exhibits regularly with the Australian Watercolour Inst., of which he was hon. secretary. He held five exhibitions at the Macquarie Galleries, Sydney, 1965–74, and a number at country centres including Armidale, Goulburn. He curated an exhibition of David Davis work for the Ballarat Fine Art Gallery, 1984.
AWARDS: 19 watercolour awards, 1960–78.
APPTS: Teaching, NSW secondary schools, 1960–69; NAS, 1970–74.
REP: TMAG; regional galleries Armidale, Bathurst; several municipal collectiions including Manly, Dubbo, Goulburn.
BIB: Germaine, AGA.
NFI

SPATE, (Prof.) Virginia

Historian, writer and lecturer.
STUDIES: Uni. of Melbourne (grad. BA, 1959, MA, 1962); Bryn Mawr Coll., USA (grad. Ph.D., 1970). She has written several books including *John Olsen* (Georgian House, Melbourne, 1963) and *Tom Roberts* (Lansdowne, Melbourne, 1972), as well as contributing frequently to journals such as *Art and Australia*.
APPTS: Lecturer in Art History, and Director of Studies, Cambridge Uni., –1978; Power Professor of Contemporary Art, Uni. of Sydney, 1979– .

SPENCE, Percy Frederick Seaton

(b. 1868, Balmain, NSW; d. Sept. 1933, London) Painter, illustrator, cartoonist.
STUDIES: Art Society of NSW classes, Sydney, c.?1888; probably some study in Fiji where he was brought up. He became known for his black-and-white contributions to the *Sydney Mail, Sydney News, Queensland Punch* and especially for his regular contributions to the *Sydney Bulletin*. A foundation member of the Sketch Club within the Art Society of NSW, 1888, he exhibited with the Society and drew and painted some fine portraits. His sketchbook of pencil portraits included one of R. L. Stevenson, who sat for Spence during his visit to Sydney. Moore records that Mrs Stevenson made him tear up the first drawing because it made Stevenson look too thin; the second is in the National Portrait Gallery collections, London. Spence moved to London in 1895 and had a successful career drawing for *The Graphic, Sphere, Black and White* and London *Punch*. He became a member of the Chelsea Arts Club and exhibited at the RA where his work was highly regarded. Like Tom Roberts, he served with the RAMC during World War I. His books include *Souvenir of the Great Election, '94,* Townsend, Sydney, 1884.
REP: AGNSW; Mitchell Library, Uni. of Sydney; High Court, Sydney; National Portrait Gallery, London (pencil drawings of Stevenson, Phil May, and a book of sketches).
BIB: Most general works on contemporary Australian art history including Moore, SAA.

SPENCER, (Sir) Walter Baldwin

(b. 1860, Lancashire, UK; arr. Aust. 1887; d. 1929, Patagonia, South America) Painter, collector, anthropologist.

STUDIES: Apart from his professional work, Spencer studied art at the Royal Institution, Manchester, where he won a prize for painting in the advanced art section, 1879. His first Aboriginal contacts were made as a member of the Horn Scientific Expedition to Central Australia, 1894. Two years later he collaborated with the telegraph controller at Alice Springs, F. J. Gillen, in a second independent expedition to Central Australia, where, like Gillen, he was initiated into the Arunta tribe. In a third expedition, in 1901, he penetrated farther north into Arnhem Land. Most of the grave-posts from Melville Island, and the magnificent bark paintings from Oenpelli and other centres, were collected during his fourth expedition in 1912. Together with numerous artefacts and valuable cinematographic records (the cinematograph which Spencer imported for this work was unique in Australia) of tribes now extinct, the bark paintings and grave-posts were presented to the National Museum of Vic. Spencer edited a paper, *The Australasian Critic*, 1890–91, and at the turn of the century started collecting paintings by the artists of the Heidelberg School, of which he became chief patron; he designed the medal in commemoration of the botanist, Baron Von Mueller (1896) and in the course of his professional studies filled his notebooks with meticulously careful drawings of fish, insects, animals and reptiles. Continuous disagreement among the trustees of the National Library, Museum and Art Gallery of Vic. led to his resignation from that body, and he moved to London to continue his anthropological studies. The epic nature of his career continued despite declining health, and the story of his last journey to Patagonia (for the purpose of making comparative anthropological studies), and subsequent death there in 1929, is as colourful as the rest of his career. He wrote *The Native Tribes of Central Australia*, 1899; *Northern Tribes of Central Australia*, 1904; *Native Tribes of the Northern Territory*, 1914; *The Arunta*, 1927; *Wanderings in Wild Australia*, 1928 – all published by Macmillan, London. (Note: In acknowledgement of F. J. Gillen's companionship and help, Spencer added the name of the telegraph operator as joint author of the 1899 and 1927 books; in fact, they were written entirely by Spencer.)

AWARDS: NSW Society of Artists medal, 1926; CMG conferred, 1904, knighthood, 1916.

APPTS: Professor of zoology and biology, Melbourne Uni., 1887–1920; trustee, National Gallery of Vic., 1895–1928.

REP: Mitchell Library, Sydney (illustrated notebooks); National Museum of Vic.

BIB: R. R. Marett and T. K. Penniman, eds, *Spencer's Last Journey*, Clarendon Press, Oxford, 1931.

SPINK AUCTIONS

Regular auctions of paintings were held by Spink in the 1960s–early 1980s. Since the mid-1980s Spink has concentrated mainly on its auctions of coins and other decorative arts.

SPONG, Jean

(b. 16/5/1868, Hobart; d. 3/3/1946) Painter. She was not, as stated in the 1984 edition of this work, the daughter of Walter Spong (see following). She exhibited with the Art Society of Tasmania 1900–45.

REP: TMAG

BIB: Backhouse, *TA*.

SPONG, Walter Brookes

(b. 1851, London; arr. Aust. 1887; d. 1929, London) Painter, stage designer. He worked at the Theatre Royal, Bristol, with George Gordon; Drury Lane, with William Beverly, and painted the scenery for *Trial by Jury*, first joint production by Gilbert and Sullivan. His paintings were shown at the RA and Royal Inst. of Painters in Watercolours before he moved to Australia under contract to the Brough-Boucicault Company. A foundation member of the Australian Artists' Association and VAS, he exhibited also with the Art Society of NSW from 1889, showing mainly views painted in various countries. He stayed in Australia for 11 years. His daughter Hilda became a well-known actress, her portrait painted by a number of artists including W. R. Sickert, Tom Roberts and Julian Ashton.

REP: AGNSW; Manly Art Gallery.

BIB: Moore, *SAA*. R. H. Croll, *Smike to Bulldog*, Ure Smith, Sydney, 1946. Algernon Graves, *A Dictionary of Artists*, Kingsmead, Bath, 1973.

(Letter from grand-daughter Elizabeth Spong, 8/10/1988)

SPOONER, John (Henry)

(b. 20/11/1946, Vic.) Cartoonist, illustrator, printmaker, painter.

STUDIES: Bachelor Jurisprudence, Monash Uni., 1970; B. Laws, Monash Uni., 1972. Cartoonist and illustrator for *The Age*, Melbourne, he often uses paints and gouaches in his cartoons and started producing prints, then paintings, in the 1980s. With a similar line style, his cartoons reflect those of British black-and-white *Punch* artists. His etchings, lithographs and paintings indicate a far-reaching artistic talent, and were seen in five solo exhibitions 1984–92 including at Powell St, Melbourne; Deakin Uni. and Westpac galleries, Melbourne. Group exhibitions in which his work appeared include *Spring Festival of Drawing*, MPAC 1988 and *Towards an Australian Portrait Gallery*, privately funded exhibition touring state galleries 1992–93. His work has been the subject of several books including *Spooner: Drawings, Caricatures and Prints 1982*, Thomas Nelson, 1982 and *Bodies and Souls: John Spooner Drawings, Caricatures and Prints 1989*, Macmillan Australia 1989.

AWARDS: Walkley Award for illustration, 1982; Black and White Artists Club awards (5), 1985–86; Fremantle print prize (shared), 1984; MPAC Festival acquisition, 1988.

Ethel Spowers, The Gust of Wind, *1931, pencil, 21.5 × 16.5cm. Private collection.*

REP: NLA; Victorian State library; several tertiary and regional collections.

SPOWERS, *Ethel Louise*

(b. 1890, Melb.; d. 1947) Painter, printmaker.
STUDIES: Académie Delecluse, Paris, c. 1905; NGV School, 1911–17; Regent Street Polytechnic, London, 1921; Académie Rauson, Paris, 1922–23; Grosvenor School of Modern Art, London (linocuts, with Claude Flight), 1928 and 1931. She was a member of the VAS from 1916, her early exhibiting work reflecting the fairyland fantasy work of Ida Rentoul Outhwaite. This changed radically after her studies of 1928–31, and her work as a foundation member of the Contemporary Group, Melbourne, reflected the British and French modernist styles which, like her friend, Eveline Syme, she had contacted in London and Paris. Her work was seen in the Bicentennial exhibitions *The Great Australian Art Exhibition* and *The Face of Australia* and in *A Century of Australian Women Artists 1840–1940*, Deutscher Galleries, Melbourne 1993 and *Important Women Artists*, Melbourne Fine Art, 1993.
REP: NGA; AGNSW; NGV; Ballarat Fine Art Gallery.
BIB: Catalogue essays exhibitions as above. Janine Burke, *Australian Women Artists 1840–1940*, Greenhouse, Melbourne, 1980.

SPREMBERG, *Alexander*

(b. 7/11/1950, Hamburg, Germany; arr. Aust. 1985) Painter.

STUDIES: Art Künsthochschule, Hamburg, 1972–78. He held six solo exhibitions 1989–92 in Perth (including Delaney Galleries, Beach Gallery, Galerie Düsseldorf) and Melbourne (Deutscher Brunswick St, Gore St). Group exhibitions in which his work appeared 1978–92 include at Praxis, PICA, AGWA.
AWARDS: Creative development grant, Dept for the Arts, WA, 1991.
REP: AGWA; NGV; several uni. and corporate collections.

SPURRIER, *Stephen*

(b. 14/12/1947, Melb.) Painter, printmaker.
STUDIES: RMIT, 1967–70. He held around 18 exhibitions 1967–90 in Melbourne (Powell St, Christine Abrahams, David Ellis), Brisbane (Ray Hughes), Perth (Galerie Düsseldorf) and Sydney (Stadia Graphics, Macquarie). He participated in numerous group exhibitions, largely print survey shows, including PCA exhibitions such as *100 × 100*, *Print Portfolio* 1988; and in the Bicentennial exhibition *The Face of Australia* as well as at the NGA and major state and international galleries. The principal feature of his work is the harmonious arrangement of small geometric shapes in space.
AWARDS: Prizes for prints in competitions at Berrima, 1967; Geelong, 1967; Maitland, 1968; MPAC Print Prize 1982; Maitland Print Prize, 1986.
APPTS: Lecturer, Melb. State Coll., 1976–80s.
REP: NGA; AGNSW; AGSA; NGV; QVMAG; regional galleries Geelong, Shepparton, Launceston, Newcastle; Uni. of Melbourne, MOMA, New York.
BIB: PCA, *Directory*, 1976, 88. Franz Kempf, *Contemporary Australian Printmakers*, Lansdowne, 1976. A&A 19/4/1982.

STACEY, *Wesley (Wes)*

(b. 1941, Fairlight, NSW) Photographer.
STUDIES: Drawing and design, ESTC, 1960–62. A graphic designer for the BBC and ABC in the 1960s, he became a freelance photographer specialising in architecture, travel, environment and advertising. His work appeared in a number of books including with Phillip Cox *Rude Timber Buildings in Australia*, Thames and Hudson, 1969; *The Australian Homestead*, Lansdowne, 1972; *Colonial Architecture in Australia*, Lansdowne 1979 and *Kings Cross Sydney* (with Rennie Ellis), Nelson 1971; *Timeless Gardens* (with Eleanor Williams), Pioneer Design Studios, 1977. He held seven solo exhibitions 1964–91 including at Uni. of NSW; Royal Inst. of British Architects, London 1965; NGV; Coventry, Sydney 1975; and a retrospective at the NGA 1991. His work appeared in numerous exhibitions 1967–91 at private galleries and many tertiary, public galleries including *Australian Perspecta*, AGNSW 1983; *Shades of Light*, NGA 1988.
AWARDS: VACB project grant, 1981; creative arts fellowship, VACB, 1992.
REP: NGA; AGNSW; NGV; a number of state libraries and regional, municipal collections.
BIB: Catalogue essays exhibitions as above.

STAINED GLASS ARTISTS
See CRAFTS IN AUSTRALIA

STAINFORTH, Martin
(b. Eng.; arr. Aust. 1909) Painter. Known for paintings of horses and racing scenes. He exhibited with the RAS, Sydney, from 1919 and VAS, Melbourne, 1920s. Moore records that he painted 'nearly all the champions since Carbine's day'. His work is highly regarded in racing circles.
REP: AGNSW.
BIB: W. H. Lang, K. Austin, S. Mackay (eds.) *Racehorses in Australia*, Art in Australia Ltd, Sydney, 1922. Moore, SAA. Smith, *Catalogue* AGNSW 1953.

STALPH, Ulrich
(b. 1945, Saxony, Germany; arr. Aust. 1964) Painter, teacher.
STUDIES: CIT, 1967–70; RMIT, 1974; State Coll., Hawthorn, 1975; Germany, 1977–78. His spontaneous drawings and paintings are capably done in an expressionistic manner. He held 9 solo exhibitions 1975–89 in Melbourne (Australian Galleries), Sydney (Barry Stern) and at VAS and Warrnambool Regional Gallery.
AWARDS: Applied Chemicals prize (VAS), 1969; Flinders (Caltex award), 1973; Daad Scholarship for study in Düsseldorf and Munich, 1977.
REP: MPAC; Artbank; La Trobe Uni.; RMIT.

STAMP, Susan (Joy)
(b. 28/1/1958, NSW) Graphic artist, lecturer.
STUDIES: Dip. Art and Design (drawing), Prahran CAE, 1980; BA Fine Art (Drawing), Victoria Coll., 1988. Showing influences of the graphic tradition of German Expressionism, her largely charcoal drawings appeared in two solo exhibitions Niagara Galleries, Melbourne 1986, 89 and in numerous group exhibitions 1985–91, largely regional award exhibitions.
AWARDS: Channel 7 Award for Drawing, 1980; Swan Hill and MPAC acquisitive prizes, 1989.
APPTS: Part-time then senior tutor, drawing, Prahran Coll. (1985–86) and VCA, 1987– .
REP: Regional galleries Mornington, Swan Hill; VCA collection.
BIB: *New Art Three*. Germaine, DAWA. Germaine, AGA.

STANFORD, William
(b. 1836 or 1837, UK; arr. Vic. 1852; d. 1880, Melb.) Sculptor.
STUDIES: Apprenticed to a London stonemason c.1850; Melbourne, with Charles Summers (while serving a prison sentence). He arrived in Vic. with the gold rush but in 1854 was sentenced to imprisonment for horse-stealing. Released on ticket-of-leave, he was arrested again for highway robbery and horse-stealing, and in May 1860 sentenced to imprisonment for 22 years. However, his talent for drawing, and particularly his carving from a meat bone, attracted the notice of the prison chaplain. The governor of the gaol (Melbourne Pentridge) permitted the lessons from Summers, and subsequently Stanford's basalt fountain

was carved in his gaol quarters. Released in Oct. 1870, he installed the fountain (a work of considerable grace and beauty) at Carpentaria Place, Spring St, Melbourne, and, assisted by a Collins Street doctor, set up in business as a monumental mason in the suburb of Windsor. He married and was well respected by his neighbours, but never recovered from the disease of phthisis, contracted in prison, mainly from inhaling the fine basalt dust. Other carvings by him include headstones, one near the main gate of the St Kilda Cemetery, the other on his wife's grave in the Melbourne Cemetery.
BIB: Moore, SAA. Scarlett, AS.

STANLEY, Owen
(b. 13/6/1811, UK; arr. NT 1838; d. 12/3/1850 at sea) Naval officer, painter. Son of the Bishop of Norwich and brother of Dean Stanley of Westminster. He surveyed the eastern and north-eastern coast of Australia as captain of the *Rattlesnake*, 1847–50, and made a large number of watercolour sketches, about 80 of which are in the TMAG. During his visit to the settlement at Essington, 1839, he painted the scenery for a play. Sir Oswald Brierly (q.v.) accompanied Stanley in *Rattlesnake* on his survey voyage of the Great Barrier Reef, the Louisiade Archipelago and New Guinea. His work was represented in *The Artist and the Patron*, AGNSW, 1988.
REP: TMAG; Mitchell Library, Sydney; NLA.
BIB: Moore, SAA. ADB 2. A. Lubbock, *Owen Stanley 1811–1850*, Melbourne 1986. Kerr, DAA.

STANNAGE, Miriam
(b. 1939, Northam, WA) Painter, printmaker.
STUDIES: No formal training. Travel studies, Europe, UK and Canada, 1962–63; France, 1970–71. Her first exhibitions were held at the Old Fire Station Gallery, Perth, 1970, 73, 75, and by 1975 her construction paintings with extensive use of photography and collage had become known throughout Australia. She held exhibitions in all capital cities and a major retrospective of her work was held at the AGWA in 1989. Her work appeared in numerous group exhibitions including *Biennale of Sydney*,1982 and *Perspecta*, AGNSW, 1983.
AWARDS: Georges Invitation Art Prize (drawing purchased), 1974; occupancy, Power Inst. studio, Cité Internationale des Arts, Paris, 1970–71; VACB grant, 1975.
APPTS: Teaching, part-time, for the Education Dept of WA.
REP: NGA; AGWA; MCA, Sydney; regional galleries Ararat, Bunbury; tertiary collections including Uni. of Sydney, Uni. of WA.
BIB: Smith, AP. A&A 20/2/1982.

STAUNTON, Madonna
(b. 1938, Murwillumbah, NSW) Painter.
STUDIES: With Roy Churcher, Jon Molvig, Bronwyn Yeates, Brisbane. She makes extensive use of collage in her work which was first seen in exhibitions at the Ray Hughes Gallery, Brisbane, from 1976, followed

by seven solo exhibitions to 1988 including at Ray Hughes; Garry Anderson, Sydney and with the IMA, Brisbane 1979. Her work was represented in numerous group exhibitions 1976–88 including *Australian Perspecta*, AGNSW 1983, 85 and *A Homage to Qld Artists Past and Present*, Centre Gallery, Gold Coast 1988.
REP: NGA; AGNSW; QAG; Parliament House; Artbank; Qld Uni. Art Museum; VACB; a number of regional and tertiary collections.
BIB: Germaine, *AGA*. McIntyre, *CC. A&A* 18/4/1981.

STAVRIANOS, Wendy
(b. 23/8/1941, Melb.) Painter.
STUDIES: Dip. Fine Art, RMIT, 1961. Her work developed along strong expressionist lines during the 1970s and 80s and often focused on the environment, women's experience and the portrayal of women in history. She held 15 solo exhibitions 1967–92 in Melbourne (including at Princes Hill, Tolarno, Luba Bilu galleries), Sydney (Gallery A), Brisbane (Ray Hughes) and Perth (Greenhill). She participated in a number of group exhibitions 1976–92 including *Perspecta*, AGNSW 1985; *Heartland*, touring regional galleries 1987; *Australian Art of the Last 20 years*, Jim Baker Collection, Brisbane; *The Intimate Experience*, Ivan Dougherty Gallery, 1991. Her commissions include a painting for St Paul's Cathedral, Melbourne.
AWARDS: MPAC *Spring Festival of Drawing* (purchase), 1977; VACB grants, 1978, 83.
APPTS: Teaching in Vic. schools, 1962–73; lecturer, tertiary colleges, 1973– including Darwin Community Coll.; Canberra School of Art; Monash Uni. (Caulfield Campus), 1988– .
REP: NGA; AGWA; NGV; several regional galleries including Castlemaine, Geelong; corporate collections including NAB, John Sands, Robert Holmes à Court.
BIB: Catalogue essays exhibitions and collections as above. Robert Walker, *Painters in the Australian Landscape*, Hale & Iremonger 1988. Germaine, *AGA*.

STEELE, Jo
(b. 18/12/1939, SA) Sculptor.
STUDIES: Engineering, Adelaide Uni.; BA (Hons) Fine Art, Central School of Art, London. He held five solo exhibitions 1978–87 at Bonython, Adelaide; Gallery A, Sydney; Stuart Gerstman, Melbourne; Anima, Adelaide and participated in group sculpture exhibitions 1976–80 including in London and at Newcastle Art Gallery 1980.
REP: AGSA; AGWA; QAG; several regional collections.

STEEN, Otto Lundbye
(b. 1902, Esbjerg, Denmark; arr. Aust. 1927) Sculptor.
STUDIES: Copenhagen, apprenticed to E. Millsen, stone carver, 1921–23; Royal Academy of Copenhagen, with Prof. Utzon Frank, 1923–25; ESTC, with Rayner Hoff, 1928–30. He worked as an assistant to Rayner Hoff on the Anzac Memorial, Hyde Park, Sydney, 1932–35, and thereafter supported himself as a full-time sculptor. His subsequent commissions were mainly for commercial sculpture and include a large number of mostly small works for public buildings and churches. He exhibited with the NSW Society of Artists and was a member of the Society of Sculptors and Associates.
BIB: Scarlett, *AS*.

STEFFANI, Arturo
(Active c. 1885–1903, Sydney) Painter. Also a teacher of singing. Exhibiting member of the Art Society of NSW, 1885– . Moore records that 'he painted excellent watercolours'. He painted views of Melbourne and Sydney and, occasionally, seascapes and landscapes.
BIB: Moore, *SAA*.

STEINMANN, Heinz
(b. 1943, Switzerland; arr. Aust. 1958) Painter.
STUDIES: Family studies with his father, Max Steinmann. His tapestry-like, intricately detailed 'naive' paintings, painted with both hands working simultaneously, colourfully depict the flora, fauna and Aboriginal legends of northern Qld. He exhibited frequently 1971–83 including with a number of wildlife exhibitions in Australia, UK and Europe.
REP: QAG.
BIB: *Each Man's Wilderness*, Rigby, Adelaide, 1980. Germaine, *AGA*.
NFI

STEINMANN, Max
(b. 1918, Switzerland; arr. Aust. 1958) Painter.
STUDIES: Ecole des Beaux-Arts, Paris. His depictive paintings of rural scenes, street scenes, figures in landscape and related genre have won him a number of prizes in NSW. He is the father of Heinz Steinmann.
AWARDS: Competitions at Orange, 1963; Bathurst, 1964, 1967 (popular choice); Cowra, 1966, 70.
NFI

STELARC (Stelios ARCADIOU)
(b. 19/6/1946, Cyprus; arr. Aust. 1948) Performance/body artist.
STUDIES: TSTC, Caulfield Tech; RMIT; Uni. of Melbourne, 1968. He left Australia in 1970, travelled in Japan, Europe, UK and Mexico and lived in Japan for some time. He became renowned for body art performances in which he suspended himself by fine meat hooks and wires attached to his body, first performed at the Maki Gallery, Tokyo, 1976. He presented around 25 such performances 1976–92, and having explored this moved on to other 'body' works including attaching artificial limbs to the body, activated by EMG muscle signals. This *Third Hand* project was documented and shown in a number of high technology expositions and displays in the 1980s in Japan, USA and Australia. He participated in many major Australian and international group exhibitions including *Biennale of Sydney*, AGNSW 1976; *Perspecta*, AGNSW 1981; *Continuum 83*, Tokyo/Australia 1983; *Australian Sculpture Triennial*, 1981; a number of exhibitions in public galleries USA, Japan; IMA, Brisbane; Aust. Centre for Photography, Sydney; ACCA Melbourne 1991–92. He was artist-in-residence at several colleges including Ballarat Uni.

and Advanced Computer Graphics Centre, RMIT 1991, 92.

AWARDS: Grants, Myer Foundation, 1972, 81; VACB grants, 1975, 76, 82, 89.

APPTS: Teaching, North Geelong and Coleraine High Schools, 1969–70; art and sociology, Yokohama International School, 1970–89; sculpture and drawing Ballarat Uni. Coll., 1989.

BIB: *Stelarc*, Ganesh Publishing, Australia. *Obsolete body/suspensions/Stelarc* J.P. Publication Davis, USA 1984. Sturgeon, *DAS*. Scarlett, *AS*. *A&A* 14/1/1976. *AL* 2/5/1982 (cover) 9/1/1989; 5/2/1985.

STEPHEN, Clive Travers

(b. 1889, Melb.; d. 1957, Melb.) Sculptor, medical doctor. One of the first Australian stone-carvers to respond to the influence of modern European sculpture, and primitive sculpture as discovered by such artists as Epstein and Gaudier Brzeska. The life-classes conducted by Clive Stephen and his wife, Dorothy, a painter of distinction, attracted artists such as Will Dyson, and were a rallying point for adherents of the modern movement in Melbourne (c. 1925–30). Stephen, an ardent collector and an artist of great energy and enthusiasm, died soon after retiring from medicine to devote his life to sculpture. A memorial exhibition was held at the National Gallery, Melbourne, 10 Feb. 1959. He was represented in the Bicentennial exhibition *The Great Australian Art Exhibition* and *Classical Modernism: The George Bell Circle* NGV, 1992.

REP: NGV.

STEPHEN, George Milner

(b. 18/12/1812, Somerset, UK; arr. Sydney in childhood; d. 16/1/1894, Melb.) Lawyer, advocate, administrator, painter. Married Mary Hindmarsh (q.v.) in 1840 and held various administrative positions in Adelaide and Sydney. Moore notes him as 'an accomplished portrait painter'. He was a member of Victoria's Legislative Assembly (for Collingwood) 1859–61 and in 1877 became the parliamentary draughtsman. He was represented in the exhibition *Australian Colonial Portraits*, TMAG 1979.

REP: AGSA; Mitchell Library.

BIB: Moore, *SAA*. Eve Buscombe, *Early Artists of Australia and their Portraits*, Sydney 1978. *ADB* 2. Kerr, *DAA*.

STEPHENS, Ethel Anna

(b. c. 1880, Sydney; d. 1944) Painter.

STUDIES: Julian Ashton's, Sydney (she was Ashton's first student); La Grande Chaumière, Paris. She exhibited at the Paris Salon, 1920–21.

REP: AGNSW.

STEPHENSON, June Ethel

(b. 3/6/1914, Melb.) Painter.

STUDIES: NGV School, 1941–45; George Bell School, 1956–59; travel studies, 1966. She was president of the Beaumaris Art Society, Vic., before moving to Qld, 1973. Her work gives emphasis to pattern, bright colour and the female nude. She held around 22 solo

exhibitions 1963–91, often at Town Gallery, Brisbane, and also at Leveson St, Melbourne, and Swan Hill and McClelland regional galleries, 1991. She participated in a number of group exhibitions including many prize exhibitions (*Wynne, Archibald*) and in *A Complementary Caste: A Homage to Women Painters*, Centre Gallery, Gold Coast, Qld 1988; *Classical Modernism: The George Bell Circle* NGV, 1992 and *Up from Down Under*, exhibition of naive art, Qld House, London and Musée d'Art Naïf, Paris 1989.

AWARDS: Student prizes at the NGV 1942, 43, 45 including Hugh Ramsay Portrait prize, 1944; Crown Lyn Pottery Design prize, 1962; Australian Fabric Design prize, Sydney, 1966; Inez Hutchison prize, Vic., 1967; Toowoomba prize, 1975; Caloundra Art Festival prize, 1976; Lismore (purchase) prize, 1978; Gold Coast (purchase) prize, 1980; Trustees (purchase) prize, QAG, 1980; Swan Hill Pioneer Art Award, 1985.

REP: QAG; Artbank; several regional galleries including Gold Coast, Lismore, Toowoomba; municipal collections including Caloundra; La Trobe Uni.

BIB: Bianca McCullough, *Australian Naive Painters*, Hill of Content, Melbourne, 1977. Elizabeth Young, *Figuratives Now*, 1972. *150 Victorian Women Artists*, 1985. Germaine, *AGA*. Women, *DAWA*.

STEPHENSON, Peter

(b. 1943, Vic.) Painter, printmaker.

STUDIES: TSA, 1971–74; Staatliche Hochschule für Bildende Kunst, Hamburg, 1975–76. He held 13 solo exhibitions 1975–92 including at Powell St, Melbourne, 1980, 81; Uni. of Tasmania, 1984; Girgis & Klym, Melbourne 1989, 90, 92. His work appeared in around 20 group exhibitions 1973–91 including at Hamburg; TMAG Hobart; *Georges Invitation Art Prize*, 1977; and private galleries including Michael Milburn, Brisbane; Girgis & Klym, Melbourne; Dick Bett, Hobart.

AWARDS: German Academic Exchange Scholarship, 1975; grant, Tasmanian Arts Advisory Board, 1981, 86.

REP: NGA; NGV; QVMAG; TMAG; Artbank; regional galleries in Tas.; corporate collections.

STEUART, Ronald Hewison

(b. 1898, Newcastle, NSW) Painter, commercial artist.

STUDIES: Sydney (with Julian Ashton, later with Will Ashton); Central School of Arts and Crafts, London.

AWARDS: Wynne prize, 1958; Calder Memorial prize at Northside Arts Festival, 1963.

REP: AGNSW; AGSA; NGV; Launceston regional gallery.

STEWART, Eric L.

(b. 1903, Melb.; d. 1970, NSW.) Painter. Naive interpreter in paint of Aboriginal myths and legends. He worked as a nightwatchman for the PMG's Dept and learned about painting during a stay in hospital due to tuberculosis. After his death the painter Clifton Pugh discovered some of his work in a junk shop in Echuca in 1971. Subsequently, enough work was discovered for an exhibition (Powell Street Gallery), 1972.

BIB: Bianca McCullough, *Australian Naive Painters*, Hill of Content, Melbourne, 1977. A&A 10/2/1972 (Barrie Reid, *In the Dreamtime – Paintings by Eric L. Stewart*).

STEWART, Helen Mary
(b. 1900, NZ; arr. Aust c. 1930s. d. 1983, NZ)
STUDIES: London, Grosvenor schools of art; Colarossi's, Paris; with Andre Lhote, Paris. She lived in Australia c. 1930s–45 painting with the Turramurra Group (q.v.) of painters and showing at the Macquarie Galleries before returning to NZ. Her striking cubist-inspired modernist, *Portrait of Treania Smith* (director, Macquarie Galleries 1938–1976) was included in *A Century of Australian Women Artists 1840s–1940s* Deutscher Fine Art, Melbourne, 1993.
BIB: AA Nov. 1938 (Thea Proctor, *Modern Art in Sydney*.)

STEWART, Janet Agnes Cumbrae
See CUMBRAE-STEWART, Janet Agnes

STIPNIEKS, Margarita Anna (née KLEBACH)
(b. 1910, Latvia) Painter.
STUDIES: State Academy of Art, Riga, Latvia. She held exhibitions in Adelaide and Melbourne 1955–78, showing mainly oils and pastels of flowers and related subjects.
REP: AGSA; AGWA; TMAG; regional galleries Castlemaine, Hamilton.
BIB: John Kroeger, *Australian Artists*, Renniks, Adelaide, 1968. Germaine, AGA.
NFI

STIRLING, Amie Livingstone
(b. 25/2/1880, Omeo, Vic.; d. 1945, ?Canada) Painter, teacher.
STUDIES: NGV School, c. 1896; Paris, c. 1903. Daughter of Vic. government geologist, James Stirling (1852–1909) and Elizabeth Stirling, painter of wildflowers (1854–94). Visitors to her childhood home at Omeo included the botanist von Mueller and the explorer A. W. Howitt. She worked as a governess in Tas., teaching French and elementary drawing, and taught English at the Berlitz School, Paris, c. 1900–03. Her friend, Agnes Goodsir, painted her portrait in Paris, c. 1903, and her *Self Portrait*, painted about the same time, reveals her as a talented painter finely attuned to the modernist movement. She married Ernest Harrison, 1905, had two children and made her home in Canada; but from the biography (*Memories of an Australian Childhood*, Schwartz Publishing Group, Melbourne, 1980) compiled from her writings after her death, seems to have abandoned painting.

STOCKS, Ernest Decimus.
(b. 3/3/1840, Manchester, UK; arr. Vic. 1854. d. 15/2/1921, Drouin, Vic.) Painter. A landscape painter in watercolour, he exhibited a watercolour of Buninyong at the Melbourne *Intercolonial Exhibition* of 1875. Auction catalogues show a South Australian landscape by him dated 1882, Tasmanian scenes of 1853 (more likely 1883), 1890 and 1891, Gippsland in 1910, views of the Yarra, Goulburn, Hawkesbury and King rivers in 1914, as well as a Qld landscape.
REP: Geelong Art Gallery.
(Dates supplied by Maurice Callow, letter 9/9/1985)

STOCQUELER, Edwin
(Active 1853–57, Vic.) Topographical artist. He painted watercolour views of Bendigo and Castlemaine and recorded his impressions during travel up the Murray and Goulburn rivers. His best-known work was a huge diorama, described in the Bendigo *Advertiser*, 1 Aug. 1857, as 'the only diorama extant of Australian scenery. The exhibition is one mile in length and comprises seventy distinct pictures. It begins with Melbourne and Bendigo four years ago – takes in McIvor, Goulburn, the Upper Murray and Ovens and back again to Sandhurst'. It was exhibited in a number of Victorian goldfield towns 1857–58 and in Melbourne in June 1859. Unfortunately the fate or whereabouts of the diorama is unknown. Few of his other works survive; these are known to include watercolours of the goldfields, and an oil of a corroboree. His work appeared in Deutscher's *Thirty Australian Paintings* exhibition in 1980 and at Sotheby's September 1978.
REP: Bendigo Art Gallery; Castlemaine Pioneer and Old Residents Association collection; NLA.
BIB: McCulloch, AAGR. Kerr, DAA.

STODDARD, Mary
(b. Scotland; d. 1901, Eng.) Painter. Known for portraits and landscapes. Daughter of Edinburgh portrait painter, Peter Devine. She exhibited with the Art Society of NSW, c. 1889–1900, as did her two daughters, Mary Jnr and Edith.
REP: AGNSW.

STOKES, Constance (née PARKIN)
(b. 1906, Miram, Vic., d. 1991, Melb.) Painter.
STUDIES: NGV School, 1925–29; RA Schools, London, 1931; with Andre Lhote, Paris, 1932; travel studies, Europe, 1935–39. Returning to Vic. in early 1933, she married in that year returning to holiday in Europe. With George Bell and others she broke with the Contemporary Art Society, Melbourne, in 1940 to form an independent group (Melbourne Contemporary Artists) in 1951. A leading figure in the modernist movement in Vic., her early paintings include still life and classically conceived figure group studies, as well as the open line drawings of nudes for which she is best known. Later her palette lightened, also her themes, which became more decorative. Her work was the subject of a NGV travelling exhibition in 1951 and a number of retrospectives have been held, including at Swan Hill, Geelong and touring regional galleries Victoria, 1985 and state galleries (NGV, QAG) and S. H. Ervin, 1986. Her work was represented in a number of significant exhibitions in Australian and overseas public galleries from the 1940s including *Art of Australia 1788–1941*, National Gallery of Canada 1941; *Twelve Australian Artists*, Arts Council of Great

Constance Stokes, Two Seated Nude Figures, *1958, chalk and ink, 27.5 × 38cm. Collection Mornington Peninsula Arts Centre.*

Britain, London 1953; *Australian Women Artists,* Ewing and George Paton Galleries, Melbourne 1975; *The Heroic Years of Australian Painting, 1940–1965, Herald* RGAV touring exhibition 1977–78; *Classical Modernism: The George Bell Circle* NGV, 1992; *A Century of Women Artists 1840s–1940s,* Deutscher Galleries, Melbourne 1993 and *Important Women Artists,* Melbourne Fine Art 1993. The NGV held an exhibition of her paintings and drawings March–May, 1993.

AWARDS: Student prizes, NGV School, 1925, 26; NGV Travelling Scholarship, 1929.

REP: NGA; AGSA; NGV; QAG; regional galleries Geelong, Mornington.

BIB: Moore, SAA. Smith, AP. Janine Burke, *Australian Women Artists 1840–1940,* Greenhouse, Melbourne, 1980.

STOKES, Wendy

(b. 31/12/1957, NSW) Painter, printmaker.

STUDIES: Dip. Visual Art, Newcastle CAE, 1979; Grad. Dip. Visual Art, SCA, 1986; travel studies, UK, Europe and Egypt, 1980; India, 1987; New York, 1992. With a confident use of colour and balanced composition, her abstract paintings and prints are often inspired by the sea. She held nine solo exhibitions 1982–93 including at Painters Gallery, Sydney 1985; Editions Southbank, Melbourne 1987, 89, 91; MCA, Melbourne 1993. Her work appeared in over 60 group exhibitions 1980–91 at galleries including Hogarth, Sydney;

Editions Melbourne, and in many print and award exhibitions at regional galleries including Henri Worland, Warrnambool 1983; Fremantle Print Prize 1986, 87; MPAC *Spring Festival* 1988, 90.

REP: Parliament House; Artbank; many regional, tertiary and corporate collections.

BIB: PCA, *Directory,* 1988. *New Art Four. Images: A Visual Sourcebook of Contemporary Australian Painting,* ed. Nevill Drury, Craftsman House, 1992. A&A 25/3/1988; 27/1/1989; 29/1/1991.

STONE, James Doveton

(Active c. 1850–79, Vic.) Painter. Known to be an artist in South Australia from 1864–1907, he exhibited in the 1857 Victorian Society of Fine Arts. He made sketches largely of Adelaide, some Melbourne drawings, and oils of landscapes and rural life. A topographical sketch, *St Kilda, 1850,* is in the collections of the La Trobe Library, Melbourne. Another work, *Picnic Ground on the Glenelg Creek, 1879,* was sold at Christie's auctions, Sydney, Oct. 1976.

REP: AGSA; La Trobe Library; NLA.

BIB: Kerr, DAA.

STONE, Phyllis (Grandma)

(b. 1905, Vic.) Painter. She began to paint in 1961, and held solo exhibitions 1967–73 including at Newcastle Regional Gallery 1969. Her work was seen in group exhibitions at a number of galleries including Manyung, Melbourne; Woolloomooloo 1987. Stone's work seeks to transform the banal, and has a strange and poetic content.

REP: NGA; regional galleries Bendigo, Newcastle.
BIB: Germaine, *AGA*.

STONER, *Dorothy Kate*

(b. 28/11/1904, Sussex, Eng.; arr. Aust. 1921; d. 18/11/1992, Hobart) Painter, teacher.
STUDIES: Uni. of Tas.; Hobart Tech. Coll.; George Bell School, Melbourne, 1939; travel studies, Europe, 1949–51; ESTC, 1961; UK and Europe, 1973. She

Dorothy Stoner, Trees, *1979, coloured pastels, 57 × 45.5 cm. Collection,* TMAC.

showed her colourful semi-abstract paintings in Tasmania as well as contributing to numerous mainland group exhibitions such as the *Archibald, Blake* and Portia Geach portrait prizes. A retrospective of her work was held by the TMAG in 1983 and Freeman Gallery, Hobart, in 1987. Hendrik Kolenberg in an obituary (*A&A* 30/4/1993) described her as 'the very best kind of regional artist. Original, and deeply responsive to her particular environment, she was able to take what she needed from the art of her time and apply it with idosyncratic frankness to her own sense of place.'
APPTS: Lecturer in art, Launceston Tech. Coll., 1936–40; Hobart Tech. Coll., 1960–64.
REP: NGV; QVMAG; TMAG; regional galleries Launceston, Devonport.
BIB: Germaine, *AGA*. *A&A* 30/4/1993.

STONES, *Margaret (Elsie Margaret)*

(b. 1920, Colac, Vic.) Botanical artist.
STUDIES: Swinburne Tech. Coll., Melb.; NGV School (c. 1938–42). Success with her early paintings of Australian wildflowers, while still working as a nurse, influenced her decision to make botanical painting her career. The quality of her work earned her further success in London where she illustrated for the Royal Botanical Gardens and other institutions. Her work includes illustrations for scientific books and a set of floral designs for Australian stamps (1958). She completed a ten-year commission in 1991 to paint *The Flora of Louisiana*, for the State Uni. of Louisiana, with exhibitions at Ashmolean Museum, Oxford; Fitzwilliam Museum, Cambridge and Edinburgh 1991.
AWARDS: Hon. doctorate of science, Louisiana State Uni.; Veitch medal, Royal Horticultural Society; Eloise Payne Luquer Medal, Garden Club of America; MBE; Order of Australia.

STOPPS, *A. J.*

(Active c. 1852–56, Vic.) Lithographer. Artist of the Vic. goldfields. He recorded the scene at Bendigo and Beechworth and made ten lithographs for the last three parts of S. T. Gill's *Diggers and Diggings in Victoria as They Are*, 1855. He appears to have worked largely as a commercial lithographer, many of his works being done from the photographs of Alexander Fox.
REP: La Trobe Library.
BIB: McCulloch, *AAGR*.

STORRIER, *Timothy Austin*

(b. 13/2/1949) Painter.
STUDIES: NAS, 1967–69; travel studies, USA, Europe and Middle East, 1972. From the 1970s he made a number of expeditions to outback Australia including with photographers Grant Mudford and Wesley Stacey, painter John Olsen, environmentalist Vincent Serventy and gallery director Stuart Purves. Painted in browns, blues and reds, his paintings of this country unite the environment with domestic, totemic and symbolic objects in a 'trompe l'oeil' manner. He held around 20 solo exhibitions 1969–93, largely at Australian Galleries, Melbourne; Bonython Sydney. In 1983 he had his first solo exhibition in London and from his 1990 exhibition at the same gallery (Fischer Fine Art) three works were purchased by MOMA, New York. In 1984 he was commissioned by Sir Garrick Agnew to visit Egypt and produce a series of works, from which emanated two solo project exhibitions, *Tickets to Egypt*, at AGNSW and AGWA. Group exhibitions in which his work appeared included *Australian Contemporary Printmakers Touring Exhibition*, PCA exhibition touring Canada, USA, UK 1979–84.
AWARDS: Sakura Colour Products prize, 1967; Sulman prize, 1968, 84; residency, Owen Tooth Memorial Cottage, France, 1972; R. M. Ansett Hamilton Award, 1978; Mining Prize, Perth, 1979.
REP: NGA; most state galleries; other public collections.

BIB: Most general texts on Australian contemporary art history.

STOWARD, Clive

(b. 1909, Adelaide; d. 1969) Painter.
STUDIES: SASA.
AWARDS: Prize in Dunlop competitions, 1954.
REP: AGSA.
BIB: John Kroeger, *Australian Artists*, Renniks, Adelaide, 1968.
NFI

STRACHAN, David Edgar

(b. 25/6/1919, Salisbury, UK; arr. Adelaide 1921; d. 23/11/1970, Yass, NSW) Painter, teacher.
STUDIES: Slade School, London, 1936–38; La Grande Chaumière, Paris, 1937; George Bell School, Melbourne, 1938-40; ESTC, 1945; extensive travel studies, UK and Europe, 1948–60. Son of an Australian army doctor who opposed him becoming an artist, Strachan received his formal education and some art instruction at Geelong Grammar School, Vic., before visiting London and Paris. He returned to Melbourne, 1938, and began work with the George Bell group. He worked in a camouflage unit before moving to Sydney, 1941, to exhibit with the NSW Society of Artists, the CAS, and the Contemporary Group. As a member of the 'Sydney charm school', he became well-known for his low-toned, gentle and lyrical evocations of still life, nudes with flowers, portraits of his friends, and other varied genre, and won a number of prizes. He was back in London in 1948 and began etching in Paris the following year when he also established a press (Stramur Presse) and printed colour lithographs in company with a Dutch printmaker. He returned to Australia after 12 years finally to settle in Sydney, teach at his old school and lead the free life of a successful painter. He died in a car accident at Yass, near Canberra, while returning to Sydney after a visit to Creswick, Vic., where he had presented a large canvas to the Creswick Shire Office as a memorial to his father. Major retrospectives of his work were held at AGNSW 1973 and many of the same works in a 1992–93 exhibition at the S. H. Ervin Gallery, Sydney and touring regional galleries. He was represented in the Bicentennial exhibition *The Face of Australia* and *Classical Modernism: The George Bell Circle* NGV, 1992.
AWARDS: Prizes at Hunters Hill, 1961; Muswellbrook, 1961; W.D. & H.O. Wills prize, Sydney, 1960; Wynne prize, 1961, 64; Devonport (Dahlia Festival), 1961; Grenfell (Henry Lawson Festival), 1965; RAGSOCNSW (three prizes), 1968.
APPTS: Teaching, ESTC, 1945–47 and 1960–?65; president, NSW Society of Artists, 1965.
REP: NGA; AGNSW; AGSA; NGV; QAG; regional galleries Ballarat, Bendigo, Newcastle.
BIB: All general books on contemporary Australian art history. Lou Klepac, Buny Pearce, John McDonald, *David Strachan*, Beagle Press, 1993. A&A 8/4/1971 (obituary); 10/4/1973.

David Strachan, Faces in Flannel Flowers, *1970, oil on canvas on board, 76.3 × 61.4cm. Collection,* AGNSW.

STRAFFORD, George

(b. 1820, India; arr. Vic. c. 1850; d. 1886, Melb.) Artist, engraver. He was one of the best of Thomas Ham's artists contributing to the *Australian Illustrated Magazine* (*see* MAGAZINES) but is remembered mainly for his engraving, *View of Melbourne*, 1865, published by De Gruchy and Leigh. Mentally unstable, he was confined at the Yarra Bend Asylum, where he drew incessantly and became known as 'the mad artist'. He died at the Asylum.
REP: NGV; La Trobe Library; British Museum.
BIB: Moore, SAA. McCulloch, AAGR. Kerr, DAA.

STRAMPP, Adriane

(b. 6/5/1960, Wisconsin, USA; arr. Aust., 1977) Painter.
STUDIES: BA Fine Art (painting), Vic. Coll., Prahran, 1984; travel studies, England, France, 1978–79. Her work of the 1980s/90s featured a series of floating medieval women's dresses, invoking the themes of women's rites of passage and love. These well-painted canvases are both romantic and poetic and were seen in six solo exhibitions 1986–93 in Melbourne (including at Reconnaissance, MCA) and Sydney (Holdsworth 1986, 88, 91). She participated in a number of group exhibitions 1984–92 including at Greenhill, Adelaide; Holdsworth, Sydney and at ROAR Studios 1984. Her

work also appeared in *A Horse Show*, Heide, 1988; *Moet & Chandon Touring Exhibition*, 1990, 93. She contributed illustrations to *Wildflowers of King's Park*, *The Western Mail*, Perth and *A Year of Orchids*, Richard Griffin, Melbourne.

AWARDS: Eltham art awards, 1988.

REP: Artbank; Dobell Foundation; several corporate, municipal collections.

BIB: Catalogue essays exhibitions as above.

STRANGE, Ben

(b. 1868, County Kildare, Ireland; arr. Perth 1885; d. 1930, Perth) Draughtsman, painter. While working on the Coolgardie, WA, goldfields he had a drawing accepted for publication in the Sydney *Bulletin*. Then a coloured drawing by him was exhibited in the office window of the *Coolgardie Sun*, by courtesy of the editor; and as a result he was commissioned to draw a weekly page for the *Goldfields Courier*. He contributed also to the *Coolgardie Pioneer* before moving to Perth. Enlisting for service in the Boer War, he was awarded the Queen Victoria Medal, and managed to get some drawings through to Perth for publication in the *Western Mail*, of which paper he was staff artist for 30 years. His drawings of Western Australian goldfields identities have considerable historical value.

BIB: Moore, *SAA*.

STRANGE, Frederick

(b. 1807, Nottingham; arr. Tas. 1838; d. 1874, Launceston) Painter, engraver, teacher. Originally a house painter, he was convicted of theft in 1837, sentenced to transportation and sent to Tas. Released on parole, he set up in Launceston as a portrait painter and teacher of drawing in 1841. A conditional pardon granted in Hobart, 1848, enabled him to continue his work in Launceston, where he became known also for his watercolour drawings of streets and buildings. The advent of photography in the late 1850s was said to have led to a sharp decline in demand for his work and eventually he became a grocer. Moore records him as 'a painter of more than ordinary ability'.

REP: QVMAG; TMAG; Allport, La Trobe Libraries.

BIB: Moore, *SAA*. Jocelyn Hackforth Jones, *The Convict Artists*, Macmillan, Melbourne, 1977. Clifford Craig and Isabella Mead, *Frederick Strange – Artist*, Royal Society of Tas. Proceedings, vol. 97, 1963. Kerr, *DAA*.

STRATTON, Brian

(b. 1936, Sydney) Painter, teacher.

STUDIES: NAS, 1952–57. Known as a watercolourist, he exhibited widely and won more than 30 prizes to 1982, mostly for watercolours in competitions in NSW.

APPTS: Teaching, NAS, 1962–75; member, National Advisory Committee for UNESCO (Visual Arts), 1965–66, 1969–71; president, Australian Watercolour Inst., 1964–72; fellow of the RAS, Sydney.

REP: Manly Art Gallery; regional galleries Bathurst, Grafton, Rockhampton.

BIB: *Douglas Dundas Remembers* limited edn, privately published, Sydney, 1976. Germaine, *AGA*.

STREETER, Catherine Elizabeth (née SHEPPARD)

(b. 1842, Cork, Ireland; arr. Aust. c. 1852; d. 1930, Brisbane) Painter, teacher.

STUDIES: NGV School. Represented at the Paris *International Exhibition*, 1879, she taught art for the Vic. Education Dept, largely in Geelong and Ballarat until 1884, after which she conducted private classes in Melbourne. She acquired a reputation as something of a child prodigy, her competent portrait of the Very Rev. Dean Hayes painted in 1869 being wrongly attributed by contemporary newspaper articles as having been painted when she was 16 (in fact she was 26). She continued to paint largely portraits and moved to Brisbane in 1921 where she held an exhibition at the age of 81. She was represented in the *Painters of the Past* exhibition at Geelong Art Gallery in 1991.

REP: Uni. of Melbourne.

BIB: Unpublished autobiography dating back to the 1850s. Moore, *SAA*. John Kroeger, *Australian Artists*, Renniks, Adelaide, 1968. Kerr, *DAA*.

STREETON, (Sir) Arthur Ernest

(b. 8/5/1867, Mt Duneed, Vic.; d. 2/9/1943, Olinda, Vic.) Painter.

STUDIES: NGV School, 1882–88. One of the founders of the Heidelberg School (q.v.). Skill in rendering distance, and atmosphere, selection of subject, the feeling of actual participation in the life of the landscape, brought Streeton nationwide popularity and fame. In adapting the high-keyed palette of Turner to the local scene he gave great emphasis to the well-known contention of the Heidelberg artists that Australia was a blue and gold country; moreover, Streeton, more than any other with the exception of Roberts, completed the work of Buvelot in convincing a large, middle-class Australian public that English oaks and elms were not the sole prerequisites of excellence in landscape painting, and that the Australian countryside, with its blue-shadowed eucalypts and golden pasturelands, had unique indigenous beauty. Thus an important local market was created. Streeton's mighty vistas, with their vigorous square brushstrokes, dominated the Australian scene for more than a decade, but his career was fraught with many frustrations. One was his inability to handle the human figure in paint, an attribute which he greatly envied in his lifelong friend and colleague, Frederick McCubbin. A much greater frustration was his comparative lack of success in London. For 25 years Streeton's career fluctuated between vain attempts to conquer the London art world, and triumphant visits home. His local success began when his picture *Still Glides the Stream* was bought for £70 for the AGNSW in 1890, on the recommendation of Julian Ashton. This success took him to Sydney, where again fluctuating fortunes caused him to live for some years in camps around the harbour with Tom Roberts, on a few shillings a week. In 1896 he completed a large picture, *The Purple Noon's Transparent Might*, painted from the top of a hill overlooking the Hawkesbury River, NSW. This work

enthroned Streeton in the hearts of the Australian public. He held an outstandingly successful exhibition in Melbourne in 1898 before leaving for England, and on his return in 1906 received a grand welcome, arranged in Melbourne by McCubbin and Sir Baldwin Spencer, which included a luncheon at the NGV. This was followed, in 1907, by an exhibition at the Guildhall, Melbourne, which returned the unprecedented profit of £2000. He held two more Australian exhibitions before his return to London. After his marriage in London in 1908, he visited Venice and produced a series of Venetian pictures based on admiration of the work of Turner and Sargent. He served first with a medical unit, then as official war artist during World War I, and finally settled in Vic. in 1924. Among the activities of these later years were: letters to newspapers deploring the inadequacy of the Australian representation at the NGV; a design for a new, separate Gallery of Australian Art (*see Herald*, Melbourne, 10 Sept. 1925); from 1929, a period spent writing art criticism for the *Argus*, Melbourne. After his death at his home in Olinda, in 1943, the Streeton paintings which appreciated most in value were not those which concerned imposing vistas of blue-shadowed hills seen from mountaintops, but the smaller, early works painted in company with the Heidelberg artists from 1887, when Streeton, then an apprentice at Troedels, lithographers, encountered Frederick McCubbin on the beach at Beaumaris. That he was himself aware of the creative stimulus of those early days is evident from the many nostalgic references in his published letters to Roberts. Popularity for Impressionism reached its zenith in 1985 with the hugely successful *Golden Summmers: Heidelberg and Beyond* exhibition curated by the NGV and travelling to other state galleries, which took its name from Streeton's *Golden Summer, Eaglemont, 1889*. He was represented in the Bicentennial exhibitions *The Great Australian Art Exhibition* and *The Face of Australia*.

AWARDS: Gold medal, Paris Salon, 1908; Wynne prize, Sydney, 1928; knighthood conferred, 1937.

REP: NGA; AGNSW; AGSA; AGWA; MAGNT; NGV; QAG; QVMAG; TMAG; AWM; many regional, uni. and other public collections.

BIB: All general books on Australian contemporary art history. R. H. Croll, *Smike to Bulldog*, letters of Streeton to Roberts, Ure Smith, Sydney, 1946. Ann Galbally, *Arthur Streeton*, Lansdowne, Melbourne, 1969. *Letters from Smike: The letters of Arthur Streeton 1890–1943*, eds Ann Galbally and Anne Gray, OUP, 1989. Christopher Wray *Arthur Streeton; painter of light*, Jacaranda, Qld, 1993. *AA* (special Streeton number) Oct. 1931. *A&A* 1/3/1963; 5/1/1967; 23/4/1986. *AL* 1/1/1981.

STRELEIN, C.

(Active c. 1875–80, Melb.) Painter. He exhibited paintings of flowers at the VAA, 1876–78. His close attention to detail and stiffly formal composition are somewhat reminiscent of the work of W. B. Gould (q.v.). His work was seen in *Australian Colonial Art*, Deutscher Galleries, Melbourne, Apr.–May 1980.

STRIZIC, Mark

(b. 9/4/1928, Berlin; arr. Aust. 1950) Photographer, painter, printmaker, book designer.

STUDIES: BA (Fine Arts), VCA, 1985. His long involvement with the NGV and related institutions has earned him a highly respected place of his own in the art life of Melbourne. He held a number of solo exhibitions, first of photographs in the 1960s–80s, and from the late 1980s of paintings, in Melbourne (Realities, Acland St Gallery) and European shows including 90 works at Museum of Art and Craft, Zagreb, Croatia 1984. He had a number of institutional and other assignments including books for BHP; UN Information Service to IrianJaya; World Bank photographing hydroelectric projects in Japan and hospitals in Bangkok. He contributed photographs to a number of books including *Historic Buildings of Victoria* and *Involvement*, by Andrew Grimwade, limited edition of artists' photographs, 1968; *Living in Australia*, Robin Boyd, Pergamon Press, 1970; *The Gardens of Edna Walling*, Peter Watts, National Trust of Australia, 1981; *Krimper*, Terence Lane, Gryphon Books, 1988; *The Sculpture of John Davis*, Ken Scarlett, Hyland House, 1988. As a muralist he uses photography and electronic image transfer system, and from 1984 added acrylics, oils, pastels and collage. Significant murals are Telecom Business Sales Centre, Canberra, Melbourne, 1984; Monash Medical Centre, 1988; ICI Research Group Mural, Vic., 1988; Royal Children's Hospital murals with John Howley and Clifton Pugh, 1990.

AWARDS: RMIT photography prize, 1955; MOMA Photovision, 1959; Australian Commercial and Industrial Artists' Association Award of Distinctive Merit, 1963; Pacific Photography Competition, 1967; Ilford Competition, 1970; VACB grants, 1980, 82; grant, Vic. Ministry for Arts, 1983; creative arts fellowship, VACB, 1991–92.

APPTS: Lecturer in photography, several Melbourne tertiary colleges, 1974–85 including Phillip Inst., VCA.

REP: NGA; NGV; Albury Regional Gallery; La Trobe Library; Melbourne Uni.; Melbourne City Council; Bibliothèque Nationale de Paris; Museum of Art and Craft, Zagreb.

BIB: Germaine, *AGA*.

STRUTT, William

(b. 3/7/1825, Teignmouth, Devon; arr. Vic. 5/7/1850; d. 3/1/1915, Wadhurst, Sussex) Painter, field artist.

STUDIES: Family studies with his father, Rev. W. T. Strutt, amateur painter and miniaturist (his grandfather, W. Joseph Strutt, was a writer, engraver and antiquary); Atelier Michel-Martin Drolling, Paris, 1840; with Nicholas Jouy; Ecole des Beaux-Arts. Developing as an illustrator, he illustrated Ferdinand Sere's *Le Moyen Age et la Renaissance*, Anna Jameson's *Sacred and Legendary Arts*, and other works requiring close attention to detail and perhaps a good deal of engraving. This work affected his eyesight and a long sea voyage was prescribed as a cure. On 25 Feb. 1850 he embarked in *Culloden*, bound for Australia. His

health was restored by the long voyage (119 days) and on 5 July the *Culloden* sailed into Port Phillip Bay, Vic. Within a few days he had found work as an illustrator for a new magazine, the *Australian Illustrated Magazine*, which had just been launched by Thomas Ham (q.v.). Strutt was to stay in the colony of Port Phillip for 12 years and his coverage of events would become, virtually, a pictorial history of the period in Vic. Events covered include Black Thursday (6 Feb. 1851), the political separation of Victoria from NSW, the meeting of the first Vic. Legislative Council, and life on the Vic. goldfields. He married Sarah Agnes Hague, 2 June 1852, took his wife and small daughter to New Zealand in 1855, made an abortive attempt to farm there, and after the birth of his son at New Plymouth, returned to Vic. in 1856. His Australian work reached its climax in his sketches for the *Departure of the Burke and Wills Expedition from Royal Park, 1860*. He embarked with his family for England on the *Great Britain*, 29 Jan. 1862. His most celebrated picture, *Black Thursday, 6 Feb. 1851*, was completed in England. It was bought for £800 by an Adelaide dealer who returned with it to Australia and took it on a protracted tour of the countryside to reap a handsome profit from admittance charges. Also completed in London was the well-known *Bushrangers on the St Kilda Road, c. 1887*. Strutt exhibited regularly at the RA, London, 1865–93, becoming known as a painter of religious mythology. He became a member of the Royal Society of British Artists. His daughter, Rosa, and son, Alfred William, also became painters, Alfred William (1856–1924) achieving a modest reputation for his portraits and other genre. His work appeared in the Bicentennial exhibitions *The Great Australian Art Exhibition* and *The Face of Australia*.

REP: NGA; AGNSW; NGV; regional galleries Ballarat, Benalla, Castlemaine; Melbourne Uni. collection; NLA; Mitchell, La Trobe Libraries; Parliamentary Library, Vic. (extensive collection).

BIB: All general books on Australian art history. George Mackaness, intro., *The Australian Journal of William Strutt*, Halstead Press, Sydney, 1958. Gil Docking, *Two Hundred Years of New Zealand Painting*, Gil Docking, Lansdowne, Melbourne, 1971. McCulloch, *AAGR*. Helen Curnow, Alister Taylor, *The Life and Work of William Strutt*, Martinborough, NZ, 1980. ADB 6. M Tipping (introduction) *Victoria the Golden by William Strutt*, Vic. Government Printer, Melbourne, 1980. Kerr, *DAA*. A&A 6/4/1969 (K. Stevenson, *William Strutt*).

STUART, *Guy*

(b. 19/8/1942, Canberra) Painter, sculptor.
STUDIES: Melbourne Grammar School (with John Brack), –1960; RMIT, 1961–62; travel studes, USA, Mexico, Europe, 1977; Australia, 1989– . His first exhibitions in Melbourne from 1969 included installation works such as an undulating wooden floor which he then proceeded to cut into sections and demolish with a chain-saw. In the 1970 Transfield Prize exhibition he showed a hanging arrangement of open skeins of rough material tied together and stained with phenyl. His search was thus consistently for the expressive, simple forms and colours that may be found

in basic shapes and raw materials. Between 1975 and 1978 his work vanished from the exhibition scene and when it reappeared in Oct. 1978 it did so tentatively, as a signal perhaps of impending drastic changes. These became clear in the next exhibition (Pinacotheca Gallery, Melbourne, Nov. 1980), when he showed a series of large symbolistic portrait drawings of his friends. The change from 'alternative art' to figurative humanism was accomplished apparently without loss of integrity. During the 1980s his work moved further into lyricism by a series of landscapes, notable for their clarity and semi-impressionistic style. He held around 16 solo exhibitions 1969–93 in Sydney (Gallery A) and Melbourne (Pinacotheca, Australian Galleries), and a retrospective at Heide 1982. Group shows in which his work appeared include *Images*, a five-person survey show at VCA, 1979; *Still Life: Still Lives*, Uni. of Melbourne Gallery 1979; group drawing shows, Powell St, Lennox St, Charles Nodrum galleries; *Off the Wall: In the Air*, ACCA, Melbourne 1991.

AWARDS: Crouch prize, Ballarat, 1967; VACB grant (for travel studies in Mexico, USA and Europe), 1976–77.
APPTS: Tutor, painting, several tertiary colleges Melbourne 1970–84 including NGV, Preston Inst., Prahran and VCA.
REP: NGA; AGNSW; NGV; QAG; Parliament House; Artbank; a number of regional galleries including Ballarat, Benalla, Burnie, Wollongong; a number of tertiary collections including Melbourne, Monash, Deakin unis.; several corporate collections including Legal and General, BHP, NAB.

BIB: Many general texts on Australian Art including Bonython, MAP; Horton, PDA. McKenzie, DIA; Scarlett, AS; Smith, AP; Sturgeon, DAS. A&A 14/2/1976.

STUART, *Richard W.*

Painter, black-and white artist, station-owner. One of the first contributors to Qld *Figaro*. He exhibited with the Qld National Association, 1886, and is given by Moore as a horseman whose equestrian skills were 'said to have rivalled Adam Lindsay Gordon'.

BIB: Moore, SAA. Julie K. Brown and Margaret Maynard, *Fine Art Exhibitions in Brisbane 1884–1916*, Fryer Memorial Library, Uni. of Qld, 1980.

STUART, *W.*

His oil, *Kangaroo Hunt near Braidwood*, is in the Nan Kivell collections, NLA and was shown in *Pastures and Pastimes*, Vic. Ministry for the Arts at VAS gallery, Melbourne, Geelong Art Gallery and S. H. Ervin Gallery, Sydney, 1983. Nothing more is known of him.

STUART, *W. E. D.*

(Active 1859–73, Vic.) Painter. Artist of the Bendigo goldfields. Gaoled for debt, he painted some pictures in the Bendigo gaol. He painted episodes from British history as well as landscapes, seascapes and views of Bendigo. Below the signatures on some of his paintings are the letters H.M.G. He participated in the

third exhibition of the Vic. Academy of Arts, Melbourne, 1873. His work was represented in *The Artist and the Patron* AGNSW, 1988.
REP: Bendigo Art Gallery.
BIB: McCulloch, *AAGR*. Kerr, *DAA*.

STUARTHOLME CONVENT COLLECTION

See COLLECTIONS AND COLLECTORS – BEHAN COLLECTION

STUBBS, *Douglas*

(b. 1927, Leongatha, Vic.) Painter.
STUDIES: NGV School. Stubbs' colourful paintings of fantastic birds and surrealist subjects appeared first in *Herald* Outdoor Art exhibitions. The interest stimulated by his exhibition at Australian Galleries, Melbourne, 1964, was greatly increased when a second exhibition (Toorak Gallery) sold out within a few days of opening. The innocence of his conceptions and the compelling sense of fantasy in his large-scale, carefully worked pictures, showed Stubbs as a true primitive of originality in outlook and method.
AWARDS: Beaumaris (Inez Hutchison prize), 1966.
NFI

STURGEON, *Graeme*

(b. 1936, Wangaratta, Vic.; d. 26/10/1990, Sydney) Painter, printmaker, critic, administrator.
STUDIES: CIT; RMIT; Uni. of Melbourne; Goldsmiths Coll., London; Central School of Arts and Crafts, London. He exhibited prints and paintings with groups, and in Feb.–Mar. 1972 held an exhibition of his paintings symbolising naturalistic and mechanical forms, at Powell Street Gallery, Melbourne. He wrote critiques as Melbourne correspondent for the *Australian* from 1975, and in 1978 published his first finely researched book on Australian sculpture *The Development of Australian Sculpture, 1788–1975* (Thames & Hudson, London, 1978). His book *Contemporary Australian Sculpture*, Craftsman House, was published posthumously in 1991.
AWARDS: Albury prize (for prints), 1966; VACB grant (for book research), 1975.
APPTS: Teaching, schools in Gippsland (four years); Exhibitions Officer, NGV, 1971–80; Director, Artbank, 1980– .
REP: QVMAG; Albury regional gallery.
BIB: *A&A* 28/3/1991 (obituary).

STURGESS, *Reginald Ward*

(b. 18/6/1892, Newport, Vic.; d. 2/7/1932, Williamstown, Vic.) Painter.
STUDIES: NGV School (drawing with Frederick McCubbin, painting with L. Bernard Hall), 1905–14. To earn a living, he decorated lampshades for Rocke's furniture shop in the city (1912–14), helped with his father's seedsman's business at Williamstown and taught at the Williamstown Grammar School. He married a colleague, NGV student Meta Townsend, in 1917, and held his first exhibition at the Athenaeum Gallery, Melbourne, in 1922. It was an immediate success.

Inspired partly by the contemporary romantic school of English watercolourists and partly by the environment of Williamstown, his lyrical silhouettes of seascapes, landscapes and objects presented as though wreathed in perpetual mists, had immediate appeal for the clientele of such connoisseurs as W. H. Gill, of the Fine Arts Society Gallery, who subsequently became his dealer. The Sturgess exhibition in Adelaide in 1927 reputedly returned a profit of £845, representing an outstanding success for a young Australian painter at that time. But Sturgess got little joy from it. His health was not good; and it deteriorated further when his jaw was broken in a car accident in 1926. Then, in 1930, his eyesight failed, bringing his working life virtually to an end. Sensitive and poetic, his work belongs to the Australian watercolour tradition of J. J. Hilder and W. Blamire Young. It was the subject of a retrospective, memorial exhibition at the Castlemaine Art Gallery and Historical Museum, and at the Ewing/Paton Galleries, Uni. of Melbourne, in 1976.
AWARDS: Student prize, NGV School, 1909, 10, 11.
REP: AGSA; NGV; QAG; regional galleries Armidale, Ballarat, Benalla, Bendigo, Castlemaine, Geelong, Hamilton.
BIB: All general books on contemporary Australian art history.

STURT, *(Captain) Charles*

(b. 1795, India; d. 1869, Eng.) Explorer, artist. Captain Sturt, the explorer who discovered the junction of the Darling and Murray rivers, was also an artist who illustrated his own journals, 1828–30, 1844–45.
REP: Mitchell, La Trobe Libraries.
BIB: Australian history books. Kerr, *DAA*.

STUYVESANT FOUNDATION –
Peter Stuyvesant Cultural Foundation
See TRUSTS and FOUNDATIONS

SULLIVAN, *Patrick*

(Active c. 1910) Black-and-white artist. Creator of a famous early animated cartoon character, Felix the Cat. Sullivan went to America early in his career; he was one of the originators of the animated cartoon.
BIB: Moore, *SAA*.

SUMBERT, *Nora*

(b. 6/1/1956, Bairnsdale, Vic.) Painter.
STUDIES: Dip. Fine Art, CIT, 1973; postgrad. studies, New York Studio School, 1978; Dip. Ed., Melb. State Coll., 1979. Her paintings could be classed as romantically abstract – being highly personal interpretations of emotions or events. She held five solo exhibitions 1980–90 including at 13 Verity St, Melbourne 1987, 88, 90, and participated in several group exhibitions 1978–90 including *Loti and Victor Smorgon Collection of Contemporary Australian Art*, ACCA 1988; *A New Generation: The Philip Morris Arts Grant Purchases*, NGA 1988; *Made with Laughter*, Heide, 1990.

AWARDS: Peter Brown Memorial Scholarship, VACB, New York Studio School, 1978; residency, Besozzo Studio, Italy, VACB, 1982; project grant, VACB, 1988; acquisitions, St Kilda City Council, 1989.
APPTS: Part-time lecturer, 1979– painting, various Vic. tertiary colleges including RMIT, Chisholm Inst., VCA.
REP: NGV; several municipal and corporate collections.
BIB: *New Art Three*.

SUMMERS, Charles

(b. 27/7/1825, East Charlton, Somerset; arr. Vic. 1852, d. 30/11/1878, Neuilly, Paris) Sculptor.
STUDIES: Carving, with his father, a stonemason; London, with his brother, Eli; he worked as an assistant to Henry Weekes, RA, and then with M. L. Watson, 1846; RA Schools, 1849–51. His father, George Summers, stonemason and builder, dissipated his earnings in drink, with the result that Charles had to work from childhood to help support his mother and six brothers and sisters. From Ken Scarlett's excellent account in his *Australian Sculptors*, we learn that all seven of George Summers' children were talented, and all went to Victoria. Eli, Charles and Albert were all trained in sculpture and, unlike Charles (who abandoned a claim which, a few weeks later, turned into one of the richest on the goldfields), Eli and Albert both found gold. In later years both joined Charles in Rome, probably as his assistants.

Summers had a brilliant career in London in the 1840s, brought to an end when he contracted tuberculosis, caused by the hardships of his youth. A sea voyage was prescribed as a cure. The cure was successful, and after a brief period of digging for gold, he resumed his career as a sculptor in Melbourne. In 1851 he married Augustine Amiot, and their son, Charles Francis Summers, was born in Melbourne in 1858.

One of his early commissions was to repair the antique plaster casts acquired overseas to form the basis of the collections for the new NGV. The casts had been badly damaged in transit. More important was his commission to supervise the stone carvings for Victoria's Parliament House, carvers including J. S. Mackennal, James Scurry and others. He designed the medal for the *Intercolonial Exhibition*, 1866, completed many other commissions and reached the zenith of his Australian career with the bronze and stone memorial to the explorers, Burke and Wills. This huge work, which stands 5.49m in height, remains the largest bronze casting ever completed by a sculptor working in Australia. The Victorian Government promised £4000 towards the costs, on the proviso that the public subscribe a further £2000 (later cancelled due to controversy). A special committee was appointed, and Summers' design was selected from six entries received. The casting (from copper and Beechworth tin) was carried out at Summers' studio premises at 92 Collins St. Months of patient work had gone into the making of the moulds. The casting pit was dug into the ground, fires were kept burning for two weeks

to dry out the surrounding earth, and a number of prominent citizens attended to witness the pouring of the 7.5 tons of molten metal. After much controversy, the completed monument was placed at the centre of the intersection of Collins and Russell Sts, where it was unveiled by Governor Sir Charles Darling, and attended by the sole survivor of the expedition, John King, on 21 Apr. 1865. To make way for the Collins St cable trams, the monument was later moved to Spring St, near the Princess Theatre, then moved again (because of the building of Melbourne's underground railway) to Carlton, before its final installation in the new City Square, where, ironically, it was placed above a cascade of rushing water. Before Summers left Australia in 1867 he sold the original clay sketch model to the Town Surveyor of Warrnambool, Alexander Kerr, for £10. Kerr's widow presented it to the Warrnambool Art Gallery after Kerr's death in 1887.

Summers was undoubtedly the most celebrated Australian sculptor of his time, generous and helpful to colleagues and students alike. (His help of the imprisoned William Stanford alone is affirmation.) He returned to London in 1867 and after a tour of the Continent, established his studio at Via Margutta, Rome, where he made his home. He completed many commissions, employed a large number of assistants, exhibited at the RA, London, and in Australia, and occasionally travelled. He died at Neuilly, Paris, 1878, and his body was taken to Rome and buried in the Protestant cemetery. His work appeared in the Bicentennial exhibition *The Great Australian Art Exhibition*.
AWARDS: Bronze medal at the RA Schools, London, 1850, bronze medal, *Great International Exhibition*, London, 1851; gold and silver medals, RA Schools, 1851; certificates of merit, *Intercolonial* and *International Exhibitions*, Melbourne, 1861, 80–81.
REP: AGSA; QVMAG; regional galleries Ballarat, Warrnambool; National Museum of Vic.; Parliament House, Melbourne; Parliament House, Sydney; Vic. State Library; Mitchell Library, Sydney; National Portrait Gallery, London; RA collections, London; public works in Vic., Australia and the UK.
BIB: Margaret Thomas, *A Hero of the Workshop*, Hamilton, Adams & Co., London, 1879. Moore, SAA. ADB 6. McCulloch, AAGR. Sturgeon, DAS. Scarlett, AS. A&A 25/2/1987.
(*See also* PUBLIC ART; SCULPTURE IN AUSTRALIA)

SUMMERS, Charles Francis

(b. 1858, Richmond, Vic.; d. 1945, Melb.) Sculptor.
STUDIES: Family studies with his father, Charles Summers (q.v.); Rome, with Prof. Seitz and Prof. Chelli, drawings and modelling. After the burial of his father in Rome, where he was brought up from the age of nine, he made regular visits to Vic. from 1881, arranging the sale of sculptures in his possession as well as seeking commissions. The sculptures included works by his father and the Italian sculptors G.B. and Giovita Lombardi and G. M. Benzoni; and he obtained commissions to make reproductions in marble of famous sculptures, many destined for the Botanic Gardens, Sydney, the public gardens in Ballarat,

and the Exhibition Gardens, Melbourne. He became a member of the Yarra Sculptors Society and collaborated on work with C. D. Richardson (q.v.). He pioneered the quarrying of marble at Limestone Creek, Vic., and received a government grant to quarry and transport large quantities of fine quality stone from the country near the headwaters of the Murray River by bullock team, a project that failed owing to the high costs involved. Disheartened by the lack of interest in sculpture in Australia generally, he sold all the sculptures in his possession in 1933 and from then on produced no more. In the same year he accepted the job of librarian for the Masonic Club, Collins Street, Melbourne, and held that position until 1940.
REP: Bendigo Art Gallery.
BIB: Moore, SAA. McCulloch, AAGR. Scarlett, AS.

SUMMONS, Elizabeth
Organiser, collector.
STUDIES: George Bell School, Melbourne, 1936–37. President, Women's Council, MOMAD, Melbourne, from 1960; later chair of the Women's Council of the NGV. A keen collector of modern drawings, her tastes developed early during her short period of study at the George Bell School. She contributed to a number of journals and books including an introduction to *The Eric Thake Picture Book*, Gryphon Books, Melbourne, 1978.
BIB: A&A 6/1/1968.

SUMNER, Alan Robert Melbourne
(b. 10/11/1911, Melb.) Painter, printmaker, teacher, stained glass designer.
STUDIES: NGV School, 1933; RMIT; George Bell School; travel studies, Europe and UK, including Académie Grande Chaumière, Paris; Courtauld Inst., London, 1950–52. After serving an apprenticeship as a stained glass designer for the firm of Brooks Robinson, Melbourne, he became head designer for the firm of Yenckens. His early painting reflected post-impressionist influences as taught by George Bell, with emphasis on the kind of design that he later applied to the stained glass which became an important activity. Among his many important commissioned works (numbering around 100) are the windows for the Services Memorial Chapel, Scots Church, Melbourne, and the memorial window for Charles Joseph La Trobe, Chapelle L'Ermitage, Neuchatel, Switzerland. Group exhibitions in which he was represented included *Classical Modernism: The George Bell Circle*, NGV 1992. However, the 1993 exhibition of his screenprints at Eastgate Gallery, Melbourne (held at the same time as a retrospective at the NGV) focused on his screenprints and demonstrated the enormous early skill he showed in this medium which enabled him to use up to 17 screens on the one print.
AWARDS: Crouch prize, Ballarat, 1948; MBE conferred (for services to art), 1979; fellow, British Society Master Glass Painters, 1980; fellow, VAS, 1989; medal of honour, VAS, 1990.

APPTS: Teaching, assistant instructor in painting, NGV School, 1947–50; head of the School, 1953–62.
REP: NGA; AGNSW; AGSA; NGV; QAG; Ballarat regional gallery.
BIB: John Kroeger, *Australian Artists*, Renniks, Adelaide, 1968. Smith, AP. M. Eagle & J. Minchin, *The George Bell School*, Deutscher Galleries, Melbourne 1981. J. Helmer, *George Bell, The Art of Influence*, Greenhouse, 1985. R. Butler (intro. and catalogue raisonné) *Alan Sumner Screenprints*, Eastgate Gallery, Melbourne, 1993.

SURREALISM
Until *Surrealism: Revolution by Night*, the major 1993 exhibition organised by the NGA, surrealism in Australia had tended to be subsumed in movements such as the 'Angry Penguins', the 'Antipodeans' and the 'Social Realists'. Writings by Bernard Smith (*Australian Painting 1788–1970*), Richard Haese (*Rebels and Precursors*, Allen Lane, 1981) and Charles Merewether (*Art and Social Commitment — the end of the city of dreams*, AGNSW, 1984) merely introduce it as a major aspect of 1940s art in Australia. But hidden in small periodicals of that time, for instance in *Stream*, *Angry Penguins*, *A Comment* and *Art in Australia*, there is considerable literature on surrealism developed by its leading proponents, James Gleeson, Albert Tucker and Max Harris.

Exhibitions defining surrealist tendencies in Australian art have been rare and include *Aspects of Australian Surrealism*, Contemporary Art Society of South Australia and Naracoorte Art Gallery, 1976; *Aspects of the Unreal – Australian Surrealism 1930s–1950s*, Geelong Art Gallery, 1983; *A Surrealist View*, Scheding Berry Fine Art, Sydney 1986; *Australian Surrealist Paintings*, Charles Nodrum Gallery Melbourne, 1991 and *Aspects of Fantasy and the Surreal in the Heide Collection*, Heide, 1990–91.

Works by Giorgio de Chirico, Salvador Dali and Max Ernst were included in Basil Burdett's *Exhibition of French and British Modern Art* (the *Herald* Exhibition) shown in Sydney and Melbourne in 1939 and constituted the first sightings of European examples. As early as 1932 however with the first exhibition of Melbourne's Contemporary Group it was evident that Eric Thake, for one, was well aware both of de Chirico and the English surrealism of Edward Wadsworth and his circle. By 1938 the avant-garde members of Melbourne's newly founded Contemporary Art Society were agog with European surrealism. The Society's first exhibition at the ngv (1939) included surrealist works by James Gleeson and Sidney Nolan. The outbreak of war soon galvanised social, political and psychological attitudes in favour of a surreal view of Australia and the world. Despair over the war and its inhuman conditions was interpreted as the ultimate failure of Western rationalism.

Surrealism thrived on the perceived poverty of material reality. Sigmund Freud's *Interpretation of Dreams* (1900) contrasted dream and waking states, elevating the importance of dream symbolism, hypnotism, hysteria, dislocation, introspection, free association of ideas

and sublimated sexuality. In 1924 André Breton's *Surrealist Manifesto* proclaimed: 'I believe in the future resolution of these two states, dream and reality, which are seemingly so contradictory, into a kind of absolute reality, a "surreality".' Breton sought an 'ever more passionate interpretation of the tangible world', such that might incorporate the elusive substance of dreams, secret desires and irrational thought. Influential surrealists like de Chirico, Dali, Ernst, André Masson, René Magritte, Roberto Matta, Man Ray, Yves Tanguy, Joan Miró and Roland Penrose rejected empirical descriptions of reality for the disquieting realm of suspended disbelief with its multiple sources and allusions. Surrealism was not a substitute for the 'real', but a way of looking at it which allowed the subconscious psyche to play a greater role in determining pictorial form.

Though the term 'Surréaliste' was invented seven years earlier by Apollinaire, Breton's *Surrealist Manifesto* (1924) and the journal *La Revolution Surréaliste* established surrealism's Paris base from whence it rapidly caught the imagination of the world. Its major influence was felt between the two wars. However, the mode of thought, giving precedence to chance, intuition, imagination, paradox and curiosity has retained its potency to this day. It infiltrated the 1940s paintings of American artists such as Jackson Pollock and Arshile Gorky, just as it was to infect the works of emerging Australian 'rebels and precursors' who related it to their own preoccupations with local culture, politics and the indigenous landscape. All were readymade for surrealist treatment.

Bernard Smith's account of the second cas exhibition shown in Sydney and Melbourne (1940) describes how the judge, the collector Gino Nibbi, shared the £5 anonymous donor's prize, for the 'best picture showing new expression of thought', between Thake's *Salvation from the Evils of Earthly Existence* (1940) and Gleeson's *We Inhabit the Corrosive Littoral of Habit* (1940) the latter influenced by Dali's *L'Homme Fleur* (*Memory of the Woman/Child*, 1933) the most debated work in the *Herald* Exhibition of 1939.

Though surrealist tendencies were noted in his paintings and 'poem-drawings' from 1937–39, it was Gleeson's lectures and writings, including *What is Surrealism?* (aa 1940), which did most to familiarise Australians with the movement. The major bases were Sydney and Melbourne but Herbert McClintock (Max Ebert) showed surrealist works in Perth before 1940 and Adelaide's Ivor Francis revealed his surrealist leanings in paintings like *Schizophrenia* (1934).

Surrealism was particularly marked in works by Tucker, Nolan and Arthur Boyd in response to surreal verse published by Max Harris, Alistair Kershaw, James Gleeson and John Reed in their journal *Angry Penguins*. The influence of poetic juxtaposition as used by Ezra Pound, James Joyce and T. S. Eliot was strongly felt, particularly Eliot's *The Waste Land* to which Gleeson, Tucker, Thake, Jeffrey Smart, Russell Drysdale, Douglas Roberts, Jacqueline Hick, Carl Plate, James Cant and Peter Purves Smith all responded. *Angry*

James Gleeson, Psychoscope II, *1980, oil on canvas. Private collection.*

Penguins also printed poems by Rimbaud and Baudelaire. After 1931, when Gino Nibbi discussed de Chirico in his journal *Stream*, surrealism became a subject of debate including Harry de Hartog's critique of 'Super Realism' which appeared in *Manuscripts* (1935). Bernard Smith also sought to explain the term in a paper delivered to the Federation Art Society, Melbourne 1940. Gleeson described surrealism as a method of elucidating reason by 'creating a synthesis between the daytime reality of our mind and the darkness of our subconscious world.' He gave it a social dimension by suggesting that the dominance of surreal works in the 1940 cas Exhibition, including Tucker's *The Futile City* (1940), Geoffrey Graham's *Bellita* (c. 1939) and his own entry, indicated 'a powerful new weapon for its [mankind's] combat of darkness and evil.' In *The Necessity for Surrealism*, a 1941 paper to the cas, later published in *A Comment*, he wrote: 'Do not commit suicide, for surrealism has been born.' Australian surrealism was thus linked with political and social change.

By far the largest group of surrealist works made in Australia are those which draw upon experience,

real or imaginary, of the landscape, rendered absurd, whimsical or dream-like by inversions of spatial logic and the presence of weird object-entities and other threatening hallucinatory psychological dramatisations of reality. Such works dominated the Australian section of the *Revolution by Night exhibition, 1993* (organised by the NGA with more than 300 works from 79 world collections and curated by Michael Lloyd, Ted Gott and Christopher Chapman). They included: Bernard Boles, *Green Bathers* (1940s); James Cant, *Objects in a Landscape* (1936) and *Returning Volunteer* (1938); David Dallwitz, *Allegory* (1944); Russell Drysdale, *Woman in Bath* (1940); Adrian Feint, *Strange Shore* (1948); Klaus Friedberger, *Voyage* (1940); James Gleeson, *Paleolithic Landscape* (1939); Geoffrey Graham, Two Figures (c. 1938–39); Oswald Hall, *Forged Dawns* (1941); Joy Hester, *un Fair* (c. 1946); Frank Hinder, *Riverbank* (1947); Roy de Maistre, *Untitled* (c. 1945); Dusan Marek, *Birth of Love* (1948); Herbert McClintock (Max Ebert), *Strange Interlude* (1940); John D. Moore, *Still Life with Painted Landscape* (1934); Carl Plate, *Untitled* (1940); Douglas Roberts, *Figures in a Landscape* (1924) and *Desert Landscape* (1947); Jeffrey Smart, *Cape Dombey* (c. 1946); Bernard Smith, *Drought* (1940); Peter Purves Smith, *Surrealist Composition: Sea Shore with Figures* (c.1939); Eric Thake, *Salvation from the Evils of Earthly Existence* (1940) and Albert Tucker, *The Philosopher* (1939) and *The Futile City* (1940).

The emphasis on the Australian landscape is explained by the fact that it was the landscape best known to most of the artists (Gleeson said in 1993 that it was all he had seen at the time) and, to some, surrealism suggested a rebirth of the 'primordial'.

That some Australian surrealists were impressed by the landscape treatments of de Chirico, Dali and Tanguy was demonstrated by Purves Smith's *New York* (1938); Cant's *The Deserted City* (1939); McClintock's *Strange Interlude* (1940); Tucker's *The Possessed* (1942) and Gleeson's *The Sower* (1944) and *Citadel* (1945).

Another important aspect of surrealism, explored by Nolan in his *Secret Life of Birds* (c. 1940), Gleeson in *Untitled Poem Drawing* (1939) and Robert Klippel in *Entities Suspended from a Detector* (1948), was the idea of pure psychic automatism. In Breton's words, 'Thought's dictation in the absence of all control exercised by reason and outside all aesthetic or moral preoccupations' (*What is Surrealism?*, 1936). This theory was also explored in Herbert Read's books *Art Now* and *Surrealism* (both published in 1936) and all three texts were available here. In Australia, Chapman suggests, this phenomenon manifested itself as a respect for 'chance' which Gleeson exploited in his experimentation with frottage and flow-drawing techniques. These techniques were also used by Nolan, Boyd and Klippel, while Nolan favoured the chance effects of collage.

In the Canberra exhibition catalogue, Chapman draws attention to the use of surrealist iconography in advertising art of the 1930s and 1940s which used parody effectively. Man Ray's *Glass Tears* (c. 1930) appeared in the February 1934 issue of *The Home*,

followed by a spate of photographs by Max Dupain including his *Surrealist Party* (1937), a double page spread recording Sydney socialites in surreal garb. His nudes, such as *Superman* (1934), were frequently transformed into surreal landscapes. Dupain published an article on Man Ray in *The Home*, October 1935.

A bridge between 1940s surrealism and the 1950s, when Barry Humphries created his neo-dada performances and exhibitions, John Olsen experimented with automatist painting and the Annandale Imitation Realists worked in assemblage and collage, was the paintings of Gleeson, Robert Boynes and Cant who did not abandon surrealism's central tenets. In the 1950s and 1960s works by Boyd, Tucker, Perceval, Vassilieff and Mike Brown retain surreal elements. Charles Nodrum suggests that contemporary painters like John Lethbridge, Robert Parr, Jeffrey Smart, William Delafield Cook, James Meldrum, Peter Ellis and Jon Cattapan might also be considered surrealists. This field would also be considerably extended by including painters like Paul Boston, Imants Tillers, Dale Frank, David Keeling and others who sometimes use found objects and assemblage. Their work often relies on principles of chance which have continued to infuse 1960s pop, 1970s conceptual art and 1980s and 1990s post-modernism. A further group might, conceivably, include Bill Brown, Tim Storrier, Guy Warren, Lawrence Daws, Ken Whisson, Stephen Killick, Dale Hickey, Keith Looby, Jan Senbergs, John R. Neeson, David Wadelton, David Walker, Caroline Williams and Vivienne Shark Le Witt.

BIB: *Surrealism – Revolution by Night* (National Gallery of Australia, Canberra, 1993) Chanin, CAP.

JENNY ZIMMER.

SUTHERLAND FAMILY

The brothers Sutherland of Glasgow, George (1829–85), John and Alexander, settled in Melbourne in the 1870s to establish a small dynasty of artists and community leaders. Science, engineering, religion, writing, education, carving, painting and music all came within their scope. Both George and John exhibited with the local art societies, George with the Victorian Academy of Arts (c. 1875–90), John with the VAS (c. 1890). Best-known of their descendants are the Victorian painters, Jane, Ruth and Jean (qq.v.); the South Australian, Stella Bowen (q.v.); and the Victorian musician and composer, Margaret. Frances Lindsay curated an exhibition, *The Story of the Sutherland Family*, at the VCA Gallery, Melbourne, in 1977.

SUTHERLAND, Charles
Early Melbourne Punch artist, c. 1885.
BIB: Moore, *SAA*.
NFI

SUTHERLAND, Jane
(b. 1855, Scotland; arr. Aust. 1864; d. 1928, Melb.)
Painter.
STUDIES: NGV School, 1871–85. She painted with the Heidelberg School artists, Roberts and McCubbin,

first at Box Hill. In company with Clara Southern, Roberts and others she rented her own studio at Grosvenor Chambers when that unique building, specially designed for artists by the decorative artist C. S. Paterson, opened on 27 Apr. 1888, at 9 Collins St, Melbourne. She was one of the first women to be elected to the Buonarotti Society (q.v.) in 1884 and the Council of the VAS in 1900. Although painting with Roberts, Streeton and other Impressionists with admirable results she was not asked by her colleagues to exhibit with them in the *9 × 5 Impressions Exhibition*. Physically much reduced as the result of a stroke at the age of 45, she became an almost complete invalid yet continued to produce impressively clear pastels until her death at the age of 73. Her work was represented in *Australian Women Artists 1840–1940* at Ewing and George Paton Galleries, Uni. of Melbourne and touring 1975; *The Story of the Sutherland Family*, VCA Gallery, Melbourne, 1977; *Golden Summers: Heidelberg and Beyond*, NGV and touring, 1986; the Bicentennial exhibition *The Great Australian Art Exhibition*; *Completing the Picture*, Heide and touring 1992; *A Century of Australian Women Artists 1840s–1940s*, Deutscher Fine Art, Melbourne 1993.
REP: NGV; regional galleries Ballarat, Newcastle.
BIB: Catalogue essays exhibitions as above and a number of general texts on Australian art. Janine Burke, *Australian Women Artists*, Greenhouse Publications, Melbourne, 1980.

SUTHERLAND, Jean Parker

(b. 6/6/1902, Melb.; d. July 1978, Melb.) Painter.
STUDIES: Family studies; NGV School, 1918–23; RAS, London, 1925–27; travel studies, UK and Europe, 1925–27. A granddaughter of John Sutherland (*see* SUTHERLAND FAMILY), her work (specifically her introspective self-portraits) had a luminosity and strength. She combined impressionist colour with academic drawing. In Oct. 1944 she held her only full-scale exhibition at the Sedon Galleries, Melbourne. Deutscher Galleries, Melbourne, held an exhibition of her work in March and April 1979 and she was represented in *The Story of the Sutherland Family*, VCA Gallery, Melbourne, 1977 and *A Century of Australian Women Artists 1840s–1940s*, Deutscher Fine Art, Melbourne, 1993.
AWARDS: NGV Travelling Scholarship, 1923.
REP: NGV.

SUTHERLAND, Lillian

(b. Newcastle, NSW) Painter.
STUDIES: Newcastle Tech. Coll., with John Passmore.
AWARDS: Prizes at Maitland, 1962; Muswellbrook, 1963; Tumut, 1964; Albury, 1964; Cheltenham, NSW, 1967; RAGSOCNSW Easter Show, Sydney, 1969.
REP: NGA; Manly Art Gallery.

SUTHERLAND, Ruth

(b. 1884, Adelaide; d. 1948, Vic.) Painter, art writer.
STUDIES: NGV, 1902–07. A niece of Jane Sutherland, and granddaughter of George Sutherland, she contributed many articles to *Art in Australia*, and for a

short time wrote art critiques for the *Age*, Melbourne. She exhibited at the VAS and was a member of the VAS Council, 1914–16 and 1918. From 1919 she is catalogued as Ruth Sutherland-Neylon. She joined the Melbourne Society of Women Painters and Sculptors, along with her cousin Jean Sutherland, and friend Lina Bryans, in 1940. Her work was represented in *The Story of the Sutherland Family*, VCA Gallery, Melbourne 1977 and *A Century of Australian Women Artists 1840s–1940s* Deutscher Fine Art, Melbourne, 1993.
BIB: Janine Burke, *Australian Women Artists*, Greenhouse Publications, Melbourne 1980.

SWAINSON, William

(b. 8/10/1789, Liverpool, UK; arr. Aust. 1851; d. 1855) Draughtsman, painter. Stationed on the Mediterranean from 1807, he researched local flora and fauna; later he worked in Brazil (1816–20) as a naturalist, producing his authoritative volume, *Birds of Brazil and Mexico*. He went to NZ in 1841, farming on the Hutt River and making many fine sketches. In Australia from 1851, dated pencil drawings show that he worked in the Dandenongs, Vic., 1852–53; Tas., 1853–54; and NSW in 1855–56. Commissioned by the respective colonial governments, these drawings show meticulous attention to detail. His work appeared in the *Spring Exhibition* at Joseph Brown Gallery, 1978, in Leonard Joel's auction, May 1978 and Deutscher Fine Art's *Australian Colonial Art*, Melbourne 1980.
REP: TMAG; NLA; Mitchell, La Trobe, Allport libraries.
BIB: Henry P. Newrick, *NZ Art Auction Records 1969–72*, Newrick, Wellington, 1973. Kerr, DAA.

SWAN, Louisa J.

(b. 29/4/1860, Hobart; d. 30/7/1955) Painter. She organised a sketching club in 1884 and later became vice-president and founder of the Art Society of Tasmania. Her work was represented in *The Artist and her Patron* AGNSW, 1988.

SWANN, Ron Robertson

See ROBERTSON-SWANN, Ron

SWANTON, Lucy Howell

(b. 28/11/1901, Kew, Vic.; d. 1/7/1981) Art dealer, collector.
STUDIES: Courtauld Inst., London, 1930s; Uni. of Sydney (archaeology), 1956–58. As senior partner at the Macquarie Galleries, Sydney, 1936–56, she had great influence during a period of vital change and development in the visual arts in Australia. A discerning collector, she presented paintings and other works to State and regional galleries as well as to the Uni. of Sydney in 1953. The remaining works in the collection were bequeathed to the NGA and AGNSW.
BIB: AN no. 5, Jan. 1982 (Daniel Thomas, *Lucy Swanton*).

SWEATMAN, Jo (Estelle Mary)

(b. 1872; d. 1956, Warrandyte, Vic.) Painter.
STUDIES: NGV School, 1890–98. She exhibited landscape and figure paintings with the VAS, 1901–17,

and was a foundation member of the Australian Art Association, 1912, and Twenty Melbourne Painters, 1917. She became identified with the group of painters working at Warrandyte and, like another Warrandyte resident, Penleigh Boyd, painted many pictures featuring wattle trees in bloom.

AWARDS: Student prizes, NGV School, 1895, 96.

REP: NGV; Castlemaine regional gallery.

BIB: Moore, *SAA*.

SWEET, Samuel White
(b. 1825; arr. Qld 1863; d. 1886) Photographer, mariner. He worked as a professional photographer, in Qld 1863–66, Sydney 1866 and Adelaide 1867–86, while still continuing his career at sea. His work was included in several exhibitions including the Calcutta *International Exhibition* 1884. He opened his own photography gallery in Adelaide in 1885 but died a year later. His work was seen in the Bicentennial exhibitions *The Great Australian Art Exhibition* and *Shades of Light*, NGA 1988.

BIB: J. Cato, *The Story of the Camera in Australia*, Melbourne 1977. ADB 6. A Sierp, *Samuel White Street*. Kerr, *DAA*.

SYDNEY ART GROUP
(1945– ?) Formed by Sydney painters in an attempt to counter the declining standards of the NSW Society of Artists. Wallace Thornton was the first president and Jean Bellette, Paul Haefliger, David Strachan, Francis Lymburner, Eric Wilson, Wallace Thornton, Wolfgang Cardamatis, Justin O'Brien, Geoffrey Graham and Gerald Lewers exhibited at the inaugural exhibition in 1945.

SYDNEY 9
(1960–62) Sydney modern group exhibiting jointly in the early 1960s. Artists included Olsen, Rapotec, Hessing, Rose, Meadmore, Eric Smith, Upward, Gilliland, Plate. Main exhibitions were in Sydney and Melbourne, 1961.

SYDNEY OPERA HOUSE
Apart from its fame as an architectural masterpiece, Joern Utzon's opera house was the venue for the first Biennale of Sydney and contains a number of visual art works, including a large tapestry drop-curtain woven at Aubusson from designs by John Coburn, and a large mural entitled *Five Bells* by John Olsen.

SYDNEY PRINTMAKERS
(Founded c. 1962) Working group formed for the promotion of standards of local printmaking. Foundation members: Sue Buckley, John Coburn, Joy Ewart, Strom Gould, Weaver Hawkins, Eva Kubbos, Ursula Laverty, Peter Laverty, Vaclovas Ratas, Elizabeth Rooney, Roy Fluke, Henry Salkauskas, James Sharp, Algirdas Simkunas, David Strachan and Earle Backen. The group held exhibitions in Sydney and Melbourne, notably at the Argus Gallery, Melbourne, in June 1962.

SYER, Walter
Contemporary illustrator of the writings of Henry Lawson, known mainly for his portraits in pencil. Lionel Lindsay made etchings from some of Syer's portraits, namely his pencil portraits of David Scott Mitchell. Fifty of his original pencil drawings were included in a limited edition of Lawson's *In the Days When the World Was Wide* (n.d.)

REP: Mitchell Library.

BIB: Moore, *SAA*.

SYKES, John
(b. 1773, Eng.; arr. Aust. 1791; d. 12/2/1858, Eng.) Naval officer, topographical draughtsman. With Vancouver in HMS *Discovery*, he visited WA in 1791, before sailing east via NZ and Hawaii to the west coast of North America. His *Deserted Indian Village in King George III Sound, New Holland* was redrawn by William Alexander (of the British Museum) and engraved by John Landseer (father and teacher of Sir Edwin) in 1798. Sykes was commissioned in 1795 and became Vice-Admiral in 1848. He was represented in *The Colonial Eye*, AGWA 1979.

REP: AGWA; Ministry of Defence, London (Hydrographic Dept).

BIB: Moore, *SAA*.

SYME, Eveline W.
(b. 1888, Melb.; d. 1961) Painter, printmaker.

STUDIES: Cambridge Uni., UK, c. 1912 (MA, 1914); Uni. of Melbourne (Dip. Ed., 1914); La Grande Chaumière, Paris, 1922–23, also with Maurice Denis; Grosvenor School of Modern Art, London (painting with Iain McNab, linocuts with Claude Flight), 1929; Académie Lhote, Paris, 1929–30; George Bell School, Melbourne, c. 1939. A granddaughter of Ebenezer Syme, co-founder of the *Age*, she exhibited at the VAS from 1924, and with the Melbourne Society of Women Painters and Sculptors, and, with her close friend Ethel Spowers, was a foundation member of the Contemporary Group, 1932. From the late 1930s, with the demise of the Contemporary Group, she began to show with the Independent Group. Her early work in both painting and printmaking strongly reflected the modernist influences derived from McNab and Lhote. She was one of the founders of the Uni. Women's Coll., Uni. of Melbourne, and during World War II organised the Red Cross Picture Library. Jim Alexander Gallery, Melbourne, held a major exhibition of her work in 1988 and she was represented in *Classical Modernism: The George Bell Circle*, NGV 1992; and *A Century of Australian Women Artists 1840s–1940s*, Deutscher Fine Art, Melbourne 1993.

REP: NGA; NGV; Ballarat Fine Art Gallery.

BIB: Catalogue essays exhibitions as above. Janine Burke, *Australian Women Artists 1840–1940*, Greenhouse Publications, Melbourne, 1980. M. Eagle & J. Minchin *The George Bell School* Deutscher Fine Art/Resolution Press, 1981.

SYMMONS, Thomas
(b. 1848; d. 1928) Engraver, painter. London wood-engraver who engraved the drawings of Henry French,

and Fred Barnard, the Dickens illustrator. Symmons migrated to Perth where he became a well-known landscape painter. (Spelling corrected from 'Symmonds' as given in Moore, SAA and previous editions of this work, from letter received by Symmons' grandson, Wilfred Symmons, 14/10/1985)

BIB: Moore, SAA.

SZABO, *Joseph*

(b. 30/10/1932, Budapest; arr. Aust. 1950. d. 1984) Painter, teacher, ceramicist.

STUDIES: NAS (ceramics and painting), 1953–54. He worked in commercial pottery soon after his arrival in Sydney and began exhibiting paintings in group exhibitions. He held three exhibitions (Barry Stern Gallery, 1962; Barefoot Gallery, Sydney, 1965; Central Street Gallery, Sydney, 1966) and in 1967 participated in the CAS interstate exhibition at Farmer's Blaxland Gallery. His geometric abstracts appeared also in *The Field* (NGV), 1968, and in the Transfield Prize exhibition, Sydney, 1969.

AWARDS: Prizes at Mosman, 1968; Sydney (Blake Prize), 1972; Rockdale, 1974; VACB grant (for exhibitions), 1975–76.

APPTS: Teaching, Jon Molvig's classes, Brisbane, 1959; Mary White School, Sydney, 1966; Bakery School, Sydney, 1974.

REP: NGA.

SZIGETI, *Imre*

(b. 1897, Budapest; arr. Aust. 1939; d. 1975, Sydney) Draughtsman, illustrator.

STUDIES: State Art Academy, Berlin. He worked as a cartoonist and illustrator in Germany and Hungary, contributing work for about 100 books, including editions of writings by Edgar Allen Poe and Charles Baudelaire. From the time of his arrival in Sydney in 1939 his open line drawings, with their vivacious art nouveau associations, added a new dimension to Australian drawing. He exhibited mainly with the Holdsworth Galleries, Sydney.

AWARDS: Prizes at Bathurst, 1965; Berrima, 1965; Muswellbrook, 1965.

REP: AGNSW; NGV; QAG; Mornington regional gallery.

BIB: Elwyn Lynn, *Drawing*, Arts in Australia series, Longman, Melbourne, 1963. *Meanjin* 4/1955 (Alan McCulloch, *Migrant Artists in Australia*). AI 14/1/1970 (Alan McCulloch, *Letter from Australia*).

Wilma Tabacco, Verso L'Oblio, *1992, ink and acrylic on paper, each panel approx. 32.5 × 25cm. Private collection.*

*T*ABACCO, *Wilma*

(b. 8/8/1953, L'Aquila, Italy; arr. Aust. 1957) Painter, printmaker.
STUDIES: B.Comm., Melbourne Uni., 1973; Dip. Fine Art, Phillip Inst., 1981. Often drawing on symbolism, her abstract paintings are denoted by rich colours and soft outlines creating a hazy luminosity. She held four solo exhibitions 1988–91 in Melbourne (Niagara

1988, 89, 91) and Sydney (Holdsworth 1988). Her work was seen in about 26 group exhibitions 1981–91 in Melbourne galleries (including Niagara; Reconnaissance) and tertiary, public galleries including *Fremantle Print Award Exhibition*, WA 1987; MPAC *Spring Festival of Prints and Drawings*, Mornington 1987, 88; *100 × 100, Print Portfolio Exhibition*, PCA 1988; *Art from Elsewhere*, Uni. of Tasmania 1990; *Freedom of Choice*, Heide, 1991 and in *Il Disegno Ritrovato*, Salone San Francesco, Como, Italy 1991. Her commissions include Banner Project, Inst. of Ed., Melb. Uni.
AWARDS: Residency, Besozzo, Italy, VACB, 1990.
APPTS: Lecturer, painting and drawing, Inst. of Education, School of Visual & Performing Arts, Uni. of Melb., 1989–90.
REP: NGA; Artbank; Heide; PCA; Latrobe Valley regional gallery; Waverley City Gallery.
BIB: PCA, *Directory* 1988. *New Art Three.*

*T*AIT, *Bess Norris (née NORRIS)*

(b. 1878; d. 1939) Painter.
STUDIES: NGV School, 1897–1901; also with Jane Sutherland; Slade School, London, 1905. Mainly a miniaturist. As Bess Norris she exhibited watercolour portraits and miniatures at the VAS, 1898–1904. She went to London, 1905, married J. Nevin Tait and exhibited at the RA, Paris Salon and in Brussels. Many of her London miniatures were of musicians.
REP: AGNSW; NGV; Walker Gallery, Liverpool; Toronto Gallery, Canada.
BIB: George P. Williamstown intro., *Miniatures of Bess Norris Tait,* London, n.d.. AA Nov. 1922 (article and reproductions). Moore, SAA.

*T*ALBOT, *Jennifer*

(b. 1941, Melb.) Painter.
STUDIES: Uni. of Melb. (degrees in Law and Arts), 1963; travel studies, Europe and UK, 1964–65, including attendance at City and Guilds of London Art School; NGV School, 1966–68. She held 7 exhibitions, mainly in Melbourne, and in 1976 became actively involved in the campaign to save the whale, a cause to which she became more and more dedicated, in 1981 writing and illustrating a book, *Whales* (Greenhouse

Publications, Melbourne). Many of her paintings and drawings deal with wildlife and conservation subjects.

BIB: PCA, *Directory*, 1976, 88.

TALBOT, Mary Victoria

(b. 1/6/1931, Melb.) Painter, illustrator.
STUDIES: CIT, Melb.; also with Justus Jorgensen, Eltham. She had immediate success with her delicately conceived, decorative, art nouveau style drawings when they were first exhibited in Melbourne and Sydney, 1957; and they had immediate appeal for magazine editors when she moved to London, 1958. From 1961 she held exhibitions in London, Paris, Los Angeles, and Zurich, as well as in Australia. From 1966 she lived mainly in Norway.
REP: NGV.
BIB: Campbell, AWP.

TAN, Laurens

(b. 1950, Den Haag, Holland; arr. Aust. 1962) Ceramicist, installation artist, draughtsman.
STUDIES: Pure maths/economics, Uni. of New England, 1969–71; design studies, ESTC, 1972–74; music theory, NSW Conservatorium, 1972–74; Master of Creative Arts, Uni. of Wollongong 1991. His ceramic and mixed media sculptures are delicate and intricate and his charcoal drawings show a similar concentration on perspective and illusion. He held 12 solo exhibitions 1980–91 in Adelaide (Greenhill, 1980; Studio 20, 1981; Jam Factory, 1983; Bonython-Meadmore, 1984), Sydney (Macquarie 1984, 87, 89, 90) and Perth Inst. of Contemporary Art, 1990; Australian Embassy, Paris 1990; Uni. of Queensland 1991; Uni. of Wollongong 1991. His work was seen in approximately 30 group exhibitions 1984–91 at public galleries including *Australian Crafts*, Meat Market 1986, 88; *Blake Prize*, 1987/88; *Australian Perspecta*, AGNSW 1991; *Alchemy & Artefact*, Orange Regional Gallery 1991. He was part of a cultural exchange program with Hunan Normal Uni., Changsha, China in 1987.
APPTS: Teaching fine arts, Adelaide CAE, 1975–78; lecturer, SACAE, school of Art & Craft, 1983–85; lecturer, School of Creative Arts, Uni. of Wollongong 1986– .
REP: AGWA; QAG; QVMAG; Parliament House; Artbank; Uni. of Wollongong; Craft Council of NT; Arts Council of SA; Orange Regional Gallery; overseas collections including Cité Internationale des Arts, Paris; Moet & Chandon Foundation, Epernay, France; Hunan Normal Uni., China.
BIB: Catalogue essays exhibitions as above. *New Art Two*. Norris Ioannou *Ceramics in South Australia 1836–1986*, Wakefield Press, SA, 1986.

TANDBERG, Ron

See CARTOONS AND CARTOONISTS; BLACK AND WHITE ART IN AUSTRALIA

TANNENBERG, Max

(Active 1860s, Melb.) Engraver, with Hans Pretorius,

for Troedel & Cooper, publishers of *The Melbourne Album*, 1863–64.
NFI

TANNER, Edwin Russell

(b. 31/12/1920, Pangam, Wales; arr. NSW 1923; d. Nov. 1980, Melb.) Painter, engineer.
STUDIES: Hobart Tech. Coll., 1951– ; Uni. of Tas. (grad. BA, 1957). He began his working career in the Port Kembla Steel Works, completed a London Uni. correspondence course, and moved into engineering to achieve distinction in this field. He was also successful as a racing cyclist. His training in engineering shaped his direction as a painter, many of his paintings containing small, precisely slotted-in, metal 'templates' associated with the theme of people and their everyday dependence on machines. This theme was central to his aesthetic philosophy, although the quality of his paintings stems also from a developed sense of fantasy, often very poetically expressed. A retrospective of his work was held at the NGV in 1976, and Charles Nodrum, Melbourne, held a number of exhibitions of his work during the 1980s.
AWARDS: Tasmanian Sesquicentenary (silver medal), 1954; Dandenong prize, 1955; Royal Adelaide Exhibition (bronze medal), 1957; Captain Cook Bicentenary prize, 1970; MPAC *Spring Festival of Drawing* (drawing acquired), 1973; VACB grants, 1973, 76.
REP: NGA; AGNSW; NGV; TMAG; regional galleries Mornington, Newcastle.
BIB: John Reed, *New Painting 1952–62*, Longman, Melbourne, 1962. Ronald Millar, *Civilized Magic*, Sorrett Publishing, Melbourne, 1974. A&A 9/3/1971; 18/4/1980.

TANNER, Les

See CARTOONS AND CARTOONISTS; BLACK AND WHITE ART IN AUSTRALIA

TANNERT, Louis

(b. c.1844, Düsseldorf; arr. Aust. ?1878) Painter. He is recorded as exhibiting in Düsseldorf and Berlin 1870–80, subjects including *Invitation to the Dance* and *Maternal Happiness*. In Melbourne he exhibited at the VAA, 1878–79, showing genre paintings such as *The Bad Conscience* and others. The following year he moved to Adelaide where he taught at the Adelaide School of Painting (SASA) till 1893 and was curator at the AGSA, 1882–89. His work ranges in quality from his interesting view of the *Eastern Market, c.1878* (Christie's, Melbourne, Mar. 1970), to sentimental genre pieces.
REP: AGSA.

TASMANIAN ART GROUP

(Founded 1970, Hobart) Replaced the Tasmanian Group of Painters. It exhibited in Drysdale House Gallery, Collins St, Hobart during the 1970s and 80s.

TASMANIAN ART SOCIETY

(Founded 1884, Hobart) In 1916 the state goverment

made rooms available for the Society in an upper storey of a public building in Macquarie St, Hobart. The Society (commonly known as the Art Association) eventually became the Art Society of Tasmania (q.v.).

TASMANIAN GROUP OF PAINTERS
(Founded 1938, Hobart) Formed by Joseph Connor and Mabel Hickey to conduct annual exhibitions and help young Tasmanian painters. Disbanded, the group was re-formed in 1970 as the Tasmanian Art Group (q.v.).

TAX INCENTIVES FOR THE ARTS
Initiated by the federal government and brought into operation on 1 Jan. 1978, for a three-year trial period. Having been adopted permanently following this, the scheme applies to gifts made to public art galleries, museums and libraries. The gifts become tax-deductible items to the full extent of their value at the time when the gift was made. The value is assessed by two approved valuers officially listed by advisers to the government, the list being available to prospective donors on request. The scheme has been of great value to Australian public art galleries, libraries and museums with many items, worth many millions of dollars, coming into public collections in this way.

TAYLER, Frederick
Painter. Artist of the Victorian goldfields. He painted in the Bendigo district.
REP: Bendigo Art Gallery.
BIB: McCulloch, *AAGR*.
NFI

TAYLER, Lawrence B.
(b. 1873) Illustrator, poster artist.
STUDIES: NGV School. He moved to London in 1913, wrote and illustrated contributions to magazines and exhibited three works at the *Australian Art Exhibition*, Spring Gardens Gallery, London, 1925. He illustrated Quiller Couch's *The Delectable Duchy*, and William Moore states that 'he was awarded the £500 prize' for a poster for the Great Western Railway from 6000 other entries. But Moore may have confused him with Fred Taylor, the most celebrated British railways poster artist of the 1920s.
BIB: Moore, *SAA*.

TAYLOR, Alexander
(Arr. Perth, 14/3/1841; d. 7/2/1877, Melb.) Topographical artist. A draughtsman with the WA Land and Survey Dept, he held pastoral leases and moved to Melbourne, probably after the death of his wife in 1864. His fine watercolour drawing, *Perth from St George's Terrace, 1850*, is historically informative and indicates sensitive use of washes. Taylor was also noted as an amateur flautist. His work was seen in *The Colonial Eye*, AGWA 1979.
REP: AGWA.
BIB: *Bulletin*, AGWA, vol. 1, no. 4, 1962. Kerr, *DAA*.

TAYLOR, Ben
(b. 5/6/1960, Sydney) Painter, printmaker.
STUDIES: Dip. Art, Canberra School of Art, 1981. Living in the NSW countryside, his work is concerned with the mix of harshness and humour that is often found in rural life. Titles of his early 1980s exhibitions, *Dried Frogs*, *The Fire* and *Grasshopper Plague*, reflect his concerns. He held eight solo exhibitions 1983–90 in Sydney (Garry Anderson, 1986; Coventry, 1989, 90), Canberra (Bitumen River, 1983; Solander, 1986; Ben Grady, 1987, 89) and Melbourne (Reconnaissance, 1988). He held 15 group exhibitions 1983–92 at private galleries in Sydney (including Coventry, BMG) and public galleries including *The Figure*, QAG 1987; *A New Generation 1983–88: The Philip Morris Arts Grant Purchases*, NGA 1988; *Packsaddle Exhibition*, Art Museum, Armidale, NSW and Contemporary Art Space, Adelaide 1989.
APPTS: Lecturer, printmaking, Canberra School of Art, 1983–85.
REP: NGA; Artbank; MOCA, Brisbane; Sir William Dobell Art Foundation; ANU; Baker & McKenzie corporate collection.

TAYLOR, David K.
(b. 25/5/1941, Melb.) Painter, teacher.
STUDIES: CIT; Melb. School of Printing and Graphic Arts. A foundation member of the Waverley Arts Society and a council member of the VAS since 1974, he is known as a skilful painter of landscapes in watercolours. He held approximately 20 solo exhibitions 1975–91, largely in Melbourne (Manyung; Wiregrass; Melbourne Fine Art galleries), Sydney (Holdsworth) and Newcastle (von Bertouch). He participated in a number of group exhibitions, largely with watercolour societies, including the Australian Watercolour Inst.
AWARDS: Prizes in Mt Waverley competitions, 1972, 73, 74, 75, 76; Clayton, 1976; VAS (Artist of the Year), 1976, 80, 89; RAS, NSW watercolour prize, 1987; Victor Harbor Watercolour Prize, 1988; Golden Anniversary Watercolour prize, Yarrawonga, 1989; Norwich Award, Camberwell Rotary, 1991.
REP: Artbank; a number of municipal collections including Camberwell, Oakleigh, Box Hill, Vic., Toowoomba, Qld; Canberra CAE; ANZ Bank.
BIB: Germaine, *AGA*, 1979. Campbell, *AWP*. Campbell.

TAYLOR, E. C.
Painter. He exhibited Victorian landscapes at the Victorian Academy of the Arts, 1870 and 1887. Moore records an Edward Taylor as attending the annual dinners held in London by resident Australian artists Lambert, Roberts, Mackennal and others, before World War I.
BIB: Moore, *SAA*.

TAYLOR, George Augustine
(b. 1872, Sydney; d. 1928) Black-and-white artist, writer, inventor. Contributed to Sydney *Bulletin* and London *Punch*. Council member of the RAS of NSW. Of versatile talents, Taylor founded the Wireless Inst.

of NSW, and published a large number of small books and articles on various subjects, including *A History of Caricature*, and *Those Were The Days*, Tyrrell's, Sydney, 1918.

BIB: Moore, SAA. Elizabeth Hanks, *Australian Art and Artists to 1950*, Library Council of Victoria, Melbourne, 1982.

TAYLOR, Helen

(b. 17/3/1943, India; arr. Aust. 1952) Printmaker, lecturer.
STUDIES: Dip. Fine Art, Claremont Tech. Coll., 1974; Dip. Printmaking, Perth Tech. Coll., 1976; M. Fine Art, Uni. of Tas., 1984. Her meticulously made etchings were included in many print survey and other group exhibitions, including travelling exhibitions (Japan, Fiji), 1977; *Western Australian Prints: Recent Acquisitions*, AGWA 1988; *Landmass: Contemporary Trends in WA Landscape Art*, touring exhibition 1990. She curated a number of exhibitions 1979–89 including for Festival of Perth; PICA and Undercroft Gallery, received print commissions from PCA and Praxis, and wrote a number of articles for art journals.
AWARDS: QEII Medical Centre Print Award, 1979, 85; grant, WA Arts Council, 1982; Dept for the Arts, 1987, 88; Commonwealth Postgrad. Award, 1983–84; Albany Art Award, 1988; City of Bunbury acquisition, 1989.
APPTS: Lecturer, printmaking and drawing, various tertiary colleges, largely WA, 1975– including Perth Tech. Coll.; WACAE; drawing co-ordinator, School of Visual Arts, Curtin Uni., 1991– .
REP: NGA; AGSA; AGWA; Fremantle Arts Centre; Artbank; a number of tertiary collections including Curtin, Edith Cowan, Griffith, WA unis; regional galleries including Bunbury; corporate and private collections including R&I Bank, Barclays Bank, Robert Holmes à Court.
BIB: Murray Mason, *Contemporary WA Painters and Printmakers*, Fremantle Arts Centre Press 1979. AL 11/3/1991.

TAYLOR, Howard

(b. 29/8/1918, Hamilton, Vic.) Painter, sculptor, graphic artist, teacher.
STUDIES: Perth Modern School, UK, 1930s; Birmingham Coll. of Art, UK, 1947–48. In World War II he was a POW at Stalag Luft III, 1940–45, and worked in the UK after the war before returning to WA. During the 1960s and 1970s sculpture was his major interest, and in the 1980s he produced a series of pastels and paintings. The abstract works are notable for their simplicity and powerful evocation of nature, drawn on from his everyday experiences of living in the remote south-west of WA. Exhibiting infrequently, his 1988 Galerie Düsseldorf exhibition (the first since a retrospective at the AGWA, 1985) was described by critic Ted Snell (*The Australian*, 15/6/1988) as meditative works, the result of a long and patient observation of natural phenomena. Taylor has focused on these experiences and in the slow methodical working methods for which he is known, he has made impeccably crafted and visually intoxicating paint-

ings.' His commissioned work includes murals for public buildings in Fremantle, and sculpture for company and school buildings in Perth. He held approximately 20 solo exhibitions 1949–90 largely in Perth (including Skinner, Düsseldorf galleries) and Sydney (Coventry Gallery) and a survey exhibition at the AGWA in 1985. Group exhibitions in which his work appeared included *Amongst the Souvenirs: Western Australian Art in the Eighties*, AGWA 1987; *The Great Australian Art Exhibition* Bicentennial exhibition 1988–89; *Australian Sculpture Triennial*, 1987; *Adelaide Biennale*, 1990; *A Backward Glance* (sculpture), PICA 1991.
AWARDS: WA Arts Council fellowship, 1975; VACB grant, 1978; Emeritus Award, VACB, 1986; Member, Order of Australia, 1989; fellow, Curtin Uni., 1991.
APPTS: Teaching, Perth Tech. Coll., 1951; later, part-time teaching, WAIT, –1970.
REP: NGA; AGNSW; AGWA; NGV; TMAG; Parliament House; VACB; regional galleries Bunbury, Wollongong; a number of tertiary collections including Uni. of WA, Curtin Uni.; a number of corporate collections including Christensen Fund, Robert Holmes à Court.
BIB: Catalogue essays exhibitions as above. Scarlett, AS. Chanin CAP.

TAYLOR, (Major) James

(b. c.1785; arr. Sydney 9/8/1817; d. 10/8/1829, Ballary, S. India) Army officer, topographical artist. Stationed with the 48th Regiment, Sydney, 1817–22, he visited Tas. with Macquarie in 1821, and after his return to England some of his topographical drawings were used by Robert Barker (a partner of Robert Burford, q.v.) to form a panorama of Sydney. The three connecting aquatints that make up his *Panoramic View of Sydney* were printed by Robert Havell and published by Colnaghi's, London, 1823. They reveal him as an accurate recorder of topographical and architectural detail. The plates for this survive in the collection of the Dixson Galleries, Mitchell Library. His work was represented in *The Great Australian Art Exhibition* Bicentennial exhibition 1988–89 and *The Artist and the Patron* AGNSW, 1988.
REP: Mitchell Library.
BIB: T. McCormick (ed.) *First Views of Australia 1788–1825*, Sydney 1988. Moore, SAA. Smith, PTT. Rienits, *Early Artists of Australia*, 1963. Kerr, DAA.

TAYLOR, James

(b. 1941, Melb.) Printmaker.
STUDIES: CIT, Melb.; RMIT, with Tate Adams and Udo Sellbach. He held exhibitions in Melbourne in 1970 and 1975, and from 1972 participated in international exhibitions including *Australian Prints*, Victoria and Albert Museum, London, 1972, New York 1973. Commissioned PCA patron print, 1972. Simple mechanical shapes, massed blacks and colourful accents are features of his intaglio etchings. He was artist-in-residence Darwin Community College, 1981.
AWARDS: Commissioned PCA patron print edition, 1972; grant, VACB, 1981.

REP: NGA; AGSA; NGV; regional galleries Newcastle, Hamilton.
BIB: PCA, *Directory* 1976, 88.
NFI

TAYLOR, James Edward

(Arr. Aust. 1840s) Rural worker, painter. Known for naive paintings. He settled at Maldon, Vic., where his grandfather built an inn, commemorated in Taylor's only known painting *Talbot's Half-way House, Muckleford*.
REP: Castlemaine Art Gallery and Historical Museum.
BIB: McCulloch, AAGR. Kerr, DAA.

TAYLOR, John H.

(b. 1921, Melb.) Painter, printmaker.
STUDIES: Footscray Tech. School, 1939 (studies interrupted during war service with the AIF); Melb. Tech. Coll., 1945–46; George Bell School (Saturday classes), 1948; Chelsea Polytechnic, London; travel studies, Europe, 1951–55.
AWARDS: Eltham prize for painting, 1968.
REP: NGV; Benalla Art Gallery.
BIB: PCA, *Directory* 1976, 88.
NFI

TAYLOR, Michael Franklin

(b. 15/10/1933, Sydney) Painter.
STUDIES: Dip. Painting, ESTC, 1953; travel studies, Asia, Europe, 1959–60, 1960–63; New York, India, Europe, 1974–75. His paintings are expressive of an ebullient, expressionistic spirit inspired by the natural phenomena that determines the colour, movement and general form of the work. He held 35 solo exhibitions 1964–90 in Sydney (including Macquarie, Watters, Coventry, Yuill/Crowley), Canberra (Solander) and Melbourne (Joseph Brown, 312 Lennox St, Flinders Lane), and participated in a number of group exhibitions including the *Biennale des Jeunes*, Paris, 1963; *Contemporary Australian Paintings*, Los Angeles, 1966; *Drawing in Australia*, NGA 1988; *Lété Australien à Montpellier*, France 1990; *Artists from Canberra and Districts in the Parliament House Collection*, 1992.
AWARDS: National Art Students Club Scholarship, 1951; NSW Travelling Scholarship, 1960; Creative Arts Fellowship, ANU, 1979.
REP: NGA; AGNSW; AGSA; AGWA; MAGNT; NGV; QAG; Parliament House; Artbank; a number of tertiary collections including Canberrra CAE, Uni. of WA, Monash, Macquarie unis.; regional galleries Newcastle, Shepparton; a number of corporate collections including BHP, Philip Morris, Western Mining.
BIB: Catalogue essays exhibitions as above and a number of texts on Australian art including Horton, PDA; Thomas, OAA 1989; McIntyre, CC; Germaine, AGA.

TAYLOR, Neil

(b. 18/2/1953, Qld.) Painter.
STUDIES: Dip. art teaching, Kelvin Grove CAE, 1972. His landscapes were described by Nadine Amadio (*This Australia*, 6/1/1986) as : '[a] fine balance of realism and mastery that evokes the purity and strength

of nature and invests his painting with a compelling freshness of vision.' He held 19 solo exhibitions 1976–92 in Sydney (Bonython; Robin Gibson; Bridge St 1992), Brisbane (Philip Bacon), Adelaide (Bonython), Newcastle (Cook's Hill), Canberra (Solander) and Melbourne (Editions). His work appeared in a number of group, mainly prize, exhibitions 1975–92 including *Wynne*, *Archibald* and *Sulman* prizes, AGNSW and in *Sea Exhibition*, Australian Pavilion Expo '75, Okinawa, 1975. His commissions include those for Hyatt Hotel, Adelaide, 1987; State Bank of SA, 1990.
APPTS: Secondary school teaching, Qld, 1973.
REP: NSW State Parliament; regional galleries Gold Coast, Wollongong.
BIB: Kym Bonython, *Lemonade and Ladies Legs*, Adelaide 1979. Bonython MAP 1980. Germaine, AGA. New Art Four.

TAYLOR, Peter

(b. 23/2/1927, NSW) Sculptor. He held seven solo exhibitions 1978–92 in Sydney (Watters 1978; Macquarie 1985, 86; Irving 1992), Melbourne (Standfield 1981) and Brisbane (Ray Hughes), and at Centre for the Arts, Uni. of Tasmania 1988. He received numerous (approximately 22 to 1992) commissions for sculptures, including the Coat of Arms for New Parliament House, Canberra 1985 and the Supreme Court, Hobart. His work appeared in approximately 25 group exhibitions 1975–92 at private galleries in Tasmania and many public sculpture shows including *Australian Sculpture Triennial*, 1981, 87; *Biennale of Sydney*, AGNSW 1984; *Australian Sculpture*, AGWA 1984; *Sculpture 3*, Penrith Regional Gallery 1987.
AWARDS: Tasmanian Centenary Sculpture Prize, 1953.
APPTS: Secondary teaching, Huonville, Tas., 1953–67, including establishing bronze casting foundry; lecturer in sculpture, TSA, 1967–90; tutor, individual students, TSA, 1990– ; member, Visual Arts/Craft Panel, Tasmanian Arts Advisory Board, 1992–
REP: NGV; AGNSW; AGSA; QAG; TMAG; Parliament House; regional galleries Newcastle, Wollongong; State Bank, Sydney; IBM and other corporate collections.
BIB: Catalogue essays exhibitions as above. Scarlett, AS. A&A 18/3/1981.

TAYLOR, R. A.

(Active c.1880, Melb.) Painter. He exhibited three watercolours of the Botanical Gardens at the Victorian Academy of the Arts in 1882.
NFI

TAYLOR, Rodney John

(b. 23/5/1944, Essex) Painter.
STUDIES: Advanced Dip. Ed., SASA; postgrad. studies, St Martin's, London. He held three solo exhibitions 1981–92 at Anima Gallery, Adelaide 1985, 88 and Contemporary Art Space, Adelaide 1981, and participated in group exhibitions 1985–92 including *Contemporary Art Survey Show*, AGSA 1988; *The Nude Show*, Travelling Arts Programme, AGSA 1991; *This Mortal Flesh*, Festival Exhibitions, Adelaide Town Hall 1992.

AWARDS: Robin Hood Painting Prize, 1975.
APPTS: Secondary teaching, SA; lecturer, Salisbury CAE, Adelaide Central School of Art, SASA.
REP: AGSA.

TAYLOR, *Stephanie*

(b. Williamstown, Vic.) Painter, lecturer.
STUDIES: NGV, c.1917. A painter of small, impressionistic landscapes, she gave guided lectures at the NGV, 1940–50, radio talks, and was a director of Tye's Gallery, Melbourne, c.1945–50. Member of the VAS and Melbourne Society of Women Painters and Sculptors (until c.1972). Her collection of drawings by C. D. Richardson was sold at Leonard Joel's auctions, Nov. 1973.
REP: Vic. Parliament House collections.
BIB: Moore, SAA.

TAYLOR, *Terry*

(b. 25/1/1958, Vic.) Painter.
STUDIES: Dip. Art & Design, Prahran CAE, 1979; Postgrad. Dip. (painting), VCA, 1986. He held four solo exhibitions in Melbourne 1985–91 (Arden St, 1985; City Gallery, 1988, 89, 91) and participated in about 16 group exhibitions 1979–91, largely award exhibitions including Diamond Valley Art Award, 1985; MPAC Spring Festival of Prints and Drawings, Mornington 1985 and in *Postgrad. Show*, Melbourne Uni. and VCA galleries 1986; Artbank's *Big Paintings*, Ivan Dougherty Gallery, Sydney 1987; *19th and 20th Century Portraiture*, Monash Uni. Gallery 1990.
AWARDS: Eric Westbrook Drawing Prize, 1985; St Kilda Arts Festival Drawing Prize, 1986; NGV Acquisition Prize, 1986.
APPTS: Tutor, life drawing, RMIT, VCA, 1988–89; tutor, painting, RMIT, 1990; teaching and co-ordinator, painting, RMIT, 1991; MA supervisor, Fine Art, Deakin Uni., 1991.
REP: NGA; NGV; Artbank; Monash Uni; St Kilda Council.
BIB: A&A 23/4/1986.

TAYLOR, *Vicky*

(b. 10/11/1946, SA) Printmaker.
STUDIES: Dip. Art Teaching, SASA, 1967; studies in printmaking, Atelier de la Main d'Or, Paris, 1977–80. Taylor's colourful prints and drawings of interiors and objects are in the French decorative art tradition and were seen in four solo exhibitions 1983–90 in Melbourne (Jester Printroom; Wiregrass), Castlemaine and Swan Hill Regional Gallery of Contemporary Art 1990, and about 13 group exhibitions, largely in private galleries including Wiregrass, Melbourne; Alpha Hall, Daylesford; Tynte Gallery, Adelaide; Bridge St, Sydney and in *9 × 5*, Castlemaine Art Gallery 1988; Fremantle Print Award, exhibitions 1985, 87–91 and MPAC Spring Festival of Prints and Drawings, Mornington 1986.
AWARDS: Swan Hill Acquisitive Print Award, 1989.
APPTS: Secondary teaching, SA and Vic., 1967–76; tutor, printmaking, Melb. CAE, 1981–83; co-director,

Wahroonga Print Workshop and Studio, Fitzroy, Vic., 1983–84.
REP: Regional galleries Bendigo, Swan Hill; State Library of Victoria; Education Dept of Vic.; Box Hill municipal collection.
BIB: PCA, *Directory*, 1982, 88. Germaine, AGA Germaine, DAWA.

TAYLOR-KELLOCH, *David*

Stained glass designer, teacher. Head of the art dept, Hobart Tech. Coll., 1939–41. He designed the chapel window for Scotch Coll., Melbourne.
NFI

TEAGUE, *Violet Helen Evangeline*

(b. 21/2/1872, Melb.; d. 1951) Painter.
STUDIES: Blanc Garin, Brussels, c.1893–96; Herkomer's School, Bushey, Herts., UK, 1896–97; NGV School, 1897–1900, Melbourne School, with E. Phillips Fox and T. St G. Tucker. Daughter of Dr James P. Teague, her stepmother Sybella took her and her half-sister and brother on a tour of Europe in 1890s, following which it was arranged she remain in Brussels to study painting. She remained in Europe and England until 1896 when she returned to Melbourne. She became well-known as a portrait painter and in 1920 her *Boy with Palette* (a portrait of Theo Scharf (q.v.) as a youthful prodigy) was hung at the Paris Salon (where it won her a silver medal) and the following year at the RA, London. She also decorated several churches in Victoria and made an altar piece for the Cathedral of the Arctic, Aklavik, NW Canada. In 1935 she travelled to Sweden on the sailing ship *C. B. Pedersen*, making many studies and sketches during the voyage. She retired to the family's home at Mt Eliza, Vic. where she painted the environs. She was represented in *Completing the Picture* Heide and touring 1992 and *A Century of Australian Women Artists 1840s–1940s* Deutscher Fine Art, Melbourne, 1993.
AWARDS: Gold medal, Jubilee Exhibition, Bendigo, 1901; bronze medal, Panama Exhibition, San Francisco, 1915; silver medal, Paris Salon, 1920.
REP: NGA; NGV; regional galleries Ballarat, Castlemaine.
BIB: Catalogue essays exhibitions as above. Moore, SAA. John Kroeger, *Australian Artists*, Renniks, Adelaide, 1968. Janine Burke, *Australian Women Artists 1840–1940* Greenhouse, 1981.

TEASDALE, *Noel*

(b. 1/6/1941, Vic.) Painter, lecturer.
STUDIES: Dip. Art and Design, Bendigo Inst. of Technology; Grad. Dip. Visual Art, Gippsland Inst. of Technology; travel studies, Europe, 1974, 75 and USA, 1981. He held nine solo exhibitions 1973–92 in Canberra (Solander), Sydney (Holdsworth) and Melbourne (David Ellis), and in Sale Regional Gallery 1973, Shepparton City Gallery 1977. Group exhibitions in which his work appeared 1969–92 include Bendigo Art Gallery 1969; Latrobe Valley Arts Centre 1978; touring exhibition co-ordinated VACB, regional galleries Vic. and to SA EAF, 1980.

APPTS: Secondary teaching, Vic., 1960–66; Teacher education, 1967–81; lecturer, Chisholm Inst., 1983–89; senior lecturer, painting and drawing, Dept Fine Art, Monash Uni., 1990– .
REP: Monash, La Trobe unis.; Bendigo CAE; Shepparton regional gallery; BHP corporate collection.

TEBBITT, Henri
(b. 1852, Paris; arr. Aust. 1889; d. 1926) Painter.
STUDIES: No formal training; extensive travel studies on the European continent. Of British parentage, though born in France, he was exiled from France for having taken part in the Communard disorders of 1871. He painted in other European countries and in the UK, where he exhibited at the RA, Royal Society of British Artists and Royal Inst. of Painters in Watercolour, before moving to Australia. His honestly expressed ambition was to paint popular pictures, an aim that appealed to the public in Australia where his many paintings of river subjects at sunset and the like became very popular.
REP: QAG; TMAG; regional galleries Bendigo, Geelong, Launceston; Christchurch Gallery, NZ.
BIB: Unpublished autobiographical manuscript, Mitchell Library, Sydney. Moore, SAA.

TECHNOLOGY & ART
In 1967 Marshall McLuhan declared society to be shaped much more by the nature of its communicating media than by the content of its communications. 'The medium, or process, of our time – electronic technology – is reshaping and restructuring patterns of social interdependence and every aspect of our personal life,' he said. 'It is forcing us to re-consider and re-evaluate practically every thought, every action and every institution formerly taken for granted.' Prophetic words belatedly acknowledged, as the use of technology in art has in the 1990s achieved widespread acceptance for the first time.

Australian modernists fascinated by mechanics such as those incorporated by Marcel Duchamp from 1917 have included painters Edwin Tanner and Mike Brown and sculptors Robert Klippel and Clifford Last. In the late 1950s Adelaide's Stanislaw Ostoja-Kotkowski and Dusan Marek experimented with technological effects for film-making and lighting shows and sparked a 1960 interest in 'Kinetic art' or art that required mechanisation to make it move. This was closely associated with the fad for 'Op art'. The activities of Americans John Cage, Les Levine and Robert Rauschenberg who encouraged 'chance' affects in their 'Happenings' affected some Australian artists as did the work of the German/American group 'Fluxus'.

In the 1970s photography, super 8 film loops, black and white closed circuit TV, colour slide and sound projection, photocopying, lasers and other technologically-controlled sources of image-making were used as adjuncts to performance and installation arts. Those basing their art on technology in the 1970s included Stelarc (whose body 'suspensions' developed into robotic manipulations of body parts), photocopied books by Ian Burn and Mike Parr, Bill Fontana's and Ros Bandt's sound sculptures and experimental films by Paul Winkler, Dusan Marek and James Clayden.

The 1984 Adelaide Festival's *Art and Technology Week* with the exhibition *Interface: A Survey of Art and Technology* focused on new developments – reported and updated in every subsequent issue of *Artlink* (the best source of information about such technology – other important sources being *Photofile* and *Art and Text*). The developments complemented the Commission for the Future's interest in linking art and technology.

By 1986–87 the establishment of Sydney's annual *Australian Video Festival* vindicated video's struggle for separate critical recognition. Major figures in video art have included Peter Calla, Tracey Moffat, Francesca da Rimini, Simon Penny, Jill Scott, Ross Harley, Susan Charlton and David Perry.

In the 1988 *Biennale of Sydney* director Rene Block explored the elliptical processes which cause ideas in art to be recycled and reassessed. Instrumental to the growing acceptance of technology-based arts have been organisations like Melbourne *Modern Image Makers Association* which from 1988 has organised *Experimenta*, a national biennial event for experimental time-based media arts.

In the 1990s technology-based arts which include video, computer, film, performance, digital recording, installation, sculpture, music, dance, documentation and drama involve not only artists but art-interested specialists from television, cinema, theatre, architecture and design. Artists working in these areas as well as those previously mentioned include Stephen Ball, Virginia Barratt, Joan Brassil, Warren Burt, Fiona MacDonald, Luke Roberts, Jude Walker, Dianne Mantzaris, Joyce Hinterding, Linda Sproull and Chris Windmill.
J. ZIMMER

TEMPSKY, Gustavus Ferdinand
See VON TEMPSKY, Gustavus Ferdinand

TERRY, Frederick Casemero
(b. 1827, Herts., UK; arr. Sydney 1852; d. 1869, Sydney) Painter. Watercolours by him were included in the first exhibition of Australian art shown in Paris, 1855 (*see* EXHIBITIONS – INTERNATIONAL AND INTER-COLONIAL), the year in which his painting of the La Pérouse monument, Sydney, was presented to the French government by the government of NSW. An exhibitor with the Society for the Promotion of Fine Arts, Sydney, 1857, Terry was an admirer of the work of Conrad Martens and an early examiner at the Sydney Mechanics School of Art. About 40 of his paintings were engraved for his splendid volume, *Landscape Scenery, Illustrating Sydney, Paramatta, Richmond, Maitland, Windsor and Port Jackson*, more succinctly known as *The Australian Keepsake*, but unfortunately 'the name of Mr F. C. Terry who has so ably portrayed the romantic beauty of the unrivalled Harbour of Port Jackson, has been misspelt throughout' (as Fleury). About 1860 he published a much slimmer volume of six lithographed views of the Parramatta River. He exhibited in the Paris *Universal Exhibition* in 1867 and was

appointed drawing master at Sydney Mechanics School of Arts but was unable to take up the position due to ill health. He died two years later in poverty, owing his landlord some £63 in rent. He was represented in *The Artist and the Patron*, AGNSW, 1988.

REP: AGNSW; AGSA; NLA; Mitchell Library; Sydney Uni.
BIB: Moore, *SAA*. Ferguson, *Bibliography of Australia*, vol. 7, NLA, Canberra, 1969. McCulloch, *AAGR*. *ADB* 6. M. Mahood, *The Loaded Line*, Melbourne, 1973. Kerr, *DAA*. *A&A* 25/4/1988.

TESCHENDORFF, John
Ceramicist, sculptor.
STUDIES: Cert. of Art CIT; Dip. Art, RMIT; Grad. Certificate, RCA, London. A leading ceramicist and lecturer, his work has been seen in 10 solo exhibitions 1974–92 including at Gryphon Gallery, Melbourne; Fremantle Arts Centre and numerous group exhibitions of ceramics and sculpture including *Impulse and Form* AGWA 1985; *Clay '86* touring Tasmania 1986; *Ceramics from the 1st International Symposium* NGV 1988; *Festival of Perth Exhibition* Fremantle Arts Centre, 1991.

THACKERAY, Ron
Painter.
STUDIES: NGV School; George Bell School. Regular contributions to Melbourne Contemporary Artists' annual group exhibitions showed Thackeray as an able draughtsman and designer.
NFI

Eric Thake, An Opera House in Every Home, *1972, linocut, 14 × 21.2cm. Joels, August 1992.*

THAKE, Eric Prentice Anchor
(b. 8/6/1904, Auburn, Vic.; d. 3/11/1982) Graphic artist, designer, painter.
STUDIES: NGV School, 1921; George Bell School, 1925–28. Apprenticed to a process engraving firm in 1918, he developed his interest in printmaking and graphic design, and these remained his most constant forms of expression. From 1926–56 he worked in advertising, enlisted in the RAAF in 1943, worked as a medical draughtsman and was commissioned to do the backdrops for the Aboriginal display cases in the National Museum of Vic. He held his first exhibition at Georges Gallery, Melbourne, 1947. By 1960 his work included designs for stamps for Australia Post, cover designs for *Meanjin*, and a large number of linocuts and bookplates. He had also become Australia's first painter of surrealist pictures, many painted during his service with the RAAF. His permanent place as a local master of graphic design is the logical outcome of an attitude that never wavered in its allegiances. He began exhibiting in 1927, showing with the Contemporary Group, Melbourne, 1932–38, with the CAS from 1938, and at the VAS in company with his lifelong friend, Len Annois. A retrospective of his work was held at the NGV in 1970, an exhibition titled *Pubs and Bars* at Geelong Art Gallery, and he was represented in *The Great Australian Art Exhibition* 1988–89 and *Classical Modernism: The George Bell Circle*, NGV 1992.

AWARDS: Hon. mention, *Los Angeles Bookplate Exhibition*, USA, 1931; CAS prize (shared with James Gleeson), 1941; Geelong prize, 1947; Yorick Club prize, 1956; Cato prize, VAS, 1957.
APPTS: Official war artist with the RAAF, 1944–45; medical draughtsman, Visual Aids Uni. of Melbourne, 1956.
REP: NGA; AGNSW; AGSA; AGWA; NGV; QAG; TMAG; AWM; regional galleries Ballarat, Castlemaine, Geelong, Mornington, Newcastle.
BIB: Catalogue essays exhibitions as above. R. H. Croll, *The Bookplates of Eric Thake*, Hawthorn Press, Melbourne, 1942. Elizabeth Summons intro., *The Eric Thake Picture Book*, Gryphon Books, Melbourne, 1978. *A&A* 21/1/1983.

THEATRE ART (Décor and Costume Design)
Although it is recorded by Viola W. Tait that the first Melbourne theatre, *The Pavilion*, was built in 1841 by a Mr Jamieson, next to his Eagle Tavern in Bourke Street, the first designs for theatre in Australia were probably made at Ballarat and Bendigo by goldfields artists such as George Fawcett Rowe (q.v.). Certainly the Victorian gold rush provided the first great impetus for the building of theatres. Australia's greatest early entrepreneur, George Coppin, went from the goldfields to make his headquarters at the successor to *The Pavilion*, the *Queen's Theatre Royal*, in Queen Street. Coppin went on to build the infamous *Iron Pot*, a structure prefabricated in Manchester entirely of iron. The first professional designer for theatre in Australia was probably William R. Barnes (b. Geelong, 1851). Barnes made the designs for the 'extravaganza' *Djin Djin*, 1891, and later became celebrated in New York as a designer of postcards. However, most early designs for theatre were imported along with the productions and performers, one of the best-known designers being Wilhelm (William John Charles Pitcher, R.I.), whose sets and costumes were frequently seen in Australian theatres c.1898–1912. It may be noted, however, that besides Coppin's successful productions, the longest running musical of its era, *Chu Chin Chow*, was written by Oscar Asche (b. Geelong, 1872), and

that its London success was repeated in Australia when Asche returned with it in 1921. Modern Australian theatre design may be said to have started with the work of Loudon Sainthill in the mid-1930s. Sainthill broke the practice of looking to London for theatre design talent. Shy and inhibited, he spoke with a severe stammer but held exhibitions in which he expressed himself brilliantly in designs for theatre décor. He worked for the Colonel de Basil Ballet and when the company left Australia for the UK in 1939, he went with it. His work and career became a prototype on which many later designers were to model successful careers. By the 1980s a whole school of Australian designers for theatre had achieved distinction overseas and within Australia. The following alphabetical listing is by no means complete: Ann Church, Hugh Colman, Desmond Digby, Ann Frazer, Barry Kay, Reg Livermore, Robin Lovejoy, Florence Martin, Kenneth Rowell, John Truscott, Timothy Walton. In addition to these specialist designers, many well-known Australian painters have designed for theatre, among them: Arthur Boyd, John Brack, Charles Blackman, Elaine Haxton, Donald Laycock, Louis Kahan, Sidney Nolan, William Kelly.

THOMAS, A. V.

(b. 1860, UK; arr. Qld 1878) Painter, cartoonist. Apprenticed to a publishing firm in London, he joined the Lands Dept as a draughtsman in Brisbane and designed the first cover for *Queensland Punch* (Oct. 1878). A keen rider, he became known for his drawings of horses.
BIB: Moore, *SAA*.

THOMAS, Barry

(b. 1943, Sydney) Painter, printmaker, teacher.
STUDIES: Sydney, with Arthur Murch (as studio assistant), 1960; travel studies, USA, UK, Europe, 1978–79. He held his first exhibition in 1972 at Ray Hughes Gallery and his work appeared in group exhibitions including at Blaxland Gallery, Sydney; Warrnambool regional gallery.
AWARDS: VACB travel grant, 1974; prizes in competitions at Berrima, 1974; Lismore, 1974; Maitland, 1976; residency, VACB studio, New York, 1978; residency, Cité Internationale des Arts, Paris, Power Inst., 1979.
APPTS: Laboratory assistant, then assistant to Curator, Power Inst., Sydney Uni., 1966–71; lecturer (part-time), NAS, 1969–74; lecturer, Alexander Mackie CAE, 1974.
BIB: Germaine, *AGA*.
NFI

THOMAS, Bronwyn J. D. (née YEATES)

(b. 1932, Melb.) Painter, gallery director.
STUDIES: Sydney, with Justin O'Brien and Stanislaus Rapotec; Brisbane, with Jon Molvig; travel studies, UK, Europe, USA, SE Asia, 1959–71, South America, 1978. As Bronwyn Yeates, she exhibited paintings in Brisbane, Sydney, Canberra and Melbourne, and married Laurie Thomas (q.v.) in Feb. 1971.
APPTS: Teaching, senior lecturer, dept of architecture, Uni. of Qld; director, Bonython Gallery, Sydney, 1971–74; director, Australian Centre for Photography, 1974–78; executive director, touring exhibition *El Dorado: Colombian Gold*, 1978.
REP: Qld Uni. collections.
NFI

THOMAS, Daniel Rhys

(b. 1931, Latrobe, Tas.) Gallery director, art writer, critic.
STUDIES: Geelong Grammar School, Vic. (art with Hirschfeld Mack); Oxford Uni., grad. BA, 1956. Organisations on which he has served include National Trust of Australia, International Association of Art Critics (Australian Division), Art Galleries Association of Australia (president, 1978). He became well-known as the director of the Art Gallery of SA and since his retirement from that position has written extensively for art magazines, catalogues and books, and 1979–82 compiled an *Authority List of Australian Artists' Names*, for the AGDC Computer Cataloguing Project. His books include *Sali Herman*, Georgian House, Melbourne, 1962; *Sali Herman*, Collins, Sydney, 1971; *Outlines of Australian Art*, Joseph Brown collection, Macmillan, Melbourne, 1974, 81, 89.
APPTS: Professional asst. then curator, finally curator of Australian art, AGNSW, 1958–78; art critic, *Sunday Telegraph* 1962–66 and 1968–69, *Sydney Morning Herald* 1970–75, *Bulletin* 1976–77; commissioner, Australian pavilion, *Venice Biennale*, 1978; curator, Australian Art, NGA, 1978–91; emeritus director AGSA 1991– .

THOMAS, David

(b. 22/8/1951, Belfast, Northern Ireland; arr. Aust. 1958) Painter, printmaker.
STUDIES: Dip. Teaching, Melb. State Coll.; Grad. Dip. Visual Art (painting), Gippsland Inst. of Advanced Education; travel studies/work, UK, Europe, 1975–76. He held six solo exhibitions 1982–91 in Melbourne (Powell St; Tony Oliver; Tolarno), in which his work moved from contemporary realist to abstract. He participated in approximately 15 group exhibitions 1981–91 including *Spring Festival of Prints and Drawing*, MPAC, Mornington 1981, 87; *Young Australians*, Ansett Collection, Budget Transport Industries, NGV and touring state regional galleries 1987; *100 × 100 Print Exhibition*, PCA 1988. His commissions include those for Trinity College, Melbourne, 1984; Cripps Family Collection painting series, England, 1987–88.
AWARDS: Residency, Fondation de France studio, Cité Internationale des Arts, Paris, 1991–92.
APPTS: Secondary teaching, 1972–75; tutor, CAE, Melbourne, 1980–87; lecturer, Faculty of Visual and Performing Arts, Inst. of Education, Uni. of Melbourne, 1987–88; lecturer, RMIT, 1989–91; guest lecturer, various art schools (RMIT, Vic. Coll.), 1988–92; Chelsea

Coll. and Wimbledon School of Art, London, 1991; Parsons School of Art and Design, Paris, 1991.

REP: Artbank; PCA; Aust. Print Workshop; Mornington regional gallery; CAE; Ansett, Western Mining, Lefebvre and Baillieu Myer corporate collections.

BIB: Catalogue essays exhibitions as above. Germaine, AGA.

THOMAS, David (David Emlyn Liddon)

(b. 23/9/1937, Ballarat) Gallery director.

STUDIES: Uni. of Melbourne, 1958–61 (grad. BA). Organisations on which he has served include the Art Galleries Association of Australia, from 1968, Museums and Libraries Committee of the Australian National Advisory Committee to UNESCO, 1972; chairman, Regional Galleries Association of NSW, 1972–74; member, VACB, 1973–76; chairman, AGDC, 1979–81; chair, Vic. Centre for the Conservation of Cultural Material, 1990–91. His writings include contributions to the *Australian Dictionary of Biography*, a monograph on Rupert Bunny (*Rupert Bunny*, Lansdowne, Melbourne, 1970), and many articles and essays for art journals including A&A.

AWARDS: Travel grant, Art Galleries Association of Australia, 1973.

APPTS: Keeper of Pictorial Collections, NLA, 1963–65; director, Newcastle City Art Gallery, 1965–76; executive officer Aust. Gallery Directors Conference 1975–76; director, AGSA, 1976–83; founding director, Carrick Hill, 1983–87; director, Bendigo Art Gallery, 1987– .

THOMAS, Edmund

(b. 1827, Cheltenham, UK; arr. Vic. 1850; d. 1867, Sydney) Topographical artist. Working as a professional artist in Melbourne, he exhibited in the Victorian Fine Art Society's exhibitions and made a number of well-known views of Melbourne which were lithographed and published (*Victorian Views* Varley, Melbourne, 1854) He moved to Sydney c.1860, where he succeeded Joseph Fowles as instructor in drawing at the Sydney Mechanics School of Art (c.1860–67). He seems likely to be the C. Thomas referred to in catalogues as the painter of a watercolour view of Sydney and a fine watercolour, *Waterhole with Two Black Swans*. He also produced lithographed portraits. His work was seen in exhibitions including Joseph Brown Gallery, Melbourne, Spring 1971; *Australian Paintings*, Christie's, Sydney, Nov. 1975; *Australian Photography 1880–1930*, Joseph Lebovic Gallery, Sydney 1983; *The Artist and the Patron*, AGNSW 1988.

REP: NGV; TMAG; regional galleries Ballarat, Geelong; NLA; Mitchell, Dixson, La Trobe Libraries; Uni. of Melbourne; Sydney Uni.

BIB: Catalogue essays exhibitions as above. Moore, SAA. McCulloch, AAGR. Kerr, DAA.

THOMAS, Emily

(Active c.1870–1905) Painter. She is first recorded as exhibiting flower paintings at the Victorian Academy of Arts, 1873–84; from 1890–1902 she showed portraits and genre with the VAS.

THOMAS, George H.

(Active, 1856–65, Vic.) Caricaturist, illustrator. He became well-known in Castlemaine for his drawings depicting local incidents and identities, many connected with the law courts. His work enjoyed a brief period of popularity following litigation caused when one of his subjects entered a shop and tore up a Thomas caricature displayed in the window. Later Thomas fell victim to strong drink and was arrested for vagrancy in Daylesford, 1865, after which he disappeared from the scene.

REP: Castlemaine Art Gallery (large collection).

BIB: McCulloch, AAGR. M. Mahood, *The Loaded Line*, Melbourne 1973. Kerr, DAA.

THOMAS, Grosvenor

(b. 1856, Sydney; d. 1923, London) Painter. No details of his early career are known. He exhibited with the Royal Watercolour Society, c.1892, the RA, London, c.1900, and with the Royal Scottish Society of Painters in Watercolours. A seascape in oils exhibited by Joseph Brown, Melbourne, Spring exhibition 1976, showed Thomas as an accomplished, impressionistic painter in this genre.

BIB: Bénézit, *Dictionnaire*. A. Graves, *Dictionary of Artists*, Kingsmead, Bath, 1973.

THOMAS, J. A.

Topographical artist. Three watercolours of Glenelg and Holdfast Bay from the collection of Sir William Jervois, a former Governor of SA, were sold by Christie's, London, 17 May 1974 (illustrated in catalogue).

NFI

THOMAS, Laurie (Laurence Nicholas Barrett)

(b. 1915, Melb.; d. 1974, Sydney) Critic, gallery director, journalist, editor.

STUDIES: Uni. of Melb., –1939. During World War II he served in the RAN, mainly at Darwin, and afterwards researched the life and work of Ian Fairweather and organised for the NGV the *Jubilee Exhibition of Australian Art* (1951), in which he took the unprecedented step of including Aboriginal bark paintings. He revitalised the AGWA, where he established the nucleus of a fine collection of contemporary Australian art under very difficult conditions, and in 1954 founded the annual Perth Art Prize. From 1956 he was a leader writer on a Sydney newspaper before becoming director of the QAG in succession to Robert Haines. He began to appear regularly on the ABC TV program *The Critics* in 1961 and three years later conducted a successful series of programs on contemporary Australian painters. As feature writer and arts editor of the *Australian*, his perceptive and sympathetic reviews were interspersed with hard-hitting criticism of things he considered harmful to art. He was never willing to compromise in matters of conscience, and it was this that led to his resignation from two state galleries. As Elizabeth Riddell wrote in an appreciation, he was 'a man somehow bigger than his achievement,

a personality who overbore his diverse occupations'. His catalogue essays and books were *Jubilee Exhibition of Australian Art* (introduction to catalogue) Ure Smith, Sydney, 1951; *Modern Australian Painting and Sculpture* (introduction), Kim Bonython, Adelaide, 1960; *Arthur Boyd Drawings 1934–70* (editor and introduction) Secker & Warburg, London, 1973.

APPTS: Art critic, *Herald*, Melbourne, 1949–50; assistant director, NGV, 1950–52; director, AGWA, 1952–56; director, QAG, 1961–67; arts editor and feature writer, *Australian*, 1968–74.

BIB: A&A 12/2/1974 (Elizabeth Riddell, *Laurie Thomas an Appreciation*); A&A 12/2/1974 (Barbara Blackman, *Epitaph for Laurie*). *The most noble art of them all: the selected writings of Laurie Thomas*, UQP, 1976.

THOMAS, Margaret

(b. 1843, Croydon, Surrey, UK; arr. Vic. 1852; d. 1929) Painter, sculptor, writer.

STUDIES: Melbourne, with Charles Summers, c.1861; South Kensington Coll. of Art, London, 1867; Rome (?with Summers), 1868–70; RA Schools, London, c.1871–73. The daughter of a ship-owner, her career in art seems to have been inextricably linked with that of Charles Summers, from the time of her first studies with him in Melbourne, to the publication of her book in his memory, *A Hero of the Workshop* (1879). She exhibited paintings and one sculpture at the one and only exhibition of the Victorian Society of Fine Art, 1857, in which Summers was also an exhibitor, as well as in the 1866 Melbourne *Intercolonial Exhibition*. Like Summers, she left Australia for ever in 1867. Apart from her studies in London and Rome, she embarked on a career as a portraitist in painting as well as sculpture and by 1893 had shown 11 portraits at the RA. Noel Hutchison has written that her work is 'strong and vigorous rather than sensitive, in the modelling of a subject's features'. In her own writing, however, she seems to stress the need for sensitivity. After the publication of her first book in 1873, she became more involved with writing books, including *Friendship*, book of poems, 1873; *A Hero of the Workshop*, 1879; *Denmark Past and Present*, 1902; *How to Judge Pictures*, 1906; *A Painter's Pastime* (poems), 1908; *How to Understand Sculpture, 1911; Friendship, Poems in Memoriam*, 1927. She also illustrated *A Scamper through Spain and Tangiers*, 1892; *Two Years in Palestine and Syria*, 1899; John Kelman, *From Damascus to Palmyra*, 1908. All these were published in London and it is of interest to note that, in 1911, she gave strong support in her writings to the new, emerging art movements in France and Italy (quoted by Ken Scarlett). Her work was seen in *Australian Art in the 1870s*, AGNSW 1976.

AWARDS: Silver medal for modelling, RA Schools, London, 1872.

REP: State Library of Vic.; National Portrait Gallery, London.

BIB: D. B. W. Sladen, *Australian Poets 1788–1888*, London, 1888. Moore, SAA. Sturgeon, DAS. Scarlett, AS. ADB 6. Kerr, DAA.

THOMAS, (Dr) Morgan

(b. 1824; d. 1903) Surgeon, art patron. South Australian surgeon and patron of the arts, he bequeathed £65,000 to the Public Library, Museum and National Gallery of South Australia, one-fourth of the bequest to be used for purchases of works of art.

THOMAS, Rover

(b. c.1926, Kuka-banyu (Well 33 on the Canning Stock Route), Central Desert, WA) Contemporary Aboriginal painter of the Joolama group he lives at Turkey Creek, WA. Thomas travels extensively in the country between the desert and Turkey Creek and paints dreamings from all these places. Using only ochres, he developed a colour-field style in which large areas of the canvas are outlined and taken up by a single colour, quite different to that of the 'dot' painting style of Central Desert artists. He was one of three artists representing Australia in the 1990 *Venice Biennale* and his work was seen in 12 group exhibitions 1987–92 including *Innovative Aboriginal Art of Western Australia*, Uni. of WA, Perth, 1988; *The Great Australian Art Exhibition*, 1988–89; *Adelaide Biennale*, AGSA, 1990; *Balance*, QAG, 1990.

REP: NGA; NGV; AGWA; AGSA; Anthropology Museum, Perth; Robert Holmes à Court Collection.

BIB: Catalogue essays in above exhibitions. Caruana, *Windows of the Dreaming*, NGA & Ellsyd Press, Sydney, 1989. Caruana, AA. *Tension*, 17/8/1989, pp. 43–45. A&A 31/1/1993.

THOMAS, William Rodolph

(b. 1822, Calcutta, India; arr. SA c.1848; d. 1880) Sketcher, painter. A member of the RSASA (q.v.) and curator of the Society's exhibitions, 1865, he was a competent watercolourist and a number of his works are in private collections in SA. He received a number of commissions for watercolours of pastoralists' properties and one of his major works is of a corroboree (collection AGSA).

AWARDS: Three prizes for watercolour, RSASA, 1864.

REP: AGSA; National Maritime Museum, Greenwich, UK.

BIB: Kerr, DAA.

THOMPSON, Francis Roy

(b. 1896, Mansfield, Vic.; d. 1966, Adelaide) Painter, teacher.

STUDIES: NGV School; Westminster School of Art, London. He exhibited at the VAS, Melbourne, and taught art at Scotch Coll., Hawthorn, Vic., 1943–53, before moving to South Australia where he became a prominent member of contemporary art groups, including the CAS, Adelaide. His painting is vigorous and expressionistic in style, and though somewhat mannered in its brushwork, remains in tune with the atmosphere of the landscape and architecture it usually portrays.

AWARDS: Hugh Ramsay Prize for portrait painting, NGV, c.1922; Crouch prize, Ballarat, 1943.

REP: AGSA; NGV; TMAG; regional galleries Ballarat, Bendigo, Launceston.

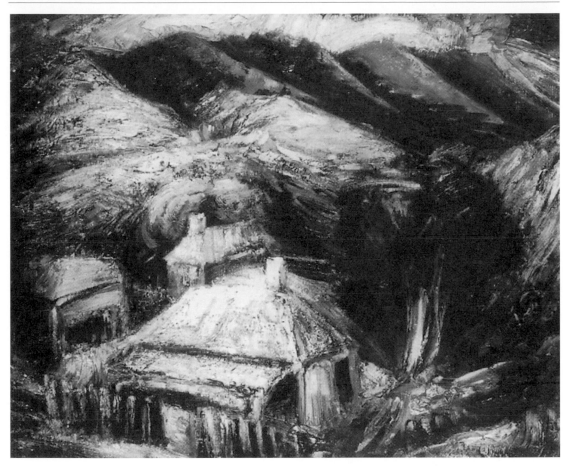

Francis Roy Thompson, In the Adelaide Hills, *oil on canvas, 60 × 70cm. Joels November 1992*

BIB: *Catalogue of Australian Paintings and Drawings in the Tasmanian Art Gallery*, Hobart, 1956.

THOMPSON, John

(b. 1800, Eng.; arr. Aust. 1827; d. 1861, Sydney) Sketcher, surveyor. Appointed principal draughtsman to the NSW Surveyor-General's Dept, he produced an album of views of the countryside as seen on surveying expeditions.
REP: Dixson Library.
BIB: Kerr, DAA.

THOMPSON, Mark

(b. 1949, Darwin) Painter, ceramic sculptor, teacher.
STUDIES: SASA and Torrens CAE, Adelaide, 1968; NAS, 1969; SASA, 1972; Torrens CAE, 1973–76. From 1973 his ceramic sculptures appeared in solo and group exhibitions, largely at craft venues such as the Jam Factory, Adelaide and in *Australian Sculpture Triennial*, 1984.
AWARDS: Awards in competitions at the AGSA (Young Artists), 1974; Adelaide Festival (Mad Hatter's Tea Party), 1976.
APPTS: Teaching, Prince Alfred Coll., 1972–78; lecturer, industrial ceramics, Torrens CAE, 1977; gallery director, Jam Factory, Adelaide, 1978.

REP: NGA; AGSA; AGWA; MAGNT; New England Uni., Armidale, NSW; WAIT collections, Perth.
BIB: R. Rowe, *Modern Australian Sculpture*, Rigby, Adelaide, 1977. Germaine, AGA.

THOMPSON, Max (Maxwell Robert Eric)

(b. 31/3/1939, St Arnaud, Vic.) Painter, teacher.
STUDIES: RMIT, 1964–67 and 1970–72 (Fellowship Dip., 1972). He taught at CIT, Melbourne, 1970–74, and held exhibitions at the Stuart Gerstman Galleries in 1973, 74, 78, and at the Macquarie Galleries, Sydney, 1975. He is primarily a painter of domestic still-life, given a highly personal character through the careful placement and relationship of objects in space and a palette restricted usually to brown, white, black and grey. His work appeared in *John McCaughey Memorial Art Prize*, NGV, 1975, 79; *Ten Caulfield Painters*, Monash Uni. Gallery, 1975 and solo exhibitions at Stuart Gerstman Gallery, Melbourne 1974, 75, 76, 77.
AWARDS: Georges Invitation Art Prize (drawing purchased), 1974.
REP: VACB; Latrobe Valley Arts Centre; Philip Morris collection.

THOMPSON, Tom (Thomas Alexander)

(b. 16/11/1923, Narrabri, NSW) Painter, teacher.
STUDIES: ESTC, 1947–50; travel studies, UK and Europe,

1951–52. Influenced by Italian renaissance painting, he painted a number of large murals, his commissioned works included murals for the International Air Terminal at Mascot, NSW, and panels in tempera for Australia House, London. His work was included in the Tate Gallery exhibition of Australian art, 1963 and he exhibited widely throughout Australia as well as undertaking a number of study tours of Europe. He was artist-in-residence at the Uni. of Newcastle in 1976 and a retrospective of his work (1950–81) was held at Artarmon Galleries, Sydney, 1989 and Goulburn regional gallery, 1989.
AWARDS: NAS college medal, 1950; residency, Moya Dyring studio, Cité Internationale des Arts, Paris, 1987.
APPTS: Teaching, SASA, 1953–55; NAS, 1956, head of the art school, 1971–76; vice-president, NSW Society of Artists, from 1962.
REP: NGA; AGSA; AGWA; NGV; Art Gallery of NZ, Wellington; several regional, municipal collections including Manly, Rockhampton, Parramatta; tertiary collections ESTC, Newcastle Uni.
BIB: John Kroeger, *Australian Artists*, Renniks, Adelaide, 1968. Germaine, *AGA*.

THOMSON, Ann
(b. 14/10/1933, Brisbane) Sculptor, painter, teacher.
STUDIES: Brisbane, with Jon Molvig, 1954; NAS, 1957–61; Paris, etching (with Paul Frank and Henry Goetz), 1978. In her large canvases, abstract, surrealist and expressionist influences added to natural perception give her work a lyrical, quality. In 1977 she was commissioned by the Uni. of Qld (assisted by the Australia Council) to paint a 37-metre long mural for the Malley refectory and in 1987 a mural for Darling Harbour Convention Centre. Her sculptures are, like her 11-metre high commissioned sculpture for the Australian Pavilion at Seville's Expo 1992, impressive for their intricacy of objects. These include wood, metal, mirrors and parts of farm machinery held together in seeming random formation but overall presenting an impressive cohesion. She held about 23 solo exhibitions 1965–93 in Sydney (including Watters, Gallery A, Coventry, Stadia Graphics), Brisbane (Michael Milburn, IMA) and Melbourne (Christine Abrahams, Australian Galleries, Meridian) and a large solo exhibition at Monash Uni. in 1980. She participated in a number of group exhibitions 1962–90 including *Perspecta '85*, AGNSW 1985; *Surface for Reflexion*, AGNSW 1987; *Australian Works on Paper*, Aion Fine Art, Dallas, USA 1987; *Drawing in Australia*, NGA 1988; *Australia*, Cartwright Hall, Bradford UK 1988.
AWARDS: David Jones Art Prize, Brisbane, 1976; residency, Power Inst. studio, Cité Internationale des Arts, Paris, 1978 and Paretaio, Tuscany 1985; VACB grant, 1980; *Canberra Times* National Art Award, 1981; Uni. of NSW Purchase Prize, 1984; *Sydney Morning Herald* Art Prize, 1985; John McCaughey Prize (Sydney), AGNSW, 1986.
APPTS: Teaching, Sydney C. of E. Girls Grammar School, 1962–74; lecturing, Brisbane Coll. of the Arts,

1975–77; lecturing part-time, Newcastle CAE, 1979– .
REP: NGA; AGNSW; Parliament House; VACB; a number of regional gallery collections including Newcastle, New England, Townsville; a number of tertiary collections including James Cook, Qld, NSW, WA unis. and Coll. of Fine Arts, Sydney; corporate collections including Alcoa, Tyssen Bornmizza, Switzerland, Myer.
BIB: McIntyre, ACD. Chanin, CAP. *New Art Five*.

THOMSON, Edward
(Active 1840s, Adelaide; 1840–50, NSW; 1850s, Qld; 1860–early 1870s, NSW) Amateur artist. He exhibited with the Society for the Promotion of Fine Art in Australia in Sydney, 1849, and the Royal Scottish Academy, 1851. A sketchbook of NSW views is in the collection of the NLA (Nan Kivell Collection). He later painted oils exhibited in exhibitions of the time including the 1870 Sydney Intercolonial Exhibition.
REP: NLA.
BIB: E. & R. Jensen, *Colonial Architecture in South Australia*, 1980. Kerr, *DAA*.

THOMSON, Gordon Andrew
(b. 1911, Vic.) Gallery director, teacher.
STUDIES: NGV School, c.1933; travel studies, USA, Italy and UK.
APPTS: Teaching, with the Vic. Education Dept; education officer, NGV, 1950–52; asst curator, 1952–58, asst director, 1958–66, curator, Power Inst. of Contemporary Art, Sydney, 1966; asst director, NGV, 1967–73, director, 1973–75.

THOMSON, Nigel
(b. 1945, Sydney) Painter.
STUDIES: Julian Ashton Art School and North Sydney Tech. Coll., 1961–62. He held 12 solo exhibitions 1967–88, largely in Sydney (Coventry, Robin Gibson). His 1981 exhibition at Coventry was surrealistic in style.
AWARDS: Thornlie prize, Bunbury prize, TMAG prize, 1970; Borthwick prize, 1972; Archibald Prize, 1983; Sulman Prize, 1983, 86.
APPTS: Part-time lecturing, Perth Tech. Coll., 1970; Koninlijke Academie van Beeldende Kunsten, The Hague, 1974–77; guest lecturer, a number of tertiary art colleges in Austria, Yugoslavia, Holland, through Dept of Foreign Affairs, Aust., 1985.
REP: TMAG; WA Uni; Bunbury City Art Museum; New England Art Museum, Armidale, NSW; Kunst Museum, Basel, Switzerland.
BIB: Germaine, *AGA*.

THORNHILL, Dorothy
See DUNDAS, Dorothy

THORNTON, Wallace Keogh
(b. 24/3/1915, Denman, NSW; d. 1991) Painter, teacher, critic.
STUDIES: RAS School, Sydney, with Dattilo Rubbo and Sydney Long, 1935–38; RA Schools, London; travel studies, Europe, 1938–40. He worked in camouflage

during World War II, exhibited with the Sydney Group, of which he was foundation president (1945), and held exhibitions at the Grosvenor and Macquarie galleries, 1946, 47. A painter of modernist, figurative works, many on the theme of women, he did not exhibit after the 1960s, becoming better known as a critic and art writer.

AWARDS: RAS School scholarship (painting and drawing); NSW Travelling Scholarship, 1938; Metro-Goldwyn-Mayer prize, 1952; Sulman prize, 1954; Hunters Hill (watercolour), 1956.

APPTS. Teaching, ESTC, c.1946–60; art critic *Sydney Morning Herald*, 1957–67; trustee, AGNSW, 1971–76.

REP: AGNSW; AGSA; AGWA; NGV; TMAG.

BIB: Smith, AP. John Kroeger, *Australian Artists*, Renniks, Adelaide, 1968. A&A 29/3/1992 (obituary).

THORPE, G. S.

Sculptor. Represented in the NSW section, *International Exhibition*, Melbourne, 1880.

THORPE, Hal (John Hall)

(b. 1874, Vic.; d. 1947) Painter, printmaker.
STUDIES: Learned drawing and engraving while apprenticed to John Fairfax & Sons, Sydney, c.1888; Heatherly's and St Martin's schools of art, London, 1902. First staff artist for the *Sydney Mail* (1886–1901) and a foundation member of the NSW Society of Artists, 1895. He made a few etchings in Sydney, 1897, and later became well-known in London for his decorative, coloured woodcuts of flowers, exhibiting at the RA and Royal Society of British Artists, and in an exhibition at the Kensington Fine Arts Society Gallery, May 1918.

REP: NGA; AGNSW; Ballarat Fine Art Gallery; print collections, British Museum and Victoria and Albert Museum, London.

BIB: Moore, SAA. *Studio* London 1919 (*Modern Woodcuts and Lithographs*).

THORPE, Lesbia

(b. 1919, Elsternwick, Vic.) Printmaker, painter.
STUDIES: Sydney, with Dattilo Rubbo, c.1935–41; London, printmaking, with Gertrude Hermes; travel studies, UK, Europe, 1960–62; Japan, 1965; Indonesia, 1970; Europe, 1972–75; Taiwan, 1976–78. Known mainly for her woodcut colour-prints as shown in group exhibitions. She is a member of the Society of Woodengravers of Great Britain and the PCA, with whom she participated in a number of Australian and international exhibitions, 1970s–90s.

AWARDS: Prizes for prints, Adelaide (Vizard-Wholohan), 1958, 64; Melbourne (VAS), 1959; Geelong, 1963; Portland, Vic., 1966; Toowoomba Art Purchase Prize, 1974; Aberdare Art Print Prize, 1985; SGIO Print Prize, 1985.

REP: NGA; AGNSW; AGSA; AGWA; MAGNT; NGV; QAG; QVMAG; TMAG; Artbank; Stanthorpe Regional Gallery; a number of tertiary collections including Deakin Uni; SE Qld Uni., Toowoomba; corporate collections including Comalco, Rheem, ICI.

BIB: B. Seidel, *Printmaking Arts in Australia series*, Longmans. PCA, *Directory* 1976,82,88. Germaine, AGA. Germaine, DAWA. A&A 21/3/1984.

THURGATE, Noel

(b. 22/9/1955, Nowra, NSW) Painter.
STUDIES: NAS, 1974; Dip. Art, Alexander Mackie CAE, 1978; Dip. Ed., Sydney Teachers Coll., 1978; travel studies, England, Europe, Egypt, Tunisia, 1980–81. Largely a portrait painter, he held three exhibitions 1983–92 in Sydney (Painters Gallery 1983, 87; King St on Burton, 1992), and his work appeared in approximately 15 group exhibitions at private galleries and awards exhibitions in public galleries including *Archibald Prize*, 1977, 78, 79; *Wollongong Purchase Prize*, 1981; *The Figure: Andrew and Lilian Pedersen Memorial Prize*, QAG 1987; *Henri Worland Print Prize*, Warrnambool Art Gallery 1991.

APPTS: Part-time teacher, drawing, School of Art and Design, ESTC, 1985–87; part-time painting teacher, Gymea Coll. TAFE, 1989; part-time teacher, painting and drawing, ESTC, 1987–91.

REP: QAG; Sydney Uni.; regional galleries Wollongong, Maitland; Tasmanian Secondary Inst. and ESTC collections.

BIB: McKenzie, DIA.

THURSTON, Eliza

(b. 5/8/1807, Somerset, UK; arr. Sydney, 1853; d. 1973) Painter. The daughter of a painter (John West) in Bath, UK, she was a drawing teacher in Bath, 1830–mid-1840s, painting also landscapes which she successfully exhibited in the UK. She arrived in Sydney as a widow with three young daughters, following her two eldest sons (the youngest arrived a year later). She became a 'professor of drawing and painting' in Sydney but was declared bankrupt in 1855. She exhibited with the Victorian Fine Arts Society in Melbourne, 1857, and the 1866 Melbourne *Intercolonial Exhibition*. Her family suffered more setbacks when the family farm flooded and was ruined in 1862, but she managed to end her life in some comfort living with a daughter married to a wealthy Sydney merchant. Most of her works remain in the family's possession. She was represented in Sotheby's Melbourne July 1988 auction and in the exhibition *The Artist and the Patron*, AGNSW 1988.

REP: Mitchell, Dixson Libraries; ANZ (Melbourne) collection.

BIB: A number of books on British art. Kerr, DAA.

THWAITES, R. F.

He exhibited at the Victorian Academy of Arts, 1887 (four NZ watercolours). His *Boats on the Yarra* was sold at Christie's auctions, Mar. 1975, and *Half Moon Bay, Vic.* at Leonard Joel's, 1977.

NFI

TIARKS, Hardy (Gerard A.)

(b. 1868; arr. Melb. 1900; d. 1951, Melb.) Painter.

STUDIES: London Coll. of Art. Landscape and sporting painter. He exhibited at the VAS, Melbourne, 1903 (*Moonrise*), and again in 1908 (probably a portrait) when he lived at Hawthorn. Christened 'Gerard', he became known as 'Hardy' due to his sturdy build. Until about 1917 he signed his pictures 'G.A. Tiarks', and thereafter 'Hardy' – thus leading to the misconception in later years that there were two artists of similar style painting at the same time. A detailed Tiarks of a racehorse, *Rawdon,* was offered at Christie's, Melbourne, 1977 and in 1992 the Tom Roberts Gallery, Melbourne, held an exhibition of some 20 of his works. (*Letter from T. Tiarks son 30/11/92.*)

TIBBITS, William

(b. 1837; arr. Aust. c.1866; d. 1906) Painter. Known for his detailed views in watercolours of mines, shops and houses in Ballarat and Melbourne. *Government House, Melbourne, The Residence of the Hon. C.J. Ham, The Red Lion Brewery* and the *Fitzroy Bowling Club* are among his works. In 1894 he painted also a fine bird's-eye view of Geelong. He also became a photo-lithographer, his main work being a large poster of portrait photographs (paid for by the sitters) for the 1888 Melbourne *Centennial International Exhibition*. An exhibition of his work was held at the Museum of Victoria in 1983.
REP: Regional galleries Ballarat, Benalla, Hamilton; NLA; La Trobe, Mitchell Libraries; Uni. of Melbourne; a number of local historical collections including at Creswick, Brighton councils, Vic.; Footscray Historical Society; National Trust of Australia.
BIB: George Tibbits *William Tibbits 1837–1905*, Melbourne, 1984. C. Downer & S. Jones *Portraits in the Landscape: The House Paintings of William Tibbits*, Historic Houses Trust, Sydney 1984. McCulloch, AAGR. Kerr, DAA.

TILLERS, Imants

(b. 30/7/1950, Sydney) Sculptor, painter, landscape designer.
STUDIES: BSc (architecture) Uni. of Sydney, 1972. His unconventional art career began when he helped Christo wrap up Little Bay in 1969. From then on, following the example of contemporary ecological and documentary artists overseas, he became interested in the aesthetic mutation of the landscape and subsequently in the 'systems' art that owed its origins to Marcel Duchamp. In 1975 his work was selected, together with that of George Baldessin, to represent Australia at the thirteenth *Bienale de São Paulo*, Brazil. His most identifiable works are his paintings and installations of internal structures, often presented as multi-panelled in which he 'deconstructs' a building in ever-more detailed layers. 'To adopt the interior as subject matter is to put on an instantly recognisable badge of regional identity, yet to transform and question it as completely as Tillers does is to throw all conventional standpoints into question,' commented critic John McDonald; 'more than any other artist Tillers has opened up a broad field of enquiry into the nature of regional art and identity' (*Regional identity and*

Australian art in *Contemporary Australian Painting* Eileen Chanin, ed. Craftsman House, 1990). Tillers held over 100 solo exhibitions 1973–93 in all Australian states and including a number of public and state galleries as well as in Europe, UK and USA. His work was included in over 300 group exhibitions 1969–93 including all major survey exhibitions of contemporary Australian art such as the Sydney *Perspecta* as well as in the Venice Biennale and numerous exhibitions in European public galleries. His commissions included the Dome of the Federal Pavilion, Centennial Park, Sydney 1985–87; and for the MCA, Sydney (Founding Donor's Commission) 1991. His work has appeared in several television documentaries in London and Paris.
AWARDS: Shared Hunter Douglas prize for communal work (CAS, Sydney, 1972); Uni. of Sydney medal for final year thesis, *Beginner's Guide to Oil Painting*, 1972; VACB standard grant, 1978; John McCaughey Memorial prize, NGV, 1981; Tokyo International ($100,000) Prize, 1993.
REP: NGA; AGNSW; AGSA; AGWA; NGV; QAG; National Gallery of NZ; MOMA, NY; MCA, Sydney; Heide; Wollongong City Gallery; a number of tertiary collections including Monash university; corporate collections inlcuding Chase Manhattan Bank (NY); Bell Resources Collection (NY); Smorgon Collection (Melb); Sussan.
BIB: Numerous catalogue essays exhibitions as above and for solo exhibitions, notably those at the Institute of Contemporary Art, London, 1988; National Art Gallery, Wellington, NZ, 1989; Wollongong City Art Gallery, 1990 and Deutscher Brunswick St, Melbourne 1990. All general texts on Australian contemporary art including Smith, AP; Chanin, CAP; Scarlett, AS. Numerous references in art journals such as *Studio International* (London); *Art International*; *Art Press* (Paris); *Artnews* (New York); *Art in America* (USA) and in A&A including (major references) 13/1/1975 ((Donald Brook, *Imants Tillers and the Redefinition of Art in Australia*); 24/2/1986 (Ronald Millar, *Venice Biennale and Past Futures*); 26/2/1988 (Michael Archer, *Bicentennial Exhibitions in London*); 27/3/1990 (*Imants Tillers as a Site of Conflict*). AM no. 12, July 1988 (*Imants Tillers in London*). Tension no. 18, October 1989 (*Tiller's McCahon's*).

TILLEY, Peter

(b. 17/2/1946, Vic.) Sculptor.
STUDIES: Part-time ceramics, Newcastle School of Art & Design, 1973–75; private tutor, Uni. Sains Malaysia, 1975–77; Certificate of Art, Newcastle School of Art and Design, 1979. He held 9 solo exhibitions in Sydney (Access 1989, 90, 92) and Melbourne and at Footscray Community Arts Centre 1985; Gryphon Gallery, Melbourne State Coll. 1989; Newcastle Region Art Gallery 1992. He participated in approximately 30 group exhibitions 1983–92 including *Fletcher Jones Invitation Award*, Warrnambool Art Gallery 1986; many at Newcastle Contemporary Gallery; Maitland City Gallery; Newcastle Regional Art Gallery 1990.
AWARDS: Acquisitive Tomago Aluminium Sculpture Prize, Fesitival of Port Stephens, 1992; Newcastle AH&I Association Sculpture Prize, 1992.

REP: Regional galleries Campbelltown, Newcastle, Maitland, Stanthorpe, Warrnambool.
BIB: Germaine, AGA.

TIMMS, Peter

(b. 1948, Melb.) Curator, gallery director, writer. His wide-ranging art career has included being an exhibitions officer, regional and municipal gallery director, project co-ordinator with the Regional Galleries Association, NSW, and freelance curator and writer for art journals. Exhibitions he co-ordinated included *Illusion and Reality* (with John Stringer), AGDC 1976; *The People: The Present*, component of *The Face of Australia* bicentennial exhibition 1988; *Australia Gold, Asialink*, SE Asian tour 1992; *The Black Show*, for Geelong Art Gallery national tour, 1993. He was a member of a number of arts organisations 1976–91 including as board member of RGANSW; Crafts Board and VACB, Aust. Council, 1986–90; chair, National Infrastructure Committee, VACB, 1987–90; member, NETS, 1991. He was also a consultant to various public organisations including Albany Council, WA; Perc Tucker Regional Gallery; Heidelberg Hospital; Gertrude St Artists Spaces.
AWARDS: Winston Churchill Fellowship, study Italy and London, 1984; fellowship, VACB, 1992.

TINDALL, Charles E. S.

(b. 1863, Aberdeenshire, Scotland; arr. Sydney 1887; d. 1951, Sydney) Painter, commercial artist.
STUDIES: Glasgow (as a lithographic artist); Sydney, lessons from Charles Conder, J. R. Ashton and Frank Mahony. Known as a marine painter of the shipping in Sydney Harbour and for his small copy (Mitchell Library) of Oswald Brierly's *HMS Rattlesnake in a Squall off the Island of Timor*. Moore refers to 'the wonderful freshness' of his watercolours. A member of the Art Society of NSW (Royal Art Society) from 1893, and a foundation member of the Australian Watercolour Inst., 1924.
REP: AGNSW; Newcastle regional gallery; Mitchell Library.
BIB: *Fifty Years of Australian Art 1879–1929*, RAS, Sydney, 1929. Moore, SAA.

TIPPING, Marjorie

Art researcher, historian. Member of the board of the Victorian Arts Council (Arts Council of Australia, Vic. division). Her writings include *Eugène von Guérard's Australian Landscapes*, 1975, *Ludwig Becker: Artist and Naturalist with the Burke and Wills Expedition*, 1979, both published by Lansdowne, Melbourne; *Victoria the Golden by William Strutt*, Victorian Government Printer, Melbourne, 1980; *The Artist as Historian*, Victorian Historical Magazine, vol. 42, no. 4, Nov. 1971.
AWARDS: MBE, 1981.

TISCHBAUER, Alfred

Painter, teacher. Teacher of perspective at ESTC, Sydney, c.1880. His bust was modelled by Lucien Henry. He

went to the USA and became successful as a scenic artist in New York.
BIB: Moore, SAA.

TITMARSH, Mark

(b. 7/6/1955, Qld) Painter, film-maker, teacher.
STUDIES: B. Laws, Uni. of Qld, 1977; Pietro Vannucci School of Fine Arts, Perugia, Italy, 1978; St Martin's School of Art, London, 1979–80; BA (Visual Arts), City Art Inst., Sydney, 1984; MA (painting), Sydney Coll. of the Arts, 1991. His works are constructed by selecting a number of paintings (often medieval or Renaissance), photographing them and repainting them with added elements (lettering, other decorations). He held 11 solo exhibitions 1987–92 in Sydney (Roslyn Oxley9; First Draft) and Brisbane (Bella), and at Artspace, Sydney 1987. His work was included in group exhibitions 1987–91 including at First Draft, Roslyn Oxley9, Sydney; Powell St, Linden, Melbourne and *New Contemporaries*, NGV 1991.
AWARDS: Travel grants, Australian Film Commission, 1983, 86; travel grants, Australian Bicentennial Authority, 1989; Grand Prix, 120th International Festival of Young Cinema, Montreal, Canada, 1989; Lake Macquarie Regional Art Prize, 1990; Thelma Clune Celebrity Prize, Artspace, Sydney, 1990.
APPTS: Lecturer, film-making, art history, School of Visual Art and Communication, Uni. of Newcastle, 1984–88; tutor, Uni. of NSW, 1985–88; SAC, 1988; NAS, 1988–92; lecturer, Art History and Theory, Coll. of Fine Art, Uni. of NSW, 1992– ; many guest lectureships, tertiary colleges and unis. including West Surrey Coll. of the Arts, UK, 1984; Massachusetts Coll. of Art, Boston, USA, 1986; NGA, 1987; Biennale of Sydney, AGNSW, 1989; ACCA, Melbourne, 1990.
REP: NGA (film collection); AGNSW; AGWA; NGV; QAG; Artbank; Lake Macquarie regional gallery.
BIB: Germaine, AGA.

'TIZ'

Pseudonym of an early Tasmanian engraver who copied the works of 'Phiz' (George Cruikshank) in a pirated edition of Dickens's *Pickwick Papers*, published by Henry Dowling, Launceston, 1838. Another Cruikshank imitator drew for the first number of Melbourne *Punch* (1855) under the pseudonym *Quiz*.
BIB: Clifford Craig, *The Engravers of Van Diemen's Land*, Foot & Playstead, Launceston, 1961. M. Mahood, *The Loaded Line*, 1973.

TJAKAMARRA, Mick Gill

(b. 1919, Western desert, NT) Painter. His exhibitions have included at Coo-ee, Sydney; Dreamtime, Perth and Lauraine Diggins Fine Art, Melbourne.
REP: AGWA; NGV.

TJAMPITJINPA, Kaapa

(b. 1920; d. 1989) Painter. A Papunya artist who was one of the first to use acrylic paints introduced by art teacher Geoffrey Bardon in 1971 and developed into the well-known Papunya style. He held numerous solo

exhibitions and his work was included in many survey exhibitions.

REP: NGA; AGWA; TMAG.

BIB: Caruana *AA*. Germaine, *AGA*. Smith, *AP. A&A* 27/4/1990 (obituary).

TJAMPITJINPA, Ronnie

(b. c.1940, North of Yumari, NT) Aboriginal painter of the Pintupi tribe. He held a solo show with Gabrielle Pizzi Gallery, Melbourne, 1991 and participated in five group exhibitions including *A Retrospective Survey of the Aboriginal Acrylic Paintings of Central Australia*, RMIT, 1986 and with ROAR Studios, Melbourne, 1986; Gabrielle Pizzi, 1987, 88, 90 and in *Contemporary Aboriginal Paintings*, Benalla Art Gallery, 1991.

AWARDS: Alice Prize, 1988.

REP: NGA; AGWA; AGSA; MAGNT; Araluen Arts Centre, Alice Springs; Musée des Arts Africains et Océaniens, Paris.

BIB: Catalogues in above exhibitions; Amadio N. & Kimber, R. *Wildbird Dreaming, Aboriginal Art from the Central Deserts of Australia*, Greenhouse, Melbourne, 1988.

TJAPALTJARRI, Mick Namarari

(b. c.1930, Nyunmanu, NT) Painter. Of the Pintupi tribe he began painting with the Papunya Tula art movement in 1971 and held a solo show with Gabrielle Pizzi, Melbourne, 1991. He participated in 12 group exhibitions 1980–93 including in the São Paulo Bienal, São Paulo, Brazil, 1983; with ROAR Studios, Melbourne, 1983, 86; Gabrielle Pizzi, Melbourne, 1987, 89, 90; *Dreamings, the Art of Aboriginal Australia*, Asia Society Gallery, New York City, USA, 1988; *L'été Australien à Montpellier*, Musée Fabre Galerie Saint Ravy, Montpellier, France, 1990; *Aboriginal Paintings from the Desert*, Union of Soviet Artists Gallery, Moscow, Russia, 1991 and State Ukrainian Museum of Art, Kiev, Ukraine, 1992.

REP: NGA; NGV; MAGNT; QAG; AGWA; AGSA; Australian Museum; Flinders Uni.

BIB: Catalogue essays in above exhibitions. G. Bardon, *Papunya Tula, Art of the Western Desert*, McPhee Gribble, Melbourne, 1991. Caruana, *AA*.

TJUPURRULA, Donkeyman Lee

(b. c.1925, near Walla Walla, WA) Aboriginal painter of the Kukatja tribe. Group exhibitions in which his work appeared include *Balgo Art*, Gabrielle Pizzi, Melbourne, 1988; *Balgo Paintings*, Dreamtime Gallery, Perth, 1989; *Mythscapes, Aboriginal Art from the Desert*, NGV, 1989; *L'été Australien à Montpellier*, Musée Fabre Galerie Saint Ravy, Montpellier, France, 1990; *Paintings by Five Senior Balgo Artists*, Gabrielle Pizzi, 1991.

REP: NGA; NGV.

BIB: Catalogue essays exhibitions as above.

TOBIN, (Rear-Admiral) George

(b. 13/12/1768, Salisbury, UK; d. 1838, Devon) Naval officer, maritime artist. Among his many voyages was one to Van Diemen's Land 1790–92 with Captain Bligh in HMS *Providence*. In Feb. 1792 he made at least 21 watercolour drawings for his own journal (Tobin's journal and two volumes of drawings are in the Mitchell Library, Sydney) and contributed 33 sheets of natural history watercolour drawings to Bligh's sketchbook. His work was seen in an exhibition at Deutscher Fine Art, Melbourne, in 1985.

REP: Mitchell Library.

BIB: Rienits, *Early Artists of Australia*, 1963. Colin Finney, *To Sail Beyond the Sunset*, Rigby, Adelaide 1984. Kerr, *DAA*.

TODD, Geoffrey David

(b. 1/10/1950, Chelsea, Vic.) Painter, teacher.

STUDIES: Dip. Fine Art, Bendigo Inst. of Technology, 1974; Grad. Dip. Visual Art, Gippland Inst.; Dip. Tech. Teaching, Hawthorn SCV. Responding to widely varied experimental art, he organised an exhibition of his work, 1978–79, touring interstate centres. His paintings since have become large and figurative, some realistic, others more abstract. He was artist-in-residence at the VCA in 1980 and lived and worked with tribal Aborigines in Arnhem Land from 1984–87 and based himself in Darwin from then. He held about 26 solo exhibitions 1969–92 in most states, including in Sydney (Holdsworth); NT Museum of Arts and Sciences, Darwin 1991 and Indonesia where he lived in 1991. Group exhibitions in which his work appeared 1980–92 included *Contemporary Australian Art*, touring contemporary art venues USA 1979–80; *Australian Contemporary Drawing*, Sydney Uni. 1990. He also designed a number of children's books and served on advisory committees for tertiary colleges in the NT and was a board member of the NT Centre for Contemporary Art, 1989–90.

APPTS: Secondary teaching, Vic., 1969–84; life drawing, Shepparton Tech. Coll., 1975–77; part-time, Dandenong College of TAFE, 1983–84; craft adviser, adult education, Maningrida, NT Aboriginal community, 1984–87; lecturer, Batchelor Coll., Rum Jungle, NT, 1987.

REP: NGA; NGV; NT Museum of Arts & Sciences; several regional collections including Alice Springs, Ballarat, Latrobe Valley, MPAC, Shepparton; several tertiary collections including VCA; Westminster Council, UK; Darwin Supreme Court.

TODD, Milan

(b. 21/3/1922, Belgrade, Yugoslavia; arr. Melb. 1950) Painter, sculptor, teacher.

STUDIES: Académie des Beaux-Arts, Paris, with Marc Chagall, 1945–48; Academy of Fine Arts, Belgrade, 1948–49. Religious symbolism and a naive, peasant style in wood-carving and painting are the chief characteristics of his work. He held over 50 solo exhibitions 1968–92 in most capital cities including Sydney (Barry Stern) and Melbourne (Clive Parry, Munster Arms, Eastgate), and a retrospective at Swan Hill regional gallery, 1990.

APPTS: Teaching, RMIT, 1965–77.

AWARDS: Flinders art prize (for sculpture), 1973; Exhibition Building Centenary Art Prize, 1973.

REP: Swan Hill regional gallery; La Trobe, Monash unis.; Artbank; corporate collections including Qantas, ICI.

BIB: Bianca McCullough, *Australian Naive Painters*, Hill of Content, Melbourne, 1977. Scarlett, AS. Germaine, AGA. *New Art One*.

TODT, Emil Hermann

(b. Berlin; arr. Melb. ?1852) Sculptor.
STUDIES: Berlin Academy. This goldfields sculptor completed a number of works in Melbourne, notably including *Virgin and Christ Child*, for St Francis Church, Melbourne, and *The Diggers*, NGV, Melbourne. His work was represented in *Early Australian Sculpture*, Ballarat Fine Art Gallery, 1976.
BIB: McCulloch, AAGR.

TOLLEY, David E.

(b. 1936, Melb.) Sculptor, musician, teacher.
STUDIES: RMIT, c.1956. He exhibited in *Mildura Sculpture Triennial*, 1964–67, and at the Tolarno Gallery, St Kilda, 1968, showing inventive abstract sculptures in high-finish polyester. In 1975 he was commissioned to make a large play sculpture for the Caulfield City Park, Melbourne.
AWARDS: Grand prize, also prize for sculpture, *Mirror-Waratah Festival*, Sydney, 1964; grant, Australia Council (for music studies), 1974; grant, VACB (for Caulfield park sculpture), 1975.
APPTS: Teaching, NAS, Newcastle, NSW, 1963–64; Prahran CAE, 1965–?; Preston Inst. of Technology, 1979–?
REP: NGA.
NFI

TOLMER, Alexander

(b. 1815, London; arr. Adelaide 1840; d. 7/3/1890, Mitcham, SA) Police inspector, amateur artist. Appointed police inspector in Adelaide (later police commissioner), he pioneered the gold escort route from Mt Alexander, Vic., to Adelaide in 1852. A skilful topographical artist, his South Australian scenes include views of Robe Town, 1869, and Hedley Park, Mount Gambier. He also did a number of illustrations for Sir George Grey's account of South Australia. Grey had them exhibited on the drawing room table at Government House. Later Tolmer claimed that the drawings were recopied and published in George Fife Angas's book (he obviously meant George French Angas), but 'my name as the original artist was never acknowledged'. His work *The Major O'Halloran Expedition to Encounter Bay*, which documents the expedition he was a part of which executed two Aborigines who supposedly murdered the survivors of the shipwreck *Maria*, was sold at Joel's auction, Melbourne, in 1975. His work was represented in *Forgotten Artists*, AGSA 1975.
REP: AGSA.
BIB: L. J. Blake, *Gold Escort*, Hawthorn Press, Melbourne, 1971. McCulloch, AAGR. E. Craig *Australian Art Auction Records, 1975–78*, Mathews, Sydney, 1978. ADB 6. Kerr, DAA.

TOLSON, Turkey Tjupurrula

(b. c.1942, east of Haast's Bluff, NT) Painter. In 1960 he moved to Papunya where he passed through his initiation ceremonies and began painting in acrylics in the early 1970s with the Papunya Tula art movement. In 1983 moved to Kintore. His paintings are distinctive for their use of horizontal or vertical closely painted stripes which create an optical illusion of movement. He was represented in approximately 25 group exhibitions 1974–93 including *The Auckland Festival*, Argyle Art Centre, Sydney, 1975; *The Face of the Centre: Papunya Tula Paintings 1971–84*, NGV, 1985; *Ageless Art*, QAG, 1988; *The Great Australian Art Exhibition* Bicentennial exhibition 1988–89; *The Painted Dream*, Auckland City Art Gallery and National Art Gallery and Museum, Wellington, NZ, 1991; *Flash Pictures*, NGA, 1991.
APPTS: Chairman, Papunya Tula Artists, 1988.
REP: NGA; NGV; AGWA; AGSA; MAGNT; Araluen Art Centre; National Museum of Australia; SA Museum; Museum of Victoria; Uni. of WA; Flinders Uni.; Qld Uni. of Tech.; Artbank; National Gallery of Ethnology, Osaka, Japan; Hudson River Museum, Yonkers, New York, USA; corporate collections including Robert Holmes à Court; Allen, Allen & Hemsley;
BIB: Catalogue essays exhibitions as above. N. Amadio & R. Kimber, *Wildbird Dreaming, Aboriginal Art from the Central Deserts of Australia*, Greenhouse, Melbourne, 1988. Sutton, P. *Dreamings: The Art of Aboriginal Australia*, Viking, New York, 1988. Caruana, AA.

TOMESCU, Aida

(b. 30/10/1955, Bucharest, Romania; arr. Aust. 1980) Painter.
STUDIES: Dip. Art, Inst. of Fine Arts, Bucharest, 1977; Postgrad. Dip. Fine Arts, City Art Inst., Sydney 1983. Her work as seen in her first exhibitions in Australia at Holdsworth Gallery, Sydney, 1981, were collages of painted fabric and scraps on canvas. The collage elements, however, were taken over by use of paint solely, which is how her work became known from the mid-1980s. Originally influenced by European expressionists including Georges Rouault and also by de Kooning and Picasso, her paintings became increasingly more abstract and expressionistic. Her preference is for dark colours and large monochromatic areas of thickly applied paint. She held ten solo exhibitions 1979–91 in Bucharest (1979), Sydney (Holdsworth 1981; Coventry 1985, 87, 89, 91), Canberra (Ben Grady 1987), Melbourne (Reconnaissance 1987; Deutscher Brunswick St 1991) and Los Angeles (Design Centre, 1986). Her work was seen in approximately 15 group exhibitions in Bucharest (1978–80) and Australia (1981–91), including private galleries (Holdsworth, Coventry) and at Artspace, Performance Space, Sydney and in *Abstraction*, AGNSW 1990.
AWARDS: Arts council grants, Bucharest, 1978, 79; project grant, VACB, 1980, 90; Myer Foundation grant, 1986.
REP: NGV; QAG; Artbank; National Gallery Bucharest; corporate collections including Allen, Allen & Hemsley; Myer; Robert Holmes à Court; Westpac (New York).
BIB: McIntyre, CC. Chanin, *New Art Five*. A&A 28/2/1990. AM. October 1987.

Aida Tomescu, Negru I, *1991, aquatint, 120 × 80cm. Courtesy Viridian Press.*

TOMORY, *(Prof.) Peter A.*

Professor of Art History, La Trobe University, Vic., 1972–90. He wrote *New Zealand Art – Painting*, Reed, Wellington, 1968 and after a successful Australian academic career returned to the UK in 1993.

TOOTH, *Owen Mackenzie Douglas*

(b. 1932, Pokataroo, NSW; d. 24/3/1969, Rabat, Morocco) Painter.
STUDIES: NAS (with Miller, Passmore and Dadswell), 1955–59; travel studies, Europe, 1968. He exhibited in Sydney group exhibitions, Clune Gallery, 1958, 59, Blaxland Gallery, 1960, and in 1960–61 painted in Northern Australia. He married Susan Wright (q.v.), and in 1968 embarked with his young family on travel studies that included Japan and Europe (via the Trans-Siberian railway) and Morocco. He died in Morocco from a cerebral haemorrhage. Later the Owen Tooth

Memorial Cottage (q.v.) at Vence, France, was constituted in his memory.
BIB: *A&A* 7/1/1969 (*Owen Tooth a tribute*).

TOOVEY, *Dora (Dorothea Elizabeth)*

(b. Bathurst, NSW) Painter.
STUDIES: RAS School, Sydney, with Dattilo Rubbo and James R. Jackson; NGV School, with McInnes; Julian Ashton School, Sydney, with John Passmore; Julian's, Paris; travel studies, UK and Europe, 1926–29; lessons in the south of France from Augustus John. Married James R. Jackson (q.v.). In 1924 she painted portraits, landscapes and other genre, toured South America, and painted during a caravan tour of Central and Western Australia.
AWARDS: Prizes at Ryde, 1962, 63; Katoomba (Blue Mountains), 1963; Northside Festival, 1965; RAgSocNSW, 1967; Portia Geach (Sydney), 1970, 78.
REP: NGA; AGNSW; AGSA; NGV; QAG; Manly Art Gallery; Newcastle Region Art Gallery.
BIB: Smith, *Catalogue* AGNSW 1953. Germaine, *AGA* 1979.

TOUANNE, *(Vicomte) E. Bigot de la*

French naval officer, marine and topographical artist. As Bougainville's lieutenant in *Thetis* during his voyage around the world (1824–26), de la Touanne made drawings of Sydney, the Warragamba River and the Blue Mountains when the expedition visited Sydney, c.1825; these were lithographed by Sabatier and others for his book *Album Pittoresque de la Frégate la Thetis et de la Corvette l'Esperance*, Paris, 1828.
BIB: Kerr, *DAA*.

TOURING AGENCIES

Several touring agencies assist in the touring of Australian art internationally and nationally. Art Exhibitions Australia (q.v.) manages the largest exhibitions while several focus on Australian art. The Australian Exhibitions Touring Agency established in 1988 and based in Melbourne organises and manages contemporary art and craft exhibitions within Australia and overseas. It managed 16 exhibitions to 62 venues nationally 1988–93 and 4 exhibitions internationally including *Angry Penguins and Realist Painting in Melbourne in the 1940s*; *Ralph Balson*; *Rover Thomas and Trevor Nickolls*; *Art from Australia. Eight Contemporary Views*; *Rediscovery – Australian Artists in Europe 1982–92*. Other touring agencies include NETS operating from Tasmania, Victoria, WA; the Regional Galleries Associations of Qld, NSW, and Victoria; and the South Australian Touring Exhibitions Program based at the AGNSW. These concentrate on intra- and interstate touring. The establishment of touring agencies has enabled many of the smaller public galleries and regional galleries to mount exhibitions on a more professional and comprehensive basis and are therefore assisting considerably in the development of Australian art.

TOWERS, *Winifred Mary*

(b. Portsmouth, UK) Painter, illustrator.

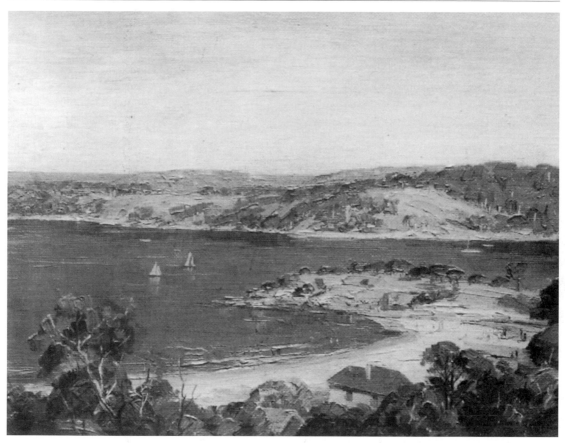

Dora Toovey, Sydney Harbour, *oil on canvas on board,*
29.5 × 37cm. Joels, April 1992.

STUDIES: Portsmouth School of Art, UK. She worked
as a press artist in Portsmouth and London; married
and migrated to Australia to live on a cattle station.
She went to Brisbane in 1940 and became a member
of the Half Dozen Group.
REP: QAG.
BIB: Exhibition cat. *Half Dozen Group of Artists*, annual exhi-
bition, Brisbane, Sept. 1963. John Kroeger, *Australian Artists*,
Renniks, Adelaide, 1968.
NFI

TOWNSEND, Lillian
(b. 13/6/1934, Vic.) Painter.
STUDIES: Dip. Art and Design, CIT. Her work appeared
in five solo exhibitions 1978–92 in Melbourne (Stuart
Gerstman 1978; Niagara 1983, 86; Women's Gallery,
1989; Terra Australis 1991), and in group exhibitions
in private galleries in Melbourne and in *Blake Prize*,
1982; MPAC *Spring Festival of Prints and Drawings*,
1981, 83, 85.
AWARDS: APM Acquisitive art award, 1985; MPAC acqui-
sition, Spring Festival of Prints and Drawings, 1985.
APPTS: Holmesglen TAFE; Templestowe Community
Art Centre.
REP: VACB; Artbank; La Trobe Uni.; Mornington
regional gallery; APM collection.

BIB: *150 Victorian Women Artists*, Women 150, Vic. Govt,
1985. Germaine, AGA. Germaine, DAWA. A&A 25/1/1987.

TOWNSHEND, Geoffrey Keith
(b. 1888, Auckland, NZ; arr. Sydney 1911; d. 15/9/1969,
Dee Why, NSW) Painter, illustrator, teacher.
STUDIES: RAS School, Sydney, with Dattilo Rubbo,
1912. Married Dorothy Reynolds, potter. Until 1915,
when he enlisted in the AIF, he earned a living in
Sydney as an engraver. He served for three and a half
years in World War I and drew cartoons for the trench
paper, *Aussie*. Returning to Sydney, he became known
for his joke drawings in the Sydney *Bulletin;* he was
known also for his watercolours exhibited with the
RAS and Australian Watercolour Inst., and was a vice-
president of both these bodies. His *Bulletin* connec-
tion was his introduction to Percy Lindsay who
influenced his work, influenced otherwise by the work
of the American Winslow Homer, and by the water-
colours of John Singer Sargent. Townshend's water-
colours are romantic and lyrical and noted for their
spontaneity and freshness.
AWARDS: Prizes for watercolours at Albury, 1961;
Berrima, 1962; Goulburn, 1965.
APPTS: Teaching, ESTC; trustee, AGNSW, 1959–61.
REP: AGNSW; AGWA; QAG; Newcastle regional gallery;
Mitchell Library, Sydney.
BIB: *A&A* 7/4/1970 (Eric Langker, *Geoffrey Keith Townshend*).

TRACY, George Wingfield
(Active c.1852–55, Bendigo) Naive painter.
REP: Castlemaine Gallery.
BIB: McCulloch, *AAGR.* Kerr, *DAA. ADB* 6.

Jessie Traill, Goodnight in the Gully, *c. 1925, etching. Collection, NGA.*

TRAILL, Jessie Constance Alicia
(b. 1881, Brighton, Vic.; d. 1967, Vic.) Painter, etcher. STUDIES: NGV School, 1901–05; also etching and painting with John Mather, c.1903; Académie Colarossi, Paris, 1907; Stratford Studio, London, with Swan and Brangwyn, 1908–09. She exhibited at the RA, 1909; Old Salon, Paris, 1909 and 1926, and during World War I served for three and a half years as a VAD nurse at Rouen. She was a member of the Society of Graphic Art, London, the Australian Painter-Etchers' Society, and the VAS. She was probably the first white Australian to paint in Central Australia and held an exhibition in Alice Springs in 1928, selling one picture. Cumbrae Stewart (q.v.) painted her portrait. The watercolours and etchings of landscapes and coastal scenes for which she is best known have much charm and feeling. The QAG held an exhibition *Industry and Nature, the etchings of Jessie, Traill,* 1989 and she was represented in *The Great Australian Art Exhibition* Bicentennial exhibition 1988–89. *A Century of Australian Women Artists 1840–1940,* Deutscher Fine Art, Melbourne 1993.
AWARDS: *Panama Exhibition,* 1914, gold medal for etching, bronze for decorative work.
REP: NGA; AGNSW; AGSA; NGV; AWM; Mitchell Library, Sydney.
BIB: Moore, *SAA.*

TRANTHIM-FRYER, James John Robertson
(b. 1858, Hobart; d. 1928, Melb.) Sculptor, teacher. STUDIES: ESTC, with Lucien Henry, 1886–89; Old Lambeth School, Central School of Arts and Crafts and Royal Coll. of Art, London, 1896–99. He exhibited busts and repoussé work on copper at the VAS, 1900–17, was president of the Arts and Crafts Association and also showed with the Yarra Sculptors Society. His work was seen in *Early Australian Sculpture,* Ballarat Fine Art Gallery, 1976.
APPTS: Teaching, Hobart Tech. Coll., 1890–96; assistant to British sculptor Onslow Ford, 1897–98; teaching at Horsham until appointed to Gordon Tech. Coll., Geelong, 1905; first director of the Swinburne Tech. Coll., 1908–28.
REP: TMAG; McClelland Gallery, Vic.

TRAVIS, Peter
(b. 1929, Sydney) Designer, teacher. STUDIES: NAS, 1956–58 and 1962–64; travel studies, USA, Europe and UK, 1969–70. He studied sculpture, music and ceramics and for a time was a part-time lecturer, NAS, Sydney. Known as a fine ceramicist, he exhibited widely in solo exhibitions from 1966. In 1974 he held a series of exhibitions in capital cities of imaginatively designed kites which he termed 'Flying colour field geometric constructions'. His work was represented in a number of Australian and international group ceramic exhibitions. A film of his work along with that of Mona Hessing and Marcus Skipper (qq.v.) was made in 1974.
AWARDS: Churchill Fellowship, 1969; prizes for ceramics, Poland, 1970, and Italy, 1973.
REP: NGA; AGNSW; QAG; regional galleries Ballarat, Shepparton.
NFI

TREEBY, George
(Active 1890s, Melb.) Black-and-white artist. In 1896 he took over the cartoon page of Melbourne *Punch* from George Dancey, during Dancey's illness, producing bold, matter-of-fact style cartoons under the pseudonym *Bron,* until Dancey's return in 1898. He also contributed to the Sydney *Bulletin* and may have been connected with a later *Bulletin* artist, Mab Treeby.
BIB: Moore, *SAA.* M. Mahood, *The Loaded Line,* 1973. Vane Lindesay, *The Inked-In Image,* Hutchinson, Melbourne, 1979.

TREMBATH, Tony
(b. 9/7/1946, Vic.) Sculptor, assembly/installation artist. STUDIES: RMIT (applied biology), 1964–71; fine art, CIT, 1973–78; travel studies, Canada exchange (part funded VACB) with Canadian sculptors, 1981. His work ranges from large, harmonious environmental sculptures to installation works in galleries described variously by Melbourne critics as 'bizarre series of scenes', 'secret shrines' or 'too ghoulish to contemplate' (referring to his pictorial representation of body parts). He held 9 solo exhibitions 1977–91 in Melbourne (CIT, 1977; Pinacotheca, 1980; 312 Lennox St, 1988; William Mora, 1992), Sydney (Avago, 1983, 84), AGNSW (1984)

and Cité Internationale des Arts, Paris (1987). His work appeared in approximately 20 group exhibitions 1978–90 including *Australian Sculpture Triennials*, 1981, 84; *Australian Perspecta*, AGNSW 1981; *Austach/Exchange*, Ivan Dougherty Gallery and Gryphon Gallery, Melbourne 1984; *Graven Images*, AGWA 1983; *Imaging Aids*, ACCA 1989; and in Australian–Canadian artists exchange, Harbourfront, Toronto, Canada 1981. He received many commissions including Wollongong Copper Industries, 1983; environmental sculpture, Albert Park primary school, 1981–82; Box Hill Mall; Glen Katherine primary school, 1989. He was artist-in-residence at Claremont School of Art, WA, in 1989 as well as several times as artist-in-community at a number of primary and secondary schools.

AWARDS: Travel grant, VACB, 1983; Heidelberg School of Painters Sculpture Competition, 1985; artist development grant, Vic. Ministry for Arts, 1986; residency, Cité Internationale des Arts, Power Inst., 1988; VACB grant, 1990.

APPTS: Tutor, sculpture, CIT, 1979; visting tutor, VCA, 1984.

REP: AGWA; NGV; Monash Uni. Gallery; Geelong regional gallery.

BIB: *New Art Three*.

TREMBLAY, Theodore Paul

(b. 20/5/1952, Cambridge, Mass., USA: arr. Aust. Oct. 1977) Printmaker, painter.

STUDIES: Boston Museum School and Tufts Uni., USA, 1970–74; Ruskin School of Drawing and Fine Art, Oxford, UK, 1976–77; Dip. Art & Design, Prahran CAE, 1980; enrolled Masters degree, Uni. of NSW, 1991– . His etchings and lithographs often depict single or grouped figures symbolically integrated with their environment. He held about nine solo exhibitions 1981–91 including at Hogarth Gallery, Sydney; Ben Grady, Canberra; MAGNT (1989) and Chiang Mai Uni., Thailand while guest lecturer there in 1989. His prints appeared in numerous national and international print exhibitions including *Print as Object*, PCA touring exhibition 1985. He received many print and other commissions including for PCA and sets and costumes for a season of three ballets, 1986. He was artist-in-residence at some 12 tertiary colleges and other arts organisations 1981–92 including a lithographic workshop in Belgium, 1987, and in the Northern Territory, 1989.

AWARDS: Kenneth Clark Special Award, Ruskin School of Drawing and Fine Art, Oxford, UK, 1977.

APPTS: Lecturer, printmaking, various tertiary colleges, 1976– including Ruskin School, Oxford, 1976–77; State Coll., Frankston, Vic., 1978–81; introduced printmaking courses, Monash Uni., 1978; Canberra School of Arts, 1981–91; Chiang Mai Uni., Thailand (semester 2), 1992; part-time, Canberra Inst. of the Arts and Uni. of NSW, 1992– .

REP: NGA; MAGNT; Artbank; a number of regional galleries including Mornington, Warrnambool; Meat Market; a number of tertiary collections including ANU, Monash Uni., Chiang Mai Uni., Thailand, Qld

Horace Trenerry Road to Perhaps, *oil on canvas. Joels, July 1987.*

Coll. of the Arts; National Library, Antwerp; Centrum Franz, Masereel.

BIB: PCA, *Directory* 1988. AL May, 1990. AM June, 1990.

TRENERRY, Horace Hurtle

(b. 5/12/1899, Adelaide; d. 1958, Fullarton, SA) Painter.

STUDIES: Adelaide (with Arthur Milbank, Archibald Collins), and James Ashton School; SA School of Arts and Crafts; SA School of Fine Arts (with F. Britton, 1921–24). Possibly for a short period, at Julian Ashton's, Sydney. Trenerry's work reflects the influences which came to him through too great a diversity of teachers, also the influence of other South Australian leading painters, but it reveals also a versatility and qualities of craftmanship that entitle Trenerry to a high place in Australian painting of the 1920s and 30s and much wider recognition than was accorded him during his lifetime and for many years afterwards. Trenerry suffered from an incurable disease which curtailed his later painting activities and brought about his early death. Two paintings by him were included in the Tate Gallery exhibition of Australian painting in 1963. His still-life paintings, particularly, have a softness of colour coupled with firm design that gives them high ranking in this genre. A memorial exhibition of his work was held at SASA, Adelaide 1964 and he was represented in *The Great Australian Art Exhibition* Bicentennial exhibition 1988–89.

AWARDS: Gold star medal, Royal Drawing Society, London, 1920.

REP: NGA; AGNSW; AGSA; Castlemaine regional gallery.

BIB: *A&A* 8/3/1970.

TREWEEKE, Vernon

(b. 1939, Sydney) Painter.

STUDIES: NAS, 1957–59; travel studies in Europe, 1961–66. His formal art training began after he won first prize 'for contemporary art' at the Bathurst

exhibition in 1956. In Europe he exhibited with other Australians living there, returned to Australia via the USA in 1966 and began showing in group exhibitions at the Central Street Gallery, Sydney. In 1967 he held exhibitions at the same Sydney gallery and at Gallery A, Melbourne, and during the following year at the Ballarat Gallery. Typical of his work during this period are the 'ultrascopic', abstract paintings that appeared in *The Field* exhibition, 1968.

AWARDS: Bathurst prize, 1956.

NFI

TREZISE, Percy J.

(b. Tallangatta, Vic.) Painter, writer, anthropologist, hotel keeper, charter pilot, photographer. A naive artist, he is known mainly for his books and illustrations, done in North Qld in collaboration with the Aboriginal artist Dick Roughsey (q.v.). These include *Quinkan Country*, A. H. & A. W. Reed, Sydney, 1969.

BIB: Bianca McCullough, *Australian Naive Painters*, Hill of Content, Melbourne, 1977.

TRIBE, Barbara (Rhonda Barbara)

(b. 1913, Sydney) Sculptor, teacher.

STUDIES: ESTC, 1928–32, with Rayner Hoff; RA Schools and City and Guilds School of Art, London, 1935–40; Regent Street Polytechnic, and St Martin's School of Art, c.1940–45. She married a sculptor and made her home in Cornwall c.1946. From 1966 she travelled extensively and made frequent visits to Australia, exhibiting with the Society of Artists, Sydney, 1932–34 and in many other exhibitions in Australia, Europe, the UK and Asia. Feeling for character (especially in portraiture) and for the human figure in action are distinguishing features of her work, a powerful influence being that of traditional sculpture assimilated during her six visits to Thailand, 1973–80. Among her many fine studies is a striking head in terracotta of Lloyd Rees, reproduced in Scarlett's book *Australian Sculptors*. She exhibited in Australia 1986 (von Bertouch Gallery, Newcastle) and 1987 (Barry Stern, Sydney).

APPTS: Assistant to Rayner Hoff, working on Anzac Memorial, Sydney, and other works; teaching, ESTC (evening classes), 1934–35; Ministry of Works, London (Ancient Monuments Dept), 1940–45; teaching, Penzance School of Art, Cornwall, 1948– .

AWARDS: Bronze medal, ESTC, 1933; NSW Travelling Scholarship, 1935.

REP: NGA; AGNSW; AWM; Stoke-on-Trent Museum and Art Gallery; Spode Potteries Museum and Art Gallery; Esperanto Museum, Vienna.

BIB: Scarlett, AS. Germaine, AGA.

NFI

TRIGGS, Murray Hugh Latimer

See LATIMER, Murray

TRINDALL, Gordon Lyall

(b. 1886, Maitland, NSW; d.?) Painter, teacher.

STUDIES: J. S. Watkins School, Sydney. Mainly a por-

trait painter and painter of nudes; he was a council member of the RAS, 1919–43.

AWARDS: Fairfax Prize, 1914.

APPTS: Teaching, RAS School, 1936–39.

REP: Manly Art Gallery.

BIB: *Fifty Years of Australian Art, 1879–1929*, RAS, Sydney, 1929.

TRISTRAM, John William

(b. 1872, ?Sydney; d. 1938) Painter, architect, poet, musician.

STUDIES: Probably RAS School (evening classes), c.1894. In 1886, aged 14, he entered the office of the Government Architect of NSW, and practised art in his spare time. He also studied music and contributed poetry to the Sydney press. Painted at Manly, Narrabeen, Broken Bay and other coastal areas, his watercolours have an art nouveau, romantic character, some depicting mermaids, centaurs and other mythological beings emerging from mists. He is said to have influenced J. J. Hilder.

REP: AGNSW; AGSA; NGV; regional galleries Bendigo, Hamilton, Newcastle.

TROEDEL, Johannes Theodor Charles

(b. 1835, Schleswig-Holstein; arr. Melb. 1860; d. 1906, Melb.) Printer, publisher. He published *The Melbourne Album*, with illustrations by F. Cogné and H. Gritten (qq.v.) in 1863 as well as many other albums including chromolithographs by Nicholas Buvelot and works by other artists including Buvelot, Streeton, Young, Wheeler and Leason. A *New South Wales Album* was produced in 1877 when Troedel also set up a Sydney branch of his firm (until 1891). He exhibited examples of lithography at the Melbourne Centennial Exhibition, 1888, and later turned to commercial lithography which included posters, packaging labels, sheet music and cheque books. The firm Troedel and Cooper (formed 1911) still operates and presented the State Library of Victoria with a historic set of lithographs. A facsimile of the original *Melbourne Album* was produced by Georgian House, Melbourne, in 1961.

REP: NGA; Mitchell, La Trobe Libraries.

BIB: *ADB* 6. Kerr, *DAA*.

TROMPF, Alexander

Painter.

AWARDS: grant VACB grant; shared Blake Prize with Ian Gentle, 1979.

NFI

TROY, Mary

(b. Sydney) Painter.

STUDIES: Sorbonne, Paris; also in London. She exhibited at the RA, London, worked as a teacher in NSW for 18 years, c.1935–53, and held her first exhibition of paintings in Sydney in 1958.

REP: AGNSW.

BIB: John Kroeger, *Australian Artists*, Renniks, Adelaide, 1968.

TRUMPIS, Karlis

(b. 1910, Dauguli, Latvia) Painter.
STUDIES: Academy of Fine Arts, Riga. His colourful semi-abstract, expressionistic paintings have been exhibited in Australia since 1960 in solo exhibitions and in group exhibitions with the Blue Brush group (q.v.).
AWARDS: Prizes at Latvian Arts Festival, 1960; Caltex award, 1969.
BIB: Germaine, *AGA.*

TRUSCOTT, John

(b. 1936, Melb.; d. Sept. 1993, Melb.) Stage designer, festival director.
STUDIES: Caulfield Tech. Coll., Melb. In 1953 Truscott designed sets for the Australian National Theatre production of *A Midsummer Night's Dream*, and was an actor and designer for the National Theatre until 1956, when he joined St Martin's Theatre (formerly the Little Theatre), South Yarra, as resident designer, designing sets for more than 80 productions. He designed sets and costumes for numerous Australian plays and for the London Festival Ballet, Sadler's Wells, and for the Hollywood films *Camelot* and *Paint Your Wagon.* Interspersed with his UK and USA work were designs for the Victoria State Opera, the Australian Opera and many other Australian projects. His work was exhibited at the Wright Hopkins Gallery, London, and included in the exhibition *The Glamorous Years of Hollywood*, Metropolitan Museum, New York. In 1979 he was appointed designer and supervisor of interior décor for the new Victorian Arts Centre, St Kilda Rd, Melbourne and in 1991 was the director of the Melbourne International Festival.
AWARDS: Academy Award for production and costume designs for film, *Camelot*, 1968.

TRUSTS and FOUNDATIONS

See Appendix 9, p. 874.

TUCK, Marie

(b. 1872, Mt Torrens, SA; d. 1947) Painter, teacher.
STUDIES: Adelaide, with James Ashton; Paris, with Rupert Bunny. After teaching in Perth, she moved to Paris where her *Toilet of the Bride* received an honourable mention at the Paris Salon. In 1908 she sent *The Fish Market* to an exhibition in Australia where it was bought for the AGSA. While living in France she painted at Etaples during the summer months and completed a series of religious paintings for Rheims Cathedral (lost in World War II). She returned to Australia in 1914, at the outbreak of World War I, and became well-known in South Australia as a teacher. In his *Computer Catalogue List*, for the NGA, Daniel Thomas gives 1866 as her birth year (Kroeger in *Australian Artists* says 1872).
AWARDS: Hon. mention, Paris Salon.
APPTS: Teaching in Perth, 1896–1904; Adelaide, SASA, c.1914.
REP: AGNSW; AGSA.

BIB: *Catalogue* AGSA 1946. John Kroeger, *Australian Artists*, Renniks, Adelaide, 1968.

TUCK, Ruth

(b. 1914, Cowell, SA) Painter, teacher, stage designer.
STUDIES: SASA, with Marie Tuck (aunt, q.v.), Ivor Hele, Louis McCubbin and Dorrit Black. She married painter Mervyn Smith (q.v.) in 1943. She held about 32 solo exhibitions 1947–91, largely in Adelaide (including John Martin's; Greenhill galleries) and Perth (Greenhill galleries), and in Stuttgart, Germany, 1983. She was secretary of *Associates Exhibition* (Adelaide Angries), forerunner of the CAS of SA.
AWARDS: AM, 1981; Burnside Sesquicentenary Prize, 1986.
APPTS: Teaching, SA tech. schools and at Adelaide High School, 1933–43; Newcastle Tech. School; Newcastle Hospital (art therapy); Adult Education classes (watercolour painting), 1956– ; art critic, *Adelaide Advertiser*, 1967–72.
REP: AGSA; AGWA; Artbank; Manly Art Gallery; universities of Adelaide and WA.
BIB: Benko, *Art and Artists of SA.* Shirley Cameron Wilson, *From Shadow to Light, SA Women Painters*, Adelaide. Campbell, *AWP.* John Kroeger, *Australian Artists*, Renniks, Adelaide, 1968.

TUCKER, Albert

(b. 29/12/1914, Melb.) Painter.
STUDIES: No formal training. Travel studies in England, Europe and America. Albert Tucker's work first attracted attention in Melbourne during the depression years, when he earned a precarious living as a freelance illustrator, painter and writer. He married Joy Hester, with whom he had a son, Sweeney (later adopted by John and Sunday Reed) (qq.v.), but the marriage broke up in the 1940s. Influenced by the work of German expressionists, such as Beckmann (then unknown in Australia), his paintings, which laid emphasis on the unrest and savagery of the times, offended prevailing conservative tastes and were attacked by reactionary academic groups. He responded vigorously in polemics published in the magazine *Angry Penguins*, and in the work he did as president of the Contemporary Art Society, Melbourne, 1943–47. In 1947 he visited Japan where he worked briefly as an official artist in company with Harry Roskolenko, an American writer attached to the Allied occupation forces; at the end of the same year he returned to Australia, then moved to Europe, where he lived and worked for the next 11 years before going to the USA. During this period he held exhibitions in Amsterdam (1951), Paris (1952), Rome (1953), London (1957) and New York (1960). In 1960 the £1000 Kurt Geiger Foundation, administered by the Museum of Modern Art, Melbourne, provided the funds for his return to Australia. In his evocations of an 'antipodean image', Tucker, like Sidney Nolan, had been largely responsible for awakening interest abroad in the potential of Australia as a painter's country, particularly in respect to its desert regions and its history. His pictures were aptly described by the critic of *Time and Tide*, London, as statements of Australia, stripping off the thin twentieth-century

veneer and displaying a scarred rock landscape or pul-
verised desert. This kind of painting is a mature dis-
tillation of environment, an uprooted and transplanted
tradition of the weirdness of the other side of the
world. Asked to define his own attitude in 1963,
Albert Tucker had this to say: 'For me, art stops with
that moment of poised tension which remains just
before the solution of an enigma, the sense of an
impending encounter with a final truth. It does not
attempt the blasphemy of reducing it to our human
scale in order to possess it and glorify our ego. To do
so destroys our sense of awe and the miraculous, humil-
ity and reverence; the area where our possible immor-
tality lies. Art is also the evidence of man's attempt
to exorcise his unknown destiny, to reach those numi-
nous emblems which lie below and above the indi-
vidual ego and outside history. It is the evidence of
his desperate struggle to metamorphose the devils he
projects and finds there, into angels.' From the time
of his return to Australia, in 1960, Tucker held a
number of increasingly successful Australian exhibi-
tions, originating mainly at the Australian Galleries,
Collingwood. A forthright critic of the preliminary
showing of the Tate Gallery *Exhibition of Australian
Art* in Adelaide, 1962, he did much to bring about
the necessary modifications and additions to the exhi-
bition before it left for London. Sculpture in bronze
was added to his accomplishments in his exhibition
Images of Modern Evil, Sweeney Reed Galleries,
Brunswick, Vic., Nov. 1972, and in 1978, 215 of his
works on paper were shown at the Tolarno Galleries.
Major solo exhibitions 1982–93 were *Albert Tucker
Paintings 1945–60*, Tolarno Galleries 1982; *Faces I
Have Met*, 55 portraits, Tolarno, Melbourne 1985;
Drawings of Albert Tucker, retrospective, NGA 1989.
Significant group exhibitions in which his work appeared
to 1993 include *Rebels and Precursors: Aspects of Painting
in Melbourne 1937–47*, NGV 1962 with 39 paintings
represented; *Art and Social Commitment: An End to the
City of Dreams 1931–48*, AGNSW and touring state
galleries 1984–85; *Angry Penguins and Realist Painting
in Melbourne in the 1940s*, Hayward and Tate galleries,
London 1988–89; *The Great Australian Art Exhibition*
and *The Face of Australia* Bicentennial exhibitions
1988–89. *Classical Modernism: The George Bell Circle*,
NGV 1992. A major retrospective of his work was
curated by the NGV and toured Australian state gal-
leries and the NGA, 1989–90.
AWARDS: *Australian Women's Weekly* Portrait Prize,
1959; Geiger Foundation grant (MOMAD, Melbourne),
1960.
REP: NGA; AGNSW; AGSA; AGWA; MAGNT; NGV; QAG;
QVMAG; TMAG; many other Australian public collec-
tions; numerous regional galleries including Bendigo,
Newcastle, Mornington; MOMA, New York; Guggenheim
Museum, NY.

BIB: Catalogue essays exhibitions as above and all general
books on Australian contemporary art history. Christopher
Uhl, *Albert Tucker* Lansdowne 1981. James Mollison, *Albert
Tucker*, Macmillan 1982. Numerous references in *A&A* includ-
ing 1/4/1964 (Robert Hughes, *Albert Tucker*); 23/2/1985.

TUCKER, Tudor St George
(b. 1862, London; arr. Melb. 1881; d. 1906, London)
Painter, teacher.
STUDIES: NGV School, 1883–87; Ecole des Beaux-Arts,
Paris, 1887–92. The son of a British cavalry officer
in the Indian Army, and grandson of a chairman of
the East India Company, Tucker received little encour-
agement to pursue a career in art. Apparently his
career began after his move to Australia for health
reasons. He soon earned distinction as a student at
the NGV School, and later in Paris where he was
awarded a gold medal at the Ecole des Beaux-Arts.
Returning to Vic., he exhibited at the VAS and at the
Art Society of NSW, painted with the Heidelberg
School artists and from 1893 to 1899 conducted the
Melbourne Art School in partnership with E. Phillips
Fox (q.v.). Educated in music and philosophy as well
as in painting, he was a sympathetic and discerning
teacher. During 1890–91 he edited a small maga-
zine, the *Australasian Critic*, jointly with Baldwin
Spencer (q.v.). Moore states that his fine work never
received due recognition. After his final return to
Europe, he exhibited at the Paris Salon and at the RA,
London, where he died at the age of 44.
AWARDS: Gold medal, Ecole des Beaux-Arts, Paris,
c.1892.
REP: NGV.
BIB: Moore, *SAA*. Smith, *AP*. McCulloch, *GAAP*.

TUCKSON, Margaret
(b. 1921, Gordon, NSW) Ceramicist.
STUDIES: ESTC, 1939–42 and 1948–52. Married to
Tony Tuckson, she taught and researched material for
a book on primitive pottery of Papua New Guinea,
1985.
APPTS: Teaching ceramics, ESTC (part-time), 1963–65;
Adult Education evening classes, 1959–63; Arts
Council classes in country schools, 1970–78.
REP: NGV; regional galleries Mildura, Newcastle;
Museum of Applied Science, Sydney.
BIB: Germaine, *AGA*.
NFI

TUCKSON, Tony (John Anthony)
(b. 1921, Ismailia, Egypt; d. 1973, Sydney) Painter,
gallery administrator.
STUDIES: Hornsey School of Art, London, 1937–38,
and at Kingston, Surrey; ESTC, 1946–49. He joined
the RAF in 1939 and was stationed with a Spitfire
squadron in Australia where he became engaged to
ceramic artist Margaret Bisset, whom he married in
1943. Posted back to England in 1945, he soon
returned to Australia and to art school at ESTC, under
the Commonwealth Rehabilitation Training Scheme.
The teachers he most admired were Ralph Balson and
Grace Crowley. Work as an odd-job man and part-
time teaching at Knox Grammar School led to a job
as an attendant at the AGNSW, 1950, but before the
year was out he had been promoted to the position
of Assistant to the Director, a post he held for the
rest of his life. From 1950 his paintings, inspired by

Tony Tuckson, Swirl, *c. 1965.* PVA *on hardboard, 122 ×
183cm. Courtesy Watters Gallery, Sydney.*

surroundings that included his wife, son, house, gar-
den and general domestic environment, developed a
quality of Bonnard-like intimacy. He took leave of
absence to paint for the NSW Travelling Scholarship
in 1953, and in 1958–59 made two trips with Dr
Stuart Scougall to acquire, at Melville Island and
Yirrkala, the carved, painted grave posts and bark
paintings that were to form the basis of the AGNSW
ethnic collections. The travelling exhibition of 1960–61,
which he subsequently organised for Australian state
galleries, was the finest exhibition of Australian
Aboriginal art put together in Australia for many
years and was sent in modified form to represent
Australian art at the *Bienale de São Paulo,* Brazil. It
established Tuckson's name as an organiser. After this
experience of primitive life and art, the direction of
his own painting changed radically, moving from
figuration to abstraction then to abstract-expression-
ism and finally to the kind of gestural painting that
formed the bulk of the work at the memorial exhi-
bition organised for the Monash Uni. Gallery in 1975.
Retrospective exhibitions 1975–93 included those at
Pinacotheca, Melbourne 1982, 89; Broken Hill and
Penrith regional galleries 1984; Watters, Sydney 1986,
89; Heide 1989; and his work was included in numer-
ous significant group exhibitions from 1948 includ-

ing CAS exhibitions in Sydney in the 1960s; *Abstract
Expressionism,* Ivan Dougherty gallery 1980; *Recent
Australian Paintings: A Survey 1970–83,* AGSA 1983;
Field to Figuration, NGV 1987; *The Great Australian
Art Exhibition* Bicentennial exhibition 1988–89;
Drawing in Australia from 1770s to 1980s, NGA 1988;
Portrait of a Gallery: Watters 25th Anniversary Exhibition,
touring eight regional centres 1989–91; *Off the Wall,
In the Air: A Seventies Selection,* Monash Uni. Gallery
and ACCA Melbourne 1991. The AGNSW held an exhi-
bition of his work *Themes and Variations* 28 June–27
August, 1989.

REP: NGA; AGNSW; AGSA; NGV; Artbank; regional gal-
leries including Ballarat, Newcastle, Shepparton;
tertiary collections including Macquarie, Qld unis.;
corporate collections including Allen, Allen & Hemsley;
Philip Morris.

BIB: Catalogue essays exhibitions as above and most general
books on Australian contemporary art history including
Smith, AP. Gary Catalano, *An Intimate Australia,* Hale &
Iremonger, 1985. G. Legge, T. Maloon, D. Thomas, *Tony
Tuckson,* Craftsman House 1989. A&A 11/3/1974; 12/2/1974;
23/2/1985.

*T*ULLOCH, David

(Arr. Melb. 1849; d. 1877) Artist, engraver. He worked
for the engraving firms of Thomas Ham (q.v.) then
Ferguson & Mitchell and finally conducted his own
engraving business. He also made sketches of the
goldfields, some reproduced in Ham's magazine,
Illustrated Australian Magazine. Best-known of Tulloch's

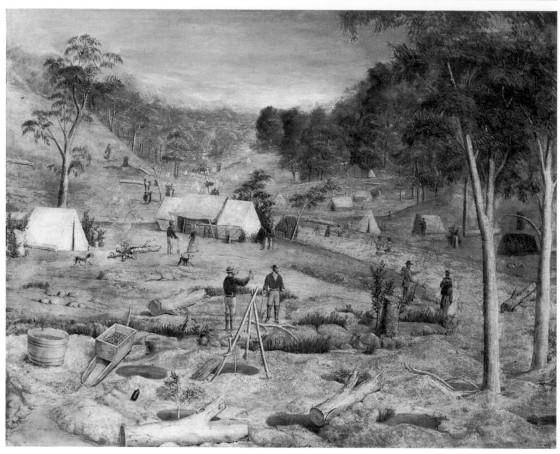

E. Tulloch, Mining Camp at Bathurst. *Collection, Dixson Gallery, Mitchell Library, NSW.*

published works is *The Great Meeting of Gold Diggers at Mt Alexander, December 15th, 1851.* His work was seen in *The Artist and the Patron,* AGNSW 1988.
REP: Regional galleries Ballarat, Castlemaine; NLA; La Trobe, Mitchell, Dixson Libraries.
BIB: McCulloch, *AAGR.* Kerr, *DAA.*

TUNKS, Noel
(b. 1942, Vic.) Painter.
STUDIES: RMIT and Prahran CAE; travel studies, India, Italy and UK, 1969–70. His work as seen in exhibitions, mainly at the Australian Galleries, Melbourne in the 1970s, dealt with horror themes reminiscent of the canvases of Francis Bacon but with the distorted viscera of men, women and animals precisely painted and often decked out in sixteenth-century trappings. He appears not to have exhibited since 1978.
AWARDS: Blake prize, 1978.
NFI

TUPICOFF, June
(b. 1949, Healesville, Vic.) Painter.
STUDIES: Private studies with Leonard French, Neil Douglas, 1966; Mervyn Moriarty, Anne Thompson, Sydney Ball, Jeff Makin, 1973–84. Her late 1980s work showed a mixture of photographs superimposed on her own images in collage fashion. She held four solo exhibitions 1985–90 at Ray Hughes Brisbane (1985, 88) and Sydney (1987, 90), and her work was seen in approximately 20 group exhibitions 1973–91 at private galleries in Sydney (including Ray Hughes' *Thinking Aloud/Allowed* exhibitions, 1986, 89, 91) and at public galleries including *Australian Perspecta '85,* AGNSW 1985; *Twenty Australian Artists,* Galleria San Vidale, Venice, QAG, Benalla Regional Art Gallery 1990. *Shifting Parameters,* QAG 1991.
APPTS: Lecturer, Mervyn Moriarty School, Brisbane; lecturer, CAE Kelvin Grove Campus, Brisbane, 1986.
REP: MOCA, Brisbane; QAG; Griffith Uni.; Qld Uni. of Technology.
BIB: McIntyre, *CC. A&A* 24/1/1986; 28/3/1991.

TURNBULL, Stanley Clive Perry
(b. 1906, Glenorchy, Tas.; d. 1975, Melb.) Critic. Melbourne *Herald* art critic, 1943–48; member of the Museum of Modern Art and Design, and of the Australian Division of the International Association of Art Critics. A strong supporter of the modern movements of the 1940s, he organised the exhibition *Australian Present Day Art,* 1945, and was one of the earliest buyers of the work of Sidney Nolan. Author of *Art Here: Buvelot to Nolan,* Hawthorn Press, Melbourne, 1947; introduction, *Artists for Peace,* exhibition cat., Tyes Gallery, Melbourne, 1954.

TURNER, Beth

(b. 1946, Burnie, Tas.) Painter, printmaker.
STUDIES: Tasmanian School of Art, Hobart, c.1963; St Martin's School of Art, London. Her romantic, figurative paintings appeared first in Tasmanian galleries and in 1976 at the Bonython Galleries, Sydney. She held approximately 15 solo exhibitions to 1989 including in Melbourne (Pinacotheca, Rhumbarallas) and many in Hobart. Her work appeared in numerous group exhibitions 1969–88 including at TMAG, QAG.
AWARDS: Perth International for Drawing (under twenty-five), 1971; Albury prize, 1974.
REP: AGWA; TMAG; Albury regional gallery.
BIB: Backhouse, TA.

TURNER, Boyd

An exhibition of small modernist abstract paintings in the name of *Boyd Turner* was held at Gallery A, Melbourne, Aug. 1959, and a painting was entered for a competition at the VAS (7 Nov. 1959). The name was suspect, however; no such artist has been heard of since and the exhibition is believed to have been a hoax.

TURNER, Charles

Painter. A colonial school painter, he showed landscape, bush and coastal subject paintings in oils and watercolours at the Victorian Academy of Arts, 1870–82, and at the Art Society of NSW, including views of Wannon Falls and the Grampians. He also illustrated several books – *Australian Stories in Prose and Verse*, Cameron, Melbourne, 1882; J. D. Dobson, *Ye Rambles and Exploits of Prof Chunk*, Troedels, Melbourne, 187?

TURNER, James Alfred

(Active c.1860–1910, Vic.) Painter. Mainly a painter of illustrative and sentimental scenes of bush life. He may have been the J. Turner listed as living in East Melbourne and Fitzroy, 1863–73, before marrying during a visit to the UK, after which he settled in Heyington House, Toorak. Rated by his contemporaries as an amateur, he exhibited at the VAA, then at the VAS, 1884–93, producing a large body of work sold at low prices. Later the regularity with which his paintings appeared in sales, coupled with increasing curiosity and interest by Australians in their own colonial history, caused the work to rise rapidly in price. In 1980 this rise took a dramatic turn when his large oil, *The Homestead Saved – an Incident of the Great Gippsland Fire of 1898*, reached an unprecedented $82,000 at Joel's auctions, Melbourne. His work was also seen in *Australian Art in the 1870s*, AGNSW 1976.
REP: Castlemaine Art Gallery.
BIB: Moore, SAA.

TURNER, Margaret Ellen

(b. 1948, NZ) Sculptor.
STUDIES: Art Certificate, Liverpool TAFE, 1978; BA Visual Arts, Alexander Mackie CAE, 1980; Grad. Dip., City Art Inst., 1982; M. Fine Arts (Sculpture), Reading Uni., UK, 1987. She held three solo exhibitions 1984–89 at Irving Sculpture, Sydney 1984; *The Grail and the Goddess*, Air and Space, London 1988; and Macquarie Galleries, Sydney 1989. Her work appeared in about 11 group sculpture exhibitions 1980–89 including *Aust. Sculpture Triennial*, 1981, 84; *Graven Images*, AGWA 1987; and in the UK including *Four Women Artists*, South Hill Park Arts Centre, Bracknell 1987.
AWARDS: First prize, art, Liverpool TAFE, 1978; Hozumi Momota Art Award for study in Japan, 1978; Mitchell Cotts award, graduating students, 1981; VACB project grant, 1983; VACB travel grant, 1985; Clifford Norton Award, Reading Uni., UK, 1986; Carter Memorial Sculpture prize, Reading Uni., 1987; London studio grant, VACB, 1988.
APPTS: Part-time lecturer, tertiary colleges, 1982–including City Art Inst., Sydney, 1982–85; South Hill Park Arts Centre, UK, 1987; Liverpool TAFE, NSW, 1989.
REP: Regional galleries Hamilton, Wollongong; Morden Art Centre, London.

TURNER, Thomas

(b. 31/7/1813, London; arr. Perth 13/3/1830; d. 3/7/1895, Melb.) Topographical artist, architect, surveyor. He made a number of fine watercolours of the Augusta–Busselton area, where he lived c.1840. He also made a survey and map, joined the rush to the Victorian goldfields in 1852 and was at Mt Alexander (Castlemaine) for a year before taking up farming. From 1858 he worked as a surveyor and architect in nearby Taradale where he designed the Holy Trinity Church. After a number of moves he was appointed to the Lands Dept in 1873, remaining till 1880. The years 1885–91 were spent farming in NSW, after which he retired to Melbourne. His best-known topographical works are the fine group in the AGWA, depicting the bush, landscape and early settlement of Augusta and Busselton. His work was represented in *The Colonial Eye*, AGWA 1979.
REP: AGWA; J. S. Battye Library, Perth; Mitchell Library, Sydney.
BIB: A&A 16/4/1979. Kerr, DAA.

TURPIN, Jennifer

(b. 19/4/1958, Perth) Installation artist.
STUDIES: BA (Fine Arts hons.), Uni. of Sydney, 1977; Academia di Belle Arti di Urbino, Italy (sculpture), 1982–83; foundation course, Sir John Cass School of Art, London, 1983–84; B. Visual Arts (sculpture), Sydney Coll. of the Arts, 1986–88; Grad Dip., SAC, 1990. She worked in a variety of art-related jobs including graphic artist, art researcher for various NSW galleries, 1986–91, assistant puppet-maker for the film *Labyrinth* for the Henson organisation, London, 1985, and historical researcher for Geoffrey Dutton in London for his book *The Innovators*, as well as lecturing and tutoring. She has become known for her

unique 'water sculptures' which range from performance pieces to installations such as those seen in the foyer of the AGNSW and the NGV (as part of the *Australian Sculpture Triennial*, 1993) which were both elegant and transfixing with delicate string-like streams of water apparently moving upwards. A permanent water installation is at BP House, Sydney.

AWARDS: Postgrad. travelling scholarship, Uni. of Sydney, 1982; grant, VACB, 1991.

APPTS: Lecturer, tutor, Art Theory Dept, SAC, 1989; asst. co-ordinator, postgrad. studies, SAC, 1991.

TURRAMURRA WALL PAINTERS

Name adopted by a group working jointly to produce the mural decorations for the children's chapel in the crypt of St James's Church, Sydney, c.1930. The group included Roland Wakelin, Roy de Maistre, Jean and Gwen Ramsay, Bethia Anderson and Mrs A. T. Anderson, the organiser of the project. Having deteriorated badly over the years a major restoration of the murals began in 1992.

BIB: Moore, SAA.

TWEDDLE, Isabel Hunter (nee HUNTER)

(b. 1877, Deniliquin, NSW; d. 1945, Melb.) Painter. STUDIES: NGV School, 1894–97. From 1905–17 she exhibited still life and portraits at the VAS, but extensive overseas travel changed her views and in 1932 she joined William Frater, Arnold Shore, George Bell and others to form the Contemporary Group. Influenced by Mediterranean architecture, she built a pink house at Heyington, Toorak, and housed in it her fine collection of modernist paintings, Japanese paintings and prints and objets d'art. She exhibited also with the Twenty Melbourne Painters, and later became president of the Melbourne Society of Women Painters and Sculptors. Her work was seen in exhibitions at *Important Women Artists* gallery, Melbourne in the 1970s and in *A Century of Australian Women Artists 1840s–1940s* Deutscher Fine Art, Melbourne 1993.

REP: NGV; QAG; Ballarat regional gallery.

BIB: Smith, AP. John Kroeger, *Australian Artists*, Renniks, Adelaide, 1968. Janine Burke, *Australian Women Artists* Greenhouse, Melbourne 1981.

TWENTY MELBOURNE PAINTERS

(Established 1917, Melb.) Founded to conduct annual exhibitions by members with common, conventional interests. Paradoxically the first modernist paintings exhibited in Melbourne (by Frater, Shore, Tweddle and others) appeared in these exhibitions. First conducted at the Athenaeum Gallery, the exhibitions are held at the VAS, having long since reverted to their original more traditional character.

TWIGG, Tony

(b. 19/4/1953) Painter, sculptor, performance artist, film-maker.
STUDIES: Dip. Art (painting), Canberra School of Art, 1976; Postgrad. Dip., professional art studies, Alexander Mackie CAE, 1981; MA (visual), Sydney CAE, 1985.

Peter Tyndall, A Person Looks At A Work Of Art/ someone looks at something *(detail), 1986.*

His works or performances were seen in 16 solo exhibitions 1975–91 in Sydney (Roslyn Oxley9 1982, 83; Garry Anderson 1985, 86; Ray Hughes 1988, 90, 91), Canberra (Abraxas 1975, 77; Bitumen River 1981; Ben Grady 1987) and Brisbane (Ray Hughes 1987, 88, 89) and in Performance Space, Sydney, 1986; Canberra Contemporary Art Space, 1989 and in about 12 group exhibitions including Ray Hughes, Holdsworth, Sydney and public galleries including *Artists' Books*, Artspace, Sydney 1983; *A New Generation: The Philip Morris Collection*, NGA 1988; *20 Australian Artists*, Gallerie San Vidal, Venice, QAG, Benalla Art Gallery 1989; *Writers in Recital*, AGNSW 1990. He performed with the Sydney Dance Company and Canberra Dance Ensemble, 1986, and his short film *A Passion Play* was screened at Cannes Film Festival, 1992.

APPTS: Technical assistant, Prints and Drawings, NGA, 1977–80; freelance designer including for Sydney Dance Company, 1983 and National Museum, 1989–90; part-time lecturer, printmaking, Canberra School of Art, 1987–91; drawing, Canberra School of Art, 1988–91.

REP: NGA; AGNSW; QAG; MOCA; Artbank.

BIB: Catalogue essays exhibitions as above, McIntyre, CC.

TYNDALL, *Peter*

(b. 12/2/1951, Melb.) Painter.
STUDIES: Uni. of Melbourne (architecture), 1970; RMIT, 1971–72. Abstract expressionism and texture painting influenced his early exhibitions at the VAS (1972), and Powell Street Gallery (1973). Later he made a series of tiny 'pillar' drawings, and then produced a large performance piece entitled *Shooting Gallery* at the *Mildura Sculpture Triennial*, 1978. Since the early 1980s he has been producing works in a commentary series *A Person Looks at a Work of Art/Someone Looks at Something* in which people within the work are looking at people looking at a work and so on. He has produced many hundreds of variations of this work, characterized by precisely drawn figures with occasionally notations on the surround. Much documented by contemporary critics they have been seen in a number of solo exhibitions including a retrospective at ACCA, Melbourne, 1987. His work was represented in group exhibitions at the Edinburgh Festival, 1986; *Biennale of Sydney*, AGNSW 1987; *The Great Australian Art Exhibition* Bicentennial exhibition 1988–89 and is often seen at contemporary art spaces including MCA, Sydney

AWARDS: Latrobe Valley Invitation Award (Caltex award), 1972, 75; Georges Invitation Art Prize (purchase award), 1974; Horsham Art Prize, 1973; Darnell de Gruchy prize, Brisbane, 1974.
REP: NGA; most state galleries.
BIB: Pam Hansford, *Dagger Definitions*, Greenhouse 1987. *A&A* 25/3/1988.

TYSON, *Geoffrey*

(b. 3/4/1911, Launceston; d. 24/4/1986) Painter, advertising artist.
STUDIES: Melbourne (commercial art). He worked in Melbourne as an advertising artist, 1930–34, then as a newspaper artist for the *Examiner*, Launceston, before enlistment in the AIF, 1940. He spent 1942–45 as a POW in prison camps in Timor, Java and Japan. Returning to Launceston, he taught at Launceston Tech. Coll. and later went back to painting and advertising art. Best-known for his sketches done as a POW, he was a member of the Tasmanian Group of Painters, Launceston Art Society and VAS. The QVMAG held a retrospective of his work in 1982.
REP: NGA; QVMAG; TMAG; AWM.
BIB: Campbell, AWP. Backhouse, TA.

ULMANN TO URE SMITH

ULMANN, Robert

(b. 1927, Zurich; arr. Aust. 1970) Sculptor, natural history artist.
STUDIES: Kunstgewerbe Schule, Zurich, 1950–54. He travelled in Canada, the USA, Mexico, South America and the South Pacific before arriving in Australia, where he taught experimental art for the education dept of the Northern Territory administration at Docker River, 1970–72. His works featuring wildlife subjects and largely watercolours were seen in exhibitions from 1950 in Australia, Switzerland and France and he received several sculpture commissions, including a fountain for the City of Zurich, 1952 and a memorial for Fletcher Jones in Warrnambool, Vic. 1977.
AWARDS: Prizes for watercolours, Society of Wildlife Artists, Melbourne, 1978–80.
NFI

UNDERHILL, Anthony

(b. 1923, Sydney; d. 1977, UK) Painter.
STUDIES: ESTC, 1939; Hobart Tech. Coll.; Melb. Tech. Coll., 1945–47 (under Commonwealth Rehabilitation Training Scheme). He lived in England from c. 1949, sending exhibitions to Australia in 1957, 1959 (Australian Galleries) and 1965 (Gallery A). The first of these showed the combined influences of Turner and French post-impressionism, the second that of abstract-expressionism, while the third and most successful equated with contemporary English painting, featuring faceless nudes whose forms were integrated with their surroundings after the manner of Francis Bacon. Sponsored by the West German government, his work was exhibited in three German cities.
REP: NGV; public collections in Britain, USA and Germany.

UNDERHILL, Nancy Dudley Hoffman

(b. 1/7/1938, New York City; arr. Aust. 1962) Lecturer, administrator, gallery director, art writer.
STUDIES: Bryn Mawr Coll., Penn., USA, grad. BA; M. Litt., Courtauld Inst., Uni. of London. As director of the Qld Uni. Art Museum she built up a fine collection and made the Museum an important centre of contemporary art in Qld. She was art critic for the Bulletin in the early 1960s and wrote many catalogue essays and publications and contributed to the Australian Dictionary of Biography. Her books include a biography of Sydney Ure Smith, Making Australian Art, 1991. Exhibitions she curated with accompanying catalogues include Margaret Cilento; Dressed to Kill 1935–50: The Impact of World War II on Queensland Women's Dress, 1986; Young Turks: Brisbane Art 1930–1950, 1988.
AWARDS: Australian Research Grants Commission, 1978–81 and 1990–91; major project grant, Uni. of Qld, 1982; Bicentennial Authority National Commissioning Grants (with funding several other bodies) to purchase artwork worth $240,000; exhibition grant, VACB, 1992.
APPTS: Lecturer in Fine Arts, 1971– , chairman, John Darnell Fine Arts Committee, 1973– , director, Uni. Art Museum and head of Fine Arts Dept, Uni of Qld, 1978– ; board member, VACB, 1976–80; board member and vice-chairperson, AGDC, 1979–81; council member and chairperson, Art Museums Association of Australia, 1976–82; interim director, Public Galleries Consultative Group, 1982– ; member of a number of consultative groups and committees of tertiary colleges, prizes, etc. including Michell Endowment, NGV, 1978–82; IMA, Brisbane, 1981–86; Fulbright Scholarship.

UNGUNMERR, Miriam Rose

(b. NT) Painter, teacher, illustrator.
STUDIES: Melbourne. A member of the Moil tribe, Daly River, NT, she supervised art classes throughout the NT and illustrated Alan Marshall's People of the Dreamtime, Hyland House, Melbourne, 1978.

UNITED ARTS CLUB

(Founded 1923, Adelaide) Chaired by H. van Raalte, members took part in Artists' Week, an event organised by John L. Preece, 29 July 1924. The program included a Federal Art exhibition, Conservatorium concert, repertory performance, banquet, etc.
BIB: Moore, SAA.

UNIVERSITIES

See SCHOOLS AND UNIVERSITIES
Appendix 8, p. 864.

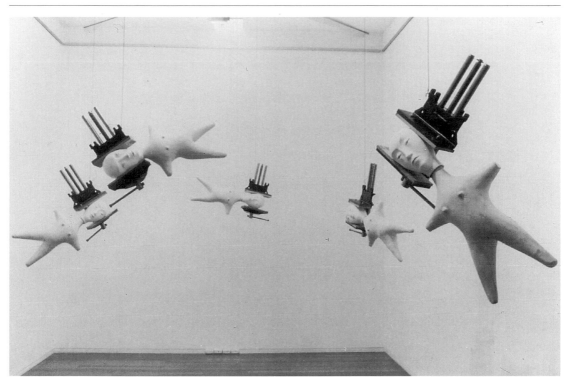

Ken Unsworth, Rapture, *1992, fired porcelain heads, laytex and 5 steel vices. Courtesy Roslyn Oxley9, Sydney.*

UNSWORTH, Ken

(b. 1931, Melb.) Painter, sculptor.
STUDIES: TSTC, Uni. of Melb., Melb. Teachers Coll., 1950; afternoon classes George Bell, Melb., 1956–57; Dip. Art, NAS, Sydney, 1962–63 with Coburn, Passmore, Miller, Peter Laverty. His work in a number of his first exhibitions at the Inst. of Contemporary Art, Sydney from 1975 was largely installation and some performances. He is equally versed as a draughtsman, painter and sculptor – his charcoal drawings being especially noteworthy. Tony Bond in *Contemporary Australian Painting* (Craftsman House, 1989) describes his images as summoning up 'a stark nightmarish world of the psyche with the minimum of gestural flourish or decoration.' He held annual exhibitions from 1975, largely at Roslyn Oxley9, Sydney, and with ICA, Sydney (1977, 79, 81); a project survey show at AGNSW, 1979 and Ivan Dougherty Gallery 1982; National Gallery of Wellington, NZ 1983; Heide 1985; and in Berlin, Tokyo 1991. Group exhibitions in which his work appeared 1976–93 include the *Venice Biennale*, 1978; *Biennale of Sydney*, 1976, 82, 86, 88, 90; *Australian Perspecta*, 1981, 85, 87, 88; *Australian Sculpture Triennial*, 1981, 85; a number of international art exhibitions and Australian art touring internationally including *Continuum*, Japan 1983, 88; *Contemporary Australian Art to Japan*, three Japanese state museums 1988; *The Australian Art Exhibition*, three German cities 1988; *Head through the Wall*, touring Germany, Poland, Sweden 1992. His charcoal draw-

ing represented in *Classical Modernism: The George Bell Circle*, NGV 1992 differed vastly from that of the formal modernist style of the majority of exhibits, being more reminiscent of German Expressionism. His commissions include sculptures for ANU, Art Gallery of Wollongong and the Darling Harbour Authority; print portfolios for Bicentennial Print Portfolio, 1988; Rene Block edition of Australian prints, 1988; Biennale Print Portfolio 1990 and for Vietnam Veterans Memorial, Canberra.
AWARDS: Capt. Cook Bicentenary Sculpture Competition, 1970; Australian/American Education Foundation Grant, travel USA, 1971; residency, Cité Internationale des Arts, Paris, VACB, 1979; Member, Order of Australia (AM), 1989; Lake Macquarie-Charlestown Square Art Prize, 1990.
APPTS: Lecturer, Bathurst Teachers Coll., 1966; lecturer, head of art teacher education, Tasmanian School of Art, 1969–71; lecturer, sculpture, Sydney CAE, 1972; delegate, UNESCO conference, Florence, Italy, 1990.
REP: NGA; AGNSW; AGWA; NGV; QAG; Kroller-Muller, Otterloo, Holland; Museum Sztuki, Lodz, Poland; NCDC, Canberra; Wollongong City Gallery; a number of tertiary collections including Flinders Uni. and ANU; corporate collections including Chase Manhattan Bank, USA.
BIB: Catalogue essays exhibitions as above. Sturgeon, DAS. A&A 20/3/1983. Chanin, CAP.

UNWIN, Ernest Ewart

(b. 1881, Kent, Eng.; arr. Tas., 1923; d. 1944, Hobart) Painter. Watercolourist, trustee of the TMAG and member of the Royal Society of Tas., he came to Tasmania

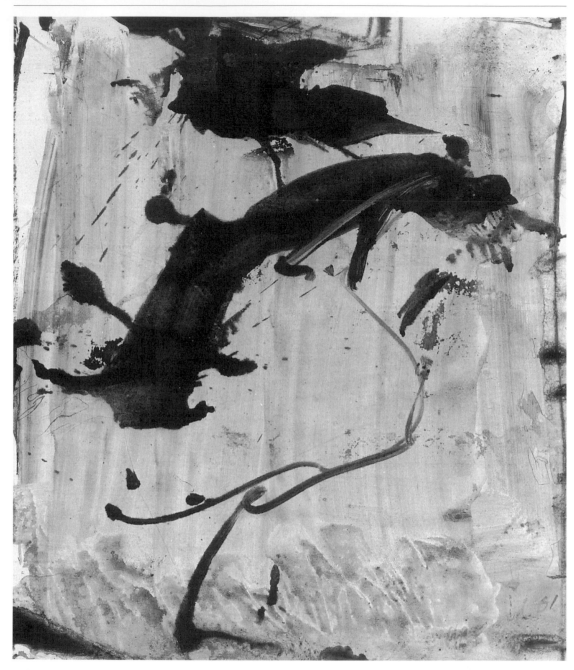

to become headmaster of Friends' School in Hobart.
REP: TMAG.

UPTON, *John A.*

(b. 1850, UK; arr. Vic. 1852; d. c. 1882, Munich)
Painter.
STUDIES: Munich Academy of Art, c. 1873; RA Schools,
London (South Kensington). His parents went to Vic.
with the goldrush and settled in Melbourne. After
formal education in Melbourne, Upton entered the
photographic firm of Johnstone & O'Shannassy as an
artist before moving to Adelaide and similar employ-
ment with the Adelaide Photographic Company, in
company with E. Wake Cook (q.v.). A work of his

was exhibited in the 1873 London *International Exhibition*
– he may have gone to Europe with his exhibit as he
was enrolled in the Munich Academy shortly after.
By 1876 he had painted *Peasant Girl at the Shrine*
(AGSA) in neo-classic Munich style. He studied in
London, became a professional portrait painter and in
1881 was appointed to the AGSA as painting master.
Too ill however to remain in the position long, he

returned to Munich where he died. His work was seen in *Visions after Light*, AGSA 1988.

APPTS: Painting master, Art Gallery of SA, 1881 (not taken up for health reasons).

REP: AGSA; NLA.

BIB: Moore, *SAA*. Kerr, *DAA*.

UPTON, Ronald W.

(b. 1937, Melb.) Sculptor, teacher.

STUDIES: Prahran Tech. Coll., Melb., 1956–57; RMIT, 1958–64. Inspired by the philosophy of Jung, he showed large sculptures in ciment fondu as well as drawings at the Argus Gallery, Melbourne, Feb. 1965. One of his drawings became the subject of (unsuccessful) police action at an exhibition at Strines Gallery, Melbourne, 1966 because of its alleged erotic content. His sculptures were seen in several solo and a number of group exhibitions 1965–87 including *Mildura Sculpture Triennial*, 1967, 70; *Australian Sculpture Triennial*, 1987.

APPTS: Teaching art and craft in Vic. secondary schools, 1959–69; lecturer in painting and drawing, Melb. State Coll.

REP: NGV; Heide; Mildura regional gallery.

BIB: Sturgeon, *DAS*. Scarlett, *AS*.

NFI

UPWARD, Peter

(b. 29/9/1932, Melb.; d. 1984, Sydney) Painter.

STUDIES: RMIT, 1948–49; ESTC, 1951; Julian Ashton School, with John Passmore, 1951–53; travel studies, Italy, France, Spain, USA. His work was shown first at the MOMAD, Melbourne, Feb. 1959, then with the group Sydney 9, in Sydney and Melbourne, 1961 and in *The Australian Painters*, 1964–66, Mertz Collection 1966. Inspired by action painting as well as Eastern calligraphy, the most dynamic of his black and white paintings is probably the enormous *June Celebration*, 1961; like the work of the Americans Kline and Motherwell, this work represents an exuberant celebration of the creative act of painting. From the early 1970s he introduced colour into his paintings – first using the clashing psychedelics popular in the late 1960s, then later in more muted colours which did not detract from the work's vigour. His solo exhibitions included those in Folkestone, UK, Berlin, 1964, and London, 1970, 73; with Rudy Komon, Sydney 1972; Uni. of NSW, 1973 and a retrospective survey show at AGNSW 1984.

REP: AGNSW; ANU.

BIB: Smith, *AP*. Robert Hughes, *The Art of Australia*, Penguin Books, Harmondsworth, 1970.

URBONAS, Leonas

(b. 1925; arr. Aust. 1948) Painter.

STUDIES: Academy of Art, Stuttgart, Germany. He held a number of solo exhibitions from 1964 in Australia and in 1966, during a nine-month stay in the USA, exhibited his surrealistic paintings in New York, Chicago, Cleveland and Toronto.

AWARDS: Prizes in competitive exhibitions at Mosman (drawing), 1959; Miranda Art Festival (watercolour), 1964; Hunters Hill (oil), 1965; Sydney CAS (Fashion Fabric Design), 1965; Ryde 1972.

REP: NGA.

BIB: Germaine, *AGA*.

NFI

URE SMITH, Sydney George

(b. 9/1/1887, Stoke Newington, UK; arr. Aust. 1888; d. 1949, Sydney) Painter, etcher, editor, publisher.

STUDIES: Julian Ashton School, Sydney; etching with Eirene Mort. His work first appeared in the *Sydney Mail*. Later he turned to advertising and with Harry Julius started the advertising firm of Smith & Julius. After severing his connections with *Art in Australia*, he founded the company of Ure Smith Pty Ltd in 1939, mainly for the purpose of publishing the quarterly *Australian National Journal* (1939–47), and for the publication of the series of books, *Present Day Art in Australia*, which drew nationwide attention to the contemporary art of Sydney, notably to the work of the expatriate Australian artists returning from Europe at the time of World War II. Another (shortlived but valuable) production was the *Australian Art Annual* containing items on art activities in all Australian states. After Sydney Ure Smith's death, the publishing business was carried on at first, in greatly modified form, by his son, Sam Ure Smith, who eventually became the publisher of *Art and Australia*, successor to *Art in Australia*. Nancy Underhill wrote his biography in 1991.

AWARDS: NSW Society of Artists medal, 1931; OBE conferred, 1937.

APPTS: Member, NSW Society of Artists, president, 1921–47; foundation member, Australian Painter-Etchers' Society, 1921; member, Australian Art Association; founder, editor and publisher, *Art in Australia* (1916–39); organiser of the 1923 *Australian Art Exhibition* at Burlington House, London.

REP: NGA; AGNSW; AGSA; AGWA; NGV; Newcastle regional gallery; British Museum (print collections).

BIB: Moore, *SAA*. Smith, *PTT*. Smith, *AP*. Nancy Underhill *The Making of Art: Sydney Ure Smith*, Ure Smith & OUP, 1991. *AA* 1920 (*The Etchings of Ure Smith*). *Studio* London, Jan. 1950 (F. A. Mercer, *Sydney Ure Smith, O.B.E., 1887–1949*, obituary). *A&A* 25/4/1988 (commemorative issue).

VAGARINI TO VOUDOURIS

VAGARINI, Cesare
(b. 14/12/1905, Rome; arr. Aust. c. 1942)
STUDIES: Florence Inst. of Art, Italy; Academy of Brera, Milan, with Prof. Aldo Corsi. Commissioned to paint frescoes for the Church of St Elizabeth, Palestine, he was interned at the outbreak of World War II and sent with his wife to the prison camp at Tatura, Vic. Later he painted religious works, including several for the Mary Immaculate Church, Glen Waverley, Vic. He also wrote critiques for the *Sydney Morning Herald* and Melbourne *Advocate*, and exhibited at the NSW Society of Artists drawing exhibition at David Jones Gallery, Sydney, in 1946, when his work was mentioned in the *Sydney Morning Herald* as among 'the more deserving' of the exhibits. After the war he returned to Palestine.
APPTS: Teaching, fresco painting, Academy of Brera; restoration work on frescoes in old churches in Tuscany.
REP: AGNSW.
BIB: John Kroeger, *Australian Artists*, Renniks, Adelaide, 1968.

VAHLAND, Wilhelm Carl
(b. 1828, Hanover; arr. Vic. 1854; d. c. 1915, Bendigo) Illustrator, architect. Unsuccessful as a digger in Bendigo, he went into partnership with Jacob Getzschmann in 1857 and designed many fine buildings in Bendigo. He exhibited illustrations in Bendigo exhibitions and in 1862 visited NZ.
BIB: McCulloch, *AAGR*.

VALADON, Rosemary
(b. 1947, Sydney) Painter.
STUDIES: BA (Visual Arts), SCA, 1984; Grad. Dip., SCA, Sydney Uni., 1986. She held four solo exhibitions 1975–92. Her 1992 Blaxland Gallery exhibition, entitled *The Goddess Within*, explored the notion of female archetypes using Greek goddess myths to portray female behaviour and personality traits as represented by well-known 20th-century women. She participated in a number of group exhibitions including *Archibald*, *Blake*, *Portia Geach* and other prize exhibitions.
AWARDS: Scholarship, SCA; VACB grants, 1988, 91; Muswellbrook Drawing Prize, 1988; Blake Prize (co-winner), 1991; Portia Geach Memorial Award, 1991.
APPTS: Teaching, SCA, 1990; private drawing classes with the Billy Blue School of Graphic Art & Design, 1990–91.
REP: Muswellbrook regional gallery.

VALAMANESH, Hossein
(b. 1949, Tehran, Iran; arr. Aust. 1973) Sculptor, installation artist.
STUDIES: School of Fine Art, Tehran, 1970; SASA, 1977. His geometric installations and sculpture are often made from a wide variety of materials including wood, steel, glass, and plants and are often concerned with the environment. His accompanying drawings mirror their style. He held 16 solo exhibitions 1972–92 largely at Macquarie Galleries, Sydney; Bonython and Bonython-Meadmore, Adelaide. His work appeared in numerous group sculpture and other survey shows 1978–91 including *Australian Sculpture Triennial*, 1981, 8/; *Australian Perspecta*, AGNSW 1983, 85; *Singular and Plural*, SASA 1985; *Common Earth Alive and Unfired*, Uni. of Tasmania 1985; *Painters and Sculptors*, QAG 1987; *Australian Contemporary Art*, Museum of Modern Art, Saitama, Japan 1987; *Some Provincial Myths*, Contemporary Art Centre, SA 1987; *Metro Mania*, Australian Regions Artists Exchange, Perth 1989; *Survey of Recent Work 1980–90*, Contemporary Art Centre, Adelaide 1990. He was artist-in-residence at Praxis, City of Noarlunga, SA in the 1980s and his commissions include those for *Roundspace Alternative Dwelling*, Adelaide Festival 1980 and environmental sculptures for the SA. Coll. of Art and Adelaide Festival Centre.
AWARDS: Several student prizes, SA, 1976, 78; VACB grants, 1979, 82; residency, Künstlerhaus, VACB, 1990–91.
REP: NGA; AGSA; AGWA; NGV; QAG; Artbank; many tertiary and several regional collections.
BIB: *New Art Two*.

VALE, May
(b. 1862, Ballarat West, Vic.; d. 1945, Burwood, Vic.) Painter.
STUDIES: RA Schools, London, c. 1875–78; NGV School, 1879–83 with von Guérard and George Folingsby;

Linton School, London, with Sir James Linton, 1890–92; travel studies, France. Her family travelled to England in 1875 where she studied, returning to Australia in 1879. She lived in Australia 1879–90 before travelling again to London and more studies, returning in 1892. She painted from a studio in Swanston St and was notable for her portraits (including one of David Syme) and exhibited at the VAS. The family having lost most of its money in the land crash of 1873 she increased the number of students at her private art classes and in 1906 travelled again to London where she attended the life classes at the Burbeck Inst. and in Paris joined the Académie Julian. In 1908, she married Alexander Gilfillan (not to be confused with the painter of the same name) – the marriage being notable for its oddity as the couple, following the ceremony, parted and never again met although corresponded frequently. She returned to Australia and settled in Melbourne where she became a painter of note, working in a tonal impressionist tradition as well as an enameller, making jewellery, bowls etc. She lived modestly in various parts of Melbourne until her death at the age of 83. Her work was represented in *Completing the Picture: Women Artists and the Heidelberg Era* Heide and touring, 1986 and *Australian Women Artists: One Hundred Years 1840–1940*, Ewing-Paton Gallery travelling exhibition, 1975–76
REP: NGV; Castlemaine, Warrnambool regional galleries.
BIB: Janine Burke, *Australian Women Artists 1840–1940*, Greenhouse, Melbourne, 1980.

VALIER, Biron (Frank)

(b. 13/3/1943, Florida, USA; arr. Aust. 1977) Painter, printmaker, lecturer.
STUDIES: Several tertiary art colleges, USA, 1962–66; BA (Fine Arts), Cranbrook Academy of Art, USA, 1967; MA (Fine Art), Yale Uni., 1969. His works, featuring artificial objects such as road signs, and urban landscapes, were seen in 12 solo exhibitions from the 1960s in the US and several in Australia including at Powell St, Melbourne 1978 and Claremont School of Art gallery, WA 1992. He received a grant from the VACB to research corporate collections reproduced in the Craft Council's book *Artfile* (1993). (*See also* COLLECTIONS)
AWARDS: Fisher's Ghost festival open prize, Campbelltown regional gallery, 1988.
APPTS: Instructor in art, several colleges, USA, including De Cordova Museum, 1969–77; senior teacher, head of foundation year, Prahran CAE, 1977–79; part-time lecturer, graduate studies, City Art Inst., Uni. of NSW, 1987–89.
REP: Artbank; MCA, Sydney; many US uni. and public collections including MOMA, NY and Museum of Fine Arts, Boston.
BIB: Germaine, AGA.

VAN DEN HOUTEN, Henricus Leonardus

See HOUTEN, Henricus Leonardus van den

VAN DER STRUIK, Berend

(b. 1929, Holland; arr. Aust. 1957) Sculptor, industrial designer, teacher.
STUDIES: School of Arts and Crafts, Eindhoven; La Grande Chaumière, Paris, with the sculptors Zadkin and Auricoste. Sculpture by Van der Struik was included in the Mildura sculpture competition exhibition in 1961. He returned to Holland in 1964.
AWARDS: Adelaide Uni. Prize for Union Hall bas-relief, 1959.
APPTS: Teaching, SASA, 1962.
REP: Adelaide Uni.
BIB: Lenton Parr, *Sculpture*, Arts in Australia Series, Longman, Melbourne, 1961. Sturgeon, DAS. Scarlett, AS.

VAN HATTUM, Ernst

(b. 1920, Holland; arr. Aust. 1958; d. Europe) Painter, gallery director.
STUDIES: Holland, 1941–50, and at National High Inst. of Fine Arts, Antwerp, 1950–53. As gallery director, Van Hattum raised the status of the Mildura Art Gallery from provincial level to that of a national centre of sculpture. The *Mildura Sculpture Triennial* which he initiated and organised with the able assistance of his wife (as the *Mildara Prize for Sculpture* in 1961) became the outstanding sculptural event in Australia. He resigned from Mildura when a scholarship took him to Europe in 1965.
AWARDS: British Council Scholarship, for study in Europe, 1965.
APPTS: Director, Mildura Art Gallery, Vic., 1958–5.
REP: Utrecht Museum, Holland; Mildura Art Gallery.
See also PRIZES, MILDURA SCULPTURE TRIENNIAL

VAN HOMRIGH, C.M.

(b. 1903, Brisbane) Painter, teacher. Early in his career this well-known Qld watercolourist helped to develop child-art teaching methods in Qld state schools. He was Qld representative at the UNESCO Seminar on Art Education, ANU, 1963, and was for six years a member of the Board of Trustees at the QAG, Brisbane. He wrote *Art and Craft*, Qld, 1947; *Introduction to Art and Craft*, Angus & Robertson, Sydney, 1965.

VAN NUNEN, David

(b. 22/5/1952, NSW) Painter.
STUDIES: Dip. Painting, Newcastle National Art School, 1974; MA, City Art Inst., 1988. Known as a landscape painter, working often in the bush and outdoors, he held 14 solo exhibitions 1974–92 in Sydney (Robin Gibson), Newcastle (Cooks Hill), Melbourne (Flinders Lane) and Canberra (Solander), and in Muswellbrook Regional Gallery and Ivan Dougherty, City Art Inst., 1988. His work appeared in a number of group exhibitions 1976–91 in private galleries in Newcastle and Sydney and annually in the *Wynne* prize, AGNSW 1978–89; in *Sydney Opera House 10th Anniversary*, AGNSW 1983 and in MAGNT exhibition, Darwin 1991. He was artist-in-residence at the artists' camp at Kakadu with the director of the MAGNT, Colin Jack Hinton; and at the AGNSW during the

Bohemians of the Bush exhibition of Impressionist work, 1991.
AWARDS: Various regional prizes, 1971–84 including at Newcastle, Camden, Picton, NSW; SMH Art Prize, 1982; residency, Power Studio, Cité Internationale des Arts, Paris, Sydney Uni., 1988.
REP: MAGNT; Parliament House; Artbank; many regional, tertiary galleries and corporate collections NSW, Vic.
BIB: *New Art One.* Germaine, AGA. A&A 19/2/1981.

VAN RAALTE, Henri Benedictus

(b. 1881, London; arr. WA 10/10/1910; d. 1929, SA)
Etcher, gallery curator.
STUDIES: St John's Wood School of Art and RA Schools, UK (with Sargent, Dicksee and Clauscen) in the 1890s. He exhibited etchings at the RA from 1901, the year he became an associate of the Royal Society of Painter-Etchers, and had a good reputation in England, his work being included in a number of *The Studio* devoted to English and American etching. In Australia he lived to be recognised as one of the best printmakers of his generation there. In Perth he held art classes, held his first exhibition, 1919, and in 1922 moved to SA where he worked as curator of the AGSA, 1923–26. He established and was the first president of the United Arts Club, Adelaide, 1923, and was also a member of the Australian Painter-Etchers' Society. His relatively early death cost the country one of its most gifted etchers of landscape. His work was seen in *The Colonial Eye*, AGWA, Perth, 1979.
REP: Print collections at AGNSW; AGSA; AGWA; MAGNT; NGV; QAG; QVMAG; TMAG; British Museum.
BIB: AA no. 5, 1918, and no. 9, 1921.

VAN RIEMSDYK, Fran

(b. 13/11/1952) Painter, printmaker, teacher.
STUDIES: RMIT, 1971–74. Her watercolours and prints, depicting tilted bridges, ladders, rivers and ravines, have a dreamlike quality and were seen in solo exhibitions including at Powell St, Melbourne, 1986.
APPTS: Teaching, printmaking, RMIT, 1979– .
REP: NGV; Artbank.
BIB: PCA, Directory, 1988.

VARVARESSOS, Vicki

(b. 7/9/1949, Sydney) Painter.
STUDIES: NAS, 1968–71; travel studies, Europe, 1979. Her strongly expressionistic paintings, first seen at Watters Gallery, Sydney, 1975–78, and Stuart Gerstman Galleries, Melbourne, 1980, often represent the human form and are occasionally satirical. She held annual exhibitions 1975–92 largely at Watters, Sydney and from 1986 at Niagara, Melbourne. Group exhibitions in which her work appeared 1975–93 include *Australian Perspecta*, 1981, 85; *Pleasure of the Gaze*, AGWA 1985; *Prints and Australia: Pre-settlement to the Present*, NGA 1989; *Portrait of a Gallery*, Watters 25th anniversary exhibition touring eight regional centres 1989; *Her Story: Images of Domestic Labour in Australian Art*, S. H.

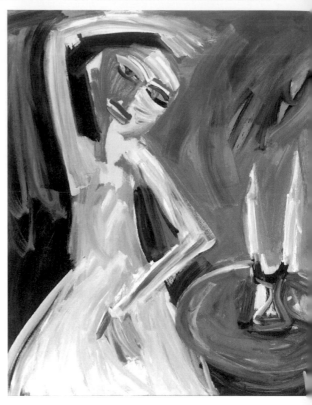

Vicki Vavaressos, Woman with Candles, *1991, 121 × 105.6cm. Courtesy Niagara Galleries, Melbourne.*

Ervin Gallery 1991; *Salon des Refusés: The Alternative Archibald*, S. H. Ervin Gallery 1993.
REP: NGA; AGNSW; AGSA; AGWA; NGV; Parliament House; Artbank; National Gallery, NZ; several regional galleries including Gold Coast, Shepparton, Wagga Wagga, Warrnambool; tertiary collections including NSW, Qld, Tas. unis.; corporate collections including IBM, Western Mining, Allen, Allen & Hemsley.
BIB: Catalogue essays exhibitions as above. McKenzie, DIA. Jennifer Phipps, *Artists' Gardens*, Bay Books, Sydney 1986. G. Sturgeon, *Australia: The Painter's Vision*, Bay Books 1987. *New Art Two.* Thomas, OAA. Janine Burke, *Field of Vision*, Viking, 1990. Smith, AP. Chanin, CAP.

VASSILIEFF, Danila Ivanovich

(b. 1897, Russia; arr. Aust. c. 1922; d. 1958, Melb.)
Painter, sculptor.
STUDIES: No formal training. He was working in the Northern Territory, Australia, as a railway contractor in 1923, and lived in Rio de Janeiro, 1930–32, where he exhibited paintings of a primitive character. He exhibited also in British and Dutch Guiana, Venezuela and West Indies, in London in 1934, and in Spain and Portugal in 1935. He returned to Australia in 1936, and the following year built a stone and log house at Warrandyte, Vic., where he taught painting and sculpture. Vassilieff's arrival in Melbourne coincided with the increasing activities of the local modern movement in painting; he became an active protagonist of modern art, especially in the early days

of the CAS, Melbourne. His colourful personality and childlike painting soon became a feature of local avant-garde exhibitions. His paintings of houses and streets in the depressed areas of Carlton and Fitzroy and the freshness of his vision introduced a new and vital note to local painting. Of particular interest to young painters such as Nolan and Boyd was the importance he attached to child art. In 1951 he started carving in stone, using Lilydale rock, an intractable material which no previous sculptor had been able to manage. His polished evocations in this stone are among the best things he produced, and their qualities were often emphasised in the writings of his wife, Elizabeth Vassilieff. Vassilieff joined the Vic. Education Dept as a teacher of art a few years before his death and taught and painted at Mildura, but left the Dept because he refused to adapt his teaching to the syllabus imposed. His work was included in the exhibition *Rebels and Precursors, 1937–47*, NGV, Melbourne, 1962, and in May–June 1973 a commemorative exhibition, *Danila Vassilieff*, was held at the Joseph Brown Gallery, Melbourne. His work since has been featured in exhibitions at Heide, Melbourne and in *Angry Penguins*, Hayward Gallery, London, 1988 and touring Australia 1989.

REP: NGA; most state galleries; regional galleries Ballarat, Mornington.

BIB: Catalogue essays exhibitions as above and all general books on contemporary Australian art history including Robert Hughes, *The Art of Australia*, Penguin Books, Harmondsworth, 1970; Smith, *AP*; Sturgeon, *DAS*; Scarlett, *AS*. Barrie Reid, ed., *Modern Australian Art*, MOMAD, Melbourne, 1958. Lenton Parr, *Sculpture*, Longman, Melbourne, 1961. Felicity Moore, *Vassilieff and His Art*, OUP, Melbourne, 1982. *Meanjin* 3/1949 (Elizabeth Vassilieff, *Vassilieff's Street Scenes*). A&A 4/2/1966 (John Reed, *Danila Vassilieff, Cossack and Artist*).

VEAL, Hayward

(b. 28/1/1913, Eaglemont, Vic.; d. 1968, Sydney) Painter, teacher.

STUDIES: Melbourne, with A. D. Colquhoun and Max Meldrum, 1928–37. A member of the RAS, Sydney, and RAS, Qld, he moved to the UK, 1951, taught there, painted portraits and landscapes and held exhibitions in England, Ireland and the USA. Abstract painting claimed his attention briefly but his work soon reverted to tonal painting and 'the science of natural appearances', as taught him by Max Meldrum. He returned to Sydney with an exhibition in 1968 and died there the same year. His books include *One Evening in the Studio; Impressionist Painting; Oil Painting Course* all published in London.

APPTS: Deputy teacher of painting, NGV, 1948; lecturer, AGNSW; art critic for Sydney *Daily News*, c. 1950; conducted Meldrum School of Painting, Sydney, 1938–50.

REP: AGNSW; AGWA; NGV; QAG; Hamilton regional gallery.

BIB: A number of general books on Australian art history.

VEALE, Laurence Rex (Karl DORN)

(b. 1916, Colac, Vic.; d. 1942, New Guinea) Painter.

STUDIES: NGV School, 1936. He used the pseudonym Karl Dorn. Enlisting in the AIF during World War II, he was killed on the Kokoda Trail, New Guinea, when a patrol in which he was serving was ambushed. His watercolour *Arabs*, painted during a period of service with the AIF in the Middle East campaign, shows him as a sensitive colourist who worked in a post-impressionist manner.

AWARDS: Student prize, NGV School, 1936.

REP: NGV; MPAC.

Danila Vassilieff, Lane Fitzroy, *c. 1940, oil on board, 59.5 × 51.5. Private Collection.*

VICKERS, Rose

(b. 1941, Sydney) Printmaker, teacher, painter.

STUDIES: NAS, 1960–64; Central School of Arts and Crafts, London, 1966–67; travel studies, Europe and Asia, 1966–69. She curated several print exhibitions, including *Australian Graphics* for the Dept of External Affairs which toured South America, 1974–75, and managed print workshops.

AWARDS: Drummoyne print prize, 1976.

APPTS: Teaching, NAS, 1968–77; lecturing, with VACB touring exhibition to South America (*Australian Graphics*), 1974–75; founder (with Max Miller and George Schwarz) of Printworkshop Zero (known also as the Miller Street Print Workshop), 1973– ; teaching, Alexander Mackie CAE, 1979– .

REP: New England, Shepparton regional galleries.

BIB: PCA, *Directory* 1976, 1988.

VICKERS, *Trevor*

(b. 1943, Adelaide) Painter, sculptor.
STUDIES: No formal training. Lived in Perth, 1944–59, then moved to Melbourne, and in 1964 exhibited with other young artists in the *Young Mind*, MOMAD, Aug. 1964. He held exhibitions in 1966, 67, at Strines Gallery; 1969, 72, 74 at the Pinacotheca Gallery; showed sculpture at the 1967 *Mildura Sculpture Triennial*, and in 1968 participated in *The Field* exhibition, NGV. In all these, his work was oriented towards systems art and primary structures, with emphasis on the use of single colours contained within simple geometric forms and the ways in which these forms can be varied.
NFI

VICKERY, *John*

(b. 1906, Bunyip, Vic.; d. 1983) Painter, advertising artist, illustrator.
STUDIES: NGV School (evening classes), c. 1924; 1929–31. He became a successful advertising artist in Melbourne but his main interest was in painting, printmaking and illustrating and his studio became a meeting place for artists, including Alan McCulloch, Annois, Thake, Flett and many others. He exhibited at the VAS and the Athenaeum Gallery (where Bernard Hall purchased work for the NGV) on a regular basis in the early 1930s. Interested in modernist styles such as cubism and vorticism, on New Year's Day, 1936, he left for New York where he became a successful illustrator. He served as a war artist with the US army during World War II and after the war met Phillip Guston (they had studios in the same building), and became friendly with de Kooning, Jackson Pollock, Joan Mitchell, Kline and others whom he joined at the old Cedar Street Bar where they met once or twice a week. But, as he wrote later in a letter: 'Suddenly the whole Village scene changed, I was no intellectual and the whole thing became too much for me [so] I moved uptown'. In the 1960s he exhibited in the public galleries of New Jersey – his work moving from the traditional style of the 1930s to abstracts (including a series of 'Cruciform paintings') in the late 1950s to a significant body of Op art in the late 1960s to 1970s. The Melbourne dealer Charles Nodrum presented Vickery's first solo Australian exhibition (of Split Spectrum and Linear Paintings) in 1988, followed by a larger survey show (of Cruciform paintings) in 1991–92 which toured also to McClelland, Latrobe Valley regional galleries, Vic. and David Jones Gallery, Sydney.
AWARDS: Prize for a poster, Athenaeum Gallery, Melbourne, 1928; many prizes for posters and industrial illustration at the Art Directors Club, New York and Philadelphia; bicentennial purchase award, Holland Township, Hunterdon County, NJ, 1976.
REP: NGA; NGV; TMAG; VCA; McClelland Gallery; public collections in the USA.
BIB: Catalogue essays exhibitions as above.

VICTORIAN ACADEMY OF ARTS

(Founded 1870) Founded 10/1/1870 at a meeting held at the St Kilda home of police magistrate James Robertson, who acted as secretary. First president was O. R. Campbell, followed by Chester Earles. Early members included Louis Buvelot, Thomas Wright, Frederick Woodhouse, J. S. Mackennal, William Pitt, Richard Shephard, Charles Gregory, H. L. Van den Houten, Thomas Clark, E. L. Montefiore, E. Wake Cook, John Mather, H. J. Johnstone, R. A. Bugg, John Kemp, Elizabeth Parsons. The first exhibition was held at the Melbourne Public Library, 1870, and the second and third at Hine's picture shop. A state government grant of land led to the erection of a building in Albert St, East Melbourne, as headquarters for the academy. Artist members raised money for the building by donating half the proceeds of a sale of their work, held at the showrooms of Gemmell Tuckett & Company, and on 30 July 1874 the building was opened by the State Governor, Sir George Bowen. In 1886 a group of professional artist members, led by Tom Roberts, seceded from the Victorian Academy of Arts, to form the Australian Artists' Association, as they opposed the control of the Academy by amateurs. In 1888 the two groups – Victorian Academy of Arts and Australian Artists' Association – reunited to form the Victorian Artists' Society.

VICTORIAN ARTISTS' SOCIETY

(Founded 1888) 430 Albert St, East Melbourne Vic 3002.
VAS PRESIDENTS: 1888–92, J. A. Panton; 1893–1901, John Mather; 1902, John Ford Paterson; 1903–04, Frederick McCubbin; 1905, Walter Withers; 1906–08, John Mather; 1909, Frederick McCubbin; 1910, F. H. Bruford; 1911, John Mather; 1912–16, W. Montgomery; 1917, Max Meldrum; 1918–24, C. Douglas Richardson; 1925, John Longstaff; 1926–30, C. Douglas Richardson; 1931–32, Paul Montford; 1933–34, Louis McCubbin; 1935–36, John Rowell; 1937–43, James Quinn; 1946–47, Orlando Dutton; 1948–50, James Quinn; 1951–58, Malcolm Warner; 1959–61, Arnold Shore; 1962–63, J. Scott Pendlebury; 1964–73, William Frater; 1973–77, Stanley Hammond; 1977–79, Edward Heffernan; 1980–82, Dorothy Baker; 1983–87, David Roper; 1988–90 Connie Walker; 1991– A. W. Harding.
ADMIN: VAS Council comprising chairman and 15 members.
MEMBERSHIP: Limited to 1000 members. There is a waiting list.
FINANCE: Membership fees, commissions, hire of galleries, catalogue sales, donations.
HISTORY: The VAS was established through the amalgamation of the Vic. Academy of Arts with the Australian Artists' Association (q.v.), and in April 1888 the first VAS exhibition was opened by Sir Henry Loch at the Grosvenor Gallery, Collins St. That year the first annual VAS dinner was held in the original Vic. Academy of Arts building, for which extensive additions were planned for the new Society. Opened by the State Governor, 27 May 1892, the new premises (designed by Richard Speight, Jnr) were reported in

the press as representing 'the most important connected with the history of art in our colony'. No further additions were made until the Cato Gallery was added in Mar. 1952, and renovations and redecoration of the entire interior structure were completed in 1965. With extensive new carpeting and painting, the building developed a very attractive atmosphere. There are three large exhibition galleries on the first floor, in addition to the smaller Cato Gallery and meeting room on the ground floor, with offices, facilities and life-class room occupying the remaining space. For many years the old premises were shared with the Albert Street Conservatorium of Music. Life classes were initiated by C. Douglas Richardson, c. 1917 and have continued ever since. Other classes have been added in recent times. Many attempts have been made to maintain regular VAS publications: *VAS Journal*, 1908, revived briefly, 1976; *Genre*, 1946; *VAS Bulletin*, 1950; *VAS Newsletter*, 1969– . The most ambitious of these was *The Australian Artist*, a small magazine of great potential. For its first few decades of existence, the VAS was a centre of art life in Vic., but after World War I the difficulties experienced by the earlier societies (of giving lay members equal rights with professional artists) caused a rapid decline in the Society's status. The situation deteriorated further in the 1930s with the rise of the modern movements. A revival began after World War II with the work done by Len Annois, and the VAS regained much of its lost prestige, particularly through such enterprises as the publication of *The Australian Artist* and the restoration and redecoration of the premises started under the presidency of Malcolm Warner. New members were attracted and the membership increased steadily. It remains Australia's oldest active art society. BIB: Moore, *SAA*. VAS catalogues, journals, bulletins and newsletters; C. B. Christesen, *The Gallery on Eastern Hill*, VAS, Melbourne, 1970.

See also PRIZES, VAS PRIZES

VICTORIAN ARTS CENTRE ART COLLECTION

The art collection of the Victorian Arts Centre (opened in 1987) in 1993 comprised some 400 works by major Australian artists, many commissioned specifically for the Centre, designed to accompany its architecture and many based on opera, theatrical or musical subjects. They include Sidney Nolan's *Paradise Gardens* consisting of 1320 images (mixed media) on paper; four large John Olsen paintings based on operas; eight large *Shoalhaven* paintings by Arthur Boyd; three Roger Kemp abstracts; the long 'freight-train' five-panelled painting by Jeffrey Smart; 13 paintings by Western Desert Aboriginal artists; and around 150 portrait drawings of leading actors, singers, musicians, conductors and composers by Louis Kahan. The collection also includes the sculpture in the grounds of the arts centre comprising a number of fine pieces by Clement Meadmore, William de Kooning, Inge King, Les Kossatz, Peter Schipperheyn and others and the foyer's huge 18m acrylic sheet, mirror, brass and metal

light sculpture spanning three levels, by Michel Santry. *See also* GALLERIES – PUBLIC (Westpac Gallery, Vic. Arts Centre)

VICTORIAN ARTS COUNCIL
See ARTS COUNCILS OF AUSTRALIA

VICTORIAN FINE ARTS SOCIETY
(Active, 1853) Established in Melbourne, only one exhibition was held at the Mechanics Inst., 20 Aug. 1853. Exhibitors included Thomas Woolner, who showed three sculpture pieces (the only time he exhibited in Australia), Conway Hart, Conrad Martens, John Skinner Prout and Marshall Claxton.

VICTORIAN PRINT WORKSHOP
See AUSTRALIAN PRINT WORKSHOP

VICTORIAN PRINTMAKERS GROUP
(1976–c. 1981) Formed 1976 by an interim committee comprising Ian Armstrong, Noel Counihan, Helen Geier, Peter Graham, Noela Hjorth, Neil Wallace. Its objective was the provision of a fully equipped, fully operative print workshop for the benefit of Melbourne printmakers and to assist the general development of printmaking. The workshop opened on 26 July 1977, in premises at Bouverie St, Carlton. Later the Group joined with the Craft Association of Vic. in a master plan to develop the old North Melbourne Meat Market as a Craft Centre. Factional differences within the Meat Market Crafts Centre, an enterprise of great complexity, brought the Victorian Printmakers Group to an end, but in Dec. 1981 it was successfully re-formed as the Victorian Print Workshop, later to become the Australian Print Workshop (q.v.)

VICTORIAN SCULPTORS' SOCIETY
Founded Melbourne, 1948. It grew from the Australian Sculptors' Society, which started in 1930, held regular meetings, but disbanded at the beginning of World War II. In 1948 a separate constitution was adopted and the Victorian Sculptors' Society was formed. Among subsequent events promoted was a special exhibition held at the NGV in 1958 and later sponsored by the Council of Adult Education as a travelling exhibition to Victorian country centres. From 1948 regular annual exhibitions were held at the VAS galleries, and from 1953 to 1963 prizes from £25 to £50 were given. Presidents: 1951, Victor Greenhalgh; 1952, George Allen; 1953, Stanley Hammond; 1954, Ray Ewers; 1955, 1956, Andor Meszaros; 1957, Stanley Hammond; 1958, 59, Jeffery Wilkinson; 1960, 61, Lenton Parr; 1962, 63, Andor Meszaros; 1966–69, Charles Miller. The Society lapsed in 1969 and was re-formed in July 1971, as the Association of Sculptors of Victoria (q.v.).

VICTORIAN SOCIETY OF FINE ARTS
(Active 1856–57) Founded Melbourne, 20 Oct. 1856 by a committee including John Pascoe Fawkner, Sir Andrew Clark, Professor Irving, Professor Wilson and

James Smith (q.v.). At the opening of the one and only exhibition (Exhibition Building, William Street, 1857), Smith suggested that a National Gallery should be built in Melbourne. Exhibitors included Charles Summers, William Strutt, Nicholas Chevalier, Ludwig Becker, Eugène von Guérard, John Alexander Gilfillan, Thomas Clark, William Dexter, James Scurry, Georgiana McCrae.
BIB: Moore, SAA.

VICTORIAN TAPESTRY WORKSHOP
See GALLERIES – PUBLIC

VICTORIAN WOMEN'S ART CLUB
(Active 1902–c. 1920s) Founded by Tina Gowds in Melbourne, 1902. President: Annie Gates. The club was known as Woombellana (Aboriginal for 'beauty') Art Club until 1912, when it became the Women's Art Club. The first exhibition was held in 1905.

VIDEO ART IN AUSTRALIA
See PERFORMANCE, VIDEO AND INSTALLATION ART

VIDLER, Edward Alexander
(b. 1863, London; arr. Aust. 1888; d. c. 1941) Journalist, lecturer, art writer, art book publisher. First secretary and one of the founders of the Geelong Art Gallery, 1896. Vidler conducted an art column for the Melbourne *Table Talk* between 1889 and 1902. In Streeton's letters to Roberts (1923) he mentions Vidler as secretary of the short-lived Australian Inst. of Arts and Literature, Melbourne. Publications by Vidler included mongraphs on Napier Waller, 1917; Hugh Ramsay, 1918; John Shirlow, 1920; Sara Levi, 1922; Frederick George Reynolds, 1923; A. E. Oakley, 1923 and he edited *The Adam Lindsay Gordon Memorial Volume*, Lothian, Melbourne, 1926.

VIEUSSEUX, Julie Elizabeth Agnes
(b. 1820; arr. Melb. 1852; d. 1878) Painter, teacher. She worked as a portrait painter in Melbourne from 1852 and exhibited at exhibitions including the Victorian Industrial Society Exhibition, 1852, and the Melbourne Intercolonial Exhibition, 1866. She and her husband opened an exclusive 'ladies' college' in Collingwood, Melbourne in 1857 at which she taught drawing and painting. An unsigned, undated portrait, *Maria O'Mullane and her Children*, c. 1855, in the NGV collection may have been hers.
BIB: Kerr, DAA.

VIGANO, Maria Teresa
(b. 7/7/1881, Pavia, Italy; arr. Aust. 1928; d. Feb. 1969, Melb.) Painter.
STUDIES: Brera Academy of Art, Italy, 1909–10; Milan, with Giovanni Sottocornola, 1906–10; Melbourne, with Arnold Shore, 1960. She lived in Canada, 1911–19, married, and on arrival in Melbourne helped her husband to establish Mario's restaurant, 1932. She held

an exhibition at La Feluca Gallery, Rome, 1963. Her impressionistic landscapes and portraits are painted with great sensitivity. A commemorative exhibition was held at the VCA Gallery, Melbourne, June 1981.
REP: NGV.

Harald Vike, Backyards, *oil on board, 32.5 × 42 cm. Joels, November 1991.*

VIKE, Harald
(b. 1906, Kodal, Norway; arr. Fremantle, WA, 1929; d. 18/8/1987, WA) Painter, illustrator, stage designer.
STUDIES: Perth, with G. Pitt Morison, 1930. He served in whaling ships before settling in Perth, where he fought in the professional boxing ring, then became a painter. He held exhibitions from 1938, and in 1945 moved to Melbourne where he freelanced as a painter and newspaper artist and painted often in company with Len Annois and Alan McCulloch. He drew many caricatures for the *Argus* and from 1958–71 was principal décor designer for HSV7 television. After extensive travels throughout Australia he settled in Adelaide in 1972. A fine draughtsman, his best paintings have a van Gogh-like freshness of colour and texture. He held 15 solo exhibitions 1937–77 and group exhibitions in which his work was represented 1933–92 included *Western Australian Artists 1920–1950*, AGWA, 1980; *Art and Social Commitment; an end to the city of dreams 1931–48*, AGNSW, 1984; *Aspects of Perth modernism 1929–42*, Undercroft Gallery, University of WA, 1986; *Classical Modernism: The George Bell Circle*, NGV 1992. Several posthumous exhibitions of his work were held to 1993 including drawing and paintings at Alexander Library, Perth, 1987; works on paper at McClelland Gallery, Vic. 1990 and a large retrospective accompanied by a well-researched and lavishly illustrated catalogue was held at the AGWA in 1990.
AWARDS: WA Society of Artists prize for watercolours, 1931.
REP: NGA; AGWA; NGV; regional gallery, Mornington;

universities of WA and Tasmania; corporate collections including Robert Holmes à Court and Wesfarmers.

BIB: Catalogue essays exhibitions as above and several general books on Australian art history including Badham, *A Study of Australian Art*, Currawong Press, 1949. A. Stephen and A. Reeves *Badges of Labour*, A&U, 1984. *A&A* 25/3/1988.

VILA-BOGDANICH, *Memnuna*

(b. 1934, Mostar, Yugoslavia) Printmaker.

STUDIES: Academy of Fine Arts, Belgrade. Prints by this artist in widely varied media have been included in international print exhibitions since 1959.

AWARDS: Alice Springs prize for graphics, 1973; Perth Prize for Drawing International, 1975.

REP: NGA; AGWA; Fremantle Arts Centre; several tertiary collections in WA; a number of European public collections.

BIB: PCA, *Directory*, 1976.

NFI

VIMPANY, *Violet Emma*

(b. 1886, Forcett, Tas.; d. 1979) Painter.

STUDIES: Hobart Tech. Coll., with Lucien Dechaineaux and Mildred Lovett, 1935–36; Melbourne, with Max Meldrum, 1936–50. She worked in oils, watercolours and etching and was an active member of the Art Society of Tas. for many years, sharing a studio in Collins St, Hobart, with Florence Rodway, Edith Holmes, Mildred Lovett and Ethel Nicholls.

REP: Lady Franklin Museum and Art Gallery.

BIB: Backhouse, *TA*.

VINCENT, *Alfred*

(b. 1874, Launceston; d. 1915, Manly, NSW) In Dec. 1896, at the age of 22, he took over the main cartoon page of Melbourne *Punch*, before transferring to the Sydney *Bulletin*, in which journal he modelled his style on that of his celebrated predecessor, Phil May. (He produced *The Career of the Colonial Premiers in England*, book of caricatures, Melbourne, 1897.) He worked for the *Bulletin* for the rest of his life, but despite his wit and great talent as a draughtsman he never escaped from May's shadow, many of his drawings being mistaken for May's work. This might have contributed to the bouts of severe melancholia from which he suffered. After a final mental collapse, he committed suicide at Manly, 1915.

REP: Print collections in AGNSW; NGV.

BIB: Mahood, *The Loaded Line*, 1973. Vane Lindesay, *The Inked-in Image*, Hutchinson, Melbourne, 1979.

VIRGIL

See REILLY, Virgil Gavan

VISUAL ARTS/CRAFTS BOARD

See AUSTRALIA COUNCIL

VIZARD-WHOLOHAN, *Elizabeth Maude*

(b. 1875; d. 1950) Painter, benefactor.

STUDIES: SA School of Design, Adelaide, with H. P. Gill and Archibald Collins, c. 1895. Her work was included in the Grafton Gallery, London, *Exhibition of Australian Art*, organised by Julian Ashton, 1898. The Maude Vizard-Wholohan Bequest resulted in an important South Australian annual art prize. (*See* PRIZES)

BIB: Rachel Biven, *Some forgotten . . . some remembered*, Sydenham Gallery, Adelaide, 1976.

VOIGT, *David John*

(b. 20/12/1944, Sydney) Painter.

STUDIES: Dip. Fine Art, NAS, 1964–68; travel studies, Europe, 1969–72. His symbolistic paintings appeared in over 50 solo exhibitions 1968–93 at numerous galleries in Sydney (including Barry Stern, Coventry), Melbourne (including Editions), Canberra (Solander), Brisbane (Michael Milburn), Adelaide (Bonython Meadmore) and country centres, and in numerous group exhibitions largely with private galleries and in prize/award exhibitions including *Mandorla Art Prize* (invitation), WA.

AWARDS: English-Speaking Union Scholarship for overseas study, 1968; occupancy, Power Inst. studio, Cité Internationale des Arts, Paris, 1969; Dyason Bequest scholarship, AGNSW, 1970; British Council grant, 1970; Townsville award, 1970; Armidale, 1976; Blake prize, 1976, 81; Canberra (Civic Permanent), 1977; Wollongong, 1977; VACB grant, 1977; Wynne Prize, 1981; Western Australian Mining Prize, 1982; Manly Art Purchase prize, 1983.

APPTS: Teaching part-time, various art colleges, NSW, including Alexander Mackie, City Art Inst., 1970s and 80s– .

REP: NGA; AGWA; QAG; TMAG; Artbank; several regional galleries including Armidale, Bathurst, Hamilton, Newcastle, Townsville, Sale; Utrecht Collection of Contemporary Art, Holland; municipal and tertiary collections including Uni. of WA; numerous corporate collections including BHP, BNP, Qantas, Philip Morris, NAB.

BIB: *New Art One*.

VOJSK, *Milan*

(b. 1922, Yugoslavia) Sculptor.

STUDIES: Munich; Yugoslavia, Ljubljana. Sculpture by this member of the Society of Sculptors and Associates was included in the Mildura Sculpture Prize exhibition, 1961.

REP: AGSA; NCDC, Canberra.

BIB: Scarlett, *AS*.

NFI

VON GUÉRARD, *Eugène (Johann Joseph Eugen von GUÉRARD)*

(b. 1812, Vienna; arr. Vic. 1852; d. 1901, UK) Painter, teacher.

STUDIES: Rome, 1826 (his father took him also to Naples and Sicily); Düsseldorf Academy, 1840–45; travel studies in Europe. Son of Bernhard von Guerard, miniaturist and court painter to Francis I of Austria. In 1852 he interrupted his work as an art teacher in London and responded to the call of adventure by going to the Victorian goldfields, arriving in Port Phillip in *Windermere* with a party of Frenchmen, 28

Dec. 1852. For about two years he dug for gold, following the rushes with reasonable success, and settled in Melbourne in 1854 to resume his career as a painter. He visited Tas. and SA, 1855, and during 1856–57 painted commissioned pictures of stately homes and properties in Victoria's Western District. He painted also at Cape Schanck and in the Baw Baws in company with Nicholas Chevalier, and worked in NSW, as well as Gippsland and Cape Otway (1859–61). An inveterate explorer and traveller, he joined William Howitt's expedition to the Australian Alps and in 1862 accompanied von Neumayer to Cape Otway, then to NE Victoria and Mt Kosciusko. He exhibited with the Vic. Society of Fine Arts, 1858, and the VAA, and sent *The Fall of the Wetterboro Creek . . . in the Blue Mountains* to the RA, London, in 1865. The triumphs of his career include the series of pen drawings 'of places of interest', commissioned by Governor Barkly, 1858; his album of lithographs, *Australian Landscapes*, published by Hamel & Ferguson, Melbourne, 1867; such fine paintings as the Western District series, *Valley of the Mitta Mitta*, presented by Archibald Mitchie to the NGV in 1866, and in particular his *Ballarat 1853–54*, painted from sketches when commissioned by James Oddie in 1884. This picture is generally rated as his masterpiece. He never lost his love of the goldfields, 'a way of life, and most of those who lived it were nostalgic for it ever afterwards.' As a teacher at the NGV, he was extremely conscientious but encouraged the students to copy the pictures in the collections. His paintings are sombre, atmospheric and romantic at their best, though suffering from picturesqueness when treating mountainscapes and such subjects, which might have been influenced by Chevalier's work. He resigned from the NGV School and returned to Düsseldorf in 1882, where he lived for the next nine years before moving to London. In 1893 he had the misfortune to lose his savings in the Australian bank crash and consequently spent the last eight years of his life in poor circumstances. His work, with the seeking out of colonial paintings commanded high prices in auctions almost a century later and was seen in survey exhibitions in the 1980s including the Bicentennial exhibitions, *The Great Australian Art Exhibition* and *The Face of Australia*.

APPTS: Curator and Master of the Art School, NGV, 1870–82.

REP: NGA; AGNSW; AGSA; NGV; regional galleries Ballarat, Geelong; La Trobe Library, Melbourne; Mitchell Library, Sydney; Turnbull Library, Wellington, NZ.

BIB: Catalogue essays exhibitions as above. All general books on Australian art history. Marjorie Tipping, *Eugene von Guérard's Australian Landscapes*, Lansdowne, Melbourne, 1975.

ADB 4. McCulloch, AAGR. A&A 18/2/1980 (*Eugene von Guérard and the Hudson River School: Romantics in the Wilderness*).

VON STIEGLITZ, Emma (née COWIE)

(b. 1807; arr. Tas. 1834; d. 1880, Launceston) Sketcher. Wife of Victorian grazier John Lewis von Stieglitz (1809–68), she was a talented artist who made many drawings of family homesteads in Tas. and Vic.

BIB: K. R. von Stieglitz, ed., *Early Van Diemen's Land*, Fuller's Bookshop, Hobart, 1963. Joseph Burke, preface, P. L. Brown, intro., K. R. von Stieglitz, ed., *Emma von Stieglitz; Her Port Phillip and Victorian Album*, Fuller's Bookshop, Hobart, 1964. ADB 2. Kerr, DAA.

VON TEMPSKY, Gustavus Ferdinand

(b. 1828, Silesia, Germany; arr. Bendigo 1858; d. 1868, NZ.) Soldier of fortune, amateur painter. His military activities took him to Central America, Mexico, Guatemala, Salvador, 1848; and the lure of gold took him to California, c. 1849, Victoria, 1858, and New Zealand, 1862. His paintings of battle scenes depict figures in action, usually with identical wildly staring eyes. In Vic. he applied for leadership of the Burke and Wills expedition; disappointment at not being selected caused his departure for NZ.

BIB: Gil Docking, *Two Hundred Years of New Zealand Painting*, Lansdowne, Melbourne, 1971. McCulloch, AAGR. Kerr, DAA.

VOSS-SMITH, Leonard

(b. 1910, Broken Hill, NSW d. 1988, Sydney) Publisher, collector, assessor. Australian representative for Hutchinson Publishing Group, London. He began collecting art of all kinds early in his career and in 1961 recommended to his London firm the publication of the first edition of this book. He moved to London in 1963, and later joined the firm of Christie, Manson and Wood, returning to Australia as their Sydney representative, 1969–71. He settled permanently in Sydney in 1979.

VOUDOURIS, George

(b. 1920, Alexandria, Egypt; arr. Perth, via USA, 1948) Painter, commercial artist.

STUDIES: Alexandria, privately, 1935–40; Cleveland School of Art, Ohio, 1946–48; travel studies, USA, 1959, Europe, 1965, Greece, 1969. His work was represented in the exhibition *Artists from the West*, at MOMAD, Melbourne, 1963 and he held numerous exhibitions of realist work from that time, largely in Perth.

AWARDS: Prize at Bunbury competitions, 1965.

APPTS: Teaching, Perth Tech. Coll.

REP: AGWA.

NFI

WADE TO WYON

WADE, Robert

(b. 29/7/1930, Vic.) Painter, graphic artist and popularly successful watercolourist who travelled widely to Europe, UK, USA, India, 1979–92. He is a member of the Aust. Watercolour Inst.; Fellow of the RSA, London; International Society of Marine Painters; Salmagundi Club, NY and VAS. Author of *Painting more than the eye can see*, North Light, Cincinnati, 1989. His many commissions include an aerogramme for Australia Post for the International Philatelic Exhibition, 1984.
AWARDS: Over 93 prizes for watercolour in Aust., UK, USA; Advance Australia Medal, 1986.
REP: Hamilton regional gallery; Royal Watercolour Society, London; Museum of Watercolour, Mexico City.
BIB: Germaine, AGA.

WADELTON, David

(b. 1955, Terang, Vic.) Painter, musician.
STUDIES: Dip. Art & Design, Phillip Inst., 1976; Grad. Dip. Art & Design, Phillip Inst., 1982. Most of the works in his six solo exhibitions 1984–92 at Pinacotheca, Melbourne, consisted of boxes or rooms filled with a seemingly random collection of objects (described by Christopher Heathcote in the *Age*, 8 April 1992, as 'a visual magpie's nest'). His 1992 and 1993 exhibitions comprised surrealist paintings and works on paper on a larger scale. A musician in several experimental music groups from 1978 which performed at, among other venues, the Organ Factory, Clifton Hill and *Sydney Biennale*, 1982, he also painted sets and backdrops for plays at La Mama, Melbourne, 1985. He participated in a number of group exhibitions 1987–92 including *Quiddity*, 200 Gertrude St, Melbourne 1987; *A New Generation 1983–88*, NGA 1988; *ICI Contemporary Art Collection*, touring regional galleries Vic. 1989; *Freedom of Choice*, Heide 1991.
AWARDS: Prizes at Box Hill, 1985; Diamond Valley, 1988; project grant, VACB, 1988; residency, Verdaccio Studio, Italy, VACB, 1992.
REP: NGA; NGV; Artbank; Monash Uni.; Uni. of Qld; corporate collections including BHP, ICI.
BIB: Catalogue essays exhibitions as above. *New Art Three*. Smith, AP. A&A 25/1/1987; 29/2/1991. AT no. 36 May 1990.

WADEN, Robert

(b. 1900, SA; d. 1946) Painter.
STUDIES: Adelaide (with James Ashton); Sydney (with Will Ashton). Known mainly for landscapes in oils. He painted extensively in the vicinity of Victor Harbor, SA.
REP: AGSA.
BIB: Moore, SAA.

WADHAM, William Joseph

(b. 1863, Liverpool, UK; arr. Aust. 1885; d. 1950) Painter. He exhibited watercolours of English and Victorian landscapes at the VAA, 1887, and was the foundation president of the Adelaide Easel Club, founded by his brother, Alfred Sinclair (q.v.), 1895. English watercolours by him were sold at Christie's auctions in 1977, some dated 1898 and others 1920–24.
BIB: Moore, SAA.

WAGNER, Conrad

(b. c. 1818; arr. NSW late 1850s; d. 1910) Painter, photographer. He worked as a painter and photographer in Grafton, NSW, 1860s–70 and Glen Innes, 1870–75 (the firm eventually went bankrupt). He produced watercolours, pastels and oil portraits from photographs but his success remained confined to rural NSW. His work was seen in *The Artist and the Patron*, AGNSW 1988.
REP: Mitchell Library; Clarence River Historical Society.
BIB: J. Cato, *The Story of the Camera in Australia*, Kerr, DAA.

WAINEWRIGHT, Thomas Griffiths

(b. 1794, London; arr. Tas. 1837; d. 17/8/1847, Hobart) Painter, writer, critic. Orphaned as a child and brought up by his uncle (Ralph Griffiths, publisher of the *Monthly Review*), Wainewright, after studying art, went into the army, then took up journalism. He wrote art criticism for *London Magazine*, and exhibited paintings at the Royal Academy in 1821 and 1825. Wainewright was alleged to have forged the names of the trustees to his grandfather's will, poisoned his uncle in order to inherit his property, his wife's mother because she suspected him, and his sister-in-law – all of whom had died in 1828 and 1830. He escaped to

729

T.G. Wainewright, Julia Sorell, *c. 1846, watercolour and chinese white highlights, 35.6 × 30.6cm. Collection,* TMAG.

France and lived there for six years, but on his return to England, he was identified by a Bow Street runner. Convicted of forgery and uttering, he was transported to Hobart, where he arrived in the *Susan* on 21 Nov. 1837. His story gaining wide publicity in London, he became the model for morality fiction including Lytton's *Lucretia*, the character of Slinkton in Dickens' *Hunted Down*, some time later Oscar Wilde's *Pen, Pencil and Poison* essay in *Intentions* (Dodd Mead, New York, 1894), and Thomas De Quincey's essay on Charles Lamb. Other books in which his story features include Hal Porter's *The Tilted Cross* (1961), whose central character, Judas Griffin Vaneleigh, is based on Wainewright. As a former exhibitor at the RA he was allowed to visit homes and paint portraits under guard. His earliest known work was done in 1839, and he painted a number of portraits of the wives of colonial officials, several of which appear overly sentimental. However their number (around 56) and subject matter make them valuable historical records of the time. He also painted a number of allegorical works in Australia similar to those he had showed at the Royal Academy, London in younger days. He died of apoplexy at the age of 53. He edited

Essays and Criticisms, with a memoir by W. Carew Hazlitt, Reeves & Turner, London, 1880. His work was seen in a number of exhibitions of colonial works including *Australian Colonial Portraits*, TMAG, 1979; *Tasmanian Vision* TMAG and QVMAG 1988 and the Bicentennial exhibition, *The Great Australian Art Exhibition*.
REP: NGA; AGSA; QVMAG; TMAG; Ballarat Fine Art Gallery; Allport, Mitchell, Dixson Libraries.
BIB: Catalogue essays exhibitions as above. T. Seccombe, *Lives of Twelve Bad Men*, Unwin, London, 1894. Robert Crossland, *Wainewright in Tasmania*, OUP, Melbourne, 1954. Kerr, DAA.

WAITE, James Clarke
(b. 1832, Whitehaven, Cumberland, UK; arr. Aust. 1886; d. 8/8/1920, Sydney) Painter.
STUDIES: School of Design, Newcastle, UK; Scottish Inst., Edinburgh; RA Schools, London; Paris. He exhibited with the Society of British Artists and at the RA, London, 1883–85. In Melbourne he showed at the Victorian Academy of Art; the Australian Artists' Association, 1887; VAS, 1888–1900, and again 1911. He painted mainly portraits and landscapes, including the well-known portraits of Louis Buvelot and the posthumous portrait of Alfred Felton (NGV). For a time he had a studio at No. 9 Collins St. Few of his paintings are known to have been preserved, mainly because many were destroyed in a fire at the Melbourne Town Hall (c. 1900).
AWARDS: Silver medals, RA Schools, London, 1853, 55, 57, and at the Crystal Palace exhibition, 1879.
REP: NGV; Bendigo Art Gallery; Manly Art Gallery.
BIB: Bénézit, *Dictionnaire*, 1976. Algernon Graves, *Dictionary of Artists*, Kingsmead, Bath, 1973. ADB 6. Edward Craig, *Australian Art Auction Records 1975–78*, Mathews, Sydney, 1978.
(Copy of letter to Waite's nephew, G. H. Waite, from Sidney C. Hutchison, librarian, RA, London, 18 Sept. 1964)

WAKE, Geoffrey
(b. 1944, Perth) Painter, printmaker, teacher.
STUDIES: Perth Tech. Coll., 1960–65. His abstract expressionist paintings were shown in Perth from 1968 (Skinner; Greenhill).
AWARDS: VACB grants, 1973, 74; occupancy, Power Inst. studio, Cité Internationale des Arts, Paris, 1973–74.
APPTS: Teaching, tutorials, painting and drawing, Fremantle Arts Centre, 1976–86.
REP: AGWA; Uni. of WA collections; WAIT collections.
BIB: *Geoffrey Wake – Painter*, Fremantle Press, 1978.
NFI

WAKELIN, Roland Shakespeare
(b. 17/4/1887, Graytown, NZ; arr. Aust. 1912; d. 28/5/1971, Sydney) Painter, teacher.
STUDIES: Wellington Tech. School, NZ, 1904–12; RAS School, Sydney, 1912–14; travel studies, UK and Europe, 1922–24. Determined from childhood to become a painter, he holidayed in Sydney, 1908, and four years

later returned to stay and study at Rubbo's RAS classes. From 1912 he earned a living as a ticketwriter in the Income Tax Dept, and five years later joined the advertising firm of Smith and Julius to work in company with de Maistre, Rees, Leason and others who achieved distinction. Greatly influenced by the prints of modern French paintings circulated at the RAS classes by Norah Simpson as well as by his contacts at Smith and Julius, he became greatly attracted to the work of Cézanne. In 1922 he went to London, worked there in advertising and made three visits to Paris before returning to Sydney in 1924 to join the Contemporary Group and become a leading figure in the Sydney modernist movement. He exhibited also with the NSW Society of Arts and from 1936 held annual exhibitions at the Macquarie Galleries. A large retrospective exhibition of his work was held at the AGNSW in 1967. Whether depicting figures, buildings, seascape, landscape or still-life, the forms in his paintings are uniformly cubist inspired and his high-keyed colours always soft, muted and serene. He was represented in the Bicentennial exhibition *The Great Australian Art Exhibition*.

AWARDS: International Co-operation for Disarmament Art Award, 1966.

APPTS: Uni. of Sydney (school of architecture), 1952– .

REP: NGA; AGNSW; AGSA; AGWA; NGV; TMAG; regional galleries Bendigo, Castlemaine, Newcastle.

BIB: All general books on contemporary Australian art history. A&A 4/4/1967 (Douglas Dundas, *Roland Wakelin*); 17/3/1980 (Lloyd Rees, *Roland Wakelin's Down the Hills to Berry Bay*).

WALKER, Ada (née ROMAINE)

(Active late 19th–early 20th century, Melb.) Painter. She exhibited flower pieces in oil and watercolour, as well as medallions and portraits, VAS, 1898.

Gerstman Abdullah, Germany 1986; Hawthorn City Gallery 1983; 200 Gertrude St, Melbourne 1990. She participated in around 34 group exhibitions 1978–92 at private galleries in Melbourne (including Gerstman Abdullah, Realities, Niagara) and Sydney (Holdsworth), and in award exhibitions including *Henri Worland Acquisition Award*, Warrnambool Art Gallery 1978, 79, 80, 83; *Fremantle Print Award*, 1981; *Recent Work*, NGV 1989.

AWARDS: Graeme Brown Prize, VCA, 1980; Henri Worland Acquisition Award, Warrnambool Art Gallery, 1978, 80, 83; scholarship, VCA, 1981; St Kilda Festival Acquisition Award, 1980; traineeship grant, VACB, 1980; Mid-year Trustees Award, NGV, 1981; Diamond Valley Acquisition Award, 1985; project grant, VACB, 1986, travel grant, VACB, 1986; residency, Trades Hall Melb., 1989; research grant, Deakin Uni.; Postcard Show prize, Linden Gallery, St Kilda Festival, 1992.

APPTS: Visiting lecturer, Phillip Inst., 1982; administrative assistant, Victorian Print Workshop, 1984; lecturer, Vic. Coll., Prahran, 1987–88; visiting lecturer, Gippsland Inst., 1987; lecturer, VCA, 1984–90; lecturer, RMIT, 1987–88.

REP: NGA; NGV; TMAG; regional galleries including Bendigo, Geelong, Wagga Wagga, Warrnambool; Queensland Uni. Union; corporate collections including Western Mining.

BIB: Catalogue essays exhibitions as above.

WALKER, John

(b. 1879, Bendigo; d. 1955, Bendigo) Sculptor.

STUDIES: Bendigo School of Mines, with Arthur T. Woodward; Royal Coll. of Art, London, with Prof. Edouard Lanteri. His surviving sculptures, *Statue of Captain Cook*, 1906, *South African War Memorial*, 1924, *Bust of Sir John Quick*, 1934, are all located in Bendigo.

Deborah Walker, Untitled, 1992, oil on wood three panels each approx. 6.5 × 8.1cm. Courtesy Niagara Galleries, Melbourne.

WALKER, Deborah

(b. 15/3/1954, Vic.) Painter, printmaker.

STUDIES: Dip. Fine Art, CIT, 1974; Postgrad. Dip. Fine Art, VCA, 1980. Her monochromatic prints using strong black outlines were seen in eight solo exhibitions 1979–91 in Hobart (Harrington Gallery 1979) and Melbourne (Oz 1979; Stuart Gerstman 1984; Gerstman Abdullah 1986; Niagara 1991), and at

REP: Bendigo Art Gallery.

BIB: Scarlett, AS. 1980.

WALKER, John

(b. 1940, Birmingham, UK; arr. Aust. 1979) Painter, teacher.

STUDIES: Birmingham School of Art, UK. He exhibited internationally from 1967 including a retrospective of prints at the Tate Gallery, London 1985; and paintings 1979–84 at the Hayward Gallery, London 1985. He came to Australia as artist-in-residence at Monash Uni. in 1979 and became the dean of visual arts at the VCA several years later. He exhibited large

figurative abstracts in Australia from 1979. Largely based in New York with his wife, art historian Memory Holloway (q.v.) since the mid 1980s, he was an important contributor to Australian, especially Melbourne, art through his modernist abstract works, as a teacher and in writings and debates on art. He continues to exhibit in Australia as well as in the USA, UK and Europe.

APPTS: Artist-in-residence, Oxford Uni.; Monash Uni., 1979; Prahran CAE, 1981; tutor, Royal Coll. of Art, London; prof. of painting, Yale Uni., USA; Dean of the School of Art, VCA, 1982–86.

AWARDS: Guggenheim Fellowship, NY, 1981–82.

REP: NGA; several Australian state galleries; Tate Gallery, London; MOMA, New York; National Gallery, Washington, DC.

BIB: Smith, AP.

WALKER, John R.
(b. 1957, Sydney) Painter. He held nine solo exhibitions 1984–90 at Mori Sydney and Tolarno Melbourne, and several in St Louis, USA. Group exhibitions in which his work appeared include *The Pleasure of the Gaze*, AGWA 1985; *Drawing in the 80s*, NGA 1988; *Budget Collection*, NGV 1987.

AWARDS: Savage Club Drawing prize, 1988.

REP: NGA; AGNSW; AGWA; NGV; Parliament House; a number of regional gallery collections including Bathurst, Broken Hill, New England, Wollongong; corporate collections including Ansett, Robert Holmes à Court, Philip Morris, Myer.

BIB: Catalogue essays exhibitions as above. McKenzie, DIA.

WALKER, Leslie James
(b. 5/8/1894, Parramatta; d. Dec. 1951) Etcher, painter. STUDIES: Granville Tech. Coll., Sydney, with Alfred Coffey; RAS classes, with Dattilo Rubbo, Norman Carter and James R. Jackson; etching, with Sydney Long. He made a reputation as an etcher before turning to portrait and landscape painting, and was a prominent member of the Australian Painter-Etchers' Society and Royal Art Society.

BIB: *Australian Art Illustrated*, RAS, Sydney, 1947.
(Information from Walker's nephew, D. Huxley, 14 June 1974)

WALKER, Mary
(b. Tas.) Painter.
STUDIES: Slade School, London; Colarossi's, Paris. She exhibited extensively in London, 1886–1908, showing mainly still life. Wife of Phillip F. Walker.

REP: TMAG.

BIB: Moore, SAA. J. Johnson and A. Greutzner, *Dictionary of British Artists, 1880–1940*, Antique Collectors Club, Woodridge, Suffolk, 1976.

NFI

WALKER, Murray
(b. 1937, Ballarat) Painter, etcher.
STUDIES: Ballarat School of Mines; Slade School, London, with Anthony Gros, 1959–62. From 1963 his etchings, in particular, were widely exhibited,

many in international PCA exhibitions and in galleries including Powell St, Melbourne and Ray Hughes, Brisbane as well as numerous group exhibitions. Their open line, lightness of touch and spontaneity are notable features, themes being often of an erotic nature. In 1980 he completed a large tapestry, woven at the Victorian Tapestry Workshop, for the Collins Place Building, Melbourne. He wrote several books on early Australian craft, including *Pioneer Crafts of Early Australia*, Macmillan 1978 and *Making Do: Memories of Australian Back Country People*, Penguin, 1982, and curated an exhibition on pioneer crafts for the NGV in 1978. In the 1980s his work became more concerned with the environment and included a series based on found woods and other objects.

AWARDS: Italian Government bursary for two months study at Perugia, 1962; PCA member print prize, 1974.

REP: NGA; AGSA; QAG; TMAG; regional galleries Ararat, Latrobe Valley, Warrnambool; ANU; Monash Uni.; Smithsonian Inst., New York.

BIB: PCA, *Directory*. Germaine, AGA.

WALKER, Ralph Trafford
(b. 1912, Sydney) Sculptor.
STUDIES: Brisbane Tech. Coll., with Lewis J. Harvey; ESTC, with Rayner Hoff; Julian Ashton School. He made 17 of the 18 relief panels for the centre bronze door of the Mitchell Library, Sydney, as well as dioramas for the AWM.

REP: AWM; Mitchell Library.

BIB: A&A 10/4/1973. Scarlett, AS.

NFI

WALKER, Rose A.
(Active from c. 1900). Painter. A watercolourist, she exhibited flower pieces, portraits, landscapes and genre at the VAS from 1903. In 1917 she was in Hobart; a watercolour, *Millers Bluff, Tasmania*, catalogued at Leonard Joel's auctions, Melbourne, Nov. 1973, under the name of Annie Walker may have been by her.

WALKER, Stephen
(b. 1927, Melb.) Sculptor, teacher.
STUDIES: Melb. Tech. Coll., 1945–48; Hobart Art School, with Carington Smith, 1948–50; UK, as assistant to Henry Moore, 1954–56; travel studies, Rome and Florence, 1960–61, Prague, 1963. He began his career as an advertising artist in Melbourne, studying fine art at evening classes. Moving to Hobart he studied painting, and around 1952 began his career in sculpture. His interest in the natural forms of stones, shells and plants was developed in the UK during a year spent as assistant to Henry Moore, and the organic sculptures of Moore and Brancusi remained central to his art. Many of his wood carvings are done in Huon pine, among the most impressive being the huge, open-structured carving in undressed timber shown suspended above the Festival Theatre plaza, Adelaide, in a special exhibition in 1978. To 1987 he had completed more than 40 mostly large commissioned works, including a number of fine fountains,

and his work was seen in many solo exhibitions (from the 1980s mainly in Tasmania) and group exhibitions including *Mildura Sculpture Triennial*, 1961, 64, 70, 78.

AWARDS: Italian Scholarship, for study in Italy, 1959; Dip. of merit, *International Sculpture Exhibition*, Saigon, 1962; UNESCO grant, for study in Prague, 1963; Sydney City Council competition, sculpture for Lake Kippax (not executed), 1965; Commonwealth Banking Corporation prize (feature for façade of new building), 1967; Advance Australia Award, 1983; Order of Australia medal, 1985.

APPTS: Teaching, Hobart Tech. Coll., 1951–53.

REP: NGA; AGNSW; AGWA; NGV; QAG; QVMAG; TMAG; regional galleries Langwarrin (McClelland Gallery), Launceston, Newcastle; Macquarie Uni.; Uni. of Tasmania.

BIB: Sturgeon, *DAS*. Backhouse, *TA*. Scarlett, *AS* Germaine, *AGA*. *AI* 14/1/1970.

WALKER, Sue

(b. 27/10/1936) Administrator.

STUDIES: BA (fine arts), Uni. of Melb., Dip. Ed., 1958; postgrad. fine art studies, Uni. of Melb., 1990–93. She started her professional career weaving in London (1960). Returning to Australia, she initiated the weaving classes at the CAE, Melbourne, as well as the workshops at Melbourne and Monash universities, before taking up her appointment as director of the Vic. Tapestry Workshop (q.v.). As well, she was involved in a number of arts committees and boards, notably the Vic. Council of the Arts, 1975–80; Australia Council, 1981–84, board member and subsequently chair, Artbank, 1980–83. She also convened and lectured to a number of crafts symposia and is a life member of the NGV.

AWARDS: Order of Australia (member), 1983.

APPTS: Secondary teaching, Australia and overseas, 1958–64; part time teaching, further education level, 1966–70; lecturer, art education, Melb. State Coll., 1971–75; director, Vic. Tapestry Workshop, 1976– .

WALKER, Theresa Susannah Eunice Snell

(b. 1807, Keynsham, UK; arr. Adelaide, 1837; d. 1867, South Yarra, Vic.) Sculptor.

STUDIES: London, 1832–36. She made a number of wax medallions in South Australia and exhibited two at the RA, London, 1841; she exhibited also at the Society for the Promotion of the Fine Arts, Sydney, 1847, 49, and at the second *Adelaide General Art Exhibition*, 1848. In 1849 her husband, Lieut. John Walker, RN, an insolvent in 1846, became Acting Port Officer at Hobart, then at Launceston, 1850. He died in 1855. The following year she married Prof. George Herbert Poole and spent four years in Mauritius, 1864–68, before returning to settle in Australia. Her medallions were seen in *Early Australian Sculpture*, Ballarat Fine Art Gallery 1976; the Bicentennial exhibition *The Great Australian Art Exhibition* and *A Century of Australian Women Artists 1840s–1940s* Deutscher Fine Art, Melbourne, 1993.

REP: NGA; AGSA; QVMAG; TMAG; Philadelphia Museum of Art.

BIB: Badham, *SAA*. Scarlett, *AS*.

WALKER, Thornton James

(b. 31/1/1953, Auckland, NZ; arr. Aust. 1965) Painter.

STUDIES: Dip. Art & Design, Prahran Coll., 1974; Postgrad. Dip. (incomplete), VCA, 1992. He held ten solo exhibitions 1980–92 in Melbourne (United Artists, 1986, 87; Deutscher, 1990), Sydney (Garry Anderson, 1991) and Canberra (Ben Grady, 1989, 90). Group exhibitions in which he participated 1982–92 include several St Kilda Acquisitive Exhibitions and the *Moet & Chandon Touring Exhibition*, 1987, with his work *The Red Cross*, which showed a Pop element. By 1993 however his paintings at Christine Abrahams Melbourne had returned to a more romantic lyrical style with some misty landscapes.

APPTS: Tutor, CAE, Melb., 1976–82.

REP: NGA; AGWA; Parliament House; Artbank; Philip Morris collection.

WALL, Edith

(b. 13/11/1904, Christchurch, NZ; arr. Aust. 1939) Painter, graphic artist.

STUDIES: Travel studies, UK and Europe. She became known first as a cartoonist and illustrator but turned later to paintings and printmaking. Done usually in line and watercolours, her work as seen in her solo exhibition at Leveson St Gallery, Melbourne, 1971, was small-scale and satirical, with emphasis on design, colour and social commentary.

AWARDS: Prizes at Bendigo, 1956; VAS (drawing prize), 1956; Ballarat (Minnie Crouch), 1971.

REP: AGSA; AGWA; QAG; TMAG.

NFI

WALLACE-CRABBE, Kenneth Eyre Inverell

(b. 1900, Qld) Business executive, painter, printmaker, writer. A distinguished dilettante, he served as a pilot during World War II, attaining the rank of Group Captain. In his early days he became friendly with many leading artists and during the 1930s gave great encouragement to younger artists. In the course of his career he has produced a large number of cartoons, illustrations, paintings and writings. From 1955 he hand-printed 22 books, including many of his own. His two sons, Christopher and Robin, both attained distinction in the arts.

AWARDS: OBE conferred.

BIB: *A&A* 18/1/1980 (Geoffrey Farmer, *Ken Wallace-Crabbe and the Cotswold Press*).

WALLACE-CRABBE, Robin

(b. 1938, Melb.) Painter, printmaker, writer.

STUDIES: RMIT, 1956–57. He held more than 30 solo exhibitions 1963–93 in capital cities as well as participating in group exhibitions including international shows organised for the PCA and *Perspecta*, AGNSW, 1981. Beginning with sensuous, Matisse-like paintings of the nude, his work became progressively more

abstract in accord with international trends during the 1970s. During the 1980s he returned to figurative themes. He is also a highly regarded crime novelist.

AWARDS: Grant, VACB, 1981; grant, Literature Board, Aust. Council, 1982; residency, Power Studio, NY, 1985.

APPTS: Lecturer, various colleges, including Prahran Tech. (1964–65), Canberra School of Art, SASA and Gippsland Inst.; art critic, *Canberra Times*, 1966–68.

REP: NGA; AGNSW; AGSA; regional galleries Ballarat, Latrobe Valley; Uni. of Melbourne; Uni. of Qld; Flinders Uni., SA.

BIB: Most general books on contemporary Australian art including Gary Catalano, *Years of Hope*, OUP; Smith, AP. A&A 15/2/1977; 26/2/1988. AL 4/2–3/1984.

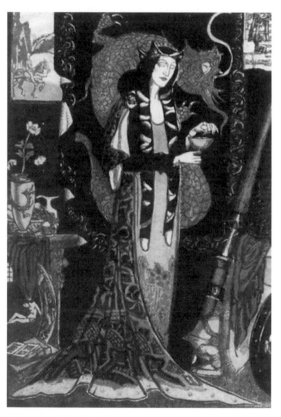

Christian Waller, Morgan Le Fay, *colour linocut, 26.8 × 18.3cm. Joels, November 1992.*

WALLER, Christian Marjory Emily Carlyle (née YANDELL)

(b. 1894, Castlemaine; d. 1954, Melb.) Illustrator, stained glass designer.

STUDIES: NGV School, 1909–14; London, stained-glass, 1929–30. She met Napier Waller at the NGV School and in 1915 they married. During Waller's absence at the war (in which he was severely wounded), she worked as an illustrator and commercial artist, and in the 1920s produced linocuts, and illustrations for the plays of Rupert Atkinson and for books published by E. A. Vidler. Her designs were influenced by the pre-Raphaelites and William Morris. Already versed in theosophy and classic literature, she studied the Irish mystical poets as well as astrology and related subjects during a visit to London with her husband, 1929–30. This led eventually to her becoming a follower of the evangelist Father Divine, partly to recover from a mental breakdown suffered in 1937. In 1939–40 she visited the USA and studied at the temple of Father Divine in New York. After her return to Australia, she secluded herself in her home at Darebin and spent the rest of her working life producing designs for stained-glass. An exhibition of her work was held at Deutscher Galleries, Armadale, 1978 and she was represented in *A Century of Australian Women Artists 1840s–1940s* Deutscher Fine Art, Melbourne, 1993.

REP: NGV.

BIB: Moore, SAA.

WALLER, Napier (Mervyn Napier)

(b. 19/6/1894, Penshurst, Vic.; d. 1972, Melb.) Painter, graphic artist, teacher, stained glass designer.

STUDIES: NGV School, 1913–14 ; travel studies (mosaics), 1929–30. Married Christian Yandell, 1915. He enlisted at the beginning of World War I and lost his right arm at Bullecourt in May 1917. Recovering from this wound he learned to paint with his left hand, held an exhibition in Melbourne (8 Aug. 1918), and pioneered the linocut in Australia when he showed a panel of six works in this medium at the Australian Art Association annual exhibition, Melbourne, 1923. He produced a book, *War Sketches on the Somme Front* (Edward A. Vidler, Melbourne, 1918), and his linocuts on medieval themes soon became well-known. He made a special study of mosaic and mural painting, 1932, and subsequently designed large murals for the Melbourne Public Library, the Mural Hall at the Myer Emporium, the Melbourne Town Hall (taken to the drawing stage only), and a large mosaic for Newspaper House, Collins Street. His monument is the vast assignment (stained glass and mural mosaic work) completed in seven years for the Australian War Memorial. He was represented in the Bicentennial exhibition *The Great Australian Art Exhibition*.

APPTS: Teaching, Melbourne Tech. Coll., 1932– ; trustee, NGV, 1944–46.

REP: AGNSW; AGSA; NGV; TMAG; AWM.

BIB: Moore, SAA. Smith, AP. John Kroeger, *Australian Artists*, Renniks, Adelaide, 1968. AA May 1923. A&A 19/2/1981.

WALLER, Ruth

(b. 1955, Sydney) Painter, illustrator.

STUDIES: Dip. Art, Alexander Mackie CAE, 1978. She was artist-in-residence and artist-in-the-community at Union Media Services, Sydney 1984; Wollongong City Council *House about Wollongong* photographic project and painted panels for Lidcome Workers Health Centre, South Sydney Visual History Project, 1984. Her work was seen in 9 solo exhibitions 1981–91 in Sydney (Watters; Artspace); Melbourne Trades Hall Gallery 1985; Wollongong City Gallery 1985; Australian Centre for Photography; Canberra Photo-Access Gallery;

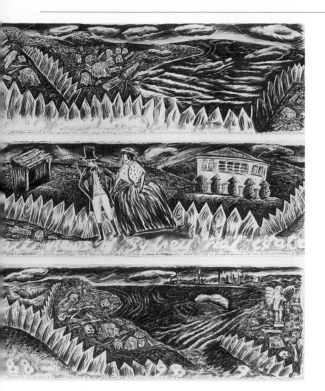

Ruth Waller, White Panorama – select views of Sydney real estate 1788–1989, *1989, charcoal and pastel on paper, 3 sections, 38 × 111.8cm. Courtesy Watters Gallery, Sydney.*

EAF, Adelaide 1986; Tin Sheds, Sydney 1988. She participated in around 16 group exhibitions 1983–92 including at Watters, Coventry, Sydney and at tertiary and public galleries including *A Changing Relationship: Aboriginal Imagery in Australian Art 1938–88*, S. H. Ervin Gallery, Sydney 1988; *Adelaide Biennale of Australian Art*, AGSA 1990; *The City and Beyond*, La Trobe Uni. Gallery and six regional NSW, Qld and Vic. galleries 1990–91; *Her Story*, S. H. Ervin Gallery 1991; *In Black and White*, Tin Sheds, Sydney 1992.
AWARDS: Project grant, VACB, 1985; residency, Verdaccio Studio, Italy, VACB, 1990; Maitland Art Prize, 1990.
APPTS: Part-time teaching, ESTC, Sydney Uni. Art Workshop, TAFE programs; part-time lecturer, painting, Canberra School of Art.
REP: NGA; AGNSW; NGV; regional galleries Ballarat, Gold Coast, Maitland, New England, Warrnambool, Wollongong; Griffith Uni.; Uni. of Sydney Union; Baker & McKenzie corporate collection.
BIB: Catalogue essays exhibitions as above.

WALLIS, (Captain) James

(b. c. 1785, Eng.; arr. Sydney 1814; d. 1858) Painter, military officer. Commander of military forces at Newcastle, NSW, 1816–19, his *Corroboree at Newcastle* is described by Bernard Smith (*PTT*) as 'the finest primitive painting that has yet to come to light in Australia'. Wallis's reputation as an artist was established by the

12 plates illustrating his publication *An Historical Account of the Colony of New South Wales and its Dependent Settlements*, London, 1821.
BIB: Rienits, *Early Artists of Australia*, 1963. Smith, PTT. ADB 2. Kerr, DAA. A&A 27/2/1989.
(*See also* LYCETT, JOSEPH)

WALLIS, Raymond

(b. 1900, Melb.; d. 1963, NSW) Painter, gallery owner.
STUDIES: NGV School, 1919; RCA, London, 1925. Proprietor of the Decoration Galleries, Collins St, Melbourne, 1920–24. He lived in London 1924–39 and on his return exhibited landscapes at the Sedon Galleries, Melbourne. He settled on the Mornington Peninsula. In 1963 an exhibition of his work was held at the South Yarra Galleries.
REP: AGNSW (etching).

WALSH, James

(b. 1833, ?Eng.; arr. WA 10/8/1854; d. ?) Painter, clerk. Sentenced to 15 years' transportation for forgery in 1852 he was conditionally pardoned, 11 June 1859, but reconvicted the same year, again for forgery, and finally granted freedom, 14 Oct. 1867. Though a topographical watercolourist of skill, he is best-known for his fine series of watercolours of Aborigines hunting, fishing, cooking, etc., nearly all painted in the 1860s. Slightly naive in style, Walsh infuses his figures with liveliness but appears quite free from the caricature and bias that spoiled the work of many of the later convict artists, such as John Carmichael (q.v.). His work was seen in *The Colonial Eye*, AGWA 1979 and *From Mount Eliza*, AGWA 1985.
REP: AGWA; Art Gallery of the Benedictine Abbey of New Norcia, WA.
BIB: Kerr, DAA.

WALSH, Peter

(b. 1958, Adelaide) Painter, printmaker.
STUDIES: Wimbledon School of Art, London, 1975–79; Dip. Fine Art, VCA, 1981. His work was seen in seven solo exhibitions 1986–91 in Melbourne (Reconnaissance 1986; Girgis & Klym 1988, 90), Sydney (Syme Dodson 1990, 91) and Canberra (Ben Grady 1986), and at 200 Gertrude St, 1986. His work appeared in 25 group exhibitions 1981–92 in Melbourne (including Girgis & Klym) and at tertiary and public galleries including *Murdoch Fellowship* exhibition, 1983; *Inaugural Exhibition*, 200 Gertrude St 1985; *Visionary Fantasies*, Victorian Print Workshop 1987; *Exquisite Corpse*, 200 Gertrude St 1987; *A New Generation: Philip Morris Arts Grant Collection*, NGA 1988; *Australian Contemporary Art Collection*, NGA 1990; *New Art: Contemporary Art Acquisitions*, NGV 1990; *John McCaughey Memorial Prize*, NGV 1991.
REP: NGA; NGV; PCA; World Congress Centre, Melbourne; Melbourne Convention Centre.
BIB: Catalogue essays exhibitions as above.

WALTER, Carl (Charles)

(b. 1831, Germany; arr. Vic. c. 1856; d. 1907)

Photographer. Described by Bill Gaskins in Kerr (*DAA*) as 'probably Australia's first photojournalist', he took photographs of the Aboriginal settlement at Coranderrk, Vic. and described a trip overland to the Falls on the Niagara Creek, Mt Torbreck in 1866, which he accomplished by camping and living off the bush as well as carrying his photographic equipment of not inconsiderable weight. The Coranderrk Aboriginal collection was seen in the 1866 Melbourne Intercolonial Exhibition, the 1867 Paris Universal Exhibition and the 1869 Melbourne Public Library Exhibition and is now in the collection of the La Trobe Library, Vic. Walter's work appeared in *Shades of Light*, NGA 1988.
REP: NGA; La Trobe, Mitchell Libraries; Museum of Victoria; Pitt Rivers Museum, Oxford.
BIB: Kerr, *DAA*.

WALTERS, Wes
(b. 1928, Mildura) Painter.
STUDIES: Architecture at the Gordon Inst. of Technology, Geelong, Vic., 1947–48. He participated in the exhibition *Supernatural Natural Image*, which toured Victorian regional galleries in 1974, and in *Pictures for People in Public Places*, Melbourne City Square, 1975. He showed photo-realist nudes at the Stuart Gerstman Galleries, Melbourne, 1975, and atmospheric landscapes at the same gallery in Oct. 1978. His romanticised, Archibald Prize-winning portrait of the columnist Phillip Adams caused a press controversy in April 1980. He has painted portraits of a number of people well known in many fields of Australian life.
AWARDS: Archibald prize, 1979.
REP: AGNSW; NGV; TMAG; Benalla, Newcastle, Mildura, regional galleries; tertiary collections including the universities of Monash and Melbourne.
BIB: Germaine, *AGA*, 1979.

WALTON, George
(b.1855, Northumberland; arr. Aust. 1888; d. 30/12/1890, Westmorland, UK) Painter.
STUDIES: Newcastle School of Art; RA School, London; Paris. He exhibited portraits at the RA, 1882–88, before moving to Australia for health reasons. Associated with painters of the Heidelberg School, he exhibited at the VAS, 1888–90. Among his Australian portrait commissions was one of the playwright Louis Esson, at the age of ten, and another of Annie Paterson, sister-in-law of John Ford Paterson (q.v.). He returned to England in 1890 where he died shortly after. His work was seen in *Golden Summers* curated by the NGV and touring 1986.
REP: AGNSW.
BIB: Bénézit, *Dictionnaire*, 1976. AA. no. 4, 1918. Christopher Wood, *Dictionary of Victorian Painters*, Antique Collectors Club, Woodridge, Suffolk, rev. edn, 1978.

WALWICZ, Ania
(b. 19/5/1951, Poland) Painter, writer.
STUDIES: Dip. Art, VCA, 1971–75; Postgrad. Dip., VCA; Grad. Dip. Ed., Uni. of Melbourne. Rhythmic linear design, strong tonal contrasts and a sensitive

eye for textures are features of her prints as shown in PCA exhibitions and in print competitions from 1972. She held 7 solo exhibitions 1981–90 in Melbourne (including Art Projects) and Sydney (Performance Space, Mori Gallery), a retrospective at EAF, Adelaide in 1986 and at ACCA, Melbourne in 1992.
AWARDS: Elaine Target Drawing prize, 1973; MPAC Prints (print acquired), 1974; Warrnambool (Henri Worland print prize, print acquired), 1974.
REP: Regional galleries Mornington, Warrnambool.
BIB: PCA, *Directory* 1976. AL 5/3–4/1985; 6/2–3/1986; 6/4/1986. *Meanjin* 4/1992.

WARD, Mark
(b. 5/4/1944, NSW) Painter, stage designer, printmaker, teacher.
STUDIES: Dip. Painting, Drawing, ESTC, 1963; Dip. Teaching (infants and primary), Sydney Teachers Coll., 1979. An artist for television sets 1964–69 in Melbourne and Sydney and set designer for the Elizabethan Theatre Trust and Australian Opera in the 1970s–80s, his work was described by Elwyn Lynn in the *Australian* (30 Sept. 1989) as 'brilliantly balanced [linocuts] with deceptively plaited whites and emphatic blacks, especially in the Gippsland landscapes'. He held four solo exhibitions in Sydney (Woolloomooloo 1968, 89; King St on Burton 1992) and Braidwood (1990), and his work appeared in several group exhibitions with the Young Contemporaries, Blaxland Gallery, Sydney 1968–70 and Sydney Printmakers 1978–90 as well as in exhibitions at Macquarie, Hogarth, King St on Burton.
AWARDS: Woollahra art prize, 1968; Berrima print prize, 1986; Drummoyne print prize, 1989; Moya Dyring studio, Cité Internationale des Arts, Paris, 1972–73.
APPTS: Art teacher, primary schools, Sydney, 1980–82; part-time art teaching, correspondence school, William St, Sydney, 1985–90.
REP: NGA; Artbank; NSW Parliament House; regional galleries Armidale, Morwell, Penrith.

WARE, Laurence Arthur
(b. 1915, London; arr. Aust. 1923) Sculptor, teacher.
STUDIES: ESTC, 1931–40. He worked as an industrial sculptor on architectural modelling and carving and also as a fitter and turner in engineering works, 1940–45. A member of the Society of Sculptors and Associates, 1963–69, he was instrumental in forming the Hunter Region Sculpture Society, 1969.
AWARDS: *Mirror*-Waratah Festival, sculpture prize, 1965.
APPTS: Senior head teacher, NAS, Newcastle, 1969–74; principal lecturer and head of art dept, 1975– .
BIB: Scarlett, *AS*.
NFI

WARE, Silver Ley (née COLLINGS)
(b. 1940, Sydney) Sculptor.
STUDIES: ESTC, –1960. During 1961–62 she assisted

Alan Warren, Studio Nude, *1970, oil on board, 86 × 119cm. Joels, April 1992.*

Alan Ingham and Douglas Annand with sculpture, and 1963–66 travelled and worked in Greece, Turkey, Italy and London. She travelled again in 1974.
AWARDS: *Mirror*-Waratah Festival prize for sculpture, 1963.
APPTS: Teaching, ESTC (summer school), 1966; NAS, Randwick (part-time), 1967; NAS, Newcastle, 1968–74; Newcastle CAE, 1975–76.
REP: AGNSW.
BIB: Scarlett, AS.
NFI

WARNER, *Ernest*

(b. 1902) Etcher, painter. Member of the NSW Society of Artists, where he showed landscapes and street scenes. Sixteen etched book-plate designs by him are in *AA* no. 5, 1923.
NFI

WARNER, *Ralph Malcolm*

(b. 1902, Geelong, Vic.; d. 1966, Qld) Painter, commercial artist.
STUDIES: No formal training. Known mainly for watercolours. President of the VAS (1950–58); official war artist in World War II.
AWARDS: Prizes in Dunlop competitions, 1950, 54; Cato prize, VAS, 1958.
REP: AGSA; NGV; QAG; TMAG; regional galleries Ballarat, Bendigo, Broken Hill, Launceston.

WARREN, *Alan*

(b. 1919, Melb.; d. 7/6/1991) Painter, critic, reader.
STUDIES: NGV School, 1937–38; George Bell School, 1938–39. Strong in design and colour, his semi-abstract paintings reflect cubist influences and remained true to the principles imparted during his early training with George Bell. Apart from his own exhibitions they were featured in Melbourne Contemporary Artists shows until this group disbanded in 1965. Eastgate gallery Melbourne held a solo exhibition of his work in 1989 and he was included in *Classical Modernism: The George Bell Circle,* at the NGV, 1992.
AWARDS: Bendigo prize, 1955; Perth prize, 1956; Crouch prize, Ballarat, 1958; Geelong prize, 1964.
APPTS: Director, Myer Art Gallery, Melbourne, 1946–47; teaching, RMIT, 1948–61; principal, Prahran Tech. School, 1961–72; art critic, *Sun News-Pictorial,* Melbourne, 1951–72; principal, Seven Hills CAE, Coll. of Art, Brisbane, 1972–86.
REP: AGWA; NGV; QAG; regional galleries Ballarat, Bendigo, Castlemaine.
BIB: Smith, AP. John Kroeger, *Australian Artists,* Renniks, Adelaide, 1968. *A&A* 29/3/1992 (obituary).

WARREN, *Garnet*

Qld artist on the staff of the *Queenslander,* 1897– . He migrated to the USA.
BIB: Moore, SAA.

WARREN, *Guy Wilkie*

(b. 16/4/1921, Goulburn, NSW) Painter, teacher.
STUDIES: J. S. Watkins Art School (private), Sydney,

1935–41; Dip. Art, NAS, 1947–49; Chelsea School of Art, and Central School of Arts and Crafts, London, followed by travel studies, UK and Europe, 1951–59. He designed the portraits for the Australian $2, $10 and $20 currency notes. As shown in a large number of exhibitions in Australia and overseas as well as in competitions, his painting largely concerns technological innovation adapted to the changing panorama of international abstraction. His work is also concerned with landscape, especially rainforests, and its relationship to the human presence. Parallel is a recurring interest in the intrinsic nature of materials of paint, paper, canvas. He exhibited at least once annually from 1959 including at Macquarie, Bonython, Gallery A, Sydney; von Bertouch, Newcastle; Stuart Gerstman, Melbourne; and participated in numerous significant group exhibitions, especially drawing and other works on paper shows, in Australia and internationally. Shows include *Archibald, Wynne, Sulman* prize exhibitions; *Drawn and Quartered*, AGSA 1980; *Perspecta* 1985, AGNSW 1985; *International Drawing Triennial* (invitation), Wroclaw, Poland 1981, 88; *Drawings in Australia: 1770s–1980s*, NGA 1988; *Prints and Australia*, NGA 1989.

AWARDS: Prizes in competitions at Mosman, 1950, 65; Hunters Hill, 1962; Rockdale, 1962, 66; *Mirror-Waratah Festival*, Sydney, 1962, 64; Robin Hood, Sydney, 1965, 67; Perth, 1967; Yass, 1967; Flotta Lauro (travelling), 1967; Maitland, 1968, 69; British Council grant for study in the UK, 1968; Dyason Scholarship for study in the USA, 1967; grant, VACB, 1974; Georges, Melbourne (purchase award), 1974; Darnell de Gruchy purchase prize, Qld, 1974; L. J. Harvey Prize for Drawing, 1979; Wynne Prize, 1980; residency, New York studio, VACB, 1982; Archibald Prize, 1985; bronze medal, 4th International Triennial Drawing, Poland, 1988; residency, Cité Internationale des Arts, Paris, 1990.

APPTS: Teaching, School of Architecture, Dept of Industrial Design; Dept of Fine Art, Uni. of Sydney and Uni. of NSW, 1966–73; director, Uni. of Sydney Art Workshop, 1973–76; consultant, environmental design, Parkes Community Centre, Adelaide, 1974–76; Wanniassa Community Coll., Canberra, 1976–79; principal lecturer, School of Art, SCA, 1976–85; travelling exhibition lecturer, *Landscape and Image, Australian Art in Indonesia*, 1978.

REP: NGA; AGNSW; AGSA; AGWA; MAGNT; NGV; QAG; QVMAG; TMAG; Artbank; a number of regional collections including Bendigo, Burnie, Newcastle, Wollongong; a number of tertiary collections including ANU, Qld, Macquarie, Sydney, James Cook unis., WAIT; Contemporary Art Society, London; National Library, Beijing; corporate collections including BHP and many others.

BIB: Catalogue essays exhibitions as above and a number of general texts on Australian art including Kroeger, *Australian Artists* Renniks, Adelaide, 1968; Horton, *PDA*; Smith, *AP*; M. Horton *Australian Painting in the 1970s*, Ure Smith 1975; Campbell, *AWP*. A&A 10/4/1973; 15/3/1978. *AI* March/April 1980.

WARREN, Joy
Ceramicist, entrepreneur.
STUDIES: Julian Ashton and NAS, Sydney, 1944–49; travel studies and employment, London, Spain, France, Holland, Italy, 1951–59; Camberwell School of Art, London, 1952–55; ceramics, NAS, 1961–63; Fine Arts (Hons), Uni. of Sydney, 1980; travel studies, USA, Europe, London, Singapore, 1982–83; Singapore, 1985. A founder member of the Crafts Council of Australia and Crafts Council of NSW 1965–69, her work was included in a number of craft touring exhibitions 1969–91 including *Australian Ceramics*, touring Australia 1974–75; Crafts Council of NSW 1976. She held three solo exhibitions 1969–92 in Sydney (Macquarie 1973, 91) and at Wollongong Uni. Gallery 1989.
AWARDS: Grant, VACB, 1972, 79.
APPTS: Lecturer, art history and theory, City Art Inst., 1979–91; lecturer, art history and theory, Ceramics Dept, SCA, 1982–91.
REP: NGA; NGV; Parliament House.

WARREN, Selby
(b. 1887, Bathurst, NSW) Painter. Naive painter and shearer, miner, rabbiter and timber cutter, he paints to depict the life and places he remembers.
REP: NGA.
BIB: Bianca McCullough, *Australian Naive Painters*, Hill of Content, Melbourne, 1977.

WATERCOLOUR SOCIETY
See AUSTRALIAN WATERCOLOUR INSTITUTE; OLD WATER COLOUR SOCIETY CLUB.

WATERHOUSE, John Latham
(b. 27/7/1933, Hastings, NZ; arr. Aust. 1949) Painter, gallery curator.
STUDIES: B. Comm, Uni. of Melbourne. No formal art training. His medium-sized abstracts, painted usually in transparent acrylics, are lyrical and atmospheric. He held around 13 solo exhibitions 1971–92 at Manyung, Raya galleries, Qdos, Lorne Vic. and David Ellis, Melbourne 1992. He participated in a number of group exhibitions largely at private galleries (often with Gareth Jones-Roberts and Charles McCubbin, Tim Guthrie, Ann Graham) and *Watercolour Today: Australia and America*, McClelland Gallery 1983.
APPTS: Curator, Monash Uni. collections, 1963–69; careers and appointments adviser and curator of collections, La Trobe Uni., 1970–90.
REP: Artbank; regional galleries including McClelland, MPAC; numerous tertiary collections including ANU, Deakin, Flinders, Melbourne, New England, Papua New Guinea, South Pacific, WA unis.; a number of secondary schools including Mount Scopus, Melbourne, St Patrick's, Goulburn; corporate collections including Westpac, Telecom.
BIB: Germaine, *AGA*.

WATERHOUSE, Phyl (Phyllis Paulina)
(b. 17/4/1917, Melb.; d. April 1989) Painter, gallery director.

STUDIES: NGV School; independent studies in London, Paris and Spain, 1950–52. Her paintings are lyrical depictions of buildings, trees and people done in a modulated post-impressionist style. She started exhibiting in 1939 at Riddell's Gallery and in 1962 she helped found the Leveson Street Gallery, North Melbourne (later the Leveson Gallery, Carlton), with June Davies. Her work was seen in numerous exhibitions largely with Leveson St galleries as well as in public exhibitions and was included in *The Changing Face of Melbourne*, Charles Nodrum Gallery, Melbourne, 1993.

AWARDS: Crouch prize, 1950, 51; Henry Caselli Richards prize, 1956; *Australian Women's Weekly* prize, 1959; Grafton prize, 1966; Albury art prize, 1980; St Catherine's Art Award, 1981; Woodend Art Award, 1981; Burke Hall Award, 1982, 83; St Kevin's Award, 1985.

REP: NGA; AGNSW; AGSA; AGWA; NGV; QAG; QVMAG; TMAG; Parliament House; Artbank; regional galleries including Bendigo, Ballarat, Benalla, Geelong, Broken Hill.

BIB: Germaine, *AGA*.

WATERLOW, Nick

(b. 1941, Hitchin, UK; arr. Aust. 1965) Lecturer, curator, gallery director.

STUDIES: University of Grenoble, France, 1961; British Institute, Florence, 1962. He worked in London galleries as well as researching at the Courtauld Institute before coming to Australia where he started art reviewing and lecturing at ESTC. He returned to London 1966–77 where one of his positions was as senior arts officer with Milton Keynes Development Corporation, helping plan the cultural direction of the new city. He returned to Australia to become a lecturer, then director of the Sydney Biennale, VAB and Ivan Dougherty Gallery. He curated the Henry Moore exhibition, AGNSW, 1992 and has been a member of a number of arts bodies, panels, committees 1965– .

AWARDS: Order of Australia medal, 1990.

APPTS: Lecturer, School of Art, Alexander Mackie CAE, 1977; director, Biennale of Sydney, 1978–79, 1984–86, 1986–88; senior lecturer, College of Fine Arts, University of NSW 1989–91; director, Ivan Dougherty Gallery, University of NSW, 1991– .

WATERS, Maynard

(b. 1936, Sydney) Painter.

STUDIES: No formal training. His naive, whimsical paintings as shown in exhibitions from 1966 in Canberra and other capital cities mainly concern environs of Broken Hill and its life. His exhibitions include with Holdsworth Galleries, Sydney, 1985; Greythorn Galleries, Melbourne, 1988, 89.

BIB: Bianca McCullough, *Australian Naive Painters*, Hill of Content, Melbourne, 1977.

WATHEN, George Henry

(Active c. 1855, Bendigo) Geologist, author, artist.

He illustrated his own book, *The Golden Colony: or Victoria in 1854*, London, 1855.

REP: Bendigo Art Gallery.

BIB: McCulloch, *AAGR*.

WATKINS, Dick (Richard John)

(b. 4/5/1937, Sydney) Painter.

STUDIES: Julian Ashton School, Sydney, 1955–58; NAS, E. Sydney, 1958; travel studies, UK, Europe and USA, 1959–61. Shown frequently in group exhibitions from 1962, his work became well-known, mainly in Sydney, its emphasis being first on geometric abstraction and hard-edge. References in it to a number of other sources, such as Léger, however, affirm the wide-ranging nature of Watkins' painting and the catholic nature of his tastes. He held at least one exhibition annually 1963–93 in Sydney (Central St, 1966–69; Hargrave St, 1970–72; Yuill Crowley 1982–) and Melbourne (Pinacotheca); also at Manly Art Gallery and Heide, 1988 and a retrospective at Wagga Wagga gallery 1989. Group exhibitions in which he participated 1961–89 include *Young Commonwealth Artists*, RBA Galleries, London 1961; survey exhibitions, MOMAD, Melbourne 1963; *The Field*, NGV 1968; *Australian Colourists*, WAIT 1977; *The Field Now*, Heide 1984; *Perspecta 81*, AGNSW 1981; *Field to Figuration*, NGV 1988; the Bicentennial exhibition *The Great Australian Art Exhibition*.

AWARDS: R. H. Taffs prize, CAS, Sydney, 1966; *Mirror*-Waratah grand prize (shared with R. Dickerson), 1966; VACB grant, for full-time work, 1976–77; Scotchmans Hill Art Prize, 1990.

REP: AGNSW; AGSA; AGWA; NGV; Artbank; Parliament House; a number of regional galleries including Ballarat, Geelong, New England, Wollongong; tertiary collections including Monash Uni.; corporate collections including Smorgon, Holmes à Court, NAB.

BIB: Catalogue essays exhibitions as above. Horton, PDA. Smith, AP. A&A 21/2/1983; 23/4/1986. AM Oct. 1990; April 1989. A&T Sept. 1984.

WATKINS, John Samuel

(b. 1866, Wolverhampton, UK; arr. Sydney 1882; d. 25/8/1942) Painter, teacher.

STUDIES: RA Schools, UK (local branch); Art Society of NSW school, Sydney, with Julian Ashton, A. J. Daplyn and Frank Mahony, 1895; Julian Ashton's school, 1896– ; Colarossi's, Paris. He conducted his own school at 56 Margaret St, Sydney, for many years. Moore lists well-known artists who attended and states that by 1934 more than 3000 students had been trained there, emphasis being on design, colour and drawing. A competent academic painter, Watkins tended to sentimentalise his portraits.

APPTS: Foundation council member, NSW Society of Artists, 1895– ; trustee, AGNSW, 1932–42; teacher of life drawing, RAS School, c. 1934.

REP: AGNSW; AGSA.

BIB: Moore, *SAA*. *Fifty Years of Australian Art, 1879–1929*, RAS, Sydney, 1929.

WATLING, Thomas

(b. 19/9/1762, Dumfries, Scotland; arr. Aust. 1792.
d. ?) Engraver, painter. Transported to Australia for
forging Bank of Scotland notes, Watling was an accom-
plished landscape painter and an accurate and reliable
zoological artist noted for his depiction of Australian
animals. In 1794 he painted the first oil painting of
Sydney (in the collection of the Dixson Galleries,
Mitchell Library), a classic-romantic work of some
finesse. In a prospectus of his work sent to England,
Watling described himself as 'the principal limner
of New South Wales'; he was not attracted to the
Australian landscape, however, and in a letter to his
aunt in Scotland he wrote: 'The landscape painter may
in vain seek here for that beauty which arises from
happy-opposed offscapes.' A prolific and competent
painter and draughtsman, his works show a breadth
of scale and quality unusual for the time and are of
considerable historical and artistic significance. He
painted in Sydney until about 1800 when, having
been pardoned (in 1797), he left for India and is
recorded as living in Calcutta, 1801–03. He is thought
to have returned to Dumfries in 1804 where he was
again tried for forgery but acquitted; there is no record
of his death although he wrote to Governor Hunter
in NSW around 1814 stating he was dying of cancer.
One hundred and twenty-three of his works are in
the collection of the British Museum, as part of a col-
lection (erroneously titled the *Watling Collection*) of
some 500 colonial works (the largest known collec-
tion) believed to have been that of the chief surgeon
of NSW, John White. His work appeared in the
Bicentennial exhibition *The Great Australian Art
Exhibition*.
REP: Watling Collection, Library of the British Museum
(Natural History); Dixson Gallery of the Mitchell
Library; NLA.
BIB: Smith, *EVSP*. Rienits, *Early Artists of Australia*, 1963;
Jocelyn Hackforth-Jones, *The Convict Artists*, Macmillan,
Melbourne, 1977. *ADB* 2. Andrew Sayers, *Drawing in Australia*,
NGA 1989. Kerr, *DAA*.

WATSON, Edward Albert Douglas

(b. 13/6/1920, Sydney; d. 1972, Sydney) Painter,
teacher.
STUDIES: ESTC, 193?–39; travel studies, UK and Europe,
1947–51. He served as a war artist during World
War II and exhibited at the RA, London, as well as
with the NSW Society of Artists, the CAS, and the Con-
temporary Group, Sydney. The muted colours and
impressionistic spontaneity of his early work stemmed
largely from his admiration for the work of Boudin
although his figure painting, nudes, portraits and
genre clearly reflect Dobell's influence. He remained
a figurative painter, the only deviation being a late
series of two-dimensional paintings symbolising the
life beneath the earth's surface. His work appeared in
Classical Modernism: The George Bell Circle NGV, 1992.
AWARDS: NSW Travelling Scholarship, 1940; Wynne
prize, 1942, 45; Bendigo prize, 1943; Crouch prize,
Ballarat, 1947; Lismore prize, 1953, 54.

REP: AGNSW; AGSA; NGV; QAG; regional galleries Ballarat,
Bendigo, Castlemaine, Geelong, Mornington.
BIB: Smith, *Catalogue* AGNSW, 1953. John Kroeger, *Australian
Artists*, Renniks, Adelaide, 1968. *A&A* 10/3/1974 (Charles
Bush, *Douglas Watson a Personal Reminiscence*).

WATSON, Izett

Painter. One of the first students at the Melbourne
National Gallery School (c. 1870). Moore states that
he had 'the outward signs of great genius' but that
'he never achieved success with a large canvas'. His
most memorable work is a painting of the Eureka
uprising done apparently in collaboration with Thaddeus
Welch. The Historical Art Association of Australia
published a print of this work in 1904.
REP: La Trobe Library.
BIB: Moore, *SAA*. McCulloch, *AAGR*.

WATSON, James Douglas

(b. 1913, Melb.) Painter, graphic artist, printmaker.
STUDIES: No formal training. He exhibited water-
colours, oils and drawings in Melbourne from about
1938, began printmaking in the early 1960s and held
a successful exhibition of colourprints at the South
Yarra Gallery in June 1965. His work was included
in touring exhibitions of Australian printmaking,
notably *Australian Graphics*, Poland, 1972–73, and
New York, 1973.
AWARDS: Prize in exhibition, *Australia at War* (War
at Sea section), NGV, 1945.
REP: AGSA; AGWA; NGV; TMAG; regional galleries
Geelong, Mornington.
BIB: PCA, *Directory*, 1976.
NFI

WATSON, Jenny

(b. 1951, Melb.) Painter.
STUDIES: Dip. Painting, NGV school, 1972; Dip. Ed.,
State Coll. of Vic., 1973; travel studies, Europe, UK
and USA, 1975–76 and 1978–79. She held her first
exhibition, of life-sized, photo-realist figure paintings
at the Powell Street Gallery, Melbourne, 1973, fol-
lowed by a similar series depicting horses, in Nov.
1974. She contributed also to the Angliss, McCaughey
and Georges prize exhibitions, all in 1975, and in her
contribution to *Survey 12* (NGV, July 1980) revealed
outstanding talent for character analysis. Her paint-
ing in the 1970s and 80s is characterised by delib-
erately child-like representations of figures, sometimes
added to with notations. Her work is strongly per-
sonal, reflecting her feelings of and view of daily life,
women's experiences, subconscious reactions and inter-
action between people. She was a partner, with John
Nixon, in the exhibition space *Art Projects* in Melbourne
1978–84 and held over 30 solo exhibitions 1973–93
in Australia (including with Christine Abrahams; City
Gallery/Anna Schwartz, Melbourne; Roslyn Oxley9,
Sydney; the IMA, Brisbane; Uni. of Melbourne Gallery)
and in Vienna, Frankfurt and New York. In 1993 she
was Australia's sole representative at the Venice Biennale.
Her work appeared in numerous group exhibitions

public galleries nationally and internationally 1983–93, including *Recent Australian Painting: A Survey of the 70s and 80s*, AGNSW 1983; *From Another Continent: Australia, the Dream and the Real*, Musée d'Art Moderne, Paris 1983; *Biennale of Sydney*, 1984; *Australian Perspecta*, AGNSW 1987, 88 (including international tour of West Germany); *Field to Figuration: Australian Art 1965–85*, NGV 1985; the Bicentennial exhibition *The Face of Australia*; *Off the Wall/In the Air: A Seventies Selection*, Monash Uni. and ACCA 1991.

APPTS: Teaching, Vic. Education Dept, tertiary colleges, private studio, 1973 86; part-time, VCA, 1988–89.

AWARDS: VACB travel grant, 1975; Georges Invitation Art Prize (work acquired), 1975; Alliance Française Art Fellowship, 1979; VACB grant, 1980; Newcastle Art Prize (jointly with Mike Parr), 1987; Portia Geach Memorial prize, 1990.

REP: NGA; AGNSW; AGWA; NGV; QAG; MCA, Sydney; a number of regional galleries including Benalla, Mildura, New England, Latrobe Valley; a number of tertiary collections including Qld Uni., Uni. of Melbourne; private and corporate collections including Philip Morris.

BIB: Catalogue essays exhibitions as above and most general books on contemporary Australian art including Leon Paroissien, *Australian Art Review*, Warner, 1982; Smith, *AP*; Chanin, *CAP*. Sandy Kirby *Sightlines*, Craftsman House, 1992. Numerous references in *A&T* and *A&A*.

WATSON, *Judy Anne*

(b. 9/10/1959, Mundubbera, Qld) Painter, printmaker. STUDIES: Dip. Creative Arts, Darling Downs Inst., Toowoomba, Qld, 1979; BA Fine Arts, Uni. of Tas., 1982; Grad. Dip. Visual Arts, Gippsland Inst. of Advanced Education, 1986. She is concerned with maintaining and representing links with her Aboriginal heritage and the land and the relationship of these to the late 20th century experience. Her work includes painting directly onto building surfaces such as in her 1990 *Groundwork* exhibit at the IMA, Brisbane, in which she painted a section of the floor with paint, powder and pastel. She held 8 solo exhibitions 1986–91 in Sydney (Aboriginal Artists; Mori), Melbourne (Deutscher Brunswick St) and Canberra (Ben Grady, AGOG), and at Griffith Uni. and IMA, Brisbane. Her art-related activities include artist-in-residence at Griffith Uni., 1989 and SCA, 1991; lithographer-in-residence, Studio One Canberra, 1990; artist commissioned for Queensland Aboriginal Creations, 1990; painting stage sets, Access Arts, Brisbane 1989; curator of *Opening the Umbrella* exhibition, Townsville artists, 1990. Her work appeared in around 60 group exhibitions 1979–91 at a number of private galleries but mainly at regional, tertiary and state galleries including *A Contemporary Caste: A Homage to Women Artists in Qld, Past and Present*, Centre Gallery, Qld 1988; *A Koori Perspective*, Artspace 1989; *Moet & Chandon Touring Exhibition*, 1990, 92; *You came to my country and didn't turn black*, Qld Museum 1990; *Aboriginal Women Artists*, AGNSW and touring 1991;

Frames of Reference: Aspects of Art and Feminism, Pier 4/5 Walsh Bay, Sydney 1991; *Adelaide Biennale of Australian Art*, AGSA 1992. She contributed to a number of artists' books including *Printmakers 85, 87, 88*, Townsville TAFE; and *Down on the Ground*, 1991. She was artist-in-residence, AGNSW, 1993.

AWARDS: Gold Coast City Art Purchase Prize, 1980; printmaking prizes Townsville, 1982; Mackay, 1987; SGIO purchase prize, Brisbane, 1985; Aberdare Art Purchase Prize, 1990; William Buttner Scholarship, QAG, 1987; project grant, Umbrella Studio, Qld, 1988; artists' development grant, VACB, 1989; residency, Verdaccio Studio, Italy, VACB, 1992.

APPTS: Lecturer, Townsville Coll. of TAFE, 1983–85, 1987–89; president, Umbrella Studio Association, 1989; co-ordinator, Umbrella Studio Etching Workshop, 1987–89; lecturer, lithography, Canberra Inst. of the Arts, 1991.

REP: NGA; AGNSW; AGWA; QAG; Brisbane City Hall Gallery; Qld and SA state museums; regional collections including Gold Coast City, Ballarat, Latrobe Valley, Townsville; tertiary collections including QIT, James Cook Uni., Canberra Inst. of the Arts Library, Uni. Coll. Southern Qld, Flinders Uni., Gippsland Inst.; corporate collections including Robert Holmes à Court, Macquarie Bank, Suncorp; Allied Queensland Coalfields Collection.

BIB: Sandy Kirby *Sightlines*, Craftsman House, 1992.

WATSON, *Percy Edward*

(b. 1919, Melb.) Painter, printmaker, industrial designer. STUDIES: Swinburne Tech. Coll., 1935–38; George Bell School, 1945–46; Melb. Tech. Coll. (RMIT), 1953. His work as industrial designer includes working as an animation artist for the CSIRO film unit. Beginning with impressionism, he changed to a more formal approach which led to abstracted subject matter. During 1951 the illustrative content was eliminated and his style was non-figurative from that time. His work was included in exhibitions at Charles Nodrum and Eastgate Galleries, Melbourne 1988– and in *Classical Modernism: The George Bell Circle*, NGV 1992.

AWARDS: Bendigo prize (for landscape), 1944.

REP: NGA; NGV; regional galleries Bendigo, Castlemaine, Warrnambool.

WATSON, *P. Fletcher*

(b. 1842, Eng.; arr. Sydney ?1887; d. 29/6/1907, Eng.) Painter. He lived in Sydney for ten years, and was secretary of the Inst. of Architects of NSW. He exhibited with the Art Society of NSW, 1883– and at the Victorian Artists Society, 1889 and 1899. His watercolour, *Coogee, NSW*, 1889, exhibited at Deutscher Fine Art Galleries, 1980, shows him as an accomplished tonal impressionist. After his return to England, he exhibited with the Royal Society of British Artists and many other groups.

BIB: *Argus*, 10 Aug. 1907.

WATT, *Victor Robert*

(b. 1886, Newcastle; d. 1970, Gordon, NSW) Painter.

Landscape painter in watercolour. Best-known for his lightly washed pastoral scenes which often appear at auctions. He was at one time manager of Swain's Art Gallery, Sydney.

WATTE, (Captain) H. J.
(Active c. 1860, WA) Painter. Topographical water-colourist whose work was seen in *The Colonial Eye* AGWA 1979.
REP: NLA; Nan Kivell Collection.
NFI

WATTERS, Max (Maxwell Joseph)
(b. 31/7/1936, Muswellbrook, NSW) Painter.
STUDIES: No formal training. Precise drawing and placement, bright colours and spongy textures are characteristic of his small 'naive sophisticate' paintings. He held around 26 solo exhibitions 1966–92 largely at Watters Gallery, Sydney also in Muswellbrook; Victor Mace, Brisbane; Stuart Gerstman, Melbourne. Four retrospectives of his work were held 1971–82 at Newcastle Region Art Gallery 1971, Maitland City Art Gallery 1978, Muswellbrook Municipal Gallery 1978, Broken Hill Gallery 1982. He participated in a number of group exhibitions, largely of naive painters, at private galleries and in local Hunter Valley artists' shows, including *Max Watters Collection*, Muswellbrook Art Gallery 1986 and *Portrait of a Gallery*, Watters 25th Anniversary exhibition touring regional galleries 1988.
AWARDS: Muswellbrook prize (local artist), 1964; Order of Australia Medal, 1992.
REP: NGA; AGNSW; NGV; Artbank; regional galleries Muswellbrook, Newcastle, Maitland, Broken Hill, Wollongong; several tertiary collections including Newcastle Uni.; corporate collections including Allen, Allen & Hemsley, Mallesons Stephen Jacques.
BIB: Horton, PDA. McCullough, *Australian Naive Painters* Hill of Content, Melbourne. *New Art Two*. A&A 18/1/1980 (Gary Catalano, *Max Watters*).

WATTERS, Stuart
(b. 3/8/1959, NSW) Painter.
STUDIES: BA, Alexander Mackie CAE, 1982. He held one solo exhibition 1982–92 at Hogarth, Sydney 1984, and participated in around 12 group exhibitions 1981–92 in Sydney (including Hogarth) and in NSW *Travelling Art Scholarship*, Blaxland Gallery 1981, 82, 85, 87; *Sir William Dobell Art Foundation Art Prize*, AGNSW 1989.
AWARDS: Sir William Dobell Art Foundation Art Prize, 1989.
REP: Artbank; Sir William Dobell Art Foundation; Sly & Weigall collection.

WATTS, James Laurence
(b. 1849, Weston-super-Mare, UK; arr. Brisbane 1884; d. 1925) Sculptor, teacher.
STUDIES: Royal Coll. of Art, London. Foundation member of the Qld Art Society.
APPTS: Instructor of modelling, North and South Brisbane Tech. Colls.

REP: QAG; public sculptures in Anzac Square, Brisbane (South African War Memorial), and Parliament House, Brisbane.
BIB: Scarlett, AS.

WATTS, John
(b. 1755, London; visited Tas. in 1777, and Sydney in 1788) Naval officer, amateur artist. As Cook's lieutenant on HMS *Resolution*, he visited Adventure Bay in 1777. He visited Sydney with the First Fleet in 1788 on the *Lady Penrhyn* and during three months' coastal exploration made two drawings of coastal profiles as well as the first known drawing of an emu, titled *New Holland Cassowary*. He returned to England via Lord Howe Island and Tahiti.
BIB: Rienits, *Early Artists of Australia*, 1963. Arthur Phillip, *The Voyage of Governor Phillip to Botany Bay . . . [with] Views drawn on the Spot by Capt. Hunter, Lieuts Shortland, Watts, Dawes, Bradley*, London, 1789 (a later edn contains a portrait of Watts). Colin Finney, *To Sail Beyond the Sunset*, Colin Finney, Rigby, 1984. Kerr, DAA.

WAUGH, Hal
(b. c. 1860; d. 1941, Eltham, Vic.) Painter, illustrator. Best-known for his bush and pastoral subjects. He painted with members of the Heidelberg School and lived with another group at *Charterisville* (q.v.). He exhibited at the VAS, 1892–1916, showing landscapes, beach scenes, genre and still life. His early work is sombre but later his palette lightened, probably under the influence of the impressionist movement. His home was destroyed in the Vic. bushfires of 1939.
REP: QVMAG.

WEAVER HAWKINS, Harold Frederick
See HAWKINS, Harold Frederick Weaver

WEAVING AND TAPESTRY
See CRAFTS IN AUSTRALIA

WEBB, Alexander
(Active from c. 1872, Geelong) Painter. A landscape painter in oil and watercolour, he exhibited at the Vic. Academy of the Arts, 1872–82 and in the 1880 Melbourne Intercolonial Exhibition. Subjects include the harbour and surrounding area of Geelong, Western District and South Australian landscapes as well as some Scottish scenes. His atmospheric work shows close attention to detail and is often of topographical and historical interest. The Geelong Art Gallery held an exhibition of his work 1989–90.
REP: Geelong Art Gallery.
BIB: Kerr, DAA.

WEBB, Archibald Bertram
(b. 4/3/1887, Ashford, Kent; arr. Perth, WA, 1915; d. 11/6/1944, Perth) Painter, teacher.
STUDIES: St Martin's School of Art, London (evening classes), with W. P. Robins, c. 1905–14. His father, Thomas Walter Webb, was part-owner and editor of the London *Critic*, but Archibald (his eldest son)

ignored his warnings about a career in art. Archibald began contributing illustrations to the *Pall Mall, Sketch* and other illustrated magazines. Overwork gave him rheumatic fever and his doctors advised the move to a warmer climate. In Perth he spent two lean years working as a freelance artist before finding work as a clerk in the Agricultural Bank, Narrogin. In 1921 he returned to Perth and teaching at Perth Tech. School. He settled at Nedlands there to discover the subjects with which his work is mainly identified. From 1921 he produced some 15 woodcuts and fulfilled commissions for posters advertising Australia (for the Empire Marketing Board). He succeeded James W. R. Linton at the Perth Tech. School in 1932, but resigned in 1934, having contracted Parkinson's disease, for which he sought a cure in London. During the next three years (1934–36) he designed posters for the Great Western Railway, designed wallpapers and held an important exhibition of his work before returning to Perth in 1936 to open the A. B. Webb School of Art, which operated from 1937 until his death. Known primarily as a watercolourist and for his coloured woodcuts, Webb did not receive due recognition during his lifetime probably because of the struggle to earn a living and the need to operate in a very wide field. His most important exhibition was at the Fine Art Society, London, Dec. 1934, when 58 works were shown. Chief characteristics of his work were its tranquillity and stillness, largely brought about by art nouveau and Japanese influences. His work was seen in *Western Australian Printmakers of the 1920s and 30s*, S. H. Ervin Gallery, 1979; *Western Australian Artists 1920–50*, AGWA, Sept. 1980.
APPTS: Teaching, assistant art master, Perth Tech. School, 1921– ; Uni. of WA, 1927–32; head of the art dept, Perth Tech. School, 1932–34.
REP: AGWA; NGV; Uni. of Sydney collections; British Museum, London.
BIB: Moore, *SAA*, June 1924; *Studio*, London, Nov. 1926. *A&A* 16/4/1979 (Hendrik Kolenberg, *A. B. Webb*)

WEBB, Donald
(b. 1910, Ilford, Eng.; arr. Vic. 1926) Administrator. A schoolteacher by profession, Webb joined the Vic. Education Dept soon after his arrival in Australia and became assistant principal at Geelong Coll. before his retirement in 1976. A member of a number of education committees, his notable contribution to art in Australia was as secretary, then chair of the Regional Galleries Association of Vic. for more than 20 years. His report to the Vic. Government on his return from a study tour of regional galleries in North America, the UK and Europe in 1967 formed the basis of subsequent regional gallery development in Vic. He resigned as Chairman in 1976 to become the Association's first Executive Officer. With the exception of the last, short period as Executive Officer, his work for the RGAV was entirely voluntary. Mainly through his efforts, the organisation flourished, became strongly independent, and set an example for the whole of the regional gallery development in Australia.
APPTS: Secretary, Chairman and finally Executive Officer of the Regional Galleries Assn of Victoria, 1957–76.

WEBB, George Alfred John
(b. 1861, Kent, Eng.; arr. Adelaide 1886) Painter. STUDIES: Liverpool, UK; France and Italy. Known for landscapes and portraits in oils, he exhibited at the VAA in 1887, showing Victorian and NSW coastal landscapes. In 1905 he showed South Australian coastal and landscape scenes at the VAS; Western District landscapes have also been recorded. He also painted leading citizens of SA and Vic.; five of his portraits of Melbourne Lord Mayors were lost in a fire at the Melbourne Town Hall, c. 1900. He usually signed Geo. A. J. Webb. His granddaughter is SA writer and artist Ninette Dutton.
REP: NGA; AGSA.
BIB: Moore, *SAA*.

WEBB, Vivian Phillip
(b. 22/8/1892, Hobart d. 28/6/1974; Hobart) Painter, teacher.
STUDIES: Hobart Tech. Coll. (with Mildred Lovett), 1918– . A member of the Art Society of Tasmania and the Tas. Group of Painters, he exhibited at the *Wembley Exhibition*, London, 1936.
APPTS: Teacher at Hobart Tech. Coll., from 1938.
REP: TMAG.
BIB: *Catalogue* TMAG, Hobart, 1956. Backhouse, *TA*.

WEBBER, John
(b. 1752, London; d. 1793, London) Painter. Topographical artist on *Resolution*, Captain Cook's last vessel (1776–80). He was the son of a Swiss sculptor and brought up in Berne, sent to Paris and later to the RA School, London. He returned to London in 1780, became an Associate of the RA in 1785, and Royal Academician in 1791. Cook's portrait by Webber is in the National Portrait Gallery, London. One of the most travelled artists of the time, he produced a number of etchings, drawings and paintings of his travels which are widely represented in public collections. His work appeared in *Tasmanian Vision* TMAG and QVMAG 1988.
REP: NGV; NLA; Mitchell, Dixson, Allport Libraries; a number of European and British collections including British Museum (natural history drawings).
BIB: Moore, *SAA*. Rienits, *Early Artists of Australia*, 1963. Kerr, *DAA*.
(*See also* WATTS, John)

WEBBER, Travis
(b. 1900, Adelaide) Painter, teacher.
STUDIES: SASA. A painter of landscapes in oils and watercolours, he taught at the SASA.
REP: AGSA; QAG.
NFI

WEBSTER, Alexander George
(b. 3/12/1830, London; arr. Hobart, Tas., 1840; d. 4/12/1914, Hobart) Merchant, amateur painter.

STUDIES: Hobart, with T. E. Chapman.
Known mainly for landscapes in watercolours.
BIB: *ADB* 6.

WEDDELL, Ronald
(b. 1926, London; arr. Aust. 1956) Painter.
STUDIES: Hornsey Coll. of Art, London; five years'
independent study in Greece and Italy. Weddell's imag-
inative, primitive-inspired painting was the subject
of an exhibition at the Richman Gallery, Melbourne,
in 1958.
APPTS: Curator of prints and drawings at the WA Art
Gallery, 1958–64.
REP: AGWA.

WEDGE, John Helder
(b. 1793; arr. Tas. 1824; d. 1872, Tas.) Artist, sur-
veyor. A member of John Batman's syndicate for the
development of Port Phillip, he made sketches for
the site of Melbourne, named the river Yarra Yarra,
1835–36, and returned to Tas. Some of his sketches
are reproduced in James Bonwick's *Port Phillip Settlement*
(London, 1883). Wedge also did extensive surveying
and exploration work in Tasmania. His work was
included in *Victorian Visions*, NGV 1985.
REP: La Trobe Library, State Library of Vic.
BIB: Moore, *SAA. Australian Encyclopaedia*, Angus & Robertson,
Sydney, 1958. ADB 2. Kerr, *DAA*.

WEEKES, Trevor
(b. 1951, Orange, NSW) Painter, sculptor.
STUDIES: NAS, 1972 and 1975; Canberra Art School,
1974; Alexander Mackie CAE, 1976–78. His annual,
colourfully titled exhibitions at the Macquarie Galleries,
Sydney (*Sopwithicus, Snipus, Species Extinctus*, 1979; *Teach
Your Chicken to Fly Kit*, 1982; *The Art of Fowlcrony*,
1985; *Trojan Life: City of Dreams*, 1987), and solo
exhibitions at regional galleries (*And the Wolf Shall
Devour the Moon*, 1988), established him as an aes-
thete and satirist with a scientist's obsession for detail.
Group exhibitions in which he participated 1984–90
included *Animal Images in Contemporary Art*, three
regional galleries Vic., NSW 1984; *The Horse Show*,
Heide 1988. Commissions include for Araluen Arts
Centre, Alice Springs; State Bank of NSW; Wong &
Associates; Hyatt Hotel. He produced a number of
limited edition, hand-coloured books.
AWARDS: VACB grant, 1979.
REP: NGA; Museum of Applied Arts and Sciences,
Sydney; regional galleries including Burnie, Tas., and
Newcastle, NSW; VACB; uni. collections including Uni.
of Qld, Brisbane, and Macquarie Uni., Sydney.
BIB: *New Art Two. AL* 2/1/1982; 5/1/1985.

WEISS, Rosie
(b. 13/8/1958, Melb.) Painter.
STUDIES: B.Ed, Melbourne, CAE, 1979. She held three
solo exhibitions 1986–91 in Melbourne (*Reconnaissance*
1986; *Verity St* 1989, 91) and participated in around
15 group exhibitions 1989–91 including *Prints and
Australia: Pre-Settlement to Present*, NGA 1989; *Heidelberg*

and Heritage, Linden, Melbourne 1989; *Faber-Castell
Drawing Prize*, Holdsworth Galleries, Sydney 1991.
Her 1992 painting *Lung* won the *Moet & Chandon Art
Fellowship* and showed her as an abstract expression-
ist with a strong concern for the environment.
AWARDS: Moet & Chandon Fellowship 1992.
APPTS: Lecturer, Institute of Education, University of
Melbourne, 1992– .
REP: NGA; NGV; Artbank; Devonport regional gallery;
tertiary collections including Flinders Uni., Brisbane
CAE, South East Community Coll., SA; corporate col-
lections including Western Mining.
BIB: Catalogue essays exhibitions as above. PCA, *Directory*,
1988. *A&A* 25/2/1987.

WEITZEL, Frank
(b. 1902, Levin, NZ; arr. Aust. c. 1929; d. 1932,
London) Sculptor, printmaker, furniture designer.
STUDIES: California School of Fine Arts, 1923–25;
New York Art Students' League, 1926; Munich
Academy (on a scholarship), c. 1928. He spent about
a year in Sydney, exhibiting with de Maistre, Feint,
Proctor (q.v.) and others but received little support
for his work, which included furniture designs and
drawing. He exhibited with the NSW Society of Artists
and the Contemporary Group, and moved to England.
In the last few years before his premature death (from
tetanus – in the house of his friend David Garnett,
the writer), his sculpture was acclaimed by Epstein.
Other artists such as Duncan Grant and Paul Nash
also praised his work. During that time he made both
figurative and abstract linocuts. His work was seen
in *A Survey of Australian Relief Prints, 1900–50*,
Deutscher Galleries, Melbourne, 1978 (catalogue illus-
trations including the front cover in colour).
BIB: *AA* 45, Aug. 1945 (Ethel Anderson, *From the Unstill'd
Cyclades*). Sturgeon, *DAS*. Scarlett, *AS*.

WELCH, E. J.
Painter. Known for *The Finding of King*, a painting
on the theme of the Burke and Wills expedition,
1861.
NFI

WELLS, Thomas George
(b. 16/7/1934, Ballarat) Painter, designer, lecturer.
STUDIES: Ballarat School of Mines; travel studies,
Europe and UK, 1964–70; RMIT, 1972–74.
AWARDS: Minnie Crouch prize, Ballarat, 1963;
Camberwell Rotary Club prize for watercolour, 1971.
APPTS: Teaching, Frankston Teachers Coll.; State Coll.
at Geelong.
REP: Regional galleries Ballarat, Castlemaine, Geelong.
(Information from the artist, 28 May 1974)

WEMYSS, W. S.
See CHARTERISVILLE

WENBAN, Ebenezer
(b. 1862; d. 1934) Painter. Represented in a special
Sydney Harbour exhibition, AGNSW, Oct.–Nov. 1963.

WENBAN, Raymond Stewart
(b. 29/10/1893, Mosman, Sydney; d. 30/12/1990, Canberra) Illustrator, painter.
STUDIES: With Julian Ashton and Elioth Gruner, Sydney 1909–1915; St Martin's School of Art, London c. 1930–38; Paris. He served in the Australian Field Ambulance in France in WWI 1915–18 including in the Battle of the Somme. On his return to Australia, he became a commercial and newspaper illustrator in Melbourne, receiving encouragement for his watercolours from Harold Herbert. On the suggestion of Will Dyson he went to London where he became an illustrator for leading newspapers and magazines including *The Illustrated News* and *English Country Life* as well as for Oxford University Press. He returned to Australia in 1938 where he continued his illustrating career, succeeding despite a depressed economic climate. During WWII he was chairman of the artists branch of the Civil Construction Corps – whose other notable artist members included William Dobell and Joshua Smith. He continued a successful illustrating career after the war in Australia and London, illustrating many books, for commercial products and educational material. Most of his work, which also included portraits, was done in watercolour. Two retrospectives of his work, featuring illustrations of historical subjects and paintings based on WWI subjects were held at Galerie des Arts, Sydney in 1989 and 90 – the first being opened by his former colleague Joshua Smith (q.v.).
REP: AWM; Power House Museum, Sydney; regional gallery Mildura; public collections UK; Europe.

WENDELL, Robert
(Arr. Vic. 1860) Lithographer. He arrived in Vic. in the *Great Britain* on 5 Feb. 1860, in company with Charles Troedel.
BIB: McCulloch AAGR
NFI

WENTCHER, Julius
(b. c. 1888, Germany; d. 1962, Melb.) Painter. Married Tina Hiam (Wentcher). His illustrative, expressionistic paintings have considerable charm though they are usually rated as the work of an amateur.

WENTCHER, Tina (née HIAM)
(b. 1887, Constantinople; arr. Aust. 1940; d. 1974, Melb.) Sculptor.
STUDIES: Berlin, Paris, Greece; extensive travels in Asia and East Indies. She lived in Malaya 1936–40, and on arrival in Australia with her husband Julius (q.v.) was interned for one year. Her portrait commissions in Germany include the *Head of Kathe Kollwitz*, commissioned by the Municipality of Berlin, 1930. Her Australian work shows the combined influences of archaic Greek and South Sea Island primitive styles. It attained great popularity for its taste and charm.
REP: NGA; AGNSW; AGWA; NGV; regional galleries Ballarat, Geelong, Langwarrin (McClelland Gallery),

Newcastle; Kaiser Friedrich Museum, Berlin; Raffles Museum, Singapore.
BIB: Sturgeon, DAS. Scarlett, AS.

WERNER, Baynard
(b. 1930, Narrogin, WA; d. 1984). Printmaker.
STUDIES: BA, WAIT, 1955; Postgrad. Dip. Art teaching, City of Birmingham Polytechnic, UK, 1977; MA, City of Birmingham Polytechnic, UK, 1980. He exhibited (mainly prints) largely in WA 1959–82 and with PCA Australian and international exhibitions.
AWARDS; Bunbury Art Prize, 1960; postgraduate study grant, WA Arts Council, 1976.
REP: NGA; AGWA; NGV; TMAG; Bunbury, Busselton regional collections; WA, CAE; corporate collections including R&I Bank.
BIB: Murray Mason, *Contemporary Western Australian Painters and Printmakers* Fremantle Arts Centre Press, 1979. PCA, *Directory*, 1988.

WERTHER, Frank
(b. 19/9/1922, Berlin; arr. Aust. 1939) Painter, printmaker, tapestry designer, teacher.
STUDIES: NGV School; RMIT (printmaking with Udo Sellbach). From 1960 to 1970 he held six solo exhibitions in Melbourne, Sydney, Adelaide, Canberra, Townsville. His figurative-expressionistic paintings of people and landscapes have notable brevity as well as strong form and colour. He taught in the Vic. education dept, TAFE colleges and privately for over 30 years.
AWARDS: Cato prize, VAS, 1959; Portland prize, 1962.
REP: NGA; NGV; Artbank; Townsville regional gallery; several tertiary colleges including Melbourne, Monash unis., Burwood and Bendigo Teachers colleges; corporate collections including ACI, Dunlop.
BIB: PCA, *Directory* 1976.

WESSELOW, Francis Guillemard Simpkinson, de
See DE WESSELOW, Francis Guillemard Simpkinson.

WEST AUSTRALIAN SOCIETY OF ARTS AND CRAFTS
(Active 1896–1936, Perth) Early presidents were: Bernard Woodward, Frederick Williams, H. C. Prinsep, G. Pitt Morison. In 1936 a breakaway group formed the Perth Society of Artists (q.v.).

WESTACOTT, Ian
(b. 1956, Myrtleford, Vic.) Painter, printmaker.
STUDIES: Dip. Art and Design, Wangaratta Tech. Coll. and CIT, 1975, 77; Dip. Ed., State Coll. of Vic., 1980; Grad. Dip. Fine Art, VCA, 1987. His work was seen in several group exhibitions including print and other prize acquisitions, 1987–93, including at the *Margaret Stewart Endowment* purchases at the NGV, 1993, where his large work on paper of an interior of a factory/warehouse revealed him as a skilled draughtsman and printmaker.

AWARDS: VCA Awards, 1986, 87; Gold Coast Acquisitive Prize, 1987; ANZ Fellowship, 1988; Henri Worland Acquisitive award, Warrnambool, 1989.
REP: NGV; Warrnambool regional gallery; Aberdeen Art Gallery, UK.

WESTALL, William

(b. 1781, Eng.; visited Aust. 1801–05; d. 1850, Eng.) Painter.
STUDIES: Family studies (with his brother, Richard Westall); RA School, as a probationer, from 1799. Known mainly for landscapes, in oil and watercolour, he was topographical artist to Matthew Flinders. He showed considerable promise as a student, won a number of prizes and was associated with many of the leading artists through his better-known half-brother, Richard. It was probably through the influence of Benjamin West, President of the RA, that he was appointed topographical artist, at a salary of £315 p.a., to Captain Matthew Flinders in *Investigator* during the survey of the east coast of Australia, 1801–05. Ferdinand Bauer (q.v.) was appointed natural history draughtsman. Places visited include King George Sound, Dec. 1801; Port Lincoln, Port Augusta, Encounter Bay, Cape Otway, Port Phillip, Port Jackson, Broken Bay, Port Bowen, Torres Strait, Gulf of Carpentaria, during Feb. 1801–Feb. 1803, also Timor and around Western Australia, thus circumnavigating the continent, to Sydney by June 1803. Rienits gives a detailed account of Westall's many further adventures and his return to England via China and Japan. Westall was disappointed by his voyage to Australia: he had expected much more exotic material and he found the coast of Australia lacked the picturesque beauty he had hoped to paint and later build up his reputation in London. Nevertheless, during the four hazardous years of Flinders' expedition, he made many accurate drawings and watercolours of coastal scenery and painted many fine landscapes of the west and east coasts, including the first Australian landscape to be shown at the RA – *Bay of Pines, New South Wales, 1805*. He returned to England via India where he spent a short time painting. Thereafter his life became more sedentary. His drawings were used to illustrate Flinders' book, *A Voyage to Terra Australis*, and he was commissioned by the Admiralty to make oil paintings of Australian views, becoming noted as a topographical and architectural illustrator as well as for his exhibits at the RA, of which he was made an Associate in 1812. His work appeared in the Bicentennial exhibition *The Great Australian Art Exhibition*.
REP: NLA (the major part of Westall's sketches); Ballarat Fine Art Gallery; Mitchell Library; Victoria and Albert Museum, London; Royal Commonwealth Society, London (143 original sketches purchased from his son in 1889); The Admiralty, London.
BIB: All books on Australian art history. Robert Westall, *Memoir of Westall*, Journal of Fine Arts, London, 1850. T. M. Perry and Donald H. Simpson, eds, *Drawings by William Westall*, Royal Commonwealth Society, London, 1962. Rienits, *Early Artists of Australia*, 1963.

WESTBROOK, Dawn
See SIME, Dawn Frances

WESTBROOK, Eric Ernest
(b. 1915, London; arr. Aust. 1956) Gallery director, administrator, artist.
STUDIES: Battersea, Clapham and Westminster schools of art, UK. A fluent speaker on a wide variety of subjects, he exercised considerable influence on art affairs in Vic. during his term of office as director of the NGV, and later as the first director of the Vic. Ministry for the Arts. In collaboration with the architect Roy Grounds, he travelled and worked on the development of the Victorian Arts Centre – specifically on the new NGV within the complex about which he wrote a book, *Birth of a Gallery* (Macmillan, Melbourne, 1969). Other major works initiated by him include the formation of the Victorian Public Galleries Group (later the Regional Galleries Association of Victoria), the Arts Victoria program, and the development of performing arts centres throughout the state. He retired in 1980 to paint and write.
AWARDS: Carnegie Fellowship grant, 1965; honorary doctorate of history conferred, Monash Uni., 1973; occupancy, Owen Tooth Memorial Cottage, Vence, ?1974.
APPTS: Director, Wakefield City Art Gallery, Yorkshire, 1946–49; Auckland City Art Gallery, 1952–56; NGV, 1956–75; Vic. Ministry for the Arts, 1975–80.

WESTERN INSTITUTE OF ARTS
(1920–21) Conducted briefly in Perth, WA, it closed after one exhibition, held in the studio of James W. R. Linton in 1921.

WESTMACOTT, (Captain) Robert Marsh
(b. c. 1801; arr. Aust. 1831; d. 1870) Sketcher, painter. Deputy Quartermaster-General with the 4th King's Own regiment, Sydney, 1832–37, he made a large number of drawings in and around Sydney, a collection of which, *Sketches in Australia*, with subjects including views of Warragamba and Wooranora rivers, was lithographed by W. Spreat, Exeter, 1848. Several other books of sketches are in the NLA, including *Drawings from New Zealand* and *Drawings from New South Wales 1840–46*. An *Album of Drawings and Watercolours of NSW 1832–52* is in the Mitchell Library.
REP: NLA; Mitchell Library.
BIB: Clifford Craig, *Old Tasmanian Prints*, Launceston, 1964. Kerr, DAA. Moore, SAA.

WESTON, Harry (Henry John)
(b. 1874, Hobart) Architect, cartoonist, painter, commercial artist. He designed posters in collaboration with Blamire Young, whose influence is visible in his watercolours (mainly landscapes). He exhibited designs for postcards (VAS, Melbourne, 1902–04), and illustrated books by Edward Dyson, Steele Rudd and J. E. Spencer. (Harry John Weston, *All's Well with the Fleet*, Bloxham, Sydney, 1915.)
BIB: Backhouse TA.

WESTON, Neville

(b. 1936, Birmingham, UK; arr. Aust. 1975) Painter, teacher, writer.

STUDIES: Stroubridge, Slade, Birmingham schools of art, UK, 1952–61. Arriving in Australia as visiting fellow at the Australian National Uni. in 1975, he remained in the country to teach, paint and write. Prior to his arrival in Australia he exhibited frequently in the UK, becoming known as a Pop Art painter exhibiting with artists including David Hockney and William Blake in the Young Contemporaries exhibitions in London during the 1960s. His style as seen in works from the late 1980s in Australia became more that of romantic realism. He held about 13 solo exhibitions in Australia 1975–90, in Adelaide (including at Greenhill; Bonython; BMG), Perth (Greenhill) and Canberra (Solander), and participated in numerous group exhibitions.

AWARDS: Perth Prize, 1978; prizes at Cloncurry, Port Adelaide, 1978.

APPTS: Lecturing at a number of art colleges in the UK including Liverpool, Uni. of Manchester; lecturer, SASA 1977– ; art correspondent *National Times*, 1979–80; art critic, *The Advertiser*, Adelaide, 1980–86.

REP: AGWA; a number of tertiary and public collections in the UK; tertiary collections in Australia including ANU, Canberra CAE.

BIB: Campbell, AWP. *New Art Four.*

WESTWOOD, Bryan Wyndham

(b. 22/9/1930, Peru) Painter, printmaker.

STUDIES: Largely self-taught, 'through visiting Prado every day for two months while in Spain'; some lessons with Justin O'Brien and Jeffrey Smart, 1968; studies with Dorothy Thornhill, ESTC, 1960s. Also a film producer, writer and advertising director, he was official artist appointed by the Federal Government to the 75th Anniversary of the Gallipoli landings in 1990, travelling with the veterans. His resulting paintings and sketches were exhibited at the AWM. Works in his first exhibitions at the Bonython Galleries, Sydney, 1969, were paintings of streets and buildings with shadows. Although photographic in style, they contained elements of surrealist painting reminiscent of the work of Magritte. Photo-realism claims his portrait studies, many of which are of artist colleagues, and he won the Archibald Prize twice – once with a portrait of critic and artist Elwyn Lynn (1989) and once with one of the Prime Minister, Paul Keating (1992). He held solo exhibitions annually 1972–92 including at Bonython Gallery, Sydney and Australian Galleries, Sydney and Melbourne, and participated in numerous group exhibitions.

AWARDS: Archibald Prize, 1989, 92.

REP: NGA; AGNSW; AGSA; AGWA; MAGNT; QVMAG; Parliament House; Artbank; High Court of NSW; City of Sydney; NSW State Parliament Offices; regional galleries Armidale, Maitland, Rockhampton; numerous corporate collections including BHP, Transfield, Qantas, John Fairfax and Sons.

WHEELER, Charles Arthur

(b. 4/1/1881, Dunedin, NZ; arr. Melb. 1892; d. Nov. 1977, Melb.) Painter, teacher.

STUDIES: Working Men's Coll., Melb.; NGV School, 1898–1907; travel studies, UK and Europe, 1912–14 and 1966. Apprenticed to the firm of Troedel & Cooper, lithographers, 1895, he began his art studies in the evening classes at the Working Men's College. Enlisting with the Royal Fusiliers in 1914, he won the DCM at Vimy, 1916, and was severely wounded; he refused a commission and ended the war as a sergeant. Resuming his career in painting, he exhibited at the RA, London, and Paris Salon before returning to Melbourne. He started teaching in the life classes at the Melbourne Tech. School and soon became known as a fine academic painter and draughtsman and as a conscientious teacher. His well-painted portraits suffer from sentimentality, while the cold flesh colours of his well-drawn nudes, posed often in the style of Velazquez, tend to deprive them of life. He exhibited with the RAS, Sydney, from 1923, the VAS, Melbourne, and the Australian Art Association, and continued painting until the late 1970s, mainly impressionistic landscapes. The VCA held an exhibition *von Guérard to Wheeler, the First Teachers at the National Gallery School, 1870–1939*, Apr. 1978 and a retrospective of his work in 1979.

AWARDS: Australian Art Quest (State Theatre prize), Sydney, 1929; Crouch prize, Ballarat, 1932, 34; Archibald prize, 1933; OBE conferred, 1951.

APPTS: Assistant instructor, drawing, NGV School, 1927–34; drawing master, 1935–39; painting master and Head of the School, 1939–45.

BIB: All books on Australian art history. J. S. MacDonald, *The Art of Charles Wheeler*, Lothian, Melbourne, 1952.

WHINNEN, George

(b. 1891, Gawler, SA; d. 1950) Painter.

STUDIES: ESTC, Adelaide (with Fred Britton). Known mainly for landscape, still life and portraits; president of the RSASA, 1940–49.

AWARDS: Melrose prize, 1929, 32.

REP: AGSA; Broken Hill gallery.

BIB: Moore, SAA.

WHISSON, Kenneth Ronald

(b. 1927, Lilydale, Vic.) Painter.

STUDIES: Swinburne Tech. Coll., Melb., 1944–45; Warrandyte, with Danila Vassilieff, 1945–46. He lived and worked in England, 1954–56, and 1969–70, and spent four months in Morocco, 1968–69, working in a Moroccan government studio for visiting artists. His twisting, triangular shapes, often representing heads and fragmented figures as well as unidentified shapes, evoke a personal dream world expressive of anguish presented in lyrical terms. His painting is literary (in the sense that Francis Bacon's painting is literary), its 'language' and imagery deriving from his early contacts with Vassilieff and other Melbourne painters of the 1950s. In July 1977, he settled in Perugia, Italy and exhibits occasionally in

Ken, Whisson, Farm Houses 2, *1986, oil on canvas, 120 × 100cm. Courtesy Watters Gallery, Sydney.*

Australia, his 1980s and 1990s exhibitions including a retrospective at Broken Hill Gallery 1987; a survey show at Pinacotheca, Melbourne and four Vic. regional galleries 1990 and Watters, Sydney. His work appeared in numerous group exhibitions 1978–92 including *Acquisitions to the Australian Collection 1956–81*, AGNSW 1982; *Australian Art of the last 20 years*, MOCA, Brisbane 1988; the Bicentennial exhibitions *The Great Australian Art Exhibition* and *The Face of Australia*; *Prints and Australia: Pre-settlement to Present*, NGA 1989; *Cross Currents*, Waikato Museum of Art, Hamilton, NZ 1990; *Her Story*, S. H. Ervin Gallery Sydney 1991.
AWARDS: John McCaughey Memorial art prize (shared), NGV, 1979; emeritus award, VACB, 1987.
REP: NGA; AGNSW; AGSA; AGWA; NGV; QAG; QVMAG; TMAG; Parliament House; a number of regional public galleries including Ballarat, Heide, Bathurst, Latrobe Valley, Orange, Newcastle; MCA, Sydney; MOCA, Brisbane; Centre for Contemporary Art, Hamilton, NZ; tertiary collections including Uni. of NSW.
BIB: Catalogue essays exhibitions as above and a number of general books on Australian art including Bonython, *MAP* 1975, 76, 80; Catalano, *The Years of Hope* OUP, 1981; Germaine, *AGA.* Peter & Susan Ward, *In Different Light*, UQP 1991. *A&A* 13/4/1976; 22/2/1984; 25/2/1987. *AL* 4/2–3/1984.

WHITCOMBE, Thomas
Painter. A marine painter who exhibited at the RA,

London, 1783–1824, his paintings include *Departure of the Whaler, Britannia, from Sydney Cove, 1798.*
REP: NLA, Nan Kivell collection.
BIB: *AA* vol. 5. no. 4. March 1968. (reproduction).

WHITE, Cyril Leyshon
(b. c. 1894; d. c. 1962) Painter, advertising artist.
STUDIES: NGV School. White contributed drawings to the *Anzac Book* during World War I (in which he won the Military Cross) and conducted a school of commercial art in Melbourne (c. 1925–35).
BIB: Moore, *SAA.*

WHITE, (Right Rev.) Gilbert
(b. 1860; d. 1933). Amateur painter; first Bishop of Carpentaria. Bishop White was the first artist to paint scenes of the eastern coast of the Gulf of Carpentaria and of Central Australia. He made a 10-week journey from Darwin to Adelaide in 1901, painting many watercolour sketches en route.
REP: Mitchell Library, Sydney.
BIB: Moore, *SAA.*

WHITE, James S.
(b. 1862, Edinburgh; arr. Aust. 1888; d. 1918, Brisbane) Sculptor.
STUDIES: Apprenticeship to plasterer, London; assistant to John Rhind (two years). After an apprenticeship with a London plasterer, he worked as assistant to John Rhind for two years and made anatomy models for London hospitals. In Sydney he assisted Simonetti with the Governor Phillip monument, carved statues for the Lands Dept building, 1891–1902, and became the leading bronze caster in Australia. Among his many public works were the Queen Victoria Memorial, Treasury Gardens, Melbourne; statue of E. G. Fitzgibbon, Alexandra Gardens, St Kilda Rd, Melbourne; South African War Memorials in Perth, WA, and Ballarat, Vic.
AWARDS: Wynne prize, 1902 (the first time this prize was given for sculpture).
REP: AGNSW.
BIB: Sturgeon, *DAS.* Scarlett, *AS.*

WHITE, John
(b. ?1756; d. 1832, Eng.) Surgeon, amateur naturalist, artist.
Appointed Surgeon General to the Colony of NSW, 1786, he arrived in Port Jackson with the First Fleet. He wrote *White's Journal of a Voyage to New South Wales*, London, 1790, which included 65 illustrations of the natural history of the Colony (mainly by English artist Sarah Stone) done from material supplied by White. The convict artist Thomas Watling (q.v.) was assigned to White and produced many drawings under his direction, although the relationship was a far from happy one. Drawings he collected are now in the collection of the British Museum and titled the *Watling* collection (as his was the only signature to appear).
BIB: *ADB* 2. Kerr, *DAA.*

WHITE, John

(b. 18/9/1851, Edinburgh; arr. Aust. 1856; d. 21/12/1933, Eng.) Painter.

STUDIES: Artisans' School of Design, Carlton, Vic., in company with some of the Heidelberg School painters; RSA School, Edinburgh, 1871– . He lived in Australia from childhood until his early twenties, exhibiting at some Australian exhibitions including the 1869 Melbourne Public Library Exhibition and the Victorian Academy of Arts, 1870. He showed works of Australian subjects in England from 1873 including the oil *Silver and Grey*, which was 'the landscape of the year', at the RA, London, 1883. He remained in England to become famous for his Pear's soap advertisements.

BIB: Moore, *SAA*. Grant M. Waters, *A Dictionary of British Artists Working 1900–1950*, Eastbourne Fine Arts, Eastbourne, 1975. Kerr, *DAA*.

WHITE, John

(b. 1855, Bath, Eng.; arr. Adelaide, 1887; d. 1943) Painter. President of the Royal SA Society of Arts, 1910–13, 1917–20 and 1922–26; member of the Board of Governors of the Public Library, Museum and Art Gallery, Adelaide. His painting, mainly of landscapes, is notable for 'painstaking fidelity to nature'.

REP: AGSA.

WHITE, John A.

(b. 1930, Auckland, NZ; arr. Aust. 1939) Painter.

STUDIES: NAS, 1945–49; Central School of Arts and Crafts, London, 1950–52; Julian Ashton School, 1960–62, John Ogburn studio, 1963–65. In 1967 he began exhibiting in group exhibitions at the gallery which he helped to sponsor, Central Street Gallery, Sydney, and in 1968 was represented by a large, geometric abstract in *The Field*.

NFI

WHITE, J. C.

(Active c. 1833, Newcastle, NSW) Topographical draughtsman. Otherwise unknown, he made a small pen-and-wash sketch of the first steamer to land coal at Newcastle.

WHITE, Laurence Oliphant Campbell

(b. 1914, Tas.; d. 1974, UK) Minister of religion, painter.

STUDIES: Tas., with Hal Waugh. Known mainly for watercolours. Member of the Independent Group, Melbourne; Royal Watercolour Society, London; chairman of the Council of Ormond Coll., Uni. of Melbourne, from 1955.

REP: NGV.

WHITE, Lorraine

(b. 1935, St Kilda, Vic.) Painter, lecturer.

STUDIES: Dip. Art, NGV School; travel studies, Greece, 1964, South America, 1974. First shown at the Argus Gallery, Melbourne in 1965, her work reflects her interest in archaeology, ancient art forms and the writings of the Japanese Yukio Mishima – her lyrical abstracts often being calligraphic in character. She

held about 24 solo exhibitions 1965–90 including at Warehouse and Standfield galleries, Melbourne and Fremantle Arts Centre 1977, 82.

AWARDS: Student prizes (16), NGV School.

APPTS: Lecturer, industrial design, RMIT, 1963– (since 1988 senior lecturer).

REP: WAIT; Uni. of WA; Frankston State Coll.

WHITE, Susan Dorothea

(b. 10/8/1941, SA) Painter, printmaker, sculptor.

STUDIES: Diploma course, SA School of Art, 1959–60; Julian Ashton Art School, 1960–61; evening classes (sculpture, drawing), ESTC, 1960–61. She produced a painting based on *The Last Supper*, entitled *The First Supper*, for Australia's bicentennial year, featuring women including a black woman wearing a Koori flag. She held around 11 solo exhibitions 1962–92 including at Broken Hill Tech. Coll. 1962; Seymour Centre, Uni. of Sydney 1977, 78, 79, 80; in Germany (Munich, 1980; Cologne, 1991) and Holland (Amsterdam, 1990), and participated in around 30 group exhibitions 1957–92 including *Wynne Prize*, AGNSW 1973, 89; *Sulman Prize*, AGNSW 1976, 92; *Portia Geach Prize*, 1977, 78, 80, 82; *Blake Prize*, Blaxland Gallery 1978, 83, 88, 89; CAS, SA exhibition, 1978; *Sydney Printmakers* exhibitions, 1981, 86; and around 30 international print exhibitions 1980–92 in Germany, Japan, Spain, Brazil, China, Hungary, Poland, Canada, Yugoslavia and England.

AWARDS: SA School of art prizes for drawing and painting, 1959; regional prizes including Broken Hill awards for oil, watercolour, 1960, 61, 62; John Gero Prize, Macquarie Uni., 1987; MPAC acquisition prize, 1978.

APPTS: Part-time drawing and painting, Glebe and Annandale Neighborhood Centres, 1982–85; Strathfield Evening Coll., 1987–89.

REP: NGA; Westmead Hospital, Sydney; MPAC; public galleries in Poland, Norway, Germany.

BIB: PCA, *Directory* 1982; Campbell, *AWP*.

WHITE, Unk (Cecil)

(b. 1900, Auckland, NZ; arr. Sydney 1922 d. March, 1986) Draughtsman, cartoonist. A draughtsman of outstanding early promise, his sensuous line and brilliant use of black gave his early contributions to Sydney *Bulletin* and Melbourne *Punch* great sparkle and originality. He was secretary of the Australian Society of Black and White Artists, c. 1925–26 and visited Europe and made a sketching tour of Mexico, 1936. Later his work included watercolours.

AWARDS: VACB grant, for exhibition expenses, 1976–77.

REP: AGNSW; Manly Art Gallery.

BIB: Moore, *SAA*.

WHITEHEAD, Isaac

(d. 1881 or 1882, Melb.) Painter, picture framer. His name first appears in the Melbourne directory of 1861, as a 'carver and gilder', of Collingwood. The business had moved to Collins St East by 1863 and by the early 1870s was known as the Gallery of Fine Art,

with special attention being paid to picture framing and the manufacture of looking-glasses and mirrors. Highly regarded and successful as a picture framer, his frames are notable for their unusual carving which from the 1870s included those of native plants and can be found on the works in public collections of artists including Louis Buvelot, von Guérard, and Nicholas Chevalier (qq.v.). Meanwhile Whitehead had become known also as a promoter of art, having loaned works to the *Works of Art Exhibition* at the Melbourne Public Library, Museum and Art Gallery, 1869, and organised a large exhibition in support of the Victorian Academy of Arts in 1870. His son, Isaac Whitehead Jnr, joined the Collins St business in 1878 and continued it until his death in 1906. Whitehead exhibited his own paintings at the Academy, 1870–78, and 1881–82, and his large *Fernshaw, Victoria*, now in the NGV collections, was shown at the *International Exhibition*, Melbourne, 1880–81. In such works he is shown as a skilled though conventional painter of romantic landscapes. His work was seen in *Australian Art in the 1870s*, AGNSW 1976, *Australian Art 1820–1920*, Deutscher Fine Art, Melbourne 1980 and *Victorian Visions*, NGV 1985.

REP: NGA; AGSA; NGV; NLA.

BIB: E. Craig, *Australian Art Auction Records*, Sydney 1978, 82. Kerr, DAA.

WHITELAW, Bridget
Curator.
STUDIES: Uni. of Melbourne, grad. BA. She has written catalogues for a number of significant exhibitions while at the NGV including *Australian Landscape Drawing 1830–1880*, 1976; *Australian Drawings of the Thirties and Forties*, 1980 and with Jane Clark (q.v.) *Golden Summers: Heidelberg and Beyond*.
APPTS: Asst. Curator, Dept of Prints and Drawings, NGV, 1976–c. 1985; curator 19th Century Australian Art, NGV 1985– .

WHITELEY, Brett
(b. 1939, Sydney; d. 15/6/1992, Thirroul, NSW) Painter.
STUDIES: Julian Ashton School, 1957–59. In 1960 an Italian scholarship took him to London where his great natural talent for drawing, his lack of inhibitions and taste for exotic influences, such as that of Francis Bacon, made the 21-year-old painter an exciting prospect for London dealers. His work was shown at the Whitechapel and Marlborough galleries from 1961, and in that year he was selected to represent his country at the *Young Painters' Convention, UNESCO*, Paris. Even more crucial to his future was his success in winning the international prize at the second *Biennale de Paris* (International Biennale for Young Artists), which brought with it the excitement, glamour and disadvantages of world publicity. The story of Brett Whiteley's life and career has already been written in detail in books as below. Of more concern is the way in which his lifestyle integrated with his art. And in this connection the poets and painters who were his acknowledged influences made a significant contribu-

tion. Verlaine, Rimbaud, Pascin, Francis Bacon, and perhaps even his near contemporary, Yves Klein (1928–62), whose intense and tragic way of life, so strangely symbolised in his irrational obsession with the colours blue and gold, were clearly echoed in Whiteley's work. Nearly all his mentors seem early in their careers to have embarked on elaborate courses of self-destruction, as if this were the natural corollary for achieving the ultimate freedom in self-expression. The whole pattern of Whiteley's life was therefore written into his drawing and painting – its scintillating brilliance, its ecstasy and its foreboding. After 1961 he returned to Australia, held exhibitions and then travelled in the USA and Asian countries. What he learned from his contacts with such countries as Cambodia, Vietnam and Japan is expressed in his drawings and paintings, and even more in sculptures such as his *Asla* (Australian Galleries, Melbourne, 28 Sept. 1966), a construction in fur, steel and acrylic in which a white wallaby was depicted with its head stuck in a sewerage pipe. During the 1970s he won a number of national prizes and settled at Lavender Bay, Sydney, there to produce the lavender-blue paintings of Sydney Harbour that seem so sensuously to sum up those rare chords of ecstasy that sustained his spirit. He remained an artist of prolific output and his work showed little of the desperate struggle his life had become – with drugs, alcohol and personal trauma including divorce from his wife and close companion, Wendy. He was found dead in a motel room on the NSW coast, the coroner's verdict being 'death due to self-administered substances' – believed to be a tragic accident, his spirits and health having improved markedly in the months before his death. A memorial service was held for him at the AGNSW.

AWARDS: Bathurst prize (for young artists), 1956; Italian travelling scholarship, 1960; Dyason grant, AGNSW, 1961; Commonwealth Art Advisory Board scholarship (for work in France), 1961; international prize, *Biennale de Paris*, 1961; T. E. Wardle Invitation Art Prize, Perth, 1965; Harkness Foundation scholarship, 1967; Sir William Angliss Memorial prize, 1975; McCaughey prize (Sydney) 1975, 76, 77; Archibald prize, 1976, 78; Sulman prize, 1976, 78; Wynne prize, 1977, 78.

REP: NGA; AGNSW; AGSA; AGWA; MAGNT; NGV; QAG; QVMAG; TMAG; many regional galleries; Tate Gallery, London; MOMA, New York.

BIB: Catalogue essays exhibitions as above and all general books on contemporary Australian art. Sandra McGrath, *Brett Whiteley*, Bay Books, Sydney, 1979. A&A 5/1/1967 (Sandra McGrath, *Profile: Brett Whiteley*); 17/1/1979 (Humphrey McQueen, *Brett Whiteley*); 24/2/1986; 30/2/1992 (obituary).

WHITFORD, Dora (nee NICHOLLS)
(b. 1898, Burnside, SA; d. 1969) Etcher, painter, commercial artist, stained glass designer.
STUDIES: SA School of Arts. Member of the Australian Painter-Etchers' Society. She designed a rose and six memorial windows for the Stow Memorial Church, Adelaide.

AWARDS: *All Australian Exhibition*, silver and bronze medals for drawing and etching, 1930 and 1936.
REP: AGSA; AGWA; regional galleries Castlemaine, Broken Hill (all with etchings).
BIB: Rachel Biven, *Some forgotten . . . some remembered*, Sydenham Gallery, Adelaide, 1976.

WHITING, Ada
(b. 1858) Painter. Known as a miniaturist, she showed portraits and flower paintings at the VAS, 1898–1916.
REP: AGNSW; NGV (portrait of Alfred Felton).

WHITMORE, Frank
(b. c. 1900, Sydney) Illustrator. He migrated to the USA, where he became a well-known illustrator.
AWARDS: Scholarship donated by A. T. Rofe of the Millions Club, Sydney, c. 1930.
REP: Manly Art Gallery.
BIB: AA Dec, 1923 (reproduction). Moore, SAA.

WHITNEY, William Montague
(b. c.1880, St Kilda, Vic.) Painter.
STUDIES: J. S. Watkins School, Sydney. He exhibited with the RAS, Sydney, from 1907, and VAS, Melbourne, and in 1926 became the founder and secretary of the Australian Art Society.
REP: Manly Art Gallery.
NFI.

WHITTLE, Bertram Charles
(b. 26/4/1921, Ipswich, UK; arr Aust 1949) Painter, teacher, gallery curator.
STUDIES: London Uni. and RAF School of Photography, UK; Uni. of WA; Claremont Teachers Coll., WA; WA Polytechnic of Art. He served as president of the Geraldton and Bunbury art societies and as a foundation member and vice president of the Art Galleries Association of Australia, 1974– . As deputy director of the AGWA, he did valuable work in helping to upgrade its professional status, but internecine difficulties within the institution caused his resignation in 1977.
APPTS: Teaching, WA Education Dept, c. 1957–64; curator of Asian art and deputy director, AGWA, 1964–77.
NFI

WHYTE, D. MacGregor
(b. 1866, Oban, Scotland; active c. ?1910, WA; d. 1953, Scotland) Painter.
STUDIES: Glasgow, Paris and Antwerp. Portrait, landscape and marine painter. Reputedly a friend of James Linton and John Horgan in Perth, he spent about ten years in Australia. He was represented in *Arthur Edgar Jones and John Columbia Horgan*, Rosalind Humphries Galleries, Sept. 1972.
REP: AGWA.
BIB: Grant M. Waters, *A Dictionary of British Artists Working 1900–1950*, Eastbourne Fine Arts, Eastbourne, 1975.

WICKHAM, Stephen Leslie
(b. 18/11/1950, Vic.) Painter, photographer.
STUDIES: Photography, School of Art & Design, Prahran Coll., 1972; painting, NGV, 1972–74; Grad. Dip. Ed., Melb. State Coll., 1981; Grad. Dip. Arts (printmaking), School of Visual Arts, Gippsland Inst., 1986; MA (Visual Arts), Monash Uni. Coll., Gippsland, 1990– . His photographs seen in a 1984 Melbourne exhibition portrayed the wilderness, while his 1991 paintings were geometric abstracts. He held eight solo exhibitions 1982–92 in Melbourne (Powell St, 1988, 90; William Mora, 1988, 91) and at Queensland Coll. of the Arts, 1982; Australian Centre for Photography, 1991. He participated in around 25 group exhibitions 1975–92 largely at tertiary and public galleries, including *Recent Acquisitions*, 1975 and *Selected Works from the Michell Endowment 1979*, NGV; MPAC *Spring Festival of Prints and Drawings*, 1984, 86, 88; *Australian Landscape Photographed*, NGV 1986 and at AZ Gallery, Tokyo 1990.
APPTS: Full-time and part-time teaching, Box Hill Coll. of TAFE, 1986–91; full-time and part-time, VCA, 1986–91.
REP: NGV; Artbank; Aust. Print Workshop; Albury Regional Gallery; State Library of Vic.; private corporations including Holmes à Court.

WICKS, Arthur
(b. 1937, Sydney) Painter, printmaker, teacher.
STUDIES: B.Sc., Uni. of Sydney; BA, ANU, 1964; travel studies, Europe, 1967–68. The basis of his art is photography as applied to the recording of natural phenomena presented in serial form. In his 1980 exhibition (Gerstman Gallery, Melbourne) he showed serialised photographs, taken over a 12-month period, of the same place at the same time on successive days. Later he received a grant to complete *Operation Equinox 80*, a 'tidal installation performance' at Durras Lake, NSW. His work appeared in a number of exhibitions at contemporary and performance art spaces and in survey shows 1978–90 including those with the PCA; in the Venice Biennale, 1980; *Australian Sculpture Triennial*, 1981 and at Wagga Wagga regional gallery 1988.
AWARDS: French scholarship, 1967; Power Inst. studio occupancy, Cité Internationale des Arts, Paris, 1967; Dyason scholarship, AGNSW, 1967; VACB grant, 1980; exchange grant, Aust. Govt and German Govt, to Berlin, 1983.
APPTS: Teaching, printmaking, Canberra Tech. Coll., 1966–71; lecturer in painting, Riverina CAE, Wagga Wagga, NSW, c. 1972– ?
REP: NGA; AGNSW; regional galleries including Albury, Tamworth, Wagga; tertiary collections including ANU, Deakin Uni., La Trobe Uni.; PCA.
BIB: Germaine, AGA. PCA *Directory*, 1988.

WIEBKE, Karl
(b. 15/10/1944, Germany) Painter.
STUDIES: Fine Arts Hochschule für bildende Kunst, Hamburg, 1976. He held six solo exhibitions 1977–91 in Germany, Perth and Melbourne (Gore St, 1990;

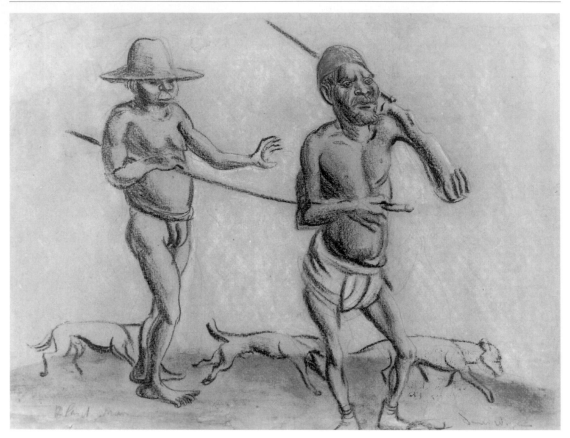

James Wigley, Blind Man, *c. 1950s, pastel and coloured chalk on brown paper, 35.5cm × 46cm. Courtesy Niagara Galleries, Melbourne.*

Deutscher Brunswick St, 1991), and participated in around six group exhibitions 1977–92 in Germany and Australia including at Fremantle Arts Centre, 1984; AGWA 1989; AGSA 1990.

AWARDS: Artists' development fellowship grant, VACB, 1990.

APPTS: Part-time teaching, Curtin Uni. of Technology, Perth, 1990.

REP: NGA; AGWA; NGV; MCA, Sydney; Robert Holmes à Court and Wesfarmers corporate collections.

BIB: *AL* 1–2, 1991. *A&A* 29/2/1991.

WIENEKE, James
(b. 1908, Bundaberg, Qld; d. 1981, Qld) Painter, gallery director.

STUDIES: Brisbane Tech. Coll. with Martyn Roberts. He conducted the Moreton Gallery, Brisbane, 1951–67. Member and former vice-president, Half Dozen Group.

APPTS: Director, QAG, 1967–74.

REP: QAG.

WIENHOLT, Anne
(b. 1920, Leura, NSW) Sculptor, printmaker.

STUDIES: ESTC, 1938–41; Art Students' League, New York, 1945; Brooklyn Museum Fine Art School, 1947–48; Paris, Atelier 17, engraving with S. W. Hayter, 1948–50; travel studies, UK and Europe. She married Masato Takashige, furniture designer and cabinet maker. Strong in its feeling for character, her early painting reflected trends in Sydney art of the

1940s. She moved to San Francisco, USA around 1945.

AWARDS: NSW Travelling Scholarship, 1944.

BIB: Horton, *PDA*. John Kroeger, *Australian Artists*, Renniks, Adelaide, 1968.

NFI

WIGHT, Normana
(b. 1936, Melb.) Painter, printmaker, teacher, fabric designer.

STUDIES: Dip. Art, RMIT, 1957; Central School of Arts and Crafts, London, 1962–63; history of art at the Uni. of Florence, 1963. She worked as a fabric designer, 1958, taught art, 1959 and, again, 1964, worked at Mittagong, NSW, 1965–66 and held eight solo exhibitions 1966–80 Melbourne and Sydney as well as contributing to CAS, PCA and other group exhibitions to 1988. She showed a large, minimal abstract in *The Field* (NGV 1968).

AWARDS: PCA (member print commissioned), 1975.

REP: AGSA; QAG; Newcastle, Shepparton regional galleries; tertiary collections including Monash Uni; Griffith Uni.

BIB: PCA, *Directory* 1976, 1988 (as 'Wright'). Germaine, *AGA*.

WIGLEY, James
(b. 21/5/1918, Adelaide) Painter.

STUDIES: School of Fine Arts, Adelaide, with Millward Grey, 1933–39; NGV School, 1945–47; travel studies, UK and Europe, 1948–52. A fine, natural draughtsman, his early assignment as official artist to the Elkins anthropological expedition into Central Australia after his discharge from the army gave him a taste for the primitive, nomadic life of NW Australia and in 1957 he settled at Port Hedland where he studied the Aboriginal life that subsequently became the theme for much of his best work. Though uneven, his painting is in close sympathy with the Aboriginal spirit, to which subject are added the ideologies of social realism. His work received little recognition until 1959 when his exhibition at the Australian Galleries, Melbourne, sold out within a few days of opening. Later, his work settled back into a pattern of high and low periods. He designed a fine, baroque-inspired catalogue cover for an exhibition for World Refugee Year (Australian Galleries, 1959–60), and his exhibition at the Acland Street Galleries, Melbourne, May–June 1981, read like a page from Northern Territory social history. His work appeared in the Bicentennial exhibition *The Face of Australia*.
AWARDS: May Day prize, 1958; Cato prize (VAS), 1963.
REP: AGSA; AGWA; NGV; AGNSW; regional galleries Bendigo, Castlemaine, Mornington, Newcastle.
BIB: John Kroeger, *Australian Artists*, Renniks, Adelaide, 1968.

WIGLEY, Julian
(b. 1943, Adelaide) Painter, writer, cartoonist.
STUDIES: B. Arch, Uni. of Melbourne, 1966; Postgrad. Dip. film and television, 1988. Son of James Wigley. He held his first exhibition at the Ewing Gallery, Uni. of Melbourne, and wrote and illustrated a number of books including (with M. Heppell) *Black out in Alice: A history of the establishment and development of town camps in Alice Springs*, ANU, Development Studies Centre, 1981; and a number of other smaller booklets on similar subjects. His exhibition at the Trades Hall Gallery, Carlton, May 1980, showed him as a satirical draughtsman. Combined with this style were paintings reflecting his experiences travelling in the Northern Territory. He held four solo exhibitions 1982–85 at MAGNT; Adelaide (Greenhill) and Melbourne (Niagara) and made a number of films.
REP: MAGNT; MPAC; La Trobe University.

WILGIE CLUB
(Formed in Perth, WA, 1890) A club which brought together the first Western Australian group of landscape painters. Members included Bernard H. Woodward, the first curator of the Western Australian Art Gallery; H. C. Prinsep, Secretary of Mines; Herbert W. Gibbs, an official in the Lands Dept; and G. Temple Poole, Western Australian Government Architect.
BIB: Moore, SAA.

WILKIE, Leslie Andrew
(b. 27/6/1879, Melb.; d. 1935, Adelaide) Painter, teacher, gallery curator.

STUDIES: NGV School, 1898–1901; travel studies, UK and Europe, 1904–05. Grand-nephew of Sir David Wilkie, RA. A conscientious and careful painter of portraits, he painted in the tradition of the Royal Scottish Academy.
APPTS: Art critic, *Age*, Melbourne (brief period); teacher of drawing, NGV School, 1907–08 (during McCubbin's absence in Europe); teaching, SASA, Adelaide; curator, AGSA, 1926–34, director, 1934–35; president, RSASA, Adelaide, 1932–35.
REP: NGA; AGNSW; AGSA; QAG; AWM; regional galleries Castlemaine, Mornington.
BIB: AA no. 7. 1919 (article and reproductions). Moore, SAA.

WILKINSON, Kenneth
(d. 1950, Melb.) Journalist. Art and drama critic for the *Sydney Morning Herald*, c. 1940, and Melbourne *Herald*, 1941–42.

WILKINSON, (Rev.) Samuel
(Arr. Melb. 1841, from Sydney) Church minister, amateur artist. The first Methodist minister in Melbourne, his work has historical value. His 1838 pencil drawing, *Slab Hut to Homestead*, was sold at Leonard Joel's, Nov. 1973.

WILLEBRANT, James Willem
(b. 11/4/1950, Shanghai) Painter, teacher.
STUDIES: Dip. Painting, NAS, 1968–72. His paintings evoke the feeling of a dream world, in which the simplified forms of empty, fort-like buildings and 'stitched' puppets are seemingly enveloped in cool, clear light. He held around 25 solo exhibitions 1971–91 largely at Bonython and BMG galleries, Adelaide; Australian Galleries, Melbourne; Barry Stern, BMG, Sydney; Solander, Canberra; and Cooks Hill, Newcastle. His work appeared in several group exhibitions including *On the Beach*, AGNSW and touring 1982; *Continuum*, Uni. of Technology, Sydney 1988.
AWARDS: Student prizes, NAS, 1970, 72; Australian writers' and art directors' award, 1979; bicentennial print award (Bridge St, Gallery), 1988.
APPTS: Teaching, Chiron Coll., Birchgrove, Sydney, 1973–76.
REP: NGV (Michell Foundation); QAG; Parliament House; several regional collections including Gold Coast, New England, Horsham; several tertiary collections including Uni. of WA; Australia–Japan Foundation; corporate collections including NAB, CBA, CBC.

WILLIAMS, Caroline Marsh
(b. 5/7/1945, Wellington, NZ; arr. Aust. 1969) Painter.
STUDIES: Europe, 1961–63; Ilam School of Art, Christchurch, NZ, 1964–67; travel studies, Europe, Africa, USA, 1968; Middle East, Europe, USA, 1971–73; Paris, 1989. Williams' works are large and often allegorical – described by Helen McDonald in *Art Monthly* (October 1991) as resonating 'with satirical allusions to patriarchy and art history'. Some of her best known series are those of Australia's first explorers, including Cook and Banks, which she painted as epic-like

Caroline Williams, The Man with a Plank, *1986, oil on canvas, 152 × 121cm. Private collection.*

images reminiscent of Gainsborough. Her 1990 exhibition at Tolarno was of a different style with hooded figures haunting bare rooms. Concerned with the male/female relationship and the bridging of the 'separatist' stance, she curated an exhibition of work of male painters at Heide, *The Male Sensibility* in 1985. A continuation of these concerns led to her 1991 portrait works, *Men*, at Melbourne Uni. Gallery. Most striking of these were those of artist Charles Blackman seen as *Alice in Wonderland*, borrowed from his own well-known imagery, and that of her husband, gallery director and art patron Georges Mora, as Whistler's Mother. These and many of her other works challenge patriarchal values. She held 14 solo exhibitions 1971–92 in Sydney (Bonython 1971, 75; Mora 1986), Melbourne (Tolarno 1987, 90, 91), Wellington, NZ (Brooker 1981, 83, 87, 90), London (Pomeroy Purdy 1989) and Paris (Cannibal Pierce 1990), and at the Uni. of Melbourne Museum of Art, 1991. Group exhibitions in which her work appeared 1986–90 include *Cross Current*, Heide, 1986; *Australian Biennale*, AGNSW, NGV 1988; ICI *Contemporary Art Collection*, ACCA, and national tour 1989.
REP: NGV; Heide Park; Walter & Eliza Hall Inst.; Uni. of Melbourne; Monash Uni.; Victoria Uni.,

Wellington, NZ; Baillieu Myer, Allen, Allen & Hemsley, Sussan, Sam and Minnie Smorgon corporate collections.
BIB: Catalogue essays exhibitions as above. Chanin CAP. AM Oct. 1991.

WILLIAMS, *Frederick Matthews*

(b. 1855, Chester, Eng.; arr. Aust. c. 1878; d. 7/7/1929, Auburn, NSW) Painter, teacher.
STUDIES: NGV School, 1881–87. In company with McCubbin, Longstaff, Fox and Davies, he was a member of the Buonarotti Club, began exhibiting with the VAA in 1883, and continued with the VAS, 1888–93, showing impressionistic coastal scenes of the Port Phillip Bay area. In the early 1890s he shared quarters at *Charterisville* with Tom Humphrey, Hal Waugh and Arthur Bassett, had a studio in Collins St and taught at Toorak Coll. He moved to WA in 1893 following the collapse of the land boom and became the first artist on the Kalgoorlie goldfields, his sketches being reproduced in local papers. He became a prominent member of the WA Society of Arts (president, 1898–1903). He founded the Art Dept of the Perth Tech. School in 1899, remaining there till 1902 when Linton (q.v.) succeeded him. In WA his interest in beach and coastal scenes appears to have remained his principal concern. He held an exhibition in 1910 and moved to Sydney around 1915 but does not appear to have exhibited there. His work appeared in *The Colonial Eye*, AGWA, Perth, 1979.
REP: AGWA; Mitchell Library.

WILLIAMS, *Fred (Frederick Ronald)*

(b. 23/1/1927, Richmond, Vic.; d. 22/4/1982, Hawthorn, Vic.) Painter, etcher.
STUDIES: NGV School, 1944–49, George Bell School, 1944–49; Chelsea Art School, London, 1951–55, Central School of Arts and Crafts (etching), London, 1954–56. Marked as a student of promise from the first showing of his work in Melbourne at the Stanley Coe Gallery in company with Harry Rosengrave and Ian Armstrong, Feb. 1951. Fred Williams developed his art rapidly during his studies in London. A period spent in framing pictures for Robert Savage, some by masters such as Rembrandt, exerted a vital influence. He worked hard, and using the facilities of the Central School of Arts and Crafts produced more than 100 etchings, many influenced by the music hall etchings and drawings of Sickert and some influenced by Daumier. His paintings of this period show clear signs of an emerging, personal vision which grew much stronger after his return home to renew his contact with the subject that would remain closest of all to his heart – the Australian landscape. Particularly in his exhibition at the Australian Galleries, Melbourne, in 1958, it was clear that a new, fresh and inspired vision had been brought to bear on the formerly much-maligned subject of the Australian eucalypt (ref. Melbourne *Herald* review, *Resurrection of the Gum Tree*, 16 July 1958). From this time on, through the use of a basic form of opposing vertical and horizontal

lines, his vision of the bush landscape was to expand in a way unknown in Australian painting since the time when Tom Roberts and his friends had discovered the lyricism of the blue-gold atmosphere of the hills and valleys of the Yarra at Eaglemont. Williams' use of scale and accent as well as his palette strikingly illustrates the differences between his work and that of these illustrious predecessors, and a close look at the swirled brushstroke in a typical landscape reveals a use of colours so unlikely that they could only have come from an original and highly personal view of the subject. Success in his post-London exhibitions affirmed his confidence and his style became all-embracing, adapted with ease to portraiture, genre, to the drawing of nudes, children and animals, and to etching. Moreover, once his style was recognised, its consistency was seen to have been residual in his very early works; and indeed this links the *Self Portrait* of his NGV School days and *Portrait of the Artist's Mother* c. 1946, with the superbly mature *Sketch Portrait of David Aspden*, 1976, and *Portrait of Professor Joseph Burke*, 1979. Success with the Helena Rubinstein Scholarship in 1963 placed his work beyond the reach of casual criticism; the leading Sydney dealer, Rudy Komon, assiduously promoted his work, and by 1970 he had become generally recognised as one of the greatest Australian painters of his generation. His bustling, energetic personality and unfailing generosity, combined with optimism and good humour, endeared him to a large circle of friends (mostly painters or writers); he served on a number of important committees such as the board of the NGA, and the Victoria-Caltex Acquisitions board, and during the last decade of his life had become a person of great influence in the Australian art world. Like Frederick McCubbin, he was one of those rare artists who lived a consistently happy family life. First official recognition of the importance of his work was in 1970 when the exhibition *Heroic Landscape: Streeton – Williams* was organised for the NGV; and in 1977 *Fred Williams: Landscapes of a Continent* introduced his work to international audiences at the MOMA, New York. His last exhibition was *Bass Strait Seascapes*, held at the TMAG in March 1981 then the regional galleries at Launceston, Burnie and Devonport; the MPAC in 1981; Monash Uni. Gallery in April 1982; and the Rudy Komon Gallery, Sydney, October 1982. In 1981 his health had collapsed; cancer was diagnosed and he was given a few months to live. His death in April 1982 cast a gloom over the art world to which the whole of his working life had been dedicated. Exhibitions of his last series, The Pilbara Series, were held in 1983–84 (touring most state galleries), in Asia 1985 and London and several other UK public galleries 1988. A major retrospective curated by the NGA toured all state galleries 1987–89. He was represented in the Bicentennial exhibitions *The Great Australian Art Exhibition* and *The Face of Australia* and in *Classical Modernism: The George Bell Circle* NGV, 1992.
AWARDS: Prize in Dunlop competitions, Melbourne, 1950; Georges Invitation Art Prize (2nd award), 1963;

Helena Rubinstein Scholarship, 1963; Transfield prize, 1964; Muswellbrook prize, 1964; Robin Hood prize, 1964; Wills prize, 1966; McCaughey prize (Sydney), 1966, 71, 81; Georges Invitation Prize, 1966; Wynne prize, 1966, 76; Trustees Watercolour prizes, 1966, 76, 78; PCA Print prize, 1967; OBE conferred, 1976.
REP: NGA; AGNSW; AGSA; AGWA; MAGNT; NGV; QAG; QVMAG; TMAG; many regional and uni. galleries; Parliament House; MOMA, New York; V&A and Tate gallery London; Metropolitan Museum, New York.
BIB: Catalogue essays exhibitions as above and all books on contemporary Australian art. Patrick McCaughey *Fred Williams*, Bay Books, Sydney, 1980. Peter Fuller, *Images of God*, Hogarth Press, London, 1980. James Mollison, *A Singular Vision – the art of Fred Williams*, NGA, 1989. Numerous references in A&A including 2/3/1964, 16/3/1979, 20/2/1982, 25/4/1988.

WILLIAMS, Liz
Sculptor, ceramicist..
STUDIES: Dip Art & Art Ed, SASA, 1963; Bachelor of Design, SACAE, 1989. Her finely-crafted sculptural ceramics have appeared in numerous group and solo exhibitions 1976–94 in Australia and internationally including the *Shameless Goddess* series BMG, Adelaide and Lyall Burton, Melbourne 1993/94.
AWARDS: Five grants 1977–94 including from VACB 1983, 86, 91.
REP: NGA; AGSA; several tertiary collections including Latrobe University.

WILLIAMS, Rhys
(b. 1894, Sydney) Engraver, painter, illustrator.
STUDIES: ESTC; J. S. Watkins School. Fellow of the RAS of NSW; official artist to the Volunteer Defence Corps during World War II.
AWARDS: Berrima prize, 1962.
REP: AGNSW.
BIB: *Australian Art Illustrated*, RAS, Sydney 1947.

WILLIAMSHURST, J. H.
(Active c. 1873, Melb.) Painter. Known for landscapes, he exhibited with the VAA in 1873, showing *Still Waters, Downhill to the Ferry* and two other paintings.
BIB: McCulloch, AAGR.

WILLIS, Gary Cashwell
(b. 1949, Coffs Harbour, NSW) Painter.
STUDIES: Canberra School of Art; PIT, 1970–72; postgrad. studies PIT, 1980–81. He held around 16 solo exhibitions 1973–90 in Canberra, Melbourne (Powell St, Reconnaissance) and Sydney (Coventry, Roslyn Oxley9, Painters), and at IMA, Brisbane 1982; Performance Space, Sydney 1985. He participated in a number of group exhibitions including *Biennale of Sydney*, 1979, 82; *Australian Art of the Last Ten Years*, Philip Morris Art Collection, NGA 1982.
REP: NGA; AGSA; AGWA; tertiary collections including ANU.
BIB: Catalogue essays exhibitions as above. Germaine, AGA.

WILLIS, *Matthew*

(b. 1811; arr. Sydney 1848; d. 1890) Sculptor, teacher. He modelled seven figures for the south front of Lichfield Cathedral, worked on stately houses and spent five years on sculpture work for the Houses of Parliament, London, before going to Australia. In Sydney, unable to find sculpture work, he started a

David, Wilson, Hope Sleeping: Grand Disguise, *1989–90, forged and welded steel, patina and varnish, 437 × 194 × 130. Collection, QAG.*

school at Cooks River. Later he taught in NSW Education Dept schools at Gosford, Hamilton and Newcastle, where he stayed for many years. His only known Australian sculpture is the *Head of Caxton* carved above the entrance to the old *Sydney Morning Herald* building. In 1929 it was transferred to a building at Pitt, Hunter and O'Connell Sts intersection, Sydney.
BIB: Moore, *SAA*.

WILLYAMA ART SOCIETY

In 1958, six pictures by members of the *Willyama Art Society* were included in an Adelaide exhibition which concerned mainly landscapes by contemporary South Australian painters who had visited Broken Hill as guests of South Australian Airlines.
NFI

WILSON, *David Keith*

(b. 16/1/1947, London; arr. Aust. 1965) Sculptor.
STUDIES: Harrow School of Art, UK, 1963–65; Dip. Art, NGV School, 1969–70; travel studies, Europe, UK, USA, 1976, 77; 1981–82. Beginning with Caro-like, welded-steel forms, his work gradually became more monumental as, for example, in his grand-scale, arched and monolithic steel forms. He held 15 solo exhibitions 1972–91 largely at Powell St, Melbourne; one each at Shepparton and Canberra and two in Sydney. He also participated in a number of group exhibitions including the *Sydney Biennale*, 1973; *Mildura Sculpture Triennial*, 1973, 75, 78, 82, 85; *Australian Sculpture Triennial*, 1981, 84, 90 and in *Fifteen Australian Sculptors*, touring exhibition 1980; touring show to Japan organised by QAG 1987; *The New Romantics*, Macquarie Galleries and touring 1988. Commissions he received include a Commonwealth Games commission, Edmonton, Canada, 1978, and a large rhythmical piece, *Hope Sleeping – Grand Disguise*, in the water mall of the QAG.
AWARDS: VACB grant, 1973, travel grant, 1976.
APPTS: Secondary schools, Vic., 1972–74; lecturer, sculpture, Prahran CAE, 1974–82; senior lecturer, sculpture, Victoria Coll., Prahran, 1982–91; senior lecturer, sculpture, VCA, 1992– .
REP: NGA; AGNSW; AGSA; AGWA; NGV; QAG; QVMAG; TMAG; Parliament House; regional and public galleries including Heide, Launceston, Mildura, McClelland; tertiary collections including La Trobe, Melbourne, Monash unis.; Australian Embassy, Washington; corporate collections including State Bank of Vic.
BIB: G. de Groen, *Conversations with Australian Artists* Quartet, 1978. Sturgeon, *DAS*. Scarlett, *AS*. Graeme Sturgeon, *Contemporary Australian Sculpture*, Craftsman House, 1991. *A&T* winter 1981.

WILSON, *Dora Lynnell*

(b. 1883, Newcastle-upon-Tyne, UK; arr. Aust. in childhood; d. 21/11/1946, Melb.) Painter.
STUDIES: NGV School, 1901–07; travel studies, UK and Europe, including France, Spain, Corsica. Known mainly for her paintings of Melbourne street scenes, many of great clarity and atmosphere, her exhibition

Dora Wilson, Evans Court off Toorak Road, *oil on board, 31.5 × 39.5cm. Christie's, August 1992.*

at the Fine Art Society Gallery, Melbourne May 1931 was entirely devoted to that subject. Her work was represented in *A Century of Australian Women Artists 1840s–1940s* Deutscher Fine Art, Melbourne, 1993 and *Important Women Artists*, Melbourne Fine Art Gallery, Melbourne, 1993.

AWARDS: Student prizes, NGV School.

REP: AGNSW; AGSA; AGWA; QAG; regional galleries Bendigo, Castlemaine.

BIB: Moore, SAA. John Kroeger, *Australian Artists*, Renniks, Adelaide, 1968.

WILSON, Eric

(b. 5/1/1911, Annandale, NSW; d. 1947, Sydney) Painter, teacher.

STUDIES: Julian Ashton School, Sydney Design School and ESTC; also with Adelaide Perry; NGV School, c. 1933–?; RA Schools, London; Westminster School (with Meninsky and Gertler), and Amédée Ozenfant's Academy, 1937–39. His meticulous painting of landscapes, cityscapes and genre was a brilliant reflection of the attitude and beliefs which gave his work a special place in Sydney modernist painting of the 1940s. He worked as a hospital orderly during the early days

of World War II, and, tragically, had only eight years of mature painting life. His work appeared in the Bicentennial exhibition *The Face of Australia.*

APPTS: Instructor in painting and design, ESTC, 1940–47.

AWARDS: Grace Joel scholarship, NGV School, 1933; NSW Society of Artists Travelling Scholarship, 1937.

REP: NGA; AGNSW; AGSA; AGWA; NGV; QAG; regional galleries Ballarat, Castlemaine, Newcastle.

BIB: Most books on Australian art history including Horton, PDA. *Meanjin* 4/1947 (Bernard Smith, *The Art of Eric Wilson*). A&A 12/1/1974 (Douglas Dundas, *Eric Wilson*).

WILSON, Geoffrey Ronald

(b. 1927, Bridgetown, WA) Painter, printmaker, teacher.
STUDIES: SASA; Hammersmith Coll., London (lithography). Trained as a watercolourist, he held an exhibition of his silk-screen prints in Adelaide, 1972; he exhibits also with the SA Graphic Art Society and in PCA exhibitions and in 1992 with Bonython-Meadmore, Adelaide.

AWARDS: Cornell prize, CAS, Adelaide, 1963.

APPTS: Teaching, SA tech. schools, 1949– ; senior lecturer, SASA, head of painting dept, 1978–1983.

REP: NGA; AGNSW; AGSA; AGWA; Newcastle regional gallery.

BIB: PCA, *Directory* 1976.

NFI

WILSON, H. Stuart
(Active c. 1893–1903) Painter. His paintings of Sydney streets have historic value.

REP: AGNSW.

BIB: John Kroeger, *Australian Artists*, Renniks, Adelaide, 1968.

WILSON, James Armstrong
(b. 1804; arr. Aust. c. 1836; d. 1852) Nigel Barbury, writing in Kerr (DAA), says that Wilson would almost have been unrecorded except for the memoirs of his daughter written in her old age around 1900. Having trained as a doctor, Wilson emigrated to NSW, took up portrait painting and following a land grant from Lady Franklin lived in Tasmania from around 1840. However, he found the life too arduous and returned to Sydney a year later. His commissioned works included portraits of Sir George FitzRoy and a number of other prominent society figures, described by Barbury as being romantic in flavour, suggestive of Gainsborough's 'fancy pictures'. His romantic style is typified in the unusual oil *Gunbal*, an Aboriginal girl painted in 1838 (collection NGA), in which she is shown dressed in silks with a turban and gold necklace and low-cut possum cloak like a ball-gown of the era. His work was seen in *The Artist and the Patron*, AGNSW 1988.

REP: NGA; Mitchell Library.

BIB: *Artists in Early Australia and their Portraits*, Eve Buscombe, Sydney 1978. Kerr, DAA.

WILSON, James Glen
(b. 1827; arr. Sydney 1853; d. 1863) Painter, photographer. Wilson was chosen as the artist on the survey vessel HMS *Herald*, which sailed from England in 1852 and arrived in Sydney six months later from where it undertook survey expeditions over seven years in the South Pacific, putting in to Sydney many times in the process. Included in Wilson's numerous paintings of the voyages were a number of those of the east coast of Australa and Sydney Harbour. Eileen Black, in Kerr's DAA, describes the inclusion of elements of figures in his otherwise topographical works as lending the scenes 'atmosphere and interest'.

REP: NLA; Mitchell, La Trobe, Allport, Crowther Libraries; a number of British and Irish public collections.

BIB: C. Craig, *More Old Tasmanian Prints*, Launceston, 1984. Kerr, DAA.

WILSON, Jean L.
(b. c. 1875, Adelaide) Painter, teacher.

STUDIES: School of Design, Adelaide (with Tannert). She taught at the Central Art Studio from 1897, and exhibited regularly with the SASA.

REP: AGSA; AGNSW.

BIB: Moore, SAA. Rachel Biven, *Some forgotten . . . some remembered*, Sydenham Gallery, Adelaide, 1976.

NFI.

WILSON, John
(b. 1930, Three Springs, WA) Painter.

STUDIES: No formal training. Known chiefly for landscapes in watercolours, Wilson began his working life as a farmer, and in 1953 joined the North-West patrol with the Native Welfare Dept. He also studied social science and in 1963 was engaged in study for a Doctorate of Sociology at Perth Uni.

AWARDS: Perth prize for watercolour, 1954; Guild Art prize, 1961.

REP: AGWA.

BIB: Campbell, AWP.

WILSON, Laurence W.
(b. c. 1860, Eng.; arr. Melb. 1904) Painter. Landscape painter in oils and watercolour of the late colonial school he was born of well-to-do parents connected with the Ellerman-Wilson Steamship Line (whose remittances he is reputed to have spent freely and fast) and lived for many years in NZ before moving to Australia. He taught art in Dunedin in the 1880s and in 1895 was a founder of the Dunedin Easel Club (together with Nerli and other prominent artists). A prolific painter of popular NZ landscapes, he was president of the Otago Art Society in 1899 before moving to Melbourne in 1904. His *Melbourne from the South Side of the Yarra, 1905* shows care and attention to the topography and rendering of buildings, though the figures, tone-colours and composition are handled rather stiffly. 'W. L. Wilson', probably the same artist, exhibited *A Sunlit Glade* and another oil at the VAS in 1906.

BIB: Henry P. Newrick, NZ *Art Auction Records 1969–72*, Newrick, Wellington, 1973.

WILSON, Margaret
(b. 1939, Melb.) Painter, printmaker.

STUDIES: Dip. Art, Alexander Mackie Coll., 1976. Her abstract watercolour and pencil drawings show a subtle gradation of colour and tone and she held ten solo exhibitions to 1991, largely at Macquarie Galleries, Sydney, also Milburn & Arte, Brisbane and at Perc Tucker Regional Gallery, Townsville 1990, 91. She participated in numerous group exhibitions at Macquarie and other galleries, especially printmaking and watercolour shows, including *Continuum*, NAS 1981; *Women at Work*, Perc Tucker Gallery, Townsville; *Jack Manton Exhibition*, QAG 1989.

AWARDS: Gruner prize, AGNSW, Camden and Wollongong prizes, 1976; Muswellbrook and Drummoyne, 1977; watercolour prize, Pacific Arts Festival, Townsville, 1984.

REP: Artbank; several regional gallery collections including Burnie, Townsville, Wagga Wagga; several tertiary collections including Uni. of WA, James Cook Uni., Qld; NSW Parliament.

BIB: *New Art Two*.

WILSON, Patricia
(b. 1944, Tamworth, NSW) Printmaker.

STUDIES: NAS, 1962–66; printmaking with Earle Backen, 1967–68; Atelier 17, Paris (with S. W. Hayter), 1969–72. She participated in group exhibitions 1970–88 in Germany, Iceland, USA and Italy, as well as in Australian exhibitions largely with the PCA.

AWARDS: Tamworth prize for prints, 1972; grant, VACB, 1973.

REP: QAG; regional galleries including Newcastle, Stanthorpe, Tamworth; collections of the Bibliothèque Nationale de Paris.

BIB: PCA, *Directory* 1976, 1988. Germaine, *AGA*.

WILSON, Shirley Cameron

(b. 22/5/1918) Writer. Author of *From Shadow into Light* (Pagel Productions, SA, 1988), a history of women artists in South Australia from colonial times to the mid 1980s, and *The Bridge over the Ocean*, on her great-grandfather, Thomas Wilson, art promoter and mayor of Adelaide in the mid-1800s.

WILSON, William George

(b. c. 1864, Pilton, Qld) Painter.

STUDIES: RA Schools, London. He exhibited with the Qld Art Society, 1892–1913; he also exhibited in London from 1894, lived there for six years (1908–14), and showed at the RA, and London Salon. His 13 *Views of Toowoomba* were sold at Sotheby's, London, Apr. 1975.

REP: Mitchell Library.

BIB: Edward Craig, *Australian Art Auction Records, 1975–78*, Mathews, Sydney, 1978; J. Johnson and A. Greutzner, *Dictionary of British Artists, 1880–1940*, Antique Collectors Club, Woodridge, Suffolk, 1976.

WILSON, William Hardy

(b. 14/2/1881, Sydney; d. 1955) Architect, artist, writer.

STUDIES: Newington Coll., Sydney; extensive travel studies, art and architecture, UK and Europe; studies also, China, USA and SE Asia. He exhibited with the Art Society of NSW from 1903, with the NSW Society of Artists, and at the RA, London, 1923. His best-known work is the set of 50 measured drawings and 100 freehand sketches grouped under the title *Old Colonial Architecture* (in Tas. and NSW, 1790–1840), acquired for the National Collection, Canberra, for £3000 in c. 1930. His volume *The Cow Pasture Road* is described by Moore as 'a rare and beautiful production'. Other books were *The Dawn of a New Civilisation*, London, 1929 and *Old Colonial Architecture in New South Wales and Tasmania,* Sydney, 1924, repr. Ure Smith, Sydney, 1975. A regular contributor of articles to *Art and Australia*, in 1911 he started the Fine Arts Gallery, Sydney, in company with Julian Ashton and Harley Griffiths Snr, and in 1936 was defeated by J. S. MacDonald for the position of director, NGV.

REP: NGA; AGNSW; NGV.

BIB: Moore, *SAA*.

WILTSHIRE, William Pitt

(b. 1807, Aust.) Painter. A portraitist and according to William Moore, 'the first artist born in Australia . . . [he] exhibited in the 1857 exhibition in Sydney and painted a portrait of Sir Daniel Cooper'.

BIB: Moore, *SAA*.

WINCH, John

(b. May 1944, Sydney) Painter, teacher.

STUDIES: NAS, 1962–66; travel studies, Europe, 1967–68, Spain and Greece, 1971–72, Greece, 1973–74. Mainly a painter of symbolic abstracts, he held ten solo shows at von Bertouch galleries, Newcastle to 1991 as well as numerous other solo exhibitions in Sydney, Melbourne, Canberra, Brisbane and regional galleries including Orange and Wollongong.

AWARDS: Prizes, Sydney, Robin Hood (watercolour), 1970, (oil) 1977; Grafton, 1970; Ashfield, 1977; Ryde, 1977.

APPTS: Teaching, King's School, Ely, Cambridgeshire, 1968; NAS and Sydney Grammar School, 1969–70; Scots Coll., Sydney, 1973– .

REP: AGNSW; TMAG; Parliament House.

WINDSOR, Robert Clive

(b. 30/7/1955, Vic.) Painter.

STUDIES: Art and Design, Gordon Inst. of Technology, 1972–74; BA (painting), VCA, 1990. He held two solo exhibitions at Linden Gallery in 1990 and while artist-in-residence at Deakin Uni., there and at Warrnambool, Ararat regional galleries, 1992. He participated in around eight group exhibitions 1973–91, largely in the Geelong region, including *Art and Artists of Geelong*, Geelong Art Gallery 1974; *Scotchmans Hill Vineyard Art Prize*, Geelong Art Gallery 1989 and *Twenty Painters*, Vic. Ministry for the Arts 1990.

AWARDS: Pat Corrigan Artist Grant, 1990.

APPTS: Tutoring, School of Education, Deakin Uni., 1991–92.

REP: Geelong Art Gallery; Deakin Uni.; Reserve Bank, Melb.

WINSTANLEY, Edward

(b. 1820, Lancashire; arr. Sydney 1833; d. 1849) Painter. Known as a painter of animals, principally of horses. Herbert Badham in *The Story of Australian Art* described him as 'the first Australian-born artist of real accomplishment', which affirms the opinion of William Moore in his *Story of Australian Art*. He contributed to Sydney magazines, notably the *Sporting Magazine*, 1848, and showed *Racehorses* and *Hunting Scene* at the first exhibition held in Sydney, 1847 (*see* EXHIBITIONS). He also drew the coach and horses for an early print, *The Post Office*, and collaborated in a small book with T. T. Balcombe (q.v.) who, like Winstanley, died prematurely. His work was represented in *Pastures and Pastimes*, organised by the Victorian Ministry for the Arts at the Victorian Artists Society gallery, 1983 and *The Artist and the Patron*, AGNSW, 1988.

REP: Mitchell Library.

BIB: Moore, *SAA*. Badham, *SAA*. Andrew Sayers, *Drawing in Australia*, NGA, 1988. Kerr, *DAA*.

WINTERS, Michael

(b. 1943, Frankston, Vic.) Painter, printmaker, teacher.

STUDIES: CIT, 1960–63; Donstfack Skolan, Stockholm, 1966–67; travel studies, Europe, UK, Scandinavia and

Israel, 1965–72. From 1965 he held exhibitions of his figurative watercolours, drawings, prints and constructions in London, Stockholm, Sydney, Brisbane, Canberra, Newcastle and Perth, as well as in Melbourne. He held 23 solo exhibitions 1965–91 including at Macquarie, Sydney; Victor Mace, Brisbane; Bathurst Regional Art Gallery 1982 and in Greece, 1984 and 1991. He spent a considerable time in Greece from the 1960s and lived there permanently from 1992. Group exhibitions in which his work appeared include *Wynne* and *Archibald* prize exhibitions and with Macquarie Galleries and *Landscape and Light*, a four-person exhibition with Stan de Teliga, John Hopkins and John R. Neeson, 1989.

AWARDS: Best Australian entry, Perth International prize for Drawing, 1975; Darnell de Gruchy Invitational Purchase prize, 1975; Invitational Purchase prize, QAG, 1982; Gold Coast purchase prize, 1982.

APPTS: Teaching, Darling Downs IAE, 1977; Central Western School of Creative Arts, Longreach, Qld, 1976–77; part-time teaching, Woollahra-Waverley Arts Centre, 1985, City Art Inst., 1987, Bathurst, 1988.

REP: AGWA; QAG; Artbank; regional and public galleries including Bathurst, Burnie, Manly, Wollongong; tertiary collections including Deakin, NSW, Qld unis., ANU.

BIB: Campbell, *AWP*. Germaine, *AGA*. PCA, *Directory* 1976.

WIRTH, Louis Wilhelm Karl

(b. 1858, Saxony; d. 10/10/1950, Brisbane) Painter, linguist.

STUDIES: UK. Wirth was a founder of the Qld Art Society together with Isaac Jenner and Oscar Fristrom, and generally of the movement that led to the founding of the QAG. He was also treasurer, New Society of Artists, 1908. A prolific painter of landscapes in watercolours, he worked from a studio in Queen St, Brisbane, and taught in private schools including Boyd Road School, Nundah.

REP: QAG.

BIB: Julie K. Brown and Margaret Maynard, *Fine Art Exhibitions in Brisbane 1884–1916*, Fryer Memorial Library, Uni. of Qld, 1980.

WISHART, George

(Active c. 1897–c. 1907, Qld) Painter.

STUDIES: Qld, with Isaac Jenner. Known for marine paintings. His *A Busy Corner on the Brisbane River* was included in the Qld Art Society section of the *Queensland International Exhibition* 1897. He exhibited also with the New Society of Artists (1904–07), of which he was a committee member and vice-president.

WITHERS, Margery Pitt

(b. 1894, Vic.; d. 1966, Heidelberg, Vic.) Painter.

STUDIES: NGV School, 1913–22; Working Men's Coll., 1913. Daughter of Walter Withers, and wife of Richard McCann. She was a foundation member of the Twenty Melbourne Painters.

AWARDS: Second place, NGV Travelling Scholarship, 1914.

APPTS: Teaching at girls' schools in Melbourne, 1913–22; Swinburne Tech. Coll., 1920–28.

REP: AGSA; Castlemaine Gallery, Vic.

WITHERS, Rod

(b. 1946, Melb.; d. 1988) Painter, sculptor.

STUDIES: Prahran Tech. Coll., 1963–64; NGV School, 1964–67; travel studies, SE and central Asia and London, 1970–71. He held about 20 solo exhibitions 1969–86 in Brisbane (Johnstone, 1969), Sydney (Macquarie, 1977, 79; Ray Hughes, 1972–79, 82, 86) and Melbourne (Powell St, 1979; Pinacotheca, 1976; Ray Hughes at Reconnaissance, 1984), and at University Gallery, Melbourne 1979. His work appeared in around 13 group exhibitions 1968–84 at private galleries in Brisbane (Johnstone, Ray Hughes), Melbourne (Powell St, Pinacotheca, ROAR Studios) and Sydney (Macquarie) and in *17 Australian Artists*, Galleria San Vidal, Venice, Italy 1988. Killed while skiing at Mt Hotham, Vic. His work was described by friend and fellow artist Roy Churcher in his tribute (*A&A* 26/3/1989) thus: 'his interest changed from the tight interior space of art school to the only space he desired and adored – "outspace" – Australia – so the painting's rigid format . . . had to bend, drop, stoop, plunge and if the paintings weren't as exciting as actually being "out there", then the painting had to change. If the paintings aren't as exciting as living – then why bother!'

AWARDS: F. E. Richardson Watercolour Award, Geelong Art Gallery, 1976; Trustees Purchase Award, QAG, 1976; Capital Permanent Award, Geelong Art Gallery, 1978; residency, Vence, Southern France, Aust. govt assisted studio, 1980.

REP: NGA; NGV; QAG; MOCA, Brisbane; Artbank; regional galleries Geelong, New England; Uni. of Melbourne; BCAE, Brisbane; Uni. of Qld; WAIT, Perth; Griffith Uni.

BIB: *A&A* 26/3/1989 (obituary).

WITHERS, Walter

(b. 22/10/1854, Handsworth, Staffs., UK; arr. Aust. Dec. 1882; d. 1914, Eltham, Vic.) Painter, lithographer, teacher.

STUDIES: RA Schools, South Kensington, London, 1870–82; NGV School (life classes only), 1884–87; Académie Julian, Paris, 1887–88. His grandfather, Edwin Withers, was an artist, his wife was a pianist and music teacher, and their daughter, Margery Pitt Withers, became a painter. Nicknamed 'the Colonel', Withers was probably the most versatile and educated member of the Heidelberg School (q.v.). Besides drawings, illustrations, oils and watercolours, he designed art nouveau décor and marble mantelpieces for Victorian stately homes, notably his panels for the Manifold family at *Purrumbete*, Camperdown. On arrival in Vic. in 1882 he humped his swag through country districts, working at odd jobs and getting to know the bush. Back in Melbourne, a stationer who bought some of his sketches showed them to the printers William Inglis & Co., and Withers was given employment as

a draughtsman, exhibiting the originals of the portraits he made for reproduction with the VAA. His return to London to marry coincided with the emergence of Whistler's protégé, Sickert, and his colleague, Wilson Steer, and the beginnings of the New English Art Club, and it may have been from such sources, as well as from Constable and Cox, that he got his penchant for the Whistlerian nocturnes and the broken, impressionistic brushstroke, trademark of much of his most celebrated Australian painting. This influence would have been extended by his studies in Paris at Julian's, where E. Phillips Fox was already enrolled. An invitation from his old employers, Ferguson and Mitchell, returned him to Melbourne in 1889 when also he joined Roberts, Streeton and others at the camp at Eaglemont and painted his celebrated *Valley of the Yarra*. In 1890 he took over the mansion *Charterisville* at Heidelberg (q.v.), sublet lodges in the grounds to other artists for 2s. 6d. per week, and painted and taught while his wife gave music lessons. He illustrated *Chronicles of Early Melbourne* by Edmund Finn, Ferguson & Mitchell, Melbourne, 1890. He opened a teaching studio in the city (AMP buildings) in 1891, and two years later moved to Creswick (where his pupils included Percy and Norman Lindsay), before returning to Heidelberg where he painted *Tranquil Winter* – acquired for the NGV in 1895. His presence and the artists he attracted to the area contributed greatly to the lustre of what was to become known as the Heidelberg School (q.v.). In 1902 he moved permanently to settle at Eltham; he died there in 1914 and was buried in the little churchyard of St Helena. His work appeared in the Bicentennial exhibitions *The Great Australian Art Exhibition* and *The Face of Australia*.

AWARDS: Wynne prize, Sydney, 1897, 1900.
APPTS: Draughtsman, William Inglis & Co., and Ferguson & Mitchell, litho printers, Melbourne, 1884–87, and again as illustrator, from 1889; Paris correspondent for London, *Magazine of Music*, 1887–88; member, committee of trustees, NGV, 1912–14. Also president, VAS, 1894, and a founding member, Australian Art Association, 1912.
REP: NGA; AGNSW; AGSA; AGWA; MAGNT; NGV; QAG; QVMAG; TMAG; regional galleries Bendigo, Ballarat, Castlemaine, Geelong; many other public collections.
BIB: All books on Australian art history. Alexander McCubbin, *The Art and Life of Walter Withers*, Melbourne, 1919.

WITTENOOM, Charles Dirk
(b. c. 1824, Eng.; arr. WA 30/1/1830; d. 10/7/1866, WA) Topographical artist. Fourth son of J. B. Wittenoom (q.v.), he married in 1853, lived on a property east of York, WA, and drew some of the plates for Ogles' *The Colony of Western Australia* (London, 1839). These included *View from the Court House, Arthur's Head, Fremantle, c. 1838*, showing the precise layout of buildings and roads. His work was seen in *The Colonial Eye*, AGWA 1979.
REP: Mitchell Library.
BIB: Kerr, *DAA*.

WITTENOOM, (Reverend) John Burdett
(b. 1789, Newmark, Notts., Eng.; arr. WA 30/1/1830; d. 23/1/1855, Perth) Clergyman, schoolmaster, amateur painter. He resigned his headmastership at Newmark in 1829, his wife having died the previous year, to take the position of chaplain to the Swan River Colony (now Perth). There he established a school and later (1847) became the first chairman of the Education Committee. He is also noted as an accomplished amateur musician and watercolourist, as is his son Charles (q.v.). His work was seen in *The Colonial Eye*, AGWA 1979.
REP: AGWA.
BIB: *ADB* 2. Kerr, *DAA*.

WOLINSKI, Joseph
(b. 1872, Germany; arr. Aust. 1883) Painter, teacher.
STUDIES: RAS School, Sydney, 1889– ; Colarossi's, Paris. He exhibited extensively with the RAS from 1896, showing a wide range of subject matter. His large canvas, *After Life's Fitful Fever he Sleeps Well* (AGNSW) connects his work with contemporary German, Dutch and English popular genre painting. He exhibited at the RA, London, 1913–15, and at the Paris Salon, and served with the Royal Academy Artists' Corps during World War I, after which he returned to Sydney, presumably via the USA. In the 1930s he ran his own art school, the Academy Wolinski, in Sydney, and with Mary Edwards (q.v.) took action against the trustees of the Art Gallery of NSW when they awarded the 1944 Archibald prize to William Dobell.
REP: AGNSW; QAG.
BIB: Bénézit, *Dictionnaire*, 1976. J. Johnson and A. Greutzner, *Dictionary of British Artists, 1880–1940*, Antique Collectors Club, Woodridge, Suffolk, 1976.

WOLLMERING, Dan
(b. 30/3/1952, Minnesota, USA; arr. Aust. 1975) Sculptor, lecturer.
STUDIES: BA Fine Arts, St John's Uni., Minnesota, USA, 1974; Minor Education, Coll. of St Benedict, Minnesota, 1975; MA Fine Art, RMIT, 1990. He held around 12 solo exhibitions 1979–92, largely at tertiary and regional galleries including Ewing and George Paton, Melbourne Uni. 1979; Mildura Arts Centre 1980, 92; and Flinders Lane Gallery, Melbourne 1990, 91. His work appeared in around 13 group exhibitions and sculpture survey shows 1978–90 including *Australian Sculpture Triennial*, 1981, 87; *Mildura Sculpture Triennial*, 1982, 85, 88; *Contemporary Gippsland Artists*, Latrobe Valley Arts Centre and travelling 11 regional galleries Vic., NSW, Qld, SA 1990–92.
APPTS: Secondary school art/craft, Melb., 1975–77; tutor, Phillip Inst., 1977–81; lecturer, sculpture and woodcraft, Gippsland Inst. of Advanced Education, 1983–86; lecturer, sculpture and drawing, School of Visual Arts, Monash Uni. Coll., Gippsland, 1987– .
REP: Regional galleries Latrobe, Mildura, Sale; Caulfield Arts Complex; Monash Uni., Caulfield Campus; Phillip Inst.
BIB: *AM* Oct 1989.

John Wolseley, Tidal Almanac with Mangrove trunk, *1988–90, watercolour on paper, 123 × 208cm. Courtesy Australian Galleries.*

WOLSELEY, *John Walter*

(b. 21/4/1938, Somerset, Eng.; arr. Aust. Apr. 1976) Painter, printmaker, teacher.

STUDIES: St Martin's School, London, 1957–58; Byam Shaw School of Art, London, 1958–60; printmaking with J. W. Hayter, Paris, 1961–63; travel studies, UK and Europe. He travelled extensively in Europe, representing the UK at Florence and Buenos Aires print biennales before moving to Australia where he continued travelling, most frequently to the outback, recording the animal, vegetable, mineral and historical aspects of the bush. Chief characteristics of his work are a thin, cursive line, detailed handwritten text, and map-like drawings tinted with soft colour, often with addition of collage demonstrating his close observation of living outdoors in the bush for extended periods. In the 1980s his work moved more into painterly representations of similar subjects while in 1993 his work included an installation of many objects at Australian Galleries, Melbourne. He held numerous solo exhibitions 1978–92 largely at Realities, Melbourne and Rex Irwin, Sydney, and two survey shows at AGWA 1988 and Uni. of Melbourne Gallery 1989. His work appeared in the Bicentennial exhibition *The Face of Australia.* He was artist-in-residence at Deakin Uni. 1978–79; Bendigo CAE 1986; Joye Art Foundation, Sydney 1987; AGWA 1988.

AWARDS: Latrobe Valley, SEC prize, 1979; Capital Permanent (acquisition) award, Geelong Art Gallery, 1979; Alice Prize, 1982, 85, 88, 90; trustee of AGNSW watercolour prize, 1983, 92; ANZ Bicentennial commission for AGNSW, 1988; VACB fellowship, 1992.

APPTS: Lecturer, Gippsland IAE, 1976–77; teaching, painting, various NT Aboriginal communities, 1978–82.

REP: NGA; AGNSW; AGWA; MAGNT; NGV; QAG; QVMAG; TMAG; Parliament House; Arts Council of Great Britain; Contemporary Art Society, London; Museum of Contemporary Art, Yugoslavia; Oxford City Art Gallery; regional galleries Geelong, Morwell, Mornington, Sale; corporate and private collections including the Christensen Fund, State Bank, NSW, Joye Art Foundation.

BIB: Catalogue essays exhibitions as above. *Orienteering, Painting in the Landscape,* Deakin Uni. Press 1981. A&A 16/2/1978.

WOMEN'S ART AND THE FEMINIST MOVEMENT

As part of the feminist movement of the 1970s, women's art – both that of earlier artists and the situation for contemporary artists – started to be reassessed.

The 'Women's Art Movement' was founded in Sydney and Melbourne (1974) and in Adelaide (1976) with the aim of assisting those who were, or wished to become, artists and the *Women's Art Register* (q.v.) established in Melbourne in 1975, continues a specialised archive and publishing program. In 1975 the exhibition *Australian Women Artists 1840–1940,* researched by Janine Burke and curated by Kiffy Rubbo and Meredith Rogers for the University of Melbourne's Ewing and George Paton Galleries and later documented more fully by Janine Burke in her pioneering text of the same name (Greenhouse Publications, Melbourne, 1980) was the first to reassess the work of earlier Australian women artists. A number of exhibitions followed. They included many at Jim Alexander's 'Important Women Artists' gallery, Melbourne in the 1980s; *Completing the Picture* curated by Juliet Peers and Victoria Hammond with 70 works

by 19 women artists made during the Heidelberg period, Heide and touring 1992; *Aboriginal Women Artists*, AGNSW, 1993; *A Century of Australian Women Artists 1840s–1940s* (193 works by 63 women) Deutscher Fine Art, Melbourne, 1993. As well a number of individual retrospectives enabled the work of women artists working in the 1930s and 40s such as Joy Hester, Margaret Preston, Thea Proctor, Grace Cossington Smith, Grace Crowley, Jean Bellette, Lina Bryans and many others to be given the recognition it deserved.

COLONIAL WOMEN ARTISTS

Joan Kerr's *Dictionary of Australian Artists: Painters, Sketchers, Photographers and Engravers to 1870* (OUP, Australia, 1992) and Grace Cochrane's *The Crafts Movement in Australia: A History* (NSW University Press, 1992) show the large numbers of women who were sketchers, watercolourists, flower-painters, miniaturists, book illustrators and cartoonists, and crafts practitioners from the earliest colonial times. The *Dictionary* explodes the myth that 19th century women lacked opportunities to participate in the arts, or were usually amateurs – though the category existed then as it does now. Many apparently led interesting lives in which the practice of art was a significant component. Some led in fields of photography, botanical art and art education. They included: Thekla Helzer, early photographer; Madame Charpiot, Ballarat goldfields photographer and Mademoiselle Dubost and Madame Ravier who conducted drawing classes.

Many were also married to artists including Anna Lewin, Mary Ann Piguenit, Elizabeth Prinsep, Maria Prout and Elizabeth Gill, de facto wife of S. T. Gill, though their work has been less well collected or has been irretrievably lost. The majority were born in the British Isles, came here as brides, teachers and businesswomen. Though lesser known than their male counterparts, their contribution to colonial culture was obviously quite outstanding.

THE TWENTIETH CENTURY

Janine Burke's *Australian Women Artists 1840–1940* and catalogues such as Juliet Peers and Victoria Hammond's catalogue of *Completing and Picture* and Victoria Hammond's catalogue of *Australian Women Artists 1840s–1940s* Deutscher Fine Art, give comprehensive accounts of the work of individual artists, their crosslinks and the society in which they operated. As early at 1909 the *Melbourne Society of Women Painters and Sculptors* (q.v.) was established. Members wrote criticism, fiction, poetry and children's literature. Among them were expatriates, committed nationalists, radicals and high society cognoscenti; a number were middle-class women with access to some form of art training in Australia and many continued their training overseas. What stands out in Burke's book and the catalogues mentioned is the women's spirit of endurance and the sacrifices they made to continue as artists – most often having to remain outside the social mores of their time.

In *Australian Painting* (OUP, first edition 1962) Bernard Smith wrote, 'The contribution of women to post-impressionism in Australia appears to have been corporately greater than that of men; and in individual achievement in every way comparable.'

However it was not until the feminist movement of the late 1960s and 1970s that specific interest was again focused on women in the arts, through retrospective exhibitions of women's work and examination of the situation for contemporary women artists. The history of the 1970s women's art movement is traced in Sandy Kirby's *Sight Lines: Women's Art and Feminist Perspectives in Australia* (Craftsman House/Gordon and Breach, Australia, 1992) and Janine Burke's *Field of Vision: A Decade of Change: Women's Art in the Seventies* (Penguin, Australia, 1990). Kirby discusses painting, mixed media, performance art, sculpture, ceramics and video art by women artists active in the 1970s and 80s and examines women's art in a context of criticism and change within post-war Australian society. The hitherto neglected topic of women sculptors has now begun to be addressed by Stephanie Radok in *Artlink*, Vol. 13/No. 2, June–August 1993. She lists women participants in five *Australian Sculpture Triennials* from 1981–1993 and research remains to be done in this area.

A detailed survey may show that women in 1994 are well represented and extremely influential in the visual arts. The mission to establish the significance of women's art in the spectrum of Australian art may therefore be thought to be complete. However the continuation of a number of major researched historical survey exhibitions suggests that this point has not yet been reached.

JENNY ZIMMER AND S. MCC.

WOMEN'S ART REGISTER

(Established 1975) Carringbush Library, 415 Church St, Richmond, Vic. 3121.
ADMIN: Managment committee voted by membership. Two part-time staff.
MEMBERSHIP: In 1993, 380 including individuals and institutions. Established to provide documentation of Australian women artists' work it had by 1993 some 14,000 slides and 750 information folders available for research. Several slide kits of subject areas (including sculpture; historical) are available and a quarterly bulletin

WOOD, C. Dudley

(b. 1905, Geelong, Vic.) Painter, teacher.
STUDIES: Swinburne Tech. Coll., also NGV School, c. 1926–27. He exhibited with the VAS, using a dribbling and spotting technique and vivid colours in depiction of bush landscapes and related subjects and was represented in the Bicentennial exhibition *The Face of Australia*.
AWARDS: Albury prize (City's choice), 1957; F. E. Richardson prize, Geelong, 1941.
APPTS: War artist, World War II, 1943–45; teaching, watercolour painting, Swinburne Tech. Coll., 1962–70.

REP: AWM; regional galleries Geelong, Shepparton.
NFI

WOOD, Louis

(Active c. 1800, Tas.) Wood, whose sketchbook is in the Mitchell Library, Sydney, was the original of 'William' in the novel *Pageant*, by 'G. B. Lancaster' (Edith Lyttleton). Wood made sketches of the Duke of Edinburgh's visit to Launceston.
REP: Mitchell Library, Sydney.
BIB: Moore, *SAA*. Campbell *AWP*. Kerr, *DAA*.

WOOD, Marshall

(d. 1882, Brighton, UK) Sculptor. He exhibited at the RA, 1854–75, and was represented in the *International Exhibitions*, Sydney (1879–80) and Melbourne (1880–81). In 1880 he visited Melbourne 'to supervise the installation of his [carved marble] statue of Queen Victoria in Parliament House'. He encouraged both Richardson and Mackennal, then students at the NGV School, to study in London, and both took this advice. However when Mackennal (to whom Wood had offered work as a studio assistant) arrived in London it was sadly to find that Wood had died a few days previously.
REP: AGNSW; AGSA; NGV.
BIB: Sturgeon, *DAS*.

WOOD, Noel

(b. 1912, Strathalbyn, SA) Painter.
STUDIES: Adelaide (with Marie Tuck). Wood lived on Bedarra Island off the North Qld coast, and painted many pictures of local subjects, from c. 1940.
REP: NGA; AGSA; Newcastle regional gallery.
NFI

WOOD, Rex Thomas Percy Reginald

(b. 1908, Laura, SA; d. 1970) Painter, journalist, critic, graphic artist.
STUDIES: SASA; Anglo-French Art Centre, and Southampton Row School of Arts, London. He held exhibitions in Australia before moving to Europe in 1938 to travel extensively and exhibit in London and Lisbon, Portugal, before returning to Australia in 1956.
REP: AGSA.

WOOD-CARVING

See CRAFTS IN AUSTRALIA

WOODHOUSE, A.

(Active c. 1837–1900) Painter, engraver. His earliest known work is *The Commandant's House, Melbourne, 1837*. On 18 Dec. 1889 he gave a paper, *Victorian Pioneers of Litho-drawing and Engraving*, at a meeting of old artists and engravers in Melbourne.
REP: La Trobe Library, State Library of Vic.

WOODHOUSE, Clarence

(b. 1852; d. 1931) Painter, lithographer. He specialised in depicting local architecture, specifically hotels in the Port Phillip area. A set of eight coloured litho-graphs by him, dated 1880 and published by Hamel and Ferguson, is listed in the exhibition catalogue *Rare Maps, Charts and Early Australian Prints*, Georges Gallery, Melbourne, Mar.–Apr. 1963.

WOODHOUSE, Edwin

(b. c. 1858; d. 21/5/1922) Painter.
STUDIES: Family studies. Son of Frederick Woodhouse. His paintings of racehorses are inferior to those of Frederick Woodhouse Snr, but his oil, *Beside the Stream* (Spink Auctions, Sydney, Apr. 1981), showed him as a capable painter in other genre.
BIB: Moore, *SAA*.

WOODHOUSE, Frederick, Jnr

(b. 1848; d. 22/5/1927) Painter. Known for paintings of racehorses. Son of Frederick William Woodhouse (q.v.). His dated paintings, c. 1885–1904, closely resemble his father's.

WOODHOUSE, Frederick William

(b. 1820, Hadley, UK; arr. Melb. 1857; d. 1909) Painter. A painter mainly of racehorses, his father, Samuel, was an artist as were his four sons, Edwin, Herbert, Frederick Jnr, and W.J. (qq.v.). From 1861 to 1888 he painted every winner of the Melbourne Cup (recorded in his *A Record of the Melbourne Cup*, Woodhouse, Melbourne, 1889), the £100 commission (given by George Sennett) being a valuable part of his income. Photography terminated this nest egg. He also painted historical pictures such as *The Settlers' First Meeting with Buckley*, which won him a premium in an art union in 1861, and from 1870 exhibited with the Vic. Academy of Arts., of which he was a founding member of the council. His work was seen in *Australian Art in the 1870s*, AGNSW 1976 and *Pastures and Pastimes*, Vic. Ministry for the Arts exhibition at Victorian Artists Society gallery, Melbourne, 1983.
AWARDS: Premium, Art Union of Vic., 1861.
REP: AGNSW; AGSA; regional galleries Benalla, Hamilton; Mitchell, La Trobe Libraries; a number of sporting clubs including Victoria Racing Club, Geelong Racing Club.
BIB: Moore, *SAA*. Colin Laverty, foreword by Barry Pearce, *Australian Colonial Sporting Painters: Frederick Woodhouse and Sons*, David Ell Press, Sydney, 1979. Kerr, *DAA*.

WOODHOUSE, Herbert J.

(b. c. 1854, UK; arr. Aust. 1857; d. late 1920s) Illustrator, sculptor, printmaker.
STUDIES: Melbourne (wood-engraving). Son of Frederick Woodhouse Snr, he left school at 14 to do lithographic work and also draw for the *New Sporting Era*. From 1868 to 1872 he worked for Adelaide *Punch* as an illustrator and for one year was its proprietor. He exhibited with the Vic. Academy of Arts, 1876–87, the Yarra Sculptors' Society, 1901, and the NSW Society of Artists. He also worked in Tas. and during the 1890s in WA. In the 1920s he was exhibiting with the VAS, Melbourne. The range of his surviving work covers mining, hunting and fishing pictures as well

as illustrations. His work was seen in *The Colonial Eye*, AGWA, Perth, 1979.

REP: AGWA.

BIB: Moore, *SAA*. M. Mahood, *The Loaded Line*, 1973.

WOODHOUSE, W. J.

(Active c. 1868–78) Cartoonist, illustrator. Son of Frederick Woodhouse Snr, he was chief contributor to *Adelaide Punch*, 1868–78. Mahood describes him as 'a spirited draughtsman'. His brother, H. J. Woodhouse, was also a *Punch* illustrator.

BIB: M. Mahood, *The Loaded Line*, 1973.

WOODS, Anthony David

(b. 17/5/1940, Hobart) Painter.

STUDIES: Dip. Art, Hobart Tech. Coll., with J. Carington Smith, 1963; travel studies, NY (on Harkness fellowship), 1968–70; London, 1970; Europe; Japan, 1973. He held his first exhibition in Hobart, 1962, followed by exhibitions at Bonython Galleries, Adelaide, 1966, and Australian Galleries, Melbourne, 1967. Strong drawing distinguished his 1967 work, which had its roots in German expressionism. In later exhibitions his work veered towards international abstraction and related trends, and later again towards minimal forms and studies of light. He lost all his work done in New York in 1969 when his studio burnt out. He held about 42 solo or two-person shows 1962–91 including with Australian Galleries, Melbourne; Bonython, Adelaide and *Bea Maddock, Tony Woods*, QVMAG 1968; Festival of Perth Exhibition with Brett Whiteley, 1971; and at ACCA 1990. Group exhibitions in which his work appeared 1966–92 included *The Australian Painters 1964–66*, from the Mertz Collection, AGSA, touring the USA; *Contemporary Australian Drawing*, Fremantle Arts Centre 1984; *Six Contemporary Artists*, TMAG 1985; *Art with Text*, Monash Uni. Gallery 1990. Of his 1990 survey exhibition at ACCA, Gary Catalano writing in the *Age* said: 'Woods is a thoroughly autobiographical artist. . . . Everything he depicts in his works tells us something about his life. But he is careful not to make these things look more important than they are.'

AWARDS: Harkness Fellowship for study in the USA, 1967; residency, Power Bequest Studio, Cité Internationale des Arts, Paris, Uni. of NSW, 1969.

APPTS: Drawing, painting, teaching, Hobart Tech. Coll., 1965.

REP: NGA; QVMAG; TMAG; Artbank; regional gallery collections including Burnie, Devonport; tertiary collections including ANU, Flinders, Tasmania, WA unis.; Reserve Bank; Chelsea Hotel, NY.

BIB: Campbell, *AWP*. Backhouse, *TA*. D. Richardson, *Art in Australia*, Longman Cheshire, 1988. *Australian Painters 1964–66, Mertz Collection*, Griffin Press, Adelaide, 1966. Smith, *AP*. *A&A* 18/3/1981 (Gary Catalano, *Tony Woods and the Remembered Image*).

WOODWARD, Arthur Thomas

(b. UK) Painter, teacher.

STUDIES: UK, with T. R. Abbett and E. R. Taylor. He taught at the Birmingham School of Art, began teaching art in Vic. in 1889 and taught at the Bendigo School of Mines for more than 27 years. The A. T. Woodward Commemoration Prize, Bendigo, was formed in his honour in 1940.

REP: NGV; Bendigo Art Gallery.

BIB: *Catalogue* NGV collections, Melbourne, 1943.

WOODWARD, Bernard H.

(b. 1847, UK; arr. Perth, WA, 1889; d. 1916) Geologist, museum curator. Son of Dr S. P. Woodward, geological dept, British Museum. Appointed as curator of the Perth geological museum, he organised the Western Australian Museum and Art Gallery (the museum and art gallery became separate institutions when the new Art Gallery of Western Australia was completed in 1979), and was director of the institution, 1895–1914. He compiled a *Guide to the Museum and Art Gallery*, 1904, and was the first president of the West Australian Society of Arts and Crafts, 1896. His portrait was painted by Florence Fuller and is now in the AGWA collections.

BIB: Moore, *SAA*.

WOODWARD, Margaret

(b. 12/01/1938, Sydney) Painter, teacher.

STUDIES: Dip. Painting, NAS, 1956–60; Grad. Dip. Ed., Sydney Teachers Coll., 1981; travel studies in Europe, 1967, 72, Indonesia, 1977. She exhibited at least once annually from 1972 including at Holdsworth, Barry Stern, Sydney; Greenhill, BMG, Adelaide and in Newcastle, Brisbane, Katoomba. She participated in numerous group shows at private galleries and in *Western Australian Artists*, AGWA; *Wynne* and *Archibald Prizes* and *Wynne Prize Retrospective*, S. H. Ervin Gallery, 1986. Her work became well-known after 1972 from exhibitions in Perth, Adelaide and Sydney.

AWARDS: Te Papa Biennial prize for drawing, 1966; prizes at Hunters Hill, 1966; Ashfield, 1966; Wynne prize, AGNSW, 1971; Gosford 1985; Aberdare, 1990; Kedumba, 1990; Portia Geach Memorial Prize, 1983, 84.

APPTS: Teaching, lecturing, various secondary schools and tech. colleges, 1961–71; WAIT, Perth, 1972–77; NSW Coll. of TAFE, 1978–85.

REP: AGNSW; MAGNT; Artbank; tertiary collections including WA, Murdoch, NSW, Curtin unis., WAIT and City Art Inst., Sydney; corporate collections including Robert Holmes à Court, Coopers & Lybrand; R&I Bank.

WOODWARD, Robert

(b. 1923) Architect, fountain designer.

STUDIES: Uni. of Sydney (grad. in architecture, 1952); Finland, with Alvar Aalto and Vilio Rewell. Installed in 1960, his *El Alamein* rose fountain at Kings Cross, Sydney, established him as an outstanding designer of fountains. His other fountains include the Alcoa forecourt fountain, San Francisco, Bank of California fountain, Portland, Oregon, the fountain for the New

Zealand pavilion, Expo '70, Tokyo, and the Chifley Square fountain, Sydney.
AWARDS: National Community Art Competition, 1973; Bondi Junction Plaza Sculpture competition, Sydney, 1976.
BIB: Scarlett, AS.

WOODWARD, Trevor Frederick
(b. 25/10/1947, WA) Painter, printmaker, installation artist, sculptor.
STUDIES: Dip. Graphic Design, Perth Tech. Coll; BA Fine Art, Cleveland Inst. of Arts, USA; MA Fine Art, Uni. of Michigan, USA. Concern for the environment was the subject of his exhibition at AGWA in 1991, *A Throwaway Disregard for the Technical and Formal Niceties of Painting*, which featured expressive abstractionist works using natural materials such as twigs, rocks, feathers. He held around 13 solo exhibitions at private galleries in WA 1970–93 and at AGWA 1991; Geraldton Regional Gallery 1987, 91; Bunbury Regional Gallery 1991.
APPTS: Lecturer, painting, drawing, printmaking, Perth Tech. Coll., 1974–75; lecturer, printmaking, drawing, basic design, foundation year Fine Art students, WAIT (Curtin Uni.), 1980–84.
REP: AGWA; Artbank; Uni. of WA; Royal Perth Hospital; Sir Charles Swan Hospital; Fremantle Arts Centre; several high schools, Perth; Robert Holmes à Court collection.

WOOLARD, Ray
(b. 1951, Ballarat) Sculptor, painter.
STUDIES: Ballarat IAE, 1969–73; VCA, 1974–75. Exhibited at *Mildura Sculpture Triennial*, 1973–78, his work moved successively from constructions in steel to the fragile *Cake Stands*, 1977, in wire, wood, feathers and string, and thence to the clinically conceived *Plastic Man* of 1978. His work was exhibited in New Orleans (ninth *National Sculpture Convention*, 1976); Germany, 1978; Linz, Austria, 1979; and Sydney (*Biennale*), 1979. In Apr. 1977 he entered also the field of performance art (*Dog Performance*), Tolarno Gallery, Melbourne.
AWARDS: VACB grant (special project) 1974, (travel) 1977.
APPTS: Part-time lecturer, CIT, 1976.
REP: NGA; regional galleries Mildura, Mornington; NCDC (public sculpture), Canberra.
BIB: Scarlett, AS.
NFI

WOOLNER, Thomas
(b. 1/12/1825, Hadleigh, Suffolk; arr. Aust. 1852; d. 7/10/1892, Hendon, UK.) Sculptor.
STUDIES: London, painting with Henry Behnes, 1838. Behnes died in 1838, the same year as Woolner's studies with him, but his promising pupil was taken over by his brother, William Behnes, sculptor (1795–1864), who taught him until 1842 when he enrolled at the RA Schools. He exhibited at the RA (*Eleanor Sucking Poison from Prince Edward's Wounds*, 1843, and The

Death of Boadicea, 1844), and in 1847 met Rossetti and joined the Pre-Raphaelite Brotherhood. By 1850 he was making mainly medallion portraits, including one of the wife of the poet Coventry Patmore, 1850, and another of Thomas Carlyle, 1851. His decision to leave England for the Victorian goldfields was brought about by an abortive love affair coupled with his failure to win the commission for a memorial to Wordsworth; also because of attacks by critics on the Pre-Raphaelites. Two other members of the Brotherhood went with him – Bernhard Smith and E. La Trobe Bateman (qq.v.). He was appalled at the scene on the Vic. goldfields ('what one might suppose the earth would appear after the day of judgement has emptied all the graves'), and soon resumed his work as a sculptor. He made a number of medallion portraits in plaster of prominent Melbourne and Sydney citizens and modelled a statue of Captain Cook for Hyde Park, Sydney. In 1854 he returned to England where he completed a bust of Tennyson as well as the medallion of Carlyle and another of Browning. These works established his reputation. He was elected ARA in 1871, RA in 1874 and in 1877 was appointed Professor of Sculpture, but gave no lectures and resigned in 1879. He died in 1892, and was buried in Hendon churchyard. His work appeared in *The Artist and the Patron* AGNSW, 1988; and the Bicentennial exhibitions *The Great Australian Art Exhibition* and *The Face of Australia*.
AWARDS: Silver medal, Society of Arts, London, 1845.
REP: AGNSW; AGSA; NGV; regional galleries Ballarat, Newcastle; La Trobe Library, State Library of Vic.; Mitchell Library, Sydney; Uni. of Sydney; many public galleries in the UK.
BIB: Most books on Australian art history. ADB 6. Sturgeon, DAS. Scarlett, AS.

WOOMBELLANA ART CLUB
See VICTORIAN WOMEN'S ART CLUB

WORKERS' EDUCATION ASSOCIATION, AUSTRALIA
(Founded 1913) The Workers' Education Association began in Australia with the visit of Albert Mansbridge (founder of WEA in Britain) and his wife in 1913. The visit was the result of a joint invitation issued by the Universities of Melbourne and Sydney, and the expenses were paid by Dr James Barrett, later Sir James Barrett, Chancellor of Melbourne Uni. By 1914 the WEA was established in all Australian states in a system of university extension lectures and other activities which aimed at general adult education, with varying degrees of emphasis on all the arts. In 1947 it was replaced in Victoria by the Council of Adult Education (q.v.) but remained strong in other states for some years.
(*See also* COUNCIL OF ADULT EDUCATION; MECHANICS INSTITUTES AND SCHOOLS OF DESIGN)

WORKSHOP ARTS CENTRE
See SCHOOLS

WORTH, John Victor

(b. 1938, Meekatharra, WA) Sculptor.
STUDIES: Munich, 1966, 67; London, Guildford Coll. of Art, 1967–68, City and Guilds Art School, 1969–71. His work was shown in student exhibitions, Royal Exchange, London, 1971, and later in group sculpture exhibitions in Launceston (QVMAG) and Perth (WAIT), 1973, as well as in the *Western Australian Artists Exhibition*, AGWA, Perth, 1974. Rhythm and respect for the block are features of his monumental abstracts in mild steel.
REP: AGWA; WAIT collections, Perth.
NFI

WRAY, (Lieut.-General) Henry

(b. 1/1/1826, Eng.; arr. Aust. 17/12/1851; d. 6/4/1900, Bournemouth) Engineer, draughtsman. A lieutenant with the Royal Engineers, he was stationed at Fremantle in charge of road construction and bridge building. With the clerk of works, James Manning, he drew up the plans and supervised the construction of the new gaol (and also designed a system to light the building with local gas but this was never implemented). He was acting Comptroller General from Feb. 1856 to Jan. 1858, when he returned to England. He was in Guatemala and British Honduras, 1859–61; Japan, 1863; Malta, 1874–79; Ireland, 1879–82; Alexandria, 1882; and was Governor of Jersey, 1887–92. His work was included in *The Colonial Eye*, AGWA 1979 and in *Out of Sight: Out of Mind*, National Trust exhibition, 1988.
AWARDS: CMG conferred (1879).
REP: AGWA; NLA; Mitchell Library.
BIB: Kerr, DAA.

WREFORD, Elaine

(b. 12/3/1913, Nairobi, Kenya; arr. SA 1923) Painter.
STUDIES: SASA, c. 1931; travel studies, 1976–77. Commencing 1964, she exhibited her semi-abstract paintings in Adelaide, Perth and Melbourne, as well as in Nairobi (1968). She held about 17 solo exhibitions 1960–91, largely in SA, including Osborne, Greenhill galleries, Adelaide, and McLaren Vale.
REP: NGA; AGSA; Hamilton regional gallery.
BIB: Nancy Benko, *Art and Artists of South Australia*, Adelaide, 1969. Shirley Cameron Wilson, *From Shadow into Light: SA Women Artists*. Germaine, AGA. Women, DAWA.

WRIGHT, Doug (Douglas Anthony)

(b. 15/12/1944, Ballarat, Vic.) Painter, lecturer.
STUDIES: Ballarat School of Mines, 1963–64; RMIT, 1966. His retrospective exhibition of 20 years work organised by Lyall Burton Gallery, Melbourne in 1993 showed a consistently developed style of abstracts impervious to stylistic trends. His subjects are largely landscape which he portrays in rich, dark backgrounds built up in many layers, interwoven with brilliantly coloured flashes of brighter, lighter colours. He held around 15 solo exhibitions 1978–93 including at David Ellis/Lyall Burton, Melb.; Michel Milburn, Brisbane; Holdsworth, Sydney and in Swan Hill (1989),

Ballarat (1991), Hamilton (1993) and McClelland (1993) regional galleries. His work appeared in a number of group exhibitions 1975–92 including at Ballarat Gallery; and in prize exhibitions at MPAC, 1983; Swan Hill, 1984; *Wynne Prize*, AGNSW 1989.
REP: NGA; NGV; Parliament House; several regional gallery collections including Ballarat, Mornington, Swan Hill; several tertiary colleges including Ballarat CAE, Uni. of Tasmania; private and corporate collections including AMP, Robert Holmes à Court, Philip Morris, Shell.
BIB: Germaine, AGA. Peter & Susan Ward, *In a Different Light*, UQP 1991. A&A 27/3/1990.

Helen Wright, Untitled, *pastel on paper, 66 × 50cm. Courtesy Niagara Galleries, Melbourne.*

WRIGHT, Helen Ruth

(b. 31/1/1956, NSW) Printmaker, painter.
STUDIES: B. Visual Arts, School of Art, TCAE; Dip. Professional Art Studies, Alexander Mackie CAE, Sydney; M. Fine Arts, School of Arts, Uni. of Tasmania. She participated in many group exhibitions 1985–90 including *Australian Prints Now*, NGA 1989; *Genius Loci*, Uni. of Tasmania 1989; *Mitchelton Print Prize Exhibition*, 1990; *October Show*, QVMAG 1989. She held

five solo exhibitions 1980–92 at private galleries in Hobart (Salamanca Place, 1989; Dick Bett, 1991), Launceston (Cockatoo) and Melbourne (Niagara, 1992), and at Tas. School of Art 1980.

AWARDS: VACB artist's development grants, 1982, 85, 91; visual arts grants, Tas. Arts Board, 1988, 89; overseas development grant, residency, Barcelona, VACB, 1991.

APPTS: Part-time tutor, several tertiary colleges, including Tas. School of Art.

REP: NGA; NGV; QAG; TMAG; Devonport and Burnie regional galleries; Uni. of Tas.

BIB: Backhouse, *TA*.

WRIGHT, Judith

(b. 4/7/1945, Qld) Painter. 'Her visual vocabulary puts us in touch with the stuff of dreams, with the dark journeys and sudden mysterious transformations our unconscious is subject to' (Anne Kirker, describing her work in *Art Monthly*, June 1991). She participated in around eight group exhibitions 1985–92 including *Queensland Works 1950–85*, Uni. Art Museum, Uni. of Qld; *A Homage to Women Artists in Queensland, Past and Present*, Centre Gallery, Surfers Paradise 1988; *Australian Perspecta*, AGNSW 1989; *Adelaide Biennale of Australian Art*, 1992. She held five solo exhibitions 1987–92 at private galleries in Brisbane (Milburn + Arte 1987, 89, 90), Sydney (Annandale 1992) and Melbourne (312 Lennox St 1989), and at Artspace, Sydney 1991.

APPTS: Tutor, Queensland Uni. of Technology, 1990–92.

REP: NGV; QAG; Artbank; Brisbane Civic Gallery and Museum; Canberra CAE; Gold Coast collection, Centre Gallery; Uni. of Southern Qld.

BIB: McIntyre, *CC*.

WRIGHT, Peter

(b. 1941, Sydney) Painter.

STUDIES: NAS, part-time in sculpture, 1958; Julian Ashton School, 1958; full-time studies, NAS, 1960–61; also with John Olsen and Robert Klippel (private art school), 1962–63. His work was shown in a number of group exhibitions Melbourne (Gallery A; Australian); Sydney (Gallery A; Robin Gibson) 1965–late 1970s as well as in group exhibitions including *Archibald Prize*, 1977.

BIB: Horton, *PDA*.

NFI

WRIGHT, Thomas

(b. 1830, Sheffield, Eng.; arr. Vic. 1852; d. 1881, Melb.) Painter. He went to Vic. with the gold rush and had some success in the diggings at Bendigo. During the decade 1852–62 he produced some fine paintings of the district, notably *Sunset on the Diggings, Bendigo Valley* and *Sandhurst in 1862*. He spent some years on the NZ diggings before returning to Vic. where, in 1867, he was teaching landscape painting at the Artisans' School of Design, Richmond. He worked as a drawing master at private schools in Melbourne and was the first art teacher at Wesley

Coll., where he painted a portrait of the founder, Dr Daniel James Draper. Plaster medallions of Wright and his wife by J. S. Mackennal were shown (1870) at the first exhibition of the Vic. Academy of Fine Arts, of which Wright was a foundation member. He continued to paint until a few days before his death which he anticipated in his last painting, an allegory on the theme of the eternal ploughman. His work was included in *Australian Art: Colonial to Modern*, Deutscher Fine Art, Melbourne 1985 and *Artists of the Bendigo Goldfields*, Bendigo Art Gallery 1989.

REP: Bendigo Art Gallery.

BIB: Moore, *SAA*. McCulloch, *AAGR*. Kerr, *DAA*.

WRIGHT, William

(b. 17/2/1937, Sydney) Painter, sculptor, teacher.

STUDIES: Dip Art, ESTC, 1958; Accademia de Belle Arti, Florence, Italy (sculpture and restoration), 1959–60; Central School of Arts and Crafts, London (printmaking), 1961–62; travel studies, Europe, UK, from 1960. He held his first exhibition in 1966 in Edinburgh followed by exhibitions in London and Sydney (Rudy Komon); Melbourne (Tolarno) in 1967. He combined a painting career with teaching and later became more involved in art administration. Group exhibitions in which his work appeared until 1982 included Edinburgh Festival exhibitions 1966, 67, 68; *Australian Artists*, South London Gallery, 1968 and *The 1960s*, AGNSW, 1982. In the mid 1970s while lecturing in NY he was instrumental in establishing the Peter Brown Scholarship (co-funded by NY Studio School and VACB) (*see* OVERSEAS STUDIOS). He returned to Australia permanently in 1980 to direct the fourth *Biennale of Sydney*, has served on numerous art advisory boards (including for National Art School; Artspace management committee). He was deputy director of the AGNSW for around 9 years during which time he curated a number of exhibitions including *The British Show*, 1984; *Mayakovsky: 20 years of Work*, 1987 and a mid-career survey of Colin Lanceley. He resigned in 1991 to become a lecturer in gallery mangement at the College of Fine Art, University of NSW and director of Sherman Gallery's Goodhope gallery, Sydney.

APPTS: Lecturer and head of department at a number of colleges including Winchester School of Art, UK 1968–73; New York Studio School of Drawing, Painting and Sculpture 1975–77; dean, visual arts State University of NY 1979–80; director, *Biennale of Sydney*, 1981–1983; curator AGNSW 1982–91; lecturer, College of Fine Arts, University of NSW 1992– ; curatorial director Sherman Galleries 1992– .

REP: AGNSW; regional gallery Armidale; public collections UK, Europe.

WROBEL, Elinor Dawn

(b. 24/8/1933, NSW) Gallery director, conservator, curator.

She curated exhibitions on fabrics, textiles and theatre designs at Woolloomooloo Gallery and also for regional galleries in NSW, including Bathurst, Campbelltown, Orange, New England, Newcastle,

Davida Allen Sisters *1991, oil on marine board, 235 ×
210cm. Courtesy Australian Galleries, Melbourne.*

1980s–90s

Plurality and diversity best describe Australian art of
the 1980s and early 90s as the number of Australian
artists of a fresh generation increased and became ever
more linked to the international scene and styles.
Lindy Lee's streaky black faces using Renaissance
images typified post-modernist (q.v.) 'appropriation';
Jenny Watson and Davida Allen produced strongly
personal works; Joe Furlonger typified the neo-expres-
sionism (*see EXPRESSIONISM*) much practised in the mid
1980s as did Sally Smart's collages of the feminist
concerns based on traditional women's crafts. The frank
sexuality of Juan Davila's works were combined with
underlying social concerns; while artists such as Aleks
Danko combined painting with installations and other's
including Gordon Bennett combined their Aboriginal
heritage with an urban twentieth century experience
of Australia.

Right: *Jenny Watson* Self portrait as a narcotic, *1989, oil, ink, animal glue and collage of paper on linen canvas, 213.2 × 289.6cm. Collection, MCA, Sydney.*

Above: *William Robinson,* Morning landscape with neighbour's bull, *1991, 76.5 × 102cm. Courtesy, Ray Hughes Gallery, Sydney.*

Right: *Joe Furlonger* Madonna & Child, *1985, oil on canvas, 205 × 135cm, Courtesy Ray Hughes Gallery, Sydney.*

Far right: *Linda Marrinon,* Green Nude with Purple Vest, *1990, oil on canvas, 1377 × 183cm. Courtesy Roslyn Oxley9, Sydney.*

Below left: *Guy Stuart,* Road to Nambour, Qld, *1991, oil on canvas, 113 × 183cm. Courtesy, Australian Galleries, Melbourne.*

Left: *Mandy Martin,* Powerhouse, *1988, oil on linen, 230 × 280cm. Collection, Museum of Modern Art at Heide.*

Below: *Mike Parr,* Cubania 1, *1991, liftground aquatint etching from steel, set of 12 prints, overall dimension 214 × 468cm Edition of 5. Courtesy, Roslyn Oxley9, Sydney.*

Bottom right: *Sally Smart,* The Large Darn, *1991, oil and acrylic on linen, 193 × 193cm.*

Bottom left: *Lindy Lee* Heartbeat and duration, *1992, photocopy and acrylic on paper, 176 × 127cm. Collection, NGA.*

Left: *Vivienne Shark LeWitt $49.95, 1990, oil on linen, 55 × 71cm. Private collection.*

Below: *Rosalie Gascoigne* Rose Red City 1, *1992–93, Courtesy Pinacotheca, Melbourne.*

Above: *Aleks Danko* Day in day out (epitah version), *1992, galvanized steel, cast aluminium, acrylic, ink, paper, tracing paper, graphite, shellac, wood, glass. Courtesy, Watters Gallery, Sydney.*

Left: *Elisabeth Kruger* Won't leave me in peace, *1991, acrylic on wood, two panels 204 × 124cm. Private collection.*

Far left: *Juan Davila,* Mexicanismo, *1990, oil and collage on canvas, 280 × 434cm. Private collection.*

Above: *Gordon Bennett* The Nine Ricochets (Fall Down Black Fella, Jump Up White Fella), *1990, oil and acrylic on canvas and canvas boards, 220 × 182cm. Courtesy, Moet & Chandon Fellowship (winner 1991).*

Top: *Imants Tillers* Diaspora, *1992, synthetic polymer paint gouache, oilstick on canvas board panels, 305 × 914cm. Private collection.*

1979–92 as well as lecturing on the history of costume and textiles and conservation to many specialist interest and public groups. A former director of Newcastle Region Gallery (1983), she became a trustee of the Passmore collection and John Passmore's biographer. She and her husband Frederick collected works from the late 1840s to the present day, which they make availalable to public galleries such as S. H. Ervin Gallery, the AGNSW and regional galleries. She was costume consultant to theatre productions including by the Sydney Theatre Company and the Adelaide Festival and curated many retrospectives of individual artists for Woolloomooloo Gallery, and around 12 exhibitions on Percy Grainger, the composer, 1982–92, including at Newcastle Gallery 1983; Grainger Museum, Melbourne Uni. 1984, 88, 90, 91 and Biennale of Sydney 1990.

APPTS: Director, Woolloomooloo Gallery, 1984–92; conservator, costume, and consultant, textiles, National Trust, Sydney Opera House, Performing Arts Museum, Museum of Applied Science, 1971; Powerhouse 1984; Textile Museum of Australia; Grainger Museum, Melb. Uni., 1982–92.

WYLIE, C. R.

Heraldic artist on the Admiralty staff, –1924. He designed the coat of arms for the Federal Capital, as well as a flag for the Sutherland Shire Council, NSW, and wrote and illustrated *Seals and Armorial Bearings* in the *Australian Encyclopaedia*. In Oct. 1929 he read a paper, *The Heraldry and Symbolism of Australia*, to members of the Royal Historical Society.

WYNES, Maud

(b. 1880, Adelaide; d. 1951, Mt Lofty, SA) Painter. STUDIES: Adelaide, with James Ashton. Watercolourist. Under Ashton's influence her early work became concentrated on marine and coastal scenes around Port Adelaide. Her later work, under the influence of Heysen, Gwen Barringer and, most importantly, MacNally, was concerned with bush and pastoral scenes in the Adelaide Hills as well as blossom and flowers. She also painted on china.

BIB: Rachel Biven, *Some forgotten . . . some remembered*, Sydenham Gallery, Adelaide, 1976.

WYON, Allen

Sculptor. Modelled the original medal traditionally given to winners of the NGV Travelling Scholarship. J. S. and A. B. Wyon are recorded also as having designed a bronze medallion for the *International Exhibition*, Sydney, 1879.

YARRA SCULPTORS' SOCIETY

(Founded 1898, Melb.) The first society of sculptors in Australia. Original members included C. Douglas Richardson (president), C. Web Gilbert, W. C. Scurry, C. Y. Wardrop, J. McDonald, J. Fawcett, Margaret Baskerville, E. S. Smellie (hon. sec.). Regular exhibitions were held of sculpture and paintings. The society terminated shortly before World War I.
BIB: Moore, SAA.

YEE, Peter

(b. 1953, Sydney) Painter.
STUDIES: NAS, 1973–74; Alexander Mackie CAE, 1975–77; VCA, 1979. He exhibited new realist drawings in Sydney, Brisbane and Melbourne, 1977–79.
REP: NGV.
NFI

YIRAWALA

(b. 1894, Arnhem Land; d. 1976, Arnhem Land) Painter. An elder of the Gunwingu tribe, he inherited the designs and law of the Maraian Ceremony, of which he was the Dua Moiety head; he was also a leading song man and painter for Lorrkon Funerary Ceremony. One of the last of the great traditional tribal painters on bark.
(See also ABORIGINAL ART)

YOUNG, Bill

(b. 14/9/1952. Vic.) Artists' printmaker.
STUDIES: Dip. Fine Art (printmaking) CIT 1974. He has been a printmaker since 1975, including print commissions for PCA; Bicentennial Folio for Aust. Government 1988. He has produced editions of many well-known artists including Jon Cattapan, Louis Kahan, Roger Kemp, Maggie May, Nick Nedelkopoulos, Graham Peebles, Clifton Pugh, David Rankin, John Spooner.
APPTS: Printmaking technician CIT 1975–76; private etching classes Melbourne with well-known artists 1979–81; part-time lecturing printmaking Chisholm Institute of Technology 1983–89.

YOUNG, Blamire (William Blamire)

(b. 1862, Londesborough, Yorks.; arr. Aust. Jan. 1885;

d. 1935, Montrose, Vic.) Painter, designer, teacher, writer, critic.
STUDIES: Forest School, Walthamstow, UK; Pembroke Coll., Cambridge Uni. (grad. MA, 1884); Herkomer's School, Bushey, 1893 (few months only). His biographer, J. F. Bruce, described him as 'Six feet three inches high, aesthetic and virile, uniting the Cambridge manner with the Bohemian spirit – a picturesque and paradoxical personality.' He took an active part in the Fine Art Society at Cambridge and it was there, apparently, that he decided on a career in art. Destined by his parents for holy orders and a country parsonage, he escaped by successfully applying for the post of mathematics master 20,000km away – at Katoomba Coll., in the Blue Mountains of NSW. In 1887, with the assistance of the school principal, he built a luxuriously equipped studio in the college grounds and to it came, first, Phil May, then a whole coterie of artists and writers, including Godfrey Rivers and the newspaper proprietor Theodore Fink. At the school he proved a good teacher and produced Shakespearian plays in which he figured also as stage manager, scene painter, costume designer and actor. He also wrote sonnets and other verse after the manner of Swinburne, experimented with his painting techniques and composed a *History of the Popes*. Meanwhile Phil May returned to England, the studio was destroyed in a fire and in 1893 Young resigned his post and returned to England determined to be an artist. A short period with Herkomer was succeeded by work as a poster artist with the Beggerstaff Bros. (Nicholson and Pryde). Within two years he returned to Australia 'with a wife, a poster-virus and no money'. With Norman and Lionel Lindsay and Harry J. Weston, he learned lithography and how to cut designs from wood and linoleum. Their first poster was for Robur Tea, and the lessons learned during this period formed the basis of his future work. He moved to Vic., exhibited with the VAS, 1901–07, and went through some years of poverty and lack of recognition, the family (two small daughters) being sustained by his wife, a talented wood-carver. Success came with his exhibition at the Guild Hall, Melbourne, in 1911, followed a few months later by an exhibition in Adelaide. A visit to Tas. led to a further successful exhibition in Sydney, and in

that year, 1912, he took his family to England via Europe. His preparations for a London exhibition were interrupted in Aug. 1914 by the outbreak of World War I, in which he served as an instructor in musketry and gunnery. After the war he exhibited at the RA, and became a member of the Royal Society of British Artists and the Royal Inst. of Painters in Watercolours, before returning to Australia in 1923. He exhibited with the NSW Society of Artists and the Australian Art Association and was art critic for the Melbourne *Herald*, 1929–34. His watercolours are poster-like, romantic, poetic and remarkable otherwise for the complexity of their techniques, which involved a dripping and staining process on saturated paper. His work was represented in the Bicentennial exhibition, *The Great Australian Art Exhibition*.
REP: AGNSW; AGSA; NGV; QAG; TMAG; regional galleries Ballarat, Bendigo, Castlemaine, Geelong, Mildura.
BIB: Catalogue essays exhibitions as above and all books on Australian art history. Elly Fink, *The Art of Blamire Young*, Golden Press, Sydney, 1983. AA 1921 (J. F. Bruce, intro., *The Art of Blamire Young*).

YOUNG, Charles
(Active c. 1900, Vic.) Painter. Painting mainly landscapes, he was probably an amateur. His paintings are fairly conventional views of river and bush landscapes, done mostly in Vic., though he also worked in Tas. and NSW, the latter in 1906. By about 1915 he was in NZ, painting on the Wanganui River, and is recorded as living in Auckland in 1919.
BIB: Henry P. Newrick, *New Zealand Art Auction Records 1969–72*, Newrick, Wellington, 1973.

YOUNG, Elizabeth
See CAMPBELL, Jean

YOUNG, John
Founding director, Macquarie Galleries, Sydney.
See GALLERIES – COMMERCIAL – Macquarie Galleries

YOUNG, John
(b. 8/2/1956, Hong Kong) Painter.
STUDIES: BA, University of Sydney, 1977; Dip. Art, SCA; MA, University of Sydney. He based a series of paintings in the 1980s on the 'colour charts' of German Modernist Gerhard Richter – showing them on their own or mixed with images of a wide range of 20th century popular culture – such as the sentimental images seen on greeting cards. He held around 18 solo exhibitions 1982–93 largely at Yuill/Crowley, Sydney and City Galleries, Melbourne (the latter also producing a monograph on his work in 1993). He participated in numerous group exhibitions 1979–93 including *Australian Perspecta*, AGNSW, 1985, 91; *Moet & Chandon Touring Exhibition*, 1987, 88; *Eight Contemporary Views* touring ASEAN countries 1990; *ARCO '90* Spain, 1990; *Transformations*, Opening exhibition, MCA, Sydney 1991.
AWARDS: Residency, Power Studio, Cité Internationale des Arts, Paris, University of Sydney 1982; fellowship and residency, Paris, VACB 1986; project grant, 1988 and artists development grant 1991 VACB.

REP: NGA; AGNSW; AGWA; NGV; QAG; NGV; MCA, Sydney; MOCA, Brisbane; several university and many corporate collections.
BIB: Germaine, *AGA. A&A* 30/3/1993.

YOUNG, J. H.
(Active c. 1895–1910, Sydney) Painter. Committee member of the Art Society of NSW, where he exhibited from 1895 to 1910, showing mainly watercolour landscapes of Sydney, the harbour and surrounding country.

YOUNG, Michael
(b. 1945, Ballarat) Sculptor.
STUDIES: Ballarat School of Mines, 1963–67; travel studies, Europe and North Africa, 1970–73. On returning to Melbourne after his study travels, he worked as a draughting assistant for architects. His elegantly finished, streamlined, minimalist sculptures in stainless steel or aluminium brought his work into prominence in the competitive sculpture exhibitions of the decade 1965–75. He also experimented with earthworks before returning to the formalist concepts and minimalist forms on which his reputation is based.
AWARDS: Morwell prize (for drawing), 1967; Flotta Lauro prize, 1968; Alcorso Sekers prize, 1968; Dyason scholarship, 1971; *Mildura Sculpture Triennial* (acquisition award), 1970, 1975; VACB grant, 1975.
APPTS: Assistant Exhibitions Officer, NGV, 1968–69; lecturer on sculpture, part-time, RMIT, 1975– .
REP: NGA; NGV; regional galleries Ballarat, Langwarrin (McClelland Gallery), Mildura
BIB: Sturgeon, *DAS*. Scarlett, *AS*.
NFI

YOUNGER GROUP OF AUSTRALIAN ARTISTS
(Established 1924) Formed by Julian Ashton to help young artists unable to exhibit at the NSW Society of Artists' exhibitions because of over-crowding. Two exhibitions were held at Anthony Hordern's Gallery, Sydney, in 1924 and 1925. Original exhibitors included H. C. Gibbons, Norman Lloyd, Adrian Feint, Herbert Gallop and Guy (Frank) Lynch. At the 1924 show controversy was aroused by Lynch's bronze-rendered plaster *Satyr*, which was condemned by many as a 'pagan' work. It was acquired later for the AGNSW.
BIB: Moore, *SAA*.

YULE, John
(b. 1923, Melb.) Painter.
STUDIES: NGV School, 1944–45. His work was included in the exhibition of Australian art which toured South Africa in 1962. During the 1980s he accompanied groups of painters on outback painting expeditions.
AWARDS: Robin Hood prize, 1956.
APPTS: Senior tutor, CAE, Melbourne.
REP: NGA.
BIB: Barrie Reid, ed., *Modern Australian Art*, MOMAD, Melbourne, 1958. Germaine, *AGA*.
NFI

ZANDER TO ZUSTERS

ZANDER, Alleyne

Art patron. A friend of Will Dyson (q.v.), she did much to help Australian artists in London, and in 1933 took a British exhibition, including paintings by John, Sickert, Gill and the Nash brothers, to Australia. Her daughter married the Sydney painter, Carl Plate (q.v.). She wrote *The New Art of Planning*, *New South Wales Society of Artists' Book*, 1933.

ZELMAN, Victor

(b. 1877, Melb.; d. 1960) Painter.
STUDIES: NGV School, 1897–1901. He came from a family of musicians and began exhibiting at the VAS, Melbourne, in 1919; later his exhibitions at the Fine Art Society made his colourful, picturesque landscapes popular during the 1920s.
REP: NGV; regional galleries Ballarat, Castlemaine.
BIB: Moore, SAA.

ZIKA, Ditmas M.

(b. 1909, Prague, Czechoslovakia; arr. Aust. 1949) Stained glass designer, teacher.
STUDIES: Charles Uni., Prague. He served an apprenticeship in the stained-glass dept of Brooks Robinson & Co., Melbourne, 1951–55, and later established the San Damiano Art Studio, where, in company with William Gleeson (q.v.) and others, he made stained-glass windows and mosaics for churches.

ZIKA, Paul (David)

(b. 11/7/1949, NSW Painter, lecturer, curator
STUDIES: Ass. Dip. Fine Art (painting) RMIT, 1970; Fellowship Dip. Fine Art (painting) RMIT, 1971; TTC, State Teachers College, Hawthorn 1972; Certificate of Advanced Studies, St Martin's School of Art, London 1974. He curated exhibitions and produced catalogues for Tasmanian exhibitions including *Landscape* 1981; *On site* 1984; *Outgrowing Assimilation?*, 1991. He held 11 solo exhibitions 1973–92 Hobart (Chameleon); Melbourne (Powell St; Christine Abrahams); Brisbane (Roz MacAllan) and site work on Mt Nelson, University Fine Arts Gallery, Hobart. Group exhibitions in which his work appeared 1970–92 included Tasmanian public and private galleries and in *Australian Contemporary*

Printmakers Canada and USA touring exhibition, 1982; *Balance 1990* QAG 1990.
AWARDS: Exhibition and projects grants VACB 1980, 82, 82, 83, 89; research and development grants Dept of Construction and National Exhibitions Touring Scheme, Tasmania 1985, 86, 90, 91.
REP: QAG; MOCA, Brisbane; Artbank; a number of tertiary, regional collections Tas, Vic.
BIB: *New Art Six*.

ZIKARAS, Joe (Teisutis)

(b. 1922, Panevzys, Lithuania; arr. Aust. 1949) Sculptor, teacher.
STUDIES: Family studies. His father was Jouzas Zikaras, Dean of Sculpture, School of Fine and Applied Arts, Kaunas, Lithuania. Teisutis graduated from the school, 1943. He worked in glass and furniture factories in Vic. before assisting the sculptors Stanley Hammond and George Allen, 1952–56, and began teaching. His first exhibition, VAS, Melbourne, 1955, followed by his involvement with Centre 5 (q.v.), marked him as the forerunner of a new era in Australian sculpture. His sculptures in metal, wood and other materials embody, in sophisticated style, the flatness and rich symbolism of Lithuanian peasant art.
AWARDS: Barnet-McCutcheon prize for religious sculpture, VAS, 1955; Eltham prize for sculpture, 1965.
APPTS: Instructor, drawing and sculpture, Ecole des Arts et Métiers, Frieburg, Germany, 1946–48; lecturer in sculpture, RMIT, Melbourne, 1956– .
REP: NGA; NGV; TMAG; Auckland City Art Gallery, NZ.
BIB: Lenton Parr, *Sculpture*, Arts in Australia series, Longman, Melbourne, 1961 Sturgeon, DAS. Scarlett, AS.

ZIMMER, Jenny

Professor of art, critic, writer.
STUDIES: Assoc. Dip. Art & Design, RMIT; Fellowship Dip. Art, RMIT; BA, University of Melbourne; MA, Monash University. She has written widely on art history and Australian art for art journals, books and the general press including as critic for the Melbourne *Sunday Herald* and craft critic for the *Age*. She curated a number of exhibitions, has lectured widely, is a member of a number of professional bodies and occasionally

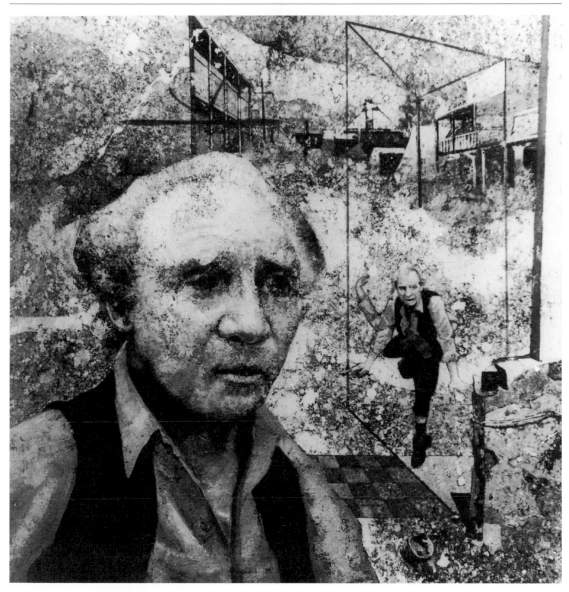

Reinis Zusters, Self Portrait in Sofala, *1981.*

accompanies archaeological surveys with the University of Melbourne to Syria and Turkey. She has contributed a number of essays to this book.

APPTS: Lecturer, art history RMIT 1975–87; Dean, School of Art and Design, CIT, 1987–90; Professor, School of Art & Design, Monash University, 1990–92; Associate Dean, Faculty of Arts, Monash University and director Monash Studios 1992– .

ZIMMER, *Klaus Rudolf*

(b. 31/3/1928, Berlin; arr. Aust. 1952) Stained glass designer, painter, printmaker, teacher.
STUDIES: Dip. Graphic Design, Berlin 1952; Dip. Fine Art, RMIT, 1966; Dip. Printmaking, RMIT, 1970; Grad. Dip., Chisholm Institute, 1987; MA, Chisholm Institute, 1989. A leading glass artist, he established the glass studios at Chisholm Institute (later Monash University). His many commissions for stained glass include five windows for the Presbyterian Church at Aspendale, Vic. He has held numerous workshops for glass, and exhibited widely including in numerou group craft exhibitions 1976–93.
AWARDS: Diamond Valley Art Award, 1983.
APPTS: Senior lecturer, Dept of Art and Design, CIT, Caulfield, Vic., 1979–86.
REP: NGV; Victorian State Craft Collection; Power House Museum, Sydney; a number of European public collections.
BIB: J. Zimmer, *Stained Glass in Australia*, OUP, 1984. Germaine, *AGA*. Numerous references in craft magazines and catalogue essays survey exhibitions.

ZOFREA, *Salvatore*

(b. 1946, Borgia, Italy; arr. Aust. 1956) Painter.
STUDIES: Julian Ashton School; with H. V. Justelius,

1961–66; travel studies, Europe and UK, 1971. Features of his otherwise surrealistic painting include sensuous, expressionistic colour and rich formal rhythm. A number of series have been based on religions and myths. His work has been seen in 35 solo exhibitions 1967–93 largely with Macquarie Galleries, Sydney. He participated in around 40 group exhibitions 1967–93 including numerous times in the *Blake*, *Archibald* and *Wynne* prizes. Known also as a portrait painter he has received a number of commissions for portraits of prominent people. He painted a five-panel mural for the State Bank of NSW, and a fresco commissioned by the Sydney Opera House Trust.

AWARDS: Sulman prize, AGNSW, 1977, 79, 82; Churchill Fellowship, 1986.

REP: NGA; AGNSW; Parliament House; New England, Orange, Mornington, Rockhampton regional galleries; The Vatican, Rome; tertiary collections including ANU; University of NSW.

BIB: A number of general books on Australian contemporary art including Bonython, MAP; Chanin, CAP; Smith, AP. S. Claire & A. Waldman (introduction by T. Maloon), *Salvatore Zofrea* Hale & Iremonger, Sydney 1983. A&A 19/3/1982 (Anna Waldman, *Salvatore Zofrea*).

ZUSTERS, Reinis

(b. 15/10/1918, Odessa, Ukraine; arr. Aust. 1950.) Painter.

STUDIES: Uni. of Riga and Riga Tech. Coll., Latvia; also Germany, Italy and NAS, 1950–52; travel studies, 1964, 68, 75. Beginning in Canberra, 1951, he held exhibitions in Sydney, Melbourne, Adelaide, Qld; also in Germany, Canada and New Zealand. At its best, his work is colourful, free and expressionistic. He worked as a draughtsman with the Dept of Works and Housing soon after arriving in Australia, then as a furniture designer and advertising artist, and exhibited with the Canberra Art Society and in 1981 *Spiral Visions* Holdsworth Gallery Sydney.

AWARDS: Hunters Hill prize, 1958, 59; Sydney *Daily Telegraph* prize, 1957; Wynne prize, 1959; Rockdale prize, 1962; Bendigo prize, 1963.

REP: NGA; AGNSW; AGSA; AGWA; QAG; TMAG.

BIB: Lloyd Rees, *Reinis Zusters*, Collins, Sydney, 1971.

Appendix 1

Collections: Private and Corporate

The first private collections arrived with early settlers. Frequently it was women like Elizabeth Macquarie, wife of Governor Lachlan Macquarie, who eased the trauma of relocation by bringing paintings, books, architectural plans and other artefacts which provided models for colonial art and architecture. Other early collectors were Tasmania's Lady Franklin, Melbourne businessmen E. L. Montefiore, banker, Sir George Verdon, artist, Carl Kahler and NGV director, L. Bernard Hall. Dame Nellie Melba and Dame Mabel Brookes were indefatigable collectors.

Joan Kerr's detailed publication DAA is sprinkled with references to diverse early collections. Works brought to Australia and commissioned by early settlers were later dispersed, or found their way into state and regional or university collections. Pastoral fortunes and success on the goldfields or in business, industry and the professions led to the development of more substantial private collections which, in a spirit of nationalism, first concentrated on colonial and early Australian painting and later supported Australian modernism.

Collections in Public Institutions

The following describes but a selection of colonial and modern Australian art which have found their way into public institutions. Major private collections now in state art galleries are also listed under GALLERIES.

CECIL ALLPORT, HOBART
Cecil Allport; Hobart solicitor and collector of colonial pictures established the Henry Morton Allport Bequest in the TMAG. Significant holdings of Allport family works.

JOHN WATT BEATTIE COLLECTION, LAUNCESTON
John Watt Beattie; Tasmanian photographer whose collected paintings, prints and drawings were purchased by the Launceston City Council in 1927.

BEHAN COLLECTION, BRISBANE
Collected by Dr Norman Behan, a Brisbane doctor and lifelong collector of Australian art from colonial to the 1950s. Around 100 works were presented to the Stuartholme Convent near Brisbane in the late 1950s and later he made a large gift of works of especially Qld contemporary paintings to the University of Qld gallery.

M. J. CARTER COLLECTION, ADELAIDE
The early Australian and impressionist works were bequeathed to the AGSA.

N & C. CHRISTESEN COLLECTION, MORNINGTON
Collection of works on paper, including drawings, posters, prints, watercolours and paintings of artists including Boyd, Counihan, Frater and Melbourne social realist artists from the 1940s, 50s presented to the Mornington Peninsula Arts Centre 1985–88.

J. H. CONNELL COLLECTION, MELBOURNE
John Henry Connell; hotel owner, grazier and his wife, Emily (Baker), gifted their collection of more than 800 pieces of decorative arts to the NGV in 1914.

COLLIE, HOLST AND EASTGATE COLLECTIONS, SWAN HILL, VIC.
Post 1960s Australian art in the Swan Hill Regional Gallery of Contemporary Art.

CHANDLER COVENTRY COLLECTION, ARMIDALE, NSW
Significant collection of Australian art given to the New England Regional Art Museum, NSW, by Chandler Coventry, Sydney art dealer and collector. Chandler Coventry then established a second collection.

J. V. DUHIG COLLECTION, BRISBANE
Dr J. V. Duhig gave his collection of books and paintings to the Uni. of Qld.

S. H. ERVIN BEQUEST, SYDNEY
Collection of Australian art from colonial to the 1940s is installed for public access in Sydney's S. H. Ervin Gallery.

S. A. EWING COLLECTION, MELBOURNE
Dr Samuel Arthur Ewing's collection of Australian painting 1890–1940 was given to the Uni. of Melbourne.

JAMES FAIRFAX COLLECTION, SYDNEY, CANBERRA, MELBOURNE
This major collection of Australian and overseas art has now been partly gifted to the AGNSW, the NGV and the NGA.

RUSSELL AND MAB GRIMWADE COLLECTION, MELBOURNE
This collection is a major holding of the Museum of Art, Uni of Melbourne.

HOWARD HINTON COLLECTION, ARMIDALE
Shipping magnate Howard Hinton's collection of 1000 paintings and 700 books is now in the New England Regional Art Museum, Armidale, NSW.

CLAUDE HOTCHIN BEQUEST WA
Dedicated to develop WA collections it has benefited the Fremantle Arts Centre and the Albany, Geraldton and Narrogin Art Galleries among others.

ARTHUR AND CAROLINE HOWARD COLLECTION, VIC.
This collection of 593 works of Australian art and Australiana given to the state of Vic. in 1978 is on permanent loan to various Victorian public galleries.

THE W. R. JOHNSTON TRUST, MELBOURNE
Established in East Melbourne and dedicated to Georgian and Regency decorative arts.

MACK JOST COLLECTION, HORSHAM, VIC.
Collection of Australian art gifted to the Horsham Art Gallery.

LEDGER COLLECTION, BENALLA, VIC.
Comprising 180 works, 1880–1930, gifted to the Benalla Art Gallery.

GERALD AND MARGO LEWERS BEQUEST, PENRITH, NSW
This magnificent gift of building and art works forms the basis of the Penrith Regional Art Gallery.

JACK MANTON COLLECTION, MELBOURNE

This collection of historic Australian art was given to the NGV in the 1970s and previously shown at Banyule before returning to the main NGV collection in the Gallery after Banyule's closure.

THE MERTZ COLLECTION

Two hundred paintings by 84 Australian painters put together by Kym Bonython for American Harold E. Mertz between 1964 and 1966. In 1967 it was shown in the Corcoran Gallery of Art, Washington DC after which it travelled the States before being presented to the American public.

DAVID SCOTT MITCHELL COLLECTION, SYDNEY

Much of it Australiana, the 61,000 artefacts were given to the Mitchell Library, Sydney when established in 1907.

DOUG MORAN PORTRAIT COLLECTION

Acquired through a prize, the works are held in the Tweed River Regional Art Gallery.

BAILLIEU MYER COLLECTION, MELBOURNE

Australian works of the 1980s and 1990s given to the Museum of Modern Art at Heide in 1992.

REX NAN KIVELL COLLECTION, CANBERRA

This London-based archaeologist and collector gave his huge collection of more than 160,000 items of Australiana to the NLA, Canberra in 1957.

JAMES ODDIE ENDOWMENT, BALLARAT, VIC

James Oddie, 19th century gold-digger, businessman and patron of the arts gifted works by Eugene von Guérard and important Eureka artefacts to the Ballarat Fine Art Gallery.

PARNELL AND POPE COLLECTIONS

Historic Australian paintings given to the Newcastle Region Art Gallery.

J. W. POWER BEQUEST, SYDNEY

Contemporary international and Australian art and 700 drawings by J. J. W. Power, previously administered by the Uni. of Sydney and now through the MCA, Sydney.

JOHN AND SUNDAY REED, MOMAD COLLECTION MELBOURNE

The Reeds gave their considerable collection of modern Australian works to Melbourne's MOMAD in 1958. The collection reverted to the Reeds in 1966 after which some were gifted to the NGA and others sold to the state of Vic. in 1979. Now in the MOMA at Heide, Vic.

ALAN RENSHAW BEQUEST, SYDNEY

A collection of Australian art at the S. H. Ervin Gallery, Sydney.

HERBERT BUCHANAN SHAW COLLECTION, HAMILTON, VIC

A major collection of decorative arts given by wealthy local grazier.

BOB SREDERSAS GIFT, WOLLONGONG

Collection of traditional Australian paintings now in the Wollongong City Gallery.

LUCY SWANTON COLLECTION, SYDNEY AND CANBERRA

Works collected by Lucy Swanton of Macquarie Galleries were bequeathed to the AGNSW and the NGA.

MARY TURNER COLLECTION, ORANGE, NSW

Collection of 20th century Australian paintings now in the Orange Regional Gallery.

ARTISTS' & DEALERS, COLLECTIONS

Some Australian artists' collections are now held in public galleries: they include a collection of *William Dobell Drawings*, AGNSW; the *Russell Drysdale Collection*, Albany Regional Art Centre; the *Lionel Lindsay Collection*, Uni. of Qld.; the *Norman Lindsay Collection*, Norman Lindsay Gallery and Museum, Faulconbridge, NSW; *Sidney Nolan, Works on Paper*, Nolan Gallery at Lanyon, ACT and the *Lloyd Rees Collection*, Bathurst Regional Art Gallery. Art dealers like Melbourne's Joseph Brown, Clinton Tweedie, Charles Nodrum, Brisbane's James Baker, Perth's Rose Skinner and Sydney's Rudy Komon also

created important private collections. (*see* Patrick Hutchings, A&A 12/2/1974)

COLLECTIONS OF NON-AUSTRALIAN WORK

Some distinctive private collections of works other than Australian have made significant contributions to public museums and galleries. They include *The Leonhard Adam Collection of Ethnographic Art*, Melbourne Uni. Museum of Art; *The J. R. Bow Memorial Collection of Old Master Paintings and Engravings*, Mildura Art Gallery; *African Art from the William Bowmore Collection*, Maitland City Art Gallery; the *Burdekin and Salvana Collection of 19th century British Oil Painting*, Tamworth City Art Gallery; the *Burnell Print Bequest*, Monash Uni.; the *Crouch Collection of Medieval Manuscripts*, Ballarat Fine Art Gallery; the *Daniel Gift of 16–20th Century Engravings*, Albury Regional Arts Centre; the *Gaussen Collection of Paul Sandby Etchings*, Hamilton Art Gallery; the *H. W. Kent Collection of Oriental Ceramics*, NGV; the *Ernst Mathei Collection of Historic Glass*, Melbourne Uni. Museum of Art; the *Neptune Scott Collection of Barbizon School Paintings*, Bendigo Art Gallery; the *Nicholson Collection* of more than 700 Egyptian, Greek, Roman and Etruscan anti-quities, the Nicholson Museum, Uni. of Sydney; the *Keith and Norman Deutscher Collection of Wedgwood Ceramics* partly gifted to the NGV; and the A. de V. Rubin Collection of Modern French Painting, QAG.

COLLECTIONS DISPERSED

Private collections are frequently dispersed. For example, the contents of William Howard's West Melbourne house took Joel's six days to auction in 1935 while Sir Keith Murdoch's collection was dispersed following his death in 1953. In 1990 the collection of Queenslanders Sir Leon and Lady Trout, with its notable paintings by Charles Conder and John Peter Russell, was divided between the QAG and the art market. Others that have been dispersed include the *George Page-Cooper Collections* of Australiana and S. T. Gill's work, the *Ruwdt Collection* of colonial to Heidelberg School paintings, which was sold at Joel's Auctions in 1966 and the *Forge Family Collections* some of which is now held by the new Victorian Uni. of Technology. The Newcastle-based *William Bowmore Collection* has been partly dispersed and the impressive *Alan Bond (Dallhold) Collection* of early colonial to 1940s Australian art, was sold at Christie's in 1992. Dr Clifford Craig's collection of Tasmanian paintings and prints, was auctioned at Christie's in 1975.

PRIVATE COLLECTIONS IN THE 1990S

Collectors include: Western Australians Dr Harold Schenberg, Dr Roy Constable, Salek Mink, Sue and Ian Berndt and financier Kerry Stokes who has begun a superior office collection with historical works; Victorians Maurice Callow, collector of English 19th century watercolours and Elizabeth Summons, collector of modern drawings; NSW's Mitty Lee Brown and Oscar Edwards, and the Sydney-based *Agapitos/ Wilson Collection of Surrealist Art* and the *James Erskine Collection of International Contemporary Art*.

Other major private collection initiatives include:

THE ELIOT ALDRIDGE COLLECTION, SOUTH AUSTRALIA

Pastoralist Aldridge collected from Heidelberg School to Brett Whiteley.

THE BESEN COLLECTION OF AUSTRALIAN CONTEMPORARY PAINTINGS AND SCULPTURE, MELBOURNE

Developed by Romanian-born company director Marc Besen (q.v.) and his wife, Eva. The works span more than four decades – from Dobell to Whiteley. Besen also provided sponsorship for exhibitions at the NGV and made generous gifts to other public galleries.

THE WILLIAM BOWMORE COLLECTION, NEWCASTLE

Dalby-born, of Lebanese parents, began collecting Australian art in the 1930s and after 1967 changed to European old

master drawings and Mediterranean anti-quities. His collection has been partly dispersed. The Australian section includes many Whiteley drawings.

THE JOSEPH BROWN COLLECTION, MELBOURNE
Dr Joseph Brown (q.v.) was born in Poland in 1918. After success in business he established the Joseph Brown Gallery and began to build his collection in 1967. Located first in Collins Street, then in South Yarra, he became a consultant to many public galleries and private collectors. Several editions of the book on the collection *Outlines of Australian Art* have been published since 1973.

THE MARGARET CARNEGIE COLLECTION, MELBOURNE
In its first six years, from c. 1960, this collection grew to some 400 works including tribal artefacts and contemporary Australian painting. Margaret and her husband Douglas Carnegie's patronage at that time, greatly assisted the development of post-war modernism in Australia. In recent years Margaret Carnegie's collection of, and research into, contemporary Aboriginal painting has been of great benefit. Parts of her collection have been gifted to public galleries.

THE LEONARD COX COLLECTION
A major collection of decorative and oriental arts acquired by Dr Cox.

THE ROBERT AND JANET HOLMES À COURT COLLECTION
One of the country's finest collections, it has three main components: Western Australian Art, Contemporary Australian Art and Aboriginal Art.

THE W. J. HUGHES COLLECTION, WA
Famed for its acquisition of *Golden Summer, Eaglemont (1890)*, the first Australian painting to sell for a price in excess of one million dollars, and currently on loan to the NGA.

CORPORATE COLLECTIONS
From the 1950s, but increasingly in the 1970s, along with prizes, scholarships, commissions and other forms of support for the arts, the corporate sector has assisted rapid cultural development by establishing major collections. In the 1980s many business organisations operating in Australia experienced exponential financial growth. Encouraged by the Federal government's 'taxation incentives for the arts' they initiated or upgraded their collections or supported the visual arts by contributing to umbrella organisations, like the Art Foundation of Victoria or the Business Council of the NGV.

Some corporations accentuate their collecting policies to promote public relations and community service opportunities. Others, like many private collectors, maintain low profiles. Their aggregated efforts have significantly improved opportunities for artists working in Australia and improved the ambience of the workplace, corporate and public buildings and public spaces by making art accessible.

Artist Biron Valier, who conducted Australia Council-supported research on corporate collectors in Australia, suggests that there were in 1993 more than 140 companies with notable holdings, although the economic downturn of the 1990s may have caused some to cease or reduce their collecting activities. The *Budget Young Australians Collection*, for instance, has been disbanded. In *Artfile* (Sydney, 1992), Valier points out that corporations sometimes develop and then donate entire collections to public galleries. Examples are the CSR *Photography Collection* given to the AGNSW. Two collections of contemporary Australian art acquired under the terms of the *Philip Morris Arts Grant* have been gifted to the NGA.

The following information on major corporate collections has been selected from Valier's research, also published in the 1990–91 edition of the *International Directory of Corporate Art Collections* (Artnews, New York). This listing indicates that Australia has a very respectable record of corporate art collecting compared with other countries with 83 per cent of art collecting corporations preferring contemporary art.

ALLEN ALLEN & HEMSLEY, SYDNEY
Collection of more than 400 contemporary works acquired since 1978 and located in the MLC Centre. Administered by Mr Hugh H. Jamieson.

ANZ BANK
Collection commenced in 1835 and contains major historical works. Contemporary works have been selected by Will Bailey with advice from Dr Joseph Brown. Now more than 150 significant works are located at Collins Place.

BHP MELBOURNE
Over 600 contemporary Australian works begun in 1972, selected by Kim Bonython and Anne Purves and located at head office, Melbourne and offices in Brisbane and Perth. In the 1980s and early 1990s the collection took on a very contemporary emphasis.

BP AUSTRALIA
A collection of contemporary Australian art started in the late 1980s. Adviser: Karyn Lovegrove.

COMALCO LIMITED, MELBOURNE
An important collection begun c. 1960 with acquisitions of major modernist painters and sculptors. Located in the Melbourne office and in the USA.

COMMONWEALTH BANKING CORPORATION, SYDNEY
Collection of more than 100 works begun in the 1930s and combining historical and contemporary works.

COLES MYER COLLECTION, MELBOURNE
Begun in the 1950s, Australian historical works.

CRA LIMITED, MELBOURNE
More than 900 works collected from c. 1962 and including Fred Williams' *Pilbara Series* 1979–81. Located in offices.

A. W. FABER-CASTELL (AUST.) PTY LTD, SYDNEY
A drawing collection begun in 1938 as the result of an annual award and located in head office.

JOHN FAIRFAX LIMITED, SYDNEY
More than 180 works representing 150 years of Australian art. Begun in 1970, and complemented by prize-winning paintings from *The Sydney Morning Herald Art Prize and Scholarship Prize* (since 1978). Located in Fairfax building.

FOSTERS BREWING GROUP LTD (FORMERLY ELDERS IXL LIMITED), MELBOURNE
A collection of more than 400 works begun in the 19th century by pastoral companies Elder Smith Goldsbrough Mort and the Henry Jones IXL companies. The Elders IXL *collection* of about 65 works dated c. 1835 to 1970 and purchased between the mid-1950s and mid-1970s continues the pastoral theme. Works are located at head office in Melbourne, and offices in Sydney and Adelaide.

GADENS RIDGEWAY, SYDNEY
Around 160 works, mainly contemporary Australian, begun in 1965 and located in offices in Sydney, Brisbane and Port Moresby, PNG.

HYATT ON COLLINS, MELBOURNE
More than 500 contemporary Australian paintings and prints located throughout the hotel. Emphasis on abstract works and collected from 1986.

ICI AUSTRALIA LIMITED, MELBOURNE
Begun in 1954, a collection of more than 400 Australian works from colonial times to the present selected on advice from Dr Joseph Brown, Chris Deutscher and John Jones with the *Younger Artist* collection selected by Robert Lindsay and Bill Wright.

JGL INVESTMENTS, MELBOURNE
A major collection put together by the Leiberman family.

NATIONAL AUSTRALIA BANK COLLECTION, MELBOURNE
A collection of 368 works begun in 1975 it comprises *The Seventies Collection* and art works acquired in merger with the Commercial Banking Company of Sydney in 1981. Its consultant was Mr Georges Mora.

RESERVE BANK OF AUSTRALIA, SYDNEY
Collection of more than 400 modern Australian works including Aboriginal bark paintings begun in 1949 and discontinued in the 1970s.

THE RURAL AND INDUSTRIES BANK OF WESTERN AUSTRALIA LIMITED, TH
Begun in 1976 it is a collection of more than 400 items of Australian painting and sculpture featuring Western Australian artists.

SGIO, PERTH
Collection of 120 paintings, sculptures and graphics begun in 1981.

THE SHELL CO. OF AUSTRALIA LTD, MELBOURNE
Begun in 1988 with a large Arthur Boyd commission and places emphasis on younger Australian artists. Selected by Robert Lindsay and Penelope Seidler.

TRANSFIELD PTY LIMITED, SYDNEY
Collection of 60 contemporary paintings and sculptures begun in 1961 and including winners of the *Transfield Art Prize* (1961–71).

WESFARMERS LIMITED, PERTH
More than 150 works, colonial to contemporary, begun in 1980 and selected with advice from Dr Joseph Brown.

WESTPAC BANKING CORPORATION, SYDNEY
Collection of more than 600 items, historical and contemporary, begun in 1970, including works from the Commercial Bank of Australia after merger in 1982.

Other corporate collections
Other significant corporate collections include *GPT/General Property Trust*, Sydney (international works selected by Harry Seidler); *Hoechst Australia Limited*, Melbourne (prize-winning textile works); *IBM Australia Limited* (contemporary Australian works); *Eve Mahlab Pty Ltd*, Melbourne (contemporary Australian painting and sculpture); *MLC Life Limited*, Sydney (Australian and international works selected by Harry Seidler); *Parmelia Hilton International*, Perth (Australian painting, sculpture and antique furniture); *Qantas Airways Limited*, Sydney (contemporary Australian and Aboriginal works); *Australian Playboy*, Sydney; *Ashton Scholastic Pty Ltd*, NSW (children's book illustrations); *Corio 5 Star Whisky Prize Collection*, Geelong (important discontinued contemporary art award).

OTHER SIGNIFICANT COLLECTIONS
Other important collections, neither corporate nor individual, include those of clubs like Victoria's Melbourne Club, the Savage Club, the Athenaeum Club and the Australian Club, Sydney – all of which acquire from time to time and occasionally sell. Their collections are mainly of traditional and historical works. Otherwise, as noted under UNIVERSITIES, most Australian universities have developed good collections, sometimes incorporating the collections of former teachers' colleges and colleges of advanced education.

E*XHIBITIONS*

Exhibitions significantly influencing Australian art and developments began with the first colonial exhibitions held within the country, followed by the International or Intercolonial exhibitions through which Australian art gradually became known overseas. In 1851, the *Great Exhibition of London* was held in the Crystal Palace. It was followed in European cities and also in the booming gold-city of Melbourne, where the first Exhibition Building, situated in William St and modelled on the lines of the Crystal Palace, was built in 1854 specially to display the Australian exhibit for the Paris *International Exhibition* of 1855.

In 1879 the Garden Palace (q.v.) was built in Sydney for Australia's own first *International Exhibition*. The Garden Palace was destroyed by fire three years later (1882) taking with it the entire 1882 exhibition of the Art Society of NSW. Much grander in scale than the Garden Palace were the Exhibition Buildings designed by Joseph Reed and erected in Melbourne for the *International Exhibition* which opened 1 Oct. 1880. The buildings cost £320,000, an £800 fountain designed and made by Joseph Hockgurtel and landscaped gardens covering a 30 hectare site on the north-eastern perimeter of the city. Both the Sydney and Melbourne exhibitions were important landmarks in Australian art history. Several state galleries obtained the nucleus of their collections from the Melbourne exhibition and the young artists who were to create the Heidelberg School were certainly influenced by it.

During the first half of the twentieth century milestone exhibitions included the 1939 *Herald Exhibition of Twentieth Century British and European Art*, the 1945 *Australia at War* and the 1953 *French Painting Today* exhibitions. Between 1960 and 1980 international exhibitions which had an impact on Australia included the 1966–67 *Two Decades of American Painting*; the 1975 *Modern Masters: Manet to Matisse*, and important Australian exhibitions included the 1968 *The Field* exhibition to mark the opening of the new NGV.

During the mid 1970s a succession of huge 'blockbuster', exhibitions began to appear in Australian state galleries. They had been made possible through indemnity granted by the Federal Government and the formation of Art Exhibitions Australia Ltd (q.v.) in Sept. 1976. During the 1980s a huge explosion of exhibitions by Australian artists in a wide variety of media, periods and styles occurred, the greatest number and most comprehensive being those for Australia's Bicentennial year in 1988. Several biennials (notably the *Sydney Biennale* and *Perspecta*) and triennials such as the *Australian Sculpture Triennial* also became established as regular events during the 1980s and have become important on-going survey shows.

E*XHIBITIONS FROM 1845*

The aim here is to list exhibitions of outstanding public interest and to pinpoint in chronological order those in public galleries which have helped to shape the character and direction of Australian art. The list is, of course, by no means complete.

1845
First exhibition held in Australia. It was organised by John Skinner Prout and held in the Legislative Council Chambers, Hobart. Opened 6 Jan. 1845, with loan paintings and local work by Mary Morton Allport, Thomas Bock, F. R. Nixon, J. S. Prout, F. G. Simpkinson. In all, 276 works.

1846
Exhibition organised by Thomas Vaughan Hood, who built a large gallery adjoining his house. Opened 24 May 1846, Hobart.

1847
An artists exhibition Organised by S. T. Gill, with various contributing artists, and opened Adelaide 3 Feb. 1847.

1847
The inaugural exhibition of the *Society for the Promotion of Fine Arts*, Sydney, held in the Australian Library, Bent St, Sydney; opened 22 June 1847. Contributing artists: Abrahams, Angas, Brierly, Elyard, Garling, Martens, Nicholas, Prout, Rodius, Winstanley. A number of loan works was also included.

1848
Launceston, Tas. Mechanics Institute. John Glover was among the exhibitors.

1849
Second exhibition, *Society for the Promotion of Fine Arts*, held in a room in Barrack Square, Sydney. Among the exhibits were portraits by Richard Read of Sir Richard Bourke and Dr Bland.

1853
Melbourne. Inaugural exhibition, *Victorian Fine Arts Society*; opened at the Mechanics Inst., 20 Aug. 1853. Artists included Claxton, Hart, Martens, Prout, Woolner.

1855
International exhibition Paris, 1855. The first occasion on which Australian art was officially shown in Europe. Abrahams, Angas, Dexter, Ironside, Martens and Terry (qq.v.) were among the artists represented.

1857
Inaugural exhibition, SA *Society of Arts*, held in Legislative Council Chambers, Adelaide. J. A. Adamson awarded a ten guinea prize for his *First Steamboat on the Murray*.

1857
Mechanics School of Art Exhibition (previously attributed as being the Third exhibition, Society for the Promotion of the Fine Arts) held at the Mechanics School of Arts, Sydney. 7 Jan. 1857. Exhibitors included Campbell, Dexter, Gill, Ironside, Terry.

Vic. Society of Fine Arts, Exhibition Building, William St. First and only exhibition of this society it included works

by Chevalier, Clark, Dexter, Gilfillan, Hart, Georgiana McCrae, Scurry, Strutt and von Guérard.

1859

State Library of Vic. Statues and reliefs bought in London exhibited in a small room in the Library building to begin the collections of the NGV. (*See* GALLERIES).

1861

Intercolonial Exhibition Melbourne, for Kensington, UK. Australia had a New South Wales court in the Kensington international exhibition of 1862; Andrew McCormac was awarded a gold medal, George Rowe was awarded a medal for his panoramic paintings of the Victorian goldfields and Adelaide Ironside gained an honourable mention.

1864

State Library of Vic., Melbourne. Exhibition in the first, small gallery of the NGV, opened 24 Dec. 1864; 43 works by painters resident in Australia entered for a 200 guinea prize, won by N. Chevalier for his oil, *Buffalo Ranges, Vic.*

1866

Intercolonial Exhibition Melbourne, for Chicago. J. H. Carse is recorded as having won a gold medal.

1870

Inaugural exhibition, *Vic. Academy of Arts* (q.v.) at the State Library of Vic.

1872

International Exhibition Melbourne, for Kensington, UK. Inaugural exhibition, NSW *Academy of Arts*, Chamber of Commerce; opened 5 Mar. 1872.

1875/6

Intercolonial Exhibition prelimary showing Melbourne 1875; Philadelphia 1876. Australia was well represented with committee of art experts responsible for the selection of art works including: T. T. a'Beckett (chairman), John Blair, O. R. Campbell, Hubert de Castella, William Johnson, Johnson Hicks, J. A. Panton and R. Twentyman. The following passages from the text of the catalogue indicate the hopes and aspirations of the organisers: 'But a few years have elapsed since Australian art emerged from its swaddling clothes. The first stage of its progress has been as marvellously rapid as the growth of the magic shrub germinating from the tiny seed sown by the cunning hand of the Oriental juggler. Buvelot follows closely the footsteps of a school adopted by two modern compatriots [Millet and Corot] who, however, are little known out of France. What they have done for France, M. Buvelot is doing for Victoria.' Among other exhibitors, William Ford and J. H. Carse gained first-class certificates, H. L. Van den Houten, 'a prolific paysagiste', a second-class certificate, and Mrs John C. Caffyn a special second-class certificate, all awarded by the Victorian Academy of Fine Arts. Others represented included Chester Earles ('the only figure painter'), A. B. Balcombe, T. Wright ('excellent but careless'), von Guérard, Isaac Whitehead, J. S. McKennal, O. R. Campbell, J. W. Curtis, H. J. Johnstone.

1879–83

International Exhibitions Garden Palace, Sydney and Royal Exhibition Buildings Melbourne 1 Oct. 1880. The Melbourne show comprised 493 art works including paintings, sculpture, engravings and stained glass, 206 of them by local artists. Austro-Hungary, Belgium, France, Italy, Germany and the UK were among the principal countries participating in the exhibition, which included manufactured articles of all kinds as well as large representations of art works. The Australian court included paintings by von Guérard, Buvelot, Ford, Van den Houten, the Ashton brothers, Reilly, Panton, and two young artists, Richardson and Roberts.

Art Society of NSW exhibitions. First 3 exhibitions convened by the Art Society of NSW (later the Royal Art Soc. of NSW) held 1880–1883. The third exhibition was lost when fire destroyed the venue (the Garden Palace) on 22 Sept. 1882.

SA Inaugural Exhibition, Port Adelaide Gallery, the first Australian provincial gallery. Initiated by E. Phillips, the exhibition opened 27 July 1880.

1884

Inaugural exhibition organised by James Oddie for the *Ballarat Fine Art Gallery* (q.v.).

1886

Australian Artists Association (q.v.), Melbourne. First of three exhibitions held by the group.

1888

Inaugural exhibition VAS, Melbourne opened Grosvenor Gallery, Collins St, in April 1888; 155 works were shown.

1888

Qld Art Society (later Royal Qld Art Society) inaugural exhibition, Masonic Hall, Brisbane.

1889

9 × 5 Impression Exhibition The most famous and controversial exhibition in early Australian art history, was opened on 17/8/1889. It had been organised by Tom Roberts who hired Buxton's Gallery in Swanston St, Melbourne and framed the works uniformly in mitred pieces of Californian red pine moulding. The cedar cigar box lids on which the works were done had been supplied (for reasons also of economy) by Louis Abrahams, whose father conducted a cigar importing business – easily transportable they enabled the Heidelberg artists to capture swift, on-the-spot impressions of the changing light and atmosphere. The exhibition opened in some style; special decor and musical programmes were arranged, attractive young women volunteered to serve tea, and Conder designed an 'art nouveau' catalogue cover. Numbers of works listed in the catalogue are: Roberts 62, Conder 46, Streeton 40, Richardson 26 (including 6 sculptured impressions), McCubbin 5, Falls 3, Daly 1. The exhibition caused considerable controversy. The most influential critic of the day, James Smith of the *Argus*, wrote that the work was 'too ephemeral for consideration', and went on to castigate all aspects of the exhibition, to which criticism the artists replied in a spirited joint letter in the *Argus*, 3 Sept. 1889. Other critics supported the exhibition, the columnist, Edward Vidler, having publicised it in advance in detailed week-by-week accounts of its organisation in *Table Talk*, Melbourne, 19 July–23 Aug. 1889. These conflicting attitudes drew public attention to the exhibition with the result that all the pictures were sold, though at very low prices.

1892

First exhibition in the new VAS building, 430 Albert St, East Melbourne. A press report gave it that 'last night's [27 May] event is . . . the most important event in the art history of the colony'.

1892

International Exhibition Exhibition Buildings, Melbourne, and in 1893 Chicago. J. H. Carse was awarded a gold medal.

1895

NSW *Society of Artists* inaugural exhibition at the York St Skating Rink, Sydney. Opened 28 Sept. 1895.

1897

First award made in the *Wynne Prize* exhibition, AGNSW. (*See* PRIZES)

1898

Grafton Gallery Exhibition of Australian Art London. Organised by Julian Ashton with expenses (£750) donated by Edith Walker. Large collection of works by contemporary Australians. Shown from 2 Apr. to 7 May 1898.

1898

Inaugural exhibition, *Yarra Sculptors Association* (q.v.). First exhibition of Australian sculpture.

1901

Federal Exhibition NSW Society of Artists, Shown Jan. 1901 in celebration of Federation. All states were represented except WA.

1905
Woombellana (later the Women's Art Club, q.v.) inaugural exhibition, Melbourne.

1907
NSW *Society of Arts* exhibition, Sydney. First appearance of work by the Lindsay brothers, Lionel and Norman, as well as J. J. Hilder, S. Ure Smith, making this exhibition one of the most memorable in the Society's history.

1907
NSW *Society of Artists* exhibition at the Guild Hall, Sydney. NGV paid a record 150 guineas for Norman Lindsay's pen-and-ink *Pollice Verso.*

Australian Exhibition of Women's Art Exhibition Buildings, Melbourne. Initiated by Lady Northcote, it opened 23 Oct. 1907. Prizes went to Ruby Lindsay and Constance Jenkins, and commendations to Clara Southern, Gwen Barringer, Vida Lahey, May Gibbs, Blanche Murphy, as outstanding representatives of their states.

1914
Panama Pacific Exhibition Melbourne and San Francisco. *International exhibition* Awards went to Jessie Traill (gold and bronze medals), Bernard Hall, Cumbrae Stewart, M. Roxburgh (silver medals), Violet Teague (bronze medal), H. B. Harrison, Leslie Wilkie (hon. mention). (*See* INTERNATIONAL AND INTERCOLONIAL EXHIBITIONS)

1918
AGNSW Convenor, G. V. F. Mann (q.v.), *loan exhibition* of Australian art covering 30 years.

Australian War Art Grafton Galleries. London. Artists: Bryant, Crozier, Lambert, Leist, Power, Quinn.

1921
First *Archibald Prize* exhibition, AGNSW. (*See* PRIZES) Education Dept Gallery, Australian Painter-Etchers' Society inaugural exhibition. Opened 7 June 1921.

1923
European Contemporary Pictures Touring exhibition, Australian states. Organiser, Penleigh Boyd. Work mostly by British artists.

Exhibition of Australian Art Burlington House, London. Organised by S. Ure Smith for the NSW Society of Artists and assisted by the Governor-General, Lord Forster. The idea of having the show arose from praise accorded the magazine *Art in Australia* by London critics. The organisation was attended by endless difficulties, mainly because of the emphasis on the art of now. A group of Vic. artists applied unsuccessfully to the courts for an injunction to prevent the departure of the exhibition until further selections were made, and in NSW a deputation went to the Minister for Education, asking for the exclusion of works by Norman Lindsay on moral grounds. The sum of £2423 was raised, mainly through the activities of the Society of Artists, which included two exhibitions, an artists' ball, and private donations of £915. The expenses of the exhibition, which was managed in London by Elioth Gruner, came to £2198, and the remaining £225 was used to revive the Society of Artists Travelling Scholarship. Writing about this contentious show in retrospect, the British critic Hesketh Hubbard, in *One Hundred Years of British Painting 1851–1951* (Longman, London, 1951) had this to say: 'The Australian exhibition which followed [1923] was respectable but not distinguished, though the word "respectable" was hardly applicable to the salacious drawings of Lionel Lindsay, before which long queues slowly shuffled'. (Hubbard apparently meant Norman, not Lionel, Lindsay.)

1924
Australian Paintings and Sculpture Faculty of Arts Gallery. It included works by Madge Arnold, L. A. Arnold, David Barker, H. Brodzsky, Anne E. Bulleid, Arthur Burgess, A. Baker-Clack, Bessie Davidson, Edith M. Fry, Bessie Gibson, Jessie Gibson, C. E. James, Marion Jones, W. A. Kermode, Max Martin, Miguel McKinlay, T. Swan, Sir Thomas Robinson.

1925
Australian Art Exhibition Spring Gardens Gallery, London. The following works are listed in the catalogue: eight by A. Baker-Clack, two by J. Hodgson Lobley, five by James F. Scott, two by Gordon Coutts, seven by Edith M. Fry, three by Marion Jones, 11 by Horace Brodzsky, one by A, S. H. Picking, three by Laurie Taylor, one by Max Martin, one by Will Dyson. A favourable press reaction to this exhibition, notably the *Daily Mail* and *Daily Herald*, London, praised the works of Dyson, Martin, Brodzsky and Baker-Clack.

1928
Australian Artists' Work Imperial Gallery of Art (Imperial Institute), London. The Imperial Gallery of Art was established from funds given by Lord Duveen. The exhibition included work by Lambert, Longstaff, Streeton, Gruner, N. Lindsay, Young, Margaret Preston, Florence Rodway, Thea Proctor, Heysen, Hall, W. Ashton, Wheeler, Goodchild, Moore and Bell.

1930
Exhibition of Australian Art Roerich Museum, New York, paid the costs of an exhibition of 100 Australian pictures. Organised by Mary Cecil Allen through the Commissioner-General for Australia, Herbert Brookes. The pictures were selected from the Australian Art Association, NSW Society of Artists and the Royal Art Society of NSW. Mary Cecil Allen toured and lectured on the exhibition in 14 cities of the USA.

1933
British Art. Touring exhibition. Organised for Australia by Alleyne Zander and shown in Sydney and Melbourne (Sedon Gallery).

1936
International Art Exhibition AGNSW. The paintings were obtained by consulates of different countries and included work by Matisse, Marquet, Utrillo, Vlaminck, Munch and many academic painters.

1938
One Hundred and Fifty Years of Australian Art Commemorative exhibition held at the AGNSW.

1939–40
French and British Contemporary Art Touring Australia. Organised by the critic Basil Burdett for the Herald and Weekly Times, Melbourne. Crucial in its effects on Australian art developments, it gave young Australian artists particularly their first glimpse of *School of Paris* original paintings. The 215 works shown included: Bauchant 2, Bonnard 6, Braque 4, Brianchon 1, Caillard 2, Cavailles 1, Ceria 2, Cézanne 7, Chagall 1, Chirico 1, Dali 1, Derain 3, de la Fresnaye 1, Dufresne 1, Dufy 4, Ernst 1, Friesz 3, Gauguin 8, Gris 1, Grommaire 2, Kars 2, Laurencin 3, Laceger 2, Luce 1, Limouse 1, Lurcat 2, Laprade 2, Manguin 2, Marquet 2, Matisse 8, Milich 2, Modigliani 2, Oudot 1, Pascin 1, Picasso 9, Poncelet 2, Prax 1, Redon 1, Rouault 2, Segonzac 7, Seurat 2, Signac 6, Soutine 1, Toulouse-Lautrec 1, Van Gogh 8, Utrillo 6, Valadon 3, Vallotton 2, Van Dongen 3, Vlaminck 3, Vuillard 5, Waroquier 2. There were also sculptures by Despiau, Malliol, Zadkine, and the British sculptors, Epstein, Lambert and Dobson, as well as paintings by 27 leading British painters including John, the Nash brothers, Spencer, Mathew Smith, Sickert, Steer, Sutherland, Tonks, Wadsworth and two Australian-born painters, John Joseph Wardell Power (catalogued as John William Power) and Derwent Lees. The final part of the organising of this exhibition was completed under difficult wartime conditions and, to make matters worse, the ship carrying the show ran aground off the coast of Tasmania. It was refloated at high tide and the exhibition finally opened in Hobart late 1939. More important was its opening at the Town Hall, Melbourne, on 16 Oct. 1939. It created an unprecedented furore in both

Melbourne and Sydney where the conflict between academics and moderns had already reached a climax. The final result of the exhibition was that, like the *Armory Show* of New York (1913), it changed the direction of art throughout a continent and established a basis for the development of an entire generation. A few of the pictures were sold and the rest remained in storage in Australia for the duration of the war.

1945

Australia at War Shown in the state galleries of Sydney and Melbourne. Convenors: Artists' Advisory Panel, Vic., War Artists' Council, NSW, and CEMA. Prizes totalling £1000 were given in various sections. (*See* PRIZES)

Australian Present Day Art Organised by Clive Turnbull for the Melbourne *Herald* and shown in the *Lower Town Hall, Melbourne, 13–27 Feb. 1945.*

1950–55

Dunlop Prize exhibitions. (*See* PRIZES)

1951

Jubilee Exhibition of Australian Art Toured all Australian state galleries. Organised by Laurence Thomas for the Plastic Arts Committee. Presented as a historical survey exhibition, it included 141 works from Aboriginal and Colonial art through to work by Dobell, Drysdale and Nolan.

Art on Wheels Queensland touring exhibition, organised by Robert Haines. To give people in outlying country districts an opportunity of seeing original art works in the state collection, a train was fitted as an art gallery and sent on a tour of Qld.

1952

Carnegie International Exhibition Pittsburgh, USA. Four Australians – William Dobell, Sidney Nolan, Donald Friend and Russell Drysdale – were included. The Australian exhibit was unfavourably received by the international jury of critics. James Thrall Soby, director of the Museum of Modern Art, New York, found 'Australian art years behind the times'. The artists 'did not yet appear to have fully absorbed the art of Europe'. Eric Newton (Britain) and Jean Bazaine (France) found Dobell 'wearing the outmoded shoes of Renoir'. Nolan's *Burke at Cooper's Creek* was 'too topographical . . . inventive but technically careless'. Friend's *Fountain of Youth* was 'too compartmentalised', and Drysdale's *Emus in Landscape* was 'the most original'.

Indian Art Exhibition Toured state galleries. Organised for the All India Fine Arts and Crafts Society and sponsored by the Government of India; 143 historical and modern Indian works, including painting, sculpture and crafts.

1953

French Painting Today Comprised 123 works, including 119 paintings and four tapestries. Picasso, Chagall, Matisse, Braque, Masson, Gromaire, Manessier, Marchand, Rouault, Leger and Miró were among the artists represented. Arranged between the French and Australian Governments through the boards of trustees of the Australian state galleries; organised by the director of the AGNSW, Hal Missingham. M. Claude Bonin-Pisarro accompanied the exhibition, but had the disadvantage of being unable to speak English. Like the modern exhibition of 1939, it caused spirited discussion and exerted a powerful, lasting influence on the work of Australian artists. Itinerary: state galleries in Hobart (Jan.–Feb.), Sydney (Mar.–Apr.), Brisbane (Apr.–May), Melbourne (June–July), Adelaide (Aug.), Perth (Sept.).

1955–59

Australian Women's Weekly Portrait Prize exhibition. (*See* prizes)

1956

Italian Art of the Twentieth Century Arranged between the Italian Government, the boards of trustees of the Australian state galleries and the boards of directors of the Sydney *Morning Herald*, the Melbourne *Herald*, the *Adelaide Advertiser*, the *West Australian*, the Brisbane *Courier-Mail* and the Hobart *Mercury*. Organised by Hal Missingham, director of the AGNSW, and Daryl Lindsay, director of the NGV. Itinerary: Perth (Mar.–Apr.), Adelaide (May–June), Melbourne (July), Hobart (Aug.–Sept.), Sydney (Oct.), Brisbane (Nov.–Dec.). The exhibition comprised 139 paintings and 16 sculptures. Represented artists included the Futurists, Balla, Boccioni, Severini, Sironi and Prampelini, as well as the 19th century painters Campigli and Carra. The sculptures of Marini, Martini and Fazzini made a particularly powerful impression and left a lasting influence on Australian sculpture.

French Tapestries Modern tapestries from Aubusson shown at state galleries in Sydney and Melbourne. The first exhibition of modern tapestries shown in Australia, it aroused great excitement and admiration, and influenced many contemporary Australian painters to take a practical interest in tapestry design.

Recent German Graphic Art Touring exhibition comprising 140 examples, shown in the print sections of Australian state galleries.

Orcades A travelling exhibition of Australian painting organised by Hannah Fairfax for the National Gallery Society of NSW, in conjunction with the Orient Line of Steamers. It included paintings by Passmore, Boyd, French, Miller, Rose, Olsen, Kemp, Eric Smith and other leading painters. James Gleeson sailed on the *Orcades* and gave lectures on board as well as for TV and radio in various ports, including Auckland, Honolulu, Vancouver, San Francisco. At the conclusion of the tour, the pictures were shown at the AGNSW.

1957

Contemporary Canadian Painters An exhibition comprising 55 paintings, organised through the National Gallery of Canada for circulation among Australian state galleries.

Australian Art Organised jointly by the Australian state galleries for showing in Canadian galleries. It was shown in three Canadian cities – Winnipeg, Montreal and Toronto. Exhibitors included Boyd, Blackman, Brack, Carington Smith, Dobell, Doutney, Drysdale, French, Friend, Guy Grey-Smith, Miller, Molvig, Nolan, Passmore, Eric Smith, Jean Bellette and Margo Lewers.

1958

Contemporary Japanese Art Comprised 95 paintings and 29 examples of craft work. Arranged by the Japanese Government in conjunction with the Australian state galleries and organised by the director of the AGNSW, Hal Missingham. Itinerary: Opened in Sydney and then went to Melbourne, Adelaide, Perth and Hobart. Main effect on Australian audiences was to illustrate the striking developments in contemporary Japanese art after World War II.

American Artists of the North West Toured Australian state galleries. Four painters – Mark Tobey, Morris Graves, Guy Anderson, Kenneth Callahan – and four sculptors – David Hare, Rye Carpan, Ezio Martinelli and Seymour Lipton.

Helena Rubinstein Travelling Scholarship exhibitions (1958–66) Shown in Sydney (Melbourne, 1960). (*See* PRIZES)

1959

Recent Paintings: Seven British Artists Organised for the British Council in conjunction with Australian state galleries. Itinerary: state galleries in Brisbane (Feb.–Mar.), Sydney (Mar.–Apr.), Melbourne (May), Hobart (June), Adelaide (July), Perth (Aug.). The seven artists were: Alan Davie, Merlyn Evans, Terry Frost, William Gear, Roger Hilton, Keith Vaughan, Bryan Winter.

The Antipodean Exhibition VAS, Melbourne. An exhibition was held in August of the paintings of Charles Blackman, John Brack, Arthur Boyd, David Boyd, Robert Dickerson, Clifton Pugh and the historian Bernard Smith who had formed a group in Melbourne in 1959 to exhibit works of figurative expressionism. (*See* ANTIPODEANS)

1960

Australian Aboriginal Art Major exhibition of traditional bark paintings. Organised by Tony Tuckson (q.v.) and toured to Australian state galleries Aug. 1960–June 1961. It had a profound and lasting effect in promoting understanding and appreciation of Aboriginal bark painting. Selected works from it were sent (at the behest of the Commonwealth Art Advisory Board) to the *Bienale de São Paulo*, Brazil, 1961.

1961

Mildura Sculpture Triennial Comprised 45 contemporary Australian sculptures. Initiated by the director, Ernst van Hattum, at the Mildura Arts Centre. The first attempt to present a major exhibition of Australian sculpture on a national scale. (*See also* GALLERIES, MILDURA ARTS CENTRE)

Trends in Dutch Painting Organised by Eric West-brook in conjunction with the Netherlands Government and shown first at the NGV, Melbourne, as a contribution to the celebrations marking the centenary of the Gallery. Comprising 60 paintings from Van Gogh to present-day painters, it introduced the work of the Cobra school to Australia (specifically the work of Appel and Corneille) as well as work by the older artists of the De Stijl movement.

Whitechapel Exhibition of Australian Painting, London. In 1959 the director of the Whitechapel Gallery, Bryan Robertson, made a selection of Australian contemporary paintings during a tour of Australian capital cities, through direct contact with gallery directors, artists and critics. The resulting show constituted a milestone in the history of Australian painting by confirming and adding greatly to the status of individual Australians who had already achieved recognition in London and New York. Paintings by the veteran Godfrey Miller, and the comparatively unknown painter Brett Whiteley, were acquired for the Tate Gallery collection. The status of painters such as Nolan, Tucker and Drysdale was greatly enhanced, and the names of Boyd, French, Blackman, Passmore, Fairweather and many others became known to the British public.

Transfield Art Prize exhibitions (1961–70). (*See* PRIZES)

1963

Georges Invitation Art Prize exhibitions (1963–70). (*See* PRIZES)

Tate Gallery Exhibition of Australian Art, London. Shown Feb. 1963. A full-scale official exhibition of Australian art covering colonial to contemporary periods – organised by Robert Campbell for the Commonwealth Arts Advisory Board, Canberra, at the request of the director of the Tate Gallery, Sir John Rothenstein. A preliminary showing took place at the AGSA to coincide with the 1962 Adelaide Festival of Arts, and largely as a result of press reviews in Melbourne and Sydney, the exhibition was modified in some departments and added to in others, before proceeding to a final Australian showing in Perth (AGWA) at the time of the Commonwealth Games. British press coverage of the show was extensive and widely varied in its opinions. The popular press gave the exhibition unqualified praise, the official London art world accorded it courtesy tempered with caution, the intellectual press was lukewarm, and in some cases hostile (*New Statesman*, 15 Feb. 1963). Robert Campbell and Jean Young who wrote the book on the exhibition (*Antipodean Vision* Cheshire, Melbourne, 1962) accompanied the exhibition to London, and contemporary Australian artists present at the opening were presented to H.M. The Queen. A final summary of opinion regarding the effects of the show suggested that, despite reservations, Australian art had weathered the test of this important official occasion.

Recent British Sculpture Organised through the British Council for showing in Australia, New Zealand and Canada. Shown in Australian state galleries, 1963. Sculptors represented: Robert Adams, Kenneth Armitage, Reg Butler, Lynn Chadwick, Hubert Dalwood, Barbara Hepworth, Bernard Meadows, Henry Moore, Eduardo Paolozzi. As a represen-

tation of one of the great sculpture movements of our time its influence on local sculpture and on public taste in sculpture was extensive and lasting.

1966

Alcorso-Sekers Travelling Scholarship exhibition. (*See* PRIZES)

Two Decades of American Painting (1966–67) Organised by Waldo Rasmussen for the Museum of Modern Art, New York, and shown in five cities: Tokyo, Kyoto, New Delhi, Melbourne and Sydney. The exhibition started in Tokyo in Oct. 1966 and was shown at the NGV, Melbourne, 5 June to 14 July 1967, and at the AGNSW, Sydney, from 17 July to 13 Aug. 1967. The exhibition consisted of 98 huge canvases by Albers, D'Arcangelo, Bluhm, Davis, Francis, Frankenthaler, Gorky, Gottlieb, Guston, Held, Hofmann, Johns, Katz, Kelly, Kline, De Kooning, Lichtenstein, Louis, Mitchell, Motherwell, Newman, Noland, Pollock, Poons, Rauschenberg, Reinhardt, Rivers, Rosenquist, Rothko, Stella, Still, Tobey, Tomlin, Twombly and Warhol. It had a powerful effect on the public and resulted in many controversial letters to the newspapers, as well as exerting wide influence on Australian artists, especially young painters who had their first viewing of original work by members of New York and Post-Abstract-Expressionist schools.

1968

The Field Inaugural exhibition of Australian art at the new NGV (temporary exhibitions gallery). Opened 20 Aug. 1968. The glamorous, illustrated catalogue sponsored by Philip Morris (Aust.) Ltd included writings by Brian Finemore, Royston Harpur, Elwyn Lynn, Patrick McCaughey and John Stringer. Forty artists, 18 of whom were aged 30 or under, were represented in paintings or sculpture. The exhibition aroused much controversy, some critics seeing it as a timely catalyst ushering in a new era of development, while others saw it as a return to an imitative style.

1969

Three Trends in Contemporary French Art Organised through the French Government and the French Embassy, Canberra, by the French Cultural Attaché, Henri Souillac. Comprised 66 works shown at the NGV, Melbourne, 28 Apr.–1 June 1969.

1970

Air Exhibition of inflatables. Sponsored by Philip Morris (Aust.) Ltd. Organiser, James Harithas. Shown at NGV, Melbourne, 17 June–19 July; AGSA, Adelaide, 7 Aug.–29 Aug.; Hordern Pavilion, Sydney, 15 Sept.–26 Sept. 1970.

Perth Prize for Drawing (*See* PRIZES) Organiser, Lou Klepac. Presented at the AGWA, Perth, the exhibition, comprising a large number of local and overseas drawings, introduced new, international standards of art in WA.

Recent British Painting Stuyvesant Trust (q.v.); toured state galleries 1970.

Portrait of Mexico Organised through the Government of Mexico for the Adelaide Festival of Arts, 1970, and toured through the state galleries with assistance from the Australian Government. Comprised 190 works dating from the pre-classical civilisation, 1500–100 BC, to present-day paintings.

Travelodge Art Prize (1970–73 Melbourne & Sydney.) (*See* PRIZES)

1971

From Cezanne to Picasso: 100 Drawings Organised by William S. Lieberman for the MOMA, New York, and shown at Auckland City Art Gallery, NZ, and NGV, Melbourne.

Bonnard Forty paintings. Organised through the Fondation Wildenstein (Aust. rep., Georges Mora) and shown at the state galleries in Melbourne (opened 13 May 1971), Adelaide, Sydney, Perth.

Italian Painting 1940–60 Organisation: Italian Government through the Italian Embassy, Canberra, and the Italian Cultural Inst., Melbourne. Comprised 84 works. Toured Australian state galleries, 2 June 1971–7 May 1972.

Morris Louis Organised by David Armitage of the Auckland

City Art Gallery. Australian itinerary: NGV, Melbourne, 8 July–31 Aug. 1971.

Scultura Italiana Stuyvesant Trust (q.v.). Comprised 60 works by modern Italian sculptors. Toured to nine Australian state and regional galleries, 1971–72.

1973

Biennale of Sydney (q.v.). First of a regular event, this international exhibition was held at the Sydney Opera House Gallery. It attracted a number of interesting contributions from Asian countries as well as major works from Australian artists.

Contemporary American Prints Comprised 61 works. Presented throughout Australia by the United States Information Service.

MPAC *Spring Festival of Drawing* First biennial Festival of Drawing conducted at the Mornington Peninsula Arts Centre, Mornington, Vic. (*See* GALLERIES)

Hommage à Jean Lurcat. Stuyvesant Trust (q.v.). Seventeen 78 large tapestries toured to state and regional galleries, June 1973–Nov. 1974, and 1978.

1974

Paul Klee Organisers, VACB with assistance from Pro Helvetia, Switzerland. Comprised 83 works. Shown at the state galleries of Adelaide, Sydney and Melbourne.

Graphic Art of German Expressionism Organisation: 75 Institute of Foreign Cultural Relations, Germany. Comprised 115 catalogue works. Toured state and regional galleries, Australia and NZ, 1974–75.

1975

Modern Masters: Manet to Matisse Organiser: International Council of the MOMA, New York, and shown at the AGNSW, Sydney, 10 Apr.–11 May; NGV, Melbourne, 28 May–22 June 1975. Comprised 113 works. The exhibition attracted record attendances at both exhibitions.

Australian Women Artists: One Hundred Years, 1840–1940 76 Comprised 71 works. Convenor: Kiffy Carter. Research by Janine Burke. Itinerary: Ewing and George Paton Galleries, Uni. of Melbourne, 2–27 Sept. 1975; AGNSW, 9 Oct.–2 Nov.; Newcastle Region Art Gallery, 4–29 Dec.; AGSA, 17 Jan.–10 Feb. 1976.

1976

Biennale of Sydney Organised by Tom McCullough, the second Biennale concentrated on sculpture with many interesting works being shown at the AGNSW with sessions devoted to performance art in surrounding parks.

Textiles of Indonesia Organiser: Indonesian Arts Society conjointly with the NGV. Comprised 95 works, shown at the NGV, Melbourne, and regional galleries of Victoria.

Sculpture of Thailand Organised for the Adelaide Festival of Arts and shown at state galleries beginning Mar. 1976. Comprised 112 works.

Australian Art in the 1870s, AGNSW. Large survey exhibition organised by Daniel Thomas.

Fernand Léger Organisation: International Council of MOMA, New York, VACB of the Australia Council, with sponsorship from Caltex Oil (Aust.) Pty Ltd. Comprised 45 works. Toured state galleries Adelaide, Sydney, Melbourne, 1976.

Barlach/Kollwitz Touring exhibition, Stuyvesant Trust (q.v.). 78 Forty-nine sculptures toured state and regional galleries, Feb. 1976–Feb. 1978.

1977

The Chinese Exhibition The $189m. collection of archaeological treasures, dating from the time of Peking Man, 500,000 years ago, was made possible through the Government of the People's Republic of China and its Ministry of Culture, the Australian Government, the Australian state galleries of Melbourne and Sydney and the Australian Art Exhibitions Corporation Ltd. It opened at the NGV, Melbourne, 15 Jan.–6 Mar. 1977, before moving to the AGNSW, Sydney, its only other venue. In both cities it attracted huge crowds and, despite the heavy expenses of freight, mounting, compre-

hensive 130-page catalogue, staffing and other costs, it yielded a substantial profit in admission charges, catalogue and other sales. The Exhibition Director was John Stringer.

The Heritage of American Art Organised by the Metropolitan Museum of Art and American Federation of Arts, sponsored by Esso Australia Ltd and assisted by the Visual Arts Board of the Australia Council, it was shown at the NGV, Melbourne, 30 Mar.–8 May 1977, and AGNSW, Sydney, 1 June–10 July 1977. Documented in a 240-page illustrated catalogue, the exhibition gave Australians their first view of original work by 78 nineteenth and twentieth century American painters. Besides Cassat, Copley, Duvenek, Eakins, Hassam, Henri, Homer, Innes, Kuhn, Luks, Peale, Remington, Sargent, Sloan and Whistler, the paintings bore the names of many other artists previously unknown in Australia.

Master Drawings from the Albertina Organiser: David Thomas; AGDC; AGSA; Albertina, Vienna, and Austrian Government. Comprised 75 drawings from fourteenth to twentieth centuries. Itinerary: state galleries Adelaide, 29 Apr.–29 May; Sydney, 17 June–10 July; Melbourne, 21 July–21 Aug. 1977.

Heroic Years of Australian Painting, 1940–65 (1977–78) Organiser, Alan McCulloch; exhibitions director, John Anderson; sponsors, Herald & Weekly Times and Victorian Government (Ministry for the Arts and Education Dept). Comprised 73 paintings from Dobell to Whiteley. Opened Melbourne Town Hall before touring 16 Victorian regional galleries and two state galleries, Adelaide and Perth, Apr. 1977–Oct. 1978.

Jean Arp (1977–78) Organisers: Madeleine Chalette Lejawa (who also designed the catalogue), and the AGDC. Shown at the state galleries of Adelaide, Sydney, Melbourne, Perth and QVMAG, Launceston.

British Painting 1600–1800 (1977–78) Organised through the British Council for the AGDC, with sponsorship from the *Age*, as a contribution to the Silver Jubilee celebrations. Itinerary: AGNSW, Sydney, 7 Oct.–20 Nov. 1977; NGV, Melbourne, 7 Dec. 1977–15 Jan. 1978.

1978

Hermitage and Tretyakov Master Drawings and Watercolours (1978–79) Comprised 107 works (57 Old Master and 50 modern drawings). Organised and presented by AGDC, with assistance from VACB and Dept of Foreign Affairs, and shown at the NGV, Melbourne, 27 Oct.–13 Dec. 1978; AGNSW, Sydney, 3 Feb.–25 Mar. 1979.

El Dorado: Colombian Gold Organised by the Australian Art Exhibitions Corporation in conjunction with the Banco de la Republica's museum, the Museo del Oro, Bogotá, Colombia, the exhibition comprised 200 related ceramic and stone pieces. It opened at the AGSA, Adelaide, 24 Feb. 1978 and was shown in all Australian state galleries except the TMAG, Hobart. The exhibition attracted much public interest but not enough to cover expenses and a considerable loss was incurred.

Aspects of Australian Art, 1900–40 NGA touring exhibition. Comprised 81 works, Piguenit to Nolan. Toured Victorian regional galleries.

Australian Crafts Organised for the Crafts Board of the Australia Council and toured by the AGDC throughout Australia, 1978. Comprised 116 works in ceramics, fibre, jewellery and other crafts. Itinerary: AGSA, 25 Feb.–27 Mar.; AGNSW, 13 Apr.–14 May; Caulfield Arts Centre, Vic., 30 May–2 July; TMAG, 8 Aug.–10 Sept.; Brisbane Civic Art Gallery and Museum, 10 Oct.–12 Nov.; Undercroft Gallery, Uni. of Perth, 4–24 Dec. 1978.

Contemporary Australian Drawing (1978 Perth Survey of Drawing). AGWA. Organiser, Lou Klepac. Comprised 96 drawings, Dobell to Williams.

Morandi Etchings, AGWA. Organiser: Lou Klepac. Opened AGWA, Oct. 1978.

Emile-Antoine Bourdelle Stuyvesant Trust (q.v.) exhibition toured state and regional galleries through AGDC 1978–79.
The Colonial Eye Included 237 catalogue works, 1798–1905. Organised by Barbara Chapman for the AGWA, 29 Aug.–7 Oct. 1979, and shown also at Bunbury, Albany, Kalgoorlie and Geraldton, WA, Oct.–Dec. 1979.
Biennale of Sydney Organised by Nick Waterlow, the third Biennale was entitled *European Dialogue*. Its exhibitions included a major survey show of contemporary European drawing at the AGNSW, and many indoor and outdoor performance pieces by European and Asian artists.
Sickert Etchings Organiser: Lou Klepac. Itinerary: AGWA, 5 June–1 July; Uni. Gallery, Melbourne, 11 Sept.–21 Oct. 1979.

1979

Sodeisha Avant-garde Japanese ceramics, 62 pieces. Presented by the AGDC, and sponsored by the Crafts Board of the Aust. Council and Sodeisha (Japanese ceramic group), and the Japanese Foundation. Shown at state galleries Sydney, Perth, Adelaide, Darwin; regional galleries, Newcastle and Wollongong, and at the Brisbane Civic Art Gallery and Caulfield Arts Centre, Melbourne, Sept. 1979–Jan. 1981.
USSR Old Master Paintings Organisation: AGDC and NGV, assisted by the Australian Government and Australia Council. Carried out under the terms of the Australia-USSR Cultural Agreement and sponsored by Commercial Bureau (Australia) Pty Ltd. Comprised 61 works, 46 European and 15 Russian from the state Hermitage, Leningrad; A. S. Pushkin State Museum of Fine Arts, Moscow; the State Russian Museum, Leningrad; and State Tretyakov Museum, Moscow. Itinerary: state galleries in Melbourne, 17 Oct.–2 Dec. 1979; Sydney, 12 Dec.–10 Feb. 1980.

1980

Australian Drawings of the Thirties and Forties Organised by Bridget Whitelaw and shown at the NGV, Melbourne. Comprised 106 drawings.
Image and Idea British ceramics. Organised by the British Council for the AGDC and the Crafts Board of the Aust. Council. Fourteen ceramic artists represented: Astbury, Baldwin, Ruth and Alan Barrett-Danes, Barton, Bennett, Britton, Burnett, Crowley, Fritsch, Lowndes, Poncelet, Rogers, Swindell. Itinerary: state galleries, Brisbane, 3 Jan.–3 Feb.; Hobart, 9 June–6 July; Melbourne, 1 Aug.–31 Aug.; Perth, 5 Dec.–9 Jan. 1981; Adelaide, 6 Feb.–8 Mar.; regional galleries, Newcastle, 11 Apr.–11 May; Shepparton, 12 Sept.–12 Oct.; Museum of Applied Arts and Sciences, 22 Feb.–23 Mar. 1982.
Contemporary Australian Printmakers Assembled by the Print Council of Australia and toured in the USA and Canada. Comprised 70 prints by 35 contemporary print-makers.
Art Nouveau in Australia. Comprised 145 works. Organised by Ron Radford for the AGDC, with sponsorship from the Crafts Board of the Aust. Council. Shown at the Ballarat Fine Art Gallery, 6 Feb.–4 Mar.; NGV, Melbourne, 21 Mar.–20 Apr.; QAG, Brisbane, 19 May–22 June; S. H. Ervin Museum and Art Gallery, Sydney, 17 July–17 Aug. 1980.
Pompeii A.D. 79 Touring NGV, AGSA, AGNSW (1980–81). Opened NGV, June 1980.
Leonardo, Michelangelo and the Century of Genius Master drawings from the British Museum. Organised for the AGDC conjointly with the AGSA with assistance from the Australian Government (indemnity) and VACB of the Australia Council. Itinerary: state galleries, Adelaide, 1–30 Mar. 1980; Melbourne, 11 Apr.–25 May 1980.

1981

Australian Sculpture Triennial Originated by Tom McCullough (q.v.) at the Preston Inst. of Technology and La Trobe Uni. campus with assistance from the Vic. Ministry for the Arts and VACB.

1982

Australian Perspecta AGNSW. First biennial of Australian contemporary art.

Biennale of Sydney The fourth Biennale was entitled *Vision in Disbelief* and organised by William Wright. Central venue was the AGNSW, the concentration of exhibitions being on New Figuration art and its natural corollary Performance art.

1983

The Great Eighteenth Century Exhibition NGV. Comprising 700 objects (including paintings, drawings, sculpture and the decorative arts) from the NGV collection it was the first 'internal blockbuster' exhibition initiated by director Patrick McCaughey. Held at NGV July 1983.
Australian Perspecta AGNSW 12 May–26 June, 1983. Second biennial of contemporary Australian art. Bernice Murphy curator.
Australian Art of the Last Ten Years, the Philip Morris Arts Grant ANU 11–28 October, 15 December 1983–27 March 1984. Curated NGA displaying works of contemporary Australian artists purchased under the Grant.
Continuum Exchange between Australian and Japanese artists. Co-ordinators Judy Annear, Ken Scarlett.

1984

Biennale of Sydney Fifth Biennale, entitled *Private Symbol: Social Metaphor* AGNSW 11 April–17 June. Director, Leon Paroissien. Theme of personal modes of expression, painting, photography, sculpture, installations and included an ancillary exhibition *Dreams, Fears and Desires* of Australian works 1942–62.
A Century of Australian Landscape – Mood and Moment AGNSW 22 May–15 July. Comprised 58 landscape oils from 1830s–1930s. Curated by Barry Pearce of the AGNSW and managed by the ICCA it toured China in 1983 before coming to the AGNSW April–May, 1984.
The Great Impressionist Exhibition NGA and touring. Comprising 100 works from the Courtauld Institute including works by Manet, Monet, Bonnard, Cézanne, Gauguin, van Gogh.
A Melbourne Mood: Cool Contemporary Art ANU. 3 July–4 August. Curated by the NGA it examined the work purchased by James Mollison in 1969, the first year of the Commonwealth Art Advisory Board purchasing for the as then unbuilt NGA.
Koori Art Now Contemporary Art Space, Sydney. 30 contemporary urban and tribal artists using European media and techniques.
Picasso NGV 29 July–23 Sept.; AGNSW 10 Oct.–2 Dec. 1984. 175 works. Included those from the Tate, MOMA; the Pompidou Centre; National Gallery of Washington; Guggenheim Museum.
Australian Sculpture Triennial Second triennial held in Melbourne. Summer 1984–85. Called *Australian Sculpture Now*. Director Graeme Sturgeon. Venue: NGV.
Art and Social Commitment: An End to the city of dreams 1931–48 AGNSW 22 Sept.–28 Oct. Curator Charles Merewether. 100 works from public and private collections included expressionism, realism, surrealism 1931–48.
John Kaldor Art Projects: An Australian Accent AGNSW 15 Dec. 1984–26 Jan. 1985. Curator John Kaldor. Australian artists Unsworth, Parr, Tillers work as seen first in NY.

1985

Pop Art 1955–70 AGNSW 27 Feb.–14 April. Works by US, UK and European artists including Lichtenstein, Oldenburg, Rauchenberg, Warhol, Rosenquist, Caulfield, Hockney. ICCA, MOMA and AGNSW organised.
The British Show AGNSW 23 April–9 June. Contemporary British art of 46 artists curated W. Wright & T. Bond (AGNSW).
Claude Monet: Painter of Light touring state galleries. Curated John House & Virginia Spate brought to Australia by ICCA.
Golden Summers – Heidelberg and Beyond NGV 30 October–27 January 1986; AGNSW 21 Feb.–20 April 1986;

AGSA 9 May–29 June 1986; AGWA 30 July–14 September 1986. Organised by the NGV. Managed by the ICCA. Curators Jane Clark and Bridget Whitelaw. 150 works. One of the most highly attended Australian-originated exhibitions in the 1980s, included most major works by the artists of the Heidelberg School.

Turner Abroad touring state galleries exhibition of Turner watercolours. Curator, Andrew Wilton.

Australian Perspecta AGNSW and other venues 24 October–8 December. Third biennial of Australian art. Curator, Tony Bond. Comprised 150 works.

1986

Biennale of Sydney Sixth Biennale called *Origins, Originality and Beyond*. 16 May–6 July. Director Nick Waterlow. Works by 111 international artists.

Print as Object Touring PCA print show major art venues all states 1986–88. Work by 22 artists. Demonstrated the wide variety of printmaking techniques on unusual fabrics – with intriguing results.

Backlash: The Australian Drawing Revival 1976–86 NGV. Curator Ted Gott. Significant smaller survey exhibition of drawings of 41 Australian artists.

Nolan: Landscapes and Legends; A Retrospective Exhibition 1937–87 Touring state galleries. NGV curated. Managed ICCA.

Art from the Great Sandy Desert AGWA. Exhibition of Balgo and other WA desert artists.

Surface for Reflexion Parts I and II AGNSW. 4 December 1986–18 January, 1987 (part I); 22 January 1987–22 February, 1987 (part II). Twenty-three Aust. artists whose work began in the 1960s.

1987

Field to Figuration NGV 21 February–29 March. Opening exhibition of the Keith and Elisabeth Murdoch Court. Curator Robert Lindsay surveyed the work of around 70 Australian artists from the *Field* exhibition of 1968 to 1986.

A First Look: The Philip Morris Arts Grant Purchases 1983–86 NGA. Curator James Mollison. Works from this important purchase grant of younger and emerging artists.

Australian Bicentennial Perspecta AGNSW 14 Oct.–29 November; AGWA 5 March 1988–17 April 1988; Frankfurter Kunstverein Sept.–Oct. 1988; Stuttgart Kunstverein March–April 1989. AGNSW. Curator Tony Bond. Work by 17 contemporary artists.

Australian Sculpture Triennial Third sculpture survey exhibition held at NGV and Melbourne sites.

1988

Tasmanian Vision: The Art of Nineteenth Century Tasmania TMAG 1 Jan.–21 Feb., 1988; QVMAG 16 March–1 May 1988. Curator. H. Kolenberg. Extensive catalogue written by Hendrik and Julianna Kolenberg. Works from 1777 to 1899 including by Augustus Earle, Sarah Ann Fogg, Haughton Forrest, A. Henry Fullwood, John Glover, Henry Gritten, Eugène von Guérard, Josph Lycett, John Mather, Frederick McCubbin, W. C. Piguenit, Tom Roberts.

Masterpieces from the Hermitage, Leningrad: Western European Art of the 15th–20th centuries Touring state galleries, 1988. USSR contribution to Aust. Bi-centennial with 50 works from the Hermitage including Botticelli, Rubens, van Dyck, Correggio, Renoir, Manet, Matisse, Picasso. Managed by ICCA.

Shades of Light – Photography and Australia 1839–1988 NGA 20 February–22 May. Curator, Gael Newton. Bicentennial exhibition. Comprehensive exhibition of Australian photography. Catalogue/book published by Collins with comprehensive essays on Australian photographic developments and techniques as well as biographic details of photographers.

The Artist and the Patron – Aspects of Colonial Art in NSW AGNSW 2 March–1 May. Curator Patricia McDonald. Co-ordinator Barry Pearce. Comprehensive illustrated catalogue 87 artists' work.

Masterpieces from the Louvre: French Bronzes and Paintings from the Renaissance to Rodin QAG 15 April–27 July. Organised by Musée du Louvre, Paris and QAG. The French Government contribution to Australia's Bicentenary.

The Face of Australia Bicentennial exhibition drawn from 54 regional collections. Co-ordinator David Hansen. Divided into four parts The Land (Past & Present) and The People (Past & Present) which toured regional galleries Vic (opening in Ballarat July–August) NSW, Qld, WA, NT to January 1989.

Australian Biennale 1988 Seventh Sydney Biennale called *From the Southern Cross, a view of world art c. 1940–80*. AGNSW 18 May–3 July. Works of 88 artists including twentieth century masters such as Mondrian, Warhol, de Kooning, Léger, Braque and Australian artists including Nolan, Boyd, Preston, Fairweather, Williams.

Terra Australis: The Furthest Shore AGNSW-curated touring state galleries. Documented Australian beginnings in the 15th century and ended with Matthew Flinders' journey in 1801–03. Two hundred and forty items including maps, drawings, paintings.

First Australian Contemporary Art Fair Exhibition Buildings, Melbourne 23–31 July 1988. Organised by the Australian Commercial Galleries Association as a trade fair/public display of their artists' work.

The Great Australian Art Exhibition 1788–1988 Bicentennial Authority touring exhibition all state galleries 1988–89. Originating gallery AGSA. Managed by ICCA. Curator Daniel Thomas; selection co-ordinated Ron Radford. QAG 17 May–17 July; AGWA 12 August–25 September; AGNSW 21 October–27 November; TMAG 21 Dec.–5 Feb., 1989; NGV 1 March–30 April; AGSA 23 May–16 July. Over 250 artists, over 400 works from colonial to contemporary. Comprehensive illustrated catalogue/book *Creating Australia 200 Years of Art 1788–1988* edited and introduced by Daniel Thomas with 44 contributions from curators and art historians.

Gold of the Pharaohs Touring state galleries. Organised by Museum of Victoria with AGNSW, managed by ICCA. Ninety-one objects from discovery of Pierre Montet with centre-piece funereal mask of Pharaoh Psusennes I. It attracted huge attendances.

1989

Treasures from the Forbidden City Touring state galleries 1989. One hundred works from Manchu court of late Imperial China 1644–1911 from Palace Museum, Peking.

Australian Perspecta AGNSW 31 May–23 July. Director, Tony Bond. Fifth biennial of Australian art showing work of 38 artists including popular culture and contemporary art.

Magiciens de la Terre Organised by Centre Georges Pompidou, Paris. Six artists from Yuendumu commissioned to create a ground painting installed in Le Halle de la Villette, Paris.

German Expressionism: the Colours of Desire Touring state galleries 1989/90. Curated by AGNSW and Museum Folkwang, Essen managed by ICCA. German art from 1906–1920s included works by Kokoshka, Gorsz, Beckmann.

Australian Drawings 1895–1988 NGA 9 July–16 October and *Drawing in Australia: Drawings, Watercolours and Pastels from the 1770s to the 1980s* 30 July–23 October.

1990

Biennale of Sydney Eighth Biennale called *The Readymade Boomerang* AGNSW. 11 April–3 June. Work of 140 artists from over 30 countries tracing the impact of Duchamp, Man Ray and others on 20th century art.

Abstraction AGNSW 2 June–8 July 1990. Curator, Victoria Lynn. Fifteen Australian abstract artists from previous 15 years work.

Second Australian Contemporary Art Fair Royal Exhibition Building, 21 June–24 June. Commercial gallery directors

organised with approx. 44 Australian commercial galleries; 6 overseas galleries with stands.

The Age of Sultan Suleyman the Magnificent Touring state galleries 1990. Organised by ICCA. One hundred and fifty objects from Topkapi Palace Museum, Istanbul including miniatures, ceremonial objects, swords, armour.

The Yellow House AGNSW 25 July–30 Sept. Catalogue author, Joanna Mendelssohn. Organised by a group of Sydney artists including Martin Sharp who lived in a house modelled on van Gogh's yellow house at Arles. Multi-media work including performance/installation.

Contemporary Aboriginal Art: The Robert Holmes à Court Collection Touring state galleries 1990. Collection featuring traditional artists from desert areas of Central Australia and the Kimberleys.

Albert Tucker retrospective NGV 21 June–12 August and touring state galleries. Major retrospective.

Australian Sculpture Triennial Fourth sculpture triennial at NGV, commercial galleries, public galleries, open sites, 13 September–28 October.

1991

Swiss Artists in Australia AGNSW 18 January–10 March. Curator Barry Pearce. Seven Swiss artists 1771–1992 including Chevalier, Buvelot, Herman, Haefliger, Felber.

Bohemians in the Bush: The Artists' Camps of Mosman AGNSW. Impressionist works including by Roberts, Streeton, Conder, Nerli and others who established camps at Edwards Beach and Little Sirius Cove, Sydney Harbour. (*See also* ARTISTS' CAMPS)

Australian Perspecta AGNSW. 7 August–15 Sept. Sixth biennial exhibition of contemporary Australian work. This one featured three-dimensional work of 40 artists and included sound, environmental and installation sculptures as well as more traditional forms. As well as the AGNSW components of it were seen at Penrith; a *Steam* exhibition was held in a factory in the Rocks area and a number of other galleries held exhibitions of three-dimensional work.

Aboriginal Women's Exhibition AGNSW 10 Sept.–10 November. Curator Hetti Perkins. Traditional and urban work in all media.

Masterpieces from the Guggenheim: Cézanne to Pollock AGNSW. 111 modern paintings from the Guggenheim in NY and the Peggy Guggenheim collection, Venice.

Frederick McCubbin retrospective touring state galleries 1991. Curated NGV.

John Olsen retrospective. NGV curated (1 Nov. 1991–3 Feb., 1992) touring other state galleries 1992.

1992

Rupert Bunny: An Australian in Paris touring state galleries and the NGA 1992. Curated NGA. Major survey of Bunny's work.

Completing the Picture: Women Artists and the Heidelberg Era Heide 3 March–26 April; Ballarat Fine Art Gallery 15 May–28 June; Castlemaine Art Gallery 13 July–16 August; Benalla Art Gallery 28 August–27 September; S. H. Ervin Gallery 2 October–25 October; Carrick Hill Gallery 5 November–6 December. Curated Victoria Hammond and Juliet Peers. Paintings and biographies of 19 women artists working in Victoria 1890s–1920s.

Rubens and the Italian Renaissance curated by the NGA (28 March–8 June) and touring several state galleries. Largest attendance at any exhibition at the NGA.

Uncommon Australians: Towards an Australian Portrait Gallery. Privately sponsored by Gordon and Marilyn Darling. Curator Julian Faigan. NGV 7 May–9 August; NGA July–4 October; QAG 26 August–4 October; AGNSW 22 October–22 November; AGSA 4 December–31 January 1993. Portraits of well-known subjects prominent in five areas of Australian life. Works from 1637–1993.

Two Hundred Years of Australian Painting, Nature, People and Art in the Southern Continent Tokyo National Museum of Art 28 April–28 June; National Museum of Modern Art, Kyoto, 11 July–6 September. Co-ordinated by the AGNSW with sponsorship Australian and Japanese Governments. Eighty works from 1800s to 1980s largely drawn from the *Great Australian Art Exhibition*.

Classical Modernism – The George Bell Circle NGV. Curator Felicity St John Moore. Smaller but significant exhibition on the work of artists associated with the George Bell School in Melbourne and his influence. Comprised 120 works of 65 artists from 1920s–1989.

Third Australian Contemporary Art Fair Royal Exhibition Buildings, Melbourne, 1–4 October. Thirty-two Australian galleries; four overseas; five public galleries/organisations represented.

John Perceval retrospective. Touring state galleries 1992. Curated NGV. Major survey exhibition of his work 1935–90.

Imperial China: The Living Past Touring state galleries organised China Cultural Relics Promotion Centre with Art Exhibitions Australia and AGNSW. One hundred works from ancient times.

Hugh Ramsay 1877–1906 NGV Dec. Touring AGNSW, AGSA 1993.

1993

Biennale of Sydney Ninth Biennale called *The Boundary Rider* AGNSW. 16 December 1992–14 March 1993. Director, Tony Bond. Conceptual and cultural boundaries explored through the work of 100 artists from 40 countries.

Images of Power: Aboriginal Art of the Kimberley NGV. May–June 1993. Curator Judith Ryan. Work of contemporary artists from the Kimberley area of WA.

Surrealism: Revolution by Night NGA; AGNSW; QAG. Curators Michael Lloyd, Christopher Chapman, Ted Gott. The most comprehensive exhibition of international and Australian surrealists to date comprising 300 works from 79 world collections (including Australia).

Mao Goes Pop Museum of Modern Art, Sydney; Melbourne International Festival. Varied exhibition of contemporary Chinese artists.

Charles Blackman: Schoolgirls and Angels NGV (18 May–16 August) touring AGNSW, QAG, AGWA. Curated by Felicity St John Moore. Comprehensive survey of Blackman's paintings and drawings 1950–90s.

Australian Sculpture Triennial Fifth triennial at the NGV, commercial galleries, public galleries, open sites. September–November.

Asia Pacific Triennial QAG 18 September–5 December. Over 200 works from artists of 13 Asian countries. (*See also* ASIA LINK)

Australian Perspecta AGNSW 6 October–28 November. Seventh biennial of Australian contemporary work.

Van Gogh – his sources, genius and influence NGV 18 November and QAG.

Arthur Boyd retrospective. Curated AGNSW touring state galleries 1993–94.

Appendix 3

F<u>ESTIVALS</u>

Though 19th century Australia enjoyed national and international expositions featuring primary production, industrial progress and the arts, the development of arts festivals was primarily a post-Second World War phenomena. Perhaps inspired by the *Festival of Britain*, one of the first major arts festivals held in Australia was *The Arts Festival of the Olympic Games*, Melbourne, 1956.

South Australia was next to take up the challenge when, in 1960, the *Adelaide Festival of the Arts* was established by Professor John Bishop as a biennial national and international event equalled only in its aspirations by the much more recent *Melbourne International Festival of the Arts* established in 1986 when Gian Carlo Menotti launched it as *Spoleto Melbourne: Festival of Three Worlds*.

Though not strictly festivals, many major exhibitions are nowadays surrounded by satellite events. Such exhibitions include the *Adelaide Biennial of Australian Art* initiated in 1990 by the Art Gallery of South Australia and held in conjunction with the Adelaide Arts Festival's *Artists' Week*; *Australian Perspecta* organised biennially since 1981 by the AGNSW; the *Biennale of Sydney* held in Sydney since 1973; ARX (Artist's Regional Exchange) held biennially in Perth since 1987; the *Australian International Crafts Triennial* arranged by the Art Gallery of Western Australian since 1989; the major new *Asia Pacific Triennial of Contemporary Art* inaugurated by the Queensland Art Gallery in 1993, the *Australian Sculpture Triennial* held at various locations in Melbourne since 1981 and the *Australian Contemporary Art Fair* held biennially at the Royal Exhibition Buildings, Melbourne since 1988.

The following list of festivals, concentrates on those featuring the visual arts. Consultation of the following is recommended: *Make a Date: Australian Tourist Commission Convention Calendar* (from the Sydney-based ATC). The *Media Diary* published by Vamosi Information Publications Pty Ltd (Sydney). Those marked* also have a separate listing.

Australian Capital Territory
CANBERRA FESTIVAL
Established as the *Canberra Week Festival* in 1977 and became the *Canberra Festival* in 1980. Held in March each year, it celebrates the founding of Canberra on 12 March 1913.
BUNYIP FESTIVAL
Originally organised by the *Blue Folk Community Arts Association* which was formed to co-ordinate and stage festivals, theatrical productions and multi-art programmes at Strathnairn Homestead, Holt, ACT. The first *Bunyip Festival*, in 1979, contributed to the *Canberra Week Festival* and then from 1980, to the *Canberra Festival*.

New South Wales
FESTIVAL OF SYDNEY
This annual festival is held in January and incorporates dance, music, community arts, crafts, street theatre, exhibitions, outdoor concerts, a gay mardi-gras and grand parade and a festival food and wine picnic. Founded by Alderman Pat Hills in 1956 it became incorporated in 1976. It has received funding from the Sydney City Council, the NSW Government, the Community Arts Board of the Australia Council and involved prominent citizens such as the Hon. Neville K. Wran.
BIENNALE OF SYDNEY*
Commenced in 1973, the intention was to mount an international and Australian exhibition of contemporary art. It has gradually been expanded over many locations and to accommodate a plethora of satellite events. Each Biennale is administered by an appointed Director in consultation with the Board of Directors chaired first by Mr Franco Belgionno Nettis and 1993 by Ms Suzanne Davies. The Biennale has been funded by a number of overseas governments, the Australia Council, Transfield Pty Ltd, the Sydney City Council and the Government of NSW. Directors have included Tom McCullough (1976), Nick Waterlow (1979), William Wright (1982), Rene Block (1990) and Tony Bond (1992).
ORANGE FESTIVAL OF THE ARTS
Established in 1965 and running until around 1985 its aim was to encourage community participation, to attract art experts to the region and to help establish the idea of regional centres for drama, music and the visual arts. Held biennially from March to April and received funds from the NSW Cultural Grants Administrative Council and the Australia Council.

Other NSW festivals
Other NSW festivals held on a regular or semi-regular basis, information on which can be gleaned from the *Media Diary* or tourist information include: the *Australian International Video Festival*, Sydney; the *Berrinba Arts Festival*; the *Camden Municipal Art Festival*; the *Castle Hill Orange Blossom Festival*; the *Condobolin Annual Arts and Crafts Exhibition and Festival*; the *Cowra Festival*; *Fisher's Ghost Festival*, Campbelltown; the *Grenfell Henry Lawson Festival of the Arts*; the *Lilac City Festival*, Goulburn; the *Griffith Art and Craft Society Vintage Festival*; the *Macquarie Towns Festival Art Exhibition*, Windsor; the *Sydney Gay and Lesbian Mardi Gras*; the *Wauchope Rotary Art and Craft Festival*; the *Wyong Shire Festival of the Arts* and the *Royal Easter Show*, NSW held in Sydney annually.

Northern Territory
BROWN'S MART COMMUNITY ARTS PROJECT
Established in 1972 and incorporated in 1977, this organisation holds a variety of festival programmes which have received assistance from the NT Government and the Australia Council.

Queensland
WARANA FESTIVAL/QUEENSLAND FESTIVAL OF THE ARTS
Staged since 1961 in late September to early October each

year as an eclectic community celebration of the creative and performing arts, the *Queensland Festival of the Arts* combined with the *Warana Festival* in 1977–78 to present opera, ballet, theatre, concerts, exhibitions of arts and crafts, public speaking and a writers' convention.

FESTIVAL OF TOWNSVILLE (UNTIL 1992 TOWNSVILLE PACIFIC FESTIVAL)
A community festival of arts, entertainment, sport and tourist activities held biennially from 1970–76 and then annually.

Other QLD festivals
Other Queensland festivals include: the *Bundaberg Art Festival*, the *Eskibition Annual Arts and Craft Festival*, Esk; the *Heritage Arts Festival* of the *Stanhope Apple and Grape Harvest Festival*; the *Mareeba Rodeo Festival Art Exhibition*; the *Heritage City Art Festival*, Maryborough; the *Yungaburra Arts Festival* and the *Queensland Royal National Show* held in Brisbane annually.

South Australia

ADELAIDE FESTIVAL OF THE ARTS
A biennial festival of performing and visual arts, film, outdoor and community events include a *Festival Fringe, Writers' Week, Artists' Week* and, from 1990, the *Adelaide Biennial of Australian Art* at the Art Gallery of South Australia. Attracting national and international events, the Festival is managed by a board and a number of committees. A three-week event held in March every alternate year, it was inaugurated in 1960 by John Bishop who died in Europe while organising the 1964 Festival. The Festival has received world-wide recognition for its excellence. Revenue sources have included the Government of SA, the Adelaide City Council, sponsors, donors, Friends of the Festival and the Australia Council. Its directors have included Professor John Bishop (1960); Sir Robert Helpmann (1970), Louis Vantyssen (1972); Anthony Steel (1974–78); Christopher Hunt (1980); Jim Sharman (1986–88); Clifford Hocking (1990); Rob Brookman (1992); Christopher Hunt (1994) and Barrie Kosky (1996).

Other SA festivals
Other South Australian festivals include the *Barossa Valley Vintage Festival*, Nuriootpa and the *Frame Festival* (for film and video), Adelaide.

Tasmania

HOBART SUMMER FESTIVAL (INCORPORATING THE SALAMANCA ARTS FESTIVAL)
Has a strong arts component and is funded by Arts Tasmania and the Hobart City Council.

other tas festivals
Other Tasmanian festivals current and no longer extant include the *Blue Gum Festival of Tasmanian Art*, *Festivale*, Launceston and the *Circular Head Arts Festival*.

Victoria

MELBOURNE INTERNATIONAL FESTIVAL OF THE ARTS
Former Arts Minister Race Mathews and Director of Arts Victoria Paul Clarkson ensured the establishment of an annual grant to this event established in 1986 as the third site of Gian Carlo Menotti's famous *Spoleto Festival*, then nearly 30 years old. Luciano Bini and Melbourne's *Italian Arts Festival* were instrumental in assisting its extension to Australia. A highlight of the first Melbourne *Spoleto* was Ken Russell's *Madama Butterfly*. In 1989 Menotti passed the directorship to John Truscott and a year later the celebrations were renamed the *Melbourne International Festival of the Arts*. He concentrated it around the Victorian Arts Centre and made it also a showcase for Australia's creative talents. Richard Wherrett became director in 1992, encouraging significant local participation. Leo Schofield was appointed director, 1994.

MOOMBA FESTIVAL
Established in 1955, Moomba was incorporated in 1958 as an eleven-day event concluding on Labour Day each year and providing popular entertainment in a carnival atmosphere with grand parade. It aimed to promote popular interest in the arts. Administered by a board of directors and executive staff, its parent body is the Corporation of the City of Melbourne.

NEXT WAVE FESTIVAL
The *Next Wave* has been held annually since 1984. It features visual and performing arts, literature and drama with exhibitions, performances and publishing initiatives. Its tendency has been to operate outside conventional art spaces and this phenomenon is increasing with current emphasis on satellite exhibitions and site-specific performance. Directors have included Arpad Mihaly, Angela Burke, Margaret Vandaleur, Palz Vaughan and Charlotte Yates.

FRINGE ARTS FESTIVAL
Established in 1988 the *Fringe* is held annually in August–September and intends to provoke the arts establishment with ideas of young artists and those on the fringe of the mainstream. It provides an important forum for experimental and emerging visual and performing artists. Launched each year by a parade and street party in Brunswick Street, Fitzroy, in 1993 it featured more than 200 events.

AUSTRALIAN FESTIVAL OF ASIAN ARTS
Arranged by the Victorian Arts Centre since 1990 it features visual and performing arts from Asia and Australia.

FESTIVAL OF ALL NATIONS
Commenced in Fitzroy in 1973 and in 1977 became a Melbourne-wide multi-ethnic festival promoting awareness of multicultural Australia. Chaired by Mr Mike Zafiropoulos.

ITALIAN ARTS FESTIVAL
Established in Adelaide in 1978 as a national body, it continued in Victoria as an annual forum for Italian-Australian artists to display their talents and to promote better understanding through cultural exchange.

Other Victorian festivals
Other Victorian festivals include the *Castlemaine Festival*; the *Chinese New Year Festival*; the *Dandenong Youth Arts Festival*; the *Lygon Street Festa*; the *Melbourne International Comedy Festival*; the *Merbein Easter Art Festival*; the *Mornington Peninsula Arts Centre Spring Festival of Drawing*; the *Tallangatta Arts Festival* and the *Royal Melbourne Show* held in Melbourne each September.

Western Australia

THE FESTIVAL OF PERTH
Established in 1953 by the Adult Education Board of the University of Western Australia, it became more independent in 1976 when it received direct funding from the State Government. Its honorary organising committee has concentrated on music, drama, dance, film, visual arts and community activities and provides an international festival of the arts attracting distinguished visitors from Europe, America, Asia and Australia.

Other WA festivals
Other Western Australian festivals include: the *Dalwallinu Festival of Arts*; the *Mandurah Festival of the Arts*; the *Shire of Derby-West Kimberley Crafts Festival* and the *Royal Perth Show*.

JENNY ZIMMER

Appendix 4

FUNDING

Although Commonwealth arts patronage dates back to the years 1908–1911, and various organisations, funds, bequests, prizes and scholarships – had greatly assisted individual artists, by 1972 the arts were in the doldrums and in great need of encouragement. Many of Australia's finest artists were overseas, arts institutions were non-existent, embryonic or relics of colonial or Edwardian times and art galleries were frequently run down, understaffed and limited in acquisitions opportunities. State-based Arts Councils had limited funds and, despite the efforts of the Australian Council of the Arts, established in 1968 and chaired by Dr H. C. Coombs, there was no effective national body responsible for allocating federal subsidies to the arts.

The Australia Council, modelled on British and Canadian Councils, was actively developed from 1973, and established as a statutory body in 1975, after preliminary research by Dr Jean Battersby and Dr H. C. Coombs. The Prime Minister Gough Whitlam proposed a 100% increase in arts funding and in 1974 another 50%.

In 1978 the Committee on Taxation Incentives for the Arts (q.v.) was established by the Commonwealth Government to encourage gifts of art works to public museums and galleries.

In the 1990s, the major public arts funding continues to be provided by the Federal Government through its advisory body, the Australia Council (AC). Though the Australian Research Council (ARC) occasionally funds arts-related research it is to the AC that artists and arts-related professionals and organisations apply for grants. All states have arts ministries (called a different name in each state) which provide some funding for visual artists.

Other funding sources
Funding is also available at the community level and enquiries should be directed to municipal councils and local arts organisations. As much arts funding is channelled through museums, galleries and contemporary art spaces the latest *Directory* of the Art Museums Associations of Australia should be consulted. Even more specifically the National Association for the Visual Arts has published a 71-page guide *Money for Visual Artists* (1991), an essential index for visual artists across Australia. A further information source is the Melbourne-based Australian Association of Philanthropy which provides details of trusts funding the visual arts.

BIB: The Spring 1992 issue of *Artlink*, an Adelaide-based art journal features a group of articles headed 'The Artworkers guide to the economy'. Australia Council research has produced the following occasional papers: *Arts grants and their uses* (Duesburys, 1988); *The arts: Some Australian data* (4th Edition, 1992); *Corporate support for the arts: a discussion paper* (1986); *Cultural funding in Australia: federal state and local government* (Guldberg, 1991); *The enterprise programme: encouraging private sector support for the arts* (Jeffrey and Brown, 1988); *Fundraising in the arts: pocket checklist for boards and managers of arts organisations* (1986); *Taxing questions: some basic income tax questions for artists* (Arts Law Centre of Australia, 1991–); *You and your sponsors: a guide to arranging business sponsorship for the arts* (1989)
(Note: This information has been written from the point of view of the individual or organisation seeking arts funding. It does not take into account the nationwide network which supports Australia's major arts institutions.)
See also SCHOLARSHIPS; TRUSTS AND FOUNDATIONS
JENNY ZIMMER

GALLERIES – PUBLIC AND PRIVATE

PUBLIC ART GALLERIES AND MUSEUMS

The public art galleries (museums) of Australia include national, state, regional, university, college and municipal galleries, and public galleries created through the benefactions of private individuals.

In 1950 these galleries were limited to six state galleries, about seven regional galleries, mostly in Victoria, and the Australian War Memorial, Canberra, in all about 14 institutions. However, with the rise of the regional galleries in Victoria in the late 1950s and 1960s, the numbers of public galleries began to increase dramatically until by 1993 there were more than 800, most of them linked through the Art Museums Association of Australia (q.v.). The first Australian public gallery planned was Hobart's (the Tasmanian Museum and Art Gallery), proposed by members of the Historical Society in 1838 and built in 1863, just two years after the first room of the National Gallery of Victoria was opened in a section of the National Library of Victoria building in Melbourne. These institutions were followed by the National Art Gallery of New South Wales, Sydney, 1874; the National Gallery of South Australia, Adelaide, 1879; the National Art Gallery of Queensland, Brisbane, 1895; the Western Australian Art Gallery, Perth, 1895; and much later the Museums and Art Galleries of the Northern Territory, in 1970, and the National Gallery of Australia in 1982.

Victoria

The first regional gallery in Australia was the Ballarat Fine Art Gallery in 1884, although an art gallery and museum (now defunct) had been established at Port Adelaide in 1872, and the sandstone building of the original Warrnambool Gallery had been in existence since 1867. The regional gallery movement had its origins in Victoria because of the number of large towns and cities that grew from the Victorian gold rush. The regional gallery at Ballarat was followed by the regional galleries at Bendigo, 1887; Geelong, 1896; Castlemaine, 1913; Shepparton, 1934; Mildura, 1956; Hamilton, 1959; Swan Hill, 1964; Sale, 1964; Ararat, 1968; Benalla, 1968; Horsham, 1968; Mornington, 1969; Latrobe Valley, 1971; McClelland (Langwarrin), 1971; Warrnambool, 1972. The Victorian public gallery system was further added to with the establishment of public galleries in the Melbourne metropolitan area in the 1980s. Some, such as the Museum of Modern Art at Heide, the Australian Centre for Contemporary Art, and Gertrude St Artists Spaces are state government owned and others, including Waverley City Gallery and the Caulfield Arts Centre, are owned by the local council. University galleries such as the University of Melbourne, Monash University, La Trobe University are members of the Art Museums Association and hold regular changing exhibitions as well as those based on their institution's collections.

NSW

In New South Wales, the regional gallery movement began with the Newcastle City Art Gallery (now the Newcastle Region Art Gallery) in 1957. NSW regional development continued with the opening of galleries in the 1970s at Wollongong, Maitland, Albury, Armidale, Penrith (Lewers Bequest and Regional Art Gallery), Muswellbrook and in the 1980s Wagga Wagga, Bathurst, Maitland, Orange, Tamworth, Shoalhaven, Lismore and Broken Hill. There are also eight affiliated municipal galleries, with collections in civic centres or town halls, at Coffs Harbour, Dubbo, Gosford, Grafton, Taree, Lake Macquarie, Bega and Griffith. Public galleries in the Sydney metropolitan area include the Manly Art Gallery, the National Trust owned S. H. Ervin Museum and Art Gallery, the Australian Centre for Photography, and the Museum of Contemporary Art.

Tasmania

In Tasmania, the first regional gallery was the Queen Victoria Museum and Art Gallery, Launceston, which opened in 1891. It was Tasmania's only regional gallery until the opening in 1978 of the galleries at Burnie and Devonport.

SA & WA

Regional galleries in SA are situated at Naracoorte, Mt Gambier (Riddoch Gallery) and Millicent. Carrick Hill and the Jam Factory are situated in the Adelaide metropolitan area. The leading regional gallery in Western Australia is the Fremantle Arts Centre with the other regional galleries situated at Bunbury, Geraldton, Narrogin and Albany (Vancouver Arts Centre).

Aboriginal arts centres

Two public art museums – Araluen Arts Centre, Alice Springs and Tandanya: National Cultural Institute, Adelaide – opened in the 1980s to focus exclusively on the work of Aboriginal artists.

Contemporary Artspaces

From the mid-1970s and particularly in the 1980s a number of art spaces, either public or attached to tertiary institutions, were opened. These have no permanent collections and are dedicated to the showing of contemporary experimental (often performance and installation) art. The earliest of these were the Experimental Art Foundation in the Jam Factory Building in Adelaide (1975) and the Institute of Modern Art, Brisbane (1975). In the 1980s more were opened including in Melbourne the Australian Centre for Contemporary Art and 200 Gertrude St Artists Space; in Sydney, Artspace Performance Space and Tin Sheds; in Canberra Contemporary Art Space; in Tasmania the Plimsoll Gallery of the University of Tasmania and Chameleon Contemporary Art Space; in Perth the Perth Institute for Contemporary Arts (PICA).

Other developments

A significant development in the 1980s was the establishment

of the Australian Exhibitions Touring Agency and National Exhibitions Touring Agency which, along with the Regional Galleries Associations in most states, facilitates the touring of exhibitions. This enables a co-ordinated and wider spread of exhibitions and assists in more professional presentation. As well as the opening of new galleries in the 1980s a number of state, regional and public galleries have been refurbished or added to significantly and overall staffing of galleries has reached higher levels of innovation and professionalism. All these developments, despite the constant difficulty in finding adequate funding faced by all arts organisations, have led to an increase in exciting activity in Australia's public gallery sector.

GALLERIES

Note: Most public galleries have support groups such as societies. These have not been listed unless of major historical significance.

ADELAIDE FESTIVAL CENTRE

(Established 1975) King William Rd, Adelaide, SA 5000 (GPO Box 1269, Adelaide, SA 5001) DIRECTOR: 1993– Vivonne Thwaites. Regular exhibitions of the necessary high standards are mounted throughout the year in Artspace and theatre foyers with biennial Adelaide Festival periods reserved for specially organised displays.

ALBURY REGIONAL ART CENTRE

(Established 1979) PO Box 664, Albury, NSW 2640. NSW regional gallery. DIRECTOR: 1980– Audray Banfield. Housed in the former Albury Town Hall (1907), the gallery was opened in April 1981. The extensive collections of Australian paintings had been accumulated since 1947 through the Albury Art Prize (*see* PRIZES). Other works in the collection include works on paper with a concentration on photography; the Drysdale collection with works by the artist, who lived and worked in Albury; and the Daniel gift of 16th–19th century European etchings and engravings. Travelling exhibitions are shown in all media and there is a comprehensive education program for all levels as well as community and special interest groups.

ALLPORT LIBRARY AND MUSEUM OF FINE ARTS

(Established 1969) 91 Murray St, Hobart, Tas. 7000. Public gallery attached to State Library. GALLERY MANAGER: 1993– G. T. Stilwell. ADMIN: State Library of Tas. Created through the bequest from Henry Allport of the historic Allport collections of art works, glass, china, silver, general Tasmaniana and library, and given as a memorial to the Allport family (q.v.). The collection consists of Australian, particularly Tasmanian, colonial art before 1880 with work by the Allport family of a later date with a few quality 18th and early 19th century watercolours.

ARALUEN CENTRE FOR ARTS & ENTERTAINMENT

(Established 1984) Lapinta Drive. Alice Springs, NT 0870 (PO Box 3521, Alice Springs, NT 0871)
DIRECTORS: 1980–85 Jonah Jones; 1985–87 Bob Peat; 1987–90 Barbara Tiernan; 1990– Christine Dunstan. Comprising a 50-seat theatre, two art galleries, a craft studio and a restaurant, it changed its name from Araluen Arts Centre in 1990. The gallery exhibits a cross-section of works from the Araluen Collection (including the Alice Prize and NT Art Award acquisitions (*see* PRIZES/SCHOLARSHIPS)), the Albert Namatjira collections and a selection of works from the Alice Craft Acquisition collection. The Exhibition Gallery includes major travelling exhibitions, annual awards and works by local artists. Touring exhibitions have included major retrospectives such as those by Fred Williams, Margaret Preston and *The Heritage of Namatjira*. Annual awards include the Alice Craft Acquisitions (May); the Central Australian Aboriginal Art and Craft Exhibition (June–July), the NT Art Award (August) and the Alice Prize (October).

ARARAT GALLERY

(Established 1968) Town Hall Building, Vincent St, Ararat, Vic. 3377 (PO Box 72, Ararat, Vic. 3377) Vic. regional gallery. ADMIN: Gallery committee of eight, elected annually by the Ararat Gallery Society. DIRECTORS: Pam Gullifer 1973–77; Joe Devilee 1977– 79; Pamela Luhrs 1979–85; David Salter 1985–90; Jeffrey Taylor (acting) 1987–88; Graeme Bird 1990– . HISTORY AND ARCHITECTURE: Founded March 1968 at a meeting called by the Mayor of Ararat. The Gallery received a $1000 state government establishment grant later in the same year, the work being done by volunteers until June 1973, when a professional director was appointed. In 1974 the institution was admitted to the RGAV as a full member gallery (the last of the 16 regional galleries admitted). From 1968 the Gallery was located in the old Municipal Offices in the Town Hall, extended to include the Council Chambers in 1971, and the former Mayor's Room as a director's office in 1973. In 1977 work commenced to convert the entire old Town Hall into an Arts Centre with the new Gallery opening in 1979. The new building opened in 1980 and its architects, Gunn Hayball Pty Ltd, received the RAIA Victorian Architecture Medal for its design. COLLECTIONS: Noted for its collection of contemporary Australian textiles/fibre art especially through the biennial acquisitive exhibitions. Regular temporary exhibitions of ceramics, glass and silver add balance.

ART GALLLERY OF NEW SOUTH WALES

(Established 1874) Art Gallery Rd, Hyde Park, Sydney, NSW 2000. State Gallery of NSW. ADMIN: Board of nine trustees, including president and vice-president. Trustees are appointed by the NSW Premier's Dept, each for a term of four years, which may be extended. STAFF: In excess of 140 in 1993. Director: Edmund Capon; Deputy Director: Norm Austin. Senior staff – Curators: Barry Pearce, Hendrik Kolenberg, Deborah Edwards (Australian Art), Renée Frée (European Art), Jackie Menzies (Asian Art), Anthony Bond (Contemporary Art), Sandra Bryan (Photography). Registrar: Ljubo Marun; Senior Education Officer: Linda Slutzkin. PROFESSIONAL HEADS OF STAFF: 1874–92, Eccleston du Faur, Hon. Secretary; 1892–94, E. L. Montefiore; 1895–1905, G. E. Layton, Secretary-Superintendent; 1905–12, G. V. F. Mann, Secretary-Superintendent, and 1912–29, Director-Secretary; 1929–36, J. S. MacDonald, Director-Secretary; 1937–44, Will Ashton, Director-Secretary; 1945–71, Hal Missingham, Director-Secretary; 1971–77, Peter Laverty, Director; 1978– , Edmund Capon, Director. HISTORY AND ARCHITECTURE: Founded in 1874 when the NSW government voted a grant of £500 for the formation of 'a Gallery of Art'. Five members of the NSW Academy of Art were elected to an administrative committee – Sir Alfred Stephen, Edwards Combes, MP, E. L. Montefiore, Eccleston du Faur, James Reading Fairfax. From June 1876 the growing collections were on view twice a week at Clarke's Assembly Rooms, and from 1880 (entitled Art Gallery of New South Wales) they were housed in a room in the Garden Palace (q.v.). In 1883 the architect J. Horbury Hunt was commissioned to plan a permanent building on the present site for 'the National Art Gallery of New South Wales', and from 1885 the collections were on display in the temporary basement rooms of the new building. The present façade and southern side historical collection galleries, designed by Government Architect W. L. Vernon, were built in sections from 1897–1909, the first being opened on the Queen's birthday, 1897. For many years the original basement building housed the Australian and drawing collections, but with the development of the new northern wing 1969–72, designed by Andrew Andersons of the Government Architect's Dept, advised by Hal Missingham, the old basement building was demolished and replaced by the present five-storey structure known as the Captain Cook Gallery, comprising a number of galleries, boardroom, offices,

theatrette, restaurant, conservation laboratories, storage and facilities. It opened in 1972. The most recent major development, completed in 1988, doubled the Gallery's size. Adjoining the eastern side of the existing structure a state Bicentennial project (again under the direction of Andrew Andersons) also houses new premises for the Art Gallery Society, the 350-seat Domain Theatre, a cafe and a rooftop sculpture garden. THE ACT: The Gallery's original Trust was reconstituted in 1876 and incorporated in 1899 under the State Government Library and Art Gallery Act. Known as the National Gallery of New South Wales until the Art Gallery of New South Wales Act in 1958, the Gallery was under the auspices of the NSW Department of Education until 1971 when it was transferred to the Ministry for Cultural Activities, which in turn became part of the Premier's Department in 1976. A new Art Gallery of New South Wales Act was passed in 1980 and since 1986 the Gallery has been part of a new Ministry for the Arts. COLLECTIONS: The first acquisitions were a watercolour by Conrad Martens (commissioned 1874) and an oil by W. C. Piguenit (donated 1875), and the policy that subsequently developed favoured the collection of contemporary Australian work. The policy gained further strength when Julian Ashton (trustee 1889–99) introduced provision for a percentage of available funds permanently to go towards the acquisition of Australian works. The Aboriginal collection was given direction and coherence 1957–73 by the deputy director Tony Tuckson, who pioneered the recognition of indigenous works as art rather than ethnic artefacts, and it continues to grow. The Gallery has since 1876 acquired contemporary European works with first purchases largely British works, the first being Ford Madox Brown's *Chaucer at the Court of Edward I* (bought for £500 in 1876). General concentration on Royal Academy and French Salon art lasted well into the 1930s but, as the collections grew and additional funds became available, the policies broadened. The emphasis from the 1970s has shifted towards acquisition of European contemporary works with purchases of works by Monet, Pissarro, Bonnard, Braque, Picasso, Kandinsky, Bechman and Kirchner, with a complementary collection of works on paper in the Prints and Drawings department. The photography collection began in 1976 with a gift of 90 photographs from the family of Australian pioneer photographer Harold Cazneaux (1878–1953), and includes largely Australian photographers such as Max Dupain, Athol Shmith and David Moore, with a small international collection. In 1979 after 100 years of collecting in the area (starting with a large gift of ceramics and bronzes from the Japanese Government in 1879) a Department of Asian Art was established, the collection being particularly strong in ceramics and Japanese and Chinese scroll painting. The first *Biennale of Sydney* in 1976 provided impetus for the establishment of a separate contemporary art section. The Biennale along with the biennial *Australian Perspecta* continues to provide a stimulating international focus for Australian contemporary art. EXHIBITIONS: The Gallery mounts approximately 30 special exhibitions per year ranging from small displays of sections of the permanent collection to large international travelling exhibitions which have included *Gold of the Pharaohs*, 1988 and *Masterpieces from the Guggenheim*, 1991. GIFTS AND BEQUESTS: Of great value to the collections have been the gifts from the various donors, including the NSW Society of Artists; Art Gallery Society; CAS, Sydney; CAS, London; National Art Collections Fund, London; and many private and corporate donors. Initially these took the form of prizes and scholarships for artists, the best known being the Wynne prize, which started in 1897; the Archibald in 1921; Sulman in 1936; Pring in 1966; Dyason scholarship in 1960; and M. E. R. Horton Bequest for purchase of contemporary art in 1983. Gifts are too numerous for individual listing but among them may be mentioned gifts by A. R. D. Watson,

1919; Tom Marshall, 1929; May Grainger, 1937; A. H. Smith, 1959; Sir Charles Lloyd Jones, 1959; Dr Stuart Scougall; Patrick White; Robert Klippel; Kenneth Myer; H. G. Slater; Margaret Olley; E. H. Stinson; A. C. Lette and Mollie Gowing. GALLERY SOCIETY: The Art Gallery Society of New South Wales was formed in 1953 to assist the general work of the AGNSW. It is active in organising lectures, films, publications, voluntary guide services and functions, as well as providing funds for special acquisitions. Membership in 1993 exceeded 31,000. BIB: Smith, *Catalogue AGNSW*, 1953. Annual catalogues of acquisitions, published 1949–67 and 1975. *Art Gallery of New South Wales Quarterly*, Oct. 1959–July 1972. AGNSW annual reports. *AGNSW Handbook* 1988. *Asian Collection Handbook* 1990. *Checklist of the Australian Collection*, 1988.

ART GALLERY OF SOUTH AUSTRALIA
(Established 1879) North Terrace, Adelaide, SA 5000. State Gallery of SA. ADMIN: Art Gallery board of nine members appointed by the Minister for Arts and Cultural Heritage. STAFF: 1993 – Director & curator European Art: Ron Radford; Deputy Director: R. G. Appleyard; Curators: Dick Richards (Decorative Arts), Alison Carroll (Prints and Drawings), Ron Radford (Painting), Dr John Tregenza (Historical Collections), Don Hein (Education). DIRECTORS: (the position called curator until 1934); 1882–89, Louis Tannert; 1889–92, Robert Kay; 1892–1909, H. P. Gill; 1909–15, position vacant; 1918–22, G. A. Barnes; 1922–26, H. B. van Raalte, 1926–35, L. A. Wilkie; 1935–50, Louis McCubbin; 1951–67, Robert Campbell; 1967–76, John Baily; 1976–84, David Thomas; 1984–90, Daniel Thomas; 1990– Ron Radford. HISTORY AND ARCHITECTURE: In 1879 the SA government provided £2000 to buy pictures from the *International Exhibition*, Melbourne, to form the nucleus of a collection for a state gallery, private gifts for this purpose having begun in 1875. The collection was placed under the control of a Board of Commissioners and opened in the name of the National Gallery of South Australia on 18 June 1881. From Oct. 1882, the governing body was the Board of Governors of the SA Institute, and from June 1884, the Board of Governors of the Public Library, Museum and Art Gallery of SA. This body was abolished when the three institutions were separated in Feb. 1940; an Art Gallery Board, comprising chairman and six members, was elected, the state government assumed responsibility for the staffing and maintenance and the name was changed by Act of Parliament to Art Gallery of South Australia. The collections were first housed in the Jervos wing of the Public Library. They were moved to the Exhibition Building in 1889 and in 1900 found a permanent home when the first part of the Art Gallery (the Elder wing) was completed. The Melrose gift made extensions possible in 1936 and further extensions were made in 1962 for the second Adelaide Arts Festival. In 1978–79 extensive additions were made, including a conservation studio and workshops, a new decorative arts section, print and storage room with air conditioning and humidity and lighting controls. In addition to the main building, there is also the Historical Museum, responsibility for the state's historical works having been passed over to the Gallery in 1940, and developed from 1946 with the aid of government grants. The Historical Museum is housed in the old Ordnance Store at the rear of the Art Gallery. Refurbished and redecorated, it opened as the SA Historical Museum in 1972. COLLECTIONS: Development of the collections began when gifts of art works for a SA state collection started to accumulate in 1875, and in 1879–80 were supplemented by the *International Exhibition* purchases. To provide the necessary weight and authority, loan works from Queen Victoria and the Prince of Wales were provided for the first exhibition. Subsequent gifts of outstanding importance to the Gallery included the Sir Thomas Elder Bequest, 1897 (the first large acquisitions

endowment given to an Australian state gallery); David Murray print collection, 1908; Sir Samuel Way collection, 1916; Alexander Melrose collection, 1944; V. K. Baumeister collection, 1956; Mrs Frank Penfold Hyland collection, 1964; Maxwell J. Carter, various works, 1967–70. Besides these gifts, there have been many donations of individual works or small collections of works, all of which have helped materially in shaping the character of the collections. The collection is especially strong in colonial art and includes a policy of collection of Aboriginal art from 1950s. Highlights include works by John Glover, von Guérard, the Australian Impressionists, E. Phillips Fox, Hans Heysen, Napier Waller, Margaret Preston, Grace Cossington Smith. Later 20th century works include those by Fred Williams, Peter Booth, Imants Tillers, Narelle Jubelin, Michael Nelson Tjakamarra, Clifford Possum Tjapaltjarri, Turkey Tolson Tjupurrula, Fiona Hall, Bill Henson. Non-Australian works include those by Claude Lorrain, Jascob van Ruisdael, Salvator Rosa, Thomas Gainsborough, Joshua Reynolds, Frederic Leighton, Stanley Spencer, Lucien Freud, Joseph Beys, Jorg Immendorf. BEQUESTS, GIFTS AND ENDOWMENTS: 1897, Sir Thomas Elder bequest, £25,000 for acquisitions; 1903, Dr Morgan Thomas, £16,260; 1908, David Murray, print collection and £3000; 1916, Sir Samuel Way collection; 1936, Carnegie Corporation of New York, £1200 (for art education); 1936, Alexander Melrose, £10,000 (for buildings); 1944, Alexander Melrose, Melrose collection plus £1000 to establish the Melrose prize; 1946, A. R. Ragless, £43,000; 1952, A. M. Ragless, £12,000; 1954, d'Auvergne Boxall, £15,000; 1956, V. K. Baumeister, £2500 collection; 1957, Maude Vizard-Wholohan bequest (for Vizard-Wholohan annual art prize); 1964, Mrs Frank Penfold Hyland gift, historical English paintings, furniture, silver, ceramics; 1968, Lisette Kohlhagen gift, $5000; 1967–70, Maxwell J. Carter, art works and monetary gifts. EXHIBITIONS: The first exhibition (of loan works and works purchased from the *International Exhibition*, Melbourne) opened 18 June 1881 in the presence of the Duke of York (later King George V) and Prince Albert (later Duke of Clarence), and by the time it closed in Oct. it had been seen by 94,000 viewers. This initial success may have established the pattern of subsequent installations; by the 1950s the AGSA had won a nationwide reputation for expert presentation of exhibitions. The exhibitions began to attain international level with the first Adelaide Festival of the Arts, when the AGSA became the centre of the special international exhibitions organised for this important event.

ART GALLERY OF WESTERN AUSTRALIA
(Established 1895) Cultural Centre, Perth, WA 6000.
State Gallery of WA. ADMIN: Art Gallery board appointed by the Governor-in-Council. PROFESSIONAL HEADS OF STAFF: 1895–1914, Bernard Woodward (Curator); 1915–28, G. Pitt Morison (Keeper of Arts and Crafts), 1928–43 (Curator); 1944–46, position vacant; 1947–49, R. R. Campbell (Curator); 1949–52, James Cook (Curator); 1952–56, Laurie Thomas (Director); 1957, R. Rose (Acting Director); 1958–76, Frank Norton (Director); 1967–77, Bertram Whittle (Acting Director); 1977–78, Keith Shimmon (Administrator); 1978–89, W. Frank Ellis (Director); 1990– Paula Latos-Valier (Director). HISTORY: Officially opened by the Administrator of the Colony of WA, Sir Alexander Onslow, on 31 July 1895 as part of the Perth Museum, the institution was renamed Public Library, Museum and Art Gallery of WA, 20 Nov. 1911, which it remained until 1959. The Library was placed under a separate administration in 1954 and five years later the Museum administration was separated from the Gallery, which then became the Western Australian Art Gallery. A further change of name occurred in 1979 when the Gallery was moved to its present new building to become the Art Gallery of Western Australia. The professional status of the AGWA in relation to other state galleries began to improve when Laurie Thomas became its first director in 1952 and initiated a policy of collecting Australian art on a scale that far transcended anything previously attempted. He formed the Gallery Society and in many other ways extended the sphere of Gallery influence. The work of applying high professional standards was resumed later by Lou Klepac in his capacity as deputy director, particularly in the areas of publications and professional curatorial staffing; during the years 1974–80, the catalogues published by the AGWA established a precedent for public gallery catalogues throughout Australia. ARCHITECTURE: The cornerstone of the Art Gallery, as a separate wing of the building (housing as well the Public Library and Museum), was laid by the Duke of York (later King George V) on 24 July 1901, the building being completed in 1907 and opened 25 June 1908. When the Art Gallery became an autonomous institution in 1959 the need for a new building became increasingly evident. The new building, comprising six large galleries with approx. 3850 square metres of exhibition space, as well as lecture auditorium and conservation laboratories, was opened by the Governor-General, Sir Zelman Cowan, on 2 Oct. 1979. COLLECTIONS: The nucleus of the collections existed in 1895, and when the Gallery itself became a reality, acquisitions continued vigorously until 1912. They were developed through a succession of advisers including Joshua Lake – who bought a fine group of works in Melbourne in 1895 including paintings by Bonnington, Buvelot and Frederick McCubbin – and Joseph Pennell, who operated from London and bought drawings by Keene, Beardsley, May, Menzel, Forain, Millais, Burne-Jones and Leighton, as well as contemporary English etchings between 1897–1904. Sir George Clausen, adviser c. 1897, Sir Edward Poynter, adviser 1899–1900, James Reeve, 1901–?02, Sir James Linton, 1903–, all made worthwhile purchases of mostly English paintings. Later advisers were Sir Kenneth Clark, who unpredictably (but wisely) purchased for the collections G. F. Watts' *Una and the Red Knight*, and John Hulton, who caused the greatest controversy of all by buying William Scott's *Mars reds*, followed by Henry Moore's *Reclining Figure*, now recognised as one of the treasures of the collections. Between 1912–53 the Gallery went through an exceptionally dismal period of collecting. For those 41 years, when the Gallery was under the control of the Chief Librarian, only £1795 was spent on acquisitions; and had it not been for gifts from a few patrons and the work of the struggling curators, the institution may well have ceased to function. The arrival of Robert Campbell as Curator gradually changed the situation, and the increasingly vigorous acquisitions program continued by his successors led ultimately to a representative body of work extending from colonial times to the present day. Many acquisitions have been contributed by the Gallery Society, one of the most important being Arturo Martini's *La Zingara*, a fine ceramic sculpture standing nearly two metres in height, acquired in 1980. Other modern sculptures acquired are by Barlach, Manzu and Alexander Calder. GIFTS, BEQUESTS AND FOUNDATIONS: 1922, W. H. Vincent, Hans Heysen's *Droving into the Light*; 1926, Sir J. Winthrop Hackett Bequest, £3000; 1937, Carnegie Corporation of New York, £600; 1954, Mrs N. Barker, £3000; 1972, Sir Claude Hotchin Art Foundation, $35,000 plus shares and securities; 1973–78, WAAG Society, contributions totalling $35,000 for acquisitions; 1978, contributions from the *Great Australian Paintings Appeal*; 1977, Dr Harold Schenberg, Boudin's *Personnages à la Plage*; 1979, Baron H. H. Thyssen-Bornexmisza, Kirchner's double-sided painting, *Woman with Hat* (verso *The Pledge*).

ARTSPACE
(Founded 1983) The Gunnery, 43–51 Cowper Wharf Rd, Woolloomooloo, NSW 2011. Contemporary art space. ADMIN: Fourteen-member board of management elected annually by

membership (50% artist representation). DIRECTORS: 1982–83 Judy Annear; 1984–87 Gary Sangster; 1987–88 Erica Green (acting); 1988–92 Sally Coucaud; 1992– Louise Petrew. Chair, Nick Waterlow. A public non-profit organisation assisted jointly by the Australia Council and the NSW Ministry for the Arts, it concentrates on contemporary art with activities including an exhibition program, seminars, lectures, publications. It operates a bookshop, slide archive and information centre for students, artists and the public. The exhibition program includes a wide range of artists and artforms showing both emerging and established artists in a variety of media including photography, painting, installation, sculpture, performance, sound video, film and computer imaging. Exhibitions change monthly and a number of international exhanges take place with exhibitions to and from countries such as Japan, Europe, New Zealand and the USA.

AUSTRALIAN CENTRE FOR CONTEMPORARY ART
(Established 1984) Dallas Brooks Drive, South Yarra, Vic. 3141. Contemporary art space (no permanent collection). ADMIN: Board of management. DIRECTOR: 1984– , Jenepher Duncan. Situated in a former residence adjacent to the Botanical Gardens, Melbourne, the building was renovated and added to by architect Darryl Jackson. It provides an annual program of exhibitions and events focusing on recent developments in Australian and international visual and performing arts practices. The broad purpose of the Centre is to foster new developments in the visual arts and to expand public understanding and awareness of contemporary art.

AUSTRALIAN CENTRE FOR PHOTOGRAPHY
(Established 1974) Dobell House, 257 Oxford St, Paddington, NSW 2021. Municipal public gallery. ADMIN: Board of directors. DIRECTOR: 1992– Denise Robinson. Formed in 1974 'to promote photography as visual art' the collection consists of works of Australian photographers including Tracey Moffat, Anne Ferran, Fiona Hall, Harold Cazneaux, Axel Poignant, Elizabeth Gertzakis. It originates its own individual and group photography exhibitions.

AUSTRALIAN NATIONAL GALLERY
See NATIONAL GALLERY OF AUSTRALIA

AUSTRALIAN PRINT WORKSHOP
(Established 1981) 210 Gertrude St, Fitzroy, Vic. 3065. (Access workshop 99 George St, Fitzroy 3065) DIRECTORS: 1981–84 John Loane; 1984–92 Neil Leveson; 1993– Suzi Melhop (administrator), Kim Westcott & Martin King (Access workshop printers). Previously the Victorian Print Workshop, the Workshop was established out of the interest of a group of artists. Located first in the Meat Market Craft Centre, it grew rapidly from a small access workshop to one of the largest print workshops in Australia. With the opening of new and much larger premises in 1991, the Workshop consists of an access workshop in a separate building, a print workshop and a gallery. As well, there is a full collection of all prints printed at the workshop and the gallery presents exhibitions of works largely printed at the workshop as well as by international visiting printmakers.

AUSTRALIAN WAR MEMORIAL
(Conceived in 1917, proclaimed by the federal government on Anzac Day, 25 Apr. 1925) Anzac Parade, Campbell, ACT 2601. ADMIN: Managed by a Council consisting of the chiefs of the armed services and ten other members appointed by the Governor-General. In 1993 the Chairman of Council was Dame Beryl Beaurepaire, AC, DBE. DIRECTORS 1983–93: 1983–87 Air Vice-Marshal J. H. Flemming AD, DFC (US), AM (US); 1987–90 Keith Pearson, AO; 1990– Brendon Kelson. STAFF: Director with senior staff. Deputy Director, Dr Michael McKernan; Assistant Director, Public Programs, Liam Hanna; Senior Curator of Art, Anne Gray; Curator of Special Art Collections, Lola Wilkins; Curator of Sculpture and Graphic Art, Jean McCauslan. HISTORY: The idea of a national memorial to commemorate Australia's involvement in World War I was conceived in 1917. The Memorial was to consist of a commemorative area, exhibition galleries, and a library to house the records relating to Australia's involvement in war. The original relics consisted of material donated by servicemen to the Australian Military History Section, and the art was to be the work of artists and soldiers at the front, with commissioned works depicting key battles. Official War Artists were also appointed, and much of the work done by them forms part of the Memorial's collection. The first Australian display of material in the Memorial's collection was opened at the Exhibition Building, Melbourne, 1 Sept. 1922, as the Australian War Museum; after two years in Melbourne the display opened, 3 April 1925, in Sydney (as the Australian War Memorial Museum) in the Exhibition Building, Prince Alfred Park. Also in 1925, the Commonwealth government passed the Australian War Memorial Act which established the Australian War Memorial. ARCHITECTURE: A national competition for the design of an appropriate memorial building was conducted by the Commonwealth government in 1927. The stylised Byzantine building designed by Emil Soderston and John Crust is built of Hawkesbury limestone and surmounted by a large copper-sheathed dome. It was built between 1934 and 1941 by Simmie and Co and opened on Armistice Day, 11 Nov. 1941. During 1968–71 two wings were added to complete the cruciform shape of the building. The commemorative area consists of a garden courtyard containing a Commemorative Stone and Pool of Reflection flanked by bronze panelled cloisters. At the northern end of the cloisters is the entrance to the Hall of Memory which is the central shrine of the building. The three large stained-glass windows and a glass mosaic are the work of Napier Waller. The mosaic, which contains more than six million tiny tessarae, is reputedly one of the largest in the world. COLLECTIONS: In 1993 the Memorial's art collection numbered about (in 1993) 25,000 items. The art is mostly the work of the Official War Artists but this is supplemented by the works of other artists who were not employed officially, including commissioned portraits, war posters, cartoons and wartime decorative arts as well as more recent acquisitions relating to Australia's military involvement, in conflicts such as the Gulf War, and peace-keeping activities. Included in the general collections are over 65,000 items of military heraldry and over 9,000 items of military technology, a library collection and archives containing 50,000 monographs approximately 800,000 photographic images, 7000 items in the sound collection, 3.5 million metres of film, 3000 serial titles, 6000 private collections of diaries and correspondence and 4.5 km of offical archives. The collection of art relating to World War I includes extensive holdings of work by Will Dyson, Arthur Streeton, George Lambert, George Bell, Fred Leist, A. Henry Fullwood and Web Gilbert. The collection relating to World War II includes work by William Dobell, Murray Griffin, Stella Bowen, Nora Heysen, Sybil Craig, Harold Herbert, Eric Thake, Donald Friend, Sali Herman, William Dargie, Ivor Hele, Arthur Murch, Frank Norton, Colin Colahan and Lyndon Dadswell. Other artists represented include Tom Roberts, Sidney Nolan (who donated 252 works of his Gallipoli series to the Memorial in 1978, in memory of his brother Raymond, Russell Drysdale, Albert Tucker, Napier Waller, Frank Hinder, Daphne Mayo, Noel Counihan, Kevin Connor, Peter Corlett, Clifton Pugh. OFFICIAL WAR ARTISTS: The Australian Official War Artist scheme was established in 1917, with Will Dyson the first to be granted official war artist status by the Australian High Commission in May 1917. Dyson's appointment was followed in Sept. 1917 by those of Fred Leist and H. Septimus Power. Following these appointments, Arthur Streeton fought publicly for an expansion of the official war artist commissions which were subsequently granted to George Lambert, A. Henry Fullwood, George Bell, John Longstaff, James

Quinn, Charles Bryant and Streeton. A further five artists, George Benson, Frank Crozier, Will Long-staff, Louis McCubbin and James Scott, were selected from the ranks by the Australian Records Section as camouflage artists. Daryl Lindsay became medical artist at the Queen Mary Hospital, Sidcup, Kent. Following the war, commissions were also given to a number of other artists to paint representations of major scenes of conflict, including George Coates, Charles Wheeler, Arthur Burgess and W. B. McInnes. In World War II, 45 artists were employed by different government authorities. The scheme was administered by the Department of Information from 1939–41. In October 1941 it was decided that the AWM was the proper body to control the official war artist program. Colonel J. Treloar, then Director, was seconded to the Military History Section. He monitored the appointment of war artists and was instrumental in 1943 in changing the status of the artists from that of war correspondents to that of enlisted members of the AMF with equivalent pay to that of service personnel. War artists were despatched to the various theatres of war for 3, 6 or 12 months to make permanent records of the activities of the Australian servicemen. Their paintings, watercolours and drawings were used during the war for publicity purposes through reproduction in the service annuals. William Dobell and Herbert McLintock worked with the Allied Works Council while Eric Thake, Harold Freedman and Max Newton were under the direction of the RAAF Historical section. In the Korean War, Ivor Hele and Frank Norton were re-appointed, and for Vietnam, Bruce Fletcher and Ken McFadyen were commissioned as war artists.

BALLARAT FINE ART GALLERY

(Established 1884) 40 Lydiard St North, Ballarat, Vic. 3350. Vic. regional gallery. ADMIN: Ballarat City Council through a Gallery Board of Management. STAFF: Director; six other full-time staff. DIRECTORS 1967–93: 1967–68, James Mollison; 1968–73, Margaret McKean; 1973–80, Ron Radford; 1980– Margaret Rich. HISTORY AND ARCHITECTURE: In 1884, James Oddie (q.v.), a wealthy Ballarat businessman and former goldminer, paid the costs (£200) of organising a large art exhibition. The success of the exhibition led to the formation of a committee which met in June 1884 and resolved to build a public art gallery. Oddie was elected President of the movement with E. Turnbull as Hon. Secretary. Collections were started and housed initially on the first floor of the Academy of Music building, but in 1886 the Victorian state government made a grant of land in Lydiard St and donated £2000 for the purchase of works of art. Oddie paid the salary of a secretary, James Powell, and took up £3000 of building fund debentures. The cost of the original building, £6000, was met by contributions from the state government, as well as Ballarat Council and private citizens, and the building was completed in 1887. A School of Design, where painting and geometry were taught, was included in early activities, with Carew Smyth as the first instructor. The Gallery continued to flourish until the depression caused by the collapse of the land boom in the 1890s retarded its growth. Later, the depression years of the 1920s and 1930s were more seriously to restrict its development. However the Lindsay family has left eloquent testimony to the gallery's turn-of-the-century influence, and when the Crouch prizes started in 1927 they drew interstate attention to Ballarat, its collections and great potential as a centre for the visual arts. The situation of all existing Victorian provincial galleries (as they were then called) greatly deteriorated during World War II, and Ballarat was no exception. Like the Bendigo and Geelong galleries, it was saved from possible extinction through the work of Daryl Lindsay and the formation of the Victorian Public Galleries Group (now the RGAV). A new milestone was reached when the first professional director, James Mollison, was appointed in 1967 to introduce high professional standards to all aspects of the Gallery's activities. The restoration of the Eureka flag was mainly the work of his successor, Margaret McKean, and the third director, Ron Radford, produced a large number of outstanding exhibitions and, with AGDC and VACB help, an equal number of professionally designed catalogues. The present director, Margaret Rich, has maintained the standards set by her predecessors and has steered the Gallery's affairs through an important change of administration and expansion which included the almost complete rebuilding of the existing gallery and addition of a large extension as a Bicentennial project in 1988. COLLECTIONS: Of major importance historically, especially in respect to the history of the Victorian gold rush and its aftermath are the Eureka flag; von Guérard's masterpiece, *Ballarat 1853–54*; the work of S. T. Gill, and many other goldfields artists. These are in themselves enough to make Ballarat an indispensable resource centre for studies of the period. The complete collection numbers more than 7000 works. Included is a rare group of Medieval and Eastern manuscripts, an extensive representation of Lindsayana, a splendidly representative collection of Australian prints and, in general, a range of works covering the entire spectrum of Australian art from Colonial, gold rush and Heidelberg School times to the expressionist artists of the 1940s and 50s and the new artists of the 1980s and 90s. GIFTS AND BEQUESTS: A complete list of the large number of gifts that have made the collections at Ballarat unique among Australian public collections is not practicable here. Listed chronologically the major gifts are: 1884, James Oddie endowments, of money, art works and in 1908 the Eureka flag; 1923, Laurence Clark Bequest, £1000; 1927, Crouch family, £500 towards costs of buildings, and funds to establish the Crouch prizes; 1949, Alan Currie Bequest; 1958, Henry Cuthbert Bequest; 1967, Anthony and Sybil Hamilton, gift of S. T. Gill watercolours (set of 18, to which was added later a Kenneth Myer gift of a Thomas Woolner plaque, *Edward Hamilton 1854*, from the Hamilton estate); 1967, Lindsay gift of 250 works and furnishings for the Lindsay Room to commemorate the family's early association with the Gallery; 1976–92, Maude Fleay Trust Fund, in memory of the artist Maude Glover Fleay, set up by her daughter Mary Beasy; 1988, The Ferry Foundation; 1990, Cecil and Kathleeen Toy Fund; 1990, Colin Hicks Caldwell Bequest Fund.

BANYULE

(1977–c. 1988) A historic house, established as an extension gallery of the NGV, in Buckingham Drive, Heidelberg, it was built c. 1846 of hand-formed bricks on sandstone foundations for the pioneer overlander, Joseph Hawdon (1813–71), and is one of the oldest surviving historic houses in Victoria. It was bought by the Victorian state government in 1974, restored, redecorated and re-opened as an affiliate gallery of the NGV, housing the Manton Collection of paintings by the painters of the Heidelberg School. It maintained a continuous program of exhibitions, mainly of Australian artists of the past, until it closed in the late 1980s with the Manton collection returning to the main gallery.

BATHURST REGIONAL ART GALLERY

(Established 1959) 70–78 Keppel Street, Bathurst, NSW 2795. (Private Mail Bag 17, Bathurst, NSW 2795) NSW regional gallery. ADMIN: Bathurst City Council. The gallery opened in 1959, housing a small collection begun in 1955 with the Carillon City Festival Art Prize (*see* PRIZES). It was a founding member of the Regional Galleries Association of NSW 1975 and a new building opened in 1980. The collection consists of a representative collection of contemporary Australian paintings, ceramics and works on paper, many acquired through the Bathurst Art Purchase, and an important Lloyd Rees and sculpture collection. A regular program of visiting exhibitions is conducted and a quarterly information bulletin produced.

BEGA ART GALLERY
(Established 1988) (PO Box 319, Bega, NSW 2550) NSW
regional gallery. ADMIN: Bega Valley Shire Council. A col-
lection of over 100 Australian pictures acquired by the Bega
Art Society. Exhibitions change monthly.

BENALLA ART GALLERY
(Established 1968) Bridge St, Benalla, Vic. 3672. (PO Box
320, Benalla, Vic. 3672) Vic. regional gallery. ADMIN: City
of Benalla Art Gallery Advisory Council of 14 members.
DIRECTORS: 1969–80, Audray Banfield; 1980–82, Alison
French; 1982– , Svetlana Karovitch; 1992– , Pamela Gullifer.
HISTORY: In March 1968 the Gallery was opened in premises
at the Benalla Memorial Hall by Sir Arthur Rylah, then
Chief Secretary of Victoria. The premises were inadequate
but in 1972 the announcement of the Laurie Ledger gift of
$75,000, plus a large number of art works from his collec-
tion, made possible the building of the new Benalla Art
Gallery. The Benalla City Council made available a site in
the Botanical Gardens overlooking the river, and the new
gallery was designed by Melbourne architects, Munro
and Sargent. The new building was opened by the Rt Hon.
R. J. Hamer, Premier of Vic., on 18 Apr. 1975. It is jointly
funded by the City of Benalla and Victorian Ministry for
the Arts. COLLECTIONS: Ledger collection of Australian paint-
ings; other Australian paintings and crafts. The Ledger col-
lection exceeds 180 works covering mainly the 50 years
1880–1930, and containing fine examples by the painters
of the Heidelberg School and the later 1910–30 period.
The gallery has a regular temporary exhibitions program
and conducts lectures, informal talks, performance, music,
and workshops.

BENDIGO ART GALLERY
(Established 1887) View St, Bendigo, Vic. 3550. Vic. regional
gallery. ADMIN: Board of 13 members. DIRECTORS 1979–93:
1979, John Henderson; 1979, Ian Ruwoult; 1980–87,
Douglas Hall; 1987– David Thomas. HISTORY AND ARCHI-
TECTURE: Inaugurated 4 July 1887 through the work of the
Bendigo Art Association. The collections were developed
mainly through gifts and bequests, through acquisition funds
given or raised by Gallery members, and later through art
prizes (e.g. the Bendigo Art Prize; *see* PRIZES). From 1887
the work of the Gallery was done mainly by the Honorary
Secretaries responsible to the President and Gallery Committee.
The first premises in 1887 were in the School of Mines but
in 1890 the Orderly Room of the Volunteer Rifle Corps
was acquired and renamed the Victoria Court. The Drury
Gallery (named after its benefactor) was completed in 1897
and the Alexander Gallery (built by public subscription)
was added in 1906. Despite this piecemeal development,
splendid architectural unity was achieved in the palatial,
European style of contemporary public art galleries or muse-
ums. From 1906 on, the building remained substantially
the same for 57 years. Unfortunately, when further neces-
sary additions became possible (through a state government
grant in 1962), there was little local understanding of the
value of Bendigonian architectural history, and the ela-
borate, double-storied, brick and glass front added, together
with steep red brick stairway giving onto View St, is totally
out of character with the original style. However plans are
in hand to restore the original character and extend the
building. COLLECTIONS: In excess of 600, the principal fea-
tures being the large, comprehensive collection of work by
Louis Buvelot, paintings by members of the Heidelberg
School and the Neptune-Scott Collection of paintings by
Daubigny and other members and adherents of the French
Barbizon School. This representation, contrasting with exten-
sive collections of goldfields art of the 1850s, makes the
Bendigo collections unique among Australian regional gallery
collections. Sculpture includes nineteenth-century marbles
and ceramics, including the Meissen Vase (presented by the
Czar of Russia to Baron von Mueller in return for his gift

of indigenous Australian plants), acquired for the Gallery
in 1926. During the 1980s and 90s the emphasis on col-
lecting included modern Australian paintings and prints,
and in 1980 the B. S. Andrew Bequest added a large num-
ber of Australian paintings, many from the decades 1920–50.

BONDI PAVILION COMMUNITY CENTRE
(Established 1978) Queen Elizabeth Drive, Bondi Beach,
NSW 2026. Municipal gallery. ADMIN: Waverley City Council.
A community access gallery, hosting fortnightly changing
exhibitions with a diverse variety of artists and artforms.
Exhibitions in 1993 included a special exhibition in con-
junction with the South American Festival; one in con-
junction with International Women's Day; the Waverley
Youth Art Award and Exhibition ($1200 prize money).
There is an artist-in-residence program, a regular festival of
children's art and theatre events and other community events.

BRISBANE CITY HALL ART GALLERY AND MUSEUM
(Established 1977) City Hall, King George Square, Brisbane,
Qld 4000 (GPO Box 1434, Brisbane, Qld 4001) City public
gallery. ADMIN: Brisbane City Council. STAFF: Curator in
1993, Pamela Whitlock. The collections had their origins
with the foundation of local government in Brisbane in
1859. For many years they were housed in a section of the
Queensland Museum but in 1977 were moved to the City
Hall, and the institution was formally established there as
the Brisbane Civic Art Gallery and Museum. The collection
consists of Australian painting, ceramics and works on paper
by local and national artists, in additon to photographs,
furniture, archives and memorabilia accumulated by Brisbane
City Council and its predecessors. It continues to acquire
both contemporary and historical material by gift, transfer
or purchase and a full exhibition program is presented with
works from the permanent collection and touring exhibitions
from Australian and international museums.

BROKEN HILL CITY ART GALLERY
(Established 1904) Civic Centre, cnr Blende and Chloride
Sts, Broken Hill, NSW 2880 (PO Box 448, Broken Hill, NSW
2880) NSW regional gallery. ADMIN: Broken Hill City Council
advised by the Broken Hill Art Gallery Advisory Committee.
DIRECTORS: 1980–82, Charles Rocco; 1982– , Michael
Pursche; 1992– , Gary Corbett. HISTORY: The Broken Hill
Gallery was opened by the Governor-General, Lord Northcote,
on 11 Oct. 1904. The idea originated in 1903 with Dr
James Booth, who co-opted the assistance of George
McCulloch, a nephew of Sir James McCulloch and a founder
of Broken Hill. McCulloch sent pictures by James Webb,
J. W. Goodward and H. Sutcliffe, and the Gallery was fur-
ther endowed by McCulloch's widow, who later married the
British painter Coutts Mitchie. In 1908 the collection val-
ued locally at £2000 was housed in the museum attached
to the Broken Hill Technical College. The Broken Hill
Council made a small annual grant available and further
endowments of pictures came from the Mining Managers'
Association, and (1947) from the Zinc Corporation Ltd. An
annual art competition began in 1953, mainly for the benefit
of local artists. The collection now consists of colonial,
English academic and Australian works from Australian
Impressionist to modern contemporary and Aboriginal works.
There is a large collection of works on paper, local Australian
and European printmakers and a representative collection of
works by local artists. In May 1970, the collections were
moved to new premises in the new Civic Centre and the
Gallery funded solely by the Broken Hill City Council.

BUNBURY ART GALLERY
(Established 1948) 64 Wittenoom Street, Bunbury, WA 6230.
Provincial gallery. DIRECTOR: 1993, Anthony Geddes. Founded
through a Hotchin endowment of 31 Australian paintings
in Jan. 1962, the Bunbury Council purchased a building
and transferred the collection, housed formerly in the Muni-
cipal Shire Hall, to the new premises. The new art gallery

building was opened in 1987 and hosts exhibitions of visual art, decorative/applied art and craft from regional, state, national and international sources. Along with temporary exhibitions, works from the City of Bunbury Art Collection, which is housed at the Gallery, are exhibited from time to time. The Gallery's flagship exhibition is the *South West Survey*, which annually surveys art and craft production from the south-west region of WA.

BURNIE ART GALLERY

(Established 1978) Civic Centre, Burnie, Tas. 7320 (PO Box 973, Burnie, Tas. 7320) Tasmanian regional gallery. ADMIN: Burnie Municipal Council. FINANCE: Burnie Municipal Council assisted by state and federal government grants. STAFF: Director and three part-time staff. DIRECTORS: 1978–80, Stephen Rainbird; 1980–c. 82 Clinton Tweedie; 1992– , W. F. Ellis. In about 1000 square metres of space within the Civic Centre building, the gallery's exhibition program is balanced to provide the general public, artists and schools in north-western Tasmania with aspects of contemporary and traditional art, with special emphasis on Australia. About 14 thematic exhibitions are staged each year, supplemented by selections from the gallery collection of some 700 items, mainly works on paper. Lectures, musical recitals, etc. are also presented.

CAMPBELLTOWN CITY ART GALLERY

(Established 1988) Art Gallery Rd, Cnr Camden and Appin Rds, Campbelltown, NSW 2560. DIRECTOR: 1988– Sioux Garside. The gallery building is a professionally designed arts complex incorporating three display galleries, a lecture room, coffee shop and workshop space for art/craft and drama classes. A studio is used for the ceramic artist-in-residence program. A Japanese garden with traditional 16th century designed tea house is a feature of the centre. COLLECTIONS: Contemporary Australian ceramics, paintings, drawings and Aboriginal art are the main media areas. The permanent collection includes historical artworks relating to early exploration and settlement of the Macarthur region. A cross-section of contemporary regional and Sydney-based artists is represented, including Joan Brassil, Suzanne Archer and John Peart. Prior to 1988 the basis for the collection was the acquisition of artworks from the annual Festival of Fisher's Ghost Prize established in 1963 (*see* PRIZES).

CANBERRA CONTEMPORARY ART SPACE INC.

(Established 1987) Gorman House, Ainslie Ave, Braddon, ACT 2601 (PO Box 885, Civic Square, ACT 2608) Contemporary art space (no collection).

CANBERRA SCHOOL OF ART GALLERY

(Established 1981) Institute of the Arts, Australian National University (GPO Box 804, Canberra, ACT 2601) Contemporary art space (no collection). DIRECTOR: 1993– Julie Ewington. Attached to the Canberra School of Art, the gallery shows work by prominent artists, both from Australia and overseas, focusing on contemporary work in all media. Regular exhibitions include a staff show, a postgraduate and masters show and a final year students' show.

CARRICK HILL

(Established 1986) 46 Carrick Hill Drive, Springfield, SA 5062. Art gallery, museum, sculpture park, botanical garden. ADMIN: Dept for the Arts, Culture and Heritage. DIRECTOR: 1993– James Schoff. The gallery's collection consists of 20th century British paintings, 20th century Australian paintings and sculpture, 17th century British oak furniture. There is an ongoing temporary exhibition program and the gallery hosts the biennial Dame Nancy Buttfield Embroidery Prize and Exhibition (established 1991).

CASTLEMAINE ART GALLERY AND HISTORICAL MUSEUM

(Established 1913) Lyttleton St, Castlemaine, Vic. 3450 (po Box 248, Castlemaine, Vic. 3450) Vic. regional gallery. admin: Three trustees and committee of 12 members. STAFF: Director-Secretary and three assistants. DIRECTORS: 1962–75,

Beth Sinclair; 1975– , Peter Perry. HISTORY AND ARCHITECTURE: In 1913 an exhibition of watercolours by Elsie Barlow, wife of a Castlemaine police magistrate, led to a group exhibition from which grew the idea of developing a public collection. Developed through gifts from artists and benefactors, and administered and managed for the first six decades of operations by volunteers, a new phase began (as with other existing Victorian regional galleries) when, in 1962, the requirements of the RGAV necessitated the appointment of professional staff. Originally the Gallery was housed in a room in the Town Hall. The collections were then moved to a shop owned by the Leviny family then, in 1914, to a room above the Post Office and, finally, to premises in Lyttleton St. In 1931 the first section of the present art deco style building, designed by Percy Meldrum, was completed. It comprised a main gallery, two smaller galleries and basement accommodation for the museum collections. Extensive additions were made 1960–61, 1971–73 and in 1987. These included extra storage space, work areas and a temporary exhibitions gallery. COLLECTIONS: An illustrated catalogue of the collections (1983) lists more than 450 works, including many historic Australian paintings dating form 1920–70, but including also earlier works by Heidelberg School and nineteenth-century artists. Collecting policy in the 1990s favours figurative paintings as opposed to abstract or other modernist forms. GIFTS AND BEQUESTS: 1913–49, Jessie Traill, paintings and etchings; 1926, R. D. Elliott, paintings and cartoons; 1926–35, J. T. Tweddle, paintings by leading artists; 1930, W. J. Mitchell, £500 towards building costs; 1931, substantial legacies from the estates of T.H. & C. McCreery; 1931, substantial legacy from the estate of T. C. Stewart; 1937, Maude Rowe Bequest, paintings; 1942, Sir John Higgins Bequest, pictures, furniture and glassware; 1942, Miss C. Higgins Bequest, £5000 for building costs; 1971, S. R. Stoneman Foundation, $11,500 towards costs of extensions to building; 1987, A. & B. Sinclair gift, $50,000, towards costs of extensions to building. In addition to the above, many gifts of their own work from artists and many small gifts from patrons, have helped greatly to give substance and character to the collections.

CAULFIELD ARTS COMPLEX

(Established 1975) Cnr Glen Eira and Hawthorn Rds, Caulfield, Vic. 3162. Victorian municipal gallery. ADMIN: Caulfield City Council. STAFF: Directors 1975–82, Jacqueline Hochman; 1982– ?, Merryn Carter; in 1993 Liz Jesky and two others. HISTORY: The idea of building the Gallery was initiated through the Caulfield Inst. of Technology seeking exhibition space, but the success of the first exhibition (Dec. 1974) encouraged extension of the concept and in 1975 the acquisition of a large oil, Fred Williams' *Lysterfield Landscape 1973*, represented the beginning of a permanent Caulfield municipal collection and arts centre. Located in the refurbished Caulfield City Hall, it houses a large art gallery, concert hall and theatre. A number of exhibitions are sponsored by the City of Caulfield each year across a broad spectrum of the arts. The modern building is an attractive venue for the temporary exhibitions and widely varied community activities. COLLECTION: The City of Caulfield Permanent Art Collection contains over 400 pieces of Australian art in the areas of painting, ceramics, sculpture, textiles and works on paper, which are displayed throughout the civic centre.

CITY ART GALLERY (WAGGA WAGGA)

(Established 1964) PO Box 20, Wagga Wagga, NSW 2650. Wagga Wagga City Art Gallery; a regional gallery of NSW. ADMIN: Committee by incorporation. DIRECTOR: 1980– Judy L. Lievre. HISTORY: Planned, from 1963, as part of a new Civic Centre complex of buildings including also a theatre, the Art Gallery was reconstituted in 1980 when a former G. J. Coles building was taken over and converted for gallery purposes. The Council allocated $200,000 and a Capital Building Fund grant of $124,000 from the Division of

Cultural Activities enabled the new building to be completed. COLLECTIONS: The major collection is of contemporary Australian art glass and editioned prints, with minor collections of sculpture and painting. ACTIVITIES: Monthly changing exhibitions cover a range of art and craft media and there is a permanent display of works from the glass collection. A national survey of recent innovative works in glass (not a prize exhibition) is held triennially.

CONTEMPORARY ART CENTRE OF SA
(Established 1942) 14 Porter St. Parkside, SA 5063. Contemporary art space (no collection). ADMIN: Council of 9 (minimum) elected by membership each AGM. Two full-time staff in 1993. FUNDING: Receives funding from the SA Dept of the Arts and Cultural Heritage and the Australia Council through the VACB. Established as the Contemporary Art Society of Australia (SA Inc) in 1942, the first exhibition, *The First Exposition of the Asssociates Contemporary Group*, was held in July 1942 followed by *The Anti-Fascist Exhibition* which included the work of founding members of the Society, Dorrit Black, Ivor Francis, Jaqueline Hick, Douglas Roberts and Ruth Tuck. The CAS moved in 1946 to its own premises as above where it operates as the Contemporary Art Centre of SA. It shows about 12 exhibitions per year of the work of established local and interstate contemporary artists. *Broadsheet*, a quarterly publication which covers the arts and cultural issues is produced with an emphasis on providing a venue for new writers and writing (*see* MAGAZINES).

CROWTHER LIBRARY IN THE STATE LIBRARY OF TASMANIA
(Established 1964.) State Library of Tasmania, 91 Murray St, Hobart, Tas. 7000. Gallery attached to State Library. ADMIN: Librarian, Special Collections. Donated to the State Library by the collector Sir William Edward Lodewyk Hamilton Crowther (b. Hobart, 1887; d. Hobart, 1981). The deed of gift was not completed until 1969 but the gift was actually made in 1964. It comprises 16,000 printed items, plus manuscripts, as well as some 200 important colonial pictures and prints, and 50 pieces of scrimshaw. Artists represented include Bull, Duke, Glover, W. B. Gould, Simpkinson (de Wesselow).

DALBY REGIONAL GALLERY
(Established 1991) Cultural & Administrative Centre, 107 Drayton Street, Dalby, Qld 4405 (PO Box 551, Dalby, Qld 4405) Qld regional gallery. ADMIN: Advisory Committee. The gallery has a collection of 1970s contemporary Australian paintings and a loan collection of ceramics, and presents changing and touring exhibitions.

DEVONPORT GALLERY AND ARTS CENTRE
(Established 1978) 44–47 Stewart St, Devonport, Tas. 310 Tasmanian regional gallery. DIRECTOR: 1993– Patrick McMurray. Established by the Devonport Municipal Council as a regional arts centre serving north-central Tas. It developed from a commercial gallery – the Little Gallery, operated first by Mrs H. R. Thomas, from 1966, then by a society until taken over by the Council in 1978. It co-ordinates a program of exhibitions by local, national and international artists with the permanent collection specialising in Tasmanian paintings, ceramics and glass.

DIXSON GALLERY AND LIBRARY
(Established 1929) Mitchell Library Buildings, Macquarie St, Sydney, NSW 2000. ADMIN: Trustees of the Public Library of NSW. A major national reference source of Australian historical pictures, illustrations, books, magazines, manuscripts and other documents covering Australian and Pacific history from the earliest times. The core of the collection is the donation made in 1929 to the Mitchell Library of over 1000 19th-century Australian paintings, drawings and prints by the collector Sir William Dixson. He made further donations to the Dixson Galleries collection until his death in 1952 and bequeathed the William Dixson Endowment to ensure continuing purchases. The Dixson Library includes the books, manuscripts, paintings, drawing, prints and photographs of Australian and Pacific subjects which remained in Sir William Dixson's possession until his death, when the entire library was left to the State Library of NSW.
(*See also* MITCHELL LIBRARY)

DUBBO REGIONAL ART GALLERY
(Established 1987) 165 Darling St, Dubbo, NSW 2830 (PO Box 1459, Dubbo NSW 2880) NSW regional gallery. DIRECTOR: 1993– Rene Sutherland. ADMIN: Art Gallery Committee. Temporary exhibitions every three to six weeks specialising on themes of 'animals in art'.

ELIZABETH BAY HOUSE
(Established as a museum, 1977) 7 Onslow Ave, Elizabeth Bay, NSW 2011. ADMIN: Historic Houses Trust of NSW. Built 1835–38 by architect John Verge for Alexander Macleay, Colonial Secretary. Regular historically based exhibitions are held.

EWING AND GEORGE PATON GALLERIES
(1938–92) Union House, Uni. of Melbourne, Parkville, Vic. 3052. Students' union. DIRECTORS: 1971–80, Kiffy Rubbo; 1980–82, Judy Annear; 1982–91, Denise McGrath. In 1938 the Ewing Gallery adjoining the Ewing Library was established to house the collection (consisting of many important works by Heidelberg School painters and other painters of the period 1890–1940) bequeathed by Dr Samuel Arthur Ewing (d. 1937). The first director was appointed in 1971 and temporary exhibitions began. The Ewing Collection did not return permanently to its place in the Ewing Gallery until the George Paton Gallery was created (1974–75) and linked to the Ewing Gallery. Lectures, films, performances, poetry readings and related features were added to the general program, which included also the production of an *Art Almanac*, a *Women's Art Register* and, in 1976, four issues of an art magazine, *Arts Melbourne*. By 1980 more than 120 temporary exhibitions had been mounted and a lively 'avant-garde' spirit had emerged to give the Ewing-Paton Galleries the character of a university-oriented, mini-museum of modern art. Due to a number of financial and other pressures the galleries almost closed several times in the mid to late 1980s and following funding cuts in the early 1990s closed as a temporary exhibition gallery in 1992. The collection was absorbed into the general University of Melbourne collection and the gallery used for occasional student exhibitions.

EXHIBITIONS GALLERY, THE
(Established 1988) Ovens St, Wangaratta, Vic. 3676 (PO Box 238, Wangaratta, Vic. 3676) Public gallery administered by Wangaratta City Council. DIRECTOR: 1993, Isabel Thompson. Program of exhibitions and activities relevant to the culture and creativity of north-eastern Victoria. The exhibitions program includes touring exhibitions, gallery-devised exhibitions and displays by local goups.

EXPERIMENTAL ART FOUNDATION
(Established 1974) Lion Arts Centre, North Terrace & Morphett St, Adelaide SA 5006. Contemporary art space (no collection). ADMIN: Council elected annually from membership consisting of 8 elected members plus a representative from visual arts student body plus no more than 4 staff members. DIRECTORS: 1975–80 Noel Sheridan; 1980–83 David Kerr; 1984–87 Louise Dauth; 1987–89 Michael Snelling; 1990–91 Martin Munz; 1991– Richard Grayson. The idea for the Foundation originated in 1974 when Donald Brook approached Richard Llewellyn, Bert Flugelman, Clifford Frith, Ian North and Aggy Read to form a committee for the purpose. It was one of two art spaces (the other being Institute of Modern Art in Brisbane) to be established with the aim of fostering, assisting and developing experimental art and artists and developing progressive and innovative practice and theory. Housed in the same building as the craft centre The Jam Factory, the two centres moved into

new premises in 1992. Changing exhibitions include local, national and international forums and the Foundation also houses studios, an archive library, and a collection of artists' books, and conducts a publishing program.

FLINDERS UNIVERSITY ART MUSEUM

(Established 1975) Sturt Rd, Bedford Park, SA 5042 (PO Box 2100, Bedford Park, SA 5042) Tertiary art museum. DIRECTOR: Dr A. K. M. Amzad Hossain Mian. A teaching and research art museum catering to the artistic needs of the wider community as well, the collections of the Art Museum consist of art and artefacts from Australia, Europe, Asia, Africa, America and Oceania, in particular those covering contemporary Aboriginal art, European and Australian graphics, post-object and documentation art. About a dozen public displays are presented every year from both the permanent collection (which also travels interstate and overseas) and visiting exhibitions. The museum's archives and collection are accessible to approved applicants for reference and exhibition purposes and are widely used. It also organises and facilitates seminars, talks, lectures and demonstrations of artistic activities.

FREMANTLE ARTS CENTRE

(Established 1950s gallery opened 1973) 1 Finnerty St, Fremantle, WA 6160 (PO Box 891, Fremantle, WA 6160) WA regional gallery. ADMIN: Management committee of four. STAFF: 14 full-time, 1 part-time. CHIEF EXECUTIVE: 1993– June Moorhouse. HISTORY: The Centre had its origins in the 1950s when Claude Hotchin (later Sir Claude Hotchin) presented a group of Australian paintings to the City of Fremantle on condition that a public art gallery be built to house the collection. This was accomplished when the old State Shipping Service building was taken over by the state government, restored 1971–72, and opened to the public as an art gallery in 1973. The Fremantle Arts Centre Press was established in 1976 and has published a number of impressive titles, and in the same year an Arts Access program began operations with the aim of taking arts and crafts workshops to outlying areas. Additional premises were acquired c. 1977 when the administrative offices and workshop were moved to a nearby separate building. The two exhibition galleries feature a regular exhibition program focusing on Western Australian artists and craftspeople and young, emerging artists. The program also includes review exhibitions of mid-career and established artists and curated theme exhibitions. There is also a Kathleen O'Connor Gallery, coffee shop, craft shop and bookshop and an annual event is the Fremantle Print Award exhibition (*see* PRIZES), open to printmakers throughout Australia. COLLECTIONS: Comprehensive collections of around 700 items including WA contemporary paintings, drawings and prints, many of the latter acquired through the annual Fremantle Print Award, commenced 1976.

GEELONG ART GALLERY

(Established 1896) Little Malop St, Geelong, Vic. 3220. Vic. regional gallery. ADMIN: Geelong Art Gallery Association Committee, President and 12 members. STAFF: Director and three others. DIRECTORS: 1936–38, A. E. Anderson; 1938–72, no appointees; 1972–75, Katrina Rumley; 1975–80, Margaret Rich; 1980–85, Pamela Gullifer; 1986– , Susie Shears. HISTORY AND ARCHITECTURE: In 1896 the Mayor of Geelong, H. F. Richardson, called a public meeting for the purpose of establishing a public art gallery. As a result, an exhibition of works, loaned permanently by the NGV trustees and the Council of the VAS, opened in the Geelong Town Hall on 1 June 1900. The exhibition, which also contained donated works, had a second showing about one year later in a section of the Free Library Building. In 1912 the Council made a site available in Johnstone Park; £3000 was raised by public subscription and, on 24 May 1915, the Geelong Art Gallery was opened and named as a memorial to the Geelong philanthropist G. M. Hitchcock. The Henry Douglass

Memorial Wing was added in 1927 (public sub. £2000, state government grant £1000), and in 1937 the H. F. Richardson and J. H. McPhillimy galleries were added and named after the donors. Other additions were made, including the W. Max Bell Gallery (1956), since used as the main print gallery, and further major extensions, costing £110,000, of which the state government contributed £75,000. Important milestones in the Gallery's history included the appointment of a professional director in 1972. GALLERY ASSOCIATION: The Association for many years provided the administrative body and much of the work and policy-making has been the responsibility of Association Presidents. In addition, many of the Presidents have made generous gifts. Presidents 1900–c. 1980s were: 1900–05, Sidney Austin; 1906–08, Tom Hawkes; 1909–10, H. P. Douglass; 1911–14, F. R. Pincott; 1915–16, Howard Hitchcock; 1917–18, H. P. Douglass; 1918–22, G. F. Walter; 1923–29, A. E. Anderson; 1930–32, Howard Hitchcock; 1932–34, G. F. Walter; 1935–40, E. A. Austin; 1940–45, C. N. Brown; 1946–63, F. E. Richardson; 1963, A. A. Gray; 1964–78, R. F. L. Annois; 1978– ? Peter A. H. Spear. COLLECTIONS: Fred McCubbin's *A Bush Burial* was purchased by public subscription in 1900. This was the first work acquired by the Gallery and has remained its most well-recognised. Other 19th century artists represented include Eugene von Guérard, Louis Buvelot, W. C. Piguenit, Walter Withers, Tom Roberts, Arthur Streeton, Julian Ashton, Marshall Claxton and John Ford Paterson, Stanhope Forbes, Thomas Faed, Benjamin Leader and Thomas Kennington. The Gallery's contemporary paintings include works by Fred Williams, John Firth-Smith, Jenny Watson, Peter Booth, Michael Johnson, Gareth Sansom, Robert Jacks, Mike Brown, Paul Partos, Dick Watkins, Robert Hunter, Jan Senbergs, Peter Tyndall, Lindy Lee, Sally Smart, Gunter Christman, David Rankin, Richard Later, Robert Rooney, Lesley Dumbrell and Janet Dawson. Works on paper date from the mid-colonial period to more recent works. Among them are the complete set of Eric Thake Christmas cards, colonial watercolours depicting the Geelong region, and prints by John Brack, George Baldessin, Roger Kemp, Charles Blackman and Colin Lanceley. The Australian sculpture collection forms two distinct groups: one relating to 19th-century Classicism, for example Bertram Mackennal's *Salome*, and the other, contemporary works by Robert Klippel, Inge King, Rosalie Gascoigne, Lenton Parr, Danila Vassilieff, Geoffrey Bartlett, Clement Meadmore and Ron Robertson-Swann. Decorative arts include collections of colonial silver, contemporary ceramics (the Gordon Jackson collection), glass, Middle Eastern and Asian artefacts, Japanese satsuma ware, early 19th-century British porcelain and pottery from the 1880s to the 1960s. This area of the collection continues to expand rapidly with funds from the Dorothy McAllister Bequest and the generosity of Dr David Chamberlain. ACTIVITIES: The exhibition program includes historical and contemporary work in a range of media and a number of prize exhibitions are held (*see* PRIZES).

GEORGE PATON GALLERY

(*See* EWING & PATON GALLERY)

GERALDTON GALLERY

(Established 1949, gallery opened 1984) Chapman Rd, Geraldton, WA 6530. Public gallery. ADMIN: City of Geraldton and Art Gallery of Western Australia. DIRECTOR: 1993– Beverley Cox. The collection consists of 38 Australian pictures given by Claude Hotchin. A Japanese cultural week is held annually as are the Geraldton TAFE final year students exhibition and a number of other exhibitions and awards (including Rotary Art Awards).

200 GERTRUDE STREET INC. GERTRUDE STREET ARTIST'S SPACES

(Established 1983) 200 Gertrude St, Fitzroy, Vic. 3065.

Contemporary art space (no collection). STAFF: Director 1993– Rose Lang and two others with the assistance of ten volunteers. FUNDING: Victorian government through Ministry for the Arts. Established to support and promote emerging artists. As well as three exhibiting galleries there are 16 artists' studios, two overseas and interstate artists' studios and one residency. The regular exhibitions include the work of studio artists as well as those of many interstate and overseas artists.

GLADSTONE REGIONAL ART GALLERY AND MUSEUM
(Established 1985) Cnr Goondoon and Bramston Sts, Gladstone, Qld 4680 (PO Box 29, Gladstone, Qld 4680). Regional art gallery and museum. DIRECTOR: 1993– Judy Miles. Exhibitions from local, state and national collections are held as well as display and preservation of the region's cultural heritage.

GOLD COAST CITY ART GALLERY
(Established 1986) 135 Bundall Rd, Surfers Paradise, Qld 4217 (PO Box 6615, Gold Coast Mail Centre, Qld 4217) Qld regional gallery. DIRECTOR: 1993– Fran Considine. Local and regional artists' exhibitions curated from permanent collection, national and international touring exhibitions, Gold Coast City Conrad Jupiters Art Prize, National Gold Coast Ceramic Art Award, lecture program.

GOSFORD ART GALLERY
(PO Box 21, Gosford, NSW 2550) Gosford Council maintains a paintings collection of approximately 50 works including those by David Rose, Suzanne Archer and David Voigt, and plans to provide a public art gallery and workshop facility.

GOULBURN REGIONAL ART GALLERY
(Established 1982) Goulburn Civic Centre, Cnr Bourke and Church Sts, Goulburn, NSW 2580 (PO Box 725, Goulburn, NSW 2580) NSW regional art gallery. DIRECTOR: 1993– Jennifer Lamb. The exhibition program features a range of temporary exhibitions covering all aspects of the visual arts and crafts. COLLECTIONS: Works on paper, canvas and board, including paintings by de Maistre, Wakelin, Hilder, Feuerring, Hanke, Wallace-Crabbe, Roggenkamp, and fibre works.

GRAFTON ART GALLERY
(Established 1988) (PO Box 24, Grafton, NSW 2460) NSW regional gallery. The Jacaranda Art Society initiated annual prizes 1961–92 with prize money in 1993 of $5000 towards purchase of works which have become the basis of the Gallery Collection. Works acquired through the prize include those by David van Nunen, Ken Done, Adrian Gemelli, Jan Riske, Michael Taylor and there is a collection of bird and flora paintings by the late local artist Gladys O'Grady.

GRIFFITH REGIONAL ART GALLERY
(Established 1983) 167–185 Banna Ave, Griffith, NSW 2680. NSW regional art gallery. DIRECTOR: 1993– Kerry Creecy. Temporary exhibitions change monthly and the permanent collection includes Australian designer jewellery.

GRYPHON GALLERY
(1972–c. 1987) The gallery of the Melbourne State Coll., Swanston St, Carlton, which under the directorship of Ken Scarlett from 1976 showed often innovative work of students and other artists, especially in craft, sculpture and installation works. The gallery held only a few regular exhibitions following his resignation in the late 1980s and closed completely in 1993.

HAMILTON ART GALLERY
(Established 1959) Brown St, Hamilton, Vic. 3300. (PO Box 9, Hamilton, Vic 3300) Vic. regional gallery. ADMIN: City of Hamilton. DIRECTORS: 1961–75, John Ashworth; 1975–85, Julian Faigan; 1985–88, Alan Sily; 1988– , Daniel McOwan. HISTORY AND ARCHITECTURE: Designed by Melbourne architect J. Alexander, the building opened in 1961 to house the Shaw Collection established by Herbert Buchanan Shaw, a

wealthy grazier of *Kiama*, Grassdale, near Hamilton. He amassed a large and valuable collection during a lifetime of travel and collecting which, on his death in 1957, he left to the City of Hamilton on condition that it was suitably housed and placed on public exhibition. Cost of the building, of which the Shaw Gallery was the main feature, was £108,000. The building was extended in 1973 to include extra storage and facilities and a new upstairs section, devoted mainly to the Gaussen Gallery and the Sandby works. Culmination of the first two decades of Gallery operations was in Oct. 1981, when the *Hamilton Arts Festival* opened with a special Sandby exhibition. COLLECTIONS: Shaw Collection, more than 750 items, including tapestries, rugs, glass, silver, paintings, drawings, carvings, Chinese ceramics (rare collection), 18th and 19th century English and European porcelain. Items in the Shaw collection date from 206 BC (Han Dynasty). The Gaussen Collection, of 29 watercolours and 74 etchings by Paul Sandby (1725–1809), is one of the most important representations of Sandby's work outside the UK. The Barber Bequest added to the Shaw and Gaussen collections many fine Oriental bronzes as well as paintings, carvings and rugs including Tibetan seventeenth-century works. There is also a representative body of contemporary Australian paintings and prints, many having come from the Friends and from the biennial R. M. Ansett Hamilton Art Award which began in Nov. 1976. A large collection of Hogarth engravings was added in 1988. CITY OF HAMILTON ART GALLERY TRUST: Formed in 1962 and administered by a Board of Trustees for the purpose of administering funds for acquisition purposes. The funds are invested and the income used for acquisitions on the recommendation of the director. Trust funds include life membership fees and donations from life members, as well as general endowments and contributions from other sources. Since inception the Trust has been responsible for many important acquisitions.

HAWTHORN CITY ART GALLERY
(1969–83) During its 13 or so years of operating the gallery showed many interesting exhibitions, outstanding of which were the annual tertiary schools exhibitions, Elaine Targett Drawing Prize (1970–74) and the *Western Pacific Print Biennale* exhibitions (1976–78).

HEIDE PARK AND GALLERY
See MUSEUM OF MODERN ART AT HEIDE

HORSHAM ART GALLERY
(Established 1968) 80 Wilson St Horsham, Vic. 3400. Vic. regional gallery. ADMIN: Board of Trustees responsible to Horsham City Council. DIRECTORS: 1968–81, Jean Davidson; 1981–87 Laurence Balshaw Blake; 1987–89 Caroline Field; 1989–92 Elizabeth McEachern; 1992– Brian Allison. HISTORY: Established in 1968, it moved to its present location in 1983. The collection includes the Mack Jost Collection of Australian art which includes paintings, prints and drawings including those by Rupert Bunny, Donald Friend, John Olsen and Charles Blackman. The gallery specialises in collecting photography ranging from vintage to contemporary and includes the work of Norma Deck, Max Dupain, David Moore, Rose Farrell and Christine Barry. Works by regional artists are also included in the gallery's collection.

INSTITUTE OF CONTEMPORARY ART
Operated in Central St, Sydney in the 1980s in the premises of the former Central Street Gallery.

INSTITUTE OF MODERN ART
(Established 1975) 4th Floor, 106 Edward St, Brisbane, Qld 4000. Contemporary art space (no collection). ADMIN: Board of Directors. DIRECTORS: 1975–79, John Buckley; 1979 John Nixon; 1992– Nicholas Tsoutas. Formed for the presentation of experimental projects and innovative art including film, video and performance art of all kinds, the Institute occupies the two floors of an old building in Brisbane,

operating like a museum of modern art. The works of Nolan, Craig Martin, Danvers, Hockney, Carl Andre, Robert Cumming, John Nixon, Mike Parr, Peter Tyndall and many other innovators, have been shown. The exhibitions program is supplemented by an ongoing program of lectures and forums, performances, film and video art screenings. It is supported by private membership and fund-raising projects, with basic funding from state and federal governments.

IPSWICH CITY COUNCIL REGIONAL ART GALLERY
(Established 1980) Cnr Limestone and Nicholas Sts, Ipswich, Qld 4305 (PO Box 191, Ipswich, Qld 4305) DIRECTOR: 1993– Alice-Anne McRobbie. The collection comprises Queensland watercolours (mostly c. 1900–50), Queensland art, Australian prints and photographs and a small collection of Australian ceramics. Exhibitions consist of works from the collection, as well as touring national and international exhibitions and shows by individual artists.

IVAN DOUGHERTY GALLERY
(Established 1977) Selwyn Street, Paddington, NSW 2021. Gallery attached to university. DIRECTOR: Nick Waterlow. HISTORY: Formed as a non-commercial gallery providing an educational resource within the Alexander Mackie CAE, but also accessible to the public, it was absorbed into the City Art Institute when that institution was created through the amalgamation of six TAFE colleges in 1982 and later into the University of New South Wales. The purpose of the gallery is to provide an educational resource for the students and staff of the College of Fine Arts, University of New South Wales and the general public. This involves the mounting of exhibitions, installations and performances of a professional standard which can be related to the activities in the College's art programs. Consequently, the exhibitions range over a wide selection of disciplines including photography, printmaking, sculpture, painting, video, film, architecture and design and the crafts. Exhibitions are usually of a thematic or survey type and focus on work in the vanguard of art practice and development.
(*See also* SCHOOLS, CITY ART INSTITUTE; COLLEGE OF THE ARTS, UNIVERSITY OF NSW)

JAM FACTORY
(Established 1973) Lion Arts Centre, 19 Morphett St. Adelaide, SA 5000 (PO Box 10090 Gouger St. Adelaide 5000) ADMINISTRATION: A state-funded incorporated association with an appointed board of 7 members. Chair in 1993, Don Dunstan. DIRECTORS: 1981–86 Winnie Pelz; 1986–89 Lynn Collins; 1989– (CEO) Frank McBride. STAFF: Principal staff in 1993, CEO; four directors of workshops; gallery curator; marketing manager. Established in 1973 as the South Australian Craft Authority, it was renamed Jam Factory Workshops Inc. in 1977 and the Jam Factory and Design Centre Inc. in 1992. In 1992 it also moved from its original premises in Payneham Road, St Peters to its present purpose-built premises. With the aim of fostering and developing standards of excellence and innovation in craft and design, it holds career development programs in training workshops in glass, ceramics, furniture design and design in metal. Graduates from tertiary institutions attend these courses which cover design, technical, business planning and marketing skills. An artist-in-residence program is also offered, the resident artist occupying a flat on the premises. As well, 11 studio spaces are offered annually to craftspeople at a subsidised rental. The Jam Factory Gallery, established in 1978, has, in the new premises, a full-time curator administering two spaces and running a program of changing exhibitions devoted exclusively to local, national and international exhibitions of contemporary craft and design. Two retail outlets – one at Morphett St and one in Gawler Place, city central – stock products from the workshop and other craft.

JEWISH MUSEUM OF AUSTRALIA
(Established 1978) 26 Alma Rd, St Kilda, Vic. 3182 (PO Box 401, South Yarra, Vic. 3141) ADMINISTRATION: Executive and general committees. DIRECTOR: Helen Light. As well as the permanent exhibition of Jewish time line, belief and ritual, the Jewish year, and Judaism in Australia, the Museum has changing exhibitions thrice yearly. New and larger premises are planned for 1994.

LADY FRANKLIN MUSEUM (GALLERY)
(Established 1842) Lenah Valley Road, Lenah Valley, Hobart, Tas. 7008. ADMIN: Art Society of Tas., responsible to the Hobart City Council. HISTORY: In 1839, Lady Franklin (1792–1875), wife of the Lieut. Governor, Sir John Franklin, purchased 130 acres (53 hectares) of land at Lenah Valley and paid for the erection of a suitable building to serve as an art and historical museum. Sir John Franklin laid the foundation stone in Mar. 1842, and the building was opened to the public on 16 Oct. 1843. The Franklins left Tasmania less than a month later, leaving the Museum in trust to be handed over to the first suitable university or college established in Hobart. The Museum was handed over to Christ College in 1846, but the College failed in its obligations. During the time of its administration (90 years), the original purpose of the Museum was forgotten and the neglected contents were handed over to other institutions. The Museum became the property of the City Corporation in 1936 and for 12 years it was used as a records store. In 1948 it was rescued by the Art Society of Tasmania (q.v.), which still occupies the building, conducts art classes, holds monthly exhibitions and has in addition built up a substantial art library.

LAKE MACQUARIE CITY ART GALLERY
(Established 1980) Main Road, Speers Point, NSW 2284 (PO Box 21, Boolaroo, NSW 2284) Municipal gallery member, RGANSW. ADMIN: Lake Macquarie Municipal Council. DIRECTORS: 1993– Sue Mitchell & Helen Walker, co-directors. Monthly changing exhibitions of both contemporary and traditional nature in all media. The permanent collection consists of works of 20th-century Australian artists including Marion Borgelt, Rodney Pople, John Smithies, Ruth Waller, Ken Unsworth, and the Hunter Valley Photographic Collection.

LA TROBE UNIVERSITY ART MUSEUM AND COLLECTION
(Established 1967 (collection), 1983 (museum)) Plenty Rd, Bundoora, Vic. 3083. Gallery attached to university. ADMIN: Curator of Art Works responsible to the Vice-Chancellor's Advisory Committee on Art Works. CURATOR OF ART WORKS: 1992, Rhonda Noble. Since 1967 the University has developed and maintained a permanent collection of high quality works of visual art for the cultural enrichment of its student body, staff and the wider community, with an emphasis placed on contemporary Australian art. COLLECTIONS: Collections include Australian art and ethnographic collections of Australian Aboriginal and Melanesian artefacts. Loan collections include the Christensen Fund Collection of Pre-Columbian Artefacts; the Dunmoochin Foundation Collection. The La Trobe University College of Northern Victoria has a separate collection of Australian art works. ACTIVITIES: Regular exhibitions are held using the collections and borrowed art works. Permanent works feature in University buildings or grounds, including *Dialogue of Circles* by Inge King and *Four Seasons and Glass Mandala* by Leonard French, as well as Fred Williams' *Scrub, Lysterfield 1967* and Bart Sanciolo's sculpture depicting Dante's *Divine Comedy*. Changing exhibitions throughout the year. Guided tours for special interest groups and educational groups. Public lectures.

LATROBE VALLEY ARTS CENTRE
(Established 1971) 138 Commercial Rd, Morwell, Vic. 3840. Vic. regional gallery. ADMIN: Advisory Committee, 11 members. DIRECTORS: 1971–72, Campbell Hughston; 1972–80, Tony Hanning; 1981–87, Pru McColl; 1987–91, Donald Coventry; 1991– Wendy Armitage. HISTORY AND

ARCHITECTURE: Pre-empted from 1967 by the Latrobe Valley Purchase Awards from which the nucleus of the collections was formed, the Arts Centre was designed by the Melbourne architects Best Overend, and built on the first floor of the Shire Offices, with access to the street by a stairway. The air-conditioned $150,000 galleries were opened to the public in Mar. 1971. COLLECTIONS: Contemporary Australian paintings, prints, sculpture, ceramics and glass include works of regional and historical significance with an emphasis on regional contemporary artists. Includes Campbell Hughston Memorial Collection of Australian prints; Bank of Melbourne Regional Art Collection and Building Union Superannuation (BUS) Collection. ACTIVITIES: About 14 temporary exhibitions annually which include touring exhibitions, solo exhibitions by regional artists as well as curated exhibitions from the permanent collection and works on long-term loan. Workshops in painting and drawing are conducted in a studio adjacent to the gallery and ceramics workshops are held in a separate building.

LAWRENCE WILSON ART GALLERY, THE UNIVERSITY OF WESTERN AUSTRALIA

(Established 1990) Mounts Bay Road, Nedlands, WA 6009. University art gallery and university art collection. CURATOR OF ART: 1993– Sandra Murray. This gallery has replaced the Undercroft Gallery and now houses the University of WA collection. It acts as a permanent home for the University of Western Australia's art collection as well as maintaining a diverse exhibition program. COLLECTIONS: Since 1927 the University collection has grown steadily, with the help of a number of generous bequests and gifts including the Tom Collins Bequest given by Samuel Furphy in 1949 in honour of his father, Joseph Furphy, author of *Such is Life*. Royalties from the book formed the substance of the bequest and paid for the acquisition of twelve works by Sidney Nolan on the theme of Furphy's masterpiece. Other bequests which have enhanced the collection include McGillvray and Sir Claude Hotchin Bequests, The Ruby Rose Maller Memorial Fund, and the Skinner and Constable Collections. Works in the collection number over 2500 and are chiefly by Australian artists, including Charles Blackman, Rupert Bunny, Sidney Nolan, Margaret Preston, Lloyd Rees and Fred Williams. The works of WA-based artists are especially featured, including Brian Blanchflower, Elise Blumann, Kathleen O'Connor, Guy Grey-Smith and Howard Taylor. EXHIBITIONS: The exhibition program's emphasis is on artists associated with Western Australia, particularly emerging artists. Occasionally interstate and international exhibitions are shown, as well as shows based on the permanent collection.

LEWERS BEQUEST AND PENRITH REGIONAL ART GALLERY

(Established 1981) 86 River Rd, Emu Plains, NSW 2750. NSW regional gallery. ADMIN: Committee of Management responsible to Penrith Council. DIRECTORS: 1982–85, Cam Gray; 1986– Michael Crayford. HISTORY AND ARCHITECTURE: In 1979 the 100-year-old home of Margo and Gerald Lewers (q.v.), together with its art works, was given by their daughters to the City of Penrith for development as a regional gallery. Situated in landscaped gardens alongside the Nepean River, the property seemed ideal and the state government and Penrith City Council jointly contributed $300,000 and appointed an architect, Sydney Ancher. His plan included restoration of the original building, a new air-conditioned exhibitions gallery, and a separate cottage for the director. COLLECTIONS: The original bequest includes works by Margo and Gerald Lewers and their collection with works of their contemporaries and other Australian artists. The policy has been to collect works by artists working in NSW 1930–78. ACTIVITIES: Exhibitions by individual artists have included those by John Olsen, Yvonne Audette, Carl Plate, Tony Tuckson and Peter Upward, and group exhibitions have included *Woodcut 1905–89* 1989; *Desiderius Orban and Selected*

Students 1988; *New Directions 1952–62* 1991; *Toll/Transformations to Memorial* 1993.

LINDEN

(Established 1985) 26 Acland St, St Kilda, Vic. 3182. Council gallery. ADMIN: Owned and administered through St Kilda City Council. Located in a large Victorian house in the heart of St Kilda, Linden incorporates an art gallery, offices, studios and a workspace. The gallery shows contemporary work in all media and particularly that of emerging artists and artists with social and political reference. The annual 'postcard exhibition' acquires works to a total of $2000 for the Council collection which is housed in the St Kilda Town Hall. An arts advisory association, modern image makers association on experimental film and video, and a community television station have their headquarters at Linden which also holds concerts, artists' talks and forums on the arts. Art classes are held at the 'New Arts Studio'.

LIONEL LINDSAY ART GALLERY AND BOLTON LIBRARY
See TOOWOOMBA UNIVERSITY ART GALLERY

LISMORE CITY ART GALLERY

(Established 1953) PO Box 23A, Lismore, NSW 2480. NSW regional gallery. ADMIN: Lismore City Council. DIRECTORS: 1981–85 Jan Renkin; 1986– Richard Maude.
STAFF: Director and three part-time. The collection numbers around 160 and includes ceramics, sculptures, paintings many of which were purchased during the annual Lismore Purchase Prize (*see* PRIZES) from 1953–82, with supplementary purchases in the 1980s with funds from VACB grants. Six works by Kevin Connor donated by bequest in 1992 are an interesting addition to the collection, which generally concentrates on the purchase of work by local artists. A new building with exhibition spaces, a cafe and bookshop was opened in September 1993 to mark the gallery's 40th anniversary.

McCLELLAND GALLERY

(Established 1971) 390 McClelland Drive, Langwarrin, Vic. 3910. Vic. regional gallery.
ADMIN: Board of trustees. DIRECTORS: 1971–75, Carl Andrew; 1975–77, John Ashworth; 1977–78, Denis Colsey; 1978–79, David Bradshaw; 1979–81, Frank McBride; 1981–84, Raymond Francis; 1985– Simon Klose. STAFF: Director and three others. HISTORY AND ARCHITECTURE: Established under the will of Miss A. M. McClelland, the gallery was established on land owned by the McClellands and dedicated to her brother, Harry McClelland. Designed by architects Munro and Sargent, the original building consisted of a large gallery, smaller gallery, storeroom and administration offices and compact catering kitchen. Further additions have included extended storeroom, administration office, library, works on paper gallery, chair and furniture store and a glazed terrace. Also situated in the extensive grounds are four community arts and crafts studios, Harry McClelland's studio and a small residence. COLLECTIONS: The collection in 1993 consisted of well over 1000 items. The collection policy is to acquire work in the areas of Australian works on paper and sculpture and supporting material for the primary collection; artworks material recording the interest or contribution of individuals or community organisations; and artists' libraries. Major gifts and patronage have assisted the collection greatly and include the original McClelland Collection of paintings, furniture and some decorative arts (1971); 25 Rupert Bunny figure drawings donated by Sir Daryl Lindsay (1973); Maurice Callow Collection of English watercolours (mainly 19th century), 75 works and further gift of 45 watercolours and engravings (1982); gift of 22 works on paper by George Bell and his library donated by his daughter Antoinette Niven; Dr Orde Pynton Gift of over 200 items including prints by Rembrandt, Dürer, and Whistler and some Australian paintings and decorative arts (1992). Bequests and foundations include the McClelland Bequest

(1961) which supported the construction, operation and maintenance of the gallery; L. M. Fornaria Bequest (1980) to support acquisition of Australian paintings, drawing and prints; Elisabeth Murdoch Sculpture Foundation (1989) to support the development and presentation of Australian sculpture at the gallery.

MAITLAND CITY ART GALLERY

(Established 1973) Brough House, Church St, Maitland, NSW 2320. NSW regional gallery. ADMIN: Maitland City Council. EXECUTIVE OFFICER: 1982– Margaret Sivyer. A permanent collection of Australian paintings, drawings, prints; African art; historic Maitland photographic collection; education kits. Temporary exhibitions change every 4–5 weeks.

MANJIMUP ART GALLERY

(Established 1960) Manjimup, WA 6258. ADMIN: Manjimup Art Gallery Committee. Hotchin endowment of 37 Australian paintings acquired by the Shire of Manjimup in 1960, and hung in the town hall. Later the collection was moved into a special hall in the new Manjimup Civic Centre.

MANLY ART GALLERY

(Established 1924) West Esplanade, Manly, NSW 2095 (PO Box 82, Manly, NSW 2095) Municipal gallery. ADMIN: Committee appointed by the Manly Municipal Council under the Local Government Act of 1919. DIRECTOR: 1993, Michael Pursche. HISTORY: In 1923, Alderman J. R. Trenerry, proprietor and editor of the *Manly Daily*, conducted a £100 art prize for paintings and etchings of Manly and environs, and built a gallery at Gilbert Park specially for the display of entries. Trenerry lost money, but a happier result of his enterprise was the formation of a committee, in 1924, to build up a Manly art and historical collection. In 1930, the Manly Concert Pavilion was made available for housing and converted into an art gallery at a cost of £1296. The Gallery opened on 14 June 1930; an annexe was added in 1940, to house the Rubbo gift, and long-term plans were announced for extensions to the Gallery. COLLECTIONS: Paintings by Dattilo Rubbo donated by the artist in 1939; P. S. Garling gift of 42 paintings, including some attributed to Old Masters; Australian paintings, mainly by Sydney figurative painters. ACTIVITIES: Changing exhibitions have an innovative edge and there is an emphasis on the exploration of Australia's beach culture. The permanent collection is regularly displayed.

MEAT MARKET

(Meat Market Arts and Crafts Centre, established 1977) 42 Courtney Street, North Melbourne, Vic. 3051. Designed by the architect George Raymond Johnson in 1880, with additions 1907, the building operated as the metropolitan meat market until 1974. In Jan. 1977 it was purchased by the Vic. state government for development as a large centre for the encouragement of Australian arts and crafts. An extensive conversion program was undertaken and by 1980 under the directorship of Marjorie Johnson, workshops, galleries, conference rooms, offices and display areas were in operation. In Dec. 1981, the Victorian Print Workshop began operations in the building. But moved to its own premises in the mid-1980s with ceramics, glass, textiles, metal, wood and leather workshops remaining in the centre. The Meat Market houses the Vic. government crafts collection. In 1991 the Meat Market suffered a severe funding crisis with government funding cuts and a downturn in attendances. Closure was imminent but the Centre was saved by a public campaign requesting support and funds. Main income is derived from rents and sales in crafts outlets, the exhibitions program, corporate sponsorship and subscriptions.

MILDURA ARTS CENTRE

(Established 1956) 199 Cureton Ave, Mildura, Vic. 3500 (PO Box 3206, Mildura, Vic. 3502) Vic. regional gallery. ADMIN: Mildura Arts Centre Board committee of 8 in 1993.

DIRECTORS: 1956–58, Rex Bramleigh (Curator); 1958–65, Ernst van Hattum; 1965–78, Tom McCullough; 1978–80, Gwen Stainton (acting director); 1980–84, Michel Sourgnes; 1984– Michael Murray. HISTORY AND ARCHITECTURE: The Mildura Arts Centre was established in 1956 when Senator R. D. Elliott, owner of the *Sunraysia Daily* and other country newspapers, left his large and valuable collection to the City of Mildura on condition that suitable gallery housing was provided. Elliott had become friendly with a number of leading British artists during visits to the UK, and was treasurer of the NGV Committee of Trustees. A forceful administrator, he served as an assistant to the British Minister for Supply, Lord Beaverbrook, during World War II. To fulfil the conditions of the bequest, the Mildura City Council purchased *Rio Vista*, former home of the pioneer Chaffey family, built in 1889. These elegant premises provided the sole housing for the collection until 1962, when new galleries, a theatre and amenities (designed by D. Alexander) were added in a $75,000 expansion program to which the state government contributed $50,000. The new buildings were completed and opened 12 Nov. 1966, in time for the third *Mildura Sculpture Triennial*, 1967 *(see* MILDURA SCULPTURE TRIENNIAL; EXHIBITIONS). COLLECTIONS: Besides the fine representations of Australian modern sculpture from the *Sculpture Triennials* (many installed in Mildura streets and parks in conformity with the aim of making Mildura a sculpture city), the collections are rich in British early twentieth-century paintings and drawings. Orpen, John, Brangwyn, Epstein, the brothers Nash, and many others of the period are well represented. Another legacy from the Elliott collection is a fine pastel by Degas. The J. R. Bow Memorial Collection has added some hundreds of fine Old Master prints and engravings to the collections and a number of modern Australian paintings and prints have been acquired or decorated by philanthropic foundations such as Georges Art Awards, Caltex Trust, Bank of Melbourne, Victorian Government Art Foundation and Friends of the Mildura Arts Centre.

MONASH UNIVERSITY EXHIBITION GALLERY

(Established 1975) Ground Floor, Gallery Building, Wellington Rd, Clayton, Vic. 3168. University gallery. ADMIN: Curator, responsible to the Vice-Chancellor, the Chairman of the Dept of Visual Arts, and the University's Art Advisory Committee. DIRECTORS: 1975–79, Grazia Gunn; 1980– , Jenepher Duncan. HISTORY: The Gallery was established with the Dept of Visual Arts in 1975 and apart from its collecting program, quickly became the venue for annual programs of temporary exhibitions of standards in accord with the cultural life of a university. It fulfils an informational and educational role within the campus and the general community providing an annual exhibition program with related catalogues and events which interpret, document and research Australian visual art. COLLECTION: Collecting began at the inception of the university in 1962, with acquisitions of works by Clifton Pugh, John Perceval and other contemporaries. An art purchasing committee was set up later and the acquisitions were supplemented by gifts from Joseph Brown, Kenneth Myer, Dr T. Lang, A. Shiff and Dr J. G. Burnell, who donated his collection of English and Australian nineteenth-century etchings. Development of the collections was greatly advanced by Patrick McCaughey, first in his capacity as hon. adviser, then as a member of staff (Teaching Fellow in the English Dept) and, finally, from 1975, as Monash Professor of Visual Arts. Successive curators, Grazia Gunn and Jenepher Duncan, continued this work. ACTIVITIES: The Gallery's public program focuses on the history of visual culture by examining the work of a period or theme, or the work of certain artists, deemed critical to the broad development of Australian art. Exhibitions of individual artists 1974–92 have included those of Alun Leach-Jones, Julie Brown-Rrap, Lesley Dumbrell, Dale Hickey, John Lethbridge, Howard Arkley, Imants Tillers,

Robert Hunter, Philip Hunter, Ian Burn. Group exhibitions have included *Re: Creation/re-creation*; *Word as Image: Art with Text*; *Off the Wall/In the Air: A Seventies Selection*; *The Body in Question*.

MORNINGTON PENINSULA ARTS CENTRE
(Established 1969) Civic Reserve, Dunns Road, Mornington, Vic. 3931. Vic. regional gallery. ADMIN: Committee of Management appointed by Mornington Shire Council. DIRECTORS: 1970–92 Alan McCulloch; 1992–93 Kim Sajet; 1993– Elizabeth Gleeson.
STAFF: Director; 3 part-time. HISTORY AND HOUSING: The proposition to establish a gallery was adopted by the Mornington Shire Council and exhibitions were held in the Shire Offices before providing interim housing in a nearby century-old house. The house was converted into a gallery by volunteer workers and the first exhibition there was opened by RGAV chairman, Donald Webb, in Apr. 1971. A reference library of art books and catalogues grew with the Centre. The vastly increased collection, library and active exhibitions program rapidly outgrew this building and in the early 1980s plans commenced for a new gallery building. The state government through the Premier's Department allocated a special grant of $800,000 towards building costs which was further subsidised by the Mornington Council. Funds were also raised through events, the largest of which raised $125,000 from a dinner and art exhibition and sale of works donated by artists on the occasion of the gallery director Alan McCulloch's 80th birthday in 1987, as well as a number of significant donations from local businesses and the Myer Foundation. The present gallery with far larger exhibition spaces, storage facilities, offices, bookshop and restaurant was opened in November 1991 by the Premier of Victoria, John Cain, who had taken a personal interest in its establishment. COLLECTIONS: The collection centres around Australian drawings, prints and other works on paper and also includes contemporary Australian prints, paintings by early artists, miscellaneous examples of primitive art and contemporary ceramics, sculpture, and 100 Australian artists' posters. Large representation exists of Russell Drysdale, Arthur Boyd, Sam Fullbrook, Fred Williams, Patrick Henigan, Mary Macqueen, Roger Kemp and Barbara Hanrahan. An important contributor to the drawing collections is the annual acquisitive Spring Festival of Drawing & Prints. ACTIVITIES: The annual program includes about ten temporary exhibitions interspersed with showings of works from the permanent collections. Many visiting exhibitions are shown and these have included *Rodin and his Contemporaries*; *Aspects of Australian Art* (from the NGA); *The Heroic Years of Australian Painting* (Melbourne *Herald*); *European Dialogue* (from the *Biennale of Sydney*); and a number of MPAC generated tribute exhibitions.

MOUNT BARKER ART GALLERY
(Established 1975) Mount Barker, WA 6324. Began with a Hotchin endowment of 40 Australian paintings hung in the Memorial Hall and administered by an art gallery committee. In 1975 the collection was allocated space in the Public Library in the new Mount Barker Civic Centre.

MUSEUM OF APPLIED ARTS AND SCIENCES
(Established 1879) 500 Harris Street, Ultimo, NSW 2007 (PO Box K346, Haymarket, NSW 2000) ADMIN: Board of Trustees. DIRECTOR: 1992– Terence Measham. The Museum of Applied Arts and Sciences (MAPS) administers three museums – the Powerhouse Museum, the Mint and Sydney Observatory. The Museum's collection of some 350,000 objects spans the fields of science, technology, social history, decorative arts and design, with an emphasis on Australian material in an international context. HISTORY AND ARCHITECTURE: Founded as the Technological, Industrial and Sanitary Museum, and established by a subcommittee of trustees from the Australian Museum (Prof. Archibald

Liversidge, Dr Alfred Roberts, and Robert Hunt), 'to form collections of industrial, scientific and applied arts specimens for technical education and proletarian inspiration'. First objects were acquired from the *International Exhibition*, Sydney, 1879–80, and installed in the Garden Palace. Most of the collection was lost when the Garden Palace burned down in 1882. Re-established in the Agricultural Hall in the Domain, the Museum opened in 1883. Ten years later it was renamed the Technological Museum and moved to a building within the Sydney Technical College complex in Ultimo, its home for the next ninety years. In 1979 the NSW Premier, the Hon. Neville Wran, announced the NSW Government's multi-million-dollar commitment to convert Ultimo Power House to the Museum's permanent home, and to develop it as a museum of science, technology, history and applied art. COLLECTIONS: Includes unique collections of Australian ceramics, many decorated with designs based on Australian flowers and complementary motifs; nineteenth and twentieth century costumes, textiles and craftworks of all kinds. Significant acquisitions include the T. H. Leonard Collection of pottery (1921), the John Shorter Collection of Doulton and other British ceramics (1932 and 1943), the Joseph Box Collection of shoes (1942), the Imogen Whyse Collection of costume (1959), a large number of donations by Christian Rose Thornett (1966), and the Anne Schofield Collection of toys and costumes (1981). The Hyde Park Barracks and Mint buildings feature displays of Australian decorative arts and a wide range of works representative of Sydney's colonial history.

MUSEUM OF CONTEMPERORY ART
(Established 1989) Circular Quay, Sydney, NSW 2000. Art museum. ADMIN: Company limited by guarantee established by the Government of NSW and the University of Sydney through the J. W. Power Bequest. STAFF: Director 1990– Leon Paroissien; senior staff – assistant directors, Bernice Murphy, Janet Parfenovics; senior curator Kay Campbell; marketing director Marian Vickery; finance director Peter Lamb. Established jointly by the University of Sydney and the NSW Government, the MCA is the home of Sydney University's Power Bequest Collection of over 4000 works. Situated in the Rocks area, it occupies the former Maritime Services Board building (1932), completely refurbished and added to by Andrew Andersons, and looks across the Harbour to the Opera House. The Power Bequest was responsible for the refurbishment of the existing building and construction of additions, and contributes to running costs. Changing exhibitions are of challenging contemporary art with an emphasis on international installations, performances, cinema and film and video. COLLECTION: Collection comprises the Power collection of some 3000 works acquired since 1965 plus 1000 works by John Power. Curators Elwyn Lynn (1969–83) and Leon Paroissien (1983–) travelled overseas frequently to purchase works. Until the establishment of the MCA, the collection was seen at Sydney University and in touring exhibitions.
(*See also* SCHOOLS AND UNIVERSITIES – SYDNEY UNIVERSITY)

MUSEUM OF CONTEMPORARY ART
(Established 1987) 8 Petrie Street, Brisbane, Qld 4000. Contemporary art space and museum. DIRECTOR: 1993– James Baker. Public gallery and collection of Australian contemporary art from 1960s. Exhibitions are from the collection and from external sources and a magazine is published monthly.

MUSEUM OF MODERN ART AND DESIGN OF AUSTRALIA
(1958–66) ADMIN: Board of 15 directors. Chairmen: 1958–61, Kurt Geiger; 1961–66, Pamela Warrender. Director: John Reed. Patrons: In Vic., Sir John Barry and Gerard Noall; NSW, Warwick Fairfax; SA, Kym Bonython. On 12 May 1958, it was announced that the former Gallery of Contemporary Art, Tavistock Place, Melbourne, had become the

Museum of Modern Art of Australia, the opening display being an exhibition of paintings by Leonard French. The objectives of the Museum were stated in the articles: '1. To serve as an educational centre in the field of modern art. 2. To establish, maintain and conduct a public museum of modern art and a public art gallery. 3. To cultivate an awareness amongst the people of Australia of the work of their own living creative artists. 4. To foster and stimulate the experimental and the new in the realm of art and design.' The Museum was financed solely through its own activities, notably through contributions organised by the Women's Council (first chair, Mrs Elizabeth Summons), through membership fees and through support given by a small number of patrons. The strength of the enterprise was drawn mainly from the collection of 200 works, most of which were donated by John and Sunday Reed. The Reed collection included important early paintings by Sidney Nolan, Albert Tucker, Arthur Boyd, John Perceval, Danila Vassilieff, Charles Blackman and many others. Two early endowments were the Geiger Foundation (a £1000 grant established for the purpose of paying the costs of invitee artists from overseas), and £1000 made available from the estate of Mrs Claire Pitblado. The first and only recipient of the Geiger Foundation was Albert Tucker. The words 'and Design' were added to the original name in 1963, when many of the exhibitions were held at Georges Gallery (q.v.). In July 1963 the Museum moved to new, modern premises made available by the management of Ball & Welch's store, Flinders St, Melbourne. John Reed resigned as director in 1965, and later the same year the Museum temporarily ceased operations. It vacated its Flinders St premises, but in April 1966 activities recommenced with an exhibition at the Argus Gallery held in conjunction with the National Gallery of Victoria under the title *One and One*. The demise of the Museum was due largely to its timing, much of the original support being siphoned off to the new NGV. The Museum finally ceased operating in 1966. Its collections were held by John and Sunday Reed, later to form the nucleus of the collections at the Museum of Modern Art at Heide (see following entry).

MUSEUM OF MODERN ART AT HEIDE
(Established 1981) 7 Templestowe Rd, Bulleen, Vic. 3105. Public art gallery and sculpture park. ADMIN: Board of Manage-ment. STAFF: Director 1980– , Maudie Palmer; in 1993 4 other full-time; volunteers. HISTORY AND ARCHITECTURE: Originally the home of John and Sunday Reed, the house (designed by David McGlashan and built 1960s) and 4.7 hectares of land, with its charming park and herb gardens, were bought by the Victorian government and converted into a public park and art gallery as a memorial to the Reeds and to the artists with whom they were most closely associated – including Hester, Nolan, Tucker, Blackman, and Vassilieff. The modifications were carried out by the original architect and the institution was opened by the Hon. R. J. Hamer, 12 Nov. 1981. In 1993 a large new extension, designed by Andrew Andersons, was opened. This new space, discrete from the original house, provides additional exhibition and storage areas and facilitates an extensive associated activities program. Heide's name changed in 1993 to Museum of Modern Art at Heide. COLLECTIONS: 113 works of art were originally acquired from the Reeds, with a further 388 bequeathed upon their deaths in 1981. Works dating from the Modernist period include examples by Sidney Nolan, Arthur Boyd, Albert Tucker, Danila Vassilieff, Joy Hester, Charles Blackman, John Perceval and Noel Counihan. Contemporary Australian additions include work by Paul Boston, Juan Davila, Peter Booth, Mandy Martin, James Gleeson, Imants Tillers, John Young and Caroline Williams. In 1992 a major gift, the Baillieu Myer Collection of the 1980s, was given to Heide. This contains 103 works by artists such as Jan Senbergs, John Nixon,

Howard Arkley, John R. Walker, Jenny Watson and Roger Kemp, augmenting the contemporary component of the permanent collection. ACTIVITIES: The exhibition program promotes and supports contemporary Australian art as well as regular exhibitions which review art of the 1930s, 40s and 50s. During its first decade Heide represented over 400 artists in 80 exhibitions. A program of 8–10 exhibitions each year is maintained in the gallery and park including an annual exhibition from Heide's collection, exhibitions which augment the collection and review Australia's recent art history, and others which focus on contemporary art. The large park has proved an excellent venue for sculpture exhibitions which include the display of works from the permanent collections and many temporary, festival and award exhibitions.

MUSEUMS AND ART GALLERIES OF THE NORTHERN TERRITORY
(Established 1964) Conacher St, Bullocky Point, Fannie Bay, Darwin, NT 0820 (PO Box 4646, Darwin NT 0801) NT state gallery. ADMIN: Board of seven members. STAFF: 1993– . Director: J. Healy; admin. officer B. Pascoe; curator (Natural Sciences, Reptiles) G. Gow; curator (Human Sciences, Aboriginal and Melanesian Ethnography) Ms M. West. Other staff: 16 full-time; five part-time. The origin of the Museum dates from 1964 when the Museums and Art Galleries Bill was introduced in the Legislative Assembly. The original Palmerston Town Hall built in 1882–3 was made available, and despite its limited size, had great charm with attractive gardens. The 1974 cyclone put paid to this modest beginning as the building was totally destroyed along with a number of items in the collection. Construction began on the Museum's present site in 1979 and the new building opened in 1981. COLLECTIONS: Major Australian artists since first settlement including Aboriginal, South-East Asian and Oceanic art, material culture and archeology.

MUSWELLBROOK ART GALLERY
Bridge St, Muswellbrook, NSW 2333 (PO Box 122) NSW regional gallery. ADMIN: Municipal Council. DIRECTOR: 1993– Peter Gill. A small gallery above the Town Hall to house the works accumulated from the Muswellbrook Art Prize. (*See also* PRIZES)

NARACOORTE ART GALLERY
(Established 1968) 128 Smith St, Naracoorte, SA 5271 (PO Box 45, Naracoorte, SA 5271) SA regional gallery. ADMIN: Board of seven. The first regional gallery to be established in SA, its annual program includes touring exhibitions and general local art and its collection consists mainly of works on paper.

NATIONAL GALLERY OF AUSTRALIA
(Established 1968) Parkes Place, Parkes, Canberra ACT 2600. The Gallery was formally opened by HM Queen Elizabeth II on 12 Oct. 1982. ADMIN: Director, secretary-manager and supportive professional staff responsible to the Council of the National Gallery of Australia, comprising a chairman and ten members. STAFF: In 1993– Director, Betty Churcher; Deputy Director, Alan Froud; Assistant Director, Collections, Michel Lloyd; Assistant Director, Marketing, Kevin Munn. In 1993, the complete NGA staff exceeded 200.
DIRECTORS: 1978–90, James Mollison; 1990-Betty Churcher. HISTORY: Inclusion of an art gallery was one of the requirements in the original master plan for the design of the national capital at Canberra. The successful architect, Walter Burley Griffin (q.v.), included sites for two galleries in his winning designs. Plans for an Australian National Gallery had started in 1911 with the foundation of a Historical Memorial Committee 'to secure portraits of representative men', together with the formation of the Commonwealth Art Advisory Board to recommend purchases of Australian art works for use in a national art museum. Two world wars

and a worldwide economic depression retarded development, but in 1965 a committee, headed by Sir Daryl Lindsay, CAAB chairman, was set up to inquire into the formation of an Australian National Gallery. The committee's recommendations were tabled and accepted by Parliament in 1967. They included provision of an acquisitions policy covering worldwide twentieth-century art as well as Australian, South-East Asian and Pacific area work, and works by great masters of all periods. In 1968 an interim council was appointed to advise the Prime Minister on the design, planning and construction of the Australian National Gallery, and in 1971 James Mollison was appointed director-designate. The Commonwealth Art Advisory Board was succeeded in 1973 by the National Gallery Acquisitions Committee, replaced one year later by the National Gallery Interim Council. The National Gallery Bill was passed in Parliament in 1975, and the National Gallery Act was proclaimed and became operative in June 1976, when the first Council of the Australian National Gallery was appointed. The Australian National Gallery operated under this name until 1993 when it formally changed its name to National Gallery of Australia. With an acquisitions policy which has from time to time drawn the Gallery into public debate, most notoriously with the purchase of Jackson Pollock's *Blue Poles*, the NGA has developed a fine permanent collection. From the early 1990s it also commenced the organisation of large scale and significant exhibitions, the first two, *Rubens and the Renaissance, 1992* and *Surrealism: Revolution by Night*, 1993, attracting huge crowds and critical acclaim. ARCHITECTURE: The design for the building (from an architectural competition held in 1968) was by Colin Madigan of Edwards, Madigan, Torzillo and Briggs Pty Ltd. It was completed in association with a working group representing the Gallery Interim Council, the Dept of the Prime Minister and Cabinet, and the National Capital Development Commission. Special consultant was James Johnson Sweeney. COLLECTIONS: The collections (approximately 70,000 works in 1993) cover the entire spectrum of Australian art, including Aboriginal and Torres Strait Islands. European and American acquisitions are centred on the modern period beginning 1850, with particular emphasis on work produced after 1940. This area of collecting is enriched by extensive representation of nineteenth-century prints and drawings, illustrations and artists' books. The collection of sculpture includes pieces for sites landscaped to harmonise with the gallery building. Primitive art includes the arts of tribal Africa, Pacific Basin, Asia and Pre-Columbian America. Buddhist and Hindu sculpture forms the nucleus of the Asian collections. Other collecting areas include photography, prints, drawings, illustrated books and theatre arts. In certain collecting areas, material acquired is not necessarily for exhibition but serves the functions of research and education. This includes large representations of drawings, studies, sketchbooks and plans. SUBSIDIES AND ENDOWMENTS: In 1971–72, the Commonwealth Art Advisory Board's budget for acquisitions for the embryonic Australian National Gallery was $392,000, increased to $1.079m. in 1972–73. In 1973–74 the budget for the National Gallery Acquisitions Committee was $4m. Government funding for acquisitions was $2,980,000 in 1977–78, $3,037,000 in 1978–79, and in 1982 the Prime Minister, the Right Hon. Malcolm Fraser, announced $28m. to be given over five years. In addition to government acquisitions funding, gifts from artists, private individuals and organisations have become an important part of the NGA's acquisitions program. The National Gallery of Australia Foundation raises funds to suppport the National Gallery and its collections.
BIB: Michael Lloyd and Michael Desmond, *European and American Paintings and Sculptures 1870–1970 in the National Gallery of Australia*. Tim Bonyhady, *The Colonial Image: Australian Painting 1800–1880*. Robyn Maxwell, *Textiles of Southeast Asia: Traditions, Trade and Transformation*.

NATIONAL GALLERY OF VICTORIA
(Established 1861) 180 St Kilda Rd, Melbourne, Vic. 3004. The State Gallery of Victoria. ADMIN: Council of nine trustees appointed by state government. COUNCIL: In 1993, Mr Will Bailey AO (president), Mr Daryl Jackson AO (deputy president), Mrs Lyn Williams, Ms Rhonda Galbally AO, Mr Darvell Hutchinson (Treasurer), Professor Jennifer Zimmer, Ms Dulcie Boling, Mr Bill Conn. STAFF: In 1993, 168 full-time, 18 part-time. Director, James Mollison; General Manager, Graeme Newcombe; Co-ordinating curator, Australian Art, John McPhee; Curata, Australia Art, Jane Clark; Principal curator, Sonia Dean; Senior curator prints and drawings, Irena Zdanowicz; Senior curator, Decorative Arts, Terence Lane; Senior curator, Asian Art, Dr Mae Anna Pars. DIRECTORS: 1882–91, George Frederick Folingsby; 1891–1935, Lindsay Bernard Hall; 1936–41, James Stuart MacDonald; 1941–56, Daryl Lindsay; 1956–75, Eric Westbrook; 1975, Gordon Thomson; 1975–80, Eric Rowlison; 1981–89, Patrick McCaughey; 1989–91, Rodney Wilson; 1991– James Mollison. HISTORY AND ARCHITECTURE: Building of the NGV, the first public gallery in Australia, was suggested by the art critic James Smith at the inaugural meeting of the Victorian Society of Fine Arts, 20 Oct. 1856. Letters were written to the parliament by Sir Redmond Barry; the O'Shanassy government then reserved the land on the south side of the public library and, advised by a leading citizen of the colony, Captain Clarke, voted £2000 'for the purchase of works of art in England'. In 1861, the Museum of Art was opened by the Governor of Victoria, Sir Henry Barkly, and on 24 Dec. 1864 the first picture gallery was opened and placed under the curatorial administration of the Public Library. It remained under this administration until 1882, although a Master of the Art School (Eugene von Guérard) was appointed in 1870 and continued in that office until 1881, the name of the institution having been changed in the meantime (1875) to National Gallery of Victoria. In 1882 the first professional director (G. F. Folingsby) was appointed and given official Public Service grading. Until 1944, the Library, Museum and Art Gallery were controlled by a single Board of Trustees, but in March of that year the three bodies were separated and became autonomous, each with its own board.

The buildings housing the three institutions, the Public Library, Museum and National Gallery of Victoria, were designed by Joseph Reed and financed by the Victorian government. Later additions to the buildings were all carried out to conform with the original style. First built were the Library buildings. A chronological listing shows the order of NGV architectural development: 1861, Museum of Art added to the Library buildings (it extended south from the west side); 1869, main picture galleries built, extending eastwards from the Museum of Art; 1870, Drawing School added; 1875, McArthur and Latrobe Galleries added; 1925, McAllan Gallery added; 1928, Buvelot (later the Murdoch) Gallery added; 1942, last structural alterations made to the old buildings.

From 1944, Sir Keith Murdoch, chairman of the trustees of the National Gallery of Victoria, with the assistance of leading citizens and representatives of the arts, urged the state government to reserve about seven acres of land at the southern end of Princes Bridge, in St Kilda Road, on which a new art gallery could be built at a cost of £2,000,000. A committee formed added the words 'culture centre', and the project became known as 'the new national art gallery and culture centre'. The site, known as Wirth's Olympia, was occupied seasonally by Wirth's circus and a dancing pavilion known as the Trocadero. It was reserved but remained undeveloped until 1956, when attempts to develop it for other purposes led to an official government proclamation and the appointment of a building committee set up by Act of Parliament. Dr W. M. Milliken, director emeritus of

Cleveland Museum of Art, visited Melbourne to advise on implementation of the scheme for which government-subsidised finance was made available, and management committees were appointed. The director of the NGV, Eric Westbrook, subsequently accompanied the architect, Roy Grounds, on a study tour of the world's art galleries. Grounds' plans included a long, bluestone-faced building surrounded by a moat, at the northern end of which was to be a bluestone-based copper tower 410 ft (125m) high. Courtyards, theatres, lecture halls, restaurants, school and offices were features of the plans displayed at the launching of the public appeal for funds at the NGV in 1961, centenary year of the foundation of the original gallery. £500,000 of public money was raised during the next year, the two largest individual amounts, of £50,000 each, coming from the Herald and Weekly Times and from Lady Grimwade. The Women's Committee (President, Mrs John Summons) raised large sums for the new National Gallery of Victoria, which opened 20 August 1968. In 1986 a northern complex designed by architect Peter Sanders and including a large display area dedicated to the showing of contemporary art, the Keith and Elisabeth Murdoch Court (sponsored by Dame Elisabeth Murdoch), was opened. Exhibitions seen in the Murdoch Court have included the McCaughey Prize and the retrospectives of artists including Sir Sidney Nolan, Albert Tucker and Charles Blackman. COLLECTIONS: The first exhibition (at the Museum of Art, 1861) comprised a collection of casts, medals, coins and *objets d'art* bought in London with the inaugural £2000 donated by the government. The first major expenditure on pictures was made by Sir Charles Eastlake, president of the Royal Academy, who bought 13 paintings by contemporary British painters at an average price of £300 each. Forty-three local paintings formed the exhibition in the first picture gallery in 1864 (when Nicholas Chevalier was awarded a £200 prize), and another temporary exhibition (a loan collection which raised £554, £450 of which was invested for a travelling scholarship) was mounted in 1869 when the rest of the galleries comprising the main part of the project were completed. During its first 45 years, the NGV enjoyed a modest enough standing in relation to the world's public art galleries, but in 1904 the death of Alfred Felton and subsequent announcement of his magnificent bequest changed the situation. Suddenly the NGV had become one of the richest privately endowed public galleries in the British Empire. In less than 50 years the famous bequest provided the NGV with many works by great masters, including Rembrandt, Poussin, Rubens, Van Dyck, Goya, Tiepolo, Gainsborough, Reynolds, Hogarth, Daumier and many others. More modern works were by Corot, Theodore Rousseau, Cézanne, Pissarro, Manet, Monet, Sisley, Degas, Matisse, Redon and numerous others. Among the most treasured works acquired was a Tiepolo and a magnificent set of watercolour drawings by William Blake. The Connell, Kent, Spensley, Short and Templeton endowments further enriched the collections, which later received a special character from portraits acquired under the terms of the Everard Studley Miller bequest. In addition to these private bequests, many works were acquired from annual government subsidies of £4000, until 1948, when the amount was reduced to £3500, at which figure it remained until increased in 1965 to £9000. By 1944, the steady accumulation of masterpieces had begun seriously to tax the display space available in the buildings and many valuable works had to be stored in the vaults. With the opening of the new NGV, state government funding of the NGV was substantially raised, especially in respect to acquisitions, so that the Felton Bequest, though continuing to provide many masterpieces, no longer bore the sole responsibility for their acquisition. The purchasing situation was further greatly improved when the Art Foundation of Victoria (q.v.) was formed in 1976, enabling the purchase of many fine works. The Everard Studley Miller Bequest has

greatly enriched the collections with Old Master portraits such as the Bernini *Self Portrait*, acquired 1977, and many important works have been acquired through smaller gifts and bequests. The growth of the collections was thus rapidly accelerated through the 1970s, and the end of the decade reached its climax with the acquisition of some 300 examples of the Pre-Columbian art of Mexico.

Works acquired during the 1980s included a significant collection of Australian Aboriginal art including major contemporary works by Tim Leura Tjapaltjarri, Emily Kngwarreye and Rover Thomas; paintings by John Glover, Eugene von Guérard, Bea Maddock, John Perceval; Picasso's *Weeping Woman* and the collection of Australian art by emerging artists from the Michell and Margaret Stewart Endowments. GIFTS AND BEQUESTS: In addition to the inaugural £2000 government fund, the McCulloch government commission 'for the promotion of the fine arts' produced another £2000 'to form the nucleus of a museum, gallery and school of art' in 1863. The government met costs of maintenance and salaries. Significant gifts and bequests have included:

Gilbee Gift: £1000 was given by a Melbourne surgeon, William Gilbee, in 1886, to enable the gallery to acquire an Australian historical painting or paintings. Two commissions, of £500 each, were given to E. Phillips Fox and J. Longstaff; Fox produced the *Landing of Captain Cook at Botany Bay, 1770*, and Longstaff the *Arrival of Burke, Wills and King at the Deserted Camp at Cooper's Creek, Sunday Evening 21st April, 1861*, a work measuring 2.8 × 4.3m (111 × 169^1/2 in.), the largest oil-painting in any Australian gallery.

McAllan Bequest: The residuary estate of James McAllan, willed to the gallery in 1903, became available in 1925 when the amount had grown to £33,237. The government added £7000 to this amount and the McAllan wing and two floors above it were added to the buildings.

Felton Bequest: In 1904 the bequest of Alfred Felton altered the status of the NGV to make it one of the richest endowed public galleries in the British Commonwealth. Sir Daryl Lindsay (q.v.) gives the sum of the estate as £383,163, the whole of the income from which was divided equally, half going to charities and half to the NGV for purchases of works of art. The value of the estate had appreciated to about £2,000,000 by 1963, by which time £260,000 had been spent on acquisitions. L. Bernard Hall made the first purchases in 1905, and during his visit overseas arranged, under the terms of the Will, for the appointment of the first Felton Bequest adviser in London. (Advisers to the Felton Bequest: Sir George Clausen, 1906–07; F. W. Gibson, 1908–15; Sir Sidney Colvin (with F. W. Gibson), 1913–15; Robert Ross, 1917–18; Frank Rinder, 1918–28; Randall Davies, 1930–34; Bernard Hall, 1934–35; Sir Sydney Cockerell, 1936–39; Daryl Lindsay, 1945; Sir Kenneth Clark and Prof. Randolph Schwabe, 1946–47; A. J. L. McDonnell, 1947–64; Dr Mary Woodall 1965–75; Dr Ursula Hoff, 1975–c. 1984.) The advisers are responsible to the Felton Bequest Committee whose members consult with the trustees of the NGV, the Felton Bequest funds being controlled by a special Felton Bequests Committee.

Connell Collection: In 1914 John Connell presented a valuable collection of pictures, furniture, glass, silver-ware and ceramics.

Kent Bequest: 129 pieces of Chinese ceramics bequeathed by W. H. Kent (a former trustee of the gallery) and his wife in 1937.

Spensley Bequest: 700 items including pictures, bronzes, ivories, china and other works, bequeathed by Howard Spensley, of England, in 1938, together with £2000 towards costs of transport and maintenance.

Short Bequest: £1000 from William Henry Short, in 1940, for the purchase of pictures.

Templeton Gift: Rare English and European porcelain given by the widow of Colin Templeton in 1941 in memory of her husband.

Everard Studley Miller Bequest: £200,000 bequeathed by Everard Studley Miller in 1956, for the purchase 'of portraits of persons of merit in history, painted, sculpted or engraved before 1800'.

Samuel E. Wills Bequest: $500,000 bequeathed in 1967 by Mrs Maude Matilda Nott, the income to be divided between the State Library of Victoria, the National Museum of Victoria, and the National Gallery of Victoria.

In the 1970s, 80s and 90s numerous bequests and gifts were received, notably two for the purchase of works by new and emerging artists – the *Michell Endowment* and the *Margaret Stewart Endowment*. EXHIBITIONS: Nearly all important international exhibitions visiting Victoria have been held at the NGV, exceptions being the early international exhibitions held in the Exhibition Building and the most important of all, *French and British Contemporary Art* (1939–40), which, because of the intensity of feeling generated by the conflict between 'traditionalists and moderns', was vetoed as 'unsuitable for the NGV' by the Director, J. S. MacDonald, and was held in the Melbourne Town Hall. Successors to this exhibition, *French Painting Today* (1953), *Italian Art of the Twentieth Century* (1953), *French Tapestries* (1956), *Trends in Dutch Painting* (1961), *Recent British Sculpture* (1963), etc. were all held at the old NGV. The first temporary exhibition in the new NGV building, *The Field*, aroused some controversy, some seeing it as a spirited, vital, energetic and youthful display in tune with the spirit of the new gallery; others, including international visitors, as a disappointing imitation of international abstraction (specifically New York School painting as represented in *Two Decades of American Painting*, the last big touring exhibition in the old NGV) and an opportunity missed of showing that Australian contemporary art had something of its own to say. *Modern Masters: Manet to Matisse* (1975) rivalled the great 1939 exhibition and, together with the *Chinese Exhibition* (1977), heralded an era of mammoth exhibitions at the NGV.

The trend to major exhibitions continued into the 1980s with the decade beginning with the Thyssen-Bornemisza private collection; the Pompeii exhibition; *Treasures of the Forbidden City* and *Entombed Warriors* in 1982 (which attracted an attendance of 148,000). Other exhibitions which attracted large crowds included the Picasso exhibition of 1984, the Monet exhibition of 1985 and in 1985 and the 1986 *Golden Summers* exhibition of Australian Impressionist work. The Murdoch Court was opened with *Field to Figuration: Australian Art 1960–1986* which featured works largely drawn from the collection and was an important survey of Australian art over a 26-year period. Popular exhibitions from 1988–93 included the Russian *Works from the Hermitage* exhibition in 1988; *The Dragon Emporer* 1988–89; *Suleyman the Magnificent* 1990; *Works of Toulouse-Lautrec* 1991; *Rubens* 1993; *Rembrandt to Renoir* 1993. Smaller exhibitions of significance included *POPISM* 1983; *Backlash: The Australian Drawing Revival 1976–86* 1986; *Classical Modernism: The George Bell Circle* 1992 and *Images of Power: Aboriginal Art of the Kimberley* 1993. During the 1970s and 80s a number of important mid-career survey shows of Australian artixts were instigated by the NGV largely by the then curator of Australian art Robert Lindsay. These all but ceased in the late 1980s, the exhibitions of Australian artists in the early 1990s tending to be large tetro-spectives of later career artists such as Nolan, Olsen, Tucker, Perceval and Blackman. NATIONAL GALLERY SOCIETY: In 1947 the National Gallery Society of Victoria was created by the Director (Daryl Lindsay) and Chairman (Sir Keith Murdoch) as an independent body with its own administration and president. Its aims were to conduct educational and other functions, provide guide lecturers and other services, and generally to operate for the welfare of the NGV, especially in respect to acquisitions. The Society was successful from the beginning, and by 1993 its membership stood at approximately 15,000. The Society has

its own rooms within the NGV, and publishes a monthly *Bulletin* and other publications. President 1993, Fairlie McColl; General Manager, Hugo Leschen. ART FOUNDATION OF VICTORIA: Established in 1976, the Foundation is run by an executive of 10 members elected for three years. The Foundation's main purpose is to raise funds for the benefit of the NGV and on announcing its initial target of $3m the Victorian state government agreed to match the figure dollar for dollar up to $2.5m. Two funds were established – a Capital Endowment Fund, income from which was to be used for acquisitions and a Trust Fund, to be used for specific acquisitions or projects.

BIB: Edmund La Touche Armstrong, *The Book of the Public Library, Museum and National Gallery of Victoria 1856–1906*, Melbourne, 1906; J. S. MacDonald, *Catalogue of the National Gallery of Victoria*, 1943, Daryl Lindsay revision, 1948; Russell Grimwade, *Flinders Lane Recollections of Alfred Felton*, MUP, 1947; *Bulletin of the National Gallery of Victoria*, quarterly 1845–58, annual from 1959; Ursula Hoff, Joan Lindsay and Alan McCulloch, *Masterpieces of the National Gallery of Victoria*, Cheshire, Melbourne, 1949; Ursula Hoff, *Catalogue of European Paintings before 1800*, NGV, 1961; Ursula Hoff, ed., *The Melbourne Dante Illustrations by William Blake*, NGV, 1961; Daryl Lindsay, *The Felton Bequest*, OUP, 1963; Franz Philipp and June Stewart, eds, *In Honour of Daryl Lindsay*, OUP, 1964; Ursula Hoff and Margaret Plant, *National Gallery of Victoria Paintings, Drawings and Sculpture*, Cheshire, Melbourne, 1968; Leonard B. Cox, *The National Gallery of Victoria 1861–1968: A Search for a Collection*, NGV, 1970; Ursula Hoff, *The National Gallery of Victoria*, Thames & Hudson, 1973, 1979; Ann Galbally, *The National Gallery of Victoria*, NGV 1988.

NEW ENGLAND REGIONAL ART MUSEUM

(Established 1979 opened 1983) Kentucky St, Armidale NSW 2350 (PO Box 508, Armidale, NSW 2350) NSW regional gallery. DIRECTORS: 1982 Helen Tyzack; 1983– Joseph Eisenberg. Established through a building fund appeal launched by the Premier of NSW, the Hon. Neville Wran, in June 1979 and opened by him in 1983. The home of the Howard Hinton and Chandler Coventry collections of Australian art. Howard Hinton established his collection for the purpose of encouraging artists, educating students and for the benefit and enjoyment of the public. The Chandler Coventry collection focuses on expressionistic and abstractionist works and strongly reflects recent art movements. The Art Museum houses its own growing collection of contemporary art. Exhibitions change every 6–8 weeks and include those from the Museum's own collections or travelling exhibitions. The Museum also initiates its own travelling exhibitions, specialising in retrospectives and mid-life surveys of artists' lives. The Museum actively promotes the visual arts in other forms through its commercial label *Artstuff*, which produces a range of clothing designed by visual artists, presents an annual art market and hosts many theatre activities, street performances, films, national and international art tours, guest lectures and workshops. (*See also* PRIZES, ARMIDALE ART GALLERY SOCIETY PRIZE; REGIONAL GALLERIES ASSOCIATION OF NSW)

NEWCASTLE REGION ART GALLERY

(Established 1957) Laman Street, Newcastle, NSW 2300 (PO Box 489G, Newcastle, NSW 2300) NSW regional gallery. ADMIN: Newcastle City Council. DIRECTORS: 1957, Paul Beadle (honorary); 1958–65, Gil Docking; 1965–75, David Thomas; 1975–80. In 1993, David Bradshaw. FUNDING AND FINANCE: Funding for the day-to-day running of the Gallery is provided by Newcastle City Council. Sponsorship is responsible for some building renovations and acquisitions of works of art from Port Waratah Coal Services (PWCS) on behalf of the Hunter Valley coal export industry. HISTORY AND ARCHITECTURE: In 1945 a Sydney ophthalmic surgeon, Dr Roland

Pope, presented his art collection and library to the City of Newcastle. A condition of the gift was that a public library and art gallery be established. Until 1977 the Gallery was known as the Newcastle City Art Gallery and the collection was housed in the War Memorial Cultural Centre, which now functions as the City Lending and Reference Library. On 11 March 1977 the new premises were opened by HM the Queen as the Newcastle Region Art Gallery. The Gallery building, designed by the City Architect, John Baker, has total area a 2,020 square metres, of which 1,390 square metres is exhibition space. The building earned the architects the Dangar Award for civic design in 1977. COLLECTIONS: The permanent collection is devoted to Australian paintings, watercolours, drawings and prints from colonial times to the present day and includes the Parnell collection of paintings by W. C. Piguenit, Edith Cusack and A. H. Fullwood, and the Pope collection of 3000 volumes and 120 pictures, including paintings by Drysdale and contemporaries, and a set of British etchings. It extends to sculpture, post-1950 ceramics and Aboriginal bark paintings. The 19th-century representation includes Joseph Lycett, John Glover, Eugene von Guérard, Louis Buvelot, Tom Roberts, Julian Ashton, Arthur Streeton and Jane Sutherland. The 20th century is represented by artists such as Elioth Gruner, Max Meldrum, Roland Wakelin, Grace Cossington Smith, Margaret Preston, Ralph Balson, William Dobell, Arthur Boyd, John Brack, William Delafield Cook, Jon Molvig, Sidney Nolan, John Olsen, Ron Robertson-Swann and John Coburn. Contemporary works of the 1970s and 80s are also well represented. Major artists associated with the Hunter Region are represented and the Gallery's collection of Japanese ceramics has become the largest public collection of contemporary Japanese pottery in Australia. The NRAG Foundation, established in 1977, is a company limited by guarantee. Its principal objective is to provide financial support to acquire art works essential to the development of the Gallery's collection.

NICHOLSON MUSEUM OF ANTIQUITIES
(Established 1860) University of Sydney, NSW 2006. Gallery attached to university. ADMIN: Uni. Board. Curator: 1993 Prof. A. Cambitoglou. COLLECTIONS: Objects from ancient Egypt, the Near East, Cyprus, the Greek and Roman worlds and northern Europe. The collections come mainly from Australian and British excavations and from the original private collection of Sir Charles Nicholson.

NOLAN GALLERY
(Established 1980) Lanyon, Tharwa Drive, Tharwa, ACT 2620 (PO Box 1119, Tuggeranong, ACT 2901) Public gallery. DIRECTOR: 1993 Angela Philp. Foundation collection of works (1945–53) donated by Sir Sidney Nolan and temporary exhibitions of work by Nolan and other 20th-century Australian artists, including contemporary art.

NORMAN LINDSAY GALLERY AND MUSEUM
(Established 1969) 14 Norman Lindsay Crescent, Faulconbridge, NSW 2776. Art gallery. ADMIN: National Trust of Australia (NSW). Norman Lindsay died in 1969, leaving to the National Trust of Australia (NSW) a large collection of his works. The Trust subsequently bought his former property at Faulconbridge and established the Gallery and Museum as a showplace for Lindsay's work. Oil paintings, watercolours, etchings, manuscripts and ship models are shown in rooms in the house, the studio remaining as he left it. His sculptures are displayed in the garden.

NORTHAM ART GALLERY
(Established 1952) Northam, WA 6401. Hotchin endowment of 36 Australian paintings acquired by the shire in 1952, and hung in the Town Hall.

NORTHERN TERRITORY UNIVERSITY GALLERY
(Established 1990) Casuarina Campus, Northern Territory University (PO Box 40146, Casuarina, NT 0811) University

gallery. ADMIN: Collection Committee with gallery director appointed by committee from Fine Art staff. Regular displays (three week duration) of NTU art collection, works by staff and students of NTU, works from region including South-East Asian and Aboriginal art.

ORANGE CIVIC CENTRE GALLERY
(Established 1982) Civic Square, Byng St (PO Box 35), Orange, NSW 2800. NSW regional gallery. ADMIN: Orange City Council. DIRECTORS: 1982–85 Jane Raffin; 1986–91 Peter O'Neill; 1991– Alan Sisley. The first gallery building, which had just been completed, burnt down in 1985, but the collection, which had not yet been moved into the new premises, was not harmed. The Gallery was rebuilt and re-opened in 1986. The collection consists of the Mary Turner collection of Australian contemporary art; a specialist collection of sculptural ceramics; jewellery and costume. Twenty-five temporary exhibitions are held annually and these include touring national and international exhibitions with some showings of the work of local artists.

PERC TUCKER REGIONAL GALLERY
(Established 1981) Flinders Mall, Townsville, Qld 4810 (PO Box 1268, Townsville, Qld 4810) Regional art gallery. ADMIN: Incorporated association. DIRECTOR: 1992– Ross Searle. The collection comprises contemporary North Queensland and Australian art (painting, drawing, printmaking, ceramics and sculpture), traditional and contemporary Aboriginal art of Northern Australia. Membership of the gallery enables members to attend previews, openings, concerts, lectures and receive newsletters. The Townsville Art Award is held annually in association with Townsville Art Society (*see* PRIZES).

PERFORMING ARTS MUSEUM
(Established 1982) 100 St Kilda Road, Melbourne, Vic 3004. Museum for the performing arts. Part of the Victorian Arts Centre. DIRECTOR: 1982– Frank van Straten. COLLECTIONS: Australia's largest collection of performing arts material such as programs, costumes, clippings. The collection is open to researchers. EXHIBITIONS: A changing program of public exhibitions, mostly curated by the Museum to reflect its own collection.

PERTH INSTITUTE OF CONTEMPORARY ART
(Established 1989) 51 James St, Perth, WA 6000 (GPO Box 1211, Perth, WA 6001) Contemporary art space (no collection). ADMIN: Company limited by guarantee. Board of directors. DIRECTOR: In 1993 Noel Sheridan. PICA promotes the creation, presentation and discussion of new and experimental arts through painting, sculpture, installation, performance, music, theatre, film. There is an artist-in-residence program and PICA Press, the publishing arm of the gallery, produces artists' books, audio tapes, catalogues and newsletters.

PITSPACE
(1979–c. 1984.) Established within Phillip Institute of Technology as a gallery and open air exhibition space, mainly for the promotion of contemporary and experimental art. Its director 1979–82 was former Mildura Gallery director Tom McCullough. During Feb.–Apr. 1981, it combined with La Trobe Uni. as a venue for the *Australian Sculpture Triennial*.

PLIMSOLL GALLERY
(Established 1986) University of Tasmania Centre for the Arts, Hunter St, Hobart, Tas. 7000. University gallery. A university gallery which shows primarily contemporary art, craft, design which would otherwise not be seen in Tasmania. Exhibitions range from solo exhibitions, including that of the visiting Chinese artist Guan Wei in 1991, to survey exhibitions such as *Splitting Heads* in 1991, a showcase for contemporary Australian and New Zealand furniture. The Gallery also mounts exhibitions for national tours such as *A Life of Blank: Works by Imants Tillers* and was commissioned by the Australia Council to curate the exhibition

Rediscovery: Australian Artists in Europe, 1982–92 for Expo 92 in Seville, Spain.

PORT ADELAIDE GALLERY

(1872–1932) Municipal gallery/museum. An Art Gallery and Museum was established at Port Adelaide, South Australia. In 1932 it was changed to a Nautical Museum. In 1958 a new building was erected at 135 St Vincent Street, Port Adelaide, and the nautical contents of the old museum transferred there. The art works not sold were passed over to the municipal corporation, pending the institution of an art gallery. In 1968 the Nautical Museum received an annual South Australian Government grant of £80, and was administered by a curator, Vernon Smith. In his *Story of Australian Art*, William Moore says that the Port Adelaide Gallery was founded in 1880 by E. Phillips, and that it was the oldest provincial gallery in Australia.

POWER BEQUEST/GALLERY

See MUSEUM OF CONTEMPORARY ART

POWERHOUSE MUSEUM, SYDNEY

See MUSEUM OF APPLIED ARTS AND SCIENCES

PRINT COUNCIL OF AUSTRALIA GALLERIES

(1978–1980s) Gallery which operated in conjunction with the PCA showing members' works and other print exhibitions.

QUEEN VICTORIA MUSEUM AND ART GALLERY

(Established 1887) Wellington St, Launceston, Tas. 7250. Tasmanian regional gallery. ADMIN: Professional director and staff responsible to the Launceston City Council. DIRECTORS: 1897–1938, H. H. Scott; 1938–42, E. O. G. Scott; 1942–46, position vacant; 1946–50, N. J. N. Plumley; 1950–53, Miss I. Thomson; 1953–55, W. Curnall; 1955–78, W. F. Ellis; 1978– Chris Tassell. HISTORY: The Royal Society of Tas. established a museum at Launceston before 1850 and the first public museum was founded by a committee of the Launceston Mechanics' Institute, 1879. In 1887 the foundation stone of the present building was laid in honour of the Jubilee of Queen Victoria, and the institution was opened on 29 Apr. 1891. In 1895 the management and control passed from the Tas. government to the Launceston Corporation, and in 1910 a vertebrate zoological gallery was added to the existing facilities which included art and anthropological galleries. The adjoining building of the Launceston Tech. Coll. was taken over in 1927 and converted to a watercolour gallery, historical gallery and lecture room. The Fall-Hartnoll Memorial wing was added in 1937, the Scott Memorial wing in 1952, and a physical science gallery and laboratory store in 1961. COLLECTIONS: Important collections of colonial paintings and drawings from Glover to Piguenit, also extensive collections of ceramics and other crafts. Collections of Australian paintings were developed and updated in the 1960s, largely through a £1000 acquisitions prize which began in 1964. BEQUESTS AND ENDOWMENTS: Adelaide Monds Bequest, £5000; Mary Nicholls Bequest, £1000; Fall-Hartnoll Bequest, £7000 and many later, small bequests and gifts. Capital expenses and administrative and maintenance costs are met mostly with annual subsidies from Launceston City Council and Tasmanian state government. ACTIVITIES: The exhibition program comprises touring exhibitions and special exhibitions drawn from permanent collections. Travelling exhibitions are also initiated in-house. Fine Art acquisitions are supported by Launceston Art Foundation.

QUEENSLAND ART GALLERY

(Established 1895) Qld Cultural Centre, South Bank, South Brisbane, Qld 4101 (PO Box 3686, South Brisbane, Qld 4101) The State Gallery of Queensland. ADMIN: Board of 13 trustees. CHAIRMAN: 1993 R. W. L. Austin, OBE. STAFF: 102 full-time. DIRECTORS: (Note: Before 1949, when Robert Campbell was appointed director, the principal gallery officer had the title of 'curator'.) 1895–1914, Godfrey Rivers, Hon. Curator; 1914–31, J. A. Watts, Custodian Curator; 1931–49, J. A. Watts, Curator; 1949–51, Robert Campbell, Director; 1951–60, Robert Haines; 1960–67, Laurence Thomas; 1967–74, James Wieneke; 1974–86, Raoul Mellish; 1987– Doug Hall. HISTORY AND ARCHITECTURE: Suggested in a letter to the government (Oct. 1883) by the painter Isaac Jenner, and vigorously promoted by Godfrey Rivers (supported by the Queensland Art Society), the QAG came into being and acquired its first premises in the old Brisbane Town Hall in Queen St, Brisbane (since demolished). It was opened as an institution by the governor, Sir Henry Wylie Norman, on 29 March 1895. In later years it was to undergo four changes of location: 1905, to the third floor of the new Executive Building; 1930, to the Exhibition Building (former Concert Hall) in Gregory Street; 1975, to the sixth floor of the MIM Building, 160 Ann Street. Crucial to QAG developments were the 44 years at Gregory Street where the Gallery opened with a presentation of pictures from the Queensland Art Fund (q.v.) and during the 1950s and 1960s gained great vitality from the leadership of Robert Haines and Laurie Thomas. These two directors brought the collections from provincial to national status and set the wheels in motion for the building of a great new gallery.

In 1959, the QAG became a body corporate constituted under the Queensland Art Gallery Act, and a site in the Botanical Gardens incorporating the old Government House building was approved for the building of the new Queensland Art Gallery. This site was abandoned in 1968 when plans began for a vast new Queensland Cultural Centre complex of buildings on the south bank of the Brisbane River, the first major component of which was to be the new QAG. Designed by Robin Gibson and Partners, the new $28m. gallery with its 15 exhibition areas, offices, facilities, cafeteria, sculpture garden and huge central Water Mall, took five years to build. It was opened at a gala ceremony, featuring five international exhibitions, by the Hon. Joh Bjelke-Petersen, Premier of Queensland, on 21 June 1982. With its clean, white lines, horizontal profile, gardens and highway bridge (to link it with the rest of the Cultural Centre), the Gallery illustrates the aim of its builders – 'to transform the southern threshold of the City into one of the most beautiful riverside areas in the world'.

Through a complete reorientation of policy positions the Gallery has now framed and built specific Collection emphases; created enhanced enjoyment of and intellectual access to the Collection through focused exhibitions, interpretive resources and documentation, and become a more proactive initiator and organiser of major international and national exhibitions which have included *Painters and Sculptors: Diversity in Contemporary Australian Art* 1987; *Masterpieces from the Louvre: French Bronzes and Paintings from the Renaissance to Rodin* 1988; *The Inspired Dream: Life as Art in Aboriginal Australia* 1988; *Japanese Ways, Western Means: Art of the 1980s in Japan* 1989; *Toulouse-Lautrec: Prints and Posters from the Bibliothèque Nationale, Paris* 1991. In 1993 the Gallery started a new triennial – the *Asia-Pacific Triennial of Contemporary Art* while Gallery 14 project space provides a venue for contemporary installation and other experimental forms of art. COLLECTIONS: For the first 65 years of operations, QAG holdings of art works were mainly paintings by Qld artists or by well-known contemporaries in other states, and were of minor significance by comparison with works in other state collections. But in 1959 the accession of the Rubin collection changed the situation. At the instigation of Robert Haines (then QAG director), the wealthy dealer and collector H. de V. Rubin (q.v.) presented to Queensland his collection of modern French paintings valued at £126,504. The gift raised the status of the QAG, and also caused a sensation throughout Australia, partly because of the circumstances in which the pictures were given. To quote the illustrated catalogue, published

by the trustees: 'This group of seven paintings was recently purchased in London by Mr David Muir, Agent-General for Queensland, acting under instructions from the Queensland government and the Trustees of the Queensland Art Gallery, at a sale at Sotheby's of paintings from the collection of Major H. de Vahl Rubin. The acquisition was made under rather unusual circumstances, for the money was made available for this special purpose by a donor who, for the present, wishes to remain anonymous.' (It was later disclosed through the press that the donor was Major Rubin himself.) This magnificent gift not only made it possible for the Queensland Art Gallery to acquire seven important French paintings, but gave worldwide publicity to its existence. The Rubin pictures are: *Trois danseuses à la classe de danse*, oil on board, by Edgar Degas; *Coco et Jean* (c. 1901–02), oil on canvas, by Auguste Renoir; *Tête de fille* (1894), oil on oval panel, by Henri Toulouse-Lautrec; *La belle Hollandaise* (1905), blue chalk, gouache and oil on board; *Tête d'homme* (1909), watercolour; *Femme au parasol couchée sur la plage* (1933), pen and indian ink, coloured wash and gouache, by Pablo Picasso; *Nature morte*, oil on canvas, by Maurice Vlaminck. The Rubin collection gave the QAG a character that attracted a number of additional gifts, and later was an important factor in influencing the Qld government to build the new QAG and at the same time proportionately increase its subsidies for acquisitions. Its collection policy has since included a commitment to purchase of contemporary Australian art and a historical and contemporary collection of Asian art with the aim of fostering understanding of Australia as part of the Asia–Pacific region. GIFTS, BEQUESTS AND ENDOWMENTS: *Godfrey Rivers Trust* 1932. Established by the widow of Godfrey Rivers with an endowment of £2000 to develop the collections of which Rivers had been first curator. Custodians of the trust from 1932 were Daphne Mayo and Vida Lahey. A Godfrey Rivers acquisitive prize (q.v.) was conducted and the winning pictures added to the collections. Among additional notable purchases from the fund were *The Cypriot*, by William Dobell; *Stove Theme*, by Eric Wilson; *Trees in Moonlight*, by Godfrey Miller; and a sculpture, *Nan*, by Sir Jacob Epstein.
John Darnell Bequest, 1935. £15,000, part of a large trust including paintings, drawings, sculpture, prints and books, the main part of which went to Queensland Uni.
L. J. Harvey Memorial Gift, 1951. £500 raised by the Queensland Half Dozen Group as a memorial to Brisbane's pioneer teacher of art, Lewis J. Harvey (q.v.).
Maria Therese Treweehe Bequest, 1951. Monetary bequest following gift of pictures which included works by Frederick McCubbin and Max Meldrum.

Additional valuable gifts and bequests to 1993 included the Chandler Trust Fund, Beatrice Ethel Mallalieu, Annie Chisholm Wilson, and Estelle Cunningham Neilson bequests, and many other smaller bequests and donations, climaxed by the Rubin gift in 1959. The Andrew and Lilian Pedersen Memorial Prizes Fund was established in 1975 with an endowment from artist Lilian Pedersen to conduct a group of biennial prizes. Other significant donors and trusts include the Trout Collection, eleven fine European graphics given by Lillian Bosch; Sir Sidney Nolan (25 etchings by the artist); Lady Russell Cuppaidge Bequest (funds for acquisitions); Grace Davies and Nell Davies Trust Fund; N. S. Blane estate and Mrs J. R. Lucas Estate in memory of their father, John Robertson Blane; the Blanche Louisa Buttner Bequest (1972); the Hobday and Hingston Bequests (1967) and the Melville Haysom Memorial Art Scholarship Trust (1979).
QUEENSLAND ART GALLERY FOUNDATION: Established in 1979 by 1993, $7.7m had been raised for the acquisition of works of art. Subsidised by the state government on a dollar for dollar basis, the Gallery's Contemporary Art Acquisition Program and Exhibitions Development Fund (Japanese companies with business interests in Queensland) bring together the financial support of private individuals and the business sector throughout Australia and overseas.
BIB: Vida Lahey, *Art in Queensland 1859–1959*, Jacaranda Press, Brisbane, 1959; Robert Haines, *French Art from Australian Collections*, also *Recent Acquisition of French Paintings*, QAG, 1959; exhibition cat., Laurie Thomas and Robert Hughes intro., *Australian Painting Today*, QAG, 1963. *Queensland Art Gallery Selected Works*, 1982.

QUEENSLAND COLLEGE OF ART GALLERY
(Established 1982) Opened Feb. 1982 at the Qld Coll. of Art, PO Box 84, Morningside, Brisbane, Qld 4170. Gallery attached to tertiary institution. Multi-purpose space available for all forms of visual and performing arts.

QUEENSLAND UNIVERSITY OF TECHNOLOGY ART COLLECTION
(Established 1945) Victoria Park Road, Kelvin Grove, Qld 4059. Public art collection attached to university. ADMIN: QUT Art Collection Committee. STAFF: 1993 – curator Stephen Rainbird; assistant curator Tracy Muche. COLLECTIONS: Collection of nearly 1000 works of art comprising early 20th-century Australian paintings, prints and drawings including those by Lambert, Preston, Cossington Smith, Wakelin; 20th-century Queensland art including Fairweather, Macqueen, Molvig, Olley, Risley, Robinson; 1970s Australian paintings including Leach-Jones, Looby, Olsen, Whisson. Contemporary Australian ceramics including works by Benwell, Bishop, Moon, Peascod, Hanssen, Pigott, McConnell and a collection of 20th-century naive paintings and sculptures.

RIDDOCH ART GALLERY
(Established 1984) 6 Commercial Street East, Mount Gambier, SA, 5290 (PO Box 899, Mount Gambier, SA 5290) Regional art gallery. ADMIN: Board of Management – South East Cultural Trust. COLLECTIONS: Contemporary Australian art including works by Peter Booth, Mandy Martin, Ann Newmarch, John Beard, Gunter Christmann, Ronni Tjampitjinpa. *Art in Wood* collection including works by Bruce Armstrong, Paul Jurazcek, Giuseppe Romeo, Tony Bishop, Tom Risley. 1970s Australian photography including works by Mike Parr, Geoff Parr, Lyn Silverman and others. Contemporary and historical art and craft of the south-east including works by George French Angas, Eugene von Guérard, Cathleen Edkins, Shay Docking, Paul Hay. Mount Gambier Institute Collection of Australian and European paintings, graphics, photographs c. 1880–1900. ACTIVITIES: The majority of exhibitions are visiting travelling exhibitions with works from the permanent collection and self-originated exhibitions comprising the rest of the changing exhibitions. The *Fletcher Jones & Staff South East Crafts Award* exhibition, an acquisitive award for the South East Crafts Collection, is held annually.

ROCKHAMPTON CITY ART GALLERY
(Established 1967) Victoria Parade, Rockhampton, Qld 4700 (PO Box 243, Rockhampton, Qld 4700) Qld regional gallery. ADMIN: Rockhampton City Council STAFF: In 1993 director Dianne Heenan; 2 full-time. HISTORY AND ARCHITECTURE: The Gallery was established as a branch of the QAG on the initiative of Laurie Thomas (q.v.) and opened in the remodelled auditorium of the old City Hall on 13 Sept. 1967. In 1976 an Art Acquisitions Fund was opened and, at the instigation of the Director assisted by the Mayor, Alderman R. B. J. Pilbeam, $500,000 was raised by public subscription subsidised by Rockhampton City Council and the Qld state government. Over the next three years, the Director and Acquisitions Committee were thus able to add a fine, representative body of contemporary Australian paintings to the works collected by the first director, G. Webb, and the building of a modern air-conditioned gallery became necessary for obvious reasons of security and presentation. This was accomplished, and the new gallery was opened by the

Governor-General, Sir Zelman Cowan, on 6 June 1979. COL-LECTIONS: A large collection of Australian paintings and works on paper, with an emphasis on the 1970s. Includes works dating from colonial times to the present about, or produced in, the region. Works by artists of national stature like John Coburn, Daryl Lindsay, William Dargie and Gil Jamieson are included along with artists currently living in the region. Post-1970s Australian ceramics include works by Les Blakebrough, Alan Peascod, Vic Greenaway, Christopher Sanders and Jeff Minchin. There are also 28 John Gould prints of Australian birds and animals, as well as a portrait by Sir Joshua Reynolds.

ROYAL MELBOURNE INSTITUTE OF TECHNOLOGY

(Established 1979) RMIT Gallery, 342 Swanston Street, Melbourne, Vic. 3000. Tertiary gallery. ADMIN: RMIT Gallery Committee. DIRECTOR: 1993– Prof. David G. Beanland. The RMIT Gallery exhibitions cover aspects of the work of outstanding artists and designers both from Australia and overseas. Work of an experimental nature is encouraged. The gallery is a place for social contact, appraisal of new ideas and a forum for both the appreciation and criticism of works of art, and holds five exhibitions per year.

SALE REGIONAL ARTS CENTRE

(Established 1964) 288 Raymond St, Sale, Vic. 3850. Vic. regional gallery. ADMIN: Committee of Management, 16 members, responsible to Sale City Council. President of Committee, in 1992, Brian Castles. DIRECTORS 1976–93: 1976–?, Gwen Webb; 1992– , Tony Dahlitz. HISTORY AND ARCHITECTURE: Established as an institution in 1964 and assisted by an initial state government grant of $40,000, the Centre was built with-in the Sale Civic Complex of buildings above the library. An intensive program of temporary exhibitions was organised, complete with educational material, and the institution soon became an important resource centre for schools, arts and crafts groups and the public, covering the whole vast area of East Gippsland. COL-LECTIONS: Relatively small collection, mainly of Australian contemporary paintings and prints. Of special interest are the appliqué hangings and bronze plaques of Annemeike Mein. ACTIVITIES: As a community oriented exhibition gallery, its aim is to foster the arts and crafts of Gippsland. Particular preference is given to works which feature the surrounding environment. Constantly changing exhibitions of historical photographs and prints as well as contemporary works in all mediums ensure a vigorous arts program. There is a gallery society and several affiliated special-interest groups.

SHEPPARTON ARTS CENTRE

(Established 1934) Civic Centre, Welsford St, Shepparton, Vic. 3630. Vic. regional gallery. ADMIN: Shepparton City Council. DIRECTORS 1967–93: 1967–72, Keith Rogers; 1972–79, Peter Timms; 1980–87, Di McLeod; 1987– Joe Pascoe. HISTORY AND ARCHITECTURE: The institution was established with the art collection started by Shepparton City Council in 1934, and the need for proper housing became clear as the collection grew. It was first accommodated in a section of the Town Hall but, in 1962, this building was sold to the federal government and plans were implemented for the building of a new Civic Centre, including a separate art gallery building. The art gallery building includes the Andrew Fairley Gallery for showing the permanent collection, a large exhibitions gallery, offices and foyer on the ground floor, and a gallery, lounge, theatrette and facilities upstairs, which were opened to the public as the Shepparton Arts Centre in Feb. 1965. COLLECTIONS: Began in 1934 when Sir John Longstaff recommended the purchase of John Rowell's *A Wet Day in Tallarook*. By 1980 the collections had grown to include many Australian contemporary paintings as well as works by earlier artists. The Shepparton Gallery Print Prize added some 250 prints to the collections, and between 1967–70 the Sir Andrew Fairley Prize added some fine modern paintings. The first director, Keith Rogers, changed the direction of the collecting policy when he organised the Caltex Ceramic Award, held first in 1970. His successor, Peter Timms, continued the policy thus established and by 1980 Shepparton had one of the finest collections of Australian ceramics in the country. A *Shepparton Art Gallery – Sidney Myer Australia Day Ceramics Award* was established in 1991.

S. H. ERVIN GALLERY

(Established 1978) National Trust Centre, Watson Road, Observatory Hill, Sydney, NSW 2000. National Trust-owned art gallery. ADMIN: National Trust of Australia (NSW). FUNDING: Interest from the Ervin estate, plus assistance from state and federal governments and other, private donations. HISTORY AND ARCHITECTURE: The centre is named after Samuel Henry Ervin (d. Oct. 1977) who during his lifetime made several large gifts to the National Trust, including $235,000 for the purpose of converting the building into an art gallery. Designed in 1856 by Henry Robertson, the original single-storey, Georgian-style building was completed in 1857 at a cost of £5000. Its purpose was to provide housing for the Fort Street Girls High School, and it remained in use as a school until 1974 when the NSW government passed it over to the National Trust. It was then fitted out as a science laboratory before finally becoming the Gallery. COLLECTIONS: Ervin Collection, Australian paintings and sculpture; Alan Renshaw Bequest collection, paintings and sculpture. ACTIVITIES: Changing exhibitions of Australian art and culture, among them many outstanding tribute exhibitions to NSW artists of the past such as Conrad Martens, 1978; Geo. W. Lambert, 1978; Sydney Long, 1979; Norman Lindsay, 1980; David Strachan, 1993. The popular *Salon refusé* from the annual Archibald Prize has been held since the early 1990s. Lectures, art forums and educational tours for school groups are conducted and the Friends of the S. H. Ervin Gallery organise art tours, visits to private and corporate collections and lectures.

STANTHORPE ART GALLERY

(Established 1972) Weeroonga Park, Lock St (PO Box 211), Stanthorpe Qld 4380. ADMIN: Committee of management, Stanthorpe Shire Council. DIRECTOR: 1991– Alexis Tacey. Housed first in the shire council building the gallery acquired its own premises in 1987. The new building has two galleries, upper and lower, and a studio. COLLECTION: Comprises acquisitions from the biennial Stanthorpe Heritage Arts Festival; purchases by the gallery; and donations especially that of the Bell family collection including paintings by David Strachan, Margaret Olley, Donald Friend. The annual Stanthorpe Festival awards have provided rich additions to the collections including works by Suzanne Archer, Leonard Howlett, Ron Robertson-Swann, Stephen Killick, William Robinson. ACTIVITIES: The exhibition program includes touring exhibitions from around Australia, some selling exhibitions and those curated from the gallery collections or other specialist exhibitions such as *From Reel to Real: Charles Chauvel, Australian Film Pioneer* which toured Australian galleries 1993.

SWAN HILL REGIONAL GALLERY OF CONTEMPORARY ART

(Established 1964) Horseshoe Bend, Swan Hill, Vic. 3585. Vic. regional gallery. ADMIN: Swan Hill City Council. Committee of 10 including Chairman. DIRECTORS: 1964–72, Ross Holloway; 1972–76, Valerie Briggs; 1976–80, Diana Tatchell; 1980–93, Dr Ernest Smith. HISTORY: Established as a Victorian regional gallery on the converted Murray River paddle steamer *Gem*, within the confines of Swan Hill Pioneer Settlement tourist enterprise, the institution soon outgrew its inadequate premises. A new mud brick building designed by Ian Douglas and Associates was opened in 1987. The Gallery hosted the Pioneer Art Award (biennially until 1986) and the annual acquisitive Swan Hill National Print and

Drawing Show (*see* PRIZES). COLLECTIONS: Post-1960 contemporary paintings, drawings and prints including a selection of Australian naive painting, with many acquisitions having been made from the annual awards. ACTIVITIES: Exhibitions are largely curated by gallery staff and in the main consist of works of young artists from Victoria and other states.

TAMWORTH CITY ART GALLERY
(Established 1919) 203 Marius St, Tamworth, NSW 2340 (PO Box 555, Tamworth, NSW 2340) NSW regional gallery. ADMIN: Management committee for Tamworth City Council. STAFF: In 1993 director and three others. HISTORY: The Gallery began with a collection of pictures and books given by the painter J. Salvana in 1919 and housed in a room provided by Tamworth Council. It became a separate municipal gallery in June 1961. COLLECTIONS: Burdekin & Salvana collections of 19th-century British oil paintings including works by J. M. W. Turner and Daniel Maclise; Australian paintings from 19th and 20th century including those by Hans Heysen, Will Ashton, Norman Lindsay, Lionel Lindsay, Sydney Long, Conrad Martens; contemporary landscapes including those by Kristin Headlam, Sandra Leveson, Euan MacLeod. The Regan Silverware Collection has colonial Australian silverware. There is a significant fibre collection arising from the biennial National Fibre Exhibition which since 1975 has attracted leading fibre artists throughout Australia. As well as fibre, the Gallery's acquisition policy actively seeks works of landscape paintings by young and leading contemporary artists. ACTIVITIES: Temporary exhibitions are drawn from the permanent collection or travelling exhibitions but consist mainly of self-originated exhibitions.

TASMANIAN MUSEUM AND ART GALLERY
(Established 1863) 40 Macquarie St, Hobart, Tas. 7000 (GPO Box 1164M, Hobart, Tas. 7001) State Gallery of Tasmania. ADMIN: Board of seven trustees, four appointed by the Governor, two by the Royal Soc. of Tas. and one by Hobart City Council. Chairman: 1992, Mr A. Blow. STAFF: 32 full-time, 4 part-time. DIRECTORS/CURATORS: 1886–1907, Alex Morton; 1908–12, Robert Hall (Curator); 1912–17, G. Hardy (Acting Curator); 1918–22, Clive Lord (Curator). From 1922, the position became that of director. 1922–23, Clive Lord; 1934–52, Dr J. Pearson; 1953–72, Dr W. Bryden; 1972–91, D. R. Gregg; 1992– , Patricia Sabine. HISTORY AND ARCHITECTURE: Proposed 1838 and developed from 1843 onwards by the Royal Society of Tasmania, the Museum was located first in a room in the cottage occupied by the secretary of the Botanical Gardens. It then went to rooms in Parliament House and thence to the headquarters of the Royal Society. Plans were made for a permanent home in 1860, and the first part of the present building, designed by Thomas Hunter, opened in Jan. 1863. Additions were made in 1889, 1901 and 1963, when the building was doubled in size, the extensions being completed in 1965.
COLLECTIONS: Large and important holdings of Tasmaniana, including paintings, drawings, prints and documents. The 1956 catalogue of Australian works lists 391 paintings and drawings, including examples by Thomas Bock, G. T. Boyes, Knud Bull, T. E. Chapman, John Glover, W. B. Gould, J. S. Prout, F. G. Simpkinson, Owen Stanley, T. G. Wainwright. Since then hundreds of works have been added, many related to the early history of Tasmania. Collections of modern Australian art have been greatly augmented by a purchase fund donated by Tasmanian organisations to the annual TMAG *Exhibition of Australian Contemporary Art*. BEQUESTS AND ENDOWMENTS: Include the Connor Memorial Fund, Morton Allport Bequest, the Robb Bequest, and more recently the Plimsol Bequest in 1990. FUNDING: Tasmanian state government; Art Foundation of Tasmania for acquisitions, and private donations and bequests.
BIB: Stan de Phoneiga, *A Catalogue of the Australian Paintings and Drawings in the Tasmanian Art Gallery*, 1956; William Bryden, intro., *Centenary of the Opening of the Tasmanian*

Museum and Art Gallery Building, Hobart, 1963; *Art Acquisitions 77–79*, TMAG, June 1979; *Art Acquisitions 1979–84*, TMAG, August 1984; *Art Acquisitions 1984–88*, TMAG, August 1988; *Twentieth Century Australian Art in the Collection of the TMAG to 1980*, TMAG 1988; *The Art Bulletin of Tasmania*, TMAG 1983–86.

TIN SHEDS ART WORKSHOP
(Established 1969 (studios), 1987 (present site)) 54 City Road, University of Sydney, NSW 2006. Contemporary art space (no collection). ADMIN: Committee of staff members. STAFF: Director and four others. DIRECTORS: 1993– Therese Kenyon. Attached to the faculty of Architecture there are seven visual art studios and a large gallery space. Architecture and fine art students at the University are able, through Tin Sheds, to select practical art subjects (such as ceramics, painting, photography, sculpture) as electives in their courses (*see* SCHOOLS AND UNIVERSITIES). For changing exhibitions concentration is on the work of both younger and emerging artists as well as mid-career artists who work in innovative and often non-commercial areas. An *Advanced Art Students* exhibition is held annually and the the the B. Sc. Architecture students' finished projects are also displayed annually. The Noel Chettle Prize of (total) $1200 is held in second semester and is open to workshop students. The workshop also offers creative arts courses through the University's Centre for Continuing Education.

TOOWOOMBA ART GALLERY
(Established 1938) First Floor, Town Hall, Ruthven St, Toowoomba, Qld 4350 (PO Box 3021, Village Fair PO, Toowoomba, Qld 4350) Qld regional gallery. ADMIN: Board of Trustees responsible to Toowoomba City Council. DIRECTOR: 1992– Diane Baker (part-time). STAFF: Director and part-time assistant; around 30 volunteer staff. HISTORY AND PREMISES: Initiated by local artists, assisted by the Toowoomba Art Society, who put together a small collection of paintings for which a room was constructed as an art gallery in the old City Hall in 1938. In 1979 the entire upper floor of the building was reconstructed and renovated (architect, Frank Brammer) as permanent housing for the Art Gallery and the separate Gould Collection of art works and *objets d'art*. COLLECTIONS: Toowoomba City Collection of 17th and 19th century portraits (English); largely Australian contemporary paintings, drawing prints, photography, works on paper, ceramics. Fred and Lucy Gould Collection of antique furniture, decorative arts and paintings, drawing and prints including European from 1600–1990s and Australian works from the 1900s. ACTIVITIES: A biennial *Contemporary Wearables* jewellery award was established in 1989 and the Gallery Society assists curating and staging exhibitions.

TRADES HALL GALLERY
(1979–c. 1988) Situated in Melbourne's Trades Hall Building, Lygon St, Carlton, the idea of a Trades Hall art gallery originated with George Selaf, secretary for many years of the Meat Workers' Union and subject of a well-known portrait by Noel Counihan. The gallery showed works of strong social content.

TWEED RIVER REGIONAL ART GALLERY
(Established 1988) Tumbulgum Rd, Murwillumbah, NSW 2484 (PO Box 816, Murwillumbah, NSW 2484) Regional art gallery. DIRECTOR: 1993– Maris Morton. Changing exhibitions of local, Australian and international arts and crafts with a collection of Australian portraits in all media. Home of the winners of the Doug Moran National Portrait Prize (*see* PRIZES).

UNDERCROFT ART GALLERY
(1973–90) The University of WA's collection of Australian works was administered by the Undercroft Gallery which also presented changing exhibitions. Following its closure the Lawrence Wilson Gallery (q.v.) took over administration of the collection.

UNION GALLERY
(Established 1974) The University of Adelaide, North Terrace, Adelaide, SA 5000. Tertiary student union gallery. DIRECTOR: Paul Hewson. Exhibitions include solo, multi-person, curated in all mediums, changing approximately every three weeks.

UNIVERSITY OF MELBOURNE ART GALLERY
The University Gallery (established 1970); Ian Potter Gallery (established 1989); Ian Potter Conservation Centre (Established 1972). Old Physics Building, Uni. of Melbourne, Parkville, Vic. 3052. DIRECTOR: In 1993 Frances Lindsay. HISTORY AND PREMISES: Proposed by R. G. Marginson in 1972 and established first in the Medley Building within the ambit of the Dept of Fine Arts, the Gallery was moved three years later to premises in the old two-storey Physics Building. The building was converted to gallery purposes and officially opened by Sir John Rothenstein in Apr. 1975. In the late 1980s another move was made to a building on Swanston St which became the Ian Potter Gallery and Conservation Centre. COLLECTIONS AND BEQUESTS: The Gallery management is the custodian of the greater proportion of the University collections consisting of some thousands of works including paintings, drawings and prints dating from Colonial times to the present. Included also is the Leonhard Adam Ethnological Collection. Norman Lindsay donated about 57 of his works in 1959; and between 1971–75 alone, about 600 works by various artists (including craft works) were added. A large number of important works have come from bequests and gifts, among them the Russell Grimwade Bequest, the Norman Macgeorge Bequest, the H. C. Disher Bequest and the gifts of paintings and drawings by Hirschfeld Mack given by Mrs Olive Hirschfeld and works given by Dr Joseph Brown. Of great historical value, the collections are unique among university collections in Australia. ACTIVITIES: Temporary exhibitions are held in the Ian Potter Gallery and are principally of contemporary Australian art, but include occasional art-historical exhibitions. Located in the Ian Potter building, the Conservation centre was established in 1989 with a full-time conservator and several assistants. Responsible for maintaining and restoring the University collection it also undertakes a limited number of outside commissions for public and private galleries and individuals. Artists-in-residence (funded by the VACB) have the use of a studio in the University Gallery building and live in the Desbrowe Annear-designed house fronting the Yarra River at Darebin, bequeathed by Norman and May Macgeorge (q.v.). Resident artists have included William Delafield Cook, Robert Jacks, Frank Hodgkinson, Brian Dunlop, John Firth-Smith, Gordon Bennett.

UNIVERSITY OF QUEENSLAND ART MUSEUM
(Established 1976; collection 1945) Department of Fine Arts, 3rd Floor, Forgan Smith Tower, Uni. of Qld, St Lucia, Qld 4067. DIRECTOR: 1973– Dr Nancy Underhill. HISTORY: In 1940, the help received from the John Darnell Bequest resulted in the implementation of a policy of collecting contemporary Australian art for the Uni. of Qld. Funds augmented in the late 1960s with grants of $1000 p.a. from the University Senate were further increased by the accession, in 1969, of the annual Darnell-de Gruchy Prize, and again, in 1974, through assistance from the Visual Arts Board. Premises were made available within the university buildings in the Forgan Smith Tower, and the Uni. Art Museum was officially opened by Prof. P. H. Karmel on 2 Aug. 1976. COLLECTIONS: By 1980 they totalled more than 1100 works, mainly Australian, covering early colonial times to the present day. The Museum authority is the custodian of the Behan Collection, housed formerly at Stuartholme Convent, as well as the Lionel Lindsay Collection of some 450 works. EXHIBITIONS: Since inception, the Museum has been increasingly important as a venue for exhibitions of Australian contemporary art (from its own collection and self-originated as well as travelling exhibitions) including some, such as *Bessie Gibson*, 1978, and *MacPherson, Shepherdson, Staunton*, 1979, emphasising the work of Qld artists. Between six and eight temporary exhibitions are mounted annually.

UNIVERSITY OF SOUTH AUSTRALIA ART MUSEUM
(Established 1991) Holbrooks Rd, Underdale, SA 5032. Gallery space and collection. ADMIN: Art Museum Committee. Contemporary local, state and national artists exhibited. COLLECTIONS: South Australian painting 1945 to present; South Australian prints 1970 to present; SA, WA and NT Aboriginal painting 1970 to present; Australian drawings 1945 to present; SA photography, sculpture, ceramics 1970 to present.

UNIVERSITY OF SYDNEY ART COLLECTION
(Established 1850) University of Sydney, NSW 2006. COLLECTION CURATOR: 1993 Pamela Bell. COLLECTIONS: The University of Sydney Collection of some 2000 items includes easel paintings, works on paper, sculpture, tapestry and silver, acquired by donation or bequest since the foundation of the University in 1850. Notable aspects include the collection of Sir Charles Nicholson, which includes some 600 works of antiquity (including about 100 Greek vases and a number of Egyptian, Etruscan and Roman objects), an extensive group of portraits and a significant collection of 20th-century Australian works. Artists represented include Dobell, Drysdale, Nolan, Cossington Smith, Preston, Friend, O'Brien and Wakelin as well as recent work by Gittoes, Storrier and Warren. The collection is available for research. Works are displayed in rotation on campus, and at the Seymour Centre Gallery. In 1988 a major exhibition of the collection was shown at the University and subsequently at country and interstate galleries. Reopening of an exhibition space on campus is anticipated (the former War Memorial Gallery of Fine Arts). The Power Collection of works of art remains the property of Sydney University but has been transferred to the present custody of the Museum of Contemporary Art (q.v.).
(*See also* SCHOOLS – UNIVERSITY OF SYDNEY; GALLERIES, PUBLIC – MUSEUM OF CONTEMPORARY ART)

VANCOUVER ARTS CENTRE AND GALLERY
(Established 1980) 85 Vancouver St, Albany, WA 6330 (PO Box 1110, Albany, WA 6330) WA regional gallery. ADMIN: Board of Management. ARTS OFFICER: 1993– Annette Grant. The Centre is the home of the Town of Albany Permanent Art Collection (282 works). It conducts a program of exhibitions, workshops, performances and special projects.

VAN DIEMEN'S LAND MEMORIAL FOLK MUSEUM
(Established 1957) 103 Hampden Rd, Battery Point, Tas. 7004. Built in 1836 as *Narryna*, the home of Captain Andrew Haig, the eight-roomed building and coach-house became a museum in 1957. Controlled by a committee of trustees, the Museum contains, as well as furniture and other historical relics, some paintings by early convict artists.

VICTORIAN COLLEGE OF THE ARTS GALLERY
(1975–) Victorian College of the Arts, 234 St Kilda Road, Melbourne, Vic. 3004. ADMIN: Director responsible to VCA admin.
DIRECTORS: 1993– John Dunkley-Smith. The Gallery operates as an important venue for student exhibitions, for the Keith and Elisabeth Murdoch Travelling Fellowship exhibitions, and for exhibitions by visiting VCA artists-in-residence. A new gallery was opened in the new VCA building in 1993.

VICTORIAN TAPESTRY WORKSHOP
(Established 1976) 260 Park St, Sth Melbourne, Vic. 3205. DIRECTOR: 1976– Sue Walker. STAFF: Depending on number of projects generally around 20. HISTORY AND ARCHITECTURE: Originally an emporium built in the 1880s and later a glove factory, the large building was dark and dingy when the Tapestry Workshop took it over in 1976. Completely

renovated, its high sawtooth ceiling allows abundant southern light mellowing the Victorian ash floor and high-lighting elegant cast-iron columns supporting the roof. The shopfront foyer provides an exhibition area for completed tapestries as well as an area for selling the Workshop's woollen yarns, catalogues, magazines and postcards. ACTIVITIES: Established by the Victorian state government to promote the art of tapestry design and making in Australia, it produced over 200 tapestries 1976–93. Works are displayed in exhibitions both in the Workshop and in other venues and have included many in Australian state and public galleries as well as in New Zealand, USA, UK, Europe and for state events such as the Commonwealth Heads of Government meeting, Royal Exhibition Building, Melbourne 1981 and annual touring exhibitions of works from the Workshop to regional and public galleries in Vic., Tas., NSW, Qld, ACT 1991–93. The wools are dyed on the premises to give exact colour match and the works of many leading Australian artists including Blackman, Boyd, Coburn, Dumbrell, Firth-Smith, Larter, Lanceley, Macqueen, Maddock, Mora, Norrie, Sansom, Sharpe, Whisson have been made into tapestries by the Workshop's weaver/artists. When funds permit there is an artist-in-residence and tours of the building are given one or two days a week.

WAGGA WAGGA CITY ART GALLERY
See CITY ART GALLERY

WARRNAMBOOL ART GALLERY
(Established 1888) 165 Timor St, Warrnambool, Vic. 3280. Vic. regional gallery, member RGAV.
ADMIN: Art Gallery Advisory Board of 13, responsible to the Warrnambool City Council. Chairman: 1993 Ronald J. Quick. DIRECTORS AND CURATORS: 1888–90, H. W. Davis (Curator). Between 1890–1972, no appointments were made. 1972–77, John A. Welsh; 1977–80, Douglas Hall; 1980–87, David Hansen; 1988– Judith Cooke. HISTORY: William Moore gives the founding year as 1882, and the founder as the police inspector, Joseph Archibald, father of J. F. Archibald (q.v.). However, the old sandstone building, originally the Mechanics Institute, had been in existence since 1867 and the movement to establish the gallery does not appear to have gained momentum until 1886, when three pictures by Robert Dowling were presented by members of the Ware family. John A. Welch gives the founding year as 1887 and indeed in the following year George Folingsby, director of the National Gallery of Victoria, was authorised to spend £1000, raised by public subscription, on buying art works for Warrnambool from the *Centennial Exhibition* in Melbourne. Nine works by French and German artists were purchased from the Exhibition with the Institute purchasing a further seven works in 1889. The collection grew with the purchase of Louis Buvelot's *Waterpool, Sunset at Coleraine* in 1889 and further donations of artworks. Under the curatorial guidance of H. W. Davis, the Gallery enjoyed several years of prosperity, which ended in the 1890s possibly because of the financial crises caused by the failure of the banks. The collection was handed over to the Town Council in 1910 and displayed in the old library building with several works being dispersed to other regional galleries. In the late 1960s the community began to lobby for the restoration of the collection to Warrnambool and the re-opening of the Gallery. Finally the City Council, with financial help from the Victorian government, acquired an old bank building which was renovated and converted and reopened as the Warrnambool Art Gallery on 5 December 1971. Donations from the corporate sector and many private individuals helped to put the Gallery back on its feet. Fletcher Jones & Staff and subsequently the Fletcher Jones Foundation sponsored the contemporary print award, the Henri Worland Memorial Print Award (*see* PRIZES), from 1972. In 1976 a Gallery Society was formed (changing to Friends of the Warrnambool Art Gallery in 1989). By 1980 the Gallery activities and collections had outgrown the old bank premises (they were originally built in 1854), and plans were made for the building of a new gallery. Designed by architects Napier Thomas, the purpose-built $1.25 million gallery was opened in October 1986, the Gallery's centenary year, and comprises three galleries including the Alan Lane Community Gallery for display of work by local and regional artists, a Temporary Exhibitions Gallery and Permanent Collection Gallery. The Gallery won the Westpac Museum of the Year Award in 1987. COLLECTIONS: Strength of the collections is basically the early Australian paintings acquired in the early days of the Gallery. They include paintings by Robert Dowling (a nephew of Joseph Ware of Gellibrand Station), Louis Buvelot, Phillips Fox, Thomas Clarke, J. H. Carse, T. St George Tucker, and many others; works which relate to the history of south-west Victoria including Eugene von Guérard's *Tower Hill* (on loan from the Department of Conservation and Resources) and works by Melbourne modernists and students of the George Bell school including Albert Tucker, John Perceval, Yvonne Atkinson, Douglas Greene. Important contemporary Australian prints have been acquired through the annual Henri Worland Print Prize and from other gifts. These plus the general exhibitions program have raised the collection to more than 1300 in 1993.
(*See also* PRIZES, HENRI WORLAND PRINT AWARD; WARRNAMBOOL ART GALLERY AWARD)

WAVERLEY CITY GALLERY
(Established 1990) 170 Jells Rd, Wheelers Hill, Vic. 3150. Public art gallery. ADMIN: Local government. DIRECTOR: 1990–93 Jim Logan; 1993– Kim Sajet. COLLECTION: Specialises in Australian photography including Nicholas Caire, Max Dupain, Bill Henson, J. W. Lindt, David Moore, Wolfgang Sievers and Anne Zahalka. The temporary exhibitions are largely of contemporary shows and photography but not exclusively and the Friends of the Gallery provides an activities program for members and some events for the public including lectures, workshops, community days. A significant touring exhibition, *Capturing the Orient: Hilda Rix Nicholas and Ethel Carrick in the East*, was initiated by the Gallery in 1993.

WESTPAC GALLERY
Victorian Arts Centre, 100 St Kilda Rd, Melbourne, 3004. (Established 1984) DIRECTOR: Jacqueline Taylor. Administered by the Arts Centre trust the Gallery is responsible for the Arts Centre collection of over 500 works which include large representation of works by Arthur Boyd, John Olsen, Roger Kemp, Sidney Nolan and art of the Western Desert. As well it has a lively temporarary exhibitions programme and due to the large number of visitors to the Centre has one of the highest attend-ances of any Melbourne gallery.

WOLLONGONG CITY GALLERY
(Established 1978) Cnr Kembla and Burelli Sts, Wollongong, NSW 2520 (PO Box 21, Wollongong East, NSW 2520) NSW regional gallery. ADMIN: Wollongong City Gallery Ltd, incorporated company limited by guarantee. The Director is responsible to the Board of Directors. STAFF: Director, assistant director, secretary, curatorial officer, education officer, public programs officer, technician, gallery assistant, voluntary gallery guides. DIRECTORS: 1978–81, Anthony Bond; 1981–86, Frank McBride; 1986–91, Barbara Tuckerman; 1991– Peter O'Neill.
The Gallery was relocated in 1991 to the former Council administration building built in the 1950s (designed in the shape of a crown to celebrate the coronation of Queen Elizabeth II). There are seven exhibiting areas including external space on the Gallery façade to display permanent and temporary exhibitions, and the exhibition program consists of local, national and international art. COLLECTIONS: Over 1000 works collected through major bequests largely

of Australian works – colonial, modern contemporary and Aboriginal. Major works with signicance to the local region include Eugene von Guérard's *Cabbage Tree Forest, American Creek* 1860 and *View of Lake Illawarra with distant mountains of Kiama* 1860, and Conrad Martens' *Mullet Creek, Illawarra.*

GALLERIES–COMMERCIAL

The increase in Australia in the number of commercial galleries has been such that it is not possible to list them all. What has been attempted therefore is to list those which have demonstrably affected the course of Australian art, whether currently or in the past, or alternatively proved themselves as galleries of outstanding interest in the quality of their exhibitions. Most of those open in 1994 are members of the Australian Commercial Galleries Association (q.v.). Many commercial galleries have made major contributions to Australian art developments and a number of their owners or directors have made or bequeathed valuable gifts to public art institutions. Those have been marked with an *.

ACCESS CONTEMPORARY ART GALLERY
(Established 1985) 115–121 Mullens St, Balmain, NSW 2039. Exhibits painting and sculpture produced by Australian artists. An 'open' stockroom, incorporating a racking system, displays an extensive range of artworks. There is also a sculpture courtyard. The gallery shows mainly emerging to mid-career artists.

ADELAIDE CENTRAL GALLERY
(Established 1991) 12–20 Gillies St, Adelaide, SA 5000. GALLERY MANAGER: Sue Tweddell. Regularly exhibiting contemporary works by South Australian and interstate artists, also artists from Central Studios. Administers the Faulding Art Scholarship – a studio residency for postgraduate students.

ALCASTON HOUSE GALLERY
(Established 1989) 2 Collins St, Melbourne 3000. Directors Beverey and Anthony Knight are involved with several Aboriginal artists and communities in the Northern Territory and Western Australian regions and represent them in their city-based gallery. Artists include Ginger Riley Munduwalawa, Willie Gudipi, Sambo Burra Burra from Ngukurr, NT; Limara Arts and Crafts, Melville Island; David Mpetyane from Alice Springs. As well as displays in its own gallery Alcaston House curates exhibitions of Aboriginal art, and the 1993 sale of Geoffrey Bardon's collection of Papunya paintings from 1971–80.

ANNA SCHWARTZ GALLERY
(Established 1982) 185 Flinders Lane, Melbourne, Vic. 3000. A previous co-director of United Artists Gallery (with Luba Bilu), Anna Schwartz represents largely the work of emerging and innovative contemporary artists. Those she has shown include Charles Anderson, Janet Burchill, Tony Clark, Christine Cornish, Peter Cripps, Graeme Hare, Lyndal Jones, Christopher Koller, Maria Kozic, Janet Laurence, John Lethbridge, Akio Makigawa, Victor Meertens, John Nixon, Robert Owen, Mike Parr, Stieg Persson, Ken Unsworth, Jenny Watson, John Young.

ANNANDALE GALLERIES
(Established 1991) 110 Trafalgar St, Annandale, NSW 2038. Occupying a large former Masonic Hall, the gallery is on two levels with a large room downstairs suitable for sculpture and large exhibitions. Artists that directors Bill and Anne Gregory have exhibited since opening include Brian Blanchflower, Lyndall Brown/Charles Green, Liz Coats, Dale Hickey, Orest Keywan and Judith Wright.

ARGUS GALLERY*
(Active 1960–69) Constructed as a well-appointed modern gallery on the 4th floor of the old *Argus* newspaper building by the owners of the building, the Herald and Weekly Times, with the aim of providing badly needed facilities for exhibitions by contemporary Australian artists. The Melbourne Contemporary Artists group held annual exhibitions there until 1966 and many young artists who later became well-known made their debut at the Argus Gallery. DIRECTORS: 1960–66, Ruth McNichol; 1966–69, Joan Healey.

ARTARMON GALLERY*
(Established 1955) 479 Pacific Highway, Artarmon, NSW 2064. DIRECTORS: Philip Brackenreg. Established by John Brackenreg (q.v.) first as the Artlovers Gallery, it represents mostly figurative work by leading Australian contemporaries, including Godfrey Miller, Lloyd Rees, Sali Herman, George Lawrence and many others, but also deals with the work of distinguished earlier artists such as Lambert, Ashton and other Sydney painters. In February 1965 a branch, the Darlinghurst Galleries, was opened with a large retrospective exhibition of paintings and drawings by Godfrey Miller, the residue of Miller's work having passed to the Gallery to be held in trust after his death in 1964. The name of the Darlinghurst Galleries appeared as publisher of the first comprehensive book on Miller's work (John Henshaw, *Godfrey Miller*, Darlinghurst Galleries, 1966). The organisation was also associated with the Legend Press, Sydney, publishers of *Australian Artist Editions*, a series including Lou Klepac, *Drawings by Lloyd Rees*, 1979, and Jean Campbell, *George Lawrence*, 1980. The Darlinghurst and Artlovers Galleries were amalgamated as the Artarmon Gallery at the present address in 1968. Retrospective exhibitions of interest to the community have included in recent years those of Clem Millward, Kenneth Jack, Ursula Laverty and retrospectives of works by Adelaide Perry, William Fletcher, Eric Wilson, Lane Cove Bicentennial Exhibition.

ART GALLERIES SCHUBERT
(Established 1985) Marina Mirage, Seaworld Drive, Main Beach, Qld 4217. Director Win Schubert has exhibited work by artists including Sam Fullbrook, Davida Allen, Judith White, Judy Cassab, Jeffrey Makin, Mal Leckie, Gil Jamieson, Jamie Boyd, Geoff Proud, Charles Blackman, Arthur Boyd, Donald Friend. There is also a link with the Gold Coast City regional gallery in joint lecture programs.

ATHENAEUM*
(Established 1839 as the Melbourne Mechanics Institute and School of Arts) The first administrative body of the Athenaeum (as it later became known) comprised: C. J. La Trobe (later Governor La Trobe) (patron), Captain Lonsdale (president), the Rev. James Forbes (secretary), John Gardiner (treasurer), Thomas Burns (librarian). The administration was changed in 1872 and the name the Melbourne Athenaeum adopted. The original building was completed in 1843 but remodelled in 1886, when the library and art gallery were added at the first floor front of the building. The art gallery opened in 1910 and the theatre, managed by Frank Talbot (1924–49), opened in 1924 with a performance of J. M. Barrie's *Dear Brutus*. After a brief period of live theatre, the theatre became a cinema. In 1965 the institution, comprising a two-storey building with a ground floor façade of shops fronting Collins Street, and incorporating cinema, library and art gallery, occupied one of the most valuable real estate sites in Melbourne, but except from rents, and a state government grant of £5000 given in 1856, it had no other assets. Administration was vested in a corporate body called the Melbourne Athenaeum, comprising president, vice-president, immediate past president, treasurer, three trustees (in whom the property was vested), and fourteen members. The cinema and art gallery were discontinued, and in 1977 the Melbourne Theatre Company took over the lease. In 1982 the building was occupied by the Company's two theatres, and the Athenaeum Library.

AUSTRALIAN GALLERIES*
(Established 1956) 35 & 41 Derby St, Collingwood, Vic. 3066. 15 Roylston St, Paddington, NSW 2021. Established

by Tom and Anne Purves in support of an emerging generation of Australian painters then greatly in need of informed patronage, its early policy included seeking patronage from business and industrial houses. An early gallery promotion was the reproduction in colour of seven major paintings acquired from selected artists, with sponsorship from Godfrey Phillips Ltd, the originals then being presented to the developing NGA, Canberra, and to state galleries. Stuart Purves joined the gallery staff in 1966 and became a director after the death of his father, Tom, in 1969. He introduced the work of a younger generation of artists and initiated by Stuart, physical extensions were undertaken in 1988 with establishment of a Works on Paper gallery at 41 Derby St, Collingwood, and in 1989 Australian Galleries Sydney was opened. Artists featured regularly in exhibitions include Boyd, Coburn, Nolan, Olsen, Tucker, Whiteley and many other leading Australian painters. By greatly increasing the patronage for contemporary Australian art, the gallery has made a consistent and valuable contribution extending over almost four decades of operations.

AUSTRALIAN GIRLS' OWN GALLERY (AGOG)

(Established 1989) 71 Leichhardt St, Kingston, ACT 2604 (PO Box 4376, Kingston, ACT 2604) Concentrates on contemporary work being produced by Australian and NZ women artists. Some historically-based exhibitions are held.

AUSTRALIAN SCULPTURE CENTRE

(1966–70) Conducted at 83 Dominion Circuit, Canberra, for the promotion of contemporary Australian sculpture. The Sculpture Centre was the first commercial gallery to sponsor Australian contemporary sculpture in the ACT.

AVANT GALLERY

(Established 1972) 579 Punt Rd, South Yarra, Vic. 3141. Established by Teura Maffai and her husband Gilbert, first on the opposite side of Punt Road, then, from August 1975, at the present address. Regular exhibitions were held until the change of address, after which they became intermittent, ranging from avant-garde painting and sculpture to colonial art.

AXIOM GALLERY

See CHRISTINE ABRAHAMS

BARRY STERN GALLERIES

(Established 1960) 42 Gurner St, Paddington, NSW 2021. Established by Barry Stern, first at 23 Roslyn Gardens, Kings Cross, as a 'museum of modern art' before moving to Paddington (1962) as the Barry Stern Gallery. A wide variety of work, mainly by contemporary Australian painters, is shown.

BEN GRADY GALLERY

19 Kennedy St, Kingston, ACT 2604. A gallery which holds innovative shows of interest especially of emerging and mid-career Australian artists.

BLAXLAND GALLERY*

(Established 1929) 6th Floor, Grace Bros, Cnr Pitt and Market Sts, Sydney 2000; 3rd Floor, Lonsdale St Bldg, Myer Melbourne 3000. The Blaxland Gallery is named after explorer Gregory Blaxland, whose family homestead stood on the present Sydney site in 1807. (The Blaxland homestead oven has been left intact and is located beneath the footpath near the George St entrance.) Established first in Farmers Department Store, George St, Sydney, reorganised in 1958, it became the Blaxland Gallery when Farmers was taken over by Myer and then by Grace Bros in Sydney. The Sydney gallery has traditionally been a venue for important group exhibitions, including the Contemporary Group, Australian Art Society, Sydney Art Group, Contemporary Art Society, Blake Prize; Archibald, Wynne and Sulman prize exhibitions (during alterations to the AGNSW, 1971–72); *100 Master Drawings* (from the MOMA, New York, 1972). With the emergence of so many commercial galleries in and around Sydney to cater for the needs of individual artists, the policy of the Gallery is to fulfil a much wider role in the life of the city of Sydney by presenting a diverse range of community interests including regular exhibitions of significance in the cultural, educational and artistic fields.

BLOCK GALLERY

(1963–c. 1978) Established by Norman Beattie Cathcart, painter and antique dealer (1908–72) at 98 Elizabeth St, Melbourne 3000. He painted conventional landscapes, exhibited often at the Sedon Galleries from 1947, before becoming a commercial gallery owner. The Block Gallery was sold to the Hogan family in 1970. Exhibitions included conventional paintings, drawings, etchings, etc.

BLOOMFIELD GALLERIES

(Established 1973) 118 Sutherland St, Paddington, NSW 2021. Founded by Lin Bloomfield first at the Pace Centre, 100 Alexander St, Crows Nest. Exhibitions include old and new Australian art, mainly figurative.

BONYTHON ART GALLERY*

(Established 1960) Founded by Kym Bonython (q.v.), it soon became a centre of modern painting and sculpture in South Australia. Special exhibitions by Nolan, Drysdale, Boyd, Tucker were organised to coincide with the Adelaide Festival of Arts. Bonython extended his art gallery interests when he took over the Hungry Horse Gallery, Sydney, from Betty O'Neill, in 1965, and Sydney remained his headquarters for the ensuing eleven years. He returned to Adelaide and his original Adelaide gallery in 1976. Later it became the Bonython–Meadmore Gallery which operated for several years in the 1980s before closing in 1990.

BONYTHON GALLERY SYDNEY

(Conducted 1967–76) Established by Kym Bonython in Nov. 1967 at 52 Victoria St, Paddington, NSW the size of the gallery and scale of its operations gave it the character of a museum of modern art. The main exhibitions space, which surrounded a large, paved, open square, resembled a huge continuous corridor in which a number of exhibitions could be mounted simultaneously. During the first 18 months of operations, no fewer than 27 overseas exhibitions were displayed. The gallery soon became a centre of Sydney's art life, one of the reasons being the number of non-commercial events held there. Among these were the *Comalco Invitation Sculpture Awards* exhibitions, *Transfield Prize* exhibitions and exhibitions of works from the Power Institute. In the end the costs of maintaining and staffing so large an institution, and the ever-increasing value of the site and buildings as real estate, proved too much. The gallery was sold and its owner moved back to his original headquarters in Adelaide.

BRIDGET McDONNELL GALLERY

(Established 1983) 130 Faraday St, Carlton, Vic. 3053. Specialising in works of Australian artists of the colonial and modernist periods, a number of interesting exhibitions are held annually.

BRIDGE STREET GALLERY

(Established 1983) 124 Jersey Rd, Woollahra, NSW 2025. DIRECTORS: Peter Moltu; Victoria Jensen. Started in 1983 in Bridge St, Sydney, it moved to Woollahra in 1989 into the old Rudy Komon Gallery building. It exhibits contemporary Australian paintings, prints and sculpture, with monthly solo exhibitions in the ground floor gallery and mixed exhibitions and a print room in the upstairs gallery.

BRUMMELS GALLERY

(1956–c. 1970s) Established as a gallery on the first floor of an espresso coffee shop at 95 Toorak Road, Toorak, Vic. at the time of inception the gallery provided an important venue for exhibitions by leading modernist artists. The premises were destroyed by fire and when, in 1962, the gallery reopened under new management, it lasted only for a few exhibitions. Ten years later (1972) it reappeared in a different part of Toorak Road as Brummels Gallery of Photography, founded by Rennie Ellis.

BUXTON'S GALLERY*

(c. 1885–1900.) 119–121 Swanston Street, opposite the Mel-bourne Town Hall. Opened by J. T. Buxton, 21 Oct. 1885, as 'a business catering in artistic stationery, artists' materials and fancy goods'; also included was an art gallery suitable for public and private exhibitions. The gallery was used by members of the Australian Artists Association for their three annual exhibitions and became famous in Aug. 1889 as the venue for the *9 × 5 Impressions Exhibition*. Buxton also managed art unions on behalf of artists. (*See also* HEIDELBERG SCHOOL)

CENTRAL STREET GALLERY*

(1966–70) A vital centre of Sydney avant-garde activity, established at Central St, Sydney, by Tony McGillick and sponsored by John White and Harald Noritis. Royston Harpur and Rollin Schlicht also participated in the management of the gallery, which later was taken over by Chandler Coventry. The gallery became the centre of the new abstraction in Australia, specifically of hard-edge, geometric and unit abstraction, colourfield and other modernist modes borrowed from the USA. It was from this centre that the bulk of the work for *The Field* (*see* EXHIBITIONS; ABSTRACTION) was drawn. Among the many novel exhibitions was Christo's display of drawings and packages, 1969. The gallery closed in 1970 owing to managerial difficulties and differences. The Director, Chandler Coventry, opened his own gallery in 1974. Charles Nodrum, Melbourne held an important commerotative exhibition of paintings from Central St 1966–69, in 1990.

CHARLES NORDRUM GALLERY

(Established 1984) 267 Church Street, Richmond, Vic. 3121. Director Charles Nodrum represents about 25 artists (including some estates) in wide a stylistic range. They include Mike Brown, Tony Coleing, Stacha Halpern, Ian Howard, James Meldrum, Mary Macqueen, Ron Robertson-Swann, Edwin Tanner. Specialised group exhibitions focus on particular periods of Australian art such as those of Modern Australian Painting, of work of artists of the 50s, 60s and 70s or significant styles, such as the Central Street Gallery (q.v.) artists in 1990 and Australian Surrealists, 1991.

CHRISTINE ABRAHAMS GALLERY

(Established 1981) 27 Gipps St, Richmond, Vic. 3121. Christine Abrahams took over as director from the gallery previously known as Axiom, in the mid-1980s. Concentrating on innovative works by contemporary artists spanning a broad spectrum of media including painting, sculpture, drawing, prints, photography and ceramics, regular exhibitions of work by some of Australia's most prominent artists are shown as well as shows by young artists and exhibitions from abroad. Artists represented include Sydney Ball, Marion Borgelt, Roy Churcher, Fred Cress, Isabel Davies, Lesley Dumbrell, Max Dupain, Craig Gough, Denise Green, Curtis Hore, Matthew Johnson, Michael Johnson, Maria Kuczynska, Bruno Leti, Hilarie Mais, Carlier Makgawa, Mandy Martin, Milton Moon, David Moore, Fiona Murphy, Bronwyn Oliver, Lenton Parr, Julie Patey, Thornton Walker.

COVENTRY GALLERY*

(Established 1974) 56 Sutherland St, Paddington, NSW 2021. Director Chandler Coventry was first a property owner and grazier, and became known as an important patron of the arts when he helped to run the Central Street Gallery (q.v.). He then started his own gallery in Hargrave Street, Paddington, before moving it to the Sutherland Street address. In 1979, he donated several hundred items from his important collection of contemporary Australian art to help the establishment of the regional gallery at Armidale, NSW. (*See also* PUBLIC GALLERIES – NEW ENGLAND REGIONAL ART MUSEUM, ARMIDALE)

CHRISTOPHER DAY GALLERY

(Established 1979) Cnr Paddington and Elizabeth Sts, Paddington, NSW 2021. Director Christopher Day presents 19th and 20th century Australian and European oil paintings and watercolours. The stock room often includes works by Ashton, Rubery Bennett, David Davies, Haughton Forrest, J. J. Hilder, J. R. Jackson, Sydney Long, H. S. Power, Lloyd Rees, J. H. Scheltema, Sir Arthur Streeton, Walter Withers.

CRAFT VICTORIA

(Established 1992) Crafts Council of Victoria, 114 Gertrude St, Fitzroy, Vic. 3065. The Crafts Council has a policy of promoting excellence and innovation within all craft areas. The Council's overall aim is to showcase, critique, represent, promote and develop the professional crafts industry.

CROSSLEY GALLERY*

(1966–80) Conducted by Tate Adams (q.v.), first at 4 Crossley St, Melbourne, this small gallery was the first of its kind in Australia to be devoted solely to the original work of printmakers, specifically Australian printmakers. Baldessin, Senbergs, Kemp, Williams and other leading Australians were well represented in the exhibitions which included also the work of leading international artists. The success of the little gallery proved its undoing when the owner of the building increased the rent beyond the capacity of the business to pay. Closed in 1977, the gallery reopened in glamorous, large, new premises in Niagara Lane in August 1979. But the timing was in-appropriate and the gallery closed permanently in 1980.

DAVID ELLIS FINE ART

See LYALL BURTON GALLERY

DAVID JONES GALLERY*

(Established 1944) 7th Floor, David Jones Elizabeth Street store, Sydney, NSW 2000. DIRECTORS: 1944–47, Will Ashton; 1947–49, Marion Hall Best; 1949–50, John Amory; 1950–53, M. P. Ferrandiere; 1953–61, George Duncan; 1961–76, Robert Haines; 1976–78, Glen Pearson; 1978– , Brian Moore. Established in a leading city retail store to provide greatly needed exhibitions space, mainly for Sydney artists, the sphere of its operations was soon widely extended. Because of the publicity attached to the name William Dobell (q.v.), the Dobell exhibitions of 1944 attracted total attendances of 53,382. Groups holding annual exhibitions at the Gallery including the Australian Art Society, NSW Society of Artists, Australian Watercolour Institute, CAS, Society of Sculptors and Associates, as well as Travelfield and Wills inter exhibitions. In 1962 the Duke of Bedford's Collection attracted huge attendances, as did the Mendel Collection of Modern European painting later in the year. In 1963 the gallery was rebuilt and redecorated and under the directorship of Robert Haines became known throughout Australia for the quality of its exhibitions and their installation. Special exhibitions which greatly advanced the status of the gallery included sculpture exhibitions by master sculptors, including Rodin, Epstein and Emilio Greco, and painters of the calibre of Walter Sickert and Mathew Smith.

DECORATION GALLERIES

(Active c. 1920–24) Conducted at 289 Collins St, Melbourne, by Raymond Wallis (q.v.). Exhibitions mainly by contemporary Australian artists. Displays in its large plate-glass window giving onto Collins St attracted much attention, in particular an exhibition of the etchings of Norman Lindsay which caused police intervention.

DEUTSCHER FINE ART*

(Established 1976) 1140 Malvern Rd, Armadale, Vic. 3143. Established by Chris Deutscher at 1092 High St, Armadale, Vic., under the title Deutsher Galleries. (The 'c' was left out in the original title.) Moved to East Melbourne in 1980, and in 1982 to 68 Drummond St, Carlton, then in May 1993 to its present address. The gallery specialises in 19th and 20th century Australian art and has held numerous survey exhibitions accompanied by well-researched illustrated

catalogues. From 1989 Deutscher Fine Art has also exhibited contemporary Australian art (first at Deutscher Gertrude Street and then at Deutscher Brunswick St galleries up to December 1991). As well it has been associated with numerous publications: *A Survey of Australian Prints 1900–1950*; *The George Bell School: Students, Friends, Influences*; *Thea Proctor: The Prints*; *Bill Henson Photographs 1974–1984*. The opening exhibition for its relocated premises in 1993, *A Century of Australian Women Artists 1840s–1940s*, created enormous interest and attendances and was among the most significant exhibitions to be seen in a private gallery in the early 1990s.

DRUMMOND STREET GALLERY
(1980–c. 1985) Run by Marian Vickery at 265 Drummond St, Carlton, as a venue for exhibitions mainly by young, unknown artists of promise.

EASTGATE GALLERY
(Established 1988) 158 Burwood Rd, Hawthorn, Vic. 3122. Directors Rod Eastgate and Jillian Holst's gallery has a particular interest in showing modernists of the 1920s to 1960s, particularly those of the George Bell school, as well as contemporary Australian artists.

EDDIE GLASTRA GALLERY
(Established 1985) 44 Gurner St, Paddington, NSW 2021. Traditional and contemporary Australian artists are shown in six solo exhibitions annually with mixed shows between exhibitions.

EDITIONS GALLERIES
(Established 1975) Roseneath Place, South Melbourne, Vic. 3205. Established by Vic Stafford and Bev Kenna as a gallery specialising in modern original prints, first at 313 Montague Street then, from Sept. 1980, in Roseneath Place. Modern Japanese, French and American printmakers, as well as Australian, are represented.

EDUCATION DEPARTMENT GALLERY*
(1913–c. 1964) Incorporated into the new Education Dept buildings, Sydney, 1913, as a result of a deputation led by Julian Ashton to the Minister, Campbell Carmichael. The gallery was a valuable addition to art exhibitions space in Sydney at a time when there was little such space available and many of the annual exhibitions of the NSW Society of Artists were held there. Importance of the gallery declined in the early 1960s with the increase in numbers of commercial galleries.

FINE ARTS GALLERY
(Active 1911–14) Founded by Julian Ashton, Harley Griffiths, Snr, and W. Hardy Wilson, 1911 in Bligh St, Sydney, it closed because of World War I, 'just as it was getting established'. (Moore, *SAA*, 1934)

FINE ARTS SOCIETY GALLERY*
(Active c. 1918–40) Established and directed by W. H. Gill at 100 Exhibition St, Melbourne. The Australian Art Association held its Victorian exhibitions there. Other exhibitions of note were the memorial exhibitions to Hugh Ramsay in 1918, the exhibitions of work by Blamire Young and R. W. Sturgess, and the first showing of the watercolours by the Aboriginal painter Albert Namatjira in 1938.

FLINDERS LANE GALLERY
(Established 1989) 137–139 Flinders Lane, Melbourne, Vic. 3000. Founded by three previous directors of Distelfink in Hawthorn, Nellie Castan, Sonya Heitlinger and Emma Kranz, Flinders Lane joined a group of galleries opening in that part of the city and represents well-known usually mid-career artists such as Judith Alexandrovics, John Howley, Jeffrey Bren, as well as younger painters and sculptors.

GALERIE DÜSSELDORF
(Established 1976) 890 Hay St, Perth, WA 6000.
DIRECTORS: Douglas and Magda Sheerer. Shows largely contemporary art by emerging and established artists, West Australian, Australian and international.

GALLERY A*
(1959–c. 1983) Its directors included Clement Meadmore, James Mollison, Janet Dawson, Ann Lewis. Established first at Flinders Lane, Melbourne, by Max Hutchinson (28 July 1959) and directed by Clement Meadmore as a gallery specialising in Australian new painting and sculpture. The gallery was inactive during the early part of 1962 but later in the year it reopened in extensive, modern premises at 275 Toorak Road, South Yarra. Among facilities at the new Gallery A was a complete print workshop and a modern art school, both supervised by Janet Dawson from 1962–64. The Sydney branch of Gallery A at 21 Gipps St, Paddington, was opened in 1964, and later in the same year a branch was started in Canberra. The Melbourne and Canberra galleries closed and in 1970 Max Hutchinson extended his sphere of operations with the opening of the Max Hutchinson Gallery, New York, to encourage an exchange of avant-garde culture between countries and act as an exhibitions venue for selected Australian artists. Hutchinson made his permanent home in New York in 1976 and Gallery A, Sydney, was taken over by a separate board of directors. Exhibitions were mainly Australian and occasionally American avant-garde painting and sculpture, with emphasis on hard-edge, abstract expressionism and related forms. The gallery had an important influence on art affairs in Sydney.

GALLERY GABRIELLE PIZZI
(Established 1987) 141 Flinders Lane, Melbourne, Vic. 3000. Exhibiting the work of selected Aboriginal artists from the communities of Papunya, Utopia, Balgo Hills, Turkey Creek, Fitzroy Crossing, Maningrida and the Yikikini Women's Centre on Melville Island, the gallery also shows the work of major urban Aboriginal artists including Lin Onus, Karen Casey, Ian W. Abdulla and Judy Watson.

GALLERY 99
(1966–67) Conducted by Alois Svihla at 99 Cardigan St, Carlton, Melbourne, with the aim of encouraging young artists. Later the gallery became the headquarters of the Arts and Crafts Society.

GALLERY OF ART AND SCHOOL OF DESIGN
(1855–56) Conducted by William and Caroline Dexter (qq.v.). Dexter taught painting and drawing, and Caroline taught elocution, grammar, composition and other appropriate subjects. The school failed.

GALLERY OF CONTEMPORARY ART*
(1956–58) Founded by John Reed (1 June 1956) as a headquarters for the CAS, of which he was president. CAS members and other artists were invited to donate pictures to assist the finances of the venture, and the large number of works contributed was shown at the inaugural exhibition. Premises were on the first floor of a former warehouse in Tavistock Place, Melbourne. In 1958 the Gallery of Contemporary Art became the Museum of Modern Art and Design of Australia (q.v.).

GEORGES GALLERY*
(Established 1987) 1st Floor, 342 Brunswick St, Fitzroy, Vic. 3065. Shurki Girgis and Marijan Klym show Australian and international contemporary art by mainly younger artists.

GALLERY RHUMBARALLA'S
(1945–c. 1985) Situated in the Georges store, Melbourne, the gallery opened under the directorship of Robert Haines (who advised also on the design and lighting), and soon became a centre of contemporary art activity in Melbourne. However, after two years of successful operations, the floor space was required for other purposes, and the gallery was closed in 1947. In 1962 a new Georges Gallery on the third floor of the Collins St store was opened and the Georges Invitation Art Prize established. Organised by Alan McCulloch, this national event revived many of the policies initiated by Haines and greatly extended Georges' involvement with Australian art at national level. In addition to exhibitions

and prizes, Georges also helped to sponsor the visits to Australia of internationally celebrated critics and gallery directors, including James Johnson Sweeney (1964), Clement Greenberg (1968), and Harald Szeemann (1971), and in many other ways promoted the interests of contemporary Australian painting and sculpture.
(*See also* PRIZES, GEORGES INVITATION ART AWARDS)

GREENHILL GALLERIES
(Established 1972) 140 Barton Terrace, North Adelaide, SA 5006. The building, originally a coach house built in 1856, has been well adapted to modern gallery purposes. In 1981 a branch was opened in Perth at 37 King St. Under the directorship of Vida Swain (and for some years in the 1980s, Louise Smith), both galleries have presented exhibitions of significance by leading Australian artists, thereby giving an important edge to the visual arts in SA and WA.

GROSVENOR GALLERY*
(1924–58) Established by the bookbinder Walter Taylor at 219 George St, Sydney. For many years the Grosvenor and Macquarie Galleries were the only commercial galleries operating in Sydney. The first exhibition of Australian 'modern art' was held at the Grosvenor in 1926, organised by Thea Proctor and George Lambert for the purpose of assisting younger painters. (Lloyd Rees, *The Small Treasures of a Lifetime*, Ure Smith, Sydney, 1969)

HORGARTH GALLERIES
7 Walker Lane, Paddington, NSW 2021. First exhibiting a general range Australian paintings, drawings, prints, since the late 1980s it has shown exclusively Aboriginal art.

HOLDSWORTH GALLERIES*
(Established 1968) 86 Holdsworth St, Woollahra, NSW 2025. Established by Gisella Scheinberg, this large gallery displays gallery stock of Australian art and imported European furniture. Regular exhibitors include Arthur Boyd, Sidney Nolan, Clifton Pugh, Donald Friend, Robert Dickerson, Stan Rapotec with exhibitions changing every three weeks, and a minimum of three artists exhibiting, with one young artist among the three.

HOTCHIN GALLERY*
(Active 1947–64) Established by Claude (later Sir Claude) Hotchin, at Boan's Department Store, Perth, as a venue for exhibitions by Australian artists. From 1948 the Claude Hotchin Art Prizes, for oils and watercolours, were conducted there. Hotchin (chairman, AGWA, 1960–64) presented the winning pictures (which were mainly by local artists) to various WA country municipalities to establish local art galleries. By 1967 he had distributed more than 1,000 pictures.

HUNGRY HORSE GALLERY
(1962–67) Established at 47 Windsor St, Paddington, NSW, above the Hungry Horse restaurant, by Betty O'Neill, it became, during its brief life, a rendezvous for Sydney's avant-garde painters. Bought by Kym Bonython in 1965, it closed when Bonython started his own Sydney gallery.

IRVING SCULPTURE GALLERY
(*See* SHERMAN GALLERIES)

JOAN GOUGH STUDIO GALLERIES
(1976–c. 1986) Best known as a Melbourne headquarters for the Contemporary Art Society, it was situated at 326 Punt Road, South Yarra, Vic.

JOHN COOPER EIGHT BELLS GALLERY
(Established 1934) 3026 Gold Coast Highway, Surfers Paradise, Qld 4217. Established by John Cooper as a gallery representing contemporary Qld and interstate artists. Closely associated with leading Australian artists for many years, Cooper has contributed much to art and artists in Queensland both as an art writer, gallery director and entrepreneur.

JOHNSTONE GALLERY*
(1951–72) Conducted by Brian and Marjorie Johnstone, first in rooms in the Brisbane Arcade, Brisbane, then, from 1957,

at 6 Cintra Road, Bowen Hills, Qld. It operated as a centre of interstate contemporary painting and for 21 years was the leading commercial gallery in Qld. Virtually every leading Australian artist was represented in exhibitions there.

JOSEPH BROWN GALLERY*
(Established 1967) Caroline House, 74 Caroline St, South Yarra, Vic. 3141. Established by Joseph Brown (q.v.) first at 5 Collins St, Melbourne, until 1976 when the building was marked for demolition, then at Caroline House, built originally for the private secretary of Sir Charles Hotham, Governor of Vic., 1854–55. From the beginning the policy was to build up public interest in Australian art from the earliest times to the present. The carefully documented, well-illustrated catalogues of the seasonal exhibitions soon became known and collected throughout Australia. Spring, Summer, Autumn and Winter catalogues read like anthologies of Australian art and many people owe their education in Australian art history to them. They have been widely copied by later galleries. The ideas and ideals of the gallery were encapsulated in the book *Outlines of Australian Art: The Joseph Brown Collection*, Daniel Thomas, Macmillan, Melbourne, first published in 1973, updated and new editions published every few years. Joseph Brown stopped regular exhibitions in the early 1980s and continues his private dealing from the premises.

JOSHUA McCLELLAND PRINT ROOM*
(Established 1927) 15 Collins St, Melbourne, Vic. 3000. Established first in premises in Little Collins St, Melbourne, by Joshua McClelland (1902–56), the business was moved to 81 Collins St in 1935, to 105 Collins St in early 1980 and to its present address in the mid-1980s. Joan McClelland carried on the work after the death of her husband in 1956, by which time both had become known as authorities on Australiana.

KOZMINSKY GALLERY
(Established 1864) Founded as a business dealing in antique jewellery, silver and furniture, which remain central to its interests, the art gallery was added later. Between 1920–60, when the gallery was situated at 4 Collins Way, off 377 Little Collins Street, it became a small but valuable centre for exhibitions of Australiana and of work by all kinds of artists ranging from craft-workers and old, conventional painters to young, modernist painters and students. In 1977 the premises changed to 421 Bourke St where the exhibitions were spasmodic but usually full of interest.

LAURAINE DIGGINS FINE ART*
(Established 1974) 5 Malakoff St, North Caulfield, Vic. 3161. Lauraine Diggins acquired Bartoni Gallery, South Yarra, in 1974 and moved to North Caulfield in the early 1980s. In 1986 the business was renamed Lauraine Diggins Fine Art. The exhibitions are of colonial, Impressionist, modern and Aboriginal art works, select extensive survey exhibitions and have included those by Haughton Forrest, Nolan, Tucker, Hester, the Australian Impressionists and the Antipodeans. The exhibition *Myriad of Dreaming: Twentieth Century Aboriginal Art* toured interstate in 1989. From 1990 the gallery represented select contemporary artists including Robert Baines, Peter Churcher, John Dent, Jeff Makin, Brian Seidel and Albert Tucker. Well documented and scholarly catalogues accompany many of the exhibitions and the gallery has also published a definitive book on Haughton Forrest (Malakoff Fine Art Press).

LEVESON GALLERY
(1962–83) Established by Charles Bush (q.v.), Phyl Waterhouse (q.v.) and June Davies, first in North Melbourne, corner of Leveson and Victoria Streets, and from Sept. 1979 until its closure at 130 Faraday St, Carlton. It began with an extensive exhibition entitled *Artists of Fame and Promise* and the title embodied the general principle which guided the gallery's policy. In the early days of its North Melbourne existence,

pictures from the gallery were featured on the Melbourne television program *Daly at Night* (1962–63). The gallery closed after the deaths of Phyl Waterhouse and Charles Bush and the premises became the Bridget McDonnell Gallery (q.v.).

LISTER GALLERY
(Established 1971) 248–250 St Georges Terrace, Perth, WA 6000. Directors are Cherry Lewis and Roshana Lewis Calder. Established in St Georges Terrace, Perth, by Cherry and the late Leonard Lewis, it was originally an exhibition gallery representing Australian artists such as Boyd, Olsen, Rees, and West Australian artist Robert Juniper and became primarily dealers in the mid-1980s and 90s.

LLEWELLYN GALLERIES
(1967–74) Conducted by Richard and Sid Llewellyn at their residence at Dulwich, Adelaide, from Dec. 1967. A specially designed gallery was added to the premises in 1968 and the gallery became noted for its encouragement of young South Australian artists. In Sept. 1972 the business moved to the former Bonython Gallery in North Adelaide, where it continued until the premises were bought by the original owner, Kym Bonython, in 1974.

LUBA BILU GALLERY
(Established 1988) 142 Greville St, Prahran, Vic. 3181. A former co-director of United Artists (q.v.) gallery, Luba Bilu holds solo shows contemporary works of painting, sculpture, photography, prints, assemblages and mixed media.

LYALL BURTON GALLERY
(Established 1981.) 309 Gore St, Fitzroy, Vic. 3065. Established as David Ellis Fine Art by David Ellis and Lyall Burton in 1981 in Ballarat, the gallery moved to Melbourne in 1986 and to the present premises in 1988. Since February 1992 the gallery has been under the sole direction of Lyall Burton. Exhibitions include those by many well-known and emerging Australian artists including painters Judy Cassab, Andrew Sibley, Doug Wright, Godwin Bradbeer, Stephen Spurrier, and sculptor Peter Blizzard. Major events have included retrospectives and new exhibitions of Vaughan Murray Griffin, Alan Sumner, Judy Cassab, Andrew Sibley and Doug Wright.

LYTTLETON GALLERY
(Established 1983) 2A Curran St, North Melbourne, Vic. 3051. Established by Jan Martin in 1983 at Castlemaine, Vic., it moved to its present address in North Melbourne in 1993. The exhibitions which she presents at intervals are always of artists of interest.

MACQUARIE GALLERIES*
(1925–93) Directors included John Young, Basil Burdett, John McDonnell, Lucy Swanton, Treania Smith, Mary Killen, Mary Turner, Penelope Meagher, Eileen Chanin. Established by John Young and Basil Burdett at 19 Bligh St, the business was moved to King Street in 1966, to 204 Clarence St, Sydney, in 1982 and to 85 McLachlan Avenue, Rushcutters Bay in 1989. The inaugural exhibitions concerned the avant-garde paintings of Roland Wakelin, and in conformity with this precedent, later exhibitions featured much of the Sydney modernist art of the 1920s. Lambert, Proctor, De Maistre, Bunny, Fairweather, Dobell, Drysdale, Cossington Smith, Purves Smith, Balson, Crowley, Miller, Friend, Rees, O'Brien were among the many exhibitors, and between 1950–59 representative exhibitions entitled *Sydney Art Today* were organised and sent interstate. The only commercial gallery in Sydney to survive the depression years, the Macquarie Gallery became an institution exercising great influence on art affairs in NSW, and its exhibitions launched many artists on successful careers. A branch of the gallery was opened in Canberra in 1965 and continued until 1978. As well as Australian art, the gallery mounted important exhibitions of British, French, Asian and other art from countries of particular interest to Australian audiences. During the 1980s Macquarie started exhibiting Australian art internationally

in a significant manner, displaying artists' work in major international art fairs and actively promoting their work to collectors, curators and galleries in the USA, UK and Europe. The 1990s premises in Rushcutters Bay were large with two floors able to accommodate two or three exhibitions concurrently. However a radical change occurred in June 1993 when the gallery closed its exhibiting operations and became a dealership.

MARTIN BROWNE FINE ART*
(Established 1992) 13 MacDonald St, Paddington, NSW 2021. In June 1992, after four years as a private dealer and consultant to leading Australian collections, former Sotheby's Australian Paintings Department Head, Martin Browne, opened his Sydney gallery in Paddington in the former premises of the Garry Anderson Gallery. As well as several exhibitions by leading 20th-century contemporary Australian and NZ artists, the gallery's yearly program finds its focus in three survey exhibitions held in April, June and October. These exhibitions often show museum-quality work and are accompanied by a fully researched and illustrated catalogue. Interspersed with these major exhibitions are smaller thematic shows dealing with individual artists, artistic movements or specific subjects. Major survey shows have included a Colin McCahon retrospective; *The Second Wave of Sydney Modernism* with works by Grace Crowley, Ralph Balson, Frank Hinder and Rah Fizelle; *Towards 2000: Australian Iconography for the Millenium*, and individual artists exhibited at the gallery include Ralph Balson, Ian Fairweather, Tony Tuckson.

MELBOURNE CONTEMPORARY ART GALLERY
(Established 1989) 163 Gertrude St, Fitzroy, Vic. 3065. Directors Lorraine Finlay and Max Joffe run a contemporary gallery specialising in the display of painting, sculpture and photography reflecting current movements in art and concentrating on emerging artists.

MELBOURNE FINE ART
(Established 1991) Holyman House, Cnr Flinders and Market Sts, Melbourne, Vic 3000. Director Bryan T. Collie exhibits and deals in works from Colonial, Heidelberg and modern periods of Australian art, and also regular exhibitions by contemporary artists of a largely traditional style. Patrons of the Swan Hill Regional Art Gallery, Collie Holst Collection.

MERIDIAN GALLERY*
(Established 1992) 10 Sping St, Fitzroy, Vic. 3065. Meridian Gallery specialises in the display of sculpture and other 3–dimensional artworks and combines regular exhibitions in the large warehouse-style gallery with an adjacent workshop and foundry. It brings together established and emerging artists, professionals, art patrons, collectors and students. A number of professional services assist corporate and government collectors, architects, designers and arts advisers to appraise and select sculptures. Artists who have shown at the gallery since it opened included James Clayden, Peter Corlett, Erwin Fabian, Paul Juraszek, Loretta Quinn, Ann Thomson.

MICHAEL MILBURN GALLERY
(Established 1982) 8–10 Petrie Terrace, Brisbane, Qld 4000. Dealing in contemporary Australian art, artists represented by Michael Milburn include Mostyn Bramley-Moore, Les Dorahy, John Firth-Smith, Richard Goodwin, Bill Henson, Hollie, Stephen Killick, Robert Kinder, Janet Laurence, Alun Leach-Jones, Mandy Martin, Mike Parr, John Peart, Jon Plapp, Imants Tillers, Judy Wright, Jacki Redgate.

MICHAEL WARDELL
(Established 1987) 13 Verity Street, Richmond, Vic. 3121. Opened in 1987 by Michael Wardell, a former curator at the NGA, it has developed a reputation for showing innovative works by contemporary artists from Australia and overseas.

MODERN ART CENTRE*
(Active 1931–33) 56 Margaret St, Sydney. A short-lived but vital enterprise conducted by Dorrit Black (q.v.) as a centre of 'exhibiting, teaching and promoting' modernist art as identified with contemporary thought and practice in Paris and London. More than eleven exhibitions were held, including one-man shows by Fizelle, Crowley, and a memorial show to Weitzel (qq.v.). The Centre closed mid-1933.

MORI GALLERY
(Established 1980) 168 Day St, Sydney. Operating first in Leichardt the gallery opened its city premises in Jan. 1994. Directors Jo Holder and Stephen Mori show works of innovative contemporary art. 'We try to be both responsive and selective towards emerging tendencies in the art world and to encourage dialogue outside Australia,' said Stephen Mori in 1993. Artists represented by the gallery include Susan Norrie, Narelle Jubelin and Tim Maguire.

NIAGARA GALLERIES*
(Established 1979) 245 Punt Rd, Richmond, Vic. 3121. Established first at Niagara Lane, Melbourne, before moving to Richmond in 1983, its director is William Nuttall. Committed to re-exhibiting contemporary Australian art which strives to communicate something of enduring quality regardless of current fashions or styles, Niagara also presents historical exhibitions to keep links with Australian art history. Retrospective exhibitions by well-known painters have included those by Annois, Hall, Fairweather, Kmit, McLintock, Orban, Miller, Lymburner, Vassilieff, Wigley. The catalogues of consistent design produced for many exhibitions provide important resource material on the artists shown.

OSBORNE AND POLLOCK GALLERY
(Active June 1971–Oct. 1972) 8 Avoca St, South Yarra, Vic. It opened with an exhibition by Sandra Leveson and continued a vigorous program of exhibitions, mostly by young modernist painters. Later the premises became the Impressions Gallery, specialising in original etchings by Whiteley, Rees and other leading painter-printmakers.

OXLEY GALLERY
See ROSLYN OXLEY9

PAINTERS GALLERY AUSTRALIA
(Established 1981) 17 O'Connell St, Sydney, NSW 2000. Shows a diverse group of artists working within and beyond the mainstream, many of whom feature the landscape prominently in their work. Artists represented by the gallery include Ruth Burgess, Roger Byrt, John Ellis, Heather Ellyard, Col Jordan, Ena Joyce, Michael Kempson, Arthur McIntyre, Sally Morgan, Lin Onus, Peter Pinson, Georgina Worth, Chris Wyatt.

PHILIP BACON GALLERIES
(Established 1974) 2 Arthur St, New Farm, Qld 4005. Long-established Brisbane gallery with an outstanding representation of leading Australian artists including Whiteley, Blackman, Daws, Olley, Shepherdson. Important historical shows initiated by the gallery include an Ian Fairweather Retrospective (1984); David Strachan (1989) and Isaac Walter Jenner (1992).

PINACOTHECA GALLERY*
(Established June 1967) 10 Waltham Place, Richmond, Vic. 3121. Established first at St Kilda by Bruce Pollard, as a centre for avant-garde exhibitions, including post-object art, conceptual art and related forms, as discovered by Australian painters. In 1970 Pollard took over an old hat factory at the present address in Richmond, converted the premises and reopened his gallery in June of that year with an exhibition of work by eleven artists. Schlicht, Balsaitis, Mortensen, Booth, Stewart, Julie Irving, Mike Brown, Patrick Henigan Robert Hunter and Rosalie Gascoigne, are among artists who have held outstanding exhibitions at Pinacotheca. Pollard publishes no catalogues and promotional activities are min-

imal, but his gallery continues to attract many exhibitors of unusual ability and promise.

POWELL STREET GALLERY*
(1969–93) 20 Powell St, South Yarra, Vic. 3141. DIRECTORS: 1969–74, David Chapman; 1974–79, Jenny Heathcote; 1980–93, Jennie Chapman and Barrett Watson. Established by David Chapman (q.v.), who ran it until his death in 1974, it was briefly owned by a group that included Christine Abrahams and David Rosenthal, until David Chapman's daughter Jennie and her partner Barrett Watson took over in 1980. It showed many well-known artists including Victor Majzner, Peter Clarke, Fred Cress, David Wilson and Jan Senbergs and also established a graphics gallery next door. The gallery closed and its buildings were sold in March 1993.

RAY HUGHES GALLERY*
(Established 1969) 11 Enoggera Terrace, Red Hill, Qld 4059. 270 Devonshire St, Surry Hills, NSW 2010. Established by Ray Hughes, first as Gallery One Eleven before moving to the present Brisbane address and change of name in 1972. In 1985 he purchased the stock of the Rudy Komon Art Gallery and traded as Ray Hughes Gallery in the old Komon premises in Paddington, Sydney, operating there until purchasing a large three-storey warehouse initially shared by several other galleries. In 1992 the Ray Hughes gallery became the sole occupant of this massive building. Exhibitions in both venues favour innovative art with emphasis on Queensland artists, notably Davida Allen, Robert McPherson, Ian Smith, Madonna Staunton, William Robinson and many post-1950 artists.

REALITIES*
(1971–92) Established by Marianne Baillieu at 60 Ross St, Toorak, the first Realities Gallery was remarkable mainly for its eccentric, modern, salon-like architecture and avant-garde exhibitions. Its development was rapid however, and by the time the gallery moved to new premises in Jackson Street, South Yarra in 1975, its director had earned a reputation as an energetic and able promoter of Australian art and artists. Realities promotions included *Realities Sculpture Survey*, 1973; *Birth of a Tympanum* (work of five painters, Baldessin, Kemp, Kossatz, Sibley and Mirka Mora, eventually acquired in 1991 by the QAG), 1977; *Pre-Columbian Art of Mexico*, 1979. Realities (situated in a former church building) attracted many leading Australian painters and sculptors, particularly those who liked to work on a big scale. In July 1980, Marianne Baillieu sold the gallery to Pauline Wrobel, who carried on the tradition already established and added to the list of exhibitors many distinguished new names, before closing in 1992.

REX IRWIN
1st Floor, 38 Queen St, Woollahra, NSW 2025. A well-known art dealer, Rex Irwin shows the work of leading contemporary artists.

RICHMAN GALLERY*
Conducted from 1958–60 by Nicholas Heiderich at 289 Little Lonsdale St, Melbourne. Two Rowney prizes for drawing were held there.

ROAR STUDIOS*
(Established 1982) 115A Brunswick St Fitzroy, Vic. 3065. Established in 1982 by a collective of talented young artists, ROAR provided a much-needed stimulus for Australia's private galleries. For several years it was an important centre for youthful artistic activity with artists in the collective becoming leading exponents of the new-expressionistic style that dominated much new art of the mid-1980s. Members of the original collective included Sarah Faulkner, Peter Ferguson, Andrew Ferguson, Karan Hayman, Mark Howson, David Larwill. The original vitality of ROAR continued until around 1988 after which time, having been approached by other galleries, a number of the artists left the collective.

Its contribution to Australian art in the 1980s was recognized in the exhibition ROAR – *The First Ten Years* held at the Museum of Modern Art at Heide in 1992 and touring. In the 1990s ROAR continues as a space available for rent by artists, and in 1993 had a membership of over 200, but has forgone its impact as a cohesive collective dedicated to a particular artistic style.

ROBIN GIBSON GALLERY

(Established 1977) 278 Liverpool St, Darlinghurst, NSW 2010. Robin Gibson established the gallery first at 44 Gurner St, Paddington, and in 1982 moved to the present large premises. Mainly well-known Australian contemporary painters are shown, often those who have been the recipients of major prizes such as the Wynne, Sulman and Archibald.

ROSLYN OXLEY9 GALLERY*

(Established 1982) Soudan Lane (off 27 Hampden Street), Paddington, NSW 2021. Founded by Roslyn and Tony Oxley, exhibitions by leading contemporary artists are shown. The gallery has consistently supported work that is difficult and challenging and always features new work in a range of media, from painting and sculpture to performance, installation and video art. During March 1990 the Gallery moved from its original warehouse space to a new gallery in Paddington. Artists showing at the gallery since 1982 have included Juan Davila, Dale Frank, Rosalie Gascoigne, Bill Henson, Lindy Lee, John Nixon, Mike Parr, Gareth Sansom, Vivienne Shark Le Witt, Jenny Watson and Ken Unsworth.

RUDY KOMON ART GALLERY*

(1958–84) Established by Rudy Komon (q.v.) in a former wine shop, the premises were converted into a gallery and in 1965 were rebuilt and redecorated to emerge as a modern, splendidly appointed art gallery on two levels. In selecting artists for exhibitions, Komon introduced European methods of full-scale patronage unknown in Australia at that time. The names of Aspden, Baldessin, Blackman, Boyd, Brack, Cassab, Dobell, French, Jomantas, Kemp, Molvig, Olsen, Powditch, Pugh, Red-path, Sibley, Senbergs, Eric Smith, Fred Williams all figured prominently in gallery exhibitions, and Komon's entrepreneural skills played an important part in establishing many reputations. After Komon's death in Oct. 1982, the gallery was carried on by his former assistant, Gwen Frolich, until 1984 when the stock and premises were sold to Ray Hughes (*see* RAY HUGHES GALLERY).

SAVILL GALLERIES

156 Hargrave St, Paddington, NSW 2021. Director Dennis Savill holds exhibitions by leading contemporary Australian artists including Brett Whiteley and Arthur Boyd and is a well-known dealer specialising in colonial, impressionist, and works from the 1930s–40s.

SEDON GALLERIES*

(Active c. 1920–60) Owned and managed by W. R. Sedon, first in Little Collins Street, then above Robertson and Mullens bookshop in Hardware Chambers, 231 Elizabeth St, Melbourne. After the death of W. R. Sedon, the business was moved to 150 Burwood Rd, Hawthorn. Exhibitions included work by Streeton, Blamire Young, Norman Lindsay, W. D. Knox, Robert Johnson, Harold Herbert, Rubery Bennett and other well-known painters. W. R. Sedon, who owned a large private collection and was strongly anti-modernist in his views, exercised great influence on Melbourne art affairs.

SKINNER GALLERIES*

(Active 1958–c. 1974) Built at a time when there was little encouragement in WA for any art except of the most conventional kind, the entrepreneurial role of Rose and Joseph Skinner soon proved of immense value to the development of art and artists in WA. The names of Guy Grey Smith, Robert Juniper and many other WA painters became well-known in the eastern states because of the Skinners, who also induced Dobell, Drysdale, Nolan, Tucker, Boyd and many other interstate artists to exhibitions in Perth. During its 16 years of operation the Skinner Galleries was the centre of Perth's art life.

SHERMAN GALLERIES

(Established 1981) 1 Hargrave St, Paddington, NSW 2021; 16–18 Goodhope St, Paddington, NSW 2021. Sherman Galleries (formerly Irving Galleries) was started by Celia Winter-Irving and originally located in Glebe. Notable for many years as a leading sculpture gallery, the gallery initiated and produced Graeme Sturgeon's *Development of Australian Sculpture*, Craftsman House, 1990. A collection of large and small-scale sculptural works are continuously on view at either the Hargrave or Goodhope Street spaces and exhibitions are those of an important group of Australian and international artists with an annual exhibition of international graphics.

SOLANDER GALLERY

(Established 1974) 36 Grey Street, Deakin, ACT 2600. Situated on a large site near the new Parliament House in Canberra, and run by Joy Warren it is surrounded by landscaped areas and courtyards for sculpture and parking. The building was designed by architect Bob Warren for his wife, Joy, and is characterised by clerestory windows. The Gallery was founded in 1974 and moved to its present address in 1987. It specialises in bringing major Australian artists to the capital with two new exhibitions each month which also include shows of young painters and overseas artists.

SOUTH YARRA GALLERIES*

(Active 1961–76) Established at 10 William St, South Yarra, Vic., by Violet Dulieu. After one year of operation, special gallery buildings were constructed at the rear of the private residence, to create one of Australia's leading commercial galleries, with Blackman, Gleeson, Laycock, O'Brien, Perceval and Smart all included among a long list of regular exhibitors. Also organised by the owner-director during extensive travels were a number of international exhibitions. As a gallery director, collector and entrepreneur, Violet Dulieu had great influence on local art affairs. It became the Libby Edwards Gallery in the 1980s.

STANDFIELD GALLERY

(1980–c. 1988) Established by Tim Standfield, formerly of the Warehouse Gallery, it moved to South Yarra, then South Melbourne during the 1980s and held exhibitions of interest including those of Jeffrey Bren, Peter Rossman and Helen Maudsley.

STANLEY COE GALLERY*

(Conducted 1950–57) Established by Stanley Coe on the upstairs floor of his antique furniture business at 435 Bourke St, Melbourne, Vic., the business was taken over in 1951 and the gallery then became the Peter Bray Gallery. During its seven years of operation, especially its early years, it was the leading gallery in Melbourne. The first Dunlop Prize exhibitions were held there and exhibitions otherwise favoured modernist art. The gallery was managed by Helen Ogilvie (q.v.), who encouraged many young exhibitors who later became well-known.

STRINES GALLERY

(Active 1966–c. 1980) Conducted by Sweeney Reed (q.v.), first on the corner of Rathdowne and Faraday Sts, Carlton, then in Brunswick St, Fitzroy (as Sweeney Reed Galleries), it became known as a gallery supportive of young avant-garde painters and sculptors. The original building subsequently became the Leveson Gallery (1979–83) and Bridget McDonnell Gallery (1983–).

STUART GERSTMAN GALLERIES

(Established 1973) Southgate, Melbourne, Vic. 3004. Gerstman studied art at RMIT and Prahran CAE and managed the Cardigan Street Gallery before starting his own gallery at

148 Auburn Road, Hawthorn. He moved the business to Punch Lane in Sept. 1980, Gipps St, Richmond in c. 1984 and the Southgate complex in 1992. During the 1980s he was awarded an Export Development Grant to assist in establishing a gallery in Cologne, Germany to display the work of Australian artists. This he operated in partnership with Tim Abdullah for several years. The Southgate mainly gallery shows prints and drawings by leading 20th-century European and some Australian artists.

SWEENEY REED GALLERIES

(Active 1972–75) Conducted by Sweeney Reed (q.v.) at 266 Brunswick St, Fitzroy, as a centre of avant-garde activity. The gallery occupied two floors of an old building, modified and luxuriously decorated for modern gallery purposes. Exhibitions included those by artists from the 1950s period patronised by Reed's foster parents, John and Sunday Reed, as well as exhibitions by many younger, modernist painters and sculptors. Albert Tucker's bronzettis on the theme of his *Images of Evil* made their first appearance there, as did the aluminium and wool 'sheep' sculptures of Les Kossatz. The gallery was also the venue for the rally, *Artists for Labor*, 1974, in support of the Whitlam government.

SYDENHAM GALLERY

(Established 1970) 16 Sydenham Road, Norwood, SA 5067. Established by Rachel Biven largely for the encouragement of young SA artists. Her book *Some forgotten . . . some remembered*, Sydenham Gallery, 1976 contained much interesting and useful information about SA women artists of the past.

THIRTY VICTORIA STREET*

(1957–c. mid 1970s.) The business was established as the Terry Clune Gallery at 59 Macleay St, Potts Point, by Terry Clune and Frank MacDonald. It became the Clune Gallery when Clune sold his interest to MacDonald in 1967, and the address changed to Macquarie St, Sydney. In 1974 the name changed again when the business was moved back to Potts Point – to 30 Victoria Street. During the 1960s the gallery was a centre of avant-garde activity and represented many leading contemporary painters, but later the focus of attention shifted to historical research and exhibitions of celebrated early artists, notably Conrad Martens, W. B. Gould, von Guérard and E. Phillips Fox.

TOLARNO GALLERIES*

(Established 1967) 121 Victoria St, Fitzroy, Vic. 3065. Established by Georges and Mirka Mora (qq.v.), first on the ground floor of Tolarno Private Hotel, 42 Fitzroy St, St Kilda, where Georges also managed the restaurant, a favourite rendezvous for artists, patrons and distinguished visitors. Consistent with Mora's French background, the character of the gallery was Gallic and frequently featured special exhibitions by Ecole de Paris masters, notably the graphic *oeuvre* of Bonnard, Matisse and Léger and a tribute exhibition of etchings by Picasso. The names of Blackman, Boyd, Hester, Perceval, Tucker, Nolan and other contemporaries figured prominently in the Australian work shown and also the work of many new, younger artists. In Sept. 1979, the gallery moved to River St, South Yarra where William Mora joined his father in running the gallery before setting up his own gallery in the city. Jan Minchin previously of the NGV, joined Georges Mora as co-director in 1989 and continued the gallery in the new and present location following Georges' death in 1992.

TOORAK GALLERY

(Active 1964–76) Established at 277–81 Toorak Rd, South Yarra, Vic., and moved to 254 Albert St, East Melbourne in Apr. 1976. Widely varied exhibitions included many mixed showings of work by Australian artists both young and old.

TOWN GALLERY AND JAPAN ROOM, THE

(Established 1973) 6th Floor, MacArthur Chambers, Edward/Queen Sts, Brisbane, Qld 4000. Verlie just is the exclusive representative in Brisbane for some established and emerging Australian artists including Judy Cassab, Graeme Inson, John Rigby. Exhibitions of original 17th–20th century Japanese woodblock prints.

TYE'S GALLERY*

(Active c. 1945–54) Large basement gallery conducted at the rear of Tye's Furniture department store, Bourke St, Melbourne. Many of the early CAS exhibitions and other important Melbourne exhibitions were held there. Its directors included Stephanie Taylor and George Page Cooper, but individual artists and groups usually ran their own shows.

UNITED ARTISTS

(Active 1980s) Established by a collective of artists in the former Tolarno Galleries, Fitzroy St, St Kilda, it held a number of exhibitions by the artist members before appointing Luba Bilu and Anna Schwartz directors. The gallery moved to Flinders Lane, Melbourne before Bilu and Schwartz dissolved their partnership to establish individual galleries.

UTOPIA ART SYDNEY

50 Parramatta Rd, Stanmore, NSW 2048. Utopia Art Sydney represents a diverse group of artists. The majority are from Alice Springs, Mulga Bore, Utopia, Papunya, Kintore and beyond, while John R. Walker and Christopher Hodges are Sydney-based. The focus of the gallery is on contemporary art and artists who continue to explore the boundaries of their work. Artists shown include Robert Cole, Christopher Hodges, Emily Kngwarreye, Lyndsay Bird Mpetyane, Ada Bird Petyarre, Billy Petyarre, Gloria Tamerre Petyarre, Maxie Tjampitjinpa, Joseph Jurra Tjapaltjarri, Mick Namerari Tjapaltjarri, Turkey Tolsen Tjupurrula, John R. Walker.

VICTOR MACE FINE ART GALLERY

(Established 1975) 35 McDougall St, Milton, Qld 4064. The gallery acts as agent for a variety of painters, ceramic and fabric artists and sculptors including Robert Grieve, Mal Leckie, Peter Rushforth, Col Levy, Leonard and Kathleen Shilam, Mary Taguchi.

VON BERTOUCH GALLERIES

(Established 1962) 61 Laman St, Newcastle, NSW 2300. Established by Anne von Bertouch for the promotion of contemporary Australian art favouring NSW painting, sculpture and crafts, the gallery has been an important regional centre for the showing of contemporary Australian art.

WAGNER ART GALLERY

39 Gurner St. Paddington, NSW 2021. Director Shirley Wagner exhibits the work of leading contemporary Australian artists including Charles Blackman.

WATTERS GALLERY*

(Established 1964) 109 Riley St, East Sydney, NSW 2010. DIRECTORS: Frank Watters, Alexander Legge, Geoffrey Legge. Sponsored by Geoffrey Legge, Watters established the business first at 397 Liverpool St, Darling-hurst, as a centre for new, creative painting and sculpture, a policy continued with the move to the present address in 1969. Frank Watters worked in a coal pit for eight years before moving to Sydney to study art (c. 1958). He began painting and collecting, exhibiting in group exhibitions and variously earning a living before joining the Barry Stern Galleries as an assistant. The logical result was the move with Geoffrey Legge to their own gallery, where his contribution to art in Sydney was such that in 1973 he received a VACB grant for overseas study. In 1974 the Watters–Legge combination was described by Daniel Thomas as 'the most conspicuous example in Australia of creative art patronage through a dealer's gallery . . . which has made an indispensable, exhilarating contribution to the general life of Sydney'. Artists associated with the gallery include Richard Larter, Tony Tuckson, Vicki Varvaressos, Mike Brown, Vivienne Binns, John Peart, Max Watters, Robert Klippel, James Gleeson and many others. In 1989 Watters Gallery held their 25th

anniversary exhibition which toured eight regional centres until 1991.

WILLIAM MORA GALLERIES

(Established 1987) 31 Flinders Lane, Melbourne, Vic. 3000. Son of Georges and Minta Mora (q.v.), William Mora joined his father in Tolarno for some years before establishing his own gallery in 1987. Artists shown at the gallery include Peter Adsett, Tane Anderson, Michael Bastow, Peter D. Cole, Christopher Croft, Merilyn Fairskye, Peter Ferguson, Katherine Hattam, Ponch Hawkes, Karan Hayman, Mark Howson, Gil Jamieson, Ellen Jose, Margaret Morgan, Mirka Mora, Philippe Mora, Ginger Riley Munduwalawala, Pie Rankine, James Smeaton, Sarah de Teliga, Jonothan Throsby, Tony Trembath, Ian Westacott, Stephen Wickham.

WOMEN'S GALLERY THE

(Established 1988) 375 Brunswick St, Fitzroy, Vic. 3065. A non-profit unfunded exhibition space run by a voluntary management committee, it displays the work of women artists in many media.

WOOLOOMOOLOO GALLERY

(Established 1984) 84–86 Nicholson St, Woolloomooloo, NSW 2011. Directors Fred Wrobel and Elinor Wrobel exhibit 'Australian artists of promise and renown'; specialising in 20th-century Australian artists. Exhibitions include solo shows of sculpture, photography, textiles. There is a yearly survey of drawings and of TAFE Randwick jewellery design students.

YUILL/CROWLEY

(Established 1982) 1st Floor, 30 Boronia St, Redfern, NSW 2016. Yuill/Crowley is a contemporary commercial gallery representing artists including John Barbour, Janet Burchill, A. D. S. Donaldson, Richard Dunn, John Dunkley-Smith, Matthys Gerber, Robert Hunter, Robert Macpherson, Imants Tillers, Peter Tyndall, Dick Watkins, John Young.

Magazines, Journals & Newsletters

The only means of disseminating public information in the early days of Australian settlement was through handbills or news-sheets, and later, newspapers and periodicals. From colonial times, this published material represented a form of visual communication which provided employment for artists. Many became fully absorbed in it, only to disappear later along with the publications for which they worked. From 1850 onwards the Australian gold-rush added greatly to the number of publications, the crowning touch to the period being given by the international exhibitions of the 1880s. Simultaneously, the introduction of the photolitho process of reproduction revolutionised the art of illustration and created a distinctive school of Australian black-and-white art. During the same period, there appeared a crop of small art magazines or reviews, short-lived publications but significant harbingers of the much later but more strongly rooted *Art and Architecture* and *Art in Australia*. All this published material combined to create the first body of informed art criticism, although criticism had existed in the daily press since the days of John Lhotsky and F. R. Nixon (qq.v.).

Professional criticism in the daily press entered the lists with the appointment of James Smith to the Melbourne *Argus* in 1856, and from then on the more important dailies gradually added art critics to their literary staffs. (*See* CRITICS AND CRITICISM). The marked increase in art publishing from the early 1980s reflects the rapid growth of the arts as a cultural phenomenon strongly supported by the Australia Council through its Visual Arts/Craft Board. It has funded visual art content in established literary/arts journals and single issues and articles in international art journals such as *Domus*, *Flash Art*, *Plus Moins Zero*, *Art Forum*, *Art in America* and UK *Studio International*. Those that have not received public funding have usually been the product of fierce enthusiasm and commitment on the parts of editors, writers and associates. Art magazines have been aptly described as 'volatile and fragile'. For some the struggle to continue became too great, others – their message delivered – died a natural death; it is part of the nature of art journals to be relatively short-lived.

The various magazines and periodicals that have affected art in Australia (on a variety of levels) are listed in chronological order. Because details frequently change, readers are advised to obtain up-to-date information from the National Association for the Visual Arts (NAVA), PO Box 60, Potts Point, NSW 2011.

Magazines

1835

Cornwall Chronicle Published in Launceston by William Lushington Goodwin (q.v.) who also illustrated the paper with his own woodcuts and etchings until 1862. The paper continued in its original form until 1880. (Mahood, *The Loaded Line*, 1973).

1847

Heads of the People Illustrated paper published in Sydney from 17 Apr. 1847 by William Baker. The portraits were drawn by William Nicholas and C. Rodius, and tailpieces by T. Clayton. The paper lasted only until 1848.

1850

Australian Illustrated Magazine The first magazine published in the colony of Victoria. Conducted by the engraver, artist and publisher, Thomas Ham (q.v.), it ran for 22 issues (July 1850–Aug. 1852), bringing together a fine group of contributing artists and engravers, including William Strutt, David Tulloch, F. Stringer Brown, George Strafford, F. Price, as well as Thomas Ham. (Paper read by H. Woodhouse at the Victorian Lithographic Artists and Engravers Club, 18 Dec. 1889; copy in La Trobe Library, Melbourne.)

1853

Armchair Melbourne magazine to which Gill (sometimes mistaken for S. T. Gill) and S. Calvert contributed illustrations. The second number contained a review of the Fine Arts Society exhibition.

1855

Melbourne Punch Founded 2 Aug. 1855, by a group whose members were: Frederick Sinnett, mining engineer and journalist; James Smith, journalist and critic; William Jardine Smith, journalist; Edgar Ray, printer. *Melbourne Punch*, which ran for 70 years, remains the longest-running weekly in Australia's history. The first issue was said to have been illustrated mainly by Gill (no connection with the goldfields artist), and from then on its artists included Nicholas Chevalier, the first staff artist, Montagu Scott, O. R. Campbell, T. Carrington, Luther Bradley, George Dancy, Alec Sass and many others. It was taken over and reformed by the Melbourne *Herald* in 1924, when its artists included Joseph Lynch, Percy Leason, Hugh McCrae, Mahdi McCrae, D. H. Souter, Daryl Lindsay, L. F. Reynolds, Unk White and Will Dyson, who returned from London in 1925 as principal *Melbourne Punch* cartoonist. The last issue of the magazine appeared in Nov. 1925. In Dec. of that year it was amalgamated with the weekly *Table Talk* (q.v.) which was itself superseded by a third *Herald*-owned paper, *Picture News* (q.v.), in 1940.

1856

Illustrated Journal of Australasia Melbourne magazine to which the critic James Smith contributed a regular 'journal of literature and art'.

Newsletter of Australasia Opposition magazine to the *Illustrated Journal of Australasia*.

1861

Illustrated Australian Mail Melbourne magazine. Its illustrations included pictures by William Strutt, Eugène von Guérard and J. Montagu Scott.

1863
Australian Monthly Melbourne magazine. Its illustrators included Thomas Carrington.
1864
Illustrated Australian News Published by David Syme & Co., Melbourne. Its illustrators included Julian Ashton, G. R. Ashton, J. W. Curtis. Julian Ashton was brought to Australia by Syme specially to work on the paper.
Illustrated Sydney News Its artists included Charles Conder, Arthur and George Collingridge and T. T. Balcombe.
Sydney Punch Artist contributors included E. J. Greig, O. R. Campbell, Montagu Scott, William Macleod, A. Clint, Sam Begg. Early abortive attempts to start *Sydney Punch* were made in 1856 and 1857 and the paper was finally launched 27 May 1864 at 233 Pitt Street, by Edgar Ray, one of the founders of *Melbourne Punch*. The magazine had about 20 prosperous years before falling into decline c. 1883, and eventual extinction.
1866
Hobart Town Punch Twelve-page, quarto fortnightly published first as *Tasmanian Punch* by Major L. Wood, lithographer, and John H. Manly, artist, at 12 Elizabeth St, Hobart Town. The name was changed to *Hobart Town Punch* on 12 Jan. 1867 but its publication was suspended when Manly started a new title, *Fun, or the Tasmanian Charivari*, using the same format. The new paper was also short-lived. A new *Tasmanian Punch*, published by Charles A. Henn, appeared on 15 Jan. 1870, its cartoons bearing the insignia S.H.J.
Queenslander Published in Brisbane by Gresley Lukin. Artist: J. Cecil Gasking.
1867
Ballarat Punch Began 7 Feb. 1867, its cover bearing the name of the litho-grapher, F. W. Niven, 19 Lydiard St. Artist: A.C. (probably Albert C. Cooke, q.v.). Its last issue appeared 9 Jan. 1870.
Fun, or the **Tasmanian Charivari:** see *Hobart Town Punch*, 1866.
Pasquin Satirical weekly published in Adelaide. Its cartoons were drawn by 'Pasquin' (Eustace Revely Mitford), who drew also for other publications. When he died in 1869, his paper died with him.
1868
Adelaide Punch Published in Adelaide from 5 Dec. 1868. Its contributing artists included Tom Carrington, F. Dane, H. J. Woodhouse, W. J. Woodhouse, John Hood, A. S. Broad. As with other colonial magazines dependent on wood engraving as their method of reproduction, *Adelaide Punch* went into decline c. 1883.
1869
Humbug Sixpenny weekly published at 72 Little Collins St East, Melbourne, beginning 8 Sept. 1869. Edited by the novelist Marcus Clarke, with cartoons by T. S. Cousins.
Touchstone Sixpenny weekly published in Melbourne at 79 Collins St and edited for a time by Henry Kendall, with cartoons by T. S. Cousins. The magazine was launched on 2 Oct. 1869 in direct response and antagonism to *Humbug*, to which Cousins also contributed the cartoons.
1870
Tasmanian Punch See *Hobart Town Punch*, 1866.
1871
Portonian Published in Adelaide; the first issue appeared on 12 Aug. 1871. Its cartoonists included 'Cerberus', 'Kostic', Pynder Willis. Printed with the paper, which survived until c. 1877, was a handsomely engraved annual *Almanac*.
1873
Australasian Sketcher Published by the *Argus* daily newspaper as a sixpenny monthly review of political, social and sporting events, handsomely illustrated with wood engravings. Its many artists included Tom Carrington, John Gully, Julian and George Rossi Ashton. The *Australasian Sketcher* became the *Australasian*, which in turn became the *Australasian*

Post (still published under that title by the Herald and Weekly Times as a popular illustrated weekly tabloid).
Mirror Short-lived Adelaide weekly illustrated with cartoons. The principal artist was A. Clint.
1874
Lantern Published in Adelaide, it was incorporated with *Quiz* in 1890, to become *Quiz and the Lantern*. Its artists included 'Leo' (J. H. Leonard), W. Wybard, A. Clint, 'E.D.', John Hood, A. S. Broad, 'Phineas', J. Bruer, 'Stys'.
1875
Sydney Mail Its artists included Arthur Collingridge.
1877
Figaro (South Australia) It began as *Peepshow* in Feb. 1877, changed to *Figaro* and featured cartoons of theatrical characters by 'Sydenham'. The paper issued also supplementary cartoons.
Port Adelaide News Featured the cartoons of 'Leo' (J. H. Leonard).
1878
Figaro (Queensland) Published in Brisbane by Edgar J. Byrne (*see Queensland Punch*). It had considerable popularity, achieving a circulation of 9000 by 1884. Its artists included Ebenezer Murray (q.v.) and 'Fosse'.
Queensland Punch The 'last of the provincial *Punches*'. Commencing 1 Oct. 1878, this sixpenny weekly was published by the fiery, opinionated J. Edgar Byrne at 204 Queen St, Brisbane. Byrne also published Queensland *Figaro* and maintained a stable of artists and engravers, among whom were A. V. Thomas, C. Tommasi, Charles Stuart, C. H. Hunt, J. E. Ward.
1879
Sam Slick in Victoria Published in Melbourne by Edward Castildine Martin, this radical paper was the first to make use in Australia of the new photolitho line-block process of reproduction. Its contributing artists included J. Davis, Tom Durkin, G. R. Ashton and 'Chicot'.
1880
Bulletin Melbourne. It amalgamated with *Melbourne Punch* in 1886. Artist: J. Davis.
Bulletin Sydney. Founded Oct. 1880. (*See* BLACK-AND-WHITE ART IN AUSTRALIA)
Tomahawk Melbourne. Artists: Claude Marquet, Tom Durkin, 'Chicot'.
1884
Australian Tit-bits Published in Melbourne and amalgamated with *Life*. Artists: Luther Bradley, H. B. Blanche, Tom Durkin, Percy Spence.
1885
Table Talk Mainly a social magazine, published weekly in Melbourne (1885–1937) and started by Maurice Brodzky. Included was a regular art column written by Edward A. Vidler (1889–1902). A full account of the *9 × 5 Impressions Exhibition* was published (19 July–23 Aug. 1889). *Table Talk* cartoonists included Herbert Woodhouse, Ambrose and Will Dyson. Brodzky's editorship ended in 1902, but the magazine was maintained until it was taken over by the Melbourne *Herald* in 1925. *Table Talk* ceased publication in 1940 when it was superseded by another *Herald* weekly, *Picture News* (q.v.).
Western Mail Perth. Artist: Ben Strange.
1887
Boomerang Brisbane magazine. Artists: E. H. Murray, Montagu Scott, J. E. Ward, T. E. Cook, A. Fischer.
Possum Published in Perth. The name was changed in 1888 to *W.A. Bulletin*.
1888
Australian Art An eight-page monthly magazine containing two full pages of engravings, edited by George Collingridge. The first number appeared in Jan. 1888 but, owing to insufficient support, the magazine terminated after three issues.

1889
Quiz See *Lantern*, 1874.
1890
Adelaide Truth Artists: 'Uno', F. Dane.
Australasian Critic Melbourne magazine published monthly, Oct. 1890–Sept. 1891. Edited by Prof. Baldwin Spencer and T. G. Tucker.
Bull-ant Melbourne. Artist: Tom Durkin.
Worker Brisbane. Artists: E. H. Murray, Montagu Scott, A. J. Hingston.
1892
Antipodean Annual magazine published by Chatto & Windus, London, 1892–93 and 1897.
1895
Champion Melbourne. Artists: Max Meldrum, Alec Laing, Ambrose Dyson, Tom Durkin.
1897
Critic Adelaide. Artists: Ambrose Dyson, J. H. Chinner.
Tocsin Published in Melbourne. The name was changed to *Labor Call* in 1906. Artists: Norman Lindsay, Lionel Lindsay.
1899
Australasian Art Review Sydney magazine of music, drama and the visual arts, published monthly Mar. 1899–Sept. 1901. Illustrations appeared in all but the first few numbers. J. Green, who wrote under the pseudonym 'De Libra', wrote regularly on Australian art, and A. J. Daplyn contributed a regular journal of art events.
1900
Arena Melbourne. Artists: Tom Durkin, Hugh McCrae, J. McDonald, Lionel Lindsay.
c. 1900
Australian Magazine Contributions included reproductions of George Lambert's *Shearer's Sunday*, and work by Souter, Garlick, Leist, Alice Muskett and Thea Proctor.
1904
Art and Architecture Sydney magazine published (1904–11) by the Institute of Architects of NSW, first under the title *Journal of the Institute of Architects of New South Wales*. D. H. Souter was the art editor and the magazine contained regular features on art, including a reprint (vol. 8, 1911) of C. Lewis Hind's sympathetic account of the exhibition, *Manet and the Post-Impressionists*, arranged at the Grafton Galleries, London, by Roger Fry in 1910. *Art and Architecture* was replaced by *The Salon* (q.v.) in 1912.
Steele Rudd's Magazine Monthly all-Australian-content magazine, publishing short stories, verse, articles, interviews and illustrations. Published in Brisbane. Artist contributors included Ruby Lindsay, James A. Crisp, Will Dyson, Sydney Ure Smith, H. W. Turner, and many others.
1906
Gadfly Adelaide magazine edited by C. J. Dennis. Staff artists included Will Dyson.
1908
Victorian Artists Society Journal Journal of the VAS, 430 Albert St, East Melbourne, Vic. 3002. The original journal ran from 1908–18. There have been various attempts at revival, the most notable being the *Australian Artist* (q.v. 1946).
1912
Salon Sydney monthly journal of art and architecture conducted (1912–16) by the Institute of Architects of NSW and printed by Weston, Wilson & Co., Sydney. *The Salon*, which replaced *Art and Architecture*, was a well-produced magazine containing black-and-white photographic illustrations, news items on current art and architecture, and a regular feature called 'The Modern Tendency in Art', conducted by Fred J. Broomfield.
1916
Art in Australia Sydney magazine (1916–42) established and edited by Sydney Ure Smith. Bertram Stevens was co-editor until his death in 1922 when his place was taken by

Leon Gellert. During its 26 years of operation, the magazine had great influence on Australian art affairs. It began as a quarterly and later was published six times a year; the price varied according to size and importance of the contents. Publicity and promotion of the visual arts in Australia was the principal aim. Through *Art in Australia* the firm of Ure Smith Pty Ltd was founded, and many special numbers, as well as books on Australian art, were published. In 1934 the magazine was taken over by the *Sydney Morning Herald*, together with another Ure Smith publication, *Home* magazine. Sydney Ure Smith remained editor until 1938 when the editorship went to Peter Bellew. Bellew turned the magazine from comparatively provincial standards into a sophisticated journal which aimed at a high level of criticism, but difficulties of war-time production ended its career. (*See also Art and Australia*, 1963)
1919
Smith's Weekly Sydney newspaper (1919–50) established by Joynton Smith. It thrived on sensation, large proportions of its space being devoted to satirical and humorous black-and-white drawings, illustrations and caricatures. Its artists and writers were paid higher rates than were paid by other periodicals such as the *Bulletin*. Much of their work was brilliant. It epitomised 'the era of the inspired larrikin', among the most famous of its artists being Jo Jonson, Syd Miller, George Finey, Stan Cross, 'Virgil', O'Reilly, and Cecil Hartt.
(*See AA special issue Caricatures by George Finey* with articles by J. S. MacDonald and Lionel Lindsay, June 1931; George Blaikie, *Remember Smith's Weekly* Rigby, Adelaide, 1966.)
1923
Vision Sydney magazine. A literary quarterly edited by Frank C. Johnson, Jack Lindsay and Kenneth Slessor, and printed by R. C. Switson & Co., Sydney. *Vision* contained art reviews and writings by Adrian Lawlor, Hugh McCrae, Norman Lindsay and Jack Lindsay, and was decorated lavishly throughout with fauns and satyrs drawn by Norman Lindsay. Four numbers only appeared.
1924
Undergrowth Sydney art students' magazine conducted 1924–30.
1931
Stream Melbourne magazine. Avant-garde monthly review of which three numbers appeared, June–Oct. 1931. It included cubistic illustrations and cover design by Dorinia Leon (q.v.) and contributions by Alwyn Lee, Cyril Pearl, Bertram Higgins and Gino Nibbi, who also helped to distribute the book from his Leonardo Bookshop, Melbourne. *Stream* was the first review to support the cause of modern art in Melbourne.
1932
Manuscripts Quarterly review conducted by H. Tatlock Miller, at Geelong, Vic.
1939
Southerly Quarterly journal of the English Association (Sydney branch), containing intermittent articles on artists who are also writers, as for example, Hugh McCrae (no. 1, 1956), Norman Lindsay (no. 3, 1959). Editors include Kenneth Slessor (1956–62), G. A. Wilkes (1963–89), Elizabeth Webby (1989–).
1940
Meanjin Review of literature and art, founded and edited by Clement Byrne Christesen and subsidised by grants from the Uni. of Melbourne and the Commonwealth Literary Fund, later by the Literature Board of the Australia Council. Christesen established the magazine in Brisbane in 1940, and brought it to Melbourne in the summer of 1944–45 at the invitation of Sir John Medley, Vice-Chancellor of Melbourne University. A review of consistently high standards, it was for many years the only Australian magazine publishing regular illustrations and articles on Australian

art. Christensen was born at Townsville, Qld, in 1911, and is a spare-time painter as well as editor and writer. Awarded the OBE for services to Australian literature in 1962, he later received an honorary Doctorate of Letter at Monash Uni., and retired as editor of *Meanjin* in 1974. Editors: 1940–74, C. B. Christensen; 1974–82, Jim Davidson; 1982–87, Judith Brett; 1987–94, Jenny Lee.

Picture News Published weekly by the Melbourne Herald and Weekly Times and edited by Alan Moyle as a war-time paper in succession to *Table Talk*. It featured half-page and full-page cartoons and lasted a little over twelve months before war-time conditions caused its cessation. Its artists included Harold Freedman and Alan McCulloch.

1941

Angry Penguins Review of art and letters conducted by Max Harris, first in Adelaide before being transferred to Melbourne in 1943, when John Reed (q.v.) became a joint editor. Policy included support for avant-garde painting as represented by Nolan, Tucker, Boyd and Perceval, then in the early stages of their development. An *Angry Penguins Broadsheet* was published in 1943. The magazine became the object of a literary fraud (the Ern Malley hoax) in 1944, when the editors accepted, and published as genuine, poems composed as a joke, according to the authors, two young writers, James McAuley and Harold Stewart. Later writers have conceded genuine poetic quality to the hoax poems and Ern Malley has attained the status of a mythical folk hero. An abortive attempt to revive the magazine was made in the 1950s.

Comment Published in Melbourne and edited by Cecily Crozier with contributions by Adrian Lawlor and others supporting the modernist movement. About 12 issues.

1944

Daub National Gallery of Victoria students' magazine, published annually, 1944–61. It contained illustrations, articles, interviews, school news and results of student prizes and scholarships.

1946

Australian Artist Melbourne quarterly published (1946–49) by the Victorian Artists' Society as a revival of the original *Victorian Artists' Society Journal* (1908–18). The magazine was founded by L. Annois, assisted by A. McCulloch, the first two numbers being published under the title *Genre*. They formed an editorial committee for the second number, and at the end of 1946 R. Haughton James became editor, renamed the publication *The Australian Artist*, and turned it into a 54–page illustrated journal, carrying advertising and selling to the public at 3s 6d a copy, as well as being distributed free to VAS members. Under Haughton James's editorship it soon became an influential review with every prospect of financial success. It ceased publication in 1949 when amateurs inside the VAS joined with outside pressure groups to force the resignation of the editor.

1952

Architecture and Arts Melbourne, intermittent review.

1954

Overland Melbourne magazine. Quarterly review of art and letters edited by Stephen Murray-Smith until his death in 1988, since then by Barrett Reid (to 1993) and John McLaren. Black-and-white features have included contributions by Noel Counihan, Rod Edwards, Vane Lindesay, Bruce Petty, Geoff La Gerche, Clem Millward, Rod Shaw.

1956

Quadrant Review of opinion, founded and edited by James McAuley, and sponsored by the Australian Association for Cultural Freedom; subsidised also from the Commonwealth Literary Fund. Quarterly until 1964, after which six issues a year were published. Occasional articles on the visual arts were contributed by G. Molnar, E. Lynn, D. Thomas, J. Burke, B. Smith. Donald Horne joined McAuley as joint

editor in 1964. Editors have included H. W. Arndt, Peter Coleman and Robert Manne.

1958

Nation Sydney magazine. A 24-page paper-covered, independ-ent fortnightly review of opinion, published and edited in Sydney by T. M. Fitzgerald. Articles, letters and reviews on art infused vitality into the art writing of Sydney, exerting an influence which spread to other magazines, and newspapers. The art critic Robert Hughes made his reputation through his contributions to the journal (1958–63).

1959

Modern Art News Melbourne magazine. Twenty-page illustrated magazine conducted by the Victorian division of the Contemporary Art Society, in conjunction with the Museum of Modern Art and Design of Australia. Two numbers only were issued; when the editors, John Gooday and Georges Mora, resigned owing to differences of opinion with other members of the editorial committee, no further issues of the magazine appeared.

Observer Sydney review amalgamated with the new Sydney Bulletin in 1961.

1961

The critic Monthly review of art and art affairs in Western Australia, published by a private committee in conjunction with the University Literary Society of the University of Western Australia. Contributing art critics included Salek Minc, Patrick Hutchings, Tom Gibbons, R. K. Constable. Editors: H. Nicholson, J. O'Brien, E. Schlusser.

1962

Westerly Perth quarterly review of arts and letters, edited by Bruce Bennett and Peter Cowan, and published by the Arts Union of the Uni. of WA The first number of *Westerly* which contained 140 pages, including six colour plates and 26 black-and-white, gave a comprehensive coverage of contemporary painting and sculpture in WA, including an account of the Tom Collins Bequest.

1963

Art and Australia Quarterly art magazine established Sydney, May 1963, and edited by Mervyn Horton for the publishers, Ure Smith. From 1975 its publisher was Sydney Ure Smith's son, Sam Ure Smith, for the Fine Arts Press. The new 74-page *Art and Australia* filled the gap created by the demise of *Art in Australia* (q.v., 1916) in 1942, and became national in its coverage, with advisory editors appointed in Australian capital cities, as well as a European representative. It includes essays, comments and features by leading writers on painting, sculpture, graphic design, photography, architecture and Australian Aboriginal art with colour and black-and-white illustrations as well as valuable 'art directory' listings of current exhibition, competitions, prize winners, recent art auctions, gallery prices, public gallery acquisitions, contemporary art news from overseas, book reviews, and obituaries. The magazine ran on advertising and subscriptions but has received substantial assistance from the Visual Arts Board of the Australia Council. In 1991 Sam Ure Smith sold the Fine Arts Press to Gordon & Breach, also owner of Craftsman House, an Australian publisher of art books. Under the new editor, Dinah Dysart, *Art and Australia* launched a stablemate magazine *Art and Asia Pacific* (1993) and *World Art*, a Melbourne-based national and international focused magazine, edited by Ashley Crawford. Editors: Mervyn Horton 1963–83; Elwyn Lynn, 1983–87; Jennifer Phipps and Leon Paroissien, 1987–92; Dinah Dysart 1993– .

1966

Imprint Quarterly magazine/newsletter of the Print Council of Australia. Melbourne-based, it caters for this specialised media area and uses guest editors.

1969

Broadside Published in Melbourne by David Syme & Co. Weekly tabloid of comment and criticism. Number for 6

Mar. 1969 contained a critical assessment of Australian art critics by Ross Lansell. Artists included Leunig, Les Tanner and its final issue surpressed because of cartoons by Leunig.
1970
Other Voices Incorporating the magazine of the Art Teachers Association of nsw and sa and published in Sydney. Forty-eight page art magazine edited by Terry Smith and Paul McGillick. Illustrated with black-and-white plates, it was issued at an advertised rate of $8 p.a. (within Australia) for 10 issues. Three issues only were published. Publisher: James Cobb.
1971
Craft Australia The Sydney-based quarterly journal of the Crafts Council of Australia, it was the initial flagship of the crafts movement providing a consistent documentation and guide to Australian crafts. Editors included April Hersey, Ken Lockwood and Michael Bogle. Ceased publication in 1988. After he demise of *Craft Australia* the newsletters of each of the various state-based Crafts Councils were substantially upgraded: in 1993 they were *Craftlink* (Crafts Council of Queensland) editor, Johanna Watson: *Object* Magazine (Crafts Council of NSW), editor Helen Zilko; *Crafts Victoria* (Crafts Council of Victoria), editor Robert Buckingham; SA *Crafts* (Crafts Council of SA), *Craft West* (Crafts Council of WA), editor Holly Story and NT *Crafts* (Craft Council of the NT). *Object* and *Craft West* are colour illustrated. Publication frequency varies from state to state. In addition to the Crafts Councils' publications, a number of media-based nationally distributed crafts newsletters and journals made their appearance in the 1970s and 1980s. Their editors tend to relocate with managing committees. They included *Lemel*, quarterly journal of the Jewellers and Metalsmiths Group of Australia; *Ausglass*, quarterly journal of the Australian Association of Glass Artists; *Textile Fibre Forum*, tri-annual, based at the Sturt Craft Centre, Mittagong. Crafts, in particular, have been well covered by NSW-based popular lifestyle magazines such as *Belle, Interior Design* and *Vogue Living*.
1972
Bonython Gallery Gazette Published in Sydney from 1972–74. Contained news of Bonython Gallery, its personnel and exhibitions, and general information about contemporary art and artists.
1973
Art Dialogue Melbourne magazine published and edited by George Collin with assistance from the VAB of the Australia Council. Aim of the magazine was reflection and comment on developments in recent theory of art. Folded 1974.
1974
Artlook Edited by Helen Weller and administered by an editorial board of eight; chairman, John Harper-Nelson. Sixty-four page illustrated monthly publication with reviews, stories, poems, articles about art and artists, selected mainly for popular appeal.
EAF An annual contemporary art magazine edited by Noel Sheridan for the Experimental Art Foundation, Adelaide, 1974–1978.
1975
Aspect Edited by Rudi Krausmann, assisted initially by Sandra McGrath and Paul McGillick and various contributing editors including Gary Catalano, Patrick McCaughey, John Tranter, Jenny Zimmer and others, this intermittent review of art and literature, usually with black-and-white illustrations and contributions from writers and critics in Australia and overseas, was among the first to devote single issues to specific themes. Although not officially defunct, the last issue, *Aspect* No. 35, appeared in 1989 with guest editors. Its theme was Outsider Art.
1976
Lip Feminist art journal published by a Melbourne collective operating from the Ewing and George Paton Gallery, University of Melbourne. Folded 1984.

Arts Melbourne (incorporated *Art Almanac*) Edited collectively and published quarterly by the Ewing and George Paton Gallery, Melbourne. Associated with it were Suzanne Davies, Ann Galbally, Ross Lansell, Memory Holloway, Meredith Rogers, Kiffy Rubbo, Gary Catalano, Lynne Cooke, Charles Merewether, Bruce Pollard and Ann Stephen. Folded 1978.
Australian Art Education A tri-annual refereed publication devoted to scholarly examination of issues in the field. Editors have included June Parrott, Graeme Sullivan and Penny McKeon.
Architecture Australia Originally eight issues per year, published by the Melbourne-based Royal Australian Institute of Architects. Prior to 1976 it was called *Architecture in Australia*. It became a quarterly. Editor in 1993: Ian McDougall.
1977
Light Vision A Melbourne-based bimonthly photography magazine edited by Steven Lowjewski and Jean-Marc Le Pechoux. Disappeared 1979.
1978
Wopoop = working papers on photography Independent Melbourne-based photographic research papers edited by Euan McGillivray and Matthew Nickson. After nine issues it ceased publication in 1983.
AATADE Annual Journal of the Australian Association for Tertiary Art and Design Education. The first issue edited by Denise Hickey, the rest, up to 1984 when it folded, by Jenny Zimmer. It included segments on current issues in aesthetics.
Australian Journal of Art Annual publication of the Art Association of Australia – a forum for academics and curators researching art history. Editors have included Robert Smith, Robyn Cooper, Margaret Plant, John Gregory, Anne Gray, Sasha Grishin and Sue-Anne Wallace.
1979
Art Network (formerly *Start*) Edited by Richard McMillan, Peter Thorn, Ross Wolfe and later Suzanne Davies. Sydney-based, it was a fully illustrated quarterly taking an activist or pluralistic stance with lively and diverse coverage of the arts in Australia by critics and art writers. Modelled on *Studio International* and *Cinema Papers* it was strongly supported by the Visual Arts Board until it folded in 1986.
Halide Occasional photography broadsheet published by the Sydney College of the Arts and the Australian Centre for Photography. Editors included Martyn Jolly and Peter Charuk. Ceased publication 1981.
The Tasmanian Review A literary and arts quarterly assisted by the Visual Arts Board it ceased publication in 1980 and became *Island Magazine*, originally edited by Michael Denholm, since 1988 by Cassandra Pybus.
Transition An RMIT Department of Architecture-based quarterly dedicated to issues in architecture and the arts. Founded by Ian McDougall and Richard Munday, more recent editors have included Harriet Edquist, Karen Burns and Paul Morgan.
1980
Art Connoisseur Originally edited and published by Stephen Nall, Brisbane, it was a bimonthly mainly of information for collectors.
1981
Art and Text Originally, a Melbourne-based polemical journal edited by Paul Taylor working from Prahran College of Advanced Education. It covered performance, painting, film, sculpture, video, art theory, books and popular culture. In 1984, Paul Foss became editor and Paul Taylor opened a New York office from 1984–1986. In late 1986 the magazine relocated to Sydney and in 1988 Ross Harley was appointed managing editor. A triannual publication, it gained an early reputation for 'creative texts', obscure language and a provocative style, but it has developed the range and

quantity of critical writing in Australia. For this reason it has been continuously and generously funded from its inception by the Australia Council.

Artlink Started as an arts information supplement to the newsletters of five South Australian arts organisations and originally distributed free. It gradually took on national and international issues as its format and distribution became more sophisticated. Its production was fully computerised by 1987. Under one editor, Stephanie Britton, this quarterly is hailed as a success story. Its special theme issues are comprehensive in their coverage.

1982

Artworkers News Journal of the Artworks Union (nsw Branch). Folded 1985.

Australian Artist Sydney-based magazine concentrating on information for practising artists.

Stages Handsome, newly revamped monthly magazine of the Victorian Arts Centre.

1983

Muse A Canberra-based multi-arts journal first published by the Canberra Community Arts Front and now by the Arts Council of the ACT.

On the Beach Sydney-based magazine of cultural theory. Collective editors included Mark Titmarsh, Lindy Lee, Ross Gibson, Catherine Lumby and David Messer. It ceased in 1988 after 13 issues.

Issue Perth-based experimental art and design magazine edited by Matthew Holden and Sonya Jeffrey who later moved to Melbourne and established the magazine distributors *Manic Exposeur*. *Issue* folded 1985.

Photofile Magazine of the Australian Centre of Photography, Sydney. Concerned with Australian and international issues. Since 1984, this quarterly has had a range of part-time and guest editors who have included Adrian Martin, Helen Grace, Ross Gibson, Jo Holder and Stephen Carter. Editor, Martin Thomas.

Praxis Began as the quarterly of the Praxis Inc. Contemporary Art Space, Fremantle and a vehicle for visual arts dialogue in WA but soon developed national aspirations. Editors have included Julian Goddard, Nigel Helyer, Alan Vizents and Marco Marcon. It was later attached to PICA (Perth Institute of Contemporary Art).

Design World: the international journal of design A comprehensive quarterly distributed world-wide. Edited and published by Colin Wood, Melbourne.

1984

Craft Arts (later *Craft Arts International*) Sydney-based quarterly contemporary crafts magazine which is marketed internationally. Editor and publisher, Ken Lockwood.

Artisan: culture-technology-education Published by the Faculty of Humanities and Social Sciences, RMIT. Its second issue, 1985, was dedicated to writings on Australian art and aesthetics, guest editor, Jenny Zimmer. Folded 1987.

1986

Art Bulletin A Sydney diary edited by Judith Denby.

1987

Eyeline (East Coast Contemporary Visual Arts) A Brisbane quarterly published by the Queensland Artworkers Alliance. Its editors have been Graham Coulter-Smith and Sarah Follent (current). It has developed national aspirations.

Art Monthly Australia Originally established under the auspices of Sydney's Fine Arts Press and edited on a part-time basis by British *Art Monthly* editor, Peter Townsend, it was intended to be a regular low-cost monthly magazine of reviews, news, topical issues and debate. Based at the Arts Centre, ANU, Canberra, it was one of the first journals to publish regularly on Asia. In late 1992 Peter Timms was appointed editor.

Rebus Biannual Melbourne-based journal featuring 'art-for-the-page'. *Editors, Chris McAuliffe and Stephanie Holt.*

1988

Agenda Direct successor of *Arts Melbourne*, a bimonthly tabloid of critical discussion and reviews launched by the Ewing and George Paton Gallery and now located in the Centre for Design, RMIT. Editors have included Juliana Engberg, Stuart Koop and Penny Webb (current). A refereed issue was published in the summer of 1992/93.

Scan + A biannual magazine for video and time-based arts published by Electronic Media Arts, Sydney.

1989

West Western Sydney-based biannual interdisciplinary journal formerly edited by Catriona Moore and Jo Holder. Editor in 1993, Colin Hood.

Art Review A biannual magazine for visual arts, crafts, architecture, published by the Centre for the Arts, Hobart.

Exedra Biannual journal of the School of Architecture, Deakin University. Editor, Roger Fay.

1990

Ceramics: Art and Perception A colour-illustrated quarterly magazine edited and published by Janet Mansfield, Sydney.

21C The magazine of the Australian Commission for the Future in association with the Australian Broadcasting Corporation. Its emphasis on technology previews a changing world. Melbourne-based, its editors have included Ashley Crawford, Don Hewett, John Jost.

Design INC: the Australian Journal of Design Melbourne-based tabloid of design news, 10 issues per year, edited and published by Colin Wood.

1991

Arm (Art Reading Material) A Perth-based black-and-white quarterly edited by Noel Sheridan at PICA.

OZ arts magazine Contributing Editor: April Hersey. Publisher Carolynne Skinner. Magazine covers arts Australia-wide.

1992

Museum National Edited by Greg Marginson for the museum community; this quarterly journal is published in Melbourne at the headquarters of the National Association for Science, Art and History Museums.

NEWSLETTERS

Alongside magazines and journals, many of the regular and irregular newsletters of a variety of arts organisations, art galleries and artists' spaces, state ministries and the Australia Council have, since the 1980s, included features, critical reviews and information. They include:

ARTS ORGANISATIONS AND GALLERIES: *AMAA News* (Art Museums Association of Australia); *ANAT Newsletter* (Australian Network of Art & Technology); *Artemis* (Women's Art Forum, Perth); *Artworkers News* (Artworkers Union, NSW); *EAF Newsletter* (Experimental Art Foundation, Adelaide); *NAVA Newsletter* (National Association for the Visual Arts); *NETS Newsletters* Tasmania, Victoria and Western Australia (National Exhibition Touring Scheme); *Queensland Artworkers Alliance Newsletter*; *Sydney Gay/Lesbian Mardi Gras Newsletter*; *Victorian Centre for Photography Newsletter*; *Women's Art Register Bulletin* (Melbourne). Various community arts, arts access and multicultural arts organisations also publish newsletters including *ACCA Pub-lications* (Australian Centre for Contemporary Art, Melbourne), *AGSA Newsletter* (Friends of the AGSA); *Artemis* (Newcastle Art Gallery Society); *Artspace Newsletter* (Artspace Visual Arts Centre, Sydney); *Bulletin* (AGNSW) *Chameleon Magazine* (Hobart); *Fremantle Arts Review* (Fremantle Arts Centre); *Gallery* (NGV Society, Melbourne); *Institute of Modern Art Publications* (Brisbane) *The Photographers Gallery Newsletter* (Brisbane); *Unreal City* (Canberra Contemporary Art Space).

FUNDING BODIES: State ministries newsletters include *Artefact* (Arts Council of the ACT); *Arts Victoria*; *Artsline Newsletter* (Department of the Arts WA); *Artsreach* (NSW Ministry for the Arts); *Arts Newsletter* (Department of the Arts/Cultural Heritage SA). The Australia Council publishes a quarterly newsletter and *From Australia*, an irregular magazine intended for overseas distribution, dedicated to contemporary art, craft and design, with news and information.

OTHER NEWSLETTERS:
Listings of art exhibitions and events appear nowadays in most daily, weekly and monthly tabloids and in newsletters and journals. *Art Almanac*, founded in Melbourne and now Sydney-based, offers comprehensive details for Victoria and New South Wales.

(Entry updated by JENNY ZIMMER)

PRIZES, AWARDS & SCHOLARSHIPS

Since the early days of Australian settlement, art prizes have had great influence on local art development and on the careers of artists. The effect of both prizes and scholarships has often been debated, many believing that the exposure of the winners to too much attention (often too soon) is ruinous. In some instances this is true but there are many exceptions; usually the good done by the prizes far outweighs the possible harm. The traditional prizes, such as the Wynne (AGNSW) 1897; Archibald, 1921; Melrose (AGSA), 1921; Crouch (Ballarat), 1927, all given or bequeathed by private patrons and all administered by public galleries, brought great vitality to art at the time of their origin, and some still do. No less stimulating are the controversies they have aroused such as with the annual Archibald Prize. Perhaps even more far-reaching in their effects have been the scholarships. The NGV Travelling Scholarship (1886–1968) attracted students from all parts of Australia to the NGV School for more than 40 years, and the Helena Rubinstein Scholarship (1958–66) was the blue ribbon event of Australian art for nearly a decade. Official apathy and neglect were prevalent in the years immediately following World War II and lasted for more than a decade, so that the gradual emergence of the national prizes was a godsend to artists whether young or old. As they appeared one by one the big prizes stimulated increasing public and media awareness and interest. In supporting large art prizes at a national level the corporate patron was a strong reminder to governments of their cultural responsibilities. With the establishment of the Australia Council arose a system of grants and residencies in overseas studios which have helped hundreds of artists (*see* AUSTRALIA COUNCIL). In the 1980s some significant awards and prizes were established including the annual National Aboriginal Art Award in 1984, the Moet and Chandon Fellowship for artists under 35 and the biennial Doug Moran Portrait Prize both in 1986. In 1994 the Moet Fellowship was $50,000 and allows for an artist to spend a year working in France. As well, the exhibition of finalists (in itself a prestigious event) tours public and state galleries for seven months. The Doug Moran Portrait Prize of $100,000 first prize and several smaller prizes of $4500 also tours the finalists, however despite the vastly more lucrative nature of the Moran prize the Archibald still remains the most widely known and controversial portrait prize with, since 1989, a spin-off of a 'salon des refusés' of non-selected entries being presented at the S.H. Ervin Galleries, Sydney fostering yet more debate. Other long-established prizes (notably the Portia Geach Award) have come under some criticism and are being rethought while other lucrative prizes such as the $40,000 A.M.E. Bale award remain in their traditional form.

The following list of prizes is from a historical viewpoint, and of necessity cannot list all smaller ones. For the latest guide to prizes, awards and professional development opportunities,

the Sydney-based National Association of Visual Artists (q.v.) booklet *Money for Visual Artists* is strongly recommended.

PRIZES

ACTA AUSTRALIAN MARITIME ART AWARD
(–1992). The prize of $20,000 was for a painting or drawing on an 'Australian commercial shipping and/or port based mari-time activity, past or present' and awarded annually for several years before being discontinued in 1992 when ACTA was taken over by P&O.

ADELAIDE ADVERTISER PRIZE
(1955–56) Sponsored by *Adelaide Advertiser* and conducted by the South Australian branch of the Contemporary Art Society. Awarded twice only.
RESULTS: 1955, Eric Smith; 1956, shared by W. Dutkiewicz and Erica McGilchrist.

ADELAIDE FESTIVALS OF THE ARTS AWARDS
Intermittent prizes given in connection with the Festival included 'Caltex Oil Company Prize' given at the Royal Society of Arts: 1960, J. Hick, D. Roberts, John Dallwitz; 1968, Inge King; 1976, Mark Thompson; 1978, Mark Thompson.

ADELAIDE UNIVERSITY PRIZE
(1959) Prize for bas-relief for Union Hall. Won by Berend van der Struik.

ALBANY ART PRIZE
(1969–) PO Box 1110, Albany, WA 6330. Prior to 1969 an Albany art competition was conducted as the 6VA Albany Art Prize. Prize money in 1993: $6500.

ALBURY ART PRIZE
(1947–) Albury Regional Art Centre, PO Box 664, Albury, NSW 2640. Biennial award conducted first as an annual award by the Albury Art Society, £400 in 1947, rising to $1500 by 1977. Divided into sections, including oil-painting, water-colour, landscape, subject other than landscape, religious subject, and 'city's choice'. Winners of the main prize have included Charles Bush, Noel Counihan, Ernest Buckmaster, Rex Bramleigh, Weaver Hawkins, A. S. Keynes, D. Braund, Roger Kemp, Gareth Jones-Roberts, George Johnson. In 1967, the prize appreciated in value and became the Albury Art Gallery Society Invitation Prize. Winners 1967–82 included Louis James, Elwyn Lynn, Maximilian Feuerring, Reinis Zusters, Arthur Wicks, Pro Hart, S. Convey, Phyl Waterhouse. In 1982 it became a biennial non-acquisitive prize for regional artists and called the Albury Art Prize. Winners 1982–92 were Neville Connor, Jenian Bravo, Olga Juskaw, Stephen Anderson.

ALCOA AWARD
(1972) Given in Melbourne, Vic., for a sculpture in aluminium, won by Robin Angwin.

ALICE PRIZE

(1970–) Box 1854, Alice Springs, NT 0871. Acquisitive award, (non-acquisitive for the first year) $2000 in 1970, rising to $7000 in 1979 and in 1993 $5000 prize plus 4 weeks resid-ency in Alice Springs and airfare. Following the top award, works in a variety of media are purchased and all acquisitions housed in the Araluen Arts Centre (*see* GALLERIES-PUBLIC). The Prize is held each October with one judge and follows a preselection process with applications closing at the end of June. The Prize exhibition follows the announcement in October and runs for two weeks at the Centre. Works have been acquired by James Meldrum, Tom Gleghorn, David Aspden, Sandra Leveson, Franz Kempf, Tim Guthrie, Victor Majzner, Richard Havyatt, J. De Lutiis, V. B. Kapociunas, Bruno Leti, Bob Jenyns, Geoff La Gerche, Richard Larter, Colin Lanceley, Ron Robertson-Swann, Robert Boynes, Lynne Eastaway, Bea Maddock, Stephen Killick, Ludmela Kooznetzoff, Trevor Nickolls, Ken Whisson, John Wolseley, Suzanne Archer, David Rankin, Ken Searle, Geoffrey Todd, Hossein Valamanesh. In 1990 the first prize was won by Mandy Marrin and in 1991 Chris Barry.

AMERICAN BICENTENNIAL PAINTING PRIZE

(1976) Brisbane. Winners were Rick Everingham, Colleen Morris.

AMPOL SCULPTURE PRIZE

(1966–70) $5000 award for sculpture. 1966, Owen Rye; 1967, Bruce Dawe; 1968, Christopher McCullough; 1969, David Tolley; 1970, C. Elwyn Dennis.

ANGLISS PRIZE (SIR WILLIAM ANGLISS ART PRIZE)

(1972–77) Held first at the Royal Melbourne Show-grounds Gallery then, 1977, at the NGV. Under the terms of the award, a painting by an Australian artist was acquired for $5000 and donated to the NGV in memory of Sir William Angliss. 1972, George Haynes; 1973, Kevin Connor; 1974, Peter Powditch; 1975, Brett Whiteley; 1976, Jan Senbergs; 1977, John Armstrong.

ANZAC HOUSE COMPETITION

(1959) Competition for a sculpture feature for the new Anzac House building in Sydney. It was won by Margel Hinder. Also featured in the building is a large Aubusson tapestry by Jean Lurcat, and a decorative mural by Douglas Annand.

ANZAC MEMORIAL COMPETITION

(1923) Conducted by the Australian Commonwealth Government. Sculpture contest for an equestrian work to be erected at Port Said in commemoration of ANZAC Light Horse cavalry achievements in Palestine during World War I. The sum of £5000 towards costs was subscribed by troops in the field and £10,000 added by the government, to cover all costs. Three prizes, of 250, 100 and 50 guineas, were given. RESULTS: C. Web Gilbert, Jess Lawson Pearcey, W. Leslie Bowles (the assessors of the prize recommended also that an entry by G. W. Lambert, considered too costly a project for the Port Said memorial, should be considered for the Australian War Memorial at Canberra). C. Web Gilbert died while working on the commission, which was then taken over and completed by Sir Bertram Mackennal. The finished bronze memorial was torn down by rioters during the Suez crisis (1956); later the parts were recovered, shipped to Australia and the work restored and re-erected by R. Ewers at Albany, WA, in 1963. (Article in the *Argus*, Melbourne, 16 June 1923.)

ARCHIBALD PRIZE

(1921–) Administered by the AGNSW. Annual national prize for portraiture. It was conducted traditionally in January of the year following that for which the prize was given (exceptions were in 1958, 1977, 1978, when it was judged in December of those years). From 1990 the prize was changed to presentation around Easter time each year. The large attendances at the annual exhibitions, which are held simultaneously with the Wynne, Sulman, Trustees and Pring com-

petitions (q.v.) and the controversies arising from the judging, which is done by the trustees of the AGNSW, have given the prize prestige and significance far in excess of its monetary value. Some idea of the extent of public interest can be gained by consideration of the events of 1944. DOBELL–JOSHUA SMITH CASE: In Jan. 1944 the paintings entered for the 1943 prize included a portrait by William Dobell, of his colleague, Joshua Smith. Aesthetically speaking, the portrait was an act of homage to Rembrandt, Dobell's admiration for the master being expressed in a range of tone-colours which moved from deep umber to a tonal climax of golden yellow. Otherwise considerable distortion had been used to emphasise the character of Smith (who had worked with Dobell in a camouflage unit), and to give the work the ominous feeling of a country at war. This unorthodox work was given the prize mainly because of the eloquent championship of Sir Lionel Lindsay and the support of another judge, Sydney Ure Smith. The announcement scandalised the more academic painters and two of them, Mary Edwards and Joseph Wolinski, took legal action to restrain the judges from releasing the prize-money, on the grounds that the winning work was 'not a portrait but a caricature'. The case, which took almost two years to finalise, soon became front-page news in all Australian newspapers; the first hearing was at the NSW Supreme Court before Mr Justice Roper. Counsels for the plaintiffs were Mr G. Barwick, K.C., and Dr Frank Louat; for Dobell, Mr F. A. Dwyer, K.C., and Mr T. Conybeare; and for the Trustees, Mr F. W. Kitto, K.C., and Mr B. Kerrigan. A great deal of interesting and often colourful evidence was produced by both sides, resulting in the verdict that no court of law was legally empowered to set aside the decision of those legally appointed to judge the work. Paradoxically, the subject of this famous portrait, Joshua Smith, was himself awarded the prize the following year. His portrait by Dobell was eventually sold to Sir Edward Hayward of Adelaide, who sent it to London where the 'skin' of the painting was removed from the cardboard on which it had been painted originally, and transferred to canvas. Unfortunately, not long after it came back to its owner, it was badly burnt in a fire in his home. Further trouble in connection with the Archibald judging occurred in 1953 when students demonstrated against the award going, for the seventh time, to the Melbourne portrait-painter William Dargie in 1976 when John Bloomfield's 1975 winning photo-realist likeness of Tim Burstall was later disqualified for having been taken from a newspaper photograph instead of being 'painted from the life', as required in the conditions and again in 1993 when artist Vladas Meskenas, successfully sued (succeeding in a damage claim of $100 and costs) gallery director Edmund Capon for negative comments Capon had made about his portrait. TERMS AND VALUE OF THE PRIZE: The published terms of the prize read: 'In terms of the Bequest of the late J. F. Archibald, the Trustees of the Art Gallery of New South Wales invite artists to submit paintings in competition for the above annual prize, which will be awarded to the best portrait, preferentially of some man or woman distinguished in Art, Letters, Science or Politics, painted by any artist resident in Australasia during the twelve months preceding the date fixed by the Trustees for sending in the pictures.' The value of the prize fluctuates according to the amount available each year as income from the bequest; this amount was less than £500 in 1945; more than £900 in 1965; in 1981, $10,000 and in 1993, $25,000. RESULTS: 1921, W. B. McInnes, *Desbrowe Annear*; 1922, W. B. McInnes, *Prof. Harrison Moore*; 1923, W. B. McInnes, *Portrait of a Lady*; 1924, W. B. McInnes, *Miss Collins*; 1925, John Longstaff, *Maurice Moscovitch*; 1926, W. B. McInnes, *Silk and Lace*; 1927, G. W. Lambert, *Mrs Murdoch*; 1928, J. Longstaff, *Dr Alexander Leeper*; 1929, J. Longstaff, *W. A. Holman, Esq.*; 1930, W. B. McInnes, *Drum Major Harry McClelland*; 1931, J. Longstaff, *Sir John Sulman*; 1932, E.

Buckmaster, *Sir William Irvine*; 1933, C. Wheeler, *Ambrose Pratt*; 1934, H. Hanke, *Self Portrait*; 1935, J. Longstaff, *A.B. (Banjo) Patterson*; 1936, W. B. McInnes, *Dr Julian Smith*; 1937, Normand Baker, *Self Portrait*; 1938, Nora Heysen, *Mme Elink Schuurman*; 1939, Max Meldrum, *Hon. G. C. Bell, Speaker of the House of Representatives*; 1940, Max Meldrum, *Dr J. Forbes McKenzie*; 1941, W. Dargie, *Sir James Elder, K.B.E.*; 1942, W. Dargie, *Corporal Jim Gordon, V.C.*; 1943, William Dobell, *Joshua Smith*; 1944, Joshua Smith, *The Hon. S. Rosevear, Speaker of the House of Representatives*; 1945, W. Dargie, *Lt-General The Hon. Edmund Herring*, 1946, W. Dargie, *L. C. Robson*; 1947, W. Dargie, *Sir Marcus Clark*; 1948, W. Dobell, *Margaret Olley*; 1949, Arthur Murch, *Bonar Dunlop*; 1950, W. Dargie, *Sir Leslie McConnan*; 1951, Ivor Hele, *Laurie Thomas*; 1952, W. Dargie, *Mr Essington Lewis*; 1953, I. Hele, *Sir Henry Simpson Newland*; 1954, I. Hele, *The Rt Hon. R. G. Menzies*; 1955, I. Hele, *Robert Campbell, Esq.*; 1956, W. Dargie, *Mr Albert Namatjira*; 1957, I. Hele, *Self Portrait*; 1958, W. Pidgeon, *Mr Ray Walker*; 1959, W. Dobell, *Dr Edward McMahon*; 1960, Judy Cassab, *Stanislaus Rapotec*; 1961, W. Pidgeon, *Rabbi Dr I. Porush*; 1962, Louis Kahan, *Patrick White*; 1963, J. Carington Smith, *Prof. James McAuley*; 1964, no award made; 1965, Clifton Pugh, *Mr R. A. Henderson*; 1966, John Molvig, *Charles Blackman*; 1967, Judy Cassab, *Margot Lewis*; 1968, William Pidgeon, *Lloyd Rees*; 1969, Ray Crooke, *George Johnson*; 1970, Eric Smith, *Neville Gruzman*; 1971, Clifton Pugh, *Sir John McEwen*; 1972, Clifton Pugh, *The Honourable E. G. Whitlam*; 1973, Janet Dawson, *Michael Boddy*; 1974, Sam Fullbrook, *Norman Stephens*; 1975, Kevin Connor, *The Hon. Sir Frank Kitto*; 1976, Brett Whiteley, *Self Portrait in the Studio*; 1977, Kevin Connor, *Robert Klippel*; 1978, Brett Whiteley, *Art, Life and the other thing*; 1979, Wes Walters, *Phillip Adams*; 1980, no award made; 1981, Eric Smith, *Rudy Komon*; 1982, Eric Smith, *Peter Sculthorpe*; 1983, Nigel Thomson, *Candler Coventry*; 1984, Keith Looby, *Max Gillies*; 1985, Guy Warren, *Flugelman with Wingman*; 1986, Davida Allen, *Dr John Shera*; 1987, William Robinson, *Equestrian Self Portrait*; 1988, Fred Cress, *John Beard*; 1989, Bryan Westwood, *Portrait of Elwyn Lynn*; 1990 Geoffrey Proud, *Dorothy Hewett*; 1991/92, Bryan Westwood, *The Prime Minister*; 1992/93, Garry Shead, *Tom Thompson*; 1994, Francis Giacco, *Homage to John Reichard*.

ARMIDALE ART GALLERY SOCIETY PRIZE (Fred Roberts Memorial Prize)
(1963–76) Conducted by the Armidale Art Gallery Society. Acquisitive prizes from £100 to £25 were offered. In 1967, awards were for artists under 30. RESULTS: 1963, W. Peascod, Eva Kubbos, Brenda Palma; 1964, no contest; 1965, Estelle Cotsell, Cameron Sparks, Lionel Taprell; 1966–67, no contest; 1968, Colette Mitchell; 1969, John Rigby; 1970, I. Amos; 1971, David Rankin, Paul Selwood; 1972–74, no contest; 1975, Winston Bailey, John Christian, Kevin Hegarty, Fay Kent, Victor Majzner, Gloria Prater; 1976, David Voigt.

ASHFIELD ART PRIZE
(1966–c. 1981. Established as an open annual award of about $1000 divided into prizes for oils and watercolours. Winners included Jean Isherwood, Terence P. O'Donnell, Brian Stratton, Mimi Jaksic-Berger, Stuart Maxwell, David Harrison, Clem Millward, Ian Gentle, Patrick Carroll.

AUBUSSON TAPESTRY DESIGN COMPETITION
(1967) Conducted in Sydney, it was won by Carl Plate, Rollin Schlicht.

AUSTRALIA AND NEW ZEALAND BANKING GROUP LTD PRIZE
(1978) Artists were invited to submit work for a commission for a major work for the new headquarters of the ANZ, Collins Street, Melbourne. Won by John Firth-Smith (his mural, *Time and Place*, comprises 32 panels covering the principal walls in the reception area on the first floor).

AUSTRALIA AT WAR: COMPETITIVE EXHIBITION
(1945) A large, competitive exhibition which toured the Australian state and regional galleries, 1945. The Artists Advisory Panel (CEMA, Victoria) and the War Art Council (CEMA, New South Wales) were the sponsors and 34 prizes, ranging in value from £100 to £10 were given in 17 sections. RESULTS: (Open) N. Counihan, R. Shaw, F. McNamara; (War on Land) F. McNamara, E. J. Smith, F. Andrew; (War in the Air) W. E. Pidgeon, C. Bush, D. Annand, N. Hedstrom; (War at Sea) J. Koskie and O. J. Dale, J. D. Watson, Olive Long; (Industrial) N. Counihan, R. Dalgarno, N. Counihan; (Women's Services) Win McCubbin; (Medical Services) W. E. Pidgeon; (Voluntary Services) J. Russell; (Civil Construction Corps) R. Shaw, A. Dyson; (Women in Industry) Ailsa O'Connor; (Front Line Sketch) F. A. Jessup; (Special Front Line Sketch) C. Dubois; (Graphic Illustration) A. Dyson, E. Marcuse; (Home Front) Margaret Cilento, F. Andrew; (Best by Serviceman) Keith Nichol; (Sculpture) Ray Ewers, T. Bass; (Amateur) G. West, J. Cowie, R. Johns, S. E. Rea.

AUSTRALIAN–AMERICAN ASSOCIATION AWARD FOR PRINTS
(1958) Won by Frank Hodgkinson.

AUSTRALIAN ART QUEST
See STATE THEATRE ART QUEST

AUSTRALIAN CAPITAL TERRITORY ELECTRICITY AUTHORITY PRIZE
(1968) Given for relief sculpture for the Electricity Commission building, Canberra, 1968. Won by Ante Dabro.

AUSTRALIAN EXHIBITION FOR WOMEN'S WORK
(1907) Conducted at the Exhibition Building, Melbourne, Vic., the winners were Bessie Gibson (for miniatures), Margaret Baskerville (for sculpture).

AUSTRALIAN INDUSTRIES FAIR COMPETITION
(1958) £150 prize given by the Victorian Chamber of Commerce at the Exhibition Building, Melbourne. Won by Desmond Norman.

AUSTRALIA MUTUAL ASSOCIATION LANDSCAPE PRIZE
(1972) Tapestry commission given in Sydney and won by Susanne Dolesch.

AUSTRALIAN NATIVES ASSOCIATION LANDSCAPE PRIZE
(1914) ANA prize given in Melbourne. Won by Louis McCubbin.

AUSTRALIAN WAR MEMORIAL COMPETITION
(1950) Conducted by the Australian Battlefields Memorial Committee for a World War II monument for Australia House, London. £450 was awarded in three prizes at an exhibition at the National Gallery of Victoria, but the monument was never built. The standard of the exhibition was poor and the prizes went to three comparatively unknown English sculptors.

AUSTRALIAN WOMEN'S WEEKLY PORTRAIT PRIZE
(1955–59) An important annual international contest conducted by the magazine *Australian Women's Weekly*, Sydney. The winner of the major, open, prize received £1500, an amount of £500 being given for the best portrait by a woman painter. The competition exhibition was held at the AGNSW, after which it travelled interstate. It was terminated in 1959 owing to differences arising between the organisers and the trustees of interstate galleries. RESULTS: 1955, J. Carington Smith, Judy Cassab; 1956, Charles Doutney, Judy Cassab; 1957, William Dobell, Vilma Kotrovoba Vrobva (Czechoslovakia); 1958, John Rigby, Ivana Vrana (Czechoslovakia); 1959, Albert Tucker, Phyl Waterhouse.

BAILLIEU LIBRARY MURAL COMPETITION
(1958) Given at the Uni. of Melbourne, Vic. and won by Norma Redpath.

BALLARAT PRIZES
See CROUCH PRIZE

BAROSSA FESTIVAL ART PRIZE
(1964–) Given in celebration of the Barossa Valley Wine

Festival in South Australia. Winners have included Brian Seidel, Cecil Hardy, Robert Boynes, Douglas Roberts.

BATHURST ART PURCHASE

(1955–) Convenor: The Secretary, Art Prize, Civic Centre, Bathurst, NSW 2795. Annual acquisitive awards for various media, the winning works going to the Bathurst Gallery collections. Sections include oils, watercolours and ceramics. VALUE: In 1968, $900, rising to $8200 by 1991.

BATHURST PRIZE FOR YOUNG ARTISTS

(1956) Winners were Brett Whiteley, Vernon Treweeke.

BEAUMARIS PRIZE (INEZ HUTCHISON AWARD)

(1953–) Convenor: Hon. Secretary, Beaumaris Art Group, Community Centre, Reserve Road, Beaumaris, Vic. 3193. Given in honour of Inez Hutchison (q.v.) as a non-acquisitive biennial prize for painting in any medium. In the 1980s a separate acquisitive award, the Sandringham Council Award, for painting, was administered by the Beaumaris Art Group. In the late 1970s the Award sought sponsorship but since 1984 has been independent of any sponsorship and remains non-acquisitive. There is also a $350 open annual prize for ceramics. VALUE: In 1966 $200, rising to $1000 1976– . RESULTS: 1966, Douglas Stubbs; 1967, June Stephenson; 1968, Ray Reardon; 1969, Jeffrey Bren; 1970, Sidney Fetter, Rosa Garlick; 1971, Christine Berkman, Laurence Peterson; 1972, Ron Bence; 1973, Basil Hadley, James Meldrum; 1974, William Ferguson; 1975, Howard Arkley; 1976, Richard Rudd; 1977, Neil Campbell; 1978, Craig Gough; 1979, Andrew McLean; 1980, no award; 1981, Ulrich Stalph; 1982, 83 no award; 1984, Jeffrey Bren; 1985 no award; 1986, Beatrice Baron; 1987, 88 no award; 1989, Jennifer Halliday; 1990 no award; 1991, Stephen Armstrong.

BENALLA ART EXHIBITION

(1970–71) Competitive exhibition; $1000 given annually for the purchase of paintings to help build up the Benalla Art Gallery collections. RESULTS: 1970, James Meldrum; 1971, Sydney Ball, George Johnson, Alun Leach Jones, Robert Jacks.

BENDIGO ART PRIZE

(1938–68) Annual acquisitive prize conducted at Bendigo Art Gallery, usually in November; originally 100 guineas for oil painting, 40 guineas for watercolour. RESULTS: 1938, John Rowell; 1939; no contest; 1940, W. A. Dargie; 1941, no contest; 1942, W. A. Dargie, J. Cook; 1943, D. Watson, R. Warner; 1944, P. Watson, M. Newton; 1945, M. Ragless, K. Jack; 1946, H. Griffiths, I. Annois; 1947, C. Bush, P. Warner; 1948, S. Herman, Enid Cambridge; 1949, S. Herman, L. Annois; 1950, G. F. Lawrence, Nornie Gude; 1951, Ludmilla Meilerts; 1952, G. Thorley, C. Bush; 1953, T. Scharf, G. Mansell; 1954, L. S. Pendlebury, K. Jack; 1955, A. Warren, R. Kirk; 1956, C. Bush, Edith Wall/H. Gilliland, Madge Freeman; 1957, V. Litherland, H. Gilliland; 1958, D. McDonald, A. McMillan; 1959, K. Jack, W. Delacca; 1960, G. Paynter, H. Gilliland; 1961, T. Gleghorn, K. Jack/M. Smith; 1962, D. McDonald, A. Gray; 1963, R. Zusters, W. Delacca; 1964, J. Henshaw, R. Grieve; 1965, Margaret Olley, Louis Kahan; 1966, Dorothy Braund, Julian Smith; 1967, David Harrex; 1968, James Meldrum, Arch Cuthbertson.

BERRIMA DISTRICT ART SOCIETY AWARDS

(1950–) Convenor: Berrima Art Society, PO Box 144, Bowral, NSW 2567. Annual exhibition and non-acquisitive art competition. Total value of awards originally £280 and in 1994, $3000 in a number of categories including open, young artists, works on paper. RESULTS: 1953, Eric Smith; 1962, Geoffrey Townshend, Rhys Williams; 1963, H. Gilliland, J. Eldershaw, U. Abolins, P. McKay; 1964, T. J. Santry, H. Gilliland, Brian Stratton; 1965, Richard Larter, Imre Szigeti, Barry Chamberlain; 1966, M. Kitching, P. Laverty; 1967, Nancy Borlase, David Aspden, Stephen Spurrier; 1968, Bill Brown, Joyce Allen; 1969, David Rose; 1970, Cameron Sparks; 1971, Royston Harpur; 1972, Joyce Allen; 1973,

David Rankin; 1974, Sue Buckley, Margaret McLelland, Barry Thomas; 1975, Thomas Maxwell Carment; 1976, Elizabeth Rooney; 1977, James Barker, Ruth Julius, Jane Trengrove; 1978, Lesley Pockley; 1979, Hetty Blythe; 1981, Elizabeth Rooney; 1982, Pam Craford; 1983, Max Miller; 1984, Elizabeth Cummings; 1987, Wayne Roberts; 1988, Louise Owen, Bruno Tucci; 1989, Karin Oom; 1990, Dinah Benfield, Betty Bray; 1991, Judy Benjamin, Ruth Burgess; 1992, Deborah Stokes, Henry Mulholland.

BLAKE PRIZE FOR RELIGIOUS ART

(1949–) Convener: Blake Society, Box 4484, GPO, Sydney, NSW 2001. Founded as an annual award by the non-denominational Blake Prize Committee, to encourage dialogue between contemporary art and religion, the prize attracts entrants from all states in Australia and overseas. Given first in 1951, its value was £300, rising to $2500 by 1977 and $10,000 1993– . The D'Arcy Morris Memorial Prize was added in 1956, lasting until 1972; the Christus Prize was given, once only, in 1958 (winner T. Gleghorn), and the Blake Prize for Sculpture, once only, in 1961 (winner M. Hinder). Main sponsors have been Mark Foys and the Commonwealth Bank and since 1985 the exhibition has been held in Blaxland Gallery, Grace Bros, Sydney. A selection of the works is toured to regional galleries in NSW and Vic. following the prize exhibition. RESULTS – D'ARCY MORRIS MEMORIAL PRIZE 1956, Michael Kmit; 1957, Eric Smith; 1958, Bob Dickerson; 1959, Matilda Lister; 1960, Jean Appleton; 1961, Kenneth Jack; 1962, Justin O'Brien; 1963, John Coburn; 1964, Roger Kemp; 1965, Gareth Jones-Roberts; 1966, Ken Reinhard; 1967, Eric Smith; 1968, Maximilian Feuerring; 1969, Keith Looby; 1970, Rodney Milgate; 1971, Keith Looby; 1972, Keith Looby. RESULTS – BLAKE PRIZE 1951, Justin O'Brien; 1952, Frank Hinder; 1953, Michael Kmit; 1954, Charles Bannon; 1955, Donald Friend; 1956, Eric Smith; 1957, Elwyn Lynn, 1958, 59; 1960, John Coburn; 1961, Stanilaus Rapotec; 1962, Eric Smith; 1963, Leonard French; 1964, Michael Kitching; 1965, Asher Bilu; 1966, Rodney Milgate; 1967, Desiderius Orban; 1968, Roger Kemp; 1969, Eric Smith; 1970, Eric Smith and Roger Kemp (shared); 1971 Desiderius Orban; 1972, Joseph Szabo; 1973, Keith Looby; 1974, Stuart Maxwell and Ken Whisson (shared); 1975, Rodney Milgate; 1976, David Voigt; 1977, John Coburn, Rodney Milgate (shared); 1978, Noel Tunks; 1979, Ian Gentle and A. Trompf (shared); 1980, Leonard French; 1981, David Voigt; 1982, Maryanne Coutts & Suzie Marston; 1983, Geoffrey Harvey and Ann Taylor; 1984, Mary Hall; 1985, John Gould; 1986, Roger Akinin; 1987, Ian Grant and Alan Oldfield; 1988, Lise Floistad; 1989, Warren Breninger; 1990, Gillian Mann; 1991, Alan Oldfield and Rosemary Valadon; 1992, George Gittoes; 1993, John Davis.

BOARD OF ARCHITECTURE PRIZE

(1958) Given in Sydney, for mural painting, won by Leonard Hessing.

BOWRAL ART PRIZE

(1895) Given at Bowral, NSW. The judge, Arthur Streeton, awarded the prize (for local landscape) to Thea Proctor.

BRERETON (ROBERT LE GAY BRERETON) PRIZE

(1955–) Initially of £75, $250 by 1976 and $1200 by 1992, for drawings by students, it is conducted by the AGNSW. RESULTS: 1955, Ronald Lambert; 1956, Elisabeth Cummings; 1957, Jocelyn Maughan; 1958, Brian Dunlop; 1959, Margaret Woodward; 1960, Madeleine Halliday; 1961, Robin Norling; 1962, Paul Delprat; 1963, Christopher Johnson; 1964, Jennifer Short; 1965, Lindsay Bourke; 1966, Adrienne Masters; 1967, shared by Alison Hartley Fraser and Richard Cornish; 1968, Narelle Swanson; 1969, Kay Greenhill; 1970, Robin Easter; 1971, Deborah Niland; 1972, Evadne Cochrane; 1973, John Mudge; 1974, Ian Chapman; 1975, Marit Hegge; 1976, no award made; 1977, Leyla Spencer; 1978, Roseanne

Truman; 1979, Kathryn Royal; 1980, Anthony Cuzzilla; 1981, Diane McCarthy and John Webb (shared); 1982, Anne Hooten; 1983, Judith Rae; 1984, Judith Rae; 1985, John Fitzgibbon; 1986, no award; 1987, Joseph Fitzpatrick; 1988, Joseph Fitzpatrick; 1989, Rebecca Murray; 1990, Simon Von-willer and Peter Marshall; 1991, Lisa Hunt and Cathy Wickenden; 1992, Dennis Zaragoza and Wendy Sharpe.

BRISBANE CENTENNIAL PRIZE
(1959) Awarded to John Rigby.

BRISBANE EISTEDDFOD CENTENARY PRIZE
(1959) Awarded to Arthur Evan Read.

BRITANNICA AUSTRALIA AWARDS
(1964–71) Annual and biennial awards of £5000 each, given in Sydney by the *Encyclopaedia Britannica* company, for art, education, literature, medicine and science. Given specifically for 'outstanding contribution to the development of Australian art', the art award was administered by a specially elected Britannica Australia Committee. RESULTS: 1964, William Dobell; 1965, Russell Drysdale; 1966, Ursula Hoff; 1967, Lyndon Dadswell; 1969, Sidney Nolan; 1971, Arthur Boyd.

BRITISH PETROLEUM COMPANY PRIZE
(1963) GIven for a design for an 18m mural for the new BP building in St Kilda Road, Melbourne. Won by S. Ostojap-Kotkowski, who was then commissioned to complete the mural.

BROKEN HILL ART GALLERY PRIZE
(1953–c. 1980) First a small group of awards for local artists, then in 1977 as a $1500 open annual. Winners have included W. G. Rogers, F. Jobson, H. J. Whisson, S. Byrne (two prizes), P. Hart, E. Heffernan (special Silver City Festival prize, 1963), Lindsay Pow, John Firth-Smith, Clark Barrett, Joyce Condon.

BUNBURY ART PRIZE
(1959–) Convener: Bunbury Art Gallery Committee, PO Box 119, Bunbury, WA 6230. Value of the annual prizes, supported by private sponsors (including the Shell Oil Company and the newspaper *South Western Times*) and conducted at Bunbury Art Gallery, WA, ranged from £70, in 1959, to £365 in 1962. Categories are for oils and watercolours, and for work by local artists. Works acquired include those by C. Lander, M. Kennedy, Bryant McDiven, Donald Friend, Robert Juniper, Ivor Hunt, Rosemary Pidgeon, Tony Davis, Basil Hadley, Howard Arkley, Elizabeth Durack, Miriam Stannage.

BUSINESS IN THE ART AWARDS
(1978–c. 1980) Formed 'to encourage business support of the Arts by recognising outstanding company programmes'. Conducted by ARTS Ltd, in co-operation with the Australia Council, and sponsored by Mobil Australia, a large number of business or industrial organisations received the award.

BYRON BAY ANNUAL NORTH COAST ART SHOW AWARDS
(1990–) PO Box 652, Byron Bay, NSW 2481. Annual group of prizes including North Coast Art Show acquisitive award of $1500 (winner James Guppy 1991); Byron Shire Art Prize of $1000 (winner Shelagh Morgan 1991); Epicentre Art Prize of $1000; and several others.

CAIRNS ART SOCIETY PRIZE
(1964–93) Convener: Hon. Secretary, Cairns Art Society Prize, Box 992, Cairns, Qld 4870. Annual prizes which have varied in total prize money from $800 in 1972 to around $10,000 in 1990 (as part of an acquisitions drive for the City of Cairns Art Collection) to approximately $5000 in 1992 given in a number of sections including contemporary, traditional, ceramics, sculpture, photographic. Sponsors have included Caltex Oil Co., Daikyo (North Qld) and local shire councils. Acquisitions for the City Collection closed in 1991 after 60 years of acquisitions and in 1992 major sponsors retained the artworks. The Society elected not to hold an exhibition in 1993.

CALTEX OIL (AUSTRALIA) PTY LTD PRIZES
Since c. 1950, numerous art prizes throughout Australia have been sponsored by Caltex (Australia). The prizes have greatly stimulated interest among local communities, especially in remote areas. To list only a few, the Caltex prizes have been given in Cairns, Charleville, Mackay and Rockhampton, in Qld; Bega, Cowra and Griffith, in NSW.; Ballarat, Flinders, Latrobe Valley and Mornington, in Vic.; Adelaide, in SA, and Alice Springs in the NT National events which have benefited from Caltex sponsorship include the Adelaide Festival of the Arts, the Alice Prize, Alice Springs, and the MPAC *Spring Festival of Drawing*, Mornington, Vic.

CANBERRA ART COMPETITION
(1913) To commemorate the site chosen for the Federal Capital, a prize for landscape painting was awarded, following the suggestion of G. F. Mann, director of the AGNSW., and accepted by the Prime Minister, the Rt Hon. Andrew Fisher. RESULTS: First prize (£250), W. Lister Lister; second prize (£150), Penleigh Boyd.

CAPTAIN COOK BICENTENARY CELEBRATION COMPETITION
(1970) Conducted in NSW, Queensland and Victoria in celebration of the bicentenary of Cook's discovery of Australia. NEW SOUTH WALES: Various prizes were offered: $2000 (*Sun-Herald*) for painting; $1500 for sculpture by an artist resident in Australia; in addition, $2000 was added to the Archibald prize for that year, $600 to the Sulman, $400 to the Wynne; regional galleries such as Tamworth also held awards. Winners were (*Sun-Herald*) Robin Norling, Stephen Earle, Ken Buckland; (sculpture) Ken Unsworth, W. J. Busby. QUEENSLAND: The QAG Society offered a prize on the theme of discovery. Won by Mervyn Moriarty. VICTORIA: The State Government of Vic. funded prizes held at the VAS, open (acquisitive) for painting, and open (acquisitive) for sculpture, both offering 1st $3500, 2nd (non-acquisitive) $1500, 3rd (non-acquisitive) $500. Winners were: (Painting) Les Kossatz, E. Tanner, Margaret Mezaks; (sculpture) Jock Clutterbuck, Clifford Last, Marc Clark.

CATHOLIC CENTENARY PRIZE
(1948) Given in Melbourne the winners were Eric Smith, painting; Ola Cohn, sculpture.

CAULFIELD CITY COUNCIL AWARD
(1976–c. 1982) Conducted at the Caulfield Arts Centre as an invitation art exhibition with $4000 available for purchases, rising to $5000 by 1980. In 1977 a ceramic award of $1000 was established. An earlier award for painting was given in 1969. RESULTS: 1969, Ludmilla Meilerts; 1976, Ivan Durrant, Geoff La Gerche; 1977, Richard Bogusz, Ludmilla Christoff, Helen Bassett; 1978 (prints), Roger Kemp, Graham Kuo, Tim Storrier, Brett Whiteley, Bruno Letti; 1979 (sculpture), Marc Clark, Jock Clutterbuck, Peter Blizzard, Ailsa O'Connor; 1980 (painting), John Borrack, Ronald Skate, Howard Arkley, Leon Morrocco, Mary Macqueen, Helen Maudsley, Ian Armstrong; Patrick O'Carrigan, Ruth Spivakovsky.

CESSNOCK PRIZE
(1958–59) Conducted by the Cessnock Arts Council, NSW. RESULTS: 1958, Roy Fluke; 1959, Norma Allen.

CIVIC PERMANENT ART AWARD
(1974–c. 1977) Annual acquisitive $3000 award for a work or works selected by the judges. RESULTS: 1974, Ross Jackson; 1975, Peter Harris, Andrew Nott, Geoffrey Palmer; 1976, Brian Dunlop, Peter Milton Moore, Trevor Nicholls; 1977, Brian Dunlop, Alan Oldfield, David Voigt.

CLEMENGER TRIENNIAL AWARD FOR CONTEMPORARY AUSTRALIAN ART
(1993–) c/- NGV, 180 St Kilda Rd, Melbourne 3004. Award of $30,000 in recognition of an individual artist's outstanding achievement. Presented by Joan and Peter Clemenger and administered by and held at the NGV, the award, to be held every three years for 20 years from 1993 is aimed at establishing a forum for viewing, discussing and evaluating

contemporary art in Australia. Open to many fields of the visual arts – painting, sculpture, printmaking, photography, design for tapestry – those invited present a number of recent works for exhibition. Winner 1993: Bea Maddock.

COFFS HARBOUR ART PRIZE

(1969–c. 1979) Acquisitive, the winning works were added to the Coffs Harbour collections. RESULTS: 1969, Ray Hilan; 1974, Louis James, Cynthia Jefferey, Gillian Grigg; 1977, Brian Dunlop.

COMALCO INVITATION AWARD FOR SCULPTURE

(1967–72) Established to encourage sculptors to use aluminium. Invitations were issued annually to six sculptors each of whom received $750 ($800 in 1971) for a maquette. The outright winner received an additional $3500 and usually a commission to complete the work. The exhibitions were mounted at the NGV, the first on 23 Sept. 1968. Subject for that year was for a large screen suitable for dividing an interior space. It was completed and placed in the new Australian Embassy building in Washington, DC. RESULTS: 1968, V. Jomantas; 1969, Ron Robertson-Swann; 1970, John Davis; 1971, George Baldessin. The prize was suspended indefinitely in 1972. During its short existence, the prize became an event of major importance in influencing the development of sculpture in Victoria.

COMMONWEALTH CENTENARY PRIZE

(1950) Won by John Eldershaw.

COMMONWEALTH GAMES ART PRIZE

(1962) Given in Perth, WA, in celebration of the Commonwealth Games. Various sponsors contributed the finance. RESULTS: Kathleen O'Connor (BP prize); Sali Herman (Jackson prize); Robert Juniper (McKellar-Hall prize).

COMMONWEALTH WORKS DEPARTMENT BUILDING COMPETITION

(1951) Sponsored mainly by the Federal Government held to celebrate the Jubilee year of the Commonwealth of Australia. NEW SOUTH WALES: £1000 for painting (Commonwealth Government), Lloyd Rees and Jean Bellette; £500 for 'painting of the Australian scene', Jeffrey Smart; Jubilee Medal design competition for sculpture, John Elischer. VICTORIA: Prize for sculpture, Victor Greenhalgh; Special Travelling Scholarship, Ian Armstrong and Michelle Wunderlich.

COMMONWEALTH ART SOCIETY PRIZES, NEW SOUTH WALES

(1962) £10,500 commission given in Sydney by the Federal Dept of Works for a set of murals for new Commonwealth office buildings in Elizabeth St. Six sculptors were invited to compete and Michael Nicholson and Leonard Hessing jointly won the commission with a design planned for completion in cast concrete and mosaic. The Dept, however, refused to accept the decision of the appointed judges (Tom Bass and two Dept of Works architects, R. Ure and E. J. Walker), the main reason being that the work was abstract. The artists sought legal advice and there was considerable press controversy.

CONTEMPORARY ART SOCIETY PRIZES, NEW SOUTH WALES

(1953–c. 1970) Various prizes given at exhibitions at the CAS, Sydney. KEITH BRUCE PRIZE, £50: 1953, H. Salkauskas. CLINT PRIZE: 1954, Robert Dickerson; 1957, Margel Hinder. MADACH PRIZE: 1955, Margel Hinder. CAS PRIZE FOR PRINTS: 1960, Earle Backen. ROY H. TAFFS PRIZE, £500: 1962, L. Hessing; 1963, Margot Lewers; 1964, C. Plate; 1965, Eric Smith; 1966, D. Watkins; 1967, Michael Johnson. TENNYSON TEXTILE MILLS and ROY H. TAFFS PRIZE, £1500 for textile designs, divided into a main prize of £800 and a number of smaller prizes: 1963, Veronica Noach, C. Meadmore, Elizabeth Vercoe, J. Coburn, Stan de Teliga; 1964, M. Kitching, D. Hill, Shirley Larcombe, R. Grieve, Carmen Blake, Bonnie Anderson, Eva Kubbos, Veronica Noach, T. Gleghorn, L. Hessing; 1965, Leonas Urbonas; 1966, the

prize was renamed AUSTRALIAN FASHION FABRIC DESIGN AWARD: 1966, Nevil Matthews, June Stephenson. CAS YOUNG CONTEMPORARIES AWARD, two prizes of £100 each for artists between 22 and 30: 1963, C. Lanceley, J. Firth-Smith; 1964, J. Firth-Smith, E. Raft; 1965, M. Kitching, S. Earle; 1966, Mike Brown, Robert Williams; 1967, Garry Shead; 1968, John Firth-Smith; 1969, David McInnes; 1970, Alan Oldfield; 1971, Terry English; 1972, Alex Trompf; 1973, Tim Johnson; 1974, n.i.; 1975, John Drew. KOLOTEX PRIZE, $1000 acquisitive, open to members: 1968, Tony Coleing. LUXAFLEX AWARD: 1970, Gunter Christmann, Ross Davis; 1971, Robert Parr. HUNTER DOUGLAS PRIZE: 1969, Stephen Earle; 1972, Imants Tillers. SUN-HERALD PRIZE: 1970, Stephen Earle.

CONTEMPORARY ART SOCIETY PRIZES, SOUTH AUSTRALIA

(1952–) CORNELL PRIZE, for painting: 1952, W. Dutkiewicz; 1953, D. Roberts; 1954, L. Dutkiewicz; 1955, W. Dutkiewicz; 1956, F. R. Thompson; 1957, S. Ostoja-Kotkowski; 1958, L. Dutkiewicz; 1959, S. Ostoja-Kotkowski; 1960, Jacqueline Hick; 1961, Barbara Hanrahan; 1962, Udo Sellbach; 1963, G. Wilson; 1964, Franz Kempf; 1965, Lynn Collins. CAS PRIZE, for sculpture: 1962–63–64, Margaret Sinclair. GMH PRIZE: 1969, Carl Van Nieuwmans.

CONTEMPORARY ART SOCIETY PRIZES, VICTORIA

(1941–) Prizes were first given at CAS Melbourne exhibitions in 1941 when £50, donated anonymously, was shared by James Gleeson and Eric Thake, winning pictures being donated to the NGV. In 1964, a special CAS award of £50 was won by R. Grieve. In 1964 and 1965, three prizes, each comprising artists' material valued at £20, were awarded. RESULTS: 1964, R. Greenaway, Erica McGilchrist, B. Kewley; 1965, Erica McGilchrist, Doreen Folkerts, B. Tolley. From 1965 various prizes were given by the Sidney Myer Charity Trust, Imperial Chemical Industries of Australia, Commercial Bank of Australia and Rowney Artists Materials. Winners included E. Lynn, Gareth Jones-Roberts, Brian Kewley, H. Salkauskas, Ludmilla Christoff, Adrian Gemelli, Ian Hance, Alex Thatcher.

CORIO PRIZE

See GEELONG ART GALLERY PRIZES

CRA SCUPTURE PRIZE

(1975) Given for sculpture for architecture, by Conzinc Riotinto of Australia, April 1975, at the Royal Inst. of Architects Hall, South Melbourne. Three prizes, $1000, $500, $200. WINNERS: Peter Hook, Ernest Fries, Ray Ewers.

CRITICS' PRIZE FOR CONTEMPORARY ART

(1955) Given in Sydney to Michael Kmit.

CROUCH PRIZE

(1927–1990) Given at the Ballarat Fine Art Gallery through an endowment from the Crouch family in memory of a local pioneer, Colonel George Crouch. Original value was 125 guineas for the best contemporary Australian painting or sculpture submitted; the value was increased to £200 for the anniversary year, 1962, and the last few prizes given were subsidised from a VAB grant. The prize was annual then biennial 1966–74 and triennial 1977–90. RESULTS: 1927, John Rowell; 1928, G. Bell; 1929, L. McCubbin; 1930, A. E. Newbury; 1931, Hans Heysen; 1932, Charles Wheeler; 1933, A. D. Colquhoun; 1934, C. Wheeler; 1935, M. Griffin; 1936, A. E. Newbury; 1937, J. Rowell; 1938, A. Shore; 1939, W. Rowell; 1940, N. Buzzacott; 1941, J. Quinn; 1942, W. Rowell; 1943, F. R. Thompson; 1944, M. Ragless; 1945, C. Bush; 1946, Elaine Haxton; 1947, D. Watson; 1948, A. Sumner; 1949, G. Lawrence; 1950, Phyl Waterhouse; 1951, Phyl Waterhouse; 1952, Ola Cohn; 1953, Michael Shannon; 1954, C. Bush; 1955, M. Shannon; 1956, N. Counihan; 1957, N. Counihan; 1958, A. Warren; 1959, L. French; 1960, C. Blackman; 1961, C. Bush; 1962, P. Abrahams; 1963, K. Hood; 1964, I. Armstrong; 1965, Clifford Last; 1966, Lina Bryans; 1968, Guy Stuart and

Peter Clarke (shared); 1970, David Aspden; 1972, Jan Senbergs; 1974, Jeffrey Bren and John Hopkins (shared); 1977, Peter Booth and Imants Tillers (shared); 1980, Robert Rooney and Aleks Danko (shared); 1983, Dick Watkins; 1986, Robert Hunter; 1990, Ian Parry.

CROUCH (MINNIE CROUCH) PRIZE FOR WATERCOLOUR OR PRINT

(1947–80) Given at Ballarat, as above. 50 guineas given for the best watercolour or etching submitted. RESULTS: 1947, C. Bush; 1948, R. M. Warner; 1949, L. Annois; 1950, L. Annois; 1951, C. Bush; 1952, C. Bush; 1953, L. Walters; 1954, M. Shannon; 1955, R. M. Warner; 1956, L. Walters; 1957, Nornie Gude; 1958, C. Pugh; 1959, Nornie Gude; 1960, K. Jack; 1961, H. Gilliland; 1962, M. Angus; 1963, T. G. Wells; 1964, Dawn Sime; 1965, David Harrex; 1966, Arch Cuthbertson; 1967, Daniel Moynihan; 1968, Richard Havyatt; 1969, Richard Havyatt; 1971, Edith Wall; 1973, George Baldessin and Roger Kemp (shared); 1975, Denyse Gibbs, Bea Maddock, Jan Senbergs, John Neeson; 1980 Peter Tyndall.

DALBY ART PRIZE

(1970–c. 1980) At first $550 given for oils and watercolours, rising to $1500 by 1974. An earlier Dalby Prize was awarded to Francis de Silva, in 1966. RESULTS: 1970, Mervyn Moriarty, Joy Roggenkamp; 1971, Shirley Kennedy, Doris Kenshead; 1972, Roy Churcher; 1973, n.i.; 1974, Davida Allen; 1975, Nancy de Freitas, Victor Majzner, Andrew Sibley, Elizabeth Turnbull; 1976, Andrew McLean, John Peart; 1977, John Firth-Smith, Michael Shannon, Jack Wilson, Mary Williams; 1978, Elsie Brimblecombe, Les Kossatz, Keith Looby, Alan Oldfield; 1979, Richard Larter, Guy Grey-Smith, Ken Whisson, Jack Wilson.

DAME NANCY BUTTERFIELD EMBROIDERY PRIZE

(1991–) Carrick Hill Trust, 46 Carrick Hill Drive, Springfield, South Australia 5062. National biennial competition for embroidery with first prize of $5000 in 1993. WINNER: 1991 Maris Herr.

DARNELL DE GRUCHY INVITATION PURCHASE AWARD

(1969–77) Given annually for paintings for the John Darnell Fine Arts Collection, Uni. of Qld. By 1974 $1000 was available. RESULTS: 1969, Tom Gleghorn; 1970, Nevil Matthews; 1971, Michael Taylor; 1972, Peter Clarke; 1973, David Rankin; 1974, Peter Powditch, Peter Tyndall, Guy Warren; 1975, Geoff La Gerche, Jock Clutterbuck, John Coburn, Keith Looby, Bea Maddock, John Olsen, Albert Shomaly, K. Whisson, M. J. Winters; 1976, n.i.; 1977, Hilary Burns, Fraser Fair, John Firth-Smith, Guy Stuart.

DEVONPORT (DAHLIA FESTIVAL) PRIZE

(1961–62) Organised by the Devonport Arts Council as a £225 prize for oils and watercolours. RESULTS: 1961, David Strachan; 1962, Elsa Krist (oil), Patricia Giles (watercolour).

DOBELL PRIZE FOR DRAWING

(1993–) Dobell Foundation, c/- Frank Clune and Sons, 9th Floor, 39 York St, Sydney 2000. Annual acquisitive award of $10,000 administered through the Dobell Foundation and the AGNSW to encourage standards of draughtsmanship. RESULTS: 1993, Kevin Connor; 1994, Thomas Spence.

DOUG MORAN NATIONAL PORTRAIT PRIZE

1986– . Moran Health Care Group Pty Ltd, Cnr Stanley and Palmer Sts, East Sydney 2010. In 1986 Tweed Shire Council launched the Doug Moran National Portrait Prize, with prize money totalling $240,000. First prize was $100,000 with 30 other finalists awards of $4600 each (this changed by 1992 to $2000 each). Works by 30 artists were selected from over 1000 entries and launched at the NGA in March 1987 and toured nationally during 1988, which became the pattern of the Prize. Administered by a 25 member committee set up by the Tweed Shire Council, sponsorship is derived from a foundation comprising Moran Health Group,

AGC and C. Itoh Group. The portrait must be a representational portrait by and of an Australian an citizes. In the year prior to the award the exhibition of 30 finalists tours nationally until the selection of the winner by an international judge in December. The exhibition continues touring the following year. Administered by the Moran Health Care Group and Tweed Shire Council, entries close in February of even-numbered years and the winning painting becomes part of the Tweed River Gallery permanent collection. WINNERS: 1988 Penny Downie; 1990 Robert Hannaford; 1992 Siv Grava.

DRUMMOYNE ART PRIZE

(1962–c. 1982) 100 gns in 1962 which rose to $1660 in 1979; four sections. Over 100 artists won awards 1962–1982.

DUNLOP PRIZES

(1950–55) Major nationwide contest conducted in Melbourne by the Dunlop Rubber Co. (Australia) Ltd. For the first year £850 was given, increased to £1000 in 1951. The prizes were divided into two main groups, for oils and watercolours, first prizes in the two sections amounting to £300 for oils and £100 for watercolours. Occasional 'special' prizes were also added to the list. Winning pictures were later reproduced on company calendars. RESULTS: 1950 (oils), Sidney Nolan, first, William Frater and R. W. Rowed, shared second, Arthur Boyd and Keith Nichol, shared third, C. Bush and L. S. Pendlebury, shared fourth; (watercolours), L. Annois, R. M. Warner, Jan Nigro, F. Williams, Ludmilla Meilerts; 1951 (oils), no first prize awarded, Lance Solomon, L. S. Pendlebury; (watercolours and special prizes), K. Jack, J. Hick, M. McLeish, R. McCann, A. Riebe, B. E. Seidel, M. Dimmack, H. Greenhill, A. D. Morris, R. Horsfield; 1952 (oils), Harold Greenhill, first, Murray Griffin and Arthur Boyd, shared second, Charles Bush; Max Ragless, R. W. Rowed, C. Ambler, Ivor Hunt; 1953, L. S. Pendlebury, Arthur Boyd, Max Ragless, Max Middleton, Howard Ashton, L. Daws, L. Annois, J. Hick, K. M. Jarvis, J. Loxton, H. R. Gallop, R. Bey; 1954 (oils), no first prize awarded, Lloyd Rees and Harley Griffiths, shared second, C. Stoward, Graham Moore, L. S. Pendlebury, Lawrence Daws; (watercolours), no first prize awarded, L. Annois, R. M. Warner, C. Bush, F. Bates; 1955 (oils), T. J. Santry, H. Gilliland, J. Hick; (watercolours), Nornie Gude.

EASTER SHOW PRIZES

See ROYAL AGRICULTURAL SOCIETY OF NEW SOUTH WALES EASTER ART SHOW PRIZES

ELAINE TARGET DRAWING PRIZE

(1971–74) Given at the Hawthorn City Art Gallery, Vic. with a prize of $250 for senior students of Melbourne art schools. RESULTS: 1971, Geoffrey Lowe; 1972, Rafael Gurvich; 1973, Ania Walwicz; 1974, David Gatiss.

ELTHAM ART AWARD

(1965–c. 1980) Conducted by the Eltham Art Society, Vic., annually. Originally first prize was of £100 and three smaller prizes, rising to $4000 by 1980, plus $2000 available to an artist under 40 for travel in Europe. Winners included W. Frater, Inge King, T. Zikaras, R. Hunter, M. Skipper, Norma Sherriff, Owen Piggott, James Meldrum, Ian Bow, John Davis, Reinis Zusters, David Armfield, Hilary Jackman.

ENGLISH-SPEAKING UNION PRIZE AND SCHOLARSHIP

(1960–69) RESULTS: 1966, William Ferguson; 1967, Tim Guthrie; 1968, Cecil Hardy; 1969, Frank Littler, Diana Cochrane, Ian Stewart Currie. SCHOLARSHIP RESULTS: 1960, Janet Alderson; 1961, Brian Seidel; 1965, Michael McKinnon; 1966, Edward Binder, Terence O'Donnell; 1967, Joseph Tann; 1968, David Voigt, Mary St Thomas.

ESSENDON CIVIC CENTRE PRIZE

(1976) $1000 for painting given at the Essendon Civic Centre, won by Godwin Bradbeer.

ETHEL BARRINGER MMEORIAL PRIZE

(1964–?) Given in SA in commemoration of Ethel Barringer

(q.v.). RESULTS: 1964, Robert Boynes; 1971, Gunther Stopa; 1973, Christine McCormack.

FAIRFAX PRIZE
(1914) Given in Sydney. WINNER: Gordon Trindall.

FEDERAL CAPITAL SITE COMPETITION
See CANBERRA ART COMPETITION

FERNTREE GULLY ART SOCIETY PRIZE
(c. 1945–46) Given by the Ferntree Gully Art Society, Vic. RESULTS: 1945, Maxwell Ragless; 1946, Alan Moore.

FESTIVAL OF FISHER'S GHOST ART PRIZE
(1963–) Campbelltown City Art Gallery, Art Gallery Rd, Campbelltown, NSW 2560. Prizes totalling $10,000 for purchases for the Campbelltown City Gallery during the annual Festival of Fisher's Ghost. WINNERS: 1988, Roy Jackson; 1989, Kevin Lincoln; 1990, Marion Borgelt, George Gittoes, Ildiko Kovacs; 1991, Suzanne Archer; 1992, (open section) Phillip Wolhagen, Marion Borgelt, Mary McKenzie, (contemporary) Aida Tomescu, (traditional) Brian Stratton, (works on paper) Frances Varitellis.

FINE ARTS GALLERY PRIZE
(1978) $3000 prize sponsored and convened by the Fine Arts Gallery, Perth, WA, won by Lindsay Pow.

FINNEY CENTENARY PRIZE
(1963) £300 prize made available to Queensland painters to mark the centenary of Finney's department store, Brisbane; won by Margaret Olley.

FIRST LEASING ART PRIZE
(1970) First Leasing Australia Ltd, holding company for the Reinher Banking Group in conjunction with the First National Bank of Boston. The exhibition was held at the NGV., Melbourne. RESULTS: First prize ($7000), Asher Bilu; second ($1500), Brett Whiteley; third ($500), shared by Jan Senbergs and Alun Leach-Jones, The bank also made funds available for additional works 'thought worthy of purchase'.

FLOTTA LAURO ART AWARD
(1967–72) Given for painting and sculpture by the Flotta Lauro Shipping Company. Discontinued, 1972. The two prizes, worth about $3000 each, incl. first-class passage to Italy (within twelve months of the award) and expenses provided by Flotta Lauro for three weeks in Italy, and then for one week in France and/or Germany. RESULTS: 1967, Guy Warren, Mike Kitching; 1968, Stan de Teliga, Michael Young; 1970, Andrew Nott; 1971, Col Jordan, Anthony Coleing; 1972, Clare Robertson, Alan Lee. (*See also* ITALIAN SCHOLARSHIPS)

FREMANTLE PRINT AWARDS
(1976–) Given annually at the Fremantle Arts Centre, WA (*see* Galleries – Public) with the aim of adding to the collections of contemporary Australian prints. In 1993 the prize money was $5000 for the Print Award and $2500 for an Indigenous Print Award. RESULTS: 1976, Ray Beattie; 1977, Jock Clutterbuck; 1978, David Rose; 1979, Basil Hadley; 1980, Jorg Schmeisser and Rod Ewins (shared); 1981, Richard Hook and Paul King (shared); 1982, Ray Arnold and Tony Pankiw; 1983, Keith Cowlam and Michael Taylor; 1984, Stewart Merrett and Monica Schmid; 1985, Alun Leach-Jones; 1986, John Spooner and Ruth Johnston; 1987, Margaret Sulikowski and Karen Turnbull; 1988, Daniel Moynihan and Ron McBride; 1989, Helen Ling and Megan Russell; 1990, Michael Hyland and Mike Parr; 1991, Jodi Heffernan and Jock Clutterbuck; 1993, Bevan Honey (Print Award) Sally Morgan (Indigenous Print Award).

GALLAHER PRIZE FOR PORTRAITS
(1965) £1500 given in Sydney for Australian portrait painting, won by John Brack.

GEELONG ART GALLERY PRIZES
(1938–) Convener: Geelong Art Gallery, Little Malop St, Geelong, Vic. 3220. Sponsors of early prizes incl. J. H. McPhillimy, F. E. Richardson, Shire of Corio, Geelong *Advertiser*, Mayor of Geelong. Winners: 1938, Fred Leist;

1939, Arnold Shore, Murray Griffin; 1940, William Dargie, John Loxton; 1941, Daryl Lindsay, C. Dudley Wood; 1942–44, no awards; 1945, Ralph Warner; 1946, T. H. Bone; 1947, Harley Griffiths, Eric Thake; 1948, Sali Herman, Nornie Gude; 1949, Mary McLeish, M. Gunnersen; 1950, W. Frater, Ian Armstrong; 1951, Charles Bush, Nornie Gude; 1952–57, no awards; 1958, Alastair Gray; 1959–60, no awards; 1961, John L. Borrack, A. W. Harding; 1962, Ernest Smith, A. W. Harding, Daryl Carnahan; 1963, Robert Grieve, Brian Seidel, Lesbia Thorpe; 1964, Alan Warren, Archibald Cuthbertson, Franz Kempf; 1965, Robert Grieve, Tate Adams; 1966, H. Salkauskas, Hertha Kluge-Pott; 1967, Stephen Spurrier, Roslyn Coope, Tay Kok Wee; 1968, Andrea Num, Margaret Elliott; 1969, Bea Maddock; 1970, George Baldessin, Allan Mitelman; 1972, John Loane, Jock Clutterbuck; 1974, Roger Kemp; Alun Leach-Jones, Akira Matsumoto, John Robinson; 1976, Elizabeth Honeybun, Mary Macqueen, Rod Withers. CORIO FIVE STAR WHISKY PRIZE (1965–74): Annual $1000, rising to $2000 (1974) and sponsored by United Distillers Pty Ltd. Results: 1965, Louis James; 1966, Jon Molvig; 1967, Sydney Ball; 1968, Tom Gleghorn; 1969, Paul Partos; 1970, Stephen Earle; 1971, Sandra Leveson; 1972, Peter Booth; 1973, Domenico de Clario; 1974, Victor Majzner, Allan Mitelman, Peter Powditch. CAPITAL PERMANENT AWARD: (1977–1981) Winners: 1977, John Firth-Smith, David Marsden; 1978, Janet Dawson, Greg Moncrieff, Rod Withers; 1979, John Wolseley, Leslie Dumbrell; 1980 Richard Larter, Bob Jenyns, Noel Counihan; 1981, Bo Jones, Peter Clarke. SCOTCHMANS HILL VINEYARD ART PRIZE (1989–90): Initiated by the Geelong Art Gallery Association the owner of Scotchmans Hill Vineyard sponsored a $15,000 annual prize with the aim of acquiring contemporary works for the gallery. Intended to be for three years, the prize however was only awarded twice. Winners: 1989 Peter Tyndall; 1990 Dick Watkins

GEIGER FOUNDATION ART AWARDS
(1960) £1000 given at the MOMAD, Melbourne and won by Albert Tucker.

GEORGES INVITATION ART AWARDS
(1963–c. 1985) Given by the retail store Georges Ltd, to assist Australian artists, and later, the regional art galleries of Victoria. Beginning as Georges Invitation Art Prize, a Victorian answer to the NSW monopoly of national prizes during the early 1960s, it was organised for Georges by Alan McCulloch, then president of the Australian division of the International Association of Art Critics. Three non-acquisitive prizes of £750, £250 and £50 were offered. For the second annual awards, 1964, a visit to Australia of the world AICA president, James Johnson Sweeney, was organised. Georges also hosted the visits to Melbourne (1968) of the American critic, Clement Greenberg, and (1971) the West German, Harald Szeemann. Values of the awards were adjusted frequently in order to keep pace with inflation, and in 1972 they became acquisitive, the winning works being presented to member galleries of the Regional Galleries Association of Vic. Later a $1000 prize for the best single work was added to the acquisition awards. In 1981 the awards were reconstituted, the value was increased to $10,000 (including a $2500 award for an outstanding work) devoted solely to acquisitions for the regional galleries, the first of the new awards being given in May 1982 for works on paper. RESULTS: 1963, John Olsen, Fred Williams, John Aland; 1964, Leonard French, Carl Plate, Jan Senbergs; 1965, Roger Kemp, Jean Bellette, Richard Crichton; 1966, Fred Williams, Louis James, Richard Havyatt; 1967, Louis James, Charles Blackman, John Adam; 1968, Syd Ball, Udo Sellbach, Richard Havyatt; 1969, Jan Senbergs, Andrew Sibley, Ian Chandler; 1970, Jeffrey Bren, Alun Leach-Jones, Keith Looby; 1971, W. Delafield Cook, Robert Boynes, William Anderson; 1972 (recipient galleries shown in parentheses), John Firth-Smith (Mildura), John Hopkins

(Mornington), Robert Boynes (Castlemaine), Noel Counihan (Hamilton), Peter Booth (Warrnambool), Jim Paterson (Benalla); 1973, Fred Cress (Langwarrin-McClelland Gallery), Keith Looby (Geelong), Victor Majzner (Sale), William Brown (Swan Hill); 1974, Guy Warren (Shepparton), Wes Placek (Mildura), John Sandler (Ballarat), Peter Tyndall (Ararat), George Balyck (Bendigo), Roy Churcher (Horsham), Max Thompson (Latrobe Valley), Peter Campbell (Castlemaine), Lesley Dumbrell (Sale), Miriam Stannage (Ararat); 1975, Lynn Collins (Latrobe Valley), George Johnson (Hamilton), Christopher Pyett (Warrnambool), Jenny Watson (Bendigo); 1976, Geoffrey Proud (Horsham), Jim Paterson (Geelong), Leah Mackinnon (Benalla), Petr Herel (Langwarrin-McClelland Gallery); 1977, ($1000, Lawrence Daws), Lawrence Daws (drawing, Castlemaine), Nick Mourtzakis (two works: Swan Hill, Latrobe Valley), Lesley Dumbrell (Shepparton), Richard Dunn (Ballarat), Dusan Marek (Mornington); 1978, (£1000 Guy Grey-Smith), Brian Blanchflower (Horsham), William Brown (Langwarrin-McClelland Gallery), Elizabeth Gower (Sale), Kerrie Lester (Benalla), James Paterson (Mornington); 1979, ($1000 Lesley Dumbrell), Ronald Hawke (Ballarat), Kerry Gregan (Bendigo), Maria Polias (Geelong), Petr Herel (Hamilton), David Rankin (Shepparton), Ronald Hawke (Swan Hill), C. van Leeuwen (Warrnambool); 1980, ($1000 Julie Irving), Julie Irving (Mildura), Robert Juniper (Mildura), Greg Moncrieff (Ararat), Gordon Shepherdson (Mornington), Geoffrey Lowe (Castlemaine), Douglas Chambers (Warrnambool), Anthony Figallo (Langwarrin McClelland Gallery); 1982, Suzanne Archer (Mildura), Janet Dawson (two works: Bendigo, Shepparton), Patrick Henigan (Latrobe Valley), James Paterson (two works: Horsham, McClelland), Jan Senbergs, winner $2500 (two works: Sale, Warrnambool), Ken Whisson (two works: Ballarat, Geelong).

GLENFIDDICH ART AWARD

(1979) $10,000 purchase award. Given by William Grant & Sons, makers of Glenfiddich Scotch Whisky. Organiser: Ron Radford (q.v.). Judged by Ron Radford and Katrina Rumley and organised for interstate touring, the exhibition comprised paintings, drawings, ceramic sculptures, photography and constructions by 29 invited artists. At the end of the tour, the acquisitions were divided among the participating public galleries including Sydney Opera House Gallery, Ballarat Fine Art Gallery, Uni. of Melbourne Gallery, Wollongong City Art Gallery, Uni. (of Qld) Art Museum.

GODFREY RIVERS BEQUEST PRIZE

(1933–61) Established by the administrators of the Godrey Rivers Memorial trust and administered by the QAG as an £80 award given intermittently. RESULTS: 1933, Will Ashton; 1935, Melville Haysom; 1938, Will Ashton; 1941, Lloyd Rees; 1961, Irene Amos.

GOLD COAST CITY ART PRIZE

(1967–) Convener: Secretary, Gold Coast City Art Prize, PO Box 6615, Gold Coast Mail Centre, Qld 4217. Annual acquisitive prize in three sections, originally $1600, rising to $15,000 in 1993. Over 200 works have been acquired by the Gallery from the prize including those by: Henry Salkauskas, Jon Molvig, Mervyn Moriarty, Stephen Earle, Ronald Millar, Jan Senbergs, Andrew Sibley, Louis James, Col Jordan, Jeff Makin, Elizabeth Prior, Michael Shannon, David Aspden, Rodney Milgate, Peter Powditch, David Rankin, Eric Smith, Robert Dickerson, John Santry, John Coburn, Janet Dawson, John Firth-Smith, Guy Grey-Smith, Michael Johnson, Veda Arrowsmith, Robert Grieve, Brian Dunlop, Basil Hadley, Joy Hutton, Victor Majzner, Barbara Brash, Inge King, Ray Beattie, Jock Clutterbuck, Lawrence Daws, Shay Docking, James Willebrant, Elizabeth Duguid, Sam Fullbrook, Patricia Hoffie, Tim Storrier, Judy Watson, Brett Whiteley, Geoff Williams, Davida Allen, Suzanne Archer, Robert Boynes, Richard Larter, Mal Leckie, Mandy Martin, Diana Mogensen, Alan Oldfield, Jenny Watson,

Ruth Faeber, Joe Furlonger, Denise Green, William Kelly, Kristin Headlam, June Tupicoff, Tom Risley.

GOSFORD ART PRIZE (FESTIVAL OF THE WATERS)

(1970–c. 1982) Acquisitive prizes for oils, watercolours and five other awards awarded by the Gosford Shire Council. The acquisitions are held by the Shire pending construction of a regional art gallery. Works acquired included those by Ludmilla Meilerts, Earle Backen, Sally Robinson, Janet Mansfield, David Rose, Judy Cowell, Mimi Jaksic-Berger, Jean Isherwood, John Aland, Jacqueline Dabron.

GOULBURN ART PRIZES (LILAC TIME)

(1957–c. 1980s) It began as a 160 guinea acquisitive award given in two, and from 1963, three sections (oils, watercolours and traditional work). By 1982 it was $2500 given in eight sections. Works acquired included those by M. Feuerring, Nancy Parker, Mollie Flaxman, Jean Isherwood, Claudia Forbes-Woodgate, Margaret Coen, Lorraine McKenzie, U. Abolins, F. Bates, Brian Stratton, Clem Millward, Cameron Sparks, Patrick Carroll.

GOYA ART AWARDS

(1964–65) Given in Melbourne, Vic., for artists under twenty-five. One hundred guineas national prize with smaller prizes given for winners in all States represented. The exhibition was held in the Block Arcade. RESULTS: 1964, Vytas Kapociunas, Rex Lay, Geoff Sharples; 1965, Ian Milton.

GRAFTON TEXTILE PRIZE

(1951–53) Three hundred guinea prize for texture design donated by F. W. Grafton & Co. and conducted by Calico Printers, NSW. RESULTS: 1951, Douglas Annand; 1952, Nancy Moore; 1953, Marion Fletcher.

GRAND AUSTRALASIAN ART COMPETITION

(1977) Advertised as a $1500 biennial award in two sections, both open for painting or drawing but one ($500) specifying a 'hotel theme'. The 1977 winners were Henry Salkauskas, Peter Campbell.

GREAT SYNAGOGUE PRIZE

(1964–72) Given in Sydney, NSW.
RESULTS: 1964, Anna Cohn; 1965, Franz Kempf; 1967, Joe Rose; 1968, Anna Cohn; 1970, Anna Cohn; 1972, Maadi Einfield.

GRENFELL (HENRY LAWSON FESTIVAL)

(1960–) Grenfell Art Prize, Box 77, Grenfell, NSW 2810. Given first as two small prizes for oils and watercolours, rising to $400 by 1975 in four sections. From 1961 the AUSTRALIAN ART AWARD was included for 'outstanding contribution to the Arts in Australia' as part of the Henry Lawson Festival. Winners have included Peter Laverty, Peter Pinson, Brian Stratton, David Strachan, Robert Louis Curtis, Clem Millward, Joy Tyack, Patrick Carroll, Lyster Holland. The AUSTRALIAN ART AWARD was won by 1961, Russell Drysdale; 1962, William Dobell; 1963, Patrick White; 1964, Douglas Stewart; 1965, Sidney Nolan; 1966, A. D. Hope; 1967, Robert Helpmann.

HALF DOZEN GROUP PRIZES AND SCHOLARSHIPS

Beginning in the early 1940s, the Half Dozen Group of Artists initiated a number of awards for the benefit of Queensland artists and students, including junior scholarships, travelling scholarships, prizes celebrating special events (e.g., Qld Centenary), and the L. J. Harvey Memorial Prize (q.v.). Junior Scholarships (1940s): Heather Broadbent, Ray Mann, Peter Abraham, Frank McMillan, Betty Cameron, John Harrington. Travelling Scholarships: 1949, Margaret Cilento; 1951, Betty Quelhurst; 1954, R. Werner, J. Barber. Qld Centenary prize: 1959, Joy Roggenkamp. (*See also* HALF DOZEN GROUP)

HAMILTON ART GALLERY PRIZE
(R. M. ANSETT ART AWARD)

(1976–1990) Given at the Hamilton Art Gallery, Vic. as a biennial $2000 invitation acquisitive award, sponsored by Ansett Transport Industries, for watercolours and associated

media. Forty-three acquisitons were added to the Hamilton Art Gallery collections and included works by Basil Hadley, Max Miller, Lawrence Daws, Clare Robertson, Michael Shannon, Tim Storrier, Joseph De Lutiis, Lesley Dumbrell, Petr Herel, Frank Marinelli, Guy Warren, Kevin Lincoln, Howard Arkley, Sarah de Teliga, John Scurry, Sarah Curtis, Terry Matassoni.

HENRI WORLAND PRINT AWARD (WARRNAMBOOL ART GALLERY AWARD)
(1972–) Established as an acquisitive prize for prints with sponsorship from the Fletcher Jones organisation. $1500 was available in 1976, rising to $2000 by 1979. Earlier awards were given in 1964 and 1971. Works have been acquired by over 150 artists 1964–93 including Robert Grieve, A. J. Coleing, Allan Mitelman, Bea Maddock, Jim Taylor, Mary Macquеen, Marek Momont, John Sandler, Geoff La Gerche, John Olsen, Brett Whiteley, Greg Moncrieff, Arthur Boyd, Jock Clutterbuck, John Coburn, John Dent, David Rose, Deborah Walker, Bonita Ely, Petr Herel, Alun Leach-Jones, Ray Arnold, Graham Fransella, Barbara Hanrahan, Heather Shimmen, Jon Catapan, Graeme Peebles, Rebecca Walker.

HENRY CASELLI RICHARDS PRIZE (TRUSTEES PRIZE)
(1951–71) Annual 100 guinea award at the QAG for landscape or seascape, acquisitive until 1958. Founded in recognition of the work of Professor H. C. Richards, a trustee of the gallery. RESULTS: 1951, John Rowell; 1952, 53, 54, Charles Bush; 1955, Arthur Evan Read; 1956, Phyl Waterhouse; 1957, Francis de Silva; 1958, Sali Herman; 1959, Max Ragless; 1960, John Rigby; 1961, John Olsen; 1962, Margo Lewers; 1963, Arthur Boyd; 1964, Lloyd Rees; 1965, Asher Bilu; 1966, Col Jordan; 1967, Sam Fullbrook; 1968, Michael Smither; 1969, Sam Fullbrook; 1970, Peter Clarke; 1971, David Aspden. In 1972 the name was changed to the 'Trustees Prize'.

HERITAGE ARTS FESTIVAL
See STANTHORPE HERITAGE ARTS FESTIVAL

HOMES ART SHOW
(1980) Conducted in Melbourne by the Royal Free-masons' Homes of Victoria. $4000 acquisitive prize, in four sections. Conditions stipulated a 'Melbourne environment' theme. Winners were Theresa Kennedy, Vanessa Kelly, David K. Taylor, Robert Miller.

HORSHAM ART GALLERY PRIZE
(1973) $1200 prize for painting (sponsored by Horsham Rotary Club), the winning picture was acquired for the Horsham Art Gallery collection. Won by Peter Tyndall.

HOTCHIN ART PRIZES
(1948–66) Given at Claude Hotchin Gallery, Boan's dept store, Perth, WA £50 for the best oil-painting and £25 for the best watercolour until 1960, when the amounts were increased to £100 and £50. Donor of the prize, Sir Claude Hotchin, OBE, Chairman of the Western Australian Art Gallery, 1960–64, donated the winning pictures to Perth Hospital collection, or one of the country town collections which he founded; Hotchin distributed more than 1000 pictures through the awards and from his private resources by 1967. RESULTS: 1948, Ernest Philpot; 1949, George Benson, Rolf Harris; 1950, Allon Cook, James Goatcher; 1951, Allon Cook, Marshall Clifton; 1952, Cyril Ross, Portia Bennett; 1953, Ernest Bearsby, Katherine Jarvis; 1954, Clem Ambler, Maurice Kennedy; 1955, A. Karafylakis, Katherine Jarvis; 1956, Ernest Bearsby, Romola Clifton; 1957, Norman Aisbet, Cyril Lander; 1958, Allon Cook, R. A. Matier; 1959, William Boissevain, Cyril Lander; 1960, Maurice Kennedy, A. Stubbs; 1961, Ailsa Small, Bryant McDiven; 1962, S. A. Smith, Leach Barker; 1963, Vlase Zanalis, S. A. Smith; 1964, David Gregson, Walter Terrell; 1965, n.i.; 1966, Ailsa Small (no watercolour prize awarded).

HUNTERS HILL ART COMPETITION
(1956–c. 1984) Non-acquisitive annual contest conducted by Hunters Hill Shire Council. Winners included G. Cossington Smith, F. Hodgkinson, H. Missingham, Margo Lewers, U. Abolins, F. Hodgkinson, R. Zusters, M. Feuerring, David Strachan, Guy Warren, Eva Kubbos, Patricia Englund, H. Weaver Hawkins, Idris Murphy, John Winch.

INTERNATIONAL CO-OPERATION ART AWARD
(1966–74) Given in Sydney by the Australian Congress for International Co-operation and Disarmament to a painter or sculptor who has made an outstanding contribution to art in Australia. Winners received a bronze medallion designed by Paul Beadle. RESULTS: 1966, Roland Wakelin; 1967, Lyndon Dadswell; 1968, Roger Kemp; 1969, Arthur Boyd; 1970, Lloyd Rees; 1971, n.i.; 1972, Yirawala; 1973, Ian Fairweather; 1974, Desiderius Orban.

INTERNATIONAL TELEPHONE AND TELEGRAPH ACQUISITIVE AWARD, AUSTRALIA
(1972) The exhibition for the Award opened in Miami and travelled in the USA, 1972. Won by M. Collocott.

JACARANDA ART PRIZE
(1961–) Director, Grafton Regional Gallery, PO Box 25, Grafton NSW 2460. About £300 acquisitive award in 1961 rising to $5000 in 1990. Works are acquired for the collection of the Grafton Regional Gallery and include those by David Allen, Mervyn Moriarty, James R. Jackson, H. Gilliland, E. Lynn, Irene Amos, Phyl Waterhouse, Tom Green, John Santry, Guy Warren, Jean Isherwood, Peter Laverty, Elisabeth Cummings, John Firth-Smith, Clem Millward, Lynne Boyd, Joe Furlonger, Tim Jones, Jan Davis.

JAMES HARDIE WILDLIFE ART PRIZE
c/- The Aust Wildlife Fund. PO Box 653, North Sydney 2059. A $50,000 first prize and five $5000 prizes for painting, drawings of Australian wildlife in its natural habitat.

JOHNSONIAN CLUB ART PRIZE
(1961–65) Given in Brisbane, Qld; 100 guineas for oil-paintings and 30 guineas for watercolours. RESULTS: 1962, Mervyn Moriarty, Thomas Pilgrim; 1963, Paula Coleman, Wilson Cooper; 1964, Margaret Olley, C. Ventnor; 1965, H. H. Power.

JOURNALISTS' CLUB ART PRIZE
(1957–58) Prize for painting given by the Journalists' Club, 36–40 Chalmers Street, Sydney, NSW. RESULTS: 1957, Ursula Laverty; 1958, James Phillips.

KATOOMBA ART PRIZE (BLUE MOUNTAINS PRIZE)
(1962–65) Non-acquisitive annual competition with £250 in 1962 and £370 in 1963, divided into first, second and third prizes in two sections. RESULTS: 1962, T. J. Santry, J. Eldershaw, Joshua Smith, Molly Johnson, T. Alban, G. F. Bissietta; 1963, A. Hansen, F. H. Spears, W. A. Salmon, H. A. Hanke, Dora Toovey, G. Kingsley; 1964, H. A. Hanke, B. Stratton, R. Campbell; 1965, Douglas Pratt, Nan Patterson, Brian Stratton.

KEDUMBA ART AWARD
(Established 1989) Blue Mountains Grammar School, Wentworth Falls, NSW 2782. An invitational acquisitive award for drawing, the prize encourages entries from some of Australia's finest draughtsmen and women, thereby maintaining an exceptionally high standard. Between 10–20 artists are invited each year, selected by a professional panel including curator Hendrik Kolenberg and artist Kevin Connor. Works acquired have included those by Arthur McIntyre, James Gleeson, Jan Senbergs, Daniel Moynihan, John Wolseley, Margaret Woodward.

KING GEORGE V MEMORIAL PRIZE
(1945) Sculpture prize given in Sydney for a memor-ial to King George V. The winner was Lyndon Dadswell.

KINGS CROSS ART AND CRAFTS EXHIBITION
(1975–76) Prizes in four sections were administered by

Kings Cross Rotary and sponsored (1975) by Cathay Pacific Airways, for two return tickets, Sydney to Hong Kong, and seven nights hotel accommodation for two in Hong Kong; (1976) by Lufthansa Airlines, return airfare to Frankfurt. In addition, three $300 awards were given by sponsors including Charles Kinsella, Cornelius Furs and Euming Gunz. RESULTS: 1975, Kate Briscoe; 1976, Tim Storrier, Louis Kahan, Kate Briscoe.

KURINGAI PRIZE
(1951–58) Given at Kuringai, NSW. RESULTS: 1951, Carl Plate; 1956, Roy Fluke, E. Mayo; 1958, Arthur Boyd.

LATROBE VALLEY ART PRIZE
(1967–76) Initiated at Morwell, Vic. by the Advance Latrobe Valley Association with sponsorship from Caltex Oil (Aust.) Pty Ltd, Morwell Shire Council, Yallourn Town Advisory Committee, Southern Newspapers Pty Ltd. By 1970 it had become a $1100 acquisitive award aimed at forming a collection for the Latrobe Valley Arts Centre, which opened 1971. Works were acquired by artists including John Brack, Jan Senbergs, Ian Armstrong, Veda Arrowsmith, Dale Marsh, John Morrissey, Sydney Ball, Peter Booth, John Firth-Smith, John Hopkins, Peter Tyndall, Grace Walker, George Baldessin, Richard Havyatt, Mary Macqueen, Bea Maddock, Fred Williams, Andrew McLean, Howard Arkley, Ken Whisson, Ivan Durrant, Mike Brown, Keith Looby, Max Thompson, Anne Graham, Terry Batt.

LATROBE VALLEY SCHOOLS' ART FOUNDATON
(1978) Initiated by the Maryvale Foundation to create a permanent art collection for the use of students at Maryvale and other participating schools. Works acquired were by W. M. Ferguson, Douglas Wright, Bramley Moore, James Taylor, Tim Storrier, Graham Roache, Andrew Kneetone, David Wilson, Chris Pyett, Lloyd Rees, Brett Whiteley, John Robinson.

LATVIAN ART PRIZES
(1958–70) Conducted in NSW, Vic. and Qld from 1958. RESULTS: NSW: 1958, Karlis Mednis; 1959, Dzem Krivs; 1973, Edgars Karabanovs; 1974, Dzem Krivs; VIC.: 1958, Karlis Mednis; 1960, Karlis Trumpis; 1963, Karlis Mednis. QLD: 1970, Edgars Karabanovs.

LAUNCESTON ART AWARDS
(1964–73) Established at the QVMAG, Launceston, Tas., as a £100 non-acquisitive award for best painting, plus purchases made for the Gallery. RESULTS: 1964, John Olsen; 1967, Stephen Earle, Peter Clarke; 1969, Andrew Sibley; 1970, Nevil Matthews, Jan Senbergs; 1973, John Armstrong, Bob Jenyns.

LEROY-ALCORSO PRIZES FOR TEXTILE DESIGN
(1953–56) Given by the Leroy-Alcorso Company. Awards ranged from £300 to £10, plus royalties for artists for successful designs printed and sold by the yard. It failed in its objective of stimulating professional painters to produce good designs for textiles. The most commercially rewarding designs were those done by children. RESULTS: 1954, Ruth Noad, F. C. Hinder; n.d., Douglas Annand. (*See also* SCHOLARSHIPS, ALCORSO SEKERS TRAVELLING SCHOLARSHIP)

LISMORE ART PRIZE (RICHMOND RIVER PRIZE)
(1953–c. 1982) Works from the prize were added to the municipal collection with the aim of forming a regional gallery. Works were acquired by artists including Douglas Watson, Jon Molvig, Margaret Olley, Joy Roggenkamp, Jean Isherwood, Peter Powditch, Patrick Carroll, Elisabeth Cummings, Jacqueline Dabron, Ursula Laverty, Stan Ostoja-Kotkowski, Anthony Pryor.

LITHUANIAN ARTS FESTIVAL
(1964–65) Competitive exhibition conducted at Toorak Galleries, Melbourne, Dec. 1964 to Jan. 1965. Prizes of £50 were won by: H. Salkauskas (watercolour), E. Kubbos (graphic), Eva Pocius (sculpture).

LIVERPOOL ART PRIZE
(Liverpool Festival of Progress Art Competition)

(1971–75) Given first as the Liverpool Bicentenary Art Prize and thereafter annually as a £1300 acquisitive award, divided into sections for oils, watercolours and works by local artists. RESULTS: 1970, John Tiplady; 1971, Margo Lewers, Michael John Taylor, Jenny Freeburn, Bettine Stewart; 1972, Allan Hansen, Alan D. Baker, Valerie Lazarus, Trevor Nixon, Frederic Bates; 1973, Anthony J. Kirkman, John Fisher, Alan Oldfield, Michael Taylor, R. Bride; 1974, Jean Isherwood, Frederic Bates, Paul Selwood; 1975, Arpad Kinka.

L. J. HARVEY MEMORIAL PRIZE
(1951–c. 1980) Acquisitive biennial prize of initially £500, and later £1500 for drawing, conducted by the trustees of the QAG in conjunction with the Half Dozen Group, in memory of Lewis J. Harvey (q.v.). RESULTS: 1951, Kathleen Shillam; 1953, Charles Bush; 1955, Kathleen Shillam; 1957, Arthur Evan Read; 1959, Joy Roggenkamp; 1961, Thomas Gleghorn; 1963, Kenneth Jack; 1965, John Aland; 1967, Mervyn Smith; 1969, Sam Fullbrook; 1971, David Rankin; 1973, Nora Heysen; 1975, Peter Clarke; 1977, n.i.; 1979, Guy Warren.

MCCAUGHEY PRIZE, MELBOURNE
(*The John McCaughey Memorial Prize*)
(1956–) Prize for painting 'of an Australian subject or way of life' given by Miss Mona McCaughey in 1956 as a memorial to her father, John McCaughey, and administered by the National Gallery Society of Victoria. First awarded 1957, the winner receiving £200. This was increased to £400 in 1960, £500 in 1965, $4000 in 1968 (when the annual sequence ended and the prize became intermittent), $6000 by 1979, $8000 by 1981 and $30,000 by 1993. The prize was fraught with contentious issues, the first and most prolonged being the interpretation of the provision, 'Australian subject or way of life'. Compromise judgements were made by the judging panels, and when, finally, a single judge was appointed, he interpreted the terms of the prize literally and at the expense of quality. His successor for the following year reversed this procedure by choosing the winning picture entirely on its merits as a painting. The donor of the prize objected to its abstract nature and in 1962 the prize was suspended until such time as the anomalies arising from the terms could be rationalised. The prize resumed in 1965 when, for that year, £500 was given 'for artists under thirty-two'. Later it developed into its present form in which the trustees of the prize invite artists of at least 10 years exhibiting experience to submit a work painted since the date of the last prize. Since 1983 the judging has been by a panel of three. RESULTS: 1957, John Perceval; 1958, Noel Counihan; 1959, Sali Herman; 1960, Kenneth de Silva; 1961, Roger Kemp; 1965, Gil Jamieson; 1966, Anthony Irving; 1968, Michael Shannon; 1972, Donald Laycock; 1975, John Firth-Smith; 1979, Ken Whisson and Paul Partos (shared); 1981, Imants Tillers; 1983, Craig Gough and Mandy Martin (shared); 1987, James Gleeson; 1991, Paul Boston; 1994, Tony Clark.

MCCAUGHEY PRIZE, SYDNEY
(*The John McCaughey Prize*)
(1965–) Convenor: AGNSW. Bequested by Miss Mona McCaughey (d. 1962) for 'the best picture of the year by an Australian artist exhibited temporarily or permanently at the AGNSW'. It is awarded in the year succeeding that during which the picture is exhibited. Winners have included Ian Fairweather, Fred Williams, Sidney Nolan, Carl Plate, Lloyd Rees, David Aspden, Rollin Schlicht, Brett Whiteley, Brian Dunlop, Michael Johnson, Brian Blanchflower, Rover Thomas, Paul Partos.

MAITLAND PRIZE
(1957–) Maitland Art Prize Committee, 64 Church St, Maitland, NSW 2230. Conducted annually by the Hunter River Agricultural and Horticultural Association to encourage interest in art. The nucleus of the Maitland City Art

Prize Collection has been formed from this Art Prize which for some time consisted of 5 sections – the Maitland Prize (invitation) 1957– ; the Bradmill Industries Limited (local artists) 1957–82; watercolour prize 1961–71; Cecily Mitchell Memorial Watercolour Prize 1971–84; Print Prize 1957– . A total of $5000 for purchases in 1993. Over 120 works were acquired 1957–93 including those by Roy Fluke, Brian Cowley, Sali Herman, Shay Docking, Len Annois, William Peascod, Eva Kubbos, Hector Gilliland, Peter Laverty, John Coburn, Nancy Clifton, Earle Backen, George Baldessin, Ted May, Col Jordan, Stephen Spurrier, James Meldrum, Nancy Clifton, Louis James, Robert Grieve, David Rose, Mimi Jaksic-Berger, Mary Macqueen, David Rankin, Max Watters, Henry Salkauskas, Royston Harpur, Geoff La Gerche, Basil Hadley, Janet Lawrence, Ryuth Waller, Peter Tilley, Fred Cress, Ray Arnold, Bruno Tuci, Noel Thurgate.

MAN WITH THE DONKEY COMPETITION

(1935) Organised by the Australian Sculptors Society, Melbourne. Three prizes were given of £350, £12 and £3. The first prize required the winner to complete the finished bronze memorial for a price not exceeding £380 10s. It attracted entries from George Allen, Leslie Bowles, Lyndon Dadswell, Paul Montford, Wallace Anderson, Ola Cohn, Orlando Dutton, Charles Oliver. WINNER: Wallace Anderson.

MANLY ART GALLERY SELECTION EXHIBITION

(1924–c. 1982) Conducted intermittently 1924–66, annually from 1967, at the Manly Art Gallery. By 1974, $1000 was made available for purchases of oils or watercolours for the Manly Art Gallery collection. Works acquired included those by James R. Jackson, Brian Stratton, Grace Paget Brook, Dorothy Oldham, Jean Isherwood, John Santry, Alexander McMillan, Lloyd Rees, Roland Wakelin, Nancy Borlase, Newton Hedstrom, Clem Millward, Ruth Faerber, James Meldrum, Jean Appleton, Ruth Tuck, Earle Backen, Hector Gilliland, Ena Joyce, Brian Dunlop, Stan de Teliga, Guy Warren.

MARLAND HOUSE SCULPTURE COMPETITION

(1971) Melbourne, Vic. National competition for a sculpture to be erected in the forecourt of Marland House, Bourke St, Melbourne £25,000 commission. Won by Ken Reinhard.

MATTHEW FLINDERS BICENTENARY FOUNTAIN PROJECT

(1975) Given in Melbourne, Vic. as a commission for a fountain to be erected at the Victorian Arts Centre. Won by Raymond Ewers.

MAY DAY PRIZE

(1954–58) Organised for the Victorian Trades Union by the May Day Celebrations Committee. For some years the pictures entered were hung on a fence on the Yarra River bank, but in 1958 the exhibition was transferred to a commercial gallery and the amount increased to £100. (A May Day Prize was conducted also in Sydney in 1968 and awarded to Richard Cornish.) RESULTS: 1954, Maurice Carter; 1955, Peter Miller; 1956, Ailsa O'Connor; 1957, Peter Miller; 1958; James Wigley, Victor O'Connor, Norma Bull, Mary Macqueen.

MELBOURNE CENTENARY ART PRIZES

(1934) Prizes for oil-painting and watercolours were won by A. D. Colquhoun, Rex Battarbee and Will Rowell.

MELBOURNE CITY COUNCIL CITY SQUARE SCULPTURE

(1978) Won by Ron Robertson-Swann with his geometric sculpture *Vault* (misguidedly dubbed 'the Yellow Peril' by its detractors) it occupied its intended site in Melbourne's City Square attracting vehement criticism and public debate for several years until its removal to a low-lying and out-of-the-way area beside the Yarra River. (*See also* ROBERTSON-SWANN, Ron)

MELBOURNE HERALD BEST PICTURE OF THE YEAR AWARD

(1937) £50 prize given for painting. The exhibition was held at the Athenaeum Gallery, Melbourne, Vic. Equal winners were John Longstaff and Arnold Shore.

MELBOURNE INTERNATIONAL CENTENARY EXHIBTION

(1980) Given at a large exhibition held to celebrate the centenary of the Melbourne Exhibition Building. Three awards of $10,000, $4500 and $2000 were given. WINNERS: Jeffrey Bren, Jeffrey Makin, Anne Graham.

MELROSE PRIZES

(1921–67) Initiated by Alexander Melrose, chairman of the Board of Trustees, AGSA (d. 1944). He made many gifts to the AGSA and, in 1936, received the NSW Society of Artists' medal for his services to art. The prizes bearing his name began in 1921, the main prizes being those that began as a memorial to him in 1949. Winners: 1921, 1922, May Grigg; 1929, 1932, George Whinnen; 1935, 1936, 1939, Ivor Hele; 1937, William Rowell; 1938, H. Orlando Dutton. MELROSE MEMORIAL PRIZE Funded from a £1000 bequest and given triennially at the Royal South Australian Society of Arts for the AGSA for portrait or figure painting. Winners 1949, Russell Drysdale; 1952, Charles Bush; 1955, J. Carington Smith; 1958, Jacqueline Hick; 1961, Dora Chapman; 1963, John Rigby; 1967, Michael Kmit.

METRO-GOLDWYN-MAYER ART PRIZE

(1952) Given in Sydney for the purpose of stimulating interest in the film *An American in Paris*. Two prizes, of £250 and £100, were given with the winners being Jean Bellette and Wallace Thornton.

MILDURA SCULPTURE TRIENNIAL

(1961–88) Mildura Arts Centre, Mildura, Vic. 3500. Founded by the first director, Ernst van Hattum. The amount available for acquisitions in the first year was £750; by 1982 it was $13,000. Known first as the Mildara Sculpture Prize, in acknowledgement of sponsorship from Mildara Winery, it became the Mildura Sculpture Prize in 1964 and in 1970 the *Mildura Sculpture Triennial*, the name for which it became famous as the chief public art gallery sponsor for sculpture in Australia. From the beginning it received strong support from the local business, trading, farming, professional and lay community as well as Mildura Council, State Government and, later, the Federal Government through the Visual Arts Board of the Australia Council. The triennial sequence was interrupted once in 1975, in support of *Arts Victoria* but resumed in 1982 until its cessation in 1988. It was the result of considerable controversy in 1975 when a new director Tom McCullough introduced works of ephemeral and avant-garde nature. Sculptors' work acquired as a result of the Triennial was numerous and included that by Norma Redpath, Vincas Jomantas, Robert Klippel, Herbert Flugelman, Noel Hutchison, Nigel Lendon, Ken Reinhard, Ron Robertson-Swann, Michael Young, Michael Kitching; Marleen Creaser, John Davis, Kevin Mortensen, Clive Murray White, Domenico de Clario, Peter Cole, Marc Clark, Inge King, Ti Parks, David Wilson, Isobel Davies, John Lethbridge, Robert Owen; Paul Hopmeier, Clifford Last, Clement Meadmore. (*See also* GALLERIES-PUBLIC.)

MINING INDUSTRY OF WESTERN AUSTRALIA AWARD

(1979) Sponsored by the WA mining industry and administered by the Fremantle Arts Centre it was given to celebrate the 150th anniversary of Western Australia; $10,000 available for painting and sculpture. In 1982 $11,000 was made available for the award, $1000 for the open and $10,000 for the invitation section. RESULTS: 1979, Tim Storrier.

MIRROR-WARATAH FESTIVAL ART COMPETITION

(1961–73) Given in Sydney at an annual, competitive, open-air art exhibition sponsored by *Mirror* newspapers in conjunction with 'the Sydney Committee', and held at Hyde Park, Sydney. Prizes in a variety of categories varied from year to year, value of the major prize ranging from $400 to $2000, minor prizes from about $100 to $500. RESULTS:

1961, S. Rapotec (two prizes), H. Gilliland, H. Salkauskas, A. Grieve, B. Stratton, L. Howlett, J. Paynter, P. Houstein; 1962, Kevin Connor, John Firth-Smith, Frank Spears, Guy Warren, B. Mallinson, H. Salkauskas, Z. Fenyes, S. Rapotec, M. McColl, N. Allen, D. Cook, K. Hiscock, K. Donaldson, R. Young, M. Ives, P. Delprat, M. Sharp, T. Holt; 1963, H. Salkauskas, Strom Gould, F. Spears, C. Plate, B. Mallinson, E. Kubbos, E. Hubble, H. Salkauskas, V. Spoogis, S. Collings, A. Collins, K. White, A. Gray, P. Powditch, M. Sharp, P. Delprat; 1964, D. Tolley, Strom Gould, John Firth-Smith, Peter Pinson, C. G. Taylor, Guy Warren, G. Austin, H. Salkauskas, Anne Collins, H. Gilliland, D. Tolley; 1965, Sydney Ball, J. T. Makin, M. Gregory, G. S. Ruddet, A. Zakaruskas, L. A. Ware, Ivan Englund, Patricia Englund, S. T. Skillitzi; 1966, Bob Dickerson and Dick Watkins (shared), Colin Williams, Ron Lambert, L. Woodyer, S. T. Skillitzi, I. Shaw; 1967, John Aland, H. M. French-Kennedy, Ron Lambert, Franz Kempf, W. J. Clements, P. A. Rodick, S. Palmer; 1968, John Peart, Colin Williams, Meg Gregory, Diana Hunt; 1969, Tim Johnson, C. G. Taylor, J. V. Larkin, K. King; 1970, J. V. Larkin, Giulio Gentile, L. Ranshaw, I. Tillers; 1971, n.i.; 1972, Royston Harpur, E. Armstrong, J. Liew, A. McIntyre; 1973, Frederic Bates, Henry Hanke, G. R. Webb, I. Grant, Charles Bush.

MOET AND CHANDON FELLOWSHIP AND TOURING EXHIBITION

(1986–) c/- Jonah Jones, PO Box 5004, Carlton, Vic. 3053. An annual award of $50,000 plus a studio for a year in the Champagne district of France for the fellowship winner, the *Moet* has become one of the most prestigious and much discussed prizes for young artists. Entrants must be under 35 years of age and from the several thousand entries submitted annually, around 25–30 works are selected from which the fellowship is awarded. This exhibition, which opens in a different state gallery each year, tours to several other state public galleries and the NGA. RESULTS: 1987 Susan Norrie; 1988 Joe Furlonger; 1989 Elisabeth Kruger; 1990 Hollie; 1991 Gordon Bennett; 1992 Rosie Weiss; 1993 Tim Maguire; 1994, Bronwyn Oliver.

MOMAD YOUNG CONTEMPORARIES PRIZE

(1963) Given by the Museum of Modern Art and Design, Melbourne, the aim being to assist young contemporary Australian artists. Won by Colin Lanceley.

MORNINGTON PENINSULA ARTS CENTRE SPRING FESTIVAL OF PRINTS AND DRAWINGS

(1973–) MPAC, Civic Reserve, Mornington, Vic. 3931. Established by Alan McCulloch, the MPAC Festival is an important prize for Australian prints and drawings. From $2000–$4000 is made available each year with the medium alternating between prints and drawings each year. Over 300 works have been acquired by artists including George Baldessin, Roger Kemp, Mary Macqueen, Edwin Tanner, Fred Williams, John Sandler, Robert Grieve, Jean Langley, Keith Looby, John Neeson, John Olsen, James Paterson, John Aland, Rick Amor, Jeffrey Bren, Brian Dunlop, Diana Mogensen, Wendy Stavrianos, Douglas Wright, David Fitts, Charles Blackman, Judy Cassab, Noel Counihan, Raphael Gurvich, Pam Hallandal, Geoffrey Lowe, Jan Senbergs, Andrew Sibley, Patrick Henigan, Jock Clutterbuck, Barbara Hanrahan, Graham Kuo, Ania Walwicz, Franz Kempf, Daniel Moynihan, Garry Shead, Ray Arnold, Graeme Peebles, Warren Breninger, Ruth Johnstone, Hertha Kluge-Pott,

MOSMAN ART PRIZE

(1947–) 1 Mosman Square, Mosman, NSW 2088. An annual acquisitive award, ranging from 50 guineas in 1947 to $10,000 (for 3 prizes) in 1993. Conducted by the Municipality for the purpose of building a public collection. Over 100 works have been acquired 1947–92 including by M. Olley, N. Hedstrom, D. Annand, G. Warren, J. Isherwood, F. Lymburner, C. Plate, G. Cossington-Smith, Weaver Hawkins,

J. R. Ashton, M. Medworth, R. Fluke, E. Cambridge, W. H. Veal, R. Fletcher, M. Feuerring, F. Hinder, E. Lynn, T. Gleghorn, L. Kahan, M. Lewers, N. Borlase, P. Laverty, H. Salkauskas, E. Backen, K. Reinhard, Joseph Szabo, Reinis Zusters, Ruth Faerber; Joan Brassil, David Rose, John Lethbridge, Lesley Pockley, Janet Dawson, Geoff Wright, Lloyd Rees, Anthony Galbraith, Cressida Campbell, Fred Cress, Paul Delprat.

MURDOCH PRIZE

(1958–59) Award comprising £200 (open) and £50 (for a Western Australian artist) given by Rupert Murdoch, newspaper owner, and conducted at the Skinner Galleries, Perth. RESULTS: 1958, R. Jarvis (British painter), Rolf Harris (local); 1959, T. Gleghorn (open), Guy Grey-Smith (local).

MUSWELLBROOK ART PRIZE

(1958–) Town Clerk, PO Box 122, Muswellbrook, NSW 2333. Annual acquisitive award of £350 rising to $1200 by 1977 and $10,000 first prize and $2500 other prize in 1993. Works acquired include those by T. Gleghorn, M. Lewers, David Strachan, Max Watters, Weaver Hawkins, David Aspden, Ronald Hawke, Henry Salkauskas, Michael Shannon, Stephen Earle, Mimi Jaksic-Berger, Dorothy Braund, Janet Dawson, David Rankin, Eric Smith, Fred Cress, Jacqueline Dabron, Colin Lanceley, Frank McNamara, Bea Maddock.

NAMATJIRA MEMORIAL ART PRIZE

(1963–66) A prize of £100 was given annually from royalties from a biography, *Namatjira, Wanderer Between Two Worlds*, by Joyce D. Batty, with sponsorship later from Ansett-ANA Airlines. First awarded in 1964 and in 1966 a 'founder's award' was added. RESULTS: 1964, Graham Cox; 1965, Helena Gibson; 1966, Carolyn Edwards, Robert Landt (founder's award).

NATIONAL ABORIGINAL ART AWARD

(1984–) Established by Margie West, curator of Aboriginal art and administered by MAGNT, Darwin. Annual award offered to Aboriginal and Islander artists living throughout Australia. Held in September each year it includes a great number of styles and provides an excellent survey of the latest Aboriginal art. Since 1992 Telecom Australia has sponsored a $15,000 award and three smaller awards of $2000 each are sponsored by Rothmans, the MAGNT and Memorial Award for Mawalan's eldest son. RESULTS: 1986, Frank Nelson; 1987, Djardi Ashley; 1988, Pauleen Nakamarra Woods; 1989, Pansy Napangardi; 1990, Mutitjpuy Munungurr; 1991, Mick Namarari Tjapaltjarri; 1992, Les Midikuria; 1993, Paddy Fordham Wanburranga.

NATIONAL GALLERY OF VICTORIA ART PRIZES

At the inaugural exhibition of the first picture galleries a £200 art prize was won by Nicholas Chevalier. Various art prizes were given later at the art school, notably a prize to Frederick McCubbin 'for original landscape', c. 1882, and other student prizes such as the Grace Joel (from c. 1944), and Hugh Ramsay, S. and A. E. Levi, Bernard Hall and numerous smaller prizes, including annual prizes for painting and drawing. A special National Gallery of Victoria Art Prize was conducted in 1941, when £500 was won by Ernest Buckmaster for a large oil-painting entitled *Once a Jolly Swagman*, a smaller prize going to Harley Griffiths. The prize was intended as an annual event, but was not continued because of the poor response.

NATIONAL GALLERY SOCIETY OF VICTORIA ART PRIZES

(1959–72) Convenor: National Gallery Society of Vic. Given as a £100 prize for drawing, available to students annually until 1967. RESULTS: 1959, Stewart McInnes, Jacqueline McNaugh-ton (shared); 1960, Georgina Press, Robin Talbot Goodall (shared); 1961, Georgina Press; 1962, Ian Burn; 1963, Arthur Talko, Janet Murray (shared); 1964, no award; 1965, Guy Stuart; 1966, Jock Clutterbuck; 1967, Catherine Nicholson, Richard Amor (shared); 1970, Graeme Davis.

NATIONAL ROADS AND MOTORISTS ASSOCIATION OF NEW SOUTH WALES PRIZE
(1947) Won by J. Salvana.

NBN CHANNEL 3 ART PRIZE
(1969) $2,000 prize for painting. Judged by Laurie Thomas, the winner was Jan Senbergs with the winning picture became the property of the Newcastle Region Art Gallery.

NEWCASTLE CIVIC FOUNTAIN COMPETITION
(1961) Won by Margel Hinder.

NEWCASTLE HOTEL PRIZE
(1962) £100 prize for painting. Won by Sali Herman.

NEWCASTLE REGION ART GALLERY PRIZES
(1957–69) First given in 1957 and re-established in 1967 to mark the tenth anniversary of the gallery. In that year two acquisitive awards were given, total value $1300, rising to $2000 in 1969. RESULTS: 1957, Michael Kmit, Brian Cowley, Tina Wentcher; 1967, Louis James; 1968, John Peart, Charles Pettinger; 1969, Jan Senbergs.

NEWCASTLE WAR MEMORIAL COMPETITION
(1955) Prize for sculpture won by Lyndon Dadswell. Considerable newspaper controversy attended the installation of Dads-well's prizewinning work, which many people claimed was too 'modern'.

NEW SOUTH WALES SOCIETY OF ARTISTS, PRESIDENT'S PRIZE
(1892) Awarded to Alfred Coffey.

NORTHSIDE ARTS FESTIVAL
(1963–73) The festival included prizes for paintings in oils and watercolours, known as the Grace, and Calder, prizes. Sponsored by the Arts Council of Australia. Value was $300, rising to $2300, distributed in various sections. RESULTS: 1963, H. Gilliland, H. Hanke, M. Flaxman, R. Steuart; 1964, no award; 1965, T. Gleghorn, A. Sibley, E. Hall, D. Toovey, G. Townshend, B. Stratton; 1966, no award; 1967, E. Hall, Jean Isherwood, R. Lambert, P. Clarke, B. Stratton, U. Abolins; 1968, n.i.; 1969, P. C. Taylor, Henry Salkauskas, Ronald Steuart; 1971, Henry Salkauskas, Enid Bradshaw, Ronald Steuart, Margaret Coen; 1972, n.i.; 1973, C. Forbes-Woodgate.

OLSEN DRAWING PRIZE
(1990–) Director, Bathurst Regional Art Gallery, PMB 17, Bathurst, NSW 2795. Although planned as an annual $5000 award sponsored by John and Katherine Olsen, this prize has been awarded only once in 1990, to Mike Parr.

ORANGE FESTIVAL ART PURCHASE
(1961–1979) Founded as the Orange (Banjo Paterson) Art Competition and given as an annual acquisitive contest with 100 guineas prize money divided into six sections, rising to $2000 (1977). In the same year it was renamed the Orange Festival Art Purchase. Works were acquired by artists including Henry Salkauskas, Patrick Carroll, George Johnson, Louis James, David Rankin, John Santry, Max Thompson, Bert Flugelman, Hector Gilliland, Lloyd Rees, Michael Shannon, Eric Thake.

PARIS PRIZE
(1980) Conducted at the VCA, sponsored by Franchville Pty Ltd, for students of art schools. It included a return air fare to Paris, five weeks accommodation and study at L'Ecole des Beaux-Arts. Won by Sonny Dalimore (RMIT).

PARRAMATTA ART PRIZE
(1965) Given at Parramatta, NSW. WINNERS: Jean Isherwood, Allan Newton, Alison Faulkner, Joe Rose.

PEACE THROUGH PRAYER ART CONTEST
(1966) Conducted in Qld. £500 for traditional oils, £250 for traditional watercolours. WINNERS: Brian Williams, Peter Abraham.

PEDERSEN PRIZE
(1976–) Established as the Andrew and Lillian Pedersen Memorial Trust Prize and administered by the QAG it provided a biennial $500 award for printmaking and drawing, alternating with sculpture. RESULTS: 1976 (printmaking and drawing), Barbara Hanrahan, Bruce Latimer; 1978 (sculpture), Les Kossatz.

PERTH CENTENARY PRIZE
(1930) Conducted Perth, WA Winners were G. Pitt Morison, Arthur Bassett.

PERTH FESTIVAL INVITATION ART PRIZE
(1965–67) Established as the 'T. E. Wardle Invitation Art Prize' in honour of the donor. A £500 annual prize for painting conducted at the Skinner Galleries as part of the annual Perth Arts Festival. A feature of the prize was the practice of inviting overseas authorities to act as judges. RESULTS: 1965, Brett Whiteley (judged by John Russell, London critic); 1966, Lawrence Daws and Robert Juniper (judged by Robert Melville, art critic for the *New Statesman*, London); 1967, Guy Warren (judged by Patrick Heron, London critic and painter).

PERTH PRIZE
(1948–52) Given at the AGWA, Perth.
RESULTS: 1948, Charles Bush, Frank McNamara; 1949, Len Annois; 1950, Leach Barker; 1951, Irene Carter; 1952, Ernest Philpot.

PERTH PRIZE FOR CONTEMPORARY PAINTING
(1954–64) Art Gallery Society of WA. Founded by Laurence Thomas (q.v.), it included a first prize (200 guineas), a separate prize for WA artists, and a prize for watercolours (60 guineas). In Jan. 1963 the event became part of the annual Festival of Perth; the amounts were increased to 500, 200 and 100 guineas, and a 100 guinea prize for an artist under 25 was added. The terms of the third prize were altered from 'watercolour' to 'painting other than oil'. RESULTS: 1954, Michael Kmit, Robert Juniper, Nornie Gude, Frank Hinder, John Wilson; 1955, Judy Cassab, Irene Carter, Guy Grey-Smith, Mervyn Smith; 1956, Alan Warren, H. Gilliland; 1957, Geoffrey Allen, shared with Robert Juniper, Mervyn Smith; 1958, Carl Plate, Kathleen O'Connor, Mervyn Smith, Ivor Hunt, John Lunghi; 1959, Geoffrey Allen, shared with B. Werner, Roy Bizley, shared with R. Juniper, Irwin Crowe, shared with Maurice Stubbs; 1960, Leonard French, Ivor Hunt; 1961, John Olsen, Robert Juniper; 1962 (prize awarded in 1963 to coincide with Perth Festival of Arts); 1963, Jon Molvig, Guy Grey-Smith, Henry Salkauskas, Harvey Wochtel; 1964, Guy Grey-Smith, I. Hunt and M. Smith.

PERTH PRIZE FOR DRAWING
(1965–68) Art Gallery Society of WA, Beaufort St, Perth, WA. In 1965 the Perth Prize for Contemporary Painting became the Perth Prize for Drawing, and five years later the Perth Prize for Drawing International (q.v.). Prizes of $420, open, and $150, under twenty-five, were sponsored by West Australian Newspapers Ltd and Swan Brewery Co. Ltd. RESULTS: 1965, Henry Salkauskas, Philippa Lightfoot; 1966, Fred Cress, Helen Lauk and Sydney McWilliam; 1967, Richard Larter, Christopher Simmons 1968, Robert Birch, David Lloyd Hughes.

PERTH PRIZE FOR DRAWING INTERNATIONAL
(1970–75) Established with prizes for $1000 (best international entry), $500 (best Australian entry), $250 (best under twenty-five entry). A fourth section (best WA entry) was added in 1971. By 1975, the amount available for prizes had risen to $3,500. RESULTS: 1970, David Warren, Clifford Jones, Edgar Snell; 1971, William Boissevain, Jan Smejkal, Domenico de Clario, Elizabeth Turner; 1973, Anthony Whishaw, Domenico de Clario, Colleen Morris, Gary Jones; 1975, M. Vila-Bogdanich, Michael Winters, Neville Weston, Michaila Levar.

PERTH SOCIETY OF ARTISTS PRIZE
(1962) Conducted by the Society as part of the Commonwealth Games festivities. Won by Kathleen O'Connor (£500 B. P.

Prize), Sali Herman (Jackson Prize), Robert Juniper (McKellar Hall Prize).

PHILIP MORRIS ARTS GRANT

(1973–) Created as a $100,000 fund (given over a five-year period) to acquire works 'by bold and innovative' artists, for exhibition in public galleries throughout Australia. Works of 26 artists were shown in the first exhibition, put together in 1974 and shown in a specially improvised gallery in the City Square, Melbourne, in Oct. 1975. Forty-six artists were shown at the Adelaide Festival of the Arts, 1976.

PINKERTON SCULPTURE COMMISSION COMPETITION

(1949) Conducted Ballarat, Vic. as a £3000 commission bequeathed by F. Pinkerton (d. 1931) for a symbolic stone statue to be erected in the Sturt Street gardens, Ballarat. Won by George Allen. The winning work became the subject of prolonged public controversy in the Ballarat press.

PORTIA GEACH MEMORIAL AWARD

(1965–) Administered by Arts Management Pty Ltd, 180 Goulburn St, Darlinghurst 2010. Annual £1000, later $2500, then $18,000 award for 'a portrait [of a man or woman distinguished in Art, Letters or Science] by a woman resident in Australia'. RESULTS: 1965, Jean Appleton; 1966, Mary Brady; 1967, Jo Caddy; 1968, Bettina McMahon; 1969, Vaike Libbus; 1970, Dora Toovey; 1971, Mary Brady; 1972, Elisabeth Cummings; 1973, Sylvia Tiarks; 1974, Lesley Pockley; 1975, Mary Brady; 1976, Jocelyn Maughan; 1977, Ena Joyce; 1978, Dora Toovey; 1979, Ivy Shore; 1980, Judy Pennefather; 1981, Susan Howard; 1982, Brenda Humble; 1983, Margaret Woodward; 1984, Margaret Woodward; 1985, Gwen Eichler; 1986, Christine Hiller; 1987, Christine Hiller; 1988, Margaret Ackland; 1989, Jenny Sands; 1990, Jenny Watson; 1991, Rosemary Valadon; 1992, Jenny Sages; 1993, Aileen Rogers.

PORTLAND ART EXHIBITION (NSW)

(1977–) $2000 annual acquisitive award was by invitation only, from 1980. Works acquired by Lillian Cox, Bob Cunningham, Henry Salkauskas, Bill Salmon, Jim Turner; 1978, Alan Baker, Frederic Bates, Brian Blanchard, Robert Cunningham, Joseph Gatt, Edward Hall, James Kiwi, William Salmon, Ian Webb.

PORTLAND ART SOCIETY ART PRIZE (VIC.)

(1961–) Annual acquisitive (originally 60 guineas for oils, 25 for watercolours) to form a local public collection and art gallery. Acquisitions included works by Jack Freeman, Frank Werther, Robert Grieve, Mary Macqueen, Yvonne Cohen, Stephen Spurrier, Ludmilla Meilerts, Klaus Zimmer, Greg Moncrieff, Robert Grieve, Howard Arkley.

PRING PRIZE

(*John and Elisabeth Pring Memorial Prize*)
(1966–) Administered by the AGNSW this annual prize is judged in conjunction with the Wynne Prize and awarded 'for the best landscape executed in watercolours by a woman artist . . . and be the one which all other things being equal best expresses the femininity of the artist'. In 1993 the prize was $250. Winners since 1966 have included Joy Roggenkamp, Margaret Coen, Eva Kubbos (7 times), Venita Salnajs, Ruth Faerber.

PRINT COUNCIL OF AUSTRALIA AWARDS

(1967–) The PCA commissions artists to make prints in limited editions which are then distributed to PCA members and patrons. Members receive a 'member print', patrons a 'patron print' and choice of 'member prints'. Intermittent PCA Print Prizes were conducted 1967–73. Artists who have been commissioned to produce Member Prints include John Brack, Robert Grieve, Eric Thake, Franz Kempf, Noel Counihan, Allan Mitelman, David Rose, Barbara Brash, David Rose, Herbert Flugelman, John Dent, Christopher Croft, Ruth Faerber, Barbara Hanrahan, Bea Maddock, Mary Macqueen, Sally Robinson, Basil Hadley, Ian Armstrong, Daniel Moynihan, Ann Newmarch, Bruno Leti, Neil Malone, Max Miller, John Robinson, Helen Taylor, Ray Arnold, Michel Kemp, John Neeson, Graeme Peebles, John Scurry, Rosemary Vickers, Jon Cattapan, Tanya Crothers, Bill Meyer, Leon Pericles, Peter Ellis. Patron Prints have been commissioned from Alun Leach-Jones, Fred Williams, Hertha Kluge-Pott, Jock Clutterbuck, Grahame King, Udo Sellbach, Robert Grieve, Earle Backen, Geoff La Gerche, Roger Kemp, Ray Beattie, Jan Senbergs, Les Kossatz, Sandra Leveson, John Olsen, Sydney Ball, Jorg Schmeisser, Peter Clarke, Janet Dawson. PRINT PRIZE RESULTS: 1967, Fred Williams; 1968, Tay Kok Wee; 1969, Jock Clutterbuck; 1973, Jock Clutterbuck.
(*See also* PRINT COUNCIL OF AUSTRALIA)

QUEENSLAND CENTENARY ART PRIZE

(1959) Given to celebrate Queensland's centenary. The winners were E. Colclough, L. Shillam, Betty Churcher (portrait prize).

QUEENSLAND NATIONAL ASSOCIATION PRIZE

(1895) Winner was A. Alder.

RAKA (RUTH ADENEY KOORI AWARD)

(1990–) c/- Australian Centre, Hugh Williamson House, University of Melbourne, Parkville, Vic. 3052. A $10,000 annual award established by art historian and writer Professor Emeritus Bernard Smith in honour of his wife Kate (who was known as Ruth Adeney in her childhood) for Aboriginal artists. Each year a different area of artistic endeavour is rewarded – creative prose, drama, the visual arts, script writing and poetry – and the judging panel has strong Aboriginal representation. First year for the visual arts was 1993 and won by Lin Onus.

RAVENSWOOD ART COMPETITION

(1967) Given at Wahroonga, NSW. $550 in five categories. Winners were J. N. Kilgour, Zolton Fenyes, Joyce Harris, Bill Wells, F. Griffen-Fisher.

REDCLIFFE ART PRIZE

(1957–) Redcliffe Art Society, PO Box 69, Redcliffe, Qld 4020. Annual acquisitive, $1400 award for painting, given in four sections, rising to $2250 in 9 sections, 1976. Works have been acquired by F. K. de Silva, George Wilson Cooper, Joy Roggenkamp; Marion Finlayson, George D. Williamson, Margaret Olley, John Aland, Roy Churcher, Elisabeth Cummings, Nutter Buzacott.

REEVES PRIZE

(1936) Given in Sydney and won by J. Salvana.

RESERVE BANK PRIZE

(1962) Sculpture prize for wall decoration for new Reserve Bank building, Sydney. Won by Margel Hinder and Bim Hilder.

ROBIN HOOD COMMITTE ART PRIZE

(1956–79) Conducted annually by the Robin Hood Committee (organising secretary, Joy Alston), at first in Melbourne then, from 1960, in Sydney. Originally £100 was given in two sections (oils and watercolours) with small prizes for psychiatric patient painters, Pentridge prisoners, handicapped children and others. By 1974 the annual amount given was $1400. A large number of sponsors supported the prize, the exhibition being held in the banking chamber of the Commonwealth Savings Bank, Martin Place, Sydney. The prize began to decline with the disappearance of Joy Alston as organiser; no results were published in 1978 and the last published reference to it was in 1979. RESULTS: 1956, Ian Bow, John Yule; 1957, Kenneth Hood, L. Annois; 1958, Laurence Hope, Maurine Boon; 1959, Jack Freeman, Nornie Gude; 1960, William Drew, Con Carter; 1961, Leonard Hessing, Daryl Hill; 1962, Guy Grey-Smith, Henry Salkauskas; 1963, Anton Holzner, Henry Salkauskas; 1964, Fred Williams, Henry Salkauskas; 1965, Guy Warren, Eva Kubbos; 1966, Elwyn Lynn, Henry Salkauskas; 1967, Guy

Warren, Eva Kubbos; 1968, John Gould, Henry Salkauskas; 1969, John Brooke, Joe Rose; 1970, John Larkin, John Winch; 1971, Henry Salkauskas (two prizes), John Gould; 1972, Henry Salkauskas; 1973, Ruth Lowe (two prizes), Donald Mackenzie; 1974, Max Enkhart, Wendy Jones, Don MacKenzie and Rob Trousselot (shared); 1975, V. Serelis, Rodney Taylor, Donald MacKenzie, Max Enkhart, Lindsay Buchanan; 1976, Henry Salkauskas; 1977, John Winch.

ROCKDALE ART PRIZE

(1955–76) Given at Rockdale, NSW, 80 guineas in two sections, rising to $1000 (1971) in four sections. RESULTS: 1955, T. J. Santry, C. F. Linaker; 1956, Alan R. Grieve, Rufus Morris; 1957, Thomas Gleghorn, J. L. Allen; 1958, Jean Appleton, Hector Gilliland; 1959, M. Feuerring, U. Abolins, 1960, John Olsen, T. Gleghorn, Frank H. Spears, Frederic Bates; 1961, Leonard Hessing, T. Gleghorn, Edward Hall, Brian Stratton; 1962, Margo Lewers, Guy Warren, Reinis Zusters, Brian Stratton, Karl Manberg; 1963, Carl Plate, Henry Salkauskas, Frederic Bates, Brian Stratton, Vincent Arnall, S. Gould; 1964, Elwyn Lynn, Eva Kubbos, H. A. Hanke, Brian Stratton; 1965, J. Isherwood, L. Bovard, M. Shaw, E. Kubbos, A. Murre (sculpture); 1966, Edward Hall and William Salmon (shared), William Salmon, Peter Laverty, Guy Warren, Anna Klinovsky (sculpture); 1967, Edward Hall, Jean Isherwood, J. T. Makin, Joyce Allen, John McInerney, S. Gould; 1968, E. A. Harvey, Brian Stratton, Joe Rose, Mimi Jaksic-Berger; 1969, E. A. Harvey, Graham P. Austin, John K. Drews, Carole Elvin, O. Kuster; 1970, G. C. Taylor, I. Tillers, Brian Stratton, Mimi Jaksic-Berger, John Tiplady; 1971, Jean Isherwood, Frederic Bates, Royston Harpur, F. Braat; 1972, C. Millward, R. Zmija, Stan de Teliga; 1973, Ian Grant, R. Morris, F. Bates; 1974, J. Szabo, Edward Hall, F. Bates; 1975, Ian Grant and Frances Yin (shared), David Harrison, Gunnars Krummins; 1976, John Conway, Frederic Bates, David Harrison.

ROCKHAMPTON ART COMPETITION AND EXHIBITION

(1970–) An annual prize held in September organised by the Royal Qld Art Society (Rockhampton Branch) and the Central Qld Contemporary Artists Club and hosted by the Rockhampton City Art Gallery. Prize money exceeded $500 with the Rockhampton Art Acquisition Trust Fund sponsoring the major painting prize which is limited to artists practising in the central Qld region. This prize is acquisitive with the winning work becoming part of the Rockhampton City Art Collection. About 7 other smaller awards are sponsored by local companies. Some works acquired since 1970 include those by Hugh Sawrey, Frederic Bates, Ian Armstrong, Charles Bush, Michael Taylor, Ben Wickham, Anne Green, Ronald Millar, Anne Willis, Leith Angelo, Jeff Makin, Idris Murphy, Geoff La Gerche, Peter Gunn.

ROWNEY DRAWING EXHIBITION

(1959–60) Conducted at the Richman Gallery, Melbourne; £50 worth of drawing materials given by Rowney & Co. RESULTS: 1959, Charles Blackman; 1960, Jon Molvig. Later Rowney prizes were given at Contemporary Art Society exhibitions, Melbourne.

ROYAL ADELAIDE EXHIBITION

(1957) The exhibition included art prizes given by the South Australian Chamber of Manufactures, total value £730, divided into eleven prizes. The main prize went to T. Gleghorn.

ROYAL AGRICULTURAL SOCIETY, AUSTRALIAN DIVISION, CENTENARY ART PRIZE

(1967) Held in Sydney, NSW. $1500 acquisitive. Won by Ben Hall.

ROYAL AGRICULTURAL SOCIETY OF NEW SOUTH WALES EASTER SHOW ART PRIZES

(1958–) Royal Agricultural Society of NSW, GPO Box 4317, Sydney, NSW 2001. Established in 1958 as a group of annual prizes £3000, rising to about $16,000 total in 1992, divided into a number of categories including watercolour, portrait painting, ceramics, modern figurative painting, miniature painting, printmaking and a range of art awards for secondary students. The prizes were inspired by Sir Charles Moses, chairman of the Australian Broadcasting Commission and many sponsors have supported the prizes over the years including Rural Bank of NSW; David Jones Ltd; Bank of NSW; James Fairfax, Warwick Fairfax; Chubb Insurance; Mercedes-Benz. In 1989 and 90, there was a Doug Moran – In search of excellence prize of a total of $20,000–$12,000, first prize; $5000 second prize, $3000 third prize by invitation and restricted to previous RAS prize winners. In 1989 Mercedes-Benz sponsored a Youth Scholarship Art Prize of $5000 for artists 19–29 towards the cost of a scholarship for art studies preferably in New York. Major prizes 1992 included 'Rural Subject' painting $2000; Portrait prize of $1500; 'Still Life' painting of $1100; 'Watercolour Painting' of $1650; 'Marine Seascape' of $1300; 'Margaret Fesq Memorial Art Prize' of $1000; 'Australian Birds or Flowers' (the Lady James Fairfax Memorial Prize) $1000.

ROYAL AGRICULTURAL SOCIETY OF WESTERN AUSTRALIA ART PRIZE

(1974–c. 1979) RESULTS: 1974, Peter Harper; 1976, Frank Spears; 1977, 1978, Greg Baker, H. Totenhofer.

ROYAL INDUSTRIAL SHOW, ADELAIDE (ADELAIDE POSTER DESIGN PRIZE)

(1951) Won by Frank Hinder.

ROYAL NATIONAL AGRICULTURAL AND INDUSTRIAL ASSOCIATION OF QUEENSLAND ART PRIZES

(1961–) R.N.Ag.A.Q. Committee, Exhibition Grounds, Gregory Tce, Fortitude Valley, Qld 4006. Annual exhibition held in the Fine Arts pavilion, Exhibition Grounds, Bowen Park, Brisbane. Approximately $3000 divided among a variety of sections. Sponsors have included David Jones Stores, Finney Isles & Co., T. C. Beirne Ltd, Barker's Book Store.

ROYAL QUEENSLAND ART SOCIETY PRIZE AND SCHOLARSHIP

(1899–1954) PRIZE RESULTS: 1899, Frederick Roberts; 1971, Robert Boyd. SCHOLARSHIP RESULTS: 1951, Betty Cameron; 1954 (£270), shared between Janice Barber and Richard Werner.

ROYAL SOUTH AUSTRALIAN SOCIETY OF ARTS PRIZE

An early prize given under this title went to W. R. Thomas in 1864. It was revived temporarily in the 1960s. RESULTS: 1961, Brian Callen; 1966, Peter Schulz.

RUBINSTEIN MURAL PRIZE

(1958) Given for a mural for the University of Melbourne. Won by Erica McGilchrist.

RUBINSTEIN PORTRAIT PRIZE

(1960–66) Convener: Boans Ltd, Perth, WA Annual £300 prize for portraits given by the Rubinstein cosmetics organisation in memory of Helena Rubinstein. RESULTS: 1960, Romola Clifton; 1961, William Boissevain; 1962, Margaret Olley; 1963, Vladas Meskenas; 1964, 1965, Judy Cassab; 1966, J. Carington Smith.

RURAL BANK ART PRIZE

(1964) John F. Kennedy Memorial Art Prize conducted in Sydney. Won by Emmanuel Raft, Ken Reinhard.

RYCROFT INVITATIN ART AWARD

(1972–74) Conducted South Australia, $1,000 award. RESULTS: 1972, 1974, Charles Bush.

ST MARY'S CATHEDRAL RELIGIOUS ART PRIZE

(1971) Conducted in Sydney, NSW. Three prizes, $1250, $500, $250, awarded to commemorate St Mary's 150th-year celebrations. Won by Weaver Hawkins, Eric Smith, David Rankin.

SAVAGE CLUB INVITATION ART PRIZE

1987– . Secretary, Melbourne Savage Club, 12 Bank Place, Melbourne 3000. The Melbourne Savage Club, established in 1894 as a club of bohemian spirit based on an appreciation

of music, art, drama, science and literature started an annual art prize of approximately $5000 in 1987. Those invited include established, mid-career and younger generation artists and the prize exhibition is displayed at public galleries – Heide, 1987; RMIT 1988, 90; Bendigo Art Gallery 1991; McClelland 1992. No prize was given in 1989 and 1993. The prize is usually non-acquisitive but in 1991, the Bendigo Gallery retained the works. Winners have included Paul Boston, Giuseppe Romeo, Mickey Allem, John R. Walker, John Olsen, Mike Parr, Peter Tyndall, Judy Watson, Maria Kozic, Helen Maudsley, Micky Allan.

SCOTCHMANS HILL PRIZE
See GEELONG ART GALLERY PRIZES

SEBEL DESIGN AWARD
(1967–70) Given in Sydney, NSW; $1000 first prize, $1000 various other awards, for best prototype design for product used in households, commerce or industry. RESULTS: 1967, Jerry Arnott; 1968, John Holt; 1970, David Henderson.

SHEPPARTON ART GALLERY PRIZE (ANDREW FAIRLEY ART PRIZE)
(1967–75) $1000 acquisitive award for paintings. In 1969 a $200 watercolour award was added, and in 1970 the prize was by invitation only. In 1971 an acquisitive $400 print prize was included and from 1972 to 1975 the prize was for ceramics. RESULTS: 1967, Peter Clarke; 1968, Ronald Millar; 1969, Andrew Sibley, Nada Hunter; 1970, n.i.; 1971, George Baldessin, Jan Senbergs; 1972, Milton Moon, Rynne Tanton, Peter Travis; 1973, n.i.; 1974, Patricia Englund and Samuel Crump (shared), Lorraine Jenyns; 1975, Derek Smith.

SHRINE OF REMEMBRANCE FORECOURT SCULPTURE COMPETITION
(1952) A $350 prize was given and $14,000 made available for expenses in completing the successful work for the forecourt of the National War Memorial of Victoria, St Kilda Rd, Melbourne. Won by George Allen.

SOUTH AUSTRALIAN CENTENNIAL PRIZE
Awarded 1936, to Ivor Hele.

SOUTH AUSTRALIAN SCULPTURE PRIZE
Given at the Adelaide Festival of the Arts, 1968 to Herbert Flugelman.

SOUTHERN MEMORIAL
(1973) Given in Melbourne for painting to Victor Majzner, Patrick O'Carrigan.

SOUTH MELBOURNE CENTENARY PRIZE
(1955) Given by the South Melbourne Council at the South Melbourne Town Hall to Desmond Norman (prize for oil painting), Len Annois (prize for watercolours).

STANTHORPE HERITAGE ARTS FESTIVAL
(1972–) Stanthorpe Art Gallery, PO Box 211, Stanthorpe, Qld 4380. Annual awards of around $20,000 for acquisitions for the Gallery. Consists of various categories including sculpture, painting, prints, ceramics, woodcraft, drawing. Works acquired 1972–93 include those by Frederic Bates, Shirley Bourne, Louis James, Doug Croston, David Rankin, John Armstrong, Andrew Nott, Irene Amos, William Robinson, Staphen Carson, Stephen Killick, Ron Robertson-Swan, Suzanne Archer.

STATE THEATRE ART QUEST
(1929) Conducted by the State Theatre, Sydney. Competition with prizes ranging in value from £50 to £300. Advertised as the £1000 Australian Art Quest, it was judged by Sydney Ure Smith, C. Lloyd Jones, W. Lister Lister and Stuart F. Doyle. WINNERS: C. Wheeler, Mary Edwards, J. R. Jackson, J. D. Moore, W. Dobell, H. Ashton, J. Rowell, Thea Proctor.

SULMAN PRIZE
(1936) Under the terms of a gift from the family of the late Sir John Sulman, the trustees of the AGNSW invite artists to submit paintings and mural designs to the competition which is awarded for the best subject painting, genre painting or design for an intended mural decoration, done by any artist resident in Australia during the two years preceding the date fixed by the trustees for sending in the pictures. In 1960 Mr Arthur Sulman (son of the donor) increased the amount of the prize, formerly $80, to $120. By 1970 the value had risen to $500, with an additional $600 prize offered during the Captain Cook bicentenary celebrations, and by 1981 the value was $5000, which it has remained. RESULTS: 1936, Henry Hanke; 1937, no award; 1938, C. M. Meere; 1939, Gert Sellheim; 1940, Harold Abbott; 1941, Douglas Annand; 1942, Jean Bellette; 1943, Elaine Haxton; 1944, Jean Bellette; 1945, Virgil Lo Schiavo; 1946, Sali Herman; 1947, Douglas Annand; 1948, Sali Herman; 1949, J. Carington Smith; 1950, Harold Greenhill; 1951, Douglas Annand; 1952, Charles Doutney; 1953, Eric Smith; 1954, Wallace Thornton; 1955, Wesley Penberthy; 1956, Harold Greenhill; 1957, Michael Kmit; 1958, no award; 1959, Susan Wright; 1960, Leonard French; 1961, Robin Norling; 1962, John Rigby; 1963, Roy Fluke; 1964, Ken Reinhard; 1965, Gareth Jones Roberts; 1966, Louis James; 1967, Cec Burns; 1968, Tim Storrier; 1969, Louis James; 1970, Michael Kmit; 1971, James Meldrum; 1972, Peter Powditch; 1973, Eric Smith; 1974, Keith Looby; 1975, Alan Oldfield and Geoffrey Proud (shared); 1976, Brett Whiteley; 1977, Salvatore Zofrea; 1978, Brett Whiteley; 1979, Salvatore Zofrea; 1980, Brian Dunlop; 1981, William Delafield Cook; 1982, Salvatore Zofrea; 1983, Nigel Thomson; 1984, Tim Storrier; 1985, Victor Morrison and Public Art Squad (shared); 1986, Wendy Sharpe and Nigel Thomson (shared); 1987, Marcus Beilby and Bob Marchant (shared); 1988, Bob Marchant; 1989, John Olsen; 1990, Robert Hollingworth; 1991/92, Kevin Connor; 1992/93, John Montefiore; 1994, Noel McKenna.

SUPREME COURT GARDENS EXHIBITION PRIZE
(1956) Given in Perth, WA, to William Boissevain.

SWAN HILL PIONEER ART PRIZE
(1976–) Swan Hill Regional Gallery of Contemporary Art, Horseshoe Bend, Swan Hill, Vic. 3585. An annual $2000 prize for purchases of prints and drawings for the Gallery collection. Works acquired 1976–93 include those by Keith Looby, Sam Byrne, Victor Majzner, Charles Bush, Judy Brownlie, William Kelly, Edward Heffernan, Stewart MacFarlane, Michael Narozny, Franz Kempf, Rob Dott, Robert Hollingworth, Deborah Klein.

SYDNEY HARBOUR BRIDGE POSTER COMPETITION
(1937) Won by Douglas Annand.

SYDNEY MORNING HERALD ART PRIZE
(1978–c. 1986) Run by John Fairfax and Sons Ltd, a $500 art prize; a separate art scholarship was also given. (*See* SCHOLARSHIPS)

SYDNEY SESQUICENTENARY PRIZE
(1937) Given in Sydney, to celebrate the Sesqui-centenary of the State. Prizes ranged from 250 guineas to 25 guineas, given in 7 sections. RESULTS: Ivor Hele (historical), B. E. Minns (oil) awarded posthumously), Howard Ashton (landscape), Julian Ashton (watercolour), Oswald Paul (historical watercolour), Frederick Emmanuel (etching), Joshua Smith (drawing). (Hele's winning picture, *Sturt's Reluctant Decision to Return*, a large, dramatic equestrian composition, made Hele known throughout Australia as a possible successor to Lambert.)

SYDNEY TRADE FAIR ART AWARD
Given in 1965 and won by K. Reinhard.

SYDNEY WATER BOARD SCULPTURE COMPETITION
(1939) Given for a set of relief panels for the entrance hall of the Sydney Water Board Building. Won by Margel and Frank Hinder, for work completed in collaboration.

TAA AND AUSTRALIAN NATIONAL ART PRIZE
(1970) Given in Melbourne by Trans-Australia Airlines and the *Australian* newspaper in June 1970. In addition to the

main $2000, $500 and $350 prizes, nine others of $100 each were given and the works of all 12 artists were reproduced in the TAA calendar for 1971. WINNERS: John Olsen, Louis James, John Firth-Smith. Others: Nevil Matthews, Michael Shannon, John Aland, Max Angus, Ron Bence, Andrew Nott, William Rose, Col Jordan, Eric Smith. A special award of $50 was given to the Aboriginal artist Yirawala for a bark painting, *Hunters of the Dream Time*.

TAMWORTH ART SOCIETY AND ART GALLERY PRIZE
(1960–76) Given at Tamworth, NSW, first as a single award of 125 guineas. No award was given 1963–69 but interest revived in 1970 with the Captain Cook Bicentenary celebrations, when two acquisitive awards were given, $600 for drawings or watercolours, $100 for prints. From 1975 the accent was on crafts, specifically weaving, the name changing to the Tamworth Fibre Exhibition, with $1200 available in prizes. RESULTS: 1960, Carl Plate; 1962, John Coburn, Henry Salkauskas; 1963–69, no awards; 1970, A. Edward, Ruth Faerber and Yvonne Gooding (shared); 1971, Henry Salkauskas, Dawn Burston; 1972, Louis James, Patricia Wilson; 1973, Stuart Maxwell, Joan Smith; 1976, Margaret Grafton, Vai Fitzpatrick, Sybil Orr.

TAREE PRIZE
(1954–77) Given at Taree, NSW. Annual award, £350 in 1954, rising to $1,500 in 1977, for the purchase of paintings and works in related media. RESULTS: 1955, Elsie Dangerfield, W. Hawkins; 1956, Max Feuerring; 1957, Alan Grieve; 1960, 1962, Claudia Forbes-Woodgate; 1964, Claudia Forbes-Woodgate, Max Ragless, John Eldershaw, Leon Urbonas, Brian Blanchard; 1966, David Harrex; 1967, Jean Isherwood, Rex Johnson, Pamela Kenny, Louise Rowland, Brian Stratton; 1968, F. Herbert, Colleen Mann; Brian Stratton, V. Massey, Phyllis Brodziak, H. M. Pittaway, Martin Gauja; 1969, Grace Hancock, E. A. Harvey, Peter Powditch, Una Robertson, C. Dudley Wood; 1970, Martin Gauja, Giulio Gentili, Alex D. Lewis, Brian Stratton; 1971, Mario Ermer, Jean Isherwood, Alex MacMillan, Rufus Morris, Lori Sachs; 1972, Mimi Jaksic-Berger, Peter Powditch, John Fisher; 1973, Allan Chawner, Bridgitte Hansen, David Milliss, Ronald Revitt, Joan Smith; 1974, n.i.; 1975, Noel Frith, Victor Majzner, Ron Robertson-Swann; 1976, n.i.; 1977, Tarpie Watts, Patrick Carroll, Thelma Wyner, D. Beal, Joan Ridgers.

TASMANIAN MUSEUM AND ART GALLERY PRIZES
(1970–78) Art awards given at the TMAG during the decade 1970–80. Included: HTC CUM FESTIVAL ART PURCHASE. Established 1970. Sponsor: British Petroleum. Two $500 acquisitive awards given in the categories of 'modern' and 'traditional' paintings, value rising to $2000 by 1973. Winners: 1971, Terence Gough and David Lloyd (shared), Glendon Edwards, Mary Ballantyne Webb; 1973, Max Angus, Patricia Giles, Margaret Thorp, Geoff Tyson; 1975, Jenny Boam, Paul Boam, Anton Holzner, David Nash. TMAG ACQUISITIVE AWARDS: Winners: 1968, Jan Senbergs and Bea Maddock (shared); 1970, Nigel Thomson; 1972, David Harrex; 1974, Christopher Pyett; 1975, Sandra Leveson; 1977, Sydney Ball; 1978, Margaret Dredge.

TASMANIAN SCULPTURE PRIZE
(1973) Given at Hobart, to Ian Bow.

TASMANIAN SESQUICENTENARY ART PRIZE
(1954) Given at Hobart, to J. Carington Smith, Edith Holmes, Edwin Tanner.

TENTH INTERNATIONAL CONGRESS OF ACCOUNTANTS ART PRIZE
(1972) Given in Sydney as a $2500 award for a landscape or seascape. Held at the AGNSW. The winner was Lloyd Rees.

T. E. WARDLE INVITATION ART PRIZE
See PERTH FESTIVAL INVITATION ART PRIZE

TOOHEYS PAINT-PUB ART PRIZE
(1976–1981) Tooheys Brewery $3400 acquisitive award. RESULTS: 1976, Tony Crago; 1977, Robert Newman, Stephen Kaldor, Noel Burrows; 1978, n.i.; 1979, David Hallman, Michael Lodge and Peter Damian Rush (shared), Strom Gould; 1980, Roland Gray, Peter Damian Rush, David S. Badcock, Mario Duarte; 1981, Brian Woolstone, Colleen M. Parker, Helene Grove, George Largent.

TOOWOOMBA ART SOCIETY PRIZE
(1961–c. 1978) Administered by the Toowoomba Gallery, given by the Toowoomba *Chronicle* to celebrate its centenary in 1961. In 1965 an acquisitive award, 100 to 250 guineas, rising to $1400 in 1972, was given by the Art Society to acquire works for the Toowoomba City Art Gallery. Works included those by Andrew Sibley, Alan Martin, Margaret Olley, Veda Arrowsmith, Geoff La Gerche.

TOWNSVILLE ART PRIZE (PACIFIC FESTIVAL AWARD)
(1967–) Townsville Art Society, PO Box 1130, Townsville, Qld 4810. Originally $450 available for acquisitions, $4000 by 1974 and $1500 in 1993. Works acquired include those by S. Fullbrook, A. Silver, Veda Arrowsmith, David Voigt, Andrew Sibley, John Firth-Smith, Anneke Silver, Ron Robertson-Swann, David Voigt, John Lethbridge.

TRANSFIELD PRIZE
(1961–71) National annual art prize originated by Franco Belgiorno-Nettis of Transfield Pty Ltd. The early prize exhibitions were held at David Jones Gallery and the later exhibitions at the Bonython Galleries, Sydney. In 1967 the Transfield Foundry, an Italian-style foundry specially for the casting of bronze sculpture, was also established by the company. The prize was given for a single painting of a specified subject, a restriction later removed. From 1961 it was the richest national prize given for a single painting, and in 1968 it became acquisitive, the value being increased to $5000. By 1971, the year in which it ceased, it was by invitation only. RESULTS: 1961, Jon Molvig; 1962, Andrew Sibley; 1963, Maximilian Feuerring; 1964, Fred Williams; 1965, Roger Kemp; 1966, Norma Redpath; 1967, William Rose; 1968, John Peart; 1969, Ron Robertson-Swann; 1970, Bill Clements; 1971, Aleksander Danko. (*See also* BIENNALE OF SYDNEY)

TRAVELODGE ART PRIZE
(1970–73) National acquisitive invitation art prize for painting for the purpose of building up the Travelodge Collection. The idea of the prize started with the Collection, which began in Melbourne in 1969. The prize exhibitions were held at Travelodge motels in Melbourne and Sydney. In addition to the $7500 paid for the winning painting, other paintings were purchased. Chairman of the Collection, Michael Parker. RESULTS: 1970, Donald Laycock; 1971, John Brack; 1972, Fraser Fair; 1973, David Aspden.

TRUSTEES PRIZE
(1972–?) Administered by the QAG a $2500 annual award for painting was awarded to Sandra Leveson (1972); Sydney Ball (1973); Nora Heysen (1975); Richard Larter (1976); Janet Dawson (1977) and Rod Withers (1978).

TRUSTEES WATERCOLOUR PRIZE
(1961–) Trustees of the AGNSW, Sydney, NSW. $400 awarded annually at the AGNSW in conjunction with the Archibald, Wynne and Sulman prizes. Winners have included Len Annois, Joy Roggenkamp, Eva Kubbos, Frederic Bates, Fred Williams, Frank McNamara, Kenneth Jack, Max Miller, Guy Warren, Elwyn Lynn, John Wolseley, Suzanne Archer, Cressida Campbell, Robert Clinch.

UNIVERSITY OF NEW SOUTH WALES ART PRIZES
See SCHOLARSHIPS

UNIVERSITY OF WESTERN AUSTRALIA PRIZES
(1965–) Intermittent prizes for painting, prints and sculpture, given at the Uni. of WA, Perth. RESULTS: 1965, Craig Gough; 1966, George Haynes; 1971, Campbell Cornish; 1972, Leon Pericles; 1973, Malcolm Leckie; 1976, Lindsay Pow.

VICTORIAN ARTISTS' SOCIETY PRIZES

(1946–) VAS, 430 Albert St, East Melbourne, Vic. 3002. Regular VAS prizes, available to members, began with donations of small annual prizes in about 1946. Annual painting prizes began with the £100 *A. H. Gibson Prize* which started in 1954. This was followed by prizes given intermittently by Applied Chemicals Pty Ltd, ANZ Bank, Barnet-McCutcheon, Camden Art Centre, Dr E. T. Cato, R. Crawford, W. G. Dean Ltd, Alistair Gray, Herald and Weekly Times Ltd, G. K. Luke, Melbourne City Council $1000 Award (sometimes called the *Lord Mayor's Acquisitive Art Award*), Norman Bros, and L. Voss Smith.

VICTORIAN SCULPTOR'S SOCIETY PRIZE

(1953–64) Sponsors: Oswald Burt, A. H. Gibson, Stanley Hammond. RESULTS: 1953, Norma Redpath; 1954, Max Lyle; 1964, Graeme Johnson.

VICTORIAN STATE HOUSES OF PARLIAMENT SCULPTURE COMPETITION

(1887) Given in Melbourne for relief carvings for the Victorian State Houses of Parliament to Edgar Mackennal.

VIZARD-WHOLOHAN PRIZE (MAUDE VIZARD-WHOLOHAN PRIZE)

(1957–77) Conducted by the Royal SA Society of Arts, in conjunction with the AGSA, under the terms of the Elizabeth Maude Vizard-Wholohan bequest. £300 given for landscapes or seascapes in oil, £100 for watercolours, and £25 for prints, rising to £3000, £750 and £200, respectively, by 1969. In 1963, £500 was made available from accumulated funds for a special sculpture prize, and in 1969 $1500 was given specially for a portrait. The winning pictures went to the AGSA which had the option of retaining or disposing of them later. RESULTS: 1957, Louis James, Hans Heysen, Alan Glover; 1958, Clifton Pugh, Hector Gilliland, Lesbia Thorpe; 1959, John Perceval, Charles Bush, Brian Seidel; 1960, no award for oil-painting, Len Annois, Robert Grieve; 1961, James Cant, Kenneth Jack, Brian Seidel; 1962, Jacqueline Hick, Len Annois, Eileen Mayo; 1963, William Peascod, Kenneth Jack. The 1963 sculpture prize attracted between 20 and 30 entries from all parts of Australia, but the judges decided that no entry fulfilled their expectations and no prize was awarded. 1964, Jacqueline Hick, H. Salkauskas, Lesbia Thorpe; 1965, D. Roberts, B. Seidel, P. Medlan, E. Baneth (sculpture); 1966, no award for oil painting, Mervyn Smith (watercolour), Geoffrey Brown (print); 1967, B. Seidel, F. Kempf (two prizes); 1968, no awards given; 1970, Samuel Fullbrook, Cecil Hardy; 1972, Peter Powditch; 1976, Alan Oldfield; 1977, Ivan Durrant; n.d., Murray Griffin.

WAGGA WAGGA INVITATION ART PURCHASE AWARDS AND ART PRIZE

(1951–78) Conducted by the Wagga Wagga City Art Gallery, the original Art Prize was given 1951–62, as an annual $100 non-acquisitive award. RESULTS: 1956, K. Jack; 1957, Ronald Kirk; 1958, Sali Herman; 1959, T. J. Santry, U. Abolins; 1960, Roger Hallett; 1961, Brian Sullivan, Joe Rose; 1962, Elwyn Lynn, Jean Isherwood. The prize was in recession, 1963–75, after which it resumed as a $2500 acquisitive award given in three sections with the aim of building up the collections for the new Wagga Wagga City Art Gallery (*see* GALLERIES). SPONSORS: Wagga Wagga City Council ($1000), Wagga Wagga Art Society ($750), R. W. Haste and Associates ($750). RESULTS: 1976, Kate Briscoe; 1978, John Coburn, Brian Seidel, Geoff Harvey. In 1981 the prize was replaced by the biennial *Wagga Wagga Contemporary Glass Exhibition*, an acquisitive $5000 award aimed at building up the Wagga Wagga City Art Gallery special glass collections.

WALKLEY AWARDS

(c. 1960–) Annual prestigious awards for journalists given annually by W. S. Walkley through the Australian Journalists' Association (from 1992, the Media, Entertainment and Arts Alliance), including awards for black-and-white cartoons, and illustrations in colour. Artists who have won include James Phillips, Arthur Boothroyd, Paul Rigby, Cedric Baxter, Larry Pickering, P. Nicholson, M. Leunig, J. Spooner.

WARRINGAH ART PRIZE

(1956–) Warringah Shire Council, Civic Centre, Pittwater Rd, Dee Why, Sydney, NSW 2099. It began when seven paintings to the value of £125 were purchased from an exhibition conducted by the Warringah Shire Council. A formal competition was conducted in 1957 with awards totalling £70. The competition was re-established 1976 as an acquisitive award with $3000 available and prize money in 1993 was $8500. Artists whose work has been acquired include Weaver Hawkins, Peter Laverty, Ruth Faerber, Susanne Archer, Lindsay Pow, Newton Hedstrom.

WELLINGTON TOURIST FESTIVAL ART PRIZE

(1962–64) £200 competition organised as part of the annual tourist festival at Wellington, NSW. Held in 1962 and again in 1964. RESULTS: 1962, Margo Lewers, Jean Isherwood, Ann Young (local), Jack McDonough (popular choice); 1964, Garth Dixon, Hector Gilliland.

WHYALLA ART PRIZE

(1978) Conducted in Adelaide, by the Arts Council of SA. The winners were Basil Hadley, Lindsay Kerr, Max Lyle.

WILLS (W. D. & H. O. WILLS) PRIZE

(1960–66) £525 given annually by the Wills company at David Jones Gallery, Sydney. RESULTS: 1960, D. Strachan and F. Bates (shared); 1961, J. Eldershaw; 1962, F. Hodgkinson; 1963, C. Reddington; 1964, L. French; 1965, I. Fairweather; 1966, F. Williams.

WINEMAKERS' ART PRIZE

(1965) Organised by the manager of the Wine and Brandy Producers Association of Vic., Christopher Daniels, as a 1000 guinea prize 'for paintings on the theme of the Australian wine industry'. Winners were Andrew Sibley and Michael Shannon (shared). The exhibition was held at the Argus Gallery, Sept. 1965.

WOLLONGONG ART PURCHASE PRIZE

(1956–c. 1981). Given at Wollongong, NSW. An acquisitive annual award, originally £500, rising to $1500 in 1977. Works from the prize formed the nucleus of the Wollongong collection. In July 1979, the Metal Trades Industry offered to fabricate a major public sculpture as a contribution to the Festival of Wollongong, and $5000 was donated by the Visual Arts Board to acquire maquettes submitted in the competition. Works included those by U. Abolins, K. Connor, H. Salkauskas, D. Rose, E. Lynn, D. Aspden, Col Jordan, Fred Bates, Desiderius Orban, Mimi Jaksic-Berger, George Baldessin, Peter Powditch, Ron Lambert, Jan Senbergs, Colin Jordan, David Rankin, John Peart, Rollin Schlicht, Allan Mitelman, John Lethbridge, Fred Cress, David Voigt, Ken Whisson, Max Miller, Vicki Varvaressos, Suzanne Archer, Ian Gentle.

WOOL BOARD PRIZE

Given in Sydney, 1953 to Bim Hilder.

WYNNE PRIZE

(1897–) The longest-running art prize in Australia. Given at the AGNSW and judged by the trustees of the Gallery simultaneously with the Archibald and Sulman prizes. Richard Wynne bequeathed £1000 from which the income would be awarded annually for a prize for landscape or sculpture in his name. The value of the prize fluctuated from £27 in 1897 to £55, then dropped to £45, and then finally to £40, at which figure it remained for many years. For the competition held in January 1961 the trustees of the AGNSW increased the amount to £200 from trustees' funds, and in 1961 an additional £100 was offered for watercolours (*see* TRUSTEES WATERCOLOUR PRIZE). By 1981 the value of the Wynne had risen to $10,000, which it remained. RESULTS:

1897, Walter Withers; 1898, W. Lister Lister; 1899, G. W. Lambert; 1900, Walter Withers; 1901, W. C. Piguenit; 1902, James S. White; 1903, E. Officer; 1904, Hans Heysen; 1905, A. J. Hanson; 1906, W. Lister Lister; 1907, G. W. L. Hirst; 1908, Will Ashton; 1909, Hans Heysen; 1910, W. Lister Lister; 1911, Hans Heysen; 1912, W. Lister Lister; 1913, W. Lister Lister; 1914, Penleigh Boyd; 1915, J. C. Wright; 1916, Elioth Gruner; 1917, W. Lister Lister; 1918, W. B. McInnes; 1919, Elioth Gruner; 1920, Hans Heysen; 1921, Elioth Gruner; 1922, Hans Heysen; 1923, G. W. L. Hirst; 1924, Hans Heysen; 1925, W. Lister Lister; 1926, Hans Heysen; 1927, G. Rayner Hoff; 1928, Arthur Streeton; 1929, Elioth Gruner; 1930, Will Ashton; 1931, Hans Heysen; 1932, Hans Heysen; 1933, Lyndon R. Dadswell; 1934, Elioth Gruner; 1935, J. Muir Auld; 1936, Elioth Gruner; 1937, Elioth Gruner; 1938, Sydney Long; 1939, Will Ashton; 1940, Sydney Long; 1941, Lorna Nimmo; 1942, Douglas Watson; 1943, Douglas Dundas; 1944, Sali Herman; 1945, Douglas Watson; 1946, Lance Solomon; 1947, Russell Drysdale; 1948, William Dobell; 1949, George Lawrence; 1950, Lloyd Rees; 1951, Charles Meere; 1952, Charles Bush; 1953, Lance Solomon; 1954, Arthur Evan Read; 1955, Charles Bush; 1956, L. Scott Pendlebury; 1957, L. Scott Pendlebury; 1958, Ronald Steuart; 1959, Reinis Zusters; 1960, John Perceval, L. Scott Pendlebury; 1961, David Strachan; 1962, Sali Herman; 1963, Sam Fullbrook; 1964, D. Strachan and Sam Fullbrook (shared); 1965, Sali Herman; 1966, Fred Williams; 1967, Sali Herman; 1968, L. Scott Pendlebury; 1969, John Olsen; 1970, Frederic Bates; 1971, Margaret Woodward; 1972, Eric Smith; 1973, Clem Millward; 1974, Eric Smith; 1975, Robert Juniper; 1976, Fred Williams; 1977, Brett Whiteley; 1978, Brett Whiteley; 1979, Robert Juniper; 1980, William Delafield Cook; 1981, David Voigt; 1982, Lloyd Rees, 1983, David Rankin; 1984, Brett Whiteley; 1985, John Olsen; 1986, Rosemary Madigan; 1987, Ian Bettinson; 1988, Elwyn Lynn; 1989, Ian Bettinson; 1990, William Robinson; 1991/92, Peter Schipperheyn; 1992/93, George Gittoes; 1994, Suzanne Archer.

YORICK CLUB ART PRIZE
(1953–63) Fifty guinea annual award for watercolours given by the Yorick Club, Melbourne.
RESULTS: 1953, Peg Tremill; 1954, Kenneth Jack; 1955, Hector Gilliland; 1956, Eric Thake; 1957, Peg Tremill; 1958, John L. Borrack; 1959, no award made; 1960, Jack Freeman; 1961, Gordon Speary, 1962, Judith Wills 1963 Peter Glass.

YOUNG (CHERRY FESTIVAL) ART PRIZE
(1962–64) Given at Young, NSW, in sections including oil painting, religious motif painting, ceramics and local artists. 350 guineas available. RESULTS: 1962, H. Gilliland, H. Boyer; 1963, J. Coburn, E. Lynn, T. J. Santry, C. Plate, W. White, W. Garnsey, J. McPherson, M. Addison, L. Young; 1964, S. F. Bissieta, W. Peascod.

SCHOLARSHIPS
Because of the distance of Australian capital cities from the world's great art centres, before the advent of air-travel, travelling scholarships were vitally important to Australian students. For more than sixty years the richest of these was the NGV Art School Travelling Scholarship, and its successor, the Keith and Elisabeth Murdoch Fellowship, given at the Victorian College of the Arts. The 1950s saw the beginning of scholarships and prizes given by various instrumentalities for studies in Italy. They foreshadowed a number of travelling scholarships which took precedence over those given in art schools, the NGV Schools scholarship in particular having greatly declined in value. Because of what it offered in rewards during its eight years of existence (1958–66), the Helena Rubinstein Travelling Scholarship attained national significance. But it was not a travelling scholarship for students; like most of the others given by the corporate sector, it demanded both experience and sophistication from its winners. The Australia Council and the various state ministries for the art from the 1970s became important funding bodies for visual artists. Although not offering student scholarships the project grants, overseas residencies and fellowships available in particular from the Australia Council offer opportunities similar to scholarships and have become important facets of on-going individual development. The following list is selective. For information about all current scholarships the booklet *Money for Visual Arts* by the National Association of Visual Arts (q.v.) is strongly recommended.

ADELAIDE SCHOOL OF MINES SCHOLARSHIP
(c. 1920) Awarded to Arthur Boxall.

ALCORSO-SEKERS TRAVELLING SCHOLARSHIP
(1966–68) $2000 given for sculpture, sponsored by Silk and Textile Printers Ltd. Interstate entries were preselected at the State galleries and sent to the AGNSW for final judging. RECIPIENTS: 1966, George Baldessin; 1967, Mike Kitching; 1968, Michael Young.
(*See also* PRIZES–ALCORSO PRIZE)

BALE (A.M.E. BALE) SCHOLARSHIP
(1969–78) Originally a committee of trustees, including W. A. Dargie, Max Meldrum, John Rowell; later the Charitable Trusts Officer, Perpetual Trustees, Melbourne. Established under the terms of Alice Bale's (q.v.) will to 'encourage painting in representational or traditional art'. The winner received an allowance to further his/her art education plus free use of the late A. M. E. Bale's furnished house and studio in Kew. Because of inadequate funds available, there was no award between 1980–82 and the estate was sold to provide funding for a cash scholarship. The scholarship has since allowed for a period of up to two years travel to European galleries which may be supplemented by a further scholarship. In 1993, the travelling scholar-ship is $40,000 and cash prizes in oils/acrylics or watercolours of $4000 and $2000 are also given. RECIPIENTS: 1969, Robert Hannaford; 1972, David Moore; 1975, John Perry; 1978, Peter Wegner; 1982 Maxwell Wilks & Patricia Moran (two awards); 1983 Angela Abbott; 1985 Hilary Jackman; 1986 Barbara McManus; 1987 Paul Tyquin; 1991 Paul Marshall; 1992 Christopher Browne.

BALLARAT CITY COUNCIL SCHOLARSHIP
(c. 1919) The only recorded winner was Victor Greenhalgh

BASIL AND MURIEL HOOPER SCHOLARSHIPS
Administered by the AGNSW for art students and available annually for those not holding other scholarships to an amount of $6000 for costs of materials, fees and living expenses.

CHURCHILL FELLOWSHIPS
(The Sir Winston Churchill Memorial Trust)
(1965–) 218 Northbourne Avenue, Braddon, ACT 2601. Trust fund of $1 million. subscribed by the public and administered by a board, initially under the chairmanship of Sir Robert Menzies, who originated the scheme. Awards are made in a variety of professions. Artists have included Colin Blumson, Frank Eidlitz, Milton Moon, Margaret Sinclair, Cecily Gibson, Stan Ostoja-Kotkowski, Peter Rushforth, Kenneth Hood, Guy Boyd, Michael Meszaros, Voitre Marek, Matcham Skipper, Mona Hessing, Tom Sanders, Raoul Mellish, V. W. Greenaway, Graeme Peebles, D. L. Jack, N. J. Birrell, Anton Dabro.

COMMONWEALTH ART ADVISORY BOARD SCHOLARSHIP
(1961) Awarded to Brett Whiteley (for study in France).

DUTCH GOVERNMENT SCHOLARSHIP
(1963–75) Awarded by the Netherlands Government to encourage artists and art curators to visit Holland. RECIPIENTS: 1963, Ursula Hoff; 1965, A. McCulloch; 1975, Hendrik Kolenberg.

DYASON BEQUEST AWARDS

(1960–) AGNSW. Administered under the terms of the will of the late Miss Anthea Dyason, provides grants to Australian art students who have already won travelling art scholarships so that such students will be better able to study architecture, sculpture or painting in countries other than Australia and New Zealand. The amount in 1993 is $5000. Artists who have received the award include Elizabeth Cummings, Charles Blackman, Leonard French, Julius Kane, Erica McGilchrist, David Gillison, Brett Whiteley, Norma Redpath, Janet Alderson, David Boyd, Thomas Gleghorn, Robin Norling, Joan Swinbourne, Janet Alderson, Michael Taylor, Eric Smith, Fred Williams, Colin Lanceley, John Montefiore, Jan Senbergs, Edward Binder, Arthur Douglas Wicks, Richard Dunn, Peter Pinson, Irene Krumins, Ian Howard, Anthony Galbraith, Irene Barbaris, David Hawkes, Tim Burns, Marion Borgelt, Bronwyn Oliver.

ENGLISH-SPEAKING UNION PRIZE AND SCHOLARSHIP
See PRIZES

FRENCH GOVERNMENT SCHOLARSHIPS

In 1964, the French Embassy, Canberra, began a program of inviting Australians, representative of the visual arts, to visit France for periods of three months as guests of the French Government. One of the early results was the purchase of Australian studios at the Cité Internationale des Arts, Paris. Invitees were: 1964, Michael Scott; 1965, Alan McCulloch; 1966, Eric Westbrook; 1967, Donald Cameron, Arthur Wicks.

GERMAN ACADEMIC SCHOLARSHIPS

(1960–?1982) Available to young Australian graduate students of painting, sculpture or music (between 18 and 32), for study in academies of art or music in the Federal Republic of Germany. Travel, accommodation and tutorial fees were offered for a period of one year. RECIPIENTS: 1960–62, Erica McGilchrist; 1970–72, Robert Brunswick; 1971–72, Katrina Rumley; 1971–72, Lutz Presser; 1972–73, Silvio Apponyi; 1973–74, Lawrence Bradford; 1974–76, Irene Krumins; 1975–76, Peter Stephenson; 1975–76, Rosemary Aliukonis; 1976–77, Christopher Croft; 1977–78, Ulrich Stalph; 1977–78, Michael Iwanoff; 1979–80, Rolf Meumann; 1979–80, Andrew Hughes; 1981–82, William Holden; 1981–82, Penelope Algar.

HOBART TECHNICAL SCHOOL TRAVELLING SCHOLARSHIP
See TASMANIA TRAVELLING SCHOLARSHIP

ITALIAN SCHOLARSHIPS

(1951–68) Given by the Italian Government, in Sydney, in conjunction with Flotta Lauro and Lloyd Triestino Shipping Companies and Dante Alighieri Society, for the purpose of enabling Australian artists to study in Italy. Later scholarships were given in other capital cities, some being awarded by application, on a noncompetitive basis. Winners received return fare to Italy, and a living allowance. The principal scholarships were decided usually at special exhibitions arranged in conjunction with state galleries in Sydney or Melbourne. RECIPIENTS: Sydney, 1951, Donald Friend; 1952, 1953, n.i.; Melbourne, 1954, Diana Robinson; 1955, Shirley Mary O'Leary, James Meldrum; 1956, Sidney Nolan; 1957, Lawrence Daws; 1958, John Rigby, June Caroline Young, Kathleen Boyle; 1959, Stephen Walker, Anne Marie Graham, Narelle Webster; 1960, Brett Whiteley, W. Delafield Cook; 1961, David Boyd, Joan Alexandra Swinbourne, Ernest Smith; 1962, Norma Redpath, Matcham Skipper, Norma Margaret Slevison, Maurice Cantlon, Murray Walker; 1965, Andor Meszaros; 1967, Domenico de Clario.
(*See also* PRIZES–FLOTTA LAURO ART AWARD)

JAPANESE GOVERNMENT SCHOLARSHIP
Given in 1964 to Bill Clements for study in Japan.

KEITH AND ELISABETH MURDOCH TRAVELLING FELLOWSHIP
In 1971 the original NGV Travelling Scholarship was replaced by the Keith and Elisabeth Murdoch Travelling Fellowship, given 1971, 1974 at the NGV, and from 1977 at the Victorian College of the Arts, for graduate VCA students. Instituted by Dame Elisabeth Murdoch to commemorate the long association of the Murdoch family with the visual arts in Victoria. Its monetary value is realistic and subject to periodical readjustment in accordance with fluctuating conditions. In 1983 the value was $12,000 and in 1993, $15,000.

McCONNELL TRAVELLING SCHOLARSHIP
Awarded in Brisbane, Qld, 1910, to William Leslie Bowles.

MARTEN BEQUEST TRAVELLING SCHOLARSHIPS

(1982–) The Marten Bequest, Permanent Trustee Company Limited, GPO Box 4270, Sydney, NSW 2000. $5800 for two-year tenure. Painters, sculptors or architects 'natural born British subjects born in Australia' and aged between 21 and 35. Given first in 1983 under the will of the late John Chisholm Marten, the scholarships are intended to augment the scholar's own resources towards study, maintenance and travel, either in Australia or overseas.

MOBIL FELLOWSHIPS IN ARTS ADMINISTRATION
(1980–) Established by Mobil Oil Aust. Ltd to help people skilled in arts management to further their training. $10,000 is available for two fellowships.

MOYA DYRING MEMORIAL FELLOWSHIP

(1970–) Bequeathed by Moya Dyring (q.v.), the Moya Dyring Studio, Cité Internationale des Arts, Paris is administered by the AGNSW. Available to established Australian artists and advanced students from periods of from two to six months. Over 100 artists have been awarded a residency 1970–93 including Carl Plate, Francis Bennie, Stanislaus Rapotec, Noel Counihan, Richard Watkins, Charles Blackman, Imants Tillers, Howard Arkley, Margaret Olley, Diego Latella, Idris Murphy, Kevin Connor, Laurel McKenzie, Lynne Roberts Goodwyn, Anthony Mortimer, Ken Whisson, Judy Cassab, Yvonne Boag, Guy Warren, William Delafield Cook, Anthony Galbraith, Elisabeth Cummings, Ian Bettinson.

NATIONAL GALLERY OF VICTORIA TRAVELLING SCHOLARSHIP

The National Gallery of Victoria Travelling Scholarship was the richest prize available to Australian students from 1886, the year in which it was established, £450 of the money from the loan exhibition which marked the opening of the main gallery buildings in 1869 having been invested for this purpose. The scholarship, worth £150 per annum, from 1886 to 1920, was awarded every three years; it provided winners with the means of three years study in Europe during which time they were required to give evidence of their progress by sending to the gallery one original picture and one copy of an old master. From 1923 to 1944 the scholarship became £225, tenable for two years, and from 1947 to 1953, £350 for two years, plus fares to the value of £200. From 1959 the winner received £400 for two years plus £200 for fares. The first seven scholarships (1887–1905) were won by men, the next nine (1908–32) by women. RECIPIENTS: 1887, John Longstaff; 1890, Aby Altson; 1893, James Quinn; 1896, George Coates; 1899, Max Meldrum; 1902, Myer Altson; 1905, Isaac Cohen; 1908, Constance Jenkins; 1911, Winifred Honey; 1914, Ethel Bishop; 1917, Marion Jones; 1920, Adelaide Perry; 1923, Jean Sutherland; 1926, Nancy Guest; 1929, Constance Parkin; 1932, Eileen Robertson; 1935, Clifford Bayliss; 1938, Oswald Hall; 1941, Nornie Gude; 1944, Laurence Phillips; 1947, Douglas Green; 1950, Rod Clark; 1953, Frances Ferrier; 1956, Janet Dawson; 1959, David Gillison; 1962, Mark Pearse; 1965, Patrick Moss; 1968, Rick Amor. In 1971 the National Gallery of Victoria Travelling Scholarship became the Keith and Elisabeth Murdoch Travelling Fellowship (q.v.), given at the Victorian College of the Arts.

NEW SOUTH WALES SOCIETY OF ARTISTS TRAVELLING SCHOLARSHIP

(1900–) First awarded in 1900. Between 1901–22, no scholarship was given. It was revived 1923, when £250 p.a. for two years was given. RECIPIENTS: 1900, G. W. Lambert; 1923, Roy de Maistre; 1925, Arthur Murch; 1927, Douglas Dundas; 1929, William Dobell; 1931, Harold Abbott; 1933, Arthur Freeman. In 1934 the NSW Government appointed a trust giving representation to the rival societies – the NSW Society of Artists and the Royal Art Society of NSW – to control the scholarship. The subsequent history of the scholarship is covered in the next entry.

NEW SOUTH WALES TRAVELLING ART SCHOLARSHIP

(1934–) NSW Ministry for the Arts, PO Box 810 Darlinghurst, NSW 2010. In 1934 the scholarship grants to the New South Wales Society of Artists and the Royal Art Society of New South Wales were taken over by the government, to form a single New South Wales Travelling Art Scholarship of £250 per annum, available for two years for figure painting or sculpture. The Travelling Scholarship works are exhibited and judged at the AGNSW. The many changes that took place from 1934 are noted chronologically. RECIPIENTS: 1935, Rhoda Barbara Tribe (sculpture); 1936, Jack Carington Smith; 1937, Eric Wilson. (In 1937 tenure of the original scholarship was extended to three years and a £250 scholarship for landscape, available for one year, was substituted in each alternate year.) 1938, Wallace K. Thornton; 1939, Lance Solomon (landscape); 1940, Douglas Watson. (During the war, the scholarships became available within Australia until the cessation of hostilities.) 1941, Lorna M. Nimmo (landscape); 1942, Harold T. Greenhill; 1943, John Wilfred Peisley (landscape); 1944, Anne Wienholt; 1945, Frederick Arthur Jessup (landscape). (In Sept. 1945, the landscape scholarship was abandoned, and from 1946 the scholarship was awarded biennially.) 1946, Ena Joyce; 1948, Oliffe Richmond (sculpture). (In 1949 the amount of the scholarship was increased to £375.) 1950, Rosemary Giles. (In 1950 the age limit was lowered to 28 years and in 1951 the amount was further increased to £395.) 1952, no award; 1954, Earle Backen; 1956, John George Henshaw (amount increased to £500); 1958, Elisabeth Cummings (age limit extended to 35); 1960, Michael Franklin Taylor; 1962, Robin Norling; 1964, John Montefiore; 1966, Richard Dunn; 1968, Peter Pinson; 1970, no award; 1972, Ian Howard; 1974, Denis Edwin Clarke; 1975 (awarded annually), Ann Frederick Jensen; 1976, Edwina Massie-Maxwell; 1977, Diego Lorenzo Latella. In 1978 the value of the scholarship became $2,850 and in 1993 $15,000 for a period of two to three years, available to art students under 26 years of age with three years' continuous residency in Australia. Winners since 1978

have included Anthony Mortimer, Martin Coyte, Ingrid Van Dyck and Bronwyn Oliver.

PHILIP MORRIS ARTS GRANT
See PRIZES

QUEENSLAND WATTLE LEAGUE SCHOLARSHIP
Intermittent (approximately £150 given) RECIPIENTS: Robert P. Cummings (n.d.); 1914, Daphne Mayo. (*See also* HALF DOZEN GROUP OF ARTISTS)

ROYAL ART SOCIETY TRAVELLING SCHOLARSHIP
See NEW SOUTH WALES SOCIETY OF ARTISTS TRAVELLING SCHOLARSHIP

ROYAL MELBOURNE INSTITUTE OF TECHNOLOGY TRAVELLING SCHOLARSHIP
Awarded 1971 to Ermes de Zan.

ROYAL QUEENSLAND ART SOCIETY PRIZE AND SCHOLARSHIP
See PRIZES

RUBINSTEIN SCHOLARSHIP

(1958–66) Given by Helena Rubinstein and organised by its first and only chairman, Hal Missingham, as a £1300 annual travelling scholarship for Australian painters, specifically for an oil painting on canvas. Not more than twelve painters were selected annually by the appointed judging panel to enter four works each. The exhibitions were held six times in Sydney, once (1960) in Melbourne, and once (1966) in Adelaide, to coincide with the Adelaide Arts Festival. Given during a period of sparse encouragement for artists, the scholarship was the most important open competitive art event in Australia and consequently caused great excitement. RECIPIENTS: 1958, Frank Hodgkinson; 1959, John Passmore; 1960, Charles Blackman; 1961, Tom Gleghorn; 1962, Eric Smith; 1963, Fred Williams; 1964, Colin Lanceley; 1965, no award; 1966, Jan Senbergs.

SYDNEY MORNING HERALD ART SCHOLARSHIP

(1978–c. 1982) A $2,500 art scholarship, including travel expenses, for study in Europe. A separate art prize was also given (*see* PRIZES). RECIPIENTS: 1978, Paul Jones; 1979, Angus Niveson; 1980, David Hawkes; 1981, Jerry Liew.

TASMANIAN TRAVELLING SCHOLARSHIP

(1949–57) Given at the Hobart Technical College. It ceased owing to lack of funds. RECIPIENTS: 1949, Dorothy Bradford; 1951, George Arthur Davis; 1953, Gwen Leitch.

UNIVERSITY OF NEW SOUTH WALES ART PRIZE AND SCHOLARSHIP

(1979–1982) The Prize was a $5000 biennial acquisitive award; the biennial Travelling Scholarship provides $2000 for an artist under thirty. RECIPIENTS: 1979, Janet Dawson; 1981, Peter Wild. SCHOLARSHIP: 1979, no award made; 1981, Margaret Morgan.

SCHOOLS AND UNIVERSITIES

SCHOOLS

Art teaching in Australia virtually began with the first artists. In early colonial times, J. W. Lewin and Richard Read both taught art in Sydney, as did Thomas Bock in Hobart. Public art teaching began in that city in 1826, with the Van Diemen's Land Mechanics School of Art, followed in Sydney, in 1843, by the Sydney Mechanics School of Art. Conrad Martens was teaching in Sydney in the 1840s and the goldrushes of the 1850s found many artists, such as S. T. Gill in Adelaide, William Strutt in Melbourne, and William Dexter in Sydney, seeking to improve their meagre incomes by taking pupils. The School of Design, Adelaide, which started in 1861, laid the foundations of public art teaching in South Australia, while in Melbourne the various Artisans' Schools of Design which began in 1867 were the forerunners of the National Gallery of Victoria Art School which opened in 1870 and maintained its position as the leading centre of academic art training in Australia for more than 40 years. The era of black-and-white art changed the situation by focusing attention on illustration and 'art nouveau', and before the outbreak of World War I the centre of art student life had switched to Julian Ashton's school in Sydney. Ashton's became a mecca for half the aspiring artists in Australia and helped to produce a whole generation of successful painters and illustrators. Much of the school's success was due to G. W. Lambert's legendary name, and its influence was carried on by teachers like Lambert's protege, Thea Proctor, who performed also the delicate service of linking the academic with the new modernist movements then coming into vogue. Ashton's School, however, went into decline with the death of its founder, and the centre of inspired art teaching moved to the East Sydney Technical College. Meanwhile, interspersed with this long period of academic art teaching were a number of schools or classes run by individual teachers. Among these, the most distinguished names recorded in Queensland are Godfrey Rivers, L. J. Harvey and F. J. Martyn Roberts; and in South Australia, J. B. Mather and James Ashton. Western Australia records the names of Frederick M. Williams, J. R. Linton and A. B. Webb; Tasmania had Lucien Dechaineux; and New South Wales, A. Dattilo Rubbo and J. S. Watkins. The Melbourne School conducted by E. Phillips Fox and T. St G. Tucker was unique but has never been properly identified. Though tied to their academic backgrounds, both partners in the school brought to their teaching what they had learned of French impressionism in Paris. Their insistence on the importance of light, colour, texture and atmosphere was quite contrary to the teaching at the NGV, and their school may therefore be considered as an important link with the modernist movements that erupted in the 1920s. Preceding that movement in Melbourne was the Meldrum School, which was strongly opposed to modernism

in all its forms. The cult of the Meldrumites had a large following in Victoria in the 1920s and early 1930s. In the mid 1920s Roland Wakelin, Rah Fizelle and Grace Crowley pioneered modernist teaching in Sydney; George Bell, Arnold Shore and William Frater performed a similar service for art in Melbourne, while in Adelaide students had their first lessons in post-impressionism and cubism from Dorrit Black and Margaret Preston.

During and after World War II, Sydney students learned much from Desiderius Orban at his school in Sydney but, with this exception, little that was new happened in practical art teaching. Theoretical teaching, however, had grown swiftly with the development of departments of fine arts in universities and graduates in fine arts were becoming increasingly influential as art critics and administrators. During the 1970s the educational and technological explosion that affected all teaching in Australia dramatically changed the situation, the various TAFE schools with their constantly changing names becoming in all states the principal centres of art teaching. In the 1980s huge rearrangements also occurred in all states (especially NSW and Victoria) with a number of tertiary colleges amalgamating with universities – with often quite geographically distant campuses linked under the one administrative umbrella.

Universities

The introduction of fine art studies in Australian universities began at the University of Melbourne in 1946 with the *Herald* Chair of Fine Arts initiated by the chairman of the NGV Committee of Trustees and also of the Herald and Weekly Times newspaper group, Sir Keith Murdoch, a strong advocate for the establishment of departments of fine arts in all Australian universities. His company gave an initial £30,000, augmented later with an additional £20,000. Interest in the visual arts as part of university life in Australia received great impetus from the announcement of the Power Bequest (q.v.) to the University of Sydney in 1961 and since then there has been rapid increase in university recognition of the importance of the visual arts as an aid to university education at universities throughout the country.

SCHOOL AND UNIVERSITY LISTINGS

While the information was current in 1993, the following listings are made from a historical viewpoint. For latest details on courses offered the institutions may be contacted directly.

ACADEMY OF ARTS

(1895–1927) Conducted in Adelaide by James Ashton after the closure of the Norwood School (q.v.).

ADELAIDE CENTRAL SCHOOL OF ART PTY LTD

(Established 1980) PO Box 7003, Hutt St, Adelaide 5000. Privately owned school of art established by Rod Taylor

and offering 9 visual art subjects including 3 drawing subjects; painting; printmaking; general designs; history and criticism.

ADELAIDE COLLEGE OF ARTS AND EDUCATION
(1861–1982)
See SOUTH AUSTRALIAN SCHOOL OF ART

ALEXANDER MACKIE COLLEGE OF ADVANCED EDUCATION
(1975–81) School of Art, 99 Flinders St, Surry Hills, Sydney. Created through the amalgamation of the National Art School (q.v.) with the Alexander Mackie Teachers Coll. It became part of the new Sydney CAE in 1982, and the Art School became the City Art Institute (q.v.) within the Sydney CAE. It became the College of Fine Arts, University of NSW in 1990. The *Ivan Dougherty Gallery* (founded 1977) also became a part of the University of NSW.
(*See* COLLEGE OF FINE ARTS, UNIVERSITY OF NSW)

ARTISANS' SCHOOL OF DESIGN
(Founded Melbourne, 1867) Established at the instigation of a group of artists, painters and decorators, they were the first public institutions offering art instruction in Melbourne. Initiators included Samuel Hartley Roberts, T. Kilby, R. Crichton, T. Javerin, C. L. Fletcher, W. Murray. Hartley Roberts conducted the largest school at the Trades Hall, Carlton, where instructors including Shew (modelling), Louis Buvelot (landscape painting), Thomas Clark (drawing). Other schools were at Collingwood (where Clark also taught), Richmond (where, from 1867, Thomas Wright taught landscape painting), and Preston. Early pupils at Carlton included Frederick McCubbin, C. D. Richardson, Peter Kirk and R. W. Bugg, and at Collingwood, Tom Roberts and John White.
See also MECHANICS INSTITUTES AND SCHOOLS OF DESIGN.

AUSTRALIAN FLYING ARTS SCHOOL AT KELVIN GROVE
(Established 1971) Kelvin Grove CAE, Victoria Park Rd, Kelvin Grove, Brisbane, Qld 4059. Established Sept. 1971 by Mervyn and Helen Moriarty (q.v.) as the Eastaus Art School. The title was changed and the school incorporated as the Australian Flying Art School (Eastaus) in 1974. In 1978 it became the Australian Flying Arts School at Kelvin Grove. Moriarty obtained a pilot's licence thus gaining access to outlying areas in Queensland and after a period fraught with financial and administrative difficulties, he reached a situation in which he was conducting two-day seminars or classes in 26 centres four times a year. In addition, students received advanced information on painting as well as a newsletter, lesson books, audio visual material and films on art. After 1978, the aims of the School were extended 'to provide and promote tuition and educational services in the creative and performing arts and in the crafts [as well as] to provide the venues, facilities and resources for the respective arts to be appreciated, experienced, practised and made accessible'.

AUSTRALIAN NATIONAL UNIVERSITY
GPO Box 4, Canberra, ACT 2601. STAFF: In 1993, Sir William Dobell Foundation Professor of Art History, Michael Greenhalgh; 6 other staff. STUDENTS: In 1993, 500. EXHIBITIONS: The Drill Hall gallery is the art venue for the ANU providing the latest and most innovative of Australian and international art. COLLECTIONS: Exceed 1000 art works, including sculpture, mural relief sculpture, fountains, portraits of Uni. personnel, paintings and prints. CREATIVE ARTS FELLOWSHIPS: Created in 1964 when Australian art and artists badly needed imaginative support and encouragement. Fellows were required to live at the ANU for a given period and received a stipend. Visual arts fellows have included Sidney Nolan, John Perceval, Arthur Boyd, Stan Ostoja-Kotkowski, Bea Maddock, Norma Redpath, Trevor Nickolls, Noel Counihan and Ron Robertson-Swann. In 1993 the Fellowship was under review.
See also CANBERRA SCHOOL OF ART, ANU

BALFOUR ART SCHOOL
(1922–24) Conducted in Sydney by J. Lawson Balfour, assisted by Reginald Payten, Balfour having taught privately for many years.
BIB: *ADB* 7.

BALLARAT COLLEGE OF MINES
(1891–1976) Founded as an academy and school of design within the Ballarat Fine Art Gallery building. It transferred to Jago's Buildings in 1893 and in 1905 was placed under the admin. of the Vic. Education Dept, School of Mines Council. New art school buildings were added to the original Jago's Buildings in 1915. HEADS OF THE ART SCHOOL: 1891–98, P. M. Carew Smyth; 1898–1905, G. R. Reynolds; 1905–40, H. H. Smith; 1940–48, D. I. Johnson; 1948, G. F. Proctor (acting); 1949–76, G. R. Mainwaring. In 1976, the old School was divided, the art dept becoming part of the Ballarat Inst. of Advanced Education which was then amalgamated with the Ballarat Tech. Coll. to form the Ballarat Coll. of Advanced Education (q.v.).

BALLARAT UNIVERSITY COLLEGE
(Established 1976) Mount Helen, Vic. 3350. DIRECTOR: In 1993 Professor John Sharpham. HEADS OF THE SCHOOL OF ARTS: 1975–77, John Gilbert (acting); 1977, Peter Sargeant (acting); 1978–80, Norman Baggeley; 1980–84; R. Macgowan; 1985–89 David Addenbrooke; 1989–92 John C. Crump; 1992– Ian Hemingway. Founded through the amalgamation of the Ballarat Inst. of Advanced Education with the Ballarat Tech. Coll in the mid 1970s. The origins of the present School of Visual and Performing Arts can be traced to the Ballarat School of Mines in the 1870s. Situated on an extensive bushland site south of the city, the college serves national and international demand. Major areas of study include ceramics, drawing, graphic design, painting, printmaking, sculpture, theatre and music education available at degree and postgraduate level.

BELL–SHORE SCHOOL
See GEORGE BELL SCHOOL.

BENDIGO SCHOOL OF MINES
(1871–1965) In 1870 Dr John Bleasdale visited Bendigo at the invitation of the Mechanics Institute and recommended the establishment of a School of Art and Design. The recommendation came into effect in June 1871, and in Apr. 1873 the School of Art became part of the newly inaugurated School of Mines, created 'for the purpose of giving miners and others a thorough education in the subjects that are of paramount importance in a district like Bendigo' (Frank Cusack *Bendigo: a History*, William Heinemann, Melbourne, 1973). The building was designed by Carl Wilhelm Vahland and in 1887 provided housing for Bendigo's first art gallery (later the Bendigo Art Gallery). A new, Vahland-designed building was opened by the Earl of Hopetoun in 1890. The first Head of the Art School was Arthur T. Woodward (q.v.) who remained with the school for more than 27 years, many of his pupils going on to become successful artists, some to exhibit at the Paris Salon. The assets of the Mechanics Institute (including the library) were taken over by the School of Mines in 1904 thus increasing the School's value as a centre of education in Bendigo. In 1965 the old school became the Bendigo Institute of Technology (now the Bendigo CAE).

BRISBANE TECHINICAL COLLEGE
(1902–15) Originally part of the Queensland School of Arts (q.v.), it became part of the Central Technical College (q.v.) in 1915.

CAMDEN ART SCHOOL
(1960–64) Melbourne. Painting and drawing classes conducted three nights a week by Max Middleton at Camden Art Centre, retail business, 188 Gertrude St, Fitzroy. The premises were destroyed by fire in 1964.

CANBERRA SCHOOL OF ART, ANU

(Founded 1976) GPO Box 804, Canberra ACT 2601.
STAFF: In 1993, Head of Dept, David Williams; Dep. Director, Nigel Lendon. GALLERIES: *CSA Gallery* shows continuing exhibitions of contemporary art/craft. *Photospace* and *The Foyer* galleries provide venues for student shows and exhibitions by school's artists-in-residence. COURSES: Workshop-based courses for Associate Diploma; BA (visual arts); hons graduate Dip. Art; MA (Vis Arts) in visual arts disciplines of ceramics, gold and silversmithing; glass; graphic arts; painting; photography; printmaking; sculpture textiles; wood.

CENTRAL TECHNICAL COLLEGE

(1915–1972) Established through the merger of the Brisbane Technical Coll., South Brisbane Tech. Coll. and Qld School of Arts. In 1972 the art dept was separated from the rest of the College to become the Queensland College of Art (q.v.). ART TEACHERS: 1915–37, J. L. Martyn Roberts; 1917–22, Josephine Muntz-Adams; 1938–71, C. G. Gibbs; 1948–c. 1960, Melville R. Haysom; 1960–66, Arthur Evan Read. COLLECTIONS: In 1968 approximately 100 Australian paintings and some European paintings as well as various drawings and etchings and 500–600 prints.
See QUEENSLAND COLLEGE OF ART.

CHARLES STURT UNIVERSITY

A multi-campus university serving south-eastern NSW, it offers several courses in the fine arts at campuses at Wagga Wagga, Albury and Griffith.

CHISHOLM INSTITUTE OF TECHNOLOGY, SCHOOL OF ART AND DESIGN

See MONASH UNIVERSITY

CITY ART INSTITUTE, SYDNEY COLLEGE OF ADVANCED EDUCATION

(1982–1990)
See COLLEGE OF FINE ARTS, UNIVERSITY OF NSW

CLAREMONT SCHOOL OF ART

(Established 1968) 7 Princess Road, Claremont, WA 6010. STAFF: In 1993, Principal Robin Phillips; 3 full-time; 17 part-time plus support staff. STUDENTS: 1993, 240 full-time; 1000 part-time. From 1975, mainly a college for studies in arts and crafts. Offers Dip. Art (art and design); Certificate of Art and Design; Advanced Certificate of Art and Design.

COLLEGE OF FINE ARTS, UNIVERSITY OF NSW

(Established 1990) STAFF: In 1993 Dean & Director Professor Ken Reinhard; Deputy Director Professor Col Jordan; Head of School Art Education, Neil C. M. Brown; Head of School, Art Theory Fay Brauer; Head of Studio Art, Rodney Milgate; Head of Design Department Allan J. Walpole; 67 full-time; 80 part-time art teachers including many well-known artists. STUDENTS: In 1993, 11,000. GALLERY: *Ivan Dougherty Gallery* (*see* GALLERIES – PUBLIC). HISTORY: In 1990 the College, which was previously the City Art Institute, NSW Institute of the Arts, became a faculty of the University of NSW. The City Art Institute (1982–1990) had been established by the amalgamation of a number of CAEs and incorporated the Alexander Mackie CAE School of Art (which had itself originated from the National Art School (*see* NATIONAL ART SCHOOL, SIT). The College offers bachelor, master and doctorate degrees in art education, art theory, fine arts, design, art administration. (*See also* UNIVERSITY OF NSW)

CURTIN UNIVERSITY OF TECHNOLOGY – SCHOOL OF ART AND DESIGN

(Previously Western Australian Institute of Technology) (Founded 1965) GPO Box U1987, Perth 6001. HEADS OF SCHOOL: 1965–83, Tony Russell; 1983–84, Dr Bill Gaskins; 1985–86, Tony Russell; 1987– (as Curtin University) Assoc. Professor, John Teschendorff. STUDENTS: In 1993, 300. COLLECTIONS: One of the largest and most significant institutional collections in Australia housed on the five Curtin campuses. From the time of inception of WAIT, it was recognised that collections of works of art would be of great importance to students. To implement this idea, an Art Acquisitions Committee was formed in 1968, the idea attracting substantial external funding ($40,000 in acquisitions and $175,000 in commissioned works by 1979), mainly from the Australia Council, the R&I Bank and private sources. This was further enriched by allocating 0.5 per cent of the cost of each new building for integrated works of art, though this has since not been funded at federal government level. In 1993 the University Council allocated 0.16 per cent of its annual budget to the Artworks Management and Artist-in-Residence committees as well as directing 0.5 per cent of each new building to integrated works of art. HISTORY: Founded as a large multi-disciplinary institute of technology on the outskirts of Perth, WAIT became Curtin University in 1987. The School of Art offers professional studies in art at undergraduate and postgraduate level and has established strong links with the SE Asian and Indian Ocean regions and also has exchange programs with major art schools in Europe and the USA. GALLERIES: *Erica Underwood Gallery* was established on the Bentley Campus in 1983 (*see* GALLERIES – PUBLIC) and a large art gallery complex is being planned for completion in 1996.

DARLING DOWNS INSTITUTE OF ADVANCED EDUCATION

See UNIVERSITY OF SOUTHERN QUEENSLAND

DEAKIN UNIVERSITY

Pigdons Rd, Waurn Ponds, Geelong, Vic. 3221. School of Humanities Program of Visual Arts (founded 1979). ART AND DESIGN COURSES: At its foundation in 1977 the Uni. absorbed the Art and Design Dept of the Gordon Institute of Tech., to create the Visual Languages Course within the School of Humanities. The course comprises an open campus program 'involving all aspects of history and philosophy of design and a study of the nature and importance of human and object relationships'. COLLECTIONS: 175 works, including sculpture, painting, prints, photographs, tapestry. PUBLICATIONS: Deakin University Press publications specific to the visual arts include *Visual Language*; *Iconic Language of Painting and Orienteering*; *Painting in the Landscape*.

EAST SYDNEY TECHNICAL COLLEGE

(1923–1961) In 1923 the School of Arts (q.v.) was moved from Ultimo to East Sydney to become part of the East Sydney Tech. Coll. Later, with the decline of Julian Ashton's school in the 1930s, it became the leading art school in NSW, with a long list of distinguished artist teachers consolidating its prestige for nearly four decades. These teachers included: 1923–37, Rayner Hoff; 1929–38, Fred Leist; 1930–61, Douglas Dundas; 1937–61, Lyndon Dadswell; 1937–38, Edgar C. Walters; 1938–47, Frank Medworth; 1946–61, Wallace Thornton; 1960–61, G. C. Bishop. Many of the teachers remained when, in 1961, the art school of the East Sydney Tech. Coll. became the National Art School
See NATIONAL ART SCHOOL

EASTAUS (FLYING) ART SCHOOL

See AUSTRALIAN FLYING ARTS SCHOOL AT KELVIN GROVE

FLINDERS UNIVERSITY OF SOUTH AUSTRALIA

(Dept of Fine Arts founded 1973) Sturt Rd, Bedford Park, SA 5042. STAFF: 1973–1989, Prof. Donald Brook; five other members of the academic staff. GALLERY: *Visual Arts Gallery* used mainly for studies. COLLECTIONS: General collections including high percentage of European prints. Collections total around 2000 works.
HISTORY: Teaching of the history of art commenced in 1966 with the appointment of Robert Smith. Donald Brook was Chair of Fine Art 1973–1989.

GEORGE BELL SCHOOL

(1922–66) George Bell (q.v.) began teaching at his house in Selbourne Rd, Toorak, in 1922. Ten years later he went into partnership with Arnold Shore and the school was conducted in Bourbe St. Melbourne as the Bell–Shore School

until 1936 when Shore left the partnership. Bell continued the school until 1939 when it reverted back to his house in Toorak. During the 1930s, the school became a centre for students interested in the modern movement. Early students at Selbourne Rd included Eric Thake, Clive Stephen, Sybil Craig and Madge Freeman. Students at the Bourke Street school included Russell Drysdale, Peter Purvis Smith, Sali Herman, Yvonne Atkinson, Geoff Jones and Alan Sumner. Adrian Lawlor, Vic O'Connor and Albert Tucker were enrolled briefly but may not have attended; Sam Atyeo, William Frater, Isabel Tweddle, Mary Cecil Allen, Moya Dyring, Danila Vassilieff, Lina Bryans and Basil Burdett were frequent visitors. Later students at Selbourne Rd included Ian Armstrong, Rod Clarke, Jack Courier, Justin Gill, Leonard French, Mary Macqueen, Anne Montgomery, Guelda Pyke, Harry Rosengrave, David Strachan and Fred Williams. Most of Bell's students were proud of their association with the School and nearly all who became prominent in later years have affirmed their indebtedness to Bell. He continued taking students until his death in 1966, although his teaching powers had diminished and in his last years his students attended mainly from a sense of loyalty. The Bell School has since been the focus of a number of exhibitions most notable being *Classical Modernism: The George Bell Circle* NGV 1992.

BIB: Mary Eagle and Jan Minchin, *The George Bell School: Students, Friends, Influences*, Deutscher Fine Art and Resolution Press, Melbourne and Sydney, 1981. Felicity St John Moore, *Classical Modernism: The George Bell Circle* NGV, 1992.

GIPPSLAND INSTITUTE OF ADVANCED EDUCATION
See MONASH UNIVERSITY

GORDON INSTITUTE OF TECHNOLOGY
See DEAKIN UNIVERSITY

HOBART TECHNICAL COLLEGE
(1889–c. 1963) The College replaced the Van Diemen's Land Mechanics School of Art (q.v.). A separate art dept was formed at the instigation of Lucien Dechaineux in 1924. Art teachers at the College included: 1890–95, Tranthim Fryer; 1900–03, Benjamin Sheppard; c. 1904–07, Joseph L. Fleury; 1903–39, Lucien Dechaineux; 1928–40, Mildred Lovett; 1933, Amy Kingston; 1940–71, J. Carington Smith; c. 1950–68, Rosamond McCulloch; 1960–63, Dorothy K. Stoner. A travelling scholarship was conducted with Tasmanian government support, 1949–57, but failed owing to lack of finance. In 1963 the art dept was separated from the Hobart Tech. Coll. to become the Tasmanian School of Art (q.v.).

JULIAN ASHTON ART SCHOOL
(Established 1890) 117 George St, Sydney, NSW 2000.
PRINCIPALS: 1890–1922 Julian Ashton; 1922–1960 Henry Cornwallis Gibbons; 1960–77 J. Richard Ashton (Julian Ashton's grandson); 1977–88 Phillip Ashton (Richard's son); 1988– Paul Ashton Delprat (Julian Ashton's great-grandson). HISTORY: After teaching for four years at the Art Society of NSW School, Julian Ashton started his own school as the Académie Julian in 1896; the school became traditionally known throughout Australia as Julian Ashton's. Sydney Long became a partner in the venture in 1907 and the name was changed to the Sydney Art School. When Long went to London in 1910, his place was taken by Mildred Lovett, who was succeeded in 1923 by H. C. Gibbons. Gibbons taught at the school for more than 40 years. In 1929, Alice Muskett, Julian Ashton's second pupil, gave £250 to the Sydney Art School to start the annual *Phillip Muskett Prize*, as a memorial to her brother. Eminent teachers at the school included Thea Proctor (composition) and Norman Lindsay (illustration). Celebrated pupils included George Lambert, William Dobell and John Passmore, who also taught at the school during the 1950s. The school was moved to the Mining Museum building, 36 George Street North, in 1935; Henry Gibbons took charge when Ashton died in 1942, and

as a gesture to Ashton, renamed the school the *Julian Ashton Art School*. In 1973 the School moved to its present location and in 1989 its equipment including easels used since the 1890s was classified by the National Trust. Several prizes and scholarships have been established for students at the school. These include two which offer a year's free tuition – the *Sir William Dobell Scholarship* sponsored by the Dobell Foundation and *John Olsen Scholarship* sponsored by Bedford Framing Studios. Other awards include Henry Gibbons prize for drawing and the Phillip Muskett prize for landscape. The school offers an art diploma course as well as holiday and intensive courses and weekend workshops in many areas of visual arts including drawing, watercolours, etching, sculpture, book illustration, design, portraiture, landscape, figure drawing.

LA TROBE UNIVERSITY
(Founded 1967; Department of Art History founded in 1972) Plenty Rd, Bundoora, Vic. 3083. HEADS OF DEPARTMENT: 1972–87, Peter Tomory; 1991– Prof. Nigel Morgan. STUDENTS: In 1993, 165. COLLECTIONS: Mainly Australian paintings, including examples by Rupert Bunny, T. St G. Tucker, J. P. Russell, William Frater, Arnold Shore, and many works by later painters. Permanent works featured in Uni. buildings or grounds include the large sculpture *Dialogue or Circles* by Inge King and *The Four Seasons*, four stained-glass panels by Leonard French for the Undercroft, David Myers Building.

MARY WHITE SCHOOL OF ART
(1963–69) Held at 211 New South Head Rd, Edgecliff, NSW, teaching including courses in modern painting and sculpture, drawing, and interior design. Teachers included Marea Gazzard, Robert Klippel, Colin Lanceley, John Olsen, Charles Reddington, Andrew Sibley, Charles Bannon. The School closed when the premises were demolished to make way for the new Edgecliff Centre.

MELBOURNE ART SCHOOL
(1893–99) Conducted by Emanuel Phillips Fox in partnership with Tudor St George Tucker. The school followed the pattern of the French schools in which the two artists had studied. It offered its students studies in French impressionism and freer methods of painting and drawing than those taught at the NGV School. As part of the program, a summer school was started at *Charterisville* (q.v.). Students of the Melbourne school included: Ambrose Patterson, Albert Enes, Violet Teague, Ina Gregory, Mary Nanson, Bertha Merfield, Henrietta Irving, Ursula Foster. The school ended when Tucker returned to London in 1899, and Fox followed in 1900.
(*See also* CHARTERISVILLE)

MELBOURNE COLLEGE OF PRINTING AND GRAPHIC ARTS
(Founded 1898) 603 Queensberry St, North Melbourne, Vic. 3051. Private school offering courses in trade and fine art. HISTORY: 1898: Classes formed at inaugural meeting at the Athenaeum on 28 April; 65 students enrolled. 1899: Classes taken over by Working Men's College. 1947: New, separate school, the Melbourne Printing Trades School, proclaimed by the Governor in Council. 1949: First principal appointed, John H. Lodge. Part of the school moved to its own premises, a former State school in Queensberry St, North Melbourne. 1950: Name changed to Melbourne School of Printing and Graphic Arts. 1954: New building commenced on site behind existing structure. 1957: All departments assembled in new building. 1972: Name changed to Melbourne College of Printing and Graphic Arts.

MELBOURNE STATE COLLEGE
(Founded 1888) 757 Swanston St (cnr Grattan St), Carlton, Vic. 3053. Student courses include teaching in painting, sculpture, graphics and a wide variety of crafts. COLLECTIONS: Over 450 works including more than 260 paintings. Collections began with A. J. Law, then principal of the

College, in 1939. Later principals continued the policy thus established and the collections, mostly of Australian contemporary paintings, grew steadily. Purchases for the College gave great encouragement to Melbourne artists at a time when the NGV had little money to spend on local art works. GALLERIES: *Gryphon Gallery* (*see* GALLERIES – PUBLIC) HISTORY: The College building was completed in 1888 and the institution opened as the Melbourne Teachers College. It became the Melbourne State College in 1972 when the Melbourne Teachers College and the Secondary Teachers College merged; the merger included also the Secondary Teachers College collection, initiated by D. M. McDonell in 1959. The name of the institution was changed to the Melbourne State College during 1974 and later became the Institute of Education, University of Melbourne (*see* UNIVERSITY OF MELBOURNE).

MELDRUM SCHOOL
(1917–54) Conducted by Duncan Max Meldrum from his studio in Kew. Meldrum's energy, personality and strong views, added to a strong Scots accent and a background which included some 13 years spent in France, mainly in studies of admired old masters, gained him a large following. Basis of his teaching was that all great painting is based on the objective observance of tonal values and all else is subservient to this principle. He pursued what he called 'the science of depictive appearance' with fanatical zeal, in lectures, demonstrations and writings, and soon attracted a large and devoted following, although his vehement rejection of all ideas except his own earned him many enemies. Meldrum was also an avowed pacifist and a critic of society in all its aspects. By 1922 the cult of the Meldrumites was very widespread and, in 1931, Meldrum went on a lecture tour of the USA. His students included Colin Colahan, Archibald Colquhoun, the brothers Rowell, Percy Leason, Hayward Veal (qq.v.), all of whom became involved later with teaching. The great strength of Meldrumism was that it offered students an easy way of achieving a quick result particularly in portraiture. Meldrum's own considerable talent for portraiture suffered from fanatical application of his own theories, the reason why his early portraits, influenced by old masters such as Rembrandt, are by far his best.

MONASH UNIVERSITY
(Dept of Visual Arts founded 1975) Wellington Rd, Clayton, Vic. 3168. PROFESSORS: 1975–82, Prof. Patrick McCaughey; 1982– Prof. Margaret Plant. STAFF: Nine full-time teaching staff. GALLERY: *Monash University Gallery* (*see* GALLERIES – PUBLIC). COLLECTIONS: In 1982, in excess of 600 works. In 1988 Monash University amalgamated with Chisholm Institute and Gippsland CAE to provide a four-campus art school – Caulfield, Frankston and Gippsland being the campuses for practical studies and art teaching courses, and Clayton having the Department of Art History and Film studies.

CAULFIELD CAMPUS
Founded 1922 as Caulfield Institute of Technology. HISTORY: 1922: Established as the Caulfield Technical School. 1958: Became Caulfield Tech. Coll. 1968: Became Caulfield Inst. of Technology. 1976: Phillip Law Building completed as housing for the School of Art and Design. 1982: Caulfield Institute of Technology merged with the former Frankston Teachers College to become the Chisholm Institute of Technology. 1988: Amalgated with Monash University.

NATIONAL ART SCHOOL
(Established 1960) Sydney Institute of Technology, East Sydney Campus, Forbes St, Darlinghurst, NSW 2010. STAFF: First principal, 1960–61, L. Roy Davis; 1961–65, Douglas Dundas; 1966–74, Lyndon Dadswell; 1974–75, Stan de Teliga; 1993 – Ted Binder. STUDENTS: In 1993, 700. HISTORY: Prior to 1974 the NAS at East Sydney Technical School (q.v.) offered the only diploma art courses in NSW. As the demand for teritary art education grew in the late 1960s and early 70s the school could no longer accommodate all

five years of the course. A two-year Art Diploma qualifying course was offered at other metropolitan colleges to feed into the final three years of the Diploma program at the NAS/ESTC. The division of Fine Art, NAS became the basis for the CAE, Alexander Mackie College which became City Art Institute which then became the College of Fine Arts, University of NSW (q.v.). The division of Design, NAS became the basis for the CAE Sydney College of the Arts, which in 1992 split again – Fine Art remaining at Sydney College of the Arts as part of Sydney University while Design went to the University of Technology, Sydney. From 1974–87 the title of National Art School became the 'School of Art & Design', ESTC but in 1987 with the reintroduction of diplomas in Fine Art, Ceramics and Fashion design the title 'National Art School' was resumed. In the early 1990s, NSW TAFE restructuring placed the school within the Sydney Institute of Technology, East Sydney campus.

NATIONAL GALLERY OF VICTORIA ART SCHOOL
(1870–1968) Swanston St, Melbourne, Vic. 3000. HEADS OF THE SCHOOL AND TEACHERS OF PAINTING: 1870–81, Eugène von Guérard; 1882–91, George Frederick Folingsby; 1891–1935, Lindsay Bernard Hall; 1935–36, William Beckwith McInnes; 1936–45, Charles Wheeler; 1945–46, William Rowell (acting head); 1946–53, William Dargie; 1948, Hayward Veal (deputy); 1953–54, Murray Griffin (acting); 1954–62, Alan Sumner; 1963–68, John Brack. TEACHERS OF DRAWING: 1870–76, Thomas Clark; 1876–86, O. R. Campbell; 1886–1917, Frederick McCubbin; 1907–08, Leslie Wilkie (acting); 1917–39, William Beckwith McInnes; 1933, George Bell (acting); 1939–41, A. E. Newbury; 1941–46, William Rowell; 1946–53, Murray Griffin; 1954–55, Charles Bush; 1956–61, Rod Clark; 1961–62, Ian Armstrong; 1962–68, Marc Clark. HISTORY: The leading Australian art school for more than 50 years, it was conducted in the old National Library, Museum and Art Gallery building. The School was first suggested in 1861 by Thomas Clark who subsequently became the first teacher of drawing. First art teacher was von Guérard who was also curator of the NGV collections. His appointment at the age of 60 did not include any assistance, and he could do little more in teaching than set the students to copy works from the collections. His successor, Folingsby, reputedly encouraged the use of a palette consisting mainly of bitumen and vermilion mixed with white. But while some students suffered from Folingsby's teaching, others recalled it with gratitude. By the turn of the century the teaching at the NGV School had settled into the familiar pattern of the Academy schools of Europe and the UK. Teaching was based on drawing with charcoal and bread, first from plaster casts and then from the nude model. Fees at the NGV School were cheap (ten shillings per term in the 1920–30s), and the entrance test was elementary, making the evening classes, at least, available to all. The best-loved teacher in the history of the school was Frederick McCubbin, teacher of drawing, and the head of the school best remembered by the immediate pre-World War II generation of students was L. Bernard Hall, who ruled at the NGV for more than 40 years. Much of the stimulus that gave the School its early reputation came from the student body attracted to it from all parts of Australia, the close proximity of the NGV collections. Also there was the added stimulus from the adjoining Museum, which provided natural history studies, and the State Library. Regular prizes were introduced in 1887, and others were added later, the ambition of most students being to win the NGV Travelling Scholarship (*see* PRIZES). When the NGV moved to its new premises at 180 St Kilda Rd in Aug. 1968, the grand old NGV School was gradually phased out to become part of the new Victorian College of the Arts, and the NGV Travelling Scholarship became the Keith and Elisabeth Murdoch Travelling Fellowship.
(*See also* VICTORIAN COLLEGE OF THE ARTS)

NEWCASTLE UNIVERSITY
(Established 1965) Rankin Drive, Waratah, NSW 2298. The School of Art offers diplomas in art and design.

NORTH ADELAIDE SCHOOL OF ART
42 Stanley St, North Adelaide, SA 5006. Offers diploma art (applied and visual arts) courses in painting, drawing, photography, sculpture and a number of crafts.

NORTH BRISBANE COLLEGE OF ADVANCED EDUCATION
(Founded 1961) Park Rd, Lutwyche, Brisbane, Qld. Established as the Kedron Park Teachers College it became the Kedron Park College of Advanced Education in 1972 and the North Brisbane CAE in 1974.

NORWOOD ART SCHOOL
(1885–95) South Australian school, established and conducted by James Ashton.
(*See also* ACADEMY OF ARTS)

ORBAN SCHOOL
(1941–c. 1985) Established by Hungarian migrant painter, Desiderius Orban (q.v.) at 2 Henrietta St, Circular Quay, Sydney, NSW 2000. Expressed in his book, *A Layman's Guide to Creative Art*, Orban's ideas were developed as a student in Paris during the early days of cubism. In sympathy with the modernist movement then gaining ground in Sydney, his teaching attracted many students. By 1945, 40 students were enrolled; by 1960, attendances were between 80 and 90, and by 1962 the figure had risen to 200. Some students stayed on as teachers, among them James Sharp, John Olsen and John Ogburn.

PERTH SCHOOL OF ART
(c. 1920–22) Founded by Henri van Raalte, the school was directed by Margaret Saunders. It closed when Van Raalte left Perth to become curator of the AGSA in 1922.

PERTH TECHNICAL COLLEGE
(1900–65) Established as the Perth Technical School by Frederick M. Williams, the first art instructor (1900–02). From 1946, Ivor Hunt was head of the art dept, which by 1961 had 973 students enrolled. The main prize available in the 1960s was the Jackson Art Scholarship, worth £100. The major part of the dept of art and craft was transferred to the Western Australian Institute of Technology (WAIT) in 1965.
See CURTIN UNIVERSITY

PHILIP INSTITUTE OF TECHNOLOGY
(1967–92) Heads of the school of Art and Design included Betty Churcher, Jeffrey Makin and Brian Seidel before it amalgamated with RMIT in 1992. GALLERY: The School of Art and Design included *Pitspace Gallery*, created in 1978 by Tom McCullough, its director until 1982. In 1981 the Gallery was the venue for part of McCullough's *Australian Sculpture Triennial* (q.v.) HISTORY: Established as the Preston Technical School, at St George's Rd, Preston, to serve the northern metropolitan area of Melbourne. In 1964 the name was changed to Preston Technical College and the Art School was started. In 1968 a new site was acquired beyond La Trobe University and the institution became the Preston Institute of Technology. In Dec. 1981 it was incorporated to become the Phillip Institute of Technology and the art school became the School of Art and Design. In 1992 it amalgamated with RMIT.
See ROYAL MELBOURNE INSTITUTE OF TECHNOLOGY

POWER INSTITUTE
See UNIVERSITY OF SYDNEY

PRAHRAN COLLEGE OF ADVANCED EDUCATION
See VICTORIAN COLLEGE OF THE ARTS

QUEENSLAND COLLEGE OF ART, GRIFFITH UNIVERSITY
(Founded 1982) Clearview Terrace, Morningside, Qld. (PO Box 84, Morningside, Qld 4170) ADMIN: Griffith University. STAFF: In 1993 Provost/director Ian Howard; 90 staff. STUDENTS: In 1993, 816. COURSES: Courses offered include B.

Vis. Arts in fine art, graphic design, gold and silversmithing, photography, animation, film and television, interior design, illustration and Associate Diploma of Arts in photography and commercial art. COLLECTIONS: 221 works. HISTORY: 1881: Established as the Brisbane Arts School. 1914: Became a branch of the Central Technical College. 1972: Became the College of Art at Seven Hills. 1973: Moved to present site. 1982: Became the Qld College of Art. 1992: Amalgamated with Griffith University.

QUEENSLAND SCHOOL OF ARTS
(1849–1915) It began in rooms in Queen St, Brisbane, as the School of Arts. TEACHERS AND STUDENTS: Distinguished artists who taught at the school included J. L. Watts (clay modelling), Matthew Fern (woodcarving), L. J. Harvey, F. J. Martyn Roberts, Josephine Muntz-Adams. Students who attained distinction included Harold Parker, Bessie Gibson, Lloyd Rees, Daphne Mayo, W. Leslie Bowles and many others. HISTORY: 1851: Moved into its own building. 1872: Vacated building because of lack of finance. 1873: Re-established in Ann St. 1881–84: President, the Hon. J. Douglas and secretary, Dudley Eglington (quoted by Moore as 'the founders of technical education in Queensland'), gained the institution the status of a technical school. Joseph Augustus Clarke was appointed first professor-teacher and started a life-class. 1890: Godfrey Rivers appointed art teacher after Clarke's death. 1902: Art school separated from rest of the school, moved to separate premises on other side of Ann St to become the Brisbane Technical School. 1915: The School of Arts, Brisbane Technical School and South Brisbane Technical College amalgamated to become the Central Technical College (q.v.)

ROYAL MELBOURNE INSTITUTE OF TECHNOLOGY (RMIT)
(Established 1887) 124 La Trobe St, cnr Swanston St, Melbourne, Vic. 3000 (GPO Box 2476V, Melbourne, Vic. 3001) EARLY TEACHERS: 1887– ?, T. S. Monkhouse; 1889–? W. McKennal (modelling and casting); 1897–1903, Westwood (drawing and painting); J. S. Davie (modelling); 1903–16, T. Levick (drawing and painting). In 1916 the various sections of the art school were amalgamated and presiding heads of the art school appointed from then on. HEADS OF THE SCHOOL OF ART: 1916–23, G. Pitkethly; 1923–31, T. Levick; 1931–54, H. R. Brown; 1955–65, V. E. Greenhalgh; 1965–69, Lindsay Edward (acting); 1969–77, Colin Barrie; 1977–80, Lindsay Edward; 1980–91, Rod Clarke; 1991– Professor Bill Gregory. GALLERIES: Storey Hall Gallery, Swanston St entrance, City Campus devoted to specially organised exhibitions, surveys, etc. The two Faculty of Art and Design Galleries (City and Northern campuses) are for exhiitions by staff, students, artists-in-residence as well as displaying the permanent art collection and occasional curated exhbitions of contemporary art and photography. HISTORY: 1881: Institution founded 16 Dec. by Hon. Francis Ormond, and named the Working Men's College after the London school of the same name established by F. D. Morris in 1854. 1934: Name changed to Melbourne Technical College. 1954: Name changed to Royal Melbourne Technical College. 1960: Became the Royal Melbourne Institute of Technology. 1992: RMIT designated a university. Ormond's original gift was increased with funds raised by public subscription, and the first building (in La Trobe St) was opened in 1887. The program included technological training in a wide variety of subjects, including art classes, conducted by T. S. Monkhouse, and classes in modelling and casting conducted from 1889 by W. McKennal. For 47 years the College was the only institution in Melbourne offering technical training in the arts. In its early days, its teaching complemented the teaching at the nearby NGV School and many of its students later became distinguished artists. In 1992 a merger took place between RMIT and Phillip Institute of Technology with the amalgamated campuses becoming a university with campuses in the city and Bundoora and the Faculty of Art

and Design supporting four departments – Fine Art; Design; Visual Communication; Fashion & Textile Design.

SCHOOL OF ARTS

(1883–1923) Founded as the Sydney Mechanics School of Arts (q.v.), it became the School of Arts when the Board of Education took it over in 1883 and appointed Lucien Henry as lecturer, a position he held until his return to France in 1891. Henry was succeeded by J. Wright, and Wright by S. V. Rowe in 1923, when the school was moved from Ultimo to East Sydney to become the East Sydney Technical College (q.v.)

SCHOOL OF DESIGN

See ADELAIDE COLLEGE OF ARTS AND EDUCATION

SCHOOL OF FINE ARTS

(1921–c. 1946) University College, Tynte St, North Adelaide, SA 5006. FOUNDER: Edith Napier Birks. ART TEACHERS: 1921–?23, Fred C. Britton; 1923–c. 46, F. Millward Grey. Edith Napier Birks started the School first in her own house before transferring it to the University College. It attracted student attendances of 24–200. F. Millward Grey took over as Director before his appointment to the SASA in 1946.

SOUTH AUSTRALIAN SCHOOL OF ARTS

(Founded 1861) Holbrooks Rd, Underdale, SA 5032. STAFF: Early teachers included Charles Hill, first art master, 1861–80; Louis Tannert painting master in 1880 and Harry P. Gill in 1881. Staff in 1993 numbered over 20. PRINCIPALS: 1909–15, H. P. Gill; 1916, J. Christie Wright, 1916–20, Charles J. Pavia (acting); 1920–41, Laurence H. Howie; 1941–46, John Goodchild; 1946–56, Milward Grey; 1957, Kenneth Lamacraft; 1957–58, Douglas Roberts (acting); 1958–60, Paul Beadle; 1961–64, Allan Sierp; 1964–77, Douglas Roberts; 1977–78, Des Bettany (acting); 1978–80, H. D. Cook; 1982–84, Max Lyle (acting head); 1984– Ian North. STUDENTS: In 1993, over 340. HISTORY: 1861: Founded as the School of Design by the SA Society of Arts and housed in the SA Institute building in North Terrace, Adelaide. 1892: Renamed School of Design, Painting and Technical Arts when control passed into the hands of the Public Library, Museum and Art Gallery Board. 1909: Control passed over to SA Education Dept and name changed to South Australian School of Arts and Crafts. 1958: Renamed South Australian School of Arts. 1963: Moved to new buildings in Stanley Street, North Adelaide. 1973: Amalgamated with Western Teachers Coll. to form the Torrens Coll. of Advanced Education at Underdale. 1980: Torrens Coll. of Advanced Education amalgamated with the Adelaide CAE to become the Adelaide Coll. of the Arts and Education. Design sections separated to form the School of Design. 1982: Adelaide Coll. of the Arts and Education became part of the South Australian Coll. of Advanced Education. 1991. South Australian School of Art became part of newly formed University of South Australia with schools of Design & Architecture; Faculty of Art, Architecture and Design.

SOUTH BRISBANE TECHNICAL COLLEGE

(c. 1902–15) Art master at the school was F. S. Martyn Roberts. In 1915 it was amalgamated with the Queensland School of Arts and Brisbane Technical College to form the Central Technical College (q.v.), George St, Brisbane.

SWINBURNE UNIVERSITY OF TECHNOLOGY (FACULTY OF ART)

(Founded 1908) John St, Hawthorn, Vic. (PO Box 218, Hawthorn, Vic. 3122) HEADS OF ART SCHOOL: 1917–28, J. Tranthim Fryer; 1928– S. W. Tompkins; – 1963, Alan Jordan; 1963–74, L. S. Pendlebury; 1974–87 Ian McNeilage; 1987–89 Brian Robinson; 1991– David Murray. STUDENTS: In 1993, 230 full-time. COLLECTIONS: Approximately 150 works. LIBRARY: Library contains more than 100,000 vols, including many volumes on art subjects, technical books, histories, fine art, industrial design, photography and over 12,000 monographs as well as 1400 audio-visual items, 250

periodicals and a large reference section. HISTORY: 1908: Foundation of the Eastern Suburbs Technical School by George Swinburne (1861–1929). Fryer appointed first director. 1909: First building completed. 1910: Renamed Swinburne Technical College. Within ten years of inception the College had achieved a reputation for excellence in the technical training of students in a wide variety of subjects, particularly in the arts after 1917. Many of the art students achieved distinction. 1917: Fryer became Head of the Art School. 1980: Name changed to Swinburne Institute of Technology. 1991: School of Design established – in 1993, two schools, School of Graphic Design, School of Industrial Design.

SYDNEY ART SCHOOL

See JULIAN ASHTON ART SCHOOL

SYDNEY COLLEGE OF THE ARTS, UNIVERSITY OF SYDNEY

(Founded 1975) 266 Glebe Point Rd, Glebe, NSW 2037 (PO Box 226, Glebe 2037) ADMIN. STAFF: Professor Richard Dunn, Director; Associate Professor Helge Larsen, head of school; 9 studio co-ordinators in areas of art theory, postgraduate glass, painting, sculpture, ceramics, jewellery, photography, print-making. STUDENTS: In 1993, 431 undergratuates, post-graduates and masters students. HISTORY: Proclaimed 25 July 1975 by the NSW Minister for Education, the College was established first in separate premises in Randwick, Balmain and North Sydney, the initial aim of the institution in terms of the Gleeson report, 1970, being 'to produce practising professional artists and designers' by means of 'a multi-discipline college of advanced education dedicated to tertiary training in all aspects of the Visual and Performing Arts'. Sydney College of the Arts became an academic College of the University of Sydney as at 1 January 1990. Sydney College of the Arts, as originally constituted, was dissolved in January 1988. The School of Design was in 1993 in the Faculty of Design, Architecture and Building of the University of Technology, Sydney. The School of Visual Art, retaining the name Sydney College of the Arts, became a semi-autonomous component of the NSW Institute of the Arts under the NSW Institute of the Arts Act, 1987. This was an interim phase in the governance of the College which on 1 January 1990 led to its becoming an academic college of the University of Sydney.

(*See also* UNIVERSITY OF SYDNEY)

SYDNEY MECHANICS SCHOOL OF ARTS

(1859–83) The first instruction at the Sydney Mechanics School of Arts was limited to classes in drawing, with Joseph Fowles as instructor to about fourteen pupils, and George French Angas as examiner. Fowles was succeeded by Edmund Thomas, the examiners then being F. C. Terry and J. Kemp. Other early teachers included F. Nixon, Thomas Hodgson and, when separate classes for girls were instituted in 1865, Miss Marsh. In the same year, classes for mechanical drawing were instituted under the tutelage of Norman Selfe. In 1881 the character of the school changed when M. Phillips, a graduate of South Kensington, became chief instructor, and Lucien Henry became the first instructor of modelling in sculpture classes which grew from nine to 50 students. The name of the school was changed to the School of Arts (q.v.) in 1883.

TASMANIAN SCHOOL OF ART, UNIVERSITY OF TASMANIA

(Founded 1963) University of Tasmania, Centre for the Arts, Hunter St, Hobart, Tas. 7000. STAFF: In 1993, School of Art Director, Geoff Parr; 11 heads of dept. STUDENTS: In 1993, 450. GALLERY: *Plimsoll Gallery* (*see* GALLERIES – PUBLIC) HISTORY: Formed within the Hobart Tech. Coll. (q.v.), the Tas. School of Art was separated from the Tech. Coll. in 1963 and for the next eight years operated as an autonomous institution. It was incorporated with the Tas. CAE in 1971 and became an independent school within the Uni. of Tas. in 1981. In the mid 1980s the School moved to the Centre

for the Arts in the former jam factory and warehouses of Jones & Co. on Hobart's historic waterfront. Combining art school faculties with artist-in-residence flats and studios; library; gallery and lecture theatre used by the public as well as students with studios for over 30 postgraduate students and researchers, the building won a Royal Institute of Architects award in 1987. COURSES: Degree and postgraduate courses in ceramics, wood, graphic design, painting, photography, printmaking, sculpture, textiles, art theory. In 1981 the School was the first to offer a studio-based Master of Fine Arts.

UNIVERSITY OF ADELAIDE
North Terrace, Adelaide, SA 5000. In 1993 the Uni. of Adelaide had no Dept of Fine Arts. COLLECTIONS: With the amalgamation of the University with the South Australian CAE in 1991, the collection comprises work from both institutions. Some artists represented are Arthur Boyd, David Boyd, Jacqueline Hick, Donald Friend, Charles Bannon. LIBRARY: Including the Carnegie Art Reference set of 2000 photographs and colour prints, and 200 books, presented by the Carnegie Corporation of New York in 1942.

UNIVERSITY OF MELBOURNE
(Dept of Fine Arts founded 1946) HEADS OF SCHOOL: 1946–78, Prof. Joseph Burke; 1978– , Prof. Margaret Manion. COURSES: In 1993 BA, graduate diploma in Arts (art history and cinema studies), postgraduate diploma in art curatorial studies, other postgraduate programs leading to MA and PhD degrees. STAFF: In 1993, 11 full-time. STUDENTS: In 1993, around 800. HISTORY: In April 1853, Sir Redmond Barry was elected foundation chancellor of the University of Melbourne. Barry's enthusiasm and interest in all things cultural was a clear pointer to the subsequent pattern of Uni. development. His interest in the arts was shared by many of his colleagues and by successive generations of Uni. administrators and academic staff. Of these, mention need be made only of Sir Baldwin Spencer (q.v.), Prof. Marshall Hall and Prof. Dale Trendall. The growth of separate collections in the various Uni. colleges, Ormond, Queen's, Newman, Ridley, St Mary's, Trinity (Rusden Collection), and Uni. Women's Coll., further affirms the extent of Uni. interest in the arts. In 1946, the *Herald* Chair of Fine Arts, the first chair of fine arts in any Australian university, was founded on the initiative of Sir Keith Murdoch (q.v.) with a £10,000 grant from the newspaper company, the Herald and Weekly Times. The first *Herald* Professor of Fine Arts (1946–78) was Joseph Burke (q.v.). There have been many donors of important works. In the consistency of its policies of support for the visual arts and their importance in the academic world, the Uni. of Melbourne is unrivalled among Australian academic institutions. The University of Melbourne also incorporated from the late 1980s the Institute of Education (formerly Melbourne State College) which offers practical fine art courses in a number of visual arts practices. GALLERIES: *Ian Potter Gallery* (*see* GALLERIES). *Percy Grainger Museum*: Built 1937–38, through the Percy Grainger Bequest and opened 10 Dec. 1938. Houses the extensive collection of paintings, drawings, letters, manuscripts, musical scores and other material accumulated by the celebrated musician and artist Percy Grainger (q.v.) during his lifetime. It comes under the authority of the Archives Dept, formed 1960, and the Curator, Dr Kay Dreyfus, appointed 1974. *Baillieu Library and Leigh Scott Room*: The Leigh Scott Room within the Baillieu Library is the repository for a large collection of rare vols; the Library itself houses the J. Orde Poynter Collection and most of the special Uni. print collection. *Ethnological Museum*: Founded by Prof. Donald Thompson in the Dept of History, c. 1942. Provides housing for the Leonhard Adam Collection of Aboriginal bark paintings, many from Groote Eylandt, as well as other ethnic art. COLLECTIONS: Portraits of Uni. personnel began in the early days of University life. Many early portraits were lost in the fire that destroyed Wilson Hall in 1932, but many survive and contemporary portraits have been added since. Portraits of particular interest are by Folingsby, Roberts, McCubbin, Bunny, Longstaff, Coates, Quinn, Hall, Ramsay, Meldrum, McInnes, Bell, Dobell, Counihan, Pugh and Williams. A concentrated policy of collecting art works began in the 1920s. Listed chronologically they include: 1927–30: The first collections, comprising ancient Greek and Islamic ceramics, Greek and Roman coins and other objects of antiquity, made for the Dept of Classical Studies. Formed through Charles Seltman of Queens Coll., Cambridge, for the John Hugh Sutton Memorial Collection. 1937–38: *Percy Grainger Collection*: Paintings, drawings, manuscripts, books, musical scores, letters and other archival material in the Percy Grainger Museum. 1938: *Ewing Collection*: Gift of Dr Samuel A. Ewing. Large and important collection of Australian oils and watercolours, including Heidelberg School paintings. Housed in the *Ewing Gallery*, University Union building. 1942–46: *Leonhard Adam Ethnological Collection*: Including Aboriginal bark paintings in the Ethnological Museum collected from Groote Eylandt from 1942. 1947: *Stephen Courtauld*: Gift of J. M. W. Turner watercolour and prints. 1948: *Rupert Bunny*: Works given by the trustees of Bunny's estate at the behest of Daryl (later Sir Daryl) Lindsay. 1950s: Early in 1950s the Vice-Chancellor, Sir John Medley, initiated a policy of collecting contemporary Australian works. The scheme attracted gifts from Daryl Lindsay, Joseph (later Sir Joseph) Burke, Sir Keith Murdoch, and Col. Aubrey Gibson who, in 1954, started a Society of Collectors, 1959–61: *Dr Orde Poynter*: Large collection of prints, as well as European and Australian oil paintings and watercolours, and a valuable library of classic vols from Renaissance time onwards. The Poynter Collection formed the basis of the Uni. print collection (more than 18,000) held in the Baillieu Library. It included also a large collection of the engraved works of Sir Lionel Lindsay from the bequest of Harold Wright, of Colnaghi's, London. 1959: *Norman Lindsay Collection*: Fifty-seven works, including oils, watercolours, drawings, etchings and models of ships. Given by the artist through representations made by Prof. Brian Lewis and W. Pemberthy of the School of Architecture. 1971: *Grimwade Collection*: More than 200 items, including paintings, prints, drawings and Oriental and European ceramics bequeathed by Sir Russell and Lady Grimwade. 1971–80: *Hirschfeld Mack Collection*: Watercolours, drawings and prints given by Mrs Olive Hirschfeld. ARTISTS IN RESIDENCE: Funded by the VACB, the historic house overlooking the Yarra River at Darebin, bequeathed by Norman and May Macgeorge (qq.v.) in 1971, is used by recipient artists as living quarters. Studio facilities are provided also at the University. Recipient artists 1975–93 have included W. Delafield Cook, Robert Jacks, Frank Hodgkinson, John Hoyland, Howard Hodgkin, John Firth-Smith, Gordon Bennett.

UNIVERSITY OF NEW ENGLAND
Includes campuses at Armidale and Lismore. The University of New England, Armidale has no fine arts department but through the Dept of Continuing Education organises Summer Schools in the Fine Arts, with classes conducted by leading artists. University of Northern Rivers, Lismore offers BA degrees in visual arts. COLLECTIONS: Approximately 250 works placed mainly in the Admin. Centre, Uni. Hall foyer, Conference Room, External Studies building and residential colleges.

UNIVERSITY OF NEW SOUTH WALES
(Founded 1949) Anzac Pde, Kensington, NSW (PO Box 1, Kensington, NSW 2033). STAFF: Dean & Director, College of

Fine Arts, Kenneth Reinhard. GALLERY: *Ivan Dougherty Gallery* (*see* GALLERIES–PUBLIC)
COLLECTIONS: Comprises around 700 paintings, sculptures and works on paper mainly 20th century Australian art including those by Ann Thomson, Brett Whiteley, Kevin Connor, Joe Furlonger, Frank Hodgkinson, Ron Robertson-Swann. COURSES: *See* COLLEGE OF FINE ARTS

UNIVERSITY OF QUEENSLAND
Department of Art History. 3rd Floor, Forgan Smith Tower, Uni. of Qld, St Lucia, Qld 4067. STAFF: In 1993, Head of Fine Arts Dept and Director of the Uni. Art Museum, Nancy Underhill; four full-time lecturers. STUDENTS: In 1993, 480. GALLERY: *University Art Museum* (*see* GALLERIES – PUBLIC)
COLLECTIONS: Began 1940 and extended 1946 through the John Darnell Bequest which made provision for collection of Australian contemporary art. The Uni. of Qld was the first university to institute a policy of collecting Australian art. By 1993 the collection had exceeded 3500 works, covering Australian art from Colonial times to the present day and included the Stuartholme-Behan Collection, housed formerly at Stuartholme Convent, and the Lionel Lindsay Collection. Besides the contemporary Australian art housed in the Museum, there are portraits of University personnel throughout the various Uni. buildings. Visiting scholars have included Humphrey Macqueen, Lucy Lippard, Dr Anthea Callen, Dr Mark Girouard.

UNIVERSITY OF SOUTH AUSTRALIA
See SOUTH AUSTRALIAN SCHOOL OF ART

UNIVERSITY OF SOUTHERN QUEENSLAND – FACULTY OF ARTS
(Founded 1967) (Previously Darling Downs Institute) PO Darling Heights, Toowoomba, Qld 4350. HEADS OF DEPT: Dean, School of Art (Darling Downs Institute) 1981–93, Leon Cantrell; 1993–Acting Dean Faculty of Arts, Laurence Lepherd. GALLERY: Campus gallery with program of changing exhibitions. COLLECTIONS: Permanent collection of contemporary Australian art featuring works on paper, some canvases, ceramics, textile pieces. COURSES: B. Creative Arts, including majors in visual arts. HISTORY: 1967: Darling Downs Institute of Advanced Education established. 1992: Darling Downs IAE & University College of Southern Queensland (1990–91) amalgamated to form University of Southern Qld. 1993: School of Arts known as Faculty of Arts.

UNIVERSITY OF SYDNEY – POWER INSTITUTE OF FINE ARTS
(Established 1967) STAFF: Power Professor and Director of the Institute: 1967–79, Bernard Smith; 1979– Virginia Spate. CURATORS, POWER GALLERY OF CONTEMPORARY ART: 1966, Gordon Thomson; 1969–83, Elwyn Lynn; 1983– Leon Paroissien. COURSES: The Dept of Fine Arts is a dept of the Uni. Faculty of Arts, providing courses leading to BA and MA degrees and co-operating with the Dept of Adult Education in the provision of University Extension courses, and with the Faculty of Architecture in the maintenance of the University Arts Workshop. HISTORY: Established in 1967 by the Senate of the University of Sydney in order to fulfil the terms of the £2 million bequest of John J. W. Power (q.v.) principally to 'bring the latest ideas and theories concerning contemporary art to the people of Australia' by means of teaching, collecting and exhibiting. The Department of Fine Arts was set up as part of the Power Institute (which also includes a research library and a public education program and the **Power Gallery** (later the *Museum of Contemporary Art*), *see* galleries – public). Between 1967–93 over 20,000 students have undertaken one of the several courses which include an introduction to twentieth century art; history of art since the Renaissance; film; design and architecture as well as postgraduate masters and doctorate courses. COLLECTIONS: Until 1961, the University of Sydney had little by way of art collections except the *Nicholson Museum of*

Antiquities (*see* GALLERIES – PUBLIC), the commissioned portraits or busts of Uni. identities and the presentation by Lucy Swanton in 1953 of a small group of contemporary Australian paintings (prefixed by the title *War Memorial* to commemorate University personnel killed in WW II). The only other art activity was the teaching of art history or practice within the depts of Art History or Architecture. But with the advent of the Power Bequest the situation changed radically. The original collection comprises J. J. W. Power's own distinguished works, including 140 oils, 200 works of various kinds in colour, and more than 700 drawings. By 1993, implementation in terms of the bequest 'to make available to the people of Australia the latest ideas and theories . . . by the purchase of the most recent contemporary art of the world' had meant the collection had grown to some 5000 works, housed in the *Museum of Contemporary Art* (*see* GALLERIES – PUBLIC). THE POWER INSTITUTE STUDIO IN PARIS: In 1967 the Power Institute participated in the Cité Internationale des Arts scheme in Paris (of making studio-apartments available by purchase to foreign countries), and a studio-apartment was purchased at the Cité for the use of Australian artists. Artists who have occupied the studio 1967–93 include Arthur Wicks, Carl Plate, Peter Pinson, George Haynes, Maurice Aladjem, Garry Shead, Jennifer Marshall, Arthur McIntyre. Since 1973 the Visual Arts Board of the Australia Council has co-operated with the Power Institute by providing artist residents of the Power Cité studio with travel grants. OTHER ACTIVITIES: The Power Research Library was established to create a national centre for postgraduate research in the form of a comprehensive, specialist library. First acquisition of books was made on the advice of Bernard Karpel, librarian of the MOMA, New York. By 1993, the Library owned 15,000 monographs and 4000 bound serial volumes, specialising in art of the twentieth century. Notable gifts have included those from the British Council (750 books in 1975) and the Stark Collection of 80,000 reproductions in colour and black and white, representing art of all places and periods. A slide library contains around 150,000 colour and black and white slides and since 1984 *Power Publications* has produced books including *Australian Figurative Painting 1942–62* and essays, conference and forum papers. In 1976 a grant from the Australian Research Grants Committee encouraged the preparation of a comprehensive dictionary under the editorship of Assoc. Professor Joan Kerr of Australian artists, architects and craftsmen, the first volume of which, the *Dictionary of Australian Artists, painters, sketchers, photographers and engravers to 1870*, was published by Oxford University Press, Melbourne in 1992.
BIB: Bernard Smith, *Concerning Contemporary Art: the Power Lectures 1968–73*, oup, Melbourne, 1975. Clive A. Evatt, *J. W. Power, 1881–1943*, Dr John Power and the Power Bequest, illustrated survey, Power Inst. of Fine Arts, Uni. of Sydney, 1977. *Meanjin* 1/1964 (Bernard Smith, *Sir Herbert Read and the Power Bequest*). A&A 6/1/1968; 11/2/1973; 13/2/1975; 29/2/1991.
(*See also* POWER, J. J; GALLERIES – PUBLIC)

UNIVERSITY OF TASMANIA
GALLERIES AND COLLECTIONS: *Classics Museum*: Small museum displaying objects of antiquity, e.g. Roman and Greek ceramics and coins. There are around 500 items. *The University Fine Arts Gallery*: Established 1976. Regular local and university exhibitions and occasional touring exhibitions. Houses a substantial collection, mainly of contemporary Australian art.
(*See also* TASMANIAN SCHOOL OF ART)

UNIVERSITY OF WESTERN AUSTRALIA
(Established 1928) Nedlands, WA 6009. William Moore mentions 'a comprehensive fine arts course' and a University Art Club, founded 1928 by W. A. Laidlaw. Exhibitors at

the first exhibition (Aug. 1929) included Beatrice Darbyshire, a pupil of Van Raalte, and R. Callot d'Herbois, who had trained in Paris. In the 1990s the University offered a Bachelor of Fine Arts and a BA through the Department of Fine Arts.

UNIVERSITY OF WOLLONGONG

(School of Creative Arts) Offers courses in a number of arts fields including, in the visual arts, undergraduate and post-graduate studies in ceramics, painting, design, printmaking, sculpture, textiles.

VAN DIEMEN'S LAND MECHANICS SCHOOL OF ART

(1826–89) The first public institution in Australia to offer instruction in the arts. Benjamin Duterrau delivered the first public lecture on art in 1833, and during the 1840s instruction in drawing was given by Thomas Evans Chapman, who received £1 per pupil per quarter for his services. In 1889 the functions of the school passed to the Hobart Technical College (q.v.).

VICTORIA COLLEGE – PRAHRAN FACULTY OF ART AND DESIGN

(1864–1992) A leading art school in the 1970s and 80s it amalgamated with the Victorian College of the Arts in 1992 and moved to new enlarged premises (*see* VICTORIAN COLLEGE OF THE ARTS) HISTORY: 1864: Established as the Prahran Mechanics Institute. 1870: Became Mechanics Institute of Art and Design. 1909: Became the Prahran Technical School. 1915: Moved to new buildings. 1967: Became the Prahran College of Technology. 1968: Moved to present buildings. 1974: Became the Prahran College of Advanced Education. 1982: Became the headquarters for the Victoria College Prahran Faculty of Art and Design. 1992: Amalgamated with Victorian College of the Arts.

VICTORIAN COLLEGE OF THE ARTS

(Founded 1972) 234 St Kilda Rd, Melb., Vic. 3004. ADMIN: VCA Council and staff; University of Melbourne. STAFF: In 1993, Dean, Assoc. Professor, Norman Baggaley; Deputy Dean John Dunkley-Smith; Heads of Department – Ceramics, Greg Wain; Drawing, Pam Hallandal; Painting, Vic Majzner; Photography, Chris Koller; Printmaking, John Scurry; Sculpture, Jock Clutterbuck; History of Art, Noel Hutchinson. LIBRARY: The Lucy Kerley collection of 2000 art monographs, mostly on artists connected with the NGV School, was transferred from the NGV School to the VCA where it has been extended to cover all fields of the arts. By 1979 it included 8300 monographs, 11,300 scores, 2300 records, 2000 cassettes, 7000 slides and subscriptions to 325 periodicals. HISTORY AND ARCHITECTURE: Founded in 1972 as a conglomerate of four autonomous schools, including art, dance, drama, music, as well as secondary schools for selected advanced students. The present school is the result of a merger between the VCA School of Art and the six fine art departments of the Prahran Faculty of Art and Design. The merger in 1992 tripled the size of the former school and introduced three additional major disciplines. In 1993 the new School moved into a new custom-refurbished stu-dio complex situated on Dodds St, adjacent to the School of Drama. There are many student awards and scholarships (a number having originated in the preceding NGV School and Prahran School of Art) available including the Keith and Elisabeth Murdoch Travelling Fellowship ($15,000) (*see* PRIZES) for past graduates. A School Gallery within the new complex opened in 1993, and shows exhibitions of relevance to the School's charter of preparing professional art practitioners and includes shows by visiting artists, ex-graduates and current students as well as some travelling exhibitions. COURSES: In 1993, Bachelor of Fine Arts in ceramics, drawing, photography, painting, printmaking or sculpture; Master of Fine Arts in painting, printmaking or sculpture by coursework; Master of Fine Arts by research and exhibition in ceramics, drawing, painting, photography, printmaking or sculpture.

WATKINS (J. S. WATKINS) SCHOOL

(c. 1906–42) Conducted by J. S. Watkins, a founding member of the NSW Society of Artists and a trustee of the AGNSW 1932–42, at 56 Margaret St, Sydney. Basic to his teaching were design, colour, drawing and study of the nude. William Moore in *SAA* writes that 'over 3000 students' had gone through Watkins' School by 1934.

WESTERN AUSTRALIAN ACADEMY OF PERFORMING ARTS – SCHOOL OF VISUAL ARTS

(Founded 1992) Edith Cowan University, 2 Bradford St, Mt Lawley, WA 6050. STAFF: In 1993 director Neville Weston 1992– ; 14 full-time, 20 part-time staff. STUDENTS: In 1993, over 300. HISTORY: The School of Visual Arts, WA Academy of Performing Arts, Edith Cowan University had its origins in the former WA College of Advanced Education Department of Art and Design which had been running BA courses since 1987 and Art Education courses since 1972. The WACAE was formed out of amalgamations of former teacher training colleges of Churchlands, Claremont, Mt Lawley and Nedlands. The Edith Cowan University was designated in 1991 with the first college on the Claremont campus having been established in 1902, making it the oldest higher education institution in Perth. COURSES: BA (Visual Arts); MA (Art Therapy) and MA (Visual Arts.)

WESTERN AUSTRALIAN INSTITUTE OF TECHNOLOGY
See CURTIN UNIVERSITY

WORKING MEN'S COLLEGE
See ROYAL MELBOURNE INSTITUTE OF TECHNOLOGY

WORKSHOP ARTS CENTRE

(Established 1963) 33 Laurel St, Willoughby, NSW 2068 ADMIN: A private non-profit art centre managed by a board of directors and an executive officer. STAFF: In 1993, 26. It conducts 46 classes in a wide variety of visual arts areas including painting, drawing, printmaking, jewellery, pottery, sculpture, as well as creative writing and film studies. There is an annual exhibitions of members' and students' work and the gallery at the Workshop is also hired to associated artists.

TRUSTS AND FOUNDATIONS

The Trusts and Foundations listed are those limited to those that may apply to the visual arts. Comprehensive information about a wide variety of Trusts is listed in the book *Australian Directory of Philanthropy* published by Thorpe, Melbourne in association with the Australian Association of Philanthropy Inc. Information about other forms of art funding can be found in the National Association of Visual Artists (q.v.) booklet *Money for Artists*. There are also numerous trusts, bequests and foundations which apply to specific public institutions which are listed under those institutions.

AME BALE ART FOUNDATION TRUST
c/- Perpetual Trustees, 50 Queen St, Melbourne. Administers the AME *Bale Art Award* (*see* PRIZES).

CALTEX-VICTORIA ART PURCHASE FUND
(Founded 1976). Established when the Victorian state government, through its Ministry for the Arts, and Caltex Oil (Australia) Pty Ltd, agreed to contribute jointly to a fund to be made available to the Regional Galleries of Victoria for acquisitions. By 1982 all Victorian regional galleries had benefited (some substantially) and during 1982–83 a selection of works acquired was put together for a special, touring exhibition of Victorian public galleries.

COLLIE (BARBARA COLLIE SETTLEMENT SCHOLARSHIP) AWARDS
c/- ANZ Trustees, 91 William St, Melbourne 3000. Substantial scholarships are made available annually to students under 40 showing outstanding promise in the graphic arts and printing industry with grants of $1000 plus.

DOBELL FOUNDATION
(Founded 19 Jan. 1971) c/- Frank Clune & Son, 9th Floor, 39 York St, Sydney 2000. The entire estate of Sir William Dobell, including all his unsold paintings and drawings, was left to establish the Foundation. In Nov. 1973, 126 of the drawings and paintings were auctioned at the Sydney Opera House by Sotheby's. They realised a total of $382,700. Organisations which have received donations from the Foundation include the Sydney Opera House (Olsen mural), AGNSW (Klippel sculpture), Newcastle Region Art Gallery (Olsen painting), NGA (Dobell sketchbooks), City of Sydney (Flugelmann sculpture), Australian Centre of Photography (Dobell House), and many others. The Foundation funds the Chair of Fine Arts at the ANU, in 1989 the *Sir William Dobell Art Foundation Art Prize* (a once-only award of five prizes of $5000 each to mark the 20th anniversary of the Foundation) and in 1992 established the Dobell Drawing prize administered by the AGNSW (*see* PRIZES).

GORDON DARLING FOUNDATION
(Established 1991) Box 7496, St Kilda Road PO, Melbourne 3004. Established by art patrons Gordon and Marilyn Darling with an initial contribution of $2m in November 1991 it was created for the 'support of the Visual Arts in Australia' and is a perpetual charitable trust, donations to which are tax deductible. Its charter is to support Australia-wide activities of all kinds in the visual arts and to give consideration to 'visionary projects that might not otherwise receive funding'. Funding is available for acquisitions, catalogues, commissions, exhibitions, publications, research projects, seeding money, symposia, scholarships and awards. It is not designed for the assistance of capital works programs. Public institutions are the beneficiaries and individuals may apply through institutions who, if the project is suitable, will then apply to the Foundation. In 1992, 13 regional galleries in all states received a grant of $2000 each to assist with mounting and travelling an exhibition from their own resources.

MOET & CHANDON AUSTRALIAN ART FOUNDATION
(Established 1986) c/- J. Jones & Associates, PO Box 5004, Carlton 3053. As well as the major annual art fellowship for artists under 35 (in 1993, $50,000) (*see* PRIZES) and its accompanying Touring Exhibition, the Foundation provides a fund of $50,000 annually as an Acquisition Fund to state galleries or the NGA. It is for the purchase of the work of young and emerging artists and is awarded to a different gallery each year. By 1993 each state gallery (except the NT) and the NGA had received the award.

MYER FOUNDATION & SIDNEY MYER FUND
(Founded 1934) Secretary, 250 Elizabeth St, Melbourne 3000. Substantial capital fund bequeathed by Sidney Myer, who died in Sept. 1934. Income from the fund goes to organisations operating within Australia.

NATIONAL ART COLLECTIONS FUND
20 John Islip St, London, SW1P 4JX, UK. Benefits public art collections in the UK and Commonwealth by helping to acquire works of art and objects of historical importance.

POTTER (IAN POTTER) FOUNDATION
Level 5, 1 Collins St, Melbourne 3000. Established as a charitable trust providing assistance for institutions. Beneficiaries include universities, colleges, schools, art galleries or art museums, libraries, research and experimental stations and other related institutions with grants of $500–$1,000,000 p.a.

POWER FOUNDATION
See UNIVERSITIES – UNIVERSITY OF SYDNEY; GALLERIES—PUBLIC – MUSEUM OF CONTEMPORARY ART

RIGG TRUST (COLIN RIGG TRUST)
c/- ANZ Trustees, 91 William St, Melbourne 3000. Offers information and educational assistance for the arts such as programs, posters, flyers to the amount of $100–$10,000.

ROTHMANS FOUNDATION
Level 31, Legal and General House, 8–18 Bent St, Sydney 2000. Beneficiaries include cultural, educational, sport divisions in a wide variety of areas including the arts.

SCHUTT (HELEN M. SCHUTT) TRUST
(Founded 1951) Level 8, 20 Queen St, Melbourne 3000. Beneficiaries include public institutions for the promotion of science and the arts, as well as charitable institutions. The *Helen Schutt Access Gallery* at the Centre for Photography, Melbourne was established in 1993.

STUYVESANT (PETER STUYVESANT) CULTURAL FOUNDATION
(1963–81) Initiated by Sir Ronald Irish (the first chairman) as a result of a visit to the Netherlands. Aims of the Foundation were to assist in advancing artistic and cultural standards in Australia by touring throughout the country representative overseas exhibitions. Exhibitions organised for the Foundation and toured throughout Australia included: *Rodin and his Contemporaries*, 1966–67 and 1978–80; *Contemporary Nordic Art*, 1968–69; *Art of the Space Age*, 1968–70; *Recent British Painting*, 1970–71; *Scultura Italiana*, 1971–72; *Australian Landscape*, 1972–73; *Picasso, Master Printmaker*, 1973; *Hommage à Jean Lurçat*, 1973–78; *Art of the Western Desert*, 1975–79; *Sculpture by Ernst Barlach and Kathe Kollwitz*, 1976–78; and many others.

VICTORIAN HEALTH PROMOTION FOUNDATION
PO Box 154, Carlton South, Vic. 3053. Set up by the Victorian Government in 1987 its aims are to promote health and fitness and replaces tobacco sponsorship in a number of areas including the arts. It is a significant funding body in Victoria and has been associated with a number of significant exhibitions, festivals and other art events.

VICTORIAN WOMEN'S TRUST
Level 1, 387 Bourke St, Melbourne 3000. Established to assist activities that promote the cultural, economic and political status of women, it is particularly supportive of innovative group projects including those in the arts.

LIST OF ILLUSTRATIONS

Colour

LIST OF ILLUSTRATIONS

Black and white